Dictionary of
Contemporary American Artists

Dictionary of
Contemporary American Artists

Sixth Edition

PAUL CUMMINGS

St. Martin's Press
New York

First published in the United States of America in 1994

ISBN 0-312-08440-4

Library of Congress Cataloging-in-Publication Data

Cummings, Paul.
 Dictionary of contemporary American artists / Paul Cummings. —
6th ed.
 p. cm.
 Includes bibliographical references and index.
 ISBN 0-312-08440-4 : $85.00
 1. Artists—United States—Biography. 2. Art, Modern—20th
century—United States. I. Title.
N6512.C854 1994
709'.2'273—dc20
 [B] 93-46372
 CIP

Design by ACME Art Inc.

Sixth edition
10 9 8 7 6 5 4 3 2 1

Contents

Acknowledgments

To the many artists who took time to complete the questionnaires sent them, I should again like to express my gratitude. Without their assistance this sixth revised edition could not have been completed with such a broad range of data.

Additionally, I should like to thank the many art dealers and their gallery staffs for so generously providing information and photographs for this and many other projects. The following individuals and institutions deserve a note of special gratitude: May Castleberry, Librarian, Whitney Museum of American Art; the staffs of the library at the Museum of Modern Art and the Frick Art Reference Library.

I should also like to acknowledge the careful processing of all this data by Cheryl Epstein Wolf, assisted by Debra Steadman. The vast amount of material was a sincere challenge, which they met with skill and good humor.

To the artists, collectors, museums, and art dealers for their permission to reproduce works of art in their possession, my grateful appreciation.

PC
June 1993
New York City

How to Use This Book

This, the sixth revised edition of the Dictionary, first published in 1966, has been changed more than previous editions. Twenty-seven artists have been deleted; 41 have been added. The annotated bibliography has been expanded by dozens of titles. It serves as a ready reference for additional research and reading on these artists and on American art of the twentieth century. There is a new selection of illustrations.

A new component has been added to this edition. This is the interleaving of the names of artists who have been deleted from previous editions. This new citation allows research into artists in previous editions. Thus, as an example, you will notice that Aach, Herbert is now designated by the line, "first to fifth edition." Reference material on him can be found in those volumes.

Questionnaires, personal interviews, and intensive research have brought together significant data regarding the careers of these 900 artists, chosen essentially on the basis of the following criteria: representation in museum, public, and private collections; representation in major American and international exhibitions; influence as teachers; recognition received from fellow artists, dealers, critics, and others with a professional interest in the fine arts. May 1993 was chosen as the terminal date for all data, except for obituary notices which are accurate through August 1, 1993.

The artists' entries are organized on the following plan: where they studied art, and with whom; teaching experience; participation in the Federal Art Project; commissions executed; scholarships and/or awards won; spouse (if prominent in art); address and dealer(s) of record; important one-man retrospectives and group exhibitions; and bibliography.

Naturally many artists have won the same awards, been represented in the same exhibitions and collections, and are mentioned in the same books. Repetition of the complete data in each case would have made this volume far too large. Therefore the data have been compressed into a series of keys, found in the front of the book; the keyed, annotated bibliography is located at the back. Abbreviations used in the body of the book are explained in the keys. The often long and complex names of museums and public collections have generally been abbreviated and codified in the Key to Museums and Institutions. Common-sense methods have been used, most often acronyms (MOMA for The Museum of Modern Art) and reductions, either to the name of the city (Mons, for the Musée des Beaux-Arts, Mons, Belgium), to a combination of city and key word (Albany/Institute for the Albany Institute of History and Art), or to city and acronym (Akron/AM for the Akron Art Museum).

In the listing entitled "Galleries Representing the Artists in This Book," addresses are given for those dealers representing the artists listed in this volume; other galleries cited in the Exhibitions portions of the entries are identified therein by city.

The Index of Artists in the front of this volume offers both a pronunciation guide and breakdown of the types of work for which each artist is best known.

EXAMPLE

December 22, 1989, NYC. To USA, 1920. **Studied:** NAD, 1925-30; with C. W. Hawthorne, ca. 1929; Hofmann School, 1935-36. Resided Italy, 1930-33. **Taught:** Pratt Institute, 1952, 54 (woodworking); U. of North Carolina, 1964; Yale U., 1964; Columbia U., summer, 1969. Federal A.P.[1]: Mural project assistant to Arshile Gorky, and easel painting. **Member:** American Abstract Artists, 1936-57. **Awards:** Guggenheim Foundation Fellowship, 1957, 63, 64; Ford Foundation, P.P.,[2] 1961, 65. **Address:** 278 Bowery, NYC 10012. **Dealer:** June Kelly Gallery, Inc., NYC. **One-man Exhibitions:** The Peridot Gallery, NYC,[3] 1956, 57, 59, 61, 62, 64, 66, 68, 69; Arts Club of Chicago, 1958; Graham Gallery, NYC,[4] 1987, 88; June Kelly Gallery, Inc., NYC, 1988, 91. **Group:** Corcoran, 1953; MOMA, 1953, 55; WMAA, 1955, 57, Annuals, 1960-63, 1965; Art Museum Association of America, circ.,[5] Emotional Impact, 1984; RISD, Life in the Big City, 1986; Bronx Museum, Nightworks, 1987; Boca Raton, Contemporary Painting, 1987; Montclair/AM, The Interior Self, 1987. **Collections:** Akron/AM[6]; Baltimore/MA; Brooklyn Museum; U. of California, Berkeley; Chase Manhattan Bank; Cleveland/MA; MOMA; Wichita State U. **Bibliography:** *Amerikanischer Fotorealismus; America 1976*[7]; *Arthur 1*[8]; *Kunst um 1970;* Lindy; Murken-Altrogge; *New in the Seventies;* Sager. Archives.[9]

[1] Participation in the Federal Arts Project.

[2] "Purchase prize," or "purchase award."

[3] Because the Peridot Gallery does not represent any of the artists in this book, it is not listed in the Gallery list.

[4] Because it functions as a dealer, the address of the Graham Gallery is given in the alphabetical Gallery list beginning on page 47 of this book.

[5] This particular exhibition circulated among various institutions.

[6] Akron/AM stands for the Akron Art Museum, and its full name may be found in the Key to Museums; the names of coded institutions are listed alphabetically in the Key.

[7] Boldface type in the bibliography sections denotes the writings of the artist himself, comprehensive exhibition catalogues, or monographs.

[8] This number indicates that this artist, among others, is referred to in the first of several similarly numbered books by Arthur listed in the bibliography at the back of this book.

[9] "Archives," indicates that the artist's papers and/or taped, in-depth interviews are available at the Archives of American Art, Smithsonian Institution. The Archives maintains complete microfilm files in their Boston, New York, Washington, D.C., Detroit, and San Marino (Los Angeles) offices.

List of Illustrations

Tony Berlant
Sunshine State, 1989.
42" x 66". Metal collage.
Louver Gallery, New York.
Photo: D. James Dee.

Eugene Berman
Medusa's Corner, 1943.
58" x 46". Oil on canvas.
Michael Rosenfeld Gallery, New York.

Charles Biederman
Painting, New York, 4/16/1936, 1936.
59" x 41¼". Oil on canvas.
Grace Borgenicht Gallery, Inc., New York.

Isabel Bishop
Little Nude, 1964.
5¾" x 5". Etching and acquatint.
Private collection.

Norman Bluhm
Royal Icons, 1989.
80" x 90". Oil on canvas.
Joan T. Washburn Gallery, New York.
Photo: Geoffrey Clements, Inc.

Mel Bochner
Vanishing Point: Over the Edge, 1991.
96" x 64". Oil on canvas (two panels).
Sonnabend Gallery, New York.
Photo: Lawrence Beck.

Jonathan Borofsky
Molecule Men 1 + 1 + 1, 1991.
4' ht. Aluminum.
Paula Cooper Gallery, New York.
Photo: Andrew Moore.

Louise Bourgeois
Blind Man's Buff, 1984.
36½" x 35" x 25". Marble.
Robert Miller Gallery, New York.
Photo: Allan Finkelman.

James Brooks
F, 1951, 1951.
31" x 40½". Oil on canvas.
Washburn Gallery, New York.

Charles Burchfield
Dream House, 1917.
17½" x 21¾". Watercolor on paper.
Kennedy Galleries, Inc., New York.

Scott Burton
Slat Chair, 1985-1986.
40⅛" x 60" x 19½". Lacquered ash.
Max Protetch Gallery, New York.
Photo: David Allison.

Paul Cadmus
The House That Jack Built, 1987.
30" x 30". Egg tempera on panel.
Midtown Galleries, New York.

Louisa Chase
Lady Macbeth, 1990.
80" x 70". Oil on canvas.
Brooke Alexander Gallery, New York.
Photo: D. James Dee.

John Clem Clarke
Dash Across the Tracks, 1991.
60" x 101". Acrylic on canvas on mylar.
Louis K. Meisel Gallery, New York.
Photo: Steve Lopez.

Manon Cleary
Self Portrait—Movement Series, 1992.
23" x 29". Graphite on rag paper.
Courtesy of the artist.

Chuck Close
Lucas, 1991.
28" x 24". Oil on canvas.
Pace Gallery, New York.
Photo: Bill Jacobson Studio.

William Copley
Unconditional Virgins, 1989.
64½" x 54½". Oil on linen.
Phyllis Kind Gallery, New York.

Robert Cottingham
Portal I, 1992.
110" x 81½". Acrylic and sand on canvas.
Private Collection.

Mary Ann Currier
Apricots Degas, 1990.
31" x 42". Oil pastel on paper.
Tatistcheff and Company, Inc., New York.

Stuart Davis
Punch Card Flutter No. 3, 1963.
24" x 33". Oil on canvas.
Salander O'Reilly Galleries, New York.

Edwin Dickinson
Sandra, 1947.
20" x 16". Oil on canvas.
Babcock Galleries, New York.
Photo: Geoffrey Clements.

Lois Dodd
Lifted House, Hanover, N.H., 1990.
50" x 30". Oil on linen.
Fischbach Gallery, Inc., New York.

Enrico Donati
*Loupe Electromagnetique Pour Dechiffrer
Les Cellules Vivant La Cellule Vivante
Est Un Centre Dynamique*, 1948.
35" x 29".
Courtesy of the artist.

Arthur G. Dove
Two Forms, 1931.
33" x 24". Oil on canvas.
Terry Dintenfass, Inc., New York.
Photo: Geoffrey Clements.

Rackstraw Downes
*The Mouth of the Passagassawaukeag at
Belfast, M.E., Seen from the Frozen
Foods Plant*, 1989.
36⅜" x 84¼". Oil on canvas.
Courtesy of the artist.
Photo: Zindman/Fremont.

Friedel Dzubas
Placidum, 1985.
40" x 40". Oil on canvas.
André Emmerich Gallery, New York.
Photo: Kevin Ryan.

Eric Fischl
Nick's Picnic, 1992.
98" x 86". Oil on linen.
Mary Boone Gallery, New York.
Photo: F. Scruton.

Audrey Flack
The Art Muse, 1988.
26" ht. Base gold-plated bronze with
jewels. Edition of six.
Louis K. Meisel Gallery, New York.
Photo: Steve Lopez.

Jared French
Business, 1959-1961.
30" x 43". Egg tempera on gesso panel.
Midtown Payson Galleries, New York.
Photo: Ellen Page Wilson.

Gregory Gillespie
Peg at Paradise Pond, 1990.
22¾" x 29". Oil on panel.
Forum Gallery, New York.

Ralph Goings
Sweet N' Low, 1992.
34" x 43". Oil on canvas.
O.K. Harris Works of Art, New York.
Photo: D. James Dee.

Joseph Goldyne
Venetian Fantasy, 1991.
10" x 8". Oil on gessoed panel.
Photo: M. Lee Fatherree.

Sidney Goodman
Waking Up, 1992.
52" x 71". Charcoal.
Terry Dintenfass Gallery, New York.

Robert Goodnough
L-Z, 1991.
30" x 40". Acrylic and oil on canvas.
ACA Galleries, New York.

Robert Graham
Figure III-B, 1989-90.
15⅛" x 4" x 5¾". Overall: 59⅞" x
11". Bronze; oil paint.
Robert Miller Gallery, New York.

Morris Graves
Still Life with Potted Plant and Figs, 1986.
25½" x 39¼". Tempera on paper.
Schmidt Bingham Gallery, New York.

Red Grooms
Clean & Press, 1989.
21½" x 29" x 8". Painted bronze; edi-
tion of nine.
Courtesy Marlborough Gallery, New York.

Roy Gussow
Crystal 2/ 12-1-83, 1983.
33" x 36" x 40". Mirror finished S.S.
Grace Borgenicht Gallery, Inc., New
York.

Philip Guston
Riding Around 1969, 1969.
54" x 79". Oil on canvas.
David McKee, Inc., New York.
Photo: Davies/Zindman, Otto E.
Nelson Fine Art Photography.

Dimitri Hadzi
Petra, 1989.
35" ht. Mixed granites.
Courtesy of the artist.

Keith Haring
Untitled, 1988.
30" x 40". Sumi ink on paper.
Courtesy of the Haring Foundation.
Photo: Ivan Dalla Tana.

Grace Hartigan
My Fair Lady, 1989.
60" x 48". Oil on canvas.
ACA Galleries, New York.

Marsden Hartley
Shell and Sea Anemones, Gloucester, 1934.
18" x 24". Oil on academy board.
Babcock Galleries, New York.

Al Held
Siena, 1990.
4" x 7". Acrylic on canvas.
André Emmerich Gallery, New York.
Photo: Steven Sloman.

Joseph Hirsch
Pickles, 1977.
15" x 20". Oil on canvas.
Kennedy Galleries, Inc., New York.

Hans Hofmann
Fall Euphony, 1959.
48" x 74". Oil on canvas.
André Emmerich Gallery, New York.
Photo: Geoffrey Clements.

Tom Holland
Linx, 1988.
83" x 57" x 45". Acrylic urethane on
aluminum.
Charles Cowles Gallery, Inc., New York.
Photo: eeva-inkeri.

John Hultberg
The Reaper, 1993.
36" x 48". Acrylic and mixed media on
paper.
Courtesy of Elaine Wechsler Fine Art,
New York.

Bryan Hunt
Axial Falls, 1990.
106¼" x 16½" x 8". 195 lbs. Bronze.
Blum Helman Gallery, Inc., New York.
Photo: Ellen Page Wilson.

Richard Hunt
Generation of Points and Arcs, 1990.
Welded bronze.
Dorsky Gallery, New York.

John Stuart Ingle
Songs of the Garden, 1992.
60" x 40". Watercolor on paper.
Tatistcheff & Company, Inc., New
York.

Mark Innerst
Badge, 1992.
9¼" x 7¼". Acrylic on canvas.
Curt Marcus Gallery, New York.

Yvonne Jacquette
Town of Skowhegan, Maine V, 1988.
78³⁄₁₆" x 64³⁄₁₆". Oil on canvas.
Brooke Alexander Gallery, New York.
Photo: Ivan Dalla Tana.

Valerie Jaudon
Azimuth, 1990.
90" x 138". Oil and alkyd on canvas.
Courtesy Sidney Janis Gallery, New York.
Photo: Allan Finkelman.

Paul Jenkins
Phenomena Tiberius Revisited, 1991.
104½" x 77⅛". Acrylic on canvas.
Courtesy of the artist.
Photo: Geoffrey Clements.

Bill Jensen
Babar, 1988-89.
39" x 33". Oil on linen.
Washburn Gallery, New York.

Buffie Johnson
Nine, 1990.
72" x 62". Oil.
Courtesy of the artist.

Donald Judd
Untitled, 1992.
97⁄8" x 393⁄8" x 97⁄8". Douglas fir ply-
wood with green plexiglass.
Pace Gallery, New York.
Photo: Bill Jacobson.

John Kacere
Laura '92, 1992.
35" x 52". Oil on canvas.
Courtesy O.K. Harris Works of Art,
New York.
Photo: D. James Dee.

Wolf Kahn
In Westport, Connecticut (Winter), 1987.
48" x 52". Oil on canvas.
Grace Borgenicht Gallery, Inc., New
York.

Alex Katz
Ada in Orange, 1991.
60" x 48". Oil on canvas.
Courtesy Marlborough Gallery, Inc.,
New York.

Ellsworth Kelly
Green Black, 1988.
102" x 131". Oil on canvas; two joined
panels.
Blum Helman Gallery, Inc., New York.
Photo: Jerry L. Thompson.

Bruce Nauman
Above Yourself (Study for Elliott's Stones),
1989.
26¼" x 40". Graphite on paper.
Sperone Westwater Gallery, New York.
Photo: Adam Reich.

Manuel Neri
Morena No. 1, 1992.
40" x 26¼". Dry pigment, charcoal,
graphite on paper.
Courtesy of the artist.
Photo: M. Lee Fatherree.

John Newman
Untitled, 1991.
60" x 39¾". Pastel, china marker, and
pencil on colored paper.
David Nolan Gallery, New York.

Gladys Nilsson
By the Pier, 1987.
40" x 60". Watercolor on paper.
Phyllis Kind Gallery, New York.
Photo: William H. Bengtson.

Jim Nutt
Pug, 1990.
26" x 26". Acrylic on canvas.
Phyllis Kind Gallery, Chicago.
Photo: William H. Bengtson.

Claes Oldenburg
Torn Notebook, Two, 1992.
30" x 24½" x 24". Muslin, chicken
wire, clothesline, steel, resin, and
latex paint. ½" x 12" x 12". Painted
aluminum plate.
Pace Gallery, New York.
Photo: Ellen Page Wilson.

Alfonso Ossorio
Spigot, 1983.
42" x 14" x 16". Mixed.
Zabriskie Gallery, New York.
Photo: D. James Dee.

Philip Pearlstein
*Models with Dirigible Weathervane and
Fire Engine*, 1992.
60" x 96". Oil on canvas.
Hirschl & Adler Modern Gallery, New
York.
Photo: Peter Muscato.

Joel Perlman
Arrow Head, 1993.
32" x 40" x 23". Bronze.
André Emmerich Gallery, New York.

Irving Petlin
Stolen Blessing II, 1980.
21½" x 29½". Pastel on paper.
Kent Fine Art, New York.

Ellen Phelan
Spring, First Drawing (b&w), 1989.
80⅜" x 78³⁄₁₆". Oil on linen.
Barbara Toll Fine Arts, New York.
Photo: Zindman/Fremont Studios.

Jody Pinto
Fingerspan Bridge, 1987.
5' x 6'. Drawing for Fingerspan Bridge,
Fairmount Park, Phila., Pa. Gouache,
pastel, graphite on paper.
Courtesy of the artist.
Photo: Adam Reich.

Martin Puryear
Untitled, 1987.
65½" x 76½" x 35½". Wire mesh cov-
ered with tar.
David McKee, Inc.

Mel Ramos
Unfinished Painting #1, 1991.
70" x 50". Oil on linen.
Louis K. Meisel Gallery, New York.
Photo: Aaron J. Miller.

Deborah Remington
Araxes, 1991.
32" x 24". Oil on canvas.
Courtesy of the artist.

Paul Resika
Square (Rope and Pier), 1991.
48" x 48". Oil on canvas.
Salander-O'Reilly Galleries.

Larry Rivers
*A Vanished World, Trnava Czechoslova-
kia, 1936, Raising Geese (I)*, 1987.
65½" x 60" x 5". Oil on canvas,
mounted on foamcore.
Courtesy Marlborough Gallery, Inc.,
New York.
Photo: Robert E. Mates.

Robert Rohm
Untitled (Two Tips), 1992.
52" x 13" x 7". Steel, copper, mesh, en-
caustic.
Courtesy of the artist.
Photo: D. James Dee.

Ernest Trova
FM/24" New Cut Figure #1, 1985.
33" x 16½" x 4½". Stainless Steel.
ACA Galleries, New York.

David True
Persona, 1990.
70¼" x 96". Acrylic on canvas.
Blum Helman Gallery, Inc.
Photo: Ellen Page Wilson.

Cy Twombly
Untitled, 1970.
Sheet: 20" x 17"; Frame: 28¼" x 25½".
Paint stick, flat paint, and pencil on
paper.
Sperone Westwater Fischer, Inc., New
York.
Photo: Zindman/Fremont Studios.

Jack Tworkov
X on Circle in the Square, 1981.
49" x 45". Acrylic on canvas.
Courtesy André Emmerich Gallery,
New York.

Peter Voulkos
Untitled (Stack), 1989.
37½" x 18". Ceramic.
Charles Cowles Gallery, Inc., New York.

Idelle Weber
Cambridge Series #9, 1992.
47" x 47". Oil on linen.
Courtesy of the artist.
Photo: Zindman/Fremont Studios.

Neil Welliver
Rock Barrier—E. Twin, 1990.
72" x 72". Oil on canvas.
Courtesy Marlborough Gallery, Inc.,
New York.

Tom Wesselmann
*Monica and Matisse Interior with Phono-
graph*, 1988-1990.
71" x 47". Oil on cut-out steel.
Courtesy Sidney Janis Gallery, New York.

H. C. Westermann
*Homage to American Art (Dedicated to
Elie Nadelman)*, 1965.
48" x 30" x 30". Douglas fir, ash, lead.
Private collection. Courtesy of Lennon,
Weinberg, Inc., New York.

Margaret Wharton
Baby Bunting, 1990.
35" x 29" x 7". Baseballs/plastic/mixed
media.
Phyllis Kind Gallery, New York.
Photo: William H. Bengtson.

John Wilde
July 1985, with a Headeian Landscape,
1991.
11½" x 14". Oil on panel.
Schmidt Bingham Gallery, New York.

William T. Wiley
For M.W. and the Pure Desire, 1988.
22" x 30". Watercolor, pen and ink, col-
ored pencil.
Courtesy of Max Protetch Gallery, New
York.

Christopher Wilmarth
Corner Skin, 1977.
84" x 24" x 24". Glass and steel.
Hirschl and Adler Modern Gallery,
New York.
Photo: Jerry L. Thompson.

Jane Wilson
American Light, 1991.
80" x 74". Oil on linen.
Fischbach Gallery, New York.

Philip Wofford
Sash, 1991.
49½" x 38". Mixed media on rag
paper.
Frumkin/Adams Gallery, Inc., New York.

Robert Yarber
Chandelier, 1991.
45" x 35". Acrylic on canvas.
Sonnabend Gallery, New York.

Jack Youngerman
Nexus, 1987.
48" x 46". Oil on linen.
Joan T. Washburn Gallery, New York.

Index of Artists and Pronunciation Guide

(A) Painter; (A¹) Watercolorist; (B) Sculptor; (C) Printmaker; (D) Assemblagist;
(E) Teacher; (F) Happenings; (G) Mosaicist; (H) Draftsman; (I) Conceptualist.

A

Acconci, Vito (B)
Ah con she
Adams, Clinton (A, C)
Adams, Pat (A)
Agostini, Peter (B)
Albers, Josef (A, C, E)
Albert, Calvin (B)
Albright, Ivan Le Lorraine (A)
Alcalay, Albert (A)
Alexander, John (A)
Alexander, Peter (A)
Allan, William (A)
Altman, Harold (C, A)
Altoon, John (A)
Amen, Irving (C)
Amenoff, Gregory (A)
Anderson, Guy Irving (A)
Anderson, Jeremy (B)
Anderson, Lennart (A)
Andre, Carl (B)
Andrejevic, Milet (A)
An dre avic
Antonakos, Stephen (B)
Antreasian, Garo (C)
An tray sian
Anuskiewicz, Richard (A)
Anu skay vitch
Arakawa, Shusaku (A, C)
Archipenko, Alexander (B, E)
Armajani, Siah (B)
See ah
Arman, Pierre (B, D)

Arneson, Robert (B)
Arnold, Anne (B)
Arnoldi, Charles (B)
Aronson, David (A)
Artschwager, Richard (A, B)
Ault, George (A)
Avery, Milton (A)
Aycock, Alice (B)
Azuma, Norio (C)

B

Baeder, John (A)
Bay der
Bailey, William (A, E)
Baizerman, Saul (B)
Baldessari, John (I)
Bannard, Darby (A)
Barnes, Robert (A)
Barnet, Will (A, C, E)
Barry, Robert (B, I)
Barth, Frances (A)
Bartlett, Jennifer (A)
Baskin, Leonard (B, C, E)
Bayer, Herbert (A)
Baynard, Edward (A, C)
Baziotes, William A. (A, E)
Beal, Jack (A)
Bearden, Romare (A)
Roh mayr
Beasley, Bruce (B)
Beauchamp, Robert (A)
Beechem

Bechtle, Robert (A)
Beck tl
Beck, Rosemarie (A)
Beckman, William G. (A)
Behl, Wolfgang (B)
Bell, Charles (A)
Bell, Larry (B)
Benglis, Lynda (B)
Bengston, Billy Al (A)
Benjamin, Karl (A)
Benton, Fletcher (B)
Benton, Thomas Hart (A, B)
Berlant, Tony (B)
Berman, Eugene (A)
Berthot, Jake (A)
Bear toe
Bertoia, Harry (B)
Ber toy a
Biddle, George (A, C)
Biederman, Charles (Karel) Joseph (B)
Bee derman
Biederman, James (A, B)
Birmelin, A. Robert (A, E)
Bischoff, Elmer (A)
Bish off
Bishop, Isabel (A)
Bishop, James (A)
Blackwell, Tom (A)
Bladen, Ronald (B)
Blaine, Nell (A)
Blanch, Arnold (A)
Blaustein, Al (A)
Bleckner, Ross (A)
Bleifeld, Stanley (A)
Bloom, Hyman (A)

Bluemner, Oscar (A)
Bloom ner
Bluhm, Norman (A)
Bloom
Blume, Peter (A)
Boardman, Seymour (A)
Bochner, Mel (B, I)
Boghosian, Varujan (B, D)
Ba **go** sian
Bohrod, Aaron (A)
Bolomey, Roger (B)
Bolo **may**
Bolotowsky, Ilya (A, B, E)
Bonevardi, Marcelo (A)
Bontecou, Lee (B)
Boothe, Power (A)
Borofsky, Jonathan (A, B)
Bosman, Richard (A, C)
Bourgeois, Louise (B)
Boor **Jwah**
Bowman, Richard (A)
Boxer, Stanley (A, B)
Boyle, Keith (A)
Boynton, James W. (A)
Brach, Paul (A)
Brock
Brady, Carolyn (A¹)
Brainard, Joe (A)
Brandt, Warren (A)
Brauntuch, Troy (A)
Brice, William (A)
Briggs, Ernest (A)
Broderson, Morris (Gaylord) (A)
Broner, Robert (A, C)
Brauner
Brook, Alexander (A)
Brooks, James (A)
Brown, Joan (A)
Brown, Roger (A)
Brown, William Theo (A)
Browne, Byron (A, E)
Browning, Colleen (A)
Bruce, Patrick Henry (A)
Buchwald, Howard (A)
Buck, John (A)
Bultman, Fritz (A, B)
Bunce, Louis (A)
Burchfield, Charles (A¹)
Burden, Chris (B, F, I)
Burkhardt, Hans Gustaf (A)
Burlin, David (A)
Burliuk, Paul (A)

Burton, Scott (B)
Butterfield, Deborah (B)
Button, John (A)
Byars, James Lee (I)

C

Cadmus, Paul (A)
Cajori, Charles (A)
Calcagno, Lawrence (A)
Cal **cahn** yo
Calder, Alexander (B)
Callahan, Kenneth (A)
Carles, Arthur B. (A, B)
Carls
Casarella, Edmond (C)
Castellon, Federico (C, A)
Cavallon, Giorgio (A)
Celmins, Vija (A)
Sell mins, **Vee** yah
Chaet, Bernard (A)
Chate
Chamberlain, John (A, B)
Chase, Louisa (A)
Chen, Hilo (A)
Chinni, Peter (B)
Keeny
Christensen, Dan (A)
Christo (B, D)
Chryssa (B)
Kree sa
Cicero, Carmen Louis (A)
Clarke, John Clem (A)
Cleary, Manon (A, E)
Clerk, Pierre (A, C)
Cloar, Carroll (A)
Clore
Close, Chuck (A)
Clutz, William (A)
Coates, Ross (A)
Congdon, William (A)
Conlon, William (A)
Conner, Bruce (D, A)
Cook, Howard (A)
Copley, William N. (CPLY) (A)
Corbett, Edward (A)
Cornell, Joseph (D)
Cornell, Thomas (A, C)
Cottingham, Robert (A)
Covert, John (A)

Cramer, Konrad (A)
Craw mer
Crawford, Ralston (A)
Cremean, Robert (A)
Cre **mee** an
Crile, Susan (A)
Cry il
Criss, Francis H. (A)
Cronbach, Robert M. (B)
Cronin, Robert (B)
Currier, Mary Ann (A)
Curry, John Steuart (A)

D

Dallman, Daniel (A)
Daphnis, Nassos (A, B)
D'Arcangelo, Allan (A)
Dasburg, Andrew (A)
Dash, Robert (A)
Davis, Brad (A)
Davis, Gene (A)
Davis, Jerrold (A)
Davis, Ronald (A)
Davis, Stuart (Λ)
De Andrea, John (B)
de Creeft, Jose (B)
Deem, George (A)
De Forest, Roy Dean (A)
Dehn, Adolf Arthur (A, C)
Dehner, Dorothy (B)
De Knight, Avel (A, A¹)
de Kooning, Elaine (A)
de Kooning, Willem (A)
De Lap, Tony (B)
Della-Volpe, Ralph (A)
De Maria, Walter (B)
Demuth, Charles (A)
Denby, Jillian (A)
De Niro, Robert (A)
de Rivera, Jose (B)
Deutsch, David (A)
Dickinson, Edwin (A, E)
Diebenkorn, Richard (A)
Dee ben korn
Dill, Laddie John (A)
Diller, Burgoyne (A, E)
Dine, Jim (A, F)
di Suvero, Mark (B)
Dodd, Lamar (A, E)
Dodd, Lois (A)
Dole, William (A)

Hartl, Leon (A)
Hartley, Marsden (A)
Hartman, Robert (A)
Harvey, Robert (A)
Hatchett, Duayne (B)
Havard, James (A)
Hayes, David V. (B)
Hebald, Milton (B)
Heizer, Michael (B)
Held, Al (A)
Heliker, John Edward (A)
Herms, George (A, D)
Hesse, Eva (B)
Heubler, Douglas (A)
 Hugh bler
Hinman, Charles (A, B)
Hirsch, Joseph (A)
Hofmann, Hans (A, E)
Holland, Tom (A)
Holty, Carl Robert (A)
Hood, Dorothy (A, H)
Hopkins, Budd (A)
Hopper, Edward (A)
Horiuchi, Paul (A)
Hornak, Ian (A)
Howard, Charles (A)
Hudson, Robert H. (B)
Hughto, Darryl (A)
 Hew toe
Hultberg, John (A)
Humphrey, David (A)
Humphrey, Ralph (A)
Hunt, Bryan (B)
Hunt, Richard (B)
Hurson, Michael (A, H)

I

Indiana, Robert (A)
Ingle, John S. (A[1])
Innerst, Mark (A)
Insley, Will (B)
Ippolito, Angelo (A)
Irwin, Robert (A, B)
Ito, Miyoko (A)

J

Jacobshagen, Keith (A)
Jacquette, Yvonne (A)
Jaudon, Valerie (A)
Jenkins, Paul (A)
Jenney, Neil (A)
Jennis, Stevan (A)
Jensen, Alfred (A)
Jensen, Bill (A)
Jess (Collins) (A, D)
Jimenez, Luis (B)
Johns, Jasper (A)
Johnson, Buffie (A)
Johnson, Lester (A)
Johnson, Ray (D)
Johnston, Ynez (A)
 Een yez
Jones, John Paul (A, C)
Judd, Donald (B)

K

Kacere, John (A)
 Ka sear ee
Kahn, Wolf (B)
Kaish, Luise (B)
Kamihira, Ben (A)
Kamrowski, Gerome (A, E)
Kamys, Walter (A, E)
 Came ease
Kanovitz, Howard (A)
Kaprow, Allan (A, D, F)
Karfiol, Bernard (A)
Kasten, Karl (A)
Katz, Alex (A)
Katzman, Herbert (A)
Kauffman, Craig (B)
Kearl, Stanley (B)
 Curl
Kearns, James (A)
 Carns
Kelly, Ellsworth (A)
Kelly, James (A)
Kelly, Léon (A)
Kendrick, Mel (B)
Kent, Rockwell (A)
Kepes, Gyorgy (A, E)
 Kep ish
Keyser, Robert (A)

Kienbusch, William (A)
 Keen bush
Kienholz, Edward (B, D)
 Keen holz
Kiesler, Frederick (B, A)
 Kees ler
King, William Dickey (B)
Kipniss, Robert (A)
Kipp, Lyman (B)
Kirschenbaum, Jules (A)
Kitaj, R. B. (A)
 Key tie
Kleeman, Ronald (A)
Kline, Franz (A)
Knaths, Karl (A)
 Cnaths
Knipschild, Robert (A, E)
 Nip shild
Koch, John (A)
 Coke
Koenig, John Franklin (A)
 Kay nig
Kohn, Gabriel (B)
Kohn, Misch (C)
Konzal, Joseph (B)
Koppelman, Chaim (C, A)
Kortlander, William Clark (A)
Koscianski, Leonard (A)
 Ko shee an skee
Kosuth, Joseph (I)
Krasner, Lee (A)
Kriesberg, Irving (A)
 Crize berg
Kroll, Leon (A)
Krushenick, Nicholas (A)
 Croosh nick
Kuehn, Gary (A, B)
Kuhn, Walt (A)
Kulicke, Robert (A)
 Cue lick
Kuniyoshi, Yasuo (A, E)
Kuntz, Roger (A)
Kushner, Robert (A)

L

Lachaise, Gaston (B)
Laderman, Gabriel (A)
La Mantia, Paul (A)
Lamis, Leroy (B)
Landau, Jacob (A, C)

Landfield, Ronnie (A)
Landon, Edward (A)
Lanc, Lois (A)
Lang, Daniel S. (A)
Langlais, Bernard (B, A)
 Langley
Laning, Edward (A)
Lansner, Fay (A)
Lanyon, Ellen (A)
Lasansky, Mauricio (C, E)
Lassaw, Ibram (B)
Laurent, John (A)
Laurent, Robert (B, E)
Lawrence, Jacob (A)
Lebrun, Rico (A, E)
Lechay, James (A, E)
 Le shey
Leiber, Gerson (C)
Lekakis, Michael (B)
Leong, James C. (A)
 Lee ong
Leslie, Alfred (A)
Le Va, Barry (B)
 Le Vay
Levee, John (A)
Levi, Josef (B)
Levi, Julian (A)
Levine, Jack (A)
Levine, Les (D, I)
Levinson, Mon (A)
Lewandowski, Edmund
 D. (A, E)
 Lew and ow ski
Lewis, Norman (A)
LeWitt, Sol (B)
Liberman, Alexander (A, B)
Lichtenstein, Roy (A)
 Lick ten stine
Ligare, David (A)
Lindner, Richard (A)
Lipchitz, Jacques (B)
Lippold, Richard (B)
Lipton, Seymour (B)
Lobdell, Frank (A)
Loberg, Robert W. (A)
Loew, Michael (A)
 Lowe
Longo, Robert (A)
Longo, Vincent (A, C, E)
Loran, Erle (A, E)
Lorber, Stephen (A)
Lostutter, Robert (A, A^1)
Louis, Morris (A)
 Lewis

Loving, Alvin (A)
Lozowick, Louis (A)
Lucchesi, Bruno (B)
Lund, David (A)
Lundeberg, Helen (A)
Lytle, Richard (A)
 Littell

M

Mac Connel, Kim (A)
Macdonald-Wright, Stan-
 ton (A)
MacIver, Loren (A)
 Mac Eye ver
Madsen, Loren (B)
Mallary, Robert (B)
Mangold, Robert (A)
Mangold, Sylvia Plimack
 (A)
Man Ray (A)
Manship, Paul (B)
Manso, Leo (A)
Marca-Relli, Conrad (A)
Marcus, Marsha (A)
Marden, Brice (A)
Margo, Boris (A, C)
Marin, John (A^1)
Marisol (Escobar) (B)
Markman, Ronald (A)
Marsh, Reginald (A, E)
Marsicano, Nicholas (A)
Martin, Agnes (A)
Martin, Fred (A, H)
Martin, Knox (A)
Maryan (A, C)
Mason, Alice Trumbull (A)
Matulka, Jan (A, E)
Mayhew, Richard (A)
Mazur, Michael B. (A)
McChesney, Robert P. (A)
McCracken, John (B)
McFee, Henry Lee (A)
McGarrell, James (A)
McLaughlin, John (A)
McLean, Richard (A)
McNeil, George (A)
Meigs, Walter (A)
 Megs
Mesibov, Hugh (B)
Middaugh, Robert (A, A^1)
 Mid dah

Milder, Jay (A)
Miller, Kenneth Hayes
 (A, E)
Miller, Richard (A)
Miller, Richard McDermott
 (A)
Mitchell, Fred (A)
Mitchell, Joan (A)
Moholy-Nagy, Laszlo (B)
 Ma holy-Nazh
Moller, Hans (A)
Moore, John (A)
Morley, Malcolm (A)
Morris, Carl (A)
Morris, George L. K. (A)
Morris, Robert (A, B, F)
Moskowitz, Robert (A)
Motherwell, Robert (A)
Moy, Seong (A)
Moyer, Roy (I)
Muller, Jan (A)
Mullican, Lee (A)
Murch, Walter Tandy (A)
Murphy, Catherine (A)
Murray, Elizabeth (A)
Murray, Robert (B)

N

Nadelman, Elie (B)
Nakian, Reuben (B)
Natkin, Robert (A)
Nauman, Bruce (B, I)
Neal, Reginald (A, C)
Nechvatal, Dennis (A)
Neri, Manuel (B)
Nesbitt, Lowell (A)
Nevelson, Louise (B)
Nevelson, Mike (B)
Newman, Barnett (A)
Newman, John (B, H)
Nice, Don (A)
Nick, George (A)
Nickson, Graham (A, E,
 H)
Nilsson, Gladys (A)
Nivola, Constantino (B)
Noguchi, Isamu (B)
Noland, Kenneth (A)
Novros, David (A)
Nowack, Wayne K. (A)
Nutt, Jim (A)

O

Ohlson, Doug (A)
Okada, Kenzo (A)
Okamura, Arthur (A)
O'Keeffe, Georgia (A)
Okulick, John (B)
Oldenburg, Claes Thure
 (A, B, F)
 Klaus
Olitski, Jules (A)
Oliveira, Nathan (A)
Onslow-Ford, Gordon (A)
Oppenheim, Dennis (I)
Opper, John (A, E)
Ortman, George (A)
Ossorio, Alfonso (A)
Osver, Arthur (A)
Ott, Jerry (A)
Owen, Frank (A)

P

Pace, Stephen (A)
Padovano, Anthony (B)
Paik, Nam June (D, I)
 Pike
Palmer, William C. (A)
Paone, Peter (A, C)
 Pay oh ni
Paris, Harold P. (B)
Park, David (A)
Parker, Raymond (A)
Parker, Robert Andrew
 (A)
Parrish, David (A)
Paschke, Ed (A)
Pearlstein, Philip (A)
Pearson, Henry Charles
 (A)
Peirce, Waldo (A)
Pepper, Beverly (B)
Perlin, Bernard (A)
Perlman, Joel (A)
Perry, Charles (B)
Peterdi, Gabor (C, A)
 Pet er di
Petersen, Roland Conrad
 (A)
Petlin, Irving (A)
Pettet, William (A)

Pfriem, Bernard (A)
 Freem
Phelan, Ellen (A)
Phillips, Matt (A, C)
Pineda, Marianna (B)
 Peen yay da
Pinto, Jody (A, B)
Plagens, Peter (A, E)
Pollack, Reginald (A)
Pollock, Jackson (A)
Ponce de Leon, Michael
 (C)
Pond, Clayton (A, C)
Poons, Lawrence M. (A, C)
Porter, Fairfield (A)
Porter, Katherine (A)
Porter, Liliana (A, C)
Portnow, Marjorie (A)
Posen, Stephen (A)
Pousette-Dart, Richard (A)
Pozzatti, Rudy (C)
Prestopino, Gregorio (A)
Price, Kenneth (B, C)
Puryear, Martin (B)

Q

Quaytman, Harvey (A)
Quisgard, Liz Whitney (A)

R

Rabkin, Leo (A)
Racz, Andre (A, C)
 Racks
Raffael, Joseph (A, C)
Ramberg, Christina (A)
Ramos, Mel (A)
Rattner, Abraham (A)
Rauschenberg, Robert (A)
Reichek, Jesse (A, H)
Reinhardt, Ad (A, E)
Remington, Deborah (A)
Renouf, Edda (A)
Resika, Paul (A)
 Res i ka
Resnick, Milton (A)
Richardson, Sam (B, C)
Richenburg, Robert B. (A)
Rickey, George (B)

Rivers, Larry (A, B)
Robus, Hugo (B)
Rockburne, Dorothea (A)
Rocklin, Raymond (E)
Rohm, Robert (B)
Rosati, James (B)
Rosenquist, James (A)
Rosenthal, Bernard (B)
Ross, Charles (B)
Rossi, Barbara (A)
Roszak, Theodore (B)
Roth, Frank (A)
Rothenberg, Susan (A)
Rothko, Mark (A)
Rotterdam, Paul Z. (A)
Ruben, Richards (A)
Ruda, Edwin (A, B)
Ruscha, Edward (A, H)
 Roo shay
Russell, Morgan (A)
Ruvolo, Felix (A, E)
Ryman, Robert (A)

S

Salemme, Attilio (A)
Salle, David
 Sally
Samaras, Lucas (D)
Sandback, Fred (B)
Sander, Ludwig (A)
Sandol, Maynard (A)
Saret, Alan (B)
Sarkisian, Paul (A, A^1)
Saul, Peter (A)
Saunders, Raymond (A)
Saunders, Wade (A)
Savelli, Angelo (A, C)
Scarpitta, Salvatore (A)
Schapiro, Miriam (A)
Schmidt, Julius (B)
Schnabel, Julian (A, D)
Scholder, Fritz (A)
 Sholder
Schrag, Karl (A, C)
Schucker, Charles (A)
Schueler, Jon (A)
 Shooler
Scully, Sean (A)
Seery, John (A)
Segal, George (B)
Seliger, Charles (A)

Seligmann, Kurt (A, C)
Sennhauser, John (A)
Serra, Richard (B)
Shahn, Ben (A)
Shapiro, Joel (B, H)
Shatter, Susan (A)
Shaw, Charles (A)
Shechter, Laura (A)
Sheeler, Charles (A)
Sheets, Millard (A)
Shields, Alan (A)
Shinn, Everett (A)
Simon, Sidney (B)
Simonds, Charles (B)
Simpson, David (A)
Singer, Michael (B)
Sinton, Nell (A)
Siporin, Mitchell (A)
Sloan, John (A, E)
Smith, David (B)
Smith, Hassel (A)
Smith, Leon Polk (A)
Smith, Tony (B)
Smithson, Robert (B)
Snelgrove, Walter (A)
Snelson, Kenneth (B)
Snyder, Joan (A)
Solomon, Hyde (A)
Sonenberg, Jack (A)
Sonfist, Alan (B, H)
Sonnier, Keith (B, I)
Soyer, Moses (A)
Soyer, Raphael (A)
Speicher, Eugene (A)
 Spiker
Spencer, Niles (A)
Stamos, Theodoros (A)
Stankiewicz, Richard P.
 (B)
 Stan kyay vitch
Stanley, Robert (A, C)
Stasik, Andrew (C)
Stefanelli, Joseph (A)
Steg, J. L. (C)
Steinberg, Saul (H)
Steiner, Michael (B)
Stella, Frank (A, C)
Stella, Joseph (A)
Stephan, Gary (A)
Sternberg, Harry (C, E)
Stevenson, Harold (A)
Still, Clyfford (A, E)
Stout, Myron (A)

Stroud, Peter Anthony (B, E)
Sugarman, George (B)
Sultan, Donald (A)
Summers, Carol (C)
Suttman, Paul (B)
Suzuki, James Hiroshi (A)
Swain, Robert (A)

T

Takal, Peter (C)
Tanguy, Yves (A, C)
 Tan ghee, Eve
Tanning, Dorothea (A)
Tansey, Mark (A)
Taubes, Frederic (A, E)
 Taubs
Tchelitchew, Pavel (A)
 Chel it cheff
Teraoka, Masami (A, C)
Thek, Paul (B)
Thiebaud, Wayne (A, E)
 Tee bowe
Thompson, Bob (A)
Ting, Walasse (A, A^1)
Tobey, Mark (A)
Todd, Michael (B)
Tomlin, Bradley Walker
 (A)
Tooker, George (A)
Tovish, Harold (B, E)
Treiman, Joyce (A, B)
 Tree man
Trova, Ernest (B, D)
True, David F. (A)
Truitt, Anne (B)
Tsutakawa, George (A, E)
Tucker, William (B)
Tum Suden, Richard (A)
Tuttle, Richard (E, I)
Twardowicz, Stanley (A)
 Twar do witz
Twombly, Cy (A)
Tworkov, Jack (A, E)

U

Urry, Steven (B)

V

Valentine, DeWain (B)
Valerio, James (A)
Van Buren, Richard (B)
Venezia, Michael (A)
Vicente, Esteban (A)
Vickrey, Robert R. (A, H)
Von Schlegell, David (B)
Von Weigand, Charmion
 (A)
 Vee gand, Sharmion
von Wicht, John (A)
 Vicht
Voulkos, Peter (B, E)
 Vole kos
Vytlacil, Vaclav (A, E)
 Vitt la sill

W

Wald, Sylvia (A, C)
Waldman, Paul (A)
Walkowitz, Abraham (A)
Warhol, Andy (A)
Washington, James W.,
 Jr. (B)
Wayne, June (A, C)
Weber, Idelle (A)
Weber, Max (A)
Weeks, James (A)
Weinberg, Elbert (B)
Weiner, Lawrence (I)
Welliver, Neil (A)
Wells, Lynton (A)
Wesley, John (A, C)
Wesselmann, Tom (A)
Westermann, H. C. (B)
Wharton, Margaret A. (B,
 D)
Wilde, John (A, E)
 Will dee
Wiley, William T. (A)
Wilfred, Thomas (B)
Willenbecher, John (B)
Williams, William T. (B)
Willis, Thornton (A)
Wilmarth, Christopher
 (B)
Wilson, Jane (A)
Winters, Terry (A)

Wirsum, Karl (A)
Witkin, Isaac (A)
Witkin, Jerome (A)
Woelffer, Emerson (A)
Wofford, Philip (A)
Wolfe, James Martin (B)
Wonner, Paul John (A)
Wood, Grant (A)
Woodman, Timothy (B)
Wyeth, Andrew (A)
Wyeth, James (A)

X

Xceron, Jean (A)
 Zeron

Y

Yarber, Robert (A)
Yektai, Manoucher (A)
 Manu shay
Yoshida, Ray (A)
Youngerman, Jack (A)
Yunkers, Adja (A, C)
 Odd ya

Z

Zacharias, Athos (A)
Zajac, Jack (A)
Zakanitch, Robert S. (A)

Zammitt, Norman (B)
Zogbaum, Wilfrid (B)
Zorach, Marguerite (A)
 Zorak
Zorach, William (B)
 Zorak
Zox, Larry (A)

Key to Museums and Institutions and Their Schools
that own works of art by the artists in this book

A

AAIAL. American Academy and Institute of Arts and Letters, NYC; formerly AAAL, American Academy of Arts and Letters, NYC

A.F.A. American Federation of Arts, NYC

AMA. American Medical Association

ARCO, Los Angeles

ASL. Art Students League, NYC

AT&T. American Telephone and Telegraph Co.

Aachen. Museen der Stadt Aachen, Germany

Aachen/Kunstverein. Kunstverein, Aachen, Germany

Aachen/Ludwig. Neue Galerie-Sammlung Ludwig, Aachen, Germany

Aachen/NG. Neue Galerie in der Stadt Aachen, Aachen, Germany

Aachen/S-L. Suermondt-Ludwig Museum, Aachen, Germany

Abbott Academy, Andover, Mass.

Abbott Laboratories

Aberdeen/AG. Aberdeen Art Gallery, Scotland

Abilene Christian College

Abilene Zoological Gardens, Texas

Académie française, Paris

Academy of Fine Arts, Warsaw—see Warsaw

Academy of Natural Sciences, Philadelphia—see PMA

Achenbach Foundation for Graphic Arts, San Francisco

Ackland. William Hays Ackland Memorial Art Center, Chapel Hill, N.C.

Addison Gallery of Art—see Andover/Phillips

Adelaide. The Art Gallery of South Australia, Adelaide

Adelphi U.

Aetna Oil Co.

Agricultural and Mechanical College of Texas

Ain Harod. Michkan Le'omanuth Museum of Art, Ain Harod, Israel

Akademie der Kunste, Berlin, Germany

Akron/AM. Akron Art Museum, Akron, Ohio; formerly Akron/AI, Akron Art Institute

Alabama Institute of Technology

Alabama Polytechnic Institute, Auburn, N.Y.

U. of Alabama

Albany/Institute. Albany Institute of History and Art, Albany, N.Y.

Albany Mall—see South Mall, Albany

Albany/SUNY. State University of New York at Albany

Josef Albers Museum, Bottrop, Germany—see Bottrop/Albers

U. of Alberta, Edmonton, Canada

Albertina (Vienna)—see Graphische Sammlung Albertina

Albion College

Albrecht Gallery Museum of Art—see St. Joseph/Albrecht

Albright-Knox Art Gallery—see Buffalo/Albright

Albuquerque Museum, Albuquerque, N.M.

Alcoa. Aluminum Company of America

Larry Aldrich Museum—see Ridgefield/Aldrich

Alfred/SUNY. State University of New York at Alfred

Allegheny College

Allen-Bradley Co., Inc.

Allen Memorial Art Museum—*see* Oberlin College
Allentown/AM. Allentown Art Museum, Allentown, Pa.
Lyman Allyn Museum—*see* New London
Alverthorpe Gallery, Jenkintown, Pa.
Amarillo Art Center, Amarillo, Tex.
Amerada Hess Corp., Inc.
American Academy, Rome
American Academy and Institute of Arts and Letters—*see* AAIAL
American Airlines
American Association of University Women
American Broadcasting Co.
American Can Corp.
American Car and Foundry Co.
American Craft Museum, NYC.
American Export Isbrandtsen Lines, Inc.
American Express Corp.
American Federation of Arts—*see* A.F.A.
American Foundation for the Arts, Miami, Fla.
American Life and Casualty Insurance Co.
American Locomotive Co.
American Museum of Immigration, NYC
American National Fire Insurance Co. Collection
American Republic Insurance Co.
American Swedish Historical Museum, Philadelphia, Pa.
American Swedish Institute, Minneapolis, Minn.
American Telephone & Telegraph Co.—*see* AT&T
American Tobacco Co.
American U.
Amherst College
Amsterdam/Stedelijk. Stedelijk Museum, Amsterdam, Holland
Amstar Corp.
Anchorage. Anchorage Historical and Fine Arts Museum, Anchorage, Alaska
Arthur Anderson & Co.
Anderson Clayton Company
Andover/Phillips. Phillips Academy, Addison Gallery of American Art, Andover, Mass.
The M.L. Annenberg Foundation, Philadelphia, Pa.
Anthology Film Archives
Antwerp. Musée Royal des Beaux-Arts, Antwerp, Belgium

Antwerp/ICC. International Cultural Center, Antwerp, Belgium
Antwerp/Middelheim. Musée de Sculpture en pleine air, Middelheim, Antwerp, Belgium
Antibes/Picasso. Musée Picasso, Antibes, France
Argentina/Nacional. Museo Nacional de Bellas Artes, Buenos Aires, Argentina
Arizona State College
Arizona State U.
U. of Arizona
U. of Arkansas
Arkansas/AC. Arkansas Art Center
Arnhem. Gemeentemuseum, Arnhem, Holland
Thurman Arnold Building, Washington, D.C.
Arnot Art Museum, Elmira, N.Y.
Art Academy of Cincinnati, Cincinnati, Ohio
Art Gallery of Ontario, Toronto, Canada
Art Council of Pakistan—*see* Karachi
Art Gallery of New South Wales—*see* Sydney/AG
Art Gallery of South Australia—*see* Adelaide
Art Gallery of Western Australia, Perth
Art Museum of South Texas, Corpus Christi
Art Students League—*see* ASL
Art of This Century (Peggy Guggenheim), Venice, Italy
Arts Club of Chicago, Illinois
Arts Council of Great Britain, London
Asheville Art Museum, Asheville, N.C.
Ashland Oil Inc.
Aspen Institute for Humanistic Studies, Aspen, Col.
Associated Coin Amusement Company
Astor Place, NYC
Atlanta/AA. Atlanta Art Association, Atlanta, Ga.
Atlanta U.
Atlantic Richfield Co., New York
Atwater Kent Museum, Philadelphia, Pa.
Auburn U.
Aubusson. College de la Manufacture d'Aubusson, Aubusson, France
Auckland. Auckland City Art Gallery, Auckland, New Zealand
Augusta, Me./State. Maine State Museum, Augusta, Me.

Austin. Texas Fine Arts Association, Austin
Australian National Bank
Australian National Gallery, Canberra—see Canberra/National
Avco Corp.
Avon Products, NYC
L.S. Ayres & Co.

B

Baden-Baden, Stadtmuseum
Baker U.
Ball State U. (formerly Teachers College) Muncie, Ind.
Baltimore/MA. Baltimore Museum of Art, Baltimore, Md.
U. of Baltimore
Baltimore/Walters. Walters Art Gallery, Baltimore, Md.
Bangor Public Library, Bangor, Me.
BankAmerica Corp.
Bank of America
Bank of California
The Bank of California N.A., Portland, Ore.
Bank of Chicago
The Bank of New York, NYC
Bank of Omaha
Bankers Trust Company, NYC
Banque Lambert, Brussels, Belgium
Barat College of the Sacred Heart
Barcelona. Museo de Arte Moderno, Barcelona, Spain
Bard College (incl. Rivendell Collection)
Barnard College
Barnes Foundation, Merion, Pa.
Baruch College of the City U. of New York, NYC
Baseball Museum, Baltimore, Md.
Basel. Kunstmuseum Basel, Basel, Switzerland
Basel/Kunsthalle. Kunsthalle Basel, Switzerland
Basel/Offentliche. Offentliche Kunstsammlung, Basel, Switzerland
Basler Denkmalpflege, Basel, Switzerland
Bass Museum of Art—see Miami/Bass
Bat-Yam Museum—see Rybak
Baton-Rouge. State of Louisiana Art Commission, Baton Rouge, La.

Bauhaus-Archiv, Darmstadt, Germany
Baxter Laboratories, Chicago
Beach Public School, Portland, Ore.
Beaumont Art Museum, Beaumont, Texas
Becton Dickinson Co., East Rutherford, New Jersey
Belgian Ministry of National Education, Brussels, Belgium
Belgrade/National. Narodni Muzej (National Museum), Belgrade, Yugoslavia
Bell Atlantic.
Bellevue Hospital, NYC
Bellevue/AM, Bellevue Arts & Crafts Association, Bellevue, Wash.
Beloit College (incl. Wright Art Center)
Belvedere. Osterreichische Galerie im Belvedere in Wein, Vienna, Austria
Bennington College
Berea College
Bergen Community College, Paramus, N.J.
John Nelson Bergstrom Art Center and Museum see Neenah/Bergstrom
Berkshire/Atheneum—see Pittsfield/Berkshire
Berlin. Staatliche Museen, Berlin, Germany
Berlin/National. Nationalgalerie, Berlin, Germany
Berne. Kunsthalle Berne, Berne, Switzerland
Best Products Corp.
Betcar Corp.
Bethlehem Steel Corp.
Bezalel Museum and Bezalel Art School—see Israel Museum
Bibliothèque Nationale, Paris
Bibliothèque Royale de Belgique, Brussels, Belgium
Bielefeld. Stadtisches Kunsthaus, Bielefeld, Germany
Birla Academy of Art and Culture—see Calcutta
Birmingham, Ala./MA. Birmingham Museum of Art, Birmingham, Ala.
Birmingham/AG, Birmingham (England) Art Gallery
Robert Blackburn Printmaking Workshop, NYC
Black Mountain College, Beria, N.C.
Blanden Memorial Art Gallery—see Fort Dodge/Blanden

Block Drug Co., Jersey City, N.J.
Blount, Inc., Montgomery, Ala.
Boca Raton Museum of Art, Boca Raton, Fla.
University of Bochum, Bochum, Germany
Bochum. Museum Bochum, Bochum, Germany
Bogota. Museo de Arte Moderno, Bogota, Columbia
Boise. Boise Gallery of Art, Boise, Idaho
Boise-Cascade Corp.
Bonn. Rheinisches Landesmuseum, Bonn, Germany
Bonn\S.K. Städtisches Kunstmuseum, Bonn.
Bordeaux/Contemporain. Musée d'Art Contemporain, Bordeaux, France
Bordighera. Galleria d'Arte Moderna, Bordighera, Italy
Borgon Associates
Borg-Warner International Corporation
Boston/MFA. Museum of Fine Arts, Boston, Mass.;
Boston Museum School
Boston Public Library, Boston, Mass.
Boston U.
Bottrop/Albers. The Josef Albers Museum, Bottrop, Germany
Boulogne. Musée des Beaux-Arts, Boulogne, France
Bowdoin College
Bowling Green State U., Bowling Green, Ohio
Bradford Junior College, Bradford, Mass.
Bradley U.
Brandeis Institute, Los Angeles
Brandeis U. (incl. Rose Art Museum)
Archie Bray Foundation, Helena, Mont.
Bremen. Kunsthalle Bremen, Bremen, Germany
Bremen/Neues. Neues Museum Weserburg, Bremen, Germany
Brenton Bank, Des Moines, Ia.
Bridgeport. Museum of Art, Science and Industry, Bridgeport, Conn.
Bridgeport/Housatonic. Housatonic Museum of Art, Bridgeport, Conn.
Bridgestone Museum, Tokyo
Brigham Young U.
Brisbane/QAG. Queensland Art Gallery, Brisbane, Australia
Bristol (R.I.) Art Museum
Bristol-Myers Co.
Britannica. Encyclopaedia Britannica

U. of British Columbia, Vancouver, Canada
British Council
British Museum, London
Brockton/Fuller. Fuller Memorial Art Center, Brockton, Mass.
Bronx Museum of the Arts, Bronx, N.Y.
Brookgreen Gardens, Georgetown, S.C.
Brookhaven College, Farmers Branch, Texas
Brookings Institute, Washington, D.C.
Brooklyn College of the City U. of New York
Brooklyn Museum, Brooklyn, N.Y.
Brooklyn Museum School
Brooklyn Union Gas
Bobbie Brooks Inc.
Brooks Memorial Art Gallery—see Memphis/Brooks
Brown and Wood, NYC
Brown U.
Bruce Museum, Greenwich, Conn.
Brunswick. Stadtisches Museum, Braunschweig, Germany
Brunswick Corp.
Brussels/Beaux-Arts. Musées Royaux des Beaux-Arts de Belgique, Brussels, Belgium
Brussels/Moderne. Musée d'Art Moderne, Brussels, Belgium
Bryn Mawr College
Buckingham Palace, London
Bucknell U.
Budapest/National. Hungarian National Gallery, Budapest, Hungary
The Budd Co.
Buenos Aires/Moderno. Museo de Arte Moderno, Buenos Aires, Argentina
Buenos Aires/Municipal. Museo Municipal de Bellas Artes y Arte Nacional, Buenos Aires, Argentina
Buffalo/Albright. Albright-Knox Art Gallery, Buffalo, N.Y.; Albright Art School (prior to 1962)
Bulgaria/International. Museum of International Art, Sophia, Bulgaria
Bundy Art Gallery—see Waitsfield/Bundy
Burlington Industries
Burlington Mills Collection
Harry and Della Burpee Gallery—see Rockford/Burpee
Burroughs Wellcome Co., Raleigh, N.C.
Busch-Reisinger Museum, Cambridge, Mass.

Business Card, Inc.
The Butler Institute of American Art—*see* Youngstown/Butler
Byer Museum of the Arts—*see* Evanston/Byer

C

CAPC—*see* Bordeaux/Contemporain
CIA. Central Intelligence Agency, Washington, D.C.
CIGNA.
CIT Corp.
CNAC. Centre National d'Art Contemporain, Paris *(see also* Paris/Beaubourg)
CSFA (California School of Fine Arts)—*see* SFAI
Calcutta. Birla Academy of Art and Culture, Calcutta, India
U. of Calgary, Alberta, Canada
Cali/Tertulia. Museo de Arte Contemporanea, Cali, Columbia
California Academy of Science, Museum and Library, San Francisco
California College of Arts and Crafts
California Federal Savings and Loan Association, Los Angeles
California Palace of the Legion of Honor, San Francisco
California School of Fine Arts—*see* SFAI
California State Fair
California State Library
California State U.
California Watercolor Society
U. of California *(see also* UCLA)
Calvin College, Grand Rapids, Mich.
Cambria County Transit Authority, Johnstown, Pa.
The Cambridge School, Weston, Mass.
Cambridge. U. of Cambridge, England
The Canada Council, Ottawa
Canadian Industries Ltd., Montreal
Canadian Society of Graphic Art
Canajoharie Library and Art Gallery, Canajoharie, N.Y.
Canberra/National. Australian National Gallery, Canberra
Canton Art Institute, Canton, Ohio
Capehart Corp.
Cape Town. South African National Gallery, Cape Town

Capitol Records, Inc.
Capitol Research Co., Los Angeles
Caracas. Museo de Bellas Artes de Caracas, Venezuela
Caracas/Contemporaneo. Museo de Arte Contemporaneo, Caracas, Venezuela
Carborundum Company
Cardiff—*see* National Museum of Wales
Cargill, Inc.
Carleton College
Carnegie Institute of Technology, Pittsburgh, Pa.
Carnegie-Mellon U.
Carolina Art Association—*see* Charleston/Carolina
Emily Carr College of Art, Vancouver, B.C.
Amon Carter Museum of Western Art, Fort Worth, Texas
Casa de las Americas, Havana
La Casa del Libro, San Juan, Puerto Rico
Case Institute of Technology
Case Western Reserve U.
The Catholic U. of America
Cedar Rapids/AA—*see* Cedar Rapids/MA
Cedar Rapids/MA. Cedar Rapids Art Museum, Cedar Rapids, Iowa
Cedar Rapids Public Library, Cedar Rapids, Iowa
Cedars-Sinai Medical Center, Los Angeles
Celle Art Sculpture Park, Pistoria, Italy
Center for Inter-American Relations, NYC
Central Florida Museum—*see* Orlando
Centraal Museum—*see* Utrecht
Central Research Corp., NYC
Centre National d'Art Contemporain—*see* CNAC
Centro Artistico de Barranquilla, Barranquilla, Colombia
Centro Cultural de los Estados Unidos, Madrid
Century Association, NYC
Ceret. Musée d'Art Moderne, Ceret, France
Chaffey College
Champion International Corp.
Charleston/Carolina. Carolina Art Association, Charleston, S.C.
Charleston/Gibbes. Gibbes Art Gallery, Charleston, S.C.
Charleston, W.Va. Charleston Art Gallery, Charleston, W.Va.
Charlotte/Mint. Mint Museum of Art, Charlotte, N.C.

Chase Manhattan Bank, NYC
Chase Park Plaza Hotel, St. Louis, Mo.
Château de Rohan, Strasbourg, France
Chattanooga/AA. Chattanooga Art Association, Chattanooga, Tenn.
Chattanooga/Hunter. Hunter Museum of Art, Chattanooga, Tenn.
Chautauqua Institute, Chautauqua, N.Y.
Cheekwood. The Tennessee Botanical Gardens and Fine Arts Center, Nashville, Tenn.
Chemical Bank, NYC
Cheney Cowles Memorial Museum, Spokane, Wash.
Chicago/AI. The Art Institute of Chicago; Chicago Art Institute School (and Junior School)
Chicago Arts Club—see Arts Club of Chicago
Chicago/Contemporary. Museum of Contemporary Art, Chicago, Ill.
Chicago Public Schools, Chicago, Ill.
Chicago/Spertus. Spertus Museum of Judaica.
Chicago/Terra. Terra Museum of American Art, Chicago; formerly in Evanston, Ill.
U. of Chicago (incl. Renaissance Society; Smart Gallery)
Chico State College (incl. Chico Art Center)
Choate-Rosemary Hall School, Wallingford, Conn.
Chouinard Art Institute, Los Angeles
Christian Theological Seminary, Indianapolis, Ind.
Chrysler Corp.
Walter P. Chrysler Museum of Art—see Norfolk/Chrysler
Ciba-Geigy Corp., Ardsley, N.Y.
Cincinnati/AM. The Cincinnati Art Museum, Cincinnati, Ohio; Cincinnati Museum School
Cincinnati/Contemporary. Contemporary Arts Center, Cincinnati, Ohio
U. of Cincinnati
Cinémathèque de Belgique, Brussels, Belgium
Cinémathèque Française, Paris
Citicorp, NYC
Citizens Fidelity Bank, Louisville, Ky.
City of Chalon-sur-Sâone, France
City of Claremont, Calif.
City College of the City U. of New York

City of Chicago
City of Detroit
City of Fresno, Calif.
City of Hamburg, Germany
City of Hannover, Germany
City Investing Corp., NYC
City of Mill Valley, Calif.
City of Oakland, Calif.
City of Portland, Ore.
City of Riverside, Calif.
City of San Antonio, Texas
City of San Francisco
City of San Jose, Calif.
City of Tilburg, Holland
City of Toronto, Canada
City of Trenton, N.J.
City of Wichita, Kansas
Civic Center Synagogue, NYC
Clairol Inc.
Claremont College
Clearwater/Gulf Coast. Florida Gulf Coast Art Center, Inc., Clearwater
Cleveland/Contemporary. Cleveland Center for Contemporary Art
Cleveland/MA. The Cleveland Museum of Art, Cleveland, Ohio
Cleveland Trust Co.
The Coca-Cola Co.
Cochran Memorial Park, St. Paul, Minn.
Coe College
Colby College
Colgate U.
Collection de l'Etat, Paris
College des Musées Nationaux de France, Paris
College of St. Benedict
College of William and Mary
Cologne. Wallraf-Richartz-Museum, Cologne, Germany
Cologne/Kunstverein. Kolnischer Kunstverein, Cologne, Germany
Cologne/Ludwig. Museum Ludwig, Cologne, Germany
Cologne/NG. Neue Galerie im Alten Kulturhaus, Cologne, Germany
Cologne/Stadt. Museen der Stadt Köln, Cologne, Germany
Colonial Bank & Trust Co., Waterbury, Conn.
Colonial Williamsburg, Williamsburg, Va.
Colorado College
Colorado Springs/FA. Colorado Springs Fine Arts Center, Colorado Springs, Col.

Colorado State U.

U. of Colorado

Columbia, Mo. State Historical Society of Missouri, Columbia, Mo.

Columbia, S.C./MA. Columbia Museum of Art, Columbia, S.C.

Columbia Banking, Savings and Loan Association, Rochester, N.Y.

Columbia Broadcasting System

Columbia Greene Community College, Hudson, N.Y.

Columbia U.

Columbus Gallery of Fine Arts—see Columbus/MA.

Columbus/MA. Columbus Museum of Art, Columbus, Ohio

Columbus, Ga. Columbus Museum of Arts and Crafts, Columbus, Ga.

Commerce Bank (or Bancshares) of Kansas City, Mo.

Commerce Bank of St. Louis

Commerce Trust Co., Kansas City, Mo.

Commodities Corp., Princeton, N.J.

Community Arts Foundation, Los Angeles

Concordia Teachers College (Ill.)

Concordia Teachers College (Neb.)

Connecticut College

Connecticut Community College

Connecticut General Life Insurance Company

U. of Connecticut

Conover-Mast Publications Inc.

Container Corp. of America

Continental Bank of Chicago

Continental Grain Company

Continental Insurance Co., NYC

Cooperative Insurance Society, Manchester, England

Cooper-Hewitt Museum, Smithsonian Institution, NYC.

Cooper Union. The Cooper Union Museum and Art School, NYC

Coos Bay Art Museum, Coos Bay, Ore.

Copenhagen. Statens Museum für Kunst, Copenhagen, Denmark

Corcoran. The Corcoran Gallery of Art, Washington, D.C.; The Corcoran Gallery School of Art

Cordoba/Municipal. Museo Municipal de Cordoba, Argentina

Cordoba/Provincial. Museo Provincial de Bellas Artes, Cordoba, Argentina

Corpus Christi. Art Museum of South Texas, Corpus Christi

Cornell College, Mt. Vernon, Iowa

Cornell U. (incl. Herbert F. Johnson Museum of Art)

Cortland/SUNY. State University of New York at Cortland

Corvallis (Ore.) First Federal Savings and Loan

County of Los Angeles

Courtauld Institute, London

Cranbrook. Cranbrook Academy of Art, Bloomfield Hills, Mich.

E. B. Crocker Art Gallery—see Sacramento/Crocker

Crocker National Bank of California

Crown Plaza Hotel, Seattle

Crown Zellerbach Foundation, San Francisco

Cuenca. Museo Municipal de Arte, Cuenca, Spain

Cummer Gallery of Art—see Jacksonville/Cummer

Currier. Currier Gallery of Art, Manchester, N.H.; Currier Gallery School

D

Dade (Miami) Public Library

Dallas Museum for Contemporary Arts—see Dallas/MFA

Dallas/MFA. Dallas Museum of Fine Arts, Dallas, Texas; Dallas Museum School

Dallas Public Library, Dallas, Texas

Dalton School, NYC

Danforth Museum, Framingham, Mass.

Darmstadt/Hessisches. Hessisches Landesmuseum, Darmstadt, Germany

Darmstadt/Kunsthalle. Kunsthalle, Darmstadt, Germany

Dartmouth College (incl. Hopkins Art Center)

Davenport/Municipal. Davenport Municipal Art Gallery, Davenport, Iowa

Davidson College, Davidson, N.C.

Davidson, N.C. Davidson Art Center, Davidson, N.C.

Davison Art Center—see Wesleyan U. (Conn.)

Dayton/AI. Dayton Art Institute, Dayton, Ohio; Dayton Art Institute School

De Beers Collection, Johannesburg, South Africa

Debevoise, Plimpton, Lyons and Gates, NYC

Decatur Art Center, Decatur, Ill.

Dechert, Price, and Rhodes, Philadelphia

De Cordova and Dana Museum—see Lincoln, Mass./De Cordova

De Kalb—see Northern Illinois U.

Delaware Art Center—see Wilmington

Delaware Art Museum, Wilmington, Del.

U. of Delaware

Isaac Delgado Museum of Art—see New Orleans/Delgado

Denison U.

Denver/AM. Denver Art Museum, Denver, Col.

De Pauw U.

Des Moines. The Des Moines Art Center, Des Moines, Iowa

Des Moines Register & Tribune, Des Moines, Iowa

Detroit/Institute. The Detroit Institute of Arts, Detroit, Mich.

Detroit Library.

de Young. M.H. de Young Memorial Museum, San Francisco

Dhondt-Dhaenens. Museum Dhondt-Dhaenens, Deurle, Belgium

Diablo Valley College

Diamond Shamrock Corporation

Didrichsen Foundation, Helsinki, Finland

Dillard U.

U. of District of Columbia

Djakarta Museum, Djakarta, Indonesia

Doane College

Donaldson, Lufkin & Jenrette, Inc.

Dord Fitz School of Art

Jay Dorf, Inc.

Dow Jones

Downey Museum of Art, Downey, Calif.

Downtown Community School, NYC

Drake U.

Dresdener Bank, Los Angeles

Dublin/Municipal. Municipal Gallery of Modern Art, Dublin, Ireland

Dublin/National. National Gallery, Dublin, Ireland

U. of Dublin, Dublin, Ireland

Dubuque/AA. Dubuque Art Association, Dubuque, Iowa

Duisburg. Wilhelm-Lehmbruck-Museum der Stadt Duisburg, Germany

Duke U.

Dulin Gallery of Art, Knoxville, Tenn.

Dunkerque/Contemporary. Musée d'Art Contemporain

Dunkin' Donuts Inc.

Düsseldorf. Kunstmuseum der Stadt, Düsseldorf, Germany

U. of Düsseldorf

Düsseldorf/KN-W. Kunstsammlung Nordrhein-Westfalen, Düsseldorf, Germany

Düsseldorf/Kunsthalle. Stadtische Kunsthalle, Düsseldorf, Germany

E

Earlham College U. of East Anglia, Norwich, England

East Tennessee State College Museum of Art, Johnson City, Tenn.

Eastern Michigan U.

Eastern Oregon College

Eastland Shopping Center, Detroit, Mich.

Eaton Paper Corp.

Edinburgh/Modern. Scottish National Gallery of Modern Art, Edinburgh,Scotland

Edinburgh/National. National Gallery of Scotland, Edinburgh, Scotland

Edmonton Art Gallery, Edmonton, Canada

Eilat. Museum of Modern Art, Eilat, Israel

Ein Hod Museum, Haifa Israel

Eindhoven. Stedelijk van Abbe-Museum, Eindhoven, Holland

Elkhart. Midwest Museum of American Art, Elkhart, Indiana

Ellerby Associates

Elmhurst College, Illinois

Elmira College (N.Y.)

El Paso Museum of Art, El Paso, Texas

Craig Elwood Associates

Emory U., Atlanta, Ga.

The Equitable. Equitable Life Assurance Society of the U.S.

Escuela Nacional de Artes Plasticas, Mexico City, Mexico

Essen. Museum Folkwang, Essen, Germany

Essen/NG. Neue Galerie, Essen, Germany

Esslingen. Stadtische Museum, Esslingen, Germany

Evanston/Byer. Byer Museum of the Arts, Evanston, Ill.

Evansville. Evansville Museum of Arts
and Sciences, Evansville, Ind.; Evansville Museum School

Everett Junior College, Everett, Wash.

Everhart Museum—*see* Scranton/Everhart

Everson Museum of Art—*see* Syracuse/Everson

Exchange National Bank, Chicago, Ill.

Exeter. Phillips Exeter Academy, The
Lamont Art Gallery, Exeter, N.H.

Exxon Corp.

F

FRAC Limousin, Limoges, France

F.T.D. Association. Florists Transworld
Delivery Association

Fabick Tractor Co.

Fairleigh Dickinson U.

Fairmont Park Association, Philadelphia

Farmers Elevator Insurance Co.

Wilham A. Farnsworth Library and Art
Museum—*see* Rockland/Farnsworth

Father Judge Mission Seminary, Lynchburg, Va.

Fayetteville Museum of Art, Fayetteville,
N.C.

Federal Deposit Insurance Corporation

Fidelity Bank, Philadelphia, Pa.

Federal Reserve Bank

Hamilton Easter Field Foundation, Portland, Me.

57th Madison Corp., NYC

Fine Arts Museum of the South—*see* Mobile/FAMS

First Bank, Minneapolis

First National Bank of Boston

First National Bank of Chicago

First National Bank of Dallas

First National Bank of Evanston, Ill.

First National Bank of Houston

First National Bank of Idaho

First National Bank of Iowa City, Iowa

First National Bank, Madison, Wisc.

First National Bank of Memphis, Tenn.

First National Bank of Nevada, Reno

First National Bank of Ohio, Columbus

First National Bank of Oregon

First National Bank of Seattle, Wash.

First National Bank, Tampa, Fla.

First National Bank of Tulsa, Ok.

First National City Bank

Fisk U.

Fitchburg/AM. Fitchburg Art Museum,
Fitchburg, Mass.

Fitzwilliam Museum, Cambridge, England

525 William Penn Plaza, Philadelphia,
Pa.

Robert Hull Fleming Museum—*see* U. of
Vermont

Flint/Institute. Flint Institute of Arts,
Flint, Mich.

Florence, Italy. Galleria dell'Accademia,
Florence, Italy

Florence (Italy)/Modern. Galleria d'Arte
Moderna, Florence, Italy

Florence, S.C. Museum. Florence Museum, Florence, S.C.

Florida Gulf Coast Art Center, Inc.—*see*
Clearwater/Gulf Coast

Florida Southern College

Florida State U.

U. of Florida

Florsheim Foundation, Chicago, Ill.

Fogg Art Museum—*see* Harvard U.

Fondation Cartier, Jouey-en-Josas, France

Fondation Daniel Templon, Frejus,
France

Fondation Maeght, St. Paul-de-Vence,
France

Fondazione Thyssen-Bornemisza,
Castagnola, Switzerland

Fontana-Hollywood Corp.

Ford Foundation

Ford Motor Company

Fordham U.

Fort Dodge/Blanden. Blanden Memorial
Art Gallery, Fort Dodge, Iowa

Fort Lauderdale. Fort Lauderdale Museum of Art, Fort Lauderdale, Fla.

Fort Wayne/AM. Fort Wayne Art Museum, Fort Wayne, Ind.

Fort Worth—*see* Fort Worth/Modern.

Fort Worth/Modern. Modern Art Museum of Fort Worth, Texas

Fort Wright College, Spokane, Wash.

405 Park Avenue, NYC

Four Seasons Restaurant, NYC

Fourth National Bank and Trust, Wichita, Kan.

France/National. Musée National d'Art
Moderne, Paris, France (*see also*
Paris/Moderne)

Franchard Corp.

Frank Construction Company

Frankfurt/Deutsches Architektur Museum
Frankfurt am Main. Stadelsches
 Kunstinstitut, Frankfurt am Main Ger-
 many
Frankfurt/Moderne. Museum für Mod-
 erne Kunst, Frankfurt, Germany
Franklin Institute, Philadelphia, Pa.
Simon Frazer U.
Fredenkstad. Museum of Contemporary
 Graphic Art, Fredenkstad, Norway
Fredonia/SUNY. State University of New
 York at Fredonia
Free Library of Philadelphia, Pa.
French Ministry of National Education,
 Paris, France
Fresno/AM. Fresno Art Museum, Califor-
 nia
Fresno State College
Friends of Art, Uniontown, Pa.
Friuli, Italy/MOMA. Museum of Mod-
 ern Art, Friuli, Italy
Fukuoka. Fukuoka Art Museum, Fuku-
 oka, Japan
Fukuoka Sogo Bank, Ltd.
Fuller Memorial Art Center—see
 Brockton/Fuller
Fullerton Junior College, Calif.
Fundacion Juan March, Madrid

G

GSA. General Services Administration
Gainsville/Harn. Samuel P. Harn Mu-
 seum of Art, Gainsville
Galerie des 20. Jahrhunderts, Berlin, Ger-
 many
Galleria Communale d'Arte Con-
 temporanea, Arezzo, Italy
Gallery of Modern Art, NYC—see New
 York Cultural Center
Gallery of Modern Art, Washington,
 D.C.—see WGMA
Galveston. Galveston Historical Founda-
 tion Inc., Galveston, Tex.
Garcia Corp.
Garnett Public Library, Garnett, Kan.
Geigy Chemical Corp.—see Ciba-Geigy
 Corp.
Gdansk/Marine. Marine Museum, Gdansk.
Gelco. Eden Praine, Minn.
Gelsenkirchen. Stadtische Kunstsammlung,
 Gelsenkirchen, Germany

General Electric Corp.
General Mills Inc.
General Motors Corp.
General Reinsurance Corp.
Geneseo/SUNY. State University of New
 York at Geneseo
George Washington U.
George Washington Carver Junior Col-
 lege, Rockville, Md.
Georgia Institute of Technology
Georgia State U.
U. of Georgia (incl. Georgia Museum of
 Art)
Gerald Ford Library, Ann Arbor
Gettysburg College
Ghent. Musée des Beaux-Arts, Ghent, Bel-
 gium
Ghent/Contemporary. Het Museum van
 Hedendaagse Kunst te Gent, Ghent,
 Belgium
Ghent/Moderne. Musée d'Art Moderne,
 Ghent, Belgium
Gibraltar Savings & Loan Association
Gimbel Bros.
Glasgow/AGM. Glasgow Art Gallery and
 Museum, Glasgow, Scotland
U. of Glasgow, Scotland
Glen Alden Corp.
Goddard Art Center, Ardmore, Ok.
Goddard College
Goethe Universitat, Berlin, Germany.
Golden Gateway Center, San Francisco
Golden State Mutual Life Insurance Co.
Goldman Sachs, & Co., NYC
Goldring International
Gonville and Caius College, Cambridge,
 England
Gothenburg—see Sweden/Goteborgs
Goucher College
Govett-Brewster Art Gallery, New Plym-
 outh, New Zealand
The Grace Line
Grand Forks. North Dakota Museum of
 Art, Grand Forks, N.D.
Grand Rapids—see Grand Rapids/AM.
Grand Rapids/AM. Grand Rapids Art
 Gallery, Grand Rapids, Mich.
Graphische Sammlung Albertina, Vi-
 enna, Austria
Graphische Sammlung der E.T.H. (Eidg.
 Technischen Hochschule), Zurich,
 Switzerland
Great Southwest Industrial Park, Atlanta,
 Ga.

Great Western Savings and Loan Association of South California, Los Angeles

Greece/National. National Picture Gallery, Athens, Greece

Greenville County Museum of Art, S.C.

Grenchen. Sammlungen der Museumgesellschaft, Grenchen, Switzerland

Grenoble. Musée des Beaux-Arts de Grenoble, France

Grenoble/Contemporain. Centre National d'Art Contemporain de Grenoble, France

Griffiths Art Center—see St. Lawrence U.

Grinnell College

Grolier Club, NYC

Groninger. Groninger Museum, Netherlands

Grunewald Foundation for Graphic Arts, Los Angeles

Guadalajara. Museo de Bellas Artes, Guadalajara, Mexico

Solomon R. Guggenheim Museum—see SRGM

Guild Hall, East Hampton, N.Y.

Guild Plastics Co.

Guilford College, Greensboro, N.C.

Gulf Coast Art Center—see Clearwater/Gulf Coast

Gulf Life Insurance Co., Jacksonville, Fla.

Gulf Oil Corp.

Gulf and Western Industries Inc.

A.V. Gumuchian, Inc.

H

Hackley Art Center—see Muskegon/Hackley

Hagen. Karl-Ernst-Osthaus-Museum, Hagen, Germany

Hagerstown/County MFA. Washington County Museum of Fine Arts, Hagerstown, Md.

The Hague. Haags Gemeentemuseum, The Hague, Netherlands

Haifa. Museum of Modern Art, Haifa, Israel

Haifa/National. National Maritime Museum, Haifa, Israel

Hall of Justice, San Francisco

Hallmark Collection

Hamburg. Hamburger Kunsthause, Hamburg, Germany

Hamburg/Kunstverein. Kunstverein in Hamburg, Germany

Hamilton College

Hamline U.

Hampton Institute

Hampton School, Townsend, Md.

Hannover. Stadtische Galerie, Hannover, Germany

Hannover/K-G. Kestner-Gesellschaft, Hannover Germany (see also Kestner-Museum, Hannover)

Hannover/Kunstverein. Kunstverein Hannover, Hannover, Germany

Hannover/Sprengel. Sprengel Museum, Hannover, Germany

Hannover Opera House, Hannover, Germany

Hara Art Museum, Kurashiki, Japan

Harcourt Brace Jovanovich Inc.

Harlem Hospital, NYC

Harmon Foundation Inc., NYC

Harris Bank, Chicago

Harrisburg, Pa./State Museum. Pennsylvania State Museum, Harrisburg, Pa. (incl. William Penn Memorial Museum)

Hartford (Conn.) State Library

Hartford/Wadsworth. The Wadsworth Atheneum, Hartford, Conn.

U. of Hartford

Harvard U. (incl. Fogg Art Museum)

Havana/Nacional. Museo Nacional, Havana, Cuba

Hayden Stone Inc.

Le Havre/Municipal. Musée Municipal, Le Havre, France (see also Musée du Havre)

Hawaii State Foundation

U. of Hawaii

Health and Hospital Corp., NYC

Hebron Academy, Hebron, Me.

Hebrew College, Brookline, Mass.

Heckscher Museum—see Huntington, N.Y./Heckscher

H.J. Heinz Co., Pittsburgh, Pa.

Hellerup Commune, Copenhagen, Denmark

Helsinki. Ateneumin Taidemuseo, Helsinki, Finland

Helsinki/Contemporary

Hemisphere Club, NYC

Hempstead Bank, Hempstead, N.Y.

Henie-Onstad Stiftelser, Hovikodden, Norway

Henkel Co., GMBH, Germany
John Herron Art Institute—*see* Indianapolis/Herron
Hershey Foods Corp., Hershey, Pa.
Christian Herter Center, Boston, Mass.
Hessisches Landesmuseum, Darmstadt—see Darmstadt/Hessisches
The Hertz Corp.
Het Museum van Hedendaagse Kunst te Gent, Ghent—*see* Ghent/Contemporary
Hickory, N.C. Hickory Museum of Art, Hickory, N.C.
High Museum of Art, Atlanta, Ga.
Hiroshima/Contemporary. Hiroshima City Museum of Contemporary Art
Hiroshima State Museum of Art, Japan
Hirshhorn. The Hirshhorn Museum and Sculpture Garden, Smithsonian Institution, Washington, D.C.
Historical Society of Montana, Helena
Hoffman-La Roche Inc.
Hofstra U.
Hokkaido Prefectural Museum of Modern Art—*see* Sapporo
Hollins College
Holyoke Public Library, Holyoke, Mass.
Home Savings and Loan Association, Los Angeles, Calif.
Honolulu Academy of Arts, Honolulu, Hawaii; Honolulu Academy School
Honolulu Advertiser, Honolulu, Hawaii
Honolulu/Contemporary
Hood Museum—*see* Dartmouth College
Hope College, Holland, Mich.
Hopkins Art Center—*see* Dartmouth College
Hospital Corp. of America
Hotel Corp. of America, NYC
Housatonic Community College, Stratford, Conn.
Houston/Contemporary. Contemporary Arts Museum, Houston, Tex.
Houston/MFA. Museum of Fine Arts, Houston, Tex.; Houston Museum School
U. of Houston
Howard College
Howard U.
J.L. Hudson Co.
Hudson River Museum, Yonkers, N.Y.
Humlebaek/Louisiana. Louisiana Museum of Art, Humlebaek, Denmark
Hunt Foods & Industries

Hunter College of the City U. of New York
Hunter Museum of Art—*see* Chattanooga/Hunter
Huntington, N.Y./Heckscher. Heckscher Museum, Huntington, N.Y.
Huntington, W. Va. Huntington Galleries, Huntington, W. Va.
Huntsville Museum of Art, Huntsville, Ala.
E.F. Hutton
Hyatt Regency Hotels
Hyde Collection, Glens Falls, N.Y.

I

IBM. International Business Machines Corp.
ICA, Boston. Institute of Contemporary Art, Boston, Mass.
ICA, Los Angeles. Institute of Contemporary Art, Los Angeles
ICA, U. of Pennsylvania. Institute of Contemporary Art, U. of Pennsylvania, Philadelphia
ICA, Washington, D.C. Institute of Contemporary Arts, Washington, D.C.
ICP. International Center of Photography, NYC
IEF. International Exhibitions Foundation, Washington, D.C.
IIE. International Institute of Education
ILGWU. International Ladies' Garment Workers Union
ITT Center, Chicago
College of Idaho
Idemitsu Museum, Tokyo, Japan
Illinois Bell Telephone Company
Illinois College, Jacksonville, Ill.
Illinois State Museum of Natural History and Art—*see* Springfield, Ill./State
Illinois State Normal U.
U. of Illinois (incl. Krannert Art Museum)
Illinois Wesleyan U.
Immaculate Heart College, Los Angeles
Imperial Household, Tokyo, Japan
Indian Head Mills, Inc.
Indiana National Bank, Indianapolis, Ind.
Indiana State U. (formerly Indiana State College), Terre Haute
Indiana (Pa.) State Teachers College
Indiana U.

Indianapolis Museum of Art, Indianapolis, Ind.

Indianapolis/Herron. John Herron Art Institute, Indianapolis, Ind.

Industrial Electronics Engineers, Inc.

Industrial Museum, Barcelona, Spain

Inland Steel Co.

Inmont Corp.

Institut für Moderne Kunst, Nurnberg, Germany

Institute of Contemporary Art—see ICA, various cities

Institute for Policy Studies, Washington, D.C.

Instituto de Cultura, San Juan, Puerto Rico

Instituto Wilfredo Lam, Havana, Cuba

Interchemical Corp.

Interchurch Center, NYC

International Center of Photography—see ICP

International Cultural Center, Antwerp—see Antwerp/ICC

International Exhibitions Foundation—see IEF

International Institute for Aesthetic Research, Turin, Italy

International Institute of Education—see IIE

International Minerals & Chemicals Corp.

International Monetary Fund, Washington, D.C.

International Nickel Co.

International Museum of Photography at George Eastman House, Rochester, N.Y.

Iowa Arts Council, Des Moines

Iowa State Teachers College

Iowa State U. of Science and Technology

U. of Iowa

Iowa Wesleyan College

The Irvine Co., Irvine, Ca.

Israel Museum, Jerusalem (incl. Bezalel National Art Museum)

Ithaca College

Ivest-Wellington Corp.

J

Jackson/MMA. Mississippi Museum of Art, Jackson

Jacksonville/AM. Jacksonville Art Museum, Jacksonville, Fla.

Jacksonville/Cummer. Cummer Gallery of Art, Jacksonville, Fla.

Jacksonville U.

Jamestown/Prendergast. James Prendergast Free Library Art Gallery, Jamestown, N.Y.

Japanese Craft Museum, Tokyo, Japan

Jay Mfg. Co.

Jersey City Museum, Jersey City, N.J.

Jerusalem/Modern—see Israel Museum

Jerusalem/National—see Israel Museum

Jesus College of Cambridge U., Cambridge, England

Jewish Museum, NYC

Jewish Theological Seminary of America

Johannesburg/Municipal. Municipal Art Gallery, Johannesburg, South Africa

John Hancock Mutual Life Insurance Co., NYC.

Johns Hopkins U.

Johnson College

Herbert F. Johnson Museum—see Cornell U.

Lyndon B. Johnson Library, Austin, Tex.

Johnson Publishing Co., Chicago, Ill.

S.C. Johnson & Son, Inc.—see NCFA

Johnson Wax Co.

J. Turner Jones, Inc.

Jones & Laughlin Steel Corp.

Joslyn Art Museum—see Omaha/Joslyn

James Joyce Museum, Dublin, Ireland

Julliard School, NYC

K

Kaiserslautern Museum, Kaiserslautern, Germany

Kalamazoo College

Kalamazoo/Institute. The Kalamazoo Institute of Arts, Kalamazoo, Mich. (incl. Kalamazoo Art Center)

Kamakura. Modern Art Museum of Kanagawa Prefecture, Kamakura, Japan

U. of Kansas

Kansas City/AI. Kansas City Art Institute and School of Design, Kansas City, Mo.

Kansas City/Contemporary Art Center

Kansas City/Nelson. Nelson-Atkins Art Gallery, Kansas City, Mo. (formerly William Rockhill Nelson Gallery of Art)

U. of Kansas City

Kansas State College
Karachi. Art Council of Pakistan, Karachi
Karamu House, Cleveland, Ohio
Karlsruhe. Staatliche Kunsthalle,
 Karlsruhe, Germany
Kassel. Stadtische Kunstsammlungen,
 Kassel, Germany
Kemper Securities Group, Long Grove, Ill.
Kemper Insurance Co.
John F. Kennedy Library, Cambridge,
 Mass.
Kent State U.
Kentucky Southern College, Louisville
U. of Kentucky
Kenyon College
Kestner-Museum, Hannover, Germany
 (see also Hannover/K-G)
Kingsborough Community College
Kitchener-Waterloo/AG. Kitchener Wa-
 terloo Art Gallery, Ontario, Canada
Kirkaldy Museum and Art Gallery,
 Kirkaldy, Scotland
Kirkland College, Clinton, N.Y.
Kitakyushu Museum, Kyushu, Japan
Knox College, Galesburg, Ill.
Kolnisher Kunstverein—see Co-
 logne/Kunstverein
Kofu/Yamanashi. Yamanashi Prefectural
 Museum of Art, Kofu, Japan
Krakow/National. National Museum,
 Krakow, Poland
Krannert Art Museum—see U. of Illinois
Krefeld/Haus Esters
Krefeld/Haus Lange. Museum Haus
 Lange Wilhelmshofallee, Krefeld, Ger-
 many
Krefeld/Kaiser Wilhelm. Kaiser Wilhelm
 Museum, Krefeld, Germany
Kresge Art Center—see Michigan State U.
Kresge Co.
Kulturministerium, Hannover, Germany
Kulturministerium Baden-Wurttemberg,
 Stuttgart, Germany
Kunsthalle Basel—see Basel/Kunsthalle
Kunstgewerbe Museum der Stadt—see Zu-
 rich/KS
Kunstkredit, Basel, Switzerland
Kunstverein in Hamburg—see Ham-
 burg/Kunstverein
Kunstverein Hannover—see Hanno-
 ver/Kunstverein
Kupferstichkabinett, Berlin, Germany
Kutztown State College

Kyoto. National Museum of Modern Art,
 Kyoto, Japan
U. of Kyoto

L

La France Art Institute, Philadelphia, Pa.
La Guardia Community College,
 Queens, N.Y.
Laguna Beach Museum of Art, Laguna
 Beach, Calif.
Laguna Gloria Art Museum, Austin, Tex.
La Jolla—see San Diego/Contemporary;
 formerly Museum of Contemporary
 Art, La Jolla, Calif.; also formerly Mu-
 seum of Art; also formerly Art Center
 in La Jolla
Lake Erie College, Painesville, Oh.
Lakeview Center for Arts and Science, Pe-
 oria, Ill.
The Lamont Art Gallery—see Exeter
Lane Foundation, Leominster, Mass.
Lannan Foundation, NYC/Palm Beach,
 Fla./Chicago
Lansing Sound Corp.
La Plata. Museo de La Plata, Argentina
H.E. Laufer Co.
Laumeier Sculpture Park, St. Louis, Mo.
Lausanne/Beaux-Arts. Musée Cantonal
 des Beaux-Arts, Lausanne, Switzerland
Lawrence College
Layton School of Art, Milwaukee, Wisc.
League of Nations, Geneva, Switzerland
Leeds/MAG, Municipal Art Gallery,
 Leeds
Lehigh U.
Lehman Bros., NYC—see Shearson Leh-
 man Bros., Inc.
Leicester Education Committee, London
Leipzig Museum der Bildenden Kunste,
 Leipzig, Germany
Lembke Construction Co.
Lenox School, Lenox, Mass.
Leverkusen. Stadtisches Museum,
 Leverkusen, Germany
Levin Townsend Computer Corp.
Lewis and Clark College, Portland, Ore.
Lewiston (Me.) Public Library
Liaison Films, Inc.
Library of Congress, Washington, D.C.
Liège. Musée des Beaux-Arts, Liège, Belgium

Liège/Moderne. Musée d'art moderne de la ville de Liège, Belgium

Lille. Palais des Beaux-Arts, Lille, France

Eli Lilly & Co.

Lima, Peru. Instituto de Arte Contemporaneo, Lima, Peru

Abraham Lincoln High School, Brooklyn, N.Y.

Lincoln, Mass./De Cordova. De Cordova and Dana Museum, Lincoln, Mass.

Lincoln Center for the Performing Arts, NYC

Lincoln Life Insurance Co.

Lindenwood College

Linz. Oberösterreichisches Landesmuseum, Linz, Austria

Linz/Neue. Neue Galerie der Stadt Linz, Linz, Austria

Lipschultz Foundation

Lisbon/Gulbenkian. Gulbenkian Foundation, Lisbon, Portugal

Little Rock/MFA. Museum of Fine Arts, Little Rock, Ark.

Lifton Industries

Liverpool/Walker. Walker Art Gallery, Liverpool, England

Lloyds Bank, London

Loch Haven Art Center, Orlando, Fla. (see also Orlando)

Lodz. Museum Sztuki w Lodzi, Lodz, Poland

London Film Society

Long Beach/MA. Long Beach Museum of Art, Long Beach, Calif.

Long Beach State College

Long Island U.

Longview Foundation

Longwood College

Los Angeles County Fair Association, Los Angeles

Los Angeles/County MA. Los Angeles County Museum of Art, Los Angeles

Los Angeles/MOCA. Museum of Contemporary Art, Los Angeles

Los Angeles Public Library, Los Angeles

Los Angeles State College, Los Angeles

Lotus Club, NYC

Louisiana Museum of Art—see Humlebaek/Louisiana

Louisville. Kentucky Center for the Arts, Louisville, Ky.

Louisville/Speed. J.B. Speed Art Museum, Louisville, Ky.

Louisiana State U. and Agricultural and Mechanical College

U. of Louisville

The Joe and Emily Lowe Art Gallery—see U. of Miami

The Joe and Emily Lowe Foundation, NYC

Lucerne. Kunstmuseum Luzern, Lucerne, Switzerland

Ludwigshafen am Rhein. Wilhelm-Hack Museum, Ludwigshafen, Germany

Lugano. Museo Civico di Belle Arti, Lugano, Switzerland

Lummis Tower Building, Houston, Tex.

Luther College

Lynchburg Art Gallery— see Randolph-Macon Women's College

Lyon/Beaux-Arts, Musée des Beaux-Arts, Lyon, France

Lyon/St. Pierre, Musée St. Pierre, Lyon, France

Lytton Savings and Loan Association

M

MIT. Massachusetts Institute of Technology, Cambridge

MMA. The Metropolitan Museum of Art, NYC

MOMA. The Museum of Modern Art, NYC; MOMA School

Maastricht. Bonnefantemuseum, Maastricht, Netherlands

Norman MacKenzie Art Gallery—see Regina/MacKenzie

MacMurray College

MacNider Museum, Mason City, Iowa

Macomb County Community College, Warren, Mich.

R.H. Macy & Co.

Madison Art Center, Madison, Wisc.

Madison College

Madison Square Garden, NYC

James Madison U.

Madrid/Nacional. Museo Nacional de Arte Contemporaneo, Madrid

Madrid/Reina Sofia, Centro Reina Sofia, Madrid

Maeght—see Fondation Maeght

Maine State Museum—see Augusta, Me./State

U. of Maine
Mainz/Mittelrhenisches. Mittelrhenisches
 Landesmuseum, Mainz, Germany
Malmo/Rooseum, Malmo, Sweden
Malmo Museum, Malmo, Sweden
Manchester, England. City of Manchester
 Art Galleries, Manchester, England
Manchester/Whitworth. Whitworth Art
 Gallery, Manchester, England
Manila. Ateneo de Manila, Philippines
Mannheim. Stadtische Kunsthalle, Mann-
 heim, Germany
Mansfield State College
Mansion House Project, St. Louis, Mo.
Manufacturers Hanover Trust Co.
Manufacturers and Traders Trust Co.,
 Buffalo, N.Y.
Marbach Galerie, Berne, Switzerland
Marin Art and Garden Center, Ross, Calif.
Marine Midland Bank and Trust Co.
Marist College, Poughkeepsie, N.Y.
Mark Twain Bankshares, St. Louis, Mo.
Marquette U.
Marseilles/Cantini. Musée Cantini, Mar-
 seilles, France
Marshall Field & Co.
Marshall U.
Martha Washington U.
Maryland Institute, Baltimore; Maryland
 Institute School of Art
U. of Maryland
Mary Washington College of the U. of
 Virginia
U. of Massachusetts
Massillon Museum, Massillon, Ohio
Mattatuck Museum, Waterbury, Conn.
McCormick Place-on-the-Lake, Chicago,
 Ill.
McCann-Erickson, Inc., NYC
McCrory Corp.
McDonald & Company
McDonnell & Co., Inc.
Marion Koogler McNay Art Institute—see
 San Antonio/McNay
Martin-Gropius-Bau, Berlin
Mead Corporation
Meadows Museum, Dallas—see Southern
 Methodist U.
Mechanics National Bank, Worcester, Mass.
Melbourne/National. National Gallery of
 Victoria, Melbourne, Australia
Mellon Bank, Pittsburgh
Memphis/Brooks. Brooks Memorial Art
 Gallery, Memphis, Tenn.

Memphis State U.
Mendoza. Museo de Historia Natural,
 Mendoza, Argentina
Mercersburg Academy, Mercersburg, Pa.
Mestrovic Gallery, Split, Yugoslavia
Mestrovic Museum, Zagreb, Yugoslavia
Metalcraft Corp.
Meta-Mold Aluminum Co.
Metropolitan Life Insurance Company,
 NYC
Metropolitan Museum and Art Center,
 Coral Gables, Fla.
The Metropolitan Museum of Art,
 NYC—see MMA
Mexico City/Contemporaneo. Centro
 Cultural de Arte Contemporaneo,
 Mexico City, Mexico
Mexico City/Moderno. Museo de Arte
 Moderno, Mexico City, Mexico
Mexico City/Nacional—see Mexico
 City/Moderno
Mexico City/Tamayo. Museo de Arte
 Contemporaneo Rufino Tamayo,
 Mexico City, Mexico
Miami/Bass. Bass Museum of Art,
 Miami, Fla.
Miami-Dade Junior College
Miami/Modern. Miami Museum of Mod-
 ern Art, Miami, Fla.
U. of Miami (incl. The Joe and Emily
 Lowe Art Gallery)
Miami U., Oxford, Ohio
James A. Michener Foundation—see U. of
 Texas
Michigan Bell, Inc.
Michigan Consolidated Gas Co.
Michigan State U. (incl. Kresge Art Cen-
 ter)
U. of Michigan
Middlebury College, Middlebury, Vt.
Middle Tennessee State U.
Middlesborough Art Gallery, York, En-
 gland
Milan. Galleria Civica d'Arte Moderna,
 Milan, Italy
Miles College, Birmingham, Ala.
Miles Laboratories Inc.
Miles Metal Corp., NYC
The Miller Co.
Millersville State College, Pa.
Millikin U.
Mills College
Mills College of Education
Milton Academy, Milton, Mass.

Milwaukee Art Center—*see* Milwaukee/AM

Milwaukee/AM. Milwaukee Art Museum, Milwaukee, Wisc.; formerly Milwaukee Art Center

Milwaukee-Downer College

Milwaukee Journal

Minneapolis College of Art & Design, Minneapolis, Minn.

Minneapolis/Institute. Minneapolis Institute of Arts, Minneapolis, Minn.; Minneapolis Institute School

Minnesota/MA. Minnesota Museum of Art, St. Paul

U. of Minnesota (incl. Tweed Gallery, Duluth)

Mint Museum of Art—*see* Charlotte/Mint

Mississippi Museum of Art—*see* Jackson/MMA

Missoula/MA. Missoula Museum of the Arts, Missoula, Mont.

U. of Missouri

Mitsubishi Collection

Mitsui Bank of Japan

Mobil Oil Co.

Mobile/FAMS. Fine Arts Museum of the South, Mobile, Ala.

Moderna Museet—*see* Stockholm/National

Monchengladbach. Stadtisches Museum, Monchengladbach, Germany

Mons. Musée des Beaux-Arts, Mons, Belgium

Montana State College

Montana State U.

U. of Montana

Montclair/AM. Montclair Art Museum, Montclair, N.J.

Montclair State College

Montevideo/Municipal. Museo Municipal de Bellas Artes, Montevideo, Uruguay

Montgomery Museum of Fine Art, Montgomery, Ala.

Montpelier/Wood. Thomas W. Wood Art Gallery, Montpelier, Vt.

Montréal/Contemporain. Musée d'Art Contemporain, Montréal, Canada

Montréal/MFA. Montréal Museum of Fine Arts, Montréal, Canada

Montréal Trust Co.

Moody's Investment Service, Inc.

Moorpark College, Moorpark, Calif.

Moravian College, Bethlehem, Pa.

The Morgan Library. The Pierpont Morgan Library, NYC

Morgan State College

Moriarty Brothers, Manchester, Conn.

Morristown/Junior. Morris Junior Museum, Morristown, N.J.

Moscow/Western. Museum of Western Art, Moscow, USSR

Mount Holyoke College

Mt. Vernon High School, Mt. Vernon, Wash.

Muckenthaler Cultural Center, Fullerton, Calif.

Muhlenberg College

Mulvane Art Museum—*see* Washburn U. of Topeka

Munich/Lenbachhaus. Stadtische Galerie im Lenbachhaus, Munich, Germany

Munich/Modern. Modern Art Museum, Munich, Germany

Munich/NP. Neue Pinakotek, Munich, Germany

Munich/SG. Stadtische Galerie, Munich, Germany

Munich/State. Munchner Stadtmuseum, Munich, Germany

Municipal U. of Omaha

Munson-Williams-Proctor Institute—*see* Utica

Munster. Landesmuseum für Kunst und Kulturgeschichte, Munster, Germany

Munster/WK. Westfalischer Kunstverein, Munster, Germany

Murray State U., Murray, Ky.

Musée d'Art, Toulon—*see* Toulon

Musée d'Art Contemporain, Bordeaux—*see* Bordeaux/Contemporain

Musée d'Art Contemporain, Montreal—*see* Montreal/Contemporain

Musée des Arts Décoratifs, Paris, France

Musée des Beaux Arts, Nice—*see* Nice

Musée Cantini—*see* Marseilles/Cantini

Musée Cantonal des Beaux-Arts, Lausanne, Switzerland

Musée-Château d'Annecy, Annecy, France

Musée de la Ville de Paris

Musée Guimet, Paris, France

Musée du Havre, Le Havre, France (*see also* Le Havre/Municipal)

Musée du Jeu de Paume, Paris, France

Musée Municipal, Brest, France

Musée de Quebec—*see* Quebec

Musée de Verviers, Verviers, Belgium

Musée du Vin, Pauillac (Gironde), France
Museen der Stadt Köln—*see* Cologne/Stadt
Museo de Arte Contemporaneo, Caracas—*see* Caracas/Contemporaneo
Museo de Arte Contemporaneo "La Tertulia," Cali, Colombia
Museo de Arte Contemporaneo Rufino Tamayo—*see* Mexico City/Contemporaneo
Museo de Arte Moderno, Barcelona—*see* Barcelona
Museo de Arte Moderno, Bogota, Colombia
Museo de Arte Moderno, Buenos Aires—*see* Buenos Aires/Moderno
Museo de Arte Moderno, Mexico City—*see* Mexico City/Moderno
Museo Dr. Genaro Perez, Cordoba, Argentina
Museo Emilio A. Caraffa, Cordoba, Argentina
Museo Juan B. Castagnino, Rosario, Argentina
Museo Municipal de Bellas Artes, Montevideo—*see* Montevideo/Municipal
Museo Nacional de Bellas Artes, Buenos Aires—*see* Argentina/Nacional
Museo Nacional de Bellas Artes, Montevideo—*see* Uruguay/Nacional
Museo Nacional de Historia, Mexico City, Mexico
Museo Provincial de Bellas Artes, Bilbao, Spain
Museo Provincial de Bellas Artes, Vitoria, Spain
Museo Rosario, Santa Fe, Argentina
Museu de Arte Contemporanea, São Paolo—*see* São Paolo/Contemporanea
Museum of African American Art, Santa Monica—*see* Santa Monica/MAAA
Museum of the City of New York
Museum of Contemporary Art, La Jolla—*see* San Diego/Contemporary
Museum of Contemporary Art, Los Angeles—*see* Los Angeles/MOCA
Museum of Contemporary Art, Utrecht—*see* Utrecht/Contemporary
Museum of Contemporary Crafts, NYC—*see* American Craft Museum
Museum Klingspor, Offenbach—*see* Offenbach/Klingspor
Museum of Living Art—*see* PMA
Museum Ludwig, Cologne—*see* Cologne/Ludwig

Museum of Military History, Washington, D.C.
Museum of Modern Art, Haifa—*see* Haifa
Museum of Modern Art, NYC—*see* MOMA
Museum of Modern Art, Saitama—*see* Saitama/Modern
Museum of Modern Art, Skopje—*see* Skopje/Modern
Museum für Moderne Kunst, Frankfurt—*see* Frankfurt/Moderne
Museum für Moderner Kunst, Vienna—*see* Vienna/Moderner
Museum of New Mexico Art Gallery—*see* Santa Fe, N.M.
Museum Schloss Marburg, Leverkusen, Germany
Museum of Science and Industry, Chicago, Ill.
Museum der Stadt Leoben, Leoben, Austria
Museum des 20. Jahrhunderts, Vienna, Austria
Muskegon/Hackley. Hackley Art Center, Muskegon, Mich.
Mutual Life Insurance Building, Chicago, Ill.

N

NAACP. National Association for the Advancement of Colored People
NAD. The National Academy of Design, NYC
NCFA. National Collection of Fine Arts, Washington, D.C. (*see also* NMAA)
NECCA. New England Center for Contemporary Art, Brooklyn, Ct.
NIAL. National Institute of Arts and Letters, NYC
NMAA. National Museum of American Art, Washington, D.C.
NMWA. National Museum of Women in the Arts, Washington, D.C.
NPG. National Portrait Gallery, Washington, D.C.
NYNEX
NYPL. The New York Public Library, NYC
NYU. New York University (incl. Grey Art Gallery)
Nabisco Corp.

Nagaoka City Hall, Nagaoka, Japan

Nagaoka, Japan. Museum of Contemporary Art, Nagaoka, Japan

Nagoya. Nagoya City Art Museum.

Nantes. Musée des Beaux-Arts, Nantes

Nantucket. Artists' Association of Nantucket, Mass.

The Naropa Institute, Boulder, Col.

Nashville. Tennessee Fine Arts Center, Nashville, Tenn.

Nassau County Museum of Fine Art, Syosset, N.Y.

The National Academy of Design—see NAD

National Academy of Sciences, Washington, D.C.

National Air and Space Museum, Washington, D.C.

National Arts Foundation, NYC

National Bank of Des Moines

National Economics Research Association

National Gallery of Canada—see Ottawa/National

National Gallery, Dublin—see Dublin/National

National Gallery, Reykjavik—see Reykjavik

National Gallery of Scotland—see Edinburgh/National

National Gallery of Art, Washington, D.C.

National Institute of Arts and Letters—see NIAL

National Life Insurance Co.

National Museum, Athens—see Greece/National

National Museum, Jerusalem—see Israel Museum

National Museum, Osaka—see Osaka/National

National Museum, Sofia—see Sofia National Museum

National Museum of American Art, Washington, D.C.—see NMAA

National Museum of Wales, Cardiff, Wales

National Museum of Western Art, Tokyo, Japan

National Museum of Women in the Arts—see NMWA

National Orange Show, San Bernardino, Calif.

National Portrait Gallery—see NPG

National U.—see George Washington U.

Nebraska State Teachers College

U. of Nebraska (incl. Sheldon Memorial Art Gallery)

Needham Harper & Steers Inc.

Neenah/Bergstrom. John Nelson Bergstrom Art Center and Museum, Neenah, Wisc.

Neiman-Marcus Co.

William Rockhill Nelson Gallery of Art—see Kansas City/Nelson

Nelson-Atkins Art Gallery—see Kansas City/Nelson

Netherlands Film Museum, Amsterdam, Holland

Neue Galerie, Essen—see Essen/NG

Neue Galerie-Sammlung Ludwig, Aachen—see Aachen/Ludwig

Neue Pinakotek, Munich—see Munich/NP

U. of Nevada

Newark Museum, Newark, N.J.

Newark Public Library, Newark, N.J.

Newberry Library, Chicago, Ill.

New Britain/American. New Britain Museum of American Art, New Britain, Conn.

New Brunswick Museum—see St. John, N.B.

Newcastle-upon-Tyne. Laing Art Gallery, Newcastle-upon-Tyne, England

New College, Sarasota, Fla.

New England Merchants National Bank, Boston

U. of New Hampshire (incl. Paul Creative Arts Center)

The New Harmony Gallery of Contemporary Art, New Harmony, Ind.

New Haven Public Library, New Haven, Conn.

New Jersey State Cultural Center, Trenton, N.J.

New Jersey State Department of Transportation

New Jersey State Library

New Jersey State Museum—see Trenton/State

New London. Lyman Allyn Museum, New London, Conn.

New Mexico State U.

U. of New Mexico (incl. University Art Museum, Albuquerque)

New Museum of Contemporary Art, NYC

New Orleans/Contemporary. New Orleans Contemporary Art Center, New Orleans, La.

New Orleans/Delgado. Isaac Delgado
Museum of Art, New Orleans, La.
New Orleans Museum of Art, New Orleans, La.
New Paltz/SUNY. State University of
New York at New Paltz
Newport Harbor Art Museum, Newport
Beach, Calif.
New School for Social Research, NYC
Newsweek Magazine
New Trier High School, Winnetka, Ill.
The New York Bank for Savings, NYC
New York Coliseum, NYC
New York Cultural Center (formerly Gallery of Modern Art, NYC)
New York Hilton Hotel
New York Hospital, NYC
The New York Public Library—see NYPL
New York School of Interior Design
New York State Art Commission, Albany
New York, State University of—see individual campuses
New York Stock Exchange
The New York Times
New York University—see NYU
Niagara U., Niagara, N.Y.
Nice. Musée des Beaux Arts, Nice, France
Nice/Contemporain. Musée d'art Moderne et d'art Contemporain de la Ville
de Nice
Niigata Museum, Japan
Norfolk. Norfolk Museum of Arts and
Sciences, Norfolk, Va.
Norfolk/Chrysler. Walter P. Chrysler Museum of Art, Norfolk, Va.
North Carolina Museum of Art—see Raleigh/NCMA
North Carolina National Bank
North Carolina/State. North Carolina
State Museum, Raleigh (see also Raleigh/NCMA)
North Carolina State U.
U. of North Carolina (incl.
Weatherspoon Art Gallery of The
Women's College at Greensboro)
North Central Bronx Hospital, Bronx,
N.Y.
U. of North Dakota
Northeast Missouri State Teachers College
Northern Illinois U., De Kalb
U. of Northern Iowa
Northern Trust Co., Chicago, Ill.
Northland College

North Shore State Bank, Milwaukee,
Wisc.
North Texas State U.
Northwest Missouri State College
Northwestern National Life Insurance Co.
Northwestern U.
Northwood Institute, Dallas, Tex.
Norton Gallery and School of Art—see
West Palm/Norton
Norton Simon Museum, Pasadena, Calif.
U. of Notre Dame
Nurnberg. Stadtische Kunstsammlung,
Nurnberg, Germany

O

OBD—see Basler Denkmalpflege
Oak Cliff Savings and Loan, Dallas, Tex.
Oakland Museum, Oakland, Calif.; formerly Oakland/AM, Oakland Art Museum
Oakland Public Library, Oakland, Calif.
Oberlin College (incl. Allen Memorial
Art Museum)
Offenbach/Klingspor. Museum
Klingspor, Offenbach, Germany
Offentliche Kunstsammlung, Basel—see
Basel/Offentliche
Ogunquit. Museum of Art of Ogunquit,
Me.
The Ohio Company, Columbus, Ohio
The Ohio State U.
Ohio U.
Ohio Wesleyan U.
Oklahoma. Oklahoma Art Center, Oklahoma City, Ok.
Oklahoma State Art Collection
U. of Oklahoma
Oldenburg. Oldenburger Stadtmuseum,
Oldenburg, Germany
Olivet College
The Olsen Foundation Inc., New Haven,
Conn.
Olympia/Washington. State Capital Museum, Olympia, Wash.
Olympic Sculpture Park, Seoul
Omaha/Joslyn. Joslyn Art Museum,
Omaha, Neb.
The 180 Beacon Collection of Contemporary Art, Boston, Mass.
Oran. Musée Demaeght, Oran, Algiers
Orange Coast College, Costa Mesa, Calif.

Oregon State U.
U. of Oregon
Orlando. Central Florida Museum, Orlando, Fla. (see also Loch Haven Art Center)
Osaka/Municipal. Osaka Municipal Art Museum, Osaka, Japan
Osaka/National. National Museum of Art, Osaka, Japan
Oslo/National. Nasjonalgalleriet, Oslo, Norway
Ostende/Stedelijk. Stedelijk Museum, Ostende, Belgium
Oswego/SUNY. State University of New York at Oswego
Otis Art Institute, Los Angeles, Calif.
Ottawa/National. National Gallery of Canada, Ottawa
Otterbein College
Outre-Mer—see Paris/Outre-Mer
Owens-Corning Fiberglas Corp.
Oxford. U. of Oxford, England
Oxford/MOMA. Museum of Modern Art, Oxford, England

P

PAFA. The Pennsylvania Academy of the Fine Arts, Philadelphia
PCA. Print Council of America, NYC
PMA. Philadelphia Museum of Art, Philadelphia, Pa. (incl. Museum of Living Art, Academy of Natural Sciences, and Rodin Museum)
P.S. 144, NYC
U. of the Pacific
Pacific Bell, Los Angeles
Pacific Indemnity Co.
Paine Webber Group, NYC
Palais des Beaux-Arts, Brussels—see Brussels/Beaux-Arts
Palm Beach Company, NYC
Palm Springs Desert Museum, Palm Springs, Calif.
Palomar College, San Marcos, Calif.
Palos Verdes Art Gallery, Palos Verdes, Calif.
Palos Verdes Community Arts Association
Panama City/Contemporaneo. Museo de Arte Contemporaneo, Panama City, Panama.

Parc del Clot, Barcelona
Paris/Beaubourg. Centre National d'Art et de Culture Georges Pompidou, Centre Beaubourg, Paris
Paris/Moderne. Musée d'Art Moderne de la Ville de Paris, France (see also France/National)
Paris/Outre-Mer. Musée de la France d'Outre-Mer, Paris
Park College
Parkersburg Art Center, Parkersburg, W.Va.
The Parrish Museum—see Southampton/Parrish
Pasadena/AM—see Norton Simon Museum
Pasadena Museum School
Paul Creative Arts Center—see U. of New Hampshire
Peabody College, Memphis, Tenn.
Peabody Institute of the City of Baltimore
Peabody Museum, Salem, Mass.
Pecos Art Museum, Marfa, Tex.
Pendleton High School, Pendleton, Ore.
William Penn Memorial Museum—see Harrisburg, Pa./State Museum
J.C. Penney Corp.
The Pennsylvania Academy of the Fine Arts—see PAFA
The Pennsylvania State U.
U. of Pennsylvania
Pensacola Art Center, Pensacola, Fla.
The Pentagon, Washington, D.C.
Pepperdine U.
Pepsico, Purchase, N.Y.
Pepsi-Cola Co.
Philadelphia Art Alliance, Philadelphia, Pa.
Philadelphia College of Art (formerly Philadelphia Museum School)
The Philadelphia Museum of Art—see PMA
Philadelphia Zoological Gardens
Philbrook Art Center—see Tulsa/Philbrook
Philip Morris Collection, NYC
Phillipines/MA. Phillipines Museum of Art, Manila
Phillips. The Phillips Gallery, Washington, D.C.; The Phillips Gallery School
Phillips Academy, Addison Gallery of American Art—see Andover/Phillips
Phillips Exeter Academy, The Lamont Art Gallery—see Exeter

Phoenix Art Museum, Phoenix, Az.
Pillsbury Co., Minneapolis, Minn.
Pinacotheca Museum, Osaka, Japan
Pinacothèque National Museum, Athens, Greece—*see* Greece/National
Pinakothiki, Athens, Greece—*see* Greece/National
Pioneer Aerodynamic Systems
Pittsfield/Berkshire. Berkshire Atheneum, Pittsfield, Mass.
Pitzer College
Plains Art Museum, Moorhead, Minn.
Plattsburgh/SUNY. State University of New York at Plattsburgh
Playboy Collections
Polaroid Corp., Cambridge, Mass.
Pomona College
Ponce Museum of Art, Ponce, Puerto Rico
Poole Technical College, Dorset, England
Port Authority of New York & New Jersey
Portsmouth Priory, Portsmouth, N.H.
Port Washington, L.I. Library Gallery, Port Washington, Long Island, N.Y.
Portland, Me./MA. Portland Museum of Art, Portland, Me.
Portland, Ore./AM. Portland Art Museum, Portland, Ore.; Portland (Ore.) Museum School
Portland (Ore.) State College
Potsdam/SUNY. State University of New York at Potsdam
Power Gallery of Contemporary Art—*see* U. of Sydney
Poznan/National. National Gallery, Poznan, Poland
Prague/National. Norodni (National) Galerie, Prague, Czechoslovakia
Pratt Institute
Premark Corp., Chicago
Prendergast Free Library Art Gallery—*see* Jamestown/Prendergast
Prentice-Hall Inc.
Princeton Print Club, Princeton, N.J.
Princeton U.
The Print Club, Philadelphia, Pa.
Print Club of Rochester, N.Y.
Print Council of America—*see* PCA
Pro-Civitate-Christiana, Assisi, Italy
Providence College, Providence, R.I.
Provident National Bank
Provincetown/Chrysler—*see* Norfolk/Chrysler
Provincetown Museum, Provincetown, Mass.

Prudential Insurance Co. of America, Newark, N.J.
Prudential Lines Inc.
Publishers Printing Co.
U. of Puerto Rico
Purchase/SUNY. State University of New York at Purchase (incl. Neuberger Museum)
Purdue U.
The Pure Oil Co.

Q

Quaker Oats Co.
Quaker Ridge School, Scarsdale, N.Y.
Quebec. Musée de Quebec, Canada
Queens Museum of Art, Flushing, N.Y.
Queensborough Community College, Queens, N.Y.
Queensborough Museum of Fine Art, Kentucky
Queens College of the City U. of New York
Queens U., Kingston, Ontario, Canada
Quimica Argentina, Buenos Aires, Argentina
Quimper. Centre d'Art Contemporain de Quimper, Quimper, France
Quito/Modern, Quito, Ecuador

R

RAC. Richmond Art Center, Richmond, Calif.
RISD. Rhode Island School of Design
Radcliffe College, Cambridge, Mass.
Radford U., Radford, Va.
Radio Corporation of America
Rahr-West Museum, Manitowoc, Wisc.
Raleigh/NCMA. North Carolina Museum of Art, Raleigh (*see also* North Carolina/State)
Randolph-Macon College
Randolph-Macon Women's College (incl. Lynchburg Art Gallery)
Ration Mfg. Co.
Raycom Industries
Ray-o-Vac Corp.
Reader's Digest

Reading/Public. Reading Public Museum and Art Gallery, Reading, Pa.

Recklinghausen. Stadtische Kunsthalle, Recklinghausen, Germany

Red Deer College, Red Deer, Alberta, Canada

U. of the Redlands

Red Wing. Interstate Clinic, Red Wing, Minn.

Reed College

Refco Collection, Chicago

Regina/MacKenzie. Norman MacKenzie Art Gallery, Regina, Canada

Remington-Rand Corp.

Renaissance Society—see U. of Chicago

Renault & Cie, Paris, France

Rennes. Musée des Beaux-Arts of the Musée de Rennes, France

Rennes/Kerguehennec. Centre d'Art Contemporain du Domaine de Kerguehennec, Rennes, France

Rensselaer Polytechnic Institute

Revere Copper & Brass, Inc.

Revlon Inc.

Reykjavik. National Gallery, Reykjavik, Iceland

Reynolda House, Winston-Salem, N.C.

R. J. Reynolds Industries

Reynolds Metals Co.

Rhode Island School of Design—see RISD

U. of Rhode Island

Rice U., Houston, Tex.

Rich-Lan Corp.

Richmond (Calif.) Art Center—see RAC

U. of Richmond (incl. Marsh Gallery)

Rider College, Trenton, N.J.

Ridgefield/Aldrich. Larry Aldrich Museum of Contemporary Art, Ridgefield, Conn.

Rijksmuseum Amsterdam, Holland

Rijksmuseum Kröller-Müller, Otterlo, Holland

Ringling. John and Mable Ringling Museum of Art, Sarasota, Fla.; Ringling School of Art

Rio Cuarto. Museo Municipal de Bellas Artes, Rio Cuarto, Argentina

Rio Hondo College, Whittier, Calif.

Rio de Janeiro Museu de Arte Moderna, Rio de Janeiro, Brazil

Ripon College

Riverside Museum, NYC—see Brandeis U.

Roanoke Fine Arts Center, Roanoke, Va.

Sara Roby Foundation, NYC

Rochester Institute of Technology, Rochester, N.Y.

U. of Rochester (incl. Rochester Memorial Art Gallery)

Rockefeller Brothers Fund, NYC

Rockefeller Center, NYC

Rockefeller Institute—see Rockefeller U.

Rockefeller U., NYC

Rockford/Burpee. Harry and Della Burpee Gallery, Rockford, Ill.

Rockland/Farnsworth. William A. Farnsworth Library and Art Museum, Rockland, Me.

Rock River (Wyo.) High School

Rodin Museum, Philadelphia—see PMA

Nicholas Roerich Museum, NYC

Will Rogers Shrine, Colorado Springs, Col.

Rome/Nazionale. Galleria Nazionale d'Arte Moderna, Rome, Italy

Rome/Vatican. Vatican Collection, Rome, Italy

U. of Rome, Italy

Roosevelt U., Chicago

Edward Root Collection—see Utica

Rose Art Museum—see Brandeis U.

Rosenthal China Co.

Rosenwald Collection—see National Gallery of Art, Washington, D.C.

Roswell Museum and Art Center, Roswell, N.M.

Rotterdam. Museum Boymans-van Beuningen, Rotterdam, Holland

Rowland Institute for Science, Cambridge, Mass.

Rouen. Musée des Beaux-Arts et de Céramique, Rouen, France

Royal College of Art, London

Rumsey Hall School, Washington, Conn.

Russell Sage College

Rutgers U.

Rybak. Rybak Art Museum, Bat Yam, Israel

S

SAGA. The Society of American Graphic Artists, NYC.

SECCA. Southeastern Center for Contemporary Art, Winston-Salem, N.C.

SFAI. San Francisco Art Institute, San Francisco, Calif.

SFMA. San Francisco Museum of Modern Art, San Francisco, Calif.; formerly San Francisco Museum of Art
SFPL. San Francisco Public Library, San Francisco, Calif.
SIT. Stevens Institute of Technology, Hoboken, N.J.
SRGM. The Solomon R. Guggenheim Museum, NYC
Saarlandmuseum, Saarbrucken, Germany
Sacramento. Art Museum of the City of Sacramento, Calif.
Sacramento/Crocker. E.B. Crocker Art Gallery, Sacramento, Calif.
Sacramento State U. (formerly Sacramento State College)
Sacred Heart Seminary, Detroit, Mich.
Safad. Glicenstein Museum, Safad, Israel
Safeco Building
Saginaw Art Museum, Saginaw, Mich.
St. Albans School, Washington, D.C.
St. Anthony's College of Oxford U., Oxford, England
St. Bernard's Church, Hazardville, Conn.
St. Cloud State College
St.-Etienne. Musée Municipal d'Art et d'Industrie, St.-Etienne, France
St. George's Episcopal Church, NYC
St. John, N.B. New Brunswick Museum, St. John, Canada
St. John's Abbey, Collegeville, Minn.
St. Joseph/Albrecht. Albrecht Gallery Museum of Art, St. Joseph, Mo.
St. Lawrence U. (incl. Griffiths Art Center)
St. Louis/City—see St. Louis/AM
St. Louis/AM. St. Louis Art Museum, St. Louis, Mo.; formerly St. Louis/City.
St. Mary's College, Indiana
St. Patrick's, Menasha, Wisc.
St. Paul Gallery and School of Art—see Minnesota/MA
St. Petersburg, Fla. Art Club of St. Petersburg, Fla.
U. of St. Thomas, Tex.
Saitama/Modern. Museum of Modern Art, Saitama, Japan
Sakura/Kawamura. Kawamura Memorial Museum of Art, Sakura, Japan
Salem (Ore.) Art Museum
Salk Institute, La Jolla, Calif.
Salt Lake City Public Library, Salt Lake City, Utah
Salzburg. Salzburger Museum Carolino Augusteum, Salzburg, Austria

San Antonio/MA. San Antonio Museum of Art, San Antonio, Tex.
San Antonio/McNay. Marion Koogler McNay Art Institute, San Antonio, Tex.
Carl Sandburg Memorial Library
San Diego. The Fine Arts Gallery of San Diego, Calif.; San Diego Fine Arts School
San Diego/Contemporary. San Diego Museum of Contemporary Art, La Jolla, Calif. (formerly La Jolla)
San Diego State U. (formerly San Diego State College)
San Fernando Valley State U.
San Francisco Art Association—see SFAI
San Francisco Municipal Art Commission, San Francisco, Calif.
San Francisco Museum of Modern Art— see SFMA
San Francisco Public Library—see SFPL
San Francisco State College
San Joaquin Pioneer Museum and Haggin Art Galleries—see Stockton
San Jose Library, San Jose, Calif.
San Jose Museum of Art, San Jose, Calif.
San Jose State U. (formerly San Jose State College)
San Juan. Museo de Bellas Artes, San Juan, Puerto Rico
San Salvador Museo Nacional, San Salvador, El Salvador
Santa Barbara/MA. Santa Barbara Museum of Art, Santa Barbara, Calif.; Santa Barbara Museum School
Santa Clara/Triton. Triton Museum, Santa Clara, Calif.
Santa Fe, N.M. Museum of New Mexico Art Gallery, Santa Fe, N.M.
Santa Monica/MAAA. Museum of African American Art, Santa Monica, Calif.
Santiago, Chile. Museo Nacional de Bellas Artes, Santiago, Chile
São Paolo. Museu de Arte Moderna, São Paolo, Brazil
São Paolo/Contemporanea. Museu de Arte Contemporanea, São Paolo, Brazil
Sapporo. Hokkaido Prefectural Museum of Modern Art, Sapporo, Japan
Sarah Lawrence College
U. of Saskatchewan, Saskatoon, Canada
Satakumman Museo, Pori, Finland
Savannah/Telfair. Telfair Academy of Arts and Sciences, Inc., Savannah, Ga.

Savings Bank Association of New York State
Schaeffer School of Design, San Francisco, Calif.
Schaffhausen. Hällen für neue Kunst, Schaffhausen, Switzerland
Scheidam/Stedelijk. Stedelijk Museum, Scheidam, Holland
Michael Schiavone & Sons Inc., North Haven, Conn.
The Schnectady Museum, Schnectady, N.Y.
J. Henry Schroder Banking Corp.
Schwebber Electronics
Scientific American Inc.
Scottish Arts Council
Scottish National Gallery of Modern Art—see Edinburgh/Modern
Scovill Mfg. Co.
Scranton/Everhart. Everhart Museum, Scranton, Pa.
Scripps College
Seagram Collection
Seaton Hall Inc., NYC
Seattle/AM. Seattle Art Museum, Seattle, Wash.
Seattle Civic Center, Seattle, Wash.
Seattle Public Library, Seattle, Wash.
Seattle U.
Security Pacific National Bank, Los Angeles, Calif.
Seibu Museum of Art, Tokyo, Japan
Seoul/Contemporary. National Museum of Contemporary Art, Seoul, Korea
Shasta College, Redding, Calif.
Shearson-Lehman Brothers, Inc., New York (formerly Lehman Brothers)
Shelburne Museum Inc., Shelburne, Vt.
Sheldon Memorial Art Gallery—see U. of Nebraska
Shell Oil Co.
E. Sheffy Truck Company
Shiga. Shiga Museum of Modern Art, Otsu, Japan
Shizuoka Museum, Shizuoka, Japan
Shuttleworth Carton Co.
Sierra Nevada Museum of Art, Reno, Nev.
Silvermine Guild of Arts, New Canaan, Conn.; Silvermine Guild School of Art
Simmons College
Norton Simon Museum, Pasadena, Calif.
The Singer Company Inc.

Sioux City Art Center, Sioux City, Iowa
Skidmore College
Skidmore, Owings & Merrill
Skirball Museum, Hebrew Union College, Los Angeles
Skopje/Modern. Museum of Modern Art, Skopje, Yugoslavia
Skowhegan School of Painting and Sculpture, Skowhegan, Me.
Slater Memorial Museum, Norwich, Conn.
W. & J. Sloane, Inc.
Smith College
Smith, Kline & French, Philadelphia
Smithsonian Institution, Washington, D.C. (see also Hirshhorn; NCFA; NPG)
Societé National des Arts Contemporains, Paris, France
The Society of American Graphic Artists—see SAGA
Society of the Four Arts, Palm Beach, Fla.
Society of New York Hospitals
Sofia. National Museum, Sofia, Bulgaria
Sofu School of Flower Arrangement, Tokyo
Sonesta Hotels
Sony Corp., NYC
Southampton/Parrish. The Parrish Museum, Southampton, N.Y.
South County Bank, St. Louis, Mo.
Southeast Banking Corp., Miami, Fla.
U. of Southern California
Southern Idaho College, Twins Falls
Southern Illinois U.
Southern Methodist U., Dallas, Texas
Southern Oregon College
Southern Vermont Art Center, Manchester
U. of South Florida
Southland Corp., Dallas, Texas
South Mall, Albany, N.Y.
Southwest Banking
Southwestern College, Chula Vista, Calif.
Southwestern (College) at Memphis
Southwest Missouri State College
J.B. Speed Art Museum—see Louisville/Speed
Spelman College
Spokane Coliseum, Spokane, Wash.
Sports Museum, NYC
Springfield Art Center, Springfield, Ohio
Springfield College, Springfield, Mass. (incl. Dana Art Center)

Springfield, Ill./State. Illinois State Museum of Natural History and Art, Springfield, Ill.

Springfield, Mass./MFA. Museum of Fine Arts, Springfield, Mass.

Springfield, Mo./AM. Springfield Art Museum, Springfield, Mo.

Staatliche Graphische Sammlung Munchen, Munich, Germany

Stadtische Galerie im Lehbachhaus, Munich, Germany

Stadtische Galerie, Munich—see Munich/SG

Stadtische Kunsthalle, Düsseldorf—see Düsseldorf/Kunsthalle

Stamford Museum, Stamford, Conn.

Standard Oil Co. of California

Standard Oil Co. of New Jersey

Stanford U.

Starr King School for the Ministry, Berkeley, Calif.

State Art Collection, Oklahoma City, Ok.

State Capitol Building, Talahassee, Fla.

State of California

State College of Iowa

State College at Salem, Mass.

State of Hawaii

State Historical Society of Missouri—see Columbia, Mo.

State of Illinois

State of Iowa

State of Louisiana Art Commission—see Baton Rouge

State Street Bank and Trust Co., Boston, Mass.

State U. of Iowa

State U. of New York—see individual campuses

Staten Island Institute of Arts and Sciences, St. George, S.I., N.Y.

Steel Service Institute, Cleveland, Oh.

Stephens College

Stephens, Inc.

Steuben Glass

Stockholm/Instituto Italiano di Cultura

Stockholm/National. Moderna Museet (National museum), Stockholm, Sweden

Stockholm/SFK. Svenska-Franska-Konstgalleriet, Stockholm, Sweden

Stockton. San Joaquin Pioneer Museum and Haggin Art Galleries, Stockton, Calif.

Stony Brook/SUNY. State University of New York at Stony Brook

Storm King Art Center, Mountainville, N.Y.

Stratford College, Danville, Va.

Studio Museum. The Studio Museum of Harlem, NYC

Stuttgart. Staatsgalerie Stuttgart, West Germany

Stuttgart/WK. Wurttembergischer Kunstverein, Stuttgart, Germany

Peter Stuyvesant Collection, Amsterdam, Holland

Suermondt-Ludwig Museum—see Aachen/S-L

Suffolk County National Bank, Riverhead, N.Y.

Sunflower Corp.

Svenska Handelsbanken, Stockholm, Sweden

Svenska-Franska Konstgalleriet—see Stockholm/SFK

Svest, Germany

Swarthmore College (incl. Wilcox Gallery)

Sweden/Goteborgs. Goteborgs Konstmuseum, Gothenburg, Sweden

Sweet Briar College

Swiss Bank Corp.

Sheldon Swope Art Gallery—see Terre Haute/Swope

Sydney/AG. The Art Gallery of New South Wales, Sydney, Australia

U. of Sydney (incl. Power Gallery of Contemporary Art)

Syracuse/Everson. Everson Museum of Art, Syracuse, N.Y.; Syracuse Museum School

Syracuse U.

T

TRW, Inc.

Tacoma Art Museum, Tacoma, Wash.

Taconic Foundation, Inc., NYC

Taft Museum, Cincinnati, Ohio

Talavara. Museo Talavara, Ciudad Bolivar, Venezuela

Tampa/MA. Tampa Museum of Art, Tampa, Fla.

Taos (N.M.) County Court House

Tate Gallery, London, England

Taubman Corp., Ann Arbor, Mich.
Technimetrics, NYC
Tel Aviv Museum of Art, Tel Aviv, Israel
Telfair Academy of Arts and Sciences, Inc.—*see* Savannah/Telfair
Temple Beth El, Detroit, Mich.
Temple Israel, St. Louis, Mo.
Temple U.
Tennessee Fine Arts Center—*see* Nashville
Tennessee State Museum, Nashville
U. of Tennessee
Terra Museum of American Art, Chicago—*see* Chicago/Terra
Terre Haute/Swope. Sheldon Swope Art Gallery, Terre Haute, Ind.
Terry Art Institute, Miami, Fla.
Texas A&M U.
Texas Fine Arts Association—*see* Austin
Texas Instruments
Texas Technological College, Lubbock
Texas Tech U., Lubbock
Texas Wesleyan College
Texas Western College
U. of Texas (incl. James A. Michener Foundation)
Texwipe Co., Upper Saddle River, N.J.
3M Company, St. Paul, Minn.
Louis Comfort Tiffany Foundation, NYC
Time Inc.
Tishman Realty & Construction Co., Inc., NYC
Tokyo/Central. Tokyo Central Museum, Tokyo, Japan
Tokyo Folk Art Museum, Tokyo, Japan
Tokyo/Hakone. Hakone Sculpture Museum, Tokyo, Japan
Tokyo/Hara. Hara Museum, Tokyo, Japan
Tokyo/Isetan. Isetan Museum of Art, Tokyo, Japan
Tokyo/Metropolitan. Metropolitan Art Museum, Tokyo, Japan
Tokyo/Modern. National Museum of Modern Art, Tokyo, Japan (*see also* National Museum of Western Art, Tokyo)
Tokyo/Western. National Museum of Western Art, Tokyo, Japan
Tokyo U. of Arts, Tokyo, Japan
Toledo/MA. Toledo Museum of Art, Toledo, Ohio
Topeka Public Library, Topeka, Kan.
Topeka U.—*see* Washburn U. of Topeka
Toronto. Art Gallery of Toronto, Canada

Torrington Mfg. Corp.
Tougaloo College
Toulon. Musée d'Art, Toulon, France
Tourcoing. Musée Municipal, Tourcoing, France
Towner Art Gallery, Eastbourne, England
Towson State U., Baltimore, Md.; formerly Towson State College
Toyama/Modern. Museum of Modern Art, Toyama, Japan
Trade Bank and Trust Company, NYC
Trade Building, Moscow, USSR
Traders National Bank, Kansas City, Mo.
Transamerica Corp.
Transco Energy Co.
Travenol Laboratories, Deerfield, Ill.
Treadwell Corp., NYC
Trenton/State. New Jersey State Museum, Trenton
Tretyakov Art Gallery, Moscow, USSR
Trinity College, Dublin, Ireland
Harry S. Truman Library, Independence, Mo.
Tucson Art Center, Tucson, Az.
Tucson Museum of Art, Tucson, Az.
U. of Tucson
Tufts Dental College, Boston, Mass.
Tufts U., Boston, Mass.
Tulane U. of Louisiana
Tulsa/Philbrook. Philbrook Art Center, Tulsa, Ok.
Tupperware Corp., Orlando, Fla.
Tupperware Museum, Orlando, Fla.
Turin/Civico. Museo Civico di Torino, Turin, Italy (incl. Galleria Civica d'Arte Moderna)
Turku Museum, Finland
Tusculum College, Greenville, Tenn.
Tweed Gallery—*see* U. of Minnesota
Twentieth Century-Fox Film Corp.
Two Trees, NYC

U

UCLA. U. of California, Los Angeles
UNESCO, Paris
USIA. United States Information Agency
US Coast Guard
US Department of the Interior
US Labor Department
US Maritime Commission
US Military Academy, West Point, N.Y.

US Navy
U.S. Rubber Co.
US State Department
U.S. Steel Corp.
US Treasury Department
USX Corp., Pittsburgh
Ucross Foundation
Uffizi Gallery, Florence, Italy
Ulster Museum, Belfast, Northern Ireland
Underwood-Neuhaus Corp.
Union Camp Corp.
Union Carbide Corp.
Union College (N.Y.)
Union of Plastic Artists, Bucharest, Romania
Union Trust Bank
Unitarian Church, Princeton, N.J.
United Aircraft Corp.
United Bank of California
United Bank of Denver
United Mutual Savings Bank
United Nations
United Tanker Ltd.
Upjohn Co.
Uris Buildings Corp.
Uris-Hilton Hotels
Uruguay/Nacional. Museo Nacional de Bellas Artes, Montevideo, Uruguay—see also Montevideo/ Municipal
Utah Museum of Fine Arts, Salt Lake City
Utah State U.
U. of Utah
Utica. Munson-Williams-Proctor Institute, Utica, N.Y. (incl. Edward Root Collection)
Utica Public Library, Utica, N.Y.
Utrecht. Centraal Museum, Utrecht, Holland
Utrecht/Contemporary. Museum of Contemporary Art, Utrecht, Holland

V

VMFA. Virginia Museum of Fine Arts, Richmond
Valley Bank of Springfield, Mass.
Valparaiso U. (Ind.)
Vancouver Art Gallery, Vancouver, Canada
Vanderbilt U.
Vassar College, Poughkeepsie, N.Y.

Venice/Contemporaneo. Museo dell'Arte Contemporaneo, Venice, Italy
U. of Vermont (incl. Robert Hull Fleming Museum)
Victoria (B.C.). Art Gallery of Greater Victoria, B.C., Canada
Victoria and Albert Museum, London, England
Vienna/Moderner. Museen für Moderner Kunst, Vienna, Austria
Virginia Commonwealth U.
Virginia Museum of Fine Arts—see VMFA
Virginia National Bank, Norfolk
Virginia State College
U. of Virginia (incl. Bayly Museum, Charlottesville)

W

WDAY, Fargo, N.D.
WGMA. Washington Gallery of Modern Art, Washington, D.C.
WMAA. Whitney Museum of American Art, NYC
Wadsworth Atheneum—see Hartford/Wadsworth
Wagner College
Waitsfield/Bundy. Bundy Art Gallery, Waitsfield, Vt.
Wake Forest U. (formerly Wake Forest College)
Wales—see National Museum of Wales
Walker. The Walker Art Center, Minneapolis, Minn.
Walker Art Gallery, Liverpool, England—see Liverpool/Walker
Wallraf-Richartz-Museum—see Cologne
Walnut Creek Municipal Collection, Walnut Creek, Calif.
Walters Art Gallery—see Baltimore/Walters
Warner Bros.
Warsaw. Academy of Fine Arts, Warsaw, Poland
Warsaw/National. Muzeum Narodwe (National Museum), Warsaw, Poland
Washburn U. of Topeka (incl. Mulvane Art Museum)
Washington Art Consortium, Seattle
Washington County Museum of Fine Arts—see Hagerstown/County MFA
Washington Federal Bank, Miami, Fla.

Washington Gallery of Modern Art—*see* WGMA

Washington Post

Washington State U. (incl. Spokane Art Center)

Washington U., St. Louis, Mo.

U. of Washington

Wasserman Development Corp.

Waterloo Municipal Galleries, Waterloo, Iowa

U. of Waterloo

Wayne State U., Detroit, Mich.

Weatherspoon Art Gallery—*see* U. of North Carolina

Webster College

Weisbaden. Museum Weisbaden, Weisbaden, Germany

Wellesley College, Wellesely, Mass.

Wellington Management Co.

Wellington/National. National Gallery of New Zealand, Wellington, N.Z.

Wells College

Wells, Rich, Greene, Inc., NYC

Wesleyan College (Ga.)

Wesleyan U. (Conn.) (incl. Davison Art Center)

Western Art Museum, Tokyo—*see* National Museum of Western Art, Tokyo

Western Art Museum, USSR—*see* Moscow/Western

Western Michigan U.

Western New Mexico U.

Western Washington State College

Westfalischer Kunstverein, Munster—*see* Munster/WK

Westfield. State College at Westfield, Mass.

Westinghouse Electric Corp.

Westminster Academy, Salisbury, Conn.

Westminster Foundation, Iowa City, Ia.

Westmoreland County/MA. Westmoreland County Museum of Art, Greensburg, Pa.

West Palm Beach/Norton. Norton Gallery and School of Art, West Palm Beach, Fla.

West Point—*see* US Military Academy

Westport Art Education Society, Westport, Conn.

Westport Savings Bank, Westport, Conn.

West Publishing Co.

West Virginia State College

Whatcom Museum of History and Art,Bellingham, Wash.

Wheaton College

The White House, Washington, D.C.

Whitman College, Walla Walla, Wash.

Whitney Communications Corp., NYC

Whitney Museum of American Art—*see* WMAA

Whitworth Art Gallery, U. of Manchester, England

Wichita/AM. The Wichita Art Museum, Wichita, Kan.

Wichita State U.

Wiesbaden. Stadtisches Museum Wiesbaden, Wiesbaden, Germany

Wilberfeld. Stadtisches Museum, Wilberfeld, Germany

Wilcox Gallery—*see* Swarthmore College

Wilkes Community College, Wilkesboro, N.C.

College of William and Mary, Williamsburg, Va.

Williams College (incl. Williams College Art Museum), Williamstown, Mass.

Williamstown/Clark. Sterling and Francine Clark Art Institute, Williamstown, Mass.

Willowbrook High School, Villa Park, Ill.

Wilmington. Delaware Art Museum, Wilmington, Del.

Windsor Art Museum, Windsor, Canada

Winston-Salem Public Library, Winston-Salem, N.C.

Wisconsin State U.

U. of Wisconsin (incl. Elvehjem Museum of Art)

Witte Memorial Museum, San Antonio, Tex.

Thomas W. Wood Art Gallery—*see* Montpelier/Wood

Woodward Foundation, Washington, D.C.

College of Wooster, Wooster, Ohio

Worcester/AM. Worcester Art Museum, Worcester, Mass.; Worcester Museum School

Wrexham Foundation, New Haven, Conn.

Wright Art Center—*see* Beloit College

Wright State U., Dayton, Ohio

Wuppertal. Stadtisches Museum, Wuppertal, Germany

Wuppertal/von der Heydt. Von der Heydt-Museum der Stadt Wuppertal, Wuppertal, Germany

Wurttembergischer Kunstverein, Stuttgart—*see* Stuttgart/WK
Wylain Corp., Fort Worth, Tex.
U. of Wyoming

X

Xerox Corp.

Y

Yaddo, Saratoga Springs, N.Y.
Yale U., New Haven, Conn.

Yellowstone Art Center, Billings, Mont.
Yokohama. Yokohama City Art Museum, Yokohama, Japan
York U., Toronto, Canada
Youngstown/Butler. Butler Institute of American Art, Youngstown, Ohio
Youngstown U.

Z

Zanesville/AI. Art Institute of Zanesville, Ohio
Zurich. Kunsthaus Zurich, Switzerland
Zurich/KS. Kunstgewerbe Museum der Stadt, Zurich, Switzerland

Galleries Representing
the Artists in This Book

ACA Galleries
41 East 57th Street
New York, NY 10022

Abante Gallery
124 Southwest Yamhill
Portland, OR 97204

Alexander Gallery
8406 Melrose Avenue
Los Angeles, CA 90069

Brooke Alexander, Inc.
59 Wooster Street
New York, NY 10012

H. V. Allison Galleries, Inc.
47 East 66th Street
New York, NY 10021

Alpha Gallery
121 Newbury Street
Boston, MA 02116

Anderson Gallery
Martha Jackson Place
Buffalo, NY 14214

Angles Gallery
1416 Sixth Avenue
Santa Monica, CA 90405

Gallery Paule Anglim
14 Geary Street
San Francisco, CA 94108

Ankrum Gallery
657 North La Cienega
 Boulevard
Los Angeles, CA 90069

Arnesen Gallery
Vail, CO 81657

Gallery Art Point
I-F 7, 6, 19 Ginza, Chuo-ka
104 Tokyo, Japan

Arts Exclusive
690 Hopmeadow Street
Simsbury, CT 06070

Asher/Faure
612 North Almont Drive
Los Angeles, CA 90069

Associated American Artists
20 West 57th Street
New York, NY 10019

Pamela Auchincloss Gal-
 lery
558 Broadway, 2nd Floor
New York, NY 10012

Babcock Galleries
724 Fifth Avenue
New York, NY 10019

Bill Bace Gallery
2 Bond Street
New York, NY 10012

Ruth Bachofner Gallery
804 North La Cienega
 Boulevard
Los Angeles, CA 90069

Josh Baer Gallery
476 Broome Street
New York, NY 10013

Baron/Boisanté Gallery
50 West 57th Street
New York, NY 10019

Jan Baum Gallery
170 S. La Brea
Los Angeles, CA 90036

Galerie Beaubourg
23, rue du Renard
75004 Paris, France

Galerie Jacques Benador
7, rue de l'Hotel-de-Ville
1204 Geneva, Switzerland

Elaine Benson Gallery
Montauk Highway
Bridgehampton, NY 11932

Benton Gallery
365 County Road 39
Southampton, NY 11968

John Berggruen Gallery
228 Grant Avenue
San Francisco, CA 94108

Galerie Claude Bernard
5-9, rue des Beaux Arts
75006 Paris, France

Berry-Hill Galleries, Inc.
11 East 70th Street
New York, NY 10021

Blum Helman Gallery Inc.
20 West 57th Street
New York, NY 10019

Mary Boone Gallery
417 West Broadway
New York, NY 10012

Grace Borgenicht Gallery
724 Fifth Avenue
New York, NY 10019

The Bradley Galleries
2639 N. Downer Avenue
Milwaukee, WI 53211

Rena Bransten Gallery
77 Geary Street
San Francisco, CA 94108

Braunstein/Quay Gallery
250 Sutter Street
San Francisco, CA 94108

Farideh Cadot
77 rue des Archives
75003 Paris, France

Campbell-Thiebaud Gallery
647 Chestnut Street
San Francisco, CA 94133

Leo Castelli Inc.
420 West Broadway
New York, NY 10012

Merrill Chase Galleries
835 North Michigan
 Avenue
Chicago, IL 60611

Cherry Stone Gallery
Wellfleet, MA 02667

Jeanne-Claude Christo
48 Howard Street
New York, NY 10013

Jan Cicero Gallery
221 West Erie
Chicago, IL 60610

Sylvan Cole
200 West 57th Street
New York, NY 10019

Condeso/Lawler Gallery
76 Greene Street
New York, NY 10012

Paula Cooper Gallery
155 Wooster Street
New York, NY 10012

Cove Gallery
Commercial Street
Wellfleet, MA 02667

Charles Cowles Gallery
420 West Broadway
New York, NY 10012

Maxwell Davidson Gallery
41 East 57th Street
New York, NY 10022

Davis & Langdale Co., Inc.
231 East 60th Street
New York, NY 10022

Marisa del Re
41 East 57th Street
New York, NY 10022

Terry Dintenfass, Inc.
50 West 57th Street
New York, NY 10019

Dolan/Maxwell Gallery
1701 Walnut Street
Philadelphia, PA 19103

Olga Dollar Gallery
210 Post Street
San Francisco, CA 94108

Theodore B. Donson, Ltd.
24 West 57th Street,
 Suite 302
New York, NY 10019

Douglas Drake Gallery
50 West 57th Street
New York, NY 10019

G.W. Einstein Co.
591 Broadway
New York, NY 10012

André Emmerich Gallery
41 East 57th Street
New York, NY 10022

Galerie Erval
15 rue de Seine
75006 Paris, France

Exhibit A Gallery
361 West Superior Street
Chicago, IL 60610

Ronald Feldman Fine
 Arts Inc.
31 Mercer Street
New York, NY 10013

Fendrick Gallery
3059 M Street, NW
Washington, DC 20007

Fischbach Gallery
24 West 57th Street
New York, NY 10019

Konrad Fischer
Platanenstrasse 7
Dusseldorf, Germany

Janet Fleisher Gallery
211 South 17th Street
Philadelphia, PA 19103

The Forum Gallery
745 Fifth Avenue
New York, NY 10151

Foster-White Gallery
311 Occidental South
Seattle, WA 98104

Fountain Gallery
115 SW Fourth Avenue
Portland, OR 97200

Pearl Fox Gallery
130 Windsor Drive
Melrose Park, PA 15126

Fraenkel Gallery
55 Grant Avenue
San Francisco, CA 94108

Jose Freire Fine Art
130 Prince Street
New York, NY 10012

Sherry French Gallery
24 West 57th Street
New York, NY 10019

Nina Freudenheim Gallery
560 Franklin Street
Buffalo, NY 14202

Marianne Friedland
355 Broad Avenue
Naples, FL 33940

Frumkin/Adams Gallery
50 West 57th Street
New York, NY 10019

Galleria Il Gabbiano
via delle Frezza 51
00186 Rome, Italy

Gagosian Gallery
980 Madison Avenue
New York, NY 10021

Gagosian Gallery
136 Wooster Street
New York, NY 10012

Thomas Gibson Fine
Art, Ltd.
44 Old Bond Street
London W1X 3A6 England

Gimpel Fils
30 Davies Street
London W1Y 1LG England

Barbara Gladstone Gallery
99 Greene Street
New York, NY 10012

Dorothy Goldeen Gallery
1547 9th Street at Colo-
rado Avenue
Santa Monica, CA 90401

Marian Goodman Gallery
(Multiples, Inc.)
24 West 57th Street
New York, NY 10019

James Graham & Sons
Graham Modern
1014 Madison Avenue
New York, NY 10021

Richard Gray Gallery
620 North Michigan
Avenue
Chicago, IL 60611

Greenberg Wilson
560 Broadway
New York, NY 10012

Gump's Gallery
250 Post Street
San Francisco, CA 94108

Stephen Haller Fine Art
560 Broadway
New York, NY 10012

Harcourts Modern and
Contemporary Art
460 Bush Street
San Francisco, CA 94108

Harcus Gallery
7 Newbury Street
Boston, MA 02116

Harmon-Meek Gallery
4262 Gulfshore Boule-
vard North
Naples, FL 33940

OK Harris Works of Art
383 West Broadway
New York, NY 10012

Jane Haslem Gallery
2025 Hillyer Place N.W.
Washington, DC 20009

Helander Gallery
415 West Broadway
New York, NY 10012

Gallery Henoch
80 Wooster Street
New York, NY 10013

Carolyn Hill Gallery
109 Spring Street
New York, NY 10012

Hirschl & Adler Galleries
21 East 70th Street
New York, NY 10021

Hirschl and Adler Modern
420 West Broadway
New York, NY 10012

Hodges/Banks Gallery
319 First Avenue South
Seattle, WA 98104

Nancy Hoffman Gallery
429 West Broadway
New York, NY 10012

Rhona Hoffman
215 West Superior Street
Chicago, IL 60610

Hokin Gallery
245 Worth Avenue
Palm Beach, FL 33480

Elaine Horwitch Gallery
4211 North Marshall Way
Scottsdale, AZ 85251

Hoshour Gallery
417 Second Street SW
Albuquerque, NM 87102

Humphrey
594 Broadway
New York, NY 10012

Images Sculptural
Concepts
16 Avery Place
Westport, CA 06880

Irving Galleries
332 Worth Avenue
Palm Beach, FL 33480

Charlotte Jackson Fine Art
123 East Marcy, Suite 208
Santa Fe, NM 87501

Sidney Janis Gallery
110 West 57th Street
New York, NY 10019

Janus Gallery
225 Canyon Road
Santa Fe, NM 87501

Kauffman Galleries
2702 West Alabama
Houston, TX 77089

Keen Gallery
423 Broome Street
New York, NY 10013

June Kelly Gallery
591 Broadway, 3rd Floor
New York, NY 10012

Kennedy Galleries
40 West 57th Street
New York, NY 10019

Phyllis Kind Gallery
136 Greene Street
New York, NY 10012

Phyllis Kind Gallery
313 West Superior Street
Chicago, IL 60610

Michael Klein, Inc.
594 Broadway, Room 302
New York, NY 10012

Klein Art Works
400 N. Morgan
Chicago, IL 60622

M. Knoedler & Co., Inc.
19 East 70th Street
New York, NY 10021

Michael Kohn
920 Colorado Avenue
Santa Monica, CA 90401

Koplin Gallery
1438 9th Street
Santa Monica, CA 90401

B.R. Kornblatt Gallery
406 Seventh Street NW
Washington, DC 20004

Kornbluth Gallery
7-21 Fairlawn Avenue
Fairlawn, NJ 07410

Kouros Gallery
23 East 73rd Street
New York, NY 10021

Barbara Krakow Gallery
10 Newbury Street
Boston, MA 02116

Kraushaar Galleries
724 Fifth Avenue
New York, NY 10021

Jan Krugier
3 place du Grand-Mézel
1204 Geneva, Switzerland

Yvon Lambert
5, rue du Grenier-St.
Lazare
75003 Paris, France

Margo Leavin Gallery
812 North Robertson
Boulevard
Los Angeles, CA 90069

A. J. Lederman Fine Art
309 Court Street
Hoboken, NJ 07030

Ledoux Gallery of Fine
Arts
P.O. Box 2418
Taos, NM 87501

Janie C. Lee
1209 Berthea
Houston, TX 77006

Leedy-Voulkos Gallery
1919 Wyandotte
Kansas City, MO 64108

Steven Leiber Gallery
37 Toledo Way
San Francisco, CA 94123

Lennon, Weinberg
580 Broadway
New York, NY 10012

Jon Leon Gallery
31 Desbrosses Street
New York, NY 10013

Levinson Kane Gallery
14 Newbury Street
Boston, MA 02116

Stuart Levy Gallery
415 West Broadway
New York, NY 10012

Galerie Gisele Linder
Elisabethenstrasse 54
4051 Basel, Switzerland

Margaret Lipworth
Fine Art Gallery Center
608 Banyan Trail, Suite 113
Boca Raton, FL 33431

Marian Locks Gallery
1524 Walnut Street
Philadelphia, PA 19102

Meredith Long & Company
2323 San Felipe Road
Houston, TX 77019

Long Point Gallery
492 Commercial Street
Provincetown, MA 02657

Lopes Art Gallery
Beethovenstrasse 8
8002 Zurich, Switzerland

Galleria Lorenzelli
via Sant'Andrea 19
20124 Milan, Italy

L.A. Louver Gallery
55 North Venice
Boulevard
Venice, CA 90291

Jean Lumbard Fine Arts
17 East 96th Street
New York, NY 10128

M-13 Gallery
72 Greene Street
New York, NY 10012

Paul Maenz Gallery
Bismarckstrasse 50
Cologne, Germany

Galerie Mai 36
Maihofstrasse 36
6005 Lucerne 9
Switzerland

Curt Marcus Gallery
578 Broadway
New York, NY 10012

Marlborough Gallery, Inc.
40 West 57th Street
New York, NY 10019

Marlborough Fine Art Ltd.
6 Albemarle Street
London, England WIX 4BY

Mary-Anne Martin/Fine Art
23 East 73rd Street
New York, NY 10021

Marsha Mateyka Gallery
2012 R Street N.W.
Washington, DC 20009

Barbara Mathes Gallery
41 East 57th Street
New York, NY 10022

McKee Gallery
745 Fifth Avenue
New York, NY 10151

Louis K. Meisel Gallery
141 Prince Street
New York, NY 10012

Mekler Gallery
651 North La Cienega
 Boulevard
Los Angeles, CA 90069

Metro Pictures
150 Greene Street
New York, NY 10012

Meyers/Bloom Gallery
2112 Broadway
Santa Monica, CA 90401

Midtown-Payson Galleries
745 Fifth Avenue
New York, NY 10151

Robert Miller Gallery
41 East 57th Street
New York, NY 10019

Miname Gallery
3-3 Chome, Nihonbashi-
 tori, Chuo-ku
Tokyo, Japan

Mincher/Wilcox Gallery
228 Grant Avenue, 6th
 Floor
San Francisco, CA 94018

Modernism Gallery
685 Market Street,
Suite 290
San Francisco, CA 94105

Moody Gallery
2815 Colquitt
Houston, TX 77098

More Gallery
1630 Walnut Street
Philadelphia, PA 19103

Robert Morrison Gallery
59 Thompson Street
New York, NY 10012

Tobey C. Moss Gallery
7321 Beverly Boulevard
Los Angeles, CA 90036

Victoria Munroe Fine Art
9 East 84th Street
New York, NY 10028

Munson Gallery
33 Whitney Avenue
New Haven, CT 06511

Daniel Newburg Gallery
580 Broadway
New York, NY 10012

Louis Newman Galleries
322 North Beverly Drive
Beverly Hills, CA 90210

Newspace
5241 Melrose Avenue
Los Angeles, CA 90038

Nielsen Gallery
179 Newbury Street
Boston, MA 02116

David Nolan Gallery
560 Broadway, 6th Floor
New York, NY 10012

Oil & Steel Gallery
30-40 Vernon Boulevard
Long Island City, NY
 11102

Osuna Gallery
406 Seventh Street NW
Washington, DC 20004

Ovsey Gallery
170 S. La Brea Avenue
Los Angeles, CA 90036

Owings-Dewey Fine Art
74 East San Francisco
Santa Fe, NM 87501

PMW Gallery
530 Rosbury Road
Stamford, CT 06902

The Pace Gallery
32 East 57th Street
New York, NY 10022

Herbert B. Palmer Gallery
802 North La Cienega
 Boulevard
Los Angeles, CA 90069

Katherina Rich Perlow
 Gallery
560 Broadway
New York, NY 10012

Gerald Peters Gallery
439 Camino del Monte Sol
P.O. Box 908
Santa Fe, NM 87504-0908

Galleria Ponce
Belgrado 5 ZP 6
Mexico City, Mexico

Princeton Gallery of Fine
 Art
8 Chambers Street
Princeton, NJ 08540

Printworks Gallery
311 West Superior Street
Chicago, IL 60610

Max Protetch Gallery
560 Broadway
New York, NY 10012

Roger Ramsay Gallery
212 West Superior Street,
 Suite 503
Chicago, IL 60610

Margarete Roeder Gallery
545 Broadway
New York, NY 10012

Rorick Gallery
637 Mason
San Francisco, CA 94108

Michael Rosenfeld Gallery
24 West 57th Street
New York, NY 10019

J. Rosenthal Fine Arts
212 West Superior Street
Chicago, IL 60610

Judi Rotenberg Gallery
130 Newbury Street
Boston, MA 02116

Jack Rutberg Fine Arts
357 N. La Brea Avenue
Los Angeles, CA 90036

Mary Ryan Gallery
24 West 57th Street
New York, NY 10019

Saidenberg Gallery
1018 Madison Avenue
New York, NY 10021

Salander-O'Reilly Galleries
20 East 79th Street
New York, NY 10021

Salander-O'Reilly/Fred
 Hoffman Gallery
456 N. Camden Drive
Beverly Hills, CA 90210

Sunne Savage Gallery
135 Cambridge Street
Winchester, MA 01890

Schmidt-Bingham Gallery
41 East 57th Street
New York, NY 10022

Barbara Schuller
345 Franklin Street
Buffalo, NY 64202

Joyce Pomeroy Schwartz
 Works of Art for Pub-
 lic Spaces
17 West 54th Street
New York, NY 10019

Francine Seders Gallery
6701 Greenwood Avenue
 North
Seattle, WA 98103

Anita Shapolsky Gallery
99 Spring Street
New York, NY 10012

William Shearburn Fine Art
4740 A McPherson
St. Louis, MO 63108

Manny Silverman Gallery
800 N. La Cienega Blvd.
Los Angeles, CA 90069

Simon/Newman Gallery
22 East 76th Street
New York, NY 10021

Smith-Andersen Gallery
200 Homer Avenue
Palo Alto, CA 94301

Snyder Fine Art
588 Broadway
New York, NY 10012

Holly Solomon Gallery
172 Mercer Street
New York, NY 10012

Carl Solway Gallery
314 West Fourth Street
Cincinnati, OH 45202

Sonnabend Gallery
420 West Broadway
New York, NY 10012

Sperone Westwater Inc.
142 Greene Street
New York, NY 10012

Darthea Speyer Gallery
6, rue Jacques Callot
75006 Paris, France

Sragow Gallery
73 Spring Street
New York, NY 10012

Stables Gallery
North Pueblo Road
Taos, NM 87571

Samuel Stein Gallery
620 North Michigan
 Avenue
Chicago, IL 60611

Bernice Steinbaum Gallery
132 Greene Street
New York, NY 10012

Simonne Stern Gallery
518 Julia Street
New Orleans, LA 70130

John C. Stoller & Co.
81 South 9th Street
Minneapolis, MN 55402

Allan Stone Gallery
48 East 86th Street
New York, NY 10028

Struve Gallery
309 West Superior Street
Chicago, IL 60610-3515

Tatistcheff & Co.
50 West 57th Street
New York, NY 10019

Tatistcheff Gallery, Inc.
1547 10th Street
Santa Monica, CA 90401

Susan Teller Gallery
568 Broadway,
 Room 405A
New York, NY 10012

Martha Tepper Gallery
120 Forest Avenue
West Newtown, MA
 02165

Thomson Gallery
231 Second Avenue North
Minneapolis, MN 55401

Edward Thorp Gallery
103 Prince Street, 2nd
 Floor
New York, NY 10012

Jack Tilton Gallery
47 Greene Street
New York, NY 10012

Barbara Toll Fine Arts
146 Greene Street
New York, NY 10012

Tomlyn Gallery,
Tequesta, FL

Tortue Gallery
2917 Santa Monica
 Boulevard
Los Angeles, CA 90404

Tower Gallery
7 Park Avenue
New York, NY 10016

Triangle Gallery
95 Minna Street
San Francisco, CA 94105

Galerie Patrice Trigano
4 bis rue des Beaux-Arts
75006 Paris, France

Jan Turner Gallery
8000 Melrose Avenue
Los Angeles, CA 90046

Twining Gallery
PO Box 939, Planetarium
 Station
New York, NY
10024-0540

Galerie Annemarie Verna
Scheuchzerstrasse 35
Zurich, Switzerland 8006

Washburn Gallery Inc.
20 West 57th Street
New York, NY 10019

John Weber Gallery
142 Greene Street
New York, NY 10012

Elaine Wechsler
245 West 104th Street,
 Suite 5B
New York, NY 10025

Julian Weissman Fine Art
26 Beaver Street
New York, NY 10004

Dietmar Werle
Spichernstrasse 44
5 Cologne 1, Germany

Galerie Michael Werner
Gertrudenstrasse 24-28
1-5000 Cologne 1,
 Germany

Michael Werner Gallery
21 East 67th Street
New York, NY 10021

Stephen Wirtz Gallery
345 Sutter Street
San Francisco, CA 94108

Woodside-Braseth Gallery
1101 Howell Street
Seattle, WA 98101

The Works Gallery
106 West 3rd Street
Long Beach, CA 90802

Gerhard Wurzer Gallery
5701 Memorial Drive
Houston, TX 77007

Howard Yezerski Gallery
186 South Street
Boston, MA 90211

Richard York Gallery
21 East 65th Street
New York, NY 10021

The Zabriskie Gallery
724 Fifth Avenue
New York, NY 10019

Galerie Zabriskie
37, rue Quincampoix
75004 Paris, France

Zaks Gallery
620 North Michigan
 Avenue
Chicago, IL 60611

Andre Zarre Gallery
379 West Broadway
New York, NY 10012

Zolla/Lieberman Gallery
356 West Huron Street
Chicago, IL 60610

AACH, HERB
from 1st to 5th edition.

ACCONCI, VITO **b.** January 24, 1940, Bronx, N.Y. **Studied:** College of the Holy Cross, Worcester, Mass., 1958-62, BA; U. of Iowa, Iowa City, with John Cellon Homes, Mark Strand, R. V. Cassill, 1962-64, MFA. Traveled Europe. **Taught:** School of Visual Arts, NYC, 1968-71, 77; UCLA, 1981; SFAI, 1983, 88; Chicago Art Institute School, 1983; Minneapolis College of Art, 1984; Yale U., 1985, 90; Cooper Union, NYC, 1981, 86. **Commissions:** The Coca-Cola Co., 1986; New Mexico State U., 1986; Town Square, Atlanta, 1986; The Palladium, NYC, 1986, La Jolla, 1987; Laumeier Sculpture Park, 1988; Long Island U., 1988; Governors State U., 1988; John Weiland Homes, Atlanta, 1988; St. Aubin Park, Detroit, 1989; Arvada, Colo., Art Center, 1992. **Awards:** Woodrow Wilson Fellowship, 1962; Guggenheim Foundation Fellowship, 1979; National Endowment for the Arts, grant, 1976, 80, 83; American Academy, grant, 1986; DAAD, Berlin, 1986. **Address:** 39 Pearl Street, Brooklyn, N.Y. 11201. **Dealer:** Barbara Gladstone Gallery, NYC. **One-man Exhibitions:** John Gibson Gallery, NYC, 1971; Ileana Sonnabend Gallery, Paris, 1972, NYC, 1972, 73, 75, 76, 79; Galleria L'Attico, Rome, 1972; Modern Art Agency, Naples, Italy, 1973-77; Galerie D., Brussels, 1973-77; Galleria Schema, Florence, 1973; Galleria Forma, Genoa, 1974; Galleria A. Castelli, Milan, 1974, 75; Portland (Ore.) Center for the Visual Arts, 1975; Museum of Conceptual Art, San Francisco, 1975; James Mayor Gallery, London, 1975; The Kitchen, NYC, 1976, 77, 81; Anthology Film Archives, NYC, 1976; Minnesota College of Art, Minneapolis, 1978; Akron/AI, 1978; SFMA, 1978; Lucerne, 1978; Amsterdam/Stedelijk, 1978; Young-Hoffman Gallery, Chicago, 1979; UCLA, 1981; Padiglione d'Arte Contemporanea, Milan, 1981; Protetch Gallery, NYC, 1981; Portland (Ore.) Center for the Visual Arts, 1982; VMFA, 1982; San Diego State U., 1982; U. of Massachusetts, 1982; Miami-Dade College, 1983; Williams College, 1983; Nature Morte, NYC, 1984; U. of Nebraska, 1984; Carpenter + Hochman Gallery, NYC, 1985; U. of North Carolina, 1985; Hartford/Wadsworth, 1985; Brooklyn Museum, 1985; The Palladium, NYC, 1986; Kent State U., 1986; International With Monument Gallery, NYC, 1987; ICP, 1987; La Jolla, 1987; Long Island U., 1988; Brooke Alexander Gallery, NYC, 1988; Rhona Hoffman Gallery, Chicago, 1988; MOMA, 1988; BR Kornblatt Gallery, Washington, D.C., 1988; Galleria Il Ponte, Rome, 1988; Mai 36 Galerie, Lucerne, 1989; NYU, circ., 1989; Sonnabend Gallery, NYC, 1991; Barbara Gladstone Gallery, NYC, 1989, 91; Landfall Press, Inc., NYC, 1990; James Corcoran Gallery, Los Angeles, 1990; Galerie Anne de Villepoix, Paris, 1991; CNAC and Grenoble, circ., 1991. **Retrospective:** Anthology Film Archives, 1977; Chicago/Contemporary, 1980; La Jolla, 1987. **Group:** Jewish Museum, Software, 1970; MOMA, Information, 1971; Düsseldorf/Kunsthalle, Prospect '71, 1971; VII Paris Biennial, 1971; Kassel, Documenta V, 1972; MOMA, Some Recent American Art, circ., 1973; Parcheggio di Villa Borghese, Rome, Contemporanea, 1974; MOMA, Eight Contemporary Artists, 1974; Cologne, Project '74, 1974; Chicago/AI, Idea and Image in

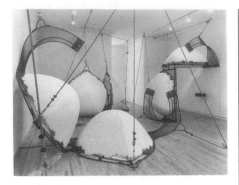

Vito Acconci, *Adjustable Wall Bra*, 1990-1991.

Recent Art, 1974; MOMA, Video Art, 1975, Chicago/Contemporary, Body Art, 1975; Venice Biennale, 1976; ICA, U. of Pennsylvania, Improbable Furniture 1977; WMAA Biennial, 1981; Chicago/Contemporary, Art of the '70s, 1977; ICA, U. of Pennsylvania, Machine Works, 1981; Hirshhorn, Metaphor, 1981; Kassel, Documenta VII, 1982; Pratt Institute, NYC, Bridges, 1983; Amsterdam/Stedelijk, The Luminous Image, 1984; C. W. Post College, Long Island Garden Estates, 1985. **Collections:** Los Angeles/County MA; MOMA; Chicago/AI; Middlebury College; New Museum; Ohio State U.; Paris/Beaubourg; WMAA; Williams College; Kunstlerwerkstatte, Munich, Process and Konstruktion, 1985; Long Island U., The Doll Show, 1985; Bard College, The Maximal Implications of the Minimal Line, 1985; AAIAL, 1985; Fort Lauderdale, An American Renaissance, 1986; Boca Raton, Art in the Environment, 1986; Indiana State U., Intimate/Intimate, 1986; Brooklyn Museum, Public and Private, American Prints Today, circ., 1986; The Vienna Festival, Weinfluss, 1986; Hamburg/Kunstverein, Zughend auf eine Biennale des Friedens, 1986; Independent Curators, Inc., NYC, The Success of Failure, circ., 1987; Walker, First Impressions, 1989; WMAA, Image World, 1989; Florida International U., American Art Today: The City, 1990; Wright State U., Assembled: Works of Art Using Photography as a

Construction Element, 1990; Milwaukee, Word as Image, circ., 1990; Indianapolis, Power: Its Myths, Icons and Structure in American Art, 1961-1991, 1991; WMAA, Biennial, 1991. **Collections:** Chicago/Contemporary; Los Angeles/MOCA; San Diego/Contemporary. **Bibliography:** *Calas* 2; *Contemporanea;* Day 1; De Wilde 2; *Drawings: The Pluralist Decade; Hunter, ed.; Lippard 3; Lucie-Smith; Meyer; Performance Anthology; Pincus-Witten; Robins; Sandler 3; Weintraub.*

ACTON, ARLO C.
from 1st to 5th edition.

ADAMS, CLINTON **b.** December 11, 1918, Glendale, Calif. **Studied:** UCLA, 1940, BA, 1942, MFA. US Army, World War II. Traveled USA and Europe extensively. **Taught:** UCLA, 1946-54; U. of Kentucky, 1954-57; U. of Florida, 1957-60; U. of New Mexico, 1961-85. Associate Director, Tamarind Lithography Workshop, 1960-61; Director, Tamarind Institute, 1970-85. Editor, *The Tamarind Papers,* 1974-90. Writes on printmaking. **Awards:** Governor's Award for Outstanding contribution to the Arts of New Mexico, 1985; NAD, Meissner Prize, 1991. **Address:** 1917 Morningside Drive, N.E., Albuquerque, NM 87110. **Dealers:** Janus Gallery, Santa Fe; Tobey C. Moss Gallery, Los Angeles; Associated American Artists, NYC. **One-man Exhibitions:** (first) UCLA, 1950; Felix Landau Gallery, 1952, 56, 58, 61, 63, 65; Pasadena/AM, 1954; Louisville/Speed, 1956; U. of Texas, 1957; U. of Florida, 1957; Galleria Mazzuchelli, Florence, Italy; Jonson Gallery, Albuquerque, N.M., 1961, 63, 68; Roswell, 1972; U. of New Mexico, 1985; California State U., Northridge, 1988: Tobey C. Moss Gallery, Los Angeles, 1989, 91; Janus Gallery, Santa Fe, 1991. **Retrospectives:** U. of New Mexico, 1973, 87; U. of Iowa; U. of Georgia. **Group:** MOMA; MMA; Brooklyn Museum; Library of Congress; Carnegie; PAFA; Cincinnati/AM; Ringling;

Oakland/AM; Northern Illinois U., National Print and Drawing Exhibition, 1968; MOMA, Tamarind: Homage to Lithography, 1969; Honolulu Academy, First Hawaiian National Print Exhibition, 1971; Albuquerque Museum, Here and Now, 1980; U. of New Mexico, Tamarind: 25 years, 1960-1985, circ., 1985; Worcester/AM, Spectrum of Innovation, 1991; Boston/MFA, American Screen Prints, 1991; NAD, 1991. **Collections:** Achenbach Foundation; Amon Carter Museum; Bibliothèque Nationale; Bradley U.; Brooklyn Museum; Canberra/National; Chicago/AI; Dallas/MFA; Northern Illinois U.; De Pauw U.; Florida State U.; Grunwald Graphic Arts Foundation; U. of Illinois; La Jolla; Los Angeles/County MA; MOMA; U. of New Mexico; NYPL; Otis Art Institute; Pasadena/AM; Phoenix; Portland, Ore./AM; San Diego; Santa Fe, N.M.; Seattle/AM; UCLA; Victoria and Albert Museum; Walker. **Bibliography:** Archives.

ADAMS, PAT b. July 8, 1928,
Stockton, Calif. **Studied:** U. of California (with Glenn Wessels, John Haley, Margaret O'Hagan, Erle Loran), 1949, BA, PBK; Brooklyn Museum School (with Max Beckmann, Reuben Tam, John Ferren). Traveled Europe, Middle East. **Taught:** Bennington College, 1964-; Yale U., 1971-72, 76, 79, 90, 91; Queens College, 1972; U. of Iowa, 1976; U. of New Mexico, 1978; U. of Massachusetts, Amherst, 1989; RISD, 1989. **Member:** College Art Association, Board of Governors, 1986-90. **Awards:** PBK; Yaddo Fellowship, 1954, 64, 69, 70; Fulbright Fellowship (France), 1956; National Council on the Arts, $5,000 award, 1968; MacDowell Colony Fellowship, 1968, 72; National Endowment for the Arts; Distinguished Teaching of Art Award, College Art Association, 1984; AAIAL, 1986; NEA, Award for Painting, 1987; Vermont Academy of Arts and Sciences, fellow, 1990. **Address:** 370 Elm Street, Bennington, VT 05201.

Dealer: The Zabriskie Gallery, NYC. **One-man Exhibitions:** (first) Stockton, 1950; Korman Gallery, NYC, 1954; The Zabriskie Gallery, NYC, 1954, 56, 57, 60, 62, 64, 70, 72, 74, 76, 78, 79, 80, 82, 84, 86; Wheaton College, 1959; Bennett College, 1959; Green Mountain College, 1962; Arts and Crafts Gallery, Wellfleet, Mass., 1963; Hotchkiss School, Lakevine, Conn., 1960; Windham College; Williams College, 1972; Yale in Norfolk, 1977; U. of Vermont, 1977; Cincinnati/Contemporary, 1978; Rutgers U., 1978; Fiedler Gallery, Washington, D.C., 1980; Galerie Zabriskie, Paris, 1980; Artemisia Gallery, Chicago, 1982; Columbia, S.C./MA, 1982; Virginia Commonwealth U., 1982; Image Gallery, Stockbridge, Mass., 1983; Stockton, 86; The Zabriskie Gallery, NYC, 1986, 88, 90; U. of Virginia, 1986 (two-man); American Association for the Advancement of Science, 1988; New York Academy of Science, NYC, 1988; Addison/Ripley Gallery, Washington, D.C., 1988; Anne Weber Gallery, Georgetown, Md., 1989. **Retrospectives:** Cincinnati/Contemporary, 1979; Pittsfield/Berkshire, 1988. **Group:** Bordighera, Americans in Europe, 1952; WMAA Annuals, 1956, 58, 61; A.F.A., Collage in America, circ., 1957-58; MOMA, 41 Watercolorists, circ., Europe, 1957; U. of Nebraska, 1958; A.F.A., The New Landscape in Art and Science, circ., 1958-59; WMAA, Fulbright Artists, 1958; Hirschl & Adler Galleries, Inc., NYC, Experiences in Art I & II, 1959, 60; Tanager Gallery, NYC, The Private Myth, 1961; A.F.A., Lyricism in Abstract Art, circ., 1962-63; PAFA, Watercolor Annual, 1959; U. of Michigan, One Hundred Contemporary American Drawings, 1965; U. of Texas, Color Forum, 1972; GEDOK, Kunsthaus, Hamburg, American Women Artists, 1972; New York Cultural Center, Women Choose Women, 1973; Hirshhorn, Inaugural Exhibitions, 1974; IIE, 20 American Fulbright Artists, 1975; U. of Texas, Austin, New in the Seventies, 1977;

Pat Adams, *World Without End.*

Chicago/AI, 100 Artists—100 Years, *Alumni of the SAIC,* 1979; Houston/MFA, Miró in America, 1982; AAIAL, 1989. **Collections:** Bordighera; Hirshhorn; U. of Michigan; U. of North Carolina; Williams College; WMAA; Brooklyn Museum; U. of California, Berkeley; IBM; Kent State U.; Maryland Institute; Montclair/AM; Mount Holyoke College; New Britain/American; PMA; Rutgers U.; U. of Vermont; Yale U. **Bibliography:** *Art: A Woman's Sensibility;* Chaet; *New in the Seventies;* Archives.

ADLER, SAMUEL M.
from 1st to 5th edition.

AGOSTINI, PETER b. 1913,
NYC. **d.** April 27, 1993, NYC. **Studied:** Leonardo da Vinci Art School, NYC. **Taught:** U. of North Carolina, Greensboro, 1967-84; New York Studio School. **Commissions:** New York World's Fair, 1964-65. **Awards:** Longview Foundation Grant, 1960, 61, 62; Brandeis U., Creative Arts Award, 1964; Guggenheim Foundation Fellowship, 1964; National Endowment for the Arts, 1969; AAIAL, 1991. **One-man Exhibitions:** Galerie Grimaud, NYC, 1959; Stephen Radich Gallery, 1960, 62-65, 67, 68; Richard Gray Gallery, 1965; U. of North Carolina, 1969; The Zabriskie Gallery, NYC, 1971, 73, 76; Artists' Choice Museum, NYC, 1977; New York Studio School, 1981, 83; Bernice Steinbaum Gallery, Ltd., NYC,

1985, 86; Anita Shapolsky Gallery, NYC, 1991. **Group:** New School for Social Research; Jewish Museum, Recent American Sculpture, 1964; WMAA; MOMA; Claude Bernard, Paris, 1960; Chicago/AI, 1962; Hartford/Wadsworth, 1962; Battersea Park, London, International Sculpture Exhibition, 1963; São Paulo Biennial, VII, 1963; WMAA Annuals, 1964, 66, 68, 70; Los Angeles/County MA, American Sculpture of the 60's, 1967; Fondation Maeght, L'Art Vivant aux États-Unis, 1970; U. of North Carolina, Art on Paper, 1981; WMAA, The Third Dimension, 1984; U. of North Carolina, 1984. **Collections:** Brandeis U.; Cleveland/MA; Hartford/Wadsworth; Hirshhorn; ILGWU; Kalamazoo/Institute; MIT; MMA; MOMA; U. of North Carolina; SRGM; U. of Southern California; U. of Texas; Trenton/State; Union Carbide Corp.; Walker; WMAA. **Bibliography:** Hunter, ed.; Lippard 5; Phillips, Lisa, 2; Read 3; Rose, B., 1. Archives.

ALBERS, JOSEF b. March 19,
1888, Bottrop, Westphalia, Germany. **d.** March 26, 1976, New Haven, Conn. **Studied:** Royal Art School, Berlin, 1913-15; School of Applied Art, Essen, 1916-19; Academy of Fine Arts, Munich, 1919-20; Bauhaus, Weimar, 1920-23, where he became an instructor (Weimar-Dessau-Berlin), 1923-33. To USA, 1933, to teach and head art department at Black Mountain College, to 1949. US citizen, 1939. Headed Department of Design at Yale U., 1950-58; Visiting Critic, 1958-60; The Josef Albers Museum, Bottrop, West Germany, opened in 1983. **Taught:** Design, drawing, color and painting. Presented courses, seminars, lecture series in many European and North and South American universities until his retirement, 1960. **Member:** American Abstract Artists; PCA.**Commissions**(murals): Harvard U.; Corning Glass Building, NYC. **Awards:** German Federal Republic, Officers Cross

First Class of the Order of Merit; Corcoran, William A. Clark Prize, 1954; Chicago/AI, Ada S. Garrett Prize, 1954; Hon. DFA, U. of Hartford, 1957, Ford Foundation Fellowship, 1959; PMA, citation, 1962; Hon. DFA, Yale U., 1962; American Institute of Graphic Art, Medal of the Year, 1964; Carnegie, 1967; Hon. DFA, California College of Arts and Crafts, 1964; Bridgeport U., 1966; U. of North Carolina, 1967; U. of Illinois, 1969; Kenyon College, 1969; Minnesota College of Art and Design, 1969. AAAL, award, 1970; Royal Society, 1971; Maryland Institute, 1972; York U., 1973; Pratt Institute, 1975. **One-man Exhibitions:** (first) Goltz Gallery, Munich, 1919; Sidney Janis Gallery, NYC, 1949, 52, 55, 58, 59, 61, 64, 68, 70, 76, 84, 86, 89; Cincinnati/AM, 1949; Yale U., 1956, 78; Galerie Denise Rene, Paris, 1957, 58; Kunstverein Freiburg im Breisgau, 1959; Zurich, 1960; Amsterdam/Stedelijk, 1961; Raleigh/NCMA, 1962; MOMA, Josef Albers, circ., Latin America, 1964; WGMA, 1965; Gimpel & Hanover Galerie, Zurich, 1965; Hannover/K-G, 1968; Landesmuseum fur Kunst und Kulturgeschichte, Munster, 1968; Bielefeld, 1968; Düsseldorf/Kunsthalle, 1970; MMA, 1971; Princeton U., 1971; Pollock Gallery, Toronto, 1972; Galerie Gmurzymska & Bargera, Cologne, 1973; Galerie Melki, Paris, 1973; Bottrop/Albers, 1983; Margo Leavin Gallery, Los Angeles, 1985; Baden-Baden, 1986; Galerie Teufel, Cologne, 1986; Galerie Karsten Greve, Cologne, 1989; U. of Hartford, Conn., 1992; and some 100 others. **Retrospective:** Yale U., 1956; WGMA, Josef Albers, The American Years, 1965; Josef Albers, circ., Germany and Switzerland; SRGM, circ., 1988; Ulmer Museum, circ., 1988. **Group:** American Abstract Artists, 1939; Herbert Hermann Gallery, Brooklyn, 1949; Galerie Stuttgart, 1948; U. of Illinois, 1951, 52, 53; Hartford/Wadsworth, Josef and Annie Albers, 1953; Zurich, 1956; WMAA, Geometric Abstraction in America, circ., 1962;

SRGM, Cezanne and Structure in Modern Painting, 1963; SRGM, Abstract Expressionists and Imagists, 1961; Smithsonian, Paintings from the Museum of Modern Art, New York, 1963; MOMA, The Responsive Eye, 1965; MOMA, Two Decades of American Painting, circ., Japan, India, Australia, 1967; and some 500 others. **Collections:** Amsterdam/Stedelijk; Baltimore/MA; Basel; Bennington College; Berea College; Brown U.; Buffalo/Albright; Carnegie; Chicago/AI; Corcoran; Currier; Denver/AM; Detroit/Institute; Duke U.; Essen; Hagen; Hartford/Wadsworth; Harvard U., Hollins College; Leverkusen; Los Angeles/County MA; U. of Louisville; MIT; MMA; MOMA; Mills College; U. of Minnesota; Morgan State College; Muhlenberg College; Munster; New London; U. of New Mexico; North Texas State U.; Park College; Portland, Ore./AM; Rio de Janeiro; SFMA; SRGM; Smith College; Smithsonian; Springfield, Mass./MFA; Stockholm/National; Svest; Toronto; Utica; VMFA; WMAA; Wesleyan U.; U. of Wisconsin; Yale U.; Zurich. **Bibliography:** *Abstraction Creation 1931-1936;* Armstrong, Thomas; Downes, ed.; *From Foreign Shores;* Gablik; Honisch and Jensen, eds.; Sandler; Tomkins 2; MOMA, The Albers Archive: 1. "Documentation in Manuscript" (photocopy, artist's personal record of his professional chronology); 2. Writings on art (photocopies of typescripts); 3. Scrapbooks, clippings, catalogues, photographs, etc. Additional and overlapping data may be found at the Bauhaus-Archiv, Darmstadt, Germany, the Busch-Reisinger Museum, Cambridge, Mass., and the Yale U. Library, New Haven, Conn.; Lane and Larsen; Murken-Altrogge; Weber, Nicholas Fox 1; Weber, Nicholas Fox 2. **Albers 1, 2, 3, 4, 5, 6, 7;** *American Abstract Artists,* ed.; Battcock, ed.; Baur 7; Bihalji-Merin; Blanchard; Blesh 1; Calas 2; Calas, N. and E.; Chaet; Cheney; Christensen; Coplans 3; Davis, D.; Dorner; Eliot; *Europa/Amerika;* Frost;

Gaunt; Gerstner; Gomringer; Goodrich and Baur 1; Haftman; **Hamilton, G.H.**; Henning; Hess, T.B., 1; Hunter, ed.; Janis and Blesh 1; Janis, S.; Kepes, ed.; Kuh 2; Lynton; MacAgy 2; McCurdy, ed.; Mendelowitz; Metro; Morris; Motherwell 1; Neumeyer; Nordness, ed.; Pearson 2; Ponente; Pousette-Dart, ed.; Read 2, 3; Rickey; Ritchie 1; Rodman 2, 3; Rose, B., 1, 4; Roters; Sandler 3; Seitz 3; Seuphor 1; Tomkins; Trier 1; Tyler, K. E.; Weller; Wingler, ed. Archives.

ALBERT, CALVIN **b.** November 19, 1918, Grand Rapids, Mich. **Studied:** Institute of Design, Chicago, with Lazlo Moholy-Nagy, Gyorgy Kepes, Alexander Archipenko. Traveled Europe. **Taught:** Institute of Design, Chicago 1941-1946; NYU, 1950; Brooklyn College, 1951-52; Pratt Institute, 1949-85. Federal A.P.: Painting, sculpture, design exhibitions. **Member:** College Art Association; AAUP (1969, president, Pratt chapter); Sculptors Guild; Artists Equity. **Commissions:** St. Paul's Episcopal Church, Peoria, Ill.; Temple Israel, Bridgeport, Conn.; Temple Israel, Tulsa, Okla.; Park Avenue Synagogue, NYC; Temple Emmanuel, Grand Rapids, Mich., 1973, 74. **Awards:** Detroit/Institute, The Haass Prize, 1944; ICA, London/Tate, International Unknown Political Prisoner Competition, Hon. Men., 1953; Audubon Artists, First Prize, 1954; Fulbright Fellowship, 1961; L. C. Tiffany Grant, 1963, 65; Guggenheim Foundation Fellowship, 1966; NIAL, P.P., 1975; NIAL, grant, 1975. **Address:** 624 95th Street, Surfside, Fla. 33154. **Dealer:** Benson Gallery, Southampton, N.Y. **One-man Exhibitions:** Paul Theobald Gallery, Chicago, 1941; Puma Gallery, NYC, 1944; Chicago/AI, 1945; California Palace, 1947; Grand Rapids, 1948; Laurel Gallery, NYC, 1950; Grace Borgenicht Gallery, Inc., NYC, 1952, 54, 56, 57; MMA, 1952; Walker, 1954; U. of Nebraska, 1955; The Stable Gallery, NYC, 1959, 64; U. of Georgia, 1970; Free Public

Library, Fair Lawn, N.J., 1973; Landmark Gallery, Inc., NYC, 1974, 77; Benson Gallery, Southampton, N.Y., 1975, 86; Guild Hall, East Hampton, N.Y., 1979; Light Gallery, Southampton, N.Y., 1981; Phoenix Gallery, Washington, D.C., 1982; Ingber Art Gallery, NYC, 1983, 85; Bologna-Landi Gallery, East Hampton, N.Y., 1983; Vered Gallery, East Hampton, N.Y., 1988; Ground Zero Gallery, Miami, 1988; Boca Raton Museum of Art, 1990; Peter Drew Gallery, Boca Raton, Fla., 1991. **Retrospective:** Jewish Museum, 1960. **Group:** Andover/Phillips, The American Line—100 Years of Drawing, 1959; Chicago/AI, Contemporary Drawings from 12 Countries, 1952; MMA, American Watercolors, Drawings, and Prints, 1952; A.F.A., The Embellished Surface, circ., 1953-54; Contemporary Drawing from the United States, circ., France, 1954; MOMA, Recent Drawings, USA, 1956; U. of Illinois, 1957, 65; WMAA Annuals, 1954, 55, 56, 58, 60, 62, 66, 68; A.F.A., God and Man in Art, circ., 1958-59; Brooklyn Museum, Golden Year of American Drawing, 1956, Chicago/AI, 1962; PAFA, 1949, 53, 64; Flint/Institute, American Sculpture, 1900-1965, 1965; PAFA Annual, 1967; U. of Nebraska, American Sculpture, 1970; AAL, 1975. **Collections:** Brooklyn Museum; Chicago/AI; Colby College; Detroit/Institute; Guild Hall; Jewish Museum; Kansas City/Nelson; MMA; U. of Nebraska; Norfolk/Chrysler; U. of North Carolina. **Bibliography:** Weller. Archives.

ALBRIGHT, IVAN LE LORRAINE **b.** February 20, 1897, North Harvey, Ill. **d.** November 18, 1983, Woodstock, Vt. **Studied:** Northwestern U., 1915-16; Illinois School of Architecture, 1916-17; École Regionale des Beaux-Arts, Nantes, 1919. US Army, 1918-19; Chicago Art Institute School, 1920-23; PAFA, 1923; NAD, 1924. Traveled Venezuela, USA, Europe. **Member:** NAD; Chicago Society of Arts, Inc. **Commissions**

(paintings): *The Portrait of Dorian Gray* for the film, 1943; *The Temptation of St. Anthony* for the film, 1943. **Awards:** Chicago/AI, Faculty Hon. Men., 1923; Chicago/AI, Hon. Men., 1926; Chicago/AI, John C. Shaffer Prize, 1928; Chicago/AI, Norman Wait Harris Medal, 1941, 43; Society for Contemporary American Art, Silver Medal, 1930, Gold Medal, 1931; Chicago/AI, First Prize, 1948; PAFA, Joseph E. Temple Gold Medal, 1942; MMA, Artists for Victory, First Prize, 1942; NAD, Benjamin Altman Prize, 1961; Corcoran, Silver Medal, 1955; Northwestern U., Centennial Award, 1951; Tate, $5,000 Dunn International Prize, 1963; NIAL, 1957. **One-man Exhibitions:** Walden Book Shop, Chicago, 1930; Chicago/AI, 1931; A.A.A. Gallery, NYC (two-man), 1945, Chicago (two-man), 1946; Kennedy Galleries, NYC; Sylvan Cole Gallery, NYC, 1986; Dartmouth, 1987. **Retrospective:** Chicago/AI, 1964. **Group:** Chicago/AI, 1918, 23, 26, 28, 41, 43, 48; PAFA, 1924, 42; Brussels World's Fair, 1958; WMAA; Corcoran, 1955; NAD; Ukrainian Institute of Modern Art, Chicago, Decay, 1989. **Collections:** Brooklyn Museum; Carnegie; Chicago/AI; Dallas/MFA; Hartford/Wadsworth; Library of Congress; MMA; MOMA; PMA; Phoenix; US Labor Department. **Bibliography:** Barker 1; Baur 7; Blesh 1; Canaday; Cheney; Cummings 1; Eliot; Flanagan; Flexner; Haftman; Hall; Jacobson, ed.; Kuh 1, 2, 3; McCurdy, ed.; Mendelowitz; Newmeyer; Pearson 1, 2; Pousette-Dart, ed.; Reese; Richardson, E. P.; Rose, B., 1, 4, **Croydon;** Sweet; Ward; Weller. Archives.

ALCALAY, ALBERT b. August 11, 1917, Paris, France. To USA 1951. Traveled France, England, Italy, Yugoslavia, Israel, 1970-71. **Studied:** School of Architecture, Belgrade. **Taught:** Harvard U. 1959-82; U. of Maryland, 1971. **Awards:** Guggenheim Foundation Fellowship, 1959; Boston Arts Festival, First Prize,

1960. **Address:** 66 Powell Street, Brookline, MA 02146. **One-man Exhibitions:** Cortile Gallery, Rome, 1947; Gaetano Chiurazzi, Rome, 1950; Boston Museum School, 1951; Lincoln, Mass./De Cordova, 1954; Philadelphia Arts Club, 1951; The Krasner Gallery, 1959, 61, 62, 64, 66; The Swetzoff Gallery, Boston, 1952-54, 56, 58; Wittenborn Gallery, NYC, 1958; The Pace Gallery, Boston, 1961, 62; Mickelson's Gallery, Washington, D.C., 1964, 67; Ward-Nasse Gallery, Boston, 1965, 67; Pucker-Safrai Gallery, 1971, 73; Smith-Andersen Gallery, Palo Alto, 1973; Elca London Gallery, Montreal, 1975; Barbara Battin Fiedler, Washington, D.C., 1976; Baak Gallery, Cambridge, Mass., 1976; Clark Gallery, Lincoln, Mass., 1979; Visconti Gallery, Boston, 1983. **Retrospective:** Lincoln, Mass./De Cordova, 1968; Harvard U., 1982. **Group:** Rome National Art Quadriennial, 1947; U. of Illinois, 1955, 57, 59; WMAA, 1956, 58, 60; ICA, Boston, View, 1960; PAFA, 1960; MOMA, 1955; AAAL. **Collections:** Andover/Phillips; Boston/MFA; Brandeis U.; Brockton/Fuller; Colby College; First National Bank of Boston; Harvard U.; Lincoln, Mass./De Cordova; MOMA; Rome/Nazionale; Tufts U.; Simmons College; Smith College; State Street Bank and Trust Co., Boston; U. of Rome; Wellesley College. **Bibliography:** Archives.

ALEXANDER, JOHN b. 1945, Beaumont, Tx. **Studied:** Lamar U., 1968, BFA; Southern Methodist U., 1970, MFA. **Taught:** U. of Houston, 1972-. **Address:** 482 Broadway, NYC 10012. **Dealer:** Marlborough Gallery, NYC; Zolla-Lieberman Gallery, Chicago. **Awards:** National Endowment for the Arts, grant, 1981; Guggenheim Foundation Fellowship, 1984. **One-man Exhibitions:** Meredith Long Gallery, Houston, 1975, 76; Houston/Contemporary, 1975; Kornblatt Gallery, Baltimore, 1976, 77; New Mexico State U., 1976; Delahunty Gallery, Dallas, 1977; Long Beach/MA, 1977; Max Hutchinson Gallery, NYC,

1978; Max Hutchinson Gallery, Houston, 1978; Corcoran, 1980; Dobrick Gallery, Chicago, 1981; Janie C. Lee Gallery, Houston, 1982, 84; Diane Brown Gallery, Washington, D.C., 1982; ICA, Boston, 1983; Marlborough Gallery, NYC, 1983, 85, 86, 90, 92; Lawrence Oliver Gallery, Philadelphia, 1983, 84; Houston/MFA, 1984; Janus Gallery, Venice, Calif., 1984; Zolla-Lieberman Gallery, 1985; Jan Turner Gallery, Los Angeles, 1986; Marlborough Fine Arts, London, 1986; Cincinnati/Contemporary, circ., 1988; Jan Turner Gallery, Los Angeles, 1988, 91; Galerie Hervé Odermatt, Paris, 1988; Alpha Gallery, Boston, 1988; Galería Freites, Caracas, 1989; Beaumont Art Museum, 1989; Earl McGrath Gallery, Los Angeles, 1991; Gerald Peters Gallery, Dallas, 1991. **Group:** ICA, U. of Pennsylvania, Philadelphia-Houston Exchange, 1976; Corcoran Biennial, 1977; New Orleans Museum Biennial, 1977; Florida State U., Four Houston Artists, 1978; Indianapolis, 1978; U. of Texas, Austin, Made in Texas, 1979; Houston/MFA, Fresh Paint, 1985; Houston/MFA, The Texas Landscape, 1986; Corcoran, American Masters: Works on Paper, circ., 1987; Houston/MFA, Directions and Diversities, 1988; MMA, The 1980s: A New Generation, 1988; U. of Arizona, The New Old Landscape, 1989; Western Washington U., Private Art/Public Visions, 1989; New York Academy of Art, Expressive Drawings, 1991. **Collections:** Beaumont Art Museum; Birmingham, Ala./MA; Chicago/Contemporary; Corcoran; Dallas/MFA; Duke U.; Fort Worth/Modern; Hirshhorn; Houston/MFA; Kansas City/Nelson; Los Angeles/County MA; Little Rock/MFA; Long Beach/MA; Louisville/Speed; MMA; Norfolk/Chrysler; Rutgers U.; San Antonio/MA; Southern Methodist U.; Texas A & M U.; U. of Texas, Austin.

ALEXANDER, PETER b. 1939,

Los Angeles. **Studied:** U. of Pennsylvania, 1957-60; Architectural Association, London, 1960-62; U. of California, Berkeley, 1962-63; U. of Southern California, 1963-64; UCLA, 1964-65, BA, 1965-68, MFA. **Taught:** California Institute of Technology, 1970-71; California State U., Long Beach, 1976; U. of Colorado, 1981; Centrum Foundation, Washington, D.C., 1982. **Commissions:** Paramount Pictures, drawings for the film, *Day of the Locust,* 1975; Rebecca's Restaurant, Venice, Calif., 1985; Santa Monica Airport, 1989; Pacific Enterprises, Los Angeles, mural. **Awards:** National Endowment for the Arts, 1980. **Address:** 4223 Glencoe #A-100, Venice, CA 90292. **One-man Exhibitions:** Robert Elkon Gallery, NYC, 1968, 69; Janie C. Lee Gallery, Dallas, 1969; Locksley-Shea Gallery, Los Angeles, 1969; Nicholas Wilder Gallery, Los Angeles, 1970; Michael Walls Gallery, San Francisco, 1971; Jack Glenn Gallery, Corona del Mar, Calif., 1972, 74; Akron/AI, 1972; Galerie Art in Progress, Munich, 1973; Morgan Gallery, Kansas City, 1973; U. of California, Irvine, 1975; Comsky Gallery, Beverly Hills, 1975; California State U., Long Beach, 1976; Fullerton College, 1976; ICA, Los Angeles, 1980; Mizuna Gallery, Los Angeles, 1980; James Corcoran Gallery, Los Angeles, 1981, 85, 86, 87, 89, 91; U. of Colorado, 1981; Thomas Babeor Gallery, La Jolla, Calif., 1982, 83; Cirrus Gallery, Los Angeles, 1982, 83; Charles Cowles Gallery, NYC, 1982, 84, 85; ARCO Center, Los Angeles, 1983; Municipal Art Gallery, Los Angeles, 1983; Stephen Wirtz Gallery, San Francisco, 1984; Van Straaten Gallery, Chicago, 1984; Fuller Goldeen Gallery, San Francisco, 1984; The Works Gallery South, Costa Mesa, Calif., 1991; Brian Gross Fine Art, San Francisco, 1991. **Group:** Portland, Ore./AM, The West Coast Now, 1968; MOMA, New Media, New Methods, circ., 1969; Walker, 14 Sculptors: The Industrial Edge, 1969; WMAA Annual, 1969; Milwaukee, A Plastic Presence, circ., 1969; Omaha/Joslyn, Looking West, 1970; Chicago/AI, 1969, 72; Kassel, Documenta V, 1972; SFMA,

California Painting and Sculpture: The Modern Era, 1976; California State U., Fullerton, California Perceptions: Light and Space, 1979; La Jolla, Artists' Quilts: Quilts by Ten Artists, 1981; College of Design, Pasadena, Decade: Los Angeles Painting in the Seventies, 1981; Corcoran Biennial, 1983; Brooklyn Museum, The American Artist as Printmaker, 1983; MOMA, International Survey of Recent Painting and Sculpture, 1984; NYU, Precious, 1985; U. of Southern California, Turning to the Landscape, 1986; San Diego/MA, The Golden Land, 1986; Kansas City/AI, Borrowed Embellishments, 1987; Amerika Haus, Berlin, Los Angeles: Contemporary Visions Today, 1987; Long Beach/MA, 20th Century Watercolors; Long Beach/MA, Artists' Artists, 1990; U. of Southern California, Finish Fetish: LA's Cool School, 1991. **Collections:** Akron/AM; Brooklyn Museum; California State U., Los Angeles; U. of California, Berkeley; Corcoran; Des Moines; Federal Reserve Bank, Los Angeles; Flint/Institute; Fort Worth; Harvard U.; Honolulu/Contemporary; La Jolla; Laguna Beach Museum of Art; Los Angeles/County MA; MMA; MOMA; Minneapolis/Institute; NYPL; New Orleans Museum; Newport Harbor; Oberlin College; Omaha/Joslyn; Pasadena/AM; U. of Rochester; Rutgers U.; SFMA; SRGM; San Diego; Stanford U.; Vancouver; Walker. **Bibliography:** *Individual Realities;* Solnit.

ALLAN, WILLIAM b. March 28, 1936, Everett, Washington. **Studied:** San Francisco Art Institute, BFA, 1958. **Taught:** U. of California, Davis, 1965-67; U. of California, Berkeley, 1969; San Francisco Art Institute, 1967-69; Sacramento State College, Sacramento, 1968-. Has made several 16mm films. **Awards:** National Endowment for the Arts, grant, 1972. **Address:** 327 Melrose Avenue, Mill Valley, CA 94941. **Dealer:** Gallery Paule Anglim, San Francisco. **One-man Exhibitions:** Scott Galleries, Seattle, 1964, 65;

Berkeley Gallery, San Francisco, 1968; SFMA, 1970; Reese Palley, San Francisco, 1971; Hansen-Fuller Gallery, San Francisco, 1973, 76, 80; WMAA, 1973; Western Association of Art Museums, circ., 1974-75; Palace of the Legion of Honor, San Francisco, 1974; Nancy Hoffman Gallery, NYC, 1977; ICA, Boston, 1977; Odyssia Gallery, NYC, 1979, 81; Arts Club of Chicago, 1978; Baltimore/MA, 1979; Chan Elliot Gallery, Sacramento, 1983. **Group:** Carnegie, 1957; PAFA Annual, 1957; Art USA, 1958; WMAA Annuals, 1969, 72, 73; La Jolla, Continuing Surrealism, 1972; Chicago/AI, 70th American Exhibition, 1972, 74; WMAA, American Drawings, 1973; U. of Illinois, Krannert, 1974; US Department of the Interior, America 1976, circ., 1976; Springfield, Mo./AM, Watercolor USA, 1976; SFMA, California Painting and Sculpture: The Modern Era, 1976; Akron/AI, Contemporary Images in Watercolor, 1976; Buffalo/Albright, American Painting of the 1970s, 1978; U. of Nebraska, Realists, 1978; Creighton U., A Century of Master Drawings, 1978; New Museum, The 1970's New American Painting, 1979; U. of California, Santa Clara, Northern California Art of the Sixties, 1982; Laguna Beach Museum of Art, West Coast Realism, circ., 1983. **Collections:** Berkeley; U. of California; Charlotte/Mint; Chicago/AI; Dallas/MFA; Detroit/Institute; Fort Worth; Gulf Oil and Chemical Corp.; U. of Iowa; MOMA; PMA; RISD; Rutgers U.; Sacramento/Crocker; Santa Barbara/MA; SFMA; WMAA; Oakland Museum; PMA. **Bibliography:** *America 1976;* Arthur 2.

ALSTON, CHARLES
from 1st to 4th edition.

ALTMAN, HAROLD b. April 20, 1924, NYC. **Studied:** ASL (with George Bridgeman, Stefan Hirsch), 1941-42; Cooper Union (with Morris Kantor, Byron Thomas, Will Barnet), 1941-43,

1946-47; New School for Social Research (with Abraham Rattner), 1947-49; Black Mountain College (with Josef Albers), 1946; Academie de la Grande Chaumiere (with McAvoy), 1949-52; US Army, 1943-46. Traveled Europe, Mexico. **Taught:** N.Y. State College of Ceramics; U. of North Carolina; Indiana U.; U. of Wisconsin, 1956-62; The Pennsylvania State U., 1962-. **Member:** SAGA; California Society of Printmakers; PCA. **Commissions** (print editions): MOMA; Jewish Museum; New York Hilton Hotel; SAGA; Container Corp. of America, "Great Ideas of Western Man" advertising series. **Awards:** Guggenheim Foundation Fellowship, 1961, 63; NIAL Grant, 1963; Chicago/AI, John Taylor Arms Medal; SAGA; PAFA; Tamarind Fellowship; Silvermine Guild; Fulbright-Hayes Research Scholar to France, 1964-65; The Pennsylvania State U., 1968, 69; Oklahoma, 1969; Silver Medal of the City of Paris, 1985, and some 200 others. **Address:** P.O. Box 57, Lemont, PA 16851. **One-man Exhibitions:** (first) Galerie Huit, Paris, 1951; Martha Jackson Gallery, 1958; Philadelphia Art Alliance, 1959, 63; Peter H. Deitsch Gallery, 1960; Chicago/AI, 1961; SFMA, 1961; Santa Barbara/MA, 1961; Escuela Nacional de Artes Plasticas, Mexico City, 1961; The Goodman Gallery, Buffalo, 1961; Kasha Heman, Chicago, 1961, 63; Felix Landau Gallery, 1962; Gump's Gallery, San Francisco, 1962, 64; Irving Galleries, Inc., Milwaukee, 1962, 64, 66; Kenmore Galleries, Inc., Philadelphia, 1963; The Pennsylvania State U., 1963; Kovler Gallery, 1963, 66; A. B. Closson Gallery, Cincinnati, 1965; Weyhe Gallery, NYC, 1966; Oklahoma, 1966; Ohio State U., 1966; Franklin Siden Gallery, Detroit, 1966; Sagot-Le Garrec Gallery, Paris, 1968, 74; Graphics Gallery, NYC, 1969, 71; Haslem Fine Arts, Inc., 1970, 71; David Barnett Gallery, Milwaukee, 1972; Gloria Luria Gallery, 1973; Gallery 1640, 1973; Malorie Kauffman Gallery, Houston, 1973, 74; Wustum Museum of Art, 1974;

Impressions Workshop, Inc., 1975; Trianon de Bagatelle, Paris, 1985. **Group:** WMAA Annuals; I Paris Biennial, 1959; PCA, American Prints Today, circ., 1959-62; SAGA, 1960-74; MOMA, Recent Painting USA: The Figure, circ., 1962-63; Festival of Two Worlds, Spoleto; St. Paul Gallery, Drawing USA, 1962, 64, 66, 71; PAFA Annuals, 1963, 66, 67, 69; MMA, Walter C. Baker Master Drawings Collection; Basel, Five American Printmakers, 1965; Santiago, Chile, II Interamerican Biennial of Printmaking, 1965; WMAA, A Decade of American Drawings, 1965. **Collections:** Achenbach Foundation; Amsterdam/Stedelijk; Auburn U.; Basel; Bibliothèque Nationale; Bibliothèque Royale de Belgique Nationale; Bibliothèque Royale de Belgique; Boston Public Library; Boston U.; Buffalo/Albright; Chicago/AI; Clairol, Inc.; Cleveland/MA; The Coca-Cola Co.; Container Corp. of America; Copenhagen; Detroit/ Institute; Escuela Nacional de Artes Plasticas, Mexico City; First National Bank of Dallas; First National Bank Minneapolis; U. of Georgia; U. of Glasgow; Grinnell College; Grunwald Foundation; Haifa; Hartford/Wadsworth; Hershey Foods Corp.; IBM; U. of Illinois; U. of Kentucky; Library of Congress; Lincoln Mass./De Cordova; Los Angeles/County MA; Lytton Savings and Loan Association; MMA; MOMA; Malmo; Milwaukee; Milwaukee Journal; NYPL; NYU; National Gallery; Newark Museum; New York Hilton Hotel; Norfolk; PAFA; PMA; The Pennsylvania State U.; Philip Morris Collection; Princeton U.; Raleigh/NCMA; SFAI; Smithsonian; Syracuse U.; Victoria (B.C.); WMAA; Walker; Woodward Foundation; Yale U.; Youngstown/Butler.

ALTOON, JOHN **b.** 1925, Los Angeles, Calif. **d.** February 8, 1969, Los Angeles, Calif. **Studied:** Otis Art Institute; Art Center School, Los Angeles; Chouinard Art Institute. US Navy, World War II. Traveled France, Spain. **Taught:**

Otis Art Institute, 1951-62; Art Center
School, Los Angeles, 1956-60; UCLA,
1962-63; Chouinard Art Institute, 1962-
63; La Jolla, summer, 1962; Pasa-
dena/AM, 1965-68. **Awards:** SFMA,
Stacy Award, 1950; Joe and Emily Lowe
Foundation Award, 1955; Pasadena/AM,
P.P., 1959; SFMA, James D. Phelan
Award, 1961; Los Angeles/County MA,
P.P., 1962; William and Noma Copley
Foundation Grant, 1964. **One-man Exhi-
bitions:** (first) Santa Barbara/MA, 1951,
also 1965; Artists' Gallery, NYC, 1953;
Ganso Gallery, NYC, 1954; Ferus Gal-
lery, Los Angeles, 1958-62; La Jolla,
1960; de Young, 1963; David Stuart
Gallery, 1964, 65; Phoenix, Hack-Light,
1965; Quay Gallery, 1966, 68, 73;
Fischbach Gallery, 1967; SFMA, 1967;
Stanford U., 1967; Tibor de Nagy Gal-
lery, NYC (three-man) 1970, 71, 73, 79;
WMAA, 1971; Galerie Hans R.
Neuendorf, Cologne, 1972; Felicity
Samuel Gallery, London, 1973; Nicholas
Wilder Gallery, Los Angeles, 1973, 75;
Seder/Creigh Gallery, Coronado, 1975;
Braunstein/Quay Gallery, San Francisco,
1977; Tortue Gallery, Santa Monica,
1979, 81, 82; Edward Thorp Gallery,
NYC, 1979, 82, 84, 85; California State
U., Fullerton, 1981; Faith and Charity in
Hope Gallery, Hope, Id., 1982; Riverside
Art Center, 1982; U. of Nevada, Las
Vegas, 1983; Arts Club of Chicago, 1984;
California Institute of Technology,
Pasadena, 1984. **Retrospective:** WMAA,
1972. **Group:** Carnegie, 1959; Santa
Barbara Invitational, 1962; WMAA, Fifty
California Artists, 1962-63; SRGM,
American Drawings, 1964; SFMA, 1964,
65; U. of Texas, 1966; WMAA, 1967;
NCFA, Eight from California, 1974;
California Painting and Sculpture: The
Modern Era, 1976, SFMA, Painting and
Sculpture in California, 1977. **Collec-
tions:** La Jolla; Los Angeles/County MA;
MOMA; Pasadena/AM; SFMA; Stanford
U.; WMAA. **Bibliography:** *John Altoon;*
Lippard 5; *The State of California Painting.*

AMEN, IRVING b. July 25, 1918,
NYC. **Studied:** ASL with Vaclav Vytlacil,
William Zorach, John Hovannes; Pratt In-
stitute; Leonardo da Vinci Art School,
NYC; Academie de la Grande Chaumiere,
1950; Florence and Rome, Italy. US Air
Force, 1942-45. Traveled Europe exten-
sively, Russia, Mexico. **Taught:** Pratt Insti-
tute, 1961; U. of Notre Dame, 1962.
Commissions: A peace medal to commem-
orate the end of the Vietnam War.
Member: Artists Equity; Audubon Artists;
Boston Printmakers; SAGA; Fellow of the
International Institute of Arts and Letters,
1960. **Address:** 90 S.W. 12th Terrace,
Boca Raton, Fla. 33432. **One-man Exhibi-
tions:** (first) New School for Social Re-
search, 1948; Smithsonian, 1949; The
Krasner Gallery, 1948; Nebraska Wesleyan
U., Lincoln, 1969. **Group:** USIA, Contem-
porary American Prints, circ., France,
1954; USIA, 20th Century American
Graphics, circ., 1959-61; MOMA, Master
Prints from the Museum Collection, 1949;
MOMA, Young American Printmakers,
1953; MMA; Graphic Arts, 1955; U. of
Illinois, 50 Contemporary American Print-
makers, 1956; ART: USA: 59, NYC,
1959; Library of Congress; Brooklyn Mu-
seum; IV Bordighera Biennial, 1957;
PAFA; NAD; Silvermine Guild; Audubon
Artists; SAGA; American Color Print Soci-
ety. **Collections:** Bezalel Museum;
Bibliothèque Nationale; Bibliothèque
Royale de Belgique; Boston/MFA; Cincin-
nati/AM; Graphische Sammlung Al-
bertina; Harvard U.; Library of Congress;
MMA; MOMA; NYPL; PMA; Smithson-
ian; Victoria and Albert Museum;
Wilberfeld. **Bibliography:** Archives.

AMENOFF, GREGORY b. Sep-
tember 16, 1948, St. Charles, Ill. **Studied:**
Beloit College, 1970, BA. **Taught:** Yale
U., 1991- ; School of Visual Arts, 1987-
92. **Commissions:** Saint Peter's Church,
Cologne, altarpiece and vestments.
Awards: Massachusetts Bicentennial Paint-
ing Award, 1976; The Artists Foundation

Gregory Amenoff, *Parable*, 1990.

(Mass.) 1979; Tiffany Foundation Grant, 1980; National Endowment for the Arts, 1980, 81, 89; CAPS, 1981. **Address:** 376 Broadway 15C, NYC 10013. **Dealer:** Hirschl & Adler Modern, NYC. **One-man Exhibitions:** Brockton/Fuller, 1972; MIT, 1976; Nielsen Gallery, Boston, 1977, 78, 80; Robert Miller Gallery, NYC, 1981, 83, 85; U. of Virginia, 1983, 86; Stephen Wirtz Gallery, San Francisco, 1983; Texas Gallery, Houston, 1984; Middendorf Gallery, Washington, D.C., 1984; Betsy Rosenfield Gallery, Chicago, 1985; Galerie Montenay-Delsol, Paris, 1985; Hirschl & Adler Modern, NYC, 1987, 90; Flanders Contemporary, Minneapolis, 1988; Youngstown/Butler, 1989; Lasorda/Iri Gallery, Los Angeles, 1989; Janet Fleisher Gallery, Philadelphia, 1989; The Fabric Workshop, Philadelphia, 1990; Galerie Marie Louise Wirth, Zurich, 1990; Galerie Bernard Vidal, Paris, 1991; Gerald Peters, Santa Fe, 1991; Saint Peter's Church, New York, 1991; Victoria Munroe Gallery, NYC, 1991. **Group:** ICA, U. of Pennsylvania, Eight Abstract Painters, 1978; WMAA Biennials, 1981, 85; Kunsthalle,

Nurnberg, Internationale Jugendtriennale, 1982; U. of North Carolina, Art on Paper, 1983; MMA, New Narrative Painting, 1984; MOMA, International Survey of Recent Painting and Sculpture, 1984; Fort Lauderdale, An American Renaissance: Painting and Sculpture Since 1940, 1986; Corcoran, Biennial, 1987; U. of Florida, Divergent Styles: Contemporary American Drawing, 1990; Santa Barbara/MA, Inner Nature, 1990; AAIAL, 1990. **Collections:** Atlantic Richfield Co.; Bank of Boston; Boston/MFA; Brandeis U.; Buffalo/Albright; Chemical Bank; Chicago/AI; First Bank of Minneapolis; Goldman Sachs, & Co.; MMA; MOMA; PAFA; PaineWebber Inc.; Purchase/SUNY; SFMA; WMAA.

ANDERSON, GUY IRVING
b. November 20, 1906, Edmonds, Wash. Traveled USA, Mexico, Canada, Europe. Federal A.P.: Spokane (Wash.) Art Center, 1938-39; staff member, Seattle/AM, 1944; Helen Bush School, Seattle, 1954-55; Fidalgo Allied Arts, La Conner, Wash., 1957-59. **Commissions:** Tacoma Art League, 1960; murals for: Hilton Inn, Seattle-Tacoma International Airport; Seattle Opera House; Bank of California, Seattle, 1973; stone mosaic for First National Bank of Seattle; Seattle World's Fair, 1962; Washington Mutual Savings Bank, Seattle; Bothell Public Library, Washington, 1981. **Awards:** L. C. Tiffany Grant, 1929; Seattle/AM, Art Award; Seattle/AM, Margaret E. Fuller P.P.; State of Washington Governor's Award, Man of the Year, 1969; Guggenheim Foundation Fellowship, 1975; Governor's Arts Award, Washington, 1983. **Address:** Box 217, La Conner, WA 98257. **Dealer:** Francine Seders Gallery, Seattle, WA. **One-man Exhibitions:** (first) Seattle/AM, 1936, also 1945, 1953 (four-man), 1960; Zoe Dusanne Gallery, 1954, 59, 63, 65; College of Puget Sound, 1954; Tacoma, 1960; Smolin Gallery, NYC, 1962; Michel Thomas Gallery, Beverly Hills, Calif., 1962; Orris Gallery, San Diego, 1962;

Kenmore Galleries, Inc., Philadelphia, 1963; Francine Seders Gallery, Seattle, 1970, 73, 75, 77, 78, 79, 80, 82, 84, 86; George Belcher Gallery, San Francisco, 1979. **Retrospective:** Seattle/AM, 1977; Henry Art Gallery, U. of Washington, Seattle, 1977. **Group:** Seattle/AM, Northwest Annual, 1929-68, with four exceptions; MMA, American Watercolors, Drawings and Prints, 1952; USIA, Eight American Artists, circ., Europe and Asia, 1957-58; Seattle World's Fair, 1962; Olympia, Wash., I Governor's Invitational, 1963; A.F.A., Drawing Society National Exhibition, 1970; NCFA, Art of the Pacific Northwest, 1974; Olympia, Two Centuries of Art in Washington, 1976; Seattle/AM, Northwest Traditions, 1977; Kobe, Japan, Portopia '81, 1981; U. of Washington, Spiritualism in Northwest Art, 1982; Osaka/National, Pacific Northwest Artists and Japan, circ., 1982. **Collections:** Brooklyn Museum; Dublin/Municipal; Long Beach/MA; Melbourne/National; Mt. Vernon High School; NCFA; U. of Oregon; Santa Barbara/MA; Seattle/AM; Seattle Public Library; Tacoma; Utah; U. of Washington, Seattle; Utica; Victoria (B.C.); Washington State U.; Whatcom; Wichita/AM; Brooklyn Museum; Rotterdam. **Bibliography:** *Art of the Pacific Northwest; Northwest Traditions;* Clark and Cowles.

ANDERSON, JEREMY R.

b. October 28, 1921, Palo Alto, Calif. **d.** June 18, 1982, Mill Valley, Calif. **Studied:** San Francisco Art Institute (with David Park, Clyfford Still, Robert Howard, Mark Rothko, S. W. Hayter, Clay Spohn), 1946-50. US Navy, 1941-45. Traveled France. **Taught:** U. of California, Berkeley, 1955-56; SFAI, 1958-74; U. of California, Davis, 1974-75. **Awards:** SFAI, I. N. Walter Memorial Sculpture Prize, 1948; Abraham Rosenberg Foundation Traveling Fellowship, 1950; San Francisco Art Association, Sculpture Prize, 1959. **One-man Exhibitions:** (first) Met-

art Gallery, San Francisco, 1949; Allan Frumkin Gallery, Chicago, 1954; The Stable Gallery, 1954; Dilexi Gallery, San Francisco, 1960-62, 1964, 66; Dilexi Gallery, Los Angeles, 1962; SFMA, 1966; Quay Gallery, 1970, 75, 78; Braunstein Gallery, 85; U. of California, Davis, 1994. **Retrospectives:** SFMA and Pasadena/AM, 1966-67. **Group:** SFMA Annual, 1948, 49, 51-53, 58, 59, 63; U. of Illinois, 1955, 57; WMAA Annuals, 1956, 62, 64; Stanford U., Some Points of View for '62, 1962; WMAA, Fifty California Artists, 1962-63; Kaiser Center, Oakland, California Sculpture, 1963; Musée Cantonal des Beaux-Arts, Lausanne, II Salon International de Galeries Pilotes, 1966; U. of California, Berkeley, Funk, 1967; Los Angeles/County MA, American Sculpture of the Sixties, 1967; Portland, Ore./AM, 1968; Expo '70, Osaka, 1970; Oakland/AM, 1973; Newport Harbor, drawing exhibition, 1975; JPL Fine Arts, London, Sculptors as Draughtsmen, 1975; SFMA, California Painting and Sculpture: The Modern Era, 1976. **Collections:** U. of California; MOMA; Oakland/AM; Pasadena/AM; SFMA; Dallas/MFA. **Bibliography:** *Forty Years of California Assemblage;* Jeremy Anderson; McChesney; **Nordland 3;** Selz, P., 2; Seuphor 3; Tuchman 1.

ANDERSON, JOHN S.
from 1st to 5th edition.

ANDERSON, LENNART **b.** August 22, 1928, Detroit, Mich. **Studied:** Chicago Art Institute School, 1946-50, BFA; Cranbrook Academy of Art, 1950-52, MFA; ASL, 1954, with Edwin Dickinson. Traveled Europe; resided Rome, 1958-61. **Taught:** Chatham College, 1961-62; Pratt Institute, 1962-64; Swain School, New Bedford, Mass., summers, 1963, 64; ASL; Yale U., 1967; Skowhegan School, 1968; Finch College, NYC; Brooklyn College, 1974-. **Member:** AAIAL, 1976; NAD, 1979. **Awards:** L. C. Tiffany Grant, 1957, 61; Prix de Rome,

1958-60; Silvermine Guild, Quinto Maganini Award, 1963; Ingram Merrill Foundation Grant, 1965; PAFA, Raymond A. Speiser Memorial Prize, 1966; National Council on the Arts, 1966; National Endowment for the Arts, grant, 1966; Guggenheim Foundation Fellowship, 1983; NAD, Emil and Dines Carlsen Award, 1988. **Address:** 877 Union Street, Brooklyn, NY 11215. **Dealer:** Davis & Langdale Co., Inc., NYC. **One-man Exhibitions:** (first) Tanager Gallery, NYC, 1962; The Graham Gallery, 1963, 67; Kansas City/Nelson (two-man, with Edwin Dickinson), 1964; Meredith Long and Co., Houston, 1974; Davis & Long Company, NYC, 1976; Suffolk Community College, 1976; Davis & Langdale Co., Inc., 1981, 84, 85; Swain School of Design, New Bedford, Mass., 1982; Darien (Conn.) Library, 1984. **Group:** American Academy, Rome, 1958-60; Kansas City/Nelson, 1962, 64; IBM Gallery of Arts and Sciences, NYC; American Heritage, 1963; Silvermine Guild, 1963; WMAA Annuals, 1963, 64; Gallery of Modern Art, NYC, 1964; Boston U., 9 Realist Painters, 1964; Corcoran, 1964, and Biennial, 1965; Carnegie, 1964, 67; Norfolk, Contemporary Art USA, 1966; Vassar College, 1968; Ravinia Festival, Highland Park, Ill., 1968; Boston U., The American Landscape, 1972; The Pennsylvania State U., Contemporary Artists and the Figure, 1974; Boston/MFA, Trends in Contemporary Realist Painting, 1974; US Department of the Interior, America, circ., 1976; PAFA, Contemporary American Realism Since 1960, 1981; NAD, 1983; Hudson River Museum, Form or Formula: Drawing and Drawings, 1986; AAIAL, Portraits from the American Academy, 1987; NAD, 163rd Annual, 1988; U. of Rochester (N.Y.), Direct Response, 1989. **Collections:** Boston/MFA; Bowdoin College; Brooklyn Museum; Hirshhorn; Mellon Bank; Minneapolis/Institute; U. of North Carolina; The Pennsylvania State U.; WMAA; Cleveland/MA; Hobart and

William Smith College; PAFA; U. of Virginia; Wilmington. **Bibliography:** *America 1976;* Cummings 4; Strand, ed.; Ward.

ANDRE, CARL **b.** September 16, 1935, Quincy, Mass. **Studied:** with Patrick Morgan, 1953, Frank Stella, 1958. US Army Intelligence Analyst. Employed by the Pennsylvania Railroad, 1960-64. Traveled England, France, Germany, Holland, Belgium. **Awards:** National Council on the Arts, 1968. **Address:** P.O. Box 1001 Cooper Station, NYC 10003. **Dealer:** Paula Cooper Gallery, NYC; Konrad Fischer, Düsseldorf 75004. **One-man Exhibitions:** (first) Tibor de Nagy Gallery, NYC, 1965, 66; Dwan Gallery, Los Angeles, 1967; Dwan Gallery, NYC, 1967, 69, 71; Konrad Fischer Gallery, Düsseldorf, 1967, 69, 71, 72, 73, 74, 76, 80, 82, 84; Monchengladbach, 1968; Galerie Heiner Friedrich, Munich, 1968, 71; Cologne, 73; Irving Blum Gallery, Los Angeles, 1969; Wide White Space Gallery, Antwerp, 1969, 71, 74; Galleria Sperone, Turin, 1969, 73; The Hague, 1969; ACE Gallery, Los Angeles, 1970, 76, 78; St. Louis/City, 1971; Yvon Lambert, Paris, 1971; Lisson Gallery, London, 1972; Janie C. Lee Gallery, Dallas, 1972; Galerie Annemarie Verna, Zurich, 1972; Max Protetch Gallery, Washington, D.C., 1973; Portland (Ore.) Center for the Visual Arts, 1973; Andover/Phillips, 1973; MOMA, 1973; Wide White Space Gallery, Brussels, 1974; John Weber Gallery, NYC, 1974, 75, 76; ACE Gallery, Vancouver, 1974, 75, 78; Cusack Gallery, Houston, 1975; Wesleyan U., Conn., 1976; The Clocktower, NYC, 1976, 83; Kabinett für Aktuelle Kunst, Bremerhaven, 1976; Minneapolis College of Art and Design, 1976; Otis Art Institute, 1977; Laguna Gloria Art Museum, Austin, 1978; Cincinnati/Contemporary, 1978; Buffalo/Albright, 1978; Chicago/AI, 1978; Newcastle Region Art Gallery, Australia, 1978; Art Gallery of South Australia, Adelaide, 1978; Van Abbemuseum,

Eindhoven, 1978; Art Agency Co. Ltd.,
Tokyo, 1978; Pinacotheca, Melbourne,
1978; U. of California, Berkeley, 1979;
Dallas/MFA, 1979; Musée d'Art Con-
temporain, Montreal, 1979; Palais des
Beaux Arts, Brussels, 1979; Paris/Moderne,
1979; ICA, Boston, 1980; Lisson Gallery,
London, 1975; Gian Enzo Sperone, 1975;
Sperone Westwater Fischer, NYC, 1975,
77, 78; Weinberg Gallery, San Francisco,
1975; Cusack Gallery, Venice, Paris, Hous-
ton, 1976; ACE Gallery, 1976, 78; Galerie
Lambert, 1976; Hartford (Conn.) Art
School, 1977; Humboldt State U., 1979;
ACA Gallery, Calgary, 1979; Paula
Cooper Gallery, NYC, 1980, 81, 83, 85,
89, 90; David Bellman Gallery, Toronto,
1980; Ottawa/National, 1980; Portland
State U., 1980; Susan Caldwell Gallery,
NYC, 1981, 82; Stuttgart/WK, 1981;
Anthony d'Offay Gallery, London, 1981;
Krefeld/Haus Lange, 1981; Alberta Col-
lege of Art, 1982; U. of New Mexico,
1982; Colorado State U., 1982; U. of Wy-
oming, 1982; Hans Mayer Gallery, Basel,
1982; U. of Miami, 1982; Konrad Fischer
Gallery, Zurich, 1983; Heath Gallery, At-
lanta, 1983; Galerie Daniel Templon,
Paris, 1983, 85; Nouveau Musée,
Villeurbanne/Lyon, 1983; Le Coin du
Miroir, Dijon, 1983; Flow Ace Gallery,
Venice, Calif., 1983; Plus-Kern, Brussels,
1983, 84, 86, 88, 90; Broward Commu-
nity College, 1984; Richland College,
1984; Munster/WK, 1984; Galleria Primo
Piano, Rome, 1984; Galerie im Korner-
park, Berlin, 1984; Stony Brook/SUNY,
1984; Galerie Andre, Berlin, 1984;
Kunstraum, Munich, 1985; Konrad
Fischer Gallery, Düsseldorf, 1985, 86, 87,
88, 90, 91; Sperone, Rome, 1985;
Eindhoven, 1987; The Hague, 1987;
Castello di Rivoli, Turin, 1987; Julian
Pretto Gallery, NYC, 1988; Galerie Yvon
Lambert, Paris, 1988; Jean Bernier,
Athens, 1988; Galerie Daniel Templon,
Paris, 1989; Anthony d'Offay Gallery,
London, 1989, 91; Galeria Edurne,
Madrid, 1989; Cloister of the Carmelites,

Carl Andre, *Merrymount*, 1992.

Frankfurt, 1991; Sor/Kunstmuseum,
1991. **Retrospective:** SRGM, 1970.
Group: Jewish Museum, Primary Struc-
ture Sculptures, 1966; Los Angeles/County
MA, American Sculpture of the Sixties,
1967; Kassel, Documenta IV, 1968; The
Hague, Minimal Art, 1968; MOMA, The
Art of the Real, 1968; Amsterdam/Sted-
elijk, Op Losse Schroeven, 1969; Berne,
When Attitudes Become Form, 1969;
WMAA, Anti-Illusion: Procedures/
Materials, 1969; Chicago/AI, 69th Ameri-
can Exhibition, 1970; Tokyo Biennial,
1970; Foundation Maeght, 1970; SFMA,
Unitary Forms: Minimal Sculptures, 1970;
Seattle/AM, 557, 087, 1969; WMAA
Sculpture Annuals, 1970, 73; MOMA,
Information, 1970; SRGM, Guggenheim
International, 1971; Arnhem, Sonsbeek
'71, 1971; ICA, U. of Pennsylvania, Grids,
1972; New York Cultural Center, 3D into
2D, 1973; Basel Diagrams and Drawings,
1973; MOMA, Some Recent American
Art, circ., 1973; Cologne/Kunstverein,
Kunst uber Kunst, 1974; Indianapolis,
1974; Hayward Gallery, London, The
Condition of Sculpture, 1975; NCFA,
Sculpture: American Directions 1945-
1975, 1975; Rijksmuseum Kröller-Müller,
Functions of Drawing, 1975; MOMA,
Drawing Now, 1976; WMAA, 200 Years
of American Sculpture, 1976; Akademie
der Kunst, Berlin, SoHo, 1976; Corcoran,
Andre, Long, Le Va, 1976; Paris/Moderne,
Paris-New York, 1977; WMAA, 20th Cen-
tury American Drawings, 1978; Venice
Biennale; Lincoln, Mass./De Cordova,

Born in Boston, 1979; Humlebaek/Louisiana, Andre, Dibbets, Long and Ryman, 1980; Hayward Gallery, London, Pier + Ocean, 1980; Dublin/Municipal, International Quadrennial (ROSC), 1980, 84; Cologne/Stadt, Westkunst, 1981; Stedelijk/Amsterdam, '60, '80-Attitudes/Concepts/Images, 1982; Kassel, Documenta VII, 1982; SRGM, The New York School: Four Decades, 1982; WMAA, The Sculptor as Draftsman, circ., 1983; Bruglingerpark, Basel, Skulptur im 20. Jahrhundert, 1984; Seattle/AM, American Sculpture: Three Decades, 1984; MOMA, Contrasts of Form: Geometric Abstract Art 1910-1980, 1985; Liege/Moderne, Resemblances, 1985; SRGM, Transformations in Sculpture, 1985; Fort Lauderdale, American Renaissance: Painting and Sculpture Since 1940, 1986; Frankfurt/Kunstverein, Vom Zeichnen: Aspeckte der Zeichnung, 1960-1986, 1986; Paris/Beaubourg, Qu'est-ce que la sculpture moderne?, 1986; Cologne/Ludwig, Europe-Amerika, 1986; Bordeaux/Contemporain, Art Minimal I, 1986; ICA, U. of Pennsylvania, At the Crossroads, 1987; Berlin, Hamburger Bhanof, Zeitlos, 1988; Berlin, DAAD, Balkon Mit Facher, 1988; Cologne/Rheinhalle, Bilderstreit, 1989; Frejus, Fondation Templon, Exposition Inaugurale, 1989; WMAA, Immaterial Objects, Circ., 1989; Düsseldorf/Kunsthalle, Um 1968-Konkrete Utopien in Kunst und Gesellschaft, 1990; Osaka/National, Minimal Art, 1990; Dhondt-Dhaenens, Betekende Ruimte, 1991; U. of Houston, The Transparent Thread: Asian Philosophy in Recent American Art, 1991; Fundacio La Caixa, Barcelona, L'Espai I La Idea, 1991; Kunsthalle der Heyp Kulturstiftung, Munich, Denk-Bilder/Kunst der Gegenward, 1960-1990, 1991; Southampton/Parrish, Minimalism and Post-Minimalism: Drawing Distinctions, 1991. **Collections:** Basel; Brandeis U.; Buffalo/Albright; Chicago/Contemporary; Cologne; Columbus; Darmstadt/Hessisches; Dayton/AI; Dhondt-Dhaenens;

Krefeld/Haus Lange; La Jolla; Liege; MOMA; Milwaukee; Monchengladbach; Ottawa/National; Pasadena/AM; Ridgefield/Aldrich; Stuttgart; Tate; Toronto; Walker; WMAA. **Bibliography:** Alloway 4; *Art Now* 74; Battcock, ed.; Calas, N. and E.; De Wilde 2; Haskell 5; **Carl Andre Sculpture;** Celant; *Contemporanea;* Cummings 1; De Vries, ed.; *Europa/Amerika;* Gablik; Gohr and Gachnang; Goossen 1; Honnef; Honisch and Jensen, eds.; Johnson, Ellen H.; Kardon 3; Krauss 2; Lippard 3; Lippard 4; Lippard, ed.; Monte and Tucker; Muller; *Performance Anthology;* Rowell; Sandler 3; Seitz 3; Siegel; Tuchman 1; **Waldman 1;** Weintraub; *When Attitudes Become Form.* Archives.

ANDREJEVIC, MILET b. September 25, 1925, Zrenjanin, Yugoslavia. d. October 20, 1989, NYC. **Studied:** School of Applied Arts, Belgrade, 1939-42; Academy of Fine Arts, Belgrade, 1942-47, BA; Academy of Fine Arts, 1951, MFA. Traveled Europe; resided Paris, 1953-58. To USA, 1958. **Taught:** NYU, 1955-56; Brooklyn College, 1973-76. **Awards:** National Endowment for the Arts, grant, 1985; New York Foundation for the Arts, grant, 1985. **One-man Exhibitions:** (first) Belgrade/National, 1948; Green Gallery, NYC, 1961, 63; Noah Goldowsky, NYC, 1970, 72, 76; Robert Schoelkopf Gallery, 1980. **Group:** Galerie Creuze, Paris, 1956-57; Dallas/MFA, 1962; Corcoran, 1963; WGMA, The Formalists, 1963; WMAA Annuals, 1963, 65; Chicago/AI, 1964; New York Cultural Center, Realism Now, 1972; Hofstra U., Green Gallery Revisited, 1972; MOMA, 76 Jefferson St., 1975; PAFA, Contemporary American Realism Since 1960, 1981; The Pennsylvania State U., Realistic Directions, 1983; IEF, Twentieth Century American Drawings: The Figure in Context, circ., 1984. **Collections:** Allentown/AM; WMAA; Hirshhorn; U. of Texas, Austin; U. of Virginia; Charlottesville; RISD; Chemical Bank;

Lehman Bros.; MMA. **Bibliography:** Lippard 4.

ANDREWS, OLIVER

from 1st to 5th edition.

ANTONAKOS, STEPHEN

b. Agios Nikolaos, Militinis, Gythion, November 1, 1926, Greece. To USA, 1930. **Studied:** Brooklyn (N.Y.) Community College. Traveled Europe. **Taught:** Brooklyn Museum School; U. of North Carolina, Greensboro, 1967, 69; U. of Wisconsin, Madison, 1968; U. of California, Fresno, 1970. Work featured in V. Kontakos film, *A Quality of Light.* **Commissions:** Dayton, Ohio, Federal Building (GSA), 1978; Hampshire College, Amherst, Mass., 1978; Atlanta International Airport, 1980; Baltimore, Md., subway, 1983; Cambridge, Mass., subway line and commuter terminal, 1984; Seattle Center Resident Theatre, 1981. Made a film of "package" projects, 1970-75; Neon for Bagley Wright Theatre, Seattle, 1983; U. of Dijon, 1984; South Campus Station, Buffalo, 1984; Southwestern Bell, Dallas, 1984; Tacoma (Wash.) Dome, 1984; Transit Center, Davenport, Iowa, 1985; Brandeis U., 1986; Columbus Museum of Art, 1986; 14th District Police Station, Chicago, 1986; La Jolla, 1986; Columbus, Ohio, 1986; York College, Jamaica, NY, 1986; 7475 Wisconsin Ave., Bethesda, Md., 1988; Embassy Suites Hotel, San Diego, 1988; Greektown Station, Detroit, 1988; Exchange Place Station, PATH, Jersey City, N.J., 1989; Backbay/South End Station, Boston, 1990; 59th St. Marine Transfer Station, NYC, 1990; Pershing Square Station, 5th/Hill Station, Los Angeles, 1991. **Awards:** CAPS, 1972; National Endowment for the Arts, 1973; DAAD, West Berlin, 1980. **Address:** 435 West Broadway, NYC 10012. **One-man Exhibitions:** Avant Garde Gallery, NYC, 1958; The Byron Gallery, 1964; Miami Modern, 1964; Schramm Galleries, Fort Lauderdale, Fla., 1964; Fischbach Gallery, NYC, 1967-

69, 70, 71, 72; Madison Art Center, 1971; Wisconsin State U., Oshkosh, 1971; Houston/Contemporary, 1971; Fresno State College, 1972; CAPS, 1973; Rosa Esman Gallery, NYC, 1974; John Weber Gallery, NYC, 1974, 75, 76, 77; Buffalo/Albright, 1974; The Clocktower, NYC, 1974; Cusack Gallery, Houston, 1974; Fort Worth, 1974; Galleria Marilena Bonomo, Bari, Italy, 1975; Galerie 27, Paris, 1975; Wright State U., 1975; Art & Project, Amsterdam, 1976; Galerie Bonnier, 1976; Nancy Lurie Gallery, Chicago, 1976; Galerie Aronowitsch, Stockholm, 1977; Bernier Gallery, Athens, 1977; U. of Massachusetts, Amherst, 1978; Young-Hoffman, Chicago, 1978; Galerie Nancy Gillespie/Elizabeth de Laage, Paris, 1979; Galerie Tanit, Munich, 1980; U. of Miami, 1980; Nassau County Museum, 1982; Jean Bernier Gallery, Athens, 1983; Bonnier Gallery, New York, 1983; Le Coin du Miroir, Dijon, France, 1983; Maison de Culture de Nevers, France, 1983; La Jolla, 1984; Davenport/MA, 1985; Sandpiper Gallery, Tacoma, 1985; Brandeis U., 1986; U. of Wisconsin/Madison, 1986; Bali Miller Gallery, NYC, 1986; Burnett Miller Gallery, Los Angeles, 1987; G. H. Dalsheimer Gallery, Baltimore, 1987; Ileana Tounta Contemporary Art Center, Athens, 1989; Kouros Gallery, NYC, 1989; Atlantic Center for the Arts, New Smyrna Beach, Fla., 1989; Gallery Camino Real, Boca Raton, Fla., 1989; Blancpain Stepczynski Galerie d'Art, Geneva, 1990; The Venetian Fortress, Rhodes, Greece, 1992. **Group:** Martha Jackson Gallery, NYC, New Media—New Forms, I & II, 1960, 61; Van Bovenkamp Gallery, NYC, 1965; Eindhoven, Kunst-Licht-Kunst, 1966; Kansas City/Nelson, Sound, Light, Science, 1966; WMAA, 1966, 68-69; Carnegie, 1967; Worcester/AM, 1967; Los Angeles/County MA and PMA, American Sculpture of the Sixties, 1967; Trenton/State, Focus on Light, 1967; Milwaukee, Light Motion Space, 1967; A.F.A., 1968; Kansas City/Nelson,

The Magic Theatre, 1968; WMAA, Light: Object and Image, 1968; UCLA, Electric Art, 1969; Newark Museum, Light in Contemporary Art, 1969; WMAA, Human Concern/Personal Torment, 1969, Annual, 1970; Jacksonville/Cummer, Light Art, 1970; Hayward Gallery, London, Kinetics, 1970; Portland, Me./MA, Light, 1971; U. of North Carolina, Works on Paper, 1971, 72; U. of Maryland, What's Happening in Soho, 1971; U. of Nebraska, Light and Motion, 1972; Katonah (N.Y.) Art Gallery, Drawing in Space, 1972; WMAA, American Drawings: 1963-1973, 1973; SFMA, Works in Spaces, 1973; Indianapolis, 1974; Webster College, Webster Groves, Mo., 4 Dimensions in 2, 1975; Ackland, Light/Sculpture, 1975; Leverkusen, USA Zeichnungen 3, 1975; Berlin/Akademie der Kunst, SoHo, 1976; Kassel, Documenta VI, 1977; SFMA, A Shade of Light, 1978; Ridgefield/Aldrich, The Minimal Tradition, 1979; ICA, U. of Pennsylvania, Urban Encounters, 1980; Wellesley College, Aspects of the Seventies: Sitework, 1980; American Center, Paris, Murs/Tensions/Lumiere, 1981; Washington Project of the Arts, Washington, D.C., Neon Fronts, 1981; Antwerp/ICC, Europalia 82 Greece: Emerging Images, 1982; Paris/Moderne, Elektra, 1983; Brooklyn Museum, Public and Private: American Prints Today, 1986. **Collections:** Brandeis U.; Chase Manhattan Bank; Ciba-Geigy Corp.; Dayton, Ohio, Federal Building; SRGM; Hampshire College; Hartford/Wadsworth; La Jolla; MOMA; U. of Maine; Miami/Modern; Milwaukee; Newark Museum; U. of Massachusetts; U. of North Carolina; Phoenix; Ridgefield/Aldrich; U. of Utah; WMAA. **Bibliography:** Antonakos; Battcock, ed.; *Report;* Sandler 3; Tuchman 1. Archives.

ANTREASIAN, GARO b. February 16, 1922, Indianapolis, Ind. **Studied:** John Herron Art Institute, B.F.A. **Taught:** John Herron Art Institute, 1948-59, 1961-

64; U. of New Mexico, 1964-. Technical director, Tamarind Lithography Workshop, 1960-61; technical director, Tamarind Institute, 1970-72; U. of New Mexico, 1981-87; Fulbright Lecturer, Brazil, 1985. **Member:** Board of Trustees, Albuquerque Museum, 1981-90. **Commissions:** (murals) Butler U.; Indiana National Bank, Indianapolis; Indiana U., Bloomington. **Awards:** Hoosier Salon, 1944, 49; MOMA, 1953; The Print Club, Philadelphia, 1958, 61; Albion College, 1968; Northern Illinois U., 1968; Hon. DFA, Purdue U., 1972; National Endowment for the Arts, 1982; Portland, Ore./AM, **P.P.**, 1985. **Address:** 421 Jefferson Street NE, Albuquerque, N.M. 87110. **One-man Exhibitions:** Tulane U.; U. of Notre Dame; Stephens College; Wabash College; Kalamazoo/Institute; Martha Jackson Gallery, 1969; Maluina Miller Gallery, San Francisco; Cottonwood Gallery, Albuquerque; Lantern Gallery, Ann Arbor; Marjorie Kauffman Gallery, Houston, 1979, 84; Elaine Horwitch Gallery, Santa Fe, 1977-78; Alice Simsar, Inc., Ann Arbor, 1979; Utah State U., 1970; The Pennsylvania State U., 1981; Foundation Gallery, NYC, 1982; Lyman-Snodgrass Gallery, Indianapolis, 1982; Wildine Gallery, Albuquerque, 1982, 83; Iowa State U., 1983; Robishon Gallery, Denver, 1984, 90; U. of New Mexico, 1985; Moss Chumley Gallery, Dallas, 1986; Louis Newman Gallery, Beverly Hills, 1989; Galleria Exposition, Mexico City, 1989; Coe College, 1990; Rettig y Martinez Gallery, Santa Fe, 1991; Cortland/SUNY, circ., 1991. **Retrospective:** Ohio State U.; Washburn U.; U. of Nebraska; Miami U., Oxford, Ohio; Kansas State U.; U. of Georgia; U. of New Mexico; Albuquerque Museum and U. of New Mexico, circ., 1988. **Group:** SFMA, 1942; NAD, 1943; Library of Congress, 1949, 66, 68; MMA, 1950; Boston/MFA; PMA; NYPL; USIA; ART; USA:59, NYC, 1959; PCA, 1959; Brooklyn Museum Print Biennials; SAGA, 1964; Florida State U., 1965, 67, 69;

Seattle/AM, 1966, 68; Smithsonian, 1968; Potsdam/SUNY, 1968; Albany/SUNY, 1968; Tokyo Print Biennial, 1972; U. of Kentucky, Graphics Now; USA, 1972; Bradford, England, III British Print Biennial, 1972; Honolulu Academy Print Biennial, 1973; California State U., Sacramento, Print Invitational, 1974; Dulin Gallery, 17th National Works on Paper Exhibition, 1985; U. of Minnesota, Artists in the Trenches, 1985; U. of New Mexico, Albuquerque, Tamarind: 25 years, 1960-1985, 1985; Worcester/AM, Spectrum of Innovation, circ., 1989. **Collections:** Albany/SUNY; Albion College; L. S. Ayres & Co.; Boston/MFA; Bradley U.; Brooklyn Museum; Chicago/AI; Cincinnati/AM; Cleveland/MA; Coos Bay; Dallas/MFA; Davidson College; Drake U.; Emory U.; Grand Rapids; Indiana National Bank; Indiana U.; Indianapolis; Kalamazoo/Institute; Library of Congress; Los Angeles/County MA; MMA; MOMA; U. of Michigan; U. of Minnesota; NCFA; National Gallery; U. of Notre Dame; Olivet College; PMA; The Print Club, Philadelphia; Phoenix; Reed College; Ringling; Roswell; SRGM; Sacramento/Crocker; San Diego; San Jose State College; Santa Fe, N.M.; Seattle/AM; Smith College; Southern Illinois U.; Stephens College; Syracuse U.; Terre Haute/Swope; USIA; US Coast Guard; U. of Wisconsin. **Bibliography:** Archives.

ANUSZKIEWICZ, RICHARD

b. May 23, 1930, Erie, Pa. **Studied:** Cleveland Institute of Art, 1948-53; Kent State U., 1955-56, BS, Ed.; Yale U., 1953-55, MFA. Traveled Western Europe, North Africa. **Taught:** Dartmouth College, Artist-in-Residence, 1967; U. of Wisconsin, 1968; Cornell U., 1968; Kent State U., 1968. **Awards:** Silvermine Guild, Philosophers Stone Prize, 1963, First Prize, 1964; Flint/Institute, P.P., 1966. **Address:** 76 Chestnut Street, Englewood, NJ 07631. **Dealer:** ACA Galleries, NYC. **One-man Exhibitions:** Youngstown/Butler, 1955;

The Contemporaries, NYC, 1960, 61, 63; Sidney Janis Gallery, 1965, 67, 69, 71, 73; Cleveland/MA, 1966; Dartmouth College, 1967; U. of Wisconsin, 1968; Kent State U., 1968; J.L. Hudson Art Gallery, Detroit, 1968; Free Public Library, Fair Lawn, N.J., 1969; Trenton/State (two-man), 1971; A.A.A. Gallery, NYC, 1973; Andrew Crispo Gallery, NYC, 1974, 75, 76; La Jolla, 1976; Pine Free Public Library, Fair Lawn, N.J., 1976; U. of California, Berkeley, 1977; Columbus, 1977; Reed College, 1977; Graphics Gallery, Toronto, 1977; Montclair State College, 1977; Galerie 99, Bay Harbor Islands, 1978; Ringling, 1978; Allentown/AM, 1978; Terre Haute/Swope, 1978; Wichita/AM, 1978; Alex Rosenberg Gallery, NYC, 1979; Williamstown/Clark, 1979; Brooklyn Museum, 1980; Carnegie, 1980; U. of Miami, 1981; Hokin Gallery, Bay Harbor Islands, Fla., 1981; Fort Lauderdale, 1982; Charles Foley Gallery, Columbus, Ohio, 1982; Atlantic Center for the Arts, New Smyrna Beach, Fla., 1983; Pembroke Gallery, Houston, 1984; Youngstown/Butler, 1984; Huntington/Heckscher, 1984; The Graham Gallery, NYC, 1984, 86; Schweyer Galdo Gallery, Birmingham, Mich., 1985; Hokin/Kaufman Gallery, Chicago, 1985; Canton Art Institute, 1985; Tampa, 1986; Cleveland/MA, 1988; ACA Galleries, NYC, 1991. **Retrospective:** Brooklyn Museum, 1980. **Group:** U. of Illinois, 1961, 63; NYU, 1961; PAFA, 1962, 67; WMAA, Geometric Abstraction in America, circ., 1962; U. of Minnesota, 1962; Silvermine Guild, 1962, 63; Allentown/AM, 1963; Lincoln, Mass./De Cordova, New Experiments in Art, 1963; MOMA, Americans 1963, circ., 1963-64; WGMA, The Formalists, 1963; WMAA Annual, 1963, 67; Chicago/AI, 1964; Tate, Painting and Sculpture of a Decade, 1954-64, 1964; Carnegie, 1964, 67; MOMA, The Responsive Eye, 1965; Corcoran Biennial, 1965, WMAA, A Decade of American Drawings, 1965;

Buffalo/Albright, Plus by Minus, 1968; Flint/Institute, I Flint Invitational, 1966; WMAA, Art of the U.S. 1670-1966, 1966; Detroit/Institute, Color, Image and Form, 1967; Trenton/State, Focus on Light, 1967; Expo '67, Montreal, 1967; Kassel, Documenta IV, 1968; WMAA, Artists under 40, 1968; Corcoran Biennial, 1975; Indianapolis, 1976; Brooklyn Museum, Thirty Years of American Printmaking, 1976; MOMA, Printed Art: A View of Two Decades, 1980; Yale U., 20 Artists: Yale School of Art, 1950-1970, 1981; Montclair/AM, Inside/Out, 1984; Venice, Biennale, 1986; Tel Aviv, Trends in Geometric Abstract Art, 1986; Olympic Center, Seoul, 1988. **Collections:** Akron/AI; Allentown/AM; Amherst College; Buffalo/Albright; Carnegie; Charlotte/Mint; Chicago/AI; Cleveland/MA; Corcoran; Dartmouth College; Detroit/Institute; Flint/Institute; Harvard U.; Hirshhorn; Honolulu/Academy; Milwaukee; MIT; Norfolk/Chrysler; MOMA; PMA; Princeton U.; Ridgefield/Aldrich; RISD; Rutgers U.; SFMA; U. of Texas; Trenton/State; VMFA; U. of Wisconsin; WMAA; Yale U.; Youngstown/Butler; Birmingham, Ala./MA; Brooklyn Museum; U. of California, Berkeley; Columbus; Cornell U.; Denver/AM; Indianapolis; MMA; Norfolk/Chrysler; PAFA; Ringling; SRGM; St. Louis/City; VMFA; Wichita; U. of Wisconsin. **Bibliography:** Battcock, ed.; Hunter, ed.; MacAgy 2; Rickey; Sandler 3; Weller. Archives.

ARAKAWA, SHUSAKU

b. 1936, Nagoya City, Japan. **Studied:** U. of Tokyo, 1954-58; Massachusetts College of Art, Boston. To USA, 1961. Traveled Germany, France. **Awards:** DAAD grant, 1972; Chevalier des Arts et des Lettres, France, 1986; Guggenheim Foundation Fellowship, 1987; Belgian Art Critics Prize, 1988. **Address:** 124 West Houston Street, NYC 10012. **Dealer:** Ronald Feldman Fine Arts, Inc.; NYC. **One-man Exhibitions:** Mudo Gallery, Tokyo, 1961;

Galerie Schmela, 1963, 65, 66; Dwan Gallery, Los Angeles, 1964, 66; Brussels/Beaux Arts, 1964; Minami Gallery, 1965; Galleria dell-Ariete, 1965; Dwan Gallery, NYC, 1966, 68, 69; Wide White Space Gallery, Antwerp, 1966; Stuttgart/WK, 1966; Eindhoven, 1966; Wuppertal/von der Heydt, 1967; Galleria Schwarz, 1967, 71; Yvon Lambert, Paris, 1969, 75; Paris/Moderne, 1970; Hannover/Kunsterverein, 1970; Badischer Kunstverein, Karlsruhe, 1970; Fendrick Gallery, Washington, D.C., 1971; Harcus-Krakow Gallery, Boston, 1971; Angela Flowers Gallery, London, 1971; Hamburg, circ., 1972; Galerie Art in Progress, Zurich, 1972; Galerie van der Loo, Munich, 1972; Ronald Feldman Fine Arts Inc., NYC, 1972, 74, 76, 79, 83, 85, 87, 88, 90; Dayton's Gallery 12, Minneapolis, 1973; Galleria A. Castelli, Milan, 1974; MOMA, 1974; U. of Wisconsin, circ., 1974; Multiples Inc., NYC, 1974, 76; Galerie Art in Progress, Munich, 1974; Humlebaek/Louisiana, 1974; Art in Progress, Düsseldorf, 1975, 77; Galerie Arnonowitsch, Stockholm, 1975; Isy Brachot, Brussels, 1975; Pasquale Trisorio, Naples, 1975; Henie Onstad Museum, Oslo, 1975; Berger Gallery, Pittsburgh, 1975; Carl Solway Gallery, Cincinnati, 1975; Galeria 42, Barcelona, 1976; Toronto, 1976; Rubicon Gallery, Los Altos, 1976; Margo Leavin Gallery, Los Angeles, 1976, 78; Delahunty Gallery, Dallas, 1976; Grupo Quince, Madrid, 1976; I.C.C. Antwerp, 1976; U. of Wisconsin, Milwaukee, 1977; Kunsthalle, Düsseldorf, 1977; Galerie Maeght, Paris, 1977, 78, 82; Museo de Arte Moderno, Bogota, 1977; Gallery Takagi, Nagoya, 1978, 80, 88; Berlin/National, 1978; Amsterdam/Stedelijk, 1978; Oesterreichisches Landesmuseum, Kunstsammlungen, Ludwigshafen, 1979; Seibu Museum, Tokyo, 1979; National Museum, Osaka, 1979; Gloria Luria Gallery, Bay Harbor Islands, Fla., 1980; Galerie Maeght, Zurich, 1980; John Stoller & Co., Minneapolis, 1980; Arts Club of Chicago, 1981; Hannover/K-G,

1981; Lenbachhaus, Munich, 1981; Galerie Yvon Lambert, Paris, 1982, 87; Hartford/Wadsworth, 1983; Kitakyushu Museum, Kyushu, 1983; Padiglione d'Arte Contemporanea, Milan, 1984; Ridgefield/Aldrich, 1984; Arnold Herstand Gallery, NYC, 1985; Galleria Blu, Milan, 1986; U. of Akron, 1985; Satani Gallery, Tokyo, 1986, 87; Van Straaten Gallery, Chicago, 1987; Seibu Museum of Art, Tokyo, 1987; Seibu Museum, Karuizawa, 1988; Williams College, 1989; Tokyo/Contemporary, Tokyo, 1989; U. of Hartford, 1990; DAAD, Berlin, 1990. **Retrospective:** Tokyo/Modern, circ., 1991. **Group:** U. of Illinois, 1965, 67; MOMA, New Japanese Paintings and Sculpture, 1966; Kassel, Documenta IV, 1968; XXXV Venice Biennial, 1970; Indianapolis, 1974; Cologne, Project '74, 1974; Brooklyn Museum Print Biennial, 1974; Cincinnati/MA, Japanese Prints of the 20th Century, 1975; Hirshhorn, The Golden Door, 1876-1976, 1976; Milwaukee, From Foreign Shores, 1976; Chicago/AI, Drawings of the 70s, 1976; Berlin/National, SoHo, 1976; Kassel, Documenta VI, 1977; Chicago/Contemporary, Words at Liberty, 1977; WMAA, Art about Art, 1978; Cleveland/MA, 4 Contemporary Painters, 1978. **Collections:** Amsterdam/Stedelijk; Basel; Berlin; Brussels/Beaux Arts; Cleveland; Dayton/AI; Des Moines; Düsseldorf; Hirshhorn; MMA; MOMA; Paris/Moderne; Walker; Washington U., St. Louis; WMAA. **Bibliography:** Alloway 4; *From Foreign Shores;* Honisch and Jensen, eds.; *Art Now 74;* Calas 2; Calas, N. and E.; *Contemporanea; Kunst um 1970;* Danto; Sandler 3.

ARCHIPENKO, ALEXANDER

b. May 30, 1887, Kiev, Ukraine. **d.** February 25, 1964, NYC. **Studied:** Kiev, an art school 1902-05; Academie des Beaux-Arts, Paris, 1908. To USA, 1923; citizen, 1928. Traveled Europe and USA extensively. **Taught:** U. of Washington, 1935-36; U. of Kansas; Allegheny College; opened school in Paris, 1910; opened school in NYC, 1939. **One-man Exhibitions:** Hagen, 1910, 60; X Venice Biennial, 1920; Andover/Phillips, 1928; Karl Nierendorf Gallery, NYC, 1944; Dallas/MFA, 100th One-Man, 1952; A.A.A. Gallery, NYC, 110th One-Man, 1954; Darmstadt/Kunsthalle, circ. Germany, 1955; Perls Galleries, 1957, 59; Grosvenor (Gallery), London, 1961; Mannheim, 1962; Palazzo Barberini, Rome, 1963; Auckland, 1964; Finch College, NYC, 1967; UCLA, 1967; NCFA, 1968; Musée Rodin, Paris, 1969; Toronto, 1971; Paine Art Center and Arboretum, Oshkosh, 1971; The Pace Gallery, NYC, 1973; The Zabriskie Gallery, NYC, 1976, 79, 82, 90; Tel Aviv, 1981; Galerie Zabriskie, Paris, 1982; Nohra Haime Gallery, NYC, 1983; Bard College, 1985; A.A.A. Gallery, NYC, 1989. **Retrospective:** Smithsonian, 1968. **Group:** Major international exhibitions. **Collections:** Amherst College; Andover/Phillips; Belvedere; Brandeis U.; Chicago/AI; Cleveland/MA; Cranbrook; Darmstadt/Kunsthalle; U. of Delaware; Denver/AM; Detroit/Institute; Düsseldorf; Essen; Hagen; Hanover; Honolulu Academy; U. of Kansas City; Leipzig; MOMA; Mannheim; Miami/Modern; U. of Michigan; U. of Minnesota; Municipal U. of Omaha; Northwestern U.; Omaha/Joslyn; U. of Oregon; Osaka/Municipal; Phillips; Phoenix; Rotterdam; SFMA; SRGM; San Antonio/McNay; Seattle/AM; Tel Aviv; WMAA; Yale U. **Bibliography:** Alexander Archipenko, A Memorial Exhibition; Archipenko 1, 2; Barr 1; Baur 7; Biddle 4; Bihalji-Merin; Blesh 1; Brown; Brumme; Bulliet 1; Cassou; Cheney; Draven, W.; Christensen; **Daubler and Goll;** Dorner; Dreier 2; Gertz; Giedion-Welcker 1, 2; Goodrich and Baur 1; Guggenheim, ed.; Haftman; **Hildebrandt;** Huyghe; *Index of 20th Century Artists;* Janis and Blesh 1; Janis, S.; **Karshan 1, 2;** Kuh 3; Langui; Lee and Burchwood; Licht, F.; Lynton; Masten; McCurdy, ed.; Mellquist; Mendelowitz; Michaelson and Guralnik;

Neumeyer; Poore; Ramsden 2; **Raynal 1**; Read 3; Rickey; Ritchie 3; Rose, B. 1; Rosenblum 1; Rowell; Salvini; Selz, J.; Seuphor 3; Trier 1, 2; Valentine 2; Verkauf; Waldman 4; Wingler, ed.; Woodstock; Zaidenberg, ed.; Zervos. Archives.

ARMAJANI, SIAH **b.** Teheran, Iran, 1939. **Studied:** Macalester College, 1963, BA. To USA, 1960; Citizen. Begins making non-permanent constructions 1968, permanent installations 1980. **Permanent installations:** Ohio State U., 1979; Roanoke College, 1980; Samuel S. Fleishner Art Memorial, Philadelphia, 1982; NOAA Bridges, Seattle, 1983; U. of Maryland; U. of Minnesota, 1988; Skybridge, Minneapolis, 1988; The Irene Hixon Whitney Bridge, Minneapolis, 1988; Battery Park City, NYC, 1989; General Mills, Minneapolis, 1990; Bandstand, Hitchcock Park, Mitchell, S.D., 1991; Lannan Foundation, Los Angeles, 1991. **Address:** 11 Kenwood Parkway, St. Paul, Minn. 55105. **Dealer:** Max Protetch Gallery, NYC. **One-man Exhibitions:** Ohio State U., 1979; New Gallery of Contemporary Art, Cleveland, 1981; Max Protetch Gallery, NYC, 1983, 84, 85; 87, 89, 91; ICA, U. of Pennsylvania, 1985; Munster/WK, circ., 1987; Galerie Ghislane Hussenot, Paris, 1987; Galerie Rudolf Zwirner, Cologne, 1987; Amsterdam/Stedelijk, 1987; Basel/Kunsthalle, 1987; MIT, 1988. **Group:** Chicago/Contemporary, Art by Telephone, 1969; Indianapolis, 1969; MOMA, Information, 1970; Walker, Drawings: 10 Minnesota Artists, 1971; Walker, Scale and Environment, 1977; ICA, U. of Pennsylvania, Dwellings, 1978; XXXIX Venice Biennial, 1980; Hirshhorn, Metaphor, New Projects by Contemporary Sculptors, 1981; WMAA Biennial, 1981; Kassel, Documenta VII, 1982; Tate Gallery, New Art, 1983; Hirshhorn, Directions, 1983; ICA, U. of Pennsylvania, Connections, 1983; MOMA, International Survey of Recent Painting and Sculpture, 1984; RISD, Furniture, Furnishings: Subject and Object, 1984; Hirshhorn, Content: A Contemporary Focus, 1974-1984, 1984; Los Angeles/County MA, The Artist as Social Designer, 1986; Purchase/SUNY, The Window in Twentieth-Century Art, 1986; Indianapolis, Painting and Sculpture Today, 1987; Arnhem, Sonsbeek, 1986; Fort Lauderdale, An American Renaissance, 1986; Syracuse/Everson, Computers and Art, 1987; Kassel, Documenta VIII, 1987; Munster/WK, Skulpture Projekt Munster '87, 1987; Los Angeles/County MA, Avant-garde in the Eighties, 1987; SRGM, View Points, 1988; Carnegie, International, 1988; Hirshhorn, Culture and Commentary, 1990; Storm King Sculpture Center, Enclosure and Encounters, 1991. **Collections:** Carnegie; Chicago/AI; Hirshhorn; U. of North Carolina; Omaha/Joslyn; Walker. **Bibliography:** Ashbery; Fox; **Kardon 1**; Pincus-Witten 2.

ARMAN, PIERRE **b.** November 17, 1928, Nice, France. **Studied:** École du Louvre; École Nationale des Arts Décoratifs. US citizen, 1972. Traveled Europe, Asia, Africa, North America. **Taught:** UCLA, 1967-68. Co-founder, Groupe des Nouveaux Réalistes, 1960, and L'École de Nice, 1961. **Member:** Artists Equity. **Commissions:** Le Montcel, France, 1982; Elysée Palace, Paris, 1984; Nice, France, 1985; The Centrum Project, 1985; designs champagne bottle for Tattinger, 1985; designs clothes for Courrèges, 1986; designs projects for Fragonard Perfume, Louis Vuitton, Porthault and Piaget, 1986; public sculpture for Dallas, 1987; creates trophies for Guttenburg Book Award and a sailing award for Loïc Caradec, 1988, and other awards. **Theatre Commission:** *L'Heyre Espagnole* for Paris Opera, 1985. **Awards:** IV International Biennial Exhibition of Prints, Tokyo, 1964, Second Prize; Premio Marzotto, 1966; Order of Merit, for artistic achievement, Paris, 1972; Commandeur des arts et lettres, 1984; Legion

of Honor, 1987. **Address:** 430 Washington Street, NYC 10013. **Dealer:** Marisa del Re, NYC; Galerie Beaubourg, Paris. **One-man Exhibitions:** (first) Galerie du Haut Pave, Paris, 1956; Iris Clert Gallery, 1958, 60; Galleria Apollinaire, Milan, 1959; Galerie Schmela, Düsseldorf, 1960, 63; Galleria Schwarz, Milan, 1961, 63, 68; Cordier and Warren, NYC, 1961; Galerie Saqqarah, Gstaad, Switzerland, 1962, 66; Dwan Gallery, Los Angeles, 1962; Galerie Lawrence, Paris, 1962, 63, 65; Sidney Janis Gallery, NYC, 1963, 64, 68; Walker, 1964; Richard Feigen Gallery, Chicago, 1965; Galerie Bonnier, Lausanne, 1965, 66, 69; Galerie de Leone, Venice, 1965; Galerie Svensk-Franska, Stockholm, 1966, 69; Ileana Sonnabend Gallery, Paris, 1967, 69; Il Punto, Turin, 1967; Galerie Françoise Meyer, Brussels, 1967; Galerie Mathias Fels, Paris, 1969; Musée des Arts Décoratifs, 1969; Humlebaek/Louisiana, 1969; Kunsthalle, Berlin, 1969; Düsseldorf/Kunsthalle, 1969; Stockholm/National, 1970; Zurich, 1970; Ileana Sonnabend Gallery, Paris, 1970; ACE Gallery, Vancouver, 1970; Galerie der Spiegel, Cologne, 1970; Galerie Lambert-Monet, Geneva, 1970; Galerie Bonnier, 1970, 71; Lawrence Rubin Gallery, NYC, 1970, 71; Galerie de la Salle, Vence, 1971; Galerie Bischofberger, Zurich, 1971; Galerie Michel Couturier & Cie., Paris, 1971; Galleria del Leone, Venice, 1972; Galeria Guillaume Campo, Antwerp, 1972; Galerie de l'Oeil, Paris, 1972; White Gallery, Lutry, 1973; John Gibson Gallery, 1973; Andrew Crispo Gallery, 1973, 74, 75; Musée d'Arles, 1974; Fort Worth, 1975; Paris/Moderne, 1975; Venice Biennial, 1976; Galerie Charles Kriwin, Brussels, 1976, 78; Wichita State U., 1977; Jollembeck Gmbh., Cologne, 1978; André Emmerich Gallery, NYC, 1979; Galleria Cavellini, Brescia, 1979; The Art Contact, Miami, 1979; Museo Civico da Portofino, 1980; Galerie Valeur, Nagoya, Japan, 1980; Galerie Bonnier, Geneva, 1985; Galerie Beaubourg, Paris, 1981, 82, 83, 84, 86, 88; OK Harris Works of Art, NYC, 1982; Marisa del Re Gallery, NYC, 1983, 84, 86, 88, 90; Christian Fayt Gallery, Knokke-Zoute, Belgium, 1984; Galerie Reckermann, Cologne, 1984; Sploto Festival, Charleston, 1984; Gloria Luria Gallery, Bar Harbor Islands, Fla., 1984; Center for the Fine Arts, Miami, 1984; Galerie Renee Ziegler, Zurich, 1984, 85; Galerie Niccoli, Parma, 1984; Parma/Moderna, 1984; Seibu Museum of Art, Tokyo, circ., 1985; Toulon, 1985; Galerie Bonnier, Geneva, 1985; Sonia Zannettacci Galerie, Geneva, 1985; Chateauroux Indre, Paris, 1985; Pavillion Werd, Zurich, 1986; Fuji-Television Gallery, Tokyo, 1986, 89; Waddington & Shiell Galleries, Toronto, 1986; Veraneman Foundation, Gand, Belgium, 1985; Galerie GKM, Malmo, Sweden, 1987; Wenger Gallery, Los Angeles, 1987; Galerie Guy Pieters, Knokke-Zoute, Belgium, 1987, 89; Galerie Ferrero, Nice, 1987; Galerie de l'Orangerais, Geneva, 1987; La Giarina Gallery, Verona, 1987; Galerie de Poche, Paris, 1988; Princeton (N.J.) Gallery of Fine Art, 1988; Musée des Beaux-Arts, Nimes, 1988; Reflex Gallery, Amsterdam, 1988; Chapelle des Penitents Blanc, Vence, 1988; James Mayor Gallery, London, 1989. **Retrospectives:** Amsterdam/Stedelijk, 1964; Krefeld/Haus Lange, 1964; Brussels/Beaux-Arts, 1966; La Jolla, circ., 1974; Galerie de la Salle, St. Paul de Vence, 1976; Hannover Kunstmuseum, 1982; Museo Civico di Belle Arti, Lugano, 1984; Wichita State U., 1986; Lunds Konsthall, Lunds, Sweden, 1989. **Group:** XXXIV Venice Biennial, 1968; Kassel, Documenta IV, 1968; Tokyo Biennial, 1969; Expo '70, Osaka, 1970. **Collections:** Amsterdam/Stedelijk; Antwerp; Brussels/Royaux; Buffalo/Albright; Chicago/Contemporary; Cologne; Dartmouth College; Eindhoven; France/National; Ghent/Moderne; Helsinki; Hirshhorn; Humlebaek/Louisiana; Krefeld/Haus Lange; MMA; MOMA; Munich/Modern; Musée des Arts

Décoratifs, Paris; PMA; Paris/Moderne; Renault & Cie., Paris; Rome/Nazionale; U. of St. Thomas (Tex.); Societé Nationale des Arts Contemporains; Stockholm/National; Stuyvesant Foundation; Sweden/Goteborgs; Talavera; Turin/Civico; Venice/Contemporaneo; Walker; Wells, Rich, Greene, Inc., NYC. **Bibliography:** Arman; *Contemporanea;* **De Wilde 2;** *Europa/Amerika;* **Hahn;** *Happening & Fluxus;* **Martin, H.;** Osterwold; Rowell; Sandler 3; Waldman 4. Archives.

ARNESON, ROBERT
b. September 4, 1930, Benicia, Calif.
d. November 2, 1992, Benicia, Calif.
Studied: College of Marin, Kentfield, Calif., 1949-51; California College of Arts and Crafts, BA, 1954; Mills College, MFA, 1958. Traveled Europe. Subject of videotape on drawing, *California Draftsmen,* produced by The Drawing Society, NYC.
Taught: Menlo-Atherton H.S., 1954-57; Santa Rosa Junior College, 1958-59; Fremont H.S., Oakland, Calif., 1960-62; Mills College, 1960-62; U. of California, Davis, 1962-1992. **Awards:** National Endowment for the Arts, grant, 1971, 78; AAIAL, 1991. American Craft Council, Fellow, 1992. **One-man Exhibitions:** Oakland/AM, 1960; de Young, 1962; Barios Gallery, Sacramento, 1962; Cellini Gallery, San Francisco, 1964; Allan Stone Gallery, NYC, 1964, 69; SFMA, 1967; Candy Store Gallery, Folsom, Calif., 1969, 70, 71; Hansen-Fuller Gallery, San Francisco, 1968, 69, 70, 71, 72, 73; Fresno State College, 1970; U. of Calgary, 1971; Manolides Gallery, Seattle (two-man), 1972; Miami-Dade College, 1972; U. of Nevada, Reno, 1973; Deson-Zaks Gallery, Chicago, 1974; Allan Frumkin Gallery, NYC, 1975, 78, 79, 81, 84; Fendrick Gallery, Washington, D.C., 1976, 80; Moore College of Art, Philadelphia, 1979; Frumkin & Struve, Chicago, 1980, 84; SFMA, 1981; U. of California, Davis, 1982; Sacramento/Crocker, 1983; Yares Gallery, Scottsdale, 1983; Fuller Goldeen Gallery,

Robert Arneson, *Scram,* 1991.

San Francisco, 1984, 85, 86; Karl Oskar Gallery, Westwood Hills, Kan., 1984, 86; Metropolitan Museum & Art Center, 1984; Pittsburgh Center for the Arts, 1986; Frumkin/Adams Gallery, NYC, 1984, 87, 90; Santa Clara/Triton, circ., 1984; U. of Miami, 1984; U. of the Pacific, 1986; U. of Illinois, 1986; Pittsburgh Center for the Arts, 1986; Moravian College, 1987; Cleveland/MA, 1987; Fuller-Gross Gallery, San Francisco, 1988; Dorothy Goldeen Gallery, Santa Monica, Calif., 1988, 92; Emily Carr College of Art, Vancouver, 1988; Hartford/Wadsworth, 1990; MIT, 1991; Springfield, Mass./MFA, 1991; James Madison U., 1991; ICA, U. of Pennsylvania, 1992. **Retrospectives:** Chicago/Contemporary, 1974; Des Moines, circ., 1986. **Group:** Oakland/AM, Sculpture, 1963; U. of California, Berkeley, Funk Art, 1967; MOMA, The Dada-Surrealist Heritage, 1968; NCFA, Objects USA, 1969; WMAA, Human Concern Personal Torment, 1969; Syracuse/Everson, Ceramics, 70, 1970; Museum of Contemporary Crafts, NYC, Clayworks: 20 Americans, 1971; SFMA, A Decade of Ceramic Art, 1962-72, 1973; U. of Illinois, 1974;

WMAA Biennial, 1979; Syracuse/Everson, Nine West Coast Clay Sculptures, 1978; Amsterdam/Stedelijk, West Coast Ceramics, 1979; San Diego, Sculpture in California, 1975-1980, 1980; SFMA, Twenty American Artists, 1980; Akron/AM, The Image in American Painting and Sculpture, 1950-1980, 1981; Oakland/AM, 100 Years of California Sculpture, 1982; WMAA, Ceramic Sculpture: Six Artists, 1981; Dayton/AI, New Portraits: Behind Faces, 1982; Mount Holyoke College, The Shadow of the Bomb, 1984; Hirshhorn, Drawings 1974-1984, 1984; WMAA, The Sculptor as Draftsman, circ., 1983; SFMA, Biennial, 1984; Katonah Gallery, Rethinking the Avant-Garde, 1985; Fort Lauderdale, An American Renaissance, 1986; SFMA, American Realism (Janss), circ., 1986; U. of California, Berkeley, Made in U.S.A., 1987; AAIAL, 1986; Moore College of Art, Bronze, Plaster and Polyester, 1987; MOMA, Committed to Print, 1988; U. of Washington, Life Stories, Myth, Fiction & History in Contemporary Art, 1988; RISD, New Visions of the Apocalypse, 1988; Madison Art Center, Sculptures on Paper, 1988; Boston/MFA, Figuring the Body, 1990; Hudson River Museum, Experiencing Sculpture, 1991. **Collections:** Amsterdam/Stedelijk; Boston/MFA; U. of California, Davis; Canberra/National; Museum of Contemporary Crafts, NYC; U. of Chicago; Chicago/AI; Chicago/Contemporary; Denver; Des Moines; Emily Carr College of Art; Hartford/Wadsworth; Hirshhorn; U. of Illinois; James Madison U.; Kansas City/Nelson; Los Angeles/County MA; MOMA; Mildura Art Center; Oakland Museum; Oberlin; PMA; Sacramento/Crocker; Santa Barbara/MA; Santa Clara/Triton; SFMA; Seattle/AM; U. of Utah; VMFA; WMAA. **Bibliography:** Adrian; Ashbery; *California Sculpture Show;* Gettings; Sandler 3. Archives.

ARNOLD, ANNE b. May 2, 1925, Melrose, Mass. **Studied:** U. of New

Hampshire, 1946, BA; The Ohio State U., 1947, MA; U. of Guadalajara, 1949; ASL, 1949-53. **Taught:** Geneseo/SUNY, 1947-49; Wagner College, 1951-52; Philadelphia College of Art, 1965-68; Brooklyn College, 1971, 73-; Columbia U. Graduate School, 1975-76. **Member:** NAD; Board of Governors, Skowhegan School of Art, 1980-. **Awards:** AAIAL, Louis Nevelon Award in Art, 1989. **Address:** 50 West 29th Street, NYC 10001. **Dealer:** Fischbach Gallery, NYC. **One-man Exhibitions:** Tanager Gallery, NYC, 1960; Fischbach Gallery, NYC, 1964, 67, 69, 71, 74, 76, 79, 86, 88; Bard College, 1971; Galerie Dieter Brusberg, Hanover, 1972; American Kennel Club, 1981; Belfast (Me.) Free Library, 1981. **Retrospectives:** Moore College of Art, Philadelphia, 1971; U. of New Hampshire, 1983. **Group:** Riverside Museum, NYC, Twelve Sculptors, 1962; Chicago/AI Annual, 1964; Milwaukee, Pop Art and the American Tradition, 1965; Sculptors Guild, 1967, 68; PAFA Annual 1968; Finch College, NYC, The Dominant Woman, 1968; City Hall, Rockport, Me., Maine Coast Artists, 1969; Roko Gallery, Homage to Tanager, 1952-1962, 1971; U. of North Carolina, 1971, 72, 73; New York Cultural Center, Women Choose Women, 1973; Indianapolis, 1974; PMA/Museum of the Philadelphia Civic Center, Focus, 1974; Renwick Gallery, Washington, D.C., Object as Poet, 1977; Syracuse/Everson, The Animal Kingdom, 1978; NYU, Tracking the Marvelous, 1981; NAD, 1983; Stamford Museum, Animals! Animals! Animals!, 1984; Stamford Museum, American Art: American Women, 1985; AAIAL, 1988, 89. **Collections:** Buffalo/Albright; Ciba-Geigy Corp.; Citibank, NYC; Housatonic Community College; MMA; NYNEX; U. of North Carolina; Norfolk/Chrysler; NYNEX. **Bibliography:** Schwartz 3.

ARNOLDI, CHARLES b. April 10, 1946, Dayton, Ohio. **Studied:** Chouinard Art School, 1968. Traveled

Japan, Europe. **Commission:** Hughes Corp., Calif., 1985. **Awards:** Guggenheim Foundation Fellowship, 1975; National Endowment for the Arts, 1974, 82; Chicago/AI, Witkowsky Award, 1972. **Address:** 721 Hampton Drive, Venice, CA 90291. **Dealers:** James Corcoran Gallery, Los Angeles; Charles Cowles Gallery, NYC. **One-man Exhibitions:** Riko Mizuno Gallery, Los Angeles, 1971; The Texas Gallery, Houston, 1972, 74, 75, 77, 79, 81, 83; Nicholas Wilder Gallery, Los Angeles, 1975, 76, 78, 79; Robert Elkon Gallery, NYC, 1975, 76, 78, 79; Charles Cowles Gallery, NYC, 1980, 85, 86, 87; Dobrick Gallery, Chicago, 1979; James Corcoran Gallery, Los Angeles, 1980, 81, 82, 83, 84, 85, 87, 89; Hansen Fuller Goldeen Gallery, San Francisco, 1981; Los Angeles/County MA, 1984; Fuller Goldeen Gallery, San Francisco, 1985, 87; Thomas Babeor Gallery, La Jolla, 1985; New City Editions, Venice, Calif., 1986; Pamila Auchincloss Gallery, Santa Barbara, 1986; Jane Beggs Fine Arts, Aspen, 1986; U. of Missouri, 1986; Ochi Gallery, Boise, Idaho, 1989; Flanders Contemporary Art, Minneapolis, 1990; Arthur Roger Gallery, New Orleans, 1990; Michael Dunev Gallery, San Francisco, 1990; Malmgran Gallery, Goteborg, Sweden, 1990; Sena Galleries, Santa Fe, 1990; Gallery Kuranuki, Osaka, 1991; Fred Hoffman Gallery, Santa Monica, 1991; Sun Gallery, Seoul, 1992. **Retrospective:** Arts Club of Chicago, 1986. **Group:** Chicago/Contemporary, Permutations: Light & Color, 1969; Pasadena/AM, Fifteen Los Angeles Artists, 1972; Chicago/AI, Seventieth American Exhibition, 1972; Kassel, Documenta V, 1972; Indianapolis, 1978; Sacramento/Crocker, Aspects of Abstract Art, 1979; WMAA, Biennial, 1981; Houston/Contemporary, Americans: The Landscape, 1981; Los Angeles/County MA, Los Angeles Prints, 1883-1980, Part II, 1981; Brooklyn Museum, The American Artist as Printmaker, 1983; Corcoran Biennial, 1983; Houston/MFA, A Century of Mod-

ern Sculpture, 1882-1982, 1983; U. of California, Los Angeles, California Sculpture Show, 1984; Sacramento/Crocker, Contemporary American Wood Sculpture, 1984; Cranbrook, Viewpoint '84, 1984; Brooklyn Museum, Public and Private, 1986; Boston/MFA, Printmaking Now: 70s into 80s, 1986; AAIAL, 1987, 93; U. of California, Santa Barbara, Collaborations in Monotypes, circ., 1988; MMA, The 1980s: A New Generation, 1988; U. of Florida, Color in Art, 1989; Boston/MFA, The Unique Print: 70s into 90s, 1990. **Collections:** Chicago/AI; Houston/MFA; Los Angeles/County MA; MOMA; Pasadena/AM; Santa Barbara/MA; Seattle/AM, SFMA. **Bibliography:** *California Sculpture Show;* Osterwald.

ARONSON, DAVID b. October 28, 1923, Shilova, Lithuania. To USA, 1929. **Studied:** Boston Museum School, with Karl Zerbe; Hebrew Teachers College, Boston. Traveled Europe, Near East. **Taught:** Boston Museum School, 1942-55; Boston U., 1954-89; Boston U., Professor Emeritus, 1989. **Member:** NAD. **Commissions:** Container Corp. of America, 1962. **Awards:** ICA, Boston, First Prize, 1944; ICA, Boston, First Popular Prize, 1955; VMFA, 1946; Boston Museum School, traveling fellowship, 1946; Boston Arts Festival, Grand Prize, 1952, 54; Boston Arts Festival, Second Prize, 1953; Tupperware Annual, First Prize, 1954; NIAL Grant, 1958; J. S. Guggenheim Fellowship, 1960; NIAL, P.P., 1961; NAD, Issac N. Maynard Prize, 1975; NAD, Joseph I. Isidor Gold Medal, 1976; NAD, Henry Ward Ranger Fund P.P., 1976. **Address:** 137 Brimstone Lane, Sudbury, MA 01776. **One-man Exhibitions:** (first) Niveau Gallery, NYC, 1945, also 1956; Boris Mirski Gallery, Boston, 1951, 59, 64, 69; The Downtown Gallery, NYC, 1953; Lee Nordness Gallery, NYC, 1960, 61, 63, 69; Rex Evans Gallery, Los Angeles, 1961; Westhampton Gallery, NYC, 1961; J. Thomas Gallery, Province-

town, Mass., 1964; Zora Gallery, Los Angeles, 1965; Hunter Gallery, Chattanooga, 1965; Kovler Gallery, Chicago, 1965; Verle Gallery, Hartford, Conn., 1967; Dannenberg Gallery, NYC 1969, 72; Pucker-Safrai Gallery, Boston, 1978, 79, 86, 90; Louis Newman Galleries, Beverly Hills, 1977, 86, 89, 92; Mickelson Gallery, Washington, D.C., 1985. **Retrospective:** Brandeis U., 1979. **Group:** MOMA, Fourteen Americans, circ., 1946; Chicago/AI; U. of Illinois; MMA; ICA, Boston; WMAA; Boston/MFA; Bridgestone Museum; Palazzo di Venezia, Rome. **Collections:** Atlanta/AA; Atlanta U.; Boston/MFA; Brandeis U.; Bryn Mawr College; Carnegie; Chicago/AI; U. of Chicago; Colby College; Guilford College; Hebrew College; U. of Illinois; Lincoln, Mass./De Cordova; MOMA; Milwaukee; NCFA; U. of Nebraska; U. of New Hampshire; PAFA; Portland, Me./MA; Syracuse U.; Tupperware Museum; VMFA; WMAA; Worcester/AM. **Bibliography:** Baur 7; Genauer; Miller, ed., 2; Nordness, ed.; Pearson 2; Soby 5; Weller. Archives.

ARTSCHWAGER, RICHARD
b. December 26, 1923, Washington, D.C. **Studied:** Privately with Amedee Ozenfant; Cornell U., BA. Traveled Mexico. **Address:** 169 South Portland Avenue, Brooklyn, NY 11217. **Dealer:** Mary Boone Gallery, NYC. **One-man Exhibitions:** Leo Castelli Inc., NYC, 1965, 67, 72, 73, 75, 77, 79, 80, 81, 85, 88, 89, 91; Galerie Rolf Ricke, Cologne, 1969, 72; Eugenie Butler, 1970; Onasch Galerie, Berlin, 1970; LoGiudice, Chicago, 1970; Chicago/Contemporary, 1973; Dunkleman Gallery, Toronto, 1973; Weinberg Gallery, San Francisco, 1974; Jared Sable Gallery, Toronto, 1976; Neuendorf, Hamburg, 1976; Walter Kelly Gallery, Chicago, 1977; Sable-Castelli Gallery, Toronto, 1978; The Texas Gallery, Houston, 1978; The Clocktower, NYC, 1978; Hamburg/Kunstverein, 1978; Fisher-Faure, Los Angeles, 1980; Young-Hoffman Gallery,

Chicago, 1980; RISD, 1980; Daniel Weinberg Gallery, San Francisco, 1980, 83; La Jolla, 1980; Cutting Gallery, Cambridge, Mass., 1981; Suzanne Hilberry Gallery, Detroit, 1982; Mary Boone Gallery, NYC, 1983, 86, 90, 92; Basel/Kunsthalle, 85; U. of California, Berkeley, 1984; Hartford/Wadsworth, 85; Crousel-Houssenot, Paris, 1985; Eindhoven, 1985; Bordeaux/Contemporain, 1986; Daniel Weinberg Gallery, Los Angeles, 1986, 89, 90; Donald Young Gallery, Chicago, 1986, 90; Van Buren/Brazelton/Cutting Gallery, Cambridge, Mass., 1986; Galerie Thaddaeus Ropac, Salzburg, 1987; Galerie Georges Lavrov, Paris, 1987; Nicola Jacobs Gallery, London, 1988; Cirrus Gallery, Los Angeles, 1988; SFMA, 1987; Los Angeles/MOCA, 1988; Palacio Velazquez, Madrid, 1988; Paris/Beaubourg, 1989; Düsseldorf/Kunsthalle, 1989; Akira Ikeda Gallery, Tokyo; Galerie Metropol, Vienna, 1989, 90; Galerie Ghislaine Hussenot, Paris, 1990; Fairleigh Dickinson U., 1990; Galerie Hans R. Neuendorf, Frankfurt, 1990; Susanne Hilberry Gallery, Birmingham, Mich., 1990; Brooke Alexander Editions, 1991; Rhona Hoffman Gallery, Chicago, 1991; U. of Wisconsin, Madison, 1991; Kunstnernes Hus, Oslo, 1992; Boston/MFA, 1992. **Retrospective:** Buffalo/Albright, circ., 1979; WMAA, circ., 1988; Brooke Alexander Editions, NYC, 1991. **Group:** Buffalo/Albright, 1964; Dwan Gallery, Boxes, 1964; SRGM, 1966; Jewish Museum, Primary Structures, 1966; WMAA, Contemporary American Sculpture, Selection I, 1966; Finch College, 1966; WMAA Sculpture Annuals, 1966, 68, 70, 72; MOMA, The 1960s, 1967; Ridgefield/Aldrich, 1968; Kassel, Documenta IV, 1968; Milwaukee, Directions 1: Options, circ., 1968; Trenton/State, Soft Art, 1969; Berne, When Attitudes Become Form, 1969; U. of Notre Dame, 1969; Indianapolis/Herron, 1969; York U., Toronto, 1969; Hayward Gallery, London, 1969; Milwaukee, Aspects of a New Realism, 1969; Buffalo/Al-

Richard Artschwager, *Diderot's Panacea*, 1992.

bright, Kid Stuff, 1971; MOMA, Information, 1971; Galerie des 4 Mouvements, Paris, Hyperréalistes americains, 1972; Kassel, Documenta V, 1972; Oakland U., American Realism—Post Pop, 1973; WMAA, American Pop Art, 1974; Leverkusen, Zeichnungen 3, USA, 1975; Musée d'Ixelles, Brussels, Je/Nous, 1975; WMAA, 200 Years of American Sculpture, 1976; XXXVII and XXXIX Venice Biennials, 1976, 80; ICA, U. of Pennsylvania, Improbable Furniture, 1977; U. of Chicago, Ideas in Sculpture 1965-1977, 1977; Buffalo/Albright, American Painting in the 1970s, 1978; MIT, Corners, 1979; Purchase/SUNY, Hidden Desires, 1980; Zurich, Reliefs, 1980; ICA, U. of Pennsylvania, Drawings: The Pluralist Decade, 1980; Brooklyn Museum, American Drawings in Black and White: 1970-1979, 1980; Basel/Kunsthalle, Amerikanische Zeichnungen der siebziger Jahre, 1981; Rice U., Variants, 1981; Documenta VII, 1982; WMAA Biennial, 1983; Tate Gallery, New Art, 1983; RISD, Furniture, Furnishings: Subject and Object, 1984; Hirshhorn, Content: A Contemporary Focus, 1974-1984; WMAA/Philip Morris, The Box Transformed, 1985; Bard College, The Maximal Implications of the

Minimal Line, 1985; Biennale de Paris, 1985; Fort Lauderdale, An American Renaissance, 1986; Whitechapel Art Gallery, London, The Painter-Sculptor in the Twentieth Century, 1986; WMAA, Biennial, 1987; Kassel, Documenta VIII, 1985; Munster/WK, Skulpture Projekte, 1987; Düsseldorf/Kunsthalle, Simula/Disimula, 1987; Carnegie, International, 1988; Wright State U., Redefining the Object, 1988; Bard College, Thou Art What Thou Eat, 1990; Martin-Gropius-Bau, Berlin, Metropolis, 1991; New York Academy of Art, Expressive Drawings, 1991; U. of North Carolina, The Chair: From Artifact to Object, 1991; Indianapolis, Power: Its Myths and Mores in American Art, 1961-1991; Royal Academy of Arts, London, Pop Art, circ., 1992; Kassel, Documenta IX, 1992. **Collections:** Aachen/NG; Basel; Basel/Kunstmuseum; Baxter Travenol Laboratories; Cologne/Ludwig; Detroit/Institute; Estee Lauder Cosmetics, Inc.; Hartford/Wadsworth; Hirshhorn; Kansas City/Nelson; La Jolla; Levi Strauss & Co.; Los Angeles/MOCA; MMA; MOMA; Milwaukee; NYU; Paris/Beaubourg; RISD; Ridgefield/Aldrich; Rotterdam; R.S.M. Co., Cincinnati; San Diego/Contemporary; Smith College; Sony Corp.; Tate Gallery; WMAA; Walker. **Bibliography:** Alloway 1, 4; Ammann; **Armstrong, Richard 2**; Atkinson; Battcock, ed.; Day 1; *Drawings: The Pluralist Decade; Gohr and Gachnang;* Honisch and Jensen, eds.; *Joachmides and Rosenthal; Kren; Kunst um 1970;* Lippard 5; Lippard, ed.; Murken-Altrogge; *New in the Seventies;* Osterwald; Sager; *Sandler 3;* Seitz 3; Storr and Tannenbaum; Weintraub; *When Attitudes Become Form.*

ATHERTON, JOHN C.
from 1st to 5th edition.

AULT, GEORGE C. **b.** October 11, 1891, Cleveland, Ohio. **d.** December 30, 1948, Woodstock, N.Y. **Studied:** U. of London, Slade School; St. John's Wood

Art School. Resided Great Britain 1899-1911. **One-man Exhibitions:** Sea Chest Gallery, Provincetown, 1922; Whitney Studio Club, NYC; Bourgeois Gallery, NYC, 1923; The Downtown Gallery, NYC, 1926, 28; J. B. Neumann's New Art Circle, NYC, 1927; The Little Gallery, Woodstock, N.Y. 1943; Woodstock (N.Y.) Art Gallery, 1949; The Milch Gallery, 1950; Charlotte/Mint, 1951; WMAA, 1973; The Zabriskie Gallery, 1973, 74, 78, 82; Vanderwoude Tananbaum Gallery, NYC, 1982, 89; WMAA, 1982; WMAA/Equitable, circ., 1989. **Retrospective:** The Zabriskie Gallery, NYC, 1957, 63, 69. **Group:** Independents, NYC, 1920; WMAA; SFMA, Images of America: Precisionist Painting and Modern Photography, 1982; NMAA, Provincetown Printers: A Woodcut Tradition, 1983. **Collections:** Albany/Institute; Andover/Phillips; Brooklyn Museum; California Palace; Columbus; Cleveland/MA; Dartmouth College; Los Angeles/County MA; MMA; MOMA; Montclair/AM; U. of Nebraska; Newark Museum; U. of New Mexico; Omaha/Joslyn; PAFA; PMA; Syracuse U.; WMAA; Walker; Worcester/AM; Yale U.; Youngstown/Butler. **Bibliography:** Armstrong, Thomas; Ault; Baur 7; Brown 2; Bulliet 1; Cahill and Barr, eds.; Schwartz 1; *Woodstock*. Archives.

AUSTIN, DARREL
from 1st to 4th edition.

AVEDISIAN, EDWARD
from 2nd to 5th edition.

AVERY, MILTON **b.** March 7, 1885, Altmar, N.Y. **d.** January 3, 1965, NYC. **Studied:** Connecticut League of Art Students, briefly 1913, with C. N. Flagg. Traveled Europe, USA. **Awards:** Chicago/AI, The Mr. & Mrs. Frank G. Logan Prize, 1929; Connecticut Academy of Fine Arts, Atheneum Prize, 1930; Baltimore Watercolor Club, First Prize, 1949; Boston Arts Festival, Second Prize, 1948; ART: USA:59, NYC, $1,000 award, 1959. *A Painter's World,* a 14-min., 16mm color sound film, shows him at work. **One-man Exhibitions:** (first) Opportunity Gallery, NYC, 1928; Gallery 144, NYC, 1932; Curt Valentine Gallery, NYC, 1935, 36, 38, 41; Phillips, 1943, 44; P. Rosenberg and Co., 1943, 44, 45, 46, 47, 50; Arts Club of Chicago, 1944; The Bertha Schaefer Gallery, NYC, 1944; Durand-Ruel Gallery, NYC, 1945, 46, 47, 49; Colorado Springs/FA, 1946; Portland, Me./MA, 1946; Laurel Gallery, NYC, 1950; M. Knoedler & Co., NYC, 1950; Grace Borgenicht Gallery, Inc., NYC, 1951, 52, 54, 56, 57, 58, 68, 70, 74, 75, 76, 77, 78, 79, 80, 81, 82, 83, 85, 86, 88, 92; Baltimore/MA, 1952; Boston/MFA, circ., 1956; U. of Nebraska, 1956, 66; Felix Landau Gallery, Los Angeles, 1956; HCE Gallery, Provincetown, Mass., 1956, 58, 59; Otto Seligman Gallery, 1958; Philadelphia Art Alliance, 1959; Waddington Gallery, London, 1962, 66; MOMA, circ., 1965-66; Richard Gray Gallery, Chicago, 1966, 70, 81; Makler Gallery, Philadelphia, 1966; Esther Suttman Gallery, Washington, D.C., 1966; David Mirvish Gallery, 1966, 67, 69; Donald Morris Gallery, 1966, 67, 69; New Britain, 1968; Reese Palley Gallery, San Francisco, 1969; NCFA, circ., 1969; Alpha Gallery, 1969, 70; Waddington Gallery, Montreal, 1970; Brooklyn Museum, 1970; U. of California, Irvine, 1971; Cynthia Comsky Gallery, 1972; A.A.A. Gallery, 1973; André Emmerich Gallery, NYC, 1973; Lunn Inc., Washington, D.C., 1973, 74; U. of Connecticut, 1976; U. of Texas, 1976; Yares Gallery, Scottsdale, 1980; Edmonton Art Gallery, 1978; Cleveland/MA (three-man), 1975; Paule Anglim Associates, San Francisco, 1981, 82; Art Gallery of Hamilton, Ont., 1981; Bard College, 1981; Emily Carr College of Art and Design, Vancouver, 1981; Dolly Fiterman Gallery, Minneapolis, 1981; Friedland Gallery, Toronto, 1981; Thomas Gibson Fine Art Ltd., London, 1981; Greenberg Gallery,

Milton Avery, *Female Painter*, 1945.

1981; Lunn Inc., Washington, D.C., 1981; Mexico City/Moderno, circ., 1981; Santa Barbara/MA, 1981; Southern Methodist U., 1981; Waddington Galleries, London, 1980, 81; Franz Wyans Gallery, Vancouver, 1981; Alpha Gallery, Boston, 1981, 82, 92; WMAA/Fairfield, 1982; Boca Raton, 1982; Harmon Gallery, Sarasota, Fla., 1982; Riva Yares Gallery, Scottsdale, Ariz., 1982; Harmon-Meek Gallery, Naples, Fla., 1986; Bridgeport, 1987; Williamstown/Clark, circ., 1980; Associated American Artists, NYC, 1980; Gerald Peters Gallery, Dallas, 1989; Brooklyn Museum, 1990. **Retrospectives:** A.F.A./Ford Foundation, circ., 1960; WMAA, circ., 1982. **Group:** Carnegie, 1944; PAFA, 1945; Chicago/AI; Corcoran; WMAA; U. of Illinois; Buffalo/Albright; MMA, The Painterly Print, 1980; Norfolk/Chrysler, American Figurative Painting, 1950-1980, 1980; WMAA, American Prints: Process & Proofs, 1981; Rutgers U., Realism and Realities, 1982. **Collections:** Andover/Phillips; Atlanta/AA; Baltimore/MA; Barnes Foundation; Brandeis U.; Brooklyn Museum; Bryn Mawr College; Buffalo/Albright; Chase Manhattan Bank; Dayton/AI; Evansville; Exeter; Honolulu Academy; Houston/MFA; U. of Illinois; MMA; MOMA; U. of Minnesota; U. of Nebraska; Newark Museum; PAFA; PMA; Phillips; Santa Barbara/MA; Smith College; Tel Aviv; Utica; WMAA; Walker; West Palm Beach/Norton; Witte; Yale U. **Bibliography:** Bazin; Blesh 1; Cummings 5; Eliot; Frost; Goodrich and Baur 1; Greenberg 1; **Hobbs**; Hughes; Kootz 2; **Kramer 3**; Mellquist; Nordness, ed.; Pousette-Dart, ed.; Rose, B., 1; Sandler; **Wight 2, 3**; *Woodstock: An American Art Colony 1902-1977*; **Haskell 6**; Armstrong, Thomas. Archives.

AYCOCK, ALICE **b.** November 20, 1946, Harrisburg, Pa. **Studied:** Douglass College, New Brunswick, NJ, 1968, BA; Hunter College, 1971, MA, with Robert Morris. **Awards:** PBK, 1968; National Endowment for the Arts, 1975, 80; CAPS, 1976. Traveled Europe, Mexico, Egypt. **Taught:** RISD, 1977; School of Visual Arts, NYC, 1977-78, 79-82; Hunter College, 1982-85; Yale U. **Address:** 62 Greene Street, NYC 10012. **Dealer:** John Weber Gallery, NYC. **One-man Exhibitions:** (first) Nova Scotia College of Art & Design, 1972; Williams College, 1974; 112 Greene Street, NYC, 1974, 77; U. of Hartford, 1976; MOMA, project room, 1977; Galerie Salvatore Ala, Milan, 1978; Cranbrook, 1978; Muhlenberg College, Allentown, Pa., 1978; Philadelphia College of Art, 1978; Portland (Ore.) Center for Visual Arts, 1978; John Weber Gallery, NYC, 1978, 79, 81, 82, 84, 86, 88, 90; RISD, 1978; Amherst College, 1979; Cincinnati/Contemporary, 1979; Protetch-McIntosh Gallery, Washington, D.C., 1979; SFAI, 1979; P.S. 1, Long Island City, 1980; U. of South Florida, 1980; Washington Project for the Arts, Washington, D.C., 1980; Plattsburgh/SUNY, 1981; Douglass College, 1982; Lawrence Oliver Gallery, Philadelphia, 1982; Chicago/Contemporary, 1983; Protetch-McNeill Gallery, NYC, 1983; Roanoke College, 1983; McIntosh-Drysdale Gallery, Houston, 1984; Salisbury State College, 1984; Humanic Corp., Graz, Austria, 1985; Insam Gallery, Vienna, 1985, 91; Madison Art Center, 1985; U. of Nebraska, 1985; Serpentine Gallery, London,

1985; Vanguard Gallery, Philadelphia, 1985; Tel Aviv, 1986; Laumeier Sculpture Park, St. Louis, 1986; Kansas City/AI, 1987; Galerie Walter Storms, Munich, 1987; Kunstforum Munich, 1987; Western Washington U., 1987; Buffalo/SUNY, 1988; City Gallery of Contemporary Art, Raleigh, N.C., 1989; Atlantic Art Center, New Smyrna Beach, Fla., 1989; Storm King Art Center, 1990; Insam/Gleicher Gallery, Chicago, 1990; Abington Art Center, Jenkintown, Pa., 1990; U. of Michigan, 1991; Yoshiaki Inoue Gallery, Osaka, 1990. **Retrospective:** Stuttgart/WK, circ., 1983. **Group:** California Institute of the Arts, C. 7500, 1974; IX Paris Biennial, 1975; Artpark, Lewiston, N.Y., 1976; Kassel, Documenta VI, 1977; Amsterdam/Stedelijk, Made by Sculptors, 1978; ICA, U. of Pennsylvania, Dwellings, 1978; XXXVIII Venice Biennial, 1978; WMAA Biennials, 1979, 81; Hirshhorn, Metaphor, New Projects by Contemporary Sculptors, 1981; Zurich, Myth & Ritual, 1981; ICA, U. of Pennsylvania, Machineworks, 1981; Stuttgart/WK, Past-Present-Future, 1982; Antwerp, Biennale Middelheim, 1983; Citywide Contemporary Sculpture Exhibition, Toledo, 1984; Hirshhorn, Content, 1984; XVIII São Paolo Biennial, 1985; Triennale di Milano, 1985; Hudson River Museum, A New Beginning, 1968-1978, 1985; Fort Lauderdale, An American Renaissance, 1986; Cincinnati/Contemporary, Standing Ground, Sculpture by American Women, 1987; Queens Museum, Sculpture of the Eighties, 1987; Kassel, Documenta VIII, 1987; Cincinnati/Contemporary, Fata Morgana, 1987; Lucerne, L'État des Choses 2, 1987; John Michael Kohler Art Center, Sheboygan, Wisc., Eccentric Machines, 1987; Hudson River Museum, DNA Cutter, 1988; Cincinnati/AM, Making Their Mark, circ., 1989; U. of California, Santa Barbara, Pulse 2, 1990; Jacksonville/AM, Photons, Phonons, Electrons, 1991. **Collections:** Antwerp/Middelheim; Basel; Brooklyn Museum; Canberra/National; Chicago/Contemporary; Cincinnati/AM; Cologne/Ludwig; The Hague; Humlebaek/Louisiana; La Jolla; MMA; MOMA; U. of Massachusetts; U. of Nebraska; PMA; Plattsburgh/SUNY; Roanoke College; Rutgers U.; Salisbury State U.; Stuttgart; WMAA; Walker. **Bibliography:** Ashbery; Fox; *Performance Anthology.*

AZUMA, NORIO b. November 23, 1928, Japan. **Studied:** Kanazawa Art College, Kanazawa City, Japan; Chouinard Art Institute; ASL (with Will Barnet). **Commissions:** IBM. **Awards:** Seattle/AM; Boston Printmakers; American Color Print Society. **Address:** 276 Riverside Drive, NYC 10025. **Dealers:** Associated American Artists, NYC, Fendrick Gallery, Washington, D.C. **One-man Exhibitions:** (first) A.A.A. Gallery, NYC, 1964, also 1969; The Print Club, Philadelphia, 1964; Tulsa/Philbrook, 1965; Benjamin Gallery, Chicago, 1965; International Monetary Fund, Washington, D.C., 1965; WGMA, 1967; Nashville, 1968; East Tennessee State U., 1969; Berman-Medalie Gallery, Massachusetts, 1969; Roanoke (Va.) Fine Arts Center, 1969. **Group:** American Color Print Society; Corcoran; Boston Printmakers; New York World's Fair, 1964-65; Brooklyn Museum Print Biennial; WMAA Sculpture Annual, 1966; SAGA. **Collections:** American Republic Insurance Co.; Boston Public Library; Brooklyn Museum; U. of California; Chase Manhattan Bank; Chicago/AI; Chouinard Art Institute; Cleveland/MA; Library of Congress; MIT; National Gallery; PAFA; PMA; Seattle/AM; Smithsonian; Trenton/State; USIA; The White House; Youngstown/Butler.

B

BABER, ALICE
from 2nd to 5th edition.

BAEDER, JOHN b. December 24, 1938, South Bend, In. **Studied:** Auburn U. **Address:** 1025 Overton Lea Road, Nashville, Tenn. 37204. **Dealer:** OK Harris Works of Art, NYC. **One-man Exhibitions:** Hundred Acres Gallery, NYC, 1972, 74, 76; Morgan Gallery, Shawnee Mission, Mo., 1973, 77; OK Harris Works of Art, 1978, 80, 82, 84, 87, 89, 91; Williams College, 1979; Graphics I & Graphics II, Boston, 1980; Thomas Segal Gallery, Boston, 1982; Cumberland Gallery, Nashville, 1983; Zimmerman/Saturn Gallery, Nashville, 1986, 88; Modernism, San Francisco, 1988. **Group:** Rice U., Gray Is the Color, 1974; Darmstadt/Kunsthalle, Realism and Reality, 1975; NCFA, America As Art, 1976; Akron/AI, Contemporary Images in Watercolor, 1976; Indianapolis, 1976; Jacksonville/AM, New Realism, 1977; Boston/MFA, Prints of the 1970's, 1977; Tulsa/Philbrook, Realism/Photorealism, 1980; San Antonio/MA, Real, Really Real, Super Real, circ., 1981; PAFA, Contemporary American Realism Since 1960, 1981; Museum of the City of New York, Painting New York, 1983; Isetan Museum of Art, Tokyo, American Realism: The Precise Image, 1985; SFMA, American Realism (Janss), circ., 1985; College of New Rochelle, Diner: An American Artforum,

1986; Youngstown/Butler, National, 1987; Indianapolis/Herron, Welcome Back, 1988; The Pennsylvania State U., Realist Watercolors, 1990; Katonah Gallery, The Technological Muse, 1990; Nassau County Museum, In Sharp Focus, 1991; North Miami Center of Contemporary Art, Get Real, 1991. **Collections:** AT&T; Cheekwood; The Coca-Cola Co.; Cooper-Hewitt; Denver/AM; De Pauw U.; Detroit/Institute; Dunkin' Donuts, Inc.; High Museum; Milwaukee; Newark Museum; Newark Public Library; RISD; Randolph-Macon College; Springfield, Mo./AM; St. Lawrence U.; Stephens, Inc.; Technimetrics, NYC; VMFA; WMAA; West Palm Beach/Norton; Yale U. **Bibliography:** Arthur 3; Lindy; Ward.

BAER, JO
from 3rd to 5th edition.

BAILEY, WILLIAM b. November 17, 1930, Council Bluffs, Iowa. **Studied:** U. of Kansas, 1948-51; Yale U., 1955; BFA, 1957, MFA, with Josef Albers. US Army, 1951-53, Korea, Japan. Traveled Europe, Far East; resided Paris, Rome. **Taught:** Yale U., 1957-62, 69-; Indiana U., 1962-69. **Member:** AAIAL. **Awards:** Alice Kimball English Traveling Fellow, 1955; US State Department Grant, 1960; Guggenheim Foundation Fellowship, 1965; Ingram Merrill Foundation, grant, 1979-80. **Address:** c/o Dealer. **Dealers:** Galerie Claude Bernard, Paris; André Emmerich Gallery, NYC; Galleria Il Gabbiano, Rome. **One-man Exhibitions:** Kanegis Gallery, 1957, 58, 61; Indiana U., 1963; U. of Vermont, 1965; Kansas City/AI, 1967; Robert Schoelkopf Gallery, NYC, 1968, 71, 74, 75, 79, 82, 86, 91; Galleria dei Lanzi, Milan, 1973; Galleria Il Fante di Spade, Rome, 1973; La Parisina, Turin, 1974; Dart Gallery, Inc., Chicago, 1976; Galerie Claude Bernard, Paris, 1978; Fendrick Gallery, Washington, D.C., 1979, 87; Galleria Il Gabbiano, Rome, 1980, 85; Southern

Methodist U., 1983; Wright State U., 1987; Donald Morris Gallery, Birmingham, MI, 1990; André Emmerich Gallery, NYC, 1992. **Group:** U. of Illinois, 1961; Vassar College, Realism Now, 1968; Cincinnati/AM, American Paintings on the Market Today V, 1968; Swarthmore College, The Big Figure, 1969; WMAA, 22 Realists, 1970; Florida State U., Realist Painters, 1971; Cleveland/MA, 32 Realists, 1972; A.F.A., Realist Revival, 1972; Kansas City/AI, Five Figurative Artists, 1972; Yale U., Seven Realists, 1973; St. John's U., The Figure in Recent American Painting, 1975; New York Cultural Center, Three Centuries of the American Nude, 1975; Palazzo Strozzi, Florence, Biennale Internazionale della Grafica, 1977; Salon de Mai, Paris, 1978; William Patterson College, N.J., The Other Realism, 1978; WMAA, The Figurative Tradition and the WMAA, 1980; WMAA Biennial, 1981; Yale U., Twenty Artists: Yale School of Art, 1950-1970, 1981; San Antonio/MA, Real, Really Real, Super Real, 1981; PAFA, Contemporary American Realism Since 1960, 1981; Montclair/AM, Josef Albers: His Influence, 1981; Akron/AM, The Image in American Painting and Sculpture, 1950-1980, 1981; Haus der Kunst, Munich, Amerikansiche Malerie: 1930-1980, 1981; U. of California, Santa Barbara, A Heritage Renewed: Representational Drawings Today, 1983; Houston/Contemporary, American Still Life, 1945-1983, 1983; SFMA, American Realism (Janss), circ., 1985; U. of Northern Iowa, The Homecoming, 1986. **Collections:** Aachen/NG; Brandeis U.; U. of Connecticut; Cortland/SUNY; Des Moines; Duke U.; Hirshhorn; Indiana U.; Kalamazoo Institute; U. of Kentucky; Little Rock/MFA; Louisville/ Speed; MOMA; U. of Massachusetts; Michigan State U.; Minneapolis/Institute; Montclair/AM; U. of New Mexico; NCFA; U. of North Carolina; Ogunquit; PAFA; St. Louis City; U. of Virginia; WMAA; Yale U. **Bibliography:** Armstrong, Thomas;

Arthur 1, 2; **Hollander and Briganti;** *Kunst um 1970;* Sager; Sandler 3; Strand, ed.; Ward.

BAIZERMAN, SAUL **b.** December 25, 1889, Vitebsk, Russia. **d.** August 30, 1957, NYC. **Studied:** Imperial Art School, Odessa; NAD; Beaux-Arts Institute of Design, NYC. To USA, 1910. Traveled England, Russia, Italy. Fire demolished New York studio, 1931, destroying almost all his work. **Taught:** American Artists School, NYC; U. of Southern California, summer, 1949; Baizerman Art School, 1934-40. **Awards:** PAFA, Hon. Men. 1949; AAAL Grant, 1951; Guggenheim Foundation Fellowship, 1952; PAFA, Alfred G. B. Steel Memorial Prize, 1952. **One-man Exhibitions:** (first) Dorien Leigh Galleries, London, 1924; Eighth Street Gallery, NYC, 1933; Artists' Gallery, NYC, 1938, 48, 57; Philadelphia Art Alliance, 1949; The New Gallery, NYC, 1952, 54; World House Galleries, NYC, 1963; The Zabriskie Gallery, NYC, 1967, 70, 72, 75, 80. **Retrospective:** Walker, circ., 1953; ICA, Boston, 1958; Huntington, N.Y./Heckscher, 1961. **Collections:** Andover/Phillips; Hirshhorn; U. of Minnesota; U. of Nebraska; U. of New Mexico; U. of North Carolina; PAFA; WMAA; Walker. **Bibliography:** Baur 7; Brumme; Chipp; Goodrich and Baur 1; Marter, Tarbell, and Wechsler; Pearson 2. Archives.

BALDESSARI, JOHN **b.** June 17, 1931, National City, Calif. **Studied:** Otis Art Institute; Chouinard Art Institute; UCLA; U. of California, Berkeley; San Diego State College, 1953, BA, 1957, MA. Traveled Europe, Mexico, Canada, Middle East. **Taught:** San Diego Fine Arts School, 1953-54; San Diego city schools, 1956-57; San Diego State College, 1956, 59-61; Southwestern College, Chula Vista, 1962-68; U. of California, San Diego, 1962-70; La Jolla, 1966-70; California Institute of the Arts, Valencia, 1970-; Hunter College, 1971. **Awards:** National Endowment for

John Baldessari, *Mountain Climber (Incomplete): Passers-by/Confrontations*, 1992.

the Arts, 1973, 74-75. **Address:** 2001 $^1/_2$ Main Street, Santa Monica, CA 90405. **Dealer:** Sonnabend Gallery, NYC. **One-man Exhibitions:** La Jolla, 1960, 66, 68; Southwestern College, Chula Vista, 1962-64, 75; Molly Barnes Gallery, Los Angeles, 1968; Eugenia Butler, 1970; Richard Feigen Gallery, 1970; Nova Scotia College of Art and Design, Halifax, 1971, 72; Art & Project, Amsterdam, 1971, 72, 75; Galerie Konrad Fischer, Düsseldorf, 1971, 73; Jack Wendler Gallery, London, 1972, 74; Galleria Toselli, Milan, 1972, 74; Galerie NHL, Brussels, 1972, 74, 75; Sonnabend Gallery, NYC, 1973, 75, 78, 80, 81, 84, 87, 90; Ileana Sonnabend Gallery, Paris, 1973, 75; Galleria Schema, Florence, 1973; Galerie Volker Skulima, Berlin, 1974; Felix Handschin Gallery, Basel, 1975; Galeria Saman, Genoa, 1975; Amsterdam/Stedelijk, 1975; Modern Art Agency, Naples, 1975; The Kitchen, NYC, 1975; U. of California, Irvine, 1976; Ewing and Paton Galleries, Victoria, Australia, 1976; Auckland, 1976; U. of Akron, 1976; Ohio State U., 1976; Cirrus Editions, Los Angeles, 1976; James Corcoran Gallery, Los Angeles, 1976; Massimo Valsecchi Gallery, Milan, 1977; Hartford/Wadsworth, 1977; Robert Self Gallery, London, 1977; Julian Pretto Gallery, NYC, 1977; Portland (Ore.) Center for the Visual Arts, 1978; Theatre Vanguard, Los Angeles, 1978; Artists' Space, NYC, 1978; Pacific Film Archives, Berkeley,

1978; WMAA (films), 1978; ICA, Boston, 1978; InK, Zurich, 1979; New Museum, 1981; Eindhoven, 1981; CEPA Gallery, Buffalo, 1981; Buffalo/Albright, 1981; Essen, 1981; Cincinnati/Contemporary, 1982; Wright State U., 1982; Houston/Contemporary, 1982; Galerie Stampa, Basel, 1983; Marianne Deson Gallery, Chicago, 1983; Arte Viva, Basel, 1983; Douglas Drake Gallery, Kansas City, Mo., 1984; Margo Leavin Gallery, Los Angeles, 1984; Gillespie-Laage-Salomon, Paris, 1984; Centre d'Art Contemporain, Dijon, France, 1985; Multiples, Inc., NYC, 1986; Galerie Peter Pakesch, Vienna, 1986; Santa Barbara/MA, 1986; Margo Leavin Gallery, Los Angeles, 1986, 88; U. of California, Berkeley, 1986; Dart Gallery, Chicago, 1987; Grenoble/Contemporary, 1987; Hannover/K-G, 1988; Galleria Primo Piano, Rome, 1988; Lisson Gallery, London, 1988; Galerie Laage-Salomon, Paris, 1988; Boston Museum School, 1989 (two-man); Madrid/Reina Sofia, circ., 1989; Stephen Wirtz Gallery, San Francisco, 1989; Lawrence Oliver Gallery, Philadelphia, 1989; C. Grimaldis Gallery, Baltimore, 1990; Cristopher Grimes, Santa Monica, Calif., 1990; Donald Young Gallery, Chicago; 1991; Mai 36 Galerie, Luzern, 1991; Galerie Crousel-Robelin, Paris, 1991; Galeria Weber, Alexander Y Cobo, Madrid, 1991. **Retrospective:** Los Angeles/MOCA, circ., 1990. **Group:** La Jolla, The Uncommon Denominator—13 San Diego Painters, circ., 1960; Long Beach/MA, Arts of Southern California VIII: Drawing, circ., 1960; SFMA Annuals, 1961, 62; San Diego State College, Seven-Man Show, 1962; Long Beach/MA, Arts of Southern California: Painting, circ., 1963; La Jolla, Some Aspects of California Painting and Sculpture, 1965; U. of California, San Diego, New Work, Southern California, 1968; Hayward Gallery, London, Pop Art, 1969; Leverkusen, Konzeption, 1969; Seattle/AM, 557, 087, 1969; California College of Arts and Crafts, Space, 1969; Chicago/Contemporary, Art

by Telephone, 1969; WMAA Annuals 1969, 72; Jewish Museum, Software, 1970; Oberlin College, Art in the Mind, 1970; Turin/Civico, Conceptual Art, Arte Povera, Land Art, 1970; Kyoto Municipal Museum of Art, Nirvana, 1970; MOMA, Information, 1971; Buenos Aires/Moderno, Art Systems, 1971; Düsseldorf/Kunsthalle, Prospect '71, 1971; Festival of Two Worlds, Spoleto, 1972; Kassel, Documenta V, 1972; Basel, Twelve-Man Show, 1972; Venice Biennial, 1972; VI International Theater Festival: Aspects, Belgrade, 1972; Houston/Contemporary, Five-Man Show, 1972; Minnesota College of Art and Design, I National Videotape Festival, 1972; Houston/Contemporary, Videotapes, 1972; Basel, Konzept Kunst, 1972; Pasadena/AM, Southern California Attitudes, 1972; Syracuse/Everson, Circuit, circ., 1973; Musée Galliera, Paris, Festival d'Automne, 1973; Düsseldorf/Kunsthalle, Prospect '73, 1973; Parcheggio di Villa Borghese, Rome, Contemporanea, 1974; Cologne, Project '74, 1974; Eindhoven, Kunst Informatie Centrum, 1974; Malmo, New Media, 1975; Auckland; Pan Pacific Biennial, 1976; SFMA, Painting and Sculpture in California, 1976; Fort Worth, American Artists: A New Decade, 1977; WMAA Biennials, 1977, 79, 83, 85; Houston/Contemporary, American Narrative/Story Art: 1967-1977, 1978; WMAA, Art about Art, 1978; ICA, London, Wit and Wisdom, 1978; Chicago/AI, American Photography in the 70's, 1979; Bochum, Words, 1979; Hayward Gallery, London, Pier and Ocean, 1980; Cologne/Stadt, Westkunst, 1981; Sydney/AG, 4th Biennial, 1982; Documenta VII, Kassel, 1982; Los Angeles/MOCA, Automobile & Culture, 1984; Paris Biennial, 1985; Carnegie, International, 1985; Metz Museum, Theatre des Realites, circ., 1986; Fort Lauderdale, An American Renaissance, 1986; Los Angeles/County MA, Avant-Garde in the 80s, 1987; Haus am Waldsee, Berlin, Blow-Up, 1987; WMAA, Image World, 1989;

MOMA, California Photography: Remaking the Make-Believe, 1989; MMA, Invention and Continuity in Contemporary Photographs, 1989; Paris/Beaubourg, Magiciens de la Terre, 1989; Chicago/AI, On the Art of Fixing a Shadow, 1989; San Jose Museum of Art, Forty Years of California Assemblage, 1989; Cologne/Ludwig, Bilderstreit, 1989; Victoria & Albert Museum, Photography Now, 1989; Anthology Film Archives, New York, Film @ Anthology, 1990; Wright State U., Assembled, 1990; ICA, U. of Pennsylvania, Devil on the Stairs, 1991; Ohio State U., Breakthroughs, 1991; Wright State U., Words & #s, 1991; Milwaukee Art Center, Word as Image, circ., 1991. **Collections:** Basel, Canberra/National; Chicago/AI; Cologne; Eindhoven, Denver/AM; Grenoble; Houston/MFA; Institut fur Moderne Kunst; International Museum of Photography; La Jolla; Los Angeles/County MA; Los Angeles/MOCA; MOMA; Miami-Dade; Newport Harbor; Oberlin College; The Ohio State U.; Transamerica Corp; WMAA. **Bibliography:** *Art Now 74;* Colpitt and Plous; *Forty Years of California Assemblage;* Individuals; *Contemporanea;* Gohr and Gachnang; Fox; Meyer; *Performance Anthology;* Plagens; *Report;* Robins; Sandler 3; Tomidy; Weintraub.

BANG, THOMAS
In 4th edition.

BANNARD, DARBY b. September 23, 1934, New Haven, Conn. **Studied:** Princeton U., BA. Contributing editor, *Artforum,* 1973-74; curator, Hans Hofmann, Hirshhorn, 1976; co-chairman, National Endowment for the Arts International Committee on the Visual Arts, 1979-. Traveled Europe, USA, Canada, Mexico. **Taught:** Columbia U., 1968; Princeton U., 1974; Brooklyn Museum, 1974; Kent State U., 1974; U. of Texas, 1975; Washington U., St. Louis, 1977; SFAI, 1979; School of Visual Arts, NYC, 1984-. **Awards:** Guggenheim Foundation Fellowship, 1968;

National Council on the Arts, 1968; Francis J. Greenberger Foundation Award, 1986. **Address:** c/o Dealer. **Dealer:** Greenberg Wilson, NYC. **One-man Exhibitions:** (first) Tibor de Nagy Gallery, NYC, 1965, 66, 67, 68, 69; Kasmin Ltd., London, 1965, 68, 69, 70, 72; Richard Feigen Gallery, Chicago, 1966; Nicholas Wilder Gallery, Los Angeles, 1967; Bennington College, 1969; David Mirvish Gallery, Toronto, 1969, 78; Lawrence Rubin Gallery, NYC, 1970, 73; Joseph Helman Gallery, St. Louis, 1970; Galerie Hans R. Neuendorf, Cologne, 1971; Newport Harbor, 1972; Pasadena/AM, 1973; Tibor de Nagy Gallery, Houston, 1973, 75; M. Knoedler & Co., Inc., NYC, 1974 (twice), 75, 77, 78, 79, 80, 82; Laguna Gloria Art Museum, Austin, Tex., 1975; Ronald Greenberg Gallery, St. Louis, 1977; Exeter, 1977; Watson/de Nagy & Co., Houston, 1979, 81; Wichita/Ulrich, 1980; Martin Girard Gallery, Edmonton, Canada, 1982; The Clayworks Studio Workshop, NYC, 1982; Princeton Country Day School, 1986; St. Lawrence U., 1987; R. H. Love Contemporary, Chicago, 1988; Greenberg Wilson, NYC, 1989, 90; Rider College, 1989; Miami-Dade Community College, 1990; Montclair/AM, 1991. **Retrospective:** Baltimore/MA, circ., 1973. **Group:** Los Angeles/County MA, Post Painterly Abstraction, 1964; MOMA, The Responsive Eye, 1965; Chicago/Contemporary, 1965; Smithsonian, 1966; U. of Pennsylvania, 1966; WMAA Annual, 1967, 72; Detroit/Institute, Color, Image and Form, 1967; MOMA, The Art of the Real, 1968; New Delhi, First World Triennial, 1968; Düsseldorf/Kunsthalle, Prospect '68, 1968; Corcoran Biennial, 1969; XXXV Venice Biennial, 1970; Buffalo/Albright, Color and Field: 1890-1970, 1970; Toledo/MA, The Form of Color, 1970; WMAA, The Structure of Color, 1971; Illinois State U., Biennial, 1971; Buffalo/Albright, Six Painters, 1971; Houston/MFA, Toward Color and Field, 1971; Boston/MFA, Abstract Painting in the

'70s, 1972; Winnipeg (Canada) Art Gallery, Masters of the Sixties, 1972; Montreal/Contemporain, 11 Artistes Americains, 1973; Houston/MFA, The Great Decade of American Abstraction: Modernist Art 1960 to 1970, 1974; Cleveland/MA, Contemporary American Artists, 1974; WMAA/Downtown, Continuing Abstraction in American Art, 1974; Indianapolis/Herron, 1978; Syracuse/Everson, New Works in Clay III, 1981. **Collections:** Brandeis U.; Baltimore/MA; Boston/MFA; Buffalo/Albright; Cleveland/MA; Dayton/AI; Harvard U.; Hofstra U.; Honolulu Academy; Houston/MFA; MOMA; Melbourne/National; Newark Museum; Oberlin College; Princeton U.; Ridgefield/Aldrich; Storm King Art Center; U. of Texas; Toledo/MA; Trenton/State; U. of Texas; SRGM; WMAA. **Bibliography:** Battcock, ed.; **Cone 2;** *The Great Decade;* Goossen 1; Plagens; Rose, Barbara, 1; Sandler 3; Wood.

BARINGER, RICHARD E.
from 1st to 4th edition.

BARNES, ROBERT **b.** September 24, 1934, Washington, D.C. **Studied:** Chicago Art Institute School, 1952-56; The U. of Chicago, 1952-56, BFA; Columbia U., 1956; Hunter College, 1957-61; U. of London, Slade School, 1961-63. Traveled Great Britain, France, USA. **Taught:** Indiana U., summers, 1960, 61; Kansas City Art Institute and School of Design, 1963-64; Indiana U., 1964-. **Commissions:** New York Hilton Hotel, 1962 (edition of lithographs). **Awards:** William and Noma Copley Foundation Grant, 1961; Fulbright Fellowship, 1961, renewed 1962; Chicago/AI, 67th Annual; AAAL, P.P., 1970; National Endowment for the Arts, grant, 1982. **Address:** c/o Dealer. **Dealer:** Struve Gallery, Chicago. **One-man Exhibitions:** (first) Allan Frumkin Gallery, NYC, 1963, 68, 74, 77, 79, 83, 85; Allan Frumkin Gallery,

Chicago, 1964, 67, 75, 78; Galerie du Dragon, Paris, 1967; Coe College, 1967; Indianapolis/Herron, 1968; Quincy (Ill.) Art Club, 1971; Il Fante di Spade, Rome, 1973; Marianne Friedland Gallery, Ontario, 1978; Frumkin & Struve Gallery, Chicago, 1981, 83, 84; Struve Gallery, Chicago, 1986, 89, 92; Natasha Nicholson Gallery, Madison, Wisc., 1989; Indiana U., 1991. **Retrospective:** Artists Choice Museum, NYC, circ., 1986. **Group:** Chicago/AI, Exhibition Monumentum, 1952-55; Chicago/AI, Prints from the Graphic Workshop, 1955; Boston Arts Festival, 1958; Chicago/AI, Annuals, 1958, 60, 61, 64; State U. of Iowa, Main Current of Contemporary American Painting, 1960; Ravinia Festival, Highland Park, Ill., 1961; WMAA Annual, 1962; Yale U., 1962; Kansas City/Nelson, 1962; SFMA, 1963; MOMA, 60 Modern Drawings, 1963; Chicago/AI, Drawings, 1963; WMAA, Young America, 1965; Salon des Jeunes Peintres, Paris, 1965; Museo Civico, Bologna, 1965; PAFA, 1966; RISD, Recent Still Life, 1966; U. of Illinois, 1967; VMFA, Works on Paper, 1970; Indianapolis, 1972; Chicago/Contemporary, Chicago Imagist Art, 1972; Galleria Comunale d'Arte Contemporanea, Una Tendenza Americana, 1973; Joslyn/Omaha, The Chosen Object, 1977; Chicago/AI, 100 Artists—100 Years; Alumni of the SAIC, 1979; Chicago/AI, Whitney Halsted Memorial Exhibition, 1980; WMAA, 50th Anniversary, 1980; New Orleans/Contemporary, The Human Figure, 1982; Chicago/Contemporary, Selections from the Dennis Adrian Collections, 1982; Indianapolis, Painting and Sculpture Today, 1986; AAIAL, 1989; Miyagi Museum of Art, Sendai, Japan, American Realism and Figurative Art, 1952-90, circ., 1991; School of the Art Insitute, Chicago, From America's Studio, 1992; Chicago Cultural Center, Face to Face, 1992. **Collections:** Chicago/AI; Chicago/Contemporary; U. of Chicago; Indiana U.; Indianapolis; MOMA; NMAA; U. of North Carolina. Pasadena/AM; St. Jo-

seph/Albrecht; WMAA. **Bibliography:** Robert Barnes; Rose, B., 1.

BARNET, WILL b. May 25, 1911, Beverly, Mass. **Studied:** Boston Museum School, with Phillip Hale; ASL, with Charles Locke. Traveled USA, Europe. **Taught:** ASL, 1936-; Cooper Union, 1945-; U. of Washington, Summer, 1963; Boston Museum School, 1963; Famous Artists Schools, Inc., Guiding Faculty, 1954-64; PAFA, 1967-; Cornell U., summers, 1968, 69. **Member:** American Abstract Artists; Federation of Modern Painters and Sculptors; Century Association; NAD, Federal A.P.: Technical advisor in lithography; Fellow, Royal Society of Arts; AAIAL. **Awards:** Corcoran, William A. Clark Prize; Ford Foundation/A.F.A. Artist-in-Residence; PAFA, Walter Lippincott Prize, 1968; Library of Congress, P.P., 1974; NAD, Benjamin Altman Prize, 1977; Massachusetts College of Art, Hon. DFA, 1989; National Arts Club, Gold Medal, 1990; Lotus Club, Lotus Medal of Merit, 1991. **Address:** 15 Gramercy Park, NYC 10003. **Dealer:** Terry Dintenfass Inc., NYC. **One-man Exhibitions:** (first) Hudson D. Walker Gallery, NYC, 1939; Gallery St. Etienne, NYC, 1943; The Bertha Schaefer Gallery, 1947, 49, 51, 53, 55, 60, 62; Peter H. Deitsch Gallery, 1960, 63; Mary Harriman Gallery Inc., Boston, 1963; Galleria Trastevere di Topazia Alliata, Rome, 1960; Waddell Gallery, 1965, 66, 68; Fairweather-Hardin Gallery, 1971; David/David Inc., Philadelphia, 1972; Hirschl & Adler Galleries, NYC, 1973, 76; Century Association, 1974, circ., 1991; Harmon Gallery, 1974; Meredith Long Gallery, 1974; Prince Arthur Galleries, Toronto, 1977; Haslem Fine Arts, Inc., Washington, D.C., 1977, 79; Alice Simsar Gallery, Inc., Ann Arbor, 1978; AAA Gallery, NYC, 1978; Charlottemont, 1979; Foster Harmon Galleries of American Art, Sarasota, 1980; Le Galerie Documents, Paris, 1980; Terry Dintenfass Inc., 1982, 91; Kennedy Galler-

ies, Inc., 1984, 87, 88; Sylvan Cole Gallery, NYC, 1988; Harmon-Meek Gallery, Naples, Fla.; Jo Ann Perse Gallery, St. Louis, 1990; Susan Conway Caroll Gallery, Washington, D.C., 1989. **Retrospectives:** U. of Minnesota, Duluth, 1958; ICA, Boston, 1961; Albany/Institute, 1962; PAFA, 1970; A.A.A. Gallery, 1972; Print Club of Philadelphia, 1977; Purchase/SUNY, circ., 1979; Currier, circ., 1984; Little Rock/MFA, 1991. **Group:** American Abstract Artists since the Mid-1940's; MMA, American Paintings Today, 1950; Yale U., 1955; Corcoran, 1960; International Biennial Exhibition of Prints, Tokyo, 1960; PAFA, 1962, 68, 69; WMAA, Geometric Abstraction in America, circ., 1962; Brooklyn Museum; Carnegie; ICA, Boston; MOMA; U. of California, 1968; U. of Illinois, 1969; Expo '74, Spokane, 1974; NAD, 1975; 100th Anniversary Exhibition of ASL, 1975; IEF, Twentieth-Century American Drawings: The Figure In Context, circ., 1984. **Collections:** Boston/MFA; Brooklyn Museum; Buffalo/Albright; U. of California; Carnegie; Cincinnati/AM; Columbus; Corcoran; Currier; Harvard U.; Honolulu Academy; Library of Congress; MMA; MOMA; Montana State College; NAD; NMAA; NYPL; NYU; National Gallery; PAFA; PMA; Phillips; Portland (Me.)/MA; Rockland/Farnsworth; SFMA; SRGM; Seattle/AM; U. of Texas; Utica; WMAA; Worcester/AM. **Bibliography:** American Artists Congress, Inc.; Cummings 4; Doty; Farrell; Hayter 1; Janis and Blesh 1; Nordness, ed.; Reese; Smith, A. Archives.

BARRY, ROBERT b. March 9, 1936, NYC. **Studied:** Hunter College, BFA, MA. **Awards:** National Endowment for the Arts, grant, 1976. **Address:** 1091 Emerson Avenue, Teaneck, NJ 10766. **Dealer:** Leo Castelli Inc., NYC. **One-man Exhibitions:** Westerly Gallery, NYC, 1964; Seth Siegelaub, Los Angeles, 1969; Art & Project, Amsterdam, 1969, 71, 72, 74; Gian Enzo Sperone, Turin, 1969, 70,

73, 74; Eugenia Butler, 1970, 71; Yvon Lambert, Paris, 1971, 73, 74, 77; Paul Maenz Gallery, Cologne, 1971, 72, 73, 74, 76, 77, 79, 80; Leo Castelli, Inc., NYC, 1971, 72, 74, 76, 78, 79, 80, 81, 83, 89, 90; Galerie MTL, Brussels, 1972; Jack Wendler Gallery, London, 1972, 73, 74; Galleria Toselli, Milan, 1972, 73; Tate, 1972; Gian Enzo Sperone, Rome, 1973, 76; Galeria Foksal, Warsaw, 1973, 91; Kabinett fur Aktuelle Kunst, Bremerhaven, 1973; Kunstmuseum, Lucerne, 1974; Rolf Preisig Gallery, Basel, 1974, 76, 79; Amsterdam/Stedelijk, 1974; Gian Enzo Sperone, NYC, 1975; Cusack Gallery, Houston, 1975; Julian Pretto Gallery, NYC, 1976; P.S. 1, Long Island City, 1976; Robert Self Ltd., London, 1977; Eindhoven, 1977; Essen, 1978; Rudiger Schottle, Munich, 1977; U. of Colorado, 1978; Galerie Françoise Lambert, Milan, 1979, 83; Rolf Preisig Gallery, Basel, 1979; Omaha/Joslyn, 1980; Galerie Yvon Lambert, Paris, 1981, 84, 88, 90; Essen, 1982; Museum of Conceptual Art, San Francisco, 1982; Ulmer Museum, Ulm, West Germany, 1983; Art & Project, Amsterdam, 1983; Galeria Locus Solus, Genoa, 1983; Galerie L'Hermitte, Coutances, France, 1983; David Bellman Gallery, Toronto, 1984; U. of Chicago, 1985; Le Consortium, Dijon, 1986, 91; Galerie Ghislain Mollet-Viéville, Paris, 1987; Galerie Edition E. Wasserman, Munich, 1988, 91; Holly Solomon Gallery, NYC, 1988, 89, 91; Meert Rihoux Gallery, Brussels, 1988, 90; Thomas Solomon's Garage, Los Angeles, 1989; Musée St. Pierre, Lyon, 1989; Magazin, CNAC, Grenoble, France, 1989; Roy Boyd Gallery, Los Angeles, 1989; The Hague, 1990; Salama-Caro Gallery, London, 1990; Galerie Ugo Ferranti, Rome, 1991, 92; Galeria 57, Madrid, 1991; Galerie Pierre Huber, Geneva, 1991. **Group:** Hudson River Museum, Eight Young Artists, 1964; SRGM, Systemic Painting, 1966; A.F.A., The Square in Painting, 1968; Berne, When Attitudes Become Form; Amsterdam/Stedelijk, Op

Losse Schroeven, 1969; Seattle/AM, 557, 087, 1969; Düsseldorf/Kunsthalle, Prospect '69, 1969; Leverkusen, Konzeption, 1969; Oberlin College, Art in the Mind, 1970; La Jolla, Projections: Anti-Materialism, 1970; New York Cultural Center, Conceptual Art and Conceptual Aspects, 1970; MOMA, Information, 1971; Kyoto Municipal Museum of Fine Art, Nirvana, 1970; Jewish Museum, Software, 1970; Kunsthalle, Nurnberg, Artist, Theory and Work, 1971; Munster/WK, Concept Art, 1971; Paris Biennial, 1971; Mills College, Notes and Scores for Sound, 1972; Kassel, Documenta V, 1972; Venice Biennial, 1972; Amsterdam/Stedelijk, Kunst Als Boek, 1972; Munster/WK, Das Konzept ist die Form, 1972; Parcheggio di Villa Borghese, Rome, Contemporanea, 1974; Kunsthalle, Cologne, Kunst bleibt Kunst, 1974; Sarah Lawrence College, Word, Image, Number, 1975; U. of Chicago, Ideas on Paper 1970-1976, 1976; Chicago/Contemporary, Words at Liberty, 1977; Bochum, Words, Words, 1979; Chicago/AI, Annual, 1979; U. of California, Santa Cruz, Music, Sound, Language, Theatre, circ., 1980; Centre d'Arts Plastiques Contemporains, Bordeaux, Arte Povera, Antiform: Sculptures 1966-1969, 1982; Dublin/Municipal, International Quadrennial (ROSC), 1984; Hirshhorn, Content: A Contemporary Focus, 1974-84, 1984; Kunsthalle, Hamburg, Im Toten Winkel, 1984; Paris/Beaubourg, Livres d'Artistes, 1985; Bard College, The Maximal Implications of the Minimal Line, 1985; Fort Lauderdale, An American Renaissance, 1985; Hamburg, More Light, 1985; Los Angeles/MOCA, Individuals: A Selected History of Contemporary Art, 1986; Cologne/Ludwig, Marcel Duchamp und die Avant Garde Zeit, 1950, 1988; Musée d'art Contemporain, Bordeaux, Art Conceptual I, 1988; York U., Toronto, From Concept to Context, 1989; Kunstverein, Frankfurt, Prostpect, 89, 1989; Paris/Moderne, L'Art Conceptuel, Une Perspective, circ., 1989; Musée des Beaux Arts, Dijon,

Une Autre Affaire, 1989; Milwaukee, Word as Image, circ., 1990; Toronto, Inquiries, Language in Art, 1990; Wuppertal/von Heydt, Buckstablich, Words and Images in Today's Art, 1990; U. of California, Santa Barbara, Knowledge, Aspects of Conceptual Art, 1992. **Collections:** Amsterdam/Stedelijk; Art Gallery of Ontario; Basel; Canberra; Chase Manhattan Bank; Cologne; Eindhoven; Ghent; Hartford/Wadsworth; Krefeld/Kaiser Wilhelm; Lyon/St. Pierre; Paris/Beaubourg; MOMA. **Bibliography:** *Art Now 74;* Celant; Colpitt and Plous; *Contemporanea;* Honnef; *Individuals;* Lippard, ed.; Meyer; Robins; Sandler 3; Weintraub; *When Attitudes Become Form.*

BARTH, FRANCES b. July 31, 1946, NYC. **Studied:** Hunter College, 1968, BFA, with Doug Ohlson, Ron Gorchov, Ralph Humphrey, Vincent Longo, George Sugarman; 1970, MA, with Tony Smith, Ray Parker. Traveled Europe, Russia, USA, Japan; lived in Amsterdam, 1978. **Taught:** Bennington College, 1975-76; Princeton U., 1976-79; Sarah Lawrence College, 1979-85; Yale U., 1986-. **Member:** College Art Association. **Commissions:** Set design for Lynne Taylor Corbett and Charles Strouse, Louisville Ballet, *Tunes,* 1984. **Awards:** CAPS, 1973; National Endowment for the Arts, 1974; Guggenheim Foundation Fellowship, 1977; National Endowment for the Arts, 1982; New Jersey State Council on the Arts Grant, 1987. **Address:** 99 Van Dam Street, NYC 10013. **Dealers:** Jan Cicero Gallery, Chicago; Nina Freudenheim Gallery, Buffalo. **One-man Exhibitions:** (first) Susan Caldwell Inc., NYC, 1974, 75, 76, 78, 79, 80, 81, 83; Jan Cicero Gallery, Chicago, 1981, 85; Jersey City Museum, 1983; Nina Freudenheim, 1985; Tomoko Liguori Gallery, NYC, 1988, 89; Jan Cicero Gallery, Chicago, 1990 (two-man); Tenri Cultural Institute, NYC, 1991. **Group:** WMAA Annuals, 1972, 73; Corcoran Annual, 1973; SFAI,

S.F./L.A./NYC, 1978; ICA, U. of Pennsylvania, Eight Abstract Painters, 1978; Buffalo/Albright, American Paintings of the 1970s, circ., 1978; NYU, American Painting: The Eighties, 1979; MOMA, New Art II, Surfaces-Textures, 1981; Indianapolis, 1984, 85; AAIAL, 1988; William Paterson College, Wayne, N.J., Scale, Space, Structure, 1989. **Collections:** Akron/AI; Buffalo/Albright; American Can Corp., Greenwich, Conn.; Amerada Hess Corp., NYC; Chase Manhattan Bank, NYC; Cornell U.; Dallas/MFA; IBM Corp., NYC; Lehman Brothers, NYC and Chicago; MMA; Milwaukee; MOMA; Prudential Insurance Co. of America; Swiss Bank Corp., NYC; WMAA. **Bibliography:** Robins.

Jennifer Bartlett, *Eleven A.M.*, from *AIR: 24 Hours Series.* 1991-1992.

BARTLETT, JENNIFER

b. March 14, 1941, Long Beach, Calif. **Studied:** Mills College, 1963, BA; Yale 1964, BFA, 1965, MFA, with Jack Tworkov, James Rosenquist, Al Held, Jim Dine. **Commissions:** Richard B. Russell Federal Building and US Court House, Atlanta; Volvo Corporate Headquarters, Gothenberg, Sweden; Institute for Scientific Information, Philadelphia, Munchner Kammerspiele, 1988; Opera Comique, Paris, 1988. **Awards:** CAPS, 1974; Chicago/AI, Harris Prize, 1976; Brandeis U., Creative Art Award, 1983; AAIAL, 1983; Chicago/AI, Harris Prize, and the M. V. Kohnstamm Award, 1986; American Institute of Architects, Award, 1987. **Taught:** School of Visual Arts, NYC, 1972-77. **Address:** 237 Lafayette Street, NYC 10012. **Dealer:** Paula Cooper Gallery, NYC. **One-man Exhibitions:** Mills College, Oakland, Calif., 1963; 119 Spring St., NYC, 1970; Reese Palley Gallery, NYC, 1972; Paula Cooper Gallery, NYC, 1974, 77, 79, 81, 82, 83, 85, 87, 88, 90, 91, 92; Jacob's Ladder, Washington, D.C., 1973 (two-man); Galleria Saman, Genoa, 1974, 78; Garage Gallery, London, 1975 (two-man); John Doyle Gallery, Chicago, 1975; Dartmouth College, 1976; Cincinnati/Contemporary, 1976; Hartford/Wadsworth, 1977; SFMA, 1978; Hansen-Fuller Gallery, San Francisco, 1978; Baltimore/MA, 1978; Margo Leavin Gallery, Los Angeles, 1979; The Clocktower, NYC, 1979; U. of Akron, 1979; Carlton College, 1970; Heath Gallery, Atlanta, 1979, 83; Galerie Mukai, Tokyo, 1980; Akron/AM, 1980; Buffalo/Albright, 1980; Margo Leavin Gallery, Los Angeles, 1981, 83; Omaha/Joslyn, 1982; Tate Gallery, 1981; McIntosh/Drysdale Gallery, Houston, 1982; Gloria Luria Gallery, Bay Harbor Islands, Fla., 1983; Brandeis U., 1984; Long Beach/MA, 1984; U. of California, Berkeley, 1984; U. of Miami, 1985; Walker, 1985; Knight Gallery, Charlotte, N.C., 1985; Carpenter + Hochman Gallery, Dallas, 1985; Kansas City/Nelson, 1985; Cleveland/MA, 1986; Greg Kucera Gallery, Seattle, 1986; Harvard U., 1987; Seibu Museum of Art, Tokyo, 1988; Milwaukee, 1988; John Berggruen Gallery, San Francisco, 1989, 90, 91; Knoedler Gallery, London, 1990, 91; Gallery Mukai, Tokyo, 1989; Richard Gray Gallery, Chicago, 1991; Randolph-Macon Women's College, 1992. **Retrospective:** Walker, circ., 1985. **Group:** MOMA, Seven Walls, 1971; WMAA Annual, 1972, Biennials 1977, 79; Indianapolis, 1972; Walker, Painting: New Options,

1972; GEDOK, Hamburg, American Women Artists, 1972; WMAA, American Drawings: 1963-1973; Corcoran, 37th Biennial, 1975; Biennale de Paris, 1975; Chicago/AI, Annual, 1976; Akademie der Kunst, Berlin, SoHo, 1976; Düsseldorf, The Pure Form, 1976; Kassel, Documenta VI, 1977; Paris/Moderne, Historical Aspects of Constructivism and Concrete Art, 1977; WMAA, New Image Painting, 1978; U. of North Carolina, Drawings about Drawing Today, 1979; WMAA, Decade in Review, 1979; Brockton/Fuller, Aspects of the 70's: Painterly Abstraction, 1980; XXXIX Venice Biennial, 1980; Yale U., Twenty Artists: Yale School of Art, 1950-1970, 1981; WMAA Biennial, 1981, 91; Paris/Moderne, Baroques 81, 1981; Haus der Kunst, Munich, Amerikanische Malerei: 1930-1980, 1981; Milwaukee, American Prints, 1982; WMAA, Block Prints, 1982; Bonn, Back to the USA, circ., 1983; Brooklyn Museum, The American Artist as Printmaker, 1983; Nassau County Museum, The House and Garden, 1985; AAIAL, 1985; Bard College, The Maximal Implications of the Minimal Line, 1985; WMAA, Three Printmakers, 1986; Fort Lauderdale, American Renaissance, 1986; Whitechapel Art Gallery, London, In Tandem, 1986; Cranbrook, Viewpoint '86, 1986; Boston/MFA, Printmaking Now: 70s into 80s, 1986; Sonoma State U., The Monumental Image, circ., 1987; Mt. Holyoke College, A Graphic Muse, circ., 1987; Middlebury College, Recent American Pastels, 1988; PMA/New Art on Paper, 1988; Cincinnati/AM, Making Their Mark, circ., 1989; Walker, First Impressions, circ., 1989; U. of North Carolina, Art on Paper, 1989; William Paterson College, The Grid, 1990; Munich/Moderne, Seiben Amerikanische Maler, 1991; AAIAL, 1991; Baltimore/MA, Marking the Decades: Prints, 1960-1990, 1991. **Collections:** Adelaide; Corpus Christi; Baltimore/MA; Brooklyn Museum; Buffalo/Albright; Burroughs Wellcome Co.; Chicago/Contemporary; Cleveland/MA;

Dallas/MFA; Denver/AM; Goucher College; Humlebaek/Louisiana; Israel Museum; Kansas City/Nelson; Keio U., Tokyo; La Jolla; Long Beach/MA; MMA; MOMA; Oberlin College; Omaha/Joslyn; PMA; Purchase/SUNY; RISD; St. Louis/City; Security Pacific Bank, Los Angeles; Tate Gallery; Tel Aviv; Toledo/MA; WMAA; Walker; Yale U. **Bibliography:** Armstrong, Thomas; Ashbery; *Back to the USA;* Bartlett; Danto; *Drawings: The Pluralist Decade;* Goldwater, Smith, and Tomkins; Haenlein; Marshall; Murken-Altrogge; Robins; Weintraub.

BASKIN, LEONARD b. August 15, 1922, New Brunswick, N.J. **Studied:** NYU, 1939-41; Yale U., 1941-43; New School for Social Research, MA, 1949; Academie de la Grande Chaumiere, 1950; Academy of Fine Arts, Florence, Italy, 1951; privately with Maurice Glickman. US Navy, 1943-46. **Taught:** Worcester Museum School, 1952-53; Smith College, 1953-74. Operates the Gehenna Press. **Member:** Royal Academy, Belgium, 1985; NIAL, 1985; Accademia del Disegno, Florence, 1985. **Awards:** Prix de Rome, Hon. Men., 1940; L. C. Tiffany Grant, 1947; Library of Congress, Pennell **P.P.,** 1952; Guggenheim Foundation Fellowship, 1953; SAGA, Mrs. A. W. Erickson Prize, 1953; Tokyo/Modern, O'Hara Museum Prize, 1954; U. of Illinois, **P.P.,** 1954; Chicago/AI, Alonzo C. Mather Prize, 1961; VI São Paulo Biennial, 1961; American Institute of Graphic Art, Medal of Merit, 1965; PAFA, Gold Medal, 1965; New School for Social Research, 1966; Hon. DFA, Clark U., 1966; Hon. LHD, Rutgers U., 1967; Hon. DFA, U. of Massachusetts, 1968; NIAL, Gold Medal, 1969; Hon. DFA, Portland School of Art, 1985; Hon. DFA, U. of Judaism, 1987; NAD, Sculpture Medal, 1988; NAD, Gold Medal, 1989. **Address:** Leeds, MA 01053. **Dealer:** Midtown-Payson Galleries, NYC. **One-man Exhibitions:** Glickman Studio, 1939; Numero Galleria d'Arte, Florence,

Leonard Baskin, *An Other Angel*, 1991.

Italy, 1951; The Little Gallery, Province-town, Mass., 1952; Mount Holyoke College, 1952; Fitchburg/AM, 1952; Boris Mirski Gallery, Boston, 1954, 55, 56, 64, 65; Grace Borgenicht Gallery, Inc., 1954, 60, 64, 66, 69; The Print Club, Philadelphia, 1956; Portland, Me./MA, 1956, 92; Wesleyan U., 1956; U. of Minnesota, 1961; U. of Louisville, 1961; Rotterdam, 1961; Amerika Haus, Berlin, 1961; American Cultural Center, Paris, 1961; Royal Watercolor Society, London, 1962; Peale House, Philadelphia, 1966; FAR Gallery, 1970; NCFA, 1970; A. Lubin, Inc., NYC, 1970; Kennedy Galleries, NYC, 1971, 73, 74, 75, 76, 78, 86; Amon Carter Museum, 1972, 82; Jewish Museum, 1974; Summit (N.J.) Art Center, 1974; SFMA, 1976; Indianapolis, 1976; Towson State College, Baltimore, 1976; Port Washington (N.Y.) Public Library, 1977; Washington U., 1978; Brookhaven National Laboratory, Upton, N.Y., 1972; Prince Arthur Galleries, Toronto, 1977; MacNider Museum, 1979; Minnesota/MA, 1979; The Cottage Gallery, London, 1981; Leinster Fine Art, London, 1981, 83; Reading Museum, Reading, England; Ulster Museum, Belfast, 1982; U. of Northern Iowa, 1982; Albertina, Vienna, 1984; Mannheim, 1984; Bowles Sorokko Galleries, Los Angeles, 1990, 92; Midtown-Payson Galleries, NYC, 1991; Rudin Museum of Judaica, Great Neck, N.Y., 1992; Southern Methodist U., circ., 1992. **Retrospective:** Bowdoin College, 1962; Rotterdam, 1961; Smith College, 1963; Worcester/AM, 1957. **Group:** MOMA; WMAA; Brooklyn Museum, 1949, 52, 53, 54, 55; Library of Congress; The Print Club, Philadelphia; SAGA, 1952, 53; São Paulo; Brandeis U.; Seattle/AM. **Collections:** Albion College; Allegheny College; Amherst College; Auburn U.; Baltimore/MA; Bezalel Museum; Boston/MFA; Bowdoin College; Brandeis U.; British Museum; Brooklyn Museum; Buffalo/Albright; Amon Carter Museum; Chase Manhattan Bank; Chicago/AI; Dallas/MFA; U. of Delaware; Detroit/Institute; Fitchburg/AM; Harvard U.; High Museum; Hirshhorn; Holyoke Public Library; U. of Illinois; Library of Congress; MMA; MOMA; Minnesota/MA; Mount Holyoke College; NAD; NYPL; National Academy of Sciences; National Gallery; U. of Nebraska; Newark Museum; New School for Social Research; Omaha/Joslyn; PAFA; PMA; Princeton U.; The Print Club, Philadelphia; Rome/Vatican; Smithsonian; St. John's Abbey, Collegeville, Minn.; St. Louis/City; Seattle/AM; Skidmore College; Smith College; U. of Texas; Trenton/State; Utica; VMFA; Victoria and Albert Museum; WMAA; Wesleyan U.; Worcester/AM; Yale U. **Bibliography:** Baskin, Leonard; Baskin, Lisa; Chaet; Craven, W.; Downes, ed.; **Fern**; Geske; Goodrich and Baur 1; Honisch and Jensen, eds.; Peterdi; Read 3; Rodman 1, 3; Sachs; Soyer, R., 1; Strachan. Archives.

BAUERMEISTER, M.
from 2nd to 3rd edition.

BAYER, HERBERT **b.** April 5, 1900, Haag, Austria. **d.** September 30,

1985, Montecito, Calif. **Studied:** Real-Gymnasium, Linz, Austria; architecture with Prof. Schmidthammer, Linz, 1919; Bauhaus, Weimar, 1921, with Vassily Kandinsky. Traveled Europe, Central America, Japan, North Africa. To USA, 1938. **Taught:** Bauhaus, Dessau, 1925-28; New York Advertising Guild, 1939-40. Designs and plans exhibitions for museums throughout the world. Typographer and designer of typefaces, packages, posters, books, and charts. Registered architect. **Member:** American Abstract Artists; Alliance Graphique Internationale; American Institute of Architects; Aspen Institute for Humanistic Studies; International Institute of Arts and Letters. **Commissions:** (architectural) Seminar Building, Aspen Institute for Humanistic Studies; factories; private residences; (murals) Harvard U.; Colonial Williamsburg; Elementary School, West Bridgewater, Mass.; Container Corp. of America; sculpture for Arco Plaza, Los Angeles, 1973. **Awards:** Poster competitions; art director awards and medals; Milan Triennial, 1930; Medal of the City of Salzburg; Oklahoma, First Prize; AIGA, Gold Medal for Excellence, 1970; Hon. DFA, Philadelphia College of Art, 1974; Austrian Honor Cross for Art and Science, 1978; Hon. DFA, Art Center College of Design, Pasadena, 1979; Fellow, American Academy of Arts and Sciences, 1979. **One-man Exhibitions:** (first) Galerie Povolotzki, Paris, 1929; Kunstverein, Linz, 1929; Bauhaus, Dessau, 1931; Kunstierhaus, Salzburg, 1936; The London Gallery, London, 1937; PM Gallery, NYC, 1939; Black Mountain College, 1939; Yale U., 1940; The Willard Gallery, 1943; Art Headquarters Gallery, NYC, 1943; North Texas State Teachers College, 1943; Outline Gallery, Pittsburgh, 1944; Cleveland/MA, 1952; H. Schaeffer Galleries, Inc., NYC, 1953; Galleria Il Milione, Milan, 1954; Kunst Kabinett Klihm, 1954, 57, 59, 62, 67, 78; Aspen Institute, 1955, 64; Fort Worth, 1958;

Walker, 1958; Düsseldorf, 1960; Bauhaus-Archiv, 1961; Andrew-Morris Gallery, NYC, 1963; The Byron Gallery, 1965; Esther Robles Gallery, Los Angeles, 1965; Boise (Idaho) Art Association, 1965; U. of New Hampshire, 1966; Conzen Gallery, Düsseldorf, 1967; Kunst-Amendt, Aachen, 1967; Marlborough Fine Art Ltd., 1968; Dunkelman Gallery, Toronto, 1970; Marlborough Gallery, Inc., NYC, 1971, 76, 79, 82; Marlborough Godard Ltd., Montreal, 1972, 75; Marlborough Galerie AG, Zurich, 1974; Arte/Contacto, Caracas, 1974; Die Neue Galerie der Stadt, Linz, Austria, 1976; Marion Locks Gallery, Philadelphia, 1977; A.F.A., Herbert Bayer: From Type to Landscape, circ., 1977-78; Museum Bochum, 1978; Galerie Breiting, Berlin, 1979; Aldis Browne Fine Arts, NYC, 1984; Denver (Colo.) Design Center, 1985. **Retrospectives:** Brown U., The Way Beyond Art, circ., USA, 1947-49; Germanisches National Museum, Nurnberg, 33 Years of Herbert Bayer's Work, circ., Germany and Austria, 1956-57; Denver/AM, 1973; Haus Deutscher Ring, Hamburg, circ., 1974. **Group:** Julien Levy Galleries, NYC, 1931, 40; MOMA, Fantastic Art, DADA, Surrealism, 1936; MOMA, Bauhaus: 1919-28, 1938; MOMA, Art and Advertising Art, circ., 1943; ART: USA: 58, NYC, 1958; American Abstract Artists Annuals, 1959-64; Marlborough Fine Art Ltd., Bauhaus, 1962; Arts Club of Chicago, 1962; Musée des Arts Décoratifs, 1966; Kunstverein, Hannover, Germany, 1967; Bauhaus Exhibition, circ., Stuttgart, London, Amsterdam, Paris, 1967-71; Berlin/National, Trends of the Twenties, 1977; Paris/Beaubourg, Paris-Berlin, 1908-1933, 1978. **Collections:** Bauhaus-Archiv; Brandeis U.; Busch-Reisinger Museum; Cologne; Denver/AM; Duisburg; Düsseldorf; Essen; Evansville; Fort Worth; Graphische Sammlung Albertina; Hagen; Hannover; Harvard U.; Hudson River Museum; Kaiserslautern; Leverkusen; Linz; MOMA; U. of Michigan; Museum

des 20. Jahrhunderts, Vienna; Nurnberg; Oklahoma; Oldenburg; Omaha/Joslyn; Roswell; Rome/Nazionale; SFMA; SRGM; Saarlandmuseum; Smith College; Stuttgart; Vassar College; Wiesbaden. **Bibliography:** Barr 1; Baur 7; **Bayer 1, 2;** Blanchard; Blesh 1; Dorner; Gaunt; Haftman; Janis; McCurdy, ed.; Neff, ed.; Rickey; Rotors; Wingler, ed.

BAYLINSON, A. S.
from 1st to 4th edition.

BAYNARD, EDWARD b. September 5, 1940, Washington, D.C. Traveled Spain, England. **Address:** 90 East 10th Street, NYC 10003. **One-man Exhibitions:** Ivan Spence Gallery, Ibiza, 1970; The Willard Gallery, NYC, 1971 (2), 76; 98 Greene Street Loft, NYC, 1972; Paley & Lowe Inc., NYC, 1972; Betty Parsons Gallery, NYC, 1973; Vick Gallery, Philadelphia, 1974; Multiples, NYC, 1977; Aronson Gallery, Atlanta, 1978; Showcase Gallery, Southfield, MI, 1978; Alexander F. Milliken Inc., NYC, 1978, 79, 80, 82; Meredith Contemporary Art Gallery, Baltimore, 1980, 81, 84; Barbara Gladstone, NYC, 1980; John Berggruen Gallery, San Francisco, 1980; Pam Adler Gallery, NYC, 1983; Galerie 99, Bay Harbor Islands, Fla., 1984; Hagerstown/County MFA, 1984; Bernice Steinbaum Gallery, NYC, 1985; Elaine Horwitch Galleries, Scottsdale, Ariz., 1987; Greene Gallery, Miami, 1989; Erika Meyerovich Gallery, San Francisco, 1989; Kleinert Foundation, Woodstock, NY, 1989; Marcuse Pfeifer Gallery, NYC, 1990; AAA, NYC, 1990; Smith-Andersen Gallery, Palo Alto, Calif., 1991; K Kimpton Gallery, San Francisco, 1991. **Group:** Utica, New American Painters, 1971; MOMA, Landscape, 1972; WMAA, American Drawing 1963-1973, 1973; Cleveland/MA, Seven Contemporary Artists, 1978; Houston/Contemporary, American Still Life, 1945-1983, 1983; Walker, Prints from Tyler Graphics, 1984.

William Baziotes, *The Toys*, 1952.

Collections: Amerada Hess Corp., Inc.; Atlanta/High; Chase Manhattan Bank; Cincinnati/AM; Hartford/Wadsworth; ICA, U. of Pennsylvania; Lehman Brothers, Inc.; MMA; MOMA; U. of Michigan; PMA; Prudential Insurance Co. of America; SFMA; Southeast Banking Corp; WMAA; Walker; West Palm Beach/Norton.

BAZIOTES, WILLIAM A.
b. June 11, 1912, Pittsburgh, Pa. **d.** June 4, 1963, NYC. **Studied:** NAD, 1933-36, with Leon Kroll. Federal A.P.: Teacher, 1936-38; easel painting, 1938-41. **Taught:** NYU, 1949-53; Brooklyn Museum School, 1949-52; Peoples Art Center (MOMA), 1951-53; Hunter College, 1952-63. Co-founder of a school, "Subject of the Artist," with Robert Motherwell, Barnett Newman, and Mark Rothko, NYC, 1948. **Awards:** Chicago/AI, Abstract and Surrealist Art, First Prize, 1948; U. of Illinois, P.P., 1951; Chicago/AI, The Mr. & Mrs. Frank G. Logan Medal, 1961. **One-man Exhibitions:** (first) Art of This Century, NYC, 1944; The Kootz Gallery, NYC, 1946-48, 1950-54, 1956, 58, 61; Galerie Maeght, 1947; Sidney Janis Gallery, 1961; Milwaukee, 1965; Marlborough Gallery, Inc., 1971; PAFA, 1971; Blum Helman Gallery, NYC, 1986, 88. **Retrospective:** SRGM, 1965; Newport Harbor Art Museum, circ., 1978. **Group:** California Palace, 1948; Chicago/AI, Abstract and Surrealist Art, 1948; WMAA Annuals, 1948, 50, 1952-57; U. of Illinois, 1949-51,

1953, 55, 61; Los Angeles/County MA, 1951; U. of Minnesota, 40 American Painters, 1940-50, 1951; I & II São Paulo Biennials, 1951, 53; MOMA, Fifteen Americans, circ., 1952; U. of Nebraska, 1952, 54; SRGM, Younger American Painters, 1954; WMAA, The New Decade, 1954-55; Brussels World's Fair, 1958; MOMA, The New American Painting, circ., Europe, 1958-59; Kassel, Documenta II, 1959; Walker, 60 American Painters, 1960; Galerie de France, Paris, 1961; MOMA, The New American Painting and Sculpture, 1969. **Collections:** Baltimore/MA; Brandeis U.; Buffalo/Albright; Chicago/AI; Detroit/Institute; Harvard U.; U. of Illinois; MMA; MOMA; Newark Museum; New Orleans/Delgado; U. of Rochester; SRGM; San Francisco Art Association; Seattle/AM; Smith College; Tel Aviv; Vassar College; WMAA; Walker; Washington U. **Bibliography:** *Abstract Expressionism;* **Alloway** 4; Armstrong, Thomas; Ashton 5; Baur 5, 7; Bazin; Biddle 4; Blesh 1; Dorner; Carleton, Hobbs, and Levin; Cummings 5; Eliot; *Europa/Amerika;* Finkelstein; Flanagan; Goodrich and Baur 1; Haftman; Hunter 6; Hunter, ed.; Janis and Blesh 1; Janis; McCurdy, ed.; Mendelowitz; *Metro;* Motherwell, ed.; Motherwell and Reinhardt, eds.; Murken-Altrogge; Neff, ed.; Neumeyer; Nordness, ed.; Paalen; Plagens, Ponente; Pousette-Dart, ed.; Read 2; Richardson, E. P.; Ritchie 1; Rodman 2; Rose, B., 1, 4; Ross, ed.; Rubin 1; Sandler 5; Soby 5; Tuchman, ed.; Tomkins 2; Waldman 4; Weller; *William Baziotes;* Archives.

BEAL, GIFFORD
from 1st to 5th edition.

BEAL, JACK **b.** June 25, 1931, Richmond, Va. **Studied:** College of William and Mary; Virginia Polytechnic Institute; Chicago/AI School (with Kathleen Blackshear). **Taught:** U. of Indiana, 1966; Purdue U., 1967; U. of Wisconsin, 1967, 69; Cooper Union, 1968; Wagner College; Cornell U.; Skowhegan School; San Francisco Art Association; Stanford U.; Fort

Worth College; Miami-Dade; College of William and Mary, 1992; New York Academy of Art, 1990-91. **Member:** NAD, Boston University, School of Visual Arts, Board of Visitors, 1973-; New York Academy of Art, Founder and Board of Advisors, 1981-. **Commissions:** Washington and Lee U., 1975; US Department of the Interior, 1976; US Department of Labor, 1976. **Awards:** Chicago/AI, Emilie L. Wild Prize, 1972; National Endowment for the Arts grant, 1972; Hon. DFA, Art Institute of Boston, 1992. **m.** Sondra Freckelton. **Address:** 67 Vestry Street, NYC 10013; 83A Delhi Stage, Oneonta, NY 13820. **Dealer:** Frumkin/Adams Gallery, NYC. **One-man Exhibitions:** (first) Allan Frumkin Gallery, NYC, 1965, also 1967, 68, 70, 72, 73, 75, 78, 80, 84, 85; Allan Frumkin Gallery, Chicago, 1966, 69, 74; Miami-Dade, 1972; Galerie Claude Bernard, Paris, 1973, 75, 81; Colorado State U., 1976; Fullerton College, 1977; Madison Art Center, circ., 1977-78; U. of Missouri, 1979; Reynolds/Minor Gallery, Richmond, Va., 1980; Alice Simsar Gallery, Ann Arbor (two-man), 1981; Robertson Center, Binghamton, N.Y., 1987; Frumkin/Adams Gallery, NYC, 1988; College of Charleston, 1990; College of William and Mary, 1992. **Retrospective:** VMFA, circ., 1973. **Group:** Chicago/AI, 1965; WMAA, Young America, 1965; A.F.A., 1965; RISD, Recent Still Life, 1966; Bennington College, 1967; Vassar College, 1968; SFMA, 1968; WMAA Annuals, 1968, 69; Milwaukee, Aspects of a New Realism, 1969; WMAA, 22 Realists, 1970; Boston U., The American Landscape, 1972; A.F.A. Realist Revival, 1972; Chicago/AI, 70th American Exhibition, 1972; Cleveland/MA, Aspects of the Figure, 1974; US Department of the Interior, America 1976, circ., 1976; Brooklyn Museum, Print Biennial, 1976; U. of Virginia, American Tradition and the Image of Post Modern Man in Contemporary Painting, Drawing, and Sculpture, 1979; PAFA, Seven on the Figure, 1979;

Jack Beal, *Sunflowers*, 1991.

Tulsa/Philbrook, Realism/Photorealism, 1980; Norfolk/Chrysler, American Figurative Painting, 1950-1980, 1980; Brooklyn Museum, American Drawings in Black and White, 1970-1979, 1980; San Antonio/MA, Real, Really Real, Super Real, circ., 1981; PAFA, Contemporary American Realism Since 1960, 1981; PAFA, Perspectives on Contemporary American Realism, 1983; IEF, Twentieth Century American Drawings: The Figure in Context, circ., 1984; Isetan Museum of Art, Tokyo, American Realism: The Precise Image, 1985; SFMA, American Realism: Twentieth Century Drawings and Watercolors, circ., 1985; New Orleans/Contemporary, Landscape, Seascape, Cityscape, 1986; NAD, Realism Today, circ., 1987; Rice U., Contemporary Interpretive Landscape, 1988; MMA, The Landscape in Twentieth Century American Art, circ., 1991; Miyagi Museum of Art, Sendai, Japan, American Realism and Figurative Art, 1952-1990, circ., 1991. **Collections:** Auckland; Bruce Museum; Brunswick Corp.; Chattanooga/Hunter; Chicago/AI; Ciba-Geigy Corp.; Delaware Art Museum; Des Moines; Exxon Corp.; Hirshhorn; Madison Art Center; MOMA; Minneapolis/Institute; Minnesota/MA; NMAA; National Gallery; U. of North Carolina; U. of Notre Dame; Purchase/SUNY; PMA;

Philip Morris Collection; Ringling; Sara Roby Foundation; SFMA; Toledo; Valparaiso U. (Ind.); U. of Vermont; U. of Virginia; WMAA; Wake Forest U.; Walker; Wilmington. **Bibliography:** *America 1976;* Adrian; Armstrong, Thomas; Arthur; Arthur 3; Arthur 4; Cummings 4; Lucie-Smith; Rose, B., 1; Sager; Sandler 3; **Shanes;** Strand, ed.; Ward. Archives.

BEARDEN, ROMARE **b.** September 2, 1912, Charlotte, N.C. **d.** March 12, 1988. **Studied:** NYU, BA; ASL (with George Grosz), 1936; Sorbonne, 1950. Traveled Europe, North Africa. US Army, 1942-45. **Taught:** Williams College, 1971; Yale College, 1980. **Member:** AAIAL; Board of New York State Council on the Arts. Designed environment for the Ed Bullins play *House Rent Party,* at The American Place Theatre, NYC, 1973. **Commissions:** murals for the New Lincoln Hospital, NYC, and City Hall, Berkeley, Calif.; Baltimore Metroline, mural, 1983; Manhattan Community College, mural, 1983. **Awards:** AAAL, Painting Award, 1966; Guggenheim Foundation Fellowship, 1969; Ford Foundation Grant, 1973; New York Urban League, Frederick Douglass Medal, 1978; NAACP, James Weldon Johnson Award, 1978; National Medal of the Arts, 1987. **One-man Exhibitions:** (first) Studio of Ad Bates, NYC, 1940; "G" Place Gallery, Washington, D.C., 1945; The Kootz Gallery, NYC, 1945, 46, 57; Duvuloy Gallery, Paris, 1945 (two-man); Niveau Gallery, NYC, 1948; Barone Gallery, NYC, 1955; Michel Warren Gallery, NYC, 1960; Cordier & Ekstrom, Inc., 1961, 64, 67, 70, 73, 74, 75, 76, 77, 78, 81, 83; Corcoran, 1966; Waitsfield/Bundy, 1966; Spelman College, 1967; NCFA, 1971; Pasadena/AM, 1971; High Museum, 1972; Raleigh/NCMA, 1972; Studio Museum, 1972; Syracuse/Everson, 1975; Nassau College, 1976; Union College, 1977; Davidson College, 1978; Birmingham, Ala./MA, 1982; New Orleans/Contemporary, 1982; Chatta-

nooga/Hunter, 1982; Memphis State U., 1982; Galerie Albert Loeb, Paris, 1975; Malcolm Brown Gallery, Shaker Heights, Ohio, 1982; Raleigh/NCMA, 1988; ACA, 1989, 91. **Retrospectives:** Albany/SUNY, 1968; MOMA, circ., 1971; Charlotte Mint, circ., 1980; Detroit/Institute, 1986; Studio Museum, NYC, circ., 1991. **Group:** Galerie Maeght, Paris, 6 American Painters, 1948; MMA, Survey of American Art, 1951; Carnegie, 1961; WMAA, Annual, 1969; Minneapolis/Institute, 30 Contemporary Black Artists; 1968; Chicago/AI; Dallas/MFA; Boston/MFA; MOMA, The New American Painting and Sculpture, 1969; Trenton/State, Six Black Americans, 1980. **Collections:** Akron/AI; Atlanta U.; Boston/MFA; Brooklyn Museum; Buffalo/Albright; Charlotte/Mint; Davidson College; Flint/Institute; Hartford/Wadsworth; Honolulu Academy; Howard U.; MMA; MOMA; Madison Art Center; Newark Museum; PMA; Princeton U.; St. Louis/City; U. of Rochester; Studio Museum; WMAA. **Bibliography:** Conwil, Campbell, and Patton; Dover; Robins; Siegel; Waldman 4. Archives.

BEASLEY, BRUCE b. May 20, 1939, Los Angeles, Calif. **Studied:** Dartmouth College, 1957-59; U. of California, 1959-62. Traveled Europe, Orient, South Pacific, Central America, Mexico. Resided in France, 1973. **Commissions:** State of California; Oakland/AM; Southland Center, Hayward, Calif.; City of San Francisco; GSA, Federal Office Building, San Diego, 1975; Taubman Co., Sterling Heights, Mich., 1976; San Francisco General Hospital, 1977; City of Salinas, California, 1977; Miami International Airport, 1977; Federal Home Loan Bank, San Francisco, 1991. **Awards:** Oakland/AM, Adele Morrison Memorial Medal, 1960; SFAI Annual, Hon. Men., 1961; Andre Malraux, P.P., Paris Biennial, 1962; Marin, Frank Lloyd Wright Memorial, P.P., 1965; San Francisco Arts Festival, P.P., 1967; Oakland Chamber of Commerce, Individual Artist Award, 1989. **Address:** 322 Lewis Street, Oakland, CA 94607. **One-man Exhibitions:** RAC, 1961; Everett Ellin Gallery, Los Angeles, 1963; The Kornblee Gallery, NYC, 1964; Hansen-Fuller Gallery, 1965; David Stuart Gallery, 1966; André Emmerich Gallery, NYC, 1971; de Young, 1972; Santa Barbara/MA, 1973; San Diego, 1973; Fuller Goldeen Gallery, San Francisco, 1981; Hooks-Epstein Galleries, Houston, 1990; Loma Linda U., 1990, 91; Pepperdine U., 1990; S. Oregon State U., 1991; Sonoma State U., 1991; California Polytechnic State U., 1991; Natsoulas/Novelozo Gallery, Davis, Calif.; Fresno/AM, 1992; Oakland Museum, 1992. **Group:** RAC Annual, 1960; Oakland/AM, Annual, 1960; MOMA, The Art of Assemblage, circ., 1961; II Paris Biennial, 1963; U. of California, Berkeley, Eleven American Sculptors, 1964; La Jolla, Some Aspects of California Painting and Sculpture, 1965; San Fernando Valley State College, Twenty-two Sculptors, 1966; U. of Illinois, 1969, 74; ICA, U. of Pennsylvania, Plastics and New Art, 1969; Jewish Museum, A Plastic Presence, 1969; Expo '70, Osaka, 1970; Stanford U., Sculpture Here and Now, 1970; Omaha/Joslyn, Looking West, 1970; Oakland/AM, Pierres de Fantaisie, 1970; U. of Nebraska, American Sculpture, 1970; Sacramento/Crocker Biennial, 1970; Stanford U., Sculpture 72, 1972; Salon de Mai, Paris, 1973; Salon de la Jeune Sculpture, Paris/Moderne, 1973; Oakland/AM, Public Sculpture, Urban Environment, 1974; NCFA, Across the Nation, 1980; Oakland Museum, 100 Years of California Sculpture, 1982; U. of Santa Clara, Northern California Art of the Sixties, 1982; U. of Southern California, California Sculpture Show, 1984; Oakland Museum, Art of the San Francisco Bay Area, 1945-1980, 1985; Walnut Creek (Calif.) Civic Center Arts Gallery, Going Public, 1985; Oakland/AM, New California Sculpture, 1991. **Collections:** U. of California, Berkeley;

California State U., Hayward; City of Anchorage; Dartmouth College; Gallaudet College; IBM; U. of Kansas; Los Angeles/County MA; MOMA; Marin; NMAA; Oakland/AM; Paris/Moderne; SRGM; Sacramento/Crocker; San Jose Museum of Art; Santa Barbara/MA; Stanford U.; Tupperware Museum; UCLA; Wichita/AM. **Bibliography:** *California Sculpture Show.*

BEATTIE, GEORGE
from 1st to 4th edition.

BEAUCHAMP, ROBERT **b.** November 19, 1923, Denver, Colo. **Studied:** U. of Denver; Cranbrook Academy of Art, BFA; Colorado Springs Fine Arts Center, with Boardman Robinson; Hofmann School. US Navy, 1943-46. Traveled Italy, 1973. **Taught:** U. of Wisconsin, 1968; Cooper Union, 1969-70; Louisiana State U., 1971; U. of Illinois, 1972; Brooklyn College, 1973; School of Visual Arts, NYC, 1974-75; U. of California, San Diego, 1977; U. of Ohio, 1978; Syracuse U., 1978; SUNY/New Paltz, 1979; U. of Arizona, 1980; U. of Georgia, 1981-85. **Member:** Artists Equity. **Awards:** Fulbright Fellowship (Italy); Walter K. Gutman Foundation Grant; National Council on the Arts, 1966; Guggenheim Foundation Grant, 1974; National Endowment for the Arts, 1986. **Address:** 463 West Street, NYC 10014. **Dealer:** M-13 Gallery, NYC. **One-man Exhibitions:** (first) Tanager Gallery, NYC, 1953; Great Jones Gallery, NYC, 1960, 61; Sun Gallery, Provincetown, 1961, 62, 63; Green Gallery, NYC, 1961, 63; Richard Gray Gallery, Chicago, 1963; Felix Landau Gallery, Los Angeles, 1963; East End Gallery, Provincetown, 1964, 65; The American Gallery, NYC, 1965; The Graham Gallery, NYC, 1965, 67, 69; Obelisk Gallery, 1966; U. of Utah, 1967; Tirca Karlis Gallery, Provincetown, 1967, 68, 71, 72; Louisiana State U., 1971; Galerie Simone Stern, New Orleans, 1971; French & Co. Inc.,

NYC, 1972; Robert Dain Gallery, NYC, 1972, 73; U. of Southern Florida, 1974; Terry Dintenfass, Inc., NYC, 1976; Monique Knowlton Gallery, NYC, 1978, 79, 80, 81, 83, 85; Fay Gold Gallery, Atlanta, 1982; Landmark Gallery Inc., NYC, 1982; Gruenebaum Gallery, NYC, 1987; Locus Gallery, San Antonio, 1988; Phoenix Gallery, Provincetown, Mass., 1988; Vanderwoude-Tananbaum Gallery, NYC, 1988; M-13 Gallery, NYC, 1989; Berta Walker Gallery, Provincetown, Mass., 1991. **Retrospective:** Syracuse/Everson, 1984. **Group:** Bernault Commission, circ., Asia; Carnegie, 1958, 61; WMAA Annuals, 1961, 63, 65, 67, 69; Corcoran; Chicago/AI; MOMA, Recent American Painting and Sculpture, circ., USA and Canada, 1961-62; MOMA, Recent Painting USA: The Figure, circ., 1962-63; U. of Illinois, 1963; SRGM, 10 Independents, 1972; IEF, Twentieth-Century American Drawings: The Figure in Context, circ., 1984; Provincetown Art Association and Museum, Provincetown, Mass. (three-man). **Collections:** Brooklyn Museum; U. of California; Carnegie; Cornell U.; Denver/AM; Hartford/Wadsworth; Hirshhorn; IT & T; MMA; MOMA; U. of Massachusetts; National Gallery; Norfolk/Chrysler; Ridgefield/Aldrich; Seattle/AM; Syracuse/Everson; U. of Texas; WMAA. **Bibliography:** Cummings 4; *The Figurative Fifties;* Robert Beauchamp: An American Expressionist. Archives.

BECHTLE, ROBERT **b.** May 14, 1932, San Francisco, Calif. **Studied:** California College of Arts and Crafts, 1954, BA, 1958, MFA; U. of California, Berkeley. Traveled Europe, Mexico. **Taught:** California College of Arts and Crafts, 1957-; U. of California, Berkeley, 1965-66, Davis, 1967-68; San Francisco State College, 1968-; SFAI, 1975. **Awards:** Oakland/AM, P.P., 1957, 59; RAC, 1958, 61, 64; Bay Printmakers Society, Oakland, Adell Hyde Morrison Me-

morial Medal, 1959, 61; SFMA, James D.
Phelan Award, 1965; National Endow-
ment for the Arts, grant, 1977. **Address:**
1250 Horton Street, Energyville, Calif.
94608. **Dealer:** OK Harris Works of Art,
NYC. **One-man Exhibitions:** (first)
SFMA, 1959, also 1964, 67; Berkeley Gal-
lery, Berkeley, 1965, San Francisco, 1967;
RAC, 1965; Sacramento/Crocker, 1966;
U. of California, Davis, 1967; Achenbach
Foundation, 1969; OK Harris Works of
Art, NYC, 1971, 74, 77, 81, 84, 87; John
Berggruen Gallery, San Francisco, 1973;
Jack Glenn Gallery, San Diego, 1973;
Daniel Weinberg Gallery, Santa Monica,
1991; Galerie Paule Anglim, San Fran-
cisco, 1991; SFMA, 1991. **Retrospective:**
Sacramento/Crocker, 1973; San Diego,
1973. **Group:** Witte, 1965; USIA 1965-
67; WMAA Annual, 1967; MOMA, The
Artist as His Subject, 1967; California Pal-
ace, Painters Behind Painters, 1967; U. of
Illinois, 1967, 69; West Coast Now,
1968; Vassar College, 1968; Milwaukee,
Aspects of a New Realism, 1969; WMAA,
22 Realists, 1970; Indianapolis, 1970;
Omaha/Joslyn, Looking West, 1970; Syra-
cuse/Everson, Cool Realism, 1970; Indi-
ana U., American Scene: 1900-1970,
1970; Chicago/Contemporary, Radical Re-
alism, 1971; Govett-Brewster, The State
of California Painting, 1971; Kassel
Documenta V, 1972; Stuttgart/WK,
Amerikanischer Fotorealismus, circ.,
1972; WMAA Biennial, 1973; Hart-
ford/Wadsworth, New/Photo Realism,
1974; Tokyo Biennial, 1974; Toledo/MA,
Image, Color, and Form, 1975; Renwick
Gallery, Washington, D.C., Signs of Life:
Symbols in the City, 1975; Centennial
Museum/Vancouver, Aspects of Realism,
1976; Baltimore, Super Realism, 1976;
Canberra/National, Illusion and Reality,
1977-78; U. of Rochester, Perceiving
Time & Space through Art, 1979; Albu-
querque/MA, Reflections of Realism,
1979-80; San Antonio/MA, Real, Really
Real, Super Real, 1981; PAFA, Contempo-

Robert Bechtle, *Ocean View Station Wagon.*

rary American Realism Since 1960, 1981;
Long Beach, Drawings by California Paint-
ers, 1982; Laguna Beach, West Coast Real-
ism, 1983; Isetan Museum of Art, Tokyo,
American Realism: The Precise Image,
1985; SMFA, American Realism (Janss),
circ., 1985; Pensacola Art Center, Carsin-
art: The Automobile Icon, 1990; Youngs-
town/Butler, California A-Z and Return,
1990; Lorretto, Southern Alleghenies Mu-
seum of Art, Against the Grain: Images in
American Art, 1960-1990, 1991; Fort Lau-
derdale, Photo-Realism Revisited, 1991.
Collections: Aachen/NG; Achenbach
Foundation; U. of California, Berkeley;
Charleston/Carolina; Chase Manhattan
Bank; Chattanooga/Hunter; Concordia
Teachers College (IL); Diablo Valley Col-
lege; Doane College; High Museum; U. of
Miami; Govett-Brewster; Indiana Na-
tional Bank; Library of Congress; MMA;
MOMA; U. of Miami; Mills College;
NCFA; U. of Nebraska; Oakland/MA;
SFMA; SGRM; Sacramento/Crocker; San
Francisco Municipal Art Commission;
San Jose State College; Southland Corp.,
Dallas; Starr King School for the Ministry;
USIA; VMFA; Valparaiso U. (Ind.);
WMAA. **Bibliography:** Alloway 4; *Amer-
ica 1976; Amerikanischer Fotorealismus;*
Arthur 1, 2, 3; Ashbery; Honisch and
Jensen, eds.; *Kunst um 1970;* Lindy; Lucie-
Smith; Meisel; Murken-Altrogge; Robins;
Sager; *The State of California Painting;*
Ward.

BECK, ROSEMARIE b. July 8, 1923, NYC. **Studied:** Oberlin College, BA; Columbia U.; NYU. Traveled Europe. **Taught:** Vassar College, 1957-58, 61-62, 64-65; Middlebury College, 1958, 59, 63; Parsons School of Design, 1965-68; Queens College, 1968-91; **Member:** NAD. **Commissions:** Ration Mfg. Co., 1956. **Awards:** Ingram Merrill Foundation Grant, 1966, 79; Yaddo Fellowship; MacDowell Colony Fellowship; National Endowment for the Arts, 1986; NAD, Benjamin Altman Prize, 1986, 89. **Address:** 6 East 12th Street, NYC 10003. **One-man Exhibitions:** (first) The Periodot Gallery, 1953, also 1955, 56, 59, 60, 63, 64, 66, 68, 70, 72; Oberlin College, 1957; Vassar College, 1957, 61; New Paltz/SUNY, 1962; Duke U., 1971; Kirkland College, 1971; Zachary Waller Gallery, Los Angeles, 1971; Poindexter Gallery, NYC, 1975, 79; Queens College, 1975; Ingber Art Gallery, NYC, 1979, 85, 89; Middlebury College, 1979; Joel Becker Gallery, Provincetown, 1987 (two-man); American U. (three-man), 1990; Dartmouth College, 1992. **Retrospective:** Wesleyan U., 1960. **Group:** PAFA, 1954; U. of Nottingham (England), 1954, 57; WMAA Annuals, 1955, 57; U. of Michigan, 1956; Chicago/AI; Brooklyn Museum; Tate; Youngstown/Butler; Arts Club of Chicago; NIAL, 1969, 70, 71, 72, 73; NAD, 1973; NAD Annual, 1981; 89. **Collections:** Corcoran; Fort Wright College; Hirshhorn; NAD; U. of Nebraska; New Paltz/SUNY; U. of North Carolina; Ration Mfg. Co.; Trenton/State; Vassar College; WMAA; Yaddo. **Bibliography:** Baur 5.

BECKMAN, WILLIAM G.

b. October 19, 1942, Maynard, Minn. **Studied:** U. of Minnesota, St. Cloud, BA; U. of Iowa, MA, MFA, with Byron Burford, Hans Brader, Miguel Conde. Traveled Europe. **Taught:** U. of Iowa, 1966-68. **Address:** North Towerhill Road, Wassaic, NY 12592. **Dealer:** Forum Gallery, NYC. **One-man Exhibitions:** U. of Iowa, 1969;

Hudson River Museum, 1969; Allan Stone Gallery, NYC, 1970, 71, 74, 76, 78, 80; Allan Frumkin Gallery, NYC, 1982, 85, 86; Frumkin/Adams Gallery, NYC, 1988, 90; Stiebel Modern, NYC, 1991. **Retrospective:** Brandeis U. (two-man, with Gregory Gillespie), circ., 1984. **Group:** Indianapolis, 1970, 78; Yale U., American Drawing: 1970-1973, 1973; Boston/MFA, Trends in Contemporary Realist Painting, 1974; Chicago/AI, 71st American Exhibition, 1974; Cleveland/MA, Aspects of the Figure, 1974; William Paterson College, Wayne, N.J., The Other Realism, 1978; PAFA, Seven on the Figure, 1979; Tulsa/Philbrook, Realism/Photorealism, 1980; Haus der Kunst, Munich, Amerikanische Malerei: 1930-1980, 1981; Hirshhorn, Directions, 1981; Newport Harbor, Inside Out: Self Beyond Likeness, 1981; PAFA, Contemporary American Realism Since 1960, 1981; San Antonio/MA, Real, Really Real, Super Real, 1981; WMMA, Focus on the Figure, 1982; SFMA, American Realism (Janss), circ., 1985; Fort Lauderdale, An American Renaissance: Painting and Sculpture Since 1940, 1986; Isetan Museum of Art, Tokyo, American Realism: The Precise Image, 1985; Wichita/AM, A Decade of American Realism, 1985; Albany/Institute, The New Response, 1985; AAIAL, 1986, 87; Florida International U., Miami, American Art Today, 1987; Little Rock/MFA, The Figure, 1989; Miyagi Museum, Sendai, Japan, American Realism and Figurative Art, 1952-1991, circ., 1991. **Collections:** Brandeis U.; Carnegie; Chicago/AI; Cologne/Ludwig; Metropolitan Life Insurance Co.; New Britain/American; Northern Trust Co., Chicago; WMAA. **Bibliography:** Adrian; Arthur 3; Arthur 4; Ward.

BEHL, WOLFGANG b. April 13,

1918, Berlin, Germany. **Studied:** Academy of Fine Arts, Berlin, 1936-39; RISD, 1939-40. US citizen. Traveled Europe, Mexico, USA, Middle East. **Taught:** Perkiomen

Charles Bell, *Sixteen Candles*, 1992.

School, 1940-42; Lake Forest Academy, 1942-44; Layton School of Art, 1944-45; College of William and Mary, 1945-52; Silvermine Guild, 1955-57; U. of Hartford, 1955-83. **Member:** Sculptors Guild. **Commissions:** Temple Beth El Sholom, Manchester, Conn.; St. Louis Priory, Creve Coeur, Miss.; Church of St. Timothy, West Hartford, Conn.; U. of Hartford; Willow Lawn Shopping Center, Richmond, Va.; St. Joseph's Cathedral, Hartford, Conn.; Church of the Resurrection, Wallingford, Conn.; Connecticut General Insurance Co. **Awards:** Chicago/AI, Joseph N. Eisendrath Prize, 1944; Milwaukee, Wisconsin Prize for Sculpture, 1945; Connecticut Academy of Fine Arts, First Prize for Sculpture, 1961; NIAL Grant, 1963; Ford Foundation, P.P., 1964. **Address:** 179 Kenyon Street, Hartford, CT 06105. **Dealer:** Arts Exclusive, Simsbury, Ct. **One-man Exhibitions:** Charlotte/Mint, 1949, 50; The Bertha Schaefer Gallery, 1950, also 1955, 63, 65, 68; Hollins College, 1951; Randolph-Macon Women's College, 1951; Sweet Briar College, 1951; Amerika Haus, Schweinfurt, Wurzberg, and Munich; Bucknell U., 1965; U. of Connecticut,

1965; New Britain/American, 1969; Bienville Gallery, 1974; U. of New Hampshire, 1974; Hampshire College, 1976; Texann Ivy Gallery, Orlando, Fla., 1979; Rosenfeld Gallery, Philadelphia, 1979; Central Connecticut State College, 1991. **Retrospective:** U. of Hartford, 1983. **Group:** Chicago/AI, 1943, 44; Milwaukee, 1945; Boston Arts Festival, 1946, 47; Silvermine Guild, 1946, 47; VMFA, 1946-49, 1951; U. of Illinois, 1957; Hartford/Wadsworth, 1957; Carnegie, 1962, 64; PAFA, 1964; Harvard U., 1966; Cranbrook, 6th Biennial, National Religious Art Exhibition, 1968; U. of Connecticut, 1987. **Collections:** Andover/Phillips; Cornell U.; U. of Hartford; U. of Massachusetts; U. of Miami; New Britain; New Britain/American; PAFA; Slater Memorial Museum.

BELL, CHARLES b. February 2, 1935, Tulsa, Ok. **Studied:** U. of Oklahoma, 1957, BA; SFAI. US Navy 1957-60. Traveled United Kingdom, Japan. **Address:** 254 West Broadway, NYC 10012. **Dealer:** Louis K. Meisel Gallery, NYC. **One-man Exhibitions:** (first) Louis K. Meisel Gallery, NYC, 1972, 74, 77, 80,

83, 86, 89, 91; Morgan Gallery, Shawnee Mission, Kan., 1976; Hokin/Kaufman Gallery, Chicago, 1983; Modernism, San Francisco, 1988. **Group:** San Jose State U., East Coast/West Coast/New Realism, 1973; Tokyo Metropolitan Art Gallery, 11th Bienniale, 1974; Hartford/Wadsworth, New/Photo Realism, 1974; Wichita State U., The New Realism: Rip-Off or Reality?, 1975; Youngstown/Butler, Midyear Show, 1975; Indianapolis, 1978; SRGM, Seven Photorealists from New York Collections, 1981; Fort Wayne/AM, Photographs by the Photorealists, 1982; Utica, An Appreciation of Realism, 1982; Saitama/Modern, Realism Now, 1983; Huntington, N.Y./Heckscher, Through the Looking Glass, 1984; Isetan Museum of Art, Tokyo, American Realism: The Precise Image, circ., 1985; SFMA, American Realism (Janss), circ., 1985; Fort Wayne/AM, Directions in American Realism, 1987; Goddard Art Center, Oklahoma Artists, 1989; Southern Alleghenies Museum of Art, 1989; Loretto, The 80s, 1990; Oklahoma City Art Museum, Spotlight on Oklahoma, 1990; Rutgers U., Intaglio Printing in the 90s, 1990; Nassau County Museum, In Sharp Focus, 1991; Miyagi Museum of Art, Sendai, Japan, American Realism & Figurative Art, circ., 1991. **Collections:** Akron/AM; Cleveland/MA; Fort Wayne/AM; Hiroshima/Contemporary; MMA; Milwaukee; NMAA; Phoenix; The Prudential Insurance Co. of America; SRGM; Tulsa/Philbrook. **Bibliography:** Arthur 3; Lindy; Meisel; Ward.

BELL, LARRY b. December 6, 1939, Chicago, Ill. **Studied:** Chouinard Art Institute, 1957-59; with Robert Irwin, Emerson Woelfer. **Awards:** Guggenheim Foundation Fellowship, 1969. **Taught:** U. of California, Berkeley; U. of California, Irvine; California State at Hayward; U. of Southern Florida; Santa Fe Museum of Fine Arts, 1986. Traveled Southeast Asia. **Commissions:** Abilene Zoological Gardens, Abilene, Tx.; GSA, Springfield,

Mass. **Address:** Box 469, Ranchos de Taos, N.M. 87557. **One-man Exhibitions:** Ferus Gallery, Los Angeles, 1962, 63, 65; The Pace Gallery, 1965, 67, 70, 71, 72, 73; Ileana Sonnabend Gallery, Paris, 1967, 68; Amsterdam/Stedelijk, 1967; Walker, 1968; Buffalo/Albright, 1968; Mizuno Gallery, 1969, 71, 75; Galerie Rudolf Zwirner, 1970; Joseph Helman Gallery, St. Louis, 1971; ACE Gallery, Los Angeles, 1972; Felicity Samuel Gallery, London, 1972; Pasadena/AM, 1972; Wilmaro Gallery, Denver, 1972; Oakland/AM, 1973; Fort Worth, 1975; Galleria del Cavallino, Venice, 1975; Marlborough Galleria d'Arte, Rome, 1975; Marion Goodman/Multiples, NYC, 1978, 81; Talley Richards Gallery, Taos, 1975, 77, 78, 79, 81; Texas Gallery, Houston, 1978; Delahunty Gallery, Dallas, 1978; Hansen Fuller Goldeen Gallery, San Francisco, 1979; U. of Massachusetts (two-man), 1977; Hudson River Museum, 1981; L.A. Louver Gallery, Venice, Calif., 1981; U. of Ohio, 1981; Wildine Gallery, Albuquerque, 1981. **Retrospective:** Pasadena/AM, 1972. **Group:** Pavillion Art Gallery, Balboa, Calif., 1964; MOMA, The Responsive Eye, 1965; VIII São Paulo Biennial, 1965; WMAA Sculpture Annual, 1966; WMAA, Contemporary American Sculpture, Selection I, 1966; U. of California, Irvine, 5 Los Angeles Sculptors, 1966; La Jolla, 1966; Seattle/AM, 1966; MOMA, The 1960s, 1967; WGMA, A New Aesthetic, 1967; Los Angeles/County MA, American Sculpture of the Sixties, 1967; SRGM, Sculpture International, 1967; Documenta IV, Kassel, 1968; Vancouver, 1968; Eindhoven Kompas IV, 1969; Walker, 14 Sculptors: The Industrial Edge, 1969; MOMA, Spaces, 1969; Princeton U., American Art since 1960, 1970; Tate (three-man), 1970; Hayward Gallery, London, 11 Los Angeles Artists, 1971; Detroit/Institute, Art in Space, 1973; Kennedy Center, Washington, D.C., Art Now '74, 1974; Chicago/AI, 74th American Exhibition, 1982; Leigh Yawkey Woodson Art Museum, Wausau, Wisc., Americans in Glass, 1984.

Collections: Albuquerque Museum; Amsterdam/Stedelijk; U. of Arizona; Buffalo/Albright; Canberra/National; Caracas/Contemporaneo; Chicago/AI; Cologne/Ludwig; Dallas/MFA; Denver/AM; Des Moines; Detroit/Institute; Fort Worth; Hartford; Hirshhorn; Houston/MFA; Los Angeles/County MA; MIT; MOMA; Milwaukee; NMAA; Oakland/AM; Paris/Beaubourg; Roswell; Rotterdam; SFMA; SRGM; Santa Fe, N.M.; Norton Simon Museum; Sydney/AG; Tate Gallery; Victoria and Albert Museum; WMAA; Walker. **Bibliography:** *Art Now 74;* Calas, N. and E.; Coplans, 3; Davis, D.; Friedman, M., 2; *Individuals;* Kozloff 3; Lucie-Smith; Plagens; *Report;* Rose, B., 1; Sandler 3; *Transparency;* Tuchman 1; *USA West Coast.*

BENGLIS, LYNDA **b.** October 25, 1941, Lake Charles, La. **Studied:** Newcomb College, Tulane U., 1964, BFA, with Pat Trivigno, Ida Kohlmeyer, and Hal Carney; Brooklyn Museum Art School, 1964-65, with Rubin Tam. Traveled Greece, Great Britain, Italy, France, Indiana. **Taught:** U. of Rochester, 1970-72; Hunter College, 1972-73; Princeton U., 1975; California Institute of the Arts, 1976; Kent State U., 1977; Skowhegan School, 1979; U. of Arizona, 1981; School of Visual Arts, NYC, 1985-87. **Commissions:** Atlanta Airport, 1979-80; Federal Building, Albany, N.Y., 1979-80; Fairmont Hotel, Denver; First City Center, Dallas; O'Brien Federal Building, Albany, N.Y. **Awards:** Guggenheim Foundation Fellowship, 1975; Artpark, grant, 1976; Australian Art Council Award, 1976; National Endowment for the Arts, grant, 1979. **Address:** 222 Bowery, NYC 10002. **Dealers:** Paula Cooper Gallery, NYC; Margo Leavin Gallery, Los Angeles. **One-man Exhibitions:** U. of Rhode Island, 1969; Paula Cooper Gallery, NYC, 1970, 71, 74, 75, 76, 78, 80, 82, 84, 87, 90; Janie C. Lee Gallery, Dallas, 1970; Galerie Hans Muller, Cologne, 1970; Kansas State

U., 1971; MIT, 1971; Hansen Gallery, San Francisco, 1972, 73, 74, 77, 79; Portland (Ore.) Center for the Visual Arts, 1973; Jack Glenn Gallery, Corona del Mar, 1973; The Clocktower, NYC, 1973; The Texas Gallery, Houston, 1974, 75, 79, 80, 81, 84; The Kitchen, NYC, 1975; Margo Leavin Gallery, Los Angeles, 1977, 80, 82, 85, 87, 89, 91; Douglas Drake Gallery, Kansas City, 1977; Dart Gallery, Chicago, 1979, 81, 83, 85; Georgia State U., 1979; Albert Baronian, Brussels, 1979, 80, 81; Chatham College, 1980; David Heath Gallery, Atlanta, 1980, 85; Susanne Hilberry Gallery, Birmingham, Mich., 1980, 83, 85; Portland (Ore.) Center for Visual Arts, 1980; U. of Arizona, 1981; Jacksonville/MA, 1981; Okhun-Thomas Gallery, St. Louis, 1982; Fuller Goldeen Gallery, San Francisco, 1982, 86; Tilden-Foley Gallery, New Orleans, 1984, 86, 89, 91; Cumberland Gallery, Nashville, 1980; Fuller-Gross Gallery, San Francisco, 1988; Michael Murphy Gallery, Tampa, 1989; Linda Farris Gallery, Seattle, 1990; Sens Galleries West, Santa Fe, 1990; High Museum, circ., 1991; Heath Gallery, Atlanta, 1991. **Retrospective:** U. of South Florida, 1980; U. of Miami, 1980. **Group:** Düsseldorf/Kunsthalle, Prospect 69, 1969; Finch College, Art in Process IV, 1969; Walker, Works for New Spaces, 1971; Milwaukee, Directions 3: Eight Artists, 1971; GEDOK, Kunsthaus, Hamburg, American Women Artists, 1972; Walker, Painting: New Options, 1972; Indianapolis, 1972; Chicago/AI, 32nd Annual, 1972; Detroit/Institute, 12 Statements, 1972; WMAA Biennial, 1973, 81; Yale U., Options and Alternatives, 1973; New Orleans Museum, Five from Louisiana, 1977; Amsterdam/Stedelijk, Made by Sculptors, 1978; Palazzo Reale, Milan, Pintura Ambiente, 1979; Houston/Contemporary, Extensions, 1980; San Diego, Sculpture in California, 1975-1980, 1980; XXXIX Venice Biennial, 1980; Jacksonville/AM, Currents: A New Mannerism, 1981; Rice U., Variants, 1981;

Chicago/AI, 74th American Exhibition, 1982; Hannover/KG, New York Now, circ., 1982; Houston/Contemporary, The Americans: The Collage, 1982; New Museum, Early Work, 1982; Bonn, Back to the USA, circ., 1983; U. of Chicago, The Sixth Day: A Survey of Recent Developments in Figurative Sculpture, 1983; Newark Museum, American Bronze Sculpture, 1850 to the Present, 1984; Seattle/AM, American Sculpture: Three Decades, 1984; Hirshhorn, Content, 1984; California State U., Long Beach, Monumental Sculpture, 1985; Princeton U., A Decade of Visual Arts at Princeton, 1985; MOMA, Made in India, 1985; Laforet Museum, Tokyo, New York: Now: Correspondences, circ., 1985; Stamford Museum, American Art: American Women, 1985; MIT, Natural Forms and Forces: 1986; Palacio de Velazquez, Madrid, Between Geometry and Gesture: American Sculpture 1965-1975, 1986; Indianapolis, Painting and Sculpture Today, 1986; Brown U., Alternative Supports, 1987; U. of Massachusetts, Amherst, circ., 1987; Minos, Crete, Minos Beach Art Symposium, 1988; Cornell U., Knots & Nets, circ., 1988; Cincinnati/AM, Making Their Mark, circ., 1989; Walker, First Impressions: Early Prints by Forty-six Contemporary Artists, circ., 1989; WMAA, The New Sculpture, 1965-75; Pensacola Art Center, Carsinart: The Automobile Icon, 1990; Columbus, Setting the Stage, 1991; Monte Carlo, IIIième Biennale de Sculpture, 1991. **Collections:** Baltimore/MA; Betcar Corp.; Buffalo/Albright; Canberra/National; Detroit/Institute; Fort Worth; Houston/MFA; Israel Museum; Kansas City/Nelson; MOMA; Melbourne; NMAA; NYU; National Gallery of Victoria; New Mexico State U.; New Orleans Museum; Oberlin College; PMA; U. of Rhode Island; Sapporo; Seattle/AM; SFMA; SRGM; Storm King Art Center; Walker; WMAA. **Bibliography:** *Art: A Woman's Sensibility; Drawings: The Pluralist Decade; Back to the USA;* Haenlein;

Lucie-Smith; *Performance Anthology;* Robins; Stearns.

BENGSTON, BILLY AL
b. June 7, 1934, Dodge City, Kans. **Studied:** Los Angeles City College; Los Angeles State College; California College of Arts and Crafts; Los Angeles County Art Institute. **Taught:** Chouinard Art Institute, 1961; UCLA, 1962-63; U. of Oklahoma, 1967; U. of Colorado, 1969; U. of California, Irvine, 1973, 79-86. **Awards:** National Council on the Arts, 1967; Tamarind Fellowship, 1968; Guggenheim Foundation Fellowship, 1975; California Arts Council, Part in Public Building Program, 1981; California Arts Council, Maestro/Apprentice Program, 1982-83. **Commissions:** Doumani House, Marina del Rey, Calif., 1978-82; State Office Building, Long Beach, Calif., 1983; Hamano Fabric Insitute, Tokyo, 1985; Contel Corp., Virginia, 1990; Calif. State Office Building, Los Angeles, 1990. **Address:** 110 Mildred Avenue, Venice, CA 90291. **One-man Exhibitions:** (first) Ferus Gallery, Los Angeles, 1957, also 1958, 1960, 61, 62, 63; Martha Jackson Gallery, NYC, 1962; SFMA, 1968; Pasadena/AM, 1969; Utah, 1969; Santa Barbara/MA, 1970; Mizuno Gallery, 1970; Galerie Hans R. Neuendorf, Cologne, 1970, 71; Galerie Hans R. Neuendorf, Hamburg, 1970, 72; Margo Leavin Gallery, Los Angeles, 1971; La Jolla, 1971; Contract Graphics Associates, Houston, 1971; Felicity Samuel Gallery, London, 1972; Corcoran & Greenberg, Inc., Coral Gables, FL, 1973; Nicholas Wilder Gallery, Los Angeles, 1973 (2), 1974; Southern Methodist U., 1973; Houston/Contemporary, 1973; The Texas Gallery, 1974, 75, 76, 77, 78, 79, 81, 84; John Berggruen Gallery, San Francisco, 1974, 78, 83; Jared Sable Gallery, Toronto, 1974; Pyramid Art Galleries Ltd., Washington, D.C., 1975; Seder/Creigh Gallery, Coronado, CA, 1975; Tortue Gallery, Santa Monica, 1975; Dootson Calderhead Gallery, Seattle, 1975; Dobrick Gallery, Chicago, 1976; Portland (Ore.) Center for the

Visual Arts, 1976; U. of Montana, 1977;
James Corcoran Galleries, Los Angeles,
1977, 78, 79, 81, 82, 83, 84, 85; Security
Pacific National Bank, Los Angeles, 1978;
Mizuno Gallery, Los Angeles, 1978; Conejo
Valley Art Museum, Thousand Oaks, CA,
1979; Acquavella Contemporary Art Gal-
lery, NYC, 1979, 81, 83; Cantor/Lemberg
Gallery, Birmingham, Mich., 1979; Hono-
lulu Academy, 1980; Thomas Babeor Gal-
lery, La Jolla, 1981-88; Corcoran, 1981; San
Diego State U., 1981; Linda Farris Gallery,
Seattle, 1982; Douglas Drake Gallery, Kan-
sas City, 1984; Smith-Andersen Gallery,
Palo Alto, CA, 1984, 86; Angles Gallery,
Santa Monica, 1985; James Corcoran Gal-
lery, Santa Monica, 1986, 87, 88, 90, 92;
Cirrus Gallery, Los Angeles, 1989; The
Works Gallery South, Costa Mesa, Calif.,
1989-91. **Retrospectives:** Los Ange-
les/County MA, circ., Vancouver, Corco-
ran, 1968; Houston/Contemporary, circ.,
1988. **Group:** Los Angeles/County MA, An-
nual, 1957; Pasadena/AM, Pacific Profile of
Young West Coast Artists, 1961; WMAA,
Fifty California Artists, 1962-63; Oak-
land/AM, Pop Art USA, 1963; Milwaukee,
Pop Art and the American Tradition, 1965;
VIII São Paulo Biennial, 1965; Seattle/AM,
Ten from Los Angeles, 1966; WMAA Annu-
als, 1967, 69; U. of California, San Diego,
Los Angeles to New York, 1968; Palazzo
Strozzi, Florence, Italy, I Biennale Inter-
nazionale della Grafica, 1968; MOMA,
New Media, New Methods, circ., 1969; Jew-
ish Museum, Superlimited: Books, Boxes,
and Things, 1969; MOMA, Tamarind:
Homage to Lithography, 1969; Eindhoven,
Kompas IV, 1969-70; Pasadena/AM, West
Coast: 1945-1969, 1969; Minnesota/MA,
Drawings USA, 1971; Govett-Brewster Art
Gallery, The State of California Painting,
1971; Kunstverein, Hamburg, USA: West
Coast, circ., 1972; Akron/AI, Four Artists,
1972; Corcoran Biennial, 1973; Santa Bar-
bara/MA, Fifteen Abstract Artists, 1974;
WMAA, American Pop Art, 1974; Scripps
College, Painting: Color, Form and Surface,
1974; U. of California, Santa Barbara, 4

from the West, 1975; Newport Harbor,
The Last Time I Saw Ferus, 1976; SFMA,
Painting and Sculpture in California: The
Modern Era, 1976; California Institute of
Technology, Pasadena, Watercolors and Re-
lated Media by Contemporary Californians,
1977; WMAA Biennial, 1979; ICA, U. of
Pennsylvania, The Decorative Impulse,
1979; U. of Miami, Fabrications, 1980;
AAIAL, 1982, 85; Houston/Contemporary,
The Americans: The Collage, 1982; Nagoya
City Museum, Nagoya, Japan, Exhibition of
Contemporary Los Angeles Artists, 1982;
ARCO Center for Visual Arts, Los Angeles
Pattern Painters, 1983; Oakland Museum,
On and Off the Wall; Shaped and Colored,
circ., 1983; ARCO Center for Visual Arts,
Los Angeles and The Palm Tree: Image of a
City, 1984; Indianapolis, 1984; San Diego
State U., Watercolors: A Contemporary Sur-
vey, 1984; Hamano Institute, Tokyo, 1985;
Los Angeles/MOCA, Individuals: A Selected
History of Contemporary Art, 1986; U. of
California, Berkeley, Made in USA, circ.,
1987; Odakyo Grand Gallery, Tokyo, POP
Art USA-UK, circ., 1987; Long Beach/AM,
20th Century Watercolors, Yesterday &
Today, 1988; Newport Harbor, LA Pop in
the Sixties, circ., 1989; Parkland College,
Champaign, Illinois, The State of the Art,
1991, 1991; U. of Southern California, Fin-
ish Fetish: LA's Cool School, 1991. **Collec-
tions:** A.F.A.; Amon Carter Museum;
Chicago/AI; Community Arts Foundation,
Fort Worth; Houston/MFA; La Jolla; Los
Angeles/County MA; MOMA; Newport
Harbor; Oakland/AM; Paris/Beaubourg;
Pasadena/AM; Ridgefield/Aldrich; SFMA;
SRGM; UCLA; WMAA. **Bibliography:** Al-
loway 1; De Salvo and Schimmel; Individu-
als; Kozloff 3; Lippard 5; Osterwold;
Plagens; *The State of California Painting;
USA West Coast.*

BENJAMIN, KARL b. December
29, 1925, Chicago, Ill. **Studied:** North-
western U.; U. of Redlands, 1949, BA;
Claremont Graduate School, with Jean
Ames, 1960, MA. US Navy, 1943-46.

Taught: General elementary school, Southern California, 1949-; Pomona College; Claremont College. **Awards:** National Endowment for the Arts, 1983, 84. **Address:** 675 West Eighth Street, Claremont, CA 91711. **Dealers:** Ruth Bachofner Gallery, Santa Monica; Snyder Fine Art, NYC. **One-man Exhibitions:** U. of Redlands, 1953, 56, 62, 72, 80; Pasadena/AM, 1954; Jack Carr Gallery, Pasadena, 1955, 56; Occidental College, 1958; Long Beach/MA, 1958; Esther Robles Gallery, 1959, 60, 62, 64, 65; Scripps College, 1960; La Jolla, 1961, 70; Bolles Gallery, 1961; Santa Barbara/AM, 1962, 68; Hollis Gallery, San Francisco, 1964, 66; Jefferson Gallery, 1965; Henri Gallery, 1968; Utah, 1971; William Sawyer Gallery, 1972; Tortue Gallery, Santa Monica, 1975, 77, 78, 80; Chaffey College, 1975, 81; Francine Seders Gallery, Seattle, 1978, 79, 80, 83, 86; Cheney Cowles Memorial Museum, 1980; Whiteman College, 1980; Abraxis Gallery, Newport Beach, CA, 1981; Claremont Graduate School, 1981; Pepperdine U., 1981; Shasta College, 1981; California State U., Bakersfield, 1982; Stella Polaris Gallery, Los Angeles, 1982; Chrysalis Gallery, Claremont, 1983, 85, 86; U. of California, Santa Barbara, 1984; Ruth Bachofner Gallery, Santa Monica, Calif., 1986, 88, 90, 91; Hemmerdinger Gallery, Palm Desert, Calif., 1986; Snyder Fine Art, NYC, 1992. **Group:** Los Angeles/County MA Annuals; A.F.A., New Talent, circ., 1959; UCLA, California Painters under 35, 1959; Los Angeles/County MA, Four Abstract Classicists, circ., 1959-61; ICA, London, West Coast Hard Edge, 1960; Carnegie, California Artists, 1961; Pasadena/AM, Pacific Profile, 1961; WMAA, Geometric Abstraction in America, circ., 1962; Fort Worth, The Artist's Environment: The West Coast, 1962; Amon Carter Museum, circ., 1962-63; WMAA, Fifty California Artists, 1962-63; Colorado Springs/FA Annual, 1964; Denver/AM, 1965; MOMA, The Responsive Eye, 1965; SFMA, The Colonists, 1965;

M. Knoedler & Co., Art Across America, circ., 1965-67; Corcoran Biennial, 1967; U. of New Mexico, Los Angeles Abstract Painting, 1979; Pomona College, Black and White Are Colors, Paintings of the 1950s-1970s, 1979; Laguna Beach Museum of Art, Southern California Artists: 1940-1980, 1981; U. of Washington, Color in Contemporary Painting, 1982; U. of Washington, Color, Color, Color, 1984; Shasta College, Ten California Colorists, 1985; Los Angeles/MOCA, Blueprints for Modern Living, 1989; San Jose Museum of Art, Ten California Colorists, 1985-86, 1989; Oakland Museum, Turning the Tide: Early Los Angeles Modernists, 1920-1956, circ., 1990. **Retrospective:** LA/Municipal, 1986. **Collections:** U. of California; Cheney Cowles Memorial Museum; City of Claremont; Denver/AM; Haifa Museum of Modern Art, Israel; Hartford/Wadsworth; La Jolla; Long Beach/MA; Los Angeles/County MA; Los Angeles/MOCA; Harvey Mudd College; NCFA; U. of Nebraska; U. of New Mexico; Newport Harbor; Oakland/Museum; Pasadena/AM; Pepsi-Cola Co.; J. Pitzer College; Pomona College; U. of Redlands; SFMA; Salk Institute; San Diego; Santa Barbara/MA; Scripps College; Seattle/AM; Utah; U. of Utah; WMAA; U. of Washington; Washington State U. **Bibliography:** Karlstrom and Ehrlich; Plagens; Rickey; *Black and White Are Colors.*

BENTON, FLETCHER **b.** February 23, 1931, Jackson, Ohio. **Studied:** Miami U., 1955, BFA. Traveled Northern Europe, Mediterranean, parts of Africa and Asia, 1963. US Navy, 1949-50. **Taught:** California College of Arts and Crafts, 1959; SFAI, 1964-67; California State U., San Jose, 1967-86. **Commissions:** Atlantic Richfield Co. **Awards:** AAAL, Distinguished Service to American Art Award, 1979; California State U., San Jose, President's Scholar Award. **Member:** Artists Equity. There are three films on his

work, 1969, 73, 75. **Address:** 250 Dore Street, San Francisco, CA 94163. **Dealer:** André Emmerich Gallery, NYC. **One-man Exhibitions:** (first) Gump's Gallery, San Francisco, 1957; California Palace, 1964; SFMA, 1965; Hansen Gallery, San Francisco, 1965, 66; Esther Robles Gallery, Los Angeles, 1966, 67, 71, 72; SFAI, 1967; Sonoma State College, 1967; Galeria Bonino Ltd., 1967, 69; Humboldt State College, 1968; Galerie Françoise Mayer, Brussels, 1969; SFMA, 1970; Buffalo/Albright, 1970; Chico State College, 1970; London Arts, Detroit, 1970; Berkeley (Calif.) Art Center, 1970; Reed College, 1970; Galeria Bonino Ltd., Buenos Aires, 1970; Estudio Actual, Caracas, 1970; Stanford U., 1971; La Jolla, 1972; Danenberg Gallery, 1972; Landry-Bonino Gallery, NYC, 1972; Phoenix, 1973; U. of California, Davis, 1973; Galeria Bonino Ltd., Rio de Janeiro, 1973; Elaine Horwitch Gallery, Scottsdale, 1974; U. of Santa Clara, 1975; Smith-Andersen Gallery, San Francisco, 1975; Fresno State U., 1977; John Berggruen Gallery, San Francisco, 1977, 80, 81, 84, 86, 89; Tortue Gallery, Los Angeles, 1978; San Jose Museum of America, 1978, Grossmont College, 1978; Arts Club of Chicago, 1979; Milwaukee, 1979; Aachen/S-L, 1980; U. of Miami, 1980; Muscatine Art Center, 1980; Newport Harbor, 1980; Oakland/AM, 1980; Portland Ore./AM, 1980; Offenbach/Klingspor, 1981; San Jose Museum of Art, 1982; Fresno Art Center, Calif., 1984; Yares Gallery, Scottsdale, 1984; Harcus Gallery, Boston, 1985, 87; Brigitte Haasner, Weisbaden, 1986, 87; Laguna Beach School of Art, 1986; Transamerica Building, San Francisco, 1986; Irvine Fine Arts, Irvine, Calif., 1987; Harcus Gallery, Boston, 1987; Dorothy Goldeen Gallery, Santa Monica, 1988. **Retrospective:** Arts Club of Chicago, circ., 1979. **Group:** Santa Barbara/MA, 1962, 66; San Francisco Art Association, 1964; La Jolla, 1965; New York World's Fair, 1964-65; U. of California, Berkeley, Directions in Kinetic Sculpture, 1966; SFMA, 1966; U. of Illinois, 1967, 69; Los Angeles/County MA and PMA, American Sculpture of the Sixties, 1967; U. of Hawaii, 1967; Carnegie, 1967; Flint/Institute, 1967; HemisFair '68, San Antonio, Tex., 1968; Milwaukee, Directions I: Options, circ., 1968; WMAA Sculpture Annual, 1968; Lytton Art Center, Los Angeles, 1968; UCLA, Electric Art, 1969; U. of Illinois, 1969; Expo '70, Osaka, 1970; Kent State U. Annual, 1970; Indianapolis, 1970; Hayward Gallery, London, Kinetics, 1970; Omaha/Joslyn, Looking West, 1970; U. of California, Santa Barbara, Constructivist Tendencies, circ., 1970; Hudson River Museum, Kinetic Art, 1971; Stanford U., A Decade in the West, 1971; WMAA Annual, 1973; U. of California, Berkeley, Kinetic Exhibition, 1973; Philadelphia Art Alliance, Sculpture of the Sixties, 1974; Hirshhorn, Inaugural Exhibition, 1974; Huntsville Museum of Art, Ala., The California Bay Area Painting and Sculpture Update, 1977; Sonoma State U., Northern California Artists, 1978; Oakland/AM, 100 Years of California Sculpture, 1982; SFMA, 20 American Artists: Sculpture, 1982, 1982; Walnut Creek (Calif.) Civic Arts Gallery, The Planar Dimension: Geometric Abstraction by Bay Area Artists, 1983; Sonoma State U., Works in Bronze, A Modern Survey, circ., 1984; Oakland Museum, Art in the San Francisco Bay Area, 1945-1980, 1985; SFMA, Seven Artists in Depth, 1986; Kleinwegers Sculpture Symposium, Krefeld, circ., 1987; Erie Art Museum, Paper Thick: Forms and Images in Cast Paper, 1988; California State U., Fresno, 5 x 5, 1989; Laforet Museum, Harajuku, American Pop Culture Today, III, 1989. **Collections:** Atlantic Richfield Co.; Banque Lambert, Brussels; U. of California; Capital Research Co., Los Angeles; Denver/AM; First National City Bank of Dallas; First National Bank of Ohio, Columbus; Hirshhorn; IBM; Interchemical Corporation; La Jolla; Milwaukee; Neiman-Marcus Co.; The New York Bank for Savings; New Orleans

Museum; Newport Harbor; Oakland/AM; Offenbach/Klingspor; City of Offenbach; Phoenix; Purchase/SUNY; Ridgefield/Aldrich; SFMA, Sacramento/Crocker; San Jose State U.; U. of Santa Clara; The Singer Company, Inc.; Stanford U.; Taubman Corp.; Thurman Arnold U. Building, Washington, D.C.; WMAA. **Bibliography:** Atkinson; *California Sculpture Show;* Davis, D.; Rickey; Selz, P., 1; Tuchman 1.

BENTON, THOMAS HART
b. April 15, 1889, Neosho, Mo. **d.** January 19, 1975, Kansas City, Mo. **Studied:** Western Military Academy, 1906-07; Chicago Art Institute School, 1907; Academie Julian, Paris, 1908-11. Gallery director and art teacher for Chelsea Neighborhood Association, NYC, 1917. US Navy, 1918-19. Traveled Europe, USA, Canada. **Taught:** ASL, 1926-36; Kansas City Art Institute and School of Design, 1935-40; lectured at many colleges and universities. **Commissions:** (murals) New School for Social Research, with Jose Clemente Orozco, 1928; WMAA, 1932; State of Indiana, 1933 (mural now located at U. of Indiana); Missouri State Capitol, 1935-36; "Achelous and Hercules" for Harzfeld Department Store, Kansas City, 1947 (Encyclopedia Britannica filmed his progress on this mural); Lincoln U., 1952-53; Kansas City River Club, 1947; New York State Power Authority, Massena, 1957-61; Truman Library, Independence, Mo., 1958-61. **Awards:** Architectural League of New York, Gold Medal, 1933; Academia Argentina de Bellas Artes, Buenos Aires, Hon. Men., 1945; Accademia Florentina dell'Arte del Disegno, Hon. Men., 1949; Accademia Senese degli Intronati, Siena, 1949; Hon. D. Litt., Lincoln U., 1957; Hon. DFA, U. of Missouri, 1948; Hon. PBK, 1948; Hon. DFA, New School for Social Research, 1968. **One-man Exhibitions:** Lakeside Press Gallery, Chicago, 1927; Ferargil Galleries, NYC, 1934, 35; Des Moines (two-man), 1939; A.A.A. Gallery, NYC, 1939, 41, 65; A.A.A. Gallery,

Chicago, 1946; U. of Arizona, circ., 1962; The Graham Gallery, NYC, 1968, 70, 85; Madison (Wisc.) Art Center, 1971; Kansas City/Nelson, 1974; U. of Kansas, 1980; Oklahoma City, 1981; Salander-O'Reilly Galleries, NYC, 1981, 82; Bard College, circ., 1984; Williams College, 1985; Little Rock/MFA, 1986; U. of Kentucky, Lexington, 1988; Louis Newman Gallery, Beverly Hills, 1992. **Retrospective:** Kansas City/Nelson, 1939; Omaha/Joslyn, 1951; New Britain, 1954; U. of Kansas, 1958; Cranbrook, 1966; A.A.A. Gallery, NYC, 1969; Rutgers U., 1972; Kansas City/Nelson, circ., 1989; U. of Washington, 1990. **Group:** Anderson Galleries, NYC, Forum Exhibition, 1916; The Daniel Gallery, NYC, 1919; PMA, Modern Americans, 1922; Architectural League of New York, 1924; Delphic Studios, NYC, 1928, 29; WMAA, The 1930's; A.A.A. Gallery, NYC, 1939, 40, 42. **Collections:** Andover/Phillips; Brooklyn Museum; California Palace; Canajoharie; Columbia, Mo.; Kansas City/Nelson; U. of Kansas City; MNU; MOMA; U. of Nebraska; New Britain; Omaha/Joslyn; PAFA; St. Louis/City; Terre Haute/Swope. **Bibliography:** Anfam; Armstrong, Thomas; Ashbery; Adams, H.; *Avant-Garde in America, 1910-1925;* **Baigell 1, 2;** Baur 7; Bazin; **Benton 1, 2, 3, 4;** Biddle 4; Biederman 1; Blesh 1; Boswell 1; Brown 2; Bruce and Watson; Bryant, L.; Cahill and Barr, eds.; Canaday; Cheney; Christensen; Cummings 1, 5; **Craven, T., 1, 2, 3;** *Cityscape 1919-39;* Danto; Downes, ed.; Eliot; *Europa/Amerika;* **Fath, ed.;** Flanagan; Flexner; Goodrich and Baur 1; Haftman; Hall; Hunter 6; Hughes; Huyghe; *Index of 20th Century Artists;* Kent, N.; Kootz 2; Lee and Burchwood; Levin 2; **Marling;** McCoubrey 1; McCurdy, ed.; Mellquist; Mendelowitz; Myers 2; Neuhaus; Newmeyer; Pagano; Pearson 1; Poore; Reese; Richardson, E.P.; Ringel, ed.; Rodman 2; Rose, B., 1, 4; Smith, S.C.K.; Soby 6; Tomkins and Time-Life Books; Wight 2; Wright 1; Zigrosser 1. Archives.

BEN-ZION
from 1st to 5th edition.

BERGER, JASON
from 1st to 5th edition.

BERLANT, TONY **b.** August 8, 1941, NYC. **Studied:** UCLA, 1961, BA, 1962, MA, 1963, MFA. Traveled Europe, China, Japan, Canada. **Taught:** UCLA, 1965-69. **Commissions:** San Francisco Airport, mural; TRD, Los Angeles, mural; California Dept. of Motor Vehicles, Davis, mural; Honolulu/Contemporary, museum doors, 1988; City of Palm Springs, Calif., Convention Center, mural, 1991; Minneapolis, mural, 1991. **Awards:** Ford Foundation, P.P., 1963. **Address:** 1304 12th Street, Santa Monica, CA 90401. **Dealer:** L. A. Louver Gallery, Venice, Calif. **One-man Exhibitions:** (first) David Stuart Gallery, Los Angeles, 1963, 65, 66, 67; Hansen Gallery, San Francisco, 1964; Wichita, 1971; WMAA, circ., 1973; Fourcade, Droll Inc., NYC, 1973; Phyllis Kind Gallery, Chicago, 1974; James Corcoran Gallery, Los Angeles, 1975; The Texas Gallery, Houston, 1976, 78; Newport Harbor, 1978; Conejo Valley Art Museum, Thousand Oaks, Calif., 1981; Xavier Fourcade, Inc., 1981, 82, 84, 86; John Berggruen Gallery, San Francisco, 1982, 83, 91; Houston/Contemporary, circ., 1982; L. A. Louver Gallery, Venice, Calif., 1982, 85, 88, 89, 90, 92; John Stoller & Co., Minneapolis, 1985, 91; Tornberg Gallery, Lund, Sweden, 1988; Santa Monica Heritage Museum, 1989; Binder Gallery, Cologne, 1990; Louver Gallery, NYC, 1990, 92; Gerald Peters Gallery, Santa Fe, 1992; Cedar Rapids/MA, 1992. **Group:** Oakland/AM, Pop Art USA, 1963; Los Angeles/County MA, Five Younger Los Angeles Artists, 1965; WMAA Annuals, 1966, 68, 70, 73; Los Angeles/County MA, American Sculpture of the Sixties, circ., 1967; WMAA, Human Concern/Personal Torment, 1969; Portland,

Tony Berlant, *Sunshine State*, 1989.

Ore./AM, The West Coast Now, circ., 1968; Omaha/Joslyn, Looking West, 1970; Buffalo/Albright, Working in California, 1972; Indianapolis, 1974; ICA, U. of Pennsylvania, Dwellings, 1978; RISD, Metals: Cast-Cut-Coiled, 1982; Oakland/AM, On and Off the Wall, 1983; Mexico City/Tamayo, Boxes, 1985; Los Angeles/MOCA, Individuals: A Selected History of Contemporary Art, 1986; U. of California, Berkeley, Made in USA, circ., 1987; U. of Southern California, Sculpture da Camera, 1988; Newport Harbor, LA Pop in the Sixties, 1989; UCLA, Forty Years of California Assemblage, circ., 1989; California State U., Hayward, Collage, Assemblage: Nine Points of View, circ., 1989; Youngstown/Butler, California A-Z and Return, 1990. **Collections:** Chicago/AI; Hirshhorn; Long Beach/MA; Los Angeles/County MA; Los Angeles/MOCA; Minneapolis/Institute; U. of Nebraska; Oakland Museum; PMA; Palm Springs Desert Museum; SFMA; WMAA; Wichita.

BERMAN, EUGENE **b.** November 4, 1889, St. Petersburg, Russia. **d.** December 15, 1972, Rome. Studied privately in St. Petersburg with P.S. Naumoff, S. Grusenberg, 1915-18; Academie Ranson, Paris, with Edouard Vuillard, Maurice Denis, Pierre Bonnard, Felix Vallaton, 1920-22; with the architect Emilio Terry, 1920. Traveled Europe. To USA, 1935; first citizenship papers, 1937. Became active in designing for ballet, opera, 1937.

Eugene Berman, *Medusa's Corner*, 1943.

Member: AAAL. **Commissions:** (murals) Wright Ludington, 1938, John Yeon, 1951; (theatre) Hartford Music Festival, 1936; *L'Opera de Quatre Sous,* Paris, 1936; *Icare* (ballet), NYC, 1939; *Concerto Barocco* (ballet), by George Balanchine, NYC, 1951. **Awards:** Guggenheim Foundation Fellowship, 1947, 49. **One-man Exhibitions:** (first) Galerie Granoff, Paris, 1927; Galerie de l'Etoile, Paris, 1928; Galerie Bonjean, Paris, 1929; Balzac Gallery, NYC, 1929; Galerie des Quatre Chemins, Paris, 1929; Julien Levy Galleries, NYC, 1932, 33, 35, 36, 37, 39, 41, 43, 46, 47; Galerie Pierre Colle, Paris, 1933; Zwemmer Gallery, London, 1935; Renoir and Lolle, Paris, 1937; Galerie Montaigne, Paris, 1939; Courvoisier Gallery, San Francisco, 1941; Princeton U., 1947; Kraushaar Galleries, NYC, 1948, 49, 54, 60; MOMA, 1945; Hanover Gallery, 1949; M. Knoedler & Co., NYC, 1965; Richard Larcada Gallery, 1967, 70, 72, 73; Utah, 1969; Maxwell Galleries, Ltd., San Francisco, 1970; La Medusa Gallery; San Antonio/McNay, 1984; Wheelock Whitney & Co., NYC, 1989; Michael Rosenfeld Gallery, NYC, 1990.

Retrospective: Institute of Modern Art, Boston, circ., 1941; U. of Texas, Austin, 1975. **Group:** Galerie Drouant, Paris, 1924; MOMA; Chicago/AI; WMAA; Hartford/Wadsworth, 1931; Musée du Petit Palais, Paris, 1934; American Center, Paris, Artistes en exil 1939-1946, 1968; New York Cultural Center, Leonid and His Friends, 1974. **Collections:** Baltimore/MA; Boston/MFA; Cincinnati/AM; Cleveland/MA; Denver/AM; Graphische Sammlung Albertina; Hartford/Wadsworth; Harvard U.; U. of Illinois; State U. of Iowa; Los Angeles/County MA; MMA; MOMA; PMA; Paris/Moderne; Phillips; St. Louis/City; Santa Barbara/MA; Smith College; Tate; Vassar College; Venice/Contemporaneo; Washington U. **Bibliography:** Armstrong, Thomas; Bazin; **Berman;** Canaday; Cummings 4; Flanagan; *Forty Years of California Assemblage;* Frost; Genauer; Holme 1, 2; Hunter 6; Huyghe; *Individuals; Individual Realities;* Kent, N.; **Levy 2;** McCurdy, ed.; Mendelowitz; Myers 2; Pearson 1, 2; Phillips 1; Richardson, E. P.; Rubin 1; Soby 1; Waldberg 4; Wight. Archives.

BERTHOT, JAKE **b.** March 30, 1939, Niagara Falls, N.Y. **Studied:** New School for Social Research, 1960-61; Pratt Institute, 1960-62. **Taught:** Cooper Union, NYC, 1974-81; Yale U., 1982. **Awards:** Guggenheim Foundation Fellowship, 1981; National Endowment for the Arts, grant, 1983; AAIAL, Award, 1992. **Address:** 66 Grand Street, NYC 10013. **Dealer:** David McKee Gallery, NYC. **One-man Exhibitions:** OK Harris Works of Art, 1970, 72, 75; Michael Wells Gallery, 1971, 72; Portland (Ore.) Center for the Visual Arts, 1973; Galerie de Gestlo, 1973, 77; Cunningham-Ward Gallery, 1973; Locksley-Shea Gallery, 1974; Daniel Weinberg, San Francisco, 1975; David McKee Gallery, NYC, 1976, 78, 82, 83, 86, 87, 88, 89, 91; Nigel Greenwood Gallery, London, 1979;

Nina Nielsen Gallery, Boston, 1979, 84, 88; U. of California, Berkeley; Southern Methodist U., 1985; Cava Gallery, Philadelphia, 1986; Gallerie Olsson, Stockholm, 1987, 90. **Group:** WMAA Annuals, 1969, 73; Indianapolis, 1970; Jewish Museum, Beautiful Painting & Sculpture, 1970; Foundation Maeght, 1970; Akron/AI, Watercolors and Drawings by Young Americans, 1970; Chicago/AI, Contemporary Drawings, 1971; U. of Rochester, Aspects of Current Painting, 1971; U. of Utah, Drawings by New York Artists, 1972; U. of California, Berkeley, Eight New York Painters, 1972; Paris Biennial, 1973; U. of Rhode Island, Drawings, 1974; Corcoran Biennial, 1975; Venice Biennial, 1976; ICA, U. of Pennsylvania, 8 Abstract Painters, 1978; Hayward Gallery, London, New Paintings—New York, 1979; Grand Palais, Paris L'Amerique aux Independents 1944-1980, 1980; MOMA, International Survey of Recent Painting and Sculpture, 1984; MOMA, Drawings: Contemporary Installation, 1984; Colby College, Landscape & Abstract Art, 1985; MOMA, Contrast of Form: Geometric Abstract Art 1910-1980, 1985; MOMA, Drawings: Contemporary Installation, 1989; Arkansas/AC, National Drawings Invitational, 1986; U. of Arkansas, Revelations Drawing/America, circ., 1988; Pratt Institute, NYC, Sightings: Drawing with Color, circ., 1988; Bard College, Drawings, 1991. **Collections:** U. of Arkansas; Baltimore/MA; Berkeley; Brandeis U.; U. of California, Canberra/National; Caracas; Carnegie; Cornell U.; Dallas/MFA; Harvard U.; High Museum; U. of Kentucky; MOMA; Malmo Museum; Minneapolis/Institute; PMA; Prudential Insurance Co. of America, Newark; SRGM; St. Louis/City; VMFA; WMAA. **Bibliography:** Anfam; *Fundamentele Schiderkunst.*

BERTOIA, HARRY b. March 10, 1915, San Lorenzo, Italy. d. October,

1978, Bally, Pa. To USA, 1930; became a citizen, 1946. **Studied:** Society of Arts and Crafts, Detroit; Cranbrook, 1936-38. Traveled Norway. Designed chairs with Charles Eames; designed the Bertoia chair for Knoll Associates, 1952. **Commissions:** General Motors Technical Center, Detroit; MIT Chapel; Manufacturers Trust Co.; Dayton Co., Minneapolis; First National Bank of Miami; First National Bank of Tulsa; Dulles International Airport, Washington, D.C.; Northwestern National Life Insurance Bldg., Minneapolis, 1964; Kodak Pavilion, New York World's Fair, 1964-65; Philadelphia Civic Center, 1967; Marshall U., 1973; Woodward Price Park, Wichita, Kan., 1974. **Awards:** Architectural League of New York, Gold Medal; Graham Foundation Grant ($10,000), 1957; American Institute of Architects, Gold Medal 1973; AAAL Award, 1975. **One-man Exhibitions:** (first) Karl Nierendorf Gallery, NYC, 1940; Staempfli Gallery, NYC, 1961, 63, 68, 70, 72, 76, 78, 81, 84, 85, 86; Fairweather-Hardin Gallery, 1984; Museum of Non-Objective Art, NYC; Smithsonian, circ.; Galerie K.B., Oslo, 1977; Gross-McLeaf Gallery, Philadelphia, 1977; Allentown/AM, 1976. **Group:** WMAA; MOMA; Battersea Park, London, International Sculpture Exhibition, 1963. **Collections:** Buffalo/Albright; Colorado Springs/FA; Dallas Public Library; Denver/AM; Des Moines; MIT; MOMA; Omaha/Joslyn; SFMA; Utica; VMFA; WMAA. **Bibliography:** Atkinson; Baur 7; Blesh 1; Craven, W.; *From Foreign Shores;* Janis; Metro; **Nelson;** Ragon 2; Seuphor 3; Trier 1. Archives.

BESS, FOREST CLEMENGER
from 1st to 5th edition.

BIDDLE, GEORGE b. January 24, 1885, Philadelphia, Pa. d. November 6, 1973, Croton-on-Hudson, N.Y. **Studied:** Groton School, 1904; Harvard U., 1908, BA with honors, 1911, LLB;

Academie Julian, Paris, 1911. Traveled Europe, Asia, Africa, Latin America, USA. **Taught:** Columbia U.; U. of California; Colorado Springs Fine Arts Center; Artist-in-Residence, American Academy, Rome. **Member:** American Society of Painters, Sculptors and Graveurs; National Society of Mural Painters; NIAL. **Commissions** (murals): Justice Department, Washington, D.C.; Supreme Court Building, Mexico City; National Library, Rio de Janeiro. **Awards:** Yaddo, MacDowell Colony, and Huntington Hartford Foundation Fellowships. **One-man Exhibitions:** (first) The Milch Gallery, 1919; RISD, 1961; U. of Delaware, 1963; Cober Gallery, NYC, 1963; more than 100 in USA, Europe, Japan, India. **Retrospective:** PAFA, 1947; USIA, Prints, circ., 1950. **Collections:** Berlin/National; Corcoran; NWA; Mexico City/Nacional; National Gallery; Norfolk/Chrysler; Tokyo/Modern; WMAA; Youngstown/Butler. **Bibliography:** American Artists Congress, Inc.; American Artists Group, Inc.; **Biddle 1, 2, 3, 4;** Birchman; Boswell 1; Brown; Bruce and Watson; Cheney; *Index of 20th Century Artists;* Mayerson, ed.; Nordmark; Pagano; Parkes; Pearson 2; Poore; Reese; Rose, B., 1; Sachs; Zigrosser 1. Archives.

BIEDERMAN, CHARLES (Karel) JOSEPH b. August 23, 1906, Cleveland, Ohio.

Studied: Chicago Art Institute School, 1926-29, with Henry Poole, Laura Papalandem, John W. Norton. Resided Prague, Paris, New York. Traveled England. **Awards:** Amsterdam/Stedelijk, Sikkens Award, 1962; Ford Foundation, **P.P.,** 1964; National Council on the Arts, 1966; Walker Biennial, Donors Award, 1966; Minnesota State Arts Council, 1969; Hon. DFA, Minneapolis College of Art and Design, 1973; National Endowment for the Arts, 1973. **Address:** 5840 Collischur Road, Red Wing, MN 55066. **Dealer:** Grace Borgenicht Gallery, NYC. **One-man Exhibitions:** (first) Chicago Art Institute School; a movie theater lobby in Chicago,

1930; Pierre Matisse Gallery, 1936; Arts Club of Chicago, 1941; Katherine Kuh Gallery, Chicago, 1941; St. Paul Gallery, 1954; Columbia U. School of Architecture, 1962; Georgia Institute of Technology, 1962; Rochester (Minn.) Art Center, 1967; Dayton's Gallery 12, Minneapolis, 1971; Grace Borgenicht Gallery, NYC, 1980, 85, 86, 89, 91; Matthew Hamilton Gallery, Philadelphia, 1984. **Retrospectives:** Walker, 1965; Hayward Gallery, London, 1969; Minneapolis/Institute, 1976. **Group:** Buffalo/Albright, 1936; Reinhardt Galleries, NYC, 1936; Galerie Pierre, Paris, 1936; Amsterdam/Stedelijk, 1962; Kunstgewerbemuseum, Zurich, 1962; Marlborough-Gerson Gallery, Inc., 1964; Chicago/Contemporary, Relief/Construction/Relief, 1968; Akron/AI, Celebrate Ohio, 1971; Dallas/MFA, Geometric Abstraction, 1926-1942, 1972; Annely Juda Fine Art, London, The Non-Objective World: 1914-1955, 1972; Rutgers U., Vanguard American Sculpture, 1919-1939, circ., 1979; Haus der Kunst, Munich, Amerikanische Malerei: 1930-1980, 1981; Carnegie, Abstract Painting and Sculpture in America, 1927-1944, 1983; Trenton/State, Beyond the Plane: American Constructions 1931-1965, circ., 1983; AAIAL, 1984. **Collections:** Buffalo/Albright; Carnegie; Chicago/AI; Chicago Public Schools; Dallas/MFA; Des Moines; U. of East Anglia; High Museum; MMA; MOMA; McCrory Corp.; Milwaukee; Minneapolis/Institute; U. of Nebraska; Newark Museum; PMA; Phoenix; Red Wing; Rijksmuseum Kröller-Müller; U. of Saskatchewan; Tate; Trenton/State; Walker; WMAA. Bibliography: Armstrong, Thomas; **Biederman 1, 2, 3, 4;** *Celebrate Ohio;* **Charles Biederman;** Cummings 5; Hill, ed.; Lane and Larsen; Marter, Tarbell, and Wechsler; Rickey; Seuphor 3; Toher, ed.; Archives.

BIEDERMAN, JAMES M. b. November 8, 1947, Bronx, N.Y.

Studied: New Paltz/SUNY, BA, Art, 1969; Yale U., MFA, 1973, with Richard

Charles Biederman, *Painting, New York, 4/16/1936*, 1936.

Serra; Whitney Museum Independent Study Program, with David Diao and Ron Clark, 1970-71; Edna St. Vincent Millay Colony, fellow, 1977. Traveled Europe, Central America, Japan, Carribean. **Taught:** NYU, 1984-85; Boston Museum School, 1983; RISD, 1983; Yale U. **Awards:** National Endowment for the Arts, grant, 1979, 82; New York Foundation for the Arts, fellowship, 1988. **Address:** R.D. 2, Box 392, Cold Spring, NY 10516. **Dealers:** John Weber Gallery, NYC; Galerie Muhlenbusch-Winkelman, Düsseldorf. **One-man Exhibitions:** (first) Artists Space, NYC, 1974; John Weber Gallery, NYC, 1981, 83, 85, 87, 88, 89, 90, 91; Carol Taylor Art, Dallas, 1982; Fuller/Goldeen Gallery, San Francisco, 1987; McIntosh-Drysdale Gallery, Washington, 1988; New York Studio School, 1988; Fay Gold Gallery, Atlanta, 1988; Galerie Muhlenbusch-Winkelman, Düsseldorf, 1990; Zoe Gallery, Boston, 1990. **Group:** Ridgefield/Aldrich, New Dimensions in Drawing, 1981; William

Paterson College, Color on Structure, 1981; Jacksonville, Currents: A New Mannerism, 1981; Arts Club of Chicago, Biederman-Kendrick-Gummer, 1981; Bowdoin College, 4 Artists, 1982; The Drawing Center, NYC, New Drawing in America, 1982; MIT, Constructed Color, 1982; Nurnberg/Kunsthalle, 2nd International Youth Triennial of Drawings, circ., 1982; Kassel, Documenta VII, 1982; Paris/Beaubourg, Choix, pour Aujourd'hui, 1982; ICI, Concepts in Construction: 1910-1980; MOMA, Large Drawings, 1985; U. of No. Carolina, Works on Paper, 1989; William Paterson College, The Grid: Organization and Idea, 1990. **Collections:** Ridgefield/Aldrich; Atlantic Richfield Co.; Canberra/National; Chase Manhattan Bank; Chemical Bank; Chicago/Contemporary; Cincinnati/AM; Hirshhorn; MIT; MMA, MOMA; Rijksmuseum Kröller-Müller; Paris/Beaubourg; Prudential Insurance Co.; Seagrams & Sons; Syracuse/Everson.

BIRELINE, GEORGE
from 2nd to 5th edition.

BIRMELIN, A. ROBERT
b. November 7, 1933, Newark, N.J. **Studied:** Cooper Union, 1951-54; Yale U., 1954-56, BFA, 1959-60, MFA; U. of London, Slade School, 1960-61. US Army, 1957-59. Traveled Europe. **Taught:** Queens College, 1964-. **Member:** Artists Equity. **Commission:** US Dept. of Interior, 1974. **Awards:** Fulbright Fellowship, 1960-61; American Academy, Rome, Fellowship, 1961-64; PAFA, J. Henry Schiedt Memorial Prize, 1962; NIAL Grant, 1968; L. C. Tiffany Grant, 1973; National Endowment for the Arts, 1976, 82; NIAL, Childe Hassam Fund, P.P., 1976; New Jersey Council for the Arts, 1980. **Address:** 176 Highwood Ave., Leonia, NJ 07605. **Dealer:** Sherry French Gallery, NYC. **One-man Exhibitions:** Kanegis Gallery, 1960, 64, 66; Ross-Talalam Gallery, New Haven,

1960; The Stable Gallery, NYC, 1960, 64, 67; Esther Baer Gallery, 1962; USIS Gallery, Milan, 1962; Florida State U., 1965; Jason-Teff Gallery, Montreal, 1965; Antioch College, 1965; Terry Dintenfass, Inc., 1970, 71, 75; Queens College Art Library, N.Y., 1970; Kirkland College, 1971; Alpha Gallery, Boston, 1968, 71, 73; Brandeis U., 1973; Cortland/SUNY, 1973; U. of California, Santa Barbara, 1976; Anapamu Gallery, Santa Barbara, 1976; Peter Rose Gallery, NYC, 1978; Capricorn Gallery, Bethesda, 1977, 79; Bowdoin College, 1980; Galerie Claude Bernard, Paris, 1980, 81; Odyssia Gallery, NYC, 1981; Fenderick Gallery, Washington, D.C., 1982, 85; Montclair/AM, 1984; U. of Richmond, 1985. **Group:** Corcoran Biennial, 1965; XXXV Venice Biennial, 1970; Indianapolis/Herron, 1972; Omaha/Joslyn, A Sense of Place, 1973; Ball State U., XX Annual, 1974; Kalamazoo/Institute, Fifty Works, 1974; US Dept. of the Interior, America 1976, circ., 1976; MIT, The Narrative Impulse, 1979. **Collections:** Andover/Phillips; U. of Washington, Seattle, Confrontations, 1984; Isetan Museum of Art, Tokyo, American Realism: The Precise Image, 1985; Seattle/AM, States of War, 1985; VMFA, Large Figurative Drawing, 1985; Boston/MFA; Bowdoin College; Brandeis U.; Brooklyn Museum; Chase Manhattan Bank; Denver/AM; First National Bank of Chicago; U. of Florida; Hirshhorn; Indiana U.; Indianapolis/Herron; Kalamazoo/Institute; Library of Congress; MMA; MOMA; U. of Massachusetts; Museum of the City of New York; NMAA; Nagaoka, Japan; U. of Nebraska; Newark Museum; U. of North Carolina; Oklahoma; Purchase/SUNY; SFMA; Terre Haute/Swope; U. of Texas; Trenton/State; Worcester/AM; WMAA; Walker; U. of Wisconsin. **Bibliography:** *America 1976;* Arthur 3; Cummings 4; Ward.

BISCHOFF, ELMER b. July 9, 1916, Berkeley, Calif. **d.** March 2, 1991,

Berkeley, Calif. **Studied:** U. of California, Berkeley, with Margaret Peterson, Erle Loran, John Haley, 1939, MA. US Air Force, 1942-46. Traveled Europe, Morocco, Great Britain, Mediterranean Basin. **Taught:** San Francisco Art Institute, 1946-52, 1956-63; Skowhegan School, 1961; U. of California, Berkeley, 1963; Yuba College, 1964. **Member:** NAD. **Awards:** RAC, First Prize, 1955; Oakland/AM, P.P., 1957; Ford Foundation Grant, 1959; NIAL Grant, 1963; Chicago/AI, Norman Wait Harris Medal, 1964; San Francisco Art Commission, Award of Honor, 1982; Otis Art Institute, Hon. DFA, 1983. **One-man Exhibitions:** (first) California Palace, 1947; King Ubu Gallery, San Francisco, 1953; Paul Kantor Gallery, Beverly Hills, Calif., 1955; SFMA, 1956, 71; Staempfli Gallery, NYC, 1960, 62, 64, 69; de Young, 1961; Achenbach Foundation (three-man drawing show), 1963; Sacramento/Crocker, 1964, 81; U. of Washington, 1968; RAC, 1969, SFAI, 1975; U. of California, Berkeley, 1975; John Berggruen Gallery, San Francisco, 1979, 83; San Jose Museum of Art, 1979; Arts Club of Chicago, 1980; Houston/Contemporary, 1980; Grossmont College, 1981; U. of Arkansas, 1984; Hirschl & Adler Modern, NYC, 1985. **Retrospective:** SFMA, circ., 1985. **Group:** San Francisco Art Association Annuals, 1942, 46, 52, 57, 59, 63; Chicago/AI, 1947, 59, 64; California Palace, 1948, 50, 1960-63; Los Angeles/County MA, 1951; RAC, 1955, 56; Oakland/AM, 1957; Minneapolis/Institute, American Painting, 1945-57, 1957; A.F.A., New Talent, circ., 1958; ART: USA:59, NYC, 1959; U. of Illinois, 1959, 61; WMAA, 1959, 61, 63; A.F.A., West Coast Artists, circ., 1959-60; Denver/AM, 1960; Youngstown/Butler, 1960; Auckland, Painting from the Pacific, 1961; PAFA, 1962; Fort Worth, The Artist's Environment: The West Coast, 1962; SFMA, Fifty California Artists, circ., 1962; MOMA, Recent Painting USA, The Figure, circ., 1962-63; Art: USA: Now, circ.,

1962-67, NIAL, 1963; Corcoran, 1963; Carnegie, 1967; Expo '70, Osaka, 1970; U. of Nebraska, 1973; U. of Illinois, 1974; Buffalo/Albright, American Painting of the 1970s, circ., 1979; Corcoran, The Human Form, 1980; WMAA, The Figurative Tradition and the WMAA, 1980; Rutgers U., Realism and Realities, 1982; NYU, The Figurative Mode: Bay Area Painting, 1956-1966, circ., 1984; IEF, Twentieth Century American Drawings: The Figure in Context, circ., 1984. **Collections:** Buffalo/Albright; Chase Manhattan Bank; Chicago/AI; Hirshhorn; Honolulu Academy; U. of Kansas; MMA; MOMA; NCFA; U. of North Carolina; Oakland/AM; Purchase/SUNY; Rockefeller Institute; SFMA; Sacramento/Crocker; U. of Texas; VMFA; WMAA; U. of Wisconsin; Yale U. **Bibliography:** Armstrong, Thomas; Cummings 4; Downes, ed.; Goodrich and Baur 1; Nordness, ed.; Rose, B., 1; Solnit; Ward. Archives.

BISHOP, ISABEL b. March 3, 1902, Cincinnati, Ohio. d. February 19, 1988, Riverdale, New York. **Studied:** New York School of Applied Design; ASL, with Kenneth Hayes Miller. **Taught:** ASL, 1937; Skowhegan School. **Member:** AAAL; NAD; NIAL; SAGA; Audubon Artists. Federal A.P.: US Post Office, New Lexington, Ohio (mural). **Awards:** NAD, Isaac N. Maynard Prize; NAD, The Adolph and Clara Obrig Prize, 1942; NAD Annual, Andrew Carnegie Prize, 1945; Corcoran, Second William A. Clark Prize, 1945; AAAL Grant, 1943; PAFA, Walter Lippincott Prize, 1953; NAD, Benjamin Altman Prize, 1955; Library of Congress, Pennell, P.P., 1946; NAD, Joseph S. Isidora Gold Medal, 1957; Hon. DFA, Moore Institute; Brandeis U., Creative Arts Award and $1,000, 1975; Women's Caucus for Art, Outstanding Achievement Award, 1979; Hon. DFA, Bates College; Mayor's Award for Art and Culture, NYC, 1979; Hon. DFA, Skowhegan School Governor's Award, 1982; Syracuse U.,

Isabel Bishop, *Little Nude*, 1964.

1982; Hon. DFA, Mt. Holyoke College, 1983; Hon. DFA, Moore Institute of Art; AAIAL, Gold Medal for Painting, 1987. New York Film Co. produced a documentary film on her. **One-man Exhibitions:** The Midtown Galleries, NYC, 1932, 35, 36, 39, 49, 55, 60, 67, 74, 87; Pittsfield/Berkshire, 1957; VMFA (two-man), 1960; Middendorf-Lane Gallery, Washington, D.C., 1979; Kirkland College, 1981; Associated American Artists, NYC, 1981; Amherst College, 1982; St. Gaudens Museum, Cooper Union, NYC, 1983; Loyola Marymount U., Los Angeles, 1985; NIAL, 1987; Lehman College/CUNY, 1988; Midtown-Payson Galleries, NYC, 1991, 92; Delaware Art Museum, 1992. **Retrospectives:** U. of Arizona, circ., 1974; Loyola U., Los Angeles, 1984; Bard College, circ., 1989. **Group:** Carnegie; VMFA; Corcoran; PAFA; New York World's Fair, 1939; Chicago/AI; WMAA; MOMA; St. Louis/City; NAD; Los Angeles/County MA, Women Artists 1940-50, 1976; Hayward Gallery, London, The Modern Spirit, 1977; St. Lawrence U., Visions of Tomorrow, circ., 1988; WMAA/Philip Morris, From the Medal, 1989; Fairfield U., Human Conditions, 1992. **Collections:** AAIAL; Andover/Phillips; Atlanta U.; Balti-

more/MA; Boston/MFA; British Museum; Brooklyn Museum; California Palace; Clearwater/Gulf Coast; Colby College; Colorado Springs/FA; Columbus; Corcoran; Cranbrook; Dallas/MFA; Davidson College; Des Moines; Fort Wayne/AM; Grinnell College; Hartford/Wadsworth; Harvard U.; Indianapolis; Kansas City/Nelson; Library of Congress; Los Angeles/County MA; MMA; Memphis/Brooks; Morgan Library; NAD; NMAA; NYPL; U. of Nebraska; Newark Museum; New Britain; PAFA; PMA; Phillips; St. Louis/City; Southampton/Parrish; Springfield, Mass./MFA; Syracuse U.; Tel Aviv; Terre Haute/Swope; Uffizi Gallery; U. of Utah; Utica; VMFA; Vanderbilt U.; Victoria and Albert Museum; WMAA; Washburn U. of Topeka; Wichita/AM; Youngstown/Butler. **Bibliography:** Baur 7; Boswell 1; Brown 2; *Celebrate Ohio;* Cheney; Cummings 4; Diamonstein; Downes, ed.; Goodrich and Baur 1; **Isabel Bishop;** Johnson 2; Kent, N.; Lunde; McCurdy, ed.; Mellquist; Mendelowitz; Nordness, ed.; Pagano; Richardson, E.P.; Rose, B., 1; St. John; **Yglesias.** Archives.

BISHOP, JAMES b. October 7, 1927, Neosho, Mo. **Studied:** Syracuse U., 1950, BA; Washington U., 1951-54; Black Mountain College, 1953, with Esteban Vicente; Columbia U., 1955-56. Traveled France, 1957-66. **Taught:** Cooper Union, 1969-70; U. of California, Irvine, 1970; Carnegie-Mellon Institute, 1971; School of Visual Arts, NYC, 1972. **Awards:** Guggenheim Foundation Fellowship, 1970. Editorial associate, *Art News,* 1969-72; National Endowment for the Arts, 1976. **Address:** 5 Lispenard Street, NYC 10013. **Dealer:** Simon/Newman Gallery, NYC. **One-man Exhibitions:** (first) Galerie Lucien Durand, Paris, 1963; Galerie Smith, Brussels, 1963; Galerie Lawrence, Paris, 1964; Fischbach Gallery, NYC, 1966, 68, 70, 72; Galerie Fournier, Paris, 1966, 71, 73, 76; The Clocktower, NYC, 1973; Rosa Esman Gallery, NYC,

1974; Alessandro Ferranti, Rome, 1975; Galerie Annemarie Verna, Zurich, 1976, 78, 81, 86; Françoise Lambert, Milan, 1977; Rudiger Schottle, Munich, 1977; Droll Kolbert Gallery, NYC, 1979; Frank Kolbert Gallery, NYC, 1980; Daniel Weinberg Gallery, San Francisco, 1981; Simon/Newman Gallery, 1987. **Group:** Salon des Realites Nouvelles, Paris, 1962-65; Salon du Mai, Paris, 1964, 65; Musée Galliera, Paris, Promesses Tenues, 1965; Amerika Haus, Berlin, Ten Americans, 1966; WMAA, 1967; Corcoran, 1967; Expo '67, Montreal, 1967; Jewish Museum, Large Scale American Painting, 1967; Foundation Maeght, 1968, 70; U. of California, Riverside, Recent Direction, 1968; NIAL, 1971; U. of North Carolina, 1971; Yale U., Options and Alternatives, 1973; Indianapolis, 1974; Paris/Moderne, Tendences actuelles de la nouvelle peinture americaine, 1975; A.F.A., Recent Drawings, 1975; Musée de Grenoble, Art americain, 1976; Bonn, Bilder ohne Bilder, 1977; Paris, Grand Palais, L'Art moderne dans les musées francaises, 1978; Paris/Beaubourg, Dessin et couleur, 1979; Paris/Beaubourg, Nature du Dessin, 1981; P.S. 1, Long Island City, N.Y., Abstract Painting: 1960-69, 1983. **Collections:** Brooklyn Museum; U. of California, Berkeley; Canberra/National; Humlebaek/Louisiana; MOMA; Musée de Grenoble; Paris/Beaubourg; Paris/Moderne; SFMA; Tel Aviv; Zurich. **Bibliography:** Ashbery; *Options and Alternatives.*

BISTRAM, EMIL
from 1st to 5th edition.

BLACKBURN, MORRIS
from 1st to 5th edition.

BLACKWELL, TOM b. March 9, 1938, Chicago, Ill. Autodidact. **Taught:** Keene State College, 1978; Dartmouth College, 1980; U. of Arizona, 1981; School of Visual Arts, NYC, 1985-89. US Navy, 1955-59. **Awards:** New Hampshire

State Council on the Arts, 1986. **Address:** R.F.D., New Kingston, NY 12459. **Dealer:** Louis K. Meisel Gallery, NYC. **One-man Exhibitions:** Roy Parsons Gallery, Los Angeles, 1961; Rex Evans Gallery, Los Angeles, 1962; Orange Coast College, Santa Ana, Calif., 1964; Sidney Janis Gallery, NYC, 1975; Morgan Gallery, Shawnee Mission, Kan., 1975; Galerie le Portail, Heidelberg, 1976; Louis K. Meisel Gallery, NYC, 1977, 80, 82; Dartmouth College, 1980; U. of Arizona, 1981; Currier, 1985; Carlo Lamagna Gallery, NYC, 1986. **Group:** WMAA, Human Concern/Personal Torment, 1969; Finch College, NYC, Projected Art, 1971; WMAA Annual, 1972; Indianapolis, 1972; Tokyo, Metropolitan Art Gallery, 11th Tokyo Biennale, 1974; Darmstadt/Kunsthalle, Realism & Reality, 1975; Baltimore/MA, Super Realism, 1975; Canberra/National, Illusion & Reality, 1977; SRGM, Seven Photorealists from New York Collections, 1981; San Antonio/MA, Real, Really Real, Super Real, circ., 1981; PAFA, Contemporary American Realism Since 1960, circ., 1981; Utica, An Appreciation of Realism, 1982; Saitama/Modern, Realism Now, 1983; College of the Mainland, Texas, Contemporary Printmaking, 1984; St. Anselm College, Manchester, N.H., The Artist and the Object, 1985; Isetan Museum, Tokyo, American Realism: The Precise Image, circ., 1985; Nassau County Museum of Art, In Sharp Focus: Hyper Realism of the 70s and 80s, 1991; Fort Lauderdale, Ten Super Realists, 1991. **Collections:** U. of Arizona; Ball State U.; Cornell U.; Currier; Detroit/Institute; Dartmouth College; Evanston/Byer; Fort Wayne/AM; Grand Rapids; MMA; MOMA; Montclair/AM; Phoenix; SRGM; U. of Texas; U. of Wisconsin. **Bibliography:** Arthur 3; Lindy; Meisel; Sandler 3; Ward.

BLADEN, RONALD b. July 13, 1918, Vancouver, B.C., Canada. d. February 3, 1988. **Studied:** Vancouver School of Art; CSFA. **Awards:** SFAI, Rosenberg Fellowship; Guggenheim Foundation Fellowship, 1970; National Council on the Arts, 1964, 77; Mark Rothko Foundation Grant, 1975; Skowhegan Award for Service to the Arts, 1988. **One-man Exhibitions:** Brata Gallery, NYC, 1953; U. of British Columbia (two-man), 1955; Six Gallery, San Francisco, 1956; Green Gallery, NYC, 1962; NYU (three-man), 1967; Fischbach Gallery, 1967, 70, 71, 72; Hofstra U., 1967; Vancouver (two-man), 1970; Pasadena/AM, 1972; Tyler School of Art, Philadelphia, 1972; U. of Wisconsin, Madison, 1972; Hudson River Museum, 1977; Hamilton Gallery of Contemporary Art, NYC, 1980; Washburn Gallery, Inc., NYC, 1986, 88, 89, 92; Compass Rose Gallery, Chicago, 1987, 90. **Group:** NYU, Concrete Expressionism, 1965; WMAA Annuals, 1966, 68, 73; Chicago/AI Annual, 1966; Jewish Museum, Primary Structure Sculptures, 1966; Los Angeles/County MA, Sculpture of the Sixties, 1967; A.F.A., Rejective Art, 1967; Corcoran, Scale as Content, 1967; Documenta IV, Kassel, 1968; Walker, 14 Sculptors: The Industrial Edge, 1969; U. of Nebraska, American Sculpture, 1970; Arnhem, Sonsbeek '71, 1971; SFMA, Works in Spaces, 1973; Detroit/Institute, Art in Space, 1973; U. of Miami, Less Is More: The Influence of the Bauhaus on American Art, 1974; William Paterson College, N.J., Contemporary Drawing, 1975; Houston/Contemporary; Monumentalists in Modern Sculpture, 1975; Hirshhorn, The Golden Door: Artist Immigrants of America 1876-1976, 1976; WMAA, 200 Years of American Sculpture, 1976; Akron/AI, Project: New Urban Monuments, 1977; Trenton/State, Beyond the Plane: American Constructions 1931-1965, 1983; Montreal/MFA, Drawings by Sculptors, 1984; Bennington College, Matter and Spirit, 1985; Ridgefield/Aldrich, Sculpture on the Wall, 1986. **Collections:** Buffalo/Albright; La Jolla;

MMA; MOMA; Marine Midland Bank and Trust Co.; Newark Museum; Raleigh/NCMA; SFMA; South Albany Mall, N.Y.; Springfield, Ohio, City Hall; Peoria, Ill., Civic Center; King Saud U., Riyadh, Saudi Arabia. **Bibliography:** Ashbery; Calas, N. and E.; Friedman, M., 2; *Report;* Sandler 3, 5; Toher, ed.

BLAINE, NELL **b.** July 10, 1922, Richmond, Va. **Studied:** Richmond (Va.) School of Art, 1939-43; Hofmann School, 1943-44; Atelier 17, NYC, with S. W. Hayter; New School for Social Research, 1952-53. Traveled Europe, Near East, West Indies, Mexico. **Taught:** Great Neck (N.Y.) Public Schools, 1943-1956, and privately. **Member:** American Abstract Artists, 1944-57; Jane Street Group, 1945-49; Artists Equity. **Commissions:** Revlon Inc. (murals); New York Hilton Hotel (lithographs). **Awards:** Norfolk, First Prize, Watercolor, 1945; MacDowell Colony Fellowship, 1957; Yaddo Fellowship, 1957, 58, 64; Ingram Merrill Grants, 1962, 64, 66; Longview Foundation Grant, 1964, 1970; CAPS, 1972; Mark Rothko Foundation Grant, 1972; Guggenheim Foundation Fellowship, 1974; National Endowment for the Arts, 1975; Governor's award, Award for the Arts in Virginia, 1979; Honorary Degree, Moore College of Art, Philadelphia, 1980; Hon. Ph.D., Virginia Commonwealth U., 1985; NAD, Benjamin Altman Prize for Landscape, 1986; Virginia Commonwealth U., First Alumni Award, 1987; AAIAL, Louise Nevelson Award in Art, 1990. Designed original logo, column headings, and styling for the *Village Voice,* 1955. **Address:** 210 Riverside Drive, NYC 10025; Eudora Cottage, 3 Ledge Road, E. Gloucester, MA 01930. **Dealer:** Fischbach Gallery, NYC. **One-man Exhibitions:** (first) Jane Street Gallery, NYC, 1945, also 1948; VMFA, 1947, 54, 73; Southern Illinois U., 1949; Tibor de Nagy Gallery, NYC, 1953, 54; Poindexter Gallery, NYC, 1956, 58, 60, 66, 68, 70, 72, 76; New Paltz/SUNY,

1959; Stewart Richard Gallery, San Antonio, 1961; Philadelphia Art Alliance, 1961; Yaddo, 1961; Longwood College, 1962; U. of Connecticut, Storrs, 1973; Webb and Parsons, Bedford Village, N.Y., 1973; Watson/de Nagy Gallery, Houston, 1977; Fischbach Gallery, NYC, 1979, 81, 83, 85, 87, 89, 91; VMFA, 1979; Hull Gallery, Washington, D.C., 1979; Jersey City Museum, 1981; Alpha Gallery, Boston, 1982; Reynolds/Minor Gallery, Richmond, Va., 1982, 85; Wyckoff Gallery, Wyckoff, N.J., 1982; Virginia Commonwealth U., 1985; MMA, 1986; Reynolds Gallery, Richmond, Va., 1992. **Retrospective:** Southampton/Parrish, 1974. **Group:** Art of This Century, NYC, The Women, 1944; Salon des Realites Nouvelles, Paris, 1950; Chicago/AI; Baltimore/MA; WMAA; PAFA; Corcoran; VMFA; ART:USA:59, NYC, 1959; MOMA, Abstract Watercolors and Drawings, USA, circ., Latin America and Europe, 1961-62; Festival of Two Worlds, Spoleto; MOMA, Hans Hofmann and His Students, circ., 1963-64; Hartford/Wadsworth, Figures, 1964; MOMA, Contemporary Still Life, circ., 1967-68; New School for Social Research, Humanist Tradition, 1968; NIAL, 1970, 74, 75; A.F.A., Painterly Realism, 1970; WMAA, Frank O'Hara: A Poet Among Painters, 1974; NAD, Annual, 1978, 84; MMA, Hans Hofmann as Teacher: Drawings by His Students, 1979; Westmoreland County/MA, The New American Still Life, 1978; Hirshhorn, The Fifties: Aspects of Painting in New York, 1980; PAFA, Contemporary American Realism Since 1960, 1981; Utica, An Appreciation of Realism, 1982; Houston/Contemporary, American Still Life, 1945-1983, 1983; Brooklyn Museum, Homer, Sargent, and the American Watercolor Tradition, 1984; SFMA, American Realism, circ., 1985; Contemporary Arts Center, New Orleans, Landscape, Seascape, Cityscape, 1960-1985, 1986; AAIAL, 1986, 90; NAD Annual, 1987, 89, 90; Nassau County Museum, A Centennial Celebra-

tion of the National Association of Women Artists, 1988; Knoxville Museum of Art, Twentieth Century Women Artists, circ., 1990; Brooklyn College, The 1950s at the Tibor de Nagy Gallery, 1990; NMWA, New Viewpoints, circ., 1991; NAD, The Artist in the Garden, 1991; Japan Association of Art Museums, American Realism & Figurative Art, 1952-1991, circ., 1991. **Collections:** The Bank of New York; Brandeis U.; Brooklyn Museum; U. of California; Chase Manhattan Bank; Ciba-Geigy Corp.; Colgate U.; U. of Connecticut; First and Merchants National Bank, Richmond, Va.; U. of Georgia; Hallmark Collection; Hirshhorn; State U. of Iowa; Longwood College; MMA; MOMA; U. of Massachusetts; Michigan State U.; NAD; NMWA; New London; Newark Museum; New Paltz/SUNY; U. of North Carolina; Reader's Digest; Revlon Inc.; Roanoke Fine Arts Center; Southern Illinois U.; Taconic Foundation; Trade Building, Moscow; Union Carbide Corp.; Utah; VMFA; WMAA. **Bibliography:** Ashbery; *Art: A Woman's Sensibility;* **Bryant, E.;** Sandler 5; Ward. Archives.

BLANCH, ARNOLD **b.** June 4, 1896, Mantorville, Minn. **d.** October 23, 1968, Kingston, N.Y. **Studied:** Minneapolis Institute School; ASL, with Kenneth Hayes Miller, Boardman Robinson, John Sloan, 1916-17. Traveled USA. **Taught:** ASL, 1915-21, 1935-39, 1947-68; California School of Fine Arts, 1930-31; Colorado Springs Fine Arts Center, summers, 1939-41; U. of Minnesota, 1949, 52; Rollins College, 1950; Florida Gulf Coast Art Center, Inc., 1950-51; Woodstock, N.Y., 1950-61; Ohio U., summers, 1952, 56; Minneapolis Institute School, 1954; U. of Hawaii, 1955; Norton Gallery and School of Art, 1961-62; Michigan State U., 1964. **Commissions:** US Post Offices, Fredonia, N.Y., Norwalk, Conn., and Columbus, Wisc. (murals). **Awards:** Chicago/AI, Norman Wait Harris Prize 1929; SFMA, P.P., 1931; California

Palace, 1931; Guggenheim Foundation Fellowship, 1933; PAFA, Medal, 1938; Carnegie Medal, 1938; Syracuse/Everson, National Ceramic Exhibition, 1949, 51; Silvermine Guild. **One-man Exhibitions:** Rehn Galleries, 1923, 25; Philadelphia Art Alliance; Dudensing Gallery, NYC, 1928, 30; Walden-Dudensing Gallery, Chicago, 1930; Ulrich Gallery, Minneapolis, 1930; Beaux Arts Gallery, San Francisco, 1930; A.A.A. Gallery, NYC, 1943, 55, 63; Des Moines, 1952; Walker, 1952; The Krasner Gallery, NYC, 1954, 58, 59, 61, 62, 69; West Palm Beach/Norton, 1961. **Retrospective:** U. of Minnesota, 1949; Woodstock Artists Association, 1970. **Group:** Chicago/AI, 1930-43; Corcoran, 1931-45; WMAA, 1931-46, 1948-52; PAFA, 1931-45, 1948-52; New York World's Fair, 1939; MOMA; Carnegie; VMFA; MMA; Library of Congress; ART:USA, NYC. **Collections:** Abbott Laboratories; U. of Arizona; Britannica; Brooklyn Museum; California Palace; Carnegie; Cincinnati/AM; Clearwater/Gulf Coast; Cleveland/MA; Colorado Springs/FA; Cranbrook; Denver/AM; Detroit/Institute; Duluth; Library of Congress; MMA; U. of Minnesota, U. of Nebraska; U. of Oklahoma; PAFA; St. Louis/City; Utica; WMAA; Youngstown/Butler. **Bibliography:** American Artists Congress, Inc.; Baur 7; **Blanch 1, 2, 3;** Boswell 1; Cheney; *Index of 20th Century Artists;* Jewell 2; Pagano; Pearson 1; Reese; Richardson, E.P.; *Woodstock;* Zaidenberg, ed. Archives.

BLAUSTEIN, AL **b.** January 23, 1924, NYC. **Studied:** Cooper Union, with Morris Kantor; Skowhegan School. US Air Force, 3 years. Traveled Mexico, Africa, the Orient; resided Rome, 1954-57. **Taught:** Pratt Institute, 1959-. Yale U, 1959-62. **Commissions:** Drawings for *Life* magazine and British Overseas Food Corporation, 1948-49; fresco mural for South Solon (Me.) Meeting House, 1953. **Awards:** Prix de Rome, 1954-57; Guggenheim Foundation Fellowship, 1958, 61; AAAL Grant, 1958; Childe

Hassam Award, 1962-68, and P.P., 1969; PAFA, Alice McFadden Eyre Medal, 1959; ART:USA:59, NYC, Graphic Prize, 1959; Youngstown/Butler, First Prize, 1961; SAGA, First Prize, 1962; Audubon Artists, Gold Medal of Honor, 1962. **Address:** 141 East 17th Street, NYC 10003. **Dealer:** Terry Dintenfass, Inc. **One-man Exhibitions:** (first) Lee Nordness Gallery, NYC, 1959, also 1961, 62; U. of Nevada, 1961; Philadelphia Art Alliance, 1962; Walter Laubli Gallery, Zurich, 1962; Philadelphia Print Club, 1964; Franklin Siden Gallery, Detroit, 1965, 66; Randolph-Macon College, 1967; C. Troup Gallery, Dallas, 1968; Terry Dintenfass, Inc., NYC, 1969, 72; Martin Sumers Graphics, NYC, 1982. **Group:** MMA, 1950; A.F.A., 1951; Buffalo/Albright, Expressionism in American Painting, 1952; Carnegie, 1952; WMAA Annuals, 1953, 57; The Downtown Gallery, 1958; SAGA, 1962. **Collections:** Albany/Institute; Boston/MFA; Brooklyn Museum; Chicago/AI; Hartford/Wadsworth; Library of Congress; MMA; U. of Nebraska; Norfolk; PAFA; Scranton/Everhart; Syracuse U.; WMAA; Washington U.; Youngstown/Butler. **Bibliography:** Chaet; Nordness, ed. Archives.

BLECKNER, ROSS b. 1949, NYC. **Studied:** NYU, 1971, BA; California Institute of the Arts, 1973, MFA. **Address:** 77 White Street, NYC 10013. **Dealer:** Mary Boone Gallery, NYC. **One-man Exhibitions:** Cunningham Ward Gallery, NYC, 1975, 77; John Doyle Gallery, Chicago, 1976; Mary Boone Gallery, NYC, 1979, 80, 81, 83, 86, 87, 88, 91; Patrick Verelist Galerie, Antwerp, 1982; Portico Row Gallery, Philadelphia, 1982; Nature Morte Gallery, NYC, 1984; Boston Museum School, 1985; Mario Diacono Gallery, Boston, 1986, 89; Margo Leavin Gallery, Los Angeles, 1987; Waddington Galleries, London, 1988; SFMA, 1988; Galerie Max Hetzler, Cologne, 1989; Milwaukee, 1989; Hous-

ton/Contemporary, 1989; Carnegie, 1989; Akira Ikeda Gallery, Tokyo, 1989; Galerie Soledad Lorenzo, Madrid, 1990; Heland Wetterling Gallery, Stockholm, 1990; Zurich/Kunsthalle, 1990; Cologne/Kunstverein, 1991; Stockholm/National, 1991; Fred Hoffman Gallery, Santa Monica, 1991; Jason Rubell Gallery, Palm Beach, 1991; Galerie Ghislaine Hussenot, Paris, 1992; Galerie Samia Saouma, Paris, 1992. **Group:** WMAA, Biennial, 1975, 87, 89; California State U., Los Angeles, New Work/New York, 1976; Hayward Gallery, London, New Painting/New York, 1979; U. of Chicago/The Meditative Surface, 1984; ICA, Boston, Currents, 1985; Ridgefield/Aldrich, Post Abstract Abstraction, 1987; Sydney Biennial, 1988; Los Angeles/MOCA, The Image of Abstraction, 1988; Boston/MFA, The Binational/Die Binationale, circ., 1988; ICI, New York Hybrid, circ., 1988; Carnegie, International, 1988; Frankfurt/Kunstverein, Prospect 89, 1989; Fort Worth/Modern, 10 + 10, circ., 1989; Martin-Gropius, Bau, Berlin, Metropolis, 1991; Rutgers U., Outrageous Desire, 1991; ICA, U. of Pennsylvania, Devil on the Stairs, circ., 1991; Wright State U., The City Influence, 1992; Cleveland/Contemporary, Recent Abstract Painting, 1992.

BLEIFELD, STANLEY b. August 28, 1924, Brooklyn, N.Y. US Navy, 1944-46. **Studied:** Stella Elkins Tyler School of Fine Arts, Temple U., with Raphael Sabatini, 1949, BFA. Traveled Israel, Mexico, and extensively in Italy; resided Rome, 1962-63. Resides part year, Pietrasanta, Italy, 1961-. **Taught:** Weston (Conn.) Public Schools, 1950-53; New Haven State Teachers College, 1953-55; Danbury State College, 1955-63; Silvermine Guild, 1963-66; Bleifeld Studio Group, Brooklyn, 1966-. **Member:** Artists Equity; National Sculpture Society, President, 1991-; Federation Internationale de la Medaille; American Medallic Sculpture

Association. **Commissions:** Vatican Pavilion, New York World's Fair, 1964-65; The Margaret Sanger Award, 1966; Kokomo (Ind.) Public Library, 1969; Knights of Columbus, New Haven, CT., 1982; US Navy Memorial, Washington, D.C., 1982, 89, 91; US Navy Memorial, Jacksonville, Fla., 1988. **Awards:** Tyler Annual, First Prize, 1951; National Sculpture Society, John Gregory Award, 1964, Bronze Medal, 1970; elected Tyler Fellow, 1964; L. C. Tiffany Grants, 1965, 67; NAD, Shikler Award, 1977; National Sculpture Society, Proskauer Prize, 1983, Bennett Prize, 1985; Temple U., Certificate of Honor, 1989; National Sculpture Society, Henry Hering P.P., 1990; National Sculpture Society, Silver Medal, 1991. **Address:** 27 Spring Valley Road, Weston, CT 06883. **Dealers:** Franz Bader Gallery, Washington, D.C.; Images Sculptural Concepts, Westport, CT. **One-man Exhibitions:** The Peridot Gallery, NYC, 1963, 68; Hoffman Fuel Co., Danbury, Conn., 1962; Kenmore Galleries, Inc., Philadelphia, 1967; New Canaan (Conn.) Public Library, 1967; Fairfield U., 1967; I.F.A. Gallery, 1968, 71; FAR Gallery, 1971, 73, 77; New Britain/American, 1974; Images Sculptural Concepts, Westport, Ct., 1986; Franz Bader Gallery, Washington, D.C., 1987, 91. **Group:** Silvermine Guild; Stella Elkins Tyler School of Fine Arts, Temple U.; International Arts Festival, Chetwode, Newport, R.I., 1964; A.F.A., 1966-67; Temple Emanuel, Houston, Tex., 1964; Indiana U., 1966; Southampton/Parrish, Sport in Art, 1968. **Collections:** Cedar Rapids Public Library; U. of Edinburgh, Scotland; Housatonic Community College; Lyndon B. Johnson Library, Austin, Texas; Museum of the City of New York; New Britain/American; The Pennsylvania State U.; Tampa/AI; Temple U.; Westmoreland County/MA.

BLOCH, A.
from 1st to 3rd edition.

BLOOM, HYMAN b. April, 1913, near Riga, Latvia. To USA, 1920. **Studied:** West End Community Center, Boston, with Harold Zimmerman; Harvard U., with Denman W. Ross. **Taught:** Wellesley College, 1949-51; Harvard U., 1951-53. Federal A.P.: Easel Painting. **Address:** 80 Hills Ferry Road, Nashua, N.H. 03060. **Dealer:** Terry Dintenfass, Inc., NYC. **One-man Exhibitions:** Stuart Gallery, Boston, 1945; Durlacher Brothers, NYC, 1946, 48, 54; ICA, Boston; Boris Mirski Gallery, Boston, 1949; The Swetzoff Gallery, Boston, 1957; WMAA, 1968; U. of Connecticut, 1969; Terry Dintenfass, Inc., NYC, 1972, 75, 79; UCLA (two-man). **Retrospective:** Buffalo/Albright, circ., 1954. **Group:** Lincoln, Mass./De Cordova, Humanism in New England Art, 1970; Minnesota/MA, Drawings USA, 1971; AAIAL, 1974, 75; Jewish Museum, Jewish Experience in Art of the 20th Century, 1976; NAD, Annual, 1977; Omaha/Joslyn, The Chosen Object, 1977; ICA, Boston, Boston Expressionism, 1979. **Collections:** Amherst College; Andover/Phillips; First National Bank of Boston; Harvard U.; Hirshhorn; Kalamazoo/Institute; Minnesota/MA; MOMA; Purchase/SUNY; Rutgers U.; St. Louis/City; Smith College; WMAA. **Bibliography:** Barker 1; Baur 7; Biddle 4; Chaet; Cummings 4; Eliot; *From Foreign Shores;* Goodrich 1; Hess, T.B., 1; Hunter 6; Joachimides and Rosenthal; Kootz 2; Kuh 3; Miller, ed., 1; Newmeyer; Pousette-Dart, ed.; Richardson, E. P.; Rodman 2, 3; Rose, B., 1; Soby 5; Storr and Tannenbaum; Wight 2; **Wight and Goodrich.** Archives.

BLUEMNER, OSCAR b. 1867, Hanover, Germany. **d.** 1938, South Braintree, Mass. **Studied:** Academy of Fine Arts, Berlin. To USA, 1892. Practicing architect, 1894-1912. **One-man Exhibitions:** Berlin, 1885, 1912; Stieglitz Gallery, NYC, 1915; Mrs. Liebman's Art Room, NYC, 1926; Stieglitz's Intimate Gallery,

NYC, 1928; Whitney Studio Club, NYC, 1929; Marie Harriman Gallery, NYC, 1935; U. of Minnesota, 1939; Today's Gallery, Boston, 1945; The Graham Gallery, NYC, 1956, 60, 67, 72; Harvard U., 1967; New York Cultural Center, 1969; Davis Gallery, 1971; Danenberg Gallery, 1972; Hirshhorn, 1979; Monique Knowlton Gallery, NYC, 1978; Sid Deutsch Gallery, NYC, 1980; Barbara Mathes Gallery, NYC, 1985. **Retrospective:** Trenton/State, 1989. **Group:** Anderson Galleries, NYC, Forum Exhibition, 1916; Bourgeois Gallery, NYC, 1917-23; J.B. Neumann Gallery, NYC, 1924-36; WMAA, Pioneers of Modern Art in America, 1946; WMAA, Juliana Force Memorial Exhibition, 1949; NCFA, Roots of Abstract Art in America, 1910-1930, 1967. **Collections:** Boston/MFA; MOMA; Phillips; WMAA. **Bibliography:** Armstrong, Thomas; *Avant-Garde Painting and Sculpture;* Baur 7; Brown 2; Cheney; Frank, ed.; *From Foreign Shores;* Goodrich and Baur 1; Hayes; Hunter 6; Janis; Levin 2; Mellquist; **Oscar Bluemner: American Colorist;** Rose, B., 1, 4; Wright 1. Archives.

BLUHM, NORMAN b. March 28, 1920, Chicago, Ill. **Studied:** Illinois Institute of Technology, 1936; 1945-47, with Mies van der Rohe. US Air Force, 1941-45. Resided Paris, 1947-56. **Address:** c/o Dealer. **Dealer:** Washburn Gallery, NYC. **One-man Exhibitions:** (first) Leo Castelli Inc., 1957, also 1960; Galleria d'Arte del Naviglio, Milan, 1959; Notizie Gallery, Turin, 1961; David Anderson Gallery, NYC, 1962; Paris, 1965; Galerie Semiha Huber, Zurich, 1963; The American Gallery, NYC, 1963; Galerie Anderson-Mayer, Paris, 1963; Galerie Smith, Brussels, 1964; Galerie Stadler, Paris, 1968, 70, 72, 75, 82, 88; Corcoran, 1969, 77, 78; Martha Jackson Gallery, 1970, 71, 74, 77; J. L. Hudson Art Gallery, Detroit, 1971; Syracuse/Everson, 1973; Vassar College, 1974; Galleria Venezia, Venice, 1974;

Norman Bluhm, *Royal Icons,* 1989.

Carlo Rubboli, Milan, 1974; Houston/Contemporary, 1976; Robinson Galleries, Houston, 1976; Stony Brook/SUNY, 1984; Herbert Palmer Gallery, Los Angeles, 1985; Washburn Gallery, NYC, 1986, 89, 90, 91; Zolla/Lieberman Gallery, Chicago, 1986; Hamilton College, 1987; Ball State U., 1988; Allentown/AM, 1988; Yares Gallery, Scottsdale, 1989; U. of Arkansas, 1989; Niagara U., Niagara Falls, N.Y., 1989. **Group:** Carnegie, 1958; Documenta II, Kassel, 1959; ICA, Boston, 100 Works on Paper, circ., Europe, 1959; Walker, 60 American Painters, 1960; WMAA Annual, 1960, 72; Chicago/AI Annual, 1961; SRGM, The G. David Thompson Collection; SRGM, Abstract Expressionists and Imagists, 1961; Salon du Mai, Paris, 1964; MOMA, Two Decades of American Painting, circ., 1966; Jewish Museum, Large Scale American Painting, 1967; MOMA, Dada, Surrealism, and Their Heritage, 1968; Galleria d'Arte, Cortina, Espaces Abstraits, 1969; MOMA, Color as Language, circ., 1975; SFMA, Aesthetics of Graffiti, 1978; California State U., Northridge, Americans in Paris: The 50s, 1979; NYU, Tracking the Marvelous, 1981; U. of Connecticut, Art with the Touch of a Poet: Frank O'Hara, 1983; Mittelrheinisches Landesmuseum, Mainz, Twenty Years of Art in France, 1960-80,

circ., 1983; Newport Harbor, Action/Precision, circ., 1984; Southampton/Parrish, Drawing on the East End, 1940-1988; Guild Hall, East Hampton, Avant-Garde: A Salute to the Signa Gallery, 1990. **Collections:** Baltimore/MA; Buffalo/Albright; CNAC; Corcoran; Cornell U.; Dallas/MFA; Dayton/AI; High Museum; Hirshhorn; Kansas City/Nelson; MIT; MMA; MOMA; U. of Massachusetts; Melbourne/National; National Gallery; NYU; National Museum of Wales; Norfolk/Chrysler; Phillips; Phoenix; Purchase/SUNY; Reed College; Stony Brook/SUNY; Syracuse/Everson; Vassar College; WMAA. **Bibliography:** Alloway 4; *Metro;* O'Hara 1; Rubin 1; Sandler 5. Archives.

BLUME, PETER **b.** October 27, 1906, Russia. To USA, 1911. **d.** November 31, 1992, New Milford, Conn. **Studied:** Educational Alliance, NYC; ASL; Beaux Arts Academy, NYC. **Commissions:** Federal A.P.: US Post Offices, Cannonsburg, Pa., Rome, Ga., and Geneva, N.Y. (murals). **Awards:** Guggenheim Foundation Fellowship, 1932, 36; Carnegie, First Prize, 1934; MMA, Artists for Victory, 1942; NIAL Grant, 1947. **One-man Exhibitions:** (first) The Daniel Gallery, NYC, 1930; Julien Levy Galleries, NYC, 1937; The Downtown Gallery, 1941, 47; Durlacher Brothers, NYC, 1949, 54, 58; Kennedy Gallery, 1968; Danenberg Gallery, 1970; Coe Kerr Gallery, 1975; Terry Dintenfass, Inc., NYC, 1980. **Retrospective:** Chicago/Contemporary, 1976. **Collections:** Boston/MFA; Chicago/AI; Columbus; Hartford/Wadsworth; Harvard U.; MMA; Newark Museum; Randolph-Macon College; WMAA; Williams College. **Bibliography:** Barker 1; Barr 3; Baur 7; Boswell 1; Brown 2; Cahill and Barr, eds.; Canaday; Cheney; Eliot; Flanagan; *From Foreign Shores;* Getlein 3; Goodrich and Baur 1; Haftman; Hunter 6; *Index of 20th Century Artists;* Janis; Jewell 2; Kootz 1, 2;

Kuh 1; McCurdy, ed.; Mellquist; Mendelowitz; Neumeyer; Nordness, ed.; Pearson 2; Poore; Pousette-Dart, ed.; Richardson, E.P.; Ringel, ed.; Rose, B., 1; Sachs; Smith, S.C.K.; Soby 5, 6; Wight 2. Archives.

BOARDMAN, SEYMOUR **b.** December 29, 1921, Brooklyn, N.Y. **Studied:** City College of New York, 1942, BS; Academie des Beaux-Arts, Academie de la Grande Chaumiere, and Atelier Fernand Leger, Paris, 1946-52. US Army, 1942-46. **Taught:** Wagner College, 1957-58. **Member:** Artists Equity. **Awards:** Longview Foundation Grant, 1963; Gottlieb Foundation Award, 1979, 83; Pollock-Krasner Foundation Grant, 1985, 91. **Address:** 234 West 27th Street, NYC, 10001. **Dealer:** Anita Shapolsky Gallery, NYC. **One-man Exhibitions:** (first) Galerie Mai, Paris, 1951; Martha Jackson Gallery, NYC, 1955, 56; Dwan Gallery, NYC, 1960; Stephen Radich Gallery, NYC, 1960-62; Esther Robles Gallery, NYC, 1965; A. M. Sachs Gallery, NYC, 1965, 67, 68; Dorsky Gallery, NYC, 1972; Cornell U., 1971; Aaron Berman, NYC, 1978; Anita Shapolsky Gallery, NYC, 1986, 87, 91. **Group:** WMAA, 1955, 61, 67; Youngstown/Butler, 1955; SFMA, 1955; Carnegie, 1955; U. of Nebraska, 1956; Santa Barbara/MA, 1964; Kunsthalle, Basel, 1964; California State U., Americans in Paris: The Fifties, 1979. **Collections:** Brandeis U.; Cornell U.; Ciba-Geigy Chemical Corp.; Mexico City/Tamayo; NYU; Newark Museum; Potsdam/SUNY; SRGM; Santa Barbara/MA; Union Carbide Corp.; WMAA; Wagner College; Walker; Westmoreland County/MA. **Bibliography:** Archives.

BOCHNER, MEL **b.** 1940, Pittsburgh, Pa. **Studied:** Carnegie, 1962, BFA. **Taught:** School of Visual Arts, NYC, 1965-; Yale U., 1980-85. **Address:** 108 Franklin Street, NYC 10013. **Dealer:** Sonnabend Gallery, NYC. **One-man Exhibitions:** Visual Arts Gallery, NYC, 1966; ACE Gallery, Los Angeles, 1969; Galerie

Mel Bochner, *Vanishing Point: Over the Edge,* 1991.

Konrad Fischer, Düsseldorf, 1969; Galerie Heiner Friedrich, Munich, 1969; Galleria Toselli, Milan, 1969, 72; MOMA, 1971; 112 Greene Street Gallery, NYC, 1971; Galerie MTL, Brussels, 1972; Galleria Marilena Bonomo, Bari, Italy, 1972; Lisson Gallery, London, 1972; Ileana Sonnabend Gallery, NYC, 1972, 73, 74, 76, 78, 80, 82, 83, 85; Ileana Sonnabend Gallery, Paris, 1972, 73, 74, 78; Galleria Schema, Florence, Italy, 1974, 78; Weinberg Gallery, San Francisco, 1974, 78; U. of California, Berkeley, 1975; Baltimore/MA, 1976; Bernier Gallery, Athens, 1977; Art in Progress, Düsseldorf, 1979; The Texas Gallery, Houston, 1981; Daniel Weinberg Gallery, San Francisco, 1981, 83; Southern Methodist U., 1981; Abbaye de Senaque, Gordes, France, 1982; Pace Editions, NYC, 1983; Yarlow Salzman Gallery, Toronto, 1983; Carol Tyler Art, Dallas, 1983; Roger Ramsay Gallery, Chicago, 1984; Janet Steinberg Gallery, San Francisco, 1985. **Retrospectives:** Carnegie-

Mellon U., 1985; Lucerne, 1986. **Group:** Finch College, NYC, Art in Series, 1967; Art in Process, 1969; Leverkusen, Konzeption—Conception, 1969; Seattle/AM, 557, 087, 1969; Chicago/Contemporary, Art by Telephone, 1969; Turin/Civico, Conceptual Art, Arte Povera, Land Art, 1970; New York Cultural Center, Conceptual Art and Conceptual Aspects, 1970; Oberlin College, Art in the Mind, 1970; MOMA, Information, 1971; Chicago/Contemporary, White on White, 1972; Kassel, Documenta V, 1972; Basel, Konzept Kunst, 1972; Musée Galliera, Paris, Festival d'Automne, 1973; Seattle/AM, American Art: Third Quarter Century, 1973; WMAA, American Drawings: 1963-1973, 1973; New York Cultural Center, 3D into 2D, 1973; Parcheggio di Villa Borghese, Rome, Contemporanea, 1974; Princeton U., Line as Language, 1974; Cologne, Project '74, 1974; Leverkusen, Drawings 3: American Drawings, 1975; MOMA, Drawing Now, 1976; Chicago/AI, Annual, 1976; Fort Worth, Fourteen Artists: The New Decade, 1976; WMAA, Biennial, 1977, 79; PMA, Eight Artists, 1978; Palazzo Reale, Milan, Pintura Ambiente, 1979; Paris/Beaubourg, Murs, 1981; Chicago/AI, 74th American Exhibition, 1982; Cranbrook, Viewpoint '84, 1984. **Collections:** Baltimore/AM; Brown U.; Buffalo/Albright; Carnegie; Chicago/AI; Cologne/Ludwig; Detroit/Institute; Hartford/Wadsworth; MMA; MOMA; Oberlin College; PMA; Paris/Beaubourg; St. Louis/City; Tate Gallery; WMAA; Yale U. **Bibliography:** Ashbery; *Contemporanea;* Cummings 5; Johnson, Ellen H.; Gablik; Kardon 3; Krauss 2; Lippard, ed.; Meyer; Pincus-Witten 1, 2; Sandler 3; Weintraub; *When Attitudes Become Form.*

BODIN, PAUL
from 1st to 4th edition.

BOGHOSIAN, VARUJAN
b. June 26, 1926, New Britain, Conn.

Studied: Yale U., 1956-59, BFA, MFA (with Josef Albers); Vesper George School of Art, 1946-48. US Navy, 1944-46. **Taught:** U. of Florida, 1958-59; Cooper Union, 1959-64; Pratt Institute, 1961; Yale U., 1962-64; Brown U., 1964-68; American Academy, Rome, 1967; Dartmouth College, 1968-. **Member:** AAIAL; Century Association. **Awards:** Fulbright Fellowship (Italy), 1953; Brown U., Howard Foundation Grant for Painting, 1966; New Haven Arts Festival, First Prize, 1958; Portland (Me.) Arts Festival, 1958; Boston Arts Festival, 1961; Providence Art Club, First Prize, 1967; Hon. MA, Brown U.; AAAL; NIAL; Guggenheim Foundation Fellowship, 1985. **Address:** 1 Read Road, Hanover, NH 03755. **One-man Exhibitions:** (first) The Swetzoff Gallery, Boston, 1949, also 1950, 51, 53, 54, 55, 59, 63, 65; R. M. Light & Co., Boston, 1962; The Stable Gallery, 1963-66; ACE Gallery, Provincetown, Mass., 1966; U. of Massachusetts, 1968; Dartmouth College, 1968; Currier, 1968; Cordier & Ekstrom, Inc., 1969, 70, 71, 73, 75, 77, 78, 79, 80, 82, 84; Arts Club of Chicago, 1970; Alpha Gallery; 1972; U. of Connecticut, 1972; Keene (N.H.) State College, 1972; Robinson Galleries, Houston, 1975; Long Point Gallery, Provincetown, Mass., 1978, 88; Philadelphia College of Art, 1980; Fine Arts Work Center, Provincetown, 1980; Van Buren/Brazelton/Cutting Gallery, Cambridge, Mass. 1983; American Academy, 1986; Boston Public Library, 1987; Bucknell U., 1987; Ridgefield/Aldrich, 1988; Century Association, 1988; Claude Bernard Gallery, NYC, 1991. **Retrospective:** Dartmouth College, 1989. **Group:** MOMA, Young American Printmakers, 1953; MOMA, Recent Drawings USA, 1956; U. of Illinois, 1961; Chicago/AI Annual, 1961; WMAA Annuals, 1963, 64, 66, 68; Yale U., 1965; ICA, Boston, As Found, 1966; WMAA, Contemporary American Sculpture, Selection 1, 1966; Grand Rapids, Sculpture of the 60s, 1969; AAIAL, 1972, 86; Indianapolis,

1972; Ringling, After Surrealism, 1972; Paris/Moderne, Boites, 1976; Montclair/AM, Collage: American Masters, 1979; Boston Public Library, Contemporary Fantasy Drawings, 1985. **Collections:** Allentown/AM; Andover/Phillips; Brandeis U.; Brooklyn Museum; Buffalo/Albright; U. of California; Cornell U.; Dartmouth College; Honolulu Academy; Indianapolis/Herron; U. of Kentucky; MMA; MOMA; U. of Massachusetts; NYPL; New Britain/American; Newark Museum; Purchase/SUNY; Phoenix; RISD; Vassar College; Williams College; WMAA; Wesleyan U. (Conn.); Worcester/AM. **Bibliography:** Archives.

BOHROD, AARON

b. November 21, 1907, Chicago, Ill. **d.** April 3, 1992, Madison, Wisc. **Studied:** Crane Junior College, 1925-26; Chicago Art Institute School, 1927-29; ASL, 1930-32, with Boardman Robinson, John Sloan, Richard Lahey. Traveled USA, Europe, South Pacific. **Taught:** Illinois State Normal U.; 1941-42; Ohio U., summers, 1949, 54; U. of Wisconsin, 1948-73. **Member:** NAD, Academician, 1952. Federal A.P.: Easel painting. Artist War Correspondent for *Life* magazine, 1942-45. **Commissions:** Eli Lilly & Co. (7 paintings, Medical Disciplines); *Look* magazine (14 paintings, Great Religions of America). **Awards:** Corcoran, William A. Clark Prize and Corcoran Silver Medal ($1,500); MMA, Artists for Victory, $1,000 Prize; Guggenheim Foundation Fellowship, 1936, renewed, 1937; Chicago/AI, The Mr. & Mrs. Frank G. Logan Prize, 1937, 45; PAFA, First Watercolor Prize, 1942; Illinois State Fair, First Award, 1955; Carnegie; NAD, Saltus Gold Medal for Merit, 1961; AAAL, Childe Hassam Award, 1962; Hon. DFA, Ripon College, 1960. **One-man Exhibitions:** (first) Rehn Galleries, NYC, circa 1935; A.A.A. Gallery, NYC, 1939, 41, 43, 45, 46, 49, 52, 55; The Milch Gallery, 1957, 59, 61, 65; Agra Gallery, 1966; The Banfer Gallery, 1967; Irving Galleries,

Inc., Milwaukee, 1968; Hammer Gallery, 1969; Dannenberg Gallery, 1971; Oehlschlaeger Gallery, Chicago, 1976; Milwaukee, 1979. **Retrospectives:** Madison Art Center, 1966, 80; Memphis/Brooks, 1975. **Group:** WMAA; Milwaukee; MMA; Boston/MFA; PAFA; Chicago/AI; Corcoran; Brooklyn Museum; Milwaukee, Leaders in Wisconsin Art, 1982. **Collections:** Abbott Laboratories; U. of Arizona; Beloit College; Boston/MFA; Britannica; Brooklyn Museum; Chicago/AI; Corcoran; Cranbrook; Davenport/Municipal; Detroit/Institute; Evansville; Hirshhorn; U. of Illinois; Library of Congress; Lawrence College; Los Angeles/County MA; MMA; MacNider Museum; Madison Art Center; U. of Maine; U. of Miami; Milwaukee; U. of Minnesota; Neenah/Bergstrom; New Britain/American; U. of New Mexico; Ohio U.; PAFA; Palm Springs Desert Museum; Phillipines/MA; Phoenix; Rahr-West Museum; Ripon College; St. Lawrence U.; San Antonio/McNay; Savannah/Telfair; Southern Illinois U.; Springfield, Mass./MFA; Springfield, Mo./AM; U. of Texas; Witte; Terre Haute/Swope; Syracuse U.; WMAA; Walker; West Palm Beach/Norton; U. of Wisconsin; U. of Wyoming; Youngstown/Butler. **Bibliography:** American Artists Group Inc., 2; Ashbery; Baur 7; Bethers; Bruce and Watson; Cheney; Christensen; Flanagan; McCurdy, ed.; Mendelowitz; Pagano; Pearson 1; Reese; Richardson, E. P.; Rose, Barbara, 1; Ward; Wight 2. Archives.

BOICE, BROCE
from 4th to 5th edition.

BOLLINGER, WILLIAM
from 3rd to 5th edition.

BOLOMEY, ROGER b. October 19, 1918, Torrington, Conn. **Studied:** Vevey, Switzerland, 1934-38; U. of Lausanne, 1947; Academy of Fine Arts, Florence, Italy, 1948-50; privately with Alfredo Cini Switzerland. **Taught:** San

Mateo Arts and Crafts, 1954-55; Dutchess Community College, Poughkeepsie, N.Y. 1965-66; Barlow School, Amenia, N.Y., 1967; Hunter College, 1968; Herbert H. Lehman College, Bronx, N.Y., 1968-75; Chairman, Department of Art, 1974-75; California State U., Fresno, 1975-83. **Commissions:** San Jose State College Art Building; South Mall, Albany (sculptures), 1967; Southridge Shopping Center, Milwaukee, 1968; Lehman High School, Bronx, N.Y., 1969; Eastridge Mall, San Jose, Calif.; Hauppauge, 1973; Mt. Hood Community College, Gresham, Ore., 1974; North Park, Dallas, 1975. **Awards:** SFMA, P.P., 1960, Sculpture Prize, 1965; Walnut Creek (Calif.) Pageant, First Prize, 1962; Waitsfield/Bundy, Bundy Sculpture Competition, First Prize, 1963. **Address:** Route 113, North Fryeburg, ME 04058. **Dealer:** Alexander Gallery, Los Angeles. **One-man Exhibitions:** (first) SFMA, 1950; Sacramento/Crocker, 1950; Passedoit Gallery, NYC, 1951; Santa Barbara/MA, 1953; de Young, 1954; California Palace, 1958; Royal Marks Gallery, 1964; Circle Gallery, New Orleans, 1976. **Group:** SFMA Annuals, 1950, 1960-63, 65; ICA, Boston, 100 Works on Paper, circ., Europe, 1959; Chicago/AI, 1963; Salon du Mai, Paris, 1964; Carnegie, 1964; WMAA Sculpture Annual, 1964, 66; New York World's Fair, 1964-65; WMAA, Contemporary American Sculpture, Selection 1966; Quatrième Exposition Suisse de Sculpture, Bienne, Switzerland, 1966; U. of Illinois, 1967; Southern Illinois U., 1967; Ridgefield/Aldrich, 1968; HemisFair'68, San Antonio, Tex., 1968; U. of Nebraska, American Sculpture, 1970; Storm King Art Center, Outdoor Sculpture Indoors, 1972; Society of Four Arts, Contemporary American Sculpture, 1974; Van Saun Park, Paramus, N.J., Sculpture in the Park, 1974. **Collections:** U. of California; Chase Manhattan Bank; Corcoran; Fontana-Hollywood Corp.; Los Angeles/County MA; MOMA; Oakland/AM; Ridgefield/Aldrich; SFAI;

San Francisco Art Association; San Jose
State College; WMAA; Waitsfield/Bundy.
Bibliography: Archives.

BOLOTOWSKY, ILYA b. July 1,
1907, Petrograd, Russia. **d.** November 22,
1981, NYC. To USA, 1923; citizen, 1929.
Studied: College of St. Joseph, Istanbul;
NAD, with Ivan Olinsky, 1924-30. US Air
Force, 1942. Traveled Russia, Europe,
North America. **Taught:** Black Mountain
College, 1946-48; U. of Wyoming, 1948-
57; Brooklyn College, 1954-56; Hunter
College, 1954-56, 1963-64; New
Paltz/SUNY, 1957-65; Long Island U.,
1965-71; Wisconsin State College, sum-
mer, 1968; U. of New Mexico, spring,
1969; Queens College, 1973. Federal A.P.:
Master easel and mural artist, teacher.
Member: Cofounder, charter member,
and former president of American Abstract
Artists; cofounder and charter member of
Federation of Modern Painters and Sculp-
tors; AAAL. Produced 16 mm experimen-
tal films. Began constructivist painted
columns, 1961. **Commissions** (murals):
Williamsburg Housing Project, NYC,
1936 (one of the first abstract murals);
New York World's Fair, 1939; Hospital
for Chronic Diseases, NYC, 1941;
Theodore Roosevelt High School, NYC,
1941; Cinema 1, NYC, 1962; Southamp-
ton College, Long Island U., 1968; North
Central Bronx Hospital, 1973; First Na-
tional City Bank, NYC 1974; P.S. 72,
Brooklyn, N.Y., 1974 (tile mosaic mural);
NYC, Passenger Ship terminal mural,
1978. **Awards:** Sharon (Conn.) Art Foun-
dation, First Prize for Painting, 1959;
Guggenheim Foundation Fellowship,
1941, 73; Yaddo Fellowship, 1935; L. C.
Tiffany Grant, 1930, 31; NAD, Hallgarten
Prize for Painting, 1929, 30; NAD, First
Prize Medal for Drawing, 1924, 25; The
U. of Chicago, Midwest Film Festival,
First Prize (for Metanois); State U. of New
York Grant, for film research, 1959, 60;
NIAL, Grant, 1971. **One-man Exhibi-
tions:** (first) G.R.D. Studios, NYC., 1930;

J. B. Neumann's New Art Circle, NYC,
1946, 52; Rose Fried Gallery, 1947, 49;
Pratt Institute, 1949; Grace Borgenicht
Gallery, NYC, 1954, 56, 58, 59, 61, 63,
66, 68, 70, 72, 74-80; New Paltz/SUNY,
1960; Dickinson College, 1960; Elmira
College, 1962; Southampton/Parrish,
1965; Long Island U., 1965; East Hamp-
ton Gallery, East Hampton, N.Y., 1965;
Buffalo/SUNY, 1965 (two-man), 1966;
Gorham State College, 1967; Wisconsin
State College, 1968, 85; Stony
Brook/SUNY, 1968, 85; London Arts,
London and Detroit, 1971; David Barnett
Gallery, Milwaukee, 1972; Reed College,
1973; Hokin Gallery, Chicago, 1976;
Washburn Gallery, NYC, 1980, 83, 84,
87; NYU, 1983; Salt Lake Art Center,
1981; Yares Gallery, Scottsdale, Ariz.,
1982; AAIAL, Memorial Exhibition, 1983;
Il Punto Blu Gallery, Southampton, N.Y.,
1984; River Gallery, Irvington-on-Hud-
son, N.Y., 1984; Pembroke Gallery, Hous-
ton, 1984. **Retrospectives:** U. of New
Mexico, circ., 1970; SRGM, 1974; NCFA,
circ., 1975; Houston/Contemporary,
1984. **Group:** American Abstract Artists
Annuals; Federation of Modern Painters
and Sculptors Annuals; WMAA Annuals;
New York World's Fairs, 1939 and 1964-
65; Seattle World's Fair, 1962; WMAA,
Geometric Abstraction in America, circ.,
1962; Corcoran, 1963; SRGM; Buffalo/Al-
bright, Plus by Minus, 1968; Dallas/MFA,
Geometric Abstraction, 1926-42, 1972;
Chicago/Contemporary, Post-Mondrian
Abstraction in America, 1973; Milwaukee,
From Foreign Shores, 1976; Indianapolis,
1976; Philadelphia College of Art, Seven-
ties Painting, 1978; AAIAL, Work by
Newly Elected Members, 1982-83; Carne-
gie, Abstract Painting and Sculpture in
America 1927-1944, 1983; NYU, Ilya
Bolotowsky and Neo-Plasticism in Amer-
ica, 1983; Fort Lauderdale, An American
Renaissance: Painting and Sculpture since
1940, 1986; La Biennale di Venezia, 1986;
Southampton/Parrish, Drawings on the
East End, 1940-1988; 1988; Brooklyn Mu-

seum, The Williamsburg Murals, 1990.
Collections: AAIAL; American Republic
Insurance Co.; Andover/Phillips; Atlantic
Richfield Co.; Bezalel Museum; Brandeis
U.; Brooklyn Museum; Buffalo/Albright;
Burlington Industries; Calcutta; Ceret;
Chase Manhattan Bank; Ciba-Geigy
Corp.; Cleveland/MA; Continental Grain
Company; Harcourt Brace Jovanovich,
Inc.; Hirshhorn; Housatonic Community
College; Indianapolis; U. of Iowa; MMA;
MOMA; Manufacturers Hanover Trust
Co.; U. of Michigan; The Miller Co.;
Montclair/AM; NCFA; NYU; U. of Ne-
braska; New London; U. of New Mexico;
New Paltz/SUNY; Norfolk/Chrysler; U. of
North Carolina; Oklahoma; PMA; Phil-
lips; RISD; Raleigh/NCMA; Ridgefield/Al-
drich; Rock River (Wyo.) High School;
SFMA; SRGM; Slater; Sweden/Goteborgs;
U. of Texas; Union Carbide Corp.; Utica:
U. of Vermont; WMAA; Walker; U. of
Wyoming; Yale U. **Bibliography:**
Armstrong, Thomas; *Black and White Are
Colors;* Blanchard; **Breeskin 2;** Brown 2;
From Foreign Shores; Goodrich and Baur 1;
Lane and Larsen; MacAgy 2; Marter,
Tarbell, and Wechsler; Rickey; Rose, B., 1.
Archives.

BONEVARDI, MARCELO
b. May 13, 1929, Buenos Aires, Argentina.
Studied: U. of Cordoba, 1948-51. Trav-
eled Italy, USA. To USA, 1958. **Taught:**
National U. of Cordoba, 1956. **Awards:**
Salon Annual de Santa Fe, P.P., 1956; Pre-
mio de Honor J. Pellanda, Cordoba, 1957;
XXXVI Salon Annual de Rosario, P.P.,
1957; Salon Ministerio de Obras Publicas
de la Nacion, Buenos Aires, First Prize,
1957; Guggenheim Foundation Fellow-
ship, 1958; New School for Social Re-
search Fellowship, 1963, 64; X São Paulo
Biennial, International Award, 1969.
Address: 799 Greenwich Street, NYC
10014. **Dealer:** Mary-Anne Martin/Fine
Art, NYC. **One-man Exhibitions:** Museo
Dr. Genario Perez, Cordoba, 1956;
Galeria 0. Rosario, 1956; Galeria Anti-

gona, Buenos Aires, 1957; Amigos del
Arte, Rosario, 1958; Radio Nacional de
Cordoba, 1958; Gallery 4, Detroit, 1959;
Roland de Anelle, NYC, 1960; Latow Gal-
lery, NYC, 1961; Galeria Bonino Ltd.,
NYC, 1965, 67, 69, 73, 78; J. L. Hudson
Art Gallery, Detroit, 1966; Arts Club of
Chicago, 1968; Galeria Bonino Ltd., Bue-
nos Aires, 1969, 70, 76; Museo Emilio A.
Caraffa, Cordoba, Argentina, 1969, 78,
88; Quebec, 1974; Montreal/Con-
temporain, 1974; Galeria Pecanins, Mex-
ico City, 1974; Galeria Ponce, Mexico
City, 1978, 80; Galeria Sandiego, Bogota,
Colombia, 1979; The Art Contact Gallery,
1979; Galeria del Retiro, Buenos Aires,
1979, 81, 82, 83; Promocion de Las Artes,
Monterrey, 1980; Galeria Jaime Conci,
Cordoba, Argentina, 1981; Museo Hara,
Tokyo, 1982; Centro de Arte Con-
temporaneo, Cordoba, Argentina, 1988;
Museo J. B. Castagnino, Rosario, Argen-
tina, 1988; Mary-Anne Martin/Fine Art,
NYC, 1989. **Retrospectives:** Center for
Inter-American Relations, NYC, 1980;
Mexico City/Moderno, 1981. **Group:** Bir-
mingham, Ala./MA, Pan American Art,
1960; Riverside Museum, NYC, 30 Latin
American Artists, 1960; ICA, Washington,
D.C., Latin American Painters, 1964; U.
of Illinois, 1965; Indianapolis, 1966;
SRGM, The Emergent Decade, 1966; Cor-
nell U., Latin American Art—Eight Argen-
tines, 1966; Finch College, NYC, Art in
Progress, 1967; PAFA, Latin American
Art, 1967; São Paulo Biennial, 1969; New
School, American Drawings of the Sixties,
1969; ICI, Latin American Paintings and
Drawings from the Collection of Barbara
and John Duncan, circ., 1971; U. of
Texas, 12 Latin American Artists Today,
1975; IEF, Recent Latin American Draw-
ings: Lines of Vision, circ., 1977; Venice,
Biennale, 1986; Bronx Museum, The
Latin American Spirit, 1988. **Collections:**
Atlantic Richfield Co.; Baltimore/MA;
Brooklyn Museum; Buenos Aires/Mod-
erno; Buffalo/Albright; Caracas; Centro
Artistico de Barranquilla; Chase

Manhattan Bank; Ciba-Geigy Corp.; MIT;
MOMA; Montreal/Contemporain; Museo
de Arte Contemporaneo R. Tamayo;
Museo Dr. Genaro Perez; Museo Emilio
A. Caraffa; Museo Juan B. Castagnino;
NYU; Owens-Corning Fiberglas Corp.;
PMA; Quimica Argentina; RISD; Ridge-
field/Aldrich; SRGM; Southern Illinois U.;
São Paulo/Contemporary; St. Jose Miner-
als Corp., NYC; Tel Aviv; U. of Texas;
J. Walter Thompson Co.; Vassar College.

BONTECOU, LEE b. January 15,
1931, Providence, R.I. **Studied:** Bradford
Junior College, with Robert Wade; ASL,
1952-55, with William Zorach, John
Hovannes. Traveled Europe. **Taught:**
Brooklyn College, 1971-75. **Commis-
sions:** New York State Theater, Lincoln
Center for the Performing Arts, NYC.
Awards: Fulbright Fellowship (Rome),
1957, 58; L. C. Tiffany Grant, 1959; Cor-
coran, 1963. **Address:** c/o Dealer. **Dealer:**
Leo Castelli Inc., NYC. **One-man Exhibi-
tions:** (first) "G" Gallery, NYC, 1959; Leo
Castelli, Inc., NYC, 1960, 62, 66, 71;
Ileana Sonnabend Gallery, Paris, 1965;
Leverkusen, 1969; Rotterdam, 1968;
Kunstverein, Berlin, 1968; Chicago/Con-
temporary, 1972; Wesleyan U., 1975;
Halper Gallery, Palm Beach, Fla., 1976;
Skidmore College, 1977. **Retrospective:**
Rotterdam, 1958. **Group:** Festival of Two
Worlds, Spoleto, 1958; Martha Jackson
Gallery, New Media—New Forms I & II,
1960, 61; WMAA Annuals, 1961, 63, 64,
66; Carnegie, 1961, 67; MOMA, The Art
of Assemblage, circ., 1961; VI São Paulo
Biennial, 1961; Seattle World's Fair, 1962;
Chicago/AI, 1962, 63, Sculpture—A Gen-
eration of Innovation, 1967; Corcoran,
1963; MOMA, Americans 1963, circ.,
1963-64; Buffalo/Albright, Mixed Media
and Pop Art, 1963; Kassel, Documenta III,
1964; Brandeis U., Recent American
Drawings, 1964; Jewish Museum, Recent
American Sculpture, 1964; U. of Texas,
Drawings and . . . , 1966; Flint/Institute, I
Flint Invitational, 1966; MOMA, The

1960s, 1967; WMAA Sculpture Annual,
1968; Denver/AM, Report on the Sixties,
1969; Fondation Maeght, L'Art Vivant,
1970; Carnegie, 1970; U. of North Caro-
lina, Works on Paper, 1971; Yale U.,
American Drawing: 1970-1973, 1973; San
Antonio/McNay, American Artists, 76,
1976; MMA, Contemporary American
Prints, 1976; Corcoran, The Liberation:
14 American Artists, 1977; Dayton/AI,
Skin, 1977; Albright College, Perspective
78: Works by Women, 1978; Zu-
rich/Kunsthaus, Reliefs, 1980; Hous-
ton/Contemporary, The Americans: The
Collage, 1982. **Collections:** Akron/AI;
Amsterdam/Stedelijk; Basel; Buffalo/Al-
bright; Carnegie; Chase Manhattan Bank;
Chicago/AI; Cleveland/MA; Corcoran;
Cornell U.; Dallas/MFA; Hirshhorn;
Houston/MFA; Little Rock/MFA;
MOMA; PAFA; The Singer Company,
Inc.; Smith College; SRGM; Stock-
holm/National; VMFA; WGMA; WMAA;
Walker; Yale U. **Bibliography:** Battcock,
ed.; Hunter, ed.; Janis and Blesh 1; Licht,
F.; *Metro;* Phillips, Lisa 2; Rose, B., 1;
Seitz 4; Trier 1; Weller; Honisch and
Jensen, eds.; Johnson, Ellen H.; Toher, ed.

BOOTHE, POWER b. March 12,
1945, Dallas, Texas. **Studied:** California
College of Arts and Crafts, 1963-64, with
Ralph Borge; Colorado College, 1963-67,
with B. Arnest, B.A. WMAA Independent
Study Program, 1967-68, with Gary
Bower; San Francisco Art Institute, 1962,
with Julius Wasserstein. Active as a set de-
signer, filmmaker, stage director. **Taught:**
School of Visual Arts, 1979-88; Princeton
U., 1988-92; traveled Western USA, Eu-
rope, Japan, Greece. **Awards:** Colorado
College, Hon. DFA, 1989; National En-
dowment for the Arts, Grant, 1975, 83;
NY State Council on the Arts, Grant,
1982, 90; Massachusetts Arts Council,
1984; Guggenheim Foundation Fellow-
ship, 1985; Pollock-Krasner Foundation
Grant, 1989. **Address:** 49 Crosby Street,
NYC 10012. **Dealer:** Robert Morrison

Gallery, NYC. **One-man Exhibitions:** (first) A.M. Sachs Gallery, NYC, 1973, 74, 76, 78, 81, 82, 85; Dance Theatre Workshop Gallery, 1982, 91; Climenhaga Fine Arts Center, Grantham, Pa., 1983; ICA, Boston, 1984; Ohio Wesleyan U., 1986; Souyun Yi Gallery, NYC, 1987, 89; PMW Gallery, Stamford, Ct., 1988; Hurlbutt Gallery, Greenwich, Ct., 1988; The Harrison Gallery, Boca Raton, Fla., 1989; Time-Life Building, NYC, 1990; Skidmore College (two-man), 1990. **Group:** SRGM, Ten Young Artists, 1971; SRGM, Art of this Decade, 1974; ICA/Boston, Painting Endures, 1975; Buffalo/Albright, Book-Objects by Contemporary Artists, 1977; Los Angeles/County MA, Private Images, 1977; The Kitchen, NYC, New Film Works, 1986; Colorado Springs/FA, Twenty Summers Past, 1987; ICA, U. of Pennsylvania, Interactions, 1991. **Collections:** Chase Manhattan Bank; Colorado College; Hirshhorn; U. of North Carolina; Philip Morris Collection; Shearson Lehman Brothers, Inc.; Sony Corp.; Stanford U.; Trenton/State.

BOROFSKY, JONATHAN
b. 1942, Boston, Mass. **Studied:** Carnegie-Mellon U., 1964, BFA; École de Fontainbleau, 1964; Yale U., 1966, MFA. **Taught:** School of Visual Arts, NYC, 1969-70; California Institute of the Arts, 1977-80. **Commissions:** Swiss Bank Corp., Basel; Messe Turm, Frankfurt; California Mart, Los Angeles; US Federal Building, Los Angeles; General Mills Corp., Minneapolis; Seattle Art Museum. **Address:** c/o Dealer. **Dealer:** Paula Cooper Gallery, NYC. **One-man Exhibitions:** Paula Cooper Gallery, 1975, 76, 79, 80, 82, 83; Hartford/Wadsworth, 1976; U. of California, Irvine, 1976; Protetch-McIntosh Gallery, Washington, D.C., 1978; Thomas Lewallen Gallery, Los Angeles, 1978; U. of California, Berkeley, 1978; Corps de Garde, Groningen, 1978; MOMA, 1978; InK Gallery, Zurich, 1979; Portland (Ore.) Center for the Visual Arts,

Jonathan Borofsky, *Molecule Men 1 + 1 + 1,* 1991.

1979; MIT, 1980; Houston/Contemporary, 1981; Galerie Rudolf Zwirner, Cologne, 1981; Basel/Kunsthalle, 1981; ICA, London, 1981; Rotterdam, 1982; Gemini G.E.L., Los Angeles, 1982, 85, 86, 89, 90; Friedrich Gallery, Bern, 1982; Basel/Kunstmuseum, 1983; Galleria dell'Arte Graffica, Milan, 1983; Akron/AM, 1983; U. of Miami, 1984; Humlebaek/Louisiana, 1984; Carl Solway Gallery, Cincinnati, 1984; Kunsthalle Bielefeld, 1984; Seattle/AM, 1984; Frankfurt am Main, 1984; St. Louis/City, 1896; Harvard U., 1986; Milwaukee Art Center, circ., 1986; Galerie Yvon Lambert, Paris, 1987, 90; Galerie Albrecht, Munich, 1988, 91; Kansas City/Nelson, 1988; Glenndash Gallery, Los Angeles, 1990; Galerie La Máquina Espanola, Madrid, 1991; Portikus Museum, Frankfurt, 1991; Dartmouth College, 1991; Greg Kucera Gallery, Seattle, 1991; Gemini G.E.L., at Jonie Moisant Weyl, NYC, 1991. **Retrospective:** PMA, circ., 1984. **Group:** Seattle/AM, 557, 087, 1970; Akademie der Kunst, Berlin, SoHo, 1976; U. of California, Santa Barbara, Contemporary Drawing/New York, 1978; WMAA Biennials, 1979, 81, 83;

Lenbachhaus, Munich, Tendencies in American Drawings of the Late Seventies, 1979; XXXIX Venice Biennial, 1980; Indianapolis, 1980, 82; Cologne/Stadt, Westkunst, 1981; Paris/Moderne, Baroques '81, 1981; Akron/AM, The Image in American Painting and Sculpture, 1950-1980, 1981; Paris/Beaubourg, Murs, 1981; Walker, Eight Artists: The Anxious Edge, 1982; Kassel, Documenta VII, 1982; Internationale Kunstausstellung, Berlin, 1982; Galeria Politi, Milan, Transavangarde International, 1982; Hannover/K-G, New York Now, circ., 1982; Hirshhorn, Directions, 1983; Bonn, Back to the USA, circ., 1983; Tate Gallery, New Art, 1983; SFMA, The Human Condition, 1984; MOMA, International Survey of Recent Painting and Sculpture, 1984; Hirshhorn, Content: A Contemporary Focus, 1974-1984, 1984; Cincinnati/Contemporary, Body and Soul, circ., 1985; Carnegie, International, 1985; XVIII São Paulo Biennial, 1985; Fort Lauderdale, An American Renaissance: Painting and Sculpture Since 1940, 1986; Corcoran, The Generic Figure, 1986; Indianapolis, 1986; Kunstverein, Frankfurt, Prospect '86, 1986; U. of North Carolina, Art on Paper, 1986; Cranbrook, Viewpoint '86, 1986; ICA, London, State of the Art, 1987; MOMA, BERLINART, 1961-1987, 1987; Paris/Beaubourg, L'Époque, La Mode, La Moreale, La Passion: Aspects de l'art d'auhourd'hui, 1977-1987, 1989; MOMA, Committed to Print, 1988; PMA, New Art on Paper, 1988; WMAA, 20th Century Drawings from the Whitney Museum, circ., 1988; WMAA, Immaterial Objects, circ., 1989; AAIAL, 1989; U. of Florida, Gainsville, Divergent Styles: Contemporary American Drawings, 1990; Milwaukee, Word as Image, circ., 1990; Martin-Gropius Bau, Berlin, Metropolis, 1991; Oakland, De-Persona, 1991; ICA, U. of Pennsylvania, Devil on the Stairs, 1991; MOMA, Allegories of Modernism, 1992. **Collections:** Aachen/Ludwig; Basel/Kunsthalle; Broida Foundation, Los Angeles; U. of California, Berkeley; Canberra/National; Carnegie; Dallas/MFA; First Bank of Minneapolis; Hartford/Wadsworth; Little Rock/MFA; Los Angeles/County MA; Los Angeles/MOCA; MOMA; Milwaukee; Minneapolis/Institute; Montreal/MFA; Nagoya; Newport Harbor; Oberlin College; Osaka/National; PMA; Rotterdam; Shiga; Tate Gallery; Tokyo/Hara; Toledo/MA; WMAA; Walker; Frederick Weisman Foundation, Los Angeles; Zurich. **Bibliography:** *Back to the USA;* Cummings 5; Danto; *Europa/Amerika;* Fox; Haenlein; Hiromoto; Joachimides and Rosenthal; *Jonathan Borofsky: Dreams 1973-1981;* Kren; Murken-Altrogge; Plagens; Robins; Rose, Bernice, 1; Rosenthal and Marshall; Stearns; Storr and Tannenbaum; Tomidy.

BOSA, LOUIS
from 1st to 5th edition.

BOSMAN, RICHARD b. 1944,
Madras, India. **Studied:** The Byam Shaw School of Painting and Drawing, London, 1964-69; New York Studio School, 1969-71; Skowhegan School, 1970. To USA, 1969. **Address:** 6 Varick Street, NYC 10013. **Dealer:** Brooke Alexander Gallery, NYC. **One-man Exhibitions:** Brooke Alexander Gallery, NYC, 1980, 81, 82, 83, 84, 86, 89, 90, 91; Cirrus Gallery, Los Angeles, 1982; Thomas Segal Gallery, Boston, 1982; Dart Gallery, Chicago, 1982, 84, 87; Fort Worth, 1982; Reconnaissance, Melbourne, 1983; The Mayor Gallery, London, 1983; Blond Fine Art, London, 1985; Asher/Faure Gallery, Los Angeles, 1985, 88; Galerie Toselli, Milan, 1986; John Berggruen Gallery, San Francisco, 1986, 90; Sala Parpallo, Valencia, 1987; Contor Lemberg Gallery, Birmingham, Mi., 1987; Roger Ramsay Gallery, Chicago, 1988; Gloria Luria Gallery, Bay Harbor Islands, Fla., 1988; Galeria Temple, Valencia, Spain, 1988; Flanders Contemporary Art, Minneapolis, 1988; Joy Emery Gallery, Grosse Pointe Farms,

Mich., 1988; Galerie Lucien Bilinelli, Brussels, 1988; U. of California, San Diego, 1989; The Seibu Museum of Art, Tokyo, 1989; Galeria La Máquina Espanola, Madrid, 1990; Galerie Biedermann, Munich, 1991. **Retrospective:** U. of Wisconsin, Madison, circ., 1989. **Group:** MIT, Body Language, 1981; WMAA, Black Prints, 1982; WMAA, Focus on the Figure, 1982; Chicago/AI, 74th American, 1982; Indianapolis, Annual, 1982; ICA, U. of Pennsylvania, The Image Scavengers, 1982; Hannover/K-G, New York Now, 1982; MOMA, Prints from Blocks: Gauguin to Now, 1983; Brooklyn Museum, 23rd National, 1983; Lucerne, Back to the USA, 1983; Walker, Images and Impressions: Painters who Print, circ., 1984; SFMA, The Human Condition, 1984; Venice Biennial, 1983; MOMA, International Survey of Contemporary Painting and Sculpture, 1984; Fort Lauderdale, American Renaissance: Painting and Sculpture since 1940, 1986; Indianapolis, Painting and Sculpture Today, 1986; Brooklyn Museum, Public and Private: American Prints Today, circ., 1986; Massachusetts College of Art, Boston, The Drawing Show, 1988; Walker, First Impressions, 1989; AAIAL, Annual, 1991. **Collections:** Baltimore; Bibliothèque Nationale; Brooklyn Museum; Buffalo/Albright; Canberra/National; Carnegie; U. of Chicago; Des Moines; Detroit; Harvard U.; Indianapolis; Library of Congress; MMA; MOMA; Memphis/Brooks; Mexico City/Tamayo; Milwaukee; U. of North Carolina; PMA; U. of Texas; Toledo/MA; WMAA; Walker; Wesleyan U.; Yale U.

BOTKIN, HENRY
from 1st to 4th edition.

BOUCHE, LOUIS
from 1st to 4th edition.

BOURGEOIS, LOUISE **b.** December 25, 1911, Paris, France. **Studied:** Lycée Fenelon, 1932, baccalaureate; Sorbonne, 1932-35; École du Louvre, 1936-37; Academie des Beaux-Arts, Paris, 1936-38; Atelier Bissiere, Paris, 1936-37; Academie de la Grande Chaumiere, 1937-38; Academie Julian, Paris, 1938; Atelier Fernand Leger, Paris, 1938. Traveled Europe extensively. To USA, 1938. **Taught:** Docent at the Louvre, 1937-38; Academie de la Grande Chaumiere, 1937, 38; Great Neck (N.Y.) Public Schools, 1960; Brooklyn College, 1963, 68; Pratt Institute, 1965-67. **Awards:** Hon. DFA, Yale U., 1977; Hon. DFA, Bard College, 1981; Hon. DFA, Maryland Institute School, 1984; Officier des Arts et Lettres, France, 1984; Skowhegan School, Medal for Sculpture, 1985; Hon. DFA, The New School for Social Research, 1987; National Arts Club, NYC, Gold Medal, 1987; MMA, Fellow for Life, 1987; Brandeis U., Creative Arts Award for Sculpture, 1989; College Art Association, Distinguished Artists Award for Lifetime Achievement, 1989; Snug Harbor, Staten Island, N.Y., Neptune Award for the Arts, 1989; MacDowell Colony, MacDowell Medalist, 1990; Sculpture Center, NYC, Award for Distinction in Sculpture, 1990; International Sculpture Center, Washington, D.C., Lifetime Achievement Award, 1991; France, Grand Prix National de Sculpture, 1991. **Member:** AAIAL; American Academy of Arts and Sciences, 1981. **Address:** 347 West 20th Street, NYC. **Dealer:** Robert Miller Gallery, NYC. **One-man Exhibitions:** The Bertha Schaefer Gallery, NYC, 1945; Norlyst Gallery, NYC, 1947; The Peridot Gallery, NYC, 1949, 50, 53; Allan Frumkin Gallery, Chicago, 1953; Cornell U., 1959; The Stable Gallery, NYC, 1964; Rose Fried Gallery, NYC, 1964; 112 Greene Street, NYC, 1974; Xavier Fourcade, Inc., NYC, 1978, 79, 80; Hamilton Gallery of Contemporary Art, NYC, 1978; U. of California, 1979; Max Hutchinson Gallery, NYC, 1980; U. of Chicago, 1981; Robert Miller Gallery, NYC, 1982, 84, 86, 87, 88, 89, 91; Daniel Weinberg Gallery, Los Angeles, 1984; Daniel Weinberg Gal-

lery, San Francisco, 1984; Serpentine Gallery, London, 1985; Galerie Maeght, Zurich, 1985; Galerie Maeght, Paris, 1985; Texas Gallery, Houston, 1986; Yares Gallery, Scottsdale, Ariz., 1987; Florida International U., 1987; Janet Steinberg Gallery, San Francisco, 1987; Cincinnati/Taft, circ., 1987; Laguna Gloria, Austin, 1988; Museum Overholland, Amsterdam, 1988; Galerie LeLong, 1989; Zurich, 1989, 91; Rhona Hoffman Gallery, Chicago, 1989; Dia Art Foundation, Bridgehampton, N.Y., 1989; York U., Ontario, 1989; Linda Cathcart Gallery, Santa Monica, Calif., 1990; Barbara Gross Galerie, Munich, 1990; Karsten Schubert, Ltd., London, 1990; Galerie Krinzinger, Vienna, 1990; Ginny Williams Gallery, Denver, 1990; Karsten Greve Gallery, Cologne, 1990; Monika Sprüth Galerie, Cologne, 1990; Ydessa Hendeles Art Foundation, Toronto, 1991. **Retrospective:** MOMA, circ., 1982; Kunstverein, Frankfurt, circ., 1989. **Group:** MOMA, 1943, 49, 51, 62; MMA, 1943; SFMA, 1944; Los Angeles/County MA, 1945; U. of Rochester, 1945; Brooklyn Museum, 1945; WMAA, 1945, 46, 53, 55, 57, 60, 62, 63, 68, 70, 72; Walker, 1954; U. of Illinois, 1957; Dallas/MFA, 1960; Galerie Claude Bernard, Paris, 1960; Salon de la Jeune Sculpture, Paris, 1965, 69; RISD, 1966; International Sculpture Biennial, Carrara, Italy, 1969; Baltimore/MA, 1969; MOMA, The New American Painting and Sculpture, 1969; Foundation Maeght, 1970; Lakeview Center, American Women: 20th Century, 1972; Storm King Art Center, The Emerging Real, 1973; PMA/Museum of the Philadelphia Civic Center, Focus, 1974; WMAA, 200 Years of American Sculpture, 1976; New Orleans Museum Sculpture: American Directions, 1976; Brandeis U., From Women's Eyes, 1977; Albright College, Perspective '78, 1978; Purchase/SUNY, Hidden Desires, 1980; WMAA, Decade of Transition, 1940-1950, 1981; Rice U., Variants, circ., 1981; SFMA, 20 American Artists: Sculp-

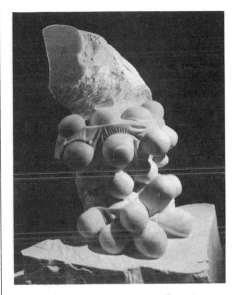

Louise Bourgeois, *Blind Man's Buff,* 1984.

ture 1982, 1982; WMAA Biennial, 1983, 86; AAIAL, 1983; Hirshhorn, Content: A Contemporary Focus, 1974-84, 1984; WMAA, The Third Dimension, 1984; MOMA, Primitivism in 20th Century Art, 1984; Sonoma State U., Works in Bronze, A Modern Survey, circ., 1984; Fort Lauderdale, An American Renaissance: Painting and Sculpture Since 1940, 1986; Cincinnati/Contemporary, Body and Soul, 1985; U. of North Carolina, Art on Paper, 1985; Fort Lauderdale, An American Renaissance, 1985; Zurich/Kunsthaus, Spuren, Skulpturen, und Monument, 1985; Lucerne, L'État des Choses I., 1986; Lausanne/Musée Cantonal des Beaux-Arts, La Femme et le Surrealisme, 1986; Kansas City/AI, Drawn Out, 1986; WMAA, Figure as Subject, circ., 1988; Paris/Beaubourg, Magiciens de la Terre, 1989; Kunstverein, Frankfurt, Prospect '89, 1989; Cincinnati/AM, Making Their Mark, 1970-85, circ., 1989; Las Palmas de Gran Canaria, El Surrealismo entre Viejo, y Nuevo Mundo, circ., 1989; U. of Wisconsin, Milwaukee, The Matter at Hand, 1990; Hofstra U., Coming of Age, 1990; Boston/MFA, Figuring the Body, 1990;

Cornell U., Black and White: Works on Paper, 1990; Bunkamura Museum, Tokyo, Four Centuries of Women's Art, circ., 1990; Monte Carlo, IIIème Biennale de Sculpture, 1991; Carnegie, Carnegie International, 1991; Fundacio Caixa de Pensiones, Barcelona, Pulsio, 1991; MOMA, Art of the Forties, 1991; Fondation Daniel Templon, Frejus, Contemporary Sculpture after 1970, 1991; Cologne/Ludwig, Die Hand des Kunstlers, 1991; MOMA, Dislocations, 1991; ICA, U. of Pennsylvania, Devil on the Stairs, circ., 1991; Hudson River Museum, Experiencing Sculpture, 1991; Kassel, Documenta, 1992. **Collections:** Buffalo/Albright; British Museum; Calcutta; Canberra/National; Ciba-Geigy Corp.; Denver/AM; Des Moines; Detroit/Institute; Graphische Sammlung Albertina; Harvard U.; MMA; MOMA; NYPL; NYU; U. of Nebraska; New Orleans Museum; Olympic Park, Seoul; PMA; Paris/Moderne; Portland, Me./AM; RISD; SRGM; Storm King Art Center; Ulmer Museum; WMAA; Walker. **Bibliography:** Baur 5; Giedion-Welcker 1; Gohr and Gachnang; Goodrich and Baur 1; Hughes; *Individuals;* Lippard 3; Miller and Swenson; Motherwell and Reinhardt, eds.; Robins; Rosen 1; Sandler 3; Seuphor 3; Storr and Tannenbaum; Trier 1. Archives.

BOWMAN, GEOFFREY
from 1st to 4th edition.

BOWMAN, RICHARD b. March 15, 1918, Rockford, Ill. **Studied:** Chicago Art Institute School, 1938-42, BFA; State U. of Iowa, 1947-49, MFA. Traveled Mexico, USA. **Taught:** Chicago Art Institute School, 1944-47, including summer school, 1944, 45; North Park College, 1944-46; State U. of Iowa, 1947-49; Stanford U., 1949-50, 57, 58, 63; U. of Manitoba, 1950-54; Washburn-White Art Center, Palo Alto, Calif., 1954. **Awards:** Chicago/AI, Scholarship, 1939-41; Rockford/Burpee Annual, First Prize, 1940; Edward L. Reyerson Traveling Fellowship,

1942; Chicago/AI, William R. French Memorial Gold Medal, 1945; Iowa State Fair, Second Prize, 1948; Montreal/MFA Annual, 1952; Oakland/AM, Hon. Men., 1955. **Address:** 178 Springdale Way, Redwood City, CA 94062. **One-man Exhibitions:** Beloit College, 1941; Rockford/Burpee, 1941, 47; Ras-Martin Gallery, Mexico City, 1943; The Pinacotheca, NYC, 1945; Chicago/AI, 1945; Milwaukee, 1946; U. of Illinois, 1946 (two-man, with Joan Mitchell), 1947; The Swetzoff Gallery, Boston, 1949; Pen and Palette Gallery, St. Louis, 1949; Contemporary Gallery, Sausalito, Calif., 1949, 50; Stanford U., 1950, 56; Bordelon Gallery, Chicago, 1950; Kelly Gallery, Vancouver, B.C., 1954; The Rose Rabow Gallery, San Francisco, 1959, 61, 64, 68, 70, 72, 74; SFMA, 1959 (two-man, with Gordon Onslow-Ford), 1951, 70; Harcourts Gallery, San Francisco, 1986. **Retrospectives:** Stanford U., 1956; Washington State U., circ., 1957; SFMA, 1961; Roswell, 1972. **Group:** Chicago/AI, 1940, 44, 45; SFMA, 1941, 49, 50, 55, 60; Cincinnati/AM, 1941; Art of this Century, NYC, 1945; Chicago/AI, Abstract and Surrealist Art, 1948; Chicago/AI, Exhibition Momentum, 1948; Omaha/Joslyn, 1948, 49; Iowa State Fair, 1948; Philadelphia Print Club Annual, 1949; Walker, 1949; Brooklyn Museum, 1949; Canadian Society of Graphic Art Annual, Toronto, 1952; Ottawa/National, Canadian Painters 1953, 1953; Il São Paulo Biennial, 1953; Royal Ontario Museum, 1954; Oakland/AM, 1955; Stanford U., 50 Contemporary American Painters, 1956; SFMA, After Surrealism, circ., 1959; USIA, Contemporary American Prints, circ., Latin America, 1959-60; California Palace, 1960, 61, 62, 63, 64; Carnegie, 1961, 64; WMAA, Fifty California Artists, 1962-63; Stanford U., Some Points of View for '62, 1962; A.F.A., circ., 1966-68. **Collections:** de Young; New Britain/American; Oakland/AM; SFMA; Santa Barbara/MA; U. of Texas.

BOXER, STANLEY b. June 26, 1926, New York City. **Studied:** Brooklyn College; Art Students League. US Navy, 1943-46. Traveled England, Germany, Canada. Designed and built set for Eric Hawkins Dance Company, *Classic Kite Tails*, 1972. **Awards:** Guggenheim Foundation Fellowship, 1975. **Address:** 37 East 18th Street, NYC 10003. **Dealer:** André Emmerich Gallery, NYC. **One-man Exhibitions:** (first) Perdalma Gallery, NYC, 1953, 54, 55, 56; Grand Central Galleries, NYC, 1965, 66, 67; Fischbach Gallery, NYC, 1966; Rose Fried Gallery, NYC, 1967, 68, 69; U. of Manitoba, 1967; NYU, 1968; Tibor de Nagy, NYC, 1971, 72, 73, 74, 75, 77, 82; Santa Barbara/MA, 1972; San Antonio/McNay, 1973; Watson/De Nagy Gallery, Houston, 1974, 76, 78; Galerie André Emmerich, Zurich, 1975; Syracuse/Everson, 1975; André Emmerich Gallery, NYC, 1975, 76, 77, 78, 79, 80, 81, 82, 83, 84, 85, 86; PAFA, 1976; Richard Gray, Chicago, 1977, 79; Boston/MFA, 1977; Max Protetch Gallery, Washington, D.C., 1977; Hokin Gallery, Palm Beach, Fla., 1978, 85; Galerie Wentzel, Hamburg, 1975, 78, 80; Meredith Long Gallery, Houston, 1979, 80; Galerie Regards, Paris, 1979, 80; Dorsky Gallery, NYC, 1980; Thomas Segal Gallery, Boston, 1980, 82, 84; Allrich Gallery, San Francisco, 1981; Meredith Long & Co., Houston, 1981, 83, 84, 85, 86; Hokin Gallery, Bay Harbor Island, Fla., 1980; Gallery One, Toronto, 1980, 82; Downstairs Gallery, Edmonton, 1981; Hokin Gallery, Chicago, 1982; Galerie Wentzel, Cologne, 1982, 85; Galerie von Braunbehrens, Munich, 1982; Amerika Haus, Berlin, 1982; Gallery Ulysses, Vienna, 1983; Aronson Gallery, Atlanta, 1983, 84, 85; Ivory Kimpton Gallery, San Francisco, 1983, 85; Salander-O'Reilly Gallery, NYC, 1983; Hokin/Kaufman Gallery, Chicago, 1984, 86; Woltjen/Udell Gallery, Edmonton, 1984; Thomas Smith Fine Arts, Fort Wayne, 1984; Ruth Bachofner Gallery, Los Angeles, 1985. **Retrospective:** U. of North Carolina, circ., 1978. **Group:** Syracuse/Everson, New Works in Clay, 1976; U. of Saskatchewan, Boxer, Natkin, Ferber, 1977; Indianapolis, 1978; Grand Palais, Paris, L'Amerique aux Indépendants, 1980; Belgrade/National, Works on Paper, 1981; Baruch College, Figural Art of the New York School, 1985. **Collections:** Ball State U.; Boston/MFA; Brandeis U.; Calcutta; Charlotte/State; Chase Manhattan Bank, Corcoran; Cornell U.; WMAA; Charlotte/Mint; Buffalo/Albright; Dayton/AI; Des Moines; Edmonton; Hirshhorn; Houston/MFA; IBM; U. of Massachusetts; NYC; Prudential Insurance Co. of America; MOMA; Milwaukee; SRGM; Santa Barbara/MA; U. of Sydney; Syracuse/Everson; Trenton/State; Vienna/Moderner; Walker; Wichita/AM.

BOYCE, RICHARD
from 1st to 5th edition.

BOYLE, KEITH b. February 15, 1930, Defiance, Ohio. **Studied:** State U. of Iowa, with James Lechay, BFA; Ringling School of Art, with Fred Sweet, Andrew Sanders. Traveled Europe; resided Rome. **Taught:** Lake Forest College, 1956; Barat College, 1957, 59; Sacramento State College, 1960; Stanford U., 1962-88. **Commissions:** St. Thomas Episcopal Church, Sunnyvale, Calif. **Awards:** State of Iowa, Department of Education, P.P., 1952; Indiana (Pa.) State Teachers College, 1953; Springfield, Mo./AM, 1955; The Pennsylvania State U., 1955; Chicago/AI, The Mr. & Mrs. Frank G. Logan Medal ($1,500), 1958; California Palace, Patrons of Art and Music Award, 1964; National Endowment for the Arts, 1981. **Address:** 6285 Thompson Creek Rd., Applegate, OR 97530. **One-man Exhibitions:** (first) Feingarten Gallery, Chicago, 1958, also 1959; Feingarten Gallery, San Francisco, 1960; Triangle Art Gallery, 1960; The Lanyon Gallery, 1963; de Young, 1964; SFMA, 1964; Stanford U.,

1964, 67, 77; Hollis Gallery, San Francisco, 1967; Hansen-Fuller Gallery, 1968; Smith Andersen Gallery, Palo Alto, 1971, 72, 77; St. Mary's College, Moraga, Calif., 1972; Linda Farris Gallery, Seattle, 1973; Martha Jackson Gallery, 1974; San Jose Museum of Art, 1978; Smith Andersen Gallery, San Francisco, 1975; Pepperdine U., 1982; Stanford U., 1984. **Retrospectives:** Stanford U., 1977; San Jose Museum of Art, 1978. **Group:** Springfield, Mo./AM, 1952-55; Des Moines, 1953; Denver/AM, 1953; Walker, 1954; Washburn U. of Topeka, 1955; Younstown/Butler, 1955, 56, 58; Omaha/Joslyn, 1956; Chicago/AI, 1957-60; Ravinia Festival, Highland Park, Ill., 1957; Chicago/AI, 53 Chicago Artists, circ., France and Germany, 1957; PAFA, 1958, 60, 62; Buffalo/Albright, 1960; SFMA, 1960, 62, 64; California Palace, 1964, Painters Behind Painters, 1967; U. of Michigan, 1965; SFMA, The Colorists, 1965; M. Knoedler & Co., NYC, Art Across America, circ., 1965-67; California Palace, A Century of California Painting, 1970; Omaha/Joslyn, Looking West, 1970; Smithsonian, New American Monotypes, circ., 1978-80. **Collections:** Barat College; Dartmouth College; Indiana (Pa.) State Teachers College; U. of Iowa; Mead Corporation; NCFA; Oakland/AM; The Pennsylvania State U.; Purchase/SUNY; SFMA; Springfield, Mo./AM; Stanford U.; State of Iowa.

BOYNTON, JAMES W. b. January 12, 1928, Fort Worth, Tex. **Studied:** Texas Christian U., BFA, MFA. **Taught:** U. of Houston, 1955-57; San Francisco Art Institute, 1960-62; U. of New Mexico, 1963; Houston Museum School, 1968-69; Northwood Institute, Dallas, 1968-69; U. of St. Thomas (Tex.), 1969-70. **Awards:** Fort Worth, P.P., 1951, 52, 54, 55; Texas Watercolor Society, First P.P., 1951, 1953-55; Denver/AM, P.P., 1952, 54, 58; Texas State Fair, P.P., 1953; Houston/MFA, P.P., 1955; Underwood-Neuhaus Corp., 1957; Youngstown/Butler, 1957; ART: USA: 59, NYC, Hon. Men., 1959; SFMA, First Prize, 1962; Longview Foundation Grant, 1966; Tamarind Fellowship, 1967; Beaumont (Tex.) Art Museum, Second Prize, 1968. **Address:** 3723 Albans, Houston, TX 77005. **Dealer:** Moody Gallery, Houston, Texas. **One-man Exhibitions:** Fort Worth, 1955; La Escondida, Taos, N.M., 1956; André Emmerich Gallery, Houston, 1957; New Arts Gallery, Houston, 1957; Fairweather-Hardin Gallery, 1958; Barone Gallery, 1958; Dord Fitz Gallery, Amarillo, 1959; Bolles Gallery, San Francisco, 1959-62; Dallas Museum for Contemporary Arts, 1959; Lynchburg Art Gallery, Lynchburg, Va., 1960; Downtown Gallery, New Orleans, 1960; Haydon Calhoun Gallery, Dallas, 1960-62; Staempfli Gallery, 1961; Louisiana Gallery, Houston, 1964; David Gallery, 1966; Louise Ferrari Gallery, 1967; Chapman Kelly Gallery, 1968; Beaumont (Tex.) Art Museum, 1969; Galerie Simone Stern, New Orleans, 1970; New Orleans/Delgado, 1970; U. of St. Thomas, Tex., 1971; Du Bose Gallery, 1975; Amarillo Art Center, 1975; Loyola U., New Orleans, 1977; Moody Gallery, Houston, 1976, 77, 79; U. of Houston, Clear Lake City, 1979. **Retrospective:** Amarillo Art Center, 1980. **Group:** Fort Worth, 1950-55; WMAA, Young America, and others; Denver/AM, 1952, 54, 56, 58; Yale U.; Corcoran; Colorado Springs/FA, 1953, 54, 57; SRGM, Younger American Painters, 1954; Carnegie, 1955; Houston/MFA, 1955, Art and the Alphabet, 1978; MOMA, Recent Drawings USA, 1956; Sante Fe, N.M., 1957; Youngstown/Butler, 1957; Chicago/AI, 1957, 58; Brussels World's Fair, 1958; SFMA, After Surrealism, circ., 1959; MOMA, 1962; SFMA, 1962, 69; Hemis-Fair '68, San Antonio, Tex., 1968; WMAA Annual, 1967; MOMA, Tamarind: Homage to Lithography, 1969; SFMA, Tamarind, 1969; International Exhibitions Foundation, Washington, D.C., Tamarind: A Renaissance of Lithography, circ., 1971-72; Houston/MFA, Wood in Art,

1979. **Collections:** Austin; Brooklyn Museum; Dallas/MFA; Denver/AM; Fort Worth; Hartford/Wadsworth; Houston/Contemporary; Houston/MFA; Inland Steel Co.; La Jolla; Los Angeles/County MA; MOMA; New Orleans/Delgado; Oak Cliff Savings and Loan; PMA; Pasadena/AM; SRGM; U. of Texas; UCLA; Underwood-Neuhaus Corp; WMAA; Witte; Youngstown/Butler. **Bibliography:** MacAgy 1. Archives.

BRACH, PAUL b. March 13, 1924, NYC. **Studied:** Fieldston School, NYC; State U. of Iowa (with Philip Guston, Mauricio Lasansky), 1941-42, 1945-48, BFA, 1967-69, MFA. US Army, 1942-45. Traveled Spain, France, Italy; resided in California, 1967-75. **Taught:** U. of Missouri, 1949-51; New School for Social Research, 1952-55; Parsons School of Design, 1956-67; Cooper Union, 1960-62, 1978-80; U. of New Mexico, A.F.A. Visiting Artist, 1965; U. of Calfornia, San Diego, 1967-69; California Institute of the Arts, 1969-75; Fordham U., 1975-79, Lincoln Center Campus, 1975; Cooper Union, NYC, 1979-82; NYU, 1986-89; Empire State College, 1979-. **Awards:** Tamarind Fellowship, 1964, 80, 82. **m.** Miriam Schapiro. **Address:** 393 W. Broadway, NYC 10012; Montauk Highway, East Hampton, NY 11037. **Dealer:** Bernice Steinbaum Gallery, NYC. **One-man Exhibitions:** (first) Leo Castelli Inc., 1957, also 1959; Union College (N.Y.), 1958; Dwan Gallery, Los Angeles, 1960; Cordier and Warren, NYC, 1962; Cordier & Ekstrom Inc., 1964; U. of New Mexico, 1965; NYU, 1966; The Kornblee Gallery, NYC, 1968; André Emmerich Gallery, NYC, 1974; Cirrus Editions Ltd., Los Angeles, 1975; Benson Gallery, Bridgehampton, N.Y., 1975; Lerner-Heller Gallery, NYC, 1978, 80; Yares Gallery, Scottsdale, Ariz., 1979, 81; Janus Gallery, Venice, Calif., 1980; Janus Gallery, Los Angeles, 1980; Bernice Steinbaum Gallery, NYC, 1983, 84, 85, 86, 87, 90, 91; Elaine

Horwitch Galleries, Palm Springs, Ca.; Vered Gallery, East Hampton, N.Y. **Retrospective:** Newport Harbor and La Jolla/MA, Paul Brach and Miriam Schapiro, 1969; Mulvane Art Center, Topeka, Ks., 1985, circ. **Group:** WMAA; Chicago/AI; Corcoran; Baltimore/MA; St. Louis/City; Jewish Museum; Brandeis U., 1964; MOMA, The Responsive Eye, 1965; SFMA, 1965; Los Angeles/County MA, 1970; MOMA, Tamarind: Homage to Lithography, 1969; Newport Harbor, 1974; Hudson River Museum, New Vistas, 1984; Bronx Museum, Nightworks, 1987; Guild Hall, Avant-Garde: A Salute to the Signa Gallery, 1957-60, 1990. **Collections:** Albion College; Albuquerque Museum; U. of Arizona; Avco Corp.; Boston Bank; U. of California, San Diego; Chemical Bank, NYC; Los Angeles/County MA; MOMA; Newport Harbor; NYU; U. of Nebraska; U. of New Mexico; Nova Scotia College of Art and Design; Phoenix; St. Louis/City; Santa Fe, N.M.; Smith College; WMAA. **Bibliography:** Blesh 1; Sandler; Weller.

BRACKMAN, ROBERT
from 1st to 5th edition.

BRADY, CAROLYN b. March 22, 1937, Chickasha, Oklahoma. **Studied:** Oklahoma State U., 1955-58; U. of Oklahoma, 1958-59, BFA, 1959-61, MFA. **Taught:** U. of Missouri, 1974. **Address:** 216 Laurens Street, Baltimore, Md., 21217. **Dealer:** Nancy Hoffman Gallery, NYC. **One-man Exhibitions:** (first) Nancy Singer Gallery, St. Louis, 1974; Nancy Hoffman Gallery, NYC, 1977, 80, 83, 85, 87, 89, 91; U. of Rhode Island, 1977; U. of Missouri, Kansas City, 1978; U. of Missouri, St. Louis, 1978; San Jose Museum of Art (two-man), 1978; Pittsburgh Center for the Arts, 1980; Charlotte/Mint, 1982; Columbia, S.C./MA, 1982; Jerald Melberg Gallery, Charlotte, N.C., 1985; G. H. Dalsheimer Gallery, Baltimore; Barbara Fendrick Gallery,

Washington, D.C., 1987; Rock-
land/Farnsworth, 1987; The Harley
School, Rochester, NY, 1989. **Retrospec-
tive:** Tulsa/Philbrook, circ., 1989. **Group:**
U. of North Carolina, Art on Paper, 1975;
San Antonio/McNay, American Artists
'76: A Celebration, 1976; Akron/AI, Con-
temporary Images in Watercolor, 1976; U.
of Nebraska, Realists, 1978; Tulsa/Phil-
brook, Realism/Photorealism, 1980; Buf-
falo/Albright, Still-Life, 1981; PAFA,
Contemporary American Realism Since
1960, 1981; San Antonio/MA, Real, Re-
ally Real, Super Real, 1981; Indianapolis,
1984; SFMA, American Realism (Janss),
circ., 1985; Springfield, Me./AM, Water-
color USA, 1986; Worcester/AM, Ameri-
can Traditions in Watercolor, circ., 1987;
NAD, Realism Today, 1987; Fort
Wayne/AM, Earthly Delights, 1988; Jack-
sonville/AM, Art in Bloom, 1989; The
Pennsylvania State U., Realist Watercolors,
1990; Fort Lauderdale, 20th Century
Flower Painting, 1991; U. of North Caro-
lina, Art on Paper, 1991; Miyagi Museum
of Art, Sendai, Japan, American Realism
and Figurative Art, 1952-1990, circ.,
1991. **Collections:** Arkansas; Char-
lotte/Mint; Chase Manhattan Bank;
Chemical Bank; Citicorp; Exxon Corp.;
Flint/Institute; Huntsville Museum; Indi-
ana U.; Louisville/Speed; MMA; Metropol-
itan Life; New Britain/American;
Oklahoma; U. of Oklahoma; Philip Morris
Collection; U. of Rochester; St. Louis/City;
San Antonio/McNay; Southwest Banking;
Springfield, Mo./AM; Tampa/AI; Union
Trust Bank; Wilmington; Worcester/AM.
Bibliography: Arthur 3; **McManus.**

BRAINARD, JOE b. March 11,
1942, Salem, Ark. A poet who has pub-
lished many books. **Taught:** Cooper
Union, 1967-68. **Commissions:** Drawings
for *Sung Sex* by K. Elmslie, 1990. **Awards:**
Copley Foundation Grant. **Address:** 8
Greene Street, NYC 10013. **Dealer:**
Fischbach Gallery, NYC. **One-man Exhi-
bitions:** The Alan Gallery, NYC, 1965;

The Landau-Alan Gallery, NYC, 1967, 69;
Gotham Book Mart, NYC, 1968; Jerrold
Morris Gallery, Toronto, 1968; Benson
Gallery, 1970; Phyllis Kind Gallery, Chi-
cago, 1970; Fischbach Gallery, NYC,
1971, 72, 74, 75; School of Visual Arts,
NYC, 1972; New York Cultural Center,
1972; Utah, 1973; Vick Gallery, Philadel-
phia, 1976; EG Gallery, Kansas City, Mo.,
1976; Suzette Schochett Gallery, Newport,
R.I., 1976; Coventry Gallery, Paddington,
N.S.W., 1976; Hamilton College, N.Y.,
1977; Elaine Benson Gallery, Bridge-
hampton, N.Y., 1977; Art 3 Associates, Sa-
vannah, Ga., 1978. **Retrospective:** U. of
California, San Diego, 1987. **Group:** U. of
North Carolina, 1967; MOMA, In Mem-
ory of My Feelings: Frank O'Hara, 1967;
VMFA, 1968; U. of Illinois, 1969; Chi-
cago/Contemporary, White on White,
1972; Corcoran, Seven Young Artists,
1972; Moore College of Art, Philadelphia,
Artists' Books, 1973; Harvard U., New
American Graphic Art, 1973; Yale U.,
American Drawing: 1970-73, 1973; Tyler
School of Art, Philadelphia, American
Drawings, 1973; William Paterson Col-
lege, N.J., Contemporary Drawing, 1975.
Collections: Amerada-Hess Corp., Inc.,
NYC; Chase Manhattan Bank, NYC; Colo-
rado Springs/FA; Harvard U.; U. of Kan-
sas; Liaison Films, Inc.; McCrory Corp.,
NYC; MOMA; RISD; Time Inc.; Utah;
WMAA. **Bibliography:** *Poets & Painters;*
Lucie-Smith.

BRANDT, WARREN b. Febru-
ary 26, 1918, Greensboro, N.C. **Studied:**
Pratt Institute, 1935-37; ASL, 1946, with
Yasuo Kuniyoshi; Washington U., with
Philip Guston, Max Beckmann, 1947-48,
BFA with honors; U. of North Carolina,
1953, MFA. Traveled Mexico, Europe.
US Air Corps, 1940-45. **Taught:** Salem
College, 1949-50; Pratt Institute, 1950-52;
Guilford College, 1952-56; U. of Missis-
sippi, 1957-59; Southern Illinois U., 1959-
61; School of Visual Arts, NYC, 1962-63;
Director, New York Studio School, 1967.

Member: NAD. **Awards:** John T. Milliken Traveling Fellowship. **m.** Grace Borgenicht. **Address:** 879 United Nations Plaza, NYC 10017. **Dealer:** Fischbach Gallery, NYC. **One-man Exhibitions:** (first) Sacramento State College, 1943; Nonagon Gallery, NYC, 1959; Memphis State U., 1960; New Gallery, Provincetown, 1960; Michigan State U., 1961; The American Gallery, NYC, 1961; Esther Stuttman Gallery, Provincetown, 1962; Grippi Gallery, NYC, 1963, 64; Obelisk Gallery, Washington, D.C., 1963; Grippi and Waddell Gallery, NYC, 1964; A. M. Sachs Gallery, NYC, 1966, 67, 68, 70, 72, 73, 74, 75; U. of North Carolina, 1967; Reed College, 1967; Benson Gallery, Bridgehampton, N.Y., 1967, 76; Eastern Illinois U., 1968; Salem College, 1968; Molly Barnes Gallery, Los Angeles, 1968; Cord Gallery, Southampton, N.Y., 1968; Allentown/AM, 1969; Grand Avenue Galleries, Milwaukee, 1969; Mercury Gallery, London, 1969, 72; David Barnett Gallery, Milwaukee, 1969, 71, 74, 78, 80, 87; Allentown/MA, 1969; Agra Gallery, Washington, D.C., 1969, 70; Pratt Manhattan Center, NYC, 1970; Hooks Epstein Gallery, Houston, 1971, 73; Agra Gallery, Palm Beach, Fla., 1971; Guild Hall, East Hampton, N.Y., 1973, 74; Vick Gallery, Philadelphia, 1976; Raleigh/NCMA, 1977; Fischbach Gallery, NYC, 1977, 80, 83, 85, 86, 88, 90; Allenhouse Gallery, Louisville, Ky., 1978; Fontana Gallery, Narbeth, Pa., 1978; Vered Gallery, East Hampton, N.Y., 1988, 89, 91. **Retrospectives:** Allentown/AM, 1962-1968; Beaumont Art Museum, 1976; Greenhill Gallery, Greensboro, 1982. **Group:** MMA, American Watercolors, Drawings and Prints, 1952; WMAA; Brooklyn Museum, Print Biennials; VMFA, Virginia Artists Biennial; PAFA; A.F.A.; Syracuse/Everson, Provincetown Painters 1890s-1970s, 1977; U. of Missouri, American Painterly Realists, 1977; Corcoran, The Human Form: Contemporary American Figure Drawing and the Academic Tradition, 1980; AFA, the Figure in Twentieth-Century American Art, circ., 1985; New Orleans/CAC, Landscape, Seascape, Citiscape, 1960-85, circ., 1986; NAD Annual, 1987, 89; Southampton/Parrish, Drawings on the East End, 1940-88, 1989; Huntington, N.Y./Heckscher, Long Island Landscape Painting in the Twentieth Century, 1990. **Collections:** Beaumont Art Museum; Carnegie; Chase Manhattan Bank; Ciba-Geigy Corp., Currier; Guild Hall; Hirshhorn; Lannan Foundation; Michigan State U.; Milwaukee; NCFA; Norfolk/Chrysler; U. of North Carolina; New Mexico State U.; U. of Rochester; Southern Illinois U.; U. of Texas; WGMA. **Bibliography:** Archives.

BRAUNTUCH, TROY **b.** 1954, Jersey City, N.J. **Studied:** California Institute of the Arts, 1975, BFA. **Address:** 182 Grand Street, NYC 10013. **Dealer:** Kent Gallery, Inc., NYC. **One-man Exhibitions:** The Kitchen, NYC, 1979; Metro Pictures, NYC, 1981; Mary Boone Gallery, NYC, 1982, 83, 85; Galerie Schellman and Kluser, Munich, 1983; Akira Ikeda Gallery, Tokyo, 1984; Larry Gagosian Gallery, Los Angeles, 1986; Kent Fine Art, NYC, 1988, 90; Michael H. Lord Gallery, Milwaukee, 1989; The Living Room, Amsterdam, 1989; Galerie Durand-Dessert, Paris, 1990. **Group:** Cologne/Stadt, Westkunst, 1981; MIT, Figurative Aspects of Recent Art, 1981; Kassel, Documenta VII, 1982; XL Venice Biennial, 1982; Hannover/KG, New York Now, circ., 1982; Osaka/National, Modern Nude Paintings, 1983; Bonn, Back to the USA, circ., 1983; Tate Gallery, New Art, 1983; Independent Curators Inc., NYC, Drawings after Photography, 1984; Houston/Contemporary, American Still Life, 1945-1983, 1983; Kunstverein, Düsseldorf, New York Now, 1983; Osaka/National, Modern Nude Paintings, 1983; MOMA, An International Survey of Contemporary Painting and Sculpture, 1984; Oberlin College, Drawings: After

Photography, 1984; Hirshhorn, Content, 1984; Purchase/SUNY, American Still Life, 1945-1983, 1984; U. of Chicago, Calarts: Skeptical Belief(s), circ., 1987; Schirnn Kunsthalle, Frankfurt, Prospect 89, 1989; WMAA, Image World, 1989; Museum Fodor, Amsterdam, Art Meets Science, 1990. **Collections:** Lannan Foundation; MMA; MOMA. **Bibliography:** *Back to the USA;* Goldstein and Jacob; Fox; Haenlein.

BRECHT, GEORGE
from 2nd to 5th edition.

BREER, ROBERT
from 2nd to 5th edition.

BREINEN, RAYMOND
from 1st to 4th edition.

BRICE, WILLIAM b. April 23, 1921, NYC. **Studied:** ASL; Chouinard Art Institute, Los Angeles. Traveled England, Spain, Greece. **Taught:** Jepson Art Institute, Los Angeles; UCLA, 1953-. **Awards:** Tamarind Fellowship, 1961; UCLA, research grants, 1964, 74, 76. **Address:** 427 Beloit Street, Los Angeles, CA 90049. **Dealers:** Robert Miller Gallery, NYC; L.A. Louver Gallery, Venice, Calif. **One-man Exhibitions:** The Downtown Gallery, 1949; Frank Perls Gallery, 1952, 55, 56, 62; The Alan Gallery, NYC, 1955, 56, 64; Santa Barbara/MA, 1958; Felix Landau Gallery, 1966; U. of California, San Diego, 1967; Colorado Springs/FA, 1967; Dallas/MFA, 1967; SFMA, 1967; The Landau-Alan Gallery, NYC, 1968; Hancock College, Santa Maria, Calif., 1975; Orange Coast College, 1975; Charles Campbell Gallery, San Francisco, 1976; U. of Redlands, 1978; ICA, Los Angeles, 1978; Nicholas Wilder Gallery, Los Angeles, 1978; Robert Miller Gallery, NYC, 1980, 84; Mary Porter Sesnon Gallery, Santa Cruz, Calif. 1980; California State U., Dominquez Hills, 1981; Smith-Anderson Gallery, Palo Alto, 1983; L.A. Louver Gal-

lery, Venice, 1984; Temple U., 1984. **Retrospective:** Los Angeles/MOCA, circ., 1986. **Group:** Santa Barbara/MA, 1945; WMAA, 1947, 50, 51; Los Angeles/County MA, 1947-50; São Paulo; Carnegie, 1948, 49, 54; U. of Illinois; MMA, 1952; MOMA, 1952, 56; Chicago/AI, 1952, 56; Paris/Moderne, 1954; California Palace, 1951, 52; WMAA, Fifty California Artists, 1963; WMAA, A Decade of American Drawings, 1965; SFMA; de Young; VMFA, 1966; Des Moines, 1967; Los Angeles/County MA, Private Images, 1976; Los Angeles/County MA, Artists at Work, 1977; Laguna Beach, Museum of Art, Drawings and Illustrations by Southern California Artists before 1950, 1981; Long Beach/MA, Drawings by Painters, 1982; IEF, Twentieth Century American Drawings: The Figure in Context, circ., 1983; U. of Southern California, Sunshine and Shadows, 1985. **Collections:** AAAL; Andover/Phillips; Chicago/AI; Florida State U.; Hirshhorn; U. of Illinois; Israel Museum; U. of Iowa; Los Angeles/County MA; Louisiana State U.; MMA; MOMA; U. of Nebraska; San Diego; Santa Barbara/MA; Stanford U.; Utica; WMMA; Wichita/AM. **Bibliography:** Armstrong 3; Cummings 4; Karlstrom and Ehrlich; Pousette-Dart, ed. Archives.

BRIGGS, ERNEST b. 1923, San Diego, Calif. d. June 12, 1984. **Studied:** California School of Fine Arts, with Clyfford Still, David Park, Mark Rothko. US Army, 1943-45. A cofounder of Metart Gallery, San Francisco, 1949. **Taught:** U. of Florida, 1958; Pratt Institute, 1961-84; Yale U., 1967-68. **Awards:** CSFA, Albert M. Bender Fellowship, 1951; SFMA, Anne Bremer Memorial Prize, 1953; CAPS, 1975. **One-man Exhibitions:** (first) Metart Gallery, San Francisco, 1949; The Stable Gallery, NYC, 1954, 55; CSFA, 1956; The Howard Wise Gallery, NYC, 1960, 62, 63; Yale U., 1968; Alonzo Gallery, NYC, 1969; Green Mountain Gallery, NYC, 1973; Susan Caldwell, Inc.,

NYC, 1975; Aaron Berman Gallery, NYC, 1977; Cape Split Place, Addison, Me., 1979; Gruenebaum Gallery, NYC, 1980, 82, 84; Anita Shapolsky Gallery, NYC (two-man, with Edward Dugmore), 1991. **Group:** San Francisco Art Association Annuals, 1948, 49, 53; WMAA Annuals, 1955, 56, 61; California Palace, Five Bay Area Artists, 1953; MOMA, Twelve Americans, circ., 1956; Corcoran, 1961; Carnegie, 1961; Dallas/MFA, "1961," 1962; SFMA, 1962, 63; Jewish Museum, Large-Scale American Painting, 1967; AAAL, 1969, 70; Oakland/AM, San Francisco, 1945-1950, 1973; SFMA, California Painting and Sculpture: The Modern Era, 1976; Huntsville, Bay Area Update, 1977; P.S. 1, Long Island City, N.Y., Underknown, 1984. **Collections:** Brooklyn Museum; Carnegie; CIBA-Geigy Corp.; Housatonic Community College; Michigan State U.; Oakland/AM; Rockefeller Institute; SFMA; WMAA; Walker. **Bibliography:** McChesney; Sandler 5. Archives.

BRODERSON, MORRIS

(Gaylord) **b.** November 4, 1928, Los Angeles, Calif. **Studied:** Pasadena Museum School; U. of Southern California, with Francis De Erdely; Jepson Art Institute, Los Angeles. Traveled Europe, Japan, India, Far East. **Awards:** Pasadena Museum School, Scholarship, 1943; Los Angeles/County MA, P.P.; *Art in America* (magazine), New Talent, 1959; Los Angeles Art Festival, 1961; Carnegie, 1961. **Address:** c/o Dealer. **Dealer:** Ankrum Gallery, Los Angeles. **One-man Exhibitions:** Dixi Hall Studio, Laguna Beach, Calif., 1954; Stanford U., 1958; Santa Barbara/MA, 1958; U. of California, Riverside, 1959; Bertha Lewinson Gallery, Los Angeles, 1959, 60; Ankrum Gallery, 1961, 62, 70, 79, 89; The Downtown Gallery, NYC, 1963, 66; Los Angeles/County MA, 1966, 68; San Diego, 1969; Staempfli Gallery, NYC, 1971. **Retrospective:** San Diego, 1969; U. of Arizona, 1975. **Group:** Santa Barbara/MA, 1958; Los Ange-

les/County MA, 1958, 59; PAFA, 1959, 60; Ringling, 1960; WMAA, 1960; de Young, 1960; California Palace, San Diego, 1961; Carnegie, 1961, 62, 64, 67; U. of Illinois, 1963; NIAL, 1967; Hirshhorn, Inaugural Exhibition, 1974; AAAL, 1976; NAD, 1977; Springfield, Mass./MFA, Bicentennial, Watercolor, USA, 1976; Santa Barbara/MA, Images of the Mind, 1976; Minnesota/MA, Art and the Law, 1979. **Collections:** Boston/MFA; Container Corp. of America; de Young; Hirshhorn; Home Savings and Loan Association; Honolulu Academy; Kalamazoo/Institute; La Jolla; Los Angeles/County MA; NIAL; Palm Springs Desert Museum; The Pennsylvania State U.; Phoenix; SFMA; San Antonio/McNay; San Diego; Santa Barbara/MA; U. of South Florida; Stanford U.; U. of Texas; WMAA; Yale U. **Bibliography:** Weller. Archives.

BRODERSON, ROBERT M.

from 1st to 4th edition.

BRODIE, GANDY

from 1st to 4th edition.

BRONER, ROBERT **b.** March

10, 1922, Detroit, Mich. **Studied:** Wayne State U., 1940-46, BFA, MA; UCLA, 1946-47; Society of Arts and Crafts, Detroit, 1942-45; Atelier 17, NYC, 1949-52, with S. W. Hayter; New School for Social Research, 1949-50, with Stuart Davis. **Taught:** City U. of New York, 1963-64; Society of Arts and Crafts, Detroit; Wayne State U., 1964-86; Haystack Mountain School of Crafts, 1964, 66, 68, 70, 75, 80; U. of Haifa, 1975; Cooper Union, 1983-87; Detroit Times, 1958-60 (art critic); *Art in America* magazine, 1958-63 (correspondent); *Craft Horizons* magazine, 1961-68 (correspondent); Birmingham *Eccentric*, 1962-63 (art critic); *Pictures on Exhibit* magazine, 1963-64 (reviewer); Manhattanville College, 1976-77; Parsons School of Design, NYC, 1977; Pratt Institute, 1978. **Member:** SAGA; Philadelphia Print Club;

British Printmakers Council; President, The Print Council; President, SAGA, 1981-84. **Awards:** Brooklyn Museum, Print Biennial, P.P., 1964; Los Angeles Art Festival, Bronze Medal, 1948; Detroit/Institute, Michigan Artist, P.P., 1961, 66; SAGA, 50th Annual Print Exhibition, $1,000 P.P., 1969; Wayne State U., Faculty Research Fellowship, 1965, 69; Probus Club, Achievement Award ($500), 1969; Michigan Council for the Arts Award, 1983, 86; New York Foundation for the Arts, Fellowship, 1990; Artist-in-Residence, The Printmaking Workshop, NYC, 1986. **Address:** 40 West 22nd Street, NYC 10010. **One-man Exhibitions:** (first) Anna Werbe Gallery, Detroit, 1953; Wellons Gallery, NYC, 1954; Philadelphia Art Alliance, 1956; Garelick's Gallery, Detroit, 1956, 61; Michigan State U., 1957; Drake Gallery, Carmel, Calif., 1960; Society of Arts and Crafts, Detroit, 1962; Feingarten Gallery, Los Angeles, 1961; Raven Gallery, Birmingham, Mich., 1963; The Ohio State U., 1969; J. L. Hudson Art Gallery, Detroit, 1971; Rina Gallery, NYC, 1973; Klein-Vogel Gallery, Royal Oak, Mich.; Delson-Richter Gallery, Tel Aviv, 1975; Troy Gallery, Mich., 1977; Manhattanville College, Purchase, N.Y., 1977; Wayne State U., 1981; Merging One Gallery, Santa Monica, 1986, 87. **Group:** MMA, American Watercolors, Drawings, and Prints, 1952; MOMA, Young American Printmakers, 1953; Brooklyn Museum, Print Biennials; USIA, circ., Europe, 1959-60 (prints); PCA, circ., Europe and France, 1959-60; PAFA, 1959, 60; Pasadena/AM, 1962; SAGA, 1962, 63; ICA, London; Salon du Mai, Paris, 1969; British International Print Biennials, 1968, 70, 72; MOMA, Pop Art Prints, Drawings, and Multiples, 1970; Paris/ Moderne, La Jeune Gravure, 1970; Bibliothèque Nationale, L'Estampe Contemporaine, 1973; Walker, Printmakers, 1973; FIT Gallery, NYC, 1981; SAFA Annual, 1981; Maine Coast Artists Gallery, Rockport, Me., 1990. **Collections:** Bibliothèque Nationale; Boston Public Library; Brooklyn Museum; Chicago/AI; Cincinnati/AM; Detroit/Institute; Harvard U.; Jerusalem/National; Los Angeles/County MA; MMA; MOMA; NYPL; National Gallery; PAFA; PMA; SRGM; Smithsonian; Walker. **Bibliography:** Archives.

BROOK, ALEXANDER b. July 14, 1898, Brooklyn, N.Y. d. February 26, 1980, Sag Harbor, N.Y. **Studied:** ASL, 1913-17, with R. W. Johnson, Frank V. DuMont, George Bridgeman, Dimitri Romanovsky, Kenneth Hayes Miller. Assistant Director, Whitney Studio Club, NYC. **Commissions:** US Post Office, Washington, D.C. (mural). **Awards:** Chicago/AI, The Mr. & Mrs. Frank G. Logan Medal, 1929; Carnegie, Second Prize, 1930; PAFA, Joseph E. Temple Gold Medal, 1931; Guggenheim Foundation Fellowship, 1931; Los Angeles/County MA, First Prize, 1934; Paris World's Fair, 1937, Gold Medal; SFMA, Medal of Award, 1938; Carnegie, First Prize, 1939. **One-man Exhibitions:** ACA Gallery; Curt Valentine Gallery, NYC, 1930; The Downtown Gallery, NYC, 1934, 37; Dayton/AI, 1942; Rehn Galleries, NYC, 1947, 60; M. Knoedler & Co., NYC, 1952; Richard Larcada Gallery, NYC, 1969, 74; Salander-O'Reilly Galleries, NYC, 1980; Santa Fe East Galleries, Santa Fe, 1981. **Retrospective:** Chicago/AI, 1929. **Group:** U. of Rochester, 1937; Brooklyn Museum; Carnegie; MMA; Toledo/MA; Buffalo/Albright; Chicago/AI; Newark Museum. **Collections:** Boston/MFA; Britannica; Brooklyn Museum; Buffalo/Albright; California Palace; Carnegie; Chicago/AI; Columbus; Corcoran; Dartmouth College; Detroit/Institute; de Young; Hartford/Wadsworth; IBM; Indianapolis; Kansas City/Nelson; Los Angeles/County MA; MMA; MOMA; Michigan State U.; Ogunquit; PAFA; U. of Nebraska; Newark Museum; SFMA; St. Louis/City; Toledo/MA; WMAA; Youngstown/Butler. **Bibliography:** Baur 7; Bethers; Biddle 4;

Boswell 1; **Brook;** Cahin and Barr, eds.;
Cheney; Eliot; Flexner; Goodrich and Baur 1;
Hall; *Index of 20th Century Artists;*
Jewell **1,** 2; Kent, N.; Mellquist;
Mendelowitz; Pagano; Pearson 1; Pousette-
Dart, ed.; Richardson, E.P.; *Woodstock.*
Archives.

BROOKS, JAMES A. **b.** October
18, 1906, St. Louis, Mo. **d.** March 9,
1992, Brookhaven, N.Y. **Studied:** South-
ern Methodist U., 1923-25; Dallas Art In-
stitute, 1925-26, with Martha Simkins;
ASL, 1927-31, with Kimon Nicolaides,
Boardman Robinson; privately with
Wallace Harrison. Federal A.P.: 1937-42.
US Army in Middle East, 1942-45. Trav-
eled Italy. **Taught:** Columbia U., 1947-48;
Pratt Institute, 1947-59; Yale U., 1955-60;
American Academy, Rome, Artist-in-Resi-
dence, 1963; New College, Sarasota, Fla.,
1965-67; Miami Beach (Fla.) Art Center,
1966; Queens College, 1966-67, 1968-69;
U. of Pennsylvania, 1971, 72; Cooper
Union, 1975. **Member:** Century Associa-
tion; NIAL. **Commissions** (murals):
Woodside, N.Y., Library; La Guardia Air-
port; US Post Office, Little Falls, N.Y.
Awards: Carnegie, Fifth Prize, 1952; Chi-
cago/AI, The Mr. & Mrs. Frank G. Logan
Medal, 1957; Chicago/AI, Norman Wait
Harris Silver Medal and Prize, 1961; Ford
Foundation, P.P., 1962; Guggenheim
Foundation Fellowship, 1967-68; National
Endowment for the Arts, 1973; National
Arts Club Gold Medal, 1985. **One-man
Exhibitions:** The Peridot Gallery, NYC,
1950, also 1951-53; Grace Borgenicht Gal-
lery, Inc., NYC, 1954; The Stable Gallery,
NYC, 1957, 59; The Kootz Gallery, NYC,
1961, 62; Philadelphia Art Alliance, 1966;
Martha Jackson Gallery, NYC, 1968, 71,
73, 75; The Berenson Gallery, 1969;
Gruenebaum Gallery, Ltd., NYC, 1979,
81, 84; Montclair/AM, 1979; Himmelfarb
Gallery, Water Mill, N.Y., 1977, 78, 81;
Dan Flavin Art Institute, Bridgehampton,
N.Y., 1985; Berry-Hill Galleries, NYC,
1989. **Retrospectives:** WMAA, circ., 1963-

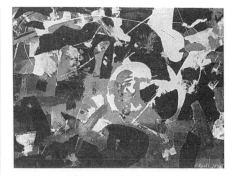

James Brooks, *F, 1951,* 1951.

64; Dallas/MFA, 1972; Finch College,
NYC, circ., 1975; Portland, Me./AM,
1983; Huntington, N.Y./Heckscher, 1988.
Group: WMAA Annuals from the 1950s;
Galerie de France, American Vanguard,
1952; Carnegie, 1952, 55, 58, 61; SRGM,
Younger American Painters, 1954;
WMAA, The New Decade, 1954-55;
MOMA, Twelve Americans, circ., 1956;
IV São Paulo Biennial, 1957; MOMA,
The New American Painting, circ., Eu-
rope, 1958-59; Kassel, Documenta II,
1959; II Inter-American Paintings and
Prints Biennial, Mexico City, 1960;
SRGM, Abstract Expressionists and Im-
agists, 1961; Seattle World's Fair, 1962;
Cleveland/MA, 1963; SFMA, 1963; Tate,
Dunn International, 1964; MOMA, The
New American Painting and Sculpture,
1969; WMAA Annuals, 1970, 72; U. of
Illinois, 1971; Ball State U., Collages by
American Artists, 1971; Cranbrook, Draw-
ings by Contemporary American Artists,
1975; Corcoran Biennial, 1975; Brooklyn
Museum, Thirty Years of American Print-
making, 1976; Hofstra U., Art for the
People, 1978; Haus der Kunst, Munich,
Amerikanische Malerie: 1930-1980, 1980;
Houston/Contemporary, The Americans:
The Collage, 1983; NMAA, Martha Jack-
son Memorial Collection, 1985; Guild
Hall, East Hampton, Avant-Garde: A Sa-
lute to the Signa Gallery, 1957-60, 1990.
Collections: Boston/MFA; Brandeis U.;
Brooklyn Museum; Buffalo/Albright; U. of

California, Berkeley; Carnegie; Chase Manhattan Bank; Chicago/AI; Ciba-Geigy Corp.; The Coca-Cola Co.; Dallas/MFA; Detroit/Institute; Fordham U.; Hartford/Wadsworth; Harvard U.; Houston/MFA; U. of Illinois; International Minerals & Chemicals Corp.; MMA; MOMA; Mexico City/Tamayo; U. of Michigan; Miles Metal Corp.; Montclair/AM; NYU; U. of Nebraska; Owens-Corning Fiberglas Corp.; PAFA; Pepsi-Cola Co.; Philip Morris; Portland, Me./AM; Rockefeller U.; SRGM; The Singer Company Inc.; Southern Methodist U.; Tate; U. of Texas; Toledo/MA; Tulsa/Philbrook; Union Carbide Corp.; Utica; VMFA; WMAA; Walker; Yale U. **Bibliography:** Armstrong; Chaet; Flanagan; Goodrich and Baur 1; Haftman; Hess, T. B., 1; **Hunter 1**, 4, 6; Hunter, ed.; McCurdy, ed.; *Metro;* Motherwell and Reinhardt, eds.; Ponente; Pousette-Dart, ed.; Ritchie 1; Rodman 2; Ross, ed.; Sandler. Archives.

BROWN, JOAN b. 1938, San Francisco, Calif. **d.** October 26, 1990, Proaddatura, India. **Studied:** California School of Fine Arts, 1955; with Elmer Bischoff, Frank Lobdell, Sonia Gechtoff, Richard Diebenkorn, Manual Neri, Robert Howard, 1957-62. **Taught:** Raymond Wilkins High School, San Francisco, 1959; Sacramento State College, 1970-71; SFAI, 1971-77; Academy of Art, San Francisco, 1971-73; U. of California, Berkeley, 1974-90. **Awards:** SFAI, Adaline Kent Award, 1973; National Endowment for the Arts, Grant, 1976, 80; Guggenheim Foundation Fellowship, 1977. **One-man Exhibitions:** Spatsa Gallery, San Francisco, 1958; Staempfli Gallery, NYC, 1960 (two-man), 1961, 64; Batman Gallery, San Francisco, 1961; Ferus Gallery, Los Angeles, 1962; Hanson-Fuller Gallery, San Francisco, 1968, 78, 79, 80, 82; Lawson Galleries, San Francisco, 1970; SFMA, 1971; SFAI, 1973; Charles Campbell Gallery, San Francisco, 1974, 75; U. of California, Berkeley,

1974; Allan Frumkin Gallery, NYC, 1974, 76, 79, 81, 82, 83, 84, 85, 86; Allan Frumkin Gallery, Chicago, 1975, 77; Clarke-Benton Gallery, Santa Fe, 1977; Re: Vision Gallery, Santa Monica, 1976; Wadsworth/Hartford, 1977; U. of Akron, 1977; San Jose/MA, 1979; Newport Harbor, 1978; U. of Colorado, 1978; San Jose, 1979; U. of California, Berkeley, 1979; Whitman College, 1980; Fountain Gallery, Portland, Ore., 1981; U. of Hawaii, 1981; Koplin Gallery, Los Angeles, 1982, 83; Frumkin & Struve Gallery, Chicago, 1984; Santa Cruz County, Calif., Historical Museum, 1984; Monterey Peninsula Museum of Art, circ., 1985; U. of Redlands, 1985; U. of California, San Diego, 1986; Frumkin/Adams Gallery, NYC, 1988, 90, 91. **Retrospective:** U. of California, Berkeley, 1974. **Group:** Oakland/AM; RAC; SFMA; PAFA; SFAI; Drawing Invitational, 1969; WMAA, 1972; Mt. Holyoke College, Art as a Muscular Principle, 1975; WMAA Biennial, 1977; New Museum, NYC, Bad Painting Show, 1978; U. of North Carolina, Art on Paper, 1978; American Foundation for the Arts, Miami, Story-Telling Art, 1979; PAFA, Seven on the Figure, 1979; Norfolk/Chrysler, American Figurative Painting, 1950-1980, 1980; Newport Harbor, Inside Out: Self Beyond Likeness, 1981; Columbus, American Painting of the 60s and 70s, 1981; Rutgers U., Realism and Realities, 1982; Palm Springs Desert Museum, The West as Art, 1982; WMAA, Focus on the Figure, 1982; Chicago/AI, 74th American Exhibitions, 1982; Corcoran Biennial, 1983; SFMA, The Human Condition, 1984; U. of Nebraska, San Francisco Bay Area Painting, 1984; Hirshhorn, Content: A Contemporary Focus, 1974-1984, 1984; NYU, The Figurative Mode, 1984; Oakland/AM, Art in the San Francisco Bay Area, 1945-1980, 1985; AAIAL, 1986; Skidmore College, Self-Portraits: The Message, The Material, 1987; U. of Houston, 6 Artists/6 Idioms, 1988; Oakland/Museum, The Artists of California, circ., 1988; SFMA, Bay Area

Figurative Painting, circ., 1990. **Collections:** Boston/MFA; Buffalo/Albright; U. of California, Berkeley; Chase Manhattan Bank; U. of Colorado; Federal Reserve Bank, San Francisco; Hirshhorn; Honolulu/Contemporary; Long Beach/MA; Los Angeles/County MA; MOMA; Madison Art Center; Miami-Dade College; Newport Harbor; U. of North Carolina; Oakland/AM; PMA; Purchase/SUNY; Sacramento/Crocker; SFMA; VMFA; WMAA; Williams College. **Bibliography:** *Art as a Muscular Principle; Art: A Woman's Sensibility;* Lucie-Smith; McChesney; Robins; Richardson, B., 1; Schwartz, 2; Selz, P., 2; Solnit. Archives.

BROWN, ROGER b. December 10, 1941, Hamilton, Alabama. **Studied:** American Academy of Art, Chicago, 1964; Chicago Art Institute School, BFA and MFA, 1970. **Commissions:** Equitable Corp., at NBC Tower, NYC. **Awards:** Renaissance Prize, Chicago/AI, 1969; Walter Campana prize, 1971, Chicago/AI. **Address:** 1926 N. Halsted, Chicago, IL. **Dealer:** Phyllis Kind Gallery, NYC and Chicago. **One-man Exhibitions:** Phyllis Kind Gallery, Chicago, 1971, 73, 74, 76, 77, 79, 80, 82, 86, 88, 91; Phyllis Kind Gallery, NYC, 1975, 77, 79, 81, 82, 84, 85, 87, 89, 92; PAFA, 1974; Darthea Speyer Gallery, Paris, 1974; PAFA, Peale House, 1974; U. of California, Berkeley, 1980; Montgomery Museum, 1980; Mayor Gallery, London, 1981; Texas Gallery, Houston, 1985; Asher/Faure Gallery, Los Angeles, 1983, 88; Fendrick Gallery, Washington, D.C., 1987; John Berggruen Gallery, San Francisco, 1986; Arthur Roger Gallery, New Orleans, 1988, 90; Heath Gallery, Inc., Atlanta, 1990. **Retrospectives:** U. of South Florida, circ., 1984; Hirshhorn, circ., 1987; Nexus Contemporary Art Center, Atlanta, circ., 1984-85. **Group:** Chicago/Contemporary, Don Baum Sez, "Chicago Needs Famous Artists," 1969; ICA, U. of Pennsylvania, Spirit of the Comics, 1969; Chicago/Contemporary, Chicago Imagist Art, 1972; WMAA Biennials, 1973, 79; São Paulo Biennial, 1974; Chicago Art Institute School, Former Famous Alumni, 1976; Sacramento/Crocker, The Chicago Connection, 1977; U. of Texas, Austin, New In the Seventies, 1977; Buffalo/Albright, American Paintings in the 1970s, 1978; Tyler School of Art, Philadelphia, Intricate Structure/Repeated Image, 1979; WMAA, The Figurative Tradition and the WMAA, 1980; Sunderland (Eng.) Arts Centre, Who Chicago?, circ., 1980; Haus der Kunst, Munich, Amerikanische Malerei: 1930-1980, 1981; Indianapolis, 1982; The New Museum, The End of the World, 1983; Los Angeles/MOCA, Automobile and Culture, 1984; MOMA, International Survey of Recent Painting and Sculpture, 1984; Hirshhorn, Contemporary Focus, 1984; XLI Venice Biennial, 1984; Corcoran Biennial, 1985; Laforet Museum, Tokyo, Correspondences: New York Art Now, circ., 1985; Chicago/AI, 75th Annual American Exhibition, 1986; SFMA, Biennial, 1986; Youngstown/Butler, Golden Anniversary, 1986; SFMA, Second Sight, 1986; RISD, The Call of the Wild, 1987; Milwaukee, Contemporary American Stage Design, 1987; Chicago/Terra, Surfaces: Two Decades of Painting in Chicago, 1987; U. of Chicago, The Chicago Imagist Print, 1987; Bowling Green U., Of New Account, 1987; ICA, London, Komic Ikonoklasm, circ., 1988; Milwaukee, The World of Art Today, 1988/89, 1989; Junior College of Albany, Contemporary Landscape, 1989; Dayton/AI, A Certain Slant of Light, 1989; John Michael Kohler Art Center, Sheboygan, Wisc., The Road Shows, 1989; Bellingham/Whatcom, A Different War, 1989; Columbus/MA, Home Again, 1990; Chicago Art Institute School, Revelations, 1991; WMAA, Image and Likeness, 1991; Hofstra U., The Realm of the Coin, 1991; Chicago/AI, From America's Studio, 1992; Chicago Cultural Center, Face to Face, 1992; Woodson/AM, Wausau, Mind and Beast,

1992. **Collections:** Akron/AI; Amsterdam/Stedelijk; Atlantic Richfield Co.; AT&T; Ball State U.; Blue Cross of Southern California; Boston/MFA; Chicago/AI; Chicago/Contemporary; Continental Bank; Corcoran; Dallas/MFA; Edinburgh/National; First National Bank of Chicago; High Museum; Indianapolis; MMA; Montgomery Museum; Museum des 20. Jahrhunderts; MOMA; NCFA; NMAA; U. of North Carolina; Northern Trust Co.; Playboy Collections; Prudential Insurance Co. of America; Rotterdam; WMAA. **Bibliography:** Adrian; Adrian and Born; Armstrong, Thomas; *The Chicago Connection;* Kirschner; *New in the Seventies;* Vine and Hale; *Who Chicago?*

BROWN, WILLIAM THEO
b. April 7, 1919, Moline, Ill. **Studied:** Yale U., 1941, BA; U. of California, Berkeley, 1952, MA. Traveled Europe. **Taught:** U. of California, Berkeley, 1954-56; San Francisco Art Institute, 1955-57; U. of California, Davis, 1956-60; 1975-76; U. of Kansas, 1967; Stanford U., 1967. **Address:** 1151 Keeler, Berkeley, CA 94708. **Dealer:** Tatischeff & Co., NYC and Los Angeles. **One-man Exhibitions:** SFMA, 1957; Felix Landau Gallery, 1958, 60, 63, 65, 67, 71; Barone Gallery, NYC, 1961; The Kornblee Gallery, 1962; Esther Baer Gallery, 1964 (two-man, with Paul Wonner); Hollis Gallery, San Francisco, 1965; Sacramento/Crocker, 1965; The Landau/Alan Gallery, NYC, 1968; Charles Campbell Gallery, San Francisco, 1978; U. of California, Santa Cruz, 1982; John Berggruen Gallery, San Francisco, 1983, 87; Maxwell Davidson Gallery, NYC, 1989; Koplin Gallery, Los Angeles, 1989, 91; Tatischeff & Co., NYC, 1990, 92; Natsoulas/Novelozo Gallery, Davis, Calif., 1991. **Group:** Oakland/AM, Annuals, 1952-58; RAC Annuals, 1952-58; SFMA Annuals, 1952-58; Minneapolis/Institute, American Painting, 1945-57, 1957; Oakland/AM, Contemporary Bay Area Figurative Painting, 1957; Santa Barbara/MA, II & III Pacific Coast

Biennials, 1957, 59; SFMA, West Coast Artists, circ., 1957, 59; California Palace, 1959; The Zabriskie Gallery, East-West, 1960; U. of New Mexico, circ., 1964-67; Louisville/Speed, 1965; VMFA, 1966; U. of Illinois, 1969; SFMA, Bay Area Figurative Art, 1950-1965, circ., 1989; AAIAL, 1991. **Collections:** California Palace; Capitol Records, Inc.; Commerce Trust Co., Kansas City, Mo.; Davenport/Municipal; Hirshhorn; U. of Kansas; MMA; U. of Nebraska; Oakland/AM; Reader's Digest; SFMA. **Bibliography:** Archives.

BROWNE, BYRON **b.** June 26, 1907, Yonkers, N.Y. **d.** December 25, 1961. **Studied:** NAD, 1924-28, with C. W. Hawthorne, Ivan Olinsky. **Taught:** ASL, 1948-61. Charter Member, American Abstract Artists. **Awards:** U. of Illinois, P.P.; PAFA, P.P; NAD, Hallgarten Prize, 1928; La Tausca Competition, Third Prize. **One-man Exhibitions:** (first) New School for Social Research, 1936, also 1937; Artists' Gallery, NYC, 1939; The Pinacotheca, NYC, 1943, 44; The Kootz Gallery, NYC, 1946-48; Grand Central, NYC, 1949, 50, 53; Grand Central Moderns, NYC, 1950, 51, 52, 54, 55, 57, 58, 61, 62; Syracuse U., 1952; Tirca Karlis Gallery, Provincetown, 1960; ASL, Memorial Exhibition, 1962; Washburn Gallery, Inc., NYC, 1975, 77, 80; Harmon Gallery, Naples, Fla., 1982; Yares Gallery, Scottsdale, Ariz., 1982; Martin Diamond Fine Arts, NYC, 1983; Gallery Schlesinger-Boisanté, NYC, 1984, 86; Harmon-Meek Gallery, Naples, Fla., 1984; Harmon Galleries, Sarasota, Fla., 1985; Meredith Long & Co., Houston, 1985; Galerie Lopes, Zurich, 1985; ASB Gallery, London, 1985. **Group:** Chicago/AI; Carnegie; WMAA; Corcoran; MOMA; MMA; ART: USA, NYC; U. of Illinois; PAFA. **Collections:** Boston/MFA; Brown U.; Cornell U.; Dallas/MFA; U. of Georgia; Harvard U.; High Museum; Hirshhorn; Indiana U.; MMA; MOMA; Milwaukee; U. of Minnesota; NIAL;

NMAA; U. of Nebraska; Newark Museum; New Paltz/SUNY; Ohio U.; U. of Oklahoma; PAFA; Pace U.; Rio de Janeiro; U. of Rochester; Roswell; San Antonio/McNay; Syracuse/Everson; Tel Aviv; U. of Texas; Trenton/State; Utica; VMFA; WMAA; Walker; Williams College; Youngstown/Butler. **Bibliography:** Armstrong, Thomas; Baur 7; Blesh 1; Cheney; Janis; Kootz 2; Marter; Pousette-Dart, ed.; Ritchie 1. Archives.

BROWNING, COLLEEN
b. May 18, 1929, Fermoy, County Cork, Ireland. **Studied:** Privately, and U. of London, Slade School. Traveled the world extensively. **Taught:** City College of New York, 1962-75; NAD, 1957-81. Illustrated many children's books. **Member:** NAD. **Awards:** Carnegie, Edwin Austin Abbey Fellowship; Tupperware National Competition; Yaddo Fellowship; Los Angeles County Fair, 1956; Columbia, S.C./MA, Biennial, 1957; MacDowell Colony Fellowship. **Address:** 100 La Salle Street, NYC 10027. **Dealer:** Kennedy Galleries, NYC. **One-man Exhibitions:** Robert Isaacson Gallery, NYC; Little Gallery, London, 1949; Hewitt Gallery, NYC, 1951, 52, 54; J. Seligmann and Co., 1965, 67; Lehigh U., 1966; Lane Gallery, Los Angeles, 1968; Kennedy Galleries, 1968-72, 76, 79, 86; Columbia S.C./MA, 1972; S.C. Museum, 1972; Columbus, Ga., 1972; Towson State College, Md., 1978. **Group:** A.F.A., 20th Century Realists; WMAA Annual; Chicago/AI; PAFA; NAD; NIAL; ART: USA, NYC; Walker; Carnegie; Festival of Two Worlds, Spoleto; Youngstown/Butler; Brandeis U.; U. of Rochester; U. of Illinois. **Collections:** California Palace; Columbia, S.C./MA; Corcoran; Detroit/Institute; U. of Miami; Milwaukee; NAD; New York State Museum, Albany; Randolph-Macon Women's College; U. of Rochester; St. Louis/City; Wichita/AM; Williams College; Youngstown/Butler.

BRUCE, PATRICK HENRY
b. April 2, 1880, Long Island, Va. **d.** November 12, 1937, NYC. **Studied:** Richmond (Va.) Art School; New York School of Art, with Robert Henri, W.M. Chase, 1901-03; with Henri Matisse in Paris, 1909. Traveled Europe; resided Paris, 1904-36. **One-man Exhibitions:** Rose Fried Gallery (three-man), 1950; Coe Kerr Gallery, 1970; Washburn Gallery, Inc., NYC, 1980, 89; Federal Reserve Board, Washington, D.C., 1981. **Retrospective:** MOMA, 1979. **Group:** Salon d'Automne, Paris, 1907-10; The Armory Show, 1913; Herbstalon, 1913; Montross Gallery, NYC, 1916, 17; Societé Anonyme, 1920; Worcester, Mass., 1921; MacDowell Club, NYC, 1922; Vassar College, 1923; WMAA, The Decade of the Armory Show, 1963; U. of New Mexico, Cubism: Its Impact in the USA, 1967; Utica, Armory Show 50th Anniversary Exhibit, 1963; NAD; Hirshhorn, Inaugural Exhibition, 1974. **Collections:** Baltimore; Carnegie; Hirshhorn; Houston/MFA; MOMA; U. of Nebraska; Oberlin; PMA; Paris/Beaubourg; Phillips; RISD; Santa Barbara; WMAA; Yale U. **Bibliography:** *Avant-Garde Painting and Sculpture;* Baur 7; Brown 2; Dreier 2; DuBois 1; Hunter 6; Levin 2; MacAgy 2; Ritchie 1; Rose, B., 1; Seuphor 1; Wright 2. Archives.

BUCHWALD, HOWARD
b. 1943, NYC. **Studied:** Cooper Union, 1960-64, BFA; Hunter College, 1972, MA. **Taught:** Hofstra U., 1969-71; Kingsborough Community College, 1972-74; Richmond Community College, 1973-74; Queens College, 1974-75; Princeton U., 1975-82; Pratt Institute, 1972-; Columbia U., 1982-. **Awards:** Guggenheim Foundation Fellowship, 1974-75; National Endowment for the Arts, 1981, 89; CAPS, grant, 1983. **Address:** 155 Suffolk Street, NYC, 10002. **Dealer:** Nancy Hoffman Gallery, NYC. **One-man Exhibitions:** French & Co., NYC, 1971; Nancy Hoffman Gallery, 1973, 74, 75, 76, 78,

82, 84, 85, 87, 88, 89; Galerie Swart, Amsterdam, 1974; Galerie Farideh Cadot, Paris, 1976, 78; Mary Boone Gallery, NYC, 1979, 80; Janet Steinberg Gallery, San Francisco, 1986; Union County College, Cranford, N.J., 1990. **Group:** WMAA Biennial, 1973; WMAA, American Drawings: 1963-73, 1973; Potsdam/SUNY, Abstraction Alive and Well, 1975; Indianapolis/MA, Painting and Sculpture Today 1978, 1978; NYU, The Eighties, 1979; U. of North Carolina, Art on Paper, 1983; Princeton U., A Decade of Visual Arts at Princeton, 1985; Hudson River Museum, Form or Formula: Drawing and Drawings, 1986; Hunter College, Artists at Hunter, 1986. **Collections:** Bank of Oklahoma; Chase Manhattan Bank; Dow Jones; Goldman Sachs & Co., NYC; McCrory Corp.; Miami-Dade U.; Prudential Insurance Co. of America; Sonesta Hotels; United Bank of California; WMAA; Youngstown/Butler.

BUCK, JOHN b. February 14, 1946, Ames, Iowa. **Studied:** Kansas City/AI, BFA, 1964-68; U. of California, Davis, MFA, 1970-72; Skowhegan School, 1971; Gloustershire College of Art and Technology, 1972-73. **Taught:** U. of California, Davis, 1971-72; Gloustershire College of Art and Design, 1972-73; Humboldt State U., 1973-75; Miracosta College, 1975; Montana State U., 1976-. **Awards:** Skowhegan School, scholarship; National Endowment for the Arts, 1980; National Artists Award, 1984. **m.** Deborah Butterfield. **Address:** 11229 Cottonwood Road, Bozeman, Mt. 59715. **Dealers:** Zolla/Lieberman Gallery, Chicago; John Berggruen Gallery, San Francisco. **One-man Exhibitions:** Miracosta College, 1974; U. of Kentucky, Lexington, 1975; Hansen Fuller Goldeen Gallery, San Francisco, 1979, 81, 83; Morgan Gallery, Shawnee Mission, Mt., 1981; U. of California, Davis, 1982; Yellowstone Art Center, circ., 1983-84; Zolla/Lieberman Gallery, Chicago, 1983, 86; Asher/Faure Gallery, Los Angeles, 1984, 87; U. of New Mexico, Las Cruces (two-man) 1983; Carlo Lamagna Gallery, NYC, 1985, 86, 88; Brunswick Gallery, Missoula, Mt., 1984; Center for Contemporary Arts, Great Falls, Mo., 1984; Fuller-Goldeen Gallery, San Francisco, 1985; Art Museum of Santa Cruz County (Calif.), 1985; Foster/White Gallery, Seattle, 1986; Honolulu/Contemporary, 1987; San Antonio/McNay, 1987; Robischon Gallery, Denver, 1987; Kansas City/AI, 1988; Moss-Chumley Gallery, Dallas, 1988; Volcano Art Center, Honolulu, 1988; John Berggruen Gallery, San Francisco, 1988, 91; Galerie Ninety-Nine, Bay Harbor Islands, Fla., 1989; Ann Reed Gallery, Ketchum, 1989; J. Noblett Gallery, Boyes Hot Springs, Calif., 1990; Morgan Gallery, Kansas City, Mo., 1991. **Retrospective:** Yellowstone Art Center, circ., 1983. **Group:** California State U., Fullerton, Visions and Figurations, 1980; Indianapolis, 1980; Palm Springs Desert Museum, The West as Art, 1982; Fresno Art Center, Forgotten Dimension, 1982; Brooklyn Museum, The American Artist as Printmaker, 1983; Corcoran, Second Western States Exhibition, 1983; MOMA, Prints from Blocks: Gauguin to Now, 1983; Brooklyn Museum, Public and Private: American Prints Today, 1986; Corcoran, Spectrum: The Generic Figure, 1987; U. of Northern Iowa, Born in Iowa: The Homecoming Exhibition, circ., 1986; Peninsula Museum of Art, Monterey, Calif., the Artist and the Myth, 1987; Greenville, Imprimature, 1988; U. of Alabama, Visions of Printmakers: New Works, 1988; Walker, First Impressions, circ., 1989; Palm Springs Desert Museum, Northwest X Southwest: Painted Fictions, circ., 1990. **Collections:** U. of California; Chicago/AI; Denver/AM; Madison Art Center; Milwaukee; Palm Springs Desert Museum; Rayovac Corp., Madison, Wisc.; SFMA; Seattle/AM; Yellowstone Art Center.

BULTMAN, FRITZ b. April 4, 1919, New Orleans, La. **d.** July 20, 1985,

Provincetown, Mass. **Studied:** Privately
with Morris Graves, 1931; New Orleans
Arts and Crafts School; Munich Prepara-
tory School; New Bauhaus, Chicago, 1937-
38; Hofmann School, 1938-41. NYC and
Provincetown, 1938-41. **Taught:** Pratt In-
stitute, 1958-63; Hunter College, 1959-
64; Fine Arts Work Center, Provincetown,
Mass., 1968-72. **Awards:** Italian Govern-
ment Scholarship, 1950; Fulbright Fellow-
ship, 1951, 1964-65 (Paris); Guggenheim
Foundation Fellowship, 1975. **One-man
Exhibitions:** (first) Hugo Gallery, NYC,
1947, also 1950; The Kootz Gallery, NYC,
1952; The Stable Gallery, NYC, 1958;
Martha Jackson Gallery, 1959, 73, 74, 76;
New Orleans/Delgado, 1959, 74; Galerie
Stadler, Paris, 1960; Michel Warren Gal-
lery, NYC, 1960; Gallery Mayer, NYC,
1960; Tibor de Nagy Gallery, 1963, 64;
Oklahoma, 1974; Newport (R.I.) Art Asso-
ciation, 1974; Long Point Gallery, Pro-
vincetown, Mass., 1977, 78, 79, 84;
Landmark Gallery, Inc., NYC, 1982;
Galerie Schlesinger-Boisanté, NYC, 1982,
86, 87; Galerie Schlesinger, NYC, 1989,
90, 91, 92; Fine Arts Work Center, Pro-
vincetown, Mass., 1986; Portland,
Me./AM, 1987; Hunter College, 1987;
Tilden-Foley Gallery, New Orleans, 1989;
Kouros Gallery, NYC, 1991. **Retro-
spective:** U. of Connecticut, 1989.
Group: WMAA, 1950, 53; Chicago/AI;
MOMA, Hans Hofmann and His Stu-
dents, circ., 1963-64; IIE, 20 American
Fulbright Artists, 1975; Syracuse, Province-
town Painters: 1970s to 1980s, 1977; Indi-
anapolis, Painting and Sculpture Today;
NYU, Tracking the Marvelous, 1981; City
U. of New York, Figural Art, 1985. **Collec-
tions:** Boston/MFA; Brandeis U.; U. of
California; Ciba-Geigy Corp.; Corcoran;
Grinnell College; Gutai Museum, Osaka;
Kalamazoo College; MMA; McCrory
Corp.; U. of Minnesota; Montclair/AM;
NMAA; NYU; U. of Nebraska; New Or-
leans/Delgado; Norfolk/Chrysler; U. of
North Carolina; Portland, Me./MA;
RISD; SRGM; Union Carbide; U. of

Texas; Tougaloo College; WMAA;
Williams College; U. of Wisconsin.
Bibliography: Pousette-Dart, ed. Archives.

BUNCE, LOUIS b. August 13,
1907, Lander, Wyo. **d.** June 11, 1983,
Portland, Ore. **Studied:** Portland (Ore.)
Museum School, 1925-26; ASL, 1927-30,
with Boardman Robinson, William Von
Schlegell. Traveled USA, Mexico, Europe
extensively. **Taught:** Salem (Ore.) Art Mu-
seum, 1937-38; Portland (Ore.) Museum
School; U. of California, Berkeley; U. of
British Columbia; U. of Washington; U.
of Illinois; U. of Oregon; Federal A.P.:
Mural Division, NYC, 1940-41. **Commis-
sions:** Federal Building, Grants Pass, Ore.,
1936-37 (mural); Portland (Ore.) Interna-
tional Airport, 1958 (mural); Portland
(Ore.) Hilton Hotel, 1963 (637 seri-
graphs). **Awards:** Seattle/AM, P.P., 1936,
62; Northwest Printmakers Annual, 1948;
U. of Washington, P.P., 1950; Portland,
Ore./AM, P.P., 1952; SFMA, Emanuel
Walter Bequest and Purchase Award,
1961; Ford Foundation, P.P., 1964; Tama-
rind Fellowship. **One-man Exhibitions:**
Seattle/AM, 1936, 53; Washburn U. of
Topeka, 1937; Hollins College, 1941, 58;
Portland, Ore./AM, 1945, 47, 56; U. of
Washington, 1947; Harvey Welch Gallery,
Portland, Ore., 1947; National Serigraph
Society, NYC, 1947; Reed College, 1947,
51; Wilmette U., 1948; Santa Bar-
bara/MA, 1948; Kharouba Gallery, Port-
land, Ore., 1950, 52; Cincinnati/AM,
1952; John Heller Gallery, NYC, 1953;
Grants Pass (Ore.) Art League, 1953, 54;
Salem (Ore.) Art Association, 1955; Morri-
son Street Gallery, Portland, Ore., 1955;
Doris Meltzer Gallery, NYC, 1956, 57,
59, 60; Artists Gallery, Seattle, 1958; U. of
California, Berkeley, 1960; Fountain Gal-
lery, Portland, Ore. 1962, 64, 66, 72, 81;
Comara Gallery, 1964; Gordon Woodside
Gallery, 1964; U. of Illinois, 1967. **Retro-
spective:** Portland, Ore./AM, 1955.
Group: Golden Gate International Exposi-
tion, San Francisco, 1939; New York

World's Fair, 1939; Chicago/AI, Abstract
and Surrealist Art, 1948; Worcester/AM,
1949; MMA, American Paintings Today,
1950; Colorado Springs/FA, Artists West
of the Mississippi, 1951, 53, 56, 59;
WMAA Annuals, 1951, 53, 54, 59, 60;
Corcoran, 1953; U. of Colorado, 1953;
Los Angeles/County MA; 1953; VMFA,
1954; Des Moines, 1954; U. of Nebraska,
1954, 57; Carnegie Annual, 1955; São
Paulo, 1955, 56; Denver/AM Annuals,
1955, 56, 59, 62; Santa Barbara/MA,
1957; PAFA, 1958; Detroit/Institute,
1958; Stanford U., Fresh Point, 1958;
Grand Rapids, 1961; Seattle World's Fair,
1962. **Collections:** AAIAL; American Asso-
ciation of University Women; Auburn U.;
Colorado Springs/FA; Hollins College; Li-
brary of Congress; MMA; U. of Michigan;
National Gallery; PMA; Portland,
Ore./AM; Reed College; SFMA; Seat-
tle/AM; Springfield, Mo./AM; US State
Department; Utica; WMAA; U. of Wash-
ington; Youngstown/Butler. **Bibliogra-
phy:** *Art of the Pacific Northwest*; Bunce;
Clark and Cowles.

BURCHFIELD, CHARLES
b. April 9, 1893, Ashtabula Harbor, Ohio.
d. January 10, 1967, West Seneca, N.Y.
Studied: Cleveland Institute of Art, 1912,
with Henry G. Keller, F. N. Wilcox,
William J. Eastman; NAD. US Army,
1918-19. **Taught:** U. of Minnesota,
Duluth, 1949; Art Institute of Buffalo,
1949-52; Ohio U., summer, 1950; U. of
Buffalo, summers, 1950, 51; Buffalo Fine
Arts School, 1951-52. **Member:** American
Academy of Arts and Sciences: NIAL;
NAD. **Commissions:** *Fortune* magazine,
1936, 37. **Awards:** Cleveland/MA, First
Prize and Penton Medal, 1921; PAFA,
Jennie Sesnan Gold Medal, 1929; Carne-
gie, Second Prize, 1935; International Arts
Festival, Newport, R.I., First Prize, 1936;
PAFA, Dana Watercolor Medal, 1940;
Chicago/AI, Watson F. Blair Prize, 1941;
NIAL, Award of Merit Medal, 1942; U. of
Buffalo, Chancellor's Medal, 1944; Hon.

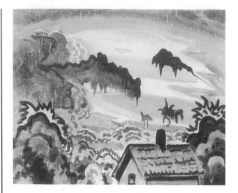

C.E. Burchfield, *Dream House*, 1917.

LHD, Kenyon College, 1944; Carnegie,
Second Hon. Men., 1946; Hon. DFA,
Harvard U., 1948; Hon. DFA, Hamilton
College, 1948; PAFA, Dawson Memorial
Medal, 1947, Special Award, 1950; Hon.
LLD, Valparaiso U., 1951; MMA, 1952
($500); Buffalo/Albright, J.C. Evans
Memorial Prize, 1952; Buffalo/Albright,
Satter's Prize, 1955; Buffalo Historical So-
ciety, Red Jacket Medal, 1958. **One-man
Exhibitions:** (first) Sunwise Turn Book-
shop, NYC, 1916; Cleveland Institute of
Art, 1916, 17, 21, 44; Laukhuff's Book-
store, Cleveland, 1918; Garrick Theater
Library, NYC, 1919; Little Theater, Cleve-
land, 1919; H. Kevorkian, NYC, 1920;
Chicago/AI, 1921; Grosvenor (Gallery),
London, 1923; Montross Gallery, NYC,
1924, 26, 28; Eastman-Bolton Co., Cleve-
land, 1928; Rehn Galleries, 1930, 31, 34-
36, 39, 41, 43, 46, 47, 50, 52, 54-64, 66,
71, 73; U. of Rochester, 1932; Phillips,
1934; Philadelphia Art Alliance, 1937;
Town and Country Gallery, Cleveland,
1948; MOMA, 1954; Buffalo/SUNY,
1963, 71; Cleveland/MA, 1966; Dan-
enberg Gallery, NYC, 1972; Kennedy Gal-
leries, NYC, 1974, 75, 76, 77, 78, 79, 92;
Smithsonian, circ., 1978; Valparaiso U.,
1976; WMAA, 1980; Boston Athenaeum,
1986. **Retrospectives:** Carnegie, 1938;
Buffalo/Albright, 1944, 63; Cleve-
land/MA, 1953 (drawings); WMAA, 1956;
AAAL, 1968; Oklahoma, 1984.

Group: WMAA Annuals; Chicago/AI; U. of Illinois; MOMA; MMA; Carnegie. **Collections:** Boston/MFA; Brooklyn Museum; Buffalo/Albright; Carnegie; Chase Manhattan Bank; Chicago/AI; Cleveland/MA; Detroit/Institute; Harvard U.; IBM; U. of Illinois; Indianapolis/Herron; Kalamazoo/Institute; Kansas City/Nelson; MMA; MOMA; Muskegon/Hackley; Newark Museum; New Britain; PAFA; Phillips; RISD; St. Louis/City; San Diego; Santa Barbara/MA; Sweet Briar College; Syracuse/Everson; Terre Haute/Swope; Utica; VMFA; Valparaiso U.; WMAA; Wichita/AM; Wilmington; Youngstown/Butler. **Bibliography:** Armstrong, Thomas; Barr 3; **Baur 1, 7;** Bazin; Beam; Blesh 1; Boswell 1; Brown; **Burchfield 1, 2, 3;** Cahill and Barr, eds.; Canaday; *Celebrate Ohio;* Cheney; Christensen; Craven 1, 2; Cummings 5; *The Drawings of Charles E. Burchfield; 8 American Masters of Watercolor;* Eliot; Flanagan; Flexner; Gallatin 1; Goodrich 1; Goodrich and Baur 1; Haftman; Hall; Hunter 6; *Index of 20th Century Artists;* Jewell 2; **Jones, ed.;** Lee and Burchwood; McCurdy, ed.; Mellquist; Mendelowitz; Newmeyer; Nordness, ed.; Pagano; Pearson 1; Phillips 1; Poore; Pousette-Dart, ed.; Richardson, E. P.; Ringel, ed.; Rose, B., 1, 4; Sachs; Soby 5; Sutton; Watson, E. W., 1; Weller; Wight 2. Archives.

BURDEN, CHRIS b. April 14, 1946, Boston, Mass. **Studied:** Pomona College, 1969, BA; U. of California, Irvine, 1971, MFA. **Taught:** SFAI, 1978; UCLA, 1987-. Presented performances 1971-82; film, video, and audio tapes, 1975-84. **Awards:** Los Angeles/County MA, New Talent Award, 1973; National Endowment for the Arts, 1974, 76, 80, 83; Guggenheim Foundation Fellowship, 1978. Performance artist. **Address:** 1780 Will Geer Road, Topanga, Calif. 90019. **Dealer:** Josh Baer Gallery, NYC. **One-man Exhibitions:** Riko Mizuno Gallery, Los Angeles, 1974, 75; Ronald Feldman

Fine Arts Inc., 1974, 75, 76, 77, 80, 83; Cincinnati/Contemporary, 1974; Galleria A. Castelli, Milan, 1975; Galleria Schema, Florence, 1975; De Appel, Amsterdam, 1975; Broxton Gallery, Los Angeles, 1976; Baum-Silverman Gallery, Los Angeles, 1977; Rosamund Felsen Gallery, Los Angeles, 1979, 80, 82, 84, 87; WMAA, 1980; Hartford/Wadsworth, 1985; U. of Miami, 1985; Lawrence Oliver Gallery, Philadelphia, 1985; New Langton Arts, San Francisco (with Nancy Rubins), 1986; Christine Burgin Gallery, NYC, 1987, 89; Los Angeles Contemporary Exhibitions (with Nancy Rubins), 1989; Fred Hoffman Gallery, Santa Monica, 1987; Josh Baer Gallery, NYC, 1989, 91, 92; Kent Fine Art, NYC, 1989; Daniel Buchholz Gallery, Cologne, 1990; Galerie Juergen Becker, Hamburg, 1990; Brooklyn Museum, 1991; Lannan Foundation, Los Angeles, 1992. **Retrospective:** Newport Harbor, circ., 1988. **Group:** La Jolla, Body Movements, 1971; Portland (Ore.) Center for the Visual Arts, Via Los Angeles, 1975; MOMA, Projects: Video, 1975; SFMA, California Painting and Sculpture: The Modern Era, 1976; WMAA, Biennial, 1977, 89; Kassel, Documenta VI, 1977; Chicago/Contemporary, A View of a Decade, 1977; Purchase/SUNY, The Sense of Self, 1978; High Museum, Contemporary Art in Southern California, 1980; San Diego, Sculpture in California, 1975-80, 1980; Potsdam/SUNY, Usable Art, 1981; Walker, Eight Artists: The Anxious Edge, 1982; Oakland Museum, Site Strategies, 1983; MOMA, International Survey of Recent Painting and Sculpture, 1984; Hirshhorn, Content, 1984; Palm Springs Desert Museum, Return of the Narrative, 1984; Bard College, Art as Social Conscience, 1984; Los Angeles/MOCA, Automobile and Culture, 1984; U. of Washington, No! Contemporary American DADA, 1985; São Paolo, Biennial, 1985; Bard College, The Maximal Implications of the Minimal Line, 1985; Los Angeles/MOCA, Individuals, 1986; Fort Lauderdale, American Re-

naissance, 1986; Cleveland Center for Contemporary Art, Fringe Patterns, circ., 1987; WMAA, Identity, 1988; MOMA, Committed to Print, circ., 1988; UCLA, Forty Years of California Assemblage, 1989; WMAA, Image World, 1989; Whitechapel Art Gallery, London, Seven Obsessions, 1990; Musée de la Poste, Paris, The Colors of Money, 1991; Hofstra U., The Realm of the Coin, 1991; MOMA, Dislocations, 1991; Indianapolis, Power, 1991; Baltimore/MA, Marking the Decades: Prints, 1960-1990, 1992. **Collections:** Corpus Christi; Dallas/MFA; Los Angeles/County MA; MOMA; Newport Harbor; Oakland Museum; Ohio State U.; SFMA; San Diego/Contemporary; WMAA. **Bibliography:** Day 1; *Chris Burden: A Twenty Year Survey; Forty Years of California Assemblage; Individuals;* Leavens and Bruce; *Performance Anthology;* Plagens; Weintraub.

BURKHARDT, HANS GUSTAV
b. December 20, 1904, Basel, Switzerland. To USA, 1924. **Studied:** Cooper Union, 1924-25; Grand Central School, NYC, 1928-29, with Arshile Gorky, and privately with Gorky, 1930-35. Resided Mexico, 1950-52. Traveled Europe, Mexico, USA. California State U., Northridge, groundbreaking for Hans Burkhardt Art and Humanities Center, 1989. **Taught:** Long Beach State College, summer, 1959; U. of Southern California, 1959-60; UCLA, 1962-63; California Institute of the Arts, 1962-64; Laguna Beach (Calif.) School of Art and Design, 1962-64; San Fernando Valley State College, 1963-73; Otis Art Institute, summer, 1963; California State U., Northridge, 1973. **Member:** Artists Equity. **Awards:** Los Angeles/County MA, First P.P., 1946; California State Fair, P.P., 1954, Second Prize, 1962; Santa Barbara/MA, Ala Story Purchase Fund, 1957; Los Angeles All-City Show, P.P., 1957, 60, 61; California Watercolor Society, P.P., 1962; AAIAL, Jimmy Ernst Award, 1992. **Address:** 1914

Jewett Drive, Los Angeles, CA 90046. **Dealer:** Jack Rutberg Fine Arts, Los Angeles. **One-man Exhibitions:** (first) Stendahl Gallery, Los Angeles, 1939; Open Circle Gallery, 1943, 44; Chabot Gallery, Los Angeles, 1946, 47, 49; Los Angeles/County MA, 1946, 62; U. of Oregon, 1947; Hall of Art, Beverly Hills, 1948; Guadalajara, 1951; Fraymart Gallery, Los Angeles, 1951, 52; Paul Kantor Gallery, Beverly Hills, 1953; Escuela de Bellas Artes, San Miguel de Allende, Mexico, 1956, 61; Esther Robles Gallery, 1957-59; Comara Gallery, 1959; Long Beach State College, 1959; Glendale (Calif.) Public Gallery, 1960; Whittier (Calif.) Art Association, 1960; SFMA, 1961; Ankrum Gallery, 1961, 63; La Jolla, 1962; Fresno Art Center, 1962; Palm Springs Desert Museum, 1964, 79; Freie Schule, Basel, Switzerland, 1965; San Fernando Valley State College, 1965; Bay City Jewish Community Center, San Francisco, 1966; Laguna Beach (Calif.) Art Gallery, 1966; San Diego, 1968; Michael Smith Gallery, Los Angeles, 1972; Four Oaks Gallery, South Pasadena, 1972; Moorpark College, 1974; California State U., Northridge, 1975; Santa Barbara/MA, 1977; Laguna Beach Museum of Art, 1978; Cerro Coso Community College, 1978; San Fernando Mission College, 1978; Robert Schoelkopf Gallery, NYC, 1979; Santa Barbara/MA, 1977; Iannetti Gallery, San Francisco, 1977; Palm Springs Desert Museum, 1979; Jack Rutberg Fine Arts, Los Angeles, 1982, 84, 85, 87, 89, 90, 91; Sid Deutsch Gallery, NYC, 1987; Cunningham Memorial Art Gallery, 1987; Oakland Museum, 1987; Muhlenberg College, circ., 1990; Laguna Beach Museum of Art, 1990; Portland, Ore./AM, (two-man), 1990. **Retrospectives:** Falk-Raboff Gallery, Los Angeles, 1954; Pasadena/AM (10-year), 1957; Santa Barbara/MA (30-year), 1961; San Diego (40-year), 1966; Long Beach/MA, 1972; California State U., Northridge, 1973, 75; Pasquale Iannetti Assoc., San Francisco, 1977. **Group:** Los Ange-

les/County MA Annuals, 1940, 45, 46, 53, 54, 57, 59; Los Angeles Art Association Annuals, 1940-63; Corcoran, 1947, 51, 53; Denver/AM 1949, 53, 54; U. of Illinois, 1951; MMA, 1951; PAFA, 1951-53; WMAA Annuals, 1951, 55, 58; III São Paulo Biennial, 1955; Long Beach/MA, 1958, 60, 64; Kunsthalle, Basel, 1966; Trinity U., San Antonio, Tex., 1967; ICA, Los Angeles, 1974; Los Angeles Municipal Art Gallery, 1975; Hirshhorn, 1984; Milwaukee, 1984; Chapman College, 1984; IEF, Twentieth Century American Drawings: The Figure in Context, circ., 1984; Loyola Marymount University, Los Angeles, Through the Eyes of an Artist, 1986; Santa Barbara/MA, Turning the Tide, circ., 1990; AAIAL, 1992; Claremont College, American Abstract Drawing, 1930-1987, 1992. **Collections:** Basel/Kunsthalle; California State U., Northridge; Calvin College; The Coca-Cola Co.; Columbia, S.C./MA; Corcoran; Downey Museum; Grunewald Foundation; Guadalajara; Hirshhorn; Home Savings and Loan Association; La Jolla; Little Rock/MFA; Long Beach/MA; Los Angeles/County MA; Lucerne; U. of Miami; Moorpark College; Muhlenberg College; U. of North Carolina; Norton Smith Museum (Pasadena); Oakland/AM; Omaha/Joslyn; Pasadena/AM; Portland, Ore./AM; Sacramento/Crocker; St. Louis/City; San Diego; Santa Barbara/MA; SRGM; State of California; Stockholm/National; Worcester/AM. **Bibliography:** Cummings 4; Selz 4; Karlstrom and Ehrlich. Archives.

BURLIN, PAUL b. September 10, 1886, NYC; **d.** March 13, 1969, NYC. Self-taught in art. Traveled Europe, North Africa, USA; resided Paris, 1921-32. **Taught:** U. of Minnesota, 1949; Washington U., 1949-54; U. of Colorado, 1951; U. of Wyoming, 1952; UCLA, 1954; Union College (N.Y.), 1954-55; Chicago Art Institute School, 1960. Federal A.P.: Easel painting. **Awards:** Portrait of America, First Prize ($2,500), 1945;

ART:USA:59, NYC, First Prize, 1959; Chicago/AI, Watson F. Blair Prize ($2,000), 1960; PAFA, J. Henry Schiedt Memorial Prize, 1963. **One-man Exhibitions:** (first) The Daniel Gallery, NYC, 1913, also 1914-20; Kraushaar Galleries, NYC, 1926, 27; Westheim Gallery, Berlin, 1927; de Hauke Gallery, NYC, 1942; Vincent Price Gallery, Los Angeles, 1944; The Downtown Gallery, 1946, 49, 52, 53; U. of Minnesota, 1949; Southern Illinois U., 1950, 60; U. of Wyoming, 1952; Washington U., circ., 1954; The Stable Gallery, NYC, 1954; Poindexter Gallery, NYC, 1958, 59; The Alan Gallery, NYC, 1959; Chicago/AI, 1960; Holland-Goldowsky Gallery, Chicago, 1960; Grace Borgenicht Gallery, Inc., NYC, 1963-66, 70, 71, 73, 75, 81; Boston U., 1964; Hillwood Gallery, Greenville, N.Y., 1983. **Retrospective:** A.F.A. circ., 1962. **Group:** The Armory Show, 1913; WMAA Annuals; Carnegie; PAFA; WMAA, Pioneers of American Art, 1946; Walker; Corcoran; U. of Nebraska; nationally since 1913. **Collections:** Auburn U.; Britannica; Brooklyn Museum; Carleton College; Exeter; Hartford/Wadsworth; IBM; S.C. Johnson & Son, Inc.; MOMA; U. of Minnesota; NYU; Newark Museum; Southern Illinois U.; Tel Aviv; WMAA; Washington U.; Wichita/AM. **Bibliography:** Baur 7; Biddle 4; Cheney; Coke 2; Genauer; Goodrich and Baur 1; Kootz 2; Nordness, ed.; Pagano; Passloff; Pearson 1, 2; Pousette-Dart, ed.; Richardson, E. P.; Rose, B., 1; *Woodstock: An American Art Colony 1902-1977;* Zaidenberg, ed. Archives.

BURLIUK, DAVID b. July 22, 1882, Kharkov, Ukraine. **d.** January 15, 1967, Southampton, N.Y. **Studied:** Art schools in Kazan, 1898-1902, Odessa, 1911, Munich, Moscow, 1914; Bayerische Akademie der Schonen Kunst, Munich; Academie des Beaux-Arts, Paris. To USA, 1922; citizen, 1930. Traveled Europe, the Orient, USA. **Taught:** Painting, art history. Federal A.P.: Easel painting. A

founder (with W. Mayakovsky and W. Kamiensky) of Futurist art movement in Russia, 1911. A founder-member of Der Blaue Reiter and Der Sturm groups, 1910-14. Cofounder (1930) and publisher (with Marussia Burliuk) of art magazine *Color Rhyme*. Owned and operated Burliuk Gallery, Hampton Bays, N.Y. **Awards:** Pepsi-Cola, 1946. **One-man Exhibitions:** (first) Cherson, South Russia, 1904; galleries in Moscow and St. Petersburg, 1907; Societé Anonyme, NYC, 1924; J. B. Neumann Gallery, NYC, 1927; Morton Gallery, NYC, 1928; California Palace, 1931; Dorothy Paris Gallery, NYC, 1933-35; Boyer Gallery, NYC, 1935-39; Phillips, 1937; ACA Gallery, 1941-50, 1952-54, 1956, 58, 60, 63, 67, 69; Havana/Nacional, 1955; Galerie Maeght; Der Blaue Reiter, 1962; Galerie Stangi, Munich, 1962; Leonard Hutton Gallery, NYC, Der Blaue Reiter, 1963; Parrish Museum, Southampton, N.Y., 1978. **Group:** Brooklyn Museum, 1923, 26; PMA, 1962. **Collections:** Boston/MFA; Brooklyn Museum; MMA; Phillips; WMAA; Yale U. **Bibliography:** Baur 7; **Dreier 1**; Richardson, E.P.; Selz, P., 3; Soyer, R., 1; Waldman 4. Archives.

BURTON, SCOTT b. June 23, 1939, Greensboro, Ala. d. December 29, 1989, NYC. **Studied:** Columbia U., 1962, BA, magna cum laude, with Trilling, Dupee, Marcus; NYU, 1963, MA; private studies 1957-60 with Leon Berkowitz, Washington, D.C., and Hans Hofmann, Provincetown, Mass. **Taught:** School of Visual Art, NYC, 1967-72; U. of North Carolina, 1976. Performance Artist & Sculptor, 1970-80. **Commissions:** Rockdale Temple, Cincinnati, 1980; National Oceanic and Atmospheric Administration, Seattle, 1983; Light Rail Rapid Transit System, Buffalo, N.Y., 1985; Pearlstone Park, Baltimore, 1985; MIT, 1985; Equitable Center, NYC, 1985; U. of Houston, 1986; Equitable Life Assurance Society of the United States, NYC, 1986,

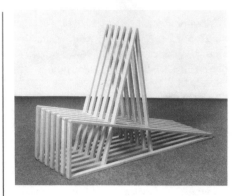

Scott Burton, *Slat Chair*, 1985-1986.

88; Tate Gallery, Liverpool, 1988; Union Bank of Switzerland, NYC, 1989; Battery Park City Authority, NYC, 1989. **Awards:** PBK; Woodrow Wilson Fellowship; National Endowment for the Arts, grant, 1973, 75, 79; CAPS, 1975; L. C. Tiffany Grant, 1980. **One-man Exhibitions:** (first) Artists Space, NYC, 1975; Finch College, NYC, 1971; WMAA, 1972; SRGM, 1976; Droll/Kolbert Gallery, NYC, 1977, 80; Brooks Jackson Gallery Iolas, NYC, 1978; Max Protetch Gallery, Washington, D.C., 1979; U. of California, 1980; Weinberg Gallery, San Francisco, 1980; Max Protetch Gallery, NYC, 1981, 82, 85, 86, 87, 90; Daniel Weinberg Gallery, Los Angeles, 1982, 86; Cincinnati/Contemporary, 1983; McIntosh-Drysdale Gallery, Houston, 1984; Tate Gallery, 1985; Baltimore/MA, 1986; John C. Stoller & Co., Minneapolis, 1988; Lisson Gallery, London, 1988. **Group:** U. of Iowa, Two Evenings, 1970; Hartford/Wadsworth, Four Theater Pieces, 1970; Oberlin College, Festival of Contemporary Arts, 1973; Akademie der Kunst, Berlin, SoHo, 1976; Kassel, Documenta VI & VII, 1977, 82; Chicago/Contemporary, performance week, 1977; ICA, U. of Pennsylvania, Improbable Furniture, 1977; SRGM, Young American Artists, 1978; Purchase/SUNY, Ten Artists/Artists Space, 1979; Detroit/Institute, Image and Object in Contemporary Sculpture, 1979;

WMAA Biennial, 1981; SFMA; 20 American Artists: Sculpture, 1982, 1982; Hirshhorn, Directions, 1983; RISD, Furniture, Furnishings: Subject and Object, 1984; Hirshhorn, Content: A Contemporary Focus, 1974-1984, 1984; WMAA, High Styles, 1985; Carnegie, International, 1985; Munster, Skulptur Projekte, Munster, 1987; Kassel, Documenta VII, 1987; American Craft Museum, NYC, Architectural Art: Affirming the Design Relationship, 1988; Frankfurt/Kunstverein, Prospect 89, 1989. **Collections:** U. of California; Chase Manhattan Bank; Cincinnati/AM; Dallas/MFA; Detroit/Institute; General Mills, Inc.; Honeywell; Humlebaek/Louisiana; La Jolla; Los Angeles/County MA; Los Angeles/MOCA; MOMA; Mellon Bank, Pittsburgh; Milwaukee; Mobil Oil Co.; National Gallery; Omaha/Joslyn; PMA; Princeton U.; SRGM; Tate Gallery; WMAA; Walker. **Bibliography:** Pincus-Witten 1, 2.

BUTTERFIELD, DEBORAH
b. May 7, 1949, San Diego, Calif. **Studied:** San Diego State College, 1966-68; U. of California, San Diego, 1969; U. of California, Davis, 1970-72, BA; 1972-73, MFA, with Robert Arneson, William T. Wiley, Roy de Forest; Skowhegan School, 1972. **Awards:** Guggenheim Foundation Fellowship, 1980; National Endowment for the Arts, 1977, 80. **Taught:** U. of Wisconsin, Madison, 1974-77; Montana State U., 1977-. **Commissions:** Circus World Museum, Baraboo, Wisc., 1975; Corporate Center, Sacramento, Calif., 1983; Kentucky Derby Festival of Arts, Louisville, 1986; Copley Square, Boston, 1987; Walker, 1988; Greenwich (Ct.) Arts Council, 1989. **m.** John Buck. **Address:** 11229 Cottonwood Road, Bozeman, Mt. 59715. **Dealer:** Edward Thorp Gallery, NYC. **One-man Exhibitions:** U. of California, Berkeley (two-man), 1974; Madison Art Center, 1976; Zolla/Lieberman Gallery, Chicago, 1976, 77, 79, 83; Hanson Fuller Gallery, San Francisco,

1978, 81, 85; OK Harris Works of Art, NYC, 1978, 79, 84; Lee Hoffman Gallery, Birmingham, Mich., 1978; Open Gallery, Eugene, Ore., 1980; Atlantic Richfield Co., 1981; Israel Museum, 1981; RISD, 1981; Dallas/MFA, circ., 1983; Oakland/AM, 1983; San Antonio/McNay, 1983; Southeastern Center for Contemporary Art, Winston-Salem, 1983; U. of Nevada, Reno, 1984; Galerie 99, Bay Harbor Islands, Fla., 1984; Ohio State U., 1985. **Group:** Chicago/AI, Chicago and Vicinity, 1977; Buffalo/Albright, Eight Sculptors, 1979; WMAA Biennial, 1979; Dayton/AI, Woodworks One, 1980; Indianapolis, 1980; Renwick Gallery, Washington, D.C., The Animal Image, Contemporary Objects and the Beast, 1981; Fresno Art Center, Forgotten Dimensions, 1982; Oakland/AM, 100 Years of California Sculpture, 1982; Palm Springs Desert Museum, The West as Art, 1982; Philadelphia Art Alliance, S/300, 1982; Seattle/AM, American Sculpture: Three Decades, 1984; Cincinnati/Contemporary, Body and Soul, circ., 1985; Cincinnati/Contemporary, Standing Ground: Sculpture by American Women, 1987; RISD, The Call of the Wild, 1987; Cheney/Cowles Memorial Museum, Editions, East and West, 1988; Missoula/MA, A Sense of Place: Contemporary Sculptors in Montana, 1988; Hudson River Museum, The Nature of the Beast, 1989; PAFA, Making Their Mark, circ., 1989; VMFA, Contemporary Sculpture, 1991. **Collections:** Atlantic Richfield Co.; Baltimore/MA; Brooklyn Museum; Chicago/Contemporary; Cincinnati/AM; Columbus; Denver/AM; Delaware Art Museum; Des Moines; Hirshhorn; Indianapolis; Israel Museum; Louisville/Speed; MMA; Oakland/AM; SFMA; WMAA; Walker; Yellowstone Art Center.

BUTTON, JOHN **b.** 1929, San Francisco. **d.** December 12, 1982, NYC. **Studied:** U. of California, Berkeley, 1947-50; California School of Fine Arts, 1949-50; U. of California Medical Center, San

Francisco; and with Altina Barrett and Willard Cummings. **Taught:** Skowhegan School, 1964, 65; School of Visual Arts, NYC, 1965-82; Cornell U., 1967-68; Swarthmore College, 1969-70; U. of Pennsylvania, 1975-82. **Awards:** Artists of Los Angeles County, Prize, 1952; Silvermine Guild Prize, 1964; Ingram Merrill Foundation, Grant, 1961, 69, 74, 82. **One-man Exhibitions:** Tibor de Nagy Gallery, NYC, 1956, 57; The Kornblee Gallery, 1963, 65, 67, 68, 70, 72, 73; Franklin Siden Gallery, Detroit, 1967; J. L. Hudson Gallery, Detroit, 1970; Gallery of July & August, Woodstock, NY, 1976; Fischbach Gallery, NYC, 1978, 79, 80, 86, 90, 91; Kean College, Union, NJ, 1984; School of Visual Arts, NYC, 1984. **Retrospective:** Currier Gallery, circ., 1989. **Group:** U. of North Carolina, 1966; Vassar College, Realism Now, 1968; A.F.A., Painterly Realism, 1970; MOMA, Eight Landscape Painters, circ., 1972; Boston U., The American Landscape, 1972; School of Visual Arts, NYC, The Male Nude, 1973; Omaha/Joslyn, A Sense of Place, 1973; Hofstra U., The Male Nude, 1973; Indiana U., Contemporary Pastels and Watercolors; College of William & Mary, Contemporary Realism, 1978; Tulsa/Philbrook, Realism/Photorealism, 1980; Utica, An Appreciation of Realism, 1982; SFMA, American Realism (Janss), circ., 1985; Brooklyn College, The 1950's at the Tibor de Nagy Gallery, 1990. **Collections:** Amerada Hess Corp.; AT&T; Chase Manhattan Bank; Chicago/AI; Colby College; Columbia U.; Commerce Bankshares, Kansas City; Debevoise, First National City Bank; Hartford/Wadsworth; Hirshhorn; Kansas City; MMA; MOMA; Newark Museum; U. of North Carolina; Plimpton, Lyons and Gates; Port Authority of New York; Portland, ME/MA; R.J. Reynolds Inc.; Utah. **Bibliography:** *American 1976*; Arthur 1, 2; Downes, ed.

BYARS, JAMES LEE b. April 10, 1932, Detroit, Mich. **Studied:** Wayne

State U., 1954; Merill Palmer School of Psychology, Detroit. **Awards:** Cassandra Foundation, grant, 1967; Architectural League of New York, award, 1968; DAAD, scholarship, 1974. Traveled USA, Europe; resided Japan, 1958-67. **Taught:** Artist-in-residence, Hudson Institute, Croton-on-Hudson, N.Y., 1969. **Address:** 1 Major Alley, Palm Beach, FL 33480. **Dealer:** Galerie Michael Werner, Cologne and NYC. **One-man Exhibitions:** (first) MOMA, 1958; Willard Gallery, NYC, 1961; City of Kyoto, 1962; Carnegie, 1964; Hudson Institute, 1968; Wide White Space Gallery, Antwerp, 1969, 73; MMA, 1970; Galerie Michael Werner, Cologne, 1971, 72, 81, 84, 85, 86, 89; Michael Werner Gallery, NYC, 1991; Musée de Louvre, Pavillon Denon, Paris, 1975; ICC, Antwerp, 1976; Domplatz, Cologne, 1977; Monchengladbach, 1977; U. of California, Berkeley, 1978; Marian Goodman Gallery, NYC, 1978; Harvard U., 1980; Galerie Helen van der Meij, Amsterdam, 1981; Westfalisher Kunstverein, Munich, 1982; Eindhoven, 1983; Paris/Moderne, 1983; ICA, Boston, 1984; Mary Boone Gallery, NYC, 1985, 88, 89; Galerie Fred Jahn, Munich, 1987; Galerie des Beaux-Arts, Brussels, 1987; Hoffman Borman Gallery, Santa Monica, 1988; Cleto Polcina Art Moderna, Rome, 1989; Turin/Contemporanea, 1989; Galerie de France, Paris, 1989; U. of California, Berkeley, 1990; Houston/Contemporary, 1990; Magazine 3, Stockholm, 1992. **Retrospective:** Berne, 1978; Düsseldorf/Kunsthalle, 1986. **Group:** Kassel, Documenta V, 1972; MOMA, Drawing Now, 1976; Kassel, Documenta VI, 1977; Venice Biennale, 1980; Martin-Gropius-Bau, Berlin, Zeitgeist, 1982; Tate, New Art, 1983; Zurich/Spuren, Skulpturen, und Momente, Reise, 1985; Sydney Biennial, 1986; Venice, Biennale, 1986; Martin-Gropius-Bau, Berlin, Der Unverbrauchte, Blick, 1987; Syracuse/Everson, Sacred Spaces, 1987; Kassel, Documenta VIII, 1987; Hamburger Banhof, Berlin, Zeitlos,

1988; Akademie der Kunste, Berlin DAAD, 1988; Paris/Beaubourg, Magiciens de la Terre, 1989; Martin-Gropius-Bau, Berlin, Metropolis, 1990; Musée de la Poste, Paris, Les Couleurs de l'argent, 1991.

Collections: Berne/Kunstmuseum; Carnegie; Eindhoven; MOMA; Paris/Beaubourg; WMAA. **Bibliography:** Elliot, J., 2; *Europa/Amerika;* Gohr and Gachnang; Honnef 2; Joachimides and Rosenthal.

C

Paul Cadmus, *The House That Jack Built*, 1987.

CADMUS, PAUL **b.** December 17, 1904, NYC. **Studied:** NAD, 1919-26; ASL, 1929-31, with Joseph Pennell, Charles Locke. Traveled Europe, the Mediterranean. Federal. A.P.: Easel painting, 1934. Designed sets and costumes for *Ballet Caravan,* 1938. Subject of documentary film by David Sutherland, *Paul Cadmus: Enfant Terrible at 80.* **Member:** Artists Equity; NAD; NIAL; SAGA. **Commissions** (mural): US Post Office, Richmond, VA, 1938. **Awards:** NAD, Bronze Medal for Life Drawing, 1922; NAD, Hallgarten Prize, 1925; Tiffany Foundation, scholarship, 1924; Chicago/AI, Annual Exhibition Prize, 1945; NIAL Grant, 1961; Norfolk, **P.P.,** 1967; NAD, Benjamin West Clinedinst Medal, 1989; Fairfield University, Gerard Manley Hopkins Award for Visual Arts, 1990. **Address:** P.O. Box 1255, Weston, CT 06883. **Dealer:** Midtown-Payson Galleries, NYC. **One-man Exhibitions:** The Midtown Galleries, NYC, 1937, 49, 76 (2), 78, 79, 83, 85, 87; Baltimore/MA (three-man), 1942; The Print Cabinet, Ridgefield, Conn., 1978; Robert Samuel Gallery, NYC, 1979; Kansas State U., 1981; Midtown-Payson Galleries, NYC, 1992; Louis Newman Galleries, Beverly Hills, 1986, 88, 91, 92. **Retrospectives:** The Midtown Galleries 1968; Miami U., Oxford, Ohio, circ., 1981. **Group:** MOMA; MMA; WMAA, 1934, 36, 37, 38, 40, 41, 45; Chicago/AI, 1935; Hartford/Wadsworth; Williams College; Golden Gate International Exposition, San Francisco, 1939; PAFA, 1941; Carnegie, 1944, 45; Corcoran; NPG, American Self-Portraits: 1970-1973, 1974; Rugers U., Realism and Realities, 1982; West Palm Beach/Norton, The Fine Line: Drawings with Silver in America, 1985; WMAA/Equitable, 1987; WMAA/Philip Morris, Straphangers, 1989; WMAA/Philip Morris, Cadmus, French and Tooker: The Early Years, 1990; NAD, 1991; WMAA, American Life in American Art, 1991; NMAA, Sport in Art from American Museums, circ., 1991. **Collections:** Achenbach Foundation; Amon Carter Museum; Andover/Phillips; Baltimore/AM; Boston/MFA; Brooklyn Museum; Carnegie; Chicago/AI; Cleveland/AM; Columbia, S.C./MA; Cranbrook; Dallas/MFA; Dartmouth College; Delaware Art Museum; Detroit/AI; Evansville; Fort Worth; U. of Georgia; Grinnell College; Hartford/Wadsworth; Harvard U.; Indianapolis; Kalamazoo/Institute; Library of Congress; Los Angeles/County MA; Louisville/Speed; MMA; MOMA; Miami U.; Michigan State U.; NAD; NMAA; NYPL; National Gallery; U. of Nebraska; PMA; Portland, Me./MA; Seattle/AM; Utica; U. of Vermont; WMAA; Westmoreland County/MA; Williams College; Yale U.

Bibliography: American Artists Congress, Inc., 3; American Artists Group, Inc., 3; Baur 7; Bazin; Boswell 1; Brown 2; Cummings 4; Goodrich and Baur 1; Hall; **Johnson** 3; Kent, N.; Kirstein 5; McCurdy, ed.; Nordness, ed.; Pagano; Reese; Rose, B., 1; Ward. Archives.

CAESAR, DORIS

from 1st to 5th edition.

CAJORI, CHARLES b. March 9,

1921, Palo Alto, Calif. **Studied:** Colorado College, 1939-40, with Boardman Robinson; Cleveland Institute of Art, 1940-42; Columbia U., 1946-48, with John Herlinker, Henry Poor; Skowhegan School, summers, 1947, 48. US Air Force, 1942-46. A co-organizer of the Tanager Gallery, NYC, 1952. Traveled Europe. **Taught:** College of Notre Dame of Maryland, 1950-56; American U., 1955-56; Cooper Union, 1956-; Philadelphia Museum School, 1956-57; U. of California, Berkeley, 1959-60; Pratt Institute, 1961-62; Cornell U., summers, 1961, 63; Yale U., 1963-64; U. of Washington, 1964; New York Studio School, 1964-69, 83-; Queens College, 1965-85. **Awards:** Fulbright Fellowship (Italy), 1952; Yale U., Distinction of Arts Award, 1959; Longview Foundation Grant, 1962; Ford Foundation, P.P., 1962; NIAL, 1970; Childe Hassam Fund, P.P., 1975, 76, 80; L. C. Tiffany Grant, NIAL, 1979; NAD, Benjamin Altman (figure) Prize, 1983; National Endowment for the Arts, 1981. **Address:** 2338 Litchfield Road, Watertown, CT 06795. **One-man Exhibitions:** (first) Tanager Gallery, NYC, 1956, also 1961; Watkins Gallery, Washington, D.C., 1956; The Bertha Schaefer Gallery, 1958; Oakland/AM, 1959; Cornell U., 1961; The Howard Wise Gallery, NYC, 1963; U. of Washington, 1964; Bennington College, 1969; Kirkland College, 1972; Landmark Gallery, Inc., NYC, 1974; Ingber Art Gallery Ltd., NYC, 1976; U. of Texas, Austin, 1976; Art Academy of Cincinnati, 1976; American U.,

Washington, D.C., 1977; Mattatuck Historical Society Museum, 1980; Landmark Gallery Inc., NYC, 1981; Gross McCleaf Gallery, Philadelphia, 1983, 85; New York Studio School, NYC, 1988. **Group:** Walker, Vanguard, 1955; WMAA Annuals, 1957, 62; U. of Kentucky, 1957, 61; U. of Nebraska, 1958; Festival of Two Worlds, Spoleto, 1958; Corcoran, 1959; Brooklyn Museum, 1959; ICA, Boston, 100 Works on Paper, circ., Europe, 1959; MOMA, Abstract Watercolors and Drawings: USA, circ., Latin America and Europe, 1961-62; Chicago/AI, 1964; Santa Barbara/MA, 1964; U. of Texas, 1966, 68; U. of Washington, 1967; New School for Social Research, Protest and Hope, 1967, Humanist Tradition, 1968; MMA, Recent Acquisitions, 1979; NAD Annuals, 1983, 84, 85, 86, 92. **Collections:** American U.; Ciba-Geigy Corp.; Corcoran; Delaware Art Museum; Fidelity Bank; Hirshhorn; Honolulu Academy; Kalamazoo/Institute; U. of Kentucky; Mattatuck; MMA; Miami U.; NYU; U. of New Mexico; U. of North Carolina; U. of Notre Dame; U. of Texas; Walker; WMAA.

CALCAGNO, LAWRENCE

b. March 23, 1913, San Francisco, CA. **d.** April 22, 1993, State College, Pa. US Air Force, 1941-45. **Studied:** California School of Fine Arts, 1947-50. Traveled Mexico, 1945-47; Europe, North Africa, 1950-55; Peru, Yucatan. **Taught:** U. of Alabama, 1955-56; Buffalo/SUNY, 1956-58; U. of Illinois, 1958-59; NYU, 1960; Carnegie Mellon U., 1965-68; Honolulu Academy, 1968-75; USIA-USSR Artists Union Cultural Exchange, 1988. **Member:** Artists Equity. **Awards:** Yaddo Fellowship, 1961-64, 1965-68; Ford Foundation Grant, 1965-68; MacDowell Colony Fellowship, 1965-68, 70, 72, 74; Wurlitzer Fellowship, 1968; National Endowment for the Arts, grant, 1988. **One-man Exhibitions:** (first) The Little Gallery, New Orleans, 1945; College of the Pacific, 1948; Lucien Labaudt Gallery, San Francisco,

1948, 54; Numero Galleria d'Arte, Florence, Italy, 1951-52; Galeria Clan, Madrid, 1955; Studio Paul Facchetti, Paris, 1955; Martha Jackson Gallery, NYC, 1955, 58, 60, 62; U. of Alabama, 1956; Howard College, 1956; Macon (GA) Art Association, 1956; Buffalo/Albright, 1956; Lima, Peru, 1957; U. of Illinois, 1959; Fairweather-Hardin Gallery, 1959; Philadelphia Art Alliance, 1960; New Arts Gallery, Houston, 1960; Mexico City U., 1961; Tirca Karlis Gallery, 1961, 62, 64; McRoberts & Tunnard Gallery, London, 1961; Galerie Kobenhavn, Denmark, 1962; Gallery 31, Birmingham, AL, 1964; The Osborne Gallery, NYC, 1964; Carnegie, 1965; Houston/MFA, 1965; Franklin Siden Gallery, Detroit, 1965, 66; Esther Robles Gallery, 1966; Meredith Long Galleries, Houston, Tex., 1968, 70, 72; U. of New Mexico, 1973; Yares Gallery, Scottsdale, 1974, 75, 78; Contemporary Art Center of Hawaii, Honolulu, 1976; Stables Gallery, Taos, 1978; U. of Kansas, 1980; Museum of Art, Fort Collins, Colorado, 1980; New Directions Gallery, Taos, NM, 1982, 83, 84; Foundations Gallery, NYC, 1984; Anita Shapolsky Gallery, NYC, 1987; David Anderson Gallery, Buffalo, 1992. **Retrospective:** Westmoreland County/MA, 1967; Roanoke Fine Arts Center, circ., 1980-87. **Group:** Art: USA: Now, circ., 1962-67; WMAA Annuals, 1963, 65, 67; Smithsonian, 1966; Flint/Institute, Flint Invitational, 1966; Santa Fe, New Mexico Fine Arts Biennial, 1973; Buffalo/Albright, The Wayward Muse, 1987. **Collections:** U. of Alabama; Allentown/AM; Amarillo Art Center; Baltimore/MA; Boston/MFA; Buffalo/Albright; California Palace; Carnegie; Chase Manhattan Bank; Cornell U.; Cranbrook; Dayton/AI; Denver/AM; Honolulu Academy; Houston/MFA; ICA, Boston; U. of Illinois, Lima, Peru; Los Angeles/County MA; MOMA; McCann-Erickson, Inc.; NCFA; NYU; National Gallery; U. of Nebraska; Newark Museum; New York State Art Commission, Albany; Nor-

folk/Chrysler; Oklahoma; Phoenix; Princeton U.; RISD; Reynolds Metals Co.; U. of Rochester; Roswell; SFMA; San Antonio/McNay; Santa Barbara/MA; Santa Fe, N.M.; Slater; Smithsonian; Union Carbide Corp.; WGMA; WMAA; Walker; Westmoreland County/MA. **Bibliography:** Baur 5; Blesh 1; McChesney, Nordness, ed. Archives.

CALDER, ALEXANDER
b. July 22, 1898, Philadelphia, PA.
d. November 11, 1976, NYC. **Studied:** Stevens Institute of Technology, 1915-19; ASL, 1923-26, with George Luks, Guy Du Bois, Boardman Robinson, John Sloan. Traveled Europe, USA, Latin America, India. To Paris, 1928. The subject of three films: Alexander Calder: Sculpture *and Constructions* (MOMA, 1944); *Alexander Calder* (Burgess Meredith and Herbert Matter, 1951); *Calder's Circus* (Pathe, 1961). Two Calder sequences are in the film *Dreams That Money Can Buy* (Hans Richter, 1948). Designed sets for *Horizons* and *Four Movements* (by Martha Graham, NYC, 1936); *Socrates* (by Eric Satie, 1936); *Happy as Larry* (by Donagh MacDonagh, NYC, 1946); *Balloons* (by Padraic Colum, Boston, 1946); *Symphonic Variations* (by Tatiana Leskova, 1949). **Member:** AAAIL. **Commissions:** Spanish Pavilion, Paris World's Fair, 1937; New York World's Fair, 1939; Hotel Avila, Caracas, 1940; Terrace Plaza Hotel, Cincinnati, 1945; Aula Magna, University City, Caracas, 1952; General Motors Corp., 1954; New York International Airport, 1958; UNESCO, Paris, 1958. **Awards:** MOMA, Plexiglas Sculpture Competition, First Prize, 1939; XXVI Venice Biennial, First Prize, 1952; São Paulo, 1953, City of Philadelphia, Outstanding Citizen Award, 1955; Stevens Institute of Technology, Medal, 1956; Carnegie First Prize, 1958; Architectural League of New York, Gold Medal, 1960; Brandeis U., Creative Arts Award, 1962; Hon. Ph.D., Harvard U., 1966; Commander of the Legion of

Honor, 1967; Gold Medal, AAAL, 1971; Grand Prix National des Arts et Lettres, France, 1974; U.N. Peace Medal, 1975. **One-man Exhibitions:** (first) Weyhe Gallery, 1928 (wire sculpture); Billiet Gallery, Paris, 1929; Neumann-Neirendorf Gallery, Berlin, 1929; 56th Street Gallery, NYC, 1930; Galerie Percier, Paris, 1931; Galerie Vignon, Paris, 1932 (first mobiles exhibited); Julien Levy Galleries, NYC, 1932; Galerie Pierre Colle, Paris, 1933; Pierre Matisse Gallery, 1934, 36, 37, 1939-43; The U. of Chicago, 1935; Arts Club of Chicago, 1935; Honolulu Academy, 1937; Mayor Gallery, London, 1937; The Willard Gallery, NYC, 1940 (first Jewelry exhibited), 1941, 42; Arts and Crafts Club, New Orleans, 1941; SFMA, 1942; Andover/Phillips, 1943; Buchholz Gallery, NYC, 1944, 45, 47, 49; The Kootz Gallery, NYC, 1945; Galerie Louis Carre, Paris, 1946; Cincinnati/AM, 1946; Berne, 1947 (two-man); Amsterdam/Stedelijk, 1947 (two-man), 1950, 59, 69; Brazilian Ministry of Education, Rio de Janeiro, 1948; São Paulo, 1948; Margaret Brown Gallery, Boston, 1949; Galerie Maeght, 1949, 64, 66, 71, 73, 75; Galerie Blanche, Stockholm, 1950; MIT, 1950; Lefevre Gallery, London, 1951; Gallery R. Hoffman, Hamburg, 1954; Palais des Beaux-Arts, Brussels, 1960; Kunstgewerbemuseum, Zurich, 1960; Galerie d'Art Moderne, Basel, 1962; Galleria d'Arte del Naviglio, Milan, 1964; Perls Galleries, 1966-68, 69, 72, 73, 74, 76; Obelisk Gallery, 1967; Kiko Gallery, Houston, 1968; Wittenborn Gallery, NYC, 1968; Dayton's Gallery 12, Minneapolis, 1968; Gimpel Fils, 1969, 71; Grand Rapids, 1969; Musée d'Art Moderne, Geneva, 1969; Fundacion Eugenio Mendoza, Caracas, 1969; Leonard Hutton Gallery, NYC, 1972; Corcoran, 1972; Parker Street 470 Gallery, Boston, 1972; Sala Pelaires, Palma, Majorca, 1972; Source Gallery, San Francisco, 1974; Deson-Zaks Gallery, Chicago, 1975; Haus der Kunst, Munich, 1975; AAAIL, 1976; Brewster Gallery, NYC, 1976, 77; Galeria Bonino Ltd.,

NYC, 1977; Galerie Maeght, Barcelona, 1977; Israel Museum, 1977; M. Knoedler & Co., Inc., 1978, 79, 80, 82, 83; Rolly-Michaux, NYC, 1978, 79; Marisa del Re Gallery, NYC, 1979; Rolly-Michaux, Boston, 1979; Waddington Galleries, London, 1981; Mayor Gallery, London, 1981; U. of California, Berkeley, 1982; Flint/Institute, 1983; Fort Worth, 1983; Galerie Maeght, Zurich, 1983; Rachel Adler Gallery, NYC, 1984; Caracas, 1984; M. Knoedler, Zurich, 1984; Galerie Maeght LeLong, NYC, 1985; MIT, 1986; U. of Nebraska, 1986; The Pace Gallery, 1987, 89; WMAA, 1988, 91; Barbara Mathes Gallery, NYC, 1988; Galleria Seno, Milan, 1988; Arnold Herstand & Company, 1988; Greenberg Gallery, St. Louis, 1989; Galerie Bonnier, Geneva, 1990; Jack Rutberg Fine Arts, Los Angeles, 1990; Gallery Urban, NYC, 1991. **Retrospectives:** Springfield, Mass./MFA, 1938; MOMA, 1943; Tate, 1962; SRGM, 1964; Akademie der Kunst, Berlin, 1967; Foundation Maeght, 1969; Long Beach/MA, 1970; Chicago/Contemporary, 1974; WMAA, 1976; City of Turin, 1983; Musée des Arts Décoratifs, circ., 1989. **Group:** Artists' Gallery, NYC, 1926 (first paintings exhibited); Salon des Humoristes, Paris, 1927; Salon des Artistes Independents, Paris, 1929, 30; MOMA, Painting and Sculpture, 1930; Salon des Surindependents, Paris, 1930; WMAA; Chicago/AI; SFMA; Cincinnati/AM, 1942; Berne, 1947; Yale U., 1950; Hannover/K-G, 1954; Kassel, Documenta III, 1964; Society of the Four Arts, Calder/Nevelson/David Smith, 1971; Newport, R.I., Monumenta, 1974; XXXCII Venice Biennial, 1976; Houston/MFA, A Century of Modern Sculpture, 1882-1982, 1983; WMAA, The Third Dimension: Sculpture of the N.Y. School, 1985; Brooklyn Museum, The Machine Age, 1986; U. of Florida, Contemporary Sculpture from Florida Collections, 1987; Fuji Television Gallery, Tokyo, The 20th Anniversary, 1990; Purchase/SUNY, Drawings from the

Permanent Collection, 1991; AFA, Abstract Sculpture in America: 1930-1970, 1991; Hudson River Museum, Experiencing Sculpture: The Figure in American Art, 1850-1990, 1991; Musée d'Art Moderne et d'Art Contemporain, Nice, Sculptures Monumentales, Parvis du Musée, 1991. **Collections:** Amsterdam/Stedelijk; Andover/Phillips; U. of Arkansas; Arts Club of Chicago; Aztec Stadium, Mexico City; Basel; Berlin/National; Berne/Kunsthalle; Caracas; Chicago/AI; Dallas/MFA; Frankfurt am Main; Hanover Opera House, Hanover, Germany; Hartford/Wadsworth; Havana/Nacional de Bellas Artes; Honolulu Academy; Humlebaek/Louisiana; Indiana U.; Berne/Kunsthalle; Cedar Rapids Public Library; Lodz; Los Angeles/County MA; MMA; MOMA; Mannheim; Marshall Field & Co.; Montreal/MFA; Moscow/Western; Museum of Science and Industry, Chicago; PAFA; Phillips; Pittsfield/Berkshire; Princeton U.; Purchase/SUNY; SIT; SRGM; St. Louis/City; U. of St. Thomas (Tex.); São Paulo; Smith College; Stockholm/National; Storm King Art Center; Toronto; VMFA; WMAA; Washington U.; Yale U. **Bibliography:** *Abstraction création, 1931-1936;* **Alexander Calder,** 1967; **Alexander Calder,** 1971; Baldinger; Barr 1; Battcock, ed.; Baur 5, 7; Beam; Biederman 1; Bihalji-Merin; Blesh 1; Breton 3; Brion 1; Brumme; Calas, N. and E.; **Calder 1, 2; Calder and Liedl;** Canaday; **Carandente;** Cheney; Christensen; Craven, W.; Cummings 4, 5; Davis, D.; *Europa/Amerika;* Evans, ed.; Flanagan; Gaunt; Gertz; Giedion-Welcker 1, 2; Goodrich and Baur 1; Guggenheim, ed.; Haftman; Hayter 2; Henning; Hess, T. B., 1; Honisch and Jensen, eds.; Hulten; Hunter 6; Hunter, ed.; Jakovski; Janis and Blesh 1; Janis, S.; Kardon 3; Kozloff 3; Krauss 2; Kuh 1, 2, 3; Lane and Larsen; Langui; Licht, F.; Lipman; Lowry; Lynton; **Marchesseau;** Marter, Tarbell, and Wechsler; McCurdy, ed.; Mellquist; Mendelowitz; **Metro; Monumenta;** Moser 1; **Mulas and**

Arnason; Myers 2; Neumeyer; Paalen; Pearson 2; Phillips, Lisa 2; Ragon 1, 2; Ramsden 1, 2; Read, 1, 3, 5, 6; Rickey; Ritchie 1, 3; Rodman 1, 3; Rose, B., 1, 4; Rowell; Rubin 1; Sachs; Seitz 3; Selz, J.; Seuphor 2, 3; Siegel; Soby 1, 5; Sutton; Strachan; Sweeney 1, Toher, ed.; Tomkins; Tomkins and Time-Life Books; Trier 1, 2; Tuchman 1; Valentine 2; Waldberg 4; Wiesinger; *"What Abstract Art Means to Me";* Weller; Wilenski. Archives.

CALLAHAN, KENNETH
b. October 30, 1907, Spokane, Wash. **d.** May 8, 1986, Seattle, Wash. Self-taught in art. Traveled USA, Europe, Central America, Mexico, Southeast Asia, South Pacific. **Taught:** Privately and as visiting artist in various parts of the USA; Boston U., 1954-66; Skowhegan School, 1958, 63, 66; Port Townsend Summer School, 1974. Curator, Seattle/AM, 1933-53. Subject of *Callahan the Artist,* a 30-minute color film, 1973; overall design for *MacBeth,* Seattle Repertory Theater, 1973. **Member:** Washington State Arts Commission, 1970-74; NAD, 1975. **Commissions** (murals): Maine Hospital, Seattle; US Post Offices, Centralia and Anacostes, Wash., and Rugby, N.D.; Washington State Library, Olympia, Wash.; Syracuse U., 1964; Seattle Civic Center, 1966. **Awards:** Guggenheim Foundation Fellowship, 1954; AAAL, Arts and Letters Grant, 1968; State of Washington Governor's Award, 1968; AAAL, P.P., 1972. **One-man Exhibitions:** (first) American-British Art Center, NYC, 1944; Maynard Walker Gallery, NYC, 11 exhibitions, 1946-64; SFMA; Santa Barbara/MA; La Jolla; Colorado Springs/FA; Phoenix; Roswell; Williams College; Columbia, S.C./MA; U. of Arkansas; U. of Rochester; Detroit/Institute; Renaissance Society, Chicago; Seattle/AM; Portland, Ore./AM; Spokane Art Center of Washington State U.; Tacoma; Galerie George Giraux, Brussels, 1947; Boston U., 1966; Kraushaar Gallery, NYC, 1967, 69, 71, 74, 76, 80, 82, 85, 90;

Foster-White Gallery, Seattle, 1975, 79, 85, 88, 91; Fountain Gallery, Portland, Oregon, 1980. **Retrospectives:** Emily Winthrop Miles Collection, circ., 1961-64; Syracuse/Everson; Henry Art Gallery, Seattle, circ., 1973. **Group:** Japan; Formosa; Korea; Philippines; Australia; New Zealand; Brazil; USA; Great Britain; France; Italy; Sweden; Denmark; Yugoslavia; Germany; Indianapolis, 1977; Seattle/AM, 1979; AAAL, 1980; ICA, Boston, Northwest Visionaries, 1981. **Collections:** Allentown/AM; Andover/Phillips; U. of Arkansas; Beloit College; Brooklyn Museum; Chase Manhattan Bank; Chicago/AI; The U. of Chicago; Colby College; Columbus; Corcoran; Des Moines; Detroit/Institute; U. of Florida; Fort Worth; Garnett Public Library; La Jolla; MMA; MOMA; Memphis/Brooks; U. of Michigan; Minneapolis/Institute; Minnesota/MA; NCFA; U. of Nebraska; Norfolk/Chrysler; PAFA; PMA; Phillips; Phoenix; Portland, Ore./AM; U. of Rochester; SFMA; SRGM; St. Louis/City; Santa Barbara/MA; Seattle/AM; Spellman College; Springfield, Mo./AM; Syracuse U.; Tacoma; Utica; WMAA; Walker; Washington; Wichita/AM; Wilkes Community College. **Bibliography:** Art of the Pacific Northwest; Baur 7; Bruce and Watson; Cheney; Clark and Cowles; Eliot; Nordness, ed.; Northwest Traditions; Pousette-Dart, ed.; Richardson, E. P.; Ritchie 1. Archives.

CALLERY, MARY
from 1st to 5th edition.

CAMPOLI, COSMO
from 1st to 4th edition.

CANDELL, VICTOR
from 1st to 4th edition.

CAPARN, RHYS
from 1st to 5th edition.

CAREWS, SYLVIA
from 1st to 4th edition.

CARLES, ARTHUR B.
b. 1882, Philadelphia, Pa. **d.** June 18, 1952, Chestnut Hill, Pa. **Studied:** PAFA. Traveled Spain, France, Italy. **Taught:** PAFA, 1917-25. **Awards:** PAFA: Cresson Fellowship; Walter Lippincott Prize, 1917; Stotesbury Prize, 1919; J. Henry Schiedt Memorial Prize, 1929; Joseph E. Temple Gold Medal, 1930; Chicago/AI, The Mr. & Mrs. Frank G. Logan Prize. **One-man Exhibitions:** Montross Gallery, NYC, 1922; Gimbel Gallery, Philadelphia, 1935; Marie Harriman Gallery, NYC, 1936; PAFA, 1941, 53; Philadelphia Art Alliance, 1944; Kart Nierendorf Gallery, NYC, 1944 (two-man), 1946, 70; Dubin Gallery, Philadelphia, 1953; Oberlin College (two-man), 1955; The Graham Gallery, 1959; Peal Gallery, Philadelphia, 1967; PMA, 1970; Janet Fleisher Gallery and David David Art Galleries, Philadelphia, 1972; PAFA, Peale House, 1972; Janet Fleisher Gallery, Philadelphia, 1975; Gross McCleaf Gallery, Philadelphia, 1975; Vendo Nubes Gallery, Philadelphia, 1975; Hirshhorn, 1977; Washburn Gallery Inc., NYC, 1984. **Retrospectives:** PAFA, 1953; PAFA, Peale House, circ., 1983. **Group:** The Armory Show, 1913; WMAA, 1963; PAFA; WMAA, The 1930s, 1968; U. of Miami, French Impressionists Influence American Artists, 1971; Delaware Art Museum, Avant-Garde Painting and Sculpture in America, 1910-1925, 1975; PAFA, In This Academy, 1976; Arts Council of Great Britain, The Modern Spirit: American Painting 1908-1935, circ., 1977; Houston/MFA, Modern American Painting, 1910-1940, 1977; WMAA, Synchronism and American Color Abstraction, 1910-1925, circ., 1978; Tulsa/Philbrook, Painters of the Humble Truth, 1979. **Collections:** Chicago/AI; MOMA; U. of Nebraska; PAFA; PMA; SFMA; Syracuse U. **Bibliography:** *Avant-Garde Painting and Sculpture in America 1910-25;* Baur 7; Brown 2; Levin 2; Richardson, E. P.; Rose, B., 1, 4; **Wolani**. Archives.

CASARELLA, EDMOND
b. September 3, 1920, Newark, N.J.
Studied: Cooper Union, 1938-42; Brooklyn Museum School, 1949-51, with Gabor Peterdi. US Army, 1944-46. Traveled Italy and Greece, 1951-52, 1960-61, France. **Taught:** Brooklyn Museum School, 1956-60; Yale-Norfolk Summer Art School, 1958; NYU, 1962; Cooper Union; ASL; Hunter College, 1963-; Columbia U., summers, 1963, 64; Pratt Graphic Art Center, 1964; Yale U., 1964-; Rutgers U., 1964-; Pratt Institute, 1964-; Finch College, NYC, 1969-74; Manhattanville College of the Sacred Heart, 1973, 74; Queens College, 1980; National Youth Administration: Designed posters. **Member:** SAGA; Sculptors Guild; Artists Equity. **Commissions:** Harcourt Brace Jovanovitch, Orlando, Fla., sculpture; 325 West 52nd Street, NYC, sculpture; 1585 Broadway, NYC, sculpture. **Awards:** Fulbright Fellowship (Italy), 1951; U. of Illinois, Graphic Art exhibitions, P.P., 1954, 56; L. C. Tiffany Grant, 1955; Bay Printmakers Society, Oakland, 1955, 57; Library of Congress, 1955, 56, 58; The Print Club, Philadelphia, 1956; Northwest Printmakers Annual, 1956; Boston Printmakers, 1957; New York State Fair, 1958; PCA, 1959; Brooklyn Museum, Print and Watercolor Biennials; Guggenheim Foundation Fellowship, 1960; SAGA, 100 Prints of the Year, 1962, 63. **Address:** 83 East Linden Avenue, Englewood, NJ 07631. **Dealer:** Susan Teller Gallery, NYC. **One-man Exhibitions:** Brooklyn Museum, 1952 (two-man); The Zabriskie Gallery, 1953, 56; Obelisk Gallery, Washington, D.C., 1956, 61; Louisiana State U., 1957; U. of Mississippi, 1957; U. of Kentucky, 1964; Rutgers U., 1964; Hudson River Museum, Yonkers, N.Y., 1965; Montclair State College, 1966; Trenton State College, 1967; Merida Gallery, Inc., 1967, 68; Louisville/Speed, 1968-69; Naroden Muzejna Bitolkiot Kraj, Bitola, Yugoslavia; Free Public Library, Fair Lawn, N.J., 1970; Cramer Gallery, 1972, 73; Landmark Gallery,

NYC, 1977, 80, 81, 82; Sculpture Center, NYC, 1977; Bloomingdale's, Paramus, N.J., 1981; Art Center of Northern N.J., 1981; Cottage Place Gallery, Ridgewood, N.J., 1986. **Retrospectives:** Naroden Muzejna Grad Skopje, Skopje, Yugoslavia, 1967; YMHA, Hackensack, N.J., 1969; Edward Williams College, 1979; Allegheny College, 1978; Fort Lee (N.J.) Public Library, 1988. **Group:** Brooklyn Museum, Print and Watercolor Biennials; International Print Exhibition, Salzburg, 1952, 58; PAFA, 1953, 59, 63; Bay Printmakers Society, Oakland, 1955-57; Library of Congress, 1955, 56, 58; Corcoran, 1955, 56, 58, 59, 63; The Print Club, Philadelphia, 1956; U. of Illinois, 50 Contemporary American Printmakers, 1956; Boston/MFA, 1957; Grenchen, Graphics International, 1958; I Inter-American Paintings and Prints Biennial, Mexico City, 1958; The Pennsylvania State U., 10 American Printmakers, 1959; Trenton/State, Contemporary Printmakers, 1959; Victoria and Albert Museum, 1959; Gallery of Modern Art, Ljubljana, Yugoslavia, III & IV International Exhibitions of Prints, 1959, 61; WMAA, American Prints Today, 1959, 62; Yale U., 1960; Cincinnati/AM, 1960; Philadelphia Art Alliance, 1960; American Academy, Rome, 1960, 61; Memphis/Brooks, 1960-62; WMAA, American Painting, 1961; A.A.A. Gallery, NYC, 100 Prints of the Year, 1962; New York Foundation/USIA, American Prints Around the World, circ., 1963; Los Angeles/County MA, 1963; Riverside Museum, 1963; WMAA, New York Hilton Hotel Collection, 1963; USIA, Graphic Arts— USA, circ., USSR, 1963; Jewish Museum, 100 Contemporary Prints, 1964; St. Louis/City, 1964; New York World's Fair, 1964-65; I Triennale Internazionale della Zilografia Contemporanea, Capri, 1969; Mostra Internazionale della Zilografia Contemporanea, Bologna, 1971; Madrid/Nacional, Exposicion Internacional de la Zilografia Contemporanea, 1972; Landmark Gallery, NYC, 1973, 74; Bergen

Community College, Outdoor Sculpture, 1974; Terrain Gallery, 25th Anniversary, NYC, 1980; NAD, 1988, 90, 92. **Collections:** Bibliothèque Nationale; Brooklyn Museum; U. of Illinois; Library of Congress; Louisville/Speed; Trenton/State; Victoria and Albert Museum; Cooper Hewitt Museum, NYC. **Bibliography:** Chaet; Peterdi.

CASTELLON, FEDERICO

b. September 14, 1914, Almeria, Spain. **d.** December 27, 1971, NYC. Self-taught in art. Traveled Europe and Latin America extensively; resided Spain, 1914-21, 1961-62; France, 1934-36, 1962-63. US citizen, 1943. **Taught:** Columbia U., 1948-61; Pratt Institute, 1951-61, 1964-71; Queens College, 1964; NAD, 1964-71. **Member:** SAGA; NAD; NIAL. **Commissions:** Illustrations for numerous books and magazines; two prints for International Graphic Arts Society. **Awards:** Four-year fellowship from the Spanish Republic, 1933; Chicago/AI, The Mr. & Mrs. Frank G. Logan Prize, ca. 1940; PAFA, Alice McFadden Eyre Medal, 1940; A.A.A. Gallery, NYC, National Print Competition, First Prize, 1948; Library of Congress, First Pennell P.P., 1949; Guggenheim Foundation Fellowship, 1940, 50; NIAL Grant, 1950; SAGA, 1963. **One-man Exhibitions:** (first) Raymond and Raymond, Inc., NYC; Weyhe Gallery, 1934-41; A.A.A., Gallery, NYC, 1947-52, 78; Bucknell U.; Philadelphia Art Alliance; Albany/Institute; Bennington College; Swarthmore College; Princeton U.; Columbia U.; California Palace; Madrid/Nacional; Caracas; La Paz, Bolivia; Argentina/Nacional; Asuncion, Paraguay; Montevideo/Municipal; a gallery in Paris; Bombay; Los Angeles/County MA; Slater, 1969; Martin Sumers Graphics, NYC, 1978, 88; Gallery Schlesinger-Boisanté, NYC, 1985; Davidson Gallery, Seattle, 1990; Michael Rosenfeld Gallery, NYC, 1992. **Retrospective:** Syracuse U., 1978. **Group:** College d'Espagne, Paris, 1934; Corcoran; Chicago/AI; Brooklyn Museum; PAFA; WMAA; SAGA; Paris, Biennial International de l'estampe, 1971. **Collections:** Brooklyn Museum; Chicago/AI; Columbia U.; Dartmouth College; U. of Georgia; U. of Illinois; Kalamazoo/Institute; Library of Congress; MMA; U. of Minnesota; Montclair/AM; NYPL; PAFA; PMA; Princeton U.; Syracuse U.; Utica; WMAA; Yale U.; Youngstown/Butler. **Bibliography:** American Artists Group, Inc. 3; Baur 7; Cummings 4, 5; Front; Goodrich and Baur 1; Mendelowitz; Pearson 1; Reese; Zigrosser 1. Archives.

CAVALLON, GIORGIO

b. March 2, 1904, Sorio, Vicenza, Italy. **d.** December 22, 1989, NYC. To USA, 1920. **Studied:** NAD, 1925-30; with C. W. Hawthorne, ca. 1929; Hofmann School, 1935-36. Resided Italy, 1930-33. **Taught:** Pratt Institute, 1952, 54 (woodworking); U. of North Carolina, 1964; Yale U., 1964; Columbia U., summer, 1969. **Member:** American Abstract Artists, 1936-57. Federal A.P.: Mural project assistant to Arshile Gorky, and easel painting. **Awards:** L. C. Tiffany Grant, 1929; Guggenheim Foundation Fellowship, 1966-67. **One-man Exhibitions:** (first) Bottege d'Arte, Vicenza, Italy, 1932; ACA Gallery, 1934; Eighth Street Playhouse, NYC, 1940; Charles Egan Gallery, 1946, 48, 51, 54; The Stable Gallery, 1957, 59; The Kootz Gallery, NYC, 1961, 63; U. of North Carolina, 1964; A.M. Sachs Gallery, 1969, 71, 72, 74, 76; Gruenebaum Gallery, NYC, 1978, 79, 81, 82, 83, 85, 86; Jason McCoy Inc., NYC, 1989, 90, 91. **Retrospective:** Purchase/SUNY, 1976; U. of Connecticut, 1990. **Group:** WMAA, 1947, 48, 59, 61; Salon des Réalites Nouvelles, Paris, 1950; MOMA, Abstract Painting and Sculpture in America, 1951; MMA, American Watercolors, Drawings and Prints, 1952; U. of Nebraska, 1955; Kassel, Documenta II, 1959; Chicago/AI, 1959; Carnegie, 1959, 61; Walker, 1960; SRGM, Abstract Expressionists and Imagists, 1961; U. of Illinois, 1963; MOMA,

60 Modern Drawings, 1963; PAFA Annual, 1966; WMAA, The 1930s, 1968; A.F.A., 1968-69; MOMA, The New American Painting and Sculpture, 1969; A.F.A., Geometric Abstraction of the 1930s, 1972; Hirshhorn, Bicentennial Exhibition, 1976; Peggy Guggenheim Collection, Venice, Three Italo-American Artists, 1988; Provincetown Art Association and Museum, The Provincetown Years 1935-1945: The Hans Hofmann School and Its Students, 1990. **Collections:** American Republic Insurance Co.; Avco Corp.; Avon Products; The Bank of New York; Buffalo/Albright; U. of California, Berkeley; Chase Manhattan Bank; Ciba-Geigy Corp.; Continental Grain Company; Delaware Art Museum; Harvard U.; MOMA; Marine Midland Bank and Trust Co.; NYU; U. of North Carolina; Prudential Insurance Co. of America; RISD; SRGM; The Singer Company, Inc.; U. of Texas; Tishman Realty & Construction Co. Inc.; Union Carbide Corp.; WMAA. **Bibliography:** Blesh 1; Hess, T. B., 1; McCurdy, ed.; O'Hara 1; Pousette-Dart, ed.; Ritchie 1; Rose, B., 1. Archives.

CELMINS, VIJA b. 1939, Riga, Latvia. To USA, 1949. **Studied:** John Herron Art Institute, Indianapolis, 1958-62, BFA; Yale U., 1961; UCLA, 1962-65, MFA. **Taught:** California State College, Los Angeles, 1965-66; U. of California, Irvine, 1967-72; California Institute of the Arts, Valencia, 1976; Skowhegan School, 1981; Cooper Union, 1984; Yale U., 1987. **Awards:** Cassandra Foundation, Award, 1968; National Endowment for the Arts, 1971, 76; US Department of the Interior, 1975; Guggenheim Foundation Fellowship, 1980. **Address:** 49 Crosby Street, NYC 10012. **Dealer:** David McKee Gallery, NYC. **One-man Exhibitions:** (first) David Stuart Galleries, Los Angeles, 1966; Riko Mizuno Gallery, Los Angeles, 1969, 73; WMAA, 1973; Felicity Samuel Gallery, London, 1975; Broxton Gallery, Los Angeles, 1975; Security Pacific National Bank, Los Angeles, 1978; David McKee Gallery, NYC, 1983, 88; Pence Gallery, Santa Monica, 1990. **Retrospective:** Newport Harbor Art Museum, circ., 1979; ICA, U. of Pennsylvania, 1992. **Group:** California State College, Hayward, Four Painters, 1966; U. of Colorado, Boulder, NYC-LA Drawings of the 60s, 1967; Fort Worth, Contemporary American Drawings, 1969; WMAA Annuals, 1970, 77; La Jolla, Continuing Surrealism, 1971; Los Angeles/County MA, 24 Young Los Angeles Artists, 1971; La Jolla, Earth, Animal, Vegetable, and Mineral, 1971; MOMA, California, Prints, 1972; Brooklyn Museum, National Print Exhibition, 1972; WMAA, American Drawings, 1963-1973, 1973; U. of Illinois, 1974; Chicago/AI, 71st American Exhibition, 1974; US Department of the Interior, America 1976, circ., 1976; Detroit/Institute, American Artists, A New Decade, 1976; SFMA, Painting and Sculpture in California: The Modern Era, 1976; Brooklyn Museum, 30 Years of American Printmaking, 1976; SFMA, California Painting and Sculpture: The Modern Era, 1977; Brooklyn Museum, Thirty Years of American Printmaking, 1977; WMAA Biennial, 1977; MIT, Great Big Drawings, 1982; Brooklyn Museum, The American Artist as Printmaker, 1983; Houston/Contemporary, American Still Life, 1945-1983, 1983; Los Angeles/MOCA, Automobile and Culture; SFMA, American Realism (Janss), circ., 1985; Brooklyn Museum, Public and Private: American Prints Today, 1986; Los Angeles/MOCA, Individuals, 1986; Mount Holyoke College, A Graphic Muse, 1987; Cincinnati/AM, Making Their Mark, 1989; Newport Harbor, L.A. Pop in the Sixties, circ., 1989; Brandeis U., The Contemporary Drawing, 1991. **Collections:** AT&T; Baltimore/MA; Fort Worth; Jackson and Curtis, Inc.; Levi Strauss & Co.; Los Angeles/County MA; MOMA; Mount Holyoke College; National Gallery, Newport Harbor; PMA, Paine Webber, SFMA;

WMAA; **Bibliography:** *Individuals;* Lippard 6; *New in the Seventies; America 1976.*

CHAET, BERNARD b. March 7, 1924, Boston, Mass. **Studied:** Tufts U., B.S. Ed.; Boston Museum School, with Karl Zerbe. Traveled Europe; resided Paris, 1949. **Taught:** Yale U., 1951-90; American Academy, Rome. Contributing editor, *Arts* magazine, 1956-59. Author: *Art of Drawing.* **Awards:** Silvermine Guild Award, 1955; Yale U., Senior Faculty Fellowship, 1962; St. Paul Art Center, Drawing USA, Merit Award, 1963; National Council on the Arts, Grant, 1966-67; AAIAL, Hassam and Speicher Fund Purchase, 1981; Hon. DFA, Maryland Institute, 1985; College Art Association, Distinguished Teaching of Art Award, 1986. **Address:** 141 Cold Spring Street, New Haven, CT 06511. **Dealer:** Alpha Gallery, Boston. **One-man Exhibitions:** (first) Boris Mirski Gallery, Boston, 1946, also 1951, 54, 57, 59, 61, 65; The Bertha Schaefer Gallery, NYC, 1954; The Stable Gallery, NYC, 1959, 61, 67; Cornell U., 1961; Alpha Gallery, Boston, 1967, 68, 69, 71, 75, 77, 80, 82, 84, 87, 89, 91; Swarthmore College, 1971; Haslem Fine Arts, Inc., 1973; The Forum Gallery, NYC, 1975; Marilyn Pearl Gallery, NYC, 1976, 78, 79, 81, 82, 84, 86, 87, 89, 91; Trinity College, 1979; Delaware Art Museum, 1982; Washington Art Association, Washington Depot, CT, 1984; J. Rosenthal Fine Arts, Chicago, 1986, 89; Boston Public Library, 1989. **Retrospective:** Brockton/Fuller, 1970. **Group:** U. of Illinois, 1951, 53, 61; PAFA; Los Angeles/County MA; Phillips; Chicago/AI; U. of Nebraska; ICA, Boston, 6 New England Painters, 1954; Corcoran; Contemporary American Drawings, circ., France, 1957-58; Hartford/Wadsworth, 8 from Connecticut, 1961; Detroit/Institute; MOMA; Brooklyn Museum; U. of North Carolina, 1977; U. of North Carolina, Art on Paper, 1983; U. of Wisconsin, Oshkosh, Modern

Masters of Classical Realism, 1984; College of the Mainland Art Gallery, Texas City, 1985; NAD, Annual, 1986; U. of Virginia, American Drawings, 1989. **Collections:** Andover/Phillips; Boston/MFA; Boston Public Library; Brandeis U.; Brooklyn Museum; Brown U.; U. of Connecticut; Cortland/SUNY; Dartmouth College; Harvard U.; Hirshhorn; Indiana U.; Lincoln, Mass./De Cordova; U. of Massachusetts; NYU; U. of North Carolina; RISD; UCLA; Worcester/AM; Yale U. **Bibliography:** Chaet.

CHAMBERLAIN, E.
from 1st to 3rd edition.

CHAMBERLAIN, JOHN
b. 1927, Rochester, Ind. **Studied:** Chicago/AI School, 1950-52; Black Mountain College, 1955-56. US Navy, 1943-46. **Awards:** Guggenheim Foundation Fellowship, 1966, 77; Brandeis University Creative Arts Award, 1984. **Member:** AAIAL. **Commission:** GSA, 1978; Kentucky Center for the Performing Arts. **Address:** 1313 10th Street, Sarasota, FL 34236. **Dealer:** Pace Gallery, NYC. **One-man Exhibitions:** (first) Wells Street Gallery, Chicago, 1957; Davida Gallery, Chicago, 1958; Martha Jackson Gallery, 1960; Dilexi Gallery, Los Angeles, 1962; Dilexi Gallery, San Francisco, 1962; Leo Castelli Inc., 1962 (two-man), 1964, 65, 68, 69, 71, 73, 76, 82; Leo Castelli Warehouse, 1969; The Pace Gallery, Boston, 1963; Robert Fraser Gallery, 1963 (two-man); Dwan Gallery, Los Angeles, 1965; Cleveland/MA, 1967; Contemporary Arts Center, Cincinnati, 1968; Mizuno Gallery, 1969; LoGiudice Gallery, Chicago, 1970; Taft Museum (two-man), 1972; Dag Hammarskjold Plaza, NYC, 1973; Walter Kelly Gallery, Chicago, 1974; Houston/Contemporary, 1975; Ronald Greenberg Gallery, St. Louis, 1975; Locksley-Shea Gallery, Minneapolis (two-man), 1975; Margo Leavin Gallery, Los Angeles, 1977, 85, 88; Dia Art Foundation, NYC, 1977, 83, 84, 90;

Heiner Friedrich, Inc., 1977; Berne, 1979; Galerie Heiner Friedrich, Cologne, 1979; Eindhoven, 1980; Sarasota/Ringling, 1983; Youngstown/Butler, 1983; Robert L. Kidd Gallery, Birmingham, Mich., 1983; Multiples, Inc., NYC, 1983; L.A. Louver Gallery, Los Angeles, 1983; Palacio de Cristal, Madrid, 1984; Xavier Fourcade, Inc., NYC, 1984, 87; U. of California, Santa Barbara (two-man), 1984; Marian Goodman Gallery, NYC, 1984; Galerie Rudolf Zwirner, Cologne, 1984; Galerie Helen van der Meij, Amsterdam, 1984; Dia Art Foundation, Marfa, Texas, 1984; Galerie Gillespie-Laage-Salomon, Paris, 1985; Galerie Fred Jahn, Munich, 1986, 91; Los Angeles/MOCA, 1986; Fabian Carlsson Gallery, London, 1987; Galerie Tanit, Munich, 1987; The Fruitmarket Gallery, Edinburgh, 1987; The Menil Collection, Houston, 1987; Galerie Pierre Huber, Geneva, 1987; The Pace Gallery, NYC, 1989, 91; Greenberg Gallery, St. Louis, 1989; Waddington Galleries, London, 1991. **Retrospective:** SRGM, 1971; Kunsthalle, Baden-Baden, circ., 1991. **Group:** MOMA, Recent Sculpture USA, 1959; Buenos Aires Museum of Modern Art, International Sculpture Exhibition, 1960; Martha Jackson Gallery, New Media—New Forms, I & II, 1960, 61; WMAA Annuals, 1960, 62, 65; Sculpture Annuals, 1966, 68; Galerie Rive Droite, Paris, Le Nouveau Realisme, 1961; VI São Paulo Biennial, 1961; MOMA, The Art of Assemblage, circ., 1961; Chicago/AI, 1961, 67; Carnegie, 1961, 67; Seattle World's Fair, 1962; SRGM, The Joseph H. Hirshhorn Collection, 1962; Battersea Park, London International Sculpture Exhibition, 1963; Musée Cantonal des Beaux-Arts, Lausanne, I Salon International de Galeries Pilotes, 1963; Pasadena/AM, New American Sculpture, 1964; New York World's Fair, 1964-65; Tate, Painting and Sculpture of a Decade, 1954-64, 1964; XXXII Venice Biennial, 1964; Jewish Museum, 1964; ICA, U. of Pennsylvania, The Atmosphere of '64, 1964, also 1965;

Flint/Institute, 1965; ICA, Boston, Painting Without a Brush, 1965; Indianapolis/Herron, 1965, 69; WMAA, Contemporary American Sculpture, Selection I, 1966; MOMA, The 1960s, 1967; HemisFair '68, San Antonio, Tex., 1968; Swarthmore College, 1969; Trenton/State, Soft Art, 1969; York U., Toronto, 1969; ICA, U. of Pennsylvania, Highway, 1970; Indianapolis, 1970, 72; Cincinnati/Contemporary, Monumental Art, 1970; WMAA Sculpture Annual, 1970; MOMA, Younger Abstract Expressionists of the Fifties, 1971; Hofstra U., Art around the Automobile, 1971; Düsseldorf/Kunsthalle, Prospect '71, 1971; NCFA, Sculpture, American Directions, 1945-75, 1975; WMAA, 200 Years of American Sculpture, 1976; Akademie der Kunste, Berlin, SoHo, 1976; Cambridge U., Jubilation, 1977; Flint/Institute, Art and the Automobile, 1978; WMAA, Art about Art, 1978; Zurich, Soft Art, 1979; Kassel, Documenta VII, 1982; Düsseldorf/Kunsthalle, 1983; U. of North Carolina, Art on Paper, 1984; École des Beaux Arts, Paris, Cinquante ans de dessins americains, 1985; Fort Lauderdale, An American Renaissance: Painting and Sculpture Since 1940, 1986; Paris/Beaubourg, Qu'est-ce que c'est la sculpture moderne?, 1986; Boston/MFA, Printmaking Now: 70s into 80s, 1986; WMAA, Biennial, 1987; Buffalo/Albright, Structure to Resemblance, 1987; Ho-Am, Seoul, Contemporary American Art, circ., 1988; U. of Florida, Color in Art, 1989; Rice U., Small-Scale Sculpture, 1990; AFA, Abstract Sculpture in America: 1930-1970, circ., 1991. **Collections:** American Broadcasting Co.; Buffalo/Albright; Chicago/AI; U. of Chicago; Cleveland/MA; Cologne/Ludwig; Cornell U.; Dallas/MFA; Detroit/Institute; Fort Worth; Frankfurt/Moderne; Hirshhorn; Kansas City/Nelson; Krefeld/Kaiser Wilhelm; Los Angeles/County MA; Los Angeles/MOCA; MOMA; Monchengladbach; NMAA; Norfolk/Chrysler; U. of North Carolina; Oberlin College; Orlando; Paris/Beaubourg;

Pasadena/AM; Purchase/SUNY; Rome/Nazionale; SRGM; St. Louis/City; Sarasota/Ringling; Stockholm/National; Tate Gallery; VMFA; Vanderbilt Vienna/Moderner; WMAA; Walker; Washington U.; Wayne State U. **Bibliography:** Battcock, ed.; Craven, W.; *Europa/Amerika;* Gohr and Gachnang; Honisch and Jensen, eds.; Hunter, ed.; Janis and Blesh 1; Kozloff 3; Kuh 3; Licht, F.; Lippard 5; *Metro; Monumenta;* Phillips, Lisa 2; **Poetterl;** Read 3; *Report:* Rose, B., 1; Rowell; Sandler 3, 5; Seitz 3, 4; Seuphor 3; **Sylvester;** Tuchman 1; Waldman 4; Warhol and Hackett.

CHASE, LOUISA b. March 18, 1951, Panama City. **Studied:** Yale U., 1971; Syracuse U., BFA, 1973; Yale U., MFA, 1975. **Address:** 185 Lafayette Street, NYC 10013. **Dealer:** Brooke Alexander Gallery, NYC. **One-man Exhibitions:** Artists Space, NYC, 1975; Edward Thorp Gallery, NYC, 1978; Robert Miller Gallery, NYC, 1981, 82, 84, 86; Harcus-Krakow Gallery, Boston, 1983; Galerie Baecker, Cologne, 1984; Mira Godard Gallery, Toronto, 1984, 89; Cava Gallery, Philadelphia, 1984; ICA, Boston, 1984; Alice Simsar Gallery, Ann Arbor, 1985; Margo Leavin Gallery, Los Angeles, 1985; Texas Gallery, Houston, 1987; Brooke Alexander Gallery, NYC, 1989, 91; Ginza Art Center Hall, Tokyo, circ., 1991; Betsy Rosenfield Gallery, Chicago, 1991. **Group:** Indianapolis, 1980; WMAA, Biennial, 1982; Hannover/K-G, New York Now, 1982; Nurnberg/Kunsthalle, Zeichnung Heute, circ., 1982; U. of South Florida, Currents II, 1982; WMAA, Block Prints, 1983; MOMA, Prints from Blocks: Gauguin to Now, 1983; U. of North Carolina, 1983; Lucerne, Back to the USA, 1983; The New Museum, Art & Ideology, 1984; MOMA, An International Survey of Recent Painting and Sculpture, 1984; SFMA, The Human Condition, 1984; Walker, Images and Impressions: Painters Who Print, circ., 1984; Hudson

Louisa Chase, *Lady Macbeth*, 1990.

River Museum, New Vistas, circ., 1984; Venice, Biennale, 1984; Southampton/Parrish, Painting as Landscape, 1985; Phoenix, Since 1980: New Narrative Painting, 1986; Mount Holyoke College, A Graphic Muse, 1987; U. of California, Santa Barbara, Collaboration in Monotype, 1988; MMA, The New Generation, The '80s, 1988; Bard College, The Figure Speaks, 1989; Cincinnati, Making Their Mark, circ., 1989; Brandeis U., The Contemporary Drawing, 1991. **Collections:** Buffalo/Albright; Denver/AM; U. of Chicago; Corcoran; Library of Congress; U. of Massachusetts; U. of Missouri; MMA; MOMA;NYPL; Portland (Me.)/MA; WMAA.

CHEN, HILO b. October 15, 1942, Yee-Num, Taiwan. US Citizen. **Studied:** Chung Yuan College, BS, Architectural Engineering, 1966. **Address:** 302 Bowery, NYC 10012. **One-man Exhibitions:** (first) Louis K. Meisel Gallery, NYC, 1974, 76, 78, 80, 82, 84, 86, 90; Union College, 1977; Hsiung Shih Gallery, Taipei, 1985; Galerie Esperanza, Montreal, 1988; Gallery Delaive B.V., Amsterdam, 1990. **Group:** Skidmore

College, Some Realists, 1974; Hartford/Wadsworth, New Photo-Realism, 1984; Baltimore/MA, Super Realism, 1975; U. of Connecticut, PhotoRealism, 1979; Arnot, Cityscapes, 1981, Marquette U., Changes, 1881-1981, 1981; PAFA, Contemporary American Realism Since 1960, circ., 1981; El Paso Museum of Art, Deja Vu, circ., 1981; San Jose State U., The Artist and the Airbrush, 1988; Utica, An Appreciation of Realism, 1982; Osaka/National, Modern Nude Paintings, 1880-1980, 1983; Youngstown/Butler, Mid-year Show, 1985; Tampa/MA, At the Water's Edge, circ., 1989. **Collections:** Evanston/Byer; SRGM.

CHESNEY, LEE, JR.
see 1st to 4th edition.

CHINNI, PETER **b.** March 21, 1928, Mt. Kisco, N.Y. **Studied:** ASL, 1947, with Edwin Dickinson, Kenneth Hayes Miller, Julian Levi; Academy of Fine Arts, Rome, 1949-50, with Emilio Sorini. Traveled Puerto Rico, Mexico, Europe; resided in Italy 19 years; US Army, 1951-53. **Member:** Sculptors Guild; Artists Equity. **Commissions:** Denver/AM (bronze mural); City of Columbia, Mo., 1979; Board of Education, NYC, 1984. **Awards:** ASL, Daniel Schnackenberg Scholarship, 1948; Silvermine Guild, First Prize, 1958, 60, 61; Denver/AM, Second Prize, 1960. **Address:** 88 West Hyatt Avenue, Mt. Kisco, NY 10549-2818. **One-man Exhibitions:** (first) Fairleigh Dickinson U., 1951; Galleria San Marco, Rome, 1955; Il Torcoliere, Rome, 1956; Kipnis Gallery, Westport, Conn., 1956; R. R. Gallery, Denver, 1957; Galleria Schneider, Rome, 1957; Janet Nessler Gallery, NYC, 1957, 61; Royal Marks Gallery, 1964; Albert Loeb Gallery, NYC, 1966; Loeb & Krugier Gallery, NYC, 1969; Harcus Krakow Rosen Sonnabend Gallery, Boston, 1976; Galerie Alexandra Monett, Brussels, 1976; Galerie Bouma, Amsterdam, 1976; Musée d'Ixelles, Brus-

sels, 1976; Beeckestijn Museum, Velsen, Holland, 1976; Hooks-Epstein Gallery, Houston, 1978; Tyler School of Art, Rome, 1979; Katonah (N.Y.) Art Gallery, 1983. **Group:** Audubon Artists Annuals, 1958, 59, 61, 62; Festival of Two Worlds, Spoleto, 1960; Boston Arts Festival, 1960, 62; Connecticut Academy of Fine Arts, 1960, 62; WMAA Annuals, 1960, 62, 64, 65; Corcoran, 1962; Galleria Pagani del Grattacielo, Milan, 1962; Waitsfield/Bundy, 1963; Sculptors Guild, NYC, 1963, 64, 66, 68, 89; Carnegie, 1964; Heseler Gallery, Munich, 1968; Rome/Nazionale, 1968; Utica, American Prints Today, 1970; WMAA, Art of the Sixties, 1975. **Collections:** Denver/AM; Fontana-Hollywood Corp.; St.Louis/City; WMAA; Beeckestijn Museum, Velsen, Holland; New School for Social Research; Louisville/Speed; National Gallery; MIT; Chase Manhattan Bank, Rome; Bank of New York, NYC; First National Bank, Chicago; Denver; Pace College, NYC; Middlebury College.

CHRISTENSEN, DAN **b.** 1942, Lexington, Neb. **Studied:** Kansas City/AI, BFA. **Taught:** Ridgewood School of Art, 1975-77; School of Visual Arts, NYC, 1976-; NYU, 1983-. **Address:** 16 Waverly Place, NYC 10003. **Dealer:** Douglas Drake Gallery, NYC. **One-man Exhibitions:** Galerie Rudolf Zwirner, 1967; Noah Goldowsky, 1967, 68; Galerie Rolf Ricke, Cologne, 1968, 71; André Emmerich Gallery, NYC, 1969, 71, 72, 74, 75, 76; Nicholas Wilder Gallery, Los Angeles, 1970, 72; Edmonton Art Gallery, Alberta, 1973; Ronald Greenberg Gallery, St. Louis, 1974; Watson/de Nagy Gallery, Houston, 1977; B. R. Kornblatt Gallery, Baltimore, 1977; Douglas Drake Gallery, Kansas City, 1978, 79, 80, 81, 82, 84; Gloria Luria Gallery, Miami, 1978; Meredith Long & Co., Houston, 1978, 80, 81, 84; Meredith Long Contemporary, NYC, 1978, 79, 80; U. of Nebraska, 1980; Salander-O'Reilly Galleries, NYC,

1981, 82, 83, 84, 86; Gallery 700, Milwaukee, 1981; Gloria Luria Gallery, Bay Harbor Islands, Fla., 1981; Harcus Krakow Gallery, Boston, 1981; Ivory/Kimpton Gallery, San Francisco, 1982; The Gallery at Lincoln Center, NYC, 1983, 84, 87; Carson-Sapiro Gallery, Denver, 1983; Il Punto Blu Gallery, Southampton, N.Y., 1984; Wichita State U., 1984; Douglas Drake Gallery, NYC, 1987, 88, 91; Vered Gallery, East Hampton, N.Y., 1989, 90; Salander-O'Reilly Galleries, Beverly Hills, 1991. **Group:** WMAA, 1967, 69, 72, 73; Washington U., Here and Now, 1979; Corcoran, 1969; Buffalo/Albright, Color and Field: 1890-1970, 1970; WMAA, The Structure of Color, 1971; WMAA, Lyrical Abstraction, 1971; Buffalo/Albright, Six Painters, 1971; Boston/MFA, Abstract Painting in the '70s, 1972; WMAA Biennial, 1973; Lehigh U., Freedom in Art, 1976; U. of Nebraska, Expressionism in the '70s, 1978; MOMA, New Work on Paper I, 1981; Houston/MFA, Miró in America, 1982; Youngstown/Butler, Midyear Show, 1982, 85. **Collections:** Boston/MFA; Buffalo/Albright; Chicago/AI; Chicago/Contemporary; Cologne/Ludwig; Dayton/AI; Denver/AM; Edmonton; Greenville; High Museum; Hirshhorn; Houston/MFA; Indianapolis; MMA; MOMA; Mutual Benefit Life Insurance Co., Kansas City; U. of Nebraska; SRGM; St. Joseph/Albrecht; St. Louis/City; Seattle/AM; Toledo/MA; WMAA. **Bibliography:** *Kunst um 1970; Siegel; Wood; New in the Seventies.*

Christo (Javacheff) b. June 13, 1935, Gabrovo, Bulgaria.

Studied: Academy of Fine Arts, Sofia, 1951-56; theater design at Burian Theater, Prague, 1956; Academy of Fine Arts, Vienna, 1957. Moved to Geneva, 1957, to Paris, 1958, to NYC, 1964. Films of Projects: *Wrapped Coast,* 1969; *Christ's Valley Curtain,* 1972; *Running Fence,* 1973-76; Greater Miami, Surrounded Islands, Biscayne Bay, 1980-83; Paris, The Pont Neuf, Wrapped, 1985; The Umbrellas, Japan-USA, 1984-91, 1991. **Member:** AAIAL, 1989. **Awards:** Cassandra Foundation Grant, 1966; Key to and Honorary Citizen of New Orleans, 1977; Key to Kansas City, 1978; American Institute of Architects, Medal, 1979; Keys to Miami, Miami Beach and Metropolitan Dade County, 1985; Hon. D.H., College of Saint Rose, Albany, 1986; College of Charleston, First Menotti Artist-in-Residence Award for the Visual Arts, 1987; Kaiser Ring Award, Goslar, Germany; Fondation d'Academie d'Architecture, Paris, Medaille des Arts Plastiques, 1991; National Arts Club, Gold Medal, 1992. **Address:** 48 Howard Street, NYC 10013. **Dealer:** Jeanne-Claude Christo, NYC. **One-man Exhibitions:** Galerie Haro Lauhus, Cologne, 1961; Galerie J. Paris, 1962; Galerie Schmela, 1963, 64; Galleria Apollinaire, Milan, 1963; Galleria del Leone, Venice, 1963, 68; Galleria la Salita, Rome, 1963; Galerie Ad Libitum, Antwerp, 1964; Gian Enzo Sperone, Turin, 1964; Eindhoven, 1966; Leo Castelli Inc., NYC, 1966; Walker, 1966; Wide White Space Gallery, Antwerp, 1967, 69; Galerie der Spiegel, Cologne, 1967, 69; John Gibson Gallery, 1968, 69; MOMA, 1968; ICA, U. of Pennsylvania, 1968; Chicago/Contemporary, 1969; Little Bay, Australia, Wrapped Coast, 1969; Central Street Gallery, Sydney, 1969; Melbourne/National, 1969; New Gallery, Cleveland, 1970; Françoise Lambert, Milan, 1970; Annely Juda Fine Art, London, 1971, 77, 79, 84, 88, 91; Zurich, 1973; Allan Frumkin Gallery, Chicago, 1973; La Jolla, 1975; White Gallery, Lutry, 1975; Edificio Galipan, Caracas, 1975; Museo de Bellas Artes, Caracas, 1975; ICA, Boston, 1975; Galerie J. Benador, Geneva, 1975; Fabian Fine Arts, Cape Town, 1975; Galerie der Spiegel, Cologne, 1975; Museum des 20. Jahrhunderts, Vienna, 1976; SFMA, 1976; Pasadena/AM, 1976; Galerie Juan Prats, 1977; Rotterdam, 1977; Bonn, 1977; Hannover/K-G, 1977; Miami Gallery, Tokyo,

1977; Humlebaek/Louisiana, 1978; Kunstgewerbe, Zurich, 1978; Brussels/Beaux-Arts, 1978; American Foundation for the Arts, Miami, 1978; Kansas City/Nelson, 1978; Hartford/Wadsworth, 1978; Wiener Secession, Vienna, 1979; ICA, London, 1979; ICA, Boston, 1979; Corcoran, 1979; Abu Dhabi, United Arab Emirates, French Cultural Center, 1980; Cabrillo College, Aptos, Calif., 1980; Jackson/MMA, 1980; New Gallery, Cleveland, 1980; Newport Harbor, 1980; Winnepeg (Canada) Art Gallery, 1980; Albuquerque Museum, 1981; Cologne/Ludwig, 1981; Hokin Gallery, Miami, 1981; Juda-Rowan Gallery, London, 1981; Madison Art Center, 1981; Metropolitan Museum & Art Center, 1981; Montreal/Contemporain, 1981; Portland (Ore.) Center for Visual Arts, 1981; U. of Texas, El Paso, 1981; Art Gallery of Hamilton, Ont., 1982; Biuro Wystaw Artsystycznych, Sopot, Poland, 1982; U. of Calgary, 1982; Colby College, 1982; Frankfurt am Main, 1982; Kunstlerhaus Bethanien, Berlin, 1982; U. of Maine, 1982; Tokyo/Hara; U. of Wisconsin, Madison, 1982; Cincinnati/Contemporary, 1983; Delahunty Gallery, Dallas, 1983; Fukuoda, 1983; U. of Notre Dame, 1983; Osaka/National, 1983; Luther Burbank Center for the Arts, Santa Rosa, Calif., 1984; Berlin/National, 1984; Hartnell College, 1984; Henies-Onstadts Stiftelser, 1984, 90; Indianapolis/Herron, 1984; Satani Gallery, Tokyo, 1984, 86, 88, 90, 91; Sun Valley (Id.) Center for the Arts and Humanities, 1984; Fondation Maeght, 1985; Hamburg, 1985; New Britain/American, 1985; Rijksmuseum Kröller-Müller, 1985; U. of West Florida, 1985; Carpenter + Hochman Gallery, Dallas, 1986; College of St. Rose, Albany, N.Y., 1986; Florida State U., 1986; Miami/Bass, 1986; Galeria Joan Prats, Barcelona, 1986; Southern Illinois U., 1986; Syracuse U., 1986; Utica College, 1986; Musée Cantonal des Beaux-Arts, Lausanne, 1987; Lehman College/CUNY, 1987; Ridgefield/Aldrich; College of Charleston, 1987;

Ghent/Moderne; Long Island U., 1987; Seibu Museum of Art, Tokyo, 1988; Southern Oregon College, 1988; Taipei Fine Arts, Taiwan, 1988; Deutsches Theatre, East Berlin, 1989; Kendall College, Evanston, Il., 1989; Laage-Salomon Gallery, Paris, 1989; Gallery Guy Pieters, Knokke Aoute, Belgium, 1989; Stanford U., 1989; Skidmore College, 1989; Nice, 1989; Universidade de São Paulo, 1989; Hiroshima Museum of Art, 1990; Sydney/AG, 1990; Hara Museum of Contemporary Art, Tokyo, 1990; Galerie Eric Van de Weghe, Brussels, 1991; Galeria Joan Prats, Barcelona, 1991; Reykjavik, 1991; Sapporo Art Park, 1991; Westmont College, Santa Barbara, 1992. **Group:** Andover/Phillips; Harvard U.; Sorbonne; WMAA; Smithsonian; Brooklyn Museum; Boston/MFA; A.F.A., circ.; Boston Arts Festival; ICA, Boston, 1959-67, incl. View, 1960, 1960; Corcoran, 1961, 64, 65; Lincoln, Mass./De Cordova, 1966; Norfolk, 1967; AAAL, 1968; PAFA, 1969; NIAL, 1969. **Collections:** Aachen/NG; Albuquerque Museum; Amsterdam/Stedelijk; Andover/Phillips; Basel; Berlin/National; Bonn; Boston/MFA; Boston U.; Bowdoin College; Brown U., Buffalo/Albright; Canberra/National; Chicago/AI; Chicago/Contemporary; Cleveland/MA; Cologne; Cologne/Ludwig; Dallas/MFA; Dartmouth College; Des Moines; Detroit/Institute; Frankfurt/Deutsches Architekturmuseum; Dublin/National; Duisburg; Fukuoka Art Museum; Grenoble; Hamburg; Hannover/Kunstverein; Harvard U.; Houston/MFA; Humlebaek/Louisiana; Israel Museum; Kansas City/Nelson; Kofu/Yamanishi; Krefeld/Kaiser Wilhelm; La Jolla; Lincoln, Mass./De Cordova; Los Angeles/County MA; MOMA: Marseilles/Cantini; U. of Massachusetts; U. of Miami; U. of Michigan; Minnesota/MA; Munich/NP; Museum des 20. Jahrhunderts; Oberlin College; PMA; Paris/Beaubourg; Paris/Moderne; Rijksmuseum Kröller-Müller; Ringling; Rotterdam; SFMA; Santa Barbara/MA;

Seattle/AM; Smith College; Stockholm; Stuttgart/WK; Sydney/AG; U. of Sydney; Tate Gallery; U. of Tennessee; Tokyo/Hara; Toulon; VMFA; Victoria and Albert Museum; WMAA; Walker; Wichita/AM; Worcester/AM; Yale U.; Yamanashi/Kofu; Zurich; Zurich/KS. **Bibliography:** Bourdon 1; De Wilde 2; Diamonstein; *Drawings: The Pluralist Decade;* Cummings 5; Elsen, et. al; Gettings; Honisch and Jensen, eds.; Hunter, ed.; Kardon 3; Osterwold; Robins; Rowell; Sandler 3; Strachan; Weintraub. Archives.

CHRISTOPHER, WILLIAM
from 1st through 4th edition.

CHRYSSA **b.** December 13, 1933, Athens, Greece. **Studied:** Academie de la Grande Chaumiere, 1953-54; California School of Fine Arts, 1954-55. US citizen, 1955. Traveled Europe, USA. **Awards:** Guggenheim Foundation Fellowship, 1973; MIT, grant, 1979-80. **Address:** 565 Broadway, NYC, 10012. **Dealer:** Leo Castelli Inc., NYC. **One-man Exhibitions:** (first) Betty Parsons Gallery, NYC, 1961; SRGM, 1961; Cordier & Ekstrom, Inc., 1962; Robert Fraser Gallery, 1962; The Pace Gallery, NYC, 1966, 67, 68; The Graphic Gallery, San Francisco, 1968; Galerie der Spiegel, Cologne, 1968; Harvard U., 1968; Obelisk Gallery, 1969; Galerie Rive Droite, Paris, 1969; WMAA, 1972; Galerie Denise Rene, NYC, 1973, 76; Galerie Denise Rene, Paris, 1974; Galerie André Emmerich, Zurich, 1974, 75; Paris/Moderne, 1979; Montreal/Contemporain, 1974; Paris/Moderne, 1979; Leo Castelli, Inc., NYC, 1988, 91; Buffalo/Albright, 1983. **Group:** MOMA, Americans 1963, circ., 1963-64; São Paulo Biennials, 1963, 69; WMAA Annuals; Carnegie; Martha Jackson Gallery, NYC, New Media—New Forms, 1, 1960; Boston Arts Festival, 1960; Seattle World's Fair, 1962; Jewish Museum; Kassel, Documenta IV, 1968; Venice Biennial, 1972; Pinacotheque National Museum,

1980. **Collections:** Berlin/National; Buffalo/Albright; Chase Manhattan Bank; U. of Chicago; Corcoran; Eindhoven; Greece/National; Hirshhorn; MIT; MMA; MOMA; Montreal/Contemporain; PMA; Princeton U.; Purchase/SUNY; Raleigh/NCMA; Rotterdam; SFMA; SRGM; Tate Gallery; WMAA; Walker. **Bibliography:** Battcock, ed.; Calas, N. and E.; Honisch; Hunter, ed.; Lippard 5; Strachan; Tuchman 1; Waldman 3.

CICERO, CARMEN LOUIS
b. August 14, 1926, Newark, N.J. US Army, World War II, Philippines. **Studied:** Newark State Teachers College, BA, 1947-51; Hunter College (with Robert Motherwell), 1953-55; Hofmann School, NYC. Traveled Europe. **Taught:** Sarah Lawrence College, 1959-68; School of Visual Arts, NYC, 1965-67; New School for Social Research, 1967-70; Newark State College, 1969-70; Montclair (N.J.) State College, 1969-. **Awards:** Guggenheim Foundation Fellowship, 1957, 63, 64; Ford Foundation, P.P., 1961, 65. **Address:** 278 Bowery, NYC 10012. **Dealer:** June Kelly Gallery, Inc., NYC. **One-man Exhibitions:** The Peridot Gallery, NYC, 1956, 57, 59, 61, 62, 64, 66, 68, 69; Arts Club of Chicago, 1958; Kendall Gallery, Wellfleet, Mass., and Palm Beach; Rankow Gallery, 1971, 72, 74, 75; Montclair College, 1975; Gallery Simone Stern, New Orleans, 1972; South Houston Gallery, NYC, 1975; Caldwell College, 1976; Long Point Gallery, Provincetown, Mass., 1977, 79, 81, 84; E. P. Gurewitsch Gallery, NYC, 1979; Gracie Mansion Gallery, NYC, 1982; Cincinnati, 1983; The Graham Gallery, NYC, 1985; Fair Lawn (N.J.) Library, 1985; Cherrystone Gallery, Wellfleet, Mass., 1986; Graham Modern Gallery, NYC, 1987, 88; June Kelly Gallery, Inc., NYC, 1988, 91. **Group:** Corcoran, 1953; MOMA, 1953, 55; WMAA, 1955, 57, Annuals, 1960-63, 1965; U. of Nebraska, 1957; Chicago/AI, 1957; Worcester/AM, 1958; PAFA;

John Clem Clarke, *Dash Across the Tracks*, 1991.

Brooklyn Museum; Museum des 20. Jahrhunderts, 1963; St. Paul Art Center, Drawings, U.S.A., 1966; New School for Social Research, American Drawings, 1969; Youngstown/Butler, Midyear Show, 1973; Montclair/AM, Collage: American Masters, 1979; Art Museum Association of America, circ., Emotional Impact, 1984; RISD, Life in the Big City, 1986; Bronx Museum, Nightworks, 1987; Boca Raton, Contemporary Painting, 1987; Montclair/AM, The Interior Self, 1987. **Collections:** Albion College; Amsterdam/Stedelijk; Boymans Van Bueningen; Brooklyn Museum; Charlotte/Mint; Cornell U.; Exeter; Hirshhorn; MMA; MOMA; U. of Michigan; Montclair/AM; NYU; U. of Nebraska; Newark Museum; Purchase/SUNY; Ridgefield/Aldrich; Rotterdam; SRGM; Scheidam/Stedelijk; Southern Illinois U.; Springfield, Mass./MFA; Toronto; Trenton/State; WMAA; West Publishing Co.; Worcester/AM. **Bibliography:** Gerdts.

CIKOVSKY, NICOLAI
from 1st to 4th edition.

CLARKE, JOHN CLEM
b. June 6, 1937, Bend, Ore. **Studied:** Oregon State U.; Mexico City College; U. of Oregon, BFA, 1960. Traveled Mexico, Europe, USA. **Address:** 465 W. Broadway, NYC 10012. **Dealer:** Louis K. Meisel Gallery, NYC. **One-man Exhibitions:** The Kornblee Gallery, NYC, 1968, 69, 71; Franklin Siden Gallery, Detroit, 1969; OK Harris Works of Art, 1970, 72, 75, 77, 79, 81, 83; Michael Walls Gallery, 1970; Galerie M. E. Thelen, Essen, 1970; Phyllis Kind Gallery, Chicago, 1971; Pyramid Art Galleries, Ltd., 1971; Galerie de Gestlo, 1971; Jack Glenn Gallery, Corona del Mar, 1972; Carl Solway Gallery, Cincinnati, 1972; D.M. Gallery, London, 1974; Morgan Gallery, Kansas City, 1977, 81; Deson-Zaks Gallery, Chicago, 1977; Louis K. Meisel Gallery, NYC, 1990; Wassermann Galerie, Munich, 1991. **Group:** WMAA, 1967, 69, 72, 75; U. of Illinois, 1969; Milwaukee, Aspects of a New Realism, 1969; WMAA, 22 Realists, 1970; Chicago/AI, 1970; Potsdam/SUNY, New Realism, 1971; Chicago/Contemporary, Radical Realism, 1971; Santa Barbara/MA, Spray, 1971; U. of Miami, Phases of New Realism, 1972; New York Cultural Center, Realism Now, 1972; Indianapolis, 1974; Hartford/Wadsworth, New/Photo Realism, 1974; Tokyo Biennial, 1974; Cleveland/MA, Aspects of the Figure, 1974; Skidmore College, New Realism, 1974; Potsdam/SUNY, The Presence and Absence of Realism, 1976; Stratford, Ontario, Aspects of Realism, circ., 1976; Indianapolis, 1976, 78; US Department of the Interior, America 1976, 1976; Fort Wayne, Hue and Far Cry of Color, 1976; Taft Museum, Look Again, 1976; Rice U., Abstract Illusionism, 1977; U. of Texas, Austin, New in the Seventies, 1977; Canberra/National, Illusion and Reality, 1977; St. Petersburg, Fla., Photo Realism, 1977; U. of Rochester, Perceiving Time and Space Through Art, 1979; Aspen Center for the Visual Arts, Portraits of the Sixties/Seventies, 1979; Tulsa/Philbrook, Realism/Photorealism, 1980; Marquette U., Changes: Art in America 1881-1981, 1981; PAFA, Contemporary American Realism Since 1960, 1981; U. of Rhode Island, Diversity: New York Artists, 1985; WMAA, Image World, 1989; U. of Virginia, The Humanist Icon, circ., 1990; Trenton/State, Emerging Art, 1990. **Collections:** Akron/AI; Baltimore/MA; Brooklyn Museum; U. of California, Berkeley; Chase Manhattan

Bank; Cleveland/MA; Dallas/MFA; Detroit/Institute; Flint/Institute; Fort Worth; U. of Georgia; Harvard U.; Hirshhorn; Indianapolis; Kansas City/Nelson; Kresge Co.; Lewis and Clark College; Los Angeles/County MA; MMA; MOMA; Milwaukee; Security Pacific National Bank; Syracuse U.; Utrecht; VMFA; WMAA; Westmoreland County/MA; Wichita State U. **Bibliography:** *Amerikanischer Fotorealismus; America 1976;* Arthur 1; *Kunst um 1970;* Lindy; Murken-Altrogge; *New in the Seventies;* Sager. Archives.

Manon Cleary, *Self Portrait—Movement Series,* 1992.

CLEARY, MANON b. November 14, 1942, St. Louis, Mo. **Studied:** Washington U., BFA, 1964, with S. Reinhart, Fred Conway, Tanasco Micovish; Temple U., MFA, 1968, with Davie Pease, Warrington Colescott; Tyler Abroad, 1968; Corcoran School, photography with Joe Cameron, 1978. Traveled Denmark, Spain, Italy. **Taught:** Oswego/SUNY, 1968-70; U. of District of Columbia, 1970-. **Member:** CAA. **Address:** 1736 Columbia Road, N.W., Washington, D.C. 20009. **Dealers:** Osuna Gallery, Washington, D.C., J. Rosenthal Fine Arts, Chicago. **One-man Exhibitions:** (first) Tyler School, Philadelphia, 1968; Franz Bader Gallery, Washington, D.C., 1972; Pyramid Gallery, Washington, D.C., 1974, 77, 79; Osuna Gallery, Washington, 1980, 84, 91; U. of the District of Columbia, 1991; Oswego/SUNY, 1991; J. Rosenthal Fine Arts, Chicago, 1991; **Retrospective:** Gulbenkian Foundation, Lisbon, 1984. **Group:** Corcoran, Cleary, Apple, Moeller, 1973; Moore College of Art, Philadelphia, East, West, North, South, and Middle, circ., 1975; San Diego, Invitational Drawing Exhibition, 1977; WPA, Washington, D.C., Meta-realities, 1980; Corcoran, Images of the '70s, 1980; Corcoran, The Human Form, 1980; Brooklyn Museum, American Drawings in Black and White, 1980; VMFA, A Bestiary, 1981; U. of Hartford, Renderings of the Modern Woman, 1981; PAFA, Perspectives on Contemporary Realism, circ., 1982; IEF, Twentieth Century American Drawings, circ., 1984; Huntsville Museum, Drawing: The New Tradition, 1987; Boca Raton, American Drawing: Realism Idealism, 1987; U. of Florida, Divergent Styles, 1990; Emporia State U., 16 Annual National Invitational Drawing Exhibition, 1992. **Collections:** Brooklyn Museum; Charlotte/Mint; Chicago/AI; Colgate U.; Corcoran; U. of District of Columbia; Emporia State U.; City of Kirkwood, Mo.; NMWA; Oswego/SUNY; Phoenix; Ponce; Rutgers U.; Ucross Foundation; Utah; U. of Virginia. **Bibliography:** Cummings 4.

CLERK, PIERRE b. March 26, 1928, Atlanta, Ga. **Studied:** McGill U., Montreal; Loyola College; Montreal/MFA; Academie Julian, Paris; Academy of Fine Arts, Florence, Italy. Traveled Canada, Europe. Resided seven years in Europe. **Commissions:** (tapestries) Skidmore College; Owings & Merrill; Commerce Trust Co., Kansas City. **Awards:** Canada Council Award, 1971, 72; Tamarind Fellowship, 1972; Municipal Art Society, NYC, award, 1977; The Canada Council Award, 1980; % for the Arts Commission, Toledo, 1983. **Address:** 55 Central Park West, NYC 10023. **One-man Exhibitions:** Numero Gallery, Florence, Italy; Galleria Totti, Milan; Cittadella Gallery, Ascona, Switzerland; Beno Gallery, Zurich; Montreal/MFA; New Gallery, NYC; Galleria

del Cavallino, Venice; Siegelaub Gallery, NYC, 1965, 67; Gimpel Fils, 1971; Gimpel & Hanover, 1971; Gimpel & Weitzenhoffer Ltd., 1971; Tirca Karlis Gallery, 1971; Gallery Moos, Montreal, 1972; Syracuse/Everson, 1977; Manila, 1978; USIA, sponsor, Central America and Far East tour, 1977-78; Waterside Plaza, NYC, 1977; Canadian Cultural Center, Paris, 1981. **Group:** XXVIII & XXIX Venice Biennials, 1956, 1958; Carnegie, 1959; Expo '67, Montreal 1967; Dublin/Municipal, International Quadriennial (ROSC), 1971; Indianapolis, 1972; Bradford, England, III British Print Biennial, 1972. **Collections:** American National Fire Insurance Co.; Atlantic Richfield Co.; Avon Corp; The Bank of New York; Brandeis U.; Buffalo/Albright; Burlington Mills; Chase Manhattan Bank; First National City Bank; U. of Glasgow; Gulf Oil Corp.; Gulf and Western Industries, Inc.; Honolulu Academy; IBM; MOMA; McCrory Corporation; Mobil Oil Corp.; Montreal/Contemporain; Montreal/MFA; NYU; Newark Public Library; U. of Northern Iowa; Ottawa/National; Philip Morris; Purchase/SUNY; Quebec; Queens College; Radio Corporation of America; Rutgers U.; SRGM; The Singer Company, Inc.; Skidmore College; U. of Virginia; U.S. Steel Corp.; WMAA.

CLOAR, CARROLL **b.** January 18, 1913, Earle, Ark. **d.** April 10, 1993, Memphis, Tn. **Studied:** Memphis Academy of Arts; ASL, with William C. McNulty, Harry Sternberg; Southwestern College, BA. US Air Force, World War II, three years. Traveled Central and South America, Europe. **Taught:** Memphis Academy of Arts, 1956. **Member:** Artists Equity. **Awards:** MacDowell Traveling Fellowship, 1940; Guggenheim Foundation Fellowship, 1946; Youngstown/Butler, P.P.; Brooklyn Museum, P.P.; Library of Congress, P.P.; Mead Painting of the Year; Hon. PBK; Hon. Ph.D., Southwestern College. **One-man Exhibitions:** (first)

Memphis/Brooks, 1955, also 1957; The Alan Gallery, NYC, 1956, 58, 60, 62, 64, 65, 68; U. of Arkansas, 1956, 61; Fort Worth, 1963; Charleston Art Gallery, Charleston, W. Va.; U. of Georgia; Montgomery (Ala.) Museum of Fine Arts; Utah State Institute of Fine Arts, Salt Lake City; Columbia, S.C./MA; Dulin Gallery; Memphis/Brooks, 1957, 62, 72; Kennedy Gallery, NYC, 1973; The Forum Gallery, NYC, 1979, 81, 83, 85; Schmidt-Bingham Gallery, NYC, 1987, 89. **Retrospectives:** Albany/SUNY, 1968; Memphis/Brooks, 1960, 76; Tennessee State Museum, 1983, Memphis State U., 1991. **Group:** PAFA; MMA; Carnegie; MOMA; WMAA; Brooklyn Museum; Dallas/MFA; U. of Nebraska; Brooklyn Museum, Black Folk Art in America, 1930-1980, circ., 1983. **Collections:** Abbott Laboratories; Albany/SUNY; Atlanta/AA; Brandeis U.; Bridgeport; Brooklyn Museum; Chase Manhattan Bank; Corcoran; First National Bank of Memphis; Friends of Art; Hartford/Wadsworth; Hirshhorn; Library of Congress; MMA; MOMA; Mead Corporation; Memphis/Brooks; Newark Museum; Phillips; Purchase/SUNY; St. Petersburg, Fla.; Southwestern (College) at Memphis; Tennessee State Museum; WMAA; Youngstown/Butler. **Bibliography:** Archives.

CLOSE, CHUCK (Charles)
b. July 5, 1940, Monroe, WA. **Studied:** U. of Washington, 1958-62, BA; Yale U. Summer School, Norfolk, CT, 1961; Yale U., 1962-64; BFA, 1963, MFA, 1964; Akademie der Bildenden Kunste, Vienna, 1964-65. Traveled Europe. Organized *Artist's Choice: Chuck Close, Head-On/The Modern Portrait,* MOMA, 1991. **Taught:** U. of Massachusetts, 1965-67; School of Visual Arts, NYC, 1967-71; NYU, 1970-73; U. of Washington, 1970; Yale U. Summer School, Norfolk, Conn., 1971, 72. **Awards:** National Endowment for the Arts, grant ($7,500), 1973; Skowhegan Arts Medal, 1991; AAIAL, award, 1991.

Address: 271 Central Park West, NYC 10024. **Dealer:** The Pace Gallery, NYC. **One-man Exhibitions:** U. of Massachusetts, 1967; Bykert Gallery, 1970, 71, 73, 75; Los Angeles/County MA, 1971; Chicago/Contemporary, 1972; MOMA, 1973; Akron/AI, 1973; Austin, 1975; Art Museum of South Texas, Corpus Christi, 1975; The Texas Gallery, Houston, 1975; Portland (Ore.) Center for the Visual Arts, 1975; Cincinnati/Contemporary, 1976; Baltimore/MA, 1976; The Pace Gallery, NYC, 1977, 79, 83, 86, 88, 91; Hartford/Wadsworth, 1977; Paris/Beaubourg, 1979; Munich, Kunstraum, 1979; U. of California, Riverside, 1982; Houston/Contemporary, 1985; Fuji Television Gallery, Tokyo, 1985; Pace-MacGill Gallery, NYC, 1985, 86, 88; Fraenkel Gallery, San Francisco, 1985; Ridgefield/Aldrich, 1987, 89; Pace Editions, 1988; Fendrick Gallery, Washington, D.C., 1988; Youngstown/Butler, 1989; Chicago/AI, circ., 1989; Guild Hall, 1991; Honolulu/Contemporary, 1991; Boston/MFA, 1991 **Retrospectives:** Walker, circ., 1980; Cheney Cowles Memorial Museum, circ., 1984. **Group:** WMAA Annuals, 1969, 72; WMAA, 22 Realists, 1970; Oberlin College, Three Young Americans (with Ron Cooper and Neil Jenney), 1970; Düsseldorf/Kunsthalle, Prospect 72, 1971; Kassel, Documenta V, 1972; Galerie des 4 Mouvements, Paris, Hyperrealistes Americains, 1972; Stuttgart/WK, Amerikanischer Fotorealismus, circ., 1972; WMAA, American Drawings: 1963-1973, 1973; Ars 74, Helsinki, 1974; Worcester/AM, Three Realists, 1974; XI Tokyo Biennial, 1974; Corcoran, Biennial, 1975; Fort Worth, American Artists: A New Decade, 1976; Stratford, Ont., Aspects of Realism, 1976; MOMA, Drawing Now, 1976; Chicago/AI, 1976; A.F.A., American Master Drawings and Watercolors, 1976; Daniel Weinberg, San Francisco (threeman), 1976; Akademie der Kunst, Berlin, SoHo, 1976; WMAA Biennials, 1977, 79, 91; Kassel, Documenta VI, 1977; Can-

berra/National, Illusion and Reality, 1977; Minnesota/MA, American Drawings, 1927-1977, 1977; Paris/Beaubourg, Paris-New York, 1977; U. of California, Santa Barbara, Contemporary Drawing/NY, 1978; Buffalo/Albright, American Painting of the 1970's, 1978; Philadelphia College of Art, Point, 1978; Great Britain Arts Council, Hayward Gallery, The Mechanized Image, 1978; Pomona College, Black and White Are Colors: Paintings of the 1950s-1970s, 1979; U. of North Carolina, Drawings About Drawing Today, 1979; NPG, American Portrait Drawings, 1980; WMAA, The Figurative Tradition and the WMAA, 1980; PAFA, Contemporary American Realism Since 1960, 1981; SRGM, Seven Photorealists from New York Collections, 1981; WMAA, American Prints: Process and Proofs, 1981; Arts Council of Great Britain, Photographer as Printmaker: 140 Years of Photographic Printmaking, 1981; MIT, Great Big Drawings, 1982; Hannover/K-G, Momentbild: Kunstlerphotographie, 1982; Maryland Institute, Drawings by Contemporary American Figurative Artists, 1984; AAIAL, 1985; Isetan Museum, Tokyo, American Realism: The Precise Image, circ., 1985; WMAA, Philip Morris, The Changing Likeness: Twentieth-Century Portrait Drawings, 1986; Fort Lauderdale, An American Renaissance: Painting and Sculpture Since 1940, 1986; Sonoma State U., the Monumental Image, 1987; ICP, Legacy of Light, circ., 1987; Cologne, Photokino 88, circ., 1988; NPG, The Instant Likeness: Polaroid Portraits, 1988; Little Rock/MFA, The Face, 1989; National Gallery, On the Art of Fixing a Shadow, circ., 1989; Walker, First Impressions, circ., 1989; Boston/MFA, Figuring the Body, 1990; Florida State U., Monochrome/Polychrome, 1990; AAIAL, 1991. **Collections:** Aachen/AG; Akron/AI; Berlin; Buffalo/Albright; Canberra/National; Chicago/Contemporary; Chicago/AI; Dayton/AI; Des Moines; Fort Worth; U. of Georgia; Helsinki; High Museum; Humlebaek/Loui-

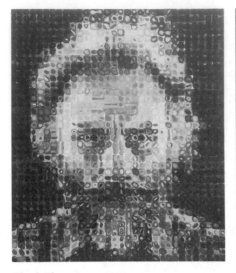

Chuck Close, *Lucas*, 1991.

siana; Indiana U.; Library of Congress; LIC; Milwaukee; MMA; MOMA; Madison Art Center; Minneapolis/Institute; NPG; National Gallery; U. of North Carolina; Oberlin College; The Ohio State U.; PMA; Paris/Beaubourg; Princeton U.; Rotterdam; SRGM; Seattle/AM; Tate Gallery; Toledo/MA; Toronto; Utrecht; WMAA; Walker; Worcester/AM; Wright State U.; Zurich. **Bibliography:** Adrian; *Amerikanischer Fotorealismus;* Armstrong, Thomas; Arthur 2, 3, 4; Cummings 5; Diamondstein; Gettings; Goldman 1; Honisch & Jensen, eds.; Kunst um 1970; Lindy; Meisel; Murken-Altrogge; Robins; Sager; Sandler 3; *Three Realists;* Ward.

CLUTZ, WILLIAM b. March 19, 1933, Gettysburg, PA. **Studied:** Mercersburg Academy, 1948-51; State U. of Iowa, with James Lechay, Stuart Edie, 1951-55, BA; ASL, 1956, with Robert Brackman. **Taught:** Artist-in-Residence, Bucknell U., 1957; Philadelphia College of Art, 1967; U. of Minnesota, 1967-68; Parsons School of Design, NYC, 1969-. **Address:** 370 Riverside Drive, NYC 10025. **Dealer:** Tatistcheff Gallery, Inc., Santa Monica and John C. Stoller & Co., Minneapolis. **One-man Exhibitions:** (first)

Penn Hall Junior College and Preparatory School, Chambersburg, Pa., 1954; Bucknell U., 1957; Mercersburg Academy, 1958, 59; Condon Riley Gallery, NYC, 1959; David Herbert Gallery, NYC, 1962; The Bertha Schaefer Gallery, 1963, 64, 66, 69; Triangle Art Gallery, 1967; The Graham Gallery, 1972; Brooke Alexander, 1973; Exeter, 1973; Alonzo Gallery, NYC, 1977, 78, 79; Moravian College, Bethlehem, Pa., 1977; Walther-Rathenau-Saal, Rathaus, Wedding, West Berlin, 1978; Choate-Rosemary Hall School, 1979; Gallery 333, Dayton, Ohio, 1981; Tatistcheff & Co., NYC, 1981, 82, 84; John Stoller & Co., 1983; P. B. van Voorst van Beest Gallery, The Hague, 1984; U. of Minnesota, Duluth, 1986; Tatistcheff Gallery, Inc., Santa Monica, 1988, 92. **Retrospectives:** Brooklyn College, 1969; Andover/Phillips, 1973; Hagerstown/County MFA, 1991. **Group:** MOMA, Recent Drawings USA, 1956; A.F.A., The Figure, circ., 1960; Houston/MFA, The Emerging Figure, 1961; MOMA, Recent Painting, USA; The Figure, circ., 1962-63; PAFA Annuals, 1964-66; MOMA, Art in Embassies, circ.; U. of Nebraska, 1965; Norfolk/Chrysler, 1966; Purdue U., 1968; Ringling, 1969; Columbus, 1970; Smithsonian, American Drawings 1976-79; Westmoreland County/AM, The New American Still Life, 1978; Brooklyn Museum, Great East River Bridge: 1883-1983, 1983; SFMA, American Realism (Janss), circ., 1985; Montclair/AM, Art of the '80s, 1989. **Collections:** Andover/Phillips; AT&T; Ashland Oil Inc.; Ball State U.; Brooklyn College; Chase Manhattan Bank; Corcoran; Dayton/AI; Exeter; Hagertown/County MFA; Harvard U.; Hirshhorn; MMA; MOMA; U. of Massachusetts; Mercersburg Academy, Mercersburg, PA; Miles College; Mills College; Milwaukee; Minnesota/MA; U. of Minnesota; NYU; U. of Nebraska; Newark Museum; New York School of Interior Design; J. Henry Schroder Banking Corp.; SRGM.

COATES, ROSS **b.** November 1, 1932, Hamilton (Ont.), Canada. US Citizen, 1965. Illustrated and wrote several children's books. **Studied:** U. of Michigan, 1951-53; Chicago Art Institute School, 1956, BFA; NYU, 1960, MA; NYU, 1972, Ph.D. Traveled Canada, USA, Europe, resided Africa, 1968-70. **Taught:** New York Community College, 1963; Kansas City Art Institute and School of Design, 1963-64; Montclair State College, 1965 68; Canon Lawrence T.T.C., Lira, Uganda, 1968-70; Russell Sage College, 1971-76; Washington State U., 1976-. **Address:** 824 Ford St., Moscow, ID 83843. **One-man Exhibitions:** (first) Isaacs Gallery, 1957, also 1961; Camino Gallery, NYC, 1961; Louis Alexander Gallery, NYC, 1963; Galerie Niepel, Düsseldorf, 1966; Springfield College, 1966; Jerrold Morris Gallery, Toronto, 1967; Galerie Seyfried, Munich, 1967; Kansas City Jewish Community Center, 1968; Russell Sage College, 1972; Schenectady Museum, 1974; U. of Rochester, 1974; Washington State U., 1978; Spokane Falls Community College, 1979; Gordon Woodside Gallery, Seattle U., 1985; N.W. Artists Workshop, Portland, Ore., 1985; Art Gallery of Hamilton (Canada), 1988; Washington State U., Pullman, 1990; Portland Community College, Portland, Ore., 1990; Cornish School of Art, Seattle, 1991; Fine Arts Center, Port Angeles, Wa., 1991; U. of the Pacific, Stockton, Calif., 1992; U. of Idaho, 1992. **Group:** Washington State U., Pullman, Living with the Volcano: Artists of Mt. St. Helens, 1983; Seattle/AM, Northwest Artists: A Review, 1980; Cameron U., Lawton, Okla., Day of the Dead, 1985; Rockford Art Museum, Rockford, Ill., Fetish Art: Obsessive Expressions, 1986; Whatcom, Facts of the Imagination, circ., 1988; Tacoma Art Museum, 100 Years of Washington Art: New Perspectives, 1989; Salt Lake Art Center, Salt Lake City, Dreams and Shields, 1992. **Collections:** U. of Alberta; Brandeis U.; Chase Manhattan Bank; U. of California; Idaho First Na-

tional Bank; NYU; Russell Sage College; The Schenectady Museum; Springfield College; Stony Brook/SUNY.

CONGDON, WILLIAM **b.** April 15, 1912, Providence, R.I. **Studied:** Yale U., BA; Cape School of Art, with Henry Hensche; PAFA; Folly Cove School of Art, with George Demetrios. American Field Service, World War II. Active in postwar Italy with American Friends Service Committee. Traveled Mexico, North Africa, India, Cambodia, Central America, Europe. **Awards:** RISD, 1949, 50; PAFA, Joseph E. Temple Gold Medal, 1951; U. of Illinois, P.P., 1951; Corcoran, William A. Clark Prize, 1952; International Novara, Trieste, Gold Medal, 1961; Hon. DFA, U. of Portland, 1969. **Address:** Via Marconi 33, 20090 Buccinasco (Mi.), Italy. **One-man Exhibitions:** (first) Betty Parsons Gallery, 1949, also 1950, 52, 53, 54, 56, 59, 62, 67; ICA, Boston, 1951; Margaret Brown Gallery, Boston, 1951, 56; Phillips, 1952; L'Obelisco, Rome, 1953, 58; Providence (R.I.) Art Club, 1953; Santa Barbara/MA, 1954; UCLA, 1954; Arts Club of Chicago, 1954; Art of This Century (Peggy Guggenheim), 1957; Denver/AM, 1957; MIT, 1958; Arthur Jeffress Gallery, London, 1958; Michigan State U., 1959; Pro-Civitate Christiana, 1961; Palazzo Reale, Milan, 1962; U. of Notre Dame, circ., 1964-65; New York World's Fair, Vatican Pavilion, 1964-65; Cambridge U., 1968; Galleria Cadario, Milan, 1969-70; Palazzo Diamante, Ferrara, Italy, 1981; Basilica San Francesco, Como, Italy, 1983; Casa G. Cini, Ferrara, Italy, 1986; Basilica di S. Ambrogio, Milan, 1990. **Retrospectives:** RISD, 1965; Galleria Cadario, 1969. **Group:** PAFA, 1936-38, 1951-53, 1956, 58, 60; NAD, 1939; Carnegie, 1940-52, 58; Andover/Phillips, 1941; MMA, American Painters Under 35, 1950; WMAA, 1950, 51, 53, 56, 58; Buffalo/Albright, 1952; California Palace, 1952; U. of Illinois, 1952, 53, 55, 57, 59; Chicago/AI,

1952, 54, 57; XXVI & XXIX Venice Biennials, 1952, 58; WMAA, The New Decade, 1954-55; Walker, Expressionism, 1900-1955, 1956; International Novara, Trieste, 1961, 66; Musée Cantonal des Beaux Arts, Lausanne, II Salon de Galeries Pilotes, 1966; Hartford/Wadsworth; Cincinnati/AM; Lincoln, Mass./De Cordova; SRGM, P. Guggenheim: Other Legacy, 1987; Los Angeles/County MA, Romance of Taj Mahal, circ., 1990. **Collections:** Andover/Phillips; Boston/MFA; Carnegie; Cleveland/MA; Detroit/Institute; Gonville and Caius College, Cambridge, England; Hartford/Wadsworth; Houston/MFA; U. of Illinois; Louisville/Speed; MMA; MOMA; Memphis/Brooks; NMAA; PAFA; Phillips; Portsmouth Priory; Pro-Civitate-Christiana; Providence College; RISD; U. of Rochester; Rutgers U.; St. Louis/City; Santa Barbara/MA; Smithsonian; Toledo/MA; Utica; Vatican Collection, Rome; Venice/Contemporaneo; WMAA. **Bibliography:** McCurdy, ed.; Nordness, ed.; Pousette-Dart, ed.; Rodman 2.

CONLON, WILLIAM b. July 30, 1941, Albany, N.Y. **Studied:** U. of Notre Dame, 1959-60; School of Visual Arts, with Michael Lowe, George Ortman; Yale U., 1965-67, BFA, MFA, with Jack Tworkov, Al Held. **Taught:** Yale U. 1967-70; Hunter College, 1971-72; U. of California, Irvine, 1972-75; Sarah Lawrence College, 1975-79; Fordham U., 1979-. Designed sets for Bat-Dorf Dance Co., 1968. **Commissions:** Saatchi and Saatchi, Los Angeles. **Awards:** Graham Foundation, grant, 1965; CAPS, 1974; National Endowment for the Arts, 1977, 89. **Address:** 461 Broome Street, NYC 10013. **Dealer:** Andre Emmerich Gallery, NYC. **One-man Exhibitions:** (first) Reese Palley Gallery, NYC, 1970, 72; André Emmerich Gallery, NYC, 1977, 80, 81, 85, 86, 87; Hokin Gallery, Palm Beach, 1989; Peregrine Gallery, Dallas, 1991. **Retrospective:** Carnegie, 1981. **Group:** Dallas/MFA, Four

Painters: Conlon, Cote, Hacklin, Rafoss, 1971; WMAA Annual, 1972; Corcoran Biennial, 1975; NYU, American Painting: The Eighties, 1979; Brooklyn Museum, American Drawings in Black and White: 1970-1979, 1980; Indianapolis, 1980; Maryland Institute, Six Abstract Painters, 1982; Third Eye Centre, Glasgow, Space Complex, 1984; San Antonio/McNay, Abstract Painting, 1988; Hunter College, Color Dimensionality, 1991. **Collections:** AT&T; Brooklyn Museum; Buffalo/Albright; Carnegie; Chemical Bank; Dallas/MFA; First National City Bank; Grand Rapids; IBM; Syracuse/Everson; Texas Instruments.

CONNER, BRUCE b. November 18, 1933, McPherson, Kans. **Studied:** U. of Nebraska, BFA; U. of Wichita; Brooklyn Museum School, with Reuben Tam; Kansas City Art Institute and School of Design; U. of Colorado. **Taught:** California College of Arts and Crafts, 1965-66; SFAI, 1966, 67, 72; UCLA, summer, 1973; San Jose State U., 1974; San Francisco State U., 1976. Produced the light show for the Avalon Ballroom; filmmaker. Traveled Japan. **Member:** Artists Equity; Filmarts Foundation; Canyon Cinema Co-op. **Awards:** IV International Art Biennial, San Marino (Europe), Gold Medal, 1963; The U. of Chicago, Midwest Film Festival, First Prize; SFMA, Nealie Sullivan Award, 1963; Ford Foundation Grant, 1964; Tamarind Fellowship, 1965; Copley Foundation Award, 1965; National Endowment for the Arts, grant, 1973; American Film Institute, grant, 1974; Francis Scott Key Award, 1975; Guggenheim Foundation Fellowship, 1975; Brandeis U. Creative Art Award for Film, 1979; National Endowment for the Arts, 1984; San Francisco Arts Commission, Award of Honor, 1985; SFAI, Hon. DFA, 1986; American Film Institute, Maya Deren Award, 1988. **Address:** 45 Sussex Street, San Francisco, CA 94131. **Dealers:** Fraenkel Gallery, San Francisco; Smith-Andersen Gallery, Palo

Alto, Calif.; Michael Kohn Gallery, Santa Monica, Calif. **One-man Exhibitions:** Rienzi Gallery, NYC, 1956; East West Gallery, San Francisco, 1958; Designers Gallery, San Francisco, 1958; Spatsa Gallery, San Francisco, 1959; The Alan Gallery, NYC, 1960, 61, 63, 64, 65, 66; Batman Gallery, San Francisco, 1960, 62; Glantz Gallery, Mexico City, 1962; Antonio Suza Gallery, Mexico City; Ferus Gallery, Los Angeles, 1963; Wichita/AM, 1963; The Swetzoff Gallery, Boston, 1963; George Lester Gallery, Rome, 1964; Robert Fraser Gallery, London, 1964, 66; Brandeis U., 1965; Western Association of Art Museums, circ., 1965-66; U. of British Columbia, 1965; Galerie J, Paris, 1965; Quay Gallery, 1966, 72, 74; ICA, U. of Pennsylvania, 1967; SFAI, 1967, 71; Molly Barnes Gallery, Los Angeles, 1971; Reese Palley Gallery, San Francisco, 1971, 72; Martha Jackson Gallery, 1972; The Texas Gallery, 1972, 73; Nicholas Wilder Gallery, 1972; Jacqueline Anhalt Gallery, 1973; Tyler (Tex.) Museum of Art, 1974; Smith-Andersen Gallery, Palo Alto, 1974, 86, 91, 92; de Young, 1974; Braunstein/Quay Gallery, San Francisco, 1975, 76; Frankel Gallery, San Francisco, 1983, 86; Redding Museum, 1985; U. of California, Berkeley, 1986; Pink and Pearl Gallery, San Diego, 1987; 56 Bleecker Gallery, Ltd., NYC, 1988; Michael Kohn Gallery, Santa Monica, Calif., 1990, 91; Richard Feigen Gallery, Chicago, 1992. **Retrospective:** ICA, U. of Pennsylvania, 1967; de Young, circ., 1974-75. **Group:** SFAI Annuals, 1958, 63; San Francisco Episcopal Diocese, Church Art Today, 1960; U. of Illinois, 1961; MOMA, The Art of Assemblage, circ., 1961; WMAA, Fifty California Artists, 1962-63; IV International Art Biennial, San Marino, 1963; Chicago/AI, 66th Annual, 1963; Brandeis U., Recent American Drawings, 1964; ICA, Boston, Selection 1964, 1964; U. of California, Berkeley, Funk, 1967; Omaha/Joslyn, Nebraska Art Today, 1967; Los Angeles/County MA, American Sculpture of the Sixties, circ.,

1967; WMAA, Human Concern/Personal Torment, 1969; Dallas/MFA, Poets of the Cities, 1974; Newport Harbor, A Drawing Show, 1975; Dallas/MFA, Poets of the Cities, circ., 1974; Hirshhorn, Different Drummers, 1988; UCLA, 40 Years of California Assemblage, 1989; WMAA, The Junk Aesthetic, 1989. **Collections:** U. of California, Berkeley; Brandeis U.; Chicago/AI; Indiana U.; Kansas City/Nelson; Los Angeles/County MA; MOMA; U. of Missouri; U. of Nebraska; Netherlands Film Museum; Oakland/AM; Pasadena/AM; SFMA; WMAA; Wichita/AM; Worcester/AM. **Bibliography:** *Art as a Muscular Principle; Bruce Conner Drawings; Forty Years of California Assemblage; Europa/Amerika;* Gettings; Janis and Blesh 1; Lippard 5; Rose, B., 1; Seitz 3; Selz, P., 2; Siegfried; Tuchman 1; Waldman 4. Archives.

CONNOVER, ROBERT
from 1st to 5th edition.

CONSTANT, GEORGE
from 1st to 4th edition.

COOK, HOWARD b. July 16, 1901, Springfield, Mass. **d.** June 24, 1980, Santa Fe, New Mexico. **Studied:** ASL, 1919-21, with George Bridgeman, Wallace Morgan, Joseph Pennell, Andrew Dasburg, Maurice Sterne. Artist War Correspondent, South Pacific, World War II. Traveled extensively, USA, North Africa, the Orient, Europe. **Taught:** U. of Texas, 1942-43; Minneapolis Institute School, 1945-50; U. of New Mexico, 1947; U. of California, Berkeley, 1948; Colorado Springs Fine Arts Center, 1949; Scripps College, 1951; Washington U., 1954; New Mexico Highlands U., 1957. **Member:** NAD; SAGA. Federal A.P.: Mural painting. **Commissions** (murals): Hotel Tasqueno, Taco, Mexico; Law Library, Springfield, Mass.; Federal Court House, Pittsburgh, Pa.; US Post Offices, Alamo Plaza (San Antonio) and Corpus Christi;

Mayo Clinic, Rochester, Minn. **Awards:** Two Guggenheim Foundation Fellowships; Architectural League of New York, Gold Medal; NAD, Samuel F.B. Morse Gold Medal; MMA, P.P., 1942; PMA, P.P.; Denver/AM, P.P.; Tupperware National Competition, P.P., 1956; Orlando, P.P.; Oklahoma, First Painting Award; Tucson Fine Arts Association, Art Prize. **One-man Exhibitions:** (first) Denver/AM, 1928; Weyhe Gallery, NYC, 1929, 31, 34, 37, 41; Springfield, Mass./MFA, 1936; The Print Club, Philadelphia, 1937; Kennedy Gallery, NYC, 1942, 44; National Gallery, 1944; Rehn Galleries, NYC, 1945, 50; Dallas/MFA, 1945, 53; Minneapolis/Institute, 1950; Grand Central Moderns, NYC, 1951, 53, 56, 60, 64; San Diego, 1952, Santa Barbara, MA, 1952; de Young, 1952; Kansas City/Nelson, 1953; Omaha/Joslyn, 1953; G.W.V. Smith Art Museum, Springfield, Mass., 1954; Houston/MFA, 1954; Dartmouth College, 1954; Montclair/AM, 1954; Carnegie, 1958; Raymond Burr Gallery, Los Angeles, 1962, 63; Prakapas Gallery, NYC, 1976. **Retrospective:** Roswell, 1975. **Group:** WMAA, 20th-Century Drawings from the Permanent Collection, 1975. **Collections:** Baltimore/MA; Chicago/AI; Denver/MFA; Dartmouth College; Denver/AM; de Young; Harvard U.; MMA; MOMA; Minneapolis/Institute; Oklahoma; Omaha/Joslyn; Orlando; PMA; U. of Rochester; Santa Barbara/MA; Santa Fe, N.M.; WMAA. **Bibliography:** American Artists Congress, Inc.; American Artists Group, Inc. 1, 3; Bethers; Bruce and Watson; Cheney; Coke 2; Hall; Kent, N.; Mellquist; Pearson 1; Pousette-Dart, ed.; Reese; Wheeler; Zigrosser 1. Archives.

COPLEY, WILLIAM N.

(CPLY) b. January 24, 1919, NYC. **Studied:** Andover; Yale U. Self-taught artist. Proprietor of the Copley Gallerie in Beverly Hills, 1947-48. Designed sets and costumes for *Crosswalk,* by George

Skibine, for the Harkness Ballet Co., 1965. Publisher of the S.M.S. Press. **Address:** 1 Frisbie Road, Roxbury, CT 06783. **Dealers:** Phyllis Kind Gallery, NYC; David Nolan Gallery, NYC. **One-man Exhibitions:** (first) Royer's Bookstore, Los Angeles, 1947; Galerie Nina Dausset, Paris, 1953; Galerie Monte Napoleone, Milan, 1954; Galerie du Dragon, 1956; Iolas Gallery, NYC, 1956, 58, 60, 63, 65, 66, 67, 70, 71, 72, 76, 78; Galerie Furstenburg, Paris, 1959; Galleria Naviglio, Milan, 1960; Galleria Cavalino, Venice, 1960; ICA, London, 1960; Galerie Schwarz, Milan, 1961; Galerie Iris Clert, Paris, 1961, 62; Hanover Gallery, London, 1962; David Stuart Gallery, Los Angeles, 1964, 70, 72; Louisiana Gallery, Houston, 1965; Southwestern College, Chula Vista, 1965; Allan Frumkin Gallery, Chicago, 1965; Galerie Iolas, Paris, 1966, 72; Bodley Gallery, NYC, 1968; Galerie Neundorf, Hamburg, 1968; Galerie Springer, Berlin, 1968, 70, 72, 78; Merida Gallery, Louisville, 1969; Galerie Aspects, Brussels, 1972; Galerie Iolas, Milan, 1972; Gallery Saxe, San Francisco, 1972; Galeria Il Fauno, Torino, 1973; Moore College of Art, Philadelphia, 1974; Onnasch Gallery, NYC, 1974; Gallerie Onnasch, Cologne, 1974; Erik Nord Gallery, Nantucket, 1975; Phyllis Kind Gallery, Chicago, 1977, 82, 90, 91; Galerie Renate Fassbender, Munich, 1978; Galerie Zwirner, Cologne, 1978; Rice U., 1979; Brooks Jackson Gallery Iolas, NYC, 1979, 80, 81; Lens Fine Art, Anvers, 1980; Galerie Klewan, Munich, 1981, 90; Kunstler Werkstatt, Munich, 1981; Reinhard Onnasch Gallery, Berlin, 1983; Phyllis Kind Gallery, NYC, 1982, 83, 85, 87, 91; The Quay Gallery, San Francisco, 1985; The New Museum, NYC, 1986; Galerie Jule Kewenig, Frechen-Bachem, 1987; Galerie 1900/2000, Paris, 1988; David Nolan Gallery, NYC, 1991. **Retrospectives:** Amsterdam/Stedelijk, 1966; Berne, circ., 1980. **Group:** Nagaoka, Exposition International de l'art

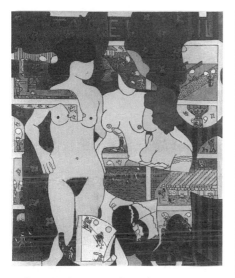

William Copley, *Unconditional Virgins*, 1989.

actuel, 1956; Salon de Mai, Paris, 1957, 58, 59, 61; Stockholm/National, Objects in Motion, 1961; Pasadena/AM, Collage out of California, 1962; Paris/Décoratifs, L'Antagonisme de l'objet, 1962; Oakland, Pop Art, 1963; Brandeis U., New Directions in American Painting, 1964; Huntington, N.Y./Heckscher, Whence Pop, 1965; U. of California, Santa Barbara, Surrealism, 1966; New School for Social Research, NYC, Erotic Art, 1971; New York Cultural Center, Three Generations of the American Nude, 1975; The New Museum, NYC, Bad Painting Show, 1977; Los Angeles/County MA; Cooper-Hewitt Museum, NYC, Box Museum, 1978; WMAA, The Figurative Tradition, 1980; Westkunst, Cologne, 1981; Kassel, Documenta VII, 1982; Los Angeles/MOCA, Art and Culture, 1984; École National Superieure des Beaux Arts, Paris, Cinquante ans de Dessins Americains, circ., 1985; Evanston Art Center, The Amused Eye, 1987. **Collections:** Amsterdam/Stedelijk; Chicago/AI; Denver/AM; Los Angeles/County MA; MOMA; Nagaoka, Japan; Newport Harbor; Oberlin College; Paris/Beaubourg; Paris/Moderne; Pasadena/AM; PMA; Princeton U.;

U. of Sydney; Tate; WMAA. **Bibliography:** *Europa/Amerika;* Gohr and Gachnang; Hunter, ed. Archives.

CORBETT, EDWARD b. August 22, 1919, Chicago, Ill. d. June 6, 1971, Provincetown, Mass. **Studied:** California School of Fine Arts, two years. Traveled Mexico, USA, Philippines. US Army, US Navy, Merchant Marine, 1941-44. **Taught:** San Francisco State Teachers College, 1947; California School of Fine Arts, 1947-50; U. of California, Berkeley, 1950; Mount Holyoke College, 1953-62; U. of New Mexico, 1955; U. of Minnesota, 1960-61; Santa Barbara, 1967-68. **Awards:** Abraham Rosenberg Foundation Fellowship, 1951. **One-man Exhibitions:** Grace Borgenicht Gallery, Inc., 1956, 59, 61, 64, 70, 73, 81; Quay Gallery, 1967; La Galleria Escondida, Taos, N.M. **Retrospective:** MIT, 1959; Walker, 1961; SFMA, 1969; Richmond (Calif.) Art Center, circ., 1990. **Group:** California Palace, 1957, 60; Riverside Museum, 1948; Chicago/AI, American Abstract Artists, 1948; de Young, 1951; MOMA, Fifteen Americans, circ., 1952; WMAA Annuals, 1953, 55, 58, 61, 63, 65-68; U. of Illinois, 1954; U. of Nebraska, 1955; Carnegie, 1955; Corcoran, 1956, 1966-68; Walker, 1961; São Paulo, 1962; NCFA, 1966; WMAA, Art of the U.S. 1670-1966, 1966. **Collections:** Andover/Phillips; Baltimore/AM; Bankers Trust Company; Brooklyn Museum; Buffalo/Albright; Burlington Mills Collection; U. of California, Berkeley; Carnegie; Chase Manhattan Bank; Chicago/AI; Corcoran; Harcourt, Brace & World, Inc.; Hirshhorn; MOMA; Michigan State U.; Mount Holyoke College; NMAA; National Gallery; Newark Museum; Oakland/AM; Phillips; SFMA; SRGM; Sweet Briar College; Tate Gallery; Trenton/State; WMAA; Walker. **Bibliography:** Landauer; McChesney. Archives.

CORBINO, JON
from 1st to 4th edition.

CORNELL, JOSEPH b. December 24, 1903, Nyack, NY. d. December 29, 1972, NYC. **Awards:** Copley Foundation Grant, 1954; Chicago/AI, Ada S. Garrett Prize, 1959; AAAL, Award of Merit, 1968. **One-man Exhibitions:** (first) Julien Levy Galleries, NYC, 1932, also 1933, 39, 40; Hugo Gallery, NYC, 1946; Copley Gallery, Hollywood, 1948; Charles Egan Gallery, 1949, 50; Allan Gallery, Chicago, 1953; Walker, 1953; The Stable Gallery, 1957; Bennington College, 1959; Richard Feigen Gallery, Chicago, 1960 (three-man); Ferus Gallery, Los Angeles, 1962; Robert Schoelkopf Gallery, NYC, 1966; J. L. Hudson Art Gallery, Detroit, 1966; Brandeis U., 1968; Allan Stone Gallery, 1972; Buffalo/Albright, 1972; Chicago/Contemporary, 1973; Castelli, Feigen, Corcoran Gallery, NYC, 1978, 79, 80, 82; ACA Gallery, NYC, 1975, 77; Wichita State U., 1980; Greenberg Gallery, Clayton, MO., 1976; Rice U., 1977; Baudoin Lebon, Paris, 1977; Chicago/AI, 1982; Betsy Rosenfeld Gallery, Chicago, 1982; NMAA, 1983; Acme Art, San Francisco, 1985; Fundacion Juan March, Madrid, 1984; The Pace Gallery, 1987, 88, 89; Museum of Art, Seibu, Tokyo, 1987; Richard Gray Gallery, Chicago, 1990. **Retrospectives:** Pasadena/AM, 1966; SRGM, 1967; MOMA, 1980. **Group:** MOMA, Fantastic Art, Dada, Surrealism, 1936; Galerie des Beaux Arts, Paris, Exposition Internationale du Surrealisme, 1938; Art of This Century, NYC, 1942; Carnegie, 1958; MOMA, The Art of Assemblage, 1961; Seattle World's Fair, 1962; WMAA Annuals, 1962, 66; NYU, Boxes and Collages, 1963; Chicago/AI, 1964; Musée Rodin, Paris, Sculpture of the 20th Century, 1965; U. of Illinois, 1967; Los Angeles/County MA, American Sculpture of the Sixties, circ., 1967; Kassel, Documenta IV, 1968; Lalit Kala Akademi, New Delhi, First Triennale, 1968; MOMA, Dada, Surrealism and Their Heritage, circ., 1968; MMA, New York Painting and Sculpture: 1940-1970, 1969;

Carnegie, International 1970; La Jolla, Continuing Art, 1971; Kassel, Documenta V, 1972; National Gallery, American Art at Mid-Century, 1973; NCFA, Sculpture, American Directions 1945-75, 1975; SRGM, 20th Century American Drawings, 1976; WMAA, 200 Years of American Sculpture, 1976; Rutgers U., Surrealism and American Art, 1931-1947, 1977; Paris/Beaubourg, Paris-New York, 1977; WMAA, Art About Art, circ., 1978; Rutgers U., Vanguard American Sculpture, 1913-1939, 1979; Ridgefield/Aldrich, Mysterious and Magical Realism, 1980. **Collections:** Boston/MFA; MOMA; Pasadena/AM; WMAA. **Bibliography:** Ashbery; **Ashton, ed.**; Baur 7; Blesh 1; Breton 2; Calas, N. and E.; Downes, ed.; Finch; Flanagan; Guggenheim, ed.; Hughes; Hunter 6; Hunter, ed.; *Individuals;* Janis and Blesh 1; Janis, S.; Johnson, Ellen H.; Kozloff 3; Licht, F.; Marter, Tarbell, and Wechsler; McShine, ed.; *Metro;* Neff, ed.; O'Doherty; Read 3; Rickey; Rose, B., 1; Rowell; Rubin 1; Steitz 3; Seuphor 3; 7; *Decades;* Tuchman 1; **Waldman 4, 5.** Archives.

CORNELL, THOMAS
b. March 1, 1937, Cleveland, Ohio. **Studied:** Amherst College, 1959, BA, with Leonard Baskin; Yale U., 1960-61, with Neil Welliver, William Bailey, Bernard Chaet. US Marine Corps, 1956-63. Traveled Europe and U.S. **Taught:** U. of California, Santa Barbara, 1960-62; Princeton U., 1969-71; Bowdoin College, Maine, 1963-. **Member:** CAA; Alliance of Figurative Artists; NAD; Union of Maine Visual Artists, president. **Commissions:** IGAS, print edition, 1966; many portrait commissions; John Hancock Mutual Life Ins. Co., Boston, 1984. **Awards:** L. C. Tiffany Grant, 1961; National Endowment for the Arts, grant, 1966; Ford Foundation, grant, 1969. **Address:** 305 Maine Street, Brunswick, Me. 04011. **Dealer:** G. W. Einstein, NYC. **One-man Exhibitions:** (first) Esther Baer Gallery, Santa Barbara,

1961, 63; Rex Evans Gallery, Los Angeles, 1962; Sabarsky Gallery, Los Angeles, 1965; Yale U., 1965; Princeton U., 1971; Dartmouth College, 1966; Tragos Gallery, Boston, 1966; Block Gallery, St. Louis, 1968; Bowdoin College, 1971; A.A.A. Gallery, NYC, 1972; Optik Gallery, Amherst, 1972; Frishman Gallery, Boston, 1974; Muhlenberg College, 1976; Barridoff Galleries, Portland, Me., 1977; A. M. Sachs Gallery, NYC, 1979, 81; U. of Redlands, Calif., 1979; Santa Barbara/MA, 1980; U. of North Carolina, 1982; G. W. Einstein, NYC, 1986, 89; Bowdoin College, 1990. **Group:** Brooklyn Museum, Print Biennial, 1960; MOMA, Contemporary Painters and Sculptors as Printmakers, 1964; Grolier Club, 1966; Ringling, Young New England Painters, 1969; The Pennsylvania State U., Contemporary Artists and the Figure, 1974; Southern Connecticut State College, In Their Own Image, 1976; Brooklyn Museum, Thirty Years of American Printmaking, 1976; NPG, American Portrait Drawings, 1980; Youngstown U., Annual, 1982; IEF, Twentieth Century Drawings: The Figure in Context, circ., 1984; Bayly Museum, Charlottesville, Studies from Life, 1987; Kuznetsky Most, Moscow, Painting Beyond the Death of Painting, 1989; Southern Alleghenies Museum of Art, Loretto, Against the Grain, 1960-1990, 1991. **Collections:** Amherst College; Bibliothèque Nationale, Paris; Bowdoin College; U. of California, Berkeley, Los Angeles, and Santa Barbara; Cleveland/MA; Harvard U.; MIT, MOMA; NCFA; U. of Nebraska; U. of North Carolina; NYPG; Princeton U. Library; Smith College; Yale U. **Bibliography:** Cummings 4.

COTTINGHAM, ROBERT

b. September 26, 1935, Brooklyn, N.Y. **Studied:** Pratt Institute, 1959-64, Associate Degree in Advertising Art. US Army, 1955-58. At one time art director for Young and Rubicam, New York and Los Angeles. **Taught:** Art Center College of Design, Los Angeles, 1969-70; Wesleyan U., 1987-89. **Member:** NAD. **Awards:** National Endowment for the Arts, 1974. **Address:** PO Box 704, Newton, CT 06470. **Dealer:** Marisa del Re Gallery, NYC. **One-man Exhibitions:** Molly Barnes Gallery, Los Angeles, 1968, 69, 70; OK Harris Works of Art, NYC, 1971, 74, 76, 78; D.M. Gallery, London, 1975; Galerie de Gestlo, Hamburg, 1975, Cologne, 79; John Berggruen Gallery, San Francisco, 1976; Morgan Gallery, Kansas City, 1978; Bethel Art Gallery, Bethel, Conn., 1978; Ridgefield/Aldrich, 1979; Beaver College, 1979; Landfall Press Gallery, Chicago, 1977, 79; Delta Gallery, Rotterdam, 1979; Thomas Segal Gallery, Boston, 1980; Coe Kerr Gallery, NYC, 1982; Wichita/AM, 1983; Fendrick Gallery, Washington, D.C., 1981, 84, 85, 88; Springfield, Mo./AM, 1984; The Art Guild, Framington, Conn., 1985; Little Rock/MFA, circ., 1985; Abilene Christian U., 1985; Roger Ramsey Gallery, Chicago, 1985, 88, 90; Reynold House Museum, N.C., 1985; U. of Arkansas, circ., 1985; Washington U., 1986; Signet Arts, St. Louis, 1986; Bridgeport, 1986; Gallery Karl Oskar, Westwood Hills, Ks., 1986; Brenda Kroos Gallery, Columbus, Ohio, 1986; Gimpel & Weitzenhoffer, Ltd., NYC, 1986, 87. **Group:** Fresno State College, The Persistent Image, 1970; ICA, U. of Pennsylvania, Highway, 1970; Chicago/Contemporary, Radical Realism, 1971; Potsdam/SUNY, New Realism, 1971; Kassel, Documenta V, 1972; Stuttgart/WK, Amerikanischer Fotorealismus, circ., 1972; New York Cultural Center, Realism Now, 1972; Lincoln, Mass./De Cordova, The Super-Realist Vision, 1973; Los Angeles Municipal Art Gallery, Separate Realities, 1973; Cincinnati/Contemporary, Options, 73/30, 1973; CNAC, Hyperrealistes Americains/Realistes Europeens, 1974; Hartford/Wadsworth, New Photo Realism, 1974; Tokyo Biennial, 1974; Toledo/MA, Image, Color and Form—Recent Paintings by Eleven Ameri-

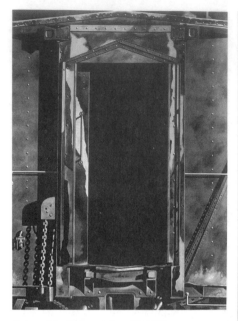

Robert Cottingham, *Portal I*, 1992.

cans, 1975; Wichita State U., The New
Realism: Rip-Off or Reality? 1975;
Nordjyllands Kunstmuseum, Aalborg,
Tendenser i Modern Kunst, 1975;
Renwick Gallery, Washington, D.C.,
Signs of Life: Symbols in the City, 1975;
NCFA, Recent American Etchings, circ.,
1975; Baltimore/MA, Super Realism,
1975; Brooklyn Museum, Thirty Years of
American Printmaking, 1976; NCFA,
America as Art, 1976; Canberra/National,
Illusion and Reality, circ., 1977; U. of
Texas, Austin, New in the '70's, 1977;
Tulsa/Philbrook, Realism-Photorealism,
1980; PAFA, Contemporary American
Realism Since 1960, 1981; San Anto-
nio/MA, Real, Really Real, Super Real,
circ., 1981; National Gallery, Contempo-
rary American Prints and Drawings, 1940-
1980, 1981; PAFA, Contemporary
American Realism Since 1960, circ., 1981;
British Arts Council, Painter as Photogra-
pher, circ., 1982; U. of California, Santa
Barbara, A Heritage Renewed, circ., 1984;
Isetan Museum, Tokyo, American Real-
ism: The Precise Image, circ., 1985; Wich-
ita/MA, A Decade of American Realism,

1985; SFMA, American Realism (Janss),
circ., 1985; NMAA, Close Focus: Prints
and Drawings and Photographs, 1987;
Emporia State U., National Drawing In-
vitational Exhibition, 1989. **Collections:**
Abilene Christian U.; Ackland; Arkansas;
Arts Council of Great Britain; Balti-
more/MA; Birmingham, Ala./MA; Carnegie;
Cedar Rapids/MA; Chattanooga/Hunter;
Chicago/AI; Cincinnati/AM, Cleve-
land/MA; College of William and Mary;
Columbus; Cornell U.; Currier; Dart-
mouth College; Detroit/Institute; Harvard
U.; High Museum; Hirshhorn; Honolulu
Academy; Hunter; Indianapolis; U. of
Iowa; Kansas City/Nelson; U. of Kansas;
Library of Congress; Little Rock/MFA;
Long Beach/MA; MOMA; Madison Art
Center; Museum of the City of New
York; New Orleans Museum; NCFA;
NMAA; U. of North Carolina; Notre
Dame U.; U. of Oklahoma; PMA;
Princeton U.; RISD; Rotterdam; Rutgers
U.; SRGM; St. Louis/City; San
Diego/Contemporary; Smith College;
Springfield, Mass./MFA; Syracuse U.;
Tate Gallery; Tampa/MA; U. of Utah;
Utrecht; VMFA; U. of Virginia; Wesleyan
U. (Conn.); WMAA; Washburn U.; Wil-
liams College; Wichita/AM; Yale U.;
Youngstown/Butler. **Bibliography:** *Amer-
ikanischer Fotorealismus;* Arthur 3, 4;
Lindy; Meisel; Murken-Altrogge; Sager;
The State of California Painting; Ward.

COVERT, JOHN b. 1882, Pitts-
burgh, Pa. **d.** December 24, 1960, NYC.
Studied: Pittsburgh School of Design,
1902-08; in Munich, 1908-12, on a Ger-
man government scholarship. Traveled
France, Germany, England. A founder and
director of the Society of Independent Art-
ists, 1916. The collection of the Societé
Anonyme was started with a gift of six of
his paintings in 1923. Stopped painting be-
tween 1923 and 1949. **One-man Exhibi-
tions:** Salander-O'Reilly Galleries, NYC,
1984. **Group:** Paris Salon, 1914; Indepen-
dent Artists, NYC, 1917; PAFA, 1921;

Societé Anonyme, 1921; Vassar College, 1923; Detroit/Institute, 1923; Brooklyn Museum, 1926; Delphic Studios, NYC, 1936; Dallas Museum for Contemporary Arts, 1961; WMAA, 1963; Hirshhorn, 1976. **Collections:** MOMA; PMA; Seattle/AM; Yale U. **Bibliography:** *Avante-Garde Painting and Sculpture in America, 1910-1925;* Baur 7; Brown 2; Hunter 6; Rose, B., 1; Tashjian.

COWLES, RUSSELL
from 1st to 4th edition.

CRAMER, KONRAD b. November 9, 1888, Wurzburg, Germany. d. January, 1965, Woodstock, N.Y. **Studied:** Academy of Fine Arts, Karlsruhe, Germany. **Taught:** Bard College, 1940. Founder, Woodstock (N.Y.) School of Photography, 1936. **One-man Exhibitions:** Woodstock (N.Y.) Art Gallery, 1952; New Paltz/SUNY, 1952; Long Island U., 1958; Rochester Institute of Technology, 1966; The Zabriskie Gallery, 1963, 73, 80, 82; Ellen Sragow Gallery, NYC, 1981; Martin Diamond Fine Arts, NYC, 1984. **Retrospectives:** Bard College, circ., 1981; U. of Texas, 1983; WMAA, 1984. **Group:** MacDowell Club, NYC, 1912; Whitney Studio Club, NYC, 1924; WMAA, Abstract Painting in America, 1935; PAFA, 1936; Carnegie, 1937, 38; Corcoran, 1938, 39; WMAA, Pioneers of Modern Art in America, 1946; Woodstock (N.Y.) Art Gallery; WMAA, The Decade of the Armory Show, 1963; U. of New Mexico, Cubism, Its Impact in the U.S.A., 1910-1930, 1967; Delaware Art Museum, Avant-Garde Painting and Sculpture in America, 1910-1925, 1978. **Collections:** International Museum of Photography; MMA; MOMA; NCFA; U. of North Carolina; PMA; San Diego; U. of Texas; WMAA. **Bibliography:** *Avant-Garde Painting and Sculpture;* Bauer 7; Brown 2; Janis, S.; Levin 2; Rose, B., 1; Tuchman 3; Woodstock. Archives.

CRAMPTON, ROLLIN
from 1st to 4th edition.

CRAWFORD, RALSTON
b. September 25, 1906, St. Catharines (Ont.), Canada. **d.** April 27, 1978, Houston, Texas. **Studied:** Otis Art Institute, Los Angeles, 1926-27; PAFA, 1927-30, with Henry Breckenridge, Henry McCarter; Barnes Foundation, 1927-30; Academie Colarossi and Academie Scandinave, Paris, 1932-33; Columbia U., 1933. Traveled Europe, Canada, South Pacific, North Africa, USA, Mediterranean. **Taught:** Art Academy of Cincinnati, 1940-41, 1949; Buffalo Fine Arts Academy, 1942; Honolulu Academy, summer, 1947; Brooklyn Museum School, 1948-49; U. of Minnesota; Louisiana State U., 1949-50; New School for Social Research, 1952-57; U. of Colorado, summer, 1953; U. of Michigan, summer, 1953; lecture tour of U.S.A. for American Association of Colleges, 1956; Hofstra College, 1960-62; U. of Southern California, summer, 1961; U. of Nebraska, 1965; U. of Illinois, 1966. **Awards:** L. C. Tiffany Grant, 1931; Wilmington, 1933; Mary Curtis Bok Foundation Fellowship, 1937; MMA, P.P., 1942; Tamarind Fellowship, 1966; NAD, Palmer Memorial Prize, 1972. **One-man Exhibitions:** (first) Maryland Institute, 1934; Boyer Gallery, Philadelphia, 1937, NYC, 1939; Philadelphia Art Alliance, 1938; Cincinnati/AM, 1941; Flint/Institute, 1942; Artists' Gallery, Philadelphia, 1943; The Downtown Gallery, 1943, 44, 46, 50; Arts Club of Chicago, 1945 (three-man); Portland, Ore./AM, 1946; Santa Barbara/MA, 1946; Howard U., 1947; MacMurray College, 1949; Hofstra College, 1952; U. of Alabama, 1953; Grace Borgenicht Gallery, Inc., NYC, 1954, 56, 58; Louisiana State U., 1956; Milwaukee, 1958; Lee Nordness Gallery, NYC, 1961, 63; U. of Nebraska, 1965; U. of Illinois, 1966; The Zabriskie Gallery, NYC, 1973, 76; Ronald Greenberg Gallery, St. Louis, 1974; Corcoran & Greenberg Gallery, Inc., Coral Ga-

bles, Fla.; Middendorf-Lane Gallery, Washington, D.C., 1977; Century Association, NYC, 1978; U. of Maryland, 1983; UCLA, 1983; Long Island U., 1983; Robert Miller Gallery, NYC, 1983, 87; Hirschl & Adler Galleries, NYC, 1985; Huntington, N.Y./Heckscher, 1989. **Retrospectives:** U. of Alabama, 1953; Milwaukee, 1958; U. of Kentucky, 1961; U. of Minnesota, 1961; Creighton U., 1968; U. of Nebraska (photographs); Utica; Montgomery Museum; WMAA, circ., 1986. **Group:** PAFA; WMAA; MOMA; MMA; Corcoran; Phillips; Chicago/AI. **Collections:** American Export Isbrandtsen Lines, Inc.; Auburn U.; Baltimore/MA; Baton Rouge; Brooklyn Museum; Buffalo/Albright; Carnegie; Chicago/AI; Cincinnati/AM; U. of Delaware; Denver/AM; Des Moines; Detroit/Institute; Flint/Institute; U. of Georgia; Hamline U.; Harvard U.; Hirshhorn; Hofstra U.; Honolulu Academy; Houston/MFA; Howard College; U. of Illinois; Illinois Wesleyan U.; Library of Congress; Los Angeles/County MA; MMA; MOMA; MacMurray College; Michigan State U.; The Miller Co., Milwaukee; U. of Minnesota; NMAA; Newark Museum; U. of Oklahoma; PMA; Phillips; SFMA; Toledo/MA; Utica; Vassar College; WMAA; Walker, Wesleyan U.; Youngstown/Butler. **Bibliography:** Agee 2; *America 1976;* Armstrong, Thomas; Baur 7; Boswell 1; Danto; *From Foreign Shores;* Frost; Halpert, Janis S.; Kootz 2; McCurdy, ed.; Nordness, ed.; Pagano; Reese; Ritchie 1; Rodman 2; Rose, B., 1. Archives.

CREMEAN, ROBERT b. September 28, 1932, Toledo, Ohio. **Studied:** Alfred U., 1950-52; Cranbrook Academy of Art, 1954, BA, 1956, MFA. **Taught:** The Detroit Institute of Arts; UCLA, 1956-57; Art Center in La Jolla, 1957-58. **Awards:** Fulbright Fellowship (Italy), 1954; Tamarind Fellowship, 1966. **Address:** c/o Dealer. **Dealer:** Braunstein Gallery, San Francisco. **One-man Exhibitions:** Esther Robles Gallery, Los Angeles,

1960-66, 73; The Landau-Alan Gallery, NYC, 1968; Wisconsin State U., 1969; Melbourne/National, 1970; Archer Gallery, London, 1972; Santa Barbara/MA, 1975; de Young, 1976; Braunstein-Quay Gallery, San Francisco, 1977. **Group:** Detroit/Institute, 1956; Houston/MFA, 1957; Santa Barbara/MA, 1957; U. of Nebraska, 1958; Chicago/AI, 1960, 61; Los Angeles/County MA, The Image Retained, 1961; SFMA, Bay Area Artists, 1961; California Palace, 1961; WMAA Annuals, 1961, 62; U. of Illinois, 1961, 63; Western Association of Art Museum Directors, Light, Space, Mass, circ., 1962; WMAA, Fifty California Artists, 1962-63; XXXIV Venice Biennial, 1968. **Collections:** Cleveland/MA; Detroit/Institute; Los Angeles/County MA; U. of Miami; U. of Michigan; U. of Nebraska; St. Louis/City; Santa Barbara/MA; Toledo/MA; UCLA. **Bibliography:** Geske.

CRILE, SUSAN b. 1942, Cleveland, Ohio. **Studied:** Bennington College, 1960-62, 64-65, BA; NYU, 1962-64; Hunter College, 1971-72. **Taught:** Fordham U., 1972-76; Princeton U., 1974-76; Sarah Lawrence College, 1976-79; School of Visual Arts, NYC, 1976-82; U. of Pennsylvania, 1980; Barnard College, 1983-86; Hunter College, 1983-. **Awards:** MacDowell Colony Grant, 1972; Ingram Merrill Foundation Grant, 1972; Yaddo Grant, 1970, 71, 75, 78; National Endowment for the Arts, fellowship, 1982, 89. **Address:** 168 West 86th Street, NYC 10024. **Dealer:** The Graham Gallery, NYC. **One-man Exhibitions:** Kornblee Gallery, NYC, 1971, 72, 73; Fischbach Gallery, NYC, 1974, 75, 77; Brooke Alexander Gallery, NYC, 1976; Phillips, 1976; The New Gallery, Cleveland, 1977; Bucknell U., 1978; Droll/Kolbert Gallery, NYC, 1978, 80; Ivory/Kimpton Gallery, San Francisco, 1981, 84, 87; Janie C. Lee Gallery, Houston, 1982; Mattingly/Baker, Dallas, 1982; Carson-Sapiro Gallery, Denver, 1982; Van Straaten Gallery, Chicago,

1983; Lincoln Center Gallery, NYC, 1983; Cleveland Center for Contemporary Art, 1984; Nina Freudenheim, Buffalo, 1984; The Graham Gallery, NYC, 1985, 87, 88, 90; Adams-Middleton Gallery, Dallas, 1986; Gloria Luria Gallery, Bar Harbor Islands, Fla., 1987, 88. **Group:** WMAA Annual, 1972; Indianapolis, 1972, 74; Chicago/AI, 1972; Corcoran Biennial, 1973; NYU, American Painting: The Eighties, 1979; Brooklyn Museum, American Drawings in Black and White: 1970-1979, 1980; Brooklyn Museum, 22nd National Print Exhibition, 1981; WMAA, Block Prints, 1982; Brooklyn Museum, The American Artist as Printmaker, 1983; Columbus, American Art Now!, 1985; Independent Curators, Inc., NYC, After Matisse, 1986; Detroit/Institute, Collaboration in Print, circ., 1991. **Collections:** Brooklyn Museum; Buffalo/Albright; Carnegie; Chase Manhattan Bank; Chemical Bank; Citibank; Cleveland/MA; Exxon Corp.; Hirshhorn; MMA; NYU; U. of North Carolina; Phillips; Portland, Me./MA; Portland, Ore./AM; Prudential Insurance Co. of America.

CRISS, FRANCIS H. **b.** April 26, 1901, London, England. **d.** November 27, 1973, NYC. **Studied:** PAFA; ASL, with Jan Matulka. **Taught:** Brooklyn Museum School; Albright Art School; ASL; Graphic Sketch Club, Philadelphia. **Awards:** PAFA, Cresson Fellowship; Guggenheim Foundation Fellowship, 1934. **One-man Exhibitions:** (first) Contemporary Arts Gallery, NYC; Mellon Galleries, Philadelphia, 1933, 34; Philadelphia Art Alliance, 1953; School of Visual Arts, NYC. **Retrospective:** School of Visual Arts, NYC, 1967. **Group:** WMAA, 1936, 37, 38, 40, 42, 51; Corcoran, 1939; PAFA, 1939, 41, 43, 45; MMA, 1941; Chicago/AI, 1942, 43; Carnegie, 1944; 45. **Collections:** Kansas City/Nelson; La France Art Institute; National Gallery; PMA; WMAA. **Bibliography:** Baur 7; Pagano. Archives.

CRONBACH, ROBERT M.
b. February 10, 1908, St. Louis, Mo. **Studied:** Washington School of Fine Arts, 1926, with Victor Holm; PAFA, 1927-30, with Charles Grafly, Albert Laesslie; assistant in Paul Manship Studio, NYC and Paris, 1930. Traveled Europe extensively. **Taught:** Adelphi College, 1947-62; North Shore Community Art Center, 1949-54; Skowhegan School, summers, 1959, 60, 64. **Member:** Sculptors Guild; Architectural League of New York; Artists Equity. Federal A.P.: Willerts Park Housing Project, Buffalo, N.Y., 1939 (sculpture). **Commissions** (architectural): St. Louis (Mo.) Municipal Auditorium, 1933; Social Security Building, Washington, D.C., 1940; Cafe Society Uptown, NYC, 1940; Hotel Hollenden, Cleveland, 1946; Hopping Phillips Motor Agency, Newark, N.J., 1948; 240 Central Park South, NYC, 1954; Dorr-Oliver Building, Stamford, Conn., 1957; Adelphi College, 1958; Ward School, New Rochelle, N.Y., 1959; National Council for U.S. Art, 1960 (a gift to the United Nations); Temple Chizuk Amuno, Baltimore, 1962, 68; Federal Building, St. Louis, 1964; Temple Israel, St. Louis, 1964; Charleston (W. Va.) Public Library, 1965. **Awards:** PAFA, Stewardson Prize, 1938; PAFA, Cresson Fellowship, 1929, 30; National Sculpture Competition for Social Security Building, Washington, D.C., First Award, 1939; National Sculpture Society, Henry Hering P.P., 1985; Audubon Artists, Gold Medal for Sculpture, 1989; Audubon Artists, Silver Medal for Sculpture, 1990. **Address:** 545 Atlantic Ave., Brooklyn, NY 11217-1913. **Dealer:** Humphrey, NYC. **One-man Exhibitions:** (first) Hudson D. Walker Gallery, NYC, 1939; The Bertha Schaefer Gallery, 1951 (two-man), 1952, 1960 (two-man), 1967, 71; The New Bertha Schaefer Gallery, 1974; Nassau County Center for Fine Arts, Roslyn Harbor, N.Y., 1976; Adelphi U., 1981; Century Association, 1984; Kouros Gallery, NYC, 1985; Philadelphia Art Alliance,

1987; Humphrey, NYC, 1988. **Group:**
New York World's Fairs, 1939, 1964-65;
Sculptors Guild, 1939-42, 1945-62, 1967;
City of Philadelphia Sculpture Interna-
tional, 1940, 49; MMA, 1943; Den-
ver/AM, The Modern Artist and His
World, 1947; WMAA Annuals, 1948,
1956-59; Riverside Museum, 1947;
Silvermine Guild, 1947, 58, 60; Brussels
World's Fair, 1958; ART: USA: 59, NYC,
1959; HemisFair '68, San Antonio, Tex.,
1968; PAFA Architectural League of New
York; Brooklyn Museum; St. Louis/City;
Houston/MFA; MOMA; AAIAL, 1987.
Collections: Adelphi U.; Colby College;
U. of Minnesota; NMAA; Reynolds
Metals Co.; Rosenthal China Co.;
Skopje/Modern; St. Louis/City; Spring-
field, Mo./AM; Walker; Wichita State U.
Bibliography: Baur 7; Archives.

CRONIN, ROBERT b. 1936, Lex-
ington, Mass. **Studied:** RISD, 1959, BFA;
Cornell U., 1962, MFA. **Taught:** Benning-
ton College; Brown U.; Michigan State U.;
Worcester Museum School; St. John's U.
Awards: R. S. Reynolds Memorial Sculp-
ture Award, 1982. **Address:** 325 West
16th Street, NYC 10011. **One-man
Exhibitions:** Brown U., 1958; Wheaton
College, 1959; Nexus Gallery, Boston,
1961; Cornell U., 1961; Bennington Col-
lege, 1967, 74; Botolph Gallery, Boston,
1968; ICA, Boston, 1971; Worcester/AM,
1974; The Zabriskie Gallery, NYC, 1974;
Helen Shlien Gallery, Boston, 1979;
Galerie Esperanza, Montreal, 1980; Sculp-
ture Center, NYC, 1981; Carnegie, 1981;
Gimpel Fils, London, 1982; Gimpel &
Weitzenhoffer Ltd., NYC, 1981, 82, 84,
89; Watson/de Nagy Gallery, Houston,
1983; G.M.B. Gallery, Birmingham,
Mich., 1983; Clark Gallery, Lincoln,
Mass., 1983; Gimpel-Hanover & Galerie
André Emmerich, Zurich, 1983;
Klonarides Gallery, Toronto, 1984.
Group: Minneapolis/Institute, Biennial,
1963; ICA, Los Angeles, Art Words/Book
Works, 1978; Brooklyn Museum, Ameri-

Mary Ann Currier, *Apricots Degas*, 1990.

can Drawings in Black and White: 1970-
1979, 1980; RISD, Metals: Cast-Cut-
Coiled, 1982. **Collections:** Boston/MFA;
Boston Public Library; Brooklyn Museum;
Carnegie; Cornell U.; U. of Oklahoma;
Worcester/AM; Worcester Polytechnic
Institute.

CURRIER, MARY ANN
b. July 23, 1927, Louisville, Ky. **Studied:**
Chicago Academy of Fine Art, 1945-47;
Louisville School of Art, 1957-61.
Awards: Brandeis U., award, 1967;
Speed/Louisville, P.P., 1971, 77, 78;
Catherine Spalding College, 1st award in
painting, 1973; **Address:** 127 Selva Ma-
rina Drive, Atlantic Beach, FL 32233.
Dealer: Tatistcheff & Co., Inc., NYC and
Santa Monica. **One-man Exhibitions:**
Byck Gallery, Louisville, Ky., 1977, 80,
84; Bellarmine College, 1978; Actors
Theatre, Louisville, 1980; Alexander F.
Milliken, Inc., NYC, 1984, 85, 88, 89;
Jacksonville/AM, 1988; U. of Northern
Florida, Jacksonville, 1990. **Group:** U. of
Louisville, Women Artists Working in
Louisville, 1975, 77; Mississippi Museum
of Art, Jackson, Southern Realism, 1979;
Houston/Contemporary, American Still
Life, 1945-83, circ., 1983; Bruce Mu-
seum, The Recognizable Image, 1985;
SFMA, American Realism (Janss), circ.,
1985; Jacksonville/AM, Art in Bloom,
1989; MMA, Contemporary American

Pastels, 1989; NAD, Annual, 1990; Florida State U., Monochrome/Polychrome, 1990. **Collections:** American Express Co.; Brookhaven College; Brown and Wood, NYC; Cargill, Inc.; Dallas/MFA; Florida National Bank, Jacksonville; Goldman Sachs & Co.; Hyatt Regency Hotels; Jacksonville/AM; Louisville/Speed; Medley Distilling Co.; MMA.

CURRY, JOHN STEUART
b. November 14, 1897, Dunavant, Kans. **d.** August 29, 1946, Madison, Wisc. **Studied:** Kansas City Art Institute and School of Design, 1916; Chicago Art Institute School, 1916-18, with E. J. Timmons, John W. Norton; Geneva College, 1918-19; Studio of B. Schoukhaieff, Paris, 1926-27. Traveled France. **Taught:** Cooper Union, 1932-34; ASL, 1932-36; U. of Wisconsin, 1936. **Commissions** (murals): Justice Department, Washington, D.C., 1936-37; Kansas State Capitol, 1938-40; U. of Wisconsin, 1940-42. **Awards:** Carnegie, 1933; PAFA, Gold Medal, 1941; MMA, Artists for Victory, Second Prize, 1942. **One-man Exhibitions:** (first) Whit-

ney Studio Club, NYC, 1930; Feragil Galleries, NYC, 1933, 35; U. of Wisconsin, 1937; Hudson D. Walker Gallery, NYC, 1938, Milwaukee, 1946; A.A.A. Gallery, NYC, 1947; Syracuse U., 1956; U. of Kansas, 1957; NCFA, 1971. **Group:** WMAA; Chicago/AI; Wichita/AM; Milwaukee. **Collections:** Andover/Phillips; Britannica; Chicago/AI; First National Bank, Madison; Kansas State College; MMA; Muskegon/Hackley; U. of Nebraska; St. Louis/City; WMAA; Wichita/AM. **Bibliography:** American Artists Group, Inc., 1; Armstrong, Thomas; Baigell 1; Baur 7; Bazin; Benton 1; Biddle 4; Blesh 1; Boswen 1; Brown 2; Bruce and Watson; Cahill and Barr, eds.; Canaday; Cheney; Christensen; Crayen, T., 1; **Curry 1, 2, 3;** Flanagan; Flexner; Goodrich and Baur 1; Hall; Hunter 6; *Index of 20th Century Artists;* Jewell 2; McCurdy, ed.; Mellquist; Mendelowitz; Newmeyer; Pagano; Pearson 1; Reese; Richardson, E.P.; Rose, B., 1; **Schmeckebler 2;** Wight 2. Archives.

CUSAMANO, STEFANO
from 1st to 4th edition.

D

Southern Alleghenies Museum of Art, Loretto, Against the Grain, 1960-1990, 1991. **Collections:** ARA Services, Inc.; Atlantic Richfield Co.; AT&T; Ball State U.; Carleton College; Chemical Bank; Chicago/AI; Citicorp; Cleveland/MA; U. of Delaware; U. of Iowa; Kemper Insurance Co.; Louisville/Speed; Mellon Bank; Metropolitan Life; Michigan Bell, Inc.; Moody's Investment Services, Inc.; Moravian College; NMAA; PMA; Price Waterhouse; Purchase/SUNY; Readers Digest; Smith College; Stephens, Inc.; Yale U.

DALLMAN, DANIEL **b.** March 12, 1942, St. Paul, Minn. **Studied:** U. of Minnesota, 1965, BS; U. of Iowa, 1968, MA; 1969, MFA. Traveled Europe; resided Rome, 1974-76. **Taught:** Tyler School of Art, Temple U., 1969-. **Awards:** Pennsylvania Council on the Arts, Visual Arts Fellowship, 1987. **Address:** 847 Horsham Road, North Wales, PA 19454. **Dealer:** Tatistcheff & Co., Inc., NYC. **One-man Exhibitions:** (first) The Print Club, 1972; Hemingway Gallery, Nantucket, 1973; Paul Kramer Gallery, St. Paul, 1973; West Chester State College, 1973; Ronnie Brenner Gallery, New Orleans, 1974; Gallery Four, Alexandria, Va., 1976; Tyler School of Art, Rome, 1976; Charlotte/Mint, 1977; Robert Schoelkopf Gallery, NYC, 1980, 84, 87; Philadelphia College of Art, 1982; Louisville/Speed (two-man), 1984; Albright College, 1986; Hobart and William Smith College, 1988; J. Rosenthal Fine Art, Chicago, 1989. **Group:** Krakow/National, Print Biennial, 1974; Brooklyn Museum, Thirty Years of American Printmaking, 1976; San Antonio/MA, Real, Really Real, Super Real, circ., 1981; U. of North Carolina, Art on Paper, 1982; Hudson River Museum, New Vistas, 1984; SFMA, American Realism (Janss), 1985; Hudson River Museum, Form or Formula: Drawing and Drawings, 1986; Yale U., Interiors and Exteriors, 1986; U. of North Carolina, Art on Paper, 1987; NAD, Realism Today, circ., 1987;

DAPHNIS, NASSOS **b.** July 23, 1914, Krockeai, Greece. To USA, 1930; citizen. Self-taught; US Army Corps of Engineers, 1942-45. Traveled USA, Greece, Italy, France. Leading tree peony hybridizer. **Taught:** Horace Mann School, Riverdale, N.Y., 1953-58. **Member:** American Abstract Artists. **Awards:** Ford Foundation, 1962; National Council on the Arts, 1966; National Endowment for the Arts, 1971; New England 350th Celebration Exhibition, 1972; A. P. Saunders Medal, Tree Peony Award, 1973; Guggenheim Foundation Fellowship, 1977; Francis J. Greenburger Foundation Award, 1986; Pollack-Krasner Foundation Grant, 1986. **Address:** 362 West Broadway, NYC 10012. **Dealers:** Leo Castelli Inc., NYC; Kouros Gallery, NYC; Andre Zarre Gallery, NYC. **One-man Exhibitions:** (first) Contemporary Arts Gallery, NYC, 1938, also 1947, 49; Charlotte/Mint, 1949; Galerie Colette Allendy, Paris, 1950; Leo Castelli Inc., 1959-61, 1963, 65, 68, 71, 73, 75, 80, 83, 85, 86, 88; Galleria Toninelli, Milan, 1961; Iris Clert Gallery, 1962; Franklin Siden Gallery, Detroit, 1967; Syracuse/Everson, 1969; Brockton/Fuller, 1970; Andre Zarre Gallery, NYC, 1974, 76, 83, 85; Kingpitcher Gallery, Pittsburgh, 1976; Muhlenberg College, 1980; Eaton/Shoen Gallery, San Francisco, 1980; Omega Gallery, Athens, Greece, 1983; Kouros Gallery, NYC, 1985; Ileana Tounta Contemporary Art

Center, Athens, 1990; Reynolds Gallery, Pittsburgh, 1990; Nicola Verato Gallery, Milan, 1991; Sid Deutsch Gallery, NYC, 1991. **Retrospectives:** Buffalo/Albright, circ. 1969; Syracuse/Everson, 1969. **Group:** Carnegie, 1955, 58, 61, 70; Corcoran Biennial, 1959, 63, 69; WMAA Annuals, 1960-65, 1967; Walker, Purist Painting, 1961; American Abstract Artists Annual, 1961; SRGM, Abstract Expressionists and Imagists, 1961; Seattle World's Fair, 1961; WMAA, Geometric Abstraction in America, circ., 1962; Musée Cantonal des Beaux-Arts, Lausanne, I Salon International de Galeries Pilotes, 1963; Lincoln, Mass./De Cordova, 1965; U. of Illinois, 1969; Carnegie, International, 1970; Syracuse/Everson, Provincetown Painters, 1890s-1970s, 1977; Brooklyn Museum, Noemata, 1977; National Gallery and Alexander Soutzos Museum, Athens, Modern American Painting, 1982; AAIAL, 1986; Bronx Museum, American Abstract Artists 50th Anniversary, circ., 1986. **Collections:** Akron/AI; Baltimore/MA; Buffalo/Albright; Carnegie; Corcoran; Basil Goulandris Museum, Andros, Greece; Hirshhorn; MOMA; U. of Michigan; Norfolk; Norfolk-Chrysler; RISD; Reading/Public; Ridgefield/Aldrich; SRGM; Seattle/AM; Ian Vores Museum, Peonia, Athens, Greece; South Mall, Albany; Syracuse/Everson; Tel Aviv; Union Carbide Corp.; Utica; WMAA. **Bibliography:** Murdock 2. Archives.

D'ARCANGELO, ALLAN
b. June 16, 1930, Buffalo, N.Y. **Studied:** U. of Buffalo, 1948-52, BA (history and government); City College of New York; New School for Social Research, 1953-54; Mexico City College, 1957-59, with Dr. John Golding, Fernando Belain; studio work with Boris Lurie, NYC, 1956-66. Traveled Mexico, USA, Japan, Far East, North Africa. **Taught:** NYC public schools, 1956-62; School of Visual Arts, NYC, 1963-68; 1983-; Cornell U., 1968; Syracuse U., 1971; U. of Wisconsin, 1972;

St. Cloud State College, 1972; Memphis Academy of Arts, 1975; Brooklyn College, 1973-. U.S. Army, 1954-55. Founder of City Walls, 1969. **Member:** SAGA; Century Association. **Commissions:** Transportation and Travel Pavilion, New York World's Fair, 1964-65 (mural); Grand Coulee Dam, 1973. **Awards:** Municipal U. of Omaha, First P.P., 1966; NIAL, 1970; AAIAL, 1970; Guggenheim Foundation Award, 1987. **Address:** P.O. Box 33, Kenoza Lake, NY 12750. **One-man Exhibitions:** Galerie Genova, Mexico City, 1958 (two-man); Long Island U., 1961; Fishbach Gallery, NYC, 1964, 65, 67, 69; Ileana Sonnabend Gallery, Paris, 1965; Galerie Rudolf Zwirner, 1965; Galerie Hans R. Neuendorf, Hamburg, 1965; Galerie Muller, 1965; Dwan Gallery, Los Angeles, 1966; Wurttembergischer Kunstverein, Stuttgart, 1967; Galerie Rolf Ricke, Kassel, 1967; Minami Gallery, 1967; Obelisk Gallery, 1967 (two-man), 1970; Franklin Siden Gallery, Detroit, 1968, 72; Lambert Gallery, Paris, 1968; Wisconsin State U., Eau Claire, 1970; Marlborough Gallery, Inc., NYC, 1971, 75; U. of Wisconsin, Madison, 1972; Hokin Gallery, Chicago, 1974; Patricia Moore Inc., Aspen, 1974; Russell Sage College, 1974; Kingpitcher Gallery, Pittsburgh, 1975; Buffalo/SUNY, 1979; Grace Borgenicht Gallery, NYC, 1982; Elizabeth Galasso Gallery, Ossining, N.Y., 1984. **Retrospective:** ICA, U. of Pennsylvania, 1971. **Group:** Sarah Lawrence College, Popular Imagery, 1963; ICA, London, 1963; Oakland/AM, Pop Art USA, 1963; Buffalo/Albright, Mixed Media and Pop Art, 1963; Salon du Mai, Paris, 1964; The Hague, New Realism, 1964; Salon des Comparaisons, Paris, 1964; Dwan Gallery, Los Angeles, Boxes, 1964, also 1965; Milwaukee, 1965; Galerie Hans R. Neuendorf, Hamburg, 1965, 66; Galerie Friedrich & Dahlem, Munich, 1966; V International Biennial Exhibition of Prints, Tokyo, 1966; Amsterdam/Stedelijk, New Shapes of Color,

1966; Expo '67, Montreal, 1967; Detroit/Institute, Color, Image and Form, 1967; Torcuato di Tella, Buenos Aires, 1967; WMAA Annual, 1967; Brandeis U., 1968; Foundation Maeght, 1968; MOMA, Social Comment in America, circ., 1968; ICA, U. of Pennsylvania, Highway, 1970; Utica, American Prints Today, 1973; WMAA, American Pop Art, 1974; Cali/Tertulia, III Bienal Americana de Artes Graficas, 1976; Flint/Institute, Art and the Automobile, 1978; Los Angeles/MOCA, Automobile and Culture, 1984; Corcoran, In Praise of Space, 1987; U. of California, Berkeley, Made in USA, circ., 1987; Odakyu Grand Gallery, Tokyo, Pop Art USA-UK, circ., 1987; Frankfurt/Moderne, Dalla Pop Art Americana alla Nuova Figurazione, circ., 1987. **Collections:** Allentown/AM; Atlantic Richfield Co.; Brandeis U.; Brooklyn Museum; Brussels/Beaux Arts; Buffalo/Albright; Cali/Tertulia; Chase Manhattan Bank; Cleveland/MA; Cologne; Cornell U.; Detroit/Institute; Fort Lauderdale; Gelsenkirchen; The Hague; Hannover/Kunstverein; Hartford/Wadsworth; The Hertz Corp.; Hirshhorn; MIT; MOMA; Munster/WK; NYU; Nagaoka, Japan; New Orleans/Delgado; Paris/Beaubourg; Ridgefield/Aldrich; SRGM; Skopje/Modern; Toronto; Trenton/State; U. of North Carolina; WMAA; Walker; U. of Wisconsin; VMFA. **Bibliography:** Alloway 4; Battcock, ed.; Calas, N. and E.; Honisch and Jensen, eds.; Hunter, ed.; *Kunst um 1970;* Lippard 5; Osterwold; Seitz 3; Siegel.

D'ARISTA, ROBERT
from 1st to 4th edition.

DARROW, PAUL GARDNER
from 1st to 5th edition.

DASBURG, ANDREW b. May 4, 1887, Paris, France. To USA, 1892. d. August 13, 1979, Ranchos de Taos, N.M. **Studied:** ASL, with Kenyon Cox,

Frank V. DuMond; privately with Birge Harrison; also with Robert Henri. **Awards:** Pan-American Exhibition, Los Angeles, 1925; Carnegie, 1927, 31; Guggenheim Foundation Fellowship, 1932; Ford Foundation Grant; Arizona Governor's Art Award, 1976. **One-man Exhibitions:** Dallas/MFA, 1957; Rehn Galleries, NYC, 1958; U. of New Mexico, 1966; Governor's Gallery, Santa Fe, 1975, 76; Mission Gallery, Taos, 1978; Salander-O'Reilly Galleries, NYC, 1985. **Retrospective:** A.F.A./Ford Foundation, circ., 1959; U. of New Mexico, Albuquerque, circ., 1979. **Group:** WMAA; SFMA; MMA; Denver/AM; Santa Fe, N.M. **Collections:** Barnes Foundation; California Palace; Cincinnati/AM; Colorado Springs/FA; Dallas/MFA; Denver/AM; Fort Worth; Hirshhorn; U. of Kansas; Kansas City/Nelson; Los Angeles/County MA; MMA; U. of Nebraska/Sheldon; U. of Nebraska; U. of New Mexico; San Antonio/McNay; SFMA; Santa Barbara/MA; Santa Fe, N.M.; WMAA. **Bibliography:** *Avant-Garde Painting and Sculpture;* Baur 7; Brown, 1, 2; **Bywaters 1, 2;** Cahill and Barr, eds.; Cheney; Coke 2; Goodrich and Baur 1, Hunter 6; *Index of 20th Century Artists;* Janis, S.; Levin 2; McCurdy, ed.; Neuhaus; Richardson, E.P.; Rose, B., 1, 4; *Woodstock;* Wright 1. Archives.

DASH, ROBERT b. June 8, 1934, NYC. **Studied:** U. of New Mexico, BA (anthropology and English). Traveled Italy, Mexico, USA, Ireland, West Germany; UK, Germany, 1991-92. **Taught:** Southampton College, 1976, 82, 84, 86; Dodfitz School, Amarillo, 1977, 82, 84; Long Island U., 1972. **Member:** Fellow, Royal Horticultural Society. **Awards:** New York State Board of Regents Scholarship. **Address:** Madoo, Sagaponack, NY 11962. **One-man Exhibitions:** (first) The Kornblee Gallery, NYC, 1961, also 1962, 63; The Osborne Gallery, NYC, 1964, 65, 66; The Graham Gallery, NYC, 1964, 68, 69, 70; Crane-Kalman Gallery, London,

1966; Munich/Modern, 1969; FAR Gallery, 1972, 73; Vick Gallery, Philadelphia, 1974; Fischbach Gallery, NYC, 1975, 77; Hirschl & Adler Galleries, NYC, 1978; Guild Hall, 1991. **Retrospective:** Southampton/Parrish, 1969; Allentown/AM, 1971. **Group:** Yale U., The New York Season, 1961; MOMA, Eight American Painters of the Landscape, circ., 1964; Corcoran; U. of Colorado; Norfolk, Contemporary Art USA, 1966; AAAL; Childe Hassam Fund Exhibition, 1973; Omaha/Joslyn, A Sense of Place, 1973; Lincoln, Mass./De Cordova, Candid Painting, 1975; U. of North Carolina, Art on Paper, 1976; U. of Missouri, American Painterly Realists, 1977. **Collections:** Allentown/AM; AT&T; The Bank of New York; Boston/MFA; Bristol-Meyers Co.; Brooklyn Museum; U. of California; Chase Manhattan Bank; Brooklyn Museum; Commerce Bank, Kansas City; Continental Grain Corp.; Corcoran; Federal Deposit Insurance Corporation; First National Bank of Memphis; The Grace Line; Hirshhorn; Munich/Modern; NYU; NATO Headquarters, Brussels; U. of North Carolina; PMA; SRGM; Southampton/Parrish; Suffolk County National Bank; Xerox Corp.; Youngstown/Butler. **Bibliography:** Downes, ed. Archives.

DAVEY, RANDALL

from 1st to 4th edition.

DAVIS, BRAD **b.** April 24, 1942, Duluth, Minn. **Studied:** St. Olaf College, 1961; U. of Chicago, 1962; School of the Art Institute of Chicago, 1963; U. of Minnesota, BA, 1966; Hunter College, graduate work, 1970. **Taught:** Brooklyn College, 1972-74; Fairleigh Dickinson U., 1975; Sarah Lawrence College, 1979; Anderson Ranch Art Center, Snowmass, Colo., 1985-92. **Awards:** National Endowment for the Arts, grant, 1988. **Address:** 152 Chambers Street, NYC 10007. **Dealer:** Holly Solomon Gallery, NYC. **One-man Exhibitions:** 98 Greene Street

Loft, NYC, 1972; Holly Solomon Gallery, NYC, 1975, 79, 81, 83, 89, 92; Mayor Gallery, London, 1979; Toni Birckhead Gallery, Cincinnati, 1980; Taft Museum, 1984; Fahey/Klein Gallery, Los Angeles, 1988; Tavelli Williams Gallery, Aspen, Colo., 1989; Gloria Luria Gallery, Bay Harbor Islands, Fla., 1990. **Group:** WMAA, Annual, 1972; Troy/SUNY, Fantastics and Eccentrics, 1974; Sarah Lawrence College, Painting '75/'76/'77, circ., 1977; Rice U., Pattern and Decoration, 1978; Aachen/Ludwig, Die Neuen Wilden, 1980; Mannheimer Kunstverein, Dekor, circ., 1980; ICA, U. of Pennsylvania, Drawing; The Pluralist Decade, circ., 1980; Ohio U., The Pattern Principle, 1981; Hanover/K-G, New York Now, 1982; Lucerne, Back to the USA, 1983; WMAA, Five Painters in New York, 1984; Groninger Museum, Holland, Americana, 1987; Florida State U., Contemporary Landscape, 1989. **Collections:** Aachen/Ludwig; Birmingham (England) Art Gallery; Denver; Groninger Museum; Kansas City/Nelson; MMA; MOMA; U. of North Carolina; Saarlandmuseum; Walker; WMAA.

DAVIS, GENE **b.** August 22, 1920, Washington, D.C. **d.** April 6, 1985, Washington, D.C. **Studied:** U. of Maryland; Wilson Teachers College. **Taught:** The Corcoran School of Art, 1967-68, 1970-85; American University, 1968-70; Skidmore College, 1969; U. of Virginia, 1972. **Member:** Washington Project for the Arts, vice-president, 1980. **Commissions:** South Mall, Albany, 1969 (mural); Neiman-Marcus Co., Bal Harbour, Fla., 1970 (mural). **Awards:** Corcoran, Bronze Medal for Painting and $1,000 Award, 1965; National Council on the Arts, $5,000 Grant, 1967; Guggenheim Foundation Fellowship, 1974. **One-man Exhibitions:** (first) The Catholic U. of America, 1953; American U., 1955; Bader Gallery, Washington, D.C., 1956; Jefferson Place Gallery, 1959, 61, 63, 67; Poindexter Gal-

lery, NYC, 1963, 65-67; Corcoran, 1964, 68, 70, 77, 78; Hofstra U., 1966; MIT, 1967; Des Moines, 1967; Galerie Rolf Ricke, Cologne, 1967; Fischbach Gallery, 1967-69, 1970, 71, 72, 73, 75, 77, 78; SFMA, 1968; WGMA, 1968; Jewish Museum, 1968; Henri Gallery, 1968-70; Chapman Kelly Gallery, 1969; Axiom Gallery, London, 1969; Nova Scotia College of Art and Design, 1970; Galerie Annemarie Verna, Zurich, 1971; Dunkelman Gallery, Toronto, 1971-73; J. L. Hudson Art Gallery, Detroit, 1972; U. of Utah, 1972; Omaha/Joslyn, 1972; Max Protetch Gallery, Washington, D.C., 1972, 77; Michael Berger Gallery, Pittsburgh, 1973; Quay Gallery, 1973; New Gallery, Cleveland, 1974; Tibor de Nagy, Houston, 1974; Reed College, 1975; Harcus Krakow Rosen Sonnabend, Boston, 1976; Walker, 1978; Dayton/AI, 1978; Protetch-McIntosh Gallery, Washington, D.C., 1978, 80; Droll/Kolbert Gallery, Inc., NYC, 1979, 80; Charles Cowles Gallery, NYC, 1982, 84, 88, 90, 91; College of William & Mary, 1983; Omaha/Joslyn, 1984; Middendorf-Lane Gallery, Washington, D.C., 1983; Washington Project for the Arts, Washington, D.C., 1983; Wilmington, 1983; Middendorf Gallery, Washington, D.C., 1984; U. of Missouri, 1984; Tampa/AM, 1985. **Retrospective:** Brooklyn Museum, 1982; NMAA, 1987. **Group:** WGMA, The Formalists, 1963; Brandeis U., New Directions in American Painting, 1963; Los Angeles/County MA, Post Painterly Abstraction, 1964; MOMA, The Responsive Eye, 1965; WGMA, circ., 1965; MOMA, Two Decades of American Painting, circ., Japan, India, Australia, 1967; Corcoran Biennial, 1967, 75; Detroit/Institute, Color, Image and Form, 1967; WMAA Annuals, 1968, 71, 73; Milwaukee, Directions I, circ., 1968; Art Fair, Cologne, 1968; Edmonton Art Gallery, Alberta, Ten Washington Artists: 1950-1970, 1970; Baltimore/MA, Washington Art: 1950-1970, 1970; ICA, U. of Pennsylvania, Two Generations of Color Painting,

1970; WMAA, The Structure of Color, 1971; U. of Texas, Color Forum, 1972; West Palm Beach/Norton, The Vincent Melzac Collection—Part One: The Washington Color Painters, 1974; SRGM, Within the Decade, 1974; Indianapolis, 1978; U. of Southern Florida, Miami, Two Decades of Abstraction, 1979. **Collections:** Akron/AI; AT&T; Bank of America; Boston/MFA; Brandeis U.; Buffalo/Albright; Carnegie; Chicago/AI; Chase Manhattan Bank, NYC; Cleveland/MA; Corcoran; Dallas/MFA; Dayton/AI; Denver/AM; Des Moines; Federal Reserve Bank of Boston; Federal Reserve Bank of Richmond, Virginia; Florsheim Foundation; Hirshhorn; High Museum; Indianapolis/Herron; Jacksonville/AM; Louisville/Speed; MIT; MMA; MOMA; Milwaukee; NCFA; NMAA; National Gallery; U. of Nebraska; Oklahoma; Omaha/Joslyn; Phillips; PMA; Princeton U.; RISD; Ringling; SFMA; SRGM; Tate Gallery; Toronto; Utah; WMAA; Walker; Washington U.; Wellesley College; Woodward Foundation; Xerox; Yale U. **Bibliography:** *Art Now 74;* Atkinson; Davis, D.; *Gene Davis; Gene Davis: Drawings;* **Naifeh and White;** Seitz 3. Archives.

DAVIS, JERROLD **b.** November 2, 1926, Chico, Calif. **Studied:** U. of California, Berkeley, BA, 1953, MA. Traveled Latin America, Europe. **Taught:** U. of California, summer, 1967. **Awards:** Sigmund Martin Heller Traveling Fellowship, 1953; Guggenheim Foundation Fellowship, 1958; Ford Foundation Artist-in-Residence, 1964. **Address:** 66 Twain Avenue, Berkeley, CA 94708. **One-man Exhibitions:** Instituto Brasil-Estados-Unidos, Rio de Janeiro, 1951; California Palace, 1957; Everett Ellin Gallery, Los Angeles, 1958; The Rose Rabow Gallery, San Francisco, 1963, 74; Esther Robles Gallery, Los Angeles, 1964; Flint/Institute, 1964; Gallery of Modern Art, 1965; Quay Gallery, San Francisco, 1967, 68; Fleischer Anhalt Gallery; 1968; Jacqueline Anhalt Gallery, Los

Angeles, 1970; Newport Harbor, 1973. **Retrospective:** Richmond Art Center, Calif., 1980. **Group:** São Paulo Biennial, 1951; Oberlin College, 3 Young Painters, 1958; Carnegie, 1958; U. of Illinois, 1959, 61, 63; California Palace, 1960-64; Flint/Institute, 1964; Phoenix, 1964; Los Angeles/County MA, 1965; U. of Arizona, 1967; Omaha/Joslyn, A Sense of Place, 1973. **Collections:** Bank of America; Carnegie; Flint/Institute; Los Angeles/County MA; Oakland/AM; SFMA; Santa Barbara/MA.

DAVIS, RONALD b. June 29, 1937, Santa Monica, Calif. **Studied:** U. of Wyoming, 1955-56; San Francisco Art Institute (with Jack Jefferson, Frank Lobdell), 1960-64; Yale-Norfolk Summer Art School (with Philip Guston), 1962. **Taught:** U. of California, 1967. **Awards:** National Council on the Arts Grant, 1968. **Address:** 6950 Grasswood Avenue, Malibu, CA 90265. **Dealer:** Blum-Helman Gallery, NYC. **One-man Exhibitions:** (first) Nicholas Wilder Gallery, Los Angeles, 1965, also 1967, 69, 73, 77, 79; Tibor de Nagy Gallery, 1966; Leo Castelli Inc., NYC, 1968, 74, 75, Kasmin Ltd., 1968, 71; David Mirvish Gallery, 1970, 75; Pasadena/AM, 1971; Galleria dell Ariete, Milan, 1972; Joseph Hellman Gallery, St. Louis, 1972; John Berggruen Gallery, San Francisco, 1973, 78, 80, 82, 89; Corcoran & Greenberg, Coral Gables, 1974; Gemini G.E.L., Los Angeles, 1974, 81; Western Galleries, Cheyenne, 1974; Boise State U., 1975; Greenberg Gallery, St. Louis, 1975, 79; Aspen Gallery of Art, 1976; Seder/Creigh Gallery, Coronado, Calif., 1976; U. of Nevada, 1977; Pepperdine U., 1979; Blum-Helman Gallery, New York, 1979, 81, 84, 88; San Diego State U., 1980; Middendorf-Lane Gallery, Washington, D.C., 1980; Asher/Faure Gallery, Los Angeles, 1982, 83, 84; Thomas Babeor Gallery, La Jolla, 1984; Margo Leavin Gallery, Los Angeles, 1984; Blum-Helman Gallery, Santa Monica, 1987, 88.

Retrospective: Oakland, 1976. **Group:** San Francisco Art Festival, 1961-63; SFMA, Arts of San Francisco, 1964; RAC, 1964; U. of Illinois, 1965; WGMA, A New Aesthetic, 1967; WMAA Annual, 1967; Kassel, Documenta IV, 1968; Corcoran, Biennial, 1967; Venice Biennial, 1972; Montreal/Contemporain, II Artistes Americains, 1973; Indianapolis, 1974; Santa Barbara/MA, Fifteen Abstract Artists, 1974; Leverkusen, Zeichnungen 3, USA, 1975; Corcoran Biennial, 1975; Leverkusen, Drawings 3: American Drawings, 1975; ICA, Los Angeles/County MA, Current Concerns, 1975; MOMA, Color as Language, circ., 1975; SFMA, California Painting and Sculpture: The Modern Era, 1977; U. of California, Santa Barbara, Photographs by Southern California Painters and Sculptors, 1977; Cleveland/MA, Four Contemporary Painters, 1978; Honolulu Academy, California: 3 by 8 Twice, 1978; Buffalo/Albright, American Painting of the 1970s, 1978; Los Angeles/County MA, Art in Los Angeles, 1981; Houston/MFA, Miró in America, 1982. **Collections:** Baltimore/MA; Boston/MFA; Bowdoin College; Buffalo/Albright; Chicago/AI; Cologne; Los Angeles/County MA; MOMA; Oakland/AM; SFMA; Seattle/AM; Tate Gallery; WMAA. **Bibliography:** Davis, D.; *New in the Seventies; Report: The State Of California Painting; USA West Coast;* Wood.

DAVIS, STUART b. December 6, 1892, Philadelphia, Pa. **d.** June 24, 1964, NYC. Studied with Robert Henri, 1910-13, US Army Intelligence, World War I. Traveled Europe, Cuba, USA. **Taught:** ASL, 1931-32; New School for Social Research, 1940-50; lectured at museums and universities. Federal A.P.: 1933-39. Editor: *Art Front* magazine. **Commissions** (murals): Radio City Music Hall, NYC, 1932; Indiana U., 1938; New York World's Fair, 1939; Municipal Broadcasting Co., NYC, 1939; Drake U., 1955; Heinz Research Center, Pittsburgh, 1957.

Stuart Davis, *Punch Card Flutter No. 3*, 1963.

Awards: Pepsi-Cola, 1944; Carnegie, Hon. Men., 1944; PAFA, J. Henry Schiedt Memorial Prize, 1945; Chicago/AI; Norman Wait Harris Silver Medal, 1948; La Tausca Competition, P.P., 1948; VMFA, John Barton Payne Medal, 1950; Chicago/AI, Ada S. Garrett Prize, 1951; Guggenheim Foundation Fellowship, 1952; Hallmark International Competition, 1956; PAFA, Hon. Men., 1956; Brandeis U., Creative Arts Award, 1957; Guggenheim International, 1958, 60; Chicago/AI, Floral Mayer Witkowsky Prize, 1961; PAFA, Joseph E. Temple Gold Medal, 1964; Chicago/AI, The Mr. & Mrs. Frank G. Logan Medal and Prize. **One-man Exhibitions:** Sheridan Square Gallery, NYC, 1917; Ardsley Gallery, 1918; Newark Museum, 1925; Whitney Studio Club, NYC, 1926-29; The Downtown Gallery, NYC, 1927, 30, 31, 32, 34, 43, 46, 52, 54, 56, 60, 62; Curt Valentine Gallery, NYC, 1928; Crillon Galleries, Philadelphia, 1931; Katherine Kuh Gallery, Chicago, 1939; Modern Art Society, Cincinnati, 1941 (two-man); Arts Club of Chicago, 1945; MOMA, 1945; Baltimore/MA, 1946; Santa Barbara/MA, 1949 (three-man); XXVI Venice Biennial, 1952; Contemporary Arts Gallery, NYC, 1955, 59; Brandeis U., 1957; Peale House, Philadelphia, 1964; Lawrence Rubin Gallery, NYC, 1971; The Zabriskie Gallery, NYC, 1976; Grace Borgenicht Gallery, NYC, 1979, 80, 83, 86; Hirschl & Adler Gallery, NYC, 1978; Esther Robles Gallery, Los Angeles, 1979; WMAA, 1980; Washburn Gallery Inc., 1983; Columbus, 1986; Salander-O'Reilly Galleries, Inc., NYC, 1985, 87, 90; West Palm Beach/Norton, 1985; Fort Worth/Amon Carter, 1986; WMAA/Philip Morris, 1987. **Retrospectives:** Walker, 1947; NCFA, 1965; Brooklyn Museum, 1978; MMA, 1992; AFA, circ., 1993. **Group:** The Armory Show, 1913; Independents, NYC, 1916; Golden Gate International Exposition, San Francisco, 1939; Tate, American Painting, 1946; I São Paulo Biennial, 1951; MOMA, 12 Modern American Painters and Sculptors, circ., Europe, 1953-55; MOMA, Modern Art in the United States, circ., Europe, 1955-56; I Inter-American Paintings and Prints Biennial, Mexico City, 1958; American Painting and Sculpture, Moscow, 1959; WMAA, The 1930's, 1968; Brown U., Graham, Gorky, Smith & Davis, 1977; Paris/Beaubourg, Paris-New York, 1977; WMAA, William Carlos Williams and the American Scene, 1920-1940, circ., 1978; Worcester/AM, The Dial: Arts and Letters in the 1920s, 1981; Carnegie, Abstract Painting and Sculpture in America, 1927-1983; Brooklyn Museum, The Machine Age in America, circ., 1986; U. of California, Berkeley, Made in U.S.A., 1987; ICA/London, Komik Ikonoklasm, 1987; MOMA, High and Low, 1990. **Collections:** AAAL; Andover/Phillips; Arizona State College; U. of Arizona; Baltimore/MA; Bezalel Museum; Brandeis U.; Britannica; Brooklyn Museum; Buffalo/Albright; Carnegie; Chicago/AI; Cincinnati/AM; Cranbrook; Dartmouth College; U. of Georgia; Hartford/Wadsworth; Harvard U.; Honolulu Academy; IBM; U. of Illinois; State U. of Iowa; U. of Kentucky; Library of Congress; Los Angeles/County MA; MMA; MOMA; Milwaukee; Minneapolis/Institute; U. of Nebraska; Newark Museum; New Trier High School; Ogunquit; U. of Oklahoma; PAFA; PMA; The Pennsylvania State U.; Phillips; Randolph-Macon Women's College; Sara Roby Foundation; U. of Rochester; Ros-

well; SFMA; SRGM; St. Louis/City; San Diego; Seattle/AM; Utica; VMFA; Vassar College; WMAA; Walker; Washington U.; Wellesley College; Wichita/AM; Yale U. **Bibliography:** Armstrong, Thomas; **Arnason 4, 5;** *Avant-Garde Painting and Sculpture in America, 1910-25;* Baigell 1; Barker 1; Barr 3; Battcock, ed.; Baur 5, 7; Bazin; Beckman; Biddle 4; Biederman 1; **Blesh 1, 2;** Brown 2; Cahill and Barr, eds.; Cheney; Chipp; Christensen; *Cityscape 1919-39;* Coke 2; Cummings 4, 5; **Davis S.;** Eliot; **Elliott;** *Europa/Amerika;* Flanagan; Flexner; Frost; Genauer; Gerdts; Goodrich and Baur 1; **Goossen 5;** Greengood; Haftman, Graham, Gorky, *Smith & Davis in the Thirties;* Halpert; Hess, T.B., 1; Honisch and Jensen, eds.; Hunter 1, 6; Hunter, ed.; Huyghe; Janis, S.; Johnson, Ellen H.; **Kelder;** Kepes 2; Kootz, 2; Kozloff 3; Kuh 2, 3; Lane and Larsen; Lee and Burchwood; Lippard, 5; Levin 2; McCurdy, ed.; Mendelowitz; Munsterberg; Murken-Altrogge; **Myers, ed.;** Newmeyer; Nordness, ed.; O'Doherty; Pagano; Pearson 1; Phillips, Lisa, 2; Pousette-Dart, ed.; Read 2; Richardson E.P.; Rickey; Ringel, ed.; Ritchie 1; Rodman 2; Rose, B., 1, 4; Rosenblum, 1; Sachs; Sandler 5; Seuphor 1; Seitz 3; **Sims, L.;** Sutton; **Sweeney 4;** Tashjian; Waldman 4; Weller; *"What Abstract Art Means to Me";* Wheeler; Wight 2; **Wilkin 2.** Archives.

DAY, WORDEN
from 1st to 4th edition.

DE ANDREA, JOHN **b.** December 24, 1941, Denver, Colo. **Studied:** U. of Colorado, 1964, BFA. Traveled Europe, Mexico, USA. **Taught:** U. of New Mexico, 1965. **Awards:** National Endowment for the Arts, 1974. **Address:** 1235 Pierce Street, Lakewood, CO 80214. **Dealer:** ACA Galleries, NYC. **One-man Exhibitions:** OK Harris Works of Art, NYC, 1970, 71, 73, 76, 78, 82, 85; Tortue Gallery, Los Angeles, 1981; Aspen Center for

the Visual Arts, 1982; Foster Goldstrom Gallery, San Francisco, 1982; Carlo Lamagna Gallery, NYC, 1987, 89; Galerie Isy Brachot, Paris, 1985; Galerie Isy Brachot, Brussels, 1988; ACA Galleries, NYC, 1991. **Group:** Chicago/Contemporary, Radical Realism, 1971; VII Paris Biennial, 1971; Kassel, Documenta V, 1972, Documenta VII, 1982; Galerie des 4 Mouvements, Paris, Hyperrealistes Americains, 1972; Harvard U., Recent Figure Sculpture, 1972; New York Cultural Center, Realism Now, 1972; Lunds Konsthall, Sweden, Amerikansk Realism, 1973; Lincoln, Mass./De Cordova, The Super-Realist Vision, 1973; Hofstra U., The Male Nude, 1973; CNAC, Hyperrealistes Americains/Realistes Europeens, 1974; Hartford/Wadsworth, New/Photo Realism, 1974; Wichita State U., Photo-Realism, 1975; Baltimore/MA, Super Realism, 1975; Vancouver, Aspects of Realism, 1976; Stamford Museum, American Salon des refusés, 1976; Canberra/National, Illusion and Reality, 1977; Venice Biennial, 1978; PAFA, Seven on the Figure, 1979; Paris/Beaubourg, Copie Conforme, 1979; PAFA; Contemporary American Realism Since 1960, 1981. **Collections:** Aachen/NG; Belger Cartage Service, Kansas City, Mo.; Syracuse/Everson; U. of Virginia. **Bibliography:** *Kunst um 1970;* Lindy; Lucie-Smith; *Recent Figure Sculpture;* Robins; Sager; Sandler 3.

DE CREEFT, JOSE **b.** November 27, 1884, Guadalajara, Spain. **d.** September 11, 1982, NYC. **Studied:** Atelier of Don Augustin Querol, Barcelona, 1906; apprenticed to Idalgo de Caviedas; Academie Julian, Paris, 1906; Maison Greber, Paris, 1910-14. To USA, 1929; citizen, 1940. **Taught:** New School for Social Research, 1932-48, 1957-62; ASL, 1934-62. **Member:** Artists Equity (founding member); Audubon Artists; National Sculpture Society; Federation of Modern Painters and Sculptors (president, 1943); NIAL, 1955; NAD, 1964; AAAL; Sculp-

tors Guild. **Commissions:** Saugues (Puy de Dome), France, 1918 (World War I Memorial); Fortress of Ramonje, Mallorca, 1932 (200 pieces of sculpture); Fairmount Park, Philadelphia, 1950; Central Park, NYC, 1959 (Alice in Wonderland group); Bronx (N.Y.) Municipal Hospital, 1962 (mosaic for nurses' residence); New Public Health Laboratory, NYC, 1966. **Awards:** Officier de l'Instruction Publique, France; MMA, Artists for Victory, First Prize, 1942; PAFA, George D. Widener Memorial Gold Medal, 1945; Audubon Artists, Gold Medal of Honor, 1954, 57; Ford Foundation Traveling Retrospective, 1960; National Sculpture Society, Therese and Edwin Richard Prize for Portrait Sculpture, 1969; Comendador de la Orden de Isabel la Catolica, 1973; National Arts Club, Gold Medal, 1975. **m.** Lorrie Goulet. **One-man Exhibitions:** (first) El Circulo de Bellas Artes, Madrid, 1903; Seattle/AM, 1929; Ferargil Galleries, NYC, 1929; Arts Club of Chicago, 1930; Philadelphia Art Alliance, 1933; Passedoit Gallery, NYC, 1936, 1938-49; Santa Barbara/MA, 1937; St. Paul Gallery, 1943; College of William and Mary, 1944; West Palm Beach/Norton, 1949, 50; The Contemporaries, NYC, 1956, 58, 60, 64, 65; Kennedy Gallery, 1970, 71, 72, 75, 79; Sid Deutsch Gallery, NYC, 1985; NMAA, 1983. **Retrospectives:** A.F.A./Ford Foundation, circ., 1960; New School for Social Research, 1974. **Group:** Salon d'Automne, Paris, 1910-29; Chicago/AI Annuals, 1939-51; MMA, National Sculpture Exhibition, 1942, 51; WMAA Annuals, 1942-57; PAFA Annuals, 1944-62; Carnegie; MOMA, Sculpture of the XXth Century, 1953; Worcester/AM; Brooklyn Museum; Sculptors Guild Annuals; Audubon Artists Annuals; Federation of Modern Painters and Sculptors; Artistes Français; Societé Nationale des Beaux Arts, Paris; Salon des Artistes Independents, Paris. **Collections:** Bezalel Museum; Brooklyn Museum; Columbia U.; Hirshhorn; IBM; MMA; MOMA; Museum of the City of New York; U. of Nebraska; New Paltz/SUNY; PAFA; U. of Puerto Rico; SFMA; Seattle/AM; Trenton/State; U. of Tucson; Utica; WMAA; West Palm Beach/Norton; Wichita/AM. **Bibliography:** Baur 7; Brumme; **Campos;** Cheney; Craven, W.; **de Creeft; Devree;** Goodrich and Baur 1; McCurdy, ed.; Marter, Tarbell, and Wechsler; Pearson 2; Ritchie 3; Selz, J.; Seuphor 3. Archives.

DEEM, GEORGE b. August 18, 1932, Vincennes, Ind. **Studied:** Vincennes U.; The U. of Chicago; Chicago Art Institute School, with Paul Wieghardt, Boris Margo, 1958, BFA. Traveled Europe; resided in England, 1966-67, Italy, 1970-77. US Army, 1951-53. **Taught:** School of Visual Arts, NYC, 1965-66; Leicester Polytechnic, England, 1966-67; U. of Pennsylvania, 1968-69; Museum of Arts and Sciences, Evansville, Ind., 1979; Illinois State U., 1982. **Awards:** MacDowell Colony Fellowship, 1977, 79. **Address:** 10 West 18th Street, NYC 10011. **Dealer:** Nancy Hoffman Gallery, NYC. **One-man Exhibitions:** (first) Allan Stone Gallery, 1962, also 1963-66, 68, 69, 75, 77; Merida Gallery, Inc., Louisville, 1964, 68, 69, 78, 83; James Goodman Gallery, Buffalo, 1965; Ferrier Gallery, Houston, 1969; Sneed-Hilman Gallery, Rockford, Ill., 1968, 69, 72, 76, 80, 81; M. E. Thelen Gallery, Essen, 1970; Indianapolis, 1975; Evansville, 1979; Ronald Greenberg Gallery, St. Louis, 1979; Witte, 1984; On View Downtown Gallery, Indianapolis, 1986; Evansville, circ., 1993. **Group:** Corcoran; Baltimore/MA, 1962; Buffalo/Albright, 1962; Chicago/AI, 1963, 65; MOMA; Barnard College; Silvermine Guild; The Hague, New Realism, 1964; Brandeis U., 1964; Cornell U., 1965; ICA, U. of Pennsylvania, 1965; U. of Illinois, 1965, 74; Indianapolis, Biennial, 1972, 76, 78; WMAA, Art about Art, 1978; Duisburg, Mona Lisa in the 20th Century, circ., 1978; PAFA, Contemporary American Re-

alism Since 1960, 1981; Allentown/AM, The Artist's Studio in American Painting, 1840-1983, 1983; Fort Wayne/AM, Indiana Influence, 1984; Flint/Institute, The Purloined Image, circ., 1993. **Collections:** Aachen/NG; Arizona State U.; Becton-Dickinson Co.; Evansville; First National Bank of Boston; Chase Manhattan Bank; Dow Jones & Co.; Hallmark Collection; Houston/MFA; Indianapolis; Louisville/Speed; Miami U.; U. of Nebraska; Oberlin College; U. of North Carolina; U. of Rochester; Rockford/Burpee; SFMA; The Singer Company, Inc.; Vassar. **Bibliography:** *Kunst um 1970;* Murken-Altrogge; Sager; Weller.

DE ERDELEY, FRANCIS
from 1st to 4th edition.

DE FOREST, ROY DEAN
b. February 11, 1930, North Platte, Neb. **Studied:** Yakima Valley Junior College, 1950, AA; California School of Fine Arts, 1950-52, with Edward Corbett, Hassel Smith, David Park; San Francisco State College, 1953, BA, 1958, MA, with Seymour Locks, Alexander Nepote. Traveled Paris, London, 1971. **Taught:** SFMA, 1955-58; Yakima Jr. College, 1958-60; Contra Costa Jr. College, 1960-61; Jr. Center of Arts and Sciences, Oakland, Calif. 1964-65; San Quentin Prison, 1964; California College of Arts and Crafts, 1964-65; U. of Calif., Davis, 1965-82. **Awards:** Bay Printmakers Society, Oakland, P.P., 1956; San Francisco Art Association, 1956; SFMA, Nealie Sullivan Award, 1962; National Endowment for the Arts, 1972. **Address:** P.O. Box 47, Port Costa, CA 94569. **Dealers:** Fuller-Gross Gallery, San Francisco; Frumkin/Adams Gallery, NYC; Darthea Speyer Gallery, Paris. **One-man Exhibitions:** (first) The East-West Gallery, San Francisco, 1955, also 1958; Stonecourt Gallery, Yakima, Wash., 1960; Dilexi Gallery, San Francisco, 1960, 63; Dilexi Gallery, Los Angeles, 1962; San Francisco Art Asso-

ciation, 1962, 65; Allan Frumkin Gallery, NYC, 1966, 73, 75, 77, 79, 85; Peninsula Gallery, Menlo Park, Calif., 1966; Sacramento City College Art Gallery, 1967; Allan Frumkin Gallery, Chicago, 1966, 77; Candy Store Art Gallery, Folsom, Calif., 1969; Mabikudes Gallery, Seattle, 1971; California Palace, 1971; Hansen-Fuller Gallery, San Francisco, 1971, 73, 74, 75, 78; Glenbow Alberta Institute, Calgary, 1974; Darthea Speyer Gallery, Paris, 1974, 77; Gallery Allen, Vancouver, 1974; Clark/Benton Gallery, Santa Fe, 1977, 81; 603 East 3rd Street Gallery, Los Angeles, 1979; Fresno State U., 1979; Michael Berger Gallery, Pittsburgh, 1979; U. of California, Davis, 1980, 83; Triton Museum of Art, Santa Clara, 1980; Fountain Gallery, Portland, Ore., 1980; Blackfish Gallery, Portland, Ore., 1980; Susan Whitney Gallery, Regina, 1980; Sacramento/Crocker, 1980; Marian Locks Gallery, Philadelphia, 1980; Hansen Fuller Goldeen Gallery, San Francisco, 1981, 84, California State U., Chico, 1982; U. of California, Davis, 1983; Frumkin & Struve Gallery, Chicago, 1983; Fuller Goldeen Gallery, San Francisco, 1986; Pittsburgh Center for the Arts, 1987; Natsoulas/Novelozo Gallery, Davis, CA, 1988, 90; Struve Gallery, Chicago, 1988; Fuller Gross Gallery, San Francisco, 1989; Frumkin/Adams Gallery, NYC, 1990. **Retrospective:** SFMA, circ., 1974. **Group:** Cincinnati/AM, 1952; SFMA, 1952, 63, 64; São Paulo, 1955; Reed College, 1957, California Palace, 1960, 63; WMAA, 1962; Pasadena/AM, 1962; Buffalo/Albright, 1963; Walker, 1963; U. of Illinois, 1964, 69; U. of California, Berkeley, Funk 1967; Portland, Ore./AM, The West Coast Now, 1968; WMAA, Extraordinary Realities, 1973; Sacramento Sampler 2, 1973; SFMA, Painting and Sculpture in California: The Modern Era, 1976; Washington State U., 6 from California, 1976; Halifax, 3 from California, 1976; U. of Texas, Austin, New in the Seventies, 1977; SFMA, Downtown Cen-

ter, Dog Images through the Century, 1978; ICA, Boston, Roy de Forest, Robert Hudson, 1977; XXXIX Venice Biennial, 1980; Brooklyn Museum, American Drawings in Black and White, 1970-1979, 1980; Sacramento/Crocker, Welcome to the Candy Store, 1981; Columbus, American Paintings of the 60s and 70s, 1981; Palm Springs Desert Museum, The West as Art, 1982; U. of Southern California, Idioms of Surrealism, 1984; Sioux City Art Center, Beasties, 1984; Florida International U., Contemporary American Wood Sculpture, 1985; Florida International U., American Art Today, 1986; Newport Harbor, Second Newport Biennial, 1986; RISD, The Call of the Wild, 1987; Hudson River Museum, The Nature of the Beast, 1989; Skidmore College, Out of Abstract Expressionism, 1991. **Collections:** Arizona State U.; U. of Arkansas; Brooklyn Museum; U. of California, Berkeley; California College of Arts and Crafts; Chicago/AI; Cornell U.; Denver/AM; Des Moines; Honolulu Contemporary; Indianapolis; U. of Kansas; La Jolla; Madison Art Center; Memphis/Brooks; U. of New Mexico; U. of North Carolina; Oakland/AM; Omaha/Joslyn; PMA; Paris/Beaubourg; RISD; U. of Rochester; SFMA; Sacramento/Crocker; San Diego; San Diego/Contemporary; San Francisco Civic Center; Stanford U.; U. of Utah; VMFA; U. of Virginia; WMAA; Yakima (Calif.) Public Library; Yale U. **Bibliography:** Drawings: The Pluralist Decade; Forty Years of California Assemblage; Humphrey; Janis and Blesh 1; New in the Seventies; Selz, P., 2; Solnit; The State of California Painting. Archives.

DEHN, ADOLF ARTHUR

b. November 22, 1895, Waterville, Minn. **d.** May 19, 1968, NYC. **Studied:** Minneapolis Institute School; ASL. **Taught:** Famous Artists Schools, Inc. **Member:** NAD. **Awards:** Philadelphia Art Alliance, 1936; The Print Club, Philadelphia,

1939; Guggenheim Foundation Fellowship, 1939, 51; Chicago/AI, 1943; Library of Congress, Pennell P.P., 1946. **One-man Exhibitions:** Macbeth Gallery, NYC, 1933; A.A.A. Gallery, NYC, 1941, 51; Brooklyn Public Library, 1944; Dayton/AI, 1946; The Milch Gallery, 1957, 60, 68; FAR Gallery, 1964, 65; Studio North, Towson, Md., 1969; Kennedy Gallery, NYC, 1971; Hirschl & Adler Galleries, Inc., NYC, 1976; Harmon Gallery, Naples, Fla., 1981, 82; Mary Ryan Gallery, 1982, 91; Fine Arts America, Inc., Richmond, Va., 1983; Harmon-Meek Gallery, Naples, Fla., 1985. **Retrospective:** Amon Carter Museum. **Group:** MMA; MOMA; NYPL; Brooklyn Museum; Chicago/AI; Boston/MFA; WMAA. **Collections:** Boston/MFA; Brooklyn Museum; Chicago/AI; Cincinnati/AM; Cleveland/MA; Indianapolis/Herron; Lehigh U.; MMA; MOMA; Minneapolis/Institute; NYPL; Newark Museum; Standard Oil Co.; US Navy; Utica; WMAA. **Bibliography:** American Artists Group Inc. 1, 2, 3; Brown; Dehn; Goodrich 1; Goodrich and Baur 1; Index of 20th Century Artists; Mellquist; Mendelowitz; Pagano; Pearson 1, 2; Pousette-Dart, ed.; Reese; Zigrosser 1. Archives.

DEHNER, DOROTHY b. December 23, 1901, Cleveland, Ohio. **Studied:** UCLA; Skidmore College, BS (Art); Pasadena Playhouse, with Gilmor Brown; ASL, with Kimon Nicolaides, Boardman Robinson, Jan Matulka, Kenneth Kayes Miller. Traveled Europe, USSR, Mexico, USA. Began as a painter, became a sculptor in 1955. **Taught:** New York State Extension Program, 1952-54; Barnard School, NYC, 1954-56; Parsons School of Design, NYC, 1950-; Boas Dance Studio, Bolton Landing, N.Y.; and privately. **Member:** Sculptors Guild; Federation of Modern Painters and Sculptors. **Commissions:** Great Southwest Industrial Park (outdoor relief), 1969; Union Camp Corp., Wayne, N.J., 1971; Rockefeller

Center, 1972. **Awards:** Audubon Artists, First Prize, 1949; ART: USA: 59, NYC, Second Prize for Sculpture, 1959; Tamarind Fellowship, 1965; Kane Memorial Exhibition, Providence, R.I., First Prize for Sculpture, 1962; Yaddo Fellowship, 1971. **Address:** 33 Fifth Avenue, NYC 10003. **Dealer:** Twining Gallery, NYC. **One-man Exhibitions:** Albany/Institute, ca. 1944 (two-man, with David Smith), also 1954; Skidmore College, 1948, 53, 59; Rose Fried Gallery, 1952; Howard U., 1954; U. of Virginia, 1954; Chicago/AI, 1955; The Willard Gallery, 1955, 57, 59, 61, 63, 66, 70, 73; Wittenborn Gallery, NYC, 1956; Gres Gallery, Washington, D.C., 1959; Columbia U., 1961; Philadelphia Art Alliance, 1962; U. of Michigan, 1963; Cornell U., 1964; Fort Wayne/AM, 1975; Benson Gallery, Bridgehampton, 1975; Jane Weis Gallery, Cleveland, 1974; Parsons-Dreyfus Gallery, NYC, 1978; Barbara Fiedler Gallery, Washington, D.C., 1980; Twining Gallery, NYC, 1986, 90; Phillips, 1990; Muhlenberg College, 1988; AAA, 1987. **Retrospective:** Jewish Museum, 1965; Hyde Collection, 1967; Jacksonville/Cummer; Fort Wayne/AM; Design Corner, Cleveland; Storm King Art Center, 1978; Baruch College, 1991. **Group:** Brooklyn Museum; Sculptors Guild Annuals; Baltimore/MA; Los Angeles/County MA; Utica; PAFA; Walker; Hartford/Wadsworth; New Sculpture Group, NYC; Rome/Nazionale; SFMA, 1944; WMAA Annuals, 1950, 51, 54, 60, 63; MMA, 1953; Carnegie, 1961; MOMA, 1962, 64. **Collections:** AT&T; Bankers Trust Company; Calcutta; Chase Manhattan Bank; Cleveland/MA; Columbia U.; Columbus; First National Bank of Chicago; Free Library of Philadelphia; Great Southwest Industrial Park; Hemisphere Club; Hyde Collection; Jacksonville/Cummer; MMA; MOMA; Minnesota/MA; NYPL; U. of New Mexico; The New York Bank for Savings; U. of North Carolina; St. Lawrence U.; Seattle/AM; Skidmore College; US State De-partment; Utica; Wellesley College; Wichita State U.; U. of Wisconsin. **Bibliography:** Bihalji-Merin; Moser 1. Archives.

DE KNIGHT, AVEL b. 1933,

NYC. **Studied:** École des Beaux-Arts, Paris, 1955-56; Academie de la Grande Chaumiere, Paris, 1956-57; Academie Julien, Paris, 1957-58. Art critic for *France-Amerique,* 1958-68. **Taught:** New School for Social Research, 1967; Brooklyn Museum School, 1969-70; NAD. **Member:** NAD; American Watercolor Society. **Awards:** NAD, Palmer Memorial Prize, 1958; Ranger Fund, P.P., 1958, 64, 66; AAAL, Childe Hassam Fund P.P., 1960, 70; US State Department Exchange Grant to travel USSR, 1961; NAD, Grumbacher Award, 1962, 64; Samuel F. B. Morse Medal, 1966; William A. Paton Prize, 1967, 71; American Watercolor Society, Grand Prize and Gold Medal, 1967; Audubon Artists Medal of Honor, 1969. **Address:** 81 Perry Street, NYC 10014. **Dealer:** Babcock Galleries, NYC. **One-man Exhibitions:** Richard Larcada Gallery, 1968, 71; Babcock Galleries, NYC, 1973. **Group:** Youngstown/Butler, 1958-73; PAFA, 1965; Boston/MFA, Black Artists; New York and Boston, 1970; WMAA, Contemporary Black Artists in America, 1971; Finch College, NYC, Projected Art, 1971; Jacksonville/Cummer, Remnants of Things Past, 1971. **Collections:** Chase Manhattan Bank; Denison U.; Lehigh U.; MMA; Massilon Museum; Mills College; NAD; Norfolk; Southern Vermont Art Center; Springfield, Mo./AM; Walker. **Bibliography:** Archives.

DE KOONING, ELAINE

b. March 12, 1918, NYC. d. February 1, 1989, Southampton, NY. **Studied:** Leonardo da Vinci Art School, NYC, 1937; American Artists School, NYC, 1938, with Conrad Marca-Relli; privately with Willem de Kooning, 1938-43. Traveled France, Belgium, Spain. **Taught:** U. of New Mexico, 1959; The Pennsylvania

State U., 1960; U. of California, Davis, 1963-64; Yale U., 1967; Pratt Institute, 1968; Carnegie-Mellon U., 1968-70; U. of Pennsylvania, 1971-72; Wagner College, 1971; New York Studio School, Paris, 1974; Parsons School of Design, NYC, 1974-75; U. of Georgia, 1976-79; Skowhegan School, 1979; Bard College. **Member:** Artists Equity. Commissioned by President Harry S. Truman to paint portrait of John F. Kennedy, 1963. **Awards:** Hon. DFA, Webster College, 1964; Moore College of Art, Philadelphia, 1972; Hon. DFA, Adelphi U., 1985; Hon. DFA, U. of Maryland, 1986. **One-man Exhibitions:** The Stable Gallery, NYC, 1954, 56; Tibor de Nagy Gallery, NYC, 1957; U. of New Mexico, 1958; Santa Fe, N.M., 1959; Gump's Gallery, San Francisco, 1959; Dord Fitz Gallery, Amarillo, 1959; Holland-Goldowsky Gallery, Chicago, 1960; The Howard Wise Gallery, Cleveland, 1960; Ellison Gallery, Fort Worth, 1960; Tanager Gallery, NYC, 1960; The Graham Gallery, NYC, 1960, 61, 64, 75, 81; De Aenlle Gallery, NYC, 1961; Drew U., 1966; Montclair/AM, 1973; Benson Gallery, 1973; Illinois Wesleyan U., 1975; St. Catherine's College, St. Paul, 1975; Greenberg Gallery, 1982; Gruenebaum Gallery, NYC, 1982, 86; Phoenix II Gallery, Washington, D.C., 1982; Port Washington (N.Y.) Library, 1982; Arts Club of Chicago, 1983; Guild Hall, 1983, 89; Adelphi U., 1984; C. Grimaldis Gallery, Baltimore, 1984, 85; Vered Gallery, East Hampton, N.Y., 1984, 87; Galerie Silvia Menzel, Berlin, 1986; Guggenheim Gallery, Miami, 1986; Wenger Gallery, Los Angeles, 1987, 88; Fischbach Gallery, NYC, 1988; Benton Gallery, Southhampton, N.Y., 1990; Brooklyn College, 1991; Washburn Gallery, NYC, 1992. **Retrospective:** New London, 1959. **Group:** The Kootz Gallery, NYC, New Talent, 1950; International Biennial Exhibition of Paintings, Tokyo; Walker, Expressionism, 1900-1955, 1956; Carnegie, 1956; A.F.A., Sports in Art, 1957; Jewish

Museum, The New York School, Second Generation, 1957; MOMA, Younger American Painters, circ., 1957, 59; Houston/MFA, Action Painting, 1958; Walker, 60 American Painters, 1960; Hallmark Art Award, 1960; WMAA Annuals 1963, 74; Carnegie, 1964; PMA/Museum of the Philadelphia Civic Center, Focus, 1974; NPG, American Self-Portraits: 1670-1973; 1974; Hirshhorn, The Fifties, Aspects of Painting in New York, 1980; Cincinnati/Contemporary, 1 + 1 + 2, 1984; Brooklyn Museum, Public and Private: Prints Today, 1986. **Collections:** Amarillo Art Center; U. of Arkansas; Buffalo/Albright; Ciba-Geigy Corp.; Corcoran; Elmira College; Greenville; Guild Hall; Hirshhorn; Kennedy Library; MOMA; Montclair/AM; NYU; Purchase/SUNY; SRGM; Harry S. Truman Library; U. of Virginia; Wake Forest U. **Bibliography:** Blesh 1; Chipp; Downes, ed.; *The Figurative Fifties;* Hughes; Hunter 6; Janis and Blesh 1; O'Hara 1. Archives.

DE KOONING, WILLEM
b. April 24, 1904, Rotterdam, Holland. **Studied:** Academie voor Beeldende Kunsten ed Technische Wetenschappen, Amsterdam, 1916-24. To USA, 1926. Federal A.P: Mural painting, 1935-39. **Taught:** Black Mountain College, 1948; Yale U., 1950-51. **Member:** NIAL; Akademie der Kunst, Berlin, 1982; Hon. Member, Royal Academy for the Visual Arts, Netherlands, 1982; Royal Academy of Fine Arts, Sweden, 1986. **Commissions** (murals): New York World's Fair, 1939; French Line Pier, NYC (with Fernand Leger); Williamsburg Housing Project, NYC. **Awards:** State Academy Medal, Rotterdam; Academy of Plastic Arts, Rotterdam, Silver Medal; Chicago/AI, The Mr. & Mrs. Frank G. Logan Medal, 1951; The President's Medal, 1963; Presidential Medal of Honor, 1964; Talen Prize, Amsterdam, 1968; Brandeis U., Creative Arts Award, 1974; MacDowell Colony Medal, 1975; AAIAL, Gold

Medal for Painting, 1975; Officer of the Order of Orange-Nassau, Netherlands, 1979; Carnegie, Andrew W. Mellon Prize, shared with Eduardo Chillida, 1979; Goslarer Kaisseringes, 1984; Max Beckmann Prize, 1984; Mayor's Liberty Medal, NYC, 1986; National Medal of the Arts, 1986. **Address:** Woodbine Drive, East Hampton, NY 11973. **One-man Exhibitions:** (first) Charles Egan Gallery, 1948, also 1951; Arts Club of Chicago, 1951; Sidney Janis Gallery, 1953, 56, 59, 62, 72; Boston Museum School, 1953; Workshop Art Center, Washington, D.C., 1953; Martha Jackson Gallery, NYC, 1955; Paul Kantor Gallery, Beverly Hills, Calif., 1961, 65; Allan Stone Gallery, NYC, 1962 (two-man), 1964, 65, 71, 72; The Goodman Gallery, Buffalo, 1964; Smith College, 1965; M. Knoedler & Co., NYC, 1967, 69, 71, Paris, 1968, 71; Betty Gold, Los Angeles, 1971; Fourcade, Droll, Inc., NYC, 1972, 75; Richard Gray Gallery, 1974; Walker, 1974; Galerie Biedermann, Munich, 1974; West Palm Beach/Norton, 1975; Seattle/AM, 1976; Amsterdam/Stedelijk, 1976, 83; Musée de Grenoble, 1977; Corcoran Gallery, Los Angeles, 1976, 77; Gimpel Fils, London, 1976; Gimpel Fils, Zurich, 1976; Xavier Fourcade, Inc., NYC, 1976, 77, 78, 79, 84, 85; Galerie Daniel Templon, Paris, 1977; U. of Houston, 1976; Belgrade, 1977-78; Duisburg, 1977; SRGM, 1978; U. of Northern Iowa, 1978; Carnegie, 1979; Richard Gray Gallery, Chicago, 1980; Richard Hines Gallery, Seattle, 1980; Guild Hall, 1981; Janie C. Lee Gallery, Houston, 1981; Galerie Maeght Lelong, NYC, 1983; Colorado State U., 1984; Lincoln Center, Fort Collins, Colo.; 1984; Mönchehause Museum, Goslar, 1984; Galerie Daniel Templon, Paris, 1984; Hans Strelow Gallery, Düsseldorf, 1984; Anthony d'Offay Gallery, London, 1985; Studio Marconi, Milan, 1985; Margo Leavin Gallery, Los Angeles, 1986; Galerie Karsten Greve, Paris, 1990; Salan-

der-O'Reilly Galleries, NYC, 1990; Pace Gallery, NYC (two-man), 1991. **Retrospectives:** Amsterdam/Stedelijk, 1968; MOMA, 1968; WMAA, circ., 1983; Stadelsches Kunst Institute, Frankfurt, 1984. **Group:** MOMA, New Horizons in American Art, 1936; WMAA Annuals, 1948, 50, 51; VMFA, American Painting, 1950; California Palace, 1950; XXV, XXVI, & XXVIII Venice Biennials, 1950, 52, 56; MOMA, Abstract Painting and Sculpture in America, 1951; São Paulo, 1951, 53; Chicago/AI, 1951, 54; Buffalo/Albright, Expressionism in American Painting, 1952; Carnegie, 1952, 55; Baltimore/MA, 1953; WMAA, The New Decade, 1954-55; WMAA, Nature in Abstraction, 1958; Brussels World's Fair, 1958; MOMA, The New American Painting, circ., Europe 1958-59; Hartford/Wadsworth, Continuity and Change, 1962; Seattle World's Fair, 1962; Art: USA: Now, circ., 1962-67; SRGM, Guggenheim International, 1964; Tate, Painting and Sculpture of a Decade, 1954-64, 1964; SRGM, American Drawings, 1964; Los Angeles/County MA, New York School, 1965; U. of Illinois, 1967; Melbourne/National, Two Decades of American Painting, 1967; Frankfurter Kunstverein, Kompass New York, 1968; ICA, London, The Obsessive Image, 1968; MOMA, The New American Painting and Sculpture, 1969; Corcoran Biennial, 1979; U. of California, Berkeley, Matrix, 1978; National Gallery, American Art Mid-Century, 1978; PAFA, Seven on the Figure, 1979; Sunderland (Eng.) Arts Center, Drawings in Air, 1983; Chicago/Terra, Woman, 1984; Hirshhorn, Drawings 1974-1984, 1984; Southampton/Parrish, Painting Naturally: Fairfield Porter and His Influences, 1984; National Gallery, Gemini G.E.L.: Art and Collaboration, 1984; Amsterdam/Stedelijk, La Grande Parade, 1984; École des Beaux Arts, Paris, American Drawing: 1930-1980, 1985; U. of Nebraska, Contemporary Bronze: Six in the Figurative

Tradition, 1985; Whitechapel Art Gallery, London, In Tandem: The Painter-Sculptor in the 20th Century, 1986; Buffalo/Albright, Abstract Expressionism, 1987; Australian National Gallery, Australian Biennial, 1988; Newport Harbor, The Figurative Fifties, circ., 1988; Rutgers U., Abstract Expressionism, Other Dimensions, 1990. **Collections:** Amsterdam/Stedelijk; Baltimore/MA; Brooklyn Museum; Buffalo/Albright; Canberra/National; Carnegie; Chicago/AI; Container Corp. of America; Hartford/Wadsworth; Hirshhorn; Inland Steel Co.; Kansas City/Nelson; Los Angeles/County MA; MMA; MOMA; National Gallery; U. of Nebraska; U. of North Carolina; Ottawa; PMA; Phillips; SRGM; RISD; Stockholm/National; Toronto; Vassar College; WMAA; Walker; Washington U. **Bibliography:** *Abstract Expressionism;* Alloway 4; Anfam; Ashbery; Ashton 5; Barr 3; Battcock, ed.; Baur 5, 7; Becker and Vostell; Biddle 4; Bihalji-Merin; Blesh 1; Brion 1; Brown 2; Calas 2; Calas, N. and E.; Canaday; Carmean and Rathbone; **Codognati;** Cummings 5; **Cummings, Merkert, and Stullig;** Chipp; Danto; **de Kooning;** De Wilde 1, 2; Downes, ed.; Eliot; Elsen 1; *Europa/Amerika; The Figurative Fifties;* Finch; Flanagan; *From Foreign Shores;* **Gaugh;** Gettings; Goodrich and Baur 1; Greenberg 1; Haftman; Henning; **Hess, T.B.,** 1, 4, 5; Hobbs and Levin; Hunter 1, 6; Hunter, ed.; *Individuals;* **Janis and Blesh 1, 2; Janis, S.;** Johnson, Ellen H.; Kozloff 3; Kuh 3; Lane and Larsen; Langui; **Larson and Schjeldahl;** Lippard 5; Lynton; McCoubrey 1; McCurdy, ed.; Mendelowitz; *Metro; Monumenta;* Motherwell and Reinhardt, eds.; Murken-Altrogge; Neumeyer; Nordness, ed.; O'Doherty; Plagens; Plous; *Poets & Painters;* Ponente; Pousette-Dart, ed.; Ragon 1; Read 2; Richardson, E.P.; Rickey; Ritchie 1; Rodman 1, 2, 3; Rose, B., 1, 4; Rosenberg; Rothschild; Sandler 3, 5; Schwartz 1; Seitz 1, 3, 4; Seuphor 1; Siegel; Soby 6; Tomkins 1, 2; Tomkins and Time-Life Books; Tuchman, ed.; Waldman 4; Weller; *"What Abstract Art Means to Me"; Willem de Kooning: Printer's Proofs.* Archives.

DE LAP, TONY **b.** November 4, 1927, Oakland, Calif. **Studied:** California College of Arts and Crafts; Menlo Junior College; Academy of Art, San Francisco; Claremont Graduate School, AA. Traveled in Europe for 3 months, 1954. **Taught:** Academy of Art, San Francisco, 1957-59; California College of Arts and Crafts, 1961-63; U. of Wisconsin, summer 1963; Scripps College, U. of California, Davis, 1964-65; Claremont College, 1964; San Francisco Art Institute, 1964-67; U. of California, Irvine, 1965-. Art Commissioner, San Francisco Municipal Art Commission. **Commissions:** Brooks Hall, San Francisco; Carborundum Co., 1969; C.C.H. Building, San Rafael, Calif., 1972; City of Inglewood, Calif., 1973. **Awards:** San Francisco Art Festival, First Prize, Mural Competition, 1957; SFMA, Nealie Sullivan Award, 1964; Ford Foundation/A.F.A. Artist-in-Residence, 1966; Long Beach/MA., P.P., 1969; 1st Prize, Los Angeles Department of Airports, sculpture competition, 1976; National Endowment for the Arts, grant, 1983. **Address:** 225 Jasmine Street, Corona del Mar, CA 92625. **Dealer:** Jan Turner Gallery, Los Angeles. **One-man Exhibitions:** (first) Gump's Gallery, San Francisco; SFMA; RAC, 1954; Oakland/AM, 1960; Dilexi Gallery, San Francisco, 1963, 67; Robert Elkon Gallery, NYC, 1965, 66, 68, 70, 73, 75, 77, 79; Felix Landau Gallery, Los Angeles, 1966, 69; Mt. San Antonio College, 1969 (two-man); Nicholas Wilder Gallery, Los Angeles, 1972, 74, 76; California State U., Long Beach, 1974; John Berggruen Gallery, San Francisco, 1974, 76; California Institute of Technology, Pasadena, 1975; Newport Harbor, 1977; Jack Glenn Gallery, Newport Beach, 1976; Casat Gallery, La Jolla, 1977; California State College,

Chico, 1979; Janus Gallery, Venice City, 1979; Janus Gallery, Los Angeles, 1981, 83; Jan Turner Gallery, Los Angeles, 1981, 87, 89, 91; Klein Gallery, Chicago, 1985; Modernism, San Francisco, 1989, 92; The Works Gallery, Long Beach, Calif., 1986, 90. **Retrospective:** U. of California, Irvine, Tony De Lap: The Last Five Years: 1963-68, 1969. **Group:** Stanford U., 1961; Kaiser Center, Oakland, Sculpture Today, 1964; Carnegie, 1964; WMAA, 1964; Chicago/AI; MOMA, 1964, The Responsive Eye, 1965, The 1960's, 1967; La Jolla, 1965, 66; Jewish Museum, Primary Structures, 1966; WMAA, Contemporary American Sculpture, Selection 1, 1966; Musée Cantonal des Beaux-Arts, Lausanne, II Salon de Galeries Pilotes, 1966; Seattle/AM, 1966; Los Angeles/County MA, American Sculpture of the Sixties, 1967; Scripps College, 1967; San Marino (Europe), Nuove Tecniche dell'immagine, 1967; Portland, Ore./AM, 1968; U. of California, Irvine, A Los Angeles Esthetic, 1969; Pasadena/AM, West Coast; 1945-1969, 1969; La Jolla, The Wall Object, 1973; Newport Harbor, Modern and Contemporary Sculpture, 1974; Corcoran, Biennial, 1978; SFMA, California Painting and Sculpture: The Modern Era, 1976. **Collections:** Arizona State U.; Atlantic Richfield Co.; Claremont College; Hartford/Wadsworth; Hirshhorn; Los Angeles/County MA; MOMA; Oakland/AM; Ridgefield/Aldrich; SFMA; San Francisco Municipal Art Commission; Santa Barbara/MA; State of California; Tate; WMAA; Walker. **Bibliography:** Tuchman 1.

DELLA-VOLPE, RALPH
b. May 10, 1923, New Jersey. **Studied:** NAD; ASL (with Edwin Dickinson, Will Barnet, Harry Sternberg). Traveled USA, Mexico. US Army, 1942-45. **Taught:** Bennett College, Millbrook, N.Y., 1949-77; Marist College, Poughkeepsie, 1977-79. **Member:** College Art Association; Association of American University Professors.

Awards: MacDowell Colony Fellowship, 1963; Library of Congress, Pennell P.P.; NIAL, Drawing Prize, 1963, 64. **Address:** Altamont Road, RD #2, Box 295, Millbrook, NY 12545. **Dealer:** Munson Gallery, New Haven, CT. **One-man Exhibitions:** Bennett College, 1949-63; Three Arts Gallery, Poughkeepsie, N.Y., 1951; Artists' Gallery, NYC, 1959; The Babcock Gallery, 1960, 62, 63; Lehigh U., 1963; Mansfield State College, 1964; Pittsfield/Berkshire, 1964; Cobleskill/ SUNY, 1968; Dutchess Community College, Poughkeepsie, N.Y.; Centenary College, Hackettstown, N.J.; The Hotchkiss School, Lakeville, Conn.; Wolfe Street Gallery, Washington, D.C., 1974, 77; Talking of Michelangelo Gallery, Washington, D.C., 1974; Barrett House Art Gallery, Poughkeepsie, N.Y., 1978; Cannio's Books, Sag Harbor, NY, 1987; Vered Gallery, East Hampton, NY, 1988. **Retrospectives:** The Gallery, West Cornwall, Conn., 1974; Columbia, S.C./MA, 1975. **Group:** PAFA; Library of Congress; NIAL; American Color Print Society; Youngstown/Butler; Bradley U.; Brooklyn Museum; Hartford/Wadsworth; San Antonio/McNay; Vassar College; Newport (R.I.) Art Association; Audubon Artists, NYC. **Collections:** ASL; Chase Manhattan Bank; Library of Congress; Mansfield State College; Slater; Wichita/AM.

DE MARIA, WALTER b. October 1, 1935, Albany, Calif. **Studied:** U. of California, BA, MA (with David Park). Traveled Europe. **Commissions:** Dia Art Foundation, NYC, 1977, 79, 81. **Films:** *Three Circles & Two Lines in the Desert,* 1969; *Hard Core,* 1969. **Awards:** Guggenheim Foundation Fellowship, 1969; AIC, Mather Sculpture Prize, 1976; State of Baden-Wurtemberg, International Prize for Fine Arts, 1986. **Commission:** The Bureau of the National Assembly, Paris, Sculpture on the Occasion of the Bicentennial, 1991. **Address:** 421 East 6th Street, NYC 10009. **Dealer:** Gagosian

Gallery, NYC. **One-man Exhibitions:**
(first) Nine Great Jones Street, NYC (two-
man, with Robert Whitman), 1963; Paula
Cooper Gallery, NYC, 1965; Cordier &
Ekstrom, Inc., NYC, 1966; Nicholas
Wilder Gallery, Los Angeles, 1968;
Galerie Heiner Friedrich, Munich, 1968,
79; Dwan Gallery, Los Angeles, 1969, 70;
Cinema Odeon, Turin, 1969; Iris Clert
Gallery, 1969; Gian Enzo Sperone, Turin,
1969, 70; Basel, 1972; Darmstadt/Hessisches,
1974; Heiner Friedrich, NYC, 1977; Dia
Art Foundation, NYC, 1979, 80, 91;
Darmstadt/Kunsthalle, 1974; Paris/Beau-
bourg, 1981; Rotterdam, 1984; Harvard
U., 1986; Xavier Fourcade Gallery, Inc.,
NYC, 1986; Staatsgalerie, Stuttgart, 1987;
Magazine 3, Stockholm, 1988; Stock-
holm/National, 1989; Gagosian Gallery,
NYC, 1989; 65 Thompson Street, NYC,
1989. **Group:** Jack London Outdoor Art
Annual, Oakland, Calif., 1959; Douglass
College, 1964; Jewish Museum, Primary
Structures, 1966; WMAA Sculpture An-
nual, 1967, 68; Museum of Contempo-
rary Crafts, 1967; Los Angeles/County
MA, American Sculpture of the Sixties,
1967; A.F.A., circ., 1967; Milwaukee, Di-
rections 1: Options, circ., 1968; Kassel,
Documenta IV, 1968; Prospect '68,
Düsseldorf, 1968; Berne, When Attitudes
Become Form, 1969; Amsterdam/Stedelijk,
1969; MOMA, circ., 1969; MOMA, In-
formation, 1970; Düsseldorf/Kunsthalle,
Prospect 71, 1971; SRGM, Guggenheim
International, 1971; Philadelphia College
of Art, Line, 1976; WMAA, 200 Years of
American Sculpture, 1976; Chicago/AI,
1976; Kassel, Documenta VI, 1977; Hay-
ward Gallery, London, Pier and Ocean,
1980; Venice Biennial, 1980; ROSC,
Dublin, 1980; Cologne/Stadt, Westkunst,
1981; WMAA, Blam!, 1984; Grand Pal-
ais, Paris, Le rime et la raison, 1984;
Kunstverein, Frankfurt, Vom Zeichnen,
1985; Fort Lauderdale, An American
Renaissance, 1986; ICA, U. of Pennsylva-
nia, 1976: At the Crossroads, 1987;
Paris/Beaubourg, L'époque, la mode, la

morale, la passion, 1987; Berlin, Ham-
burger Branhof, Zeitlos, 1989; Makuhari
Messe, Tokyo, Pharmakon '90, 1990; In-
dianapolis, Power: Its Myths and Mores in
American Art, 1961-1991, circ., 1991.
Collections: Dia Art Foundation;
MOMA; Rotterdam; SRGM; Stock-
holm/National; WMAA. **Bibliography:**
Adrian; Atkinson; Battcock, ed.; Calas, N.
and E.; **Beeren 2;** Celanti; *Contemporanea;*
Davis, D.; Day 1; *Europa/Amerika;*
Happening & Fluxus; Kunst um 1970;
Haskell 5; Kardon 3; Lippard, ed.; Muller;
Report; Robins; Ruhe; Sandler 3; Seitz 3;
Tuchman 1; Waldman 4; Weintraub;
When Attitudes Become Form. Archives.

DE MARTINI, JOSEPH
from 1st to 4th edition.

DEMUTH, CHARLES **b.** No-
vember 8, 1883, Lancaster, Pa. **d.** October
23, 1935. **Studied:** Franklin and Marshall
College; Drexel Institute of Technology,
1901; Pennsylvania School of Industrial
Art, Philadelphia; PAFA, 1905-08, with
Thomas Anshutz, Henry McCarter;
Academie Colarossi, Academie Moderne,
and Academie Julian, Paris, 1912-14. Trav-
eled Europe, eastern USA. **One-man Exhi-
bitions:** (first) The Daniel Gallery, NYC,
1915, also 1916, 17, 18, 20, 22, 23, 24,
25; Stieglitz's Intimate Gallery, NYC,
1926, 29; An American Place (Gallery),
NYC, 1931; The Downtown Gallery,
NYC, 1931, 50, 54, 58; Smith College,
1934; WMAA, 1935; WMAA Memorial
Exhibition, 1937; U. of Minnesota, 1937;
Franklin and Marshall College, 1941, 48;
Cincinnati/AM, 1941; Phillips, 1942;
PMA, 1944; The U. of Chicago, 1946;
Graphische Sammlung Albertina, 1949;
Ogunquit, 1959; U. of California, Santa
Barbara, 1971; Kennedy Galleries, 1971;
Salander-O'Reilly Galleries, NYC, 1981;
Tacoma, 1981; Carnegie, 1983. **Retrospec-
tive:** MOMA, 1949; Harrisburg, Pa./State
Museum, 1966. **Group:** MOMA; WMAA;
MMA; PAFA; Phillips; Pomona College,

Stieglitz Circle, 1958. **Collections:** Amherst College; Andover/Phillips; Arizona State College; Baltimore/MA; Barnes Foundation; Boston/MFA; Brooklyn Museum; Buffalo/Albright; Chicago/AI; Cleveland/MA; Columbus; Detroit/Institute; Fisk U.; Hartford/Wadsworth; Harvard U.; Honolulu Academy; MMA; MOMA; Milwaukee; National Gallery; U. of Nebraska; Newark Museum; New Britain; Ogunquit; PMA; Phillips; Princeton U.; RISD; San Antonio/McNay; Santa Barbara/MA; Toledo/MA; Utica; WMAA; Walker; Wellesley College; West Palm Beach/Norton; Wichita/AM; Worcester/AM; Yale U. **Bibliography:** *Avant-Garde Painting and Sculpture in America, 1910-25;* Barnes; Baur 7; Bazin; Biddle 4; Blesh 1; Born; Brown; Brown 2; Cahill and Barr, eds.; **Charles Demuth;** Cheney; Christensen; Cummings 4, 5; Dijkstra, ed.; *8 American Masters of Watercolor;* Eliot; **Farnham;** Forerunners; Frost; Gallatin 1; Goodrich and Baur 1; Haftman; Hall; Hunter 6; Huyghe; *Index of 20th Century Artists;* Janis, S.; Jewell 2; Kootz 1, 2; Lane; Mather 1; McCoubrey 1; McCurdy, ed.; Murken-Altrogge; Murrell 1; Neuhaus; Phillips 2; Poore; Richardson, E.P.; Rigel, ed.; **Ritchie 2;** Rose, B., 1.; Rosenblum 1; Sachs; Sager; Schwartz 3; Soby 5; Sutton; Tashjian; Tomkins and Time-Life Books; Wight 2. Archives.

DENBY, JILLIAN b. February, 1944, NYC. **Studied:** Pratt Institute, 1971, BFA; Brooklyn College, 1973, MFA. **Traveled:** Rome, 1969-71; Virgin Islands, 1967; New Mexico, 1973-75. **Taught:** Illinois State U., 1975; Temple U., 1978. **Awards:** National Endowment for the Arts, 1985. **Address:** RD #3, Box 198, Greenwich, NY 12834. **One-man Exhibitions:** A. M. Sachs Gallery, NYC, 1974, 75, 77; Tyler School of Art, Philadelphia, 1978; Alexander F. Milliken, NYC, 1981; Tatistcheff & Co., NYC, 1985. **Group:** U. of Miami, Phase of New Realism, 1972; Hofstra U., The Male Nude,

1973; The Pennsylvania State U., Contemporary Artists and the Figure, 1974; U. of North Carolina, Art on Paper, 1974, 77; Lehigh U., American Figure Drawings, circ., 1976; U. of Missouri, Kansas City, The Opposite Sex: A Realistic Viewpoint, 1979; Utica, An Appreciation of Realism, 1982. **Collections:** Bank of New York; Chase Manhattan Bank; Reader's Digest; Roswell; Schenectady; Union College; Utica.

DE NIRO, ROBERT b. May 3, 1922, Syracuse, N.Y. **d.** May 3, 1993, New York, NY. **Studied:** Syracuse Museum School, 1935-39; Hofmann School, Provincetown, summers, 1939, 40; Black Mountain College, with Josef Albers. Traveled France; resided Paris. **Taught:** New School for Social Research, 1966-; School of Visual Arts, NYC, 1966-70; Buffalo/SUNY, summers, 1969, 70, 71; Wagner College, 1970, 71; Cooper Union, 1971-92; The Pennsylvania State U., 1973; Fine Arts Work Center, Provincetown, Mass., 1973; Michigan State U., 1974; New York Studio School, Paris, 1974; U. of California, Santa Cruz, 1979. **Awards:** V Hallmark International Competition; Longview Foundation Grant; Guggenheim Foundation Fellowship, 1968; Tamarind Institute Grant, 1974. **One-man Exhibitions:** (first) Art of This Century, NYC, 1946; Charles Egan Gallery, 1950, 52, 54; Poindexter Gallery, 1955, 56, 76; The Zabriskie Gallery, NYC, 1958, 60 (2), 62, 65, 67, 68, 70 (2); Ellison Gallery, Fort Worth (two-man), 1959; Buffalo/SUNY, 1967; Galleries Reese Palley, Atlantic City and San Francisco, 1968, 69; Bard College, 1969; Brenner Gallery, Provincetown, 1971; The Pennsylvania State U., 1973; Kansas City/AI, 1974; The Graham Gallery, NYC, 1979, 80, 82, 84, 86; Swain School of Design, New Bedford, Mass., 1979; Charles Campbell Gallery, San Francisco, 1978, 79; David Stuart Gallery, Los Angeles, 1978; Hobart College, 1980; Char-

lotte/Mint, 1981; Asheville Art Museum, 1981; Foster White Gallery, Seattle, 1981; David Hamilton Gallery, Charleston, S.C., 1983; St. Paul's School, Concord, 1984; Crane Kalman Gallery, London, 1986. **Group:** WMAA Annuals; Jewish Museum, The New York School, Second Generation, 1957; ICA, Boston, 100 Works on Paper, circ., Europe, 1959; U. of Nebraska, 1960; A.F.A., The Figure, circ., 1960; Felix Landau Gallery, Los Angeles-New York, 1960; Colorado Springs/FA Annual, 1961; MOMA, Recent Painting USA; The Figure, circ., 1962-63; Illinois Wesleyan U. Annual, 1962; New School for Social Research, Portraits from the American Art World, 1965; IEF, Twentieth Century American Drawings: The Figure in Context, 1984; Hudson River Museum, Form or Formula, 1986. **Collections:** Baltimore/MA; Brandeis U.; Brooklyn Museum; Charlotte/Mint; Corcoran; Hirshhorn; Houston/MFA; Longview Foundation; MMA; U. of North Carolina; Oakland/AM; Syracuse/Everson; Yellowstone Art Center. **Bibliography:** Cummings 4; Sandler 5. Archives.

DE RIVERA, JOSE b. September 18, 1904, West Baton Rouge, La. **d.** March 19, 1985, NYC. **Studied:** Studio School, Chicago, with John W. Norton, 1928-30. Traveled USA, Europe, Mediterranean, North Africa. Federal A.P.: Mural painting, 1937-38. US Army Air Corps, 1942-43. **Taught:** Brooklyn College, 1953; Yale U., 1954-55; North Carolina School of Design, Raleigh, 1957-60. **Member:** NIAL. **Commissions:** Cavalry Monument, El Paso, 1938-40; Newark Airport, 1938; Soviet Pavilion, New York World's Fair, 1939; Wm. Kaufman Inc., NYC, 1955; Hotel Statler-Hilton, Dallas, 1956; Moore-McCormack Lines Inc., SS *Argentina,* 1958; Reynolds Metals Co., 1958; City of Lansing, Mich. **Awards:** Chicago/AI, Watson F. Blair Prize, 1957; NIAL Grant, 1959; Hon. Ph.D., Washington U. **One-man Exhibitions:** Harvard U.

(two-man, with Burgoyne Diller), 1945; Mortimer Levit Gallery, NYC, 1946; Grace Borgenicht Gallery Inc., 1952, 56, 57, 58, 59, 60, 72, 78, 80, 85, 88; Walker, 1957. **Retrospective:** A.F.A./Ford Foundation, circ., 1961; La Jolla, 1972. **Group:** Chicago/AI, 1934; Brooklyn Museum, 1938; WMAA Annuals, 1938-78; MOMA, Twelve Americans, circ., 1956; Brussels World's Fair, 1958; American Painting and Sculpture, Moscow, 1959; MOMA, Recent Sculpture USA, 1959; Public Education Association, NYC, 1966; U. of New Mexico, 1966, Los Angeles/County MA, Sculpture of the Sixties, circ., 1967. **Collections:** The M. L. Annenberg Foundation; Brooklyn Museum; Chicago/AI; Des Moines; Fort Dodge/Blandend; Hirshhorn; La Jolla; Lembke Construction Co.; MMA; MOMA; Newark Museum; U. of New Mexico; U. of Pennsylvania; Purchase/SUNY; Ridgefield/Aldrich; U. of Rochester; SFMA; St. Louis/City; Smithsonian; Tate Gallery; Toronto; Utica; VMFA; WMAA. **Bibliography:** Baur 7; Brumme; Craven, W.; Flanagan; Gerdts; Goodrich and Baur 1; *Jose de Rivera;* Licht, F.; Marter, Tarbell, and Wechsler; McCurdy, ed.; Mendelowitz; Read 3; Rickey; Ritchie 1, 3; Rodman 3; Seuphor 3; Trier 1. Archives.

DESHAIES, ARTHUR
from 1st to 5th edition.

DEUTSCH, DAVID b. 1943, Los Angeles. **Studied:** UCLA, 1966, BA; California Institute of the Arts, 1968. **Address:** 225 West 13th Street, NYC 10011. **Dealer:** Blum Helman Gallery, NYC. **One-man Exhibitions:** Michael Walls Gallery, Los Angeles, 1972; Gagosian/Nosei-Weber Gallery, NYC, 1980; 112 Greene Street, NYC, 1980; Annina Nosei Gallery, NYC, 1981, 82; MIT, 1983; Gallery 5, Stockholm, 1984; Blum Helman Gallery, NYC, 1985, 87, 89; Massimo Audiello Gallery, NYC, 1987; Galerie Montenay, Paris, 1988. **Group:** Pomona College, Six

Attitudes, 1969; La Jolla, Projections: Anti-materialism, 1970; Kassel, Documenta V, 1972; MIT, Great Big Drawings, 1982; XL Venice Biennial, 1982; Newport Beach, Shift-L.A./N.Y., 1982; MOMA, International Survey of Recent Painting and Sculpture, 1984; Hudson River Museum, New Vistas, 1984; Museo Tamayo, Mexico City, El Arte Narrativo, circ., 1984; Kunsthalle/Tubigen, 7000 Eichen, 1985; Youngstown/Butler, Mid-year Exhibition, 1986; Cincinnati/AM, New Vision, circ., 1986; Marquette U., Romanticism and Cynicism in Contemporary Art, 1986; Carnegie Mellon U., Drawings from the Eighties, 1987; Dayton/AI, A Certain Slant of Light, 1989; The Art Gallery of Western Australia, Perth, Romance and Irony—Recent Painting in New York, circ., 1990; VMFA, Harmony and Discord, 1990. **Collections:** Boston/MFA; Brooklyn Museum; Cincinnati/AM; Los Angeles/County MA; MOMA; Mexico City/Tamayo; Phoenix; Walker.

DICKINSON, EDWIN b. October 11, 1891, Seneca Falls, N.Y. d. December 2, 1978, Orleans, Mass. **Studied:** Pratt Institute, 1910-11; ASL, 1911-12, with William M. Chase; Provincetown, summers, 1912, 13, 14, with C. W. Hawthorne. US Navy, 1917-19. Traveled Europe, Near East, North Africa, Greece. **Taught:** Buffalo Fine Arts Academy, 1916, 39; ASL, 1922-23, 1944-66; Provincetown Art Association, 1929-30; Stuart School, Boston, 1940-41; Association of Art and Music, Cape Cod, 1941; Cooper Union, 1945-49; Midtown School, NYC, 1946-47; Brooklyn Museum School, 1946-47; Pratt Institute, 1950-58; Dennis Foundation, Dennis, Mass., 1951; Skowhegan School, 1956, 58; Cornell U., 1957; Boston U., 1961. **Member:** NAD, 1948; NIAL; AAAL; Audubon Artists; The Patteran Society. Federal A.P.: Easel painting, 1934. **Awards:** NAD, Benjamin Altman Prize, 1929, 58; Benjamin West Medal; NAD, First Prize, 1949; Century

Edwin Dickinson, *Sandra,* 1947.

Association, Medal; NIAL Grant, 1954; Brandeis U., Creative Arts Medal, 1959; Ford Foundation Grant, 1959. **One-man Exhibitions:** (first) Buffalo/Albright, 1927, 77; Worcester/AM, Boston/MFA; Houston/MFA; U. of Rochester; Cornell U.; Provincetown/Chrysler; Passedoit Gallery, NYC, 1939; Wood Memorial Gallery, Provincetown, 1939; Wellesley College, 1940; Nantucket Museum, 1943; Cushman Gallery, Houston, 1958; MOMA (circ. only), 1961; The Graham Gallery, NYC, 1961, 65, 68, 72, 86; Kansas City/Nelson, 1964 (two-man, with Lennart Anderson); Peale House, Philadelphia, 1966; Katonah (N.Y.) Art Gallery, 1966; Gilman Galleries, Chicago, 1966; Provincetown Art Association, 1967; Bristol (R.I.) Art Museum, 1970; Pratt Manhattan Center, 1970; Wellfleet (Mass.) Art Gallery, 1970, 75; Cape Cod Conservatory, Barnstable, 1970, 74; ICA, Boston, 1970; Wellfleet (Mass.) Historical Society, 1972; Hammelbacker Gallery, Nashville, 1975; Provincetown Art Association, 1976; Buffalo/SUNY, Burchfield Center, circ., 1977; Hirschl and Adler Modern, NYC, 1983, 86; Babcock Galleries, NYC,

1990. **Retrospective:** Boston U., 1958; WMAA, 1965; NAD, 1982. **Group:** MOMA, Fifteen Americans, circ., 1952; WMAA; Brooklyn Museum; Boston/MFA; PMA; PAFA; Carnegie; U. of Rochester; XXXIV Venice Biennial, 1968; Buffalo/Albright, The Wayward Muse, 1987; de Young, View Points VII, 1989; NAD, 1989. **Collections:** Atlanta/AA; Bowdoin College; Brooklyn Museum; Buffalo/Albright; Chicago/AI; Cornell U.; Hirshhorn; MMA; MOMA; Montpelier/Wood; NAD; U. of Nebraska; Sara Roby Foundation; Springfield, Mass./MFA; Syracuse U.; Yale U. **Bibliography:** *America 1976;* Cummings 5; Goodrich 2, 5; Goodrich and Baur 1; Haftman; Kuh 2; McCurdy, ed.; Mellquist; Nordness, ed.; Plagens; Pousette-Dart, ed.; Rose, B., 1; Soyer, R., 1; Vine and Hales; Ward. Archives.

DIEBENKORN, RICHARD

b. April 22, 1922, Portland, Ore.
d. March 30, 1993, Berkeley, Calif.
Studied: Stanford U., 1940-43; U. of California, Berkeley, 1943-44; CSFA, 1946; Stanford U., 1949, BA; U. of New Mexico, 1952, MA. US Marines, 1943-45. Traveled USSR. **Taught:** U. of Illinois, 1952-53; California College of Arts and Crafts, 1955-57; SFAI, 1959-63; Stanford U., 1963-64; UCLA, 1966-73; U. of Colorado; U. of California at Los Angeles, 1966-73. **Member:** National Council on the Arts, 1966-69; AAIAL, 1985. **Awards:** CSFA, Albert M. Bender Fellowship, 1946; Rosenberg Traveling Fellowship, 1959; Olivet College, P.P.; NIAL, 1962; PAFA, Gold Medal, 1968; Skowhegan School, Medal for Painting, 1979; MacDowell Colony Medal, 1978; National Endowment for the Arts, National Medal of the Arts, 1991. **One-man Exhibitions:** (first) California Palace, 1948, also 1960; U. of New Mexico, 1951; Paul Kantor Gallery, 1952, 54; SFMA, 1954, 73; Allan Frumkin Gallery, Chicago, 1954; Poindexter Gallery, 1955, 58, 61, 63, 66, 68; Phil-

lips, 1958, 61; de Young, 1963; Stanford U., 1964; Pavilion Art Gallery, Newport Beach, Calif., 1965; Waddington Galleries, London, 1965, 67; U. of Washington, 1967; Kansas City/Nelson, 1968; RAC, 1968; Los Angeles/County MA, 1969; Irving Blum Gallery, Los Angeles, 1971; Marlborough Gallery, Inc., NYC, 1971, 74; James Corcoran Galleries, Los Angeles, 1975; John Berggruen Gallery, San Francisco, 1975, 83; UCLA, 1976; M. Knoedler & Co. Inc., NYC, 1977, 79, 82, 84, 85, 87, 91; U. of California, Berkeley, 1981, 90; Marlborough Gallery, 1981; Crown Point Gallery, Oakland, 1982; Brooklyn Museum, 1982; L. A. Louver Gallery, Venice, Calif., 1984; U. of Nebraska, 1985; Patricia Heesy Gallery, NYC, 1985; Greg Kucera Gallery, Seattle, 1985, 86; Crown Point Press, NYC, 1986, 88; Pamela Auchincloss Gallery, NYC, 1988; Hara Museum, Tokyo, 1989; Yellowstone Art Center, Billings, Montana, 1990; Associated American Artists, NYC, 1991; Whitechapel Art Gallery, London, circ., 1991. **Retrospectives:** Pasadena/AM, 1960; WGMA, 1964; Jewish Museum, 1964; UCLA, circ., 1976; Minneapolis/Institute, circ., 1981; SFMA, 1983; MOMA, circ., 1988. **Group:** SRGM, Younger American Painters, 1954; WMAA Annuals, 1955, 58, 61; Carnegie, 1955, 58, 61, 70; IV São Paulo Biennial, 1957; Brussels World's Fair, 1958; MOMA, New Images of Man, 1959; Tate, Paintings and Sculpture of a Decade, 1964; Edinburgh/National, Two American Painters: Sam Francis and Richard Diebenkorn, 1965; WMAA, Art of the United States: 1670-1966, 1966; XXIV Venice Biennial, 1968, 78; SFMA, Untitled 1968, 1968; Eindhoven, Kompas IV, 1969-70; Omaha/Joslyn, Looking West, 1970; Boston U., Drawings: Elmer Bischoff and Richard Diebenkorn, 1974; Oakland/AM, California Landscape, 1975; Corcoran Biennial, 1975; PAFA, Young Americans, 1975; Newport Harbor, The Last Time I Saw Ferus, 1976; Buffalo/Albright, Ameri-

can Paintings of the 1970's, 1978; Brooklyn Museum, American Drawings in Black and White: 1970-1979, 1981; Corcoran Biennial, 1981; Long Beach/MA, Drawings by Painters, 1982; Hirshhorn, Drawing 1974-1984, 1984; NYU, The Figurative Mode: Bay Area Painting, 1956-1966, 1984; IEF, Twentieth Century American Drawings: The Figure in Context, circ., 1984; Houston/Contemporary, American Still Life, 1945-1983, 1983; Oakland/AM, Art in the San Francisco Bay Area, 1945-1980, 1985; MOMA, Contrasts of Form: Geometric Abstract Art 1910-1980, 1985; U. of Southern California, Sunshine and Shadow, 1985; Independent Curators Inc., NYC, After Matisse, circ., 1986; Los Angeles/MOCA, Individuals, 1986; Harvard U., California Light, 1988; Dartmouth, Minimalism and Post-Minimalism, 1990. **Collections:** Albany/SUNY; U. of Arkansas; Baltimore/MA; Brooklyn Museum; Buffalo/Albright; California Palace; U. of California, Berkeley; Carnegie; Chicago/AI; Cincinnati/AM; Cleveland/MA; Colorado Springs; U. of Connecticut; Corcoran; Des Moines; Fort Worth; Grand Rapids; Hirshhorn; Houston/MFA; U. of Iowa; Kansas City/Nelson; Little Rock/MFA; Los Angeles/County MA; U. of Michigan; MMA; MOMA; U. of Nebraska; U. of New Mexico; Norfolk/Chrysler; Oklahoma; Oakland/AM; Oberlin College; Olivet College; PAFA; Pasadena/AM; Phillips; Phoenix; Purchase/SUNY; Raleigh/NCMA; Reader's Digest; SFMA; SRGM; Santa Barbara/MA; Skidmore College; Stanford U.; Toronto; WMAA; Washington U.; Witte. **Bibliography:** Armstrong, Thomas; Arthur 2; Blesh 1; Cummings 4, 5; Geske; Gettings; Hughes; *Individuals;* Johnson; Mendelowitz; Murken-Altrogge; Neumeyer; Nordness, ed.; Plagens; Read 2; Robins; Rose, B., 1; *Richard Diebenkorn;* Sandler 5; Ward.

DILL, LADDIE JOHN b. September 14, 1943, Long Beach, Calif.

Studied: Chouinard Art Institute, Los Angeles, 1968, BA, with M. Kanemitsu, E. Woelffer, R. Irwin. Traveled Europe, South Seas, Mexico, and Central America. **Taught:** U. of California, Irvine, 1974; UCLA, 1975-88. **Awards:** National Endowment for the Arts, 1975, 82; Guggenheim Foundation Fellowship, 1979; California Arts Council, Art in Public Building Grant, 1983. **Address:** 1625 Electric Avenue, Venice, Calif. 90291. **One-man Exhibitions:** (first) Ileana Sonnabend Gallery, NYC, 1971, 72; Pasadena/AM, 1971; Portland State U., 1971; The Morgan Gallery, Shawnee Mission, Kans., 1972; Mizuno Gallery, Los Angeles, 1973; James Corcoran Gallery, Los Angeles, 1974, 75, 77, 78, 79, 82, 83, 86; Douglas Drake Gallery, Kansas City, 1975, 78; Kansas State U., 1976; Dootson Calderhead Gallery, Seattle, 1976; Seder/Creigh Gallery, Coronado, 1976; Dobrick Gallery, Chicago, 1976, 78; Grapestake Gallery, San Francisco, 1977, 81; Landfall Press, Chicago, 1978; California Institute of Technology, Pasadena, 1978; Linda Farris Gallery, Seattle, 1980, 82, 84, 90; Osuna Gallery, Washington, D.C., 1980; Charles Cowles Gallery, NYC, 1981, 83, 86; Thomas Babeor Gallery, La Jolla, 1981, 83, 85, 88; Landfall Press Gallery, Chicago, 1981; U. of Redlands, 1981; Zolla Lieberman, Chicago, 1981, 84; ICA, Los Angeles, 1982; California State U., Long Beach, 1983; West Beach Cafe, Los Angeles, 1983; Fuller Goldeen Gallery, San Francisco, 1984, 87; Ochi Gallery, Boise, 1984, 88; San Jose State U., 1985; Cirrus Gallery, Los Angeles, 1986; Site 311, Pacific Grove, Calif., 1987; Santa Monica Heritage Museum, 1987; Sun Gallery, Seoul, Korea, 1988, 89; Mixografia Gallery, Santa Monica, 1988, 89; Galeria Joan Prats, NYC, 1988; Gensler & Assoc., Los Angeles, 1988; Smith-Anderson Gallery, Palo Alto, Calif., 1989; Cypress College, 1989; Persons & Lindell Gallery, Helsinki, 1989; Christopher Grimes Gallery, Carmel,

1989; Crossroads School for the Arts and Sciences, Santa Monica, 1990; Ernie Wolfe Gallery, Los Angeles, 1991. **Retrospectives:** California Institute of Technology, 1978; Long Beach/MA, 1986. **Group:** California State U., Los Angeles, Venice, California, 70, 1970; Los Angeles/County MA, 24 Young Los Angeles Artists 1971; Walker, Works for New Spaces, 1971; Govett-Brewster Art Gallery, New Plymouth, N.Z., The State of California Painting, 1972; California State U., Fullerton, Guy Dill/Laddie John Dill, 1972; Webster College, St. Louis, Some California Artists, 1973; Santa Barbara/MA, 15 Abstract Artists, 1974; Scripps College, Claremont, Light, 1974; Newport Harbor/Art Museum, Modern and Contemporary Sculptures, 1975; Brandeis U., Three California Painters, 1975; SFMA, Painting and Sculpture in California; The Modern Era, 1976; Kansas City/AI, Spectrum 77, 1977; Indianapolis, 1978; Buffalo/Albright, Painting of the Seventies, 1979; Sacramento/Crocker, Aspects of Abstraction, 1979; AAAL, 1979; Municipal Art Gallery, Los Angeles, It's All Called Painting, 1980; La Jolla, Artists Quilts: Quilts by Ten Artists, 1981; Houston/Contemporary, The Americans: The Collage, 1982; Paris/Moderne, Echange entre artistes, 1931-1982, Pologne-USA, 1982; Corcoran, Second Western States Exhibition, 1983; Palo Alto (Calif.) Cultural Center, Unity of Opposites: Art About Architecture, 1985; Stanford U., The Anderson Collection: Two Decades of American Graphics, 1967-1987, 1987; Madison Art Center, Coming of Age, 1989. **Collections:** Chicago/AI; Corcoran; Greenville; Humlebaek/Louisiana; Kansas City/Nelson; Laguna Beach Museum of Art; Los Angeles/County MA; Los Angeles/MOCA; Miami-Dade; Newport Harbor; Oakland Museum; Phillips; Phoenix; SFMA; San Diego; Santa Barbara/MA; São Paolo/Contemporanea; Seattle/AM; Norton Simon Museum. **Bibliography:** *California Sculpture Show.*

DILLER, BURGOYNE **b.** 1906, NYC. **d.** January 30, 1964, NYC. **Studied:** Michigan State College; ASL. US Navy, World War II. **Taught:** Brooklyn College, 1945-64; Pratt Institute, 1945-64. **Member:** American Abstract Artists. Federal A.P.: Head, Mural Division, 1935-40; Assistant Technical Director, New York Art Project, 1940-41; Director, New York Art Project, 1940-41; Director, New York City Art Section, 1939-42. **Awards:** Ford Foundation, P.P., 1963. **One-man Exhibitions:** Harvard U., 1945 (two-man, with Jose de Rivera); The Pinacotheca, NYC, 1946; Galerie Chalette, 1961, 64; Goldowsky Gallery, 1968, 72; Los Angeles/County MA, 1968; Washburn Gallery, Inc., NYC, 1978; Meredith Long Gallery, Houston, 1979, 84, 89; Meredith Long Contemporary, NYC, 1979; André Emmerich Gallery, NYC, 1981, 84, 86; Margo Leavin Gallery, Los Angeles, 1987; Harcourts Contemporary, San Francisco, 1988. **Retrospectives:** Trenton/State, 1966; Walker, circ., 1971. **Group:** American Abstract Artists Annuals to 1940; WMAA, Geometric Abstraction in America, circ., 1962; VII São Paulo Biennial, 1963; Corcoran, 1963; WMAA, 1964; SFMA, Colorists 1950-1965, 1965; SRGM, Guggenheim International, 1967; WMAA, The 1930s, 1968; MMA, New York Painting and Sculpture: 1940-1970, 1969-70; U. of New Mexico, America Abstract Artists, 1977; Yale U., Mondrian and Neoplasticism in America, 1979; Walker, De Stijl, 1917-1931: Visions of Utopia, circ., 1982; Haus der Kunst, Munich, Amerikanisch Malerei: 1930-1980, 1982; Houston/Contemporary, The Americans: The Collage, 1982; Carnegie, Abstract Painting and Sculpture in America, 1927-1944, 1983; Independent Curators, Inc., NYC, Concepts in Construction: 1910-1980, circ., 1983-85; Bennington, Crossovers: Artists in Two Mediums, 1985; MOMA, Contrasts of Form, Geometric Abstract Art, 1910-1980, 1985; Paris/Beaubourg, Qu'est-ce

que la sculpture moderne?, 1986; Kunstmuseum, St. Gallen, Red Yellow Blue, 1988. **Collections:** Baltimore/MA; Buffalo/Albright; Chicago/AI; Chicago/Contemporary; Corcoran; The Hague; Hirshhorn; Little Rock/MFA; MMA; MOMA; Milwaukee; NYU; Newark Museum; SRGM; Springfield, Mass./MFA; Trenton/State; WMAA; Yale U. **Bibliography:** Armstrong, Thomas; Blesh 1; Brown 2; Cummings 5; Gerdts; Hess, T.B., 1; Janis and Blesh, 1; Janis, S.; Lane and Larsen; **Larson;** MacAgy 2; McCurdy, ed.; Marter, Tarbell, and Wechsler; Rickey; Ritchie 1; Rose, B., 1, 4; Seuphor 1, 3; Toher, ed. Archives.

DINE, JIM b. June 16, 1935, Cincinnati, Ohio. **Studied:** U. of Cincinnati; Boston Museum School; Ohio U., 1957, BFA, and 1958. **Taught:** Cornell U., 1966; Dartmouth College, 1975. An early creator of Happenings and Environments. Subject of a 16mm. sound film, *Jim Dine,* directed by Lane Slate, produced by National Educational Television; Subject of film, *Jim Dine,* 16mm., 28 min., produced by Blackwood Productions, Inc. Resided London, 1966-1971. **Commissions:** Set and costumes for *A Midsummer Night's Dream* for Actor's Workshop, San Francisco, 1965; Interiors for Biltmore Hotel, Los Angeles, 1975; Humlebaek/Louisiana, Library, 1982; Papas Companies, White Plains, NY, 1984; John Nuveen & Co., Chicago, mural, 1985; sets and costumes for *Salomé,* Houston Grand Opera, 1986; Bulfinch Triangle, Boston, sculpture, 1987; Centennial Plaza, Cincinnati, sculpture, 1988; 1301 Avenue of the Americas, NYC, sculpture, 1989; Broadgate, London, sculpture, 1989; Seibu Department Store, Tokyo, painting, 1989. **Member:** AAIAL. **Address:** 90 Prince Street, NYC 10012. **Dealer:** The Pace Gallery, NYC. **One-man Exhibitions:** Judson Gallery, NYC, 1959 (two-man, with Claes Oldenburg); Reuben Gallery, NYC, 1959 (two-man, with Oldenburg); Reuben

Gallery, NYC, 1960; Martha Jackson Gallery, 1952; Galleria dell'Ariete, 1962; Ileana Sonnabend Gallery, Paris, 1963, 69, 72, 75, NYC, 71, 73, 74; Brussels/Beaux-Arts, 1963, 70; Sidney Janis Gallery, 1963, 64, 67; Galleria Sperone, Turin, 1965; Oberlin College, 1965; Robert Fraser Gallery, London, 1965, 66, 69; Galerie Rolf Ricke, Kassel, 1967; Galerie Rudolf Zwirner, 1967; The Gallery Upstairs, Buffalo, 1967; Harcus-Krakow Gallery, 1967; Toronto, circ., 1967 (three-man, with Oldenburg, George Segal); MOMA, Jim Dine Designs for "A Midsummer Night's Dream," 1967; Amsterdam/Stedelijk, 1967; Cornell U., 1967; MOMA, 1969; Dunkelman Gallery, Toronto, 1970; Turin/Civico, 1970; Düsseldorf/Kunsthalle, 1970; Hannover/K-G, 1970; Rotterdam, 1970; Berlin Festival, 1970; Gimpel & Hanover, Gallery, 1972; Aronson Gallery, Atlanta, Ga., 1972; Modern Art Agency, Naples, 1972; Gimpel Fils, 1973; D. M. Gallery, London, 1973; Felicity Samuel Gallery, London, 1973; Galerie Sonnabend, Geneva, 1974; La Jolla, 1974; Dartmouth College, 1974; Petersburg Press, NYC, 1974; Centre d'Arts Plastiques Contemporains, Bordeaux, 1975; Gian Enzo Sperone, Rome, 1975; Williams College, 1976; The Pace Gallery, NYC, 1977, 78, 80, 81, 84, 86, 88, 90, 91; Waddington, Tooth Galleries II, London, 1977; Makler Gallery, Philadelphia, 1978; The Pace Gallery, Columbus, 1978; MOMA, 1978; Katonah Gallery, Katonah (N.Y.) 1979; Galerie Claude Bernard, Paris, 1979; California State U., Long Beach, circ., 1979; Galerie Alice Pauli, Lausanne, 1980, 86; Janie C. Lee Gallery, Houston, 1980; Harcus-Krakow Gallery, Boston, 1980; Pace Gallery, Columbus, 1981; Galerie Isy Brachot, Brussels, 1981; Waddington Galleries, London, 1981, 89; Richard Gray Gallery, Chicago, 1983, 85; Los Angeles/County MA, 1983; John Berggruen Gallery, San Francisco, 1984; Barbara Krakow Gallery, Boston, 1984; Fay Gold Gallery, Atlanta, 1984; Cantor

Lemberg Gallery, Detroit, 1984; Thorden Wetterling Galleries, Goteborg, 1984; Toni Birckhead Gallery, Cincinnati, 1985; Galerie Kaj Forsblom, Helsinki, 1986; Fuji Television Gallery, Tokyo, 1986; Galerie Baudoin-Lebon, Paris, 1986; Museo d'Arte Moderna Ca-Pesaro, Venice, 1988; Cincinnati/Contemporary, circ., 1988; Graphische Sammlung Albertina, Vienna, 1989; Glyptothek, Munich, circ., 1990; Joanne Chappell Gallery, San Francisco, 1990; Augun Gallery, Portland, Ore., 1990; Blum-Helman Gallery, Santa Monica, 1990; Erika Meyerovich Gallery, San Francisco, 1990; Spark Gallery, Tokyo, 1990; Isetan Museum, Tokyo, circ., 1990; Beaubourg/Paris, 1991. **Retrospectives:** WMAA, circ., 1970; Walker, circ., 1984; Wesleyan U., circ., 1986. **Happenings:** Judson Gallery, NYC, The Smiling Workman, 1959; Reuben Gallery, NYC, Car Crash, 1960; Jim Dine's Vaudeville, 1960, The Shining Bed, 1960; First New York Theatre Rally, NYC, Natural History (The Dreams), 1965. **Group:** Cornell U., Young Americans, 1960; Martha Jackson Gallery, New Media—New Forms I, 1960; USIA Gallery, London, Modern American Painting, 1961; Dallas/MFA, "1961," 1961; Sidney Janis Gallery, The New Realists, 1962; Philadelphia YM-YWHA Arts Council, Art, A New Vocabulary, 1962; Pasadena/AM, New Paintings of Common Objects, 1962; International Biennial Exhibition of Paintings, Tokyo; SRGM, Six Painters and the Object, circ., 1963; Houston/MFA, Pop Goes the Easel, 1963; WGMA, The Popular Image, 1963; ICA, London, The Popular Image, 1963; Buffalo/Albright, 1963; Cincinnati/AM, An American Viewpoint, 1963; Jewish Museum, Black and White, 1963; Hartford/Wadsworth, Black, White and Gray, 1964; Tate, Gulbenkian International, 1964; Chicago/AI, 1964, 69; Milwaukee, Popular Art and the American Tradition, 1965; Worcester/AM, New American Realism, 1965; WMAA, A Decade of American Drawings, 1965; WMAA, Art of the U.S.

1670-1966, 1966; Dublin/Municipal, I International Quadrennial (ROSC), 1967; Expo '67, Montreal, U.S. Pavilion, 1967; Honolulu Academy, Signals of the 60's, 1967; Corcoran Annual, 1967; Kassel, Documenta IV, 1968; Hayward Gallery, London, 1969; Cincinnati/AM, 1973; WMAA, American Drawings: 1963-1973, 1973; Musée Galliera, Paris, Festival d'Automne, 1973; Parcheggio di Villa Borghese, Contemporanea, 1974; Dallas/MFA, Poets of the Cities, 1974; Moore College of Art, Philadelphia, 1975; Hayward Gallery, London, The Human Clay, 1976; Kassel, Documenta VI, 1977; Chicago/AI, Drawings of the 70's, 1977; U. of North Carolina, Drawings about Drawing, 1979; SFMA, Twenty American Artists, 1980; WMAA, Blam!, 1984; Cincinnati/Contemporary, Body and Soul, circ., 1985; Milwaukee, Contemporary American Stage Design, 1987; Boston/MFA, 10 Painters and Sculptors Draw, 1988; U. of Arkansas, The Face, 1988; MOMA, Painters for the Theatre, 1989; Fairfield U., Defining Modernism, 1990; Fort Lauderdale, 20th Century Flower Painting, 1991; Guild Hall, Aspects of Collage, 1991; Royal Academy, London, The Pop Art School, 1991; WMAA, American Life in American Art, 1991. **Collections:** Amsterdam/Stedelijk; Ball State U.; Baltimore/MA; Boston/MFA; Brandeis U.; Brooklyn Museum; Buffalo/Albright; Carnegie; Chicago/AI; Chicago/Contemporary; Cincinnati/AM; Cleveland/MA; Dallas/MFA; Dayton/AI; Detroit/Institute; Eindhoven; Harvard U.; Graphische Sammlung Albertina; High Museum; Hirshhorn; Indiana U.; Indianapolis; Jewish Museum; Los Angeles/County MA; La Jolla; MMA; MOMA; NCFA; New Orleans Museum; NYU; Oberlin College; Ohio U.; Paris/Beaubourg; Princeton U.; RISD; SRGM; Stockholm/National; St. Louis/City; Tate; Toronto; VMFA; WGMA; WMAA; Walker; Art Gallery of Western Australia, Perth; Williams College; Worcester; Woodward Founda-

tion; Yale U. **Bibliography:** Allen, V.;
Alloway 1, 4; Armstrong, Thomas;
Ashbery; Battcock, ed.; Becker and Vostell;
Bihalji-Merin; Calas, N. and E.; *Celebrate
Ohio; Contemporanea;* Dench and
Feinberg; De Salvo and Schimmel;
De Wilde 2; Diamonstein; Dienst 1;
Europa/Amerika; Finch; Gettings; **Glenn;**
Goldman 1; Hansen; *Happening & Fluxus;*
Haskell 5; Honisch and Jensen, eds.;
Hunter, ed.; Janis and Blesh 1; Johnson,
Ellen H.; Kaprow; Kirby; Kozloff 3;
Lippard 5; *Metro;* Osterwold; Rose,
Barbara 1; Rubin 1; *Poets & Painters;*
Russell and Gablik; Sager; Sandler 3, 5;
Seitz 3; Sontag; Tomkins 2; Tomkins and
Time-Life Books; Waldman 4.

DI SUVERO, MARK **b.** September 18, 1933, Shanghai, China. To USA, 1941.

Studied: California School of Fine
Arts, 1953-54; U. of California, Santa Bar-
bara, 1954-55, with Robert Thomas; U.
of California, Berkeley, BA in Philosophy,
1956, with Stephen Novak. Traveled
USA, Mexico. **Awards:** Longview Founda-
tion Grant; Walter K. Gutman Founda-
tion Grant; Chicago/AI, 1963; National
Endowment for the Arts, grant; Brandeis
U., Creative Arts Award; Skowhegan
School Award for Sculpture. **Address:**
P.O. Box 2128, Long Island City, N.Y.
11102. **Dealer:** Oil & Steel Gallery, Long
Island City, N.Y. **One-man Exhibitions:**
(first) Green Gallery, NYC, 1960; Dwan
Gallery, Los Angeles, 1965; Park Place
Gallery, NYC, 1966; Goldowsky Gallery,
1968; Lo Guidice Gallery, Chicago, 1968;
Eindhoven, 1972; Duisburg, 1972; City
of Chalon-sur-Saone, 1973; Le Jardin des
Tuileries, Paris, 1975; Janie C. Lee Gal-
lery, Houston, 1978; ConStruct Gallery,
Chicago, 1979; Oil & Steel Gallery, 1983,
85, 87; Esprit Park, San Francisco, 1983;
Storm King Art Center, 1985; Hill Gal-
lery, Birmingham, Mich., 1986; Akira
Akida Gallery, Tokyo, 1987; Kunstverein,
Stuttgart, 1988; Valence, France, 1990;
Galerie de France, Paris, 1990; L.A. Lou-
ver, Venice, Calif., 1990. **Retrospective:**
WMAA, 1975. **Group:** Hartford/Wads-
worth, Continuity and Change, 1962;
March Gallery, NYC (three-man); Chi-
cago/AI, 1963; 79 Park Place Gallery,
NYC, 1963, 64; Peace Tower, Los Ange-
les, 1966; Los Angeles/County MA, Amer-
ican Sculpture of the Sixties, 1967;
WMAA, 1966, 67, 68, 70; SFMA, 1969;
MMA, New York Painting and Sculpture:
1940-1970, 1969-1970; Cincinnati/Con-
temporary, Monumental Art, 1970;
Walker, Works for New Spaces, 1971;
WMAA, American Drawings: 1963-1973,
1973; Seattle/AM, American Art—Third
Quarter Century, 1973; Vassar College,
Contemporary College, 1974; Venice Bi-
ennial, 1975; SFMA, California Painting
and Sculpture: The Modern Era, 1976;
Fine Arts Gallery, San Diego, Drawing
Invitational, 1977; U. of Chicago, Ideas in
Sculpture, 1977; Hayward Gallery, Lon-
don, The Condition of Sculpture, 1975;
Akron/AM, Project/New Urban Move-
ments, 1977; WWAA, American Sculp-
ture, 1980; Nassau County Museum,
Sculpture: The Tradition in Steel, 1983;
Los Angeles/MOCA, The First Show,
1984; Toledo/MA, 3D Sculpture: New
York School, 1984; WMAA, The Third
Dimension, 1985; Fort Lauderdale, An
American Renaissance, 1986; AAIAL,
1989; Newport Harbor, 2nd Newport Bi-
ennial, 1989; SRGM, Aspects of Collage,
1988; Williams College, BIGlittle Sculp-
ture, 1988. **Collections:** Baylor U. Medi-
cal Center; Chicago/AI; Cincinnati/AM;
City of Chalon-sur-Saone; City of To-
ronto; Dallas/MFA; Federal Reserve Bank,
Dade County, Fla.; Hartford/Wadsworth;
Hirshhorn; Honeywell Corp., Minneapo-
lis; U. of Iowa; Los Angeles/County MA;
Los Angeles/MOCA; MIT; Muhlenberg
College; NYU; U. of Nebraska; Rijks-
museum Kröller-Müller; RISD; St.
Louis/City; Storm King Art Center;
Toledo/MA; WMAA; Walker; Western
Washington State College. **Bibliography:**
Battcock, ed.; Hunter, ed.; *Individuals;*

Krauss 2; Phillips, Lisa, 2; MacAgy 2; *Report;* Rose, B., 1; Rowell; Sandler 3, 5; Seitz 3; Tuchman 1.

DOBKIN, ALEXANDER
from 1st to 5th edition.

DODD, LAMAR b. September 22, 1909, Fairburn, Ga. **Studied:** Georgia Institute of Technology, 1926-27; ASL, 1929-33, with George Luks, Boardman Robinson, John Steuart Curry, Jean Charlot, George Bridgeman. Traveled USA, Europe. **Taught:** Five Points, Ala., 1927-28; U. of Georgia, 1937-76, emeritus, 1976-. **Member:** NAD; Audubon Artists. Federal A.P.: Easel painting. **Awards:** Chicago/AI, 1936; Pepsi-Cola, 1947, 48; LHD, LaGrange College, 1947; VMFA, Virginia Artists Biennial, P.P., 1948; NIAL Grant, 1950; NAD, Edwin Palmer Memorial Prize, 1953; PAFA, P.P., 1958; WMAA, P.P., 1958; DFA, U. of Chattanooga, 1959; DFA, Florida State U., 1968. **Address:** 590 Springdale, Athens, GA 30606. **One-man Exhibitions:** (first) Ferargil Galleries, NYC, 1933; Columbia, S.C./MA, 1961; LaGrange College, Ga., 1964, 78; College of St. Catherine, 1964; Grand Central Modern, NYC, 1948, 52, 55, 57, 61, 64, 65, 67, 68; U. of Georgia, 1969; Clemson U. 1972; Georgia Southern College, 1977; Fischbach Gallery, NYC, 1986, 88, 90, 92; Anne Weber Gallery, Georgetown, Me., 1987; Caldbeck Gallery, Rockland, Md., 1990; Dartmouth College, 1990. **Retrospective:** High Museum, 1970; U. of Georgia, circ., 1971; Columbia, S.C., 1954. **Group:** U. of Nebraska; PAFA; NIAL; Audubon Artists; Chicago/AI; Corcoran; Boston/MFA; NAD; U. of Illinois; Santa Barbara/MA; Carnegie, 1936; WMAA Annuals, 1937-57; Golden Gate International Exposition, San Francisco, 1939; New York World's Fair, 1939; AAIAL, 1986, 90; NAD, 1987, 90; Colby College, Vision and Tradition, 1988. **Collections:** Andover/Phillips; Atlanta/AA; Chicago/AI; CIT Corporation; Cranbrook; High Museum; U. of Georgia; IBM; Kalamazoo/Institute; MMA; Montclair/AM; Montgomery Museum; NAD; PAFA; Pepsi-Cola Co.; U. of Rochester; Rockland/Farnsworth; Savannah/Telfair; VMFA; WMAA; Wilmington. **Bibliography:** Baur 7; Bethers; Cheney; Wheeler. Archives.

DODD, LOIS b. April 22, 1927, Montclair, N.J. **Studied:** Cooper Union, with Byron Thomas, Peter Busa. Traveled Italy, France, Switzerland. **Taught:** Philadelphia College of Art, 1963, 65; Wagner College, 1963-64; Brooklyn College, 1965-69, 1971-. A co-founder of the Tanager Gallery, NYC. **Member:** Board of Governors, Skowhegan School; NAD. **Commissions:** New York Hilton Hotel (lithographs). **Awards:** Italian Government Scholarship, 1959-60; Longview Foundation Grant, 1962; Ingram Merrill Foundation Grant, 1971; AAIAL, award, 1986; AAIAL, Hassam P.P., 1991; NAD, Leonilda S. Gervase Award, 1987; Cooper Union, Distinguished Alumni Award, 1987. **Address:** 30 East Second Street, NYC 10003. **Dealer:** Fischbach Gallery, NYC. **One-man Exhibitions:** (first) Tanager Gallery, NYC, 1954, also 1957, 58, 61, 62; Purdue U., 1965; Ithaca College, 1966; Wilmington, 1967; Green Mountain Gallery, 1969, 70, 71, 74, 76; Colby College, Waterville, Me., 1977; Washington (Conn.) Art Association, 1977; Cape Split Place, Addison, Me., 1977, 83; Fischbach Gallery, NYC, 1978, 82, 86, 88, 90, 92; New London, 1980; Trenton/State, 1981; Louisiana State U., Baton Rouge, 1984; Anne Weber Gallery, Georgetown, Me., 1987; Caldbeck Gallery, Rockland, Me., 1990; Dartmouth College, 1990. **Retrospective:** Cape Split Place, circ., 1979. **Group:** The Stable Gallery Annuals, 1956, 58; USIA, Americans in Rome, Rome, 1960; U. of Kentucky, Drawings, 1961; Yale U., Drawings and Watercolors, 1964; A.F.A., Painterly Realism, 1970; U. of Vermont, New England Landscapes, 1971; New York Cultural Center, Women Choose Women, 1973; Omaha/Joslyn, A Sense of

Lois Dodd, *Lifted House, Hanover, N.H.*, 1990.

Place, 1973; Queens Museum, New Images, 1974; Brooklyn College, Brooklyn College Art Department: Past and Present, 1942-1977, 1977; Queens Museum, Flushing, N.Y., New Images, 1974; AAIAL, 1986, 90; NAD, 1987, 90; Colby College, Vision and Tradition, 1988. **Collections:** AT&T; Brooklyn Museum; Chase Manhattan Bank; Ciba-Geigy Corp.; Colby College; Commerce Bank of Kansas City; Cooper Union; First National City Bank; Hartford/Wadsworth; Kalamazoo/Institute; Reynolds Metals Co.; Rockland/Farnsworth; NAD; New York Hilton Hotel; WMAA. **Bibliography:** Archives.

DOLE, WILLIAM b. September 2, 1917, Angola, Ind. **d.** January 13, 1983, Santa Barbara, Calif. **Studied:** Olivet College (with George Rickey, Harris King Prior), 1937, BA; Mills College, 1940, 49; U. of California, Berkeley, 1947, MA.

Traveled Mexico, Europe; resided Florence, Rome. **Taught:** U. of California, Berkeley, 1947-49, Santa Barbara, 1949-83. **Member:** Trustee, Santa Barbara/MA. **Awards:** DFA, Olivet College, 1978; AAIAL, 1978. **One-man Exhibitions:** (first) Santa Barbara/MA, 1951, also 1954, 58, 62, 68; de Young, 1951; Mills College, 1951; Geddis-Martin Studios, Santa Barbara, 1952; Rotunda Gallery, San Francisco, 1954; La Jolla, 1954, 64; Bertha Lewinson Gallery, Los Angeles, 1955; Eric Locke Gallery, San Francisco, 1956; Galerie Springer, Berlin, 1956, 64; Galleria Sagittarius, Rome, 1957; U. of California, Santa Barbara, 1958; Duveen-Graham Gallery, NYC, 1958, 60; Esther Baer Gallery, 1960, 61, 63, 65, 67, 70, 71, 73; Galeria Antonio Souza, Mexico City, 1961; The Thatcher School, Ojai, Calif., 1961; Rex Evans Gallery, 1961, 63, 64, 65, 67, 68, 69; California Palace, 1962; McRoberts & Tunnard Gallery, London, 1966; San Antonio/McNay, 1969; U. of California, Santa Cruz, 1969; Mary Moore Gallery, 1971; Jodi Scully Gallery, 1971, 74, 77; Graphics Gallery, 1972; Mount Holyoke College, 1974; Stacmpfli Gallery, NYC, 1974, 76, 78, 80, 82, 83, 84; William Sawyer Gallery, San Francisco, 1977, 80, 82; Loyola Marymount U., Los Angeles, 1980; Cheekwood, 1981; Mekler Gallery, 1981; Santa Cruz City Museum, 1981; U. of Redlands, 1982; Santa Barbara/MA, 1983. **Retrospectives:** U. of California, Santa Barbara, 1965; Los Angeles Municipal Art Gallery, circ., 1976; Oakland/AM, 1980. **Group:** California Palace, 1947, 52; Denver/AM, 1948; SFMA, 1948-51; California State Fair, 1950, 51; PAFA, 1950, 60, 65, 68; Los Angeles County Fair, 1951; Long Beach/MA, 1953, 60, 63, 69; Santa Barbara/MA, 1955, 57; Los Angeles/County MA, 1958; Hallmark Art Award, 1958; AAIAL, NYC, 1978. **Collections:** Allentown/AM; Amherst College; Atlantic Richfield Co.; Brooklyn Museum; U. of California; Chase Manhattan Bank; Fort Worth; Harvard U.; Hirshhorn; Ho-

nolulu Academy; Long Beach/MA; Mills College; Minnesota/MA; Mount Holyoke College; Newark Museum; Olivet College; Phillips; Phoenix; Rockefeller Institute; Santa Barbara/MA; Storm King Art Center; Walker. **Bibliography:** Archives.

DONATI, ENRICO **b.** February 19, 1909, Milan, Italy. To USA, 1934; citizen, 1945. **Studied:** U. of Pavia, Italy; New School for Social Research; ASL. Traveled Europe, India, USA. **Taught:** Yale U., 1960-62. **Member:** Advisory Board of Brandeis U., 1956-; Jury of Fulbright Program, 1954-56, 1963-64; Yale U. Council for Arts and Architecture, 1962-72; belonged to the Surrealist group of André Breton, to 1950. **Address:** 222 Central Park South, NYC 10019. **Dealers:** Louis Newman Galleries, Beverly Hills; The Zabriskie Gallery, NYC and Paris; Berry-Hill Galleries, NYC. **One-man Exhibitions:** New School for Social Research, 1942; Passedoit Gallery, NYC, 1942, 44; Arts Club of Chicago, 1944, 59; Durand-Ruel Gallery, NYC, 1945, 46, 47, 49; Galerie Drouant, Paris, 1947; P. Rosenberg and Co., 1950; L'Obelisco, Rome, 1950; Galleria Il Milione, Milan, 1950; Alexander Iolas Gallery, NYC, 1952; Galleria del Cavallino, Venice, 1952; Galleria d'Arte del Naviglio, Milan, 1953; Betty Parsons Gallery, 1954, 55, 57, 59, 60; Syracuse U., 1958; Neue Galerie, Munich, 1962; Staempfli Gallery, NYC, 1962, 64, 66, 68, 70, 72, 74, 76, 80, 82; MIT, 1964; J.L. Hudson Art Gallery, Detroit, 1964, 66, 69; Obelisk Gallery, 1965; Minnesota/MA, 1977; Ankrum Gallery, Los Angeles, 1977, 79; Norfolk/Chrysler, 1977; Phillips, Washington, D.C., 1979; Grand Palais, Paris, 1980; Fairweather-Hardin Gallery, Chicago, 1977; Chattanooga/Hunter, 1978; West Palm Beach/Norton, 1979; Osuna Gallery, Washington, D.C., 1979; Palm Springs Desert Museum, 1980; Carone Gallery, Fort Lauderdale, Fla., 1984, 90; Galerie Georges Fall, Paris, 1985; Gimpel

Enrico Donati, *Loupe Electromagnetique Pour Dechiffrer Les Cellules Vivant La Cellule Vivante Est Un Centre Dynamique*, 1948.

Weitzenhoffer Gallery, NYC, 1984, 86, 87; Louis Newman Gallery, Beverly Hills, 1986, 89, 91; The Zabriskie Gallery, NYC, 1987; Galerie Zabriskie, Paris, 1989. **Retrospective:** Palais des Beaux-Arts, Brussels, 1961. **Group:** Carnegie, 1950, 52, 54, 56, 58, 61; Venice Biennial; São Paulo, 1953; International Biennial Exhibition of Paintings, Tokyo; A.F.A., The Embellished Surface, circ., 1953-54; Chicago/AI, 1954, 57; WMAA Annuals, 1954, 56, 58, 59, 61, 62, 64, 70; Santa Barbara/MA, 1954; SRGM, Younger American Painters, 1954; Utica, 1955; SFMA, 1955; Indiana U., 1957, 59; PAFA, 1957; VMFA, American Painting, 1958; Inter-American Paintings and Prints Biennial, Mexico City, 1958; U. of Illinois, 1959; Lincoln, Mass./De Cordova, Decade in Review, 1959; A.F.A., V International Exhibition, 1959; Corcoran, 1960; St. Paul Gallery, 1960; Walker, 60 American Painters, 1960; SRGM, Abstract Expressionists and Imagists, 1961; New York World's Fair, 1964-65; U. of Texas, Austin, Michener Collection, 1970; Civico Museo Arte Contemporanea, Milan, I Sur-

realisti, 1989; Schirn Kunsthalle, Frankfurt, Die Surrealisten, 1989; Paris/Beaubourg, André Breton: La Beauté Convulsive, 1991. **Collections:** American Republic Insurance Co.; Arthur Anderson & Co.; Anderson Clayton Company; Atlantic Richfield Co.; Avon Products; Baltimore/MA; Bezalel Museum; Brussels/Moderne; Buffalo/Albright; U. of California; Chase Manhattan Bank; Detroit/Institute; Doane College; Ford Motor Company; Fort Lauderdale; High Museum; Houston/MFA; J.L. Hudson Co.; IBM; Indian Head Mills, Inc.; International Institute for Aesthetic Research; Johns Hopkins U.; MIT; MOMA; Michigan Consolidated Gas Co.; U. of Michigan; Milan; Minnesota/MA; Needham, Harper & Steers, Inc.; Newark Museum; Northwestern National Life Insurance Co.; Orlando; Oslo/National; Owens-Corning Fiberglas Corp.; Palm Beach Company; Prudential Life Insurance Co.; St. Louis/City; The Singer Company, Inc.; Temple Beth El; U. of Texas; Tougaloo College; Turin/Civico; U.S. Steel Corp.; WGMA; WMAA; Washington U.; Yale U. **Bibliography:** Breton 2, 3; Goodrich and Baur 1; Read 2; Rubin 1; Wolff.

DOVE, ARTHUR G. **b.** August 2, 1880, Canandaigua, N.Y. **d.** November 1946, Huntington, N.Y. **Studied:** Cornell U., 1903. Commercial illustrator, 1903-07. Traveled Europe, 1907-09, with Alfred Maurer and Arthur B. Carles, Jr. Met Alfred Stieglitz, 1910. **One-man Exhibitions:** (first) Photo-Secession, NYC, 1912; Scott Thurber Gallery, Chicago, 1912; Stieglitz's Intimate Gallery, NYC, 1926, 27, 29; An American Place (Gallery), NYC, annually, 1930-46; Springfield, Mass./MFA, 1933; Phillips, 1937; Vanbark Studios, Studio City, Calif., 1947; Utica, 1947; The Downtown Gallery, 1949, 52, 54, 55, 56, 67; Houston/MFA, 1951; Walker, 1954; Deerfield (Mass.) Academy, 1956; Paul Kantor Gallery, Beverly Hills, Calif., 1956; U. of Maryland,

1967; Terry Dintenfass, Inc., NYC, 1970, 71, 77, 78, 79, 80, 84; Asher/Faure, Los Angeles, 1981; Hobart and William Smith College, Geneva, N.Y., 1981; Barbara Mathes Gallery, NYC, 1984; Salander-O'Reilly Galleries, NYC, 1984; John Berggruen Gallery, San Francisco, 1991 (two-person); Richard York Gallery, NYC, 1990. **Retrospectives:** The Downtown Gallery, 1947; Cornell U., 1954; UCLA, circ., 1958-59; SFMA, circ., 1974; Phillips, circ., 1981. **Group:** Salon d'Automne, Paris, 1908, 09; National Arts Club Annual, NYC, 1914; Anderson Galleries, NYC, Forum Exhibition, 1916; Society of Independent Artists, NYC, 1917; PAFA, 1921; Wildenstein & Co., NYC, Tri-National Art, 1926; Brooklyn Museum, International Exhibition of Modern Art (assembled by Societé Anonyme), 1926; Salons of America, NYC, 1929; MOMA, Paintings by 19 Living Americans, 1929; Cleveland/MA Annuals, 1931, 32, 35; WMAA Annuals, 1932, 34; A.F.A., Abstraction, 1932; A Century of Progress, Chicago, 1933-34; WMAA, Abstract Painting in America, 1935; Buffalo/Albright, 1935; U. of Minnesota, 1937; Cleveland/MA, American Painting from 1860 until Today, 1937; Worcester/AM, 1938; Musée du Jeu de Paume, Trois Siècles d'Art aux États-Unis, 1938; MOMA, Art in Our Time: 10th Anniversary Exhibition, 1939; Boston/MFA, 10 American Watercolor Painters, 1939; Golden Gate International Exposition, San Francisco, 1939; Cornell U., 1940; MOMA, Cubist and Abstract Art, 1942; PMA, History of an American, Alfred Stieglitz: "291" and After, 1944. **Collections:** American U.; Andover/Phillips; Arizona State College; Baltimore/MA; Boston U.; Brittanica; Brooklyn Museum; Buffalo/Albright; Carnegie; Chicago/AI; Colorado Springs/FA; Columbus; Cornell U.; Des Moines; Detroit/Institute; Fisk U.; Fort Worth; Hartford/Wadsworth; Honolulu Academy; IBM; Inland Steel Co.; MMA; MOMA; Milwaukee; U. of Minnesota; National

Arthur G. Dove, *Two Forms*, 1931.

Gallery; U. of Nebraska; Omaha/Joslyn; PMA; Phillips; Phoenix; Randolph-Macon Women's College; U. of Rochester; SFMA; Smith College; Springfield, Mass./MFA; Utica; WMAA; Washington U.; Wellesley College; West Palm Beach/Norton; Wichita/AM; Wilmington; Yale U. **Bibliography:** *Arthur Dove: The Years of Collage;* Ashton 5; *Avant-Garde Painting and Sculpture in America, 1920-25;* Barr 3; Baur 5, 7; Blanchard; Blesh 1; Brown 2; Cahill and Barr, eds.; Cheney; Cummings 5; Downes, ed.; *8 American Masters of Watercolor;* Eisler; Eliot; *Forerunners;* Frank, ed.; Frost; Gerdts; Goodrich and Baur 1; Haftman; Haskell 1; Hess, T. B., 1; Hunter 6; Janis and Blesh; Janis, S.; Kootz 1; Kozloff 3; Mather 1; McCurdy, ed.; Mellquist; Mendelowitz; Morgan; Neuhaus; Newmeyer; Phillips 1, 2; Poore; Read 2; Richardson, E.P.; Ringel, ed.; Ritchie 1; Rodman 2; Rose, B., 1, 4; Rosenblum 2; Rubin 1; Schwartz 3; Seitz 4; Sutton; Tashijan; Tuchman 3; Waldman 4; Ward; Wight 2; Wright 1. Archives.

DOWNES, RACKSTRAW
b. November 8, 1939, England. **Studied:** Cambridge U., BA, 1961, with Donald Davie; Yale U., MFA, 1964, with Neil Welliver, Alex Katz, Al Held; U. of Pennsylvania, post-graduate fellowship, 1964-65. **Taught:** Parsons School of Design, 1964-67; U. of Pennsylvania, 1967-79; Skowhegan School, 1975; Yale U., 1979-80; New York Studio School, 1981-82. Art critic and writer. **Member:** Board of Governors, Skowhegan School. **Awards:** Yaddo Fellowship, 1970; Ingram Merrill Foundation Grant, 1974; CAPS, 1978; National Endowment for the Arts, grant, 1980; AAIAL, 1989. **Address:** 16 Greene Street, NYC 10013. **Dealer:** Hirschl & Adler Modern, NYC. **One-man Exhibitions:** (first) Swarthmore College, 1969; The Kornblee Gallery, NYC, 1972, 74, 75, 78, 80; McLeaf Gallery, Philadelphia, 1969; Swain School of Design, New Bedford, Mass., 1978; Tatistcheff & Co., NYC, 1980; Hirschl & Adler Modern, NYC, 1984, 87; Middlebury College (two-man), 1991. **Group:** A.F.A., Painterly Realism, 1970-72; Colgate U., Painters of the Land and Sky, 1972; Omaha/Joslyn, A Sense of Place, 1973; Queens County Art and Cultural Center, New Images in American Painting, 1974; US Department of the Interior, America 1976, 1976; Los Angeles/County MA, Eighteen Artists, 1976; AAAL, 1977; Brooklyn Museum, American Drawings in Black and White: 1970-1979, 1980; San Antonio/MA, Real, Really Real, Super Real, circ., 1981; Haus der Kunst, Munich, Amerikanische Malerei, 1930-1980, 1981; WMAA Biennial, 1981; PAFA, Contemporary American Realism Since 1960, 1981; Utica, An Appreciation of Realism, 1982; Carnegie, International, 1983; U. of California, Santa Barbara, A Heritage Renewed: Representational Drawings Today, 1983; PAFA, Perspective on Contemporary American Realism, 1983; Hudson River Museum, Form or Formula: Drawing and Drawings, 1986; Summit (N.J.) Art Cen-

Rackstraw Downes, *The Mouth of the Passagassawaukeag at Belfast, M.E., Seen from the Frozen Foods Plant,* 1989.

ter, Contemporary American Landscapes, 1987; Adelphi U., Urban Visions, 1987; U. of Rochester, Direct Response, 1989; Florida International U., American Art Today: Contemporary Landscape, 1989; AAIAL, 1989; Madison Art Center, Urban Images, 1989; Maryland Institute, The Landscape Observed, 1989; Miyagi Museum, Sendai, Japan, American Realism and Figurative Art, 1952-1990, circ., 1992. **Collections:** Amerada Hess; U. of California, Santa Barbara; Carnegie; Chase Manhattan Bank, Chemical Bank; Corcoran; The Equitable; Exxon Corp.; Hirshhorn; Indiana U.; Kansas City/AI; MMA; U. of North Carolina; PAFA; Tulsa/Philbrook; WMAA. **Bibliography:** *America 1976;* Arthur 3; Ashbery; Cummings 5; Seitz 3.

DOYLE, TOM **b.** May 23, 1928, Jerry City, Ohio. **Studied:** Miami U.; The Ohio State U., with Roy Lichtenstein, Stanley Twardowicz, BFA, MA. Traveled Europe. **Taught:** Brooklyn Museum School, 1961-68; New School for Social Research, 1961-68; School of Visual Arts, NYC, 1969; Queens College, CUNY, 1970-82; Artist-in-residence, La Napoule Foundation, France, 1989. **Member:** American Abstract Artists. **Commissions:** GSA, for Fairbanks, Alaska, 1980; Cooper Square Housing, NYC, 1985; Queens Col-

lege, 1988. **Awards:** Ohio State Fair, two First and two Second Prizes; Guggenheim Foundation Fellowship, 1982; City University Faculty Research Award in Sculpture, 1989; NEA, fellowship, 1990. **Address:** 130 West 18th Street, NYC 10011. **Dealer:** Bill Bace Gallery, NYC. **One-man Exhibitions:** (first) The Ohio State U., 1956; Allan Stone Gallery, NYC, 1961, 62; Dwan Gallery, NYC, 1966, 67, 72; Brata Gallery, NYC, 1972; 55 Mercer Street, NYC, 1974, 76; Colgate U., 1976; Sculpture Now, Inc., 1978; Max Hutchinson Gallery, NYC, 1982; Miami-Dade, 1982; Sculpture Center, NYC, 1988; Bill Bace Gallery, NYC, 1991. **Group:** Cornell U., 1960; Martha Jackson Gallery, New Media—New Forms, I & 11, 1960, 61; Oberlin College, 1961; Carnegie, 1961; Seattle World's Fair, 1962; Bern, 1964; WMAA Annual, 1966, 67; Los Angeles/County MA, American Sculpture of the Sixties, 1967; Jewish Museum, Primary Structures, 1967; Kassel, Documenta V, 1972; Taft Museum, Painting and Sculpture Today, 1974; Indianapolis, 1974; Pratt Institute, Sitesights, 1980; NMAA, Across the Nation, 1980; Stockholm/National, Flyktpunkter-Vanishing Points, 1984; Queens College, The Ways of Wood, 1984; Bronx Museum, American Abstract Artists 50th Anniversary Celebration, circ., 1986; Verona, Italy, Idiomi

della scultura contemporanea 2, 1989.
Collections: Bard College; Brooklyn
Museum; Carnegie; Federal Building
and Court House, Fairbanks, Alaska;
Manhattanville College; Nassau County
Museum; Ohio State U.; Purchase, N.Y.;
South Dakota State U.; Wright State U.
Bibliography: Atkinson; Tuchman 1.
Archives.

DREWES, WERNER b. July 27,
1899, Canig, Germany. **d.** June 21, 1985,
Reston, Va. **Studied:** Gymnasium, Bran-
denburg/Havel, 1909-17; Charlottenburg
Technische Hochschule, Berlin, 1919;
Stuttgart School of Architecture, 1920;
Stuttgart School of Arts and Crafts, 1921;
Bauhaus, Weimar, 1921-22, with Josef
Itten, Paul Klee; Bauhaus, Dessau, 1927-
28, with Vassily Kandinsky, Lyonel
Feininger. To USA, 1930; citizen, 1936.
Traveled Europe, South and Central Amer-
ica, Asia, USA. **Taught:** Columbia U.,
1937-40; Master Institute of United Arts,
Inc., NYC, 1940; Brooklyn College, 1944;
Institute of Design, Chicago, 1945;
Washington U., 1946-65. Federal A.P.:
Instructor, Brooklyn Museum, 1934-36;
Technical Supervisor, Graphic Art Project,
1940-41. **Member:** American Artists Con-
gress; co-founder, American Abstract Art-
ists, 1936. **Commissions:** International
Graphic Arts Society, 1954, 57. **Awards:**
50 Best Prints of the Year, 1932, 44; PAFA,
P.P., 1933; MOMA; Plexiglas Sculpture
Competition, Third Prize, 1939; MOMA,
Textile Design Competition, First and Sec-
ond Prizes, 1941; The Print Club, Philadel-
phia, Hon. Men., 1946; A.A.A. Gallery,
NYC, **P.P.**, 1959; St. Louis Artists' Guild,
Bader Art Prize, 1960. **One-man Exhibi-
tions:** Madrid/Nacional, 1923; Montevi-
deo/Municipal, 1924; St. Louis Public
Library, 1924; Gump's Gallery, 1926;
Flechtheim and Kahnweiler, Frankfurt,
1928; Galerie del Vecchio, Leipzig, 1929;
Morton Gallery, NYC, 1932, 33; New
School for Social Research, 1935; Artists'
Gallery, NYC, 1939, 41; Lilienfeld Gal-

lery, NYC, 1945; Indiana U., 1945;
Kleemann Gallery, NYC, 1945, 46, 47,
49; Princeton U., 1946 (four-man);
Smithsonian, 1948; Pen and Palette Gal-
lery, St. Louis, 1949; Lutz and Meyer Gal-
lery, Stuttgart, 1951; Argent Gallery,
NYC, 1951; Neue Gallerie Gurlitt, 1952;
St. Louis Artists' Guild, 1953; Beloit Col-
lege, 1954, 77; Schermahorn Gallery,
Beloit, 1955, 56; Los Angeles/County MA,
1956; Memphis/Brooks, 1957; Springfield,
Mo./AM, 1958; Oregon State College,
circ., 1959; Cleveland/MA, 1961; Wash-
ington U., 1962; Hom Gallery, Washing-
ton, D.C., 1971; Princeton Gallery of Fine
Art, 1972, 76; Haslem Fine Arts, Washing-
ton, D.C., 1978; Tobey C. Moss Gallery,
Los Angeles, 1983, 90; AAA Gallery, 1986;
Snyder Fine Art, NYC, 1991. **Retro-
spectives:** California Palace, 1962; Wash-
ington U., 1965; Smithsonian, 1969; US
Embassy Program, Turkey, 1974; St. Olaf
College, circ., 1978. **Group:** Carnegie;
Brooklyn Museum; Chicago/AI; MMA;
USIA; WMAA; U. of Illinois; PAFA;
SRGM; Bennington College. **Collections:**
U. of Alabama; Andover/Phillips;
Bibliothèque Nationale; Boston/MFA; Bos-
ton Public Library; Brooklyn Museum;
Chicago/AI; Cleveland/MA; Cologne;
Frankfurt am Main; Hartford/Wadsworth;
Harvard U.; Honolulu Academy; U. of
Illinois; Kansas City/Nelson; Karlsruhe;
Library of Congress; Los Angeles/County
MA; MOMA; Memphis/Brooks; Mills Col-
lege; NCFA; NYPL; National Gallery;
Newark Public Library; PAFA; RISD;
SFMA; SRGM; St. Louis/City; Seat-
tle/AM; Springfield, Ill./State; Springfield,
Mo./AM; Trenton/State; Victoria and
Albert Museum; Washington U.; Wells
College; Wichita/AM; Worcester/AM;
Yale U. **Bibliography:** American Artists
Congress, Inc.; Baur 7; Bazin; Cheney;
Lane and Larsen; **Rose,** I. Archives.

DRUMMOND, SALLY
HAZELET b. June 4, 1924, Evans-
ton, Ill. **Studied:** Rollins College, 1942-44;

Columbia U., with John Heliker, Peppino Mangravite, 1946-48, BA; Institute of Design, Chicago, 1949-50, with Hugo Weber, Emerson Woelffer; U. of Louisville, with Ulfert Wilke, 1950-52, MA. Traveled Italy, France, England. A co-organizer of the Tanager Gallery, NYC. **Taught:** Skowhegan School, 1973. **Awards:** Fulbright Fellowship (Italy), 1952; Guggenheim Foundation Fellowship, 1967-68. **Address:** 129 Camp Creek Road, Germantown, NY 12526. **Dealer:** Margarete Roeder Gallery, NYC. **One-man Exhibitions:** (first) Hadley Gallery, Louisville, 1952, also 1961; Art Center Association, Louisville, 1955; Tanager Gallery, NYC, 1955, 57, 60; Green Gallery, NYC, 1962; Louisville/Speed, 1967 (two-man); Fischbach Gallery, NYC, 1968, 72, 78; Ridgefield/Aldrich, 1981; Merida Gallery, Louisville, 1982; Artists Space, NYC, 1984; Rollins College, 1988; Louisville Visual Art Association, 1990; Margaret Roeder Gallery, NYC, 1990. **Retrospective:** Corcoran, 1972; Stamford, Ct., 1986. **Group:** American Embassy, Rome, 1953; Bordighera, 1953; A.F.A., Fulbright Artists, circ., 1958; Houston/MFA, 1959; WMAA Annual, 1960; A.F.A., Lyricism in Abstract Art, circ., 1962-63; MOMA Americans, 1963, circ., 1963-64; Trenton/State, Focus on Light, 1967; Silvermine Guild, 1970; PMA, FOCUS, 1974; Wanesboro Museum, Wanesboro, Ky., Kentucky Expatriates, 1984; Stamford Museum, American Art—American Women, 1986; P.S. 1, Long Island City, N.Y., Underknown, 1986; National Arts Club, NYC, The Kentuckians, 1987. **Collections:** Avco Corp.; Chase Manhattan Bank; Ciba-Geigy Corp.; Corcoran; Currier; Hirshhorn; Interchemical Corporation; U. of Iowa; Louisville/Speed; MOMA; MMA; U. of North Carolina; Union Carbide Corp.; WMAA.

DU BOIS, GUY PENE **b.** January 4, 1884, Brooklyn, N.Y. **d.** July 18, 1958, Boston, Mass. **Studied:** W. M. Chase

School, NYC, 1899-1905, with J. C. Beckwith, Frank V. DuMond, Robert Henri, Kenneth Hayes Miller; Academie de la Grande Chaumiere, with Theophile A. Steinlen. Traveled USA, Europe. Reporter and critic for *New York American, New York Tribune, New York Evening Post;* editor of *Arts and Decoration* magazine for seven years. **Awards:** Pan-American Exhibition, Los Angeles, 1925, Third Prize; Chicago/AI, Norman Wait Harris Silver Medal, 1930; NAD, Benjamin Altman Prize, 1936; Corcoran, Second William A. Clark Prize, 1937. **One-man Exhibitions:** Kraushaar Galleries, 1922, 24, 30, 32, 35, 36, 38, 42, 43, 46; Staten Island, 1954; The Graham Gallery, NYC, 1961, 63, 79, 83; Northwestern U., 1981; WMAA, 1988. **Retrospective:** Hagerstown/County MFA, 1940. **Group:** Salon des Beaux Arts, Paris, 1906; Corcoran; Chicago/AI; PAFA; WMAA. **Collections:** Amherst College; Andover/Phillips; Baltimore/MA; Barnes Foundation; Brooklyn Museum; Chicago/AI; Cleveland/MA; Detroit/Institute; Los Angeles/County MA; MOMA; Milwaukee; Newark Museum; New Britain; PAFA; PMA; Phillips; San Diego; Toledo/MA; WMAA. **Bibliography:** Baur 7; Bazin; Brown 2; Bruce and Watson; Cahill and Barr, eds.; Cheney; **Cortissoz** 2; Cummings 4; **Du Bois** 1, 2, 3, 4, 5, 6; Ely; Gerdts; Glackens; *Cityscape 1919-39;* Goodrich and Baur 1; Hall; Hunter 6; *Index of 20th Century Artists;* Jewell 2; Kent, N.; Mather 1; McCoubrey 1; **Medford;** Mellquist; Neuhaus; Pagano; Pearson 1; Phillips 2; Poore; Richardson, E.P.; Ringel, ed.; Rose, B., 1, 4; Smith, S.C.K. Archives.

DUCHAMP, MARCEL **b.** July 28, 1887, Blainville, near Rouen, France. **d.** October 1, 1968, Neuilly, France. **Studied:** Academie Julian, Paris, 1904. To USA, 1915; citizen, 1955. Traveled Europe, Argentina, USA. Founding member, Society of Independent Artists, 1916. Cofounder (with Man Ray and Francis Picabia) of DADA group, NYC, 1917.

Co-organizer (with Katherine S. Dreier and Man Ray) of Societé Anonyme (Museum of Modern Art), 1920. Published one issue of *New York DADA* with Man Ray, 1921. Produced a film, *Anemic Cinema*, 1925. **One-man Exhibitions:** Montross Gallery, NYC, 1916 (four-man); Arts Club of Chicago, 1937; Rose Fried Gallery, 1952 (three-man); SRGM, 1957 (three-man); Galerie de l'Institut, Paris, 1957; Sidney Janis Gallery, 1958, 59; La Hune, Paris, 1959; Pasadena/AM, 1963; Eva de Buren Gallery, Stockholm, 1963; Walker, 1965; Milwaukee, 1965; Cordier & Ekstrom, Inc., 1965, 67, 68; Tate, 1966; Fourcade, Droll, Inc.; Galerie Rene Block, Berlin, 1971; Galleria Civica d'Arte Moderna, Ferrara, 1971; Galleria Schwarz, 1972; Jerusalem/National, 1972; L'Uomo e l'Arte, Milan, 1973; Dayton's Gallery 12, Minneapolis, 1973, 74; Holly Solomon Gallery, 1977; L.A. Louver Gallery, Venice, Calif., 1982; Gallery Yves Arman, NYC, 1984; Florida International U., 1985; Arnold Herstand & Co., NYC, 1986; Luhring, Augustine & Hodes, NYC, 1987. **Retrospectives:** Gimpel Fils Ltd., 1964; Galleria Solaria, Milan, 1967; Paris/Moderne, 1967; Cologne, 1968; PMA, 1969, 73. **Group:** Salon des Artistes Independents, Paris, 1909-12; Salon d'Automne, Paris, 1909-12; Salon de la Section d'Or, 1912, The Armory Show, 1913; Societé Anonyme, NYC, 1920; Salon DADA, Paris, 1920; A Century of Progress, Chicago, 1933-34; MOMA, Cubism and Abstract Art, 1936; MOMA, Fantastic Art, DADA, Surrealism, 1936; WMAA, European Artists in America, 1945; MOMA, Eleven Europeans, 1946; XXIV Venice Biennial, 1948; California Palace, 1948; Chicago/AI, 1949; MOMA, The Machine, 1968; Haus der Kunst, Munich, Der Surrealismus, 1922-1942, 1972. **Collections:** MOMA; Ottawa/National; PMA; SRGM; Yale U. **Bibliography:** *Abstract Expressionism;* Alloway 4; Ashbery; Barr 1, 3; Battcock, ed.; Baur 7; Becker and Vostell; Biddle 4; Biederman 1; Bihalji-

Merin; Blesh 1; Breton 2; Brion 2; Brown; Bulliet 1, 2; **Cabanne;** Calas 2; Calas, N. and E.; Canaday; Cassou; Chipp; Christensen; Coplans 3; Davidson 1; Davis, D.; De Vries; **D'Harnoncourt and McShine, eds.;** Dorival; Dorner; Dreier 2; **Duchamp 1, 2;** Elsen 1; *Europa/Amerika;* Finch; Flanagan; Frost; Gablik; Gascoyne; Gaunt; Gerdts; Giedion-Welcker 1, 2; Gohr and Gachnang; Guggenheim, ed.; Haftman; **Hamilton, R.;** Honnef; Hulten; Hunter 6; Hunter, ed.; Huyghe; Janis and Blesh 1; Johnson, Ellen H.; Kepes 2; Kozloff 3; Krauss 2, 3; **Kuenzli, ed.;** Kuh 1, 2, 3; Kyrou; Langui; Lippard 3; **Lebel;** Lee and Burchwood; Licht, F.; Lippard 5; Lippard, ed.; Lowry; Lynton; McCurdy, ed.; Marter, Tarbell, and Wechsler; Mellquist; Metro; Motherwell 1; Murken-Altrogge; Neff, ed.; Neumeyer; Newmeyer; Pach 2, 3; Plagens; Ramsden 1; **Raymond Duchamp-Villon/Marcel Duchamp;** Raynal 3, 4; Read 2, 3; Richardson, E. P.; Richter; Rickey; Rose, B., 1, 4; Rosenblum 1; Rowell; Rubin 1; Sager; Schwarz 1, 2; Sandler 3, 5; Seitz 4, 5; Selz, J.; Seuphor 1, 3; Siegel; Soby 1, 5, 6; **Sweeney 2;** Tashijian; Tomkins; Tomkins and Time-Life Books; Tomkins 2; Trier 1, 2; Tuchman 3; Valentine 2; Verkauf; Waldberg 2, 3, 4; Waldman 4; Weller. Archives.

DUFF, JOHN b. December 2, 1943, Lafayette, Indiana. **Studied:** SFAI, with Manuel Neri, Paul Harris, Roy Nagle, 1967, BFA. **Address:** 5 Doyer Street, NYC 10013. **Dealer:** Blum Helman Gallery, NYC. **One-man Exhibitions:** Brady Gallery, San Francisco, 1967; David Whitney Gallery, NYC, 1970, 71; Galerie Rolf Ricke, Cologne, 1971; Irving Blum Gallery, Los Angeles, 1972; Janie C. Lee Gallery, Dallas, 1972; John Bernard Myers Gallery, NYC, 1972, 73; Daniel Weinberg Gallery, San Francisco, 1974, 75, 77, 80; Willard Gallery, NYC, 1975, 76, 77, 78; Galerie Swart, Amsterdam, 1978; Sonoma State U., 1979; Margo

Leavin Gallery, Los Angeles, 1981, 84; Blum-Helman Gallery, NYC, 1985, 86, 88, 89, 90; The Clocktower, NYC, 1985; Blum-Helman Gallery, Los Angeles, 1987; Amy Lipton Gallery, NYC, 1990; Galeria 57, Madrid, 1992. **Group:** WMAA, Anti-Illusion Procedures/Materials, 1969; WMAA Annual, 1970; SRGM, Nine Young Artists, 1977; WMAA Biennial, 1973, 85; West Palm Beach/Norton, Material Matters, circ., 1980; WMAA, Developments in Recent Sculpture, 1981; AAIAL, 1981; NYU, Tracking the Marvelous, 1981; U. of Illinois, Champaign, Three Sculptors, 1985; Laforet Museum, Tokyo, Correspondences, 1985; Los Angeles/MOCA, Individuals, 1986; Corcoran, 1987; U. of Rhode Island, Microsculpture, 1989. **Collections:** Art Museum of South Texas; Chase Manhattan Bank; Chicago/Contemporary; Krefeld/Kaiser Wilhelm; Los Angeles/County MA; MOMA; PMA; Purchase/SUNY; SRGM; Storm King Art Center; WMAA; Walker.

DUGMORE, EDWARD **b.** February 20, 1915, Hartford, Conn. **Studied:** Hartford Art School, 1934-38; California School of Fine Arts (with Clyfford Still), 1948-50; U. of Guadalajara, 1951-52, MA. US Marine Corps, 1943-44. Traveled Mexico, USA extensively, Europe, 1966-67. **Taught:** St. Joseph College, 1946-49; Southern Illinois U.; Pratt Institute, 1964-72; U. of Minnesota, 1970; Des Moines, 1972; Maryland Institute, 1973, 74. A cofounder of Metart Gallery, San Francisco. **Awards:** Chicago/AI, The M.V. Kohnstamm Prize, 1962; Guggenheim Foundation Fellowship, 1966-67; National Endowment for the Arts, 1976, 85; AAAL Award, 1980. **Address:** 118 West 27th Street, NYC 10001. **Dealer:** Manny Silverman Gallery, Los Angeles. **One-man Exhibitions:** (first) Metart Gallery, San Francisco, 1949; The Stable Gallery, 1953, 54, 56; Holland-Goldowsky Gallery, Chicago, 1959; The Howard Wise Gallery, Cleve-

land, 1960; The Howard Wise Gallery, NYC, 1960, 61, 63; Green Mountain Gallery, NYC, 1971, 73; Des Moines, 1972; H. Marc Moyens, Alexandria, Va., 1975; Carlson Gallery, San Francisco, 1990; Manny Silverman Gallery, Los Angeles, 1991, 92; Anita Shapolsky Gallery, NYC (two-man), 1991. **Group:** Carnegie, 1955; Walker, Vanguard, 1955; WMAA Annual, 1959; SRGM, Abstract Expressionists and Imagists, 1961; Chicago/AI Annual, 1962; SFMA, Directions—Painting U.S.A., 1963; U. of Texas, Recent American Painting, 1964, also 1968; Green Mountain Gallery, 1971; Buffalo/Albright, Abstract Expressionism: First and Second Generations, 1972; Oakland/AM, A Period of Exploration, 1973; SFMA, California Painting and Sculpture: The Modern Era, 1976; NCFA, 1977; AAAL, 1980; Baruch College, Selections from the Ciba-Geigy Collection, 1985. **Collections:** Buffalo/Albright; Ciba-Geigy Corp.; Civic Museum and Gallery, Udine, Italy; Corcoran; Des Moines; U. of Guadalajara; Hirshhorn; Housatonic Community College; Laguna Beach Museum of Art; Michigan State U.; Minneapolis/Institute; U. of North Carolina; Southern Illinois U.; Walker. **Bibliography:** *Individuals;* McChesney; Sandler 5. Archives.

DURAN, ROBERT
from 3rd to 5th edition.

DZUBAS, FRIEDEL **b.** April 20, 1915, Berlin, Germany. To USA, 1939. Traveled Europe extensively. **Taught:** U. of South Florida, 1962; Artist-in-Residence, Dartmouth College, 1962; Aspen Institute, 1965, 66; Cornell U., 1967, 1969-74; U. of Pennsylvania, 1968; Sarah Lawrence College, 1968-69. **Commissions:** National Shawmut Bank of Boston (mural). **Awards:** Guggenheim Foundation Fellowship, 1966; J. S. Guggenheim Fellowship, 1968; National Council on the Arts, 1968. **Address:** c/o Dealer. **Dealer:** André Emmerich Gallery, Inc., NYC. **One-**

Friedel Dzubas, *Placidum*, 1985.

man Exhibitions: Tibor de Nagy Gallery, NYC, 1952, 76; Leo Castelli Inc., NYC, 1958; French & Co., Inc., NYC, 1959; Dwan Gallery, 1960; The Elkon Gallery, Inc., NYC, 1961-65, 84; Kasmin Ltd., 1964, 65; Nicholas Wilder Gallery, Los Angeles, 1966; André Emmerich Gallery, Inc., NYC, 1966, 67, 68, 87, 89, 90; Jack Glenn Gallery, Corona del Mar, 1971; Lawrence Rubin Gallery, NYC, 1971, 72, 73; Gallerie Hans Strelow, Cologne, 1971, 72; David Mirvish Gallery, 1973, 74, 75, 76; Knoedler Contemporary Art, 1974, 75, 76; Watson/de Nagy Gallery, Houston, 1976; Margo Leavin Gallery, Los Angeles, 1976; John Berggruen Gallery, San Francisco, 1977, 79, 83; M. Knoedler & Co., NYC, 1977, 78, 79, 80, 82, 83, 84, 85, 86; Kunsthalle, Bielefeld, 1977; Dart Gallery, Chicago, 1978; Thomas Segal Gallery, Boston, 1982; Galerie Ninety-Nine, Bay Harbor Islands, Fla., 1982; Martha White Gallery, Louisville, 1982; M. Knoedler & Co., Zurich, 1982; Meredith Long Gallery, Houston, 1983, 87; Gallery One, Toronto, 1984, 85, 90; Ochi Gallery, Boise, Idaho, 1984; Hokin Gallery, Palm Beach, Fla., 1986; Cornell U., 1987; Nassau County Museum, 1987; Brandeis U., 1988; Harcus Gallery, Boston, 1988; Garner Tullis, NYC, 1988; Ann Jaffe Gallery, Bay Harbor Islands, Fla., 1990; Fort Lauderdale, 1991. **Retrospectives:** Houston/MFA, 1974; Boston/MFA, 1975. **Group:** Chicago/AI Annuals, 1942, 43, 44; MMA, American Painters under 35, 1950; Ninth Street Exhibition, NYC, 1951; WMAA Annuals, 1958, 59, 64; Corcoran, 1959, 63, Biennial, 1967; The Kootz Gallery, NYC, New Talent, 1960; Carnegie, 1961; SRGM, Abstract Expressionists and Imagists, 1961; Dayton/AI, 1963; Jewish Museum, Black and White, 1963; Los Angeles/County MA, Post Painterly Abstraction, 1964; Detroit/Institute, Color and Image and Form, 1967; U. of Illinois, 1967; Expo '67, Montreal, 1967; Buffalo/Albright, Color and Field, 1890-1970, 1970; Boston/MFA, Abstract Painting in the '70s, 1972; Houston/MFA, The Great Decade of American Abstraction: Modernist Art 1960 to 1970, 1974; Corcoran Biennial, 1975; Syracuse/Everson, New Works in Clay, 1976; US Embassy, Ottawa, Eighteen Contemporary Masters, 1977; Brockton/Fuller, Aspects of the Seventies, 1980; AAIAL, 1981; Brown U., Definitive Statements, circ., 1986; AAIAL, 1987. **Collections:** Baltimore/MA; Boston/MFA; Brandeis U.; Buffalo/Albright; Chase Manhattan Bank; Cornell U.; Dayton/AI; Dartmouth College; Edmonton Art Gallery; Fort Wayne/AM; Hirshhorn; Houston/MFA; Iowa State U.; MMA; Manufacturers Hanover Trust; Memphis/Brooks; NMAA; NYU; Newark Museum; Oberlin College; Phillips; Princeton U.; Ridgefield/Aldrich; Rutgers U.; SFMA; SRGM; St. Louis/City; U. of South Florida; Syracuse/Everson; Tufts Dental College; Utica; WMAA; Wellesley College; Yale U. **Bibliography:** *The Great Decade;* Rose, B., 1; Sandler 1.

E

EDDY, DON b. November 4, 1944, Long Beach, Calif. **Studied:** Fullerton Junior College; U. of Hawaii, 1967, BFA, 1969, MFA; U. of California, Santa Barbara, 1969-70. US Navy, 1967-68. **Taught:** U. of Hawaii, 1967-69; NYU, 1973-78; School of Visual Arts, NYC, 1977-. **Address:** 543 Broadway, NYC 10012. **Dealer:** Nancy Hoffman Gallery, NYC. **One-man Exhibitions:** Ewing Krainin Gallery, Honolulu, 1968; Molly Barnes Gallery, Los Angeles, 1970, 71; Esther Baer Gallery, 1970; Galerie M. E. Thelen, Essen and Cologne, 1970; Galerie de Gestlo, 1971; French & Co. Inc., NYC, 1971; Aktionsgalerie, Bern (two-man), 1971; Nancy Hoffman Gallery, NYC, 1973, 74, 76, 79, 83, 86, 90, 92; Galerie Petit, Paris, 1973; Williams College, Williamstown, Mass., 1975; Miami-Dade Community College, 1976; U. of Hawaii, Manoa, 1982. **Group:** Stockton, Beyond the Actual, 1970; Sacramento/Crocker, West Coast '70, 1970; Munster/WK, Verkehrskultur, 1971; Santa Barbara/MA, Spray, 1971; VII Paris Biennial, 1971; Potsdam/SUNY, New Realism, 1971; Kassel, Documenta V, 1972; Cleveland/MA, 32 Realists, 1972; Stuttgart/WK, Amerikanischer Fotorealismus, circ., 1972; Recklinghausen Kunsthalle Mit Pensil und Camera und Spritzpistole, 1973; Los Angeles Municipal Art Gallery, Separate Realities, 1973; U. of Illinois, 1974; Hartford/Wadsworth, New/Photo Realism, 1974; Toledo, Image, Color and Form, 1975; Baltimore/MA, Super Realism, 1976; Canberra/National, Illusion and Reality, circ., 1977; Dayton/AI, Photo Images, 1977; U. of Texas, New in the 70's, 1977; Kansas City/Sheldon, Things Seen, 1978; Tulsa/Philbrook, Realism/Photorealism, 1980; Brooklyn Museum, American Drawings in Black and White: 1970-1979, 1980; San Antonio/MA, Real, Really Real, Super Real, circ., 1981; PAFA, Contemporary American Realism Since 1960, 1981; Hannover/Kunstverein, Spiegel Bilder, circ., 1982; MOMA, A Feast for the Eyes, 1984; Wichita/AM, Decade of American Realism, 1976-1985; New Orleans/Contemporary, Landscape, Seascape, Citiscape, 1960-1985, 1986; Tampa Museum, At the Water's Edge, 1989; Nassau County Museum, In Sharp Focus: Hyper Realism of the 70s and 80s, 1991. **Collections:** Aachen/NG; American Republic Insurance Co.; Akron/AI; Claremont College; Cleveland/MA; Des Moines; Fort Wayne/AM; Harvard U.; Honolulu Academy; Israel Museum; Jackson/MMA; Louisville/Speed; U. of Massachusetts; Museo de Arte Moderno, Bogota; U. of Nebraska; Oklahoma; RISD; SRGM; St. Etienne; San Antonio/McNay; Santa Barbara/MA; Springfield, Mo./AM; Storm King Art Center; Toledo/MA; Utrecht; Warner Bros., Los Angeles; Williams College; WMAA. **Bibliography:** Alloway 4; *Amerikanischer Fotorealismus;* Arthur 4; Honisch and Jensen, eds.; *Kunst um 1970;* Lindy; Meisel; *New in the Seventies;* Sager; Ward.

EDIE, STUART
from 1st to 4th edition.

EDMONDSON, LEONARD
from 1st to 5th edition.

ELLIOT, RONNIE
from 1st to 4th edition.

ENGMAN, ROBERT
from 2nd to 5th edition.

ERLEBACHER, MARTHA MEYER b. 1937, Jersey City, N.J.

Studied: Gettysburg College, 1955-56; Pratt Institute, 1956-60, BA, Industrial Design, 1963, MFA, Ed. **Taught:** School Art League, NYC, 1962, 64; Pratt Institute, 1964-65; Parsons School of Design, NYC, 1965-66; Philadelphia College of Art, 1966-; University of the Arts, Philadelphia, 1978-92; New York Academy of Art, 1992-. **Commissions:** Numerous portraits. **Awards:** Yaddo Fellowship, 1966, 77; Ingram Merrill Foundation, grant, 1978; National Endowment for the Arts, 1982; Mellon Venture Fund, grant; University of the Arts, Philadelphia, 1987; Pennsylvania Council on the Arts Fellowship, 1988. **Address:** 7733 Mill Road, Elkins Park, PA 19917. **Dealer:** Fischbach Gallery, NYC. **One-man Exhibitions:** The Other Gallery, Philadelphia, 1967; Robert Schoelkopf Gallery, NYC, 1973, 75, 78, 79, 85; Dart Gallery, Chicago, 1976, 83; U. of Connecticut (two-man), 1977; PFA, 1978; U. of North Carolina, 1983; J. Rosenthal Fine Arts, Chicago, 1987, 90; Koplin Gallery, Santa Monica, 1989, 91; Kalamazoo/Institute, 1989. **Group:** St. Cloud State College, New Realism, '69, 1969; Yale U., American Drawing, 1970-1973, 1973; PMA/Museum of the Philadelphia Civic Center, Woman's Work, 1974; Library of Congress, National Exhibition of Prints, 1975; St. Joseph/Albrecht, Drawing-America: 1976, 1976; PMA, 300 Years of American Art, 1976; Chicago/AI, Drawings of the '70s, 1977; PMA, Contemporary Drawings, II, 1979; U. of Missouri, Kansas City, The Opposite Sex: A Realistic Perspective, 1979; Brooklyn Museum, Drawings in Black and White: 1970-1979, 1980; PAFA, Contemporary American Realism, 1981; U. of California, Santa Barbara, A Heritage Renewed: Representational Drawings Today, 1983; SFMA, American Realism (Janss), circ., 1985; AAIAL, 1985, 81; Hudson River Museum, Form or Formula: Drawings and Drawings, 1986; U. of Virginia, Studied from Life, 1987; U. of Arkansas, The Face, 1988; U. of Arkansas, The Figure, 1990; Orlando, Exquisite Painting, 1991. **Collections:** AMA; AT&T; Amerada Hess Corp., Inc.; Ball State U.; Chemical Bank; Chicago/AI; Cleveland/MA; Federal Reserve Bank; Flint/Institute; Fort Wayne/AM; Harvard U.; Library of Congress; U. of Michigan; U. of North Carolina; U. of Notre Dame; PAFA; PMA; The Pennsylvania State U.; Provident National Bank; St. Joseph/Albrecht; Trenton/State; Valparaiso U. (Ind.); Yale U.

ERNST, JIMMY b. June 24, 1920, Cologne, Germany. d. February 6, 1984, NYC.

Studied: Cologne-Lindenthal Real-Gymnasium; Altona Arts and Crafts School. To USA, 1938. **Taught:** U. of Colorado, summers, 1954, 56; Museum of Fine Arts of Houston, 1956; Brooklyn College, 1951-84; Pratt Institute; lectured extensively. Sent by US State Department to USSR, 1961. **Commissions:** General Motors Technical Center, Detroit (10-ft. mural); NBC-TV, "Producers' Showcase," 1954 (plastic sculpture signature); Abbott Laboratories, 1955; *Fortune* magazine, 1955, 61 (paintings); NBC-TV, "Playwrights '56" (welded steel sculpture signature, with Albert Terris); American Resident Lines, USS *President Adams,* 1956 (mural); Continental National Bank, Lincoln, Neb., 1956 (96-ft. mural); Envoy Towers, 300 East 46th Street, NYC, 1960 (relief mural). **Awards:** Pasadena/AM, Hattie Brooks Stevens Memorial, **P.P.**, 1946; WMAA, Juliana Force Memorial, **P.P.**, 1951; Chicago/AI, Norman Wait Harris Bronze Medal 1954; Brandeis U., Creative Arts Award, 1957; Guggenheim Foundation Fellowship, 1961. **One-man Exhibitions:** (first) Norlyst Gallery, NYC, 1941; Philadelphia Art Alliance, 1948; Grace Borgenicht Gallery, Inc., NYC, 1951-55, 1957, 61, 62, 68, 71, 72, 76; Walker, 1954; Silvermine Guild, 1955; Houston/MFA, 1956; Brandeis U., 1957; Detroit/Institute, 1963; PAFA, 1965; West

Palm Beach/Norton, 1965; Des Moines, 1966; Arts Club of Chicago, 1968; Harmon Gallery, Naples, Fla., 1981; Guild Hall, 1985; Century Association, 1985; Harmon-Meek Gallery, Naples, Fla., 1987; Galerie 1900-2000 Paris, 1990. **Retrospective:** Guild Hall, 1985. **Group:** Pasadena/AM, 1946; Brooklyn Museum Watercolor Biennial; California Palace, 1952; U. of Colorado, 1953, 54, 56; Detroit/Institute, 1953, 59; *Life* magazine, Painters Under 35, NYC, 1954; MMA, 100 Years of American Painting, 1954; SRGM, Younger American Painters, 1954; American Embassy, Paris, American Drawing, 1954; Toronto, 1954; Toledo/MA, 1954, 55; Carnegie, 1955; WMAA, Young America, 1955; XXVIII Venice Biennial, 1956; U. of Nebraska, 1956; U. of Illinois, 1957; Brooklyn Museum, Golden Years of American Drawing, 1957; Brussels World's Fair, 1958; NIAL, 1958, 60, 65; PAFA, 1959, 65; Chicago/AI, Directions in American Painting, 1960; WMAA Annual, 1966; Washburn U. of Topeka, 1966; WMAA, Art of the U.S. 1670-1966, 1966; Honolulu Academy, 1967. **Collections:** Allentown/AM; Bielefeld; Brandeis U.; Brooklyn Museum; Buffalo/Albright; Chicago/AI; Clearwater/Gulf Coast; Cologne; U. of Colorado; U. of Connecticut; Corcoran; Cranbrook; Detroit/Institute; Hartford/Wadsworth; Houston/MFA; Lehigh U.; MMA; MOMA; Michigan State U.; U. of Michigan; NCFA; NYU; U. of Nebraska; PAFA; Pasadena/AM; SFMA; SRGM; Southern Illinois U.; Toledo/MA; Toronto; Tulsa/Philbrook; Utica; VMFA; WMAA; Walker; West Palm Beach/Norton. **Bibliography:** *Abstract Expressionism;* Baur 7; Beekman; Blesh 1; Goodrich and Baur 1; Guggenheim, ed.; McCurdy, ed.; Janis and Blesh 1; Janis, S.; Mendelowitz; Motherwell and Reinhardt, eds.; Nordness, ed.; Pousette-Dart, ed.; Read 2; Ritchie 1; Ward. Archives.

ESTES, RICHARD b. May 14, 1936, Kewanee, Ill. **Studied:** Chicago/AI

School, 1952-56. **Address:** 300 Central Park West, NYC 10024. **Dealer:** Allan Stone Gallery, NYC. **One-man Exhibitions:** Allan Stone Gallery, 1968, 69, 70, 72, 74, 83; Hudson River Museum, 1968; Chicago/Contemporary, 1974; New Gallery of Contemporary Art, Cleveland (three-man), 1979; Boston/MFA, 1978; Louis K. Meisel Gallery, NYC, 1985; Toyko/Isetan, circ., 1990; Portland, Me./MA, 1991. **Retrospective:** Harvard U., 1990. **Group:** Milwaukee, Aspects of a New Realism, 1969; U. of Illinois, 1969; Newport Harbor, Directly Seen: New Realism in California, 1970; WMAA, 22 Realists, 1970; Syracuse/Everson, Cool Realism, 1970; Chicago/Contemporary, Radical Realism, 1971; Kassel, Documenta V, 1972; Stuttgart/WK, Amerikanischer Fotorealismus, circ., 1972; California State U., San Jose, East Coast/West Coast/New Realism, 1973; Serpentine Gallery, London, Photo Realism, 1973; Seattle, American Art: Third Quarter Century, 1973; Worcester/AM, Three Realists, 1974; VMFA, Twelve American Painters, 1974; US Department of the Interior, America 1976, 1976; NCFA, America as Art, 1976; Australian Council, Illusion and Reality, 1976; A.F.A., American Master Drawings and Watercolors, 1977; WMAA Annual, 1977; SRGM, Seven Photorealists from New York Collections, 1981; San Antonio/MA, Real, Really Real, Super Real, 1981; Fort Wayne, Photographs by the Photorealists, 1982; PAFA, Contemporary American Realism, circ., 1981; Huntington/Heckscher, Through the Looking Glass: Reflected Images in Contemporary Art, 1984; Tokyo/Isetan, American Realism: The Precise Image, 1985; Fort Lauderdale, An American Renaissance: Painting and Sculpture since 1940, 1986; SFMA, American Realism (Janss), circ., 1986. **Collections:** Aachen/Ludwig; Académie Française; Air and Space Museum; American Broadcasting Co.; Chicago/AI; Chicago/Contemporary; Currier; Detroit/Institute; High Museum; Hirshhorn;

Ivest-Wellington Corp.; Kansas City/Nelson; NMAA; SRGM; Toledo/MA; WMAA. **Bibliography:** *America 1976; Amerikanischer Fotorealismus;* Armstrong; Thomas; Arthur 1, 2, 3; Honish and Jensen, eds.; Hunter, ed.; Lindy; Meisel; Robins; Sager; Sandler 3; *Three Realists;* Ward.

ETTING, EMLEN b. August 24, 1905, Philadelphia, Pa. **Studied:** Harvard U., 1928; Academie de la Grande Chaumiere; with Andre Lhote in Paris. **Taught:** Philadelphia Museum School; Stella Elkins Tyler School of Fine Arts, Temple U.; Philadelphia College of Art. **Member:** President and co-founder, Philadelphia chapter of Artists Equity; National President of Artists Equity, 1955-57; Hon. President of The Alliance Française of Philadelphia; Society of Cincinnati; National Society of Mural Painters; Philadelphia Art Alliance and Athenaeum. **Commissions** (murals): Market Street National Bank, Philadelphia; Italian Consulate, Philadelphia. **Awards:** Italian Star of Solidarity; Chevalier de la Legion d'Honneur; Philadelphia Friends of Artists, Silver Medallion Award for Service to the Arts, 1980. **Address:** 1927 Panama Street, Philadelphia, PA 19103. **Dealer:** Midtown-Payson Galleries, NYC. **One-man Exhibitions:** The Midtown Galleries, NYC, 1940, 43, 44, 46, 48, 50, 51, 57, 66, 71, 75, 80, 84; ICA, Boston; Cleveland/MA; Warwick Gallery, Philadelphia; Philadelphia Art Alliance, 1946; Phoenix, 1965; Century Association, 1979. **Retrospectives:** Florida Southern College, 1973; Allentown/MA, 1974. **Group:** WMAA; Corcoran; PAFA; Florida Southern College; VMFA; NAD; Audubon Artists; St. Louis/City; Philadelphia Art Alliance; Youngstown/Butler; Dayton/AI; Indiana U.; Illinois Wesleyan U.; West Palm Beach/Norton. **Collections:** Andover/Phillips; Atwater Kent Museum, La France Institute; PAFA; PMA; WMAA. **Bibliography:** Etting; Frost; Hall. Archives.

EVERGOOD, PHILIP HOWARD FRANCIS DIXON b. October 26, 1901, NYC. **d.** March 11, 1973, Bridgewater, Conn. **Studied:** Eton College, England, 1914-18; Trinity Hall, Cambridge, 1918-20; U. of London, Slade School, 1920-23, with Henry Tonks; ASL, 1923-25, with George Luks, William Von Schlegell; Academie Julian, Paris, 1925, with Jean Paul Laurens, Andre Lhote. Traveled North Africa, USA and Europe, extensively. **Taught:** The Kalamazoo Institute of Arts; American Artists School, NYC; Contemporary School of Art, NYC; Iowa State College, 1952-58; U. of Minnesota, Duluth, 1955; Muhlenberg College; Settlement Music School, Philadelphia; extensive lecturing. Wrote for *Art Front* and *Direction* magazines. **Member:** NIAL; Artists Equity. Federal A.P.: Mural painting; Managing Supervisor, Easel Painting Division; mural for Richmond Hill (N.Y.) Public Library. **Commissions** (murals): Kalamazoo College; US Post Office, Jackson, Ga. **Awards:** Chicago/AI, The M.V. Kohnstamm Prize, 1935; MMA, P.P., 1942; Carnegie, Hon. Men., 1945; Chicago/AI, W.H. Tuthill, P.P., 1946; Carnegie, Second Prize, 1949; PAFA, Carol H. Beck Gold Medal, 1949, Joseph E. Temple Gold Medal, 1958; Corcoran, Second Prize, 1951; AAAL Grant, 1956; Ford Foundation, P.P., 1962. **One-man Exhibitions:** (first) Dudensing Gallery, NYC, 1927; Montross Gallery, NYC, 1929, 33, 35; Balzac Gallery, NYC, 1931; Denver/AM, 1936; Atheneum Gallery, Melbourne, 1937; ACA Gallery, NYC, 1938, 40, 42, 44, 46, 48, 51, 53, 1955-62, 86; Kalamazoo/Institute, 1941; Norlyst Gallery, NYC, 1948; State U. of Iowa; Utica; Hartford/Wadsworth; Halkins College, 1953; Garelick's Gallery, Detroit, 1953, 55; Tulane U., 1957; Gallery 63, Inc., Rome, 1963, NYC, 1964; Hammer Gallery, 1967; Kennedy Gallery, 1972; Terry Dintenfass, Inc., NYC, 1974, 85, 90; Hirshhorn, 1978; Bucknell U., 1986. **Retrospective:** U. of Minnesota, Duluth,

1955; WMAA, 1960. **Group:** An American Group (Gallery), NYC; American Society of Painters, Sculptors and Graveurs; Salon d'Automne, Paris, 1924; NAD; Independent Artists, NYC; WMAA Annuals since 1934; PAFA; Chicago/AI; Brooklyn Museum; Corcoran; Carnegie; Venice Biennial. **Collections:** Arizona State College; Atlanta/AA; Baltimore/MA; Boston/MFA; Britannica; Brooklyn Museum; Carnegie; Chicago/AI; Corcoran; Cornell U.; Dallas/MFA; Denver/AM; Free Library of Philadelphia; Grolier Club; Hartford/Wadsworth; Harvard U.; IBM; U. of Illinois; Kalamazoo/Institute; Lehigh U.; Library of Congress; Los Angeles/County MA; U. of Louisville; MMA; MOMA; Melbourne/National; Muhlenberg College; PAFA; Pepsi-Cola Co.; Santa Fe, N.M.; Smith College; Syracuse U.; WMAA; Youngstown/Butler. **Bibliography** American Artists Congress, Inc.; **Baur 6**, 7; Biddle 4; Cheney; Cummings 4; Eliot; Finkelstein; Genauer; Goodrich and Baur 1; Haftman; Kootz 2; **Lippard 3**, 5; McCurdy, ed.; Mendelowitz; Nordness, ed.; Pagano; Pousette-Dart, ed.; Reese; Richardson, E.P.; Rose, B., 1; Shapiro, ed.; Ward. Archives.

EVERSLEY, FREDERICK JOHN

b. August 28, 1941, Brooklyn, N.Y. **Studied:** Carnegie-Mellon U., B.S., Electrical Engineering, 1963. **Taught:** Artist-in-residence, Smithsonian Institution, 1977-80. Traveled Mexico, Europe, North Africa, the Americas. **Address:** 1110 Abott Kinney Blvd., Venice, CA 90291. **Dealer:** Lorenzelli Arte, Milan. **One-man Exhibitions:** (first) WMAA, 1970; Phyllis Kind Gallery, Chicago, 1970; OK Harris Gallery, NYC, 1970; Jack Glenn Gallery, Corona Del Mar, Calif., 1970; Morgan Gallery, Kansas City, 1971; Quay Gallery, San Francisco, 1971, 77; J. L. Hudson Gallery, Detroit, 1973; Andrew Crispo Gallery, NYC, 1975; National Academy of Sciences, Washington, D.C., 1976, 81; ICA, Los Angeles, 1976; Palm Springs Desert Museum, 1978; American Institute of Architects, Washington, D.C., 1981; Pepperdine U., 1982; Braunstein Gallery, San Francisco, 1983; Bacardi Art Gallery, Miami, 1984; Loyola Marymount U., Los Angeles, 1985; Hokin Gallery, Palm Beach, Fla., 1988; Eva Cohon Gallery, Chicago, 1991; Lorenzelli Arte, Milan, 1992. **Group:** The Jewish Museum, A Plastic Presence, 1969; La Jolla, Dimensions in Black, 1970; California State U., Two Generations of Black Artists, 1970; Omaha/Joslyn, Looking West, 1970; WMAA, Annual, 1970, 72; WMAA, Contemporary Black Artists in America, 1971; Humlebaek/Louisiana, American Art, 1959-1970, 1971; California Institute of the Arts, Valencia, The Last Plastics Show, 1972; U. of Colorado, Six Sculptors, 1973; New York Cultural Center, Blacks, USA, Now, 1973; Cornell U., Directions in Afro-American Art, 1974; Los Angeles/County MA, Hard and Clean, 1975; NCFA, America As Art, 1976; SFMA, California Painting and Sculpture: The Modern Era, 1976; Indianapolis, 1976; Otis Art Institute, Contemporary Black Artists, 1977; Oakland, 100 Years of California Sculpture, 1982; Cologne/Ludwig, Constructivist Art, 1988; U. of Southern California, Finish Fetish: The LA Cool School, 1991. **Collections:** The California State U; Cranbrook; Currier; U. of Kansas; Laguna Beach Museum of Art; Los Angeles/County MA; MIT; Milwaukee; NMAA; National Academy of Sciences; National Air and Space Museum; Oakland Museum; Palm Springs Desert Museum; Purchase/SUNY; SRGM; Smith College; Taft Museum; WMAA.

F

FAHLSTROM, OYVIND
b. 1928, São Paulo, Brazil. **d.** November 9, 1976, Paris. To Sweden, 1939; to USA, 1961. Wrote plays, poetry, journalism, criticism, 1950-55; manifesto for concrete poetry (Stockholm), 1953; produced happenings, 1966-68. **Awards:** São Paulo Biennial, Hon. Men., 1959; Guggenheim Foundation Fellowship, 1964. **One-man Exhibitions:** (first) Numero Gallery, Florence, Italy, 1952; Daniel Cordier, Paris, 1959, 62; Galerie Blanche, Stockholm, 1959; Cordier & Ekstrom, Inc., NYC, 1964; Sidney Janis Gallery, NYC, 1967, 69, 71, 73; MOMA, circ., 1969; Galerie Rudolf Zwirner, 1969; U. of Minnesota, 1969; Baudoin Lebon Gallery, Paris, 1977; Redbird Galleries, Brooklyn, 1978; Arnold Herstand Gallery, NYC, 1984, 87. **Group:** Exposition Phases, Paris, 1956; V São Paulo Biennial, 1959; Carnegie, 1960, 67; Venice Biennials, 1964, 66; EAT, NYC, 1966; Chicago/Contemporary, Pictures to Be Read/Poetry to Be Seen, 1967; Musée des Arts Décoratifs, 1967; Kassel, Documenta IV, 1968; ICA, U. of Pennsylvania, The Spirit of the Comics, 1969; Hayward Gallery, London, Pop Art, 1969; Los Angeles/County MA, Art & Technology, 1971; Tokyo/Modern, Swedish Art 1972, 1972. **Collections:** Cologne; Los Angeles/County MA; Stockholm/National; Stuttgart.

FARR, FRED
from 1st to 4th edition.

FAULKNER, FRANK
b. July 24, 1946, Sumter, South Carolina. **Studied:** U. of North Carolina, BFA, 1968, MFA, 1972. **Awards:** National Endowment for the Arts, 1974; SECCA 1976; American Institute of Architects, Collaborating Artist Award, 1976. **Address:** 150 West 26th Street, NYC 10010. **One-man Exhibitions:** North Carolina Central U., 1968; The Other Ear Gallery, Chapel Hill, N.C., 1968; Art Gallery of Chapel Hill (two-man), 1971; Southeastern Center for Contemporary Art, 1974, 77; Monique Knowlton Gallery, NYC, 1976, 77, 79, 80, 81, 82, 83; East Tennessee State U., 1977; Alexandra Monett Gallery, Brussels, 1978; Roy Boyd Gallery, Chicago, 1979; Davidson College, 1979; Galerie Haberman, Cologne, 1980; Arts Club of Chicago, 1981; Davis/McClain Gallery, Houston, 1983, 87. **Group:** WMAA Biennial, 1975; The Pennsylvania State U., The Material Dominant, 1977; High Museum, Southwestern Painters and Sculptors, 1977; Phoenix, New York Now, 1979; Buffalo/Albright, Patterns, 1979; Wesleyan U., Bloomington, Pattern Painters, 1980. **Collections:** Becton Dickinson & Co.; Buffalo/Albright; Chase Manhattan Bank; Delaware Art Museum; The Hanes Corp.; Harris Bank, Chicago; Henkel Co., GMBH, Germany; Hirshhorn; Hollywood (Fla.) Federal Savings and Loan Assoc.; NCFA; North Carolina State, U.; U. of North Carolina; Owens-Corning Fiberglas Corp; The Pennsylvania State U.; Raleigh/NCMA; R.J. Reynolds Corp.; Smith College; Southeastern Banking Corp., Miami; Springfield, Mo./AM; Toledo/MA.

FEELEY, PAUL
from 1st to 5th edition.

FEININGER, LYONEL
b. July 17, 1871, NYC. **d.** January 13, 1956, NYC. Studied the violin with his father and played in concerts from the age of 12; went to Germany in 1880 to study music,

but changed to painting. **Studied:** Kunstgewerbeschule, Hamburg; Academy of Fine Arts, Berlin, with Ernst Hancke, Woldemar Friedrich; Jesuit College, Liege, Belgium, 1887-91; Academie Colarossi, Paris, 1892-93. Traveled Europe, USA. **Taught:** Bauhaus, Weimar, 1919-24; Bauhaus, Dessau, 1925-33; Mills College, summers, 1936, 37. Cartoonist and illustrator for *Ulk* and *Lustige Blätter,* Berlin, 1893-1906; *Le Temoin,* Paris, 1906-07; and Chicago *Sunday Tribune.* A member of the Blue Four, 1924 (with Vassily Kandinsky, Paul Klee, and Alexej von Jawlensky). **Commissions:** New York World's Fair, 1939 (murals for Marine Transport Building and Masterpieces of Art Building). **One-man Exhibitions:** Emil Richter Gallery, Dresden, 1919; Anger Museum, Erfurt, Germany, 1920, 27, 29, 30; Kunst und Bucherstube, Erfurt, 1921; Goldschmidt-Wallerstein, Berlin, 1922, 25; Anderson Galleries, NYC, 1923; Wiesbaden, 1925; Neue Kunstfides, Dresden, 1925, 26, 31; Brunswick, 1926; Kassel, 1927; Staatliche Galerie Moritzburg, Halle, Germany, 1928; Anhalt Gallery, Dessau, 1929; Kunstverein, Prague, 1930; Mills College, 1936, 37; SFMA, 1937; Los Angeles/County MA, 1937; Seattle/AM, circ., 1937; Andover/Phillips, 1938; Curt Valentine Gallery, NYC, 1941, 44, 46, 48, 50, 52, 54; Buchholz Gallery, NYC, 1941, 43, 44; Karl Nierendorf Gallery, NYC, 1943; The Willard Gallery, NYC, 1943, 44; Dalzell Hatfield Gallery, 1944; Fort Worth, 1956; Harvard U., 1958; Detroit/Institute, 1964; R. N. Ketterer, Campione, Switzerland, 1965; Pasadena/AM, 1966; La Boetie Gallery, NYC, 1966; MOMA, 1967; Marlborough-Gerson Gallery, Inc., 1969; A.A.A. Gallery, 1972; Serge Sabarsky Gallery, NYC, 1972, 74, 79, circ. 91; Haus der Kunst, Munich, 1973; Marlborough Gallery, Inc., NYC, 1974, 87; Society of the Four Arts, 1976; AAA, NYC, 1974; Achim Moeller Fine Art Ltd., NYC, 1985, 90, 91; Acquavella Galleries, NYC,

1985; Phillips, 1985; Galerie Orangerie-Reinz, Cologne, 1987; Galerie Utermann, Dortmund, 1988, 90; Galerie Antonia Gmurzynska, Cologne, 1989; Marlborough Fine Art, Tokyo, 1990; Trento/Contemporanea, 1990; Ruggerini & Zonca, Moderna e Contemporanea, 1991; Stiftung Langmatt, Baden, circ., 1991; Lyonel-Feininger Galerie, Quedlinburg, 1991; Halle, Staatliche, 1991; Museo Cantonale d'Arte, Lugano, 1991; Galleria D'Arte Il Castello, Trento, 1991; Kulturforum Lünneburg, 1991; Norton Simon Museum, Pasadena, 1991; Galerie Thomas, Munich, 1992; Germanisches National Museum, Nurnberg, circ., 1992; Regensburg/Ostdeutsche, circ., 1992; Nurnberg/Kunsthalle, 1992. **Retrospectives:** MOMA, 1944 (two-man); ICA, Boston, 1949; Jeanne Bucher, Paris, circ., Europe, 1950-51; Print Club of Cleveland, 1951; Hannover, circ., Europe, 1954-55; SFMA, circ., 1959-61. **Collections:** Baltimore/MA; Buffalo/Albright; Chicago/AI; Cranbrook; U. of Houston; Kansas City/Nelson; Lehigh U.; MMA; MOMA; U. of Michigan; Milwaukee; Minneapolis/Institute; PMA, Phillips; RISD; Raleigh/NCMA; SRGM; San Antonio/McNay; Seattle/AM; Toledo/MA; Utica; WMAA; Walker; Washington U. **Bibliography:** Barr 1; Baur 5, 7; Bazin; Beekman; Biddle 4; Blanchard; Blesh 1; Born; Brion 2; Brown; Bulliet 1; Cassou; Cheney; *Cityspace 1919-39;* Eliot; **Feininger and Tobey;** Feininger, T.L.; Flanagan; Frost; Goodrich and Baur 1; Gettings; Haftman; Hess, H.; Hess, T. B., 1; Hulten; Hunter 6; Huyghe; Janis S.; Kouvenhoven; Kuh 1; Langui; Lee and Burchwood; MacAgy 2; McCurdy, ed.; Mendelowitz; Munsterberg; Murken-Altrogge; **Ness, ed.;** Neumeyer; Newmeyer; Pousette-Dart, ed.; **Prasse;** Raynal 3, 4; Read 2; Richardson, E.P.; Rickey; Ritchie 1; Rose, B., 1; Rosenblum 1, 2; Roters; Sachs; Scheyer; Selz, P., 3; Sutton; Valentine 2; Verkauf; Wiesinger; Wight 2; Wingler, ed. Archives.

FEITELSON, LORSER b. 1898, Savannah, Ga. d. May 24, 1978, Los Angeles, Calif.

Taught: Art Center School, Los Angeles. **One-man Exhibitions:** The Daniel Gallery, NYC, 1924; San Diego, 1928; California Palace, 1928, 32; Los Angeles/County MA, 1929, 44; SFMA, 1944; Lucien Labaudt Gallery, San Francisco, 1949; San Antonio/McNay, 1955; Paul Rivas Gallery, Los Angeles, 1959 (two-man); Scripps College, 1958, 61; Long Beach/MA, 1962; Chapman College, Los Angeles, 1963; Occidental College, Los Angeles, 1965; Los Angeles, Art Association Galleries, 1968, 79; David Stuart Gallery, Los Angeles, 1977; WMAA, 1978; Jan Baum Gallery, Los Angeles, 1982; Tobey C. Moss Gallery, Los Angeles, 1983, 85, 90. **Retrospectives:** Pasadena/AM, 1952; Los Angeles Municipal Art Gallery, 1972; SFMA, 1980. **Group:** Brooklyn Museum, 1936; SFMA, 1936; MOMA, Fantastic Art, DADA, Surrealism, 1936; Chicago/AI, Abstract and Surrealist Art, 1948; U. of Illinois, 1950, 51, 53, 65; São Paulo, 1955; WMAA, 1955, Annuals, 1965, 67; MOMA, The Responsive Eye, 1965; Sacramento/Crocker, 1967, 68; Pasadena/AM, West Coast: 1945-1969, 1969; Museum of Fine Arts, St. Petersburg, Color in Control, 1969; Sacramento/Crocker, Century of California Painting, 1970; VMFA, American Painting, 1970; Painting and Sculpture in California: The Modern Era, 1976; Rutgers U.; Surrealism and American Art: 1931-47, 1977. **Collections:** Atlantic-Richfield Co.; Bank of Omaha; Brooklyn Museum; Craig Elwood Associates; Great Western Savings and Loan Association; Hirshhorn; Industrial Electronics Engineers, Inc.; Lansing Sound Corp.; Long Beach/MA; Los Angeles/County MA; MOMA; SFMA; Xerox Corp. **Bibliography:** *Avant-Garde Painting and Sculpture;* Baur 7; *Black and White Are Colors;* Feitelson and Lundeberg; Flanagan; Kalstrom and Ehrlich; Plagens; Rickey. Archives.

FELTUS, ALAN b. May 1, 1943, Washington, D.C.

Studied: Tyler School of Art, Philadelphia, 1961-62; Cooper Union, 1966, BFA; Yale U., 1968, MFA, with Jack Tworkov, Lester Johnson; Jerry Farnsworth School, No. Truro, Mass., 1959. Traveled Europe, Guatemala. **Taught:** Dayton Art Institute School, 1968-70; American U. 1972-85. **Awards:** National Endowment for the Arts, 1981; L. C. Tiffany Grant, 1980; Prix de Rome Fellowship, 1970-72; NAD, The Clarke Prize, 1984; National Endowment for the Arts, fellowship, 1981; Louis C. Tiffany Foundation grant, 1980; NAD, Benjamin Altman Prize, 1990. **Commissions:** Montana Building, New York, 1986; 999 E Street N.W., Washington, D.C., 1985. **Address:** c/o Dealer. **Dealer:** The Forum Gallery, NYC. **One-man Exhibitions:** (first) American Academy, Rome, 1972; Jacob's Ladder Gallery, Washington, D.C., 1973; The Forum Gallery, NYC, 1976, 80, 83, 85, 87, 91; Northern Virginia Community College, Annandale, 1976; Wichita/AM, 1987; Simms Fine Art, New Orleans, 1988. **Group:** AAIAL, 1977, 79, 81; Corcoran, 10 + 10, 1982; NAD, 1982, 84, 86, 88, 90; St. Mary's College of Maryland, Southern Maryland Artists, 1985; Wichita/AM, A Decade of American Realism, 1986; NMAA, Modern American Realism, 1987. **Collections:** AMA; California Palace; Dayton/AI; Hirshhorn; Little Rock/MFA; NMAA; Oklahoma; Springfield, Mass./MFA; Trenton/State; U. of Virginia, Charlottesville.

FENTON, ALAN
from 1st to 4th edition.

FERBER, HERBERT b. April 30, 1906, NYC. d. August 20, 1991, North Egermont, MA.

Studied: City College of New York, 1923-26; Columbia U. School of Dental and Oral Surgery, 1927, BS, 1930, DDS; Beaux-Arts Institute of Design, NYC, 1927-30; NAD, 1930. **Taught:** U. of Pennsylvania, 1963-64;

Rutgers U., 1965-67; Yale U., 1967; Rice U., 1979. **Commissions:** B'nai Israel Synagogue, Millburn, N.J., 1950; Brandeis U., Jewish Chapel, 1955; Temple Anshe Chesed, Cleveland, 1955; Temple of Aaron, St. Paul, 1955; WMAA, Sculpture as Environment, 1961; Rutgers U., 1968; John F. Kennedy Federal Office Building, Boston, 1969; American Dental Association Building, Chicago, 1974. **Awards:** Beaux-Arts Institute of Design, NYC, Paris Prize, 1929; L. C. Tiffany Grant, 1930; MMA, Artists for Victory, $1,000 Prize, 1942; ICA, London/Tate, International Unknown Political Prisoner Competition, 1953; Guggenheim Foundation Fellowship, 1969; AFA, Reynolds Metal Award, 1979. Associate Fellow, Morse College, Yale U., 1967. **One-man Exhibitions:** (first) The Midtown Galleries, 1937, also 1943; Betty Parsons Gallery, 1947, 50, 53; The Kootz Gallery, NYC, 1955, 57; Columbia U., 1960; André Emmerich Gallery, 1960, 62, 67, 69, 70, 71, 72, 73, 75, 76, 77; U. of Vermont, 1964; Rutgers U., 1968; M. Knoedler & Co., Inc., NYC, 1978, 79, 80, 81, 83, 84, 85, 86, 87, 89, 90, 91; Roy Boyd Gallery, Chicago, 1978; Des Moines, 1981; Martha White Gallery, Louisville, 1981; Weintraub Gallery, NYC, 1983; Hokin Gallery, Palm Beach, Fla., 1984; M. Knoedler & Co., Inc., Zurich, 1984; Pittsfield/Berkshire, 1984; Adams-Middleton Gallery, Dallas, 1985, 88; Lorenzelli Arte, Milan, 1988. **Retrospectives:** Bennington College, 1958; WMAA, 1961; SFMA, 1962; Walker, circ., 1962-63; Houston/MFA, circ., 1981. **Group:** NAD, 1930; Brooklyn Museum; PAFA, 1931, 42, 43, 45, 46, 54, 58; Corcoran, 1932; Philadelphia Art Alliance, 1933; American Artists Congress, 1936, 40; Musée du Jeu de Paume, 1938; Sculptors Guild, 1938-42, 1944, 48, 64; Golden Gate International Exposition, San Francisco/AI, 1940, 41, 45; WMAA Annuals, 1940, 42, 1945-; Federation of Modern Painters and Sculptors, 1941-49; A.F.A., Sculpture in Wood,

1941; MMA, 1942; São Paulo, 1951; MOMA, Abstract Painting and Sculpture in America, 1951; MOMA, Fifteen Americans, circ., 1952; Tate, 1953; WMAA, The New Decade, 1954-55; Brussels World's Fair, 1958; Carnegie, 1958; A.F.A., God and Man in Art, circ., 1958-59; Kassel, Documenta II, 1959; St. Paul Gallery, Drawings, USA, 1961; Baltimore/MA; Cranbrook; Battersea Park, London, International Sculpture Exhibition, 1963; Musée Rodin, Paris, 1965; MOMA, The New American Painting and Sculpture, 1969; Newport, R.I., Monumenta, 1974; NCFA, Sculpture, American Directions, 1945-1975, 1975; Indianapolis, 1978; Rutgers U., Vanguard American Sculpture, 1919-1939, 1979; WMAA, Decade of Transition, 1940-1950, 1981; Newark Museum, American Bronze Sculpture, 1850 to the Present, 1984; WMAA, The Third Dimension, 1984; Sarah Lawrence College, Sculpture Expressions, 1985; Hofstra U., Jung and Abstract Expressionism, 1986; Philadelphia Art Alliance, Sculpture of the American Scene, 1987; Williams College, BIGLittle Sculpture, 1988. **Collections:** Bennington College; Brandeis U.; Buffalo/Albright; Carnegie; Cranbrook; Detroit/Institute; Grand Rapids; Hirshhorn; Houston/MFA; U. of Indiana; Indiana U.; MMA; MOMA; NYU; National Gallery; Newark Museum; Paris/Beaubourg; Pasadena/AM; Pittsfield/Berkshire; Princeton U.; Purchase/SUNY; Rutgers U.; SRGM; Storm King Art Center; U. of Vermont; WMAA; Walker; Williams College; Yale U. **Bibliography:** *Abstract Expressionism;* Baur 5, 7; Blesh 1; Brumme; Chipp; Craven, W.; Flanagan; Giedion-Welcker 1; Goodrich and Baur 1; **Goossen 4, 6;** Henning; Hunter 6; Hunter, ed.; Krauss 2; McCurdy, ed.; Marter, Tarbell, and Wechsler; *Monumenta;* Motherwell and Reinhardt, eds.; Phillips, Lisa 2; Read 3; Ritchie 3; Rose, B., 1; Rubin 1; Seuphor 3; Strachan; Trier 1. Archives.

FERRARA, JACKIE (Jacqueline Hirshhorn) **b.** 1929, Detroit, Mich. Autodidact. **Commissions:** Minneapolis College of Art, 1978; Federal Building, Carbondale, Ill. 1980; Laumeier Sculpture Park, St. Louis, Mo., 1981; Memorial Lake Park, Norwalk, Ohio, 1984; Columbus, 1984; Loch Haven Art Center, 1985; Fulton County Government Center, Atlanta, garden courtyard, 1989; Seattle Convention Center, lobby area, 1989; First Tyne International Exhibition of Contemporary Art, Newcastle, England, rooms, 1990; U. of California, San Diego, terrace, 1991; numerous furniture designs and installations. **Awards:** CAPS, 1971, 75; National Endowment for the Arts, grant, 1973, 77, 87; Guggenheim Foundation Fellowship, 1976; Art Commission of New York, Excellence in Design, 1988; American Institute of Architects, Honoree, 1990. **Address:** 121 Prince Street, NYC 10012. **Dealer:** Michael Klein, Inc., NYC. **One-man Exhibitions:** (first) A.M. Sachs Gallery, NYC, 1973, 74; Daniel Weinberg Gallery, San Francisco, 1975; Max Protetch Gallery, Washington, D.C., 1975; Max Protetch Gallery, NYC, 1975, 76, 77, 78, 79, 81, 82, 83, 84; Ohio State U., 1977; Minneapolis College of Art, 1978; U. of Rhode Island, 1979; Glen Hanson Gallery, Minneapolis, 1979; U. of Southern California, 1980; U. of Massachusetts, 1980; Okhun-Thomas Gallery, St. Louis, 1980; Laumeier Sculpture Park, St. Louis, 1981; Marianne Deson Gallery, Chicago, 1981; U. of Miami, 1982; Galleriet, Lund, Sweden, 1983; Janus Gallery, Venice, Calif., 1983; U. of North Carolina, 1983; Susan Montezinos Gallery, Philadelphia, 1984; B. R. Kornblatt Gallery, Washington, D.C., 1987; San Antonio/McNay, 1987; Moore College of Art, Philadelphia, 1987; Genovese Gallery, Boston, 1990; Michael Klein, Inc., NYC, 1991. **Retrospective:** Ringling, circ., 1992. **Group:** WMAA Annual, 1970; GEDOK, Hamburg, American Woman Artist Show, 1972; WMAA Biennials, 1973, 79; Indianapolis, 1974, 80; U. of North Carolina, 1979; XXXIX Venice Biennial, 1980; ICA, U. of Pennsylvania, Connections, 1983; Cleveland Center for Centemporary Art, Artists + Architects, Challenges in Collaboration, 1985; Sculpture Center, NYC, A Rational Imperative, 1985; Stamford Museum, American Art: American Women, 1985; Queens Museum, Sculpture of the Eighties, 1987; Sculpture Center, NYC, In the Making, Drawings by Sculptors, 1988; Long Island U., Lines of Vision, circ., 1989; Cincinnati, Making Their Mark, 1989; Purchase/SUNY, Geometric Abstraction, 1991; U. of North Carolina, Height x Length x Width, 1991; Brooklyn Museum, Contemporary Sculpture, 1992. **Collections:** AMA; Amherst; Baltimore/MA; Brandeis U.; Brooklyn Museum; Burroughs Wellcome Co.; Carnegie; Chase Manhattan Bank; Cincinnati/AM; Columbus; Cornell U.; Dallas/MFA; Des Moines; Detroit/Institute; Exxon Corp.; Gelco; General Mills, Inc.; Hartford/Wadsworth; High Museum; Humlebaek/Louisiana; Indianapolis; Laumeier Sculpture Park; Loch Haven Art Center; MMA; MOMA; U. of Massachusetts, U. of Miami; Millersville State College; Minneapolis College of Art; Mobil Oil Co.; NCFA; NMAA; U. of North Carolina; Phillips; Prudential Insurance Co. of America; Ridgefield/Aldrich; Ringling; SRGM; St. Lawrence U.; St. Louis/City; WMAA; Walker; Wellesley College; Williams College.

FERREN, JOHN **b.** October 17, 1905, Pendleton, Ore. **d.** July 24, 1970, Southampton, N.Y. **Studied:** Academie de la Grande Chaumiere; Sorbonne; U. of Florence; U. of Salamanca; Academie Ranson, Paris; Academie Colarossi, Paris. Traveled Europe, USA, Middle East; resided, worked in Paris, 1931-38. Civilian employee of War Department and OWI, 1941-45; Psychological Warfare Division, SHAEF (Propaganda Chief, Italian Radio

Section); Algiers headquarters (Chief of Publications for France); received Bronze Star. **Taught:** Brooklyn Museum School, 1946-50; Cooper Union, 1947-54; Art Center School, Los Angeles, summer, 1948; Queens College, 1952-70; UCLA, summer, 1953; privately in New York; U. of Saskatchewan, summer, 1960; Yale U., summer, 1962; lectured extensively and published essays. Advisory work on *The Trouble with Harry* (1955) and *Vertigo* (1958), films directed by Alfred Hitchcock. **Member:** Advisory Council to the School of Art and Architecture, Yale U., 1959-62. **One-man Exhibitions:** Art Center, San Francisco, 1930; Galerie Zak, Paris, 1932; Gallerie Pierre, Paris, 1936; Pierre Matisse Gallery, 1936, 37, 38; Minneapolis/Institute, 1936; Howard Putzell Gallery, Hollywood, 1936; SFMA, 1936, 52; Arts Club of Chicago, 1937; Galerie Beaune, Paris, 1938; The Willard Gallery, NYC, 1942; Art Project Gallery, Hollywood, 1942; Kleemann Gallery, NYC, 1947, 49; Santa Barbara/MA, 1952; Tacoma, 1952; Portland (Ore.) Arts Club, 1952; Alexander Iolas Gallery, NYC, 1953; UCLA, 1953; U. of Washington, 1953; The Stable Gallery, NYC, 1954, 55, 56, 57, 58; Phillips, 1958; U. of Wisconsin, 1959; Glassboro State College, 1959; Trenton State College, 1959; Rose Fried Gallery, NYC, 1962, 1965-68; Queens College, 1963; Centre d'Art Gallery, Beirut, Lebanon, 1964; American Embassy, London, 1965; Pageant Gallery, Florida, 1968; Southampton College, 1968 (two-man); A.M. Sachs Gallery, NYC, 1969, 72, 74, 75, 77, 82, 83, 85; Southampton/Parrish, 1969; The Century Assoc., NYC, 1971; Katharina Rich Perlow Gallery, NYC, 1985, 86, 87, 88, 90, 92; Queens College, circ., 1992. **Group:** Los Angeles/County MA Annuals, 1925-29; SFMA Annuals, 1925-29; California Palace, 1931; American Abstract Artists 1934, 35, 37; Musée de l'Orangerie, Paris, 1937; Salon des Surindependants, Paris, 1937; Royal Institute of the Arts, Copenhagen, 1937; Corcoran, 1940; Chi-

cago/AI, 1947; Brooklyn Museum, 1949; U. of Minnesota, Pioneers in American Abstract Art, 1951; Ninth Street Exhibition, NYC, 1951; MOMA, Abstract Painting and Sculpture in America, 1951; WMAA Annuals, 1952, 55, 56, 58, The 1930's, 1968; Carnegie 1955; MOMA, 7 American Watercolorists, circ., Europe, 1956; Chicago/AI, 1956; U. of Illinois, 1957; WMAA, Nature in Abstraction, 1958; U. of Kentucky, Graphics, 1958, 59; Pasadena/AM, A Decade in the Contemporary Gallery, 1959; ART:USA:59, NYC, 1959; Walker, 60 American Painters, 1960; SRGM, Abstract Expressionists and Imagists, 1961; A.F.A., Affinities, circ., 1962; PAFA, 1964, 66; Gallery of Modern Art, NYC, 1965; WMAA, Annual, 1968; Carnegie, Abstract Painting and Sculpture in America, circ., 1983; WMAA, Vital Signs, 1988; Phillips, Kandinsky and the American Avant-Garde, 1992; Delaware Art Museum, The Second Wave: American Abstraction of the 1930's and 1940's, 1992. **Collections:** Allentown/AM; Art of This Century (Peggy Guggenheim); Arts Club of Chicago; Birmingham, Ala./MA; Brandeis U.; Buffalo/Albright; California Palace; U. of California; Cedar Rapids/AA; Cleveland/MA; Detroit/Institute; Hartford/Wadsworth; High Museum; Hirshhorn; Los Angeles/County MA; MMA; MOMA; NYU; U. of Nebraska; Norfolk/Chrysler; Oklahoma; PMA; Phillips; SFMA; SRGM; Sacramento/Crocker; Santa Barbara/MA; Scripps College; Tel Aviv; U. of Texas; Tougaloo College; VMFA; WGMA; WMAA; Washington U.; Yale U. **Bibliography:** Armstrong, Thomas; Ashbery; Baur 5, 7; Chipp; Downes, ed.; Eliot; Frost; Goodrich and Baur 1; Guggenheim, ed.; Hayter 2; Janis, S.; Lane and Larsen; Passloff; Ritchie 1; Rose, B., 1, 4; Sandler 5. Archives.

FIENE, ERNEST **b.** November 2, 1894, Eberfeld, Germany. **d.** August 10, 1965, Paris, France. To USA, 1912; citizen 1928. **Studied:** NAD, 1914-18; Beaux-

Arts Institute of Design, NYC, 1916-18; ASL, 1923; Academie de la Grande Chaumiere, 1929; Florence, Italy (fresco painting), 1932. Traveled Europe, Mexico, USA. **Taught:** Westchester County Center, 1930-31; Colorado Springs Fine Arts Center, 1935; Cooper Union, 1938-39; ASL, 1938-65; Ogunquit School of Painting, 1950-51; Famous Artists Schools, Inc., 1956-65; NAD, 1960-65. **Member:** Artists Equity (Hon. President); NAD; Century Association; ASL. **Commissions** (portraits): Columbia U.; New York Hospital; Ohio U.; Abbott Laboratories (series of paintings); Scruggs, Vandervoort, and Barney; Gimbel's, Philadelphia; Central Needle Trades High School of New York; (murals): International Ladies' Garment Workers Union, NYC; Abraham Lincoln High School, Brooklyn (2); US Post Office, Canton, Mass.; New Interior Building, Washington, D.C. **Awards:** Guggenheim Foundation Fellowship, 1932; Chicago/AI, Norman Wait Harris Prize, 1937; Corcoran, William A. Clark Prize, 1938; Carnegie, Hon. Men., 1938; Chicago/AI, Ada S. Garrett Prize, 1940; Library of Congress, Pennell, P.P., 1940; Library of Congress, First Pennell, P.P., 1944; NAD, Edwin Palmer Memorial Prize, 1961. **One-man Exhibitions:** (first) Whitney Studio Club, NYC, 1923; The New Gallery, NYC, 1924; Kraushaar Galleries, NYC, 1927; The Downtown Gallery, NYC, 1928, 33, 36; Rehn Galleries, NYC, 1930-32; Western Association of Art Museum Directors, circ., 1938; A.A.A. Gallery, NYC, 1938-41, 1945; M. Knoedler & Co., NYC, 1949-51; The Midtown Galleries, NYC, 1959; Stonington Gallery, Conn., 1963; Bay Head Art Center, 1964; Washington Irving Gallery, NYC, 1969; ACA Gallery, NYC, 1981. **Group:** WMAA, 1930-45; Carnegie, 1930-45; PAFA, 1930-45; NAD; MOMA; Youngstown/Butler; Chicago/AI, 1930-33, 1936-45; Corcoran, 1931-45; MMA; Boston/MFA. **Collections:** ASL; Abbott Laboratories; Boston/MFA; Bowdoin College;

Britannica; Brooklyn Museum; California Palace; Chicago/AI; Cleveland/MA; Columbia U.; Dartmouth College; Denver/AM; Detroit/Institute; Drake U.; Library of Congress; Los Angeles/County MA; MIT; MMA; MOMA; NAD; NYPL; U. of Nebraska; Newark Museum; Ogunquit; Ohio U.; PAFA; Phillips; SFMA; Syracuse U.; Tel Aviv; Terre Haute/Swope; Tulsa/Philbrook; WMAA; Yale U. **Bibliography:** American Artists Congress, Inc.; American Artists Group, Inc., 1, 2, 3; Cahill and Barr, eds.; Goodrich and Baur 1; Hall; Pearson 1; Phillips 1; Reese; Richardson, E.P.; *Woodstock: An American Art Colony, 1902-1977.* Archives.

FISCHL, ERIC b. 1948, NYC. **Studied:** California Institute of the Arts, 1972, BFA. **Taught:** Nova Scotia College of Art, 1974-78. **m.** April Gornik. **Address:** 77 Reade Street, NYC 10007. **Dealer:** Mary Boone Gallery, NYC. **One-man Exhibitions:** Dalhousie Art Gallery, Halifax, 1975; Studio, Halifax, 1976; Galerie B., Montreal, 1976, 78; Edward Thorp Gallery, NYC, 1980, 81, 82; U. of Akron, 1980; Sable-Castelli Gallery, Ltd., Toronto, 1981, 82, 85, 87; U. of Colorado, 1982; U. of Montreal, 1983; Larry Gagosian Gallery, Los Angeles, 1983; Mario Diacono Gallery, Rome, 1983; Mary Boone Gallery, 1984, 86, 87, 88, 90; Multiples, 1983; Mendel Art Gallery, Saskatoon, Canada, 1985; Eindhoven, circ., 1985; U. of California, Berkeley, 1986; Honolulu/Contemporary, 1987; Galerie Michael Werner, Cologne, 1988; Waddington Gallery, London, 1989; Academie der Bildenen Kunste, Vienna, 1990; Musée Cantonal des Beaux-Arts, Lausanne, 1990; Koury-Wingate Gallery, NYC, 1990; UCLA, circ., 1990; Cleveland/Contemporary, 1990; Dartmouth, 1991; Aarhus Kunstmuseum, Denmark, 1991; Guild Hall, 1991; Milwaukee, 1991; Michael Kohn Gallery, Santa Monica, 1992; Montgomery Museum, circ., 1992. **Retrospective:** WMAA, 1986. **Group:**

Eric Fischl, *Nick's Picnic*, 1992.

P. S. 1, Long Island City, The Big Drawing Show, 1978; WMAA, Focus on the Figure, 1982; WMAA Biennial, 1983, 85, 91; Bonn, Back to the USA, circ., 1983; Indianapolis, 1984; MOMA, International Survey of Contemporary Painting and Sculpture, 1984; XLI Venice Biennial, 1984; Biennale de Paris, 1985; Carnegie, International, 1985; Fort Lauderdale, An American Renaissance, 1986; Biennial of Sydney, 1986; Ludwig/Cologne, Europa/Amerika, 1986; Los Angeles/MOCA, Individuals, 1986; ICA, NYC, The Success of Failure, circ., 1986; Los Angeles/County MA, Avant-Garde in the Eighties, 1987; Kassel, Documenta VIII, 1987; Southampton/Parrish, Drawing on the East End, 1940-1988, 1988; Cologne/Ludwig, Bilderstreit, 1989; Museum of the 20th Century, Vienna, Viennese diva: Sigmund Freud Nowadays, 1989; Munich/Bayerische, Seiben Americanische Maler, 1991; Museo D'Arte Moderna, Trento, Albere, Trento; Provinciale, Anni 80: Artisti a New York, 1991; ICA, U. of Pennsylvania, Devil on the Stairs, 1992. **Collections:** Houston/MFA; Los Angeles/MOCA; Cologne/Ludwig; MMA; MOMA; National Gallery; SFMA; Saint Louis/City; WMAA. **Bibliography:** Danto; *The Decade Show;*

Fox; Gohr and Gachnang; Honnef 2; Hughes; *Individuals;* Murken-Altrogge; Pincus-Witten 2; Schwartz 1.

FISH, JANET b. May 18, 1938, Boston, Mass. **Studied:** Smith College, BA, 1960; Yale U., MFA, 1963. **Awards:** Chicago/AI; MacDowell Colony Fellowship, 1968, 69, 72; Norman Wait Harris Award, 1974; Australia Council for the Arts, Grant, 1975. **Taught:** Skowhegan School, 1973, 74; School of Visual Arts, NYC, 1968-69; U. of Bridgeport, 1971, 91; Parsons School of Design, NYC, 1974; Syracuse U., 1974; U. of Chicago, 1976. **Member:** Board of Governors, Skowhegan School; AAIAL. **Address:** 101 Prince Street, NYC 10012. **Dealer:** Borgenicht Gallery, Inc., NYC. **One-man Exhibitions:** (first) Fairleigh Dickinson U., 1967; Stony Brook/SUNY, 1967, 78; Ours Gallery, NYC, 1968; Mercer Street, NYC, 1969; The Kornblee Gallery, NYC, 1971, 72, 73, 74, 75, 76; Pace College, NYC, 1972; Russell Sage College, 1972; Galerie Alexandra Monett, Brussels, 1974; Galerie Kostiner-Silvers, Montreal, 1974; Hogarth Gallery, Paddington, Sydney, Australia, 1975; Tolamo Gallery, Stokitha, Victoria, 1975, 77; Phyllis Kind Gallery, Chicago, 1976; Robert Miller Gallery, Inc., NYC, 1978, 79, 80, 83, 85, 87, 89, 91; Union College, 1981; Wilmington, 1982; Texas Gallery, Houston, 1983, 85, 88; Columbus (Ga.) College, 1983; Columbia, S.C./MA, 1984; Smith College, 1985; U. of Richmond, 1987; Marianne Friedland Gallery, Toronto, 1987, 90, 92; Marianne Friedland Gallery, Naples, Fla., 1992; Simms Fine Art, New Orleans, 1988; Brevard Art Center and Museum, Melbourne, Fla., 1990; Art and Culture Center, Hollywood, Fla., 1990; Linda Cathcart Gallery, Santa Monica, 1990; Tavelli Gallery, Aspen, Co., 1990; U. of Connecticut, Bridgeport, 1991; Gerald Peters Gallery, Santa Fe, 1991; Orlando, 1992; Atlantic Center for the Arts, New Smyrna Beach, Fla., 1992; The Gallery of the State

Theater for the Arts, Easton, Pa., 1992. **Group:** A.F.A., Still Life Today, 1970-71; NIAL, 1972; Chicago/AI, 1972, 74; Indianapolis, 1972; Lakeview Center, American Women: 20th Century, 1972; Randolph-Macon College, Paintings by Some Contemporary American Women, 1972; Cleveland/MA, 32 Realists, 1972; A.F.A., The Realist Revival, 1972; WMAA, American Drawings: 1963-1973, 1973; Yale U., 7 Realists, 1973; PMA/Museum of the Philadelphia Civic Center, Focus, 1974; Tokyo Biennial, 1974; Queens Museum, New Images, 1974; U. of North Carolina, 1975, 78; Ohio State U., Concepts of Reality: Recent Art, 1975; Minnesota/MA, Drawings USA/75, 1975; Baltimore/MA, Super Realism, 1975; US Department of the Interior, America 1976, circ., 1976; PAFA, 8 Contemporary American Realists, 1977; Centro Colombo Americano, Bogota, 16 Realists, 1979; Lincoln, Mass./De Cordova, Born in Boston, 1979; Tulsa/Philbrook, Realism-Photorealism, 1980; NAD, 1980; Yale U., Twenty Artists: Yale School of Art, 1950-1970, 1981; San Antonio/MA, Real, Really Real, Super Real, circ., 1981; AAIAL, 1982, 84; Houston/Contemporary, American Still Life, 1945-1983, 1983; AAIAL, 1984, 85, 86, 88, 90, 91; Huntington/Heckscher, Through the Looking Glass, 1984; The Artists' Choice Museum, NYC, The First Eight Years, 1984; Florida International U., American Art Today: Still Life, 1985; Tokyo/Isetan, American Realism: The Precise Image, circ., 1985: Wichita/AM, A Decade of American Realism, 1975-85, 1985; Trenton/State, Contemporary American Still Life, 1986; Skidmore College, Self-Portraits: The Message, The Material, 1987; Little Rock/MFA, The Face, 1989; Long Island U., Lines of Vision, 1989; Bard College, Art What Thou Eat, 1990; NAD, 1991, 92; Miyagi Museum of Art, Sendai, Japan, American Realism and Figurative Art, 1952-1990, circ., 1991; Seville, Expo 92, 1992. **Collections:** A.F.A.; Art Museum of South Texas; AT&T; Ameri-

can Airlines; Amstar Corp.; Buffalo/Albright; Chase Manhattan Bank; Chicago/AI; Cleveland/MA; Colby College; Commerce Bank of Kansas City; Dallas/MFA; Heublein Inc.; Houston/MFA; U. of Indiana; Indianapolis; MMA; Millersville State College, Pa.; Minneapolis/Institute; IBM; Melbourne/National; Minnesota/MA; National Gallery; Newark Museum; New York State Health and Hospitals Corp.; Niagara U.; Oberlin College; Oklahoma; PAFA; Port Authority of New York & New Jersey; RISD; Reader's Digest; United Bank of Denver; Union Camp Corp.; U. of Sydney; VMFA; WMAA; Wellington Management Corp.; Westmoreland County/MA; Yale U. **Bibliography:** *America 1976;* Arthur 1, 2, 3, 4; Goodyear; *New in the Seventies;* Ward.

FISHER, JOEL b. June 6, 1947, Salem, Ohio. **Studied:** Kenyon College, 1969, BA, magna cum laude. Traveled Europe; resided England, 1977-82. **Member:** Artists Equity. **Awards:** PBK, 1969; Kress Foundation Fellowship, 1967, 68; Thomas J. Watson Traveling Fellowship, 1969; DAAD Grant, 1973-74; National Endowment for the Arts, 1984; Howard Foundation Fellowship, 1986. **Taught:** Shiller College, Berlin, 1973-74; Goldsmith College, London, 1979; Bath Academy of Art, 1980-82; RISD, 1985. **Address:** 99 Commercial Street, Brooklyn, NY 11222. **One-man Exhibitions:** Robert Brown Gallery, Gambier, Ohio, 1968; The Mansfield (Ohio) Arts Center, 1970; Whitney Museum Independent Study Program, NYC, 1970; Corso's Wine Shop, Salem, Ohio, 1971; Nigel Greenwood Inc., Ltd., London, 1971, 76, 78, 79, 82, 86, 89; Victoria and Albert Museum, 1971; Galeria Marilena Bonomo, Bari, Italy, 1972, 76; Galerie Sonnabend, Paris, 1972, 74; New Gallery, Cleveland, 1973; Galerie Stampa, Basel, 1973; Aachen/NG, 1974; Galerie Folker Skulima, Berlin, 1974, 75; Galerie Joachim Ernst, Hannover, 1975; Galleria Forma, Genoa, 1975; 112 Greene Street,

NYC, 1975; Monchengladbach, 1975; Max Protetch Gallery, Washington, D.C., 1975; Galerie Salvatore Ala, Milan, 1976, 78; Galeria 2, Stuttgart, 1976; Max Protetch Gallery, NYC, 1976, 77; Gallerie Akumulatory, Poznan, Poland, 1977; Brussels/Beaux-Arts, 1977; Oliver Dowling Gallery, Dublin, 1977; Galerie Diki Maier-Hahn, Düsseldorf, 1977; Lia Rumma Studia d'Arte, Naples, 1977; Amsterdam/Stedelijk, 1978; Galeria Foksal, Warszawa, 1978; Galerie Michele Lachowsky, Brussels, 1979, 81; Matt's Gallery, London, 1979, 84; Graeme Murray Gallery, Edinburgh, 1979; Galerie Farideh Cadot, Paris, 1980, 83, 86, 87; Galerie Toni Gerber, Bern, 1980, 84; New 57 Gallery, Edinburgh, 1980; LYC Museum, Banks, Cumbria, 1981; Galleriet, Lund, Sweden, 1981; Spectro Arts Workshop, Newcastle, 1981; Riverside Studios, London, 1982; Diane Brown Gallery, NYC, 1984, 85, 87, 88, 89, 91; Lucerne, 1984; Munster/WK, 1984; Galerij S. 65, Aalst, Belgium, 1985, 88, 91; Dart Gallery, Inc., Chicago, 1986; Anders Tornberg Gallery, Lund, Sweden, 1986; Faridet Cadot Gallery, NYC, 1987, 90; U. of California, Santa Barbara, 1987; U. of California, Berkeley, 1987; Galerie Susanna Kulli, St. Gallen, 1987; Galerie Shimada Yamaguchi, 1988; Galerie Comicos, Lisbon, 1989; C. Grimaldis Gallery, Baltimore, 1989; Galerie Hubert Winter, Vienna, 1991; Galerie Raymond Bollag, Zurich, 1991; Barbara Gross Gallery, Munich, 1991. **Group:** Youngstown/Butler, 1962, 65, 67, 69; Sir George Williams U., Montreal, 45! 39'N - 73! 36'W, Conceptual Art, 1970; Kassel, Documenta V, 1972; VIII Paris Biennial, 1973; Leverkusen, Drawings 3: American Drawings, 1975; MOMA, Handmade Paper Prints & Unique Works, 1976; Wrokaw Ministry of Culture and Art, The International Drawing Triennial, 1978; U. of North Carolina, Drawings, 1979; MOMA, International Survey of Contemporary Painting and Sculpture, 1984; Harvard U.,

Smart Art, 1985; Muhlenberg College, Allentown, Pa., Archaic Echos, 1986; Cologne/Ludwig, Europa/Amerika, 1986; Düsseldorf/Kunsthalle, Sculpture Sein, 1986; Buffalo/Albright, Structure to Resemblance, 1985; Lucerne, L'État des Choses, 1986; U. of Rhode Island, Micro-Sculpture, 1989; Matera, Italy, Sculpture Biennale, 1990; William Paterson College, Hand, Body, House, 1990. **Collections:** Amsterdam/Stedelijk; Arts Council of Great Britain; Berlin; Berne/Kunstmuseum; Bremen/Neues; Canberra/National; Chase Manhattan Bank; Cincinnati/Contemporary; FRAC/Limousin; U. of Georgia; Ghent/Contemporary; Groningen; Hartford/Wadsworth; Kenyon College; Leeds/MAG; Lodz; Lucerne; MOMA; Monchengladbach; National Gallery; New York Stock Exchange; Niagara U.; Paris/Beaubourg; Prudential Insurance Co. of America; Stockholm/National; Tate Gallery; Toulon; VMFA; Victoria and Albert Museum; Youngstown/Butler.

FLACK, AUDREY b. May 30, 1931, NYC. **Studied:** Cooper Union, 1951; Yale U., 1952, with J. Albers; NYU; Institute of Fine Arts, 1953. Traveled USA, Europe, India. Author, *Audrey Flack on Painting, Art & Soul, The Daily Muse, Sketchbook.* **Taught:** Pratt Institute, 1960-68; NYU, 1960-68; Riverside Museum Master Institute, 1966-67; School of Visual Arts, NYC, 1970-74; Bridgeport U., 1975. **Member:** College Art Association, Board of Directors. **Commissions:** *Time* magazine, Man of the Year cover, Anwar Sadat, 1979. Gateway to the City, Rock Hill, S.C., 1991; Olympia Park, NYC. **Awards:** Hon. Ph.D., Cooper Union, 1977; Cooper Union, Saint-Gaudens Medal, 1982; NYC Art Teachers Association, Teacher of the Year, 1985. **Address:** 110 Riverside Drive, NYC 10024. **Dealer:** Louis K. Meisel Gallery, NYC. **One-man Exhibitions:** Roko Gallery, NYC, 1959, 63; French & Co., Inc.,

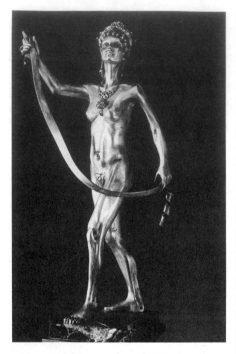

Audrey Flack, *The Art Muse*, 1988.

NYC, 1972; Louis K. Meisel Gallery, NYC, 1974, 76, 78, 83; U. of Hartford, 1974; U. of Bridgeport, 1975; Carnegie Mellon U., 1984; Cooper Union, 1986. **Retrospective:** U. of South Florida, Tampa, 1981; UCLA, circ., 1992. **Group:** NAD, 1948; The Stable Gallery, Annual, NYC, 1960; School of Visual Arts, NYC, 65 Self-Portraits, 1965; WMAA, 22 Realists, 1970; WMAA, Annual, 1972; Indianapolis, 1972; Cleveland/MA, 32 Realists, 1972; WMAA, American Drawings, 1963-73, 74; Serpentine Gallery, London, Photo Realism, 1973; U. of Illinois, 1974; Tokyo Metropolitan Art Gallery, IIth Tokyo Biennial, 1974; PMA/Museum of the Philadelphia Civic Center, Women's Work: American Art 1974, 1974; California Institute of the Arts, Art: A Woman's Sensibility, 1975; Toledo/MA, Image, Color and Form, 1975; Wichita State U., The New Realism, 1975; Baltimore/MA, Super Realism, 1975; Stratford, Ont., Aspects of Realism, circ., 1976-78; WMAA,

Art About Art, circ., 1978; Akron/AM, The Image in American Painting and Sculpture, 1950-1980, 1981; PAFA, Contemporary American Realism Since 1960, 1981; San Antonio/MA, Real, Really Real, Super Real, circ., 1981; WMAA, Sacred Images in Secular Art, 1986. **Collections:** Akron/AI; U. of Arizona; Brandeis U.; Canberra/National; MMA; MOMA; NMWA; NYU; Oberlin College; SRGM; St. Louis/City; WMAA. **Bibliography:** *Art: A Woman's Sensibility;* Arthur 3; **Gouma-Peterson;** Lindy; Meisel; *New in the Seventies;* Robins; Ward.

FLANNAGAN, JOHN b. April 7, 1895, Fargo, N.D. d. January 6, 1942, NYC.

Studied: Minneapolis Institute School, 1914-17, with R. Koehler. US Merchant Marine, 1914-17. Traveled Ireland, USA, France. **Awards:** Guggenheim Foundation Fellowship, 1932; MMA, Alexander Shifling Prize, 1940. **One-man Exhibitions:** Whitney Studio Club, NYC, 1925; Weyhe Gallery, NYC, 1927, 28, 30, 31, 34, 36, 38, 73, 78; Arts Club of Chicago, 1934; Vassar College, 1936; Bard College, 1937; Buchholz Gallery, NYC, 1942 (2); VMFA, 1946; A.F.A., circ., 1959; International Exhibitions Foundation, Washington, D.C., 1965-76. **Group:** WMAA; MOMA; MMA; Brooklyn Museum; Carnegie, Forerunners of American Abstraction, 1971. **Collections:** Andover/Phillips; Cincinnati/AM; Cleveland/MA; Detroit/Institute; Dublin/Municipal; Harvard U.; Honolulu Academy; MMA; U. of Nebraska; Oberlin College; Vassar College; WMAA; Wichita/AM. **Bibliography:** *Avant-Garde Painting and Sculpture;* Baur 7; Brumme; Cheney; Craven, W.; Fierens; *Forerunners;* Goodrich and Baur 1; Hunter 6; Jackman; Licht, F.; Marter, Tarbell, and Wechsler; McCurdy, ed.; Mellquist; Mendelowitz; **Miller, ed., 3;** Ritchie, 3; Rose, B., 1, 4; Selz, J.; Seuphor 3; Seymour; **Valentine 1, 2;** Wheeler. Archives.

FLAVIN, DAN b. April 1, 1933,

NYC. **Studied:** Cathedral College of the Immaculate Conception, 1947-52; US Air Force Meteorological Technician Training School, 1953; U. of Maryland (Extension, Korea), 1954-55; New School for Social Research, 1956; Columbia U., 1957-59. **Awards:** Skowhegan Medal for Sculpture, 1976; Dan Flavin Art Institute opens at the Dia Art Foundation, Bridgehampton, N.Y., 1983. **Address:** Wainscott, NY. **Dealer:** The Pace Gallery, NYC. **One-man Exhibitions:** Judson Gallery, NYC, 1961; Kaymar Gallery, NYC, 1964; Green Gallery, NYC, 1964; Ohio State U., 1965; Galerie Rudolf Zwirner, 1966; Nicholas Wilder Gallery, 1966; The Kornblee Gallery, NYC, 1967; Chicago/Contemporary, 1968; Galleria Sperone, Turin, 1968; Galerie Heiner Friedrich, Munich, 1968, 70; Konrad Fischer Gallery, Düsseldorf, 1969; Irving Blum Gallery, Los Angeles, 1969; Galerie Bischofberger, Zurich, 1969; Ottawa/National, 1969, 79; Vancouver, 1970; Jewish Museum, 1970; Dwan Gallery, NYC, 1970; Leo Castelli Inc., NYC, 1970, 71, 72, 73, 74, 75, 76, 78, 79, 81, 84, 85, 89; Los Angeles/County MA, 1970; ACE Gallery, Los Angeles, 1971, 77; John Weber Gallery, NYC, 1971, 73; Galerie Heiner Friedrich, Cologne, 1971, 73; Janie C. Lee Gallery, Dallas, 1971; Rice U., 1972; St. Louis/City, 1973; U. of Bridgeport, 1973; Locksley-Shea Gallery, 1973; Lisson Gallery, London, 1973; Ronald Greenberg Gallery, St. Louis, 1974; Jared Sable Gallery, Toronto, 1974; Pasquale Trisorio Naples, 1974; Weinberg Gallery, San Francisco, 1974; Rotterdam, 1975; Basel, 1975; Charlotte Square Gallery, Edinburgh, 1976; Portland (Ore.) Center for the Visual Arts, 1976; Heiner Friedrich, Inc., NYC, 1976, 77, 78 (two-man); Otis Art Institute, 1977; Chicago/AI, 1977; ACE Canada, Vancouver, 1977; Cincinnati/Contemporary, 1977; Austin, 1979; Laguna Gloria, 1980; SRGM, 1982; Ottawa, 1980; Melinda Wyatt Gallery, Venice, Calif., 1983;

Margo Leavin Gallery, Los Angeles, 1984, 86; Corcoran, 1984; Galerie Daniel Templon, Paris, 1984; Bordeaux/Contemporain, 1985; Galerie Onnasch, Berlin, 1985; A.R.C.A., NYC, 1985; Brooke Alexander Gallery, NYC, 1985; Harvard U., 1986; Amsterdam/Stedelijk, 1986; Texas Gallery, Houston, 1987; Galerie Nikki Diana Marquardt, Paris, 1987, 89; Galerie Annemarie Verna, Zurich, 1987, 90; Galerie Thaddaeus Ropac, Salzburg, 1987; Donald Young Gallery, Chicago, 1987, 89, 90; Karsten Schubert Gallery, London, 1988; Pat Hearn Gallery, NYC, 1988; Kunsthalle, Baden-Baden, 1989; Galerie Nachst St. Stephan, Vienna, 1989, 90; Lyon/Contemporain, 1989; Daniel Weinberg Gallery, Los Angeles, 1989, 90; 65 Thompson Street, NYC, 1989, 90; Galerie Pierre Huber, Geneva, 1989 (2); Galerie Tanit, Cologne, 1989; Waddington Galleries, London, 1990; Rubin Spangle Gallery, NYC, 1990, 92; Galerie Grässlin-Ehrhardt, Frankfurt, 1990; Galerie Jean Bernier, Athens, 1991; Mary Boone Gallery, NYC, 1991; The Pace Gallery, NYC, 1992; SRGM, 1992. **Retrospectives:** Fort Worth, 1976; Southampton/Parrish, circ., 1978; Los Angeles/MOCA, 1984. **Group:** Hartford/Wadsworth, Black, White and Gray, 1964; ICA, Boston, 1966; U. of California, Irvine, 5 Los Angeles Sculptors, 1966; Jewish Museum, Primary Structures, 1966; Finch College, 1966; Eindhoven, Kunst-Licht-Kunst, 1966; Los Angeles/County MA; PMA, American Sculpture of the Sixties, 1967; Trenton/State, Focus on Light, 1967; Goethe U., Frankfurt, Germany, 1967; WGMA, A New Aesthetic, 1967; VI International Art Biennial, San Marino (Europe), 1967; Buffalo/Albright, Plus by Minus, 1968; The Hague, Minimal Art, 1968; Kassel, Documenta IV, 1968; WMAA, Light: Object and Image, 1968; UCLA, Electric Art, 1969; MMA, New York Painting and Sculpture, 1940-1970, 1969-70; Fort Worth, Drawings, 1969; U. of California, Irvine, Five Sculptors, 1969;

MOMA, Spaces, 1969; WMAA Annual, 1970; SRGM, Guggenheim International, 1971; Buffalo/Albright, Kid Stuff, 1971; Walker, Works for New Spaces, 1971; Los Angeles/County MA, Art & Technology, 1971; High Museum, The Modern Image, 1972; Detroit/Institute, Art in Space, 1973; MOMA, Some Recent American Art, circ., 1973; Musée Galliera, Paris, Festival d'Automne, 1973; Parcheggio di Vina Borghese, Rome, Contemporanea, 1974; Indianapolis, 1974; U. of North Carolina, Light/Sculpture, 1975; NCFA, Sculpture; American Directions 1945-1975, 1975; MOMA, Drawing Now, 1976; WMAA, 200 Years of American Sculpture, 1976; Chicago/AI, 1976; U. of Chicago, Ideas in Sculpture 1965-1977, 1977; ICA, Boston, The Reductive Object, 1979; Zurich, Reliefs, 1980; Cologne, International, 1981; Grand Palais, Paris, La rime et la raison, 1984; Dublin/Municipal, International Quadriennial (ROSC), 1984; WMAA, Blam!, 1984; Bordeaux/Contemporain, Art Minimal I, 1985; Bard College, The Maximal Implications of the Minimal Line, 1985; Pittsburgh Center for the Arts, Illuminations, 1985; Fort Lauderdale, An American Renaissance, 1985; Brown U., Definitive Statements, circ., 1986; Montreal/Contemporain, Light, 1986; I.C.I., NYC, After Matisse, 1986; Düsseldorf/Kunsthalle, Similia/Dissimilia, circ., 1987; Hamburger Banhof, Berlin, Zeitlos, 1988; Southampton/Parrish, Drawing on the East End, 1988; Cologne/Ludwig, Bilderstreit, 1989; St. Gallen, Kunstmuseum, Rot, Gelb, Blau, circ., 1989; Tate/Liverpool, Minimalism, 1990. **Collections:** Amsterdam/Stedelijk; Basel; Cologne; Denver/AM; Eindhoven; Fort Worth/Modern; Frankfurt/Moderne; Harvard U.; Hudson River Museum; Humlebaek/Louisiana; Krefeld/Kaiser Wilhelm; Los Angeles/County MA; MMA; MOMA; Ottawa/National; Pasadena/AM; RISD; Rijksmuseum Kröller-Müller; SRGM; San Diego/Contemporary; Tate; Toronto; WMAA; Walker. **Bibliography:**

Abstract Expressionism; Art Now 74; Battcock, ed.; Calas, N. and E.; *Contemporanea; Dan Flavin;* Davis, D.; De Vries; Gablik; Gohr and Gachnang; Haskell 5; Honisch and Jensen, eds.; *Individuals;* Johnson, Ellen, H.; Krauss 2; Lippard 4, 5; MacAgy 2; Muller; Plagens; *Report;* Rowell; Sandler 3; Schwartz 1; Siegel; Tuchman 1; Waldman 4; Weintraub.

FLEISCHMANN, ADOLPH
from 1st to 4th edition.

FLEISCHNER, RICHARD
b. July 1, 1944, NYC. **Studied:** RISD, 1962-66, BFA, 66-68, MFA. **Taught:** Rhode Island Council on the Arts, 1971-74; Brown U., 1971-74; RISD, 1977. **Awards:** Tiffany Fellowship, 1972; AAAL/NIAL Award, 1974; National Endowment for the Arts, 1975, 80, 86; Rhode Island Governor's Award, 1986. **Address:** 224 Williams Street, Providence, RI 02906. **One-man Exhibitions:** Dartmouth, 1971; Terry Dintenfass Inc., NYC, 1971, 73, 75; Dag Hammerskjöld Plaza, NYC, 1976; U. of Massachusetts, 1977; RISD, 1980; Max Protetch Gallery, NYC, 1980, 81; Philadelphia College of Art, 1983; U. of Rhode Island, 1983; Harcus Gallery, Boston, 1986; McIntosh/Drysdale Gallery, Washington, D.C., 1987; Gerald Peters Gallery, Dallas, 1991; Des Moines, 1992. **Group:** AAAL/NIAL, 1974; Newport, R.I., Monumenta, 1974; Kassel, Documenta VI, 1977; Hirshhorn, Probing the Earth, 1977; Seattle/AM, Earthworks, 1979; ICA, Boston, Drawing/Structures, 1980; XXXIX Venice Biennial, 1980; NCFA, Across the Nation, 1980; WMAA Biennial, 1981; PAFA, Form and Function, 1982; WMAA, New American Art Museum, 1982; La Jolla, Sitings, 1986; Los Angeles/MOCA, Individuals, 1986; San Diego/Contemporary, Faux Arts, 1987; Laumeier Sculpture Park, Ten Sites, 1991. **Collections:** Buffalo/Albright; U. of California, San Diego; Dallas/MFA; General Mills, Inc.; High Museum; Laumeier

Sculpture Park; Los Angeles/MOCA; U. of Massachusetts; RISD; SRGM; San Diego/Contemporary; WMAA.

FLOCH, JOSEPH
from 1st to 4th edition.

FOLLETT, JEAN
from 1st to 4th edition.

FORST, MILES
from 1st to 5th edition.

FORTESS, KARL
from 1st to 4th edition.

FOULKES, LLYN b. November 17, 1934, Yakima, Wash. **Studied:** Central Washington College, 1953; U. of Washington, 1952-54; Chouinard Art Institute, 1957-59, with Richards Ruben, Emerson Woelffer, Don Graham. US Army, Germany, 1955-56. Traveled Europe, North Africa, USA. **Taught:** UCLA, 1965-71; Art Center College of Design, Pasadena, 1971-77; U. of California, Irvine, 1981; California State U., Long Beach, 1982-83; U. of California, Santa Barbara, 1983-84; Otis Art Institute, 1986-87. **Awards:** Chouinard Art Institute, First Prize, 1959; SFMA, First Prize, 1963; V Paris Biennial, First Prize, 1967; Guggenheim Foundation Fellowship, 1977; National Endowment for the Arts, grant, 1986. **Address:** 2002 Tuna Canyon, Topanga, Calif. 90290. **Dealers:** Kent Fine Art, Inc., NYC; Darthea Speyer Gallery, Paris. **One-man Exhibitions:** (first) Ferus Gallery, Los Angeles, 1961; Pasadena/AM, 1962, 67 (four-man); Rolf Nelson Gallery, Los Angeles, 1963-65; Oakland/AM, 1964; Robert Fraser Gallery, 1966 (four-man); David Stuart Gallery, 1969, 74; Darthea Speyer Gallery, 1970, 75; The Willard Gallery, 1975; Gruenebaum Gallery, NYC, 1977; Chicago/Contemporary, 1978; Asher/Faure, 1983; ICA, Los Angeles, 1984; Zolla/Liberman Gallery, Chicago, 1984; Gallery Paule Anglim, San Francisco, 1985, 88; U. of

California, Santa Barbara, 1986; Kent Fine Art, Inc., NYC, 1987-90; Hooks-Epstein Galleries, Houston, 1988; U. of Massachusetts, Amherst, 1989; Los Angeles/MOCA, 1992. **Retrospective:** Newport Harbor, 1974. **Group:** Los Angeles/County MA Annuals, 1960, 61, 63; Pomona College, Object Makers, 1961; SFMA, West Coast Artists, circ., 1961; SFMA, Directions—Painting U.S.A., 1963; Pasadena/AM, Director's Choice, 1964; São Paulo, 1964; New York World's Fair, 1964-65; SRGM, 1966; V Paris Biennial, 1967; WMAA Annuals, 1967, 69, 71, 74; IX São Paulo Biennial, 1967; Brandeis U., 1968; Foundation Maeght, 1968; Los Angeles/County MA, 5 Los Angeles Artists, 1968; VMFA, American Painting, 1970; ICA, U. of Pennsylvania, The Topography of Nature: The Microcosm and Macrocosm, 1972; Los Angeles Municipal Art Gallery, Separate Realities, 1973; Chicago/AI, 71st American Exhibition, 1974; Corcoran Biennial, 1975; ARCO Center, Los Angeles, Los Angeles and the Palm Tree, 1984; U. of Southern California, Sunshine and Shadows, 1985; U. of Washington, Seattle, No! Contemporary American Dada, 1986; U. of California, Santa Barbara, Southern California Assemblage, 1989; Newport Harbor, L.A. Pop in the Sixties, circ., 1989; Oakland/AM, de-Persona, 1991. **Collections:** Chicago/AI; Laguna Beach Museum of Art; La Jolla; Los Angeles/County MA; MOMA; Museum des 20. Jahrhunderts; Newport Beach; Oakland/AM; Palm Springs Desert Museum; Paris/Beaubourg; Pasadena/MA; Rotterdam; SFMA; SRGM; Seattle/AM; Stanford U.; UCLA; WMAA. **Bibliography:** *Forty Years of California Assemblage; Individual Realities; Individuals;* Leavens and Bruce; *New in the Seventies;* Tomidy; Weller.

FRANCIS, SAM b. June 25, 1923, San Mateo, Calif. **Studied:** U. of California, Berkeley, 1941-43; 1949, BA; 1950, MA; Atelier Fernand Leger, Paris. US Air Force, 1943-45. Began painting

under the encouragement of David Park while hospitalized in 1945. Traveled Europe, Japan, USA; resided and worked in Paris, 1950-57. Subject of films: *Sam Francis: These Are My Footsteps,* WNED-TV, 1972; *Sam Francis,* 1975, Blackwood Productions, Inc. Founder, Lapis Press, 1984. **Commissions** (murals): Kunsthalle, Berne, 1957; Sofu School of Flower Arrangement, Tokyo, 1957; Chase Manhattan Bank, NYC, 1959; Opera National, Theatre Royal de la Monnaie, Brussels, 1986. **Awards:** III International Biennial Exhibition of Prints, Tokyo, First Prize, 1963; Hon. DFA, U. of California, 1969; Legion of Honor, 1981; Skowhegan School, Medal for Painting, 1983. **Address:** 345 West Channel Road, Santa Monica, Calif. **Dealers:** Minami Gallery, Tokyo; André Emmerich Gallery, NYC; Brooke Alexander, NYC. **One-man Exhibitions:** (first) Galerie Nina Dausset, Paris, 1952; Galerie du Dragon, 1952; Galerie Rive Droite, Paris, 1955, 56; Martha Jackson Gallery, 1956, 58, 63, 64, 68, 70; Gimpel Fils Ltd., 1957; Klipstein & Kornfeld, Berne, 1957, 61, 66, 68, 73, 76; Zoe Dusanne Gallery, Seattle, 1957; Tokyo Department Store Gallery, 1957; Kintetsu Department Store Gallery, Osaka, 1957; Phillips, 1958; Seattle/AM, 1959; SFMA, 1959, 67; Minami Gallery, Tokyo, 1961, 64, 66, 68, 69, 70, 74, 77, 78, 79; Esther Baer Gallery, 1962, 63; Galerie Engelberts, Geneva, 1962; Galerie Pauli, Lausanne, 1962; A. Tooth & Sons, London, 1965; Pierre Matisse Gallery, 1967; Houston/MFA, 1967; U. of California, 1967; Kunstverein, Basel, 1968; Galerie Gunther Franke, Munich, 1968; CNAC, 1968; Shasta College, 1969; André Emmerich Gallery, NYC, 1969, 70, 71, 72, 73, 74, 75, 76, 78, 79, 81, 82, 83, 84, 86, 87, 89; Felix Landau Gallery, 1970; Los Angeles/County MA, 1970, 80; Nicholas Wilder Gallery, 1970, 71, 73, 75, 78; Pace Editions, NYC, 1973; Galerie Fournier, Paris, 1973-75, 76, 78, 79, 81, 83, 85, 86, 88; Margo Leavin Gallery, 1974; Jack

Glenn Gallery, San Diego, 1975; Smith-Anderson Gallery, Palo Alto, 1972, 73, 76, 78, 88; Smith-Anderson Gallery, San Francisco, 1975; Richard Gray Gallery, Chicago, 1975, 82, 85; Kornfeld and Klipstein, Zurich, 1975; Humlebaek/Louisiana, 1977; Otis Art Institute, 1978; Paris/Beaubourg, 1978; Honolulu, 1977; Ace Gallery, Vancouver, 1970; Maxwell Davidson Gallery, NYC, 1979; Thomas Segal Gallery, Boston, 1979, 83; The Elkon Gallery, NYC, 1979, 84; Brooke Alexander, Inc., NYC, 1979, 84; Richard Hines Gallery, Seattle, 1979; Mizuno Gallery, Los Angeles, 1980; James Corcoran Gallery, Los Angeles, 1980, 91; Abbaye de Senaque, Gordes, France, 1980; Foster Goldstrom Gallery, San Francisco, 1980; Pal Sui Loong Galleries, Hong Kong, 1981; Ace Gallery, Venice, Calif., 1981; Ruth S. Schaffner Gallery, Santa Barbara, 1981; Flow Ace Gallery, Venice, Calif., 1982; Nantenshi Gallery, Tokyo, 1982, 83, 87; Makler Gallery, Philadelphia, 1982; Studio Marconi, Milan, 1983; John Berggruen Gallery, San Francisco, 1983; Art Attack Gallery, Boise, Id., 1983; Jane Kahan Gallery, NYC, 1983; Foundation Maeght, 1983; Thomas Babeor Gallery, La Jolla, 1984; Knoedler Gallery, London, 1984, 87, 89; Gemini G.E.L., Los Angeles, 1984; Hokin Gallery, Bay Harbor Islands, Fla., 1985; Michael Dunev Gallery, San Francisco, 1986; Pamela Auchincloss Gallery, San Francisco, 1986; Angles Gallery, Santa Monica, 1986, 91; Pavilion des Arts, Paris, 1986; Le Maire de Paris, 1986; G. H. Dalsheimer Gallery, Baltimore, 1987; Galerie Eude, Barcelona, 1987; Manny Silverman Gallery, Los Angeles, 1987; Galerie Pudelko, Bonn, 1987; Heland Thorden Wetterling Galleries, Stockholm, 1987, 90; Lever/Meyerson Galleries, NYC, 1987; Museum of Modern Art, Toyama, Japan, circ., 1988; Bernard Jacobson Gallery, London, 1988; Greenberg Gallery, St. Louis, 1989; Cantor/Lemberg Gallery, Birmingham, Mich., 1989; AAA, NYC, 1990, 91; Ochi Gallery, Sun Valley, Idaho, 1990;

James Corcoran Gallery, Los Angeles, 1991; Gagosian Gallery, NYC, 1991; Toulouse-Labege, 1991. **Retrospectives:** Berne, 1960; Hannover/K-G, 1963; Amsterdam/Stedelijk, 1968; CNAC, 1969; Buffalo/Albright, circ., 1972; ICA, Boston, 1979; Phillips, 1980; Galerie Kornfeld, Bern, 1991. **Group:** Salon du Mai, Paris, 1950; Studio Paul Facchetti, Signifiants de l'Informal, 1952; Studio Paul Facchetti, Un Art Autre, 1953; ICA, London, Opposing Forces, 1953; Berne, Tendances Actuelles, 1955; Carnegie, 1955; MOMA, Twelve Americans, circ., 1956; International Biennial Exhibition of Paintings, Tokyo; Arts Council Gallery, London, New Trends in Painting, 1957; Brussels World's Fair, 1958; MOMA, The New American Painting, circ., Europe, 1958-59; American Cultural Center, Paris, 3 Americans, 1958; Brooklyn Museum, 1959; São Paulo, 1959; III International Biennial Exhibition of Prints, Tokyo, 1962; Chicago/AI, 1962; Musée Cantonal des Beaux-Arts, Lausanne, I Salon International de Galeries Pilotes, 1963; Tate, Dunn International, 1964; Gulbenkian International, 1964; Flint/Institute, The Coming of Color, 1964; WMAA, Annuals, 1964, 65; Toronto, 1964; SRGM, American Drawings, 1964; Los Angeles/County MA, Post Painterly Abstraction, 1964; U. of Arkansas, 1965; Dayton/AI, 1966; Tokyo/Modern, 1966; II Internationale der Zeichnung, Darmstadt, 1967; Kunsthalle, Cologne, 1968; Carnegie, 1970; Buffalo/Albright, Color and Field, 1890-1970, 1970; Foundation Maeght, L'Art Vivant, 1970; VMFA, American Painting, 1970; Indianapolis, 1970; Chicago/AI Annual, 1970; Wilmington, 1970; Corcoran Biennial, 1971; Chicago/Contemporary, White on White, 1971-72; Toledo/MA, The Fresh Air School, 1973; Buffalo/Albright, Abstract Expressionism: The First and Second Generations, 1972; U. of Illinois, Contemporary American Painting and Sculpture, 1974; Santa Barbara/MA, 15

Abstract Artists, 1974; U. of California, Riverside, A View of Lithography in Los Angeles, 1975; SFMA, Painting and Sculpture in California: The Modern Era, 1977; California State U., Northridge, Americans in Paris, The 50's, 1979; Grand Palais, Paris, Societé des Artistes, 1980; MMA, The Painterly Print, 1980; SFMA, Twenty American Artists, 1980; Los Angeles/County MA, Art in Los Angeles, 1981; Haus der Kunst, Munich, Amerikansiche Malerei: 1930-1980, 1981; Cologne/Stadt, Westkunst, 1981; WMAA, American Prints: Process and Proofs, 1981; Milwaukee, American Prints, 1982; SFMA, Fresh Paint, 1982; Brooklyn Museum, The American Artist as Printmaker, 1983; U. of Texas, American Abstract Impressionist Paintings, 1984; U. of North Carolina, Annual, 1984; Fort Lauderdale, An American Renaissance, 1986; Brooklyn Museum, Public and Private: American Prints Today, 1986; Sarah Lawrence College, Inner Worlds, 1987; U. of California, Santa Barbara, Collaborations in Monotype, circ., 1988; Nagoya/City, Abstraction, circ., 1990. **Collections:** Amsterdam/Stedelijk; Basel/Offentliche; Belfast/Ulster; Berlin/National; Berne; Buffalo/Albright; U. of California; Carnegie; Dallas/MFA; Dayton/AI; Düsseldorf/KN-W; Eindhoven; Essen; Fort Worth; Hamburg; Hannover/K-G; Hirshhorn; Humlebaek/Louisiana; Idemitsu Museum; Kansas City/Nelson; Little Rock/MFA; Los Angeles/County MA; MOMA; Montreal/MFA; NCFA; National Gallery; National Museum of Western Art, Tokyo; OBD/Basel; Hara Art Museum; Paris/Beaubourg; Paris/Moderne; Pasadena/AM; Phillips; SFMA; SRGM; St. Louis; Santa Barbara/MA; Seattle/AM; Sofu School of Flower Arrangement; Stockholm/National; Stuttgart; Tate; Toronto; Washington U.; Yale U.; Zurich. **Bibliography:** *Abstract Expressionism;* Armstrong, Thomas; Ashbery; Blesh 1; Goldman 1; Haftman; Honisch and Jensen, eds.;

Hunter 1; Hunter, ed.; *Individuals;* Langui; **Lembark;** Lippard 5; Lynton; McCurdy, ed.; *Metro;* Nordness, ed.; Plagens; Ponente; Read 2; *Report;* Restany 2; Rickey; Rose, B., 1; *Sam Francis;* Sandler 5; Schneider; Seuphor 1; *The State of California Painting;* **Sweeney 3;** Tapie 1; Weller. Archives.

FRANK, MARY **b.** February 4, 1933, London, England. **Studied:** NYC, with Max Beckmann, 1950; Hans Hofmann, 1951. Traveled Spain, France, England. **Taught:** New School for Social Research, 1970-75; Queens College, 1970-75; Skowhegan School, 1976. **Member:** AAIAL, 1984. **Awards:** Ingram Merrill Foundation Grant, 1962; Longview Foundation Grant, 1964-66; National Council on the Arts, 1969; Guggenheim Foundation Fellowship, 1973, 83; CAPS, 1973; Brandeis U., Creative Arts Award, 1977. **Address:** 139 West 19th Street, NYC 10003. **Commissions:** Illustrations for *Shadows of Africa,* collaboration with Peter Matthiesen, writer, 1992. **Dealer:** Midtown-Payson Galleries, NYC. **One-man Exhibitions:** (first) Stephen Radich Gallery, 1961, also 1963, 66; Boris Mirski Gallery, Boston, 1964, 66; The Drawing Shop, NYC; Bennett College, 1966; The Zabriskie Gallery, NYC, 1968, 70, 71, 73, 75, 77, 78, 79, 81, 83, 84, 85, 86, 88, 90; Donald Morris Gallery, 1968; Richard Gray Gallery, 1969; U. of Connecticut, 1975; Harcus Krakow Gallery, Boston, 1976; Connecticut College, 1976; Arts Club, Chicago, 1976; Hobart College, 1976; Alice Simsar Gallery, Ann Arbor, 1976; U. of Bridgeport, 1976; Makler Gallery, Philadelphia, 1982; Quay Gallery, San Francisco, 1984; Marsha Mateyka Gallery, Washington, D.C., 1985; Brooklyn Museum, 1987; Roger Ramsay Gallery, Chicago, 1987; Nielsen Gallery, Boston, 1988; Lincoln, Mass./De Cordova, 1988; G. H. Dalsheimer Gallery, Baltimore, 1988; Syracuse/Everson, 1989; PAFA, 1989; Rena Bransten Gallery, San Francisco, 1990; Art Awareness, Lexington, N.Y., 1991; Allene Lapides Gallery, Santa Fe, 1992; Galerie Zabriskie, Paris, 1992. **Retrospective:** Purchase/SUNY, 1978. **Group:** MIT; Yale U.; Brandeis U.; MOMA, Hans Hofmann and His Students, circ., 1963-64; SRGM, 10 Independents, 1972; GEDOK, Hamburg, American Women Artists Show, 1972; WMAA Annuals, 1972, 73; PMA/Museum of the Philadelphia Civic Center, Focus, 1974; New York Cultural Center, Three Centuries of the American Nude, 1975; Philadelphia College of Art, Private Notations: Artists' Sketchbooks, 1976; Brooklyn Museum, Contemporary Women, 1977; Chicago/AI, 1977; PMA, Eight Artists, 1978; Albright College, Perspective 78, 1978; WMAA Biennial, 1979; MMA, The Painterly Print, 1980; WMAA, The Figurative Tradition and the WMAA, 1980; Brooklyn Museum, The American Artist as Printmaker, 1983; Cincinnati/Contemporary, Body and Soul, circ., 1985; MOMA, Committed to Print, 1988; WMAA, The Figure as Subject, circ., 1988; Boston/MFA, The Unique Print, 80s Into 90s, 1990. **Collections:** Akron/AI; Boston/MFA; Brandeis U.; Bridgeport; Brown U.; Chicago/AI; Connecticut College; Bank of Chicago; Des Moines; Hirshhorn; The Jewish Museum; Kalamazoo/Institute; Library of Congress; Lincoln, Mass./De Cordova; MMA; MOMA; U. of Massachusetts; U. of New Mexico; U. of North Carolina; Purchase/SUNY; Southern Illinois U.; Storm King Art Center; Syracuse/Everson; VMFA; WMAA; Wichita/AM; Worcester/AM; Yale U. **Bibliography:** *Woodstock: An American Art Colony, 1902-1977.*

FRANKENTHALER, HELEN **b.** December 12, 1928, NYC. **Studied:** Dalton School, NYC, with Rufino Tamayo; Bennington College, with Paul Feeley, 1945-49, BA; ASL, with Vaclav Vytlacil, 1946; with Wallace Harrison, NYC, 1948; with Hans Hofmann, 1950.

Traveled Europe extensively. **Taught:** NYU, 1958; U. of Pennsylvania, 1958; Yale U., 1967, 70; School of Visual Arts, NYC, 1967; Hunter College, 1970; U. of Rochester, 1971; Bennington College, 1972; Brooklyn Museum School, 1973; Swarthmore College, 1974; Drew U., 1975. **Member:** Trustee, Bennington College, 1967-82; Fellow, Calhoun College, Yale U., 1968; AAIAL, 1990. Member of the Corporation of Yaddo, 1974. **Commissions:** Designed and executed set for *Of Love* for Erick Hawkins Dance Company, 1971. Temple of Aaron, St. Paul (ark curtain tapestry); First Wisconsin National Bank, Milwaukee, 1973; North Central Bronx Hospital (mural), 1973-74; The Fourth National Bank, Wichita (tapestry), 1974. **Awards:** I Paris Biennial, First Prize, 1959; PAFA; Joseph E. Temple Gold Medal, 1968; Honorary Doctor of Humane Letters, Skidmore College, 1969; Albert Einstein College, Spirit of Achievement Award, 1970; Chicago/AI, Ada S. Garrett Prize, 1972; III Biennale della Grafica d'Arte, Florence, Italy, Gold Medal, 1972; Hon. DFA, Smith College, 1973; Hon. DFA, Moore College of Art, Philadelphia, 1974; Creative Arts Award, American Jewish Congress, National Women's Division, 1974; Hon. DFA, Bard College, 1976; Hon. Ph.D., Radcliffe College, 1978; Hon. Ph.D., Amherst College, 1979; Hon. DFA, NYU, 1979; Hon. DFA, Philadelphia College of Art, 1980; Hon. DFA, Williams College, 1980; Hon. DFA, Harvard U., 1980; Hon. DFA, Yale U., 1981; Hon. DFA, Brandeis U., 1982; Hon. DFA, U. of Hartford, 1983; Hon. DFA, Syracuse U., 1985; Hon. DFA, Adelphi U., 1989; Hon. DFA, Marymount College, 1989; Hon. DFA, Washington U., St. Louis, 1989. Subject of the film *Frankenthaler: Toward a New Climate,* 1978, produced and directed by Perry Miller Adato. **Address:** 173 East 94th Street, NYC 10028. **Dealer:** M. Knoedler & Co., Inc., NYC. **One-man Exhibitions:** (first) Tibor de Nagy Gallery,

1951, also 1952-58; André Emmerich Gallery, NYC, 1959-63, 1965, 66, 68, 69, 71, 72, 73, 77, 78, 79, 82, 83, 84, 86, 87, 88, 89, 91; Jewish Museum, 1960; Everett Ellin Gallery, Los Angeles, 1961; Bennington College, 1962, 78; Galerie Lawrence, Paris, 1961, 63; Galleria dell'Ariete, 1962; Kasmin, Ltd., 1964; David Mirvish Gallery, 1965, 71, 73, 75; St. John, N.B., 1966 (three-man, with Kenneth Noland, Jules Olitski); Gertrude Kasle Gallery, Detroit, 1967; Nicholas Wilder Gallery, Los Angeles, 1967; Heath Gallery, Atlanta, 1971; Fendrick Gallery, 1972, 74; Portland, Ore./AM, 1972, Waddington Galleries, London, 1973, 74; Janie C. Lee Gallery, Dallas, 1973; MMA, 1973; Swarthmore College, 1974; Corcoran, 1975; SRGM, 1975; John Berggruen Gallery, San Francisco, 1976, 79, 82, 86, 87; Fendrick Gallery, Washington, D.C., 1974, 79, 80; Janie C. Lee Gallery, Houston, 1975, 76, 78, 79, 80, 82; SRGM, 1975; ACE Gallery, Vancouver, 1975; Rosa Esman Gallery, NYC, 1975; Diane Gilson Gallery, Seattle, 1976; Greenberg Gallery, St. Louis, 1977; Galerie Wentzel, Hamburg, 1977; Knoedler Gallery, London, 1978, 81, 83, 85; Jacksonville, Fla., 1978; Kansas City/Nelson, 1978; Saginaw, circ., 1980; Gallery Ulysses, Vienna, 1980; Brandeis U., 1981; Thomas Segal Gallery, Boston, 1981; Getler/Pall Gallery, NYC, 1982; Gallery One, Toronto, 1983, 85, 88; Katonah Gallery, 1985; Houston/MFA, 1986; Galerie Joan Prats, NYC, 1988; Heleand Thorden Wetterling Galleries, Stockholm, 1988; Douglas Drake Gallery, NYC, 1989; Buschlen/Mowatt Gallery, Vancouver, 1989; Kukje Gallery, Seoul, 1991. **Retrospectives:** WMAA, 1969; John Berggruen Gallery (prints) 1972; Corcoran, circ., 1975; International Communications Agency (World Tour), 1978; Williamstown/Clark, circ., 1980; IEF, circ., 1984; MOMA, circ., 1989-90. **Group:** The Kootz Gallery, NYC, New Talent, 1951; Ninth Street Exhibition, NYC, 1951; WMAA Annuals, 1955, 58,

61, 63, 67, 69, 70, 71, 72, 73, Young America, 1957, Nature in Abstraction, 1958, The Structure of Color, 1971; Carnegie, 1955, 58, 61; São Paulo, 1958; International Biennial Exhibition of Paintings, Tokyo; Kassel, Documenta II, 1959; U. of Illinois, 1959, 63, 65, 67; SRGM, Abstract Expressionists and Imagists, 1961; Chicago/AI, 1961, 63; Seattle World's Fair, 1962; PAFA Annuals, 1963, 66, 68; Los Angeles/County MA, Post Painterly Abstraction, 1964; New York World's Fair, 1964-65; U. of Michigan, 1965; Detroit/Institute, 1965, Color, Image and Form, 1967; ICA, Boston, Painting Without a Brush, 1965; XXXIII Venice Biennial, 1966; Public Education Association, NYC, 1966; Expo '67, Montreal, 1967; Corcoran Biennial, 1967; MOMA, Two Decades of American Painting, circ., Japan, India, Australia, 1967; U. of Oklahoma, East Coast-West Coast Paintings, 1968; SFMA, Untitled 1968, 1968; Washington U., The Development of Modernist Painting, 1969; MMA, New York Painting and Sculpture, 1940-1970, 1969-70, Prints by Four New York Painters, 1969; Baltimore/MA, Washington Art: 1950-1970, 1970; Boston U., American Artists of the Nineteen Sixties, 1970; Foundation Maeght, L'Art Vivant, 1970; Buffalo/Albright, Color and Field: 1890-1970, 1970; ICA, U. of Pennsylvania, Two Generations of Color Painting, 1970; Boston/MFA, Abstract Painting in the '70s, 1972; Lakeview Center, American Women: 20th Century, 1972; Museum of Fine Arts, St. Petersburg, Flowing Form, 1973; Houston/MFA, The Great Decade of American Abstraction: Modernist Art 1960-1970, 1974; A.A.A. Gallery, One Hundred Prints, 1975; Wesleyan U., Middletown, Recent American Etching, 1975; Syracuse/Everson, New Work in Clay, 1976; PAFA, In This Academy, 1805-1976, 1976; Baltimore/MA, 200 Years of American Painting, 1976; Brooklyn Museum, 30 Years of American Printmaking, 1977; Syracuse/Everson, New Works in Clay, 1976;

Chicago/AI, Drawings of the 70's, 1977; Syracuse/Everson, Provincetown Painters, 1977; Grand Rapids, Two Centuries of American Art, 1977; Buffalo/Albright, American Painting of the 70s, 1978; U. of Tampa, Two Decades of American Abstraction, 1979; MMA, Hans Hofmann as Teacher, 1979; Montgomery/Museum, Art, Inc., 1979; Syracuse/Everson, A Century of Ceramics in the U.S., 1979; Brockton/Fuller, Aspects of the 70s: Painterly Abstraction, 1980; MOMA, Printed Art: A View of Two Decades, 1980; Sierra Nevada Museum of Art, Artists in the American Desert, circ., 1980; Centre d'Arts Plastiques Contemporains de Bordeaux, France, Depuis la couleur, 1958/1964, 1981; Haus der Kunst, Munich, Amerikanische Malerei: 1930-1980, 1981; Houston/MFA, Miró in America, 1982; WMAA, American Prints: Process and Proofs, 1981; MOMA, The Modern Drawing, 1983; MOMA, Prints from Blocks: Gauguin to Now, 1983; Walker, Prints from Tyler Graphics, 1984; Stamford Museum, American Art: American Women, 1985; Fort Lauderdale, An American Renaissance: Painting and Sculpture Since 1940, 1986; Independent Curators Inc., NYC, After Matisse, 1986; Brown U., Definitive Statements, 1986; Brandeis U., Ten at the Rose, 1987; Utica, Two Hundred Years of American Art, circ., 1988; AAIAL, 1990; Wiesbaden, Kunstlerinnen des 20 Jahrhunderts, 1990. **Collections:** Auckland; Baltimore/MA; Belfast/Ulster; Bennington College; Boston/MFA; Brooklyn Museum; Buffalo/Albright; U. of California; Carnegie; Canberra/National; Chicago/AI; Cincinnati/AM; Cleveland/MA; Cologne; Columbia U.; Columbus; Corcoran; Cooper-Hewitt; Detroit/Institute; Fort Worth; Hartford/Wadsworth; Harvard U.; High Museum; Hirshhorn; Honolulu Academy; Houston/Contemporary; Houston/MFA; Jerusalem/National; Johannesburg/Municipal; Kansas City/Nelson; Little Rock/MFA; Louisville/Speed; MMA;

MOMA; Mexico City/Nacional; Melbourne/National; Milwaukee; NCFA; NYU; Nagaoka, Japan; U. of Nebraska; Newark Museum; Omaha/Joslyn; Paris/Beaubourg; Pasadena/MA; Phoenix; PMA; Purchase/SUNY; RISD; San Antonio/McNay; Seattle/AM; SFMA; SRGM; St. Louis/City; Smithsonian; Springfield, Mass./MFA; U. of Sydney; Syracuse/Everson; U. of Texas; Ulster Museum; Victoria and Albert Museum; Vienna/Stadt; WGMA; WMAA; Walker; Wichita/AM; U. of Wisconsin; Yale U. **Bibliography:** Alloway 4; Anfam; Armstrong, Thomas; Battcock, ed.; Baur 5; **Elderfield 2;** Friedman, ed.; Goldman 1; Goodrich and Baur 1; Goossen 3; *The Great Decade;* Hunter 1, 6; Honisch and Jensen, eds.; Hunter, ed.; *Individuals;* Janis and Blesh 1; Kozloff *3; METRO;* Murken-Altrogge; O'Hara 1; **Rose, B.,** 1, 3; Sandler 3, 5; Schwartz 1, 2; Wilken, K. Archives.

FRASCONI, ANTONIO b. April 28, 1919, Montevideo, Uruguay. **Studied:** Circulo de Bellas Artes, Montevideo; ASL, 1946 with Yasuo Kuniyoshi; New School for Social Research, 1947, with Camilio Egas. To USA, 1945. **Taught:** New School for Social Research, 1951-52; Brooklyn Museum School; Pratt Institute; Vassar College; Atlanta Art Institute; Purchase/SUNY, 1977-85. **Member:** SAGA; Educational Film Library; NAD. **Awards:** Guggenheim Foundation Fellowship, 1952; NIAL Grant, 1954; Venice International Film Festival, 1960, Grand Prix for *The Neighboring Shore* (15 minutes, more than 300 woodcuts); US Post Office Department, Design Competition, 1963; Connecticut State Commission on the Arts, 1974; IX International Biennial Exhibition of Prints, Tokyo; NAD, Cannon Prize, 1979; Xerox Corporation, grant, 1978; NAD, Ralph Fabri Prize, 1983; UNESCO, I Bienal de la Habana, Award, 1984; NAD, Leo Meissner Prize, 1985. **Address:** 26 Dock Road, South Norwalk, CT 06854. **Dealer:** Terry Dintenfass, Inc.,

NYC. **One-man Exhibitions:** Ateneo Gallery, Montevideo, 1939; Montevideo YMCA, 1940; Agrupacion Intelectual, Montevideo, 1944; Brooklyn Museum, 1946; San Jose State College, 1946; Pasadena/AM, 1946; Santa Barbara/MA, 1946, 50, 51, 55, 77; New School for Social Research, 1947; Philadelphia Art Alliance, 1948; Weyhe Gallery, NYC, 1948-54, 1956, 60; Pan-American Union, Washington, D.C., 1949; Utica, 1949; San Diego, 1950; SFMA, 1950, 75; Princeton Print Club, 1950, 52; Art Association, Madison, Wisc., 1951; Pratt Institute, NYC, 1951; U. of Delaware, 1951; Bennington College, 1952; Louisville/Speed, 1953; Detroit/Institute, 1953; Los Angeles/County MA, 1953; Currier, 1955; Chattanooga/AA, 1955; Fort Worth, 1955; Wesleyan U., 1956; U. of Maine, 1956; Scripps College, 1958; Berea College, 1958; Collectors Art Center, Tallahassee, 1958; Atlanta/AA, 1959; Carnegie, 1959; San Antonio/McNay, 1959; Terry Dintenfass, Inc., NYC, 1962, 63, 64, 66, 69, 71, 76, 79, 83; The Print Club, Philadelphia, 1963; The Pennsylvania State U., 1963; Ankrum Gallery, 1963; Esther Baer Gallery, 1967, 75; Bridgeport, 1967; Lincoln, Mass./De Cordova, 1967; Haslem Fine Arts, Washington, D.C., 1976; Dunne/Steen Fine Arts, Old Greenwich, Ct., 1981; WMAA, Block Prints, 1982; MOMA, Prints from Blocks, 1983; Museum of Contemporary Hispanic Arts, 2nd Biennial, 1986; Museo d'Arte Contemporanea, Bologna, Xylon 9, 1986; U. of Puerto Rico, San Juan, A Lorca, 1986; Bronx Museum, The Latin American Spirit, 1990; Pratt Manhattan Gallery, NYC, Prints of the Eighties, 1990. **Retrospectives:** Cleveland/MA, 1952; Smithsonian, circ., 1953-55; Montevideo/Municipal, 1961; Baltimore/MA, 1963; Brooklyn Museum, 1964; Missouri State Council of the Arts, circ., 1976; Musedel Grabado, San Juan, Obra Grafica 1943-1975, 1976. **Group:** Brooklyn Museum; Corcoran; Boston/MFA; Detroit/In-

stitute; Hartford/Wadsworth; PAFA; Newark Museum; MOMA; Carnegie; St. Louis/City; San Diego; Baltimore/MA; New School for Social Research, Protest and Hope, 1967; XXXIV Venice Biennial, 1968; Intergraphic 76, Berlin, 1976; Smithsonian, American Prints from Wood, circ., 1976; York U., Toronto, Spain 1936-1976, 1976; Purchase/SUNY, Americans, 1977. **Collections:** Akron/AI; Albion College; Allegheny College; Alverthorpe Gallery; U. of Arizona; Arts Council of Great Britain; Atlanta/AA; Baltimore/MA; Boston/MFA; Boston Public Library; Brandeis U.; Brooklyn Museum; U. of California, Berkeley; Carnegie; La Casa del Libro; Chicago/AI; Cincinnati/AM; Cleveland/MA; Dartmouth College; U. of Delaware; Des Moines; Detroit/Institute; Fort Worth; Geneseo/SUNY; Georgia State U.; Grand Rapids; Hamilton College; Hartford/Wadsworth; Harvard U.; Honolulu Academy; Hunter College; State College of Iowa; Kalamazoo/Institute; U. of Kentucky; Lawrence College; Library of Congress; Louisville/Speed; MMA; MOMA; U. of Maine; Memphis/Brooks; U. of Michigan; U. of Minnesota; Minnesota/MA; Montclair/AM; Montevideo/Municipal; NYPL; Newark Museum; New Britain; New Paltz/SUNY; U. of Notre Dame; Omaha/Joslyn; PAFA; PMA; The Pennsylvania State U.; Princeton U.; U. of Puerto Rico; RISD; U. of Rochester; Rutgers U.; St. Louis/City; San Diego; Santa Barbara/MA; Seattle/AM; Smith College; Smithsonian; Springfield, Mo./AM; Uruguay/Nacional; Utica; Wake Forest U.; Washington U.; Wesleyan U.; College of William and Mary; Williams College; U. of Wisconsin. **Bibliography:** Frasconi; Sachs. Archives.

FRECKELTON, SONDRA
b. June 23, 1936, Dearborn, Mich. **Studied:** U. of Chicago; School of the Art Institute of Chicago; Exhibited sculpture 1959-65 under the name Sondra Beal. **Taught:** Downtown Community School,

NYC, 1960-63; Cooper Union, 1966; Eastern Michigan U., 1991. **Member:** NAD. **Awards:** Ingram Merrill Foundation Grant, 1960; Michigan Artists Show, Prize, 1965; 6th British Interaction Print Biennial, prize, 1979. **m.** Jack Beal. **Address:** 83A Delhi Stage, Oneonta, NY 13820; and 67 Vestry Street, NYC 10013. **Dealer:** Maxwell Davidson Gallery, NYC. **One-man Exhibitions:** (first) Tibor de Nagy, NYC, 1960, 61, 63; B.C. Holland Gallery, Chicago, 1965; Lo Guidice Gallery, Chicago, 1970; Brooke Alexander, Inc., NYC, 1976, 79, 80, 81; Allan Frumkin Gallery, Chicago, 1978; Fendrick Gallery, Washington, D.C., 1980; John Berggruen Gallery, San Francisco, 1982; Robert Schoelkopf Gallery, NYC, 1985, 86, 88, 90; Alice Simsar Gallery, Ann Arbor, 1987; U. of Michigan, 1990; Louis Newman Gallery, Beverly Hills, 1991; Travers City, 1991; Eastern Michigan U., 1991. **Group:** MOMA, Recent Sculpture USA, 1959; Chicago/AI, American Exhibition, 1962, 65; WMAA, Annual, 1964; A.F.A., Colored Sculpture, circ., 1965; Chicago/AI, 100 Artists—100 Years, 1976; Brooklyn Museum, Print Exhibition, 1978; Bradford Art Gallery, England, Print Biennial, 1979; PAFA, Contemporary American Realism Since 1960, 1981; PAFA, Perspective on Contemporary American Realism, 1983; SFMA, American Realism, circ., 1985; AAIAL, 1985; Springfield (Mo.)/AM, Watercolor USA, 1986; Bronx Museum, The Food Show, 1987; Youngstown/Butler, Mainstream America, 1987; NMAA, Modern American Realism, 1987; Mount Holyoke College, Prints by Contemporary American Women Artists, circ., 1987; Pennsylvania State U., Realist Watercolors, 1990; Detroit/Institute, Collaborations in Print, circ., 1991. **Collections:** Amerada Hess Corp., Inc.; The Bank of New York; Best Products Co.; Madison Art Center; Prudential Insurance Co. of America; Reader's Digest; Sara Roby Foundation; Shearson Lehman Brothers; Southeast Banking

Corp.; Springfield Mo./AM; VMFA.
Bibliography: Arthur 2; Ward.

FREILICHER, JANE **b.** November 19, 1924, NYC. **Studied:** Brooklyn College, BA; Columbia U., MA; Hofmann School. Traveled Europe, Morocco. Designed set for *Red Robbins,* by Kenneth Koch. Designed sets for *The Heroes* by John Ashberry for Eye & Ear Theatre, NYC, 1981. **Taught:** Great Neck (N.Y.) Adult Education Program; New Jersey public schools; U. of Pennsylvania, 1968; Skowhegan School, 1968; Boston U., 1968; Swarthmore College, 1969, Carnegie-Mellon Institute, 1971; Cooper Union, 1972; Louisiana State U., 1973; Galveston Arts Center, 1973; Maryland Institute, 1973; Brandeis U., 1979; American U., 1979. **Member:** AAIAL, 1990. **Awards:** Hallmark International Competition, 1960; *Art News* magazine, 10 Best Shows of 1962; National Endowment for the Arts, 1976. **Address:** 51 Fifth Avenue, NYC 10003. **Dealer:** Fischbach Gallery, NYC. **One-man Exhibitions:** (first) Tibor de Nagy Gallery, 1952, also 1953-64, 70; John Bernard Myers Gallery, NYC, 1971; Benson Gallery, 1972, 74; Fischbach Gallery, NYC, 1975, 77, 79, 80, 83, 85; Hartford/Wadsworth, 1976; Utah, 1979; Louise Himmelfarb Gallery, Water Mill, N.Y., 1980; Kornbluth Gallery, Fair Lawn, N.J., 1980; College of the Mainland, Texas City, Tx., 1982; Kansas City/AI, 1983. **Retrospective:** Currier, circ., 1986. **Group:** RISD, Four Young Americans, 1955; MOMA, Recent Drawings, USA, 1956; WMAA Annual, 1958; PAFA, 1961; U. of Nebraska, 1963; MOMA, Hans Hofmann and His Students, circ., 1963-64; Chicago/AI; Brooklyn Museum; Yale U.; Corcoran; A.F.A., 1965; MOMA, 1966; A.F.A., Painterly Realism, 1970; Omaha/Joslyn, A Sense of Place, 1973; PMA/Museum of the Philadelphia Civic Center, Focus, 1974; AAAIL, 1975; US Department of the Interior, America 1976, 1976; U. of Missouri, American Painterly Realists, 1977; Westmoreland County/MA, The New American Still Life, 1979; Denver/AM, Poets and Painters, 1979; Houston/Contemporary, American Still Life, 1945-1983, 1983; Brooklyn Museum, Public & Private: American Prints Today, 1984; NAD, 1985; SFMA, American Realism (Janss), circ., 1985. **Collections:** AT&T; Brandeis U.; Brooklyn Museum; Chase Manhattan Bank; Colby College; Commerce Bank of Kansas City; Corcoran; Greenville; Hampton Institute; Hirshhorn; Lehman Brothers; MMA; MOMA; NAD; NYU; New Orleans/Contemporary; U. of North Carolina; Prudential Insurance Co. of America; RISD; Rahr-West Museum; San Antonio/McNay; Southampton/Parrish; Stratford College; Union Carbide Corp.; Utah; U. of Utah; WMAA. **Bibliography:** *America 1976; Art: A Woman's Sensibility;* Arthur 1, 2; Ashbery; Doty, ed.; Downes, ed.; *Poets & Painters;* Sandler 5; Strand, ed.; Ward. Archives.

FRENCH, JARED **b.** February 4, 1905, Ossining, N.Y. **d.** January 15, 1988, Rome. **Studied:** ASL, with Thomas Hart Benton, Boardman Robinson, Kimon Nicolaides; Amherst College, 1925, BA, with Robert Frost. Traveled Europe, 1927-28, 1931-33; northern USA. Federal A.P.: US Post Offices, Richmond, Va., and Plymouth, Pa., 1935-39 (murals). Designed costumes and sets for the ballet *Billy the Kid.* **Awards:** NIAL Grant, 1967. **One-man Exhibitions:** (first) Julien Levy Galleries, NYC, 1939; Hewitt Gallery, NYC, 1950; Robert Isaacson Gallery, NYC; The Banfer Gallery, NYC, 1967; Midtown-Payson Gallery, NYC, circ., 1992. **Retrospective:** The Banfer Gallery, 1969. **Group:** Arts Club of Chicago; PAFA; WMAA; Chicago/AI; Carnegie; NAD; Walker; U. of Rochester, 1964-65; Youngstown/Butler, 1967; WMAA, Romantic Realism, 1975; Rutgers U., Realism and Realities, 1982; WMAA, American Life in American Art, 1991. **Collections:** Balti-

Jared French, *Business*, 1959-1961.

more/MA; Baseball Museum; Dartmouth College; WMAA. **Bibliography:** Armstrong, Thomas; Baur 7; Goodrich and Baur 1.

FRIEDENSOHN, ELIAS b. December 12, 1924, NYC. **Studied:** Stella Elkins Tyler School of Fine Arts, Temple U., 1942-43, with Rafael Sabatini; Queens College, with Cameron Booth, 1946-48, AB; NYU, Institute of Fine Arts, 1949-50; privately with Gabriel Zendel in Paris. Traveled Europe and Tunisia. **Taught:** Queens College, 1959-; Kirkland College, 1970-71. **Member:** College Art Association. **Awards:** Joe and Emily Lowe Foundation Award, 1951; Fulbright Fellowship (Italy), 1957; U. of Illinois, P.P., 1957; National Arts Club Annual, NYC, Stephens Award, 1958; Guggenheim Foundation Fellowship, 1960; MacDowell Colony Fellowship, 1969, 70; AAAL, P.P., 1972; New Jersey Council on the Arts Grant, 1981, 85; CUNY, University Research Foundation Grant, 1981, 85. **Address:** 209 Hillcrest Avenue, Leonia, NJ 07605. **One-man Exhibitions:** (first) Roko Gallery, NYC, 1951; Hewitt Gallery, NYC, 1955, 57, 59; Vassar College, 1958; Robert Isaacson Gallery, NYC, 1960; Feingarten Gallery, NYC, San Francisco, Los Angeles and Chicago, 1961, 62; Feingarten Gallery, Los Angeles, 1964; The Contemporaries, NYC, 1964; Terry Dintenfass, Inc., NYC, 1967, 70, 74, 76, 80, 85; Kirkland College, 1972; Moravian College, 1977; Jersey City State College,

1978; Magnes Memorial Museum, 1981; Pine Library, Fair Lawn, N.J., 1985. **Retrospective:** Jersey City, State College, 1982. **Group:** Audubon Artists Annual 1957; WMAA, Young America, 1957, Fulbright Artists, 1958, Annuals, 1958, 59, 60, 62; Chicago/AI Annuals, 1957, 59; U. of Illinois, 1957, 59, 61, 63; National Arts Club Annual, NYC, 1958; Galleria Schneider, Rome, Fulbright Artists, 1958; Festival of Two Worlds, Spoleto, 1958; Corcoran Annuals, 1960, 62; Denver/AM, 1962; Smithsonian; Buffalo/Albright; Philadelphia Art Alliance; Syracuse U.; U. of Wisconsin; PAFA Annual, 1967; New School for Social Research, 1969; Minnesota/MA, Drawings USA, 1971, 73; NAD, 1971; VMFA, Works on Paper, 1974. **Collections:** Chicago/AI; Hampton Institute; U. of Illinois; Huntington, N.Y./Heckscher; Indianapolis; Kalamazoo/Institute; Kirkland College; Little Rock/MFA; The Joe and Emily Lowe Foundation; U. of Massachusetts; NMAA; U. of Oklahoma; Queens College; St. Mary's College, Md.; Sara Roby Foundation; WMAA; Walker. **Bibliography:** Weller.

FULLER, SUE b. August 11, 1914, Pittsburgh, Pa. **Studied:** with Hans Hofmann, 1934; with S. W. Hayter, 1943-44; privately with Josef Albers, T. Tokuno; Carnegie Institute of Technology, 1936, BA; Teachers College, Columbia U., 1939, MA. Traveled Europe, Africa, Japan. **Taught:** U. of Minnesota, 1950; Stourbridge (England) School of Arts and Crafts, 1951; U. of Georgia, 1951, 52; Teachers College, Columbia U., 1958; Pratt Institute, 1964-65. **Commissions:** All Souls Unitarian Church, NYC, 1980; Tobin Library, San Antonio/McNay, 1984. **Awards:** Charles M. Rosenbloom Prize, 1942; The Print Club, Philadelphia, 1944, 1945; Charles M. Lea Prize, 1949; Northwest Printmakers Annual, P.P., 1945; Society of American Etchers and Engravers, NYC, 1947; L. C.

Tiffany Grant, 1948; Guggenheim Foundation Fellowship, 1949; NIAL Grant, 1950; Eliot D. Pratt Foundation Fellowship, 1966, 67, 68; Carnegie-Mellon U., Alumni Merit Award, 1974; National Sculpture Conference, Honoree, 1987. **Address:** P.O. Box 1580, Southampton, NY 11969-1580. **Dealers:** Mary Ryan Gallery, NYC; Susan Teller Gallery, NYC. **One-man Exhibitions:** Village Art Center, NYC, 1947; Corcoran, 1951; U. of Georgia, 1951; The Bertha Schaefer Gallery, NYC, 1952, 55, 56, 61, 65, 67, 69; Nishi Machi School, Tokyo, 1954; Fort Worth, 1956; Currier, 1956; San Antonio/McNay, 1956, 66; Grand Rapids, 1957; Charlotte/Mint, 1957; Grinnell College, 1960; Chatham College, 1960; Eleanor Rigelhaupt Gallery, Boston, 1965; Storm King Art Center, 1966; Norfolk, 1967; McNay Art Institute, 1967; Southern Vermont Art Center, 1968; Chattanooga/AA, 1969; Port Washington Public Library, 1978; Benson Gallery, Bridgehampton, 1978; Plum Gallery, Kensington, Md., 1978. **Group:** MOMA, Master Prints from the Museum Collection, 1949, Abstract Painting and Sculpture in America, 1951, The Responsive Eye, 1965; SAGA, 1951; São Paulo Biennial, 1951; WMAA Annuals, 1951, 53, 54, 56, The New Decade, 1954-55, Geometric Abstraction in America, circ., 1962; Salon du Mai, Paris, 1952; PMA, A Decade of American Printmaking, 1952, also 1964; III Biennial of Spanish-American Art, Barcelona, 1955; Brooklyn Museum, 14 Painter-Printmakers, 1955; Chicago/AI Annual, 1957; A.F.A., 14 Painter-Printmakers, circ., 1957, Collage in America, circ., 1957-58, The New Landscape in Art and Science, circ., 1958-59, Explorers of Space, circ., 1961-62, Hayter and Atelier 17, circ., 1961-62; USIA, American Prints, circ., Middle East, 1957-59, Plastics—USA, circ., USSR, 1961; Corcoran Biennials, 1963, 65; Buffalo/Albright, Box Show, 1966; Cornell U., Small Sculpture, 1967; Flint/Institute, Made of Plastic, 1968; Denver/AM, Report on the Sixties, 1969; Colgate U., Viewpoints 3, 1969; Skidmore College, Contemporary Women Artists, 1970; U. of Nebraska, American Sculpture, 1970; Finch College, NYC, Projected Art, 1971; Potsdam/SUNY, Women in Art, 1971; PMA/Museum of the Philadelphia Civic Center, Focus, 1974; Sculptors Guild, NYC, 1983, 85; Carnegie-Mellon U., 75 Years of Pittsburgh Art, 1985; Stamford Museum, American Art: American Women, 1985. **Collections:** Albion College; American Republic Insurance Co.; Amherst College; Andover/Phillips; Baltimore/MA; Boston/MFA; British Museum; Brooklyn Museum; CIT Corporation; Carnegie; Chase Manhattan Bank; Chicago/AI; Des Moines; Ford Foundation; Hartford/Wadsworth; Harvard U.; Honolulu Academy; Indianapolis; NYPL; National Gallery; Norfolk; PMA; Peabody Institute; Ridgefield/Aldrich; St. Louis/City; San Antonio/McNay; Seaton Hall, Inc.; Storm King Art Center; Tate; Union Carbide Corp.; WMAA. **Bibliography:** Hayter 2; Janis and Blesh 1; Moser; Newmeyer; Reese; Ritchie 1. Archives.

G

GABLIK, SUZI
In 4th edition.

GABO, NAUM NEEMIA PEVSNER **b.** August 5, 1890, Briansk, Russia. **d.** August 23, 1977, Waterbury, Conn. **Studied:** U. of Munich, medical faculty, 1910, natural science, 1911; Polytechnic Engineering School, Munich, 1912. Traveled Italy, Scandinavia, Great Britain, USA, Russia. To USA, 1946; citizen, 1952. **Taught:** Harvard U., 1953-54. Designed set for *La Chatte* (Ballet Russe, 1926). Edited *Circle* (with Leslie Martin and Ben Nicholson), 1937. **Member:** AAAL, 1965. **Commissions:** Bijenkorf Building, Rotterdam, 1955; U.S. Rubber Co. Building, NYC, 1956. **Awards:** ICA, London/Tate, International Unknown Political Prisoner Competition, Second Prize, 1953; Guggenheim Foundation Fellowship, 1954; Chicago/AI, The Mr. & Mrs. Frank G. Logan Medal, 1954; Hon. DFA, Royal College of Art, London, 1967; NIAL. **One-man Exhibitions:** Gallery Percier, Paris, 1924; Little Review Gallery, NYC, 1926; Hannover/K-G, 1930; Arts Club of Chicago, 1934, 1952 (two-man); Lefevre Gallery, London, 1936; Musée du Jeu de Paume, 1937; The London Gallery, London, 1937; Julien Levy Galleries, NYC, 1938; Hartford/Wadsworth, 1938, 53; Museum of the City of London, 1942; MOMA, 1948; Baltimore/MA, 1950; MIT, 1952; Pierre Matisse Gallery, 1953; France/National, Paris, 1971; Berlin/National, 1971; Martin-Gropius-Bau, Berlin, 1992. **Retrospectives:** Amsterdam/Stedelijk, circ., 1965-66; Buffalo/Albright, 1968; Dallas/MFA and Düsseldorf/KN-W, circ., 1986. **Group:** Golden Gate International Exposition, San Francisco, 1939; MOMA; WMAA; Chicago/AI; Paris/Moderne. **Collections:** Buffalo/Albright; Hartford/Wadsworth; MOMA; Princeton U.; Tate; U.S. Rubber Co.; WMAA; Yale U. **Bibliography:** *Abstraction creation 1931-36;* Baldinger; Barr 1; Battcock, ed.; Baur 7; Biederman 1; Bihalji-Merin; Blanchard; Blesh 1; Calas, N. and E.; Canaday; Cassou; Chipp; Craven, W.; Davis, D.; Flanagan; **Gabo;** Gaunt; Gertz; Giedion-Welcker 1, 2; Goodrich and Baur 1; Guggenheim, ed.; Henning; Hess, T.B., 1; Hulten; Hunter, ed.; Janis and Blesh 1; Janis, S.; Kepes 2; Kepes, ed.; Krauss 2; Kuh 1, 2, 3; Langui; Licht, F.; Lowry; Lynton; MacAgy 2; McCurdy, ed.; **Martin, Nicholson, and Gabo, eds.;** Mendelowitz; *Metro;* Murken-Altrogge; Myers 2; Nash and Merkert, eds.; Neumeyer; Newmeyer; Newton 2; **Olson and Chanin;** Ramsden 1, 2; Read 1, 3, 6; **Read and Martin;** Rickey; Ritchie 3; Rose, B., 1; Rowell; Seiz, J.; Pela, P., 3; Seuphor 3; Seymour; Trier 1, 2; Valentine 2; Zervos. Archives.

GALLATIN, ALBERT E.
b. 1882, Villanova, Pa. **d.** June 17, 1952. **Studied:** Cutler School, Vermont; New York Law School. Traveled Europe, USA. Founder of Museum of Living Art, now housed at the Philadelphia Museum of Art. **One-man Exhibitions:** (first) Galerie Pierre, Paris, 1938; Passedoit Gallery, NYC, 1938, 42; Pittsfield/Berkshire, 1939; J. Seligmann and Co., 1939 (three-man); The Willard Gallery, NYC, 1941; Mortimer Brandt, NYC, 1945; Durand-Ruel Gallery, NYC, 1947, 48; The Pinacotheca, NYC, 1950; The Zabriskie Gallery, NYC, 1972. **Retrospective:** Rose Fried Gallery, NYC. **Group:** Salon des Sur-

independants, Paris, 1938; American Abstract Artists Annuals, 1938-48; New York World's Fair, 1939; Arts Club of Chicago, 1940; MOMA, 1942; Federation of Modern Painters and Sculptors, 1943; PMA, 1945; Corcoran, 1947. **Collections:** Black Mountain College; MMA; MOMA; PMA; Phillips; Pittsfield/Berkshire; SFMA; SRGM. **Bibliography:** American Abstract Artists, ed.; Armstrong, Thomas; Baur 7; Bazin; Blesh 1; Frost; Gallatin 1, 2, 3, 4, 5, 6, 7, 8; Lane and Larsen; McCurdy, ed.; Morris; Ritchie 1; Rose, B., 1.; Toher, ed. Archives.

GALLO, FRANK **b.** January 13, 1933, Toledo, Ohio. **Studied:** Toledo/MA, 1954, BFA; Cranbrook, 1955; U. of Iowa, 1959, MFA. **Taught:** U. of Illinois, 1959-64, 68; U. of Iowa, 1967-68. **Awards:** Des Moines, First Prize, 1958, 59; Guggenheim Foundation Fellowship, 1966. **Address:** RR 2, Box 303A, Urbana, IL 61081. **One-man Exhibitions:** Toledo/MA, 1955; Gilman Galleries, Chicago, 1963-66; Sherry Netherland Hotel, NYC, 1964; The Graham Gallery, NYC, 1965, 67; Felix Landau Gallery, Los Angeles, 1966; Time, Inc., 1966; Danenberg Gallery, NYC, 1972; Puck Gallery, NYC, 1974; Jack Gallery, NYC, 1974; Circle Gallery Ltd., 1974, 82; Spencer-Howard Gallery, Laguna Beach, 1978; Cherry Creek Gallery of Fine Art, Denver, 1980; Old Town Gallery, San Diego, 1980; Collectors Fine Arts Gallery, Cleveland, 1981; U. of Nebraska, 1981; G. Oatis Gallery, Houston, 1981; Pioneer Square Gallery, Seattle, 1981; Akron/AM, 1982; Carolyn Summers Gallery, New Orleans, 1982; ArtExpo, NYC, 1983, 84. **Retrospectives:** Paine Art Center and Arboretum, Oshkosh, 1981; Colorado State U., 1984. **Group:** Des Moines, 1958, 59; U. of Illinois, 1963-65; Chicago/AI, 1964; WMAA Annual, 1964-67; Youngstown/Butler, 1965; WMAA, Young America, 1965; Toronto International Sculpture Symposium, 1967; XXXIV Venice Biennial, 1968; Owens-Corning Fiberglas

Corp., Corning, N.Y., 1970; Harvard U., Recent Figure Sculpture, circ., 1972. **Collections:** Baltimore/MA; Caracas; Chicago/AI; Cleveland/MA; Colorado State U.; Helsinki; Hirshhorn; U. of Illinois; Springfield/Illinois State; Los Angeles/County MA; MMA; MOMA; Melbourne/National; Montréal/MFA; National Gallery; U. of Nebraska; New Orleans Museum; Princeton U.; RISD; St. Louis/City; Toronto; WMAA; U. of Wisconsin. **Bibliography:** Geske; *Recent Figure Sculpture.*

GANSO, EMIL **b.** April 4, 1895, Halberstadt, Germany. **d.** April 18, 1941, Iowa City, Iowa. To USA, 1912. **Studied:** NAD. **Taught:** Lawrence College, 1940; State U. of Iowa, 1941. **Awards:** Guggenheim Foundation Fellowship, 1933. **One-man Exhibitions:** Weyhe Gallery, NYC, 1926-28, 1930-36, 1944, 46; Washington Irving Gallery, NYC, 1960; Kenan Center, Lockport, N.Y., 1969; U. of Connecticut, 1976; Martin Sumers Graphics, NYC, 1978, 80. **Retrospectives:** WMAA, 1941; Brooklyn Museum, 1944; U. of Iowa, 1979. **Group:** WMAA; Salons of America, NYC; Brooklyn Museum; Chicago/AI; Cleveland/MA; PAFA; Corcoran; NAD. **Collections:** Boston/MFA; Dartmouth College; Denver/AM; MMA; U. of Rochester; WMAA. **Bibliography:** American Artists Group, Inc. 1, 3; Cahill and Barr, eds.; Cheney; Hall; *Index of 20th Century Artists;* Jewell 3; Mellquist; Moser 2; Pearson 1; Reese; Ringel, ed.; *Woodstock: An American Art Colony, 1902-1977;* Zigrosser 1. Archives.

GARET, JEDD **b.** 1955, Los Angeles. **Studied:** RISD, 1975-76; School of Visual Arts, NYC, 1977, BFA. **Address:** 99 East 7th Street, NYC 10009. **Dealer:** Robert Miller Gallery, NYC. **One-man Exhibitions:** Robert Miller Gallery, NYC, 1979, 81, 83, 84, 89, 91; Felicity Samuel Gallery, London, 1979; Galerie Bischofberger, Zurich, 1980;

Larry Gagosian Gallery, Los Angeles, 1981; Texas Gallery, Houston, 1982, 85; John Berggruen Gallery, San Francisco, 1982; Michael Lord Gallery, Milwaukee, 1983; Stephen Wirtz Gallery, San Francisco, 1984; Betsy Rosenfield Gallery, Chicago, 1984; ICA, U. of Pennsylvania, 1984; Totah-Stelling Art, NYC, 1985; Galerie Daniel Templon, Paris, 1986; Michael Kohn Gallery, Los Angeles, 1987; Galerie Lelong, NYC, 1987; Origrafica Malmo, Malmo, Sweden, 1988. **Group:** Norfolk/Chrysler, American Figure Painting, 1950-1980, 1980; XXXIX & XLI Venice Biennials, 1980, 84; WMAA Biennials, 1981, 85; Cincinnati/Contemporary, Dynamix, circ., 1982; Hannover/K-G, New York Now, circ., 1982; Indianapolis, 1982, 84; XVII São Paulo Biennale, 1983; Houston/Contemporary, American Still Life, 1945-1983, 1983; Bonn, Back to the USA, circ., 1983; New Museum, The 1970s: New American Painting, 1984; MOMA, International Survey of Recent Painting and Sculpture, 1984; SFMA, The Human Condition, 1984; Houston/Contemporary, The Heroic Figure, circ., 1984; Indianapolis, 1984; ICA, U. of Pennsylvania, Investigations, 1984; U. of North Carolina, Art on Paper, 1985; Laforet Museum, Harajuki, Tokyo, Correspondence; New York Art Now, circ., 1985; Ridgefield/Aldrich, A View of Nature, 1987; WMAA, Figure as Subject, circ., 1988; Kuznetsky Most Exhibition Hall, Moscow, Painting Beyond the Death of Painting, circ., 1989; Oakland Museum, de-Persona, 1991. **Collections:** Atlantic Richfield Co.; Bank of America; Bowdoin College; Brooklyn Museum; Chase Manhattan Bank; Harvard U.; Honolulu Academy; MOMA; U. of Minnesota; PaineWebber Group, Inc.; Tate Gallery; WMAA. **Bibliography:** *Back to the USA;* Haenlein; Plagens; Stearns; Tomidy.

GATCH, LEE b. September 10, 1902, Baltimore, MD. d. November 10,

1968, Trenton, N.J. **Studied:** Maryland Institute, 1924; Academie Moderne, Paris, 1924, with Andre Lhote, Moise Kisling. Traveled France, Italy. **Member:** NIAL, 1966. **Commissions:** (murals) US Post Offices, Mullins, S.C., and Elizabethtown, Pa. **Awards:** Chicago/AI, Watson F. Blair Prize, 1957; Corcoran, 1960. **One-man Exhibitions:** (first) J. B. Neumann's New Art Circle, NYC, 1927, also 1932, 37, 46, 49; The Willard Gallery, NYC, 1943; Grace Borgenicht Gallery, Inc., NYC, 1954; Phillips, 1954, 56, 60; World House Galleries, NYC, 1958; Staempfli Gallery, NYC, 1963, 67, 72, 74; NCFA, 1971; Newark Museum, 1981. **Retrospective:** WMAA, 1960. **Group:** XXV & XXVIII Venice Biennials, 1950, 56; Santa Barbara/MA, 1952; Detroit/Institute, 1959; U. of Illinois, 1961. **Collections:** Andover/Phillips; Atlanta U.; Baltimore/MA; Boston/MFA; Detroit/Institute; Hartford/Wadsworth; U. of Illinois; Los Angeles/County MA; MMA; MOMA; U. of Nebraska; PAFA; PMA; Phillips; St. Louis/City; Utica; WMAA; Washington U. **Bibliography:** Baur 5; Blesh 1; *Cityscape 1919-37;* Eliot; Frost; Gerdts; Goodrich and Baur 1; Hess, T. B., 1; Janis and Blesh 1; Janis, S.; McCurdy, ed.; Nordness, ed.; Pousette-Dart, ed.; Richardson, E.P. Archives.

GECHTOFF, SONIA b. September 25, 1926, Philadelphia, Pa. **Studied:** Philadelphia Museum School, BFA. Traveled Europe. **Taught:** California School of Fine Arts, 1957-58; NYU, 1961-70; Queens College, 1970-74; U. of New Mexico, 1974-75; Skidmore College, summers, 1988, 89, 90; Adelphi U., 1991. **Member:** National Advisory Board, Tamarind Institute; Artists Equity. **Awards:** SFMA, P.P.; Santa Barbara/MA, P.P.; Tamarind Fellowship, 1963; Phoenix Art Museum, drawing award, 1975; Gottlieb Foundation Fellowship, 1987; NEA, grant, 1988. m. James Kelly. **Address:** 463 West Street, NYC 10014.

Dealer: Kraushaar Galleries, NYC.
One-man Exhibitions: (first) Dubin Gallery, Philadelphia, 1949; Lucien Labaudt Gallery, San Francisco, 1952, 53; Gallery Six, San Francisco, 1955; de Young, 1957; Ferus Gallery, San Francisco, 1957, 59; Poindexter Gallery, 1959, 60; East Hampton Gallery, 1963, 67, 68; Montclair State College, 1974; Cortella Gallery, NYC, 1976, 78; Gruenebaum Gallery, Ltd., NYC, 1979, 80, 82, 83, 85, 87; Witkin Gallery, NYC, 1989; Kraushaar Galleries, NYC, 1990, 92; Adelphi U., 1991; 871 Fine Arts, San Francisco, 1991. Group: SFMA Annuals, 1952-58; SRGM, Younger American Painters, 1954; Brussels World's Fair, 1958; Carnegie, 1958; I Paris Biennial, 1959; WMAA Annual, 1959; WMAA, Young America, 1960; Walker, 60 American Painters, 1960; VI São Paulo Biennial, 1961; MOMA, Abstract American Drawings and Watercolors, circ., Latin America, 1961-63; U. of Texas, 1966; Florida State U., 1967; Los Angeles/County MA, 1968; New York Cultural Center, Women Choose Women, 1973; SFMA, California Painting and Sculpture: The Modern Era, 1976; MOMA, Extraordinary Women, 1977; MOMA, American Drawn and Matched, 1977; U. of California, Davis, Directions in Bay Area Painting, 1983; Stamford Museum, American Art: American Women, 1985; U. of North Carolina, Art on Paper Now, 1987; Randolph-Macon Women's College, Annual, 1990; Skidmore College, Out of Abstract Expressionism, 1991; Wilkes College, Nature as Muse, 1992. Collections: Achenbach Foundation; AT&T; U. of California; Amon Carter Museum; Baltimore/MA; Chase Manhattan Bank; U. of Iowa; La Jolla; Little Rock/MFA; Los Angeles/County MA; MMA; MOMA; U. of Massachusetts; Oakland/AM; Pasadena/AM; SFAI; SFMA; SRGM; The Singer Company, Inc.; Stanford U.; Utah State U.; Woodward Foundation. Bibliography: *Art: A Woman's Sensibility;* Solnit. Archives.

GELB, JAN
from 1st to 4th edition.

GEORGE, THOMAS b. July 1,
1918, NYC. Studied: Dartmouth College, 1940, BA; ASL; Academie de la Grande Chaumiere; Academy of Fine Arts, Florence, Italy. US Navy, 1942-46. Traveled Europe, Far East, North Africa, China. Taught: Dartmouth College, 1979; Art League of San Juan, Puerto Rico, 1982. Member: MacDowell Colony. Awards: Brooklyn Museum, P.P., 1955; Rockefeller Foundation Grant, 1957; Ford Foundation, P.P., 1962, 63; Dartmouth College, Presidential Medal for Life Achievement, 1992. Address: 20 Greenhouse Drive, Princeton, NJ 08540. Dealer: Snyder Fine Art, NYC. One-man Exhibitions: Ferargil Galleries, NYC, 1951, 53; Korman Gallery, NYC, 1954; Dartmouth College, 1956, 79, 90; The Contemporaries, NYC, 1956; Bridgestone Museum, 1957; Diamaru, Osaka, 1957; Betty Parsons Gallery, NYC, 1959, 70, 72, 74, 76, 78, 81; The Reid Gallery, London; Bennington College, 1967; U. of California, Santa Cruz, 1967; Axiom Gallery, London, 1968; Esther Baer Gallery, Santa Barbara, 1969; Delaware Art Museum, 1971; Henies-Onstadts Stiftelser, 1971; Tranegarden Gallery, Hellerup, Copenhagen, 1971; Princeton Gallery of Fine Art, 1972, 74, 83, 85; Oslo Kunstforening, 1973; Jefferson Place Gallery, Washington, D.C., 1974; Princeton U., 1975; NCFA, 1977; Artes Galleri, Oslo, 1979; Oslo/National, 1980; Galerie Ravel, Austin, 1981; Riis Gallery, Oslo, 1982, 84, 86, 88, 90; Maxwell Davidson Gallery, NYC, 1983, 85; Snyder Fine Art, NYC, 1990. Retrospectives: Dartmouth College, 1965; Trenton/State, 1987. Group: MOMA, Recent Drawings, USA, 1956; Carnegie, 1958, 61; WMAA, Annuals, 1960-62, 1965; PAFA, 1962; Corcoran, 1963; International Biennial Exhibition of Paintings, Tokyo; Lincoln, Mass./De Cordova, 1963; San Antonio/McNay, 1964; SFMA, 1965;

Musée Cantonal des Beaux-Arts, Lausanne, 11 Salon International de Galeries Pilotes, 1966; NCFA, 1968; US Mission to the United Nations; New School for Social Research, NYC, American Drawings of the Sixties, 1970; Trenton/State, New Jersey 6, 1971. **Collections:** Brandeis U.; Bridgestone Museum; Brooklyn Museum; Buffalo/Albright; U. of California, Santa Cruz; Chase Manhattan Bank; Colby College; Dartmouth College; Delaware Art Museum; Flint/Institute; Ford Motor Company; Henies-Onstadts Stiftelser; Houston/MFA; Library of Congress; MOMA; Musée Cantonal des Beaux-Arts; NCFA; NMAA; Oklahoma; Oslo/National; Princeton U.; U. of Rochester; SFMA; SRGM; Tate Gallery; U. of Texas; Trenton/State; WGMA; WMAA; Yale U.

GEORGES, PAUL b. June 15, 1923, Portland, Ore. **Studied:** U. of Oregon; Hofmann School; Atelier Fernand Leger in Paris, 1949-52. Traveled France, USA. **Taught:** U. of Colorado, 1960; Dartmouth College, 1961; Yale U., 1964; Brandeis U., 1977-85. **Member:** NAD. **Awards:** Longview Foundation Grant; Hallmark International Competition, P.P., 1961; PAFA, Carol H. Beck Gold Medal, 1964; NAD, Benjamin Altman Prize, 1981; NAD, Andrew Carnegie Prize, 1982; AAIAL, 1986; Gottlieb Foundation Grant, 1992; AAIAL, P.P., 1990; NAD, The Gladys Emerson Cook Prize, 1991. **Address:** Sagaponack, NY 11962; 85 Walker Street, NYC 10013; La Champagne, Gefosse-Fontenay, 14230 Isigny sur Mer, France. **Dealer:** Salander-O'Reilly Galleries, NYC. **One-man Exhibitions:** Reed College, 1948, 56, 61; Tibor de Nagy Gallery, 1955, 57; The Zabriskie Gallery, 1959; Great Jones Gallery, NYC, 1960, 61; Allan Frumkin Gallery, NYC and Chicago, 1962, 64, 66, 67, 68; Dorsky Gallery, 1968; Fischbach Gallery, 1974, 76; Green Mountain Gallery, 1975; Union College, Cranford, NJ, 1979; Meghan

Williams Gallery, Los Angeles, 1979; Northern Illinois U., 1980; Brandeis U., 1981; Zolla/Lieberman Gallery, Chicago, 1982; College of the Mainland, 1983; Charles Moore Gallery, Philadelphia, 1983; Manhattan Art, NYC, 1984; Amherst College, 1985; Anne Plumb Gallery, 1986, 88, 91; Vered Gallery, Easthampton, 1989, 91; Greenville, 1989; Salander-O'Reilly Galleries, NYC, 1992. **Group:** Salon du Mai, Paris, 1949; The Kootz Gallery, NYC, New Talent, 1952; PAFA, 1952, 64; Corcoran, 1962; Chicago/AI, 1962; WMAA, 1962, 63; MOMA; U. of Colorado; U. of Kentucky, Drawings, 1963; MOMA, Hans Hofmann and His Students, circ., 1963-64; Boston U., 1964; Silvermine Guild, 1964; Youngstown/Butler, 1964; Southampton/Parrish, Drawings on the East End, 1940-88, 1988; Stony Brook/SUNY, 20th Century Landscape Painting, 1990; Seville World's Fair, 1992. **Collections:** Corcoran; 57th Madison Corp.; Guild Hall; Hallmark Collection; Hirshhorn; Indianapolis; MIT; MOMA; U. of Massachusetts; NYU; Newark Museum; U. of North Carolina; PAFA; Portland, Ore./AM; Purchase/SUNY; Ray-O-Vac Corp.; Reed College; Smith, Kline & French, Philadelphia; Springfield Art Center; WMAA. **Bibliography:** Adrian; Downes, ed.; Ward. Archives.

GIAMBRUNI, TIO
from 1st to 4th edition.

GIANAKOS, STEVE b. 1938, NYC. **Studied:** Pratt Institute, 1964, BID. **Taught:** School of Visual Arts, NYC, 1965-70. **Awards:** SRGM, Theodoron Award, 1977; National Endowment for the Arts, grant, 1977. **Address:** 4 East 12th Street, NYC 10003. **Dealer:** Barbara Toll Fine Arts, NYC. **One-man Exhibitions:** Fischbach Gallery, NYC, 1969; The Clocktower, NYC, 1974; Alessandra Gallery, NYC, 1976; Droll/Kolbert Gallery, NYC, 1971, 79; Houston/Contemporary, 1979; Texas Gallery, Houston, 1980;

Asher/Faure Gallery, Los Angeles, 1982, 90; Barbara Gladstone Gallery, NYC, 1983; Barbara Toll Fine Arts, NYC, 1984, 85, 88, 90, 91. **Group:** Flint/Institute, Made of Plastic, 1968; ICA, U. of Pennsylvania, Plastic and New Art, 1969; Milwaukee, A Plastic Presence, circ., 1969; Toronto, Chairs, 1975; P.S. 1, Long Island City, Rooms, 1976; U. of North Carolina, Art on Paper, 1977; Brooklyn Museum, Contemporary Greek American Artists, 1977; SRGM, Theodoron Awards, 1977; ICA, U. of Pennsylvania, Improbable Furniture, circ., 1977; Hirshhorn, Directions, 1979; The New Museum, NYC, Not Just for Laughs, 1981; P.S. 1, Long Island City, Eight Funny Artists, 1981; U. of Texas, New American Painting, 1984; MOMA, International Survey of Painting and Sculpture, 1984; Moore College of Art, Philadelphia, Memento Mori, 1985; WMAA, Sacred Images in Secular Art, 1986; Indianapolis, Painting and Sculpture Today, 1986; ICA, London, Komic Ikonoklasm, 1986; Milwaukee, Word as Image, circ., 1991. **Collections:** Brooklyn Museum; U. of California, Berkeley; Chase Manhattan Bank; Houston/Contemporary; Purchase/SUNY; SRGM; WMAA.

GIBRAN, KAHLIL
from 1st to 5th edition.

GIKOW, RUTH
from 1st to 4th edition.

GILL, JAMES
from 2nd to 4th edition.

GILLESPIE, GREGORY
b. November 29, 1936, Roselle Park, New Jersey. **Studied:** Cooper Union, 1945-60; SFAI, BA, MFA, 1960-62. **Awards:** Fulbright Fellowship, 1962, 65; Chester Dale Fellowship, 1964, 65; L. C. Tiffany Grant, 1960; NAD, Childe Hassam Fund, P.P., 1965. Resided Italy, 1962-70. **Address:** c/o Dealer. **Dealer:** Forum Gallery, NYC. **One-man Exhibitions:** Forum Gallery,

Gregory Gillespie, *Peg at Paradise Pond*, 1990.

NYC, 1966, 68, 70, 73, 76, 79, 82, 84, 86, 89, 91, 92; American Academy, Rome, 1969; U. of Georgia, 1970; Alpha Gallery, Boston, 1971, 74, 82, 86; Smith College, 1971; Galleria il Fante de Spade, Rome, 1974; John Berggruen Gallery, San Francisco, 1983; College of William and Mary, 1983; Brandeis U., (two-man) 1984; Duke U., 1986; U. of Connecticut, 1986; J. Rosenthal Fine Arts, Ltd., Chicago, 1986; Neilsen Gallery, Boston, 1990. **Retrospective:** Hirshhorn, 1977. **Group:** AAAL, 1961, 64, 69; WMAA Annuals, 1965, 68; NAD, 1971, 72, 79; MOMA, 1975; U. of Bridgeport, 1980; New York Cultural Center, Realism Now, 1972; Ringling, After Surrealism, 1977; Haus der Kunst, Munich, Amerikanische Malerei: 1930-1980, 1981; NAD, 1983. **Collections:** Arkansas/AC; Boston/MFA; Bowdoin College; U. of Georgia; Hirshhorn; Lincoln/Woods; Little Rock/MFA; MMA; NMAA; U. of Nebraska; U. of North Carolina; The Pennsylvania State U.; San Diego/Contemporary; Trenton/State; VMFA; U. of Virginia; West Virginia U.; Wichita/AM; WMAA. **Bibliography:** Armstrong, Thomas; Lucie-Smith; Ward.

GILLIAM, SAM **b.** 1933, Tupelo, Mississippi. **Studied:** U. of Louisville, 1952-56, BA; 1958-61, MA, with Mary Spencer Nay, Charles Crodel, Eugene Leake, Ulfert Wilke. **Awards:** National

Endowment for the Arts, grant, 1967, 73, 74; Chicago/AI, Norman B. Harris Prize, 1969; Longview Grant, 1970; Guggenheim Foundation Fellowship, 1971. **Address:** 1752 Lamont Street, N.W., Washington, D.C. 20010. **Dealer:** Klein Art Works, Chicago. **One-man Exhibitions:** U. of Louisville, 1956; Frame House Gallery, Louisville, 1963; Alan Morgan Gallery, Washington, D.C., 1963, 64; Jefferson Place Gallery, Washington, 1965, 66, 67, 68, 70, 71; Phillips Gallery, 1967; Byron Gallery, NYC, 1968; Galerie Darthea Speyer, Paris, 1970, 73; MOMA, 1971; New Gallery, Cleveland, 1973; Greenberg Gallery, St. Louis, 1973; U. of California, Irvine, 1973; Maison de la Culture, Rennes, 1973; Linda Farris Gallery, Seattle, 1974, 75; Phoenix Gallery, Seattle, 1974; Solway Gallery, Cincinnati, 1974; Fendrick Gallery, Washington, D.C., 1975, 76, 78; PMA, 1975; Collectors Gallery, Baltimore, 1975; Louisville/Speed, 1976; U. of Kentucky, 1978; Virginia Commonwealth U., 1978; Solway Gallery, NYC, 1978; Nina Freudenheim Gallery, Buffalo, 1979; Middendorf-Lane Gallery, Washington, D.C., 1979, 80, 84; Hamilton Gallery of Contemporary Art, NYC, 1979, 80; Monique Knowlton Gallery, NYC, 1985; Davis/McClair Gallery, Houston, 1987; Klein Art Works, Chicago, 1986, 87, 88, 91; Iannetti Lanzone Gallery, San Francisco, 1988; Middendorf Gallery, Washington, D.C., 1989; Fendrick Gallery, NYC, 1981; Koplin Gallery, Santa Monica, 1990. **Group:** ICA, Washington, D.C., Artists in Washington, 1966; UCLA, The Negro in American Art, 1966; First World Festival of Negro Arts, Dacca, 1966; Minneapolis/MA, Thirty Contemporary Black Artists, 1968; Corcoran, (three-man) 1969; MOMA, Works on Paper, 1970; U. of Texas, Color Forum, 1972; Venice Biennial, 1972; Corcoran Biennial, 1975; Brooklyn Museum, 30 Years of American Printmaking, 1976; NAD, 1979; Trenton/State, 6 Black Americans, 1980. **Collections:** Chicago/AI; Balti-

more/MA; Carnegie; Corcoran; Howard U.; Madison/Art Center; Phillips; U. of Iowa; MOMA; Smithsonian; Oberlin College; Oklahoma; Walker; MMA; Rotterdam; Tate; Princeton U.; Museum of African Art, Washington, D.C.; NCFA.

GINNEVER, CHARLES b. August 28, 1931, San Mateo, Calif. **Studied:** with Ossip Zadkine, William Stanley Hayter, Paris, 1953-55; SFAI, 1955-57, BFA; Cornell U., 1957-59, MFA. Traveled Europe, USA. USAF, 1951-52. **Taught:** Cornell U., 1957-59; Pratt Institute, 1963; New School for Social Research, NYC, 1964; Brooklyn Museum School, 1964-65; Newark School of Fine and Industrial Art, 1965; Dayton/AI, 1966; Aspen (Colo.) School of Contemporary Art, 1966; Orange County Community College, Middletown, N.Y., 1966; Windham College, 1967-75; Hobart School of Welding Technology, summer sculpture program, Troy, Ohio, 1974; Vermont Studio School, Johnson, Vt., 1987; U. of California, Berkeley, 1989. **Commissions:** GSA, St. Paul Courthouse, 1974; Walker, 1976; City of Houston, 1977; U. of Michigan; National Endowment for the Arts, 1977; Albany/SUNY, 1978; U. of Houston, 1979; K & B Plaza, New Orleans, 1979; Charleston, West Virginia, 1980; Dayton/AI, 1980; Buffalo/SUNY, 1981; Hurd Development Corp., Dallas, 1983; Hewlett-Packard Corp., Palo Alto, Calif., 1985; Koll-Bernal Associates, Pleasanton, Calif., 1987. **Awards:** Vermont State Council on the Arts, 1971; Guggenheim Foundation Fellowship, 1974; National Endowment for the Arts, 1975. **Address:** P.O. Box 411, Putney, VT 05346. **Dealers:** Dorothy Goldeen Gallery, Los Angeles; Marlborough Gallery, NYC. **One-man Exhibitions:** (first) Allan Stone Gallery, 1961; Bennington College, 1965; Washington Square Park, 1968; Battery Park, NYC, 1969-74; Paula Cooper Gallery, 1970-72; Dag Hammarskjöld Plaza, NYC, 1973; Sculpture Now, NYC, 1978, 79; Max

Hutchinson Gallery, Houston, 1978; Max Hutchinson Gallery, NYC, 1978, 80; Smith-Anderson Gallery, Palo Alto, 1978, Long Beach/AM, 1978; Galerie Simone Stern, New Orleans, 1978; ConStruct, Chicago, 1979, 81; Storm King Art Center, 1980; Marlborough Gallery, 1983; Fuller-Goldeen Gallery, San Francisco, 1984, 86; Lee Park, Dallas, 1984; Hurd Development Corp., Dallas, 1984; Max Hutchinson's Sculpture Fields, Kenoza Lake, N.Y., 1986; Dorothy Goldeen Gallery, Santa Monica, 1987, 90; Gerald Peters Gallery, Santa Fe, 1989, 91. **Retrospective:** Sculpture Now, Inc., NYC, 1975. **Group:** SFMA Annuals, 1955, 56; SFMA, Bay Area Sculpture, 1956; Cornell U., New York Artists, 1961; Martha Jackson Gallery, NYC, New Forms—New Media, 1960; Riverside Museum, NYC, 10 New York Sculptors, 1963; Walker, Sculpture Made in Place, 1976; A.F.A., Color Sculpture, 1965; Greenwich, Conn., Sculpture '76, 1976; Washington State U., Two Decades 1957-77, 1977; Lake George Arts Project, Lake George, N.Y., Prospect Mountain Sculpture Show, An Homage to David Smith, 1979; NCFA, Across the Nation, 1980; Palo Alto (Calif.) Cultural Center, Outdoor Sculpture Invitational, 1982; Nassau County Museum, Sculpture: The Traditional in Steel, 1983; AAIAL, 1985; Laumeier Sculpture Park, The Success of Failure, circ., 1987; Anchorage, Sculpture: Looking Into Three Dimensions, circ., 1987. **Collections:** Chicago; Cornell U.; Hartford/Wadsworth; Hirshhorn; U. of Houston; U. of Michigan; Norfolk/Chrysler; Park 470 Corp.; Storm King Art Center; Walker.

GIOBBI, EDWARD b. July 18, 1926, Waterbury, Conn. US Army, 1944-46. **Studied:** Whitney School of Art, 1946, 47; Vesper George School of Art, 1947-50; ASL, 1950-51; Academy of Fine Arts, Florence, Italy, 1951-54, 1955-56. Traveled Europe. **Taught:** Memphis Academy of Arts, 1960, 61 (Artist-in-Residence); Dart-

mouth College, 1972. **Member:** Century Association. **Awards:** Joe and Emily Lowe Foundation Award, 1951, and Special Grant, 1952; Yaddo Fellowship, 1957; Ford Foundation, 1966; Guggenheim Foundation Fellowship, 1971; NAD, Joseph S. Isidor Memorial Medal, 1991. **Address:** 161 Croton Lake Road, Katonah, NY 10536. **Dealer:** Irving Galleries Inc., Palm Beach, Fla. **One-man Exhibitions:** (first) Ward Eggleston Gallery, NYC, 1950, also 1952; Galerie An der Reuss, Lucerne, 1953 (two-man); Nexus Gallery, Boston, 1956 (two-man); Artists' Gallery, NYC, 1956; John Heller Gallery, NYC, 1957, 58; The Contemporaries, NYC, 1960, 61, 63; Memphis/Brooks, 1961, 70; Memphis Academy, 1962; Katonah (N.Y.) Art Gallery, 1963, 69, 75; The New Art Centre, 1964, 67, 70; The Bear Lane Gallery, Oxford, 1964; The Queen Square Gallery, Leeds, 1964; Tirca Karlis Gallery, 1965-66; Mickelson's Gallery, Washington, D.C., 1966; The Alan Gallery, NYC, 1966; Waddell Gallery, 1967, 69; Obelisk Gallery, 1968; Gertrude Kasle Gallery, 1968, 70; Galleria Obelisco, Rome, 1974; Crane Kalman Gallery, London, 1975; Galleria del Naviglio, Milan, 1976; Purchase/ SUNY, 1977; Gruenebaum Gallery, NYC, 1978, 79, 82; Lee Hoffman Gallery, Detroit, 1978; Mattatuck Museum, Waterbury, Conn., 1978; Irving Gallery, Palm Beach, 1978; Long Point Gallery, Provincetown, Mass., 1988, 90. **Retrospective:** West Palm/Norton, 1989. **Group:** WMAA Annuals, 1957, 61, 66, Young America, 1961, Forty Artists under Forty, circ., 1962; MOMA, Recent Drawings USA, 1956, Recent Painting USA: The Figure, circ., 1962-63; PAFA, 1961; U. of Arkansas, 1966; Finch College, 1967; AAIAL, 1991, 92; NAD, 1991. **Collections:** Allentown/AM; Baltimore/MA; Boston/MFA; Brandeis U.; Brooklyn Museum; Buffalo/Albright; Cambridge; Chicago/AI; Dartmouth College; Detroit/Institute; Florence, Italy; Mattatuck Museum, Waterbury, Conn.; Mem-

phis/Brooks; U. of Michigan; Oxford; Poole Technical College; San Antonio/McNay; Spelman College; Syracuse U.; Tate Gallery; WMAA; Wesleyan College; Williams College; U. of Wisconsin.

GIRONA, JULIO
from 1st to 4th edition.

GLACKENS, WILLIAM
b. March 13, 1870, Philadelphia, Pa. **d.** May 22, 1938, Westport, Conn. **Studied:** Central High School, Philadelphia, BA; PAFA. Traveled France, Spain, Canada. Newspaper illustrator for many years. **Member:** Society of Independent Artists, NYC (first president, 1916-17); The Eight; NAD, 1937 (Associate, 1896); NIAL. **Awards:** Buffalo/Albright, Gold Medal, 1901; St. Louis Exposition, 1904, Silver and Bronze Medals; Carnegie, Hon. Men., 1905; Panama-Pacific Exposition, San Francisco, 1915, Bronze Medal; PAFA, Joseph E. Temple Gold Medal, 1924; Carnegie, Second Prize, 1929; PAFA, Carol H. Beck Gold Medal, 1933; PAFA, Jennie Sesnan Gold Medal, 1936; Paris World's Fair, 1937, Grand Prix; PAFA, J. Henry Schiedt Memorial Prize, 1938. **One-man Exhibitions:** (first) New Arts Club, NYC; Academy of Fine Arts, Berlin, 1910; Kraushaar Galleries, NYC, 1925, 28, 35, 42, 57, 85, 91; Andover/Phillips, 1936; Louisville/Speed, 1939; 10 West Ninth Street, NYC, Memorial Exhibition, annually, 1939-49; NCFA, 1972. **Retrospectives:** WMAA, 1938, 67; Carnegie, 1939; Kraushaar Galleries, 1949; Dartmouth College, 1960; St. Louis/City, 1966; NCFA, 1967. **Group:** Paris Salon, 1895, 1900; Macbeth Gallery, NYC, The Eight, 1908; Independents, NYC, 1910; The Armory Show, 1913; WMAA, New York Realists, 1937; Brooklyn Museum, The Eight, 1943; PMA, Artists of the Philadelphia Press, 1945; Renaissance Society, Chicago, 1955; Syracuse/Everson, The Eight, 1958. **Collections:** Andover/Phillips; Barnes Foundation; Boston/MFA;

Buffalo/Albright; Chicago/AI; Columbus; Detroit/Institute; MMA; U. of Nebraska; Newark Museum; PMA; Sweet Briar College; WMAA. **Bibliography:** Barnes; Bazin; Biddle 4; Born; Bulliet 1; Canaday; Cheney; Cummings 4; **Du Bois 5, 6;** Gallatin 2; **Glackens;** Hall; Hartmann; Huyghe; *Index of 20th Century Artists;* Jackman; **Katz;** Kent, N.; McCoubrey 1; McCurdy, ed.; Neuhaus; Pach 1; Perlman; Phillips 2; Poore; Ringel, ed.; Robins; Rose, B., 1, 4; Sachs; **Watson, F.** Archives.

GLARNER, FRITZ
b. July 20, 1899, Zurich, Switzerland. **d.** September 18, 1972, Locarno, Switzerland. **Studied:** Academy of Fine Arts, Naples. To USA, 1936. **Commissions:** Time & Life Building, lobby, NYC, 1960 (mural); Dag Hammarskjöld Library, United Nations, NYC. **Awards:** Corcoran, 1957. **One-man Exhibitions:** Galerie Povolotzki, Paris, 1930; Civic Club, NYC, 1931; The Kootz Gallery, NYC, 1945; Rose Fried Gallery, 1949, 51; Galerie Louis Carre, Paris, 1952, 55; ICA, U. of Pennsylvania, 1971; SFMA, 1971; Gimpel & Hanover Gallery, 1972; Gimpel Fils, 1972; Graham Gallery, NYC (three-man), 1980. **Retrospective:** Berne, 1972. **Group:** Buffalo/Albright, 1931; American Abstract Artists, 1938-44; Chicago/AI, 1947, 58, 64; Toronto, 1949; California Palace, 1950; WMAA, 1950, 51, 53, 54, 55; VMFA, 1950, 58; São Paulo, 1951; Brooklyn Museum, 1951; U. of Minnesota, 1951; MOMA, 1951, 52, 54, 55; U. of Illinois, 1952, 65; Carnegie, 1952, 58, 61; Tokyo/Modern, 1953; SRGM, 1954; U. of Nebraska, 1955; Kassel, Documenta I, 1955; Corcoran, 1955, 57, 60; Zurich, 1956; Musée Neuchatel, 1957; Kunstverein, Winterthur, 1958; Kongresshalle, Berlin, 1958; XXIX & XXXII Venice Biennials, 1958, 64; Heimathaus, Zurich, 1960; Seattle World's Fair, 1962; WMAA, Geometric Abstraction in America, circ., 1962; WGMA, The Formalists, 1963; St. Paul Gallery, Drawing USA, 1963; Tate, Dunn

International, 1964; Musée Cantonal des Beaux-Arts, Lausanne, 1964; MOMA, Contemporary Painters and Sculptors as Printmakers, 1964; Indiana U., 1965; PAFA, 1965. **Collections:** Baltimore/MA; Boston/MFA; Brandeis U.; Brooklyn Museum; Buffalo/Albright; Chase Manhattan Bank; Florida State U.; Karachi; MOMA; Minnesota/MA; NYU; National Gallery; U. of Nebraska; PMA; Phillips; Rockefeller Institute; Smithsonian; WMAA; Walker; Yale U.; Zurich. **Bibliography:** *Abstract Expressionism; Abstraction Creation 1931-1936;* Armstrong, Thomas; Baur 7; Biddle 4; Blesh 1; *Fritz Glarner;* Haftman; Hess, T.B., 1; Janis, S.; Lane and Larsen; MacAgy 2; McCurdy, ed.; Neumeyer; Pousette-Dart, ed.; Read 2; Rickey; Ritchie 1; Rose, B., 1; Seuphor 1; Staber; *"What Abstract Art Means to Me."*

GLASCO, JOSEPH b. January 19, 1925, Paul's Valley, Okla. **Studied:** U. of Texas, 1941-43; Jepson Art Institute, Los Angeles; Art Center School, Los Angeles, 1946-48; privately with Rico Lebrun, 1946-48; Escuela de Bellas Artes, San Miguel de Allende, Mexico, 1948; ASL, 1949. US Army Air Force, 1943-45, Infantry, 1945-56. Traveled Mexico, Europe, Africa. **Member:** National Society of Literature and the Arts. **Commissions:** Amarillo (Tex.) Air Field (mural). **Address:** c/o Dealer. **Dealer:** Meredith Long & Co., Houston. **One-man Exhibitions:** (first) Perls Galleries, 1950; Caterine Viviano Gallery, NYC, 1951, 52, 53, 54, 56, 58, 61, 63, 70; Arts Club of Chicago, 1954, 57; U. of Oklahoma, 1965 (three-man); Rizzoli Gallery, NYC, 1967; Kiko Gallery, Houston, 1968, 69, 70; Louisiana Gallery, Houston, 1973, 75; Gimpel & Weitzenhoffer, NYC, 1979, 82, 83, 86; Waddington Galleries, London, 1986; Meredith Long & Co., Houston, 1989. **Retrospectives:** Houston/Contemporary, 1986; U. of Oklahoma, 1992. **Group:** MOMA, New Talent; MMA; WMAA; Corcoran; SRGM; Brooklyn Museum;

Chicago/AI; Dallas/MFA; Detroit/Institute; Los Angeles/County MA; U. of Illinois; U. of Nebraska; Carnegie, 1958; PAFA; WMAA, Forty Artists under Forty, 1963; Houston/MFA, Fresh Paint, circ., 1985; Menil Collection, Houston, Texas Art, 1988. **Collections:** Brooklyn Museum; Buffalo/Albright; Corcoran; Detroit/Institute; High Museum; Hirshhorn; Houston/MFA; MMA; MOMA; Newark Museum; Princeton U.; SRGM; WMAA; Yale U. **Bibliography:** Goodrich and Baur 1; Mendelowitz; Rodman 1; Tapie 1.

GOINGS, RALPH b. May 9, 1928, Corning, Calif. **Studied:** California College of Arts and Crafts, 1953, BFA; Sacramento State U., 1966, MA. US Army, 1946-48. Traveled England, Europe. **Taught:** La Sierra High School, 1969; U. of California, Davis, 1971. **Address:** Charlotteville, NY 12036. **Dealer:** OK Harris Works of Art, NYC. **One-man Exhibitions:** Artists Cooperative Gallery, Sacramento, 1960, 62, 68; OK Harris Works of Art, 1970, 73, 77, 80, 83, 85, 88, 91; MOMA, 1977. **Group:** SFMA Annual, 1961; Milwaukee, Aspects of a New Realism, 1969; Newport Harbor, Directly Seen: New Realism in California, 1970; Potsdam/SUNY, New Realism, 1971; Hamburg/Kunstverein, USA: West Coast, circ., 1972; Kassel, Documenta V, 1972; Stuttgart/WK, Amerikanischer Fotorealismus, circ., 1972; Cincinnati/Contemporary, Options, 73/30, 1973; Randers Kunstmuseum, Denmark, Amerikanske Realister, 1973; Tokyo Biennial, 1974; CNAC, Hyperrealistes Americains/Realistes Europeens, 1974; Akron/AI, Selections in Contemporary Realism, 1974; Hamilton College, California Climate, 1974; Queens Museum, Urban Aesthetics, 1976; Akron/AI, Contemporary Images in Watercolor, 1976; Albright College, Buffalo, Perspective 1976, 1976; Canberra/National, Illusion and Reality, circ., 1977; U. of Nebraska, Things Seen, circ., 1978; Tulsa/Philbrook, Realism/Pho-

Ralph Goings, *Sweet N' Low*, 1992.

torealism, 1980; PAFA, Contemporary American Realism Since 1960, 1981; San Antonio/MA, Real, Really Real, Super Real, circ., 1981; Houston/Contemporary, American Still Life: 1945-1983, 1983; Los Angeles/MOCA, Automobile and Culture, 1984; Isetan Museum of Art, Tokyo, American Realism, The Precise Image, 1985; SFMA, American Realism (Janss), circ., 1985; Younstown/Butler, California A-Z and Return, 1990; Orlando, Exquisite Painting, 1991; Fort Lauderdale, Photo-Realism: Revisited, 1991. **Collections:** Borgon Associates; Chicago/Contemporary; Essen/NG; F.T.D. Association; Hamburg/ Kunstverein; ICA, U. of Pennsylvania; U. of Miami; MOMA; U. of Nebraska; Portland, Ore./AM; SRGM; Tampa/AI; WMAA. **Bibliography:** Alloway 4; *Amerikanischer Fotorealismus;* Armstrong, Thomas; Arthur 1, 3, 4; Goings; Honisch and Jensen, eds.; *Kunst um 1970;* Meisel; Sager; Seitz 3; *The State Of California Painting; USA West Coast;* Ward.

GOLDBERG, MICHAEL b. July 13, 1924, NYC. **Studied:** ASL, 1938-42, 1946, with Jose de Creeft; City College of New York, 1940-42, 1946-47; Hofmann School, 1941-42, 1948-50. US Army 1942-46. **Taught:** U. of California, 1961-62. **Address:** 222 Bowery, NYC 10012. **Dealer:** Lennon, Weinberg, Inc., NYC. **One-man Exhibitions:** (first) Tibor de

Nagy Gallery, 1953; Poindexter Gallery, NYC, 1956, 58; Martha Jackson Gallery, NYC, 1960, 64, 66; Paul Kantor Gallery, Beverly Hills, Calif., 1960; Holland-Goldowsky Gallery, Chicago, 1960 (two-man); B.C. Holland Gallery, Chicago, 1961; Galerie Anderson-Mayer, Paris, 1963; Bob Keene, Southampton, N.Y., 1963; Paley & Lowe Inc., NYC, 1971 (two-man), 1972, 73; Vancouver, 1971 (two-man); Cunningham-Ward Gallery, NYC, 1975, 76; Ghent Gallery, Norfolk, Va., 1973; Galerie Hecate, Paris, 1975; Galerie Denise Rene, NYC, 1977; Galerie Sonnabend, Paris, 1978; Galerie December, Düsseldorf, 1978; Young-Hoffman Gallery, Chicago, 1978, 83; Loyse van Oppenheim Gallery, Geneva, 1978; Daniel Weinberg Gallery, San Francisco, 1978; Sonnabend Gallery, NYC, 1979, 80, 81, 83; Thomas Segal Gallery, Boston, 1979; Artline, The Hague, 1980; Galerie Art in Progress, Düsseldorf, 1980; L.A. Louver Gallery, Venice, Calif., 1981, 82, 87; Cleveland/MA, 1981; Plurima, Udine, Italy, 1982, 84, 90; Galleria Roberto Peccolo, Livorno, Italy, 1982, 84, 88, 90; Virginia Commonwealth U., 1983; Vanderwoude Tananbaum Gallery, NYC, 1984, 85, 86, 87, 90; Nadia Bassanese, Trieste, 1984; U. of Nebraska, 1984; Jack Tilton Gallery, NYC, 1985; Galerie Biedermann, Munich, 1985, 87, 91; Colby College, 1986; Lafayette College, 1988; Stalke, Copenhagen, 1988; Compass Rose, Chicago, 1989, 90; Turchetto/Plurima, Milan, 1990, 91; Gallerie Winberger, Copenhagen, 1990, 92; Lennon, Weinberg, Inc., NYC, 1990; Jason McCoy, Inc., NYC, 1992. **Group:** Ninth Street Exhibition, NYC, 1951; The Stable Gallery Annuals, 1952-57; Sidney Jarvis Gallery, Four Younger Americans, 1956; Carnegie, 1958; WMAA Annuals, 1958, 67, 73; Gutai 9, Osaka, 1958; Turin Art Festival, 1959; Kassel, Documenta II, 1959; Walker, 60 American Painters, 1960; Columbus, Contemporary American Painting, 1960; MOMA, Hans Hofmann and

His Students, circ., 1963-64; Musée Cantonal des Beaux-Arts, Lausanne, I Salon International de Galeries Pilotes, 1963; Lehigh U., 1966; Smithsonian, 66; Star Turtle Gallery, NYC, The Tenants of Sam Wapnowitz, 1969; Corcoran, 1969; Salon de Mai, Paris, 1969; Indianapolis, 1978; Hirshhorn, The Fifties, 1980; Newport Harbor, Action/Precision, circ., 1984; AAIAL, 1984. **Collections:** Baltimore/MA; Buffalo/Albright; U. of California, Berkeley; Chicago/AI; Corcoran; Cornell U.; Hartford/ Wadsworth; Hirshhorn; Israel Museum; Lincoln, Mass./De Cordova; Louisville/Speed; MOMA; U. of Nebraska; Norfolk/Chrysler; PMA; Rutgers U.; SFMA; SRGM; Tokyo/Modern; WMAA; Walker. **Bibliography:** Downes, ed.; Janis and Blesh 1; O'Hara; Sandler 5. Archives.

GOLDIN, LEON b. January 16, 1923, Chicago, Ill. **Studied:** State U. of Iowa, with Mauricio Lasansky, 1948, BFA, 1950, MFA; Chicago Art Institute School, with Robert Von Neuman. Traveled Europe extensively; resided Paris, 1952-53, Rome, 1955-58. **Taught:** California College of Arts and Crafts, 1950-52, 1954-55; Philadelphia Museum School, 1960-62; Queens College, 1960-62; Cooper Union, 1961-64; Columbia U., 1962-. **Member:** NAD. **Awards:** L. C. Tiffany Grant, 1951; Fulbright Fellowship (France), 1952; SFMA, H.S. Crocker Co. Award, 1952; Prix de Rome, 1955, renewed 1956-57; Guggenheim Foundation Fellowship, 1959; Ford Foundation, P.P., 1960; PAFA, Jennie Sesnan Gold Medal, 1965; National Endowment for the Arts Grant, 1966; NIAL Grant, 1968; National Endowment for the Arts, 1980; CAPS grant, 1981; and many print awards. **Address:** 438 West 116th Street, NYC, 10027. **Dealer:** Kraushaar Galleries, NYC. **One-man Exhibitions:** (first) Oakland/AM, 1955; Felix Landau Gallery, 1956, 57, 59; Galleria L'Attico, Rome, 1958; Kraushaar Galleries, NYC, 1960, 64, 68, 72, 84, 88, 90; U. of Houston,

1981. **Group:** Chicago/AI Annuals, 1946, 48; SFMA Annuals, 1948, 51-54; Los Angeles/County MA, 1949, 50; MMA, American Paintings Today, 1950; PAFA, 1951, 1960-64; MOMA, Contemporary American Painting, 1953; Santa Barbara/MA, 1955; MOMA, Recent Drawings, USA, 1956; Corcoran, 1963; Carnegie, 1964. **Collections:** Andover/Phillips; Arts Council of Great Britain; Ball State U.; Baltimore/MA; Brooklyn Museum; Cincinnati/AM; Los Angeles/County MA; Louisville/Speed; Morgan State College; NCFA; U. of Nebraska; Oakland/AM; PAFA; Portland, Me./AM; RAC; St. Louis/City; Santa Barbara/MA; U. of Southern California; Syracuse/Everson; Utica; VMFA; Worcester/AM. **Bibliography:** Nordness, ed.

GOLDYNE, JOSEPH b. April 20, 1942, Chicago, IL. **Studied:** U. of California, Berkeley, 1961-64, AB; U. of California, San Francisco, Medical School, 1964-68, MD; Harvard, 1970, MA. **Taught:** U. of California, Berkeley, 1973-75. Illustrated many fine printed books, including *Het Achterhuis/Anne Frank: Diary of a Young Girl* (Pennyroyal Press, 1985); *Quartet* (Pacific Editions, 1986); *Sonnets of Guido Cavalcanti* (Arion Press, 1991). Subject of video, *The California Draftsmen: Joseph Goldyne*, produced by The Drawing Society, New York, 1985. **Address:** 1 Maple Street, San Francisco, CA 94118. **Dealers:** Richard York Gallery, NYC; Roger Ramsay Gallery, Chicago; John Berggruen Gallery, San Francisco; Thomas Gibson Fine Art Ltd., London. **One-man Exhibitions:** (first) Quay Gallery, San Francisco, 1973, 74; Sacramento/Crocker, 1973; USIA, circ., Europe, 1975; Braunstein/Quay Gallery, San Francisco, 1976; Newport Harbor, 1975; Thomas Gibson Fine Art Ltd., London, 1976, 89; James Corcoran Gallery, Los Angeles, 1978; John Berggruen Gallery, San Francisco, 1979, 81, 83; Smith-Andersen Gallery, Palo Alto, Calif., 1981;

Joseph Goldyne, *Venetian Fantasy*, 1991.

Kline Gallery, Chicago, 1982; NMAA, circ., 1982; The Jewish Community Museum, San Francisco, 1986; New York Academy of Science, circ., 1987; Associated American Artists, NYC, 1987, 91; Roger Ramsay Gallery, Chicago, 1989; Schmidt-Bingham Gallery, NYC (two-man), 1989; Anne Reed Gallery, Ketchum, Idaho, 1990; Christopher Grimes Gallery, Carmel, Calif., 1990; Gump's Gallery, San Francisco, 1990; Gerald Peters Gallery, Santa Fe, 1991. **Group:** Davidson College, National Print and Drawing Exhibition, 1973; NCFA, Twenty-Fourth National Exhibition of Prints, 1975; Phillips, New American Monotypes, circ., 1978; SFMA, Six Printmakers, 1978; Newport Beach, California: The State of Landscape, 1972-81, 1981; NYPL, Suites and Series: Eleven Artists, Santa Rosa Jr. College, The Poetic Image, 1984; Norfolk/Chrysler, Contemporary American Monotypes, 1985; Santa Clara U., Contemporary Monotypes: Six Masters, 1985; Oakland/AM, Cream of California Prints, 1987. **Collections:** Fine Arts Museum/San Francisco; Boston/MFA; Sacramento/Crocker; Chi-

cago/AI; Honolulu Academy of Art; NYPL; Oakland/MFA; Minneapolis/MFA.

GOLUB, LEON b. January 23, 1922, Chicago, IL. **Studied:** The U. of Chicago, 1942, BA; Chicago Art Institute School, with Paul Wieghardt, Kathleen Blackshear, Robert Lifuendahl, 1949, BFA, 1950, MFA. US Army, 1942-46. Traveled Europe; resided Italy, 1956-57, Paris, 1959-64. **Taught:** Illinois Institute of Technology, 1955-56; Indiana U., 1957-59; Wright Junior College; Northwestern U.; Stella Elkins Tyler School of Fine Arts; Temple U., 1965-66; School of Visual Arts, NYC, 1966-69; Fairleigh Dickinson U., 1969-70; Rutgers U., 1970-91. **Awards:** Chicago/AI, Florsheim Memorial Prize, 1954; Ford Foundation Grant, 1960; Chicago/AI, Watson F. Blair Prize; II Inter-American Paintings and Prints Biennial, Mexico City, Hon. Men., 1960; Cassandra Foundation Grant, 1967; Guggenheim Foundation Fellowship, 1968; AAAL; NIAL, 1973; Hon. DFA, Chicago Art Institute School, 1982; Hon. DFA, Swarthmore College, 1985. **m.** Nancy Spero. **Address:** 530 LaGuardia Place, NYC 10012. **Dealers:** Josh Baer Gallery, NYC; Galerie Darthea Speyer, Paris; Rhona Hoffman Gallery, Chicago. **One-man Exhibitions:** (first) Contemporary Gallery, Chicago, 1950; Purdue U., 1951; Wittenborn Gallery, NYC, 1952, 57; Kerrigan-Hendricks Gallery, Chicago, 1954; Artists' Gallery, NYC, 1954; Allan Frumkin Gallery, Chicago, 1955, 60, 64, NYC, 1959, 61, 63; Feigl Gallery, NYC, 1955, 56; Chicago Public Library, 1956; Pomona College, 1956; Pasadena/AM, 1956; ICA, London, 1957, 82; Indiana U., 1958; American Cultural Center, Paris, 1960; Iris Clert Gallery, 1962; Hanover Gallery, 1962; Gallery A., Melbourne, 1963; The U. of Chicago, 1966; Pro Graphica Arte, 1968; MIT, 1970; Melbourne/Nacional, 1970; Galerie Darthea Speyer, Paris, 1971, 85; Herbert H.

Lehman College, Bronx, N.Y., 1972; Bienville Gallery, 1972; Stony Brook/SUNY, 1975; Trenton/State, 1975; Haverford College, 1976; SFAI, 1976; Olympia Galleries, Glen Cove, Pa. 1977; Walter Kelly Gallery, Chicago, 1977; Colgate U., 1978; School of Visual Arts, NYC, 1979; Protetch-McIntosh Gallery, Washington, D.C., 1980; Swarthmore College (two-man), 1981; Susan Caldwell, Inc., NYC, 1982, 84; Kipnis Works of Art, Atlanta, 1982; Young Hoffman Gallery, Chicago, 1982; U. of California, Berkeley, 1983; College of Art and Design, Detroit, 1983; Honolulu Academy, 1983; U. of Houston, circ., 1983; U. of New Mexico (two-man) 1983; Paule Anglim Associates, San Francisco, 1984; Installation Gallery, San Diego, 1984; Rhona Hoffman Gallery, Chicago, 1985; Printworks, Chicago, 1985; Stanford U., 1985; Donald Young Gallery, Chicago, 1985; Barbara Gladstone Gallery, NYC, 1986; Greenville, with Nancy Spero, 1986; Lucerne, 1987; Saatchi Collection, London, 1988; Elie Broad Family Foundation, Los Angeles, 1989; Chicago/Spertus, 1990; Brooklyn Museum, circ., 1991; Montreal/Contemporain, 1992; ICA, U. of Pennsylvania, 1992. **Retrospectives:** Temple U., 1964; Chicago/Contemporary, 1974; New York Cultural Center, 1975; New Museum, circ., 1984. **Group:** Chicago/AI, Exhibition Momentum, 1948-58; SRGM, Younger American Painters, 1954; Chicago/AI, 1954, 62; Carnegie, 1955, 64, 67; Premio Marzotto; U. of Illinois, 1957, 61, 63; MOMA, New Images of Man, 1959; Kassel, Documenta II & III, 1959, 64; São Paulo, 1962; Corcoran, 1962; Salon des Realites Nouvelles, Paris, 1962; MOMA, Recent Painting, USA: The Figure, circ., 1962-63; Art: USA: Now, circ., 1962-67; SFMA, Directions—Painting U.S.A., 1963; Smithsonian, Graphics, circ., USA, 1963; Ghent, Figuration d'Aujourd'hui, 1964; Paris/Moderne, Mythologiques Quotidiennes, 1964; PAFA Annuals, 1964, 65; New York World's Fair, 1964-

65; VMFA, American Painting, 1966, 70; II Internationale der Zeichnung, Darmstadt, 1967; Paris/Moderne, Le Monde en Question, 1967; ICA, London, The Obsessive Image, 1968; Madrid/Nacional, II Biennial, 1969; Chicago/Contemporary, Chicago Imagist Art, 1972; Chicago Art Institute School, Visions, 1976; Paris/Beaubourg, Paris-New York, 1977; U. of Michigan, Chicago: The City and Its Artists, 1945-78, 1977; Chicago/AI, Centennial Exhibition, 1979; Brandeis U., Aspects of the 70s—Mavericks, 1980; Indianapolis, 1982; Rutgers U., Realism & Realities, 1982; Contemporary Arts Center, New Orleans, Sex and Violence, 1983; WMAA Biennial, 1983; Hirshhorn, Content: A Contemporary Focus 1974-1984, 1984; Studio Museum, Transition and Conflict: Images of a Turbulent Decade, 1984; Grande Halle de la Villette, Paris, Nouvelle Biennale de Paris, 1985; Seattle/AM, States of War, 1985; Fort Lauderdale, An American Renaissance: Painting and Sculpture Since 1940, 1986; NYU, Morality Tales, 1987; Kassel, Documenta VIII; Queens Museum, Classical Myth and Imagery in Contemporary Art, 1988; MOMA, Committed to Print, circ., 1988; Whatcom, A Different War, circ., 1989; CNAP/Paris, Estampes et Revolution 200 Ans Après, circ., 1989; Frankfurt/Kunstverein, Prospect 89, 1989; Düsseldorf/Kunsthalle, 1968—Concrete Utopia in Art and Society, circ., 1990; Chicago/Contemporary, Toward the Future, 1990; Museum of Contemporary Hispanic Art, NYC, The Decade Show, 1990; Dublin/Modern, Inheritance & Transformation, 1991. **Collections:** Allentown/AM; Amon Carter Museum; U. of California; Chicago/AI; Chicago/Contemporary; U. of Chicago; Corcoran; Des Moines; Grunwald Foundation; Hampton Institute; Hirshhorn; Indiana U.; Kansas City/Nelson; Jewish Museum; Kent State U.; La Jolla; Los Angeles; MMA; MOMA; Melbourne/National; Montreal/MFA; NCFA; Nashville; Nashville/State; U. of

North Carolina; Pasadena/AM; Seattle/AM; Southern Illinois U.; Tate Gallery; Tel Aviv; U. of Texas. **Bibliography:** Adrian; Danto; *The Decade Show; Europa/Amerika;* Fox; Honnef 2; **Kuspit;** Nordness, ed.; Sandler 3, 5; Schulze; Siegel; Storr and Tannenbaum. Archives.

GONZALEZ, JUAN J. **b.** January 12, 1945, Camayuey, Cuba. **Studied:** U. of Miami, BFA, MFA. US Citizen. **Taught:** School of Visual Arts, NYC, 1977-. **Member:** New York Foundation for the Arts, Board of Governors, 1984-. **Awards:** Cintas Fellowship, 1973, 75; CAPS, 1976; National Endowment for the Arts, 1980, 85, 91. **Address:** 42 West 17th Street, NYC 10011. **Dealer:** Nancy Hoffman Gallery, NYC. **One-man Exhibitions:** (first) Allan Stone Gallery, NYC, 1972; Corcoran and Corcoran, Miami, 1973; Nancy Hoffman Gallery, NYC, 1975, 78, 82, 85, 88, 91; Union College, Cranford, N.J., 1978; Miami-Dade, 1980; Center for Inter-American Relations, 1981; Cleveland/Contemporary, 1988; Southern Methodist U.; circ., 1991. **Group:** Miami Art Center, Thirty-Three Miami Artists, 1971; WMAA Annual, 1972; Indianapolis, 1974; Center for Inter-American Relations, 6 Cuban Painters Working in New York, 1975; Rice U., Drawing Today in New York, circ., 1977; Bronx Museum, Images of Horror and Fantasy, 1977; IEF, Recent Latin American Drawings 1969-1976, 1977; IEF, Twentieth Century American Drawings: The Figure in Context, circ., 1984; SFMA, American Realism (Janss), circ., 1985; Danforth Museum, New Works: Drawings, 1987; Lehman College, CUNY, Convergences/Convergencies, 1988; Fairleigh Dickinson U., Enigma, 1990; U. of Florida, Divergent Styles, 1990; U. of North Carolina, Art on Paper, 1990; Orlando, Exquisite Painting, 1991; Miyagi Museum, Sendai, Japan, American Realism and Figurative Art, 1955-1990, circ., 1991. **Collections:** Carnegie; Chase Manhattan Bank; Cleveland/Contemporary; Danforth Museum; Hirshhorn; Indianapolis; MMA; U. of Oklahoma; Southern Methodist U.; Vassar College. **Bibliography:** Arthur 3; Cummings 4.

GONZALEZ, XAVIER **b.** February 15, 1898, Almeria, Spain. **d.** January 9, 1993. US citizen, 1930. **Studied:** Chicago/AI. Traveled Greece, Crete, USA, Orient; resided Paris, 1930-40. **Taught:** H. Sophie Newcomb Memorial College; Brooklyn Museum School; Case Western Reserve U., 1953-54; Summer School of Art, Wellfleet, Mass. President, National Society of Mural Painters. **Member:** NAD; Century Association; Trustee, Lewis Comfort Tiffany Foundation. **Awards:** AAAL Grant; PAFA, Dawson Memorial Medal, 1946; Guggenheim Foundation Fellowship, 1947; Audubon Artists, Gold Medal of Honor; National Arts Club, Gold Medal, 1978. **One-man Exhibitions:** Joseph Luyber Galleries, NYC, 1946, 47; Arts and Crafts Club, New Orleans, 1948; Philadelphia Art Alliance, 1949; Norlyst Gallery, NYC; Shore Studio, Boston; Grand Central Moderns, NYC, 1951, 52, 53; The Howard Wise Gallery, Cleveland, 1958; Widdifield Gallery, NYC, 1958; The Milch Gallery, 1960, 63; Richard Larcada Gallery, 1974; Summitt Art Gallery, NYC, 1983. **Group:** PAFA; Corcoran; U. of Nebraska; Carnegie; Brooklyn Museum; WMAA; Indianapolis/Herron. **Collections:** Wellesley College. **Bibliography:** Biddle 4; Cheney; Pearson 2; Pousette-Dart, ed. Archives.

GOODE, JOE **b.** March 23, 1937, Oklahoma City, Okla. **Studied:** Chouinard Art Institute. Traveled Mexico, England, Europe, South America, India, Iceland. **Awards:** Cassandra Foundation Grant; National Endowment for the Arts, grant; American Foundation of Artists; California Art Council, Maestro Grant. **Address:** 1159 S. Hayworth, Los Angeles, CA 90035. **Dealer:** Jack Tilton Gallery,

NYC. **One-man Exhibitions:** Nicholas Wilder Gallery, 1966, 69, 70, 72, 74, 75, 78, 79; Rowan Gallery, London, 1967; Gallery Hans R. Neuendorf, Hamburg, 1970, 72, 73, 75; Galleria Milano, Milan, 1971; La Jolla, 1971; Mueller Gallery, 1971; Felicity Samuel Gallery, London, 1972, 73; Fort Worth, 1973; Houston/Contemporary, 1973; Contract Graphics, Houston, 1972, 75; Cirrus Gallery, Los Angeles, 1974; California State College, Northridge, 1974; Seder/Creigh Gallery, Coronado, 1975; James Corcoran Gallery, Los Angeles, 1976; Washington U., 1976; St. Mary's College, L.A., 1977; Texas Gallery, Houston, 1979; Charles Cowles Gallery, NYC, 1980; Arco Center for the Visual Arts, Los Angeles, 1982; Braunstein Gallery, San Francisco, 1985; James Corcoran Gallery, Santa Monica, 86, 89, 90; Thomas Babeor Gallery, La Jolla, 1986; Pence Gallery, Santa Monica, 1987; Compass Rose Ltd., Chicago, 1989; Karsten Greve Gallery, Paris, 1991; Jack Tilton Gallery, NYC, 1992. **Group:** WMAA Annuals, 1966, 67, 69; Carnegie, 1967; Portland, Ore./AM, The West Coast Now, 1968; WMAA, American Pop Art, 1974; Chicago/AI, 1974, School of Visual Arts, NYC, 4 Los Angeles Artists, 1975; LAICA, Current Concerns, Part I, 1975; SFMA, California Painting and Sculpture: The Modern Era, 1976; Austin (two-man), 1976; Scripps College, Claremont, Black and White Are Colors, 1978; Buffalo/Albright, American Painting in the Seventies, 1978; Sacramento/Crocker, Aspects of Abstract, 1978; California State U., Northridge, Abstraction in Los Angeles, 1950-1980, 1981; Los Angeles/County MA, Art in Los Angeles, 1981; U. of Southern California, LA Seen, 1983; Brooklyn Museum, The American Artist as Printmaker, 1983; National Gallery, Gemini G.E.L., 1984; U. of California, Berkeley, Made in U.S.A., 1987; Sierra Nevada Museum of Art, West Coast Contemporary, 1988; Newport Harbor, L.A. Pop in the Sixties, 1989; Los Angeles Municipal

Sidney Goodman, *Waking Up*, 1992.

Art Gallery, LA/Brazil Projects '90, 1990. **Collections:** Fort Worth; Los Angeles/County MA; Minneapolis/Institute; MOMA; National Gallery, London; Newport Harbor; Oakland Museum; Oklahoma State Art Collection; Pasadena/AM; SFMA, Stanford U.; Victoria and Albert Museum; WMAA. **Bibliography:** Alloway 1; *Black and White Are Colors;* De Salvo and Schimmel; *New in the Seventies;* Osterwold; *The State of California Painting; USA West Coast.*

GOODMAN, SIDNEY b. January 19, 1936, Philadelphia, Pa. **Studied:** Philadelphia Museum School, 1958, with Jacob Landau, Larry Day, Morris Berd. US Army, 1958-59. Traveled Europe. **Taught:** Philadelphia College of Art, 1960-78; Tyler School, Philadelphia, 1977; PAFA, 1978-; Skowhegan School, 1985; Maryland Institute, 1986; Illinois State U., 1986; U. of Georgia, Lamar Dodd Professorial Chair, 1991. **Awards:** PAFA, First Watercolor Prize, 1961; Guggenheim Foundation Fellowship, 1963; Ford Foundation Fellowship, 1963; Ford Foundation, P.P.; Yale-Norfolk Summer School Fellowship; National Endowment for the Arts, 1974; PAFA, Fellowship Prize, 1974; Governor's Award for Excellence in the Arts in Pennsylvania, 1986. **Address:** 413 South 24th Street, Philadelphia, Pa. 19146. **Dealer:** Terry Dintenfass, Inc., NYC. **One-man Exhibitions:** (first) The

Print Club, Philadelphia, 1958, also 1963; Terry Dintenfass, Inc., NYC, 1961, 1963-1966, 68, 75, 77, 78, 80, 82, 84, 85, 87, 89, 90, 91; Bard College, 1968; George Washington U., 1969; PAFA, Peale House, 1969 (two-man), 1975 (two-man); U. of Rhode Island, 1974; Moravian College, 1974; The Schenectady Museum, 1977; Rhode Island College, 1979; College of William and Mary, 1979; VMFA, circ., 1981; Arkansas Arts Center, 1981; Boston U., 1982; Wichita/AM, 1984; PMA, 1985; Southern Alleghenies Museum of Art, 1986; Swarthmore College, 1987; U. of Georgia, 1991. **Retrospective:** Queens Museum, circ., 1980. **Group:** PAFA, 1960-64, 67, 68; MOMA, 1962; NAD, 1962, 77, 78; WMAA, Forty Artists under Forty, circ., 1962; MOMA, Recent Painting USA: The Figure, circ., 1962-63; WMAA Annuals, 1962-64, 1967-68; 73; Corcoran, 1963; Brooklyn Museum, 1963, 1968-69; Newark Museum, 1967; New School for Social Research, Protest and Hope, 1967; Vassar College, 1968; U. of Miami, 1968; U. of Kentucky, 1968; Indianapolis/Herron, 1969; U. of Illinois, 1969; Southern Methodist U., 1969; Tulsa/Philbrook, 1969; Iowa State U., American Drawing, 1971; Boston U., The American Landscape, 1972; Cleveland/MA, 32 Realists, 1972; Sweden/Gotenborgs, Warmwind: American Realists, 1972; Omaha/Joslyn, A Sense of Place, 1973; VMFA, Works on Paper, 1974; AAAL, 1974; Harrisburg, Pa./State Museum, The Figure in American Art, 1975; PMA, Three Centuries of American Art, 1976; Queens Museum, Urban Aesthetics, 1976; US Department of the Interior, America, 1976; U. of North Carolina, Art on Paper, 1977; PMA, Contemporary Drawing; Philadelphia II, 1979; WMAA, 20th Century Drawings from the Whitney Museum of American Art, circ., 1979-81; PAFA, Contemporary American Realism Since 1960, 1981; NAD, 1982; IEF, Twentieth Century American Drawings: The Figure in Context, circ., 1984; SFMA, American Re-

alism (Janss), circ., 1985; Wichita/AM, A Decade of American Realism, 1986; Youngstown/Butler, 1986; Moravian College, Intimate and Intense, 1986; Huntsville Museum, Drawings: The New Tradition, 1987; Anchorage, Portraits: Here's Looking at You, 1989; U. of North Carolina, Art on Paper, 1991. **Collections:** U. of Arkansas; Brandeis U.; Brooklyn Museum; Chicago/AI; Delaware Art Museum; Grinnell College; Hirshhorn; Kalamazoo/Institute; Library of Congress; MMA; MOMA; U. of Maine; Miami-Dade; Minnesota/MA; Moravian College; NAAL; NAD; NMAA; U. of Nebraska; U. of North Carolina; PAFA; PMA; The Pennsylvania State U.; Syracuse U.; Tulsa/Philbrook; WMAA; Wake Forest U.; Wichita/AM; U. of Wisconsin; Youngstown/Butler. **Bibliography:** *America 1976;* Arthur 2; Cummings 4; Goodyear; Ward.

GOODNOUGH, ROBERT b. October 23, 1917, Cortland, N.Y. **Studied:** Syracuse U., BFA; NYU, MA; New School for Social Research; Hofmann School; Ozenfant School of Art, NYC. **Taught:** Cornell U.; NYU; Fieldston School, NYC. Critic for *Art News* magazine, 1950-57. Secretary, Documents of Modern Art (edited by Robert Motherwell), 1951. **Commissions:** Manufacturers Hanover Trust Co. **Awards:** Syracuse U., Hiram Gee Fellowship; Chicago/AI, Ada S. Garrett Prize, 1962; Ford Foundation, P.P., 1962. **Address:** 68 Allison Lane, Thornwood, NY. **Dealer:** ACA Galleries, NYC. **One-man Exhibitions:** (first) Tibor de Nagy Gallery, 1952, also 1953-70, 84, 85, 86; RISD, 1956; Dwan Gallery, 1959-62; Jefferson Place Gallery, 1960; Ellison Gallery, Fort Worth, 1960; Nova Gallery, Boston, 1961; U. of Minnesota; U. of Notre Dame, 1964; Arts Club of Chicago, 1964; New Vision Center, London, 1964; USIS Gallery, London, 1964; Gertrude Kasle Gallery, 1966, 69, 72, 74; Reed College, 1967; Buffalo/Albright, 1969; Axiom Gallery, London, 1969; Cayuga Museum of

History and Art, Auburn, N.Y., 1969; Galerie Simone Stern, New Orleans, 1969, 70; Kasmin Ltd., 1970; Harcus-Krakow Gallery, 1972; Nicholas Wilder Gallery, 1972; Syracuse U., 1972; André Emmerich Gallery, NYC, 1972, 73, 74, 80, 82; David Mirvish Gallery, 1973, 75; Waddington, Tooth Galleries II, London, 1975; M. Knoedler & Co., NYC, 1977; Hokin Gallery, Chicago, 1978; Nina Freudenheim Gallery, Buffalo, 1978, 83; Watson/de Nagy, Houston, 1979, 81, 83; Wichita State U., 1978; Klonaridis, Inc., Toronto, 1979, 81, 86; Klonaridis, Inc., NYC, 1982, 86; Modern Master Tapestries, Inc., NYC, 1982; Martha White Gallery, Louisville, 1982; Lincoln Center, NYC, 1983; Elca London Gallery, Montreal, 1985, 86; Watson Gallery, Houston, 1986; Shippee Gallery, NYC, 1987, 89; R. H. Love Contemporary, Chicago, 1987; Wright Gallery, Dallas, 1987; Oklahoma State U., 1987; Youngstown/Butler, 1988; ACA Galleries, NYC, 1991, 92. **Group:** The Kootz Gallery, NYC, New Talent, 1950; Sidney Janis Gallery, Four Younger Americans, 1956; WMAA; Yale U.; Carnegie; Chicago/AI; NIAL, 1964; MOMA, The New American Painting and Sculpture, 1969; U. of Illinois, 1969; Indianapolis, 1969; XXV Venice Biennial, 1970; AAAL, 1971; Grand Palais, Paris, L'Amerique aux Independants, 1980; Houston/Contemporary, The Americans: The Collage, 1982; St. Lawrence U., Pre-Postmodern: Good in the Art of Our Time, 1985. **Collections:** Baltimore/MA; Birmingham, Ala./MA; Boston/MFA; Buffalo/Albright; Chase Manhattan Bank; Chicago/AI; Hartford/Wadsworth; MMA; MOMA; Manufacturers Hanover Trust Co.; Michigan State U.; NYU; Newark Museum; U. of Notre Dame; The Pennsylvania State U.; RISD; Raleigh/NCMA; SRGM; Syracuse U.; WMAA. **Bibliography:** *Abstract Expressionism;* Baur 5; Blesh 1; **Bush and Moffett;** Downes, ed.; *The Figurative Fifties;* Friedman, ed.; Goodrich and Baur 1; Guest and Friedman; Janis and Blesh 1; Nordness, ed.; Rose, B., 1; Sandler 5; Seitz 4.

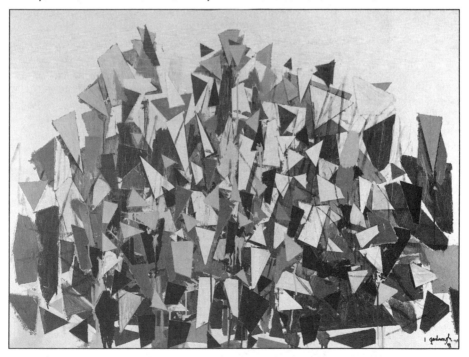

Robert Goodnough, *L-Z,* 1991.

GOODYEAR, JOHN b. October 22, 1930, Los Angeles, CA. **Studied:** U. of Michigan (with Richard Wilt, Chet LaMore, Gerome Kamrowski), B. Design, 1952, M. Design, 1954. US Army, 1954-56. Traveled Mexico, Western Europe; resided USA, Japan. **Taught:** U. of Michigan; U. of Massachusetts, Douglass College 1964-. **Member:** American Abstract Artists. **Commissions:** Legislative Services Building, Trenton, NJ, 1991. **Awards:** Graham Foundation Fellowship, 1962, 70; Trenton/State, Gov. Hughes, P.P., 1967; MIT, Center for Advanced Visual Studies Grant, 1970-71. **Address:** RD #2, Box 94A, Lambertville, NJ 08530. **Dealer:** Snyder Fine Art, NYC. **One-man Exhibitions:** The Amel Gallery, NYC, 1964-66; ICA, Boston, 1971; Musée de Quebec, 1971; Electric Gallery, Toronto, 1971; Cornell U., 1972; Syracuse U., 1972; Allegheny College, 1972; Inhibodress Gallery, Sydney, 1972; New Jersey State Cultural Center, 1975; Currier, 1976; MIT, 1976; Trenton/State, 1981; U. of Michigan, Ann Arbor, 1981; Princeton Gallery of Fine Art, 1987; Pyramid Gallery, NYC, 1989; Jersey City Museum, 1991; Snyder Fine Art, NYC, 1992. **Group:** MOMA, The Responsive Eye, 1965; Buffalo/Albright, 1965; ICA, Boston, 1965; Harvard U., 1965; WMAA, Art of the U.S. 1670-1966, 1966; Walker and Milwaukee, Light Motion Space, 1967; Buffalo/Albright, Plus by Minus, 1968; Milwaukee, Directions I: Options, circ., 1968; WMAA Sculpture Annual, 1968; Newark Museum, 1969; Jewish Museum, Software, 1970; Boston/MFA, Elements of Art, 1971; Centro de Arte y Communicacion, Buenos Aires, Arte de Sistemas, II, 1972; MIT, Interaction, 1973; New Jersey Cultural Central, Constructivist Art, 1975; Purchase/SUNY, Spirit of Constructivism, 1980; Trenton/State, Beyond the Plane, 1983; Purchase/SUNY, Geometric Abstraction & the Modern Spirit, 1989; Deutsche-Amerikanische Instituts, Frankfurt, Kunstler Zwischen Idea und Realization,

circ., 1989. **Collections:** Corcoran; Cornell U.; Detroit/Institute; Jersey City Museum; MOMA; U. of Massachusetts; Mills College; U. of Michigan; Milwaukee; Muskegon/Hackley; NMAA; NYU; Newark Museum; New Jersey Cultural Center; Norfolk/Chrysler; U. of North Carolina; Princeton U.; Purchase/SUNY; Quebec; Smith College; Spelman College; SRGM; U. of Texas; Trenton/State; WMAA. **Bibliography:** Atkinson; MacAgy 2; Rickey; Toher, ed.

GORCHOV, RON b. April 5, 1930, Chicago, Ill. **Studied:** U. of Mississippi, 1947-48; Roosevelt College; Chicago/AI School, 1948-50; U. of Illinois, 1950-51. Traveled USA, Europe. **Taught:** Hunter College, 1962-. Designed stage sets for Theater Club of New York production of Lorca's *Shoemaker's Prodigious Wife,* 1957. **Awards:** Ingram Merrill Foundation Grant, 1959; National Arts Club Annual, NYC, Hon. Men., 1959. **Address:** 461 Broome Street, NYC 10013. **Dealer:** Jack Tilton Gallery, NYC. **One-man Exhibitions:** Tibor de Nagy Gallery, NYC, 1960, 63, 66; Syracuse/Everson, 1972; The Texas Gallery, 1974; Fischbach Gallery, NYC, 1975; Henri 2, Washington, D.C. (two-man), 1975; Texas Gallery, Houston, 1976; Suzanne Hilberry Gallery, Birmingham, Mich., 1977, 79, 90; Galerie M. Bochum, Germany (two-man), 1978; U. of California, Berkeley, 1978; Palazzo Reale, Milan, 1979; P.S. 1, Long Island City, 1979; Young-Hoffman Gallery, Chicago, 1979; Hamilton Gallery of Contemporary Art, NYC, 1979; Marlborough Gallery, NYC, 1983; Benjamin Mangel Gallery, Philadephia, 1984; Jack Tilton Gallery, NYC, 1990. **Group:** The Stable Gallery, NYC, Invitational, 1958; National Arts Club Annual, NYC, 1959; WMAA, Young America, 1960; VMFA, 1964; Syracuse/Everson, 1971; Akademie der Kunst, Berlin, SoHo, 1976; Brockport/SUNY, Recent Abstract Painting, 1976; California State U., Los Ange-

les, New Work/New York, 1976; New Museum, NYC, Early Work by Five Contemporary Artists, 1977; WMAA Biennial, 1977; NYU, American Painting of the 1980s, 1979. **Collections:** Chicago/AI; Detroit/Institute; Glen Alden Corp.; Hartford/Wadsworth; MOMA; MMA; SRGM; Syracuse/Everson; WMAA.

GORDIN, SIDNEY b. October 24, 1918, Cheliabinsk, Russia. **Studied:** Cooper Union, 1937-41, with Morris Kantor, Carol Harrison, Leo Katz. **Taught:** Pratt Institute, 1953-58; Brooklyn College, 1955-58; New School for Social Research, 1956-58; Sarah Lawrence College, 1957-58; U. of California, Berkeley, 1958-86. **Commissions** (sculpture): Temple Israel, Tulsa, Okla., 1959; Envoy Towers, 300 East 46th Street, NYC, 1960. **Address:** 903 Camilia Street, Berkeley, CA 64700. **Dealer:** Gallery Paule Anglim, San Francisco. **One-man Exhibitions:** Bennington College, 1951; Peter Cooper Gallery, NYC, 1951; Grace Borgenicht Gallery, Inc., NYC, 1953, 55, 58, 60, 61; New School for Social Research, 1957; Dilexi Gallery, San Francisco, 1959, 63, 65; de Young, 1962; Los Angeles/County MA, 1963; Zabriskie Gallery, NYC, 1979; Sid Deutsch Gallery, NYC, 1980, 84; Newspace, Los Angeles, 1979, 83, 84; Gallery Paule Anglim, San Francisco, 1981, 84, 88, 91. **Retrospectives:** de Young, 1961; Berkeley Art Center, 1967. **Group:** MMA, 1951; WMAA Annuals, 1952-57; MOMA; Chicago/AI; PAFA, 1954, 55; Brooklyn Museum; Newark Museum; SFNU; Oakland/AM; Tulsa/Philbrook, 1960. **Collections:** Chicago/AI; Corcoran; Newark Museum; Norfolk/Chrysler; Oakland/AM; Southern Illinois U.; WMAA. **Bibliography:** Goodrich and Baur 1; Mendelowitz; Seuphor 3; Toher, ed. Archives.

GORDY, ROBERT b. October 14, 1933, Jefferson Island, Louisiana. **d.** September 24, 1986. **Studied:** Louisi-

ana State U., Baton Rouge, BA, MA; Yale U., 1953, and with Hans Hofmann. **Awards:** National Council of the Arts, grant, 1967; National Endowment for the Arts, 1978. **One-man Exhibitions:** Emily Lowes Gallery, New Orleans, 1965; Glade Gallery, New Orleans, 1967, 68; Tampa Bay Art Center, 1969; Hank Baum Gallery, San Francisco, 1969, 71, 73; Cranfill Gallery, Dallas, 1971; Glasgow College of Arts, Scotland, 1972; Galerie Simone Stern, New Orleans, 1968, 70, 71, 72, 73, 80, 81, 83; Mills College, 1973; Long Beach/MA, 1975; Phyllis Kind Gallery, Chicago, 1976; Delahunty, Inc., Dallas, 1977; Phyllis Kind Gallery, NYC, 1979, 85; Carol Shapiro Gallery, St. Louis, 1983; Mobile/FAMS, 1984; New Orleans Museum, circ., 1984; Arthur Roger Gallery, New Orleans, 1984; U. of South Florida, circ., 1985. **Retrospective:** New Orleans Museum, 1981. **Group:** ICA, U. of Pennsylvania, The Spirit of the Comics, 1969; Fort Worth, Contemporary Drawings, 1969; WMAA Biennials, 1967, 73; Memphis/Brooks, American Painting and Sculpture, 1973; NCFA, Divergent Representation, 1973; WMAA, Extraordinary Realists, 1973; Moore College of Art, Philadelphia, North, East, South, West, and Middle, 1975; Brooklyn Museum, 21st National Print Exhibition, 1978; Brooklyn Museum, American Drawings in Black and White, 1970-1979; Norfolk/Chrysler, American Figurative Painting, 1950-1980, 1980; WMAA, The Figurative Tradition and the WMAA, 1980; Brooklyn Museum, The American Artist as Printmaker, 1983; Houston/Contemporary, Southern Fictions, 1983; IEF, Twentieth Century Drawings: The Figure in Context, circ., 1984; New Orleans, Louisiana World Exposition, 1984; Southeastern Center for Contemporary Art, Winston-Salem, N.C., The Art of New Orleans, 1984. **Collections:** Chicago/Contemporary; Corcoran; Dallas/MFA; Fort Worth; Greenville; MMA; Mobile/FAMS; Montgomery; NMAA; New Orleans Museum; U. of

North Carolina; Oklahoma; Tampa Bay Art Center; WMAA; Wichita/AM; Witte. **Bibliography:** Cummings 4.

GORKY, ARSHILE (Vosdanig Manoog Adoian) **b.** April 15, 1904, Khorkom Vari Haiyotz Dzor, Armenia. **d.** July 21, 1948, Sherman, Conn. To USA, 1920. **Studied:** Polytechnic Institute, Tiflis, 1916-18; RISD; Providence (R.I.) Technical High School; New School of Design, Boston, 1923; NAD, 1925. Subject of *Arshile Gorky,* Cort Productions, 1982; *Windows to Infinity: The Life and Work of Arshile Gorky,* Armenian General Benevolent Union of America, 1979. **Taught:** New School of Design, Boston, 1924; Grand Central School, NYC, 1925-31. **Commissions:** Federal A.P.: Newark (N.J.) Airport 1935-38 (mural). Aviation Building, New York World's Fair, 1939 (mural). Fire destroyed 27 paintings in his studio, January 1946. **One-man Exhibitions:** (first) Guild Art Gallery, NYC, 1932, also 1935, 36; Mellon Galleries, Philadelphia, 1934; Boyer Gallery, Philadelphia, 1935; Boyer Gallery, NYC, 1938; The Kootz Gallery, NYC, 1942, 50, 51; Julien Levy Galleries, NYC, 1945, 46, 47, 1948 (two-man, with Howard Warshaw); WMAA, Memorial Exhibition, 1951; Princeton U., 1952; Paul Kantor Gallery, Beverly Hills, Calif., 1952; Sidney Price Gallery, NYC, 1952, 55, 57; U. of Maryland, 1969; M. Knoedler & Co., NYC, 1969, 70, 73, 75; Dunkelman Gallery, Toronto, 1972; Galatea Galleria d'Arte, Turin, 1972; Allan Stone Gallery, NYC, 1973; Richard Feigen Gallery, NYC, 1973; U. of Texas, Austin, 1975; Oxford/MOMA, 1975; Washburn Gallery, NYC, 1978; Newark Museum, 1978; Xavier Fourcade, Inc., NYC, 1979, 87; Hirshhorn, 1979; Jeremy Stone Gallery, San Francisco, 1983; Gerald Peters Gallery, Santa Fe, 1990. **Retrospectives:** SFMA, 1941; MOMA, 1963; SRGM, 1981. **Group:** WMAA Annuals; MOMA, 46 Painters and Sculptors under 35 Years of Age, 1930; WMAA, Abstract Painting in America, 1935; MOMA, Fourteen Americans, circ., 1946; Galerie Maeght, 6 Surrealists in 1947, 1947; XXIV & XXV Venice Biennials, 1948, 50; Galerie de France, Paris, 1952; MOMA, The New American Painting, circ., Europe, 1958-59; MOMA, The New American Painting and Sculpture, 1969; SRGM, 20th Century American Drawing, Three Avant-Garde Generations, 1976; Hirshhorn, The Golden Door, 1976; MOMA, The Natural Paradise: Painting in America 1800-1950, 1976; Milwaukee, From Foreign Shores, 1976; Oswego/SUNY, The New Deal for Art, 1977; Brown U., Graham, Gorky, Smith and Davis in the Thirties, 1977; Paris/Beaubourg, Paris-New York, 1977; Houston/MFA, American Paintings, 1910-1949, 1977; Royal Scottish Academy, Edinburgh, Modern Spirit in American Painting, 1908-1935, 1977; Cornell U., Abstract Expressionism: The Formative Years, 1978; National Gallery, Washington, D.C., American Art at Mid-Century, 1978; Cleveland/MA, The Spirit of Surrealism, 1979. **Collections:** U. of Arizona; Baltimore/MA; Brooklyn Museum; Buffalo/Albright; Canberra/National; Chicago/AI; Cleveland/MA; High Museum; Hirshhorn; Indiana U.; Kansas City/Nelson; Los Angeles/County MA; MMA; MOMA; NYU; National Gallery; Oberlin College; Art Gallery of Ontario, Toronto; SFMA; SRGM; Seattle; Tate; U. of Texas, Austin; Utica; WMAA; Washington U.; Yale U. **Bibliography:** *Abstract Expressionism;* Anfam; Armstrong, Thomas; Ashbery; Ashton 5; Barr 3; Baur 5, 7; Blesh 1; Breton 2, 3; Calas 1, 2; Cheney; Chipp; Cummings 5; De Wilde 1; Eliot; *Europa/Amerika;* Flanagan; Gerdts; Goodrich and Baur 1; Greenberg 1; Haftman; Hess, T.B., 1; Hughes; Hunter 1, 6; Hunter, ed.; Janis, S.; Jordan and Goldwater; **Joyner;** Kozloff 3; Lader; Lane and Larsen; Langui; **Levy 1;** Lynton; McCoubrey 1; McCurdy, ed.; Miller, ed., 2; Murken-Altrogge; Myers 2; Neff, ed.; Neumeyer; Newmeyer;

Passloff; Ponente; Pousette-Dart, ed.;
Ragon 1; Rand 3; Read 2; Richardson,
E.P.; Ritchie 1; Rodman 2; Rose, B., 1, 4;
Rosenberg 1; Rubin 1; Sandler 5;
Schwabacher; Seitz 1, 2, 3; Seuphor 1;
Soby 6; Tomkins and Time-Life Books;
Tuchman, ed.; Waldbert 3, 4;
Waldman 4, 1; Weller. Archives.

GORNIK, APRIL b. April 20,
1953, Cleveland. **Studied:** Cleveland Insti-
tute of Art, 1971-75; Nova Scotia College
of Art and Design, BFA, 1976. **m.** Eric
Fischl. **Address:** 13 Laight Street, NYC,
10013. **Dealer:** Edward Thorp Gallery,
NYC. **One-man Exhibitions:** Edward
Thorp Gallery, NYC, 1981, 82, 83, 84,
86, 87, 90; U. of Colorado, 1982; New
Gallery, Cleveland, 1984; Texas Gallery,
Houston, 1984; Galerie Springer, Berlin,
1985; Sable-Castelli Gallery, Toronto,
1985, 88; California State U., Long Beach,
1988. **Group:** Youngstown/Butler,
Women's Invitational, 1976; Venice Bi-
ennale, 1984; Taft Museum, Night Light,
1985; U. of North Carolina, Art on Paper,
1986; NAD, Realism Today, 1988; South-
ampton/Parrish, Drawing on the East End,
1940-1988, 1988; WMAA, Biennial,
1989; Fort Worth/Modern, 10 + 10, circ.,
1989; Brooklyn Museum, Public and Pri-
vate, 1986. **Collections:** Chase Manhattan
Bank; Chemical Bank; MMA. **Bibliogra-
phy:** Vine and Hales.

GOTO, JOSEPH
from 1st to 5th edition.

GOTTLIEB, ADOLPH b. March
14, 1903, NYC. **d.** March 4, 1974, NYC.
Studied: ASL, 1919, with John Sloan,
Robert Henri; Academie de la Grande
Chaumiere, 1921; Parsons School of De-
sign, 1923. Exhibited with The Ten, NYC,
1935-40. President, Federation of Modern
Painters, 1944-45. **Taught:** Pratt Institute,
1958; UCLA, 1958. **Awards:** Winner of
Dudensing National Competition, 1929;
US Treasury Department, Mural Competi-

tion, 1939; Brooklyn Museum, First Prize,
1944; U. of Illinois, P.P., 1951; Carnegie,
Third Prize, 1961; VII São Paulo Biennial,
First Prize, 1963; American Academy of
Achievement 1965; Flint/Institute, P.P.,
1966. **One-man Exhibitions:** (first)
Dudensing Gallery, NYC, 1930; Uptown
Gallery, NYC, 1934; Theodore A. Kohn
Gallery, NYC, 1934; Artists' Gallery,
NYC, 1942, 43; Wakefield Gallery, NYC,
1944; "67" Gallery, NYC, 1945; Karl
Nierendorf Gallery, NYC, 1945; The
Kootz Gallery, NYC, 1947, 1950-54;
J. Seligmann and Co., 1949; Area Arts
Gallery, San Francisco, 1953; Williams
College, 1954; The Kootz Gallery, Pro-
vincetown, Mass., 1954; Martha Jackson
Gallery, 1957; HCA Gallery, Province-
town, Mass., 1957; André Emmerich Gal-
lery, 1958, 59, 77, 78, 79, 80; Galerie Rive
Droite, Paris, 1959; Paul Kantor Gallery,
Beverly Hills, Calif., 1959; ICA, London,
1959; French & Co. Inc., NYC, 1960;
Sidney Janis Gallery, 1960, 62; Galleria
dell' Ariete, 1961; Galerie Handschin,
Basel, 1961; Walker, 1963; Marlborough-
Gerson Gallery, Inc., 1964-66, 71, 72, 73,
74; MIT, 1966; Arts Club of Chicago,
1967; U. of Maryland, 1970; Galleria
Lorenzelli, Bergamo, 1970; Gertrude Kasle
Gallery, Detroit, 1970, 74; Marlborough
Fine Art Ltd., London, 1972; MOMA,
1974; Edmonton Art Gallery, Alberta,
circ., 1977-78; Thomas Segal Gallery, Bos-
ton, 1978; Klonaridis, Inc., Toronto,
1979, 82; Currier, 1979; Omaha/Joslyn,
1979; Phoenix, 1979; Corcoran, circ.,
1981; M. Knoedler & Co., Inc., NYC,
1982, 87, 88, 90; M. Knoedler & Co.,
Inc., Zurich, 1983; Muhlenberg College,
1984; Galerie Wentzel, Cologne, 1984;
M. Knoedler & Co., Inc., London, 1986;
Heland Thorden Wetterling Gallery,
Stockholm, 1989; Gallery One, Toronto,
1989; Manny Silverman Gallery, Los
Angeles, 1990; Hans Strelow Gallery,
Düsseldorf, 1990. **Retrospectives:** Ben-
nington College, 1954; Jewish Museum,
1957; WMAA and SRGM, 1968; Tel

Aviv, 1983. **Group:** WMAA Annuals, 1944, 45, 46, 48, 51, 53, 55, 61; PAFA; Walker; Chicago/AI, Abstract and Surrealist Art, 1948; Carnegie, 1952, 55, 58, 61; SRGM, Younger American Painters, 1954; WMAA, The New Decade, 1954-55; MOMA, The New American Painting, circ., Europe, 1958-59; Kassel, Documenta II, 1959; Seattle World's Fair, 1962; VII São Paulo Biennial, 1963; Tate, Gulbenkian International 1964, Dunn International, 1964; Chicago/AI Annual, 1966; Flint/Institute, Flint Invitational, 1966; Corcoran, 1966, Biennial, 1967; Winnipeg Art Gallery, 1967; MOMA, The New American Painting and Sculpture, 1969; Boston/MFA, Abstract Painting in the 70s, 1972; WMAA Biennial, 73; Cornell U., Abstract Expressionism: The Formative Years, 1978; São Paulo Biennial, circ., 1979; MMA, The Painterly Print, 1980; Nassau County Museum, Sculpture: The Tradition in Steel, 1983; Vassar College, The Artist's Perception 1948-1984, 1984; Newport Harbor, The Interpretive Link, circ., 1986; WMAA, Stanford, Convulsive Beauty, 1988; U. of Miami, Abstract Expressionism, circ., 1989; Los Angeles/County MA, The Spiritual in Art, 1986; Brooklyn Museum, Images and Reflections, 1989. **Collections:** Andover/Phillips; Atlanta/AA; Ball State U.; Bezalel Museum; Brandeis U.; Brooklyn Museum; Buffalo/Albright; Carnegie; Chicago/AI; Columbia U.; Corcoran; Cornell U.; Dallas/MFA; Des Moines; Detroit/Institute; Flint/Institute; Hartford/Wadsworth; U. of Illinois; Jewish Museum; Los Angeles/County MA; MMA; MOMA; U. of Miami; NYU; U. of Nebraska; U. of Nevada; Newark Museum; New Orleans/Delgado; Pasadena/AM; Phillips; SRGM; San Jose Library; Santa Barbara/MA; Seagram Collection; Smith College; Society of the Four Arts; Tel Aviv; Utica; VMFA; WMAA; Walker; Yale U.; Youngstown/Butler. **Bibliography:** *Abstract Expressionism;* Alloway 4; Anfam; Armstrong, Thomas; Ashton 5; Barr 3; Baur 5, 7;

Blesh 1; Chipp; Eliot; *Europa/Amerika;* Friedman, M., **1**; Goodrich and Baur 1; *The Great Decade;* Greenberg 1; Haftman; Hess, T.B., **1**; Hobbs and Levin; Hunter 1, 6; Hunter, ed.; Janis, S.; Kootz 2; Mendelowitz; *Metro;* Motherwell and Reinhardt, eds.; Myers 2; Neumeyer; Nordness, ed.; Pousette-Dart, ed.; Read 2; Richardson, E.P.; Rodman 1, 2, 3; Rose, B., **1**, 4; Rosenblum 2; Rubin 1; Sandler; Seuphor 1, Siegel; Soby 5; Tomkins 2; Tuchman, ed.; Tuchman 3; Weller; Wight 2. Archives.

GOULET, LORRIE b. August 17, 1925, Riverdale, NY. **Studied:** Black Mountain College, 1943-45, with Josef Albers, Jose de Creeft. Traveled USA, Europe. **Taught:** Scarsdale Art Workshop, and privately, 1957-61; MOMA School, 1957-64; New School for Social Research, 1961-75; ASL, 1981-. **Member:** Sculptors Guild; Artists Equity; Audubon Artists; National Sculpture Society, 1987; NAD, NA, 1989. **Commissions:** Grand Concourse (Bronx) Public Library, 1958 (ceramic relief); Nurses Residence and School, Bronx Municipal Hospital Center, 1961 (relief); 48th Precinct Police and Fire Station, Bronx, 1971. CBS-TV, lecture-demonstrations on sculpture for children's series "Around the Corner," 1964, 66, 67, 68. **Awards:** West Palm Beach/Norton, First Prize, 1949, 50; Westchester (NY) Art Society, First Prize, 1964; Audubon Artists, Solten Engel Memorial Award, 1966; Audubon Artists, Vincent Glinsky Award, 1988. m. Jose de Creeft. **Address:** 241 West 20th Street, NYC 10011. **Dealer:** Carolyn Hill Gallery, NYC. **One-man Exhibitions:** (first) Clay Club, NYC, 1948; Sculpture Center, 1955; The Contemporaries, NYC, 1959, 62, 66, 68; New School for Social Research, 1968; Temple Emeth, NJ, 1969; Kennedy Galleries, 1971, 72, 75, 78, 80, 83, 86; Carolyn Hill Gallery, NYC, 1988, 91. **Retrospective:** Caldwell College, NJ, 1989. **Group:** PAFA, annually since 1948; Audubon Art-

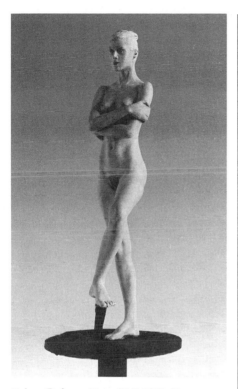

Robert Graham, *Figure III-B*, 1989-90.

ists, annually since 1948; WMAA Annuals, 1948, 49, 50, 53, 55; Philadelphia Art Alliance, 1950; MMA, 1951; Sculptors Guild, annually since 1960; AAAL, 1961; A.F.A., Mother and Child in Modern Art, circ., 1963; Carroll Reece Memorial Museum, Johnson City, TN; Black Mountain College, 1964; New York World's Fair, 1964-65; NAD, 1966; New School for Social Research, Erotic Art, 1973; National Arts Club, NYC, 1978; Hofstra College, The Coming of Age of American Sculpture, 1990. **Collections:** Hirshhorn; Trenton/State; NMWA; WMAA; Wichita/AM. **Bibliography:** Archives.

GRAHAM, JOHN D. (Ivan

Dombrowski) **b.** January 9, 1887, Warsaw, Poland. **d.** June 27, 1961, London, England. **Studied:** U. of Kiev, degree in law, 1911; ASL, 1921, with John Sloan. To USA, 1920; became a citizen. Traveled Europe, Asia, Africa, USA. **Taught:** Wells College, 1932. **One-man Exhibitions:** (first) Baltimore/MA, 1926; Galerie Zborowski, Paris, 1929; Societé Anonyme, NYC, 1931; Eighth Street Gallery, NYC, 1933; Artists' Gallery, NYC, 1941; The Pinacotheca, NYC, 1946; Dudensing Gallery, NYC; The Stable Gallery, NYC, 1954; Gallery Mayer, NYC, 1960; Arts Club of Chicago, 1963; U. of Minnesota, 1964; André Emmerich Gallery, NYC, 1966, 87; MOMA, 1968; Phyllis Kind Gallery, Chicago, 1970; Donald Morris Gallery, 1972; Allan Stone Gallery, NYC, 1973, 81; The Zabriskie Gallery, NYC, 1973; School of Visual Arts, NYC, 1984. **Group:** MOMA; WMAA; U. of Minnesota; Societé Anonyme, NYC; Brown U., Graham, Smith, Gorky, & Davis in the Thirties, 1977; Minnesota/MA, American Drawing, 1927-1977, circ., 1977; Carnegie, Abstract Painting and Sculpture in America 1927-1944, 1983. **Collections:** Carnegie; MOMA; Nashville; Phillips; WMAA. **Bibliography:** *Abstract Expressionism;* Armstrong, Thomas; Baur 7; Brown 2; Downes, ed.; *Europa/Amerika; From Foreign Shores; George 2; Graham; Graham, Gorky, Smith & Davis in the Thirties;* Hunter 6; Janis, S.; Kootz 2; Lane and Larsen; Passloff; Phillips 1; Rose, B., 1, 4; Sandler. Archives.

GRAHAM, ROBERT b. August

19, 1938, Mexico, D.F. **Studied:** San Jose State College, 1961-63; SFAI, MFA, 1963-64. Traveled Germany, Switzerland, England. US Citizen. **Address:** 69 Windward Avenue, Venice, CA 90291. **Dealer:** Robert Miller Gallery, NYC. **One-man Exhibitions:** The Lanyon Gallery, 1964; Nicholas Wilder Gallery, 1966, 67, 69, 74, 75, 77; M.E. Thelen Gallery, Essen, 1967; The Kornblee Gallery, 1968, 69; Galerie Hans R. Neuendorf, Hamburg, 1968, 70, 74, 76, 79, Cologne, 1968, 70; Galerie Rudolf Zwirner, 1970; Galerie Rene Block, Berlin, 1970; Whitechapel Art Gallery, London, 1970; Ileana Sonnabend Gal-

lery, NYC, 1971; Hamburg/Kunstverein, 1971; Galerie Herbert Meyer-Ellingen, Frankfurt, 1972; Dallas/MFA, 1972; Felicity Samuel Gallery, London, 1974; Gimpel & Hanover, 1975; Greenberg Gallery, St. Louis, 1975; Texas Gallery, Houston, 1975; Rosenthal Gallery, Chicago, 1975; Gimpel Fils, London, 1976; John Stoller Gallery, Minneapolis, 1977; Robert Miller Gallery, NYC, 1977, 79, 82, 89, 90, 92; Dag Hammarskjold Plaza, NYC, 1979; Dorothy Rosenthal Gallery, Chicago, 1980, 81, 84; School of Visual Arts, NYC, 1981; Badischer Kunstverein, Karlsruhe, 1983; Gemini G.E.L., Los Angeles, 1984; ARCO Center, Los Angeles, 1984; Robert Graham Studio, Venice, Calif., 1985; Los Angeles/County MA, 1988; Hamburg, Kunstverein, 1988; **Retrospective:** Walker, circ., 1981. **Group:** WWAA Sculpture Annuals, 1966, 69, 71; Washington U. (St. Louis), Here and Now, 1969; Victoria and Albert Museum, Three Americans, 1971; Hamburg/Kunstverein, USA: West Coast, circ., 1972; NCFA, Sculpture: American Directions 1945-1975, 1975; Los Angeles/County MA, Los Angeles—Eight Artists, 1975; SFMA, Painting and Sculpture in California: The Modern Era, 1976; Rutgers U., Contemporary Artists Series Number 1, 1978; WMAA Biennial, 1979; Los Angeles/County MA, The Museum as Site, 1981; PAFA, Contemporary American Realism Since 1960, 1981; SFMA, 20 American Artists, Sculpture 1982, 1982; Oakland/AM, 100 Years of California Sculpture, 1982; Hirshhorn, Content: A Contemporary Focus, 1974-1984, 1984; National Gallery, Gemini G.E.L.: Art and Collaboration, circ., 1984; Cincinnati/Contemporary, Body and Soul, 1985; Palm Springs Desert Museum, California Figurative Sculpture, 1987; Houston/MFA, Hispanic Art in the United States, circ., 1987; WMAA, Figure as Subject, circ., 1988; Monte Carlo IIIème Biennale de Sculpture, 1991. **Collections:** Aachen; Bank of America; Cologne; Dal-

las/MFA; Des Moines; City of Detroit; Hamburg/Kunstmuseum; Hirshhorn; County of Los Angeles; Los Angeles/County MA; Los Angeles/MOCA; MOMA; National Museum of Wales; Oakland Museum; Paris/Moderne; Pasadena/AM; Rotterdam; SFMA; City of San Jose; Smith College; UCLA; Victoria and Albert Museum; WMAA; Walker. **Bibliography:** *Individuals; Kunst um 1970;* Plagens; Sager; *USA West Coast.*

GRANLUND, PAUL
from 1st to 5th edition.

GRANT, JAMES
from 2nd to 5th edition.

GRAVES, MORRIS COLE
b. August 28, 1910, Fox Valley, Ore. Studied with Mark Tobey. Traveled Europe, the Orient, USA. Federal A.P.: Easel painting, 1936-39. US Army, 1943. **Awards:** Seattle/AM, Northwest Annual, $100 Award, 1933; Guggenheim Foundation Fellowship, 1946; Chicago/AI, Norman Wait Harris Medal, 1947; Chicago/AI, Watson F. Blair Prize, 1949; U. of Illinois, P.P., 1955; NIAL Grant, 1956; Windsor Award, 1957. **Address:** Box 90, Loleta, CA 95551. **Dealer:** Schmidt-Bingham Gallery, NYC. **One-man Exhibitions:** (first) Seattle/AM, 1936, also 1956; The Willard Gallery, NYC, 1942, 44, 45, 48, 53, 54, 55, 59, 71, 73, 81; Arts Club of Chicago, 1943; U. of Minnesota, 1943; Detroit/Institute, 1943; Phillips, 1943, 54; Philadelphia Art Alliance, 1946; Santa Barbara/MA, 1948; Los Angeles/County MA, 1948; Chicago/AI, 1948; Margaret Brown Gallery, Boston, 1950; Beaumont (Tex.) Art Museum, 1952; Kunstnernes hus Oslo, 1955; La Jolla, 1957; Bridgestone Museum, 1957; Phoenix, 1960; Roswell, 1961; Kalamazoo/Institute, 1961; Richard White Gallery, Seattle, 1969; Foster/White Gallery, Seattle, 1977, 78, 80, 82; Charles Campbell Gallery, San Francisco, 1979;

John Berggruen Gallery, San Francisco, 1977; Visual Arts Museum, NYC, 1978; U. of Oregon, 1982; Art Museum of Santa Cruz County (Calif.), 1984; Schmidt-Bingham Gallery, NYC, 1988, 90, 92. **Retrospectives:** California Palace, 1948; WMAA, circ., 1956; Pavilion Gallery, Balboa, Calif., 1963; U. of Oregon, 1966; Tacoma, 1971. **Group:** Seattle/AM; WMAA; U. of Illinois; Chicago/AI; Phillips; MOMA, Americans 1942, circ., 1942; Houston/MFA, 1956; ICA, London, 1957; Brussels World's Fair, 1958; Seattle World's Fair, 1962; ICA, Boston, American Art since 1950, 1962; Amon Carter Museum, The Artist's Environment, West Coast, 1962; PAFA, 1963; Columbia, S.C./MA, Ascendancy of American Painting, 1963; Tate, American Painting, 1963; St. Louis/City, 200 Years of American Painting, 1964; U. of Michigan, One Hundred Contemporary American Drawings, 1965; MOMA, The Object Transformed, 1966; U. of Illinois, 1969; Minnesota/MA, Drawings USA, 1971; St. Joseph/Albrecht, Drawing—America: 1973, 1973; NAD, 1974; ICA, U. of Pennsylvania, Improbable Furniture, 1977; Omaha/Joslyn, The Chosen Object: European and American Still Life, 1977; Seattle/AM, Northwest Traditions, circ., 1978; Kunsthalle, Düsseldorf, 2 Jahrzehnte Amerikanische Malerei, 1920-1940, circ., 1979; ICA, Boston, Northwest Visionaries, 1981; Los Angeles/County MA, The Spiritual in Art, 1987; WMAA, 20th-Century Drawings from the WMAA, 1987; Museums of Carcassone, Seattle Style, circ., 1987; UCLA, Visions of Inner Space, circ., 1988. **Collections:** Baltimore/MA; Boston/MFA; Buffalo/Albright; U. of California; Chicago/AI; Cincinnati/AM; Cleveland/MA; Denver/AM; Detroit/Institute; Fort Wayne/AM; Hartford/Wadsworth; Harvard U.; Hirshhorn; U. of Illinois; MMA; MOMA; Milwaukee; NIAL; U. of Nebraska; Ogunquit; Pasadena/AM; Phillips; Portland, Ore./AM; Purchase/SUNY; SFMA; SRGM; Santa Barbara/MA; Seattle/AM; Tacoma; U. of Texas; Toronto; Upjohn Co.; Utica; WMAA; U. of Washington; Wilmington; Worcester/AM. **Bibliography:** *Art of the Pacific Northwest;* Baldinger; Barker 1; Barr 3; Baur 7; Bazin;

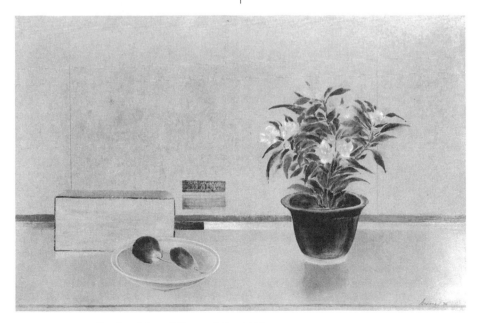

Morris Graves, *Still Life with Potted Plant and Figs,* 1986.

Beekman; Blesh 1; **Cage;** Canaday; Clark and Cowles; Cummings 5; Flanagan; Flexner; Frost; Goodrich and Baur 1; Graves; Haftman; Honisch and Jensen, eds.; Hunter 6; Janis, S.; **Kass;** Kootz 2; Kuh 1, 2; Langui; McCurdy, ed.; Mendelowitz; Miller, ed., 1; Munsterberg; Neumeyer; Nordness, ed.; *Northwest Traditions;* Pousette-Dart, ed.; Ragon 1; Read 2, 3; Richardson, E.P.; Rodman 1, 2; Rose, B., 1; Sachs; Soby 5; Sutton; Tuchman 3; Valentine 2; Weller; Wight 2; **Wight, Baur, and Phillips.** Archives.

GRAVES, NANCY STEVENSON **b.** December 23, 1940, Pittsfield, Mass. **Studied:** Vassar College, 1961, BA; Yale U., 1962, BFA, 1964, MFA. **Member:** AAIAL. **Awards:** Fulbright Fellowship, 1965; Vassar College Grant, 1971; Paris Biennial Grant, 1971; National Endowment for the Arts, 1972; CAPS, 1973; American Academy, Rome, Fellowship, 1979; Skowhegan School, Medal for Drawing/Graphics, 1980; Yale Arts Medal for Distinguished Artistic Achievement, 1985; Vassar College, Distinguished Visitor Award, 1986; PAFA, Award of American Art, 1987; Skidmore College, honorary degree, 1989. Also produces films. Designed sets and costumes for Trisha Brown's *Lateral Pass,* 1985. **Address:** 69 Wooster Street, NYC 10012. **Dealer:** M. Knoedler & Co., Inc., NYC. **One-man Exhibitions:** The Graham Gallery, 1968; WMAA, 1969; Ottawa/National, 1970, 71, 73; Reese Palley Gallery, NYC, 1971; Aachen/NG, 1971; Vassar College, 1971, circ., 1986; MOMA, 1971; New Gallery, Cleveland, 1972; Janie C. Lee Gallery, Dallas, 1972, 73, 75; ICA, U. of Pennsylvania, 1972; Janie C. Lee Gallery, Houston, 1974, 75, 76, 77, 78, 83, 84; Pittsfield/Berkshire, 1973; Art Museum of South Texas, Corpus Christi, 1973; André Emmerich Gallery, NYC, 1974, 77; Buffalo/Albright, 1974, 80; Galerie André Emmerich, Zurich, 1977; Galerie im Schloss, Munich, 1977;

M. Knoedler & Co., Inc., NYC, 1978, 79, 80, 81, 82, 84, 86, 88, 89, 91; Diane Gilson Gallery, Seattle, 1978; Richard Gray Gallery, Chicago, 1981, 86; M. Knoedler & Co., Inc., Zurich, 1982; Gloria Luria Gallery, Bay Harbor Islands, Fla., 1983; Santa Barbara (Calif.) Contemporary Arts Forum, 1983; Greenberg Gallery, St. Louis, 1985; M. Knoedler & Co., Inc., London, 1987, 89; Associated American Artists, 1988; Linda Cathcart Gallery, Santa Monica, 1989; Gerald Peters Gallery, Santa Fe, 1990; Marian Locks Gallery, Philadelphia, 1991; Meredith Long & Co., Houston, 1991. **Retrospective:** Buffalo/Albright, circ., 1980; Fort Worth/AM, circ., 1987. **Group:** WMAA Annuals, 1970, 71, 73; MOMA, Information, 1971; Corcoran, Depth and Presence, 1971; Düsseldorf/Kunsthalle, Prospect '71, 1971; Chicago/Contemporary, Six Sculptors, 1971; VII Paris Biennial, 1971; Kunsthaus, Hamburg, American Women Artists, 1972; Kassel, Documenta V, 1972; New York Cultural Center, 3D into 2D, 1973; WMAA, American Drawings, 1963-1973, 1973; Cologne, Project 74, 1974; Sarah Lawrence College, Drawings by Women, 1975; Corcoran, The Liberation, 1976; US Department of the Interior, America 1976, circ., 1976; WMAA, 200 Years of American Sculpture, 1976; Kassel, Documenta VI, 1977; U. of Texas, Austin, New in the Seventies, 1977; U. of California, Santa Barbara, Contemporary Drawing/New York, 1977; Albright College, Perspective 78, 1978; Buffalo/Albright, American Painting of the 1970s, circ., 1978; Zurich/Kunsthaus, Weich und Plastisch—Soft Art, 1979; ICA, U. of Pennsylvania, Masks, Tents, Vessels, Talismans, 1979; NYU, American Painting: The Eighties, 1979; XXXIX Venice Biennale, 1980; U. of Kansas, 4 Artists and the Map: Image/Process/Data/Place, 1981; Houston/Contemporary, In Our Time, 1982; Stuttgart/WK, Past-Present-Future, 1982; Yale U., Prints by Contemporary Sculptors, 1982; WMAA Biennial, 1983;

MOMA, Primitivism in 20th Century Art, 1984; Newark Museum, American Bronze Sculpture, 1850 to the Present, 1984; Purchase/SUNY, Hidden Desires, 1984; Seattle/AM, American Sculpture: Three Decades, 1984; Sonoma State U., Works in Bronze, A Modern Survey, circ., 1984; Williams College, Six in Bronze, circ., 1984; U. of Pittsburgh, Sculpture by Women in the Eighties, 1985; Brooklyn Museum, Public and Private: American Prints Today, 1986; Fort Lauderdale, An American Renaissance: Painting and Sculpture Since 1940, 1986; MIT, Natural Forms and Forces, 1986; Boston/MFA, Printmaking Now: 70s into 80s, 1986; Brown U., Alternative Supports, 1987; Detroit/Institute, Reconnecting, 1987; Buffalo/Albright, Structure to Resemblance, 1987; Mt. Holyoke College, A Graphic Muse, circ., 1987; Long Island U., Lines of Vision, 1989; Cincinnati/AM, Making Their Mark, circ., 1989; Walker, First Impressions, 1989; AAIAL, 1990; U. of Florida, Color in Art, 1990; Palace of Exhibitions, Budapest, 8th International Small Sculpture Triennial, 1990; Monte Carlo, IIIème Biennale de Sculpture, 1991; NAD, 1991. **Collections.** Aachen/NG; Akron/AI; Art Museum of South Texas; Brooklyn Museum; Buffalo/Albright; CNAC; U. of California, Berkeley; Birmingham, Ala./MA; Chicago/AI; Chicago/Contemporary; Cologne; Corcoran; Dallas/MFA; Des Moines; Fort Worth; Hirshhorn; Houston/MFA; La Jolla; Los Angeles/County MA; Memphis/Brooks; MMA; MOMA; U. of North Carolina; Oberlin College; Ottawa/National; PAFA; Pittsfield/Berkshire; Purchase/SUNY; SRGM; St. Louis/City; Vassar College; Vienna/Stadt; WMAA; Walker. **Bibliography:** *America 1976; Art: A Woman's Sensibility; Art Now 74;* Carmean, Jr., et al 2; *Drawings: The Pluralist Decade; Kunst um 1970;* Lippard 3; Lucie-Smith; *New in the Seventies; Nancy Graves,* 1971; *Nancy Graves,* 1973; Sager. Archives.

GRAY, CLEVE b. September 22, 1918, NYC. **Studied:** Princeton U., 1940, BA summa cum laude, PBK; Academie Andre Lhote; privately with Jacques Villon in Paris. US Army, 1943-46. Traveled: India, Indonesia, Japan, China, Europe, USA. **Taught:** Honolulu Academy, 1970-71; American Academy, Rome, 1980, Visiting Scholar, 84-86. **Member:** Century Association; Trustee, New York Studio School, 1970-. **Awards:** U. of Illinois, P.P.; Ford Foundation, P.P. **Address:** Cornwall Bridge, Cornwall, CT 06754. **Dealer:** Berry-Hill Galleries, NYC. **One-man Exhibitions:** (first) J. Seligmann and Co., 1947, also 1948, 49, 50, 52, 54, 57, 59; Staempfli Gallery, NYC, 1960, 62, 64; Galleria Pagani del Grattacielo, Milan, 1963; Jerrold Morris Gallery, Toronto, 1963; Oklahoma, 1963; Saidenberg Gallery, NYC, 1965, 67; Hargate Art Center, Concord, Mass., 1969; Betty Parsons Gallery, NYC, 1970, 72, 74, 76, 80, 82; Sneed-Hillman Gallery, 1970, 73, 74; Honolulu Academy, 1970, 71; Princeton U., 1970; Purchase/SUNY, 1972, 74, 79, 83, 84; Buffalo/Albright, 1977; Columbus, 1977; U. of Illinois, 1977; Museum of Art, Providence, R.I., 1978; Mattatuck Museum, 1980; Yale U. Divinity School, 1980; Irving Galleries, Palm Beach, 1980-91; Caracas, 1980; Yale U., 1981; Michael Lord Gallery, Milwaukee, 1981; Benjamin Mangel Gallery, Philadelphia, 1983, 86; American Embassy, Prague, 1984; Robert L. Kidd Gallery, Birmingham, Mich., 1984; Griffin-Haller Gallery, Washington Depot, Ct., 1984; Gallery Two Nine One, Atlanta, 1984; Armstrong Gallery, NYC, 1984, 86, 87; Fairweather-Hardin Gallery, Chicago, 1984, 86; Central Connecticut State U., 1990; Eva Cohon Gallery, Chicago, 1991. **Retrospective:** Brooklyn Museum, circ., 1987. **Group:** WMAA Annuals; Chicago/AI; SRGM, Abstract Expressionists and Imagists, 1961; Hartford/Wadsworth; PAFA; El Retiro Parquet, Arte de America y España, 1963; Andover/Phillips, Decades, 1969; Minne-

sota/MA, Drawings USA, 1973; Hartford/Wadsworth, Nine Connecticut Artists, 1974; Cathedral of St. John the Divine, NYC, Sacred Images—East and West, 1978; Jewish Museum, Jewish Themes/Contemporary American Artists, 1982; Bruce Museum, Greenwich, Ct., Connecticut Biennial, 1989. **Collections:** Andover/Phillips; Boston/MFA; Brandeis U.; Brooklyn Museum; Buffalo/Albright; U. of California; Corcoran; Columbia U.; Columbus; Hartford/Wadsworth; Honolulu Academy; Houston/MFA; U. of Illinois; Jewish Museum; MMA; Mattatuck; Minnesota/MA; NCFA; NYU; Nashville; U. of Nebraska; New Britain/American; New School for Social Research; Newark Museum; U. of Notre Dame; Oklahoma; Phillips; Princeton U.; Purchase/SUNY; RISD; SRGM; St. Paul Gallery; Vanderbilt U.; WMAA; West Palm Beach/Norton; Williams College; Yale U. **Bibliography:** Goodrich and Baur 1; *7 Decades.* Archives.

GREEN, ART b. May 13, 1941, Frankfort, Ind. Canadian Citizen, 1976. **Studied:** Chicago Art Institute School, 1965, BFA, with Ray Yoshida, Vera Berdich, Paul Weighart, T. Kapsalis. Traveled Canada, USA, England. **Taught:** Wright Jr. College, Chicago, 1967-68; Kendall College, Evanston, Ill., 1968-69; Nova Scotia College of Art & Design, Halifax, 1969-71; U. of British Columbia, 1975; U. of Waterloo, 1977-. **Member:** "The Hairy Who," Chicago, 1966-69. **Awards:** Cassandra Foundation Grant, 1970; The Canada Council Award, 1971, 72, 76; U. of Waterloo, Ont., Distinguished Teaching Award, 1990. **Address:** 5 Elizabeth Street, Stratford, Ont., Canada N5A 4ZI. **Dealer:** Phyllis Kind Gallery, NYC & Chicago. **One-man Exhibitions:** (first) Kendall College, 1968; Mt. Allison U., 1973; Phyllis Kind Gallery, NYC, 1976, 79, 86; Phyllis Kind Gallery, Chicago, 1974, 75, 78, 80, 81, 83, 86; Bau-Xi Gallery, Toronto, 1973, 79, 83; PAFA,

Peale House, 1976; The Gallery, Stratford, Ont., 1976, 79, 92; U. of Waterloo, 1979; Burnaby (B.C.) Art Gallery, 1979; Cambridge (Ont.) Library and Art Gallery, 1991. **Group:** Hyde Park Art Center, Chicago, The Hairy Who, 1966, 67; School of Visual Arts, NYC, The Hairy Who—Drawings, 1969; Chicago/Contemporary, Don Baum Sez, "Chicago Needs Famous Artists," 1969; WMAA, Human Concern/Personal Torment, 1969; Ottawa/National, What They're Up To in Chicago, 1972; 12th São Paulo Biennial, 1973; WMAA, Extraordinary Realities, 1973; Sunderland (Eng.) Arts Center, Who Chicago?, circ., 1980; Kansas City/AI, Chicago Imagists, 1982; Fort Wayne/MA, Indiana Influence, 1984; U. of Chicago, The Chicago Imagist Print, 1987; U. of Chicago, The Drawings of the Chicago Imagists, 1987; Bowling Green State U., Of New Account, 1987; Indianapolis/Herron, Welcome Back, 1988; Madison Art Center, Coming of Age, 1989. **Collections:** Baxter Laboratories; Chase Manhattan Bank; Chicago/AI; Chicago/Contemporary; Commodoties Corp.; Continental Bank; Dalhousie U.; Elkhart; Halifax; Madison Art Center; NMAA; New Orleans Museum; Northern Illinois U.; Ottawa/National; PAFA; Vienna/Moderner; U. of Waterloo. **Bibliography:** Adrian and Born.

GREEN, GEORGE D. b. June 24, 1943, Portland, Ore. **Studied:** Oregon State U., 1961-62; U. of Oregon, 1965, BS, with Jack Wilkenson, Gordon Gilkey; Washington State U., 1968, MFA. **Taught:** U. of Texas, 1969-72; SUNY, 1972-80. **Address:** 451 West Broadway, NYC 10012. **Dealer:** Louis K. Meisel Gallery, NYC. **One-man Exhibitions:** Boise College, 1968; Eastern Washington State College, 1968; Clarke College, 1969; Lawson Galleries, San Francisco, 1969; Winn Galleries, Austin, 1969, 70, 71; Comora Gallery, Los Angeles, 1970; Witte, 1970; Artists' Space, NYC, 1974; Hansen Gal-

lery, NYC, 1974; Potsdam/SUNY (two-man), 1974; Missoula/MA, 1976; Montana State U., 1976; Salem (Ore.) Art Museum, 1976; Corvallis Art Center, 1977; Triangle Art Gallery, San Francisco, 1977, 80; Syracuse/Everson, 1978; Louis K. Meisel Gallery, NYC, 1978, 79, 81, 82, 83, 84, 85, 86, 87, 89, 90; Hokin Gallery, Chicago, 1981; St. Lawrence U., 1981; Union College, Cranford, N.J., 1982; Hokin Gallery, Palm Beach, 1983; Hokin-Kaufman Gallery, Chicago, 1984, 85, 87; Galerie Lavignes-Basteille, Paris, 1986; Cultural Center, Douai, France, 1986; Hokin Gallery, Bar Harbor Islands, 1986; J.J. Brookings Gallery, San Jose, 1986; Muhlenberg College, Allentown, Pa., 1986; U. of Oregon, 1987; Art Now Gallery, Gotenborg, Sweden, 1987; Posner Gallery, Milwaukee, 1991. **Group:** Fort Worth/AM, National Drawing Invitational, 1969; MWP/Utica, New York Annual, 1973; Potsdam/SUNY, Invitational '78, 1978; Pittsburgh Arts and Crafts Center, Photorealism and Abstract Illusionism, 1978; Springfield, Mass./MFA, Abstract Illusionism, 1978; Denver/AM, Reality of Illusions, circ. 1979; Randolph Macon Women's College, NoHo, SoHo, and Tribeca, 1983, Annual, 1990. **Collections:** Akron/AM; Brandeis U.; Chase Manhattan Bank; Chency Cowles Memorial Museum; Chicago/AI; Cornell U.; Currier; Dartmouth College; Denver/AM; Detroit/Institute; Fort Worth; ICA, U. of Pennsylvania; Indianapolis; Jacksonville/AM; Lloyds Bank; Los Angeles/County AM; Marquette U.; U. of Oklahoma; U. of Oregon; Portland (Ore.)/AM; Potsdam/SUNY; Prudential Insurance Co. of America; SRGM; St. Lawrence U.; Syracuse/Everson; TRW, Inc.; U. of Texas; Utica. **Bibliography:** Toher, ed.

GREENE, BALCOMB b. May 22, 1904, Shelby, N.Y. d. November 12, 1990, Montauk Point, N.Y. **Studied:** Syracuse U., 1922-26, AB; Columbia U., 1927; U. of Vienna, 1926-27; NYU, 1943,

MA; self-taught in art. Traveled Europe extensively. **Taught:** Dartmouth College (English), 1928-31; Carnegie, 1942-59. Editor, *Art Front* magazine, 1935-36. Fire in New York studio, 1941, destroyed many early paintings. **Member:** American Abstract Artists (first chairman, 1936-37, 1938-39, 1940-41); International Institute of Arts and Letters; Cosmopolitan Club, NYC. Federal A.P. Mural Division: New York World's Fair, 1939; Federal Hall of Medicine (mural); Bronx (N.Y.) High School of Science (stained-glass window); Williamsburg Housing Project, Brooklyn, 1939 (mural); NIAL. **Awards:** *Art News* (magazine) Critics Choice, 1950, 53, 55, 56; PAFA, Carol H. Beck Gold Medal, 1961; NAD, Benjamin Altman Prize for Figure Painting, 1976. **One-man Exhibitions:** (first) a gallery in Paris, 1932; J. B. Neumann's New Art Circle, NYC, 1947; The Bertha Schaefer Gallery, NYC, 1952, 54, 55, 56, 58, 59, 61; Arts and Crafts Center, Pittsburgh, 1953, 66; American U., 1957; Brookhaven National Laboratory, 1959; American Cultural Center, Paris, 1960; Saidenberg Gallery, 1962, 63, 65, 67, 68; Feingarten Gallery, Los Angeles, 1963, 64; La Jolla, 1965; U. of Florida, 1965; Tampa/AI, 1965; James David Gallery, Miami, 1965, 66; Main Street Gallery, Chicago, 1966; Santa Barbara/MA, 1966; Phoenix, 1966; Adele Bednarz Gallery, 1966-69; Occidental College, 1967; The Berenson Gallery, 1967, 68, 69; Makler Gallery, Philadelphia, 1968; The Forum Gallery, 1970, 73, 74, 75; Fairweather-Hardin Gallery, Chicago, 1972, 73; Harmon Gallery, Naples, Florida, 1974, 75, 76, 77, 79; International Oceanographic Institute, Key Biscayne, Fla., 1976; ACA Gallery, NYC, 1977, 79, 82; Yares Gallery, Scottsdale, Az., 1979; Katharine Rich Perlow Gallery, NYC, 1986, 88, 90; A.M. Sachs Gallery, NYC, 1984; Harmon-Meek Gallery, Naples, Fla., 1982, 85; Roanoke/MFA, 1986; Skidmore College, 1986. **Retrospectives:** WMAA/A.F.A., circ., 1961; Guild Hall,

East Hampton, 1978. **Group:** American Abstract Artists Annuals; WMAA Annuals; U. of Illinois; Chicago/AI; Walker; SRGM; Brooklyn Museum; Carnegie. **Collections:** Ball State U.; Baltimore/MA; Brooklyn Museum; Carnegie; Chicago/AI; Corcoran; Guild Hall; Hartford/Wadsworth; Houston/MFA; Indianapolis/Herron; U. of North Carolina; MIT; MMA; MOMA; Metropolitan Life Insurance; U. of Miami; NCFA; U. of Nebraska; U. of North Carolina; Omaha/Joslyn; PAFA; Pasadena/AM; Portland, Ore./AM; Purchase/SUNY; SRGM; Southampton/Parrish; U. of Texas; Vassar College; U. of Virginia; WMAA; Walker; Youngstown/Butler. **Bibliography:** Baur 5, 7; Flanagan; Frost; Goodrich and Baur 1; Hess, T.B., 1; Janis, S.; Kootz 2; Lane and Larsen; Newmeyer; Nordness, ed.; Pousette-Dart, ed.; Read 2; Richardson, E.P.; Ritchie 1; Rodman 3; Rose, B., 4; Sandler 3. Archives.

GREENE, STEPHEN b. September 19, 1918, NYC. **Studied:** ASL, with Morris Kantor, 1937; State U. of Iowa, with Philip Guston, 1939-42, 1944-45, BFA, MA. Traveled Europe, North Africa. **Taught:** Indiana U., 1945-56; Washington U., 1946-47; Pratt Institute, 1959-64; Parsons School of Design; NYU; Princeton U., Artist-in-Residence, 1956-59; ASL, 1959-65; Columbia U., 1961-68; Stella Elkins Tyler School of Fine Arts, Temple U., 1968-85; Princeton U., 1985-86. **Member:** Trustee, Louis Comfort Tiffany Foundation. **Awards:** Prix de Rome, 1949; Corcoran, William A. Clark Prize and Corcoran Medal, 1966; National Council on the Arts, $5,000, 1966; NIAL, $2,500, 1967; NAD, Andrew Carnegie Prize, 1970; NAD, Obrig Award, 1985. **Address:** 408A Storms Road, Valley College, NY 10989. **Dealer:** Galeria Ponce, Mexico City. **One-man Exhibitions:** (first) Durlacher Brothers, 1947, also 1949, 52; Grace Borgenicht Gallery, Inc., NYC, 1955, 57, 58; Staempfli Gallery, NYC,

1961 (circ., 1964), 64, 66, 69; William Zierler Gallery, Inc., NYC, 1971, 72, 73; U. of Wisconsin, 1972; U. of Alberta, circ., 1972; Galleria d'Arte l'Obelisco, 1975; College of William and Mary, 1977; U. of Connecticut, 1977; Marilyn Pearl Gallery, NYC, 1978, 80, 83, 85; Galeria Ponce, Mexico City, 1977, 79, 82; Ruth Bachofner Gallery, Los Angeles, 1985; Matthew Hamilton Gallery, Philadelphia, 1984. **Retrospectives:** Corcoran, 1963; Lincoln, Mass./De Cordova, 1953; Akron/AI, circ., 1978. **Group:** MMA, American Paintings Today, 1950; Chicago/AI, Contemporary Drawings from 12 Countries, 1952; Walker, Reality and Fantasy, 1954; Paris/Moderne, American Drawings, 1954; WMAA, The New Decade, 1954-55; MOMA, Recent Drawings USA, 1956; I International Religious Art Biennial, Salzburg, 1958; VI São Paulo Biennial, 1961; WMAA Annuals; SRGM, Abstract Expressionists and Imagists, 1961; Corcoran; Carnegie; Chicago/AI; El Retiro Parquet, Madrid, Arte de America y España, 1963; Internationale der Zeichnung, Darmstadt, 1964; MMA, American Paintings, Drawings and Watercolors from the Museum's Collections, 1969; WMAA, Human Concern/Personal Torment, 1969; Foundation Maeght, L'Art Vivant, 1970; Museo Comunale, Prato, Italy, American Painters in Europe, 1973; SRGM, American Painters Through Two Decades, 1973; Rome Quadriennial, 1977; WMAA, The Figurative Tradition and the WMAA, 1980; NAD, 1981, 85; WMAA, Decade of Transition 1940-1950, 1981; AAIAL, 1982; Rutgers U., Realism and Realities, 1982. **Collections:** American Republic Insurance Co.; Andover/Phillips; Atlantic Richfield Co.; Brandeis U.; Brooklyn Museum; Carnegie; Chase Manhattan Bank; Chicago/AI; Columbia U.; Corcoran; Dayton/AI; Detroit/Institute; Hamline U.; Hartford; High Museum; Hirshhorn; U. of Illinois; Indiana U.; Indianapolis/Herron; Kalamazoo/Institute; Kansas City/Nelson; U. of Kentucky;

MMA; MOMA; Minnesota/MA; NYU; Nashville; New Orleans/Delgado; New Orleans Museum; Owens-Corning Fiberglas Corp.; Pasadena/AM; Princeton U.; SFMA; SRGM; St. Louis/City; Santa Barbara/MA; Tate; Trenton/State; Utica; VMFA; WMAA; Yale U. **Bibliography:** Baur 7; Bazin; Genauer; Mendelowitz; Sachs; Soby 5; Ward. Archives.

GREENLY, COLIN b. January 21, 1928, London, England. **Studied:** Harvard U., 1948, AB; American U. (with Robert Gates); Columbia U. (with Oronzio Maldarelli, Peppino Mangravite). Traveled western USA, France, Italy, England. **Taught:** Established art programs for employee groups at Standard Oil, Metropolitan Life Insurance Co., Union Carbide Corp., New York Life Insurance, all NYC, 1951-53; US Dept. of Agriculture, Graduate School, 1954-56; Madeira School, Greenway, Va., 1955-68; Colgate U., 1972-73; Central Michigan U., 1972; Finch College, NYC, 1974; Windham College, 1976. **Commissions:** New York State Office Building, Utica (twelve color panels), 1973. **Awards:** Corcoran, P.P., 1956; The Corcoran School of Art, National Playground Sculpture Competition, First Prize, 1967; National Council on the Arts, Grant, 1967; CAPS, 1972, 77; Committee for the Visual Arts Grant, NYC, 1974. **Address:** Hulestour Rd., Campbell Hall, NY 10916. **One-man Exhibitions:** (first) Jefferson Place Gallery, 1958, also 1960, 63, 65; The Bertha Schaefer Gallery, 1964, 66, 68; Corcoran, 1968; Royal Marks Gallery, 1968, 70; Syracuse/Everson, 1971; Cornell U., 1972; Fredonia/SUNY, 1973; Colgate U., 1973; The Schenectady (N.Y.) Museum, 1973; Alfred/SUNY, 1974, 75; Nassau Community College, Garden City, N.Y., 1974; Finch College, NYC, 1974; Creative Arts Workshop, New Haven, 1975; 112 Greene Street, NYC, 1976. **Retrospective:** Corcoran, 1968. **Group:** MOMA, Young American Printmakers, 1953; Corcoran, 1955-57; Lincoln,

Mass./De Cordova, 1965; Flint/Institute, Made of Plastic, 1968; Grand Rapids, Sculpture of the 60s, 1969; Baltimore/MA, Washington; Twenty Years, 1970; New York State Fair, Enviro-Vision, circ., 1972; U. of Illinois, 1974. **Collections:** Buffalo/Albright; Corcoran; Cornell U.; Des Moines; High Museum; MOMA; Manufacturers and Traders Trust Co., Buffalo, N.Y.; NCFA; National Gallery; PMA; Virginia National Bank.

GREGOR, HAROLD LAURENCE b. September 10, 1929, Detroit, Mich. **Studied:** Wayne State U., 1951, BS, Ed., with Jane Betsy Welling, Earl Weilley; Michigan State U., 1953, MS, with Louis Raynor, Murray Jones; Ohio State U., 1960, Ph.D., with Hoyt Sherman. Traveled Europe, USA. US Army, 1953-55. **Taught:** Ohio State U., 1957-60; San Diego State College, 1960-62; Purdue U., 1963-66; Chapman College, 1966-70; Illinois State U., 1970-. **Awards:** National Endowment for the Arts, 1973. **Address:** 107 West Market Street, Bloomington, Ill. 61701. **Dealers:** Richard Gray Gallery, Chicago; Sherry French Gallery, NYC. **One-man Exhibitions:** (first) Jefferson Gallery, La Jolla, 1963; Countryside Gallery, Arlington Heights, Ill., 1973; Virginia Commonwealth U., 1973; Metropolitan State College, 1973; Fresno State U., 1973; 118: An Art Gallery, Minneapolis, 1974; Central Michigan U. (two-man), 1975; Cynthia Comsky Gallery, Beverly Hills, 1976; Northern Indiana Art Association, Hammond, 1976; Western Illinois U., 1977; Parkland College, Champaign, Ill., 1984; Nancy Lurie Gallery, Chicago, 1974, 76, 77, 78, 79, 80, 81, 83; Richard Gray Gallery, 1983; Tibor de Nagy Gallery, NYC, 1977, 78, 79, 81, 82; Peoria (Ill.) Art Guild, 1985. **Group:** Omaha/Joslyn, Midwest Biennial, 1972; West Palm Beach/Norton, Imagist Realism, 1974; Sacramento/Crocker, The Chicago Connection, circ., 1976; Youngstown/Butler,

National Mid-year Show, 1976; Chicago/AI, 1978; U. of Nebraska, Things Seen, circ., 1979; U. of North Carolina, 1979; PAFA, Contemporary American Realism Since 1960, circ., 1981. **Collections:** Brandeis U.; Chicago/Contemporary; Dartmouth College; U. of Georgia; U. of Guam; Illinois State Museum; The Pennsylvania State U.; Rockford/Burpee; San Diego; Southwestern College; Syracuse U.; Western Illinois U.; Yavapai College.

GRIEFEN, JOHN ADAMS
b. November 24, 1942, Worcester, Mass. **Studied:** Williams College, 1966, BA; Bennington College, 1965-66, with Jules Olitski; Hunter College, 1966-68; Chicago/AI, 1964-65. Traveled Europe. Designed sets for opera and theater. **Taught:** Bennington College, 1968. **Address:** 57 Laight Street, NYC 10013. **Dealer:** Salander-O'Reilly Galleries, NYC. **One-man Exhibitions:** (first) The Kornblee Gallery, NYC, 1969, 70, 73; Harcus-Krakow Gallery, Boston, 1972; Phyllis Kind Gallery, Chicago, 1973; Frank Watters Gallery, Sydney, Australia, 1975; Deitcher-O'Reilly Gallery, NYC, 1976; William Edward O'Reilly Inc., NYC, 1978; B.R. Kornblatt Gallery, Baltimore, Md., 1978; Diane Brown Gallery, Washington, D.C., 1978; Martha Jackson Gallery, NYC, 1979; Sunne Savage Gallery, Boston, 1979; Galerie Wentzel, Hamburg, 1980; Williams College, 1980; Martin Gerard Gallery, Edmonton, 1981; Gallery Moos, Toronto, 1981; Salander-O'Reilly Galleries, NYC, 1981, 82, 85, 91; W. R. Mitchell & Associates, Calgary, 1983; Edmonton Art Gallery, 1984; Hirondelle Gallery, NYC, 1986; Salander-O'Reilly Galleries, Beverly Hills, 1991. **Group:** Ridgefield/Aldrich, Lyrical Abstraction, 1970; Akron/AI, Watercolors and Drawings by Young Americans, 1970; Indianapolis, 1970, 72; WMAA, Lyrical Abstraction, 1971; Edmonton Art Gallery, The Threshold of Color, 1982; Youngstown/Butler, 1985. **Collections:** Barnard

College; Boston/MFA; Brandeis U.; Brisbane/QAG; Brooklyn Museum; Carnegie; Chase Manhattan Bank; Detroit/Institute; Edmonton Art Gallery; Fort Lauderdale; Hirshhorn; Lincoln, Mass./De Cordova; MMA; MOMA; U. of Massachusetts; Mechanics National Bank, Worcester; Newark Museum; Oberlin College; Ridgefield/Aldrich; Sydney/AG; St. Lawrence U.; U. of Texas; Utica; Vassar College; WMAA; Williams College; Worcester/AM.

GRILLO, JOHN **b.** July 4, 1917, Lawrence, Mass. **Studied:** Hartford Art School, 1935-38; California School of Fine Arts, 1946; Hofmann School, NYC, 1949-50. US armed forces, 1944-46. **Taught:** Southern Illinois U., 1960; School of Visual Arts, NYC, 1961; U. of California, Berkeley, 1962-63; New School for Social Research, 1964-66; Pratt Institute, 1965-66; State U. of Iowa, 1967-; U. of Massachusetts, Artist-in-Residence, 1968-69. **Awards:** CSFA, Albert M. Bender Fellowship, 1947; Ford Foundation Fellowship (Tamarind Lithography Workshop and Youngstown/Butler), 1964. **Address:** c/o Dealer. **Dealer:** Jean Lumbard Fine Arts, NYC. **One-man Exhibitions:** Daliel Gallery, Berkeley, 1947; Artists' Gallery, NYC, 1948; Tanager Gallery, NYC, 1952, 60; Tibor de Nagy Gallery, NYC, 1953, 70; The Bertha Schaefer Gallery, NYC, 1955, 57, 59; HCE Gallery, Provincetown, Mass., 1959, 62; The Howard Wise Gallery, NYC, 1961, 62, 63; Ankrum Gallery, 1962; U. of California, Berkeley, 1962; East End Gallery, Provincetown, 1963; Youngstown/Butler, 1964; Waitsfield/Bundy, 1966; New School for Social Research, 1967; State U. of Iowa, 1967; Simmons College, 1968; Eleanor Rigelhaupt Gallery, Boston, 1968; Benedict Art Center, St. Joseph, Minn. 1969; Horizon Gallery, NYC, 1969; Robert Dain Gallery, NYC, 1970; Landmark Gallery Inc., NYC, 1973; Borgenicht Gallery, Inc., NYC, 1975, 77, 78; Pisces Gallery, Wellfleet, Mass., 1977; Union College,

Cranford, N.J., 1977; Art Association of Newport, R.I., 1979; Jean Lumbard Fine Arts, NYC, 1983. **Retrospectives:** The Olsen Foundation, Inc., circ., USA, 1956-60; Provincetown Art Association, 1988. **Group:** The Kootz Gallery, NYC, Fifteen Unknowns, 1950; Walker, Vanguard, 1955; WMAA Annual, 1959; Walker, 60 American Painters, 1960; SRGM, Abstract Expressionists and Imagists, 1961; Yale U., Contemporary Painting, 1961; Dallas/MFA, 1961, 62; Seattle World's Fair, 1962; MOMA, Hans Hofmann and His Students, circ., 1963-64; SFMA, Directions—Painting U.S.A., 1963, Buffalo/Albright, 1964; Brooklyn Museum Print Biennial, 1970; Oakland/AM, California Artists, 1944-1952, 1973; SRGM, 40 Modern Masters, 1977; Syracuse/Everson, Provincetown Painters, 1890s-1970s, 1977; MMA, Hans Hofmann as Teacher: Drawings by His Students, 1979. **Collections:** Baton Rouge; Bennington College; Brooklyn Museum; Ciba-Geigy Corp.; Dartmouth College; Hartford/Wadsworth; Hayden, Shearson, Inc., NYC; Los Angeles/County MA; MMA; Newark Museum; Norfolk/Chrysler; The Olsen Foundation, Inc.; Pittsburgh; Portland, Me./MA; SRGM; Smith College; Southern Illinois U.; U. of Texas; Union Carbide Corp.; WMAA; Waitsfield/Bundy; Walker; Westinghouse; Youngstown/Butler. **Bibliography:** Blesh 1; McChesney; Sandler 1.

GRIPPE, PETER b. August 8, 1912, Buffalo, N.Y. **Studied:** Albright Art School; Buffalo Fine Arts Academy, with E. Wilcox, Edwin Dickinson, William Ehrich; Atelier 17, NYC. Traveled Europe. **Taught:** Black Mountain College, 1948; Pratt Institute, 1949-50; Smith College, 1951-52; Atelier 17, NYC, 1951-52; Brandeis U., 1953-80. Federal A.P.: Taught sculpture and drawing, 1939-42. **Commissions:** Creative Arts Award Medallion design for Brandeis U., 1954; Puerto Rican Information Center, NYC, 1958 (two

sculpture murals); Theo Shapiro Forum, Brandeis U., 1963 (sculpture). **Awards:** Brooklyn Museum, P.P., 1947; MMA, $500 First Prize, 1952; The Print Club, Philadelphia, Charles M. Lea Prize, 1953; National Council for United States Art, $1,000 Sculpture Award, 1955; Boston Arts Festival, First Prize for Sculpture, 1955; Rhode Island Arts Festival, Sculpture Award, 1961; Guggenheim Foundation Fellowship, 1964, 70. **Address:** 1190 Boylston St., Newton, MA 02164. **One-man Exhibitions:** (first) Orrefors Galleries, NYC, 1942; The Willard Gallery, NYC, 1944, 45, 46, 48; Brandeis U., 1957; The Peridot Gallery, 1957, 59; Lee Nordness Gallery, NYC, 1960, 63; College of the Holy Cross, Worcester, 1986. **Group:** MMA, Contemporary American Art, 1942; WMAA, Annuals, 1944, 45, 47, 48, 50, 51, 52, 54, 56, 57, 60, 62; Federation of Modern Painters and Sculptors, 1944, 45, 52; American Abstract Artists Annuals, 1946, 47, 49; Carnegie, 1946, 48; Brooklyn Museum, 1947, 48, 49, 53, 56, 58; Detroit/Institute, Origins of Modern Sculpture, 1948; Chicago/AI, Abstract and Surrealist Art, 1948; A.F.A., Tradition and Experiment in Modern Sculpture, circ., 1950-51; MMA, National Sculpture Exhibition, 1951; MOMA, Abstract Painting and Sculpture in America, 1951; Ninth Street Exhibition, NYC, 1951; MOMA, From Sketch to Sculpture, 1952; PAFA, 1952, 59; U. of Illinois, 50 Contemporary American Printmakers, 1956; ART:USA:59, NYC, 1959; PCA, American Prints Today, circ., 1959-62; ICA, Boston, View, 1960; U. of Illinois, 1961; Chicago/AI, 1961; Smithsonian, Drawings by Sculptors, circ., USA, 1961-63; A.F.A., Hayter and Atelier 17, circ., 1961-62; Hartford/Wadsworth, Eleven New England Sculptors, 1963; MOMA, The New American Painting and Sculpture, 1969; Brandeis U., 1973. **Collections:** Andover/Phillips; Brandeis U.; Brooklyn Museum; Buffalo/Albright; Fort Dodge/Blanden; U. of Georgia; Library of

Congress; MMA; MOMA; U. of Michigan; Milwaukee-Downer College; NYPL; National Gallery; Newark Museum; Norfolk/Chrysler; PCA; PMA; The Print Club, Philadelphia; Raleigh/NCMA; Simmons College; Tel Aviv; Toledo/MA; USIA; WMAA; Walker; Washington U. **Bibliography:** Baur 7; Blesh 1; Brumme; Flanagan; Hayter 1; Mendelowitz; Moser 1; Motherwell and Reinhardt, eds.; Ritchie 1; Seuphor 3; Trier.

GROOMS, RED **b.** June 2, 1937, Nashville, Tenn. **Studied:** Peabody College; privately with J. Van Sickle; New School for Social Research; Chicago Art Institute School; Hofmann School, Provincetown. Traveled Europe, Near East. Sets and costumes for *Guinevere,* a play by Kenneth Koch, 1964; Designed sets for *Red Robins,* play by Kenneth Koch, 1978; Sets and costumes for *City Junketh,* play by Kenward Elmslie for Eye and Ear Theatre, NYC, 1980; Set for *Creation of the World,* dance by Jacques d'Amboise, 1984. **Commissions:** Center for Modern Culture, Florence, Italy (mural, with Mimi Gross); Hudson River Museum, bookstore, 1978; Northern Kentucky U., 1978; ICA, U. of Pennsylvania, 1982. American Museum of the Moving Image, *Tut's Fever Movie Palace,* 1988; Set design for *Meilleurs Amis* by Jacques d'Amboise, 1989; Set design for *The Shooting of Dan McGrew* by Jacques d'Amboise; Set design

Red Grooms, *Clean & Press,* 1989.

for *The Mysteries* and *What's So Funny* by David Gordon, Spoleto Festival, USA, 1991; Set design for *Chakra: A Celebration of India* by Jacques d'Amboise, 1991. **Awards:** Ingram Merrill Foundation Grant, 1968; AAAL Grant, 1969; CAPS, 1970; RISD, President's Award, 1985; National Arts Club, Gold Medal, 1986; Tennessee Governor's Award in the Arts, 1986; PAFA, Founders Medal, 1990. **Address:** 85 Walker Street, NYC 10013. **Dealer:** Marlborough Gallery, Inc., NYC. **One-man Exhibitions:** (first) Sun Gallery, Provincetown, 1958; City Gallery, NYC, 1958-59; Reuben Gallery, NYC, 1960; Tibor de Nagy Gallery, NYC, 1963, 65, 66, 67, 69, 70; Artists Guild, Nashville, 1962; Walker, 1970; John Bernard Myers Gallery, 1971, 74; Allan Frumkin Gallery, Chicago, 1972; Fendrick Gallery, 1972; Graphics 1 & Graphics 2, Boston, 1972; Nashville, 1972; Rutgers U., 1973; Brooks Alexander Gallery, NYC, 1975; Marlborough Gallery, NYC, 1976, 77, 81, 84, 86, 87, 89, 90, 92; Galerie Roger d'Amecourt, Paris, 1977; Van Straaten, Gallery, Chicago, 1976; Benjamin Mangel Gallery, Bala Cynwyd, 1977; Santa Barbara, 1977; Philadelphia, 1985; New Gallery, Cleveland, 1977; Showcase Galleries, Southfield, Mich., 1977; Martin Wiley Gallery, Nashville, 1978; Purchase/SUNY, 1978; Hudson River Museum, 1979; Virginia Commonwealth U., 1979; Colorado State U., 1980; Camp Gallery, St. Louis, Mo., 1980; U. of Miami, 1980; Aspen Center for the Visual Arts, 1981; Montgomery Bell Academy, Nashville, 1981; Marlborough Fine Arts, London, 1985; Hokin/Kaufman Gallery, Chicago, 1985; Circulo des Bellas Artes, Madrid, 1985; Cumberland Gallery, Nashville, 1986; Harvard U., 1987; Kathryn Ellman Gallery, Aspen, 1991; Arvada (Colo.) Center for the Arts and Humanities, 1991. **Happenings:** Fire, Sun Gallery, Provincetown, 1958; Walking Man, Sun Gallery, Provincetown, 1959; Burning Building, Delancey Street Museum, NYC, 1959;

Magic Train Ride, Reuben Gallery, NYC, 1960; U. of California, Berkeley, 1968; Ruckus Studio, NYC, 1972; *In 32 Chromosomes,* by Elizabeth Ross, 99 Prince Street, NYC, 1980. **Films:** *Unwelcome Guests,* 1961; *Shoot the Moon,* 1962; *Miracle on the BMT,* 1963; *Lurk,* 1964; *Spaghetti Trouble,* 1964; *Man or Mouse,* 1964; *Umbrellas, Bah!,* 1965; *Big Sneeze,* 1965; *Secret of Wendel Sampson,* 1965-66; *Before 'n' After,* 1966; *Washington's Wig Whammed!,* 1966; *Fat Feet,* 1966; *Meow, Meow!,* 1967; *Tappy Toes,* 1969-70; *Hippodome Hardware,* 1972-73; *The Conquest of Libya by Italia, 1913-1912,* 1972-73; *Ruckus Manhattan,* 1975-76; *Little Red Riding Hood,* 1978; *Hippodrome Hardware,* 1980; *Small Fry Gangsters,* 1985. **Group:** Delancey Street Museum, NYC, 1959, 60; Chicago/AI, 1964; Provincetown/Chrysler; SRGM, 1965; Southampton/Parrish, 1965; Worcester/AM, 1965; A.F.A., 1965-66; Chicago/AI, Twenty Americans, 1966; MOMA, 1966; XXXIV Venice Biennial, 1968; Cologne/Kunstverein, Happening & Fluxus, circ., 1970; ICA, U. of Pennsylvania, The Spirit of the Comics, 1969; SRGM, 10 Independents, 1972; Harvard U., Recent Figure Sculpture, 1972; WMAA, Extraordinary Realities, 1973; Hirshhorn Inaugural Exhibition, 1974; Dallas/MFA, Poets of the Cities, 1974; Fort Worth, The Great American Rodeo, 1975; Stamford, Conn., American Salon des refusés, 1976; Potsdam/SUNY, Off the Beaten Path, 1977; WMAA, Art About Art, 1978; Chicago/AI, Centennial Exhibition, 1979; Denver/AM, Poets and Painters, 1979; XXXIX Venice Biennial, 1980; Dublin/Municipal, International Quadriennial (ROSC), 1980; Brooklyn Museum, Drawings in Black and White: 1970-1979, 1980; PAFA, Contemporary American Realism Since 1960, 1981; Carnegie, International, 1983; Brooklyn Museum, The Great East River Bridge, 1883-1983, 1983; California State U., Long Beach, Figurative Sculpture, 1984; WMAA, Blam!, 1984; Fort Lauderdale, An American Renaissance, 1986; ICI, NYC, After Matisse, circ., 1986; Colgate U., Printmaking: The Third Dimension, 1987; Walker, Sculpture Inside Outside, circ., 1988; Miami/Bass, The Future Now, 1989; Florida International U., American Art Today: The City, 1990; Miyagi Museum of Art, Sendai, Japan, American Realism and Figurative Art, 1952-1991, circ., 1991. **Collections:** Brooklyn Museum; Caracas/Contemporaneo; Carnegie; Charlotte/Mint; Chatanooga/Hunter; Chicago/AI; Chicago/Contemporary; Cleveland/MA; Delaware Art Museum; Denver/AM; Des Moines; Fort Worth; Hirshhorn; Hudson River Museum; Little Rock/MFA; MMA; MOMA; Nashville/Cheekwood; New School for Social Research; Norfolk/Chrysler; Northern Kentucky U.; Oberlin College; PAFA; PMA; Raleigh/NCMA; SRGM; Southern Illinois U.; Stockholm/National; Syracuse/Everson; Trenton/State; WMAA; Youngstown/Butler. **Bibliography:** Arthur 2; Ashbery; Becker and Vostell; Cummings 4; *Drawings, The Pluralist Decade; Figures/Environments;* Geske; *Happening & Fluxus;* Haskell 5; Honisch and Jensen, eds.; Janis and Blesh 1; Kaprow; Kardon 3; Kirby; Lippard 5; Osterwold; *Poets & Painters; Recent Figure Sculpture;* Sandler 3, 5; Sontag. Archives.

GROPPER, WILLIAM b. December 3, 1897, NYC. d. January 4, 1977, Manhasset, N.Y. **Studied:** Ferrar School, San Francisco, with Robert Henri, George Bellows, 1912-13; NAD, 1913-14; New York School of Fine and Applied Art, with Howard Giles, Jay Hambidge, 1915-18. Traveled Europe, USA, USSR. Staff Artist, *New York Tribune,* 1919-21; *New York World,* 1925-27. **Taught:** American Art School, NYC, 1946-48. **Member:** Artists Equity; NIAL, 1968; NAD. **Commissions:** New Interior Building, Washington, D.C.; Northwestern Postal Station, Detroit; US Post Office, Freeport, N.Y.; Schenley Industries, Inc., NYC. **Awards:**

Young Israel Prize; Los Angeles/County MA., P.P.; Indianapolis/Herron, Prize for Lithography; *Collier's* (magazine) Prize for Illustration, 1920; Harmon Foundation Award, 1930; J. S. Guggenheim Fellowship, 1937; Carnegie, Third Prize; MMA, Artists for Victory, Lithography Prize, 1942; Tamarind Fellowship, 1967; NAD, Thomas B. Clarke Prize, 1973; Andrew Carnegie Prize, 1975. **One-man Exhibitions:** ACA Gallery, NYC, 1983. **Retrospectives:** Phoenix; Evansville; Palm Springs Desert Museum; Syracuse U.; U. of Miami, 50 Years of Drawing and Cartoons, circ., 1968. **Group:** MMA; WMAA; Chicago/AI; MOMA; Los Angeles/County MA. **Collections:** Abbott Laboratories; U. of Arizona; Brandeis U.; Britannica; Canton Art Institute; Chicago/AI; Cornell U.; Evansville; Hartford/Wadsworth; Harvard U.; Hirshhorn; Library of Congress; Los Angeles/County MA; MMA; MOMA; Montclair/AM; Moscow/Western; NYPL; Newark Museum; PAFA; Phillips; St. Louis/City; Sofia; Storm King Art Center; Syracuse U.; Tate; U. of Tucson; WMAA; Walker; Youngstown/Butler. **Bibliography:** American Artists Congress, Inc.; Barr 3; Baur 7; Bazin; Boswell 1; Brown; Brown 2; Canaday; Cheney; Christensen; **Freundlich;** Goodrich and Baur 1; Hall; Kootz 2; McCurdy, ed.; Melliquist; Mendelowitz; Pagano; Pearson 1; Reese; Richardson, E.P.; Rose, B., 1; Shapiro, ed.; Wight, 2. Archives.

GROSS, CHAIM b. March 17, 1904, Kolomea, East Austria. **d.** May 4, 1991, NYC. To USA, 1921. **Studied:** Kunstgewerbe Schule; Educational Alliance, NYC; Beaux-Arts Institute of Design, with Elie Nadelman; ASL, with Robert Laurent. Traveled Europe, Israel, Turkey. **Taught:** Educational Alliance, NYC; New School for Social Research. **Member:** Sculptors Guild (President); Artists Equity; Federation of Modern Painters and Sculptors; NIAL. Federal A.P.:

Teacher, supervisor, sculptor. **Commissions:** Main Post Office, Washington, D.C., 1936; Federal Trade Commission Building, Washington, D.C., 1938; France Overseas Building, New York World's Fair, 1939; US Post Office, Irwin, Pa., 1940; Reiss-Davis Child Guidance Clinic, Beverly Hills, 1961; Hadassah Hospital, Jerusalem, 1964; Temple Shaaray Tefila, NYC, 1964; U. of Rhode Island, 1972; International Synagogue, Kennedy International Airport, 1972. **Awards:** L. C. Tiffany Grant, 1933; Paris World's Fair, 1937, Silver Medal; MMA, Artists for Victory, $3,000 Second Prize, 1942; Boston Arts Festival, Third Prize for Sculpture, 1954; PAFA, Hon. Men., 1954; Audubon Artists, Prize for Sculpture, 1955; NIAL Grant, 1956; Boston Arts Festival, First Prize, 1963; NIAL, Award of Merit Medal, 1963; Hon. DFA, Adelphi U., 1980; Hon. DHL, Yeshiva U., 1978; NAD, Waltrous Gold Medal, 1979, 84; Hon. DHL, Hebrew Union College, 1984. **One-man Exhibitions:** (first) Gallery 144, NYC, 1932; Boyer Gallery, Philadelphia, 1935; Boyer Gallery, NYC, 1937; A.A.A., NYC, 1942, 69; Massilon Museum; Akron/AI, 1946; Youngstown/Butler, 1946; New Paltz/SUNY, 1952; Jewish Museum, 1953; Shore Studio, Boston, 1954; Muriel Latow Gallery, Springfield, Mass., 1956; Duveen-Graham Gallery, NYC, 1957; WMAA, circ., 1959; The Marble Arch Gallery, Miami Beach, 1961; Anna Werbe Gallery, Detroit, 1962; The Forum Gallery, NYC, 1962, 64, 67, 72, 73, 74, 77, 80, 87; Irving Galleries, Inc., Milwaukee, 1963; New School for Social Research, 1971; NCFA, 1974; Leonard Hutton Gallery, NYC, 1974; U. of Miami, Fla., 1977; Montclair/AM, 1977; Jewish Museum, NYC, 1977; Prince Arthur Galleries, Toronto, 1977; Wichita/AM, 1982; Nassau County Museum of Art, 1984; Provincetown Art Association, 1984; Shulman Park, White Plains, N.Y. **Group:** WMAA Sculpture Annuals; Sculptors Guild Annuals; PAFA; A.F.A., Sculpture in Wood,

circ., 1941-42; American Painting and Sculpture, Moscow, 1959; MOMA, The Making of Sculpture, circ., 1961-62; Smithsonian, Drawings by Sculptors, circ., USA, 1961-63; New York World's Fair, 1964-65. **Collections:** Ain Harod; Andover/Phillips; Atlanta/AA; Baltimore/MA; Bezalel Museum; Boston/MFA; Brandeis U.; Brooklyn Museum; Bryn Mawr College; Chicago/AI; Colby College; Dayton/AI; Des Moines; Fairleigh Dickinson U.; U. of Georgia; Haifa; Jewish Museum; Kalamazoo/Institute; Kansas City/Nelson; U. of Kansas; La Jolla; MMA; MOMA; Massillon Museum; Milwaukee; U. of Minnesota; Newark Museum; Ogunquit; PAFA; PMA; Phoenix; Queens College; Reading/Public; Reed College; Rutgers U.; Scranton/Everhart; Scripps College; Smith College; Tel Aviv; WMAA; Walker; West Palm Beach/Norton; Worcester/AM; Youngstown/Butler. **Bibliography:** Baur 7; Brumme; Cheney; Craven, W.; Flanagan; Getlein 1; Goodrich and Baur, 1, 2; Gross; Lombardo; Martin; McCurdy, ed.; Marter, Tarbell, and Wechsler; Mendelowitz; Sutton; Wheeler. Archives.

GROSSER, MAURICE b. October 23, 1903, Huntsville, Ala. **d.** December 22, 1986, NYC. **Studied:** Harvard U., 1920-24, with M. Mower. Traveled Europe, USA, Latin America, Africa. Art Critic for *The Nation*, 1961-67. **Taught:** U. of Ife, Nigeria, 1970. **Member:** The Travelers, London, NAD. Librettist of the Gertrude Stein–Virgil Thomson operas *Four Saints in Three Acts* and *The Mother of Us All*. **One-man Exhibitions:** Grace Home Galleries, Boston, 1925; Grand Central Palace, NYC, 1928; Galerie Vignon, Paris, 1931; Galerie des Quatre Chemins, Paris, 1933, 39; Hendrix, Inc. (Gallery), NYC, 1935; Arts Club of Chicago, 1939; Julien Levy Galleries, NYC, 1940, 41, 42, 44, 46; High Museum, 1941; Houston/MFA, 1942; M. Knoedler & Co., 1948, 50; Hugo Gallery, NYC, 1954; Alexander Iolas Gallery, 1955; Car-

stairs Gallery, NYC, 1957, 60, 62; Garlen Gallery, Philadelphia, 1958; The Banfer Gallery, 1963, 65; U. of Ife, 1970; Hirschl & Adler Galleries, 1971; Capricorn Gallery, Washington, D.C., 74; Boston Atheneum, 1975; Richard Larcada Gallery, NYC, 1975, 77; Fischbach Gallery, NYC, 1979, 80, 82, 84, 87. **Group:** U. of Minnesota; MOMA; WMAA; Cleveland/MA; VMFA. **Collections:** The Bank of New York; Brooklyn Museum; Cleveland/MA; Columbus; MOMA; U. of Minnesota; Rockland/Farnsworth; Springfield Art Center; VMFA; U. of Vermont. **Bibliography:** Grosser, 1, 2. Archives.

GROSSMAN, NANCY b. April 28, 1940, NYC. **Studied:** Pratt Institute, BFA. **Taught:** Boston Museum School, 1985. **Member:** Sculptors Guild; Foundation for the Community of Artists. **Awards:** Ida C. Haskell Scholarship for Foreign Travel, 1962; Guggenheim Foundation Fellowship, 1965; Pratt Institute, Inaugural Contemporary Achievement Award, 1966; AAAL, 1974; National Endowment for the Arts, 1984; AAIAL, Hassam and Speicher Fund, P.P., 1989; New York Foundation for the Arts, Fellowship in Sculpture, 1991. **Address:** 105 Eldridge Street, NYC 10002. **One-man Exhibitions:** The Krasner Gallery, NYC, 1964, 65 (2), 67; Cordier & Ekstrom, Inc., NYC, 1969, 1971, 73, 75, 76 (two-man); U. of Nevada, Reno, 1978; Barbara Gladstone Gallery, NYC, 1980; Heath Gallery, Atlanta, 1981, 86; Terry Dintenfass, Inc., 1984; Columbus College, 1988. **Retrospectives:** U. of Nevada, Reno; Sculpture Center, NYC, 1991; Long Island U., circ., 1991. **Group:** PAFA, 1963; Corcoran, 1963; WMAA Annuals, 1968, 73, Contemporary American Sculpture, 1968-69, Human Concern/Personal Torment, 1969; Museum of Contemporary Crafts, Face Coverings, 1970-71; Harvard U., Recent Figure Sculpture, 1972; PMA/Museum of the Philadelphia Civic Center, Focus, 1974; Soho Center for

Visual Artists, Drawing Now: Ten Artists, 1976; Brooklyn Museum, Works on Paper—Women Artists, 1977; Kohler Art Center, Sheboygan, WI, Unpainted Portrait, 1979; Dade Community College, Miami, Fla., The Figure of 5, circ., 1979, 80; NYU, Perceiving Modern Sculpture, 1980; MIT, Body Language, circ., 1981; Houston/Contemporary, The Americans: The Collage, 1982; WMAA, The Sculptor as Draftsman, circ., 1983; Hofstra U., Maelstrom, 1986. **Collections:** Alcoa; U. of Arizona; Baltimore/MA; U. of California, Berkeley; Cleveland/Contemporary; Columbia Broadcasting System; Cornell U.; Dallas/MFA; Hamline U.; Honolulu/Contemporary; U. of Illinois; Kutztown State College; Little Rock/MFA; MMA; Minneapolis/MA; NMAA; Phoenix; Pratt Institute; Princeton U.; Ridgefield/Aldrich; Rotterdam; U. of Utah; WMAA. **Bibliography:** Lucie-Smith; Nemser; *Recent Figure Sculpture.*

GROSVENOR, ROBERT
b. 1937, NYC. **Studied:** École des Beaux-Arts, Dijon, 1956; École Nationale des Arts Décoratifs, 1957-59; Universita di Perugia, 1958. Traveled France, England, Italy, Germany, USA, Mexico. **Taught:** School of Visual Arts, NYC. **Awards:** National Council on the Arts, 1969. **Address:** 543 Broadway, NYC 10013. **Dealer:** Paula Cooper Gallery, NYC. **One-man Exhibitions:** Park Place Gallery, NYC, 1962-66; Dwan Gallery, Los Angeles, 1966; NYU, 1967; Galerie Rolf Ricke, Cologne, 1970; Fischbach Gallery, NYC, 1970; Paula Cooper Gallery, NYC, 1970, 71, 74, 75, 78, 79, 81, 85, 86, 88, 91; La Jolla, 1971; City U. of New York Graduate Center, NYC, 1973; Francoise Lambert, Milan, 1974; Galerie Stampa, Basel, 1975; Galerie Eric Fabre, Paris 1975, 77; Pasquale Trisorio, Naples, 1975; The Clocktower, NYC, 1976; P.S. 1, Long Island City, N.Y., 1984; Margo Leavin Gallery, Los Angeles, 1990. **Group:** New York World's Fair, 1964-65; Jewish Museum, Primary Structures, 1966; ICA, U. of Pennsylvania, 1967; Buffalo/Albright, Plus by Minus, 1968; The Hague, Minimal Art, 1968; WMAA Sculpture Annual, 1968-69; U. of Minnesota, 1969; Walker, 1969; Chicago/Contemporary, 1969; ICA, Boston, Art on Paper, 1970; Cincinnati/Contemporary, Monumental Art, 1970; Arnhem, Sonsbeek '71, 1971; Middelheim Park, Antwerp, XI Sculpture Biennial, 1971; Houston/Contemporary, Eight, 1972; WMAA, 1973; Newport, R.I., Monumenta, 1974; Leverkusen, Zeichnungen III, 1975; Paris/Moderne, Tendances actuelles de la peinture americaine, 1975; WMAA, 200 Years of American Sculpture, 1976; Sydney/AG, Biennale, 1976; Kassel, Documenta VI, 1977; Minnesota/MA, American Drawings, 1927-1977, 1977; U. of Rochester, Drawings and Prints—New York, 1977; Lenbachhaus, Munich, Tendencies in American Drawings of the Late Seventies, 1979; U. of South Florida, Objects, Structures, Artifice, 1983; Bard College, The Maximal Implications of the Minimal Line, 1985; ICI, The Success of Failure, circ., 1987; Kassel, Documenta VIII, 1987; Paris/Beaubourg, L'Époque, La Mode, La Morale, La Passion, 1977-87, 1987. **Collections:** Lannan Foundation; Lipschultz Foundation; MIT; MOMA; NYU; Ridgefield/Aldrich; WMAA; Walker. **Bibliography:** Battcock, ed.; Friedman, M., 2; Kren; Lippard; MacAgy, 2; *Monumenta;* Tuchman 1; Weintraub. Archives.

GROSZ, GEORGE
b. July 26, 1893, Berlin, Germany. d. July 6, 1959, Berlin, Germany. **Studied:** Royal Saxon Academy of Fine Art, Dresden, 1909-11, R. Muller, O. Schindler, R. Sterl, R. Wehle; School of Fine and Applied Arts, Berlin, 1911, with E. Orlik; Academie Colarossi, Paris, 1913. German Army, 1914-16, 1917-18. Traveled Russia, Europe, USA. To USA, 1932; citizen, 1938. **Taught:** Maurice Sterne School, NYC, 1933; ASL, 1933-36,

1940-42, 1943-44, 1950-53; Columbia U., 1941-42. Designed sets for Max Reinhardt Theatre, 1920-30. **Commissions:** A. Harris & Co., Dallas (portfolio of drawings entitled *Impressions of the City*). **Awards:** Chicago/AI, Watson F. Blair Prize, 1931, 40; Guggenheim Foundation Fellowship, 1937; PAFA, Carol H. Beck Gold Medal, 1940; Carnegie, Second Prize, 1945. **One-man Exhibitions:** (first) Goltz Gallery, Berlin, 1918; Gallery A. Flechtheim, Berlin, 1926; M. Wasservogel, Berlin, 1926; A.A.A. Gallery, NYC, 1926, 41, 43, 46, 48, 54; Club of Chicago, 1933; Crillon Galleries, Philadelphia, 1933; Milwaukee, 1933; Mayor Gallery, London, 1934; An American Place (Gallery), NYC, 1935; Contemporary Arts Gallery, NYC, 1935; Harvard U., 1935, 49, 73; Municipal U. of Omaha, 1936; Smith College, 1936 (three-man); Chicago/AI, 1938; Currier, 1939; Hudson D. Walker Gallery, NYC, 1938 (2), 1941; MOMA, 1941, 69; Denver/AM, 1943; Baltimore/MA, 1944; Leicester Gallery, London, 1946; Print Club of Cleveland, 1949; The Swetzoff Gallery, Boston, 1950; Dallas/MFA, 1952; Vera Lazuk, Cold Spring Harbor, N.Y., 1959; The Forum Gallery, 1963, E. V. Thaw, NYC, 1963; Arts Council of Great Britain, circ., 1963; Paul Kantor Gallery, Beverly Hills, Calif., 1964; Graphische Sammlung Albertina, 1965; Claude Bernard, Paris, 1966; Ira Spanierman Gallery, NYC, 1967, 69; Donald Morris Gallery, 1968; Peter H. Deitsch Gallery, 1968, 69; Lo Guidice Gallery, Chicago, 1969; Stuttgart/WK, 1969; La Medusa Gallery, 1970; Richard Feigen Gallery, NYC, 1971; Harvard U., 1973; Lunn Inc., Washington, D.C., 1974; Serge Sabarsky Gallery, NYC, 1975; Weintraub Gallery, NYC, 1978; Huntington/Hecksher, 1977; Hirshhorn, 1978; Villa Stuck, Munich, circ., 1985; Gillian Jason Gallery, London, 1988; Galerie Salis, Salzburg, 1986. **Retrospective:** WMAA, 1954. **Group:** WMAA Annuals; MOMA; Chicago/AI; Los Angeles/County MA; SFMA; Newark Museum; St. Louis/City; Dallas/MFA. **Collections:** Berlin/National; Boston/MFA; Chicago/AI; Cleveland/MA; Detroit/Institute; Essen; Galerie des 20. Jahrhunderts; Harvard U.; Huntington, N.Y./Heckscher; MOMA; Newark Museum; Stuttgart; WMAA. **Bibliography:** Ballo, ed.; Baur 2, 7; Bazalgette; Bazin; Biddle 4; Bihalji-Merin; **Bittner**; Blesh 1; Bulliet 1, 2; Canaday; Cassou; Cheney; Christensen; *Cityscape 1919-39;* Craven, T., 1, 2; Cummings 4; Davidson 2; *Dessins et Aquarelles;* Flanagan; **Flavell**; Frost; Genauer; *George Grosz;* Goodrich and Baur 1; **Grosz 1, 2, 3, 4, 5**; Haftman; Hess, T. B., 1; Hulten; Hunter, ed.; Huyghe; Janis, S.; Kent, N.; Kouvenhoven; Kuh 1, 3; Langui; Lynton; McCurdy, ed.; **Mehring**; Mendelowitz; Murken-Altrogge; Newmeyer; Pagano; Pearson 1, 2; Pousette-Dart, ed.; Read 2; Richardson, E.P.; Richter; Rodman 3; Rose, B., 7; Rubin 1; Sachs; Salvini; Sietz 3; Selz, P., 3; **Tavolato**; Verkauf; Waldman 4; Wingler, ed. Archives.

GUERRERO, JOSÉ **b.** October 29, 1914, Granada, Spain. **d.** 1991, Barcelona, Spain. **Studied:** Escuela de Artes y Oficios Artisticos, Granada, 1930-34; Real Academia de Bellas Artes de San Fernando, Madrid, 1940-44; Academie des Beaux-Arts, Paris, 1945-46. Traveled Europe, 1947-49; resided Spain, 1965-68. To USA, 1949; citizen, 1952. **Taught:** New School for Social Research, 1962-65; Cleveland Institute of Art, 1974; Atlanta College of Art, 1975; Iowa State U., 1978. **Awards:** *Art in America* magazine, New Talent, 1958; Graham Foundation Grant, 1958-59; Chevalier of the Order of Arts and Letters (France), 1959; Society for Contemporary American Art annual prize donation to The Art Institute of Chicago, 1959; Officer Order of Arts and Letters, 1979. **One-man Exhibitions:** Galerie Altarriba, Paris, 1946 (two-man); Galleria Secolo, Rome, 1948; Lou Cosyn Gallery, Brussels, 1948; St. George's Gallery, London, 1949 (two-man); Buchholz Gallery, Madrid, 1950; Arts Club of Chicago, 1954 (two-man); Betty Parsons Gal-

lery, NYC, 1954, 57, 58, 60, 63; Rose Fried Gallery, 1964; Galeria Juana Mordo, 1964, 67, 71, 75, 76; Buchholz Gallery, Lisbon, 1967; French & Co. Inc., 1967, 70; Galleri Ostermalm, Stockholm, 1970; The Graham Gallery, NYC, 1970; Vali 30 Gallery, Valencia, 1972; Mikelki Gallery, Bilbao, 1972; A. M. Sachs Gallery, NYC, 1974; Galerie Wolfgang Ketterer, Munich, 1975; Juana de Azipuru Gallery, Seville, 1976; Hoover Gallery, San Francisco, 1976, 78; Museo Provincial de Bellas Artes, Victoria, Spain, 1977; Museo Provincial de Bellas Artes, Bilbao, Spain, 1976; Galeria Luzaro, Bilbao, 1978; Gruenebaum Gallery, Ltd., NYC, 1978, 80; Galeria Fucares, Almagro, Spain, 1979; Galerie Ditesheim, Neuchatel, Switzerland, 1979. **Group:** SRGM, Younger American Painters, 1954; Galerie de France, 10 Jeunes Peintres de l'École de Paris, 1956; Salon des Realites Nouvelles, Paris, 1957; Worcester/AM, 1958; Dallas/MFA, 1958; Rome-New York Foundation, Rome, 1958; Buffalo/Albright, 1958; I Inter-American Paintings and Prints Biennial, Mexico City, 1958; WMAA Annuals, 1958, 59, 62; American Abstract Artists, 1958, 61, 62; Carnegie, 1958, 61, 63; Corcoran, 1959; Spanish Art Today, circ., Germany, Holland, Denmark, 1967-68; Spanish Culture Institute, Munich, 1968; Sweden/Goteborgs, Spanish Painters, 1970; Dublin/Municipal, International Quadriennial (ROSC), 1971; Madrid, March Foundation Collection, circ., 1973-74; Mexico City/Nacional, Masters of Spanish Contemporary Art, 1974. **Collections:** Belgian Ministry of National Education; Beloit College; Brooklyn Museum; Buffalo/Albright; California Palace; Carnegie; Chase Manhattan Bank; Chicago/AI; Cornell U.; Cuenca; Dartmouth College; French Ministry of National Education; Fundacion Juan March, Madrid; Harvard U.; Houston/MFA; Humlebaek/Louisiana; Indianapolis; Madrid/Nacional; Mobil Oil Co.; NYU; New School for Social Research; PAFA; Prudential Insurance Co. of America, Newark; Purchase/SUNY; RISD; SRGM; Swe-

den/Goteborgs; Toronto; WMAA; Westinghouse Electric Corp.; Yale U. **Bibliography:** Moser 1. Archives.

GUGLIELMI, O. LOUIS

b. April 9, 1906, Cairo, Egypt. **d.** September 3, 1956, Amagansett, N.Y. To USA, 1914. **Studied:** NAD, 1920-25. Corps of Army Engineers, 1943-45. **Taught:** Louisiana State U., 1952-53; New School for Social Research, 1953. Federal A.P.: Easel painting. **Awards:** L.C. Tiffany Grant, Yaddo Fellowship, and MacDowell Colony Fellowship, 1925-32; Chicago/AI, Ada S. Garrett Prize, 1943; Pepsi-Cola, Hon. Men., 1944; Carnegie, Hon. Men., 1944; AAAL Grant, 1946; PAFA, Joseph E. Temple Gold Medal, 1952. **One-man Exhibitions:** (first) The Downtown Gallery, NYC, 1938, also 1942, 46, 47, 51, 67; New Art Center, NYC; J. Seligmann and Co.; Julien Levy Galleries, NYC; Lee Nordness Gallery, NYC, 1958, 61, 62; WMAA, 1981. **Retrospective:** Rutgers U., 1980. **Group:** Musée du Jeu de Paume; New York World's Fair, 1939; MOMA, Americans 1943; Realists and Magic-Realists, circ., 1943; Chicago/AI, 1943; WMAA, The Precisionists, 1961; PAFA; Pepsi-Cola Co.; Newark Museum; U. of Minnesota; Denver/AM; PMA. **Collections:** Auburn U.; Britannica; Chicago/AI; Cornell U.; Cranbrook; U. of Georgia; MMA; MOMA; Newark Museum; SFMA; Tel Aviv; WMAA; Walker. **Bibliography:** Armstrong, Thomas; Baur 7; Bethers; Blesh 1; *From Foreign Shores;* Genauer; Goodrich and Baur 1; Haftman; Hall; Halpert; Janis, S.; McCurdy, ed.; Pagano. Archives.

GUSSOW, ALAN **b.** May 8, 1931, NYC. **Studied:** Middlebury College, 1952, AB; Cooper Union, 1952-53, with Morris Kantor; Atelier 17, NYC. Traveled Europe, USA, El Salvador; Australia; resided Rome, two years. **Taught:** Parsons School of Design, 1956-68, Chairman, Department of Fashion Illustration, 1959-68; Sarah Lawrence College, 1958-59; U. of Massachusetts,

Roy Gussow, *Crystal 2/ 12-1-83*, 1983.

1968-69; Rockland Community College, Suffern, NY, 1974; Pace U. 1977; Bard College, 1978; New York Studio School, 1980, 82; Queens College, 1983; Artist-in-Residence, American Academy, Rome, 1986; College of the Atlantic, 1989; U. of California, Santa Cruz, 1990. **Film:** *A Sense of Place, The Artist and the American Land,* 1973; Creative consultant, *The Shadow Project,* 1982, an anti-nuclear art work; narrator, *Gustave Stickley and the American Craftsman Movement,* 1983, produced by Nabisco. Designed costumes, lighting, posters, choreography for Avodah Dance Ensemble, 1985. Publishes writings on art and on ecology. **Commissions:** Skidmore, Owings and Merrill, Architects (mural). **Awards:** Prix de Rome, 1953-54, renewed 1954-55; Artist-in-Residence, Cape Cod National Seashore, 1968; CAPS, 1971; AFE Grant, Artist-in-Residence, Delaware Water Gap, 1974-75. US Department of the Interior, National Parks Service, Environmental Consultant, 1968-; AAIAL, 1977. **Address:** 121 New York Avenue, Congers, NY 10920. **One-man Exhibitions:** (first) Hagerstown/County MFA, 1961; Middlebury College, 1961, 77; The Peridot Gallery, NYC, 1962, 63, 66, 67, 69, 70; Kendall Gallery, Wellfleet, MA, 1971; The Joe and Emily Lowe Art Gallery, Syracuse, 1972; Washburn Gallery Inc., 1972, 73, 77,

80; Jacobs Ladder Gallery, Washington, D.C., 1974; Joe de Mers Gallery, Hilton Head Island, SC, 1978; VMFA, 1979; St. Paul's School, Concord, NH, 1979; Hull Gallery, Washington, D.C., 1980, 83; William Sawyer Gallery, San Francisco, 1980; U. of California, Santa Cruz, 1981; Hopper House Gallery, Nyack, NY, 1983; Sid Deutsch Gallery, NYC, 1984; Iowa State U., 1984; U. of Maine, 1986. **Retrospectives:** Portland, Me./MA, 1971; Arnot, 1975; Rockland Center for the Arts, West Nyack, NY, 1978; Marywood College, 1984; U. of Maine, 1986; Thorp-Intermedia Gallery, Sparkill, NY, 1986. **Group:** III Mostra di Pittura Americana, Bordighera, 1955; Maine State Art Festival, 1961; Youngstown/Butler, 1963; U. of Nebraska; PAFA Annual, 1966; A.F.A., Maine—50 Artists of the 20th Century, circ., 1966; AAAL, 1966; Colgate U., Viewpoints 7, 1972; Omaha/Joslyn, A Sense of Place, 1973; Queens Museum, New Images, 1974; AAIAL, 1977. Collections: Arnot; Bowdoin College; U. of California, Santa Cruz; Corcoran; Guild Hall; Middlebury College; Montgomery Museum; U. of Nebraska; Portland, Me./MA; VMFA; Wichita/AM.

GUSSOW, ROY b. November 12, 1918, Brooklyn, N.Y. **Studied:** New York State Institute of Applied Agriculture (Farmingdale), 1938; Institute of Design, Chicago, 1945, with Lazlo Moholy-Nagy, and 1946, with Alexander Archipenko, 1948, BS. Traveled Europe and USA extensively. **Taught:** Bradley U., 1948; Colorado Springs Fine Arts Center, 1949-51; North Carolina State College, 1951-62; Pratt Institute, 1962-68; Columbia U., 1981-85; U. of Pennsylvania, 1991. **Member:** Sculptors Guild, President, 1976-; Artists Equity Association of New York; Artists Equity Association of N.Y., Vice-President, 1980-84, President, 1985-87; Fine Arts Federation of New York, Board of Directors, 1987; Vice-President, 1992. **Commissions:** US Commerce Department Trade Fair, circ., Bangkok and Tokyo, 1956 (American Pavil-

ion); Lenoir-Rhyne College, 1957; Cooperative Savings & Loan Association, Wilmington, N.C., 1959; North Carolina State College, 1961; North Carolina State College Faculty Club, 1962; San Francisco Museum of Science and Industry, 1962; Phoenix-Mutual Building, Hartford, Conn., 1963 (8-ft. stainless-steel structure commissioned by Max Abramovitz); Reynolds Metal Co., 1967; Tulsa Civic Center, 1968; Xerox Corp., 1968; Creedmore State Hospital, Queens, N.Y., 1970; Heublein Inc., Farmington, Conn., 1974; Family Court Building, NYC, 1975; Combustion Engineering Corp., Stamford, Conn., 1976; City of Reading, Pa., 1979; City Hall, Harrisburg, Pa., 1983; J. C. Penney Co., Plano, Tx., 1985. **Awards:** Raleigh/NCMA, P.P., 1957, 61; PAFA, Hon. Men., 1958; Ford Foundation, P.P., 1960, 62; National Gold Medal Exhibition for the Building Arts, NYC, 1962. **Address:** 4040 24th Street, Long Island City, NY 11101. **Dealer:** Grace Borgenicht Gallery, Inc., NYC. **One-man Exhibitions:** (first) Design Associates Gallery, Greensboro, N.C., 1952; The Pennsylvania State U., 1959; Grace Borgenicht Gallery, Inc., NYC, 1964, 71, 73, 77, 80, 87. **Group:** Chicago/AI, 1947, 48, 49; U. of Arkansas, 1948; Omaha/Joslyn, 1949, 50; Denver/AM, 1949-51; SFMA, 1951; MMA, 1951; PAFA, annually 1951-59; Raleigh/NCMA, annually 1952-61; WMAA, 1956; Oakland/AM, 1959; WMAA, Sculpture Annual, 1964, 66, 68; WMAA, Contemporary American Sculpture, Selection II, 1969; Albright College, 1979; Nassau Community College, Garden City, N.Y., 1985. **Collections:** American Tobacco Co.; Atlanta/AA; Brooklyn Museum; California Academy of Science; Equitable Life Assurance Society; MOMA; Newark Museum; U. of North Carolina; Radcliffe College; Raleigh/NCMA; Tulsa/Philbrook; VMFA; WMAA. **Bibliography:** Craven, W. Archives.

GUSTON, PHILIP b. June 27, 1913, Montreal, Canada. **d.** June 9, 1980, Woodstock, N.Y. To USA, 1916. **Studied:** Otis Art Institute, Los Angeles, for 3 months, 1930. Traveled Spain, Italy, France, USA. **Taught:** State U. of Iowa, 1941-45; Washington U., 1945-47; U. of Minnesota, 1950; NYU, 1951-59; Pratt Institute, 1953-57; Yale U., 1963; Brandeis U., 1966; Columbia U., 1969, 70, 74; New York Studio School; Skidmore College, 1968; Boston U., 1973-80. **Commissions:** Federal A.P., 1935-40, murals: WPA Building, New York World's Fair, 1939 (facade); Queensbridge Housing Project, 1940; Forestry Building, Laconia, N.H., 1941. Section of Fine Arts (murals), Social Security Building, Washington, D.C., 1942; US Post Office, Commerce, Ga., 1938. Trustee, American Academy, Rome. **Member:** NIAL. **Awards:** Carnegie, First Prize, 1945; Guggenheim Foundation Fellowship, 1947, renewed 1968; Prix de Rome, 1948; AAAL Grant, 1948; Ford Foundation Grant, 1948, $10,000, 1959; Hon. DFA, Boston U., 1970; College Art Association, Distinguished Teaching of Art Award, 1975; Brandeis U., Creative Arts Award, 1980. **One-man Exhibitions:** (first) The Midtown Galleries, 1945; Boston Museum School, 1947; Utica, 1947; U. of Minnesota, 1950; The Peridot Gallery, 1952; Charles Egan Gallery, 1953; Sidney Janis Gallery, 1956, 58, 60, 61; Dwan Gallery, Los Angeles (two-man, with Franz Kline), 1962; Jewish Museum, 1966; Santa Barbara/MA, 1966, 67; Gertrude Kasle Gallery, 1969, 73, 74; Marlborough Gallery Inc., NYC, 1970; Boston U., 1970, 74; La Jolla, 1971; MOMA, 1973; David McKee Gallery, NYC, 1974, 76, 77, 78, 79, 80, 82, 83, 85, 87, 90, 91; Allan Frumkin Gallery, Chicago, 1978; MIT, 1984; Reconnaisance Gallery, Fitroy, Australia, 1985; Phillips, circ., 1980; Whitechapel Art Gallery, London, circ., 1982; Melbourne/National, circ., 1984; Greenville, circ., 1986; Skidmore College, 1987; Cava Gallery, Philadelphia, 1988; Galerie Lelong, NYC, 1991. **Retrospectives:** V São Paulo Biennial, 1950; XXX Venice Biennial, 1960; SRGM, 1962; Amsterdam/Stedelijk, 1962; Los Ange-

Philip Guston, *Riding Around 1969*, 1969.

les/County MA, 1963; Brandeis U., 1966; SFMA, circ., 1980-81; MOMA, circ., 1988; Centro de Arte Reine Sofia, Madrid, 1989. **Group:** U. of Illinois, 1944, 67; Walker, Contemporary American Painting, 1950; U. of Minnesota, 40 American Painters, 1940-50, 1951; MOMA, Abstract Painting and Sculpture in America, 1951; Baltimore/MA, Abstract Expressionists, 1953; MOMA, Twelve Americans, circ., 1956; São Paulo, 1957; WMAA, Nature in Abstraction, 1958; I Inter-American Paintings and Prints Biennial, Mexico City, 1958; MOMA, The New American Painting, circ., Europe, 1958-59; St. Louis/City, Modern American Painting, 1959; WMAA, 18 Living American Artists, 1959, also Annuals; Kassel, Documenta II, 1959; Ringling, 1961; SRGM/USIA, American Vanguard, circ., Europe, 1961-62; PAFA; SFMA; Chicago/AI; Corcoran; SRGM, circ., 1963; Tate, Painting and Sculpture of a Decade, 1954-64, 1964; Carnegie, 1964; Los Angeles/County MA, New York School: The First Generation, 1965; U. of St. Thomas (Tex.), 1967; ASL, 1967-68; MOMA, The New American Painting and Sculpture: The First Generation, 1969; MMA, New York Painting and Sculpture: 1940-1970, 1969-70; Ente Manifestazioni Genovesi, Immagine per la Citta, Genoa, 1972; National Gallery, American Art at Mid-Century, 1973; MIT, Drawings by Five Abstract Expressionist Painters, 1975; Buffalo/Albright, American Painting in the 1970s, 1978; Hayward Gallery, London, New Painting—New York, 1979; WMAA Biennial, 1979; Denver/AM, Poets-Painters, 1979; Akron/AI, Dialogue, 1980; Brandeis U., Mavericks, 1980; Houston/Contemporary, American Still Life, 1945-1983, 1983; MOMA, The Modern Drawing, 1983; AFA, Social Concern and Urban Realism, circ., 1984; IEF, Twentieth Century American Drawings: The Figure in Context, circ., 1984; Los Angeles/MOCA, Automobile and Culture, 1984; National Gallery, Gemini G.E.L.: Art and Collaboration, 1984; Amsterdam/Stedelijk, La Grande Parade, 1984; École des Beaux Arts, Paris, American Drawing: 1930-1980, 1985; Fort Lauderdale, An American Renaissance: Painting and Sculpture Since 1940, 1986; ICA, London,

Komik Ikonoklasm, 1986; Kansas City/AI, Drawn Out, 1987; Bronx Museum, Return to the Figure: Three Studies, 1988; National Gallery, 1980s: Prints from the Collection of Joshua P. Smith, 1989; Rutgers U., Abstract Expressionism: Other Dimensions, 1990; MOMA, High & Low, 1990; Centre d'Art Contemporain, Quimper, La Compagnie des Objets, 1990-91. **Collections:** Allentown/AM, Baltimore/MA; Bezalel National Museum, Jerusalem; Brandeis U.; Buffalo/Albright; Canberra/National; Carnegie; Chicago/AI; Cleveland/MA; Denver/AM; Detroit/Institute; Harvard U.; High Museum; Hirshhorn; IBM; U. of Illinois; Illinois Wesleyan U.; State U. of Iowa; Los Angeles/County MA; MMA; MOMA; Minneapolis/Institute; NCFA; U. of Nebraska; Phillips; Purchase/SUNY; SFMA; SRGM; St. Louis/City; San Jose State College; Seagram Collection; Tate; U. of Texas; Utica; VMFA; WMAA; Washington U.; Worcester/AM; Yale U. **Bibliography:** *Abstract Expressionism;* Anfam; Armstrong, Thomas; Arnason 3; Ashton 2, 3, 5, 6; Baur 5; Bazin; Biddle 4; Blesh 1; Canaday; Cummings 4, 5; De Wilde 1; *Europa/Amerika;* From Foreign Shores; Genauer; Gohr and Gachnang; Goodrich and Baur 1; Haftman; Henning; Hunter 1, 6, 7; Hunter, ed.; Kozloff 3; Lucie-Smith; McCoubrey 1; McCurdy, ed.; Nordness, ed.; O'Hara 1; Plagens; *Poets and Painters;* Ponente; Read 2; Ritchie 1; Robins; Rose, B., 1; Sandler 3, 5; Schwartz 1; Seuphor 1; Tuchman, ed.; Tuchman, ed.; Weller; *Woodstock: An American Art Colony, 1902-1977.* Archives.

GUY, JAMES
from 1st to 5th edition.

GWATHMEY, ROBERT **b.** January 24, 1903, Richmond, Va. **d.** September 21, 1988, Southampton, N.Y. **Studied:** North Carolina State College, 1924-25; Maryland Institute, 1925-26; PAFA, 1926-30, with George Harding, Daniel Garber. Traveled Europe, Carib-

bean, Mexico, Egypt. **Taught:** Beaver College, 1930-37; Carnegie Institute of Technology, 1938-42; Cooper Union, 1942-68; Boston U., 1968-69; Syracuse U., 1970. **Member:** Artists Equity; NIAL; NAD. **Commissions:** US Post Office, Eutaw, Ala. **Awards:** PAFA, Cresson Fellowship, 1929, 30; US Government, 48-State Mural Competition winner, 1939; San Diego, First Prize, Watercolors, 1940; Carnegie, Second Prize, 1943; Lessing J. Rosenwald Fund Fellowship, 1944; AAAL Grant, 1946; Corcoran, Fourth Prize, 1957; NAD, Joseph Isidor Gold Medal, 1971; NAD, Saltus Gold Medal, 1977; Adolph and Clara Obrig Prize, 1978; Benjamin Altman Prize (figure) 1979. **One-man Exhibitions:** (first) ACA Gallery, 1940, also 1946, 49; VMFA; Terry Dintenfass, Inc., NYC, 1961, 64, 68, 71, 74, 76, 80, 84, 89. **Retrospectives:** Randolph-Macon Women's College, 1967; Boston U., 1969; St. Mary's College of Maryland, 1976; Guild Hall, 1984. **Group:** WMAA Annuals; Corcoran; PAFA; MMA; Boston/MFA; Carnegie, 1964, 65; U. of Illinois, 1965; NAD, 1973; St. Joseph/Albrecht, Drawing-America: 1973, 1973; Ball State U. Annual, 1974; Skidmore College, An Exhibition of Twentieth-Century Drawings, 1975; Youngstown/Butler, Midyear show, 1973, 78, 81. **Collections:** Alabama Institute; Auburn U.; Birmingham, Ala./MA; Boston/MFA; Brandeis U.; Brooklyn Museum; California Palace; Carnegie; U. of Georgia; Guild Hall; Hirshhorn; IBM; U. of Illinois; Los Angeles/County MA; U. of Nebraska; U. of Oklahoma; PAFA; PMA; Randolph-Macon Women's College; U. of Rochester; St. Joseph/Albrecht; San Diego; São Paulo; Savannah/Telfair; Springfield, Mass./MFA; U. of Texas; VMFA; WMAA; Youngstown/Butler. **Bibliography:** Baldinger; Baur 7; Bazin; Goodrich and Baur 1; McCurdy, ed.; Mendelowitz; Nordness, ed.; Pousette-Dart, ed.; Reese. Archives.

H

HAAS, RICHARD b. August 29, 1936, Spring Green, Wisc. **Studied:** U. of Wisconsin, Milwaukee, 1954-58, BS; U. of Wisconsin, with Joseph Friebert, Robert von Neuman, Harold Altman; U. of Minnesota, 1961-64, MFA, with Jack Tworkov, Peter Busa, Malcolm Myers. Traveled Mexico, Europe, Morocco. US Army, 1959. **Taught:** Lincoln High School, Milwaukee, 1959-61; School of Visual Arts, NYC, 1966-80; U. of Minnesota, 1963-64; Michigan State U., 1964-68; Bennington College, 1968-80. **Member:** Art Commission of the City of New York, 1978-80; Architectural League of New York, vice-president, 1978-80; Board of Directors, Public Art Fund, 1981-; Board of Governors, Skowhegan School, 1982-; Century Association. **Commissions:** Numerous wall murals indoors-outdoors nationwide. **Awards:** Taliesen Fellowship, 1955, 56; Ford Foundation, P.P., 1964; CAPS, 1972; National Endowment for the Arts grant, 1978; AIA, Medal of Honor, 1978; Municipal Art Society, NYC, award, 1979; Guggenheim Foundation Fellowship, 1983; U. of Wisconsin, 1991, Hon. Ph.D.; Doris C. Freedman Award, NYC, 1989. **Address:** 29 Overcliff Street, Yonkers, NY 10705. **Dealers:** Brooke Alexander Gallery, NYC; Young-Hoffman Gallery, Chicago. **One-man Exhibitions:** Bennington College, 1968, 71, 74; Hundred Acres Gallery, Ltd., NYC, 1971, 73, 74; Brooke Alexander Gallery, NYC, 1972, 75, 79, 80, 82, 85, 89; Contract Graphics Associates, Houston, 1973; Boston U., 1973; WMAA, 1974; Harcus-Krakow Gallery, Boston, 1975; Delahunty Gallery, Dallas, 1976; Marion Locks Gallery, Philadelphia, 1976; Tyler School of Art, Philadelphia, 1977; The Art Center, Waco, 1977; Quincy College, 1978; Young-Hoffman Gallery, Chicago, 1978; Galerie Biedermann, Munich, 1978; Swain's Art Store, Plainfield, N.J., 1979; SFMA, 1980; Municipal Art Society, NYC, 1981; Young Hoffman Gallery, Chicago, 1982; American Institute of Architects Foundation, Washington, D.C., 1982; Norfolk/Chrysler, 1983; Rhona Hoffman Gallery, Chicago, 1983, 90; U. of Tennessee, 1984; Chattanooga/Hunter, 1984; Aspen Museum, 1985; Giffels Associates, Inc., Southfield, Mi., 1985; Robert Martin Gallery, White Plains, N.Y., 1986; Williams College, 1987; Miramar Gallery, Sarasota, Fla., 1992; Condeso/Lawler Gallery, NYC, 1992. **Retrospective:** West Palm Beach/Norton, 1977. **Group:** Walker, Five Young Minnesota Artists, 1963; Indianapolis, 1972; Yale U., American Drawing: 1969-1973, 1973; Brooklyn Museum Print Biennial, 1974; Akron/AI, Contemporary Images in Watercolor, 1976; Davidson, N.C., Art on Paper, 1976; U. of North Carolina, Art on Paper, 1976; A.F.A., American Master Drawings and Watercolors, 1976; Brooklyn Museum, Thirty Years of American Printmaking, 1976; US Department of the Interior, America, 1976, 1976; Library of Congress and NCFA, 25th National Exhibition of Prints, 1977; Cooper-Hewitt Museum, Ornament in the 20th Century, 1978; Tulsa/Philbrook, Realism/Photorealism, 1980; Architectural League of NY, Collaboration: Artists & Architects, circ., 1981; PAFA, Contemporary American Realism Since 1960, 1981; Cooper-Hewitt Museum, Urban Documents, 1983; Paris/Beaubourg, Images et Imaginaires d'Architecture, 1984; U. of New Mexico, Tamarind: 25 Years, 1960-1985, 1985;

SFMA, American Realism (Janss), 1985; U. of North Carolina, Art on Paper, 1986; NAD, Realism Today, circ., 1987; Palm Beach Community College, Directly on and Off the Wall, 1991. **Collections:** Allentown/AM; Boston/MFA, Boston Public Library; Brooklyn Museum; Chicago/AI; Detroit/Institute; Fort Worth; Free Library of Philadelphia; Hartford/Wadsworth; Harvard U.; High Museum; Houston/MFA; Library of Congress; MOMA; MMA; Minneapolis/Institute; NCFA; Newark Museum; NYPL; Saint Louis/City; San Antonio/McNay; Walker; West Palm Beach/Norton: WMAA; Yale U. **Bibliography:** *America 1976;* Arthur 1, 2, 3; *Richard Haas: An Architecture of Illusion.*

HADZI, DIMITRI b. March 21, 1921, NYC. **Studied:** Brooklyn Polytechnic Institute, 1940-43; Cooper Union, NYC, 1946-50; Brooklyn Museum School, 1948-50; Polytechnion, Athens, 1950-51; Museo Artistico Industriale, Rome, 1952-53. US Air Force, 1943. Traveled Europe, USA. **Taught:** Dartmouth College, 1969; Fullerton Junior College, 1973; U. of Oregon, summer, 1974; Harvard U., 1975-89. **Member:** AAIAL, 1983; NAD. **Commissions:** MIT; Philharmonic Hall, Lincoln Center for the Performing Arts, NYC; sculpture for the Reynolds Metal Co. Memorial Award; Sun Life Insurance Co., Baltimore; John F. Kennedy Federal Office Building, Boston; Federal Reserve Bank, Minneapolis, 1971; St. Paul's Church, Rome; Lane County's Public Service Building; Federal Office Building, Portland, Ore., 1976; Johnson Wax Co., Racine, Wisc., 1978-79; Dallas Center, Dallas, 1978-79; Harvard Square, Cambridge, 1979; City of Columbus, Ohio, 1980; Owens-Illinois Co., Toledo, 1980; City of Appleton, Wisc., 1981; Stanford U., 1981; Copley Place sculpture fountain, Boston, 1982; Carleton College, Northfield, Minn., 1986; Pine Manor College, Boston, 1987; Embarcadero Center, San Francisco, 1989; Hugo Black Court-

Dimitri Hadzi, *Petra*, 1989.

house, Birmingham, Ala., 1990. **Awards:** Fulbright Fellowship (Greece), 1950; L. C. Tiffany Grant, 1955; Guggenheim Foundation Fellowship, 1957; NIAL, 1962; American Academy, Rome, 1973-74; Hon. MA, Harvard U., 1977; American Academy of Arts and Sciences, fellow, 1978; Art Directors Club, Gold Medal Awards, 1978; Cooper Union, St. Gaudens Medal, 1989; St. Lawrence U., Hon. DFA, 1987; Hakone Sculpture Museum, Tokyo; Henry Moore Competition, Museum Award, 1987. **Address:** 7 Ellery Square, Cambridge, MA 02138. **Dealers:** Richard Gray Gallery, Chicago; Levinson-Kane Gallery, Boston. **One-man Exhibitions:** Galleria Schneider, Rome, 1958, 60; Seiferheld Gallery, NYC, 1959; Galerie Van der Loo, Munich, 1961; Stephen Radich Gallery, 1961; Gallery Hella Nebelung, Düsseldorf, 1962; MIT, 1963; Temple U., Rome, Temple Abroad, 1968; Felix Landau Gallery, Los Angeles, 1969; Dartmouth College, 1969; Alpha Gallery, Boston, 1971, 77; Richard Gray Gallery, Chicago, 1972, 87; Jodi Scully Gallery, 1973; Galleria d'Arte l'Obelisco, 1974; Harvard U., 1975, 76,

84, 89; Mekler Gallery, Los Angeles, 1978, 80, 82; Gruenebaum Gallery, Ltd., NYC, 1978, 81, 84; Martin Sumers Gallery, NYC, 1988; Kouros Gallery, NYC, 1989; St. Luke's Gallery, Washington, D.C., 1990; Louis Newman Galleries, Beverly Hills, 1990, 91; Smith-Anderson Gallery, Palo Alto, Calif., 1990; Art Complex Museum, Duxbury, Mass, 1991; Levinson-Kane Gallery, Boston, 1991, 92; Phillips, 1991. **Retrospective:** MIT, 1963; Tyler School, Temple U., Rome, 1968. **Group:** MOMA, New Talent, 1956; Middelhelm Park, Antwerp, Outdoor Sculpture, 1957, 59, 71; Carnegie, 1958, 61; MOMA, Recent Sculpture, USA, 1959; Smith College, New Sculpture Now, 1960; WMAA, Business Buys American Art, 1960; RISD, Bronze Figure Sculpture Today, 1960; U. of Nebraska, 1960; Claude Bernard, Paris, Aspects of American Sculpture, 1960; WMAA Annuals, 1960, 63; Boston Arts Festival, 1961; XXXI Venice Biennial, 1962; Seattle World's Fair, 1962; Battersea Park, London, International Sculpture Exhibition, 1963; New York World's Fair, 1964-65; Hannover/Kunstverein, 1965; The White House, Washington, D.C., 1965; Musée Rodin, Paris, 1966; Rome/Nazionale, 1970; Athens Panhellenic Exhibitions, 1973; Quadriennale, Rome, 1977; AAAL, 1978; Boston Athenaeum, Four Sculptors, 1982; Sonoma State U., Works in Bronze, A Modern Survey, 1983; Antwerp/ICC, Europalia, 1982; Harvard U., Seven Sculptors at Harvard, 1983; Hakone Sculpture Museum, Tokyo, Henry Moore Competition, Invitational, 1987; Boston/MFA, The Unique Print, 1990. **Collections:** Andover/Phillips; Buffalo/Albright; Chase Manhattan Bank; U. of Chicago; Ciba-Geigy Corp.; City of Tilburg; Cleveland/MA; Currier; Dallas/MFA; Fullerton Junior College; Hartford/Wadsworth; Harvard U.; Hirshhorn; Humlebaek/Louisiana; U. of Massachusetts; MIT; MOMA; Montreal/MFA; Mount Holyoke College; Newark Museum; New School for Social Research; NYU; PMA; Phillips;

Phoenix; Princeton U.; UCLA; RISD; U. of Chicago; SRGM; Seattle/AM; Smith College; U. of Southern California, Los Angeles; Sweet Briar College; Tokyo/Hakone; UCLA; Union Carbide Corp.; U. of Vermont; WMAA; Yale U. **Bibliography:** Craven, W.

HAINES, RICHARD
from 1st to 4th edition.

HALE, NATHAN CABOT
b. July 5, 1925, Los Angeles, Calif. **Studied:** Chouinard Art Institute, Los Angeles, 1945; ASL, 1945-50; Santa Monica City College, 1952; Saratoga Springs/SUNY, Empire State College, 1975, BS in Morphology; Union College (N.Y.), 1976, Ph.D. in Organomic Morphology. Traveled Mexico, Europe, South Pacific, USA, Greece, Israel. **Taught:** Los Angeles City Art Education and Recreation Program, 1956-57; Pratt Institute, 1963-64; ASL, 1966-72; Sculptor's Society of Ireland, 1982; Walden U., 1978-; ASL, 1966-91. Designed sets for off-Broadway production of *The Affairs of Anatole*, 1958. Senior Editor *Art/World*, 1985-90. **Member:** Architectural League of New York; The Century Association; Municipal Art Society of New York; NAD. **Commissions:** Architectural and portrait; sculpture for St. Anthony of Padua, East Northport, N.Y. **Awards:** Los Angeles/County MA, P.P. for Sculpture, 1953; Audubon Artists, 1974; NAD, Gold Medal, 1991. **Address:** Sheffield Road, Amenia, NY 12501. **One-man Exhibitions:** (first) Felix Landau Gallery, 1957; Washington Irving Gallery, NYC, 1960; Feingarten Gallery, NYC and Chicago, 1961; The Midtown Galleries, NYC, 1964, 68, 74; Hazleton Art League, 1966; Fort Wayne/AM, 1966; Queens College, 1966; Franklin and Marshall College, 1967; NYU, 1967; Quinata Gallery, Nantucket, 1968. **Group:** J. Seligmann and Co., 1947-49; Roko Gallery, NYC, 1948-50; Los Angeles/County MA, 1953-55; Colorado Springs/FA,

1961; Hirschl & Adler Galleries, Inc., NYC, Continuing Traditions of Realism in American Art, 1962; Lehigh U., 1963; Corcoran, 1963, 64; Buffalo/Albright, 1963, 68; Wayne State U., 1964; United States Government, Art in the Embassies, 1964-66; National Art Museum of Sport, NYC, 1969; The Century Association, 1989. **Collections:** Indianapolis/Herron; Los Angeles/County MA; Sara Roby Foundation; Wake Forest U.

HALE, ROBERT B.
from 1st to 4th edition.

HALEY, JOHN CHARLES
b. September 21, 1905, Minneapolis, Minn. **Studied:** Minneapolis Institute School, with Cameron Booth; Hofmann School, Munich and Capri; Scuola Mosaico, Ravenna, Italy. US Navy, World War II. Traveled Europe, USA. **Taught:** U. of California, Berkeley, 1930-72. Federal A.P.: Fresco painter, briefly. **Commissions:** Stained glass in churches in St. Paul, Duluth, Rochester, and Benson, Minn.; a fresco at Government Island. **Awards:** San Francisco Art Association, 1936, 39, 44, 51, 53, 56; California State Fair, 1950, 51; RAC, 1956, 58. **Address:** P.O. Box 31, Point Station, Richmond, CA 94807. **One-man Exhibitions:** (first) SFMA, mid-1930; Mortimer Levitt Gallery, NYC, 1949, 52; U. of California, Worth Ryder Gallery, 1962; de Young, 1962, 80; Chico State College, 1963; Four Winds Gallery, Kalamazoo, 1974. **Group:** SFMA Annuals, 1932-; California Palace Annuals; U. of Illinois Annuals, 1948-51; III & VI São Paulo Biennials, 1955, 61; Chicago/AI; MMA; PAFA; Dallas/MFA; Denver/AM; RAC; Pasadena/AM; Colorado Springs/FA; Santa Barbara/MA; St. Louis/City; MOMA, circ. **Collections:** U. of California, Berkeley; Chico State College; First National Bank of Nevada; IBM; Mills College; MMA; Oakland/MA; Phillips; SFMA.

HALLEY, PETER
b. September 24, 1953, NYC. **Studied:** Yale U., B.A., 1975; U. of New Orleans, M.F.A., 1978. **Address:** 12 Harrison Street, NYC 10013. **Dealer:** Gagosian Gallery, NYC. **One-man Exhibitions:** New Orleans/Contemporary, 1978; U. of Southwestern Louisiana, 1979; P.S. 122, NYC, 1984; International With Monument Gallery, NYC, 1985, 86; Daniel Templon Gallery, Paris, 1986; Margo Leavin Gallery, Los Angeles, 1987; Sonnabend Gallery, NYC, 1987, 89; Galerie Jablonka, Cologne, 1988, 90; Arthur Roger Gallery, New Orleans, 1988; Galerie Bruno Bischofberger, Zurich, 1988, 91; Rhona Hoffman Gallery, Chicago, 1988, 91; Galleria Lia Rumma, Naples, 1989; Maison de la Culture, St. Etienne, 1989; Krefeld/Esters, 1989; ICA, London, 1989; Michael Kohn Gallery, Santa Monica, 1990; Mario Diacono Gallery, Boston, 1990; Daniel Weinberg Gallery, Santa Monica, 1990; 303 Gallery, NYC, 1990; Jason Rubell Gallery, Palm Beach, 1991; Bordeaux/Contemporain, circ., 1991. **Group:** AAIAL, 1979; Andover/Phillips, Tradition, Transition, New Vision, 1983; ICA, Boston, Currents, 1985; São Paulo Biennial, 1985; ICA, Boston, End Game, 1986; Cologne/Ludwig, Europa-America, 1986; Indianapolis Painting and Sculpture Today, 1986; Cleveland/Contemporary, New York New, 1986; Kassel, Documenta VIII, 1987; Düsseldorf/Kunsthalle, Similia/Dissimilia, circ., 1987; Los Angeles/County MA, Avant-Garde in the Eighties, 1987; Long Island U., Perverted by Language, 1987; WMAA, Biennial, 1987; Boston/MFA, Bi-National, circ., 1988; North Texas State U., Hybrid Neutral, 1988; Sydney/AG, Biennial, 1988; Brooklyn Museum, Projects and Portfolios, 1989; Buffalo/Albright, Abstraction-Geometry-Painting, 1989; Fort Worth/Modern, 10 + 10, circ., 1989; Frankfurt/Kunsthalle, Prospect 89, 1989; Wright State U., Science-Technology-Abstraction, 1989; Amsterdam/Stedelijk, Horn of Plenty, 1989; Krefeld/Haus

Lange, Weitersehen, 1990; Milwaukee, Word as Image, circ., 1990; Indianapolis, Power: Its Myths and Mores in American Art, circ., 1990; Martin-Gropius-Bau, Berlin, Metropolis, 1991; WMAA, Biennial, 1991. **Collections:** Andover/Phillips; Dayton/AI; SFMA; SRGM; Wright State U.

HAMMERSLEY, FREDERICK
b. January 5, 1919, Salt Lake City, Utah. **Studied:** U. of Idaho, 1936-38; San Francisco Junior College, 1938-39; Academy of Advertising Art, San Francisco, 1939-40; Chouinard Art Institute, Los Angeles, 1940-42; 1946-47, with Henry McFee; Jepson Art Institute, Los Angeles, 1947-49, with Rico Lebrun; Academie des Beaux-Arts, Paris, 1945. US Army, 1942-46. **Taught:** Jepson Art Institute, Los Angeles, 1949-51; Pomona College, 1953-62; Pasadena Museum School, 1956-61 (children's painting class); 1963- (adult classes); occasional private lessons; Chouinard Art Institute, 1964-68; U. of New Mexico, 1968-71. **Awards:** Laguna Beach Art Gallery, First Prize, 1949; City of Claremont, First Prize, 1960; Youngstown/Butler, P.P., 1961; Guggenheim Foundation Fellowship, 1973; National Endowment for the Arts, Grant, 1975, 77. **Address:** 608 Carlisle S.E., Albuquerque, NM 87106. **Dealers:** Modernism, San Francisco; Owings-Dewey Fine Art, Santa Fe. **One-man Exhibitions:** (first) Fullerton (Calif.) Art Museum, 1959; Pasadena/AM, 1961; Heritage Gallery, Los Angeles, 1961, 63; Occidental College, 1962; California Palace, 1962; La Jolla, 1963; Santa Barbara/MA; Hollis Gallery, San Francisco; Whittier College; U. of New Mexico, 1969-75; L. A. Louver Gallery, Venice, Calif., 1978, 81; Middendorf Lane Gallery, Washington, D.C. (two-man), 1977; Lise Hoshour Gallery, Albuquerque, 1984, 86; Modernism, San Francisco, 1987, 90; New Mexico State Fair, Albuquerque, 1988; Graham Gallery, Albuquerque, 1989. **Retrospective:** U. of New Mexico, 1975. **Group:** SFMA,

Abstract Classicists, circ.; Los Angeles/County MA; ICA, London; USIA, Drawings from California, circ., Europe, 1958-59; Queens U., Belfast, 1959-60; Western Association of Art Museum Directors, circ., 1960-61; A.F.A., Purist Painting, circ., 1960-61; WMAA, Geometric Abstraction in America, circ., 1962; WMAA, Fifty California Artists, 1962-63; MOMA, The Responsive Eye, 1965; M. Knoedler & Co., Art Across America, circ., 1965-67; U. of Nebraska, Geometric Abstraction, 1974; Los Angeles/County MA, California, 5 Footnotes to Modern Art History, 1977; Corcoran Biennial, 1977; Denver/AM Biennial, 1979; Albuquerque Museum, Here and Now, 1980; AAIAL, 1986; California State U., Northridge, Paris, Berlin, and Albuquerque, 1989; Santa Barbara/MA, Turning the Tide: Early Los Angeles Modernists, 1920-1956, circ., 1990. **Collections:** Albuquerque Museum; U. of California, Berkeley; City of Claremont; Corcoran; Foote, Cone & Belding Communications, Inc., Los Angeles; Los Angeles/County MA; U. of Nebraska; U. of New Mexico; Oakland/AM; Roswell; SFMA; San Diego/Contemporary; Santa Barbara/MA; Santa Fe, N.M.; US Navy; Youngstown/Butler. **Bibliography:** Day 1; Fox; Joachimides and Rosenthal; Honnef 2; Karlstrom and Ehrlich. Archives.

HANSEN, JAMES LEE
b. June 13, 1925, Tacoma, Wash. **Studied:** Portland (Ore.) Museum School. **Taught:** Oregon State U., 1957-58; U. of California, Berkeley, 1958; Portland (Ore.) State College, 1964-69. Founder of The Fine Arts Collaborative, 1959. **Commissions:** Vancouver (Wash.) Federal Savings and Loan Building; Land Title Building, Vancouver, Wash.; Sacred Heart Nurses Dormitory, Eugene, Ore.; Corvallis (Ore.) First Federal Savings and Loan; Alder Way Building, Portland, Ore.; St. Louis Church, Bellevue, Wash.; Providence Heights College, Pine Lake, Wash.; St. Mary's Mis-

sion, Pioneer, Wash.; Fresno (Calif.) Civic Mall; St. Ann's Church, Butte, Mont., 1966; Holy Trinity Parish, Bremerton, Wash., 1967; Graphic Arts Center, Portland, Ore., 1968; Harrison Square, Portland (Ore.) Civic Center; State Capitol Campus, Olympia, Wash.; U. of Oregon; Clark College; Stadium Plaza, Pullman, Wash.; Civic Center Fountain, Salem, Ore.; BLM Regional Headquarters, Medford, Ore. **Awards:** SFMA, First P.P., 1952, 60; Seattle/AM, First P.P., 1952; SFMA, American Trust Co. Award, 1956; Seattle/AM, Norman Davis P.P., 1958, Fellow of the International Institute of Arts and Letters. **Address:** 6423 N.E. 248th Street, Battle Ground, WA 98604. **Dealers:** Hodges/Banks Gallery, Seattle; Abante Gallery, Portland, Ore. **One-man Exhibitions:** The Morris Gallery, NYC, 1951; Kraushaar Galleries, NYC, 1952; Dilexi Gallery, San Francisco; Fountain Gallery, Portland, Ore., 1966, 69, 77, 81, 84; U. of Oregon, 1969; Cheney Cowles Memorial Museum, Spokane, 1972; Polly Friedlander Gallery, Seattle, 1973, 78; Hodges/Banks Gallery, Seattle, 1983, 85. **Retrospective:** Portland, Ore./AM, 1971. **Group:** Portland, Ore./AM, 1951-60; Santa Barbara/MA; U. of Oregon; Fort Worth; U. of Washington; SFMA, 1952, 56, 60; Seattle/AM, 1952-57, 1959, 60, Northwest Annual, 1967; Denver/AM, 1952, 61; WMAA, 1953; San Diego; State of Washington Governor's Invitational, circ., 1964-75; U. of Washington, Seattle, An American Tradition: Abstraction, 1981. **Collections:** The Bank of California, N.A., Portland, Ore.; First Federal Savings and Loan Association of Corvallis; First National Bank of Oregon; First National Bank of Seattle; U. of Oregon; Portland, Ore./AM; SFMA; Seattle/AM. **Bibliography:** *Art of the Pacific Northwest; Recent Figure Sculpture.*

HANSEN, ROBERT **b.** January 1, 1924, Osceola, Neb. **Studied:** U. of Nebraska, with Kady Faulkner, Dwight

Kirsch, 1948, AB, BFA; Escuela de Bellas Artes, San Miguel de Allende, Mexico, with Alfredo Zalce. US Army, 1943-46. Resided Mexico, Hawaii, India, Spain. **Taught:** Bradley U., 1949-55; Occidental College, 1956-87. **Commissions** (murals): Public School and State Library, Morelia, Mexico. **Awards:** Fulbright Fellowship (India), 1961; Guggenheim Foundation Fellowship, 1961; Tamarind Fellowship, 1965. **Address:** 1498 Santa Ynez, Carpenteria, CA 93013. **One-man Exhibitions:** (first) Peoria (Ill.) Art Center, 1951; Occidental College, 1957; Ferus Gallery, Los Angeles, 1958; Bertha Lewinson Gallery, Los Angeles, 1959; Huysman Gallery, Los Angeles, 1961; Comara Gallery, 1963, 64, 66, 68, 70, 72, 75. **Retrospective:** Long Beach/MA, 1967; Los Angeles Municipal Art Gallery, 1973. **Group:** SFMA Annuals, 1957-59; Ball State Teachers College Annuals, 1957, 58, 60; U. of Nebraska, 1958; Oakland/AM Annuals, 1958, 60; UCLA, California Painters Under 35, 1959; Pasadena/AM, Pacific Profile, 1960; Carnegie, 1961, 1964; WMAA, Fifty California Artists, 1962-63; MOMA, Recent Painting USA, 1963; Pasadena/AM, Ten Californians, 1964; WMAA Annual, 1965; US State Department, circ., 1968-70; MOMA, 1969. **Collections:** Long Beach/MA; Los Angeles/County MA; MOMA; U. of Nebraska; Princeton U.; San Diego; WMAA.

HANSON, DUANE **b.** January 17, 1925, Alexandria, Minn. **Studied:** Luther College, 1943-44; U. of Washington, 1944-45; Macalester College, 1945-56, BA; Cranbrook, 1950-51, MFA. Traveled Western Europe, Egypt, USSR, Mexico, Canada, West Indies; resided seven years in Germany. **Taught:** public high schools, 1946-47, 49-50, 52-53, 60-62; US Army schools, Germany, 1953-60; private school, Greenwich, Conn., 1951-52; Oglethorpe U., 1963-65; Miami-Dade Junior College, 1965-69; U. of Miami, 1979-.

Commissions: Chase Manhattan Bank, 1975; Kansas City/Nelson, 1975; Fort Lauderdale Airport, 1990. **Awards:** Harvard U., Ella Ayman Cabot Trust, 1963; Chicago/AI, Blair Award, 1974; DAAD Grant (Berlin), 1974; Hon. DHL, Nova U., Ft. Lauderdale. **Address:** 6109 Southwest 55 Court, Davie, FL 33314. **Dealer:** OK Harris Works of Art, NYC. **One-man Exhibitions:** Cranbrook, 1951; Wilton (Conn.) Gallery, 1952; Galerie Netzel, Bremen, 1958; U. of South Florida, 1968; West Palm Beach/Norton, 1968; Ringling, 1968; OK Harris Works of Art, 1970, 72, 74, 76, 80, 84; Onnasch Galerie, Berlin, 1972; Berlin/Adademie der Kunst, 1975; Humlebaek/Louisiana, 1975; U. of Nebraska, 1976; Des Moines, 1977; U. of California, Berkeley, 1977; Portland, Ore./AM, 1977; Kansas City/Nelson, 1977; Colorado Springs/FA, 1977; VMFA, 1977; Corcoran, 1977; WMAA, 1978; Jacksonville/AM, circ., 1980; Wichita State U., circ., 1984; Cranbrook, 1985, 90; Brown U., 1990; PAFA, 1990. **Retrospectives:** Stuttgart/WK, circ., 1974; Wichita State U., 1976. **Group:** WMAA, Human Concern/Personal Torment, 1969; WMAA Annuals, 1970, 73; Walker, Figures/Environments, circ., 1970-71; Aachen/NG, Klischee und Antiklischee, 1970; Corcoran, Depth and Presence, 1971; Chicago/Contemporary, Radical Realism, 1971; Kassel, Documenta V, 1972; Galerie des 4 Mouvements, Paris, Hyperrealistes Americains, 1972; Harvard U., Recent Figure Sculpture, 1972; Lunds Konsthall, Sweden, Amerikansk Realism, 1973; Lincoln, Mass./De Cordova, The Super-Realist Vision, 1973; Randers Kunstmuseum, Denmark, Amerikanske Realister, 1973; Hartford/Wadsworth, New/Photo Realism, 1974; Chicago/AI, 1974; CNAC, Hyperrealistes Americains/Realistes Europeens, 1974; Baltimore/MA, Super Realism, 1975; PAFA, 8 Contemporary American Realists, 1977; Yale U., Seven Realists, 1976; Berlin/Na-

tional, Aspekts der 60er Jahre, 1978; Denver/AM, Reality of Illusion, 1979; WMAA, The Figurative Tradition and the WMAA, 1980; San Antonio/MA, Real, Really Real, Super Real, circ., 1981; WMAA Biennial, 1981; PAFA, Contemporary American Realism Since 1960, 1981; California State U., Long Beach, Figurative Sculpture, 1984; Sydney/AG, Pop Art, circ., 1985. **Collections:** Aachen/NG; Adelaide; Caracas; Cologne; Duisburg; Edinburgh/National; Hannover/K-G; Lewis and Clark College; U. of Miami; Milwaukee; RAC; Rotterdam; Hartford/Wadsworth; Kansas City/AI; Kansas City/Nelson; Utrecht; West Palm Beach/Norton; VMFA; WMAA. **Bibliography:** Adrian; Bush 3; *Figures/Environments;* Goodyear; *Kunst um 1970;* Lindy; Sager.

HANSON, PHILIP b. January 8, 1942, Chicago, Ill. **Studied:** U. of Chicago, BA, 1965; Chicago Art Institute School, 1969, MFA. **Taught:** Chicago Art Institute School, 1969-72; Illinois Institute of Technology, 1970-72. **Awards:** Cassandra Foundation Grant, 1973; National Endowment for the Arts, 1978, 83. **Address:** c/o Dealer. **Dealer:** Phyllis Kind Gallery, Chicago and NYC. **One-man Exhibitions:** (first) Phyllis Kind Gallery, Chicago, 1975, 76, 82; Phyllis Kind Gallery, NYC, 1984. **Group:** Chicago/AI, Chicago and Vicinity, 1969; Chicago/Contemporary, Don Baum Sez, "Chicago Needs Famous Artists," 1969; Chicago/Contemporary, Chicago Imagist Art, 1972; Ottawa/National, What They're Up To In Chicago, 1972; 12th São Paolo Biennial, 1973; Sacramento/Crocker, The Chicago Connection, circ., 1976; Sunderland (Eng.) Arts Center, Who Chicago?, circ., 1980; Kansas City/AI, Chicago Imagists, 1982. **Collections:** AT&T; Ball State U.; Chicago/Contemporary; Elmhurst College; NMAA; Vienna/Moderner. **Bibliography:** Adrian and Born; Kirschner.

HARDY, DE WITT **b.** June 25, 1940, St. Louis, Mo. **Studied:** Syracuse U., 1956-62, BA. Curator and Assoc. Dir., Ogunquit, 1964-; Scenic designer, Hackmatack Theater, Benwick, Me., 1978-81. **Member:** Union of Maine Visual Artists; Ogunquit Art Association. **Address:** Oak Woods Road, RFD #1, Box 318, North Berwick, ME 03906. **Dealer:** Gallery Henoch, NYC. **One-man Exhibitions:** Pietrantonio Gallery, NYC, 1959; Syracuse U., 1962; The Gallery, Wellesley, Mass., 1963; Pinetree Designs, Ogunquit, Me., 1961, 63; Argus Gallery, Madison, N.J., 1965, 66; Rehn Gallery, NYC, 1966-77; 10 Oak Gallery, Springvale, Me., 1967; The Point Gallery, Kittery, Me., 1967; Shore Gallery, Boston, 1968; Ogunquit Gallery, 1968-77; Nasson College, 1968, 71; Frost Gully Gallery, Freeport, Me., 1972, 74, 88; Lehigh U., 1972; Thayer Academy, 1972; Cove Bookstore, Ogunquit, Me., 1973, 74, 75, 76, 77; U. of Maine, 1973, 74, 75, 76, 77; Tomlinson Gallery, Baltimore, 1974; Polk Public Museum, 1974; Bates College, 1975; Wilkes College, 1976; Robert Schoelkopf Gallery, NYC, 1981, 83, 86; Allport Gallery, San Francisco, 1989; Olga Dollar Gallery, San Francisco, 1992. **Retrospective:** Polk Museum of Art, Lakeland, Fla. **Group:** Youngstown/Butler, National Midyear Shows, 1969; The Pennsylvania State U., Living American Artists and the Figure, 1974; U. of North Carolina, Art on Paper, 1981; SFMA, American Realism (Janss), circ., 1986. **Collections:** Beloit College; Bowdoin College; British Museum; Chattanooga/Hunter; Chemical Bank; Cleveland/MA; Davidson College; Dayton/AI; Drake U.; Dublin/Municipal; Emory U.; Hirshhorn; Indiana State U.; Kalamazoo/Institute; Library of Congress; Madison Art Center; U. of Maine; Minneapolis/Institute; NMAA; U. of Nebraska; U. of Nevada; U. of North Carolina; Ringling; Rockford College; St. Lawrence U.; U. of Washington; Youngstown/Butler.

HARE, DAVID **b.** March 10, 1917, NYC. **d.** December 21, 1992, Jackson Hole, Wyoming. Studied in New York, Arizona, Colorado (majored in experimental color photography). Researched and published a portfolio of color photographs on the American Indian, in collaboration with Dr. Clark Whissler of the American Museum of Natural History, 1940. Editor, *VVV* (surrealist magazine), 1942-44. Lectured extensively. **Taught:** Philadelphia College of Art, 1964-65; U. of Oregon. **Commissions** (sculpture): NYC; Massachusetts; Rhode Island; Illinois. **Awards:** Hon. DFA, Maryland Institute of Arts. **One-man Exhibitions:** (first) Hudson D. Walker Gallery, NYC, 1939; Julien Levy Galleries, NYC, 1946; Art of This Century, 1946, 47; The Kootz Gallery, NYC, 1946, 48, 51, 52, 55, 56, 58, 59; SFMA, 1947; Galerie Maeght, 1948; Saidenberg Gallery, 1960-63; Staempfli Gallery, NYC, 1969; Tibor de Nagy, Houston, 1974; Alessandra Collection, NYC, 1976; SRGM, 1977; Hamilton Gallery of Contemporary Art, NYC, 1978, 80; Zolla-Lieberman, Chicago, 1978; NYU (two-man), 1982; Gruenebaum Gallery, NYC, 1987. **Retrospective:** PMA, 1969. **Group:** MOMA, Fourteen Americans, circ., 1946; I & IV São Paulo Biennials, 1951, 57; WMAA, The New Decade, 1954-55; MOMA, Modern Art in the United States, circ., Europe, 1955-56; Musée Rodin, Paris, International Sculpture, 1956; Seattle/AM, circ., Far East and Europe, 1958; Brussels World's Fair, 1958; Chicago/AI, 1961; Seattle World's Fair, 1962; Pittsburgh Bicentennial, 1962; WMAA, 1962; MOMA, Dada, Surrealism and Their Heritage, 1968; MOMA, The New American Painting and Sculpture, 1969; Foundation Maeght, L'Art Vivant, 1970; Baltimore/MA, The Partial Figure in Modern Sculpture, 1970; WMAA, 200 Years of American Sculpture, 1976; Washington, D.C./Renwick Gallery, Object as Poet, 1977; Arts Council of Great Britain, Dada and Surrealism Revisited, 1978; Buf-

falo/Albright, American Painting in the 1970s, circ., 1978. **Collections:** Akron/AI; Brandeis U.; Brooklyn Museum; Buffalo/Albright; Carnegie; Hartford/Wadsworth; MMA; MOMA; New Orleans/Delgado; SFMA; SRGM; WMAA; Washington U.; Yale U. **Bibliography:** *Abstract Expressionism;* Baur 5; Biddle 4; Blesh 1; Breton 3; Brumme; Calas; Craven, W.; *Europa/Amerika;* Giedion Welcker 1; Goodrich and Baur 1; **Goossen 6;** Hess, T.B., 1; Hunter 6; Janis and Blesh 1; Janis, S.; Muane 2; McCurdy, ed.; Mendelowitz; Miller, ed., 2; Motherwell and Reinhardt, eds.; Paalan; Read 3; Ritchie 3; Rodman 1; Rose, B., 1; Rubin 1; Seuphor 3; Trier 1; Waldberg 4. Archives.

HARING, KEITH **b.** May 4, 1958, Kutztown, Pa. **d.** February 16, 1990, NYC. **Studied:** School of Visual Arts, NYC, 1978-79, with Joseph Kosuth, Keith Sonnier, Barbara Schwartz. Traveled worldwide. **Taught:** Fort Greene Day Care Center, Brooklyn, N.Y., 1982. **One-man**

Exhibitions: (first) Pittsburgh Center for the Arts, 1978; Westbeth Gallery, NYC, 1981; Club 57, NYC, 1982; Rotterdam Arts Council, 1982; Tony Shafrazi Gallery, NYC, 1982, 83, 85, 87, 88, 90; Lucio Amelio Gallery, Naples, Italy, 1983; Fun Gallery, NYC, 1983; Hartford/Wadsworth, 1983; Galerie Watari, Tokyo, 1983; Galeria Salvatore Ala, Milan, 1984; Galerie Corinne Hummel, Basel, 1984; U. of Iowa, 1984; Paul Maenz Gallery, Cologne, 1984; Paradise Garage, NYC, 1984; Semaphore East, NYC, 1984; Bordeaux/Contemporain, 1985; Leo Castelli Inc., 1985; Galerie Schellmann & Klüser, Munich, 1985; Amsterdam/Stedelijk, 1986; Galerie Daniel Templon, Paris, 1986; WMAA/Connecticut, 1986; Galerie Kaj Forsblom, Helsinki, 1987; Casino Knokke, Belgium, 1987; Kutztown (Pa.) New Arts Program, 1987; Galerie Rivolta, Lausanne, 1987; Michael Kohn Gallery, Los Angeles, 1988; Hans Mayer Gallery, Düsseldorf, 1988; Hokin Gallery, Bay Harbor Island, Fla., 1988; Gallery 121, Antwerp, 1989; Casa Sin Nombre, Santa Fe

K. Haring, *Untitled,* 1988.

(two-man), 1989; Fay Gold Gallery, Atlanta (two-man), 1990; Hete A.M. Hünermann Gallery, Düsseldorf, 1990; Galerie 1900-2000, Paris, 1990; Charles Lucien Gallery, NYC, 1990; Philip Samuels Fine Art, St. Louis, 1990; Queens Museum, 1990; Galerie Nikolaus Sonne, Berlin, 1990; Illinois State U., 1991; Tampa/MA, 1991. **Group:** NYC, Times Square Show, 1980; New Museum, Events: Fashion Moda, 1980; P.S. 1, Long Island City, New York/New Wave, 1981; Kassel, Documenta VII, 1982; Kunsthalle, Nurnberg, 2, Internationale Jugendtriennale, circ., 1982; P.S. 1, Long Island City, Beast: Animal Imagery in Recent Painting, 1982; Bonn, Back to the USA, circ., 1983; Palacio de Velasquez, Madrid, Tendencias en Nueva York, circ., 1983; 12th São Paolo Biennial, 1983; WMAA Biennial, 1983; Hirshhorn, Content: A Contemporary Focus 1974-1984, 1984; Montreal/Contemporain, Via New York, 1984; SFMA, The Human Condition, 1984; XLI Venice Biennial, 1984; La Biennale de Paris, 1985; Fort Lauderdale, An American Renaissance: Painting and Sculpture Since 1940, 1986; WMAA, Sacred Images in Secular Art, 1986; Corcoran, Spectrum: The Generic Figure, 1986; Vienna Biennial, 1986; ICA, London, Komic Ikonoklasm, 1986; Havana, Cuba, Biennial, 1986; Paris/Beaubourg, L'Époque, La Mode, La Morale, La Passion, 1977-87; Los Angeles/County MA, Avant-Garde in the Eighties, 1987; Syracuse/Everson, Computers and Art, 1987; MOMA, Committed to Print, 1988; Washington Project for the Arts, The Blues Aesthetic, 1989; Phoenix, Keith Haring, Andy Warhol, and Walt Disney, circ., 1991; Cleveland Center for Contemporary Art, Cruciformed: Images of the Cross since 1980, 1992. **Collections:** Amsterdam/Stedelijk; Bordeaux/Contemporain; MOMA; Malmo Museum; Paris/Moderne; WMAA. **Bibliography:** *Abstract Expressionism; Back to the USA;* Cummings 4; Danto; Fox; **Gruen;** Honnef 2; *Keith*

Haring; Murken-Altrogge; Rose, Bernice, 1; Storr and Tannenbaum.

HARRIS, PAUL b. November 5, 1925, Orlando, Fla. **Studied:** with Jay Karen Winslow, Orlando, Fla.; Chouinard Art Institute; New School for Social Research (with Johannes Molzahn); U. of New Mexico; Hans Hofmann School. US Navy, WW II. **Taught:** U. of New Mexico; Knox College, Jamaica, W.I.; New Paltz/SUNY; Montclair State College; California Institute of the Arts, Valencia; Universidad Catolica, Santiago; California College of Arts and Crafts, 1968-; Editorial Associate, *Art News* magazine, 1955-56; U. of California, Berkeley. **Commissions:** U. of New Mexico. **Awards:** Fulbright Fellowship (Chile), 1962-63; Tamarind Fellowship, 1969-70; Guggenheim Foundation Fellowship, 1979; MacDowell Colony Fellowship, 1977; Longview Foundation Grant, 1978. **Address:** P.O. Box 930, Bolinas, CA 94924. **One-man Exhibitions:** Poindexter Gallery, 1961, 63, 67, 70, 72; The Lanyon Gallery, 1965; Berkeley Gallery, San Francisco, 1965; Candy Store Art Gallery, Folsom, Calif., 1967; William Sawyer Gallery, 1969, 71; M. E. Thelen Gallery, Essen, 1970; SFMA, 1972; U. of California, Santa Barbara, 1972; U. of New Mexico, 1973; Arkansas Art Center, Little Rock, 1974; Loch Haven Art Center, 1981; Greenville, 1982; Stanford U., 1982; Fuller Goldeen Gallery, San Francisco, 1983. **Group:** New School for Social Research; U. of New Mexico; MOMA, Recent Sculpture USA, 1959; Hans Hofmann and His Students, circ., 1963; Chicago/AI, 1965; New York World's Fair, 1964-65; IX São Paulo Biennial, 1967; Los Angeles/County MA, American Sculpture of the Sixties, circ., 1967; Düsseldorf/Kunsthalle, Prospect '68, 1968; NCFA, New American Figurative, 1968; Trenton/State, Soft Art, 1969; IEF, Tamarind: A Renaissance of Lithography, circ., 1971-72. **Collections:** Aachen/NG; Los

Angeles/County MA; MOMA; U. of
New Mexico; Yale U. **Bibliography:**
Tuchman 1.

HARTELL, JOHN **b.** January 30,
1902, Brooklyn, N.Y. **Studied:** Cornell U.
(Architecture), 1925; Royal Academy of
Fine Arts, Stockholm. Traveled Europe,
Puerto Rico, England. **Taught:** Clemson
College (Architecture), 1927-28; U. of
Illinois, 1928-30; Cornell U., 1930-68.
Awards: Utica, 1948, 52; Illinois
Wesleyan U., 1950; New York State Fair,
1951; U. of Rochester, 1953; Fellow of the
American Scandinavian Foundation.
Address: 319 The Parkway, Ithaca, NY
14850. **Dealer:** Kraushaar Galleries, NYC.
One-man Exhibitions: Kleemann Gallery,
NYC, 1937; Kraushaar Galleries, NYC,
1943, 45, 49, 53, 57, 63, 66, 69, 72, 75,
77, 80, 83, 86, 89; Cornell U., 1943, 46,
53, 57, 62, 66, 84; Wells College, 1945,
49, 55; Utica, 1952; U. of Rochester,
1954; Upstairs Gallery, Ithaca, N.Y., 1968,
73, 80; Lehigh U., 1971; New Visions Gal-
lery, Ithaca, N.Y., 1990. **Retrospective:**
Cornell U., 1982. **Group:** Architectural
League of New York, 1932; U. of Roches-
ter, 1943, 53, 54; ICA, Boston; Cincin-
nati/AM, 1945; St. Louis/City, 1945;
Carnegie, 1945-47; WMAA, 1946, 50, 53;
Utica, 1948, 51, 52, 54; Illinois Wesleyan
U., 1950, 57; U. of Illinois, 1951; PAFA,
1953; US State Department, Traveling
Show to Australia, 1967-68; Indianapo-
lis/Herron, 1970; AAIAL, 1990. **Collec-
tions:** Atlanta U.; Brooklyn Museum;
Cornell U.; Illinois Wesleyan U.; U. of Ne-
braska; Northern Trust Co., Chicago, Ill.;
E. R. Squibb Co., Princeton; Utica; Wake
Forest U.

HARTIGAN, GRACE **b.** March
28, 1922, Newark, N.J. Studied with Isaac
Lane Muse, NYC, mid 1940s. Traveled Eu-
rope; resided Mexico, 1949. Designed set
for *Red Riding Hood,* by Kenneth Koch, for
the Artists Theater, NYC, 1953. **Taught:**
Maryland Institute, Artist-in-Residence,

Grace Hartigan, *My Fair Lady,* 1989.

1967-; Bard College, 1983. **Awards:**
Moore Institute of Art, Science and Indus-
try, Hon. DFA, 1969; AAAL, Childe Has-
sam Fund P.P., 1975. **Address:** 1710½
Eastern Avenue, Baltimore, MD 21231.
Dealer: ACA Galleries, NYC. **One-man
Exhibitions:** (first) Tibor de Nagy Gallery,
1951, also 1952-55, 1957, 59; Vassar Col-
lege, 1954; Gres Gallery, Washington,
D.C., 1960; Chatham College, 1960;
Carnegie, 1961; Martha Jackson Gallery,
NYC, 1962, 64, 67, 70; U. of Minnesota,
1963; Franklin Siden Gallery, Detroit,
1964; Kent State U., 1966; The U. of Chi-
cago, 1967; Maryland Institute, 1967; Ger-
trude Kasle Gallery, Detroit, 1968, 70, 72,
74, 76; Grand Rapids, 1968 (two-man);
William Zierler Inc., 1975; American Uni-
versity, Washington, D.C., 1975; Genesis
Galleries, NYC, 1977, 78; U. of Maryland,
1979; Grimaldis Gallery, Baltimore, 1979,
81, 82, 84; Plattsburg/SUNY, 1980; Ham-
ilton Gallery of Contemporary Art, NYC,
1981; Lafayette College, 1983;
Gruenebaum Gallery, NYC, 1984, 86;
Charlotte/Mint, 1981; Baltimore/MA,
1980; U. of Maryland, 1980; Kouros Gal-
lery, NYC, 1989; ACA Galleries, NYC,

1991. **Retrospective:** Fort Wayne, 1981. **Group:** Ninth Street Exhibition, NYC, 1951; U. of Minnesota, Rising Talent, 1955; MOMA, Modern Art in the United States, circ., Europe, 1955-56; MOMA, Twelve Americans, circ., 1956; Jewish Museum, The New York School, Second Generation, 1957; International Biennial, Exhibition of Paintings, Tokyo; IV São Paulo Biennial, 1957; MOMA, The New American Painting, circ., Europe, 1958-59; Brussels World's Fair, 1958; ART:USA:59, NYC, 1959; Kassel, Documenta II, 1959; Walker, 60 American Painters, 1960; SRGM, Abstract Expressionists and Imagists, 1961; SRGM/USIA, American Vanguard, circ., Europe, 1961-62; WMAA Annual, 1963; PAFA, 1963, 68; Ghent, The Human Figure Since Picasso, 1964; White House Festival of the Arts, Washington, D.C., 1965; Drexel Institute of Technology, 1966; Flint/Institute, 1966; U. of Illinois, 1967, 69; Ball State U., Collages by American Artists, 1971; Delaware Art Museum, American Painting since World War II, 1971; WMAA, Frank O'Hara; A Poet Among Painters, 1974; Corcoran Biennial, 1975; NCFA, Poets & Painters, 1976; Syracuse/Everson, Critics Choice, 1977; Hirshhorn, Art of the Fifties, 1980; National Gallery, Contemporary American Prints and Drawings, 1940-1980, 1981; Houston/Contemporary, The Americans: The Collage, 1982; Newport Harbor, Action/Precision, circ., 1984. **Collections:** American Republic Insurance Co.; American U.; Baltimore/MA; Bezalel Museum; Brandeis U.; Brooklyn Museum; Buffalo/Albright; Carnegie; Chicago/AI; The U. of Chicago; Flint/Institute; Grand Rapids; Hartford/Wadsworth; Kansas City/Nelson; MMA; MOMA; Minneapolis/Institute; NCFA; New Paltz/SUNY; New School for Social Research; Oklahoma; PAFA; PMA; Princeton U.; RISD; Raleigh/NCMA; Ringling; SRGM; St. Louis/City; Vassar College; WGMA; WMAA; Walker; Washington U.; Woodward Foundation. **Bibliography:** *Abstract Expressionism; Art: A Woman's Sensibility;* De Salvo and Schimmel; Downes, ed.; *The Figurative Fifties;* Friedman, ed.; Goodrich and Baur 1; Haftman; Hunter 1, 6; Hunter, ed.; McCurdy, ed.; *Metro;* Nemser; Nordness, ed.; Read 2; Sandler 5.

HARTL, LEON b. January 31, 1889, Paris, France. d. December 1973, Schenectady, N.Y. To USA, 1912; citizen, 1922. Self-taught. Expert on aniline dyes. **Taught:** Brooklyn Museum School. **Member:** Artists Equity. Federal A.P.: Easel painting. **Awards:** NIAL, Marjorie Peabody Waite Award, 1959; Youngstown/Butler, Hon. Men., 1960; MacDowell Colony Fellowship, 1959-61; Yaddo Fellowship, 1960, 61, 63; Ingram Merrill Foundation Grant, 1968. **One-man Exhibitions:** (first) Whitney Studio Club, NYC, 1925, also 1926; Curt Valentine Gallery, NYC, 1927, 30, 36; Joseph Brummer Gallery, NYC, 1934, 38; The Peridot Gallery, NYC, 1954, 55, 58, 60, 62, 64, 66; The Zabriskie Gallery, NYC, 1967; Ingber Art Gallery, 1971, 76. **Group:** Youngstown/Butler; Carnegie; Chicago/AI; Corcoran; Independent Artists, NYC, 1917, 18, 19; NIAL; Palazzo del Parco, Bordighera; PAFA; U. of Nebraska. **Collections:** Corcoran; Hallmark Collection; Hartford/Wadsworth; U. of Nebraska; Phillips; Society of New York Hospitals; Syracuse U.; WMAA. **Bibliography:** Downes, ed. Archives.

HARTLEY, MARSDEN b. January 4, 1877, Lewiston, Me. d. September 2, 1943, Ellsworth, Me. **Studied:** Cleveland Institute of Art, 1892, with C. Yates, N. Waldeck, C. Sowers; privately with John Semon; W. M. Chase School, NYC, 1898-99, with Frank V. DuMond, William M. Chase, F. L. Mora; NAD, 1900, with F. C. Jones, E. M. Ward, G. W. Maynard, E. H. Glashfield, F. J. Dillman, F. S. Hartley. Traveled USA extensively; Germany, France, Mexico. Federal A.P.:

Marsden Hartley, *Shell and Sea Anemones, Gloucester,* 1934.

Easel painting. **Awards:** Guggenheim Foundation Fellowship, 1931. **One-man Exhibitions:** (first) Photo-Secession, NYC, 1909, also 1912, 14; The Daniel Gallery, NYC, 1915; Montross Gallery, NYC, 1920; Anderson Galleries, NYC, 1921; Stieglitz's Intimate Gallery, NYC, 1926-29; Arts Club of Chicago, 1928, 45; An American Place (Gallery), NYC, 1930, 36, 37; The Downtown Gallery, 1932; Galeria de la Escuela Nacional de Artes Plasticas, Mexico City, 1933; Hudson D. Walker Gallery, NYC, 1938, 39, 40; Carlen Gallery, Philadelphia, 1938; Symphony Hall, Boston, 1939; Portland, Ore./AM, 1940; California Palace, 1940; Walker, 1940; M. Knoedler & Co., 1942, 44, 68; Phillips, 1943; P. Rosenberg and Co., 1944, 47, 48, 50, 55; Macbeth Gallery, NYC, 1945; Indianapolis/Herron, 1946; The Bertha Schaefer Gallery, 1948, 56; U. of Minnesota, Minneapolis, 1952, 79; Santa Fe, N.M., 1958; The Babcock Gallery, NYC, 1959-61, 75, 92; Shore Studio, Boston, 1962; Alfredo Valente Gallery, NYC, 1966; La Jolla, 1966; Colby College, 1967; U. of Southern California, 1968; Tucson Art Center, 1969; U. of Texas, 1969; Danenberg Gallery, 1969; U. of Kansas, 1972; C. W. Post College, 1977; Bates College, 1978; Washburn Gallery, NYC, 1978; Florida International U., Miami, 1984; Robert Miller Gallery, NYC, 1984; Salander-O'Reilly Galleries, NYC, 1985, 90; Portland Me./AM, 1985.

Retrospectives: Cincinnati/AM, 1941; MOMA, 1944; A.F.A., circ., 1960; Danenberg Gallery, 1969; WMAA, 1980. **Group:** The Armory Show, 1913; The Forum Gallery, 1916; Brooklyn Museum, 1926; WMAA, 1935, 38; U. of Minnesota, 1937; Baltimore/MA, 1942; Delaware Art Museum, Avant-Garde Painting and Sculpture in America, 1910-1925, 1975; U. of California, Santa Barbara, O'Keeffe, Hartley and Marin in the Southwest, 1975; SRGM, 20th Century American Drawings, 1976; MOMA, The Natural Paradise, 1976; Royal Scottish Academy, Edinburgh, The Modern Spirit: American Painting 1908-1935, 1977; WMAA, William Carlos Williams and the American Scene, 1978; WMAA, Synchronism and American Color Abstraction, 1978; Düsseldorf, Two Decades of American Painting, 1929-1940, 1979. **Collections:** Andover/Phillips; Barnes Foundation; Boston/MFA; Bowdoin College; Brooklyn Museum; Buffalo/Albright; Carnegie; Amon Carter Museum; Cleveland/MA; Colorado Springs/FA; Columbus; Cornell U.; Denver/AM; Des Moines; Detroit/Institute; U. of Georgia; Hartford/Wadsworth; Indiana U.; Kalamazoo/Institute; Lewiston (Me.) Public Library; Los Angeles/County MA; Louisville/Speed; MMA; MOMA; U. of Michigan; Milwaukee; U. of Minnesota; U. of Nebraska; Newark Museum; Omaha/Joslyn; PMA; Pasadena/AM; Phillips, Phoenix; Portland, Ore./AM; SFMA; St. Louis/City; San Antonio/McNay; Santa Barbara/MA; Santa Fe, N.M.; Smith College; U. of Texas; Utica; VMFA; Vassar College; WMAA; Walker; Wichita/AM; Williams College; Worcester/AM; Yale U.; Youngstown/Butler. **Bibliography:** Ashbery; Armstrong, Thomas; *Avant-Garde Painting and Sculpture in America, 1910-25;* Barker 1; Baur 7; Bazin; Biddle 4; Blesh 1; Born; Brown; Brown 2; Cahill and Barr, eds.; Canaday; Chipp; Coke 2; Cummings 5; Dijkstra, ed.; Eisler; Eliot; Flexner; Frank, ed.; Frost; Goldwater and

Treves, eds.; Goodrich and Baur 1; Haftman; **Hartley**; Haskell 4; Hunter 6; *Index of 20th Century Artists;* Janis, S.; Kootz 1, 2; Levin 2; Ludington; **McCausland;** McCoubrey 1; McCurdy, ed.; Mellquist; Mendelowitz; Phillips 2; Read 2; Richardson, E.P.; Ritchie 1; Rodman 2; Rose, B., 1, 4; Schwartz 1, 3; **Scott;** Soby 6; Sutton; Tashjian; Tuchman 3; **Well, ed.;** Wight 2; Wright 1. Archives.

HARTMAN, ROBERT **b.** December 17, 1926, Sharon, Pa. **Studied:** U. of Arizona, BFA, MA; Colorado Springs/FA, with Peppino Mangravite, 1947, with Vaclav Vytlacil, Ludwig Sander, Emerson Woelffer, 1951; Brooklyn Museum School, with William King, Hui Ka Swong, 1953-54. **Taught:** U. of Arizona, 1952-53; Texas Technological College, 1955-58; U. of Nevada, 1958-61; U. of California, Berkeley, 1961-91. **Awards:** Youngstown/Butler, P.P., 1955; La Jolla, 1962; SFMA, Emanuel Walter Bequest and Purchase Award, 1966; IV International Young Artists Exhibit, America-Japan, Tokyo, Hon. Men., 1967. **Address:** 1265 Mountain Boulevard, Oakland, CA 94611. **Dealer:** Triangle Gallery, San Francisco. **One-man Exhibitions:** (first) Kipnis Gallery, Westport, Conn., 1954; Roswell, 1957; U. of Nevada, 1958; U. of California, 1961; RAC, 1963; Comara Gallery, 1963, 65; Berkeley Gallery, 1965, 67, 68; The Bertha Schaefer Gallery, 1966, 69, 74; Santa Barbara/MA, 1973; Hank Baum Gallery, San Francisco, 1973, 78; Shirley Cerf Gallery, San Francisco, 1980; San Jose Museum of Art, 1983; Wesleyan U., 1983; U. of California, Berkeley, 1985, 86; Bluxome Gallery, San Francisco, 1985, 86; Victor Fischer Galleries, San Francisco, 1991; Triangle Gallery, San Francisco, 1992. **Retrospectives:** California State U., Hayward, circ., 1991. **Group:** New York World's Fair, 1964-65; U. of Illinois, 1965; M. Knoedler & Co., Art Across America, 1965-67; San Francisco Art Association, 1966; VMFA, Ameri-

can Painting, 1966; U. of Washington, 1967; Colorado Springs/FA, 1967; IV International Young Artists Exhibit, America-Japan, Tokyo, 1967; Redding Museum, Art and Aviation, 1984; Pacific, Artists Invitational, 1985; San Francisco Arts Commission Gallery, SNAP Photography 85, 1985; Grand Forks, Skyborne, 1987; Center for the Visual Arts, Boulder, New Work from the Bay Area, 1988; Osaka, Japan, Expo 90, 1990. **Collections:** Achenbach Foundation; Colorado Springs/FA; Dublin/Municipal; Grand Forks; Kaiser Industries, Oakland, Calif.; Long Beach/MA; Mead Corporation; NCFA; Oakland/AM; Princeton U.; Redding Museum; Roswell; SFAI; City of San Francisco; San Jose Museum of Art; U. of Washington; Youngstown/Butler; Zischke Organization, San Francisco.

HARVEY, JAMES
from 1st to 4th edition.

HARVEY, ROBERT **b.** September 16, 1924, Lexington, N.C. **Studied:** Ringling School of Art, with Elmer Harmes, Georgia Warren; San Francisco Art Institute with Nathan Oliveira, Sonia Gechtoff. Traveled Great Britain, France, North Africa, Italy; Resided Spain, 1966-. **Awards:** Corcoran, Hon. Men., and Ford Foundation Purchase, 1963; San Francisco Art Festival, Award of Merit, 1963; Western Washington State College, P.P., 1965; Mead Painting of the Year, 1967; Hon. Men., 1st Concurso de Pintura, L'Oréal, Madrid, 1985. **Address:** La Huerta del Angel, Macharaviaya, Malaga, Spain. **Dealer:** Gump's Gallery, San Francisco. **One-man Exhibitions:** (first) Saidenberg Gallery, 1954; Gump's Gallery, 1959, 61, 63, 64, 83, 86; La Escondida, Taos, N.M., 1962; Bedell Gallery, Santa Fe, N.M., 1962; Terry Dintenfass, Inc., NYC, 1963; Phoenix, 1964; Jefferson Gallery, 1964; David Stuart Gallery, 1964, 65, 67, 69; 75; Wichita/AM, 1965; Sacramento/Crocker, 1965; The Krasner Gallery, 1967-74, 78; San

Diego, 1968; Richard White Gallery, Seattle, 1969; Owen Gallery, Denver, 1970-74; Charles Campbell Gallery, 1972, 74, 77; Parlade, Marbella, 1972; Galeria Diaz Lario, Malaga, 1975; Gallery Malacke, 1975; Centro Cultural de los Estados Unidos, Madrid, 1977; David Marshall Gallery, Puerto Banus, Spain, 1979; Galeria Estudio, Cordoba, 1981; Galeria Harras, Malaga, 1982; Castillo Bil-Bil, Benaladena, 1983; La Alhambra, Granada (two-man), 1984; Woodwrith Gallery, Toronto, 1985. **Retrospective:** Ringling, 1970; Sacred Heart College, Atherton, Calif., 1974. **Group:** Corcoran, 1963, Biennial, 1967; de Young, New Images of San Francisco; Oakland/AM; California Palace; Kansas City/Nelson; Denver/AM; Santa Barbara/MA; Phoenix; Santa Fe, N.M.; Raleigh/NCMA, 1965; VMFA, American Painting, 1966; Youngstown/Butler, 1966; U. of Illinois, 1967, 69; San Diego, Invitational American Drawing Exhibition, 1977; Oakland/AM, Bay Area Artist, 1977; City of Zamora, 6th Biennial of Painting, 1981; Alicante, 7th Convocatoria de Artes Plasticas, 1986. **Collections:** City of Benalnadena; City of San Francisco; Corcoran; Crown Zellerbach Foundation; Hirshhorn; L'Oréal; Mead Corp.; Mobile/FAMS; Museo Municipal, La Corufia, Spain; Stanford U.; Storm King Art Center; Western Washington State College; Wichita/AM.

HATCHETT, DUAYNE b. May 12, 1925, Shawnee, Okla. **Studied:** U. of Oklahoma (with John O'Neill), 1950, BFA, 1952, MFA; US Army Air Corps, 1943-46. **Taught:** U. of Oklahoma, 1949-50; Oklahoma City U., 1951-54; U. of Tulsa, 1954-64; The Ohio State U., 1964-65; Buffalo/SUNY, 1968-80. **Commissions:** First National Bank of Tulsa; Boston Avenue Methodist Church, Tulsa; Traders National Bank, Kansas City, Mo.; Northeastern State College; Tulsa Fire Department. **Address:** 347 Starin Avenue, Buffalo, NY 14216. **Dealer:** Barbara

Schuller Gallery, Buffalo, N.Y. **One-man Exhibitions:** Haydon Calhoun Gallery, Dallas; U. of Oklahoma; Oklahoma State U.; Oklahoma; Bryson Gallery, Columbus, Ohio; Royal Marks Gallery, 1966, 68, 69, 70; Tulsa/Philbrook (three-man), 1973; Rochester Institute of Technology, 1973; Buffalo/Albright, 1974; Nina Freudenheim Gallery, Buffalo, N.Y., 1976, 77. **Group:** New York World's Fair, 1964-65; WMAA Sculpture Annual, 1966, 68; U. of Illinois, 1967; Los Angeles/County MA, American Sculpture of the Sixties, 1967; Carnegie, 1967; HemisFair '68, San Antonio, 1968; U. of Minnesota, 1969; U. of Nebraska, American Sculpture, 1970; Carnegie, 1970. **Retrospective:** Buffalo/Albright, 1974. **Collections:** Alcoa; Andover/Phillips; Atlanta Corp.; Carnegie; Columbus; Dallas/MFA; First National Bank of Tulsa; Fort Worth; State U. of Iowa; Milwaukee; U. of Minnesota; The Ohio State U.; Oklahoma; U. of Oklahoma; Ridgefield/Aldrich; San Antonio/McNay; Traders National Bank, Kansas City, Mo.; WMAA. **Bibliography:** Stearns; Tuchman 1.

HAVARD, JAMES P. b. June 29, 1937, Galveston, Texas. **Studied:** Sam Houston State College, 1959, BS; Atelier Chapman Kelley, Dallas, 1960; PAFA, 1965. **Awards:** Cresson scholar, 1964; PAFA, J. Henry Schiedt Memorial Prize, 1965; PAFA, Mabel Wilson Woodrow Award, 1962. **Address:** c/o Dealer. **Dealer:** Elaine Horwitch Galleries, Santa Fe. **One-man Exhibitions:** Chapman Kelley Gallery, Dallas, 1965, 70; Temple U., 1967; Vanderlip Gallery, Philadelphia, 1969; Marian Locks Gallery, Philadelphia, 1970, 73, 74, 77; Henri Gallery, Washington, D.C., 1970; OK Harris Works of Art, NYC, 1971; Galerie Reckermann, Cologne, 1973; Gimpel & Weitzenhoffer, Ltd., NYC, 1973; Gallerie Arnesen, Copenhagen, 1974; Galleriet Lunda, Sweden, 1974; Gallerie Fabian Carlsson, Goteborg, 1974; Gallerie Ahlner, Stockholm, 1974;

Deson-Zaks Gallery, Chicago, 1975; Louis K. Meisel Gallery, NYC, 1975, 77, 79; Gallerie Krakeslatt, Bromolla, Sweden, 1975; Delahunty Gallery, Dallas, 1976; Morgan Gallery, Shawnee Mission, Kansas, 1976; Galerie le Portaff, Heidelberg, 1977; Hanson-Cowles Gallery, Minneapolis, 1977; Irving Galleries, Palm Beach, 1978; Janus Gallery, Venice, Calif., 1978; Union College, 1980; Janus Gallery, Los Angeles, 1984; Jeremy Stone Gallery, San Francisco, 1985. **Group:** PAFA, Annuals, 1962-67; A.F.A., Recent Drawing, 1967; Silvermine, Annual, 1969; PAFA, Sculpture: New Forms, New Materials, 1970; U. of North Carolina, Art on Paper, 1975; PAFA, Three Centuries of American Art, 1976; SRGM, 1977; Springfield, Mass./MFA, Abstract Illusionism, circ., 1979. **Collections:** Atlantic Richfield Co.; AT&T; First Pennsylvania Banking & Trust Co., Philadelphia; Kemper Insurance Co., Chicago, Ill.; NCFA; NYU; PAFA; PMA; Prudential Insurance Co. of America, N.J.; SRGM; Stockholm/National; Temple U.; Westinghouse Corp., NYC; Witte. **Bibliography:** Lucie-Smith.

HAYES, DAVID V. b. March 15, 1931, Hartford, Conn. **Studied:** U. of Notre Dame, with Antony Lauck, 1949-53, AB; Indiana U., with Robert Laurent, David Smith, 1955, MFA; Ogunquit School of Painting; Atelier 17, Paris, with Stanley Hayter. Resided Paris, 1961-68. US Navy, 1955-57; Traveled USA, Europe. **Taught:** Harvard U., 1972-73. **Awards:** Hamilton Easter Field Foundation Scholarship, 1953; Silvermine Guild, Sculpture Award, 1958; Fulbright Fellowship, 1961; Guggenheim Foundation Fellowship, 1961; Chicago/AI, The Mr. & Mrs. Frank G. Logan Medal, 1951; NIAL, 1965. **Address:** P.O. Box 509, Coventry, CT 06238. **Dealer:** Anderson Gallery, Buffalo, NY. **One-man Exhibitions:** (first) Indiana U., 1955; Wesleyan U., 1958; New London, 1959; The Willard Gallery, NYC, 1961, 63, 64, 66, 69, 71; David Anderson

Gallery, Paris, 1966; Galerie de Haas, Rotterdam, 1968; Bard College, 1969; U. of Arizona, 1969; U. of Connecticut, 1970; Manchester Community College, 1970; St. Joseph College, West Hartford, Conn., 1970; Connecticut College, 1971; Agra Gallery, Washington, D.C., 1971, 72; Gallery 5 East, East Hartford, Conn., 1971, 73; Harvard U., 1972; New Britain, 1972; Munson Gallery, 1973; Sunne Savage Gallery, 1973, 74; Albany/Institute, 1973; Copley Square, Boston, 1974; Martha Jackson Gallery, 1974; Columbus, 1974; Syracuse/Everson, 1975; Brockton Art Center, 1975; Bader Gallery, Washington, D.C., 1977; George Washington U., Washington, D.C., 1977; Lincoln, Mass./De Cordova, 1977; Springfield, Mass./MFA, 1978; Albany/SUNY, 1978; Dartmouth College, 1978; Amherst College, 1979; Nassau County Museum, 1979; Shippee Gallery, NYC, 1986; Stamford Museum, 1987; Cavalier Galleries, Stamford, Ct., 1988; Nevelle-Sargent Gallery, Chicago, 1988; U. of Notre Dame, 1989. **Retrospectives:** U. of Notre Dame, 1962; Utica, 1963; New London, 1966. **Group:** MOMA, New Talent; SRGM, 1958; MOMA, Recent Sculpture USA, 1959; Boston Arts Festival, 1960; Galerie Claude Bernard, Paris, 1960; Chicago/AI, 1961; Forma Viva sculpture symposium, Portoroz, Yugoslavia, 1963; Salon du Mai, Paris, 1966; Musée Rodin, International Sculpture, 1966; Houston Festival of Arts, 1966; Carnegie, 1967; Paris/Moderne, 1968; Galerie D'Eendt NV, Amsterdam, Three Americans, 1970; Lincoln, Mass./De Cordova, Sculpture in the Park, 1972; Corcoran, 1973. **Collections:** Andover/Phillips; Albany/SUNY; Arizona State U.; Boston Public Library; Brooklyn Museum; Carnegie; U. of Connecticut; Columbus; Currier; Dallas/MFA; Dartmouth College; Detroit/Institute; Elmira College; First National Bank of Chicago; Great Southwest Industrial Park; Hartford/Wadsworth; Harvard U.; Hirshhorn; Houston/MFA; Indiana U.; Lincoln, Mass./De

Cordova; Lydall Inc.; MOMA; U. of Michigan; Moriarty Brothers; Musée des Arts Décoratifs; The Norton Co., Worcester, Mass.; NCFA; U. of Notre Dame; Price, Waterhouse, Inc., Hartford, Conn.; Ringling; SRGM; Michael Schiavone & Sons, Inc.; Syracuse/Everson; U. of Vermont; Williams College. **Bibliography:** Archives.

HEBALD, MILTON b. May 24, 1917, NYC. **Studied:** ASL, with Ann Goldwaithe, 1927-28; NAD, with Gordon Samstag, 1931-32; Roerich Master Institute of Arts, Inc., NYC, 1931-34; Beaux Arts Institute of Design, NYC, 1932-35. US Army, 1944-46. Traveled Europe, Near East, North Africa, USSR; resided Italy, 1955-92. **Taught:** Brooklyn Museum School, 1946-51; Cooper Union, 1946-53; U. of Minnesota, 1949; Skowhegan School, summers, 1950-52; Long Beach State College, summer, 1968, 74. Federal A.P.: Taught sculpture and worked on sculpture project, three years. **Member:** Sculptors Guild, 1937-86. **Commissions:** Ecuador Pavilion, New York World's Fair, 1939 (facade); US Post Office, Toms River, N.J., 1940 (relief); Republic Aviation Trophy, 1942; Isla Verde Aeroport, San Juan, P.R., 1954; East Bronx (N.Y.) TB Hospital, 1954; AAAL, 1957 (portrait bust of Archibald MacLeish); Pan American Airways Terminal, NYC, 1957-58 (110-ft. bronze relief, *Zodiac);* 333 East 79th Street Building, NYC, 1962 (bronze fountain); U. of North Carolina, 1962; James Joyce Monument, Zurich, 1966; Central Park, NYC, 1973, 79; C.V. Starr Memorial, Tokyo, 1974; Augenhaug Press, Oslo, 1975; YMCA, Los Angeles, 1986. **Awards:** ACA Gallery Competition, Exhibition Prize, 1937; Brooklyn Museum, First Prize, 1950; Prix de Rome, 1955-59. **Address:** Travi Quatro Del Lago 13, Brassiano, Italy 00062. **Dealer:** Harmon-Meek Gallery, Naples, Fla. **One-man Exhibitions:** ACA Gallery (prize show), 1937, also 1940; Grand Central Moderns, NYC, 1949, 52; Galleria Schnei-

der, Rome, 1957, 63; Lee Nordness Gallery, NYC, 1959-61, 1963, 66; Mickelson Gallery, Washington, D.C., 1963, 67, 79; Cheekwood, 1966, 78; Penthouse Gallery, San Francisco, 1966; Gallery of Modern Art, 1966, 68; VMFA, 1967; London Arts; Cincinnati/AM; Kovler Gallery, Chicago, 1968-70; West Palm Beach/Norton, 1969; Sestiero Galleria, Rome, 1975; Ostaehag Gallery, Oslo, 1975; Heritage Galleries, Los Angeles, 1978; Yares Gallery, Scottsdale, Az., 1976-78; Harmon Gallery, Naples, Fla., 1978; Randall Galleries, NYC, 1978, 81; Byck Gallery, Louisville, Ky., 1978; Foster Harmon Gallery, Sarasota, Fla., 1981; Harmon-Meek Gallery, Naples, Fla., 1981, 83, 92; Academy of Art College, San Francisco, 1983. **Group:** Sculptors Guild, 1937-46; WMAA Annuals, 1937-63; PAFA, 1938-64; Arte Figurativo, Rome, 1964, 67; Carnegie, 1965. **Collections:** AAIAL; U. of Arizona; Bezalel Museum; Billedgaileri, Bergen, Norway; Brandeis U.; Calcutta; Cheekwood; James Joyce Museum; Little Rock/MFA; MOMA; Museum of the City of New York; Nashville; U. of North Carolina; Northwestern U.; U. of Notre Dame; Oslo U.; PAFA; PMA; Pan American Airways, NYC; Tel Aviv; UCLA; VMFA; WMAA; Yale U. **Bibliography:** Brumme; Cheney.

HEIZER, MICHAEL b. 1944, Berkeley, Calif. **Studied:** SFAI, 1963-64. **Commissions:** Seattle, Wash., 1976; MMA, 1979; Capitol Plaza, Lansing, Mich., 1977; Oakland Museum, 1980; Wells Fargo Building, Los Angeles, 1982; IBM Building, NYC, 1982; Ottawa, Ill., 1983; Rice U., Houston, 1984; Menil Collection, Houston, 1991; U. of Nebraska, 1991. **Awards:** Skowhegan Medal for Painting, Grahpics, and Sculpture. **Address:** c/o Dealer. **Dealer:** Knoedler & Co., NYC. **One-man Exhibitions:** Gallerie Heiner Friedrich, Munich, 1969; Dwan Gallery, NYC, 1970; Detroit/Institute, 1971; ACE Gallery, Los Angeles,

1974, 77; Fourcade, Droll Inc., 1974; Xavier Fourcade, Inc., NYC, 1976, 77, 79, 80, 82, 83, 85; ACE Gallery, Venice, Calif., 1977; Galerie am Promenadenplatz, Heizer und Kinnius, Munich, 1977; Richard Hines Gallery, Seattle, 1979; St. Louis/City, 1980; Janie C. Lee Gallery, 1981, 84; Flow Ace Gallery, Venice, Calif., 1982; Oil and Steel, Long Island City, N.Y., 1983; Barbara Krakow Gallery, Boston, 1983; Patricia Heesy Gallery, NYC, 1983; Los Angeles/MOCA, 1984; Rice U., 1984; WMAA, 1985; Knoedler & Co., NYC, 1988, 90; Akira Ikeda Gallery, Tokyo, 1988, 89; Ochi Gallery, Ketchum, Idaho, 1988, 89; Waddington Galleries, London, 1990. **Retrospective:** Essen, 1979. **Group:** WMAA, 1968, 70; Amsterdam/Stedelijk, Op Losse Schroeven, 1969; Detroit/Institute, Other Ideas, 1969; Berne, When Attitudes Become Form, 1969; Düsseldorf/Kunsthalle, Prospect '70, 1970; XXXV Venice Biennial, 1970; Cornell U., Earth Art, 1970; SRGM, Guggenheim International, 1971; Durer Centennial, Nurnberg, 1971; Rijksmuseum Kröller-Müller, Diagrams and Drawings, 1972; WMAA, American Drawings: 1963-1973, 1973; New York Cultural Center, 3D into 2D, 1973; MIT, Interventions in Landscape, 1974; Chicago/AI, 71st American Exhibition, 1974; MOMA, Drawing Now, 1975; Chicago/AI, 1976, 79; WMAA, 200 Years of American Sculpture, 1976; Kassel, Documenta VI, 1977; U. of Texas, New in the Seventies, 1977; Hirshhorn, Probing the Earth, 1977; Indianapolis, 1978; Purchase/SUNY, Hidden Desires, 1980; Sierra Nevada Museum of Art, Artists in the American Desert, 1980; Houston/Contemporary, The Americans: The Landscape, 1981; Rice U., Variants, 1981; SFMA, 20 American Artists: Sculpture, 1982, 1982; National Gallery, Gemini G.E.L.: Art and Collaboration, 1984; École des Beaux Arts, Paris, American Drawing: 1930-1950, 1985; Fort Lauderdale, An American Renaissance, 1986; Los Angeles/MOCA, Indi-

viduals, 1986; ICA, U. of Pennsylvania, 1967: At the Crossroads, 1987; WMAA, Twentieth Century Drawings and Watercolors from the Whitney Museum, circ., 1987; WMAA, Vital Signs, 1988; Makuhari Messe, Tokyo, Pharmakon, '90, 1990. **Collections:** MMA; MOMA; WMAA. **Bibliography:** Alloway 4; *Art Now 74;* Brown, Julia, ed.; Calas, N. and E.; Celant; *Contemporanea;* Cummings 5; *Europa/Amerika;* Honisch and Jensen, eds.; *Individuals;* Kardon 3; *Kunst um 1970;* Lippard, ed.; Lucie-Smith; Muller; *New in the Seventies;* Robins; Sandler 3; Seitz 3; Weintraub; *When Attitudes Become Form.*

HELD, AL **b.** October 12, 1928, Brooklyn, N.Y. **Studied:** ASL, with Kimon Nicolaides, Robert B. Hale, Harry Sternberg; Academie de la Grande Chaumiere; Siquieros in Mexico, 1949. US Navy, 1945-47. Traveled France, USA. **Taught:** Yale U., 1962-80; Artist-in-Residence, American Academy, 1981. **Member:** Board of Trustees, American Academy, 1982-; AAIAL, 1984. **Commissions:** Tower East, Cleveland, Oh., 1967; Empire State Plaza, Albany, N.Y., 1976; Social Security Building, Philadelphia, 1977; Southland Center, Dallas, 1983; Akron (Oh.) Government Building, 1985. **Awards:** Chicago/AI, The Mr. and Mrs. Frank G. Logan Medal, 1964; Guggenheim Foundation Fellowship, 1966; Brandeis U., Creative Arts Award, 1983; AAIAL, 1984. **Address:** 435 West Broadway, NYC 10012. **Dealers:** André Emmerich Gallery, NYC; Robert Miller Gallery, NYC. **One-man Exhibitions:** (first) Galerie Huit, Paris, 1952; Poindexter Gallery, NYC, 1958 (two-man), 1959, 61, 62; Galeria Bonino, Buenos Aires, 1961; Ziegler Gallery, 1964, 70; Galerie Gunar, Düsseldorf, 1964; André Emmerich Gallery, NYC, 1965, 67, 68, 70, 72, 73, 75, 76, 78, 79, 80, 82, 84, 85, 86, 87, 88, 89, 91; Amsterdam/Stedelijk, 1966; Galerie Muller, 1966; SFMA, 1968; Corcoran, 1968; ICA, U. of Pennsylvania,

1968; Houston/Contemporary, 1969; Current Editions, Seattle; Galerie André Emmerich, Zurich, 1974, 77, 80; Jared Sable Gallery, Toronto, 1975; Adler Castillo Gallery, Caracas, 1975; Galerie Renée Ziegler, Zurich, 1977, 90; Galerie Roger d'Amecourt, Paris, 1977; Annely Juda Fine Art, London, 1977, 80; Donald Morris Gallery, Birmingham, Mich., 1971, 74, 77, 83; ICA, Boston, 1978; Friedland Gallery, Toronto, 1978, 84; Janus Gallery, Venice, Calif., 1979; Robert Miller Gallery, NYC, 1980, 82, 87, 90; Gimpel-Hanover and André Emmerich Galleries, Zurich, 1980, 84; Quadrat Gallery, Bottrop, 1980; American Academy, Rome, 1982; Juda Rowan Gallery, London, 1982; Richard Gray Gallery, Chicago, 1984; John Berggruen Gallery, San Francisco, 1989; Marianne Friedland Gallery, Naples, Fl., 1989. **Retrospective:** WMAA, 1974. **Group:** SRGM, Abstract Expressionists and Imagists, 1961; Marlborough Fine Art, Ltd., 1961; ICA, Boston, 1961; Carnegie, 1961; Dallas/MFA, 1961, 62; MOMA, Abstract American Drawings and Watercolors, circ., Latin America, 1961-63; WMAA; Geometric Abstraction in America, circ., 1962; Yale U., 1962; Corcoran, 1962; Jewish Museum, Toward a New Abstraction, 1963; Chicago/AI, 1963, 64; Los Angeles/County MA, Post Painterly Abstraction, 1964; WMAA Annuals, 1964, 65, 67, 69, 72, 73; Kunsthalle, Basel, Signale, 1965; U. of Michigan, 1965; NYU, 1965; Amsterdam/Stedelijk, New Shapes of Color, 1966; WMAA, Art of the U.S. 1670-1966, 1966; SRGM, Systematic Painting, 1966; Flint/Institute, I Flint In-

vitational, 1966; Jewish Museum, 1967; Kassel, Documenta V, 1968; Chicago/AI, 1969; Fort Worth Art Museum, Drawings, 1969; VMFA, 1970; Dublin/Municipal, International Quadriennial (ROSC), 1971; Indianapolis/Herron, 1974; Corcoran Biennial, 1975; Tulane U., Drawing Today in New York, 1977, 1976-77; Chicago/AI, Drawings of the 70's, 1976; Kassel, Documenta VI, 1977; U. of Texas, New in the Seventies, 1977; Minnesota/MA, American Drawing 1927-1977, 1977; Philadelphia College of Art, Point, 1978; Pomona College, Black and White Are Colors, 1979; Purchase/SUNY, Hidden Desires, 1980; Brooklyn Museum, American Drawings in Black and White, 1970-1979, 1980; WMAA Biennial, 1981; Haus der Kunst, Munich, Amerikanische Malerei: 1930-1950, 1981; Brooklyn Museum, The American Artist as Printmaker, 1983; Newport Harbor, Action/Precision, circ., 1984; Independent Curators, Inc., NYC, Concepts in Construction, circ., 1983; WMAA, American Art Since 1970, circ., 1984; AAIAL, 1984; Newport Beach, Action/Precision, The New Direction in New York 1955-1960, circ. 1984-86; Independent Curators Inc., NYC, After Matisse, circ., 1986-89; Institute de Estudios Norteamericanos, Barcelona, Sightings, circ., 1988-89; The New York Academy of Art, The Humanist Icon, 1990. **Collections:** Akron/AI; Berlin/National; Brandeis U.; Buffalo/Albright; Canberra/National; Ciba-Geigy Corp.; Cleveland/MA; Cleveland Trust Co.; Dallas/MFA; Dartmouth College; Delaware Art Museum; Dayton/AI; First National Bank of Seattle; Gallery of Modern Art, Iwaki City, Japan; Greenville; Harvard U.; High Museum; Hirshhorn; Kunsthalle, Basel; MMA; MOMA; Milwaukee; U. of North Carolina; SFMA; San Diego/MOCA; Santa Barbara/MA; Stuttgart; Syracuse/Everson; Treadwell Corp.; WMAA; Yale U.; Zurich. **Bibliography:** *Al Held;* Alloway 3; Armstrong, Thomas; Battcock, ed.; *Black and White Are Colors;* Calas, N. and E.;

Al Held, *Siena*, 1990.

Cummings 5; Honisch and Jensen, eds.; Hunter, ed.; Kardon 3; Lucie-Smith; *New in the Seventies;* Rose, B., 1; **Sandler** 3, 5, 6; Tucker. Archives.

HELIKER, JOHN EDWARD
b. January 16, 1909, Yonkers, N.Y. **Studied:** ASL, 1927-29, with Kimon Nicolaides, Thomas Hart Benton, Kenneth Hayes Miller, Boardman Robinson. Traveled Europe; resided Italy, two years. **Taught:** Colorado Springs Fine Arts Center; Columbia U. Federal A.P.: Easel painting. **Member:** NIAL, 1969, vice-president, 1971-74. **Awards:** Corcoran, First Prize, 1941; Pepsi-Cola, 1946; Prix de Rome, 1948; NAD, The Adolph and Clara Obrig Prize, 1948; Guggenheim Foundation Fellowship, 1952; NIAL Award, 1957; Ford Foundation, **P.P.**, 1960, 61; AAAL, Award of Merit Medal and $1,000, 1967; NAD, Benjamin Altman Prize for Landscape, Benjamin Altman Prize for Figure, 1977, 89; Hon. DFA, Bard College, 1991. **Address:** 865 West End Avenue, NYC. **Dealer:** Kraushaar Galleries, NYC. **One-man Exhibitions:** (first) Maynard Walker Gallery, NYC, 1936, also 1938, 41; Kraushaar Galleries, NYC, 1945, 51, 54, 68, 71, 74, 77, 86, 89, 92; Lehigh U., 1970; Drew U., Madison, N.J., 1971; Saint-Gaudens National Historical Site, Comish, N.H., 1972; Edmonton Art Gallery, Alberta, 1974; New York Studio School, NYC, 1982; Parsons School of Design, NYC, 1989. **Retrospectives:** WMAA, 1968; Ogunquit, 1990. **Group:** MOMA; MMA; Corcoran; VMFA; WMAA, 1941-46, 1955-57; Chicago/AI, 1942, 43, 45; Toldeo/MA, 1942, 43, 45; Carnegie, 1943-45; PAFA, 1944, 46; WMAA, The New Decade, 1954-55; Brussels World's Fair, 1958; U. of Illinois, 1961; New York World's Fair, 1964-65; Expo '70, Osaka, 1970; Huntington, N.Y./Heckscher, Windows and Doors, 1972; ASL Centennial, 1975; US Department of the Interior, America 1976, circ., 1976; Taft Museum, At the Table, 1989;

Maine Coast Artists Gallery, Rockport, Me., On the Edge, 1992. **Collections:** Arizona State College; Atlanta U.; Atlantic Richfield Co.; Ball State U.; Bowdoin College; Britannica; Brooklyn Museum; Chicago/AI; Clearwater/Gulf Coast; Cleveland/MA; Colby College; Colorado Springs/FA; Columbia U.; Commerce Trust Co., Kansas City, Mo.; Corcoran; Currier; Denver/AM; Des Moines; Hartford/Wadsworth; Harvard U.; Hirshhorn; Illinois Wesleyan U.; U. of Illinois; Kansas City/Nelson; Lehigh U.; Louisville/Speed; MMA; U. of Miami; NCFA; U. of Nebraska; New Britain/American; U. of Notre Dame; Ogunquit; PAFA; PMA; The Pennsylvania State U.; RISD; U. of Rochester; SFMA; Savannah/Telfair; Storm King Art Center; U. of Texas; Utica; WMAA; Walker; Washington U.; Whitney Communications Corp.; Wichita/AM. **Bibliography:** *America 1976;* Baur 5, 7; Goodrich and Baur 1; **Goodrich and Mandel;** Kent, N.; Nordness, ed.; Pagano; Pousette-Dart, ed.; Ritchie 1. Archives.

HENDLER, RAYMOND
from 1st to 5th edition.

HENRY, CHARLES T.
from 1st to 3rd edition.

HERMS, GEORGE **b.** 1935,
Woodland, Ca. **Studied:** U. of California, Berkeley, Engineering, 1953; Art autodidact. **Taught:** California State U., Fullerton, 1977-79; UCLA, 1980-81, 1987-90; Otis/Parsons, Los Angeles, 1987; Santa Monica College of Design, 1991-92; The Robbins Foundation, Philadelphia, Artist-in-Residence, 1991. **Awards:** Servant of the Holy Beauty Award, 1962; National Endowment for the Arts, fellowsihp, 1968, 77, 89; American Academy, Prix de Rome, 1982-83; Guggenheim Foundation Fellowship, 1983; Pollock-Krasner Foundation Grant, 1987. **Address:** 821 Millwood, Venice, CA 90291. **Dealer:** L.A. Louver, Venice, CA. **One-man Exhibitions:** Hermosa

Beach, Secret Exhibition, 1957; Toulumne, Calif., Jubilee, 1959; Semina Gallery, Larkspur, Calif., 1960; Batman Gallery, San Francisco, 1961; Aura Gallery, Pasadena, 1962; Rolf Nelson Gallery, Los Angeles, 1963, 66; Laguna Beach, Foggy Wagons, 1969; Molly Barnes Gallery, Los Angeles, 1969, 70; California State U., Los Angeles, 1972; U. of California, Davis, 1973; California State U., San Jose, 1975; TJB Gallery, Newport Beach, 1975; L.A. Louver Gallery, Venice, Calif., 1976, 82, 86, 89; Pasadena, Calif., Artists' Coop, 1976; Arco Center, Los Angeles, 1978; Stage One Gallery, Orange, Calif., 1980; Orange County Center for Contemporary Art, 1980; Ruth Schaffner Gallery, Santa Barbara, 1981; U. of Denver, 1981; Beyond Baroque, Venice, Calif., 1982; California State U., Fullerton, 1984; Barnsdall Municipal Park, Los Angeles, 1985; Oscarsson/Siegeltuch Gallery, NYC, 1986; Temple U., 1988; Santa Rosa, Calif., Museum of Fine Arts, 1988; Cypress College, 1990; D.P. Fong Gallery, San Jose, 1991. **Retrospective:** Los Angeles Municipal Art Gallery, 1992. **Group:** MOMA, The Art of Assemblage, circ., 1961; WMAA, Fifty California Artists, circ., 1962; Pasadena/AM, California Collage Shows, 1962; U. of California, Irvine, Assemblage in California, 1968; Palomar College, Assemblage of Assemblage, 1976; Sacramento/Crocker, Westcoast '72, 1972; La Jolla, Kurt Schwitters and Related Developments, 1973; Dallas/MFA, Poets of the Cities, 1950-1965, 1974; ICA, Los Angeles, Assemblage, 1975; Mount Holyoke College, Other Voices, 1975; SFMA, Painting and Sculpture in California, circ., 1976; U. of California, Santa Barbara, Photographs by Southern California Painters and Sculptors, 1977; U. of California, San Diego, The Artist's Book, 1977; Downey Museum of Art, Déja Vu, 1978; ICA, Los Angeles, Current Directions, 1978; California State U., San Diego, Gray Matter Mail Art Shows, 1978; Mt. San Antonio College, Realism—Points of View, 1978; California

State College, San Bernadino, 10 Sculptors Outdoors—15 Works, 1979; San Diego, Sculpture in California, 1975-80, 1980; Sonoma State U., Art of Assemblage, 1981; Laguna Beach Museum of Art, Southern California Artists, 1981; Jackson/MMA, Collage and Assemblage, circ., 1982; ICA, Los Angeles, Humor in Art, 1981; Laguna Beach, Boxed Art, 1983; Houston/MFA, Collage: The Americans, 1983; Claremont College, 1983; Oakland Museum, Art in the San Francisco Bay Area, 1980, 1985; San Antonio/MA, Poetic Objects, circ., 1989; Vancouver, Rezoning, 1989; UCLA, Forty Years of California Assemblage, 1989; Newport Harbor, The Denim Jacket Show, 1990; Laguna Beach Museum of Art, Novel Ideas, 1990; Pomona College, Crossing the Line, 1990; The Armory Center, Pasadena, California Artists' Books, 1991. **Collections:** U. of California, Berkeley; Los Angeles/County MA; Los Angeles/MOCA; Pasadena/AM; San Diego. **Bibliography:** *Forty Years of California Assemblage; Individuals.*

HESSE, EVA b. January 11, 1936, Hamburg, Germany. d. May 29, 1970, NYC. **Studied:** Cooper Union, 1954-57; Yale U. Summer School, Norfolk, Conn., 1957; Yale U., 1969, BFA. **Taught:** School of Visual Arts, NYC, 1968; Oberlin College, 1968. **One-man Exhibitions:** Allan Stone Gallery, 1963; Düsseldorf/Kunsthalle, 1965; Fischbach Gallery, NYC, 1968, 70; School of Visual Arts, NYC, 1971; Droll/Kolbert Gallery, NYC, 1977; Whitechapel Art Gallery, circ., 1979; Mayor Gallery, London, 1979; Metro Pictures, NYC, 1983; Brandeis U., 1985; Pat Hearn Gallery, NYC, 1987; Robert Miller Gallery, NYC, 1989, 91; Kicken Pauseback, Cologne, 1990; Galerie Renos Xippas, Paris, 1991. **Retrospectives:** SRGM, circ., 1972; Oberlin College, circ., 1982; Yale U., circ., 1992. **Group:** Brooklyn Museum, Watercolor Biennial, 1961; Riverside Museum, NYC,

American Abstract Artists, 1966; Ithaca College, Drawings, 1967, 1967; U. of North Carolina, 1967; New York State Fair, Art Today: 1967, 1967; Finch College, NYC, Art in Process, 1967, 69; Moore College of Art, Philadelphia, American Drawings, 1968; Milwaukee, Directions I: Options, circ., 1968; A.F.A., Soft Sculpture, 1968; WMAA, 1968; Fort Worth Art Museum, Drawings, 1969; Trenton/State, Soft Art, 1969; ICA, U. of Pennsylvania, Plastics and New Art, 1969; Seattle/AM, 557, 087, 1969; Milwaukee, A Plastic Presence, circ., 1969; Berne, When Attitudes Become Form, 1969; WMAA, Anti-Illusion: Procedures/Materials, 1969; Princeton U., American Art Since 1960, 1970; Foundation Maeght, 1970; ICA, U. of Pennsylvania, Projected Art, 1970; New York Cultural Center, 3D into 2D, 1973; WMAA (downtown), Sculpture of the Sixties, 1975; WMAA, 200 Years of American Sculpture, 1976; New Orleans Museum, Sculpture: American Directions, 1976; Kassel, Documenta VI, 1977; U. of Chicago, Ideas in Sculpture, 1977; Amsterdam/Stedelijk, Made by Sculptors, 1978; Purchase/SUNY, Hidden Desires, 1980; Cologne/Stadt, Westkunst, 1981; Fort Lauderdale, An American Renaissance: Painting and Sculpture Since 1940, 1986; Purchase/SUNY, The Window in Twentieth Century Art, circ., 1986; ICA, U. of Pennsylvania, 1967: At the Crossroads, 1987; WMAA, The New Sculpture: Between Geometry and Gesture, 1990; Wiesbaden, Positions of Art in the 20th Century: 50 Women Artists, 1990; Bukamura/MA, Shibuya, Japan, Four Centuries of Women's Arts, circ., 1990. **Collections:** Buffalo/Albright; U. of California, Berkeley; Canberra/National; Chicago/AI; Cologne; Des Moines; Düsseldorf/Kunsthalle; Israel Museum; Krefeld Museum; MOMA; Milwaukee; NMWA; U. of North Carolina; Oberlin College; Ohio State U.; Paris/Beaubourg; Ridgefield/Aldrich; Rijksmuseum Kröller-Müller; Stockholm/National; Tate Gallery;

WMAA. **Bibliography:** Celant; *Europa/Amerika; Eva Hesse: A Memorial Exhibition;* Gohr and Gachnang; *Individuals;* Kardon 3; Nemser; Rowell; Sandler 3; Weintraub; *When Attitudes Become Form.* Archives.

HEUBLER, DOUGLAS b. October 27, 1924, Ann Arbor, Mich. **Studied:** U. of Michigan, Ann Arbor, MFA; Cleveland School of Art; Academie Julien, Paris. US Marine Corps. **Taught:** Harvard U. **Address:** Box 102, Turo, Mass. 02666. **Dealer:** Holly Solomon Gallery, NYC. **One-man Exhibitions:** Phillips Gallery, Detroit, 1953; Obelisk Gallery, Boston, 1967; Windham College, 1968; Seigelaub Gallery, NYC, 1968; Eugenia Butler Gallery, Los Angeles, 1969; Konrad Fischer Gallery, Düsseldorf, 1970, 71, 72, 74; Andover/Phillips, 1970; Gian Enzo Sperone, Turin, 1970, 74; Yvon Lambert, Paris, 1970, 74, 80; Art & Project, Amsterdam, 1970, 71; Leo Castelli Inc., NYC, 1971, 72, 73, 76, 78, 81, 83, 90; California Institute of the Arts, Valencia, 1972; Galleria Toselli, Milan, 1972; Jack Wendler Gallery, London, 1972, 73, 74; Boston/MFA, 1972; Munster/WK, 1973; Kunsthalle, Kiel, 1973; Kunsthalle, Bielfeld, 1973; Fischer Sperone Galleria, Rome, 1973; Israel Museum, 1973; Galerie MTL, Brussels, 1973, 74, 79; Oxford/MOMA, 1973; Nova Scotia College of Art and Design, 1973; Lia Rumma Studio, Naples, 1974; Rolf Preisig Gallery, Basel, 1974; Francoise Lambert, Milan, 1975; Barbara Cusack Gallery, Houston, 1975; Sperone Westwater Fischer Inc., NYC, 1976; Galleric Akumulatory, Poznan, Poland, 1977; Thomas Lewallen Gallery, Los Angeles, 1977; Galerie Rüdiger Schöttle, Munich, 1978, 79, 90; U. of California, San Diego, 1979; Eindhoven, 1979; Los Angeles/County MA, 1979; Northwestern U., 1980; Los Angeles/Contemporary, 1984; Los Angeles Center for Photographic Studies, 1984; Buffalo/Albright, 1985; San Diego/Contemporary, 1988; Lyon/St.

Pierre, 1989; Richard Kuhlenschmidt Gallery, Los Angeles, 1990; Holly Solomon Gallery, NYC, 1990; Gallerie Lia Rumma, Naples, 1990. **Group:** Corcoran Biennial, 1957; WMAA Annual, 1966; The Pennsylvania State U., Six Sculptors, 1967; Berne, When Attitude Becomes Form, 1969; Amsterdam/Stedelijk, Op Losse Schroeven, 1969; Seattle/AM, 557, 087, 1969; Düsseldorf/Kunsthalle, Prospect 69, 1969; MOMA, Information, 1970; Arnhem, Sonsbeek '71, 1971; Basel, Konzept Kunst, 1972; Kassel, Documenta V, 1972; Chicago/AI, 72nd American Exhibition, 1976; Houston/Contemporary, American Narrative/Story Art, 1977; ICA, Boston, Narration, 1978; Wichita State U., Artists and Books, 1979; ICI, Verbally Charged Images, 1984; Bard College, The Maximal Implications of the Minimal Line, 1985; Ridgefield/Aldrich, A Second Talent, 1985; Fort Lauderdale, An American Renaissance, 1985; Queens Museum, The Real Big Picture, 1986. **Collections:** Amsterdam/Stedelijk; Andover/Phillips; Brandeis U.; Columbia, S. C./MA; Israel Museum; MOMA; Ottawa; Tate Gallery. **Bibliography:** Fox; Robins.

HIGGINS, EDWARD
from 1st to 4th edition.

HILLSMITH, FANNIE
from 1st to 5th edition.

HINMAN, CHARLES b. December 29, 1932, Syracuse, N.Y. **Studied:** Syracuse U., BFA, 1955; ASL (with Morris Kantor), 1955-56. Played professional baseball, Milwaukee Braves, 1954-55. US Army, 1956-58. Traveled Japan, India, Europe, and around the world. **Taught:** Staten Island Academy, 1960-62; Woodmere Academy, 1962-64; Cornell U., 1968-69; Syracuse U., 1971; Pratt Institute, 1975; School of Visual Arts, NYC, 1976; Cooper Union, NYC, 1977; University of Georgia, 1991-93; Aspen Institute, 1967-77. **Member:** Artists Equity.

Commissions: Neiman-Marcus Co., Atlanta (sculpture); Grand Hyatt Hotel, NYC; Madison Green Building, NYC; Mack Plaza, Tampa, Fla. **Awards:** Syracuse U., Augusta Hazard Fellowship, 1955-56; Nagaoka, Japan, First Prize, 1965; Flint/Institute, First Prize, 1966; Torcuato di Tella, Buenos Aires, Special Mention, 1967; National Endowment for the Arts, 1980. **Address:** 231 Bowery, NYC 10002. **Dealers:** Douglas Drake Gallery, NYC; Margaret Lipworth, Boca Raton, Fla.; Irving Galleries, Palm Beach. **One-man Exhibitions:** (first) Richard Feigen Gallery, NYC, 1964, also 1966, 67; Feigen-Palmer Gallery, Los Angeles, 1964; Oberlin College (three-man), 1965; Richard Feigen Gallery, Chicago, 1965, 66; Tokyo Gallery, 1966; Galerie Denise Rene/Hans Mayer, Krefeld, W. Germany, 1970; Galerie Denise Rene, Paris, 1971, NYC, 1972, 73, 75; Hokin Gallery, Chicago, 1976, 79; Hokin Gallery, Palm Beach Fla., 1977; Irving Galleries, Milwaukee, 1976; Donald Morris Gallery, Birmingham, Mich., 1979; Bellman Gallery, NYC, 1983; Gallery 99, Bay Harbor Island, Fla., 1985; Irving Feldman Galleries, West Bloomfield, Mich., 1986; Virginia Lust Gallery, NYC, 1989; Douglas Drake Gallery, NYC, 1990, 91; North Carolina State U., Raleigh, 1990; Hickory, N.C., 1991. **Retrospective:** Lincoln Center, 1969. **Group:** Riverside Museum, 1965; WMAA, Young America, 1965; Chicago/AI, 1965, 66, 69; SFMA, The Colorists, 1965; Nagaoka, Japan, 1975; U. of Notre Dame, 1965; Finch College, 1966; WMAA, Art of the U.S. 1670-1966; U. of Illinois, 1967; VI International Art Biennial, San Marino (Europe), 1967; Carnegie, 1967; WMAA Annual, 1967; Honolulu Academy, 1968; Jewish Museum, Superlimited, 1969; A.F.A., 1969; Indianapolis/Herron, 1969; Princeton U., American Art Since 1960, 1970; NCFA, Disappearance and Reappearance of the Image, circ., 1969; U. of Illinois, 1971; Indianapolis, 1976; Kuznetsky Most Exhibi-

Joseph Hirsch, *Pickles*, 1977.

tion Hall, Moscow, American Painting Since the Death of Painting, circ., 1989; National Gallery, Graphic Studio, 1991. **Collections:** American Republic Insurance Co.; Aspen Institute; Boise-Cascade Corp.; Buffalo/Albright; Chase Manhattan Bank; Continental Grain Corp.; Delaware Art Museum; Denver/AM; Detroit/Institute; Fort Lauderdale; Hirshhorn; Humlebaek/Louisiana; U. of Illinois; Laguna Gloria; Lehigh U.; Los Angeles/County MA; MIT; MOMA; McCrory Corp.; Milwaukee; Nagaoka, Japan; U. of North Carolina; Oberlin College; The 180 Beacon Collection: The Pennsylvania State U.; Princeton U.; Raleigh/NCMA; Ridgefield/Aldrich; Syracuse/Everson; U. of Texas; WMAA; Wake Forest U.; Williams College. **Bibliography:** Battcock, ed.; Colpitt and Plous; Hunter, ed.; Johnson, Ellen H.; Sandler 3; Weintraub.

HIRSCH, JOSEPH **b.** April 25, 1920, Philadelphia, Pa. **d.** Sept. 25, 1981, NYC. **Studied:** Philadelphia Museum School, 1927-31; privately with Henry Hensche in Provincetown; with George Luks in NYC. Traveled Europe, the Orient, USA; resided France, five years. **Taught:** Chicago Art Institute School; American Art School, NYC; U. of Utah; ASL, 1959-67; Dartmouth College, 1966; Utah State U., 1967; Brigham Young U., 1971; NAD. Artist war correspondent, 1943-44. **Member:** Artists Equity (founder

and first treasurer); NAD; Philadelphia Watercolor Club; NIAL, 1967. Federal A.P.: Easel painting; first WPA murals in Philadelphia, for Amalgamated Clothing Workers Building and Municipal Court. **Awards:** Scholarship from the City of Philadelphia; PAFA, Walter Lippincott Prize; American Academy, Rome; International Institute of Education Fellowship, 1935-36; New York World's Fair, 1939, First Prize; Guggenheim Foundation Fellowship, 1942-43; Library of Congress, Pennell P.P., 1944, 45; NIAL Grant, 1947; Carnegie, Second Prize, 1947; Chicago/AI, Watson F. Blair Prize; Fulbright Fellowship, 1949; MMA, 1950; NAD, Benjamin Altman Prize, 1959, 66; NAD Annual Andrew Carnegie Prize, 1968; Davidson College, P.P., 1972, 73; Oklahoma, P.P., 1974; NAD, Altman Prize for Figure Painting, 1978. **One-man Exhibitions:** ACA Gallery, Philadelphia; A.A.A. Gallery, NYC, 1946, 48, 54; The Forum Gallery, NYC, 1965, 69, 74; Oklahoma, 1974; Century Association, NYC, 1980; Kennedy Galleries, NYC, 1975, 76, 78, 80. **Group:** WMAA; Newark Museum; Walker; MMA; Kansas City/Nelson; PAFA. **Collections:** AAAL; Andover/Phillips; U. of Arizona; Boston/MFA; Dartmouth College; U. of Georgia; IBM; Kansas City/Nelson; Library of Congress; MMA; MOMA; Museum of Military History; NAD; U. of Oklahoma; PMA; Southampton/Parrish; Springfield, Mass./MFA; Harry S. Truman Library; WMAA; Walker; College of Wooster. **Bibliography:** Baur 7; Cheney; Cummings 4; Genauer; *Joseph Hirsch;* Miller, ed., 1; Nordness, ed.; Pagano; Phillips 2; Reese; Richardson, E. P.; Wight 2. Archives.

HOFMANN, HANS **b.** March 21, 1880, Weissenberg, Bavaria, Germany. **d.** February 17, 1966, NYC. **Studied:** Gymnasium, Munich; Academie de la Grande Chaumiere, 1904. Resided Paris, 1904-14, with the patronage of Phillip Freudenberg, department-store owner and

art collector. US citizen, 1941. **Taught:** Opened first art school, 1915, in Munich; held summer sessions at Ragusa, 1924, Capri, 1925-27, Saint Tropez, 1928, 29; Chouinard Art Institute, Los Angeles, 1930; U. of California, Berkeley, summer, 1930; ASL, 1932-33; Thurn School, Provincetown, summers, 1923, 33; opened own school in NYC, 1933, own summer school in Provincetown, 1934. Stopped teaching 1958, to devote full time to painting. **Awards:** U. of Illinois, P.P., 1950; Society for Contemporary American Art, Chicago, P.P., 1952; PAFA, J. Henry Schiedt Memorial Prize, 1952; Chicago/AI, The Mr. & Mrs. Frank G. Logan Medal, 1953; Chicago/AI, Flora Mayer Witkowsky Prize, 1959; II Inter-American Paintings and Prints Biennial, Mexico City, 1960, Hon. Men.; Chicago/AI, Ada S. Garrett Prize, 1961; hon. degree, Dartmouth College, 1962; hon. degree, U. of California, 1964; elected to the NIAL, 1964. **One-man Exhibitions:** (first) Paul Cassirer Gallery, Berlin, 1910; California Palace, 1931; New Orleans/Delgado, 1940; Art of This Century, NYC, 1944; "67" Gallery, NYC, 1944, 45; Betty Parsons Gallery, 1946, 47; The Kootz Gallery, NYC, 1947, 49, 1950-55, 1957, 58, 1960-64, 1966; Galerie Maeght, 1949; Boris Mirski Gallery, Boston, 1954; Baltimore/MA, 1954; Rutgers U., 1956; Dartmouth College, 1962; Stanford U., 1966; André Emmerich Gallery, NYC, 1967-69, 1972, 73, 74, 75, 76, 77, 78, 79, 80, 82, 83, 84, 85, 86, 88, 89, 90, 91 (2); Richard Gray Gallery, 1968, 72, 80; Obelisk Gallery, 1969; David Mirvish Gallery, 1969, 73, 74; MMA, 1972; John Berggruen Gallery, 1973; Buffalo/Albright, 1973; Art Museum of South Texas, Corpus Christi, 1974; MMA, 1974; Santa Ana/Bowers, 1975; Waddington Galleries, Montreal, 1975, 80; Garage Gallery, Birmingham, Ala., 1975; Fendrick Gallery, Washington, D.C., 1975; Deutsch Gallery, NYC, 1976; Schaffner Gallery, Los Angeles, 1976; Janie C. Lee Gallery, Houston, 1977, 87; B.R.

Kornblatt Gallery, Washington, D.C., 1977, 83; David Mirvish Gallery, Toronto, 1977; Hokin Gallery, Chicago, 1977; Freudenheim Gallery, Buffalo, 1978; Thomas Segal Gallery, Boston, 1978; Richard Gray Gallery, Chicago, 1978; Hokin Gallery, Palm Beach, 1978; MMA, Hans Hofmann as Teacher, 1979; Marianne Friedland Gallery, Toronto, 1979, 81, 82, 84, 86, 87, 91; Denver/AM, 1979; MMA, 1980; Provincetown Art Association, 1980; Asher/Faure, 1981; Harcus-Krakow Gallery, Boston, 1981; Makler Gallery, Philadelphia, 1981; Martha White Gallery, Louisville, 1981; Edmonton Art Gallery, 1982; Douglas Drake Gallery, Kansas City, 1984; Yares Gallery, Scottsdale, 1984; Thomas Babeor Gallery, La Jolla, 1985, 87, 89, Fort Worth, 1985; C. Grimaldis Gallery, Baltimore, 1986, 87, 90; Arthur Roger Gallery, New Orleans, 1986; Martina Hamilton Gallery, NYC, 1986; John C. Stoller & Co., 1986; Lever/Meyerson Gallery, NYC, 1987; U. of California, Berkeley, 1987; Tate Gallery, 1988; John Berggruen Gallery, San Francisco, 1989; Crane Gallery, London, 1990. **Retrospectives:** Arts Club of Chicago, 1944; Andover/Phillips, 1948; Bennington College, 1955; Philadelphia Art Alliance, 1956; WMAA, circ., 1957; The Kootz Gallery, NYC, 1959; Germanisches National Museum, Nurnberg, circ., Germany, 1962; MOMA, circ., USA, Latin America, and Europe, 1963; WMAA, circ., 1990. **Group:** Chicago/AI; U. of Illinois; Carnegie; Kassel, Documenta II, 1959; XXX & XXXIV Venice Biennials, 1960, 68; WMAA Annual, 1965; Corcoran Biennial, 1965; Marlborough-Gerson Gallery, Inc., 1967; MOMA, The New American Painting and Sculpture, 1969; Albright/Buffalo, Color and Field 1890-1970, 1970; WMAA, The Structure of Color, 1971; Birmingham, Alabama, American Watercolors 1850-1972, 1972; National Gallery, American Art at Mid Century, 1973; Houston/MFA, The Great Decade of American Abstraction, 1974;

Hans Hofmann, *Fall Euphony*, 1959.

Kennedy Gallery, NYC, The Art Students League, 1875-1975, 1975; Harvard U., The New York School: From the First Generation, 1975; SRGM, Twentieth Century Drawings, 1976; A.F.A., American Master Drawings and Watercolors, 1976; Bonn, 200 Years of American Painting, 1976; Baltimore/MA, 200 Years of American Painting, 1977; Syracuse/Everson, Provincetown Painters, 1977; Cornell U., Abstract Expressionism, The Formative Years, 1978; Flint/Institute, Art and the Automobile, 1978; Sierra Nevada Museum of Art, The New York School, 1940-1960, 1979; Grande Palais, Paris, L'Amerique aux Independants, 1980; Hirshhorn, The Fifties: Aspects of Painting in New York, 1980; Cologne/Stadt, Westkunst, 1981; Houston/Contemporary, The Americans: The Collage, 1982; Houston/MFA, Miró in America, 1982; NYU, Tracking the Marvelous, 1981; Carnegie, Abstract Painting and Sculpture in America, 1927-1944, circ., 1983; École des Beaux-Arts, Paris, American Drawing: 1930-1980, 1985; Hofstra U., Avant-Garde Comes to New York, 1985; Fort Lauderdale, An American Renaissance: Painting and Sculpture Since 1940, 1986; Cologne/Ludwig, Europa/Amerika, 1986; Newport Harbor, The Interpretive Link, circ., 1986; Purchase/SUNY, The Window in 20th-Century Art, circ., 1986; Cologne/Ludwig, Kunst im 20. Jahrhundert, 1986; Kunsthalle, Bielefeld, Hans von Marees un die Moderne in Deutschland, circ., 1987; I.C.I., NYC, After Matisse, circ., 1986;

WMAA, The Gestural Impulse, 1989; Katonah Gallery, Watercolors from the Abstract Expressionist Era, 1990; Cologne/Ludwig, Die Hand Des Kunstlers, 1991; MOMA, The Art of the Forties, 1991; Potsdam/SUNY, From Omaha to Abstract Expressionism, 1991. **Collections:** Abbott Laboratories; Andover/Phillips; U. of Arkansas; Art of This Century (Peggy Guggenheim); Baltimore/MA; Buffalo/Albright; U. of California (Museum Hofmann); Canberra/National; Carnegie; Chicago/AI; Chicago/Contemporary; Cleveland/MA; Columbia Broadcasting System; Dallas/MFA; Dayton/AI; Fort Dodge/Blanden; Fort Worth; Grenoble; High Museum; Hirshhorn; U. of Illinois; Indianapolis/Herron; International Minerals & Chemicals Corp.; U. of Kansas; Louisville/Speed; MMA; MOMA; U. of Miami; U. of Michigan; Montreal/MFA; NMAA; U. of Nebraska; Newark Museum; PMA; U. of Rochester; SRGM; Santa Barbara/MA; Tate Gallery; U. of Texas; Toledo/MA; Toronto; WMAA; Walker; Washington U.; Wilmington; Yale U. **Bibliography:** *Abstract Expressionism;* Alloway 4; Anfam; Armstrong, Thomas; Ashton 5; Barker 1; Baur 5, 7; Biddle 4; Blesh 1; Brion 1; Cheney; Chipp; Danto; Eliot; *Europa/Amerika; From Foreign Shores;* **Goodman;** Goodrich and Baur 1; *The Great Decade;* **Greenberg 1, 2;** Haftman; Henning; Hess, T. B., 1; Hobbs and Levin; **Hofmann; Hunter 1, 2, 6;** Hunter, ed.; Janis and Blesh 1; Janis, S.; Kozloff 3; Kuh 2; Lane and Larsen; **Loran 2;** McCurdy, ed.; Mendelowitz; *Metro;* Motherwell and Reinhardt, eds.; Murken-Altrogge; Newmeyer; Nordness, ed.; Ponente; Pousette-Dart, ed.; Read 2; Richardson, E.P.; Ritchie 1; Rose, B., 1, 4; Rothschild; Sandler 5; **Seitz 1, 3, 5;** Tapie 1; Tomkins 2; Tuchman, ed.; Weller; **Wight 1.** Archives.

HOLLAND, THOMAS b. June 15, 1936, Seattle, Wash. **Studied:** Wilamette U., 1954-56; U. of California, Santa

Barbara and Berkeley, 1957-59. Traveled Chile. **Awards:** Fulbright Fellowship, 1960; National Endowment for the Arts, 1975; Guggenheim Foundation Fellowship, 1979. **Taught:** SFAI, 1962-67, U. of California, Berkeley; San Francisco Art Institute, 1961-68, 72-80; U. of California, Los Angeles, 1968-70; U. of California, Berkeley, 1978-79; Cornish Institute, Seattle, 1978. **Awards:** National Endowment for the Arts, grant, 1976; Guggenheim Foundation Fellowship, 1980-81. **Address:** 28 Roble Road, Berkeley, CA 94705. **Dealers:** Charles Cowles Gallery, NYC; James Corcoran Gallery, Los Angeles. **One-man Exhibitions:** Universidad Catolica, Santiago, 1961; RAC, 1962; New Mission Gallery, San Francisco, 1962; Hansen-Fuller Gallery, San Francisco, 1962-66, 68, 70, 72, 73, 74, 76, 77, 80; The Lanyon Gallery, Palo Alto, Calif., 1963-65; Nicholas Wilder Gallery, Los Angeles, 1965, 68, 72, 73, 75, 76, 77, 79; Robert Elkon Gallery, 1970; Galerie Hans R. Neuendorf, Cologne, 1971; Lawrence Rubin Gallery, NYC, 1972; Ronald Greenberg Gallery, St. Louis, 1972, 75, 83; Corcoran and Greenberg, Inc., Miami, 1972; Multiples, Los Angeles, 1972; Felicity Samuel Gallery, London, 1973; Knoedler Contemporary Art, NYC, 1973, 75; Current Editions, Seattle, 1973; Dootson Calderhead Gallery, Seattle, 1975; Sedar/Creigh Gallery, Coronado, Calif., 1975; Watson/deNagy Gallery, Houston, 1977; Smith-Andersen Gallery, Palo Alto, 1978, 82; Charles Casat Gallery, La Jolla, 1978; Droll-Kolbert Gallery, NYC, 1978; SFAI, 1979; Linda Farris Gallery, Seattle, 1979, 81, 83, 86; Blum Helman, NYC, 1979, 81; Watson-Willour & Co., Houston, 1979; James Corcoran Gallery, Los Angeles, 1980, 82, 83, 86, 89; South Alberta Art Gallery, 1981; John Berggruen Gallery, 1984, 86, 87, 89; Arts Club of Chicago, 1985; Charles Cowles Gallery, NYC, 1981, 83, 84, 85, 86, 88. **Retrospective:** RAC, 1975. **Group:** SFMA, Bay Area Artists, 1964; Stanford U., Current Paint-

ing and Sculpture of the Bay Area, 1964; La Jolla, 1965; PAFA, 1968; Ringling, California Painters, 1968; U. of Illinois, 1969; Corcoran, 1969; WMAA Annual, 1969; Pasadena/AM, West Coast: 1945-69, 1969; SFAI Centennial Exhibition, 1971; Hamburg/Kunstverein, USA: West Coast, circ., 1972; U. of Illinois Biennial, 1974; SFMA, California Painting and Sculpture: The Modern Era, 1976; Invitational American Drawing Exhibition, San Diego, 1977; U. of Texas, New in the Seventies, 1977; Sacramento/Crocker, Aspects of Abstract Art, 1979; MOMA, New Works on Paper I, circ., 1981; Oakland/AM, On and Off the Wall, 1983; Cranbrook, Viewpoint '84, 1984; U. of Southern California, Los Angeles, California Sculpture Show, 1985; Oakland/AM, Art in the San Francisco Bay Area, 1945-80; AAIAL, 1987; U. of North Carolina, Art on Paper, 1988. **Collections:** U. of California, Berkeley; Brooklyn Museum; Chicago/AI; Hirshhorn; Honolulu Academy; Los Angeles/County MA; MOMA; U. of Nebraska;

Tom Holland, *Linx*, 1988.

Oakland/AM; Phoenix; Ridgefield/Aldrich; RISD; St. Louis/City; Seattle/AM; SFMA; SRGM; Stanford U.; Walker; WMAA. **Bibliography:** *California Sculpture Show; New in the Seventies; The State of California Painting; USA West Coast.*

HOLTY, CARL ROBERT
b. June 21, 1900, Freiburg, Germany. **d.** March 23, 1973, NYC. To USA, 1900; citizen, 1906. US Army, 1917-18. **Studied:** Marquette U., 1918-19; NAD, 1920-22; Academy of Fine Arts, Munich, 1925-26; Hofmann School, Munich. Traveled Europe. **Taught:** ASL, 1939-40, 1950-51; U. of Georgia, 1948-50; summer, U. of California, Berkeley, 1951; U. of Florida, 1952-53; Brooklyn College, 1955-60, 1964-73; U. of Wisconsin, 1961; U. of Louisville, 1962-63; lectured extensively. **Member:** Abstraction-Creation, Paris, 1931-32; American Abstract Artists, 1936-43. **Awards:** U. of Illinois, P.P., 1948; Ford Foundation, 1963. **One-man Exhibitions:** J. B. Neumann Gallery, NYC, 1936-44; Karl Nierendorf Gallery, NYC, 1938; The Kootz Gallery, NYC, 1946, 48; J.B. Neumann's New Art Circle, 1951, 52; Duveen-Graham Gallery, NYC, 1956; The Graham Gallery, NYC, 1959-62, 64, 67; Poindexter Gallery, NYC, 1972; City U. of New York Graduate Center, 1972; Andrew Crispo Gallery, NYC, 1974; Milwaukee, 1981; The Graham Gallery, 1983. **Group:** WMAA; PAFA; Corcoran; Chicago/AI; MMA; St. Louis/City; Los Angeles/County MA; Cincinnati/AM; Columbus. **Collections:** U. of Arkansas; U. of California; Chattanooga/AA; Exeter; U. of Georgia; U. of Illinois; Louisville/Speed; Milwaukee; NYU; U. of Nebraska; SRGM; St. Louis/City; Seattle/AM; U. of Tennessee; U. of Texas; WMAA; U. of Wisconsin; Youngstown/Butler. **Bibliography:** Armstrong, Thomas; Baur 7; Blesh 1; **Carl Holty Memorial Exhibition;** Hess, T. B., 1; Janis, S.; Kootz 2; Lane and Larsen; McCurdy, ed.; Passloff; Ritchie 1; Seuphor 1. Archives.

HOOD, DOROTHY
b. August 22, 1919, Bryan, Texas. **Studied:** RISD; ASL, NYC. Traveled Mexico, South and Central America, Europe, extensively. Subject of documentary film by Carl Colby, *Dorothy Hood: The Color of Life,* 1985. **Taught:** Museum School of Fine Arts, Houston, 1963-77; Colorado State U., 1976. **Commissions:** Mural, St. Worth National Bank, 1972; mural, Lumm's Tower Building, Houston, 1980; sets for several ballet companies. **Awards:** National Scholastic Scholar, 1937-41; NAAL Childe Hassam P.P., 1973; Brown Foundation, travel grant, 1973; Italian Academy of Arts & Labor, 1978. **Address:** 819 Highland Avenue, Houston, Tx. 77009. **Dealer:** Meredith Long Gallery, Houston. **One-man Exhibitions:** (first) The Willard Gallery, NYC, 1950; Proteo Gallery, Mexico City, 1955; Duveen-Graham Gallery, NYC, 1958; Galerie Genova, Mexico City, 1955; Philadelphia Art Alliance, 1958; Atelier Chapman Kelley, Dallas, 1961; Witte, 1965; Houston/Contemporary, 1970; Syracuse/Everson, 1972; Rice U., 1971; Houston Art Museum of South Texas, Corpus Christie, 1975; Houston/MFA, 1974; Tibor de Nagy, NYC, 1974; Potsdam/SUNY, 1974; Davis & Long Company, NYC, 1975; U. of Texas, 1975; Meredith Long Gallery, Houston, 1962, 64, 66, 68, 70, 72, 74, 76, 82; Marianne Friedland Gallery, Toronto, 1976; Meredith Long Contemporary, NYC, 1978, 80, 82; San Antonio/McNay, 1978; Wallace Wentworth Gallery, Washington, D.C., 1986. **Retrospectives:** San Antonio/McNay, 1978; Syracuse/Everson, circ., 1980. **Group:** Brooklyn Museum, Golden Years of American Drawing, 1905-56, 1956; RISD, Four Young Americans, 1959; MOMA, Young American Printmakers, 1953; Potsdam/SUNY, Women in Art, 1972; Syracuse/Everson, New Works in Clay by Contemporary Painters and Sculptors, 1976; Houston/Contemporary, The Americans: The Collage, 1982; Houston/MFA, Fresh Paint, 1985. **Collections:**

Boston/MFA; Brooklyn Museum; California State College, Long Beach; Dallas/MFA; Fort Worth; U. of Houston; Houston/Contemporary; La Jolla; Mexico City Nacional; MOMA; Montreal Contemporary; National Gallery; The New Harmony Gallery of Contemporary Art; PMA; Potsdam SUNY; Rice U.; RISD; San Antonio/McNay; Santa Barbara/MA; SFMA; Syracuse/Everson; U. of Texas; Texas A & M; WMAA; Worcester/AM. **Bibliography:** Archives.

HOPKINS, BUDD b. June 15, 1931, Wheeling, W. Va. **Studied:** Oberlin College, 1949-53, BA. Traveled Europe. Published author on UFOs. **Taught:** Wagner College, 1955; MOMA, summers, 1955, 56; WMAA, 1957-60; Pratt Institute, 1959, Provincetown, summer, 1974; RISD, 1967, 68, 69, 76, 77; U. of Minnesota, 1975. **Commissions:** Provincetown/Chrysler, 1958 (large painting). **Awards:** West Virginia Arts and Humanities Council; Guggenheim Foundation Fellowship, 1976; National Endowment for the Arts, grant, 1979; NY State Council on the Arts, special project grant, 1982. **Member:** American Abstract Artists; Provincetown Art Assoc. **Address:** 246 West 16th Street, NYC 10011. **One-man Exhibitions:** (first) Poindexter Gallery, NYC, 1956, also 1962, 63, 66, 67, 69, 71; Tirca Karlis Gallery, Boston, 1958, 60, 1962-69, 73, 75; The Zabriskie Gallery, NYC, 1959; Kasha Heman, Chicago, 1962, 63; Art Galleries Ltd., Washington, D.C., 1963; Athena Gallery, New Haven, 1964; Bradford Junior College, 1965; Obelisk Gallery, 1966; Reed College, 1967; Exeter, 1968; William Zierler Inc., 1972, 73, 74, 76; Galerie Liatowitsch, Basel, 1974; Landmark Gallery, NYC, 1975; Pelham-von Stoffler Gallery, Houston, 1977; Andre Zarre Gallery, NYC, 1978; Middlebury College, Vt., 1978; Lerner-Heller Gallery, NYC, 1977, 78, 80, 81, 82; Cultural Activities Center, Temple, Texas, 1979; Fedele Fine Arts, NYC, 1981; Long Point Gallery, Provincetown, 1978, 80, 82; U. of Vermont, 1981; Marilyn Pearl Gallery, NYC, 1985. **Retrospectives:** Huntington, W. Va., 1973; U. of North Carolina, 1974; Michigan State U., 1974. **Group:** Wagner College, 1957; Oberlin College, 3 Young Painters, 1957; Festival of Two Worlds, Spoleto, 1958; WMAA, 1958, 63, Annuals, 1965, 67, 72; WMAA, Young America, 1960; Charlotte/Mint, 1960; PAFA, 1964; Cincinnati/AM, 1968; WMAA, Free Form Abstraction, 1972; SRGM, American Painters Through Two Decades, 1973; New School for Social Research, Erotic Art, 1973; Montclair/AM, Collage, 1979; U. of North Carolina, American Abstract Artists, 1983. **Collections:** Ashland Oil Co.; Auckland; Block Drug Co.; Bradford Junior College; Brooklyn Museum; Ciba-Geigy Corp.; Conesta International Hotels; Corcoran; Delaware Art Museum; Hirshhorn; Historical Society of Montana; Hotel Corp. of America; Huntington, W. Va.; International Minerals and Chemicals Corp.; Litton Industries; U. of Massachusetts; MIT; Michigan State U.; Montana Historical Society; Norfolk/Chrysler; U. of North Carolina; Oberlin College; Oklahoma State Art Collection; Pepsi-Cola Co.; Pet Milk Co.; Pioneer Aerodynamic Systems; Reading/Public; Reed College; SRGM; SFMA; Simmons College; United Aircraft Corp.; United Grain Co.; WMAA; Westinghouse; Williams College. **Bibliography:** Archives.

HOPPER, EDWARD b. July 22, 1882, Nyack, N.Y. **d.** May 15, 1967, NYC. **Studied:** New York School of Art, 1900-06, with Kenneth Hayes Miller, Robert Henri, George Luks, A.B. Davies; a commercial art school, NYC, 1899-1900; Paris, 1906-07, 1909-10. Traveled USA, France. **Awards:** US Shipping Board, Poster Prize, 1918; Los Angeles/County MA, W. A. Bryan Prize, 1923; Chicago Society of Etchers, The Mr. & Mrs. Frank G. Logan Medal, 1923; NIAL, Gold Medal; Baltimore/MA, Hon. Men., 1931; Brook-

lyn Museum, 1931; PAFA, Joseph E. Temple Gold Medal, 1935; Worcester/AM, First P.P., 1935; Corcoran, William A. Clark Prize, 1937; Chicago/AI, The Mr. & Mrs. Frank G. Logan Medal, 1945; Chicago/AI, Hon. Men. 1946; Chicago/AI, Hon. DFA, 1950; Hon. Litt. D., Rutgers U., 1953; Hallmark International Competition, 1957; Edward MacDowell Medal, 1966. **One-man Exhibitions:** (first) Whitney Studio Club, NYC, 1919, also 1922; Rehn Galleries, 1924, 27, 29, 46, 48, 65; PAFA, 1925, 71; Arts Club of Chicago, 1934; Carnegie, 1937; Currier, 1959; U. of Arizona, 1963; WMAA, 1971; Rutgers U., 1985; Musée Cantini, Marseilles, circ., 1989; Hirschl & Adler Galleries, NYC, 1987, 88; WMAA, 1989; NMAA, 1987. **Retrospectives:** MOMA, 1933; WMAA, 1960, 64, 80. **Group:** WMAA; Chicago/AI; Boston/MFA; PAFA; Corcoran; The Armory Show, 1913; Smith College, Five Americans, 1934; Cincinnati/AM, 1948; IX São Paulo Biennial, 1967. **Collections:** Andover/Phillips; U. of Arizona; Boston/MFA; Brooklyn Museum; California State Library; Carnegie; Chicago/AI; Cleveland/MA; Corcoran; Hartford/Wadsworth; Harvard U.; IBM; Indianapolis/Herron; Kansas City/Nelson; Library of Congress; MMA; MOMA; Montclair/AM; Muskegon/Hackley; NYPL; U. of Nebraska; Newark Museum; New Orleans/Delgado; PAFA; Phillips; Randolph-Macon College; Terre Haute/Swope; Toledo/MA; Victoria and Albert Museum; WMAA; Walker; West Palm Beach/Norton; Wichita/AM; Worcester/AM; Yale U.; Youngstown/Butler. **Bibliography:** Alloway 4; Anfam; Armstrong, Thomas; Ashbery; Barker 1; **Barr 2, 3;** Baur 7; Bazin; Blesh 1; Boswell 1; Brown 2; Canaday; Cheney; Christensen; *Cityscape 1919-39;* Cummings 4, 5; **Du Bois 2;** Eliot; Flexner; Goldwater and Treves, eds.; **Goodrich** 1, **3,** 4; Goodrich and Baur 1; Haftman; Hall; **Hopper;** Hughes; Hunter 6; *Index of 20th Century Artists;* Jewell 2; Kozloff 3; Kuh 1, 2;

Langui; Levin 1; McCoubrey 1; McCurdy, ed.; Mellquist; Mendelowitz; Murken-Altrogge; Neuhaus; Newmeyer; Nordness, ed.; O'Doherty; Pagano; Pearson 1; Phillips 1, 2; Poore; Pousette-Dart, ed.; Print Council of America; Reese; Richardson, E.P.; Ringel, ed.; Rodman 1; Rose, B., 1, 4; Sachs; Sager; Sandler 3; Schwartz 1; Seitz 3; Soby 5, 6; Soyer, R., 1; Sutton; Tomkins and Time-Life Books; Ward; Weller; Wight 2. Archives.

HORIUCHI, PAUL **b.** April 12, 1906, Yamanashiken, Japan. Self-taught. **Commissions:** Seattle World's Fair, 1962 (free-standing mural). **Awards:** Ford Foundation, P.P.; Tupperware National Competition; Rockford/Burpee, 1966; U. of Puget Sound, Hon. H.H.D.; Hon. DFA, St. Martin College, 1979; and some 30 other awards. **Address:** 9773 Arrowsmith Avenue So., Seattle, WA 98118. **Dealer:** Woodside-Braseth Gallery, Seattle. **One-man Exhibitions:** (first) Seattle/AM, 1954, also 1958; Little Rock/MFA, 1958; Zoe Dusanne Gallery, Seattle, 1959, 63; Everett Junior College, 1960; U. of Arizona, 1962; Lee Nordness Gallery, NYC, 1963, 65; Felix Landau Gallery, 1963, 66; Reed College, 1964; Spelman College, 1965; Utica, 1965; Gordon Woodside Gallery, Seattle, 1965, 67, 72, 74, 76, 78; San Francisco, 1966, 68; Tacoma, 1967; Fountain Gallery, Portland, Ore. **Retrospective:** U. of Oregon, 1969; Seattle/AM, 1969. **Group:** Rome-New York Foundation, Rome, 1959; ART: USA:59, NYC, 1959; SFMA Annuals; Denver/AM; Seattle/AM; Carnegie, 1961; Seattle World's Fair, 1962; Rikkikai (Group), Tokyo, 1963; M. Knoedler & Co., Art Across America, circ., 1965-67; VMFA, American Painting, 1966; Expo '74, Spokane, 1974; NCFA, Art of the Pacific Northwest, 1974. **Collections:** U. of Arizona; Chase Manhattan Bank; Colorado Springs/FA; Denver/AM; Everett Junior College; First National Bank of Seattle; Fort Worth; Hartford/Wadsworth; Harvard U.; Imperial

Household, Tokyo; Little Rock/MFA;
Lytton Savings and Loan Association;
Marylhurst College; Mead Corporation;
National Economics Research Association;
U. of Oregon; Reed College; SFMA;
Safeco Building; Santa Barbara/MA; Seat-
tle/AM; Seattle Civic Center; Seattle Pub-
lic Library; Seattle U.; Spelman College;
Spokane Coliseum; Tacoma; Tokyo/Mod-
ern; Tupperware Museum; U.S. Steel
Corp.; Utica; Vancouver; Victoria (B.C.);
U. of Washington. **Bibliography:** *Art of
the Pacific Northwest;* Clark and Cowles;
Northwest Traditions.

HORNAK, IAN **b.** January, 9,
1944, Philadelphia, Pa. **Studied:** U. of
Michigan, Wayne State U., BFA, MFA.
Traveled Europe. **Taught:** Wayne State
U., 1965-67; Henry Ford College, Dear-
born, 1966-67. **Address:** Hands Creek
Road, East Hampton, N.Y. 11937.
Dealer: Katharina Rich Perlow Gallery,
NYC. **One-man Exhibitions:** (first) Tibor
de Nagy Gallery, NYC, 1971, 72, 73, 74,
75, 76; Fischbach Gallery, NYC, 1977, 79,
81, 83; Wood Gallery, Philadelphia, 1979;
Gertrude Kasle Gallery, Detroit, 1974;
Jacob's Ladder Gallery, Washington, D.C.,
1971, 72; Sneed Gallery, Rockford, Ill.,
1976; Selby Museum, Sarasota, 1980; The
John Pence Gallery, San Francisco, 1980;
Museum of Botany and Art, Sarasota, Fla.,
1981; Armstrong Gallery, NYC, 1985;
Katharina Rich Perlow Gallery, NYC,
1988, 89, 91. **Group:** Moore College of
Art, Philadelphia, The New Landscape,
1971; Indianapolis, 1972; A.F.A., The Re-
alist Revival, 1972; Oklahoma Art Center,
Contemporary Landscape, 1975; Pots-
dam/SUNY, Landscape/Cityscape, 1978;
Guild Hall, East Hampton, N.Y., Artists
and East Hampton, 1976; Huntington,
N.Y./Heckscher, Aspects of Change: Draw-
ing Today, 1978; Potsdam/SUNY, Con-
temporary Realism, 1982. **Collections:**
AT&T; Canton Art Institute; Chase Man-
hattan Bank; Citibank Corp.; Dartmouth
College; Commerce Bank, Kansas City;

Corcoran; Detroit/Institute; Indianapolis;
IT&T; U. of Maryland; NMAA; Nabisco
Corp.; Oberlin College; Oklahoma;
Owens-Corning Fiberglas Corp.; Rutgers
U.; St. Joseph/Albrecht; Toldeo/MA;
Wayne State U.; Xerox Corp., NYC.

HORWITT, WILL
from 1st to 4th edition.

HOVANNES, JOHN
from 1st to 4th edition.

HOWARD, ROBERT A.
from 1st to 4th edition.

HOWARD, CHARLES **b.** Janu-
ary 2, 1899, Montclair, N.J. **d.** 1978, Ponte,
Italy. **Studied:** U. of California, Berkeley,
1921; Harvard U.; Columbia U. Traveled
USA, Europe. **Taught:** Camberwell School,
London, 1959. Federal A.P.: Design Supervi-
sor, mural at US Naval Air Station, Alameda,
Calif. **Awards:** SFMA, P.P., 1940; SFMA,
1942; MMA, Artists for Victory, 1942; Pasa-
dena/AM, Third Prize, 1946; California
Palace, First Prize; La Tausca Competition,
P.P., 1947. **One-man Exhibitions:** (first)
Whitney Studio Club, NYC, 1926; Julien
Levy Galleries, NYC, 1933; Bloomsbury
Gallery, London, 1935; Guggenheim Jeune
(Gallery), London, 1939; Courvoisier Gal-
lery, San Francisco, 1941; U. of California,
Berkeley, 1941; SFMA, 1942; Karl
Nierendorf Gallery, NYC, 1946; Hanover
Gallery, 1949; Heller Gallery, Cambridge,
England, 1951; Santa Barbara/MA, 1953; St.
George's Gallery, London, 1958; The
Howard Wise Gallery, 1965; Hirschl &
Adler Gallery, NYC, 1993. **Retrospectives:**
California Palace, 1946; Whitechapel Art
Gallery, London, 1956. **Group:** Salons of
America, NYC, 1933; New Burlington
Galleries, London, International Surrealist
Exhibition, 1936; São Paulo, 1938; SFMA,
1940-46; Carnegie, 1941, 46; MOMA,
Americans 1942, circ., 1942; Chicago/AI,
1942, 46, 48; MMA, 1942, 52; WMAA,
1943-46; Corcoran, 1943-47; California

Palace, 1945-59; Tate, American Painting, 1946; Salon des Realites Nouvelles, Paris, 1949. **Collections:** Chicago/AI; Container Corp. of America; Dallas/MFA; Jesus College; MMA; Pasadena/AM; SFMA; SRGM. **Bibliography:** Baur 7; Blesh 1; Frost; Genauer; Guggenheim, ed.; Howard; Janis, S.; McCurdy, ed.; Miller, ed., 1; Ragon 2; Read 2; Richardson, E.P.; Ritchie 1; **Robertson 1.**

HUDSON, ROBERT H. b. September 8, 1938, Salt Lake City, Utah.
Studied: San Francisco Art Institute, BFA, MFA. **Taught:** U. of California, Berkeley, 1966-73; Davis; SFAI, 1976-. **Awards:** RAC, 1959; San Francisco Art Festival, P.P., 1961; SFMA, 1963; San Jose State College, P.P., 1964; SFMA, Nealie Sullivan Award, 1965; Guggenheim Foundation Fellowship, 1976. **Address:** 392 Eucalyptus Avenue, Cotati, CA 94928. **Dealer:** Fuller Goldeen, San Francisco. **One-man Exhibitions:** RAC, 1961; Batman Gallery, San Francisco, 1961; Bolles Gallery, San Francisco, 1962; The Lanyon Gallery, 1964; San Francisco Art Institute, 1965; Allan Frumkin Gallery, Chicago, 1964, 68, 72, NYC, 1965, 71, 76, 78, 80, 81, 84; Nicholas Wilder Gallery, Los Angeles, 1967; Michael Walls Gallery, NYC, 1970; U. of California, Berkeley, 1971, 72; Hansen-Fuller Gallery, San Francisco, 1973, 75, 77, 79, 82; Moore College of Art, Philadelphia, 1977; Miami-Dade Community College, 1979; U. of California, Davis, 1983; Morgan Gallery, Shawnee Mission, Kan., 1983. **Retrospectives:** Moore College of Art, Philadelphia, 1977; SFMA, circ., 1985. **Group:** RAC, 1959-61; La Jolla, 1961; Oakland/AM, 1961, 63; Stanford U., Some Points of View for '62, 1962; SFMA, 1962, 64; WMAA Sculpture Annual, 1964, 67, 68; WMAA, Young America, 1965; Westmoreland County/MA, 1966; U. of California, Berkeley, Funk, 1967; Los Angeles/County MA, American Sculpture of the Sixties, 1967; Chicago/AI, 1967; Walker, 1969; ICA, U. of Pennsylvania, The Spirit of the

Comics, 1969; Walker, 14 Sculptors: The Industrial Age, 1969; U. of California, Berkeley, Impossible Dreams (two-man), 1970; U. of California, Santa Barbara, Six Californians, 1971; Corcoran Biennial, 1975; Hayward Gallery, London, The Condition of Sculpture, 1975; ICA, Boston, Hudson and De Forest, 1977; U. of Texas, New in the Seventies, 1977; SFMA, Aesthetics of Graffiti, 1978; Hirshhorn, Directions, 1979; Oakland/AM, 100 Years of California Sculpture, 1982. **Collections:** American Republic Insurance Co.; Amsterdam/Stedelijk; Los Angeles/County MA; Oakland/AM; SFMA. **Bibliography:** *California Sculpture Show; Forty Years of California Assemblage;* Friedman, M., 2; *New in the Seventies;* Selz, P., 2; Tuchman 1.

HUETER, JAMES
from 1st to 4th edition.

HUGHTO, DARRYL b. June 10, 1943, Watertown, N.Y. **Studied:** Buffalo/SUNY, BS, 1965; Cranbrook Academy of Art, MFA, 1969. **Awards:** SRGM, Theodoran Award, 1977; National Endowment for the Arts, grant, 1984. **Address:** RD 2, Box 411, Canastoga, NY 13032. **Dealer:** Salander-O'Reilly Galleries, NYC. **One-man Exhibitions:** Syracuse/Everson, 1973; Tibor de Nagy Gallery, NYC, 1971, 73, 74, 76, 77; Meredith Long Contemporary, NYC, 1978, 79, 80; Meredith Long & Co., Houston, 1978, 79, 81; Edmonton Art Gallery, 1981; Lincoln Center Gallery, NYC, 1983; Utica, 1986; Gallery 99, Bay Harbor Island, 1980, 81, 86, 87; Gallery One, Toronto, 1981, 83, 88; Galerie Elca London, Montreal, 1986, 87, 89; Salander-O'Reilly Galleries, NYC, 1981, 82, 83, 84, 86, 89. **Group:** Edmonton Art Gallery, New Abstract Art, 1977; SRGM, Theodoran Award, 1977; MMA, Twentieth Century Paintings and Sculpture, 1979; Paris/Beaubourg, The New Generation, 1981; Youngstown/Butler, Midyear show, 1985; St. Lawrence U., Pre-Post Modern, 1985; **Collections:** Boston/MFA; Den-

ver/AM; Detroit/Institute; Edmonton Art Gallery; Gulf & Western; Houston/MFA; Prudential Insurance Co. of America; SRGM; Syracuse/Everson.

HULTBERG, JOHN b. February 8, 1922, Berkeley, Calif. **Studied:** Fresno State College, 1939-43, BA; ASL, 1941-51, with Morris Kantor, California School of Fine Arts, with Clay Spohn, Richard Diebenkorn, David Park, Clyfford Still, Mark Rothko. US Navy, 1943-46.
Taught: Boston Museum School, 1958; ASL, summer 1960; Portland, Ore./AM, Artist-in-Residence, 1964; ASL, 1992-.
Member: AAIAL; NAD. **Commissions:** *Fortune* magazine (portfolio of drawings of Newport News Shipbuilding Co.).
Awards: CSFA, Albert M. Bender Fellowship, 1949; Corcoran, First Prize, 1955; Congress for Cultural Freedom, First Prize, 1955; Carnegie, Hon. Men., 1955; Guggenheim Foundation Fellowship, 1956; Hallmark International Competition, 1957; Chicago/AI, Norman Wait Harris Medal, 1962; Ford Foundation/A.F.A. Artist-in-Residence, 1964; NAD, Benjamin Altman Prize, 1972, 85; National Endowment for the Arts, 1981; Pollock-Krasner Foundation Grant, 1989.
Address: 2673 Broadway #210, NYC, 10025. **Dealer:** Elaine Wechsler, NYC.
One-man Exhibitions: (first) Contemporary Gallery, Sausalito, Calif., 1949; Korman Gallery, NYC, 1953; Martha Jackson Gallery, 1955, 58, 59, 61, 63, 66, 67, 69, 79; ICA, London, 1956; Galerie Rive

John Hultberg, *The Reaper*, 1993.

Droite, Paris, 1957; The Swetzoff Gallery, Boston, 1957; Phoenix, 1957; Galerie du Dragon, Paris, 1957, 59, 70; Numero Galleria d'Arte, Florence, Italy, 1958; Main Street Gallery, NYC, 1961; Piccadilly Gallery, 1961, 65; Museum of Malmo, Sweden, 1962; Esther Baer Gallery, 1962, 64; Roswell, 1963; Galerie Pauli, Lausanne, 1965; Galerie Anderson-Mayer, Paris, 1966; Museum of Contemporary Crafts Council, 1966; Honolulu Academy, 1967; Gallery of Modern Art, 1967; Apiaw (Gallery), Paris, 1968; Long Island U., 1968; American Cultural Center, Paris, 1968; David Anderson Gallery, NYC, 1978; Anita Shapolsky Gallery, NYC, 1989, 90; Gallery 127, Portland, Me., 1989; Nicholas Roerich Museum, NYC, 1990. **Retrospective:** Hamilton College, circ., 1985. **Group:** California Palace, 1947; MOMA, New Talent; Corcoran, 1955; WMAA Annuals, 1955, 64, 68; XXVIII Venice Biennial, 1956; Gutai 9, Osaka, 1958; Carnegie, 1958; ART:USA:59, NYC, 1959; Chicago/AI, 1962; Brooklyn Museum, 1964; Salon du Mai, Paris, 1964; Ghent, 1964; VIII São Paulo Biennial, 1965; Museo Civico, Bologna, 1965; U. of Kentucky, 1968; PAFA, 1968; AAAL, 1969; VMFA, American Painting, 1970; U. of Illinois, American Painting & Sculpture, 1948-1969, 1971.
Collections: U. of Arizona; Atlanta/AA; Baltimore/MA; Boston U.; Buffalo/Albright; U. of California; Carnegie; Chase Manhattan Bank; Corcoran; Dallas/MFA; Davenport/Municipal; Dayton/AI; Eindhoven; Fort Lauderdale; Grinnell College; Hirshhorn; Honolulu Academy; U. of Illinois; Indianapolis/Herron; MIT; MMA; MOMA; U. of Michigan; Musée Cantonal des Beaux-Arts; NAD; NYU; U. of Nebraska; Newark Museum; New School for Social Research; Oakland Museum; PAFA; Philadelphia Art Alliance; Phoenix; Portland/AM; Quaker Ridge School; RISD; Roswell; SRGM; Santa Barbara/MA; St. Louis/City; The Singer Company Inc.; Stamford Museum;

Stockholm/National; U. of Texas; WMAA; Walker. **Bibliography:** Blesh 1; Janis and Blesh 1; Hunter, ed.; McChesney; Nordness, ed. Archives.

HUMPHREY, DAVID b. August 30, 1955, Augsburg, Germany. U.S. Citizen. **Studied:** Maryland Institute College of Art, 1973-77, BFA; New York Studio School, 1976-77; NYU, 1977-80, MFA. **Awards:** CAPS grant, 1979; New York State Council for the Arts, grant, 1985; National Endowment for the Arts, fellowship, 1987. **Address:** 439 Lafayette Street, NYC 10003. **Dealer:** McKee Gallery, NYC. **One-man Exhibitions:** Washington Square Gallery, NYC, 1979; McKee Gallery, NYC, 1984, 85, 88, 90, 91; Rena Bransten Gallery, San Francisco, 1987, 91; Alpha Gallery, Boston, 1988; Cone Editions, NYC, 1988; Krygier/Kandau Contemporary Art, Santa Monica, 1989, 90; Neenah/Bergstrom, 1991. **Group:** Hobart College, Thirty New York Painters, 1981; Nordjyllands Kunstmuseum, Aalborg, Drawings by Young American Artists, 1984; Bennington College, Artists in Two Mediums, 1985; U. of North Carolina, Art on Paper, 1985; Florida International U., American Art Today: The Figure in the Landscape, 1986; Brooklyn Museum, Public and Private, 1986; AAIAL, 1986; Morristown/Junior, The Potent Image, 1986; Colby College, Inner Images, 1986; Boston/MFA, The Unique Print: 70s into the 90s, 1990. **Collections:** Boston/MFA; Carnegie; Chemical Bank; Cleveland/Contemporary; Exxon Corp.; Jersey City Museum; MMA; Walker.

HUMPHREY, RALPH b. 1932, Youngstown, Ohio. **d.** July 15, 1990, NYC. **Studied:** Youngstown U., 1951-52, 1954-56. **Taught:** ASL; Harley House, NYC, 1959-60; Bennington College, 1961-63; New School for Social Research; Hunter College. **One-man Exhibitions:** Tibor de Nagy Gallery, NYC, 1959, 60; Gallery Mayer, NYC, 1961; Green Gallery, NYC, 1965; Bykert Gallery, NYC, 1967, 68, 69, 70, 72, 73, 74, 75; Dunkleman Gallery, Toronto, 1970; André Emmerich Gallery, NYC, 1971; The Texas Gallery, 1973; Daniel Weinberg Gallery, San Francisco, 1975; John Weber Gallery, NYC, 1976, 77; Daniel Weinberg Gallery, Los Angeles, 1983; Willard Gallery, NYC, 1982. **Group:** SRGM, Abstract Expressionists and Imagists, 1961; SRGM, Systemic Painting, 1966; Ithaca College, 1967; Trenton/State, Focus on Light, 1967; ICA, U. of Pennsylvania, A Romantic Minimalism, 1967; MOMA, The Art of the Real, 1968; WMAA, 1969; Buffalo/Albright, Color and Field: 1890-1970, 1970; WMAA, The Structure of Color, 1971; Indianapolis, 1972; Chicago/AI, 1974; UCLA, Fourteen Abstract Painters, 1975; Baltimore/MA, Fourteen Artists, 1975; U. of Chicago, Ideas on Paper, 1970-1976, 1976; WMAA Biennial, 1979; ICA, Boston, The Reductive Object, 1979. **Collections:** Bennington College; Brandeis U.; Canberra/National; Dayton/AI; Hartford/Wadsworth; MOMA; U. of North Carolina; SFMA; VMFA; WMAA. **Bibliography:** Alloway 3; Battcock, ed.; **Crile;** Goossen 1; *New in the Seventies;* Robins.

HUNT, BRYAN b. June 7, 1947, Terre Haute, Indiana. **Studied:** U. of South Florida, Tampa, 1966-68; Otis Art Institute, Los Angeles, 1969-70; BFA; WMAA, Independent Study Program, 1972. Traveled Europe 1969, around the world 1979-80. **Taught:** School of Visual Arts, NYC, 1978. **Commissions:** Edgar Kaufman, *Falling Water,* sculpture for Frank Lloyd Wright, 1979. **Awards:** National Seoul Art Festival; National Museum of Contemporary Art, Grand Prize, 1990. **Address:** 9 White Street, NYC, 10013. **Dealer:** Blum Helman Gallery, NYC. **One-man Exhibitions:** The Clocktower, NYC, 1974; Jack Glenn Gallery, Corona del Mar, 1974; Brussels/Beaux-Arts, 1976; Weinberg Gallery, San Francisco, 1976, 78, 82; Blum Helman

Gallery, NYC, 1977, 78, 79, 81, 83, 85, 86, 87, 89, 90; Greenberg Gallery, St. Louis, 1978; Bernard Jacobson Gallery, London, 1979; Galerie Bischofberger, Zurich, 1979; Margo Leavin Gallery, Los Angeles, 1980, 83; Akron/AM, 1981; Galerie Hans Strelow, Düsseldorf, 1981; Jean Bernier Gallery, Athens, 1982; Amerika Haus, Berlin, 1983; Los Angeles/County MA, 1983; John C. Stoller & Co., Minneapolis, 1984; M. Knoedler & Co., Zurich, 1985; Gillespie, Laage, Solomon, Paris, 1986; Akira Ikeda Gallery, Tokyo, 1986; Daniel Weinberg Gallery, Los Angeles, 1986; Barbara Mathes Gallery, 1987; Duisburg, 1987; Blum Helman Gallery, Santa Monica, 1988; Cornell U., 1988; Evelyn Aimis Fine Art, Toronto, 1988; U. of Rhode Island, 1988; Crown Point Press, NYC, 1989; Galeria Arteunido, Barcelona, 1989; Galerie Daniel Templon, Paris, 1990; Tokyo Ginza Art Gallery, Tokyo, 1991. **Retrospectives:** California State U., Long Beach, 1983; Orlando, 1992. **Group:** Portland Oregon, Center for the Visual Arts, Via Los Angeles, 1976; SRGM, Young American Artists, 1978; Amsterdam/Stedelijk, Made by Sculptors, 1978; WMAA Biennial, 1979, 81, 85; Venice Biennale, 1980; Akron/AM, The Image in American Painting & Sculpture, 1950-1980, 1981; Rice U., Variants, 1981; Chicago/AI, 74th American Exhibition, 1982; Cincinnati/Contemporary, Dynamix, circ., 1982; Indianapolis, 1982; Houston/MFA, A Century of Modern Sculpture, 1882-1982, 1983; Palacio de Velazquez, Madrid, Tendencias en Nueva York, circ., 1983; MOMA, International Survey of Contemporary Painting and Sculpture, 1984; Newark Museum, American Bronze Sculpture, 1850 to the Present, 1984; Purchase/SUNY, Hidden Desires, 1984; Seattle/AM, American Sculptures, Three Decades, 1984; Sonoma State U., Works in Bronze, A Modern Survey, circ., 1987; Laforet Museum, Tokyo, Correspondences: New York Art Now, 1985; Buffalo/Albright, Contemporary Landscapes on Paper, 1986; MOMA, Sculptors' Drawings, 1986;

Bryan Hunt, *Axial Falls*, 1990.

Brooklyn Museum, Monumental Drawings, 1986; AAIAL, Annual, 1986; Carnegie Mellon U., Drawings from the Eighties, 1987; Purchase/SUNY, The Window in Twentieth Century Art, 1987; SRGM, Viewpoints, 1988; Williams College, BIGlittle Sculpture, 1988; WMAA, Vital Signs, 1988; Kunstraum, Vienna, Skulpturen Republik, 1988; Little Rock/MFA, American Abstract Drawings, 1989; U. of Rhode Island, Microsculpture, 1989; Purchase/SUNY, Figuratively Speaking: Drawings by Seven Artists, 1989; U. of North Carolina, Art on Paper, 1990; National Museum of Contemporary Art, Seoul, Seoul International Art Festival, 1990; New Mexico State U., Drawings: An Invitational, 1991. **Collections:** Akron/AM; Amsterdam/Stedelijk; Boston/MFA; Brandeis U.; Buffalo/Albright; Chicago/AI; Cornell U.; Dallas/MFA; Des Moines; Duisburg; Harvard U.; High Museum; Hirshhorn; Hous-

Richard Hunt, *Generation of Points and Arcs,*
1990.

ton/MFA; Humlebaek/Louisiana; Lannan
Foundation; Little Rock/MFA; Los Ange-
les/County MA; MMA; MOMA; NMAA;
U. of Nebraska; Newark Museum; Newport
Harbor; Olympic Park, Seoul; Park del
Clot, Barcelona; St. Louis/City; SFMA;
SRGM; Fondation Daniel Templon, Frejus,
France; VMFA; Vassar College; Vi-
enna/Moderner; WMAA; Yale U. **Bibliogra-
phy:** Stearns.

HUNT, RICHARD b. September
12, 1935, Chicago, Ill. **Studied:** U. of
Illinois; The U. of Chicago; Chicago Art
Institute School, 1959, BA, Ed. US Army,
1958-60. Traveled Europe. **Taught:** U. of
Illinois, 1960-62; Chicago Art Institute
School, 1960-61; Yale U., 1964;
Chouinard Art Institute, Los Angeles,
1964-65; Purdue U., 1965; Northern
Illinois U., 1968; Northwestern U., 1968-
69; Wisconsin State U., Oshkosh, 1969;
Southern Illinois U., 1969; Western
Illinois U., 1970; U. of Indiana, 1975; U.
of Georgia, 1977; Washington U., 1977-
78; U. of Arizona, 1980; Utah State U.,
1982; Harvard U., 1989-90; Kalamazoo
College, 1990; Binghamton/SUNY, 1990.
Member: National Council on the Arts,
1968-74; Illinois Arts Council, 1970-75;
Board of Trustees, Chicago/Contempo-
rary, 1975-79; Board of Trustees, Ameri-
can Academy in Rome, 1980-82;
Commissioner, NMAA, 1980-; Board of
Trustees, The Institute for Psychoanalysis,
Chicago, 1981-89; President/Founder,
Chicago Sculpture Society, 1982-89;
Board of Governors, Skowhegan School,
1979-84; Commissioner, NMAA, 1980-
88; National Chairman, Alumni Council,
School of the Chicago Art Institute, 1983-
87; Advisory Committee, Getty Center for
Education in the Arts, 1984-88; Director,
International Sculpture Center, 1984-;
Board of Governors, School of the Chi-
cago Art Institute, 1985-91. **Commis-
sions:** Louisiana State U., 1960; Johnson
Publishing Co., Chicago, 1974; U. of Chi-
cago, 1975; U. of California, Los Angeles,
1975; U. of Illinois, Chicago Campus,
1975; Martin Luther King Community
Service Center, Chicago, 1975; U. of Mich-
igan, 1975; Social Security Center, Rich-
mond, Calif., 1976; Roosevelt Square,
NYC, 1976; Justice Center, Cleveland,
1977; Cartwright Park, Evanston, Ill.,
1977; Martin Luther King Memorial,
Memphis, Tenn., 1977; Carter Woodson
Library, Chicago, 1977; Prairie View A. &
M. U., 1978; Howard U., 1978; Green-
ville, 1978; Cultural Activities Center,
Temple, Tex., 1979; Northwestern U.,
1979. **Awards:** Chicago/AI, James Nelson
Raymond Traveling Fellowship, 1957;
Guggenheim Foundation Fellowship,
1962; Chicago/AI, The Mr. & Mrs. Frank
G. Logan Prize; Cassandra Foundation Fel-
lowship, 1970. Honorary Degrees: Lake
Forest College, 1972; Dayton Art Insti-
tute, 1973; U. of Michigan, 1976; Illinois
State U., 1977; Colorado State U., 1979;
Northwestern U., 1984; Monmouth Col-
lege, 1986; Roosevelt U., 1987; Tufts U.,
1991. **Address:** 1017 West Lill Avenue,
Chicago, IL 60614. **Dealer:** Dorsky Gal-
lery, NYC. **One-man Exhibitions:** (first)
The Alan Gallery, NYC, 1958, also 1960,
63; Stewart Rickard Gallery, San Antonio,
1960, 64; B. C. Holland Gallery, 1961,
63, 70, 76; U. of Tulsa, 1964; Wesleyan
College, 1964; Felix Landau Gallery;
Cleveland/MA; Milwaukee; U. of Illinois;

U. of Notre Dame; The Ohio State U.; Dorsky Gallery, NYC, 1968, 69, 71, 73, 75, 76, 77, 79, 87, 89; Wisconsin State U., Oshkosh, 1969; Southern Illinois U., 1970; MOMA, 1971; Indianapolis, 1973; U. of Iowa, 1975; Sears Bank and Trust Co., Chicago, 1976; Greenville, 1978; Terry Dintenfass, Inc., NYC, 1983, 84, 86; Springfield, Mo./AM, 1981; Wichita/AM, 1979; G. R. N'Namdi Gallery, Detroit, 1985, 90; Martin Gallery, Washington, D.C., 1985; Columbia College, Chicago, 1986; Youngstown State U., 1986; De Graaf Fine Art, Inc., Chicago, 1987; Century City, Los Angeles, 1987; USIS, tour, Los Angeles Museum of African-American Art, circ., 1987-88; Printworks Gallery, Chicago, 1990; Kalamazoo College, 1990; Gwenda Jay Gallery, Chicago, 1991; Louis Newman Galleries, Beverly Hills, 1991. **Retrospectives:** MOMA, 1971; Chicago/AI, 1971; Milwaukee, 1967. **Group:** New Sculpture Group, NYC, 1960, 61; U. of Illinois; MOMA; WMAA; Michigan State U.; Smith College; Yale U.; Newark Museum; Carnegie; Seattle World's Fair, 1962; HemisFair '68, San Antonio, Tex., 1968. **Collections:** Bezalel Museum; Buffalo/Albright; Chicago/AI; Cleveland/MA; Cincinnati/AM; Hirshorn; Israel Museum; Kansas City/Nelson; Los Angeles/County MA; MMA; MOMA; Milwaukee; NMAA; National Gallery; Storm King Art Center; Trenton/State; Vienna/Moderner; WMAA; Wichita/AM. **Bibliography:** *The Chicago Connection;* Cummings 5; Dover.

HUOT, ROBERT
from 1st to 5th edition.

HURSON, MICHAEL b. 1941, Youngstown, Ohio. **Studied:** School of the Art Institute of Chicago, 1959-63; Oxbow Summer School, 1960-61; Yale U., Norfolk,

1962. **Awards:** Chicago/AI, Eisendrath Prize, 1963; Chicago/AI, G. C. Brown Traveling Fellowship; Chicago/AI, Logan Medal, 1964; Chicago/AI, Palmer Prize, 1973; National Endowment for the Arts, grant, 1974, 75; Chicago/Contemporary, Vaklova P.P., 1980. **Address:** 22 East 10th Street, NYC 10003. **Dealer:** Paula Cooper Gallery, NYC. **One-man Exhibitions:** Michael Wyman Gallery, Chicago, 1972; Chicago/Contemporary, 1973; MOMA, 1974; Dart Gallery, Chicago, 1978, 80; Daniel Weinberg Gallery, San Francisco, 1980, 83; Paula Cooper Gallery, NYC, 1982, 85, 86, 87, 89, 91; The Clocktower, NYC, 1984; Heath Gallery, Atlanta, 1986; Joe Fawbush Editions, NYC, 1987. **Group:** Chicago/AI, Annual, 1961, 63, 64, 73; U. of Chicago, Contemporary Still Life, 1974; U. of Chicago, Recent Portraiture, 1977; SRGM, Nine Young Artists: Theodoran Awards, 1977; ICA, U. of Pennsylvania, Improbable Furniture, 1977; Chicago/AI, Drawings of the Seventies, 1977; U. of California, Santa Barbara, Contemporary Drawing/New York, 1978; WMAA, New Image Painting, 1978; U. of Chicago, Visionary Images, 1979; Chicago/Contemporary, Chicago/Chicago, 1980; U. of California, Santa Barbara, Contemporary Drawings, 1981; Ridgefield/Aldrich, New Dimensions in Drawing, 1981; Bard College, Figures, 1981; Florida State U., New New York, 1982; ICA, London, Artist's Architecture, Scenes and Conventions, 1983; P.S. 1, Long Island City, The New Portrait, 1984; WMAA, American Art Since 1970, 1984; Katonah Gallery, Rethinking the Avant-Garde, 1985; Carnegie Mellon U., Drawings from the Eighties, 1987; Greenville County, Imprimature, circ., 1988; U. of North Carolina, Height x Length x Width, 1991; Nice/Contemporain, Collage du XXième Siècle, 1991. **Collections:** Canberra/National; Chicago/AI; Chicago/Contemporary; SRGM; MMA; WMAA.

I

INDIANA, ROBERT **b.** September 13, 1928, New Castle, Ind. **Studied:** John Herron Art Institute, 1945-46; Munson-Williams-Proctor Institute, Utica, N.Y., 1947-48; Chicago Art Institute School, 1949-53, BFA; Skowhegan School, summer, 1953; U. of Edinburgh, Edinburgh College of Art, 1953-54; Aspen Institute, Artist-in-Residence, summer, 1968. Traveled USA, Mexico, Europe. **Commissions:** New York State Pavilion, New York World's Fair, 1964-65 (mural); New York State Theater, Lincoln Center for the Performing Arts, NYC (poster); costumes, sets, and poster for the Walker Art Center Opera Company's production of the Virgil Thomson-Gertrude Stein opera *The Mother of Us All,* Tyrone Guthrie Theater, Minneapolis, 1967; 8¢ US postage stamp (400,000,000 printed), 1973; numerous posters, banners, and several volumes of poetry with Robert Creely. **Awards:** Chicago/AI, Traveling Fellowship, 1953; Hon. DFA, Franklin and Marshall College, 1970; Indiana State Commission on the Arts Award, 1973; Hon. DFA, U. of Indiana, 1977. **Address:** Vinalhaven, ME 04863. **One-man Exhibitions:** (first) The Stable Gallery, 1962, also 1964, 66; ICA, Boston, 1963; Walker, 1963 (two-man, with Richard Stankiewicz); Rolf Nelson Gallery, Los Angeles, 1965; Dayton's Gallery 12, Minneapolis, 1966; Galerie Schmela, 1966; Eindhoven, 1966; Krefeld/Haus Lange, 1966; Wurttem-

bergischer Kunstverein, Stuttgart, 1966; ICA, U. of Pennsylvania, 1968; San Antonio/McNay, 1968; Indianapolis/Herron, 1968; Toledo/MA, 1968; Hunter Gallery, Aspen, Colo., 1968; Creighton U., 1969; St. Mary's College (Ind.), 1969; Colby College, 1969; Dartmouth College, 1970; Bowdoin College, 1970; Brandeis U., 1970; Badischer Kunstverein, Karlsruhe, 1971; Humlebaek/Louisiana, 1972; Galerie Denise Rene, NYC, 1972, 75, 76; Didrichsenin Konsmuseum, Helsinki, 1972; Santa Fe, N.M., 1976; U. of Texas, Austin, 1977; Norfolk/Chrysler, 1977; Indianapolis, 1978; Purchase/SUNY, 1978; Art Center, South Bend, 1978; Flint/Institute, 1984; NMAA, 1984. **Group:** MOMA, The Art of Assemblage, circ., 1961; Chicago/AI Annual, 1963; WMAA, New Directions in American Painting, 1963; ICA, London, The Popular Image, 1963; Bertrand Russell Peace Foundation, Woburn Abbey, England, 1963; MOMA, Americans 1963, circ., 1963-64; Tate, Dunn International, 1964; Tate, Painting and Sculpture of a Decade, 1954-64, 1964; Museum des 20. Jahrhunderts, 1964; New York World's Fair, 1964-65; WMAA Annuals, 1964, 65, 67, Sculpture Annual, 1966; Corcoran Biennial, 1965; Palais des Beaux-Arts, Brussels, 1965; WMAA, A Decade of American Drawings, 1965; SRGM, 1965; Milwaukee, 1965; U. of Illinois, 1965, 67; PAFA, 1966; ICA, Boston, 1966; Eindhoven, Kunst-Licht-Kunst, 1966; Expo '67, Montreal, 1967; VI International Art Biennial, San Marino (Europe), 1967; IX São Paulo Biennial, 1967; Carnegie, 1967; Dublin/Municipal, I International Quadrennial (ROSC), 1967; Kassel, Documenta IV, 1968; Chicago/Contemporary, 1968; WMAA, Contemporary American Sculpture, Selection II, 1969; Cologne, 1969; Fine Arts Academy of Finland, Helsinki, 1969; Jewish Museum, Superlimited, 1969; WMAA, Seventy Years of American Art, 1969; Hayward Gallery, London, Pop Art, 1969; ICA, U. of Pennsylvania, Highway, 1970;

Cincinnati/Contemporary, Monumental Art, 1970; Foundation Maeght, L'Art Vivant, 1970; Museo de Arte Contemporaneo, Cali, Colombia, S.A., I Bienal Graficas, 1971; Düsseldorf, Zero Raum, 1973; WMAA (downtown), Nine Artists/Coenties Slip, 1974; WMAA, American Pop Art, 1974; Newport, R.I., Monumenta, 1974; Hirshhorn, Inaugural Exhibition, 1974; Corcoran, 1975; MOMA, American Art Since 1945, 1975; Philadelphia College of Art, Artists' Sets and Costumes, 1977; Indianapolis, Perceptions of the Spirit in 20th Century American Art, 1977. **Collections:** Aachen/NG; Allentown/AM; Amsterdam/Stedelijk; Baltimore/MA; Brandeis U.; Brigham Young U.; Buffalo/Albright; Carnegie; Cologne; Detroit/Institute; Delaware Art Museum; U. of Dublin; Eindhoven; Honolulu Academy; Humlebaek/Louisiana; ICA, U. of Pennsylvania; U. of Illinois; Indianapolis; Indianapolis/Herron; Krefeld/Kaiser Wilhelm; Los Angeles/County MA; MMA; MOMA, U. of Michigan; U. of Nebraska; Oklahoma; Purchase/SUNY; Ridgefield/Aldrich; SFMA; Spelman College; Stanford U.; U. of Texas; Toronto; VMFA; WGMA; WMAA; Walker; Wuppertal/von der Heydt. **Bibliography:** Alloway 1; Calas, N. and E.; De Salvo and Schimmel; Dienst 1; Diamonstein; Honisch and Jensen, eds.; Hunter, ed.; Kardon 3; *Kunst um 1970;* Lippard 5; **McCoubrey 2;** *Monument;* Osterwold; Russell and Gablik; Sandler 3; Seitz 4; **Sheehan;** Weller. Archives.

INGLE, JOHN STUART b. September 18, 1933, Evansville, Ind. **Studied:** U. of Arizona, BFA, 1964, MFA, 1966; Musées Royaux des Beaux-Arts de Belgique, Brussels. **Taught:** U. of Minnesota, Morris, 1966-. **Awards:** Minnesota State Fair, 1st Prize, watercolor, 1976, 77, 78. Traveled Europe. **Address:** 210 Colorado Avenue, Morris, Minn. 56267. **Dealer:** Tatistcheff & Co., NYC. **One-man Exhibitions:** (first) U. of Arizona, Tucson, 1966; Springfield College, 1975; South-

John Stuart Ingle, *Songs of the Garden,* 1992.

west State U., Marshall, Minn., 1976; Capricorn Gallery, Bethesda, Md., 1979; Tatistcheff & Co., NYC, 1981, 83, 85, 88; Transco Energy Gallery, Houston, 1985. **Retrospective:** Tatistcheff & Co., NYC, circ., 1988. **Group:** Springfield, Mo./AM, Watercolor USA, 1976, 77, 78, 86; PAFA, Contemporary American Realism Since 1960, circ., 1981; Chicago/AI, Perspectives on Contemporary American Realism, 1983; SFMA, American Realism (Janss), circ., 1985; Wilmington, NYC: New Work, 1986; Southern Alleghenies Museum of Art, Loretto, Nature Morte, 1986; NAD, Realism Today, circ., 1988; The Pennsylvania State U., Realist Watercolors, 1990. **Collections:** Allied Bank of Texas; Amerada Hess Corp.; American Express; Becton Dickinson & Co.; Chemical Bank; Evansville; Little Rock/MFA; MMA; McCrory Corporation, NYC; Metropolitan Life Insurance Co.; NYNEX; St. Louis/City; Philip Morris Collection; Springfield, Mo./AM; Stephens, Inc.; Transco Energy Co.; Yale U.

Mark Innerst, *Badge*, 1992.

INNERST, MARK　b. 1957, York, Pa. **Studied:** Kutztown State College, 1980, BFA. **Address:** 607 East 11th Street, NYC 10009. **Dealer:** Curt Marcus Gallery, NYC. **One-man Exhibitions:** The Kitchen, NYC, 1982; Grace Borgenicht Gallery, NYC, 1984; Curt Marcus Gallery, NYC, 1986, 88; Robert Fraser Gallery, London, 1985; Galerie Montenay, Paris, 1987; Illinois State U., circ., 1988; Kansas City/Nelson, 1989; Folker Skulima Gallery, Berlin, 1989; Houston/Contemporary, 1989; Michael Kohn Gallery, Santa Monica, 1991. **Group:** The Drawing Center, NYC, New Drawing in America, circ., 1982; Indianapolis, Paintings and Sculpture Today, 1984; ICI, NYC, Drawings After Photography, circ., 1984; MOMA, An International Survey of Recent Painting and Sculpture, 1984; ICA, Boston, Currents, 1984; SRGM, New Horizons in American Art, 1985; U. of California, Santa Barbara, Scapes, circ., 1985; Lehman College/CUNY, Landscape in the Age of Anxiety, 1986; Brussels/Beaux Arts, Au Coeur du Maelstrom, 1986; Venice Biennial, 1986; Dayton/AI, A Certain Slant of Light, 1989, WMAA, Biennial, 1989; Port-

land, Ore./AM, Strange Vistas, Imagined Histories, 1991. **Collections:** Buffalo/Albright; Brooklyn Museum; Chase Manhattan Bank; Chicago/Contemporary; SRGM; Los Angeles/County MA; Los Angeles/MOCA; MMA; MOMA.

INSLEY, WILL　b. October 15, 1929, Indianapolis, Ind. **Studied:** Amherst College, BA, 1951; Harvard U., B. Arch., 1955. Traveled USA, Europe. US Army, 1955-57. **Taught:** Oberlin College, Artist-in-Residence, 1966; U. of North Carolina, 1967-68; Cornell U., 1969; School of Visual Arts, NYC, 1969; Cooper Union, 1972. **Commissions:** Great Southwest Industrial Park, 1968; Cambridge Arts Council, 1978. **Awards:** National Council on the Arts, 1966; Guggenheim Foundation Fellowship, 1969-70. **Address:** 231 Bowery, NYC 10002. **Dealers:** Max Protetch, NYC; Galerie Annemarie Verna, Zurich; Paul Maenz, Cologne. **One-man Exhibitions:** (first) Amherst College, 1951; The Stable Gallery, NYC, 1965-68; Oberlin College, 1967; U. of North Carolina, 1967; Walker, 1968; Buffalo/Albright, 1968; Cornell U. (three-man), 1969; ICA, U. of Pennsylvania, 1969; John Gibson Gallery, 1969; MOMA, 1971; School of Visual Arts, NYC, 1972; Paul Maenz Gallery, Cologne, 1972; Krefeld/Haus Lange, 1973; Fischbach Gallery, NYC, 1973, 74, 76; Galerie Annemarie Verna, Zurich, 1974; Stuttgart/WK, 1974; Wisconsin State U.; Max Protetch Gallery, NYC, 1977, 80, 82, 84, 85, 88, 90, 92; Protetch/McIntosh, Washington, D.C., 1977; Galerie Orny, Munich, 1978; SRGM, 1984. **Group:** WMAA Annuals, 1965, 67; Riverside Museum, 1966; SRGM, Systemic Painting, 1966; U. of Illinois, 1967; VI International Art Biennial, San Marino (Europe), 1967; U. of North Carolina, 1967; Ridgefield/Aldrich, 1968; J. L. Hudson Art Gallery, Detroit, 1968; New Delhi, First World Triennial, 1968; ICA, U. of Pennsylvania, 1969; Fort Worth, Drawings, 1969; Foundation Maeght,

L'Art Vivant, 1970; Finch College, NYC, Projected Art, 1971; Arnhem, Sonsbeek '71, 1971; U. of Washington, Drawings from New York, 1972; ICA, U. of Pennsylvania, Grids, 1972; Kassel, Documenta V, 1972; WMAA, American Drawings: 1963-1973, 1973; Tyler School of Art, Philadelphia, American Drawings, 1973; Kennedy Center, Art Now '74, 1974; Minnesota/MA, Drawings USA '75, 1975; Stamford (Conn.) Museum, American Salon des refusés, 1976; Rice U., Drawing Today in New York, 1976; Kassel, Documenta VI, 1977; ICA, U. of Pennsylvania, Dwellings, 1978; U. of North Carolina, Drawings about Drawings, 1979; Hayward Gallery, London, Pier and Ocean, 1980; Humlebaek/Louisiana, American Drawings of the Seventies, circ., 1981; ICA, U. of Pennsylvania, Connections, 1983; Hirshhorn, Dreams and Nightmares, 1984; Fort Wayne/AM, Indiana Influence, 1984; Purchase/SUNY, Geometric Abstraction and the Modern Spirit, 1989; Oberlin College, The Living Object, 1992. **Collections:** Brandeis U.; Colby College; U. of North Carolina. **Bibliography:** Alloway 3; *Art Now 74;* Battcock, ed.; Kren; Lucie-Smith.

IPPOLITO, ANGELO b. November 9, 1922, St. Arsenio, Italy. **Studied:** Ozenfant School of Art, NYC, 1946-47; Brooklyn Museum School, 1948; Instituto Meschini, Rome, 1949-50. Traveled Europe. **Taught:** Cooper Union, 1956-59, 1962-64; Sarah Lawrence College, 1957; Yale U., Visiting Critic, 1961; U. of California, Berkeley, 1961-62; Queens College, 1963-64; Michigan State U., Artist-in-Residence, 1966-67; Binghamton/SUNY, 1971-. A cofounder of the Tanager Gallery, NYC. **Commissions:** New York Hilton Hotel, 1963. **Awards:** Fulbright Fellowship (Italy), 1959; SUNY, Research Grant, 1973, 74, 81; L. C. Tiffany Foundation Award, 1979; AAIAL, Childe Hassam P.P., 1973. **Address:** Friendsville Stage, Binghamton, NY

13903. **Dealer:** Grace Borgenicht Gallery, NYC. **One-man Exhibitions:** (first) Galleria della Rotondo, Bergamo, 1950; Tanager Gallery, NYC, 1954, 62; The Bertha Schaefer Gallery, 1956, 58; HCE Gallery, Provincetown, Mass., 1957, 61; Massillon Museum; Canton (Ohio) Museum; Cleveland Institute of Art, 1960; U. of California, 1961; Michigan State U., 1962; Bolles Gallery, 1962 (two-man, with Harold P. Paris); Grace Borgenicht Gallery, NYC, 1962, 64, 67, 72, 75, 77, 84; Jesse Besser Museum, Alpena, Mich., 1968; Albion College, 1969; Western Michigan U., 1969; Grand Valley State College, Allandale, Mich., 1970; City Hall, Binghamton, N.Y., 1982. **Retrospective:** Binghamton/SUNY, 1975. **Group:** Arts Club of Chicago, 1953; Walker, Vanguard, 1955; Utica, 1955, 57; SMAA Annuals, 1955, 57, 59, 62; USIA, 20th Century Graphics, circ., 1956-58; WMAA, Young America, 1957; A.F.A., College in America, circ., 1957-58; WMAA, Nature in Abstraction, 1958; VI São Paulo Biennial, 1961; Silvermine Guild, 1963; IIE, 1975; Carnegie, International, 1956, 58, 61. **Collections:** Amerada Hess Corp.; U. of California; Chase Manhattan Bank; CIT Corporation; General Electric Corp.; Hirshhorn; IIE; U. of Kentucky; Lehman Bros.; MMA; MOMA; Massillon Museum, Michigan State U.; U. of Michigan; Milwaukee; Montreal Trust Co.; NYU; Norfolk/Chrysler; Phillips; Purchase/SUNY; Sarah Lawrence College; Utica; WMAA. **Bibliography:** Baur 5; Goodrich and Baur 1; Janis and Blesh 1; Sandler 5.

IRWIN, ROBERT b. September 12, 1928, Long Beach, Calif. **Studied:** Otis Art Institute, 1938-50; Jepson Art Institute, Los Angeles, 1951. **Taught:** Chouinard Art Institute, 1957-58; UCLA, 1962; U. of California, Irvine, 1968-69; Rice U., 1987-89; lectures. Numerous commissions, some realized, others not. **Member:** Advisory Policy Panel for the Na-

tional Endowment for the Arts, 1981.
Awards: Guggenheim Foundation Fellowship, 1976; San Francisco Art Institute, Hon. DFA, 1979; MacArthur Fellowship, 1984-89. **Address:** 2926 Kellogg Street, San Diego, Calif. 92106. **Dealer:** The Pace Gallery, NYC. **One-man Exhibitions:** Felix Landau Gallery, Los Angeles, 1975; Ferus Gallery, Los Angeles, 1959, 60, 62, 64; Pasadena/AM, 1960, 68; The Pace Gallery, NYC, 1966, 68, 69, 71, 73, 74, 85; Los Angeles/County, MA (two-man), 1966; Jewish Museum, 1968; Fort Worth, 1969 (two-man), 75; MOMA, 1970; Walker, 1971, 76; ACE Gallery, Los Angeles, 1972; Harvard U., 1972; Ileana Sonnabend Gallery, Paris, 1972; Wright State U., 1974; U. of California, Santa Barbara, 1974; Mizuno Gallery, Los Angeles, 1972, 74, 76; Chicago/Contemporary, 1975; Palomar College, San Marcos, Calif., 1975; Walker, 1976; U. of California, San Diego, 1983; Public Safety Building, Seattle, 1984; Humlebaek/Louisiana, 1982. **Retrospective:** WMAA, 1977. **Group:** Los Angeles/County MA Annual, 1952-53, 1956-60; WMAA Annual, 1957; UCLA, 1960; SFMA, Fifty California Artists, circ., 1962; MOMA, The Responsive Eye, 1965; VIII São Paulo Biennial, 1965; Vancouver, 1968; Kassel, Documenta IV, 1968; Walker, 1968; Eindhoven, Kompas, 1970; U. of Washington, 1971; Corcoran, 1971; Hayward Gallery, London, 11 Los Angeles Artists, 1971; SMFA, Works in Spaces, 1973; Kennedy Center, Art Now '74, 1974; Long Beach State U., Transparencies, 1975; WMAA, 200 Years of American Sculpture, 1976; Philadelphia College of Art, Projects for PCA, 1976; ICA, U. of Pennsylvania, Urban Encounters, 1980; ICA, U. of Pennsylvania, Drawing: The Pluralist Decade, 1980; Los Angeles/County MA, Seventeen Artists in the Sixties, 1981; PAFA, Form and Function, 1982. **Collections:** Art Gallery of New South Wales; Buffalo/Albright; U. of California, Berkeley; U. of California, San Diego; Boston/MFA; Chicago/AI; Cleveland/MA;

Des Moines; Fort Worth; Harvard U.; La Jolla; Los Angeles/County MA; Los Angeles/MOCA; MOMA; Melbourne/National; Oberlin College; Omaha/Joslyn; Pasadena/AM; Public Safety Building, Seattle, Wash.; RISD; SFMA; Sydney/AG; Tate Gallery; Vancouver; WMAA; Walker; Wellesley College. **Bibliography:** *Abstract Expressionism;* Armstrong, Thomas; *Art Now 74;* Davis, D.; *Drawings of the Pluralist Decade; Individuals;* Plagens; Robert Irwin; *Report;* Sandler 3; *The State of California Painting; Transparency;* Tuchman 3; *USA West Coast.*

ITO, MIYOKO **b.** 1918, Berkeley, Calif. **d.** August 18, 1983, Chicago. **Studied:** U. of California, Berkeley, BA, 1942; Smith College; School of the Art Institute of Chicago. **Awards:** MacDowell Colony Fellowship, 1970-77; Guggenheim Foundation Fellowship, 1977; Chicago/AI, Broadus James Clark Memorial Prize. **One-man Exhibitions:** Hyde Park Art Center, Chicago, 1971; Phyllis Kind Gallery, Chicago, 1973, 80, 81, 85, 88; Kornblee Gallery, NYC, 1976; Phyllis Kind Gallery, NYC, 1978, 82, 85. **Retrospective:** U. of Chicago, 1980. **Group:** WMAA Biennial, 1975; School of the Art Institute of Chicago, Former Famous Alumni, 1976; U. of Illinois, 1976; Sacramento/Crocker, The Chicago Connection, 1977; Chicago Public Library Cultural Center, Masterpieces of Chicago Art, 1977; U. of Northern Iowa, Contemporary Chicago Painters, 1978; Chicago/AI, Chicago and Vicinity, 1981; Ukranian Institute of Modern Art, Chicago, Ten Years Later, 1982; Hyde Park Art Center, Chicago, Abstract/Symbol/Image, 1984. **Collections:** AT&T, NYC; Atlantic Richfield, Co., San Francisco; Chicago/AI; Continental Bank; First National Bank of Chicago; Illinois State U.; U. of Illinois; Kemper Insurance Co.; Madison Art Center; McDermott, Will and Emery, Chicago; NMAA; PAFA; SFMA; Vulcan Materials Co., New Orleans. **Bibliography:** Adrian; *Chicago Connection.*

J

Art, Landscape, Seascape, Cityscape, 1960-1985, circ., 1986; SFMA, American Realism (Janss), circ., 1986; U. of Nebraska, Interiors, 1987; California Palace, Viewpoint Seven, 1989. **Collections:** AT&T; Achenbach Foundation; Brandeis U.; Chase Manhattan Bank; Chemical Bank; General Mills, Inc.; Grinnell College; IBM; U. of Kansas, Kansas City/Nelson; U. of Nebraska; U. of North Carolina; Norton Simon Museum; Oakland; Omaha/Joslyn; PAFA; Pillsbury Co.; Shearson Lehman Co.; Tulsa/Philbrook.

JACOBS, DAVID
from 1st to 4th edition.

JACOBSHAGEN, KEITH **b.** September 8, 1941, Wichita, Kansas. **Studied:** Wichita State U., 1959-60; Art Center College of Design, Pasadena, 1963-64. **Taught:** U. of Kansas, 1968. **Address:** c/o Dealer. **Dealer:** Babcock Galleries, NYC. **One-man Exhibitions:** U. of Nebraska (first), 1969, 79, 88; Fort Dodge/Blanden, 1970; Eastern Carolina U., 1971; Alfred U., 1972; Mark Four Gallery, Lincoln, Neb., 1974; Robert Mondavi Winery Gallery, Oakville, Calif., 1975; Doane College, 1975; Charles Campbell Gallery, San Francisco, 1976, 80, 82, 85; E. G. Gallery, Kansas City, 1976; Wichita/AM, 1978; Dorry Gates Gallery, Kansas City, 1978, 80, 81, 82, 83, 84, 85, 86, 88; Robert Schoelkopf Gallery, NYC, 1979, 82; Mount Marty College, 1979; Elizabeth Paul Gallery, Cincinnati, 1981; Washburn U., 1982; Rober Ramsay Gallery, Chicago, 1983, 86, 89; Omaha/Joslyn, 1983; Emporia State U., 1984; Utah State U., 1984; Signet Arts, St. Louis, Mo., 1986; Landfall Press Gallery, NYC, 1987; Peru State College, 1987; Reuben Saunders Gallery, Wichita, 1988; Babcock Galleries, NYC, 1990. **Group:** PAFA, Contemporary American Realism Since 1960, 1981; AAIAL, 1984, 86; Tucson Museum of Art, New Vistas: Contemporary American Landscape, 1984; The New York Academy of

JACQUETTE, YVONNE **b.** December 15, 1934, Pittsburgh, Pa. **Studied:** RISD, 1952-56, with John Frazier; privately with Herman Cherry. **Traveled:** Japan, Europe, Hong Kong. **Taught:** Moore College of Art, Philadelphia, 1972; U. of Pennsylvania, 1972-75, 79-84; Tyler School of Art, Philadelphia, 1974; Parsons School of Design, NYC, 1974-78. **Member:** Artists Equity. **Commissions:** North Central Bronx Hospital, N.Y.; GSA, federal building and post office, Bangor, Maine; set design for *The Big Picture*, 1987. **Film:** *Night Fantasies,* with Rudy

Yvonne Jacquette, *Town of Skowhegan, Maine V,* 1988.

Burckhardt and music by Elliott Carter, 1991, 16mm. **Awards:** Ingram Merrill Foundation grant, 1975; CAPS, grant, 1979; N.Y. Foundation for the Arts, grant, 1985. **m.** Rudolph Burckhardt. **Address:** 50 West 29th Street, NYC 10001. **Dealers:** Brooke Alexander, Inc., NYC; John Berggruen, San Francisco. **One-man Exhibitions:** (first) Swarthmore College, 1965; Fischbach Gallery, NYC, 1971, 74; Tyler School of Art, Philadelphia, 1972; Brooke Alexander, Inc., NYC, 1974, 76, 79, 81, 82, 83, 86, 88, 90; St. Louis/City, 1983; Seibu Museum of Art, Tokyo, 1985; Barbara Krakow Gallery, Boston, 1986; Bowdoin College, 1986; Syracuse U., 1988; O'Farrell Gallery, Brunswick, Me., 1990; John Berggruen, San Francisco, 1991; U. of Maine, Augusta, 1991. **Group:** Vassar College, Realism Now, 1968; U. of North Carolina, Art on Paper, 1969; Buffalo/Albright, Cool Realism, 1970; WMAA Annual, 1972; New York Cultural Center, Women Choose Women, 1972; WMAA, Drawings 1963-1973; 1973; Chicago/AI, Small Scale in Contemporary Art, 1975; Minnesota/MA, Drawings USA, 1975; San Antonio/McNay, American Artists '76, 1976; P.S. 1, Long Island City, Couples, 1979; Brooklyn Museum, American Drawings in Black & White, 1970-1979, 1980; MOMA, New Work on Paper I, circ., 1981; Brooklyn Museum, The American Artist as Printmaker, 1983; Hirshhorn, Drawing 1974-1984, 1984; MOMA, International Survey of Recent Painting and Sculpture, 1984; Taft Museum, Night Lights, 1985; Brooklyn Museum, Public & Private, circ., 1986; Huntsville Museum, Drawings: The New Tradition, 1987; Cincinnati/AM, Making Their Mark, circ., 1989; U. of Virginia, Charlottesville, The Humanist Icon, 1990; WMAA, Equitable, Nocturnal Visions, 1989; AAIAL, 1990; Boston/MFA, The Unique Print: 70s into 90s, 1990; Fairfield U., Urban Realities, 1992. **Collections:** AAIAL; Akron/AI; Bowdoin College; Brooklyn Museum; Carnegie; Colby

College; Concordia College; Corcoran; Delaware Art Museum; Hirshhorn; U. of Iowa; Library of Congress; Minnesota/MA; MMA; MOMA; Museum of the City of New York; New Orleans Museum; U. of North Carolina; Ohio State U.; Pomona College; RISD; Rutgers U.; St. Louis/City; WMAA; Yale U. **Bibliography:** Arthur 2; Gettings; Lippard 3; *Poets and Painters.*

JARVAISE, JAMES
from 1st to 4th edition.

JAUDON, VALERIE **b.** August 6, 1945, Mississippi. **Studied:** Mississippi U. for Women, 1963-65; U. of the Americas, Mexico City, 1966-67; St. Martin's School of Art, London, 1968-69; Memphis Academy of Arts, 1965. Traveled Mexico, Europe. **Taught:** School of Visual Arts, NYC, 1983-84; Hunter College, 1986. **Commissions:** ceiling mural, Insurance Co. of North America, Philadelphia, 1977; Metropolitan Transit Authority, NYC, 1988; City of New York, Police Plaza, 1989; 1675 Broadway, NYC, mural, 1991. **Awards:** CAPS, grant, 1980; Mississippi Institute of Arts & Letters, art award, 1981; Art Commission of the City of New York, special commendation, 1987; National Endowment for the Arts, fellowship, 1988. **Address:** 139 Bowery, NYC 10002. **Dealer:** Sidney Janis Gallery, NYC. **One-man Exhibitions:** (first) Holly Solomon Gallery, NYC, 1977, 78, 79, 81; PAFA, 1977; Galerie Bischofberger, Zurich, 1979; Galerie Hans Strelow, Düsseldorf, 1980; James Corcoran Gallery, Los Angeles, 1981; Amerika Haus, Berlin, 1983; Dart Gallery, Chicago, 1983; Sidney Janis Gallery, NYC, 1983, 85, 86, 88, 90; Quadrat Gallery, Bottrop, 1983; Fay Gold Gallery, Atlanta, 1985; McIntosh/Drysdale Gallery, Washington, D.C., 1985. **Group:** Sarah Lawrence College, Painting 1975-77, 1977; P.S. 1, Long Island City, Pattern Painting at P.S. 1, 1977; Utica, Critic's Choice, 1976-77, 1977; Rice U., Pattern

Valerie Jaudon, *Azimuth*, 1990.

and Decoration, 1978; Rutgers U., Decorative Art: Recent Work, 1978; Claremont College, Black and White Are Colors, 1979; Dayton/AI, Patterns Plus, 1979; Brussels/Beaux-Arts, Patterning Painting, 1979; Mannheimer Kunstverein, Mannheim, Dekor, 1980, Aachen, Les Nouveau Fauves/Die Neuen Wilden, 1980; Illinois Wesleyan U., New York Pattern Show, 1980; Venice Biennale, 1980; Ohio U., The Pattern Principle, 1981; Ridgefield/Aldrich, A Look Back, A Look Forward, 1982; Purchase/SUNY, The Spirit of Orientalism, 1982; Hudson River Museum, Ornamentalism, 1983; Stamford Museum, American Art: American Women, 1985; Hunter College, Systems and Abstraction, 1988; Cincinnati/AM, Making Their Mark, circ., 1989. **Collections:** Aachen/Ludwig; Buffalo/Albright; Dayton/AI; Harvard U.; Hirshhorn; Humlebaek/Louisiana; Indiana U.; MOMA; Ridgefield/Aldrich. **Bibliography:** *Black and White Are Colors.*

JENKINS, PAUL b. July 12, 1923, Kansas City, Mo. **Studied:** Kansas City Art Institute and School of Design, 1938-41; US Naval Air Corps, 1943-45; ASL, 1948-51. Also resides Paris, 1953-. Published *Anatomy of a Cloud*, autobiography, 1983. **Taught:** Santa Fe Institute of Fine Arts, 1986. Traveled Japan, India, Russia; Europe, China. **Commissions:** Insignia for Maison Internationale du Théâtre, Paris, 1981; medal for the Center of French Civilization and Culture, NYU,

1985; designs costumes, sets, and stages his dance/drama *Shaman to the Prism Seen*, 1986-87; silk decor for performance at the Great Hall of the People, Beijing, during *The Return of Marco Polo*, 1988; designs insignia for Imago Terrae Publishing Co., 1988. **Member:** The Century Association. **Awards:** Corcoran Biennial, Silver Medal, 1966; Golden Eagle Award for a film, *The Ivory Knife*, of which he is the subject, 1966; Honorary Doctor of Humanities, Linwood College, 1973; Officer des Arts et Lettres, 1980; Commandeur des Arts et Lettres, France, 1983. **Address:** 831 Broadway, NYC 10003. **Dealers:** Samuel Stein Gallery, Chicago; Gimpel Fils, London; Galerie Patrice Trigano, Paris; Galleria Lorenzelli, Milan; Gallery Art Point, Tokyo. **One-man Exhibitions:** (first) Studio Paul Facchetti, Paris, 1954; Zimmergaleries Franck, Frankfurt am Main, 1954; Zoe Dusanne Gallery, Seattle, 1955; Martha Jackson Gallery, NYC, 1956, 58, 60, 61, 64, 66, 68, 69, 70, 71; Galerie Stadler, Paris, 1957, 59; A. Tooth & Sons, London, 1960, 63; Galerie Karl Flinker, 1960, 61, 63, 65, 73, 76; Galleria Toninelli, Milan, 1962; Galerie Charles Leinhard, Zurich, 1962; Galleria Odyssia, Rome, 1962; Cologne/Kunstverein, 1962; Esther Robles Gallery, 1963; Eva de Buren Gallery, Stockholm, 1963; Hannover/K-G, 1964; Tokyo Gallery, 1964; Court Gallery, Copenhagen, 1964; Gutai Museum, Osaka, 1964; Gertrude Kasle Gallery, Detroit, 1965, 71; Gallery of Modern Art, 1965, 66; Makler Gallery, Philadelphia, 1966; SRGM, 1966; Moss Gallery Ltd., Toronto, 1968; Daniel Gervis Gallery, Paris, 1968; Bernard Raeder Gallery, Lausanne, 1968; Richard Gray Gallery, 1971; Suzanne Saxe Gallery, San Francisco, 1971; SFMA, 1972; Images Gallery, Toledo, 1972; Gimpel Fils, London, 1972, 80, 82, 86, 91; Corcoran, 1972; Baukunst Galerie, Cologne, 1974; Gimpel & Weitzenhoffer Ltd., NYC, 1974, 76, 78, 79, 81, 83, 85, 86, 88, 91; Galerie Ulysses, Vienna, 1974; Galerie Tanit, Munich,

1975; Galerie Farber, Brussels, 1975; Ohio U., 1975; Miami U., Oxford, 1975; Ft. Lauderdale, 1975; Carone Gallery, Ft. Lauderdale, 1975; A.B. Classon Co., Cincinnati, 1975, 77; Tampa Bay Art Center, 1975; Montgomery Museum, 1975; Columbus, 1975; Haslem Fine Arts, Inc., Washington, D.C., 1976; Gimpel & Hanover, Zurich, 1977; La Galerie Cour St.-Pierre, Geneva, 1977; Contemporary Gallery, Dallas, 1977; Tulsa/Philbrook, 1977; Diane Gilson Gallery, Seattle, 1977; Galleria d'Arte Narciso, Turin, 1978; Balcon des Arts, Paris, 1978; Elaine Horwitch Gallery, Scottsdale, Ariz., 1978, 79, 80, 86; Carone Gallery, Fort Lauderdale, Fla., 1981, 84; Galerie Georges Fall, Paris, 1982, 83, 85; Maison Internationale du Theatre, Theatre du Rond-Point, Paris, 1981; Samuel Stein Gallery, Chicago, 1976, 78, 81; Nicoline Pon Gallery, Zurich, 1982; Contemporary Gallery, Dallas, 1980, 82, 83; Amherst College, 1983; Dunkerque/MAC, 1984; Gallery Art Atrium, Stockholm, 1985, 87; Gallery Moos, Toronto, 1985; Galerie Sapone, Nice, 1985; Gallery Art Point, Tokyo, 1986, 92; MR Galleria d'Arte Contemporaneo, Rome, 1986; Galerie Michel Delorme, Paris, 1986; Roswitha Haftmann, Zurich, 1986, 92; Youngstown/Butler, 1986; Focus Gallery, Lausanne, 1986; Gallery 63, Klosters, Switzerland, 1987; Galerie Regis Dorval, Lille, France, 1987; Atelier Bordas, Paris, 1988, 92; Galerie Patrice Trigano, Paris, 1988, 90; Galerie Régis Dorval, Le Touquet, 1988; Gana Gallery, Seoul, 1988; Galleria La Loggia, Bologna, 1988; Nice/Contemporarain, 1989; Castello Dorai, Porto Venere, 1991; Guy Pieters Gallery, Knokke-Zoute, 1992. **Retrospectives:** Hannover/KG, 1964; Houston/MFA, 1971; Palais des Beaux Arts, Charleroi, Belgium, 1974; Palm Springs Desert Museum, 1980; Antibes/Picasso, 1987. **Group:** Musée du Petit Palais, Paris, 1955; MOMA, Recent Drawings USA, 1956; Arts Council Gallery, London, New

Paul Jenkins, *Phenomena Tiberius Revisited*, 1991.

Trends in Painting, 1957; WMAA, Young America, 1957; WMAA, Nature in Abstraction, 1958; Carnegie, 1958, 61; Corcoran, 1958, 66; SRGM, Abstract Expressionists and Imagists, 1961; Salon du Mai, Paris, 1962; Seattle World's Fair, 1962; WMAA Annuals, 1962, 65; Art:USA:Now, circ., 1962-67; Salon des Realites Nouvelles, Paris, 1963; Tate, Painting and Sculpture of a Decade, 1954-64, 1964; PAFA, 1965; ICA, Boston, Painting Without a Brush, 1965; M. Knoedler & Co., Art Across America, circ., 1965-67; Smithsonian, 1966; U. of Illinois, 1967, 68; U. of Oklahoma, 1968; Indianapolis, 1969; U. of California, Santa Barbara, 1970; VMFA, American Painting 1970, 1970; Brooklyn Museum, Annual, 1970; Musée des Beaux Arts de Caen, Peinture Contemporaine, 1970; U. of Illinois, 1971; Indianapolis, 1974, 76; Springfield, Mass./MFA, Watercolor USA, 1977; Butler/Youngstown, Midyear Show, 1978, 85; Brooklyn Museum, Homer, Sargent and the American Watercolor Tradition, 1984; Osaka/National, Action and Emotion, 1985; Dunkerque/Contemporain, Les Années 50, 1985; Abbaye Saint-Germain, Auxerre, Le Tondo aujourd'hui, 1992. **Collections:** Amsterdam/Stedelijk; Antibes/Picasso; Baltimore/MA; Bezalel Museum; Brooklyn Museum; Buffalo/Albright; Busch-Reisinger Museum; U. of California, Berkeley; Canberra/National; Carnegie; Cologne/Kunstverein; Colum-

bus; Corcoran; Dallas/MFA; Des Moines; Detroit; Dunkerque/Contemporary; France/National; Hannover/K-G; Hiroshima/Contemporary; Hirshhorn; U. of Illinois; Indianapolis; Jewish Museum; Liverpool/Walker; Los Angeles/County MA; Louisville State; MIT; Milwaukee; MOMA; Musée Guimet; NCFA; Tokyo/Western; Niigata Museum; Norfolk/Chrysler; PMA; Paris/Beaubourg; Phoenix; SFMA; SRGM; Seattle/AM; Stanford U.; Stuttgart; Tate; U. of Texas; Tokyo/Western; Toronto; Toyoma/Modern; Victoria and Albert Museum; U. of Virginia; Walker; WMAA; Worcester/AM; Youngstown/Butler. **Bibliography:** Elsen 1; **Jenkins with Jenkins; Nordland 3;** Sandler 5. Archives.

JENNEY, NEIL **b.** 1945, Torrington, Conn. Autodidact. **Address:** 69 Wooster Street, NYC 10012. **Dealer:** Barbara Mathes Gallery, NYC. **One-man Exhibitions:** (first) Galerie Rudolf Zwirner, Cologne, 1968; Noah Goldowsky Gallery, NYC, 1970; David Whitney Gallery, NYC, 1970; Blum Helman Gallery, 1975; Hartford/Wadsworth, 1975; Barbara Mathes Gallery, NYC, 1987, 90; Oil and Steel Gallery, Long Island City, N.Y., 1984, 85; Vivian Horan Fine Art, NYC, 1988; Carpenter-Hochman Gallery, NYC, 1985. **Group:** Cornell U., Earthart, 1969; Berne, When Attitude Becomes Form, circ., 1969; WMAA, Anti-Illusion: Procedures/Materials, 1969; WMAA, New Image Painting, 1978; Amsterdam/Stedelijk, '60-'80 Attitudes/Concepts/Images, 1982. **Collections:** SRGM; WMAA. **Bibliography:** *Back to the USA;* De Wilde 2; Fox; Murken-Altrogge; Robins; Rosenthal; Vine and Hales.

JENNIS, STEVAN **b.** 1945, Newark, N.J. **Studied:** San Fernando Valley College, 1967, BFA; UCLA, 1970, MA; U. of Massachusetts, 1973, MFA. **Taught:** Mount Holyoke College, 1973; U. of Massachusetts, 1973-74. **Awards:** CAPS grant,

1979. **Address:** 434 Greenwich Street, NYC 10013. **Dealer:** Helander Gallery, NYC. **One-man Exhibitions:** ICA, Boston, 1972; Hundred Acres Gallery, NYC, 1972, 75; Westfield State College, 1976; Robert Freidus Gallery, NYC, 1978; Barbara Toll Fine Arts, NYC, 1979, 80, 82, 85; Connecticut College, 1979; The Red Studio, NYC, 1984; Helander Gallery, NYC, 1991. **Group:** U. of North Carolina, Art on Paper, 1975, 82; WMAA, Recent Drawings by Younger Artists, 1978; Buffalo/Albright, With Paper, About Paper, 1980; ICA, Los Angeles, Wallpaper/Roompaper, 1981; Chicago/Contemporary, Dogs!, 1983; Denver/AM, Another Great Love Affair, 1983; Hudson River Museum, New Vistas, 1984. **Collections:** U. of Massachusetts; Newark Museum; U. of North Carolina; Purchase/SUNY; Washington and Jefferson College.

JENSEN, ALFRED **b.** December 11, 1903, Guatemala City, Guatemala. **d.** April 4, 1981, Livingston, N.J. **Studied:** San Diego Fine Arts School, 1925; Hofmann School, Munich, 1927-28; Academie Scandinave, Paris, with Charles Despiau, Charles Dufresne, Othon Friesz, Marcel Gromaire, Andre Masson. Traveled USA, Europe. **Taught:** Maryland Institute, 1958. **Commissions:** Time Inc. (mural); National Institute of Health, Bethesda (mural), 1980. **Awards:** Tamarind Fellowship, 1965. **One-man Exhibitions:** (first) John Heller Gallery, NYC, 1952; Tanager Gallery, NYC, 1955; The Bertha Schaefer Gallery, 1957; Martha Jackson Gallery, 1957, 59, 61, 67; SRGM, 1961, 84; Fairleigh Dickinson U., 1963; The Graham Gallery, 1963-65; Klipstein & Kornfeld, Berne, 1964; Rolf Nelson Gallery, Los Angeles, 1964; Kunsthalle, Basel, 1964 (two-man, with Franz Kline); Amsterdam/Stedelijk, 1964; Ziegler Gallery, 1966; Cordier & Ekstrom, Inc., 1967, 68, 70; The Pace Gallery, NYC, 1972, 73, 76, 83, 84, 87, 91; Hannover/K-G, 1973;

Humlebaek/Louisiana, 1973; Kunsthalle, Baden Baden, 1973; Düsseldorf/Kunsthalle, 1973; Berne, 1973; Daniel Weinberg Gallery, Los Angeles, 1986; Waddington Galleries, London, 1988; Susanne Hilberry Gallery, Birmingham, MI, 1989; Linda Cathcart Gallery, Santa Monica, 1990. **Retrospectives:** Buffalo/Albright, circ., 1977; SRGM, 1985. **Group:** San Diego; Baltimore/MA; MOMA; The Stable Gallery, 1954-57; II Inter-American Paintings and Prints Biennial, Mexico City, 1960; ICA, Boston, 1960; Chicago/AI, 1961; Corcoran Biennial, 1962; WMAA, Geometric Abstraction in America, circ., 1962; WMAA Annual, 1963; Los Angeles/County MA, Post Painterly Abstraction, 1964; XXXII Venice Biennial, 1964; International Biennial Exhibition of Paintings, Tokyo; Buffalo/Albright, Plus by Minus, 1968; Kassel, Documenta IV, 1968; Lafayette College, Black-White, 1969; Indianapolis, 1970; VMFA, 1970; WMAA, The Structure of Color, 1971; ICA, U. of Pennsylvania, Grids, 1972; Kassel, Documenta V, 1972; WMAA Biennials, 1973, 77; São Paulo Biennial, 1977; Brandeis U., Aspects of the 70s: Mavericks, 1980; Cologne/Ludwig, Bilderstreit, 1989; U. of Florida, Gainsville, Color in Art, 1990. **Collections:** Aachen/NG; American Republic Insurance Co.; Baltimore/MA; Berne; Brandeis U.; Buffalo/Albright; Chase Manhattan Bank; Cornell U.; Dallas/MFA; Dayton/AI; Health and Hospital Corp.; Hirshhorn; Humlebaek/Louisiana; Los Angeles/County MA; MOMA; Omaha/Joslyn; Phoenix; Ridgefield/Aldrich; SFMA; SRGM; San Diego; Time Inc.; WMAA; Zurich. **Bibliography:** Armstrong, Thomas; **Alfred Jensen;** Calas, N. and E.; *From Foreign Shores;* Gettings; Gohr and Gachnang; Honisch and Jensen, eds.; *Kunst um 1970;* MacAgy 2; Sandler 3, 5; Tuchman 3.

JENSEN, BILL b. November 26, 1945, Minneapolis, Minn. **Studied:** U. of Minnesota, BFA, 1964, MFA, 1970, with

Peter Busa. **Taught:** U. of Minnesota, 1968-70; Brooklyn Museum School, 1971-75. **Awards:** CAPS, 1978; National Endowment for the Arts, 1985. **Address:** 429 West 14th Street, NYC, 10014. **Dealer:** Washburn Gallery Inc., NYC. **One-man Exhibitions:**(first) U. of Minnesota, 1970; Fischbach Gallery, 1973, 75; Washburn Gallery, NYC, 1980, 81, 82, 84, 86, 87, 88, 89, 91; MOMA, 1986; Phillips, circ., 1987; David Grob Gallery, London, 1991; Margo Leavin Gallery, Los Angeles, 1991; **Group:** P.S. 1, Long Island City, Rooms, 1976; P.S. 1, Long Island City, A Painting Show, 1977; WMAA Biennial, 1981; MIT, Affinities, 1983; U. of Chicago, The Meditative Surface, 1984; MOMA, International Survey of Recent Painting and Sculpture, 1984; WMAA, Five Painters in New York, 1984; Carnegie, International, 1985; Los Angeles/County AM, The Spiritual in Art, 1986; Corcoran, Biennial, 1987; WMAA, Twentieth Century Drawing, circ., 1987; Dublin, ROSC '88; Pratt Institute, Sightings: Drawing with Color, circ., 1988. **Collections:** Carnegie; Chase Manhattan Bank; Columbia Greene Community College; Currier; First National Bank, Minneapolis; Graphische Sammlung Albertina; Harvard U.; Los Angeles/County

Bill Jensen, *Babar,* 1988-89.

MA; MMA; MOMA; McCrory Corp.; Paine Webber Inc.; WMAA; Worcester/AM. **Bibliography:** Armstrong and Marshall; Cummings 5; Tuchman 3.

JESS (COLLINS) b. 1923, Long Beach, Calif. **Studied:** California Institute of Technology, BS, 1948; California School of Fine Arts, 1949-51, with Clyfford Still, Edward Corbett, Elmer Bischoff, David Park, and Hassel Smith. Opened the King Ubu Gallery, San Francisco, in 1953, with Harry Jacobus and Robert Duncan. Traveled Europe. **Address:** 3267 20th Street, San Francisco, CA 94110. **One-man Exhibitions:** The Place (a bar), San Francisco, 1954; Gump's Art Gallery, San Francisco, 1959; City Lights Book Shop, San Francisco, 1959; Dilexi Gally, San Francisco, 1960; Borregaard's Museum, San Francisco, 1961; Rolf Nelson Gallery, Los Angeles, 1965; Cheney Cowles Museum, Spokane, 1967; SFMA, 1968; Odyssia Gallery, NYC, 1971, 78; Chicago/Contemporary, 1972; MOMA, 1974; Hartford/Wadsworth, 1975; Galleria Odyssia, Rome, 1975; Dallas/MFA, circ., 1977; Newport Harbor, 1984; Gallery Paule Anglim, San Francisco, 1983. **Group:** King Ubu Gallery, San Francisco, 1953; MOMA, The Art of Assemblage, 1961; Oakland/AM, Pop Art USA, 1963; U. of New Mexico, The Painter and the Photograph, 1964; SFMA, Looking Back, 1968; ICA, U. of Pennsylvania, The Spirit of the Comics, 1969; Hayward Gallery, London, Pop Art Redefined, 1969; Chicago/AI, 70th American Exhibition, 1972; WMAA, Extraordinary Realities, 1973; U. of Illinois, 1974; Dallas/MFA, Poets of the Cities, 1974; SFMA, California Painting and Sculpture: The Modern Era, 1976; Indianapolis, Perceptions of the Spirit in 20th Century American Art, 1977; ICA, Boston, Narration, 1978. **Collections:** Chicago/AI; Dallas/MFA; MMA; MOMA; PMA. **Bibliography:** Ashbery; De Salvo and Schimmel; *Forty Years of California Assemblage;* Gettings; Tuchman 3.

JIMENEZ, JR., LUIS A. b. July 30, 1940, El Paso, Texas. **Studied:** U. of Texas, Austin, BA; Ciudad Universitaria, Mexico, 1964. **Awards:** AAIAL, P.P. 1977. **Commissions:** Steuben Glass, NYC, 1972; Moody Park, Houston, 1977; Fargo, North Dakota, 1977; City of Albuquerque, 1981; Sacramento, 1982; Niagara Frontier Transportation Authority, Buffalo, 1982; Veterans Administration Hospital, Oklahoma City, 1982; Wichita State U., 1983; MacArthur Park, Los Angeles, 1986; International Bridge, San Diego, 1987; The Benenson Capital Co., Miami, 1987; Martineztown/Longfellow Park, Albuquerque, 1988. **Address:** P.O. Box 175, Hondo, NM 88336. **Dealer:** Phyllis Kind Gallery, New York and Chicago. **One-man Exhibitions:** Graham Gallery, NYC, 1969, 70; Bienville Gallery, New Orleans, 1973, 75, 78; Long Beach Museum, 1973; Houston/Contemporary, 1974; OK Harris Works of Art, NYC, 1972, 75; Meredith Long & Co., Houston, 1976, 77; New Mexico State U., Las Cruces, 1977; North Texas State U., 1977; Tucson, 1977; U. of North Dakota, Grand Forks, 1977; U. of Arizona, 1977; U. of Santa Clara, 1977; Yuma Art Center, Yuma, Arizona, 1978; Hill's Gallery, Santa Fe, 1975, 79; Santa Fe, N.M., 1976; Plains Art Museum, Moorhead, Minn., 1979, 82; El Paso Museum of Art, 1979; Omaha/Joslyn, 1980; Pepperdine U., 1980; Frumkin-Struve, Chicago, 1979, 81; Amarillo Art Center, 1981; Sebastian Moore Gallery, Denver, 1981; Heydt-Bair Gallery, Santa Fe, 1982; Candy Store Gallery, Folsom, 1983; Yares Gallery, Scottsdale, 1893; Laguna Gloria, 1983, 84; Roswell, 1984; Art Attack Gallery, Boise, 1984; Phyllis Kind Gallery, NYC, 1984; Alternative Museum, NYC, 1984; U. of Arizona, 1985; Loch Haven Art Center, 1985; Callas/MFA, 1985. **Group:** U. of North Carolina, Art on Paper, 1969, 71; WMAA, Human Concern/Personal Torment, circ., 1969; Harvard U., Recent Figure Sculpture, 1972; Phoenix, First International Motorcycle

Art Show, 1973; WMAA Annual, 1973; Hofstra U., The Male Nude, 1973; Houston/Contemporary, Twelve Texas Artists, 1974; Colorado Springs/FA, 20 Colorado/20 New Mexico, 1975; ARCO Center for Visual Art, Los Angeles, New Art, New Mexico, 1975; Corpus Christi, Arists Make Toys, 1976; AAIAL, 1977; USIA, Paris, Three Texas Artists, 1977; NCFA, Raices Antiguas/Visiones Nuevas, circ., 1977; U. of Texas, Austin, Made in Texas, 1979; Houston/Contemporary, Fire, 1982; Palm Springs Desert Museum, The West as Art, 1982; Houston/Contemporary, In Our Time, 1982; Library of Congress, Myth of the Cowboy, 1983; San Antonio/McNay, Texas Figure Drawing, 1983; New Museum, NYC, Language, Drama, Source and Vision, 1983; San Diego, Insight, 1983; Corpus Christi, Images of Texas, 1983; Los Angeles/MOCA, Automobile and Culture, 1984; U. of Houston, Collision, 1985; Houston/MFA, Hispanic Art in the United States, circ., 1987; Hirshhorn, Different Drummers, 1988. **Collections:** AAIAL; Chicago/AI; Denver/AM; Long Beach/MA; MMA; NCFA; New Orleans Museum; Phoenix; Plains Art Museum; Roswell; U. of Nebraska; Witte. **Bibliography:** *The Decade Show.*

JOHNS, JASPER **b.** May, 1930, Augusta, Ga. **Studied:** U. of South Carolina. Artistic adviser to Merce Cunningham Dance Company. A director of the Foundation for Contemporary Performance Arts since 1963. **Member:** NIAL, 1973; AAIAL, South Carolina Hall of Fame; Royal Academy of Arts, London, Honorary Academician, Officier, Order des Arts et Lettres, France. **Awards:** Gallery of Modern Art, Ljubljana, Yugoslavia, VII International Exhibition of Prints, First Prize, 1967; IX São Paulo Biennial, 1967; Skowhegan School, Award for Graphics, 1977; New York City Mayor's Award of Honor for Arts and Culture, 1978; AAIAL, Gold Medal, 1986; Wolf

Foundation (Israel), Prize for Painting, 1986; Brandeis U., Creative Arts Award for Painting, 1988; Venice Biennale, Grand Prize, The Golden Lion, 1988; National Medal of Arts, USA, 1990. **Address:** 153 East 63rd Street, NYC, 10021; St. Martin, French West Indies. **Dealer:** Leo Castelli Inc., NYC. **One-man Exhibitions:** Leo Castelli Inc., NYC, 1958, 60, 61, 63, 66, 68, 70, 71, 76, 77, 79, 81, 82, 84, 86, 91; Galleria d'Arte del Naviglio, Milan, 1959; Galerie Rive Droite, Paris, 1959, 61; Columbia, S.C./MA, 1960; U. of Minnesota, 1960; Ferus Gallery, Los Angeles, 1960 (two-man); Ileana Sonnabend Gallery, Paris, 1962; Everett Ellin Gallery, Los Angeles, 1962; Whitechapel Art Gallery, London, 1964; Pasadena/AM, 1965; Ashmolean Museum, Oxford, England, 1965; American Embassy, London, 1965; Minami Gallery, 1965; NCFA, 1966; MOMA, circ., 1968; Eva de Buren Gallery, Stockholm; Castelli-Whitney, NYC, 1969; PMA, 1970; U. of Iowa, 1970; MOMA, 1970; Minneapolis/Institute, 1971; Dayton's Gallery 12, Minneapolis, 1971; Chicago/Contemporary, 1971; MOMA, Thirty Lithographs: 1960-68, circ., 1972; Fendrick Gallery, Washington, D.C., 1972; Houston/MFA, 1972; Hofstra U., 1972; Lo Spazio, Rome, 1974; Modern Art Agency, Naples, 1974; Galerie Folker Skulima, Berlin, 1974; Galerie Mikro, Berlin, 1974; Museum of Modern Art, Oxford, England, 1974; Arts Council of Great Britain, Drawings, 1975; Janie C. Lee Gallery, Houston, 1976, 79; Brooke Alexander, NYC, 1977; Margo Leavin Gallery, Los Angeles, 1978, 81; Galerie Nancy Gillespie, Paris, 1978; Galerie Valeur, Nagoya, 1978, 79; Baltimore/MA, 1978; John Berggruen Gallery, San Francisco, 1978; Basel, circ., 1979; Tucson Museum of Art, 1979; Getler/Pall and Patricia Heesey Fine Art, NYC, 1980; Greenberg Gallery, St. Louis, 1980; Toledo/MA, 1980; Tyler, Texas, 1980; Thomas Segal Gallery, Boston, 1981; Tate Gallery, 1981; L. A. Louver Gallery, Venice, Calif., 1982;

WMAA, 1982; Akira Ikeda Gallery, Tokyo, 1983; Delahunty Gallery, Dallas, 1983; Lorence-Monk Gallery, NYC, 1985, 87, 89; Brooke Alexander, Inc., NYC, 1985; St. Louis/City, 1985; Fondation Maeght, St. Paul de Vence, France, 1986; St. Louis/City, 1986; Patricia Heesey Gallery, NYC, 1986; Pence Gallery, Santa Monica, 1986; UCLA, circ., 1987; Galerie Daniel Templon, Paris, circ., 1987; Purchase/SUNY, 1987; Walker, 1988; Greg Kucera Gallery, Seattle, 1988; Venice Biennale, circ., 1988; French Institute, NYC, 1988; Gagosian Gallery, NYC, 1989, 92; Youngstown/Butler, 1989; Basel/Kunstmuseum, 1989; Anthony D'Offay Gallery, London, 1989, 90; Musée Cantonal des Beaux Arts, 1990; Seibu Museum, Tokyo, 1990; Cleveland/Contemporary, 1990; Yoshiaki Inoue Gallery, Tokyo, 1990; Galerie Humanite, Tokyo, circ., 1990; Walker, circ., 1990; Isetan Museum, Tokyo, circ., 1990; Brenau College, 1991; Stux Modern, NYC, 1991; Tel Aviv, circ., 1991; Heland Wetterling, Stockholm, 1991; Brooke Alexander Editions, NYC, 1991; Palais de Luppe, Arles, 1992. **Retrospectives:** Jewish Museum, 1964; Whitechapel Art Gallery, London, 1964; Pasadena/AM, 1965; WMAA, circ., 1977; MOMA, 1986; MOMA, circ., 1986; National Gallery, circ., 1990; Milwaukee, circ., 1992. **Group:** Jewish Museum, The New York School, Second Generation, 1957; A.F.A., Collage in America, circ., 1957-58; Houston/MFA, Collage International, 1958; XXIX & XXXII Venice Biennials, 1958, 64; Carnegie, 1958, 61, 64, 67; Houston/MFA, Out of the Ordinary, 1959; Daniel Cordier, Paris, Exposition Internationale de Surrealisme, 1959; Columbus, Contemporary American Painting, 1960; A.F.A., School of New York—Some Younger American Painters, 1960; Martha Jackson Gallery, New Media—New Forms, I & II, 1960, 61; WMAA, Annuals, 1960, 61, 62, 64, 65; SRGM, Abstract Expressionists and Imagists, 1961; Dal-las/MFA, 1961-62; SRGM/USIA, American Vanguard, circ., Europe, 1961-62; MOMA, Abstract Watercolors and Drawings: USA, circ., Europe, 1961-62; MOMA, Lettering by Hand, 1962; Seattle World's Fair, 1962; Beme, 4 Americans, 1962; Chicago/AI, 1962; Stockholm/National; Amsterdam/Stedelijk; Salon du Mai, Paris, 1962, 64; SRGM, Six Painters and the Object, circ., 1963; WGMA, The Popular Image, 1963; Musée Cantonal des Beaux-Arts, Lausanne, I Salon International de Galeries Pilotes, 1963; ICA, London, The Popular Image, 1963; Buffalo/Albright, Mixed Media and Pop Art, 1963; El Retiro Parquet, Madrid, Arte de America y España, 1963; Jewish Museum, Black and White, 1963; Hartford/Wadsworth, Black, White, and Gray, 1964; Tate, Dunn International, 1964; Tate, Painting and Sculpture of a Decade, 1954-64; SRGM, 1964; Kassel, Documenta III & IV, 1964, 68; Palais des Beaux-Arts, Brussels, 1965; MOMA, Art in the Mirror, 1966; Jewish Museum, 1966; Expo '67, Montreal, 1967; IX São Paulo Biennial, 1967; Gallery of Modern Art, Ljubljana, Yugoslavia, VII International Exhibition of Prints, 1967; MOMA, Dada, Surrealism and Their Heritage, 1968; Vancouver, 1969; Cincinnati/Contemporary, Monumental Art, 1970; Dublin/Municipal, International Quadriennial (ROSC), 1971; Chicago/Contemporary, White on White, 1971-72; ICA, U. of Pennsylvania, Grids, 1972; WMAA Biennial, 1973, 85, 91; New York Cultural Center, 3D into 2D, 1973; Seattle/AM, American Art—Third Quarter Century, 1973; Parcheggio di Villa Borghese, Rome, Contemporanea, 1973; Art Museum of South Texas, Corpus Christi, Eight Artists, 1974; Chicago/AI, Idea and Image in Recent Art, 1974; WMAA, American Pop Art, 1974; Walker, Eight Artists, 1974; NCFA, Sculpture, American Directions 1945-1975, 1975; MOMA, Drawing Now, 1976; Chicago/AI, 1976; A.F.A., American Master Drawings and Watercol-

ors, 1976; Cambridge, Jubilation, 1977; Minnesota/MA, American Drawing, 1927-1977, circ., 1977; Amsterdam/Stedelijk, At Second Sight, 1978; WMAA, Art About Art, circ., 1978; Buffalo/Albright, American Painting of the 1970's, circ., 1978; Corcoran Biennial, 1979; WMAA, American Prints: Process and Proofs, 1981; Amsterdam/Stedelijk, '60-'80: Attitudes, Concepts, Images, 1982; MOMA, A Century of Modern Drawing, circ., 1982; Brooklyn Museum, The American Artist as Printmaker, 1983; Houston/Contemporary, American Still Life, 1945-1983, circ., 1983; MOMA, The Modern Drawing, 1983; Amsterdam/Stedelijk, La Grande Parade, 1984; WMAA, Blam!, 1984; MOMA, Pop Art: 1955-1970, circ., 1985; SRGM, Transformations in Sculpture, 1985; Fort Lauderdale, An American Renaissance, 1986; Los Angeles/MOCA, Individuals, 1986; Whitechapel/London, In Tandem, The Painter-Sculptor, 1986; Purchase/SUNY, The Window in 20th Century Art, circ., 1986; Venice Biennale, 1986; Los Angeles/County MA, The Spiritual in Art, circ., 1986; ICA, London, Komic Ikonoklasm, circ., 1986; Düsseldorf/Kunsthalle, Similia/Dissimilia, circ., 1987; U. of California, Berkeley, Made in U.S.A., circ., 1987; Stockholm/National, Implosion, 1987; SRGM, Aspects of Collage, 1988; Cologne/Ludwig, Marcel Duchamp und die Avant Garde Zeit 1950, 1988; MOMA, Committed to Print, 1988; Milwaukee, The World of Art Today, 1988; Kassel/Fredericianum, Rot, Gelb, Blau, circ., 1988; Lyon/St. Pierre, The Color Alone, 1988; AAIAL, 1989; Walker, First Impressions, circ., 1989; Bard College, Art What Thou Eat, circ., 1990; Katonah Gallery, The Technological Muse, 1990; ICI, NYC, Contemporary Illustrated Books, circ., 1990; Boston/MFA, The Unique Print: 70s into 90s, 1990; Hofstra U., The Transparent Thread, circ, 1990; Dartmouth, Minimalism and Post-Minimalism, 1990; Graphische Sammlung Albertina, Ameri-

can Drawings in the Eighties, circ., 1990; Milwaukee, Word as Image, circ., 1991; Martin-Gropius-Bau, Berlin, Metropolis, 1991; MOMA, Seven Master Printmakers, circ., 1991; Nice/Contemporain, Collage of the Twentieth Century, 1991. **Collections:** Amsterdam/Stedelijk; Basel; Buffalo/Albright; Cologne; Dallas/MFA; Des Moines; Hartford/Wadsworth; Hirshhorn; Houston/MFA; MOMA; Hara Art Museum; SFMA; Seibu Museum of Art, Tokyo; Stockholm/National; Tate; Victoria and Albert Museum; WMAA. **Bibliography:** Alloway 1; Armstrong, Thomas; Ashbery; Battcock, ed.; Becker and Vostell; Bihalji-Merin; Calas 2; Calas, N. and E.; *Contemporanea;* **Crichton;** Cummings 5; Danto; Davis, D.; De Salvo and Schimmel; De Vries, ed.; De Wilde 1, 2; Dienst 1; Downes, ed.; *Europa/Amerika;* Finch; Friedman, ed.; Gablik; Gettings; Gohr and Gachnang; Goldman 1; Haskell 5; Krauss 2, 3; Honnef; Hunter, ed.; *Individuals;* Janis and Blesh 1; Honisch and Jensen, eds.; **Kozloff 2,** 3; Johnson, Ellen H.; Licht, F.; Lippard 5; Lynton; *Metro;* Murken-Altrogge; Osterwold; *Poets & Painters;* Rickey; Rodman 3; Rose, B., 1, 4; **Rosenthal and Fine;** Rubin 1; Russell and Gablik; Sandler 3, 5; Shapiro; Seitz 4; Siegel; Solnit; **Steinberg, L.;** Tomkins; Tomkins 2; Tomkins and Time-Life Books; Tuchman 3; Waldman 4; Warhol and Hackett; Weller.

JOHNSON, BUFFIE b. February 20, 1912, Duxbury, MA. **Studied:** ASL; Atelier 17, Paris, with S. W. Hayter (engraving); Academie Julie, Paris, 1938; privately with Francis Picabia; U. of California, Berkeley, BFA; UCLA, MA. Traveled extensively, Europe, Mexico, Tangiers, USA. **Taught:** Parsons School of Design, 1946-50; US State Department lecturer; UCLA; Aegina Art Center, Greece, 1973. **Member:** Artists Equity. **Commissions:** Astor Theater, NYC, 1959 (murals). **Awards:** Le Salon International de la Femme, Nice, Second Prize, 1970;

Yaddo Fellowship, 1974; Pollock-Krasner Foundation grant, 1990. **Address:** 102 Greene Street, NYC 10012. **Dealer:** PMW Gallery, Stamford, Ct. **One-man Exhibitions:**(first) Jake Zeitlin Gallery, Los Angeles, 1937; Galerie Rotge, Paris, 1939; Wakefield Gallery, NYC, 1939; Vose Gallery, Boston, 1942; Caresse Crosby, Washington, D.C., 1944; "67" Gallery, NYC, 1945; Ringling, 1948; Galleria del Cavallino, Venice, 1948; Hanover Gallery, 1949; Galerie Colette Allendy, Paris, 1949; Betty Parsons Gallery, NYC, 1950; Choate School, Wallingford, Conn., 1951; Galleries Bing, Paris, 1956, 60; Bodley Gallery, NYC, 1960; Thibaut Gallery, NYC, 1961; Granville Gallery, NYC, 1964; Galeria Antonio Souza, Mexico City, 1964; Max Hutchinson Gallery, 1973; Palm Beach Gallery, Palm Beach, Fla., 1975; New School; Andre Zarre Gallery, NYC; Stamford Museum, 1979; Ringling; Landmark Gallery, NYC; U. of California, 1990. **Retrospective:** PMW Gallery, Stamford, Ct., 1992. **Group:** Carnegie, 1941; Art of This Century, NYC, 1943; Salon des Realités Nouvelles, Paris, 1949, 50; Baltimore/MA; Walker; Brooklyn Museum, 1950, 54; WMAA; U. of Illinois, 1955; Kunsthaus, Hamburg, American Women

Buffie Johnson, *Nine*, 1990.

Artists, 1972; New York Cultural Center, Women Choose Women, 1973; WMAA Biennial; Cranbrook, Waves, 1974. **Collections:** Baltimore/MA; Bezalel Museum; Boston/MFA; Brooklyn Museum; Calcutta; Ciba-Geigy Corp.; Cincinnati/AM; City Investing Corp; Corcoran; Cornell U.; U. of Illinois; International Nickel Co.; Israel Museum; Layton School of Art; MMA; U. of Michigan; NCFA; NYU; Newark Museum; U. of New Mexico; New Orleans Museum; The Ohio State U.; Purchase/SUNY; RISD; Santa Barbara/MA; SRGM; Tanger Museum, Morocco; U. of Texas; Utica; Valley Bank of Springfield; WMAA; Walker; Yale U. **Bibliography:** Archives.

JOHNSON, LESTER b. January 27, 1919, Minneapolis, Minn.

Studied: Minneapolis Institute School (with Alexander Masley, Glen Mitchell); St. Paul School of Art (with Cameron Booth); Chicago Art Institute School, 1942-47. Traveled Europe. **Taught:** St. Bernard School, NYC, 1955-61; The Ohio State U., 1963; U. of Wisconsin, 1964; School of Visual Arts, NYC, 1964; Yale U., 1964-; American Center, Paris, summer, 1966; Director of Studies, Graduate Painting, Yale U., 1969-74. **Awards:** Alfred Pillsbury Scholarship; St. Paul Gallery Scholarship; Midwestern Artists Competition, First Prize, 1942; Guggenheim Foundation Fellowship, 1973; Brandeis U., Creative Arts Award, Painting, 1978. **Address:** 191 Milbank Avenue, Greenwich, Conn., 06830. **Dealer:** The Zabriskie Gallery, NYC & Paris. **One-man Exhibitions:** (first) Artists' Gallery, NYC, 1951; Korman Gallery, NYC, 1954; The Zabriskie Gallery, 1955, 57, 58, 59, 61; Sun Gallery, Provincetown, 1956-59; City Gallery, NYC, 1959; HCE Gallery, Provincetown, 1960-62; Minneapolis/Institute, 1961; B.C. Holland Gallery, 1962; Dayton/AI, 1962; Fort Worth; The Ohio State U.; Martha Jackson Gallery, NYC, 1962, 63, 66, 69, 71, 73, 74, 75; Donald Morris Gal-

lery, Detroit, 1965, 74; 78; Smithsonian, 1968; Alpha Gallery, Boston, 1972, 76, 82; Gallery Moos, Toronto, 1973, 77, 86; Richard Gray Gallery, 1973; Ruth S. Schaffner Gallery, Santa Barbara, 1973, 74; Smith-Anderson Gallery, Palo Alto, 1974; Peter M. David Gallery, Minneapolis, 1974, 78; Livingstone-Learmonth Gallery, NYC, 1975; U. of Connecticut, Storrs, 1975; Gimpel & Weitzenhoffer Ltd., NYC, 1977, 80, 82, 86, 90; Ruth S. Schaffner Gallery, Los Angeles, 1978; Louisiana State U., 1979; Gimpel Fils, London, 1979; Gimpel-Hanover, Zurich, 1980; Galerie André Emmerich, Zurich, 1980; Swain School of Art, New Bedford, Conn., 1980; Donald Morris Gallery, Birmingham, Mich., 1981, 91; U. of Virginia, 1981; Paperwork Gallery, Larchmont, 1983; Zabriskie Gallery, NYC, 1983, 85; Kansas City/AI, 1984; U. of Hartford (twoman), 1984; David Barnett Gallery, Milwaukee, 1985, 91; Munson Gallery, New Haven, 1986. **Retrospective:** Westmoreland County/MA, 1987. **Group:** PAFA; Minneapolis/Institute; Jewish Museum, The New York School, Second Generation, 1957; Minneapolis/Institute, American Painting, 1945-57, 1957; Baltimore/MA, Critics Choice, 1958; WMAA, 1958, 68, Annual 1967; ICA, Boston, 100 Works on Paper, circ., Europe, 1959; A.F.A., The Figure, circ., 1960; ICA, Boston, Future Classics, 1960; A.F.A., Graphics '60, 1960; Carnegie, 1961, 68; MOMA, Recent American Painting and Sculpture, circ., USA and Canada, 1961-62; Chicago/AI, Recent Trends in Painting, USA, 1962; MOMA, Recent Painting USA, The Figure, circ., 1962-63; Lehigh U., 1967; MOMA, The 1960's, 1967; Dublin/Municipal, International Quadrennial (ROSC), 1967; U. of Kentucky, 1968; Madrid/Nacional, II Biennial, 1969; Star Turtle Gallery, NYC, The Tenants of Sam Wapnowitz, 1969; Philadelphia Art Alliance, 1969; Smithsonian, Neue Figuration USA, circ., 1969; Brooklyn Museum Print Biennial, 1970; Carne-

gie, 1970; U. of North Carolina, Works on Paper, 1971; SRGM, 10 Independents, 1972; Chicago/AI, 70th American Exhibition, 1972; Minnesota/MA, 1973; WMAA, 1973; NAD, 1974; Indianapolis, 1976; Provincetown Art Association, Provincetown Artists, 1977; Chicago/AI, 100 Artists—100 Years, 1979; Oklahoma, Masters of the Portrait, 1979; Ridgefield/Aldrich, Homo Sapiens: The Many Images, 1982; MMA, Aspects of the City, 1984; MOMA, Naked/Nude, 1986. **Collections:** U. of Arizona; Baltimore/MA; Buffalo/Albright; California College of Arts and Crafts; Chase Manhattan Bank; Chicago/AI; Ciba-Geigy Corp.; Dayton/AI; Detroit/Institute; Fort Worth; Goldring International; Hirshhorn; Hartford/Wadsworth; MOMA; U. of Michigan; Minneapolis/Institute; NCFA; U. of Nebraska; New School for Social Research; Norfolk/Chrysler; Northwestern U.; Ohio State U.; PMA; Philip Morris Collection; Phoenix; Purchase/SUNY; SRGM; Smithsonian; Stony Brook/SUNY; Tulsa/Philbrook; U.S. Steel Corp.; Walker; U. of Wisconsin; Yale U. **Bibliography:** *The Figurative Fifties;* Sandler 5.

JOHNSON, RAY b. October 16, 1927, Detroit, Mich. **Studied:** ASL; Black Mountain College (with Josef Albers, Robert Motherwell, Mary Callery, Ossip Zadkine), 1945-48. **Member:** American Abstract Artists, 1949-52. Operates the New York Correspondence School. **Awards:** NIAL Grant, $2,000, 1966; National Endowment for the Arts, 1976, 77; CAPS, 1977. **Address:** 44 West Seventh Street, Locust Valley, NY 11560. **Dealer:** Steven Leiber Gallery, San Francisco. **One-man Exhibitions:** (first) The Willard Gallery, NYC, 1965, also 1966, 67; Richard Feigen Gallery, Chicago, 1966, NYC, 1968, 70, 71; Wooster Community Art Center, Danbury, Conn., 1968; Kunstmarkt, Cologne, 1968; U. of Virginia, 1968; U. of British Columbia (twoman), 1969; Boylston Print Center

Gallery, Cambridge, Mass.; U. of Sacramento, 1969; WMAA, New York Correspondence School, 1970; Betty Parsons Gallery, 1972; Angela Flowers Gallery, London, 1972; Jacob's Ladder Gallery, Washington, D.C., 1972; Chicago/AI, Correspondence Show, 1972; Marion Locks Gallery, Philadelphia, 1973; Gertrude Kasle Gallery, 1975; Massimo Valsecchi Gallery, Milan, 1975; Brooks Jackson Gallery Iolas, NYC, 1978; Sid Deutsch Gallery, NYC, 1976; Nassau County Museum of Fine Art, Roslyn Harbor, 1984. **Retrospective:** Raleigh/NCMA, 1976. **Group:** American Abstract Artists, 1949-52; MOMA, Art in the Mirror, 1966; Chicago/Contemporary, Pictures to Be Read/Poetry to Be Seen, 1967; Finch College, NYC; A.F.A., circ., 1967; Hayward Gallery, London, Pop Art, 1969; U. of British Columbia, Concrete Poetry, 1969; Fort Worth, Drawings, 1969; Dallas/MFA, Poets of the Cities, 1974. **Collections:** Chicago/AI; Dulin Gallery; Houston/MFA; Lincoln, Mass./De Cordova; MOMA. **Bibliography:** Alloway 4; Becker and Vostell; *Correspondence;* Hansen; *Happening & Fluxus;* Kardon 3; Osterwold; Ruhe; Russell and Gablik; Schwartz 1. Archives.

JOHNSTON, YNEZ b. May 12, 1920, Berkeley, Calif. **Studied:** U. of California, Berkeley, BA, 1946, MA. Traveled Europe, USA, India, England, Italy, Japan. **Taught:** Colorado Springs Fine Arts Center, summers, 1945, 55; U. of California, Berkeley, 1950-51; Otis Art Institute; Fullerton College, 1982; Laguna Beach School of Art, 1984. **Commissions:** International Graphic Arts Society, 1958, 60. **Awards:** Guggenheim Foundation, Fellowship, 1952; MMA, 1952; L.C. Tiffany Grant, 1955; SFMA, James D. Phelan Award, 1958; Tamarind Fellowship, 1966; National Endowment for the Arts, 1976, 86. **Address:** 569 Crane Boulevard, Los Angeles, CA 90065. **Dealers:** Arnesen Gallery, Vail, Colo.; Tomlyn Gallery,

Tequesta, Fla. **One-man Exhibitions:** SFMA, 1943; U. of Redlands, 1947; American Contemporary Gallery, Hollywood, 1948; Fraymont Gallery, Los Angeles, 1952; Chicago/AI, 1952 (two-man); Santa Barbara/MA, 1952, 57; Paul Kantor Gallery, Beverly Hills, Calif., 1952, 53, 57, 58, 59, 64; Pasadena/AM, 1954; Colorado Springs/FA, 1955; California Palace, 1956; Ohana Gallery, London, 1958; California State U., Long Beach, 1967; Moore Galeries, Inc., San Francisco, 1968; Benjamin Galleries, Chicago, 1969; Jodi Scully Gallery, 1971, 72, 74; Tokyo-Shoten Gallery, NYC, 1976; Elizabeth Weiner Gallery, NYC, 1977; Mitsukoshi Gallery, Tokyo, 1977; Cornell U., 1978; Mekler Gallery, Los Angeles, 1978, 82, 84, 87, 89; Ericson Gallery, NYC, 1979; Worthington Galleries, Inc., Chicago, 1979, 83, 86, 87; Fullerton College, 1982; San Diego Print Club, 1982; Laguna Beach School of Art, 1984; Hank Baum Gallery, San Francisco, 1985. **Retrospectives:** Mount San Antonio College, 1974; Fresno Art Museum, 1992. **Group:** WMAA, 1951-55; U. of Illinois, 1951-54; Carnegie, 1955; SFMA; Los Angeles/County MA; MOMA, New Talent; Ohio U., Ultimate Concerns, 1968; Palazzo Strozzi, Florence, Italy, I Biennale Internazionale della Grafica, 1968; California State U., Los Angeles, Small Images, 1969; California Institute of Technology, Pasadena, Four Printmakers, 1969; U. of Kentucky, Graphics '71, 1971; International Exhibitions Foundation, Washington, D.C., Tamarind: A Renaissance of Lithography, circ., 1971-72; Scripps College, California Women Artists, 1972; SFMA, Painting and Sculpture in California: The Modern Era, 1976; SFMA, World Print, 1977; College of St. Rose, Albany, N.Y., Drawing Invitational, 1980; Taipei, Taiwan, Second International Print Exhibition, 1985; UCLA, Visions, 1988; Amon Carter Museum, Fort Worth, Color in American Printmaking, 1980-1960, circ., 1990. **Collections:** Albion College; California State U., Los Angeles; Cedars-

Sinai Medical Center, Los Angeles; Cornell U.; Fresno Art Center; Hartford/Wadsworth; Hirshhorn; U. of Illinois; Israel Museum; La Jolla; Los Angeles/County MA; MMA; MOMA; Michigan State U.; U. of Michigan; Milwaukee; Montclair/AM; Oakland; PMA; Pasadena/AM; RISD; St. Louis/City; San Diego; Santa Barbara/MA; Santa Fe, N.M.; Schaeffer School of Design; Tulsa/Philbrook; Tusculum College; WMAA; Worcester/AM. **Bibliography:** Pousette-Dart, ed.

JONES, HOWARD
from 1st to 4th edition.

JONES, JOHN PAUL b. November 18, 1924, Indianola, Iowa. **Studied:** State U. of Iowa, 1949, BFA, 1951, MFA. Traveled Europe; resided Great Britain, 1960-61. **Taught:** U. of Oklahoma, 1951-52; State U. of Iowa, 1952-53; UCLA, 1953-63; U. of California, Irvine, 1969. **Awards:** L. C. Tiffany Grant, 1951; Guggenheim Foundation Fellowship, 1960; and more than 40 others. **Address:** 22370 Third Avenue, South Laguna, CA 92677. **Dealers:** Mekler Gallery, Los Angeles; The Works Gallery, Long Beach, Calif. **One-man Exhibitions:** Iowa Wesleyan College, 1951; Des Moines, 1951; Fort Dodge/Blanden, 1951; San Antonio/McNay, 1951; U. of Oklahoma, 1952; Los Angeles/County MA, 1954 (two-man); Kalamazoo/Institute, 1955; Oakland/AM, 1956; Felix Landau Gallery, Los Angeles, 1956, 58, 62, 64, 67, 70; Laguna Blanca School, Santa Barbara, 1958; Santa Barbara/MA, 1958; Pasadena/AM, 1959; Taft College, 1959; Galleria Cadario, 1961; Arizona State U., 1962; U. of Minnesota, 1963; U. of Nebraska, 1963; Terry Dintenfass, Inc., NYC, 1963, 65; Louisville/Speed, 1964; San Jose State College, 1965; Container Corp. of America, 1965; Brook Street Gallery, London, 1965; The Landau-Alan Gallery, NYC, 1967, 69; La Jolla, 1970; Graphics Gallery, 1973; Jodi Scully Gallery, 1973, 75; Charles

Campbell Gallery, 1974; U. of California, Riverside, 1975; The Works Gallery, Long Beach, Calif., 1987. **Retrospectives:** Brooklyn Museum, 1963; Los Angeles/County MA, 1965. **Group:** Youngstown/Butler; U. of Illinois; State U. of Iowa; MOMA; WMAA; Oakland/AM; Santa Barbara/MA; SFMA; Pasadena/AM; Library of Congress; Brooklyn Museum; U. of Minnesota. **Collections:** Achenbach Foundation; Ball State U.; Bibliothèque Nationale; Bradley U.; Brooklyn Museum; U. of Calgary; California State Fair; UCLA; Coos Bay; Dallas/MFA; Des Moines; Fort Dodge/Blanden; U. of Illinois; Iowa State Fair; Iowa Wesleyan College; State U. of Iowa; Kalamazoo/Institute; Kansas City/Nelson; Kansas State College; Karachi; Kentucky Southern College; La Jolla; Library of Congress; Los Angeles/County MA; Lytton Savings and Loan Association; MOMA; Michigan State U.; Minnesota/MA; NYPL; National Gallery; U. of Nebraska; Oakland/AM; Omaha/Joslyn; Otis Art Institute; Palomar College; Pasadena/AM; SFMA; San Diego; Santa Barbara/MA; Seattle/AM; Texas Western College; Tulane U.; Utica; Victoria and Albert Museum; Walker; Youngstown/Butler. **Bibliography:** Murken-Altrogge.

JUDD, DONALD b. June 3, 1928, Excelsior Springs, Mo. US Army, 1946-47. **Studied:** College of William and Mary, 1948-49; Columbia U., BS, 1949-53, MFA; ASL, with Johnson, Stewart Klonis, Robert Beverly Hale, Louis Bouche, Will Barnet. Traveled western Europe, southwestern USA. Critic for *Arts Magazine,* 1959-65. **Taught:** Allen Stevenson School, 1957-61; Hunter College, 1966; Yale U., 1967. Opens installation of art at Chinati Foundation, Marfa, Texas, 1986. **Awards:** Swedish Institute Grant, 1965; U.S. Government Grant, 1967; Guggenheim Foundation Fellowship, 1968; Skowhegan Medal for Sculpture, 1987; Brandeis U., medal for

sculpture, 1987. **Address:** 101 Spring Street, NYC 10012; Ayala de Chinati, TX. **Dealer:** The Pace Gallery, NYC. **One-man Exhibitions:** (first) Green Gallery, NYC, 1964; Leo Castelli Inc., NYC, 1966, 67, 73, 76, 78, 79, 81, 83, 84; WMAA, 1968; Ileana Sonnabend Gallery, Paris, 1969; Galerie Rudolf Zwirner, 1969; Eindhoven, 1970, 79; Joseph Helman Gallery, St. Louis, 1970; Essen, 1970; Hannover/Kunstverein, 1970; Whitechapel Art Gallery, London, 1970; Locksley-Shea Gallery, 1970, 73; Janie C. Lee Gallery, Dallas, 1970, Houston, 1976; Galerie Heiner Friedrich, Munich, 1971, 78; Ronald Greenberg Gallery, St. Louis, 1972; Galerie Rolf Ricke, 1972; Galerie Daniel Templon, Paris, 1973, 75; Gian Enzo Sperone and Galerie Konrad Fischer, Rome, 1973; Gian Enzo Sperone, Turin, 1973; Galerie Annemarie Verna, Zurich, 1973, 79, 80, 83, 85, 90; Lisson Gallery, London, 1974, 75; Portland (Ore.) Center for the Visual Arts, 1974; Basel, circ., 1976; Sable-Castelli Gallery Ltd., Toronto, 1976; Heiner Friedrich Gallery, NYC, 1977, 78; Corpus Christi, 1977; Cincinnati/Contemporary, 1977; Heiner Friedrich, Cologne, 1977, 79; Moderne Galerie, Bottrop (Switzerland), 1977; ACE Gallery, Venice, Calif., 1977; Berlin/National, 1978; Foyer MGB, Zurich, 1978; Vancouver, 1978; Kröller-Müller, Otterlo, 1978; Young-Hoffman Gallery, Chicago, 1978; Akron/AI, 1979; Thomas Segal Gallery, Boston, 1979, 90; Newport Harbor, 1981; Larry Gagosian Gallery, Los Angeles, 1982; Carol Taylor Gallery, Dallas, 1983; Knight Gallery, Charlotte, N.C., 1983; Blum Helman Gallery, NYC, 1983; Max Protetch Gallery, NYC, 1984; 101 Spring Street, NYC, 1984; Margo Leavin Gallery, Los Angeles, 1984, 87, 89; Purchase/SUNY, 1984; Texas Gallery, Houston, 1985; Galleria Lia Rumma, Naples, 1985; Galerie Barbel Grasslin, Frankfurt-am-Main, 1985; Paula Cooper Gallery, NYC, 1985, 86, 88, 90; Rhona Hoffman Gallery, Chicago, 1985;

Donald Judd, *Untitled*, 1992.

Waddington Galleries, London, 1986, 89; Galerie Rolf Ricke, Cologne, 1987, 90, 91; Lawrence Oliver Gallery, Philadelphia, 1987; Galerie Maeght LeLong, Paris, 1987; Adair Margo Gallery, El Paso, 1987; Galerie Nächt St. Stephan, Vienna, 1988; Galerie Aronowitsch, Stockholm, 1988; Castello di Rivoli, Italy, 1988; Vivian Horan Fine Art, NYC, 1988; WMAA, circ., 1988; Munster/WK, 1989; Donald Young Gallery, Chicago, 1989; Baden-Baden/Kunsthalle, 1989; Mönchengladbach, 1989; Barbara Krakow Gallery, Boston, 1990; Brooke Alexander Gallery, NYC, 1990; Jean Bernier, Athens, 1990, 91; Gallery Shimada Yamaguchi, Osaka, 1990; St. Gallen/Kunstverein, 1990; Soviet Cultural Foundation, Moscow, 1990; Persons & Lindell Gallery, Helsinki, 1990; OMFAK, Vienna, 1991; St. Louis/City, 1991; Inkong Gallery, Seoul, 1991; Galerie Varisella, Frankfurt, 1991; Galerie Theo-spacio, Madrid, 1991; Galleria Victoria Miro, Florence, 1991; The Pace Gallery, NYC, 1991; Galerie Lelong, Paris, 1991; Galerie Meert Rihoux, Brussels, 1991. **Retrospectives:** WMAA; Ottawa/National, 1975. **Group:** VIII São Paulo Biennial, 1965; ICA, U. of Pennsylvania, 1965; Stockholm/National, 1965; Jewish Museum, Primary Structures, 1966; WMAA, Contemporary American Sculpture, Selection I, 1966; Walker, 1966; WMAA Sculpture Annuals, 1966, 68, 70, 73; Los Angeles/County MA, American Sculpture of the Sixties, 1967; Detroit/Institute, Color, Image and Form,

1967; WGMA, A New Aesthetic, 1967; SRGM, Sculpture International, 1967; Walker, 1969; Vancouver, 1969; Expo '70, Osaka, 1970; Indianapolis, 1970; Princeton U., American Art Since 1960, 1970; Brooklyn Museum, Attitudes, 1970; Cincinnati/Contemporary, Monumental Art, 1970; SRGM, Guggenheim International, 1971; Dublin/Municipal, International Quadriennial (ROSC), 1971; High Museum, The Modern Image, 1972; Rijksmuseum Kröller-Müller, Diagrams and Drawings, 1972; New York Cultural Center, 3D into 2D, 1973; Musée Galliera, Paris, Festival d'Automne, 1973; Parcheggio di Villa Borghese, Rome, Contemporanea, 1974; Art Museum of South Texas, Corpus Christi, Eight Artists, 1974; Cologne/Kunstverein, Kunst uber Kunst, 1974; Otterlo, Functions of Drawing, 1975; NCFA; Sculpture: American Direction, 1945-1975, 1975; MOMA, Drawing Now, 1976; MOMA, Oxford, Eng. (four-man), 1976; WMAA, 200 Years of American Sculpture, 1976; Dallas/MFA, American Art Since 1945, 1976; Venice Biennial, 1976; Cambridge U., Jubilation, 1977; U. of Chicago, Ideas in Sculpture, 1965-1977, 1977; Kansas City/AI, Project Drawings, 1978; WMAA, 20th Century American Masters of the 60s and 70s, 1978; ICA, Boston, The Reductive Object, 1979; Milwaukee, Emergence & Progression, circ., 1979; Kassel, Documenta VII, 1982; WMAA, Block Prints, 1982; WMAA, The Sculptor as Draftsman, 1983; WMAA, Minimalism to Expressionism, 1983; Sunderland (Eng.) Arts Center, Drawing in Air, 1983; WMAA, Blam!, 1984; WMAA Biennial, 1985; MOMA, Contrasts in Form: Geometric Abstract Art 1910-1980, 1985; WMAA, High Styles, 1985; SRGM, Transformation in Sculpture, 1985; Fort Lauderdale, An American Renaissance: Painting and Sculpture Since 1940, 1986; MOMA, Contrasts of Form: Geometric Abstract Art, 1910-1980, 1985; Frankfurt/Kunstverein, Vom Zeichnung: Aspekte der Zeichnung, 1960-1985, circ., 1985; Brown U., Definitive Statements, 1986; Dunkerque, Pompidou, Minimal et Conceptuel, 1986; Paris/Beaubourg, Qu'est-ce que la sculpture moderne? 1986; Wright State U., The Use of Geometry in the Eighties, 1985; ICA, U. of Pennsylvania, 1967: At the Crossroads, 1987; Paris/Beaubourg, L'Époque, La Mode, La Morale, La Passion, 1987; Kassel/Fredericianum, Schlaf der Vernuft, 1988; Rotterdam, Furniture as Art, 1988; WMAA, The New Sculpture, 1965-1975, 1990; Osaka/National, Minimal Art, 1990; AFA, Abstract Sculpture in America, 1930-70, circ., 1991. **Collections:** Art Gallery of Ontario; Basel; Chicago/AI; Detroit/Institute; Fort Worth; Krefeld/Kaiser Wilhelm; Los Angeles/County MA; MOMA; Ottawa/National; Pasadena/AM; SRGM; St. Louis/City; Stockholm/National; WMAA; Walker. **Bibliography:** Alloway 4; *Art Now 74;* Ashbery; Battcock, ed.; *Black and White Are Colors;* Calas, N. and E.; *Contemporanea;* Danto; Davis, D.; Day 1; De Vries, ed.; *Europa/Amerika;* Friedman, M., 2; Friedman and van der Marck; Gablik; Gohr and Gachnang; Goossen 1; Haskell 5; Honnef; Honisch and Jensen, eds.; Hunter, ed.; *Individuals;* Johnson, Ellen H.; Kardon 3; Kozloff 3; Krauss 2; Lippard 3, 4, 5; Lucie-Smith; MacAgy 2; *Report;* Rickey; Robins; Rose, B., 4; Rowell; Sandler 3, 5; Schwartz 1; Seitz 3; Siegel; Smith, B., 1975; Toher, ed.; Trier 1; Tuchman 1; Waldman 4; Weintraub. Archives.

K

KABAK, ROBERT
from 1st to 4th edition.

KACERE, JOHN **b.** June 23,
1920, Walker, Iowa. **Studied:** Mizen Academy of Art, Chicago, 1938-42; State U. of
Iowa, BFA, 1946-49, MFA, 1950-51.
Taught: State U. of Iowa, 1949-50 (graduate assistant to Mauricio Lasansky); U. of
Manitoba, 1950-53; U. of Florida, 1953-65; Cooper Union; Parsons School of Design, NYC; U. of New Mexico, 1964-72;
NYU, 1973-77; School of Visual Arts,
NYC, 1977. **Address:** 152 Wooster Street,
NYC 10013. **Dealer:** OK Harris Works of
Art, NYC. **One-man Exhibitions:** The Little Art Gallery, Cedar Rapids, Iowa, 1942;
U. of Florida, 1953, 57; Korman Gallery,
NYC, 1954; Mirell Gallery, Miami, 1955;
Cedar Rapids/AA, 1955; The Zabriskie
Gallery, NYC, 1956; Louisiana State U.,
1957; Allan Stone Gallery, NYC, 1963;
OK Harris Works of Art, NYC, 1971, 73,
75, 78, 80, 82, 84, 87, 89; Galerie de
Gestlo, Hamburg, 1972, 73; Lavignes-Bastille, Paris, 1981, 83, 89. **Group:**
Walker, circ., USA, Canada, South America, 1949-51; MOMA; Chicago/AI; PMA;
Omaha/Joslyn; Dallas/MFA; Ringling;
Jacksonville/AM; U. of Georgia; Corcoran,
1963; U. of Illinois, 1965; John Michael
Kohler Arts Center, Sheboygan, The
Human Image, 1970; Chicago/Contemporary, Radical Realism, 1971; Cleveland/MA, 32 Realists, 1972; MOMA, The
Realist Revival, 1972; Stuttgart/WK, Amerikanischer Fotorealismus, circ., 1972;
Lincoln, Mass./De Cordova, The Super-Realist Vision, 1973; Tokyo Biennial,
1974; Chicago/AI, 1974; Wichita State U.,
PhotoRealism, 1975; Xerox Art Exhibition, Rochester, N.Y., Unordinary Realities, 1975; WMAA, downtown branch,
Nothing but Nudes, 1977; Williamstown/Clark, The Dada/Surrealist Heritage,
1977; PAFA, Contemporary American Realism Since 1960, circ., 1981; Potsdam/SUNY, Contemporary Realism,
1982; Isetan Museum of Art, Tokyo,
American Realism: The Precise Image,
1985; U. of Northern Iowa, Born in Iowa,
circ., 1986; Nassau County Museum, In
Sharp Focus, 1991. **Collections:** Amsterdam/Stedelijk; Brandeis U.; Hartford/Wadsworth; Louisville/Speed; Mt.
Holyoke College; Portland, Ore./AM; Yale
U. **Bibliography:** *Amerikanischer
Fotorealismus;* Arthur 3; Honisch and
Jensen, eds.; Hunter, ed.; Sager.

KAHN, WOLF **b.** October 4,
1927, Stuttgart, Germany. To Great Britain, 1939; to USA, 1940. **Studied:**
Hofmann School, 1947-49; The U. of Chicago, 1950-51, BA. Traveled Europe, Mexico, USA. **Taught:** U. of California,
Berkeley, 1960; Cooper Union, 1961-77;
Haystack School, Deer Isle, Me., 1961, 62;
Columbia U., 1978; RISD, 1978-79; Santa
Fe Institute of Fine Art, 1988, 90, 92. Subject of film *Wolf Kahn—Landscape Painter,*
with Alan Dater. **Member:** Associate,

John Kacere, *Laura '92,* 1992.

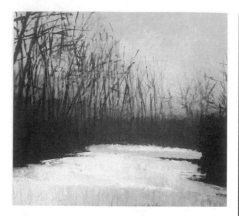

Wolf Kahn, *In Westport, Connecticut (Winter)*, 1987.

NAD; AAIAL. **Commissions:** Jewish Theological Seminary, NYC (portraits). **Awards:** Ford Foundation, P.P., 1962; Fulbright Fellowship, 1962, 64; J.S. Guggenheim Fellowship, 1966-67; NAD, Ranger Fund, P.P., 1977; AAAL, Childe Hassam Fund, P.P., 1978, AAAL, Award, 1979; NAD, Benjamin Altman Prize for Landscape, 1991. **m.** Emily Mason. **Address:** 813 Broadway, New York, NY 10003. **Dealers:** Grace Borgenicht Gallery, NYC; Marianne Friedland Gallery, Toronto and Naples, Fla.; Gerald Peters Gallery, Santa Fe. **One-man Exhibitions:** (first) Hansa Gallery, NYC, 1953, also 1954; Grace Borgenicht Gallery, NYC, 1956, 58, 60, 61, 62, 65, 67, 69, 71, 73, 74, 75, 77, 79, 81, 83, 85, 86, 87, 89, 90, 91; U. of California, 1960; U. of Michigan, 1961; Ellison Gallery, Fort Worth, 1961; RISD, 1961, 79; Kansas City/Nelson, 1962; Michigan State U., 1963; Stewart Richard Gallery, San Antonio, 1964; Obelisk Gallery, 1964; Nashville, 1964; Sabarsky Gallery, Los Angeles, 1966; Marlboro College, 1967; Princeton Gallery of Fine Art, 1970, 72, 74, 75; Meredith Long Gallery, Houston, 1971, 73, 74, 76, 77, 78, 80, 82, 85; Harcus Krakow Rosen Sonnabend, 1972; U. of Nebraska, 1973; Norfolk/Chrysler, 1973; Rudolph Galleries, Coral Gables, 1974; David Barnett Gallery, Milwaukee, 1972,

75, 77; L. Kornbluth Gallery, Fair Lawn, N.J., 1978, 79, 82, 87, 91; Harcus-Krakow Gallery, Boston, 1976; Waddington Gallery, London, 1980; Arts Club of Chicago, circ., 1981; Cheekwood, 1981; Thomas Segal Gallery, Boston, 1981, 83, 84, 85, 87, 89, 91; The Schenectady Museum, 1982; Utica, 1982; Dartmouth U., circ., 1984; San Diego, circ., 1984; Reynolds/Minor Gallery, Richmond, Va., 1989, 91; Gerald Peters Gallery, Santa Fe, 1988, 90; B. R. Kornblatt Gallery, Washington, D.C., 1987, 89, 90; Fort Lauderdale, circ., 1990; Jerald Melberg Gallery, Inc., Charlotte, N.C., 1991; Nina Freudenheim Gallery, Buffalo, 1990; Marianne Friedland Gallery, Toronto, 1992, Naples, Fla., 1991, 92; Carone Gallery, Fort Lauderdale, 1991, 92; Nan Miller Gallery, Rochester, N.Y., 1992. **Group:** The Stable Gallery Annuals, 1954, 55; WMAA Annuals, 1958, 60, 61; Utica, 1959; ART: USA: 59, NYC, 1959; WMAA, Young America, 1960; International Biennial Exhibition of Paintings, Tokyo; SFMA, 1961; PAFA, 1961, 65; American Art Gallery, Copenhagen, 1963; MOMA, Hans Hofmann and His Students, circ., 1963-64; Omaha/Joslyn, A Sense of Place, 1973; IIE, 20 American Fulbright Artists, 1975; US Department of the Interior, America 1976; MMA, Hans Hofmann as Teacher: Drawings by His Students, 1979; SFMA, American Realism (Janss), circ., 1985; MMA, American Pastels, 1990. **Collections:** Arts Club of Chicago; Boston/MFA; Brandeis U.; Brooklyn Museum; U. of California; Carnegie Mellon U.; Charlotte/Mint; Chase Manhattan Bank; Cleveland/MA; Columbus; Corcoran; Los Angeles County/MA; MMA; Dallas/MFA; El Paso Museum of Art; Fort Worth; Hirshhorn; Houston/MFA; ICA, Boston; U. of Illinois; Jewish Museum; Lincoln Life Insurance Co.; Springfield, Mass./MFA; MOMA; U. of Massachusetts; Michigan State U.; NAD; NMAA; U. of Nebraska; U. of Nevada; New Orleans/Museum; U. of Rochester; San

Diego; St. Louis/City; Union Carbide Corp.; VMFA; WMAA; Worcester/AM. **Bibliography:** Blesh 1; Downes, ed.; Ward; Archives.

KAISH, LUISE **b.** September 8, 1925, Atlanta, Ga. **Studied:** Syracuse U., with Ivan Mestrovic, BFA, MFA; Escuela de Pintura y Escultura, Mexico City, with Alfredo Zalce, J.G. Galvan. Traveled Europe, Scandinavia, Italy, Israel, Middle East. **Taught:** Columbia U., 1974-75, 80-; Dartmouth College, 1974; U. of Washington, Seattle, 1979. **Member:** Sculptors Guild; Trustee, American Academy in Rome, 1973-; Trustee, The Augustus Saint Gaudens Memorial, National Park Service, 1978-; executive board, The Sculptors Guild, 1974-. **Commissions:** Temple B'rith Kodesh, Rochester, N.Y.; Container Corp. of America; Syracuse U.; Amoco Building, NYC; Jewish Museum; Temple Beth Shalom, Washington, Del.; Temple Israel, Westport, Conn.; Holy Trinity Mission Seminary, Silver Spring, Md.; Beth El Synagogue Center, New Rochelle, N.Y.; Temple B'nai Abraham, Essex County, N.J.; U.A.H.C., Jerusalem, Israel. **Awards:** Guggenheim Foundation Fellowship; L.C. Tiffany Grant; Audubon Artists, Medal; Ball State Teachers College, P.P.; Joe and Emily Lowe Foundation Award; National Association of Women Artists; U. of Rochester; Syracuse/Everson; American Academy, Rome, Fellowship, 1970-71. **Address:** 610 West End Avenue, NYC 10024. **One-man Exhibitions:** U. of Rochester, 1954; Sculpture Center, NYC, 1955, 58; Staempfli Gallery, NYC, 1968, 81, 84, 88; St. Paul Gallery, 1969; Dartmouth College (two-man), 1974; U. of Haifa (two-man), 1985. **Retrospective:** Jewish Museum, 1973. **Group:** MMA, National Sculpture Exhibition, 1951; WMAA, 1955, 62, 64, 66; MOMA, Recent Sculpture USA, 1959; U. of Nebraska; Ball State Teachers College; U. of Notre Dame; Ohio U.; NAD; Sculptors Guild; Buffalo/Albright; AAAL; Newark

Museum, Women Artists of America, 1966; U. of Illinois, 1968; New School for Social Research, Drawings by Painters and Sculptors, 1967; U. of Nebraska, American Sculpture, 1970; Minnesota/MA, Drawings, USA, 1970; Finch College, NYC, Artists at Work, 1970; USIS, Rome, 1973; Minnesota/MA, Drawings USA, 1976. **Collections:** Export Khleb, Moscow; General Mills Corp., Minneapolis; High Museum; Jewish Museum; MMA; Minnesota/MA; NMAA; U. of Rochester; Syracuse U.; WMAA.

KAMIHIRA, BEN **b.** March 16, 1925, Yakima, Wash. **Studied:** Art Institute of Pittsburgh; PAFA, 1948-52. US Army, 1944-47. **Taught:** The Pennsylvania State U.; Philadelphia Museum School; PAFA, 1953-. **Awards:** PAFA, Cresson Fellowship, 1951; PAFA, J. Henry Schiedt Scholarship, 1952; NAD, Haligarten Prize, 1952; L.C. Tiffany Grant, 1952, 58; Guggenheim Foundation Fellowship, 1955, 56; PAFA, Walter Lippincott Prize, 1958; NAD, Benjamin Altman Prize, 1958, 62; Corcoran, First William A. Clark Prize, 1961; NAD, Gold Medal, 1975. **Address:** 957 North 5th Street, Philadelphia, PA 19123. **Dealer:** Pearl Fox Gallery, Melrose Park, Pa. **One-man Exhibitions:** Dubin Gallery, Philadelphia, 1952; Philadelphia Art Alliance, 1954; PAFA, 1956; Janet Nessler Gallery, NYC, 1951; Durlacher Brothers, NYC, 1964; The Forum Gallery, NYC, 1966, 73, 76; Maxwell Gallery, San Francisco, 1969. **Group:** NAD, 1952, 54, 56, 58, 61; Youngstown/Butler, 1953, 1958-61; PAFA, 1954, 58, 60; WMAA, 1958; Corcoran, 1961; PAFA, Seven on the Figure, 1979. **Collections:** Colorado Springs/FA; Dallas/MFA; NAD; Oklahoma; PAFA; Ringling; WMAA. **Bibliography:** Goodrich and Baur 1; Ward.

KAMROWSKI, GEROME **b.** January 29, 1914, Warren, Minn. **Studied:** St. Paul School of Art, with L. Turner,

Cameron Booth; ASL; Hofmann School. **Taught:** U. of Michigan, 1946-84. Federal A.P.: mural painting in Minnesota and New York. **Awards:** Guggenheim Foundation Fellowship; Detroit/Institute, 1949, 54, 55, 61, Merit Prize, 1967; Cranbrook, Horace H. Rackham Research Grant, 1957; U. of Michigan, Heller Distinguished Professorship, 1977. **Address:** 1501 Beechwood Drive, Ann Arbor, MI 48103. **One-man Exhibitions:** Mortimer Brandt, NYC, 1946; Betty Parsons Gallery, 1948; Alexander Iolas Gallery; Galerie Creuze, Paris, 1950, 58; Hugo Gallery, NYC, 1951; U. of Michigan, 1952, 59, 61; The Saginaw Museum, 1954; Jackson Art Association; Cranbrook, 1947; Gallery Mayer, NYC, 1961; S.W. Wind Gallery, Ann Arbor; Eastern Michigan U. (two-man); Monique Knowlton Gallery, NYC, 1978; Washburn Gallery, NYC, 1987, 89; Detroit Focus Gallery, Detroit, 1990. **Group:** Chicago/AI, 1945, 46; Buffalo/Albright, 1946; Galerie Maeght, 6 American Painters, 1947; WMAA Annuals, 1947, 48, 51, 53; Detroit/Institute, 1948, 50, 52, 54, 58; U. of Illinois, 1950; Sidney Janis Gallery, Surrealist and Abstract Art; MOMA; SRGM; U. of Michigan (four-man); 12 Canadian and American Painters, NYC; Hayward Gallery, London, Dada and Surrealism Revisited, 1978; Rutgers U., Surrealism and American Art, 1931-1947, 1947; U. of New Mexico, American Abstract Artists, 1977; MMA, Hans Hofmann as Teacher, 1979; MMA, Drawings by Hofmann Students, 1979; Newport Harbor, The Interpretive Link, circ., 1986; U. of Miami, Abstract Expressionism, circ., 1989; Katonah Gallery, Watercolors from the Abstract Expressionist Era, 1990; Provincetown Art Association, The Provincetown Years: 1935-1945, 1990. **Collections:** Detroit/Institute; Flint/Institute; Simon Frazer U.; Knoll Associates, Inc.; MMA; MOMA; U. of Michigan; Minnesota/MA; U. of New Mexico; U. of North Carolina; Phillips; Rutgers U.; WMAA. **Bibliography:** Baur 7; Breton 3; Calas; Janis, S.; Ritchie 1.

KAMYS, WALTER **b.** June 8, 1917, Chicago, Ill. **Studied:** Chicago Art Institute School, 1943, with Hubert Ropp, Boris Anisfeld, privately in Mexico with Gordon Onslow-Ford, 1944. Traveled Mexico, Europe. **Taught:** The Putney School, Vermont, 1945; G. W. V. Smith Art Museum, Springfield, Mass., 1947-60; U. of Massachusetts, 1960-. Director, Art Acquisition Program, U. of Massachusetts Collection, 1962-74. **Awards:** Prix de Rome, 1942; Chicago/AI, Anna Louise Raymond Fellowship, 1942-43; Chicago/AI, Paul Trebilcock P.P., 1943; Chicago/AI, James Nelson Raymond Traveling Fellowship, 1943-44; Boston Arts Festival, Second Prize, 1955; State College at Westfield, P.P., 1968; Polish Ministry of Culture, grant, 1978. **Address:** P. O. Box 104, Sunderland, MA 01375. **Dealer:** Amherst Gallery of Fine Art, Amherst, MA. **One-man Exhibitions:** (first) Cliff Dwellers Club, Chicago, 1944; Dartmouth College, 1946; Margaret Brown Gallery, Boston, 1949; The Little Gallery, Springfield, Mass., 1951; Mortimer Levitt Gallery, NYC, 1954; Muriel Latow Gallery, Springfield, Mass., 1954; The Bertha Schaefer Gallery, NYC, 1955, 57, 61; Deerfield (Mass.) Academy, 1956, A Painter with a Camera (abstract photos), 1960; Concordia College, 1957; Springfield, Mass./MFA, 1948, 59; New Vision Center, London, 1960; Univision Gallery, London, 1960; U. of Massachusetts, 1961; Stanhope Gallery, Boston, 1963; Ward-Nasse Gallery, Boston, 1968; East Hampton Gallery, N.Y., 1970; Pisces Gallery, Wellfleet, Mass., 1976; Danco Gallery, Northampton, Mass., 1978; Castleton (Vt.) State College, 1981; Greenfield (Mass.) College, 1985; Amherst Gallery of Fine Art, Amherst, Mass., 1991. **Retrospective:** U. of Massachusetts, 1986. **Group:** Chicago/AI; Salon des Realites Nouvelles, Paris; PAFA; Carnegie; USIA, 20th Century American Graphics, circ.; Corcoran; ICA, Boston, Younger

New England Graphic Artists, 1954;
MOMA, Recent Drawings, 1956; ICA,
Boston, View, 1960; Northeastern U.,
1965; Silvermine Guild, 1967; Smithson-
ian, The Art of Organic Forms, 1968; U.
of Connecticut, New England Artists,
1971; G.W.V. Smith Museum, Spring-
field, Mass., 1973. **Collections:** Albion
College; Hampshire College; Harvard U.;
U. of Massachusetts; Mount Holyoke Col-
lege; NYU; Smith College; U. of Ver-
mont; WDAY; Westfield; Wright State
U.; Yale U. **Bibliography:** Janis and
Blesh 1.

KANEMITSU, MATSUMI
from 1st to 5th edition.

KANOVITZ, HOWARD b. Feb-
ruary 9, 1929, Fall River, Mass. **Studied:**
Providence College, 1949, BS; RISD,
1949-51; ASL, Woodstock, 1951; with
Yasuo Kuniyoshi; New School for Social
Research, 1949-52; U. of Southern Califor-
nia, 1958; NYU, 1960-61. Traveled Eu-
rope, North Africa, 1956-58. **Taught:**
Brooklyn College, 1961-64; Pratt Insti-
tute, 1964-66; Long Island U., 1977-78;
School of Visual Arts, 1981-85. **Commis-
sions:** Designs for film and theater: *Paint-
ing with Air,* 1974; *The Party* by Arnold
Weinstein, 1977; *The Poet in New York* by
Arnold Weinstein, ca. 1969; *The Bacchae,*
1988. **Awards:** DAAD Fellowship, 1979.
Address: 463 Broome Street, NYC 10013.
One-man Exhibitions: The Stable Gal-
lery, NYC, 1962; Fall River (Mass.) Associ-
ation, 1964; Jewish Museum, 1966;
Waddell Gallery, 1969, 71; Everyman Gal-
lery, NYC, 1970; M.E. Thelen Gallery,
Cologne, 1970, 73; Benson Gallery,
Bridgehampton, N.Y., 1970, 71, 77;
Galleri Ostergren, Malmo, 1971;
Hedendaagse Kunst, Utrecht, 1973; Duis-
burg, 1974; Stefanotti Gallery, NYC,
1975; Galerie Jollembeck, Cologne, 1977,
80; Alex Rosenberg Gallery, NYC, 1978,
82; Guild Hall, East Hampton, N.Y.,
1978; Hamburg/Kunstverein, 1979;

Hannover/K-G, 1979; Forum Kunste,
Rottweil, 1980; Kunstverein, Freiburg,
1980; Indianapolis (two-man), 1985; Ben-
son Gallery, Southampton, N.Y., 1986;
Galerie Inge Baecker, Cologne, 1987, 88;
Marlborough Gallery, NYC, 1987, 90;
Hokin Kaufman Gallery, Chicago, 1989;
Galerie Gering-Kulenhampff, Frankfurt,
1989. **Retrospective:** Akademie der
Kunste, 1979. **Group:** Chicago/AI, 1961;
U. of Illinois, 1963; WMAA, 1965, 67,
72; Riverside Museum, NYC, Paintings
from the Photo, 1969; Sweden/Goteborg,
Warmwind, 1970; WMAA, 22 Realists,
1970; VMFA, American Painting, 1970;
Chicago/Contemporary, Radical Realism,
1971; NIAL, 1972; Stuttgart/WK, Amer-
ikanischer Fotorealismus, circ., 1972;
Kunsthalle, Recklinghausen, Mit Kamera,
Pinsel und Spritzpistole, 1973; Kassel,
Documenta VI, 1977; Guild Hall, East
Hampton, Aspects of Realism, 1977; Ber-
lin/National, 1979; Youngstown/Butler,
1983; Los Angeles/MOCA, Automobile
and Culture, 1984; Kunstverein Frankfurt,
Von Zeichnen, circ., 1986; Southamp-
ton/Parrish, Drawing on the East End,
1988; Florida International U., American
Art Today: Contemporary Landscape,
1989; U. of North Carolina, Art on Paper,
1991. **Collections:** Aachen/NG; Bre-
men/Wesserburg; Cologne; Cologne/Lud-
wig; Duisburg; F.T.D. Association; Guild
Hall; Hamburg; Hanover/Sprengel;
Helsinki; Hirshhorn; Indianapolis; Jewish
Museum; Kunstsalle zu Kiel; Los Ange-
les/County MA; Landessammlung;
MMA; Moderne Galerie, Salzburg;
Müllheim/Kunst; Rotterdam; Staat-
liche Museen Berlin-Dahlem; Swe-
den/Goteborg; Ulm/Museum der Stadt;
Utrecht; Vienna/Moderner; WMAA. **Bibli-
ography:** *Amerikanischer Fotorealismus;*
Honisch and Jensen, eds.; *Howard
Kanovitz; Kunst um 1970;* Osterwold;
Sager; Ward.

KANTOR, MORRIS
from 1st to 4th edition.

KAPROW, ALLAN b. August 23, 1927, Atlantic City, N.J. **Studied:** NYU, 1945-49, BA; Hofmann School, NYC, 1947-48; Columbia U., with Meyer Schapiro, 1950-52, MA (art history); privately with John Cage in NYC, 1956-58. Traveled Europe, USA. **Taught:** Rutgers U., 1953-61; Pratt Institute, 1960-61; Stony Brook/SUNY, 1961-69; California Institute of the Arts, Los Angeles, 1969-. A co-founder of Hansa Gallery, NYC, 1952, and Reuben Gallery, NYC, 1959. Designed sets and costumes for Eileen Passloff Dance Co., 1958. Initiated the first Environments and Happenings, 1958. **Awards:** Katherine White Foundation Grant, 1951; Rutgers U., Research Fund Grant, 1957; Copley Foundation Grant, 1962; Guggenheim Foundation Fellowship, 1967. **Address:** 1225 Linda Rose Avenue, Los Angeles, CA 90041. **One-man Exhibitions:** (first) Hansa Gallery, NYC, 1953, also 1955, 57; Rutgers U., 1953, 55; Urban Gallery, NYC, 1955, 56; Sun Gallery, Provincetown, 1957; John Gibson Gallery, NYC, 1969; Galerie Rene Block, Berlin, 1970; Galleria Bertesca, Milan, 1973; Stefanotti Gallery, NYC, 1974; U. of Northern Iowa, 1979. **Environments:** Hansa Gallery, NYC, 1958; Judson Gallery, NYC, 1960; Martha Jackson Gallery, NYC, 1961; U. of Michigan, 1961; Rijksmuseum, Amsterdam, and Stockholm/National, 1961; Smolin Gallery, NYC, and Stony Brook/SUNY, 1962; Smolin Gallery, NYC, 1964. **Happenings:** Douglass College, 1958; Reuben Gallery, NYC, 1959, 61; Judson Memorial Church, NYC, 1960; U. of Michigan, 1961; Maidman Playhouse, NYC, 1962; Walker, 1962; Theatre des Nations, Paris, 1963; Edinburgh, Scotland, 1963; Southern Illinois U., 1964; Miami, Fla., 1964; U. of California, Berkeley, 1964; Cornell U., 1964; Florida State U., 1965; Judson Hall, NYC, 1965; ICA, Boston, 1966; Central Park, NYC, 1966; Westchester Art Society, White Plains, N.Y., 1966; Stony Brook/SUNY, 1967; Aspen Design Confer-ence, 1970; Merriewold West Gallery, Far Hills, N.J., 1975; and many others. **Retrospectives:** Pasadena/AM, 1967; Dortmund Museum, Germany, 1986. **Group:** Boston Arts Festival, 1957; A.F.A., College in America, circ., 1957-58; Cornell U., 1958; Carnegie, 1958; A.F.A., New Talent, circ., 1958; Rijksmuseum, Amsterdam, and Stockholm/National, 1960; MOMA, Hans Hofmann and His Students, circ., 1963-64; Jewish Museum, Work, 1969, Software, 1970; Cologne/Kunstverein, Happening & Fluxus, circ., 1970; WMAA, Blam!, 1984; Bronx Museum, Emerging Expressionism, 1985. **Bibliography:** *Abstract Expressionism;* Alloway 4; Battcock, ed.; Becker and Vostell; *Contemporanea;* Danto; Davis, D.; De Salvo and Schimmel; *Europa/Amerika;* Downes, ed.; Hansen; *Happening & Fluxus;* Haskell 5; Honisch and Jensen, eds.; Hunter, ed.; Janis & Blesh 1; Johnson, Ellen H.; **Kaprow;** Kirby; Kozloff 3; Lippard 5; Lippard, ed.; *Metro; Performance Anthology;* Rubin 1; Sandler 3, 5; Seitz 3; Siegel; Sontag; Waldman 4.

KARFIOL, BERNARD b. May 6, 1886, Budapest, Hungary. d. 1952. **Studied:** Academie Julian, Paris, 1901, with Jean Paul Laurens; Academie des Beaux-Arts, Paris; Pratt Institute, 1899; NAD, 1900. Traveled Mexico, Europe, West Indies. **Awards:** Pan-American Exhibition, Los Angeles, 1925; Carnegie, 1927, 29; Corcoran, First William A. Clark Prize and Corcoran Gold Medal, 1928; Fort Dodge/Blanden, P.P., 1940; VMFA, P.P., 1942. **One-man Exhibitions:** (first) Joseph Brummer Gallery, NYC, 1924, also 1925, 27; The Downtown Gallery, NYC, 1931, 33, 35, 41, 43, 46, 50, 56; Baltimore/MA, 1939; Vanbark Studios, Studio City, Calif., 1946; Grover Cronin Gallery, Waltham, Mass., 1957; The Forum Gallery, NYC, 1967, 78. **Group:** Grand Salon, Paris, 1903; Salon d'Automne, Paris, 1904; The Armory Show, 1913; MOMA, Paintings by 19 Living Ameri-

cans, 1929; Carnegie; Corcoran; Baltimore/MA, Six Americans, 1939. **Collections:** AAAL; Andover/Phillips; Baltimore/MA; Brandeis U.; Britannica; Brooklyn Museum; California Palace; Carnegie; Corcoran; Dartmouth College; Detroit/Institute; Fisk U.; Fort Dodge/Blanden; Los Angeles/County MA; MMA; MOMA; Newark Museum; New Britain/American; New London; Ogunquit; Phillips; Southhampton/Parrish; Upjohn Co.; VMFA; WMAA; Wellesley College; Wichita/AM. **Bibliography:** Bethers; Blesh 1; Brown; Cahill and Barr, eds.; Cheney; Goodrich and Baur 1; Hall; Halpert; Huyghe; *Index of 20th Century Artists;* Jewell 2; **Karfiol;** Kootz 1, 2; McCurdy, ed.; Mellquist; Neuhaus; Pagano; Phillips 2; Pousette-Dart, ed.; Richardson, E.P.; Ringel, ed.; **Slusser;** Wight 2. Archives.

KASTEN, KARL b. March 5, 1916, San Francisco, Calif. **Studied:** U. of California, with Worth Ryder, John Haley, Erle Loran; State U. of Iowa, with Mauricio Lasansky; Hofmann School; San Francisco Art Institute (AB, MA). Traveled Europe, Turkey, Morocco, Russia, Far East. **Taught:** San Francisco Art Institute, 1941; U. of Michigan, 1946-47; San Francisco State College, 1947-50; U. of California, Berkeley, 1950-83, Professor Emeritus, 1983. **Member:** California Society of Printmakers. **Commissions:** North American Title Co., Berkeley, Calif. (Mural). **Awards:** U. of California Institute for Creative Work in the Arts, 1964-65; Tamarind Fellowship, 1968. **Address:** 1884 San Lorenzo Avenue, Berkeley, CA 94707. **Dealers:** Rorick Gallery, San Francisco; Sragow Gallery, NYC; Gallerita, Milan; Galerie Gisele Linder, Basel. **One-man Exhibitions:** (first) U. of Michigan, 1946; SFMA; Galerie Breteau, Paris; Rennes; California Palace; The Lanyon Gallery; Hollis Gallery, San Francisco; St. Mary's College (Ind.); Oakland/AM; Lanai Gallery; Chico State College; Bolles Gal-

lery, 1965, 68, 71, 73; RAC, 1968; The Catholic U. of America, 1968; Dohan Gallery, Sherman Oaks, Calif., 1969; Sacramento/Crocker, 1969; Achenbach Foundation, 1975; Turkish-American Gallery, Ankara, 1975; U. of Alaska, 1976; Fairbanks Civic Art Gallery, 1976; Wellesley College, 1976; Arlene Lind Gallery, San Francisco, 1975, 80; Gallerita, Milan, 1981, 89; Rorick Gallery, San Francisco, 1982, 85; Worth Ryder Gallery, 1983; Gallery Sho, Tokyo, 1985; KALA Institute Gallery, Berkeley, Ca., 1989; Holloway Gallery, San Francisco, 1990; Stanford U., 1991. **Retrospectives:** Walnut Creek Civic Arts Gallery, 1973; Valley Art Center, Walnut Creek, Ca., 1978; Valley Art Center, Clarkson, Wash., 1978. **Group:** de Young; SFMA; WMAA; MMA; Chicago/AI; Detroit/Institute; Seattle/AM; Pasadena/AM; Oakland/AM; I & III São Paulo Biennials, 1951, 55; U. of Illinois, 50 Contemporary American Printmakers, 1956, Contemporary American Painting and Sculpture, 1969; Pomona College, California Drawing, 1957; Art Center, Berkeley, 1967; Los Angeles Printmakers Society, 1968; Moore College of Art, Philadelphia, American Drawings, 1968; U. of the Pacific, 1969; U. of Illinois, 1969; Georgia State U., Annual Print Exhibition, 1970; Oakland/AM, Prints California, 1975; Florida State U., National Printmaking Invitational, 1985. **Collections:** Achenbach Foundation; Auckland; U. of California; Colby College; de Young; College of Idaho; Ithaca College; Los Angeles/County MA; MOMA; Mills College; NYPL; Oakland/AM; U. of Oklahoma; U. of the Pacific; Pasadena/AM; RISD; Rennes; SFMA; San Francisco State College; US State Department; U. of Texas; Victoria and Albert Museum; College of Wooster. **Bibliography:** Archives.

KATZ, ALEX b. July 24, 1927, NYC. **Studied:** Cooper Union; Skowhegan School, 1959; Yale U., 1960-61; Pratt Institute, 1963-66; School of

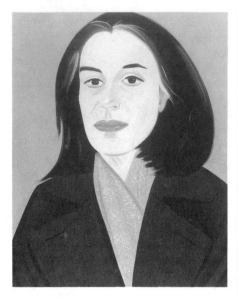

Alex Katz, *Ada in Orange*, 1991.

Visual Arts, NYC, 1965, 66; New York Studio School, 1968-69. Stage sets and costumes for Paul Taylor Dance Company, Festival of Two Worlds, Spoleto, 1960, 64; Kenneth Koch's *George Washington Crossing the Delaware*, 1962; Artists' Festival Theater, Southampton, *Little Eyolf*, by Henrik Ibsen, 1968; *Polaris*, sets and costumes, and set for *Diggity*, 1979; Kenneth Koch's *Red Robin*, 1977-78. **Commissions:** Mural, Federal Courthouse Annex, NYC. Sets and Cutouts for National Dance Institute's collaboration between USA and the People's Republic of China, 1986. **Member:** Cooper Union, Trustee; Skowehan School, Trustee Emeritus, 1988; AAIAL, 1988. **Awards:** Guggenheim Foundation Fellowship, 1972; National Endowment for the Arts, 1976; US Government Cultural Exchange Grant to USSR, 1978; Cooper Union, Saint-Gaudens Medal, 1980; Skowhegan School, Medal for Painting, 1980; Art Direction Magazine Award for *Time* magazine cover, 1982; Graphic Design USA Award for *Time* magazine cover, 1983; Hon. DFA, Colby College, 1984. **Address:** 435 West Broadway, NYC

10013. **Dealers:** Marlborough Gallery, NYC; Robert Miller Gallery, NYC. **One-man Exhibitions:** Tanager Gallery, NYC (two- and three-man shows), 1953, 57, 60; Roko Gallery, NYC, 1954, 57; The Pennsylvania State U., 1957; Sun Gallery, Provincetown, 1958; Tanager Gallery, NYC, 1959, 62; The Stable Gallery, NYC, 1960; Martha Jackson Gallery, 1962; Fischbach Gallery, NYC, 1962-68, 70, 71; Thibaudt Gallery, NYC, 1963; David Stuart Gallery, 1966; Bertha Eccles Art Center, Ogden, Utah, 1968; Phyllis Kind Gallery, Chicago, 1969, 71; Galerie Dieter Brusberg, Hanover, 1971; M.D. Thelen Gallery, 1971; Reed College, 1972; Sloan O'Sickey Gallery, Cleveland, 1972; Carlton Gallery, NYC, 1973; Assa Galleria, Helsinki, 1973; Marlborough Gallery, NYC, 1973, 76, 78, 80, 82, 83, 86; Colgate U., 1974; Wesleyan U. (Conn.), 1974; Marlborough Godard Ltd., Toronto and Montreal, 1974, 76, 78; Marlborough Fine Art Ltd., London, 1975, 82; Galerie Arensen, Copenhagen, 1975; American Foundation for the Arts, Miami, 1976; Marlborough Gallerie AG, Zurich, 1977; Galerie Roger d'Arnecourt, Paris, 1977; Fresco Arts Center, Calif., circ., 1977-78; Brandeis U., 1978; Beaver College, 1978; Benjamin Mangel Gallery, Bala Cynwyd, Pa., 1978-79, 80, 84; Susanne Hilberry Gallery, Birmingham, Mich., 1978, 82, 83, 84, 87; Hokin Gallery, Chicago, 1978, 82; Brooke Alexander, NYC, 1979, 82; Robert Miller Gallery, NYC, 1980, 81, 84, 85, 87; Queens Museum, 1980; Mira Godard Gallery, Toronto, 1980, 81, 82, 84, 87, 90; Stony Brook/SUNY, 1980; Gallery Odin, Port Washington, N.Y., 1980; Fay Gold Gallery, Atlanta, 1980; Hokin Gallery, Palm Beach, 1980, 83; Middendorf-Lane Gallery, Washington, D.C., 1980; Hartnell College, 1980; Portland, Ore./AM, 1981; Cincinnati/Contemporary, 1981; U. of California, Santa Barbara, 1981; John Stoller & Co., Inc., Minneapolis, 1982; Texas Gallery, Hous-

ton, 1983, 86; McIntosh-Drysdale Gallery, Houston, 1983; Michael Lord Gallery, Milwaukee, 1984; Colgate U., 1984; Asher/Faure Gallery, Los Angeles, 1984; Cooper Union, NYC, 1985; Marlborough Gallery, Tokyo, 1985; Cleveland Center for Contemporary Arts, 1985; Bowdoin College, 1985; Wichita State U., 1985; O'Farrel Gallery, Brunswick, Me., 1985; Mario Diacono Gallery, Boston, 1985, 89; Rockland/Farnsworth, 1985; WMAA, 1986; MacIntosh-Drysdale Gallery, Washington, D.C., 1986; Hokin Gallery, Palm Beach, 1989, 90; Hokin-Kauffman Gallery, Chicago, 1987; Galerie Templon, Paris, 1988; Erika Meyerovich Gallery, San Francisco, 1988; Cleveland/MA, 1988; Galerie Bernd Klüser, Munich; Riva Yares Gallery, Scottsdale, 1989; Michal Kohn Gallery, Los Angeles, 1989, 91; Raleigh/NCMA, circ., 1990, Galerie Ascan Crone, Hamburg, 1990; Honolulu/Contemporary, 1991. **Retrospectives:** U. of Utah, circ., 1971; WMAA, circ., 1974; Centro Colombo-Americano, Bogota, 1980; WMAA, circ., 1986; Brooklyn Museum, 1988; Seibu Museum, Tokyo, circ., 1988; Utica, circ., 1991. **Group:** New York Art Alliance, Younger Artists, 1959; PAFA, 1960; WMAA, Young America, 1960, Annual, 1967-68, 72, 73; Houston/MFA, 1961; Chicago/AI, 1961, 62, 64; Colby College, Maine and Its Artists, 1963; Swarthmore College, Two Generations of American Art, 1964; MOMA, 1964-65, American Collages, 1965, The Inflated Image, circ., 1968; RISD, Recent Still Life, 1966; Milwaukee, 1966; Bennington College, 1967; U. of California, San Diego, The Impure Image, 1969; Tulsa/Philbrook, The American Sense of Reality, 1969; Milwaukee, Aspects of a New Realism, 1969; Walker, Figures/Environments, circ., 1970-71; Sweden/Goteborg, Warmwind, 1970; Corcoran Biennial, 1971; PAFA, Contemporary Realism, 1971; SFMA, Color/Constructivism/Realism in Contemporary Graphics, 1971-72; Boston U., The

American Landscape, 1972; WMAA, American Drawings: 1963-1973, 1973; Cleveland/MA, 1974; Lincoln, Mass./De Cordova, Candid Painting: American Genre 1950-1975, 1975; US Department of the Interior, America 1976, 1976; Tulane U., Drawing Today in New York, 1977; Philadelphia College of Art, Artists' Sets and Costumes, 1977; Aspen Center for the Visual Arts, American Portraits of the Sixties and Seventies, 1979; Brooklyn Museum, American Drawings in Black and White: 1970-1979, 1980; San Antonio/MA, Real, Really Real, Super Real, 1981; PAFA, Contemporary American Realism Since 1960, 1981; WMAA, Focus on the Figure, 1982; Houston/Contemporary, American Still Life, 1945-1983, circ., 1983; MOMA, Pop Art: 1955-1970, circ., 1985; ICI, After Matisse, circ., 1986; Whitechapel Art Gallery, In Tandem, 1986; Florida International U., American Art Today: The City, 1990; AAIAL, 1985, 87; Newport Harbor, Figurative Fifties: New York Figurative Expressionism, circ., 1988; WMAA, Figure as Subject, circ., 1988; Kusnetsky Most Exhibition Hall, Moscow, Paintings Beyond the Death of Painting, circ., 1989; Miyagi Museum, Sendai, Japan, American Realism & Figurative Art: 1952-1990, circ., 1991. **Collections:** Aachen/NG; Allentown/AM; Atlantic Richfield Corp., Los Angeles; Berlin; Boston/MFA; Bowdoin College; Brandeis U.; Chase Manhattan Bank; Chicago/AI; Ciba-Geigy Corp.; Cincinnati/AM; Cleveland; Colby College; Commerce Bank of St. Louis; Dartmouth College; Delaware; Des Moines; Detroit/Institute; Hartford/Wadsworth; Harvard U.; Hirshhorn; Helsinki; MMA; MOMA; Madison Art Center; Mexico City/Tamayo; Miami-Dade; Milwaukee; Museum of Contemporary Art, Utrecht; NCFA; NYU; U. of North Carolina; Oberlin College; Omaha/Joslyn; Rice U.; RISD; Scranton/Everhart; J. Henry Schroeder Banking Corp.; U. of Southern California; Syracuse U.; Trenton/State;

US State Department; Utah; WMAA; Wake Forest U.; Wichita/AM. **Bibliography:** Alloway 4; *America 1976;* Armstrong, Thomas; Arthur 1; Arthur 2; Ashbery; Downes, ed.; *The Figurative Fifties; Figures/Environments;* Honisch and Jensen, eds.; Hughes; Hunter, ed.; *Kunst um 1970;* Lippard 5; **Marshall,** ed.; **Marvell;** O'Hara 1; *Poets & Painters;* **Sandler** 1, 5; Sager; Sandler 3; Schwartz 1, 3; Strand, ed.; Ward. Archives.

KATZMAN, HERBERT b. January 8, 1923, Chicago, Ill. **Studied:** Chicago Art Institute School, 1940-46. Traveled Great Britain; resided Paris, Florence. **Taught:** Rockland Foundation, 1952-53; Pratt Institute; School of Visual Arts, NYC, 1969-87. **Awards:** Chicago/AI, Traveling Fellowship, 1946; Chicago/AI, Campana Prize, 1951; PAFA, J. Henry Schiedt Memorial Prize, 1954; Fulbright Fellowship, 1956; AAAL Grant, 1958; National Council on the Arts, 1967; Guggenheim Foundation Fellowship, 1968. **Address:** 463 West Street, NYC 10014. **Dealer:** Terry Dintenfass, Inc., NYC. **One-man Exhibitions:** (first) The Alan Gallery, NYC, 1954, 57, 59; Terry Dintenfass, Inc., NYC, 1962, 64, 66, 68, 71, 72, 75, 78, 81, 88; U. of Illinois; Brooklyn Museum. **Group:** Chicago/AI, 1951; MOMA, Fifteen Americans, circ., 1952; U. of Illinois; PAFA, 1952, Annuals, 1967, 69; Carnegie, 1953, 55; WMAA, The New Decade, 1954-55; XXVIII Venice Biennial, 1956; WMAA, Forty Artists Under Forty, circ., 1962; Gallery of Modern Art, NYC, 1967-68; New School for Social Research, 1968; Skidmore College, Contemporary Drawings, 1975; U. of North Carolina, Art on Paper, 1977; Indianapolis, 1978; NAD, 1979. **Collections:** Chicago/AI; Hirshhorn; MOMA; U. of Massachusetts; Minnesota/MA; NCFA; Sacramento/Crocker; St. Lawrence U.; WMAA; Wright State U. **Bibliography:** Cummings 4; Nordness, ed.; Pousette-Dart, ed.

KAUFFMAN, CRAIG b. March 31, 1932, Eagle Rock, Calif. **Studied:** U. of Southern California, 1950-52; UCLA, BA, MA, 1952-56. Traveled Europe, 1956-57; resided Paris, 1960-62. **Taught:** U. of California, 1967-. **Awards:** National Endowment for the Arts, grant, 1968; Chicago/AI, Prize, 1970. **Address:** 4988 Mount Royal Drive, Los Angeles, CA 90041. **Dealer:** Asher/Faure Gallery, Los Angeles. **One-man Exhibitions:** (first) Felix Landau Gallery, Los Angeles, 1953; Dilexi Gallery, San Francisco, 1958, 60; Ferus Gallery, Los Angeles, 1958, 63, 65, 67; The Pace Gallery, 1967, 69, 70, 73; Ferus/Pace Gallery, Los Angeles, 1967; Irving Blum Gallery, Los Angeles, 1969, 72; Pasadena/AM, 1970; U. of California, Irvine, 1970; Darthea Speyer Gallery, 1973; Mizuno Gallery, 1975; Robert Elkon Gallery, NYC, 1976; Cynthia Comsky Gallery, Los Angeles, 1976; Arco Center for Visual Arts, Los Angeles, 1978; Blum Helman Gallery, NYC, 1979, 82; Janus Gallery, Venice, Calif., 1979; Grapestake Gallery, San Francisco, 1979; Asher/Faure Gallery, Los Angeles, 1981, 83, 88; Cirrus Gallery, Los Angeles, 1982; Thomas Segal Gallery, Boston, 1982; Fuller-Goldeen Gallery, San Francisco, 1985. **Retrospective:** La Jolla, circ., 1981. **Group:** SFMA Annual, 1952, 54, 59-61; UCLA, California Painters Under 35, 1959; U. of Illinois, 1961, 67; Seattle/AM, 1966; Detroit/Institute, Color, Image and Form, 1967; MOMA, The 1960's, 1967; WGMA, A New Aesthetic, 1967; V Paris Biennial, 1967; CSCS, Los Angeles, 1968; Des Moines, Painting Out from the Wall, 1968; Vancouver, 1968; Pasadena/AM, West Coast: 1945-1969, 1969; Jewish Museum, Using Walls, 1970; Govett-Brewster, The State of California Art, 1971; Corcoran Biennial, 1973; Chicago/AI, 71st American Exhibition, 1974; WMAA/Downtown, Illuminations and Reflections, 1974; U. of Illinois, 1974; ICA, Los Angeles, Current Concerns, 1975; Newport Harbor, The Last Time I Saw

Ferus, 1976; Indianapolis, 1976; SFMA, 75 Years of California Art, 1976; SFMA, Painting and Sculpture in California: The Modern Era, 1977; Laguna Beach Museum of Art, Southern California 100, 1977; WMAA Biennial, 1979; Laguna Beach Museum of Art, Southern California Artists, 1981; Los Angeles/County MA, Art in Los Angeles, 1981; Long Beach/MA, Drawings by Painters, 1982. **Collections:** Arco Corp.; U. of Arizona; Australia; Buffalo/Albright; Chicago/AI; Fort Worth; Laguna Beach/AM; Long Beach/MA; Los Angeles/County MA; Milwaukee; MOMA; Newport Harbor; Pasadena/AM; Philip Morris Collection; Ridgefield/Aldrich; Santa Barbara/MA; Seagram Collection; SFMA; Tate; U. of Sydney, Australia; WMAA; Walker. **Bibliography:** Davis, D.; Friedman, M., 2; Plagens; *The State of California Painting.*

KEARL, STANLEY b. December 23, 1913, Waterbury, Conn. **Studied:** Yale U., 1941, BFA, 1942, MFA; State U. of Iowa, 1948, Ph.D. Traveled the world extensively; resided Rome, nine years. **Taught:** U. of Minnesota, Duluth, 1947-48; Pratt Institute, 1967; YMHA, Scarsdale, 1974-75. Federal A.P.: Easel painting. **Awards:** Fulbright Exchange Professor to Rome U., Italy, 1949-50; Institute of Contemporary Arts, Florence, Italy, 1952; Connecticut Academy Sculpture Prize, 1958. **Address:** 344 Sprain Road, Scarsdale, NY 10583. **One-man Exhibitions:** (first) L'Obelisco, Rome, 1950; Galerie d'Art Moderne, Basel, 1951; Samlaren Gallery, Stockholm, 1951; Marbach Galerie, Berne, 1952; Galerie 16, Zurich, 1952; Beaux Arts Gallery, London, 1956; Galleria Selecta, Rome, 1957; Obelisk Gallery, Washington, D.C., 1958; Wakefield Gallery, NYC, 1961; D'Arcy Gallery, NYC, 1962; Hudson River Museum, 1964; Grand Central Moderns, NYC, 1965, 68; IIE, NYC, 1967; Benson Gallery, Bridgehampton, N.Y., 1976, 88; Benton Gallery, Southampton, N.Y.,

1986. **Group:** XXVI Venice Biennial, 1952; PAFA, 1959; MOMA, 1961; WMAA Annual, 1962; Hudson River Museum, 1963; Institute of International Education; The Graham Gallery, NYC, 1969; Stamford Museum, 1974. **Collections:** State U. of Iowa; Marbach Galerie; U. of Minnesota; Northland College; Rome/Nazionale; Stockholm/National; Sweden/Goteborg. **Bibliography:** Seuphor 3.

KEARNS, JAMES b. August 7, 1924, Scranton, Pa. **Studied:** Chicago Art Institute School; De Paul U.; The U. of Chicago, 1946-50, BFA. **Taught:** School of Visual Arts, NYC, 1959-; Skowhegan School, summer, 1961-64; Fairleigh Dickinson U., 1962-63. Illustrated *Can These Bones Live?* by Edward Dahlberg (New Directions, 1960), and *The Heart of Beethoven,* by Selman Rodman (Shorewood Press, 1962). **Awards:** NIAL Grant in Art, 1954; Montclair/AM, First Prize for Painting, 1961. **Address:** 452 Rockaway Road, Dover, NJ 07801. **One-man Exhibitions:** (first) Grippi Gallery, 1956, also 1957, 60, 62, 68; Fairleigh Dickinson U., 1962; Scranton/Everhart, 1963; Lee Nordness Gallery, NYC, 1964; Bloomfield College, 1967, 72; David Gallery, 1969, 71; Free Public Library, Fair Lawn, N.J., 1972; Sculpture Center, NYC, 1973; River Run Gallery, Edgartown, Mass., 1975, 77; Somerset Art Association, Bernardsville, N.J., 1975; Cramer Gallery, Glen Rock, N.J., 1976; Caldwell College, N.Y., 1976; Spook Farm Gallery, Far Hills, N.J., 1977. **Group:** A.F.A., Drawings, 1959; WMAA Annuals, 1959-61; A.F.A., New Talent, circ., 1960; A.F.A., Private Worlds, 1960; Newark Museum, Survey of American Sculpture, 1962; PAFA Annual; New York World's Fair, 1964-65; Monmouth Museum, Three Centuries of Art in New Jersey, 1969; San Diego, National Invitational Print Show, 1969; SAGA Annual, 1971; Schenectady Museum, Sculpture, 1976; NYC Audubon Artists,

1977. **Collections:** Caldwell College;
Colby College; Hirshhorn; MMA;
MOMA; Montclair/AM; NCFA; Newark
Museum; Scranton/Everhart; Topeka
Public Library; Trenton/State; WMAA.
Bibliography: Gerdts; Nordness, ed.;
Rodman 1, 3.

KELLY, ELLSWORTH b. May
31, 1923, Newburgh, N.Y. **Studied:** Bos-
ton Museum School; Academie des Beaux
Arts, Paris; Pratt Institute, 1941-42. US
Army, 1943-46. Traveled France, 1948-
54. **Taught:** Norfolk House Center,
Boston, 1946; American School, Paris,
1950-51. **Commissions:** Transportation
Building, Philadelphia, 1957 (sculpture);
Eastmore House, NYC (mural); New York
State Pavilion, New York World's Fair,
1964-65 (sculpture); UNESCO, Paris,
1969 (mural); Central Trust Co., Cincin-
nati, 1979; Lincoln Park, Chicago, 1979,
81; Dallas/MFA, 1983; General Maragues
Plaza, Barcelona, 1985; Meyerson
Symphony Center, Dallas, 1989; Nestlé,
S.A., Vevey, Switzerland, 1991. Designed
sets and costumes for Paul Taylor Dance
Co. **Member:** NIAL. **Awards:** Brandeis
U., 1962; Carnegie, 1962, 64; Interna-
tional Biennial Exhibition of Paintings,
Tokyo; Chicago/AI; Flora Mayer
Witkowsky Prize, 1964; Chicago/AI, Paint-
ing Prize, 1974; Skowhegan School, award
for sculpture, 1981; Chevalier de l'Ordre
des Arts et des Lettres, France, 1987.
Address: P.O. Box 151, 45 South St.,
Spencertown, N.Y. 12165. **Dealers:** Leo
Castelli Inc., NYC; Blum Helman Gallery,
NYC; Margo Leavin Gallery, Los Angeles;
Janie C. Lee, Houston. **One-man Exhibi-
tions:** (first) Galerie Arnaud, 1951; Betty
Parsons Gallery, NYC, 1956, 57, 59, 61,
63; Galerie Maeght, 1958, 64; A. Tooth &
Sons, London, 1962; WGMA, 1964; ICA,
Boston, 1964; Ferus Gallery, Los Angeles,
1965; Sidney Janis Gallery, 1965, 67, 71;
Irving Blum Gallery, Los Angeles, 1967,
68, 73; Galerie Denise Rene/Hans Mayer,
Düsseldorf, 1972; Buffalo/Albright, 1972;

Leo Castelli Inc., NYC, 1973, 75 (2), 77
(2), 80, 81, 84, 85; Greenberg Gallery, St.
Louis, 1973, 82, 89, 91; ACE Gallery,
Venice, Calif., 1975; Blum Helman Gal-
lery, NYC, 1975, 77, 79, 81, 82, 84, 85,
86, 87, 88, 89; Janie C. Lee Gallery,
Houston, 1976; Margo Leavin Gallery,
Los Angeles, 1977, 82, 84, 92; MOMA,
1978; MMA, 1979; Amsterdam/Stedelijk,
circ., 1979-80; Buffalo/Albright, 1980;
Larry Gagosian Gallery, Los Angeles,
1981; John Berggruen Gallery, 1982; The
Greenberg Gallery, 1982; Katonah (N.Y.)
Gallery, 1985; Thomas Segal Gallery,
Boston, 1982; Ann Weber Gallery, George-
town, Me., 1985; Boston/MFA, 1987;
Blum Helman Gallery, Santa Monica,
1988; Castelli Graphics, NYC, 1988, 90;
Galerie Daniel Templon, Paris, 1989;
Chicago/AI, 1989; Gemini G.E.L., Los
Angeles, 1990; Susan Sheehan Gallery,
NYC, 1990; Gallery Kasahara, Osaka,
1990; Lawrence Oliver Gallery, Philadel-
phia, 1990; Portikus, Frankfurt, 1990; 65
Thompson Street, NYC, 1990; Dia
Center, Bridgehampton, N.Y., 1991.
Retrospectives: MOMA, 1973; Walker,
1974; Detroit/Institute, 1974; WMAA,
1982; Detroit/Institute, circ., 1987; Fort
Worth, circ., 1987. **Group:** Salon des
Realites Nouvelles, Paris, 1950, 51; Galerie
Maeght, Tendence, 1951, 62; Brussels
World's Fair, 1958; Carnegie, 1958, 62,
64, 66, 67; MOMA, Sixteen Americans,
circ., 1959; SRGM, Abstract Expressionists
and Imagists, 1961; VI São Paulo Biennial,
1961; Chicago/AI, 1961, 62, 64, 66;
Seattle World's Fair, 1962; Jewish Mu-
seum, Toward a New Abstraction, 1963;
Los Angeles/County MA, Post Painterly
Abstraction, 1964; Tate, Gulbenkian
International, 1964; SRGM, American
Drawings, 1964; Tate, Dunn Interna-
tional, 1964; MOMA, The Responsive
Eye, 1965; Amsterdam/Stedelijk, New
Shapes of Color, 1966; SRGM, Systemic
Painting, 1966; Jewish Museum, Primary
Structures, 1966; XXXIII Venice Biennial,
1966; Brandeis U., 1966; WMAA,

Sculpture Annuals, 1966, 68, Annual, 1967; Tokyo/Modern, 1966-67; Detroit/Institute, Color, Image and Form, 1967; Expo '67, Montreal, 1967; Los Angeles/County MA, American Sculpture of the Sixties, 1967; SRGM, 1967; MOMA, The Art of the Real, 1968; Buffalo/Albright, Plus by Minus, 1968; Kassel, Documenta IV, 1968; Pasadena/AM, Serial Imagery, 1968; WMAA, Contemporary American Sculpture, 1968-69; WMAA Annuals, 1969, 73; MMA, New York Painting and Sculpture, 1940-1970, 1969-70; Chicago/Contemporary (four-man), 1970; WMAA, The Structure of Color, 1971; MOMA, Technics and Creativity; Gemini G.E.L., 1971; ICA, U. of Pennsylvania, Grids, 1972; Kunstmuseum, Lucerne, 1973; Musée Galliera, Paris, Festival d'Automne, 1973; Parcheggio di Villa Borghese, Rome, Contemporanea, 1974; Rijksmuseum/Kröller-Müller, Functions of Drawing, 1975; NCFA, Sculpture: American Directions 1945-1975, 1975; MOMA, Drawing Now, 1976; SRGM, 20th Century American Drawings, 1976; Chicago/AI Annual, 1976; WMAA, 200 Years of American Sculpture, 1976; A.F.A., American Master Drawing and Watercolors, 1976; Paris/Beaubourg, Paris-New York, 1977; Cambridge, Jubilation, 1977; Minnesota/MA, American Drawings 1927-1977, 1977; Venice, Biennial, 1978; Buffalo/Albright, American Painting of the 1970's, 1978; WMAA Biennial, 1979, 81, 91; Corcoran Biennial, 1979; California State U., Northridge, Americans in Paris, the 50s, 1979; Brooklyn Museum, American Drawings in Black and White: 1970-1979, 1980; MOMA, Printed Art: A View of Two Decades, 1980; SFMA, Twenty American Artists, 1980; Walker, Artist and Printer, 1980; Cologne, International, 1981; Cologne/Stadt, Westkunst, 1981; Paris/Beaubourg, Paris-Paris/Créations en France 1937-57, 1981; Toulon, Espace Peint, Espace Traverse: La Danse, 1981;

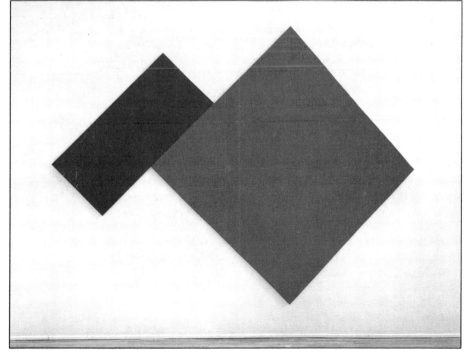

Ellsworth Kelly, *Green Black*, 1988.

ARS 83, Helsinki, 1983; Sunderland (Eng.) Arts Centre, Drawing in Air, 1983; Amsterdam/Stedelijk, La Grande Parade, 1984; Boston/MFA, 10 Painters and Sculptors Draw, 1984; National Gallery and Yale U., The Folding Image, 1984; Carnegie, International, 1985; École des Beaux Arts, Paris, Cinquante Ans de Dessins Americains, 1930-1980, 1985; MOMA, Contrasts of Form, 1985; Fort Lauderdale, An American Renaissance: Painting and Sculpture Since 1940, 1986; Los Angeles/County MA, The Spiritual in Art, 1986; Purchase/SUNY, The Window in Twentieth Century Art, 1986; Tate Gallery, Forty Years of Modern Art, 1945-1985, 1986; Whitechapel Art Gallery, London, In Tandem: The Painter-Sculptor in the Twentieth Century, 1986; National Gallery, Seven Modern Masters, 1986; Brown U., Definitive Statements, 1986; ICA, U. of Pennsylvania, 1967: At the Crossroads, 1987; WMAA, 20th Century Drawings from the Whitney Museum of American Art, circ., 1987; SRGM, Aspects of Collage, 1988; Kassel/Fredericianum, Red, Yellow, Blue, circ., 1988; WMAA, Vital Signs, circ., 1988; Paris/Beaubourg, Les Années 50, 1988; Los Angeles/MOCA, Abstract Painting Since the 1960s, 1988; Frankfurt, Prospect 89, 1989; Cologne/Ludwig, Bilderstreit, 1989; Frejus/Musée Temporaire, Exposition Inaugurale, 1989; Dallas/MFA, Painting in Parts, 1989; Buffalo/Albright, Abstraction, Geometry, Painting, 1989; SRGM, Geometric Abstraction and Minimalism in America, 1989; Tate Gallery, Past Present Future, 1990; Louvre, Poytyques, 1990; Los Angeles/MOCA, Pop Art and Minimalism, 1960-1975, 1991; Kassel, Documenta IX, 1992; Jeu de Paume, Paris, circ., 1992. **Collections:** Amsterdam/Stedelijk; Baltimore/MA; Berlin/National; Brandeis U.; Buffalo/Albright; Canberra/National; Carnegie; Chicago/AI; Cincinnati/AM; Cleveland/MA; Cologne; Corcoran; Dallas/MFA; Dartmouth College; Detroit/Institute; Düsseldorf/KN-W; Eindhoven; Fort Worth; Foundation Maeght; Fukuoda; Frejus; Grenoble; Harvard U.; High Museum; Hirshhorn; Humlebaek/Louisiana; La Jolla; Los Angeles/County MA; MMA; MOMA; Madrid/Reina Sofia; Milwaukee; Munster/WK; Omaha/Joslyn; PMA; Paris/Moderne; Pasadena/AM; Portland, Ore./AM; RISD; Rijksmuseum Kröller-Müller; St. Louis/City; SFMA; SRGM; Seattle/AM; Stockholm/National; Tate Gallery; Tel Aviv; U. of Texas; Toronto; UNESCO; VMFA; Vienna/Moderner; WGMA; WMAA; Walker; Worcester/AM; Yale U. **Bibliography:** Alloway 3; Armstrong, Thomas; Ashbery; **Axsom 1; Axsom with Floyd;** Battcock, ed.; *Black and White Are Colors;* Calas, N. and E.; *Contemporanea;* **Coplans 1, 3;** Cummings 5; Davies; Davis, D.; De Wilde 1, 2; *Europa/Amerika;* Friedman, M., 2; Gaunt; Gohr and Gachnang; **Goossen 1, 2;** Honisch and Jensen, eds.; Hunter, ed.; *Individuals;* Kardon 3; Kozloff 3; *Kunst um 1970;* Lippard 5; MacAgy 2; Murken-Altrogge; Nordness, ed.; *Report;* Rickey; Rose, B., 1; Sandler 3, 5; Seitz 3; Seuphor; Sims and Pulitzer; Toher, ed.; Tuchman 1, 3; **Upright 1;** Waldman 4; Weintraub; Weller.

KELLY, JAMES

KELLY, JAMES b. December 19, 1913, Philadelphia, Pa. **Studied:** Philadelphia Museum School, 1937; PAFA, 1938; Bames Foundation, 1941; California School of Fine Arts, 1951-54. US Air Force, 1941-45. **Taught:** U. of California, Berkeley, 1957. **Member:** Artists Equity. **Awards:** Ford Foundation Grant for Tamarind, 1963; National Endowment for the Arts, grant, 1977; Peter and Madeleine Martin Foundation for the Creative Arts, grant, 1990. **Address:** 463 West Street, NYC 10014. **One-man Exhibitions:** (first) California Palace, 1954; SFMA, 1956; The Stryke Gallery, NYC, 1963; East Hampton Gallery, N.Y., 1965, 69;

Albright College, Reading, Pa., 1966; Long Island U., 1968; Westbeth Gallery, NYC, 1971, 72. **Retrospective:** College of Notre Dame, Belmont, Calif., 1990. **Group:** PAFA, 1951; SFMA Annuals, 1955-58; U. of Minnesota, California Painters, 1956; Minneapolis/Institute, American Painting, 1945-57, 1957; Santa Barbara/MA, II Pacific Coast Biennial, 1957; A.F.A., West Coast Artists, circ., 1959-60; Los Angeles/County MA, Late Fifties at the Ferus, 1968; Oakland/AM, A Period of Exploration, 1973; Newport Harbor, The Last Time I Saw Ferus, 1976; SFMA, California Painting: The Modern Era, 1976; Oakland/AM, Art in the San Francisco Bay Area, 1945-1980, 1985. **Collections:** Amon Carter Museum; Chase Manhattan Bank, NYC; Chicago/AI; Fort Worth; La Jolla; Los Angeles/County MA; MOMA; U. of Massachusetts; Oakland/AM; Pasadena/AM; Richmond (Calif.) Art Center; Sacramento/Crocker; SFMA; UCLA; Westinghouse. **Bibliography:** McChesney. Archives.

KELLY, LÉON (Léon Kelly y Corrons)

b. October 21, 1901, Philadelphia. **d.** June 28, 1982, Loveladies Harbor, N.J. **Studied:** Philadelphia Museum School; PAFA; privately with Arthur B. Carles, Jr., and Earl Horter. Traveled Europe, North Africa, USA; resided Paris, 1924-30. Federal A.P.: Supervisor of artists in Philadelphia; mural and easel painting. Designed sets and costumes for several ballet companies, including the Ballet Russe de Monte Carlo. **Taught:** Brooklyn Museum School. **Commissions:** Portraits. **Awards:** PAFA, Cresson Fellowship, 1924; William and Noma Copley Foundation Grant, 1959. **One-man Exhibitions:** (first) Little Gallery of Contemporary Art, Philadelphia, 1925, also 1932; Galerie du Printemps, Paris, 1926; Contemporary Arts Gallery, NYC, 1933; Julien Levy Galleries, NYC, 1942, 44, 45; Philadelphia Art Alliance, 1943; Hugo Gallery, NYC, 1950; Galleria

Amici di Francia, Milan, 1954; Hewitt Gallery, NYC, 1956; Alexandre Iolas Gallery, NYC, 1959, 61; The Zabriskie Gallery, NYC, 1963; Washburn Gallery Inc., NYC, 1981. **Retrospectives:** Philadelphia Art Alliance, 1928; International Gallery, Baltimore, 1965. **Group:** European International, 1927: A Century of Progress, Chicago, 1933-34; WMAA Annuals; Carnegie; U. of Nebraska; PMA; Chicago/AI; Corcoran; Newark Museum, 1968. **Collections:** Allentown/AM; Andover/Phillips; Chicago/AI; Clearwater/Gulf Coast; Hartford/Wadsworth; La France Art Institute; MMA; MOMA; Museo Nacional de Historia; National Arts Foundation; U. of Nebraska; Newark Museum; PAFA; PMA; The Pennsylvania State U.; Steuben Glass; Tel Aviv; Utica; WMAA. **Bibliography:** *Avant-Garde Painting and Sculpture in America;* Cummings 4; Gerdts; Janis, S. Archives.

KENDRICK, MEL **b.** 1949, Boston. **Studied:** Trinity College, Hartford, BA, 1971; Hunter College, NYC, MA, 1973. **Awards:** CAPS, grant, 1974, 78; National Endowment for the Arts, Fellowship, 1978, 81. **Address:** 134 Duane Street, NYC 10007. **Dealer:** John Weber Gallery, NYC. **One-man Exhibitions:** Artists' Space, NYC, 1974; A. M. Sachs Gallery, NYC, 1979; John Weber Gallery, NYC, 1980, 83, 85, 87, 89; U. of Connecticut, 1981; Carol Taylor Gallery, Dallas, 1982; Margo Leavin Gallery, Los Angeles, 1983, 85, 88; Barbara Krakow Gallery, Boston, 1986; U. of Massachusetts, Amherst, circ., 1986; St. Louis/City, 1987; Trinity College, Hartford, circ., 1988; Salama-Caro Gallery, London, 1989; G. Grimaldis Gallery, Baltimore, 1990; Editions Ilene Kurtz, NYC, 1990; Galerie Carola Mosch, Berlin, 1991. **Group:** Syracuse U., Current/New York, 1980; Maryland Institute, Sculpture 80, 1980; Cleveland/Contemporary, New Talent/New York, 1981; Ridgefield/Aldrich, New Visions, 1981; Jacksonville, Currents, circ., 1981; ICI, NYC, Concepts

in Construction, 1910-1980, circ., 1983; MOMA, The International Survey of Painting and Sculpture, 1984; WMAA, Biennial, 1985; U. of Massachusetts, 24 Cubes, 1988; Williams College, BIGlittle Sculpture, 1988; Budapest, Trienniel, 1990. **Collections:** Andover/Phillips; Brooklyn Museum; Canberra/National; Chase Manhattan Bank; Chicago/AI; Dallas/MFA; Dartmouth College; High Museum; MMA; Mexico City/Tamayo; New Britain/American; Newark Museum; Prudential Insurance Co. of America; Saint Louis/City; Storm King Art Center; WMAA; Walker.

KENT, ROCKWELL b. June 21, 1882, Tarrytown Heights, N.Y. d. March 13, 1971, Plattsburg, N.Y. **Studied:** Columbia U., 1906-10, with William M. Chase, Robert Henri, Kenneth Hayes Miller, Abbott Thayer. Traveled Canada, USA, Europe, Latin America, Greenland. **Member:** NIAL; Hon. Member, Academy of Fine Arts of the USSR. **Commissions** (murals): US Post Office, Washington, D.C.; Federal Building, Washington, D.C. **One-man Exhibitions:** Clausen Galleries, NYC, 1908, 19; Wildenstein & Co., NYC, 1925, 42; Macbeth Gallery, NYC, 1934; Richard Larcada Gallery, 1966, 69, 72; Bowdoin College, 1969; Plattsburgh/SUNY, 1982; Santa Barbara/MA, 1985; Associated American Artists, NYC, 1990. **Retrospectives:** Wildenstein & Co., NYC, 1924; Syracuse/Everson, 1937; Bowdoin College, 1969. **Group:** NAD, 1905; Academy of Fine Arts, Berlin, 1910; Century Association, 1940; Cleveland/MA; WMAA. **Collections:** American Car and Foundry Co.; Andover/Phillips; Baltimore/MA; Boston/MFA; British Museum; Brooklyn Museum; Chicago/AI; Cleveland/MA; Columbus; Corcoran; Detroit/Institute; Harvard U.; Honolulu Academy; Houston/MFA; Indianapolis/Herron; Library of Congress; MMA; NYPL; Newark Museum; Phillips; Victoria and Albert Museum; WMAA; Yale U. **Bib-**

liography: American Artists Congress, Inc.; American Artists Group, Inc., 1, 3; **Armitage**; Baur 7; Biddle 4; Birchman; Blesh 1; Brown; Cahill and Barr, eds.; Cheney; Cummings 1; Finklestein; Goodrich and Baur 1; Hall; Hartmann; *Index of 20th Century Artists;* Jackman; **Jones, D.B.; Kent, N.; Kent, R., 1, 2, 3; Kent, R., ed.;** Lee and Burchwood; Mather 1; Mellquist; Narodny; Neuhaus; Pagano; Pearson 1; Phillips 1, 2; Reese; Richardson, E.P.; Ringel, ed.; Ritchie 1; Rose, B., 1; Smith, S.C.K.; Zigrosser 1. Archives.

KEPES, GYORGY b. October 4, 1906, Selyp, Hungary. **Studied:** Academy of Fine Arts, Budapest, 1924-28. **Taught:** New Bauhaus, Chicago, 1937-43; a founding collaborator, with Lazlo Moholy-Nagy and Robert Wolff, of the Institute of Design, Chicago, 1938-42; MIT, 1946-. Codirector, Rockefeller Foundation Research Project: Perceptual Form of Cities. **Commissions** (murals): Harvard U. Graduate Center; KLM Royal Dutch Airlines, NYC; Travelers Insurance Companies, Los Angeles; Sheraton Hotels, Dallas and Chicago; Children's Library, Fitchburg, Mass.; American Housing Exhibit, Paris, 1946. **Awards:** American Institute of Graphic Art, 1944, 49; U. of Illinois, P.P., 1954; Guggenheim Foundation Fellowship, 1960-61; Art Directors Club, Chicago, 1963. **Address:** 90 Larchwood Drive, Cambridge, MA 02138. **Dealer:** Saidenberg Gallery, NYC. **One-man Exhibitions:** Katherine Kuh Gallery, Chicago, 1939; Chicago/AI, 1944, 54; Outline Gallery, Pittsburgh, 1945; Royal Academy, Copenhagen, 1950; Margaret Brown Gallery, Boston, 1951, 55; San Diego, 1952; Amsterdam/Stedelijk, 1952; Long Beach/MA, 1952; U. of California, Berkeley, 1952; SFMA, 1952, 54; Currier, 1953; Cranbrook, 1954; ICA, Boston, 1954; Syracuse/Everson, 1957; Houston/MFA, 1958; Dallas/MFA, 1958; L'Obelisco, Rome, 1958; Ivrea Gallery, Florence, Italy, 1958; The Howard Wise Gallery, Cleveland, 1959; Baltimore/MA, 1959;

Saidenberg Gallery, NYC, 1960, 66, 68, 70, 72, 80; Lincoln, Mass./De Cordova, 1969; NCFA, 1970; Alpha Gallery, Boston, 1970; 72, 74, 86; Museum of Science and Hayden Planetarium, Boston, 1973; Dartmouth College, 1977; Prakapas Gallery, NYC, 1977; ICP, NYC, 1984; Galereabon, Budapest, 1986; MIT, 1984. **Retrospective:** MIT, 1978. **Group:** MOMA, 1947, 52; Chicago/AI, 1951, 53, 57; U. of Illinois, 1952, 53; SFMA; Cranbrook; Dallas/MFA; Andover/Phillips; San Diego; WMAA; Denver/AM, 1953; Carnegie, 1955. **Collections:** Andover/Phillips; Boston/MFA; Buffalo/Albright; Chase Manhattan Bank; Cranbrook; Dallas/MFA; Des Moines; Houston/MFA; U. of Illinois; Indianapolis/Herron; Lincoln, Mass./De Cordova; MIT; MOMA; SFMA; San Diego; VMFA; WMAA. **Bibliography:** Alfieri; Davis, D.; Janis and Blesh 1; Janis, S.; **Kepes 1, 2;** Kepes, ed.; Kuh 1; Nordness, ed.; Pearson 1; Rickey. Archives.

KEYSER, ROBERT b. July 27, 1924, Philadelphia, Pa. **Studied:** U. of Pennsylvania; Atelier Fernand Leger, Paris, 1949-51. US Navy, World War II (three years). Traveled Europe, North Africa (two years). **Taught:** Philadelphia Museum School, 1963; Temple U., Rome, 1975-77. **Awards:** U. of the Arts, Philadelphia, Print Edition Award, 1992. **Address:** Box 328 R.D. #4, Quakertown, PA 18951. **Dealer:** Dolan/Maxwell Gallery, Philadelphia. **One-man Exhibitions:** (first) Galerie Huit, Paris, 1951; Hendler Gallery, Philadelphia, 1952; Parma Gallery, NYC, 1954, 56, 58; P. Rosenberg and Co., 1959, 60, 62, 66, 71, 75, 79; Gimpel Fils, 1962; Gallery Marc, Washington, D.C., 1972; Marion Locks Gallery, Philadelphia, 1974, 1979; Temple U., Rome, 1977; Dolan/Maxwell Gallery, Philadelphia, 1988; Dolan/Maxwell Gallery, NYC, 1989. **Retrospective:** Temple U., circ., 1987. **Group:** PAFA Annual; WMAA Annual; A.F.A., Collage in America, circ., 1957-58; Joachim Gallery, Chicago, 1960;

U. of Illinois, 1961; Salon du Mai, Paris; Salon d'Automne, Paris; Salon des Realites Nouvelles, Paris; Corcoran, 1975; PMA, 300 Years of American Art, 1976; PAFA, Contemporary Drawing: Philadelphia I, 1978; ICA, U. of Pennsylvania, Artists Choose Artists, 1991. **Collections:** AT&T; Brandeis U.; NYPL; New London; PAFA; PMA; Phillips; Utica; Vassar College.

KIENBUSCH, WILLIAM b. April 13, 1914, NYC. d. March 23, 1980, NYC. **Studied:** Princeton U., 1936, BA, PBK (fine arts major); ASL, 1936-37; Colorado Springs Fine Arts Center, with Henry Poor; Academie Colorossi, Paris; privately with Anton Refregier and Stuart Davis in New York. US Army, World War II. **Taught:** Brooklyn Museum School, 1948-1979. **Awards:** Brooklyn Society of Artists Annual, First Prize, 1952; MMA, Drawing Prize, 1952; Columbia, S.C./MA, First P.P., Watercolors, 1957; Guggenheim Foundation Fellowship, 1958; Ford Foundation, P.P., 1961; Boston Arts Festival, First Prize for Watercolor, 1961; NIAL, Childe Hassam Fund, 1970. **One-man Exhibitions:** Kraushaar Galeries, NYC, 1949, 52, 56, 59, 63, 65, 69, 72, 78, 83; U. of Maine, 1956; Cornell U., 1958; Princeton U., 1962; Fort Worth, 1964 (two-man); Portland, Me./AM, 1973; Drew U., 1973. **Retrospectives:** Carnegie, 1954 (two-man, with Dioda); Colby College, circ., 1981. **Group:** Buffalo/Albright; Chicago/AI; MMA, 1952; Brooklyn Museum, 1953, 59; WMAA, The New Decade, 1954-55; Carnegie, 1955; WMAA, 1955; MOMA, Twelve Americans, circ., 1956; Brussels World's Fair, 1958; PAFA Annuals, 1962, 65, 67; New York World's Fair, 1964-65; WMAA, Art of the U.S. 1670-1966, 1966; Indianapolis, 1969; Omaha/Joslyn, A Sense of Place, circ., 1973; VMFA, American Marine Painting, 1976. **Collections:** Atlanta U.; Boston/MFA; Bowdoin College; Brooklyn Museum; Buffalo/Albright;

Carnegie; Colorado Springs/FA; Columbia, S.C./MA; Commerce Trust Co.; Currier; Dartmouth College; U. of Delaware; Des Moines; Detroit/Institute; Fort Worth; Hartford/Wadsworth; Houston/MFA; Kansas City/Nelson; Lehigh U.; MMA; MOMA; U. of Maine; U. of Michigan; U. of Minnesota; Montclair/AM; NCFA; U. of Nebraska; Newark Museum; New Britain; Norfolk/Chrysler; PAFA; PMA; Portland, Me./MA; U. of Rochester; Toledo/MA; Toronto; Utica; VMFA; WMAA; Wichita/AM; Williams College. **Bibliography:** Baur 5; Eliot; Goodrich and Baur 1; McCurdy, ed.; Nordness, ed.; Pousette-Dart, ed.; Ritchie 1; Seitz 3. Archives.

KIENHOLZ, EDWARD b. 1927,
Fairfield, Wash. **Studied:** Eastern Washington College of Education. Founded the Now Gallery, Los Angeles, 1956, and later the Ferus Gallery, Los Angeles. Since 1979, works of art created jointly are co-signed by Edward Kienholz and Nancy Reddin Kienholz and credit for works created jointly was granted to 1972. **Address:** Hope, Idaho 83836. **Dealer:** L.A. Louver, Inc., Venice, Calif. **One-man Exhibitions:** (first) Cafe Galleria, Los Angeles, 1955; Syndell Studios, Los Angeles, 1956; Exodus Gallery, San Pedro, Calif.; Ferus Gallery, Los Angeles, 1958 (three-man), 1959 (two-man), 60, 62; Pasadena/AM, 1961; Alexander Iolas Gallery, 1963; Dwan Gallery, Los Angeles, 1963-65; Dwan Gallery, NYC, 1967 (2); WGMA, 1967; Gallery 699, Los Angeles, 1968; Eugenia Butler, 1969; Stockholm/National, 1970; Düsseldorf/Kunsthalle, 1970; CNAC, 1970; Zurich, 1971; ICA, London, 1971; Wide White Space Gallery, Antwerp, 1972; Galerie Onnasch, Cologne, 1973; Galleria Bocchi, Milan, 1974; Humlebaek/Louisiana, 1976; Trinity College, Dublin, 1981; Art Museum of South Texas, 1982; Braunstein Gallery, San Francisco, 1984, 87; Dibbert Gallery, Berlin, 1982; Brunswick Gallery, Missoula, Mo.,

1983; Galerie Maeght, Paris, 1983; Cheney Cowles Museum, Spokane, Wa., 1984; Touchstone Gallery, Spokane, 1984; SFMA, circ., 1984; Chicago/Contemporary, 1985; Martin-Gropius-Bau, Berlin, 1986; Portland, Ore., Center for the Visual Arts, 1986; The American Center, Paris, 1986; L.A. Louver, Venice, Ca., 1986, 92; The Zabriskie Gallery, NYC, 1988; Gemini G.E.L. Gallery, Los Angeles, 1988, 89; Art Museum of Santa Cruz, circ., 1989; Louver Gallery, NYC, 1989; Kunsthalle/Düsseldorf, circ., 1989; Nishimura Gallery, Tokyo, 1990. **Group:** MOMA, The Art of Assemblage, circ., 1961; WMAA, Fifty California Artists, 1962; Los Angeles/County MA, Sculpture of the Sixties, 1967; MOMA, The Machine, 1968; MOMA, Dada, Surrealism and Their Heritage, 1968; WMAA, Human Concern/Personal Torment, 1969; Kassel, Documenta IV & V, 1968, 72; XXXVIII Venice Bienniale, 1976; WMAA, 200 Years of American Sculpture, 1976; WMAA Biennial, 1981; Oakland Museum, 100 Years of California Sculpture, 1982; Amsterdam/Stedelijk, '60-'80 Attitudes/Concepts/Images, 1982; Kunsthalle, Berlin, 1933—Wege zur Diktatur, 1983; California State U., Fullerton, The House That Art Built, 1983; Antwerp/Middelheim, Biennial, 1983; Palm Springs Desert Museum, Narrative Sculpture, 1984; Hirshhorn, Content, 1984; Japanese American Cultural and Community Center, Los Angeles, Imagine There's a Future, 1985; Seattle/AM, American Sculpture: Three Decades, 1984; SRGM, Transformations in Sculpture, 1985; U. of Washington, No! Contemporary American DADA, 1986; Purchase/SUNY, The Window in Twentieth Century Art, circ., 1986; U. of California, Berkeley, Made in U.S.A., 1987; Martin-Gropius-Bau, Berlin, Der Unverbrauchte Blick, 1987; MOMA, BERLINART, circ., 1987; WMAA, Sculpture Since the Sixties, 1988; MOMA, Committed to Print, 1988; Sydney/AG, Biennial, 1988; U. of

California, 40 Years of California Assemblage, 1989; Walker, First Impressions, 1989; Cheney Museum, Spokane, Wa., Masters of the Inland Northwest, 1989; WMAA, The Junk Aesthetic, 1989; Venice Biennale, 1990; Royal Academy, London, Pop Art, circ., 1991; Cleveland/Contemporary, Cruciformed: Images of the Cross Since 1980, 1992. **Collections:** Aachen/NG; Amsterdam/Stedelijk; Los Angeles/County MA; MOMA; Tokyo/Modern; WMAA. **Bibliography:** Battcock, ed.; Calas, N. and E.; Davis, D.; De Wilde 2; *Edward Kienholz; Edward Kienholz: 11 + 11 Tableaux; Forty Years of California Assemblage;* Hulten; *Individuals;* Kozloff 3; Leavens and Bruce; Lippard 5; Lippard, ed.: Osterwold; Plagens; Rose, Barbara, 1; Rubin 1; Russell and Gablik; Sandler 3; Seitz 3; Solnit; Tuchman 1, 2; Waldman 4; *When Attitudes Become Form.*

KIESLER, FREDERICK J.

b. September 22, 1890, Czernowitz, Romania. **d.** December 27, 1965, NYC. To USA, 1926; citizen. Scenic Director, Julliard School of Music, NYC, 1933-57. Registered Architect; designed and built the Art of This Century Gallery, NYC (1940); the Galerie Maeght, Paris (1947); the World House Galleries, NYC (1957); and the Kamer Gallery, NYC (1959). **One-man Exhibitions:** MOMA, 1951 (sculpture); MOMA, Endless House, 1960, also 1966; U. of Houston, Architectural Plans, 1960; Leo Castelli Inc., NYC, 1961, 62; SRGM, Environmental Sculpture, 1964; The Howard Wise Gallery, NYC, 1969; André Emmerich Gallery, NYC, 1979, 80; Alfred Kren Gallery, NYC, and Jason McCoy, Inc., NYC, 1986, 91. **Retrospectives:** Galerie Nächt St. Stephan, Vienna, 1975; WMAA, 1989. **Group:** WMAA; A.F.A., Universal Theater, circ., 1961-64; WMAA, The Third Dimension, 1984; WMAA, High Styles, 1985; Kunstlerhaus, Vienna, Dreams in Reality in Vienna, 1985; Paris/Beaubourg, Vienna 1880-1938, 1986. **Collections:** MOMA.

Bibliography: Arp; Barr 1; Blesh 1; Breton 3; Calas; *Europa/Amerika; Frederick Kiesler;* Gohr and Gachnang; Janis and Blesh 1; Janis, S.; *Metro;* Phillips, Lisa, 1, 2; Rose, B., 1; Rubin 1; Seuphor 3; Tuchman 1. Archives.

KING, WILLIAM DICKEY

b. February 25, 1925, Jacksonville, Fla. **Studied:** U. of Florida, 1942-44; Cooper Union, 1945-48, with Milton Hebald, John Hovannes; Brooklyn Museum School, 1948-49, with Hebald; Central School of Arts and Crafts, London, 1952. Traveled Italy, Greece. **Taught:** Brooklyn Museum School, 1953-60; U. of California, Berkeley, 1965-66; ASL, 1968-69; U. of Pennsylvania, 1972-73; SUNY, 1974-75. **Commissions:** (murals) SS *United States,* 1952; Bankers Trust Company, NYC, 1960; Miami-Dade, 1972; Potsdam/SUNY, 1973-74; Detroit Medical Center, 1979; Madison Art and Civic Center, Wisconsin, 1979; Lincoln Library, Fort Wayne, 1980; Orlando (Fla.) International Airport, 1983; Florida Atlantic U., 1984; Sterling Plaza, NYC, 1985. **Awards:** Cooper Union, Sculpture Prize, 1948; Augustus Saint Gaudens Medal, 1964; Fulbright Fellowship (Italy), 1949; Margaret Tiffany Blake Competition, First Prize, 1951; Moorehead Patterson Award (sculpture/to AMF Company), 1960; CAPS, 1974; Hakone Open-Air Museum, Japan, Distinction Prize, 1980; NAD, Gold Medal, 1986. **Address:** c/o Dealer. **Dealer:** Terry Dintenfass, Inc., NYC. **One-man Exhibitions:** The Alan Gallery, NYC, 1954, 55, 61; Terry Dintenfass, Inc., NYC, 1962, 64-71, 1973, 74, 76, 80, 81, 82, 83, 86, 89, 90, 92; The Gallery, Norwalk, Ohio, 1963; Donald F. Morris Gallery, Detroit, 1964; Washington Federal Savings & Loan Association of Miami Beach, Fla., 1965; Felix Landau Gallery, Los Angeles, 1966; Berkeley Gallery, San Francisco, 1966; Feigen-Palmer Gallery, Los Angeles, 1966; U. of Miami, 1967; Guild Hall, 1969, 82; Galerie Ann, Hous-

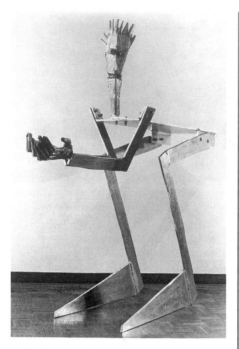

William King, *All Mine*, 1983.

ton, 1970; The Berenson Gallery, 1970; SFMA, 1970, circ., 1974; Alpha Gallery, 1971; U. of Nebraska, 1972; U. of Connecticut, 1973, 79; Aronson Gallery, Atlanta, 1973; Moravian College, 1974; San Antonio/McNay, circ., 1973; Davis Stuart Galleries, Los Angeles, 1974; Wingspread Gallery, Northeast Harbor, Me., 1981; Albany/SUNY, 1981; Alpha Gallery, Boston, 1982; Lise Hoshour Gallery, Albuquerque, 1981, 87; Hooks-Epstein Gallery, Houston, 1986; Gallery Paule Anglim, San Francisco, 1985, 87; David Heath Gallery, Atlanta, 1987; Montgomery (Ala.) Museum, 1987; Chatanooga/Hunter, 1987; Polk Museum, Lakeland, Fla., 1989; Hokin Gallery, Bay Harbor Islands, Fla., 1991. **Retrospective:** SFMA, circ., 1970, 74. **Group:** City of Philadelphia, Sculpture International, 1949; MOMA, New Talent; Brooklyn Museum, 1949, 50, 54, 55, 57, 58; WMAA Annuals, 1950-56, 1958-60, 1962-64, 66, 68; U. of Illinois, 1954, 56, 62, 63, 65; New Sculpture Group, NYC, 1957-60; Carnegie, 1958; MOMA, Recent Sculpture USA, 1959; Newark Museum, Survey of American Sculpture, 1962; SRGM, The Joseph H. Hirshhorn Collection, 1962; Museum of Contemporary Crafts, 1966; Drexel Institute, 1966; Indianapolis/Herron, 1968; AAAL, 1970, 74; New School for Social Research, Humor, Satire, Irony, 1972; Harvard U., Recent Figure Sculpture, 1972; Art Gallery of Budapest, II International Biennial of Small Sculpture, 1973; San Diego, Sculpture in the Street, 1973; Cranbrook, WAVES, An Artist Selects, 1974; Newport, R.I., Monuments, 1974; AAAL, 1974; Minnesota/MA, Drawings/USA, 1975; Potsdam/SUNY, Directions in Metal, 1982; NAD, 1982, 89; Southampton/Parrish, Drawing on the East End, 1988. **Collections:** Allentown/AM; American Export Isbrandtsen Lines, Inc.; Andover/Phillips; U. of Arkansas; Bankers Trust Company; Brandeis U.; U. of California; Columbus; Cornell U.; Creekwood; Dartmouth College; First National Bank of Chicago; Guild Hall; Hunter/Chatanooga; Little Rock/MFA; Los Angeles/County MA; MMA; U. of Massachusetts; Miami-Dade; NYU; U. of North Carolina; Potsdam/SUNY; SRGM; Syracuse U.; Temple U.; WMAA. **Bibliography:** Downes, ed.; Lippard 5; *Monumenta: Recent Figure Sculpture;* Seuphor 3. Archives.

KIPNISS, ROBERT b. February 1, 1931, NYC. **Studied:** Wittenberg College, 1948-50; State U. of Iowa, 1950-54, BA (English literature), MFA (painting and art history); ASL, with Alice Murphy. US Army, 1956-58. **Member:** Board of Directors of Audubon Artists; NAD. **Awards:** SAGA, 1979; Audubon Artists, 1976, 78; NAD, 1976; Hon. Ph.D., Wittenberg U., 1979; Hon. Ph.D., Illinois College, 1989. **Address:** P.O. Box 7112, Ardsley-on-Hudson, NY 10503. **Dealers:** Gerhard Wurzer Gallery, Houston; Enatsu Gallery, Tokyo; Theodore B.

Donson, Ltd., NYC. **One-man Exhibitions:** (first) Creative Gallery, NYC, 1951; The Salpeter Gallery, NYC, 1953; The Contemporaries, NYC, 1959, 60, 66, 67; Alan Auslander Gallery, NYC, 1963; Gallery Vendome, Pittsburgh, 1964; U. of Louisville, 1965; FAR Gallery, 1968, 70, 72, 75; Merrill Chase Galleries, Atlanta, 1972, 74, 76, 77, 78, 79, 80, 91; Centro de Arte Actual, Pereira, Colombia, 1975; Kalamazoo/Institute, 1975; Galerie Sandiego, Bogota, Colombia, 1975, 77; Xochipili Gallery, Rochester, Mich., 1977; Quadrum Gallery, Marblehead, Mass., 1977, 78; River Gallery, Irvington-on-Hudson, N.Y., 1977, 78, 80; A. B. Closson Co., Cincinnati, 1979; Wittenberg U., 1979; Canton Art Institute, Ohio, 1979; Museo de Arte Contemporaneo, Cali, Colombia, 1975, 1980; Hirschl & Adler Galleries, NYC, 1977, 80; Illinois College, 1989; Enatsu Gallery, Tokyo, 1989, 90; Jo Ann Perse Gallery, St. Louis, 1991; OK Harris Gallery, NYC, 1991; Park West Gallery, Southfield, Mich., 1992. **Retrospectives:** Youngstown/Butler, 1951; Museo de Arte Contemporaneo, Cali, Colombia, S.A., 1975; AAA, Ten Years of Lithography, 1977. **Group:** Columbus, 1958; A.F.A., New Talent, circ., 1961; U. of Minnesota, Duluth; A.F.A., circ., 1963-65; Indianapolis/Herron, 1964; Utah State Institute of Fine Arts, Salt Lake City, 1964; Cornell U., 1964; Cranbrook, 1964; Corcoran, 1966, 67; Buffalo/Albright, 1966, 67; MOMA, 1966, 67; Massillon Museum, 1967; NAD, 1974; NYPL, 1974; NAD, 1974, 76, 77; SAGA, 1979; AAIAL, 1978; Museo de Arte Contemporanea, III Biennal Graficas, 1976; AAIAL, 1988. **Collections:** AT&T; Atlantic Richfield Co.; Ball State U.; Buffalo/Albright; Canton Art Institute; Chase Manhattan Bank, NYC; Chicago/AI; Cleveland/MA; Continental Grain Company, NYC; Detroit/Institute; Dubuque/AA; Esmark, Chicago; Flint/Institute; Glen Alden Corp., NYC; IBM, Chicago; Illinois College; U. of Iowa; Irving Trust Co.; Los Angeles/County MA; Library of Congress; Miami U.; Minnesota/MA; NCFA; Notre Dame U.; NYPL; Ohio U.; RISD; Scranton/Everhart; Singer Company, Inc., NYC; WMAA; Wittenberg U.; Yale U.

KIPP, LYMAN b. December 24, 1929, Dobbs Ferry, N.Y. **Studied:** Pratt Institute, 1950-54; Cranbrook, 1952-53. Traveled Europe, India, Morocco, Australia. **Taught:** Bennington College, 1960-63; Hunter College, 1963-86; Herbert H. Lehman College, Bronx, N.Y., 1968-75; Dartmouth College, 1969. **Member:** American Association of University Professors; Artists Equity. **Commissions:** Lambert Corp., Dallas; General Services Administration, Federal Office Building and Post Office, Van Nuys, Calif.; Lake Placid, N.Y. **Awards:** Guggenheim Foundation Fellowship, 1965; Fulbright Fellowship, 1965. **Address:** Route 100, Somers, N.Y. 10589. **One-man Exhibitions:** Cranbrook, 1954; Betty Parsons Gallery, 1954, 56, 58, 60, 62, 64, 65, 68; Arizona State College, 1957; Myrtle Todes Gallery, Glencoe, Ill., 1956, 60; Bennington College, 1961; Dartmouth College, 1965; Buffalo/Albright, 1967; Katonah (N.Y.) Art Gallery, 1968; Obelisk Gallery, 1969; A.M. Sachs Gallery, 1970; Chapman Kelley Gallery, Dallas, 1971; Adam Gallery, NYC, 1972; CUNY Graduate Center, 1972; Richard Gray Gallery, 1973; Galerie Denis Rene, NYC (two-man), 1974; Bridge Gallery, White Plains, N.Y., 1975; Greenway Plaza, Houston, 1975; Laguna Gloria Museum, Austin, Texas, 1976; The Art Center, Waco, Texas, 1976; Nielson Memorial Museum, Amarillo, Texas, 1977; U. of Alabama, 1977; Max Hutchinson Gallery, NYC, 1977; Sculpture Now, Inc., NYC, 1978; Construct, Chicago, 1978, 80; William Paterson College (three-man), 1979; Calvin College, Grand Rapids, Mich., 1979; Carolyn Schneebeck Gallery, Cincinnati, 1980; Irving Sculpture

Gallery, Glebe, N.S.W., Australia, 1985; Robert L. Kidd Gallery, Birmingham, Mich., 1985. **Group:** RISD, Four Young Americans, 1955; WMAA Annuals, 1956, 60, 62, 66, 68; Pensacola, Freedom of Inspiration, 1958; Claude Bernard, Paris, 1960; U. of Illinois, 1961; Carnegie, 1961, 62; Chicago/AI, 1961, 62; São Paulo, 1963; Drawing Society, National Exhibition, 1965; Jewish Museum, Primary Structures, 1966; Musée Cantonal des Beaux-Arts, Lausanne, II Salon International de Galeries Pilotes, 1966; Los Angeles/County MA, American Sculpture of the Sixties, 1967; Ridgefield/Aldrich, 1968; MOMA, The Art of the Real, 1968; U. of Nebraska, American Sculpture, 1970; San Diego, Art Is for People, 1973; Grand Rapids, Sculpture off the Pedestal, 1973; Newport, R.I., Monumenta, 1974; Akron/AI, Project: New Urban Monuments, circ., 1977-79. **Collections:** U. of Alaska; Andover/Phillips; Buffalo/Albright; U. of California; Cranbrook; Dartmouth College; Fort Worth; High Museum; Jackson/MMA; U. of Kentucky; MIT; U. of Michigan; U. of Nebraska; New York Bank for Savings; PMA; The Pennsylvania State U.; South Mall, Albany; State College at Salem; Storm King Art Center; WMAA. **Bibliography:** Battcock, ed.; Goossen 1; MacAgy 2; *Monumenta;* Seuphor 3; Tuchman 1.

KIRSCHENBAUM, JULES
b. March 25, 1930, NYC. **Studied:** Brooklyn Museum School, 1948-50. **Awards:** Joe and Emily Lowe Foundation Award, 1950; PAFA, Dana Watercolor Medal, 1952; NAD, Hallgarten Prize, 1953; NAD, Isaac N. Maynard Prize, 1954; NAD, S. J. Wallace Truman Prize, 1955; Fulbright Fellowship (Italy), 1956; PAFA, Hon. Men., 1957; AAAL, Childe Hassam Award, 1957; Youngstown/Butler, First Prize, 1957; NAD, First Prize, Figure Painting, 1960; NAD, Thomas R. Proctor Prize, 1983; NAD, Grumbacher Award and Gold Medal, 1984; NAD, Emil and

Dines Carlsen Award, 1985. **Address:** 2829 Forest Drive, Des Moines, IA 50312. **Dealer:** The Forum Gallery, NYC. **One-man Exhibitions:** The Salpeter Gallery, NYC, 1955, 56; Des Moines, 1964, 84; The Forum Gallery, NYC, 1965, 69, 72, 77, 85. **Group:** MMA, 1952; MOMA; PAFA, 1952, 53, 54, 57; WMAA, 1953-57; Brooklyn Museum; NYU; Chicago/AI, 1957; U. of Illinois, 1957; Youngstown/Butler, 1957; Corcoran; Festival of Two Worlds, Spoleto, 1958; Santa Barbara/MA; Pasadena/AM; Houston/MFA; Dallas/MFA. **Collections:** Des Moines; U. of Nebraska; WMAA; Youngstown/Butler.

KITAJ, R. B. (Ronald Brooks)
b. October 19, 1932, Cleveland, Ohio. Traveled Europe, North Africa. U.S. Army 1955-57. **Studied:** Cleveland/MA, Children's Classes, 1937-42; Cooper Union, 1950, with Sidney Delevante; Akademie der Bildenden Kunste, Vienna, 1951-54, with A. P. von Gutersloh, Fritz Wotruba; U. of Oxford, Ruskin School of Drawing and Fine Art, 1957, 1959, Certificate of Fine Art; Royal College of Art, 1960-62. **Taught:** Camberwell School of Art and Crafts, Ealing Technical College, 1961-63; Slade School of Fine Art, 1963, 64, 66, 67; Dartmouth College, 1978. **Organized:** *The Human Clay,* exhibition for the Hayward Gallery, London, 1976. **Address:** 62 Elm Park Road, London S.W. 3, England. **Dealer:** Marlborough Gallery, Inc., NYC, and Marlborough Fine Art Ltd., London. **One-man Exhibitions:** (first) Marlborough Fine Art Ltd., London, 1963, 70, 77, 80, 85; Marlborough Gallery, Inc., NYC, 1965, 74, 79, 86; Los Angeles/County MA, 1965; Cleveland/MA, 1967; Amsterdam/Stedelijk, 1967; U. of California, Berkeley, 1967; Galerie Mikro, Berlin, 1969; Hannover/K-G, 1970; Graphic Gallery, San Francisco, 1971; Amerika Haus, Berlin, 1973; New 57 Gallery, Edinburgh, 1975; Petersburg Press, NYC, 1975, 76; Mala Galerija, Ljubljana, 1976; Ikon Gallery, Birming-

ham, England, 1977; Dartmouth College, 1978. **Retrospective:** Hirshhorn, circ., 1981. **Group:** Royal College of Art, London, Young Contemporaries, 1961; Eindhoven, Lompass 2, 1962; Beaverbrook Art Gallery, Fredericton, New Brunswick, Canada, Dunn International, 1963; SRGM, Guggenheim International, 1964; Tate Gallery, Painting and Sculpture of a Decade, 1964; XXXII & XXXV Venice Biennials, 1964, 70; Kassel, Documenta III, 1964; Museum des 20. Jahrhunderts, Pop, etc., 1964; Carnegie, International, 1964, 67; Brussels/Beaux-Arts, Pop Art, 1965; WMAA Annuals, 1965, 67; U. of Illinois, 1967; Chicago/Contemporary, Pictures to Be Read/Poetry to Be Seen, 1967; ICA, London, The Obsessive Image, 1968; Musée des Arts Décoratifs, Paris, Peintres européens d'aujourd'hui, 1968; Hayward Gallery, London, Pop Art, 1969; Los Angeles/County MA, Art & Technology, 1971; Hayward Gallery, London, British Painting '74, 1974; Los Angeles/County MA, European Painting in the Seventies, 1975; Hayward Gallery, London, The Human Clay, circ., 1976; Hayward Gallery, London, Hayward Annual, 1977; Royal Academy, London, A New Spirit in Painting, 1981. **Collections:** Berlin/National; Edinburgh/National; MOMA; Rotterdam; Tate Gallery. **Bibliography:** Cummings 4; Gettings 1; Murken-Altrogge.

KLEEMAN, RONALD b. July 24, 1937, Bay City, Michigan. **Studied:** U. of Michigan, BS, in design, 1961. **Address:** c/o Dealer. **Dealer:** Louis K. Meisel Gallery, NYC. **One-man Exhibitions:** French & Co., NYC, 1971, 74; Louis K. Meisel Gallery, NYC, 1974, 76, 79, 83, 92; Reed College, 1976; Indianapolis, 1977; Bay City (Mi.) City Council on the Arts, 1985; **Group:** SFMA, Annual, 1961; Hofstra U., Art Around the Automobile, 1971; Potsdam/SUNY, New Realism 1971; Chicago/Contemporary, Radical Realism, 1971; Indianapolis, Painting and Sculpture Today, 1972, 74; U. of Miami,

Ronald Kleeman, *Volunteer 1*, 1988.

Phases of the New Realism, 1972; Tokyo Metropolitan Museum, Biennial, 1974; Hartford/Wadsworth, New Photo-Realism, 1974; Potsdam/SUNY, New Realism Revisited, 1974; Youngstown/Butler, Midyear Show, 1974; Wichita State U., The New Realism: Rip Off or Reality?, 1975; Auckland, N.Z., Barrington Gallery, Photorealism: American Painting and Prints, circ., 1975; The Gallery, Stratford, Ontario, Aspects of Realism, circ., 1976; U. of Texas, New in the '70s, 1977; Canberra/National, Illusion and Reality, circ., 1977; Flint/Institute, Art and the Automobile, 1976; PAFA, Contemporary American Realism Since 1960, circ., 1981; San Antonio/MA, Real, Really Real, Super Real, circ., 1981; Utica, An Appreciation of Realism, 1982; SFMA, American Realism (Janss), circ., 1985; Nassau County Museum, In Sharp Focus, 1991; New Jersey Center for Visual Arts, Summit, Traffic Jam, 1991. **Collections:** Bonn/S.K.; Chicago/Contemporary; Hirshhorn; Indianapolis; U. of Massachusetts; MOMA; National Air and Space Museum; Rider College; Ridgefield/Aldrich; SRGM; Tampa/AI; Utrecht; U. of Virginia. **Bibliography:** Meisel.

KLINE, FRANZ b. May 23, 1910, Wilkes-Barre, Pa. **d.** May 13, 1962, NYC. **Studied:** Girard College; Boston U., 1931-35; Heatherley School of Fine Art, London, 1937-38. **Taught:** Black Mountain College, 1952; Pratt Institute, 1953;

Philadelphia Museum School, 1954. **Awards:** NAD, S. J. Wallace Truman Prize, 1944; Chicago/AI, 1957; XXX Venice Biennial, 1960. **One-man Exhibitions:** (first) Charles Egan Gallery, 1950, also 1951, 54; Margaret Brown Gallery, Boston, 1952; Institute of Design, Chicago, 1954; Allan Frumkin Gallery, Chicago, 1954; Sidney Janis Gallery, 1956, 58, 60, 61, 63; La Tartaruga, Rome, 1958; Galleria d'Arte del Naviglio, Milan, 1958; Arts Club of Chicago, 1961; Collectors Gallery, NYC, 1961; New Arts Gallery, Atlanta, 1961; Galerie Lawrence, Paris, 1962; Dwan Gallery, 1962 (two-man, with Philip Guston); Kunsthalle, Basel, 1964 (two-man, with Alfred Jensen); Marlborough-Gerson Gallery, Inc., 1967; Marlborough Fine Art Ltd., London, 1972; David McKee Gallery, NYC, 1975; Binghamton/SUNY, 1977; Phillips, 1979. **Retrospectives:** WGMA, 1962; Whitechapel Art Gallery, London, 1964; WMAA, 1968; Cincinnati/AM, circ., 1985. **Group:** NAD, 1942-45; Galerie de France, Paris, 1952; 10th Inter-American Conference, Caracas, 1954; WMAA, The New Decade, 1954-55; MOMA, Twelve Americans, circ., 1956; Tate Gallery, 1956; XXVIII & XXX Venice Biennials, 1956, 60; São Paulo, 1957; MOMA, The New American Painting, circ., Europe, 1958-59; Baltimore/MA, 1960; SRGM, 1961; Hartford/Wadsworth, 1962; WMAA, 1966, 69; U. of St. Thomas (Tex.), 1967; MOMA, The New American Painting and Sculpture, 1969. **Collections:** Baltimore/MA; Buffalo/Albright; Carnegie; Cleveland; Houston/MFA; International Minerals & Chemicals Corp.; Kansas City/Nelson; Kunsthalle, Basel; MMA; MOMA; Norfolk/Chrysler; PMA; Raleigh/NCMA; Rockefeller Institute; SRGM; Tate; Toronto; Utica; WMAA. **Bibliography:** *Abstract Expressionism;* Anfam; Armstrong, Thomas; Ashbery; Ashton 5; Baur 5; Bihalji-Merin; *Black and White Are Colors;* Blesh 1; **Breeskin 1;** Calas, N. and E.; Cummings 5; Danto;

Dawson; Eliot; Elsen 2; *Europa/Amerika;* Flanagan; **Gaugh 2;** Gaunt; Goodrich and Baur 1; **Gordon 1;** Greenberg 1; Haftman; Henning; Hess, T.B., 1; Honisch and Jensen, eds.; Hunter 1, 6; Hunter, ed.; *Individuals;* Janis and Blesh 1; Johnson, Ellen H.; Kuh 2, 3; Langui; Lynton; McCoubrey 1; McCurdy, ed.; Mendelowitz; Murken-Altrogge; Neumeyer; Nordness, ed.; O'Hara 1, 3; Ponente; Pousette-Dart, ed.; Read 2; Rodman 1, 3; Rose, B., 1, 4; Sandler 3, 5; Seuphor 1; Tomkins and Time-Life Books; Tomkins 2; Tuchman, ed.; Waldman 4; Weller. Archives.

KNATHS, KARL **b.** October 21, 1891, Eau Claire, Wis. **d.** March 9, 1971, Provincetown, Mass. **Studied:** Chicago Art Institute School. **Taught:** The Phillips Gallery School; Bennington College. **Member:** Audubon Artists. Federal A.P. (murals): Falmouth (Mass.) High School; US Post Office, Rehoboth Beach, Del.; Provincetown (Mass.) Town Hall. **Awards:** Chicago/AI, Norman Wait Harris Prize, 1928; Boston Tercentenary Art Exhibit, Gold Medal; Carnegie, First Prize, 1946; Carnegie International, Third Hon. Men., 1950; Chicago Art Institute School, Hon. DFA, 1951; elected to NIAL, 1955; Brandeis U., Creative Arts Award, 1961; NAD Annual, Andrew Carnegie Prize, 1962. **One-man Exhibitions:** (first) The Phillips Gallery and The Daniel Gallery, NYC (concurrently); P. Rosenberg and Co., NYC, 1946-69, 1974-75; Bard College, 1982; Phillips, 1982; Syracuse/Everson, 1982. **Retrospective:** Provincetown Art Association, 1974. **Group:** WMAA; Corcoran; Chicago/AI; Carnegie; U. of Illinois; PAFA; MMA. **Collections:** Boston/MFA; Brooklyn Museum; Buffalo/Albright; California Palace; Chicago/AI; Corcoran; Currier; Dayton/AI; Des Moines; Ford Foundation; Hartford/Wadsworth; U. of Illinois; Indianapolis/Herron; Los Angeles/County MA; MMA; MOMA; Mary Washington Col-

lege; U. of Nebraska; PAFA; PMA; Phillips; U. of Rochester; Rockefeller Institute; St. Louis/City; Santa Barbara/MA; Stanford U.; Toledo/MA; Utica; WMAA; Walker; West Palm Beach/Norton; Wilmington; Woodward Foundation; Worcester/AM. **Bibliography:** American Abstract Artists, ed.; Baur 5, 7; Bazin; Bethers; Blanchard; Blesh 1; Cheney; Eliot; Frost; **Goodrich and Baur 1, 2**; Hess, T.B., 1; Janis, S.; Jewell 2; Kootz 2; Leepa; McCurdy, ed.; Mellquist; **Mocsanyi**; Morris; Nordness, ed.; Pearson 1; Phillips 1, 2; Pousette-Dart, ed.; Read 2; Richardson, E.P.; Ringel, ed.; Ritchie 1; Wight 2. Archives.

KNIPSCHILD, ROBERT b. August 17, 1927, Freeport, Ill. **Studied:** U. of Wisconsin, with Alfred Sessler, 1947-50, BA, 1950, MFA, 1951; Cranbrook, with Zoltan Sepeshy. Traveled USA, Canada, Mexico, China, Japan. US Army, 1945-47. **Taught:** Baltimore/MA, 1951-52; American U., 1952; U. of Connecticut, 1954-56; U. of Wisconsin, 1956-60; U. of Iowa, 1960-66; U. of Cincinnati, 1966-. **Address:** 3245 Bishop Street, Cincinnati, OH 45220. **One-man Exhibitions:** Cranbrook, 1951; Baltimore/MA, 1952-53, 55; American U., 1952; The Alan Gallery, NYC, 1953-55, 57, 58, 61; U. of Iowa, 1960; U. of Wisconsin, 1960-65; Lugetkin Gallery, Des Moines, 1962; Sneed-Hillman Gallery, 1962, 64, 67, 68, 75; Skidmore College, 1969; Louisiana State U., 1970; U. of Massachusetts, Madison College, 1972; U. of Cincinnati, 1974; Western Michigan U., 1975; Birmingham Gallery, Inc., Birmingham, Mich., 1975; Miami U., 1976; Findlay College, Ohio, 1976; Virginia Beach Art Center, 1976; Piedmont Gallery, Augusta, 1977, 78, 79; Yares Gallery, Scottsdale, Ariz., 1978; Ohio Wesleyan U., 1978; Western Kentucky U., 1978; Toni Birckhead Gallery, Cincinnati, 1982; Case Western Reserve U., 1982; Gallery K, Washington, D.C., 1984; Idaho State U., 1986. **Retrospec-**

tives: U. of Cincinnati, 1974; Western Michigan U., 1975. **Group:** MMA, American Painting Today, 1950; PAFA Biennial, 1951, 53; WMAA Annual, 1952; Youngstown/Butler Biennial, 1954; Corcoran; Carnegie. **Collections:** AT&T; Baltimore/MA; Brandeis U.; Bell Telephone Co.; Cedar Rapids/AA; Chase Manhattan Bank; U. of Cincinnati; Corcoran; Cranbrook; Davenport/Municipal; Grinnell College; Hirshhorn; Hope College; Illinois Wesleyan U.; Library of Congress; Madison College; U. of Michigan; Milwaukee Journal; U. of Minnesota; Murray State U.; PAFA; Phillips; Skidmore College; Springfield, Ill./State; Stephens College; Tucson Museum of Art; Upjohn Co.; U. of Wisconsin; Wisconsin State U. **Bibliography:** Archives.

KOCH, GERD from 1st to 4th edition.

KOCH, JOHN b. August 18, 1909, Toledo, Ohio. d. April 19, 1978, NYC. Self-taught in art. Traveled France, Great Britain; resided Paris, 1929-33. **Taught:** ASL, 1944-45; Chairman of the School Committee, NAD. **Member:** NAD; Century Association; Lotus Club; Audubon Artists; NIAL. **Awards:** Salon de Printemps, Paris, Hon. Men., 1929; Carnegie, First Hon. Men., 1943; NAD, 1952; NAD, Benjamin Altman Prize, 1959; NAD, 137th Annual, Saltus Gold Medal for Merit; Youngstown/Butler, Dr. John J. McDonough Award, 1962; Lotus Club, 1964. **One-man Exhibitions:** (first) Bonestell Gallery, Detroit, 1927; Curt Valentine Gallery, NYC, 1935; Kraushaar Galleries, NYC, 1939, 41, 43, 46, 49, 51, 54, 58, 61, 65, 69, 72, 80; Kansas City/Nelson, 1940; J. L. Hudson Art Gallery, 1941; Whyte Gallery, Washington, D.C., 1944; Philadelphia Art Alliance, 1945; Portraits, Inc., NYC; Syracuse/Everson, 1951; Cowie Galleries, Los Angeles, 1951; 460 Park Avenue Gallery, NYC, 1951; Colgate U., 1977; The Pennsylvania State U.,

John Koch, *Nude Eating a Peach.*

1977. **Retrospectives:** Suffolk Museum, Stony Brook, N.Y., 1951; Museum of the City of New York, 1963; Pittsfield/Berkshire, 1963; VMFA, 1962; Louisville/Speed, 1971; Akron/AI, 1971; Columbia, S.C./MA, 1978. **Group:** Salon de Printemps, Paris, 1929; Salon des Tuileries, Paris, 1929; NAD, 1939. **Collections:** ASL; Bennington College; Boston/MFA; Brooklyn Museum; California Palace; Canajoharie; Chicago/AI; Des Moines; Detroit/Institute; U. of Georgia; Kansas City/Nelson; Lehigh U.; MMA; MOMA; NAD; Newark Museum; New Britain; Norfolk; Omaha/Joslyn; U. of Rochester; Southampton/Parrish; Springfield, Mass./MFA; Storm King Art Center; Toledo/MA; VMFA; Youngstown/Butler. **Bibliography:** *Celebrate Ohio;* Cummings 4; Eliot; Koch, J.; Soyer, R., 1. Archives.

KOENIG, JOHN FRANKLIN
b. October 24, 1924, Seattle, Wash. **Studied:** U. of California, Berkeley; Washington State College; U. of Washington, 1948, BA (Romance Languages); U. of Biarritz; Sorbonne, MA. US Army, 1943-45. Traveled Europe and the Orient exten-

sively. General Secretary, *Cimaise* (art magazine), Paris, 1953-58. Resided Paris, 1948-79. Was co-director of Galerie Arnaud, Paris. Organized exhibitions: *Northwest Art in Corporate Collections,* Seattle, 1984; *Seattle Style* for Musée de Carcassonne, circ., 1986. **Taught:** School of Applied Arts, Istanbul, 1976. **Commissions:** Hopital St. Antoine, Paris, 1964; Theatre de Poche, Paris, 1949; Pacific Northwest Ballet, 1982. **Awards:** Paris/Moderne, (Third) Prix des Peintres Etrangers, 1959; I Paris Biennial, 1959; Prix des Critiques d'Art de la Presse Parisienne; Officier l'Ordre des Arts et des Lettres, France, 1985; Medaille Vermeil de la Ville de Paris, 1986. **Address:** 400 18th Avenue East, Seattle, WA 98112; 20 rue Cdt. Mouchotte, 75014, Paris, France. **Dealers:** Foster-White Gallery, Seattle; Galerie Erval, Paris. **One-man Exhibitions:** Librairie Selection, Paris, 1948; Galerie Arnaud, 1952 (collages), 1953, 55, 57, 59-61, 63, 66, 68, 72, 74, 75; La Citadella d'Arte Internazionale e d'Avanguardia, Ascona, Switzerland, 1955, 57; Galleria del Cavallino, Venice, 1957; Brussels/Beaux-Arts, 1957; Grange (Gallery), Lyon, 1958; Zoe Dusanne Gallery, Seattle, 1958, 60; Tokyo Gallery, 1960, 62; Seattle/AM, 1960, 61, 70, 71; Gordon Woodside Gallery, Seattle and San Francisco, 1962, 65, 67; The Willard Gallery, 1963, 65; Musée de Verviers, 1963; San Antonio/McNay, 1963; Le Lutrin, Lyon, 1965, 66; Montreal/Contemporain, 1966, 73; Holst Halvorsen Konsthandel, Oslo, 1966, 69; Quebec, 1966; Portland, Ore./AM, 1966; Tacoma, 1967; Musée Vivenel, Compiegne, 1969; Galleria Lorenzelli, Bergamo, 1970; Galerie Gilles Corbeil, Montreal, 1970, 71; Jongeward Gallery, Seattle, 1971; Galleria San Fedele, Milan, 1972; Foster/White Gallery, 1973, 74, 77, 88, 90; American Cultural Center, Istanbul, 1975; i.e. Graphics, Copenhagen, 1975; American Cultural Center, Katmandu, 1975; Galerie Kutter, Annenberg, 1976; Triveni Gallery, New Delhi, 1976; American Cultural Center,

Madras, circ., 1976; American U., Calcutta, 1977; Galerie Influx, Marseilles, 1977; Fuji Television Gallery, Tokyo, 1977; Ochano-mizu Gallery, Tokyo, 1977; The John Pence Gallery, San Francisco, 1978, 81, 88; Galerie Erval, Paris, 1979, 82; École de Poto-Poto, Brazzaville, Congo, 1979; La Petite Galerie, Lyon, 1980; Galerie Jourdain, Montreal, 1981; Paris Art Center, Paris, 1982; Galerie d'Art International, Chicago, 1982; College St. Pierre, Port-au-Prince, Haiti, 1982; Greg Kucera Gallery, Seattle, 1983, 86; Free Atelier Gallery, Kuwait, 1985; Shoshana Wayne Gallery, Los Angeles, 1985; Paris/Moderne, 1986; Grace Gallery, Vancouver, 1986; Galleria Fumagalli, Bergamo, 1986; Paris/Moderne, 1986; Carolyn Staley Fine Prints, Seattle, 1986; Galerie Fabien Boulakia, Paris, 1987; Galerie Erval, Paris, 1987, 90, 92; Galerie Protée, Paris, 1992. **Retrospectives:** Musée Vivenel, Compiegne, 1969; Seattle/AM, 1970; Galerie Arnaud, Paris, 1974; Tacoma, 1980; Reykjavik, 1985; Bellevue/AM, 1988; Paris Art Center, 1989; Abbaye de Bouchemaine, France, circ., 1990; Centre Culturel, St. Herblain, circ., 1992; Museo de la Nación, Lima, circ., 1992. **Group:** International Congress of Museums, Marseilles, 1953; ICA, London, Collages and Objects, 1954; Palais des Beaux-Arts, Brussels, 1954; Amsterdam/Stedelijk, 1956; Palais des Beaux-Arts, Charleroi, Belgium, L'Arte de XXième Siecle, 1958; ICA, Boston, 100 Works on Paper, circ., Europe, 1959; Salon des Realites Nouvelles, Paris, Artistes Americains en France, circ., France, 1960; Tate, École de Paris, 1962; Havana/Nacional; Carnegie, 1964; USA: Nouvelle Peinture, circ., French museums, 1965; Musée de Lyon, USA: Groupe 68, 1968; Musée Municipal, Brest, 21 Peintres Americains, 1968; Salon des Realities Nouvelles, 1973; Menton Biennale de Tapisserie, 1975. **Collections:** Basel; Bellevue/AM; Bibliothèque Nationale; CNAC; Grenoble; Houston/MFA; L'Imperial Palace, Annecy;

MMA; Montreal/Contemporain; Montreal/MFA; Musée de Verviers; NYPL; Nantes; National Museum of Western Art, Tokyo; Osaka/National; Ottawa/National; Paris/Moderne; Reykjavik; St.-Etienne; Salzburg; San Antonio/McNay; Seattle/AM; Seattle Public Library; Tacoma; Tokyo/Modern; Seafirst Mortgage Corporation; Venice/Contemporaneo. **Bibliography:** Ragon 1; Read 4; Restany 1, 2. Archives.

KOHN, GABRIEL b. 1910, Philadelphia, Pa. d. May 21, 1975, Los Angeles, Calif. **Studied:** Cooper Union, 1929; Beaux-Arts Institute of Design, NYC, 1930-34; Zadkine School of Sculpture, Paris, 1946. **Awards:** Augustus Saint-Gaudens Medal from Cooper Union, 1925; Beaux-Arts Institute of Design, NYC, 14 awards in sculpture, 1929-32, and a Silver Medal, 1932; Nicholas Roerich Society, First Prize, 1932; Cranbrook, George A. Booth Scholarship, 1952; ICA, London/Tate, International Unknown Political Prisoner Competition, 1953; Ford Foundation Grant, 1960; Guggenheim Foundation Fellowship, 1967; Mark Rothko Foundation Grant, 1971. **One-man Exhibitions:** Atelier Mannucci, Rome, 1948; Galleria Zodiaco, Rome, 1950; Cranbrook, 1953; Tanager Gallery, NYC, 1958; Leo Castelli Inc., 1959; Otto Gerson Gallery, NYC, 1963; Ringling, 1964; La Jolla, 1963; David Stuart Gallery, 1963-66, 72; The Zabriskie Gallery, NYC, 1972-77; Midtown Galleries, NYC, 1986. **Retrospectives:** Newport Harbor, circ., 1971; Corcoran, 1977. **Group:** Pershing Hall, Paris, American Veterans in Paris, 1948; Paris, Salon de la Jeune Sculpture, 1950; Los Angeles/County MA, 1950; Salon d'Art Libre, Paris, 1951; MMA, National Sculpture Exhibition, 1951; PAFA, 1953; WMAA Annuals, 1953, 60, 62; II Sculpture Biennial, Antwerp, 1953; MOMA, New Talent; MOMA, Recent Sculpture USA, 1959; São Paulo, 1959; Claude

Bernard, Paris, Aspects of American Sculpture, 1960; New School for Social Research, Mechanism and Organism, 1961; Seattle World's Fair, 1962; MOMA, Americans 1963, circ. 1963-64; Ringling, 1964; WMAA, The Third Dimension, 1984. **Collections:** Buffalo/Albright; Cranbrook; Hirshhorn; MOMA; Pasadena/AM; Ringling; WMAA. **Bibliography:** Downes ed.; Goodrich and Baur 1; Hunter, ed.; Phillips, Lisa 2; Read 3; Rose, B., 1; Sandler 1; Seuphor 3; Tuchman 1.

KOHN, MISCH b. March 26, 1916, Kokomo, Ind. **Studied:** John Herron Art Institute, 1939; in Mexico, 1943-44, with Jose Clemente Orozco, Mendez, Diego Rivera. **Taught:** Institute of Design, Chicago; Illinois Institute of Technology, 1949-75; Indiana U.; California State U., Hayward, 1972-80. **Awards:** PAFA, Alice McFadden Eyre Medal, 1949; Seattle/AM, P.P., 1950; Brooklyn Museum, P.P., 1950, 51; The Print Club, Philadelphia, 1950, 51, 55, 56, 58; Chicago/AI, 1951, 52, 58; PAFA, Pennell Memorial Medal, 1952; Guggenheim Foundation Fellowship, 1952, 54; Indianapolis/Herron, 1952, 56; NAD, 1955; Salon du Mai, Paris, 1960; Gallery of Modern Art, Ljubljana, Yugoslavia, IV International Exhibition of Prints, 1961; Tamarind Fellowship, 1961; Ford Foundation Grant. **Address:** 1860 Grove Way, Castro Valley, CA 94546. **One-man Exhibitions:** Philadelphia Art Alliance; Chicago/AI; St. Amands Gallery, Sarasota, Fla., 1969; Weyhe Gallery, 1970; Los Angeles/County MA; Kansas City/Nelson. **Retrospectives:** A.F.A./Ford Foundation, 1961; Brooklyn Museum, 1981. **Group:** PAFA, 1949, 52, 56; Brooklyn Museum, 1949-57; Boston/MFA; Seattle/AM; Chicago/AI, 1949-58; The Print Club, Philadelphia, 1949-58; Salon du Mai, Paris, 1952, 53. **Collections:** Brooklyn Museum; Chicago/AI; Library of Congress; MOMA; NYPL; National Gallery; PMA;

Rio de Janeiro; Stockholm/National. **Bibliography:** Hayter 1; Peterdi.

KONZAL, JOSEPH b. November 5, 1905, Milwaukee, Wis. **Studied:** ASL, with Max Weber, Walt Kuhn, Robert Laurent, 1926-30; Layton School of Art, 1927; Beaux-Arts Institute of Design, NYC, 1928-30. **Taught:** Brooklyn Museum School, 1949-71; Adelphi U., 1954-71; Newark (N.J.) Public School for Fine and Industrial Art, 1960-67; Queens College, 1966-69; Kent State U., 1971-76; Federal A.P.: Supervised Federal Art Project Gallery; architectural sculpture project. **Awards:** Brooklyn Museum Biennial, 2 First Prizes; Guggenheim Foundation Fellowship, 1966. **Address:** 160 East 3rd Street, NYC 10009. **One-man Exhibitions:** (first) Eighth Street Playhouse, NYC, 1938; Contemporary Arts Gallery, NYC, 1950, 52, 55; The Bertha Schaefer Gallery, NYC, 1960, 63, 65, 67, 71; Canton Art Institute, 1974, 75; Andre Zarre Gallery, NYC, 1978, 80; Berman/Daferner Gallery, NYC, 1992. **Retrospectives:** Adelphi U., 1965; Kent State U., 1971. **Group:** Chicago/AI, 1938; MOMA, Subway Art, 1938; New York World's Fair, 1939; Sculptors Guild Annuals, 1941-71; WMAA Annuals, 1948, 61, 62, 64, 66, 68; Riverside Museum, NYC, 14 Sculptors, 1958; MOMA, Recent Sculpture USA, 1959; Newark Museum, 1961, 64; Carnegie International, 1962; WMAA, Geometric Abstraction in America, circ., 1962; New York World's Fair, 1964-65; Federation of Modern Painters and Sculptors Annuals, 1964-71; Cleveland/MA, 1972; Canton Art Institute, 1973; Dayton/AI, 1974. **Collections:** American Sugar Co.; American Can Corp.; Canton Art Institute; Garcia Corp.; Grays Harbor College; Kent State U.; R. H. Macy & Co.; New School for Social Research; San Antonio/McNay; Storm King Art Center; Tate; Trenton/State; Union Carbide Corp.; Vero Beach; WMAA; West Palm Beach/Norton. **Bibliography:** Archives.

KOPMAN, BENJAMIN
from 1st to 4th edition.

KOPPELMAN, CHAIM b. November 17, 1920, Brooklyn, N.Y. **Studied:** Brooklyn College, 1938; Educational Alliance, NYC, 1938; American Artists School, NYC, 1939, with Eugene Morley, Carl Holty; New School for Social Research, with Amedee Ozenfant; Art College of Western England, Bristol, 1944; École Regionale de Beaux-Arts, Reims, 1945; ASL, 1946, with Will Barnet, Jose de Creeft; privately with Amedee Ozenfant, 1946-49 (and served concurrently as his assistant). US Air Force, 1942-45. **Taught:** NYU; Brooklyn College; New Paltz/SUNY; School of Visual Arts, 1959-; Aesthetic Realism Foundation, NYC, 1971-. **Member:** Society for Aesthetic Realism; NAD, Associate, 1979. **Commissions:** International Graphic Arts Society, 1958; A.A.A. Gallery, NYC, 1959, 61, 64. **Awards:** L.C. Tiffany Grant, 1956, 59; PAFA, Hon. Men., 1959; Audubon Artists, Medal for Graphics, 1960; Library of Congress, Pennell P.P., SAGA, List Prize ($1,000), 1967; IBM Gallery of Arts and Sciences, NYC, III International Miniature Print Exhibition, 1968; Brooklyn Museum, Print Biennial, 1968; CAPS, 1976; NAD, Cannon Prize, 1986; The Print Club, 1987; NAD, Fabri Prize, 1989. **Address:** 498 Broome Street, NYC 10012. **Dealer:** Susan Teller Gallery, NYC. **One-man Exhibitions:** (first) Outline Gallery, Pittsburgh, 1943; "67" Gallery, NYC, 1945; The Terrain Gallery, 1956, 69 (two-man, with wife, Dorothy), 74, 83; Philadelphia Art Alliance, 1959; Kornbluth Gallery, Paterson, N.J., 1964; Hinckley and Brohel Galleries, Washington, D.C., 1967; A.A.A. Gallery, NYC, 1973; AFS Gallery, Binghamton, N.Y., 1973; U. of Maine, 1974; Warwick (Eng.) Gallery (two-man), 1975; Yvonne Rapp Matchmaker Arts Space, Louisville, 1985; Merida Rapp Graphics, Louisville, 1985; The Print Club, 1988. **Retrospectives:** A.A.A, NYC, Prints, 1973; The Terrain Gallery, NYC, Drawings, 1974. **Group:** Boston/MFA; Los Angeles/County MA; Chicago/AI; Walker; Baltimore/MA; Detroit/Institute; Brooklyn Museum Print Biennial; WMAA Annuals, 1948, 50, 61, 63; Yale U., 1949, 60; Kassel, Documenta II, 1959; USIA, Contemporary American Prints, circ., Latin America, 1959-60; II Inter-American Paintings and Prints Biennial, Mexico City, 1960; MOMA, Recent Painting USA: The Figure, circ., 1962-63; Graphics: USA, Moscow, 1964; St. Paul Gallery, 1966; Mexico City/Nacional, 1967; IBM Gallery of Arts and Sciences, NYC, 1968, Cranbrook, 6th Biennial, National Religious Art Exhibition, 1968; Western New Mexico U., 1969; Library of Congress Print Annual, 1969; A.F.A., The Indignant Eye, 1971; Purdue U., Print Invitational, 1972; Utah State U. Print Invitational, 1972; 1972, Anchorage, Print Invitational, 74; NAD, Annuals 1978, 79, 80, 1985-92; The Terrain Gallery, NYC, 25th Anniversary Exhibition, 1980; NAD, 1986; Brooklyn Museum, 1989. **Collections:** Anchorage; Boston/MFA; Brooklyn Museum; CSCS, Long Beach; Caracas; Long Beach State College; MMA; MOMA; National Gallery; Otis Art Institute; PMA; Peabody Museum; SRGM; Syracuse U.; US State Department; Victoria and Albert Museum; Walker; Western New Mexico U.; Yale U. **Bibliography:** Archives.

KORTLANDER, WILLIAM CLARK b. February 9, 1925, Grand Rapids, Mich. **Studied:** Michigan State U., BA; State U. of Iowa, MA, Ph.D. US Army, 1943-46. Traveled USA, Western Europe; resided Western Europe, 1967-68. **Taught:** State U. of Iowa, 1950-54; Lawrence U., 1954-56; U. of Texas, 1956-61; Michigan State U., 1960; Ohio U., 1961-. **Awards:** Mead Painting of the Year, 1965; Ohio U., Baker Award, 1967-68. **Address:** 7414 Angel Ridge Road, Athens, OH 45701. **One-man Exhibitions:** (first) A.M. Sachs Gallery, NYC, 1967,

also 1968; The Jewish Center, Columbus, Ohio, 1964; Bryson Gallery, Columbus, 1965; Denison U., 1965; Otterbein College, 1965; Battelle Memorial Institute, Columbus, 1966; George Bennett Gallery, Toledo, Ohio, 1966; Western Electric Co., Columbus, 1966; West Virginia State College, 1966; Zanesville/AI, 1966; Merida Gallery, Inc., 1967; Montana State College, 1969; Gallery 200, Columbus, Ohio, 1974; Springfield Art Center, Ohio, 1974; Northern Ohio U., 1974; Haber/Theodore Gallery, NYC, 1980, 82, 84; Mercersburg Academy, Mercersburg, Pa., 1986; Foster Harmon Galleries, Sarasota, 1987. **Retrospectives:** Springfield Art Center, 1974; Ohio U., 1976; Southeastern Ohio Cultural Arts Center, Athens, Ohio, 1984. **Group:** Dallas Museum for Contemporary Arts, 1959; Witte, 1961; Ball State U., Drawings and Sculpture Annual, 1964-65; PAFA Annual, 1965; Dayton/AI, 1965; Villanova U., 1968; U. of Wisconsin, 1968; U. of North Carolina, 1970; New School for Social Research, American Drawings of the Sixties, 1970; Roanoke Fine Arts Center, Va., 1978; Marietta College, 1980; Northern Ohio U., 1985. **Collections:** Abraham and Straus, Brooklyn; AT&T; Chemical Bank; Chubu Institute, Nagoya; Columbus; Huntington, W. Va.; Mead Corporation; The Ohio Co.; Ohio U.; Oppenheimer Co., NYC; Otterbein College; Premark Corp.; Tupperware Corp.; Wylain Corp., Fort Worth; West Virginia State College; Zanesville/AI.

KOSCIANSKI, LEONARD
b. April 20, 1952, Cleveland, Ohio. **Studied:** U. of Detroit, 1971; U. of Cincinnati, 1972; Skowhegan School, 1976; Cleveland Institute of Art, BFA, 1977; U. of California, Davis, MFA, 1979. **Address:** 1712 Harbor Lane, Annapolis, MD 21405. **Dealer:** Phyllis Kind Gallery, New York and Chicago. **One-man Exhibitions:** George Belcher Gallery, San Francisco, 1979; U. of California, Davis, 1979; New-

Leonard Koscianski, *Fire Eater's*, 1989.

port Harbor, 1984; Karl Bornstein Gallery, Los Angeles, 1981, 83, 85, 87; Greenville, 1988; Brody's Gallery, Washington, D.C., 1989; Arthur Roger Gallery, New Orleans, 1990; Phyllis Kind Gallery, NYC, 1983, 84, 86, 88, 90; Phyllis Kind Gallery, Chicago, 1987, 89, 90; Fendrick Gallery, Washington, D.C., 1991. **Group:** California State Fair, Sacramento, 1979; Cleveland/MA, The May Show, 1980; U. of Tennessee, Faculty Exhibition, 1981; U. of North Carolina, Art on Paper, 1982; MMA, Ten New Narrative Paintings, 1983; Indianapolis, Painting and Sculpture Today, 1984; Greenville, Innocence and Experience, 1985; New Orleans/Contemporary, Landscape, Seascape, Cityscape, circ., 1986; U. of California, San Diego, Not About Nature, 1986; Florida State U., Nocturnes and Nightmares, 1987; RISD, Call of the Wild, 1987; VMFA, Harmony & Discord, 1990; Southern Alleghenies Museum of Art, Loretto, The 1980s: The Post Pop Generation, 1990; Woodson Art Museum, Wausau, WI, Mind & Beast, 1992. **Collections:** AT&T; Chase Manhat-

tan Bank; Chicago/AI; Cleveland/MA; Greenville; MMA; Milwaukee; Montgomery Museum; Newport Harbor; PMA.

KOSUTH, JOSEPH b. January 13, 1945, Toledo, Ohio. **Studied:** Toledo Museum School of Design, with Line Bloom Draper, 1955-62; Cleveland Institute of Art, 1963-64; private study with Roger Barr, Paris, 1964-65; School of Visual Arts, NYC, 1965-67; New School for Social Research, 1971-72. Traveled Europe, South America, Asia, the Orient, Pacific Islands. **Taught:** School of Visual Arts, NYC, 1968. Founded and directed the Museum of Normal Art, NYC, 1967; Hochschule fur Bildende Kunste, Hamburg, 1988-90; Staatliche Akademie der Bildende Kunste, Stuttgart, 1991-. Organized exhibitions, installations, architectural and public projects. **Member:** The Editorial Board of the Art and Language Press. **Award:** Cassandra Foundation Grant, 1968. **Address:** 561 Broadway, NYC 10012. **Dealer:** Leo Castelli Inc., NYC. **One-man Exhibitions:** Museum of Normal Art, NYC, 1967; Gallery 669, Los Angeles, 1968; Bradford Junior College (two-man), 1968; Douglas Gallery, Vancouver, 1969; Instituto Torcuato di Tella, Buenos Aires, 1969; Nova Scotia College of Art and Design, Halifax, 1969; St. Martin's School of Art, London, 1969; Art & Project, Amsterdam, 1969; Coventry (Eng.) College of Art and Design, 1969; Gian Enzo Sperone, Turin, 1969, 70; A 37 90 89, Antwerp, 1969; Pinacotheca, St. Yilda, Virginia, Australia, 1969; Leo Castelli, Inc., NYC, 1969, 71, 72 (2), 1975, 79, 82, 85, 86, 88; Toronto, 1969, 81; Pasadena/AM, 1970; Iysk Kunstgalerie, Copenhagen, 1970; Galerie Daniel Templon, Paris, 1970; Paul Maenz Gallery, Cologne, 1971, 79; Protetch-Rivkin, Washington, D.C., 1971; Centro de Arte y Comunicacion, Buenos Aires, 1971; Lia Rumma Studio d'Arte, Naples, 1971, 75; Carmen Lamanna Gallery, Toronto, 1971, 72, 74, 78, 81; Galeria Toselli, Milan, 1971; Gian Enzo Sperone and Konrad Fischer Gallery, Rome, 1972, 74; Galerie Gunter Sachs, Hamburg, 1973; Paul Maenz Gallery, Brussels, 1973; Kunstmuseum, Lucerne, 1973; Claire S. Copley Gallery, Los Angeles, 1974; Galeria La Bertesca, Düsseldorf, 1974; Galleria Peccolo, Livorno, 1975; Galerie MTL, Brussels, 1975; Durand-Desert Gallery, Paris, 1975; U. of Chicago, 1976; International Cultural Center, Antwerp, 1976; Ghent, 1977; Eindhoven, 1978; Museum of Modern Art, Oxford, 1978; New 57 Gallery, Edinburgh, 1979; Galerie Eric Fabre, Paris, 1979, 82; Rudiger Schottle, Munich, 1979; Galeria Samon, Genoa, 1979, 81; Musée de Charters, 1979; P.S. 1, Long Island City, 1980; Françoise Lambert, Milan, 1981; Stuttgart, 1981; Galerie Mario Diacono, Rome, 1982; Michelle Larchowsky, Antwerp, 1982; France Morin Gallery, Montreal, 1982; Galerie Ghislain Mollet-Vieville, Paris, 1982; Centre d'Art Contemporain, Geneva, 1985; Galleria Lia Rumma, Naples, 1985, 91; Geneva/Contemporain, 1985; Lyon/St. Pierre, 1985; Marcello Silva Gallery, Rome, 1985, 88; Galerie Kubinski, Stuttgart, 1985; Musée des Beaux Arts, La-Chaux-de-Fonds, Switzerland, 1985; Galerie Ascan Crone, Hamburg, 1985, 86; Galerie Nächt St. Stephan, Vienna, 1986; Galerie Anselm Dreher, Berlin, 1986; Kamakura Gallery, Tokyo, 1986, 87; Galeria Thaddaeus Ropac, Salzburg, 1987; Giorgio Persano Gallery, Turin, 1987; Galerie Crousel-Houssenot, Paris, 1987; Galleriea George Bertsch, Barcelona, 1987; Kabinett für Aktuelle Kunst, Bremerhaven, 1988; Museo di Capodimonte, Naples, 1988; International Cultural Center, Antwerp, 1989; Galerie Le Gall Peyroulet, Paris, 1989; Kubinski, Cologne, 1990; Galeria Juana de Aizpuru, Madrid, 1990; Brooklyn Museum, 1990; Galerie Peter Pakesch, Vienna, 1991; Rubin Spangle Gallery, NYC, 1991; Galeria Ruth Benzacar, Buenos Aires, 1991; Galerie Renée Ziegler, Zurich, 1992.

Group: Lannis Gallery, NYC, Non-Anthropomorphic Art, 1967; U. of Rochester, New York Art, 1968; A.F.A., The Square in Painting, 1968; UCLA, Electric Art, 1969; Berne, When Attitudes Become Form, 1969; Amsterdam/Stedelijk, Op Losse Schroeven, 1969; Seattle/AM, 557,087, 1969; Düsseldorf/Kunsthalle, Prospect '69, 1969; Chicago/Contemporary, Art by Telephone, 1969; WMAA Annual, 1969; Turin/Civico, Conceptual Art, Arte Povera, Land Art, 1970; Jewish Museum, Software, 1970; Galerie im Taxispalais, Innsbruck, Concept Art, 1970; MOMA, Information, 1971; SRGM, Guggenheim International, 1971; VII Paris Biennial, 1971; Buenos Aires/Moderno, Art Systems, 1971; Kunsthalle, Nurnberg, Biennial, 1971; Munster/WK, Das Konzept ist die Form, 1972; Kunstmuseum, Lucerne, Joseph Kosuth; Investigationen uber Kunst and 'Problemkreise' seit 1965, 1973; Chicago/AI, Idea and Image in Recent Art, 1974; Kennedy Center, Art Now, '74, 1974; Cologne/Kunstverein, Kunst uber Kunst, 1974; Indianapolis, 1974; Chicago/AI Annual, 1976; Canberra/National, Illusion & Reality, circ., 1977; Berlin/Akademie der Kunst, SoHo, 1976; Museum Bochum, Words, 1979; MOMA, Printed Art: A View of Two Decades, 1980; Amsterdam/Stedelijk, '60-'80: Attitudes/Concepts/Images, 1982; Kassel, Documenta VII, 1982; Hirshhorn, Content, 1984; Geneva/Contemporain, Promenades, 1985; Fort Lauderdale, An American Renaissance, 1985; Queens Museum, The Real Big Picture, 1986; Laumeier Sculpture Garden, St. Louis, Regarding the Success of Failure, circ., 1987; WMAA, Biennial, 1987; Palazzo Ducale, Massa, Italy, Luoghi della Second Avanguardia, 1958/70, 1987; Humlebaek, Blow-Up, circ., 1988; U. of Massachusetts, 16 Cubes, 1988; Bordeaux/Contemporain, Art Conceptuel, 1988; RISD; Aquarian Artists, 1990; Ridgefield/Aldrich, Language in Art, 1990; U. of California, Santa Barbara, Knowledge, Aspects of Conceptual Art, 1992; Kassel, Documenta IX, 1992. **Collections:** Amsterdam/Stedelijk; Canberra/National; Eindhoven; Ghent; MOMA; Melbourne/National; Oberlin College; Ottawa/National; Paris/Beaubourg; SRGM; Tate Gallery; WMAA. **Bibliography:** *Art Now 74;* Celant; Colpitt and Plous; *Contemporanea;* Davis, D.; De Wilde 2; Honisch and Jensen, eds.; Honnef; Kardon 3; Lippard, ed.; Meyer; Robins; Sager; Sandler 3; Seitz 3; Siegel; Waldman 4; *When Attitudes Become Form.*

KRASNER, LEE **b.** October 27, 1908, Brooklyn, N.Y. **d.** June 19, 1984, NYC. **Studied:** Cooper Union; NAD; Hofmann School, 1938. Federal A.P.: Mural Painting. **Commissions:** 2 Broadway Building, NYC (86-ft. mural). Subject of the film *Lee Krasner: The Long View,* made by Barbara Rose. **Awards:** Cooper Union, Saint-Gaudens Medal, 1974; Chevalier de l'Ordre des Arts et des Lettres, France, 1982; Hon. DFA, Stony Brook/SUNY. **m.** Jackson Pollock (1944). **One-man Exhibitions:** (first) Betty Parsons Gallery, NYC, 1950; The Stable Gallery, NYC, 1955; Martha Jackson Gallery, NYC, 1958; The Howard Wise Gallery, NYC, 1961, 62; Arts Council Gallery, London, circ., 1966; U. of Alabama, 1967; Marlborough Gallery, Inc., NYC, 1968, 69, 73; Reese Palley Gallery, San Francisco, 1969; WMAA, 1973; Miami-Dade, 1974; Gibbes Art Gallery, Charleston, S.C., 1974; The Pace Gallery, NYC, 1977, 79, 81; Susanne Hilberry Gallery, Birmingham, Mich., 1977; Janie C. Lee Gallery, Houston, 1978, 81; Tower Gallery, Southampton, 1980; Guild Hall (two-man), 1981; Robert Miller Gallery, 1982, 85, 86, 88, 91; Brooklyn Museum, 1985; Cooper Union, NYC, 1985; Meredith Long Gallery, Houston, 1981, 85, 87; Betsy Rosenfield Gallery, Chicago, 1986; Stony Brook/SUNY, 1988;

Bern/Kunstmuseum, 1989 (two-man). **Retrospectives:** Whitechapel Art Gallery, London, circ., 1965; Corcoran, circ., 1975; Houston/MFA, 1983. **Group:** MacMillin Gallery, NYC, French and American Painting, 1942; Howard Putzell Gallery, Hollywood, 1945; Marlborough Fine Arts Ltd., London, The New, New York Scene, 1961; PAFA, 1962; PMA; MOMA, Hans Hofmann and His Students, circ., 1963-64; SRGM, American Drawings, 1964; Gallery of Modern Art, NYC, 1965; U. of Illinois, 1969; MOMA, The New American Painting and Sculpture; The First Generation, 1969; Finch College, NYC, Projected Art, 1971; WMAA, 1973; PMA/Museum of the Philadelphia Civic Center, Focus, 1974; Cornell U., Abstract Expressionism: The Formative Years, 1978; Buffalo/Albright, American Painting of the 1970's, 1978; MMA, Hans Hofmann as Teacher: Drawings by His Students, 1979; NYU, Tracking the Marvelous, 1981; Carnegie, International, 1982; Houston/Contemporary, The Americans: The Collage, 1982; WMAA, Reflections of Nature, 1984; Brown U., Flying Tigers, 1985; Kenkeleba House, Inc., NYC, 1985; Fort Lauderdale, An American Renaissance, 1986; Venice Biennale, 1986; Los Angeles/MOCA, Individuals, 1986; ICI, NYC, After Matisse, 1986; Buffalo/Albright, Abstract Expressionism, 1987; U. of Massachusetts, Contemporary American Collage, 1960-86, circ., 1986; Southampton/Parrish, Drawings on the East End, 1940-1988; Rutgers U., Abstract Expressionism: Other Dimensions, 1990; Bunkamura Museum, Shibuya, Japan, Four Centuries of Women's Art, circ., 1990; MOMA, Art of the Forties, 1991. **Collections:** U. of Alabama; Buffalo/Albright; Brooklyn Museum; Canberra/National; Dallas/MFA; Flint/Institute; Hartford/Wadsworth; High Museum; Houston/MFA; IBM; Indianapolis; MMA; MOMA; NMAA; NMWA; NYU; PMA; Purchase/SUNY; Reynolda House; SRGM; Sony Corp.;

Tate Gallery; WMAA; Yale U. **Bibliography:** *Abstract Expressionism;* Anfam; Armstrong, Thomas; *Art: A Woman's Sensibility;* Danto; Diamonstein; Hobbs and Levin; Hughes; Hunter 6; Janis and Blesh 1; Janis, S.; Nemser. Archives.

KRIESBERG, IRVING b. March 13, 1919, Chicago, Ill. **Studied:** Chicago Art Institute School, 1941, BFA; Escuela Nacional de Artes Plasticas, Mexico City, 1941-44; NYU, 1972, MA (cinema). Traveled Mexico, India, Japan. **Taught:** Parsons School of Design, NYC, 1955-61; Pratt Institute, 1961-72; Yale U., 1962-69; City U. of New York, 1969-72; SUNY, 1972-76; Columbia U., 1977, 78. **Awards:** Ford Foundation, P.P., 1946; Fulbright Fellowship (India), 1965-66; CAPS (films), 1974; CAPS (Painting), 1974; Guggenheim Foundation Fellowship, 1977; National Endowment for the Arts, 1981. **Address:** 160 Sixth Avenue, NYC 10013. **Dealer:** The Graham Gallery, NYC. **One-man Exhibitions:** Curt Valentine Gallery, NYC; Chicago/AI, 1946; MOMA, 1953; St. Louis/City, 1954; Detroit/Institute, 1954; The Graham Gallery, Delhi, 1966; Yale U., 1967; Terry Dintenfass, Inc., NYC, 1978, 80, 82; Fairweather-Hardin Gallery, Chicago, 1979; Syracuse/Everson, 1980; Brandeis U., 1980; Galerie Elizabeth, Chicago, 1980; Brandeis U., 1981; Fiedler Gallery, Washington, D.C., 1981; Jack Gallery, NYC, 1981, 83; Washington U., 1982; Zenith Gallery, Pittsburgh, 1982; The Graham Gallery, NYC, 1985, 87. **Retrospective:** Jewish Museum, NYC, 1962. **Group:** Chicago/AI, 1946; MOMA, New Talent; MOMA, Fifteen Americans, circ., 1952; Detroit/Institute, 1953; St. Louis/City 1954; Milwaukee, Directions 1: Options, circ., 1968; SRGM, 1972; SRGM, Ten Independents, 1972. **Collections:** Baltimore/MA; Brandeis U.; Chase Manhattan Bank, NYC; Cincinnati/AM; Corcoran; Detroit/Institute; Mead Corporation; MOMA; The Naropa

Institute, Boulder; Santa Barbara/MA; St. Louis/City; WMAA. **Bibliography:** Atkinson.

KROLL, LEON b. December 6, 1894, NYC. d. October 25, 1974, NYC.
Studied: ASL, with John Henry Twachtman; NAD; Academie Julian, Paris, with Jean Paul Laurens. Traveled France, USA. **Taught:** NAD and ASL, 1911-73; Maryland Institute, 1919-21; Chicago Art Institute School, 1924-25; PAFA, 1929-30. **Member:** NAD; AAAL; NIAL. Federal A.P.: Mural Division. **Commissions** (murals): US Justice Department, Washington, D.C., 1936-37; Worcester (Mass.) War Memorial Building, 1938-41; Johns Hopkins U.; US Military Cemetery, Omaha Beach, France. **Awards:** Chicago/AI, The Mr. & Mrs. Frank G. Logan Prize, 1919, 32, 35; NAD, Benjamin Altman Prize, 1923, 32, 35; Chicago/AI, Potter Palmer Gold Medal, 1924; PAFA, Joseph E. Temple Gold Medal, 1927; Carnegie, First Prize, 1936; Chevalier of the Legion of Honor; and more than 20 others. **One-man Exhibitions:** (first) NAD, 1910; Buffalo/Albright, 1929; Toronto, 1930 (three-man); Worcester/AM, 1937; Cleveland/MA, 1945; French & Co. Inc., NYC, 1947; The Milch Gallery, 1947, 59; Danenberg Gallery, 1970; ACA Galleries, NYC, 1992. **Retrospectives:** Fort Lauderdale, 1980; ACA Gallery, 1984. **Group:** The Armory Show, 1913; Chicago/AI; Cleveland/MA; St. Louis/City; U. of Nebraska; WMAA; Detroit/Institute; Baltimore/MA; MMA. **Collections:** Baltimore/MA; Britannica; Carnegie; Chicago/AI; Cleveland/MA; Corcoran; Dayton/AI; Denver/AM; Detroit/Institute; U. of Illinois; Indianapolis/Herron; Los Angeles/County MA; MMA; MOMA; Minneapolis/Institute; Municipal U. of Omaha; U. of Nebraska; PAFA; SFMA; St. Louis/City; San Diego; VMAA; West Palm Beach/Norton; Wilmington. **Bibliography:** Baur 7; Biddle 4; Boswell 1; Brown; Bruce and Watson; Bryant, L.; Cheney; Coke 2; Eliot; Gerdts; Hall; *Index of 20th Century Artists;* Jackman; Jewell 2; Kent, N.; **Kroll 1, 2;** Mather 1; McCurdy, ed.; Mellquist; Narodny; Neuhaus; Pagano, Poore; Watson 1; *Woodstock: An American Art Colony 1902-1977.* Archives.

KRUSHENICK, NICHOLAS
b. May 31, 1929, NYC. **Studied:** ASL, 1948-50; Hofmann School, NYC, 1950-51. US Army, 1947-48. **Taught:** U. of Wisconsin, 1969; Dartmouth College, 1969; Yale U., 1969, 70; Cornell U., 1970; Ball State U., 1971; Herbert H. Lehman College/CUNY, 1972; California State U., Long Beach, 1973; U. of Alabama, 1973; St. Cloud State College, 1973; U. of California, Berkeley, 1973-74; The Ohio State U., 1974; U. of Washington, 1974; U. of Maryland, 1977-91. **Commissions:** Designed production of Haydn's *Man in the Moon,* Guthrie Theater, Minneapolis, 1968. **Awards:** Longview Foundation Grant, 1962; Tamarind Fellowship, 1965; Guggenheim Foundation Fellowship, 1967. **Address:** 319 Newtown Turnpike, Redding, CT 06896. **Dealer:** Daniel Newburg Gallery, NYC. **One-man Exhibitions:** (first) Camino Gallery, NYC, 1956; Brata Gallery, NYC, 1958, 60; The Graham Gallery, 1962, 64; Cinema I and Cinema II, NYC, 1964; Fischbach Gallery, NYC, 1965; WGMA, 1965; Galerie Muller, 1966, 67; Ileana Sonnabend Gallery, Paris, 1967; The Pace Gallery, 1967, 69, 72; Galerie Nächt St. Stephan, Vienna, 1967; Walker, 1968; Galerie der Spiegel, Cologne, 1968; Galerie Rene Ziegler, Zurich, 1969, 70; Dartmouth College, 1969; Harcus-Krakow Gallery, Boston, 1969; U. of Southern Florida, 1970; Galerie Beyeler, 1971; Herbert H. Lehman College/CUNY, 1972; Hannover/KG, 1972; Galerie Denise Rene/Hans Mayer, Düsseldorf, 1973; U. of Alabama, 1973; Jack Glenn Gallery, Corona del Mar, 1973; California State U., Long Beach, 1974; ADI Gallery, San Francisco, 1974; Portland (Ore.)

Nicholas Krushenick, *Color and Design Revisited; Ancient Image*, 1984.

Center for the Visual Arts, 1974; Reed College, 1974; Foster-White Gallery, Seattle, 1975; Bucknell U., 1977; Newport Art Association, 1978; Pyramid Gallery, Washington, D.C., 1978; Hokin Gallery, Chicago, 1978; Elizabeth Weiner Gallery, NYC, 1978; Suzette Schochett Gallery, Newport, R.I., 1977; Carnegie Mellon U., 1981; Gallery K, Washington, D.C., 1981; Ridgefield/Aldrich, 1981; Kaber Gallery, NYC, 1982; Medici/Berenson Gallery, Miami, 1982; River Gallery, Westport, Ct., 1982; 18th Street Gallery, Santa Monica, Calif., 1984; U. of Florida, Pensacola, 1988; Daniel Newburg Gallery, NYC, 1990. **Retrospectives:** Walker, 1968; Stamford Museum, 1992. **Group:** Wagner College, 1958; Galerie Creuze, Paris, 1958; Tokyo/Modern, 1959, 66; The Howard Wise Gallery, Cleveland, 1960; Barnard College, 1962; Lincoln, Mass./De Cordova, 1962; WMAA Annuals, 1963, 65, 67; Los Angeles/County MA, Post Painterly Abstraction, 1964; MOMA, Contemporary Painters and Sculptors as Printmakers, 1964; Corcoran Biennial, 1965; MOMA, American Collages, 1965; SRGM, Systemic Painting, 1966; Amster-

dam/Stedelijk, New Shapes of Color, 1966; Expo '67, Montreal, 1967; Kassel, Documenta IV, 1968; Ars 69, Helsinki, 1969; ICA, U. of Pennsylvania, The Spirit of the Comics, 1969; Humlebaek/Louisiana, Amerikanst Kunst, 1950-1960, 1969; Berhn/National, 1973; WMAA Biennial, 1973; Long Beach/MA, Mixing Masters, 1974; Cleveland/Contemporary, The Turning Point, 1968, circ., 1988; Stadtisches Kunstmuseum, Reutlingen, Konkrete Kunst, 1990. **Collections:** Albany/SUNY; Amsterdam/Stedelijk; Ball State U.; Baruch College; Bibliothèque National, Paris; Buffalo/Albright; Chase Manhattan Bank; Cleveland/Contemporary; Cornell U.; Dallas/MFA; Essen; Fort Lauderdale; Guild Hall; Kalamazoo/Institute; Los Angeles/County MA; MMA; MOMA; NMAA; Norfolk; Norfolk/Chrysler; Ridgefield/Aldrich; VMFA; WGMA; WMAA; Walker. **Bibliography:** Alloway 3; Honisch and Jensen, eds.; Lippard 5; Rose, B., 1. Archives.

KUEHN, GARY b. 1939, Plainfield, N.J. **Studied:** Drew U., BA, Art History, 1962; MFA, 1964. **Taught:** Fairleigh Dickinson College, 1965; Drew U., 1965-68; School of Visual Arts, NYC, 1968; Douglass College, 1973-. **Awards:** National Council on the Arts, Grant, 1967; Trenton/State, N.J. Governor's Purchase Award, 1971; L. C. Tiffany Foundation Grant, 1977; National Endowment for the Arts, grant, 1977; DAAD fellowship, Berlin, 1979; Francis J. Greenburger Award, 1989. **Address:** 133 West 24th Street, NYC 10011. **Dealer:** Douglas Drake Gallery, New York. **One-man Exhibitions:** Douglass College, 1965; Bianchini Gallery, NYC, 1965, 66; Galerie Rolf Ricke, Kassel, 1966, 68, 69, 72, 77, 79; Galerie Christian Stein, Turin, 1968; Milwaukee, 1968; Fischbach Gallery, NYC, 1971; Aachen/NG, 1971; Paley and Lowe, NYC, 1972; Stefanotti Gallery, NYC, 1974; Galerie Fabian Carlsson, Goteburg, 1974; Douglas Drake Gallery, Kansas City, 1974, 76, 80; Galerie Arnesen,

Copenhagen, 1975; Landau Gallery, Los Angeles, 1976; Marion Locks Gallery, Philadelphia, 1976, 83; 112 Greene Street, NYC, 1976; Galerie Nothelfer, Berlin, 1977; Eugenie Cuchalon Gallery, NYC, 1977, 78; Drew U., 1978; P.S. 1, Long Island City, 1978; Galerie Zellermayer, Berlin, 1979; Stuttgart/Kunstverein, 1980; Amerika Haus, Berlin, 1981; Sergio Tosli Gallery, NYC, 1981, 82; Art Galaxy, NYC, 1985; Galerie Rudolf Zwirner, Cologne, 1986; Galerie Jule Kewenig, Frechen-Bachem, Germany, 1986, 88; Margaret Roeder Gallery, NYC, 1986, 90; Rudolf Zwirner Gallery, NYC, 1986; Douglas Drake Gallery, NYC, 1987, 89, 91; Galerie Sylvia Menzel, Berlin, 1987. **Group:** WMAA, Annual, 1966; Indianapolis/Herron, Painting and Sculpture Today, 1967; Los Angeles/County MA, American Sculpture of the Sixties, circ., 1967; WMAA, Annual, 1968; Berne, When Attitudes Become Form, circ., 1969; Schloss Morsbroech, Leverkusen, 4 X Minimal Art, 1974; Ridgefield/Aldrich, A Change of View, 1975; Kassel, Documenta VI, 1977; DAAD Galerie, Berlin, 1978; Vienna/Moderner, Kunst Letzen 20 Jahre, 1979; U. of Massachusetts, Amherst, Sixteen Cubes, 1988. **Collections:** Aachen/NG; Amsterdam/Stedelijk; Martin-Gropius-Bau, Berlin; Bonn/S.K.; Brussels/Moderne; Denver/AM; Duisberg; Graphische Sammlung Albertina; Hanover; Indianapolis/Herron; Krefeld/Kaiser Wilhelm; Rijksmuseum Kröller-Müller; Leverkusen; Milwaukee; Quito/Modern; MOMA; Vienna/Moderner; Trenton/State; Newark Museum; Stuttgart; Wuppertal/von der Heyt; Hartford/Wadsworth; U. of North Carolina; WMAA.

KUHN, WALT b. October 27, 1877, Brooklyn, N.Y. **d.** July 13, 1949, NYC. **Studied:** Academie Colarossi, Paris, 1901; Academy of Fine Arts, Munich, 1901, with H. von Zugel; Artists Sketch Class, NYC, 1905. **Taught:** New York School of Art, 1908-09. Executive Secretary, Association of American Painters and Sculptors, sponsor of The Armory Show, NYC, 1913. Founder of the Penguin Club, 1917-19. Designed sets and directed many revue skits for Broadway in the 1920s. **One-man Exhibitions:** (first) Madison Gallery, NYC, 1910, also 1911; Montross Gallery, NYC, 1914, 15, 22, 24, 25; DeZayas Gallery, NYC, 1920; Grand Central, NYC, 1927; M. Knoedler & Co., 1928; The Downtown Gallery, NYC, 1928; Marie Harriman Gallery, NYC, 1930-42; Durand-Ruel Gallery, NYC, 1944, 45, 46, 48; Colorado Springs/FA, 1947, 64; Maynard Walker Gallery, NYC, 1954, 57, 62, 66; Amon Carter Museum, 1964; Kennedy Galleries, NYC, 1967, 68, 72, 77, 80; Salander-O'Reilly Galleries, NYC, 1985; Youngstown/Butler, 1987; WMAA, 1988; Nevada State Museum, Las Vegas, circ., 1988; U. of Maine, Orono, 1989; Midtown Galleries, NYC, 1989; Midtown-Payson Galleries, NYC, 1991; Museum of Ogunquit, 1992. **Retrospectives:** Phillips, 1944 (two-man); A.F.A., circ., 1951; Albany/Institute, 1958; Cincinnati/AM, 1960; Fort Worth, 1964; U. of Arizona, 1966. **Group:** WMAA; Chicago/AI; Detroit/Institute; Cincinnati/AM; MOMA; Phillips, Men of the Rebellion, 1990. **Collections:** Buffalo/Albright; Cincinnati/AM; Colorado Springs/FA; Columbus; Currier; Denver/AM; Des Moines; Detroit/Institute; New York Cultural Center; Indianapolis/Herron; Kansas City/Nelson; MMA; MOMA; U. of Nebraska; Ogunquit; Phillips; WMAA; Wellesley College; Wichita/AM. **Bibliography:** Adams 1, 2; Armstrong, Thomas; Baur 7; Bazin; Biddle 4; **Bird;** Blesh 1; Brown 1, 2; Bulliet 1; Cahill and Barr, eds.; Cheney; Eliot; Flanagan; Genauer; Gerdts; Goodrich and Baur 1; Hunter 6; *Index of 20th Century Artists;* Janis, S.; Jewell 2; Kootz 1; **Kuhn 1, 2;** Marter, Tarbell, and Wechsler; McCurdy, ed.; Mellquist; Mendelowitz; Newmeyer; Pagano; Phillips 2; Poore; Richardson, E. P.; Ringel, ed.; Rose, B., 1; Smith, S.C.K.; Wight 2. Archives.

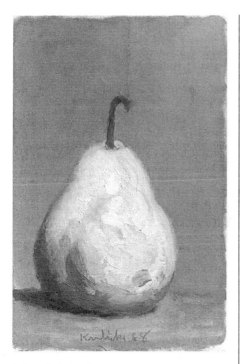

Robert Kulicke, *Pear*, 1968.

KULICKE, ROBERT **b.** March 9, 1924, Philadelphia, Pa. **Studied:** Temple U., Philadelphia Museum School, Atelier Fernand Leger, 1946-50. **Taught:** U. of California, 1964, 1970; Kulicke Cloisonne Workshop, NYC, 1964-; Jewelry Arts Institute, 1987-. **Member:** NAD, 1988. **Awards:** American Institute of Interior Designers, International Design Award, 1968. **Address:** 320 W. 90th St., NYC 10024. **Dealer:** Davis & Langdale Co., Inc., NYC. **One-man Exhibitions:** Parma Gallery, NYC, 1960; Allan Stone Gallery, 1962, 63; Multiples, 1966; The Kornblee Gallery, NYC, 1968, 69, 72; Benson Gallery, 1968, 69; Davis & Long Co., Inc., NYC, 1977, 78, 79, 80, 81, 82, 83, 84, 85, 86; Columbia, S.C./MA, 1983; John Stoller & Co., Minneapolis, 1985; Davis & Langdale, Co., NYC, 1986, 88, 89, 90, 91, 92; Locks Gallery, Philadelphia, 1992; Campbell-Thiebaud Gallery, San Francisco, 1991; John F. Warren, Phildelphia,

1988. **Retrospective:** The Pennsylvania State U., 1978. **Group:** WGMA, 1964; Silvermine Guild, 1964; Chicago/AI, Dayton/AI; A.F.A., 100 Years of American Realism, 1965; WMAA, 1969. **Collections:** PMA. **Bibliography:** Archives.

KUNIYOSHI, YASUO **b.** September 1, 1893, Okayama, Japan. **d.** May 14, 1953, NYC. To USA, 1906. **Studied:** Los Angeles School of Art, three years; NAD; Robert Henri School, 1910; Independent School of Art, 1914-16, with Homer Boss; ASL, 1916-20, with Kenneth Hayes Miller. Traveled Europe, Japan, USA. **Taught:** ASL, 1933-53; New School for Social Research, 1936-53; Brooklyn Museum School. **Member:** Salons of America, 1922-38 (director); Hamilton Easter Field Foundation; American Artists Congress; An American Place (president, 1939-44); Artists Equity (president, 1947-50, Hon. president until his death). Federal A.P.: Graphics Division, two years, ca. 1936. **Commissions:** Radio City Music Hall, NYC (mural). **Awards:** Carnegie, Hon. Men., 1931, Second Prize, 1939, and First Prize, 1944; Los Angeles/County MA, Second Prize, 1934; PAFA, Joseph E. Temple Gold Medal, 1934; Guggenheim Foundation Fellowship, 1935; Golden Gate International Exposition, San Francisco, 1939, First Prize; PAFA, J. Henry Schiedt Memorial Prize, 1944; VMFA, P.P., 1944; Chicago/AI, Norman Wait Harris Bronze Medal and Prize, 1945; La Tausca Competition, Fifth Award, 1947, 48; *Look* magazine poll of "Ten Best Painters," February, 1948; MMA, Second Prize, 1950. **One-man Exhibitions:** The Daniel Gallery, NYC, 1922, also 1928, 30; Tokyo/Modern and Osaka/Municipal, 1931-32; The Downtown Gallery, 1933, 36, 39, 40, 41, 45, 48, 50, 52, 55, 61, 65; ASL, 1936; Baltimore/MA, 1939; Boston Museum School, 1950; Woodstock (N.Y.) Art Gallery, 1956; FAR Gallery, 1970; Paul Gallery, 1971; U. of Texas, 1975; Salander-O'Reilly Galleries, NYC, 1981,

82; WMAA (Philip Morris), circ., 1986; The Zabriskie Gallery, NYC, 1986. **Retrospectives:** The Downtown Gallery, benefit for United China Relief, 1942; WMAA, 1948; Tokyo/Modern, 1954; Boston U., 1961; U. of Florida, 1969. **Group:** Society of Independent Artists, NYC; Penguin Club, NYC, 1917; MOMA, Paintings by 19 Living Americans, 1929; MOMA, Twentieth Century Portraits, 1942; U. of Chicago, 1948; Portland, Me./MA, 1949; XXVI Venice Biennial, 1952; U. of Illinois; U. of Nebraska. **Collections:** AAIAL; Agricultural and Mechanical College of Texas; Andover/Phillips; Arizona State College; U. of Arizona; Atlanta/AA; Auburn U.; Baltimore/MA; Britannica; Brooklyn Museum; Buffalo/Albright; Carnegie; Chicago/AI; Cincinnati/AM; Clearwater/Gulf Coast; Cleveland/MA; Columbus; Cranbrook; Dallas/MFA; Des Moines; Detroit/Institute; Hamilton Easter Field Foundation; Fort Worth; U. of Georgia; Hartford/Wadsworth; Honolulu Academy; Houston/MFA; U. of Illinois; Indiana U.; Indianapolis/Herron; Kalamazoo/Institute; Kansas City/Nelson; Library of Congress; MMA; MOMA; U. of Michigan; Milwaukee; U. of Nebraska; Newark Museum; New London; Ogunquit; PMA; Phillips; Portland, Ore./AM; Santa Barbara/MA; São Paulo; Tel Aviv; Tokyo/Modern; Utica; VMFA; WMAA; Walker; Washington U.; West Palm Beach/Norton; Wichita/AM; Wilmington; Youngstown/Butler. **Bibliography:** American Artists Congress, Inc.; American Artists Group, Inc., 3; Armstrong, Thomas; Barker 1; Baur 7; Bazin; Bethers; Biddle 4; Blesh 1; Boswell 1; Brown 2; Cahill and Barr, eds.; Cheney; Coke 2; Cummings 4, 5; Eliot; *From Foreign Shores;* Genauer; Goodrich 8; Goodrich and Baur 1; Goodrich and Imgizumi; Haftman; Hall; Halpert; Hunter, ed.; *Index of 20th Century Artists;* Jewel 2; Kootz 1, 2; **Kuniyoshi;** McCurdy, ed.; Mellquist; Newmeyer; Pagano; Pearson 1, 2; Poore; Pousette-Dart, ed.;

Reese; Richardson, E.P.; Ringel, ed.; Rose, B., 1; Ward; Wheeler; Wight 2; *Woodstock: An American Art Colony 1902-1977;* Zaidenberg, ed.; Zigrosser 1. Archives.

KUNTZ, ROGER **b.** January 4, 1926, San Antonio, Tex. **d.** August, 1975, Laguna Beach, Calif. **Studied:** Pomona College, 1943-44, 1946-48, BA; Claremont Graduate School, 1948-50, MFA; in France and Italy, 1950. **Awards:** Arizona State Fair, Second Prize, 1949, and First Prize, 1950; NAD Annual, Andrew Carnegie Prize, 1952; Denver/AM, P.P., 1952, 53; Los Angeles/County MA, P.P., 1953, 55, and First Prize, 1954; U. of Illinois, P.P., 1955; Jose Drudis Foundation, P.P., ($400), 1956; Guggenheim Foundation Fellowship, 1956; Los Angeles Art Festival, 1959; Chaffey College, First Award, 1960. **One-man Exhibitions:** Scripps College, 1950, 54; San Diego, 1951; Felix Landau Gallery, Los Angeles, 1952, 54, 56, 58, 62, 64; Pasadena/AM, 1953, 63; Urban Gallery, NYC, 1955; Barone Gallery, NYC, 1957; Gump's Gallery, 1957; Sierra Madre (Calif.) Public Library, 1958; San Bernardino Valley College, 1959; Whittier (Calif.) Art Association, 1960; Mount San Antonio College, 1961. **Group:** Los Angeles/County MA, California Centennial Art Exhibition, 1949, Annuals, 1951, 53, 57; NAD, 1952, 53; Denver/AM, 1952, 53, 54, 55; PAFA, 1952, 55; Corcoran, 1953; Carnegie, 1955, 64; São Paulo, 1955; U. of Illinois, 1955, 57; Santa Barbara/MA, I West Coast Biennial, 1958; Long Beach/MA, Arts of Southern California II, 1958; Oakland/AM, Pop Art USA, 1963. **Collections:** Denver/AM; U. of Illinois; Los Angeles/County MA; NAD; Pasadena/AM; Scripps College.

KUPFERMAN, LAURENCE from 1st to 4th edition.

KUSHNER, ROBERT **b.** August 19, 1949, Pasadena, Calif. **Studied:** U. of California, San Diego, BA. Traveled Iran, Afghanistan, Europe, India. Also active as an

actor. **Commissions:** Exxon Building, Houston. Designed sets and costumes for theatrical and dance groups. **Awards:** National Endowment for the Arts, 1977, 79. **Address:** 17 East 16th Street, NYC 10003. **Dealer:** Midtown-Payson Galleries, NYC. **One-man Exhibitions:** (first) Holly Solomon Gallery, NYC, 1975, 77, 79 (2), 81, 82, 83, 85, 87, 89, 90, 91; U. of Kentucky, 1975; Thorpe Intermedia Gallery, Sparkill, N.Y., 1977; Philadelphia College of Art, 1977; Lunn Gallery, Washington, D.C., 1978; F. H. Mayor Gallery, London, 1979, 80, 81, 85; Daniel Templon, Paris, 1979; Dart Gallery, Chicago, 1980, 83; Akira Ikeda Gallery, Nagoya, Japan, 1981; Asher/Faure, Los Angeles, 1981; Galerie Bischofberger, Zurich, 1981; American Graffiti Gallery, Amsterdam, 1982; Castelli-Goodman-Solomon, East Hampton, 1982; U. of Colorado, 1982; U. of Southern California, Los Angeles, 1982; Studio Marconi, Milan, 1982; Gallerie Rudolf Zwirner, Cologne, 1982, 86; Brentwood Gallery, St. Louis, 1984; Brooklyn Museum, 1984; Galleria Guilia, Rome, 1984; McIntosh/Drysdale Gallery, Houston, 1984; WMAA, 1984; Capricorno Gallerie, Venice, 1985; Crown Point Press, NYC, 1985, 90; Rugg Road Gallery, Boston, 1986; Fay Gold Gallery, Atlanta, 1987; ICA, U. of Pennsylvania, 1987; Ianneti-Lanzone Gallery, San Francisco, 1988; Michael Lord Gallery, Milwaukee, 1988, 90; D. & J. Bittker Gallery, Birmingham, Mich., 1988; Louisville/Speed, 1988; Aspen Art Museum, 1989; Stony Brook/SUNY, 1989; Gloria Luria Gallery, Bay Harbor Islands, 1990; Gallery Basque, Fukuoka, circ., 1990; The American Craft Museum, 1991-92; First Gallery, Moscow, 1991; Timothy Brown Fine Arts, Aspen, 1992; Kunsthallen Brandts Klaedefabrik, Odense, Denmark, 1992; Yoshiaki Inoue Gallery, Osaka, 1992. **Retrospective:** ICA, U. of Pennsylvania, 1987. **Group:** U. of California, San Diego, Costumes for Moving Bodies, 1971; Museum of Contemporary Crafts, NYC, Vegetables and Flowers Weeks, 1973; WMAA Biennials, 1975, 81, 85; American Foundation for the Arts, Miami, Patterning and Decoration, 1977; U. of North Carolina, Art on Paper, 1977; P.S. 1, Long Island City, N.Y., Projects of the 70's, 1977; Cincinnati/Contemporary, Arabesque, 1978; Rice U., Pattern and Decoration, 1978; Brussels/Beaux-Arts, Patterning Painting, 1978; Dayton/AI, Patterns +, 1979; Buffalo/Albright, Patterns, 1979; Aspen Center for the Visual Arts, American Portraits of the 60's and 70's, 1979; ICA, U. of Pennsylvania, The Decorative Impulse, 1979; Mannheim, Dekor, 1980; Aachen/NG, Les nouveaux fauves-Die neuen Wilden, 1980; XXXIX & XLI Venice Biennials, 1980, 84; Hannover/KG, New York Now, circ., 1982; Houston/Contemporary, The Americans: The Collage, 1982; Sydney/AG, 4th Biennial, 1982; WMAA, Focus on the Figure, 1982; Bonn, Back to the USA, circ., 1983; Bard College, The Decorative Image, 1983; Lucerne, Back to the USA, 1983; C. W. Post College, Artists in the Theatre, 1984; MOMA, An International Survey of Recent Painting and Sculpture, 1984; U. of North Carolina, Art on Paper, 1984, 86; WMAA, Biennial, 1985; ICI, NYC, After Matisse, 1986; Groninger, Americana, 1987; Canberra/National, The Artist and the Printer, 1987; Milwaukee, The World of Art Today, 1988; Bard College, The Figure Speaks, 1988; Kuznetsky Most Exhibition Hall, Moscow, Painting Beyond the Death of Painting, circ., 1989; Nice/Contemporain, Les Années 80, 1991. **Collections:** Baltimore/MA; Brooklyn Museum; Buffalo/Albright; Canberra/National; Cologne/Ludwig; Denver/AM; Honolulu Academy; Kansas City/Nelson; Library of Congress; Los Angeles/County MA; Louisville/Speed; MMA; MOMA; Milwaukee; Minneapolis/Institute; Oakland Museum; PMA; SFMA; Tate; WMAA. **Bibliography:** *Back to the USA; Drawings: The Pluralist Decade;* Haenlein; Hiromoto; Honnef 2; Lucie-Smith; Murken-Altrogge; Robins.

L

LABAUDT, LUCIEN
from 1st to 5th edition.

LACHAISE, GASTON b. March
19, 1882, Paris, France. d. October, 1935, NYC. **Studied:** École Bernard Palissy, Paris, 1895; Academie des Beaux-Arts, Paris, 1898-1904, with G. J. Thomas. Worked for Rene Lalique. To USA, 1906. Worked for H. H. Kitson in Boston, 1906-12. **Commissions:** Electricity Building, A Century of Progress, Chicago, 1933-34; Rockefeller Center, NYC; Fairmount Park, Philadelphia. **One-man Exhibitions:** (first) Bourgeois Gallery, NYC, 1918, also 1920; Stieglitz's Intimate Gallery, NYC, 1927; Joseph Brummer Gallery, NYC, 1928; Philadelphia Art Alliance, 1932; WMAA, 1937, 80; Brooklyn Museum, 1938; M. Knoedler & Co., NYC, 1947; Weyhe Gallery, NYC, 1956; Margaret Brown Gallery, Boston, 1957; MOMA, circ. only, 1962; Robert Schoelkopf Gallery, NYC, 1964, 66, 69, 73, 82; Felix Landau Gallery, Los Angeles, 1965; Cornell U., 1974; UCLA, 1975; The Zabriskie Gallery, NYC, 1975; U. of Rochester, 1979; Palm Springs Desert Museum, 1982; Meredith Long Gallery, Houston, 1992. **Retrospective:** MOMA, 1935; Los Angeles/County MA, 1963; SFMA, 1967. **Group:** MOMA; WMAA; Phillips; Hartford/Wadsworth; Harvard U., Three American Sculptors and the Female Nude, 1980. **Collections:** Andover/Phillips; Ari-

zona State College; Cincinnati/AM; Cleveland/MA; Hartford/Wadsworth; Harvard U.; Los Angeles/County MA; MMA; MOMA; Museum of the City of New York; New London; PMA; Phillips; U. of Rochester; Santa Barbara/MA; Smith College; U. of Texas; WMAA. **Bibliography:** *Avant-Garde Painting and Sculpture in America 1910-25;* Baur 7; Biddle 4; Blesh 1; Brumme; Cahill and Barr, eds.; Cheney; Elsen 2; Fierens; *From Foreign Shores;* **Gallatin 4;** Goodrich and Baur 1; Hunter 6; **Kramer 4;** Lee and Burchwood; Marter, Tarbell, and Wechsler; McCurdy, ed.; **Nordland 1, 2;** Parkes; Ringel, ed.; Ritchie 3; Rose, B., 1, 4; Schwartz 3; Selz, Jr.; Seuphor 3; Seymour; Sutton; Archives.

LADERMAN, GABRIEL b. October 26, 1929, Brooklyn, N.Y. **Studied:** Hans Hofmann School, 1949; privately with Willem de Kooning, 1949-50; Brooklyn College, 1948-52, BA; Atelier 17, Paris, 1949-50, 1952-53; Cornell U., 1955-57, MFA; Academy of Fine Arts, Florence, Italy, 1962-63. **Taught:** Cornell U., 1955-57; New Paltz/SUNY, 1957-59; Art Center of Northern New Jersey, 1960-64; Brooklyn College, 1961-62, 1967-68; Queens College, 1965-66, 1968-75; Pratt Institute, 1959-68, 1968-75; Yale U., 1968-69, 1983-84; Louisiana State U., 1966-67. **Awards:** L. C. Tiffany Award, 1969; Yaddo Fellowship, 1960, 61, 65; Fulbright Fellowship, 1962-63; Ingram Merrill Foundation Grant, 1975; National Endowment for the Arts, grant, 1981, 82, 86. **Address:** 760 West End Avenue, NYC 10025. **One-man Exhibitions:** Cornell U., 1957; New Paltz/SUNY, 1958; Woodstock (N.Y.) Artists' Association, 1958, 59; Three Arts Gallery, 1959; Montclair State College (three-man), 1961; Pratt Institute, 1961; Robert Schoelkopf Gallery, NYC, 1964, 67, 69, 72, 74, 75, 76, 77, 86, 90; Felix Landau Gallery (four-man), 1965; Louisiana State U., 1966; Gallery 331, New Orleans, 1967; Hobart and William Smith College, 1970; U. of Rhode Island,

1970; Tyler School of Art, Philadelphia, 1971; Harwood Gallery, Springfield, Mo., 1972; Tanglewood, Mass., 1973; IIE, 1978; Jessica Darraby Gallery, Los Angeles, 1987. **Group:** Laurel Gallery, NYC, 1949; Brooklyn College, 1951, 57, 58, 60; Library of Congress, 1955, 56, 57; Philadelphia Print Club, 1955, 56, 58; Tanager Gallery, NYC, 1957, 62; Utica, 1957; SAGA, 1960; Cornell U., Arts Festival, 1961; Boston U., Nine Realists, 1964; Columbia U., The Natural Vision, 1965; U. of North Carolina, 1966, 67; Tulsa/Philbrook, The American Sense of Reality, 1969; Milwaukee, Aspects of a New Realism, 1969; Indiana U., Six Figurative Artists, 1969; New Paltz/SUNY, 20 Representational Artists, 1969; WMAA, 22 Realists, 1970; Trenton/State, Four Views, 1970; Lincoln, Mass./De Cordova, Landscape, 1971; A.F.A., Realist Revival, 1972; Boston U., The American Landscape, 1972; AAAL, 1972; Arts Club of Chicago, American Landscape, 1973; The Pennsylvania State U., Contemporary Artists and the Figure, 1974; Boston/MFA, Trends in Contemporary Realist Painting, 1974; Museum of Fine Arts, St. Petersburg, Fla., The Figure as Form: American Painting 1930-1975, 1975; NAD, 1977; PAFA, Contemporary American Realism Since 1960, circ., 1981; Houston/Contemporary, American Still Life, 1945-1983, 1983; Florida International U., American Art Today: Still Life, Annual President's Choice Exhibition, 1985. **Collections:** Chase Manhattan Bank; Cornell U.; Fidelity Bank, Philadelphia; Montclair State College; New Paltz/SUNY; Uris-Hilton Hotels. **Bibliography:** *America 1976;* Sager; Ward.

LA MANTIA, PAUL b. January 20, 1938, Chicago. **Studied:** Chicago Art Institute School, 1968, BFA, MFA. Worked as advertising designer in Chicago, 1960-64. **Taught:** Chicago Public Schools, 1966-. **Address:** 315 West Concord Place, Chicago, IL 60614. **Dealer:** Zaks Gallery,

Chicago. **One-man Exhibitions:** Milwaukee, 1968; Illinois Arts Council Gallery, Chicago, 1970; Deson-Zaks Gallery, Chicago, 1974; Douglas Kenyon Gallery, Chicago, 1975; U. of Illinois, 1977; Zaks Gallery, 1977, 81. **Retrospective:** Hyde Park Art Center, Chicago, 1982. **Group:** Momentum, Chicago, 1962; Chicago/AI, Chicago and Vicinity, 1962, 64, 71, 78, 84; Chicago/Contemporary, Violence in Recent American Art, 1968; AAAL, 1975; Moore College, North, East, West, South, and Middle, circ., 1975; Chicago Art Institute School, Visions, 1976; Sacramento/Crocker, The Chicago Connection, 1976; NCFA, Chicago Currents, circ., 1979; Madison Art Center, Chicago: Some Other Traditions, circ., 1983; Hyde Park Art Center, Chicago, Then and Now, 1985. **Collections:** AT&T; Chicago/AI; U. of Chicago; Madison Art Center; NCFA. **Bibliography:** Adrian.

LAMIS, LEROY b. September 27, 1925, Eddyville, Iowa. **Studied:** New Mexico Highlands U., BA, 1953; Columbia U., MA, 1956. Traveled Europe, Canada, Mexico, England. Since 1982, working with computer programming for art. **Taught:** Cornell College, 1956-60; Indiana State U. (Terre Haute), 1961-; Dartmouth College, Artist-in-Residence, 1970. **Member:** American Abstract Artists. **Commissions:** New York State Council on the Arts, 1970. **Award:** New York State Council on the Arts, 1970. Ceased producing plastic sculpture in 1978. Founded PC ART, 1983, dedicated to learning and teaching computer graphics. **Address:** 3101 Oak Street, Terre Haute, IN 47803. **One-man Exhibitions:** (first) Staempfli Gallery, NYC, 1966, also 1969; Gilman Galleries, Chicago, 1967; Fort Wayne/AM, 1968; Louisville/Speed, 1969; Indianapolis/Herron, 1969; Des Moines, 1969; La Jolla, 1969; Dartmouth College; Indiana State U., 1976; Sheldon Swope Art Gallery, Terre Haute, Ind., 1979. **Group:** Buffalo/Albright, Mixed Media

and Pop Art, 1963, Art Today, 1965; WMAA Sculpture Annual, 1964, 66, 68; MOMA, The Responsive Eye, 1965; Ridgefield/Aldrich, 1965-66; Riverside Museum, 1965-67; U. of Illinois, 1965-69; Flint/Institute, I Flint Invitational, 1966; Des Moines, Born in Iowa—The Homecoming, 1986; Bronx Museum, American Abstract Artists, 50th Anniversary, 1986; Indianapolis, Four Computer Sculptors, 1992. **Collections:** Brooklyn Museum; Buffalo/Albright; Des Moines; Evansville; Hirshhorn; Indianapolis; Louisville/Speed; Lytton Savings and Loan Association; Ridgefield/Aldrich; Terre Haute/Swope; Trenton/State; WMAA; Walker.

LANDAU, JACOB b. December 17, 1917, Philadelphia, Pa. **Studied:** Philadelphia Museum School, with Franklin Watkins, H. C. Pitz; New School for Social Research, 1947-48, 1952-53; Academie de la Grande Chaumiere, Paris, 1949-52. US Army, 1943-46. **Taught:** School of Visual Arts, NYC, 1954; Philadelphia College of Art, 1954-56; Pratt Institute, 1957-82. **Member:** Philadelphia Watercolor Club; NAD; SAGA. **Commissions:** International Graphic Arts Society; A.A.A.; National Broadcasting Co.; The Limbach Co.; McGraw-Hill, Inc. **Awards:** The Print Club, Philadelphia, Lessing J. Rosenwald P.P., 1955, 59; L. C. Tiffany Grant, 1962; PAFA, Watercolor Prize, 1963; Tamarind Fellowship, 1965; National Council on the Arts, Sabbatical Leave Grant ($7,500), 1966; Guggenheim Foundation Fellowship, 1968; AAAL, Childe Hassam P.P., 1973; Ford Foundation Grant, 1974; SAGA, P.P., 1977, 79; Philadelphia College of Art, Alumni Silver Star Award, 1985; Governor's (NJ) Award for Distinguished Services, Arts in Education, 1988. **Address:** 2 Pine Drive, Roosevelt, NJ 08555. **Dealer:** A.A.A. **One-man Exhibitions:** (first) Galerie Le Bar, Paris, 1952; Philadelphia Art Alliance, 1954; Samuel S. Fleisher Art Memorial, Philadel-

phia, 1959; A.A.A. Gallery, NYC, 1960, 70; U. of Maine, 1961, 71; Cober Gallery, 1961, 63; Zora Gallery, Los Angeles, 1964; Glassboro State College, 1966; Manhattanville College of the Sacred Heart, 1966; Earlham College, 1967; Instituto General Electric, Montevideo, 1967; U. of Notre Dame, 1969; U. of New Hampshire, 1970; U. of Connecticut, 1971; Galeria Pecanins, Mexico City, 1972; The Ohio State U., 1973; Imprint, San Francisco, 1973; ACA Gallery, 1976; Schneider-Sato Gallery, Karlsruhe, 1977; Evangelische Akademie, Arnoldshain, 1978; U. of Arizona, 1979; Daberkow Gallery, Frankfurt, 1979; U. of Northern Iowa, 1979; U. of Northern Michigan, 1979; U. of Georgia, 1982; Mary Ryan Gallery, NYC, 1982; Galerie Neuheisel, Saarbrucken, 1985; Galerie Michael Hagen, Offenburg, 1985; Holiday Inn Gallery, Strasbourg, 1985; Philadelphia College of Arts, 1986; Winniger Graphics, Boston, 1987; Martin Sumers Graphics, 1988; Art Studio Gallery, Rahway, N.Y., 1988; Mukaida Fine Arts, Metuchen, N.J., 1991; Peddie School, Heightstown, N.J., 1991. **Retrospectives:** Trenton/State, 1981; Western Carolina U., 1982; Rider College, 1988. **Group:** NAD Annual, 1953; Boston/MFA, 1955; Seattle/AM, 1957; Cober Gallery, The Insiders, 1960; Brooklyn Museum Biennials, 1960, 62; SAGA; PAFA Annuals, 1961, 63; St. Paul Gallery, Drawings, USA, 1961, 68; A.A.A. Gallery, NYC, 100 Prints of the Year, 1962; MOMA, Recent Painting USA: The Figure, circ., 1962-63; USIA, Graphic Arts—USA, circ., USSR, 1963; Library of Congress, 1963; PCA-USIA, 30 Contemporary Prints, circ., Europe, 1964; Corcoran, 1964; Otis Art Institute, 1964; New York World's Fair, 1964-65; PMA, 1965; New Jersey Tercentenary Exhibition, New Brunswick, 1965; WMAA Annual, 1966; U. of Southern California, 1967; Mexico City/Nacional, 1967; U. of Kentucky, 1968; MOMA, Tamarind: Homage to Lithography, 1969; SAGA, Fifty Years of

American Printmaking, 1969; WMAA, Human Concern/Personal Torment, 1969; A.F.A., The Indignant Eye, 1971; Museo de Arte Contemporaneo, Cali, Colombia, S.A., 1971, 73; São Paulo, American and Brazilian Printmakers, 1972; NAD, 1974; NCFA, Print Annual, 1977; Hirshhorn, Dreams and Nightmares, 1984; NMAA, Art, Design, and the Modern Corporation, 1985; Purdue U., Invitational, 1986; Trenton State College, Illustration, 1986; Guild Hall, Prints of the Eighties, 1990. **Collections:** Baltimore/MA; Bibliothèque Nationale; Brooklyn Museum; U. of California; High Museum; U. of Kentucky; Library of Congress; Los Angeles/County MA; MMA; MOMA; U. of Maine; Malmo; U. of Minnesota; Montclair/AM; NMAA; NYPL; Newark Museum; New Orleans/Delgado; Norfolk; Nurnberg; PAFA; PMA; Princeton U.; Rutgers U.; San Antonio/McNay; Slater; Syracuse U.; Trenton/State; Utica; VMFA; WMAA; Yale U.; Youngstown/Butler. **Bibliography:** Archives.

LANDFIELD, RONNIE b. January 9, 1947, NYC. **Studied:** Kansas City/AI; SFAI, 1963-65. **Taught:** School of Visual Arts, NYC, 1975-. **Awards:** Cassandra Foundation Grant, 1969; National Endowment for the Arts, 1983. **Address:** 31 Desbrosses Street, NYC 10013. **Dealer:** Stephen Haller Fine Art, NYC. **One-man Exhibitions:** David Whitney Gallery, NYC, 1969, 71; Helman Gallery, St. Louis, 1970; Jack Glenn Gallery, Corona Del Mar, 1970; Corcoran and Corcoran Gallery, Coral Gables, 1971, 74, 76; Andre Emmerich Gallery, NYC, 1973, 74, 75; B. R. Kornblatt Gallery, Baltimore, 1976, 78, 80, 84; Sara Rentschler Gallery, NYC, 1978, 79; Linda Farris Gallery, Seattle, 1978, 81, 84; Medici-Berensen Gallery, Miami, 1979, 81, 83; Charles Cowles Gallery, NYC, 1980, 82, 83, 84; Bank of America, San Francisco, 1981; Nexus Gallery, Atlanta, 1982; Hokin Gallery, Miami, 1985; Hokin-

Kaufman Gallery, Chicago, 1985; Stephen Haller Fine Art, NYC, 1989, 92; Galerie Nadeau, Philadelphia, 1991. **Group:** WMAA Annuals, 1967, 69; ICA, U. of Pennsylvania, Two Generations of Color Painting, 1970; Houston/MFA, Toward Color and Field, 1971; WMAA, Lyrical Abstraction, 1971; WMAA Biennial, 1973; NYU, The Big Picture Show, 1978. **Collections:** Art Museum of South Texas; Chicago/AI; Cornell U.; Greenville; Hirshhorn; Kansas City/Nelson; MMA; MOMA; Munich/SG; NYU; U. of Nebraska; Oberlin College; RISD; Raleigh/NCMA; Ridgefield/Aldrich; Seattle/AM; Norton Simon Museum; Smith College; Stanford U.; Udine; Utica; WMAA; Walker.

LANDON, EDWARD b. March 13, 1911, Hartford, Conn. **Studied:** Hartford Art School; ASL, with Jean Charlot, privately in Mexico with Carlos Merida. Traveled Europe, Scandinavia, Mexico. **Taught:** privately (serigraphy). Subject of a film, *How to Make a Serigraph*, produced by the Harmon Foundation. **Member:** Charter member and past president National Serigraph Society; Boston Printmakers; American Color Print Society; The Print Club, Philadelphia. Federal A.P.: Easel painting and murals. **Awards:** Northwest Printmakers Annual, 1944, 46, 52; Brooklyn Museum, 1947; American Color Print Society, 1947, 54, 57, 58; Boston Printmakers, 1979; San Francisco Art Association, 1949; Fulbright Fellowship (Norway), 1950, 51. **Address:** Lawrence Hill Road, Weston, VT 05161. **Dealers:** Gallery 2, Woodstock, Vt.; Gallery North Star, Grafton, Vt. **One-man Exhibitions:** (first) Boston/MFA, 1934; Smith College, 1941; Norlyst Gallery, NYC, 1945; Unge Kunstneres Samfund, Oslo, 1950; The Print Club, Philadelphia, 1953; Fine Arts Gallery, Hartford, 1954; Doris Meltzer Gallery, NYC, 1957, 58; Bennington, Vt., 1967; Sunapee, N.H., 1968; Woodstock, Vt., 1969; Southern Vt. Artists Assn., Manchester; Garden Gallery,

Londonderry, Vt., 1984. **Retrospective:** Wenniger Graphics, Boston, 1986. **Group:** Brooklyn Museum; Northwest Printmakers Annuals; American Color Print Society; National Serigraph Society; MOMA; Library of Congress; MMA; Cooper Union, 1968; Lincoln, Mass./De Cordova, By the People, for the People: New England, 1947. **Collections:** Bezalel Museum; Bibliothèque Nationale; Brooklyn Museum; Buffalo/Albright; Library of Congress; Kansas City/Nelson; MMA; MOMA; NCFA; PMA; SFMA; Tel Aviv; Turku Museum, Finland; Victoria and Albert Museum; Worcester/AM. **Bibliography:** American Artists Congress, Inc.; Landon; Reese. Archives.

LANDSMAN, STANLEY
from 1st to 4th edition.

LANE, LOIS **b.** January 6, 1948, Philadelphia, Pa. **Studied:** Philadelphia College of Art, 1969, BFA; Yale U., Summer School, 1968; Yale U., 1971, MFA. **Awards:** CAPS grant, 1977; National Endowment for the Arts, 1978. **Address:** c/o Dealer. **Dealer:** Barbara Toll Fine Arts, NYC. **One-man Exhibitions:** Artists Space, NYC, 1974; The Willard Gallery, NYC, 1977, 79, 83, 85, 87; Greenberg Gallery, St. Louis, 1980; Akron/AM, 1980; PAFA, 1982; Nigel Greenwood Gallery, London, 1982; Margo Leavin Gallery, Los Angeles, 1986; John Berggruen Gallery, San Francisco, 1987; Barbara Mathes Gallery, NYC, 1988, 89; Barbara Krakow Gallery, Boston, 1989; Dartmouth, 1990; Barbara Toll Fine Arts, NYC, 1991, 93. **Group:** WMAA, New Image Painting, 1978; WMAA Biennial, 1979; Purchase/SUNY, Ten Artists, 1979; NYU, American Painting: The Eighties, 1979; Indianapolis, 1980; Bonn, Back to the USA, 1983; Youngstown/Butler, Midyear Show, 1983; Lucerne, Back to the USA, 1983; PMA, The Hunt Collection, 1988; Long Island U., Hundred Drawings by Women, circ., 1989; RISD, Terra In-

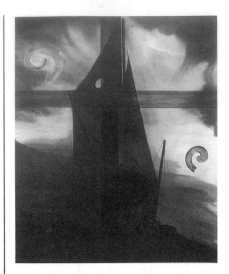

Lois Lane, *Untitled,* 1991.

cognita, 1990; The Print Club of Philadelphia, Crossing Over, Changing Places, 1991. **Collections:** Akron/AM; Art Museum of South Texas; Brooklyn Museum; Buffalo/Albright; Des Moines; Houston/MFA; MOMA; National Gallery; Purchase/SUNY; WMAA. **Bibliography:** *Back to the USA.*

LANG, DANIEL S. **b.** March 17, 1935, Tulsa, Okla. **Studied:** Tulsa U., BFA, with Alexandre Hogue and Louis Weinberg; U. of Iowa, MFA, with Mauricio Lasansky and James Lechay; ASL, Woodstock, N.Y., with Yasuo Kuniyoshi. US Army, 1954-56. Resided London 9 years, Italy 15 years. **Taught:** Chicago Art Institute School, 1962-64; Washington U., 1964-65; U. of South Florida; U. of Ohio; U. of Utah, 1986-. **Member:** Artists Equity. Designed sets for the Kent Opera (England) and Jonathan Miller's production of Monteverdi's *Orfeo,* filmed by BBC, 1979. **Awards:** Yaddo Fellowship; MacDowell Fellowship. **Address:** 38 West 56th Street, NYC 10019 and Montone (PG) 06014, Italy. **Dealers:** Sherry French Gallery, NYC; Hokin Gallery, Palm Beach. **One-man Exhibitions:**

(first) Boston/MFA, 1961; U. of Chicago, 1965; Ivan Spence Gallery, Ibiza, Italy, 1966; Boston Public Library, 1970; Arthur Tooth & Sons, London, 1971, 74; Fairweather Hardin Gallery, Chicago, 1971, 80; French & Co. Inc., NYC, 1972; Galerie Alexandra Monett, Brussels, 1973; Tampa/AI, 1974; Gimpel & Weitzenhoffer Ltd., NYC, 1974, 75; Il Gabbiano Gallery, Rome, 1975; Fischbach Gallery, NYC, 1977, 79; Graphic International, Stuttgart, 1979; Galleria Il Bisonte, Florence, 1981; Watson/de Nagy Gallery, Houston, 1981; Richard Demarco Gallery, Edinburgh, 1981, 83; David Findlay Jr. Gallery, NYC, 1981, 83; Galleria Gina Ferrari, Milan, 1984; Sherry French Gallery, NYC, 1984, 86; William Hardie, Ltd., Glasgow, 1986, 92; Meredith Long Gallery, Houston, 1983; Hokin Gallery, Palm Beach, 1991. **Group:** ICA, U. of Pennsylvania, Highway, 1970; Omaha/Joslyn, A Sense of Place, circ., 1973; U.S. Department of the Interior, America 1976, circ., 1976. **Collections:** AT&T; Boston Public Library; California Palace; Carlton Steel; Chicago/AI; Citicorp; Dallas/MFA; Denver/AM; IBM; U. of Illinois; Kansas City/Nelson; Lanvin-Charles of the Ritz; Library of Congress; MOMA; U. of Massachusetts; Newark Museum; Oklahoma State Art Collection; J. C. Penney; St. Joseph/Albrecht; Springfield, Ill./State; Tulsa/Philbrook; Victoria & Albert Museum.

LANGLAIS, BERNARD b. July 23, 1921, Old Town, Me. d. December 27, 1977, Portland, Me. **Studied:** The Corcoran School of Art; Skowhegan School; Brooklyn Museum School; Academie de la Grande Chaumiere; Academy of Art, Oslo. US Navy, 1942-48. **Taught:** The Pennsylvania State U., 1972; U. of Pennsylvania, 1974. **Member:** Maine State Commission on the Arts and Humanities. **Commissions:** Samoset Hotel, Rockland, Me., 1974; GSA, Federal Building, Sandpoint, Idaho. **Awards:** Fulbright Fellowship (Nor-

way), 1954; Ford Foundation, P.P., 1963; Guggenheim Foundation Fellowship, 1972; Maine State Commission on the Arts and the Humanities Award, 1972; Hon. DFA, U. of Maine; National Endowment for the Arts, grant, 1977. **One-man Exhibitions:** Roko Gallery, NYC, 1956; Area Gallery, NYC, 1959; U. of Maine, 1960, 67, 74, 81; Leo Castelli Inc., 1961; Allan Stone Gallery, NYC, 1962; Grippi and Waddell Gallery, NYC, 1964; Seton Hall U., 1965; Makler Gallery, 1966, 72; Portland, Me./MA, 1968; Maine Art Gallery, 1969; Marlboro (Vt.) College, 1969; Bowdoin College, 1969; Lee Ault & Co., NYC, 1971, 76; Alpha Gallery, Boston, 1972; Exeter, 1972; Governor Dummer Academy, Byfield, Mass., 1973; Frost Gully Gallery, 1974; Bates College, 1974; Colby College, 1974; Ahima Gallery, Wellfleet, Mass., 1976; Manchester Institute of Arts and Sciences, Manchester, N.H., 1977; Unity College, Unity, Me., 1976; Waldoboro Gallery, Waldoboro, Me., 1977; Hobe Sound Gallery, Hobe Sound, Fla., 1978; Hurlbutt Gallery, Greenwich, Ct., 1978; Rockland/Farnsworth, 1978; Wingspread Gallery, Northeast Harbor, Me., 1978, 81; Maine Coast Artists Gallery, Rockport, Me., 1978, 84; Payson-Weisberg Gallery, NYC, 1981, 82, 84; Ann Weber Gallery, Georgetown, Me., 1984; Midtown Galleries, 1986. **Group:** ART:USA:58 and ART:USA:59, NYC, 1958, 59; Yale U., Best of Contemporary Painting from New York Galleries, 1960; Boston Arts Festival, 1960, 61; Martha Jackson Gallery, New Media—New Forms, I & II, 1960, 61; Chicago/AI Annuals, 1960, 61, 64; WMAA Annuals, 1960, 63; Houston/MFA, New Media, 1961; MOMA, The Art of Assemblage, circ., 1961; Carnegie, 1961; A.F.A., circ., 1961-62; Colby College, Maine and Its Artists, 1963, Drawing Exhibition, 1970; Queens Museum, American Sculpture: Folk & Modern, 1977. **Collections:** Chase Manhattan Bank; Chicago/AI; Chrysler Corp.; Colby College; U. of Indiana; U. of

Maine; Norfolk/Chrysler; Ogunquit; Olsen Foundation Inc.; PMA; Philadelphia Zoological Gardens; Rockland/Farnsworth; The Singer Company, Inc.; J. Walter Thompson Co.; WMAA. **Bibliography:** Archives.

LANING, EDWARD b. April 26, 1906, Petersburg, Ill. d. May 6, 1981, NYC. **Studied:** The U. of Chicago; ASL, with Boardman Robinson, Max Weber, John Sloan, Kenneth Hayes Miller; Academy of Fine Arts, Rome. Traveled USA, Europe, North Africa. **Taught:** Cooper Union, 1938-41; Kansas City Art Institute and School of Design, 1945-50; Pratt Institute, 1952-56; ASL, 1952-75. **Member:** NAD; ASL; National Society of Mural Painters. Federal A.P. (murals): Ellis Island; New York Public Library; US Post Offices, Rockingham, N.C., and Bowling Green, Ky. **Commissions:** *Life* magazine (paintings); murals for Sheraton Corporation hotels in Los Angeles, Dallas, Louisville, Niagara Falls, NYC; US Department of Interior, Bureau of Reclamation, 1969; Union Station, Ogden, Utah, 1979. **Awards:** Guggenheim Foundation Fellowship, 1945; AAAL Grant; VMFA, 1945; Chicago/AI, 1945; Fulbright Fellowship, 1950. **One-man Exhibitions:** (first) Dudensing Gallery, NYC, 1932; The Midtown Galleries; Kansas/Nelson, 1945; Hewitt Gallery, NYC, 1950; The Griffin Gallery, NYC, 1963; Dannenberg Gallery, 1969; NAD, 1973; Kennedy Galleries, 1992. **Group:** WMAA; MMA; Chicago/AI; Cleveland/MA; VMFA; NAD; Audubon Artists. **Collections:** Kansas City/Nelson; MMA; WMAA. **Bibliography:** Boswell 1; Cheney; Hall. Archives.

LANSNER, FAY b. June 21, 1921, Philadelphia, Pa. **Studied:** Wanamaker Institute, 1939-41; Stella Elkins Tyler School of Fine Arts, Temple U., 1945-47; Columbia U., 1947-48; ASL, with Vaclav Vytlacil; Hofmann School, 1948; Atelier Fernand Leger, Paris, 1950; Academie

Andre Lhote, Paris, 1950. Traveled Europe extensively; resided Paris, 1950-52. **Taught:** New School for Social Research, 1974-75; coproducer, writer, editor, *The Circle of Charmion von Wiegand,* 1977, videotape, for WNET. **Address:** 317 West 80th Street, NYC 10024. **Dealer:** Benton Gallery, Southampton, N.Y. **One-man Exhibitions:** (first) Galerie Huit, Paris, 1951; Le Gerrec, Paris, 1952; Peretz Johannes Gallery, NYC, 1952; Hansa Gallery, NYC, 1955, 56, 58; Hood College, 1961; David Herbert Gallery, NYC, 1961; The Zabriskie Gallery, NYC, 1963; The Kornblee Gallery, NYC, 1963, 65; James David Gallery, Miami, 1965; Douglass College, 1975; Lehigh U., 1976; Ingber Art Gallery, NYC, 1980, 83, 90; Benson Gallery, Bridgehampton, N.Y., 1970, 72, 76, 78, 80, 82, 92; Phoenix II Gallery, Washington, D.C., 1982; Benton Gallery, Southampton, N.Y., 1986, 88, 91. **Group:** Finch College, NYC, Paul Magriel Collection; Southampton/Parrish; Houston/MFA, The Emerging Figure, 1961; Louis Alexander Gallery, NYC, Recent American Drawings, 1962; Stanhope Gallery, Boston, Works on Paper; New School for Social Research, International Year of the Woman, 1975; Huntington, N.Y./Heckscher, Aspects of Change: Drawing Today, Guild Hall, East Hampton, N.Y., 1978; Tenth Street Days—The Coops of the 50s, 1978; Denver, Poets and Painters, 1979; MMA, Hans Hofmann as Teacher, 1979; Knoxville Museum of Art, Twentieth Century Women Artists, 1989. **Collections:** Ciba-Geigy Corp.; Corcoran; Douglass College; Lehigh U.; MMA; NYU; Newsweek; U. of North Carolina; Purchase/SUNY. **Bibliography:** *Art: A Woman's Sensibility; Fay Lansner; Poets & Painters.* Archives.

LANYON, ELLEN b. December 21, 1926, Chicago, Ill. **Studied:** Chicago Art Institute School; The U. of Chicago; Roosevelt College (with Max Kahn, Kathleen Blackshear, Joseph Hirsch, 1944-

48, BFA); State U. of Iowa, with Mauricio Lasansky, Eugene Ludnis, 1948-50, MFA; Courtauld Institute, 1950-51. Traveled Ireland, Egypt, Mexico. **Taught:** U. of Iowa, 1945-84; Chicago/AI, 1952-54 (Junior School), 1964-65, 73; Rockford College, 1954; Saugatuck Summer School of Painting, 1961, 62, 67, 68, 69; U. of Illinois, 1966; Oxbow Summer School, 1970, 71, 72, 73; U. of Wisconsin, 1972; Stanford U., 1973; U. of California, Davis, 1973; Sacramento State U., 1973; The Pennsylvania State U., 1974; Boston U., 1975; U. of Iowa, 1975; Cooper Union, 1979-80; Parsons School of Design, NYC, 1979-80; Director, Oxbow Summer School of Painting, Workshop, 1978; School of Visual Arts, 1980. **Member:** Chicago/AI Exhibition Momentum, 1948-52; CAA, Women's Caucus for Art. **Awards:** Chicago/AI, Mr. & Mrs. Frank H. Armstrong Prize, 1946, 55, 77; Denver/AM, P.P., 1950; Library of Congress, Pennell P.P., 1950; Fulbright Fellowship (England), 1950; Chicago/AI, Martin B. Cahn Award, 1961; Chicago/AI, Pauline Palmer Prize, 1962, 64; Dallas/MFA, 1965; Chicago/AI, Vielehr Award, 1967; Cassandra Foundation Grant, 1971; Yaddo Fellowship, 1974, 75, 76; National Endowment for the Arts, grant, 1974; Herewood Lester Cook Foundation, grant, 1981; Hon. DFA, Associated College of the Twin Cities, St. Paul, 1977; Hon. DFA, Carleton College, Northfield, Minn., 1979; Distinguished Teaching Award, College Art Association, 1980; Hon. DFA, Coe College, 1985. m. Roland Ginzel. **Address:** 138 Prince Street, NYC 10012. **Dealers:** Berland Hall, NYC; Printworks Gallery, Chicago; Struve Gallery, Chicago; William Shearburn Fine Art, St. Louis. **One-man Exhibitions:** (first) Carlebach Gallery, NYC, 1949; Bordelon's, Chicago, 1952; Superior Street Gallery, Chicago, 1958; Stewart Rickard Gallery, San Antonio, 1962, 65 (two-man); Fairweather-Hardin Gallery, 1962; The Zabriskie Gallery, 1962, 64, 69, 72; Haydon Calhoun Gal-

lery, Dallas, 1963; B.C. Holland Gallery, 1965, 68; Fort Wayne/AM, 1967; Kendall College, 1967; Richard Gray Gallery, 1970, 73, 76, 79, 82, 85; Wabash Transit Gallery, Chicago, 1972; Madison Art Center, 1972; NCFA, 1972; Stephens College, 1973; U. of California, Davis, 1974, 80; The Pennsylvania State U., 1974; Odyssia Gallery, Rome, 1975, 76; Documenta Gallery, Rome, 1975; Harcus Krakow Rosen Sonnabend, Boston, 1976; U. of Illinois, 1976; Oshkosh Public Museum, 1976; U. of Missouri, 1976; The Woman's Building, L.A., 1977; Lake Forest College, 1977; Fendrick Gallery, Washington, D.C., 1978; U. of Houston, 1977; Culver-Stockton College, 1978; Kentucky State U., 1978; Bradley U., 1979; Illinois Wesleyan U., 1979; Landfall Press Gallery, Chicago, 1980; U. of California, Davis, 1980; Odyssia Gallery, NYC, 1980; Alverno College, Milwaukee, 1981; Susan Caldwell Gallery, NYC, 1983; St. Louis Community College, 1984; Barat College, 1987; J. L. Becker Gallery, Provincetown, 1987; Union League Club, Chicago, 1989; Julian Pretto/Berland Hall Gallery, NYC, 1989; Struve Gallery, Chicago, 1990; Printworks Gallery, Chicago, 1989; Sioux City Art Center, Iowa, 1992; Berland Hall Gallery, NYC, 1992. **Retrospectives:** Rockford College, 1970; One Illinois Center, Chicago, 1973; John Michael Kohler Arts Center, Sheboygan, Wisc., 1974; Kansas State U., 1976; U. of Missouri, 1976; Northern Illinois U., 1978; N.A.M.E. Gallery, Chicago, 1983; U. of Illinois, 1987; Chicago Cultural Center, circ., 1987. **Group:** PMA, 1946, 47, 50, 54; Chicago/AI Annuals, 1946, 47, 51, 53, 55, 57, 58, 60, 61, 62, 66, 69; Chicago/AI, Exhibition Momentum, 1948, 50, 52, 54, 56; Omaha/Joslyn, 1949, 58; Library of Congress, 1950, 52; Denver/AM, 1951, 52; MMA, 1952; U. of Illinois, 1953; MOMA, Young American Printmakers, 1953, The Downtown Gallery, Chicago Artists—1954; Chicago/AI, Prints from The Graphic Workshop, 1955; Corcoran,

1961; MOMA, Recent Painting USA: The Figure, circ., 1962-63; Northern Illinois U., 1966; Illinois Arts Council, circ., 1967-69; Chicago/Contemporary, 1968, Chicago Imagist Art, 1972; Moore College of Art, Philadelphia, Artists' Books, 1973; Galleria Comunale d'Arte Contemporanea, Una Tendenza Americana, 1973; Sacramento State U., National Print Annual, 1974; US Department of the Interior, America 1976, circ., 1976; Illinois Arts Council, Naive Art in Illinois, 1839-1976, 1976; Purdue U., Chicago Art, 1976; San Antonio/McNay, American Artists, 76, 1976; Sacramento/Crocker, The Chicago Connection, circ., 1976; Chicago Culture Center, Masterpieces of Chicago Art, 1977; U. of Michigan, Chicago: The City & Its Artists, 1945-78, 1978; Los Angeles/County MA, Private Images: Photographs by Painters, 1977; Chicago/AI, 100 Artists—100 Years, 1979; Chicago/AI, Chicago and Vicinity, Prizewinners Revisited, 1980; Milwaukee, American Prints 1960-1980, 1982; Rutgers U., Realism and Realities, 1982; San Antonio/McNay, The Artist and the Quilt, 1983; Indianapolis, 1984; SFMA, American Realism (Janss), circ., 1985; U. of North Carolina, Art on Paper, 1985; U. of California, Berkeley, Made in the USA, circ., 1987; NAD, Realism Today, circ., 1988; Long Island U., Lines of Vision, circ., 1989; William Paterson College, The Legacy of Surrealism in American Art, 1988; Chicago Art Institute School, From America's Studio, 1992; Chicago Cultural Center, Face to Face, 1992. **Collections:** Albion College; AT&T; Borg-Warner International Corporation; Boston Public Library; Brandeis U.; Brooklyn Museum; Chicago/AI; Chicago/Contemporary; Container Corp. of America; Cornell U.; Crocker Bank, San Francisco; U. of Dallas; Denver/AM; Des Moines; F.T.D. Association; First National Bank of Chicago; Galleria Communale d'Arte Contemporanea; IIE; Illinois Bell Telephone Company; U. of Illinois; Illinois Wesleyan U.;

Kansas State U.; Library of Congress; Madison Art Center; U. of Massachusetts; NCFA; NMAA; The Singer Company, Inc.; Springfield, Ill./State; Trenton/State; Walker. **Bibliography:** Adrian; *Art: A Woman's Sensibility;* Arthur 2. Archives.

LASANSKY, MAURICIO
b. October 12, 1914, Buenos Aires, Argentina. **Studied:** Superior School of Fine Arts, Buenos Aires. Traveled Europe, Latin America. To USA, 1943; citizen, 1952. **Taught:** Director, Free Fine Arts School, Villa Maria, Argentina, 1936; Taller Manualidad, 1939; Atelier 17, NYC; U. of Iowa, 1954-84. **Awards:** Guggenheim Foundation Fellowship (USA), 1943, renewed 1944; Seattle/AM, Seattle International, First Prize, 1944; The Print Club, Philadelphia, P.P., 1945, 48; Library of Congress, Pennell P.P., 1945, 48, 50, 56, 59, 62, 63; Denver/AM, P.P., 1946, 47; Des Moines, P.P., 1946, 49, 51, 57, 58; Iowa State Fair, First Prize, 1947; Society of American Etchers and Engravers, NYC, 1947; PAFA, Alice McFadden Eyre Medal, 1948, 57; Brooklyn Museum, P.P., 1948, 58; Northwest Printmakers Annual, P.P., 1948, 51, 55, 59, 61; Walker, First and Second Prizes, 1949; The Print Club, Philadelphia, Charles M. Lea Prize, 1951, 57, 62; Printmakers of Southern California, P.P., 1952; Bradley U., P.P., 1952; Des Moines, IV Annual, Edmundson Award, 1952; Des Moines, V Annual, Special Commendation, 1953; Des Moines, Prize in Painting, 1955; Des Moines Younkers Professional Award, 1956; I Inter-American Paintings and Prints Biennial, Mexico City, Posada Award, 1958; Silvermine Guild, P.P., 1958; Walker Biennial, P.P., 1958; DePauw U., P.P., 1959; Hon. DFA, Illinois Wesleyan College, 1959; Kansas City/Nelson, P.P., 1960; II Inter-American Paintings and Prints Biennial, Mexico City, Special Hon. Men. with Gold Medal, 1960; PAFA, Hon. Men., and one-man exhibition, 1961; Pasadena/AM, P.P., 1962; Ford

Foundation, P.P., 1962; Guggenheim Foundation Fellowship (Spain and France), 1963, 64; Hon. DFA, Pacific Lutheran U., 1969; Philadelphia Print Club Annual, Bertha von Moschzisker Prize, 1971; Dickinson College Arts Award, 1974. **Address:** 216 East Washington Street, Iowa City, IA 52240. **One-man Exhibitions:** (first) Fort General Roca, Rio Negro, Argentina, 1935; Whyte Gallery, Washington, D.C., 1945; SFMA, 1945, 50; Chicago/AI, 1947; U. of Louisville, 1948; Walker, 1949; Houston/MFA, 1949; Milwaukee, 1949; Purdue U., 1949; Santa Barbara/MA, 1950; Northwestern U., 1950; Cornell U., 1951; Tulane U., 1952; Memphis/Brooks, 1953; Madrid/Nacional, 1954; Oakland/AM, 1958; USIA, Intaglios (one-man and his students), circ., Latin America and USA, 1959-61; PAFA Annual, 1961; Des Moines, 1967; Carleton College, 1965; PMA, circ., 1966; Dickinson College, 1972; Fort Dodge/Blanden, 1973; Jane Haslem Gallery, Washington, D.C., 1982. **Retrospectives:** State U. of Iowa, 1957; A.F.A./Ford Foundation, circ., 1960-62; Iowa State U., 1967; U. of Iowa, 1976. **Group:** Carnegie, American Prints, 1949; São Paulo, 1951; U. of Illinois, Graphic Art, USA, 1954; France/National, 50 Ans d'Art aux États-Unis, circ., Europe, 1955; Gallery of Modern Art, Ljubljana, Yugoslavia, I, II, and V International Exhibitions of Prints, 1955, 57, 63, 67, 71; Michigan State U., 20 American Printmakers, 1956; Achenbach Foundation, Prints Since the 14th Century, 1957; SAGA, 1957; U. of California, Berkeley, Modern Master Prints, 1958; I and II Inter-American Paintings and Prints Biennials, Mexico City, 1958, 60; ICA, Boston, 100 Works on Paper, circ., Europe, 1959; PAFA, 1959, 60; PCA, American Prints Today, circ., 1959-62; Yale U., American Prints, 1950-60, 1960; USIA, Graphic Arts— USA, circ., USSR, 1963; I & II International Print Biennials, Krakow, 1966, 68; MOMA, The Artist as His Subject, 1967;

National Academy of Fine Arts, Amsterdam, American Prints, 1968; Bradford, England, British Print Biennial, 1969; XXXV Venice Biennial, 1970; San Juan, Puerto Rico, Biennial del Grabado, 1970, 72, 74; Graphische Sammlung Albertina, Graphik der Welt, 1971; WMAA, Oversized Prints, 1971. **Collections:** Albion College; American Life and Casualty Insurance Co.; Argentina/Nacional; Barcelona; Bradley U.; Brooklyn Museum; Buenos Aires/Municipal; Cedar Rapids/AA; Chicago/AI; Colorado Springs/FA; Cordoba/Municipal; Cordoba/Provincial; U. of Delaware; DePauw U.; Des Moines; Detroit/Institute; First National Bank, Iowa City; Flint/Institute; U. of Georgia; Gettysburg College; IBM; Illinois State Normal U.; U. of Illinois; Indiana U.; Iowa Wesleyan College; State College of Iowa; State U. of Iowa; Kansas City/Nelson; La Plata; Library of Congress; Louisiana State U.; Luther College; MOMA; Madrid/Nacional; U. of Maine; Melbourne/National; Mendoza; U. of Michigan; Millikin U.; U. of Minnesota; Museo Rosario; NYPL; National Gallery; U. of Nebraska; New Britain; Oakland/AM; Omaha:/Joslyn; PAFA; PMA; Pasadena/AM; Portland, Ore./AM; Rio Cuarto; SFMA; St. Louis/City; Salt Lake City Public Library; Seattle/AM; Silvermine Guild; Southwest Missouri State College; Springfield, Mo./AM; Syracuse U.; Time Inc.; USIA; U. of Utah; Walker; Washburn U. of Topeka; Washington U.; U. of Washington; Wesleyan U.; Yale U. **Bibliography:** *From Foreign Shores;* Hayter 1, 2; Marter, Tarbell, and Wechsler; **Honig;** Moser 1; Reese; Soyer, R., 1; **Zigrosser 2.**

LASSAW, IBRAM b. May 4,
1913, Alexandria, Egypt. To USA, 1921; citizen, 1928. **Studied:** City College of New York; Clay Club, 1926-30; Beaux-Arts Institute of Design, NYC, 1930-31; Ozenfant School of Art, NYC. Traveled Europe. US Army, 1942-44. **Taught:** American U., 1950; Duke U., 1962-63;

Long Island U., 1966-; U. of California, Berkeley, 1965-66; Brandeis U., 1972; Mt. Holyoke College, 1978; and privately. **Member:** A founder and member of American Abstract Artists (president, 1946-49); charter member, Artist's "Club," 1949. Federal A.P.: 1933-42; Artists Equity; AAIAL. **Commissions:** Beth El Temple, Springfield, Mass.; Beth El Temple, Providence, R.I.; Temple of Aaron, St. Paul; Temple Ansche Chesed, Cleveland; Kneses Tifereth Israel Synagogue, Port Chester, N.Y.; House of Theology of the Franciscan Fathers, Centreville, Ohio; Washington U., 1959; New York Hilton Hotel; Yale & Towne Inc.; Rockefeller Center, NYC, Celanese Building; Long Island Hall of Fame; Springfield, Mass./MFA. **Awards:** AAIAL, 1975; Hon. DFA, Long Island U. **Address:** P. O. Box 487, East Hampton, N.Y. 11937. **Dealer:** Harmon-Meek Gallery, Naples, FL. **One-man Exhibitions:** (first) The Kootz Gallery, NYC, 1951, also 1952, 54, 58, 60, 63, 64; Duke U., 1963; Benson Gallery, Southampton, NY, 1966, 86; Gertrude Kasle Gallery, 1968; Carnegie Mellon U., 1969; Vanderbilt U., 1970; Guild Hall, 1971, 88; The Zabriskie Gallery, NYC, 1977; Yares Gallery, Scottsdale, 1970; Phoenix II Gallery, Washington, D.C., 1982; Sid Deutsch Gallery, NYC, 1986; Harmon-Meek Gallery, Naples, Fla., 1991. **Retrospectives:** MIT, 1957; Huntington, N.Y./Heckscher, 1973. **Group:** WMAA Annuals, 1936-46; American Abstract Artists Annuals, 1937-; Salon des Realités Nouvelles, Paris, 1950; MOMA, Abstract Painting and Sculpture in America, 1951; MOMA, Sculpture of the XXth Century, 1953; XXVII Venice Biennial, 1954; Chicago/AI, 1954; WMAA, The New Decade, 1954-55; U. of Illinois, 1955, 57, 59, 61; MOMA, Twelve Americans, circ., 1956; IV São Paulo Biennial, 1957; Brussels World's Fair, 1958; Kassel, Documenta II, 1959; Cleveland/MA, Paths of Abstract Art, 1960; Carnegie, 1961; Seattle World's Fair, 1962; WGMA, Sculptors of Our

Time, 1963; WMAA, Between the Fairs, 1964; Musée Rodin, Paris, 1965; Indianapolis/Herron, 1965; Public Education Association, NYC, 1966; WMAA, Art of the U.S. 1670-1966, 1966; WMAA, The 1930's, 1968; MOMA, The New American Painting and Sculpture, 1969; Washburn Gallery Inc., Art of the 1940s, 1972; Duke U., 1972; Katonah (N.Y.) Art Gallery, Drawing in Space, 1972; Society of the Four Arts, Contemporary American Sculpture, 1974; NIAL, 1974; Sculpture—American Directions, 1945-75, 1976; Hirshhorn, The Golden Door, 1976; WMAA, 200 Years of American Sculpture, 1976; Rutgers U., Vanguard American Sculpture, 1919-1939, 1979; MMA, An American Choice, 1981; Hirshhorn, Five Distinguished Alumni, 1982; WMAA, The Third Dimension, 1984; Brown U., Flying Tigers, 1985; Detroit/Institute, Constructions in America, 1985. **Collections:** Baltimore/MA; Brooklyn Museum; Buffalo/Albright; Bulgaria/International; Calcutta; U. of California; Carnegie; U. of North Carolina; Chase Manhattan Bank; Cornell U.; Hartford/Wadsworth; Harvard U.; Israel Museum; MOMA; Metalcraft Corp.; NCFA; U. of Nebraska; Newark Museum; U. of North Carolina; Rio de Janeiro; SRGM; Springfield, Mass./MFA; Trenton/State; WMAA; Washington U.; Wichita/AM; Williams College; Worcester/AM. **Bibliography:** *Abstract Expressionism;* Baur 5, 7; Blesh 1; Brumme; Craven, W.; Giedion-Welcker 1; Goodrich and Baur 1; *From Foreign Shores;* **Goossen 6;** Henning; Hunter 6; Hunter, ed.; Lane and Larsen; Marter, Tarbell, and Wechsler; Mendelowitz; Myers 2; Phillips, Lisa 2; Read 3; Ritchie 1, 2; Rose, B., 1; Seuphor 3; Toher, ed.; Trier 1; Weller. Archives.

LAUFMAN, SIDNEY
from 1st to 4th edition.

LAURENT, JOHN **b.** November 27, 1921, Brooklyn, N.Y. **Studied:** Syracuse U.; Indiana U. (MFA); Academie de

la Grande Chaumiere (with Walt Kuhn, Othon Friesz, Stephen Greene). Traveled France, Italy. **Taught:** Virginia Polytechnic Institute, 1949-53; Ogunquit School of Painting, 1946-60; U. of New Hampshire, 1954-. **Commissions:** U. of New Hampshire (mural for Student Union building). **Awards:** L.C. Tiffany Grant; Syracuse U., Traveling Fellowship; Silvermine Guild, Larry Aldrich Prize; National Council on the Arts, Sabbatical Leave Grant ($7,500), 1966. **Address:** Mill Lane Road, York, ME 03909. **Dealer:** Sunne Savage Gallery, Boston. **One-man Exhibitions:** (first) Kraushaar Galleries, NYC, 1955; Smithsonian; U. of New Hampshire, 1956, 67; Lincoln, Mass./De Cordova, 1959; Bowdoin College, 1959; Indiana U.; Currier, Ogunquit, 1967; Frost Gully Gallery, Portland, Me., 1977: St. Paul's School, Concord, Vt., 1978; Midtown Galleries, NYC, 1985, 86. **Retrospective:** Andover/Phillips, 1973. **Group:** WMAA Annual; PAFA, 1951, 54; ART:USA:58, NYC, 1958; Boston Arts Festival; U. of Nebraska; MMA; Carnegie; Corcoran; Chicago/AI; Audubon Artists; Newark Museum. **Collections:** Andover/Phillips; Colby College; Hollins College, Illinois Wesleyan U.; U. of Illinois; Indiana U.; Lehigh U.; U. of Nebraska; Syracuse U. **Bibliography:** Archives.

LAURENT, ROBERT b. June 29, 1890, Concarneau, France. d. April 20, 1970, Cape Neddick, Me. **Studied:** British School, Rome, 1908-09, with Frank Burty; also with Hamilton Easter Field, Maurice Sterne, Giuseppe Doratore. US Naval Aviation, World War I. Traveled Europe, Cuba, Canada, Mexico, USA; resided France, Italy. **Taught:** ASL, fifteen years intermittently (sculpture); Vassar College, 1939-40; Goucher College, 1940-41; The Corcoran School of Art, 1940-42; Indiana U., 1942-60 (prof. emeritus, 1960-69). **Member:** Sculptors Guild; National Sculpture Society; Audubon Artists; Indiana Artists; New England Sculptors Associ-

ation, Cambridge, Mass. **Commissions:** Federal A.P.: Federal Trade Building, Washington, D.C. (relief); New York World's Fair, 1939; US Post Office, Garfield, N.J.; Fairmount Park, Philadelphia (sculpture); Radio City Music Hall, NYC; Indiana U. (a relief, a fountain, and several sculptures); many portrait busts. **Awards:** Chicago/AI, First Prize, and the Mr. & Mrs. Frank G. Logan Medal, 1924, 38; Fairmount Park (Philadelphia), International Sculpture Competition, 1935 (monument); Brooklyn Museum, First Prize, 1942; Audubon Artists, 1945; Indianapolis/Herron, five First Prizes; Louisville/Speed, First Prize, 1954; Artist-in-Residence, American Academy, Rome, 1954-55. **One-man Exhibitions:** (first) The Daniel Gallery, NYC, 1915; Bourgeois Gallery, NYC; Curt Valentine Gallery, NYC; Worcester/AM; Arts and Crafts Club, New Orleans; Vassar College; Corcoran; Indiana U.; Indianapolis/Herron; Kraushaar Galleries; Galleria Schneider, Rome; Art Association of Richmond, Ind.; New England Sculptors Association, Cambridge, Mass. **Retrospectives:** Indiana U., Laurent; Fifty Years of Sculpture, 1961; U. of New Hampshire, 1972. **Group:** Salons of America, NYC; Society of Independent Artists, NYC; Audubon Artists; Sculptors Guild; American Society of Painters, Sculptors and Graveurs; National Sculpture Society; WMAA; MMA; Brooklyn Museum; Newark Museum; Portland, Me./MA; Boston/MFA; Colby College; Riverside Museum; Louisville/Speed; Indianapolis/Herron; Chicago/AI; PMA; American Painting and Sculpture, Moscow, 1959. **Collections:** Barnes Foundation; Brookgreen Gardens; Brooklyn Museum; Chicago/AI; Colby College; Hartford/Wadsworth; IBM; Indiana U.; MMA; MOMA; U. of Nebraska; Newark Museum; Ogunquit; PAFA; Society of the Four Arts; Vassar College; WMAA. **Bibliography:** *Avant-Garde Painting and Sculpture;* Baur 7; Blesh 1; Brumme; Cahill and Barr, eds.; Cheney; Craven, W.;

Goodrich and Baur 1; *Index of 20th Century Artists;* **Moak;** Parkes; Richardson, E.P.; Ringel, ed.; Rose, B., 1; *Sculpture of the Western Hemisphere.* Archives.

LAWRENCE, JACOB b. September 7, 1917, Atlantic City, N.J. **Studied:** College Art Association, Harlem Workshop, 1932, with Charles Alston, Federal Art Project class, NYC, 1934-37, with Henry Bannarn; American Artists School, NYC, 1937-39, with Anton Refregier, Sol Wilson, Eugene Morley. Traveled USA, British West Indies, Africa. **Taught:** Black Mountain College, summer, 1947; Five Towns Music and Art Foundation, Cedarhurst, N.Y., 1956-60; Pratt Institute, 1956-71; Brandeis U., 1965; New School for Social Research, 1966-70; ASL, 1967-71; U. of Washington, 1972-; California State College, Hayward, 1970-71. **Member:** NIAL. Federal A.P.: Easel painting, 1938-39; Artists Equity; NAD; American Academy and Institute of Arts and Letters. **Commissions:** *Fortune* magazine, 1947 (10 paintings); Mural for Kingdome Stadium, Seattle; Howard U. **Awards:** Scholarship to American Artists School, NYC, 1937; Lessing J. Rosenwald Fund Fellowship, 1940, 41, 42; MMA, Sixth P.P., 1942; Guggenheim Foundation Fellowship, 1946; PAFA, Hon. Men., 1948; Brooklyn Museum, Hon. Men., 1948; Chicago/AI, Norman Wait Harris Silver Medal, 1948; NIAL Grant, 1953; Chapelbrook Foundation Grant, 1954; NAACP, Springarn Medal, 1970; NAD, 1971; Hon. DFA, Pratt Institute, 1972; Hon. Ph.D., Colby College and Dennison U.; Maryland Institute College of Art, Hon. DFA, 1979; Carnegie Mellon U., 1981. **Member:** Artists Equity; NAD; Washington State Arts Commission. **Address:** 4316 J7 Avenue, N.E., Seattle WA 98105. **Dealer:** Francine Seders Gallery, Seattle. **One-man Exhibitions:** (first) Harlem YMCA, NYC, 1938; Baltimore/MA, 1938; Columbia U., 1940; The Downtown Gallery, NYC, 1941, 43, 45,

47, 50, 53; Portland, Me./MA, 1943; MOMA, 1944; Institute of Modern Art, Boston, 1945; Trenton/State, 1947; The Alan Gallery, NYC, 1957, 60; Terry Dintenfass, Inc., NYC, 1963, 65, 68, 73, 78; Seattle/AM, 1974; St. Louis/City, 1974; Birmingham, Ala./MA, 1974; Kansas City, 1975; Norfolk/Chrysler, 1979; Francine Seders Gallery, Seattle, 1976, 78, 79, 82, 85; Spelman College, 1978; Detroit/Institute, 1978; Wentz Gallery, Portland, Ore., 1979; Norfolk/Chrysler, 1979; Brockman Gallery, Los Angeles, 1981; Akron/AM, 1981; Crystal Britton Gallery, Atlanta, 1982; Stockton State College, 1983; Purdue U., 1983; Youngstown/Butler, 1983; Massachusetts College of Art, 1984; Portland, Ore./AM, 1984; Buffalo/Albright, 1986. **Retrospectives:** A.F.A., circ., 1960; WMAA, 1974; Scripps College, circ., 1981; Jamaica Arts Center, N.Y., 1984; Seattle/AM, 1986. **Group:** WMAA; Brooklyn Museum; Phillips; PAFA Annuals, 1966, 67; City College, 1967; Johnson C. Smith U., 1968; Dartmouth College, 1968; Carnegie, 1968; MOMA, The Artist as Adversary, 1971; Princeton U., Fragments of American Life, 1976; Lewis and Clark College, Blacks in the Arts, 1979; Trenton/State, Six Black Americans, 1980; Jackson/MMA, Black History Month, 1982; AFA, Social Concern and Urban Realism, circ., 1983; Studio Museum of Harlem, Tradition and Conflict, circ., 1986. **Collections:** Alabama Polytechnic; Andover/Phillips; U. of Arizona; Atlanta U.; Auburn U.; Baltimore/MA; Boston/MFA; Brandeis U.; Brooklyn Museum; Buffalo/Albright; U. of California; Container Corp. of America; Cornell U.; Detroit/Institute; George Washington Carver Junior College; Harmon Foundation, Inc.; Hirshhorn; Howard U.; IBM; Johnson Publishing Co.; Karamu House; MMA; MOMA; Milwaukee; NCFA; Newark Public Library; Olympia State Capitol Museum; Omaha/Joslyn; Phillips; Portland, Me./MA; RISD; São Paulo; Southern Illinois U.; Spelman

College; Tougaloo College; Trenton/State; The Vatican, Rome; VMFA; WMAA; Wichita/AM; Worcester/AM. **Bibliography:** Dover; Eliot; Finkelstein; Goodrich and Baur 1; Halpert; McCurdy, ed.; Newmeyer; Nordness, ed.; Pearson 2; Richardson, E.P.; Shapiro, ed.; Siegel. Archives.

LEBRUN, RICO b. December 10, 1900, Naples, Italy. **d.** May 10, 1964, Malibu, Calif. **Studied:** Academy of Fine Arts, Naples, 1919-21. Italian army, 1917-18. To USA, 1924. Traveled USA, Europe. **Taught:** ASL, 1936-37; Chouinard Art Institute, Los Angeles, 1938-39; H. Sophie Newcomb Memorial College, 1942-43; Colorado Springs Fine Arts Center, 1945; Jepson Art Institute, Los Angeles, 1947-50; Escuela de Bellas Artes, San Miguel de Allende, Mexico, 1953; Yale-Norfolk Summer Art School, 1956; UCLA, summers, 1956, 57; Yale U., 1958-59; American Academy, Rome, 1959-60; Santa Barbara Museum School, 1962. **Commissions** (murals): Pomona College; Pennsylvania Station, NYC, 1936-38. **One-man Exhibitions:** San Diego, 1940; Faulkner Gallery, Santa Barbara, 1940, 47; de Young, 1942; Santa Barbara/MA, 1942, 47, 51, 56 (three-man, with Channing Peake and Howard Warshaw); Julien Levy Galleries, NYC, 1944; Colorado Springs/FA, 1945; Philadelphia Art Alliance, 1945, 50; Jepson Art Institute, Los Angeles, 1947, 49; A.F.A., Drawings, 1949; J. Seligmann and Co., 1950, 51; Los Angeles/County MA, 1950, 61; Frank Perls Gallery, 1958; Chicago/AI, 1955; Whyte Gallery, Washington, D.C., 1956; Pomona Gallery, 1956; Toronto, 1958; Yale U., 1958; Boston U.; Boris Mirski Gallery, Boston, 1959, 62; U. of California, Santa Barbara, 1960; Esther Baer Gallery, 1960; Princeton U., 1961; Obelisk Gallery, Washington, D.C., 1962; Cornell U., 1962; Syracuse U., 1962; Nordness Gallery, NYC, 1962, 64, 69; AAAL, 1965; Antioch College, 1966; Koplin Gallery, Santa Monica, 1992. **Retrospective:** Los

Angeles/County MA, 1967. **Group:** U. of Illinois; MOMA; Chicago/AI; SFMA; Oakland/AM; Carnegie, 1945, 52, 55, 59; PMAA, 1948, 50, 52, 57, 58, 60; XXV Venice Biennial, 1950; PAFA, 1951, 52, 53, 56. **Collections:** Andover/Phillips; Boston/MFA; Britannica; Colby College; de Young; Denver/AM; Harvard U.; U. of Hawaii; U. of Illinois; Kansas City/Nelson; Los Angeles/County MA; MMA; MOMA; Mills College; U. of Nebraska; Pomona College; RISD; Santa Barbara/MA; Syracuse U.; Toronto; Utica; WMAA. **Bibliography:** Barker 1; Baur 7; Biddle 4; Frost; Getlein, F. and D.; Goodrich and Baur 1; Karlstrom and Ehrlich; Mendelowitz; Miller, ed., 1; Nordness, ed.; Pearson 2; Pousette-Dart, ed.; Rodman 1, 2, 3; Sachs; Seldis; Weller; Wight 2. Archives.

LECHAY, JAMES b. July 5, 1907, NYC. **Studied:** U. of Illinois, 1928, BA; privately with Myron Lechay. Traveled Canada, Europe, USA. **Taught:** State U. of Iowa, 1945-75; Stanford U., 1949; NYU, 1952; Skowhegan School, summer, 1961. Federal A.P.: Easel painting; Chinese U. of Hong Kong, 1976; Studio Art School of the Aegean, Samos, Greece, 1986, 87, 88. **Awards:** Chicago/AI, Norman Wait Harris Medal, 1941; PAFA, Lambert P.P., 1942; Society for Contemporary American Art, Presentation Prize, 1942; Chicago/AI, Hon. Men., 1942, 43; Portrait of America Prize, 1945; Iowa State Fair, First Prize, 1946, Second Prize, 1951; Denver/AM, Hon. Men., 1946; Walker, First Prize, 1947; Des Moines, Edmundson Trustee Prize, 1950, Davenport/Municipal, 1950; Des Moines, First Prize, 1952, 53; Hon. DFA, Coe College, 1961; two University Fellowships, 1962, 67; Tamarind Fellowship, 1973; AAAL, Childe Hassam Fund P.P., 1974; NAD, Benjamin Altman Prize for Landscape, 1977; NAD, Ranger Fund, P.P., 1979; NAD, Benjamin Altman Prize, 1991; NAD, Henry Ward Ranger Fund, P.P., 1986. **Address:** 1191 Hotz Avenue, Iowa

City, IA 52240; summer, Box 195, Wellfleet, MA 02667. **Dealers:** Kraushaar Galleries, NYC; Cherry Stone Gallery, Wellfleet, Mass. **One-man Exhibitions:** (first) Another Place, NYC, 1936; Artists' Gallery, NYC, 1938, 40; Ferargil Galleries, NYC, 1942, 43; Toledo/MA, 1943; Wally Findlay Galleries, Chicago, 1944; American-British Gallery, NYC, 1945; Macbeth Gallery, NYC, 1946, 47, 50; Cedar Rapids/AA, 1946; Springfield (Ill.) Art Association, 1946; Louisville (Ky.) Art Center, 1949; Des Moines, 1951, 60; U. of Iowa, 1951, 55, 59, 64, 67, 72; Fort Dodge/Blanden, 1952; Wesleyan U. (Conn.), 1953; Kraushaar Galleries, NYC, 1955, 64, 68, 70, 73, 77, 81, 85, 88; Cedar Falls Art Association, 1955; Davenport/Municipal, 1956; Sioux City (Iowa) Art Center, 1958; Omaha/Joslyn, 1958; Coe College, 1959; Dubuque/AA, 1961; Rochester (Minn.) Art Center, 1962; U. of Northern Iowa, 1962; Lubetkin Gallery, Des Moines, 1963; Hollins College, 1964; Waterloo, 1970; MacNider Museum, 1971; Luther College, 1971; Cherry Stone Gallery, Wellfleet, Mass., 1975, 79; Iowa Arts Council, 1976; La Lanterna, 1974; Provincetown Art Association, 1984; Binghamton/SUNY, 1989; Dartmouth, 1991. **Retrospective:** U. of Iowa, 1972. **Group:** Toledo/MA; MMA; Corcoran; RAC; WMAA; Carnegie; Arts Club of Chicago; St. Louis/City; Worcester/AM; California Palace; U. of Illinois; Indiana U.; Phillips; NAD, 1982, 83, 85, 86; Provincetown Art Association, Contemporary Provincetown, 1989. **Collections:** American Life and Casualty Insurance Co.; Andover/Phillips; U. of Arizona; Brooklyn Museum; Chicago/AI; Coe College; Davenport/Municipal; Des Moines; First National Bank of Chicago; First National Bank, Iowa City; Grinnell College; Hirshhorn; Illinois Wesleyan U.; State College of Iowa; State U. of Iowa; Luther College; Memphis/Brooks; NAD; NCFA; U. of Nebraska; New Britain; U. of Northern Iowa; Omaha/Joslyn; PAFA; Potsdam/SUNY; Rensselaer Polytechnic Institute; U. of Rochester; Syracuse U.; Tulsa/Philbrook; Washburn U. of Topeka; Waterloo; Wichita/AM.

LEIBER, GERSON b. November, 1921, Brooklyn, N.Y. **Studied:** Academy of Fine Arts, Budapest; ASL, with Will Barnet, Louis Bosa, Vaclav Vytlacil, Morris Kantor; Brooklyn Museum School, with Gabor Peterdi. US Armed Forces, 1943-47. Traveled Europe. **Taught:** Creative Graphic workshop, NYC (five years); Newark (N.J.) School of Fine and Industrial Art, 1959-66. **Member:** Boston Printmakers; SAGA; California Society of Printmakers; American Color Print Society; ASL; NAD; SAGA, president, 1978-80. **Awards:** L. C. Tiffany Grant (2); Audubon Artists, Joseph Mayer Award, Gold Medal of Honor, Presidents Award; Brooklyn Museum, P.P.; Arden Prize; Francesca Wood Award; A.A.A. Gallery, NYC, National Print Competition, Second Prize; Henry B. Shope Prize; Hunterdon County (N.J.) Art Center, P.P.; SAGA, $1,000 P.P., 1968; American Color Print Society, Sonia Wather Award, 1968; NAD, John Taylor Arms Memorial Prize, 1971; Los Angeles Printmaking Society, P.P.; NAD, Benjamin Altman Prize, 1985. **Address:** 7 Park Avenue, NYC 10016. **Dealer:** Tower Gallery, Beverly Hills. **One-man Exhibitions:** Oakland/AM, 1960; Matrix Gallery, NYC, 1960; A.A.A. Gallery, NYC, 1961-64; Roko Gallery, NYC, 1961-64, 72; East Side Gallery, NYC, 1963; Riverdale-on-the-Hudson Museum, Riverdale, N.Y., 1963; Queens College; Raleigh/NCMA, 1964. **Retrospective:** Fine Arts Museum of Long Island, Hempstead, N.Y., 1991. **Group:** Library of Congress; Cincinnati/AM; Cincinnati International Biennial of Contemporary Color Lithography; PCA, American Prints Today, circ., 1959-62; Brooklyn Museum; PAFA; WMAA; Oakland/AM; Lincoln, Mass./De Cordova; MMA; Cincinnati/AM; SAGA; Ohio State U., 1968; Workshop Gallery of

Letterio Calapai, Ill., 1969, 70; Artist's Proof Gallery, East Hampton, N.Y., 1982; Benson Gallery, Bridgehampton, 1985; Alex Rosenberg Gallery, NYC, 1985. **Collections:** Abbot Academy; Anchorage; Boston/MFA; Brooklyn Museum; Cincinnati/AM; Clairol Inc.; Cooper Union; U. of Delaware; Free Library of Philadelphia; Guild Hall; Hamilton College; Karachi; Library of Congress; Lincoln, Mass./De Cordova; Lindenwood College; MMA; U. of Maine; Malmo; Memphis/Brooks; Minneapolis/Institute; Montclair/AM; NCFA; NYPL; NYU; National Gallery; U. of Nebraska; New York Hilton Hotel; Norfolk; The Ohio State U.; PMA; Potsdam/SUNY; Rutgers U.; Seattle/AM; Topeka Public Library; USIA; US State Department; Victoria and Albert Museum; WMAA; Wilmington; Walker; Wesleyan U.; Yale U.

LEKAKIS, MICHAEL b. March 1, 1907, NYC. d. November 8, 1987. Self-taught, US Army Air Corps, 1942-45. Traveled Mexico, Europe, Egypt, Greece. **Awards:** Guggenheim Foundation Fellowship; Pollock-Krasner Foundation, grant, 1985. **One-man Exhibitions:** Artists' Gallery, NYC, 1941; San Antonio/McNay, 1946; The Bertha Schaefer Gallery, NYC, 1946, 48; American U., 1949; Signa Gallery, East Hampton, N.Y., 1959; The Howard Wise Gallery, NYC, 1961; Dayton/AI, 1968, 69; Flair Gallery, Cincinnati, 1968, 69; WMAA, 1973; Kouros Gallery, NYC, 1983, 84. **Group:** WMAA Annuals, 1948-52, 58, 60, 62; SRGM, Sculpture and Drawings, 1958; Cleveland/MA, 1961; Boston Arts Festival, 1961; Hartford/Wadsworth, Continuity and Change, 1962; Seattle World's Fair, 1962; MOMA, Americans 1963, circ., 1963-64; WMAA, The Third Dimension, circ., 1984; Provincetown Museum, Crosscurrents, 1986. **Collections:** Dayton/AI; Greece/National; Guild Hall; Hartford/Wadsworth; U. of Kentucky; MOMA; U. of Nebraska; U. of North

Carolina; PMA; Pinakothiki, Athens; Portland, Ore./AM; SRGM; Seattle/AM; Tel Aviv; Vassar College; WMAA. **Bibliography:** Friedman, B.H. 3; Phillips, Lisa, 1; *Sculpture and Drawings.* Archives.

LEONG, JAMES C. b. November 27, 1929, San Francisco, Calif. **Studied:** California College of Arts and Crafts, 1951-53, BFA, MFA; San Francisco State College, 1954, MA. US Army, 1952-53. Traveled Europe, USA; U. of Oslo, 1956-58. **Taught:** U. of Georgia, 1971. Prologue sequence for *Freud,* directed by John Huston, 1962. **Commissions** (murals): Chung Mei Home for Boys, El Cerrito, Calif., 1950; Ping Yuen Federal Housing Project, San Francisco, 1951; San Francisco State College, 1951. **Awards:** Fulbright Fellowship; Guggenheim Foundation Fellowship; San Francisco Art Festival, Third Prize, 1951; SFMA, 1962. **Address:** 89 Yesler Way, Seattle, WA 98104-2535. **One-man Exhibitions:** (first) Hungry i, San Francisco, 1951; Barone Gallery, NYC, 1955, 56, 57, 60; American Gallery, Los Angeles, 1955; Holst Halvorsen Gallery, Oslo, 1956; Galerie Paletten, Oslo, 1957; Erling Haghfelt, Copenhagen, 1957; L'Obelisco, Rome, 1960, 61; Feingarten Gallery, NYC, 1962; Galleria dell'Ariete, 1962; Royal Athena II, NYC, 1963, 67; Temple U., Rome, 1967; Cerberus Gallery, 1969; Gloria Luria Gallery, 1970; U. of Georgia, 1971; Middle Tennessee State U., 1971; The Pennsylvania State U., 1971; Kama Studio, 1975; Richard Larcada Gallery, 1975; Galleria Galtung, Oslo, 1976; Gallery 47, Copenhagen, 1976; Gallerie Oljemark, Helsinki, 1976; Studiodue, Rome, 1976; Galleria Il Ponte, Rome, 1985, 86; Centro Culturale Canadese, Rome, 1988. **Group:** SFMA; de Young; WMAA, 1955; American Academy, Rome; MOMA, 1960; Internazionale di Arte Astratta, Prato, Italy, 1960; Brooklyn Museum, 1961; Carnegie, 1961; U. of Rochester, 1962; Rome National Art Qua-

drennial, 1967; NIAL, 1967; AFA, Inverse Illusionism, 1971-72; USIA, Rome, Four American Artists, 1972; Rome, V Quadrennial, 1977. **Collections:** Brooklyn Museum; Dallas/MFA; U. of Georgia; Harvard U.; Indianapolis; MIT; Middle Tennessee State U.; NYU; U. of North Carolina; Princeton U.; Purchase/SUNY; U. of Rochester; U. of Texas. **Bibliography:** Archives.

LESLIE, ALFRED **b.** October 29, 1927, NYC. **Studied:** with Tony Smith, Wilham Baziotes, Hale Woodruff, John McPherson; NYU, 1956-57; Pratt Institute; ASL. US Coast Guard, 1945-46. **Taught:** Great Neck (N.Y.) Adult Education Program, 1956-57; San Francisco Art Institute, summer, 1964. Codirector-producer (with Robert Frank and Jack Kerouac) of the film *Pull My Daisy*. **Awards:** Guggenheim Foundation Fellowship, 1969; Butler Institute of American Art, First Prize, 1977. **Address:** 1641 South East Street, South Amherst, MA 01002; 8 West 13th Street, NYC 10011. **Dealer:** Oil & Steel Gallery, Long Island City, N.Y. **One-man Exhibitions:** (first) Tibor de Nagy Gallery, 1951, also 1952, 53, 54, 57; Martha Jackson Gallery, 1959, 60; Holland-Goldowsky Gallery, Chicago, 1960; Noah Goldowsky, 1968, 69, 71; Allan Frumkin Gallery, NYC, 1975, 78; Allan Frumkin Gallery, Chicago, 1977; Youngstown State U., 1977; U. of Connecticut, 1978; Texas Gallery, Houston, 1986; Hill Gallery, Birmingham, Mich., 1987; Compass Rose Gallery, Chicago, 1987; Krygier/Landau Gallery, Los Angeles, 1987; The College of Saint Rose, Albany, 1988; Boca Raton, 1988; Flynn Gallery, NYC, 1991 (2); 92 (2); St. Louis/City, 1991. **Retrospective:** U. of Hartford, 1991. **Group:** Festival of Two Worlds, Spoleto, 1958; Paris/Moderne, Young Americans, 1958; V São Paulo Biennial, 1959; Walker, Sixty American Painters, 1960; Carnegie, 1961; Stockholm/National, Four Americans, 1961;

WMAA Annuals, 1961, 65, 67, 68, 71, 72, 73; Kunsthalle, Basel, 4 Americans, 1963; Bennington College, Recent Figurative Art, 1967; MOMA, In Memory of My Feelings: Frank O'Hara, 1967; WMAA, 22 Realists, 1970; MIT, Contemporary Views of Man, 1971; WMAA, American Drawings: 1963-1973, 1973; St. John's U., The Figure in Recent American Painting, 1974; New York Cultural Center, Three Centuries of the American Nude, 1975; St. Petersburg, Fla./MFA, The Figure as Form: American Painting 1930-1975, 1975; Venice Biennial, 1976; US Department of the Interior, America '76, circ., 1976; Youngstown/Butler, 41st Annual Midyear Show, 1977; Indianapolis, Perceptions of the Spirit in 20th Century American Art, 1977; PAFA, 8 Contemporary American Realists, 1977; Hirshhorn, The Fifties, 1980; WMAA, The Figurative Tradition, 1980; Tulsa/Philbrook, Realism/Photorealism, 1980; San Antonio/MA; Real, Really Real, Super Real, 1981; PAFA, Contemporary American Realism Since 1960, 1981; Haus der Kunst, Munich; Amerikanische Malerei, 1930-80, 1981; Houston/Contemporary, American Still Life, 1945-1983, circ., 1983; Newport Harbor, Action/Precision, circ., 1984; Isetan Museum, Tokyo, American Realism: The Precise Image, 1985; Fort Lauderdale, American Renaissance, 1986; ICA, U. of Pennsylvania, 1967: At the Crossroads, 1987; MOMA, Artist's Choice: Chuck Close: Head On, 1991; WMAA, American Life in American Art, 1991; The Pennsylvania State U., Realist Watercolors, 1990. **Collections:** Aachen; U. of Alabama; Amsterdam/Stedelijk; Basel/Kunsthalle; Boston/MFA; Buffalo/Albright; Chicago/AI; Cornell U.; Des Moines; Hirshhorn; Indiana U.; MMA; MOMA; Milwaukee; Minneapolis/Institute; NPG; Norfolk/Chrysler; PAFA; St. Louis/City; São Paulo; Stockholm/National; VMFA; U. of Virginia; WMAA; Walker; Washington Art Consortium. **Bibliography:** *America 1976;* Armstrong, Thomas;

Arthur 2, 3; Cummings 4; Downes, ed.; Friedman, ed.; Goodyear; Hunter 1; Hunter, ed.; Janis and Blesh 1; Kardon 3; *Kunst um 1970;* Sager; Sandler 3, 5; **Stein and Shapiro**; Vine and Hales; Ward. Archives.

LE VA, BARRY b. 1941, Long Beach, Calif. **Studied:** Los Angeles Art Center School; Otis Art Institute, Los Angeles, BA, MFA, 1964-67. **Taught:** Minneapolis College of Art and Design, 1969-70; Princeton U., 1973-74; Yale U., 1976. **Awards:** Los Angeles County/MA, Young Talent Grant, 1968; Guggenheim Foundation Fellowship, 1974; National Endowment for the Arts, 1976. **Address:** 74 Grand Street, NYC, 10013. **Dealer:** Sonnabend Gallery, NYC. **One-man Exhibitions:** Minneapolis School of Art, 1969; Galerie Ricke, Cologne, 1970, 71, 72, 73, 76; Nigel Greenwood Gallery, London, 1971, 80; U. of Utrecht, 1971; Bykert Gallery, NYC, 1972, 73, 74, 75; Gallery Projection, Cologne, 1972; Felix Handshin Gallery, Basel, 1973; Zwirner Gallery, Cologne, 1973; The Texas Gallery, Houston, 1974, 76, 78, 85, 89; Hartford (Conn.) Art School, 1974; Galleria Toselli, Milan, 1974; Daniel Weinberg Gallery, San Francisco, 1975, 76, 82; Claire Copley Gallery, Los Angeles, 1975, 76; Espace 5, Montreal, 1975; Montreal/Contemporain, 1975; Sonnabend Gallery, NYC, 1976, 78, 79, 81, 83, 86, 88, 91; Galerie Sonnabend, Paris, 1976; Wright State U., 1977; Hartnell College, 1979; Michelle Lachowsky Gallery, Brussels, 1980; ICA, Los Angeles, 1980; The New Gallery, Cleveland, 1981; P.S. 1, Long Island City, 1982; Beaver College, 1982; Yarlow-Salzman Gallery, Toronto, 1982; Daniel Weinberg Gallery, Los Angeles, 1986, 89; Galerie Fred Hahn, Munich, 1987; Rijksmuseum Kröller-Müller; Monchengladbach, 1989; David Noland

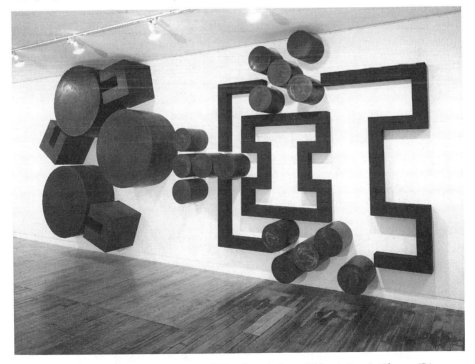

Barry Le Va, *Dissected Situations: Institutional Templates. A. Spaces/Abbreviations B. Close-ups/Distances C. Observers/Participants,* 1990-1991.

Gallery, NYC, 1989, 90. **Retrospectives:** The New Museum, NYC, 1979; Carnegie Mellon U., circ., 1988. **Group:** California State College, Los Angeles, 2 Painters, 1 Sculptor, 1968; SFA, Conception-Perception, 1968; WMAA, Anti-Illusion, 1969; Seattle/AM, 557,087, 1969; La Jolla, Projections, 1970; MOMA, Information, 1970; WMAA Annuals, 1971, 76; Düsseldorf/Kunsthalle, Prospect, 1971; Kassel, Documenta V, 1971; Yale U., Options and Alternatives, 1973; Cincinnati/Contemporary, Bochner, La Va, Rockburne, Tuttle, 1975; Baltimore/MA, Fourteen Artists, 1975; Leverkusen, U.S.A. Drawings III, 1975; WMAA, 200 Years of American Sculpture, 1976; Philadelphia College of Art, Line, 1976; U. of Chicago, Installations, 1977; U. of Santa Barbara, Contemporary Drawing New York, 1978; U. of North Carolina, Drawings About Drawing Today, 1979; XXXIX Venice Biennial, 1980; Humlebaek/Louisiana, Drawing Distinctions, 1981; Kassel, Documenta VIII, 1982; MIT, Great Big Drawings, 1982; New Museum, Language, Drama, Source & Vision, 1983; Wesleyan U., Large Drawings, 1984; U. of Chicago, Large Drawings, 1984; Carnegie Mellon U., Drawing from the Eighties, 1987; ICA, U. of Pennsylvania, 1967: At the Crossroads, 1987; U. of Michigan, Ann Arbor, Grounded, 1990; WMAA, The New Sculpture, 1956-75, circ., 1990; WMAA, Immaterial Objects, circ., 1991. **Collections:** Los Angeles County/MA; WMAA. **Bibliography:** *Drawings: The Pluralist Decade; Europa/Amerika;* Gablik; Kardon 3; Kren; *Performance Anthology;* Pincus-Witten; Robins; Sandler 3.

LEVEE, JOHN b. April 10, 1924, Los Angeles, Calif. **Studied:** UCLA, BA (philosophy); New School for Social Research, with Stuart Davis, Yasuo Kuniyoshi, Adja Yunkers, Abraham Rattner; Academie Julian, Paris. Traveled Europe, North Africa, Middle East; resides Paris, 1949-. **Taught:** U. of Illinois, 1965;

Washington U. (St. Louis), 1967, 68; NYU, 1967-68; U. of Southern California, Los Angeles, 1971. **Commissions:** Hotel de Vaudreuil, Paris; Parc de Noiseil, France; Prudential Insurance Co. of America, Los Angeles; Lycee d'Enseignement Professionel, Château Chinon, France. **Awards:** Deauville Salon, 1951; California Watercolor Society, 1955, 56; I Paris Biennial, First Prize, 1959; VMFA, Virginia Artists Biennial, P.P., 1966; Tamarind Fellowship, 1969; Woolmark Foundation Prize, 1974. **Address:** 119 rue Notre Dame des Champs, Paris 75006, France. **Dealers:** Margo Leavin Gallery, Los Angeles; André Emmerich Gallery, NYC. **One-man Exhibitions:** (first) Galerie Huit, Paris, 1951; Twenster, Rotterdam, 1953; Felix Landau Gallery, Los Angeles, 1954; André Emmerich Gallery, NYC, 1956, 58, 59, 62, 65, 66; Gimpel Fils Ltd., 1958, 60, 66; Galerie de France, Paris, 1958, 61, 62, 64, 69; Esther Robles Gallery, Los Angeles, 1962, 63, 65; Haifa, 1964; Phoenix, 1964; U. of Illinois, 1965; Walker, 1965; Margo Leavin Gallery, Los Angeles, 1970; Galerie Henri Mayer, Lausanne, 1971; Galerie Liatowitsch, Basel, 1972; American Embassy, London, 1974; Palm Springs Desert Museum, 1976, 77. **Retrospectives:** Tel Aviv, 1969; Galerie la Tortue, Paris, 1975; Galerie Callu Merite, Paris, 1986; Galerie Le Gall, Paris, 1986. **Group:** Carnegie, 1955, 58; Corcoran, 1956, 58, 66; WMAA, Young America, 1957; Brooklyn Museum, Watercolor Biennials; MOMA, Younger American Painters, circ., 1957-59; Arts Club of Chicago, 1958; Smithsonian, American Painters in France, circ., USA; WMAA Annuals, 1958, 59, 65, 66; Foundation Maeght, L'Art Vivant, circ., French museums, 1966, 67; UNESCO, 1975; Comparison Salon, Paris, 1978; American Cultural Center, Paris, 1981. **Collections:** Allentown/AM; Amsterdam/Stedelijk; U. of Arizona; Baltimore/MA; Basel; CNAC; U. of California, Berkeley; Carnegie; Cincinnati/AM; Columbus; Corcoran; Dallas/MFA; Des

Moines; Djakarta Museum; Grenoble; Haifa; Harvard U.; Hirshhorn; Honolulu Academy; Los Angeles/County MA; MOMA; Musée du Havre; NYPL; Oberlin College; Oklahoma; Palm Springs Desert Museum; Phoenix; SRGM; Santa Barbara/MA; Smith College; U. of Sydney; Tel Aviv; Towner Art Gallery; VMFA; WGMA; WMAA; Walker; Washington U.; Yale U. **Bibliography:** Juin; Read 2.

LEVI, JOSEF **b.** February 17, 1938, NYC. **Studied:** U. of Connecticut (with Walter Meigs), BA; Columbia U. Traveled Spain, France, Belgium, Holland, England, Mexico, Middle East. US Army, 1960-67. **Taught:** Appalachian State U., Artist-in-Residence, 1969; Fairleigh Dickinson U., 1971; Director, Encounter, Inc. (drug rehabilitation program), NYC, 1974; Pennsylvania State U., 1977. **Awards:** U. of Illinois, P.P., 1967. **Member:** Artists Equity. **Address:** 171 West 71st Street, NYC 10023. **Dealer:** OK Harris Works of Art, NYC. **One-man Exhibitions:** (first) The Stable Gallery, NYC, 1966, also 1967, 69, 70; Arts Club of Chicago, 1968; Louisville/Speed, 1968; Appalachian State U., 1969; Lambert Studios, Inc., Los Angeles, 1971; Jacob's Ladder Gallery, Washington, D.C., 1972; Images Gallery, Toledo, 1972; A.M. Sachs Gallery, NYC, 1975, 76, 78; OK Harris Works of Art, NYC, 1983, 85, 87, 90, 92; Adams-Middleton Gallery, Dallas, 1986. **Group:** Houston/Contemporary, 1966; Kansas City/Nelson, Sound, Light, Silence, 1966; U. of Illinois, 1967; Walker, Light Motion Space, 1967; MOMA, The 1960's, 1967; Flint/Institute, 1967; Indianapolis/Herron, 1968; WMAA Annual, 1968; Brooklyn Museum, 1969; RISD, 1972; WMAA, Art About Art, 1978; U. of Rochester, Uncommon Visitations, 1979; Worcester/AM, Illusions of Light, 1981; Youngstown/Butler, Midyear, 1987; Danville, KY/Center College, The Hot Centre: Contemporary Art Selected by Ivan Karp, 1987; U. of Virginia, The Humanist Icon,

1990. **Collections:** Albion College; AT&T; The Bank of New York; Brooklyn Museum; Buffalo/Albright; Chattanooga/Hunter; Chrysler Corp.; Corcoran; Dartmouth College; Des Moines; Exxon Corp., NYC; U. of Illinois; Louisville/Speed; Minolta Corp., NYC; MOMA; U. of Maryland; Newark Museum; U. of Notre Dame; Prudential Insurance Co. of America; Ridgefield/Aldrich; Spelman College; Storm King Art Center; VMFA; Worcester/AM. **Bibliography:** Archives.

LEVI, JULIAN **b.** June 20, 1900, NYC. **d.** February 28, 1982, NYC. **Studied:** PAFA, with Henry Breckenridge, Arthur B. Carles, Jr.; and five years in France and Italy. **Taught:** ASL; PAFA, 1964-77; New School for Social Research. **Awards:** PAFA, Cresson Fellowship, 1920; Chicago/AI, The M.V. Kohnstamm Prize, 1942; Chicago/AI, Norman Wait Harris Medal, 1943; Carnegie, Hon. Men., 1945; NAD, The Adolph and Clara Obrig Prize, 1945; U. of Illinois, 1948; PAFA, Fellowship, 1954; NIAL Grant, 1955; elected to the NIAL, 1960. **One-man Exhibitions:** Crillon Galleries, Philadelphia, 1933; The Downtown Gallery, NYC, 1940, 42, 45, 50, Philadelphia Art Alliance, 1953, 63; The Alan Gallery, NYC, 1955; Lee Nordness Gallery, NYC, 1961; Anna Werbe Gallery, Detroit, 1961. **Retrospective:** Boston U., 1962; New Britain; Rehn Galleries, 1974. **Group:** Detroit Institute, 1961; PAFA; NAD; U. of Illinois; WMAA; Newark Museum; Youngstown/Butler. **Collections:** U. of Arizona; Britannica; Buffalo/Albright; Chicago/AI; Cranbrook; Des Moines; Detroit/Institute; U. of Georgia; U. of Illinois; MMA; MOMA; Michigan State U.; NAD; NCFA; U. of Nebraska; Newark Museum; New Britain; PAFA; Reed College; Santa Barbara/MA; Scripps College; Springfield, Mass./MFA; Toledo/MA; WMAA; Walker/Wilmington; Youngstown/Butler. **Bibliography:** Baur 7; Blesh 1; Halpert;

Hess, T.B., 1; Kootz 2; Nordness, ed.; Pagano; Passloff; Rose, B., 1; Watson, E.W., 2; Wheeler. Archives.

LEVINE, JACK b. January 3, 1915, Boston, Mass. Studied with Denman W. Ross, Harold Zimmerman. Traveled Europe, Mexico; resided Rome, one year. He is the subject of a film directed by Zina Voynow, 1963, and one directed by David Sutherland, 1985. **Member:** NIAL; American Academy of Arts and Sciences; Artists Equity. Federal A.P.: Easel painting. **Taught:** American Art School, NYC; PAFA; Skowhegan School; Cleveland/MA; Chicago/AI; U. of Illinois. **Awards:** Carnegie, 1946; Corcoran, 1959; PAFA, 1948; NIAL, 1946; Guggenheim Foundation Fellowship, 1946; Hon. DFA, Colby College; NAD, Benjamin Altman Prize, 1975. **m.** Ruth Gikow. **Address:** 68 Morton Street, NYC 10014. **Dealer:** Midtown-Payson Galleries, NYC. **One-man Exhibitions:** The Downtown Gallery, NYC, 1939, 48, 52; Boris Mirski Gallery, Boston, 1950; The Alan Gallery, NYC, 1953, 57, 59, 63, 66; Chicago/AI, 1955; Philadelphia Art Alliance, 1955; Colby College, 1956; Randolph-Macon Women's College, 1960; New Art Center, Detroit, 1962; B'nai B'rith Building, Washington, D.C., 1965; Kovler Gallery, Chicago, 1966; Athena Gallery, New Haven, 1967; Graphics, Inc., NYC, 1967; George Washington U., 1967; Galeria Colibri, San Juan, 1968; Lincoln, Mass./De Cordova, 1968; Galleria d'Arte il Gabbiano, Rome, 1968; Muggleton Art Gallery, Auburn, N.Y., 1968; Art Harxis Art Gallery, L.A., 1970; Kennedy Galleries, NYC, 1972, 73, 75, 77; Rodman Hall Arts Center, St. Catherines, Ont., 1978; Midtown-Payson Galleries, NYC, 1990; St. Botolph Club, Boston, 1992; Ogunquit, 1992. **Retrospectives:** Long Beach/MA, 1971; The Jewish Museum, circ., 1979. **Group:** MOMA, New Horizons in American Art, 1936; WMAA Annuals, 1937 to 1967; Musée du Jeu de Paume, Paris, Three Centuries of American Art, 1938; Carnegie, International Exhibition, 1938-1955; MOMA; Art in Our Time, 1939; PAFA Annuals, 1940-1968; MOMA, Thirty-Five Under Thirty-Five, circ., 1940; Institute of Modern Art, Boston, Painting by 50 Oncoming Americans, 1941; MMA, Artists for Victory, 1942; WAC, 92 Artists, 1943; NAD, 1946; Tate Gallery, London, American Painting from the Eighteenth Century to the Present Day, 1946; Corcoran Biennials, 1947-1959; ICA, Boston, American Painting in Our Century, circ., 1949; U. of Illinois, 1949-1967; MMA, American Painting Today, 1950; U. of Minnesota, 40 American Painters, 1940-1950; São Paulo, Biennial, 1951; Youngstown/Butler, The American Jew in Art, 1955; MOMA, Modern Art in the U.S.A., circ. internationally, 1955; XXVIII Venice, Biennial, 1956; Smithsonian, Fulbright Painters, circ., 1958, U.S. Dept. of State, American Painting and Sculpture, circ., internationally, 1959; Milwaukee Art Center, ART: USA: NOW, 1962; Washington (D.C.) Gallery of American Art, US Government Art Projects: Some Distinguished Alumni, 1963; Minneapolis/Institute, Four Centuries of American Art, 1963; MMA, Three Centuries of American Paintings, 1965; Corcoran, Two Hundred Fifty Years of American Art, 1966; Cleveland/MA, Four Centuries of American Art, 1966; WMAA, Art in the United States, 1670-1966, 1966; WMAA, The 1930s; Painting and Sculpture in America, 1968; Omaha/Joslyn, The Thirties Decade: American Artists and Their European Contemporaries, 1971; Pushkin Museum, Moscow, Representations of America, circ., 1977; Oklahoma, American Masters of the Twentieth Century, circ., 1982. **Collections:** Andover/Phillips; U. of Arizona; Boston/MFA; Brandeis U.; Brooklyn Museum; California Palace; Chicago/AI; Colby College; U. of Connecticut; Des Moines; Harvard U.; Hirshhorn; State U. of Iowa; Israel Museum; Jewish Museum;

Jewish Theological Seminary of America; U. of Kansas; Lincoln, Mass./De Cordova; MMA; MOMA; Memphis/Brooks; Montclair/AM; Montgomery Museum; NMAA; National Gallery; U. of Nebraska; Oklahoma; U. of Oklahoma; PAFA; Phillips; Portland, Ore./AM; Purchase/SUNY; Randolph-Macon Women's College; Reed College; SFMA; Seattle/AM; Trenton/State; Utica; WMAA; Wichita/AM; Walker; Williams College; Youngstown/Butler. **Bibliography:** Barker 1; Baur 7; Blesh 1; Cheney; Christensen; Eliot; Finkelstein; Frost; Genauer; **Getlein 2;** Getlein, F. and D.; Goodrich and Baur 1; Halpert; Hunter 6; Kootz 2; McCurdy, ed.; Mendelowitz; Miller, ed., 1; Munsterberg; Newmeyer; Nordness, ed.; Pousette-Dart, ed.; Read 2; Richardson, E.P.; Rodman 1, 2, 3; Rose, B., 1: Sachs; Shapiro, ed.; Soby 5, 6; Soyer, R., 1; Ward; Wight 2. Archives.

LEVINE, LES **b.** October 6, 1935,

Dublin, Ireland. **Studied:** Central School of Arts and Crafts, London. To Canada, 1958; to USA, 1966. Traveled Australia, Europe, South America. Founder/President, The Museum for Mott Art, Inc., 1970. Produced many videotapes. **Taught:** NYU, 1972-73; William Paterson College; Nova Scotia College of Art and Design, 1973; Artist-in-Residence, Aspen Institute, 1967, 69; U. of Illinois, 1975-76; Columbia U., 1978. Produced *Levine's Restaurant,* NYC, 1969. **Member:** National Arts Club. **Awards:** National Endowment for the Arts, 1974; CAPS, 1980; The Architectural League of New York, Grant, 1972; National Endowment for the Arts, 1980; National Endowment for the Arts, Sculpture Award, 1974; CAPS, Video Award, 1979; International Video Festival, San Francisco, Award, 1983. **Address:** 20 East 20th Street, NYC 10003. **Dealers:** Carl Solway Gallery, Cincinnati; Mai 36 Galerie, Lucerne. **One-man Exhibitions:** U. of Toronto, 1964; Blue Barn Gallery, Ottawa, 1964, 66; David Mirvish Gallery, 1965; Isaacs Gallery, 1965, 67, 70,

73; Fischbach Gallery, NYC, 1966, 67, 68, 69, 70, 72, 73; Toronto, 1966; Lofthouse Gallery, Ottawa, 1966; Walker, 1967; MOMA, 1967; York U., 1968; John Gibson Gallery, 1968; Molly Barnes Gallery, Los Angeles, 1969; ICA, Chicago, 1969; U. of Michigan, 1969; Rowan Gallery, London, 1969; Phyllis Kind Gallery, Chicago, 1969; NYU, 1969; Galerie de Gestlo, 1971, 73, 74; Finch College, NYC, 1972; Rivkin Gallery, Washington, D.C., 1972; Nova Scotia College of Art and Design, 1973; Vancouver, 1974; U. of California, San Diego, 1974; Stefanotti Gallery, NYC, 1974; The Video Distribution Inc., 1974; Gallerie Gilles Gheerbrant, Montreal, 1976; M. L. D'Arc Gallery, NYC, 1976, 77; Hartford/Wadsworth, 1976; California State U., Los Angeles, 1976; Art Gallery of New South Wales, Adelaide, Australia, 1976; National Gallery of Victoria, Melbourne, Australia, 1976; U. of Melbourne, Australia, 1976; Syracuse/Everson, 1977; Buffalo/Albright, 1977; Galerie de Gestlo, Hamburg, 1977; Vehicule Art, Inc., Montreal, 1977; Galerie Arnesen, Copenhagen, 1977; International Cultural Centrum, Antwerp, 1978; Rotterdamse Kunststichting, Rotterdam, 1978; Station Gallery, Whitby, Canada, 1978; Laurentian U., 1978; Parry Sound Public Library, Canada, 1979; Canadian Cultural Center, Paris, 1979; Northwestern Illinois U., 1979; Ronald Feldman Fine Arts, NYC, 1979, 83; Galerie Jollembeck, Cologne, 1979; PMA, 1979; Plattsburgh/SUNY, 1979; Alberta College of Art, Calgary, 1979; Marion Goodman Gallery, NYC, 1980; Carpenter & Hochman Gallery, NYC, 1986; ICA, London, 1985; Ted Greenwald Gallery, NYC, 1984; Mai 36 Galerie, Lucerne, 1988; Art Frankfurt, 1989; Galerie Wassermann, Munich, 1991; Galerie Brigitte March, Stuttgart. **Retrospectives:** Syracuse/Everson, 1990; Muhka, Antwerp, 1992. **Group:** Ottawa/National, Canadian Sculpture Exhibitions, 1964, 65, 67; MOMA, The Object Transformed, 1966;

ICA, Boston, Nine Canadians, 1967; Expo '67, Montreal, 1967; MOMA, Dada, Surrealism, and Today, 1967; MOMA, Canadian Prints Today, 1967; Union Carbide Corp., NYC, Canada '67, 1967; ICA, Boston, The Projected Image, 1967; Finch College, NYC, Schemata 7, 1967; U. of North Carolina, Works on Paper, 1968; Newark College of Engineering, Light as Art, 1968; Edinburgh Festival, 1968; Finch College, NYC, Destructionists, 1968; HemisFair '68, San Antonio, Tex., 1968; Brandeis U., Vision and Television, 1969; Milwaukee, A Plastic Presence, circ., 1969; Edmonton Art Gallery, Alberta, Place and Process, 1969; X São Paulo Biennial, 1969; ICA, U. of Pennsylvania, Between Object and Environment, 1969; Buffalo/Albright, Manufactured Art, 1969; UCLA, Electric Art, 1969; Cincinnati/Contemporary, Monumental Art, 1970; Moore College of Art, Philadelphia, Recorded Image, 1970; ICA, London, Multiple Art, 1970; Jewish Museum, Software, 1970; MOMA, Information, 1971; Montreal/Contemporain, Conceptual Decorative, 1971; Dalhousie U., Halifax, Morbus Exhibition, 1973; Walker, New Learning Spaces, 1974; Cologne, Project '74, 1974; ICA, Philadelphia, Video and Television, 1975; XII São Paulo Biennial, 1975; Milwaukee, From Foreign Shores, 1976; Philadelphia College of Art, Artists' Maps, 1977; Kunsthaus, Zurich, Painting and Photography in Dialogue from 1840 to Today, 1977; Kassel, Documenta VI, 1977; Documenta VIII, 1987; Smith College, Artists' Stamps, 1977; Museum of Contemporary Crafts, NYC, The Great American Foot, 1978-80; Purchase/SUNY, The Sense of Self, 1978; ICA, Boston, Wit and Wisdom, 1978; Hirshhorn, Content, 1984; MOMA, Committed to Print, 1988; MOMA, American Documentary Video, 1988; Cologne/Kunstverein, Video-Skulptur, 1980; Milwaukee, Word as Image, 1990. **Collections:** Art Gallery of Ontario; Art Gallery of South Australia; Brooklyn Museum; Brown U.; Corcoran;

U. of Georgia, Athens; Hartford/Wadsworth; Honolulu Academy; Indianapolis; Lenbachhaus; Los Angeles/MOCA; Munich; MMA; MOMA; NMAA; NYPL; National Gallery of Australia; National Gallery, Victoria; New Orleans Museum; Ottawa/National; PMA; Paris/Beaubourg; Purchase/SUNY; Sydney/AG; Toronto; WMAA. **Bibliography:** Calas, N. and E.; Davis, D.; *From Foreign Shores;* Lippard, ed.; *Report.* Archives.

LEVINSON, MON b. January 6, 1926, NYC. **Studied:** U. of Pennsylvania, 1948, BS Econ.; self-taught in art. US Army, 1945-46. Traveled Mexico, Europe. **Taught:** Boston Museum School, 1969; C. W. Post College, 1970-72. **Commissions:** Betsy Ross Flag & Banner Co., 1963 (banner); MOMA, 1964 (greeting card); Astor Foundation Grant, 1967 (sculpture for P.S. 166, NYC); Housing and Redevelopment Board, NYC, 1967-69 (murals for demountable vest-pocket parks); Great Southwest Industrial Park, 1968 (mural); Machpelah Cemetery, Flint, Mich., 1969 (sculpture). **Awards:** Cassandra Foundation Grant, 1972; CAPS, New York State Council on the Arts, 1974; National Endowment for the Arts, 1976; National Endowment for the Arts, grant. **Address:** 309 West Broadway, NYC 10013. **One-man Exhibitions:** (first) The Kornblee Gallery, NYC, 1961, also 1963-66, 68, 69, 71, 72; Cinema I and Cinema II, NYC, 1965; Franklin Siden Gallery, Detroit, 1965-67, 69; Obelisk Gallery, 1968; C. W. Post College, 1970; A Clean Well-Lighted Place, Austin, Tex., 1970; Southern Methodist U., 1971; John Weber Gallery, 1973; Gertrude Kasle Gallery, 1975; Rosa Esman Gallery, NYC, 1976 (two-man), 77; Deson-Zaks Gallery, Chicago, 1976; Suzette Schochett Gallery, Newport, R.I., 1976; St. Peter's Church, NYC, 1985; Andre Zarre Gallery, NYC, 1989; Fridholm Fine Arts Gallery, Asheville, N.C., 1989. **Group:** Martha Jackson Gallery, New Media—New Forms, I,

1960; MOMA, 1962, 63; Sidney Janis Gallery, 1964; Chicago/AI, 1964; A.F.A., circ.; Buffalo/Albright, 1964; RISD, 1965; Staatliche Kunsthalle, Baden-Baden, 1965; MOMA, 1967; Buffalo/Albright, Plus by Minus, 1968; Finch College, 1968; Museum of Contemporary Crafts, 1968; Flint/Institute, Made of Plastic, 1968; Grand Rapids, 1969; Jewish Museum, Superlimited, 1969; Foundation Maeght, L'Art Vivant, 1970; WMAA, 1970, 73; Lincoln, Mass./De Cordova, Refracted Images, 1973; Indianapolis, 1973; U. of Miami, Less Is More: The Influence of the Bauhaus on American Art, 1974; Renwick Gallery, Washington, D.C., The Object as Poet, 1978; NCFA, New Ways with Paper, 1978; NYU, Drawing and Collage, 1977; Albright/Buffalo, Paper About Paper, 1980. **Collections:** Brandeis U.; Brooklyn Museum; Caracas; Cornell U.; NYU; Princeton U.; Spelman College; Springfield, Mo./AM; Storm King Art Center: WMAA. **Bibliography:** MacAgy 2; Rickey.

LEVITAN, ISRAEL
from 1st to 5th edition.

LEWANDOWSKI, EDMUND D.
b. July 3, 1914, Milwaukee, Wis. **Studied:** Layton School of Art, 1932-35. **Taught:** Florida State U., 1949-54; Layton School of Art, 1945-49, 1954-72; Winthrop College, 1973-84. **Commissions:** Commemorative Stamp, Polish Millennium. **Awards:** Hallmark International Competition, 1950, 53, 57; Milwaukee, Medal, 1940. **Address:** 537 Meadowbrook Lane, Rockhill, SC 29730. **Dealer:** H.V. Allison Galleries, Inc., NYC. **One-man Exhibitions:** Layton School of Art; Minnesota State Fair; Florida State U., 1950; Fairweather-Hardin Gallery, Chicago, 1973, 1978; Sid Deutsch Gallery, NYC, 1983, 85; H.V. Allison Galleries, Inc., NYC, 1990; Greenville, 1990. **Retrospective:** Augusta (Ga.) College, 1991; Museum of York County, Rock Hill, S.C., 1992.

Group: Chicago/AI; Carnegie; Corcoran; PAFA; Brooklyn Museum; New York World's Fair, 1939; Phillips; Milwaukee, 100 Years of Wisconsin Art, 1988; South Carolina State Museum, Beyond Tomorrow, 1989. **Collections:** AAAL; Allen-Bradley Co. Inc.; Andover/Phillips; Beloit College; Boston/MFA; Brooklyn Museum; Chicago/AI; Corcoran; Dartmouth College; Flint/Institute; Florida State U.; U. of Georgia; Gimbel Bros.; Grand Rapids; Hallmark Collection; High Museum; Krakow/National; Layton School of Art; MOMA; Marquette U.; Milwaukee; Minnesota/MA; U. of Oklahoma; Orlando; Queens College; St. Patrick's, Mensasha, Wis.; Shell Oil Co.; US Maritime Commission; Warsaw; Warsaw/National; Winthrop College; U. of Wisconsin. **Bibliography:** Baur 7; Cheney; Halpert; Pousette-Dart, ed.; Ritchie, 1.

LEWIS, NORMAN **b.** July 23, 1909, NYC. **d.** August 27, 1979, NYC. **Studied:** Columbia U., with Augusta Savage. **Taught:** Junior high school, NYC, 1935; Harlem Art Center, NYC, 1937; Thomas Jefferson School, NYC, 1944-49; Indian Hill Music School, Stockbridge, Mass., 1954; HARYOUACT, 1965-70; ASL, 1972-78. Traveled Europe, North Africa, Greece. Organized an art center at Bennett College under government sponsorship, 1938. Supervised a mural for Thomas Jefferson High School, St. Albans, N.Y., 1939; cofounder of Cinque Gallery, NYC. **Awards:** Carnegie, Popularity Prize, 1955; AAAL, 1970; NIAL, 1971; Mark Rothko Foundation, 1972; National Endowment for the Arts, 1972. **One-man Exhibitions:** Harlem Artists Guild, 1936; Fisk U., 1939; Baltimore/MA, 1939; The Willard Gallery, NYC, 1949, 51, 52, 54, 56. **Retrospective:** City U. of New York, 1976. **Group:** Carnegie, 1955; XXVIII Venice Biennial, 1956; U. of Illinois; NIAL; PAFA; PMA; Library of Congress; Boston/MFA, Black Artists: New York and Boston, 1970.

Collections: Andover/Phillips, Chicago/AI; IBM; MOMA; Manufacturers Hanover Trust Co.; Utica. **Bibliography:** Baur 5; Dover; Motherwell and Reinhardt, eds.; *Norman Lewis: A Retrospective;* Ritchie 1. Archives.

LeWitt, Sol b. 1928, Hartford, Conn. **Studied:** Syracuse U., 1945-49, BFA. **Taught:** MOMA School, 1964-67; Cooper Union, 1967. **Commissions:** GSA, Syracuse, N.Y., 1979; Hartford (Conn.) Coliseum, 1980. DANCE, in collaboration with Lucinda Childs and Philip Glass, Brooklyn Academy of Music, 1979; New Mexico State U., Las Cruces, 1981; Light Rail Transit System, Pittsburgh, Pa., 1984; 10 West Jackson Street, Chicago, 1985; The Equitable Center, NYC, 1985; BOC Group, Windlesham, Surrey, England, 1985. **Address:** 26 Ferry Road, Chester, CT 06412. **Dealers:** John Weber Gallery, NYC; Paula Cooper Gallery, NYC. **One-man Exhibitions:** The Daniel Gallery, NYC, 1965; Dwan Gallery, NYC, 1966, 68, 70, 71; Dwan Gallery, Los Angeles, 1967; Galerie Bischofberger, Zurich, 1968; Galerie Heiner Friedrich, Munich, 1968; Konrad Fischer Gallery, Düsseldorf, 1968, 69, 71, 75, 77, 79, 84, 87; ACE Gallery, Los Angeles, 1968; Galleria l'Attico Rome, 1969, 73; Galerie Ernst Joachim, Hanover, 1969; Krefeld/Haus Lange, 1969; Wisconsin State U., 1970; Art & Project, Amsterdam, 1970, 71, 72, 73, 75; Yvon Lambert, Paris, 1970, 73, 74, 79, 81, 84, 87; The Hague, 1970; Pasadena/AM, 1970; Protetch-Rivkin, Washington, D.C., 1971; Galleria Toselli, Milan, 1971; Lisson Gallery, London, 1971, 73, 74, 77, 79, 84, 88, 89, 91; John Weber Gallery, NYC, 1971, 73, 74, 77, 78, 80, 82, 86, 87, 88; Dunkelman Gallery, Toronto, 1971; MIT, 1972; Harkus-Krakow Gallery, Boston, 1972; Dayton/AI, 1972; Berne, 1972, 74; Rosa Esman Gallery, 1973, 79; Vehicule Art Inc., Montreal, 1973; Museum of Modern Art, Oxford, England, 1973; Galerie MTL, Brussels, 1973; Portland

(Ore.) Center for the Visual Arts, 1973; Cusack Gallery, Houston, 1973; Max Protetch Gallery, Washington, D.C., 1974; Galerie December, Munster, 1974; Brussels/Beaux-Arts, 1974; Rijksmuseum Kröller-Müller, 1974; Amsterdam/Stedelijk, 1974, 75; Douglas Christmas, Los Angeles, 1974; Daniel Weinberg Gallery, San Francisco, 1974, 81; Gian Enzo Sperone, Turin, 1970, 74, 75; Vancouver, 1974; Galerie Vega, Liege, 1974; Sperone Westwater Fisher Inc., NYC, 1974; Galleria Scipione, Macerata, Italy, 1975; Young-Hoffman Gallery, Chicago, 1979, 80, 82; Israel Museum, 1975; Basel/Kunsthalle, 1975; National Gallery of Victoria, 1977; Sydney/AG, 1977; Brooklyn Museum, 1978; Galeria Genoa, Italy, 1974, 75, 77; Galerie Annemarie Verna, Zurich, 1975, 81, 84, 86, 87; Hartford, 1976; Utah, 1977; Galerie Watari, Tokyo, 1980; Protetch-McIntosh Gallery, Washington, D.C., 1980; Ugo Alessandro Ferranti Gallery, Rome, 1980, 82, 83; Texas Gallery, Houston, 1980, 89; Paula Cooper Gallery, NYC, 1981; Miami-Dade Community College, 1981; Larry Gagosian Gallery, Los Angeles, 1981; Bellman Gallery, Toronto, 1981, 82; Max Protetch Gallery, NYC, 1981; New Mexico State U., Las Cruces, 1981; Hartford/Wadsworth, 1981; Graeme Murray Gallery, Edinburgh, 1981, 87; Marilena Bonomo Gallery, Bari, Italy, 1982, 84, 87, 89; Aronowitsch Gallery, Stockholm, 1982; Rudiger Schottle Gallery, Munich, 1982; Barbara Toll Gallery, NYC, 1982; Eindhoven, 1983, 84; Centre d'Art Contemporaine, Geneva, 1983; Lisson Gallery, London, 1983, 84; Brooke Alexander Gallery, NYC, 1983; U. of California, Berkeley, 1983; Amsterdam/Stedelijk, 1984; Gallery A, Amsterdam, 1984; Raum für Kunst, Hamburg, 1984; Galerie Daniel Templon, Paris, 1984; Daniel Weinberg Gallery, Los Angeles, 1985, 89; Brooklyn Museum, 1985; Fausto Scaramucci, Spoleto, 1985; Harvard U., 1985; Galleria Mario Pieroni, Rome,

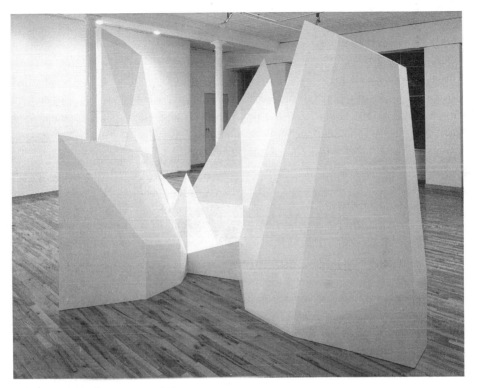

Sol LeWitt, *Complex Forms #7*, 1987.

1985; The Hague, 1985; Rhona Hoffman Gallery, Chicago, 1986, 90; Galerie Peter Pakesch, Vienna, 1986, 88; The Drawing Center, NYC, 1986; Tate Gallery, 1986; Studio G7, Bologna, 1986; Cincinnati/Contemporary, 1986; Galleria Spazio Immagine, Foligno, Italy, 1986; Galerie Vega, Plainevaux, Belgium, 1986; Donald Young Gallery, Chicago, 1986, 88, 90; ICA, London, 1986; Washington U., 1987; Galleria Ugo Ferranti, Rome, 1987, 90; Munster/WK, 1987; Galerie Ressle, Stockholm, 1987; Galerie Vega, Liege, 1987; Cleveland/Contemporary, 1987; Ohio U., 1987; La Jolla, 1987; Hirshhorn, 1987; Paris/Moderne, 1987; Galleria Alessandra Bonomo, Rome, 1987; Walker, 1988; Williams College, 1988; Secession Gallery, Vienna, 1988; Des Moines, 1988; Le Case D'Arte Milan, 1988; Lawrence Oliver Gallery, Philadelphia, 1988; Museo di Capodimonte, Naples, 1988; Massimo Minini, Brescia, Italy, 1988; Hanover/K-G, 1988; B. R. Kornblatt Gallery, Washington, D.C., 1988, 89; New Britain/American, 1989; Wesleyan U., 1989; Galerie de Expeditie, Amsterdam, 1989; Galerie Le Gall Peyroulet, Paris, 1989; Berne, 1989; Galerie Tanit, Munich, 1989; Galleria Artiaco, Naples, 1989; Galerie Berndt & Krips, Cologne, 1989; Thomas Segal Gallery, Boston, 1989; Brooke Alexander Editions, 1989; Shea & Beker, NYC, 1989; Galeria 57, Madrid, 1989; Galeria Juana de Aizpuru, Madrid, 1989; Galleria Mario Pieroni, Rome, 1989; Galerie de Poche, Paris, 1990; Portikus Gallery, Frankfurt, 1990; Galerie Onrust, Amsterdam, 1990; Touko Museum, Tokyo, 1990; Galerie Pierre Huber, Geneva, 1990; Galerie Juana de Aizpuru, Seville, 1990. **Retrospectives:** SFMA (drawings), circ., 1974-76; MOMA, circ., 1978.

Group: World House Galleries, NYC, 1965; Finch College, 1966, 67; WMAA Sculpture Annual, 1967; Los Angeles/County MA; PMA, American Sculpture of the Sixties, 1967; Ridgefield/Aldrich, 1968; The Hague, Minimal Art, 1968; Kassel, Documenta IV, 1968; Düsseldorf, Prospect '68, 1968; Munich/Modern, New Art: USA, 1968; Stadtische Kunsthalle, Düsseldorf, 1969; U. of British Columbia, 1969; U. of Illinois, 1969; Berne, When Attitudes Become Form, 1969; ICA, U. of Pennsylvania, Between Object and Environment, 1969; Seattle/AM, 557,087, 1969; Chicago/Contemporary, Art by Telephone, 1969; Chicago/AI, 1970; Tokyo Biennial, 1970; Turin/Civico, Conceptual Art, Arte Povera, Land Art, 1970; MOMA, Information, 1971; SRGM, Guggenheim International, 1971; Arnhem, Sonsbeek '71, 1971; Chicago/Contemporary, White on White, 1971-72; ICA, U. of Pennsylvania, Grids, 1972; Walker, Painting: New Options, 1972; New York Cultural Center, 3D into 4D, 1973; Basel, Diagrams and Drawings, 1973; WMAA, American Drawings: 1963-1973, 1973; Hartford Art School, Drawings: Seventies, 1973; Princeton U., Line as Language, 1974; Cologne/Kunstverein, Kunst uber Kunst, 1974; Neuer—Berliner Kunstverein, Berlin, Multiples, 1974; Indianapolis, 1974; Kassel, Documenta VI, 1977; Cleveland/MA, Book Art, 1978; La Jolla, Numerals, 1978; ICA, Boston, The Reductive Object, 1979; Dublin/Municipal, 1980; Hayward Gallery, London, Pier and Ocean, 1980; Brooklyn Museum, American Drawings in Black and White, 1970-1979, 1980; Cologne/Stadt, Westkunst, 1981; MOMA, A Century of Modern Drawing, 1982; Amsterdam/Stedelijk, '60-'80: Attitudes, Concepts, Images, 1982; Kassel, Documenta VII, 1982; WMAA, The Sculptor as Draftsman, circ., 1983; Ars 83, Helsinki, 1983; Trenton/State, Beyond the Plane: American Constructions 1931-1965, 1983; Stockholm/National, Flyktpunkter—Vanishing Points, 1984; Amsterdam/Stedelijk, La Grande Parade, 1984; Bordeaux/Contemporain, Art Minimal 1, 1985; Ridgefield/Aldrich, A Second Talent, 1985; Frankfurt/Kunstverein, von Zeichnen, 1985; Bordeaux/Contemporain, Art Minimal I, 1985; Fundacion Caja de Pensiones, Madrid, Italia Aperta, 1985; MOMA, Contrasts of Form, 1985; Carnegie, International, 1985; Fort Lauderdale, An American Renaissance, 1986; Tate Gallery, Forty Years of Modern Art, 1986; Indianapolis, Painting and Sculpture Today, 1986; Los Angeles/MOCA, Individuals, 1986; Bordeaux/Contemporain, Art Minimal II, 1986; Eindhoven, Ooghoogte, (Eye-level), 1986; WMAA, Biennial, 1987; Baltimore/MA, Drawing Now I, 1987; Royal Scottish Academy, Edinburgh, International, 1987; Venice Biennial, 1987; Hamburger Banhof, Berlin, Zeitlos, 1988; Fredericianum Museum, Kassel, Rot Gelb Blau, 1987; Museum Boymans van Bueningen, Rotterdam, Furniture as Art, 1988; Milwaukee, 1988: The World of Art Today, 1988; Cleveland/Contemporary, The Turning Point, 1968, circ., 1988; U. of Massachusetts, 16 Cubes, 1988; Osaka/National, Drawing as Itself, 1989; Paris/Moderne, L'Arte Conceptuel, Une Perspective, circ., 1989; Tate Gallery, Liverpool, Minimalism, 1989; Die Deichtorhallen, Hamburg, Einleuchten, 1989; U. of Virginia, The Humanist Icon, 1990; William Paterson College, The Grid, 1990; Ohio State U., Works for New Spaces, 1990. **Collections:** Akron/AM; Amsterdam/Stedelijk; Baltimore/MA; Basel; Bordeaux/Contemporain; Bowdoin College; Brooklyn Museum; Buffalo/Albright; U. of California, Berkeley; Canberra/National; Carnegie; Chicago/AI; Columbus; Dallas/MFA; Dayton/AI; Detroit/Institute; Edinburgh/Modern; Edinburgh/National; Eindhoven; Gilman Paper Corp.; Grenoble; The Hague; Hartford/Wadsworth; High Museum; Hirshhorn; Hous-

ton/MFA; Humlebaek/Louisiana; U. of
Illinois; Indianapolis; Israel Museum; U.
of Kentucky; Krefeld/Kaiser Wilhelm; La
Jolla; Los Angeles/County MA; MMA;
MOMA; U. of Massachusetts; Milwaukee;
Minneapolis/Institute; New Britain/Ameri-
can; U. of North Carolina; Oberlin Col-
lege; The Ohio State U.; PMA;
Paris/Beaubourg; RISD; Rijksmuseum
Kröller-Müller; Rotterdam; SFMA;
SRGM; St. Louis/City; Smith College;
Stockholm/National; Storm King Art Cen-
ter; Tate Gallery; Toronto; U. of Virginia;
WMAA; Walker; Worcester/AM. **Bibliog-
raphy:** Alloway 4; *Art Now 74;* Battcock,
ed.; Calas, N. and E.; *Contemporanea;* De
Vries, ed.; De Wilde 1, 2; *Drawings: The
Pluralist Decade; Europa/Amerika;* Gilsok;
Gohr and Gachnang; Goossen 1; Honnef;
Honisch and Jensen, eds.; Johnson,
Ellen H.; Kardon 3; Krauss 2, 3;
Lippard 2, 3, 4; Lippard, ed.; Meyer;
Muller; Pincus-Witten, 1, 2; Robins;
Rose, Bernice, 1; Rowell; Sandler 3;
Sol Le Witt; Toher, ed.; Tuchman 1;
Weintraub; *When Attitudes Become Form.*
Archives.

LIBERMAN, ALEXANDER

b. September 4, 1912, Kiev, Russia.
Studied: Academie Andre Lhote, Paris,
1929-31 (painting); Academie des Beaux-
Arts, Paris, with August Perret (architec-
ture). With the Louvre Museum, made *La
Femme française,* 1936, one of the first
color films on painting. US citizen, 1946.
Art editor of VU, 1933-37. Joined *Vogue*
magazine, 1941; became its art director,
1943; became art director of Condé Nast
Publications, Inc., USA and Europe,
1944, and the organization's editorial di-
rector, 1962. Subject of film: *Alexander
Liberman: A Lifetime Burning,* 1982, pro-
duced by Guy L. Smith IV, given to
Laumeier Sculpture Park Assoc., St. Louis.
Commissions: Grand Bay Hotel, Coco-
nut Grove, Miami, 1983; San Diego Tech
Center, 1983; Designed 1984 Governor's
Art Award, New York State Council on

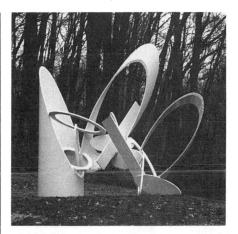

Alexander Liberman, *Trope III,* 1986.

the Arts; TRW, Inc., Lyndhurst, Ohio,
1985; Seattle Center, Wash., 1985.
Awards: Chevalier, Legion of Honor,
1946; Henry Moore Grand Prize, The
Hakone Open-Air Museum, Japan, 1983;
International Exhibition, Paris, Gold
Medal; RISD, Hon. Ph.D., 1980.
Address: 870 U.N. Plaza, NYC 10017.
Dealer: André Emmerich Gallery, NYC.
One-man Exhibitions: MOMA, The
Artist in His Studio, 1959; Betty Parsons
Gallery, NYC, 1960, 62, 63, 64, 67, 69;
Robert Fraser Gallery, 1964; Bennington
College, 1964; Galleria dell'Ariete, 1965;
Galeria d'Arte, Naples, 1965; Jewish Mu-
seum, 1966; André Emmerich Gallery,
NYC, 1967-69, 73, 74 (two-man), 79
(two-man), 80, 81, 83, 86, 87, 88, 89, 91;
Janie C. Lee Gallery, Houston, 1974; Van
Straaten Gallery, Chicago, 1977;
Vernissage, Rome, 1978; Greenberg Gal-
lery, St. Louis, 1979; Landau/Alexander
Gallery, Los Angeles, 1979; Arts Gallery
Limited, Baltimore, 1979; Hokin Gallery,
Bay Harbor Islands, Fla., 1981, 83, 85,
87; Galerie Ulysses, Vienna, 1982; Mi-
chael H. Lord Gallery, Milwaukee, 1982;
Heath Gallery, Atlanta, 1982; Galleria Il
Ponte, Rome, 1983; Palazzo Dei Leone,
Messina Italy, 1983; Fort Worth, 1985;
Riva Yares Gallery, Scottsdale, Az., 1988;
Carl Schlossberg Fine Arts, Sherman

Oaks, Ca., 1991. **Retrospectives:** Houston/MFA, 1970; Corcoran, 1970; Honolulu Academy, 1972; Storm King Art Center, 1977. **Group:** SRGM, Younger American Painters, 1954; A. Tooth & Sons, London, Six American Painters, 1961; MOMA, Modern American Drawings, circ., Europe, 1961-62; Chicago/AI, 1961, 62; WMAA, Geometric Abstraction in America, circ., 1962; III International Biennial Exhibition of Prints, Tokyo, 1962; WMAA Annuals, 1962, 63, 65; Corcoran, 1963; Roswell, 1963; Hartford/Wadsworth, 1964; Los Angeles/County MA, Post Painterly Abstraction, 1964; MOMA, Contemporary Painters and Sculptors as Printmakers, 1964; SRGM, American Drawings, 1964; Galerie Denise René, Paris, Hard Edge, 1964; New York World's Fair, 1964-65; PAFA, 1965; MOMA, The Responsive Eye, 1965; Amsterdam/Stedelijk, New Shapes of Color, 1966; WMAA Sculpture Annuals, 1966, 69; Los Angeles/County MA, American Sculpture of the Sixties, 1967; U. of Illinois, 1967; HemisFair '68, San Antonio, Tex., 1968; MOMA, The Art of the Real, 1968; PMA, 1969; MOMA, The New American Painting and Sculpture, 1969; Newport, R.I., Monumenta, 1974; MOMA, Color as Language, circ., 1975; Pomona College (Calif.), Black and White Are Colors, 1979; Houston/MFA, Miró in America, 1982; Ridgefield/Aldrich, A Second Talent, 1985; Tel Aviv, Trends in Geometric Abstract Art, 1986; ICP, NYC, Art Circles, 1987. **Collections:** Akron/AI; Andover/Phillips; U. of Arkansas; Atlantic Richfield Co.; Brandeis U.; Buffalo/Albright; U. of California, Berkeley; Chase Manhattan Bank; Chicago/AI; Civic Center Synagogue, NYC; U. of Connecticut; Corcoran; Dayton/AI; Hartford/Wadsworth; U. of Hawaii; Houston/MFA; Kanagawa; Laumeier Sculpture Park; Los Angeles/County MA; MMA; MOMA; Memphis/Brooks; Mexico City/Tamayo; U. of Minnesota;

NCFA; NMAA; U. of Nebraska; Oklahoma; U. of Pennsylvania; Purchase/SUNY; RISD; SRGM; Seattle/AM; Smith College; Storm King Art Center; Tate Gallery; VMFA; WGMA; WMAA; Woodward Foundation; Yale U. **Bibliography:** *Alexander Liberman;* Alloway 4; Battcock, ed.; *Black and White Are Colors;* Calas, N. and E.; Goossen 1; *Monumenta;* Rickey; Siegel; Tuchman 1.

LICHTENSTEIN, ROY b. October 27, 1923, NYC. **Studied:** The Ohio State U., 1940-43, BFA, 1946-49, MA; ASL, 1940, with Reginald Marsh. US Army, 1943-46. **Taught:** The Ohio State U., 1946-51; New York State College of Education, Oswego, 1957-60; Douglass College, 1960-63. **Member:** American Academy of Arts and Science. **Commissions:** New York State Pavilion, New York World's Fair, 1964-65 (mural); The Equitable Center, NYC, 1985. **Awards:** Skowhegan Award for Graphics, 1977; Hon. DFA, California Institute of the Arts, 1977. **Address:** P.O. Box 1369, Southampton, NY 11968. **Dealer:** Leo Castelli Inc., NYC. **One-man Exhibitions:** (first) Carlebach Gallery, NYC, 1951; John Heller Gallery, NYC, 1952, 53, 54, 57; Leo Castelli Inc., NYC, 1962-65, 67, 69, 71, 72, 73, 74, 75, 77, 78, 79, 80, 81, 83, 84, 85, 86, 87, 90, 91, 92; Ferus Gallery, Los Angeles, 1963; Ileana Sonnabend Gallery, Paris, 1963, 65, 70; Il Punto, Turin, 1964; Galleria Apollinaire, Milan, 1965; Cleveland/MA, 1966; Contemporary Arts Center, Cincinnati, 1967; Amsterdam/Stedelijk, 1967; Berne, 1968; Irving Blum Gallery, Los Angeles, 1968, 69, 70; Hannover/KG, 1969; U. of Puerto Rico, 1970; Kansas City/Nelson, 1970; Chicago/Contemporary, 1970; Seattle/AM, 1970; Columbus, 1970; U. of California, Irvine, 1970; Houston/Contemporary, 1972; Ronald Greenberg Gallery, St. Louis, 1973; Galerie Beyeler, 1973; Galerie Mikro, Berlin, 1974; Margo Leavin Gallery, 1974, 76; Current Edi-

tions, Seattle, 1974; F.H. Mayor Gallery, London, 1974, 76, 77; CNAC, 1975; ACE Gallery, Los Angeles, Calif., 1975, 78; Albert White Gallery, Toronto, 1975; Galerie de Gestlo, Hamburg, 1976; Seattle, 1976; School of Visual Arts, NYC, 1976; California State U., Long Beach, 1977; Mannheim, 1977; Blum Helman Gallery, NYC, 1977, 87; Washington Gallery, Indianapolis, 1978; ICA, Boston, 1978; U. of Miami, 1979; Stony Brook/SUNY, 1979; Mayor Gallery, London, 1980; Portland (Ore.) Center for the Visual Arts, 1980; U. of Wisconsin, 1980; Getler/Pall Gallery, NYC, 1981; Magnuson-Lee Gallery, Boston, 1981; Gallerie André Emmerich, Zurich, 1982; Gimpel & Hanover, Zurich, 1982; Mattingly Baker Gallery, Dallas, 1982; Colorado State U., 1982; Nantenshi Gallery, Tokyo, 1983; Ohio State U., 1983, Galerie Daniel Templon, Paris, 1983, 91; Columbus, 1984; Galerie Beyeler, Basel, 1984, 91; James Goodman Gallery, NYC, 1984; Richard Gray Gallery, Chicago, 1984, 86; Galerie Humanite Nagoya, 1984; Columbus, 1985; Walker, 1985; Focus Gallery, Lausanne, 1986; Greg Kucera Gallery, Seattle, 1986; Judith Goldberg Gallery, NYC, 1987; Thomas Segal Gallery, Boston, 1987; Gemini G.E.L., Los Angeles, 1988, 91; Larry Gagosian Gallery, NYC, 1988; Heland Wetterling Gallery, Stockholm, 88; 65 Thompson Street, NYC, 1989, 92; Mary Boone Gallery, NYC, 1989; Michael Mahoney Contemporary Art Gallery, Santa Monica, 1989; Palazzo Delle Albere, Trento, 1990; Tyler Graphics Ltd., Mount Kisco, N.Y., 1990; Galerie Eric van de Weghe, Brussels, 1991; Musei Civici, Padova, 1991; Galerie Hans Strelow, Düsseldorf, 1991. **Retrospectives:** Pasadena/AM, 1967; Tate Gallery, 1968; SRGM, 1969; St. Louis/City, circ., 1981; MOMA, circ., 1987. **Group:** Dayton/AI, 1962; Pasadena/AM, New Paintings of Common Objects, 1962; Sidney Janis Gallery, NYC, The New Realists,

1962; Galerie Saqqarah, Gstaad, Switzerland, The Figure and the Object from 1917 to the New Vulgarians, 1962; Chicago/AI, 1963; SRGM, Six Painters and The Object, circ., 1963; WGMA, The Popular Image, 1963; ICA, London, The Popular Image, 1963; Houston/Contemporary, Pop Goes the Easel, 1963; Brandeis U., New Directions in American Painting, 1963; Festival of Two Worlds, Spoleto, 1965; SRGM, Word and Image, 1965; WMAA Annuals, 1965, 68, 70, 72, 73; ICA, U. of Pennsylvania, The Other Tradition, 1966; RISD, Recent Still Life, 1966; XXXIII Venice Biennial, 1966; Expo '67, Montreal, 1967; U. of St. Thomas (Tex.), 1967; Carnegie, 1967; IX São Paulo Biennial, 1967; Kassel, Documenta IV, 1968; Brooklyn Museum, Print Biennial, 1968; Turin/Civico, 1969; Ars 69, Helsinki, 1969; Expo '70, Osaka, 1970; Foundation Maeght, L'Art Vivant, 1970; Cincinnati/Contemporary, Monumental Art, 1970; Corcoran Biennial, 1971; Buffalo/Albright, Kid Stuff, 1971; Chicago/AI, 70th American Exhibition, 1972; Indianapolis, 1972; Detroit/Institute, Art in Space, 1973; Art Museum of South Texas, Corpus Christi, Eight Artists, 1974; Chicago/AI, Idea and Image in Recent Art, 1974; WMAA, American Pop Art, 1974; MOMA, Works from Change, 1974; MOMA, Drawing Now, 1976; SRGM, 20th Century American Drawings, 1976; Cambridge U., Jubilation, 1977; Minnesota/MA, American Drawing 1927-1977, circ., 1977; Syracuse/Everson, The Cartoon Show, 1978; WMAA, Art About Art, circ., 1978; Philadelphia College of Art, Point, 1978; Düsseldorf/Kunsthalle, About the Strange Nature of Money, circ., 1978; Buffalo/Albright, American Painting of the 1970s, 1978; U. of Illinois, 1979; Aspen Center for the Visual Arts, American Portraits of the Sixties and Seventies, 1979; Milwaukee, Emergence and Progression, circ., 1979; Brooklyn Museum, American Drawings in Black & White: 1970-79, 1980;

Hirshhorn, The Fifties: Aspects of Painting in New York, 1980; Instituto di Cultura di Palazzo Grassi, Venice, Pop Art: Evolution of a Generation, 1980; MOMA, Printed Art: A View of Two Decades, 1980; Purchase/SUNY, Hidden Desires, 1980; Societé des Artistes Indépendants, Paris, 91st Annual Exhibition, 1980; Walker, Artist and Printer, 1980; Amsterdam/Stedelijk, '60-'80; Attitudes/Concepts/Images, 1982; WMAA, Block Prints, 1982; Houston/Contemporary, American Still Life, 1945-1983, circ., 1983; Krefeld/Haus Lange, Sweet Dreams Baby!: American Pop Graphics, 1983; Boston/MFA, 10 Painters and Sculptors Draw, 1984; XL Venice Biennale, 1984; WMAA, Blam!, 1984; Sydney/AG, Pop Art 1955-70, 1985; Bard College, The Maximal Implications of the Minimal Line, 1985; Bard College, Reflections on the World, 1985; Fort Lauderdale, An American Renaissance, 1985; Brown U., Definitive Statements, 1986; Whitechapel Art Gallery, London, In Tandem: The Painter-Sculptor, 1986; Purchase/SUNY, The Window in 20th Century Art, circ., 1986; College of New Rochelle, Pop: Then and Now, 1986; ICA, London, Komic Ikonoklasm, 1986; Los Angeles/County MA, Gemini G.E.L.: Art and Collaboration, 1987; U. of California, Berkeley, Made in USA, circ., 1987; Cologne/Ludwig, Marcel Duchamp und die Avant-Garde Zeit, 1950, 1988; Kassel/Fredericianum, Schlaf der Vernuft, 1988; Milwaukee, The World of Art Today, 1888/1988, 1988; Milwaukee, Word as Image, circ., 1991; MOMA, High and Low, 1990; Bard College, Art What Thou Eat, 1990; MOMA, Seven Master Printmakers, circ., 1991; WMAA, Biennial, 1991; National Gallery, Graphic Studio, 1991; Nice/Contemporain, Collage du XXième Siècle, 1991; Indianapolis, Power: Its Myths and Mores in American Art, 1961-91, circ., 1991; Cologne/Ludwig, Die Pop Art Show, 1991.

Collections: Aachen/Ludwig; Amsterdam/Stedelijk; Baltimore/MA; Brandeis U.; Buffalo/Albright; Chicago/AI; Cologne; Corcoran; Darmastadt/Hessisches; Dayton/AI; Denver/AM; Des Moines; Detroit/Institute; U. of Düsseldorf; Düsseldorf/KN-W; Hartford/Wadsworth; Hirshhorn; Houston/MFA; Humlebaek/Louisiana; Indiana U.; Kansas City/AI; Kansas City/Nelson; Library of Congress; Los Angeles/County MA; MMA; MOMA; Mainz/Mittelrhenisches; Milwaukee; Minneapolis/Institute; U. of Minnesota; NMAA; NPG; Nagoya; National Gallery; PMA; Pasadena/AM; RISD; Rotterdam; SFMA; SRGM; St. Louis/City; Stockholm/National; Syracuse/Everson; Tate; Tokyo/Seibu; Victoria and Albert Museum; Vienna/Moderner; WMAA; Walker; Wellesley College; Wolverhampton; Yale U. **Bibliography:** Alloway 1, 4; Armstrong, Thomas; Ashbery; Battcock, ed.; Becker and Vostell; **Beeren 1**; Bihalji-Merin; Calas 2; Calas, N. and E.; *Contemporanea;* **Coplans 2**; **Coplans, ed.**; Cummings 4, 5; Danto; Davis, D.; Day 1; De Salvo and Schimmel; De Wilde 2; Dienst 1; Diamonstein; Downes, ed.; *Europa/Amerika;* Finch; Gohr and Gachnang; Haskell 5; Honisch and Jensen, eds.; Hughes; Hunter, ed.; *Individuals;* Johnson, Ellen H.; Kardon 3; Kozloff 3; Kunst um 1970; Lippard 5; Lucie-Smith; *Metro;* Murken-Altrogge; Osterwold; *Report;* Rose, Barbara, 1, 4; Rose and Rea; Rubin 1; Rublowsky; Russell and Gablik; Sandler 3, 5; Schwartz 1; Seitz 3; Siegel; Tomkins 2; Tomkins and Time-Life Books; Warhol and Hackett; Waldman 4; Weintraub; Wener. Archives.

LIGARE, DAVID　b. 1945, Oak Park, Ill. **Studied:** Art Center College of Design, Los Angeles. **Address:** 19518 Creek Side Court, Salinas, Calif. 93908. **Dealer:** Koplin Gallery, Los Angeles. **One-man Exhibitions:** Wickersham

Gallery, NYC, 1969; Monterey, 1970; Andrew Crispo Gallery, NYC, 1974, 78; Hall Galleries, Fort Worth, 1983; Koplin Gallery, Los Angeles, 1983, 85, 92; Robert Schoelkopf Gallery, NYC, 1985, 90; Bank of America, San Francisco, 1985. **Group:** Santa Barbara/MA, Photo-realist Painting in California: A Survey, 1980; Houston/MFA, Modern American Painting, circ., 1982; U. of California, Santa Barbara, A Heritage Renewed: Representational Drawings Today, 1983; Laguna Beach Museum of Art, West Coast Realism, circ., 1983; SFMA, American Realism (Janss), circ., 1985. **Collections:** Canton Art Institute; Fairleigh Dickinson U.; U. of Georgia; Hartford/Wadsworth; U. of Kansas; MOMA; NMAA; Newark Museum; Syracuse U.

LINDNER, RICHARD b. November 11, 1901, Hamburg, Germany. d. April 16, 1978, Paris. **Studied:** School of Fine and Applied Arts, Nurnberg; Academy of Fine Arts, Munich, 1924; in Berlin, 1927-28. Concert pianist, 1919-23. To Paris, 1933-39; English army, 1939-41; to USA, 1941; citizen, 1948. Traveled Europe, Mexico. **Taught:** Pratt Institute, 1951-63; Yale U., 1963. **Awards:** Copley Foundation Grant, 1957. **One-man Exhibitions:** Betty Parsons Gallery, NYC, 1954, 56, 59; Cordier and Warren, NYC, 1961; Robert Fraser Gallery, 1962; Cordier & Ekstrom, Inc., NYC, 1963-67; Claude Bernard, Paris, 1965; Galleria d'Arte Contemporanea, Turin, 1966; Il Fante di Spade, Rome, 1966; Leverkusen, 1968; Hannover/K-G, 1968; Kunstverein Museum, Berlin, 1969; Staatliche Kunsthalle, Baden-Baden, 1969; U. of California, Berkeley, 1969; Galerie Rudolph Zwirner, 1969; Spencer A. Samuels & Co., NYC, 1971; Kunstsalon Wolfsberg, Zurich, 1971; Fischer Gallery, London, 1972; Rotterdam, 1974; Düsseldorf/Kunsthalle, 1974; Harold Reed Gallery, NYC, 1977; Galerie Maeght, Paris, 1977; Hooks-Epstein Galleries,

Houston, 1985. **Retrospectives:** Paris/Moderne, 1974; Chicago/Contemporary, 1977. **Group:** Walker, 1954; Chicago/AI, 1954, 57, 66; Brooklyn Museum, 1955; Yale U., 1955; WMAA, 1959, 60, 61, 67; MOMA, Americans 1963, circ., 1963-64; Tate, Dunn International, 1964, Gulbenkian International, 1964; Kassel, Documenta III, 1964; Brandeis U., Recent American Drawings, 1964; Corcoran, 1965; Milwaukee, 1965; Worcester/AM, 1965; International Biennial Exhibition, Tokyo; SFMA, 1966; Flint/Institute, I Flint Invitational, 1966; Detroit/Institute, Color, Image, and Form, 1967; U. of Colorado, 1967; IX São Paulo Biennial, 1967; ICA, London, The Obsessive Image, 1968. **Collections:** Chicago/AI; Cleveland/MA; MOMA; Tate; WMAA. **Bibliography:** Armstrong, Thomas; **Ashton 4**; Battcock, ed.; **Cummings 5**; **Dienst 2**; Honisch and Jensen, eds.; Hunter, ed.; **Kramer 2**; Lippard 5; Osterwold; Plagens; **Tillim**. Archives.

LIPCHITZ, JACQUES b. August 22, 1891, Druskieniki, Lithuania. d. March 26, 1973, NYC. **Studied:** Academie des Beaux-Arts, Paris, 1909-11, with Jean Antonine Ingalbert, Dr. Richet; Academie Julian, Paris, with Raoul Verlet; Academie Colarossi, Paris. Became French citizen, 1924; to USA, 1941. Traveled Europe, Middle East, USA. Fire destroyed Manhattan studio, 1952. **Commissions:** Dr. Albert Barnes, 1922 (5 bas-reliefs); Vicomte Charles de Noailles, Hyeres, France, 1927 (*Joy of Life*); Paris World's Fair, 1937 (*Prometheus*); Brazilian Ministry of Health and Education, 1943 *(Prometheus Strangling the Vulture);* Notre Dame de Toute-Grace, Assy, Haute-Savoie, France, 1956 (baptismal font); Mrs. John D. Rockefeller III, 1950 (bas-relief); Fairmount Park Association, Philadelphia, 1958 (sculpture); Presidential Scholars Medallion (USA), 1965; U. of Minnesota, Duluth, 1964 (9-ft. statue of Sieur Duluth). **Awards:** Academie Julian,

Paris. First Prize for Sculpture, 1909; Paris World's Fair, 1937, Gold Medal; Legion of Honor (France), 1946; PAFA, George D. Widener Memorial Gold Medal, 1952; Hon. DFA, Brandeis U., 1958; AAAL, Gold Medal, 1966. **One-man Exhibitions:** (first) Leonce Rosenberg Gallery, Paris, 1920; Galerie de la Renaissance, Paris, 1930; Joseph Brummer Gallery, NYC, 1935; Musée du Petit Palais, Paris World's Fair, 1937; Buchholz Gallery, NYC, 1942, 43, 46, 48, 51; Galerie Maeght, 1946; Petite Galerie Seminaire, Brussels, 1950; Portland, Ore./AM, 1950; SFMA, 1951, 63; Cincinnati/AM, 1951; Frank Perls Gallery, NYC, 1952, 57; Santa Barbara/MA, 1952; XXVI Venice Biennial, 1952; MOMA, 1954; Walker, 1954, 63; Cleveland/MA, 1954; Otto Gerson Gallery, NYC, 1957, 59, 61; Amsterdam/Stedelijk, 1958; Rijksmuseum Kröller-Müller, 1958; Brussels/Royaux, 1958; Basel, 1958; Paris/Moderne, 1959; Tate, 1959; Cornell U., 1961; Denver/AM, 1962; UCLA, 1963; Fort Worth, 1963; Buffalo/Albright, 1963; Des Moines, 1964; PMA, 1964; Omaha/Joslyn, 1964; Marlborough-Gerson Gallery Inc., 1964, 66; Newark Museum, 1965; Boston U., 1965; AAAL, 1966; Dunkelman Gallery, Toronto, 1967; Marlborough Gallery Inc., NYC, 1968, 77, 79, 81, 85; Tel Aviv, 1971; Marlborough Godard Ltd., Toronto, 1972; Marlborough Fine Art Ltd., London, 1973; Makler Gallery, 1973; MIT, 1985. **Retrospectives:** Berlin/National, 1971; MMA, 1972. **Group:** Salon d'Automne, Paris, 1913; WMAA; MOMA; Tate; Paris/Moderne; Chicago/AI. **Collections:** Baltimore/MA; Barnes Foundation; Buffalo/Albright; Carleton College; Chicago/AI; Cleveland/MA; Cornell U.; Currier; Dartmouth College; Des Moines; Detroit/Institute; Harvard U.; Hunt Foods & Industries; Jewish Museum; Los Angeles/County MA; MOMA; Mansion House Project; U. of Minnesota; Mon-

treal/MFA; U. of Nebraska; New Orleans/Delgado; PMA; Paris/Moderne; Phillips; Princeton U.; Regina/MacKenzie; Rijksmuseum Kröller-Müller; Rouen; SRGM; St. Louis/City; Syracuse Tate; Tel Aviv; Toronto; Utica; Zurich. **Bibliography:** *Abstract Expressionism;* Barr 1; Baur 7; Biddle 4; Biederman 1; Bihalji-Merin; Blesh 1; Canaday; Cassou; Craven, W.; Elsen 2; Fierens; George 1; Gertz; Giedion-Welcker 1, 2; Goodrich and Baur 1; Greenberg; Hayter 1, 2; Henning; Hess, T.B., 1; **Hope;** Huyghe; Kuh 2, 3; Langui; Licht, E.; Lipchitz; Lowry; McCurdy, ed.; Mendelowitz; *Metro;* Moser 1; Myers 2; Neumeyer; **Raynal 2;** Read 1, 3; Rickey; Rodman 1; Rose, B., 1; Rosenblum 1; Rothschild; Rowell; Rubin 1; Sachs; Salvini; Selz, J.; Seuphor 3; Seymour; Strachan; Tomkins and Time-Life Books; Trier 1, 2; Valentine 2; **Van Bork;** Waldberg 4; Wingler, ed.; Zervos.

LIPPOLD, RICHARD b. May 3, 1915, Milwaukee, Wisc. **Studied:** The U. of Chicago and Chicago Art Institute School, 1933-37, BFA (industrial design). Traveled Mexico, Europe, Greece, Turkey, North Africa. **Taught:** Layton School of Art, 1940-41; U. of Michigan, 1941-44; Goddard College, 1945-47; Trenton Junior College (Head of Art Department), 1947-52; Queens College, 1947-48; Black Mountain College, 1948; Hunter College, 1952-68. Designer, Chicago Corporation, 1937-41. Began wire constructions, 1942. **Member:** American Academy of Arts & Letters. **Commissions:** Harvard U. Law School, 1950; MMA, 1952-56; Inland Steel Building, Chicago, 1957; Longview Bank, Longview, Tex., 1958; Four Seasons Restaurant, NYC, 1959; Festival of Two Worlds, Spoleto, 1959 (stage set); Benedictine Chapel, Portsmouth, R.I., 1960; Musée du Vin, Chateau Mouton Rothschild, Pouillac, France, 1960; J. Walter Thompson, NYC, 1960; Pan-Am Building, NYC, 1961; Philharmonic Hall, Lincoln

Center for the Performing Arts, NYC, 1961; Jesse Jones Hall, Houston, Tex.; Cathedral of St. Mary, San Francisco, 1969; North Carolina National Bank, Charlotte, 1969; Fairlane, Dearborne, 1974; Christian Science Center, Boston, 1974; Hyatt Regency Hotel, Atlanta, 1975; National Air and Space Museum, Washington, D.C., 1975; Hyatt Regency, Milwaukee, 1980; Atrium Tower Building, NYC, 1981; Shiga Sacred Garden, Kyoto, Japan, 1981; One Financial Center, Boston, 1984; Deutsche Bank, Frankfurt, 1985; First Interstate Bank, Seattle, 1985; Crystal City, Va., 1986; Singapore, 1986; SoHio Oil Co., Cleveland, 1986; Crystal City, VA, 1986; Dae-Han Building, Seoul, South Korea, 1986; Orange County Center for Performing Arts, Costa Mesa, 1987; One Skyline Towers, Alexandria, Va., 1988; Emerald Shapery Center, San Diego, 1990. **Awards:** ICA, London/Tate, International Unknown Political Prisoner Competition, Third Prize, 1953; Brandeis U., Creative Arts Award, 1953, 58; American Institute of Architects, Chicago Chapter, Honors Award, 1958; American Institute of Architects, New York Chapter, Silver Medal, 1960; Hon. PBK, NYC, 1961; Municipal Art Society of New York, Citation, 1963; elected to NIAL, 1963; Hon. DFA, Ripon College, 1968; American Institute of Architects, Fine Arts Medal, 1970; Guild for Religious Architecture, Honorary member, 1970. **Address:** P.O. Box 248, Locust Valley, NY 11560. **One-man Exhibitions:** (first) The Willard Gallery, NYC, 1947, also 1948, 50, 52, 68, 73; Arts Club of Chicago, 1953; Brandeis U., 1958; Corcoran, 1954; Utica, 1959; U. of Chicago, 1965; Boston/MFA (two-man), 1966. **Retrospective:** Marquette U., 1990. **Group:** MOMA, Fifteen Americans, circ., 1952; PMA, Sculpture of the Twentieth Century, 1953; ICA, London/Tate, International Unknown Political Prisoner Competition, 1953; WMAA, The New Decade, 1954-55; France/National, 50 Ans d'Art aux États-Unis, circ., Europe, 1955; Brooklyn Museum, Sculpture in Silver, 1955; Newark Museum, Abstract Art, 1910 to Today, 1956; WMAA, Geometric Abstraction, 1962; NCFA, Sculpture; American Directions, 1945-1975, 1975; WMAA, 200 Years of American Sculpture, 1976; Indianapolis, Perception of the Spirit in 20th Century American Art, circ., 1978; Chicago/AI, 100 Artists—100 Years, 1979; WMAA, The Third Dimension, 1984; Venice Biennale, 1988. **Collections:** Andover/Phillips; Des Moines; Detroit/Institute; Harvard U.; Hartford/Wadsworth; MMA; MOMA; Memphis/Brooks; Milwaukee; Mobile Art Center and Gallery, Ala.; Musée du Vin; Newark Museum; Utica; VMFA; WMAA; Yale U. **Bibliography:** *Abstract Expressionism;* Baur 7; Blesh 1; Brumme; Craven, W.; Flanagan; Giedion-Welcker 1; Hunter 6; Licht, F.; McCurdy, ed.; Mendelowitz; *Metro;* Motherwell and Reinhardt, eds.; Neumeyer; Phillips, Lisa, 2; Read 1, 3; Rickey; Ritchie 1, 3; Rose, B., 1; Seuphor 3; Trier 1; Weller. Archives.

LIPTON, SEYMOUR b. November 6, 1903, NYC. d. December 5, 1986, Glen Cove, N.Y.

Studied: City College of New York, 1922-23; Columbia U., 1923-27. **Taught:** Cooper Union, 1943-44; Newark State Teachers College, 1944-45; Yale U., 1957-59; New School for Social Research, 1940-64. **Member:** NIAL, 1975. **Commissions:** Temple Israel, Tulsa, Okla.; Temple Beth-El, Gary, Ind.; Manufacturers Hanover Trust Co., NYC; Inland Steel Building, Chicago; Reynolds Metals Co. (NYC); International Business Machines Corp. (Yorktown Heights, N.Y.); Dulles International Airport, Washington, D.C.; Golden Gateway Redevelopment Project, San Francisco; Philharmonic Hall, Lincoln Center for the Performing Arts, NYC; Milwaukee Center for the Performing Arts, 1967. **Awards:** Chicago/AI, 1957; IV São Paulo Biennial, Acquisition Prize, 1957; NIAL, 1958; Guggenheim Foundation Fellowship,

1960; New School for Social Research, 1960; Ford Foundation Grant, 1961; PAFA, George D. Widener Memorial Gold Medal, 1968. **One-man Exhibitions:** ACA Gallery, 1938; Gallery St. Etienne, NYC, 1943; Betty Parsons Gallery, NYC, 1948, 50, 52, 54, 58, 62; Watkins Gallery, Washington, D.C., 1951; New Paltz/SUNY, 1955; Troy, N.Y., 1961; Phillips, 1964; Marlborough-Gerson Gallery, Inc., 1965; Milwaukee, 1969; U. of Wisconsin, 1969; Marlborough Gallery, Inc., NYC, 1971, 76; MIT, 1971; VMFA, 1972; Cornell U., 1973; Syracuse/Everson, 1973; Marlborough Galerie AG, Zurich, 1974; C. W. Post College, Long Island U., 1984; Charlotte/Mint, circ., 1983; Hodges Taylor Gallery, Charlotte, N.C., 1982; Sid Deutsch Gallery, NYC, 1986; Babcock Galleries, NYC, 1991. **Retrospectives:** NCFA, 1979; Charlotte/Mint, 1983; Hofstra U., 1988. **Group:** WMAA Annuals since 1941; IV São Paulo Biennial, 1957; XXIX Venice Biennial, 1958; Carnegie, 1958, 61; Brussels World's Fair, 1958; Seattle World's Fair, 1962; New York World's Fair, 1964-65; Chicago/AI Annual, 1966; Flint/Institute, I Flint Invi-

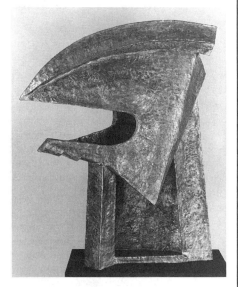

Seymour Lipton, *Scream,* 1981.

tational, 1966; MOMA, Dada, Surrealism and Their Heritage, 1968; PAFA Annual, 1968; Smithsonian, 1968; MOMA, The New American Painting and Sculpture; WMAA, The Third Dimension, 1984. **Collections:** Baltimore/MA; Brooklyn Museum; Buffalo/Albright; Corcoran; Cornell U.; Davenport/Municipal; Des Moines; Detroit/Institute; Didrichsen Foundation; Franklin Institute; Hartford/Wadsworth; H. J. Heinz Co.; Helsinki; Hirshhorn; IBM; Inland Steel Co.; U. of Kansas; MMA; MOMA; Manufacturers Hanover Trust Co.; U. of Massachusetts; U. of Michigan; NCFA; National Gallery; New School for Social Research; NYU; PMA; Pepsico Museum; Phillips; Phoenix; RISD; Reynolds Metals Co.; Santa Barbara/MA; South Mall, Albany; Purchase/SUNY; Sperry Rand Corp.; Tamayo/Mexico City; Tel Aviv; Toronto; Utica; VMFA; WGMA; WMAA; Yale U. **Bibliography:** *Abstract Expressionism;* Baur 5, 7; Biddle 4; Blesh 1; Brumme; Chaet; Craven, W.; Christensen; Elsen 1, 3; Flanagan; Goodrich and Baur 1; Henning; Hunter 6; Hunter, ed.; Krauss 2; Langui; McCurdy, ed.; Marter, Tarbell, and Wechsler; Mendelowitz; *Metro:* Myers 2; Neumeyer; Phillips, Lisa, 2; Rand 2; Read 3; Ritchie 1, 3; Rose, B., 1; Seuphor 3; Strachan; Trier 1; Weller. Archives.

LOBDELL, FRANK **b.** 1921, Kansas City, Mo. **Studied:** St. Paul School of Art, 1938-39, with Cameron Booth; California School of Fine Arts, 1947-50; US Army, 1942-46. Resided Paris, 1950-51. **Taught:** California School of Fine Arts, 1957-65; Stanford U., 1965-. **Awards:** SFMA, Artists Council Prize, 1948; SFMA, P.P., 1950; SFMA, Nealie Sullivan Award, 1960; Tamarind Fellowship, 1966; A Knight of Mark Twain, 1971. **Address:** 340 Palo Alto Avenue, Palo Alto, CA 94301. **One-man Exhibitions:** (first) Lucien Labaudt Gallery, San Francisco, 1949; Martha Jackson Gallery, N.Y., 1958, 60, 63, 72, 74, 77; de Young,

1959; Pasadena/AM, 1961; Ferus Gallery, Los Angeles, 1962; Galerie D. Benador, Geneva, 1964; Galerie Anderson-Mayer, Paris, 1965; Pasadena/AM and Stanford U., 1966; Maryhurst College, 1967; SFMA, 1969; St. Mary's College, Moraga, Calif., 1970, 71; Smith-Anderson Gallery, Palo Alto, 1978, 81; Oscarsson-Hood Gallery, NYC, 1983, 84, 85; Portland, Me./AM, 1985; John Berggruen Gallery, San Francisco, 1987; Charles Campbell Gallery, San Francisco, 1988. **Retrospectives:** Pasadena/AM, 1963; SFMA, 1983. **Group:** San Francisco Art Association Annual, 1950; III São Paulo Biennial, 1955; WMAA, Fifty California Artists, 1962-63; SRGM, American Drawings, 1964; U. of Washington, Drawings by Americans, 1967; Albany/SUNY, Giant Prints, 1967; Eindhoven, Kompas IV, 1969-70; Pasadena/AM, West Coast, 1945-69, 1969; Corcoran, 1971; WMAA Annual, 1972; U. of Illinois; Oakland/AM, A Period of Exploration, 1973; U. of Illinois, 1974; Newport Harbor, The Last Time I Saw Ferus, 1976; SFMA, California Painting and Sculpture: The Modern Era, 1976; U. of North Carolina, Art on Paper, 1983. **Collections:** Los Angeles/County MA; Oakland/AM; Pasadena/AM; SFMA; Stanford U. **Bibliography:** Hopps.

LOBERG, ROBERT W. b. December 1, 1927, Chicago, Ill. US Marine Corps, 1946-47. **Studied:** Glendale College, 1948, City College of San Francisco, 1948-50, AA; U. of California, Berkeley, 1950-52, BA, 1953-54, MA (painting, with Karl Kasten, Ward Lockwood, John Haley, Erle Loran, James McCray, Glenn Wessels, Worth Ryder, Felix Ruvulo, William H. Calfee, Carl Holty, Kyle Morris); Hofmann School, Provincetown, 1956, with Hans Hofmann. Traveled northern China, Japan, Europe. **Taught:** U. of California, Berkeley, 1955, 56, 58, 59, 65; California College of Arts and Crafts, 1961-62; San Francisco Art Institute, 1962-66; U. of Washington, 1967-

68. **Awards:** California State Fair, Hon. Men., 1955; RAC, Prize in Graphics, 1955; Yaddo Fellowship, 1957; RAC, Prize in Watercolors, 1959; MacDowell Colony Fellowship, 1959, 60; SFMA, Anne Bremer Memorial Prize, 1961; San Francisco Art Festival, P.P., in Painting, 1962; La Jolla, Prize in Painting, 1962. **Address:** 2020 Vine Street, Berkeley, CA 94709. **One-man Exhibitions:** (first) Artist's Gallery, NYC, 1959; SFMA (three-man), 1961; Staempfli Gallery, NYC, 1962; David Stuart Gallery, 1962, 64; Richard White Gallery, Seattle, 1968; California College of Arts and Crafts, 1969; Berkeley Gallery, 1969; California College of Arts and Crafts, 1969; Berkeley Craft Center, 1977; San Jose Museum, 1978; Paule Anglim Gallery, San Francisco, 1979. **Retrospective:** U. of Washington, 1968. **Group:** Chicago/AI, 1948, 62; RAC; Oakland/AM; SFMA Annuals since 1955; de Young; California Palace; Carnegie, 1959; SFMA, Abstract Expressionism in the West, circ., 1961; SFMA, Collage in San Francisco, 1962; WMAA, Fifty California Artists, 1962-63; SFMA, New Paintings, 1964. **Collections:** California College of Arts and Crafts; Chicago/AI; Oakland/AM; Portland, Ore./AM; San Francisco Municipal Art Commission; WGMA; U. of Washington. Archives.

LOEW, MICHAEL b. May 8, 1907, NYC. d. November 14, 1985, NYC. **Studied:** City College of New York; ASL, 1926-29, with Richard Lahey, Boardman Robinson; Academie Scandinave, Paris, 1930, with Othon Friesz; Hofmann School, NYC, 1947-49; Atelier Fernand Leger, Paris, 1950, with F. Leger. US Navy "Seabees," Battalion Artist, Pacific theater, 1943-46. Traveled France, Germany, Italy, Africa, Mexico, Central America, Spain, England. **Taught:** Portland (Ore.) Museum School, 1956-57; U. of California, Berkeley, 1960-61, 1967; School of Visual Arts, NYC, 1958-85. **Member:** American Abstract Artists; Feder-

ation of Modern Painters and Sculptors. Federal A.P.: Gustave Straubenmuller Junior High School, NYC (series of 5 murals); U. of California, Berkeley, 1960-61, 1966. **Commissions:** (murals) Hall of Man and Pharmacy Building, New York World's Fair, 1939; US Post Offices, Amherst, Ohio, and Belle Vernon, Pa. **Awards:** Sadie May Fellowship, 1929; Section of Fine Arts, National Mural Competition for Social Security Building and War Department Building, Washington, D.C., Hon. Men., 1941, 42; Ford Foundation, P.P., 1964; Chicago/AI Annual, 1964; National Endowment for the Arts, grant, 1976; Guggenheim Foundation Fellowship, 1979. **One-man Exhibitions:** (first) Artists' Gallery, NYC, 1949; Rose Fried Gallery, 1953, 55, 57, 59; Portland, Ore./AM, 1956; Rutgers U. (two-man), 1959; T.K. Gallery, Provincetown, Mass., 1959; Holland-Goldowsky Gallery, Chicago, 1960; U. of California, Berkeley, 1960, 67; The Stable Gallery, NYC, 1961, 62, 64, 65; Landmark Gallery, Inc., NYC, 1973, 76; Marilyn Pearl Gallery, NYC, 1977, 79, 81, 82, 84, 86, 87, 89, 90. **Retrospectives:** Holland-Goldowsky Gallery, Chicago, 1960; The Stable Gallery, 1962. **Group:** American Abstract Artists Annuals, 1949-; Salon des Realites Nouvelles, Paris, 1950; WMAA, 1950, 61; MMA, 1952; Walker, The Classic Tradition, 1953; International Association of Plastic Arts, Contemporary American Painting, circ., Europe, 1956-57; A.F.A., Collage in America, circ., 1957-58; Douglass College, 1959; ART:USA:59, NYC, 1959; Federation of Modern Painters and Sculptors Annuals, 1959-; WMAA, Geometric Abstraction in America, circ., 1962; MOMA, Hans Hofmann and His Students, circ., 1963-64; Chicago/AI, 1964; Colby College, 100 Artists of the 20th Century, 1964; PAFA, 1966; Allentown/AM, Monhegan Island Painters, 1974; Newark Museum, Geometric Abstraction and Related Works, 1978; Portland, Me./MA, Maine Drawing Biennial,

1984. **Collections:** Buffalo/Albright; Atlanta U.; Calcutta; U. of California, Berkeley; Carnegie; Ciba-Geigy Corp.; Dallas/MFA; Detroit/Institute; Hampton Institute; Hirshhorn; Humlebaek/Louisiana; Lehman Bros.; McCrory Corp.; U. of Nebraska; PMA; Portland, Me./AM; Rutgers U.; SRGM; St. Lawrence U.; Tel Aviv; Union Carbide Corp.; WMAA; Wichita State U. **Bibliography:** Archives.

LONGO, ROBERT **b.** 1953,
Brooklyn, N.Y. **Studied:** Buffalo/SUNY, BFA, 1975. Active as a performer and designer of installations. **Address:** 85 South Street, NYC 10038. **Dealer:** Metro Pictures, NYC. **One-man Exhibitions:** Hallwalls, Buffalo, 1976; The Kitchen, NYC, 1979; Studio Cannaviello, Milan, 1980; U. of Rhode Island, 1981; Metro Pictures, 1981, 83, 84; Larry Gagosian Gallery, Los Angeles, 1981, 84; Texas Gallery, Houston, 1982; Brooke Alexander Gallery, NYC, 1983; Galerie Schellmann & Klusher, Munich, 1983; Akron/AM, 1984; Amsterdam/Stedelijk, 1985; Brooklyn Museum, 1985; U. of Iowa, 1985; Lia Rumma Gallery, Naples, 1985. **Group:** MIT, Body Language, circ., 1980; Cologne/Stadt, Westkunst, 1981; Cincinnati/Contemporary, Dynamix, 1982; Kassel, Documenta VII, 1982; Milwaukee, New Figuration in America, 1982; WMAA, Focus on the Figure, 1982; Walker, Eight Artists: The Anxious Edge, 1982; Bonn, Back to the USA, circ., 1983; Hirshhorn, Directions, 1983; WMAA, Biennial, 1983; Cincinnati/Contemporary, Disarming Images, 1984; Hirshhorn, Content, 1984; Houston/Contemporary, The Heroic Figure, 1984; MOMA, International Survey of Recent Painting and Sculpture, 1984; SFMA, The Human Condition, 1984; Sydney/AG, 5th Biennale, 1984; Carnegie, International, 1985; Fort Lauderdale, An American Renaissance, 1986. **Collections:** Buffalo/Albright; High Museum; MOMA; U. of North Carolina; SRGM; U. of Sydney;

Tate Gallery; WMAA; Walker. **Bibliography:** *Back to the USA;* Day 1; Fox; Goldstein and Jacob; Honnef 2; Pincus-Witten; Rose, Bernice, 1; Stearns.

LONGO, VINCENT b. February 15, 1923, NYC. **Studied:** Cooper Union, with Leo Katz, Sidney Delevant, 1942-46; Brooklyn Museum School, 1950, with Max Beckmann, 1953, with Louis Schanker. Traveled Europe. **Taught:** Brooklyn Museum School, 1955-56; Yale U. Summer School, Norfolk, Conn., 1967-68; Bennington College, 1957-67; Hunter College, 1967-. **Member:** SAGA; American Abstract Artists. **Awards:** Fulbright Fellowship (Italy), 1951; Philadelphia Print Club, First Prize, 1954; Yaddo Fellowship, 1954; Guggenheim Foundation Fellowship, 1971; Cooper Union, Achievement Citation, 1973; National Endowment for the Arts, 1974. **Address:** 50 Greene Street, NYC 10013. **Dealer:** Condeso/Lawler Gallery, NYC. **One-man Exhibitions:** Regional Arts Gallery, NYC, 1949; Korman Gallery, NYC, 1954; The Zabriskie Gallery, NYC, 1956; Yamada Art Gallery, Kyoto, 1959; Area Gallery, NYC, 1960; Wheaton College, 1969; Thibault Gallery, NYC, 1963; U. of Vermont, 1965; Reese Palley Gallery, NYC, 1970; Susan Caldwell Inc., 1974; Bard College, 1975; U. of Notre Dame, 1976; Andrew Crispo Gallery, NYC, 1976, 80; Alfred U., 1978; Adam Gimbel Gallery, NYC, 1981; Condeso/Lawler Gallery, 1984, 85, 90. **Retrospectives:** Bennington College, 1970; Corcoran, 1970; Detroit/Institute, 1970. **Group:** WMAA Annuals, 1951, 71; PAFA Annual, 1953; MOMA, Young Printmakers, 1954; Brooklyn Museum, 1954, 55; Philadelphia Print Club (three-man), 1955; MOMA, Drawings USA, 1956; American Abstract Artists, 1957, 58, 59; New York Coliseum, ART:USA:59, 1959; U. of Kentucky, Graphics '60, 1960; USIA, Contemporary American Woodcut and Its Variations, 1962; PCA, American Prints Today, 1962; Brooklyn Museum, Two Decades of American Prints, 1969;

WMAA, American Drawings, 1963-1973, 1973; WMAA, American Prints: Process and Proofs, 1982; WMAA, Block Prints, 1982; Hunter College, Repetitions, 1985. **Collections:** Bibliothèque Nationale; Brooklyn Museum; Chemical Bank; Ciba-Geigy Corp.; Corcoran; Detroit/Institute; Guild Hall; Library of Congress; Milwaukee-Downer Institute; MMA; MOMA; NCFA; NYPL; National Gallery; New London; Oakland/AM; PMA; Stockholm/National; Syracuse/Everson; U. of Vermont; Washington U.; WMAA. **Bibliography:** Goldman 1. Archives.

LORAN, ERLE b. October 3, 1905, Minneapolis, Minn. **Studied:** U. of Minnesota; Minneapolis Institute School, with Cameron Booth; Hofmann School, 1954. Traveled Europe extensively. **Taught:** U. of California, Berkeley. Federal A.P.: Easel painting, teaching. **Awards:** Chaloner Prize Foundation Award ($6,000), 1926; SFMA, Artists' Fund Prize, 1944; Pepsi-Cola Bronze Medal, 1949; San Francisco Art Association, P.P., 1956; California Palace, H.S. Crocker Co. Award, 1963; U. of Illinois, P.P., 1965; Minneapolis Institute School, Hon. MFA, 1968; and some 20 others. **Address:** 10 Kenilworth Court, Berkeley, CA 94707. **Dealer:** John Berggruen Gallery, San Francisco. **One-man Exhibitions:** (first) Kraushaar Galleries, NYC, 1931; SFMA, 1936, 39, 44; Artists' Gallery, NYC, 1938; Pasadena/AM, 1947; Santa Barbara/MA, 1947, 50; Dalzell Hatfield Gallery, 1949; de Young, 1949, 54, 63; Catherine Viviano Gallery, 1952, 54; Comara Gallery, 1964; The Bertha Schaefer Gallery, 1965; Arleigh Gallery, 1969; Oakland/AM, 1981; John Berggruen Gallery, San Francisco, 1989; U. of California, Berkeley, 1990. **Group:** MOMA, 1935; Oakland/AM, 1936, 46; SFMA, 1936-64; WMAA, 1937, 41, 44, 48, 51, 52; Chicago/AI, 1938, 39, 43, 44, 46, 48; Carnegie, 1941; Toledo/MA, 1943; PAFA, 1945; U. of Illinois, 1949,

52, 53, 63, 65, 69; MMA, 1951, 53; Cranbrook, 1953; São Paulo, 1955, 56, 61; California Palace, 1961, 62, 63; MOMA, Hans Hofmann and His Students, circ., 1963-64. **Collections:** Brigham Young U.; U. of California; Denver/AM; IBM; U. of Illinois; U. of Minnesota; SFMA; San Diego; Santa Barbara/MA; Smithsonian; US State Department; Utah State U. **Bibliography:** Bethers; Blanchard; Cheney; Flanagan; **Loran 1, 2;** Pousette-Dart, ed. Archives.

LORBER, STEPHEN **b.** August 30, 1943, Brooklyn, N.Y. **Studied:** Pratt Institute, BFA, 1961-66; Brooklyn College, MFA, 1966-68; Yale, 1964. Resided Rome, 1969-70; New Mexico, 1973-74. **Taught:** Roswell, 1973-74. **Awards:** Stoeckel Fellow, Yale U., 1964; Yaddo Fellowship, 1971, 75; National Endowment for the Arts; Fellowship, 1976. **Address:** R.D. 3, Box 198, Greenwich, NY 12834. **One-man Exhibitions:** (first) A. M. Sachs Gallery, NYC, 1974, 75, 76, 77, 78; Russell Sage College, Troy, N.Y., 1976; Delahunty Gallery, Dallas, 1975, 77, 80; Roswell, 1974; Alexander F. Milliken Gallery, NYC, 1981, 83, 84, 85; Dubins Gallery, Los Angeles, 1983. **Group:** PAFA, 1969; U. of North Carolina, Art on Paper, 1974, 76; Minnesota/MA, American Drawing, 1927-77, circ., 1977; U. of Nebraska, Things Seen, 1978; Utica, A Painter's Appreciation of Realism, 1982. **Collections:** AT&T; Amerada Hess Corp.; American Airlines; Atlantic Richfield Corp.; A.G. Beck Co., Inc.; Brooklyn Museum; Chase Manhattan Bank; Chemical Bank; Chicago/AI; Harvard U.; E.F. Hutton, Inc.; U. of Illinois; Lehman Bros.; Mobil Oil Corp.; U. of North Carolina; Oklahoma; Owens-Corning Fiberglas Corp.; Prudential Insurance Co. of America; Reynolds Tobacco, Inc.; Roswell; 3M Corp.; Western New Mexico U.

LOSTUTTER, ROBERT
b. 1939, Emporia, Kan. **Studied:** Chicago Art Institute School, 1958-63. **Awards:** Chicago/AI, Tuthill Prize, 1977; Illinois Arts Council Grant, 1984. **Address:** 207 West St. Paul Avenue, Chicago, Ill. 60614. **Dealer:** Phyllis Kind Gallery, New York and Chicago. **One-man Exhibitions:** Deson-Zaks Gallery, Chicago, 1971, 73, 75; Richard Demarco Gallery, Edinburgh, 1972; Dart Gallery, Chicago, 1976, 78, 80, 84, 87; Nancy Lurie Gallery, Chicago, 1978; Monique Knowlton Gallery, NYC, 1981, 84; U. of Chicago, circ., 1984; LedisFlam Gallery, NYC, 1991; Phyllis Kind Gallery, Chicago, 1992. **Retrospective:** Northern Illinois U., 1989. **Group:** Chicago/AI, Chicago and Vicinity, 1971, 73; Ringling, After Surrealism, 1972; Indianapolis, 1972; Brooklyn Museum, Biennial, 1974; Sacramento/Crocker, The Chicago Connection, circ., 1976; Chicago Art Institute School, Visions, 1976; Chicago/AI, Drawings of the '70s, 1977; Madison Art Center, Chicago/Some Other Traditions, circ., 1983; ICA, Boston, Currents, 1984; Corcoran, Biennial, 1985; U. of Chicago, Works: Art from the Windy City, circ., 1989; Chicago/Contemporary, Realism, Figurative Painting, 1991. **Collections:** Brooklyn Museum; Chicago/AI; Chicago/Contemporary; Illinois State U.; Kansas City/AI; Kansas City/Nelson; Madison Art Center; Springfield, Mo./AM. **Bibliography:** Adrian; Kirschner.

LOUIS, MORRIS **b.** November 28, 1912, Baltimore, Md. **d.** September 7, 1962, Washington, D.C. **Studied:** Maryland Institute, 1920-33. **One-man Exhibitions:** (first) Martha Jackson Gallery, 1957; French & Co. Inc., NYC, 1959, 60; ICA London, 1960; Bennington College, 1960; Galleria dell'Ariete, 1960; Galerie Neufville, Paris, 1961; Galerie Schmela, 1962; Galerie Lawrence, Paris, 1962; Galerie Muller, 1962; André Emmerich Gallery, NYC, 1961, 62, 65, 68, 69, 72, 78, 79, 82, 85, 89, Zurich, 1973, 81; Ziegler Gallery, 1964; Staatliche Kunsthalle, Baden-Baden, 1965; WGMA, 1966; Seattle/AM, 1967; MOMA (three-

man), 1968; Lawrence Rubin Gallery, NYC, 1970, 73, 74; David Mirvish Gallery, 1971; National Gallery, 1976; Walker, 1977; NCFA, 1979; Asher/Faure, Los Angeles, 1979; Medici-Berenson Gallery, Bay Harbor Islands, Fla., 1979; Waddington Gallery, London, 1979; Israel Museum, 1980; Wichita State U., 1980; M. Knoedler & Co., 1983; Fort Worth, 1986; Boston/MFA, 1986; Shiga/Modern; Lannan Museum, Lake Worth, Fla., 1987; Hirshhorn, 1987; Riva Yares Gallery, Scottsdale, Ariz., 1989; Maryland Institute, 1989; Padiglione d'Arte Contemporanea, Milan, 1990; Galerie Neuendorf, Frankfurt, 1990, 91. **Retrospectives:** SRGM, 1963; XXXII Venice Biennial, 1964; WGMA, 1967; Boston/MFA, circ., 1967; NMAA, circ., 1979; MOMA, 1986. **Group:** The Kootz Gallery, NYC, New Talent, 1954; Rome-New York Foundation, Rome, 1960; SRGM, Abstract Expressionists and Imagists, 1961; Seattle World's Fair, 1962; WMAA, 1962; Jewish Museum, Toward a New Abstraction, 1963; Tate, Painting and Sculpture of a Decade, 1954-64, 1964; Corcoran; Los Angeles/County MA, Post Painterly Abstraction, 1964; Kassel, Documenta III & IV, 1964, 68; MOMA, The Responsive Eye, 1965; SFMA, The Colorists, 1965; WGMA, 1965-66; WMAA, Art of the U.S. 1670-1966, 1966; Chicago/AI Annual, 1966; Wurttembergischer Kunstverein, Stuttgart, 1967; Detroit/Institute, Color, Image and Form, 1967; Trenton/State, Focus on Light, 1967; MOMA, The Art of the Real, 1968; Pasadena/AM, Serial Imagery, 1968; MOMA, The New American Painting and Sculpture, 1969; WMAA, 1970; Edmonton Art Gallery, Alberta, Ten Washington Artists: 1950-1970, 1970; Auckland, 1971; Hayward Gallery, London, 1974; Houston/MFA, The Great Decade of American Abstraction, Modernist Art 1960 to 1970, 1974; Norfolk/Chrysler, 300 Years of American Art, 1976; Baltimore/MA, Two Hundred Years of American Painting, 1977; Milwau-

kee, Washington Color Painters, 1980; Grand Palais, Paris, L'Amerique aux Indépendants, 1980; Purchase/SUNY, Hidden Desires, 1980; Cologne/Stadt, Westkunst, 1981; Haus der Kunst, Munich, Amerikanische Malerie: 1930-1980, 1981; Oklahoma, American Masters of the Twentieth Century, 1982; SRGM, The New York School: Four Decades, 1982; U. of Maryland, 350 Years of Art & Architecture in Maryland, 1984; Fort Lauderdale, An American Renaissance: Painting and Sculpture Since 1940, 1986; Tel Aviv, Trends in Geometric Abstract Art, 1986; Cologne/Ludwig, Kunst im 20. Jahrhundert, 1986; Orlando, Washington Color Painters: The First Generation, 1990. **Collections:** Allentown/AM; Amsterdam/Stedelijk; Baltimore/MA; Belfast; Berlin/National; Boston/MFA; Brandeis U.; Buffalo/Albright; CNAC; Canberra/National; Chicago/AI; Cologne; Corcoran; Dayton/AI; Detroit/AI; Eindhoven; Fort Worth; Greenville/County MA; Harvard U.; Hirshhorn; Honolulu; Houston/MFA; Humlebaek/Louisiana; Israel Museum; Jerusalem/National; Los Angeles/County MA; MMA; MOMA; Michigan State U.; Milwaukee; National Gallery; Nice; PMA; Phillips; Raleigh/NCMA; SFMA; SRGM; St. Louis/City; Sydney/AG; Syracuse/Everson; Tate Gallery; Tel Aviv; Toronto; WGMA; WMAA; Walker. **Bibliography:** Anfam; Armstrong, Thomas; Ashbery; Battcock, ed.; Calas, N. and E.; Coplans 3; Davis, D.; Elderfield 2; Fried 1, 2; Goossen 1; *The Great Decade;* Headley; Honisch and Jensen, eds.; Hughes; Hunter, ed.; *Individuals;* Kozloff 3; Murken-Altrogge; Rickey; Sandler 3, 5; Schwartz 1; Seitz 3; Tomkins 2; Upright 2; Weller. Archives.

LOVING, ALVIN b. September 2, 1953, Detroit, Michigan. **Studied:** U. of Illinois, BFA; U. of Michigan, MFA. **Awards:** U. of Michigan Rakham Memorial Fellowship, 1964; National Endow-

ment for the Arts, grant, 1970-71, 75-76; 85; CAPS, grant, 1975; Guggenheim Fellowship, 1986. **Commissions:** City of Detroit, Millender Station; Kennedy International Airport, International Departure Hall; The Empire State Mall, Albany, N.Y. **Taught:** Virginia Commonwealth U., 1985-86. **Address:** 463 West Street, NYC 10014. **Dealer:** June Kelly Gallery, Inc., NYC. **One-man Exhibitions:** WMAA, 1969; Gertrude Kasle Gallery, Detroit, 1969-70; William Zierler, Inc., NYC, 1971, 72, 73; Tyler School of Art, Philadelphia, 1973; Ohio U., 1974; Ohio State U., 1974; Notre Dame U., 1975; Elaine Benson Gallery, Bridgehampton, N.Y., 1976; Fishbach Gallery, NYC, 1976; Studio Museum of Harlem, 1977, 86; U. of Wisconsin, Oshkosh, 1978; Grippe-Zivian Gallery, NYC, 1979; Dianne Brewer Gallery, NYC, 1983; Andrea Olitzky Gallery, NYC, 1983; N'Namdi Reed Gallery, Detroit, 1983, 88, 90; U. of Vermont, 1984; Onyx Art Gallery, NYC, 1984; U. of Tennessee, 1987; U. of Vermont, 1987; Harris Brown Gallery, Boston, 1987; June Kelly Gallery, NYC, 1988, 90, 92; Liz Harris Gallery, Boston, 1988; The Harlem School of the Arts, NYC, 1989; Bronx Museum, 1989; GMA Engineering & Management Institute, Flint, Mich., 1990; Galbreath Gallery, Lexington, Ky., 1991; Birmingham-Bloomfield Art Association, Birmingham, Mich., 1991; Sande Webster Gallery, Philadelphia, 1991; Pace U., NYC and Westchester, 1992. **Group:** Detroit/Institute, Afro-American Arts, 1968; Brooklyn College, Afro-American Art After 1950, 1969; WMAA, Contemporary Black Artists in America, 1971; WMAA, Annual, 1972; Boston/MFA, Lamp Black, 1973; WMAA Biennial, 1973, 75; U. of North Carolina, Works on Paper, 1975, 91; Studio Museum, Another Generation, 1979; P.S. 1, Long Island City, N.Y., Afro-American Abstraction, 1981; Currier, Color, Material, Form, 1982; Polytechnical U., Manchester, England, New York Celebrates

Britain, 1983; Cleveland/MA, Seven American Artists, 1983; Toledo/MA, Since the Harlem Renaissance, 1984; Cleveland U., New Color Abstraction, 1985; Buffalo/Albright, The Appropriate Object, 1989; Newport Museum, R.I., Directions, 1990; Manhattanville College, NYC, The Harlem Renaissance Remembered, 1991; Kenkeleba Gallery, NYC, The Search for Freedom, circ., 1991; AAIAL, 1991. **Collections:** Akron/AM; Bell Atlantic; Chemical Bank; Cornell U.; Currier; Detroit; Detroit Library; Franklin & Marshall College; U. of Illinois; U. of Michigan; Montclair/AM; New Jersey State Library; Newark Museum; Prudential Insurance Co. of America; Studio Museum; Syracuse/Everson; Trenton/State; Vassar College; MMA; WMAA.

LOZOWICK, LOUIS b. December 10, 1892, Ludvinovka, Russia. d. September 9, 1973, South Orange, N.J. To USA, 1906. **Studied:** The Ohio U., 1915-1918, BA; NAD, with Carlson, Ivan Olinsky, 1912-15. US Army, 1918-19. Traveled Europe, Russia, the Orient. **Taught:** Educational Alliance, NYC; and privately. **Member:** SAGA; Boston Printmakers. Federal A.P.: Main Post Office, NYC (mural); printmaker. **Awards:** Brewster Prize for Lithography; PMA, International Print Competition, First Prize; Society of American Etchers and Engravers, NYC, Knobloch Prize; Brooklyn Museum, P.P.; U. of Rochester, 150 Years of Lithography, Second Prize; SAGA; Audubon Artists. **One-man Exhibitions:** (first) Heller Gallery, Berlin, 1923; Weyhe Gallery; Courvoisier Gallery, San Francisco; Stendahl Gallery, Los Angeles; Casson Gallery, Boston; J. B. Neumann's New Art Circle, NYC; The Zabriskie Gallery, NYC, 1961, 71, 72; Galerie Zak, Paris; Smithsonian; Argus Gallery, Madison, N.J., 1965; Heritage Art Gallery, South Orange, N.J., 1967; WMAA, 1972; Robert Dain Gallery, NYC, 1973; Lynn Gallery, Washington, D.C., 1975; Hirschl & Adler

Gallery, NYC, 1980, 90; Summit Art Gallery, NYC, 1983; Vanderwoude Tananbaum Gallery, NYC, 1985; Associated American Artists, 1990. **Retrospectives:** Newark Public Library, 1969; Seton Hall U., South Orange, N.J., 1975; Long Beach/MA, 1975; NCFA, 1975. **Group:** Brooklyn Museum, 1926; Chicago/AI, 1929; Carnegie, 1930, 39; Corcoran, 1932; A Century of Progress, Chicago, 1933-34; WMAA Annuals, 1933, 41; New York World's Fair, 1939; MMA, 1942; MOMA, 1943; Youngstown/Butler, 1960; Gallery of Modern Art, NYC, 1965; Boston/MFA. **Collections.** Boston/MFA, Cincinnati/AM; Cleveland/MA; Honolulu Academy; Houston/MFA; Library of Congress; Los Angeles/County MA; MMA; MOMA; Montclair/AM; Moscow/Western; NYPL; Newark Museum; PMA; U. of Rochester; Syracuse/Everson; Trenton/State; Victoria and Albert Museum; WMAA. **Bibliography:** American Artists Congress, Inc.; American Artists Group, Inc., 3; Armstrong, Thomas; Baur 7; Brown 2; *Cityscape 1919-39;* Cummings 5; Flint; Gerdts; *Index of 20th Century Artists;* Mellquist; Reese. Archives.

LUCCHESI, BRUNO b. July 31, 1926, Fibbiano, Italy. To USA, 1957.
Studied: Institute of Art, Lucca, 1953, MFA. **Taught:** Academy of Fine Arts, Florence, 1952-57; New School for Social Research, 1962-. **Commissions:** Trade Bank and Trust Co., NYC; Cornell U. **Awards:** NAD, Elizabeth N. Watrous Gold Medal, 1961; Guggenheim Foundation Fellowship, 1962; National Arts Club, NYC, Gold Medal, 1963; NAD, Samuel F. B. Morse Medal, 1965; NAD, Gold Medal, 1970, 74; City of Lucca, Medal for Honoring Italy Abroad, 1976; National Sculpture Society, Gold Medal, 1977; The Italian Cultural Society, The Lion of San Marco, 1981; NAD, Artists Fund Prize for Sculpture, 1983; NAD, Gold Medal, 1990. **Address:** 14 Stuyvesant Street, NYC 10003. **Dealer:** The Forum Gallery, NYC.

One-man Exhibitions: The Forum Gallery, NYC, 1961, 63, 66, 72, 75, 76, 80, 84, 85, 90; Washington & Lee U., 1979; Shirlee Raushbach Gallery, Bay Harbor Islands, Fla., 1983; Blue Hill Cultural Center, Pearl River, N.Y., 1984; Foster Harmon Galleries, Sarasota, 1980, 86; Casey Gallery, Scottsdale, 1986. **Group:** Corcoran; NAD; PAFA; WMAA. **Collections:** Brooklyn Museum; Columbia, S.C./MA; Cornell U.; Dallas/MFA; Hirshhorn; U. of Nebraska; PAFA; Ringling; Syracuse U.; U. of Utah; WMAA.

LUKIN, SVEN
from 1st to 4th edition.

LUND, DAVID b. October 16, 1925, NYC. **Studied:** Queens College, with Vaclav Vytlacil, Cameron Booth, 1944-48, BA (major in painting); NYU, 1948-50, with Hale Woodruff; New School for Social Research, with Yasuo Kuniyoshi. Traveled Europe, southwestern USA, Mexico. **Taught:** Cooper Union, 1955-57, 1959-69; Parsons School of Design, 1963-66, 1967-; Queens College, 1964-66; Washington U., St. Louis, 1966-67, 85; Columbia U., 1969-82. **Member:** Artists Equity, NAD. **Awards:** Fulbright Fellowship (Rome), 1957-58, renewed 1958-59; WMAA Annual, Ford Foundation Purchase, 1961; AAAL, Childe Hassam Fund P.P., 1978. **Address:** 470 West End Avenue, NYC 10024. **Dealers:** Olga Dollar Gallery, San Francisco; A.J. Lederman Fine Art, Hoboken, N.J.; Kornbluth Gallery, Fair Lawn, N.J.; Grace Borgenicht Gallery, NYC. **One-man Exhibitions:** (first) Grand Central Moderns, NYC, 1954; Galleria Trastevere di Topazia Alliata, Rome, 1955; Grace Borgenicht Gallery, NYC, 1960, 63, 67, 69, 76, 78, 80, 83, 86; Martin Schweig Gallery, 1966; U. of Alaska, 1983; Allport Associates, San Francisco, 1984; Washington U., 1985, A. J. Lederman Fine Arts, Hoboken, N.J., 1990. **Group:** Tanager Gallery, NYC, Invitational; The Stable Gallery Annual, 1956; Galleria Schneider, Rome, Fulbright Artists, 1958,

59; WMAA, Fulbright Artists, 1958; Hirschl & Adler Galleries, Inc., NYC, Experiences in Art I, 1959; WMAA, Young America, 1960; WMAA Annual, 1961; WMAA, Forty Artists Under Forty, circ., 1962; PAFA, 1965, 69; School of Visual Arts, NYC, 1966; Omaha/Joslyn, A Sense of Place, 1973; City Hall, Rockport, Me., Maine Coast Artists, 1974; Oklahoma, Contemporary American Landscape Painting, 1975; IIE, 20 American Fulbright Artists, 1975; NAD, 1977; Youngstown/Butler, Mid-year Shows, 1978, 84; Colby College, Landscape and Abstract Art: A Continuing Dialogue, 1985; NAD, 1991. **Collections:** AAIAL; AT&T; Amherst College; Baltimore/MA; Brandeis U.; Bristol-Meyers Co., NYC; Buffalo/Albright; Burlington Industries, NYC; Chase Manhattan Bank; Colby College; Commerce Trust Co., Corcoran; Cornell U.; Delaware Art Museum; J. C. Penney Co.; Kansas City/IA; Fort Worth; Harcourt Brace Jovanovich Inc.; U. of Illinois; Manufacturers Hanover Trust Co.; U. of Massachusetts; Mellon Bank; Montclair/AM; McDonnell & Co. Inc.; U. of Nebraska; U. of North Carolina; Prudential Insurance Co. of America, Newark; The New York Times; The Pure Oil Co., NYC.; South County Bank; Toronto; Trenton/State; Union Carbide Corp., NYC; WMAA; Wilmington.

LUNDEBERG, HELEN b. June 1908, Chicago, Ill. **Studied:** Privately with Lorser Feitelson. Federal A.P.: Painting, lithography, mural designer. Subject of film, *Helen Lundeberg: American Painter,* 1987. **Awards:** Florsheim Foundation Award. **m.** Lorser Feitelson. **Address:** 465 Ogden Drive, Los Angeles, CA 90036. **Dealer:** Tobey C. Moss Gallery, Los Angeles. **One-man Exhibitions:** (first) Stanley Rose Gallery, Hollywood, 1933; Mid-20th Century Art Gallery, Los Angeles, 1947; Art Center School, Los Angeles (two-man); Lucien Labaudt Gallery, San Francisco (two-man), 1949; Pasadena/AM; Santa Barbara, 1958; Paul Rivas Gallery, Los An-

geles, 1959; Long Beach/MA, 1963; Occidental College, 1965; David Stuart Gallery, 1970, 71, 77; The Graham Gallery, NYC, 1982; Tobey C. Moss Gallery, 1982, 83, 84, 85, 89; Palm Springs Desert Museum, 1983. **Retrospectives:** Pasadena/AM, 1953; La Jolla, 1971; Los Angeles Municipal Art Gallery, 1979; SFMA, 1980; UCLA, 1981; Laguna Beach Museum of Art, 1987; Los Angeles/County MA, 1988; Fresno/AM, 1989. **Group:** Brooklyn Museum, 1936; SFMA, 1936; MOMA, Fantastic Art, DADA, Surrealism, 1936; MOMA, Americans 1942, circ., 1942; Chicago/AI, Abstract and Surrealist Art, 1948; U. of Illinois, 1950-52, 55, 57, 65; Carnegie, 1952; III São Paulo Biennial, 1955; WMAA, Geometric Abstraction in America, circ., 1962; WMAA, Fifty California Artists, 1962-63; WMAA Annuals, 1965, 67; Sacramento/Crocker, 1968; Los Angeles Institute of Contemporary Art, 1974; MOMA, Painting and Sculpture in California: The Modern Era, 1976; San Antonio/McNay, American Artists '76, 1976; Rutgers U., Surrealism and American Art: 1931-1947, 1977; Denver/AM Biennial, 1979; Laguna Beach Museum of Art, Southern California Artists: 1940-1980, 1981; Rutgers U., Realism and Realities, 1982; Huntington, N.Y./Heckscher, The Artists' Mother, circ., 1987; Oakland Museum, The Artists of California, circ., 1988; Santa Barbara/MA, Turning the Tide, circ., 1990; Irvine Fine Arts Center, Irvine, Calif., Greater Years: Greater Visions, 1991. **Collections:** Atlantic Richfield Co.; Bank of Tulsa, Tulsa; Boston/MFA; Chaffey College; Craig Ellwood Associates; Fresno/AM; Great Western Savings and Loan Association; Hirshhorn; Honolulu Academy; La Jolla; Laguna Beach Museum of Art; Lansing Sound Corp.; Los Angeles/County MA; NCFA; NYPL; U. of Nebraska; Oakland/AM; Palm Springs Desert Museum; Pasadena/AM; Rutgers U.; SFMA; Santa Barbara/MA; Xerox Corp.; WMAA. **Bibliography:** Armstrong, Thomas;

Feitelson and Lundeberg; Karlstrom and Ehrlich; Plagens; Rickey. Archives.

LYE, LEN
from 1st to 5th edition.

LYTLE, RICHARD b. February 14, 1935, Albany, N.Y. **Studied:** Cooper Union, with Nicholas Marsicano, Victor Candell; Yale U., with Josef Albers (whom he assisted as teaching fellow in color and drawing), James Brooks, Bernard Chaet, 1957, BFA, 1960, MFA. Traveled Europe, northeastern USA. **Taught:** Yale U., 1960-63, 1966-: Dean, Silvermine Guild, 1963-66. **Commissions:** Fairfield U. (concrete relief mural). **Awards:** Scholarship to the Cummington School of Fine Arts, 1956; Fulbright Fellowship (Italy), 1958; New Haven Arts Festival, First Prize, 1958; Augustus Saint Gaudens Award for Professional Achievement, from the Cooper Union, 1985. **Address:** Sperry Road, Woodbridge, CT 06525. **Dealer:** Munson Gallery, New Haven, CT. **One-man Exhibitions:** (first) Grace Borgenicht Gallery, Inc., NYC, 1961, also 1963, 64, 66, 68, 72; Silvermine Guild, 1964; Cortland/SUNY, 1969; U. of Hartford, 1970; U. of Connecticut, 1973; Lincoln, Mass./De Cordova, 1974; Marilyn Pearl Gallery, NYC, 1977, 79, 82, 84; Munson Gallery, New Haven, 1979, 83, 88, 91; Munson Gallery, Santa Fe, 1980; Dartmouth College, 1986; Virigina Miller Galleries, Coral Gables, Fla., 1987. **Group:** Brooklyn Museum, 1956; A.F.A., American Art, circ., Europe, 1956-59; Boston Arts Festival, 1958; MOMA, Sixteen Americans, circ., 1959; Chicago/AI Annuals, 1960, 61; Houston/MFA, The Emerging Figure, 1961; Seattle World's Fair, 1962; PAFA, 1962, 63, 64; Art: USA: Now, circ., 1962-67; WMAA, 1964; Silvermine Guild, 1964; U. of Illinois, 1967, Yale U., 1967; Ringling, Young New England Painters, 1969; Yale U., American Drawing, 1970-1973, 1973; Harvard U., Works by Students of Josef Albers, 1974; IIE, 20 American Fulbright Artists, 1975; U. of North Carolina, 1978, 80; Buffalo/Albright, Works on Paper, 1979; Montclair/AM, Josef Albers: His Influence, 1981; Bruce Museum, Greenwich, Ct., Biennial, 1989. **Collections:** AT&T; Chase Manhattan Bank; Cincinnati/AM; Citicorp; Columbia U.; E. F. Hutton; Lincoln, Mass./De Cordova; MOMA; U. of Massachusetts; Minneapolis/Institute; NCFA; St. Joseph/Albrecht; Williams College; Yale U. **Bibliography:** Nordness, ed.

M

MAC CONNEL, KIM b. 1946, Oklahoma City, Oklahoma. **Studied:** U. of California, San Diego, BA, honors, 1969; MFA, honors, 1972. **Taught:** U. of California, San Diego, 1977-. Active as an actor. **Awards:** California State Scholar, 1970. **Address:** 1090 Devonshire, Encinatas, CA 92024. **Dealer:** Holly Solomon Gallery, NYC. **One-man Exhibitions:** Holly Solomon Gallery, NYC, 1975, 77, 78, 79, 80, 82, 84, 86, 87, 89, 91; Metropolitan Museum and Art Center, Miami, 1975; La Jolla, 1975; Galerie Ehrensperger, Zurich, 1976; U. of California, Berkeley, 1978; Galerie Bischofberger, Zurich, 1978; F. H. Mayor Gallery, London, 1978, 81; Dart Gallery, Chicago, 1979, 80; U. of North Carolina, 1980; Galerie Rudolf Zwirner, Cologne, 1981; James Corcoran Gallery, Los Angeles, 1982, 86; Studio Marconi, Milan, 1984; Quint Gallery, San Diego, 1986; Jan Baum Gallery, Los Angeles, 1987; Cappelleni International Arts, Milan, 1989; Aspen Art Museum, 1990; Galleria Sperone, Rome, 1992. **Group:** U. of California, San Diego, Decorations, 1971; The Clocktower, NYC, Toys Artists Make, 1974; WMAA Biennials, 1975, 77, 79, 85; American Foundation for the Arts, Miami, Patterning and Decoration, 1977; Philadelphia College of Art, Artists, Sets and Costumes, 1977; ICA, U. of Pennsylvania, Improbable Furniture, 1977; La Jolla, Southern California, Styles of the 60's and 70's, 1978; Rice U., Pattern and Decoration, 1978; Cincinnati/Contemporary, Arabesque, 1978; ICA, U. of Pennsylvania, The Decorative Impulse, 1979; Hirshhorn, Directions, 1979; Buffalo/Albright, Patterns, 1979; Mannheim, Dekor, 1980; Aachen/NG, Les Nouveaux Fauves/Dineuen Wilden, 1980; Bonn, Back to the USA, circ., 1983; WMAA, American Art Since 1980, circ., 1984; MOMA, An International Survey of Recent Painting and Sculpture, 1984; Venice Biennale, 1984; ICI, NYC, After Matisse, circ., 1986; Fort Lauderdale, An American Renaissance, 1986; Groninger Museum, Holland, Americana, 1987; Los Angeles/County MA, Living Spaces, 1987; U. of Massachusetts, Contemporary American Collage, 1960-1986, circ., 1987; Nice/Contemporain, Les Années 80, 1991; New York Academy of Art, Expressive Drawings, 1991. **Bibliography:** *Back to the USA; Drawings: The Pluralist Decade;* Haenlein; Honnef 2; Lucie-Smith; Murken-Altrogge; Robins.

MACDONALD-WRIGHT, STANTON b. July 8, 1890, Charlottesville, Va. **d.** August 24, 1973, Pacific Palisades, Calif. **Studied:** Sorbonne; Academie des Beaux-Arts, Paris; Academie Colarossi, Paris; Academie Julian, Paris; ASL, with W. T. Hedges, J. Greenbaum. Met Morgan Russell in Paris, 1912, and with him founded the Synchromist movement in 1913. Studied the color theories of Michel Eugene Chevreul, Herman von Helmholz, and O. N. Rood. Returned to USA, 1916. Traveled Japan, 1937, 1952-53. **Taught:** U. of California, 1942-50; U. of Southern California; Scripps College, 1946; U. of Hawaii, 1949; Fulbright Exchange Professor to Japan, 1952-53; lectured on art history and Oriental aesthetics. Federal A.P.: California State Director, 1935-42, and technical advisor to seven western states. **Commissions** (murals): Santa Monica (Calif.) Public Library; Santa Monica City Hall; Santa Monica High School (mosaic).

One-man Exhibitions: (first) Photo-Secession, NYC, 1917; Stendahl Gallery, Los Angeles, 1942 (two-man); Rose Fried Gallery, 1955; Duveen-Graham Gallery, NYC, 1956; Esther Robles Gallery, Los Angeles, 1965; UCLA, 1970; Suzuki Graphics, 1972; St. Petersburg Museum, 1977; Harmon Gallery, Naples, 1975, 78; The Forum Gallery, NYC, 1982; Joseph Chowning Gallery, San Francisco, 1984. **Retrospectives:** Los Angeles/County MA, 1956; NCFA, 1967. **Group:** Salon d'Automne, Paris, 1910; The Synchromists, Munich and Paris, 1913; Salon des Artistes Independants, Paris, 1913-14; MMA; Brooklyn Museum; Honolulu Academy. **Collections:** Boston/MFA; Brooklyn Museum; Carnegie; Chicago/AI; Columbus; Corcoran; Denver/AM; Detroit/Institute; Grand Rapids; Los Angeles/County MA; MMA; MOMA; U. of Minnesota; Newark Museum; Omaha/Joslyn; PMA; Pasadena/AM; San Diego; Santa Barbara/MA; Toledo/MA; WMAA; Walker. **Bibliography:** *Avant-Garde Painting and Sculpture in America, 1910-25;* Baur 7; Blanchard; Blesh 1; Brown 2; Cheney; Chipp; Christensen; Craven, T., 1; Goodrich and Baur 1; Haftman; Hess, T. B., 1; Hunter 6; Huyghe; Jackman; Janis, S.; Levin 2; Karlstrom and Ehrlich; McCurdy, ed.; Mellquist; Neuhaus; Read 2; Richardson, E.P.; Rickey; Ringel, ed.; Ritchie 1; Rose, B., 1, 4; **Scott**; Seuphor 1, 2; Wright 1, 2. Archives.

MacIVER, LOREN b. February 2, 1909, NYC. **Studied:** ASL, 1919-20. Traveled Europe. Lighting and decor for four Coffee Concerts, MOMA, 1941. **Member:** NIAL, 1959. Federal A.P.: 1936-39, New York; Artists Equity. **Commissions** (murals): Moore-McCormack Lines, Inc., SS *Argentina,* 1947; American Export Lines, SS *Excalibur,* SS *Exeter,* SS *Exochorda,* SS *Excambion,* 1948. **Awards:** Corcoran, First Prize, 1957; Ford Foundation Grant, 1960; Mark Rothko Foundation Grant, 1972; Guggenheim

Foundation Fellowship, 1976; Pollock-Krasner Foundation grant, 1992. **Address:** 61 Perry Street, NYC 10014. **One-man Exhibitions:** (first) East River Gallery, NYC, 1938; Pierre Matisse Gallery, NYC, 1940, 44, 49, 56, 61, 70, 81; Arts Club of Chicago, 1941; MOMA, circ., 1941; Baltimore/MA, 1945; Vassar College, circ., 1950; Santa Barbara/MA, circ., 1951; Margaret Brown Gallery, Boston, 1951; Phillips, 1951; Corcoran, 1956; Fairweather-Hardin Gallery, 1959; Southern Vermont Art Center, Manchester, Vt., 1968; Paris/Moderne, 1968; Musées Classes de Nice, 1968; Rutgers U., 1982. **Retrospectives:** WMAA, circ., 1953; Paris/Moderne, 1968; Newport Harbor, 1985. **Group:** WMAA annuals; MOMA, Fourteen Americans, circ., 1946; Corcoran. **Collections:** Andover/Phillips; Baltimore/MA; Bibliothèque Nationale; Brooklyn Museum; Chicago/AI; Corcoran; Detroit/Institute; Hartford/Wadsworth; Harvard U.; Hirshhorn; Los Angeles/County MA; MMA; MOMA; NMAA; National Gallery; Newark Museum; U. of Oklahoma; PMA; Phillips; SFMA; Smith College; Utica; Vassar College; WMAA; Walker; Williams College; Yale U. **Bibliography:** Barr 3; **Baur 4**, 5, 7; Bazin; Blesh 1; Eliot; Flanagan; Genauer; Goodrich and Baur 1; Hunter 6; Janis, S.; McCurdy, ed.; Mendelowitz; Miller, ed., 2; Newmeyer; Nordness, ed.; Pousette-Dart, ed.; Read 2; Richardson, E.P.; Soby 5, 6; Ward; Wight 2. Archives.

MADSEN, LOREN b. March 29, 1943, Oakland, Calif. **Studied:** Reed College; UCLA, BA, 1966; MA, 1970. Traveled Switzerland, 1959-60, Europe, 1963-64. **Taught:** UCLA. **Commissions:** Prudential Insurance Co., Florham Park, N.J., 1974; Los Angeles Museum of Art, Calif., 1977; Prudential Insurance Co., Woodland Hills, Calif.; Cedars-Sinai Medical Center, Beverly Hills, Calif., 1977; Michael's Restaurant, Santa Monica, Calif., 1979; Newport Harbor Art

Museum, Newport Beach, Calif., 1980; First Bank Atrium, Pillsbury Center, Minneapolis, Minn.; SSA Metro West (G.S.A.), Baltimore, Md.; Stamford Town Center, Stamford, Conn.; Iowa State University, Ames, Iowa, 1980-81; 1st Bank Atrium, Pillsbury Center, Minneapolis, 1981; Brookhollow Atrium, San Antonio, 1984; Republic Bank, San Antonio, 1984; Horton Plaza, San Diego, 1985; Quorum, Dallas, 1985; Chevy Chase (Md.) Metro Center, 1986; Schering Corp., Kenilworth, N.J., 1986; Pacific Enterprises, Los Angeles, 1989; La Guardia Community College, N.Y., 1991. **Awards:** Los Angeles/County MA, New Talent, **P.P.**, 1975; National Endowment for the Arts, Fellowship, 1975 and 1980. **Address:** 428 Broome Street, NYC 10013. **Dealer:** David McKee Gallery, NYC. **One-man Exhibitions:** (first) Mizuno Gallery, Los Angeles, 1973, 74; MOMA, 1975; David McKee Gallery, NYC, 1976, 77, 82, 84, 86, 90; Site, San Francisco, 1976; L.A. Louver Gallery, Los Angeles, 1976; Zolla-Lieberman, Chicago, 1978; Wright State U., 1980; Hansen Fuller Goldeen Gallery, San Francisco, 1980; U. of Massachusetts, 1981; Miami-Dade, 1984; U. of Florida, 1991; Haines Gallery, San Francisco, 1991. **Group:** Scripps College, Young Sculptors, 1972; Long Beach/MA, Constructions, 1974; Los Angeles/County MA, Six Artists, 1974; Los Angeles Municipal Art Gallery, 24 from Los Angeles, 1974; SFAI, 8 Los Angeles Artists, 1974; Hayward Gallery, The Condition of Sculpture, 1975; Walker, Dill, Ginnever, Madsen, 1975; Omaha/Joslyn, L.A. in the Seventies, 1979; Hirshhorn, Directions, 1979; Sacramento/Crocker, Aspects of Abstract Art, 1979; San Diego Museum of Art, Sculpture in California, 1975-80, 1980; Newport Harbor, Shift—L.A./N.Y., 1983; U. of Massachusetts, Ten, 1985; Albright College, Computer Assisted, 1987. **Collections:** Akron/AM; Hirshhorn; Israel Museum; Los Angeles/County MA; MOMA; Newport Harbor; Paris/Beaubourg; Vancouver; Walker. **Bibliography:** Robins.

MALDARELLI, ORONZIO
from 1st to 4th edition.

MALLARY, ROBERT b. December 2, 1917, Toledo, Ohio. **Studied:** La Escuela de las Artes del Libro, Mexico City, 1938; privately with Koloman Sokol (graphics), Mexico City and New York, 1941-42. **Taught:** Pratt Institute, 1959-67; The Pennsylvania State U., 1962; U. of California, Davis, 1963, 67; U. of Minnesota, 1965; U. of Massachusetts, 1967-. Director, ARSTECNICA, U. of Massachusetts, Amherst. **Commissions:** Beverly Hilton Hotel, Beverly Hills, Calif., 1954-55 (mural, with Dale Owen); New York State Pavilion, New York World's Fair, 1964-65. **Awards:** Tamarind Fellowship, 1962; Guggenheim Foundation Fellowship, 1964. **Address:** P.O. Box 48, Conway, MA 01341. **Dealer:** Allan Stone Gallery, NYC. **One-man Exhibitions:** SFMA, 1944; Sacramento/Crocker, 1944, 52; Santa Barbara/MA, 1952; Gump's Gallery, 1953; San Diego, 1953; Urban Gallery, NYC, 1954; U. of New Mexico, 1956-59; Jonson Gallery, Albuquerque, N.M., 1957-59; Santa Fe, N.M., 1958; Allan Stone Gallery, 1961, 62, 66; Yale U. (two-man), 1965; Purdue U., 1974; U. of Massachusetts, Amherst, 1991; Springfield, Mass./MFA, 1992. **Retrospective:** Potsdam/SUNY, 1969. **Group:** Salon de Grabado, Mexico City, 1942; SFMA, 1945; Los Angeles/County MA Annuals, 1951, 53, 56; Denver/AM Annual, 1955; III & VII São Paulo Biennials, 1955, 63; Smithsonian, California Painters, circ., USA, 1956-58; MOMA, Recent Sculpture USA, 1959; MOMA, Sixteen Americans, circ., 1959; SRGM, Guggenheim International, 1960; WMAA Annuals, 1960, 62; MOMA, The Art of Assemblage, circ., 1961; Martha Jackson Gallery, New Media—New Forms, II, 1961; Seattle

World's Fair, 1962; A.F.A., Relief Sculpture, circ., 1964; Brandeis U., Recent American Drawings, 1964; ICA, London, Cybernetic Serendipity, 1968; WMAA, Human Concern/Personal Torment, 1969; Akron/AI, Celebrate Ohio, 1971. **Collections:** Brandeis U.; Buffalo/Albright; U. of California; Houston/MFA; Kalamazoo/Institute; Los Angeles/County MA; MOMA; U. of New Mexico; U. of North Carolina; Roswell; Smith College; U. of Texas; WMAA. **Bibliography:** *Celebrate Ohio; Davis, D.;* Hunter, ed.; Janis and Blesh 1; *Report;* Seitz 4; Weller.

MALLORY, RONALD
from 1st to 4th edition.

MANGOLD, ROBERT **b.** October 12, 1937, North Tonawanda, N.Y. **Studied:** Cleveland Institute of Art, 1956-59; Yale U., 1959, 1960-62, BFA, 1963, MFA. **Taught:** School of Visual Arts, NYC, 1963-; Hunter College, 1964-65; Skowhegan School, 1968; Yale U. Summer School, Norfolk, Conn., 1969; Cornell U., 1970. **m.** Sylvia Plimack Mangold. **Address:** Bull Road, Washingtonville, NY. **Dealer:** The Pace Gallery, NYC. **One-man Exhibitions:** Thibaut Gallery, NYC, 1964; Fischbach Gallery, 1965, 67, 69, 70, 71, 73; Galerie Muller, 1968; SRGM, 1971; Yvon Lambert, 1973; Galleria Toselli, Milan, 1973; Lisson Gallery, 1973; Galerie Annemarie Verna, Zurich, 1973, 80; Galleria Marilena Bonomo, Bari, Italy, 1973; Max Protech, Washington, D.C., 1973; Weinberg Gallery, San Francisco, 1973; John Weber Gallery, 1974, 76, 77, 79, 80; Konrad Fischer Gallery, Düsseldorf, 1974, 82, 87; Protetch-McIntosh Gallery, Washington, D.C., 1978; Bielefeld, Kunsthalle, 1980; Young Hoffman Gallery, Chicago, 1980; Texas Gallery, Houston, 1980; Richard Hines Gallery, Seattle, 1980; Lisson Gallery, London, 1981, 86, 90; Hoshour Gallery, Albuquerque, 1981; Carol Taylor Gallery, Dallas, 1981; Sidney Janis Gallery, NYC,

1982; Amsterdam/Stedelijk, 1982; Daniel Weinberg Gallery, Los Angeles, 1983, 88, 91; U. of California, Berkeley, 1983; Paula Cooper Gallery, NYC, 1984, 86, 87, 88, 90, 91; Akron/AM, circ., 1985; Galerie Annemarie Verna, Zurich, 1985, 88; Donald Young Gallery, Chicago, 1986; Hallen für neue Kunst Schaffhausen, 1987; Baltimore/MA, 1987; Fabian Carlsson Gallery, London, 1988; Galerie Meert Rihoux, Brussels, 1988, 89; Galerie Yvon Lambert, Paris, 1988; Maastricht, 1988, 89; Galerie LeLong, NYC, 1989; The Pace Gallery, NYC, 1991. **Group:** SRGM, Systemic Painting, 1966; Yale U., Twelve Yale Artists, 1966; ICA, U. of Pennsylvania, A Romantic Minimalism, 1967; Ithaca College, Selected New York Artists, 1967; Trenton/State, Focus on Light, 1967; WMAA, Artists Under Forty, 1968; Buffalo/Albright, Modular Paintings, 1970; Kassel, Documenta V, 1972; WMAA, American Drawings, 1963-1973, 1973; Parcheggio di Villa Borghese, Rome, Contemporanea, 1973; Chicago/Contemporary, Five Artists: A Logic of Vision, 1974; MOMA, Color as Language, circ., 1975; MOMA, Drawing Now, 1976; Kassel, Documenta VI, 1977; Buffalo/Albright, American Paintings of the 1970s, 1978; U. of North Carolina, Drawings About Drawing Today, 1979; ICA, Boston, The Reductive Object, 1979; Lenbachhaus, Munich, Tendencies in American Drawings of the Late Seventies, 1979; Paris/Beaubourg, Nature du Dessin, 1981; Kassel, Documenta VII, 1982; SRGM, The New York School: Four Decades, 1982; WMAA, Biennial, 1983, 85; Amsterdam/Stedelijk, La Grande Parade, 1984; Grand Palais, Paris, La rime et la raison, 1984; Bordeaux/Contemporain, Art Minimal II, 1986; Corcoran, Biennial, 1987; Milwaukee, The World of Art Today, 1888/1988, 1988; Lausche State Office Building, Cleveland, Geometric Abstraction: A Cleveland Tradition, circ., 1988; MOMA, Abstraction, 1989; Frankfurt/Kunstverein, Prospect '89, 1989; Kansas City/Nelson, Essential

Painting, 1989; Cleveland/Contemporary, Minimalist Vision, 1990. **Collections:** Amsterdam/Stedelijk; Brandeis U.; Buffalo/Albright; Chicago/AI; Corcoran; Dallas/MFA; Eindhoven; Frankfurt/Moderne; Grenoble; High; Houston/MFA; Humlebaek/Louisiana; Krefeld/Kaiser Wilhelm; Los Angeles/County MA; Los Angeles/MOCA; Maastricht; MMA; MOMA; McCrory Corporation; Minneapolis/Institute; Monchengladbach; U. of North Carolina; Oberlin College; Hara Art Museum; Phillips; Portland/Ore./AM; RISD; Ridgefield/Aldrich; SFMA; SRGM; San Diego/Contemporary; Seattle/AM; Toledo/MA; WMAA; Walker. **Bibliography:** *Art Now 74; Contemporanea;* De Wilde 1; *Fundamentele Schilderkunst;* Gablik; Honisch and Jensen, eds.; Lippard 2; Murdoch 1; Murken-Altrogge; *Options and Alternatives;* Plagens; Sandler 3; **Waldman 8**; Ward.

MANGOLD, SYLVIA PLIMACK

b. September 18, 1938. **Studied:** Cooper Union, NYC, 1956-59; Yale U., BFA, 1961. **Taught:** School of Visual Arts, NYC, 1970-71. **Address:** Bull Road, Washingtonville, NY. **Dealer:** Brooke Alexander, NYC. **One-man Exhibitions:** Fischbach Gallery, NYC, 1974, 75; Daniel Weinberg Gallery, San Francisco, 1974; Droll/Kolbert Gallery, NYC, 1978, 80; Galerie Annemarie Verna, Zurich, 1978, 91; Ohio State U., 1980; Young Hoffman Gallery, Chicago, 1980; Hartford/Wadsworth, 1981; Houston/Contemporary, 1981; Duke U., 1982; Madison Art Center, circ., 1982; Brooke Alexander, NYC, 1982, 84, 85, 87, 89; Rhona Hoffman Gallery, Chicago, 1985; Texas Gallery, Houston, 1986; Fuller Goldeen Gallery, San Francisco, 1987. **Group:** Vassar College, Realism Now, 1968; U. of North Carolina, Art on Paper, 1968; Potsdam/SUNY, New Realism, 1972; WMAA Annual, 1972; Yale U., American Drawing 1970-1973, 1973; Yale U., Seven Realists, 1974; California Institute of the Arts,

Valencia, Anonymous Was a Woman, 1974; Skidmore College, 20th Century Drawings, 1975; San Antonio/McNay, American Artists, '76, 1976; Akron/AI, Contemporary Images in Watercolor, 1976; Indianapolis, 1976; Kassel, Documenta VI, 1977; Buffalo/Albright, American Painting of the 1970's, 1978; Ljubljana, 13th Print Biennial, 1979; Denver, The Reality of Illusion, 1979; Walker, Eight Artists: The Elusive Image, 1979; XXXIX Venice Biennial, 1980; PAFA, Contemporary American Realism Since 1960, 1981; San Antonio/MA, Real, Really Real, Super Real, circ., 1981; Hudson River Museum, New Vistas, 1985; Stamford Museum, American Art: American Women, 1985; Yale U., Interiors and Exteriors, 1986; Mount Holyoke, A Graphic Muse, circ., 1987; U. of North Carolina, Art on Paper, 1987; AAIAL, Annual, 1989, 92; Cincinnati, Making Their Mark, circ., 1989; Ljubljana, Yugoslavia, Biennial of Graphic Art, 1991. **Collections:** Buffalo/Albright; Dallas/MFA; Detroit/Institute; Hartford/Wadsworth; Houston/MFA; Indianapolis; MOMA; Madison Art Center; Milwaukee; U. of North Carolina; Oberlin College; Utah; U. of Utah; WMAA; Walker; Yale U. **Bibliography:** *Art: A Woman's Sensibility; Drawings: The Pluralist Decade;* Lindy; Lippard 3.

MAN RAY (Emmanuel Radinski)

b. August 27, 1890, Philadelphia, Pa. **d.** November 18, 1976, Paris. **Studied:** NAD, 1908; ASL; Ferrer Center, NYC, with Robert Henri and George Bellows. Cofounder (with Marcel Duchamp and Francis Picabia) of DADA group, NYC, 1917. Co-organizer (with Katherine S. Dreier and Marcel Duchamp) of Societé Anonyme (Museum of Modern Art), 1920. Published one issue of *New York DADA* with Marcel Duchamp, 1921. To Paris, 1921, and became a member of the DADA and Surrealist groups, 1924-39. Developed the rayography technique in photography, 1921. Created abstract and surrealist films:

Le Retour de la Raison, 1923; *Emak Bakia*, 1926; *L'Etoile de Mer*, 1928; *Les Mysteres du Chateau de Des*, 1929. Resided Hollywood, 1940-50; returned to Paris. **One-man Exhibitions:** (first) Daniel Gallery, NYC, 1915, also 1916, 19; Librairie Six Paris, 1922; Galerie Surrealiste, Paris, 1926; Myrbor Galerie, Paris, 1929; Galerie Vanleer, Paris, 1929; Galerie Vignon, Paris, 1932; Curt Valentine Gallery, NYC, 1936; Galerie Beaune, Paris, 1939; The London Gallery, London, 1939; Frank Perls Gallery, 1941; Julien Levy Galleries, NYC, 1945; Copley Gallery, Hollywood, Calif., 1948; Paul Kantor Gallery, Beverly Hills, 1953; Galerie Furstenberg, Paris, 1954; Galerie Rive Droite, Paris, 1959; Bibliothèque Nationale, 1962; Cordier & Ekstrom, Inc., 1963, 70; Princeton U., 1963; Gaileria Schwarz, 1964, 71; Los Angeles/County MA, 1966; Martha Jackson Gallery, 1968; Galerie der Spiegel, Cologne, 1968, 75; Hanover Gallery, 1969; Trenton/State, 1969; Noah Goldowsky, 1971; La Boetie, NYC, 1972; MMA, 1973; Alexandre Iolas Gallery, NYC, 1974; Galleria Il Fauno, Turin, 1974; Studio Marconi, Milan, 1975; Chicago/Contemporary, 1975; Stephen Wirtz Gallery, San Francisco, 1982; The Zabriskie Gallery, NYC, 1982, 85, 88; Robert Miller Gallery, 1983, 91; Center for Photography, Film and Television, Zagreb, Yugoslavia, 1985; Light Gallery, NYC, 1985; G. Ray Hawkins Gallery, Los Angeles, 1986; Lucio Amelio, Naples, 1988; Jeffrey Fuller Fine Art, Los Angeles, 1989; ICP, 1990; Middendorf Gallery, Washington, D.C., 1989; Galeries 1900-2000, Paris, 1991. **Retrospectives:** Paris/Moderne, 1971; New York Cultural Center, 1974; Paris/Beaubourg, 1981; NMAA, circ., 1988. **Group:** Societé Anonyme, NYC, 1920; Brooklyn Museum, 1926; Springfield, Mass./MFA, 1929; MOMA, 1936; WMAA, 1946; Yale U., 1948. **Collections:** MOMA. **Bibliography:** Ammann and Bussmann; *Avant-Garde Painting and Sculpture in America, 1910-25;* Barr 1;

Baur 7; Biddle 4; Blesh 1; **Bourgeade;** Breton 1, 2, 3; Brown 2; Cassou; Christensen; Crespelle; Davis, D.; *Europa/Amerika;* Flanagan; **Forresta et al;** *Forty Years of California Assemblage;* Gascoyne; Gerdts; Gohr and Gachnang; Guggenheim, ed.; Haftman; Hulten; Honisch and Jensen, eds.; Hunter 6; Hunter, ed.; Kozloff 3; Krauss 2, 3; Kyrou; **Langsner; Man Ray 1, 2, 3, 4;** *Man Ray;* McCurdy, ed.; Marter, Tarbell, and Wechsler; Mellquist; Motherwell 1; Murken-Altrogge; Neff, ed.; **Penrose;** Raynal 3; Read 2, 3, 5; **Ribemont-Dessaignes;** Richter; Ritchie 1; Rose, B., 1; Rowell; Rubin 1; Seitz 4; Soby 1; Tashijian; Tomkins; Tomkins and Time-Life Books; Verkauf; Waldberg 2, 3, 4; Waldman 4; Wiesinger; Wright 1; Zervos.

MANSHIP, PAUL b. December 25, 1885, St. Paul, Minn. d. February 1, 1966, NYC. **Studied:** St. Paul School of Art, 1892-1903; ASL, 1905; PAFA, 1906-8; American Academy, Rome, 1909-12. Traveled Europe, USA; resided Paris, 1922-26. **Taught:** PAFA, 1943-46. **Member:** (Federal) Commission of Fine Arts (president, 1937-41); National Sculpture Society (president, 1939-42); AAAL (president, 1948-53); Century Association (president, 1950-54); Academy of St. Luca, Rome, 1952. **Commissions:** Designed coinage for Irish Free State, 1927. Awards: NAD, Helen Foster Barnett Prize, 1913, 17; PAFA, George D. Widener Memorial Gold Medal, 1914; Panama-Pacific Exposition, San Francisco, 1915, Gold Medal; NAD, 1920; elected to the NIAL, 1920; American Independent Artists Medal, 1921; American Institute of Architects, Gold Medal, 1921; NAD, Saltus Gold Medal for Merit, 1924; Philadelphia Art Week, Gold Medal, 1925; Philadelphia Sesquicentennial, Gold Medal, 1926; Legion of Honor, 1929; elected to the AAAL, 1932; Paris World's Fair, 1937, Diplome d'Honneur; National Sculpture Society, Medal of Honor, 1939; NIAL, Gold Medal, 1945.

One-man Exhibitions: Architectural League of New York, 1912; A.F.A., 1914; Corcoran, 1920, 37; Leicester Gallery, London, 1921; PMA, 1926; U. of Rochester, 1927; Toronto, 1928; Averell House, NYC, 1933; Tate Gallery, 1935; Century Association, 1935; VMFA, 1936; Arden Gallery, NYC, 1941; AAAL, 1945; Walker, 1948; St. Paul Gallery, 1967; Robert Schoelkopf Gallery, NYC, 1971, 72; Hamline U., 1972; Hudson River Museum, 1985; WMAA, 1986. **Retrospectives:** Smithsonian, 1958; NCFA, 1966; NMAA, 1991. **Group:** Corcoran, 1920; PAFA; NAD; WMAA; MMA; and many others in America and abroad. **Collections:** American Academy; Andover/Phillips; Chicago/AI; Cochran Memorial Park; Detroit/Institute; Harvard U.; League of Nations; MMA; Minneapolis/Institute; New York Coliseum; Pratt Institute; Rockefeller Center; St. Louis/City; Smith College; West Palm Beach/Norton. **Bibliography:** Baur 7; **Beggs;** Birnbaum; Brumme; Cahill and Barr, eds.; Cortissoz 1; **Gallatin 7;** *Index of 20th Century Artists;* Jackman; Lee and Burchwood; **Leach;** Licht, F.; Mather 1; Mellquist; Mendelowitz; **Murtha;** Pach 1; *Paul Manship: Changing Taste in America;* Poore; **Rand 1;** Rose, B., 1; **Vitry.** Archives.

MANSO, LEO b. April 15, 1914, NYC. d. February 5, 1993, NYC. **Studied:** Educational Alliance, NYC, 1929; NAD, 1930-34; New School for Social Research. Traveled Mexico, Africa, India, Nepal, Italy, Sicily, Tunisia. **Taught:** Cooper Union, 1947-70; NYU, 1950-80; Columbia U., 1950-55; Provincetown Workshop, 1959 (cofounder); ASL, 1974, 1977; New School for Social Research, 1975. **Member:** American Abstract Artists; NAD; Artists Equity. **Commissions:** Public Library, Lincoln, Neb. (mural), 1965. **Awards:** U. of Illinois, P.P., 1951; Audubon Artists, 1952, 57; Ford Foundation, P.P., 1963; AAAL, Childe Hassam Award, 1968; AAIAL, grant, 1981; Guggenheim

Foundation Fellowship, 1983. **One-man Exhibitions:** (first) Norlyst Gallery, NYC, 1947; Guadalajara Institute, Mexico, 1948; Mortimer Levitt Gallery, NYC, 1950; Babcock Galleries, NYC, 1953, 56; Columbia U., 1954; NYU, 1957; Grand Central Moderns, NYC, 1957, 60, 61, 63, 64; Philadelphia Art Alliance, 1961, 69; Tirca Karlis Gallery, 1963, 65, 67, 69, 70, 72, 73; Arts Council of Winston-Salem (N.C.), 1966; Rose Fried Gallery, 1966, 68, 70; George Washington U., 1968; Rehn Galleries, 1974; E. P. Gurewitsch Gallery, NYC, 1975, 78; Syracuse/Everson, 1976; Long Point Gallery, Provincetown, Mass., 1977, 79, 80, 83, 85; American Academy, Rome, 1979; AAIAL, 1981; Arras Gallery, 1983; Pace U., 1983; Dartmouth College, 1985; Armstrong Gallery, NYC, 1988; Stuart Levy Gallery, NYC, 1992. **Group:** PAFA, 1947-50, 1952, 54, 61, 62, 64, 68; WMAA Annuals, 1948-66; U. of Illinois, 1950, 51, 52, 54, 57; A.F.A., circ.; U. of Nebraska Annual; American Abstract Artists Annual; Brooklyn Museum, Watercolor Biennials; ART:USA:58, NYC, 1958; MOMA, The Art of Assemblage, circ., 1961; NIAL, 1961, 68; MOMA, 1965. **Collections:** Alcoa; Boston/MFA; Brandeis U.; Brooklyn Museum; Cape Town; Charleston, W. Va.; Corcoran; Dartmouth College; Hirshhorn; U. of Illinois; MOMA; Michigan State U.; Mount Holyoke College; NAD; NYU; U. of Nebraska; Norfolk; PAFA; Portland, Ore./AM; RISD; Safad; Syracuse U.; WMAA; Wesleyan U.; West Palm Beach/Norton; Worcester/AM. **Bibliography:** Seitz 4. Archives.

MARCA-RELLI, CONRAD
b. June 5, 1913, Boston, Mass. **Studied:** Cooper Union, one year; mostly self-taught. US Army, 1941-45. Traveled Europe, USA, Mexico. **Taught:** Yale U., 1954-55, 1959-60; U. of California, Berkeley, 1958; New College, Sarasota, Fla., 1966. Federal A.P.: Easel and mural painting; also art teacher. **Member:** NIAL,

1976. **Awards:** Chicago/AI, The Mr. & Mrs. Frank G. Logan Medal, 1954; Ford Foundation, 1959; Detroit/Institute, **P.P.**, 1960; II Inter-American Paintings and Prints Biennial, Mexico City, 1960, Hon. Men.; Chicago/AI, The M.V. Kohnstamm Prize, 1963. **Address:** 235 East 56th Street, NYC, 10022. **Dealer:** Marisa del Re, NYC. **One-man Exhibitions:** (first) Niveau Gallery, NYC, 1948, also 1950; The New Gallery, NYC, 1951; The Stable Gallery, 1953-58 (4); Frank Perls Gallery, 1956; La Tartaruga, Rome, 1957, 62; The Kootz Gallery, NYC, 1959-64; Bolles Gallery, 1961; Galerie Schmela, 1961 (two-man, with Robert Motherwell), 71; Lima, Peru, 1961; Joan Peterson Gallery, 1961; Galerie de France, Paris, 1962; Galerie Charles Leinhard, Zurich, 1963; Tokyo Gallery, 1963; James David Gallery, Miami, 1966, 67; Makler Gallery, 1967, 74; Brandeis U., 1967-68; U. of Alabama, 1968; Buffalo/Albright, 1968; Alpha Gallery, 1968; Reed College, 1969; Seattle/AM, 1969; Marlborough Gallery, Inc., NYC, 1970, 75; U. of Maryland, 1970; West Palm Beach/Norton, 1970; Fort Lauderdale, 1971; U. of Miami, 1971; Galeria Carl van der Voort, Ibiza, 1972; Darthea Speyer Gallery, 1972; Galerie Numaga, Auvernier, Switzerland, 1973; Galeria Inguanzo, Madrid, 1973; Marlborough Galerie AG, Zurich, 1974; Marlborough Godard Ltd., Toronto, 1975; Alex Rosenberg Gallery, NYC, 1984; Marisa del Re Gallery, NYC, 1985, 87, 89; R.H. Love Modern, Chicago, 1986. **Retrospective:** WMAA, 1967. **Group:** Ninth Street Exhibition, NYC, 1951; WMAA Annuals; Chicago/AI; U. of Illinois; U. of Nebraska; Carnegie; Venice Biennial; Yale U.; Corcoran; Arts Club of Chicago; Rome-New York Foundation, Rome; Boston Arts Festival; Minneapolis/Institute; PAFA; Montreal/MFA; Brussels World's Fair, 1958; Kassel, Documenta II, 1959; American Painting and Sculpture, Moscow, 1959; São Paulo Biennial; Seattle World's Fair, 1962; A.F.A., 1967-68;

MOMA, The New American Painting and Sculpture, 1969; WMAA Annual, 1969; New School for Social Research, NYC, American Drawings of the Sixties, 1969; U. of California, Santa Barbara, Trends in Twentieth Century Art, 1970; VMFA, American Painting, 1970; NAD, Annual, 1972; AAAL, Newly Elected Members, 1976; Medellin, Colombia, Bienal, 1970; VMFA, American Paintings 1970, 1970; U. of Massachusetts, Contemporary American Collage, 1960-86, 1986. **Collections:** U. of Alabama; Brandeis U.; Buffalo/Albright; Carnegie; Chase Manhattan Bank; Chicago/AI; Cleveland/MA; Colby College; Columbia Broadcasting System; Detroit/Institute; Hartford/Wadsworth; Harvard U.; High Museum; Hirshhorn; Houston/MFA; Indianapolis/Herron; International Minerals & Chemicals Corp.; Los Angeles/County MA; MMA; MOMA; U. of Michigan; Minneapolis/Institute; Minnesota/MA; NCFA; U. of Nebraska; PAFA; U. of Rochester; SFMA; SRGM; Seattle/AM; The Singer Company Inc.; U. of Texas; Union Carbide Corp.; Utica; WMAA; Waitsfield/Bundy; Walker; Washington U.; Yale U. **Bibliography:** Agee; Armstrong, Thomas; **Arnason 1**; Chaet; Goodrich and Baur 1; Henning; Hunter, ed.; Janis and Blesh 1; *Metro;* Nordness, ed.; Rodman 3; Rose, Barbara, 1; Seitz 4; Tyler, P., 2.

MARCUS, MARCIA b. January 11, 1928, NYC.

Studied: NYU, 1943-47, BFA; Cooper Union, 1950-52; ASL, 1954, with Edwin Dickinson. Traveled Europe, India. **Taught:** Purdue U.; Moore Institute of Art, Science and Industry; RISD; Cooper Union, 1970-71; Louisiana State U., 1972; NYU, 1972; Vassar College, 1973-74; Cornell U., 1975; Iowa State U., 1979-80; Colorado State U., 1984; Northern Arizona U., 1984; U. of California, Davis, 1989; Chautauqua Institute, 1990; College of Staten Island, 1991. **Member:** Artists Equity. **Awards:** Ingram Merrill Grant,

1964; NIAL, Richard and Hinda Rosenthal Foundation Award, 1964; Ford Foundation Grant, 1966; Gottlieb Foundation Grant, 1983; National Endowment for the Arts, grant, 1991. **Address:** 80 North Moore Street, NYC 10013. **One-man Exhibitions:** (first) March Gallery, NYC, 1957; Delancey Street Museum, NYC, 1960; Cober Gallery, 1961; The Alan Gallery, NYC, 1962; RISD, 1966; The Graham Gallery, NYC, 1966; Tirca Karlis Gallery, 1966, 67; The Zabriskie Gallery, NYC, 1970; Makler Gallery, 1972; Louisiana State U., 1972; Vassar College, 1974; ACA Gallery, 1974; Syracuse/Everson, 1975; Bloomsburg College, 1976; Benson Gallery, Bridgehampton, N.Y., 1978; Terry Dintenfass Inc., NYC, 1979; Wheaton College, 1980; Cedar Rapids Art Center, 1980; Benton Gallery, Southampton, N.Y., 1986. **Retrospective:** Canton Art Institute, 1984. **Group:** WMAA, Young America, 1960; WMAA Annual, 1963; NIAL, 1964; MOMA, Contemporary Portraits, circ.; New York Cultural Center, Women Choose Women, 1973; PMA/Museum of the Philadelphia Civic Center, Focus, 1974; Syracuse/Everson, Provincetown Painters, 1977; Indianapolis, 1978; U. of Missouri, Kansas City, The Opposite Sex: A Realistic Viewpoint, 1979; Lehigh U., The Revival of Realism, 1979; Guild Hall, Crosscurrents, 1986. **Collections:** Canton Art Institute; Hampton Institute; Hirshhorn; Housatonic Museum, Bridgeport, Conn.; NIAL; NMWA; Newark Museum; Phoenix/SUNY; Phoenix; Purdue U.; RISD; Randolph-Macon Jr. College; Syracuse/Everson; WMAA; Williamstown/Clark; U. of Wyoming. **Bibliography:** *Art: A Woman's Sensibility.* Archives.

MARDEN, BRICE b. October

15, 1938, Bronxville, N.Y. **Studied:** Boston U., 1958-61, BFA; Yale U. Summer School, Norfolk, Conn., 1961; Yale U., 1961-63, MFA. Traveled USA, France,

Brice Marden, *Cold Mountain 5 (Open)*, 1988-1991.

Greece, Middle East, Asia. **Taught:** School of Visual Arts, NYC, 1969-74. **Address:** 6 St. Luke's Place, NYC 10014. **Dealer:** Mary Boone Gallery, NYC. **One-man Exhibitions:** (first) Swarthmore College, 1964; Bykert Gallery, NYC, 1966, 68, 69, 70, 72, 73, 74; Yvon Lambert, 1969, 73; Françoise Lambert, Milan, 1970; Gian Enzo Sperone, Turin, 1971, 77; U. of Utah, 1971; Locksley-Shea Gallery, Minneapolis, 1972, 74; Jack Glenn Gallery, Corona del Mar, 1973; Konrad Fischer Gallery, Düsseldorf, 1972, 73, 75, 80; John Berggruen Gallery, San Francisco (two-man), 1972; Cirrus Editions, Ltd., 1974; Jared Sable Gallery, Toronto, 1974; SRGM, 1975; Alessandro/Ferranti, Rome, 1975; Sperone, Westwater, Fischer, NYC, 1976; Brown U., 1977; Jean and Karen Bernier, Athens, 1977; Max Protetch Gallery, Washington, D.C., 1977; The Pace Gallery, NYC, 1978, 80, 82, 84; Kunstraum, Munich, 1979; Institut fur Moderne Kunst, Nurnberg, 1980; Rice U. (three-man), 1975; InK, Zurich, 1980; Amsterdam/Stedelijk, 1981; Whitechapel Art Gallery, London, 1981; Mizuno Gallery, Los Angeles, 1982; Daniel Weinberg Gallery, Los Angeles, 1984; Mary Boone Gallery, NYC, 1987, 88; Anthony D'Offay Gallery, London, 1987-88; Galerie Montenay, Paris, 1987; Galerie Michael Werner, Cologne, 1989; Larry Gagosian Gallery, NYC, 1991;

Boston/MFA, 1992; Matthew Marks Gallery, NYC, 1991; Dia Center for the Arts, NYC, 1991; Walker, 1992; Houston/Menil, 1991; Madrid/Reina Sofia, 1992; Tate Gallery, 1992. **Retrospective:** Paris/Moderne, 1992. **Group:** New London, Drawings by New England Artists, 1960; U. of Illinois, 1967; Ithaca College, Drawings, 1967, 1967; ICA, U. of Pennsylvania, A Romantic Minimalism, 1967; WMAA Annuals, 1968, 73; Buffalo/Albright, Modular Painting, 1970; Foundation Maeght, L'Art Vivant, 1970; WMAA, The Structure of Color, 1971; U. of Utah, 1971; U. of Rochester, Aspects of Current Painting, 1971; Chicago/Contemporary, White on White, 1971-72; Indianapolis, 1972; U. of California, Berkeley, Eight New York Painters, 1972; Chicago/AI, 1972; Walker, Painting: New Options, 1972; Kassel, Documenta V, 1972; Yale U., Options and Alternatives, 1973; WMAA, American Art: Third Quarter Century, 1973; MOMA, Some Recent American Art, circ., 1973; Chicago/Contemporary, Five Artists: A Logic of Vision, 1974; MOMA, Eight Contemporary Artists, 1974; UCLA, 14 Abstract Painters, 1975; Paris/Moderne, Tendances Actuelles de la Nouvelle Peinture Americaine, 1975; Amsterdam/Stedelijk, Fundamental Painting, 1975; Rijksmuseum Kröller-Müller, Functions of Drawings, 1975; MOMA, Drawing Now, 1976; WMAA Biennial, 1977, 89; Brooklyn Museum, American Drawings in Black and White: 1970-1979, 1980; Royal Academy, London, A New Spirit in Painting, 1981; MIT, Affinities, 1983; U. of Chicago, The Meditative Surface, 1984; Carnegie, International, 1985, 88; Fort Lauderdale, An American Renaissance, 1986; Los Angeles/MOCA, Individuals, 1986; Los Angeles/County MA, The Spiritual in Art, 1986; Bordeaux/Contemporain, Art Minimal II, 1986; Cologne/Kunsthalle, Bilderstreit, 1989; ICA, U. of Pennsylvania, Devil on the Stairs, 1991; MOMA, Allegories of Modernism,

1992. **Collections:** Amsterdam/Stedelijk; Baltimore/MA; Buffalo/Albright; Carnegie; Chicago/AI; Cologne/Ludwig; Fort Worth; Musée de Grenoble; Harvard U.; Hirshhorn; Los Angeles/MOCA; MMA; National Gallery of Canada; MMA; MOMA; PMA; Paris/Beaubourg; SRGM; Tate Gallery; VMFA; WMAA; Walker. **Bibliography:** Ashbury; *Contemporanea;* De Wilde 1, 2; *Fundamentele Schilderkunst;* Gohr and Gachnang; Honisch and Jensen, eds.; *Individuals;* **Lewison;** Licht, J.; Murdoch 1; Murken-Altrogge; *New in the Seventies; Options and Alternatives;* Robins; Rose, Bernice, 1; Schwartz 1; **Shearer;** Storr and Tannenbaum; Tuchman 3. Archives.

MARGO, BORIS **b.** November 7, 1902, Wolotschisk, Russia. **Studied:** Polytechnic School, Odessa, 1919; Futemas, Moscow, 1924; Filonoy School, Leningrad, 1927. To USA, 1930; citizen, 1937. Traveled Western Europe, Israel, 1968; Hawaii. **Taught:** Master Institute of United Arts, Inc., 1932; American U., 1946; U. of Michigan, 1957; Chicago Art Institute School, 1957; Michigan State U., 1959; U. of Illinois, 1960; U. of Minnesota, Duluth, 1962; U. of North Carolina, 1963; Ford Foundation/A.F.A., Artist-in-Residence, 1965; Syracuse U., 1966-67; The Ohio State U., 1968; Honolulu Academy, 1973; Potsdam/SUNY, 1974; Fine Arts Work Center, Provincetown, Mass., 1974. **Member:** SAGA. Federal A.P.: Newark (N.J.) Airport (assisted Arshile Gorky on a mural). **Commissions:** Honolulu Academy (sculpture), 1973. **Awards:** Chicago/AI, Watson F. Blair Prize, 1947; Brooklyn Museum, Print Exhibitions, 1947, 53, 55, 60, 64, 68; Portland, Me./MA, P.P., 1960; National Endowment for the Arts, grant, 1974. **m.** Jan Gelb. **Address:** 261 Ponce de Leon, Venice, FL 34285. **Dealer:** Stuart Levy Gallery, NYC. **One-man Exhibitions:** (first) Artists' Gallery, NYC, 1939, also 1941, 42; Norlyst Gallery, NYC, 1943;

John Marin, *Movement Lower Manhattan*, 1932.

Mortimer Brandt, NYC, 1946, 47; American U., 1946, 47; J. Seligmann and Co., 1947; Brooklyn Museum, 1947; Smithsonian, 1948; Betty Parsons Gallery, NYC, 1950, 53, 55, 57, 60; World House Galleries, NYC, 1964; Honolulu Academy, 1973; Monique Knowlton Gallery, NYC, 1974; Stuart Levy Gallery, NYC, 1991; Sylvan Cole Gallery, NYC, 1991. **Retrospectives:** Syracuse U., 1966; A.A.A. Gallery, NYC, 1967; Provincetown Art Association, circ., 1988. **Group:** MMA, Artists for Victory, 1942; Mortimer Brandt, NYC, Abstract and Surrealist Art in the U.S., circ., western museums, 1944; NAD, 1946; Library of Congress, 1946; Carnegie, 1946, 52; WMAA Annuals, 1947-50, 1953-55; Chicago/AI, Abstract and Surrealist Art, 1948; U. of Illinois, 1950, 52; Chicago/AI, 1950, 54; I São Paulo Biennial, 1951; MOMA, 25th Anniversary Exhibition, 1954; Federation of Modern Painters and Sculptors Annual, 1955; XXXV Venice Biennial, 1970; U. of Illinois, 1971; MMA, The Presence of Abstraction, 1984. **Collections:** Albion College; Andover/Phillips; Baltimore/MA; Brooklyn Museum; Brown U.; Buffalo/Albright; Chase Manhattan Bank; Chicago/AI; Cincinnati/AM; Corcoran; Cornell U.; Currier; Dartmouth College; Evansville; U. of Georgia; U. of Illinois; Kalamazoo/Institute; Los Angeles/County MA; Louisville/Speed; MIT; MMA; MOMA; U. of Maine; U. of Michigan; U. of Minnesota; NYPL; National Gallery; New Orleans/Delgado; U. of North Carolina; The Ohio State U.; Omaha/Joslyn; PMA; Phoenix; RISD; SFMA; San Jose State College; São Paulo; Slater; Syracuse U.; Utica; WMAA; Yale U. **Bibliography:** Baur 5, 7; Blesh 1; Hayter 1; Janis, S.; Peterdi; Pousette-Dart, ed.; Reese; **Schmeckebler** 1. Archives.

MARIN, JOHN b. December 3, 1870, Rutherford, N.J. **d.** October 1, 1953, Cape Split, Me. **Studied:** Hoboken Academy; Stevens Preparatory School; Stevens Institute of Technology; PAFA, 1899-1901, with Thomas Anshutz, Henry Breckenridge; ASL, 1901-03, with Frank V. DuMond. Worked as a free-lance architect. Traveled Europe, 1905-11. **Member:** AAAL, 1945. **Awards:** Philadelphia Watercolor Club, 1940; American Institute of Architects, 1948; Hon. DFA, U. of Maine, 1940; MMA, 1952; PAFA, Joseph E. Temple Gold Medal, 1954; Hon. DFA, Yale U. **One-man Exhibitions:** (first) Photo-Secession, NYC, 1909, also 1910, 13, 15; Brooklyn Museum, 1922; Montross Gallery, NYC, 1922, 24; Stieglitz's Intimate Gallery, NYC, 1925, 28; An American Place (Gallery), NYC, 1929-35, 1937-42, 1944-50; Cleveland/MA, 1939; The Downtown Gallery, 1939, 48, 1950-54, 1963; ICA, Boston, 1947; de Young, 1949; XXV Venice Biennial, 1950; A.F.A., 1952-54; Detroit/Institute, 1954; Philadelphia Art Alliance, 1954; The Willard Gallery, 1965; La Jolla, 1966; M. Knoedler & Co., 1967; U. of Utah, 1969; PMA, 1969; Los Angeles/County MA, 1970; Marlborough Gallery Inc., NYC, 1972, 77, 78; Kennedy Galleries, Inc., NYC, 1981, 86, 87, 91;

Portland Me./AM, 1985; Phillips, 1985; Meredith Long Gallery, Houston, 1988. **Retrospectives:** The Daniel Gallery, NYC, 1920; MOMA, 1936; Trenton/State, 1950; U. of Michigan, 1951; Houston/MFA, 1953; AAAL, 1954; UCLA, 1955; National Gallery, 1991. **Group:** Salon d'Automne, Paris, 1908; Salon des Artistes Independants, Paris, 1904; The Armory Show, 1913; WMAA; MOMA; Chicago/AI; Detroit/Institute; Cleveland/MA; Walker; Cincinnati/AM; SFMA; Toronto; Dallas/MFA; Utica; Corcoran; MMA. **Collections:** Andover/Phillips; Arizona State U.; Auburn U.; Baltimore/MA; Brooklyn Museum; Buffalo/Albright; Chicago/AI; Cleveland/MA; Colorado Springs/FA; Columbus; Cranbrook; Denver/AM; Des Moines; Detroit/Institute; Fisk U.; U. of Georgia; Hagerstown/County MFA; Hartford/Wadsworth; Harvard U.; Houston/MFA; IBM; Indiana U.; Indianapolis/Herron; Lane Foundation; MMA; MOMA; U. of Maine; The Miller Co.; National Gallery; U. of Nebraska; Newark Museum; New Britain; Ogunquit; Omaha/Joslyn; PAFA; Phillips; U. of Rochester; Roswell; SFMA; St. Louis/City; San Antonio/McNay; San Diego; Santa Barbara/MA; Springfield, Mo./AM; Utica; WMAA; Walker; Wellesley College; West Palm Beach/Norton; Wichita/AM; Wilmington; Yale U.; Youngstown/Butler. **Bibliography:** American Artists Group, Inc. 3; Armstrong, Thomas; *Avant-Garde Painting and Sculpture in America, 1910-25;* Baldinger; Becker 1; Barr 3; Baur 5, 7; Bazin; Beekman; Benson; Bethers; Biddle 4; Blesh 1; Born; Brown 1, 2; Bryant, L.; Cahill and Barr, eds.; Canaday; Cassou; Cheney; Chipp; Christensen; *Cityscape 1919-39;* Coke 2; Craven, T., 1; Cummings 4; Downes, ed.; Dijkstra, ed.; *8 American Masters of Watercolor;* Eisler; Eliot; Elsen 2; **Fine;** Flanagan; Flexner; Flockhart; *Forerunners;* Frank, ed.; Frost; Gallatin 1; Gaunt; Gerdts; Goldwater and Treves, eds.; Goodrich 1; Goodrich and Baur 1; Haas; Haftman;

Hartmann; **Heim; Heim and Wight;** Hess, T. B., 1; Hunter 6; Huyghe; *Index of 20th Century Artists;* Janis, S.; Jewell 2; Johnson, Ellen H.; Kootz 1, 2; Kuh 1, 3; Lane; Langui; Lee and Burchwood; Leepa; Mather 1; **McBride;** McCoubrey 1; McCurdy, ed.; Mellquist; Mendelowitz; Munsterberg; Neuhaus; Newmeyer; **Norman; Norman, ed.;** Pach 1; Pearson 2; Phillips 1, 2; Pousette-Dart, ed.; Raynal 3, 4; Read 2; **Reich;** Richardson, E.P.; Ritchie 1; Rodman 2; Rose, B., 1, 4; Rosenblum 1; Rubin 1; Sachs; Schwartz 1; **Seligmann, ed.;** Soby 5, 6; Sutton; Tashijian; Terenzio 1, 2, Tomkins and Time-Life Books; Valentine 2; Wiesinger; Wight 2; Wright 1; Zigrosser 1. Archives.

MARISOL (Escobar) **b.** May 22, 1930, Paris, France. **Studied:** ASL, 1950, with Yasuo Kuniyoshi; Hofmann School, 1951-54; Academie des Beaux-Arts, Paris, 1949; New School for Social Research, 1951-54. Traveled Venezuela, USA, Europe. Designed sets for Martha Graham and Louis Falco dance companies. **Awards:** Academy of Achievement, San Diego; Hon. DFA, Moore College of Art; Hon. DFA, RISD, 1986. **Taught:** State U. of Montana. **Commission:** Fiorello H. LaGuardia High School, NYC. **Member:** AAAL. **Address:** 427 Washington Street, NYC 10013. **Dealer:** Sidney Janis Gallery, NYC. **One-man Exhibitions:** (first) Leo Castelli Inc., NYC, 1957; The Stable Gallery, NYC, 1962, 64; Arts Club of Chicago, 1965; Sidney Janis Gallery, NYC, 1966, 67, 73, 75, 81, 84, 89; Hanover Gallery, 1967; XXIV Venice Biennial, 1968; Moore College of Art, Philadelphia, 1970; Worcester/AM, 1971; New York Cultural Center, 1973; Ohio U., 1974; Estudio Actual, Caracas, 1974; Makler Gallery, Philadelphia, 1975; Houston/Contemporary, 1977; Boca Raton, 1988; Dolly Fiterman Gallery, Minneapolis, 1988; Galerie Tokoro, Tokyo, 1989. **Retrospective:** NPG, 1991. **Group:** Festival of Two Worlds, Spoleto, 1958; Dallas/MFA,

Humor in Art, 1958; Chicago/AI, Pan American Art, 1959; Carnegie, 1959, 64, 67; U. of Illinois, 1961; MOMA, The Art of Assemblage, circ., 1961; A.F.A., Wit and Whimsy in 20th Century Art, circ., 1962-63; WMAA Annuals, 1962, 64, 66; MOMA, Americans 1963, circ., 1963-64; Chicago/AI, 1963, 66, 68; Tate Gallery, Painting and Sculpture of a Decade, 1954-64, 1964; The Hague, New Realism, 1964; WMAA, Art of the U.S. 1620-1966, 1966; II Internationale der Zeichnung, Darmstadt, 1967; Los Angeles/County MA, American Sculpture of the Sixties, 1967; Houston Festival of Arts, 1967; ICA, London, 1968; MOMA, circ., 1968-70; Finch College, NYC, The Dominant Woman, 1968; Chicago/AI, 1969; Hayward Gallery, London, Pop Art, 1969; Carnegie, 1970; Foundation Maeght, 1970; Skidmore College, Contemporary Women Artists, 1970; Potsdam/SUNY, Contemporary Women Artists, 1972; Baltimore/MA, Drawing Exhibition, 1973; Art Students League, 100th Anniversary, NYC, 1975; New York Cultural Center, The Nude in America, 1975; Hirshhorn, The Golden Door, 1976; Williamstown/Clark, The Dada/Surrealist Heritage, 1976; Bronx Museum, The Year of the Woman, 1976; San Antonio/McNay, Women Artists, 1976, 1977; Brooklyn Museum, Contemporary Women, 1977; U. of Missouri, The Opposite Sex, 1979; Ridgefield/Aldrich, New Dimensions in Drawing, 1981; Hirshhorn, Drawings 1974-1984, 1984; PMA, Forms in Wood, 1985; Kenkeleba House, NYC, The Gathering of the Avant Garde, 1985; Venice Biennale, 1988; Long Island U., 100 Drawings by Women, circ., 1989; National Museum of Contemporary Art, Seoul, International Art Festival, 1990. **Collections:** Arts Club of Chicago; Brandeis U., Buffalo/Albright; Caracas/Contemporaneo; Chicago/AI; Chicago/Contemporary; Cologne; Hakone Open Air Museum, Japan; MMA; MOMA; Memphis/Brooks; Ringling; WMAA; Yale U. **Bibliography:** Bihalji-

Marisol, *Working Women,* 1987.

Merin; Calas, N. and E.; Craven, W.; *From Foreign Shores;* Gettings; **Grove;** Hunter, ed.; Lippard 5; **Medina;** Nemser; Osterwold; Seitz 4; Seuphor 3; Trier 1; Tuchman 1; Weller. Archives.

MARKMAN, RONALD b. May 29, 1931, Bronx, N.Y. **Studied:** Yale U., BFA, 1957, MFA, 1959. US Army, 1952-54. Resided in Rome and London. **Taught:** U. of Florida, 1959; Chicago/AI, 1960-64; Indiana U., 1964. **Commissions:** Murals for Riley Children's Hospital, Indianapolis, 1986; Ortho Child Care Center, Raritan, N.J., installation, 1991. **Awards:** Fulbright Fellowship, 1962; Indiana Commission on the Arts Award, 1990. **Address:** 719 South Jordan, Bloomington, IN 47401. **One-man Exhibitions:** Terry

Dintenfass, Inc., NYC, 1965, 66, 68, 71, 72, 76, 79, 82, 84, 85; Reed College, 1966; U. of Manitoba, 1972; Curwen Gallery, London (two-man), 1971; The Gallery, Bloomington, Ind., 1972, 79; Queens College, N.Y., 1972; Indianapolis, 1974; Indianapolis/Herron, 1976, 85; Tyler School of Art, Philadelphia, 1976; Franklin College, 1980; J. Walter Thompson, NYC, 1977; Dart Gallery, Inc., 1981; Patrick King Gallery, Indianapolis, 1983, 86, 88; New Harmony Gallery, Indianapolis, 1985; Evanston Art Center, 1989; Focus Gallery, Detroit, 1986. **Group:** Boston Arts Festival, 1959, 60; WMAA, Young America, 1960; Chicago/AI, 1964; Ball State U., 1966; PAFA Annual, 1967; Anderson (Ind.) Fine Arts Center, 1967; Brooklyn Museum, Print Biennial; Indianapolis/Herron, 1968, 69; New School for Social Research, Humor, Satire, and Irony, 1972; Indianapolis, 1972, 74; Harvard U., Work by Students of Josef Albers, 1974; AAAL, 1977; U. of New Mexico, Works on Paper, 1980; AAIAL, 1989. **Collections:** U. of Alberta; U. of Arkansas; Brooklyn Museum; Chicago/AI; Cincinnati/AM; Library of Congress; Cornell U.; Hirshhorn; Indiana U.; U. of Manitoba; MMA; MOMA; Worcester/AM.

MARSH, REGINALD b. March 14, 1898, Paris, France. d. July 3, 1954, Dorset, Vt. **Studied:** The Lawrenceville School, 1915-16; Yale U., 1916-20, AB; ASL, 1919, 1920-24, 1927-28, with John Sloan, Kenneth Hayes Miller, George Bridgeman, George Luks. Traveled Europe extensively. Artist War Correspondent for *Life* magazine, 1943. **Taught:** ASL; Moore Institute of Art, Science and Industry, Philadelphia, 1953-54. **Commissions:** US Post Office, Washington, D.C., 1937; US Customs House, NYC, 1937. **Awards:** Chicago/AI, The M. V. Kohnstamm Prize, 1931; Wanamaker Prize, 1934; NAD, The Thomas B. Clarke Prize, Limited Editions Club, 1938; Chicago/AI, Watson F. Blair

Prize, 1940; PAFA, Dana Watercolor Medal, 1941; NAD, 1943; Corcoran, First William A. Clark Prize, 1945; Salmagundi Club, NYC, T. J. Watson Prize, 1945; NIAL, 1946; NIAL, Gold Medal for Graphics, 1954. **One-man Exhibitions:** (first) Whitney Studio Club, NYC, 1924, also 1928; Curt Valentine Gallery, NYC, 1927; Weyhe Gallery, NYC, 1928; Marie Sterner Gallery, NYC, 1929; Rehn Galleries, 1930-34, 36, 38, 40, 41, 43, 44, 46, 48, 50, 53, 62, 64, 65, 70, 73; Yale U., 1937; Andover/Phillips, 1937; McDonald Gallery, NYC, 1939; Carnegie, 1946; Print Club of Cleveland, 1948 (two-man); Philadelphia Art Alliance, 1950; Martha Jackson Gallery, NYC, 1953; Steeplechase Park, Coney Island, NYC, 1953; Moravian College, 1954; Kennedy Gallery, 1964; Danenberg Gallery, 1969, 71; U. of Arizona, 1969; City Center Gallery, NYC, 1969; Sid Deutsch Gallery, NYC, 1981; WMAA (Philip Morris), 1983; Richard Gray Gallery, Chicago, 1984; Hirschl & Adler Galleries, NYC, 1986; Louis Newman Galleries, Beverly Hills, 1987, 90. **Retrospectives:** Gallery of Modern Art, NYC, 1964; Newport Harbor, 1972. **Group:** WMAA; MMA; MOMA; Corcoran; Carnegie. **Collections:** Andover/Phillips; Boston/MFA; Chicago/AI; Hartford/Wadsworth; MMA; U. of Nebraska; PAFA; Springfield, Mass./MFA; WMAA. **Bibliography:** American Artists Group, Inc., 1, 3; Armstrong, Thomas; Baigell 1; Barker 1; Baur 7; Bazin; Boswell 1; Brown 2; Bruce and Watson; Cahill and Barr, eds.; Canaday; Cheney; Christensen; *Cityscape 1919-39;* Craven, T., 2; Cummings 4, 5; Eliot; *Europa/Amerika;* Flanagan; Flexner; Gerdts; **Goodrich 1, 11;** Goodrich and Baur 1; Hall; Hunter 6; Kent, N.; Kuh 1; McCoubrey 1; McCurdy, ed.; **Marsh;** Mellquist; Mendelowitz; Moser 1; Newmeyer; Nordmark; Pagano; Pearson 1; Reese; Richardson, E.P.; Ringel, ed.; Rose, B., 1, 4; **Sasowsky;** Soyer, R., 1; Sutton; Wight 2. Archives.

MARSICANO, NICHOLAS
b. October 1, 1914, Shenandoah, Pa.
d. March 1991, NYC. **Studied:** PAFA
and Barnes Foundation, 1931-34; abroad,
1933-36. Traveled Europe, North Africa,
Mexico, USA. **Taught:** Cooper Union,
1948-; U. of Michigan, summer, 1950;
Yale U., summers, 1951-54; Brooklyn Mu-
seum School, 1951-58; Pratt Institute,
1957-60; Cornell U., summer, 1959;
Silvermine College of Fine Arts, 1965-69;
Davenport/Municipal, summer, 1972;
Purchase/SUNY, 1974. **Awards:** PAFA,
Cresson Fellowship, and Barnes Founda-
tion Scholarship, 1933-36; V. Hallmark
International Competition, Second Prize,
1960; Guggenheim Foundation Fellow-
ship, 1974. **One-man Exhibitions:** The
Salpeter Gallery, NYC, 1948; The Bertha
Schaefer Gallery, NYC, 1957, 59, 60, 61;
San Joaquin Pioneer Museum and Haggin
Art Galleries, Stockton, Calif., 1959;
Stewart Richard Gallery, San Antonio,
1959; The Howard Wise Gallery, NYC,
1963; Des Moines, 1963, 64; Hunting-
ton, W. Va., 1967; A. M. Sachs Gallery,
1971, 72, 73; Davenport/Municipal,
1972; Landmark Gallery, NYC, 1976;
Utica, 1979; Gruenebaum Gallery, NYC,
1980. **Group:** U. of Nebraska, 1954, 58,
60; Walker, Vanguard, 1955; II Inter-
American Paintings and Prints Biennial,
Mexico City, 1960; A.F.A., The Figure,
circ., 1960; WMAA Annuals, 1960-62;
Chicago/AI, 1961, 64; Dallas/MFA,
1961, 62; MOMA, Abstract American
Drawings and Watercolors, circ., Latin
America, 1961-63; PAFA, 1962-64;
MOMA, Recent Painting USA: The Fig-
ure, circ., 1962-63; U. of Kentucky, 1963;
U. of Texas, 1968; MOMA, The New
American Painting and Sculpture, 1969.
Collections: Amarillo; Baltimore/MA;
Chicago/AI; Ciba-Geigy Corp.; Dal-
las/MFA; Davenport/Municipal; Des
Moines; Hallmark Collection; Housatonic
Community College; Huntington, W.
Va.; ICA, Boston; MIT; MOMA; U. of
Massachusetts; NYU; U. of North Caro-

lina; Ridgefield/Aldrich; SFMA; U. of
Texas. **Bibliography:** Archives.

MARTIN, AGNES
b. March 22,
1912, Maklin, Canada. **Studied:** Colum-
bia U. Teachers College, 1941-42, 1951-
52, with Arthur Young; Columbia U.,
MFA; Western Washington College; U. of
New Mexico. To USA, 1932; citizen,
1950. Traveled the world; resided many
U.S. locations. Stopped painting, 1967-74.
Member: AAIAL. **Awards:** National En-
dowment for the Arts Grant, $5,000,
1966. Hon. DFA, New Mexico State U.;
Skowhegan Medal for Painting, 1978; Mu-
seum Weisbaden, Jawlensky Prize, 1990;
Austrian Government, Oskar Kokoschka
Prize, 1992. **Address:** Galisteo, NM
87540. **Dealer:** The Pace Gallery, NYC.
One-man Exhibitions: Betty Parsons Gal-
lery, NYC, 1958, 59, 61; Robert Elkon
Gallery, NYC, 1961, 63, 66, 70, 72, 76;
Nicholas Wilder Gallery, Los Angeles,
1966, 67, 73; Visual Arts Gallery, NYC,
1971; Kunstraum, Munich, 1973; Pasa-
dena/AM, 1973; ICA, U. of Pennsylvania,
1973; MOMA, 1973; The Pace Gallery,
NYC, 1975, 76, 77, 78, 79, 80, 81, 83,
84, 85, 86, 89, 90; F. H. Mayor Gallery,
London, 1978, 84; Galerie Rudolf
Zwirner, Cologne, 1978; Harcus-Krakow
Gallery, Boston, 1978; Margo Leavin
Gallery, Los Angeles, 1979, 85; Santa Fe,
N.M., 1979; Wichita State U., circ., 1980;
Richard Gray Gallery, Chicago, 1981;
Anderson Gallery, Sydney, 1986;
Waddington Galleries, London, 1986, 90;
Galerie Yvon Lambert, Paris, 1987; Akira
Ikeda Gallery, Tokyo, 1989; Cleve-
land/MA, 1989; Mary Boone Gallery,
NYC, 1991; Chinati Foundation, Marfa,
Texas, 1991; Boston/MFA, with Donald
Judd, 1989. **Retrospective:** Hayward
Gallery, London, circ., 1977; Amster-
dam/Stedelijk, circ., 1991. **Group:**
Carnegie, 1960; WMAA, Geometric
Abstraction, 1962; Hartford/Wadsworth,
Black, White, and Grey, 1964; SRGM,
American Drawings, 1964, Systemic Paint-

ing, 1966; MOMA, The Responsive Eye, 1965; ICA, U. of Pennsylvania, A Romantic Minimalism, 1967; WMAA Annual, 1967; Detroit/Institute, Color, Image and Form, 1967; Corcoran, 1967; PMA, The Pure and Clear, 1968; Chicago/Contemporary, White on White, 1971-72; ICA, U. of Pennsylvania, Grids, 1972; Kassel, Documenta V, 1972; WMAA (downtown), Nine Artists/Coenties Slip, 1974; Amsterdam/Stedelijk, Fundamental Painting, 1975; U. of Massachusetts, Critical Perspectives in American Art, 1976; Venice Biennial, 1976; MOMA, Drawing Now, 1976; WMAA Biennial, 1977; Cleveland/MA, Four Contemporary Painters, 1978; Buffalo/Albright, American Painting of the 1970's; 1978; ICA, Boston, The Reductive Object, 1979; XXXIX Venice Biennial, 1980; Dublin/Municipal, International Quadrennial (ROSC), 1980; Corcoran Biennial, 1981; MOMA, Contrasts of Form: Geometric Abstract Art 1910-1980, 1985; AAIAL, 1983, 85; Youngstown/Butler, Midyear, 1986; Art Gallery of Western Australia, America: Art and the West, 1986; Los Angeles/MOCA, Individuals, 1986; Carnegie, 1988; Cincinnati, Making Their Mark, circ., 1989; AAIAL, 1989; Cologne/Ludwig, Bilderstreit, 1989; Buffalo/Albright, Abstraction-Geometry-Painting, 1989; Los Angeles/MOCA, Constructing a History, 1989; Brandeis U., The Image of Abstract Painting into the 80s, 1990; Ohio State U., Art in Europe and America, 1990; Weisbaden Museum, Kunsterlinnen des 20. Jahrhunderts, 1990; Osaka/National, Minimal Art, 1990; Bunkamura Museum, Shibuya, Japan, Four Centuries of Women's Art, circ., 1990. **Collections:** AAIAL; Aachen/NG; Amsterdam/Stedelijk; Albright/Buffalo; Canberra/National; Cleveland/MA; Hartford/Wadsworth; Harvard U.; High Museum; Hirshhorn; Israel Museum; Kansas City/Nelson; La Jolla; Los Angeles/County MA; Los Angeles/MOCA; MOMA; Milwaukee; NYU; U. of North Carolina;

Oberlin College; Ontario; Paris/Beaubourg; Pasadena/AM; Purchase/SUNY; Ridgefield/Aldrich; RISD; SFMA; SRGM; Santa Fe, N.M; Tate; Walker; WMAA; Worcester/AM; Yale U. **Bibliography:** Armstrong, Thomas; De Wilde 2; *Fundamentele Schilderkunst;* Gohr and Gachnang; *Individuals;* Kardon 3; Lippard 3; *Options and Alternatives;* Sandler 3.

MARTIN, FLETCHER
from 1st to 4th edition.

MARTIN, FRED **b.** June 13, 1927, San Francisco, Calif. **Studied:** U. of California (with James McCray, Glenn Wessels), BA, 1949, MA, 1954; California School of Fine Arts (with David Park, Clyfford Still, Mark Rothko), 1949-50. **Taught:** Oakland/AM, 1954-56; San Francisco Art Institute, 1958-; Director, 1965-. **Awards:** National Council on the Arts Fellowship, 1971. **Address:** 232 Monte Vista, Oakland, CA 94611. **Dealer:** Rena Bransten Gallery, San Francisco. **One-man Exhibitions:** (first) Contemporary Gallery, Sausalito, Calif., 1949; Lucien Labaudt Gallery, San Francisco, 1950; Zoe Dusanne Gallery, Seattle, 1952; de Young, 1954, 64; 6 Gallery, San Francisco, 1955; Oakland/AM, 1958; SFMA, 1958; Spatsa Gallery, San Francisco, 1959; Dilexi Gallery, San Francisco, 1961, 66, 68; Cain Gallery, Aspen, 1962; Minami Gallery, 1963; The Lanyon Gallery, 1964; Royal Marks Gallery, 1965, 66, 68, 70; RAC, 1969; Berkeley Gallery, San Francisco, 1970, 71; SFAI, 1972; SFMA, 1973; Quay Gallery, San Francisco, 1979. **Group:** de Young; California Palace; SFMA, Bay Area 1945-1962, 1968; WMAA Annual, 1969, Extraordinary Realities, 1973. **Collections:** Achenbach Foundation; Oakland/AM; Pasadena/AM; RAC; SFMA; WMAA. **Bibliography:** *Art as a Muscular Principle.* Archives.

MARTIN, KNOX **b.** February 12, 1923, Barranquilla, Colombia. **Studied:** ASL. US Coast Guard, 1941-45. **Taught:**

Yale U., 1965-71; ASL, 1972, 1974-; U. of Minnesota, 1972. **Member:** Society of American Magicians. **Commissions:** City Walls Inc., NYC, 1971; Mercor, Inc., Fort Lauderdale, 1972; Neiman Marcus Co., White Plains, N.Y., 1980; Mural for John Wayne School, Brooklyn, N.Y., 1982. **Address:** 128 Fort Washington Avenue, NYC. **One-man Exhibitions:** Charles Egan Gallery, 1954, 61; Avant Garde Gallery, NYC, 1956; Holland-Goldowsky Gallery, Chicago, 1958; Rose Fried Gallery, 1963; Fischbach Gallery, NYC, 1964, 66; Galeria Bonino Ltd., 1972, 74; Ingber Art Gallery, NYC, 1974, 76, 80, 82; IKI, Düsseldorf, 1974; National Arts Club, NYC, 1975; Gallery G., Wichita, 1975; Jack Gallery, NYC, 1978; Jankovsky Gallery, NYC, 1975; River Gallery, Irvington-on-Hudson, 1980, 82; John Wayne School, Brooklyn, 1982. **Group:** WGMA, 1963; Chicago/AI, 1963; Baltimore/MA, 1963; Buffalo/Albright, 1963; WMAA, 1972; Bradford, England, British Print Biennial, 1974; Ljubljana (Yugoslavia) Biennial, 1981. **Collections:** Austin; Baltimore/MA; Bibliothèque Nationale, Paris; U. of California, Berkeley; Chicago/AI; Corcoran; Denver/AM; U. of Illinois; MOMA; U. of Miami; NYU; U. of North Carolina; WMAA.

MARTINELLI, EZIO
from 1st to 5th edition.

MARYAN **b.** January 1, 1927, Nowy-Sacz, Poland. **d.** June 14, 1977, NYC. **Studied:** Bezalel Art School; L'École National Superieure des Beaux-Arts, Paris, 1951-53. Traveled Israel, Europe, USA; resided Paris, 1950-62; resided NYC, 1962-77; citizen, 1969. Produced film, *Ecce Homo*, 1975. **Awards:** Prix des Critiques d'Art à Paris, 1959; Order of Arts and Letters, France. **One-man Exhibitions:** (first) Y.M.C.A. Building, Jerusalem, Israel, 1949; Galerie Breteau, Paris, 1952; Galerie Le Miroir, Brussels, 1954; Tourcoing, 1956; Galerie Rive Gauche, Paris (two-

man), 1957; Galerie de France, Paris, 1958, 60, 65, 78; Galerie Kunstnemes Kunsthandel, Copenhagen, 1959; Andre Emmerich Gallery, 1960; Allan Frumkin Gallery, NYC, 1963-66, 68, 69, 85; Chicago, 1963-66, 70; Galeria Juana Mordo, 1964; David Stuart Gallery, 1964; Galerie D. Benador, Geneva, 1966; Galerie Van der Loo, Munich, 1966; Galerie Nova Spectra; The Hague, 1966, 71; Claude Bernard, Paris, 1966, 70; Galeria Sen., Madrid, 1970; Galerie Nord, Lille, 1970; Eindhoven, 1970; Galerie Nicholas, Amsterdam, 1971, 73; Galeria d'Arte la Bussola, Turin, 1971; Galerie Espace, Amsterdam, 1973, 74; Galerie Ariel, Paris, 1977; U. of Haifa, 1979; Spertus Museum, Chicago, 1983; Galeria Sonai Zannettacci, Geneva, 1984; Claude Bernard Gallery, NYC, 1985, 90; Galerie Ariel Rive Gauche, Paris, 1987; Galerie Fanny Guillon-Laffaille, Paris, 1988; Galerie Nova Spectra, The Hague, 1990; Galerie Jacques Benador, Geneva, 1990. **Retrospectives:** Galerie de France, Paris, 1974; Château d'Ancey-le-France, Ancey-le-France, 1980. **Group:** Salon des Surindependants, Paris, 1952, 53; Salon du Mai, Paris, 1953-65; Festival de l'Art d'Avant-Garde, Marseilles, 1956; Paris Biennial, Musée de Nantes, 1958; Festival de Bayreuth, 1958; Walker, 1958, 59; XXX Venice Biennial, 1960; Carnegie, 1961, 64, 67; SFMA, Directions—Painting U.S.A., 1963; Torcuato di Tella, Buenos Aires, 1963; Ghent, The Human Figure Since Picasso, 1964; The Hague, New Realism, 1964; Chicago/AI, 1964; Paris/Moderne, 1965; PAFA Annual, 1965; Foundation Maeght, 1967; U. of Colorado, 1967; MOMA, 1969; SRGM, 10 Independents, 1972; Barbican Art Center, London, Chagall to Kitaj, Jewish Experience in Twentieth Century Art, 1990. **Collections:** Berlin; Carnegie; Chicago/AI; Chicago/Contemporary; U. of Chicago; Grenoble; The Hague; LeHavre/Municipal; MOMA; Museum des 20 Jahrhunderts; Paris/Beaubourg; Paris/Moderne; Tel Aviv; Tourcoing.

MASON, ALICE TRUMBULL
b. November 16, 1904, Litchfield, Conn. **d.** June 28, 1971, NYC. **Studied:** British School, Rome, 1972; NAD, 1923; privately with C. W. Hawthorne, 1924, and Arshile Gorky, 1926. Traveled Italy and around the world, 1920. **Member:** American Abstract Artists; Federation of Modern Painters and Sculptors; SAGA; American Color Print Society. **Awards:** The Print Club, Philadelphia, Charles M. Lea Prize, 1945; Longview Foundation Grant, 1963. **One-man Exhibitions:** (first) Museum of Living Art, NYC, 1948; Hansa Gallery, NYC, 1958; The XXth Century Gallery, NYC, 1967; Washburn Gallery, Inc., NYC, 1974, 77, 80, 82, 84, 85, 88; Tulane U., 1982. **Retrospectives:** Nassau Community College, Garden City, N.Y., 1967; WMAA, circ., 1974. **Group:** Federation of Modern Painters and Sculptors Annuals; A.A.A. Gallery, NYC, Annuals: PMA, "8 x 8," 1945; Brooklyn Museum, 1949; Chicago/Contemporary, Post-Mondrian Abstraction in America, 1973; Springfield, Mass./MFA, Three American Purists, 1975; Los Angeles/County MA, Women Artists 1550-1950, 1976; Houston/MFA, Miró in America, 1982; WMAA/Equitable, Generations of Geometry, 1987. **Collections:** Brooklyn Museum; Free Library of Philadelphia; Hirshhorn; ICA, Washington, D.C.; Library of Congress; MMA; MOMA; NYPL; U. of Nebraska; PMA; The Pennsylvania State U.; SRGM; Springfield, Mass./MA; WMAA. **Bibliography:** Lane and Larsen; Moser 1; Reese. Archives.

MATULKA, JAN **b.** November 7, 1890, Vlachovo Brezi, Bohemia. **d.** June 22, 1972, Queens, N.Y. To USA, 1907. **Studied:** NAD, with G.W. Maynard, 1908-17. ASL, 1924-25. Traveled Europe, USA. **Taught:** ASL, 1929-31. Federal A.P.: Mural for a hospital in Brooklyn, N.Y. **Awards:** Pulitzer Scholarship for Painting. **One-man Exhibitions:** (first) The Artists' Gallery, NYC, 1925; Whitney

Studio Club, NYC, 1926, 29; Art Center, NYC, 1926; Modern Gallery, NYC, 1927, also 1930; Rehn Galleries, 1928, 29, 31, 32, 33, 35, 56; The Zabriskie Gallery, NYC, 1965; SRGM; Columbia U., 72; ACA Gallery, NYC, 1944; Robert Schoelkopf Gallery, NYC, 1970, 72, 79; Elizabeth Ives Bartholet Gallery, NYC, 1969, 79, 83, 92. **Retrospective:** NCFA, 1979. **Group:** MMA; Chicago/AI; Carnegie, 1944; U. of New Mexico, 1967; Galleries of the Societé Anonyme, NYC, Second Exhibition of Modern Art, 1920; Brooklyn Museum, 1923; Salon des Indépendants, Paris, 1924; AIGA, Annual, 1925, 26; PAFA, Annual, 1930, 31, 32, 33; Carnegie Annual, 1930, 33; WMAA, First Annual, 1931, Annuals 1933, 36, 41, 44; WMAA, Abstract Painting in America, 1935; Delaware Art Museum, Avant-Garde Painting and Sculpture in America 1910-25, 1975; NCFA, America as Art, 1976; Houston/MFA, Modern American Painting 1910-40, 1977; WMAA, Synchromism and American Color Abstraction 1910-1925, 1978. **Collections:** ASL; Boston/MFA; Brooklyn Museum; Chicago/AI; Cincinnati/AM; Des Moines; Detroit/Institute; Hartford/Wadsworth; Hirshhorn; MMA; MOMA; Nashville; NCFA; U. of Nebraska; Newark Public Library; U. of New Mexico; U. of North Carolina; NYPL; PAFA; Portland Ore./AM; Prague/National; Seattle/AM; SFMA; St. Louis/City; SRGM; Syracuse/Everson; Yale U. **Bibliography:** Armstrong, Thomas; *Avant-Garde Painting & Sculpture in America, 1910-25;* Blesh 1; Hunter; Hunter 6; *Jan Matulka;* Janis, S.; Lane and Larsen; Rose, B., 1.

MAYHEW, RICHARD **b.** April 3, 1924, Amityville, N.Y. **Studied:** Brooklyn Museum School, with Edwin Dickinson, Reuben Tam. Traveled Europe, England. **Taught:** Brooklyn Museum Art School, 1963-68; Pratt Institute, 1967-68; Art Students League, 1965-71; Smith College, 1969-70; California State

U., Hayward, 1974; Hunter College, 1971-75; San Jose State U., 1975-76; Sonoma State U., 1976-77; The Pennsylvania State U., 1977-92. **Member:** NAD. **Awards:** John Hay Whitney Fellowship, 1958; Ingram Merrill Foundation Grant, 1960; L.C. Tiffany Grant, 1963; NAD, P.P., 1964; NIAL Grant, 1966; NAD, Benjamin Altman Prize, 1970; NAD, Grumbacher Art Award and Gold Medal, 1983. **Address:** PO Box 7720 Santa Cruz, CA 95061. **Dealer:** Midtown-Payson Galleries, NYC. **One-man Exhibitions:** The Morris Gallery, NYC, 1957; Washington Irving Gallery, NYC, 1958; Robert Isaacson Gallery, NYC, 1959, 61, 62; Durlacher Brothers, NYC, 1963, 66; The Contemporaries, NYC, 1967; The Midtown Galleries, NYC, 1969, 71, 73, 74, 76, 78, 82, 87; Grand Central Galleries, NYC; Hampton U.; The Pennsylvania State U., 1979; Kingsborough College, 1984; Young Gallery, San Jose, 1979, 83, 85; Hampton U., 1986; U. of Maryland, 1987; Sherry Washington Gallery, Detroit, 1991. **Retrospective:** Studio Museum, 1978. **Group:** NAD, 1955, 59; Brooklyn Society of Artists Annual, 1956; ART:USA:58, NYC, 1958; Chicago/AI, 1961; Youngstown/Butler, 1961; Carnegie, 1961; Brooklyn Museum, 1961; WMAA Annuals; U. of Illinois, 1963; NAD, 1975, 77, 79, 89; Fine Arts Museum of Long Island, Hempstead, Black American Artists, 1983; The Hartley School, Rochester, N.Y., Rediscovering America, 1988. **Collections:** Albion College; Ball State U.; Brooklyn Museum; Hudson River Museum; MMA; Mills College; Minnesota/MA; Museum of African Art, Washington, D.C.; NAD; NMAA; NYU; Newark Museum; RISD; Studio Museum; Tougaloo College; WMAA; Youngstown/Butler.

MAZUR, MICHAEL B. **b.** November 2, 1935, NYC. **Studied:** Amherst College, 1954-58, BA; Academy of Fine Arts, Florence, Italy, 1956-57; Yale U.,

with Gabor Peterdi, Rico Lebrun, Josef Albers, Jon Schueler, Bernard Chaet, Nicholas Carone, 1959-61, BFA, MFA; privately with Leonard Baskin (printmaking), 1956-58. **Taught:** Yale U., 1960-61, 1972; RISD, 1961-64; Yale U. Summer School, Norfolk, Conn., 1963; Brandeis U., 1965, 1972-; Queens College, 1973; Brown U., 1974; U. of California, Santa Barbara, 1974, 75; Harvard U., 1989, 92. **Commissions:** US Department of the Interior; MIT, monotype mural, 1983. **Awards:** Memphis/Brooks, P.P., 1961, 62; Boston Printmakers, P.P., 1962; L.C. Tiffany Grant, 1962; Guggenheim Foundation Fellowship, 1964; NIAL, 1964; Library of Congress, Pennell P.P.; SAGA, Second Prize; Tamarind Fellowship, 1968; NAD, 1974; Philadelphia Print Club, P.P. **Address:** 5 Walnut Avenue, Cambridge, MA 02140. **Dealers:** Barbara Krakow Gallery, Boston; Barbara Mathes Gallery, NYC; Mary Ryan Gallery, NYC; John Stoller & Co., Minneapolis; Jan Turner Gallery, Los Angeles. **One-man Exhibitions:** (first) The Kornblee Gallery, NYC, 1961, also 1962, 63, 65; The Gallery, Northampton, Mass., 1963; Boris Mirski Gallery, Boston, 1964; Silvermine Guild, 1964; Alpha Gallery, Boston, 1966, 68, 74; Juniata College, 1966; A.A.A. Gallery, NYC, 1968; Finch College, NYC, 1971; U. of Connecticut, 1972; Exeter, 1972; Kutztown State College, 1973; Cortland/SUNY (two-man), 1973; The Ohio State U., 1975; Colgate U., 1973; Terry Dintenfass, Inc., NYC, 1974, 76; Robert Miller Gallery, Inc., NYC, 1978, 80; Harcus Krakow Gallery, Boston, 1978, 80, 82; College of William and Mary, 1981; The Greenberg Gallery, St. Louis, 1981; Rutgers U., 1981; John Stoller & Co., Minneapolis, 1981, 85, 91; Gustavus Adolphus College, St. Peter, Minn., 1982; Smith-Anderson Gallery, Palo Alto, Calif., 1982; Janus Gallery, Venice, Calif., 1982, 84; MIT, 1983; Barbara Mathes Gallery, 1983, 84; Barbara Krakow Gallery, Boston, 1984, 87, 89, 90; Arts Club of Chi-

cago, 1985; Beaver College, 1986; Macalester College, 1988; Joe Fawbush Gallery, NYC, 1988; Hiram Butler Gallery, Houston, 1989; Mary Ryan Gallery, NYC, 1990. **Retrospectives:** Brandeis U., 1969; Colgate U., 1973. **Group:** USIA, 10 American Printmakers, circ., Europe; MOMA, 60 Modern Drawings, 1963, also 1965; Seattle/AM; Kansas City/Nelson; Smith College; The Print Club, Philadelphia; Boston Arts Festival; WMAA Annual, 1967; PAFA, 1967, 69; ICA, Boston, Boston Now; Boston/MFA, Prints of the Sixties; Salon du Mai, Paris, 1969; Museo de Arte Contemporaneo, Cali., Colombia, S.A., I & II Biennials Graficas; XXXV Venice Biennial, 1970; Pratt Graphics Center, NYC, Monotypes, 1972; Library of Congress, 1972, 73, 74; Cleveland/MA, 32 Realists, 1972; Omaha/Joslyn, A Sense of Place, 1973; MOMA, American Prints: 1913 1963, 1974-75; Smithsonian, New American Monotypes, circ., 1978-80; Brussels/Beaux Arts, La Nouvelle Subjectivite, 1979; MMA, The Painterly Print, 1980; Brooklyn Museum, American Drawings in Black and White: 1970-1979; 1980; WMAA, American Prints: Process and Proofs, 1981; Boston/MFA, Contemporary Realist Paintings, 1983; PAFA, Perspectives on Contemporary American Realism, 1983; IEF, Twentieth Century American Drawings: The Figure in Context, circ., 1984; SFMA, American Realism (Janss), circ., 1985; Brooklyn Museum, Print Biennial, 1986; Sonoma State U., The Monumental Image, 1987; Boston/MA, 70's into 80's: Printmaking Now, 1987; Fort Wayne/AM, Earthly Delights, 1988; Boston/MFA, The Unique Print, 1990; Museum of Contemporary Art, Seoul, 1990. **Collections:** Amherst College; Andover/Phillips; Boston/MFA; Boston Public Library; Brandeis U.; Brooklyn Museum; Chicago/AI; Cincinnati/AM; Colgate U.; Cortland/SUNY; Delaware Art Museum; Fredonia/SUNY; Harvard U.; Kalamazoo/Institute; Library of Congress; Los Angeles/County MA; MIT;

MMA; MOMA; U. of Maine; U. of Massachusetts; Memphis/Brooks; Minneapolis/Institute; Montreal/MFA; The Ohio State U.; PMA; The Pennsylvania State U.; Portland, Ore./AM; RISD; Rutgers U.; Smith College; Toledo/MA; USIA; WMAA; Wellesley College; Westminster Foundation; Worcester/AM; Yale U. **Bibliography:** *America 1976;* Arthur 2; Cummings 4; Goldman 1.

McCHESNEY, ROBERT P.

b. January 16, 1913, Marshall, Mo. **Studied:** Washington U., with Fred Conway; Otis Art Institute, Los Angeles. Resided Mexico, one year. Traveled around the world, Mexico, Cuba. **Taught:** California School of Fine Arts, 1949-51; Santa Rosa Junior College, 1957-58. Federal A.P.: Federal Building, Golden Gate International Exposition, San Francisco, 1939 (mural). **Member:** San Francisco Art Institute, board of trustees. **Commissions:** SS *Monterey* (wall decoration); San Francisco Social Service Building (mural), 1978. **Awards:** San Francisco Municipal Art Commission, P.P., 1950, 69; WMAA Annual, P.P., 1955; SFMA, First Prize, 1960; San Francisco Art Festival, Prize, 1979. **Address:** 2955 Sonoma Mountain Road, Petaluma, CA 94952. **One-man Exhibitions:** (first) Raymond and Raymond, Inc., San Francisco, 1944; Pat Wall Gallery, Monterey, 1946; Lucien Labaudt Gallery, San Francisco, 1947, 51; Marquis Gallery, Los Angeles, 1949; SFMA, 1949, 53, 57, 64; Daliel Gallery, Berkeley, 1950; Gump's Gallery, San Francisco, 1952, 53, 55; Myrtle Todes Gallery, Glencoe, Ill., 1958; Bolles Gallery, NYC, 1960; San Francisco, 1960, 61; Parsons Gallery, Los Angeles, 1960, 61; Marshall Art Gallery, Marshall, Calif., 1964; Twentieth Century West Gallery, NYC, 1965; Triangle Art Gallery, 1966; San Francisco Theological Seminary, San Anselmo, Calif., 1966, 69; California State College, Sonoma, 1970; Both-Up Gallery, Berkeley, Calif., 1973, 74; Santa Rosa City Hall, Calif., 1974; Califor-

nia State U., Hayward, 1977; Capricorn Asunder Gallery, San Francisco, 1974; Lincoln Arts Center, Santa Rosa, 1978; Marin County Civic Center, 1980; Adlen Fine Arts, Santa Rosa, Calif., 1986; Edward S. Curtis Gallery, San Anselmo, Calif., 1989; Carlson Gallery, San Francisco, 1990. **Retrospective:** Capricorn Asunder Gallery, San Francisco, 1974. **Group:** SFMA, 1945, 50, 53, 60; Phillips, 1947; de Young, 1947, 51, 53, 59, 60, 61; Chicago/AI Annuals, 1947, 54, 60, 61; Los Angeles/County MA, 1949; São Paulo, 1955; WMAA Annual, 1955; Corcoran, 1957; California Palace, 1962, 64; Oakland/AM, 1972; Reed College, 1973; UCLA Extension Gallery, 1975. **Collections:** Chicago/AI; Oakland/AM; SFMA; San Francisco Municipal Art Commission; Utah State U., Logan; WMAA; Worcester/AM. **Bibliography:** McChesney. Archives.

McCLELLAN, DOUGLAS E.
from 1st to 4th edition.

McCRACKEN, JOHN b. December 9, 1934, Berkeley, Calif. **Studied:** California College of Arts and Crafts, 1962, BFA, and 1962-65. **Taught:** U. of California, Irvine and Los Angeles, 1965-68; School of Visual Arts, NYC, 1968-69; Hunter College, NYC, 1971; U. of Nevada. **Address:** 1001 East 1st Street, Los Angeles, CA 90012. **Dealer:** Fred Hoffman Gallery, Santa Monica, Calif. **One-man Exhibitions:** Nicholas Wilder Gallery, Los Angeles, 1965, 67, 68; Robert Elkon Gallery, 1966, 67, 68, 72, 73; Ileana Sonnabend Gallery, Paris, 1969, Toronto, 1969, NYC, 1970; ACE Gallery, Vancouver, 1970; Pomona College, 1971; U. of Nevada, 1974; Fred Hoffman Gallery, Santa Monica, 1990, 92. **Retrospective:** P.S. 1, Long Island City, 1986. **Group:** Barnsdall Park Municipal Art Gallery, Los Angeles, Los Angeles Sculpture, 1965; Jewish Museum, Primary Structure Sculptures, 1966; WMAA, 1966, 68, 70; Seattle/AM, Ten from Los Angeles, 1966; Los

Angeles/County MA, Sculpture of the Sixties, circ., 1967; WGMA, A New Aesthetic, 1967; Paris/Moderne, 1967; Milwaukee, Directions 1: Options, circ., 1968; MOMA, The Art of the Real, 1968; ICA, U. of Pennsylvania, Between Object and Environment, 1969; Eindhoven, Kompas IV, 1969-70; Chicago/AI, 1970; Chicago/Contemporary, Permutations: Light & Color, 1970; MOMA, Ways of Looking, 1971; Kassel, Documenta V, 1972. **Collections:** Chicago/AI; Los Angeles/County MA; MOMA; Milwaukee; Pasadena/AM; SRGM; Toronto; WMAA. **Bibliography:** *Report; USA West Coast;* Weintraub.

McFEE, HENRY LEE b. April 14, 1886, St. Louis, Mo. **d.** 1953, Claremont, Calif. **Studied:** Washington U. School of Fine Arts; ASL, Woodstock, N.Y., 1908, with Birge Harrison; Stevenson Art Center, Philadelphia. **Awards:** Carnegie, Hon. Men., 1923; Corcoran, Fourth William A. Clark Prize, 1928; Carnegie, First Hon. Men., 1930; VMFA, P.P., 1935; PAFA, Joseph E. Temple Gold Medal, 1937; Los Angeles County Fair, P.P., 1940, 49; Guggenheim Foundation Fellowship, 1941; NIAL, 1945; elected an associate of the NAD, 1949. **One-man Exhibitions:** Rehn Galleries, 1927, 29, 33, 36, 50; Pasadena/AM, 1950; Bucknell U., 1986. **Retrospective:** Scripps College, 1950. **Group:** Panama-Pacific Exposition, San Francisco, 1915; Detroit/Institute; Cleveland/MA; Anderson Galleries, NYC, Forum Exhibition, 1916; Carnegie, 1923-49; Corcoran, 1924, 26, 1928-44; PAFA; Chicago/AI; St. Louis/City; U. of New Mexico, Cubism: Its Impact in the USA, 1967. **Collections:** Brooklyn Museum; Buffalo/Albright; Carnegie; Cleveland/MA; Columbus; Corcoran; Detroit/Institute; Los Angeles County Fair Association; MMA; PMA; Phillips; St. Louis/City; Scripps College; Taft Museum; VMFA; WMAA. **Bibliography:** Barker 2; Baur 7; Brown; Brown 2; Cahill and Barr, eds.; Cheney; Hall; Hunter 6; Huyghe;

Index of 20th Century Artists; Janis, S.; Kent, N.; Mellquist; Mendelowitz; **Miller 1;** Pearson 2; Poore; Pousette-Dart, ed.; Richardson, E.P.; Smith, S.C.K.; Watson, E.W., 2; *Woodstock: An American Art Colony 1902-1977;* Wright 1.

McGARRELL, JAMES b. February 22, 1930, Indianapolis, Ind. **Studied:** Indiana U., with Alton Pickens, Leo Steppat, AB; UCLA, with John Paul Jones, Gordon Nunes, MA; Skowhegan School; Academy of Fine Arts, Stuttgart. Traveled USA, Europe; resided Paris, 1964-65, Italy, 1971-. **Taught:** Reed College, 1956-59; Indiana U., 1959-93; Skowhegan School, summers, 1964, 68. Foreign correspondent member of the Academie des Beaux-Arts de l'Institut de France, 1970; Indiana U., 1959-81; Washington U., 1981-. **Member:** CAA, board of directors, 1969-73; National Advisory Board, Tamarind Institute, 1977-; NAD, 1992. **Awards:** Fulbright Fellowship, 1955; Tamarind Fellow, 1962; NIAL, Grant, 1963; Ford Foundation, P.P., 1963, 64; J.S. Guggenheim Fellowship, 1964; National Council on the Arts, Sabbatical Grant to Artists Who Teach; National Endowment for the Arts, 1985. **Address:** 224 N. Newstead, St. Louis, MO 63108. **Dealers:** Frumkin/Adams Gallery, NYC; The More Gallery, Philadelphia; Simone Stern Gallery, New Orleans; The Struve Gallery, Chicago; Jane Haslem Gallery, Washington, D.C. **One-man Exhibitions:** (first) Frank Perls Gallery, 1955, also 1957, 58, 62, 64; Portland, Ore./AM, 1959, 62; Indiana U., 1960, 63; Allan Frumkin Gallery, Chicago, 1960, 62, 65, 67, 71, 74; Salt Lake Art Center, Salt Lake City, 1962; Gallery 288, St. Louis, 1963; U. of Florida, 1964; Galleria Galatea, Turin, 1965, 66, 68; Pittsfield/Berkshire, 1966; Tragos Gallery, Boston, 1967; Galleria II Fante de Spada, Rome, 1967, 71, 72, 74, 76; Claude Bernard, Paris, 1967, 68, 74; Galleria dei Lanzi, Milan, 1970, 72; Utah, 1972; Allan Frumkin Gallery, NYC,

1961, 64, 66, 71, 73, 78, 81, 84; Bedford House Gallery, London, 1973; Clark-Benton Gallery, Santa Fe, 1977; Frumkin & Struve Gallery, Chicago, 1979; Yares Gallery, Scottsdale, 1980; U. of Nebraska, 1980; Fountain Gallery, Portland, Ore., 1980, 82; Galleria Gian Ferrari, Milan, 1981; U. of New Mexico, 1982; Wentz Gallery, Portland, Ore., 1983; U. of Bridgeport, 1984; St. Louis/City, 1985; Southern Methodist U., 1985; Peregrine Gallery, Dallas, 1985; Jane Haslem Gallery, Washington, D.C., 1987; More Gallery, Philadelphia, 1987; Struve Gallery, Chicago, 1988, 92; Frumkin/Adams Gallery, NYC, 1989, 90, 91, 93; Miami-Dade Community College, circ., 1990; Dartmouth College, 1993. **Group:** WMAA Annuals, 1957, 59, 60, 67; MOMA, New Images of Man, 1959; U. of Illinois, 1959, 61, 63; Carnegie, 1959, 64; III International Biennial Exhibition of Prints, Tokyo, 1962; WMAA, Fifty California Artists, 1962-63; Chicago/AI Annual, 1963; Tate, Dunn International, 1964; Kassel, Documenta III, 1964; PAFA, 1964; U. of Kentucky, 1966, Graphics 1968, 1968; XXXIV Venice Biennial, 1968; SFMA, 1968; Smithsonian, 1969; Indiana U., American Scene: 1900-1970, 1970; Le Centre Cultural Americain, Paris (four-man), 1971; Kansas City/AI, Narrative Painting, 1972; Dayton/AI, Eight American Painters, 1972; Galleria Communale d'Arte Contemporanea, Una Tendenza Americana, 1973; MOMA, American Prints 1913-1963, 1974-75; Boston U., Drawings by American Realists, 1977; WMAA, Art About Art, 1978; Venice Biennale, 1980; Houston/Contemporary, Modern American Paintings, circ., 1982; New Orleans/Contemporary, The Human Figure in Contemporary Art, 1982; Florida International U., American Art Today: Still Life, 1985; MMA, Since 1980: New Narrative Paintings, 1986; U. of Illinois, Chicago, Tragic and Timeless Today, 1987; Florida International U., American Art Today: Narrative

Painting, 1988; Little Rock/MFA, The Figure, 1989; Miyagi Museum of Art, Sendai, Japan, American Realism and Figurative Art, 1952-1990, circ., 1991. **Collections:** U. of Arizona; U. of Arkansas; Boston/MFA; Brooklyn Museum; Chicago/AI; Hamburg; Hirshhorn; Indianapolis; Kansas City/AI; MMA; MOMA; U. of Massachusetts; National Gallery; U. of Nebraska; New Orleans Museum; PAFA; Paris/Beaubourg; Paris/Moderne; Portland, Ore./AM; SFAI; SFMA; St. Louis/City; Santa Barbara/MA; Sioux City Art Center; U. of Texas; Utah; WMAA; U. of Wichita. **Bibliography:** Arthur 2; Geske; Honisch and Jensen, eds.; Ward.

McLAUGHLIN, JOHN b. May 21, 1898, Sharon, Mass. d. March 1976, Dana Point, Calif. **Studied:** Roxbury Latin School; Andover/Phillips; self-taught in art. US Army Intelligence, 1941-45. Traveled the Orient, resided Japan for many years beginning 1935. Began to paint 1938. **Awards:** Tamarind Fellowship, 1963; Corcoran Biennial, Bronze Medal, 1967; National Council on the Arts, Visual Arts Award, 1967. **One-man Exhibitions:** Felix Landau Gallery, Los Angeles, 1953, 58, 62, 63, 66; U. of California, Riverside, 1958; Long Beach/MA, 1960; K. Kazimir Gallery, Chicago, 1964; Occidental College, 1968; The Landau-Alan Gallery, NYC, 1968; U. of California, Irvine, 1971; Nicholas Wilder Gallery, 1972, 79; André Emmerich Gallery, NYC, 1972, 74, 79, 82, 87, 88; Corcoran and Corcoran, Coral Gables, 1973; Felicity Samuel Gallery, London, 1975; Galerie André Emmerich, Zurich, 1976, 81, 82; U. of California, Santa Barbara, 1978; Annely Juda Fine Art, London, 1981; Modern Galerie, Quadrat Bottrop, West Germany, 1981; Galerie Mueller-Roth, Stuttgart, 1981; James Corcoran Gallery, Los Angeles, 1982; Ulmer Museum, Ulm, West Germany, 1982; Gatodo Gallery, Tokyo, 1983, 85. **Retrospectives:** Pasadena/AM, 1956, 63; Corcoran, 1968; WMAA, 1974;

La Jolla, 1973. **Group:** Los Angeles/County MA Annuals, 1949, 50, 54-60; California State Fair, 1950; Los Angeles/County MA, Contemporary Painting in the United States, 1951; São Paulo, 1955; SFMA, Art in the Twentieth Century, 1955; Corcoran, 1955; Long Beach/MA, Fifteen Americans, circ., 1956; Walker, 1956; Houston/MFA, The Sphere of Mondrian, 1957; VMFA, American Painting, 1958; U. of Nebraska, 1958; Denver/AM, 1958; Los Angeles/County MA, Four Abstract Classicists, circ., 1959-61; ICA, London, 1960; A.F.A., Purist Painting, circ., 1960-61; SFMA, Fifty California Artists, circ., 1962; WMAA, Geometric Abstraction in America, circ., 1962; Chicago/AI, 1964; MOMA, The Responsive Eye, 1965; Corcoran, 1967; Pasadena/AM, West Coast: 1945-1969, 1969; Hayward Gallery, London, 11 Los Angeles Artists, 1971; MOMA, Color as Language, circ., 1975; Los Angeles/County MA, Los Angeles Hard Edge, 1977; Los Angeles/County MA, California: Five Footnotes to Modern Art History, 1977; Lincoln, Mass./De Cordova, Born in Boston, 1979; Claremont Colleges, Black and White Are Colors, 1979; Los Angeles/County MA, Art in Los Angeles, 1981; P.S. 1, Long Island City, Underknown, 1984; MOMA, Contrasts of Form: Geometric Abstract Art 1910-1980, 1985. **Collections:** Amherst College; Andover/Phillips; Bowdoin College; U. of California; Corcoran; Hartford/Wadsworth; Long Beach/MA; Los Angeles/County MA; MIT; MMA; MOMA; NCFA; U. of New Mexico; Oakland/AM; Pasadena/AM; Santa Barbara/MA; Stanford U. **Bibliography:** *Black and White Are Colors; John McLaughlin; 7 Decades;* Karlstrom and Ehrlich; Plagens; *The State of California Painting;* Tuchman 3; Weller. Archives.

McLEAN, RICHARD b. April 12, 1934, Hoquiam, Wash. **Studied:** California College of Arts and Crafts, 1958, BFA; Mills College, 1962, MFA;

Richard McLean, *Western Tableau with Green Chaps*, 1992.

Oakland/AM, 1962. US Army, 1958-60. Traveled Asia, Australia, Europe. **Taught:** San Francisco State U., 1963-; California College of Arts and Crafts, 1963-65. **Awards:** National Endowment for the Arts, 1986. **Address:** 5840 Heron Bridge, Oakland, CA 94718. **Dealer:** OK Harris Works of Art, NYC. **One-man Exhibitions:** Lucien Labaudt Gallery, San Francisco, 1957; RAC, 1963; Berkeley Gallery, San Francisco, 1964, 66, 68; Valparaiso U. (Ind.), 1965; U. of Omaha, 1967; OK Harris Works of Art, NYC, (two-man) 1971, 73, 75, 78, 81, 83, 85, 86, 89; Galerie de Gestlo, Hamburg, 1976; John Berggruen Gallery, San Francisco, 1976; Lavignes-Bastille, Paris, 1984. **Group:** SFAI Annuals, 1961, 62; East Bay Realists, circ., 1966; Hayward Gallery, London, Four Painters, 1967; U. of Arizona, 80 Contemporaries in the West, 1967; U. of California, Davis, People Painters, 1970; WMAA, 22 Realists, 1970; Expo '70, Osaka, 1970; Chicago/Contemporary, Radical Realism, 1971; Kassel, Documenta V, 1972; Buffalo/Albright, Working in California, 1972; Stuttgart/WK, Amer-

ikanischer Fotorealismus, circ., 1972; Cleveland/MA, 32 Realists, 1972; New York Cultural Center, Realism Now, 1972; Lunds Konsthall, Sweden, Amerikansk Realism, 1973; Los Angeles Municipal Art Gallery, Separate Realities, 1973; CNAC, Hyperrealistes Americains/Realistes Europeens, 1974; Hartford/Wadsworth, New/Photo Realism, 1974; Tokyo Biennial, 1974; Wichita State U., The New Realism, Rip-Off or Reality?, 1975; Reed College, American Realism, 1975; Purchase/SUNY, PhotoRealist Watercolors, 1976; SFMA, Painting and Sculpture in California: The Modern Era, 1976; Stratford, Ontario, Aspects of Realism, 1976; California State U., Chicago, A Comparative Study of 19th Century California Painting and Contemporary California Realism, 1977; Canberra/National, Illusion and Reality, 1977; Santa Barbara/MA; Photo-Realist Painting in California, 1980; Akron/AM, The Image in American Painting and Sculpture, 1981; PAFA, Contemporary American Realism Since 1960, 1981; San Antonio/MA, Real, Really Real, Super Real, circ., 1981; Palm

Springs Desert Museum, The West as Art, 1982; U. of Santa Clara, Northern California Art of the Sixties, 1982; U. of California, Davis, Directions in Bay Area Painting, 1983; Laguna Beach Museum of Art, West Coast Realism, circ., 1983; Saitama/Modern, Realism Now, 1983; U. of Nebraska, San Francisco Bay Area Painting, 1984; Isetan Museum of Art, Tokyo, American Realism: The Precise Image, 1985; Oakland/AM, Art in the San Francisco Bay Area, 1945-1980, 1985; SFMA, American Realism (Janss), circ., 1985; Youngstown/Butler, Midyear, 1987; Youngstown/Butler, California A to Z and Return, 1990; Fort Lauderdale, Photo-Realism: Revisited, 1991. **Collections:** Aachen/NG; A.V. Gunuchian, Inc.; Hannover/K-G; Milwaukee; NMAA; Oakland/AM; Omaha/Joslyn; Pacific Bell; Portland, Ore./AM; Reed College; Rotterdam; SFMA; SRGM; Southland Corp.; Utrecht/Contemporary; VMFA; WMAA. **Bibliography:** *Amerikanischer Fotorealismus;* Arthur 3; *Kunst un 1970;* Lindy; Sager; Seitz 3; *The State of California Painting;* Ward.

McNEIL, GEORGE b. February 22, 1908, NYC. **Studied:** Pratt Institute, 1927-29; ASL, 1930-33; Hofmann School, 1933-36; Columbia U., BS, MA, Ed.D. US Navy, 1943-46. Traveled Cuba, Europe, North Africa, the Orient. **Taught:** Pratt Institute, 1948-81; U. of Wyoming, 1946-48; U. of California, Berkeley, 1955-56; Syracuse U., 1974; Columbia U., 1975; New York Studio School, 1966-81. Federal A.P.: Designed abstract murals, 1935-40. **Awards:** Ford Foundation, P.P., 1963; National Council on the Arts, 1966; Guggenheim Foundation Fellowship, 1969; AAIAL, prize, 1989. **Address:** 195 Waverly Avenue, Brooklyn, NY 11205. **Dealer:** Julian Weissman Fine Art, NYC. **One-man Exhibitions:** (first) Lyceum Gallery, Havana, 1941; Black Mountain College, 1947; U. of Wyoming, 1948; U. of New Mexico, 1948; U. of Colorado, 1948;

Charles Egan Gallery, Boston, 1953; Hendler Gallery, Philadelphia, 1954; Poindexter Gallery, NYC, 1957, 59; The Howard Wise Gallery, NYC, 1960, 62, 64, 67; Nova Gallery, Boston, 1961; Colby Junior College, 1965; U. of Texas, 1966; Great Jones Gallery, NYC, 1966; Des Moines, 1969; Pratt Institute, Manhattan Center, NYC, 1973; U. of California, Santa Cruz, 1974; Northern Arizona U., 1975; Landmark Gallery, NYC, 1975; Aaron Berman Gallery, NYC, 1977; Terry Dintenfass, Inc., NYC, 1979; Fort Lauderdale, 1982; U. of Connecticut, 1982; Gruenebaum Gallery, 1981, 83, 85; Montclair/AM, 1981; U. of Hartford, 1989; M. Knoedler & Co., NYC, 1989; Hirschl & Adler Modern, NYC, 1991. **Group:** American Abstract Artists, 1936; MOMA, New Horizons in American Art, 1936; New York World's Fair, 1939; Chicago/AI, Abstact Painting and Sculpture in America, 1951; WMAA Annuals, 1953, 57, 61; Carnegie, 1953, 55, 58; Walker, 60 American Painters, 1960; Cleveland/MA, Some Contemporary American Artists, 1961; SRGM, Abstract Expressionists and Imagists, 1961; USIA, American Painting, circ., Latin America, 1961; PAFA, 1962; Hartford/Wadsworth, 1962; Chicago/AI, 1963; MOMA, Hans Hofmann and His Students, circ., 1963-64; WMAA, The 1930's, 1968; MOMA, The New American Painting and Sculpture, 1969; U. of New Mexico, American Abstract Artists, 1977; Southampton/Parrish, The Painterly Figure, 1983; Montclair/AM, The Interior Self, 1987; Brooklyn Museum, Working in Brooklyn—Paintings, 1987. **Collections:** Alcoa; Brooklyn Museum; Ciba-Geigy Corp.; Cornell U.; Fort Lauderdale; Havana/Nacional; U. of Michigan; MMA; MOMA; Montclair/AM; NYU; Newark Museum; U. of New Mexico; U. of North Carolina; Oklahoma; U. of Texas; WGMA; WMAA; Waitsfield/Bundy; Walker. **Bibliography:** *The Figurative Fifties;* Passloff; Pousette-Dart, ed.; Ritchie 1; Sandler 5. Archives.

MEEKER, DEAN JACKSON
from 1st to 5th edition.

MEHRING, HOWARD
from 1st to 4th edition.

MEIGS, WALTER b. September
21, 1918, NYC. d. 1988, Canarias, Spain.
Studied: École des Beaux-Arts, Fontaine-
bleau, Diplome, 1939; Syracuse U., BFA,
1941; State U. of Iowa, MFA, 1949; and
with R. Lotterman. US Army, more than
three years, World War II. Traveled
France, Greece; resided Greece, 1961-64,
Spain, 1965-. Taught: U. of Nebraska,
1949-53; U. of Connecticut, 1953-61.
Awards: Walker, 1951; Silvermine Guild,
1954; Slater, First Prize, 1955, 56; Boston
Arts Festival, Grand Prize, 1956; and some
20 others. One-man Exhibitions: (first)
The Downtown Gallery; U. of Nebraska,
1952; The Alan Gallery, NYC, 1954;
Wesleyan U., 1956; New London, 1956;
Boris Mirski Gallery, Boston, 1957; Lee
Nordness Gallery, NYC, 1958, 64, 67;
Lincoln, Mass./De Cordova, 1959; Frank
Oehlschlaeger Gallery, Sarasota, Fla.,
1965; Harmon Gallery, Naples, Fla.,
1966, 70-80; Florida Southern College,
1979; Harmon-Meek Gallery, Naples,
Fla., 1981. Group: Walker Biennial, 1951;
Omaha/Joslyn, 1952; Boston Arts Festival;
Berkshire Art Festival; Youngstown/Butler,
1957; Carnegie; WMAA Annuals; U. of
Illinois. Collections: Amherst College;
Birmingham, Ala./MA; Denver/AM; Fort
Worth; Hartford/Wadsworth; Lincoln,
Mass./De Cordova; The Pennsylvania
State U.; Springfield, Mo./AM; USIA;
Utica; Youngstown/Butler. Bibliography:
Nordness, ed. Archives.

MENKES, SIGMUND
from 1st to 5th edition.

MESIBOV, HUGH b. December
29, 1916, Philadelphia, PA. Studied:
Graphic Sketch Club, Philadelphia; PAFA;
Barnes Foundation. Traveled Europe, Med-
iterranean, Israel, USA. Taught: Lenox
Hill Neighborhood Association, NYC,
1949-57; Wiltwyck School for Boys, Es-
opus, N.Y., 1957-66; Rockland Commu-
nity College, Suffern, N.Y., 1966-86.
Member: PAFA Fellowship Association;
Philadelphia Watercolor Club. Federal
A.P.: Graphics, drawings, watercolors, oils,
mural design. Commissions: US Post Of-
fice, Hubbard, Ohio (mural). Awards: The
Print Club, Philadelphia, 1941, 46; Hall-
mark International Competition, 1952;
PAFA, 1952, 58; Philadelphia Watercolor
Club, Thornton Oakley Memorial Prize,
1968, 76; Rockland Council on the Arts,
Executive Arts Award for Visual Arts,
1988. Address: 4 Margaretts Road, Chest-
nut Ridge, NY 10952. Dealers: Sragow
Gallery, NYC; Midtown-Payson Gallery,
NYC. One-man Exhibitions: (first) Car-
len Gallery, Philadelphia, 1940; Philadel-
phia Art Alliance, 1945; Chinese Gallery,
NYC, 1947; Bookshop Gallery, Aspen,
Colo., 1951, 53; The Morris Gallery,
NYC, 1954; Pied Piper Gallery, Aspen,
Colo., 1954; Artists' Gallery, NYC, 1956,
58; Sunken Meadow Gallery, Kings Park,
N.Y., 1958; Gallery Mayer, NYC, 1959;
Elizabeth Nelson Gallery, Chicago, 1962;
Rockland Community College, 1964-68,
69, 72; Mansfield State College, 1968;
High Point Galleries, Lenox, Mass., 1968;
Tappan Zee Theater, Nyack, N.Y., 1967,
68, 69; St. Thomas Aquinas College,
Sparkhill, N.Y., 1971; Finkelstein Memo-
rial Library, Spring Valley, N.Y., 1978;
Hopper House Gallery, Nyack, N.Y.,
1979, 82; Ringwood Manor Art Associa-
tion, Ringwood, N.J., 1983; Wyckoff Gal-
lery, Wyckoff, N.J., 1987; Dolan/Maxwell
Galleries, Philadelphia, 1987; Sragow
Gallery, NYC, 1992. Group: New York
World's Fair, 1939; Carnegie, 1939; Phila-
delphia Art Alliance, 1940, 41, 45, 67;
Harrisburg, Pa.; PAFA, 1943, 1952-55,
57; Library of Congress, 1951; Brooklyn
Museum, 1951, 1953-55; WMAA, 1956-
59; Corcoran, 1959; MOMA, 1961;
AAAL, 1967; AFA, American Prints, 1900-

1950, circ., 1991. **Collections:** Albion College; Barnes Foundation; Canadian Society of Graphic Art; Carnegie; Free Library of Philadelphia; MMA; NYU; New York Hilton Hotel; U. of Oregon; PAFA; PMA; WMAA; U. of Wyoming.

MESTROVIC, IVAN
from 1st to 4th edition.

METCALF, JAMES
from 1st to 4th edition.

MIDDAUGH, ROBERT b. 1935,
Chicago, Ill. **Studied:** U. of Illinois, 1954-55; Chicago Art Institute School, 1960-64, BFA. **Address:** 1318 West Cornelia, Chicago, Ill. 60657. **One-man Exhibitions:** Kovler Gallery, Chicago, 1965, 67, 69; Covenant Club, Chicago, 1966; Barat College, 1970; Martin Schweig Gallery, St. Louis, 1970, 72, 79, 83; Deson-Zaks Gallery, Chicago, 1974; St. Mary's College, 1975; U. of Wisconsin, Milwaukee, 1976; Fairweather-Hardin Gallery, Chicago, 1977, 80, 83, 85; Racine, 1980; Countryside Art Center, Arlington Heights, Ill., 1981; Evanston, 1982; Fine Arts Forum, Chicago, 1982; Lake Forest College, 1982; U. of Wisconsin, Marinette, 1982. **Group:** Chicago/AI, 2nd Biennial, 1964; U. of Illinois, Biennial, 1965; Chicago/AI, Chicago and Vicinity, 1966, 73, 78; PAFA, Annual, 1967; U. of Chicago, The Chicago Style: Graphics, 1974; AAIAL, 1975; Chicago/AI, 100 Artists—100 Years, 1979; U. of Wisconsin, Other Realities, 1981. **Collections:** Boston/MFA; Chicago/AI; Davenport; Des Moines; Los Angeles/County MA; Mobile/FAMS; Northern Illinois U.; Phoenix; Portland, Ore./AM; Springfield, Ill./State; Worcester.

MILDER, JAY b. May 12, 1934,
Omaha, Nebraska. **Studied:** U. of Nebraska, 1953-54; 1954-56; La Grande Chaumiere and the Sorbonne, Paris, with Zadkine, Hayter, L'Hote; School of the Art Institute of Chicago, 1956-57, with Isobell McKinnon; Hans Hofmann School, Provincetown, 1958-62. Traveled North Africa, Paris, 1953-55. **Taught:** Dayton Art Institute, 1963-65; New York Institute of Technology, 1965; Pratt Institute, 1966; Brandeis Institute, Santa Susana, Ca, 1967-68; Maryland Art Institute, 1969; Chrysler Museum School, Norfolk, 1970; Vermont Studio School, Johnstown, 1989; Skidmore College, 1991; City College/CUNY, 1971-. **Address:** 117 West 26th Street, NYC 10001. **One-man Exhibitions:** Sun Gallery, Provincetown, 1958; City Gallery, NYC, 1958; Martha Gallery, Omaha, 1960; Fulton Gallery, NYC, 1960; The Zabriskie Gallery, NYC, 1960; Delancey Street Museum, 1960; Museo de la Universidad de Puerto Rico, San Juan, 1960; Allan Stone Gallery, NYC, 1960, 61, 62; Museo de Bellas Artes, San Juan, 1961; Dayton Art Institute, 1963; Ohio Wesleyan U., 1964; Martha Jackson Gallery, NYC, 1964; Omaha/Joslyn, 1964; Antioch College, 1965; Bienville Gallery, New Orleans, 1968, 69-72, 73, 74; Uppsala Universtits, Sweden, 1973; Charlotte/Mint, 1973-78; Lerner-Heller Gallery, NYC, 1975; Gallery One, Rochester, NYC, 1979; Ronald Hunning Gallery, NYC, 1981; Oscarsson Hood Gallery, NYC, 1982; Shahin Requicha Gallery, Rochester, NYC, 1984; Richard Green Gallery, NYC, 1986, 87; Sid Deutsch Gallery, NYC, 1986; Harcourts Modern and Contemporary Art, San Francisco, 1987; Yares Gallery, Scottsdale, 1987; Girgis & Klym Gallery, Fitzroy, Australia, 1988. **Retrospective:** Skidmore College, 1991. **Group:** Dayton/AI, International Selection, 1961; Yale U., Four Young Painters, 1962; Yale U., Seven Young Painters, 1964; AFA, One Hundred Contemporary Drawings, 1965; MOMA, International Sculpture Exhibition, 1967; St. John's College, Annapolis, Tenth Street Days, circ., 1979; Newport (R.I.) Art Association, 1900 to Now, 1988; Virginia Commonwealth U., Private Stories, 1991. **Collections:** AT&T; Binghamton/SUNY;

Brandeis Institute; Charlotte/Mint; Cornell U.; Dayton/AI; Ein Hod Museum; Norfolk/Chrysler; U. of North Carolina; Provincetown Museum; Purchase/SUNY; Radford U.; Randolph-Macon Women's College; San Juan; Skidmore College; Skirball Museum, Hebrew Union College, Los Angeles; Tel Aviv; U. of Virginia; Yale U.

MILLER, KENNETH HAYES
b. March 11, 1878, Oneida, N.Y. **d.** January 1, 1952, NYC. **Studied:** ASL, with H.S. Mowbray, Kenyon Cox, F.L. Mora, Frank V. DuMond. Traveled Europe. **Taught:** New York School of Art, 1899-1911; ASL, 1911-35, 1937-43, 1945-52. **Member:** NAD; Artists Equity; NIAL. **Awards:** Chicago/AI, Ada S. Garrett Prize, 1945; NAD, Gold Medal, 1943; NIAL, 1947. **One-man Exhibitions:** Montross Gallery, NYC, 1922, 23, 25, 28; Rehn Galleries, NYC, 1929, 35; Utica, 1953; ASL, 1953; The Zabriskie Gallery, NYC, 1970, 71, 79; AAA, NYC, 1979; Bethesda Art Gallery, Bethesda, Md., 1981. **Group:** Chicago/AI; The Armory Show, 1913; Buffalo/Albright; RISD; PAFA; Musée de Luxembourg; Paris; Brooklyn Museum; Carnegie; Corcoran; NAD; WMAA. **Collections:** Andover/Phillips; Bibliothèque Nationale; Chicago/AI; Cleveland/MA; Columbus; Hartford/Wadsworth; Hirshhorn; Library of Congress; Los Angeles/County MA; MMA; MOMA; NMAA; NYPL; PAFA; Phillips; San Diego; Utica; VMFA; WMAA; Youngstown/Butler. **Bibliography:** Brown 2; Ward. Archives.

MILLER, RICHARD
b. March 15, 1930, Fairmount, W. Va. **Studied:** PAFA, with Franklin Watkins, 1948; American U., with William H. Calfee, BA, 1949-53; Columbia U., with John Heliker, MA, 1956. Traveled Europe and USA extensively. **Taught:** Kansas City/AI, 1968-69; Scarsdale Studio School, 1970-75; Rye Art Center, 1976-80; Westchester Community College, 1979-86; privately. Professional actor-singer. **Commissions:** General Motors Building, NYC. **Awards:** Gertrude V. Whitney Scholarship, 1948, 56; Fulbright Fellowship (Paris), 1953. **Address:** 222 West 83rd Street, NYC 10024. **One-man Exhibitions:** (first) Washington, D.C., Public Library, 1945; Trans-Lux Gallery, Washington, D.C., 1948; Watkins Gallery, Washington, D.C., 1951; Bader Gallery, Washington, D.C., 1954, 61; Baltimore/MA, 1955; The Graham Gallery, 1960, 62, 63, 65; Jefferson Place Gallery, 1966; Drew U., 1967; Jewish Community Center, Kansas City, Mo., 1969; Albrecht Gallery, St. Joseph, Mo., 1969; Long Island U., 1973; Rye (N.Y.) Library Gallery, 1980; Westbeth Gallery, NYC, 1982; Aaron Berman, NYC, 1983; Westchester Gallery of Art, White Plains, N.Y., 1989; Westchester Community College, White Plains, N.Y., 1989. **Group:** WMAA Annual; PAFA Annual; WMAA, Fulbright Artists, 1958; Salon National, Paris; Pan-American Union, Washington, D.C.; U. of Nebraska; San Antonio/McNay, 1960; Carnegie, 1961; Corcoran, 1961; Finch College; V International Biennial Exhibition of Prints, Tokyo, 1966; Museum of the Hudson Highlands, Cornwall-on-Hudson, N.Y., 1988. **Collections:** U. of Arizona; Columbia U.; Hirshhorn; Phillips; U. of Rochester; St. Joseph/Albrecht.

MILLER, RICHARD McDERMOTT
b. April 30, 1922, New Philadelphia, Ohio. **Studied:** Cleveland Institute of Art, 1940-42, 1949-52. US Army, 1942-46. Traveled Mexico, Europe, China. **Taught:** Queens College, City University of New York, 1967-. **Members:** Sculptors Guild; NAD Alliance of Figurative Artists. **Awards:** May Page Scholarship, Cleveland Institute of Art, 1951; Youngstown/Butler, P.P., 1970; NAD, Elizabeth N. Watrous Gold Medal, 1974; AAIAL, 1978. **Address:** 53 Mercer Street, NYC 10013. **One-man Exhibitions:** Peridot Gallery, 1964, 66, 67, 69;

Holland Gallery, 1965; Feingarten, 1966; Duke U., 1967; Raleigh/NCMA, 1967; Cleveland/MA 1968; Alwin Gallery, London, 1968; Columbia, S.C./MA, 1969; Duke U. (two-man), 1971; Washburn Gallery, Inc., NYC, 1971, 74, 75, 77; Joe deMers Gallery, Hilton Head, S.C., 1971; Queens College, N.Y., 1978; Canton Art Institute, 1980; Imprimature Gallery, Minneapolis, 1985; Springfield, Mo./AM, 1985. **Retrospective:** Artist's Choice Museum, NYC, 1985. **Group:** WMAA, Sculpture Annual, 1964; NIAL, 1965; New Paltz/SUNY, 20 Representational Artists, 1969; Baltimore/MA, The Part Is the Whole, 1969; Youngstown/Butler, Sculpture Annual, 1970, 71; U. of Nebraska, American Sculpture, 1970, 73; St. Cloud State College, New Realism, '70, 1970; WMAA Biennial, 1971; The Pennsylvania State U., Living American Artists and the Figure, 1974; New York Cultural Center, Three Centuries of the American Nude, 1975; Sculptors Guild Annual, NYC, 1977; Nassau County Museum, Monuments and Monoliths: A Metamorphosis, 1978; PAFA, Contemporary American Realism Since 1960, 1981; Pratt Institute, Sculpture of the 70s: The Figure, 1981. **Collections:** Ashland Oil Inc., NYC; Canton Art Institute; Columbia, S.C./MA; Duke U.; Hirshhorn; U. of Houston; Massillon Museum; U. of Nebraska; U. of North Carolina; Union National Bank & Trust Co., Kansas City, Mo.; WMAA; Youngstown/Butler.

MILLMAN, EDWARD
from 1st to 4th edition.

MITCHELL, FRED **b.** November 24, 1923, Meridian, Miss. **Studied:** Carnegie Institute of Technology, 1942-43; Cranbrook Academy of Art, 1946-48, BFA, MFA; Academy of Fine Arts, Rome. **Taught:** Cranbrook Academy of Art, 1955-59; Positano (Italy) Art Workshop, 1956; NYU, 1961-71; Cornell U., 1969; Binghamton/SUNY, 1976-77; Utica, 1977. A

cofounder of the Tanager Gallery, NYC. **Commissions:** Mississippi State College for Women (cast concrete screen). **Awards:** Scholarship to Carnegie Institute of Technology; Traveling Fellowship (Italy), 1948-51; Ford Foundation Artist-in-Residence, Columbia, S.C./MA. **Address:** 1901 Park Avenue, NYC 10035. **One-man Exhibitions:** (first) Municipal Gallery Jackson, Miss., 1942; Tanager Gallery, NYC, 1953; Positano (Italy) Art Workshop, 1956; The Howard Wise Gallery, Cleveland, 1957, 59; The Howard Wise Gallery, NYC, 1960, 63; i Gallery, La Jolla, 1964; Kasha Heman, Chicago, 1964; Columbia, S.C./MA, 1965; Wooster Community Center, Danbury, Conn., 1966; Cornell U. (three-man), 1969; Roko Gallery, 1973; Landmark Gallery, NYC, 1982; Kingsborough Community College, 1987; Meridian (Miss.) Museum of Art, 1988. **Group:** SRGM, Younger American Painters, 1954; Dallas/MFA, 1954; Walker, Vanguard, 1955; Cranbrook, 1958; Carnegie, 1961; Central New York Arts Council Gallery, Utica, N.Y., Four Abstract Artists, 1991. **Collections:** Columbus; Cranbrook. **Bibliography:** Archives.

MITCHELL, JOAN **b.** February 21, 1926, Chicago, Ill. **d.** October 30, 1992, Paris. **Studied:** Smith College, 1942-44; Columbia U.; Chicago Art Institute School, 1944-47, BFA; NYU, 1950, MFA. **Awards:** Chicago/AI, Edward L. Ryerson Travelling Fellowship, 1947; Hon. DFA, Miami U., 1971; Brandeis U., Creative Arts Award, Painting, 1973; Hon. DFA, School of the Art Institute of Chicago; French Ministry of Culture, Award for Painting, 1989; Ville de Paris, Le Grand Prix des Arts (Painting), 1991; Hon. DFA, RISD, 1992. **One-man Exhibitions:** U. of Illinois, 1946 (two-man, with Richard Bowman); St. Paul Gallery, 1950; The New Gallery, NYC, 1952; The Stable Gallery, NYC, 1953, 54, 55, 57, 58, 61, 65; Galerie Neufville, Paris, 1960; B. C. Holland Gallery, 1961; Dwan

Gallery; Southern Illinois U.; Jacques Dubourg, Paris, 1962; Galerie Lawrence, Paris, 1962; Klipstein & Kornfeld, Berne, 1962; MIT, 1962; Galerie Fournier, Paris, 1967, 69, 71, 76, 78, 80, 83, 84, 87, 90; Martha Jackson Gallery, NYC, 1968, 71, 72; Syracuse/Everson, 1972; Ruth S. Schaffner Gallery, Santa Barbara, 1974; Arts Club of Chicago, 1974; Xavier Fourcade, Inc., NYC, 1976, 77, 80, 81, 83, 85, 86; Ruth S. Schaffner Gallery, Los Angeles, 1978; Webb & Parsons, Bedford Village, N.Y., 1978; Paule Anglim Gallery, San Francisco, 1979; Richard Hines Gallery, Seattle, 1980; Gloria Luria Gallery, Bay Harbor Islands, Fla., 1981; Janie C. Lee Gallery, Houston, 1981; Paris/Moderne, 1982; Keny & Johnson Gallery, Columbus, 1986; Manny Silverman Gallery, Los Angeles, 1988; Robert Miller Gallery, NYC, 1989, 90, 91; Barbara Mathes Gallery, NYC, 1990; WMAA, 1992. **Retrospective:** WMAA, 1974. **Group:** U. of Illinois, 1950, 67; WMAA, 1950, 65-66, Annuals, 1967, 73; Chicago/AI; Walker, Vanguard, 1955; Corcoran; Arts Club of Chicago; U. of North Carolina; Minneapolis/Institute; PAFA, 1966; MOMA, Two Decades of American Painting, circ., Japan, India, Australia, 1967; U. of Illinois, 1967; Jewish Museum, 1967; Montclair/AM, The Recent Years, 1969; Carnegie, 1970; VMFA, 1970; MOMA, Younger Abstract Expressionists of the Fifties, 1971; Carnegie, Fresh Air School, circ., 1972; New York Cultural Center, Women Choose Women, 1973; WMAA, American Drawings, 1963-1973, 1973; Indianapolis, 1974; Corcoran, 1975; San Antonio/McNay, American Artist 76, 1976; Albright College, Reading, Pa., Perspective 78, 1978; Buffalo/Albright, American Painting of the 1970s, 1978; Hirshhorn, The Fifties: Aspects of Painting in New York, 1980; Corcoran Biennial, 1981; WMAA Biennial, 1983; Newport Harbor, Action/Precision, 1984; Fort Lauderdale, An American Renaissance: Painting and

Joan Mitchell, *Tilleul*, 1992.

Sculpture Since 1940, 1986; Mount Holyoke College, Prints by Contemporary American Women Artists, circ., 1987; Greenville, Just Like A Woman, 1988; Southampton/Parrish, Drawing on the East End, 1988; Long Island U., Lines of Vision, 1989; Weisbaden, Position of Art in the 20th Century—50 Women Artists, 1990; U. of Florida, Color in Art, 1990; Bunkamura Museum, Shibuya, Tokyo, Four Centuries of Women's Arts, circ., 1990; NAD, 1991; WMAA, Biennial, 1991; Nassau County Museum, Landscape of America, 1991. **Collections:** Arts Club of Chicago; Basel; Buffalo/Albright; Carnegie; Chase Manhattan Bank; Chicago/AI; Ciba-Geigy Corp.; Corcoran; First National Bank of Miami; Fondation Cartier; U. of Georgia; Harvard U.; IBM; MOMA; U. of Michigan; NMAA; Paris/Beaubourg; Phillips; Prudential Insurance Co. of America; Rockefeller Institute; The Singer Company, Inc.; SRGM; U. of Texas; Texwipe Company; USX Corp; Union Carbide Corp.; WMAA; Walker; Worcester/AM; Yale U.. **Bibliography:** Armstrong, Thomas; Ashbery; Baur 5; **Bernstock;** Blesh 1; Downes, ed.; Friedman, ed.; Hunter 1; Hunter, ed.; Johnson, Ellen H.; *Joan Mitchell;* McCoubrey 1; *Metro;* Nordness, ed.; O'Hara 1; Plous; Read 2; Sandler 5; Seuphor 1.

MITCHELL, WALLACE
from 1st to 4th edition.

MOHOLY-NAGY, LASZLO
b. July 20, 1895, Bacsbarsod, Hungary.
d. November 24, 1946, Chicago, Ill.
Studied: U. of Budapest, 1913-14, LL.B.
Taught: Staatliches Bauhaus, Berlin, 1922;
a founding collaborator with Gyorgy
Kepes and Robert Wolff of the Institute of
Design, Chicago, 1938-42; director of the
New Bauhaus, Chicago. Designed for State
Opera and the Piscator Theatre, Berlin,
1928. Traveled Europe extensively. To En-
gland, 1935, where he produced three vol-
umes of photo documents and a film, *Life
of the Lobster*. To USA, 1937. **One-man
Exhibitions:** Amsterdam/Stedelijk; Brno,
Czechoslovakia; Hamburg; Mannheim;
Cologne; Budapest/National; Stock-
holm/National; A.F.A.; The London
Gallery, London, 1937; Houston/Contem-
porary, 1948; Harvard U., 1950; Rose
Fried Gallery, 1950; Colorado Springs/FA,
1950; Zurich, 1953; Kunst Kabinett
Klihm, 1956, 59, 62, 66, 71; Kleeman Gal-
lery, NYC, 1957; New London Gallery,
London, 1961; Düsseldorf, 1961;
Eindhoven, 1967, 72; Brandeis U., 1968;
The Howard Wise Gallery, NYC, 1970;
Galerie Rudolf Zwirner, 1971; Bauhaus-
Archiv, Berlin, 1972; Ileana Sonnabend
Gallery, NYC, 1973; Stephen Wirtz
Gallery, San Francisco, 1978; Bronx
Museum, 1983. **Retrospectives:** SRGM,
1947; Chicago/AI, 1969; Chicago/Con-
temporary, circ., 1969; Stuttgart/WK,
1974. **Group:** WMAA; SRGM; Yale U.;
Harvard U.; MOMA, The Machine as
Seen at the End of the Mechanical Age,
1968, and others. **Collections:** Chi-
cago/AI; Dayton/AI; Detroit/Institute;
Jacksonville/AM; Los Angeles/County
MA; MOMA; SFMA; SRGM. **Bibliogra-
phy:** Barr 1; Battcock, ed.; Bihalji-Merin;
Blanchard; Calas, N. and E.; Cassou;
Craven, W.; Davis, D.; *Europa/Amerika;*
Frost; Giedion-Welcker 2; Goodrich and
Baur 1; Hulten; Huyghe; Janis and Blesh 1;
Janis, S.; **Kostelanetz;** Krauss 3; Lane and
Larsen; Langui; Licht, F.; MacAgy 2;
Moholy-Nagy, L., 1, 2; **Moholy-Nagy, S.,**

1, 2; Morris; Motherwell 1; Murken-
Altrogge; Ramsden 1; Read 3; Roters;
Rowell; Selz, J.; Seuphor 3; Tomkins;
Trier 1; Valentine 2; Waldman 4;
Weitemeir; Weller; Wingler, ed. Archives.

MOLLER, HANS **b.** March 20,
1905, Wuppertal-Barmen, Germany.
Studied: Art School, Barmen, 1919-27;
Academy of Fine Arts, Berlin, 1927-28; To
USA, 1928; US Citizen, 1944. **Taught:**
Cooper Union, 1944-56. **Member:** Federa-
tion of Modern Painters and Sculptors.
Commissions: William Douglas
McAdams, Inc., NYC (mural); Percival
Goodman, Architect; tapestry design for
synagogue ark curtains; A.F.A./Stained
Glass Industry (stained-glass window);
Christ Church, Washington, D.C. (stained-
glass windows), 1968. **Awards:** Art Direc-
tors Club, NYC, Distinctive Merit Award,
1944, 55, 56; Corcoran, Hon. Men.,
1949; American Institute of Graphic Art,
Certificate of Excellence, 1949 (2), 51; Na-
tional Religious Art Exhibition, Detroit,
First Prize, 1964; Audubon Artists Annual,
Salmagundi Club Award, 1967; NAD,
Edwin Palmer Memorial Prize, 1968,
1980; NAD, Samuel F.B. Morse Gold
Medal, 1969; Audubon Artists, Murray
Kupferman Prize, 1973; NAD, Andrew
Carnegie Prize, 1974, 85; AAAL, Childe
Hassam Fund, 1976; Youngstown/Butler,
1st Prize, 1978; Audubon Artists, Nicholas
Peal Memorial Award, 1985; Aububon
Artists, Gold Medal of Honor, 1992.
Address: 2207 Allen Street, Allentown, PA
18104; summer: Monhegan, ME 04852.
Dealer: Midtown-Payson Galleries, NYC.
One-man Exhibitions: (first) Bonestell
Gallery, NYC, 1942, also 1943; Arts Club
of Chicago, 1945; U. of Michigan, 1945;
Kleeman Gallery, NYC, 1945, 47, 49, 50;
Pen and Palette Gallery, St. Louis, 1949;
Macon, Ga. 1949; Atlanta/AA, 1950;
Grace Borgenicht Gallery, NYC, 1951, 53,
54, 56; Fine Arts Associates, NYC, 1957,
60; Albert Landry, NYC, 1962; The Mid-
town Galleries, NYC, 1964, 67, 70, 73,

76, 79, 81, 84, 87; Philadelphia Art Alliance, 1968; Allentown/AM, 1969; Norfolk, 1970; Muhlenberg College, 1977; Hunterdon Art Center, Clinton, N.J., 1978; Northeastern Pennsylvania Art Alliance, 1980. **Retrospectives:** The Olsen Foundation Inc., Leetes Island, Conn., Hans Moller, 1926-56, circ., 1956-64; Lehigh U., 1977. **Group:** MMA; Brooklyn Museum; PAFA; Chicago/AI; The Print Club, Philadelphia; Des Moines; Detroit/Institute; Corcoran; U. of Illinois; Walker; Buffalo/Albright; SFMA; Colby College, 100 Artists of the 20th Century, 1964; WMAA Annual, 1965 (and others); NAD Annuals, 1965, 67, 68, 69; Federation of Modern Painters and Sculptors, 1966, 67; NIAL, 1969; Minnesota/MA, Drawings USA 75, 1976; Art USA, New York, 1959. **Collections:** Allentown/AM; Bennington College; Bowdoin College; Brooklyn Museum; Canberra/National; Container Corp. of America; Detroit/Institute; U. of Georgia; Hirshhorn; IBM; MMA; MOMA; U. of Maine; Melbourne/National; MetaMold Aluminum Co.; U. of Minnesota; NAD; NYPL; NYU; Norfolk; PAFA; Phillips; Princeton U.; Sacred Heart Seminary; Society of the Four Arts; Spelman College; U. of Texas; USIA; U.S. Rubber Co.; VMFA; WMAA; Walker; Washington U.; Wesleyan U.; Wichita/AM; Wuppertal; Yellowstone Art Center; Youngstown/Butler. **Bibliography:** Baur 5; Cummings 4; Genauer.

MOORE, JOHN b. April 25, 1941, St. Louis, Missouri. **Studied:** Washington U., 1962-66, BFA, with A. Osver, E. Boccia, B. Schactman; Yale U., 1966-68; MFA, with B. Chaet, J. Tworkov, L. Anderson. Traveled France, Spain, Italy. **Taught:** Tyler School of Art, Philadelphia, 1968-80, 83-86; Skowhegan School, 1974, 80, 84; U. of California, Berkeley, 1981-82; Temple U., 1982-88; Boston U., 1988-. **Commissions:** Poster for Lincoln Center, NYC, 1977; John Hancock Building, Boston, 1985; Smith Kline Co., Philadelphia,

1986; Becton-Dickson, N.J., 1986. **Awards:** National Endowment for the Humanities, grant, 1966; John F. Milliken Foreign Travel Fellowship, 1968; Schless Memorial Prize, Yale U., 1968; AAAL, Hassam Award, 1973; National Endowment for the Arts, 1982, 91. **Address:** 30 Clarendon Street, Boston, MA 02116. **Dealer:** Hirschl & Adler Modern, NYC. **One-man Exhibitions:** Princeton U., 1970; Fischbach Gallery, NYC, 1973, 75, 78, 80; PAFA, 1973; David Gallery, Pittsfield, N.Y., 1974; Vick Gallery, Philadelphia, 1974; Alpha Gallery, Boston, 1974; Dart Gallery, Chicago, 1977; Vick, Klaus, Rosen Gallery, Philadelphia, 1977; U. of Missouri, 1978; Marion Locks Gallery, Philadelphia, 1979; College of William and Mary, 1981; Capricorn Gallery, Washington, D.C., 1981; Niagara U., 1983; Hirschl & Adler Modern, NYC, 1983, 85, 90; Boston U., 1989; Sala Nonell, Barcelona, 1990. **Group:** U. of Rhode Island, From Life, 1971; Potsdam/SUNY, New Realism, 1971; U. of Illinois, 1974; Queens Museum, New Images in American Painting, 1974; Minnesota/MA, Drawings U.S.A., '75, 1975; Akron/AI, Contemporary Images in Watercolor, 1976; U. of North Carolina, Art on Paper, 1976; Chicago/AI, Drawings of the 70s, 1977; William and Mary College, American Realism, 1978; Kent State U., Still Life, 1980; Tulsa/Philbrook, Realism/Photorealism, 1980; PAFA, Contemporary American Realism Since 1960, 1981; San Antonio/MA, Real, Really Real, Super Real, circ., 1981; MMA, Aspects of the City, 1984; Isetan Museum of Art, Tokyo, American Realism: The Precise Image, 1985; Minnesota/MA, American Landscape, 1983; Miyagi Museum of Art, Sendai, Japan, American Realism and Figurative Art, 1952-1990, circ., 1992. **Collections:** American Can Corp.; Arizona State U.; AT&T; Boston/MFA; CIGNA; Chase Manhattan Bank, NYC; Commerce Bank of Kansas City; Dartmouth College; First National Bank, Houston; Hallmark

Collection; IBM Corp.; John Hancock; Lehman Brothers, NYC; MMA; U. of Massachusetts; Minnesota/MA; PAFA; PMA; Purchase/SUNY; RISD; SFMA; San Antonio/McNay; Smith College; Yale U. **Bibliography:** Arthur 3; Ward.

MORIN, THOMAS
from 1st to 4th edition.

MORLEY, MALCOLM **b.** 1931,
London, England. **Studied:** Camberwell School of Arts and Crafts, London, 1953; Royal College of Art, London, 1957; Yale U., MFA. **Taught:** Ohio State U., 1965, 66; School of Visual Arts, NYC, 1967-69; Stony Brook/SUNY, 1971. **Awards:** Tate Gallery, Turner Prize, 1984. **Address:** 224 Beaver Dam Road, Brookhaven, NY 11719. **Dealer:** Mary Boone Gallery, NYC. **One-man Exhibitions:** The Kornblee Gallery, 1967, 69; Stefanotti Gallery, NYC, 1973, 74; Galerie Gerald Piltzer, Paris, 1973; The Clocktower, NYC, 1976, 79; Galerie Jurka, Amsterdam, 1977; Nancy Hoffman Gallery, NYC, 1979; Susanne Hilberry Gallery, Birmingham, Mich., 1979; Hartford/Wadsworth, 1980; Xavier Fourcade, Inc., NYC, 1981, 82, 84, 86; Akron/AM, 1981; Ponova Gallery, Inc., Toronto, 1984; Galerie Nicoline Pon, Zurich, 1984; Fabian Carlsson Gallery, London, 1985; Carnegie, 1985; Pace Editions, 1986; Temperance Hall Gallery, Bellport, N.Y., 1988; The Pace Gallery, NYC, 1988, 91; Bonnefantemuseum, Maastricht, 1991; Basel/Kunsthalle, 1991; Tate/Liverpool, circ., 1991; Wildenstein & Co., NYC, 1992; Anthony D'Offay Gallery, London, 1990. **Retrospective:** Whitechapel, London, circ., 1983. **Group:** SRGM, The Photographic Image, 1966; IX São Paulo Biennial, 1967; Vassar College, Realism Now, 1968; Akron/AI, Directions 2: Aspects of a New Realism, 1969; Riverside Museum, NYC, Paintings from the Photo, 1969; WMAA, 22 Realists, 1970; Princeton U., American Art Since 1960,

Malcolm Morley, *The Boat, the Knight, and the Tank,* 1990.

1970; Kassel, Documenta V and VI, 1972, 77; Wurttemburgischer Kunstverein, Amerikanischer Fotorealismus, 1972; Serpentine Gallery, London, Photo-Realism, 1973; Akademie der Kunste, Berlin, SoHo, 1976; Royal Academy of Arts, London, British Painting 1952-1977, 1977; Zurich, Painting in the Age of Photography, 1977; Canberra/National, Illusion of Reality, 1977; Oklahoma, Cityscape, 78, 1978; Royal Academy, London, A New Spirit in Painting, 1981; Akron/AM, The Image in American Painting and Sculpture, 1981; Indianapolis, 1982; Internationale Kunstausstellung Berlin, 1982; Houston/Contemporary, American Still Life, 1945-1983, 1983; Tate Gallery, New Art, 1983; MOMA, International Survey of Painting and Sculpture, 1984; Carnegie, International, 1985; Royal Academy of Arts, London, British Art in the 20th Century, 1987; Youngstown/Butler, Midyear,

1988; Los Angeles/MOCA, Constructing a History, 1989. **Collections:** Aachen/NG; Chicago/Contemporary; Cologne/NG; Detroit/Institute; Fordham U.; Hartford/Wadsworth; Hirshhorn; Humlebaek/Louisiana; MMA; MOMA; The Ohio State U.; Paris/Moderne; Utica; Utrecht; Victoria and Albert Museum. **Bibliography:** Alloway, 4; *Amerikanischer Fotorealismus;* Honisch and Jensen, eds.; Hughes; Joachimides and Rosenthal; Johnson, Ellen H.; *Kunst um 1970;* Lindy; Lucie-Smith; Murken-Altrogge; Robins; Sager; Sandler 3; Schwartz 1; Seitz 3; Ward.

MORRIS, CARL b. May 12, 1911, Yorba Linda, Calif. d. June 3, 1993, Portland, Ore. **Studied:** Fullerton Junior College, 1930-31; Chicago Art Institute School; Kunstgewerbeschule, Vienna, 1933-34. Traveled Italy. **Taught:** ASL, 1937-38; privately 1940-41; U. of Colorado, summer, 1957. Federal A.P.: Director at Spokane, Wash., 1938-39. **Commissions** (murals): US Post Office, Eugene, Ore., 1941-42; Hall of Religion, Oregon Centennial Exposition, Portland, 1959. **Awards:** Austro-American Scholarship, 1935; Institute of International Education Fellowship (Paris), 1935-36; Werkbund Scholarship, 1939, Seattle/AM, Hon. Men., 1939, 46, 47; Seattle/AM, Second Prize, 1943; Denver/AM, P.P., 1946; Seattle/AM, Margaret E. Fuller Award, 1946; SFMA, Anne Bremer Memorial Prize, 1946; Pepsi-Cola Bronze Medal, 1948; SFMA, James D. Phelan Award, 1950; U. of Illinois, P.P., 1958; Distinguished Service Award, Oregon Health Science U., 1987; Oregon Governor's Award, 1985. **One-man Exhibitions:** (first) Fondation des États-Unis, Paris, 1935; Paul Elder Gallery, San Francisco, 1937; Seattle/AM, 1940; Portland, Ore./AM, 1946, 52, 55; California Palace, 1947; U. of Oregon, 1947; Opportunity Gallery, NYC, 1948; Santa Barbara/MA, 1956; Zivile Gallery, Los Angeles, 1956; Mills College, 1956; Rotunda Gallery, San Francisco, 1956; Kraushaar Galleries, NYC, 1956, 57, 58, 61, 64, 67, 73, 89; Reed College, 1959, 69 (two-man, with Hilda Morris), 1972; U. of Colorado, 1957; Fountain Gallery, Portland, Ore., 1963, 64, 65, 69, 71, 75; Feingarten Gallery, San Francisco, 1965; Triangle Art Gallery, San Francisco, 1966, 68, 70, 73; Gordon Woodside Gallery, Seattle, 1966, 69, 73. **Retrospective:** A.F.A./Ford Foundation, circ., 1960. **Group:** Chicago/AI; Carnegie; Corcoran; MMA; WMAA; SRGM; Younger American Painters, 1954; III São Paulo Biennial, 1955; Colorado Springs/FA, 1965; Denver/AM, 1965, Art in the USA, 1965; Tamarind Lithography Workshop, 1967; PAFA, 1969; SFMA, Tamarind, 1969; MOMA, Tamarind: Homage to Lithography, 1969; Minnesota/MA, Drawings USA, 1971; NCFA, Art of the Pacific Northwest, 1974; NAD, 1974; Seattle/AM, Northwest Traditions, 1978; Portland (Ore.)/AM, Faces, Figures, Gestures and Signs, 1990; Seattle/AM, Views and Visions in the Pacific Northwest, 1990. **Collections:** Allentown/AM; Buffalo/Albright; California Palace; Chicago/AI; Colorado Springs/FA; U. of Colorado; Columbus; Corcoran; Dayton/AI; Denver/AM; Eastern Oregon College; Hartford/Wadsworth; Houston/MFA; Hirshhorn; U. of Illinois; Kansas City/Nelson; MMA; Mead Corporation; Michigan State U.; Mills College; Minnesota/MA; NCFA; Norfolk/Chrysler; U. of Oregon; City of Portland, Ore.; Portland, Ore./AM; Portland State College; Reed College; U. of Rochester; SFMA; SRGM; Santa Barbara/MA; São Paulo; Seattle/AM; Southern Oregon College; Stanford U.; U. of Texas; Toronto; Utah State U.; Utica; WMAA; Walker; Wichita. **Bibliography:** *Art of the Pacific Northwest;* Monte and Tucker; Nordness, ed.; *Northwest Traditions;* Pousette-Dart, ed.; Read 2.

MORRIS, GEORGE L. K.
b. November 14, 1905, NYC. **d.** June 26, 1975, Stockbridge, Mass. **Studied:** Groton

School, 1924; Yale U., 1928, BA; ASL, with John Sloan, Kenneth Hayes Miller; Academie Moderne, Paris, with F. Leger, Amedee Ozenfant. Traveled around the world and spent much time in Paris. **Taught:** ASL, 1943-44; St. John's College, Annapolis, Md., 1950-61. Editor: Yale Literary Magazine, 1928; *The Miscellany,* 1929-31; *Plastique, Paris,* 1937-39; *Partisan Review,* 1937-43. **Member:** American Abstract Artists (a founder, 1936, and president, 1948-50); Federation of Modern Painters and Sculptors; NAD, Saltus Gold Medal, 1973. **Commissions:** Lenox (Mass.) Elementary School (mosaic). **Awards:** Pepsi-Cola, 1948; Pittsfield/Berkshire, Berkshire Hills Award, 1963; PAFA, Joseph E. Temple Gold Medal, 1965. **One-man Exhibitions:** (first) Valentine Dudensing Gallery, 1933; Pittsfield/Berkshire, 1933; Museum of Living Art, NYC, 1935; Passedoit Gallery, NYC, 1938; The Downtown Gallery, 1943, 44, 50, 64, 67; Galerie Colette Allendy, Paris, 1946; The Alan Gallery, NYC, 1955; Montclair/AM, 1971; Jacksonville/Cummer, 1973; Chattanooga/AA, 1973; Charleston/Carolina, 1973; Hirschl & Adler Galleries, NYC, 1974, 79; Daytona Beach, 1973; NIAL, 1975; Williams College, 1992. **Retrospectives:** ICA, Washington, D.C., 1958; Sharon (Conn.) Creative Arts Foundation; Century Association; Corcoran; Pittsfield/Berkshire; Hirschl & Adler Galleries, NYC, 1971. **Group:** WMAA; American Abstract Artists, annually; Salon des Réalites Nouvelles, Paris; MOMA; SRGM; Chicago/AI; SFMA; Rome/Nazionale. **Collections:** Brandeis U.; Brooklyn Museum; Chattanooga/AA; Corcoran; Dallas/MFA; Darmstadt/Kunsthalle; U. of Georgia; High Museum; Honolulu Academy; U. of Illinois; MMA; Madison Square Garden; U. of Michigan; Montclair/AM; U. of Oklahoma; PAFA; PMA; Phillips; Pittsfield/Berkshire; Portland, Ore./AM; Raleigh/NCMA; Syracuse U.; Utica; WMAA; Wichita/AM; Yale U. **Bibliography:** American Abstract Artists,

ed.; Armstrong, Thomas; Arp; Baur 7; Biederman 1; Blanchard; Blesh 1; Cheney; Flanagan; Frost; Kootz 2; Lane and Larsen; Marter, Tarbell, and Wechsler; McCurdy, ed.; **Morris;** Newmeyer; Pagano; Pearson 2; Pousette-Dart, ed.; Read 2; Ritchie 1; Rose, B., 1, 4; Seuphor 1, 3; "What Abstract Art Means to Me." Archives.

MORRIS, KYLE
from 1st to 4th edition.

MORRIS, ROBERT **b.** February 9, 1931, Kansas City, Mo. **Studied:** Kansas City Junior College; Kansas City Art Institute, 1948-50; U. of Kansas City; San Francisco Art Institute; Reed College, 1953-55; Hunter College, MA, 1966. US Army Engineers, 1951-52. Traveled USA, Orient, Europe. **Taught:** Hunter College, 1967-. **Commissions:** National Planning Commission, Ottawa, Earth Project. **Awards:** National Council on the Arts, P.P.; Chicago/AI, 1966; SRGM, 1967; Torcuato di Tella, Buenos Aires, 1967; Guggenheim Foundation Fellowship, 1969; Skowhegan Medal of Progress and Environment, 1978. **Address:** No. Mountain Road, Gardiner, NY 12525. **Dealers:** Leo Castelli Inc., NYC; Sonnabend Gallery, NYC. **One-man Exhibitions:** (first) Dilexi Gallery, San Francisco, 1957, also 1958; Green Gallery, NYC, 1963, 64, 65; Galerie Schmela, 1964; Dwan Gallery, Los Angeles, 1966; Leo Castelli Inc., NYC, 1967, 68, 69, 70, 72, 74, 76 (two-man), 79, 80, 83, 85, 88, 90; Eindhoven, 1968; Ileana Sonnabend Gallery, Paris, 1968, 71, 73, 77, NYC, 1974, 76, 79, 83, 85, 88, 91; Corcoran, 1969, 77; Gian Enzo Sperone, Turin, 1969; Irving Blum Gallery, Los Angeles, 1969, 70; Tate, 1971; Konrad Fischer Gallery, Düsseldorf, 1973; Max Protetch Gallery, Washington, D.C., 1973; Galleria Forma, Genoa, 1973; Modern Art Agency, Naples, 1973; ICA, U. of Pennsylvania, 1974; Galerie Art in Progress, Munich, 1974; Belknap Park, Grand Rapids, 1974; Alessandro Ferranti Gallery,

Rome, 1975; Humlebaek/Louisiana, 1977; Williams College, 1977; Portland (Ore.) Center for the Visual Arts, 1977; Amsterdam/Stedelijk, 1977; Galerie Art in Progress, Düsseldorf, 1977; Swarthmore College, 1978; Beaver College, 1978; Ferrara/Moderna, 1978; Wright State U., 1979; Chicago/AI, 1980; Richard Hines Gallery, Seattle, 1980; Waddington Gallery, London, 1980; Houston/Contemporary, 1981, 84; Williamstown/Clark, circ., 1982; U. of Illinois, 1983; Galerie Daniel Templon, Paris, 1983, 86, 88; Malmo, 1984; Galerie Nordenhake, Malmo, 1984; Padiglione d'Arte Contemporanea, Milano, 1984; Portland (Ore.) Center for the Visual Arts, 1984; Chicago/Contemporary, 1986; Margo Leavin Gallery, Los Angeles, 1988; NYU, 1989; Lang & O'Hara Gallery, NYC, 1990; JGM Galerie, Paris, 1990; Runkel-Hue-Williams Gallery, London, 1990; Corcoran, 1990; 65 Thompson Street, NYC, 1991; Bellas Artes, Santa Fe, 1991. **Retrospectives:** WMAA, 1970; Detroit/Institute, 1970. **Group:** Hartford/Wadsworth, Black, White and Gray, 1964; WMAA, Young America, 1965; ICA, U. of Pennsylvania, The Other Tradition, 1966; Jewish Museum, Primary Structures, 1966; WMAA, Contemporary American Sculpture, Selection 1, 1966; Chicago/AI, 1966; Walker, 1966; WMAA Sculpture Annuals, 1966, 68, 70; Detroit/Institute, Color, Image and Form, 1967; Los Angeles/County MA and PMA, American Sculpture of the Sixties, 1967; MOMA, The 1960's, 1967; Torcuato di Tella, Buenos Aires, 1967; Eindhoven, 1967; SRGM, Guggenheim International, 1967, 71; Buffalo/Albright, 1968; The Hague, Minimal Art, 1968; Foundation Maeght, 1968; MOMA, The Art of the Real, 1968; PMA, 1968; ICA, U. of Pennsylvania, 1969; Berne, When Attitudes Become Form, 1969; Walker, 14 Sculptors: The Industrial Edge, 1969; Indianapolis, 1969; WMAA, Anti-Illusion: Procedures/Materials, 1969; Hayward Gallery, London, Pop Art, 1969; MOMA, Spaces,

1969; MMA, New York Painting and Sculpture, 1940-1970, 1969-70; New School for Social Research, American Drawings of the Sixties, 1970; Boston U., American Artists of the Nineteen Sixties, 1970; Cornell U., Earth Art, 1970; Cincinnati/Contemporary, Monumental Art, 1970; ICA, U. of Pennsylvania, Against Order: Chance and Art, 1970; MOMA, Information, 1971; Kunsthalle, Nurnberg, Artist-Theory-Work, 1971; Buffalo/Albright, Kid Stuff, 1971; Düsseldorf/Kunsthalle, Prospect '71, 1971; Dublin/Municipal, International Quadrennial (ROSC), 1971; Chicago/Contemporary, Six Sculptors, 1971; Los Angeles/County MA, Art & Technology, 1971; Rijksmuseum Kröller-Müller, Diagrams and Drawings, 1972; New York Cultural Center, 3D into 2D, 1973; Parcheggio di Villa Borghese, Rome, Contemporanea, 1974; Princeton U., Line as Language, 1974; MIT, Interventions in Landscapes, 1974; Cologne/Kunstverein, Kunst uber Kunst, 1974; CNAC, Art/Voir, 1974; Düsseldorf/Kunsthalle, Surrealist-Bildrealitat: 1924-1974, 1974; Ackland, Light/Sculpture, 1975; Leverkusen, Drawings 3: American Drawings, 1975; MOMA, Drawings Now, 1976; ICA, U. of Pennsylvania, Improbable Furniture, 1977; Chicago/AI, Drawings of the 70's, 1977; U. of Chicago, Ideas in Sculpture, 1977; Kansas City/AI, Project Drawings, 1978; Ontario, Structures for Behaviour, 1978; WMAA, Art About Art, 1978; Düsseldorf/Kunsthalle, About the Strange Nature of Money, circ., 1978; ICA, Boston, The Reductive Object, 1979; Milwaukee, Emergency & Progression, circ., 1979; U. of North Carolina, Drawings About Drawing Today, 1979; P.S. 1, Long Island City, A Great Big Drawing Show, 1979; Brooklyn Museum, American Drawing in Black and White: 1970-1979, 1980; Exposition Société des Artistes Indépendents, Paris, 1980; ICA, Boston, Drawing/Structures, 1980; ICA, U. of Pennsylvania, Drawings: The Pluralist Decade, 1980;

Purchase/SUNY, Hidden Desires, 1980; XXXIX Venice Biennial, 1980; AAIAL, 1981; Hirshhorn, Metaphor, New Projects by Contemporary Sculptors, 1981; Purchase/SUNY, Soundings, 1981; Centre d'Arts Plastiques Contemporains, Bordeaux, Art Povera, Antiform: Sculptures 1966-69, 1982; Internationale Kunstausstelung Berlin, 1982; Tate Gallery, New Art, 1983; WMAA, Twentieth Century Sculpture: Process and Presence, 1983; Hirshhorn, Content: A Contemporary Focus, 1974-1984, 1984; Hirshhorn, Dreams and Nightmares, 1984; WMAA, Blam!, 1984; MOMA, New Work on Paper 3, 1985; U. of Chicago, Large Scale Drawings by Sculptors, 1985; Seattle/AM, States of War, 1985; Bard College, The Maximal Implications of the Minimal Line, 1985; Bordeaux/Contemporain, Art Minimal I, 1985; Brown U., Definitive Statements, 1986; Fort Lauderdale, An American Renaissance, 1986; RISD, Visions of the Apocalypse, 1988; Bordeaux/Contemporain, Art Conceptuel, 1988; Milwaukee, 1988: The World of Art Today, 1988; MOMA, Committed to Print, 1988; Cologne/Ludwig, Marcel Duchamp und die Avant-Garde Zeit 1950, 1988; U. of Rhode Island, Aquarian Artists, 1990; Indianapolis, Power: Its Myths and Mores in American Art, 1961-1991, 1991. **Collections:** Dallas/MFA; Detroit/Institute; Hartford/Wadsworth; Melbourne/National; Milwaukee; National Gallery of Victoria, Melbourne; Oberlin College; Ottawa/National; Pasadena/AM; Stockholm/National; Tate; WMAA; Walker. **Bibliography:** *Art Now 74;* Alloway 4; Battcock, ed.; Calas 2; Calas, N. and E.; Celant; *Contemporanea;* Danto; Davis, D.; Day 1; *Drawings; Europa/Amerika;* Fox; Kardon 3; *Drawings The Pluralist Decade;* De Vries, ed.; De Wilde 2; Friedman, M., 2; Friedman and van der Marck; Fry and Kuspit; Gablik; Goossen 1; *Happening & Fluxus;* Haskell 5; Honisch and Jensen, eds.; Honnef; Hunter, ed.; Joachimides and Rosenthal; Johnson, Ellen H.; Krauss 2, 3; Kozloff 3; *Kunst um 1970;* Lippard 3, 4, 5; Lippard, ed.; Lucie-Smith; Meyer; Muller; *Report;* Rowell; Russell and Gablik; Robins; Sandler 3, 5; Seitz 3; Siegel; Trier 1; Tuchman 1; Waldman 4; Weintraub; *When Attitudes Become Form.* Archives.

MOSKOWITZ, ROBERT b. June 20, 1935, NYC. **Studied:** Pratt Institute, NYC. **Address:** 81 Leonard Street, NYC 10013. **Dealer:** Blum Helman Gallery, NYC. **One-man Exhibitions:** Leo Castelli Inc., NYC, 1962; French & Co., NYC, 1970; MIT, 1971; Nancy Hoffman Gallery, NYC, 1973, 74; The Clocktower, NYC, 1977; Daniel Weinberg Gallery, San Francisco, 1979, 80; Margo Leavin Gallery, Los Angeles, 1979, 80; Walker, 1981; Basel/Kunsthalle, 1981; Blum Helman Gallery, NYC, 1983, 86, 88, 92; Portland (Ore.) Center for the Visual Arts, 1983; MIT (two-man), 1985; U. of California, Berkeley, 1986; Toronto, 1989; Hirshhorn, circ., 1989; David Grob Gallery, London, 1991. **Group:** MOMA, The Art of Assemblage, circ., 1961; Buffalo/Albright, Mixed Media and Pop Art, 1963; Brandeis U., New Directions in American Painting, 1963; Oakland/AM, Pop Art USA, 1963; Hartford/Wadsworth, Black, White and Grey, 1964; WMAA, A Decade of American Drawings, 1955-1965, 1965; WMAA, Artists Under Forty, 1968; WMAA Annual, 1969; WMAA Biennials, 1973, 79, 81; WMAA, New Image Painting, 1978; Buffalo/Albright, American Painting of the 1970s, circ., 1978; U. of Chicago, Visionary Images, 1979; NYU, American Painting: The Eighties, 1979; XXXIX Venice Biennial, 1980; Indianapolis, 1980; MIT, Great Big Drawings, 1982; Chicago/AI, American, 1982; Palacio de Velazquez, Madrid, Tendencias en Nueva York, circ., 1983; MOMA, International Survey of Recent Painting and Sculpture, 1984; Hirshhorn, Content, 1984; Brooklyn Museum, Monumental Drawings, 1986. **Collections:** Ashville Art Museum;

Bennington College; Brandeis U.; Buffalo/Albright; U. of California, Berkeley; Chicago/Contemporary; Denver/AM; Hartford/Wadsworth; La Jolla; Los Angeles/MOCA; MOMA; Minneapolis/Institute; NYU; Omaha/Joslyn; PMA; Paine Webber; SRGM; Seattle/AM; WMAA. **Bibliography:** Hiromoto.

MOTHERWELL, ROBERT

b. January 24, 1915, Aberdeen, Wash.
d. July 16, 1991, Provincetown, Mass.
Studied: Stanford U., 1932-37, AB (philosophy); California School of Fine Arts, ca. 1935; Harvard U., 1937-38; U. of Grenoble, summer, 1938; Columbia U., 1940-41; primarily self-taught in art. Traveled extensively, USA, Europe, Mexico.
Taught: Hunter College, 1951-57; Columbia U., 1964-65; lectured extensively in American universities and museums. Series of paintings *Elegy to Spanish Republic* began 1947. Cofounder of a school, "Subject of the Artist," with William Baziotes, Barnett Newman, and Mark Rothko, NYC, 1948. Art Director, *Partisan Review,* 1962-65. Director, *Documents of Modern Art,* NYC, and *Documents of 20th Century Art.* **Member:** NIAL. **Commissions:** John F. Kennedy Federal Office Building, Boston, 1966; Stanford U., 1975; U. of Iowa; National Gallery, mural, 1978. **Awards:** IV Guggenheim International, 1964 ($2,500); Grande Medaille de Vermeil de la Ville de Paris, 1978; PAFA, Gold Medal of Honor, 1979; Skowhegan School, Medal for Printmaking, 1981; National Arts Club, Gold Medal of Honor, 1983; MacDowell Colony Medal, 1985. **One-man Exhibitions:** (first) Raymond Duncan Gallery, Paris, 1939; Art of This Century, NYC, 1944; Arts Club of Chicago, 1946; The Kootz Gallery, NYC, 1946, 47, 49, 52; SFMA, 1946, 67; New London, 1953; Sidney Janis Gallery, 1957, 59, 61, 62; Bennington College, 1959; John Berggruen Gallery, Paris, 1961, San Francisco, 1973; São Paulo, 1961; Pasadena/AM, 1962; Galle-

ria Odyssia, Rome, 1962; Galerie der Spiegel, Cologne, 1962; Smith College, 1963; MIT, 1963; Galerie Schmela (two-man, with Conrad Marca-Relli); Duke U., 1965; Walker, 1965, 72, 74; College of St. Benedict, 1965; U. of Utah, 1966; Witte, 1966; U. of South Florida, 1966; Baltimore/MA, 1966; Indiana U., 1966; Amsterdam/Stedelijk, 1966; Whitechapel Art Gallery, London, 1966; Essen, 1966; Turin/Civico, 1966; WMAA, 1968; VMFA, 1969; Toledo/MA, 1969; Marlborough-Gerson Gallery Inc., 1969; David Mirvish Gallery, 1970, 73; Gallerie im Erker, St. Gallen, Switzerland, 1971; Kunstverein, Freiburg, 1971; Dayton's Gallery 12, Minneapolis, 1972; Lawrence Rubin Gallery, NYC, 1972, 73; MMA, 1972; U. of Iowa, 1972; Fendrick Gallery, 1972; Houston/MFA, 1972; Gertrude Kasle Gallery, 1972; Cleveland/MA, 1973; Princeton U., 1973; Current Editions, Seattle, 1973; Hartford/Wadsworth, 1973; Knoedler Contemporary Art, 1974, 75, 76, 78, 80; Brooke Alexander, NYC, 1974, 76, 79; Otis Art Institute, 1974; Museum of Modern Art, Mexico City, 1975; Janie C. Lee Gallery, Houston, 1976, 79; Watson/de Nagy, Houston, 1977, 79; Galerie André Emmerich, Zurich, 1977; Diane Gilson Gallery, Seattle, 1977, 79; Graphics 1 & Graphics 2, Boston, 1977; Hanson-Cowles Gallery, Minneapolis, 1977; Knoedler Gallery, London, 1978; Douglas Drake Gallery, Kansas City, Mo., 1978; Alice Simsar Gallery, Ann Arbor, 1978; U. of Connecticut, 1979; Ehrlich Gallery, NYC, 1979; Wichita State U., 1979; Galerie Veith Turske, Cologne, 1979; 2RC, Rome, 1979; U. of Missouri, 1979; Galerie Ponce, Mexico City, 1979; Gump's Gallery, San Francisco, 1979, 88; Peter M. David Gallery, Minneapolis, 1979; West Coast Gallery, Newport Beach, 1979; Centre Cultural de la Caixa de Pensions, Barcelona, 1980; M. Knoedler & Co., Inc., NYC, 1981, 82, 83, 86, 87, 88, 89, 91; Turske Fine Art, Cologne, 1981; M. Knoedler, Zurich,

1983; Albany/SUNY, 1984; L. A. Louver Gallery, Los Angeles, 1984; Harcourts Gallery, San Francisco, 1984, 89; Dolan/Maxwell Gallery, Philadelphia, 1984; Marianne Friedland Gallery, Toronto, 1985; Fort Worth, 1985; Walker, circ., 1985; The Century Association, 1987; Galerie Joan Prats, Barcelona, 1986, 89; Palau Solleric, Palma de Mallorca, Spain, 1986; Heland Thorden Wetterling Galleries, Stockholm, 1987, 91; Galerie Alice Pauli, Lausanne, 1988; Provincetown Art Association, 1988; Cooper Union, NYC, 1988; Jerald Melberg Gallery, Charlotte, N.C.; Greg Kucera Gallery, Seattle, 1988; Associated American Artists, NYC, 1988, 89, 90, 91, 92; Marisa del Re Gallery, NYC, 1989; Padiglione d'arte Contemporanea, Milan, 1989; Marion Locks Gallery, Philadelphia, 1989, 92; Waddington Graphics, London, 1989; Randall Beck Gallery, Boston, 1990; Artcurial, Paris, 1990; Mexico City/Tamayo, circ., 1991. **Retrospectives:** Düsseldorf/Kunsthalle, circ., 1976, prints, circ., 1977; Phillips, 1965; MOMA, 1965-66; U. of Connecticut, 1979; MOMA & AFA, circ., 1980; Buffalo/Albright, circ., 1983. **Group:** Venice Biennial; São Paulo Biennial; WMAA Annuals; Brussels World's Fair, 1958; American Painting and Sculpture, Moscow, 1959; Kassel, Documenta II & III, 1959, 64; Tate, Dunn International, 1964; Tate, Gulbenkian International, 1964; U. of Illinois, 1967; Winnipeg Art Gallery, 1967; Chicago/AI Annuals; Boston Arts Festival; ICA, Boston, 1968; Carnegie, 1968, and others; MOMA, The New American Painting and Sculpture, 1969; Edmonton Art Gallery, Alberta, Masters of the Sixties, 1972; VMFA, Twelve American Painters, 1974; Corcoran Biennial, 1975; Minnesota/MA, American Drawings, 1927-1977, circ., 1977; National Gallery, American Art at Mid-Century, 1978; Cornell U., Abstract Expressionism: The Formative Years, 1978; Montclair College, American Masters, 1979; Claremont College, Black and White Are Colors, 1979;

Corcoran, Gesture on Paper, 1980; Brooklyn Museum, American Drawings in Black and White, 1970-1979, 1980; Hirshhorn, The Fifties: Aspects of Painting in New York, 1980; Nassau County Museum, The Abstract Expressionists and Their Precursors, 1981; Scottish Arts Council & International Council of MOMA, American Abstract Expressionists, 1981; SRGM, The New York School: Four Decades, 1982; Youngstown/Butler, Midyear Show, 1983; IEF, Twentieth Century American Drawings: The Figure in Context, circ., 1984; ICI, NYC, After Matisse, circ., 1986; Newport Harbor, The Interpretive Link, circ., 1986; Purchase/SUNY, The Window in Twentieth Century Art, circ., 1987; AAIAL, 1987; Paterson (N.J.) Museum, New Perspectives, 1987; U. of Massachusetts, Contemporary American Collage, circ., 1987; Southampton/Parrish, Drawing on the East End, 1988; Paris/Beaubourg, Les Années 80, 1988; Lyon/St. Pierre, The Color Alone, 1988; Toledo/MA, Bonnard to Kiefer: Illustrated Books, circ., 1988; Rutgers U., Abstract Expressionism: Other Dimensions, circ., 1990. **Collections:** Amsterdam/Stedelijk; Andover/Phillips; Baltimore/MA; Bennington College; Brooklyn Museum; Brown U.; Buffalo/Albright; Chicago/AI; Cleveland/MA; Dallas/MFA; Dayton/AI; Fort Dodge/Blanden; Fort Worth; Harvard U.; Hirshhorn; Houston/MFA; U. of Illinois; Kulturministerium Baden-Wurttemberg; Kunsthalle Stuttgart; Los Angeles/County MA; MMA; MOMA; U. of Minnesota; NYU; National Gallery; U. of Nebraska; PAFA; Paris/Moderne; Pasadena/AM; Pepsico, Inc.; Phillips; Provincetown/Chrysler; Raleigh/NCMA; Rio de Janeiro; SFMA; SRGM; Smith College; Smithsonian; Society of the Four Arts; South Mall, Albany; Tel Aviv; Toronto; WMAA; Walker; Washington U.; U. of Washington; Yale U. **Bibliography:** *Abstract Expressionism;* Alloway 4; Anfam; Armstrong, Thomas; **Arnason 2;** Ashbery; Ashton 3, 5; Baur 7; Biederman 1; Bihalji-Merin; *Black and*

White Are Colors; Blanchard; Blesh 1;
Danto; Carmean, Rathbone, and Hess;
Chipp; Downes, ed.; Eliot; *Europa/Amer-
ika;* Finkelstein; Flanagan; Goldman 1;
Goodrich and Baur 1; *The Great Decade;*
Greenberg 1; Haftman; Henning; Hess,
T.B., 1; Hughes; Hunter 1, 6; Honisch
and Jensen, eds.; Hunter, ed.; Janis and
Blesh 1; Janis, S.; Kozloff 3; McCoubrey 1;
McCurdy, ed.; Mendelowitz; *Metro;*
Miller, ed., 2; **Motherwell 1, 2;
Motherwell, ed.; Motherwell and Rein-
hardt, eds.;** Murken-Altrogge; Nordness,
ed.; O'Hara; Paalen; Plous; Ponente;
Pousette-Dart, ed.; Read 2; Ritchie 1;
Rose, B., 1, 4; Rubin 1; Sandler 5; Seitz 1,
3, 4; Seuphor 1; Soby 5; Terentio;
Tomkins 2; Tuchman, ed.; Waldman 4;
Weller; *"What Abstract Art Means to Me."*
Archives.

MOY, SEONG b. October 20,
1921, Canton, China. To USA, 1931.
Studied: Federal Art Project School, with
Ben Swanson; St. Paul School of Art, 1936-
40, with Cameron Booth; ASL, with
Vaclav Vytlacil; Hofmann School, 1941-
42, with Hans Hofmann; Atelier 17, NYC,
1948-50. US Air Force, 1943-46. **Taught:**
U. of Minnesota, 1951; Indiana U., 1953;
Smith College, 1954; Vassar College,
1955; Cooper Union, 1957-70; Columbia
U., 1959-70; ASL, 1963-87; Moy Summer
School, Provincetown, 1975-; City College
of New York, 1970-89. Federal A.P.: Assis-
tant in graphic shop. **Member:** Artists
Equity; SAGA; Audubon Society.
Commissions: International Graphic Arts
Society (3 editions); New York Hilton
Hotel; Fourth National Bank and Trust,
Wichita (2 murals). **Awards:** Minneapo-
lis/Institute, First Prize, 1939; The Print
Club, Philadelphia, First Prize, 1948; John
Hay Whitney Fellowship, 1950; Brooklyn
Museum, **P.P.,** 1953; Guggenheim Foun-
dation Fellowship, 1955; CAPS, 1973;
Research Foundation of City U. of New
York, 1977. **Address:** 100 La Salle Street,
NYC 10027; studio, 2231 Broadway,

NYC 10024. **Dealer:** Sylvan Cole, NYC;
Martha Tepper, Boston. **One-man Exhibi-
tions:** (first) Carmel (Calif.) Art Associa-
tion, 1943; Ashby Gallery, NYC, 1947;
Carlebach Gallery, NYC, 1949; Spring-
field, Ill./State, 1949; Hacker Gallery,
NYC, 1950; Dubin Gallery, Philadelphia,
1950; U. of Minnesota, 1951; The New
Gallery, NYC, 1951, 52, 54; Boris Mirski
Gallery, Boston, 1955; The Contemporar-
ies, NYC, 1955; The Howard Wise Gal-
lery, Cleveland, 1958; Grand Central
Moderns, NYC, 1959; Yamada Gallery,
Kyoto, 1959; The Miller Gallery, Cincin-
nati, 1974, 76; Lantern Gallery, Ann
Arbor, 1975; Kornbluth Gallery, Fair
Lawn, N.J., 1976; Provincetown, 1977;
Signature Gallery, Hartford, 1977; Sum-
mit Gallery, NYC, 1987. **Retrospective:**
Provincetown Art Association, 1991.
Group: MMA, 1950; U. of Illinois, 1951,
53, 54; Carnegie, 1955; U. of Minnesota;
Brooklyn Museum; Chicago/AI; MOMA;
PAFA; Library of Congress; New York
World's Fair, 1964-65; Canberra/Na-
tional, Spontaneous Gesture, 1987;
Worcester/AM, Spectrum of Innovation,
1989. **Collections:** AT&T; Abbott Labora-
tories; American Express; Andover/Phil-
lips; Baltimore/MA; Bank of New York;
Bibliothèque Nationale; Boston/MFA;
Brooklyn Museum; Canberra/National;
Chase Manhattan Bank; Indiana U.; Li-
brary of Congress; MMA; MOMA; Mem-
phis/Brooks; U. of Minnesota; NYPL;
PAFA; PMA; Phillips; Smith College;
Smithsonian; Tel Aviv; Victoria and Albert
Museum; WMAA; Walker; Worces-
ter/AM. **Bibliography:** Archives.

MOYER, ROY b. August 20,
1921, Allentown, Pa. **Studied:** Columbia
U., BA, MA; U. of Oslo; self-taught in art.
Traveled extensively; resided in Europe
(mainly Greece), four years. **Taught:** U. of
Salonica, Greece, 1948-51; U. of Toronto,
1953-55. Director, American Federation
of Arts, 1963-72; retired art officer for
UNICEF. Wrote video script for *Earth,*

Air, Fire & Water, 1991, for Hofstra U. **Member:** President, American Society of Contemporary Artists; AREA (Artists Representing Environmental Art), Vice President. **Awards:** Audubon Artists, Jane Peterson Award, 1969, 72; Youngstown/Butler, First Prize for Painting, 1973; NAD, Emil and Dines Carlsen Award, 1977. **Address:** 440 Riverside Drive, NYC 10027. **Dealer:** Keen Gallery, NYC. **One-man Exhibitions:** (first) Salonica, Greece, 1949; The Contemporaries, NYC, 1958, 59, 61, 62, 65; The Midtown Galleries, 1967; Rockford/Burpee, 1969; Sneed-Hillman Gallery, Rockford, Ill., 1969; Rolly-Michaux, NYC, 1974, Boston, 1975; Kendall Gallery, Wellfleet Mass., 1975; Carl Battaglia Galleries Ltd., NYC, 1981; Fordham U., at Lincoln Center, NYC, 1981; Rolly-Michaux, Boston, 1981. **Retrospective:** Sneed-Hillman Gallery, Rockford, Ill., 1979. **Group:** U. of Illinois, 1959; WMAA Annual, 1960; Washington U., 1967; Colorado Springs/FA, 1967; Louisville/Speed, 1967; Akron/AI, 1968; U. of Georgia, 1968; and others. **Collections:** Brandeis U.; Fordham U.; NMAA; Sara Roby Foundation; U. of Rochester; Rockford Art Association; Rockford/Burpee; Wichita/AM; Youngstown/Butler.

Roy Moyer, *Still-life,* 1991.

MULLER, JAN b. December 27, 1922, Hamburg, Germany. **d.** January 29, 1958, NYC. Traveled Czechoslovakia, Switzerland, Holland, southern France, 1933-41. To USA, 1941. **Studied:** Hofmann School, 1945-50. Cofounder of Hansa Gallery, NYC, 1952. **One-man Exhibitions:** (first) Hansa Gallery, NYC, 1953, also 1954, 55, 56, 57, 58; Sun Gallery, Provincetown, 1955, 56; U. of Minnesota, 1960; The Zabriskie Gallery, 1961; Noah Goldowsky, 1970, 71, 72; Gruenebaum Gallery, NYC, 1976, 77; Rosa Esman Gallery, NYC, 1980; Oil and Steel, Long Island City, N.Y., 1985. **Retrospectives:** Hansa Gallery, NYC, 1959; SRGM, 1962. **Group:** 813 Broadway (Gallery) NYC, 1952; Chicago/AI, 1953; U. of Minnesota, 1955; The Stable Gallery Annual, 1956; Jewish Museum, The New York School, Second Generation, 1957; WMAA, Young America, 1957; Carnegie, 1958; Festival of Two Worlds, Spoleto, 1958; ICA, Boston, 1958, 59; MOMA, New Images of Man, 1959; A.F.A., The Figure, circ., 1960. **Collections:** Charlotte/Mint; MOMA; Newark Museum. **Bibliography:** Armstrong, Thomas; *The Figurative Fifties;* Messer; Sandler 5.

MULLICAN, LEE b. December 2, 1919, Chickasha, Okla. **Studied:** Abilene Christian College, 1937; U. of Oklahoma, 1939; Kansas City Art Institute and School of Design, 1941, with Fletcher Martin. Corps of Army Engineers, 1942-46. Traveled Europe, South America, Asia. **Taught:** UCLA, 1962-86; U. of Chile, Artist-in-Residence Exchange Program, 1968. **Awards:** Guggenheim Foundation Fellowship, 1959; U. of California, Creative Arts Grant, 1964; Tamarind Fellowship, 1964-65. **Address:** 370 Mesa Road, Santa Monica, Calif. **Dealer:** Herbert B. Palmer Gallery, Los Angeles. **One-man Exhibitions:** SFMA, 1949; The Swetzoff Gallery, Boston, 1950; The Willard Gallery, NYC, 1950, 52, 53, 59, 61, 67; Dynation Exhibition, San Francisco, 1951;

Oklahoma, 1951, 67; Paul Kantor Gallery, Beverly Hills, Calif., 1952, 53, 56; The Rose Rabow Gallery, San Francisco, 1955, 74; Santa Barbara/MA, 1958; Silvan Simone Gallery, 1965-67; Santiago, Chile, 1968; UCLA, 1969; Jodi Scully Gallery, 1973; Contemporary Art Gallery, Santa Fe, 1973; Paule Anglim Gallery, San Francisco, 1979; Schreiner Gallery, NYC, 1981; Stables Gallery, Taos, N.M., 1977; Artists' Space, NYC, 1986; Herbert B. Palmer Gallery, Los Angeles, 1985, 89. **Retrospective:** Santa Barbara/MA, 1973. **Group:** Corcoran, 1948; Denver/AM Annuals, 1950, 55, 56, 57; Chicago/AI, 1951, 54; Carnegie, 1951, 64, 66; WMAA Annuals, 1952, 56; U. of Nebraska, 1953; U. of Illinois, 1953, 55, 57; MMA, 1954; São Paulo, 1955; Santa Barbara/MA, 1957; MOMA, 1957; PAFA, 1958, 67; Rome-New York Foundation, Rome, 1960; Pasadena/AM, 1961; Newport Harbor, The Artist Collects, 1975; Los Angeles/County MA, 5 Footnotes to Art History, 1977. **Collections:** U. of California; Amon Carter Museum; Colorado Springs/FA; Denver/AM; Detroit/Institute; La Jolla; Los Angeles/County MA; MOMA; New Orleans/Delgado; U. of North Carolina; Oakland/AM; Oklahoma; Paris/Moderne; Pasadena/AM; Phillips; Roswell; SFMA; San Francisco Municipal Art Commission; Santa Barbara/MA; Santa Fe, N.M.; Santiago, Chile; Smith College; Syracuse U.; Tulsa/Philbrook; Wichita State U. **Bibliography:** Karlstrom and Ehrlich; Pousette-Dart, ed.; Richardson, E.P.; Tuchman 3. Archives.

MURCH, WALTER TANDY

b. August 17, 1907, Toronto, Canada. **d.** December 11, 1967, NYC. **Studied:** Ontario College of Art, 1924-27, with Arthur Lismer, L. Harris; ASL, 1929-30, with Kenneth Hayes Miller, William Von Schlegell; Grand Central School, NYC, 1930, with Arshile Gorky; and privately, with Gorky, 1931-32. US citizen, 1948. Traveled Mexico, Canada, France.

Taught: Pratt Institute, 1952-61; NYU, 1961; Boston U., 1961-67; Columbia U., 1964. **Commissions:** *Scientific American; Fortune* magazine. **Awards:** U. of Illinois, P.P., 1949; NIAL, Grant, 1961; Ford Foundation, P.P. (2). **One-man Exhibitions:** (first) Wakefield Gallery, NYC, 1941; Mortimer Brandt, NYC, 1946; Betty Parsons Gallery, NYC, 1947, 49, 51, 54, 57, 59, 62, 66, 70, 71, 83; St. Louis Art Center, 1949; Allan Frumkin Gallery, Chicago, 1953; Worth Avenue Gallery, Palm Beach, Fla., 1955; Choate School, Wallingford, Conn., 1959; Hampton Gallery, Huntington, W. Va., 1964; Lehigh U., 1966; Galerie Jan Krugier, Geneva, 1976; Montclair/AM, 1978; Long Island U., Greenvale, circ., 1986; Sid Deutsch Gallery, NYC, 1987; C. W. Post College, 1987; WMAA/Philip Morris, 1986. **Retrospective:** RISD, 1966. **Group:** Andover/Phillips, 1945; Corcoran, 1945, 52-55, 56, 58, 61, 64; Chicago/AI, 53, 54, 55, 57, 59, 60, 63, 64; WMAA Annuals, 1945-64; Worcester/AM, 54, 61, 1947; U. of Illinois, 1951, 52, 63; Contemporary American Painting, Tokyo, 1952; Detroit/Institute, 1952, 57; MMA, Edward Root Collection, 1953; PMA, 1954; Indianapolis/Herron, 1954; WMAA, The New Decade, 1954-55; Walker, 1955; A.F.A., World at Work, 1955; ICA, London, American Painting; XXVIII Venice Biennial, 1956; Minneapolis/Institute, American Painting, 1945-57, 1957; ART: USA: 59, NYC, 1959; A.F.A., Private Worlds, 1960; Milwaukee, American Painting, 1760-1960, 1960; NIAL, 1961; New School for Social Research, The Creative Process, 1961; Carnegie, 1964; U. of Rochester, In Focus, 1964; New York World's Fair, 1964-65; Detroit/Institute, 40 Key Artists of the Mid-20th Century, 1965; WMAA, A Decade of American Drawings, 1965; RISD, Recent Still Life, 1966. **Collections:** Andover/Phillips; Barnes Foundation; Brooklyn Museum; Buffalo/Albright; Carnegie; Chase Manhattan Bank; Corcoran; First National City Bank;

Hallmark Collection; Hartford/Wadsworth; IBM; U. of Illinois; Jay Mfg. Co.; Kalamazoo/Institute; Lane Foundation; MMA; MOMA; NCFA; Newark Museum; Omaha/Joslyn; PAFA; Scientific American Inc.; Toledo/MA; Union Carbide Corp.; Upjohn Co.; Utica; WGMA; WMAA; Westmoreland County/MA. **Bibliography:** Armstrong, Thomas; Baur 7; Cummings 5, 6; Flanagan; *From Foreign Shores;* Goodrich and Baur 1; Nordness, ed.; Pousette-Dart, ed.; **Robbins;** Soby 5; Ward. Archives.

MURPHY, CATHERINE b. January 22, 1946, Cambridge, Mass. **Studied:** Pratt Institute, BFA, 1967; Skowhegan School of Painting and Sculpture, with Elmer Bischoff, 1966. **Taught:** Yale U., 1989-90; American U., 1990. **Awards:** National Endowment for the Arts, 1979; Guggenheim Foundation Fellowship, 1982; Ingram Merrill Foundation Grant, 1986; National Endowment for the Arts, 1989. **m.** Harry Roseman. **Address:** Rt. 1, Box 47, E. Dorsey Lane, Poughkeepsie, N.Y. 12601. **Dealer:** Lennon, Weinberg, Inc., NYC. **One-man Exhibitions:** Piper Gallery, Mass., 1972; First Street Gallery, NYC, 1972; Fourcade Droll, Inc., NYC, 1975; Xavier Fourcade, Inc., NYC, 1975, 79, 85; J. Rosenthal Fine Arts, Chicago, 1988; Lennon, Weinberg, Inc., 1989, 92. **Retrospective:** Phillips, 1976. **Group:** WMAA Annuals, 1972, 73; Sheldon Memorial Art Gallery, Poughkeepsie, A Sense of Place, 1973; Storm King Art Center, Painting and Sculpture, 1973—The Emerging Real, 1973; Museum of the Philadelphia Civic Center, Woman's Work, 1974; U. of North Carolina, Art on Paper, 1974; PMA, In Her Own Image, 1974; Lincoln, Mass./De Cordova, Candid Painting: American Genre 1950-1975, 1975; Albright College, Perspective 78, 1978; AAIAL, 1980; Brooklyn Museum, American Drawings in Black and White: 1970-1979, 1980; Akron/AM, The Image in American Painting and Sculpture, 1950-

1980, 1981; Houston/Contemporary, Americans: The Landscape, 1981; PAFA, Contemporary American Realism Since 1960, 1981; Houston/Contemporary, American Still Life, 1945-1983, 1983; U. of North Carolina, Art on Paper, 1985; SFMA, American Realism (Janss), circ., 1985; Isetan Museum, Tokyo, American Realism: The Precise Image, circ., 1985; Purchase/SUNY, The Window in Twentieth Century Art, 1986; AAIAL, 1987, 90; Cincinnati/AM, Making Their Mark: Women Artists Move into the Mainstream, 1970-85, circ., 1989; Miyagi Museum of Art, Sendai, Japan, American Realism and Figurative Art, 1952-1991, circ., 1991. **Collections:** Chase Manhattan Bank, NYC; Exxon Corp.; Hirshhorn; MMA; Newark Museum; U. of North Carolina; Phillips; Security Pacific National Bank, Los Angeles; Trenton/State; VMFA; Vassar College; WMAA. **Bibliography:** Arthur 2, 3; Ward.

MURRAY, ELIZABETH **b.** June 9, 1940, Chicago, Ill. **Studied:** Chicago Art Institute School, BFA, 1962; Mills College, Oakland, MFA, 1964. **Taught:** Bard College, 1974-75, 76-77; Wayne State U., 1975; California Institute of the Arts, 1975-76; Chicago Art Institute School, 1975-76; Princeton U., 1977; Yale U., 1978-79; New York Studio School, 1987. **Member:** AAIAL, 1992. **Awards:** Chicago/AI, Walter M. Campana Award, 1982; AAIAL, 1984; Skowhegan School, Medal for Painting, 1986; Hon. DFA, School of the Art Institute of Chicago, 1992. **Address:** 17 White Street, NYC 10013. **Dealer:** Paula Cooper Gallery, NYC. **One-man Exhibitions:** Jacob's Ladder Gallery, Washington, D.C. (two-man), 1974; Paula Cooper Gallery, NYC (two-man) 1975, 76, 78, 81, 83, 84, 87, 88, 90, 92; Jared Sable Gallery, Toronto, 1975; Ohio State U., 1978; Phyllis Kind Gallery, Chicago, 1978; Galerie Mukai, Tokyo, 1980, 90; Susanne Hilberry Gallery, Birmingham, Mich., 1980; Smith

Elizabeth Murray, *Temptation*, 1992.

College, 1982; Daniel Weinberg Gallery, Los Angeles, 1982, 88; Portland (Ore.) Center for the Visual Arts, 1983; Knight Gallery, Charlotte, N.C., 1984; Brooke Alexander Gallery, NYC, 1984; U. of New Mexico, 1985; Carnegie-Mellon U., 1986; California State U., Long Beach, circ., 1987; Dallas/MFA, circ., 1987; SFMA, 1988; Greg Kucera Gallery, Seattle, 1989; Mayor Rowan Gallery, London, 1989; John Berggruen Gallery, San Francisco, 1990; Barbara Krakow Gallery, Boston, circ., 1990; U. of Ohio, 1991; Galerie Jahn und Fusban, Munich, 1992; Newark Museum, 1992; Baruch/CUNY, 1992. **Retrospectives:** Dallas/MFA, circ., 1987; Barbara Krakow Gallery, Boston, circ., 1990. **Group:** WMAA Annuals, 1972, 73, 77, 79; WMAA, Contemporary American Drawings, 1973; California State U., Los Angeles, New Work/New York, 1976; SRGM, Nine Artists; Theodoron Awards, 1977; RISD, Space Window, 1977; Syracuse U., Critics' Choice, 1977; New Museum, NYC, Early Work by Five Contemporary Artists, 1977; Chicago/Contemporary, Ten Years, 1977; ICA, U. of Pennsylvania, Eight Abstract Painters, 1978; Tampa Bay Art Center, Two Decades of Abstraction, 1978; Hayward Gallery, London, New Painting, New York, 1979; U. of North Carolina, Art on Paper, 1979; Brooklyn Museum, American Drawing in Black and White: 1970-1979; 1980; Haus der Kunst, Munich, Amerikanische Malerie: 1930-1980, 1981; WMAA, 1972, 73, 77, 79, 81, 85; Chicago/AI, 74th American Exhibition, 1982; High Museum, Art in Our Time, 1982; Jacksonville/AM, Currents: A New Mannerism, circ., 1982; MIT, Great Big Drawings, 1982; WMAA, Abstract Drawings, 1911-1981, 1982; Brooklyn Museum, The American Artist as Printmaker, 1983; Hirshhorn, Directions, 1983; Cranbrook, Viewpoint '84, 1984; MOMA, International Survey of Recent Painting and Sculpture, 1984; WMAA, Five Painters in New York, 1984; MOMA, Large Drawings, 1985; Fort Lauderdale, An American Renaissance: Painting and Sculpture Since 1940, 1986; Circulo de Bellas Artes, Madrid, Pintar con Papel, 1986; Brooklyn Museum, Public and Private: American Prints Today, 1986; PMA, Philedelphia Collects, 1986; Boston/MFA, 70s into 80s: Printmaking Now, 1986; ICA, London, Komic Ikonoklasm, 1986; Los Angeles/MOCA, Individuals, 1986; Junior College of Albany, The Shape of Abstraction, 1987; AAIAL, 1987; Corcoran, 40th Biennial, 1987; Mount Holyoke College, The Graphic Muse, 1987; RISD, Three Contemporary Painters, 1987; Dublin, ROSC, '88, 1988; Milwaukee, The World of Art Today, 1988; Ho-Am Gallery, Seoul, American Contemporary Art Exhibition, 1988; WMAA, 20th-Century Drawings from the WMAA, 1988; Carnegie, International, 1988; Middlebury College, Recent American Pastels, 1988; Duke U., SoHo at Duke, 1988; Cincinnati/AM, Making Their Mark, circ., 1989; Walker, First Impressions, circ., 1989; AAIAL, Annual, 1989, 90; Albuquerque Museum, The Elusive Surface, 1989; Ringling, Abstraction in Question, circ., 1989; U. of Wisconsin, Milwaukee, The Matter at Hand, 1990; Little Rock/MFA, National Drawings Invitational, 1990; Brandeis U., The Image of Abstract Painting in the 80s,

1990; Graphische Sammlung Albertina, American Drawing in the Eighties, circ., 1990; MOMA, High and Low, 1990; U. of Florida, Gainsville, Color in Art, 1990; Cleveland State U., Abstraction/Plane to Plane, 1990; Samuel P. Harn Museum, Gainesville, Fla., Color in Art, 1990; Hunter College, Physicality, circ., 1991; Munich/Modern, Seven American Painters, 1991; WMAA, Biennial, 1991; ICA, U. of Pennsylvania, The Devil on the Stairs, 1991; Brooklyn Museum, Prints and Drawings by Contemporary Artists, 1991; American Academy in Rome, Annual, 1991; Baltimore/MA, Marking the Decade: Prints, 1960-1990, 1992; San Jose Museum of Art, Drawing Redux, 1992; Chicago Art Institute School, Twelve Contemporary Masters, 1991; AAIAL, 1992. **Collections:** Ackland; Baltimore/MA; Boston/MFA; Brooklyn Museum; California State U.; Carnegie; Chicago/AI; Cincinnati/AM; Dallas/MFA; Detroit/Institute; Fukuoka Sogo Bank, Ltd.; High Museum; Hirshhorn; Los Angeles/MOCA; MIT; MMA; MOMA; Memphis/Brooks; Milwaukee; Morristown/Morris; U. of North Carolina; Ohio State U.; Orlando; PMA; RISD; SRGM; St. Louis/City; WMAA; Walker; Yale U. **Bibliography:** Armstrong and Marshall; Cummings 5; Hughes; *Individuals;* Plagens; Stearns; Storr and Tannenbaum.

MURRAY, ROBERT b. March 2, 1936, Vancouver (B.C.), Canada.
Studied: School of Art, U. of Saskatchewan (with Arthur McKay, Roy Kiyooka, Kenneth Lochhead, R. Simmons), 1956-58; Emma Lake Artist's Workshops, U. of Saskatchewan, with Will Barnet, 1957, Barnett Newman, 1959, John Ferren, 1960, Clement Greenberg, 1962, Jack Shadbolt. Traveled Western Hemisphere. Royal Canadian Air Force (auxiliary). **Taught:** U. of Saskatchewan; Hunter College; Yale U.; U. of Oklahoma; School of Visual Arts, NYC. **Commissions:** Saskatoon City Hall, 1959-60; Long Beach

State College, 1965; Expo '67, Montreal, 1967; Vancouver International Airport, 1967; Juneau Court Office Building, Juneau, Alaska, 1978. **Awards:** Canada Arts Council Scholarship, 1960, Grant, 1969; National Council on the Arts, 1968; National Endowment for the Arts, grant, 1969; São Paulo Biennial, Second Prize, 1969. **Address:** RFD, Unionville, PA. **One-man Exhibitions:** (first in US) Betty Parsons Gallery, NYC, 1965, also 1966, 68; Jewish Museum, 1967; David Mirvish Gallery, 1967, 68, 70, 72, 74, 75; Vancouver (two-man), 1969 and 1970; Battery Park, NYC; Dag Hammarskjold Plaza, NYC, 1971; Paula Cooper Gallery, 1974; Janie C. Lee Gallery, Houston, 1977; Hamilton Gallery of Contemporary Art, NYC, 1977, 79, 80; Rice U., 1978; Kionaridis, Inc., Toronto, 1979, 81; Phillips Exeter Academy, 1983; Richard Green Gallery, NYC, 1986; Gallery 291, Atlanta, 1986; Gallery One, Toronto, 1986; Centro Culturale Canadese, Rome, 1985. **Group:** Ottawa/National, Outdoor Sculpture Exhibition, 1962; Hart House, U. of Toronto, 1964; Finch College, NYC, Artists Select, 1964; U. of Toronto Sculpture Annuals, 1964, 67; WMAA Sculpture Annuals, 1964, 66, 68, 70, 73; WMAA, Young America, 1965; Toronto, 1965; Musée Cantonal des Beaux-Arts, Lausanne, II Salon International de Galeries Pilotes, 1966; Los Angeles/County MA, American Sculpture of the Sixties, circ., 1967; Expo '67, Montreal, 1967; ICA, Boston, Nine Canadians, 1967; SRGM, Guggenheim International, 1967; WMAA, 1967; Paris/Moderne, Canada: Art d'Aujourd'hui, 1968; Walker, 14 Sculptors: The Industrial Edge, 1969; X São Paulo Biennial, 1969; Grand Rapids, 1969; Cincinnati/Contemporary, Monumental Art, 1970; Chicago/Contemporary, 49th Parallel; New Canadian Art, 1971; Middelheim Park, Antwerp, XI Sculpture Biennial, 1971; Grand Rapids, Sculpture off the Pedestal, 1973; Newport, R.I., Monumenta, 1974; Akron/AI, Project; New Urban Monu-

ments, 1977. **Collections:** U. of Alberta; Allied Chemical Building, Houston; City of Saskatoon; Columbus; Dayton/AI; Fredonia/SUNY; Hirshhorn; Honeywell, Inc., Minneapolis; Long Beach State College; Melbourne/National; MMA; Montreal/MFA; New Brunswick Museum; Ottawa/National; St. John, N.B.; Seagram Collection; Storm King Art Center; Swarthmore College; U. of Sydney; Syracuse/Everson; Toronto; Vancouver; WMAA; Walker; Wayne State U. **Bibliography:** Davies; Friedman, M.; *Monumenta;* Siegel; Tuchman 1; Weintraub.

N

NADELMAN, ELIE b. February 20, 1882, Warsaw, Poland. d. December 28, 1946, NYC. **Studied:** Art Academy, Warsaw, 1901; Academie Colarossi Paris, 1904; privately with Konstantin Lazczka, 1902. Imperial Russian Army, 1900. Traveled Russia, Europe, USA. To USA, 1914. **Awards:** Sztuka Prize, 1902. **One-man Exhibitions:** (first) Galerie Drouant, Paris, 1909, also 1913; Photo-Secession, NYC, 1915; Scott and Fowles Gallery, NYC, 1917, 25; M. Knoedler & Co., NYC, 1919, 27; Galerie Bernheim Jeune, Paris, 1920, 27; Arts Club of Chicago; MOMA, 1948; The Zabriskie Gallery, NYC, 1967, 80, 82; Stanford U., 1968; Galerie Zabriskie, Paris, 1982; Hamilton College, 1984; Fairweather-Hardin Gallery, Chicago, 1985; Edward Thorp Gallery, NYC, 1986, 91. **Retrospective:** WMAA, 1975. **Group:** Salon des Artistes Independants, Paris, 1905-08; Salon d'Automne, Paris, 1905-08; Non Jury Salon, Berlin, 1913; The Armory Show, 1913; Photo-Secession, NYC, 1915; Carnegie, 1938; WMAA; MOMA; MMA. **Collections:** MOMA; Newark Museum; Utica; WMAA. **Bibliography:** *Avant-Garde Painting and Sculpture in America 1910-25;* **Baur 7; Biddle 4;** Birnbaum; Blesh 1; Brumme; Cherry; Craven, W.; Cummings 5; *From Foreign Shores;* Goodrich and Baur 1; Hunter 6; Huyghe; *Index of 20th Century Artists;* **Kirstein 1, 2, 4;** Licht, F.; Marter, Tarbell, and Webster; McCurdy, ed.; Mendelowitz;

Motherwell 1; **Murrell 2;** Richardson, E.P.; Ringel, ed.; Rose, B., 1; Seiz, J.; Schwartz 3; Strachan. Archives.

NAKIAN, REUBEN b. August 10, 1897, College Point, N.Y. d. December 4, 1986, Stamford, Conn. **Studied:** Robert Henri School, with Homer Boss, A. S. Baylinson; ASL, 1912; apprenticed to Paul Manship, 1917-20, and Gaston Lachaise. Traveled Italy, France. **Taught:** Newark Fine Arts and Industrial Arts College; Pratt Institute, 1949. **Commissions:** NYU, 1960 (sculpture). **Awards:** Guggenheim Foundation Fellowship, 1930; Ford Foundation Grant, 1959 ($10,000); São Paulo, 1960; RISD, Athena Award, 1979; Skowhegan Medal for Sculpture, 1983. **One-man Exhibitions:** (first) The Downtown Gallery, NYC, 1933, also 1935; Charles Egan Gallery, NYC, 1949, 50, 52, 63, 64, 65, 68, 70; Stewart-Marean Gallery, NYC, 1958; São Paulo, 1961; Los Angeles/County MA, 1962; WGMA, 1963; Felix Landau Gallery, Los Angeles, 1967; U. of Bridgeport, 1972; New York Studio School, Paris, 1974; The Graham Gallery, NYC, 1974; Alice Simsar Gallery, Ann Arbor, 1979; Landau/Alexander Gallery, Los Angeles, 1979; Hokin Gallery, Chicago, 1979; Gruenebaum Gallery, NYC, 1979; Benjamin Mangel Gallery, Philadelphia, 1981; Hirshhorn, 1981; David Settles Gallery, Houston, 1981; Marlborough Gallery, NYC, 1982; Addison/Ripley Gallery, Washington, D.C., 1982; U. of Northern Iowa, 1982; Ridgefield/Aldrich, 1984; DiLaurenti Gallery, NYC, 1985; Belian Art Center, Troy, Mich., 1985; Grejillion & Co., Houston, 1986, 90; Batuz-Stiftung, Schaumburg, 1986; Mekler Gallery, Los Angeles, 1986; Galerie Basmadjian, Paris, 1987; Gulbenkian Foundation, Lisbon, 1988; U. of Michigan, Ann Arbor, 1988; Trinity Gallery, Atlanta, 1990; Kouros Gallery, NYC, 1991. **Retrospective:** MOMA, 1966. **Group:** Salons of America, NYC, 1922; Whitney Studio Club, NYC; WMAA; Chicago/AI; PAFA; XXXIV Venice Biennial, 1968; MOMA, The New

American Painting and Sculpture, 1969; WMAA, The Third Dimension, 1984. **Collections:** Buffalo/Albright; Canberra/National; Chicago/AI; Cincinnatti/Contemporary; Cleveland/MA; U. of Connecticut; Detroit/Institute; Fort Worth/Modern; U. of Syracuse; U. of California; Hartford/Wadsworth; High Museum; Hirshhorn; Honolulu Academy; U. of Houston; Houston/MFA; Lisbon/Gulbenkian; Los Angeles/County MA; MMA; MOMA; U. of Michigan; Milwaukee; NMAA; NPG; NYU; Newark Museum; U. of Nebraska; U. of Northern Iowa; PAFA; PMA; SRGM; San Antonio/McNay; Skidmore College; WMAA; Walker. **Bibliography:** Cahill and Barr, eds.; Cheney; Craven, W.; Downes, ed.; Geske; Hunter, ed.; O'Hare 1, 5; *New in the Seventies;* Phillips, Lisa, 2; Rose, B., 1; Tuchman 1.

NATKIN, ROBERT b. November 7, 1930, Chicago, Ill. **Studied:** Chicago/AI School, 1952. Designed backdrop for Paul Sanasardo Dance Co., NYC, 1974. **Address:** 24 Mark Twain Lane, West Redding, CT 06896. **Dealer:** Gimpel Fils, London. **One-man Exhibitions:** Wells Street Gallery, Chicago, 1957, 58; Poindexter Gallery, 1959, 61, 63, 65, 67, 68; Ferus Gallery, Los Angeles, 1960; Fairweather-Hardin Gallery, Chicago, 1963, 64, 66, 68, 73, 75; Gertrude Kasle Gallery, Detroit, 1966, 68, 74, 75; Meredith Long Gallery, 1968; André Emmerich Gallery, NYC, 1970, 73, 74, 76, 78, Zurich, 1974, 77; The Pennsylvania State U. (two-man), 1973; Jack Glenn Gallery, Corona del Mar, 1973; Makler Gallery, Philadelphia, 1974, 75; Holburne of Menstrie Museum and Festival, Bath, England, 1974; William Sawyer Gallery, San Francisco, 1974, 75; Galerie Merian Edition, Krefeld, 1974; Il Cerhio, Milan, 1974; Galleria Venezia, Venice, 1974; Chicago/AI, 1975; Hokin Gallery, Chicago, 1975, 79; Hokin Gallery, Palm Beach, 1975; Linda Farris Gallery, Seattle, 1975; Douglas Drake Gallery, Kansas City, 1976, 78, 81; Gimpel Fils, London, 1977, 80, 81, 84, 90;

Hoshour Gallery, Albuquerque, 1978, 81, 84; Galerie Pudelko, Bonn; Thomas Segal Gallery, Boston, 1979; Gimpel & Weitzenhoffer, Ltd., NYC, 1979, 80, 82, 84, 85, 87; Galerie Brusberg, Hannover, 1979; Tortue Gallery, Santa Monica, 1979, 81, 84; ABCD Gallery, Paris, 1979; Ivory/Kimpton Gallery, San Francisco, 1981; GMB, Detroit, 1981; Gloria Luria Gallery, Bay Harbor Islands, Fla., 1981, 84; Hirshhorn, 1981; Gimpel-Hanover, Zurich, 1981; Ridgefield/Aldrich, 1982; Rosenberg Gallery, Toronto, 1982; Ginza Art Center, Tokyo, 1983; Nagoya Art Center, 1983; Columbus, 1983; Helander-Rubenstein Gallery, Palm Beach, 1985; Brenda Kroos Gallery, Columbus, 1985; The Watson Gallery, Houston, 1988. **Retrospectives:** SFMA, 1969; Kansas City Art Institute, 1976; Moore College of Art, Philadelphia, 1976; Manus Presse GMBH; Stuttgart, 1980. **Group:** Chicago/AI, Exhibition Momentum, 1950, 56, 57, also 1955, 57, 59, 62; WMAA, Young America, 1960; Carnegie, 1961; ICA, Boston, 1961; WGMA, Lyricism in Abstract Art, 1962; International Mitsubishi, Tokyo and other Japanese cities, 1963; WMAA Annuals, 1966, 68; Galerie Paul Facchetti, 1968; SFMA, Annual, 1969; SRGM, 1970, 74; Festival of Two Worlds, Spoleto, 1972. **Collections:** Akron/AI; Brandeis U.; Brooklyn Museum; Buffalo/Albright; Carnegie; Charlotte/Mint; City of Oakland; Columbus; Duke U.; Hartford/Wadsworth; Hirshhorn; Houston/MFA; ICA, Boston; U. of Illinois; Los Angeles/County MA; MOMA; Milwaukee; NYU; U. of Oklahoma; Paris/Beaubourg; The Pennsylvania State U.; RISD; SFMA; SRGM; WMAA; Worcester/AM.

NAUMAN, BRUCE b. December 6, 1941, Fort Worth, Ind. **Studied:** U. of Wisconsin, BS, 1960-64, with Italo Scanga; U. of California, Davis, 1965, MA. **Taught:** U. of California, Irvine, 1970. **Awards:** National Endowment for the Arts, grant, 1968; Aspen Institute, 1970. **Address:** 4630 Rising Hill Road,

Altadena, CA 91001. **Dealers:** Leo Castelli, Inc., NYC; Sperone Westwater, Inc., NYC. **One-man Exhibitions:** Nicholas Wilder Gallery, Los Angeles, 1966, 69, 70, 77; Leo Castelli, Inc., NYC, 1968, 69, 71, 73, 75, 76, 78, 80, 82, 84, 85, 89, 90; Konrad Fischer Gallery, Düsseldorf, 1968, 70, 71, 74, 75, 78, 81; Sacramento State College, 1968; Ileana Sonnabend Gallery, Paris, 1969, 72, 76; Gian Enzo Sperone, Turin, 1970; ACE Gallery, Vancouver, 1971, 76, 78; Joseph Helman Gallery, St. Louis, 1971; Françoise Lambert, Milan, 1971; U. of California, Irvine, 1973; Eindhoven, 1973; Galerie Art in Progress, Munich, 1974; Wide White Space Gallery, Antwerp, 1974; Cirrus Editions, Ltd., 1974; Buffalo/Albright, 1975; U. of Nevada, 1976; Sperone Westwater Fischer, Inc., NYC, 1976; Minneapolis, 1978; InK, Zurich, 1978, 81; Galerie Schmela, Düsseldorf, 1979; Deson-Zaks Gallery, Chicago, 1979; Portland (Ore.) Center for the Visual Arts, 1979; Hester van Royen Gallery, London, 1979; Hills Gallery, Santa Fe, 1980; Konrad Fischer Gallery, Düsseldorf, 1980, 83, 85, 88; Carol Taylor Gallery, Dallas, 1980; Nigel Greenwood Gallery, London, 1981; Rijksmuseum Kröller-Müller, circ., 1981; Young Hoffman Gallery, Chicago, 1981; Maude Boreel Print Art, The Hague, 1981; Albuquerque Museum, 1981; Sperone Westwater, Inc., NYC, 1982, 84, 88, 89, 90; Baltimore/MA, 1982; Museum Haus Esters, Krefeld, 1983; Daniel Weinberg Gallery, Los Angeles, 1984, 87, 90, 91; Donald Young Gallery, Chicago, 1985, 87, 88; Texas Gallery, Houston, 1986, 89; Galerie Elisabeth Kaufmann, Zurich, 1985, 88; Galerie Jean Bernier, Athens, 1986; Galerie Yvon Lambert, Paris, 1986, 89; Stadt Museum, Graz, Austria, 1986; Galerie Gabrille, Maubrie, Paris, 1986; Lenbachhaus Städtische Galerie, Munich, 1986; Basel/Kunsthalle, 1987; Los Angeles/MOCA, 1987; Hamburg/Kunsthalle, 1987; Mexico City/Moderno, 1987;

Monchengladbach, 1987; Galerij Micheline Szwajcer, Antwerp, 1988; U. of California, San Diego, 1988; Basel Museum Für Gegenwartskunst, 1989, 90; Anthony D'Offay Gallery, London, 1990, 92; 65 Thompson Street, NYC, 1990; Galerie Juergen Becker, Hamburg, 1990; Galerie Langer Fain, Paris, 1990; Galerie B. Coopens and R. Van de Velde, Brussels, 1990; Lorence-Monk Gallery, NYC, 1990; Des Moines/AC, 1990; Rotterdam, 1991; Galerie Hummel, Vienna, 1991; Espai Poblenou, Barcelona, 1991; ICA, London, 1991; Ydessa Hendeles Foundation, Toronto, 1992. **Retrospectives:** Düsseldorf/Kunsthalle, 1973; Los Angeles/County MA, 1973; Whitechapel Art Gallery, London, circ., 1986; Museum für Gegenwartskunst, Basel, circ., 1986. **Group:** SFMA, New Directions, 1966; Los Angeles/County MA, American Sculpture of the Sixties, circ., 1967; Kassel, Documenta IV, 1968; Oberlin College, Three Young Americans, 1968; A.F.A., Soft Sculpture, 1968; Corcoran, 1969; Berne, When Attitudes Become Form, 1969; WMAA, Anti-Illusion: Procedures/Materials, 1969; SRGM, 1969; Chicago/Contemporary, Holograms and Lasers, 1970; ICA, U. of Pennsylvania, Against Order; Chance and Art, 1970; WMAA, 1970; Düsseldorf/Kunsthalle, Prospect '71, 1971; MOMA, Information, 1971; Hayward Gallery, London, 11 Los Angeles Artists, 1971; Rijksmuseum Kröller-Müller, Diagrams and Drawings, 1972; Hamburg/Kunstverein, USA: West Coast, circ., 1972; New York Cultural Center, 3D into 2D, 1973; Seattle/AM, American Art—Third Quarter Century, 1973; Parcheggio di Villa Borghese, Rome, Contemporanea, 1974; Chicago/AI, Idea and Image in Recent Art, 1974; Indianapolis, 1974; CNAC, Art/Voir, 1974; MOMA, Drawing Now, 1975; Chicago/AI, 1976; WMAA, 200 Years of American Sculpture, 1976; Detroit/Institute, American Artists: A New Decade, 1976; U. of Chicago, Ideas on Paper 1970-76,

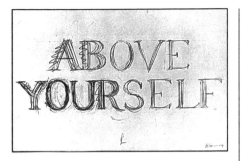

Bruce Nauman, *Above Yourself (Study for Elliott's Stones)*, 1989.

1976; WMAA Biennials 1977, 85, 87, 91; The U. of Chicago, Ideas in Sculpture, 1965-1977, 1977; Williamstown/Clark, The Dada/Surrealist Heritage, 1977; SFMA, Painting and Sculpture in California: The Modern Era, 1976; Madison Art Center, Works on Paper by American Artists, 1977; Amsterdam/Stedelijk, Made by Sculptors, 1978; Krefeld/Haus Lange, The Broadening of the Concept of Reality in the Art of the Sixties and Seventies, 1979; Aspen Center for the Visual Arts, American Portraits of the 60s and 70s, 1979; Franklin Institute, New Spaces: The Holographer's Vision, 1979; U. of Hartford, Conn., Southern California Drawings, 1980; Hayward Gallery, London, Pier & Ocean, 1980; Purchase/SUNY, Soundings, 1981; Kassel, Documenta VII, 1982; MOMA, A Century of Modern Drawings, circ., 1982; Amsterdam/Stedelijk, '60-'80: Attitudes/Concepts/Images, 1982; Ridgefield/Aldrich, Postminimalism, 1982; SFMA, 20 American Artists: Sculpture 1982, 1982; U. of South Florida, Objects, Structures, Artifice: American Sculpture 1970-1982, 1983; Basel/Kunstmuseum, Neue Zeichnungen, circ., 1983; Florida International U., The Sculptor as Draftsman, 1984; Dublin, ROSC '84, 1984; Hirshhorn, Content, 1984; Miami/Bass, Large Drawings, 1985; Bard College, The Maximal Implications of the Minimal Line, 1985; U. of Chicago, Large-Scale Drawings by Sculptors, 1985; Pittsburgh Center for the Arts, Illuminations, 1985; Fort Lauderdale, An American Renaissance, 1985; SRGM, Transformations in Sculpture, 1985; Carnegie International, 1985; Frankfurt/Kunstverein, Vom Zeichnen, 1985; Queens Museum, The Real Big Picture, 1986; Arnhem, Sonsbeek '86, 1986; Ghent/Contemporary, Chambres d'amis, 1986; Los Angeles/MOCA, Individuals, 1986; Brooklyn Museum, Monumental Drawing, 1986; Santa Fe, N.M., Big Drawings, 1987; Paris/Beaubourg, L'Époque, La Mode, La Morale, La Passion, 1987; Los Angeles/County MA, Photography and Art: Interactions Since 1946, 1987; Syracuse/Everson, Computers and Art, 1987; Cleveland/MA, Illuminations: The Art of Light, 1988; Cologne/Ludwig, Marcel Duchamp und die Avangarde Zeit 1950, 1988; Kassel/Fridericanum, Schlaf der Vernuft, 1988; MOMA, Committed to Print, 1988; Los Angeles/County MA, The Spiritual in Art, 1987; Hamburger Bahnhof, Zeitlos, 1988; WMAA, Image World, 1989; Walker, First Impressions, 1989; Amsterdam/Stedelijk, Energies, 1990; WMAA, The New Sculpture, 1956-75, circ., 1990; Sydney, The Sydney Biennial, 1990; Bard College, Art What Thou Eat, circ., 1990; Hofstra U., The Transparent Thread, circ., 1990; MOMA, High and Low, 1990; Nippon Convention Center, Tokyo, Pharmakon '90, 1990; Milwaukee, Word as Image, circ., 1990; Martin-Gropius-Bau, Berlin, Metropolis, 1991; Milwaukee, The Pleasure Machine, 1991; Carnegie International, 1991; MOMA, Dislocations, 1991; Nice/Contemporain, College of the Twentieth Century, 1991; ICA, U. of Pennsylvania, Devil on the Stairs, 1991; Kassel, Documenta IX, 1992. **Collections:** Aachen/Kunstverein; Amsterdam/Stedelijk; Buffalo/Albright; Canberra/National; Chicago/AI; Cologne; Harvard U.; Krefeld/Hans Lange; MOMA; Rijksmuseum Kröller-Müller; Rotterdam; Southwestern College, Chula Vista; SRGM; St. Louis/City; WMAA. **Bibliography:** *Art Now 74; Bruce*

Nauman; Calas 2; Celant; *Contemporanea;* Davis, D.; Day 1; *The Decade Show;* De Wilde 2; Fox; Gohr and Gachnang; Honisch and Jensen, eds.; Hunter, ed., 2; *Individuals;* Joachimides and Rosenthal; Johnson, Ellen H.; Kardon 3; Krauss 2, 3; Kren; *Kunst um 1970;* Lippard, ed.; Lippard 3; Livingston and Tucker; Meyer; Muller; *Performance Anthology;* Pincus-Witten; Plagens; Report; Robins; Rose, Bernice, 1; Sandler 3; Seitz 3; Storr and Tannenbaum; Tuchman 3; *USA West Coast;* Waldman 4; Weintraub; *When Attitudes Become Form.*

NEAL, REGINALD b. May 20, 1909, Leicester, England. **Studied:** Yale U., 1929-30; Bradley U., BA, 1932; State U. of Iowa, summer, 1936; The U. of Chicago, MA (art history), 1939; Colorado Springs Fine Arts Center, summer, 1941. **Taught:** Millikin U., 1940-46; Escuela de Bellas Artes, San Miguel de Allende, Mexico, summer, 1944; U. of Mississippi, 1951-57; The Contemporaries Graphic Center, NYC, summer, 1956; New Paltz/SUNY, 1957-58; Southern Illinois U., 1958-59, 1966, 67; Douglass College, Rutgers, 1959-77; Yale U., 1966. **Commissions:** A.A.A. Gallery, NYC (two editions of lithographs). **Awards:** Film Council of America, Golden Reel Award, 1956 (American Film Festival, Chicago), for a 30-min. color film, *Color Lithography—An Art Medium.* **Address:** 21 Circle Drive, RD 1, Lebanon, NJ 08833. **Dealers:** Princeton Gallery of Fine Arts, Princeton, N.J.; Haslem Fine Arts, Inc., Washington, D.C. **One-man Exhibitions:** Decatur, 1944; Davenport/Municipal, 1945, 51; South Bend (Ind.) Art Center, 1950; A.A.A. Gallery, Chicago, 1950; U. of Mississippi, 1951, 55; The Salpeter Gallery, NYC, 1953; New Paltz/SUNY, 1953; Pratt-Contemporaries, NYC, 1960; Allan Stone Gallery, 1962; Primus-Stuart Gallery, Los Angeles, 1962; Rutgers U., 1965, 79; A.M. Sachs Gallery, NYC, 1968; Haslem Fine Arts, Inc., Washington, D.C.,

1973; Princeton Gallery of Fine Arts, Princeton, N.J., 1973; Rider College, Lawrenceville, N.J., 1984. **Retrospectives:** Somerset (N.J.) Art Association, 1975; Rutgers U., 1975, 86. **Group:** MMA; Cincinnati/AM, 1954, 56, 58; Brooklyn Museum; Library of Congress; Houston/MFA, 1956; Oakland/AM; Riverside Museum; Gallery of Modern Art, Ljubljana, Yugoslavia, III & IV International Exhibitions of Prints, 1959, 61; Albany/Institute, 1965; U. of North Carolina, 1965; Trenton State, 1965, 67, 68, 71, 72; Newark Museum, 1966, 68, 69, 72, 77. **Collections:** Allentown/AM; American Republic Insurance Co.; Atlanta/AA; Cincinnati/AM; Davenport/Municipal; Decatur; Des Moines; Grenchen; Hartford/Wadsworth; Library of Congress; MOMA; U. of Massachusetts; Memphis/Brooks; National Gallery; Philip Morris Collection; Newark Museum; Princeton U.; Queens U.; U. of Rochester; Rutgers U.; Southern Illinois U.; Trenton/State; WGMA. **Bibliography:** Bihalji-Merin; Reese.

NECHVATAL, DENNIS b. 1948, Dodgerville, Wisc. **Studied:** Stout State U., BA, BS, 1971. Indiana U., MFA, 1974. **Address:** c/o Dealer. **Dealer:** Phyllis Kind Gallery, Chicago and New York. **One-man Exhibitions:** U. of Colorado, 1977; Water Street Art Gallery, Milwaukee, 1977, 79; Santa Clara/Triton, 1979; Illinois State U., 1981; Madison Art Center, 1982, 88; Indianapolis/Herron, 1983; Siegel Contemporary Art, NYC, 1984; Zolla-Lieberman Gallery, Chicago, 1980, 82, 84, 88, 89; Stout State U., 1989; Pittsburgh Center for the Arts, 1989; Phyllis Kind Gallery, Chicago, 1991, 92. **Group:** Newport Harbor, Inside Out, circ., 1981; Indianapolis, Painting and Sculpture Today, 1982, 84; Madison Art Center, New Faces—Old Friends, 1982; Milwaukee, Emerging Imagists, 1983; Chicago/AI, Chicago & Vicinity Drawing Exhibition, 1985; Corcoran, Biennial, 1985; John Michael Kohler Art

Center, Sheboygan, Wisc., Masked Allusions, 1987; Madison Art Center, Triennial, 1987, 90; Chicago Cultural Center, Urgent Messages, 1987; Milwaukee, Individuals, 1988; Milwaukee, 100 Years of Wisconsin Art, 1988; U. of Arkansas, Drawing Invitational, 1992. **Collections:** AT&T; U. of Arkansas; Chicago/AI; Chemical Bank; Continental Illinois Bank & Trust Co.; First National Bank of Evanston; Kemper Group; Madison Art Center; Milwaukee; Rayovac Corp.

NEPOTE, ALEXANDER
from 1st to 5th edition.

NERI, MANUEL **b.** April 13, 1930, Sanger, Calif. **Studied:** San Francisco City College, 1949-50; U. of California, Berkeley, 1951-52; California School of Arts and Crafts, Oakland, 1952-57; California School of Fine Arts, San Francisco, 1957-59, with Elmer Bischoff; U. of California, Davis, 1964-90. **Taught:** California School of Fine Arts, San Francisco, 1959-64; U. of California, Davis, 1964-. **Commissions:** Bateson Building, Sacramento, Calif., 1982; North Carolina National Bank, Tampa, Fla., 1987; Christina Gateway Project, Wilmington, Delaware, 1987; US Courthouse, Portland, Ore., 1987; Second and Seneca Building, Seattle, 1990; Harold Washington Library, Chicago, 1990. **Awards:** Oakland/AM, first award in sculpture, 1953; Oakland/AM, P.P. in painting, 1957; Nellie Sullivan Award, 1959; National Art Foundation award, 1965; Guggenheim Foundation Fellowship, 1979; National Endowment for the Arts, grant, 1980; AAIAL, 1985; San Francisco Arts Commission, Award of Honor for Outstanding Achievement in Sculpture. **Address:** 135 West J Street, Benicia, CA 94510. **Dealers:** John Berggruen Gallery, San Francisco; Charles Cowles Gallery, NYC. **One-man Exhibitions:** Six Gallery, San Francisco, 1957; Spatsa Gallery, San Francisco, 1959; Dilexi Gallery, San Francisco, 1960; New Mission

Manuel Neri, *Morena No. 1*, 1992.

Gallery, San Francisco, 1963; Berkeley Gallery, Berkeley, 1964; Quay Gallery, San Francisco, 1966, 68, 71, 75; Louisiana State U., 1969; St. Mary's College, Moraga, Calif., 1970; SFMA, 1971; Sacramento State College, 1972; Davis Art Center, Calif., 1972; San Jose State U., 1974; Braunstein Quay Gallery, NYC, 1976; 60 Langton St., San Francisco, 1976; Oakland/AM, 1976; Sacramento/Crocker, 1977; Gallery Paule Anglim, San Francisco, 1979; Whitman College, 1980; Richmond (Calif.) Art Center, 1980; Grossmont College, 1980; The Mexican Museum, San Francisco, 1981; Seattle/AM, 1981; Charles Cowles Gallery, NYC, 1981, 82, 86, 89, 91; John Berggruen Gallery, 1981, 84, 88, 90; Middendorf/Lane Gallery, Washington, D.C., 1983; California State U., Chico, 1984; Galerie André Emmerich, Zurich, 1984; Gimpel-Hanover & Middendorf Gallery, Washington, D.C., 1984; California State U., Sacramento, 1985; Fay Gold Gallery, Atlanta, 1987; San Antonio/McNay, 1987; College of Notre Dame, 1988;

James Corcoran Gallery, Santa Monica, 1988; U. of Nevada, 1989; SFMA, 1989; Greg Kucera Gallery, Seattle, 1989; Riva Yares Gallery, Scottsdale, 1989, 91; Sacramento/Crocker, 1990; Bingham Kurts Gallery, Memphis, 1990; Dominican College, San Rafael, 1990; Margulies/Taplin Gallery, Coconut Grove, Fla., 1990; U. of California, Davis, 1991; Eve Mannes Gallery, Atlanta, 1991. **Group:** Oakland/AM Annuals, 1955, 57; SFMA, four-man show, 1959; California Palace, San Francisco, The Nude, 1962; Stanford U., Some Points of View, 1962; Oakland/AM, Sculpture Today, 1963; Stanford U., Current Painting and Sculpture of the Bay Area, 1964; U. of California, Irvine, Abstract Expressionist Ceramics, 1966; U. of California, Berkeley, Funk Art, 1967; SFMA, On Looking Back: Bay Area 1945-1962, 1969; WMAA Annual, 1970; U. of California, Berkeley, The Eighties, 1970; SFAI, two-man show, 1970; U. of Nevada, two-man show, 1971; Sacramento/Crocker, Sacramento Sampler 1, 1972; SFMA, A Third World Painting and Sculpture Exhibition, 1974; De Anza College, Survey of Sculptural Directions in the Bay Area, 1975; Sydney/AG, Biennial, 1976; SFMA, California Painting and Sculpture: The Modern Era, 1976; Santa Barbara/MA, The Handmade Paper Object, 1976; Syracuse/Everson, A Century of Ceramics in the U.S. 1878-1978, 1978; San Diego, Sculpture in California 1975-1980; SFMA, 20 American Artists, 1980; Oakland/AM, 100 Years of California Sculpture, 1982; California State U., Long Beach, Figurative Sculpture: Ten Artists/Two Decades, 1984; Hirshhorn, Drawings 1974-1984, 1984; Oakland/AM, Dilexi: The Dilexi Years, 1958-1970, 1984; Seattle/AM, American Sculpture: Three Decades, 1984; U. of Southern California, California Sculpture Show, circ., 1984; U. of Nebraska, Contemporary Bronze: Six in the Figurative Tradition, circ., 1985; Oakland/AM, Art in the San Francisco Bay Area, 1945-1980, 1985;

SFMA, California Sculpture, 1959-1980, 1986; Palm Springs Desert Museum, California Figurative Sculpture, 1987; Houston/MFA, Contemporary Hispanic Art in the United States, circ., 1987; Tulsa/Philbrook, The Eloquent Object, circ., 1987; Madison Art Center, Sculptors in Paper, circ., 1987; The Bronx Museum, The Latin American Spirit, circ., 1988; SFMA, Bay Area Figurative Art, circ., 1989; U. of Arkansas, National Drawing Invitational, 1990; Youngstown/Butler, California A-Z and Return, 1990. **Collections:** U. of California, Davis; Chattanooga/Hunter; U. of Colorado; Des Moines; Honolulu Academy; U. of Nebraska; The Mexican Museum, San Francisco; Oakland/AM; SFMA; Sacramento/Crocker; Seattle/AM. **Bibliography:** *California Sculpture Show; Gettings; Solnit.* Archives.

NESBITT, LOWELL **b.** October 4, 1933, Baltimore, Md. **d.** July 8, 1993, NYC. **Studied:** Temple U., BFA, 1950-55; Royal College of Art, London, 1955-56. US Army, 1957-58. Traveled Europe. **Taught:** Baltimore/MA; Towson State Teachers College; Morgan State College; School of Visual Arts, NYC. **Commissions:** National Aeronautics & Space Administration. **One-man Exhibitions:** (first) Baltimore/MA, 1958, also 1959-69; Bader Gallery, Washington, D.C., 1963; Corcoran, 1964; Rolf Nelson Gallery, Los Angeles, 1966; Henri Gallery, 1965-67, 1969; The Howard Wise Gallery, NYC, 1965, 66; Gertrude Kasle Gallery, 1966-69, 70, 72, 74; Jefferson Gallery, 1967; Temple U., 1967; Galleria Sperone, Turin, 1967 (two-man, with Joseph Raffael); The Stable Gallery, NYC, 1968, 69; U. of Richmond; M. E. Thelen Gallery, Cologne, 1969, 70, 72; Gimpel Fils, 1970, 74; Gimpel & Weitzenhoffer Ltd., 1971, 73; Pyramid Art Galleries, 1971, 75; Hansen-Fuller Gallery, 1972; Gimpel & Hanover, 1972; Gallerie Fabian Carlson, Goteborg, 1972; Corcoran and Corcoran, Coral Gables, 1972; Gallerie Ostergren, Malmo,

1972; Kunstverein, Freiburg, 1972; Galerie Arnesen, Copenhagen, 1972, 74; Galerie Aronowitsch, Stockholm, 1972; Marion Locks Gallery, Philadelphia, 1973; Galerie Craven, Paris, 1973; Corcoran, 1973; Stefanotti Gallery, NYC, 1973, 74; Fendrick Gallery, 1974; Brooke Alexander, 1974; Walton Gallery, San Francisco, 1974; H.M., Brussels, 1974, 76; Museo de Bellas Artes, San Juan, 1974; U. of Rochester, 1975; City Center, NYC, 1975; Hokin Gallery, Palm Beach, 1976; Hokin Gallery, Chicago, 1976; Gump's Gallery, San Francisco, 1977; Andrew Crispo Gallery, 1977, 78, 79; Wichita/Ulrich, 1977; Janus Gallerie, Venice; Cleveland, 1977; Arte/Contacto, Caracas, 1977, 80; Strong's Gallery, Cleveland, 1978; Kent State; B.R. Kornblatt Gallery, Baltimore, 1978; The Art Contact, Miami, 1978; San Antonio/McNay, 1980; Ridgefield/Aldrich, 1980; DiLaurenti Gallery, 1986; Temple U., 1986, 89; Wally Findlay Gallery, Palm Beach, 1986; Joy Tash Gallery, Scottsdale, 1987, 88, 89, 91; Louis Newman Galleries, Beverly Hills, 1987; Peri Remeth Gallery, Southampton, N.Y., 1987; Martin Lawrence Gallery, Baltimore, 1990; Miami-Dade Public Library, 1991; Sarasota (Fla.) Design Gallery, 1991; Wessel/O'Connor Gallery, NYC, 1991. **Group:** Pan-American Union, Washington, D.C., circ., Latin America, 1964-66; New York World's Fair, 1964-65; Ridgefield/Aldrich, 1965; Flint/Institute, Realism Revisited, 1966; U. of Illinois, 1967; Milan, 1967; Los Angeles/County MA, 1967; International Biennial of Paintings, Tokyo, 1967; IX São Paulo Biennial, 1967; ICA, London, 1968; WMAA Annual, 1967; Milwaukee Aspects of a New Realism, 1969; Sweden/Goteborg, Warmwind, 1970; Cologne, Target Moon, 1971; Brooklyn Museum, Print Exhibition, 1972; Galerie des 4 Mouvements, Paris, Hyperrealistes Americans, 1972; Bibliothèque Nationale, L'Estampe Contemporaine, 1973; Tokyo Biennial, 1974; Paris/Moderne, 1974; West Palm Beach/Norton, Imagist Realism, 1975; U. of Redlands, Handcolored Prints, circ., 1975; US Department of the Interior, America 1976, circ., 1976; Brooklyn Museum, Thirty Years of American Printmaking, 1977; Museum of Contemporary Crafts, NYC, The Great American Foot, 1978-80; U. of Virginia, Humanist Icon, 1990. **Collections:** Aachen/NG; Amerada Hess Corp; AT&T; Baltimore/MA; The Bank of New York; Bibliothèque Nationale; CNAC; Chase Manhattan Bank; Chicago/AI; Cleveland/MA; Corcoran; Dallas/MFA; Detroit/Institute; F.T.D. Association; Ford Motor Company; Fort Worth; General Mills, Minneapolis; Goucher College; International Monetary Fund; La Jolla; Library of Congress; Milwaukee; MIT; MOMA; U. of Maryland; NCFA; National Art Gallery; Newark; Oberlin College; J. C. Penney Corp.; Phillips; PMA; Ponce; Prudential Insurance Co. of America; U. of Rochester; Saginaw; Temple U.; U. of Virginia; Wellington, N.F.; Wells, Rich, Greene, Inc., NYC; Worcester/AM; Yale U. **Bibliography:** *America 1976;* Arthur 1, 2; Davis, D.; Honisch and Jensen, eds.; *Kunst um 1970;* Sager.

NEUMAN, ROBERT S.
from 1st to 5th edition.

NEVELSON, LOUISE b. 1900, Kiev, Russia. To USA, 1905. d. April 17, 1988, NYC. **Studied:** ASL, 1929-30, with Kenneth Hayes Miller; Hofmann School, Munich, 1931; assistant to Diego Rivera in Mexico City, 1932-33. Legion Memorial Square, in the Wall Street area of Manhattan, was renamed Louise Nevelson Plaza, 1978. *Shadows and Flags,* seven large metal sculptures, are installed there. Traveled Europe, Central and South America. **Taught:** Educational Alliance, NYC; Great Neck (N.Y.) Adult Education Program; New York School for the Deaf. **Member:** Artists Equity (President); Sculpture Guild (Vice-President); Federation of Modern Painters

and Sculptors (Vice-President). Federal A.P.: Easel painting; AAAL, 1979. **Commissions:** Princeton U., 1969; Temple Beth-El, Great Neck, N.Y., 1970; Temple Israel, Boston, 1973; City of Scottsdale, 1973; City of Binghamton, N.Y., 1973; Federal Courthouse, Philadelphia, 1975; MIT; St. Peter's Lutheran Church, NYC; World Trade Center, NYC; City of Jackson, Mich.; Embarcadero Center Plaza, San Francisco; Pepsico Co., Purchase, N.Y.; Bendix Corp., Southfield, Mich.; Federated Department Stores, Cincinnati, Ohio; Hallmark Center, Kansas City, 1980; U. of Iowa, 1980. **Awards:** ART: USA:59, NYC, Grand Prize, 1959; Chicago/AI, The Mr. & Mrs. Frank G. Logan Prize, 1960; Tamarind Fellowship, 1963; MacDowell Colony Medal, 1969; Hamline U., Honorary Doctor of Humanities; Brandeis U., Creative Arts Award, 1971; Hobart and William Smith College, Honorary Doctor of Humane Letters, 1971; Hon. DFA, Smith College, 1973; President's Medal of the Municipal Art Society of New York; Hon. DFA, Columbia U., 1978; Hon. DFA, Boston U.; AAIAL, Gold Medal for Sculpture, 1983; National Medal of the Arts, 1985; Chevalier de la Légion d'Honneur, Paris, 1986; Hon. Ph.D., Boston U. **One-man Exhibitions:** (first) Karl Nierendorf Gallery, NYC, 1941, also 1943, 44, 46; Norlyst Gallery, NYC, 1941, 43; Lotte Jacobi Gallery, NYC, 1950; Grand Central Moderns, NYC, 1951, 54, 56, 57, 58; Esther Stuttman Gallery, NYC, 1958; Martha Jackson Gallery, NYC, 1959, 61, 70; Daniel Cordier, Paris, 1960; David Herbert Gallery, NYC, 1960; Devorah Sherman Gallery, 1960; The Pace Gallery, Boston, 1960, 64, NYC, 1965, 66, 69, 72, 74, 76, 78, 80, 83, 85, 86, 89; Sidney Janis Gallery, 1963; Hanover Gallery, 1963; Gimpel & Hanover Galerie, Zurich, 1964; Berne, 1964; Galleria d'Arte Contemporanea, Turin, 1964; David Mirvish Gallery, 1965; Galerie Schmela, 1965;

Ferus/Pace Gallery, Los Angeles, 1966; Arts Club of Chicago, 1968; Turin/Civico, 1969; Harcus Krakow Gallery, 1969; Galerie Jeanne Bucher, Paris, 1969; The Pace Gallery, Columbus, 1969, 74, 78, 81; Houston/MFA, 1969; Rijksmuseum Kröller-Müller, 1969; U. of Texas, 1970; WMAA, 1970; Makler Gallery, 1971, 74, 76, 78; Dunkelman Gallery, Toronto, 1972; Parker Street 470 Gallery, Boston, 1972; Studio Marconi, Milan, 1973; Stockholm/National, 1973; Brussels/Beaux-Arts, 1974; Paris/Moderne, 1974; Berlin/National, 1974; Minami Gallery, 1975; Galleria d'Arte Spagnoli, Florence, Italy, 1975; Harcus Krakow Rosen Sonnabend, Boston, 1975; Purchase/SUNY, 1977; Richard Gray Gallery, Chicago, 1978, 82, 89; Linda Farris Gallery, Seattle, 1978; Rockland, Maine, 1979; West Palm Beach/Norton, 1979; Jacksonville/AM, 1979; Wildenstein & Co., NYC, 1980; Scottsdale Center for the Arts, 1980; Phoenix/AM, 1980; Seattle/AM, 1980; Winnipeg Art Gallery, Ontario, Canada, 1980; U. of Iowa, 1980; Dayton/AI; 1980; Wildenstein & Co., London, 1981; Galerie de France, Paris, 1981; Harcus Krakow Gallery, Boston, 1982; Wildenstein & Co., Tokyo, 1982; NYU, 1983; Barbara Krakow Gallery, Boston, 1984; Hokin Gallery, Bay Harbor Islands, Fla., 1984, 85; Makler Gallery, Philadelphia, 1984; Storm King Art Center, 1984; Buffalo/SUNY, Burchfield Center, 1984; Rockland/Farnsworth, 1985; Galerie Claude Bernard, Paris, 1986; Galerie Alice Pauli, Lausanne, Switzerland, 1986; SRGM, 1986; MIT, 1986; WMAA/Stanford, 1986; Hokin Gallery, Palm Beach, 1988. **Retrospectives:** WMAA, 1966; Walker, circ., 1973; WMAA, 1980. **Group:** Sezession Gallery (Europe), 1933-38; Contemporary Arts Gallery, NYC; Jacobsen Gallery, NYC; Society of Independent Artists, NYC; Brooklyn Museum; ACA Gallery; Federal Art Project Gallery, NYC, 1933-38; PAFA, 1944; VMFA, 1957; Riverside Museum, Directions in

Sculpture, 1957; A.F.A., Art and the Found Object, circ., 1959; Jeanne Bucher, Paris (three-man), 1958; MOMA, Sixteen Americans, circ., 1959; ART:USA:59, NYC, 1959; Rome-New York Foundation, Rome, Ciphers, 1960; Utica, Art Across America, 1960; A.F.A., Unique Impressions, 1960; XXXI Venice Biennial, 1962; WMAA Annuals, 1947, 57, 61, 64, 66, 69; Federation of Modern Painters and Sculptors Annuals, 1955, 56, 57, 59; A.F.A., Contemporary Trends, circ., 1955-56; American Abstract Artists Annuals, 1956, 57, 59, 60; Kassel, Documenta III, 1964; MOMA, Contemporary Painters and Sculptors as Printmakers, 1964; Dallas/MFA, 1965; WMAA, Art of the U.S. 1670-1966, 1966; Chicago/AI, 1966, 67; Los Angeles/County MA, American Sculpture of the Sixties, 1967; SRGM, 1967; Jewish Museum, 1968; WMAA, 1969, 73; MOMA, Tamarind; Homage to Lithography, 1969; Princeton U., American Art Since 1960, 1970; Expo '70, Osaka, 1970; Carnegie, 1970; Society of the Four Arts, Calder/Nevelson/David Smith, 1971; Seattle/AM, American Art—Third Quarter Century, 1973; National Gallery, American Art at Mid-Century, 1973; Newport, R.I., Monumenta, 1974; WMAA, The 20th Century: 35 Artists, 1974; WMAA, 200 Years of American Sculpture, 1976; XLV Venice Biennale, 1976; Montclair/AM, Collage: American Masters, 1979; Rutgers U., Vanguard American Sculpture, 1919-1939, 1979; Knoxville Museum, American Women Artists: The 20th Century, 1989; Ohio State U., Art in Europe and America: The 1950s and 1960s, 1990. **Collections:** Allentown/AM; Arts Club of Chicago; Birmingham, Ala./MA; Brandeis U.; Buffalo/Albright; Brooklyn Museum; Carnegie; Chicago/AI; Chicago/Contemporary; Cleveland/MA; Corcoran; Dallas/MFA; Detroit/Institute; Edinburgh/Modern; Fairmount Park Association; Grenoble; High Museum; Hirshhorn; Hospital Corp. of America; Houston/MFA; U. of Illinois; Indiana U.;

Israel Museum; Jewish Museum; Julliard; Kansas City/Nelson; Los Angeles/County MA; MMA; MOMA; Montreal/MFA; NYU; U. of Nebraska; Newark Museum; New Orleans Museum; Norfolk/Chrysler; PAFA; Paris/Moderne; Pasadena/AM; Phoenix; Princeton U.; Queens College; Rijksmuseum Kröller-Müller; Sara Roby Foundation; Rockland/Farnsworth; Rotterdam; SRGM; St. Louis/City; South Mall, Albany; Tate Gallery; WMAA; Walker; Wilmington; Yale U. **Bibliography:** Baur 5; Calas, N. and E.; Craven, W.; Diamonstein; Davies; **Friedman, M., 3**; *From Foreign Shores;* **Glimcher**; Goodrich and Baur 1; **Gordon 4**; Honisch and Jensen, eds.; Hunter, ed.; *Louise Nevelson: Atmosphere and Environments;* Janis and Blesh 1; Licht, F.; Marter, Tarbell, and Wechsler; *Metro; Monumenta;* Nemser; Moser 1; Neumeyer; Phillips, Lisa, 2; Rickey; Rose, B., 1; Rowell; Seitz 4; Selz, J.; Seuphor 3; Siegel; Strachan; Toher, ed.; Trier 1; Tuchman 1. Archives.

NEVELSON, MIKE b. February 23, 1922, NYC. **Studied:** NYU; self-taught in art. Traveled Europe, Mediterranean, Africa, Central and South America. **Taught:** Wooster Community Art Center, Danbury, Conn., 1965-68; Brookfield (Conn.) Craft Center, 1968; U. of New Mexico, 1969-70. **Member:** Artists Equity. **Awards:** Silvermine Guild, 1966. **Address:** P.O. Box N, New Fairfield, CT 06812. **One-man Exhibitions:** Roko Gallery, 1945; Rockland/Farnsworth, 1953; U. of Maine, 1953; Haystack Mountain School of Crafts, 1956; Carl Seimbab Gallery, 1959; Staempfli Gallery, NYC, 1961; The Amel Gallery, NYC, 1964; Wooster Community Art Center, Danbury, 1966; Dartmouth College, 1966; Grand Central Moderns, NYC, 1967; Expo '67, Montreal, 1967; Sachs New York, Inc., NYC, 1969; A.A.A. Gallery, NYC (two-man), 1970; Christ-Janer Gallery, New Canaan, Conn. (two-man), 1975. **Group:** Portland, Me./MA, 1956; Boston Arts Festival,

1959; Norfolk Art Festival, Va., 1959; Carnegie, 1961; Houston/Contemporary, 1961; U. of Illinois, 1961; WMAA, 1962, 64; Hartford/Wadsworth, 1963; Silvermine Guild, 1964, 68, 69; Lincoln, Mass./De Cordova, 1964; Four Seasons Restaurant, Pop Exhibition, 1965; U. of Connecticut, 1965; Brooklyn Museum, 1972; Potsdam/SUNY, 1973; Norske Internasjonale Grafikk Biennale, Fredrikstad, Norway, 1974. **Collections:** Colby College; Hartford/Wadsworth; Housatonic Community College; Slater; Stratford College; WMAA; Youngstown/Butler. **Bibliography:** Archives.

NEWMAN, BARNETT b. January 29, 1905, NYC. d. July 4, 1970, NYC. **Studied:** Cornell U., 1922-26; City College of New York, BA, 1927; ASL, with Duncan Smith, John Sloan, William Von Schlegell. Traveled USA, Canada, Europe. **Taught:** U. of Saskatchewan, 1959; U. of Pennsylvania, 1962-64. Cofounder of a school, "Subject of the Artist," with William Baziotes, Robert Motherwell, and Mark Rothko, NYC, 1948. **One-man Exhibitions:** (first) Betty Parsons Gallery, NYC, 1950, also 1951; Bennington College, 1958; French & Co., Inc., NYC, 1959; Allan Stone Gallery (two-man), NYC, 1962; SRGM, 1966; M. Knoedler & Co., NYC, 1969; Irving Blum Gallery, Los Angeles, 1970; Kammerkunsthalle, Berlin, 1970; U. of Washington, 1971; Baltimore/AM, circ., 1980; U. of Massachusetts, 1983; The Pace Gallery, NYC, 1988; Lorence Monk Gallery, NYC, 1990; MMA, 1988. **Retrospectives:** Pasadena/AM, 1970; MOMA, 1971; Tate Gallery, 1972; Baltimore/MA, 1979. **Group:** Chicago/AI, Abstract and Surrealist Art, 1948; Minneapolis/Institute, American Painting, 1945-57, 1957; MOMA, The New American Painting, circ., Europe, 1958-59; Kassel, Documenta II, 1959; Kimura Gallery, Tokyo, 1959; SRGM, Abstract Expressionists and Imagists, 1961; SRGM/USIA, American Vanguard,

circ., Europe, 1961-62; Seattle World's Fair, 1962; WMAA Annual, 1963; Brandeis U., New Directions in American Painting, 1963; Jewish Museum, Black and White, 1963; Tate, Dunn International, 1964; Chicago/AI Annual, 1964; SRGM, Guggenheim International, 1964; Kunsthalle, Basel, International Painting Since 1950, 1964; MOMA, The New American Painting and Sculpture, 1969. **Collections:** Amsterdam/Stedelijk; Basel; Basel/Kunsthalle; MOMA; Stockholm/National. **Bibliography:** *Abstract Expressionism;* Alloway 4; Anfam; Armstrong, Thomas; Ashbery; Battcock, ed.; Calas 2; Calas, N. and E.; Carmean, Rathbone, and Hess; Chipp; Danto; De Vries, ed.; De Wilde 1, 2; *Europa/Amerika;* Gohr and Gachnang; *The Great Decade;* Goossen 1; Greenberg 1; Haftman; Hess, T. B., 2, 3; Hobbs and Levin; Honisch and Jensen, eds.; Hunter, ed.; Hunter 1; *Individuals;* Johnson, Ellen H.; Kardon 3; Kozloff 3; Lippard 5; *Metro; Monumenta;* Motherwell and Reinhardt, eds.; Murken-Altrogge; Plagens; Richardson 1; Rickey; Rose, B., 1, 4; Rosenblum 2; Rubin 1; Sandler 3, 5; Schneider; Schwartz 1; Seitz 3; Seuphor 1; Siegel; Tomkins 2; Tuckman, ed.; Tuchman 3. Archives.

NEWMAN, JOHN b. 1952, NYC. **Studied:** WMAA, Independent Study Program, 1972; Oberlin College, BA., 1973; Yale U., MFA, 1975. **Address:** c/o Dealer. **Dealer:** David Nolan Gallery, NYC. **One-man Exhibitions:** Thomas Segal Gallery, Boston, 1979; Reed College, 1981; Daniel Weinberg Gallery, Los Angeles, 1985, 88; Jeffrey Hoffeld & Co., NYC, 1986; Jay Gorney Modern Art, NYC, 1987; New York Academy of Sciences, 1988; Editions Ilene Kurtz, NYC, 1988; Gagosian Gallery, NYC, 1988; Galerie Jahn und Fusban, Munich, 1990; Tyler Graphics, Mt. Kisco, N.Y., 1990; Heland Wetterling Gallery, Stockholm, 1990; David Nolan Gallery, NYC, 1990, 91; Galerie Schmela, Düsseldorf, 1990; John

John Newman, *Untitled*, 1991.

Berggruen Gallery, San Francisco, 1991; Galerie Carola Mosch, Berlin, 1991; Greenberg Gallery, St. Louis, 1992; Barbara Mathes Gallery, NYC, 1992. **Group:** WMAA, ISP Exhibition, 1973; Worcester/AM, Between Painting and Sculpture, 1977; MIT, Art of the State, 1977; MIT, Corners, 1979; ICI, Inc., New Sculpture: Icon and Environment, circ., 1983; WMAA, Biennial, 1985; MIT, Natural Forms & Forces, 1986; Brooklyn Museum, Monumental Drawings, 1986; Arkansas/AC, Revelations: Drawings/America, 1988; Ridgefield/Aldrich, Innovations in Sculpture, 1988; Walker, Sculpture: Inside/Outside, 1988; WMAA, Vital Signs, 1988; Brooklyn Museum, Projects & Portfolios, 1989; Brooklyn Museum, Four Americans, 1989; Dartmouth College, Minimalism & Post-Minimalism, 1990; Graphische Sammlung, Albertina, Amerikanische Zeichnungen in der achtziger Jahren, circ., 1990; Boston/MFA, The Unique Print, 1990; AAIAL, 1991; U. of North Carolina, Art on Paper, 1991; Katonah Gallery, Drawn in the Nineties, 1992. **Collections:** Chemical Bank; WMAA; Walker.

NICE, DON **b.** June 26, 1932, Visalia, Calif. **Studied:** U. of Southern California, 1959-64, BFA; Yale U., 1962-64, MFA. **Taught:** Minneapolis School of Art, 1960-62; School of Visual Arts, NYC, 1963-; Dartmouth College, 1982. **Address:** Indian Brook Road, Garrison, N.Y. 10524. **Dealer:** John Berggruen Gallery, San Francisco. **One-man Exhibitions:** Richard Feigen Gallery, Chicago, 1963; Allan Stone Gallery, NYC, 1967, 69, 71, 74; Galerie Alexandra Monett, Brussels, 1973, 75; Gallery A, Sydney, Australia, 1983; U. of Rochester, 1974; Arnhem, 1974; Nancy Hoffman Gallery, NYC, 1975, 77, 79, 80, 81, 83, 84; D. M. Gallery, London, 1975; Dorry Gates Gallery, Kansas City, 1977; Thomas Segal Gallery, Boston, 1979; Brandeis U., circ., 1979; Gallery Moos, Toronto, 1980; U. of Michigan, 1982; Pace Editions, NYC, 1982; Dartmouth College, 1982; Palm Springs Desert Museum, 1983; Joe Chowning Gallery, San Francisco, 1983; John Berggruen Gallery, San Francisco, 1983; Lincoln Center Art Gallery, NYC, 1983; Images Gallery, Toledo, 1983. **Retrospective:** Fine Arts Museum of Long Island, 1985. **Group:** Vassar College, Realism Now, 1968; Indianapolis, 1974; Brooklyn Museum, Print Biennial, 1976; US Dept. of Interior, America 1976, circ., 1976; Contemporary Crafts Museum, NYC, The Great American Foot, 1978; U. of Nebraska, Things Seen; San Antonio/MA, Real, Really Real, Super Real, 1981; PAFA, Contemporary American Realism Since 1960, circ., 1981; Utica, A Painter's Appreciation of Realism, 1982. **Collections:** Arnhem; Canberra/National; Flint/Institute; MOMA; Miami U.; Minneapolis/Institute; Ottawa/National; WMAA; Walker; Wilmington.

NICK, GEORGE b. March 28, 1927, Rochester, N.Y. **Studied:** Cleveland Institute of Art, 1948-51; Brooklyn Museum School, 1951-52, with Edwin Dickinson; Art Students League, 1957-58, with Edwin Dickinson; Yale U., 1961-63, BFA, MFA. **Taught:** Garland Jr. College, 1963-64; Carnegie, 1964-65; Maryland Institute, 1965-66; U. of Pennsylvania, 1966-69; Massachusetts State College of Art, 1969-. **Awards:** National Endowment for the Arts, 1976; AAIAL, Childe Hassam Fund P.P., 1976, 80. **Address:** 86 Philip Farm Road, Concord, Mass. 01742. **Dealer:** Fischbach Gallery, NYC. **One-man Exhibitions:** Carnegie Institute, 1964; Robert Schoelkopf Gallery, NYC, 1965, 67; Richard Gray Gallery, Chicago, 1969, 72, 74, 77, 82, 89; 100 Acres Gallery, NYC, 1971; Harcus Krakow Gallery, Boston, 1974, 79, 82; Tibor de Nagy Gallery, NYC, 1977, 78, 79, 80, 81, 82, 84, 85; Gross McCleaf Gallery, Philadelphia, 1984; The Harcus Gallery, Boston, 1984, 87; Fischbach Gallery, NYC, 1986, 88, 91. **Group:** Omaha/Joslyn, A Sense of Place, 1973; US Department of the Interior, America 1976, circ., 1976; Youngstown/Butler, Midyear Show, 1977, 83; Flint/Institute, Art and the Automobile, 1976; U. of Nebraska, Things Seen, 1978; Tulsa/Philbrook, Realism/Photorealism, 1980; PAFA, Contemporary American Realism Since 1960, 1981; Youngstown/Butler, Midyear, 1983; AAIAL, Annual, 1987, 88, 89; Miyagi Museum of Art, Sendai, Japan, American Realism and Figurative Art, 1952-1991, circ., 1991. **Collections:** AT&T; Boston/MFA; Brandeis U.; Charlotte/Mint; Chemical Bank; Currier; Essen; Grinnell College; Hirshhorn; ICA/Boston; Johannesberg/Municipal; Lincoln/De Cordova; MMA; NYNEX; U. of North Carolina; Omaha/Joslyn.

NICKSON, GRAHAM b. 1946, Knowle Green, Lancashire, England. **Studied:** Harris College, England, 1963-

65; Camberwell School of Art, London, 1965-69; Royal College of Art, London, 1969-72. To USA, 1976. US citizen. **Awards:** Lord Carron P.P., 1968; David Murray Scholarship, 1970, 72; British Institute Fund Scholarship, 1971; John Minton Scholarship, 1971; Prix de Rome, 1972-74; Italian Government Scholarship, 1974; Arts Council of Great Britain Award, 1975; Harkness Fellowship, 1976; Howard Foundation Fellowship, 1980; Guggenheim Foundation, fellowship, 1989. **Taught:** Camberwell School of Arts, 1969-76; Byam Shaw School of Art, London, 1974-76; Yale U., 1976-78; Philadelphia School of Art, 1980; New York Studio School, 1981-88, Dean, 1988-. **Address:** 535 Broadway, NYC 10012. **Dealer:** Salander-O'Reilly Galleries, NYC. **One-man Exhibitions:** Gallery Z, Syracuse, 1979; Susan Caldwell & Co., NYC, 1980, 82; U. of Connecticut, 1982; Hirschl & Adler Modern, NYC, 1983, 86; Dart Gallery, Chicago, 1984, 87; John Berggruen Gallery, San Francisco, 1984; Northern Centre for Contemporary Art, Sunderland, U.K., circ., 1986; Riva Yares Gallery, Scottsdale, Ariz., 1989; Gallery Camino Real, Boca Raton, Fla., 1990; U. of North Carolina, 1991. **Group:** The Drawing Center, NYC, Previously Unseen, 1979; ICI, Large Drawings, circ., 1985; Northern Centre for Contemporary Art, Sunderland, U.K., Japonisme, 1986; Bard College, Drawings, 1991; Miyagi Museum, Sendai, Japan, American Realism & Figurative Art, 1955-1990, circ., 1991. **Collections:** Amerada Hess Corp.; American Express Co.; Buffalo/Albright; Chase Manhattan Bank; U. of Connecticut; MMA; Middlesborough Art Gallery; Purchase/SUNY; Royal College of Art; San Diego/Contemporary; Wellesley College.

NILSSON, GLADYS b. May 6, 1940, Chicago. **Studied:** Chicago Art Institute School, 1962, BA. **Commissions:** ART Park, Lewiston, N.Y., 1979. **Awards:** Chicago/AI, Logan Medal, 1967;

Chicago/AI, Bartels Prize, 1978; National Endowment for the Arts, Grant, 1974. **m.** Jim Nutt. **Address:** 1035 Greenwood, Wilmette, IL 60091. **Dealers:** Phyllis Kind Gallery, Chicago and NYC; Janet Fleisher Gallery, Philadelphia; Ovsey Gallery, Los Angeles; Braunstein/Quay Gallery, San Francisco. **One-man Exhibitions:** SFAI, 1969; Candy Store Gallery, Folsom, Calif., 1971, 72, 73; WMAA, 1973; U. of Wisconsin, Madison, 1977; Phyllis Kind Gallery, Chicago, 1970, 73, 74, 77, 78, 81, 83, 87, 91; Phyllis Kind Gallery, NYC, 1975, 79, 82, 87; Portland (Ore.) Center for Visual Arts, 1979; Wake Forest U., 1979; Randolph Street Gallery, Chicago, 1984; Galerie Bonnier, Geneva, 1985; Janet Fleisher Gallery, Philadelphia, 1991; Braunstein-Quay Gallery, San Francisco, 1991; Xochipilli Gallery, Birmingham, Mich., 1992; Ovsey Gallery, Los Angels, 1992. **Group:** Hyde Park Art Center, Chicago, The Hairy Who, 1966, 67, 68; Chicago/Contemporary, Don Baum Sez, "Chicago Needs Famous Artists," 1969; ICA, U. of Philadelphia, Spirit of the Comics, 1969; WMAA, Human Concern/Personal Torment, 1970; SFMA, Poetic Fantasy, 1971; Chicago/Contemporary, Chicago Imagist Art, 1972; Ottawa/Ontario, What They're Up to in Chicago, 1972; São Paulo, XII Biennial; Madison Art Center, Contemporary Figurative Painting in the Midwest, 1977; Sacramento/Crocker, The Chicago Connection, 1977; Chicago/AI, 100 Artists—100 Years, 1979; U. of North Carolina, Some Recent Art from Chicago, 1980; Sunderland (Eng.) Art Centre, Who Chicago?, circ., 1980; Kansas City/AI, Chicago Imagists, 1982; Illinois Wesleyan U., Contemporary Chicago Images, 1983; Chicago/Terra, Two Hundred Years of American Paintings, 1983; U. of Chicago, The Drawings of the Chicago Imagists, 1987; Bowling Green State U., Of New Account, 1987; U. of Chicago, The Chicago Imagist Print, 1987; Fresno Art Center, The Years of Passage, 1969-1975; Randolph-Macon Women's College, 78th Annual: Chicago, 1989; Chicago/AI, Chicago and Vicinity, 1990; South Bend Art Center, South Bend, Indiana, Watercolor Alternatives, 1990; Los Angeles/County MA, Parallel Vision, circ., 1992.

Gladys Nilsson, *By the Pier*, 1987.

Collections: Art Gallery of Western Australia; Chicago/AI; Chicago/Contemporary; Continental Bank, Chicago; First National Bank of Chicago; State of Illinois; MOMA; Milwaukee; Museum des 20. Jahrhunderts, Vienna; NMAA; New Orleans Museum; PMA; Phoenix; U. of Rochester; WMAA. **Bibliography:** Adrian; Adrian and Born; *Who Chicago?*

NIVOLA, CONSTANTINO
b. July 5, 1911, Orani, Sardinia. **d.** 1988, Bridgehampton, N.Y. **Studied:** Istituto Superiore d'Arte, Monza, Italy, with Marino Marini, Marcello Nizzoli, 1930-36, MA. Art Director for Olivetti Company, 1936-39. Traveled Europe, USA. To USA, 1939. Art Director, *Interiors* magazine, 1941-45. **Taught:** Director, Design Workshop of Harvard U. Graduate School, 1953-57; Columbia U., 1961-63; Harvard U., 1970-73; International U. of Art, Florence, Italy, 1971; Dartmouth College, 1978; U. of California, Berkeley, 1978-79. **Member:** Artists Equity; Architectural League of New York; NIAL. **Commissions:** Milan Triennial, 1933 (mural, with S.R. Francello); Italian Pavilion, Paris World's Fair, 1937; Olivetti Showroom, NYC, 1953-54 (mural); Four Chaplains Memorial Fountain, Falls Church, Va., 1955; 1025 Fifth Avenue, NYC, 1955 (gardens); William E. Grady Vocational High School, Brooklyn, N.Y., 1957; Mutual Insurance Co. of Hartford, Hartford, Conn., 1957 (facade); P.S. 46, Brooklyn, N.Y., 1959 (murals and sculptures for playground); McCormick Place, Exposition Hall, Chicago, 1960 (facade); Motorola Building, Chicago, 1960 (murals); Saarinen Dormitories, Yale U., 1962 (35 sculptures); designed a memorial plaza in Nuoro, Italy, 1966; P.S. 320, Brooklyn, N.Y., 1967 (sculpture); Mexico City/Nacional, 19th Olympiad, 1968 (sculpture). **Awards:** Philadelphia Decorators Club Award, 1959; Carborundum Major Abrasive Marketing Award, 1962; Municipal Art Society of New York, Certif-icate of Merit, 1962; Regional Exhibition of Figurative Art, Cagliari, Italy, Gold Medal; Federation of Graphic Arts, Diploma; Park Association of New York, NYC, Certificate of Commendation, 1965; American Institute of Architects, Fine Arts Medal, 1968. **One-man Exhibitions:** (first) Sassari Gallery, Sardinia, 1927 (paintings); Betty Parsons Gallery, NYC, 1940 (two-man, with Saul Steinberg); (first one-man in USA) Tibor de Nagy Gallery, NYC, 1950; The Peridot Gallery, NYC, 1954, 57; Harvard U., 1956; The Bertha Schaefer Gallery, NYC, 1958; Architectural League of New York, 1958; Galleria Il Milione, Milan, 1959; Arts Club of Chicago, 1959; A.F.A., circ., 1960; Galleria dell' Ariete, 1962; The Byron Gallery, 1964-67; Andrew-Morris Gallery, NYC; Marlborough Galleria d'Arte, Rome, 1973; The Willard Gallery, NYC, 1973; Cagliari U., Italy, 1973; ICA, Boston, 1974; Gallery Paule Anglim, San Francisco, 1978; Washburn Gallery, Inc., NYC, 1984. **Group:** Brooklyn Museum, 1947; American Abstract Artists, 1947; Rome National Art Quadriennial, 1950, 73; Riverside Museum, NYC, 1955; WMAA, 1957; Carnegie, 1958; Museum of Contemporary Crafts, 1962; National Gold Medal Exhibition of the Building Arts, NYC, 1962; A.F.A., American Drawing, circ., 1964. MOMA. **Collections:** U. of California, Berkeley; Harvard U.; Hirshhorn; MOMA; PMA; Uffizi Gallery; WMAA. **Bibliography:** Giedion-Welcker 1; Licht, F.; Metro; Seuphor 3; Trier 1.

NOGUCHI, ISAMU
b. November 17, 1904, Los Angeles, Calif. Resided Japan, ages 2-14. **d.** December 30, 1988, NYC. **Studied:** Columbia U., 1923-25 (premedical); apprenticed briefly to Gutzon Borglum; Leonardo da Vinci Art School, NYC; East Side Art School, NYC; apprenticed to Constantin Brancusi, Paris, 1927-29. Traveled Mexico, USSR, the Orient, Europe, Israel, USA. Designed numerous stage sets for Martha Graham Dance

Co. In May 1985, The Isamu Noguchi Garden Museum opened in Long Island City, N.Y. **Member:** National Sculpture Society. **Commissions:** Connecticut General Life Insurance Co. (gardens and sculpture); First National Bank of Fort Worth, Tex. (piazza and sculpture); John Hancock Building (fountain and sculpture); Chase Manhattan Bank, NYC (garden); Associated Press, NYC (relief), 1938; Yale U. Library of Precious Books; Keyo U., Japan (2 gardens); UNESCO, Paris (garden); International Business Machines, Armonk, N.Y.; Billy Rose Garden, Jerusalem; Detroit Civic Center Memorial Fountain, 1974; Pepsico, Purchase, N.Y., 1974; Horace E. Dodge & Son Memorial Fountain, and Philip A. Hart Plaza, Detroit, Mich., 1973-79; stepped garden for Sogetsu School of Flower Arrangement, Tokyo, 1977-78. **Awards:** Guggenheim Foundation Fellowship, 1927; Bollingen Foundation Fellowship, 1950; Chicago/AI, The Mr. & Mrs. Frank G. Logan Medal; Hon. DFA, New School for Social Research, 1974; Hon. DFA, Columbia U., 1984; New York State Council on the Arts Governor's Arts Award, 1984; Japanese-American Citizens' League Biennium Award, 1984; Israel Museum Fellowship, 1985; Municipal Arts Society, NYC, President's Medal, 1985; Inomori Foundation, Japan, Kyoto Prize, 1986; National Medal of Arts, presented by Ronald Reagan, 1987; Order of the Sacred Treasurer, Japan, 1988. **One-man Exhibitions:** (first) Eugene Schoen Gallery, NYC, 1929; Marie Sterner Gallery, NYC, 1930; Harvard Society for Contemporary Art, 1930; Arts Club of Chicago, 1930; Buffalo/Albright, 1930; Reinhardt Galleries, NYC, 1932; Demotte Gallery, NYC, 1932; Mellon Galleries, Philadelphia, 1933; Marie Harriman Gallery, NYC, 1934; Sidney Burney Gallery, London, 1934; Western Association of Art Museum Directors, circ., 1934; Honolulu Academy, 1934, 39; John Becker (Gallery), NYC, 1939, 42; SFMA, 1942; Charles Egan Gallery, 1948;

Daniel Cordier, Paris; Cordier & Ekstrom, Inc., NYC, 1963, 65, 67-69, 70; Gimpel & Hanover, 1968, 72; Gimpel Fils, 1968, 72; Minami Gallery, 1973; The Pace Gallery, NYC, 1975, 80, 83, 86, 88; MOMA, 1977; Walker, circ., 1978-79; André Emmerich Gallery, NYC, 1980; WMAA, 1980; Galerie Maeght, Paris, 1981; Gemini G.E.L., Los Angeles, 1982; Richard Gray Gallery, Chicago, 1983; XLII Venice Biennial, 1986; Gallery Kasharara, Osaka, 1983, 85, 89; Sogetsus School of Flower Arranging, Tokyo, 1984; Arnold Herstand Gallery, NYC, 1985, 88; Seibu Department Store, Tokyo, 1985; Venice Biennial, 1986; WMAA/Philip Morris, 1989. **Retrospectives:** WMAA, 1968; Tokyo/National Museum, circ., 1992. **Group:** MOMA, Fantastic Art Dada, Surrealism, 1936; Musée du Jeu de Paume, Trois Siècles d'Art aux États-Unis, 1938; MOMA, Art in Our Time, 1939; MOMA, 14 Americans, 1946; MOMA, Abstract Painting and Sculpture in America, 1951; WMAA, Nature and Abstraction, 1958; Kassel, Documenta II & III, 1959, 64; WMAA, American Art of Our Century, 1961; Seattle World's Fair, 1962; Los Angeles/County MA, American Sculpture of the Sixties, circ., 1967; WMAA, 1970; Carnegie, 1970; Venice Biennial, 1972; SRGM, Masters of Modern Sculpture, 1974; WMAA, 200 Years of American Sculpture, 1976; WMAA, The Third Dimension, 1984; WMAA, William Carlos Williams and the American Scene, 1920-1940, 1978; London/Hayward, Dada & Surrealism Reviews, 1978; Syracuse/Everson, A Century of Ceramics in America, 1878-1978, 1979; Rutgers U., Vanguard American Sculpture, 1913-1939; Carnegie, Abstract Painting and Sculpture in America, 1927-1944, circ., 1983; Southampton/Parrish, Flying Tigers, 1985; Brooklyn Museum, The Machine Age, 1986; AFA, Abstract Sculpture in America, 1930-70, circ., 1991. **Collections:** Art Gallery of Ontario, Toronto; Brooklyn Museum; Buffalo/Albright; Chicago/AI;

Cleveland/MA; Des Moines; Hartford/Wadsworth; Hirshhorn; Honolulu Academy; Jerusalem/National; Kamakura; Los Angeles/County MA; MMA; MOMA; Nagoya; U. of Nebraska; New School for Social Research; Princeton U.; Rijksmuseum Kröller-Müller; SFMA; SRGM; Society of Four Arts; Storm King Art Center; Tate; Toledo/MA; Toronto; WMAA; Walker; West Palm Beach/Norton; Yale U. **Bibliography:** Baur 5, 7; Biddle 4; Blesh 1; Breton 3; Brumme; Cahill and Barr, eds.; Calas; Cheney; Craven, W.; Cummings 1; Downes, ed.; Flanagan; Giedion-Welcker 1; Goodrich and Baur 1; **Gordon 2; Hunter 3,** 6; *Index of 20th Century Artists; Individuals; Isamu Noguchi;* **Noguchi 2;** Krauss 2; Kuh 2; Lane and Larsen; Licht, F.; McCurdy, ed.; Marter, Tarbell, and Wechsler; Mendelowitz; *Metro;* Miller, ed., 2; Neumeyer; **Noguchi;** Phillips, Lisa, 2; Read 3; Ritchie 1, 3; Rose, B., 1; Rowell; Rubin 1; Seuphor 3; Seymour; Strachan; **Takiguchi;** Trier 1; Tuchman 1. Archives.

NOLAND, KENNETH b. April 10, 1924, Asheville, N.C. **Studied:** Black Mountain College, 1946, with Ilya Bolotowsky; Zadkine School of Sculpture, Paris, 1948-49. US Air Force, 1942-46. **Taught:** The Catholic U. of America; ICA, Washington, D.C.; Emma Lake Artist's Workshops, U. of Saskatchewan; Bennington College; Bard College, 1985. Designed sets for *Futurities,* a Steve Lacy/Robert Creeley ballet. **Awards:** Corcoran, 1967. **Member:** AAAL. **Address:** 125-A Kitchawan Road, South Salem, N.Y. 10590. **Dealer:** Salander-O'Reilly Galleries, Inc., NYC. **One-man Exhibitions:** (first) Galerie Creuze, Paris, 1949; French & Co. Inc., NYC, 1959; Galleria dell'Ariete, 1960; Galerie Lawrence, Paris, 1961; Bennington College, 1961; André Emmerich Gallery, NYC, 1961-64, 1966, 67, 71, 73, 75, 77, 80, 81, 82, 83, 84, 85, 86; Galerie Charles Leinhard, Zurich, 1962; Galerie Schmela, 1962, 64; Kasmin

Ltd., 1963, 65, 68; David Mirvish Gallery, 1965, 74, 76; Harvard U., Three American Painters (with Jules Olitski, Frank Stella), circ., Pasadena, 1965; St. John, N.B., 1966 (three-man, with Helen Frankenthaler, Jules Olitski); MMA, 1968 (three-man, with Morris Louis, Anthony Caro); Lawrence Rubin Gallery, 1969; Dayton's Gallery 12, Minneapolis, 1969 (three-man, with Anthony Caro, Frank Stella); Galerie Mikro, Berlin, 1972; Waddington Galleries, London, 1973, 78, 79, 81; Jack Glenn Gallery, Corona del Mar, 1974; Janie C. Lee Gallery, Houston, NYC, 1974; Rutland Gallery, 1974; School of Visual Arts, 1975; Watson/de Nagy, 1975; Leo Castelli Inc., NYC, 1976, 79, 80; Galerie Wentzel, Hamburg, 1977; Thomas Segal Gallery, Boston, 1977, 79; Medici II Gallery, Bay Harbor Islands, Fla., 1978; Waddington Gallery, Montreal, 1979; Waddington Gallery, Toronto, 1979; Katonah (N.Y.) Art Gallery, 1979; Hokin Gallery, Palm Beach, 1979; Ridgefield/Aldrich, 1980; Wichita State U., 1980; Sandra K. Bertsch Gallery, Oyster Bay, N.Y., 1982; Gimpel-Hanover & André Emmerich Gallerien, Zurich, 1982; Thomas Segal Gallery, Boston, 1982; Galerie Wentzel, Cologne, 1982, 84; Hokin Gallery, Bay Harbor Island, Fla., 1983, 89; Mexico City/Moderno, 1983; Galeria Joan Prats, Barcelona, 1983, 85; U. of California, Berkeley, 1984; Galerie de France, Paris, 1984; Makler Gallery, Philadelphia, 1984; Mixografia Gallery, Los Angeles, 1984; Galerie Onnasch, Berlin, 1984; Galeria Joan Prats, NYC, 1984, 86, 87, 89; Stadtische Galerie Villa Zanders, Bergisch Gladbach, 1984; Waddington & Shiell Galleries, Toronto, 1984; Diputacio De Valencia, Spain, 1985; Museu Provincial de Bellas Artes, Bilbao, 1985; Museo del Patriarca, Dupatacio de Valencia, Spain, 1985; Gallery One, Toronto, 1986, 88; R. H. Love Modern, Chicago, 1986; Satani Gallery, Tokyo, 1986; Galerie Don Steward, Montreal, 1987; Heath Gallery, Atlanta, 1989; Salander-O'Reilly Galleries, NYC, 1989,

90, 91; Meredith Long & Co., Houston, 1990; Helander Gallery, Palm Beach, 1990; Edmonton Art Gallery, Edmonton, Canada, 1990; Galerias Afinsa and Almirante, Madrid, 1991. **Retrospectives:** The Jewish Museum, 1964; SRGM, circ., 1977. **Group:** The Kootz Gallery, NYC, New Talent, 1954; Corcoran, 1958, 63, 67; SRGM, Abstract Expressionists and Imagists, 1961; Seattle World's Fair, 1962; WMAA, Geometric Abstraction in America, circ., 1962; Jewish Museum, Toward a New Abstraction, 1963; XXXII Venice Biennial, 1964; Los Angeles/County MA, New Abstraction, 1964; Tate, Gulbenkian International, 1964; Carnegie, 1964-65, 67; Detroit/Institute, Color, Image and Form, 1967; Expo '67, Montreal, 1967; Dublin/Municipal, I International Quadrennial (ROSC), 1967; International Biennial Exhibition of Paintings, Tokyo; Kassel, Documenta IV, 1968; MOMA, The Art of the Real, 1968; Pasadena/AM, Serial Imagery, 1968; Washington U., The Development of Modernist Painting, 1969; U. of California, Irvine, New York: The Second Breakthrough, 1959-1964, 1969; MMA, New York Painting and Sculpture: 1940-1970, 1969-70; Buffalo/Albright, Color and Field: 1890-1970, 1970; WMAA, The Structure of Color, 1971; Carnegie, 1971; Boston/MFA, Abstract Painting in the '70s, 1972; Houston/MFA, The Great Decade of American Abstraction: Modernist Art 1960-1970, 1974; Corcoran Biennial, 1975; MIT, Paper Forms: Handmade Paper Projects, 1977; Chicago/Contemporary, A View of a Decade, 1977; Indianapolis, 1976; Syracuse/Everson, A Century of Ceramics in the United States, 1878-1978, 1979; Montreal/Contemporain, Artistes Americains Contemporains, 1978; Buffalo/Albright, American Painting of the 1970s, 1978; U. of Illinois, 1978; Tokyo/Modern, Print Biennial, 1979; Brockton (Mass.)/Art Center, Aspects of the '70s: Painterly Abstraction, 1980; Grand Palais, Paris, L'Amerique aux

Independants, 1980; Walker, Artist & Printer, 1980; Cologne, Westkunst, 1981; Haus der Kunst, Munich, Amerikanische Malerei, 1930-1980, 1981; Edmonton Art Gallery, The Threshold of Color, 1982; SRGM, The New York School, 1982; Brooklyn Museum, The American Artist as Printmaker, 1984; Cleveland Center for Contemporary Art, Artists + Architects, Challenges in Collaboration, 1985; MOMA, Contrasts of Form: Geometric Abstract Art 1910-1980, 1985; Fort Lauderdale, An American Renaissance: Painting and Sculpture Since 1940, 1986. **Collections:** Adelaide; Baltimore/MA; Basel; Boston/MFA; Brandeis U.; Buffalo/Albright; Canberra/National; Chicago/AI; Cleveland/MA; Columbus; Corcoran; Des Moines; Detroit/Institute; Düsseldorf/KN-W; Harvard U.; Hirshhorn; Honolulu Academy; Humlebaek/Louisiana; Los Angeles/County MA; MMA; MOMA; Milwaukee; National Gallery; Paris/Beaubourg; Pasadena/AM; Phillips; SRGM; St. Louis/City; Tate Gallery; WMAA; Walker; Youngstown/Butler; Zurich. **Bibliography:** Alloway 3, 4; Anfam; Armstrong, Thomas; Ashbery; Battcock, ed.; Bihalji-Merin; Calas, N. and E.; *Contemporanea;* Coplans 3; Cummings 1; De Vries, ed.; Gablik; *The Great Decade;* Goossen 1; Honisch and Jensen, eds.; Hunter, ed.; Kozloff 3; Lippard 5; Lynton; *Metro;* Murken-Altrogge; Plagens; Rickey; Rose, B., 1; Sandler 3, 5; Seitz 3; Tomkins 2; Waldman **6;** Weller. Archives.

NORDEFELD, B. J. O.
from 1st to 4th edition.

NOVROS, DAVID b. August 8, 1941, Los Angeles, Calif. **Studied:** U. of Southern California, BFA, 1963. US Army Reserves, 1964. Traveled Europe, Mexico, USA. Writer on art. **Award:** Guggenheim Foundation, fellowship, 1970. m. Joanna Pousette-Dart. **Address:** 433 Broome

Street, NYC, 10013. **One-man Exhibitions:** Dwan Gallery, Los Angeles, 1966, NYC, 1967; Galerie Muller, Stuttgart, 1967; Bykert Gallery, 1968, 69, 73, 74; Mizuno Gallery, 1969, 70; The Texas Gallery, 1973, 75; Weinberg Gallery, San Francisco, 1973; Rosa Esman Gallery, 1973; Sperone Westwater Fischer Inc., NYC, 1976, 78; Jon Leon Gallery, 1983. **Group:** SRGM, Systemic Painting, 1966; Kansas City/Nelson, Sound, Light, Silence, 1966; ICA, U. of Pennsylvania, A Romantic Minimalism, 1967; A.F.A., Rejective Art, 1967; WMAA, 1967, 69, 73; Washington U., The Development of Modernist Painting, 1969; Buffalo/Albright, Modular Painting, 1970; WMAA, The Structure of Color, 1971; Corcoran Biennial, 1971; Chicago/Contemporary, White on White, 1971-72; Chicago/AI, 1972; Chicago/Contemporary, Five Artists: A Logic of Vision, 1974; Buffalo/Albright, Geometric Painting, 1990. **Collections:** Dallas/MFA; Los Angeles/MOCA; MOMA; NMAA; WMAA. **Bibliography:** Murdock 1; *New in the Seventies.*

NOWACK, WAYNE K. b. May

7, 1923, Des Moines, Iowa. **Studied:** Drake U., 1943-45; State U. of Iowa, with Maurico Lasansky, James Lechay, Stuart Edie, 1945-57, BA, PBK, 1948, MA (art history), 1950, MFA (painting). Traveled Mexico. **Awards:** Des Moines, First Prize, 1950; Danforth Foundation Grant, 1962; National Endowment for the Arts Grant, 1973. **Address:** R.D. 1, Box #346, Spencer, N.Y. 14883. **Dealer:** Allan Stone Gallery, NYC. **One-man Exhibitions:** (first) Des Moines, 1950, also 1957; Union College (N.Y.), 1957; Albany/Institute, 1961; Schenectady Museum Association, 1961; Allan Stone Gallery, NYC, 1967, 70, 74. **Group:** Omaha/Joslyn Annuals, 1947, 50; Denver/AM, 1948; Library of Congress Print Annual, 1948; Des Moines, 1948, 50-53; Silvermine Guild, 1954; Utica, 1961; Skidmore College, 1961; Brandeis U., Recent American Drawings, 1964;

Jim Nutt, *Pug*, 1990.

New School for Social Research, Albert List Collection, 1965; WMAA, Human Concern/Personal Torment, 1969; Minnesota/MA, American Drawings 1927-1977, 1977; Purchase/SUNY, The Private Eye, 1984. **Collections:** Des Moines; Drake U.; Fort Worth; Hirshhorn; State U. of Iowa; Skidmore College; Union College (N.Y.); Williams College.

NUTT, JIM (James Trueman)

b. November 28, 1938, Pittsfield, Mass. **Studied:** Washington U., 1958-59; Chicago Art Institute School, 1960-65, BFA. **Awards:** National Endowment for the Arts, fellowship, 1990. **m.** Gladys Nilsson. **Address:** 1035 Greenwood, Wilmette, IL 60091. **Dealer:** Phyllis Kind Gallery, Chicago and NYC. **One-man Exhibitions:** Candy Store Gallery, Folsom, Calif., 1971, 72, 73; Chicago/Contemporary, 1974; Walker, 1974; SFAI, 1975; Portland (Ore.) Center for Visual Arts, 1975; Phyllis Kind Gallery, Chicago, 1970, 72, 75, 77, 79, 82, 85, 91; Phyllis Kind Gallery, NYC, 1976, 77, 80, 84, 88, 91; James Mayor Gallery, London, 1983; Galerie Bonnier, Geneva, 1992. **Retrospective:** Rotterdam, Kunstichting, 1980. **Group:** Hyde Park Art Center, Chicago, The Hairy Who, 1966, 67, 68; School of Visual Arts, NYC, The Hairy Who, 1969;

Chicago/Contemporary, Don Baum Sez, "Chicago Needs Famous Artists," 1969; ICA, U. of Pennsylvania, Spirit of the Comics, 1969; WMAA, Human Concern/Personal Torment, 1970; SFAI, Surplus Slop from the Windy City, 1970; Chicago/Contemporary, Chicago Imagist Art, 1972; Sacramento/Crocker, Sacramento Sampler, 1972; Venice Biennial, 1972; WMAA, American Drawings, 1963-73, 1973; São Paulo Biennial, 1974; Chicago/AI, Annual, 1976; U. of Illinois, 1974; WMAA Biennials, 1973, 77; U. of Texas, Austin, New in the Seventies, 1977; Chicago/AI, Drawings of the 70s, 1977; Chicago/Contemporary, View of a Decade, 1977; Brooklyn Museum, American Drawings in Black and White, 1970-1979, 1980; Norfolk/Chrysler, American Figure Painting, 1980; WMAA, The Figurative Tradition and the WMAA, 1980; Sunderland (Eng.) Arts Centre, Who Chicago?, circ., 1980; Munich, Haus der Kunst, Amerikanische Malerie, 1930-1980, 1981; WMAA, Focus on the Figure, 1982; Milwaukee, American Prints, 1982; Illinois Wesleyan U., Contemporary Chicago Imagists, 1983; IEF, Twentieth Century American Drawings: The Figure in Context, circ., 1984; Hirshhorn, Contemporary Focus, 1984; Chicago/AI, Chicago and Vicinity Drawing Exhibition, 1985; Corcoran, Biennial, 1985; Northwest Illinois U., Chicago Figurative Imagery, 1986; Bowling Green State U., Of New Account, 1987; U. of Chicago, Drawings of the Chicago Imagists, 1987; Chicago/Terra, Surfaces, 1987; Chicago Public Library Cultural Center, Urgent Messages, 1987; U. of Chicago, The Chicago Imagist Print, 1987; U. of Florida, Divergent Styles, 1990; U. of Massachusetts, Amherst, Diverging Styles, 1990; Milwaukee, Word as Image, circ., 1990; State of Illinois, Art Gallery, Chicago, Spirited Visions, circ., 1991; Los Angeles/County MA, Parallel Visions, 1991; Chicago/AI, From America's Studios, 1992. **Collections:** Arkansas Art Center; Chicago/AI; Chicago/Contemporary; Glasgow/AGM; High Museum; State of Illinois; U. of Illinois; MMA; MOMA; Memphis/Brooks; Milwaukee; Museum des 20. Jahrhunderts, Vienna; NMAA; New Orleans; U. of North Carolina; PMA; U. of Rochester; WMAA. **Bibliography:** Adrian; Adrian and Born; Armstrong, Thomas; *The Chicago Connection;* Cummings 4, 5; Kirschner; *New in the Seventies; Who Chicago?*

O

O'HANLON, RICHARD
from 1st to 4th edition.

OHASHI, YUTAKA
from 1st to 4th edition.

OHLSON, DOUG **b.** November 18, 1936, Cherokee, Iowa. **Studied:** U. of Minnesota, 1959-61, BA. US Marine Corps, 1955-58. **Taught:** Hunter College, 1964-. **Awards:** Guggenheim Foundation Fellowship, 1969; CAPS Grant, 1974; National Endowment for the Arts, grant, 1976. **Member:** Board of Governors, Skowhegan School. **Address:** 35 Bond Street, NYC 10012. **Dealer:** Andre Zarre Gallery, NYC. **One-man Exhibitions:** Fischbach Gallery, NYC, 1964, 66, 67, 68, 69, 70, 72; Susan Caldwell Inc., NYC, 1974, 76, 77, 79, 81, 82, 83; Portland (Ore.) Center for the Visual Arts, 1977; Andre Zarre Gallery, NYC, 1985, 90, 92; Ruth Siegel Ltd., NYC, 1985; Gallery 99, Bay Harbor Island, Fla., 1986; Nina Freudenheim Gallery, Buffalo, N.Y., 1986; Ruth Siegel, Ltd., NYC, 1987; Ann Jaffe Gallery, Bay Harbor Islands, Fla., 1989; Jaffe Baker Gallery, Boca Raton, Fla., 1990. **Retrospective:** Bennington College, 1983. **Group:** Detroit/Institute, Color, Image and Form, 1967; MOMA, The Art of the Real, 1968; WMAA, The Structure of Color, 1971; Corcoran, 1975; UCLA, Fourteen Abstract Painters, 1975; NYU, Project Rebuild, 1976; Old West-

bury/SUNY, Transitions I, 1979; P.S. 1, Long Island City, Abstract Painting: 1960-69, 1983; Frankfurt/Moderne, Bilder für Frankfurt, 1985; U. of Northern Iowa, Born in Iowa: The Homecoming, circ., 1986; Hunter College, 8 Young Artists, 1991; AAIAL, 1991. **Collections:** AT&T; Brooklyn Museum; Buffalo/Albright; Chase Manhattan Bank; Coudert Brothers, NYC; Corcoran; Dallas/MFA; Frankfurt/Moderne; Helsinki/Contemporary; IBM; U. of Iowa; Isham, Lincoln & Beale, Chicago; MMA; Minneapolis/Institute; National Gallery; U. of North Carolina; Utah; Security Pacific National Bank. **Bibliography:** Murdock 1.

OKADA, KENZO **b.** September 28, 1902, Yokohama, Japan. **d.** July 25, 1982, Tokyo. **Studied:** Meijigakuin Middle School; Tokyo U. of Arts, three semesters; in Paris, 1924-27. **Taught:** Nippon Art College, 1940-42; Musashino Art Institute, 1947-50; Tama College of Fine Arts, Tokyo, 1949-50. To USA, 1950; citizen, 1960. **Member:** Nikakai (Group), Japan, 1938-82. **Awards:** Nikakai (Group), Japan 1936; Showa Shorei, 1938; Yomiuri Press, 1947; Chicago/AI, 1954, 57; Carnegie, 1955; Columbia, S.C./MA, First Prize, 1957; XXIX Venice Biennial, 1958; Tate, Dunn International Prize, 1964; Mainichi Art Award, 1966; AAAL, Marjorie Peabody Waite Award, 1977. **One-man Exhibitions:** Nichido Gallery, Tokyo, 1929-35; Hokuso Gallery, 1948, 50; US Army Education Center, Yokohama, 1950; Betty Parsons Gallery, 1953, 55, 56, 59, 62-64, 67, 69, 71, 73, 76, 78; Corcoran, 1955; São Paulo, 1955; Fairweather-Hardin Gallery, Chicago, 1956; Myrtle Todes Gallery, Glencoe, Ill., 1957; Venice/Contemporaneo, 1958; Ferus Gallery, Los Angeles, 1959; MIT, 1963; Buffalo/Albright, 1965; Columbus Gallery, 1979; U. of Texas, 1979; Indianapolis, 1979; Phillips, 1979; Marisa del Re Gallery, NYC, 1984, 86, 88; Gallery Urban, Paris, 1988. **Retrospectives:** Traveling Exhibition, 1966-67, circ., Tokyo, Kyoto, Honolulu,

San Francisco, and Austin, Tex.; Seibu Museum of Art, 1982. **Group:** Salon d'Automne, Paris, 1924-27; Nikakai (Group), Japan, 1938-82; WMAA; Chicago/AI; U. of Illinois; III São Paulo Biennial, 1955; Corcoran; MOMA; XXIX Venice Biennial, 1958; Tate, Dunn International, 1964. **Collections:** Baltimore/MA; Boston/MFA; Brooklyn Museum; Buffalo/Albright; Carnegie; Chase Manhattan Bank; Chicago/AI; U. of Colorado; Columbia, S.C./MA; Denver/AM; Equitable Life Assurance Society; Fukuoka; Hartford/Wadsworth; Honolulu Academy; Indianapolis; Kyoto/Modern; Lincoln Center; MMA; MOMA; Memphis/Brooks; Osaka/Contemporary; Phillips; Portland, Ore./AM; Purchase/SUNY; Reynolds Metals Co.; Rockefeller Institute; Rome/Nazionale; SFMA; SRGM; St. Lawrence U.; St. Louis/City; Santa Barbara/MA; Tokyo/Modern; Toledo/MA; Tougaloo College; Toyama (Japan)/Modern; Utica; WMAA; Yale U. **Bibliography:** Baur 5; Hunter, ed.; Goodrich and Baur 1; Nordness, ed.; Ponente; Read 2; Rodman 1.

OKAMURA, ARTHUR b. February 24, 1932, Long Beach, Calif. **Studied:** Chicago Art Institute School, with Paul Wieghardt, 1950-54; The U. of Chicago, 1951, 53, 57; Yale U., 1954. US Army, 1954. Traveled France, Spain, North Africa, Japan, Bali, Indonesia; resided Mallorca for a year. **Taught:** Central YMCA College, Chicago, 1956-57; Evanston (Ill.) Art Center, 1956-57; Northshore Art League, Winnetka, Ill., 1957; Academy of Art, San Francisco, 1957; Chicago Art Institute School, 1957; California School of Fine Arts, 1958; California College of Arts and Crafts, 1958-59, 1966-69; Saugatuck Summer School of Painting, 1959, 62; U. of Utah, 1964. **Awards:** The U. of Chicago, Religious Arts, 1953; four-year scholarship to the Chicago Art Institute School; Edward L. Ryerson Traveling Fellowship, 1954; Chicago/AI, Martin B. Cahn Award, 1957; U. of Illinois, P.P.,

1960; WMAA, Neysa McMein P.P., 1960; NIAL, P.P.; SFMA, Schwabacher-Frey Award, 1960. **Address:** 210 Kale Street, Bolinas, CA 94924. **Dealer:** Braunstein/Quay Gallery, San Francisco. **One-man Exhibitions:** (first) Frank Ryan Gallery, Chicago, 1953; La Boutique, Chicago, 1953, 54; Feingarten Gallery, Chicago, NYC, San Francisco, and Los Angeles, 1956-64, 69, 71, 73, 75, 77, 80; Santa Barbara/MA, 1958; Oakland/AM, 1959; California Palace, 1961; Dallas/MFA, 1962; La Jolla, 1963; U. of Utah, 1964; Hansen Gallery, San Francisco, 1964, 65, 66, 68, 71, 74; M. Knoedler & Co., 1965; College of the Holy Name, Oakland, Calif., 1966; SFMA, 1968; California College of Arts and Crafts, 1972; Southern Idaho College, 1972; Kent State U., 1973; Honolulu Academy, 1973; Hansen-Fuller Gallery, San Francisco, 1974; Walnut Creek Art Center (two-man), 1975; Ruth Braunstein Gallery, San Francisco, 1981, 82, 84, 86. **Group:** Chicago/AI Annuals, 1951-54; U. of Illinois, 1955, 59; Ravinia Festival, Highland Park, Ill., 1956, 64; Los Angeles/County MA, Contemporary Americans, 1957; SFMA, Art in Asia and the West, 1957; PAFA, 1954; de Young, Fresh Paint, 1958; U. of Nebraska, 1958; Denver/AM, 1958; USIA, Drawings from California, circ., Europe, 1958-59; A.F.A., New Talent, circ., 1959; Dallas/MFA, 1959; California Palace, 1959, Painters Behind Painters, 1967; WMAA, 1960; Forty Artists Under Forty, circ., 1962, Annuals, 1962, 63, 64; Friends of the Whitney, 1964; SFMA, Sculpture and Drawings, 1961, 1966; Sacramento/Crocker, 1966; Carnegie, 1967; Expo '70, Osaka, 1970; Scripps College, Lyric View, 1973. **Collections:** Achenbach Foundation; Borg Warner International Corporation; California College of Arts and Crafts; California Palace; Chicago/AI; The U. of Chicago; Cincinnati/AM; Container Corp. of America; Corcoran; Hirshhorn; Illinois Bell Telephone Company; Illinois State

Normal U.; U. of Illinois; Kalamazoo/Institute; Miles Laboratories Inc.; NCFA; NIAL; Oakland/AM; Phoenix; SFMA; Santa Barbara/MA; Southern Idaho College; Stanford U.; Steel Service Institute; WMAA. **Bibliography:** Nordness, ed.

O'KEEFFE, GEORGIA b. November 15, 1887, Sun Prairie, Wisc. **d.** March 6, 1986, Santa Fe, N.M. **Studied:** Chatham Episcopal Institute (Va.), 1901; Chicago Art Institute School, 1904-05, with John Vanderpoel; ASL, 1907-08, with William M. Chase; Columbia U., 1916, with Arthur Dow, Alan Bement. Traveled Europe, Mexico, USA, Peru, Japan. **Taught:** U. of Virginia; Supervisor of Art in public schools, Amarillo, Tex., 1912-16; Columbia College (S.C.); West Texas Normal College. **Awards:** Hon. DFA, College of William and Mary, 1939; Hon. Litt.D., U. of Wisconsin, 1942; elected to the NIAL, 1947, AAAL, 1962; Brandeis U., Creative Arts Award, 1963; Hon. DFA, Randolph-Macon Women's College, 1966; NIAL, gold medal, 1970; Hon. DHL, Columbia U., 1971; Hon. DFA, Brown U., 1971; Bryn Mawr College, M. Carey Thomas Prize, 1971; Hon. DFA, Minneapolis College of Art & Design, 1972; Edward MacDowell Medal, 1972; Skowhegan School of Painting and Sculpture, medal for Painting and gold medal, 1973; Hon. DFA, Harvard U., 1973; Governors' Award (New Mexico), 1974; Presidential Medal of Freedom, 1977; Hon. D. of Visual Arts, College of Santa Fe, 1977. **m.** Alfred Stieglitz (1924). **One-man Exhibitions:** (first) "291," NYC, 1917, also 1926; Anderson Galleries, NYC, 1924; Stieglitz's Intimate Gallery, NYC, 1927, 29; An American Place (Gallery), NYC, 1931, 32, 35-42, 44-46, 50; U. of Minnesota, 1937; The Downtown Gallery, NYC, 1937, 52, 55, 58, 61; College of William and Mary, 1938; La Escondida, Taos, N.M., 1951; Dallas/MFA, 1953; Mayo Hill, Delray Beach, Fla., 1953; Gibbs Art Gallery, Charleston, S.C.,

1955; Pomona College, 1958; Milton College, 1965; U. of New Mexico, 1966; SFMA, 1971; Bryn Mawr College, 1971; Santa Fe, 1985; Hirschl & Adler Galleries, NYC, 1986; Gerald Peters Gallery, Santa Fe, 1990. **Retrospectives:** Anderson Galleries, NYC, 1923; Chicago/AI, 1943; MOMA, 1946; Dallas/MFA, 1953; Worcester/AM, 1960; Amon Carter Museum, 1966; WMAA, 1970. **Group:** "291," NYC, 1916; MOMA, Paintings by 19 Living Americans, 1929; U. of Minnesota, 5 Painters, 1937; U. of Illinois, 1955, 57, 59, 69; Pomona College, Stieglitz Circle, 1958; MMA, 14 American Masters, 1958. **Collections:** Amon Carter Museum; Andover/Phillips; Arizona State College; U. of Arizona; Auburn U.; Baltimore/MA; Brooklyn Museum; Bryn Mawr College; Buffalo/Albright; Chicago/AI; Cleveland/MA; Colorado Springs/FA; Currier; Dallas/MFA; Detroit/Institute; Fisk U.; Fort Worth; U. of Georgia; IBM; Indianapolis/Herron; MMA; MOMA; The Miller Co.; Milwaukee; U. of Minnesota; NCFA; National Gallery; U. of Nebraska; Newark Museum; U. of Oklahoma; Omaha/Joslyn; PMA; Phillips; Randolph-Macon Women's College; Reed College; U. of Rochester; Roswell; SFMA; St. Louis/City; Santa Barbara/MA; Shelburne; Smith College; Springfield, Mass./MFA; Tate; Texas Technological College; Toledo/MA; Utica; Valparaiso U. (Ind.); WMAA; Walker; Wellesley College; Westminster Academy; West Palm Beach/Norton; Wichita/AM; Wilmington. **Bibliography:** Armstrong, Thomas; *Avant-Garde Painting and Sculpture in America,* 1910-1925; Barker 1; Baur 5, 7; Bazin; Bethers; Biddle 4; Blanchard; Blesh 1; Boswell 1; Brown 2; Bulliet 1; Cahill and Barr, eds.; Cheney; Christensen; Coke 2; Craven, T., 1; Cummings 5; Downes, ed.; Eisler; Flanagan; Frank, ed.; Frost; *Forerunners;* Goodrich and Baur 1; Goossen 1; Haftman; Hall; Hunter 6; Huyghe; *Index of 20th Century Artists;* Janis, S.; Jewell 2; Kootz 1; Kozloff 3; Kuh 1, 2, 3; Lane; Lee

and Burchwood; Lisle; Johnson, Ellen H.; Levin 2; Lippard 3; Mather 1; McCoubrey 1; McCurdy, ed.; Mellquist; Mendelowitz; Murken-Altrogge; Neuhaus; Newmeyer; Nordness, ed.; Pearson 1; Phillips 1, 2; Plagens; Poore; Pousette-Dart, ed.; **Rich 1, 2**; Richardson, E.P.; Ringel, ed.; Ritchie 1; Rose, B., 1, 4; Rosenblum 2; Schwartz 3; Smith, S.C.K.; Soby 6; Sutton; Tuchman 3; Weller. Archives.

OKULICK, JOHN b. March 3, 1947, NYC. Studied: U. of California, Santa Barbara, 1969, BA; U. of California, Irvine, 1974, MFA, with Barbara Rose, Frank Stella, Robert Morris. **Taught:** U. of California, Irvine, 1973-. **Address:** 604 Hampton Drive, Venice, Calif. 90291. **Dealer:** Nancy Hoffman Gallery, NYC. **One-man Exhibitions:** (first) Jack Glenn Gallery, Corona Del Mar, 1972, 74; California State U., Long Beach, 1973; Nancy Hoffman Gallery, 1973; Palomar College, 1975; Phyllis Kind Gallery, Chicago, 1976; California State U., Fullerton, 1977; ICA, Los Angeles, 1977; Grapestake Gallery, San Francisco, 1978, 79; Union College, 1979; Asher/Faure Gallery, Los Angeles, 1980, 81, 83, 85, 87; Santa Barbara (Calif.) Contemporary Arts Forum, 1982; John Berggruen Gallery, San Francisco, 1983, 85, 88, 90; Richard Gray Gallery, Chicago, 1986, 89; Fay Gold Gallery, Atlanta, 1992; Palm Springs Desert Museum, circ., 1991. **Group:** Cincinnati/Contemporary, Options, 73/30, 1973; Indianapolis, 1974, 76; San Diego, Sculpture in California, 1975-80, 1980; Laguna Beach Museum of Art, Southern California Artists, 1940-80, 1981; Sacramento/Crocker, Contemporary American Wood Sculpture, 1984; Ridgefield/Aldrich, Sculpture on the Wall, 1986; La Foret Museum, Tokyo, Images of American Pop Culture Today, III, 1989; Honolulu/Contemporary, Collected Sculptures, 1990. **Collections:** Atlantic Richfield Co.; Bell Atlantic; California State U.; Chase Manhattan Bank; Chattanooga/Hunter;

Cornell U.; Harvard U.; Hirshhorn; Honolulu/Contemporary; Los Angeles/County MA; Memphis/Brooks; Newport Harbor; Oakland/AM; Phoenix; SFMA; U. of Sydney; VMFA.

OLDENBURG, CLAES THURE b. January 28, 1929, Stockholm, Sweden. **Studied:** Yale U., 1950, BA; Chicago Art Institute School, 1952-55, with Paul Wieghardt. Traveled USA, Europe, Japan. Apprentice reporter, City News Bureau, Chicago, 1950-52. Films: *Colossal Keepsake No. 1*, 1969; *Sort of a Commercial for an Icebag*, 1969; *The Great Ice Cream Robbery*, 1970; *Birth of the Flag, Part One and Two*, 1965-74; *Ray Gun Theater*, 1962-75. **Member:** NIAL; AAIAL. **Commissions:** Oberlin College, 1970; Southern Methodist U., 1970; St. Louis/City, 1971; Rijksmuseum Kröller-Müller, 1971; Morse College, Yale U., 1974; Walker, 1974; South Mall, Albany, 1975; Hirshhorn, 1975; GSA, Social Security Administration, Chicago, 1975-77; City of Munster, 1976-77; Oberlin College, 1975-80; U. of Nevada, 1978-80; Salinas Community Center, Salinas, Calif., 1978-80; Civic Center, Des Moines, Iowa, 1978-79; Rotterdam, 1977-80. **Awards:** Brandeis U., Creative Arts Award; Skowhegan School Medal; Fellow of Morse College, Yale U.; Honorary Degrees: Oberlin College, 1973; Minneapolis College of Art and Design, 1974; Moore College of Art, Philadelphia, 1974. **Address:** 556 Broome Street, NYC 10013. **Dealer:** Leo Castelli, Inc., NYC. **One-man Exhibitions:** (first) Judson Gallery, NYC, 1959 (sculpture, drawings, poems); Judson Gallery, NYC (two-man, with Jim Dine), 1959; Reuben Gallery, NYC, 1960; Green Gallery, NYC, 1962; Dwan Gallery, 1963; Sidney Janis Gallery, 1964-67, 69, 70; The Pace Gallery, Boston, 1964; Ileana Sonnabend Gallery, Paris, 1964; Stockholm/National; 1966; Robert Fraser Gallery, 1966; U. of Illinois, 1967; Toronto, 1967 (three-man, with Jim Dine, George Segal); Chicago/Contempo-

Claes Oldenburg, *Torn Notebook, Two*, 1992.

rary, 1967; Irving Blum Gallery, 1968; Richard Feigen Gallery, Chicago, 1969; UCLA, 1970, 77; Margo Leavin Gallery, 1971, 75; Kansas City/Nelson, 1972; Fort Worth, 1972; Des Moines, 1972; PMA, 1972; Chicago/AI, 1973; Minami Gallery, 1973; Leo Castelli, Inc., NYC, 1974, 76, 80, 86; Yale U., 1974; Lo Spazio, Rome, 1974; Kunsthalle, Tubingen, circ., 1975; Margo Leavin Gallery, Los Angeles, 1975, 76, 78, 83; F. H. Mayor Gallery, London, 1975; Walker, circ., 1975; Krefeld/Haus Lange, 1975; Petersburg Press, NYC, 1975; Jered Sable Gallery, Toronto, 1976; Multiples, Inc., NYC, 1976; John Berggruen Gallery, San Francisco, 1976; Hannover K-G, 1976; Amsterdam/Stedelijk, 1977; Richard Gray Gallery, Chicago, 1977; Akron/AI, 1977; Chicago/Contemporary, circ., 1977; Cologne/Ludwig, 1980; Salinas (Calif.) Community Center, 1982; Galerie Schmela, Düsseldorf, 1982; Wave Hill, 1984; Campo di Arsenale, Venice, 1985; SRGM, 1986. **Environments:** Judson Gallery, NYC, Ray Gun Street, 1960; Ray Gun Mfg. Co., The Store, 1961; Sidney Janis Gallery, Bedroom Ensemble, 1964.

Happenings: Judson Gallery, NYC, Snapshots from the City, 1960; Reuben Gallery, NYC, Ironworks and Fotodeath, 1961; Dallas/MFA, Injun, 1962; Ray Gun Mfg. Co., Ray Gun Theater, 1962; The U. of Chicago, Gayety, 1963; WGMA, Stars, 1963; Los Angeles/County MA, Autobodys, 1963; Al Roon's Health Club, NYC, Washes, 1965; Film Maker's Cinematheque, NYC, Moviehouse, 1965; Stockholm/National, Massage, 1966; *Esquire* Magazine, The Typewriter, 1969. **Retrospectives:** MOMA, 1969; Pasadena/AM, 1971; Walker, circ., 1975; Kunsthalle, Tubingen, circ., 1975. **Group:** Buffalo/Albright, Mixed Media and Pop Art, 1963; Oberlin College, 3 Young Painters, 1963; Chicago/AI, 1962, 63; Brandeis U., New Directions in American Painting, 1963; Cincinnati/AM, An American Viewpoint, 1963; Dallas/MFA; Tate, Dunn International, 1964; ICA, London, The Popular Image, 1963; Martha Jackson Gallery, NYC, New Media—New Forms, I & II, 1960, 61; Stockholm/National, American Pop Art, 1964; MOMA, Americans 1963, circ., 1963-64; Oakland/AM, Pop Art USA, 1963; Hartford/Wadsworth, Continuity and Change, 1962; WGMA, The Popular Image, 1963; Philadelphia YM-YWHA Arts Council, Art, A New Vocabulary, 1962; Sidney Janis Gallery, The New Realists, 1962; XXXII Venice Biennial, 1964; Akademie der Kunst, Berlin, Neue Realism und Pop Art, 1965; WMAA, A Decade of American Drawings, 1965; Musée Rodin, Paris, Sculpture of the 20th Century, 1965; WMAA Annuals, 1965, 68, 69; RISD, Recent Still Life, 1966; Walker, Eight Sculptors, 1966; Los Angeles/County MA, American Sculpture of the Sixties, 1967; IX São Paulo Biennial, 1967; SRGM, 1967; Carnegie, 1967; Expo '67, Montreal, US Pavilion, 1967; Moore College of Art, American Drawing, 1968; ICA, London, The Obsessive Image, 1968; Kassel, Documenta IV, 1968; Hayward Gallery, London, Pop Art, 1969; Berne, When Attitudes Become Form,

1969; MMA, 1969; MOMA, Technics and Creativity: Gemini G.E.L., 1971; Los Angeles/County MA, Art & Technology, 1971; Arnhem, Sonsbeek '71, 1971; Expo '70, Osaka, 1970; Foundation Maeght, 1970; Kassel, Documenta V, 1972; Seattle/AM, American Art—Third Quarter Century, 1973; WMAA, American Pop Art, 1974; Newport, R.I., Monumenta, 1974; Moore College of Art, Philadelphia, North, East, West, South and Middle, 1975; U. of Massachusetts, Artists and Fabricators, 1975; NCFA, Sculpture: American Directions, 1945-57, 1975; MOMA, Drawing Now, circ., 1976; SRGM, 20th Century American Drawings, 1976; Chicago/AI Annual, 1976; Akron/AI, Contemporary Images in Watercolor, 1976; WMAA, 200 Years of American Sculpture, 1976; Indianapolis, 1976; U. of Chicago, Ideas in Sculpture, 1976; Indianapolis, 1976; U. of Chicago, Ideas in Sculpture, 1965-1977, 1977; ICA, Philadelphia, Improbable Furniture, 1977; Cambridge, Jubilation, 1977; Minnesota/MA, American Drawing 1927-1977, circ., 1977; Flint/Institute, Art and the Automobile, 1978; WMAA, Art About Art, 1978; Nassau County Museum, Syosset, Monuments and Monoliths: A Metamorphosis, 1978; WMAA (downtown), Auto-Icons, 1979; Aspen Center for the Visual Arts, American Portraits of the Sixties & Seventies, 1979; U. of North Carolina, Drawings About Drawing Today, 1979; MOMA, Printed Art, 1980; WMAA, American Sculpture, 1980; Purchase/SUNY, Hidden Desires, 1980; Zurich, Reliefs, 1980; Brooklyn Museum, American Drawings in Black and White: 1970-1979, 1980; ICA, U. of Pennsylvania, Urban Encounters, 1980; Ridgefield/Aldrich, New Dimensions in Drawing, 1950-1980, 1981; Cologne/Stadt, Westkunst, 1981; WMAA, American Prints: Process and Proofs, 1981; Kassel, Documenta VII, 1982; Houston/Contemporary, The Americans: The Collage, 1982; Houston/MFA, A Century of Modern Sculpture, 1882-

1982, 1983; Sunderland (Eng.) Arts Centre, Drawing in Air, 1983; Houston/Contemporary, American Still Life, 1945-1983, 1983; Boston/MFA, 10 Painters and Sculptors Draw, 1984; WMAA, Blam!, 1984; Sydney/AG, Pop Art 1955-1970, 1985; Fort Lauderdale, An American Renaissance: Painting and Sculpture Since 1940, 1985; Paris/Beaubourg, Livres d'Artistes. **Collections:** Amsterdam/Stedelijk; Baltimore/MA; Basel; Brandeis U.; Brussels/Beaux-Arts; Buffalo/Albright; Chicago/AI; Cologne; Des Moines; Fort Worth; Houston/MFA; U. of Illinois; Kansas City/Nelson; Los Angeles/County MA; MOMA; Milwaukee; Norfolk/Chrysler; Oberlin College; Paris/Beaubourg; Pasadena/AM; Rijksmuseum Kröller-Müller; SFAI; St. Louis/City; Southern Methodist U.; Stockholm/National; Tate Gallery; Toronto; Vancouver; Victoria & Albert Museum; WMAA; Walker. **Bibliography:** *Abstract Expressionism;* **Adriani, Koepplin, and Rose;** Alloway 4; Alloway 1; Armstrong, Thomas; Ashbery; Battcock, ed.; Becker and Vostell; Bihalji-Merin; Callas, W.; Celant 3; *Claes Oldenburg;* Cummings 5; Danto; Davies; Davis, D.; De Salvo and Schimmel; De Vries, ed.; De Wilde 2; Dienst 1; *Europa/Amerika;* Finch; Friedman and van der Marck; *From Foreign Shores;* Gettings 1; Goldman 1; Hansen; *Happening & Fluxus;* **Haskell 2, 5;** Honisch and Jensen, eds.; Hunter, ed.; *Individuals;* Janis and Blesh 1; Johnson, Ellen H.; Kaprow; Kardon 3; Kirby; Kozloff 3; Krauss 2; Lippard 3; Lippard 5; Lippard, ed.; Lucie-Smith; *Metro; Monumenta;* Osterwold; **Oldenburg 1, 2, 3;** *Oldenburg; Report;* **Rose, B., 1, 2, 4;** Rowell; Rubin 1; Rublowsky; Russell and Gablik; Sandler 3, 5; Seitz 3; Siegel; *Six Themes;* Strachan; Sontag; Tomkins and Time-Life Books; Tomkins 2; Trier 1; Tuchman 1; Van Bruggen and Oldenburg; Waldman 4; Warhol and Haskell; Weller; *When Attitudes Become Form.* Archives.

OLITSKI, JULES (Jevel
Demikovosky) b. March 27, 1922,
Gomel, Russia. Studied: NAD, with
Sidney Dickinson, 1939-42; Beaux-Arts
Institute of Design, NYC, 1940-47;
Zadkine School of Sculpture, Paris, 1949;
Academie de la Grande Chaumiere, 1949-
50; NYU, BA, 1952; MA (Art Education),
1954; and privately with Chaim Gross.
Traveled USA, Europe, Mexico. Taught:
New Paltz/SUNY, 1954-55; C. W. Post
College of Long Island U., Chairman of
Fine Arts, 1956-63; Bennington College,
1963-67. Curator, NYU Art Education
Gallery, 1955-56. Awards: Carnegie Sec-
ond Prize, 1961; Ford Foundation, P.P.,
1964; Corcoran, 1967. Address: 827
Broadway, NYC 10003; summer: RD #1,
Lovejoy Sands Road, Meredith, NH
03253. Dealers: M. Knoedler and Co.,
NYC; André Emmerich Gallery, NYC.
One-man Exhibitions: (first) Galerie
Huit, Paris, 1950; Alexandre Iolas Gallery,
1958; French & Co. Inc., NYC, 1959-61;
Poindexter Gallery, 1961-65, 1968; Ben-
nington College, 1962; Galleria Santa
Croce, Florence, Italy, 1963; Galleria
Trastevere, Rome, 1963; Galleria
Toninelli, Milan, 1963; Richard Gray Gal-
lery, Chicago, 1964; David Mirvish Gal-
lery, Toronto, 1964-75, 78; Kasmin Ltd.,
1964-66, 1968-70, 1972; Galerie
Lawrence, Paris, 1964; Harvard U. (three-
man with Kenneth Noland, Frank Stella),
1965; St. John, N.B., 1966; Nicholas
Wilder Gallery, 1966, 73; André
Emmerich Gallery, NYC, 1966-68, 77,
80, 82, 84, 86; Zurich, 1973, 79; ICA, U.
of Pennsylvania, 1968; MIT, 1968;
MMA, 1969; Lawrence Rubin Gallery,
NYC, 1969-73; Knoedler Contemporary
Art, 1973, 75, 76, 77, 79; Galerie
Wentzel, Hamburg, 1975, 77; Dart Gal-
lery, Inc., Chicago, 1975; Watson/deNagy,
Houston, 1976; Boston/MFA, 1977;
Hirshhorn, 1977; Amerika Haus, Berlin,
1977; Knoedler Gallery, London, 1978,
81; Edmonton Art Gallery, Edmonton,
1979; Downstairs Gallery, Edmonton,

1980; Galerie Daniel Templon, Paris,
1980, 84; Waddington Galleries, To-
ronto, 1980; Gallery One, Toronto, 1981,
82, 83, 84; Harcus-Krakow Gallery, Bos-
ton, 1981, 82; Janus Gallery, Venice,
Calif., 1981; M. Knoedler & Co., NYC,
1981, 83, 85; Meredith Long Gallery,
Houston, 1981, 82; Martha White Gal-
lery, Louisville, 1982; Harcus Gallery, Bos-
ton, 1983; Fondation du Château de Jau,
France, 1984; Yares Gallery, Scottsdale,
1984, 86; Exeter, 1985; Musée des
Beaux-Arts, Valance, France, 1985.
Retrospectives: Corcoran, circ., 1967;
Boston/MFA, circ., 1973. Group: Carne-
gie, 1961, 64; WMAA Annuals, 1962, 68,
69, 70, 72; WGMA, The Formalists,
1963; Festival of Two Worlds, Spoleto,
1963; SFMA, Directions: American Paint-
ing, 1963; MOMA, Recent Acquisitions,
1963; Worcester/AM, 1963; IV Interna-
tional Art Biennial, San Marino, 1963;
Chicago/AI Annuals, 1964, 69; ICA, U.
of Pennsylvania, The Atmosphere of
1964, 1964; Los Angeles/County MA,
Post Painterly Abstraction, 1964; SRGM,
American Drawings, 1964; Chicago/AI,
67th American Exhibition, 1967;
Kunsthalle, Basel, Austellung Signale,
1965; XXXIII Venice Biennial, 1966;
Corcoran, 1967; Detroit/Institute, Color,
Image and Form, 1967; Tokyo Biennial,
1967; Trenton/State, Focus on Light,
1967; Jewish Museum, Large Scale Ameri-
can Paintings, 1967; Honolulu Academy,
1967; Kassel, Documenta IV, 1968;
MMA, New York Painting and Sculpture:
1940-1970, 1969-70; Pasadena/AM,
Painting in New York: 1944 to 1969,
1969; Chicago/AI, 69th American Exhibi-
tion, 1969; Buffalo/Albright, Color and
Field, 1890-1970, 1970; ICA, U. of Penn-
sylvania, Two Generations of Color Paint-
ing, 1970; Boston U., American Artists of
the 1960s, 1970; Youngstown/Butler
Annual, 1970; WMAA, The Structure of
Color, 1971; Boston/MFA, Abstract
Painting in the '70s, 1972;
Düsseldorf/Kunsthalle, Prospect '73,

1973; Montreal/Contemporain, 11 Artistes Americains, 1973; Houston/MFA, The Great Decade of American Abstraction: Modernist Art 1960-1970, 1974; Indianapolis, 1974; Monumenta, Newport, R.I., 1974, Biennial, 1975; Caracas, El Lenguaje del Color, 1975; Syracuse/Everson, New Works in Clay, Contemporary Painting and Sculpture, 1976; Indianapolis, 1976; Chicago/AI, Drawings of the 70's, 1977; U. of Nebraska, Expressionism in the Seventies, 1978; Buffalo/Albright, American Painting of the 1970s, circ., 1979; Boston/MFA, Monumental Abstractions, 1979; Grand Palais, Paris, L'Amerique aux Indépendants, 1980; Syracuse/Everson, A Century of Ceramics in the United States, circ., 1980; Haus der Kunst, Munich, Amerikanische Malerie: 1930-1980, 1981; Houston/MFA, Miró in America, 1982; St. Lawrence U., Pre-Postmodern, 1985; Fort Lauderdale, An American Renaissance: Painting and Sculpture Since 1940, 1986. **Collections:** Boston/MFA; Brooklyn Museum; Buffalo/Albright; Canberra/National; Cleveland/MA; Chicago/AI; U. of Chicago; Corcoran; Dallas/MFA; Dayton/AI; Detroit/Institute; Edmonton Art Gallery; Harvard U.; Hirshhorn; Houston/MFA; U. of Illinois; Jerusalem/National; Milwaukee; MIT; MMA; MOMA; NGA; Norfolk/Chrysler; Ottawa/National; Pasadena/AM; Princeton; Regina/MacKenzie; SRGM; St. Louis/City; U. of Saskatchewan; Seattle National Bank; Syracuse/Everson; Tel Aviv; Toronto; WMAA. **Bibliography:** Alloway 4; Ashbery; Battcock, ed.; Calas, N. and E.; De Vries, ed.; *From Foreign Shores; The Great Decade;* Honisch and Jensen, eds; Hunter, ed.; Kardon 3; Kozloff 3; Krauss; Moffett; *Monumenta;* Murken-Altrogge; Report; Rose, B., 4; Sandler 3, 5.

OLIVEIRA, NATHAN b. December 19, 1928, Oakland, Calif.
Studied: Mills College, California College of Arts and Crafts (MFA, 1952). US

Army, 1953-55. Traveled Europe.
Taught: San Francisco Art Institute; California College of Arts and Crafts, 1955-56; U. of Illinois, 1961-62; UCLA, 1963-64; Cornell U., 1964; Stanford U., 1964-; U. of Colorado, 1965; U. of Hawaii, 1971; Cranbrook, 1972; Baltimore Art Institute, 1972; Indianapolis/Herron, 1972; Kent State U., 1973. **Member:** NAD. **Awards:** L.C. Tiffany Grant, 1957; Guggenheim Foundation Fellowship, 1958; Chicago/AI, Norman Wait Harris Bronze Medal, 1960; El Refiro Parquet, Madrid, Arte de America y Espana, Special Prize, 1963; Tamarind Fellowship, 1964; National Endowment for the Arts, 1974; AAIAL, 1984. **Address:** 785 Santa Mari Avenue, Stanford, CA 94305.
Dealers: Salander-O'Reilly Galleries, NYC and Beverly Hills; John Berggruen Gallery, San Francisco; Richard Gray Gallery, Chicago. **One-man Exhibitions:** (first) The Alan Gallery, NYC, 1958, also 1959, 60, 63, 65; Paul Kantor Gallery, Beverly Hills, Calif., 1959, 60, 62, 63; U. of Illinois, 1961; Walker, 1961; Felix Landau Gallery, Los Angeles, 1965, 68; The Landau-Alan Gallery, NYC, 1967; Gump's Gallery, 1968; Galerie Bleue, Stockholm, 1968; Stanford U., 1968; SFMA, 1969; Martha Jackson Gallery, 1969; Wisconsin State U., Oshkosh, 1970; Terry Dintenfass, Inc., 1971; Michael Smith Gallery, Los Angeles, 1971; Smith Anderson Gallery, Palo Alto, 1971, 74, 76; Charles Campbell Gallery, 1972, 75, 77, 79; Jack Glenn Gallery, Corona del Mar, 1973; Fullerton Junior College, 1973; U. of California, Santa Cruz, 1976; Wichita State U., 1976; U. of Connecticut, 1976; Galerie Veith Turske, Cologne, 1978, 79; Harvard U., 1978; Dorsky Gallery, NYC, 1978, 90; John Berggruen Gallery, San Francisco, 1977, 79, 82, 83, 89, 90; Charles Cowles Gallery, 1980, 83; Arts Club of Chicago, 1981; Honolulu Academy, 1983, 85; Galeriea Il Bisonte, Florence, 1986; Richard Gray Gallery, Chicago, 1986; Dorothy Goldeen Gallery, Santa Monica,

1987; Kansas City/AI, 1988; G. H. Dalsheimer Gallery, Baltimore, 1989; Palos Verdes Art Gallery, 1989; Salander-O'Reilly Galleries, NYC, 1991. **Retrospectives:** UCLA, circ., 1963; Oakland/AM, circ., 1973; California State U., Long Beach, 1980; SFMA, circ., 1984. **Group:** SFMA, 1954; Denver/AM, 1956; Carnegie, 1958; Mexico City, I Inter-American Paints and Prints Biennial, 1958; WMAA Annuals, 1958-61, 67; I Paris Biennial, 1959; MOMA, New Images of Man, 1959; U. of Illinois, 1961, 63, 67, 69, 74; SRGM, 1961; Amon Carter Museum, The Artist's Environment: West Coast, 1962; Chicago/AI, 1962; MOMA, Recent Painting USA: The Figure, circ., 1962; Seattle World's Fair, 1962; WMAA, Fifty California Artists, circ., 1962; MOMA, Contemporary Painters and Sculptors as Printmakers, 1964; PAFA, 1966; California Palace, Painters Behind Painters, 1967; U. of Oklahoma, East Coast-West Coast Paintings, 1968; Brooklyn Museum, Two Decades of American Prints, 1969; Corcoran, 1970; Los Angeles, Crocker-Citizens National Bank, A Century of California Painting 1870-1970, 1970; La Jolla, Continuing Art, 1971; SFMA, California Painting and Sculpture: The Modern Era, 1976; Brooklyn Museum, Thirty Years of American Printmaking, 1977; Indianapolis, Perceptions of the Spirit in 20th Century American Art, 1977; MMA, The Painterly Print, 1980; WMAA, American Prints: Process and Proofs, 1981; Rutgers U., Realism and Realities, 1982; NYU, The Figurative Mode: Bay Area Painting, 1956-1966, 1984; Oakland/AM, Art in the San Francisco Bay Area, 1945-1980, 1985; Brooklyn Museum, Public and Private, 1986; SFMA, Bay Area Figurative Art, 1950-1965, circ., 1989; Worcester/AM, A Spectrum of Innovation, 1989; Boston/MFA, The Unique Print: 70s into 90s, 1990. **Collections:** Brooklyn Museum; U. of California; Chicago/AI; Cleveland/MA; Dallas/MFA; Hirshhorn; Illinois Wesleyan U.; Lytton Savings and Loan Association; MOMA; U. of Michigan; NCFA; Oakland/AM; PMA; Ridgefield/Aldrich; SFMA; SRGM; Stanford U.; UCLA; Walker; Youngstown/Butler. **Bibliography:** Goldman 1; *Nathan Oliveira: Survey; New in the Seventies;* Nordness, ed.; Ward; Wener; Wight 4. Archives.

ONSLOW-FORD, GORDON
b. December 26, 1912, Wendover, England. **Studied:** Dragon School, Oxford, England; Royal Naval College, Dartmouth and Greenwich. Self-taught in art; frequent visits to the studio of Fernand Leger. Traveled Europe, the Orient, and most of the world; resided in Paris, 1936-39, and Mexico, 1941-47. **Taught:** Series of lectures, New School for Social Research, 1940-41; California College of Arts and Crafts, 1956-58. **Address:** Inverness, CA 94937. **One-man Exhibitions:** N.S.F.S.R., NYC, 1940; Karl Nierendorf Gallery, NYC, 1946; SFMA (three-man, with Wolfgang Paalen, Lee Mullican), 1950; SFMA (two-man, with Richard Bowman), 1959; The Rose Rabow Gallery, San Francisco, 1956, 64, 72; Galerie Samy Kinge, Paris, 1985. **Retrospectives:** SFMA; de Young; Victoria (B.C.), 1971; Oakland/AM, 1977. **Group:** SFMA, 1948, 60; de Young, 1962; Artists' Space, NYC, Moderns in Mind, 1986; Los Angeles/County MA, The Spiritual in Art, 1986; Newport Harbor, The Interpretive Link, circ., 1986; UCLA, Visions of Inner Space, circ., 1987; Musée Rath, Geneva, Minotaure, circ., 1987; Laguna Beach Museum of Art, Pursuit of the Marvelous, 1990; Pepperdine U., Dynaton and Beyond, 1992. **Collections:** Boston/MFA; U. of California; de Young; Harvard U.; Honolulu Academy; MOMA; Oakland/AM; SFMA; SRGM; Tate; WMAA. **Bibliography:** *Black and White Are Colors;* Breton 2; *Gordon Onslow-Ford;* Paalen; Ragon 1; Rubin 1; Tuchman 3; Weller. Archives.

OPPENHEIM, DENNIS b. September 6, 1938, Electric City, Wash. **Studied:** Stanford U., BA, MA; California College of Arts and Crafts, with Norman Kantor. Traveled Europe, 1969-75. Produced films, 1969-75, and videotapes, 1969-74. **Taught:** Yale U.; Chicago/AI; Stony Brook/SUNY. **Awards:** Guggenheim Foundation Fellowship, 1972, 79; National Endowment for the Arts, 1974, 81. **Address:** 54 Franklin Street, NYC 10013. **Dealer:** Blum Helman Gallery, Inc., NYC. **One-man Exhibitions:** John Gibson Gallery, NYC, 1968, 69, 70, 74, 77; Yvon Lambert, Paris, 1969, 71, 75; MOMA, 1969; Reese Palley Gallery, San Francisco, 1970; Gallery 20, Amsterdam, 1971; Harcus-Krakow Gallery, Boston, 1971; Françoise Lambert, Milan, 1971, 75; Gallery D., Brussels, 1972, 73, 74; Galleria l'Attico, Rome, 1972; Tate, 1972; Mathias Fels & Cie, Paris, 1972; Nova Scotia College of Art and Design, Halifax, 1972; Ileana Sonnabend Gallery, NYC, 1972, 73, Paris, 1973; M.O.C.A., San Francisco, 1973; F.H. Mayor Gallery, London, 1973; Galleria Forma, Genoa, 1973, 74; Rivkin Gallery, Washington, D.C., 1973; Paolo Barrozzi, Milan, 1974; Amsterdam/Stedelijk, 1974; Galleria A. Castelli, Milan, 1975; School of Visual Arts, NYC, 1979; Multiples, NYC, 1977, 78; Deson Gallery, Chicago, 1978; d'Arc Gallery, NYC, 1976, 77; Robert Self Gallery, Newcastle-upon-Tyne, 1976; Akira Ikeda Gallery, Tokyo, 1983; Flow Ace Gallery, Venice, Calif., 1983; Galerie Schum, Stuttgart, 1983; Felicie Gallery, NYC, 1983; WMAA, 1983; SFMA, 1984; Grand Rapids, 1985; Pierides Collection, Athens, 1989. **Retrospectives:** Brussels/Beaux-Arts, 1975; Rotterdam, 1976; Toronto, 1978. **Group:** WMAA Annuals, 1968, 70; Seattle/AM, 557, 087, 1969; Berne, When Attitudes Become Form, 1969; Amsterdam/Stedelijk, Op Losse Schroeven, 1969; MOMA, New Media, New Methods, circ., 1969; ICA, U. of Pennsylvania, Against Order: Chance and Art, 1970; Turin/Civico, Conceptual Art, Arte Povera, Land Art, 1970; New York Cultural Center, Conceptual Art and Conceptual Aspects, 1970; Finch College, NYC, Artist/Videotape/Performance, 1971; VII Paris Biennial, 1971; Düsseldorf/Kunsthalle, Prospect '71, 1971; Kassel, Documenta V, 1972; WMAA, American Drawings, 1963-73, 1973; Cologne, Project '74, 1974; MIT, Interventions in Landscape, 1974; Venice, Biennale, 1974; Berlin/National, Kunst mit Fotographi, 1983; WMAA Biennial, 1981; Hirshhorn, Metaphor, New Projects by Contemporary Sculptors, 1981; Artpark, Lewiston, N.Y., 1984. **Collections:** Akron/AM; Amsterdam/Stedelijk; Art Gallery of Ontario; Art Gallery of Winnipeg; Bordeaux/Contemporain; U. of California, Berkeley; Chicago/AI; Chicago/Contemporary; Corcoran; Cornell U.; Cranbrook; Denver/AM; Detroit/Institute; Edmonton Art Gallery; Geneva; The Hague; Humlebaek/Louisiana; Israel Museum; La Jolla; Los Angeles/County MA; MOMA; Milwaukee; Monchengladbach; U. of New Mexico; Newport Harbor; Oakland Museum; PAFA; PMA; Paris/Beaubourg; Paris/Moderne; Potsdam/SUNY; Purchase/SUNY; Rijksmuseum Kröller-Müller; Rotterdam; SFMA; Stuttgart; Syracuse/Everson; Tate Gallery; Toulon; Utica; WMAA; Worcester/AM; Zurich. **Bibliography:** Alloway 4; *Art Now 74;* Celant; *Contemporanea;* De Wilde 2; *Europa/Amerika;* Honisch and Jensen, eds.; Honnef; Hunter, ed.; Johnson, Ellen H.; Kardon 3; Lippard, ed.; Lippard 3; Lucie-Smith; Meyer; Sandler 3; Seitz 3; Tomidy; Weintraub.

OPPER, JOHN b. October 29, 1908, Chicago, Ill. **Studied:** Cleveland Institute of Art, 1926-28; Chicago Art Institute School, 1928-29; Western Reserve U., BS, 1931; Hofmann School, 1936; Columbia U., MA, 1942, Ed.D., 1952. Traveled Europe. **Taught:** U. of Wyo-

ming, 1945-49; U. of North Carolina, 1952-57; Columbia U.; NYU, 1957-74. **Member:** American Abstract Artists, since 1936. Federal A.P.: Easel painting. **Awards:** Guggenheim Foundation Fellowship, 1969-70; National Endowment for the Arts, 1974; Guild Hall, Spaeth Award, 1989; Cleveland Institute of Art, Distinguished Alumnus, 1990. **Address:** Box 347, Amagansett, NY 11930. **Dealer:** Grace Borgenicht Gallery, Inc., NYC. One-man Exhibitions: (first) Artists' Gallery, NYC, 1938, also 1940; SFMA, 1939; San Diego, 1939; Charles Egan Gallery, 1955; The Stable Gallery, 1959, 60, 61, 62; Drew U., 1966; Grace Borgenicht Gallery, Inc., NYC, 1966, 68, 69, 71, 73, 75, 77, 79, 84, 86, 91; Benson Gallery, 1967, 74; Guild Hall, 1973; Foster Harmon Galleries, Sarasota, Fla., 1990; Vered Gallery, East Hampton, N.Y., 1989, 90. **Retrospectives:** Drew U., 1976; Montclair/AM, 1978; Cleveland Institute of Art, 1990. **Group:** MMA, Contemporary Watercolors, 1941; California Palace, Painting Annual, 1947; Chicago/AI, Abstract and Surrealist American Art, 1947; WMAA, Annual, 1952, 61; Corcoran Biennial, 1953; Carnegie International, 1961; PAFA, Annual, 1941, 62; Kent State U. (two-man), 1969; AAIAL, 1973, 82, 89; Bronx Museum, American Abstract Artists 50th Anniversary Celebration, circ., 1986. **Collections:** Amstar Corp., NYC; Atlantic Richfield Co.; Chase Manhattan Bank; Columbus, Ga.; Corcoran; First National City Bank; Harcourt Brace Jovanovich, Inc.; High Museum; Inmont Corp, NYC; MMA; Marine Midland Bank, Buffalo, N.Y.; MOMA; Milwaukee; Montclair/AM; NMAA; NYU; Newark Museum; U. of North Carolina; Prudential Insurance Co. of America, U. of Texas; Union Carbide Corp.; United Mutual Savings Bank; WMAA; Williams College. **Bibliography:** Archives.

ORTMAN, GEORGE **b.** October 17, 1926, Oakland, Calif. **Studied:** Califor-

nia College of Arts and Crafts, 1947-48; Atelier 17, NYC, 1949, with S.W. Hayter; Academie Andre Lhote, Paris, 1950; Hofmann School, 1950-51. Traveled Europe, North America. **Taught:** School of Visual Arts, NYC, 1960-65; NYU, 1963-65; Fairleigh Dickinson U., summer, 1964; Princeton U., 1966-69; Honolulu Academy, 1969-70; Cranbrook, 1970-. **Awards:** Birmingham, Ala./MA, 1966; Trenton/State, 1967; Guggenheim Foundation Fellowship; Ford Foundation Grant. **m.** Constance Whidden. **Address:** 45 Academy Way, Bloomfield Hills, MI 48013; summer: Box 192, Castine, ME 04421. **One-man Exhibitions:** (first) Tanager Gallery, NYC, 1953; Wittenborn Gallery, NYC, 1956; The Stable Gallery, NYC, 1957, 60; The Swetzoff Gallery, Boston, 1961, 62; The Howard Wise Gallery, NYC, 1962, 63, 64, 67, 69; Fairleigh Dickinson U., 1962; David Mirvish Gallery, 1964; Container Corp. of America, 1965; Walker, 1965; Milwaukee, 1966; Dallas/MFA, 1966; Akron/AI, 1966; Portland, Me./MA, 1966; Harcus-Krakow Gallery, 1966; David Stuart Gallery, 1966; The U. of Chicago, 1967; Galeria Van der Voort, 1967-69; Princeton U., 1967; Temple U., 1968; Middlebury College, 1969; Reed College, 1970; Cranbrook, 1970, 81; J.L. Hudson Art Gallery, Detroit, 1971; Indianapolis, 1971; Western Michigan U., 1972; Gimpel & Weitzenhoffer, Ltd., 1972; Gertrude Kasle Gallery, Detroit, 1976. **Retrospectives:** Fairleigh Dickinson U., 1963; Walker, 1965; Princeton U., 1967; Indianapolis, 1991. **Group:** Salon du Mai, Paris, 1950; SFMA Annual, 1952; Martha Jackson Gallery, NYC, New Media—New Forms I, 1960; WMAA, Young America, 1960; Carnegie, 1960, 64, 67, 70; Chicago/AI Annuals, 1961, 62; WMAA, Geometric Abstraction in America, circ., 1962; Seattle World's Fair, 1962; MOMA, Hans Hofmann and His Students, circ., 1963-64; Amsterdam/Stedelijk, 1963; Jewish Museum, Toward a New Abstraction, 1963; SFMA,

Directions—Painting U.S.A., 1963; WMAA Annuals, 1962-67; A.F.A., Contemporary Wall Sculpture, circ., 1963-64; A.F.A., Decade of New Talent, circ., 1964; International Biennial Exhibition of Paintings, Tokyo; WMAA, A Decade of American Drawings, 1965; U. of Illinois, 1965; WMAA, Art of the U.S. 1670-1966, 1966; Finch College, NYC, Holograms, 1971. **Collections:** Allentown/AM; American Republic; U. of California; Christian Theological Seminary; Des Moines; Detroit/Institute; Indianapolis; Lincoln, Mass./De Cordova; Los Angeles/County MA; MOMA; Manufacturers Hanover Trust Co.; U. of Massachusetts; Milwaukee; WPL; NYU; Omaha/Joslyn; P.S. 144, NYC; Portland, Me./MA; St. George's Episcopal Church, Princeton, N.J.; SRGM; Trenton/State; Newark Museum; WMAA; Walker; Worcester/AM. **Bibliography:** Calas, N. and E.; Honisch and Jensen, eds.; Janis and Blesh 1; Moser 1; Sandler 5; Weller. Archives.

OSSORIO, ALFONSO b. August 2, 1916, Manila, Philippine Islands. **d.** December 5, 1990, Wainscott, N.Y. **Studied:** in England, 1924; Harvard U., BA, 1938; RISD, 1938-39. To USA, 1929. US citizen, 1939. US Army, 1943-46. Co-organizer of Signa Gallery, East Hampton, 1957-60. **One-man Exhibitions:** (first) Wakefield Gallery, NYC, 1941, also 1943; Mortimer Brandt, NYC, 1945; Galerie Paul Facchetti, 1951; Betty Parsons Gallery, NYC, 1951, 53, 56, 58, 59, 61; Galerie Stadler Paris, 1960, 61; Cordier & Ekstrom, Inc., NYC, 1961, 64, 65, 67, 68, 69, 72; Yale U., 1974; Guild Hall, 1980; Oscarsson Hood Gallery, NYC, 1982, 84; Carl Hammer Gallery, Chicago, 1982, 85; Oscarsson Siegeltuch & Co., 1986; Galerie Zabriskie, Paris, 1991; Vanderwoude-Tananbaum, NYC, 1991. **Group:** WMAA Annual, 1953; The Downtown Gallery, 1954; The Stable Gallery Annuals, 1955, 56; Rome-New York Foundation, Rome, 1957-59; Turin Art Festival, 1959; Martha

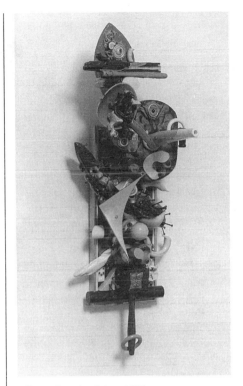

Alfonso Ossorio, *Spigot*, 1983.

Jackson Gallery, NYC, New Media—New Forms; Osaka (Japan) Art Festival; Gutai Sky Festival, Osaka; MOMA; The Art of Assemblage, circ., 1961; SRGM/USIA, American Vanguard, circ., Europe, 1961-62; Musée Cantonal des Beaux-Arts, Lausanne, I Salon International de Galeries Pilotes, 1963; St.-Etienne, 1964; Kassel, Documenta III, 1964; Intuitiones y Realizaciones Formales, Buenos Aires, 1964; U. of Illinois, 1965; Chicago/AI, 1966; WMAA, Art of the U.S. 1670-1966, 1966; MOMA, The 1960s, 1967; Munich/Modern, New Art: USA, 1968; MOMA, Dada, Surrealism and Their Heritage, 1968; MOMA, The New American Painting and Sculpture, 1969; WMAA, Human Concern/Personal Torment, 1969; NCFA, The Object as a Poet, 1977; Guild Hall, Poets and Artists, 1982; Hofstra U., Androgyny in Art, 1982; U. of North Carolina, Art on Paper, 1983; IEF, Twentieth

Century American Drawings: The Figure in Context, circ., 1984; XLII Venice Biennial, 1986; WMAA, 20th Century Drawings and Watercolors from the Whitney Museum of American Art, circ., 1987; Houston/Contemporary, The Americans: The Collage, 1982. **Collections:** Brandeis U.; Cuenca; Hartford/Wadsworth; International Institute for Aesthetic Research; MMA; Manila; NYU; PMA; WMAA; Yale U. **Bibliography:** Armstrong, Thomas; Calas, N. and E.; Cummings 4, 5; *Europa/Amerika;* Friedman, B.H., 1; *From Foreign Shores;* Hunter, ed.; Seitz, 3; Tapie 1, 2. Archives.

OSVER, ARTHUR **b.** July 26, 1912, Chicago, Ill. **Studied:** Northwestern U., 1930-31; Chicago Art Institute School, with Boris Anisfeld. Traveled Europe; resided in France and Italy for several years. **Taught:** Brooklyn Museum School, 1947; Columbia U., 1950-51; U. of Florida, 1954; Cooper Union, 1955, 58; Yale U., 1956-57; American Academy, Rome, 1957-58; Washington U., 1960-81. **Member:** Artists Equity; Audubon Artists. Federal A.P.: teaching, painting. **Commissions:** *Fortune* magazine, 1960 (cover). **Awards:** Chicago/AI, James Nelson Raymond Traveling Fellowship ($2,000), 1936; VMFA, John Barton Payne Medal; Pepsi-Cola, $500 Award, 1947; PAFA, Joseph E. Temple Gold Medal, 1947; Guggenheim Foundation Fellowship, 1948, renewed 1949; U. of Illinois, P.P., 1949; Prix de Rome, 1952, renewed 1953; Audubon Artists, Emily Lowe Prize, 1961; Art Directors Club, Chicago, Medal, 1961; PAFA, J. Henry Schiedt Memorial Prize, 1966; National Council on the Arts, Sabbatical Leave Grant ($7,500), 1966; AAAL, P.P., 1974; AAIAL, Prize ($7,500), 1991. **Address:** 465 Foote Avenue, St. Louis, MO 63119. **Dealer:** William Shearburn Fine Art, St. Louis. **One-man Exhibitions:** (first) Mortimer Brandt, NYC, 1943; Grand Central Moderns, NYC, 1947, 49, 51, 57; Hamline U., 1950; U. of

Florida, 1951, 55; Fairweather-Garnett Gallery, Evanston, 1955; Fairweather-Hardin Gallery, Chicago, 1955, 57, 62, 64, 66, 82; U. of Chattanooga, 1958; Syracuse U., 1959; Philadelphia Art Alliance, 1959; Milton College, 1964; Maryville College (Mo.), 1966; Martin Schweig Gallery, 1966; Coe College, 1966; Iowa State U., 1968; Webster College, 1968; Terry Moore Gallery, St. Louis, 1975, 77; Timothy Burns Gallery, St. Louis, 1981, 84; Valley House Gallery, Dallas, 1989, Philip Samuels Fine Art, St. Louis, 1989; Randall Gallery, St. Louis, 1991. **Retrospective:** St. Louis Artists' Guild, 1964. **Group:** AAIAL; Chicago/AI; PAFA; MMA; PMA; WMAA; MOMA; Carnegie; Corcoran; Phillips; Detroit/Institute; Brooklyn Museum; VMFA; Des Moines; Walker; Venice Biennial; Tokyo/Modern; AAIAL, 1991. **Collections:** Abbott Laboratories; Brooklyn Museum; Carnegie; Cincinnati/AM; Colorado Springs/FA; Corcoran; Davenport/Municipal; Des Moines; Detroit/Institute; U. of Georgia; Houston/MFA; IBM; U. of Illinois; Inland Steel Co.; S. C. Johnson & Son, Inc.; MMA; MOMA; U. of Michigan; Montclair/AM; U. of Nebraska; New Orleans/Delgado; PAFA; PMA; Peabody Museum; Phillips; Rio de Janeiro; U. of Rochester; St. Louis/City; Syracuse/Everson; Tokyo/Modern; Toledo/MA; WMAA; Walker; Washington U.; Wilmington. **Bibliography:** Bethers; Nordness, ed. Archives.

OTT, JERRY **b.** July 31, 1947, Albert Lea, Minn. **Studied:** Mankato State College; U. of Minnesota. **Taught:** St. Cloud State U., 1990-91. **Address:** 1034 E. St. Gerurdia #55, St. Cloud, MN 56304. **Dealer:** Thomson Gallery, Minneapolis. **One-man Exhibitions:** Mankato State College, 1967; One Hundred and Eighteen Gallery, Minneapolis, 1973; Louis K. Meisel Gallery, NYC, 1973, 75, 79; Smith Fine Art, Monte Carlo, Monaco, 1974; Morgan Gallery, Shawnee Mis-

sion, Kansas, 1977, 79; Hanson-Cowles Gallery, Minneapolis, 1978; St. Cloud State U., 1978; Art Banque Gallery, Minnapolis, 1991; R. H. Love Gallery, Chicago, 1991; Thomson Gallery, Minneapolis, 1992. **Group:** Minnesota/MA, Drawings USA, 1971; Recklinghausen, Mit Camera, Penzil und Spritzpistol, 1973; Indianapolis, 1974; Tokyo, Biennial, 1974; New York Cultural Center, Three Centuries of the American Nude, 1975; Christchurch, New Zealand, Photo Realism, American Paintings and Prints, circ., 1975; Potsdam/SUNY, The Presence and Absence of Realism, 1976; Madison Art Center, Figurative Painting in the Midwest, 1977; U. of Kansas, Artists Look at Art, 1978; Minneapolis/Institute, Five Realist Painters, 1979. **Collections:** Federal Reserve Bank, Minneapolis; U. of Georgia; U. of Kansas; Minneapolis/Institute; Tokyo/Contemporary; Walker. **Bibliography:** Ward.

OWEN, FRANK b. May 13, 1939, Kalispell, Montana. **Studied:** Antioch College; California State U., Sacramento; U. of California, Davis, BA, 1966; MFA, 1968. **Taught:** U. of California, Davis, 1966; California State U., Sacramento, 1967-68; School of Visual Arts, NYC, 1970-80. **Awards:** U. of California, Regent's Fellowship, 1967-68; National Endowment for the Arts, fellowship, 1978, 89. **Address:** P.O. Box 703, Keene Valley, NY 12943. **Dealer:** Nancy Hoffman Gallery, NYC. **One-man Exhibitions:** Sacramento/Crocker, 1976; U. of California, Davis, 1968; Joseph Helman Gallery, St. Louis, 1968; French & Co., Inc., NYC, 1971; The New Gallery, Cleveland, 1972; Leo Castelli Gallery, NYC, 1972; Morgan Gallery, Kansas City, Mo., 1973; Madison Art Center, 1973; Ronald Greenberg Gallery, St. Louis, Mo., 1973; Galerie de Gestlo, Hamburg, 1973; Sable-Castelli Gallery, Toronto, 1977; Wake Forest U., 1981; Nancy Hoffman Gallery, NYC, 1981, 84, 86, 88; Galerie Ninety-Nine, Bay Harbor Islands, 1981; Knoedler Gallery, London, 1983; U. of Vermont, 1983; U. of North Carolina, 1984; Lake Placid (N.Y.) Art Center, 1986; The Cook Company Gallery, Rancho Cordova, 1987; Iannetti Lanzone Gallery, San Francisco, 1988. **Group:** U. of California, Davis, New Northern California Artists, 1963; AFA, New York—New York, circ., 1970; U. of Maryland, What's Happening in SoHo, 1971; Corcoran Biennial, 1971; Madison/AC, New American Abstract Painting, 1972; Düsseldorf, Prospect 73, 1973; Potsdam/SUNY, Tight and Loose, 1974; U. of Illinois, National, 1974; Kunstmuseum, Berlin, SoHo in Berlin, 1976; Buffalo/SUNY, Approaching Painting, Part II, 1976; Hirshhorn, Content, 1984; Maryland Institute, Baltimore Painters-in-Residence, 1989; Youngstown/Butler, California A to Z and Return, 1990. **Collections:** Buffalo/Albright; Corcoran; Des Moines; Grinnell College; U. of North Carolina; Oberlin College; Sacramento/Crocker; St. Louis/City; Webster College; U. of Wisconsin.

P

PACE, STEPHEN b. 1918, Charleston, Mo. **Studied:** Evansville Museum School, 1937-41, with Robert Lahr; Escuela de Bellas Artes, San Miguel de Allende, Mexico, 1945-46; ASL, 1948-49, with Cameron Booth, Morris Kantor; Academie de la Grande Chaumiere, 1950; Academy of Fine Arts, Florence, Italy, 1951; Hofmann School, 1951. US Army, 1943-46. Traveled Mexico, Europe, Canada, USA. **Taught:** Washington U., 1959; Pratt Institute, 1962-69; U. of California, Berkeley, 1968; Bard College, 1969-71; Des Moines, 1970; Kansas City/AI, 1973; Syracuse U., 1975. **Awards:** Dolia Laurian Fund Award, 1954; Hallmark International Competition, 1961; CAPS Grant, 1974; Guggenheim Foundation, fellowship, 1980. **Address:** 164 Eleventh Avenue, NYC 10011. **One-man Exhibitions:** (first) Evansville, 1946; Hendler Gallery, Philadelphia, 1953; Artists' Gallery, NYC, 1954; Poindexter Gallery, 1956, 57; HCE Gallery, Provincetown, Mass., 1956-59, 62-66; Washington U., 1959; Dilexi Gallery, San Francisco, 1960; Holland-Goldowsky Gallery, Chicago, 1960; The Howard Wise Gallery, Cleveland, 1960, NYC, 1960, 61, 63, 64; Dwan Gallery, 1961; MIT, 1961; Walker, 1962; Columbus, 1962; Kalamazoo/Institute, 1962; Ridley Gallery, Evansville, Inc., 1966; U. of California, 1968; The Graham Gallery, 1969; Des Moines, 1970; U. of Texas, 1970; Kansas City/AI, 1973; A. M. Sachs Gallery, 1974, 76, 78, 79, 83, 85; Drew U., 1975; Robert Polo Gallery, Washington, D.C., 1976; New Harmony, New Harmony, Ind., 1977; Farm Gallery, Far Hills, N.J., 1978; Barbara Fiedler, Washington, D.C., 1980; Chastenet Fine Arts Gallery, Washington, D.C., 1980; Leighton Gallery, Blue Hill, Me., 1985; Katharina Rich Perlow Gallery, NYC, 1987, 89, 90; Vanderwoude-Tananbaum Gallery, NYC, 1991; U. of North Carolina, 1991; Evansville, 1992. **Retrospective:** Bard College, 1975; American U., 1976. **Group:** Brooklyn Museum, 1953, 55; WMAA Annuals, 1953, 54, 56, 57, 58, 61; PAFA, 1954; Carnegie, 1955; Walker, Vanguard, 1955; International Biennial Exhibition of Paintings, Tokyo; Walker, 60 American Painters, 1960; Cleveland/MA, Paths of Abstract Art, 1960; Brandeis U. (two-man), circ., 1961; USIA, American Paintings, circ., Latin America, 1961; Corcoran, 1963; MOMA, Hans Hofmann and His Students, circ., 1963-64; U. of Texas, Recent American Painting, 1964; MOMA, circ., Europe, Asia, Australia, 1964-66; Chicago/AI, 1966; AAA Gallery, NYC, Childe Hassam Purchase Exhibition, 1977; U. of North Carolina, Art on Paper, 1978-79; Syracuse/Everson, Provincetown Painting, 1890s-1970s, 1977; MMA, Hans Hofmann as Teacher, 1979; Corcoran, 10 + 10 + 10, 1982; Corcoran, Washington Watercolors, 1984. **Collections:** AT&T; American U.; Boston/MFA; Bristol-Myers Co.; U. of California; Chase Manhattan Bank; Ciba-Geigy Corp.; Corcoran; Des Moines; Evansville; Hirshhorn; Indianapolis; Lannan Foundation; MMA; Norfolk; Norfolk/Chrysler; U. of North Carolina; Phillips; Prudential Insurance Co. of America; Southern Illinois U.; U. of Texas; Utica; WMAA; Waitsfield/Bundy; Walker. **Bibliography:** Archives.

PACHNER, WILLIAM
from 1st to 4th edition.

PACKARD, DAVID
from 1st to 3rd edition.

PADOVANO, ANTHONY
b. July 19, 1933, NYC. **Studied:** Brooklyn Museum School; Pratt Institute, with Alexander Kostellow; Columbia U., with Oronzio Maldarelli, 1957, BFA; Carnegie Institute of Technology. US Army, 1957-59. Traveled Italy, Switzerland; resided Rome, two years. **Taught:** U. of Connecticut, 1962-64; Columbia U., 1964-70; Queens College, 1971-73; Sarah Lawrence College, 1974-79; Westchester County Center, 1973-75; 1974-79; Columbia Greene Community College, 1976-79; Kingsborough Community College, 1978-86. Subject of *Anthony Padovano, Sculptor,* by National Educational Television. **Member:** Silvermine Guild; American Association of University Professors; Sculptors Guild (vice-president). **Commissions:** World Trade Center, NYC, 1971; U. of Northern Iowa, 1972. **Awards:** Prix de Rome, 1960-62; III International Exhibition of Figurative Art, Rome, First Prize, 1962; Silvermine Guild, Olivetti Prize for Sculpture, 1963, 64; Guggenheim Foundation Fellowship, 1964; Ford Foundation, P.P., 1964; AAAL, 1976; NAD, Gold Medal for Sculpture, 1983. **Address:** R.D. #1, Box 64, Putnam Valley, N.Y. 10579. **One-man Exhibitions:** Lincoln, Mass./De Cordova, 1954 (drawings); Geejon Gallery, NYC, 1957; Sculptors Studio, Washington, D.C., 1958; Galleria George Lester, Rome, 1962; Ruth White Gallery, 1962; U. of Connecticut, 1962, 63; Richard Feigen Gallery, NYC, 1964; The Bertha Schaefer Gallery, NYC, 1968, 70; The Graham Gallery, NYC, 1972, 75, 78, 81; IFA Gallery, Washington, D.C., 1975, 76; Alwin Gallery, London, 1978. **Group:** Carnegie, 1952; Portland, Me./MA, 1959; American Academy, Rome, 1960, 61, 62; Palazzo dell'Esposizione, Rome, 1961, 62; WMAA Annual, 1962; Baltimore/MA, 1963; Waitsfield/Bundy, Bundy Sculpture Competition, 1963; Lincoln, Mass./De Cordova, New England Sculpture, 1964, 66, 68, 72, 75, 76; Finch College, 1964; HemisFair '68, San Antonio, Tex., 1968. **Collections:** American Academy, Rome; U. of Delaware; First National City Bank, Chicago; U. of Illinois; Indianapolis/Herron; Kingsborough Community College; U. of Missouri; NCFA; U. of Nebraska; U. of Northern Iowa; Port Authority of New York & New Jersey; Ridgefield/Aldrich; Rutgers U.; St. Lawrence U.; Silvermine Guild; Trenton/State; Wichita/AM; WMAA; Worcester/AM.

PAIK, NAM JUNE b. 1932,
Seoul, Korea. **Studied:** U. of Tokyo, 1965, BA; U. of Munich; Conservatory of Music, Freiburg. To Germany, 1956; to USA, 1964. Composer/performer; Fluxus artist; TV, video, and film manipulator. **Awards:** JDR 3rd Fund Grant, 1965; Rockefeller Foundation Grant, 1967. **Address:** 110 Mercer Street, NYC 10012. **Dealers:** Holly Solomon Gallery, NYC; Carl Solway Gallery, Cincinnati. **One-man Exhibitions:** (first) Galerie Parnass, Wuppertal, 1963; New School, 1965; Galerie Bonino, NYC, 1965, 68; Syracuse/Everson, 1974; Rene Block Gallery, NYC, 1975; Cologne/Kunstverein, 1976; MOMA, 1977; Paris/Beaubourg, 1978; Berlin, Kunstverein, 1981; Holly Solomon Gallery, NYC, 1986, 88, 89; Dorothy Goldeen Gallery, Santa Monica, 1988; Galerie du Genie, Paris, 1989; Mayor Rowan Gallery, London, 1989; Galerie Esperanza, Quebec, 1989; Weisses Haus, Hamburg, 1989; SFMA, 1989. **Retrospective:** WMAA, circ., 1980; Hayward Gallery, London. **Group:** ICA, Boston, Art Turned On, 1965; Walker, Light, Motion, Space, 1967; MOMA, The Machine, 1968; Brandeis U., Vision and Television, 1969; WMAA, Videoshow, 1971; Kassel, Documenta V, VI and VIII, 1972, 77, 87; WMAA Biennials, 1981, 87; Kunsthalle, Cologne, Project 74, 1974; ICA, U. of Pennsylvania, Video Art, 1975; São Paulo, Biennal, 1975; Akademie der Kunste,

Berlin, SoHo, 1976; WMAA, Biennial, 1977; Cologne/Stadt, Westkunst, 1981; Amsterdam/Stedelijk, '60 '80: Attitudes/Concepts/Images, 1982; Hirshhorn Content, 1984; Venice Biennale, 1984; São Paulo, Bienal, 1985; Paris/Beaubourg, L'Époque, La Mode, La Moral, La Passion, 1987; Milwaukee, 1988: The World of Art Today, 1988; Venice Biennale, 1988; MOMA, The Arts for Television, 1989; École Nationale des Beaux-Arts, Paris, Artistes des Happenings et de Fluxus, 1958-88, 1989. **Collections:** Amsterdam/Stedelijk; Cologne/Ludwig; Humlebaek/Louisiana; Los Angeles/County MA; Paris/Beaubourg; Vienna/Moderner; WMAA. **Bibliography:** Fox; Hughes; Weintraub.

PALMER, WILLIAM C.
b. January 20, 1906, Des Moines, Iowa. **d.** 1987, Clinton, N.Y. **Studied:** ASL, 1924-26, with Boardman Robinson, Henry Schnakenberg, A. Tucker, Thomas Hart Benton, Kenneth Hayes Miller, and privately with Miller, 1928-29; École des Beaux-Arts, Fontainebleau, with M. Baudoin. US Army, 1943-45. **Taught:** ASL, 1936-40; Hamilton College, 1941-47; Munson-Williams-Proctor Institute, Utica, N.Y., 1941-73. Federal A.P.: Mural painter and supervisor, 1933-39; murals for: Queens General Hospital, Jamaica, N.Y., 1934-36; US Post Office Department Building, Washington, D.C., 1936; US Post Offices at Monticello, Iowa, 1935, and Arlington, Mass., 1938. **Member:** NAD; National Society of Mural Painters. **Commissions** (murals): First National City Bank, Socony Building, NYC; Homestead Savings and Loan Association, Utica, N.Y., 1957. **Awards:** Paris Salon Medal, 1937; NAD, 1946, elected National Academician, 1965; Audubon Artists, 1947; AAAL Grant, 1953; NAD, Andrew Carnegie Prize, 1980; Hon. DFA, Hamilton College, 1975; Director Emeritus, Utica, 1973. Subject of a film produced by David Sutherland in 1986.

One-man Exhibitions: (first) The Midtown Galleries, NYC, 1932, also 1937, 40, 44, 50, 52, 54, 57, 59, 62, 67, 68, 69, 74, 77, 81, 82, 84, 85; Des Moines, 1948, 49, 79; Cazenovia Junior College, 1949; Utica, 1956; Syracuse U.; Skidmore College; Kansas City/Nelson; Colgate U.; St. Lawrence U.; Jacksonville/Cummer, 1972; Hamilton College, 1964, 75, 81. **Retrospectives:** Utica, 1971; Wichita/AM, 1985. **Group:** Audubon Artists; Carnegie, International, 1936, 39, 40, 44; New York World's Fair, 1939; San Francisco Golden Gate International Exposition, 1939, 40; Corcoran Biennial, 1939; Brooklyn Museum; Chicago/AI; Kansas City/Nelson; MOMA; Toledo/MA; VMFA; WMAA. **Collections:** AAAL; Allentown/AM; Andover/ Phillips; Atlanta U.; Baltimore/MA; Britannica; Columbia S.C./MA; Columbus; Columbus, Ga.; Continental Grain Company; Cranbrook; Dallas/MFA; Des Moines; MMA; Phoenix; U. of Rochester; St. Lawrence U.; Syracuse U.; Transamerica Corp.; Trenton/State; Upjohn Co.; Utica; WMAA; The White House, Washington, D.C. **Bibliography:** Boswell 1; Bruce and Watson; Palmer; Robins; Watson, E.W., 2. Archives.

PAONE, PETER **b.** October 2, 1936, Philadelphia, Pa. **Studied:** Barnes Foundation, 1953-54; Philadelphia Museum School, 1953, BA. Traveled Europe; resided London, two years. **Taught:** Pratt Institute, 1956-66, 1970-72; Philadelphia Museum School, 1958-59; Samuel S. Fleisher Art Memorial, Philadelphia, 1958-65; Positano (Italy) Art Workshop, 1961; U. of New Mexico, 1974; PAFA, 1979-. **Member:** SAGA; NAD. **Awards:** PMA, P.P., 1959; Library of Congress; Pennell P.P., 1962; L.C. Tiffany Grants, 1962, 64; The Print Club, Philadelphia, P.P., 1963; Syracuse U., P.P., 1964; Pennsylvania Council on the Visual Arts, grant, 1986. **Address:** 1027 Westview Street, Philadephia, PA 19119. **One-man Exhibitions:** (first) Dubin Gallery, Philadelphia,

1957; The Print Club, Philadelphia, 1958, 61, 62, 83; Gallery Ten, New Hope, Pa., 1959; Grippi Gallery, NYC, 1959-62; Fort Worth, 1964; The Forum Gallery, 1965; Jessop Gallery, London, 1967; Benson Gallery, 1967; David Gallery, 1968; Roswell, 1977; Amarillo Art Center; Art Center, Waco; Hooks-Epstein Gallery, Houston, 1978, 83, 85, 86, 87, 89; PAFA, 1983. **Group:** PMA, 1959, 62; Brooklyn Museum, 1962, and Print Biennials; Escuela Nacional de Artes Plasticas, Mexico City, 1963; III Paris Biennial, 1963; Dallas/MFA, Four Young Artists, 1964; Syracuse/Everson, American Printmakers, 1964; New York World's Fair, 1964-65; Otis Art Institute, Drawings Biennial, 1964; Paris/Moderne, Biennale, 1965; Detroit Graphic Arts Society, The Bite of the Print, 1965; Youngstown/Butler, Annual, 1969; PAFA, Contemporary Drawing: Philadelphia, 1978; NIAL, 1966; Temple U., The Renaissance Revisited, 1982. **Collections:** British Museum; Chicago/AI; Delaware Art Museum; Flint/Institute; Fort Worth; Free Library of Philadelphia; General Mills Inc.; U. of Kansas; Lehigh U.; Library of Congress; MOMA; U. of Massachusetts; National Gallery; PAFA; PMA; Princeton U.; The Print Club, Philadelphia; Carl Sandburg Memorial Library; Southern Nevada U.; Syracuse U.; Trenton/State; U. of Utah; Victoria and Albert Museum; Yale U.; Youngstown/Butler. **Bibliography:** Rodman 3.

PARIS, HAROLD P. **b.** August 16, 1925, Edgemere, N.Y. **d.** 1979, Oakland, Calif. **Studied:** Atelier 17, NYC, 1949; Creative Workshop, NYC, 1951-52; Academy of Fine Arts, Munich, 1953-56. Traveled Europe. **Taught:** U. of California, Berkeley. **Awards:** L. C. Tiffany Grant, 1949; Guggenheim Foundation Fellowship, 1953; Fulbright Fellowship (Germany), 1953; U. of California, Creative Arts Award and Institute Fellowship, 1967-68. **One-man Exhibitions:** (first) Argent Gallery, NYC, 1951; Philadelphia Art Alli-

ance, 1951; Village Art Center, NYC, 1952; Wittenborn Gallery, NYC, 1952; Galerie Moderne, NYC, 1953; Esther Stuttman Gallery, NYC, 1960; Tulane U., 1960; Pratt Graphic Art Center, 1960; Silvan Simone Gallery, 1960; U. of California, Berkeley, 1961; Paul Kantor Gallery, Beverly Hills, Calif., 1961; Bolles Gallery, 1962 (two-man, with Angelo Ippolito); Humboldt State College, 1963; Hansen Gallery, San Francisco, 1965, 67; Mills College, 1967; Reed College, 1967; Sally Judd Gallery, Portland, Ore., 1968; Michael Smith Gallery, Los Angeles, 1972; Smith Anderson Gallery, San Francisco, 1975, 76, 77; Stephen Wirtz Gallery, San Francisco, 1979, 84; Sonoma State U., 1987; Harcourts Gallery, San Francisco, 1991. **Group:** MMA; Boston/MFA; Vienna Sezession; The Hague; Amerika Haus, Munich; California Palace; Baltimore/MA; Smithsonian; New Orleans/Delgado; Pasadena/AM; Brooklyn Museum, 1948, 49, 50, 52, 54; PAFA, 1949, 50, 52, 54; Galerie Kunst der Gegenwart, Salzburg, 1952; MOMA, 1953; PMA, 1953-56, 1959, 64; SFMA, 1953, 1960-65, Annual, 1963; III Biennial of Spanish-American Art, Barcelona, 1955; Ottawa/National, 1956; WMAA, 1956, Sculpture Annual, 1964; Salon de la Jeune Sculpture, Paris, 1958; Stanford U., Some Points of View for '62, 1961; Museum of Contemporary Crafts, 1963, 66; U. of California, circ., 1963-64; France/National, 1964; San Francisco Art Institute, 1964; New School for Social Research, 1964; La Jolla, 1965; The Pennsylvania State U., 1965; Newport Harbor Art Museum, Balboa, Calif., 1965; M. Knoedler & Co., Art Across America, circ., 1965-67; Los Angeles/County MA, 1966. **Collections:** California Palace; U. of California; Chicago/AI; U. of Delaware; Goddard College; La Jolla; Library of Congress; MOMA; Memphis/Brooks; NYPL; U. of North Dakota; Oakland/AM; Ottawa/National; PMA; SFMA; WMAA; U. of Wisconsin. **Bibliography:** Selz, P., 2; Tuchman 1.

PARK, DAVID b. March 17, 1911, Boston, Mass. d. September 20, 1960, Berkeley, Calif. **Studied:** Otis Art Institute, Los Angeles, 1928; assistant to Ralph Stackpole, 1929. **Taught:** Various private schools, San Francisco, 1931-36; Winsor School, Boston, 1936-41; California School of Fine Arts, 1943-52; U. of California, Berkeley, 1955-60. Designed sets and costumes for the U. of California, Berkeley, production of the opera *The Sorrows of Orpheus,* by Darius Milhaud, 1958. Federal A.P.: Mural painting, San Francisco. **Awards:** SFMA, 1935, 51, 53, 55, 57; Oakland/AM, Gold Medal, 1957; PAFA, Walter Lippincott Prize, 1960. **One-man Exhibitions:** SFMA, 1935, 40; Delphic Studios, NYC, 1936; New Gallery, Boston, 1939; Albany/Institute (two-man, with Dorothy Dehner), ca. 1944; California Palace, 1946; Paul Kantor Gallery, Beverly Hills, Calif., 1954; RAC, 1955; U. of California, College of Architecture, 1956; Oakland/AM, 1957; de Young, 1959; Staempfli Gallery, NYC, 1959, 61, 63, 65; U. of California, Berkeley, circ., 1964; Santa Barbara/MA, 1968; Maxwell Galleries, Ltd., San Francisco, 1970; Salander-O'Reilly Galleries, NYC, 1983, 85, 87, 90; Stanford U., 1988; John Berggruen Gallery, San Francisco, 1992. **Retrospectives:** Oakland/AM, 1977; WMAA, circ., 1988. **Group:** PAFA, 1950; U. of Illinois, 1952, 57, 59, 61; III São Paulo Biennial, 1955; ART:USA:58 and ART:USA:59, NYC, 1958, 59; WMAA Annual, 1959; Indiana U., New Imagery in American Painting, 1959; A.F.A., The Figure, circ., 1960; Chicago/AI; Corcoran; SRGM/USIA, American Vanguard, circ., Europe, 1961-62; J.L. Hudson Art Gallery, Detroit, Four California Painters, 1966. **Collections:** U. of California, Berkeley; ICA, Boston; U. of Illinois; Indian Head Mills, Inc.; Oakland/AM; SFMA; WMAA. **Bibliography:** Armstrong, R., 1; Armstrong, Thomas; Goodrich and Baur 1; Sandler 5; Schwartz 1; Solnit; Ward. Archives.

PARKER, RAYMOND b. August 22, 1922, Beresford, S.D. d. April 13, 1990, NYC. **Studied:** U. of Iowa, 1946, BA, 1948, MFA. **Taught:** Hunter College, 1955-; U. of Southern California, summer, 1959; State U. of Iowa; U. of Minnesota; Columbia U., 1970-71. **Awards:** Ford Foundation, P.P., 1963; Ford Foundation/A.F.A., Artist-in-Residence Grant, 1965; National Council on the Arts, 1967; Guggenheim Foundation Fellowship, 1967. **One-man Exhibitions:** Walker, 1950; Memphis/Brooks, 1953; Paul Kantor Gallery, Beverly Hills, Calif., 1953, 56; Louisville/Speed, 1954; Union College (N.Y.), 1955; Widdifield Gallery, NYC, 1957, 59; U. of Southern California, 1959; Dwan Gallery, NYC, 1960, 62; Galerie Lawrence, Paris, 1960; The Kootz Gallery, NYC, 1960-64; Galleria dell'Ariete, 1961; SRGM, 1961; Bennington College, 1961; Des Moines, 1962 (three-man); Gertrude Kasle Gallery, 1966, 70; U. of New Mexico, 1967; Galerie Muller, 1967; Simone Sterne Gallery, New Orleans (two-man), 1968; Molly Barnes Gallery, Los Angeles, 1968, 70; Quay Gallery, San Francisco, 1970, 72, 74; Fischbach Gallery, 1971, 73, 74; Arts Club of Chicago, 1971; Miami-Dade, 1971; Michael Berger Gallery, Pittsburgh, 1974; Portland (Ore.) Center for the Visual Arts, 1974; Benson Gallery, 1974; Berenson Gallery, Miami, 1974; American U., 1975; Susan Caldwell Gallery, NYC, 1976, 77, 80; U. of Maryland, 1977; U. of Texas, Austin, 1977; The Billiard Room Gallery, Cambridge, Mass., 1979; Betty Cunningham, NYC, 1979, 80; Phillips, 1979. **Retrospectives:** Dayton/AI, 1965; WGMA, 1966; SFMA, 1967; School of Visual Arts, NYC, 1971. **Group:** Minnesota State Historical Society, St. Paul, Centennial Minnesota; Walker Biennials, 1949, 51; MOMA, New Talent; MMA, American Paintings Today, 1950; WMAA Annuals, 1950, 52, 58, 67, 69, 72, 73; Oberlin College, 1951; Walker, Vanguard, 1955; Tokyo/Modern, 1957; Walker, 60 American Painters,

1960; II Inter-American Paintings and
Prints Biennial, Mexico City, 1960;
SRGM, Abstract Expressionists and Im-
agists, 1961; U. of Illinois, 1961, 62; Seat-
tle World's Fair, 1962; Corcoran, 1963;
Jewish Museum, Toward a New Abstrac-
tion, 1963; Hartford/Wadsworth, Black,
White, and Gray, 1964; Chicago/AI,
1964; Los Angeles/County MA, Post Paint-
erly Abstraction, 1964; Tate, Painting and
Sculpture of a Decade, 1954-64, 1964;
XXXII Venice Biennial, 1964; Cambridge,
1964, 65; MOMA, The Art of the Real,
1968; MOMA, Younger Abstract Expres-
sionists of the Fifties, 1971; U. of Texas,
Color Forum, 1972. **Collections:** AAAL;
Akron/AI; Allentown/AM; Brandeis U.;
Buffalo/Albright; Chicago/AI; Ciba-Geigy
Corp.; Cleveland/MA; Commerce Bank of
Kansas City; Dayton/AI; Des Moines; Fort
Worth; Hartford/Wadsworth; Interna-
tional Minerals & Chemicals Corp.; State
U. of Iowa; Los Angeles/County/MA;
MIT; MMA; MOMA; Miami-Dade; Min-
neapolis/Institute; Minnesota State Histori-
cal Society; U. of New Mexico; New
Orleans/Delgado; PMA; Portland,
Ore./AM; Phillips; Princeton U.; Ridge-
field/Aldrich; SFMA; SRGM; Tate; U. of
Texas; Vassar College; WMAA; Walker.
Bibliography: Friedman, ed.; Goossen 1;
McChesney; *New in the Seventies; Metro;*
Rickey; Sandler 5; Weller.

PARKER, ROBERT ANDREW
b. May 14, 1927, Norfolk, Va. **Studied:**
Chicago Art Institute School, with Paul
Wieghardt, Rudolph Pen, Max Kahn,
1948-52, B.A., Ed.; Atelier 17, NYC,
1952-53, with Peter Grippe. US Army Air
Force, 1945-46. Traveled Europe, Africa,
Central and South America. **Taught:** New
York School for the Deaf, 1952-55;
School of Visual Arts, NYC, 1959-63;
RISD, 1984; Syracuse U.; Parsons School
of Design, NYC; Pratt Institute, 1985.
Member: American Federation of Musi-
cians; NAD. Worked on film *The Days of
Wilfred Owen,* with Richard Burton.

Commissions: Illustrated 8 poems by
Marianne Moore (MOMA, 1962); sets for
the MOMA production of *The Mighty
Casey,* opera by William Schuman; New
York World's Fair, 1964-65. **Awards:** Chi-
cago/AI, 1952; Skowhegan School, 1952;
Chicago/AI, Maurice L. Rothschild Schol-
arship, 1962; NIAL, Richard and Hinda
Rosenthal Foundation Award, 1962;
Tamarind Fellowship, 1967; Guggenheim
Foundation Fellowship, 1969. **Address:**
River Road, W. Cornwall, Ct. 06796.
Dealer: Terry Dintenfass, Inc., NYC.
One-man Exhibitions: (first) The Little
Gallery, Chicago, 1949; Roko Gallery,
NYC, 1953, 54, 57, 58, 59; Palmer
House Galleries, Chicago, 1957; Nexus
Gallery, Boston, 1957; Katonah (N.Y.)
Library, 1957, 63; Felix Landau Gallery,
1961; St. Paul Gallery, 1961; Nashville,
1961; World House Galleries, NYC,
1961, 62, 64; Raymond Burr Gallery, Los
Angeles, 1962; Obelisk Gallery, Washing-
ton, D.C., 1963; J. L. Hudson Art Gal-
lery, Detroit, 1963, 69; Terry Dintenfass,
Inc., NYC, 1966, 67, 69, 70, 71, 72, 78,
79, 82, 91; The Schuman Gallery, Roches-
ter, N.Y., 1967; Lehigh U., 1969; U. of
Connecticut, 1971; Achim Moeller Ltd.,
London, 1973; Martin Sumers Graphics,
NYC, 1978; Bethel (Conn.) Art Gallery,
1978; Moravian College, 1978; Pennsylva-
nia State U., 1981; Brooklyn Museum,
1982; Rossi Gallery, Morristown, N.J.,
1982; Jay Gallery, NYC, 1983; Little
Rock/MFA, 1984; Mattatuck, 1985;
Washington U., 1985; Munson Gallery,
Santa Fe, 1985; Bucknell U., 1992.
Group: MMA, American Watercolors,
Drawings and Prints, 1952; MOMA,
Young American Printmakers, 1953;
WMAA Annuals, 1955, 56, 59; A.F.A.,
New Talent, circ., 1956; La Napoule,
France, 5 Masters of Line, 1957; WMAA,
Young America, 1957; USIA, Contempo-
rary Graphic Art in the USA, circ., Europe
and Asia, 1957-59; WMAA, Forty Ameri-
cans Under Forty, circ., 1962; Brooklyn
Museum, 1963, 1968-69; MOMA, 1966;

PAFA Annuals, 1966, 67; Indianapolis/Herron, 1967, 68; Brooklyn Museum Print Biennials, 1968, 69; U. of North Carolina, 1969, 71; New School for Social Research, Humor, Satire, and Irony, 1972; NAD Annual, 1977; Indiana U., Contemporary Pastel and Watercolors, 1977; Potsdam/SUNY, Off the Beaten Path, 1977; NAD, Ward Ranger Annual Exhibition, 1979; Redding (Calif.) Museum and Art Center, Art and Aviation, 1984; IEF, 20th Century American Drawings: The Figure in Context, circ., 1984. **Collections:** Amerada Hess Corp.; U. of Arkansas; Brooklyn Museum; Dublin/Municipal; Hirshhorn; Indianapolis; Kalamazoo/Institute; Los Angeles/County MA; MMA; MOMA; U. of Massachusetts; U. of Michigan; Minnesota/MA; Montclair/AM; The Morgan Library; NAD; Nashville; Newark Museum; Pasadena/AM; Phoenix; Raleigh/NCMA; Smith College; Tacoma; WMAA.

PARRISH, DAVID **b.** June 19, 1939, Birmingham, Ala. **Studied:** U. of Alabama, BFA. **Address:** 700 Cleermont Drive, S.E., Huntsville, AL 35801. **Dealer:** Louis K. Meisel Gallery, NYC. **One-man Exhibitions:** Memphis/Brooks, 1971; Sherry French Gallery, NYC, 1972; Galerie Petit, Paris, 1973; Sidney Janis Gallery, NYC, 1975; Huntsville, 1977; Birmingham, Ala./MA, circ., 1981; Nancy Hoffman Gallery, 1981; Greenville, 1987; Louis K. Meisel Gallery, NYC, 1990. **Group:** U. of North Carolina, Art on Paper, 1968; Youngstown/Butler, Midyear Show, 1969; Indianapolis, 1972, 78; Baltimore/MA, Super Realism, 1975; U. of Nebraska, Things Seen, circ., 1978; San Antonio/MA, Real, Really Real, Super Real, circ., 1981; PAFA, Contemporary American Realism Since 1960, 1981; SFMA, American Realism (Janss), circ., 1985; Huntsville Museum, Expressions & Discoveries, 1989. **Collections:** Birmingham, Ala./MA; Brandeis U.; Flint/Institute; Hartford/Wadsworth; Huntsville

Museum; Memphis/Brooks; Montgomery Museum; Nashville; Syracuse/Everson.

PASCHKE, ED **b.** June 22, 1939, Chicago. **Studied:** Chicago Art Institute School, BFA, MA. US Army, 1962-64. **Taught:** Meramac College, St. Louis, 1970-71; Chicago Art Institute School, 1973; Barat College, Lake Forest, 1971-77; Northwestern U., 1978-. **Address:** 6129 North Kilbourn, Chicago, Ill. 60646. **Dealers:** Phyllis Kind Gallery, NYC, Chicago; Galerie Darthea Speyer, Paris. **One-man Exhibitions:** Deson Zaks Gallery, Chicago, 1970, 72, 73, 75; Richard DeMarco Gallery, Edinburgh, 1973; Cincinnati/Contemporary, 1974; Hundred Acres Gallery, NYC, 1971, 74; Pyramid Gallery, Washington, D.C., 1975; Marion Locks Gallery, Philadelphia, 1976; Galerie Darthea Speyer, Paris, 1974, 76, 78, 81, 83, 85, 86, 88, 89, 91; Phyllis Kind Gallery, Chicago, 1977, 79, 83, 88, 90, 92; Phyllis Kind Gallery, NYC, 1978, 79, 80, 82, 83, 84, 85, 86, 87, 88, 90, 91, 92; Carnegie Mellon U., 1983; Galerie Bonnier, Geneva, 1984, 85, 87, 88, 91; Fuller-Goldeen Gallery, San Francisco, 1984, 86; Luhring Augustine Hodes Gallery, NYC, 1987; Dorothy Goldeen Gallery, Los Angeles, 1988, 90, 92; U. of Miami, 1988; Indiana State U., 1991; Ripon College, 1992. **Retrospectives:** U. of Chicago, circ., 1981; Paris/Beaubourg, 1989; Chicago/AI, circ., 1989. **Group:** Chicago/Contemporary, Don Baum Sez, "Chicago Needs Famous Artists," 1969; Chicago/AI, Chicago and Vicinity, 1962, 67, 73; Chicago/Contemporary, Chicago Imagist Art, 1972; Ottawa/Ontario, What They're Up to in Chicago, 1972; WMAA Biennial, 1973, 81, 85; Chicago Art Institute School, Former Famous Alumni, 1976; Sacramento/Crocker, The Chicago Connection, 1977; U. of Texas, New in the Seventies, 1977; Grand Palais, Paris, Salon de Mai, 1978; Sunderland (Eng.) Arts Centre, Who Chicago?, circ., 1980; Haus der Kunst, Munich, Amerikanische Malerei,

1930-1980, 1981; Kansas City/AI, Chicago Imagists, 1982; Indianapolis, 1982; Hirshhorn, Correspondences: New York Choice '84, 1984; MOMA, International Survey of Recent Painting and Sculpture, 1984; Corcoran Biennial, 1985; U. of Washington, Sources of Light, 1985; Seattle/AM, States of War, 1985; Los Angeles/MOCA, T.V. Generation, 1986; Northwestern U., Painting at Northwestern, 1986; U. of California, Berkeley, Made in USA, circ., 1987; U. of Chicago, Drawings of the Chicago Imagist, 1987; Bowling Green U., Of New Account: The Chicago Imagist, 1987; Chicago/Terra, Surfaces: Two Decades of Painting in Chicago, 1987; U. of Chicago, The Chicago Imagist Print, 1987; Milwaukee, The World of Art Today, 1988; U. of Wisconsin, Realism, 1988; MOMA, Committed to Print, 1988; Randolph-Macon Women's College, Chicago, 78th Annual, 1989; Savannah/Telfair, Speaking Out, 1989; Oakland/AM, de-Persona, 1991; Evanston Art Center, Eight from Northwestern, 1992; Chicago/AI, From America's Studio, 1992; Chicago/AI, Distinguished Alumni, 1992. **Collections:** Baltimore/MA; Borg-Warner International Corporation; Brooklyn Museum; Chicago/AI; Chicago/Contemporary; Continental Bank; Exxon Corp.; First National Bank of Chicago; General Electric Corporation; State of Illinois; Illinois Bell Telephone Company; Jacksonville/AM; Kalamazoo/Institute; MMA; Museum des 20. Jahrhunderts, Vienna; John F. Kennedy Library; NMAA; U. of North Carolina; Paris/Beaubourg; Paris/Moderne; Phoenix; Rotterdam; VMFA; Vienna/Moderner; WMAA; Wake Forest U. **Bibliography:** Adrian; Adrian and Born; Armstrong, Thomas; *The Chicago Connection;* Kirschner; *New in the Seventies;* Tomidy; *Who Chicago?*

PASILIS, F.
from 1st to 3rd edition.

PATTISON, ABBOTT
from 1st to 4th edition.

PEAKE, CHANNING
from 1st to 4th edition.

PEARLSTEIN, PHILIP **b.** May 24, 1924, Pittsburgh, Pa. **Studied:** Carnegie Institute of Technology, with Sam Rosenberg, Robert Lepper, Balcomb Greene; NYU, BA, MFA. US Army, 1943-45. **Taught:** Pratt Institute, 1959-63; Brooklyn College, 1963-87. **Member:** Tanager Gallery, NYC; AAIAL; Century Association; NAD. **Awards:** Fulbright Fellowship (Italy), 1958; National Council on the Arts Grant, 1969; AAAL, P.P., 1973; American Academy, Rome, Artist-in-Residence, 1982; Skowhegan School, Gold Medal, 1985. Subject of video, *Philip Pearlstein Draws the Artist's Model,* 1985, produced by Interactive Media Corp., NYC. **Address:** 361 West 36 Street, NYC 10018. **Dealer:** Hirschl & Adler Modern, NYC. **One-man Exhibitions:** (first) Tanager Gallery, NYC, 1955, 59; The Peridot Gallery, NYC, 1956, 57, 59; Allan Frumkin Gallery, Chicago, 1960, 65, 69, 73, 75; Allan Frumkin Gallery, NYC, 1961-67, 69, 72, 74, 76, 78, 80, 82; Kansas City/Nelson, 1962; Reed College, 1965, 79; Ceeje Galleries, Los Angeles, 1965, 66; Bradford Junior College, 1967; Carnegie, 1968; U. of South Florida, 1969; Chatham College, Pittsburgh, 1970; Graphics I & Graphics II, Boston, 1971, 81; M.E. Thelen Gallery, Cologne, 1972; Galleri Ostergren, Malmo, 1972; Galerie Kornfeld, Zurich, 1972, Berlin, 1972; Donald Morris Gallery, 1972, 76, 80, 82; Parker Street 470 Gallery, Boston, 1973; Galerie La Tortue, Paris, 1973; Finch College, NYC, circ., 1974; Purchase/SUNY, 1975; Marianne Friedland Gallery, Toronto, 1975, 81, 84, 87; Michael Berger Gallery, Pittsburgh, 1975, 83; Fendrick Gallery, Washington, D.C., 1976; Harcus-Krakow Gallery, Boston, 1978; Carnegie Mellon U., 1979; Gimpel Fils, London, 1979; Jollembeck, Cologne, 1979; Plattsburgh/SUNY, 1979; Wesleyan U., 1979; Associated American Artists, NYC, 1980;

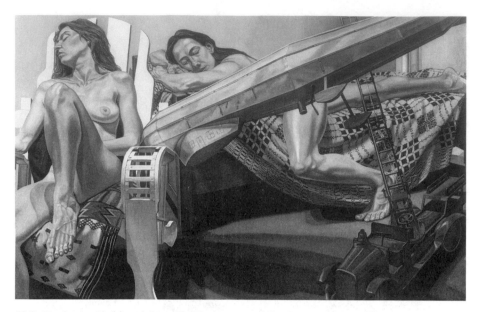

Philip Pearlstein, *Models with Dirigible Weathervane and Fire Engine*, 1992.

Brooke Alexander, Inc., 1981; Columbus College, 1981; U. of North Carolina, 1981; North Dakota State U., 1981; Reynolds/Minor Gallery, Richmond, Va., 1981; Ringling, 1981; Springfield, Mo./AM; 1981; Summit (N.J.) Art Center, 1982; American Academy, Rome, 1983; Galleria Il Ponte, Rome, 1983; U. of Northern Iowa, 1983; Fay Gold Gallery, Atlanta, 1984; Richmond U., 1984; Hirschl & Adler Modern, 1985, 88, 91; James Madison U., 1986; Palace Theatre of the Arts, Stamford, Ct., 1986; Atlantic Center for the Arts, New Smyrna Beach, Fla., 1986; Amherst College, 1986; Northern Illinois U., 1987; Binghamton/SUNY, 1987; Galerie Rudolf Zwirner, Cologne, 1989; Brooklyn Museum, 1989; Printworks Gallery, Chicago, 1990; Condeso/Lawler Gallery, NYC, 1991; Compass Rose Gallery, Chicago, 1991. **Retrospectives:** U. of Georgia, 1970; Springfield, Mass./MFA, 1978; Milwaukee, circ., 1983. **Group:** The Kootz Gallery, NYC, New Talent, 1954; The Stable Gallery, NYC, Annuals, 1955-57; Carnegie, 1955, 66, 73; U. of Nebraska, 1956, 57; Walker, Expressionism, 1900-1955, 1956, also 1958; Chicago/AI, 1959, 62; Kansas City/Nelson, 1962; U. of Colorado, 1962, 67; SFMA, Directions—Painting U.S.A., 1963, also 1968; Boston U., 1964; U. of Illinois, 1965, 67, 69; U. of Texas, 1966; Corcoran, 1967; Harvard U., 1967; Trenton/State, Focus on Light, 1967; Torcuato di Tella, Buenos Aires; Vassar College, 1968; Smithsonian, circ., Latin America, 1968-70; Milwaukee, Aspects of a New Realism, 1969; WMAA, 22 Realists, 1970; MIT, Leslie, Pearlstein, Thiebaud, 1971; Indianapolis, 1972; A.F.A., Realist Revival, 1972; WMAA, American Drawings, 1963-1973, 1973; Yale U., American Drawing: 1970-1973, 1973; Hofstra U., The Male Nude, 1973; Ars 74, Helsinki, 1974; VMFA, Twelve American Painters, 1974; Westminster College, The Figure in Recent American Painting, 1974; Cleveland/MA, Aspects of the Figure, 1974; Yale U., Seven Realists, 1973; Corcoran Biennial, 1975; Lincoln, Mass./De Cordova, Candid Painting: American Genre 1950-1975, 1975; PAFA, Eight Contemporary Realists, 1977;

Darmstadt/Kunsthalle, Realism and Reality, 1975; U. of Colorado, Six Painters of the Figure, 1979; US Dept. of the Interior, America 1976, circ., 1976; WMAA Biennial, 1979; Corcoran, The Human Form, 1980; NPG, American Portrait Drawings, 1980; Brooklyn Museum, American Drawing in Black and White, 1970-1979,1980; Akron/AM, The Image in American Painting and Sculpture, 1950-1980, 1981; San Antonio/MA, Real, Really Real, Super Real, circ., 1981; Haus der Kunst, Munich, Amerikanische Malerie, 1930-1980, 1981; PAFA, Contemporary American Realism Since 1960, circ., 1982; Isetan Museum of Art, Tokyo, American Realism, The Precise Image, 1985; Fort Lauderdale, An American Renaissance: Painting and Sculpture Since 1940, 1986; New Orleans/Contemporary, Landscape, Seascape, Citiscape, 1987; Cranbrook, Viewpoints: Painting and the Third Dumension, 1986; ICA, London, Komic Ikonoklasm, circ., 1987; Little Rock/MFA, The Figure, 1989; Fashion Institute of Technology, NYC, New York 20+ Art for Artist's Sake, 1990; WMAA, Biennial, 1991. **Collections:** Alhany/SUNY; Akron/AM; Berlin/National; Boston/MFA; Brandeis U.; Brooklyn College; Brooklyn Museum; Brown U.; Canton Art Institute; Carnegie; Charleston/Gibbs; Chicago/AI; Chicago/Spertus; Cleveland/MA; Cornell U.; Chicago/AI; Chicago/Contemporary; U. of Chicago; Colgate U.; Colorado Springs/FA; Corcoran; Des Moines; Hirshhorn; Hunter College; U. of Indiana; Indiana U.; Kalamazoo/Institute; Kansas City/AI; Kansas City/Nelson; Loch Haven Art Center; Louisville/Speed; MMA; MOMA; Milwaukee; NYU; National Gallery; U. of Nebraska; Newark Museum; U. of North Carolina; Oklahoma; Orlando; PMA; The Pennsylvania State U.; Princeton U.; RISD; Reed College; Rensselaer Polytechnic Institute; Ringling; San Antonio/MA; Syracuse U.; U. of Texas; Toledo/MA; Trenton/State; Vassar College; WMAA; Williams College; Yale U.

Bibliography: Adrian; *America 1976;* Armstrong, Thomas; Arthur 1, 2, 3; **Bowman;** Cummings 1, 4; Goldman 1; Goodyear; Honisch and Jensen, eds.; Hughes; *Kunst um 1970;* Murken-Altrogge; Nochlin; Rubin 1; Sandler 3, 5; Sager; Seitz 3; Strand, ed.; Ward; Weller. Archives.

PEARSON, HENRY CHARLES
b. October 8, 1914, Kinston, N.C. **Studied:** U. of North Carolina; Yale U., BA, MFA; ASL, 1953-55, with Reginald Marsh, Will Barnet, Robert Hale. US Army and Air Force, 1942-53. Traveled USA, the Orient. The bibliographer of Seamus Heaney. Designed sets and costumes for the theater, 1937-42. Illustrated special editions of Seamus Heaney poems, 1981, 1982. **Taught:** Boston Museum School; New School for Social Research; U. of Minnesota, Duluth; Ball State U.; PAFA; and privately. **Member:** American Abstract Artists; Century Association. **Awards:** Raleigh/NCMA, 1957; Tamarind Fellowship, 1964; Corcoran, P.P., 1965; PAFA, J. Henry Schiedt Memorial Prize, 1968; North Carolina Governor's Arts Medal, 1969. **Address:** 58 West 58th Street, NYC 10019; 1601 Cambridge Drive, Kinston, NC 28501. **One-man Exhibitions:** (first) Workshop Gallery, NYC, 1958; Stephen Radich Gallery, NYC, 1961, 62, 66, 69; Ball State U., 1965; U. of Minnesota, 1965; Betty Parsons Gallery, NYC, 1971, 73; Parsons-Truman Gallery, NYC, 1975, Jock Truman Gallery, 1977; Marilyn Pearl Gallery, NYC, 1980, 83, 86, 88, 91; Century Association, 1982; U. of Minnesota, 1965. **Retrospective:** Raleigh/NCMA, 1969. **Group:** Scranton/Everhart, Contemporary Americans, 1956; PAFA, 1956, 64; American Abstract Artists Annuals, 1958-64; A.F.A., Purist Painting, circ., 1960-61; A.F.A., Drawings from the WMAA Annual 1960, circ., 1961-62; WMAA, Geometric Abstraction in America, circ., 1962; MOMA, Contemporary Painters and Sculptors as Printmakers, 1964, The Responsive Eye, 1965,

also 1969; Corcoran Biennial, 1965; Chicago/AI, 1965; Gallery of Modern Art, NYC, 1965; WMAA Annuals, 1965, 66, 68; Brooklyn Museum, Print Biennial; Grolier Club, 1966; Gallery of Modern Art, Ljubljana, Yugoslavia, VII International Exhibition of Prints, 1967; Utica, 1968; WMAA, Twentieth-Century Drawings from the Whitney Museum of American Art, circ., 1979-81; U. of North Carolina, Art on Paper, 1980; Bard College, White & Black, 1983. **Collections:** Ackland; Allentown/AM; Buffalo/Albright; Burlington Mills Collection; Chase Manhattan Bank; Chicago/AI; Ciba-Geigy Corp.; Cincinnati/AM; Columbia Broadcasting System; Corcoran; Hirshhorn; Housatonic Community College; Kansas City/Nelson; MMA; MOMA; Malmo; U. of Massachusetts; Minneapolis/Institute; Minnesota/MA; U. of Minnesota; NYPL; National Gallery; U. of Nebraska; Newark Museum; U. of North Carolina; Oslo/National; Raleigh/NCMA; St. Louis/City; The Singer Company, Inc.; Southern Illinois U.; SRGM; Trinity College, Dublin; U.S. Steel Corp.; Union Carbide Corp.; WMAA; Wells College. **Bibliography:** Archives.

PEIRCE, WALDO **b.** December 17, 1884, Bangor, Me. **d.** March 8, 1970, Newburyport, Mass. **Studied:** Phillips Academy; Harvard U., 1908, A.B.; Academie Julian, Paris, 1911. Traveled Europe, North Africa, Spain. **Commissions** (murals): US Post Offices, Westbrooke, Me., Troy, N.Y., and Peabody, Mass.; Field Service Building, NYC, 1961. **Awards:** Pomona College, 1939; Pepsi-Cola, 1944; Carnegie, First Hon. Men., 1944. **One-man Exhibitions:** (first) Wildenstein & Co., NYC, 1926, 41 (two-man); The Midtown Galleries, 1939, 41, 44, 45, 49, 60, 68, 72; U. of Maine, 1985. **Retrospective:** Rockland/Farnsworth, 1950. **Group:** Salon du Mai, Paris, 1912, 13, 14; Salon d'Automne, Paris, 1922. **Collections:** Andover/Phillips; Arizona State U.; U. of Arizona; Augusta, Me./State;

Bangor Public Library; Britannica; Brooklyn Museum; Carnegie; Colby College; Columbus; Harvard U.; MMA; U. of Maine; U. of Nebraska; PAFA; Pepsi-Cola Co.; Rockland/Farnsworth; Upjohn Co.; WMAA; Youngstown/Butler. **Bibliography:** American Artists Group, Inc., 3; Baur 7; Bazin; Bethers; Boswell 1; Eliot; Hale; Hall; Mellquist; Peirce; *7 Decades;* Varga. Archives.

PENNEY, JAMES
from 1st to 5th edition.

PEPPER, BEVERLY **b.** December 20, 1924, Brooklyn. **Studied:** Pratt Institute, 1939-41, BA; Art Students League, 1946; Academie de la Grande Chaumiere, Paris; Atelier Andre L'Hote, 1948, and Atelier Fernand Leger. Painted from 1949-60, then began sculpture. Advertising art director, 1942-48. Traveled Europe, North Africa, Israel, Orient; since 1949 has lived in Italy. **Taught:** U. of Perugia, Prof. Emeritus, 1987. **Commissions:** Festival di Due Mondi, Spoleto, 1962; U.S. Plywood Building, NYC, 1963; Weizmann Institute, Rehovoth, Israel, 1964; Southland Mall, Memphis, 1966; Government Center, Boston, 1971; North Park Shopping Mall, Dallas, 1971; Albany (N.Y.) Mall, 1973; Federal Reserve Bank, Philadelphia, 1974; San Diego Federal Building, 1975; AT&T, Long Lines Building, Bedminster, N.J., 1974; Dartmouth College, 1975; The Carborundum Co., Niagara Falls, 1978; City Hall, Toledo, Ohio, 1979; Physiocontrol Co., Seattle, 1979; City of Niagara Falls, 1979; Todi, Italy, 1979; Toledo (Oh.) Civic Center, 1979; Buffalo (N.Y.) Convention Center, 1979; Richard J. Hughes Justice Complex, Trenton, N.J., 1981; Four-Leaf Towers, Houston, 1982; Phoenix Center, Pontiac, Mich., 1982; Laumeier Sculpture Park, 1983; Johns Hopkins Hospital, Baltimore, 1983; Buffalo/SUNY, 1983. **Awards:** Hon. DFA, Pratt Institute, 1982; Hon. DFA, Maryland Institute, 1983. **Address:** Torre Gen-

tile di Todi, Perugia 06059, Italy; 86 Thomas Street, NYC 10013. **Dealer:** André Emmerich Gallery, NYC. **One-man Exhibitions:** (first) Galleria dello Zodiaco, Rome, 1952; Barone, NYC, 1954, 56, 68; Obelisk Gallery, Washington, D.C., 1955; Galleria d'Arte l'Obelisco, Rome, 1959; Galleria Pogliani, Rome, 1961; Thibaut Gallery, NYC, 1961; Marlborough Galleria d'Arte, Rome, 1965, 68, 72; McCormick Place-on-the-Lake, Chicago, 1966; Galleria d'Arte La Bussola, Turin, 1968; Paola Barozzi, Venice, 1968; Marlborough Gallery, NYC, 1969; Chicago/Contemporary, 1969; MIT, 1969; Buffalo/Albright, 1969; Syracuse/Everson, 1970; Piazza della Rotonda, Milan, 1970; Studio Marconi, Milan, 1971; Galerie Hella Nebelung, Düsseldorf, 1971; Piazza Margana, Rome, 1971; Parker Street 470 Gallery, Boston, 1971; Qui Arte Contemporanea, Rome, 1972; Tyler School, Temple U.; Rome, 1973; Hammarskjold Plaza, NYC, 1975; André Emmerich Gallery, NYC, 1975, 77, 79, 82, 83, 84, 87, 88, 89, 91; SFMA, 1976; Seattle/AM, 1977; Indianapolis, 1977, 78; Dartmouth College, 1977; Princeton U., 1978; Hofstra U., 1979; Thomas Segal Gallery, Boston, 1980; André Emmerich Gallery, Zurich, 1980; Nina Freudenheim Gallery, Buffalo, 1980; Makler Gallery, Philadelphia, 1981; Linda Farris Gallery, Seattle, 1981; Davenport, 1981; Hansen Fuller Goldeen Gallery, San Francisco, 1981; Laumeier International Sculpture Park, 1982; Yares Gallery, Scottsdale, 1982; Galleria Il Ponte, Rome, 1982; Gimpel-Hanover & Galerie André Emmerich, Zurich, 1983; Huntington Galleries, 1983; John Berggruen Gallery, San Francisco, 1983, 85; Baumgartner Gallery, Washington, D.C., 1987; Hokin Gallery, Bay Harbor Islands, Fla., 1987; Wilson Arts Center, Rochester, N.Y., 1988; MIT, 1989; Harcus Gallery, Boston, 1989; Gerald Peters Gallery, Santa Fe, and Dallas, 1989; James Corcoran Gallery, Los Angeles, 1989; Charles Cowles Gallery, NYC,

1990; MMA, 1991; Narni Alla Rocca, Narni, 1991; Lemberg Gallery, Birmingham, Mich., 1992. **Retrospective:** Buffalo/Albright, circ., 1986. **Group:** Rome-New York Foundation, Rome, The Quest and the Quarry, 1961; Buffalo/Albright, Plus by Minus, 1968; Indianapolis, 1970; Venice, Biennale, 1972; Philadelphia Civic Center, Women's Work: American Art, 1974, 1974, Quandrenniale, 1977; Kassel, Documenta VI, 1977; GSA, Washington, D.C., Drawings for Outdoor Sculpture: 1946-1977, 1978; NCFA, Across the Nation, circ., 1980; Nassau County Museum of Fine Art, Sculpture: The Tradition in Steel, 1983; Seattle/AM, American Sculpture, Three Decades, 1984; Sonoma State U., Works in Bronze, circ., 1984; Los Angeles/MOCA, The Artist as Social Designer, 1985; Cincinnati/Contemporary, Standing Ground: American Art by American Women, 1987; Williams College, BIGlittle Sculpture, 1988; Pinacoteca Comunale, Ravenna, Viaggio in Italia, 1988; Haus Der Architectur, Graz; Barcelona, Spaces and Sculptures, circ., 1989. **Collections:** AT&T; Atlantic Richfield Co.; Boston/MFA; Buffalo/Albright; Dartmouth College; Davenport/Municipal; Federal Reserve Bank; Fidelity Union Life Insurance Co.; Florence (Italy)/Modern; Graphische Sammlung Albertina; Harvard U.; Hirshhorn; Indianapolis; Jacksonville/AM; MIT; MMA; Milwaukee; Mount Holyoke College; Parkersburg (W. Va.) Art Center; U. of Rochester; Rutgers; Stockholm/Instituto Italian di Cultura; Syracuse/Everson; Turin/Civico; Vassar College; Walker; Worcester/AM. **Bibliography:** Weintraub.

PEREIRA, I. RICE
from 1st to 5th edition.

PERLIN, BERNARD b. November 21, 1918, Richmond, Va. **Studied:** New York School of Design, 1934-36; NAD, 1936-37, with Leon Kroll; ASL, 1936-37, with Isabel Bishop, William Palmer, Harry

Sternberg. Traveled Europe, Mediterranean, the Orient; resided Italy, 1948-54. **Taught:** Brooklyn Museum School, 1947-48; Wooster Community Art Center, Danbury, Conn., 1967-69. **Commissions:** US Treasury Department; US Post Office Department, 1940. **Awards:** Kosciuszko Foundation, 1938; Chaloner Prize Foundation Award, 1948; Fulbright Fellowship, 1950; Guggenheim Foundation Fellowship, 1954, 59; NIAL, 1964. **Address:** 56 Shadow Lake Road, Ridgefield, CT 06877. **One-man Exhibitions:** M. Knoedler & Co., 1948; Catherine Viviano Gallery, 1955, 58, 63, 66, 70; Wooster School, Danbury, Conn., 1968. **Retrospective:** U. of Bridgeport, 1969. **Group:** Chicago/AI Annuals, 1948, 54, 59; Carnegie, 1949, 52; MMA, 1950; Palazzo di Venezia, Rome, 1950; ICA, London, 1950; WMAA Annuals, 1951, 55; Corcoran, 1953, 59; WMAA, The New Decade, 1954-55; U. of Illinois, 1955, 59; XXVIII Venice Biennial, 1956; Brussels World's Fair, 1958; Cincinnati/AM, 1958; Detroit/Institute, 1960; PAFA, 1960. **Collections:** California Palace; Chicago/AI; Denver/AM; Detroit/Institute; Kansas City/Nelson; MOMA; NCFA; Princeton U.; Springfield, Mass./MFA; Tate; WMAA. **Bibliography:** Baur 7; Eliot; Goodrich and Baur 1; McCurdy, ed.; Mendelowitz; Pousette-Dart, ed.; Rodman 1, 2; Ward. Archives.

PERLMAN, JOEL b. June 12, 1943, NYC. **Studied:** Cornell U., 1965, BFA, with Jack Squier; U. of California, Berkeley, 1968, MA; Central School of Art, London, with Brian Wall. Resided England, 1964-69, excluding 1968. **Member:** Sculptors Guild. **Taught:** Central School, London, 1967-68; U. of Rhode Island, 1968; Winchester College, 1968-69; Bennington College, 1969-72; Middlebury College, 1972; School of Visual Arts, 1973-; Fordham U., 1974-80. **Awards:** Guggenheim Foundation Fellowship, 1974; National Endowment for the Arts, 1979. **Commissions:** Storm King Art Center,

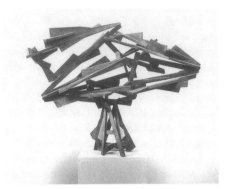

Joel Perlman, *Arrow Head*, 1993.

1977; Winter Olympics, 1979; R. S. Reynolds Memorial Sculpture Award, 1988. **Address:** 250 West Broadway, NYC 10013. **Dealer:** André Emmerich Gallery, NYC. **One-man Exhibitions:** (first) Axiom Gallery, London, 1969; Bennington College, 1970; André Emmerich Gallery, NYC, 1973, 76, 78, 80, 82, 85, 87; Galerie André Emmerich, Zurich, 1977; Galerie Pudelko, Bonn, 1978; Roy Boyd Gallery, Chicago, 1978, 80, 81, 83, 86, 88; Ehrlich Gallery, NYC, 1980; Gloria Luria Gallery, Bay Harbor Island, Fla., 1983, 89, 90; Cornell U., 1990; St. Lawrence U., 1990; RVS Fine Art, Southampton, N.Y., 1991; U. of Florida, 1991. **Group:** WMAA Biennial, 1973; Cornell U., Cornell Then, Sculpture Now, 1978; Indianapolis, 1979; Lake George Arts Project, Lake George, N.Y., Prospect Mountain Sculpture Exhibition: An Homage to David Smith, 1979; Sonoma State U., Works in Bronze, A Modern Survey, circ., 1984; Sierra Nevada Museum of Art, Works in Bronze, 1986. **Collections:** Bremen/Neues; Brooklyn Museum; Cornell U.; Guild Hall; Hirshhorn; Leeds/MAG; Los Angeles/County MA; MMA; U. of Miami; Newark Museum; New York Stock Exchange; Niagara U.; Ridgefield/Aldrich; Storm King Art Center; VMFA.

PERRY, CHARLES O. b. October 18, 1929, Helena, Montana. **Studied:** Columbia U., 1954; Yale U., with Josef

Albers, BA, 1954-58, Architecture. US Army, 1951-53. **Awards:** Prix de Rome, 1964-66; NAD, 1987. Traveled the world, resided Italy, 1964-77. **Commissions:** Hyatt Regency Hotel, San Francisco; Ministry of Defense, Riyadh and some 80 plus. **Member:** Sculptors Guild; NAD. **Address:** 20 Shore Haven Road, Norwalk, CT 06855. **One-man Exhibitions:** (first) Hansen Fuller Gallery, San Francisco, 1964; Waddell Gallery, NYC, 1967, 69; Arts Club of Chicago, 1972; Alpha Gallery, Boston, 1970; Dartmouth College, 1972. **Retrospective:** Dartmouth College, 1973; Jacksonville/Cummer, 1990. **Group:** Venice Biennial, 1972; Spoleto Festival, 1968; NAD; WMAA, Annual, 1964, 66. **Collections:** Andover/Phillips; Chicago/AI; de Young; Jacksonville/Cummer; MOMA; U. of Michigan; National Air and Space Museum; Oakland Museum.

PETERDI, GABOR **b.** September 17, 1915, Budapest, Hungary. **Studied:** Academy of Fine Arts, Budapest, 1929; Academie Julian, Paris, 1931; Academie Scandinave, Paris, 1932; Academy of Fine Arts, Rome, 1930; Atelier 17, Paris, 1935. **Taught:** Brooklyn Museum School, 1948-53; Hunter College, 1952-59; Yale U., 1960- . **Member:** Silvermine Guild; NAD, Accademia del Disegno, Florence. **Awards:** Prix de Rome, 1930; Paris World's Fair, 1937, Gold Medal (jointly with Lurcat); Brooklyn Museum, 1950, 52, 60; American Color Print Society, 1951; Oakland/AM, 1957, 60; PAFA, Gold Medal, 1957; Boston Printmakers, 1959; Seattle/AM, P.P., 1960; Pasadena/AM, P.P., 1960; Bay Printmakers Society, Oakland, Adell Hyde Morrison Memorial Medal, 1960; Ford Foundation Grant, 1960; PAFA, Pennell Memorial Medal, 1961; IV International Biennial Exhibition of Prints, Tokyo, Museum of Western Art Prize, 1964; Guggenheim Foundation Fellowship, 1964-65; AAIAL, Louise Nevelson Prize; Honolulu Academy, P.P.; National Biennial, 1971, 75; AAIAL, Childe

Hassam Fund, 1976. **Address:** 108 Highland Avenue, Rowayton, CT 06853. **Dealers:** Grace Borgenicht Gallery, Inc., NYC; Haslem Fine Arts, Inc., Washington, D.C.; Nielsen Gallery, Boston. **One-man Exhibitions:** (first) Ernst Museum, Budapest, 1930, also 1934; Bratislava, Czechoslovakia, 1930; Prague/National, 1930; Rome/Nazionale, 1930; Jeanne Bucher, Paris, 1936; Julien Levy Galleries, NYC, 1939; Norlyst Gallery, NYC, 1943, 44; Laurel Gallery, NYC, 1948, 49; Philadelphia Art Alliance, 1950, 55; Smithsonian, 1951; Silvermine Guild, 1952; Grace Borgenicht Gallery, Inc., NYC, 1952, 55, 59, 61, 66, 74, 79; Kanegis Gallery, 1956, 57, 59, 61; St. George's Gallery, London, 1958; The Howard Wise Gallery, Cleveland, 1959; Boston/MFA, 1959; Achenbach Foundation, 1960; Lincoln, Mass./De Cordova, 1964; Corcoran, 1964; Michigan State U., 1964; Yale U., 1964; Atlanta/AA, 1965; Ridgefield/Aldrich, 1965; Honolulu Academy, 1968, 72; U. of Connecticut, 1974; Haslem Fine Arts, Washington, D.C., 1992. **Group:** Salon des Surindependants, Paris, 1936, 38; Library of Congress, 1943, 47; The Print Club, Philadelphia, 1948; Brooklyn Museum, 1948, 49, 64; WMAA, 1949; MOMA, 1949; Yale U., 1949; Corcoran, 1949; PAFA, 1949, 61; Silvermine Guild; NYPL; Chicago/AI; Achenbach Foundation; U. of Nebraska; Minneapolis/Institute; Oakland/AM; U. of Illinois. **Collections:** Abilene Christian College; Achenbach Foundation; Albion College; Andover/Phillips; Baltimore/MA; Beloit College; Berea College; Boston/MFA; Brandeis U.; Brooklyn Museum; Brown U.; Budapest/National; Buffalo/Albright; Chicago/AI; Clearwater/Gulf Coast; Cleveland/MA; Columbia, S.C./MA; Corcoran; Cranbrook; Currier; Dartmouth College; U. of Georgia; Hartford/Wadsworth; Honolulu Academy; Illinois Wesleyan U.; U. of Illinois; Indiana MMA; MOMA; Memphis/Brooks; Michigan State U.; U. of Michigan; Minneapolis/Institute;

NYPL; U. of Nebraska; Northwestern U.; Oakland/AM; U. of Oklahoma; Oregon State U.; PAFA; PMA; Pasadena/AM; Prague/National; Princeton U.; RISD; Rome/Nazionale; Rutgers U.; São Paulo; Seattle/AM; Smith College; Smithsonian; Texas Wesleyan College; Vassar College; WMAA; Walker. **Bibliography:** Baur 5; Chaet; Goodrich and Baur 1; Hayter 1; **Johnson 1**; Peterdi. Archives.

PETERSEN, ROLAND CONRAD **b.** March 31, 1926, Endelave, Horsens, Denmark. **Studied:** With Glenn Wessels, Chiura Obata, Erle Loran, John Haley, Worth Ryder, James McCray, U. of the Pacific and U. of California, AB, 1949, MA, 1950; Hofmann School, 1950-51; Atelier 17, Paris, 1950, and with S. W. Hayter, Paris, 1963, 70; California School of Fine Arts, 1954. To USA, 1928. US Navy, 1943-45. Traveled Europe. **Taught:** Washington State U.; 1952-56; U. of California, Davis, 1956-91. **Member:** California Printmakers Society. **Awards:** Sigmund Martin Heller Traveling Fellowship, 1950; SFMA, Anne Bremer Memorial Prize, 1950; Oakland/AM, First Prize, Gold Medal, 1953; California State Fair, P.P., 1957, 60; Guggenheim Foundation Fellowship, 1963; U. of the Pacific, P.P., 1969; Fulbright Fellowship, 1970; U. of California Regents Fellow, 1977; Accademia Italia dell'Arte e del Lavoro, Terme, Gold Medal, 1985. **Address:** 6 Lanai Way, P.O. Box 1, Dillon Beach, Calif. 94929. **Dealer:** Harcourts Modern and Contemporary Art, San Francisco. **One-man Exhibitions:** (first) Oakland/AM, 1954; Spokane Art Center of Washington State U., 1954, 55, 57; Boise (Idaho) Art Association, 1954; Esther Robles Gallery, Los Angeles, 1961; City Library, Sacramento, Calif., 1961; California Palace, 1961; Gump's Gallery, 1962; Staempfli Gallery, NYC, 1963, 65, 67; Sacramento/Crocker, 1966; Adele Bednarz Gallery, 1966, 69, 72, 73, 75, 76; Chico State College, 1966; de Young, 1968; Western Association of Art Museum Directors, circ.,

1968-69; Phoenix, 1972; Santa Barbara/MA, 1973; Whitman College, 1974; Solano Community College, Solano, 1975; U. of California, Davis, 1976; American River College, 1976; College of Siskiyous, 1977; Artists Cooperative Gallery, Sacramento, 1977; California State College, Stanislaus, 1978; Shasta College, Redding, 1978; Brubacher Gallery, Sarasota, Fla., 1979; U. of Nevada, 1980; U. of Reading (England), 1980; Davis (Calif.) Art Center, 1981, 84; The Print Mint, Chicago, 1981; Forick Gallery, 1981, 82, 83, 84, 85; Rara Avis Gallery, Sacramento, 1982; University Club, Chicago, 1982; Cunningham Memorial Art Gallery, Bakersfield, Calif., 1983; Art Works, Fair Oaks, Calif., 1984, 85; Smith-Anderson Gallery, Palo Alto, 1984; Sacramento, State Capital, 1984; Harcourts Modern and Contemporary Art, 1991. **Retrospectives:** Chico State College (15-year, 1950-65), 1966; de Young (5-year, 1963-68), 1968; U. of California, Davis, 1978; Washington State U., Pullman, 1976. **Group:** Pasadena/AM, Pacific Profile, 1961; Poindexter Gallery, 1961; U. of Illinois, 1961, 63, 69; Santa Barbara/MA, 1962; Carnegie, 1964; Chicago/AI Annual, 1965; VMFA, American Painting, 1966; New School for Social Research, Humanist Tradition, 1968; Oakland/AM, California Landscape, 1975; U. of Wisconsin, Madison, Atelier 17, 1977. **Collections:** Achenbach Foundation; CSCS; U. of California, Davis; Chase Manhattan Bank; De Beers Collection; de Young; Hirshhorn; Illinois Wesleyan U.; La Jolla; Long Beach/MA; MOMA; U. of Miami; Musée Municipal, Brest; NCFA; U. of North Carolina; Oakland/AM; Oakland Public Library; Ohio U.; PMA; U. of the Pacific; Phoenix; SFMA; Sacramento/Crocker; San Diego; Santa Barbara/MA; Shasta College; Spokane Coliseum; VMFA; WMAA; Washington State U. **Bibliography:** Hager 1.

PETLIN, IRVING **b.** December 17, 1934, Chicago, Ill. **Studied:** Chicago/AI, 1952-56, BFA; Yale U., 1959,

Irving Petlin, *Stolen Blessing II*, 1980.

MFA, with Josef Albers. US Army, 1957-59. Traveled USA; resided France, 1959-63. **Taught:** UCLA, 1963-66; RISD, 1978; Cooper Union, NYC, 1977-80; U. of California, Santa Cruz, 1981; Dartmouth College, 1983; PAFA, 1990-92. **Commission:** Sets for the opera, *The Double Life of Amphibians* by Morton Subotnik, 1984. **Awards:** Ryerson Fellowship, 1956; Copley Foundation Grant, 1961; Guggenheim Foundation Fellowship, 1971. **Address:** 257 West 11th Street, NYC 10014. **Dealers:** Kent Fine Art Inc., NYC; Jan Krugier Gallery, Geneva. **One-man Exhibitions:** (first) Dilexi Gallery, San Francisco, 1958; Cliffdweller Gallery, Chicago, 1956; Galerie du Dragon, Paris, 1960, 62, 63, 64, 68; Galatea, Turin, 1962; Hanover Gallery, London, 1964; Palais des Beaux-Arts, Paris, 1965; Rolf Nelson Gallery, Los Angeles, 1966; Odyssia Gallery, NYC, 1967, 68, 69, 70, 79, 81, 83; Galleria Odyssia, Rome, 1969, 71, 76; Galleria il Fante di Spade, Rome, 1968; Galleria Bergamini, Turin, 1974; Documenta, Turin, 1974; Rebecca Cooper Gallery, Washington, D.C., 1976; Galleria Bergamini, Milan, 1977; Purchase/SUNY, 1978; Arts Club, Chicago, 1978; Gallerie Nina Dausset, Paris, 1980; Dart Gallery, Chicago, 1983; Dartmouth College, 1983; Marlborough Gallery, Inc., NYC, 1986; Simms Fine Art, New Orleans, 1987; Galerie Jean Briance, Paris, 1987; Kent

Fine Art, NYC, 1987, 89, 90; Galleria La Parisian, Turin, 1988; Elizabeth Franck Gallery, Knokke-Le-Zoute, Belgium, 1988; U. of Chicago, 1990; Printworks, Chicago, 1990. **Retrospective:** Brussels/Beaux-Arts, 1965. **Group:** Chicago/AI, 1953, 56, 72; Paris/Moderne, 1961-66; WMAA, 1973; Chicago/Contemporary, Chicago Imagist Art, 1972; Chicago Art Institute School, Visions, 1976; Chicago/AI, American Drawings of the '70s, 1977; Jewish Museum, Jewish Themes/Contemporary American Artists, 1982; IEF, Twentieth Century American Drawings: The Figure in Context, circ., 1984; Paris/Beaubourg, Art Americain, 1984; AAIAL, 1985; Little Rock/AC, Revelations: Drawing/America, 1988; ICI, A Different Ward, Vietnam in Art, circ., 1989; Barbican Art Gallery, London, Chagall to Kitaj, 1990. **Collections:** Amsterdam/Stedelijk; U. of Arkansas; Chicago/AI; Chicago/Contemporary; Dartmouth College; Des Moines; First National Bank of Chicago; Hirshhorn; Jewish Museum; Little Rock/AC; MMA; MOMA; PAFA; Paris/Beaubourg; Paris/Moderne; Reckfinghausen. **Bibliography:** Cummings 3, 4; Schulze.

PETTET, WILLIAM

PETTET, WILLIAM b. October 10, 1942, Whittier, Calif. **Studied:** California Institute of the Arts, Valencia; Chouinard Art Institute, 1965, BFA. Traveled Canada, Europe, Mexico. **Taught:** Skowhegan School, 1972; Empire State College, N.Y., 1977. **Awards:** Tamarind Fellowship, 1970. **Address:** 14 Beach 213th St., Breezy Point, NY 11697. **One-man Exhibitions:** (first) Nicholas Wilder Gallery, 1966, 68, 70; Robert Elkon Gallery, 1968, 69; David Whitney Gallery, NYC, 1970, 71; Dunkelman Gallery, Toronto, 1971, 73; The Willard Gallery, 1973, 74, 75; S. & G. Mathews Gallery, San Antonio, 1978, 79. **Group:** Trenton/State, Focus on Light, 1967; WMAA Annuals, 1967, 69, 73; Corcoran, 1969; Washington U., Here and Now, 1969;

Ridgefield/Aldrich, Lyrical Abstraction, 1970; ICA, U. of Pennsylvania, Two Generations of Color Painting, 1970; Santa Barbara/MA, Spray, 1971; WMAA, Lyrical Abstraction, 1971; Hamburg/Kunstverein, USA: West Coast, circ., 1972; WMAA, 35 American Artists, 1974; MOMA, 60s and 70s, 1974; U. of Texas, Austin, New in the Seventies, 1977. **Collections:** Hirshhorn; MOMA; WMAA. **Bibliography:** *New in the Seventies; USA West Coast.*

PFRIEM, BERNARD **b.** September 7, 1916, Cleveland, Ohio. **Studied:** John Huntington Polytechnical Institute, 1934-36; Cleveland Institute of Art, 1936-40. US Air Force, 1942-46. Traveled Europe, Mediterranean; resided Mexico, 1940-42, Paris, 1952-63. **Taught:** Cleveland Institute of Art School, 1938-40; Peoples Art Center (MOMA), 1946-51; Cooper Union, 1963-71; Sarah Lawrence College, 1969-76; US Army Air Force, 1942-46. Assistant to Jose Clemente Orozco on frescoes, Jiquilpan (Michoacan), Mexico, and to Julio Castellanos on murals, Mexico City; Chief Designer, US Government exhibitions and pavilions in Europe, 1953-56; Director Emeritus, Lacoste School of the Arts, France, 1971-91. **Awards:** Agnes Gund and Mary S. Ranney Traveling Fellowship, 1940; Copley Foundation Grant, 1959. **Member:** Century Association; Chelsea Arts Club, London. Designer for Tibor de Nagy Marionette Co., 1946-50. **Address:** 115 Spring Street, NYC 10012. **One-man Exhibitions:** (first) Hugo Gallery, NYC, 1951; US Cultural Center, Paris, 1954; Galerie du Dragon, 1960; Alexandre Iolas Gallery, NYC, 1961, 63; Obelisk Gallery, Washington, D.C., 1963; International Gallery, Baltimore, 1965; Wooster Community Art Center, Danbury, Ct., 1965; Richard Feigen Gallery, Chicago, 1966; Sarah Lawrence College, 1969; U. of Arkansas, 1970; Midtown Gallery, Atlanta, 1971. **Retrospective:** Cleveland Institute

of Art, 1963. **Group:** Cleveland/MA, 1939-41; Youngstown/Butler, 1941; Columbus, 1942; Carnegie, 1942; Hugo Gallery, NYC, 1948, 49, 50; WMAA Annual, 1951; Smithsonian, American Drawings, circ., 1965; WMAA, A Decade of American Drawings, 1955-1965, 1965; American Drawing Society, 1970; Cleveland Institute of Art, 1973; The Pennsylvania State U., 1974. **Collections:** U. of Arkansas; Brooklyn Museum; Chase Manhattan Bank; Chicago/AI; Columbia Banking, Savings and Loan Association; Corcoran; MMA; MOMA; Minnesota/MA; Utah; Worcester/AM. **Bibliography:** Waidberg 1, 2.

PHELAN, ELLEN **b.** November 3, 1943, Detroit, Mich. **Studied:** Wayne State U., with Robert Wilbert, BRA, 1969; MFA, 1971. **Taught:** Wayne State U., 1969-72; Fairleigh Dickinson U., 1974; Michigan State U., 1974-75; California Institute of Arts, 1978-79, 83; Bard College, 1980; NYU, 1981; School of Visual Arts, 1981-83. **Awards:** National Endowment for the Arts, grant, 1978; Wayne State U., Arts Achievement Award, 1988. **m.** Joel Shapiro. **Address:** 290 Lafayette Street, NYC 10012. **Dealer:** Barbara Toll Fine Arts, NYC. **One-man Exhibitions:** Willis Gallery, Detroit, 1972 (first), 74; Artists' Space, NYC, 1975; Susanne Hilberry Gallery, Birmingham, Mich., 1977, 79, 81, 82, 84, 86, 88, 90; Hartford/Wadsworth, 1979; Ruth Schaffner Gallery, Los Angeles, 1979; The Clocktower, NYC, 1980; Hansen-Fuller-Goldeen Gallery, San Francisco, 1980, 82; Dart Gallery, Chicago, 1981; Barbara Toll Fine Arts, NYC, 1982, 85, 86, 87, 89, 90; Asher/Faure, Los Angeles, 1989, 92; Baltimore/MA, 1989; Buffalo/Albright, 1991. **Group:** Academie der Kunst, Berlin, SoHo, 1976; Kansas City/AI, Spectrum 77, 1977; MOMA, New Art for the New Year, 1978; Cranbrook, 21 Artists, 1979; U. of North Carolina, Art on Paper, 1979; Olympic Winter Games, Lake Placid, 1980; Port-

Ellen Phelan, *Spring, First Drawing (b&w)*, 1989.

land (Ore.)/AM, Drawings of a Different Nature, 1980; Detroit/Institute, Kick out the Jams, circ., 1980; Drawing Center, NYC, New Drawing in America, circ., 1982; Cranbrook, Out of Square, 1984; WMAA, Fairfield, The New Romantic Landscape, 1987; WMAA, Recent Drawings, 1988; C. W. Post College, 100 Drawings by Women, 1989; MOMA, Drawings of the Eighties, 1988; Dartmouth College, Minimalism and Post-Minimalism, circ., 1990; WMAA, Biennial, 1991; MOMA, Allegories of Modernism, 1991; ICI, Drawing in the Nineties, circ., 1992. **Collections:** Baltimore; Bank of America; Brooklyn Museum; Buffalo/Albright; Chase Manhattan Bank; Chemical Bank; Detroit/Institute; High Museum; MIT; Mexico City/Tamayo; Philip Morris Collection; Stockholm/National; Toledo/MA; MOMA; WMAA; Walker. **Bibliography:** Rose, Bernice, 1.

PHILLIPS, MATT **b.** December 8, 1927, NYC. **Studied:** Barnes Foundation, 1950-52; U. of Chicago, 1952, MA; Stanford U., 1952-54; Atelier 17, Paris. US Coast Guard, 1944-45. **Taught:** The Pennsylvania State U., 1956-62; American College in Paris, 1962-64; Bard College, 1964-87. Resided Paris, 1962-64. **Awards:**

Guggenheim Foundation Fellowship, 1974; National Endowment for the Arts, 1975. **Address:** 721 Kansas, San Francisco, CA 94017. **Dealers:** The Forum Gallery, NYC; Marsha Mateyka Gallery, Washington, D.C. **One-man Exhibitions:** Peter Deitsch Gallery, NYC, 1962, 65; Makler Gallery, Philadelphia, 1962; Bernheim-jeune Gallery, Paris, 1962; Bard College, 1964, 69; The Print Club, 1966; William Zierler Inc., NYC, 1973, 74, 76; Vassar College, 1976; Marilyn Pearl Gallery, 1977, 79, 80, 81, 83, 84, 87, 89; Middendorf-Lane Gallery, Washington, D.C., 1978; Des Moines, 1978; William Sawyer Gallery, San Francisco, 1978; Phillips, 1978; Donald Morris Gallery, Detroit, 1978, 81, 88; Marianne Friedland Gallery, Toronto, 1979; A.A.A. Gallery, NYC, 1979; A.A.A. Gallery, Philadelphia, 1982; Dolly Fiterman Gallery, Minneapolis, 1982; Smith-Anderson Gallery, Palo Alto, 1982; Michael Berger Gallery, Pittsburgh, 1983; Addison Ripley Gallery, Washington, D.C., 1983; Keny and Johnson Gallery, Columbus, Ohio, 1984; Stephen Wirtz Gallery, San Francisco, 1988, 89; Allport Gallery, San Francisco, 1989; Marsha Mateyka Gallery, Washington, D.C., 1990; Roger Ramsay Gallery, Chicago, 1991; The Forum Gallery, NYC, 1991. **Retrospective:** Baltimore/MA, 1976; Bard College, 1988. **Group:** Indianapolis, 1972; Smithsonian, New American Monotypes, circ., 1978; MMA, The Painterly Print, 1980; Santa Clara U., Contemporary American Monotypes: Six Masters, 1985. **Collections:** Achenbach Foundation; Akron/AM; U. of Arizona; Bard College; California Palace; Chicago/AI; Des Moines; Free Library of Philadelphia; High Museum; Hirshhorn; Huntsville Museum; Indianapolis; Library of Congress; MMA; NYPL; National Gallery; U. of Nebraska; New Britain/American; PMA; Philadelphia Free Library; Phillips; Toledo; WMAA; U. of Wisconsin.

PINEDA, MARIANNA **b.** May 10, 1925, Evanston, Ill. **Studied:** Cran-

brook with Carl Milles, 1942; Bennington College, 1942-43; U. of California, Berkeley, with Raymond Puccinelli, 1943-45; Columbia U., with Oronzio Maldarelli, 1945-46; with George Stanley, Los Angeles (sculpture); with Ossip Zadkine, Paris, 1949-50; Scholar, Radcliffe Institute for Independent Study, 1962-64. Resided Paris, 1949-51, Florence, 1954-57, Rome, 1966. **Taught:** Newton College of the Sacred Heart, Newton, Mass., 1972-75; Boston U., 1974-78, 82-84, 89-90; Boston College, 1975-77. **Member:** Artists Equity; Sculptors Guild; Boston Visual Artists Union; NAD. **Commissions:** Boston Conservatory of Music, Jan Veen Memorial Medal; State Capitol, Honolulu, 1980. **Awards:** Buffalo/Albright, 1948; Walker, P.P., 1951; Boston Arts Festival, 1957, 60; San Francisco Art Association, First Prize for Sculpture, 1955; Chicago/AI, 1957; NAD, Gold Medal, 1987; National Sculpture Society, Gold Medal, 1988, 89. m. Harold Tovish. **Address:** 380 Marlborough Street, Boston, MA 02115. **Dealer:** Judi Rotenberg Gallery, Boston. **One-man Exhibitions:** (first) Slaughter Gallery, San Francisco, 1951; Walker, 1952; The Swetzoff Gallery, Boston, 1953, 64; Lincoln, Mass./De Cordova, 1954; Premier Gallery, Minneapolis, 1963; Alpha Gallery, 1972; Bumpus Gallery, Duxbury, 1974; Lyman Museum, Hilo, Hawaii, 1982; Kona Palace, Kona, Hawaii, 1982; Honolulu/Contemporary, 1982; Pine Manor College, Chestnut Hill, Pa., 1984; Judi Rotenberg Gallery, Boston, 1990; College of William and Mary, 1992. **Group:** Buffalo/Albright, 1948; WMAA, 1953, 54, 57, 59; MMA, 1957; U. of Illinois, 1957; Chicago/AI, 1957, 60; Boston Arts Festival, 1957, 58, 60; Carnegie, 1958; MOMA, 1959; Waitsfield/Bundy, 1963; New York World's Fair, 1964-65; Lincoln, Mass./De Cordova, Sculpture in the Park, 1972; The Pennsylvania State U., Contemporary Artists and the Figure, 1974; Lincoln, Mass./De Cordova, New England

Jody Pinto, *Fingerspan Bridge*, 1987.

Women, 1975; Los Angeles/County MA, Women Artists 1550-1950, 1976; Brockton/Fuller, Artists in Boston, 1978; NAD, Annual, 1983, 87, 91; Mount Holyoke College, Through Women's Eyes, 1989. **Retrospectives:** Honolulu Academy, 1970; Newton College, 1972. **Collections:** Andover/Phillips; Boston/MFA; Boston Public Library; Bowdoin College; Dartmouth College; Hartford/Wadsworth; Harvard U.; U. of Massachusetts; Mount Holyoke College; Radcliffe College; State of Hawaii; Utica; Walker; Williams College.

PINTO, JODY b. August 4, 1942, NYC. **Studied:** PAFA, 1964-68; Philadelphia College of Art, 1971-73, BFA. Traveled Europe. **Taught:** U. of Guelph, 1977; Wright State U., 1978; PAFA, 1980-; RISD, 1980-. **Awards:** PAFA, Cresson Fellowship, 1967; National Endowment for the Arts, 1979; Pennsylvania Council on the Arts Grant, 1980; N.J. Council on the Arts Grant, 1982; Art in Public Spaces, Winning Entry for *Fingerspan Bridge* (1987), given by AIA, 1988; Fleischer Memorial Award for Excellence in Art, Philadelphia, 1992; Honeywell Environmental Excellence Award, Phoenix, 1992. **Commissions:** Fairmount Park, Philadelphia, Fingerspan Bridge, 1981-87; Washington International Agricultural Trade Center,

Spokane, 1989-91; Phoenix, Papago Park, 1990-92; Consultant to develop master plan extension to link Saint Louis Arts District, University, and Metro Link Transport System, 1992. Designed sets and costumes for South Street Dance Co., Philadelphia, and Theatre for the New City, NYC, 1985. **Address:** 124 Chambers Street, NYC 10007. **One-man Exhibitions:** (first) Nexus Gallery, Philadelphia, 1977; Hal Bromm Gallery, NYC, 1978, 79, 80, 81, 83, 85, 87; 112 Greene Street, NYC, 1979; Richard Demarco Gallery, Edinburgh, 1979; Marion Locks Gallery, Philadelphia, 1980, 87; California State U., Northridge, 1980; PAFA, 1980; Wilkes College, 1980; Kutztown State College, 1981; ICA, U. of Pennsylvania, 1984; Roger Ramsay Gallery, Chicago, 1985; Bucks County Community College, 1985; Real Art Ways, Hartford, Ct., 1988. **Group:** ICA, U. of Pennsylvania, Dwellings, 1978; ICA, U. of Pennsylvania, Material Pleasures, 1979; PMA, Contemporary Drawing: Philadelphia II, 1979; WMAA Biennial, 1979; XXXIX Venice Biennial, 1980; PAFA, Form and Function, 1982; IEF, 20th Century American Drawings: The Figure in Context, circ., 1984; Bard College, Landmarks, 1985; Cincinnati/Contemporary, Standing Ground: Sculpture by American Women, 1987; Sculpture Center, NYC, In the Making: Drawings by Sculptors, 1988; Queens Museum, Classical Myth and Imagery in Contemporary Art, 1988; Dayton/AI, Art for the Public, 1988; Long Island U., Lines of Vision, 1989; Seattle/AM, 2D-3D, 1989; Milwaukee, Sounding the Depths, circ., 1990; U. of Florida, Divergent Styles, 1990; U. of North Carolina, Art on Paper, 1991; U. of North Carolina, In Search of Form, 1992; International Public Art Fair, Yokohama, Japan, Public Art Proposals, 1992. **Collections:** Chemical Bank; Des Moines; PAFA; PMA; Prudential Insurance Co. of America; Purchase/SUNY; SRGM; WMAA; Wake Forest U.

PITTMAN, HOBSON
from 1st to 4th edition.

PLAGENS, PETER **b.** March 1, 1941, Dayton, Ohio. **Studied:** Syracuse U., MFA, 1964; U. of Southern California, MFA, magna cum laude, 1962. **Taught:** U. of Texas, Austin, 1966-69; California State U., Northridge, 1969-78; U. of Southern California, 1978-80, 84-85; U. of North Carolina, 1980-84; California State U., Long Beach, 1985; Columbia U., 1985-86; Hofstra U., 1985-86; Princeton U., 1985-86. Contributing editor, *Artforum*, 1966-76. **Member:** Chairman, Board of Directors, ICA, Los Angeles, 1977-79. **Awards:** Guggenheim Foundation Fellowship, 1972; National Endowment for the Arts, Grant in Criticism, 1973; National Endowment for the Arts, Grant, Painting, 1977, 85. **Address:** 56 Lispenard Street, NYC 10013. **Dealers:** Nancy Hoffman Gallery, NYC; Jan Baum Gallery, Los Angeles. **One-man Exhibitions:** Riko Mizuno, Los Angeles, 1971; Reese Palley Gallery, NYC, 1971; Reese Palley Gallery, San Francisco, 1972; SFAI, 1972; U. of Oklahoma, 1973; Texas Gallery, Houston, 1973, 75; Leslie Collins Art Works, Dallas, 1973; John Berggruen Gallery, San Francisco, 1974, 77; California State U., San Jose, 1974; Betty Gold Gallery, Los Angeles, 1974; Dootson-Calderhead, Seattle, 1975; Nancy Hoffman Gallery, NYC, 1975, 76, 77, 80, 81, 84, 87, 90, 92; Galerie Doyle, Paris, 1975; Hirshhorn, 1976; Baum-Silverman Gallery, Los Angeles, 1977, 80; Marianne Deson Gallery, Chicago, 1978; ICA, Los Angeles, 1979; Lincoln Center, 1983; Jan Cicero Gallery, Chicago, 1983, 85; Southeast Center for Contemporary Art, Winston-Salem, N.C., 1984; California State U., Long Beach, 1985; Jan Baum Gallery, Los Angeles, 1988. **Group:** Oakland/AM, Contemporary American Drawings and Prints, 1969; LA/County MA, 24 Young Los Angeles Artists, 1971; Oakland/AM, Off the Stretcher, 1972; Scripps

College, Painting: Color, Form, Surface, 1974; Utrecht, Young Americans, 1975; Potsdam/SUNY, New Directions in Abstraction, 1975; Fort Wayne, Hue and Far Cry of Color, 1976; Youngstown/Butler, 1976; SFMA, Painting and Sculpture in California: The Modern Era, 1977; ICA, Los Angeles, 100+, 1977; ICA, Los Angeles, Unstretched, 1977; U. of Southern California, Sunshine and Shadow, 1985; Princeton U., A Decade of Visual Arts at Princeton, 1975-85, 1985; High Museum, Working on Paper, 1990; Randolph-Macon Women's College, Annual, 1990. **Collections:** Baltimore/MA; Buffalo/Albright; Chase Manhattan Bank; Chemical Bank; Continental Grain Corp.; Dechert, Price and Rhodes; Denver/AM; Harris Bank; Hirshhorn; The Irvine Co.; Miami-Dade Community College; Newark Museum; U. of North Carolina; Owens-Corning Fiberglas Corp.; Prudential Insurance Co. of America; San Diego/Contemporary; Santa Fe., N.M.; U. of Sydney; Toledo. **Bibliography:** *Performance Anthology.*

POLLACK, REGINALD b. July 29, 1924, Middle Village, N.Y. **Studied:** ASL, with Wallace Harrison, Moses Soyer, Boardman Robinson. US Navy, 1941-45. Resided France, 1948-59, 1960-61. Traveled France, Italy, Caribbean Islands. Author and illustrator of many children's books. **Taught:** Yale U., 1962-63; Cooper Union, 1963-64. **Member:** Board, WPA, Washington, D.C., 1975-79. **Commissions:** Seagram Corporation; Container Corp. of America; New York State Telephone System; original film using his painting on the theme of riots, segregation, and war, commissioned by Zubin Mehta for the Los Angeles Philharmonic Orchestra; Washington Cathedral, 1974. **Awards:** Prix Neumann, Paris, 1952; Prix Othon Friesz, Paris, Menton, 1954, 57; Paris/Moderne, Prix de Peintres Etrangers, Second Prize, 1958; Ingram Merrill Foundation Grant, 1964, 70, 71. **Address:** Rte.

1, Box 955, Waterford, VA 22190. **One-man Exhibitions:** (first) Charles Fourth Gallery, NYC, 1948; The Peridot Gallery, NYC, 1949, 52, 55, 56, 57, 59, 61, 63, 65, 67, 69; Galerie Saint-Placide, Paris, 1952; Dwan Gallery, 1960; Goldwach Gallery, Chicago, 1964-66; Felix Landau Gallery, Los Angeles, 1964, 66; Original Graphics Ltd., Los Angeles, 1968; Olson-Resnick Gallery, Los Angeles, 1968; Jefferson Gallery, Los Angeles, 1969; Gallery Z, Beverly Hills, 1973, 75; Jack Rasmussen Gallery, Washington, D.C., 1978, 80, 81, 82; Tartt Gallery, Washington, D.C., 1986; The Gallery, Leesburg, Va., 1992. **Retrospective:** WPA, Washington, D.C., 1977. **Group:** WMAA, 1953, 55, 56, 58, 63; U. of Nebraska, 1957; Chicago/AI; Carnegie; NIAL; PAFA, 1962, 66; Salon du Mai, Paris; U. of Illinois, 1964; Salon des Artistes Independants, Paris, 1952, 53, 54; Corcoran, 1963; Newark Museum, 1964; New School for Social Research, 1964; Lytton Art Center, Los Angeles, 1967; Long Beach/MA, circ.; Smithsonian, circ., 1968-69. **Collections:** Bezalel Museum; Brooklyn Museum; Collection de l'État; Fort Lauderdale; U. of Glasgow; Haifa; MOMA; U. of Miami; NMAA; U. of Nebraska; Newark Museum; New York Hilton Hotel; Purchase/SUNY; Rockefeller Institute; Southern Illinois U.; Tel Aviv; WMAA; Worcester/AM; Yale U. **Bibliography:** Cummings 4; Tomkins. Archives.

POLLOCK, JACKSON b. January 28, 1912, Cody, Wyo. **d.** August 11, 1956, Southampton, N.Y. **Studied:** ASL, 1929-31, with Thomas Hart Benton. Federal A.P.: Easel painting, 1938-42. **m.** Lee Krasner (1944). Subject and narrator of a 1951 film, *Jackson Pollock,* produced by Hans Namuth and Paul Falkenberg. **One-man Exhibitions:** (first) Art of This Century, NYC, 1943, also 1946, 47; Arts Club of Chicago, 1945, 51; Museo Civico Correr, Venice; Galleria d'Arte del Naviglio, Milan, 1950; Galerie Paul

Facchetti, 1952; Sidney Janis Gallery, 1952, 54, 55, 57; Zurich, 1953; IV São Paulo Biennial, 1957; Marlborough Galleria d'Arte, Rome, 1962; Marlborough-Gerson Gallery, Inc., NYC, 1964, 69; Marlborough Fine Art Ltd., London, 1965; WMAA, 1970; Berry-Hill Galleries, NYC, 1977; Yale U., 1978; American Cultural Center, Paris, 1979; Paris/Moderne, 1979; Betty Parsons Gallery, NYC, 1983; Jason McCoy Inc., NYC, 1987, 92; Anthony D'Offay Gallery, London, 1989. **Retrospectives:** MOMA, 1956, 67, 80; Guild Hall, 1981; Paris/Beaubourg, 1982. **Group:** XXIV, XXV, and XXVIII Venice Biennials, 1948, 50, 56; I São Paulo Biennial, 1951; MOMA, Fifteen Americans, circ., 1952; Galerie de France, Paris, American Vanguard, 1952; MOMA, 12 Modern American Painters and Sculptors, circ., Europe, 1953-55; WMAA, The New Decade, 1954-55; SRGM, 75 Paintings from The Solomon R. Guggenheim Museum, circ., Europe, 1957; PAFA; Chicago/AI; Brooklyn Museum; Buffalo/Albright; MOMA, The New American Painting and Sculpture, 1969; Buffalo/Albright, Abstract Expressionism: The Critical Development, 1987. **Collections:** Andover/Phillips; Baltimore/MA; Brooklyn Museum; Buffalo/Albright; Canberra/National; Carnegie; Chicago/AI; Dallas/MFA; Düsseldorf/KNW; Hartford/Wadsworth; State U. of Iowa; Los Angeles/County MA; MMA; MOMA; Hara Art Museum; Omaha/Joslyn; Ottawa/National; Rio de Janeiro; SFMA; SRGM; Stuttgart; Utica; WMAA; Washington U.; West Palm Beach/Norton; Yale U. **Bibliography:** Alloway 4; Anfam; Armstrong, Thomas; Ashbery; Ashton 5; Barr 3; Battcock, ed.; Baur 5, 7; Bazin; Beekman; Biddle 4; Bihalji-Merin; *Black and White Are Colors;* Blesh 1; Brion 1; Carmean, Rathbone, and Hess; Calas 2; Calas, N. and E.; Canaday; Chipp; Christensen; Cummings 5; Danto; Davis, D.; De Vries, ed.; De Wilde 1; Downes, ed.; Eliot; Elsen 2; *Europa/Amerika;* The Figurative Fifties; Finch;

Flanagan; **Friedman, B. H., 2;** Gablik; Gaunt; Gohr and Gachnang; Goodrich and Baur 1; Goossen 1; Greenberg 1; Greengood; Haftman; Henning; Hess, T. B., 1; Hobbs and Levin; Honisch & Jensen, eds.; Hunter 1, 6; Hunter, ed.; *Individuals;* Janis and Blesh 1; *Jackson Pollock;* Janis, S.; Johnson, Ellen H.; **Kligman;** Kozloff 3; Krauss 2, 3; Kuh 3; Langui; Leepa; Lippard 3; Lowry; Lynton; McCoubrey 1; McCurdy, ed.; Mendelowitz; Moser 1; Motherwell, ed.; Murken-Altrogge; **Naifeh and Smith 2;** Neff, ed.; Neumeyer; **O'Conner and Thaw;** O'Doherty; **O'Hara 1, 4;** Paalen; Plagens; Ponente; Potter; Pousette-Dart, ed.; Ragon 1, 2; Read 2, 3, 6; Restany 2; Richardson, E.P.; Rickey; Ritchie 1; **Robertson 2;** Rodman 1, 2, 3; Rose, B., 1, 4; **Rose, Bernice, 2;** Rosenblum 2; Rubin 1; Sandler 3, 5; Seitz 3; Seuphor 1; Siegel; Soby 5; **Solomon;** Tapie 1; Tomkins 2; Tomkins and Time-Life Books; Tuchman, ed.; Tuchman 3; Waldman 4; Weller. Archives.

PONCE DE LEON, MICHAEL

b. July 4, 1922, Miami, Fla. **Studied:** NAD; ASL, with Cameron Booth, Vaclav Vytlacil, Will Barnet, Harry Sternberg; PAFA; Brooklyn Museum, with Ben Shahn, Gabor Peterdi, John Ferren; U. of Mexico City, BA. US Air Force, 1945-50. Traveled Mexico, Norway, Europe (extensively), Pakistan, India. **Taught:** Vassar College; Cooper Union; Pratt Graphic Art Center; Hunter College; in India and Pakistan, 1967-68; NYU, 1977; Pratt Institute, 1978; ASL, 1978. **Member:** SAGA; Audubon Artists. **Commissions:** US Post Office Department (design for fine-arts commemorative stamp). **Awards:** L.C. Tiffany Grant, 1953, 55; Bradley U., P.P., 1954; Dallas/MFA, P.P., 1954; SAGA, Gold Medal, 1954; U. of Nebraska; Oakland/AM, Gold Medal; Fulbright Fellowship, 1956, 57; The Print Club, Philadelphia, 1958; Audubon Artists, Gold Medal of Honor; Guggenheim Foundation

Fellowship, 1967. **Address:** 463 West Street, NYC 10014. **One-man Exhibitions:** (first) Galeria Proteo, Mexico City, 1954; Oslo/National; Oakland/AM; Corcoran, 1967; Cynthia Comsky Gallery, 1970. **Retrospective:** Pioneer-Moss Gallery, NYC, 1975. **Group:** MMA; MOMA; Brooklyn Museum; Walker; Victoria and Albert Museum; PAFA; SAGA; Portland, Me./MA; Audubon Artists; Denver/AM; Bradley U.; Chicago/AI; I Inter-American Paintings and Prints Biennial, Mexico City, 1958; NAD; Boston/MFA; U. of Illinois. **Collections:** Achenbach Foundation; Brooklyn Museum; Cincinnati/AM; Columbia, S.C./MA; Dallas/MFA; U. of Florida; U. of Illinois; Indiana U.; Jacksonville/AM; Library of Congress; MOMA; Melbourne/National; Mexico City/Nacional; NYPL; NYU; National Gallery; U. of Nebraska; Oslo/National; PAFA; PMA; Paris/Moderne; SFMA; US State Department; United Nations; Victoria and Albert Museum; Walker. **Bibliography:** Archives.

POND, CLAYTON **b.** June 10, 1941, Bayside, N.Y. **Studied:** Hiram College, 1959-61; Carnegie Tech, BFA, 1964; Pratt Institute, MFA, 1964-66. Traveled Europe, Africa, Japan. **Taught:** Junior High School, Palm Beach, Fla., 1964; C. W. Post College, 1966-68; School of Visual Arts, NYC, 1968-70; U. of Wisconsin, Madison, 1972. **Member:** Boston Printmakers; The Print Club, Philadelphia. **Commissions:** New York State Council on the Arts, 1967. **Awards:** Bradley U., Print Annual, P.P., 1966; Kalamazoo/Institute, P.P., 1966; Arden Prize, 1966; US State Department Grant, 1967; Albion College, P.P., 1968; Boston Printmakers, P.P., 1968; Dulin Gallery Fifth National Print and Drawing Exhibition, P.P., 1969. **Address:** 130 Greene Street, NYC 10012; Tumbridge, VT 05077. **One-man Exhibitions:** (first) Pratt Institute, 1966; Dartmouth College, 1966; C.W. Post College (two-man), 1966; Gordon Craig Gallery, Miami, Fla., 1968; WGMA, 1968;

Princeton U. (two-man), 1968; Martha Jackson Gallery, 1968, 72, 73, 75, 77; Port Washington (N.Y.) Public Library, 1968, 72; Kalamazoo/Institute, 1969; The Print Club, Philadelphia, 1969; Nassau Community College, Garden City, N.Y., 1969; Upstairs Gallery, Ithaca, 1970; Gallery 2, Woodstock, Vt., 1970; Van Staaten Gallery, 1971, 73; Images Gallery, Toledo, 1971; Lincoln, Mass./De Cordova, 1972; Madison Art Center, 1972; Arts & Crafts Center of Pittsburgh, 1972; Langman Gallery, Jenkintown, Pa., 1973; Graphics I & Graphics II, Boston, 1973, 75; Montgomery Museum, 1973; U. of Florida, Gainsville, 1973; U. of Nebraska, 1974; Phoenix, 1974; Yumi Gallery, Tokyo, 1975; Roanoke Art Center, 1976; Editions Limited Gallery, Indianapolis, 1977; Graphic Eye Gallery, Port Washington, N.Y., 1977; Jack Gallery, NYC, 1979; Schenectady, 1983. **Group:** San Francisco Art Institute Annual, 1965; Brooklyn Museum, Print Biennial; NAD, 1966; Pratt Institute, 1966; Pacific Print Invitational, 1966-67; WMAA Sculpture Annual, 1966; Boston/MFA 1967-69; Gallery of Modern Art, Ljubljana, Yugoslavia, VII International Exhibition of Prints, 1967; Seattle Civic Center, 1968; Library of Congress Print Annual, 1969; Boston/MFA, Boston Printmakers, 1969; Expo '70, Osaka, 1970; Paris/Moderne, International Exhibition of Colored Prints, 1970; USIA, Vienna, New American Prints, circ., 1971; City Museum and Art Gallery, Hong Kong, Graphics Now! USA, 1972; NCFA, XXIII Library of Congress Exhibition, 1973. **Collections:** AT&T; Albany/SUNY; Albion College; American Republic Insurance Co.; The Bank of New York; Bezalel Museum; Boston/MFA; Bradley U.; Buffalo/Albright; U. of California; Amon Carter Museum; Chase Manhattan Bank; Chicago/AI; Colgate U.; College of St. Benedict; Columbus, Ga.; Dartmouth College; Dulin Gallery; First National Bank of Chicago; Fort Worth; Grunwald Foundation; Indiana U.; India-

napolis/Herron; Kalamazoo/Institute; Library of Congress; Los Angeles/County MA; MOMA; Manufacturers Hanover Trust Co.; Minneapolis/Institute; NCFA; PMA; Pasadena/AM; Potsdam/SUNY; Princeton U.; Quaker Oats Co.; U. of Tennessee; Toledo/MA; US State Department; *Washington Post;* Western Michigan U.; U. of Wisconsin.

POONS, LAURENCE M.

b. October 1, 1937, Tokyo, Japan. **Studied:** New England Conservatory of Music, 1955-57; Boston Museum School, 1958. **Address:** 831 Broadway, NYC 10013. **Dealer:** Salander-O'Reilly Gallery, NYC and Beverly Hills. **One-man Exhibitions:** (first) Green Gallery, NYC, 1963, also 1964, 65; Leo Castelli, Inc., NYC, 1967, 68, 69; Kasmin Ltd., 1968, 71; Lawrence Rubin Gallery, NYC, 1969, 70, 72; David Mirvish Gallery, 1970, 76; ACE Gallery, Los Angeles, 1975, 77; Galerie André Emmerich, Zurich, 1975; Knoedler Contemporary Art, NYC, 1975, 76, 77; Daniel Templon, Paris, 1976; Watson/de Nagy, Houston, 1977; Galerie 99, Bay Harbor Islands, Fla., 1978, 81; André Emmerich Gallery, NYC, 1979, 81, 82, 83, 85, 86; Hett Gallery, Edmonton, 1980; Galerie Ulysses, Vienna, 1980; Waddington Gallery, Toronto, 1980, 82; Galerie Artline, The Hague, 1981; Gallery One, Toronto, 1981, 82, 84, 86; Meredith Long & Co., Houston, 1982; Galerie Montaigne, Paris, 1989; Helander Gallery, Palm Beach, 1990; Salander-O'Reilly Galleries, Beverly Hills, 1991. **Retrospective:** Boston/MFA, circ., 1981. **Group:** WGMA, 1963; Sidney Janis Gallery, The Classic Spirit, 1964; SRGM, American Drawings, 1964, Systemic Painting, 1966; MOMA, The Responsive Eye, 1965; Smithsonian, 1965; VIII São Paulo Biennial, 1965; WMAA Annuals, 1965, 67, 69, also Young America, 1965; Chicago/AI, 1966; Corcoran, 1967; Carnegie, 1967; Kassel, Documenta IV, 1968; MMA, New York Painting and Sculpture,

1940-1970, 1969; Washington U., The Development of Modernist Painting: Jackson Pollock to the Present, 1969; Pasadena/AM, Painting in New York: 1944-1969, 1969; Buffalo/Albright, Color and Field, 1890-1970, 1970; WMAA, The Structure of Color, 1971; Buffalo/Albright, Six Painters, 1971; Boston/MFA, Abstract Painting in the '70s, 1972; Kansas City/Nelson, Color Field Painting to Post Color Field Abstraction, 1972; Houston/MFA, The Great Decade of American Abstraction: Modernist Art, 1960-1970, 1974; U. of Miami (Fla.), Less Is More: The Influence of the Bauhaus on American Art, 1974; Caracas, El Lenguaje del Color, 1974; Corcoran Biennial, 1975; Syracuse/Everson, New Works in Clay by Contemporary Painters and Sculptors, 1976; Syracuse/Everson, A Century of Ceramics in the U.S., 1878-1978, 1979; Grand Palais, Paris, L'Amérique aux Indépendants, 1980; Houston/MFA, Miró in America, 1982; St. Lawrence U., Pre-Postmodern, 1985; AAIAL, 1986; Brown U., Definitive Statements, circ., 1986. **Collections:** Boston/MFA; Buffalo/Albright; Cleveland/MA; Denver/AM; Eindhoven; Hirshhorn; MMA; Milwaukee; MOMA; Oberlin College; PMA; SRGM; Santa Barbara/MA; Tate. **Bibliography:** Alloway 3; Battcock, ed.; Calas, N. and E.; Goossen 1; *The Great Decade;* Hansen; Haskell 5; Hunter, ed.; Johnson, Ellen H.; Kozloff 3; Lippard 2, 5; MacAgy 2; Murken-Altrogge; Rickey; Rose, Bernice, 1; Sandler 3; Wood.

POOR, HENRY VARNUM

from 1st to 5th edition.

PORTER, DAVID

from 1st to 5th edition.

PORTER, FAIRFIELD b. June

10, 1907, Winnetka, Ill. **d.** September 18, 1975, Southampton, N.Y. **Studied:** Harvard U.; ASL, with Boardman Robinson, Thomas Hart Benton. Traveled Europe,

USSR, Scandinavia, USA, Canada.
Taught: Long Island U., Southampton College, 1965-66; Queens College, 1968; Amherst College, 1969-70; School of Visual Arts, NYC, 1974-75. Editorial associate, *Art News* magazine, 1951-58; art critic, *The Nation* magazine, 1959-60. **Awards:** Longview Foundation (for art criticism), 1959; Purdue U., P.P., 1966; NAD, P.P. **One-man Exhibitions:** (first) Community House, Winnetka, Ill., 1939; Tibor de Nagy Gallery, 1951-70; RISD, 1959; U. of Alabama, 1963; Reed College, 1965; Trinity College (Conn.), 1966; Kent State U., 1967; Swarthmore College, 1967; Hirschl & Adler Galleries, NYC, 1972, 74, 76, 79, 85, 92; Southampton/Parrish, 1971, 76, 77; Maryland Institute, 1973; Brooke Alexander, 1975; U. of Connecticut, 1975; Alpha Gallery, Boston, 1977; Colby College, 1977; Harbor Gallery, Cold Spring Harbor, N.Y., 1977; Gross-McCleaf Gallery, Philadelphia, 1978, 79; Esther Robles Gallery, Los Angeles, 1978; Artists' Choice Museum, NYC, 1979; Barridoff Galleries, Portland, Me., 1979; Hull Gallery, Washington, D.C., 1979; Mickelson Gallery, Washington, D.C., 1979; WMAA/Fairfield, 1984; Middlebury College (two-man), 1991. **Retrospectives:** Cleveland/MA, 1966; Huntington, N.Y./Heckscher, circ., 1974; Boston/MFA, circ., 1982. **Group:** Dayton/AI, 1961; MOMA, 1961; Yale U., 1961-62; WMAA Annuals, 1961-66; PAFA, 1962; NIAL, 1962; U. of Nebraska, 1963; Colby College, Maine and Its Artists, 1963; Chicago/AI; Venice Biennial; New York World's Fair, 1964-65; Gallery of Modern Art, NYC, 1965; Purdue U., 1966; Akron/AI, 1967; Flint/Institute, 1967; US Dept. of the Interior, America 1976, 1976; PAFA, Contemporary Realism Since 1960, circ., 1981; Guild Hall, Art and Friendship: A Tribute to Fairfield Porter, 1984; Southampton/Parrish, Painting Naturally: Fairfield Porter and His Influences, 1984. **Collections:** Boston/MFA; Brooklyn Museum; Chase Manhattan Bank; Cleve-

land/MA; Corcoran; Dayton/AI; Hartford/Wadsworth; Hirshhorn; MMA; MOMA; U. of Nebraska; U. of North Carolina; Purdue U.; Santa Fe, N.M.; Toledo/MA; Woodward Foundation. **Bibliography:** *America 1976;* Armstrong, Thomas; Arthur 1; Ashbery; Ashbery and Moffett; Cummings 1, 4; Downes, ed.; *The Figurative Fifties;* Geske; Lindman; Ludman; McCoubrey 1; Porter; Sandler 5; Spike; Ward. Archives.

PORTER, KATHERINE
b. 1941, Cedar Rapids, Iowa. **Studied:** Colorado College, BA, 1959-1963; Boston U., 1962. **Awards:** Hon. DFA, Colby College, 1982. **Address:** c/o Dealer. **Dealer:** Victoria Munroe, NYC. **One-man Exhibitions:** Parker 470 Gallery, Boston, 1971, 72; U. of Rhode Island, 1971; Henri Gallery, Washington, D.C., 1972; Worcester, 1973; MIT, 1974; David McKee, Inc., NYC, 1975, 78, 79, 82, 84, 86; Harcus-Krakow Gallery, Boston, 1976; Alpha Gallery, Boston (two-man), 1979; San Francisco/Achenbach, 1980; Dartmouth College, 1981; Arts Club of Chicago, 1984; Brandeis U., 1985; Sidney Janis Gallery, 1987; Hill Gallery, Birmingham, Mich., 1987; William Halsey Gallery, Charleston, S.C., 1986; Albany/SUNY, 1987; Knoedler Gallery, London, 1988; Virginia Polytechnic Institute, 1988; André Emmerich Gallery, Inc., 1988. **Group:** WMAA Annuals, 1969, 73; MIT, Six Artists, 1970; ICA, Boston, Drawings Re-examined, 1970; ICA, U. of Pennsylvania, Six Visions, 1973; SRGM, Theodoron Awards, 1977; Brandeis U., From Women's Eyes, 1977; Otis Art Institute, Los Angeles, New York: A Selection from the Last 10 Years, 1979; Winter Olympics, Lake Placid, NY, 1980; WMAA Biennial, 1981; Chicago/AI, 74th American Exhibition, 1982; MOMA, International Survey of Recent Painting and Sculpture, 1984; Fort Lauderdale, An American Renaissance: Painting and Sculpture Since 1940, 1986; U. of Kansas, New Work/New

York, circ., 1988; AAIAL, 1988; Instituto de Estudio Norteamericanos, Barcelona, Sightings, circ., 1988. **Collections:** Andover/Phillips; U. of Arkansas; Brandeis U.; Carnegie; Chase Manhattan Bank, NYC; Colby College; Currier; Denver/AM; Detroit/Institute; Harvard U.; High Museum; Honolulu/Contemporary; MIT; MOMA; PAFA; PMA; Portland, Ore./AM; Portland, Me./MA; Prudential Insurance Co. of America, Newark; SRGM; San Francisco/Achenbach; WMAA; Worcester/AM. **Bibliograpy:** Lucie-Smith.

PORTER, LILIANA **b.** October 6, 1941, Buenos Aires, Argentina. **Studied:** National School of Fine Arts, Buenos Aires, 1954-57; Universidad Iberoamericana, Mexico City, 1958-60; School of Fine Arts, Buenos Aires, 1961-63. Traveled Mexico, Europe, South America. **Taught:** New York Graphic Workshop, 1965-70; Old Westbury/SUNY, 1974-76; Purchase/SUNY, 1987; Queens College, 1991-. **Member:** Artists Equity. **Awards:** Salon de Otono, Buenos Aires, first prize, 1962; Salon Artes Plasticas Hebraica Argentina, first prize, 1962; San Juan, first prize, 1st Latin American Biennial of Prints, 1970; Museum of Fine Arts, Buenos Aires, first prize, 1978; Guggenheim Foundation Fellowship, 1980; Montevideo, First Iberoamerican Graphics Biennial, 1st prize, 1983; New York Foundation for the Arts, 1985; Krakow, Print Biennial, Grand Prix, 1986; San Juan, Latin American Print Biennial, 1986. **Address:** 178 Franklin Street, NYC 10013. **Dealer:** Bernice Steinbaum Gallery, NYC. **One-man Exhibitions:** (first) Galeria Proteo, Mexico City, 1959; Galeria Mude Veracruz, Mexico, 1960; Galeria Galatea, Buenos Aires, 1961; Galeria Nice, Buenos Aires, 1962; Galeria Plasticas de Mexico, Mexico City, 1963; Prints International, Toronto, 1963; Galeria Lirolay, Buenos Aires, 1963, 66; Van Bovenkamp Gallery, NYC, 1964; Galeria Amigos del Arte, Montevideo, 1966; Caracas, 1969; A.A.A. Gallery, NYC,

1969; Santiago, Chile, 1969; Instituto Torcuato Di Tella, Buenos Aires, 1969; Galleria Diagramma, Milan, 1972; Hundred Acres Gallery (two-man), 1973, 75, 77; MOMA, 1973; Galleria Conz, Venice, 1973; Galeria Colibri, San Juan, 1974; Galeria Conkright, Caracas, 1974; Galerie Stamps, Basel, 1974; Museo de Arte Moderno, Bogota, 1974; Galeria Belarca, Bogota, 1975; Galleria della Villa Schifanoia, Florence, 1976; Galeria Artemultiple, Buenos Aires, 1977, 78; Barbara Toll Fine Arts, NYC, 1979, 80, 82, 84; Cali/Tertulia, 1978, 83; Galerie Arte Nuevo, Buenos Aires, 1980; Center for Inter-American Relations, NYC, 1980; Galeria Garces Valesquez, Bogota, 1982, 84; Galerie Jolliet, Montreal, 1983; Galeria Taller, 1983; U. of Alberta, 1984; Centro de Arte Actual, Pereira, Colombia, 1984; Panama City, Museo de Arte Contemporaneo, 1984; Dolan/Maxwell Gallery, 1985; Galeria Luigi Marrozzini, San Juan, 1986; Cali, Moderna, 1987, 91; Galeria Diners, Bogota, 1987, 91; Galeria Krysztofory, Krakow, 1988; Casa de las Americas, Cuba, 1988; The Space, Boston, 1988; Syracuse U., 1989; U. of North Carolina, 1991. **Retrospectives:** School of Architecture, Caracas, 1969; Galerie Arte Nuevo, Buenos Aires, Center for Inter-American Relations, NYC, 1980; Fundacion San Telmo, Buenos Aires, 1990; Uruguay/Nacional, 1990; Bronx Museum, 1992; U. of Texas, 1993. **Group:** Jewish Museum, NYC, 100 Contemporary Prints, 1965; Ljubijana Biennials, 1965, 73, 75, 77, 79; NYU, Art in Editions, 1968; Krakow, Print Biennials, 1968, 70, 74; ICA, London, Printmaking in America, 1969; San Juan, Print Biennials, 1970, 72; MOMA, Information, 1970; Paris/Bibliothèque Nationale, L'Estampe Contemporaine, 1973; U. of California, Berkeley, Books Made by Artists, 1973; Segovia, Print Biennial, 1974; Bradford (England) Print Biennials, 1974, 76, 79; Canberra/National, Illusion and Reality, 1977; William Paterson College, Works on the Wall, 1979; Syracuse/Everson, Roots—Visions, 1979; Jackson/MMA, Collage and Assemblage,

circ., 1981; U. of North Carolina, Art on Paper, 1982; Queens College, Latin American Artists in the US 1950-1970, 1983; SFMA, World Print Four, 1983; 1st Bienal de la Habana, Cuba, 1984; Mexico City/Moderno, Pintura Argentina Contemporanea, 1985; Hostos Community College, NYC, Contemporary Master Printmakers from Latin America, 1986; Cali/Moderno, V Bienal American des Arts Fraicas, 1986; Instituedo de cultural Puertoriquena, San Juan, VII Bienal de San Juan, 1986; Krakow, XI International Print Biennial, 1986; Uruguay/Nacional, Del Pop Art a le Nueve Imagen, 1986; U. of Texas, Latin American Artists in New York Since 1970, 1987; Taiwan, International Biennial Prints Exhibit, 1987, 89; Bronx Museum, The Latin American Spirit, 1988; Bronx Museum, Ideas and Images from Argentina, 1989; Intergraphik, Berlin 1990; Museum of Contemporary Hispanic Art, NYC, The Decade Show, 1990; San Diego/MA, Latin American Drawings Today, 1991; AAIAL, Annual, 1991; Bucknell U., Six Latin American Women Artists, 1992; Brooklyn College, Five Centuries After the Collisions, 1992. **Collections:** Bogota; Cali/Tertulia; Caracas; Casa de las Americas, Havana; Chase Manhattan Bank, NYC; Chattanooga/Hunter; Columbia U.; Crocker National Bank of California; Fredrikstad; Instituto de Cultura, San Juan; Instituto Wilfredo Lam, Havana; Lodz; Mexico City/Tamayo; Montreal/Contemporain; MOMA; Museo de Arte Moderno, Bogota; Musée del Grabado, Buenos Aires; Museo Universitario, Mexico City; NYPL; Panama City/Contemporaneo; Paris/Bibliothèque Nationale; PMA; Santiago, Chile; RCA Corp.; Rio de Janeiro; U. of Texas.

PORTNOW, MARJORIE b. September 30, 1942, NYC. **Studied:** Case Western Reserve U., 1960-64, BA, Art History, magna cum laude, with Dr. Sherman E. Lee; Pratt Institute, 1964, with Alex Katz, Gabriel Laderman; Skowhegan School, 1965, with Lennart Anderson,

Alfred Leslie, John Button; Brooklyn College, 1970-72, MFA, summa cum laude, with Alfred Russell, Joe Groell, Philip Pearlstein, Larry Campbell. Traveled USA. **Taught:** Queens College, 1973-74; Boston Museum School, 1974-75; Virginia Polytechnic Institute, 1982, 84; PAFA, 1988, 89; U. of Pennsylvania, 1988-91. **Awards:** L.C. Tiffany Grant, 1972, 78; Ingram Merrill Foundation Grant, 1975; National Endowment for the Arts, 1980; CAPS, 1981; New York Foundation for the Arts, grant, 1986; AAIAL, Childe Hassam P.P., 1990; Djerassi Foundation Grant, 1991. Designed sets and multimedia works for poet Bob Holman. **Address:** 67 Vestry Street, NYC 10013. **Dealers:** Fischbach Gallery, NYC; Harcus Gallery, Boston. **One-man Exhibitions:** First Street Gallery, NYC, 1972; The Kornblee Gallery, 1974; Harcus-Krakow Gallery, Boston, 1978, 83; Odyssia Gallery, 1983; Fischbach Gallery, NYC, 1985; AAIAL, 1989, 90; **Group:** Colgate U., Painters of the Land and Sky, 1972; Corcoran, The Delaware Water Gap, 1975; Bronx Museum, Personal Visions, 1978; NAD, 1981; Albany/Institute, The New Response, 1985. Maryland Institute, The Landscape Observed, 1989; Charleston/Gibbs, The Italian Tradition in Contemporary American Landscape Painting, 1990; MMA, The Landscape in 20th Century American Art, circ., 1991-93. **Collections:** AT&T; Albany/Institute; Amherst College; Bronx Museum; Chase Manhattan Bank; Chemical Bank; Citicorp; The Commerce Bancshares of Kansas City; Crocker National Bank of California; MMA; Mellon Bank; U. of Nebraska; U. of North Carolina; Philip Morris Collection.

POSEN, STEPHEN b. September 27, 1939, St. Louis, Mo. **Studied:** Washington U., 1962, BFA; Yale U., 1964, MFA. US Army, 1957. Traveled Europe. **Taught:** Cooper Union. **Awards:** Fulbright Fellowship, 1964-66; Milliken Traveling Scholarship, 1964; CAPS, 1973; Guggenheim Foundation, fellow-

ship, 1986. **Address:** 115 Spring Street, NYC 10012. **Dealer:** Jason McCoy, Inc., NYC. **One-man Exhibitions:** OK Harris Works of Art, 1971, 74; Robert Miller Gallery, Inc., NYC, 1978; Jason McCoy, Inc., NYC, 1986, 90. **Group:** Chicago/Contemporary, Radical Realism, 1971; Eindhoven, Relativerend Realisme, 1972; WMAA Annual, 1972; Kassel, Documenta V, 1972; Cleveland/MA, 32 Realists, 1972; Yale U., 7 Realists, 1973; Chicago/AI, New Realism, 1973; Lunds Konsthall, Sweden, Amexikansk Realism, 1974; Tokyo Biennial, 1974; Chicago/AI, 71st American Exhibition, 1974; Potsdam/SUNY, New Realism Revisited, 1974; Taft Museum, Tromp L'Oeil, 1975, Canberra/National, Illusion and Reality, circ., 1977-78; PAFA, Eight Contemporary American Realists, 1977; Tulsa/Philbrook, Realism-Photorealism, 1980; San Antonio/MA, Real, Really Real, Super Real, circ., 1981; PAFA, Contemporary American Realism Since 1960, 1981; SFMA, American Realism (Janss), circ., 1985. **Collections:** Chase Manhattan Bank; Louisville/Speed; PAFA; Potsdam/SUNY; RAC; SRGM; VMFA. **Bibliography:** Arthur 1, 2; Goodyear; Hunter, ed.; Lucie-Smith; Sager; Ward.

POUSETTE-DART, NATHANIEL
from 1st to 4th edition.

POUSETTE-DART, RICHARD
b. June 8, 1916, St. Paul, Minn. **d.** October 25, 1992, NYC. **Studied:** Bard College, 1936. Traveled France. **Taught:** New School for Social Research, 1959-61; School of Visual Arts, NYC, 1965; Columbia U., 1968-69; Sarah Lawrence College, 1970-74; Art Students League, 1980-81; Bard College, 1983. **Awards:** Guggenheim Foundation Fellowship, 1951; Ford Foundation Grant, 1959; Corcoran Biennial, Silver Medal, 1965; Bard College, Honorary Doctor of Humane Letters, 1965; National Endowment for the Arts Grant,

1967; L. C. Tiffany Foundation, Distinguished Lifetime in Art Award, 1981. **One-man Exhibitions:** (first) Artists Gallery, NYC, 1941; The Willard Gallery, NYC, 1943, 45, 56; Art of This Century, NYC, 1947; Betty Parsons Gallery, NYC, 1948-51, 53, 55, 58, 59, 61, 64, 67; Katonah (N.Y.) Art Gallery, 1967; Washington U., 1969; Obelisk Gallery, 1969; Andrew Crispo Gallery, NYC, 1974, 76, 78; MOMA, circ., 1969-70; Allentown/AM, 1975; Wichita State U., 1975; Arts Club of Chicago, 1978; Marisa del Re Gallery, NYC, 1981, 82, 83, 86, 90; Schwartz-Galdo Gallery, Birmingham, Mich., 1983, Makler Gallery, Philadelphia, 1983; Fort Lauderdale, 1986; Virginia Miller Gallery, Coral Gables, Fla., 1986; ACA Galleries, NYC, 1990, 91; Le Marie Tranier Gallery, Washington, D.C., 1992. **Retrospectives:** WMAA, 1963, 74; Indianapolis, circ., 1990. **Group:** Chicago/AI, Abstract and Surrealist Art, 1948; WMAA Annuals, 1949, 51, 53, 1955-59, 1961, 72, 73; MOMA, Abstract Painting and Sculpture in America, 1951; U. of Illinois, 1951-53; Buffalo/Albright, Expressionism in American Painting, 1952; WMAA, The New Decade, 1954-55; WMAA, Nature in Abstraction, 1958; I Inter-American Painting and Prints Biennial, Mexico City, 1958; Carnegie, 1958, 61; Kassel, Documenta II, 1959; SRGM, Abstract Expressionists and Imagists, 1961; MOMA, The Art of Assemblage, circ., 1961; Hartford/Wadsworth, Continuity and Change, 1962; MOMA, The New American Painting and Sculpture, 1969; National Gallery, American Art at Mid-Century, 1973; Philadelphia College of Art, Private Notations: Artists' Sketchbooks, 1976; Bronx Museum of the Arts, The Magic Circle, 1977; Indianapolis, Perceptions of the Spirit in 20th Century American Art, circ., 1977; Cornell U., Abstract Expressionists: Formative Years, 1978; Chicago/Terra, Solitude: Inner Visions in American Art, 1982; Haus der Kunst, Munich, Amerikanische Malerie: 1930-1980, 1982; XL Venice

Biennial, 1982. **Collections:** Andover/Phillips; Buffalo/Albright; Chase Manhattan Bank; Ciba-Geigy Corp., Ardsley; Corcoran; Cornell U.; Equitable Life Assurance Society; Hirshhorn; Indianapolis; U. of Iowa; Los Angeles/County MA; MMA; MOMA; U. of Nebraska; NCFA; NMAA; Newark Museum; North Central Bronx Hospital; Oklahoma; PMA; Palm Springs Desert Museum; Pasadena/AM; Phillips; Ringling; The Singer Company, Inc.; SRGM; Uffizi Gallery; Union Carbide Corp.; Upjohn Co.; WMAA; Washington U.; Wichita State U. **Bibliography:** *Abstract Expressionism;* Anfam; Armstrong, Thomas; Baur 5; Blesh 1; Goodrich and Baur 1; Janis and Blesh 1; Motherwell and Reinhardt, eds.; Nordness, ed.; Pousette-Dart, ed.; Ragon 2; Ritchie 1; Seitz 4; Tuchman, ed.; Tuchman 3. Archives.

POZZATTI, RUDY **b.** January 14, 1926, Telluride, Colo. **Studied:** U. of Colorado, with Wendell Black, Ben Shahn, Max Beckmann, 1948, BFA, 1950, MFA. US Army, 1943-46. Traveled Europe, USSR, Mexico, South America; resided Italy. **Taught:** U. of Colorado, 1948-50, summers, 1951, 54; U. of Nebraska, 1950-56; Cooper Union, summer, 1955; Indiana U., 1956-; Yale-Norfolk Summer Art School, 1957; The Ohio State U., summer, 1959; Florence, Italy, Print Workshop, summer, 1967; Honolulu Academy, 1971; Instituto d'Arte, Massa, Italy, 1974. **Member:** SAGA; Board of Directors, College Art Association, 1974-78; NAD. Subject of *Artists in America,* half-hour TV color film, N.E.T., 1971; Academia Italia della Arte e del Lavoro. **Commissions:** International Graphic Arts Society (3 editions); Print Club of Cleveland; New York Hilton Hotel. **Awards:** U. of Illinois, Graphic Art Exhibition, First Prize, 1949; Walker, P.P., 1951; Youngstown/Butler, P.P., 1951, 52; St. Louis/City, Vladimir Golschmann Prize, 1952; Fulbright Fellowship (Italy), 1952-53; St. Louis/City, Henry V. Putzell Prize,

1955; The Print Club, Philadelphia, Mildred Boericke Award, 1955, also 1969; PAFA, Alice McFadden Eyre Medal, 1957; Library of Congress, Pennell P.P., 1958; Boston Printmakers, Paul J. Sachs Award 1958, 61; PAFA, P.P., 1959 (2); AAAL, P.P., 1960; SAGA, 100 Prints of the Year, First Prize, 1963; Guggenheim Foundation Fellowship, 1963-64; Ford Foundation Grant; US State Department Cultural Exchange Grant, 1965; Flint/Institute, 1965; American Color Print Society, P.P., 1968; III Annual 500 Mile Race Art Exhibit, Indianapolis, First Prize, ($1,000), 1968; U. of Colorado, George Norlin Silver Medal for Distinguished Achievements in Chosen Profession, 1972; Honorary Doctor of Humane Letters, U. of Colorado, 1973; Carl Zigrosser Memorial Award, American Color Print Society, 1979; and many others. **Address:** 117 South Meadowbrook, Bloomington, IN 47401. **Dealer:** Haslem Fine Arts, Inc., Washington, D.C. **One-man Exhibitions:** (first) Chicago/AI, 1953; Philadelphia Art Alliance, 1953; Martha Jackson Gallery, 1954; Cleveland/MA, 1955; Kansas City/Nelson, 1955; U. of Maine, 1956; U. of Nebraska, 1956; Gump's Gallery, San Francisco, 1956, 60; Weyhe Gallery, NYC, 1957; Clarke College, 1957; Carleton College, 1957; U. of Minnesota, 1958; Louisville/Speed, 1958, 73; Ohio U., 1960; Walker, 1960; J. Seligmann and Co., 1961; U. of Louisville, 1963; Jane Haslem Gallery, Durham, N.C., 1963; Kalamazoo/Institute, 1967; Merida Gallery, Inc., 1967; Daberkow Gallery, Frankfurt, 1969; Karlsruhe, 1969; Honolulu Academy, 1971; Institute of Fine Arts, Salvador, Brazil, 1974; Institute of Fine Arts, São Paulo, 1974; I.B.E.U., Rio de Janeiro, 1974; US Embassy, Ankara (two-man), 1975; Terre Haute/Swope, 1979, 81; Cushing Gallery, Dallas, 1977; Roswell, 1980; Heath Gallery, Atlanta, 1982; U. of Tennessee, 1982; U. of West Virginia, 1982; Evansville, 1983; Lake Erie College, 1983; American Embassy,

Belgrade, 1984; U. of Arkansas, 1985; Centre College, 1985. **Retrospectives:** U. of Nebraska, 1971; Southern Illinois U., circ., 1982. **Group:** The Print Club, Philadelphia, 1954; U. of Oklahoma, 1956; WMAA, Fulbright Artists, 1958; U. of Michigan, 1959; The Pennsylvania State U., 10 American Printmakers, 1959; WMAA, Young America, 1960; Syracuse U., 1962; PCA, American Prints Today, circ., 1962; U. of Kentucky, Graphics IV, 1962; IBM Gallery of Arts and Sciences, NYC, 30 American Printmakers, circ., 1974. **Collections:** Achenbach Foundation; Albion College; Allegheny College; Alverthorpe Gallery; Anchorage; Ashland Oil Inc.; Ball State U.; Baltimore/MA; Bibliothèque Nationale; Boston/MFA; Bradley U.; Brooklyn Museum; U. of California, Berkeley; Cleveland/MA; U. of Colorado; Concordia Teachers College (Neb.); Davidson, N.C.; Dayton/AI; U. of Delaware; DePauw U.; Duke U.; Eastern Michigan U.; Hamline U.; Harvard U.; Indiana U.; Indianapolis/Herron; State College of Iowa; Jacksonville/AM; Kansas City/Nelson; Kansas State College; Kemper Insurance Co.; La Jolla; Library of Congress; Los Angeles/County MA; Louisville/Speed; U. of Louisville; MMA; MOMA; U. of Maine; Malmo; Marshall U.; U. of Michigan; National Gallery; Nebraska State Teachers College; U. of Nebraska; Newark Museum; Oakland/AM; Oberlin College; The Ohio State U.; Oklahoma City U.; U. of Oklahoma; Omaha/Joslyn; PAFA; PMA; U. of Puerto Rico; SFMA; St. Cloud State College; St. Lawrence U.; St. Louis/City; St. Mary's College (Ind.); San Jose State College; Seattle/AM; Sioux City Art Center; Springfield, Mo./AM; Syracuse U.; Texas Western College; Toronto; Texas Tech U.; US State Department; Utica; Victoria and Albert Museum; Walker; Washburn U. of Topeka; Wichita/AM; College of William and Mary; U. of Wisconsin; Yale U.; Youngstown/Butler; Youngstown U. **Bibliography:** Chaet; Print Club of Cleveland.

PRESTOPINO, GREGORIO

b. June 21, 1907, NYC. **d.** December 19, 1984, Princeton, N.J. **Studied:** NAD, with C. W. Hawthorne. Traveled Europe, southwestern USA, Mexico. **Taught:** Veterans Art Center, MOMA, 1946-48; Brooklyn Museum School, 1946-59; New School for Social Research, 1949-56, 57, 65; American Academy, Rome, 1968-69. Federal A.P.: Easel painting. **Awards:** PAFA, Joseph E. Temple Gold Medal, 1946; Pepsi-Cola, Third Prize, 1946; Youngstown/Butler, First Prize, 1958; Cannes Film Festival, First Prize (for the art film *Harlem Wednesday*), 1958; NIAL Grant, 1961; NAD, Benjamin Altman Prize, 1972; NAD, Emily Goldsmith Award, 1977; NAD, Benjamin Altman (Figure) Prize, 1984. **One-man Exhibitions:** (first) ACA Gallery, NYC, 1943, also 1946, 48, 50, 51, 53, 54, 57; Lee Nordness Gallery, NYC, 1959, 60, 61, 62, 64; Rex Evans Gallery, Los Angeles, 1961; Terry Dintenfass, Inc., NYC, 1966, 68, 71, 74; Virginia Union U., 1967; Keene (N.H.) State College, 1974; Pine Public Library, Fair Lawn, N.J., 1979; Midtown Galleries, 1983, 85; Sheraton Arts Center, Sharon, N.H., 1985. **Retrospectives:** Michigan State U.; Fort Lauderdale, 1980. **Group:** WMAA Annuals; MOMA; Corcoran; New York World's Fair, 1939; Golden Gate International Exposition, San Francisco, 1939; Chicago/AI; Venice Biennial; USIA; PAFA Annual, 1967; and others. **Collections:** U. of Alabama; Andover/Phillips; Brandeis U.; Chicago/AI; Currier; U. of Hawaii; IBM; U. of Illinois; MOMA; Martha Washington U.; Mary Washington College; Montclair/AM; NCFA; U. of Nebraska; U. of Notre Dame; U. of Oklahoma; Phillips; U. of Rochester; Southern Methodist U.; U. of Texas; Trenton/State; WMAA; Walker; Youngstown/Butler. **Bibliography:** Genauer; Nordness, ed.; Pousette-Dart, ed. Archives.

PRICE, CLAYTON

from 1st to 4th edition.

PRICE, KENNETH b. 1935, Los Angeles, Calif. Studied: U. of California; Otis Art Institute; Chouinard Art Institute; U. of Southern California, BFA, 1956; Alfred/SUNY, MFA, 1958. Awards: Tamarind Fellowship, 1968. Address: P.O. Box 1356, Taos, N.M. 87571. One-man Exhibitions: U. of California, 1956; Ferus Gallery, Los Angeles, 1960, 61, 64; Los Angeles/County MA (two-man), 1966, 78; Kasmin Ltd., 1968, 70; WMAA, 1969; Mizuno Gallery, 1969, 71; David Whitney Gallery, NYC, 1971; Galerie Hans R. Neuendorf, Cologne, 1971, Hamburg, 1971; D.M. Gallery, London, 1972; Nicholas Wilder Gallery, 1973; Felicity Samuel Gallery, London, 1974; The Willard Gallery, NYC, 1974, 79, 82, 83, 85; Ronald Greenberg Gallery, St. Louis, 1976, 89; James Corcoran Gallery, Los Angeles, 1976, 80, 82; Los Angeles/County MA, 1978; Gallery of Contemporary Arts, Taos, 1978; The Texas Gallery, Houston, 1979, 80, 84; Hansen Fuller Goldeen Gallery, San Francisco, 1979; School of Visual Arts, NYC, 1980; Houston/Contemporary, 1980; Betsy Rosenfield Gallery, Chicago, 1980, 84; Leo Castelli Gallery, Inc., NYC, 1983; Harcus Gallery, Boston, 1984; Jane Beggs Fine Arts, Aspen, Col., 1985; Rena Bransten Gallery, San Francisco, 1989. Retrospective: Menil Collection, Houston, circ., 1992. Group: SFMA, Fifty California Artists, circ., 1962; Pasadena/AM, New American Sculpture, 1964; Seattle/AM, Ten from Los Angeles, 1966; U. of California, Irvine, Abstract Expressionist Ceramics, 1966; Los Angeles/County MA, American Sculpture of the Sixties, 1967; MOMA, Tamarind: Homage to Lithography, 1969; Fort Worth, Drawings, 1969; Pasadena/AM, West Coast: 1945-69, 1969; Eindhoven, Kompas IV, 1969-70; WMAA Biennial, 1970, 79, 81; Brooklyn Museum, Print Annual, 1980; Hayward Gallery, London, Eleven Los Angeles Artists, 1971; MOMA, Technics and Creativity: Gemini G.E.L., 1971; Cologne/Kunstverein, USA, West

Coast, 1972; Rotterdam (three-man exhibition), 1972; NCFA, Sculpture: American Directions, 1945-1975, 1975; WMAA, 200 Years of American Sculpture, 1976; Brooklyn Museum, 30 Years of American Printmaking, 1976; Syracuse/Everson, New Works in Clay by Contemporary Painters and Sculptors, 1976; Syracuse/Everson, A Century of Ceramics in the U.S., 1878-1978, 1979; WMAA, Ceramic Sculpture: Six Artists, 1981; Indianapolis, 1982; Düsseldorf/Kunsthalle, A Different Climate, 1984; MOMA, International Survey of Recent Painting and Sculpture, 1984; American Craft Museum, Craft Today: Poetry of the Physical, 1986; Seattle/AM, Clay Revisions, 1987; Williams College, BIGlittle Sculpture, 1987. Collections: Chicago/AI; Eindhoven; Denver; Hirshhorn; Los Angeles/County MA; MOMA; Pasadena/AM; Art Museum of South Texas; SFMA; Victoria and Albert; WMAA. Bibliography: *Individuals;* Selz, P., 2; *The State of California Painting; USA West Coast.*

PURYEAR, MARTIN b. May 23, 1941, Washington, D.C. Studied: Catholic U. of America, 1963, BA, art; Swedish Royal Academy, Stockholm, 1966-68; Yale U., 1969-71, MFA; Peace Corps in Sierra Leone, West Africa, 1964-66; São Paulo Biennale, 1969. Taught: Yale U., 1969-71; Fisk U., 1971-73; U. of Maryland, 1973-77; U. of Illinois, 1978-87. Awards: Scandinavian-American Foundation, Study Grant, 1967; U. of Maryland, Creative and Performing Arts Grant, 1975, 78; CAPS grant; Change, Inc., Foundation Grant, 1977; National Endowment for the Arts, fellowship, 1977; L. C. Tiffany Grant, 1982; Guggenheim Foundation, fellowship, 1982; Francis J. Greenburger Foundation Award, 1988; Brandeis U., Creative Arts Award, 1989; Skowhegan Award, 1990. Address: c/o Dealer. Dealer: David McKee Gallery. One-man Exhibitions: Grona Palleten Gallery, Stockholm, 1968; Fisk U., 1972; Henri

Martin Puryear, *Untitled*, 1987.

Gallery, Washington, D.C., 1972, 73; Corcoran, 1977; Protetch-McIntosh Gallery, Washington, D.C., 1978, 79; Young Hoffman Gallery, Chicago, 1980, 82; Chicago/Contemporary, 1980; Delahunty Gallery, Dallas, 1981; and/or Gallery, Seattle, 1981; Donald Young Gallery, Chicago, 1983, 85, 87; Margo Leavin Gallery, Los Angeles, 1985, 89; U. of California, Berkeley, 1985; Chicago Public Library, 1987; David McKee Gallery, NYC, 1987; Carnegie-Mellon U., 1987; MacIntosh/Drysdale Gallery, Washington, D.C., 1988; Boston/MFA, 1990. **Retrospectives:** U. of Massachusetts, Amherst, circ., 1984; Hirshhorn, 1991.

Group: Baltimore/MA, Annual, 1962; Swedish Academy of Art, Annual, 1965, 68; U. of Wisconsin, Madison, Prints and Paintings by Black Artists, 1971; SRGM, Young American Artists, 1978; WMAA Biennial, 1979, 81, 89; Art Museum Association, Afro-American Abstraction, circ., 1980; Cincinnati/Contemporary, Chicago Chicago, 1980; Chicago/AI, 74th American Exhibition, 1982; VMFA, American Abstraction Now, 1983; MOMA, An International Survey of Recent Paintings and Sculpture, 1984; MOMA, Primitivism in 20th Century Art, 1984; SRGM, Transformation in Sculpture, 1985; Los Angeles/MOCA, Individuals, 1986; Buffalo/Albright, Structure to Resemblance, 1987; SRGM, Emerging Artists, 1978-1986, 1987; Sydney/AG, From the Southern Cross, 1988; Lausanne, Skulptur Material + Abstraktion, 1988; WMAA, Vital Signs, 1988; Walker, Sculpture Inside Out, circ., 1988; California Afro-American Museum, Los Angeles, Introspectives, 1989; Museum Overholland, Amsterdam, Black USA, 1990; ICA, U. of Pennsylvania, Devil on the Stairs, 1991; São Paulo Biennale, 1989; MOMA, Allegories of Modernism, 1992. **Collections:** Chicago/AI; Chicago/Contemporary; Corcoran; Dallas/MFA; Hirshhorn; Kansas City/Nelson; Los Angeles/MOCA; MMA; MOMA; National Gallery; Omaha/Joslyn; PMA; SRGM; San Diego/Contemporary; Seattle/AM; WMAA; Walker. **Bibliography:** *Individuals;* Rose, Bernice, 1; Storr and Tannenbaum.

Q

QUAYTMAN, HARVEY
b. April 20, 1937, Far Rockaway, N.Y.
Studied: Syracuse U., 1955-57;
Skowhegan School, 1957; Boston Museum School, with Jan Cox, 1957-60;
Tufts U., 1957-60, BFA; Royal College of Art, London, 1961-62. **Taught:** Tufts U., 1959; Boston Museum School, 1960, 1962-63; Middlebury College, 1961; Newton Creative Arts Center, 1961, 63, 64; Roxbury (Mass.) Latin School, 1962-63; Harvard U., 1961, 64, 65; School of Visual Arts, NYC, 1969-71; Cooper Union, 1972-77; Syracuse U., 1977; Parsons School of Design, 1978. **Awards:** New York Board of Regents Scholarship, 1955-57; Boston/MFA, James William Paige Traveling Fellowship, 1960; CAPS, 1973; Guggenheim Foundation Fellowship, 1979, 85; National Endowment for the Arts, 1983. **Address:** 231 Bowery, NYC 10002. **Dealer:** David McKee Gallery, NYC. **One-man Exhibitions:** A.I.A. Gallery, London, 1962; Ward-Nasse Gallery, Boston, 1964; Royal Marks Gallery, 1966; Ohio State U., 1967; Houston/Contemporary, 1967, 73; Paula Cooper Gallery, 1967, 71; U. of Rochester, 1972; Galerie Onnasch, Cologne, 1971; Galerie Mikro, Berlin, 1971; Galleri Ostergren, Malmo, 1973; Henri 2, Washington, D.C., 1973; Cunningham-Ward Gallery, 1974; David McKee Gallery, 1975, 77, 78, 80, 82, 84, 85; Nielsen Gallery, Boston, 1976, 78, 80, 83; Charles Casat Gallery, La Jolla, 1977;

Galerie Arnseen, Copenhagen, 1981; Galerie Nordenhake, Malmo, 1982, 86; Harvard U., 1983; Storrer Gallery, Zurich, 1983; Galleria Katarina, Helsinki, 1984. **Group:** ICA, Boston, Painting Without a Brush, 1965; U. of Illinois, 1967; WMAA Annuals, 1969, 71, 73; Indianapolis, 1970; Jewish Museum, Beautiful Painting & Sculpture, 1970; Foundation Maeght, 1970; WMAA, The Structure of Color, 1971; UCLA, Fourteen Abstract Painters, 1975; ICA, Boston, Contemporary Painters, 1975; High Museum, The New Image, 1975; Rice U., Drawing Today in New York, 1976; U. of Texas, Austin, New Painting in New York, 1977; Rutgers U., Contemporary American Abstractionists, 1979; Buffalo/Albright, Contructivism and the Geometric Tradition, 1979; Grand Palais, Paris, L'Amerique aux Independants, 1980; Denver/AM, Constructivism in the Geometric Tradition, 1982; Long Island U., Abstract Painting as Surface and Object, 1985. **Collections:** Boston/MFA; Brandeis U.; Canberra/National; Carnegie; Chase Manhattan Bank; Corcoran; Cornell U.; Dartmouth College; Emory U.; Harvard U.; Houston/MFA; Humlebaek/Louisiana; Israel Museum; Kent State U.; U. of Massachusetts; MIT; MOMA; Malmo; McCrory Corp., NYC; Middlebury College; U. of Minnesota, Duluth; NYU; Oberlin College; Pasadena/AM; Port Authority of New York & New Jersey; Prudential Insurance Co. of America; Purchase/SUNY; Rutgers U.; Satakumman Museo; U. of Sydney; Tate Gallery; Tel Aviv; Trenton/State; VMFA; Wellington/National Gallery; WMAA; Worcester/AM; Wright State U. **Bibliography:** *New in the Seventies.*

QUIRT, WALTER
from 1st to 4th edition.

QUISGARD, LIZ WHITNEY
b. October 23, 1929, Philadelphia, Pa.
Studied: Johns Hopkins U.; U. of Balti-

more; Maryland Institute, 1947-49, MFA, 1966; privately with Morris Louis, 1957-60. Traveled Europe, North America. **Taught:** Baltimore Hebrew Congregation, 1962-78; Maryland Institute, 1965-76; Goucher College, 1966-68; U. of Maryland, 1970-71; Baltimore Jewish Community Center, 1974-78; Villa Julia College, 1978-81. Art critic, *Baltimore Sun*, 1968-70. Set designer for theater productions at Goucher College, Center Stage, and Theater Hopkins, 1966-; Villa Julia College, Stevenson, Md.; Beth El Congregation, Baltimore. **Commission:** William Fell School, Baltimore, mural. **Awards:** Baltimore/MA, Second Prize, 1958; Maryland Institute, Fellow of the Rinehart School of Sculpture, 1964-65; National Scholastic Art Awards Scholarship; E. M. Reed Scholarship; Maryland Arts Council, Grant, 1979. **Address:** 145 Reade Street, NYC 10013. **Dealer:** Merrill Chase Gallery, Chicago. **One-man Exhibitions:** (first) Ef Gallery, Baltimore, 1954; Main Gallery, Maryland Institute, 1955; Martick's Gallery, Baltimore, 1956, 58; Johns Hopkins

U., 1958; Jefferson Place Gallery, 1961; Key Gallery, NYC, 1961; André Emmerich Gallery, NYC, 1962; Arts and Science Center, Nashua, N.J., 1975; Gannon College, Erie, Pa., 1978; Mechanics Gallery, Baltimore, 1978; Fells Point Gallery, Baltimore, 1980; Marymount Manhattan College, 1983; Mussavi Arts Center, NYC, 1984; Elaine Starkman Gallery, NYC, 1984; Fordham U., 1985; Art Institute of Pittsburgh, 1987; Henri Gallery, 1987; Artemisia Gallery, Chicago, 1987; Western Maryland College, Westminster, Md., 1988; Savannah College of Art and Design, 1987; Franz Bader Gallery, Washington, D.C., 1989; Fairleigh Dickinson U., 1990; Huntington (Ind.) College, 1991; College of New Rochelle, 1992; Galerie Françoise et ses Frères, Baltimore, 1992. **Group:** Peale Museum, Baltimore, 1947, 50; Baltimore/MA, 1951, 52, 53, 58; Youngstown/Butler, 1956; Corcoran, 1957, 64; PAFA Annual, 1964. **Collections:** U. of Arizona; U. of Baltimore; Fordham U.; Hampton School; Johns Hopkins U.; U. of Maryland.

R

RABKIN, LEO b. July 21, 1919,
Cincinnati, Ohio. **Studied:** U. of Cincin-
nati, BA, B. Ed.; Art Academy of Cincin-
nati; NYU, with Robert Iglehart, Hale
Woodruff, Tony Smith, William Baziotes,
MA. Traveled Mexico, Europe, Guate-
mala. **Taught:** NYC public school system.
Member: American Abstract Artists (past
president). **Awards:** MOMA, Larry
Aldrich P.P., 1959; Ford Foundation,
P.P., 1961, Silvermine Guild, Watercolor
Award, 1961, 64. **Address:** 218 West 20th
Street, NYC 10011. **One-man Exhibi-
tions:** (first) Stairway Gallery, NYC, 1954;
Muriel Latow Gallery, NYC, 1961;
Gotham Gallery, New Hope, Pa., 1961;
Louis Alexander Gallery, NYC, 1962, 63;
Gertrude Kasle Gallery, Detroit, 1965;
Richard Feigen Gallery, NYC, 1965, 67;
Drew U., 1966; Benson Gallery, 1970;
Fairleigh Dickinson U., 1971; Allen-
town/AM, 1977; Truman Gallery, NYC,
1978, 79; Parsons-Dreyfuss Gallery, NYC,
1980; Hal Bromm Gallery, NYC, 1980;
La Jolla, 1981; Marilyn Pearl Gallery,
NYC, 1981, 83, 84; Deicas Art Gallery, La
Jolla, 1982. **Retrospective:** Storm King
Art Center, 1970. **Group:** Brooklyn Mu-
seum, Watercolor Biennial; Hirschl &
Adler Galleries, Inc., NYC, Experiences in
Art, I & II, 1959, 60; MOMA, New
Talent; WMAA Annual, 1959; Martha
Jackson Gallery, NYC, New Media—New
Forms, I & II, 1960, 61; MOMA, Abstract
American Drawings and Watercolors, circ.,
Latin America, 1961-63; A.F.A., Affinities,
circ., 1962; SRGM, 1962, 65; American
Abstract Artists Annuals, 1963, 64, 66, 68,
70; WMAA, 1959, 60, 61, 64, 66, 68, 69;
Eindhoven, 1966; Walker, Light Motion
Space, 1967; Smithsonian, 1967; Tren-
ton/State, Focus on Light, 1967; Brooklyn
Museum Print Exhibitions; Finch College,
NYC, Destructionists, 1968; Milwaukee,
A Plastic Presence, circ., 1969; Honolulu
Academy, 1971; Sculptors Guild, 1972,
74; Brooklyn Museum, Print Exhibition,
1972; Drew U., Reality in Art, 1978; Betty
Parsons Gallery, NYC, American Abstract
Artists, 1979; Albright College, Small Is
Beautiful, 1979; U. of North Carolina,
American Abstract Artists, 1983. **Collec-
tions:** Brooklyn Museum; U. of California,
Berkeley; Chase Manhattan Bank; Ciba-
Geigy Corp.; La Jolla; MOMA; McCrory
Corporation; NYU; Purchase/SUNY; Ra-
leigh/NCMA; Randolph-Macon College;
SRGM; Savings Bank Association of New
York State; The Singer Company, Inc.;
Smithsonian; Storm King Art Center; Vir-
ginia Commonwealth U.; WMAA; Wood-
ward Foundation. **Bibliography:** Toher,
ed. Archives.

RACZ, ANDRE b. November 21,
1916, Cluj, Rumania. **Studied:** U. of Bu-
charest, 1935, BA; Atelier 17, NYC, 1943-
45; New School for Social Research,
1943-45. To USA, 1939; citizen, 1948.
Traveled Europe, Latin America, Mexico.
Taught: U. of Chile, 1957; Columbia U.,
1951-83; U. of Kentucky, 1960. **Member:**
American Association of University Profes-
sors; SAGA. **Awards:** SAGA, Mrs. A. W.
Erickson Prize, 1953; Noyes Memorial
Prize, 1955; Guggenheim Foundation Fel-
lowship, 1956; Fulbright Research Scholar
(Chile), 1957; U. of Kentucky, P.P., 1959;
Ford Foundation, P.P., 1962; Columbia
U., Bankroft Award for Distinguished
Teacher, 1983. **Address:** P.O. Box 43,
Demarest, NJ 07627. **One-man Exhibi-
tions:** (first) New School for Social Re-
search, 1942; A.F.A., circ., 1948-51;

Columbia U., 1983; and exhibits in NYC nearly every year. **Retrospectives:** NYPL, 1954; Museo de Bellas Artes, Santiago, Chile, 1957; U. of Kentucky, 1960. **Group:** MOMA; WMAA Annuals; Brooklyn Museum; Corcoran; Library of Congress; MOMA, 50 Years of American Art, circ., Europe, 1955; I Inter-American Paintings and Prints Biennial, Mexico City, 1958; I International Religious Art Biennial, Salzburg, 1958; MOMA, American Prints, 1913-1963, 1974-75; Rutgers U., Surrealism and American Art, 1977; U. of Wisconsin, Atelier 17, 1977. **Collections:** Bibliothèque Nationale; Brooklyn Museum; Columbia U.; Cordoba/Provincial; George Washington U.; U. of Kentucky; Library of Congress; MMA; MOMA; Melbourne/National; U. of Minnesota; NYPL; National Gallery; Oslo/National; PMA; SFMA; Salzburg; Smith College; Smithsonian; WMAA; Youngstown/Butler. **Bibliography:** Baur 7; Hayter 2; Janis, S.; Moser 1.

RAFFAEL, JOSEPH **b.** February 22, 1933, Brooklyn, N.Y. **Studied:** Cooper Union, 1951-54, with Sidney Delevante, Leo Manso; Yale U., with Josef Albers, James Brooks, BFA. Traveled Europe, Hawaiian Islands; resided Rome and Florence, 1958-60. **Taught:** U. of California, Davis, 1966, Berkeley, summer, 1969; School of Visual Arts, NYC, 1967-69; California State U., Sacramento, 1969-74. **Awards:** Yale-Norfolk Summer Art School Fellowship, 1954, 55; Fulbright Fellowship, 1958; L.C. Tiffany Grant, 1961; Tokyo Biennial, First Prize, Figurative Painting, 1974. **Address:** c/o Dealer. **Dealer:** Nancy Hoffman Gallery, NYC; John Berggruen Gallery, San Francisco; Fendrick Gallery, Washington, D.C. **One-man Exhibitions:** (first) Kanegis Gallery, 1958; Numero Galleria d'Arte, Florence, Italy, 1959; D'Arcy Gallery, NYC, 1962, 63; The Stable Gallery, NYC, 1965, 66, 68; Galleria Sperone, Turin, 1967 (two-man, with Lowell Nesbitt); Berkeley Gal-

lery, San Francisco, 1968; Sacramento State U., 1969; U. of California, Berkeley, 1969, 73; Wichita/AM, 1970; Reese Palley Gallery, San Francisco, 1970, 72; U. of California, San Diego, 1971; Nancy Hoffman Gallery, NYC, 1972, 73, 74, 76, 79, 80, 82, 83, 84, 86, 87, 89, 90, 92; Chicago/Contemporary, 1973; Worcester/AM (three-man), 1974; de Young, 1975; Barbara Okum Gallery, St. Louis, 1974; U. of Saskatchewan, 1975; U. of Nevada, Las Vegas, 1975; Quay Gallery, San Francisco, 1976; Roy Boyd Gallery, Chicago, 1977; Arco Center for Visual Arts, Los Angeles, 1977; Museum of Fine Arts, St. Petersburg, Fla., 1977; Fendrick Gallery, Washington, D.C., 1978; Valparaiso U., 1971; John Berggruen Gallery, San Francisco, 1978, 81, 82, 86; Columbus, Ga., 1980; Wake Forest U., 1980; U. of Connecticut, 1981; U. of Wisconsin, 1981; Allport Assoc. Gallery, Larkspur, Calif., 1982; Jacksonville/AM, 1982; Saddleback Community College, 1982; Santa Ana Community College, 1982; Richard Gray Gallery, Chicago, 1983, 86; U. of Texas, 1983; Gibbes Art Gallery, Charleston, N.C., 1985; New York Academy of Sciences, 1985; Salt Lake City Art Center, 1985; Woltjen/Udell Gallery, Edmonton, 1986; Danvenport/Municipal, 1987; Experimental Workshop, San Francisco, 1988; Fairleigh Dickinson U., 1991; Youngstown/Butler, 1991; Chattanooga/Hunter, 1992; Naples (Fla.) Philharmonic Center, 1992. **Retrospective:** SFMA, circ., 1978-79. **Group:** Brooklyn Museum; Chicago/AI, 1965; Corcoran, 1966; MOMA, Art in the Mirror, 1966, and others; ICA, U. of Pennsylvania, The Other Tradition, 1966; IX São Paulo Biennial, 1967; Los Angeles/County MA, 1967; U. of Illinois, 1967; U. of Miami, 1968; ICA, London, The Obsessive Image, 1968; Indianapolis/Herron, 1969; WMAA, Human Concern/Personal Torment, 1969; VMFA, American Painting, 1970; Darmstadt Biennial, 1970; U. of Miami, Phases of New Realism, 1972;

Chicago/AI, 1972, 74; WMAA Annual, 1973; Cincinnati/Contemporary, Options, 70/30, 1973; Los Angeles Municipal Art Gallery, Separate Realities, 1973; Hartford/Wadsworth, New/Photo Realism, 1974; Indianapolis, 1974; U. of Illinois, 1974; Oklahoma, Contemporary American Landscape, 1974; Rutgers U., A Response to the Environment, 1975; Akron/AI, Contemporary Images in Watercolor, 1976; SFMA, California Painting and Sculpture: The Modern Era, 1976; Fort Wayne/AM, Hue and Far Cry of Color, 1976; PAFA, 8 Contemporary American Realists, 1977; U. of Missouri; St. Louis, West Coast Art 1970-76, 1977; Chicago/AI, Drawings of the '70's, 1977; Huntsville Museum of Art, Ala., The Modern Era: Bay Area Update, 1977; US Department of the Interior, America 1976, 1976; Sydney, Australia, Gallery Directors Council, Illusions and Reality, 1976; Indianapolis, Perceptions of the Spirit in 20th Century American Art, 1977; Creighton U., A Century of Master Drawings, 1978; Smithsonian, New American Monotypes, circ., 1978-80; Santa Barbara, Photorealist Painting in California: A Survey, 1980; Montclair/AM, Josef Albers: His Influence, 1981; PAFA, Contemporary American Realism Since 1960, circ., 1981; San Antonio/MA, Real, Really Real, Super Real, circ., 1981; Brooklyn Museum, The American Artist as Printmaker, 1983; Laguna Beach Museum of Art, West Coast Realism, 1983; Gallery Association of N.Y. State, Hamilton, Twentieth-Century American Watercolor, 1984; U. of Nebraska, San Francisco Bay Area Painting, 1984; WMAA, Reflections of Nature, 1984; Oakland/AM, Art in the San Francisco Bay Area, 1945-1980, 1985; SFMA, American Realism (Janss), 1985; Hudson River Museum, Form or Formula: Drawing and Drawings, 1986; NMAA, Modern American Realism, 1987; RISD, The Call of the Wild, 1987; Florida International U., American Art Today: The Portrait, 1987; NAD, Realism Today, circ., 1987; The

Pennsylvania State U., Realist Watercolors, 1990; Valparaiso U., Revelation and Devotion, 1990; Youngstown/Butler, California A to Z and Return, 1990; Fort Lauderdale, 20th Century Flower Painting, 1991; Youngstown/Butler, The Flower in American Art, 1991; U. of North Carolina, Art on Paper, 1991; Miyagi Museum, Sendai, Japan, American Realism and Figurative Art, 1955-1990, circ., 1991; Leigh Yawkey Woodsen Art Museum, Wassau, Wisconsin, circ., 1992. **Collections:** Allentown/AM; Bank of America; Brooklyn Museum; U. of California, Berkeley; California College of Arts and Crafts; Charlotte/Mint; Chicago/AI; Chicago/Contemporary; Cleveland/MA; U. of Connecticut; Delaware Art Museum; Denver/AM; Des Moines; U. of Florida; Fort Worth; U. of Georgia; Hagerstown/County MFA; Hirshhorn; U. of Illinois; Jacksonville/AM; Library of Congress; Long Beach/MA; Los Angeles/County MA; MMA; U. of Massachusetts; U. of Miami; NCFA; U. of New Mexico; Oakland/AM; Omaha/Joslyn; PMA; SFMA; Sacramento/Crocker; St. Petersburg, Fla.; Santa Barbara/MA; Syracuse/Everson; Toledo/MA; Utah; VMFA; WMAA; Walker; Youngstown/Butler. **Bibliography:** *America 1976;* Arthur 1, 2, 4; Goodyear; Lindy; Lucie-Smith; Sandler 3; *Three Realists;* Ward.

RAMBERG, CHRISTINA

b. August 21, 1946, Fort Campbell, Ky. **Studied:** Chicago Art Institute School, 1968, BA; 1973, MFA. **Address:** c/o Dealer. **Dealer:** Phyllis Kind Gallery, NYC & Chicago. **One-man Exhibitions:** Phyllis Kind Gallery, Chicago, 1974, 81; Phyllis Kind Gallery, NYC, 1977, 82. **Group:** Hyde Park Art Center, Chicago, False Image, 1968, 69; Chicago/Contemporary, Don Baum Sez, "Chicago Needs Famous Artists," 1969; ICA, U. of Pennsylvania, Spirit of the Comics, 1969; Chicago/Contemporary, Chicago Imagist Art, 1972; Ottawa/Ontario, What They're Up to in Chicago, 1972; WMAA Biennials, 1972,

79; São Paulo, Biennale, 1973; Chicago
Art Institute School, Former Famous
Alumni, 1976; Sacramento/Crocker, The
Chicago Connection, 1976; WMAA, The
Figurative Tradition and the WMAA,
1980; Sunderland (Eng.) Arts Centre,
Who Chicago?, circ., 1980; Kansas
City/AI, Chicago Imagists, 1982; Chi-
cago/Contemporary, Alternative Spaces: A
History in Chicago, 1984. **Collections:**
Ball State U.; Baltimore/MA; Baxter Labo-
ratories, Chicago; Chase Manhattan Bank;
Chicago/AI; Chicago/Contemporary;
Elmhurst College; Museum des 20.
Jahrhunderts, Vienna; NCFA; Phoenix; U.
of Rochester; South Bend Art Center;
Springfield, Ill./State; WMAA. **Bibliogra-
phy:** Adrian and Born; *The Chicago
Connection;* Kirschner; *Who Chicago?*

RAMOS, MEL **b.** July 24, 1935,
Sacramento, Calif. **Studied:** San Jose State
College, 1954-55; Sacramento State Col-
lege, AB, MA, 1955-58. Traveled England,
Spain, France, Italy, 1964, Hawaii, 1967,
Africa. **Taught:** Mira Loma High School,
Sacramento, Calif., 1960-66; California
State College at Hayward, 1966- ; Arizona
State U., 1967. **Awards:** SFMA, P.P.,
1948; Oakland/AM, P.P., 1959. **Address:**
5941 Ocean View Drive, Oakland, CA
94618; Moragrega 38, Horta de San Juan
(Tarragone), Spain. **Dealer:** Louis K.
Meisel Gallery, NYC. **One-man Exhibi-
tions:** (first) The Bianchini Gallery, NYC,
1964, also 1965; David Stuart Gallery, Los
Angeles, 1965, 67, 68, 74; Galerie Rolf
Ricke, Kassel, 1966; Galerie Tobies-Silex,
Cologne, 1967; Berkeley Gallery (two-
man), 1967; SFMA, 1967; Galleries Reese
Paley, NYC, 1969; Galerie Bischofberger,
Zurich, 1971; Utah, 1972; Louis K. Meisel
Gallery, NYC, 1974, 76, 81; Krefeld/Haus
Lange, 1975; U. of Nevada, 1978; Galleria
Cadaques, Spain, 1979; Morgan Gallery,
Shawnee Mission, Mo., 1977; California
State U., Chico, 1979; U. of Nevada,
1978; Galeria Plura, Milan, 1978. **Retro-
spectives:** Krefeld/Kaiser Wilhelm, 1975;

Mel Ramos, *Unfinished Painting #1*, 1991.

Oakland/MA, 1977; Brandeis U., 1980.
Group: California Palace, 1959, 60, 61,
Painters Behind Painters, 1967; Hous-
ton/Contemporary, Pop Goes the Easel,
1963; Oakland/AM, Pop Art USA, 1963;
Los Angeles/County MA, 1963; Buffalo/Al-
bright, Mixed Media and Pop Art, 1963;
ICA, London, The Popular Image, 1963;
II American Art Biennial, Cordoba, Argen-
tina, 1964; Akademie der Kunst, Berlin,
1965; Palais des Beaux-Arts, Brussels,
1965; Hamburg, 1965; Milwaukee, 1965;
La Jolla, 1966; Portland, Ore./AM, 1968;
WMAA, Human Concern/Personal Tor-
ment, 1969; Omaha/Joslyn, Looking
West, 1970; WMAA, American Pop Art,
1974; U. of Illinois, 1974; New York Cul-
tural Center, Three Centuries of the Ameri-
can Nude, 1975; SFMA, California
Painting and Sculpture: The Modern Era,
1976; WMAA, Art About Art, 1978;
Berlin/National, Aspekte der 60er Jahre,
1978; Indianapolis, 1980; Brooklyn Muse-
um, American Drawings in Black and
White: 1970-1979, 1980; WMAA (Down-
town Branch), The Comic Art Show,

1983. **Collections:** Aachen; Indianapolis; Krefeld/Kaiser Wilhelm; Norfolk/Chrysler; Oakland/AM; SFMA; U.S. Pro Action, Inc., Reno. **Bibliography:** Alloway 1; Cummings 4; De Salvo and Schimmel; Honisch and Jensen, eds.; *Kunst um 1970;* Lippard 5; Lucie-Smith; *Mel Ramos: Watercolors;* Murken-Altrogge; Osterwold; Sager.

RANDELL, RICHARD, K.
from 2nd to 5th edition.

RATTNER, ABRAHAM **b.** July 8, 1895, Poughkeepsie, N.Y. **d.** February 14, 1978, New York. **Studied:** George Washington U.; The Corcoran School of Art; PAFA, 1916-17; Academie des Beaux-Arts, Paris; Academie Julian, Paris; Academie Ranson, Paris; Academie de la Grande Chaumiere, 1920. US Army, 1917-19. Traveled Europe, USA; resided New York and Paris. **Taught:** New School for Social Research, 1947-55; Yale U., 1949; Brooklyn Museum School, 1950-51; American Academy, Rome, 1951; U. of Illinois, 1952-54; ASL, 1954; PAFA, 1954; Sag Harbor Summer Art Center, 1956; Michigan State U., 1956-58. **Commissions:** St. Francis Monastery, Chicago, 1956; Fairmount Temple, Cleveland, 1957; Loop Synagogue, Chicago, 1958; Duluth (Minn.) Synagogue; De Waters Art Center, Flint, Mich., 1958; US Navy Department, Washington, D.C. **Awards:** PAFA, Cresson Fellowship, 1919; PAFA, Joseph E. Temple Gold Medal, 1945; Pepsi-Cola, Second Prize, 1946; La Tausca Competition, First Prize, 1947; Carnegie, Hon. Men., 1949; U. of Illinois, P.P., 1950; Corcoran, First Prize, 1953; NIAL, 1958. **One-man Exhibitions:** (first) Galerie Bonjean, Paris, 1935; Julien Levy Galleries, NYC, 1936-41; Courvoisier Gallery, San Francisco, 1940; Arts Club of Chicago, 1940; P. Rosenberg and Co., NYC, 1943, 44, 46, 48, 50, 52, 56; Stendahl Gallery, Los Angeles, 1943; Santa Barbara/MA 1943; Philadelphia Art Alliance, 1945; Arts and Crafts Club, New Orleans, 1952;

Chicago/AI, 1955; Renaissance Society, 1957; The Downtown Gallery, NYC, 1957, 58, 60, 66; Corcoran, 1958; North Shore Congregation Israel, Chicago, 1958; YWAA, 1959 (four-man); Galerie Internationale, NYC, 1961; The Contemporaries, NYC, 1967; Kennedy Gallery, NYC, 1969, 70, 72, 74, 75, 78, 79, 81; New School for Social Research, 1970; NCFA, 1976. **Retrospectives:** Baltimore/MA, 1946; Vassar College, 1948; U. of Illinois, 1952; A.F.A., circ., 1960. **Group:** PAFA; Corcoran; Chicago/AI; U. of Illinois; Carnegie; MMA; WMAA; Buffalo/Albright; Baltimore/MA; Detroit/Institute; Des Moines; New School for Social Research. **Collections:** Arizona State College; Ball State U.; Buffalo/Albright; CIT Corporation; Chicago/AI; Cornell U.; Dartmouth College; Des Moines; Detroit/Institute; Fort Worth; Hartford/Wadsworth; U. of Illinois; Jewish Museum; Johnson College; MMA; Manufacturers Hanover Trust Co.; Marquette U.; Michigan State U.; Musée du Jeu de Paume; U. of Nebraska; Newark Museum; New School for Social Research; U. of Oklahoma; PAFA; PMA; Phillips; St. Louis/City; Santa Barbara/MA; Vassar College; WMAA; Walker; Washington U.; Williams College; Yale U.; Youngstown/Butler. **Bibliography:** Baur 5, 7; Biddle 4; Eliot; Frost; Genauer; Getlein 2; **Goodrich and Baur 1, 2;** Hayter 1, 2; Janis, S.; Kootz 2; Leepa; Mendelowitz; Moser 1, Newtown 1; Nordness ed.; Pagano; Pearson 2; Pousette-Dart, ed.; Read 2; Richardson, E.P.; Weller, Wight 2. Archives.

RAUSCHENBERG, ROBERT
b. October 22, 1925, Port Arthur, Tex. **Studied:** Kansas City Art Institute and School of Design, 1946-47; Academie Julian, Paris, 1947; Black Mountain College, 1948-49, with Josef Albers; ASL, 1949-50, with Vaclav Vytlacil, Morris Kantor. US Navy. Traveled Italy, North Africa, 1952-53. In 1985 began the Rauschenberg Overseas Cultural Inter-

change (ROCI) to travel the world for five years. **Taught:** Black Mountain College, 1952. Designs stage sets and costumes for the Merce Cunningham Dance Co. (since 1955); technical director since early 1960s. **Awards:** Gallery of Modern Art, Ljubljana, Yugoslavia, V International Exhibition of Prints, First Prize, 1963; XXXII Venice Biennial, First Prize, 1964; Corcoran, First Prize, 1965; New York City Mayor's Award of Honor in Arts and Culture, 1977; RISD, President's Fellow Award, 1978; Skowhegan School, Medal for Painting, 1982; Officier des Arts et Lettres, France, 1981; Royal Academy of Fine Arts, Sweden, elected foreign member; Gallery of Modern Art, Ljubljana, Yugoslavia, International Print Biennale, Bronze Award, 1983; Grammy Award, Best Album Package for Talking Heads group, 1984; NYU, Hon. DFA, 1984; Certificate of Merit, Ministry of Culture, Beijing, 1985; American Academy of Achievement, Golden Plant Award, 1986; ICP, Art Award for Use of Photography, 1987; Florida Arts Recognition Award, for 1986, 87; National Arts Club, NYC, Gold Medal of Honor, 1989; Southern Methodist U., A. H. Meadows Award, 1989. **Address:** 381 Lafayette Street, NYC 10003. **Dealer:** M. Knoedler & Co., NYC. **One-man Exhibitions:** Betty Parsons Gallery, NYC, 1951; The Stable Gallery, NYC, 1953; Gallerie d'Arte Contemporanea, Florence, Italy, 1953; Charles Egan Gallery, 1955; Leo Castelli, Inc., NYC, 1958-61, 63, 65, 67-69, 70, 71, 73, 74, 75, 77, 79, 80, 82, 83, 84, 86; La Tartaruga, Rome, 1959; Galerie 22, Düsseldorf, 1959; Daniel Cordier, Paris, 1961; Galleria dell'Ariete, 1961; Dwan Gallery, 1962; L'Obelisco, Rome, 1963; Ileana Sonnabend Gallery, Paris, 1963, 64, 71, 72, 73, 75, 77, NYC, 1974, 77, 79, 81, 82, 83, 84; Galleria Civica d'Arte Moderna, Turin, 1964; Amerika Haus, Berlin, 1965; Contemporary Arts Society, Houston, 1965; Walker, 1965; Stockholm/National, 1965; MOMA, 1966, 68; Douglas Gallery, Vancouver,

1967, 69; Amsterdam/Stedelijk, 1968; Peale House, Philadelphia, 1968; Cologne/Kunstverein, 1968; Paris/Moderne, 1968; Fort Worth, 1969; Newport Harbor, 1969; Phoenix, 1970; Seattle/AM, 1970; ICA, U. of Pennsylvania, 1970, 71, 75; Automation House, NYC, 1970; New York Cultural Center, 1970; Minneapolis/Institute, 1970; Hannover/Kunstverein, 1970; Chicago/Contemporary, 1970; Fort Worth, 1970; Galerie Rene Ziegler, Zurich, 1970; Visual Arts Gallery, NYC, 1970; Chicago/AI, 1971; Centro C., Caracas, 1971; Galerie Buren, Stockholm, 1972; F. H. Mayor Gallery, London, 1973, 78; ACE Gallery, Venice, Calif., 1973, 74, 77, 79; Jack Glenn Gallery, San Diego, 1973; Galerie Mikro, Berlin, 1974; Jerusalem National, 1974; Modern Art Agency, Naples, 1974; Galerie Sonnabend, Geneva, 1974; Jared Sable Gallery, Toronto, 1974; Margo Leavin Gallery, Los Angeles, 1975, 76; Galerie de Gestlo, Hamburg, 1975; ACE Gallery, Vancouver, 1973, 75, 80; Galerie Tanit, Munich, 1975, 79; Museo d'Arte Radema, Venice, 1975; Greenberg Gallery, St. Louis, 1976; H.M., Brussels, 1976; Alberta College, 1976; Robinson Galleries, Houston, 1977; Galerie Rudolf Zwirner, Cologne, 1977; Linda Farris Gallery, Seattle, 1977; Janie C. Lee Gallery, Houston, 1977; Vancouver Art Gallery, 1978; Richard Gray Gallery, Chicago, 1979; Richard Hines Gallery, Seattle, 1979; Portland (Ore.) Center for the Visual Arts, 1979; Kunsthalle, Tubingen, 1979; Musée d'Art, Toulon, France, 1979; Tucson/MA, 1979; Palm Springs Desert Museum, 1979; Galerie Mathilde, Amsterdam, 1979; Ohio State U. 1980; West Coast Gallery, Newport Beach, 1980; Baltimore/MA, 1980; Cranbrook, 1980; Galleriet Kungsgatan, Lund, Sweden, 1980; Mattingly Baker Gallery, Dallas, 1980; School of Visual Arts, NYC, 1980; Galerie im Lenbachhaus, Munich, 1981; Gibbes Art Gallery, Charleston, N.C., 1981; C. Grimaldis Gallery, Baltimore, 1981; ICA, Boston, 1981; Magnuson-Lee

Gallery, Boston, 1981; The New Gallery, Cleveland, 1981; Paris/Beaubourg, 1981; Galerie Watari, Tokyo, 1981; Rosamund Felsen Gallery, Los Angeles, 1982; Flow Ace Gallery, Paris, 1982; Hara Museum, Tokyo, 1982; Long Beach/MA, 1982; MOMA, 1982; Van Straaten Gallery, Chicago, 1982; Thomas Babeor Gallery, La Jolla, Calif., 1983, 90; Canberra/National, 1983; Cooper Union, 1983; G. H. Dalsheimer, Baltimore, 1983; Flow Ace Gallery, Los Angeles, 1983; Susanne Hilberry Gallery, Birmingham, Mich., 1983; Galerie Beyeler, Basel, 1984; Foundation Maeght, 1984; Fay Gold Gallery, Atlanta, 1984; Helland Thorden Wetterling Galleries, Stockholm, 1984; Houston/Contemporary, 1984; Port Arthur (Tex.) Public Library, 1984; Center for the Fine Arts, Miami, 1984; Allan Street Gallery, Dallas, 1984; Edison Community College, 1974, 84; Castelli Graphics, NYC, 1984, 87, 89, 90; Sarasota/Ringling, 1985; Daniel Templon Gallery, Paris, 1985; Houston/Contemporary, circ., 1985; Gagosian Gallery, NYC, 1986; Acquavella Galleries, NYC, 1986; Dallas/MFA, 1986; MMA, 1987; Wetterling Gallery, Stockholm, 1987, 89; Kaj Forblom Gallery, Helsinki, 1987; Blum-Helman Gallery, NYC, 1987, 88, Los Angeles, 1987; Galerie Hans Meyer, Düsseldorf, 1987; Galerie Lucio Amelio, Naples, 1987; Texas Gallery, Houston, 1987; Waddington Galleries, London, 1987; Blue Sky Gallery, Portland, Ore., 1987; Pace/MacGill Gallery, NYC, 1988, 91; Galerie Alfred Kren, Cologne, 1988, 90; M. Knoedler & Co., NYC, 1988 (2), 89, 90, 91; Galerie Isy Brachot, Brussels, 1988; Galerie Jamileh Weber, Zurich, 1988, 89, 91; Wetterling Gallery, Gotler, Sweden, 1988; Greene Gallery, Coral Gables, 1988, 90; Fabian Carlsson Gallery, London, 1989; Ivory Kimpton Gallery, San Francisco, 1989; Akira Ikeda Gallery, Tokyo, 1989; Ace Contemporary Exhibitions, Los Angeles, 1989; Heland Wetterling Gallery, Götenberg, Sweden,

1989; Southern Methodist U., 1989; Martina Hamilton Gallery, NYC, 1989; Lorence/Monk Gallery, NYC, 1990; Scott Hanson Gallery, NYC, 1990; Lang & O'Hara Gallery, NYC, 1990; Runkel-Hue Williams, Ltd., London, 1990; Galerie Montaigne, Paris, 1990; Scott Hanson Gallery, Santa Monica, 1990; Galerie Fabien Boulakia, Paris, 1990; Feigen Gallery, Chicago, 1990; WMAA, 1990; B. R. Kornblatt Gallery, Washington, 1991; Galleria Il Gabbiano, Rome, 1991. **Retrospectives:** Jewish Museum, 1963; Whitechapel Art Gallery, London, 1964; NCFA, circ., 1976; Berlin, circ., 1980; Tate Gallery, 1981; Fundacion Juan March, Madrid, circ., 1985; Houston/Contemporary, 1985; De Menil Collection, Houston, circ., 1991. **Group:** The Stable Gallery Annuals, 1951-56; Jewish Museum, The New York School, Second Generation, 1957; A.F.A., Collage in America, circ., 1957-58; Houston/MFA, Collage International, 1958; Carnegie, 1958, 61, 64, 67; A.F.A., Art and Found Object, circ., 1959; I Paris Biennial, 1959; Daniel Cordier, Paris, Exposition Internationale de Surrealisme, 1959; MOMA, Sixteen Americans, circ., 1959; V & IX São Paulo Biennials, 1959, 67; Kassel, Documenta II & IV, 1959, 68; A.F.A., School of New York—Some Younger American Painters, 1960; Martha Jackson Gallery, New Media—New Forms, I & II, 1960, 61; Des Moines, Six Decades of American Painting, 1961; MOMA, The Art of Assemblage, circ., 1961; SRGM, Abstract Expressionists and Imagists, 1961; Galerie Rive Droite, Paris, Le Nouveau Realisme, 1961; MOMA, Abstract Watercolors and Drawings: USA, circ., Latin America and Europe, 1961-62; SRGM/USIA, American Vanguard, circ., Europe, 1961-62; Stockholm/National, 4 Americans, circ., 1962; Salon du Mai, Paris, 1962; Seattle World's Fair, 1962; III International Biennial Exhibition of Prints, Tokyo, 1962; Art: USA: Now, circ., 1962-67; SRGM, Six Painters and

the Object, circ., 1963; WGMA, The Popular Image, 1963, Musée Cantonal des Beaux-Arts, Lausanne, I Salon International de Galeries Pilotes, 1963; ICA, London, The Popular Image, 1963; El Retiro Parquet, Madrid, Arte de America y Espana, 1963; Gallery of Modern Art, Ljubljana, Yugoslavia, V International Exhibition of Prints, 1963; Brandeis U., New Directions in American Painting, 1963; Jewish Museum, Black and White, 1963; Corcoran, 1963, 65; Chicago/AI, 1963, 66; Tate, Dunn International, 1964; Hartford/Wadsworth, Black, White, and Gray, 1964; New York State Pavilion, New York World's Fair, 1964-65; SRGM, 1964, 65; Kunstverein in Hamburg, 1965; U. of Texas, 1965; Cincinnati/Contemporary, 1965; Kansas City/Nelson, Sound, Light, Silence, 1966; Flint/Institute, I Flint Invitational, 1966; Expo '67, Montreal, 1967; MOMA, The 1960's, 1967; Eindhoven, 1967; Foundation Maeght, L'Art Vivant, circ., French museums, 1968; MOMA, Dada, Surrealism and Their Heritage, 1968; Milwaukee, Directions 1: Options, circ., 1968; Jewish Museum, 1968; Vancouver, 1968; U. of California, Irvine, 1968; Arts Council of Great Britain, 1968; MMA, New York Painting and Sculpture: 1940-1970, 1969-70; Expo '70, Osaka, 1970; Los Angeles/County MA, Art & Technology, 1971; WMAA, 1973; Parcheggio di Villa Borghese, Rome, Contemporanea, 1974; Chicago/AI, Idea and Image in Recent Art, 1974; WMAA, American Pop Art, 1974; MOMA, Drawing Now, 1976; WMAA, 200 Years of American Sculpture, 1976; WMAA, New York on Paper, 1977; Williamstown/Clark, The Dada/Surrealist Heritage, 1977; Cambridge, Jubilation, 1977; Minnesota/MA, American Drawings, 1927-1977, 1977; NCFA, New Ways with Paper, 1978; WMAA, Art About Art, 1978; MOMA, Artists and Writers, 1978; Buffalo/Albright, American Painting of the 1970s, circ., 1978; Corcoran Biennial, 1979;

Denver/AM, Poets and Painters, 1979; Brooklyn Museum, American Drawings in Black and White: 1970-1979, 1980; Grand Palais, Paris, Exposition des Artistes Indépendants, 1980; Hirshhorn, The Fifties: Aspects of Painting in New York, 1980; Purchase/SUNY, Hidden Desires, 1980; Akron/AM, The Image in American Painting and Sculpture 1950-1980, 1981; Purchase/SUNY, Soundings, 1981; Amsterdam/Stedelijk, '60-'80: Attitudes/Concepts/Images, 1982; Houston/ Contemporary, The Americans: The Collage, 1982; ICA, U. of Pennsylvania, Connections, 1983; Boston/MFA, 10 Painters and Sculptors Draw, 1984; WMAA, Blam!, 1984; Venice Biennale, 1984; Los Angeles/MOCA, Automobile and Culture, 1985; Boston/MFA, 10 Painters and Sculptors Draw, 1984; National Gallery, Gemini: G.E.L., circ., 1985; Sydney/AG, Pop Art, 1955-1970, 1985; Rice U., Fifty Years of American Drawing, 1930-1980, circ., 1985; Bard College, The Maximal Implications of the Minimal Line, 1985; Frankfurt/Kunstverein, On Drawing, 1985; Brooklyn Museum, Public and Private, 1986; Munich/Lenbachhaus, Hommage a Beuys, 1986; National Gallery, Seven American Masters, 1986; Los Angeles/MOCA, Individuals, 1986; Haus der Kunst, Munich, The Automobile in Art, 1986; ICA, U. of Pennsylvania, 1967: At the Crossroads, 1987; Bard College, The Arts at Black Mountain College, 1933-1957, circ., 1987; U. of California, Berkeley, Made in USA, 1987; WMAA, 20th Century Drawings and Watercolors from the WMAA, circ., 1987; New York State Museum, Albany, Diamonds are Forever, circ., 1987; Los Angeles/County MA, Photography and Art: Interactions Since 1946, circ., 1988; U. of Massachusetts, Amherst, Contemporary American Collage, circ., 1986; Cologne/Ludwig, Marcel Duchamp and the Avant Garde Since 1950, 1988; MOMA, Committed to Print, circ., 1988; Miyagi Museum of Art, Sendai, Pictures

for the Sky, circ., 1988; SRGM, Aspects of Collage, 1988; Lyon/St. Pierre, The Color Alone, 1988; WMAA, Identity, 1988; U. of Southern Florida, Made in Florida, circ., 1989; Purchase/SUNY, Pop Prints, 1989; Paris/Moderne, L'art conceptual, une perspective, 1989; Milwaukee, Word as Image, American Art, 1960-1990, circ.,1990; Hofstra U., The Transparent Thread, circ., 1990; Makuhari Messe, Japan, Pharmakin '90, 1990; MOMA, High and Low, circ., 1990; MOMA, Seven Master Printmakers, 1991; ICA, U. of Pennsylvania, Interactions, 1991; WMAA, Biennial, 1991. **Collections:** Aachen/Ludwig; Aachen/NG; Amsterdam/Stedelijk; Baltimore/MA; Brandeis U.; Buffalo/Albright; Canberra/National; Chicago/AI; Chicago/Contemporary; Cleveland; Cologne/Ludwig; Cornell U.; Dallas/MFA; Des Moines; Detroit; Düsseldorf/KN-W; Fort Worth/AM; Goucher College; Hartford/Wadsworth; Harvard U.; Hirshhorn; Honolulu/Academy; Humlebaek/Louisiana; Israel Museum; Kansas City/Nelson; Krefeld/Kaiser Wilhelm; Louisville/Speed; MOMA; Minneapolis/Institute; NCFA; New Orleans/Museum; U. of North Carolina; PMA; Paris/Beaubourg; Pasadena/AM; SFMA; SRGM; San Diego/Contemporary; The Singer Company, Inc.; Stockholm/National; Stuttgart; Tate; Toronto; Vancouver; WMAA; Walker; Zurich. **Bibliography:** Alloway 4; Armstrong, Thomas; *Art Now 74;* Ashbery; Ashton 5; Atkinson; Battcock, ed.; Becker and Vostell; Bihalji-Merin; Calas 2; Callas, N. and E.; *Contemporanea;* Cummings 5; Danto; Davis, D.; De Salvo and Schimmel; De Vries, ed.; De Wilde 2; Diamonstein; Dienst 1; Downes, ed.; Elsen 2; *Europa/Amerika;* Finch; Friedman, ed.; Gablik; Gohr and Gachnang; *Happening & Fluxus;* Haskell 5; Honisch and Jensen, eds.; Hulten; Hunter, ed.; *Individuals;* Janis and Blesh 1; Johnson, Ellen H.; Kaprow; Kardon 3; **Katz, M.;** Kozloff 3; Kramer 2; *Kunst um*

1970; Licht, F.; Lippard 5; Lynton; *Metro;* Murken-Altrogge; Newmeyer; Nordness, ed.; O'Doherty; Osterwold; *Poets & Painters;* Read 3; *Report;* Rickey; Robert Rauschenberg; Rodman 3; Rose, B., 1, 4; Rubin 1; Russell and Gablik; Sager; Sandler 3, 5; Schwartz 1; Seitz 3; Siegel; Solnit; Sontag; Tomkins and Time-Life Books; Tuchman 1; Warhol and Hackett; Waldman 4; Weintraub; Weller.

REDER, BERNARD
from 1st to 5th edition.

REICHEK, JESSE **b.** August 16, 1916, Brooklyn, N.Y. **Studied:** Institute of Design, Chicago, 1941-42; Academie Julian, Paris (diploma), 1947-51. US Army Engineers, 1942-46. Traveled Europe, India, the Orient; resided Paris, India. **Taught:** U. of Michigan, 1946-47; Illinois Institute of Technology, 1951-53; U. of California, Berkeley, 1953-; American Academy, Rome, 1971. **Awards:** Graham Foundation Grant, 1962; Tamarind Fellowship, 1966. **Address:** 5925 Red Hill Road, Petaluma, CA 94952. **One-man Exhibitions:** (first) Galerie des Cahiers d'Art, 1951, also 1959; U. of California, 1954; Betty Parsons Gallery, 1958-60, 63, 65, 67, 68, 70; Wittenborn Gallery, NYC, 1962; Molton Gallery, London, 1962; Bennington College, 1963; American Cultural Center, Florence, Italy, 1964; U. of New Mexico, 1966; Axiom Gallery, London, 1968; Yoseido Gallery, Tokyo, 1968; Galeria Van der Voort, 1969; Los Angeles/County MA, 1971. **Retrospective:** U. of Southern California, 1967. **Group:** Brooklyn Museum, 1959; MOMA, 1962; Buffalo/Albright, 1965; Cincinnati/AM, 1966; Arts Club of Chicago, 1966; Cranbrook, 1967; Finch College, 1967; Caracas, 1969; Foundation Maeght, 1971. **Collections:** Bibliothèque Nationale; U. of California; Amon Carter Museum; Chicago/AI; Grunwald Foundation; La Jolla; Los Angeles/County MA; MOMA; U. of New Mexico; Pasadena/AM; San Diego;

Victoria and Albert Museum. **Bibliography:** *Report*.

REINHARDT, AD **b.** December

24, 1913, Buffalo, N.Y. **d.** August 30, 1967, NYC. **Studied:** Columbia U., with Meyer Schapiro, 1931-35, BA, 1936-37; NAD, 1936-37, with Francis Criss, Carl Holty; NYU, Institute of Fine Arts, 1945-51, with Alfred Salmony. US Navy photographer, 1944-45. Traveled Europe and Asia extensively. **Taught:** Brooklyn College, 1947-67; California School of Fine Arts, 1950; U. of Wyoming, 1951; Yale U., 1952-53; Syracuse U., 1957; Hunter College, 1959-67. Worked for *PM* (newspaper), NYC, 1944-47. Articles in *Art International, Art News, College Art Journal, It Is* (magazines). **Member:** American Abstract Artists, 1937-47; Asia Society; Chinese Art Society. Federal A.P.: Easel painting, 1936-39. **Awards:** Guggenheim Grant, 1967. **One-man Exhibitions:** (first) Columbia U., 1943; Artists Gallery, NYC, 1944; Mortimer Brandt, NYC, 1945; Brooklyn Museum School, 1946; Betty Parsons Gallery, NYC, 1946-53, 55, 56, 59, 60; Syracuse U., 1957; Leverkusen, 1961; Dwan Gallery, 1961, 63; Iris Clert Gallery, 1963; ICA, London, 1964; Marlborough Gallery Inc., NYC, 1970, 74, 77, 80; Irving Blum Gallery, Los Angeles, 1970; Richard Feigen Gallery, 1970; Düsseldorf/Kunsthalle, 1972; Eindhoven, 1973; Marlborough Galerie AG, Zurich, 1974; The Pace Gallery, NYC, 1976, 82; Truman Gallery, 1976; WMAA, 1980; SRGM, 1980; Margo Leavin Gallery, Los Angeles, 1984; Galerie Karsten Greve, Cologne, 1985; Staatsgalerie, Stuttgart, 1985. **Retrospectives:** Jewish Museum, 1967; Maastricht, 1990; MOMA, 1991. **Group:** New York World's Fair, 1939; American Abstract Artists Annuals; MOMA, Abstract Painting and Sculpture in America, 1951; WMAA, The New Decade, 1954-55, and others; Brussels World's Fair, 1958; SRGM, Abstract Expressionists and Imagists, 1961; Seattle World's Fair, 1962;

MOMA, Americans 1963, circ., 1963-64; Tate, 1964; WMAA, The 1930's, 1968; MOMA, The New American Painting and Sculpture, 1969; Buffalo/Albright, Color and Field: 1890-1970, 1970; Milwaukee, Color Renaissance, 1974; Indianapolis, Perceptions of the Spirit, circ., 1977; Cornell U., Abstract Expressionism: The Formative Years, circ., 1978. **Collections:** Baltimore/MA; Buffalo/Albright; Dayton/AI; Leverkusen; Los Angeles/County MA; MOMA; U. of Nebraska; Oslo/National; PMA; SFMA; Toledo/MA; WMAA; Yale U. **Bibliography:** *Abstract Expressionism;* Alloway 4; Anfam; Armstrong, Thomas; Battcock, ed.; Blesh 1; **Bois;** Calas, N. and E.; *Contemporanea;* Coplans 3; Cummings 5; Danto; De Vries, ed.; Downes, ed.; *Europa/Amerika;* Goossen 1; Hess, T.B., 1; Hobbs and Levin; Honisch and Jensen, eds.; Janis and Blesh 1; Janis, S.; Lane and Larsen; Lippard 1, 3, 7; MacAgy 2; McChesney; **Motherwell and Reinhardt, eds.;** Murken-Altrogge; Plagens; Rickey; Ritchie 1; Robins; Rodman 1; Rose, B., 1, 4; **Rose, Barbara, ed., 1, 2;** Sandler 3, 5; Seitz 3; Siegel; Tomkins 2; Tuchman, ed.; Tuchman 3; Waldman 4; Weller. Archives.

REINHARDT, SIEGFRIED GERHARD
from 1st to 5th edition.

REMINGTON, DEBORAH
b. June 25, 1930, Haddonfield, N.J. **Studied:** California School of Fine Arts, 1949-52; San Francisco Art Institute, BFA, 1955. Traveled Asia, 1955-58, Europe, 1967-68. **Taught:** San Francisco Art Institute, 1958-65, 66, 68; U. of California, Davis, 1962; San Francisco State College, 1965; Cooper Union, 1970-. **Commissions:** Cleveland Print Club, 1990; AAIAL, Purchase Award, 1988. **Awards:** Tamarind Fellowship, 1973; National Endowment for the Arts, fellowship, 1979; Guggenheim Foundation Fellowship, 1984. **Address:** 309 West Broadway, NYC 10013. **One-man Exhibitions:** SFMA,

1964; Dilexi Gallery, San Francisco, 1962, 63, 65; Bykert Gallery, 1967, 69, 72, 74; Darthea Speyer Gallery, 1968, 71, 73, 92; Obelisk Gallery, 1971; Pyramid Art Galleries, Washington, D.C., 1973, 76; Michael Berger Gallery, Pittsburgh, 1974, 79; Brooke Alexander, 1974; Zolla-Lieberman, Chicago, 1976; Hamilton Gallery of Contemporary Art, NYC, 1977; Portland (Ore.) Center for the Visual Arts, 1977; U. of Missouri, Kansas, 1977; Miami-Dade Community College, 1978; Bonfoey Gallery, Cleveland, 1980; Mary Ryan Gallery, NYC, 1982; Ramon Osuna Gallery, Washington, D.C., 1983; Adams-Middleton Gallery, 1984; Paule Anglim Associates, San Francisco, 1984; Ianuzzi Gallery, Phoenix, 1985; Southern Methodist U., 1987; Jack Shainman Gallery, NYC, 1987; Shoshana Wayne Gallery, Los Angeles, 1988. **Retrospectives:** Newport Harbor, 1983; Oakland/AM, 1984. **Group:** WMAA Annuals, 1965, 67, Recent Acquisitions, 1966; Musée Cantonal des Beaux-Arts, Lausanne, II Salon International de Galeries Pilotes, 1966; U. of Illinois Biennial, 1967; Smithsonian, The Art of Organic Forms, 1968; Foundation Maeght, l'Art Vivant, circ., French museums, 1968; U.

of North Carolina, Works on Paper, 1968; Foundation Maeght, 1970; VMFA, American Painting, 1970; Oakland/AM, A Period of Exploration, 1973; PMA/Museum of the Philadelphia Center, Focus, 1974; Chicago/AI, 71st American Exhibition, 1974; Toledo/MA, Image, Color and Form, 1975; ICA, Boston, Painting Endures, 1975; San Antonio/McNay, American Artists, '76: A Celebration, 1976; SFMA, Painting and Sculpture in California: The Modern Era, 1976; North Texas State U., Three Artists, Three Viewpoints, 1976; Chicago/AI, Drawings of the '70's, 1977; U. of Texas, Austin, New in the Seventies, 1977; Oakland/AM, Dilexi: The Dilexi Years: 1958-1970, 1984. **Collections:** Achenbach Foundation; Andover/Phillips; Auckland; CNAC; CSCS; California Palace; U. of California, Berkeley; Cleveland/MA; Crown Zellerbach Foundation; Delaware/AM; Fort Wayne/AM; Gainsville/Harn; Hartford/Wadsworth; Indianapolis; Milwaukee; NMAA; U. of New Mexico; Newport Harbor; Oakland/AM; Phoenix; Rotterdam; SFMA; Toledo/MA; WMAA. **Bibliography:** *Art: A Woman's Sensibility;* McChesney; *New in the Seventies;* Robins; Solnit. Archives.

Deborah Remington, *Araxes,* 1991.

RENOUF, EDDA b. June 17, 1943, Mexico City. **Studied:** Putney School, 1957-61; Sarah Lawrence College, BA, 1961-65; Institut d'art et d'archeologie, Paris, 1963-64; Academie Julian, Paris, 1963-64; Atelier Geitlinger, Munich, 1966-67; ASL, 1967-68; Columbia U., MFA, 1968-71; Akademie der Bildenden Kunste, Munich, 1969-70. Traveled Mexico, Iran, Turkey, India; resided Paris, 1963-64, 71-75; Munich, 1966-67, 69-70. **Taught:** Sarah Lawrence College, Paris, 1974. **Awards:** National Endowment for the Arts, 1978. **Address:** 20 West 30th Street, NYC 10001. **Dealers:** Blum-Helman Gallery, NYC; Yvon Lambert, Paris. **One-man Exhibitions:** (first) Yvon Lambert, Paris, 1972, 74, 75, 78, 84; Françoise Lambert, Milan,

Paul Resika, *Square (Rope and Pier)*, 1991.

1973, 75, 76, 78, 83; Konrad Fischer Gallery, Düsseldorf, 1974, 79; Galerie MTL, Brussels, 1974, 77; Galleria Marilena Bonomo, Bari, 1975; Rolf Preisig Gallery, Basel, 1976; Allesandro Ferranti, Rome, 1976; Julian Pretto and Co., New York, 1976; Weinberg Gallery, San Francisco, 1977, 79; Kathryn Markel Fine Arts, Inc., New York, 1977; Hartford/Wadsworth, 1978; Blum-Helman Gallery, NYC, 1978, 79, 80, 82, 85; Ugo Ferranti, Rome, 1978; Graeme Murray Gallery, Edinburgh, 1978, 81; Margo Leavin Gallery, Los Angeles, 1978; Young-Hoffman Gallery, Chicago, 1978; Ronald Greenberg Gallery, St. Louis, 1980; Carol Taylor Gallery, Dallas, 1982. **Group:** VIII Paris Biennale, 1973; Düsseldorf, Prospekt, 1973; Rome, Contemporanea, 1973; Amsterdam/Stedelijk, Fundamental Painting, 1975; Paris/Moderne, Tendances actuelles de la nouvelle peinture americaine, 1975; MOMA, Extraordinary Women, 1977; U. of California, Santa Barbara, Contemporary Drawing/New York, 1978; WMAA Biennial, 1979; Paris/Beaubourg, Livres d'Artistes, 1985; WMAA, Drawing Acquisitions 1981-85, 1985. **Collections:** Canberra/National; Chicago/AI; Cincinnati/AM; Dallas/MFA; Detroit/Institute; Grenoble; MMA; MOMA; McCrory Corp.; NYPL; PMA; Paris/Beaubourg; Purchase/SUNY; St. Louis/City; WMAA; Yale U. **Bibliography:** *Fundamentele Schilderkunst.*

RESIKA, PAUL b. August 15, 1928, NYC. **Studied:** Privately in NYC with Sol Wilson, 1940-44, and Hans Hofmann, 1945-47. Traveled France, Italy. **Taught:** U. of Oregon, 1965; ASL, 1968-69; Cooper Union, 1966-77; Dartmouth College, 1972; Skowhegan School, 1973; U. of Pennsylvania, 1974; Purchase/SUNY, 1977. **Awards:** Bordighera, Americans in Europe, P.P., 1952; L. C. Tiffany Grant, 1959; NAD, Ranger Fund P.P., 1961; Ingram Merrill Grant, 1969; AAAL, Childe Hassam Fund P.P., 1970; AAAL, 1977; NAD, Benjamin Altman Prize for Landscape, 1982; Guggenheim Foundation Fellowship, 1984. **Address:** 114 East 84th Street, NYC 10028. **Dealer:** Graham Gallery, NYC. **One-man Exhibitions:** (first) George Dix Gallery, NYC, 1948; The Peridot Gallery, 1964, 65, 67-69, 70; Washburn Gallery, Inc., 1971-73; Dartmouth College, 1972; Swain School of Design, New Bedford, Mass., 1974; Carlton Gallery, NYC, 1975; Graham Gallery, 1976, 81, 83, 85, 86; Century Association, 1982; Long Point Gallery, Provincetown, Mass., 1984; Crane Kalman Gallery, London, 1986; Kornbluth Gallery, Fair Lawn, N.J., 1986. **Retrospective:** Artists' Choice Museum, NYC, 1985. **Group:** American Painters in Venice, 1952; Hartford/Wadsworth, Figures, 1964; Swarthmore College, 1968; Rijksakademie Amsterdam, 1968; State University of New York, 1969; AAAL, 1969, 70, 71, 75; A.F.A., Realism and Surrealism in American Art, 1971; NAD, 1972, 83, 84, 85; Omaha/Joslyn, A Sense of Place, 1973; Queens Museum, New Images, 1974; AAAL, Childe Hassam Fund Exhibition, 1976; Parsons School of Design, NYC, In Praise of Space, 1976; NAD Annual, 1977. **Collections:** Bordighera; Chase Manhattan Bank; Colby College; Dartmouth College; Goddard Art Center;

Hirshhorn; Indianapolis/Herron; Lenox School; Memorial Sloan-Kettering Cancer Center, NYC; Mitsubishi Collection; NAD; U. of Nebraska; Owensboro. **Bibliography:** Ward.

RESNICK, MILTON b. January 8, 1917, Bratslav, Russia. **Studied:** Pratt Institute, 1935; American Artists School, 1936-37. US Army, 1940-45. Resided Paris, 1946-48. **Taught:** Pratt Institute, 1954-55; U. of California, Berkeley, 1955-56. Federal A.P.: Teacher. **Address:** 80 Forsyth Street, NYC 10002. **Dealer:** Robert Miller Gallery, Inc. NYC. **One-man Exhibitions:** (first) Poindexter Gallery, NYC, 1955, also, 1957, 59; de Young, 1955; Ellison Gallery, Fort Worth, 1959; Holland-Goldowsky Gallery, Chicago, 1959; The Howard Wise Gallery, Cleveland, 1960; The Howard Wise Gallery, NYC, 1960, 61, 64; Feiner Gallery, NYC, 1964; Anderson Gallery, Edgartown, Mass., 1969; Fort Worth, 1971; Max Hutchinson Gallery, NYC, 1972, 77, 79, 80, 82; Robert Miller Gallery, NYC, 1979, 85; Gruenebaum Gallery, NYC, 1983; San Jose State U., 1983; Hand in Hand Galleries, NYC, 1985. **Retrospective:** Houston/Contemporary, 1985. **Group:** WMAA Annuals, 1957, 59, 61, 63; Carnegie, 1958; Walker, 60 American Painters, 1960; SRGM, Abstract Expressionists and Imagists, 1961; USIA, Contemporary American Prints, circ., Latin America, 1961-62; Chicago/AI Annual, 1962; PAFA Annual, 1962; Seattle World's Fair, 1962; SFMA, Directions—Painting U.S.A., 1963; MOMA, The New American Painting and Sculpture, 1969; U. of California, Santa Barbara, 5 American Painters, 1974; WMAA, Frank O'Hara, A Poet Among Painters, 1974; Milwaukee, From Foreign Shores, 1976; Buffalo/Albright, American Painting of the 1970s, circ., 1978. **Collections:** Akron/AI; U. of California, Berkeley; Canberra/National; Ciba-Geigy Corp.; Cleveland/MA; Dartmouth College; Fort Worth; Hartford/Wadsworth; Honolulu Academy;

Milwaukee; MOMA; National Gallery; U. of North Carolina; NYU; Ottawa/National; Reed College; Roswell; Skidmore, Owings & Merrill, NYC; WMAA; Waitsfield/Bundy. **Bibliography:** Cathcart; *From Foreign Shores;* Goodrich and Baur 1; Hunter 1; Nordness, ed.; Passloff; Plous; Sandler 5. Archives.

RICE, DAN
from 1st to 4th edition.

RICHARDSON, SAM b. July 19, 1934, Oakland, Calif. **Studied:** California College of Arts and Crafts, 1956, BA, 1960, MFA. **Taught:** Oakland City College, 1959-60; San Jose State College, 1963-. Art Director, Museum of Contemporary Crafts, 1960-63. **Address:** 4121 Sequoyah Road, Oakland, CA 94605. **Dealer:** Fuller Goldeen, San Francisco. **One-man Exhibitions:** Hansen Gallery, San Francisco, 1961, 66, 68, 69; Humboldt (Calif.) State College, 1967; Esther Robles Gallery, Los Angeles, 1968; California State U., Fullerton, 1968, 77; U. of Nebraska, 1968; Martha Jackson Gallery, NYC, 1969, 70, 73, 74, 75, 76; Hansen-Fuller Gallery, San Francisco, 1971, 74, 75; Akron/AI, 1972; Contemporary Arts Center, Cincinnati, 1972; Mills College, 1973; Cranbrook, 1973; St. Mary's College, Moraga, Calif., 1975; Rutgers U., 1975; Dallas/MFA, 1976; Richard Gray Gallery, Chicago, 1976; Oakland/AM, 1976; U. of California, Davis, 1978; San Jose Museum of Art, 1969, 78, 82; Oakland/AM, 78; Hansen Fuller Goldeen Gallery, San Francisco, 1979, 80; Palomar College, 1979; Woodworks Gallery, San Jose, 1979; Janus Gallery, Los Angeles, 1980; Santa Barbara/MA, 1981; Klein Gallery, Chicago, 1982, 84; Fuller Goldeen, San Francisco, 1983, 85; Gwenda Jay Gallery, Chicago, 1990. **Group:** California Palace, Winter Invitational, 1961; SFMA, 1965, 66; California Palace, Painters Behind Painters, 1967; U. of Illinois, 1967, 69; Sacramento/Crocker, West Coast '68,

1968; Museum of Contemporary Crafts, Plastic as Plastic, 1968; VMAA, 1968; ICA, U. of Pennsylvania, Plastics and New Art, 1969; MOMA, New Media, New Methods, circ., 1969; Occidental College, Los Angeles, Four Directions, 1969; WMAA, Contemporary American Sculpture, 1968-69; Milwaukee, A Plastic Presence, circ., 1969; SFAI, Centennial Exhibition, 1971; Chicago/Contemporary, White on White, 1971-72; Stanford U., Sculpture '72, 1972; Vassar College, New American Landscapes, 1972; Museum of Contemporary Crafts, Creative Casting, 1973; Rutgers U., Response to the Environment, 1975; Oakland/AM, California Landscape, 1975; SFMA, California Painting and Sculpture: The Modern Era, 1976; Cornell U., Landscape: New Views, 1978; Honolulu Academy, California 3x8 Twice, 1978; Palm Springs Desert Museum, The West as Art, 1982; Oakland/AM, 100 Years of California Sculpture, 1982; Fresno Art Center, Forgotten Dimension, 1982; U. of Southern California, California Sculpture Show, circ., 1984; Oakland/AM, Art in the San Francisco Bay Area, 1945-1980, 1985. **Collections:** Dallas/MFA; Denver/AM; de Young; Fort Worth; Hirshhorn; Milwaukee; NMAA; U. of Nebraska; Oakland Museum; Palomar College; SFMA; Sacramento/Crocker; San Jose Museum of Art; U. of Sydney; WMAA; U. of Wisconsin. **Bibliography:** *California Sculpture Show.*

RICHENBURG, ROBERT B.

b. July 14, 1917, Boston, Mass. **Studied:** Boston Museum School; George Washington U.; Boston U.; The Corcoran School of Art; Ozenfant School of Art, NYC; Hofmann School; ASL, with Reginald Marsh, George Grosz. US Army, 1942-45. **Taught:** Schrivenham American U.; Brooklyn-Queens Central YMCA, 1947-51; City College of New York, 1947-52; Pratt Institute, 1951-64; Cooper Union, 1954-55; NYU, 1960-61; Cornell U., 1964-67; Hunter College, 1967-70; Ithaca

College, 1970-83. **Awards:** Boston Museum School, Scholarship; *Art in America* (magazine), New Talent. **Address:** 1006 Fireplace Road, Springs, East Hampton, N.Y. 11307. **One-man Exhibitions:** (first) Hendler Gallery, Philadelphia, 1954; Artists' Gallery, NYC, 1957; Artists' Gallery, Provincetown, 1958; Hansa Gallery, NYC, 1958; Tibor de Nagy Gallery, 1959-64; Dwan Gallery, 1960; RISD, 1960 (four-man); Santa Barbara/MA, 1961; Dayton/AI, 1962; Cornell U., 1964, 82; Colgate U., 1970; Ithaca College, 1971; Upstairs Gallery, Ithaca, N.Y. , 1976, 81; Benson Gallery, Southampton, N.Y., 1986. **Retrospectives:** Colgate U., 1970; Ithaca College, 1971. **Group:** SRGM, 1949; Eighth Street Exhibition, NYC; Ninth Street Exhibition, NYC; MOMA, The Art of Assemblage, circ., 1961; SRGM, Abstract Expressionists and Imagists, 1961; Baltimore/MA, 1961; WMAA Annuals, 1961, 64, 68, Sculpture Annuals, 1966-69; Dayton/AI, 1962; Kansas City/Nelson, 1962; U. of Illinois, 1963; Corcoran, 1963; MOMA, Hans Hofmann and His Students, circ., 1963-64; U. of Nebraska; A.F.A., New Talent, circ., 1964, also 1968-69; Seattle/AM, 1965; Hamilton College, 1965; A.F.A., The Square in Painting, 1968. **Collections:** Allentown/AM; U. of California; Hirshhorn; Ithaca College; MOMA; Norfolk; Norfolk/Chrysler; PMA; Pasadena/AM; Ridgefield/Aldrich; U. of Texas; WMAA; College of William and Mary. **Bibliography:** Seitz 4.

RICKEY, GEORGE

b. June 6, 1907, South Bend, Ind. To Scotland, 1913. **Studied:** Trinity College, Glenalmond, Scotland, 1921-26; Balliol College, Oxford, 1926-29, BA, 1941, MA with honors; Ruskin School of Drawing and of Fine Art, Oxford, 1928-29; Academie Andre Lhote and Academie Moderne, Paris, 1929-30; NYU, 1945-46; State U. of Iowa, 1947, with Maurico Lasansky; Institute of Design, Chicago,

1948-49. Traveled Europe and Mexico extensively; resided Paris, 1933-34. US Army Air Corps, 1941-45. **Taught:** Groton School, 1930-33 (history department); Knox College, 1940-41; Muhlenberg College, 1941, 1946-48; U. of Washington, 1948; Indiana U., 1949-55; Tulane U., 1955-62; U. of California, Santa Barbara, 1960; Rensselaer Polytechnic Institute, 1961-65. Editorial department, *Newsweek* magazine, 1936. Director, The Kalamazoo Institute of Arts, 1939-40. Shifted emphasis from painting to sculpture, 1950. **Member:** NIAL. **Commissions:** (murals) Olivet College, 1938-39; US Post Office, Selinsgrove, Pa., 1938; Knox College, 1940-41; (sculpture), Belle Boas Memorial Library, Baltimore Museum, 1955; Union Carbide Corp., Toronto, 1960; The Joseph H. Hirshhorn Collection, NYC, 1962; Hamburger Kunsthalle, 1963; Westland Center, Detroit, 1964; Keene Teachers College, 1964; Lytton Savings and Loan Association, Oakland, Calif., 1964; The Singer Company, Inc., 1964; Hood College, 1964; Berlin/National; Rijksmuseum Kröller-Müller; Oakland/AM; Siemens Research Center, Erlangen, Germany; Henkel GMBH, Germany; NCFA; Nordpark, Düsseldorf, 1965; State Employment Building, Albany, 1966; Omaha National Bank, 1967; Berlin/National, 1969; High Museum, 1969; The Free University, Berlin, 1969; Neue Heimat Bayern, Munich, 1969; U. of Glasgow, 1971; U. of Heidelberg, 1972; Fort Worth City Hall, 1974; US Federal Courthouse, Honolulu, 1975; Universitatsbauamt, Ulm, 1977; Ruhr U., 1978; K & B Plaza, New Orleans, 1978; Peoria Airport, 1978; Pasadena/AM, 1978; Central Trust Co., Cincinnati, 1979; Oliver Tyrone Corp., Cleveland, 1980; Jackson Hospital, Miami, 1980. **Awards:** Guggenheim Foundation Fellowship, 1960, 61; Hon. DFA, Knox College, 1970; American Institute of Architects, Fine Arts Honor Award, 1972; Hon. DFA, Williams College, 1972; Skowhegan School, Medal for Sculpture, 1973; Union College, 1973; Hon. DFA, Indiana U., 1974; Hon. Degree, Kalamazoo College, 1977; Hon. Doctor of Letters, York U., 1978; Brandeis U., Creative Arts Award, 1979; Hon. DFA, Tulane U., 1983; New York Governor's Arts Award, 1986; Elected to Akademie der Kunst, Berlin, 1987. **Address:** RD #2, East Chatham, N.Y. **Dealer:** The Maxwell Davidson Gallery, NYC. **One-man Exhibitions:** (first) Caz-Delbo Gallery, NYC, 1933; Denver/AM, 1935, 43, 45, 48; Indianapolis/Herron, 1953 (first sculpture shown); The Little Gallery, Louisville, 1954; Kraushaar Galleries, NYC, 1955, 59, 61; New Orleans/Delgado, 1956; Amerika Haus, Hamburg, 1957; Orleans Gallery, New Orleans, 1960; Santa Barbara/MA, 1960; U. of Oklahoma, 1961; Phoenix, 1961; Primus-Stuart Gallery, Los Angeles, 1962; Galerie Springer, Berlin, 1962; Grand Rapids, 1962; Hyde Park Art Center, Chicago, 1963; Williams College, 1963; U. of Rochester, 1963; Dartmouth College, 1963; ICA, Boston, 1964; David Stuart Gallery, 1964; Kalamazoo/Institute, 1964 (two-man, with Ulfert Wilke); Staempfli Gallery, NYC, 1964, 67, 71, 75; Skidmore College, 1965; Walker, 1967; Haus am Waldsee, Berlin, circ., 1969; Kunsthalle, Nurnberg, 1969; Trenton/State, 1969; Whatcom, 1970; U. of Washington, 1970; Indiana U., (three-man), 1970; U. of Iowa, 1972; Hannover/K-G, 1973; Berlin/National, 1973; Galerie Buchholz, Munich, 1974; Galerie Espace, Amsterdam, 1974; Gimpel & Hanover, Zurich, 1975, 78; Gimpel Fils, 1975; Fordham U., 1975; Bielefeld, 1976; Frankfurt am Main, 1977; Gallery Kasahara, Osaka, 1978; Amerika Haus, Berlin, 1979; Ministry of Cultural Affairs, Montreal, 1980; John Berggruen Gallery, San Francisco, 1982; The Zabriskie Gallery, 1986; Maxwell Davidson Gallery, NYC, 1988, 91. **Retrospectives:** Corcoran, 1966; SRGM, 1979; UCLA, circ., 1971; U. of Notre Dame, 1985. **Group:** Salon des

Artistes Independents, Paris, 1930; MMA, National Sculpture Exhibition, 1951; WMAA, 1952, 53, 66, 68-69, Annual, 1964; PAFA, 1953, 54; Chicago/AI, Exhibition Momentum, 1954, 55; U. of Nebraska, 1955; U. of Minnesota, 1955; MOMA, Recent Sculpture, USA, 1959; Santa Barbara/MA, 1960; Amsterdam/Stedelijk, Art in Motion, circ., Europe, 1961-62; Battersea Park, London, International Sculpture Exhibition, 1963; Kassel, Documenta III & IV, 1964, 68; Berne, 1965; Palais des Beaux-Arts, Brussels, 1965; Staatliche Kunsthalle, Baden-Baden, 1965; St. Louis Bicentennial Sculpture Exhibition, 1965; Park Sonsbeek, Holland, 1966; Los Angeles/County MA, 1967; Carnegie, 1967; XXXIV Venice Biennial, 1968; Denver/AM, Report on the Sixties, 1969; Hayward Gallery, London, Linetics, 1970; U. of Nebraska, American Sculpture, 1970; Katonah (N.Y.) Art Gallery, Drawing in Space, 1972; Newport, R.I., Monumenta, 1974; Kassel, Documenta IV, 1968; Antwerp Biennial, 1971; Hayward Gallery, London, Pier and Ocean, 1980. **Collections:** Allentown/AM; Andover/Phillips; Atlanta/AA; Auckland; Ball State U.; Baltimore/MA; Bern/Kunstmuseum; Bethlehem Steel Corp.; Bochum; Boston/MFA; Buffalo/Albright; Cincinnati/AM; Columbus; Corcoran; Dallas/MFA; Dartmouth College; Denver/AM; Detroit/Institute; Edinburgh/National; Flint/Institute; Gerald Ford Library; U. of Glasgow; Goethe Universitat; Hamburg; High Museum; Hirshhorn; Honolulu Academy; Humlebaek/Louisiana; Indiana U.; U. of Iowa; Jackson Hospital, Miami; Kalamazoo/Institute; Kansas City/Nelson; Long Beach/MA; MOMA; Max Planck Institute; Freiburg; Memphis/Brooks; Minnesota/MA; Raleigh/NCMA; NCFA; Newark Museum; U. of North Carolina; Oakland/MA; Princeton U.; Ruhr U.; St. Louis/City; Santa Barbara/MA; The Singer Company, Inc., NYC; SRGM; Storm King Art Center; Syntex Research Center, Palo Alto; Tate; Toronto; Trenton/State; Ulm U.; Union Carbide Corp.; WMAA; Walker; Yale U.; York U. **Bibliography:** Battcock, ed.; Calas, N. and E.; Chipp; Craven, W.; Davis, D.; *George Rickey;* MacAgy 2; *Monumenta;* Read 3; **Rickey;** Rodman 1; **Rosenthal, N.;** Sandler 3; Seitz 3; Selz, P., 1; Trier 1; Tuchman 1; Weintraub. Archives.

RIVERS, LARRY (Yitzroch Loiza Grossberg) **b.** August 17, 1923, Bronx, NY. 1940, changes name to Larry Rivers. US Army Air Corps, 1942-43. **Studied:** Julliard School of Music, NYC, 1944-45; Hofmann School; NYU, 1947-48. Traveled Europe, USA, USSR, Africa, Dominican Republic. Began career as a jazz saxophonist. Began sculpture 1953. Appeared on "$64,000 Question" (CBS-TV) as an art expert and ran his winnings to $32,000 on "$64,000 Challenge," 1957-58. **Commissions:** Outdoor billboard for First New York Film Festival, 1963. **Awards:** Corcoran, Third Prize, 1954. **Address:** 92 Little Plains Road, Southampton, NY 11968. **Dealers:** Marlborough Gallery, Inc., NYC; Robert Miller Gallery, NYC. **One-man Exhibitions:** (first) Jane Street Gallery, NYC, 1949; Tibor de Nagy

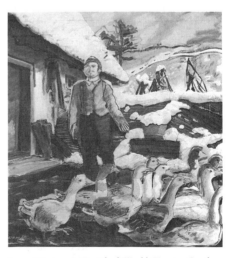

Larry Rivers, *A Vanished World, Trnava Czechoslovakia, 1936, Raising Geese (I),* 1987.

Gallery, NYC, 1951-54, 1957-60, 1962; The Stable Gallery, NYC, 1954 (sculpture); Martha Jackson Gallery, NYC, 1960 (sculpture); Dwan Gallery, 1960; Galerie Rive Droite, 1962; Gimpel Fils, London, 1962, 64, 76; Marlborough Gallery, Inc., 1970, 71, 73, 75, 77, 79, 81, 86, 88, 90; Brandeis U.; Chicago/AI, circ., 1970; Quay Gallery, 1972; Tower Gallery, Southampton, 1973; Olympia Galleries, Glenside, Pa., 1975; Robert Miller Gallery, NYC, 1977; Hokin Gallery, Chicago, 1977; ACA Gallery, NYC, 1977; Marlborough Gallery, London, 1981; Ridgefield/Aldrich, 1983; Guild Hall, 1983; Hirshhorn, 1984; Kouros Gallery, NYC, 1984; The Jewish Museum, NYC, 1984; ICA, U. of Pennsylvania, 1985; Marlborough Fine Art, Ltd., Tokyo, 1985; Simms Fine Art, New Orleans, 1987; Charleston/Gibbs, 1988; Marlborough Fine Art, London, 1990; Galerie Beaubourg, Paris, 1990; Fandos y leonarte, Valencia, 1990; Galeria Antonio Machon, Madrid, 1991; Galleria D'Arte Il Gabbiano, Rome, 1992. **Retrospectives:** Caracas/Contemporaneo, 1980; Hannover/K-G, circ., 1980; Guild Hall, circ., 1983; Youngstown/Butler, circ., 1990; Nassau County Museum, 1992. **Group:** WMAA Annuals, 1954, 58, 60, 61, 63, 66; MOMA, Twelve Americans, circ., 1956; São Paulo, 1957; Carnegie, 1958, 61; WMAA, Business Buys American Art, 1960; II Inter-American Paintings and Prints Biennial, Mexico City, 1960; Seattle World's Fair, 1962; PAFA, 1963; WMAA, Between the Fairs, 1964; WMAA, Art of the U.S. 1670-1966, 1966; Flint/Institute, I Flint Invitational, 1966; Indianapolis/Herron, 1966; SFMA, 1966; MOMA, Two Decades of American Painting, circ., Japan, India, Australia, 1967; U. of Illinois, 1967; Kassel, Documenta IV, 1968; Hirshhorn, Drawings, 1974-1984, 1984. **Collections:** Allentown/AM; Baltimore/MA; Brandeis U.; Brooklyn Museum; Buffalo/Albright; Caracas/Contemporaneo; Chicago/AI; Container Corp.

of America; Corcoran; Cuenca; Dallas/MFA; Fort Wayne/AM; Hirshhorn; Jewish Museum; Kansas City/AI; Kansas City/Nelson; Los Angeles/County MA; MMA; MOMA; Mexico City/Tamayo; Minneapolis/Institute; National Gallery; New England Merchants National Bank, Boston; New Paltz/SUNY; Norfolk/Chrysler; U. of North Carolina; RISD; Raleigh/NCMA; SFMA; Seagram Collection; Southampton/Parrish; Stockholm/SFK; Tate; Utica; Victoria and Albert Museum; Youngstown/Butler; WMAA. **Bibliography:** Alloway 1; Armstrong, Thomas; Ashbery; Calas, N. and E.; De Salvo and Schimmel; Dienst 1; Diamonstein; *The Figurative Fifties;* Friedman, ed.; Gaunt; Gettings; Goldman 1; **Harrison;** Honisch and Jensen, eds.; **Hunter 4, 5;** Hunter, ed.; Lippard 5; McCurdy, ed.; *Metro;* Murken-Altrogge; Nordness, ed.; O'Hara 1; Osterwold; *Poets & Painters;* Rivers with Brightman; Rivers with Weinstein; Rodman 1; Russell and Gablik; Sandler 3, 5; Seitz 3; Siegel; Soby 6; Tomkins 2; Ward; Warhol and Hackett; Waldman 4; Weller. Archives.

ROBINSON, BOARDMAN
from 1st to 5th edition.

ROBUS, HUGO b. May 10, 1885, Cleveland, Ohio. **d.** January 14, 1964, NYC. **Studied:** Cleveland Institute of Art, 1904-08; NAD, 1910-11; Academie de la Grand Chaumiere, 1912-14, with Antoine Bourdelle. **Taught:** Myra Carr Art School, ca. 1915-17; Columbia U., summers, 1942, 43, 46, 48, 50, 52, 53, 55, 56; Munson-Williams-Proctor Institute, Utica, N.Y., 1948; Hunter College, 1950-58; Brooklyn Museum School, 1955-56. Changed from painting to sculpture, 1920. Federal A.P.: 1937-39. **Awards:** MMA, Artists for Victory, Second Prize, 1942; PAFA, George D. Widener, Memorial Gold Medal, 1950; PAFA, Alfred G. B. Steel Memorial Prize, 1953; NIAL, Citation and Grant, 1957. **One-man**

Exhibitions: (first) Grand Central, NYC, 1946, also 1948; Utica, 1948; Corcoran, 1958; The Forum Gallery, 1963, 66, 74, 79; NCFA, 1979. **Retrospective:** A.F.A./Ford Foundation, 1961. **Group:** WMAA; PAFA; MMA; Corcoran. **Collections:** Brooklyn Museum; Cleveland/MA; Corcoran; Fairleigh Dickinson U.; IBM; Israel Museum; MMA; MOMA; NMAA; SRGM; Utica; WMAA; Walker. **Bibliography:** *Avant-Garde Painting and Sculpture in America 1910-25;* Baur 7; Brumme; Craven, W.; Goodrich and Baur 1; Mendelowitz; Marter, Tarbell, and Wechsler; Pearson 2. Archives.

ROCKBURNE, DOROTHEA

b. 1929, Verdun, Quebec, Canada. **Studied:** École des Beaux-Arts, Paris, 1947-50; Black Mountain College, 1951-56. Traveled Europe, South America, Egypt. **Taught:** School of Visual Arts, NYC; Bard College. **Award:** Brandeis U., Creative Arts Award, 1985. **Address:** 140 Grand Street, NYC 10013. **One-man Exhibitions:** (first) Bykert Gallery, NYC, 1970, 72, 73; Ileana Sonnabend Gallery, Paris, 1971; New Gallery, Cleveland, 1972; U. of Rochester, 1972; Galleria Toselli, Milan, 1972, 73, 74; Hartford College of Art, 1983; Lisson Gallery, London, 1973; Galleria Schema, Florence, 1973, 75; Daniel Weinberg Gallery, San Francisco, 1973; Galerie Charles Kriwin, Brussels, 1975; John Weber Gallery, NYC, 1976, 78; Texas Gallery, Houston, 1979, 81; David Bellman Gallery, Toronto, 1981; Xavier Fourcade, Inc., 1981, 82, 85; Galleriet, Lund, Sweden, 1982; Margo Leavin Gallery, 1982, 83. **Group:** WMAA, Annuals, 1970, 72, 73; Chicago/AI, 1972, 76; Chicago/Contemporary, White on White, 1972; Festival of Two Worlds, Spoleto, 1972; Kassel, Documenta V & VI, 1972, 77; New York Cultural Center, 3D into 2D, 1973; WMAA, American Drawings: 1963-1973, 1973; MOMA, Eight Contemporary Artists, 1974; Corcoran, 1975; Houston/MFA, Modern Paint-

ing, 1900 to the Present, 1975; Paris/Moderne, Tendances actuelles de la peinture americaine, 1975; MOMA, Drawing Now, 1976; MOMA, Extraordinary Women, 1977; WMAA Biennials, 1977, 79; U. of California, Santa Barbara, Contemporary Drawing/New York, 1978; U. of North Carolina, Drawings About Drawing Today, 1979; New Museum, The 1970s: New American Painting, 1979; Brooklyn Museum, American Drawings in Black and White: 1970-1979, 1980; XXXIX Venice Biennial, 1980; MOMA, A Century of Modern Drawing, 1982; WMAA, Abstract Drawings, 1911-1981, 1982; New Museum, Language, Drama, Source & Vision, 1983; U. of North Carolina, Art on Paper, 1984; Fort Lauderdale, An American Renaissance: Painting and Sculpture Since 1940, 1986. **Collections:** Aachen/Ludwig; Auckland; Harvard U.; High Museum; MMA; MOMA; U. of Michigan; Minneapolis/Institute; Ohio State U.; WMAA. **Bibliography:** Robins; Tuchman 3; Weintraub.

ROCKLIN, RAYMOND

b. August 18, 1922, Moodus, Conn. **Studied:** MOMA School, 1940; Cooper Union, 1951, with Milton Hebald, John Hovannes, Warren Wheelock; Educational Alliance, NYC, with Abbo Ostrowsky; Temple U., 1942; Cooper Union, BFA, 1977. Traveled Europe, USA, Middle East. **Taught:** American U., 1956; City University of New York, 1959-; U. of California, Berkeley, 1959-60; Scarsdale Studio Workshop, 1960-; Ball State Teachers College, 1964; YMHA, Essex County, N.J., 1971-74; Manhattan Community College, 1977-. **Member:** Sculptors Guild. **Awards:** Fulbright Fellowship (Italy), 1952; Yaddo Fellowship, 1956. **Address:** 232B Watch Hill Road, Peekskill, NY 10566. **One-man Exhibitions:** (first) Tanager Gallery, NYC, 1956; American U., 1956; Oakland/AM, 1956; U. of California, Berkeley, 1959; Pomona College, 1960; Santa Barbara/MA, 1960;

Dilexi Gallery, San Francisco, 1960; The Bertha Schaefer Gallery, NYC, 1960 (two-man); Ball State Teachers College, 1964; Briarcliff College, 1973. **Group:** WMAA, Young America; WMAA, New Talent, 1957; U. of Illinois, 1959; WMAA Annual, 1960; Claude Bernard, Paris, 1960; American Abstract Artists Annuals; U. of Nebraska, 1960. **Collections:** Diamond Shamrock Corp.; Norfolk/Chrysler; Skowhegan School; Temple Israel, St. Louis; WMAA. **Bibliography:** Seuphor 3.

ROESCH, KURT
from 1st to 4th edition.

ROGALSKI, WALTER
from 1st to 4th edition.

ROHM, ROBERT b. February 6,
1934, Cincinnati, Ohio. **Studied:** Pratt Institute, B. Industrial Design, 1956; Cranbrook Academy of Art (with Bethold Schweitz), MFA, 1960. Traveled USA, England; resided Mexico, 1964; traveled around the world, 1980. **Taught:** Columbus College of Art and Design, 1956-59; Pratt Institute, 1960-65; U. of Rhode Island, 1965-; Stourbridge (Eng.) College of Art, 1974. **Member:** Sculptors Guild. **Awards:** PAFA, Hon. Men., 1959; Columbus, Sculpture Prize, 1957, 59; Guggenheim Foundation Fellowship, 1964; U. of Rhode Island, Research Grant-in-Aid, 1965, 66, 69; Cassandra Foundation, 1966; Rhode Island State Council on the Arts Grant, 1973, 82; National Endowment for the Arts, 1974. **Address:** 26 Lake Street, Wakefield, RI 02879. **Dealers:** OK Harris Works of Art, NYC; Nielsen Gallery, Boston. **One-man Exhibitions:** Columbus (two-man), 1958; Aspen, (Colo.) Art Gallery, 1963; Royal Marks Gallery, 1964; U. of Rhode Island, 1966, 72; U. of Maine (two-man), 1969; Nova Scotia College of Art and Design, Halifax, 1969; Massachusetts College of Art, Boston, 1970; Parker Street 470 Gallery, Boston, 1970, 72; OK Harris Works

Robert Rohm, *Untitled (Two Tips)*, 1992.

of Art, NYC, 1970, 72, 73, 76, 77, 80, 82, 84, 86; U. of Rochester, 1971; Hobart and William Smith College, 1973; Boston/MFA (two-man), 1974; Suzette Schochett Gallery, Newport, R.I., 1978; Worcester/AM, 1979; Nielsen Gallery, 1985.; La Jolla, 1985; U. of Rhode Island, 1981. **Group:** PAFA, 1961; Silvermine Guild, 1962; Aspen (Colo.) Art Gallery, 1963; Waitsfield/Bundy, Bundy Sculpture Competition, 1963; WMAA Annual, 1963, 64, 70, 73; Tufts U., 1968; The Pennsylvania State U., 1968; WMAA, 1969; Lincoln, Mass./De Cordova, 1969; Trenton/State, Soft Art, 1969; WMAA, Anti-Illusion: Procedures/Materials, 1969; Seattle/AM, 557,087, 1969; Indianapolis,

1970; MIT, Six Artists, 1970: ICA, Boston, Art on Paper, 1970; New Delhi, Second World Triennial, 1971; Harvard U., Recent Abstract Art, 1971; U. of Rochester, N.Y., Drawings and Prints—New York, 1977; WMAA, The Sculptor as Draftsman, circ., 1983. **Collections:** Brandeis U.; Columbus; Federal Reserve Bank, NYC; Fontana-Hollywood Corp.; MMA; MOMA; Oberlin College; U. of New Mexico; The Pennsylvania State U.; St. Lawrence U.; Sarah Lawrence College; VMFA; Waitsfield/Bundy; Worcester/AM; WMAA; Zurich. **Bibliography:** Monte and Tucker.

RONALD, WILLIAM
from 1st to 4th edition.

ROOD, JOHN
from 1st to 4th edition.

ROSATI, JAMES b. 1912, Washington, Pa. Violinist with the Pittsburgh Symphony for two years. **Taught:** Cooper Union; Pratt Institute; Yale U., 1960-73; U. of Pennsylvania, 1977-79; Dartmouth College, 1960-73; Federal A.P.: Sculptor. **Commissions:** St. John's Abbey, Collegeville, Minn. (sculpture). **Awards:** Brandeis U., Creative Arts Award, 1960; Chicago/AI, The Mr. & Mrs. Frank G. Logan Medal and Prize, 1962; Carborundum Major Abrasive Marketing Award, 1963; Guggenheim Foundation Fellowship, 1964; National Council on the Arts Grant, 1968; Design in Steel Award, American Iron and Steel Institute, 1973. **Address:** 56 Seventh Avenue, NYC, 10014. **Dealer:** Marlborough Gallery, Inc., NYC. **One-man Exhibitions:** (first) The Peridot Gallery, NYC, 1954; Otto Gerson Gallery, NYC, 1959, 62; Dartmouth College, 1963; Colgate U., 1968; Brandeis U., 1969; Buffalo/Albright, 1970; Yale U., 1970; Marlborough Gallery, Inc., NYC, 1970, 77, 81; Gibbes Art Gallery, Charleston, S.C., 1981. **Group:** Ninth Street Exhibition, NYC, 1951;

WMAA Annuals, 1952, 53, 54, 60, 62, 66; Carnegie, 1958, 61, 64; Claude Bernard, Paris, 1960; A.F.A., Contemporary Sculpture, 1960; International Outdoor Sculpture Exhibitions, Otterlo, Holland, 1961; Chicago/AI, 1961, 62; Seattle World's Fair, 1962; WMAA, First Five Years, 1962; Festival of Two Worlds, Spoleto, 1962; Battersea Park, London, International Sculpture Exhibition, 1963; New York World's Fair, 1964-65; Flint/Institute, I Flint Invitational, 1966; Colby College, 1967; Museum of Contemporary Crafts, circ., 1967-68; HemisFair, San Antonio, 1968; Grand Rapids, Sculpture of the 60s, 1969; Foundation Maeght, l'Art Vivant Aux Etats Unis, 1979; U. of Nebraska, American Sculpture, 1970; Baltimore/MA, The Partial Figure in Modern Sculpture, 1970; Antwerp, Biennial Middleheim, 1971; Newport, R.I., Monumenta, 1974; U. of Massachusetts, Artist and Fabricator, 1975; Stamford Museum, The American Salon des refusés, 1976. **Collections:** Atlantic Richfield Oil Co., Los Angeles; Bank of Oklahoma, Tulsa; Blount, Inc.; Buffalo/Albright; Brandeis U.; Carnegie; Ciba-Geigy Corp.; Colby College; Crown Plaza Hotel; Dartmouth College; Davenport/Municipal; Drake U.; Edmonton Art Gallery; Hirshhorn; Honolulu Academy; The Hubert Humphrey Building, Washington, D.C.; Mexico City/Tamayo; MOMA; National Gallery; City of Riverside; Spencer Museum of Art, Lawrence, Kans.; NYU; Newark Museum; Park Hilton Hotel, Seattle; Prudential Insurance Co. of America; Rockefeller University; WMAA; City of Wichita; World Trade Center; Yale U. **Bibliography:** Davies; *Monumenta;* Read 3; Selz, J.; Seuphor 3.

ROSEMAN, HARRY
In 5th edition.

ROSENBORG, RALPH
from 1st to 3rd edition.

ROSENQUIST, JAMES b. November 29, 1933, Grand Forks, N.D. **Studied:** U. of Minnesota, AA, 1954. **Commission:** Florida State Capitol, Tallahassee, 1978 (Mural). **Awards:** Torcuato di Tella, Buenos Aires, International Prize, 1965. **Address:** Box 4, Aripeka, FL 33502; 162 Chambers Street, NYC 10007. **Dealer:** Leo Castelli, Inc., NYC. **One-man Exhibitions:** (first) Green Gallery, NYC, 1962, also 1964; Dwan Gallery, 1964; Ileana Sonnabend Gallery, Paris, 1964, 65, 68, 79; Ganeria d'Arte Contemporaneo, Turin, 1965; Leo Castelli, Inc., 1965, 66, 69, 70, 73, 75, 77, 81; Stockholm/National, 1966; Amsterdam/Stedelijk, 1966, 73; Berne, 1966; Humlebaek/Louisiana, 1966; Staatliche Kunsthalle, Baden-Baden, 1966; Ottawa/National, 1968; Galleria Sperone, Turin, 1968; MMA, 1968; Galerie Rolf Ricke, 1970; Cologne, 1972; Margo Leavin Gallery, 1972, 74; Chicago/Contemporary, 1972; Courtney Sales Gallery, Dallas, 1973; Jack Glenn Gallery, Corona del Mar, 1973; Portland (Ore.) Center for the Visual Arts, 1973; Max Protetch Gallery, Washington, D.C., 1974; Jared Sable Gallery, Toronto, 1974; Galerie Michael Pabst, Vienna, 1974; Gallery A, Sydney, Australia, 1976; The Berenson Gallery, Bay Harbor Islands, Miami Beach, Fla., 1976; Corcoran & Greenberg, Inc., Coral Gables, Fla., 1976; F.H. Mayor Gallery, London, 1976, 78, 82; Paule Anglim Associates, San Francisco, 1976; Ronald Greenberg Gallery, St. Louis, 1976; Sable-Castelli Gallery, Ltd., Toronto, 1977; National Gallery of Victoria, Melbourne, Australia, 1977; Institute of Modern Art, Brisbane, 1977; Ringling, 1979; The Plains Art Museum, Moorhead, Minn., 1979; Multiples, NYC, 1978; Buffalo/Albright, 1979; Castelli Feigen Corcoran, NYC, 1980, 82; Texas Gallery, Houston, 1980; Castelli-Goodman-Solomon, East Hampton, N.Y., 1981; Dolly Fiterman Gallery, Minneapolis, 1981; Colorado State U., 1982; Barbara Gillman Gallery, Miami, 1982; Thorden Wetterling Galleries, Goteborg, 1983, 84; Van Straaten Gallery, Chicago, 1983; U. of Southern Florida, 1984. **Retrospective:** Denver/AM, circ., 1985. **Group:** Hartford/Wadsworth, 1962; Dallas/MFA, 1962; WGMA, The Popular Image, 1962; Chicago/AI, 1962, 66; SRGM, Six Painters and the Object, 1963; Buffalo/Albright, Mixed Media and Pop Art, 1963; ICA, U. of Pennsylvania, The Atmosphere of '64, 1964; Salon du mai, Paris, 1964; Tate, Dunn International, 1964; Amsterdam/Stedelijk, American Pop Art, 1964; New York State Pavilion, New York World's Fair, 1964-65; Worcester/AM, 1965; Palais des Beaux-Arts, Brussels, 1965; Torcuato di Tella, Buenos Aires, 1965; Hamburger Kunstkabinett, 1965; MOMA, Around the Automobile, 1965; Kansas City/Nelson, Sound, Light, Silence, 1966; Flint/Institute, I Flint Invitational, 1966; Expo '67, Montreal, 1967; IX São Paulo Biennial, 1967; MOMA, The 1960s, 1967; Eindhoven, 1967; Palazzo Grassi, Venice, 1967; WMAA Annual, 1967; Kassel, Documenta IV, 1968; Vancouver, 1969; U. of California, Irvine, New York: The Second Breakthrough 1959-1964, 1969; Hayward Gallery, London, Pop Art, 1969; MMA, Prints by Four New York Painters, 1969, New York Painting and Sculpture: 1940-1970, 1969-70; VMFA, American Painting, 1970; Foundation Maeght, 1970; Indiana U., American Scene: 1900-1970, 1970; Buffalo/Albright, Kid Stuff, 1971; Los Angeles/County MA, Art & Technology, 1971; Musee Galleria, Paris, Festival d'Automne, 1973; Yale U., American Art—Third Quarter Century, 1973; WMAA, American Pop Art, 1974; MOMA, Works from Change, 1974; MMA, Contemporary American Prints, 1976; Williamstown/Clark, The Dada/Surrealist Heritage, 1977; Cambridge, Jubiliation, 1977; Venice Biennial, 1978; Flint/Institute, Art and the Automobile, 1978; Buffalo/Albright, American Painting of the 1970s, circ., 1978; Scripps College,

Black and White Are Colors: Paintings of the 1950s-1970s, 1979; Brooklyn Museum, American Drawings in Black and White: 1970-1979, 1980; Istituto di Cultura di Palazzo Grassi, Venice, Pop Art: Evolution of a Generation, 1980; Norfolk/Chrysler, American Figurative Painting, 1950-1980, 1980; Purchase/SUNY, Hidden Desires, 1980; Walker, Artist and Printer, 1980; Akron/AM, The Image in American Painting and Sculpture, 1950-1980, 1981; WMAA, American Prints: Process and Proofs, 1981; WMAA Biennial, 1981; Houston/Contemporary, The Americans: Collage, 1982; Krefeld/Haus Lange, Sweet Dreams Baby!: American Pop Graphics, 1983; Boston/MFA, 10 Painters and Sculptors Draw, 1984; WMAA, Blam!, 1984. **Collections:** Aachen; Brandeis U.; Buffalo/Albright; Chicago/Contemporary; Dallas/MFA; Hirshhorn; MMA; MOMA; Nagaoka, Japan; Norfolk/Chrysler; Oberlin College; Ottawa/National; Paris/Beaubourg; Pasadena/AM; State Capitol Building, Tallahassee; Stockholm/National; Purchase/SUNY; Toronto; Tate; WMAA. **Bibliography:** Alloway 1; Armstrong, Thomas; Becker and Vostell; Bihalji-Merin; *Black and White Are Colors;* Calas 2; Cummings 5; Danto; De Salvo and Schimmel; Goldman 1; **Goldman 2;** Haskell 5; Honisch and Jensen, eds.; Hughes; Hulten; Hunter, ed.; *Individuals;* Johnson, Ellen H.; Kozloff 3; Lippard 2; *Metro;* Murken-Altrogge; Osterwold; Pincus-Witten; *Report;* Rose, B., 1; Rublowsky; Russell and Gablik; Sandler 3, 5; Seitz 3; Siegel; Tomkins 2; Tomkins and Time-Life Books; Waldman 4; Warhol and Hackett; Weller.

ROSENTHAL, BERNARD

(Tony) b. August 9, 1914, Highland Park, Ill. **Studied:** U. of Michigan, 1936, BA; Chicago Art Institute School; Cranbrook Academy of Art, with Carl Milles. Corps of Army Engineers, 1942-46. Traveled Mexico, Europe, USA, France. **Taught:** California School of Art, 1947-48; UCLA, 1953. Federal A.P.: U.S. Post Office, Nakomis, Ill. (relief). **Commissions:** Elgin Watch Building, New York World's Fair, 1939; Museum of Science and Industry, Chicago, 1941; General Petroleum Building, Los Angeles, 1949; 260 Beverly Drive, Beverly Hills, 1950 (bronze reliefs, 3 stories high); Bullock's Westwood, Los Angeles, 1951; RKO Studios, Hollywood, 1952; UCLA Elementary School, 1952; J. W. Robinson Department Store, Beverly Hills, 1952; Capri Theatre, San Diego, 1954; 1000 Lake Shore Drive, Chicago, 1954 (30-ft. relief); Beverly Hilton Hotel, Beverly Hills, 1955; Temple Emanuel, Beverly Hills, 1955; Century City (Alcoa Development), 1963; U. of Michigan, 1968; CSCS, Fullerton, 1969; NYC Department of Parks, for Astor Place, 1967; City of New York, Police Headquarters, 1971; to design and execute a sculpture park in NYC, 1980; Temple Beth-El, Birmingham, Michigan, 1973; Cranbrook, 1980. **Awards:** SFMA, Sculpture Award, 1950; Los Angeles/County MA, P.P., 1950; Los Angeles All-City Show, Sculpture Prize, 1951; Audubon Artists, Sculpture Award, 1953; PAFA, Hon. Men., 1954; Los Angeles/County MA, Sculpture Award, 1957; American Institute of Architects, Southern California Chapter, Honor Award, 1959; Ford Foundation, P.P., 1963; Tamarind Fellowship, 1964; U. of Michigan, Outstanding Achievement Award, 1967; Carborundum Major Abrasive Marketing Award, 1969; American Iron and Steel Instrument, Design in Steel Award, 1975. **Address:** 173 East 73rd Street, NYC 10021. **Dealer:** M. Knoedler & Co., NYC. **One-man Exhibitions:** (first) Pat Wall Gallery, Monterey, 1947; A.A.A. Gallery, Chicago, 1947; Scripps College, 1948; SFMA, 1950; A.A.A. Gallery, NYC, 1950; Santa Barbara/MA, 1952; Long Beach/MA, 1952; Catherine Viviano Gallery, NYC, 1954, 58, 59; Carnegie, 1959; The Kootz Gallery, NYC, 1961, 63, 66;

M. Knoedler & Co. 1968, 77; Gertrude Kasle Gallery, Detroit, 1973; Hammarskjöld Sculpture Plaza, NYC, 1977; Federal Plaza, NYC, 1977; Cranbrook, 1980. **Group:** MMA; MOMA; São Paulo Biennial; Brussels World's Fair, 1958; Chicago/AI; PAFA; Sculptors Guild; Audubon Artists; Walker; ICA, Boston; Yale U.; WMAA, 1964, 66, 68; Buffalo/Albright, 1965; Boston/MFA, 1966; Sculpture in Environment, New York Citywide Exhibition, 1967; HemisFair '68, San Antonio, Tex., 1968; Grand Rapids, Sculpture of the 60s, 1969; Cincinnati/Contemporary, Monumental Art, 1970; Indianapolis, Seven Outside, 1971; U. of Illinois, 1971; Newport, R.I., Monumenta, 1974; Stamford Museum, The American Salon des refusés, 1976; P.S. 1, Long Island City, N.Y., A Great Big Drawing Show, 1979. **Collections:** Antwerp/Middelheim; Arizona State College; Astor Place, NYC; Baltimore/MA; Buffalo/Albright; Calcutta; Carborundum Company; Connecticut College; U. of Illinois; Indianapolis; Indianapolis/Herron; Jerusalem/National; Lincoln, Mass./De Cordova; Long Beach/MA; Los Angeles/County MA; Lytton Savings and Loan Association; MOMA; U. of Michigan; Milwaukee; NCFA; NYU; New School; Newark Museum; Norfolk/Chrysler; Princeton U.; Ridgefield/Aldrich; SRGM; San Diego; Santa Barbara/MA; South Mall, Albany; Springfield, Ill./State; Stony Brook/SUNY; UCLA; Yale U.; WMAA; Xerox Corp. **Bibliography:** Hunter 8; *Monumenta;* Read 3; Rodman 2; Trier 1. Archives.

ROSS, CHARLES b. December 17, 1937, Philadelphia, Pa. **Studied:** U. of California, AB, 1960, MA, 1962, **Taught:** U. of California, 1962, 65; Cornell U., 1964; U. of Kentucky, Artist-in-Residence, 1965; School of Visual Arts, NYC, 1967, 70-71; Herbert H. Lehman College, Bronx, N.Y., 1968; U. of Utah, 1972-74; MIT, 1977. Codirector and collaborator, Dancers' Workshop Company, San Fran-

cisco, 1964-66. Films: *Sunlight Dispersion,* 16 mm, 1972; *Arisaig, July 10, 1972,* 16 mm, 1972. **Commissions:** Temple of Porat Yeshivat Joseph, Jerusalem, 1972; GSA, Federal Building, Lincoln, Neb., 1975; U. of Pennsylvania, 1977; Prestonwood Town Center, Dallas, 1978; Dietrich Foundation, Phila., 1978; Lincoln Court Building, Denver, 1980; Grand Rapids, 1982; Towson State U., 1983; Plaza of the Americas, Dallas, 1985; Wells Fargo Bldg., San Diego, 1986. **Awards:** U. of California, James D. Phelan Traveling Scholarship, 1962; National Endowment for the Arts, grant, 1976. **Address:** 383 West Broadway, NYC 10012. **Dealer:** Joyce Schwartz Ltd., NYC. **One-man Exhibitions:** (first) Dilexi Gallery, San Francisco, 1961, also 1965, 66, 68; RAC, 1962; Cornell U., 1964; U. of Kentucky, 1965; Dwan Gallery, 1968, 69, 71; Dayton's Gallery 12, Minneapolis, 1968; John Weber Gallery, 1972, 79, 81; The Clocktower, NYC, 1974; Utah, 1975; La Jolla, 1976; Chicago/Contemporary, 1977; John Weber Gallery and Susan Caldwell Inc., 1977; MIT, 1977; Portland (Ore.) Center for the Visual Arts, 1981; Heydt-Blair Gallery, Santa Fe, 1982; BMW Museum, Munich, 1983; Bard College, 1984; School of Visual Arts, NYC, 1985. **Group:** Judson Dance Theater, NYC, A Collaborative Event (with the Judson Dancers), 1963; Musée Cantonal des Beaux-Arts, Lausanne, II Salon International de Galeries Pilotes, 1966; Paris Biennial; Architectural League of New York, 1967; A.F.A., 1967; Finch College, 1967; Ridgefield/Aldrich, 1967; Kansas City/Nelson, The Magic Theatre, 1968; Newark Museum, 1968; Milwaukee, Directions I: Options, circ., 1968; Prospect '68, Düsseldorf, 1968; ICA, U. of Pennsylvania; WMAA Sculpture Annual, 1969; Toronto, New Alchemy: Elements, Systems, Forces, 1969; Düsseldorf/Kunsthalle, Prospect '69, '71, 1969, 71; Finch College, NYC, Projected Art, 1971; U. of Wisconsin, Earth, Air, Fire, Water, 1974; Indianapolis, 1974;

Leverkusen, Drawings 3: American Drawings, 1975; U. of Colorado, Locate, Order, Measure, 1975; Philadelphia College of Art, Time, 1977; Museum of Natural History, NYC, Maps: Their Science and Their Art, 1977; Hirshhorn, Probing the Earth, 1977; Worcester, Two Decades of American Printmakers, 1957-1977, 1978; Taft Museum, Galaxies, 1978. **Collections:** U. of California, Berkeley; Champion International Corp.; City of Chicago; Indianapolis; Kansas City/Nelson; Security Pacific National Bank; Towson State U.; WMAA. **Bibliography:** Atkinson; Weintraub.

ROSSI, BARBARA b. September 20, 1940, Chicago. **Studied:** Chicago Art Institute School, 1968-70, MFA, with Ray Yoshida and Whitney Halsted. Traveled India, Western Europe. **Taught:** Chicago Art Institute School, 1971-. **Awards:** National Endowment for the Arts, 1971, 85; Indo-US Subcommission on Education and Culture Research, fellowship, 1985. **Address:** 1420 Newcastle, Westchester, Ill. 60153. **Dealer:** Phyllis Kind Gallery, Chicago and NYC. **One-man Exhibitions:** Phyllis Kind Gallery, NYC, 1975, 76, 78, 82; Phyllis Kind Gallery, Chicago, 1980, 83. **Group:** Chicago/Contemporary, Dan Baum Sez, "Chicago Needs Famous Artists," 1969; ICA, U. of Pennsylvania, Spirit of the Comics, 1969; Chicago/Contemporary, Chicago Imagist Art, 1972; Ottawa/Ontario, What They're Up to in Chicago, 1972; WMAA, American Drawings, 1963-1973, 1973; São Paulo, Biennial, 1973; WMAA Biennial, 1975; Chicago Art Institute School, Former Famous Alumni, 1976; Sacramento/Crocker, The Chicago Connection, 1977; U. of Texas, New in the Seventies, 1977; Hirshhorn, Directions, 1979; Ridgefield/Aldrich, New Dimensions in Drawing, 1981; Sunderland (Eng.) Arts Centre, Who Chicago?, circ., 1980; Kansas City/AI, Chicago Imagists, 1982; Illinois Wesleyan U., Contemporary Chicago Imagists, 1983. **Collections:** Ball State U.; Baltimore/MA; Chase Manhattan Bank;

Chicago/AI; Chicago/Contemporary; Harvard U.; Indianapolis; Mid-America Club, Chicago; Museum des 20. Jahrhunderts, Vienna; NMAA; U. of North Carolina; Northwestern U. **Bibliography: Adrian** 1, 2; Adrian and Born; *The Chicago Connection;* Kirschner; *New in the Seventies; Who Chicago?*

ROSZAK, THEODORE b. May 1, 1907, Pozman, Poland. **d.** Sept. 2, 1981, NYC. **Studied:** Columbia U., 1925-26; Chicago Art Institute School, 1922-29, with John W. Norton, Boris Anisfeld; NAD, 1925-26, with C. W. Hawthorne. Traveled Latin America, Europe extensively. **Taught:** Chicago Art Institute School, 1927-29; Design Laboratory, NYC, 1938-40; Sarah Lawrence College, 1940-56; Columbia U., 1970-72; lectured at many museums and universities. Began abstract constructions, 1936, free-form sculpture, 1946. **Member:** Commission of Fine Arts, Washington, D.C. (appointed for 1963-67); Advisory Committee on the Arts, US State Department (appointed for 1963-67); National Council on Art and Government. Federal A.P.: Easel painting; New York City Art Commission, 1969-75; NIAL. **Commissions:** Yale & Towne, Inc.; MIT (spire and bell tower); Reynolds Metals Co. (aluminum sculpture memorial); American Embassy, London; Maremont Building, Chicago; New York World's Fair, 1964-65; New Public Health Laboratory, NYC (outdoor sculpture), 1968; Lafayette Square, Washington, D.C.; Court of Claims, NYC. **Awards:** World's Fair, Poland, 1929, Silver Medal; Chicago/AI, Joseph N. Eisendrath Prize, 1934; Chicago/AI, The Mr. & Mrs. Frank G. Logan Medal, 1947, 51; I São Paulo Biennial, 1951; ICA, London/Tate, International Unknown Political Prisoner Competition, 1953; PAFA, George D. Widener Memorial Gold Medal, 1958; Chicago/AI, Campana Prize, 1961; Ball State Teachers College, Griner Award, 1962; elected to the NIAL; Century Association, Medal for

Sculpture. **One-man Exhibitions:** (first) Allerton Galleries, Chicago, 1928; Nicholas Roerich Museum, 1935; Albany/Institute, 1936; Artists' Gallery, NYC, 1941; Julien Levy Galleries, NYC, 1941; Pierre Matisse Gallery, NYC, 1957, 62, 74, 76; ICA, Boston, circ., 1959; XXX Venice Biennial, 1960; Century Association, 1971; Harold Ernst Gallery, 1973; Arts Club of Chicago, 1977; Fairweather-Hardin Gallery, Chicago, 1977; The Zabriskie Gallery, NYC, 1978, 85; MIT, 1979; Fort Lauderdale, 1981; WMAA, 1984; SFMA, 1984; Hirschl & Adler Galleries, NYC, 1989, 92; Wichita/AM, 1986. **Retrospectives:** WMAA, circ., 1956; The Drawing Society, circ., 1992. **Group:** Chicago/AI Annuals, 1931, 32, 35, 37, 38, 41; WMAA Annuals, 1932-38, 41, 57, 58, 59, 62, 64-68; A Century of Progress, Chicago, 1933-34; MOMA, Fourteen Americans, circ., 1946; PAFA, 1946, 64; A.F.A., Tradition and Experiment in Modern Sculpture, circ., 1950-51; Kassel, Documenta I & II, 1955, 59; Brussels World's Fair, 1958; Carnegie, 1958; NIAL, 1958, 59; Tate, 1959; American Painting and Sculpture, Moscow, 1959; Seattle World's Fair, 1962; Silvermine Guild, 1962; Museum des 20. Jahrhunderts, 1962; MOMA, 1963; Cleveland/MA, 1964; MOMA, The New American Painting and Sculpture, 1969; WMAA, Third Dimension, 1984; Sarah Lawrence College, Sculptural Expressions, 1985; WMAA, Drawing Acquisitions 1981-85, 1985; Brooklyn Museum, The Machine Age, circ., 1986; Walker, Sculpture Inside Outside, 1988; AFA, Abstract Sculpture in America, 1939-1970, circ., 1991; Katonah Gallery, The Technological Muse, 1990; MOMA, Art of the Forties, 1991. **Collections:** Akron/AI; U. of Arizona; Baltimore/MA; Chicago/AI; Cleveland/MA; U. of Colorado; Hirshhorn; Houston/MFA; U. of Illinois; Industrial Museum, Barcelona; U. of Iowa; MIT; MOMA; U. of Michigan; Newark/Museum; U. of North Carolina; PAFA; SRGM; Purchase/SUNY; St. Joseph/Albrecht; São Paulo; Smithsonian; Tate; Trenton/State; WMAA; Walker; West Palm Beach/Norton; Wichita/Ulrich; U. of Wisconsin; Worcester/AM; Yale U. **Bibliography:** Arnason 6; Baur 7; Blesh 1; Brumme; Chipp; Craven, W.; Cummings 5; *From Foreign Shores;* Gertz; Giedion-Welcker 1; Goodrich and Baur 1; Hunter 6; Kepes 2; Kuh 1, 3; Lane and Larsen; Langui; Licht, F.; Marter, Tarbell, and Wechsler; McCurdy, ed.; Mendelowitz; *Metro;* Miller, ed., 2; Myers 2; Neumeyer; Phillips, Lisa, 2; Read 3; Ritchie 1, 3; Rodman 3; Seuphor 3; Seymour; Toher, ed.; Trier 1; Weller. Archives.

ROTH, FRANK b. February 22, 1936, Boston, Mass. **Studied:** Cooper Union, 1954; Hofmann School, 1955. Traveled Europe, Mexico. **Taught:** School of Visual Arts, NYC, 1963-79; State U. of Iowa, 1964; U. of California, Berkeley, 1968, Irvine, 1971-73. **Awards:** Chaloner Prize Foundation Award, 1961; Guggenheim Foundation Fellowship, 1964; Ford Foundation Artist-in-Residence, 1966; IV International Young Artists Exhibit, America-Japan, Tokyo, Minister of Foreign Affairs Award, 1967; National Endowment for the Arts, Grant, 1977. **Address:** 135 Wooster Street, NYC 10012; 120 Acabonac Road, East Hampton, NY 11973. **Dealer:** Louis K. Meisel Gallery, NYC. **One-man Exhibitions:** (first) Artists' Gallery, NYC, 1958; Grace Borgenicht Gallery, Inc., 1960, 1962-65; The American Gallery, NYC, 1962; Galerie Anderson-Mayer, Paris, 1964; American Embassy, London, 1965; Hamilton Galleries, London, 1965, 67; U. of Utah, 1967; Martha Jackson Gallery, 1967, 68, 70, 71; Molly Barnes Gallery, Los Angeles, 1968; Galerie Paul Facchetti, 1968; Obelisk Gallery, 1969; Gimpel & Weitzenhoffer Ltd., 1974; OK Harris Works of Art, NYC, 1975; Oklahoma, 1981; Louis K. Meisel Gallery, 1981, 82, 84; Martha White Gallery, Louisville, 1981. **Group:** Buffalo/Albright, 1958;

WMAA Annuals, 1958; WMAA, Young America, 1960; Walker, 60 American Painters, 1960; Corcoran, 1962; Flint/Institute, 1963; Tate, 1965; U. of Illinois, 1965; M. Knoedler & Co., Art Across America, circ., 1965-67; IV International Young Artists Exhibit, America-Japan, Tokyo, 1967; RISD, 1967; Kent State U., 1968; A.F.A., 1968; Moore College of Art, Science and Industry, 1969; Philadelphia Art Alliance, 1969; VMFA, American Painting, 1970; Foundation Maeght, 1970; Indianapolis, 1970; Amherst College, Color Painting, 1972; Lehigh U., Contemporary American Painting, 1972. **Collections:** American Republic Insurance Co.; Baltimore/MA; Bellevue Hospital; Buffalo/Albright; Chase Manhattan Bank; Colonial Bank & Trust Co.; Cornell U.; Des Moines; Hirshhorn; Leicester Education Committee; MOMA; Manufacturers Hanover Trust Co.; McDonald & Company; Mead Corporation; Michigan State U.; NYU; U. of Oklahoma; Pasadena/AM; Prudential Insurance Co. of America; RISD; Ringling; Santa Barbara/MA; Schiedam/Stedelijk; Tate; U. of Utah; WMAA; Walker. **Bibliography:** Gerdts.

ROTHENBERG, SUSAN b. January 20, 1945, Buffalo, N.Y. **Studied:** Cornell U., 1967, BFA. **Awards:** CPAD, 1976; National Endowment for the Arts, 1979; Guggenheim Foundation Fellowship, 1980; AAIAL, 1983; Ljubliana (Yugoslavia) Biennial, Grand Prize for Prints, 1985. **Address:** c/o Dealer. **Dealer:** Sperone Westwater, Inc., NYC. **One-man Exhibitions:** (first) 112 Greene Street, 1974; The Willard Gallery, NYC, 1976, 77, 79, 81, 83, 85; U. of California, Berkeley, 1978; Greenberg Gallery, St. Louis, 1978; Walker, 1978; Mayor Gallery, London, 1980; Galeric Rudolf Zwirner, 1980; Akron/AM, 1981; Amsterdam/Stedelijk, 1982; Los Angeles/County MA, circ., 1983; Barbara Krakow Gallery, Boston, 1984; Wesleyan U., 1984; Bank of America, San Francisco, 1985; U. of California,

Susan Rothenberg, *Untitled*, 1990

Long Beach, 1985; Des Moines, 1985; A.P. Giannini Gallery, San Francisco, 1985; Phillips, 1985; Portland (Ore.) Visual Arts Center, 1985; Gemini G.E.L., Los Angeles, 1985; Gagosian Gallery, NYC, 1987; Sperone Westwater Gallery, NYC, 1987, 90, 92; U. of Iowa, 1987; Galerie Gian Enzo Sperone, Rome, 1988; Baltimore, 1988; Malmo/Rooseum, 1990. **Retrospective:** Buffalo/Albright, circ., 1992. **Group:** MOMA, American Drawn and Matched, 1977; MOMA, Extraordinary Women, 1977; Buffalo/Albright, American Paintings of the 1970s, circ., 1978; Cleveland/MA, Seven Artists: Contemporary Drawings, 1978; WMAA, New Image Painting, 1978; U. of Chicago, Visionary Images, 1979; NYU, American Painting: The Eighties, 1979; Indianapolis, 1980; XXXIX Venice Biennial, 1980; Akron/AM, The Image in American Painting and Sculpture, 1981; U. of California, Santa Barbara, Contemporary Drawings: In Search of an Image, 1981; Internationale Kunstausstellung, Berlin, 1982; Chicago/AI, 74th American Exhibition, 1982;

Milwaukee, New Figuration in America, 1982; WMAA, American Prints: Process and Proofs, 1982; AAIAL, 1983, 85; ARS 83, Helsinki, 1983; Bonn, Back to the USA, circ., 1983; MOMA, Prints from Blocks: Gauguin to Now, 1983; Palacio de Velasquez, Madrid, Tendencias en Nueva York, circ., 1983; Pall Mall Canada Ltd., American Accents, circ., 1983; Youngstown/Butler, 1983; Hirshhorn, Content: A Contemporary Focus, 1974-1984, 1984; MOMA, International Survey of Recent Painting and Sculpture, 1984; Potsdam/SUNY, Pressures of the Hand, 1984; Walker, Images and Impressions: Painters Who Print, 1984; Carnegie, International, 1985; WMAA, Three Printmakers, 1986; WMAA, Biennial, 1985; AAIAL, annual, 1985; Frankfurt/Kunstverein, Vom Zeichnen, circ., 1985; Youngstown/Butler, Mid-year, 1986; Schirn Kunsthalle, Frankfurt, Prospect 86, 1986; Los Angeles/MOCA, Individuals, 1986; Sonoma State U., The Monumental Image, circ., 1987; Milwaukee, 1988—The World of Art Today, 1988; Ohio State U., Art in Europe and America, 1990; AAIAL, 1990; Munich/Moderne, Seven American Painters, 1991; ICA, U. of Pennsylvania, Devil on the Stairs, circ., 1991; MOMA, Allegories of Modernism, 1992; Kassel, Documenta IX, 1991; San Jose Museum of Art, Drawing Redux, 1992. **Collections:** Akron/AM; Amsterdam/Stedelijk; Art Museum of South Texas; Buffalo/Albright; Carnegie; Dallas/MFA; Des Moines; High Museum; Houston/MFA; Israel Museum; Kansas City/Nelson; Los Angeles/County MA; MOMA; Milwaukee; National Gallery; Purchase/SUNY; St. Louis/City; Seattle/AM; Utica; WMAA; Walker. **Bibliography:** *Back to the USA;* Fox; Hiromoto; Honnef 2; Hughes; Joachimides and Rosenthal; Murken-Altrogge; Robins; Rose, Bernice, 1; Schwartz 1; Storr and Tannenbaum.

ROTHKO, MARK b. September 25, 1903, Dvinska, Russia. **d.** February 25,

1970, NYC. To USA, 1913. **Studied:** Yale U., 1921-23; ASL, 1925, with Max Weber. Traveled Europe, USA. **Taught:** Center Academy, Brooklyn, N.Y., 1929-52; California School of Fine Arts, summers, 1947, 49; Brooklyn College, 1951-54; U. of Colorado, 1955; Tulane U., 1956. A cofounder of the Expressionist group The Ten, 1935. Cofounder of a school, "Subject of the Artist," with William Baziotes, Robert Motherwell, and Barnett Newman, NYC, 1948. Federal A.P.: 1936-37. **Awards:** Hon. DFA, Yale U., 1969. **One-man Exhibitions:** (first) Contemporary Arts Gallery, NYC, 1933; Portland, Ore./AM, 1933; Art of This Century, NYC, 1945; Santa Barbara/MA, 1946; Betty Parsons Gallery, 1946-51; RISD, 1954; Chicago/AI, 1954; Sidney Janis Gallery, 1955, 58; Houston/MFA, 1957; XXIX Venice Biennial, 1958; Phillips, 1960; MOMA, 1961; Whitechapel Art Gallery, London, 1961; Amsterdam/Stedelijk, 1961; Palais des Beaux-Arts, Brussels, 1962; Kunsthalle, Basel, 1962; Paris/Moderne, 1962, 72; Marlborough Fine Art Ltd., London, 1964, 70; Marlborough Gallery, Inc., NYC, 1970, Zurich, 1971; Berlin/National, 1971; Newport Harbor, 1974; The Pace Gallery, NYC, 1978; Mantova (Italy), 1977; SFMA, 1983; Walker, 1983; National Gallery, circ., 1984; Tate Gallery, 1986. **Retrospective:** SRGM, 1978. **Group:** PAFA, 1940; WMAA, 1945-50; XXIV Venice Biennial, 1948; MOMA, Abstract Painting and Sculpture in America, 1951; MOMA, Fifteen Americans, circ., 1952; 10th Inter-American Conference, Caracas, 1954; 3rd International Contemporary Art Exhibition, New Delhi, 1957; Carnegie, 1958, 61; MOMA, The New American Painting, circ., Europe, 1958-59; Kassel, Documenta I, 1959; Federation of Modern Painters and Sculptors Annuals; Walker, 60 American Painters, 1960; Cleveland/MA, 1966; MOMA, The New American Painting and Sculpture, 1969; MMA, New York Painting and Sculpture:

1940-1970, 1969-70; Venice Biennial, 1974; SRGM, 20th Century American Drawing: Three Avant-Garde Generations, 1976. **Collections:** U. of Arizona; Baltimore/MA; Brooklyn Museum; Buffalo/Albright; Chicago/AI; Düsseldorf/KN-W; Kansas City/Nelson; MMA; MOMA; Paris/Moderne; Phillips; Rio de Janeiro; SFMA; Tate Gallery; Utica; Vassar College; WMAA. **Bibliography:** *Abstract Expressionism;* Alloway 4; Anfam; Ashbery; Ashton 3, 5; Barker 1; Barr 3; Battcock, ed.; Baur 7; Bihalji-Merin; Blesh 1; Calas, N. and E.; Carmean, Rathbone, and Hess; Chipp; Clearwater; Cummings 4; De Wilde 1; Downes, ed.; Eliot; Elsen 2; *Europa/Amerika;* Finch; Friedman, ed.; *From Foreign Shores;* Goodrich and Baur 1; Goossen 1; *The Great Decade;* Greenberg 1; Haftman; Henning; Hess, T.B., 1; Hobbs and Levin; Honisch and Jensen, eds.; Hughes; Hunter 1, 6; Hunter, ed.; *Individuals;* Janis and Blesh 1; Janis, S.; Johnson, Ellen H.; Kozloff 3; Lucie-Smith; Lynton; McChesney; McCoubrey 1; McCurdy, ed.; *Metro;* Motherwell, ed.; Murken-Altrogge; O'Doherty; Ponente; Read 2; Restany 2; Richardson, E.P.; Rickey; Ritchie 1; Rodman 1; Rose, B., 1, 4; Rosenblum 2; Rubin 1; Sandler 3, 5; Seitz 1, 3; Selz, P., 5; Seuphor 1; Soby 5; Tomkins 2; Tuchman, ed.; Tuchman 3; Waldman 7; Weller. Archives.

ROTTERDAM, PAUL Z.
(Werner Paul Zwietnig-Rotterdam)
b. February 12, 1939, Neustadt, near Vienna. **Studied:** Academy of Fine and Applied Arts, Vienna, 1959-60; U. of Vienna. Resided Paris, Rome, Vienna, 1961; to USA, 1968; to NYC, 1973. **Taught:** Harvard U., 1968; Cooper Union, NYC, 1974. **Awards:** Premio internazionale d'art grafica, Livorno, 1965; Ancona, prize, prints, 1968. **Address:** 115 West Broadway, NYC 10013. **One-man Exhibitions:** (first) Numero Gallery, Florence, 1961; Lincoln, Mass./De Cordova, 1970; Kunstverein, Freiburg, 1971;

Graz/Johanneum, 1971; Nielsen Gallery, Boston, 1973, 76, 81, 85; Susan Caldwell Inc., NYC, 1975, 76, 78, 81; Musée l'Abbaye, St. Croix, Les Sables d'Olonne, France, 1976; Galerie Parallele, Geneva, 1976; Galerie Maeght, Paris, 1979, 82; Nice/Municipal, 1976; Annely Juda Fine Art, London, 1978; Galerie Charles Kriwin, Brussels, 1980; Nantenshi Gallery, Tokyo, 1982, 85; Adams-Middleton Gallery, 1983, 84; Galerie Maeght Lelong, NYC, 1984; Storrer Gallery, Zurich, 1985, 91; Arnold Herstand Gallery, NYC, 1988, 91; Denise Cadé Gallery, NYC, 1991. **Group:** Vienna/Stadt, Oesterreichische Kunst seit 1960, 1963; Tokyo/Modern Biennial, 1965; Biennial of Young Artists, Paris, 1965; WMAA Biennial, 1975; Hirshhorn, The Golden Door: Immigrant Artists of America, 1876-1976, 1976; Tulane U., Drawing Today in New York, 1976; Brooklyn Museum, American Drawings in Black and White: 1970-1979, 1980; Little Rock Art Center, Revelations: Drawing/America, 1988; Fondation Maeght, St. Paul de Vence, Dessins, 1980. **Collections:** Birmingham (Mich.) Museum of Art; Brooklyn Museum; Busch-Reisinger Museum; Des Moines; Graphische Sammlung Albertina; Graz Johanneum; Little Rock/MFA; MMA; MOMA; Milwaukee; Museum der Stadt Leoben, Austria; Nice; Osaka/National; Paris/Beaubourg; Portland, Ore./AM; SRGM; U. of Sydney; Vassar College.

RUBEN, RICHARDS **b.** November 29, 1925, Los Angeles, Calif. **Studied:** Chouinard Art Institute, 1944-46; Bradley U., BFA, 1951. US Army, 1942-44. **Taught:** Arts and Crafts Center, Pittsburgh, 1949; Chouinard Art Institute, 1954-61; Pomona College, 1958-59; Pasadena Museum School; UCLA, 1958-62; Cooper Union, 1962-64; Otis Art Institute; NYU, 1963-. **Awards:** International Arts Festival, Newport, R.I., First Prize, 1951; Bradley U., P.P., 1952; Brooklyn Museum, First Prize, 1953, 54; SFMA,

Anne Bremer Memorial Prize, 1954; L.C. Tiffany Grant, 1954; Ford Foundation, 1964; National Endowment for the Arts, 1980. **Address:** 85 Mercer Street, NYC 10012. **Dealer:** Anita Shapolsky Gallery, NYC. **One-man Exhibitions:** Felix Landau Gallery, Los Angeles, 1952, 54; Pasadena/AM, 1954, 55, 61; Oakland/AM, 1957; Paul Kantor Gallery, Beverly Hills, Calif., 1958; Grand Central Moderns, NYC, 1958; Ferus Gallery, Los Angeles, 1960, 61, 63; California Palace, 1961; Poindexter Gallery, NYC, 1962, 64, 69; SFMA, 1970; Cornell U., 1976; Peter Rose Gallery, NYC, 1977; Ericson Gallery, NYC, 1979; Purchase/SUNY, 1977; Harm Bouckaert Gallery, NYC, 1981; Race Gallery, Philadelphia, 1981; Baruch College, NYC, 1984; Anita Shapolsky Gallery, 1986. **Group:** Los Angeles/County MA, 1948, 53, 55, 57; Bradley U., 1952; U. of Illinois, 1952, 56; Dallas/MFA, 1953; Corcoran, 1953; PAFA, 1954; SRGM, Younger American Painters, 1954; São Paulo, 1955; Carnegie, 1955; Santa Barbara/MA, 1955, 58; Brooklyn Museum, 1957, 59; I Paris Biennial, 1959; WMAA, Fifty California Artists, 1962-63; El Retiro Parquet, Madrid, Arte de America y Espana, 1963; WMAA, 1964; Cornell U., Eight New York Artists, 1987. **Collections:** AT&T; Boston/MFA; Bradley U.; Brooklyn Museum; U. of California; Corcoran; Cornell U; The Equitable; Laguna Beach/MA; Los Angeles/County MA; U. of New Mexico; Milwaukee; Newport Harbor; U. of North Carolina; Oakland Museum; Pasadena/AM; Pomona College; Raleigh/NCMA; SFMA; San Diego; Santa Barbara/MA; W. & J. Sloane, Inc.; UCLA; U. of Southern California; Stanford U.; Worcester/AM.

RUDA, EDWIN b. May 15, 1922, NYC. **Studied:** ASL, 1940-41; Cornell U., 1947, BS; New School for Social Research, 1948; Columbia U., 1949, MA; School of Painting and Sculpture, Mexico City,

1949-51; U. of Illinois, 1956, MFA. Traveled Mexico, Europe, Southwest Pacific, Australia. US Naval Reserve, 1943-46. **Taught:** School of Visual Arts, NYC; Pratt Institute; U. of Texas; Syracuse U., 1978; Ohio State U., 1978; Tyler School of Art, Philadelphia, 1979. **Awards:** CAPS, 1978. **Address:** 44 Walker Street, NYC 10013. **One-man Exhibitions:** (first) Globe Gallery, NYC, 1961; Feiner Gallery, NYC, 1963; Park Place Gallery, NYC, 1966-67; Paula Cooper Gallery, 1969, 71, 73, 75; Gallery A, Sydney, 1973; Tyler School of Art, Philadelphia, 1974, 79; Max Hutchinson Gallery, NYC, 1978-79; Ohio State U., 1978. **Group:** New York World's Fair, 1965; SRGM, Systemic Painting, 1966; U. of Illinois, 1967, 74; ICA, U. of Pennsylvania, Art in the City, 1967; Newark Museum, Cool Art, 1968; Fort Worth Art Museum, Drawings, 1969; WMAA Annuals, 1969, 73; Indianapolis, 1970, 72; Chicago/AI, 1970; ICA, U. of Pennsylvania, Two Generations of Color Painting, 1970; U. of Texas, Color Forum, 1972; Cincinnati/Contemporary, Options, 73/70, 1973; U. of Illinois, 1974; Buffalo/Albright, SoHo Scenes, 1975; Baltimore/MA, Drawing Exhibition, 1976. **Collections:** Allentown/AM; Canberra/National; Chase Manhattan Bank; U. of Connecticut; Cornell U.; Great Southwest Industrial Park; Greenville; Indianapolis; U. of North Carolina; South Mall, Albany.

RUSCHA, EDWARD b. December 16, 1937, Omaha, Neb. **Studied:** Chouinard Art Institute (with Richards Ruben). Traveled Europe. **Taught:** U. of Arizona; U. of North Dakota; UCLA; Vancouver (B.C.) School of Art; SFAI. **Films:** *Premium*, 16 mm, 1970; *Miracle*, 16mm, 1974. **Commission:** Metropolitan Dade County, Fla., Art in Public Places (mural), 1985. **Awards:** National Council on the Arts, 1967; Guggenheim Foundation Fellowship, 1971; Ljubljana Biennial, P.P., 1977; National Endowment for the Arts, 1978. **Address:** 1024 3/4 N. West-

ern Avenue, Hollywood, CA 90029. **Dealer:** Leo Castelli Inc., NYC. **One-man Exhibitions:** (first) Ferus Gallery, Los Angeles, 1963, also 1964, 65; Alexandre Iolas Gallery, NYC, 1967, 70; Irving Blum Gallery, Los Angeles, 1968, 69; Galerie Rudolf Zwirner, Cologne, 1968; Pavilion Art Gallery, Newport Beach, Calif. (two-man), 1968; Galerie Heiner Friedrich, Munich, 1970; Nigel Greenwood Ltd., London, 1970; Contract Graphics Associates, Houston, 1971; Janie C. Lee Gallery, Dallas, 1972; Corcoran and Corcoran, Coral Gables, 1972; Minneapolis/Institute, 1972; D.M. Gallery, London, 1972; Leo Castelli, Inc., NYC, 1973, 74, 78, 80, 81, 82, 84, 86, 87, 88, 89, 91; John Berggruen Gallery, San Francisco, 1973; Projections: Ursula Wevers Gallery, Cologne, 1973; Ronald Greenberg Gallery, St. Louis, 1973; ACE Gallery, Los Angeles, 1973, 75, 77; Colgate U., 1973; Yvon Lambert, 1973; Françoise Lambert, Milan, 1973; The Texas Gallery, 1974, 79, 86; Galerie Rolf Ricke, Cologne, 1975, 78; Jared Sable Gallery, Toronto, 1975; U. of North Dakota, Grand Forks, 1975; Arts Council of Great Britain, circ., 1975; Northern Kentucky State College, Highland Heights, 1975; ACE Gallery, Vancouver, 1976, 78, 81; ICA, Los Angeles, 1976; Hartford/Wadsworth, 1976; Amsterdam/Stedelijk, 1976; Dootson Calderhead Gallery, Seattle, 1976; ICA, London, 1976; Sable-Castelli Gallery, Toronto, 1976; U. of Lethbridge, Alberta, 1977; U. of Calgary, 1977; Fort Worth, 1977; Galerie MTL, Brussels, 1978; Rudiger Schottle, Munich, 1978; U. of Redlands, 1978; Auckland, 1978; Getler/Pall, NYC, 1978; Richard Hines Gallery, Seattle, 1979; InK, Zurich, 1979; Portland (Ore.) Center for the Visual Arts, 1980; Ace Gallery, Venice, Calif., 1980; Foster Goldstrom Fine Arts, San Francisco, 1980; ARCO Center for the Visual Arts, Los Angeles, 1981; Douglas Dean Courtenier Inc., East Hampton, N.Y., 1981; Castelli Feigen Corcoran,

NYC, 1982; Flow Ace Gallery, Los Angeles, 1982; Jacobson/Hochman Gallery, NYC, 1982; Bernard Jacobson Ltd., Los Angeles, 1983; Route 66, Philadelphia, 1983; Morgan Gallery, Kansas City, 1984; Gilbert Brownstone & Cie, Paris, 1985; Galerie Tanja Grunert, Cologne, 1985; Munster, 1986; U. of Southern California, 1985; James Corcoran Gallery, Los Angeles, 1985, 89; Lyon/St. Pierre, 1985; Munster/WK, 1986; Galerie Susan Wyss, Zurich, 1986, 88; Fuller Goldeen Gallery, San Francisco, 1986; Janie Beggs Fine Arts, Aspen, 1986; Acme Art, San Francisco, 1987; Cirrus Gallery, Los Angeles, 1987; Robert Miller Gallery, NYC, 1987, 90, 92; Lannan Museum, Lake Worth, Florida, 1987; Chicago/Contemporary, 1988; Henry Vincent Gallery, San Diego, 1988; Karsten Schubert Gallery, London, 1988, 90; Rhona Hoffman Gallery, Chicago, 1988, 89; Williams College, 1988; Institute of Contemporary Art, Nagoya, 1988; Tony Shafrazi Gallery, NYC, 1988, 92; Gallery Takagi, Nagoya, 1988; Touko Museum of Contemporary Art, 1989; Thomas Babeor Gallery, La Jolla, 1989; Michael Maloney Contemporary Art Gallery, Santa Monica, 1989; Thomas Segal Gallery, Boston, 1990; Richard Green Gallery, Santa Monica, 1990; Galerie Bebert, Rotterdam, 1990; Judith Goldberg Fine Art, NYC, 1990; Galleria Pasquale Trisorio, Naples, 1990; Galerie Joan Prats, Barcelona, 1990; Galerie Ghislaine Hussenot, Paris, 1990; Galerie Carola Mosch, Berlin, 1991. **Retrospectives:** Buffalo/Albright, 1976; SFMA, circ., 1982; Musée St. Pierre, 1986; Paris/Beaubourg, circ. 1990. **Group:** Oklahoma, 1960; Pasadena/AM, New Paintings of Common Objects, 1962; Oakland/AM, Pop Art USA, 1963; SRGM, American Drawings, 1964; M. Knoedler & Co., Art Across America, circ., 1965-67; SRGM, 1965; Seattle/AM, 1966; IX São Paulo Biennial, 1967; V Paris Biennial, 1967; WMAA Annual, 1967; Hayward Gallery, London, Pop Art,

1969; XXX Venice Biennial, 1970; Hayward Gallery, London, Eleven Los Angeles Artists, 1971; Akron/AI, Four Artists, 1972; Amerika Haus, Berlin, 1973; Yale U., American Drawings: 1970-1973, 1973; Oakland/AM, Cirrus Editions, 1974; WMAA, American Pop Art, 1974; VMFA, Works on Paper, 1974; Malmo, New Media I, 1975; Moore College of Art, Philadelphia, North, East, West, South, and Middle, 1975; Newport Harbor, The Last Time I Saw Ferus, 1976; SFMA, Painting and Sculpture in California: The Modern Era, 1976; The Image and the Myth, Beverly Hills, L.A. Art 2001, 1976; Brooklyn Museum, Twenty Years of American Printmaking, 1976; ICA, Los Angeles, 100+, Current Directions in Southern California Art, 1977; Laguna Gloria Art Museum, Austin, Texas; Joe Goode, Edward Ruscha, Drawings, 1977; Philadelphia College of Art, Time, 1977; Williamstown/Clark, The Dada/Surrealist Heritage, 1977; MOMA, Bookworks, 1977; Minnesota/AM, American Drawing, 1927-1977, circ., 1977; X Paris Biennial, 1977; Honolulu Academy, California: 3 by 8 Twice, 1978; SFMA, Aesthetics of Graffiti, 1978; MOMA, Mirrors and Windows, 1978; U. of North Carolina, Drawings About Drawing Today, 1979; Buffalo/Albright, American Painting of the 1970s, circ., 1978-79; Bochum, Words, circ., 1979; Albuquerque Museum, Reflections of Realism, 1979; Chicago/AI, 73rd American Exhibition, 1979; Brooklyn Museum, American Drawings in Black and White: 1970-1979, 1980; MOMA, Printed Art: A View of Two Decades, 1980; Purchase/SUNY, Hidden Desires, 1980; Houston/Contemporary, Americans: The Landscape, 1981; Kassel, Documenta VII, 1982; Paris/Beaubourg, Livres d'Artistes, 1982; New Museum, Language, Drama, Source & Vision, 1983; Sydney/AG, Pop Art 1955-1970, 1985; Fort Lauderdale, An American Renaissance: Painting and Sculpture Since 1940, 1986; Nexus Art Center, Atlanta,

Public Art: A Blunt Instrument, circ., 1985; SFMA, American Realism (Janss), circ., 1985; Frankfurt/Stadtische Galerie, Amerikanische Zeichnungen, 1930-80, circ., 1985; Paris/Beaubourg, Livres d'artistes, 1985; Frankfurt/Kunstverein, Vom Zeichnen, 1985; ICA, London, Komic Ikonoklasm, 1987; WMAA, Biennial, 1987, 89; MOMA, For 25 Years: Crown Point Press, 1987; U. of California, Berkeley, Made in USA, circ., 1987; Taipei Fine Arts Museum, Taiwan, Contemporary Southern California Art, circ., 1987; Amerika Haus, Berlin, Los Angeles: Contemporary Visions, circ., 1987; ICA, U. of Pennsylvania, At the Crossroads, 1987; Milwaukee, 1988: The World of Art Today, 1989; Newport Beach, LA Pop in the Sixties, 1989; Brooklyn Museum, National Print Exhibition, 1989; Schirn Kunsthalle, Frankfurt, Prospect 89, 1989; Walker, First Impressions, 1989; New York Academy of Art, NYC, The Humanist Icon, 1990; MOMA, High and Low, circ., 1990; Milwaukee, Word as Image: American Art, 1960-1990, circ., 1990; Nice/Contemporain, Collage of the 20th Century, 1991. **Collections:** Amsterdam/Stedelijk; Art Museum of South Texas; Auckland; U. of California, Berkeley; Buffalo/Albright; Chicago/AI; Dade Public Library; First City National Bank of Houston; Fort Worth; Hirshhorn; Los Angeles/County MA; Lyon/St. Pierre; MOMA; U. of Massachusetts; Mead Paper Co.; Minneapolis/Institute; Musée St. Pierre; Oklahoma City; Pasadena/AM; Pomona College; Reynolda House, Winston-Salem; U. of Rochester; SFMA; VMFA; WMAA; Walker; Yale U. **Bibliography:** Alloway 1; Armstrong, Thomas; *Contemporanea;* Cummings 5; De Salvo and Schimmel; De Wilde 2; Finch; **Hickey and Plagens;** Honisch and Jensen, eds.; Hunter, ed.; *Individuals;* Joachimides and Rosenthal; Kardon 3; Lippard 5; Lippard, ed.; Meyer; Murken-Altrogge; Osterwold; Sandler 3; Seitz 3; *The State of California Painting: USA West Coast.*

RUSSELL, MORGAN **b.** January 25, 1886, NYC. **d.** 1953, Broomall, Pa. **Studied:** Privately, with Robert Henri; ASL (with James E. Fraser). Traveled Europe; resided Paris, 1906-1946. Developed Synchromism, with Stanton Macdonald-Wright, in Paris, 1912. **One-man Exhibitions:** Galerie Bernheim-jeune, Paris, 1913; Neue Kunstsalon, Munich, 1913; Carrol Gallery, NYC, 1914; Galerie la Licome, Paris, 1923; Rose Fried Gallery, 1953; Walker, 1954; Washburn Gallery, NYC, 1978, 80; Flow Ace Gallery, Los Angeles, 1985; Salander-O'Reilly Galleries, 1985. **Group:** Salon d'Automne, Paris, 1910; Salon des Artistes Indépendants, Paris, 1913; The Armory Show, 1913; Anderson Galleries, NYC, Forum Exhibition, 1916; Dallas/Contemporary, 1960; WMAA, 1963; M. Knoedler & Co., 1965; Marlborough-Gerson Gallery, Inc., 1967; U. of New Mexico, Cubism: Its Impact in the USA, 1967; WMAA, Synchromism and American Color Abstraction, 1978; Los Angeles/County MA, California: 5 Footnotes to Modern Art History, 1977. **Collections:** Evansville; Los Angeles/County MA; MOMA; NYU; Utica; WMAA. **Bibliography:** *Avant Garde Painting & Sculpture in America 1910-25;* Baur 7; Blesh 1; Brown; Brown 2; Canaday; Haftman; Hunter 6; Levin 2; Richardson, E.P.; Rickey; Rose, B., 1; Seuphor 1; Wright 2; Archives.

RUVOLO, FELIX **b.** April 28, 1912, NYC. Throughout his youth, family resided in Italy, where he first attended art school (Catania). **Studied:** Chicago Art Institute School. Traveled Europe, Mexico, Canada, USA. **Taught:** Chicago Art Institute School, 1945-47; Mills College, summer, 1948; U. of California, Berkeley, 1950-; U. of Southern California, 1963. **Federal A.P.:** Easel painting. **Commissions:** Merchandise Mart, Chicago (murals). **Awards:** SFMA, Anne Bremer Memorial Prize, 1942; Chicago/AI, P.P., 1942, 46, 47; California Palace, Gold Medal, 1946; Milwaukee, Kearney Memorial Prize, 1946; Pepsi-Cola, 1947, 48; Hallmark International Competition, 1949; U. of Illinois, P.P., 1949; SFMA, P.P., 1950; U. of California Institute for Creative Work in the Arts, Travel Fellowship, 1964; and some two dozen others. **Address:** 78 Strathmoor Drive, Berkeley, CA 94705. **One-man Exhibitions:** (first) Durand-Ruel Gallery, NYC, 1946; Mills College, 1947; de Young, 1947, 58; Grand Central Moderns, NYC, 1948; Catherine Viviano Gallery, 1949, 50, 52, 54; Poindexter Gallery, 1957, 58; U. of Southern California, 1963; Galleria Van der Voort, 1970; Jason Avers Gallery, San Francisco, 1971; Gruenebaum Gallery, 1982. **Group:** U. of Illinois, 1947, 61; MOMA, Abstract Painting and Sculpture in America, 1951; Buffalo/Albright, Expressionism in American Painting, 1952; Walker, 60 American Painters, 1960; Chicago/AI Annuals; MMA; Corcoran; PAFA; WMAA. **Collections:** Auckland; U. of California; Chicago/AI; Denison U.; Denver/AM; Des Moines; U. of Illinois; Mills College; SFMA; U. of Southern California; Tulsa/Philbrook; Walter. **Bibliography:** Genauer; Pousette-Dart, ed.; Ritchie 1.

RYMAN, ROBERT **b.** May 30, 1930, Nashville, Tenn. **Studied:** Tennessee Polytechnic Institute, 1948-49; George Peabody College, 1949-50. US Army, 1950-52. **Member:** American Abstract Artists; Art Commission, City of New York, 1982-. **Awards:** Guggenheim Foundation Grant, 1973; Skowhegan Medal, 1985. **Address:** 17 West 16th Street, NYC 10003. **Dealer:** The Pace Gallery, NYC. **One-man Exhibitions:** Paul Bianchini Gallery, NYC, 1967; Konrad Fischer Gallery, Düsseldorf, 1968, 69, 73, 80, 87, 92; Galerie Heiner Friedrich, Munich, 1968, 69, 73; Fischbach Gallery, NYC, 1969, 70, 71; Françoise Lambert, Milan, 1969; Yvon Lambert, 1969; ACE Gallery, Los Angeles, 1969; Current Editions, Seattle, 1971,

72; Dwan Gallery, NYC, 1971; Galerie Heiner Friedrich, Cologne, 1971, 72; John Weber Gallery, NYC, 1972, 73, 74; 75, 89; Galerie Annemarie Verna, Zurich, 1972, 77; Galleria del Cortile, Rome, 1972; Lisson Gallery, 1972; Galleria San Fedele, Milan, 1973; Art & Project, Amsterdam, 1973; Brussels/Beaux-Arts, 1975; Basel, 1975; P.S. 1, Long Island City, N.Y., 1977; Gian Enzo Sperone, Rome, 1977; Whitechapel Art Gallery, London, 1977; Galerie Charles Kriwin, Brussels, 1977; InK, Zurich, 1978, 80; Sidney Janis Gallery, NYC, 1979, 81; Kunstraum Munich, 1980; Paris/Beaubourg, 1981; Young Hoffman Gallery, Chicago, 1982; Kunsthalle, Cologne, 1982; The Mayor Gallery, London, 1982; Galerie Maeght-Lelong, NYC, 1984, 85, 86; Schaffhausen, 1983; Rhona Hoffman Gallery, Chicago, 1985; Leo Castelli, Inc., NYC, 1986; ICA, Boston, 1986; Raum fur Malerei, Cologne, 1986; Chicago/AI, circ., 1987; Dia Art Foundation, NYC, 1988; Nohra Haime Gallery, NYC, 1990; The Pace Gallery, 1990, 92; RENN/Espace d'Art Contemporain, Paris, 1991. **Retrospective:** SRGM, 1972. **Group:** New York World's Fair, 1964-65; American Abstract Artists, 1965; SRGM, Systemic Painting, 1966; A.F.A., Rejective Art, 1967; ICA, U. of Pennsylvania, A Romantic Minimalism, 1967; A.F.A., The Square in Painting, 1968; Washington U., Here and Now, 1969; Berne, When Attitudes Become Form, 1969; WMAA, Anti-Illusion: Procedures/Materials, 1969; Seattle/AM, 557,087, 1969; Düsseldorf/Kunsthalle, Prospect '69, 1969; Fort Worth Art Museum, Drawings, 1969; Amsterdam/Stedelijk, Op Losse Schroeven, 1969; Buffalo/Albright, Modular Painting, 1970; Cincinnati/Contemporary, Monumental Art, 1970; New Delhi, Second World Triennial, 1971; SRGM, Guggenheim International, 1971; Chicago/Contemporary, White on White, 1971-72; Chicago/AI, 1972; Kassel, Documenta V, 1972; Seattle/AM, American Art:

Third Quarter Century, 1973; MOMA, U. of California, Santa Barbara, 1975; UCLA, Fourteen Abstract Painters, 1975; Amsterdam/Stedelijk, Fundamental Painting, 1975; MOMA, Drawing Now, 1976; Detroit/Institute, American Artists, A New Decade, 1976; WMAA, Biennial, 1977, 87; Kassel, Documenta VI, Sarah Lawrence College, Ferra, Lichtenstein, Nevelson, Ryman, 1977; Worcester/AM, Two Decades of American Printmaking, 1957-1977, 1977; Chicago/AI, 1979; AAAL, Childe Hassam Fund Exhibition, 1979; ICA, Boston, The Reductive Object, 1979; Humlebaek/Louisiana, Andre, Dibbets, Long, Ryman, 1980; MOMA, Printed Art, 1980; XXXIX Venice Biennale, 1980; Royal Academy, London, A New Spirit in Painting, 1981; Cologne/Stadt, Westkunst, 1981; Haus der Kunst, Munich, Amerikanische Malerei, 1981; Amsterdam/Stedelijk, '60-'80: Attitudes/Concepts/Images, 1982; Kassel, Documenta VII, 1982; P.S. 1, Long Island City, N.Y., Abstract Painting, 1960-69, 1983; WMAA, Minimalism to Expressionism, 1983; Helsinki/Kunstmuseum, Ars 83, 1983; U. of Chicago, The Meditative Surface, 1984; Winterthur, Kunstmuseum, Une collection imaginaire, 1984; Grand Palais, Paris, Le rime et la raison, 1984; WMAA, American Art Since 1970, circ., 1984; Amsterdam/Stedelijk, Le grande parade, 1984; MOMA, New Works on Paper, 1984; Bard College, The Maximal Implications of the Minimal Line, 1984; Carnegie, International, 1985; Frankfurt/Kunstverein, Vom Zeichnen, 1960-85, circ., 1986; MOMA, Contrasts of Form, circ., 1985; Fort Lauderdale, The American Renaissance, 1985; Bordeaux/Contemporain, Art Minimal II, 1986; Los Angeles/MOCA, Individuals, 1986; Paris/Beaubourg, L'Époque, la morale, la passion, 1987; Düsseldorf/Kunsthalle, Similia/Dissimilia, 1987; Hamburger Bahnhof, Berlin, Zeitlos, 1988; Milwaukee, 1988, 1988; Lyon/St. Pierre, The

Color Alone, 1988; Carnegie, International, 1988, Cologne/Ludwig, Bilderstreit, 1989; SRGM, Geometric Abstraction and Minimalism in America, 1989; Makuhari Messe, Tokyo, Pharmikon '90, 1990; Osaka/National, Minimal Art, 1990; Paris/Beaubourg, Manifeste, 1990. **Collections:** Amsterdam/Stedelijk; Bard College; Boston/MFA; Brandeis U.; Buffalo/Albright; Canberra/National; Chicago/AI; Cologne/Ludwig; Dayton/AI; Des Moines; Frankfurt/Moderne; Hartford/Wadsworth; Hirshhorn; Humlebaek/Louisiana; Israel Museum; Los Angeles/MOCA; MMA; MOMA; Maastricht; Milwaukee; Minneapolis/Institute; Oberlin College; Ottawa/National; PMA; Paris/Beaubourg; Refco Collection; SRGM; Sakura/Kawamura; Schaffhausen; Seattle/AM; Stockholm/National; Tate Gallery; Tokyo/Metropolitan; Toronto; WMAA. **Bibliography:** Armstrong, Thomas; *Contemporanea;* Danto; De Wilde 1, 2; Diamonstein; *Europa/Amerika;* Finch; Friedman, ed.; *Fundamentele Schilderkunst;* Gablik; Gohr and Gachnang; Honisch and Jensen, eds.; *Individuals;* Lippard 3; Lippard, ed.; Murdock 1; Murken-Altrogge; *Robert Ryman;* Storr and Tannenbaum; *When Attitudes Become Form.* Archives.

S

SAGE, KAY
from 1st to 5th edition.

SALEMME, ATTILIO b. October 18, 1911, Boston, Mass. d. January 24, 1955, NYC. Self-taught. US Marine Corps, 1927-28. Traveled USA. **Commissions** (murals): Moore-McCormack Lines, Inc., 1949; 200 East 66th Street, NYC, 1950. **Awards:** Chicago/AI, Flora Mayer Witkowsky Prize, 1949; MMA, P.P., 1950; William and Noma Copley Foundation Grant, 1954. **One-man Exhibitions:** (first) "67" Gallery, NYC, 1945; Carlebach Gallery, NYC, 1947; Passedoit Gallery, NYC, 1948; Saidenberg Gallery, NYC, 1950; Grace Borgenicht Gallery, Inc., NYC, 1953, 81, 82, 83; Duveen-Graham Gallery, NYC, 1955; ICA, Boston, 1958; Walker, 1958; Catherine Viviano Gallery, NYC, 1960; Staempfli Gallery, NYC, 1963; Terry Dintenfass, Inc., NYC, 1974. **Retrospectives:** WMAA, 1960; NCFA, 1978. **Group:** Carnegie; WMAA Annuals; Chicago/AI Annuals; U. of Illinois, 1955. **Collections:** Brooklyn Museum; MMA; MOMA; WMAA. **Bibliography:** Cummings 4; Goodrich and Baur 1; Kent, N.; McCurdy, ed.; Newmeyer; Pousette-Dart, ed. Archives.

SALLE, DAVID b. September 28, 1952, Norman, Ok. **Studied:** California Institute of Arts, 1973, BFA; 1975, MFA. **Address:** c/o Dealer. **Dealer:** Gagosin Gallery, NYC. **One-man Exhibitions:** Project Inc., Cambridge, Mass, 1975; Copley Gallery, Los Angeles, 1975; Fondation Corps de Garde, Groningen, 1976, 78; Artists' Space, NYC, 1976; Foundation de Appel, Amsterdam, 1977, 79; The Kitchen, NYC, 1977, 79; Real Art Ways, Hartford, Ct., 1978; Nova Scotia College of Art and Design, 1979; Gagosian/Nosei/Weber Gallery, NYC, 1979; Annina Nosei Gallery, NYC, 1980; Galerie Bischofberger, Zurich, 1980, 84; Mary Boone Gallery, NYC, 1981, 82, 83, 85, 87; Larry Gagosian Gallery, Los Angeles, 1981, 83; Lucio Amelio Gallery, Naples, 1981; Galleria Mario Diacono, Rome, 1982, 84; Anthony d'Offay Gallery, London, 1982; The Greenberg Gallery, St. Louis, 1983; Rotterdam, 1983; B. R. Kornblatt Gallery, Washington, D.C., 1983; Ascan Crone Gallery, Hamburg, 1983; Gallerie Schellmann & Kluser, Munich, 1983; Leo Castelli Inc., NYC, 1982, 84, 86; Texas Gallery, Houston, 1985; Galerie Daniel Templon, Paris, 1985, 88, 92; Andover/Phillips, 1983; Akira Ikeda, Tokyo, 1983; American Graffiti Gallery, Amsterdam, 1982; Chicago/Contemporary, 1985; Galerie Michael Werner, Cologne, 1985, 89; Donald Young Gallery, Chicago, 1985; Galerie Bernard Klauser, Munich, 1985; Mario Diacono Gallery, Boston, 1986, 90; Castelli Graphics, NYC, 1986, 90; Museum am Ostwall, Dortmund, circ., 1986; ICA, Boston, 1986; Gallery Bruno Bischofberger, Zurich, 1986, 87, 88, 91; ICA, Galleria Franca Mancini, Pesaro, Italy, 1987; The Fruitmarket Gallery, Edinburgh, 1987; Spiral Garden, Wacoal Art Center, Tokyo, 1987; Mary Boone/Michael Werner Gallery, NYC, 1988; Menil Collection, Houston, 1988; Fundacion Caja de Pensiones, Madrid, circ., 1988; MOMA, 1988; Tony Shafrazi Gallery, NYC, 1989; Waddington Galleries, London, 1988, 90; Fred Hoffman Gallery, Santa Monica, 1990; Gagosian Gallery, NYC, 1991, 92. **Retrospective:** ICA, U. of Pennsylvania,

circ., 1986. **Group:** Grand Palais, Paris, L'Amerique aux Indépendants, 1980; Cologne/Stadt, West 1981; Buffalo/Albright, Figures: Forms and Expressions, 1981; Kassel, Documenta VII, 1982; Internationale Kunstausstellung Berlin, 1982; Houston/Contemporary, The Americans: The Collage, 1982; Hirshhorn, Directions, 1983; WMAA, Biennials, 1983, 85, 91; Bonn, Back to the USA, circ., 1983; Milwaukee, New Figuration in America, 1982; Hirshhorn, Content, 1984; Independent Curators, Inc., NYC, Drawings: After Photography, 1984; XL Venice Biennial, 1982; ICA, U. of Pennsylvania, Image Scavengers, 1982; São Paulo Biennial, 1983; MOMA, International Survey of Contemporary Painting and Sculpture, 1984; SFMA, The Human Condition, 1984; Carnegie, International, 1985; Montreal/Contemporain, Via New York, 1984; MOMA, An International Survey of Contemporary Painting and Sculpture, 1984; Kitakyushu Municipal Museum of Art, The Restoration of Painterly Figuration, 1984; Houston/Contemporary, The Heroic Figure, circ., 1984; Hirshhorn, Content, 1984; Aachen/Ludwig, 1984; Carnegie, International, 1985; Fort Lauderdale, An American Renaissance, 1985; XIII Biennale de Paris, 1985; ICA, London, Komik Ikonoklasm, 1986; Paris/Beaubourg, L'Époque, la morale, la passion, 1987; Milwaukee, The World of Art Today, 1988; Southampton/Parrish, Drawing on the East End, 1940-1988, 1988; Nippon Convention Center, Tokyo, Pharmakon 90, 1990; Ludwig/Cologne, Bilderstreit, 1990; Fort Worth/Modern, 10+10, 1990; MOMA, High and Low, 1990. **Collections:** Aachen/Ludwig; Chicago/AI; Chicago/Contemporary; Los Angeles/MOCA; MMA; MOMA; Milwaukee; Paris/Beaubourg; Tate Gallery. **Bibliography:** Fox; Gohr and Gachnang; Haenlein; Hiromoto; Honnef 2; *Individuals;* Joachimides and Rosenthal; **Kardon 2;** Murken-Altrogge; Pincus-Witten 2; Plagens; Rose, Bernice, 1; Schwartz 1; Storr and Tannenbaum; Tomidy.

SAMARAS, LUCAS b. September 14, 1936, Kastoria, Macedonia, Greece. To USA, 1948; citizen, 1955. **Studied:** Rutgers U., 1955-59, BA; Columbia U. Graduate School, 1959-62; Stella Adler Theatre Studio, NYC, 1960. **Taught:** Yale U., 1969; Brooklyn College, 1971-72. **Commissions:** GSA, for Hale Boggs Federal Courthouse, New Orleans, 1976. Traveled Europe, Near East, Japan. Completed film, *Self,* 22½ minutes, with Kim Levin, 1969. **Awards:** Woodrow Wilson Fellow, Columbia U. **Address:** 156 West 56th Street, NYC 10019. **Dealer:** The Pace Gallery, NYC. **One-man Exhibitions:** Rutgers U., 1955, 58; Reuben Gallery, NYC, 1959; Green Gallery, NYC, 1961, 64; Dwan Gallery, Los Angeles, 1964; The Pace Gallery, NYC, 1966, 68, 70, 71, 72, 74, 75, 76, 78, 80, 82, 84, 85, 87, 88, 91; Hannover/Kunstverein, 1970; MOMA, 1975; Makler Gallery, Philadelphia, 1975; California State U., Long Beach, 1975; U. of North Dakota, 1976; Wright State U., 1976; ICA, Boston, 1976, 83; Seattle, 1976; Alberta College, Calgary, 1976; Margo Leavin Gallery, Los Angeles, 1976, 80; Zabriskie Gallery, Paris, 1977; Walker, 1977; F.H. Mayor Gallery, London, 1978, 86; Akron/AI, 1978; Richard Gray Gallery, Chicago, 1979; Galerie Watari, Tokyo, 1981; Jean Bernier Gallery, Athens, Greece, 1983, 86; Paris/Beaubourg, 1983; ICP, circ., 1984; Pace-MacGill Gallery, NYC, 1984, 86, 88, 91; Reed College, 1985; Hokin Gallery, Bay Harbor Islands, Fla., 1991; Waddington Galleries, London, 1990; Galerie Renos Xippas, Paris, 1991. **Retrospectives:** Chicago/Contemporary, 1971; WMAA, 1972; Denver/AM, circ., 1983; Polaroid Corp., Rochester, N.Y., circ., 1984; Yokohama City Art Museum, circ., 1991. **Group:** Martha Jackson Gallery, New Media—New Forms, II, 1961; MOMA, The Art of Assemblage, circ., 1961; MOMA, Lettering by Hand, 1962; Corcoran, 1963; Brandeis U., Recent American Drawings, 1964; WMAA Annu-

Lucas Samaras, *Mosaic Painting #4,* 1991.

als, 1964, 68, 70, Young America, 1965; SRGM, 1965; RISD, 1965, Recent Still Life, 1966; WMAA, Contemporary American Sculpture, Selection I, 1966; MOMA, 1966; Walker, 1966; Los Angeles/County MA, American Sculpture of the Sixties, 1967; Chicago/AI, 1967, 74; ICA, London, The Obsessive Image, 1968; MOMA, Dada, Surrealism and Their Heritage, 1968; Kassel, Documenta IV & V, 1968, 72; Monumenta, Newport, R.I., 1974; Chicago/Century, Bodyworks, 1975; WMAA, 200 Years of American Sculpture, 1976; Kassel, Documenta VI, 1977; Williamstown/Clark, The Dada/Surrealist, Heritage, 1977; ICA, Philadelphia, The Decorative Impulse, 1979; XXXIX Venice Biennale, 1980; AAIAL, 1984; WMAA, Blam!, 1984; Hera Art Foundation, Cambridge, Mass., Offset: A Survey of Artists' Books, 1985; SRGM, Forty Years of Sculpture, 1985; California Institute of Technology, Painting as Landscape, 1985; Chicago/AI, 75th American, 1985; MIT, Nude, Naked, Stripped, 1985; Middlebury College, Recent American Pastels, 1988;

High Museum, First Person Singular: Self Portrait Photographs, 1988; Ho Am Art Hall, Seoul, Contemporary Art form New York, circ., 1988; Walker, Vanishing Presence, 1989; Chicago Arts Club, Drawings of the Eighties, 1989; NPG, Photographic Treasures, 1990; Guild Hall, Aspects of Collage, 1991. **Collections:** Buffalo/Albright; Canberra/National; Chicago/AI; Chicago/Contemporary; Dallas/MFA; Denver/AM; Fort Worth; Hartford/Wadsworth; Harvard U.; Hirshhorn; Honolulu Academy; Indiana U.; Los Angeles/County MA; Miami-Dade; Minneapolis/Institute; MMA; MOMA; National Gallery; New Orleans/Museum; PMA; Phoenix; Polaroid Corp.; Princeton U.; Prudential Insurance Co. of America; Ridgefield/Aldrich; RISD; SFMA; Seattle; SRGM; St. Louis/City; U. of St. Thomas (Tex.); WMAA; Walker. **Bibliography:** Alloway 2, 4; Battcock, ed.; Cummings 1, 4, 5; Diamonstein; Davies; *Drawings: The Pluralist Decade; Europa/Amerika;* Finch; Friedman and van der Marck; *From Foreign Shores;* Hansen; *Happenings & Fluxus;* Haskell 5; Hunter, ed.; *Individuals;* Kardon 3; Kozloff 3; Lippard 5; *Monumenta;* Pincus-Witten; Plagens; Rickey; **Samaras, 2;** Sandler 3; Schwartz 1, 3; Seitz 3, 4; Tuchman 1; Waldman 4. Archives.

SANDBACK, FRED b. August 29, 1943, Bronxville, N.Y. **Studied:** Williston Academy, 1957-61; Theodor Heuss Gymnasium, Heilbronn, 1961-62; Yale U., 1962-66; Yale School of Art and Architecture, 1966-69. The Fred Sandback Museum is part of the Dia Art Foundation and is located at 74 Front St., Wincherdon, Mass. 01475. **Awards:** CAPS Grant, 1972. **Address:** 561 Broadway, NYC 10012. **Dealer:** John Weber Gallery, NYC. **One-man Exhibitions:** (first) Konrad Fischer Gallery, Düsseldorf, 1968; Galerie Heiner Friedrich, Munich, 1968, 70, 72, 73, 74, 75, 76, 78; Dwan Gallery, NYC, 1969, 70; ACE Gallery, Los Angeles, 1969; Françoise

Lambert, Milan, 1970; Yvon Lambert, 1970; Galerie Reckermann, Cologne, 1970, 72; Galerie Annemarie Verna, Zurich, 1971, 72, 76; John Weber Gallery, 1972, 74, 76; Galerie Diogenes, Berlin, 1972; Galerie Nachst St. Stephen, Vienna, 1973; Galerie im Taxispalais, Innsbruck, 1973; Berne, 1973; Galleria Martano Due Torino, 1974; Galleria Milano, Milan, 1974; Galleria Primo Piano, Rome, 1974, 76; Leverkusen, 1974; Essen, 1974; Kunstraum, Munich, 1975; Darmstadt/Hessisches, 1975; Galerie d & c Mueller-Roth, Stuttgart, 1975; Galerie Dorothea Loehr, Frankfurt, 1975; Galerie Klein, Bonn, 1975; Brooke Alexander, Inc., NYC, 1976; Galleria Durand-Dessert, Paris, 1976; Lisson Gallery, London, 1977; Hester Van Royen Gallery, London, 1977; Heiner Friedrich Gallery, NYC, 1978; P.S. 1, Long Island City, 1978; MOMA, 1978; Marian Goodman Gallery, NYC, 1985; David Nolan Gallery, NYC, 1988; Nina Freudenheim Gallery, Buffalo, 1989; Burnett Miller Gallery, Los Angeles, 1991. **Group:** WMAA, 1968; Düsseldorf/Kunsthalle, Prospect '68, 1968; MOMA, New Media, New Methods, circ., 1969; Berne, When Attitudes Become Form, 1969; ICA, U. of Pennsylvania, Between Object and Environment, 1969; Arnhem, Sonsbeek '71, 1971; Neuer Berliner Kunstverein, Berlin, Multiples, 1974; MOMA, Drawing Now, 1976; Leverkusen, Drawings 3, 1975; Sydney, Biennial, 1976; Chicago/AI, Americans, 1979. **Collections:** Krefeld/Kaiser Wilhelm; MOMA; RISD; WMAA. **Bibliography:** Honisch and Jensen, eds.; Kren; Weintraub.

SANDER, LUDWIG b. July 18, 1906, NYC. d. July 31, 1975, NYC.
Studied: NYU, BA; Hofmann School, Munich, two semesters. Traveled Europe, 1927, 1931-32. US Army, World War II. **Taught:** Colorado College, summers, 1951, 52, 53; Bard College, 1956-58. **Member:** NIAL. **Awards:** Hallmark Inter-

national Competition; Longview Foundation Grant; National Council on the Arts; Guggenheim Foundation Fellowship, 1968; AAAL, Childe Hassam Fund Purchase, 1973. **One-man Exhibitions:** (first) Morton Gallery, NYC, 1930; Hacker Gallery, NYC, 1952; Leo Castelli, Inc., 1959, 61; The Kootz Gallery, NYC, 1962, 64, 65; A. M. Sachs Gallery, 1967, 69; Lawrence Rubin Gallery, NYC, 1970, 71, 73; Waddington Galleries, London, 1972; Knoedler Contemporary Art, 1974, 75, 77, 79; The Berenson Gallery, Bay Harbor Islands, Miami, 1975; Rosa Esman Gallery, NYC, 1977; M. Knoedler & Co., NYC, 1982, 85. **Group:** Ninth Street Exhibition, NYC, 1951; SRGM, Abstract Expressionists and Imagists, 1961; Chicago/AI Annuals, 1961, 62; MOMA, Recent American Painting and Sculpture, circ., USA and Canada, 1961-62; WMAA, Geometric Abstraction in America, circ., 1962; Seattle World's Fair, 1962; Los Angeles/County MA, Post Painterly Abstraction, 1964; XXXII Venice Biennial, 1964; Toledo/MA, Form of Color, 1970; WMAA, 1973; SRGM, American Painters Through Two Decades, 1973; U. of Miami, Less Is More: The Influence of the Bauhaus on American Art, 1974; Corcoran, 1975; Brooklyn Museum, American Drawings in Black and White: 1970-1979, 1980; MOMA, Contrasts of Form: Geometric Abstract Art 1910-1980, 1985. **Collections:** American Republic Insurance Co.; Baltimore/MA; Brandeis U.; Buffalo/Albright; Chase Manhattan Bank; Chicago/AI; Ciba-Geigy Corp; Columbia Broadcasting System; Corcoran; Fort Worth; International Minerals & Chemicals Corp.; MIT; MMA; Ridgefield/Aldrich; SFMA; SRGM; U. of Texas; Union Carbide Corp.; Uris Building Corp.; WMAA; Walker. **Bibliography:** MacAgy 2; Weller. Archives.

SANDOL, MAYNARD b. 1930, Newark, N.J. **Studied:** Newark State Teachers College, 1952. Traveled Europe.

Taught: Hackettstown (N.J.) High School, 1964-; Fairleigh Dickinson U., 1965-68. **Address:** Bunn Street, Box 364, R.R. 2, Clifton, NJ 07830. **One-man Exhibitions:** Suttman-Riley Gallery, NYC, 1958; Artists' Gallery, NYC, 1959; Castellane, NYC, 1960, 63; Castellane, Provincetown, 1962, 63; Athena Gallery, New Haven, 1963; Chapman Kelly Gallery, 1964; The Peridot Gallery, NYC, 1967, 68; Washburn Gallery Inc., NYC, 1971. **Group:** Newark Museum; Hartford/Wadsworth; MOMA; Corcoran; New York World's Fair, 1964-65; Trenton/State. **Collections:** Brandeis U.; Hartford/Wadsworth; Hirshhorn; Newark Museum; Princeton U. **Bibliography:** Gerdts.

SARET, ALAN b. December 25, 1944, NYC. **Studied:** Cornell U., 1961-66, B. Arch.; Hunter College, 1967-68. Traveled Europe, Mexico, North Africa; resided in India, 1971-73. **Taught:** U. of California, Irvine, 1979. **Awards:** Guggenheim Foundation Fellowship, 1969; National Endowment for the Arts, grant, 1975; CAPS, award, 1976. **Address:** 54 Leonard Street, NYC 10013. **Dealer:** Charles Cowles Gallery, NYC. **One-man Exhibitions:** Bykert Gallery, NYC, 1968, 70; The Clocktower, NYC, 1973; Seattle/AM, 1977; U. of California, Berkeley, 1978; SITE, San Francisco, 1979; Weinberg Gallery, San Francisco, 1979; Charles Cowles Gallery, NYC, 1980; U. of California, Santa Barbara, 1984. **Group:** WMAA, 1968; Oberlin College, 1968; U. of North Carolina, 1969; Amsterdam/Stedelijk, Op Losse Schroeven, 1969; Berne, When Attitudes Become Form, 1969; MOMA, New Media, New Methods, circ., 1969; New Delhi, Second World Triennial, 1971; Akademie der Kunst, Berlin, SoHo, 1976; U. of Georgia, Open to New Ideas, 1977; Venice Biennial, 1980; ICA, Boston, Drawing/Structures, 1980; Wave Hill, NYC, Temporary Structures, 1980. **Collections:** Art Museum of South Texas; Chi-

cago/Contemporary; Dallas/MFA; Detroit/Institute; U. of Georgia; Los Angeles/County MA; MOMA; SFMA; Society of the Four Arts; Toronto; WMAA. **Bibliography:** *Drawings: The Pluralist Decade;* Johnson, Ellen H.; *When Attitudes Become Form.*

SARKISIAN, PAUL b. August 18, 1928, Chicago, Ill. **Studied:** Chicago Art Institute School, 1945-48; Otis Art Institute, Los Angeles, 1953-54; Mexico City College, 1955-56. **Taught:** Pasadena/AM, 1965-69; U. of Southern California, Los Angeles, 1969; U. of California, Berkeley, 1970; U. of Oregon, 1971; U. of Southern Florida, 1972. **Address:** Cerrillos, NM 87010. **Dealer:** Nancy Hoffman Gallery, NYC. **One-man Exhibitions:** Nova Gallery, Boston, 1958; Aura Gallery, Pasadena, 1962; La Jolla, 1963; Pasadena/AM, 1968; Corcoran, 1970; Michael Walls Gallery, San Francisco, 1970; Santa Barbara/MA, 1970; Chicago/Contemporary, 1972; Michael Walls Gallery, Los Angeles, 1973; Houston/Contemporary, 1977; Nancy Hoffman Gallery, NYC, 1978, 80, 82; Arts Club, Chicago, 1979; Wright State U., 1980; ARCO Center for the Visual Arts, Los Angeles, 1981; Fendrick Gallery, Washington, D.C., 1981; Aspen Center for the Visual Arts, 1982; Union County College, Cranford, N.J., 1984. **Group:** Pasadena/AM, Annual, 1960; Pasadena/AM, 100 California Artists, 1963; Los Angeles/County MA, Late Fifties at the Ferus, 1968; WMAA Annual, 1969; Los Angeles Municipal Art Gallery, Separate Realities, 1973; Expo '74, Spokane, 1974; Chicago/AI, 71st American Exhibition, 1974; Corcoran Biennial, 1975; Indianapolis, 1976; SFMA, Painting and Sculpture in California: The Modern Era, 1976; Chicago/AI, Visions, 1976; Jacksonville/AM, New Realism, 1977; Zurich, Painting in the Age of Photography, 1977; Canberra/National, Illusions of Reality, 1977; Denver/AM, Biennial, 1979. **Collections:** Aachen; Albuquerque; Chicago/AI;

Corcoran; Des Moines; U. of Georgia; Hirshhorn; Indianapolis; Little Rock/MFA; MMA; Milwaukee; Minneapolis/Institute; U. of Nebraska; U. of New Mexico; Oakland/AM; Pasadena/AM; Roswell; Santa Barbara/MA; Santa Fe. **Bibliography:** Arthur 1; Ward.

SATO, TADASHI
from 1st to 4th edition.

SAUL, PETER **b.** August 16, 1934, San Francisco, Calif. **Studied:** Stanford U.; California School of Fine Arts, 1950-52; Washington U., with Fred Conway, 1952-56, BFA. Traveled Europe. Resided Holland, 1956-58; Paris, 1958-62; Rome, 1962-64. **Awards:** *Art in America* (magazine), New Talent, 1962; William and Noma Copley Foundation Grant, 1962; National Endowment for the Arts, Grant, 1980. **Address:** c/o Dealer. **Dealer:** Frumkin/Adams Gallery, NYC. **One-man Exhibitions:** Allan Frumkin Gallery, Chicago, 1961, 63, 64, 66, 69, 72, 74, 77, NYC, 1962-64, 66, 68, 69, 71, 73, 75, 77, 78, 81, 84, 85, 87; Galerie Breteau, Paris, 1962, 63, 64, 67; La Tartaruga, Rome, 1963; Rolf Nelson Gallery, Los Angeles, 1963; Notizie Gallery, Turin, 1964; Galerie Anne Abels, Cologne, 1965; Contemporary Gallery, Kansas City, 1967; Palos Verdes Estates, Calif., 1967; Wanamaker Gallery, Philadelphia, 1967; San Francisco Art Institute, 1968; Reed College, 1968; California College of Arts and Crafts, 1968; Darthea Speyer Gallery, Paris, 1969, 72; Musée d'Art et d'Industrie, Paris, 1971; California State U., Sacramento, 1973; Housatonic Museum of Art, Bridgeport, Conn., 1976; Frumkin Struve Gallery, Chicago, 1984, 89; Rena Bransten Gallery, San Francisco, 1986; Texas Gallery, Houson, 1987, 90; Chicago/Contemporary, 1989; Frumkin/Adams Gallery, NYC, 1989, 90, 92; Galerie du Centre, Paris, 1991. **Retrospectives:** U. of Northern Illinois, circ., 1980; Aspen Art Museum, circ., 1989. **Group:**

Peter Saul, *Telephone Call*, 1988.

Salon des Jeunes Peintres, Paris, 1959, 60; Dayton/AI, International Selection, 1961; U. of Colorado, 1962; Chicago/AI, 1962, 63, 64; SFMA, Directions—Painting U.S.A., 1963; U. of Michigan, 1963, 65; Musée Cantonal des Beaux-Arts, Lausanne, I Salon International de Galeries Pilotes, 1963; Abbey Saint-Pierre, Ghent, Forum, 1963; Brandeis U., Recent American Drawings, 1964; The Hague, New Realism, 1964; Des Moines, 1965; Indianapolis/Herron, 1966; U. of Kentucky, 1966; Carnegie, 1967; MOMA, circ., 1968; U. of Oklahoma, 1968; U. of Illinois, 1969; WMAA, Human Concern/Personal Torment, 1969; Corcoran, 1971; Chicago/AI, 1972; Paris/Beaubourg, Paris—New York, 1977; WMAA, Art About Art, 1978; Haus der Kunst, Munich, Amerikanische Malerei, 1930-1980, 1981; Fort Lauderdale, An American Renaissance, 1986; ICA, London, Komic Ikonoklasm, 1987; U. of California, Berkeley, Made in the USA, circ., 1987; Florida International U., American Art Today: The Portrait, 1987; Skidmore College, Self-Portrait: The Message, The Material, circ., 1987; RISD, Call of the Wild, 1987; MOMA, Committed to Print, 1988; Hirshhorn, Different Drummers, 1988; Bucknell U., Reagan: American Icon, circ., 1989; U. of North Carolina, Art on Paper, 1989; Youngstown/Butler, California A to Z and Return, 1990; Milwaukee, Word as

Image, circ., 1990. **Collections:** U. of California, Berkeley; Carnegie; Chicago/AI; U. of Illinois; Kansas City/AI; Los Angeles/County MA; MMA; MOMA; Madison Art Center; Marseilles/Cantini; U. of Massachusetts; Oberlin College; Paris/Beaubourg; SFMA; Stedelijk/Ostende; Stockholm/National; U. of Texas; WMAA. **Bibliography:** Adrian; Armstrong, Thomas; De Salvo and Schimmel; Gettings 2; Lucie-Smith.

SAUNDERS, RAYMOND
b. October 28, 1934, Homestead, Pa. **Studied:** U. of Pennsylvania, 1954-57; Barnes Foundation, 1953-55; PAFA, 1953-57; Carnegie Institute of Technology, 1959-60, BFA; California College of Arts and Crafts, 1960-61, MFA. Traveled Mexico, Europe, USA. **Taught:** RISD; California State U., Hayward, 1968-; Hunter College, 1981; U. of Texas, 1983. **Awards:** PAFA, Cresson Fellowship, 1956; AAAL Grant, 1963; Eakins Prize; Ford Foundation, **P.P.**, 1964; Prix de Rome, 1964, 65; Guggenheim Foundation Fellowship, 1976; National Endowment for the Arts, grant, 1977, 84. **Address:** 6007 Rock Ridge Boulevard, Oakland, CA 94618. **Dealer:** Stephen Wirtz Gallery, San Francisco. **One-man Exhibitions:** (first) Pittsburgh Playhouse Gallery, 1953, also 1955; Terry Dintenfass, Inc., NYC, 1962, 64, 66-69, 71, 73, 75, 86; Dartmouth College, 1969; Simpson College, Indianola, Iowa, 1969; Lehigh U., 1970; Miami-Dade, 1971; Spelman College, 1972; RISD, 1972; Carleton College, 1974; Peale House, Philadelphia (two-man), 1974; U. of California, Berkeley, 1975; U. of California, La Jolla, 1979; Baum/Silverman Gallery, Los Angeles, 1979; Stephen Wirtz Gallery, San Francisco, 1970, 80, 82, 83, 85, 86, 87; Los Angeles Municipal Art Gallery, 1980; Santa Clara/Triton, 1980; Seattle/AM, 1981; Portland (Ore.) Museum School, 1981; Hunsaker/Schlesinger Gallery, Los Angeles, 1981, 85; Hunter College, 1981; Arizona State U., 1982; Miami-Dade Community College, 1982; U. of California, Santa Cruz, 1982; U. of Texas, 1983; Los Angeles/Municipal, 1984; Angles Gallery, Santa Monica, 1985; Thomas Babeor Gallery, La Jolla, 1985; Boise, 1985; St. Mary's College, 1986; U. of Idaho, 1986; Ohio State U., 1987; Cava Gallery, Philadelphia, 1987; Andover/Phillips, 1987; Greenville, 1989; Buffalo/Albright, 1989; Galerie Resche, Paris, 1990; Santa Monica College, 1992. **Group:** PAFA Annuals, 1962-67; SFMA Annuals; New School for Social Research; WMAA, 1971, Annuals, 1972, 73; NAD; UCLA, The Negro in American Art, 1966; A.F.A., 1966, 67; Dartmouth College, 1968; 30 Contemporary Black Artists, circ., 1968-69; Westmoreland County/MA, 1969; Boston/MFA, Black Artists: New York and Boston, 1970; Oakland/AM, Oakland Artists, 1974; VMFA, 1974; Cranbrook, Drawings by Contemporary American Artists, 1975; Skidmore College, Contemporary Drawings, 1975; Afro-American Art Pavilion, Expo 74, Spokane, 1974; Oakland/AM, 1979; Sacramento/Crocker, Aspects of Abstract Art, 1979; SFMA, Resource/Resevoir, 1982; Corcoran Biennial, 1983; SFMA, Biennial, 1984; Bucknell U., Harlem Renaissance, 1985; AAIAL, 1985; Sacramento/Crocker, Works of Art on Paper, 1986; Studio Museum of Harlem, Tradition and Conflict: Images of a Turbulent Decade, circ., 1985. **Collections:** Achenbach Foundation; Allentown/AM; Andover/Phillips; Arizona State U.; California College of Arts and Crafts; California State College, San Bernardino; U. of California, Berkeley; Carnegie; Dartmouth College; Fisk U.; Howard U.; Hunter College; MMA; Miami-Dade Community College; MOMA; Mount Holyoke College; NIAL; Oakland/AM; U. of North Carolina; PAFA; SFMA; St. Louis/City; Seattle/AM; U. of Texas; Tougaloo College; U. of Utah; WMAA; U. of Wisconsin.

SAUNDERS, WADE b. 1949,
Berkeley, Calif. **Studied:** Wesleyan U.,
1971, BA; U. of California, San Diego,
1974, MFA. **Address:** 26 Bernon Street,
Providence, R.I. 02908. **One-man Exhibitions:** Grossmont College, 1975; Pyramid
Art Galleries Ltd., Washington, D.C.,
1975, 77; Braunstein-Quay Gallery, San
Francisco, 1976; Newspace, Los Angeles,
1977, 79, 81, 83, 85; PAFA, 1980; Diane
Brown Gallery, Washington, D.C., 1981,
84; Charles Cowles Gallery, NYC, 1981,
82; Jeffrey Fuller Fine Art, Philadelphia,
1982; C. Grimaldis Gallery, Baltimore,
1983, 84; Helen Shlein Gallery, Boston,
1984; Linda Durham Gallery, Santa Fe,
1984; Lawrence Oliver Gallery, Philadelphia, 1984, 86; Diane Brown Gallery,
NYC, 1984, 85, 86, 88, 90; Quint Gallery, San Diego, 1985; San Diego State U.,
1985; Portland (Ore.) Center for the Visual Arts, 1985; Pence Gallery, Santa
Monica, 1989; Betsy Rosenfield Gallery,
Chicago, 1990. **Group:** Oakland/AM,
Public Sculpture: Urban Environment,
1974; ICA, U. of Pennsylvania, Dwellings,
1978; San Diego, Sculpture in California,
1975-80, 1980; ICA, U. of Pennsylvania,
Connections, 1983; ICA, U. of Pennsylvania, Made in Philadelphia, 1984. **Collections:** Andover/Phillips; Baltimore/MA;
Best Products Corp.; Corcoran; MMA;
Milwaukee; Newark Museum; U. of
Nebraska; Newport Harbor; PMA;
Seattle/AM.

SAVELLI, ANGELO b. October
30, 1911, Pizzo Calabro, Italy. **Studied:**
Liceo Artistico, Rome, 1930-32; Academy of Fine Arts, Rome, with Ferruccio
Ferrazzi, Diploma di Decorazione, 1932-
36. To USA, 1954. Traveled Europe,
USA. A cofounder of The Art Club,
Rome, with Gino Severini, Enrico
Pramolini, Fazzini, and others, 1944.
Taught: Collegio Nazionale, Rome, 1939-
40; Liceo Artistico, Rome, 1940-43,
1948-54; Scarsdale Art Workshop, 1957-
61; New School for Social Research,

1959-64; Positano (Italy) Art Workshop,
1960-62; U. of Pennsylvania, 1960-69,
76; Columbia U., 1966; Hunter College,
1968; U. of Minnesota, 1974; Cornell
U., 1974; PAFA, 1975; U. of Arkansas,
1975; U. of Texas, Arlington, 1977-82.
Member: Artists Equity. **Commissions:**
Sora, Italy (church facade, fresco);
F.A.U., Rome (mural); Italian Line (paintings for SS *Leonardo da Vinci* and SS *Michelangelo);* Lincoln Plaza, Syracuse, N.Y.;
Audubon Art Center, New Haven, Conn.
Awards: Fellowship from the Italian Ministry of Education, 1948; Bergamo, First
Prize, 1941, 42; Battistoni, First Prize,
1958; XXXII Venice Biennial, 1964,
Grand Prize for Graphics; Potsdam/SUNY, P.P., 1965; Vancouver,
P.P., 1968; Tiffany Grant, 1976;
Guggenheim Foundation Fellowship,
1979; AAAL, 1983. **Address:** 257 Water
Street, NYC 10038. **Dealer:** Galleria
Lorenzelli, Milan. **One-man Exhibitions:** (first) Galleria Roma, Rome, 1941;
La Spiga, Milan, 1942; Galleria Ritrove,
Rome, 1943; Galleria San Marco, Rome,
1944, 51; Galleria Cronache, Bologna,
Italy, 1946; Oblo Capri, 1946; Galleria
d'Arte del Naviglio, Milan, 1947, 54, 61;
Galleria Sandri, Venice, 1947; Centre
d'Art Italien, Paris, 1952; Numero Galleria d'Arte, Florence, Italy, 1953; The Contemporaries, NYC, 1955; D'Arnecourt
Gallery, Washington, D.C., 1956; Leo
Castelli, Inc., NYC, 1958; Galleria del
Cavallino, Venice, 1958; Galleria Selecta,
Rome, 1959; U. of Minnesota, 1960, 74;
Peter H. Deitsch Gallery, 1962; D'Arcy
Gallery, NYC, 1963; Philadelphia Art Alliance, 1963; XXXII Venice Biennial, 1964;
Eastern Illinois U., 1964; Wellfleet Art
Gallery, 1964; Contemporary Prints and
Drawings, Chicago, 1966; Henri Gallery,
1969; Peale House, Philadelphia, 1969;
Syracuse/Everson, 1972; Stout State U.,
Menomonie, Wisc., 1973; U. of Minnesota, Duluth, 1973; The Pennsylvania
State U., 1975, 76; Max Hutchinson Gallery, NYC, 1978; Sculpture Now, NYC,

1978; Parsons-Dreyfuss Gallery, NYC, 1978; Galleria Lorenzelli, 1981; Arco d'Alibert, Rome, 1981; Gimpel-Hanover, Zurich, 1981; Studio Bonifacio, Genoa, 1986; Galleria Editalia, Rome, 1981; Civico Padiglione d'arte Contemporanea, Milan, 1984; Studio Bonifacio, Genoa, 1986; Castello Murat, Pizzo Calabro, 1986; Art Coop Palladio, Zurigo, 1986; Studio Renato Brazzani, Torino, 1987; Studio D'Ars, Milan, 1987; Galleria Il Salotto, Como, 1988; Wichita/AM, 1988; Allentown/AM, 1990; Casa del Mantegna, Mantova, 1990; Galleria d'Arte Niccoli, Parma, 1991; Galleria Elleni, Bergamo, 1991; Kodama Gallery, Osaka, 1992. **Retrospectives:** Cantanzaro, Italy, 1954; Padiglione d'Arte Contemporanea, Milan, 1984. **Group:** Rome National Art Quadrennial, 1943; Venice Biennial, 1948; Rose Fried Gallery, NYC, International Collage Exhibition, 1956; Hartford/Wadsworth, Graphics, 1956; A.F.A., Collage in America, circ., 1957-58; Library of Congress, 1959; Brooklyn Museum, 1962, 63; Gallery of Modern Art, Ljubljana, Yugoslavia; A.F.A., Moods of Light, circ., 1963-64; Sidney Janis Gallery, 1964; WMAA Annuals, 1966, 67; PAFA Annual, 1963; Brooklyn Museum, 1968; Corcoran Biennial, 1969; Salon du Mai, Paris, 1969; Madrid/Nacional, II Biennial, 1969; Corcoran, 1969; Chicago/Contemporary, White on White, 1971-72; Festival of Two Worlds, Charleston, N.C., 1978; Italian Cultural Institute, NYC, 1979; AAIAL, 1981; XXX Biennial Nationale d'Arte Citta di Milano, 1987; Biennale d'Arte Calabrese, Monterosso, 1991. **Collections:** Brooklyn Museum; Chase Manhattan Bank; Cincinnati/AM; Corcoran; Eliat; Helsinki; High Museum; Kalamazoo/Institute; Library of Congress; MOMA; U. of Minnesota; National Gallery; NCFA; NYPL; Norfolk/Chrysler; PMA; U. of Pennsylvania; Phoenix; Rome/Nazionale; Syracuse/Everson; Turin/Civico; Vancouver; Victoria and Albert Museum; WMAA.

SCARPITTA, SALVATORE

b. March 23, 1919, NYC. To Italy to study, 1936; returned to NYC, 1959. Traveled Italy, Switzerland. **Studied:** Royal Academy of Fine Arts, Rome. **Taught:** Maryland Institute, 1965-. US Navy, 1945; and underground in WWII, in Italy. Subject of award-winning video, *Sal Is Racer,* 1986, at C.A.G.E. Video Festival, Cincinnati, 1986. **Address:** 307 East 84th Street, NYC 10028. **Dealer:** Leo Castelli Inc., NYC. **One-man Exhibitions:** Gaetano Chiurazzi, Rome, 1949; Galleria II Pincio, Rome, 1951; La Tartaruga, Rome, 1955, 57, 58, 76; Galleria d'Arte del Naviglio, Milan, 1956, 58; Leo Castelli Inc., NYC, 1959, 60, 63, 65, 75, 80, 82, 84, 92; Leo Castelli Warehouse, NYC, 1969; Dwan Gallery, NYC, 1961; Galerie Schmela, 1963; Galleria dell'Ariete, 1963; Brussels/Royaux, 1964; Galleria Notizie, Turin, 1972; Galerie Jacques Benador, Geneva, 1973; L'Uomo e l'Arte, Milan, 1974; Robinson Galleries, Houston, 1978; Portland (Ore.) Center for the Visual Arts, 1978; Padiglione d'Arte Contemporanea, Milano, 1985; Leonarda Di Mauro Gallery, NYC, 1986; Studio Simonis, Turin, Italy, 1986; Studio Guezani, Milan, 1988, 90; U. of California, Berkeley, 1989; Scott Hanson Gallery, NYC, 1990; Greenberg Wilson Gallery, NYC, 1990; Anina Nosei Gallery, NYC, 1992. **Retrospective:** Houston/Contemporary, 1977. **Group:** Galleria Roma, Rome, 1944; Rome National Art Quadrennial, 1948; XXVI, XXVIII, and XXIX Venice Biennials, 1952, 56, 58; Columbus, 1960; Martha Jackson Gallery, New Media—New Forms I & II, 1960, 61; Houston/MFA, Ways and Means, 1961; Corcoran, 1963; Musée Cantonal des Beaux-Arts, Lausanne, I Salon International de Galeries Pilotes, 1963; Maryland Institute, 1964; Chicago/AI, 1964; U. of Illinois, 1965; ICA, U. of Pennsylvania, Highway, 1970; Hofstra U., Art Around the Automobile, 1971; Rome, III Quadrennial, 1972; The Fine Arts Building, NYC, Personal Mythologies, 1976; Vassar Col-

lege, Contemporary Primitivism, 1976; Queens Museum, Private Myths, 1978; The New Museum, NYC, Sustained Vision, 1979; Indianapolis, Painting and Sculpture Today, 1980; P.S. 1, Long Island City, The Shaped Field: Eccentric Formats, 1981; Houston/Contemporary, In Our Time, 1982; Los Angeles/MOCA, The Automobile and Culture, 1983; Hirshhorn, Content, 1984; John Michael Kohler Arts Center, Sheboygan, The Road Show, 1989. **Collections:** Amsterdam/Stedelijk; Buffalo/Albright; Los Angeles/County MA; MOMA; Tel Aviv. **Bibliography:** Janis and Blesh 1; *Metro;* Weller. Archives.

SCHANKER, LOUIS
from 1st to 4th edition.

SCHAPIRO, MIRIAM **b.** November 15, 1923, Toronto, Canada. **Studied:** State U. of Iowa, 1945, BA; 1946, MFA; 1949. **Taught:** State U. of Iowa, 1946-49; Scarsdale School of Art, 1965-66; Connecticut College for Women, 1966; Parsons School of Design, NYC, 1966-67; U. of California, 1967-69; California Institute of the Arts, Valencia, 1971-75; Nova Scotia College of Art and Design, Halifax, 1974; Bryn Mawr College, 1977; Tyler School of Art, Philadelphia, 1977-78; Amherst College, 1978. **Awards:** Tamarind Fellowship, 1963; National Endowment for the Arts, 1976, 85; Ford Foundation Grant, 1964; Skowhegan Award, 1982; College of Wooster, Hon. DFA, 1983; California College of Arts and Crafts, Hon. DFA, 1989; National Association of Schools of Art and Design, 1992. **Member:** Board of directors, College Art Association and Los Angeles Institute of Contemporary Art; ICA, Los Angeles, founding member, 1974-75; CAA, board of directors, 1974-78; Women's Caucus for Art, Advisory Board, 1974-; Heresies Collective, founding member, 1976-; Feminist Art Institute, founding member, 1977. **Commissions:** Stained glass windows, Temple Shalom, Chicago,

1984; 1525 Wilson Boulevard Building, Rosslyn, Va., sculpture; Marriott Hotel, San Francisco, fan, 1989; Pasquerilla Performing Arts Center, Johnstown, Pa., painting, 1991. **m.** Paul Brach. **Address:** 393 W. Broadway, NYC 10012; Montauk Highway, East Hampton, NY 11037. **Dealer:** Bernice Steinbaum Gallery, NYC. **One-man Exhibitions:** U. of Missouri, 1950; Illinois Wesleyan U., 1951; André Emmerich Gallery, NYC, 1958, 61, 63, 67, 69, 71, 73, 76, 77; Skidmore College, 1964; Franklin Siden Gallery, Detroit, 1965; Vassar College, 1973; Cynthia Comsky Gallery, 1974, 75; Douglass College Library, 1975; Benson Gallery, 1975; Mills College, 1975; College of St. Catherine, St. Paul, Minn., 1976; U. of Wisconsin, La Crosse, 1976; A.R.C. Gallery, Chicago, 1976; Douglas Drake Gallery, Kansas City, Kansas, 1976, 82; Douglass College, New Brunswick, N.J., 1976; Oberlin College, 1977; State U. of Oregon, Corvallis, 1977; Reed College, 1978; Lerner Heller Gallery, NYC, 1979, 80; Gladstone/Villani Gallery, NYC, 1979; Barbara Gladstone Gallery, NYC, 1980, 81, 82; Dart Gallery, 1980, 84; Galerie Rudolf Zwirner, Cologne, 1981; Axiom Gallery, New South Wales, Australia, 1982; David Heath Gallery, Atlanta, 1982; Hodges Taylor Gallery, Charlotte, N.C., 1982; Yares Gallery, Scottsdale, 1982; Barbara Gilman Gallery, Miami, 1983; Kent State U., 1983; Koplin Gallery, Los Angeles, 1983; Marion Locks Gallery, Philadelphia, 1983; Thomas Segal Gallery, Boston, 1983; New Smyrna Beach, Fla., 1984; Brentwood Gallery, St. Louis, 1985, 86; Bernice Steinbaum Gallery, NYC, 1986, 88, 90, 91, 92; Guilford College, 1986; Vared Gallery, East Hampton, 1986; Charleston/Gibbs, 1987; Simms Fine Art Gallery, New Orleans, 1987; Lew-Allen/Butler Fine Art, Santa Fe, 1990; Fairleigh Dickinson U., 1990; Brevard Art Center, Melbourne, Fla., 1991; Mendelson Gallery, Chicago, 1992; Fullerton College, 1992; Colorado State U., 1992.

Retrospectives: New London, 1966; Newport Harbor and La Jolla, Paul Brach and Miriam Schapiro, 1969; U. of California, San Diego, 1975; College of Wooster, 1980. **Group:** MOMA, New Talent; U. of Nottingham (England), Abstract Impressionists, 1958; International Biennial Exhibition of Paintings, Tokyo; Carnegie, 1959; WMAA, 1959; MOMA, Abstract American Drawings and Watercolors, circ., Latin America, 1961-63; Jewish Museum, Toward a New Abstraction, 1963; SFMA, Directions—Painting U.S.A., 1963; Walker; Denver/AM; Brooklyn Museum; Chicago/AI; Brandeis U., New Directions in American Painting, 1963; PAFA 1963, 64; Dayton/AI, 1967; Fort Worth Art Museum, Drawings, 1969; Jewish Museum, Superlimited: Books, Boxes, and Things, 1969; Long Beach/MA, Invisible/Visible, Twenty-one Artists, 1972; Scripps College, California Women Artists, 1972; Womanhouse, Los Angeles, 1972; U. of North Dakota, 14 Women, 1973; Womanspace, Los Angeles, Female Sexuality/Female Identity, 1973; PMA/Museum of the Philadelphia Civic Center, Focus, 1974; Newport Harbor, The Audacious Years, 1974; Cerritos College Art Gallery, Norwalk, Calif., 16 Los Angeles Women Artists, 1974; Bronx Museum of Art, The Year of the Woman, 1975; San Antonio/McNay, American Artists, '76, 1976; Guild Hall, Artists of East Hampton, 1850-1975, 1976; West Palm Beach/Norton, Hi Mom, What's New?, 1977; The American Foundation for the Arts, Miami, Patterning and Decoration, 1977; Brussels/Beaux Arts, Pattern and Decoration, 1979; Aachen/Ludwig, Les Nouveaux Fauves-Die Neuen Wilden, 1980; Dublin/Municipal, International Quadrennial (ROSC), 1980; Indianapolis, 1980; Houston/Contemporary, The Americans: The Collage, 1982; Bonn, Back to the USA, circ., 1983; Boston/MFA, Brave New Works, 1983; Hudson River Museum, Ornamentalism, 1983; Pittsfield/Berkshire, New Decorative Art, 1983; San Antonio/McNay, The Artist and the Quilt, 1983; U. of Southern Florida, Humanism, 1984; C.W. Post College, The Doll Show, 1985; Bradley U., The Artist and the Quilt, circ., 1985; ICI, After Matisse, circ., 1986; Syracuse/Everson, Computers and Art, 1987; U. of Massachusetts, Contemporary American Collage, circ., 1987; Huntington, N.Y./Heckscher, The Artists' Mother, circ., 1987; Southampton/Parrish, Drawing on the East End, 1988; C.W. Post College, 100 Women's Drawings, 1988; MOMA, Committed to Print, 1988; Cincinnati/AM, Making Their Mark, circ., 1989; U. of North Carolina, Art on Paper, 1990; Douglass College, Rutgers U., Designing Women, 1991; NMWA, Presswork, circ., 1991; Los Angeles/County MA, Parallel Visions, 1992. **Collections:** Aachen/Ludwig; Albion College; Amstar Corp.; Avco Corp.; Bank of America; Best Products Co.; Boston/MFA; Brooklyn Museum; U. of California, Berkeley; Canberra/National; College of William and Mary; Hirshhorn; IBM: Illinois Wesleyan U.; U. of Iowa; Kalamazoo; La Jolla; Levin Townsend Computer Corp.; MOMA; Miami U.; Mills College; Milwaukee; Minneapolis/Institute; Missoula/MA; Mulvane; NYU; National Gallery; Newport Harbor; Oberlin College; Orlando; Purchase/SUNY; Rutgers U.; St. Louis/City; San Diego/Contemporary; Security Pacific Bank; Southampton/Parrish; Stanford U.; Stephens College; Syracuse/Everson; Tougaloo College; United Nations; Williams College; WMAA; Worcester/AM. **Bibliography:** *Art: A Woman's Sensibility; Back to the USA;* Lippard 3; Lucie-Smith; *Miriam Schapiro;* Robins.

SCHLEMOWITZ, ABRAM
from 1st to 4th edition.

SCHMIDT, JULIUS **b.** June 2, 1923, Stamford, Conn. **Studied:** Oklahoma A & M College, 1950-51; Cranbrook Academy of Art, 1952, BFA, 1955, MFA; Zadkine School of Sculpture,

Paris, 1953; Academy of Fine Arts, Florence, Italy. Traveled Europe, USA, Mexico, Mediterranean. **Taught:** Silvermine Guild School of Art, summers, 1953, 54; Cleveland Institute of Art, 1957; Kansas City/AI, 1954-59; RISD, 1959-60; U. of California, Berkeley, 1961-62; Cranbrook, 1962-70; U. of Iowa, 1970-. **Commission:** Iowa State U., bronze sculpture, 1985. **Awards:** Mid-American Biennial, First Prize and P.P.; Guggenheim Foundation Fellowship, 1963. **Address:** U. of Iowa, Art Department, Iowa City, IA 52242. **One-man Exhibitions:** Silvermine Guild, 1953; Kansas City/AI, 1956, 1965-66; Santa Barbara/MA, 1961; Otto Gerson Gallery, NYC, 1961, 63; Franklin Siden Gallery, Detroit, 1964; Gertrude Kasle Gallery, Detroit, 1965, 67, 72, 74; U. of Arkansas, 1966; Talladega College, 1966; Marlborough-Gerson Gallery Inc., 1966, 71; Rockford (Ill.) College Museum of Art, 1974; Terre Haute/Swope, 1980; Augusta College, 1981; Monmouth College, 1984; Terre Haute, 1985. **Retrospective:** U. of Iowa, 1974. **Group:** Detroit/Institute, 1958; PAFA, 1958, Annual, 1964; MOMA, Sixteen Americans, circ., 1959; Claude Bernard, Paris, Aspects of American Sculpture, 1960; Chicago/AI, 1960; WMAA Annuals, 1960-63; Carnegie, 1961; Dayton/AI, 1961; Boston Arts Festival, 1961; MOMA, American Painting and Sculpture, circ., 1961; New School for Social Research, Mechanism and Organism, 1961, also 1966; SFMA, 1962; SRGM, The Joseph H. Hirshhorn Collection, 1962; Battersea Park, London, International Sculpture Exhibition, 1963; São Paulo, 1963; Walker, Ten American Sculptors, 1964; Flint/Institute, 1965; WMAA, Contemporary American Sculpture, Selection 1, 1966; U. of Illinois, 1967; PMA, American Sculpture of the Sixties, 1967; U. of California, 1968; U. of Wisconsin, 1975. **Collections:** American Republic Insurance Co.; Brenton Bank; Buffalo/Albright; Buffalo/SUNY; Chase Manhattan Bank; Chicago/AI; Cranbrook; Daven-

port/Municipal; Detroit/Institute; U. of Illinois; U. of Iowa; Iowa State U.; Kalamazoo/Institute; Kansas City/Nelson; MOMA; U. of Massachusetts; U. of Michigan; U. of Nebraska; Oswego/SUNY; Princeton U.; Santa Barbara/MA; WMAA; Walker; Washington U.; U. of Wisconsin. **Bibliography:** Read 3.

SCHNABEL, JULIAN b. 1951,

NYC. **Studied:** U. of Houston, 1969-72, BFA; WMAA, Independent Study Program, 1973-74. **Address:** 24 East 20th Street, NYC 10003. **Dealer:** The Pace Gallery, NYC. **One-man Exhibitions:** Houston/Contemporary, 1976; Galerie December, Düsseldorf, 1978; Mary Boone Gallery, NYC, 1979, 81, 82; Daniel Weinberg Gallery, San Francisco, 1979, 82; Gallerie Bischofberger, Zurich, 1980, 82, 83, 84, 85, 88; Young Hoffman Gallery, Chicago, 1980; Anthony D'Offay Gallery, London, 1981; Amsterdam/Stedelijk, 1982; Margo Leavin Gallery, Los Angeles, 1982; Los Angeles/MOCA, 1982; U. of California, Berkeley, 1982; Tate Gallery, 1982; Leo Castelli Inc., NYC, 1981, 82; Akron/AM, 1983; Galleria Mario Diacono, Rome, 1983; Waddington Galleries, London, 1983, 85, 88, 91; Akira Ikeda, Nagoya, 1983; Akira Ikeda, Tokyo, 1984, 87, 90; The Pace Gallery, NYC, 1984, 86, 89, 90; Gian Enzo Sperone, Rome, 1985; Mario Diacono Gallery, Boston, 1986; Pace Editions, NYC, 1985; Whitechapel Gallery, London, circ., 1986; Galerie Yvon Lambert, Paris, 1987, 88, 90; Milwaukee, 1987; Hoffman/Borman Gallery, Santa Monica, 1987; Daniel Weinberg Gallery, Los Angeles, 1987; Israel Museum, Jerusalem, 1988; Galleria Gian Enzo Sperone, Rome, 1988, 91; U. of Houston, 1988; Museo de Arte Contemporaneo, Seville, 1988; Kunsthalle, Basel, 1989; Bordeaux/Contemporain, 1989; Osaka/National, 1989; Museo de'Arte Contemporanea, Prato, 1989; Galerie Feuerle, Cologne, 1991; Galerie Soledad Lorenzo, Madrid, 1991; Kansas

City/Nelson, 1991; Galerie de Poche, Paris, 1991; Galerie Beaubourg, Paris, 1991. **Retrospective:** Museum für Gegenwartskunst, Basel, circ., 1989. **Group:** WMAA, WISP, 1974; Grand Palais, Paris, L'Amerique aux Indépendants, 1980; XXXIX & XL Venice Biennials, 1980, 82; Indianapolis, 1980; The Royal Academy, London, A New Spirit in Painting, 1981; WMAA Biennials, 1981, 83, 87, 91; Cologne/Stadt, Westkunst, 1981; Amsterdam/Stedelijk, '60-'80: Attitude, Concepts, Images, 1982; Chicago/AI, 1982; Galeria Politi, Milan, Transavangarde International, 1982; Houston/Contemporary, The Americans: Collage, 1950-1982, 1982; Internationale Kunstausstellung, Berlin, 1982; Hannover/KG, New York Now, circ., 1982; Milwaukee, New Figuration in America, 1982; Dublin/Municipal, International Quadrennial (ROSC), 1984; Carnegie, International, 1985; Los Angeles/MOCA, Individuals, 1986; Berlin, Zeitgeist II, 1987; Ho-Am Gallery, Seoul, Contemporary Art from New York, circ., 1988; Vienna/Moderner, Wiener, 1989; Martin-Gropius-Bau, Berlin, 1990; Sydney, Biennial, 1990; Martin-Gropius-Bau, Berlin, Metropolis, 1991; Museo de Arte Contemporaneo, Monterrey, Mexico, Myth and Magic in the Americas, 1991. **Collections:** Aachen/Ludwig; Amsterdam/Stedelijk; Basel; Canberra/National; Carnegie; Chicago/AI; Dallas/MFA; Harvard U.; Lannan Foundation; Los Angeles/MOCA; MMA; MOMA; Milwaukee; Ottawa/National; Paris/Beaubourg; SFMA; Tate Gallery; WMAA; Yokohama; Youngstown/Butler. **Bibliography:** *Back to the USA;* Danto; De Wilde 1; De Wilde 2; Gohr and Gachnang; Haenlein; Hiromoto; Honnef 2; Hughes; *Individuals;* Joachimides and Rosenthal; Murken-Altrogge; Pincus-Witten 2; Plagens; Rose, Bernice, 1; Schwartz 1.

SCHNAKENBERG, HENRY
from 1st to 5th edition.

SCHOLDER, FRITZ b. October 6, 1937, Breckenridge, Minn. **Studied:** Sacramento City College, 1958, AA, with Wayne Thiebaud; Sacramento State U., 1960, BA; U. of Arizona, MFA. Traveled USA. **Taught:** Institute of American Indian Arts, Santa Fe; Dartmouth College; U. of Southern Calif. **Awards:** John Hay Whitney Foundation, fellow, 1962-63; Ford Foundation, P.P., 1962, Hon. DFA, Ripon College, 1984; Hon. DFA, U. of Arizona, 1985; Hon. DFA, Concordia College, 1986; Hon. DFA, College of Santa Fe, 1990. Subject of films *Fritz Scholder,* PBS, 1976; *Fritz Scholder: An American Portrait,* PBS, 1983. **Address:** 118 Cattle Track Road, Scottsdale, Ariz. 85253. **Dealer:** Charlotte Jackson Fine Art, Santa Fe. **One-man Exhibitions:** Sacramento City College, 1958; Artists' Cooperative Gallery, Sacramento, 1959; Sacramento/Crocker, 1959, 72; U. of Arizona, 1964; College of Santa Fe, 1967; Roswell, 1968; Lee Nordness Gallery, NYC, 1970; Esther Baer Gallery, Santa Barbara, Calif., 1971; Heard Museum, Phoenix, 1971; Jamison Galleries, Santa Fe, 1971; Talley Richards Gallery, Taos, N.M., 1981; Southwest Missouri State College, 1981; Art Wagon Gallleries, Scottsdale, 1972; Cedar Rapids/AA, 1972; Cordier & Ekstrom Gallery, NYC, 1972, 74, 76, 78; Luther College, 1972; St. John's College, Santa Fe, 1972; Dartmouth College, 1973; MIT, 1973; U. of North Carolina, 1973; U. of Nebraska, 1973; Charles Russell Gallery, Great Falls, Mont., 1973; Yellowstone Art Center, 1973; Brigham Young U., 1974; Memphis/Brooks, 1974; Gallery Moos, Toronto, 1974; U. of Santa Clara, 1975; Bradley U., 1976; Fresno Art Center, 1976; Moody Gallery, Houston, 1976; U. of New Mexico, 1976; U. of North Dakota, 1976; U. of Notre Dame, 1976; Gimpel & Weitzenhoffer, NYC, 1977; Oakland Museum, 1977; Smith-Andersen Gallery, Palo Alto, 1979, 84; El Paso Museum of Art, 1980, 82; U. of Minnesota, 1980; Plains Art Museum, Moorhead,

Minn., 1980; Augsburg College, 1981; Marilyn Butler Fine Art, Scottsdale, Az., 1981, 83, 84, 85; Tucson Museum of Art, 1981; ACA Galleries, NYC, 1982, 84; U. of Texas, Odessa, 1984; U. of Arizona, 1985; Nimbus Gallery, Dallas, 1985. **Group:** Denver; Youngstown/Butler; U. of North Carolina; NCFA; Brooklyn Museum; Museum of Contemporary Crafts, NYC; Corcoran; Grand Palais, Paris. **Collections:** Albuquerque Museum; Arizona State U.; U. of Arizona; Baltimore/MA; Bibliothèque Nationale, Paris; Boston/MFA; Brooklyn Museum; Buffalo/Albright; U. of California, Berkeley; Carnegie; Chicago/AI; Chicago/Contemporary; Cincinnati/AM; Corcoran; Dallas/MFA; Dartmouth U.; Denver/AM; El Paso Museum of Art; Flint/Institute; Fort Worth; Hartford/Wadsworth; Harvard U.; High Museum; Hirshhorn; Houston/MFA; Indianapolis; Kansas City/Nelson; Los Angeles/County MA; MOMA; Milwaukee; U. of Minnesota; NMAA; Omaha/Joslyn; PMA; Princeton U.; RISD; Roswell; Sacramento City College; Sacramento/Crocker; San Diego; Seattle/AM; Syracuse/Everson; U. of Texas; Toronto; Tucson; Utah; Walker; Wichita/AM; Worcester; Yale U.

SCHRAG, KARL b. December 7, 1912, Karlsruhe, Germany. **Studied:** Humanistisches Gymnasium, Karlsruhe, 1930; École des Beaux-Arts, Geneva, 1931; Atelier Lucien Simon, Paris; Academie Ranson, Paris, with Roger Bissiere; Academie de la Grande Chaumiere, 1931-35; ASL, with Harry Sternberg; Atelier 17, NYC, with S.W. Hayter. To USA, 1938; citizen, 1944. Traveled Europe, Mexico. **Taught:** Brooklyn College, 1953; Cooper Union 1954-68; Director of Atelier 17, NYC, 1950. **Member:** Artists Equity; SAGA; ASL; NAD. **Awards:** Brooklyn Museum Biennials, P.P., 1947, 50; SAGA, P.P., 1954; The Print Club, Philadelphia, Charles M. Lea Prize, 1954; American Color Print So-

ciety, 1958; Florence Tonner Prize, 1960; Sonia Wather Award, 1964; Ford Foundation Fellowship for work at Tamarind Lithography Workshop; Syracuse State Fair, Nelson Rockefeller Award, 1963; AAAL, 1966; Albion College, P.P., 1968; AAAL, Childe Hassam Fund P.P., 1969, 73; Ball State U., Drawing Prize, 1970; Davidson College, P.P., 1974; SAGA, award, 1971; SAGA, James R. Marsh Memorial Award, 1977; NAD, Benjamin Altman (Landscape) Prize, 1981; NAD, Andrew Carnegie Prize, 1986; Richard A. Florsheim Art Foundation Award, 1991; NAD, Carnegie Prize, 1986. **Address:** 127 East 95th Street, NYC 10028. **Dealers:** Kraushaar Galleries, NYC; A.A.A. Gallery, NYC. **One-man Exhibitions:** (first) Galerie Arenberg, Brussels, 1938; Smithsonian, 1945; Kraushaar Galleries, NYC, 1947, 50, 52, 56, 59, 62, 64, 66, 68, 71, 75, 77, 79, 82, 84, 86, 89, 91; U. of Alabama, 1949; Philadelphia Art Alliance, 1952; U. of Maine, 1953; State U. of New York, Oneonta, 1958; Gesellschaft der Freunde Junger Kunst, Baden-Baden, Germany, 1958; Storm King Art Center, 1967; NCFA, 1972; A.A.A. Gallery, 1986, 90; Bethesda (Md.) Art Gallery, 1977; Syracuse U., 1981, 91; St. Mary's College, 1981; Kornbluth Gallery, Fair Lawn, N.J., 1987; Jane Haslam Gallery, Washington, D.C., 1989, 91; St. Tolotoph's Club, Boston, 1991. **Retrospectives:** A.F.A./Ford Foundation, circ., 1960-62; A.A.A. Gallery, 1972, 80; NCFA, 1972; U. of Wisconsin, 1988; Rockland/Farnsworth, 1992. **Group:** SAGA; PAFA; The Print Club, Philadelphia; Brooklyn Museum; Graphische Sammlung Albertina; SFMA, 1941, 45, 46; WMAA, 1943, 55, 57; Carnegie, 1944, 47; Musée du Petit Palais, Paris, 1949; Chicago/AI; Instituto Nacional de Bellas Artes, Mexico City, 1958; U. of Nebraska, 1973; MOMA, 1975; MOMA, American Prints 1913-1963, circ., internationally, 1976; MMA, Contemporary American Prints from the Singer Collection, 1976; Brooklyn Mu-

Karl Schrag, *Mid Summer*, 1991.

seum, 30 Years of American Printmaking, 1976; MOMA, American Prints, 1913-61, 1976; MOMA, Artist's Choice: Chuck Close, Head-On/The Modern Portrait, 1991; Boston/MFA, Printed Portraits, 1991. **Collections:** Achenbach Foundation; U. of Alabama; Atlanta U.; Bibliothèque Nationale; Boston/MFA; Bradley U.; Brandeis U.; Brooklyn Museum; Chicago/AI; Cleveland/MA; Colby College; Commerce Trust Co., Kansas City, Mo.; Dartmouth College; Detroit/Institute; Hartford/Wadsworth; Hirshhorn; U. of Illinois; Karlsruhe; Lehigh U.; Library of Congress; Lincoln Life Insurance Co.; Los Angeles/County MA; MMA; MOMA; U. of Maine; U. of Nebraska; NYPL; National Gallery; Newark Museum; Oakland/AM; Omaha/Joslyn; PMA; The Pennsylvania State U.; RISD; Smithsonian; Springfield, Mass./MFA; SRGM; Syracuse/Everson; Syracuse U.; U.S. Rubber Co.; Uffizi Gallery; Utica; Victoria and Albert Museum; WMAA; Yale U.; Youngstown/Butler. **Bibliography: Gordon** 3; Hayter 1, 2; *Karl Schrag;* Moser; Reese. Archives.

SCHUCKER, CHARLES b. January 19, 1908, Gap, Pa. **Studied:** Maryland Institute, 1928-34. **Taught:** NYU, 1947-54; Pratt Institute, 1956-90; CCNY,

1955-56. **Member:** Yaddo Board of Directors. Federal A.P.: Easel painting in Chicago, 1938-42. **Awards:** Henry Walters Traveling Fellowship; Guggenheim Foundation Fellowship, 1953; Audubon Artists, Prize for Oil Painting; AAAL, Childe Hassam Fund P.P., 1952. **Address:** 33 Middagh Street, Brooklyn, NY 11201. **Dealer:** Anita Shapolsky Gallery, NYC. **One-man Exhibitions:** (first) Renaissance Society, Chicago; Albert Roullier Gallery, Chicago; Chicago/AI; The Chicago Artists Room; Macbeth Gallery, NYC, 1946, 49, 53; Passedoit Gallery, NYC, 1955, 58; Katonah (N.Y.) Art Gallery, 1955, 73, 78; The Howard Wise Gallery, NYC, 1963; Lincoln Center, 1968; WMAA, 1971; Max Hutchinson Gallery, NYC, 1972, 74, 75; Aaron Gallery, Washington, D.C., 1978; Gallery Camino Real, Boca Raton, Fla., 1980, 81, 84; Brooklyn Borough Hall, 1981; Peri/Renneth Gallery, Westhampton Beach, N.Y., 1983; Katonah (N.Y.) Museum, 1990. **Group:** MOMA, Painting and Sculpture from 16 American Cities, 1933; Carnegie, 1949; Walker, Contemporary American Painting, 1950; MMA, American Paintings Today, 1950; PAFA, 1951, 52, 53; California Palace Annual, 1952; WMAA Annuals, 1952-57, 60, 61, 63, 73; Chicago/AI, 1954; SFMA, Art in the Twentieth Century, 1955; WMAA, Nature in Abstraction, 1958; Corcoran; Brooklyn Museum; Riverside Museum, NYC; Amherst College, Color Painting, 1972; Cincinnati/Contemporary, Options, 73/30, 1973; Katonah (N.Y.) Art Gallery, 1973; Potsdam/SUNY, Abstraction Alive & Well, 1975; Brooklyn Museum, Great East River Bridge: 1883-1983, 1983; Pratt Institute, Centennial Exhibition, This Was Pratt, 1988; Pratt Manhattan Gallery, 5 Emeritus Faculty, 1990. **Collections:** AAAL; Brooklyn Museum; Brooklyn Union Gas; Harcourt Brace Jovanovich Inc.; Newark Museum; New Britain; Pratt Institute; WMAA. **Bibliography:** Baur 5; Goodrich and Baur 1. Archives.

SCHUELER, JON b. September
12, 1916, Milwaukee, Wisc. d. August 5,
1992, NYC. **Studied:** U. of Wisconsin,
1934-38, BA (economics), 1939-40, MA
(English literature); Bread Loaf School of
English, Middlebury, Vt., 1941; California
School of Fine Arts, 1948-51, with David
Park, Elmer Bischoff, Richard
Diebenkorn, Hassel Smith, Clyfford Still,
Clay Spohn. US Air Force, 1941-43. Trav-
eled Europe, Great Britain, USA exten-
sively. **Taught:** U. of San Francisco,
1947-49 (English literature); Yale U.,
1960-62, and summer school, 1960, 61;
Maryland Institute, 1963. **Member:** Artists
Equity. Subject of film, *Jon Schueler: An
Artist and His Vision.* **Commissions:** New
York Hilton Hotel, 1962 (lithograph).
Awards: National Endowment for the
Arts, 1980. **One-man Exhibitions:** (first)
Metart Gallery, San Francisco, 1950; The
Stable Gallery, NYC, 1954, 62, 64; Leo
Castelli Inc., NYC, 1957, 59; B.C. Hol-
land Gallery, Chicago, 1960; Hirschl &
Adler Galleries, Inc., NYC, 1960; Cornell
U., 1962; Columbia U. School of Architec-
ture, 1962; Maryland Institute, 1962, 64;
Richard Demarco Gallery, Edinburgh,
1973; Edinburgh College of Art, 1973;
WMAA, 1975; Cleveland/MA (three-
man), 1975; Landmark Gallery, NYC,
1977; House Gallery, London, 1978; John
Stoller & Co., Minneapolis, 1980; U. of
Edinburgh, 1981; Dorry Gates Gallery,
Kansas City, Mo., 1981, 86, 91; Dorothy
Rosenthal Gallery, Chicago, 1981, 84;
A. M. Sachs Gallery, NYC, 1983, 84;
William Sawyer Gallery, 1984; Katharina
Rich Perlow Gallery, NYC, 1986, 87, 89,
91; Washington Gallery, Glasgow, 1988;
Scottish Gallery, Edinburgh, 1990, 91.
Group: Walker, 1955; WMAA Annuals,
1956, 59, 61, 63; Corcoran, 1958, 62;
A.F.A., School of New York—Some Youn-
ger American Painters, 1960; Walker, 60
American Painters, 1960; WMAA, 50
Years of American Art, 1964; Cleve-
land/MA, Landscape, Interior, and Exte-
rior, 1975; Edinburgh/Modern, Creation,

Modern Art and Nature, 1984. **Collec-
tions:** AT&T; U. of California, Santa
Cruz; Cleveland/MA; Edinburgh/Modern;
Glasgow/AGM; Greenville; Hallmark Col-
lection; Kirkaldy; New York Hilton Hotel;
Purchase/SUNY; Scottish Arts Council; U.
of Stirling; Union Carbide Corp.; WMAA.
Bibliography: Baur 5; Friedman, ed.;
Goodrich and Baur 1; McChesney.

SCHWABACHER, ETHEL
from 1st to 4th edition.

SCHWARTZ, MANFRED
from 1st to 4th edition.

SCULLY, SEAN b. 1945, Dub-
lin, Ireland. To USA, 1975; citizen, 1983.
Studied: Croyden College of Art, London,
1965-68; Newcastle U., 1968-71; Harvard
U., 1972-73. **Taught:** Princeton U., 1977-
83. **Awards:** Guggenheim Foundation Fel-
lowship, 1983; National Endowment for
the Arts, 1984. **Address:** 110 Duane
Street, NYC 10007. **Dealer:** Mary Boone
Gallery, NYC. **One-man Exhibitions:**
Rowan Gallery, London, 1973, 75, 77, 79;
Tortue Gallery, Santa Monica, 1975, 76;
Duffy-Gibbs Gallery, NYC, 1977; Nadin
Gallery, NYC, 1977; The Clocktower,
NYC, 1979; Susan Caldwell Gallery,
NYC, 1980, 81; William Beadleston Gal-
lery, NYC, 1982; David McKee Gallery,
1983, 85, 87, 89, 90; Juda Rowan Gallery,
London, 1984; Galerij S.65, Aalst, Bel-
gium, 1984; Carnegie, circ., 1985; Barbara
Krakow Gallery, Boston, 1985; Galerie
Schmela, Düsseldorf, 1985, 87; Flanders
Contemporary Art, Minneapolis, 1987;
Mayor Rowan Gallery, London, 1987; U.
of California, Berkeley, 1988; AIC, 1987;
Fuji Television Gallery, Tokyo, 1988;
Crown Point Press, NYC and San Fran-
cisco, 1988; Whitechapel Art Gallery, circ.,
1989; Grob Gallery, London, 1989;
Karsten Greve Gallery, Cologne, 1990;
Galerie de France, Paris, 1990; Jamileah
Weber Gallery, Zurich, 1991; Weinberger
Gallery, Copenhagen, 1992; Pamela

Auchincloss Gallery, NYC, 1992; Brooke Alexander Editions, NYC, 1992; Bobbie Greenfield Fine Art, Los Angeles, 1992; Stephen Soloby Fine Art, Chicago, 1992; Daniel Weinberg Gallery, Santa Monica, 1992. **Retrospective:** Ikon Gallery, Birmingham, England, circ., 1981. **Group:** Hayward Gallery, London, British Painting, 1983; MOMA, International Survey of Recent Painting and Sculpture, 1984; AAIAL, 1984; U. of North Carolina, Art on Paper, 1985; ICI, After Matisse, 1986; Fort Lauderdale, An American Renaissance, 1986; Brooklyn Museum, Public and Private, 1986; Corcoran, Biennial, 1987; Pratt Institute, Sightings: Drawing with Color, circ., 1988; Victoria and Albert, London, Postmodern Prints, 1991. **Collections:** British Council; Canberra/National; Carnegie; Chicago/AI; Cleveland/MA; Corcoran; Dallas/MFA; Denver/AM; Düsseldorf/KN-W; First Bank, Minneapolis; Fitzwilliam Museum; Fort Worth/Modern; Harvard U.; High Museum; Humlebaek/Louisiana; MMA; MOMA; Madrid/Reina Sofia; Manchester, England; Manchester/Whitworth; McCrory Corp.; Melbourne/National; Mellon Bank; Mexico City/Contemporaneo; Munich/Lenbachhaus; Newcastle-upon-Tyne; PaineWebber Group; Phillips; Philip Morris Collection; Santa Barbara/MA; U. of Sydney; Tate Gallery; Walker. **Bibliography:** Hughes.

SEERY, JOHN b. October 29, 1941, Cincinnati, Ohio. **Studied:** Miami U., 1959-63; Cincinnati Art Academy, 1963; Ohio State U., 1963-64. Traveled Europe, Australia, Pacific Islands. **Taught:** Hunter College, 1973. **Address:** c/o Dealer. **Dealer:** Cove Gallery, Wellfleet, Mass. **One-man Exhibitions:** André Emmerich Gallery, NYC, 1970, 72, 74, 77; Richard Gray Gallery, Chicago, 1971, 72, 75, 78, 81; New Gallery, Cleveland, 1971; Ohio State U., 1972; Gallery A, Sydney, 1974; Madison Art Center (two-man), 1974; Galerie André Emmerich,

Zurich, 1975; Reed College, 1977; Berenson Gallery, Bay Harbor Islands, Miami, Fla., 1979; Max Hutchinson, Houston, 1979; Medici/Berenson Gallery, Miami, 1979, 82; Gruenebaum Gallery, NYC, 1981, 85; Peter Noser Gallery, Zurich, 1982; Hokin/Kaufman Gallery, Chicago, 1983; Elaine Horwitch Gallery, Scottsdale, 1983; Harvard U., 1984; Harcus Gallery, Boston, 1989. **Group:** ICA, U. of Pennsylvania, Two Generations of Color Painting, 1970; Cincinnati/Contemporary, Young American Artists, 1970; Spoleto, Festival of Two Worlds, 1972; Glassboro State College, Paintings on Paper, 1972; U. of North Carolina, Six Painters of the 70s, 1973; WMAA Annual, 1973; Milwaukee, Art Works, 1976; Syracuse U., The Critics' Choice, 1977; Indianapolis, 1978. **Collections:** Baltimore/MA; Boston/MFA; Brooklyn Museum; Canberra/National; Chicago/AI; Cincinnati/Contemporary; Fort Lauderdale; Harvard U.; Hirshhorn; Houston/Contemporary; ICA, Boston; Louisville/Speed; Madison Art Center; NMAA; RISD; SRGM; Santa Barbara/MA; Toledo/MA; WMAA. **Bibliography:** *Poets and Painters;* Rowell.

SEGAL, GEORGE b. November 26, 1924, NYC. **Studied:** NYU, 1950, BS; Rutgers U., 1963, MFA. **Taught:** New Jersey high schools, 1957-63. **Awards:** Walter K. Gutman Foundation Grant, 1962; Chicago/AI, First Prize, 1966; Hon. Ph.D., Rutgers U., 1970. **Address:** RFD #4, Box 323, North Brunswick, NJ 08902. **Dealer:** Sidney Janis Gallery, NYC. **One-man Exhibitions:** (first) Hansa Gallery, NYC, 1956, also 1957, 58, 59; Rutgers U., 1958; Green Gallery, NYC, 1960, 62, 64; Ileana Sonnabend Gallery, Paris, 1963; Galerie Schmela, 1963; Sidney Janis Gallery, NYC, 1965, 67, 68, 70, 71, 73, 74, 77, 78, 80, 82, 84, 86, 88, 89, 91; Toronto (three-man, with Jim Dine, Claes Oldenburg); Chicago/Contemporary, 1968; Darthea Speyer Gallery, Paris, 1969, 71; Galerie der Spiegel, Cologne, 1970;

Galerie Onnasch, Cologne, 1971; Zurich, circ., 1971, 73; Trenton/State (two-man), 1971; U. of Wisconsin, Milwaukee, 1973; André Emmerich Gallery, Zurich, 1975; Dartmouth College, 1975; ICA, U. of Pennsylvania, 1976; Nina Freudenheim Gallery, Buffalo, 1976; Newport (R.I.) Art Association, 1976; Suzette Schochett Gallery, Newport, R.I., 1976; Santa Barbara/MA, 1976; Greenwich (Conn.) Arts Council, 1977; Ohio U., 1978; Serge De Bloe Gallery, Brussels, 1979; Makler Gallery, Philadelphia, 1979, 84; Akron/AM, 1980; Gatodo Gallery, Tokyo, 1980; Fay Gold Gallery, Atlanta, 1980; Gloria Luria Gallery, Bay Harbor Islands, Fla., 1980; Contemporary Sculpture Center, Tokyo, 1982; Hara Museum of Art, Kurashiki, 1982; Museum of Modern Art, Toyama, 1982; Seibu Museum of Art, Tokyo, 1982; Takanawa Museum, Karuizawa, 1982; Jewish Museum, 1983, 85; U. of Miami, 1983; Osaka/National, 1983; Il Ponte Gallery, Rome, 1984; Galerie Esperanza, Montreal, 1985, 87; Galerie Maeght, Paris, 1985; Youngstown/Butler, 1985; Galerie Brusberg, Berlin; California State U., Long Beach, 1986; Galerie Joan Prats, Barcelona, 1986; Richard Gray Gallery, Chicago, 1987; Riva Yares Gallery, Scottsdale, Ariz., 1988; New Jersey Center for the Visual Arts, Summit, N.J. 1989; Casino Knokke, Knokke, Belgium, 1989; Fort Worth/Modern, circ., 1989; Margulies/Tablin Gallery, Bay Harbor Islands, Fla., 1990; Galerie Tokoro, Tokyo, 1990; Gallery Ueda, Tokyo, 1990; Galerie Beaubourg, Paris, 1990; Caracas/Contemporaneo, 1991; Trenton/State, circ., 1991. **Retrospectives:** California State U., Long Beach, circ., 1977-78; Walker, circ., 1978-79. **Group:** Boston Arts Festival, 1956; Jewish Museum, The New York School, Second Generation, 1957, Recent American Sculpture, 1964, also 1966; WMAA Annuals, 1960, 64, 68; A.F.A., The Figure, circ., 1960, also 1968; Sidney Janis Gallery, The New Realists, 1962; VII & IX São Paulo Biennials, 1963, 67; Stock-

holm/National, American Pop Art, 1964; Corcoran Biennial, 1965; Cordier & Ekstrom, Inc., 1965; Palais des Beaux-Arts, Brussels, 1965; WMAA, A Decade of American Drawings, 1965; SRGM, 1965, 67; RISD, Recent Still Life, 1966; Chicago/AI, 1966, 74; Walker, 1966; Los Angeles/County MA, American Sculpture of the Sixties, 1967; MOMA, The 1960's, 1967; Carnegie, 1967; II Internationale der Zeichnung, Darmstadt, 1967; Trenton/State, Focus on Light, 1967; Gelsenkirchen, 1967; Kassel, Documenta IV, 1968; St. Paul Gallery, 1968; ICA, London, The Obsessive Image, 1968; Fort Worth Art Museum, Drawings, 1969; Grand Rapids, Sculpture of the 60s, 1969; Boston U., American Artists of the Nineteen Sixties, 1970; Expo '70, Osaka, 1970; Indianapolis, 1970; Carnegie, 1970; WMAA, 1970; Walker, Figures/Environments, circ., 1970-71; Chicago/AI, Contemporary Drawings, 1971; Chicago/Contemporary, White on White, 1971-72; Utica, 1972; Harvard U., Recent Figure Sculpture, 1972; Cleveland/MA, Contemporary American Artists, 1974; Chicago/Contemporary, 1974, 76;

George Segal, *Helen in Front of Multi-Colored Doorway*, 1989.

Darmstadt, Kunsthalle, Realism and Reality, 1975; New York Cultural Center, Three Centuries of the American Nude, 1975; NCFA, Sculpture: American Directions 1945-75, 1975; Philadelphia College of Art, Artists' Sketchbooks, 1976; Kassel, Documenta VI, 1977; WMAA, Art About Art, 1978; Purchase/SUNY, Hidden Desires, 1980; NAD, 1981; Newport Harbor, Inside Out, Self Beyond Likeness, 1981; PAFA, Contemporary American Realism Since 1960, 1981; AAIAL, 1982; San Antonio/MA, Real, Really Real, Super Real, 1982; Houston/Contemporary, American Still Life, 1945-1983, circ., 1983; Ridgefield/Aldrich, A Second Talent, 1984; Williams College, Six on Bronze, circ., 1984; WMAA, Blam!, 1984. **Collections:** Aachen/NG; Aachen/S-L; Akron/AM; Amsterdam/Stedelijk; Birmingham, Ala./MA; CNAC; U. of California, Berkeley; Caracas; Carnegie; Charlotte/Mint; Chicago/AI; Cleveland/MA; Cologne; Columbus; Darmstadt/Hessisches; Dartmouth College; Des Moines; Detroit/Institute; Fort Worth/Modern; Hartford/Wadsworth; Helsinki; Hiroshima/Contemporary; Hirshhorn; Indiana U.; Israel Museum; ITT Center; Krefeld/Kaiser Wilhelm; MMA; MOMA; Mexico City/Tamayo; Milwaukee; Montreal/Contemporain; Mönchengladbach; Munich/Lenbachhaus; Munich/SG; NCFA; National Gallery; Newark Museum; U. of North Carolina; Omaha/Joslyn; Osaka/National; Ottawa/National; PAFA; PMA; Paris/Beaubourg; Pasadena/AM; Portland, Ore./AM; Princeton U.; Purchase/SUNY; Rotterdam; SFMA; SRGM; St. Louis/City; Seattle/AM; Schwebber Electronics; Stockholm/National; Stuttgart; Syracuse/Everson; U. of Texas; Tokyo/Central; Tokyo/Hara; Toronto; Trenton/State; Vancouver; WMAA; Walker; Wuppertal; Zurich. **Bibliography:** Alloway 4; Battcock, ed.; Becker and Vostell; Bihalji-Merin; Calas, N. and E.; *Contemporanea;* Craven, W.; Diamonstein; Dienst 1; *Figures/Environments;* Finch; Friedman and

van der Marck; Gerdts; Hansen; Haskell 5; Honisch and Jensen, eds.; Hunter, ed.; Johnson, Ellen H.; Kaprow; Kozloff 3; *Kunst um 1970;* Licht, F.; Lippart 5; Osterwold; *Recent Figure Sculpture;* Rowell; Sandler 3, 5; Seitz 3; Siegel; Trier 1; Tuchman 1; Waldman 4; Weller. Archives.

SELEY, JASON
from 1st to 4th edition.

SELIGER, CHARLES b. June 3, 1926, NYC. Self-taught in art. Traveled Switzerland, France. **Taught:** Mt. Vernon (N.Y.) Art Center, 1950-51; George Washington U., 1990. **Address:** 10 Lenox Avenue, Mount Vernon, NY 10552. **Dealers:** Michael Rosenfeld Gallery, NYC; Galerie Lopes, Zurich. **One-man Exhibitions:** (first) Art of This Century, NYC, 1945, also 1946; Carlebach Gallery, NYC, 1948, 49; de Young, 1949; Art Center School, Los Angeles, 1949; Willard Gallery, NYC, 1951, 53, 55, 57, 61, 62, 65, 66, 67, 78; Otto Seligman Gallery, 1955, 58, 65, 66; Haydon Calhoun Gallery, Dallas, 1962; Nassau Community College, Garden City, N.Y., 1966; Andrew Crispo Gallery, NYC, 1974, 76, 78, 79, 81, 83; Les Copains Art Ltd., Buffalo, N.Y., 1976; Makler Gallery, Philadelphia, 1979; Miami-Dade Community College, Miami, 1981; Jacksonville/AM, 1981; Gallery Schlesinger-Boisanté, NYC, 1985, 86, 87; Galerie Lopes, Zurich, 1986, 89, 90; Saidenberg Gallery, NYC, 1990; Michael Rosenfeld Gallery, NYC, 1991, 92. **Retrospectives:** Wooster Community Art Center, Danbury, Conn., 1969; SRGM, 1986. **Group:** VMFA, 1946; Chicago/AI, Abstract and Surrealist Art, 1948; XXIV Venice Biennial, 1948; WMAA Annuals, 1948, 49, 51, 52, 53, 54, 55, 56, 57, 58, 60; Guggenheim Collection; Brooklyn Museum, 1949; Cornell U., Young Painters, 1951; MOMA, Abstract Painting and Sculpture in America, 1951; Chicago/AI, 1952; USIA, American Painting, circ., Europe, 1956; Utica, 1957;

Charles Seliger, *Wind Seeds*, 1989.

Rome-New York Foundation, Rome, 1960; Norfolk; St. Paul Gallery, 1966; AAAL, 1966, 68; The Willard Gallery, 1967; Smithsonian, The Art of Organic Forms, 1968; Skidmore College, Watercolors: Historical and Contemporary, 1976; Chicago/Terra, Solitude, Inner Visions in American Art, 1982; Rutgers U., Abstract Expressionism: Other Dimensions, circ., 1989; MOMA, Art of the Forties, 1991; Utica, Nature into Art, 1987; UCLA, Visions of Inner Space, 1987; U. of North Carolina, Art on Paper, 1989. **Collections:** Andover/Phillips; Baltimore/MA; Brandeis U.; Carnegie; Chicago/AI; Chicago/Terra; The Hague; Hartford/Wadsworth; High Museum; Hirshhorn; Iowa State U.; Jacksonville/AM; Jerusalem/National; Karlsruhe; MMA; MOMA; Newark Museum; Phillips; Rutgers; Seattle/AM; Southern Illinois U.; SRGM; Tel Aviv; US State Department; Utica; Vancouver; Vassar College; WMAA; Worcester/AM. **Bibliography:** Baur 7; Read 2, 4; Richardson, E.P.; Ritchie 1. Archives.

SELIGMANN, KURT b. July 20, 1900, Basel, Switzerland; d. January 2, 1962, NYC.

Studied: École des Beaux-Arts, Geneva, 1920; Academy of Fine Arts, Florence, Italy, 1927. To USA, 1939; became a citizen. **Taught:** Brooklyn Museum School. Designed sets for modern dance and ballet groups. Authority on magic. **One-man Exhibitions:** Jeanne Bucher, Paris, 1932, 35; Zwemmer Gallery, Lon-

don, 1933; Mitsukoshi, Tokyo, 1935; Wakefield Gallery, NYC; Karl Nierendorf Gallery, NYC, 1939, 41; New School for Social Research, 1940; Mexico City/Nacional, 1943; Durlacher Brothers, NYC, 1944, 46, 48, 50, 53; Arts Club of Chicago, 1946; Alexander Iolas Gallery, 1953; Walker, 1958; Fine Arts Associates, NYC, 1960; Ruth White Gallery, 1960, 61, 68; D'Arcy Gallery, NYC, 1964; Berne, 1967; Galerie Jacques Benador, Geneva, 1974; John Bernard Myers Gallery, NYC, 1974; Springfield, Mass./MFA, 1974; La Boetie, Inc., NYC, 1973, 76; Buffalo/Albright, 1983. **Retrospective:** La Boetie, NYC, 1973. **Group:** WMAA; MOMA; Chicago/AI; Detroit/Institute; U. of Illinois; MMA; NYPL; PAFA; Buffalo/Albright, Drawings and Watercolors, 1968. **Collections:** Aubusson; Bibliothèque Nationale; Brooklyn Museum; Buffalo/Albright; Chicago/AI; College des Musées Nationaux de France; U. of Illinois; Kunstkredit; Lodz; MMA; MOMA; Mexico City/Nacional; NYPL; PAFA; Smith College; WMAA. **Bibliography:** *Abstraction Creation 1931-1936;* Blesh 1; Breton 2; Dorner; Flanagan; Frost; Goodrich and Baur 1; Huyghe; Jakovski; Janis and Blesh 1; Janis, S.; Kuh 1; Murken-Altrogge; Neff, ed.; Pearson 1; Pousette-Dart, ed.; Richardson, E.P.; Rubin 1; Sachs; **Seligmann**; Tomkins and Time-Life Books; Waldberg 4. Archives.

SENNHAUSER, JOHN b. December 10, 1907, Rorschach, Switzerland. d. January 7, 1978, Escondido, Calif.

Studied: Technical Institute, Treviso, Italy; Academy of Fine Arts, Venice; Cooper Union. Traveled Europe, USA. **Taught:** Leonardo da Vinci Art School, NYC, 1936-39; Contemporary School of Art, NYC, 1939-42. **Member:** American Abstract Artists; Federation of Modern Painters and Sculptors; International Institute of Arts and Letters. **Commissions:** Murals for banks and private buildings in NYC and other cities. **Awards:** WMAA,

P.P., 1951; Tulsa/Philbrook, P.P., 1951; Mark Rothko Foundation Grant, 1971, 72. **One-man Exhibitions:** (first) Leonardo da Vinci Art School Gallery, NYC, 1936; Contemporary Arts Gallery, NYC, 1939; Theodore A. Kohn Gallery, NYC, 1942; Artists' Gallery, NYC, 1947, 50, 52; Brown U., 1954; U. of Maine, 1955; Black Mountain College, 1956; The Zabriskie Gallery, 1956, 57; Knapik Gallery, NYC, 1961; The Salpeter Gallery, NYC, 1964; Meierhans Art Galleries, Perkasie, Pa., 1963, 68; Lenox (Mass.) Library, 1972; San Diego Public Library, 1979; Martin Diamond Gallery, NYC, 1980. **Group:** Brunswick U.; Bennington College; Worcester/AM; Walker; Dallas/MFA; NAD; PAFA; Chicago/AI; Museum of Non-Objective Art, NYC; Corcoran; U. of Illinois; Brooklyn Museum; Baltimore/MA; Salon des Realites Nouvelles, Paris; A.F.A., Collage in America, 1958; A.F.A., Geometrical Abstraction of the 1930s, 1972. **Collections:** American Museum of Immigration; Calcutta; U. of Georgia; St. Lawrence U.; SRGM; Tulsa/Philbrook; Utica; Wichita State U.; WMAA. **Bibliography:** Lane and Larsen; Pousette-Dart, ed. Archives.

SERISAWA, SUEO
from 1st to 4th edition.

SERRA, RICHARD b. November 2, 1938, San Francisco, Calif. **Studied:** U. of California, Berkeley and Santa Barbara, 1957-61, BA, MA; Yale U., 1961-64; BA and MA. Traveled Italy. **Commissions:** Western Washington U., Bellingham, 1978; General Services Administration, 1979; Tilted Arc, Federal Plaza, NYC, later destroyed, 1989. **Awards:** Fulbright Fellowship, 1965-66; Skowhegan School Medal, 1975; Officier de l'Ordre des Arts et des Lettres, France, 1991; City of Duisburg, Lehmbruck Sculpture Award, 1991. **Address:** 319 Greenwich Street, NYC 10013. **Dealer:** Leo Castelli, Inc., NYC. **One-man Exhibitions:** Galleria la Salita, Rome, 1966; Galerie Rolf Ricke, Cologne, 1968, 73; Galerie Lambert, Milan, 1969; Leo Castelli, Inc., NYC, 1970, 72, 74, 81, 82, 84, 85, 86, 87, 89; ACE Gallery, Los Angeles, 1970, 72, 74, 76; U. of California, San Diego, 1970; Pasadena/AM, 1970; School of Visual Arts, NYC, 1974; Portland (Ore.) Center for the Visual Arts, 1974; Galerie de Gestlo, Hamburg, 1975; ACE Gallery, Venice, Calif., 1976, 78; Galerie Daniel Templon, Paris, 1977, 84; Galerie Bochum-Weitmar, West Germany, 1977; Amsterdam/Stedelijk, circ., 1977; Blum Helman Gallery, NYC, 1976, 78, 81, 83; Oxford, MOMA, 1978; Richard Hines Gallery, Seattle, 1979; U. of California, Berkeley, 1979; KOH Gallery, Tokyo, 1979, 81; Galerie Schmela, Düsseldorf, 1979; Hudson River Museum, 1980; Rotterdam, 1980; Monchenhausmuseum, Goslar, West Germany, 1981; Gemini G.E.L., Los Angeles, 1982; St. Louis/City, 1982; Carol Taylor Gallery, Dallas, 1982; Akira Ikeda Gallery, Tokyo, 1983, 85, 87; Larry Gagosian Gallery, Los Angeles, 1983, 84; Galerie Nordenhake, Malmo, Sweden, 1983, 84; Richard Onnasch Gallery, Berlin, 1983; Galerie Maeght Lelong, NYC, 1985, 86; Krefeld/Haus Lange, 1985; Le Coin du Miroir, Dijon, 1985; Galleria Stein, Milan, 1985; Middendorf Gallery, Washington, D.C., 1986; Galerie M. Bochum, 1986, 88, 89; MOMA, 1986; New City Editions, Venice, Calif., 1986; Musée de Bourg-en-Bresse, France, 1986; Hoffman Borman Gallery, Santa Monica, 1986, 87; The Pace Gallery, NYC, 1987, 89; Munster/W.K., 1987; Munich/Lenbachhaus, 1987; Kunsthalle, Basel, 1988; Neuer Berliner Kunstverein, Berlin, 1988; Eindhoven, 1988; Galerie Nordenhake, Stockhom, 1988; Fred Hoffman Gallery, Santa Monica, 1988; Ludwigschafen am Rhein, 1988; Donald Young Gallery, Chicago, 1989; Zurich/Kunsthaus, 1990; Maastricht, 1990; Galerie Yvon Lambert, Paris, 1990; Bordeaux/Contemporain, 1990; Frankfurt am

Main, 1991; Malmö Museum, 1991; Gagosian Gallery, NYC, 1991; MOMA, 1991. **Group:** Yale U., Drawings, 1966; Ithaca College, Drawings 1967, 1967; A.F.A., Soft Sculpture, 1968; WMAA, 1968, 70, 73; MOMA, New Media, New Methods, circ., 1969; Seattle/AM, 557,087, 1969; Trenton/State, Soft Art, 1969; Berne, When Attitudes Become Form, 1969; WMAA, Anti-Illusion: Procedures/Materials, 1969; SRGM, Nine Young Artists, 1969; Chicago/Contemporary, Art by Telephone, 1969; U. of California, Irvine, Five Sculptors, 1969; Hannover/Kunstverein, Identifications, 1970; SRGM, Guggenheim International, 1971; Düsseldorf/Kunsthalle, Prospect '71, 1971; Los Angeles/County MA, Art & Technology, 1971; Arnhem, Sonsbeek '71, 1971; Kassel, Documenta V, 1972; Rijksmuseum Kröller-Müller, Diagrams and Drawings, 1972; Festival of Two Worlds, Spoleto, 1972; New York Cultural Center, 3D into 2D, 1973; Yale U., Options and Alternatives, 1973; Detroit/Institute, Art in Space, 1973; Yale U., American Drawings, 1970-1973, 1973; Parcheggio di Villa Borghese, Rome, Contemporanea, 1974; Princeton U., Line as Language, 1974; MIT, Interventions in Landscapes, 1974; CNAC, Art/Voir, 1974; Oakland/AM, Public Sculpture; Urban Environment, 1974; Baltimore/MA, Artists, 1975; Hayward Gallery, London, The Condition of Sculpture, 1975; WMAA, Projected Video, 1975; NCFA, Sculpture: American Directions, 1945-1975, 1975; MOMA, Drawing Now, 1976; WMAA, 200 Years of American Sculpture, 1976; Philadephia College of Art, Private Notation: Artists' Sketchbooks II, 1976; Akademie der Kunst, Berlin, SoHo, 1976; Kassel, Documenta VI, 1977; WMAA Biennial, 1977; U. of Chicago, Ideas in Sculpture, 1977; Worcester/AM, Between Sculpture and Painting, 1978; Amsterdam/Stedelijk, Made by Sculptors, 1978; Krefeld/Haus Lange, The Broadening of the Concept of Reality in the Art of the 60s and 70s, 1979; P.S. 1, Long Island City, Great Big Drawing Show, 1979; Brooklyn Museum, American Drawings in Black and White: 1970-1979, 1980; Corcoran Biennial, 1981; Grand Palais, Paris, L'Amerique aux Indépendants, 1980; XXXIL Venice Biennale, 1980; Zurich, Reliefs, 1980; Amsterdam/Stedelijk, 60-'80: Attitudes/Concepts/Images, 1982; Centre d'Arts Plastiques Contemporains, Bordeaux, Art Povera, Antiform: Sculptures 1966-69, 1982; Kassel, Documenta VII, 1982; Dublin/Municipal, International Quadrennial (ROSC), 1984; Hirshhorn, Content, 1984; Venice Biennale, 1984; WMAA, American Art Since 1970, circ., 1984; Wesleyan U., Large Drawings, 1984; Lisbon/Gulbenkian, Exhibition—Dialogue, 1985; Carnegie, International, 1985; U. of Chicago, Large-Scale Drawings by Sculptors, 1985; Kunsthalle, Nurnberg, Triennal der Zeichnung, 1985; Brooklyn Museum, Public and Private, 1986; Bremen, Kunsthalle, Bodenskulptur, 1986; Madrid/Reina Sofia, Referencias, 1986; Paris/Beaubourg, Qu'est-ce que la sculpture moderne?, 1986; Brooklyn Museum, Monumental Drawings, 1986; Paris/Beaubourg, L'époque, la mode, la morale, la passion, 1970-1987, 1987; Kassel, Documenta VIII, 1987; Munster/W.K., Skulptur Projekte Munster, 1987; Berlin/National, Positionen heutiger kunst, 1987; Berlin, Hamburger Bahnhoff, Zeitlos, 1987; Sidney, Australian Biennial, 1987; Fundacio Joan Miró, Barcelona, I Triennial, 1989; SRGM, Geometric Abstraction and Minimalism in America, 1989; WMAA, The New Sculpture, 1965-75, 1990; Oslo/Contemporary, Terskel/Threshold, 1990; Makuhari Messe, Tokyo, Pharmakon '90, 1990; Kunstminen, Düsseldorf, 1990; Boston/MFA, 70s into 90s: The Unique Print, 1990; Dartmouth College, Minimalism and Post-minimalism, 1990; Osaka/National, Minimal Art, 1990; Indianapolis, Power: Its Myths and Mores in American Art, 1961-1991, circ., 1991;

Carnegie, International, 1991; Schloss Charlottenburg, Berlin, Schwereloss, 1991. **Collections:** Amsterdam/Stedelijk; Baden Baden; Berlin/National; Berne/Kunstmuseum; Bielefeld; U. of Bochum; Canberra/National; Carnegie; Chicago/AI; Chicago/Contemporary; Cleveland/MA; Cologne; Dallas/MFA; Des Moines; Detroit/Institute; Düsseldorf; Eindhoven; Harvard U.; Humlebaek/Louisiana; Israel Museum; Krefeld/Haus Lange; Krefeld/Kaiser Wilhelm; Kyoto; U. of Kyoto; La Jolla; Linz/Neue; Los Angeles/County MA; Ludwigshafen am Rhein; MMA; MOMA; Madrid/Reina Sofia; Melbourne/National; Montréal/Contemporain; Monchengladbach; Munich/Lembachhaus; Oberlin College; Ontario; Ottawa/National; PMA; Paris/Beaubourg; Pasadena/AM; Ridgefield/Aldrich; Rijksmuseum Kröller-Müller; Rotterdam; SFMA; SRGM; St. Louis/City; Stockholm/National; Storm King Art Center; Stuttgart; Tate; Toronto; Universitat Bochum; WMAA; Walker; Yale University. **Bibliography:** *Abstract Expressionism; Art Now 74;* Celant; *Contemporanea;* Danto; Day 1; De Wilde 2; *Europa/Amerika;* Gablik; Grevenstein; Honnef 2; Honisch and Jensen, eds.; *Individuals;* Johnson, Ellen H.; Kardon 3; Krauss 2, 3; *Kunst um 1970;* Lippard, 3; Lippard, ed.; Muller; *Options and Alternatives;* Pincus-Witten; *Report;* Robins; Sandler 3; Weintraub; *When Attitudes Become Form.*

SHAHN, BEN **b.** September 12, 1898, Kovno, Lithuania. **d.** May 14, 1969, NYC. To USA, 1906. **Studied:** NYU; City College of New York, 1919-22 (biology); NAD, 1922; ASL. Traveled Europe, Japan, North Africa, USA. Photographer and designer for Farm Security Administration, 1935-38. Designed posters for Office of War Information, 1942, and for CIO, 1944-46. Designed sets for *Ballets: USA* and for the Festival of Two Worlds, Spoleto, 1958. **Commissions:**

Community Building, Roosevelt, N.J., 1938-39; US Post Offices, Bronx, N.Y., 1938-39 (with Bernarda Bryson), and Jamaica, N.Y., 1939; Social Security Building, Washington, D.C., 1940-42; William E. Grady Vocational High School, Brooklyn, N.Y., 1957 (mosaic). **Awards:** PAFA, Pennell Memorial Medal, 1939, 53, Alice McFadden Eyre Medal, 1952, Joseph E. Temple Gold Medal, 1956; *Look* magazine poll of "Ten Best Painters," 1948; II São Paulo Biennial, 1953; XXVII Venice Biennial, 1954; Harvard U., Medal, 1956; American Institute of Graphic Art, Medal, 1958; North Shore, Long Island, N.Y., Art Festival Annual Award, 1959. **One-man Exhibitions:** The Downtown Gallery, NYC, 1930, 32, 33, 44, 49, 51, 52, 55, 57, 59, 61; Julien Levy Galleries, NYC, 1940; MOMA, 1947; Arts Council of Great Britain, circ., 1947; Albright Art School, 1950; Perls Galleries, 1950; Arts Club of Chicago, 1951; Santa Barbara/MA, circ., 1952, also 1967; Houston/MFA, 1954; Detroit/Institute (three-man), 1954; Chicago/AI, 1954; XXVII Venice Biennial, 1954; Southern Illinois U., 1954; American Institute of Graphic Art, 1957; St. Mary's College (Ind.), 1958; Bucknell U., 1958; Katonah (N.Y.) Art Gallery, 1959; Leicester Gallery, London, 1959, 64; U. of Louisville, 1960; U. of Utah, 1960; Library of the New Haven (Conn.) Jewish Community Center, 1961; Institute of Modern Art, Boston, Documentary, 1957; Amsterdam/Stedelijk, 1961; Rome/Nazionale, 1962; MOMA, Ben Shahn, circ., Europe, 1962; Randolph-Macon Women's College, 1966; PMA, 1967; Orlando, 1968; Kennedy Gallery, 1968-69, 70, 71, 73; Nantenshi Gallery, Tokyo, 1970; Syracuse U., 1977; Nardin Gallery, NYC, 1979; Hooks-Epstein Galleries, Houston, 1983, 84; Terry Dintenfass Inc., NYC, 1987. **Retrospectives:** MOMA, 1947; ICA, Boston, 1948; Osaka Municipal, 1970; National Museum of Western Art, Tokyo, 1970; Jewish Museum, NYC, 1976; Fort

Worth, 1977. **Group:** Corcoran; Carnegie; WMAA; Chicago/AI; U. of Nebraska; Brooklyn Museum; MOMA; Buffalo/Albright. **Collections:** Abbott Laboratories; Andover/Phillips; Arizona State College; U. of Arizona; Auburn U.; Baltimore/MA; Brandeis U.; Brooklyn Museum; Buffalo/Albright; California Palace; Carnegie; Chicago/AI; Container Corp. of America; Cranbrook; Dartmouth College; Des Moines; Detroit/Institute; Fort Wayne/AM; U. of Georgia; Grand Rapids; Hartford/Wadsworth; Harvard U.; U. of Illinois; Indiana U.; Inland Steel Co.; Jewish Museum; MMA; MOMA; Mary Washington College; U. of Michigan; Museum of the City of New York; U. of Nebraska; Newark Museum; U. of Oklahoma; Omaha/Joslyn; PAFA; Phillips; Sara Roby Foundation; St. Louis/City; Santa Barbara/MA; Smith College; Springfield, Mo./AM; Syracuse U.; Terry Art Institute; VMFA; WMAA; Walker; Wellesley College; Wesleyan U.; Wichita/AM; Youngstown/Butler. **Bibliography:** Armstrong, Thomas; Baigell 1; Barr 3; Baur 7; Bazin; Biddle 4; Bihaiji-Merin; Blesh 1; **Bush 1;** Brown 2; Canaday; Christensen; *Cityscape 1919-39;* Cummings 4; Eliot; Finkelstein; Flanagan; Flexner; *From Foreign Shores;* Gaunt; Gerdts; Goodrich and Baur 1; Greengood; Haftman; Honisch and Jensen, eds.; Hunter 6; Kepes 2; Kuh 1, 2; Langui; Lee and Burchwood; McCurdy, ed.; Mendelowitz; *Metro;* **Morse;** Munsterberg; Newmeyer; Newton 1; Nordness, ed.; Pearson 1, 2; Pousette-Dart, ed.; Read 2; Richardson, E.P.; Rodman 1, 2, 3; Sachs; **Shahn 1, 2; Shahn, B.B.;** Shapiro; **Soby 2, 3, 4, 5;** Sutton; Ward; Weller; Wight 2. Archives.

SHAPIRO, JOEL **b.** September 27, 1941, New York City. **Studied:** NYU, 1964, BA; 1969, MA; with the Peace Corps in India, 1965-66. **Taught:** Princeton U., 1974-76; School of Visual Arts, 1977-82. **Commissions:** Cigna

Corp., Philadelphia, 1983; Creative Artists Agency, Los Angeles, 1988; Fukuoka Sogo Bank, 1988; Kawamura Memorial Museum of Art, Chiba, Japan, 1988; Dartmouth College, 1989; US Holocaust Memorial Museum, 1991. **Awards:** National Endowment for the Arts, grant, 1975; Brandeis U., Creative Arts Award, 1984; Skowhegan School, Medal for Sculpture, 1986; AAIAL, Award of Merit for Sculpture, 1990. **m.** Ellen Phelan. **Address:** 284 Lafayette Street, NYC 10012. **Dealer:** The Pace Gallery, NYC. **One-man Exhibitions:** (first) Paula Cooper Gallery, NYC, 1970, 72, 74, 75, 76, 77, 79, 80, 82, 83, 84, 86, 88, 89, 90, 92; The Clocktower, NYC, 1973; Galerie Salvatore, Ala, Milan, 1974; Garage Gallery, London (two-man), 1975; Walter Kelly Gallery, Chicago, 1975; Chicago/Contemporary, 1976; Max Protetch Gallery, Washington, D.C., 1977; Buffalo/Albright, 1977; Susanne Hilberry Gallery, Detroit, 1977; Galerie Nancy Gillespie-Elisabeth de Laage, Paris, 1977, 79; Galerie Aronowitsch, Stockholm, 1977, 80, 83, 84, 90; Greenberg Gallery, St. Louis, 1978, 90; Galerie M. Bochum, West Germany, 1978; Akron/AI, 1979; Ohio State U., 1979; Whitechapel Art Gallery, London, 1980; Brown U., 1980; Israel Museum, 1981; Galerie Mukai, Tokyo, 1981, 88, 91; U. of North Carolina, 1981; John Stoller & Co., Inc., 1981; Young Hoffman Gallery, Chicago, 1981; Susanne Hilberry Gallery, Birmingham, Mich., 1982, 88; Portland (Ore.) Center for the Visual Arts, 1982; Yarlow/Salzman Gallery, Toronto, 1982; Asher/Faure Gallery, Los Angeles, 1983, 86, 89, 91; Knoedler Kasmin Gallery, London, 1985; Seattle/AM, 1986; Galerie Daniel Templon, Paris, 1986, 88; Ringling, 1986; Hal Bromm Gallery, NYC, 1987; John Berggruen Gallery, San Francisco, 1987, 91; Hirshhorn, 1987; Hans Strelow Gallery, Düsseldorf, 1988; Cleveland/MA, 1988; Toledo/MA, 1989; Waddington Galleries, London, 1989; Pace Editions,

NYC, 1990; Museet I Varberg, Varberg, Sweden, 1990; Baltimore/MA, circ., 1990; Humlebaek/Louisiana, circ., 1990; Miami Center for the Fine Arts, 1991. **Retrospectives:** WMAA, circ., 1982; Amsterdam/Stedelijk, circ., 1985. **Group:** WMAA, Anti-Illusion: Procedure/Material, 1969; MOMA, Paperworks, 1970; WMAA Annual, 1970; WMAA, American Drawings, 1963-1973, 1973; Chicago/AI, 1974; U. of Massachusetts, Critical Perspectives in American Art, 1976; Venice Biennial, 1976; Akademie der Kunst, Berlin, SoHo, 1976; ICA, U. of Pennsylvania, Improbable Furniture, 1977; Kassel, Documenta VI, 1977; Walker, Scale and Environment, 1977; U. of Chicago, 33 Ideas in Sculpture, 1977; WMAA Biennials, 1977, 79, 81, 89; Vassar College, five-man show, 1978; Amsterdam/Stedelijk, Made by Sculptors, 1978; Hayward Gallery, London, Pier and Ocean, 1979; Lenbachhaus, Munich, Tendencies in American Drawings of the Late Seventies, 1979; U. of North Carolina, Drawings About Drawing Today, 1979; Brooklyn Museum, American Drawings in Black and White: 1970-1979, 1980; XXXIX Venice Biennial, 1980; Akron/AM, The Image in American Painting and Sculpture, 1950-1980, 1981; Rice U., Variants, 1981; Kassel, Documenta VII, 1982; MIT, Body Language, circ., 1982; MIT, Great Big Drawings, 1982; Milwaukee, American Prints, 1960-1980, 1982; ARS '83, Helsinki, 1983; Bonn, Back to the USA, 1983; Brooklyn Museum, The American Artist as Printmaker, 1983; Dublin/Municipal, International Quadrennial (ROSC), 1984; Hirshhorn, Drawings 1974-1984, 1984; MOMA, International Survey of Recent Painting and Sculpture, 1984; Newark Museum, American Bronze Sculpture, 1850 to the Present, 1984; Purchase/SUNY, Hidden Desire, 1984; Seattle/AM, American Sculpture: Three Decades, 1984; Hudson River Museum, A New Beginning, 1968-1978, 1985; U. of Nebraska, Contemporary Bronze: Six in the Figurative Tradition, 1985; Fort Lauderdale, An American Renaissance: Painting and Sculpture Since 1940, 1986; Frankfurt/Kunstverein, Vom Zeichen, 1986; Frankfurt/Kunstvertein, Prospect 86, 1986; Boston/MFA, Printmaking Now: 70s into 80s, 1986; AAIAL, 1986; Carnegie Mellon U., Drawings from the Eighties, 1987; Lannan Museum, Lake Worth, Fla., Abstract Expressions: Recent Sculpture, 1987; Williams College, BIGlittle Sculpture, 1988; PMA, New Art on Paper, 1988; Carnegie, International, 1988; AAIAL, 1989, 90, 91; WMAA, The New Sculpture, 1965-75, 1990; Kunstnerses Hus, Oslo, The Art of Drawing, 1990; Makuhari Messe, Tokyo, Pharmakon '90, 1990; Dartmouth College, Minimalism and Post-minimalism, 1990; Boston/MFA, The Unique Print: 70s into 90s, 1990; Frejus, La sculpture contemporain: après 1970, 1991; MOMA, Allegories of Modernism, 1992; Baltimore/MA, Marking the Decades: Prints, 1960-1990, 1992. **Collections:** Amsterdam/Stedelijk; Art Museum of South Texas, Corpus Christi; Baltimore/MA; Boston/MFA; British Museum; Brooklyn Museum; Buffalo/Albright; Canberra/National; Cincinnati/AM; Cleveland/MA; Colby College; Colgate U.; Corcoran; Dallas/MFA; Dartmouth College; Detroit/Institute; Denver/AM; Des Moines; Fort Worth; Friuli, Italy; MMA; MOMA; Harvard U.; High Museum; Hirshhorn; Jerusalem/National; La Jolla; Los Angeles/County MA; Los Angeles/MOCA; Humlebaek/Louisiana; MOMA; McCrory Corporation; Milwaukee; National Gallery; U. of Nebraska; Newark Museum; U. of North Carolina; Ohio State U.; PMA; Paris/Beaubourg; Ringling; R.S.M. Co., Cincinnati; SRGM; St. Louis/City; Southampton/Parrish; Stockholm/National; Tate Gallery; Toledo/MA; Toronto; Walker; Whitney Communications, NYC; WMAA; Zurich/Kunsthaus. **Bibliography:** *Drawings: The Pluralist Decade;* Gettings 1; *Individuals;* Kren; Lucie-Smith; **Ormond;** Rose, Bernice, 1; Schwartz 1, 3.

SHATTER, SUSAN **b.** January
17, 1943, NYC. **Studied:** U. of Wisconsin; Skowhegan School, 1964, with John
Button, Fairfield Porter; Pratt Institute,
1965, BFA, with Alex Katz, Gabriel
Laderman, Philip Pearlstein; Boston U.,
1972, MFA, with James Weeks. Traveled
USA, Peru, Greece, Italy. **Taught:**
Skowhegan School, 1977, 79; Bennington
College, 1979; School of Visual Arts,
NYC, 1979, 83, 84; U. of Pennsylvania,
1985; Tyler School of Art, 1985; Vermont
Studio School, 1989; Brooklyn College,
1991-92. **Commissions:** AT&T, 1976;
Chevron Corp., 1985; Bank of New England, 1988. **Member:** Skowhegan School,
Board of Governors, Chairman, 1988-91.
Awards: Ingram Merrill Foundation
Grant, 1976-77; National Endowment for
the Arts, 1980; New York State Foundation for the Arts, grant, 1985; National
Endowment for the Arts, grant, 1987.
Address: 26 West 20th Street, NYC
10011. **Dealers:** Fischbach Gallery, NYC;
Harcus Gallery, Boston; John Berggruen
Gallery, San Francisco. **One-man Exhibitions:** (first) Fischbach Gallery, 1973, 76,
78, 80, 82, 84, 87, 88, 91; Harcus Krakow
Rosen Sonnabend, Boston, 1975; Harcus-
Krakow Gallery, Boston, 1977, 79;
Mattingly Baker Gallery, Dallas, 1981;
Harcus Gallery, 1984, 87; John Berggruen
Gallery, 1986; Heath Gallery, Atlanta,
1987. **Group:** American Federation of the
Arts, Painterly Realism, 1970; AAIAL,
1972; Omaha/Joslyn, A Sense of Place,
1973; Lincoln, Mass./De Cordova, New
England Women, 1975; US Department
of the Interior, America 1976, circ., 1976;
PAFA, Contemporary American Realism
Since 1960, 1981; SFMA, American Realism (Janss), circ., 1985; Springfield,
Mo./AM, Watercolor USA 1986, 1986;
Florida International U., American Art
Today: Contemporary Landscape, 1989;
The Pennsylvania State U., Realist Watercolors, 1990; NMWA, Presswork, 1991;
Miyagi Museum of Art, Sendai, Japan,
American Realism & Figurative Art: 1952-

Susan Shatter, *Iceberg I*, 1990.

1991, circ., 1991. **Collections:** AT&T;
Boston/MFA; Boston Public Library;
Chemical Bank; Chicago/AI; Citicorp;
Currier; Dartmouth College; MIT; PMA;
R.J. Reynolds Industries; St. Joseph/Albrecht; Tufts U.; Utah.

SHAW, CHARLES **b.** May 1,
1892, NYC. **d.** April 2, 1974, NYC.
Studied: Yale U., Ph.D.; Columbia U.
School of Architecture; ASL, with Thomas
Hart Benton; and privately with George
Luks. US Army, World War I. Traveled
Europe extensively, Scandinavia, West Indies. Author of children's books, poetry,
and articles for *Vanity Fair, The Bookman,
Smart Set,* and other magazines. **Member:**
American Abstract Artists; Federation of
Modern Painters and Sculptors; Fellow of
the International Institute of Arts and Letters. **Commissions:** *Vanity Fair* (magazine
covers); Shell-Mex Ltd. (poster). **Awards:**
Nantucket, First and Second Prizes; Century Association. **One-man Exhibitions:**
(first) Curt Valentine Gallery, NYC, 1934,
also 1938; Museum of Living Art, NYC,
1935; SRGM, 1940; Passedoit Gallery,
NYC, 1945, 46, 50, 51, 54, 1956-59; Nantucket, 1954-68; Albert Landry, NYC,
1960, 61; Art Association of Newport
(R.I.), 1960, 62; U. of Louisville, 1963;
Southampton East Gallery, Southampton,
N.Y., 1963, 64; The Bertha Schaefer Gallery, 1963, 64, 66, 68, 71; Faure Gallery,
La Jolla, 1964; Century Association, 1967,
75; Washburn Gallery, NYC, 1976, 79,
82, 83, 89, 91; Helander Gallery, Palm

Beach, Fla., 1985. **Group:** WMAA Annuals; Chicago/AI; Carnegie; Walker; SFMA; U. of Illinois; Corcoran; American Abstract Artists, annually, 1936-68; Federation of Modern Painters and Sculptors, annually, 1940-68; PMA, "8 x 8," 1945; MOMA, Abstract Painting and Sculpture in America, 1951; International Association of Plastic Arts, Contemporary American Paintings, circ., Europe, 1956-57; WMAA, Geometric Abstraction in America, circ., 1962; PAFA, 1966; U. of Colorado, 1966; Carnegie, Abstract Painting and Sculpture in America, 1927-1944, circ., 1983; Trenton/State, Beyond the Plane: American Constructions, 1931-65, circ., 1984. **Collections:** Akron/AM; Andover/Phillips; Atlanta U.; Baltimore/MA; Boston/MFA; Brandeis U.; Brooklyn Museum; California Palace; Chase Manhattan Bank; Chicago/AI; Cincinnati/AM; Cleveland/MA; Colby College; Colgate U.; Corcoran; Cornell U; Dallas/MFA; Dayton/AI; Denver/MA; Detroit/Institute; Fort Worth; U. of Georgia; Hartford/Wadsworth; High Museum; Library of Congress; Los Angeles/County MA; U. of Louisville; MMA; MOMA; NMAA; NYU; Nantucket; U. of Nebraska; Newark Museum; Norfolk/Chrysler; U. of North Carolina; PMA; Paris/Moderne; Phillips; Pittsfield/Berkshire; RISD; Raleigh/NCMA; Rockefeller Institute; SFMA; SRGM; Santa Barbara/MA; Syracuse U.; Tel Aviv; Utica; WMAA; Walker; Wichita/AM; Williams College; Yale U. **Bibliography:** Armstrong, Thomas; Baur 7; Cheney; Kootz 2; Lane and Larsen; Marter, Tarbell, and Wechsler; Pousette-Dart, ed.; Ritchie 1; Toher, ed. Archives.

SHECHTER, LAURA b. August 26, 1944, Brooklyn, N.Y. **Studied:** Brooklyn College, BFA, Magna cum laude, 1961-65, with Ad Reinhardt and Alfred Russell. Traveled worldwide. **Taught:** Parsons School of Design, NYC, 1984; NAD, 1985, 86. **Awards:** CAPS, 1981, 82. **Member:** Artists Equity. **Address:** 429 4th Street, Brooklyn, N.Y. 11215. **Dealer:** Katharina Rich Perlow Gallery, NYC. **One-man Exhibitions:** (first) Green Mountain Gallery, NYC, 1971; Suffolk County Historical Museum, 1971; Larcada Gallery, NYC, 1972; The Forum Gallery, NYC, 1976, 80, 83; Capricorn Gallery, Bethesda, Md., 1977; Suffolk County Community College, 1978; Nicholas Roerich Museum, 1981; Pucker Safrai Gallery, Boston, 1981; Greenville, 1982; U. of Wisconsin, 1982; Van Straaten Gallery, Chicago, 1983; Robert Schoelkopf Gallery, NYC, 1985; Staempfli Gallery, NYC, 1988; Loring Gallery, Cedarhurst, NY, 1988, 91; Rahr-West Museum, 1991; U. of Richmond, 1991; Katharina Rich Perlow Gallery, 1991; Hanae Kent Gallery, NYC, 1991. **Group:** St. Joseph/Albrecht, Drawing, America 1975, 1975; Westmoreland County/AM, New American Still Life, 1979; PAFA, Perspectives on Contemporary American Realism, 1983; Brooklyn Museum, Homer, Sargent and the American Watercolor Tradition, 1984; West Palm Beach/Norton, The Fine Line, 1985; SFMA, American Realism (Janss), circ., 1986; West Palm Beach/Norton, Drawing in Silverpoint, 1985; Saville, Spain, ExPo, 1991; Hunstville Museum, Drawing: The New Tradition, 1988. **Collections:** Arizona State U.; Arkansas/AC; Boston; Buffalo/Albright; Carnegie; Chicago/AI; Greenville; U. of Indiana; Indianapolis; Israel Museum; Jewish Museum; U. of Minnesota; NMAA; NYPL; Queensborough Community College; Nicholas Roerich Museum; Rutgers U.; Tel Aviv.

SHEELER, CHARLES b. July 16, 1883, Philadelphia, Pa. **d.** May 7, 1965, Dobbs Ferry, N.Y. **Studied:** Pennsylvania School of Industrial Art, Philadelphia, 1900-03; PAFA, 1903-6, with William M. Chase. Traveled Europe, USA. **Taught:** Phillips Academy, 1946; Currier Gallery School, 1948. Collaborated with Paul Strand on the film *Manhattan*.

Commissions: Ford Motor Co., photographed the Ford Plant, 1927. **Awards:** Chicago/AI, Norman Wait Harris Medal, 1945; PAFA, Alumni Award, 1957; Hallmark International Competition, 1958 ($1,000); AAAL, Award of Merit Medal, 1962. **One-man Exhibitions:** (first) Modern Gallery, NYC, 1918 (photographs); DeZayas Gallery, NYC, 1922; Whitney Studio Club, NYC, 1924; J. B. Neumann Gallery, NYC (two-man), 1926; Art Center, NYC, 1926; The Downtown Gallery, 1931, 38, 40, 41, 43, 46, 49, 51, 56, 58, 65, 66; Arts Club of Chicago, 1932; Harvard U. (three-man), 1934; Society of Arts and Crafts, Detroit, 1935; Cincinnati/AM (four-man), 1941; Dayton/AI, 1944; Andover/Phillips, 1946; Currier, 1948; Houston/MFA (two-man), 1951; Walker, 1952; Detroit/Institute (three-man), 1954; Katonah (N.Y.) Art Gallery, 1960; State U. of Iowa, 1963; NCFA, 1968; Terry Dintenfass, Inc., NYC, 1974, 80; WMAA, 1980; MMA, 1982; Chicago/Terra, 1985. **Retrospectives:** MOMA, 1939; UCLA, circ., 1954; MIT, 1959; Allentown/AM, 1961; Cedar Rapids/AA, 1967; NCFA, 1968. **Group:** NAD, 1906; PAFA, 1907, 1908-10; The Armory Show, 1913; Anderson Galleries, NYC, Forum Exhibition, 1916; Society of Independent Artists, NYC, 1917; Brooklyn Museum, 1923, 25; Cincinnati/AM, 1924, 1927-31, 34, 35, 39; Whitney Studio Club Annuals, NYC, 1925, 27, 30; Cleveland/MA, 1926, 1927-29, 31, 32, 34; Royal Academy, London, 1930; St. Louis/City, 1931-34, 41, 42, 44, 45; Carnegie, 1931, 33, 35, 37, 40, 41, 43, 45, 48, 52; WMAA, 1932, 34, 36, 42; XVII & XXVIII Venice Biennials, 1934, 56; Chicago/AI, 1935, 37, 38, 41, 46, 48, 49, 51, 54. **Collections:** Albany/Institute; Andover/Phillips; Arizona State College; Boston/MFA; Britannica; Brooklyn Museum; Buffalo/Albright; California Palace; Chicago/AI; Cleveland/MA; Colonial Williamsburg; Columbus; Currier; Detroit/Institute; General Motors Corp.; Harvard U.; Kansas City/Nelson; MMA; MOMA; The Miller Co.; Mount Holyoke College; U. of Nebraska; Newark Museum; New Britain; PAFA; PMA; Phillips; RISD; Sara Roby Foundation; Santa Barbara/MA; Smith College; Springfield, Mass./MFA; Tel Aviv; Toledo/MA; Utica; VMFA; WMAA; Walker; Wesleyan U.; West Palm Beach/Norton; Wichita/AM; Williams College; Worcester/AM; Yale U.; Youngstown/Butler. **Bibliography:** Armstrong, Thomas; *Avant-Garde Painting and Sculpture in America, 1910-25;* Barker 1; Barr 3; Baur 7; Bazin; Beam; Biddle 4; Blesh 1; Born; Boswell 1; Brown 2; Bulliet 1; Cahill and Barr, eds.; *Charles Sheeler;* Cheney; Christensen; *Cityscape, 1919-39;* Cummings 5; Dijkstra, ed.; **Dochterman;** Dorner; Eliot; Flanagan; Flexner; *Forerunners;* Frank, ed.; Frost; Goldwater and Treves, eds.; Goodrich and Baur 1; Hartman; Hall; Halpert; **Hirsch;** Hunter 7; Huyghe; *Index of 20th Century Artists;* Janis and Blesh 1; Janis, S.; Jewell 2; Kootz 1, 2; Kouvenhoven; Kuh 1; Levin 2; **Lucic;** Mather 1; McCoubrey 1; McCurdy, ed.; Mellquist; Mendelowitz; Murken-Altrogge; Nauhaus; Newmeyer; Nordness, ed.; Pagano; Phillips 1, 2; Poore; Pousette-Dart, ed.; Rose, B., 1, 4; Rosenblum 1; **Rourke;** Sachs; Sager; Seitz 3; Soby 5; Tashijan; **Troyen and Hirshler;** Wight 2; **Williams, W. C.** Archives.

SHEETS, MILLARD b. June 24, 1907, Pomona, Calif. **Studied:** Chouinard Art Institute, Los Angeles, 1925-29, with F.T. Chamberlain, Clarence Hinkle. Traveled Europe, Central America, Mexico, USA, Pacific, China, Russia, the Orient, Southeast Asia, West Africa. **Taught:** Chouinard Art Institute, 1928-35; Scripps College, 1932-54, 1955-72; Director, Los Angeles County Art Institute, 1953-60. **Member:** California Watercolor Society; NAD; American Watercolor Society; Society of Motion Picture Art Directors; Bohemian Club. President, Millard Sheets Designs, Inc.; architectural designer; Federal A.P.: Assistant Director with Merle Armitage, S.

MacDonald-Wright. **Commissions** (murals): Pomona (Calif.) First Federal Savings and Loan Association; Our Lady of the Assumption Church, Ventura, Calif. (interior and exterior); over 100 murals and mosaics, including San Jose Airport Terminal, 1977. **Awards:** Witte, Edgar B. Davis Prize; California Watercolor Society, 1927; Arizona State Fair, 1928, 29, 30; California State Fair, 1930, 32 (first prize), 33, 38; Los Angeles/County MA, First Prize, 1932, and 1945; Chicago/AI, 1938; Hon. LLD, U. of Notre Dame; American Watercolor Society, Dolphin Medal Award, 1986. **Address:** 35800 South Highway One, Gualala, Calif. 95445. **Dealer:** Kennedy Galleries, NYC. **One-man Exhibitions:** (first) Los Angeles, Calif., 1929; Los Angeles/County MA; California Palace; San Diego; Fort Worth, 1931, 34; Milwaukee; Baltimore/MA; Buffalo/Albright; Albany/Institute; Witte, 1931, 34; New Orleans/Delgado; Memphis/Brooks; Springfield, Mass./MFA; U. of Oklahoma; U. of Rochester; A. Tooth & Sons, London, 1964; Dalzell-Hatfield Gallery, Los Angeles, 1975; Kennedy Galleries, NYC, 1978, 80, 82, 85. **Retrospectives:** Scripps College, 1976; Laguna Beach Museum of Art, 1983; Ontario Museum of Art and History, 1985. **Group:** Chicago/AI, 1931-35; NAD Annuals, 1932-35; A Century of Progress, Chicago, 1933-34; Denver/AM, 1935; São Paulo, 1955; WMAA; Carnegie; Oakland/AM; Buffalo/Albright; Kansas City/Nelson; U. of Nebraska. **Collections:** Albany/Institute; Britannica; Brooklyn Museum; Carnegie; Cleveland/MA; Chicago/AI; Dayton/AI; de Young; Fort Worth; High Museum; Houston/MFA; Los Angeles/County MA; Los Angeles Public Library; MMA; MOMA; Montclair/AM; Montpelier; Muskegon/Hackley; U. of Oklahoma; RISD; SFMA; San Diego; Seattle/AM; WMAA; Witte. **Bibliography:** Cheney; Hall; **Miller 2;** Pagano. Archives.

SHIELDS, ALAN **b.** February 4, 1944, Lost Springs, Kansas. **Studied:** Kansas State U., 1963-66; U. of Maine, sum-

mers, 1966-67. **Award:** Guggenheim Foundation Fellowship, 1973. **Address:** P.O. Box 1554, Shelter Island, NY 11964. **Dealer:** Paula Cooper Gallery, NYC. **One-man Exhibitions:** Paula Cooper Gallery, NYC, 1969, 70, 72, 74, 76, 78, 80, 82, 83, 84, 85, 86, 88, 91; Janie C. Lee Gallery, Dallas, 1970, 71; New Gallery, Cleveland, 1971; Ileana Sonnabend Gallery, Paris, 1971; Galleria dell'Ariete, 1972; Hansen-Fuller Gallery, San Francisco, 1973; U. of Rhode Island, 1973; Madison Art Center, 1973; Galerie Aronowitsch, Stockholm, 1973; Richard Gray Gallery, Chicago, 1974, 76; Phoenix Gallery, San Francisco, 1974; Barbara Okun Gallery, St. Louis, 1974, 77, 78; The Texas Gallery, 1974; U. of Kansas, 1975; E.G. Gallery, Kansas City, 1975; Dootson Calderhead Gallery, Seattle, 1975; Galerie Daniel Templon, Paris, 1975, 78; St. Etienne, 1976; Portland (Ore.) Center for the Visual Arts, 1976; Rio de Janeiro, 1976; Galerie Simone Stern, New Orleans, 1976; Moore College of Art, Philadelphia, 1977; Nina Freudenheim Gallery, Buffalo, 1977; Strasbourg/Moderne, 1977; Galerie Munro, Hamburg, 1978; P.S. 1, Long Island City, 1978; Galeria Luisa Strina, São Paulo, 1978; Thomas Segal Gallery, Boston, 1979, 83; Gimpel & Hanover Gallery, Zurich, 1979; André Emmerich Gallery, Zurich, 1979, 84; Williams College, 1979; Dorry Gates Gallery, Kansas City, 1980, 87; Bowdoin College, 1981; Heath Gallery, Atlanta, 1981; Middlebury College, 1982; Mobile/FAMS, 1982; Purchase/SUNY, 1982; Stony Brook/SUNY, 1982; Memphis/Brooks, circ., 1983; Gallery Ueda, Tokyo, 1983; U. of Massachusetts, 1985; Cleveland/Contemporary, circ., 1986; Purchase/SUNY, 1987; New Jersey Center for the Visual Arts, Summit, 1987; James Madison U., 1988; Richland Community College, 1988; Roger Ramsay Gallery, Chicago, 1991. **Retrospectives:** Chicago/Contemporary, 1973; Houston/Contemporary, 1973. **Group:** Trenton/State, Soft Art, 1969; WMAA, 1969,

Alan Shields, *Numbers Game for T.T.*, 1990.

72; Indianapolis, 1970; Chicago/AI, 1970, 72, 73; ICA, U. of Pennsylvania, Two Generations of Color Painting, 1970; U. of North Carolina, 1970; Corcoran, Depth and Presence, 1971; U. of Rochester, Aspects of Current Painting, 1971; SRGM, Contemporary Prints and Drawings, 1971; ICA, U. of Pennsylvania, Grids, 1972; U. of California, Berkeley, Eight New York Painters, 1972; Kassel, Documenta V, 1972; Detroit/Institute, 12 Statements, 1972; New York Cultural Center, Soft as Art, 1973; Seattle/AM, American Art: Third Quarter Century, 1973; VIII Paris Biennial, 1973; Indianapolis, 1974; MOMA, Printed, Folded, Cut and Torn, 1974; Corcoran Biennial, 1975; Toledo/MA, Image, Color and Form, 1975; Tyler School of Art, Philadelphia, Drawings, 1975; Akron/AI, Contemporary Images in Watercolor, 1976; Venice Biennial, 1976; Brooklyn Museum, 30 Years of American Printmaking, 1976; Chicago/AI, Drawings of the 70s, 1977; Ljubljana Biennial, 1977; Minnesota/MA, American Drawing 1927-1977, circ. 1977; The American Foundation for the Arts, Miami, Patterning and Decoration, 1970; WMAA, Recent Drawings by Younger Artists, 1978; Tampa Bay Art Center, Two Decades of Abstraction, 1978; Buffalo/Albright, American Painting in the 70s,

1978; Georgia State U. (two-man), 1979; U. of North Carolina, Drawings About Drawings, 1979; U. of North Carolina, Art on Paper, 1979; ICA, U. of Pennsylvania, Masks, Tents, Vessels, Talismans, 1979; XXXIX Venice Biennial, 1980; Rice U., Variants, 1981; Houston/Contemporary, The Americans: The Collage, 1982; MOMA, Handmade Paper, 1982; WMAA, Block Prints, 1982; Arts Council of Great Britain, Paper as Image, circ., 1983; U. of North Carolina, Art on Paper, 1983; MOMA, About Paper, 1984; Indiana State U., Paper Transformed, 1984; Bard College, The Maximal Implications of the Minimal Line, 1985; U. of Massachusetts, Ten, 1985; MOMA, Made in India, 1985; Youngstown/Butler, Midyear, 1986; Stamford Museum, Color: Pure and Simple, 1987; Kalamazoo/Institute, The Cutting Edge, circ., 1988; Southampton/Parrish, Drawing on the East End, 1940-88, 1988; Walker, First Impressions, circ., 1989; U. of Florida, Divergent Styles, 1990. **Collections:** Akron/AI; U. of Arizona; Berlin; Boston/MFA; Chase Manhattan Bank; Chicago/AI; Cincinnati/AM; Cleveland/Contemporary; Cleveland/MA; Commerce Bank; Corcoran; Cornell U.; Dallas/MFA; First City National Bank; Harvard U.; High Museum; Hirshhorn; Illinois State U.; Indianapolis; Kansas City/Nelson; U. of Kansas; Kansas State College; MIT; MOMA; U. of Massachusetts; McCrory Corporation; Memphis/Brooks; Milwaukee; Mobile/FAMS; National Gallery; U. of North Carolina; Oberlin College; U. of Pennsylvania; PMA; Prudential Insurance Co. of America, Newark; Ridgefield/Aldrich; RSM Co., Cincinnati; Rutgers U.; SRGM; Strasbourg/Moderne; Vassar College; Walker; Wellington/National; Westinghouse Electric Corp.; WMAA. **Bibliography:** *Art Now 74;* Robins; Weintraub.

SHINN, EVERETT **b.** November 6, 1876, Woodstown, N.J. **d.** January 2, 1953, NYC. **Studied:** PAFA. Wrote and

produced a number of melodramas in NYC. **Member:** The Eight. **Commissions** (murals): Trenton (N.J.) City Hall; Spring Garden Institute, Philadelphia. **Awards:** Chicago/AI, Watson F. Blair Prize, 1939; elected to the NIAL, 1951. **One-man Exhibitions:** M. Knoedler & Co. 1903, 69; 56th Street Gallery, NYC, 1930; Metropolitan Gallery, NYC, 1931; Morton Gallery, NYC, 1935; One-Ten Gallery, NYC, 1939; Ferargil Galleries, NYC, 1943; James Vigeveno Gallery, Los Angeles, 1945, 47, 48; American-British Art Center, NYC, 1945, 49, 56; The Graham Gallery, 1952, 58, 65; Davis Gallery, 1959; U. of Pennsylvania, 1959; Trenton/State, 1971. **Retrospective:** Trenton/State, 1973. **Group:** Macbeth Gallery, NYC, The Eight, 1908; The Armory Show, 1913; Brooklyn Museum, The Eight, 1943; PMA, 1945; Syracuse/Everson, The Eight, 1958; U. of Pittsburgh, 1959. **Collections:** Boston/MFA; Brooklyn Museum; Buffalo/Albright; Chicago/AI; Detroit/Institute; MMA; New Britain; Phillips; WMAA. **Bibliography:** Baur 7; Biddle 4; Blesh 1; Brown; Brown 2; Canaday; Cheney; Eliot; Flanagan; Flexner; Ganatin 8; Gerdts; Glackens; Goodrich and Baur 1; Hartmann; Hunter 6; Kent, N.; McCoubrey 1; McCurdy, ed.; Mellquist; Mendelowitz; Neuhaus; Pagano; Perlman; Richardson, E.P.; Rose, B., 1; Sutton. Archives.

SIMON, SIDNEY b. June 21, 1917, Pittsburgh, Pa. **Studied:** Carnegie Institute of Technology; PAFA; U. of Pennsylvania, with George Harding, BFA; Barnes Foundation. US Army artist, 1943-46. Traveled Austria, Italy, Morocco. **Taught:** Skowhegan School, 1946-58 (vice-president and director), 1975; Cooper Union, 1947-48; Brooklyn Museum School, 1950-52, 1954-56; Parsons School of Design, 1962-63; Salzburg Center for American Studies, 1971; ASL, 1973-; Castle Hill Art Center, 1973-74; U. of Pennsylvania, 1980. **Member:** Artists Equity

(national director, treasurer, vice-president, 1946-60); Century Association; Architectural League of New York; vice-president, Sculptors Guild; New York City Art Commission, 1975-79; NAD. Federal A.P.: US Post Office, Fleminsburgh, Ky. (mural). **Commissions:** Fort Belvoir, Va., 1942 (3 murals); Temple Beth Abraham, Tarrytown, N.Y.; Walt Whitman Junior High School, Yonkers, N.Y.; stage set for NYC production of *Ulysses in Nighttown,* by James Joyce, 1959; Federation of Jewish Philanthropies; *The Family,* sculpture group for the film *David and Lisa,* 1962 (with Robert Cook and Dorothy Greenbaum); Protestant Council of New York (Family of Man Medal, presented to President John F. Kennedy, 1963); *The Circus,* sculpture for Woodland House, Hartford, Conn., 1963; Our Lady of the Angels Seminary, Glenmont, N.Y., 1965; Downstate Medical Center, Brooklyn, N.Y. 1967; Prospect Park Playground, 1968; 747 Third Avenue Building, NYC, 1973; West Point, Jewish Chapel, 1984-85; Graham Building, City Hall Plaza, Philadelphia, 1987; St. Lukes in the Field, NYC, 1987; Academie Française, Florence Gould Grand Prize, 1988; World Wide Plaza, NYC, 1988-89. **Awards:** PAFA, Cresson Fellowship; Edwin Austin Abbey Fellowship, 1940; Prix de Rome, Hon. Men., 1940; Chicago/AI, Posner Painting Prize; PAFA, Fellowship, 1960; Chautauqua Institute, Babcock Memorial Award, 1963; Century Association, Gold Medal for Sculpture, 1969; AAAL, Award, 1976; National Arts Club, Silver Medal, 1978; NAD, Gold Medal, 1980; National Sculpture Society, Proskauer Prize, 1991; NAD, Isaac N. Maynard Prize, 1987. **Address:** 95 Bedford Street, NYC 10014. **Dealer:** Long Point Gallery, Provincetown, MA. **One-man Exhibitions:** (first) PAFA, 1946; Niveau Gallery, NYC, 1949; Grand Central Moderns, NYC, 1951, 53; Rockland Foundation, 1955; Motel on the Mountain, 1959; Market Fair, Nyack, N.Y., 1960; Grippi Gallery, NYC, 1963

Pittsburgh Plan for Art; Yale U., 1966; Wellfleet Art Gallery, Wellfleet, Mass., 1966-67, 69, 71, 73; New School for Social Research, 1969; The Graham Gallery, 1970; Longpoint Gallery, 1977, 79, 87, 89, 91; Sculpture Center, NYC, 1979. **Retrospective:** Sarah Lawrence College, 1971. **Group:** NAD Annuals, 1944-60; PAFA, 1948-53, 1962; MMA, American Painters Under 35, 1950; WMAA, 1950, 52-55, 59, 62, 63; International Biennial Exhibition of Paintings, Tokyo; Brooklyn Museum, 1953; U. of Nebraska Annuals, 1954, 55; Corcoran, 1955; MOMA, The Art of Assemblage, circ., 1961; A.F.A., Educational Alliance Retrospective, 1963; Sculptors Guild, NYC, 1990, 91; NAD, 1991, 92; Utsukushi-Ga Open Air Museum, Hara, Japan, 7th Henry Moore Grand Prize Exhibition, 1991; Provincetown Art Association and Museum, Sculptors and Their Drawings, 1991. **Collections:** ASL; Century Association; Chautauqua Institute; Colby College; Corcoran; Cornell U.; Dartmouth College; Kennedy Library; MMA; MOMA; U. of North Carolina; The Pentagon; Sports Museum; Smith College; US State Department; Williams College. **Bibliography:** Seitz 4. Archives.

SIMONDS, CHARLES b. November 14, 1945, New York City.
Studied: U. of California, Berkeley, 1963-67, BA; Rutgers U., 1967-69; MFA. **Taught:** Newark State College, 1969-71. **Member:** Lower East Side Coalition for Human Housing. **Commissions:** Artpark, Lewiston, N.Y., 1974; Lannan Foundation, Palm Beach, 1981; WMAA, 1981; Zurich, 1981; Chicago/Contemporary, 1981; Denver/AM, 1981. **Awards:** National Endowment for the Arts, grant, 1974; New York State Council on the Arts, grant, 1974. Also active as a filmmaker. **Address:** 26 East 22nd Street, NYC 10010. **Dealer:** Leo Castelli Inc., NYC. **One-man Exhibitions:** Paris, CNAC, 1975; Galleria Saman, Genoa, 1975;

MOMA, 1976; Buffalo/Albright, 1977; Munster/WK, circ., 1978; Cologne, circ., 1979; Dartmouth College, 1980; California State U., Los Angeles, 1980; Chicago/Contemporary, circ., 1981; Phoenix, 1983; Memphis/Brooks, 1983; SRGM, 1983; Leo Castelli, Inc., 1984, 89; Architekturmuseum, Basel, 1985; Galerie Maeght LeLong, Paris, 1986; Galerie Baudoin-Lebon, Paris, 1987, 91; Corcoran, 1988. **Group:** Biennale de Paris, 1973, 75; WMAA Biennials, 1975, 77; Vassar College, Primitive Presence in the 70s, 1975; Chicago/AI, Small Scale, 1975; XXXVII & XXXVIII Venice Biennials, 1976, 78; Walker, Scale and Environment, 1977; Hirshhorn, Probing the Earth, circ., 1977; Amsterdam/Stedelijk, Made by Sculptors, 1978; ICA, U. of Pennsylvania, Dwellings, 1978; Hayward Gallery, London, Pier & Ocean, 1980, Dublin/Municipal, International Quadrennial (ROSC), 1980; Zurich, Myth & Ritual, 1981; Palm Springs Desert Museum, Return of the Narrative, 1984; Fort Lauderdale, An American Renaissance, 1985; Williams College, BIGlittle Sculpture, 1988; Corcoran, Sculpture & Architectural Design, 1988. **Collections:** Adelaide; Chicago/Contemporary; Cologne; Denver/AM; Des Moines; Israel Museum; MIT; MOMA; Oberlin College; Paris/Beaubourg; Paris/CNAC; Storm King Art Center; WMAA; Walker; Zurich. **Bibliography:** Lucie-Smith.

SIMPSON, DAVID b. January 20, 1928, Pasadena, Calif. **Studied:** California School of Fine Arts, with Leonard Edmondson, Clyfford Still, 1956, BFA; San Francisco State College, 1958, MA. US Navy, 1945-46. Traveled Mexico, 1953, Western Europe, 1969. **Taught:** American River Junior College, 1959-61; Contra Costa College, 1961-65; U. of California, Berkeley, 1965-. **Address:** 565 Vistamont Avenue, Berkeley, CA 94708. **Dealers:** Mincher/Wilcox Gallery, San Francisco; Angles Gallery, Santa Monica,

Calif. **One-man Exhibitions:** (first) San Francisco Art Association, 1958; David Cole Gallery, Sausalito, Calif., 1959; Santa Barbara/MA, 1960; Esther Robles Gallery, Los Angeles, 1960; de Young, 1961; Joachim Gallery, Chicago, 1961; Robert Elkon Gallery, NYC, 1961, 63, 64; David Stuart Gallery, 1963, 64, 66, 68; Henri Gallery, 1968; Galeria Van der Voort, 1969; Hank Baum Gallery, San Francisco, 1972, 73, Los Angeles, 1972; Cheney Cowles Memorial Museum, Spokane, 1962; St. Mary's College, Moraga, Calif., 1974; Modernism Gallery, San Francisco, 1979, 80, 82, 84, 85, 86; Los Angeles State U., 1980; Mincher/Wilcox Gallery, San Francisco, 1990, 92; U. of Nebraska, 1990; Angles Gallery, 1991; Bemis Foundation, Omaha, 1991. **Retrospectives:** SFMA, 1967; Oakland, 1978. **Group:** Carnegie, 1961, 62, 67; Portland (Ore.)/AM, 1968; U. of Illinois, 1963, 69; Los Angeles/County MA, Post Painterly Abstraction, 1964; Chicago/AI; Walker; PAFA, 1967; U. of Illinois, 1969; Spokane World's Fair, 1974; SFMA, California, Painting and Sculpture: The Modern Era, 1976; U. of Santa Clara, Northern California Art of the Sixties, 1982; SFMA, On Reflection, 1982; U. of California, Davis, Directions in Bay Area Painting, 1983; Oakland/AM, Art in the San Francisco Bay Area, 1945-1980, 1985; Youngstown/Butler, California A to Z and Return, 1990. **Collections:** Baltimore/MA; U. of California; Central Research Corp.; Colgate U.; Columbia Broadcasting System; Crown Zellerbach Foundation; First National Bank of Seattle; Golden Gateway Center; Laguna Beach/MA; La Jolla; MOMA; NCFA; U. of Nebraska; Oakland/AM; PMA; Phoenix; SFMA; Seattle/AM; Stanford U.; Storm King Art Center. **Bibliography:** Solnit.

SINGER, MICHAEL b. 1945,
Brooklyn, N.Y. **Studied:** Cornell U., 1963-67, BFA; Rutgers U., 1968; Yale U., Norfolk Program, 1968. **Commissions:**

Riverline Environment, Grand Rapids, Michigan, 1992; Long Wharf Park, New Haven, 1990; Wellesley College, 1991; Becton-Dickinson Corp., Franklin Lakes, N.J., 1989; Solid Waste Management and Recycling Facility, Phoenix, 1992. **Awards:** A.I.A., Gold Award, 1989. **Address:** Box 682, Parsons Road, Wilmington, VT 05363. **Dealer:** Sperone Westwater Inc., NYC. **One-man Exhibitions:** Sperone Westwater Fischer Inc., NYC, 1975, 78, 81; Hartford/Wadsworth, 1976; Smith College, 1977; Corpus Christi, 1977; Purchase/SUNY, 1977; Greenburgh Nature Center, Scarsdale, N.Y., 1977; Portland (Ore.) Center for the Visual Arts, 1979; School of Visual Arts, NYC, 1979; U. of California, Berkeley, 1979; U. of Chicago, 1980; Galerie Zabriskie, Paris, 1981; J. Walter Thompson Art Gallery, NYC, 1983; SRGM, 1984; Sperone Westwater Inc., 1986; Stony Brook/SUNY, 1987; Santa Barbara Botanic Garden, 1987; Williams College, 1990. **Group:** SRGM, Ten Young Artists, 1971; SRGM, Museum Collection: Recent American Arts, 1975; Rice U., Drawing Today

Michael Singer, *7 Moon Ritual Series 3-14-85*, 1985.

in New York, circ., 1977; Kassel, Documenta VI, 1977; WMAA Biennial, 1979; Wenken Park Riehen, Basel, Skulptur in 20. Jahrhundert, 1980; ICA, U. of Pennsylvania, Drawings: The Pluralist Decade, circ., 1980; Zurich, Myth & Ritual, 1981; Rice U., Variants, circ., 1981; Wesleyan U., Large Drawings, 1984; U. of North Carolina, Art on Paper, 1984; SRGM, Transformations in Sculpture, 1985; São Paulo, Biennial, 1987; Wellesley College, Sculptor and Architect: A Collaboration, 1987; Walker, Sculpture Inside Outside, 1988; U. of North Carolina, Art on Paper, 1990; Hofstra U., The Transparent Thread, circ., 1990. **Collections:** Buffalo/Albright; Canberra/National; Chase Manhattan Bank; Denver/AM; Fort Worth; Humlebaek/Louisiana; MMA; MOMA; PMA; Paine Webber Inc.; Prudential Insurance Co. of America; SRGM; Seagram Collection; Walker; Yale U. **Bibliography:** Robins.

SINTON, NELL **b.** June 4, 1910, San Francisco, Calif. **Studied:** California School of Fine Arts, with Maurice Sterne, Spencer Mackay, Ralph Stackpole. Traveled Europe, India, the Orient, Africa, South America, Middle East, USA, Mexico. **Taught:** SFAI, 1970, 71; San Francisco Student League, 1973-75; Institute for Creative and Artistic Development, Oakland, 1974, 75; College of Marin, Professor Emeritus, 1985-. **Member:** San Francisco City Art Commission; Artists Committee, San Francisco Art Institute (Trustee). **Award:** San Francisco City Art Commission, Award of Honor, 1984. **Address:** 1020 Francisco Street, San Francisco, CA 94109. **Dealer:** Braunstein-Quay Gallery, San Francisco. **One-man Exhibitions:** (first) California Palace, 1949; Santa Barbara/MA, 1950; SFMA (two-man), 1957; Bolles Gallery, San Francisco and New York, 1962; SFMA (four-man), 1962; Quay Gallery, San Francisco, 1969, 71, 74; SFMA, 1970; Jacqueline Anhalt Gallery, San Francisco, 1972; U. of Califor-

nia, San Francisco, 1975; Louisiana State U., 1976; Oakland/AM, 1977; Temple Emanu-El, San Francisco, 1977; Braunstein-Quay Gallery, NYC, 1977, 78; U. of Illinois, 1978; Mills College, 1979; Braunstein Gallery, San Francisco, 1980, 81, 83, 86, 87, 89; U. of Illinois, 1982. **Retrospective:** Mills College, 1981. **Group:** MMA, 1952; ART:USA:58, NYC, 1958; Vancouver, 1958; Denver/AM, 1958, 60; SFMA; de Young; California Palace; Oakland/AM; Scripps College, 1961; Los Angeles/County MA, 1961; A.F.A.; Stanford U.; U. of Nevada, 1969; Claremont College, 1973; SFAI, 1974; SFMA, California Painting and Sculpture: The Modern Era, 1976; Fresno/AC, In the Advent of Change, 1945-1969, 1986. **Collections:** AT&T; U. of California, Berkeley; Chase Manhattan Bank; Lytton Savings and Loan Association; Mills College; Oakland/AM; SFMA. **Bibliography:** Archives.

SIPORIN, MITCHELL **b.** May 5, 1910, NYC. **d.** June 11, 1976, Newton, Mass. **Studied:** Crane Junior College; Chicago Art Institute School; privately, with Todros Geller; American Academy, Rome, 1949-50. US Army, 1942-45. Traveled Mexico, Latin America, Africa, Europe. **Taught:** Boston Museum School, 1949; Columbia U., 1951; Brandeis U., 1957-76; American Academy, Rome, Artist-in-Residence, 1966-67. **Member:** Brandeis U. Creative Arts Award Commission; Fellow, American Academy, Rome. Federal A.P.: Mural painting. **Commissions:** Bloom Township High School, Chicago, 1938 (mural); US Post Offices, Decatur, Ill., 1940, and St. Louis, Mo. (with Edward Millman), 1940-42 (mural); Berlin Chapel, Brandeis U. (ark curtain). **Awards:** Chicago/AI, Bertha Aberle Florsheim Prize, 1942; Guggenheim Foundation Fellowship, 1945, 46; PAFA, Pennell Memorial Medal, 1946; Chicago/AI, The Mr. & Mrs. Frank G. Logan Medal, 1947; State U. of Iowa, First P.P., 1947; Prix de Rome, 1949; Hallmark International Com-

petition, Second Prize, 1949; Boston Arts Festival, Second Prize, 1954; and Third Prize, 1955; AAAL, 1955; Youngstown/Butler, First Prize for Watercolors, 1961; Fulbright Fellowship (Italy), 1966-67. **One-man Exhibitions:** The Downtown Gallery, NYC, 1940, 42, 46, 47, 57; Springfield, Mass./MFA; Chicago/AI, 1947; Philadelphia Art Alliance, 1949; Boris Mirski Gallery, Boston, 1952; Jewish Community Center, Cleveland, 1953; The Alan Gallery, NYC, 1954; Lincoln Mass./De Cordova, 1955; U. of Vermont, 1956; Park Gallery, Detroit, 1960; Lee Nordness Gallery, NYC, 1960; U. of Oklahoma, 1980; Babcock Galleries, NYC, 1990. **Retrospectives:** Lincoln, Mass./De Cordova, 1954; Brandeis U., 1976. **Group:** A Century of Progress, 1933-34; MOMA, New Horizons in American Art, 1936; New York World's Fair, 1939; Golden Gate International Exposition, San Francisco, 1939; MOMA/USIA, Pintura Contemporanea Norteamericana, circ., Latin America, 1941; MOMA, Americans 1942, circ., 1942; Chicago/AI, 1942-46; WMAA, 1942-57; Carnegie, 1944-49; Paris/Moderne, 1946; ICA, Boston, American Painting in Our Century, circ., 1949; Contemporary American Drawings, circ. France, 1956; Art: USA: Now, circ., 1962-67; NCFA, After the Crash, 1980. **Collections:** Andover/Phillips; U. of Arizona; Auburn U.; Brandeis U.; Britannica; Chicago/AI; Cranbrook; U. of Georgia; Harvard U.; U. of Illinois; State U. of Iowa; MMA; MOMA; NCFA; NYPL; U. of Nebraska; Newark Museum; U. of New Mexico; PMA; Smith College; WMAA; Wichita/AM; Woodstock Art Association; Worcester/AM; Youngstown/Butler. **Bibliography:** Baur 7; Goodrich and Baur 1; Halpert; Miller, ed., 1; Nordness, ed.; Pagano; Pousette-Dart, ed.; Wight 2. Archives.

SLOAN, JOHN **b.** August 2, 1871, Loch Haven, Pa. **d.** September 7, 1951, Hanover, N.H. **Studied:** Spring Garden Institute, Philadelphia; PAFA, 1892, with Thomas Anshutz. **Taught:** ASL, 1914-26, 1935-37; Archipenko School of Art, 1932-33; George Luks School, 1934. Art Editor of *The Masses* (magazine), 1912-16. Organized a group called The Eight. **Member:** Society of Independent Artists, NYC (President, 1918-42); NIAL. **Awards:** Carnegie, Hon. Men., 1905; Panama-Pacific Exposition, San Francisco, 1915, Medal; Philadelphia, Sesquicentennial, 1926, Medal; PAFA; Carol H. Beck Gold Medal, 1931; MMA, 1942 ($500); NIAL, Gold Medal, 1950. **One-man Exhibitions:** (first) Whitney Studio Club, NYC, 1916; Hudson Guild, NYC, 1916; Kraushaar Galleries, 1917, 26, 27, 30, 37, 39, 43, 48, 52, 60, 66, 84; Corcoran, 1933; Montross Gallery, NYC, 1934; WMAA, 1936, 52, 80; Carnegie, 1939; Currier, 1940; The U. of Chicago, 1942; PMA, 1948; Santa Fe, N.M., 1951; Wilmington, 1961; Bowdoin College, 1962; Kennedy Gallery, 1964 (two-man), 84; U. of Connecticut, 1971; Harbor Gallery, Cold Spring, N.Y., 1972; Salander-O'Reilly Galleries, Inc., NYC, 1980; Bowdoin College, 1981; Dartmouth College, 1981; NMAA, 1981; Mary Ryan Gallery, NYC, 1983; WMAA (Downtown Branch), 1983; Queens Museum, 1985. **Retrospectives:** Wanamaker Gallery, Philadelphia, 1940; Dartmouth College, 1946; Andover/Phillips, 1946; National Gallery, 1971. **Group:** Macbeth Gallery, NYC, The Eight, 1908; The Armory Show, 1913; MMA; Brooklyn Museum, The Eight, 1943; PMA; Syracuse/Everson, The Eight, 1958; Chicago/AI; Detroit/Institute; PAFA; Carnegie; Corcoran; WMAA, The 1930's, 1968, and others. **Collections:** Barnes Foundation; Boston/MFA; Brooklyn Museum; Carnegie; Chicago/AI; Cincinnati/AM; Cleveland/MA; Corcoran; Detroit/Institute; Hartford/Wadsworth; IBM; MMA; NYPL; Newark Public Library; PMA; The Pennsylvania State U.; Phillips; U. of Rochester; San Diego; Santa Fe, N.M.; WMAA; Walker. **Bibliography:** Baur 7; Bazin; Beam; Blesh 1; Boswell 1;

Brooks; Brown; Brown 2; Bryant, L.; Cahill and Barr, eds.; Canaday; Cheney; *Cityscape 1919-39;* Coke 2; Craven, T., 1, 2; Cummings 4; Downes, ed.; Du Bois 4; Eliot; Ely; Finkelstein; Flanagan; Flexner; **Gallatin 2, 5;** Gerdts; Glackens; **Goodrich 7;** Goodrich and Baur 1; Greengood; Haftman; Hall; Hartmann; Hunter 6; Huyghe; *Index of 20th Century Artists;* Jackman; Jewell 2; Kent, N.; Kouvenhoven; Mather 1; McCoubrey 1; McCurdy, ed.; Mendelowitz; Newmeyer; Pach 1, 3; Pagano; Pearson 1; Perlman; Phillips 2; Poore; Pousette-Dart, ed.; Reese; Richardson, E.P.; Ringel, ed.; Rose, B., 1, 4; Sachs; St. John; St. John, ed.; Sloan, H.F.; Sloan, ed.; Sloan, J., 1, 2, 3, 4, 5; Smith, S.C.K.; Sutton; Wight 2. Archives.

SMITH, DAVID b. March 9, 1906, Decatur, Ind. d. May 24, 1965, Bennington, Vt. **Studied:** Ohio U., 1924; ASL, 1926-30, with John Sloan, Jan Matulka. Traveled Europe, USSR, 1935; resided Voltri and Spoleto, Italy, 1962. **Taught:** Sarah Lawrence College, 1948; U. of Arkansas, 1953; Indiana U., 1954; U. of Mississippi, 1955. Created a series of 15 bronze "Medals of Dishonor," 1937-40. **Awards:** Guggenheim Foundation Fellowship, 1950, 51; Brandeis U., Creative Arts Award, 1964. **One-man Exhibitions:** East River Gallery, NYC, 1938; Skidmore College, 1939, 43, 46; Neumann-Willard Gallery, NYC, 1940; The Willard Gallery, NYC, 1940, 43, 46, 47, 50, 51, 54, 55, 56; Kalamazoo/Institute, 1941; Walker, 1943, 48, 52; Buchholz Gallery, NYC, 1946; Cooling Gallery, London, 1946; Utica, 1947; Kleemann Gallery, NYC, 1952; Tulsa/Philbrook, 1953; The Kootz Gallery, NYC, 1953; Cincinnati/AM, 1954; MOMA, 1957; Fine Arts Associates, NYC, 1957; Otto Gerson Gallery, NYC, 1957, 61; French & Co., Inc., NYC, 1959, 60; MOMA, circ. only, 1960; Everett Ellen Gallery, Los Angeles, 1960; ICA, U. of Pennsylvania, 1964; Marlborough-

Gerson Gallery Inc., 1964, 67, 68; Harvard U., 1966; Storm King Art Center, 1971, 76, 82; Glens Falls, N.Y., 1974; Dart Gallery, Chicago, 1975; Knoedler Contemporary Art, NYC, 1974, 76, 77, 78, 80, 81, 82; Galerie Wentzel, Hamburg, 1979; Caracas, 1979; Hyde Collection, 1974; Hirshhorn, 1979; M. Knoedler Ltd., London, 1980; Mekler Gallery, Los Angeles, 1981; Janie C. Lee Gallery, Houston, 1982; Arts Club of Chicago, 1983; Milwaukee, 1983; Washburn Gallery, Inc., NYC, 1983; Jeffrey Hoffeld & Co., NYC, 1984; Nielson Gallery, Boston, 1984; Klonaridis Inc., Toronto, 1981; American Academy, Rome, 1983; Rutgers U. (two-man), 1984; Anthony d'Offay Gallery, London, 1985; Hans Strelow, Düsseldorf, 1986; Düsseldorf/KN-W, circ., 1986; M. Knoedler & Co., NYC, 1986, 90; Akira Ikeda Gallery, Tokyo, 1988; Heide Park and Art Gallery, Melbourne, 1990. **Retrospectives:** Tate, 1966; SRGM, 1968; WMAA, circ., 1979; Edmonton Art Gallery, circ., 1982; National Gallery, 1982; Hirshhorn, circ., 1982; IEF, circ., 1986; Düsseldorf/KN-W, circ., 1986. **Group:** XXIX Venice Biennial, 1958; São Paulo, 1959; Kassel, Documenta II & III, 1959, 64; WMAA; Chicago/AI; Carnegie; MOMA, The New American Painting and Sculpture, 1969, and others; Houston/MFA, The Great Decade of American Abstraction, 1974; Edmonton Art Gallery, Sculpture in Steel, 1974; U. of California, Santa Barbara, Sculptors in the 1950s, Alberta, 1976; Syracuse/Everson, New Works in Clay, 1976; Norfolk/Chrysler, 300 Years of American Art, 1976; WMAA, 200 Years of American Sculpture, 1976; Brown U., Graham, Gorky, Smith, and Davis, 1977; Minnesota/MA, American Drawing, 1927-1977, 1977; National Gallery, American Art at Mid-Century: The Subjects of the Artists, 1978; Rutgers U., Vanguard American Sculpture, 1919-1939, 1979; Drawing Center, NYC, Sculptor's Drawings Over Six Centuries, 1981; Fondation Maeght, Sculpture of the

20th Century, 1981; Carnegie, Abstract Painting and Sculpture in America, 1927-44, circ., 1983; Houston/Contemporary, American Still Life, 1945-1983, 1983; MOMA, The Modern Drawing, 1983; Sunderland (Eng.) Arts Center, Drawing in Air, 1983; Seattle/AM, American Sculpture: Three Decades, 1984; SRGM, Transformations in Sculpture, 1985; Sarah Lawrence College, Sculptural Expressions, 1985; WMAA, The Third Dimension, 1985; Paris/Beaubourg, Qu'est-ce que la sculpture moderne?, 1986; Newport Harbor, The Interpretive Link, circ., 1986; Brooklyn Museum, The Machine Age, circ., 1986; WMAA, Convulsive Beauty, 1988; Sydney/AG, From the Southern Cross, circ., 1988; Andover/Phillips, Sculpture Drawings from the Rose, 1990. **Collections:** Andover/Phillips; Baltimore/MA; Boston/MFA; Brandeis U.; Brooklyn Museum; Buffalo/Albright; Carnegie; Chicago/AI; Cincinnati/AM; Cologne/Ludwig; Dallas/MFA; Des Moines; Detroit/Institute; Duisburg; Harvard U.; Hirshhorn; Houston/MFA; Israel Museum; Los Angeles/County MA; MMA; MOMA; U. of Michigan; U. of Minnesota; National Gallery; Norfolk/Chrysler; U. of North Carolina; Ottawa/National; PMA; Phillips; Rijksmuseum Kröller-Müller; SFMA; SRGM; St. Louis/City; Seattle/AM; Southern Methodist U.; Storm King Art Center; Tate Gallery; Utica; WMAA; Walker. **Bibliography:** Alloway 4; Anfam; Battcock, ed.; Baur 5, 7; Blesh 1; Brumme; Calas, N. and E.; Carmean, Rathbone, and Hess; Chipp; **Cone 1;** Craven, W.; Cummings 2, 4, 5; *David Smith: The Prints;* Davis, D.; Downes, ed.; Fry; Gertz; Giedion-Welcker 1; Gohr and Gachnang; Goodrich and Baur 1; Goossen 1; *Graham, Gorky, Smith & Davis in the Thirties; The Great Decade;* Greenberg 1; Henning; Honisch and Jensen, eds.; Hughes; Hunter 6; Hunter, ed.; *Individuals;* Janis and Blesh 1; Kozloff 3; **Kramer 1;** Krauss 2; Kuh 1, 2, 3; Lane and Larsen; Licht, F.; Lynton;

Marten, Tarbell, and Wechsler; **McCoy;** McCurdy, ed.; Mendelowitz; **Merkert, ed.;** *Metro; Monumenta;* Moser 1; Motherwell, ed.; Motherwell and Reinhardt, eds.; Myers 2; **O'Hara 1,** 2; Passloff; Phillips, Lisa, 2; Read 3; Rickey; Ritchie 1, 3; Rodman 1, 3; Rose, B., 1, 4; Rowell; Rubin 1; Sandler 3, 5; Seitz 3, 4; Selz, J.; Seuphor 3; Seymour; Schwartz 1; **Smith, D.;** Strachan; Trier 1; Tuchman 1. Archives.

SMITH, HASSEL W., JR.

b. April 24, 1915, Sturgis, Mich. **Studied:** Northwestern U., BS; California School of Fine Arts, with Maurice Sterne. Traveled Europe, USA, Mexico. **Taught:** California School of Fine Arts, 1945, 47, 48, 52; San Francisco State College, 1946; U. of Oregon, 1947-48; Presidio Hill School, San Francisco, 1952-55; U. of California, Berkeley, 1963-65, 77-80; UCLA, 1965-66; Bristol (Eng.) Polytechnic, 1966-; SFAI, 1978, 79, 80. **Awards:** Abraham Rosenberg Foundation Fellowship, 1941. **Address:** 19 Ashgrove Road, Bristol 6, England. **Dealer:** John Berggruen Gallery, San Francisco. **One-man Exhibitions:** (first) California Palace, 1947, also 1952; California School of Fine Arts, 1956; New Arts Gallery, Houston, 1960, 62; Ferus Gallery, Los Angeles, 1960; Gimpel Fils Ltd., 1961; Pasadena/AM, 1961; André Emmerich Gallery, NYC, 1961, 62, 63; Dilexi Gallery, San Francisco, 1962; U. of Minnesota, 1962; Galleria dell'Ariete, 1962; David Stuart Gallery, 1963, 68, 73; U. of California, Berkeley, 1964; Santa Barbara/MA, 1969; Suzanne Saxe Gallery, San Francisco, 1970, 73; City Art Gallery, Bristol, 1972; ARCO Center for Visual Art, Los Angeles, 1978; Tortue Gallery, Santa Monica, 1980; Gallery Paule Anglim, San Francisco, 1977, 78, 79; John Berggruen Gallery, San Francisco, 1986; Dartmouth College, 1989. **Retrospectives:** San Francisco State College, 1964; SFMA, 1976. **Group:** California Palace; Pasadena/AM; WMAA Annuals; Los Ange-

les/County MA; Oakland/AM; SFMA; U. of California, Berkeley; Oakland/AM, A Period of Exploration, 1973; SFMA, 200 Years of California Painting, 1976. **Collections:** Buffalo/Albright; Corcoran; Dallas/MFA; Hirshhorn; Houston/MFA; Los Angeles/County MA; New Paltz/SUNY; Oakland/AM; Pasadena/AM; Phillips; SFMA; St. Louis/City; Tate; WMAA; Washington U. **Bibliography:** McChesney; Solnit. Archives.

SMITH, KIMBER
from 1st to 4th edition.

SMITH, LEON POLK b. May 20, 1906, Chickasha, Okla. **Studied:** East Central State College, AB; Columbia U., MA. Traveled Mexico, Europe, Canada, USA, Venezuela. **Taught:** Oklahoma public schools, 1933-39; Georgia University System, Teachers College, 1939-41; State Supervisor, Delaware, 1941-43; Rollins College, 1949-51; Mills College of Education, 1951-58; Artist-in-Residence, Brandeis U., 1968, and U. of California, Davis, 1972; Philadelphia College of Art, 1982-83; Yale U., 1983. **Awards:** Guggenheim Foundation Fellowship, 1944; Longview Foundation Grant, 1959; National Council on the Arts; Tamarind Fellowship; AAIAL, P.P., 1979. **Address:** 31 Union Square West, NYC 10003. **Dealer:** Meyers/Bloom Gallery, Santa Monica, Calif. **One-man Exhibitions:** (first) Uptown Gallery, NYC, 1940; Savannah/Telfair, 1941; Rose Fried Gallery, NYC, 1942, 46, 49; Santa Fe, N.M., 1943; Charles Egan Gallery, 1945; Betty Parsons Gallery, NYC, 1957, 59; The Stable Gallery, NYC, 1960, 62; Caracas, 1962; Galerie Muller, 1964; Galerie Chalette, 1967, 68, 69, 70; Brandeis U., 1968; SFMA, 1968; Fort Worth Art Museum, 1968; Galerie Denise Rene, Paris, 1973, 75; Pelham-von Stoffler Gallery, Houston, 1977, 78; Old Westbury/SUNY, 1978; Susan Caldwell Inc., NYC, 1979; ACE Gallery, Vancouver, 1979; ACE Gallery, Venice, Calif., 1979; Paule Anglim Associates, San Francisco,

1979; Washburn Gallery, Inc., NYC, 1981, 82, 84; Virginia Commonwealth U., 1980; Stony Brook/SUNY, 1981; U. of Nebraska, 1983; Nationalgalerie, Berlin, 1984; DiLaurenti Gallery, NYC, 1986. **Retrospective:** Ludwigshafen am Rhein, circ., 1988. **Group:** WMAA, 1959; Helmhaus Gallery, Zurich, Konkrete Kunst, 1960; SRGM, Abstract Expressionists and Imagists, 1961; WMAA Annual, 1962; WMAA, Geometric Abstraction in America, circ., 1962; Chicago/AI, 1962; Dallas/MFA, "1961," 1962; Corcoran, 1963; Brandeis U., New Directions in American Painting, 1963; MOMA, American Collages, 1965; MOMA, The Responsive Eye, 1965; SFMA, Colorists 1950-1965, 1965; SRGM, Systemic Painting, 1966; Carnegie, 1967, 70; Buffalo/Albright, Plus by Minus, 1968; Chicago/Contemporary, Post-Mondrian Abstraction in America, 1973; Carnegie, Celebration, 1974-75; Paris/Moderne, Paris-New York, 1977; Claremont College, Black and White Are Colors, 1979; Yale U., Mondrian and Neoplasticism in America, 1979; Haus der Kunst, Munich, Amerikanische Malerei, 1930-1980, 1981; National Gallery and Yale U., The Folding Image, 1984; XLII Venice Biennial, 1986. **Collections:** Aachen; Birmingham, Ala./MA; Brandeis U.; Buffalo/Albright; Carnegie; Cleveland/MA; Detroit/Institute; First National Bank of Chicago; Fort Worth; Grenoble; Hirshhorn; Indianapolis; Los Angeles/County MA; Ludwigshafen am Rhein; U. of Massachusetts; Milwaukee; MMA; MOMA; U. of Nebraska; Oklahoma State Art Collection; RISD; SFMA; SRGM; Springfield, Mass./MFA; U. of Sydney; Weisbaden; WMAA. **Bibliography:** Alloway 3; Armstrong, Thomas; *Black and White Are Colors;* American Artists Group, Inc., 2; Battcock, ed.; Calas, N. and E.; *Kunst um 1970;* MacAgy 2; Rickey; Sandler 5; Seuphor 1.

SMITH, TONY b. 1912, South Orange, N.J. **d.** December 26, 1980, NYC. **Studied:** ASL, 1933-36; New Bauhaus, Chi-

cago, 1937-38. Worked on new buildings designed by Frank Lloyd Wright, 1938-39. **Taught:** NYU, 1946-50; Cooper Union, 1950-53; Pratt Institute, 1950-53, 1957-58; Bennington College, 1958-61; Hunter College, 1962-74; 1979-80; Princeton U., 1975-78. **Member:** AAIAL, 1979. **Awards:** Longview Foundation Grant, 1966; National Council on the Arts, 1966; Guggenheim Foundation Fellowship, 1968; College Art Association, Distinguished Teaching of Art Award, 1974; Brandeis U., Creative Arts Award for Sculpture, 1974. **One-man Exhibitions:** Hartford/Wadsworth, 1966; ICA, U. of Pennsylvania, 1966; Walker, 1967; Galerie Muller, Stuttgart, 1967; Bryant Park, NYC, 1967; Galerie Rene Ziegler, 1968; Yvon Lambert, 1968; Donald Morris Gallery, Detroit, 1968; MOMA, circ., 1968; U. of Hawaii, 1969; Newark Museum, 1970; Montclair/AM, 1970; Princeton U., 1979; Trenton/State, 1970; Knoedler Contemporary Art, 1970; MOMA, 1970; U. of Maryland, 1974; Fourcade, Droll Gallery, NYC, 1976; Susanne Hilberry Gallery, Birmingham, Mich., 1977, 86, 87; The Pace Gallery, 1979, 83; Ace Gallery, Venice, Calif., 1980; Richard Gray Gallery, Chicago, 1980; Kean College, Union, N.J., 1981; Moira Kelly Fine Art, London, 1982; Hunter College, 1984; Paula Cooper Gallery, NYC, 1985, 87, 91; Margo Leavin Gallery, 1985; Xavier Fourcade, Inc., NYC, 1986; Galerie Daniel Templon, Paris, 1986; MIT, 1987; Munster/WK, circ., 1988; Socrates Sculpture Park, Long Island City, 1988; Galerie Pierre Huber, Geneva, 1989; Galerie Ressle, Stockholm, 1990. **Retrospective:** U. of St. Thomas, Houston, 1989. **Group:** Hartford/Wadsworth, Black, White, and Grey, 1964; Jewish Museum, Primary Structure Sculptures, 1966; WMAA, 1966, 71, 73; Detroit/Institute, Color, Image and Form, 1967; Chicago/AI, A Generation of Innovation, 1967; Los Angeles/County MA, American Sculpture of the Sixties, circ., 1967; Carnegie, 1967; Corcoran, Scale as Content, 1967; SRGM; Guggenheim Interna-

Tony Smith, *For P.C.*, 1969.

tional, 1967; A.F.A., Rejective Art, 1967; Finch College, NYC, Schemata 7, 1967; Kassel, Documenta IV, 1968; Buffalo/Albright, Plus by Minus, 1968; HemisFair '68, San Antonio, Tex., 1968; MMA, New York Painting and Sculpture: 1940-1970, 1969-70; Akademie der Kunst, Berhn, Minimal Art, 1969; Expo '70, Osaka, 1970; Cincinnati/Contemporary, Monumental Art, 1970; U. of Nebraska, American Sculpture, 1970; Los Angeles/County MA, Art & Technology, 1971; Foundation Maeght, 1971; Arnhem, Sonsbeek, '71, 1971; Indianapolis, 1974; NCFA, Sculpture: American Directions 1945-75, 1975; Indianapolis, 1976; WMAA, 200 Years of American Sculpture, 1976; AAIAL, 1978; SFMA, Twenty American Artists, 1980; Paris/Beaubourg, Qu'est-ce-que la sculpture moderne?, 1986; Fort Lauderdale, An American Renaissance, 1986; Hunter College, Beyond Formalism, 1986; Los Angeles/County MA, The Spiritual in Art, circ., 1986; ICA, U. of Pennsylvania, 1967: At the Crossroads, 1987; William Paterson College, The Grid, 1990; Monte Carlo, Monaco, IIIième Biennale de Sculpture, 1991. **Collections:** Banque Lambert, Brussels; Buffalo/Albright; Case Western Reserve U.; Corcoran; Dallas/MFA; Detroit/Institute; Hartford/Wadsworth; U. of Hawaii; Hirshhorn; Hunter College; Louisville;

MIT; MOMA; Mutual Life Insurance Building; MMA; National Gallery; U. of Nebraska; Newark Museum; New Orleans Museum; Ottawa/National; U. of Pennsylvania; Princeton U.; Rice U.; Rijksmuseum Kröller-Müller; U. of Rochester; SFMA; SRGM; St. Louis/City; City of San Antonio; Trenton/State; WMAA; Walker. **Bibliography:** Calas, N. and E.; Kardon 3; Krauss 3; *Monumenta; Report;* Rowell; Sandler 3; Seitz 3; Siegel; *Tony Smith;* Tuchman 3. Archives.

SMITHSON, ROBERT b. January 2, 1938, Passaic, N.J. d. July 20, 1973, Tecovas Lake, Tex. **Studied:** ASL, 1953, with John Groth; Brooklyn Museum School, 1956. US Army Reserve Forces, Special Services. Traveled USA, Mexico, London, Rome. **One-man Exhibitions:** (first) Artists' Gallery, NYC, 1959; Galleria George Lester, Rome, 1961; Dwan Gallery, NYC, 1966-69, 70; Konrad Fischer Gallery, Düsseldorf, 1968-69; Galleria l'Attico, Rome, 1969; ACE Gallery, Los Angeles and Vancouver, 1970; New York Cultural Center, circ., 1974; Kunstmuseum, Lucerne, circ., 1975; John Weber Gallery, NYC, 1976, 82, 83, 87, 91; Portland (Ore.) Center for Visual Arts, 1977; U. of Massachusetts, 1976; Centre d'Art Contemporain, Geneva, 1981; Humlebaek/Louisiana, 1984; Diane Brown Gallery, NYC, 1984, 85; Middendorf Gallery, Washington, D.C., 1985; Stockholm/Moderna, 1984; International With Monument, NYC, 1986; Lucerne, 1988; Salama-Caro Gallery, London, 1989; Munster/WK, circ., 1989; Galeria La Máquina Española, Madrid, 1990; Kent State U., 1990; Galerie Gabrielle Maubrie, Paris, 1991; Archives of American Art, NYC, 1992. **Retrospectives:** Cornell U., 1980; Columbia U., 1991; Musée Cantini, Marseilles, circ., 1993. **Group:** ICA, U. of Pennsylvania, Current Art, 1965; Jewish Museum, Primary Structure Sculptures, 1966; Finch College, NYC, 1966, 67; WMAA, 1966, 69, 70, Annual, 1969; Los Angeles/County MA, American Sculpture

of the Sixties, 1967; Trenton/State, Focus on Light, 1967; The Hague, Minimal Art, 1968; MOMA, The Art of the Real, 1968; Buffalo/Albright, Plus by Minus, 1968; Düsseldorf/Kunsthalle, Prospect '68, '69, 1968, 69; Milwaukee, Directions 1: Options, circ., 1968; Amsterdam/Stedelijk, Op Losse Schroeven, 1969; Berne, When Attitudes Become Form, 1969; ICA, U. of Pennsylvania, Between Object and Environment, 1969; Chicago/Contemporary, Art by Telephone, 1969; Seattle/AM, 557,087, 1969; ICA, U. of Pennsylvania, Against Order: Chance and Art, 1970; Chicago/AI, 69th and 70th American Exhibitions, 1969, 72; MOMA, Information, 1971; Kassel, Documenta V, 1972; Rijksmuseum Kröller-Müller, Diagrams and Drawings, 1972; New York Cultural Center, 3D into 2D, 1973; MIT, Interventions in Landscape, 1974; Neuer Berliner Kunstverein, Berlin, Multiples, 1974; Rutgers U., Response to the Environment, 1975; ICA, Boston, The Reductive Object, 1979; U. of North Carolina, Drawings About Drawing Today, 1979; Brooklyn Museum, American Drawings in Black & White: 1970-1979, 1980; Hayward Gallery, London, Pier & Ocean, 1980; XXXIX and XL Venice Biennials, 1980, 82; Rice U., Variants, 1981; MOMA, Primitivism in 20th Century Art, 1984; WMAA, The Sculptor as Draftsman, circ., 1984; Andover/Phillips, Land/Space/Sculpture, 1984; Bard College, The Maximal Implications of the Minimal Line, 1985; Cologne/Kunstverein, Aus meiner Sicht, 1989; U. of Virginia, The Humanist Icon, circ., 1990; Ohio State U., Art in Europe and America, 1990; Los Angeles/MOCA, The New Sculpture, 1965-75: Between Geometry and Gesture, 1991; Brandeis U., Breakdown, 1992. **Collections:** Aachen/Ludwig; Bibliothèque Nationale; Canberra/National; Chicago/AI; Chicago/Contemporary; Des Moines; Gdansk/Marine; Harvard U.; High Museum; Indianapolis; Kingsborough Community College; Krakow/National; Los Angeles/County MA; MMA; MOMA; Mex-

Robert Smithson, *Gravel Mirrors with Cracks and Dust*, 1968.

ico City/Tamayo; Milwaukee; Minneapolis/Institute; Ontario; Ottawa; Paris/Beaubourg; Poznan/National Institute; Rijksmuseum Kröller-Müller; Rome/Nazionale; Rotterdam; São Paulo/Contemporanea; Stockholm/National; Stuttgart; Tate Gallery; Tokyo/Hara; WMAA; Walker; Warsaw/National. **Bibliography:** Alloway 4; Atkinson; Battcock, ed.; Calas 2; Calas, N. and E.; Celant; Cummings 1, 4; De Vries, ed.; *Drawings: The Pluralist Decade; Europa/Amerika;* Gablik; Goossen 1; Holt, ed.; Honisch and Jensen, eds.; Johnson, Ellen H.; Krauss 2, 3; *Kunst um 1970;* Lippard 3, 4; Lippard, ed.; MacAgy 2; Muller; *Report;* Robins; Rowell; Sandler 3; Seitz 3; Tuchman 1; Waldman 4; Weintraub; *When Attitudes Become Form.* Archives.

SMYTH, DAVID
from 1st to 4th edition.

SNELGROVE, WALTER
b. March 22, 1924, Seattle, Wash. **Studied:** U. of Washington; U. of California, Berkeley, with James McCray, M. O'Hagan, BA, MA; California School of Fine Arts, with Hassel Smith, Antonio Sotamayor, James Weeks. US Navy, 1941-46. Traveled Europe; resided Florence, Italy. **Taught:** U. of California, 1951-53. **Awards:** U. of California, James D. Phelan Traveling Scholarship, 1951; SFMA, M. Grumbacher Award, 1959; Oakland/AM, First Prize, 1962. **Address:** 2966 Adeline Street, Berkeley, Calif. 94903. **Dealer:**

Gump's Gallery, San Francisco. **One-man Exhibitions:** (first) Oakland/AM, 1959; California Palace; Santa Barbara/MA; Gump's Gallery; Colorado Springs/FA; Denver/AM. **Retrospective:** Foothill College, 1967. **Group:** de Young; SFMA; RAC; Oakland/AM, Contemporary Bay Area Figurative Painting, 1957; Los Angeles/County MA; WMAA, Fifty California Artists, 1962-63; VMFA; U. of Illinois, 1963; Carnegie, 1964; Denver/AM, 1964; U. of Washington; Des Moines. **Collections:** A.F.A.; California Palace; Colorado Springs/FA; Oakland/AM; Stanford U.; WMAA.

SNELSON, KENNETH **b.** June
29, 1927, Pendleton, Ore. **Studied:** U. of Oregon (with Jack Wilkinson); Black Mountain College (with Josef Albers, Buckminster Fuller, Willem de Kooning); Academie Montmartre, Paris (with Fernand Leger). US Naval Reserve, 1945-46. Traveled Europe, Near East, Far East. **Taught:** Cooper Union; Pratt Institute; School of Visual Arts, NYC; Southern Illinois U.; Yale U. **Member:** I.A.T.S.E. **Commission:** Reynolds Metals Co., Sculpture Award, 1974. **Awards:** Milan Triennial, Silver Medal, 1964; New York City Council on the Arts Award, 1971; DAAD Fellowship, Berlin, 1975, 76; National Endowment for the Arts, 1975; American Institute of Architects, Medal, 1981; Hon. DFA, Rensselaer Polytechnic Institute, 1985; AAIAL, 1987; Prix Ars Electronica, Linz, 1989; American Institute of Architects, Kansas City Biennial Award, 1991. **Address:** 140 Sullivan Street, NYC 10012. **Dealer:** The Zabriskie Gallery, NYC. **One-man Exhibitions:** (first) Pratt Institute, 1963; New York World's Fair, 1964-65; Dwan Gallery, NYC, 1966, 68; Dwan Gallery, Los Angeles, 1967; Bryant Park, NYC, 1968; Fort Worth, 1969; Rijksmuseum Kröller-Müller, 1969; Stadtische Kunsthalle, Düsseldorf, 1969; Hannover/Kunstverein, 1971; John Weber Gallery, 1972; Galeria van der Voort, Ibiza,

1972; Waterside Place, NYC, 1974; Galerie Buchholz, Munich, 1975; Berlin/National, 1977; Duisburg, 1977; Gallery de Gestlo, Hamburg, 1977; Maryland Academy of Science, Baltimore, 1978; Sonnabend Gallery, NYC, 1978, 80; The Zabriskie Gallery, 1979, 81, 84, 86, 90; Galerie Zabriskie, Paris, 1980, 84, 86; Birmingham, Ala./AM, 1980; Tampa/AI, 1981; Hirshhorn, 1981; Construct, Chicago, 1981; Buffalo/Albright, 1981; U. of Houston, 1982; U. of Pittsburgh, 1982; Museum of Science and Industry, Tampa, 1982; North Carolina Museum of Life and Science, Durham, 1982; Fleet Space Theatre and Science Center, San Diego, 1983; The Schenectady Museum, 1983; Columbus, 1984; Lincoln, Mass./De Cordova, 1984; Taft Museum, 1985; Cleveland/MA, 1985; New York Academy of Sciences, 1990; Yoh Art Gallery, Osaka, 1990. **Group:** MOMA, 1959, 62; Milan Triennial, 1964; WMAA Sculpture Annual, 1966-69; Los Angeles/County MA, American Sculpture of the Sixties, 1967; CSCS, Los Angeles, 1967; Chicago/AI, 1967; Buffalo/Albright, Plus by Minus, 1968; Düsseldorf/Kunsthalle, Prospect '68, 1968; PMA, 1968; Grant Park, Chicago, Sculpture in the Park, 1974; AAAL, 1977; NYU, Panoramic Photography, 1977; Brooklyn Museum, Great East River Bridge, 1883-1983, 1983; MOMA, Big Pictures by Contemporary Photographers, 1983; NYU, The Arts at Black Mountain College, 1987; IBM Gallery, NYC, Computers and Art, 1988; Ohio Wesleyan U., Digital Visions, 1989; Paris, Centre Nationale de la Photographie, Panorama des Panoramas, 1991; AFA, Abstract Sculpture in America, 1930-1970, circ., 1991. **Collections:** Amsterdam/Stedelijk; ARCO; City of Baltimore; Birmingham, Ala./AM; Buffalo/Albright; Bundeswehr; Canberra/National; Carnegie; Chattanooga/Hunter; Chicago/AI; Cleveland/MA; Columbus; Dallas/MFA; Duisburg; City of Hamburg; City of Hannover; Hirshhorn; City of Iowa; Japan

Iron and Steel Federation, Osaka; Louisville/Speed; MMA; MOMA; Milwaukee; New York Stock Exchange; Pepsico; Portland, Ore./AM; Princeton U.; Rijksmuseum Kröller-Müller; City of San Diego; Shiga; Stanford U.; Storm King Art Center; Trenton/State; WMAA. **Bibliography:** MacAgy 2; Sandler 3; Tuchman 1.

SNYDER, JOAN b. April 16, 1940, Highland Park, N.J. **Studied:** Douglass College, 1962, BA; Rutgers U., 1966, MFA. **Taught:** Princeton U., 1975-79; Yale U. **Awards:** National Endowment for the Arts, 1974; Guggenheim Foundation Fellowship, 1982. **Address:** 850 Carroll Street, Brooklyn, NY 11215. **Dealer:** Hirschl & Adler Modern, NYC. **One-man Exhibitions:** Rutgers U., 1966; Little Gallery, New Brunswick, N.J., 1967; Palley & Lowe Inc., NYC, 1970, 71, 73; Michael Walls Gallery, San Francisco, 1971; Douglass College, 1972, 76; Parker Street 470 Gallery, Boston, 1972; Broxton Gallery, Los Angeles, 1976; ICA, Los Angeles, 1976; Portland (Ore.) Center for the Visual Arts, 1976; Reed College, 1976; Carl Solway Gallery, NYC, 1976; Wake Forest U., 1977; Hamilton Gallery of Contemporary Art, NYC, 1978, 79, 82; Purchase/SUNY, 1978; Women's Art Registry, Minneapolis, 1978; SFAI, 1979; Hartford/Wadsworth, 1981; Nielsen Gallery, Boston, 1981, 83, 86, 91; Hirschl & Adler Modern, NYC, 1985, 88, 90; Compass Rose Gallery, Chicago, 1988, 89; Contemporary Arts Forum, Santa Barbara, 1988; Ann Jaffe Gallery, Bay Harbor Islands, 1991. **Group:** U. of California, Berkeley, Eight New York Painters, 1972; Detroit/Institute, 12 Statements, 1972; GEDOK, Hamburg, American Woman Artist Show, 1972; ICA, U. of Pennsylvania, Grids, 1972; WMAA Annuals, 1972, 73; New York Cultural Center, Women Choose Women, 1973; Corcoran Biennial, 1975; UCLA, Fourteen Abstract Painters, 1975; Brooklyn Museum, Works on Paper—Women Artists, 1977; WMAA, Bi-

ennial, 1981; VMFA, American Abstraction Now, 1983; Stamford Museum, American Art: American Women, 1985; Corcoran, Biennial, 1987; Mt. Holyoke College, A Graphic Muse, 1987; Queensborough Community College, The Politics of Gender, 1988; Cincinnati/AM, Making Their Mark, 1989; Brandeis U., The Image of Abstraction in the 80s, 1990. **Collections:** Allentown/AM; American Can Corp.; Bank America Corp.; Boston/MFA; Brandeis U.; Chase Manhattan Bank; Dallas/MFA; Grand Rapids; Harvard U.; High Museum; Jewish Museum; Louisville/Speed; MMA; MOMA; Oberlin College; Southampton/Parrish; United Bank of California; WMAA.

SOLOMON, HYDE b. May 3, 1911, NYC. **Studied:** Columbia U., with Meyer Shapiro; American Artists School, NYC, 1938; Pratt Institute; ASL, 1943, with Ossip Zadkine. Traveled Europe. **Taught:** Princeton U., 1959-62; Goddard College, summers, 1954, 55. **Member:** American Abstract Artists. **Awards:** MacDowell Colony Fellowship, 1949, 50, 51, 52; Yaddo Fellowship, 1951, 56, 57, 58, 59, 62, 63, 64; AAAL, P.P., 1971; Mark Rothko Foundation, 1973; Wurlitzer Foundation Grant, 1974; Rothko Foundation Grant, 1973; Gottlieb Foundation Grant, 1978. **Address:** P.O. Box 2538, Taos, NM 87571. **Dealers:** Stables Gallery, Taos; Ledoux Gallery, Taos. **One-man Exhibitions:** (first) Vendome Galleries, NYC, 1941; Jane Street Gallery, NYC, 1945, 48; The Peridot Gallery, NYC, 1954, 55, 56; Poindexter Gallery, NYC, 1956, 58, 60, 63, 65, 67, 69, 70, 71, 73; Princeton U., 1959; Rutgers U., 1961; Skidmore College, 1962; Ledoux Gallery, Taos, 1979; Stables Gallery, Taos, 1980. **Group:** MOMA; Walker; Brooklyn Museum; Newark Museum; Yale U.; Hartford/Wadsworth; PMA; The Kootz Gallery, NYC, New Talent, 1950; WMAA, Nature in Abstraction, 1958, Annual, 1965, and others; Carnegie, 1964, 67;

VMFA, American Painting, 1966; New School for Social Research, Humanist Tradition, 1968; Allentown/AM, Monhegan Island Painters, 1974; NAD, 1977, 78. **Collections:** Brandeis U.; U. of California, Berkeley; Chase Manhattan Bank; Ciba-Geigy Corp.; Ford Foundation; Hartford/Wadsworth; Mitsui Bank of Japan; Newark Museum; Reader's Digest; Utica; WMAA; Walker; Westinghouse. **Bibliography:** Archives.

SOLOMON, SYD
from 1st to 4th edition.

SONENBERG, JACK b. December 28, 1925, Toronto, Canada. **Studied:** NYU; Washington U., BFA, 1951, with Paul Burlin; Farnham School of Art, England, 1945-56; Ontario College of Art, 1942. **Taught:** School of Visual Arts, NYC, 1962-74; Pratt Institute, 1967-80; Brooklyn College, 1972; U. of New Mexico, 1970. **Commissions:** International Graphic Arts Society; New York Hilton Hotel. **Awards:** L. C. Tiffany Grant (printmaking), 1962; Silvermine Guild, First Prize, 1962; St. Paul Gallery, Drawing USA, P.P.; Bradley U. Print Annual, P.P.; Ford Foundation/A.F.A., Artist-in-Residence, 1966; Guggenheim Foundation Fellowship, 1973; CAPS, New York State Council of the Arts, 1973, 76; National Endowment for the Arts, 1984; New York Foundation for the Arts, Award, 1989. **Address:** 217 East 23rd Street, NYC 10010. **One-man Exhibitions:** (first) Washington Irving Gallery, NYC, 1958; Carl Siembab Gallery, Boston, 1959; Roko Gallery, NYC, 1961; Feingarten Gallery, Los Angeles, 1962, NYC, 1963; Des Moines, 1964; The Byron Gallery, 1965, 68; Hampton Institute, 1966; Grand Rapids, 1968; U. of Iowa, 1969; Flint/Institute, 1973; Fischbach Gallery, 1973; 55 Mercer Street, NYC, 1980. **Group:** Brooklyn Museum, Print Biennials; Chicago/AI; Silvermine Guild; SRGM; Des Moines; WMAA, American Prints Today, 1959,

Annual, 1968; Youngstown/Butler, 1961; U. of Illinois, 1963; New York World's Fair, 1964-65; Finch College, 1965; PAFA, 1969; WMAA, 1973; MOMA, Printed, Folded, Cut and Torn, 1974; Kent State U., Blossom Festival, 1978; NCFA, New Ways with Paper, 1978; National Gallery, Contemporary American Prints and Drawings, 1940-1980, 1981; Pratt Manhattan Center, Exceptions 3: Paperworks, 1985; ICI, Large Drawings, circ., 1985; Kuznetsky Most Exhibition Hall, Moscow, Painting Beyond the Death of Painting, 1989; Spoleto Festival, Charleston, Painting, Self-Evident: Abstraction, 1992. **Collections:** Bradley U.; Brandeis U.; Grand Rapids; Hampton Institute; MMA; MOMA; Minnesota/MA; NYPL; PMA; Purchase/SUNY; SRGM; Syracuse U.; WMAA; Washington U.

SONFIST, ALAN b. May 26, 1946, New York City. **Studied:** ASL, 1963; Pratt Institute, 1965, 66; Western Illinois U., 1964-67, BA; Hunter College, 1969; Ohio State U., 1968. **Taught:** Lombard (Ill.) H.S., 1967; Ohio State U., 1968; MIT, 1967-76; Philadelphia College of Art, 1975-76; Cooper Union; Parsons School of Design. Editor, *Art in the Land,* published by E.P. Dutton. **Commissions:** Airco Industries, Mountainville, N.J.; Chase Manhattan Bank, NYC; Ponderosa Inc., Dayton; Best Products, Inc., Richmond, Va.; Brooklyn Planning Board, NYC; Sunforest Medical Center, Toledo. **Awards:** National Endowment for the Arts, grant, 1975, 78, 90; Citibank Foundation grant; Gilman Foundation grant; CAPS, 1977; Graham Foundation grant, 1972; Australian Council for the Arts, travel grant, 1981; National Endowment for the Arts, 1981. **Address:** 205 Mulberry Street, NYC 10012. **One-man Exhibitions:** Reese Palley Gallery, NYC, 1970; Harcus-Krakow Gallery, Boston, 1971; Deson Zaks Gallery, Chicago, 1971; Finch College, NYC, 1971; ICA, London, 1972; Automation House, NYC, 1972;

Akron/AI, 1972; Palley & Lowe Gallery, NYC, 1977; Solway Gallery, Cincinnati, 1974, 77; Galerie Thelen, Cologne, 1974; Stefanotti Gallery, NYC, 1975; Cornell U., 1975; Adiene Gallery, NYC, 1975; Galeria Massimo Valsecchi, Milan, 1976; Galleria Cavellino, Venice, 1976; Purchase/SUNY, 1978; Leo Castelli Gallery, NYC, 1978; Marian Goodman Gallery, NYC, 1981; Louisville/Speed, 1981; Melbourne/National, 1981; U. of Miami, 1982; Carl Solway Gallery, Cincinnati, 1982; Cavallino Gallery, Venice, 1984; Corcoran, 1984; Auckland, 1985; Kansas City/Nelson, 1985; Celle Art Spaces, Celle, Italy, 1986; First Street Forum, St. Louis, Mo., 1986; U. of Massachusetts, Amherst, 1986; Penn State, 1987; Indianapolis Art League, 1989; Arsenal Gallery, Los Angeles, 1989; West Palm Beach/Norton, Ann Norton Sculpture Gardens, 1989; Eiteljorg Museum, 1990; Fresno (Calif.) Art Museum, 1990; Max Protetch Gallery, NYC, 1990; Atlantic Center for the Arts, New Smyrna Beach, Fla., 1991; LedisFlam Gallery, NYC, 1991. **Group:** Indianapolis, 1972; Cologne, Projects 74, 1974; Paris, Biennale, 1975; Aachen, 1975; Venice, Biennale, 1976; Boston/MFA, 1977; Kassel, Documenta VI, 1977; U. of Colorado, Boulder, and Independent Curators, NYC, Mapped Art, 1982; Ringling, Common Ground, 1982; Bard College, Landmarks, 1984; World's Fair, Osaka, 1988; Berlin, Akademie der Kunste, Nature as Art, 1989; Pasadena/AC, The Endangered Earth, 1990. **Collections:** Aachen/Ludwig; Akron/AM; Boston/MFA; Brandeis U.; Brooklyn Museum; Buffalo/Albright; U. of California, Berkeley; Canberra/National; Chicago/Contemporary; Cologne; Cologne/Ludwig; Dallas/MFA; Des Moines; Hartford/Wadsworth; High Museum; Houston/MFA; Los Angeles/County MA; Los Angeles/MOCA; Louisville/Speed; MMA; MOMA; U. of Miami; Oberlin College; Paris/Moderne; Pistoria, Italy, Celle Art Sculpture Park; U. of

Miami/Coral Gables; Princeton U.;
Queens Museum; Rutgers U.; U. of Syd-
ney; Toronto; Trenton/State. **Bibliogra-
phy:** Lucie-Smith; Robins; Sandler 3.

SONNIER, KEITH b. July 31,
1941, Mamou, La. **Studied:** U. of South-
western Louisiana, 1959-63, BA; Rutgers
U., 1965-66, MFA. Resided France, 1963-
64. **Awards:** Tokyo Print Biennial, First
Prize, 1974; Guggenheim Foundation Fel-
lowship, 1974. **Address:** 33 Rector Street,
NYC 10006. **Dealer:** Leo Castelli, Inc.,
NYC. **One-man Exhibitions:** Douglass
College, New Brunswick, N.J., 1966;
Galerie Rolf Ricke, Cologne, 1968, 71, 72,
75, 78, 81, 84, 87, 91; Leo Castelli, Inc.,
NYC, 1970, 72, 74, 75, 76, 78, 79, 82,
84, 85, 89, 92; ACE Gallery, Los Angeles,
1970, 75, 77; Eindhoven, 1970; MOMA,
1971; Seder/Creigh Gallery, Coronado,
1974, 76; Rosamund Felsen Gallery, Los
Angeles, 1978, 82, 85; The Clocktower,
NYC, 1978; Krefeld, 1979; Galerie
Michele Lachowsky, Brussels, 1979; Eric
Fabre Gallery, Paris, 1979; Paris/Beau-
bourg, 1979; Galerie France Morin, Mon-
treal, 1980; Tony Shafrazi Gallery, NYC,
1980; David Bellman Gallery, Toronto,
1981; Michele Lachowsky Gallery, Ant-
werp, 1981; Portland (Ore.) Center for the
Visual Arts, 1981; Galerie Eric Fabre,
Paris, 1982; P.S. 1, Long Island City,
1983; Tokyo/Hara, 1984; Galeria Schema,
Florence, 1984, 89; Carol Taylor Art Gal-
lery, Dallas, 1984; Virginia Polytechnic In-
stitute, 1984; Susanna Hilberry Gallery,
Birmingham, Mich., 1985; Galerie
Montenay Delsol, Paris, 1986; Tilden-
Foley Gallery, New Orleans, 1986, 89;
Galerie Nature Morte, NYC, 1987;
Rennes/Kerguehennec, 1987; Annina
Nosei Gallery, NYC, 1987; Norfolk/Chry-
sler, 1988; Barbara Gladstone Gallery,
NYC, 1989; Galerie Montenay, Paris,
1989; Studio Guenzani, Milan, 1989;
Galerie Varisella, Frankfurt, 1989; Galerie
Juergen Becker, Hamburg, 1989; Douglas
Hyde Gallery, Dublin, circ., 1989;

Monchengladbach, 1990; Blum Helman
Gallery, Santa Monica, 1990; Galerie
Faust, Geneva, 1990; Harcus Gallery, Bos-
ton, 1990; Liverpool Gallery, Brussels,
1990; Galleria Il Ponte, Rome, 1990; Cali-
fornia State U., Long Beach, 1990; Galerie
Schröder, Monchengladbach, 1991; Musée
Chateau d'Annecy, 1992; 65 Thompson
Street, NYC, 1992; Castelli Graphics,
NYC, 1992; Editions Ilene Kurtz, NYC,
1992; Galerie Carola Mosch, Berlin, 1992;
Gallery Interform, Osaka, 1992. **Retro-
spective:** Alexandria (La.) Museum of Art,
1987. **Group:** A.F.A., Soft Sculpture,
1968; American Abstract Artists, 1968;
Trenton/State, Soft Art, 1969; Washing-
ton U., Here and Now, 1969; Berne,
When Attitudes Become Form, 1969;
WMAA, Anti-Illusion: Procedures/Materi-
als, 1969; Chicago/AI, 1970; ICA, U. of
Pennsylvania, Against Order: Chance and
Art, 1970; WMAA, 1970; MOMA, Infor-
mation, 1971; Düsseldorf/Kunsthalle, Pros-
pect '71, 1971; New Delhi, Second World
Triennial, 1971; Humlebaek/Louisiana,
American Art, 1950-1970, 1971; Venice
Biennial, 1972; Festival of Two Worlds,
Spoleto, 1972; Yale U., Options and Alter-
natives, 1973; New York Cultural Center,
3D into 2D, 1973; Parcheggio di Villa
Borghese, Rome, Contemporanea, 1974;
WMAA, 1973; Seattle/AM, American
Art—Third Quarter Century, 1973;
CNAC, Art/Voir, 1974; WMAA, Pro-
jected Video, 1975; NCFA, Sculpture:
American Directions 1945-1975, 1975;
WMAA, 200 Years of American Sculpture,
1976; Fort Worth, American Artists: A
New Decade, 1976; New Orleans Mu-
seum, Five from Louisiana, 1977; Rutgers
U., Twelve from Rutgers, 1977; Aspen
Center for the Visual Arts, American Por-
traits of the Sixties and Seventies, 1979;
Basel/Kunsthalle, Amerikanische Zeich-
nungen der Siebziger Jahre, 1981; XL
Venice Biennial, 1982; MOMA, Made in
India: Fall 1985, 1986; Los Ange-
les/MOCA, Individuals, 1986; Mon-
treal/Contemporain, Light, 1986;

Laumeier Sculpture Garden, The Success
of Failure, circ., 1987; Cleveland/MA,
Illuminations: The Art of Light, 1988;
Monchengladbach, Neon-Kunst, 1987;
AAIAL, 1988; Southampton/Parrish,
Drawing on the East End, 1940-1988,
1988; Cleveland/Contemporary, The
Turning Point, 1968, circ., 1988; Florida
International U., American Art Today:
The City, 1990; WMAA, The New Sculp-
ture, 1965-75, circ., 1990; Hunter Col-
lege, Color Dimensionality, 1991; Palazzo
della Ragione, Padova, Biennale, 1991.
Collections: Aachen; Canberra/National;
Cologne; Harvard U.; Krefeld/Haus
Lange; Los Angeles/MOCA; Lyon/St.
Pierre; MOMA; New Orleans Museum;
U. of North Carolina; Rennes/Ker-
guehennec; Stockholm/National;
Tokyo/Hara; WMAA. **Bibliography:** *Art
Now 74;* Celant; *Contemporanea;* Davis,
D.; *Individuals;* Kren; *Kunst um 1970;*
Lippard, ed.; Muller; *Options and Alterna-
tives;* Honisch and Jensen, eds.; Robins;
Pincus-Witten; *When Attitudes Become
Form.* Archives.

SOYER, MOSES **b.** December 25,
1899, Tombov, Russia. **d.** September 2,
1974, NYC. To USA, 1913; citizen, 1925.
Studied: Cooper Union; NAD; Educa-
tional Alliance, NYC; Ferrer School, San
Francisco, with Robert Henri, George
Bellows. Traveled Europe, Russia. **Taught:**
Contemporary School of Art, NYC; New
School for Social Research; Educational
Alliance, NYC; and elsewhere. **Member:**
NAD; Artists Equity; Audubon Artists;
NIAL. Federal A.P.: US Post Office, Phila-
delphia, Pa.; Greenpoint Hospital, Brook-
lyn, N.Y. (mural, with James Penney); 10
portable murals for libraries. **Awards:**
AAAL, Childe Hassam Award (2); NAD,
Annual, Andrew Carnegie Prize. **One-man
Exhibitions:** (first) J. B. Neumann's New
Art Circle, NYC, 1928; Kleeman Gallery,
NYC, 1935; Macbeth Gallery, NYC,
1940, 41, 43; Boyer Gallery, NYC; ACA
Gallery, 1944, 47, 70, 72, 77; Guild Hall,

Raphael Soyer, *Miriam Resting,* 1982.

1972. **Retrospective:** U. of North Caro-
lina, 1972. **Group:** MMA; WMAA;
Brooklyn Museum; Detroit/Institute;
Youngstown/Butler; NAD. **Collections:**
AAAL; Birmingham, Ala./MA; Brooklyn
Museum; Detroit/Institute; Hart-
ford/Wadsworth; U. of Kansas; Library of
Congress; MMA; MOMA; NAD; Newark
Museum; PMA; Phillips; Toledo/MA;
WMAA; Youngstown/Butler. **Bibliogra-
phy:** Brown 2; Cheney; Finkelstein;
Mendelowitz; Smith, B.; Soyer, M.;
Soyer, R., 1; Wheeler; Willard. Archives.

SOYER, RAPHAEL **b.** Decem-
ber 25, 1899, Tombov, Russia. **d.** Novem-
ber 4, 1987, NYC. To USA, 1912.
Studied: Cooper Union; NAD, 1919-21;
ASL, with Guy DuBois. Subject of the film
Raphael Soyer: New York Artist, produced
by Erwin Leiser Film Productions, 1981.
Taught: ASL; American Art School, NYC;
New School for Social Research; NAD,
1965-67. **Member:** NIAL; NAD. Federal
A.P.: Easel painting. **Commissions:** US
Post Office, Kingsessing. **Awards:** Carne-
gie, Hon. Men. (3); Chicago/AI, The M.
V. Kohnstamm Prize, 1932; Chicago/AI,
Norman Wait Harris Gold Medal, 1932;
PAFA, Carol H. Beck Gold Medal, 1934;
Chicago/AI, Norman Wait Harris Bronze
Medal, 1940; PAFA, Joseph E. Temple
Gold Medal, 1943; PAFA, Walter
Lippincott Prize, 1946; Corcoran, William
A. Black Prize and Corcoran Gold Medal,

1951; ART:USA:59, NYC, $1,000 Prize, 1959. **One-man Exhibitions:** The Daniel Gallery, NYC, 1929; L'Elan Gallery, NYC, 1932; Curt Valentine Gallery, NYC, 1933, 34, 35, 37, 38; Frank K.M. Rehn Gallery, NYC, 1939; Treasury Section, Fine Arts Division, 1939; A.A.A. Gallery, NYC, 1940, 41, 48, 53, 55; Weyhe Gallery, NYC, 1944; Philadelphia Art Alliance, 1949; ACA Gallery, 1960; Alfredo Valente Gallery, NYC, 1961; Bernard Crystal Gallery, NYC, 1962; The Forum Gallery, NYC, 1964, 66, 67, 72, 77, 81, 82, 85, 87, 90; The Margo Feiden Galleries, NYC, 1972; Galerie Albert Loeb, Paris, 1980; Hirshhorn, 1982; University of California, Santa Barbara, 1983; Pembroke Gallery, Houston, 1983; Snug Harbor Cultural Center, Staten Island, NYC, 1983; Cooper Union, NYC, 1984; Boston U., 1984. **Retrospectives::** WMAA, circ., 1967; Hirshhorn, 1982. **Group:** Salons of America, NYC, 1926; WMAA Annuals, 1932; PAFA, 1934, 43, 46; Corcoran, 1937, 51; VMFA, 1938; Chicago/AI, 1940; Brooklyn Museum, 1941; Carnegie, 1944; Phillips, 1944; Dallas/MFA, 1945; California Palace, 1945; MOMA, 1946; NAD, 1951, 52; A.F.A., 1967; NAD, American Portrait Drawings, 1980; Trenton/State, American Art of the 1930's, 1979; Akademie der Kunst, Berlin, American Art: 1920-1940, 1980. **Collections:** Andover/Phillips; U. of Arizona; Boston/MFA; Brooklyn Museum; Buffalo/Albright; Columbus; Corcoran; Detroit/Institute; Hartford/Wadsworth; MMA; MOMA; Montclair/AM; U. of Nebraska; Newark Museum; Norfolk/Chrysler; Oslo/National; Phillips; WMAA. **Bibliography:** American Artists Congress, Inc.; American Artists Group, Inc., 3; Bazin; Biddle 4; Boswell 1; Brown 2; Cheney; Cummings 4; Finkelstein; **Foster;** *From Foreign Shores;* **Goodrich 10;** Goodrich and Baur 1; **Gutman;** Hall; Kent, N.; Mellquist; Mendelowitz; Nordness, ed.; Pagano; Reese; **Soyer, R.,** 1, 2, 3; Wheeler; Zigrosser 1. Archives.

SPEICHER, EUGENE b. April, 5, 1883, Buffalo, N.Y. d. 1962. **Studied:** Buffalo Fine Arts Academy, 1902-06; ASL, 1907-8, with Frank V. DuMond, William M. Chase; Robert Henri School, 1909, with Robert Henri. Traveled Europe extensively. **Member:** NIAL; NAD; National Arts Club. **Awards:** ASL, Kelley Prize, 1907; NAD, Thomas R. Proctor Prize, 1911; Salmagundi Club, Jose S. Isadora Prize, 1913; NAD, Hallgarten Prize, 1914, 15; Panama-Pacific Exposition, San Francisco, Silver Medal, 1915 ; PAFA, Carol H. Beck Gold Medal, 1920; Carnegie, Third Prize, 1921, Second Prize, 1923; Chicago/AI, Potter Palmer Gold Medal, 1926; Corcoran, Second William A. Clark Prize, 1928; Corcoran, First Prize; VMFA, P.P.; Hon. DFA, Syracuse U., 1945. **One-man Exhibitions:** Montross Gallery, NYC, 1918; M. Knoedler & Co., 1920; Carnegie, 1924; Boston Arts Club, 1925; Rehn Galleries, 1925, 29, 34, 41, 43; Des Moines, 1926; Denver/AM, 1948; Wildenstein & Co., NYC, 1954; AAAL, Memorial Exhibition, 1963; ACA Gallery, 1965; Salander-O'Reilly Galleries, NYC, 1981. **Retrospective:** Buffalo/Albright, 1950. **Group:** WMAA; PAFA; Carnegie; Century Association, Robert Henri and Five Pupils, 1946; MOMA; Chicago/AI. **Collections:** ASL; Andover/Phillips; Boston/MFA; Britannica; Brooklyn Museum; Buffalo/Albright; Cincinnati/AM; Cleveland/MA; Corcoran; Decatur; Des Moines; Detroit/Institute; Galveston; Harvard U.; IBM; Indianapolis/Herron; Kansas City/Nelson; Los Angeles/County MA; MMA; MOMA; Minneapolis/Institute; Phillips; RISD; St. Louis/City; Toledo/MA; VMFA; WMAA; West Palm Beach/Norton; Worcester/AM; Yale U. **Bibliography:** Baur 7; Bazin; Biddle 4; Blesh 1; Boswell 1; Brown; Bryant, L.; Burchfield 3; Cahill and Barr, eds.; Cheney; Elliot; Goodrich and Baur 1; Hall; *Index of 20th Century Artists;* Jackson; Jewell 2; Kent N.; **Mather 1, 2;** McCurdy, ed.; Mellquist; Mendelowitz; Narodny;

Neuhaus; Pagano; Phillip 2; Poore; Richardson, E.P.; Sachs; Smith, S.C.K.; **Speicher;** Watson, E.W., 1; *Woodstock: An American Art Colony, 1902-1977;* Zaidenberg, ed. Archives.

SPENCER, NILES b. May 16, 1893, Pawtucket, R.I. d. May 15, 1952, Dingman's Ferry, Pa. **Studied:** RISD, 1913-15; Ferrer School, NYC (with Robert Henri, George Bellows), 1915; ASL (with Kenneth Hayes Miller), 1915. Traveled Europe, 1921-22, 1928-29. **Taught:** RISD, 1915. **Awards:** Carnegie, Hon. Mention, 1930; MMA, P.P., 1942. **One-man Exhibitions:** (first) The Daniel Gallery, NYC, 1925, also 1928; The Downtown Gallery, 1947, 52; Washburn Gallery Inc., 1972. **Retrospectives:** MOMA, 1954; U. of Kentucky, 1965. **Group:** Whitney Studio Club, NYC, from 1923; MOMA, Paintings by 19 Living Americans, 1929; Cincinnati/AM, A New Realism, 1941; Providence (R.I.) Art Club; Carnegie; MMA, Artists for Victory, 1942; Walker, The Precisionist View, 1960; WMAA, 1966; U. of New Mexico, Cubism: Its Impact in the USA, 1967. **Collections:** Andover/Phillips; Arizona State College; U. of Arizona; Buffalo/Albright; Columbus; Cornell U.; Illinois Wesleyan U.; MMA; MOMA; U. of Michigan; U. of Nebraska; Newark Museum; Phillips; RISD; SFMA; San Francisco Art Institute; Santa Barbara/MA; WMAA; Walker; Wichita/AM; Youngstown/Butler. **Bibliography:** Armstrong, Thomas; Baur 7; Brown 2; Hunter 6; *Cityscape 1919-39; Index of 20th Century Artists;* Kootz 1, 2; Pousette-Dart, ed. Archives.

SQUIER, JACK
from 1st to 5th edition.

STAMOS, THEODOROS b. December 31, 1922, NYC. **Studied:** American Artists School, NYC, with Simon Kennedy, Joseph Konzal. Traveled Europe, Near East, Greece. **Taught:** Black Mountain College; Cummington School of Fine Arts; ASL, 1958-75; Brandeis U. **Commissions:** Moore McCormack Lines Inc., SS *Argentina* (mural). **Awards:** L.C. Tiffany Grant, 1951; NIAL, 1956; Brandeis U., Creative Arts Award, 1959; National Arts Foundation, 1967. **Address:** Plateia Hrwon, Paralia 6, Lefkada, Greece; 120 West 70th Street, NYC 10023. **Dealer:** ACA Galleries, NYC. **One-man Exhibitions:** (first) Wakefield Gallery, NYC, 1940; Mortimer Brandt, NYC, 1945; Betty Parsons Gallery, 1947, 56; Phillips, 1950, 54; Philadelphia Art Alliance, 1957; André Emmerich Gallery, NYC, 1958, 59, 60, 63, 66, 68; San Antonio/McNay, 1960; Gimpel Fils Ltd., 1960; Galleria d'Arte del Naviglio, Milan, 1961; Brandeis U., 1967; Waddington Fine Arts Ltd., Montreal, 1968; Marlborough Gallery, Inc., NYC, 1970; Omaha/Joslyn, 1973; Athens Gallery, 1974; Louis K. Meisel Gallery, NYC, 1977, 79, 81; Galerie Le Portail, Heidelberg, 1977; Morgan Art Gallery, Shawnee Mission, 1977; Union College, 1978; Hokin Gallery, Palm Beach, 1978; Wichita State U., 1979; Utica, 1980; Hokin Gallery, Chicago, 1980; Turske Fine Art, Cologne, 1980; Bernier Gallery, Athens, 1982;

Theodoros Stamos, *Infinity Field T. Series 120,* 1991.

Knoedler & Co., Inc., Zurich, 1984; Ericson Gallery, NYC, 1985; Harcourts Gallery, San Francisco, 1985, 86; Kouros Gallery, NYC, 1985, 86; Turske & Turske Gallery, Zurich, 1985; Wurthle Gallery, Vienna, 1985; Hokin Gallery, Bay Harbor Islands, Fla., 1986; C. Grimaldis Gallery, Baltimore, 1986; Pierides Gallery of Modern Art, Athens, 1987; Ileana Tounta Contemporary Art Center, Athens, 1989; ACA Galleries, NYC, 1992; Galeria Verlotto, Milan, 1990; Galerie Pudelko, Bonn, 1991. **Retrospectives:** Corcoran, 1959; New Paltz/SUNY, 1980; Leverkusen, circ., 1987. **Group:** Carnegie, 1955, 58, 61, 64; International Biennial Exhibition of Paintings; Tokyo; MOMA, The New American Painting, circ., Europe, 1958-59; WMAA, Nature in Abstraction, 1958, Annual, 1963; Venice Biennial; Kassel, Documenta II, 1959; SRGM, Abstract Expressionists and Imagists, 1964; MMA, 1965; WMAA, Art of the U.S. 1670-1966, 1966; Corcoran Biennial, 1967; MOMA, Dada, Surrealism and Their Heritage, 1968; MOMA, The New American Painting and Sculpture, 1969; Cornell U., Abstract Expressionism, The Formative Years, 1978. **Collections:** Andover/Phillips; U. of Arizona; Baltimore/MA; Brandeis U.; Buffalo/Albright; California Palace; Case Institute; Chase Manhattan Bank; Chicago/AI; Ciba-Geigy Corp.; Colorado Springs/FA; Columbus; Corcoran; Cornell U.; Des Moines; Detroit/Institute; Greece/National; Hartford/Wadsworth; Hirshhorn; U. of Illinois; State U. of Iowa; La Jolla; MIT; MMA; MOMA; Memphis/Brooks; Michigan State U.; U. of Michigan; Montclair/AM; NMAA; NYU; U. of Nebraska; U. of North Carolina; Notre Dame U.; Phillips; Phoenix; Rio de Janeiro; SFMA; SRGM; San Antonio/McNay; Smith College; Tel Aviv; Toronto; Trenton/State; Utica; Vassar College; Vienna/Moderner; WGMA; WMAA; Walker; Wellesley College; Yale U.; Youngstown/Butler. **Bibliography:**

Abstract Expressionism; Alloway 4; Anfam; Armstrong, Thomas; Barker 1; Baur 5, 7; Biddle 4; Blesh 1; Eliot; *Europa/Amerika;* Goodrich and Baur 1; Haftman; Hobbs and Levin; Janis and Blesh 1; McCurdy, ed.; Mendelowitz; Nordness, ed.; **Pomeroy;** Pousette-Dart, ed.; Read 2; Richardson, E.P.; Ritchie 1; Rubin 1; Sandler 5; Seuphor 1; Soby 5. Archives.

STANCZAK, JULIAN
from 2nd to 5th edition.

STANKIEWICZ, RICHARD P.
b. October 18, 1922, Philadelphia, PA. **d.** March 27, 1983, Worthington, Mass. **Studied:** Hofmann School, 1948-49, with Hans Hofmann; Atelier Fernand Leger, Paris, 1950-51; Zadkine School of Sculpture, Paris, 1950-51. **Taught:** Albany/SUNY, 1967-82. Traveled Europe, Australia, USA. An organizer of Hansa Gallery, NYC, 1952. US Navy, 1941-47. **Member:** International Institute of Arts and Letters; NIAL; Century Association. **Awards:** Brandeis U.; National Academy of Arts and Sciences; Ford Foundation Grant. **One-man Exhibitions:** (first) Hansa Gallery, NYC, 1953, also 1954-58; The Stable Gallery, 1959-63; Galerie Neufville, Paris, 1960; The Pace Gallery, Boston, 1961; Walker, 1963 (two-man, with Robert Indiana); Daniel Cordier, Paris, 1964; Tampa/AI, 1965; Frank Watters Gallery, 1969; Melbourne/National, 1969; The Zabriskie Gallery, 1972, 73, 75, 77, 79, 81, 83, 84. **Retrospective:** Albany/SUNY, 1979. **Group:** PAFA, 1954; WMAA, 1956, 60, 62, Young America, 1957; Houston/MFA, Irons in the Fire, 1957; XXIX Venice Biennial, 1958; Carnegie, 1958, 61; A.F.A., Recent Sculpture, USA, 1959; MOMA, Sixteen Americans, circ., 1959; Claude Bernard, Paris, Aspects of American Sculpture, 1960; Amsterdam/Stedelijk, 1961; Chicago/AI, 1961, 62; VI São Paulo Biennial, 1961; MOMA, The Art of Assemblage, circ., 1961; Stockholm/National, 4 Americans, circ., 1962;

Richard Stankiewicz, *Untitled*, 1979.

Seattle World's Fair, 1962; SRGM, The Joseph H. Hirshhorn Collection, 1962; WMAA, Forty Artists Under Forty, circ., 1962; Amsterdam/Stedelijk, Four Americans, 1962; MOMA, Hans Hofmann and His Students, circ., 1963-64; Battersea Park, London, International Sculpture Exhibition, 1963; Jewish Museum, Recent American Sculptors, 1964; MOMA, The Machine, 1968; Dallas/AM, Poets of the Cities, circ., 1974; U. of California, Santa Barbara, Sculptors in the 1950s, 1976; Storm King Art Center, Sculpture: A Study in Materials, 1978; WMAA, The Third Dimension, 1984. **Collections:** Akron/AI; Buffalo/Albright; Chicago/AI; Dayton/AI; Fredonia/SUNY; Hirshhorn; Houston/MFA; MOMA; NMAA; Newark Museum; Paris/Beaubourg; PAFA; PMA; Portland, Ore./AM; Smith College; SRGM; Stockholm/National; Storm King Art Center; Springfield, Mass./MFA; Tel Aviv; WMAA; Walker. **Bibliography:** Blesh 1; Chipp; Craven, W.; Downer, ed.; Friedman, ed; Goodrich and Baur 1; Hulten; Hunter, ed.; Janis and Blesh 1; Kuh 3; Licht, F.; Lowry; *Metro;* Phillips, Lisa, 2; Read 3; Rowell; Sandler 5; Seitz 3, 4; Seuphor 3; Waldman 4; Weller. Archives.

STANLEY, ROBERT b. January 3, 1932, Yonkers, N.Y. **Studied:** Oglethorpe U. (with Marion O'Donnell, Wendell Brown), BA, 1953; ASL, 1953; Brooklyn Museum School (with Yonia Fain, William King), 1954-56. Traveled USA, Holland, Germany, Caribbean. **Taught:** School of Visual Arts, NYC, 1970-72, 84-; Louisiana State U., 1976; Syracuse U., 1978; Princeton U., 1979-80. **Awards:** Cassandra Foundation, 1969; Igor Foundation Purchase Award, 1987. **Address:** 3 Crosby Street, NYC 10013. **Dealer:** Dietmar Werle, Cologne. **One-man Exhibitions:** (first) The Bianchini Gallery, NYC, 1965, also 1966; Orez International Gallery, The Hague, 1966; Cincinnati/Contemporary, 1966; Galerie Rolf Ricke, Kassel, 1966, 67; Galerie Kuckels, Bochum, Germany, 1967; Kleine Galerie, Frankfurt, 1968; Gegenverkehr, Aachen, 1969; On First, NYC, 1969; Warren Benedek Gallery, NYC, 1972; New York Cultural Center, 1974; Louisiana State U., 1976; P.S. 1, Long Island City (two-man), 1977; Hal Bromm Gallery, NYC, 1978, Elizabeth Weiner Gallery, NYC, 1978; St. Thomas Aquinas College, 1978; Bucklew-Goehring Gallery, Tampa, 1983; Centre d'Art Contemporain, Dijon, France, 1986; Le Consortium, Dijon, 1986; John Davis Gallery, NYC, 1987, 89; Galerie Georges Lavrov, Paris, 1987, 89; New Arts Program, Kutztown, Pa., 1987; Galerie Johnny Ericsson, Gothenburg, 1988; Galerie Bebert, Rotterdam, 1989; The Painted Bride Art Center, Philadelphia, 1991; Greenville, 1991; Barbierato Arte Contemporanea, Asiago, Italy, 1992; Dietmar Werle, Cologne, 1992. **Retrospective:** Holly Keenberg Contemporary Art, Winnipeg, 1980. **Group:** Van Bovenkamp Gallery, NYC, 1965; Chicago/AI, 1965-69; Indianapolis/Herron, 1967; WMAA Annual, 1967; Kassel, Documenta IV, 1968; ICA, London, The Obsessive Image,

1968; Milwaukee, Aspects of a New Realism, 1969; David Stuart Gallery, 1969; Chicago/AI, 1969; Cincinnati/Contemporary, Monumental Art, 1970; WMAA, 1972, 73; Eindhoven, Relativerend Realisme, 1972; U. of North Carolina, 1973; New York Cultural Center, Three Centuries of the American Nude, 1975; P.S. 1, Long Island City, Another Aspect of Pop, 1978; AAIAL, 1982. **Collections:** American Republic Insurance Co.; Brooklyn Museum; Cincinnati/Contemporary; Cologne; Corcoran; Des Moines; Donaldson, Lufkin, & Jenrette, Inc.; Fort Worth; Harvard U.; High Museum; Housatonic Community College; MMA; Madison Art Center; McCrory Corporation; Milwaukee; NECCA; Norfolk/Chrysler; Rutgers U.; Time Inc.; WMAA; Washington U. (St. Louis); Westport Art Education Society; Yeshiva U. **Bibliography:** Honisch and Jensen, eds.; Lippard 5.

STASIK, ANDREW b. March 16, 1932, New Brunswick, N.J. **Studied:** NYU; Columbia U., BA; State U. of Iowa; Ohio U., MFA. **Taught:** New School for Social Research; Ohio U.; Ball State Teachers College; Pratt Graphic Art Center; Pratt Institute; Yale U.; U. of Calgary. Editorial Staff, *Artist's Proof* magazine. Traveled Europe, Scandinavia, Orient. Director, Pratt Graphics Center, 1966-85; Founder and editor, *Print Review,* 1972-76; Gallery Director, Silvermine (Conn.) Galleries; Director, International Graphic Arts Foundation, NYC. **Awards:** Cleveland/MA, First Prize in Lithography, 1958; Bay Printmakers Society, Oakland, P.P., 1958; Cleveland/MA, First Prize in Serigraphy, 1958; Pasadena/AM, P.P., 1958; Gallery of Modern Art, Ljubljana, Yugoslavia, III International Exhibition of Prints, 1959, Le Prix Internationale de 100,000 dn; Achenbach Foundation, Open Award for All Media, 1961; The Print Club, Philadelphia, Collins Prize; L.C. Tiffany Grant, 1966; Audubon Artists Medal, 1969; Silvermine Guild, P.P., 1974; Texas Tech

U., P.P., Colorprint USA, 1974. **Address:** 395 West Avenue, Darien, Conn. 06840. **One-man Exhibitions:** Ohio U., 1956; Avant Garde, NYC, 1958; Ball State Teachers College, 1959; Ross Widen Gallery, Cleveland, 1960; Miami/Modern, 1960; Samuel S. Fleisher Art Memorial, Philadelphia, 1961; Yoseido Gallery, Tokyo, 1961; Castagno Gallery, NYC, 1966; Gallery of Graphic Arts, NYC, 1967; Pollock Gallery, Toronto, 1968; Museu de Arte, Rio Grande do Sul, Brazil, 1968; Union of Plastic Gallery, Krakow, 1968; Centar Gallery, Zagreb, 1968; Galeria Colibri, San Juan, Puerto Rico, 1968; U. of Calgary, 1969; Mala Gallery, Ljubljana, Yugoslavia, 1969; Bader Gallery, Washington, D.C. (two-man), 1969; Secession Gallery, Vienna, 1970; Spectrum Gallery, NYC, 1971; A.A.A. Gallery, 1971; Graphics Gallery, 1971; Molloy College, Rockville Centre, N.Y., 1971; Jacques Baruch Gallery, 1973; Montclair State College (two-man), 1974; J. Fields Gallery, NYC, 1982; Ana Sklar Gallery, Miami, 1985; Galerie Vivant, Tokyo, 1985. **Group:** Cincinnati/AM Biennials, 1956, 58, 60, 62, 68; PCA, American Prints Today, circ. 1959-62; Gallery of Modern Art, Ljubljana, Yugoslavia, III, IV, VI, VII & VIII International Exhibition of Prints, 1959, 61, 65, 67, 69; A.F.A., Prints of the World, 1962; The Print Club, Philadelphia, 1962; Library of Congress; MOMA, Prize-Winning American Prints, circ., Canada; Krakow Print Biennials, 1968, 70, 72; U. of Washington, 1969; International Print Biennials, Ljubljana, Yugoslavia, 1969, 71, 73; U. of Washington, Prints/Multiples, 1970; IV American Biennial, Santiago, 1970; Taipei, Taiwan, International Print Exhibition, 1983, 85. **Collections:** Amsterdam/Stedelijk; Ball State U.; Budapest/National; California Palace; Cincinnati/AM; Library of Congress; MMA; MOMA; NCFA; NYPL; NYU; National Gallery; U. of Nebraska; Oakland/AM; PMA; Pasadena/AM; Rockefeller Brothers Fund; Warsaw/National.

STEFANELLI, JOSEPH

b. March 20, 1921, Philadephia, Pa.
Studied: Philadelphia Museum School,
1938-40; PAFA, 1941-42; ASL, 1946-48;
Hofmann School, 1948-49. Traveled Europe, Middle East. **Taught:** U. of California, Berkeley, 1960, 63; Princeton U.,
1963-66; Columbia U., 1966-74;
Princeton U., 1963-66; Brooklyn College,
1974-77; New School for Social Research,
1966; NYU, 1979-80. Artist for *Yank*
magazine, 1942-46 (field drawings made
during World War II are in the permanent collection of the War Archives
Building, Washington, D.C.). **Awards:**
Fulbright Fellowship (Rome), 1958-59;
New York State Council on the Arts
Grant, 1971. **Address:** 463 West Street,
NYC 10014. **One-man Exhibitions:**
Artists' Gallery, NYC, 1950, 54; The New
Gallery, NYC, 1952; Hendler Gallery,
Philadelphia, 1953; Ganymede Gallery,
NYC, 1956; Poindexter Gallery, NYC,
1957, 58, 60; Hacker Gallery, NYC,
1962; Thibaut Gallery, NYC, 1963;
Princeton U., 1964; U. of Arkansas, 1965;
Westbeth Gallery, NYC, 1971; New
School for Social Research, 1972; The
New Bertha Schaefer Gallery, 1973, 74;
Terry Dintenfass Gallery, NYC, 1974;
Andre Zarre Gallery, NYC, 1977; Temple
U., Rome, 1978; Landmark Gallery,
NYC, 1980; Benson Gallery, Southampton, N.Y., 1981; New School for Social
Research, 1982; Ingber Art Gallery, Ltd.,
NYC, 1986; Armstrong Gallery, NYC,
1988, 89; R. H. Love Gallery, Chicago,
1989. **Retrospective:** PAFA, 1988.
Group: Ninth Street Exhibition, NYC,
1951; PAFA; WMAA; Corcoran; Carnegie; U. of Illinois; Buffalo/Albright;
Walker; Chicago/AI; MOMA. **Collections:** Baltimore/MA; U. of California,
Berkeley; Chase Manhattan Bank; Chicago/AI; Cornell U.; U. of Massachusetts;
U. of Montana; NYU; Norfolk/Chrysler;
Sarah Lawrence College; Union Carbide
Corp.; WMAA; Walker. **Bibliography:**
Sandler 5.

STEG, J. L.

b. February 6, 1922,
Alexandria, Va. **Studied:** Rochester Institute of Technology; State U. of Iowa, BFA,
MFA. Traveled Europe, Mexico, Spain.
Taught: Cornell U., 1949-51; Tulane U.,
1951. **Member:** SAGA. **Awards:** Carnegie
Exchange Fellowship (Italy); VIII Lugano
Drawing and Print Show, 1,000 Franc
Award; Brooklyn Museum, P.P.; Seattle/AM, P.P.; Dallas/MFA, P.P.; Birmingham, Ala./MA, P.P.; U. of Minnesota,
P.P.; Syracuse State Fair, P.P.; The Print
Club, Philadelphia, P.P.; Minnesota/MA,
P.P., 1980; Southern Graphic Arts Council, Printmaker Emeritus Award, 1991.
Address: 7919 Spruce Street, New Orleans, LA 70118. **Dealer:** Associated American Artists, NYC. **One-man Exhibitions:**
(first) Weyhe Gallery, 1945; Utica, 1951;
Philadelphia Art Alliance, 1957; Davenport/Municipal, 1958; Dallas/MFA;
Orleans Gallery, New Orleans; A.A.A.
Gallery, NYC; U. of South Florida; Baton
Rouge; Studio Craft Gallery, Miami; Bienville Gallery, 1970; The Ohio State U.,
1971; Tulane U., 1972, 74; USIS, Ankara,
1975; Newcomb College, 1975; Circle Gallery Ltd., NYC, 1976, 78; USIA, Cultural
Center, Ankara, Turkey, 1977; U. of Mississippi, Oxford, 1978; Tulane U., 1990;
U. of Alabama, 1991. **Retrospective:** New
Orleans Museum, circ., 1978. **Group:**
ART:USA, NYC; New York World's Fair,
1964-65; Oakland/AM; USIA; Philadelphia Art Alliance, 50th Anniversary, 1968;
U. of Pittsburgh; Oneonta/SUNY, 1969;
Smithsonian Exhibition, American Drawings II, circ., 1965; Trenton State, National Drawings, 1979; Arkansas/AC,
Annual Drawing Exhibition, 1987; Bradley U., Works on Paper, 1987; Trenton/State, National Print Exhibition,
1980. **Collections:** Albion College; Bezalel
Museum; Bowling Green State U.; Brooklyn Museum; Carnegie; Cleveland/MA;
Colgate U.; Dallas/MFA; U. of Delaware;
George Washington U.; Georgia State U.;
Harvard U.; IBM; Library of Congress;
MOMA; Malmo; U. of Minnesota; NYPL;

U. of Nebraska; New Orleans/Delgado; The Ohio State U.; Oklahoma; Oslo/National; PMA; Princeton Print Club; The Print Club, Philadelphia; Print Club of Rochester; Randolph-Macon College; Remington-Rand Corp.; Roanoke; São Paulo; San Antonio/McNay; Seattle/AM; Smithsonian; Southern Illinois U.; USIA; US State Department; Utica; Worcester/AM.

STEIN, RONALD
from 1st to 4th edition.

STEINBERG, SAUL b. June 15, 1914, Ramnicul-Sarat, Romania. **Studied:** U. of Milan, 1932-40. To USA, 1942; citizen, 1943. US Navy, 1943-46. **Commissions:** Terrace Plaza Hotel, Cincinnati, 1948 (mural); Decor for *Count Ory* by Rossini at Julliard School of Music, NYC, 1958. **Address:** Amagansett, NY 11930. **Dealer:** The Pace Gallery, NYC. **One-man Exhibitions:** (first) Wakefield Gallery, NYC, 1943; Young Brooks, Inc., NYC, 1945; Institute of Design, Chicago, 1948; Betty Parsons Gallery, NYC, 1950, 52, 66, 69, 73, 76; RISD, 1950; Galleria l'Obelisco, Rome, 1951, 52; Galeria de Arte, São Paulo, 1952; ICA, London, 1952, 57; Sidney Janis Gallery, 1952, 66, 69, 73, 76; Leopold-Hoesch-Museum, Duren, 1952; Frank Perls Gallery, Los Angeles, 1952; Wuppertal, 1952; Amsterdam/Stedelijk, 1953; Arts Club of Chicago, 1953; Galerie Blanche, Stockholm, 1953; Galerie Maeght, Paris, 1953, 66, 71, 74, 76; VMFA, 1953; Basel, 1954; Corcoran, 1954; Dallas/MFA, 1954; Dortmund, 1954; Frankfurt am Main, 1954; Santa Barbara/MA, 1954; Harvard U., 1955; Allan Frumkin Gallery, Chicago, 1956; U. of California, Santa Barbara, 1962; Wesleyan U., 1965; Cologne, 1966; B.C. Holland Gallery, Chicago, 1967; Rotterdam, 1967; Brussels/Moderne, 1967, 69; Caracas, 1968; Hamburg, 1968; Stockholm/National, 1968; Felix Landau Gallery, Los Angeles, 1970; Richard Gray Gallery, Chicago, 1971, 82; NCFA, 1973; ICA, Boston, 1974; The Pace Gallery, 1982, 87; U. of Bridgeport, 1983; Gemini G.E.L., Los Angeles, 1983; Harvard U., 1985; Columbus, 1986; Kunsthalle, Nurnberg, 1988; Galerie Adrien Maeght, Paris, 1988; John Berggruen Gallery, San Francisco, 1990; Blum Helman Gallery, Santa Monica, 1991. **Retrospectives:** Cologne/Kunstverein, circ., 1974-75; WMAA, circ., 1978. **Group:** MOMA, Fourteen Americans, circ., 1946; Chicago/AI, 1949; L'Obelisco, Rome, 1951; ICA, London, 1952; Brussels World's Fair, 1958; Salon du Mai, Paris, 1966; Carnegie, 1970; Foundation Maeght, L'Art Vivant, 1970; Chicago/AI, 1971; Bibliothèque Nationale, Paris, Les Dessins d'humor, 1971; Recklinghausen, Zeitgenossische Karikaturen Zeitgenossen, 1972; Yale U., American Drawing, 1970-1973, 1973; Akron/AI, Contemporary Images in Watercolor, 1976; Kassel, Documenta VI, 1977; Renwick Gallery, Washington, D.C., The Object as Poet, 1977; Minneapolis/MA, American Drawings 1927-1977, 1977; MOMA, High and Low, circ., 1990; Fondation Maeght, St. Paul de Vence, Le cabinet des dessins, 1991. **Collections:** AAIAL; Baltimore/MA; Bridgeport/Housatonic; Buffalo/Albright; Columbus; Detroit/Institute; Harvard U.; Hirshhorn; Hughes; Indiana U; Israel Museum; MMA; MOMA; NMAA; NYU; Utica; Victoria and Albert Museum; WMAA. **Bibliography:** Armstrong, Thomas; Ashbery; **Baudson;** Baur 7; Biddle 4; Cummings 4; Kepes 2; *From Foreign Shores;* Kepes 2; *Metro;* Miller, ed. 2; Richardson, E.P.; Rodman 1; Rosenberg 3; Sachs; Schneider; Siegel; **Steinberg, S., 1, 2, 3.** Archives.

STEINER, MICHAEL b. 1945, NYC. **Studied:** ASL, with Stephen Green. **Awards:** Guggenheim Foundation Fellowship, 1971. **Address:** 704 Broadway, NYC 10003. **Dealer:** Salander-O'Reilly Galleries, Inc., NYC. **One-man Exhibitions:**

(first) Fischbach Gallery, 1964; Dwan Gallery, NYC, 1966, 68; U. of Saskatchewan, Regina, 1970; Marlborough Gallery, Inc., NYC, 1970, 72, 74; Mackler Gallery, 1970; David Mirvish Gallery, 1970, Toronto 1976, 78; U. of Toronto, 1971; Noah Goldowsky/Richard Bellamy, NYC, 1972; Boston/MFA, 1974; André Emmerich Gallery, NYC, 1976, 78, 79, 80, 81, 82, 83, 85, 87; Galerie Wentzel, Hamburg, 1976, 79, 81, 82; Bielefeld/Kunsthalle, 1977; Watson/de Nagy, Houston, 1977; Galerie André Emmerich, Zurich, 1977; Harcus-Krakow Gallery, Boston, 1977, 79; Galerie Gerard Piltzer, Paris, 1978; Kunst-und-Museumsverein, Wuppertal, 1978; America House, Berlin, 1979; Amerika Haus, Hannover, 1979; Gallery Ninety-Nine, Bay Harbor Islands, Fla., 1980; Meredith Long & Co., Houston, 1980, 81, 85; Gallery One, Toronto, 1981; Barbara Balkin Gallery, Chicago, 1982; Harcus-Krakow Gallery, Boston, 1982; The Hett Gallery Ltd., Edmonton, 1982; Martha White Gallery, Louisville, 1983; Douglas Drake Gallery, Kansas City, 1985; Eica London Gallery, Montreal, 1985; Salander-O'Reilly Gallery, 1990, 92; Helander Gallery, Palm Beach, 1990; Fort Lauderdale, 1992. **Group:** Ridgefield/Aldrich, 1968; The Hague, 1968; Wellesley College, 1970; Toledo/MA, The Form of Color, 1970; WMAA, 1970, 72; Akron/AI, 20th Century Sculpture, 1971; Edmonton Art Gallery, Alberta, Masters of the Sixties, 1972; Montreal/Contemporain, 11 Artists Americains, 1973; NIAL, 1975; Syracuse/Everson, New Works in Clay, 1976; Wuppertal, Skulpturen und Gemalde aus New York, 1978; Syracuse/Everson, A Century of Ceramics in the United States, 1878-1978, 1979; Grand Palais, Paris, L'Amerique aux Indépendants, 1980; Sonoma State U., Works in Bronze, A Modern Survey, circ., 1984; St. Lawrence U., Pre-Postmodern: Good in the Art of Our Time, 1985; Sierra Nevada Museum of Art, Works in Bronze, 1986; U. of Michigan, Grounded: Sculpture on the Floor, 1990. **Collections:** Art Gallery of Hamilton; Bielefeld; Boston/MFA; Denver/AM; Des Moines; Duisburg; Edmonton Art Gallery; Hirshhorn; Houston/MFA; Kitchener-Waterloo/AG; Laumeier Sculpture Park; Louisville/Speed; Ludwigshafen; MIT; MOMA; Nice/Contemporain; U. of North Carolina; Paris/Beaubourg; SRGM; Simon Fraser U.; Storm King Art Center; U. of Sydney; Syracuse/Everson; Walker; Wellesley College; Wuppertal/von der Heydt.

STELLA, FRANK b. May, 12, 1936, Malden, Mass. **Studied:** Phillips Academy, with Patrick Morgan; Princeton U. with William Seitz, Stephen Greene, AB, 1958. **Taught:** Dartmouth College, 1963; Brandeis U., 1969. **Awards:** International Biennial Exhibition of Paintings, Tokyo, First Prize, 1967; Skowhegan School, Medal for Painting, 1981; Mayor of the City of New York, Award for Arts and Culture, 1982; Princeton U., Dartmouth College, Hon. DFA, 1985; PAFA, Award of American Art, 1985; Harvard U., Charles Eliot Norton Professorship of Poetry, 1983. **Address:** 17 Jones Street, NYC 10013. **Dealers:** Leo Castelli, Inc., NYC; M. Knoedler & Co., NYC. **One-man Exhibitions:** Leo Castelli Inc., 1960, 62, 64, 66, 67, 69, 70, 73, 75, 79, 82; and two-man, 1962; Galerie Lawrence, Paris, 1961, 64; Ferus Gallery, Los Angeles, 1963, 65; Kasmin Ltd., 1964, 66, 68, 71; Harvard U., Three American Painters (three-man, with Kenneth Noland, Jules Olitski), circ., Pasadena, 1965; Pasadena/AM, 1966, 71; David Mirvish Gallery, 1966, 68, 71; Seattle/AM, 1967; Galerie Bischofberger, Zurich, 1967; Douglas Gallery, Vancouver, 1967; WGMA, 1968; Irving Blum Gallery, Los Angeles, 1968, 69, 70, 72; Bennington College, 1968; U. of Puerto Rico, 1969; Brandeis U., 1969; MOMA, 1970; Lawrence Rubin Gallery, NYC, 1970, 71; Galerie Rene Ziegler, 1970; Hayward Gal-

lery, London, 1970; Amsterdam/Stedelijk, 1970; Joseph Helman Gallery, St. Louis, 1970; Toronto, 1971; Hansen-Fuller Gallery, 1971; John Berggruen Gallery, 1971; Knoedler Contemporary Art, NYC, 1973, 75; Portland (Ore.) Center for the Visual Arts, 1974; U. of Washington, Seattle, 1974; ACE Gallery, Vancouver, 1974, Venice, Calif., 1975; Galerie Daniel Templon, Paris, 1975, 81, 91; Janie C. Lee Gallery, Houston, 1975; Galerie André Emmerich, Zurich, 1976; Basel, 1976, 80; Sears Bank, Chicago, 1976; David Mirvish Gallery, Toronto, 1976; B. R. Kornblatt Gallery, Baltimore, 1976; Galerie M., Bochum, 1977; Baltimore/MA, 1977; Bielefeld, 1977; Museum of Modern Art, Oxford, 1977; Linda Farris Gallery, Seattle, 1977; Knoedler Ltd., London, 1977, 85, 87, 91; School of Visual Arts, NYC, 1978; MOMA, 1979; Brandeis U., 1979; Galerie Valeur, Nagoya, 1979, 80; Galerie 99, Bay Harbor Islands, Fla., 1980; Akira Ikeda Gallery, Nagoya, Japan, 1980, 81, 82, 83, 84, 85; Centre d'Arts, Bordeaux, 1980; Knoedler Kasmin Ltd., London, 1980; Koh Gallery, Tokyo, 1980; M. Knoedler & Co., NYC, 81, 85, 89; Hans Strelow Gallery, Düsseldorf, 1981, 87, 91; Albert White Gallery, Toronto, 1981; Andover/Phillips, 1982; Larry Gagosian Gallery, Los Angeles, 1982; Hamilton/AG, 1982; Kitakushu (Japan) City Museum of Art, 1982; MOMA, 1982; Harcus Gallery, Boston, 1983; Jacksonville/AM, 1983; Jewish Museum, 1983, 85; Knoedler Gallery, Zurich, 1983; Princeton U., 1983; SFMA, 1983; Cleveland/AM, 1984; Fort Worth, 1984; Galerie Wurthle, Wien, Switzerland, 1984; Bordeaux/Contemporain, 1985; Richard Gray Gallery, Chicago, 1985; L. A. Louver Gallery, Venice, Calif., 1985; ICA, London, 1985; Laumeier Sculpture Park, 1986; Osaka/National, 1988; Kawamura Memorial Museum of Art, Japan, circ., 1991; Greenberg Gallery, St. Louis, 1986; Akira Ikeda Gallery, Tokyo, 1986; Gagosian Gallery, NYC, 1987, 90; Galerie

Beaubourg, Paris, 1990; Galerie Kaj Forsblöm, Helsinki, 1990; 65 Thompson Street, NYC, 1990; Heland Wetterling Gallery, Stockholm, 1990; Casino, Knokke, 1991; Rubin Spangle Gallery, NYC, 1991. **Retrospectives:** Fort Worth, circ., 1978; U. of Michigan, circ., 1982; MOMA, circ., 1987-89. **Group:** Oberlin College, 3 Young Painters, 1959; MOMA, Sixteen Americans, circ., 1959; SRGM, Abstract Expressionists and Imagists, 1961; Houston/MFA, Ways and Means, 1961; A.F.A., Explorers of Space, circ., 1961-62; Seattle World's Fair, 1962; WMAA, Geometric Abstraction in America, circ., 1962; Chicago/AI, 1963, 65; Corcoran, 1963, Biennial, 1967; WGMA, The Formalists, 1963; Jewish Museum, Toward a New Abstraction, 1963; Musée Cantonal des Beaux-Arts, Lausanne, 1 Salon International de Galleries Pilotes, 1963; Brandeis U., New Directions in American Painting, 1963; Jewish Museum, Black and White, 1963; Hartford/Wadsworth, Black, White and Gray, 1964; Los Angeles/County MA, Post Painterly Abstraction, 1964; XXXII Venice Biennial, 1964; WMAA Annuals, 1964, 67; MOMA, The Responsive Eye, 1965; VII São Paulo Biennial, 1965; SRGM, Systemic Painting, 1966; Kansas City/Nelson, Sound, Light, Silence, 1966; Amsterdam/Stedelijk, New Shapes of Color, 1966; Expo '67, Montreal, 1967; International Quadrennial (ROSC), 1971; High Museum, The Modern Image, 1972; Kansas City/Nelson, Color Field Painting to Post Color Field Abstraction, 1972; Houston/MFA, The Great Decade of American Abstraction: Modernist Art 1960-1970, 1974; U. of Miami, Less Is More: The Influence of the Bauhaus on American Art, 1974; VMFA, Twelve American Painters, 1974; High Museum, The New Image, 1975; SRGM, 20th Century American Drawing, 1976; Cambridge U., Jubilation, 1977; Museum of the American Foundation for the Arts, Miami, Pattern & Decorative Painting, 1977; NCFA, New Ways with Paper, 1977; Flint/Insti-

tute, Art and the Automobile, 1976; Worcester/AM, Between Sculpture & Painting, 1978; WMAA, Art About Art, 1978; Buffalo/Albright, American Painting of the 1970s, 1978; Pomona College, Black and White Are Colors, 1979; ICA, Boston, The Reductive Object, 1979; P.S. 1, Long Island City, A Great Big Drawing Show, 1979; WMAA Biennial, 1979, 83, 91; School of Visual Arts, NYC, Shaped Paintings, 1979; Lincoln/De Cordova, Born in Boston, 1979; ICA, U. of Pennsylvania, The Decorative Impulse, 1979; ICA, U. of Pennsylvania, Drawings: The Pluralist Decade, 1980; MOMA, Printed Art, 1980; Montgomery Museum, American Painting of the 60's and 70's, 1980; Purchase/SUNY, Hidden Desires, 1980; SFMA, Twenty American Artists, 1980; XXXIX Venice Biennial, 1980; Zurich, Reliefs, 1980; Corcoran Biennial, 1981; Royal Academy, London, A New Spirit in Painting, 1981; Amsterdam/Stedelijk, '60-'80: Attitudes/Concepts/Images, 1982; Houston/Contemporary, The Americans: The Collage, 1982; Internationale Kunstausstellung Berlin, 1982; Brooklyn Museum, The American Artist as Printmaker, 1983; Bordeaux/Contemporaine, Art Minimal 1, 1985; Carnegie, 1985; MOMA, Contrasts of Form, 1985; MOMA, Made in India, 1985; AAIAL, 1986; Bordeaux/Contemporain, Art Minimal II, 1986; Hirshhorn, Directions 1986, 1986; ICI, After Matisse, circ., 1986-88; Frankfurt/Kunstverein, Prospect 86, 1986; Los Angeles/MOCA, Individuals, 1986; Berlin/National, Positionen heutiger Kunst, 1988; MOMA, Seven Master Printmakers, 1991; Frejus, La sculpture contemporaine après 1970, 1991. **Collections:** Amsterdam/Stedelijk; Baltimore/MA; Basel; Berlin/National; Bochum; Brandeis U.; Brooklyn Museum; Brown U.; Buffalo/Albright; Chicago/AI; Chicago/Contemporary; Cleveland/MA; Cologne; Dallas/MFA; Denver; Des Moines; Detroit/Institute; Eindhoven; Fort Worth; Hartford/Wadsworth; Har-

vard U.; High Museum; Hirshhorn; Houston/MFA; Humlebaek/Louisiana; Indiana U.; Jacksonville/AM; Kansas City/Nelson; Kitakyushu Museum; Los Angeles/County MA; Los Angeles/MOCA; MMA; MOMA; U. of Miami; Milwaukee; Minneapolis; NCFA; NMAA; Nagaoka; Nagoya Museum, Japan; National Gallery; Northwestern U; PMA; Paris/Beaubourg; Pasadena/AM; Phillips; Phillips Academy; Princeton U.; Rotterdam/Boymans; SFMA; SRGM; Seattle; St. Louis; Stockholm/National; Tate; Toledo/MA; Toronto; VMFA; WMAA; Walker. **Bibliography:** Alloway 3, 4; Armstrong, Thomas; Ashbery; Axsom 2; Battcock, ed.; Bihalji-Merin; *Black and White Are Colors;* Calas 2; Calas, N. and E.; *Contemporanea;* Coplans 2; Day 1; De Wilde 1, 2; De Vries, ed.; *Drawings: The Pluralist Decade; Europa/Amerika;* Gablik; Gohr and Gachnang; Goldman 1; Goossen 3; *The Great Decade;* Haskell 5; Honisch and Jensen, eds.; Honnef 2; Hunter, ed.; *Individuals;* Joachimides and Rosenthal; Johnson, Ellen H.; Kardon 3; Krauss 2; Kozloff 3; Lippard 5; Lucie-Smith; MacAgy 2; Murken-Altrogge; Plagens; Rickey; Robins; Rose, B., 1, 4; **Rubin, Lawrence; Rubin 2;** Sandler 3, 5; Schwartz 1; *7 Decades;* Siegel; Stearns; **Stella;** Tomkins, 2; Waldman 4; Warhol and Hackett.

STELLA, JOSEPH b. June 13, 1877, Muro Lucano, Italy. **d.** November 5, 1946, NYC. To USA, 1896; citizen, 1923. **Studied:** medicine and pharmacology, 1896; ASL, 1897; New York School of Art, 1898-1900, with William M. Chase. Traveled Europe, USA. **Member:** Societé Anonyme. **Awards:** One-year scholarship to New York School of Art, 1899. **One-man Exhibitions:** (first) Carnegie, 1910; Italian National Club, NYC, 1913; Bourgeois Gallery, NYC, 1920; Societé Anonyme, NYC; Dudensing Gallery, NYC, 1924; The New Gallery, NYC, 1926; Des Moines Art Association, 1926;

Curt Valentine Gallery, NYC, 1926, 28, 31, 35; Angiporto Galleria, Naples, 1929; Galerie Sloden, Paris, 1930; Washington Place, Paris, 1932; Cooperative Gallery, Newark, 1937; A.A.A. Gallery, NYC, 1941; M. Knoedler & Co., NYC, 1942; ACA Gallery, 1943; The Zabriskie Gallery, 1958, 59, 60, 61; MOMA, circ., 1960 (drawings); Robert Schoelkopf Gallery, NYC, 1963, 64, 66, 70, 77, 79, 81, 84; U. of Maryland, 1968; Rutgers U., 1970; Hirshhorn, 1983. **Retrospectives:** Newark Museum, 1939; WMAA, 1963. **Collections:** Indiana State College; Iowa State Education Association; MMA; MOMA; U. of Nebraska; Newark Museum; WMAA; Walker; Yale U. **Bibliography:** *Arthur Dove: The Years of Collage; Avant-Garde Painting and Sculpture in America, 1910-25;* **Baur 3,** 5, 7; Bethers; Biddle 4; Blanchard; Blesh 1; Brown 2; Cahill and Barr, eds.; Christensen; Cummings 5; Dreier 2; Eliot; Elsen 2; Flanagan; *Forerunners; From Foreign Shores;* Frost; Gerdts; Goodrich and Baur 1; Haftman; Hess, T.B., 1; Hulten; Hunter 6; Janis and Blesh 1; Janis, S.; Kozloff 3; Kuh 1; Levin 2; McCoubrey 1; McCurdy, ed.; Mellquist; Mendelowitz; Poore; Richardson, E.P.; Ritchie 1; Rose, B., 1, 4; Rosenblum 1; Rubin 1; Seitz, 3; Soby 5; Tashijian; Tomkins and Time-Life Books; Wiesinger. Archives.

STEPHAN, GARY b. December 24, 1942, Brooklyn, N.Y. **Studied:** Parsons School of Design, NYC, 1960-61; ASL, 1961; Pratt Institute, 1961-64; San Francisco Art Institute, 1964-67, MFA. Traveled France, Italy. **Taught:** School of Visual Arts, NYC, 1973, 1988-; Cooper Union, 1985-87. **Awards:** Guggenheim Foundation, fellowship, 1988; National Endowment for the Arts, grant, 1985, 91. **Address:** 530 Canal Street, NYC 10013. **Dealer:** Mary Boone Gallery, NYC. **One-man Exhibitions:** (first) David Whitney Gallery, NYC, 1969, 70, 71; Quay Gallery, San Francisco, 1971; Galleri Hans R.

Neuendorf, Cologne, 1972; Galleri Hans R. Neuendorf, Hamburg, 1972; The Texas Gallery, Houston, 1973, 75, 76, 78, 83; Galleri Ostergren, Malmo, 1973; Galleri Fabian Carlson, Goteborg, 1973; Daniel Weinberg Gallery, San Francisco, 1973, 75, 77, 82; Alfred/SUNY, 1974; Bykert Gallery, NYC, 1974, 75, 76; Mary Boone Gallery, NYC, 1978, 79, 80, 81, 82, 83, 86, 90; Arnold Gallery, Atlanta, 1978; Margo Leavin Gallery, Los Angeles, 1979, 80, 81, 83, 86; Mattingly-Baker Gallery, Dallas, 1981; The Greenberg Gallery, St. Louis, 1982; Marlborough Gallery, NYC, 1984; Portico Row Gallery, Philadelphia, 1984; U. of Rhode Island, 1984; Dart Gallery, Chicago, 1986; Lia Rumma Gallery, Naples, Italy, 1986; Diane Brown Gallery, NYC, 1986; Galerie Gabrielle Maubrie, Paris, 1988; Hirschl & Adler Modern, NYC, 1988; Galeria Lino Silverstein, Barcelona, 1989; Fuller Gross Gallery, San Francisco, 1990; Baumgartner Galleries, Washington, D.C., 1990. **Group:** WMAA Biennials, 1969, 71, 73; Pratt Institute, NYC, Recent Abstract Paintings, 1973; P.S. 1, Long Island City, The Altered Photograph/20 Walls, 20 Curators, 1979; NYU, American Painting: The Eighties, 1979; MIT, Great Big Drawings, 1982; WMAA, Five Painters in New York, 1984; MOMA, International Survey of Painting and Sculpture, 1984; Milwaukee, Currents 6, 1984; Fort Lauderdale, An American Renaissance, 1986; Ridgefield/Aldrich, Post Abstract Abstraction, 1987; Los Angeles/MOCA, The Image of Abstraction, 1988. **Collections:** MMA; MOMA, SRGM; WMAA. **Bibliography:** Pincus-Witten 2.

STERNBERG, HARRY b. July 19, 1904, NYC. **Studied:** ASL; and privately with Harry Wickey. Traveled Mexico, Canada, Great Britain. **Taught:** ASL, 1933-68; New School for Social Research, 1942-45, 1950-51; Brigham Young U., 1958; U. of Southern California, 1959-69; Palomar College, 1974. Directed and pro-

duced a film, *The Many Worlds of Art,* 1960. Federal A.P. (murals): US Post Offices, Sellersville, Pa., and Chester, Pa. (1935-37); advisor on graphic project. **Commission:** mural, Escondido, Calif., Community Clinic, 1979. **Awards:** Fifty Prints of the Year, 1930; Fine Prints of the Year, 1932, 33, 34; Guggenheim Foundation Fellowship, 1936; 100 Prints of the Year, 1938; The Print Club, Philadelphia, 1942; Audubon Artists, 1955; AAAL, P.P., 1972. **Address:** 1606 Conway Drive, Escondido, CA 92027. **Dealer:** Susan Teller Gallery, NYC. **One-man Exhibitions:** Keppel & Co., NYC, 1937; Weyhe Gallery, 1941; ACA Gallery, 1947, 50, 56, 58, 61, 62, 64, 66, 68, 70, 72, 74; U. of Minnesota, 1957; Garelick's Gallery, Detroit, 1958; Brigham Young U., 1958; Idylwild Art School, 1958; Gallery Eight, Santa Barbara, 1961; Salt Lake Art Center, Salt Lake City, 1961; Art and Design Gallery, Nonsall, Calif., 1976; Tobey C. Moss Gallery, Los Angeles, 1986; San Diego Print Club, 1986. **Group:** WMAA; Chicago/AI; Walker; U. of Minnesota; de Young; Brooklyn Museum; MOMA; 100th Anniversary Exhibition of ASL, NYC, 1976. **Collections:** ASL; Andover/ Phillips; Auckland; Bibliothèque Nationale; Brooklyn Museum; Chicago/AI; City College, NYC; Cleveland/MA; de Young; Harvard U.; Hirshhorn; Keene State College; Library of Congress; MMA; MOMA; U. of Minnesota; NYPL; National Gallery; U. of Nebraska; Phillips; U. of Southern California; Syracuse U.; Tel Aviv; Victoria and Albert Museum; WMAA; Walker. **Bibliography:** American Artists Congress, Inc.; American Artists Group, Inc., 3; Hayter 1; *Index of 20th Century Artists;* Mellquist; Reese; Smith, A.; Sternberg 1, 2; Zigrosser 1. Archives.

STERN, GERD
from 1st to 3rd edition.

STERNE, HEDDA
from 1st to 4th edition.

STERNE, MAURICE
from 1st to 5th edition.

STEUMPFI, WALTER
from 1st to 4th edition.

STEVENSON, HAROLD
b. March 11, 1929, Idabel, Okla. **Studied:** U. of Oklahoma; U. of Mexico; ASL. Traveled Europe, Mexico, USA; resided Paris ten years. Subject of the Andy Warhol film *Harold,* 1964. Designed the Tennessee Williams gold medallion for National Committee for the Literary Arts, 1981. **Taught:** Austin College, Artist-in-Residence. **Address:** 302 Southeast Adams, Idabel, OK 74745; P.O. Box 1211, Wainscott, NY 11975-1211; and 21-14 45th Avenue, Long Island City, NY 11101. **One-man Exhibitions:** (first) Alexandre Iolas Gallery, NYC, 1956, also 1958, 65, 72, 73, 74; Galerie la Cour d'Ingres, Paris, 1960; Iris Clert Gallery, 1962, 63, 68; Robert Fraser Gallery, 1962; Richard Feigen Gallery, Chicago, Los Angeles, and NYC, 1964; Galerie Svensk-Franska, Stockholm, 1965; American Embassy, Paris, 1969; Knoedler & Co., Paris, 1970; Galeria Blu, Milan, 1971; La Medusa Gallery, Rome, 1970, 73; Alexandre Iolas Gallery, Paris, 1973; Galeria Zoumbulaskis, Athens, 1973; Brooks Jackson Iolas Gallery, NYC, 1976, 77, 82, 84; Galerie Iris Clert, Paris, 1979; Keith Green Gallery, NYC, 1986. **Group:** Salon du Mai, Paris, 1962; WMAA Annual, 1964; Musée de la Haye, Amsterdam, 1964; Palais des Beaux-Arts, Brussels, 1965; Galerie Svensk-Franska, Stockholm, 1965; ICA, London, The Obsessive Image, 1968; Düsseldorf/Kunsthalle, Prospect '68, 1968; HemisFair '68, San Antonio, Tex., 1968; Musée du Louvre, Paris, Comparaisons, 1969; CNAC, L'Image en Question, 1971; Paris, Salon d'Automne, 1971; Musée du Louvre, La famille des portraits, 1980; Paris/Beaubourg, Americans in Paris, 1979; IEF, Twentieth Century

Harold Stevenson, *Breakfast of Mars*, 1963.

American Drawings: The Figure in Context, circ., 1984. **Bibliography:** Cummings 4; Lippard 5. Archives.

STILL, CLYFFORD **b.** November 30, 1904, Grandin, N.D. **d.** June 23, 1980, Baltimore, Md. **Studied:** Spokane U., 1933, BA; Washington State College, MA. **Taught:** Yaddo, 1934, 35; Washington State College, 1935-45; College of William and Mary, 1944; California School of Fine Arts, 1946-50; "Subject of the Artist," NYC, 1947-48; Hunter College, 1952; Brooklyn Museum School, 1952; U. of Pennsylvania, 1963; Encouraged California students to form a group, which became the Metart Gallery. **Awards:** Skowhegan School, Medal for Painting,

1975; AAAL, award of merit medal for painting, 1972; Hon. DFA, North Dakota U., 1972; Hon. DFA, SFAI, 1976. **One-man Exhibitions:** (first) SFMA, 1943; Art of This Century, NYC, 1946; Metart Gallery, San Francisco, 1950; ICA, U. of Pennsylvania, 1964; Marlborough-Gerson Gallery Inc., 1969, 71; Buffalo/Albright, 1980; Basel, 1991; Mary Boone Gallery, NYC, 1990; Philippe Briet Gallery, NYC, 1990. **Retrospectives:** Buffalo/Albright, 1959; MMA, 1979, 91. **Group:** MOMA, Fifteen Americans, circ., 1952; MOMA, The New American Painting, circ. Europe, 1958-59; Kassel, Documenta II, 1959; MOMA, The New American Painting and Sculpture, 1969; Corcoran Biennial, 1971; Carnegie, International, 1978. **Collections:** Baltimore/MA; Buffalo/Albright; MOMA; Phillips; SFMA; WMAA. **Bibliography:** Alloway 4; Anfam; Armstrong, Thomas; Ashbery; Ashton 5; Battcock, ed.; Blesh 1; Chipp; *Clyfford Still;* Downes, ed.; *Europa/Amerika;* Finkelstein; Flanagan; Gaunt; Gohr and Gachnang; Goossen 1; *The Great Decade;* Greenberg 1; Haftman; Hess, T.B., 1; Hobbs and Levin; Honisch and Jensen, eds.; Hunter 1, 6; Hunter, ed.; *Individuals;* O'Neill, ed.; McChesney; McCurdy, ed.; *Metro;* Murken-Altrogge; Ponente; Read 2; Richardson, E.P.; Rickey; Rose, B., 1; Rosenblum 2; Rubin 1; Sandler 3, 5; Schwartz 1; Seitz 3; Seuphor 1; Solnit; Tomkins 2; Tuchman, ed. Archives.

STONE, SYLVIA
from 3rd to 5th edition.

STOUT, MYRON **b.** December 5, 1908, Denton, Tex. **d.** October 1987, Provincetown, Mass. **Studied:** North Texas State U., 1930, BS; Columbia U., with C. J. Martin, MA; Academia San Carlos, Mexico City, 1933; Hofmann School. US Army and Air Force, 1943-45. Traveled France, Italy, Mexico, Greece, Turkey. **Taught:** Fine Arts Work Center, Provincetown, Mass., Artist-in-Residence, 1968;

Kamehameha Schools, Honolulu, 1938-45, 46-49. **Awards:** National Council on the Arts, 1966; J. S. Guggenheim Fellowship, 1969; AAIAL, Award of Merit, 1982. **One-man Exhibitions:** (first) The Stable Gallery, NYC, 1954; Hansa Gallery, NYC, 1957, 58, (three-man); Houston/Contemporary, 1977; Cherrystone Gallery, Wellfleet, Mass., 1980; DIA Foundation, Bridgehampton, N.Y., 1990; Kent Fine Art, NYC, 1990; Flynn Gallery, NYC, 1990. **Retrospective:** WMAA, 1980. **Group:** WMAA Annual, 1958; Carnegie, 1959; ICA, Boston, 100 Works on Paper, circ., Europe, 1959; ICA, Boston, Paintings, USA, 1959; A.F.A., New Talent, circ., 1960; WMAA, Geometric Abstraction in America, circ., 1962; Jewish Museum, 1964; SRGM, American Drawings, 1964; Corcoran Biennial; Buffalo/Albright, Plus by Minus, 1968; WMAA, American Drawings: 1963-1973, 1973; Syracuse/Everson, Provincetown Painters, 1977; WMAA, 20th Century American Drawings and Watercolors, 1978; MMA, Hans Hofmann as Teacher, 1979; Buffalo/Albright, Constructivism and the Geometric Tradition, circ., 1979; AAIAL, 1982; Houston/Contemporary, In Our Time, 1982; Bennington College, New York to Bennington, 1985; MIT, Affinities, 1983; Menil Collection, Houston, Fifty Years of American Drawings, circ., 1985; WMAA, Vital Signs, 1988; Cologne/Ludwig, Bilderstreit, 1989. **Collections:** Brooklyn Museum; Buffalo/Albright; Carnegie; Chicago/AI; Hirshhorn; MOMA; McCrory Corp., NYC; NYU; National Gallery; Portland, Me./MA; SRGM; WMAA; Woodward Foundation. **Bibliography:** Armstrong, Thomas; Gohr and Gachnang; MacAgy 2.; Sandler 5; Schwartz 1, 3. Archives.

STROUD, PETER ANTHONY
b. May 23, 1921, London, England. **Studied:** London University; Central School of Arts and Crafts, London, 1950, BFA, 1952, BA. Ed., 1953, MFA. British Army, 1939-45. Traveled Europe, China,

Near East. **Taught:** Maidstone College of Art, 1962-63; Bennington College, 1963-64, 1966-68; Hunter College, 1965-66; Maryland Institute, 1968; Rutgers U., 1968-. **Commissions:** Royal Festival Hall, London, "Groupe Espace" Project, 1958; International Union of Architects, London (mural), 1961; State School, Leverkusen, Germany (mural), 1963; Manufacturers Hanover Trust Co., NYC (mural), 1969; Watertown (N.Y.) State Office Building, 1970. **Member:** Groupe Espace; American Abstract Artists. **Address:** 171 Nichol Avenue, New Brunswick, NJ 08901. **Dealer:** Newspace, Los Angeles. **One-man Exhibitions:** ICA, London, 1961; Bennington College, 1964; U. of Vermont, 1966; Marlborough-Gerson Gallery Inc., 1966; Nicholas Wilder Gallery, 1967; Axiom Gallery, London, 1968; Galerie Muller, 1969; Gertrude Kasle Gallery, 1969; Rutgers U., 1969; Max Hutchinson Gallery, 1970, 72, 73; Bernard Jacobson Gallery, London, 1971; Hoya Gallery, London, 1974; Annely Juda Fine Art, London, 1977; Union College, N.J., 1978, 88; Central College of Art, Beijing, 1987. **Retrospective:** Trenton/State, 1988. **Group:** Groupe Espace, London and Paris, 1957; New Vision Centre, London, Form and Experiment, 1957; Drian Gallery, London, Construction Great Britain: 1950-60, 1960; Carnegie, 1961, 64; Leverkusen, Construction 1962, 1962; Kunsthane, Basel, Seven Young British Painters, 1963; MOMA, The Responsive Eye, 1965; Jewish Museum, European Painters Today, 1968; MOMA, Oxford, Painters of the Sixties, 1969; Melbourne/National, Form and Structure, 1970; U. of California, Santa Barbara, Constructivist Tendencies, circ., 1970; Ulster Museum, From Sickert to Conceptual Art, 1971; Finch College, NYC, The Constructivist Tradition, 1972; American Abstract Artists, annual, 1988, 89, 90, 91. **Collections:** Detroit/Institute; Leverkusen; Los Angeles/County MA;

New Jersey State Department of Transportation; Newark Museum; Pasadena/AM; SRGM; San Diego; Tate; Trenton/State; U. of Vermont; Whitworth.

SUGARMAN, GEORGE b. May 11, 1912, NYC. **Studied:** Zadkine School of Sculpture, Paris, 1955-56. Traveled Mexico, USA, Europe; resided Paris, 1951-55. **Taught:** Hunter College, 1960-70; Yale U., 1967-68. **Commissions:** Geigy Chemical Corp. (wall structure); Xerox Data Systems, El Segundo, Calif.; First National Bank of St. Paul, Minn.; Albert M. Greenfield School, Philadelphia; City of Leverkusen, West Germany; South Mall, Albany; Brussels World Trade Center; Garmatz Federal Building, Baltimore; International Building, Miami, Fla., Airport, 1977; Federal Court House and Office Building, Baltimore, 1976-78; Detroit General Hospital, 1980; Columbia Plaza, Cincinnati; GTE Realty, Irving, Texas; Koll Center, Irvine, Calif.; Mercantile Bank, San Antonio; NCNB Plaza, Tampa; The Pavillions at Buckland Hills, Manchester, Ct.; Summer Best Subway Station, Buffalo. **Awards:** Longview Foundation Grant, 1960, 61, 63; Carnegie, Second Prize, 1961; Ford Foundation, 1965; National Council on the Arts, 1966; AAIAL, 1985. **Address:** 21 Bond Street, NYC 10012. **Dealer:** Washburn Gallery, NYC. **One-man Exhibitions:** Union Dime Savings, NYC, 1958; Widdifield Gallery, NYC, 1960; Stephen Radich Gallery, 1961, 64, 65, 66; Philadelphia Art Alliance, 1965; Dayton's Gallery 12, Minneapolis, 1966; Fischbach Gallery, NYC, 1966-69; Galerie Schmela, 1967; Renee Ziegler Gallery, Zurich, 1967, 81; Kunsthalle, Basel, 1969; Krefeld/Kaiser Wilhelm, 1969; One Hundred and Eighteen: An Art Gallery, Minneapolis, 1971; Dag Hammarskjold Plaza, NYC, 1974; The Zabriskie Gallery, NYC, 1974; Robert Miller Gallery, NYC, 1978, 79, 80, 82, 85; Galerie Liatowitach, Basel, 1979; Galerie Rudolf Zwirner, Cologne, 1980;

George Sugarman, *Untitled*, 1990.

Smith-Andersen Gallery, Palo Alto, 1981; Springfield, Mass./MFA, 1981; San Jose State U., 1982; Fuller Goldeen Gallery, San Francisco, 1984; Todd Capp Gallery, NYC, 1987; Washburn Gallery, NYC, 1990; WMAA, 1986; Aspen Art Museum, 1990. **Retrospectives:** Kunsthalle, Basel, circ., 1969; Omaha/Joslyn, circ., 1981; WMAA, 1985. **Group:** A.F.A., Sculpture in Wood, circ., 1941-42; Salon de la Jeune Sculpture, Paris, 1952, 54; Salon des Réalites Nouvelles, Paris, 1954; Silvermine Guild, 1958; Claude Bernard, Paris, 1960; Carnegie, 1961; Seattle World's Fair, 1962; Hartford/Wadsworth, 1962; A.F.A., Sculpture for the Home, circ., 1962; Chicago/AI, 1962, 66; VII São Paulo Biennial, 1963; Walker, Ten American Sculptors, 1964; Jewish Museum, Recent American Sculpture, 1964; ICA, U. of Pennsylvania, 1964; New York World's Fair, 1964-65; NYU, 1965; Flint/Institute, 1965; WMAA, Art of the U.S., 1670-1966, 1966; Los Angeles/County MA, American Sculpture of the Sixties, 1967; WMAA Sculpture Annuals, 1967, 69; Foundation Maeght, L'Art Vivant, circ., French museums, 1968; XXXIV Venice Biennial, 1968; MOMA, 1969; Foundation Maeght, L'Art Vivant, 1970; U. of Nebraska, American Sculpture, 1970; WMAA, 1970, 73; Cincinnati/Contemporary, Monumental Art, 1970; Middelheim Park, Antwerp, XI Sculpture Biennial, 1971; MIT, Outdoor Sculpture, 1972; WMAA, American Drawings: 1963-1973, 1973; Newport, R. I., Monumenta, 1974; NCFA, Sculpture: American Directions, 1945-1975, 1975; WMAA, 200 Years of American Sculpture, 1976; ICA, U. of Pennsylvania, The Decorative Impulse, circ., 1979; Buffalo/Albright; ICA, U. of Pennsylvania; NCFA, Across the Nation, 1980; Rice U., Variants, 1981; Houston/Contemporary, The Americans: The Collage, 1982; Pittsfield/Berkshire, New Decorative Art, 1983; WMAA, The Third Dimension, 1984; WMAA, 1985; AAIAL, 1985; Princeton U., A Decade of Visual Arts at Princeton, 1975-85, 1985; Hunter College, Beyond Formalism, 1986; U. of North Carolina, Art on Paper, 1987; WMAA, Vital Signs, 1988; U. of Florida, Color in Art, 1989; WMAA, Philip Morris, Painted Forms, 1991. **Collections:** Basel; Buffalo/Albright; Chicago/AI; Ciba-Geigy Corp.; Kalamazoo/Institute; Krefeld/Haus Lange; MMA; MIT; MOMA; Museum Schloss Marberg; NCFA; NYU; St. Louis/City;

The Singer Company, Inc.; Torrington Mfg. Corp.; WMAA; Walker; Wuppertal. **Bibliography:** Battcock, ed.; Calas, N. and E.; Danto; Davies; **Day 2;** Janis and Blesh 1; *Monumenta;* Phillips, Lisa, 2; Rickey; Robins; Sandler 3, 5; Tuchman 1. Archives.

SULTAN, DONALD b. March 5, 1951, Asheville, N.C. **Studied:** U. of North Carolina, 1973, BFA; Chicago Art Institute School, 1975, MFA. **Awards:** CAPS grant, 1978; National Endowment for the Arts, 1980. **Address:** 54 Leonard Street, NYC 10013. **Dealer:** Knoedler & Co., NYC. **One-man Exhibitions:** N.A.M.E. Gallery, Chicago, 1976; Artists' Space, NYC, 1977; P.S. 1, Long Island City, N.Y., 1977; The Willard Gallery, NYC, 1979, 80; Young Hoffman Gallery, Chicago, 1979; Daniel Weinberg Gallery, San Francisco, 1981; Blum Helman Gallery, NYC, 1982, 84, 85, 86, 87, Los Angeles, 1986, 87, 88; Gallerie Hans Strelow, Düsseldorf, 1982; Akira Ikeda, Tokyo, 1983; Barbara Krakow Gallery, Boston, 1985, 87; Gian Enzo Sperone, Rome, 1985, 87; Bank of America, San Francisco, 1986; Galerie Montenay-Delsol, Paris, 1986; Bibliothèque Nationale, 1986; The Greenberg Gallery, St. Louis, 1986, 89; Akira Ikeda Gallery, Nagoya, 1987; Chicago/Contemporary, circ., 1987; Greg Kucera Gallery, Seattle, 1987, 90, 91; MOMA, 1988; Martina Hamilton Gallery, NYC, 1988; Galerie Montenay, Paris, 1988; Galerie Alice Pauli, Lausanne, 1988; Paul Kasmin Gallery, NYC, 1989; Runkle-Hue-Williams, Ltd., London, 1989; Knoedler & Co., NYC, 1989, 90, 91; Waddington Galleries, London, 1990; Richard Green Gallery, NYC, 1989; Equinox Gallery, Vancouver, 1990; John Berggruen Gallery, San Francisco, 1991; Mary Ryan Gallery, NYC, 1991; Meredith Long & Co., Houston, 1991; Richard Green Gallery, Santa Monica, 1991; The Hill Gallery, Birmingham, Mich., 1992. **Group:** WMAA Biennial, 1979; U. of Chi-

cago, Visionary Images, 1979; Indianapolis, 1980, 82; MOMA, Prints from Blocks: Gauguin to Now, 1983; Palacio de Velazquez, Madrid, Tendencias en Nueva York, circ., 1983; MOMA, International Survey of Recent Painting and Sculpture, 1984; Walker, Images and Impressions: Painters Who Print, 1984; Laforet Museum, Tokyo, Correspondences, 1985; Brooklyn Museum, Public and Private, 1986; Marquette U., Milwaukee, Romanticism and Cynicism in Contemporary Art, 1986; Los Angeles/MOCA, Individuals, 1986; Sonoma State U., The Monumental Image, circ., 1987; Fort Worth/Modern, 10 + 10, circ., 1989; Walker, First Impressions, 1989; Brooklyn Museum, Projects and Portfolios, 1989; National Gallery, The 1980s: Prints from the Collection of Joshua P. Smith, 1989; Bard College, Art What Thou Eat, circ., 1990; ICI, Contemporary Illustrated Books, circ., 1991; AAIAL, 1991. **Collections:** Andover/Phillips; Arkansas/AC; Bank America Corp; Boston/MFA; Buffalo/Albright; Canberra/National; Chicago/AI; Dallas/MFA; Des Moines; Fort Worth; Harvard U.; High Museum; Hirshhorn; Kitakyushu Museum; La Jolla; MMA; MOMA; U. of North Carolina; Purchase/SUNY; SFMA; SRGM; St. Louis/City; San Diego/Contemporary; Toledo/MA; WMAA; Walker. **Bibliography:** Hiromoto; *Individuals.*

SUMMERS, CAROL b. December 26, 1925, Kingston, N.Y. **Studied:** Bard College, with Stefan Hirsch, Louis Schanker, 1951, BA. US Marine Corps, 1944-48. Traveled the Orient, Italy, France, Czechoslovakia, Central America, India, Nepal. **Taught:** Hunter College, 1963-64; Brooklyn Museum School; School of Visual Arts, NYC; Pratt Graphics Center, NYC; Columbia U.; Haystack Mountain School of Crafts; U. of Pennsylvania; SFAI, 1973. **Awards:** Italian Government Travel Grant, 1955; L. C. Tiffany Grant, 1955, 61; J. S. Guggenheim Fellow-

ship, 1959; Fulbright Fellowship (Italy), 1961. **Address:** 131 Prospect Court, Santa Cruz, CA 95065. **One-man Exhibitions:** (first) The Contemporaries, NYC, 1954, also 1961; MOMA, circ., 1964-66; A.A.A. Gallery, NYC, 1967, 80; Bard College, 1968; ADI Gallery, San Francisco, 1980; Beck Gallery, Boston, 1986; Christie's Contemporary, NYC, 1986. **Retrospectives:** SFMA, 1967; Brooklyn Museum, 1977. **Group:** Major national print exhibitions. **Collections:** Baltimore/MA; Bibliothèque Nationale; Boston/MFA; Bradley U.; Brooklyn Museum; Chicago/AI; Cincinnati/AM; Cornell U.; Free Library of Philadelphia; U. of Kentucky; Library of Congress; Los Angeles/County MA; Lugano; MMA; MOMA; Milwaukee; Downer College; U. of Minnesota; NYPL; National Gallery; U. of Nebraska; New Britain; Ohio U.; PMA; Seattle/AM; U. of Tennessee; U. of Utah; Victoria and Albert Museum; Walker. **Bibliography:** *Carol Summers. Woodcuts 1950-1967.* Archives.

SUTTMAN, PAUL

b. July 16, 1933, Enid, Okla. **d.** April 21, 1993, South Kent, Ct. **Studied:** Adelphi College, with Robert Cronbach; U. of New Mexico, with Adja Yunkers, Robert Mallory, 1956, BFA; Cranbrook, with Tex Schwetz, Maija Groten, 1958, MFA; with Giacomo Manzu, 1960. Traveled Europe, Latin America; resided Mexico, Italy. **Taught:** U. of Michigan, 1958-62; Dartmouth College, 1973; U. of Nevada, 1976. **Commissions:** Roswell (N.M.) Museum and Art Center (bronze relief for facade); National Educational Television, 1961 ("The Bronze Man," a film illustrating casting techniques); Hughes, Hatcher & Suffrin Building, Detroit, 1964; U. of Michigan, 1967. **Awards:** Cranbrook, Horace H. Rackham Research Grant (Florence, Italy), 1960; Fulbright Fellowship (Paris), 1963; Prix de Rome, 1965, 66, 67; Ingram Merrill Foundation Grant, 1972. **One-man Exhibitions:** Roswell, 1959; Park Gallery, Detroit, 1959, 62; Donald Morris Gallery,

1959, 62, 65, 67, 69; U. of Michigan, 1962; Terry Dintenfass, Inc., NYC, 1962, 64, 65, 67, 69, 71, 73; Felix Landau Gallery, Los Angeles, 1970; Robinson Galleries, Houston, 1971, 82, 87; Galleria Nuovo Carpine, Sardinia, 1972; Dartmouth College, 1973. **Group:** Youngstown/Butler; Detroit/Institute; U. of Michigan; Santa Barbara/MA; de Young; U. of New Mexico; American Academy, Rome, 1966-68; Musée Rodin, Paris, International Sculpture, 1968; Indianapolis/Herron, 1969; PAFA Annual, 1969; USIS, Rome, 1969, 70, 72; Colorado Springs Fine Arts Center, Ten Take Ten, 1977. **Collections:** Detroit/Institute; First National Bank of Chicago; Kalamazoo/Institute; Layton School of Art; MOMA; Macomb County Community College; U. of Michigan; Roswell. **Bibliography:** Walker. Archives.

SUZUKI, JAMES HIROSHI

b. September 19, 1933, Yokohama, Japan. **Studied:** Privately with Yoshio Markino; Portland (Me.) School of Fine and Applied Art, 1952; The Corcoran School of Art, 1953-54. To USA, 1952. Traveled USA, Japan. **Taught:** U. of California, Berkeley, 1962-63; U. of Kentucky, 1966-68. **Awards:** Corcoran, Eugene Weiss Scholarship, 1954; John Hay Whitney Fellowship, 1958; Silvermine Guild, Larry Aldrich Prize, 1959. **Address:** 2021 E. 29th Street, Oakland, CA 94606. **Dealer:** Braunstein Quay Gallery, San Francisco. **One-man Exhibitions:** (first) The Graham Gallery, 1957, also 1958, 59, 61, 62; U. of California, Berkeley, 1963; Nihonbashi Gallery, Tokyo, 1963; Seido (Gallery), Kyoto, 1963; Comara Gallery, 1970; Palos Verdes, 1970; Quay Gallery, 1973; Braunstein Quay Gallery, 1976, 78; Sacramento State U., 1978. **Group:** Corcoran, 1956, 58, 60; WMAA; Baltimore/MA; ICA, Boston, Contemporary Painters of Japanese Origin in America; Cincinnati/AM; Des Moines; A.F.A., Cross-Currents, circ., 1957-58; Syra-

cuse/Everson, 1958; Silvermine Guild, 1959; Hartford/Wadsworth, 1959; Houston/MFA, Waning Moon and Rising Sun, 1959; U. of Nebraska, 1960; SFMA, 1963, 64; Tokyo/Modern, 1964; SFMA, Aesthetics of Graffiti, 1978. **Collections:** Corcoran; Hartford/Wadsworth; Kamakura; McDonnell & Co. Inc.; Rockefeller Institute; Tokyo/Modern; Toldeo/MA.

SWAIN, ROBERT **b.** December 7, 1940, Austin, Texas. **Studied:** American U., Washington, D.C., BA, 1964. Traveled Central America, Europe. **Taught:** Hunter College, 1968-. **Commissions:** American Republic Insurance Co., Des Moines, 1969; Schering Laboratories, Bloomfield, N.J., 1970; Phillip Mallis, NYC, 1972; Harris Bank, Chicago, 1977; Upperware World Headquarters, Orlando, 1981; IBM, Charlotte, N.C., 1981; Johnson & Johnson, New Brunswick, N.J., 1982; Buffalo/SUNY, 1985. **Awards:** Guggenheim Foundation Fellowship, 1969; National Endowment for the Arts, grant, 1976, 89; CAPS, 1982. **Address:** 57 Leonard Street, NYC 10013. **One-man Exhibitions:** (first) The The-

nen Gallery, NYC, 1965; Fischbach Gallery, NYC, 1968, 69; Syracuse/Everson, 1974; Susan Caldwell Inc., NYC, 1974, 75, 78, 81; The Texas Gallery, Houston, 1975; Columbus, 1975; Lockwood-Matthews Mansion Museum, Norwalk, Conn., 1978; Darien, Conn., Library, 1978; Nina Freudenheim Gallery, Buffalo, 1978, 89; Toni Birckhead Gallery, Cincinnati, 1980, 88. **Group:** MOMA, The Art of the Real, circ., 1968; Corcoran Biennial, 1968; U. of North Carolina, Art on Paper, 1968; WMAA, The Structure of Color, 1971; Indianapolis, 1974; MOMA, Color as Language, circ., 1974; UCLA, Fourteen Abstract Painters, 1975; Hunter College, Repetitions, 1985; Hunter College, A Debate on Abstraction, 1989. **Collections:** Amerada Hess Corp.; American Republic Insurance Co.; Ardsley; Ball State U.; Buffalo/Albright; Chase Manhattan Bank; Ciba-Geigy Corp.; Columbus; Corcoran; Denver/AM; Detroit/Institute; The Harris Bank; Lehman Brothers; MMA; McCrory Corp.; Milwaukee; Mobil Oil Co.; Prudential Insurance Co. of America; Syracuse/Everson; Travenol Laboratories; Trina Inc.; VMFA; Walker.

T

TAKAI, TEIJI
from 1st to 4th edition.

TAKAL, PETER b. December 8,
1905, Bucharest, Rumania. **Studied:** Paris,
Berlin. To USA, 1939; citizen, 1944. Traveled Europe, Africa, North and South America, Mexico. **Taught:** Beloit College, 1965;
Central College, Iowa, 1968. **Member:**
Artists Equity; Color Print Society; SAGA.
Commissions (graphic art): International
Graphic Arts Society, 1956, 59, 63; Print
Club of Cleveland, 1956, 57; The Contemporaries, NYC, 1957; A.A.A. Gallery, NYC,
1958. **Awards:** The Print Club, Philadelphia, Max Katzman Award, 1957; Silvermine Guild, Nancy A. Fuller Award, 1959;
Yaddo Fellowship, 1961; Pasadena/AM Annual, P.P., 1962; Tamarind Fellowship,
1963-64; Ford Foundation/A.F.A., Artist-in-
Residence, 1965. **Address:** Saylorsburg, PA
18353; 116 East 68th Street, NYC 10021;
40 rue du Mole, CH 1201, Geneva, Switzerland. **Dealer:** Galerie Benador, Geneva.
One-man Exhibitions: (first) Gallery
Gurlitt, Berlin, 1932; Galerie Zak, Paris,
1933; Galerie Jeanne Castel, Paris, 1935,
37; Galerie Derche, Casablanca, 1937;
Katherine Kuh Gallery, Chicago, 1937, 39,
41; Galerie Charpentier, Paris, 1939;
Chauvin Gallery, Algiers, 1939; Carstairs
Gallery, NYC, 1940; Santa Barbara/MA,
1941, 57; de Young, 1942; Karl Nierendorf
Gallery, NYC, 1942; Artists' Gallery, NYC,
1954; Duveen/Graham Gallery, NYC,
1955, 1957-58, circ., American museums
and colleges; Wittenborn Gallery, NYC,
1956; Pasadena/AM, 1956; Minneapolis/Institute, 1957; Los Angeles/County MA,
1957; Dallas/MFA, 1957; La Jolla, 1957;
Carnegie College of Art, 1957; Mills College, 1957; The Print Club of Philadelphia,
1958; Kansas City/Nelson, 1958; Cleveland/MA, 1959; Memphis/Brooks, 1959;
Galeria de Arte Mexicano, Mexico City,
1959; Smithsonian, circ., USA, 1959-60;
Cushing Galleries, Dallas, 1959-60, 1966;
The Contemporaries, NYC, 1959, 60, 62,
66; Palazzo Strozzi, Florence, Italy, 1960;
Sabersky Gallery, Los Angeles, 1961;
Kestner-Museum, circ., Germany, 1961-62;
Philadelphia Art Alliance, 1962; Mary Harriman Gallery, Inc., Boston, 1964; Weyhe
Gallery, NYC, 1964, 65, 68, 72; Beloit College, 1965; Scranton/Everhart, 1967; Central College, 1968; Carnegie Mellon U.,
1969; Hunt Botanical Library, Pittsburgh,
1969; Galerie Benador, Geneva, 1977;
Michigan State U., 1986. **Retrospective:**
Galerie du Grand-Mezel, Geneva, 1970.
Group: Salon d'Automne, Paris, 1933-35;
PAFA, 1953, 59, 60, 63, 65, 67, 69; Brooklyn Museum, Print Biennials, 1955-64;
WMAA Annuals, 1955-60, 1962-64;
Library of Congress Print Annuals, 1955,
58, 59, 60, 62; MOMA, Recent Drawings
USA, 1956; The Print Club, Philadelphia,
1956-58, 1961-63; Boston Printmakers,
1956-59, 1962, 63, 64; ICA, Boston, 100
Works on Paper, circ., Europe, 1959; PCA,
American Prints Today, circ., 1959-62; Gallery of Modern Art, Ljubljana, Yugoslavia,
IV International Exhibition of Prints, 1961;
MOMA, circ., Europe and Far East, 1961
(drawings); St. Paul Gallery, Drawings,
USA, 1963; SAGA Annual, 1963, 65; Minnesota/MA, 1963, 1966-68, 1971-73; The
Japan Print Association, Tokyo, 1967;
WMAA, 1968, 69; MOMA, Tamarind:
Homage to Lithography, 1969; SAGA,
1979. **Collections:** Achenbach Foundation;
Albion College; Andover/Phillips; Baltimore/MA; Beloit College; Berlin/National;
Bibliothèque Nationale; Brandeis U.;

Bremen; Brooklyn Museum; U. of California, Berkeley; Carnegie; Chicago; Cincinnati/AM; Cleveland/MA; Copenhagen; Dallas/MFA; Darmstadt/Hessisches; de Young; Exeter; Fort Worth; Graphische Sammlung der E.T.H.; Grenoble; Hamburg; Indianapolis/ Herron; Karlsruhe; Kassel; Kestner-Museum; Kupferstichkabinett; La Jolla; Library of Congress; Lincoln, Mass./De Cordova; Los Angeles/County MA; MMA; MOMA; U. of Maine; Mills College; U. of Minnesota; Minnesota/MA; Montreal/ MFA; NYPL; NYU; National Gallery; Omaha/Joslyn; Oran; PAFA; PMA; Paris/Moderne; Paris/Outre-Mer; Pasadena/ MA; RISD; Recklinghausen; Saarlandmuseum; Stockholm/National; Stuttgart; Stuttgart/WK; U. of Texas; Topeka Public Library; UCLA; USIA; US State Department; Uffizi Gallery; Victoria and Albert Museum; WMAA; Walker; U. of Wisconsin; Wuppertal; Yale U. **Bibliography:** Kent, N.

TALBOT, WILLIAM
from 1st to 4th edition.

TAM, REUBEN
from 1st to 5th edition.

TANGUY, YVES
b. January 5, 1900, Paris, France. d. January 15, 1955, Woodbury, Conn. French Army, 1920-22. Traveled Africa, USA. To USA, 1939; citizen, 1948. m. Kay Sage. Subject of film, *Esquisse Tanguy,* 1981, 90 minutes, produced by Jose-Pierre and Fabrice Maze. **One-man Exhibitions:** (first) Galerie Surrealiste, Paris, 1928; Galerie des Cahiers d'Art, Paris, 1935, 47; Stanley Rose Gallery, Hollywood, 1935; Julien Levy Galleries, NYC, 1936; Howard Putzell Gallery, Hollywood, 1936; Palais des Beaux-Arts, Brussels (three-man), 1937; Bucher-Myrbor Galerie, Paris, 1938; Guggenheim Jeune Gallery, London, 1938; Hartford/Wadsworth, 1939; Pierre Matisse Gallery, NYC, 1939, 42, 43, 45, 46, 50, 63; Arts Club of Chicago, 1940; "G" Place

Gallery, Washington, D.C., 1943; SFMA, 1946; Musée du Luxembourg, Paris, 1947; Galerie Maeght, 1947; Copley Gallery, Hollywood, 1948; Galerie Nina Dausset, Paris, 1949; ICA, Washington, D.C., 1952; Kunsthalle, Basel, 1952; L'Obelisco, Rome, 1953; Hartford/Wadsworth, 1954 (two-man); MIT (two-man); Bodley Gallery, NYC, 1960; Petit Galerie, Paris, 1961, 77; Galatea Galleria d'Arte, Turin, 1971; Acquavella Gallery, NYC, 1974; Kunsthandel, Düsseldorf, 1976. **Retrospectives:** MOMA, 1955; Paris/Beaubourg, circ., 1982; SRGM, 1983. **Group:** Chicago/AI; Hartford/Wadsworth; WMAA; MOMA; Fantastic Art, DADA, Surrealism, 1936; Palais des Beaux-Arts, Brussels, 6 Surrealist Painters, 1967; MOMA, Dada, Surrealism and Their Heritage, 1968; Paris/Beaubourg, Paris-New York, 1977; MOMA, Art of the Twenties, 1979. **Collections:** Buffalo/Albright; Chicago/AI; Hartford/Wadsworth; U. of Illinois; MMA; MOMA; PMA; WMAA; Washington U. **Bibliography:** Armstrong, T.; Ashbery; Battcock, ed.; Baur 7; Blanchard; Blesh 1; **Broton 1, 2, 3, 4;** Calas 2; Canaday; Christensen; *Europa/Amerika;* Flanagan; Ford; Gascoyne; Genauer; Goodrich and Baur 1; Guggenheim, ed.; Haftman; Hunter 6; Hunter, ed.; Janis, S.; Kozloff 3; Kuh 1; Langui; McCurdy, ed.; Mendelowitz; Murken-Altrogge; Neff, ed.; Pearson 2; Pousette-Dart, ed.; Ramsden 1; Raynal 3; Read 5; Richardson, E.P.; Rosenblum 2; Rubin 1; Sachs; Seitz 4; **Soby 1, 8;** Tanguy; Tomkins and Time-Life Books; Waldberg 3, 4; *Yves Tanguy: Retrospective, 1925-1955;* Waldman 4; Zervos. Archives.

TANIA
from 1st to 4th edition.

TANNING, DOROTHEA
b. August 25, 1910, Galesburg, Ill. **Studied:** Knox College, 1928-30; Chicago Academy of Arts; The School of the Art Institute of Chicago, 1930. **Taught:** U. of Hawaii,

1952. Designed sets, costumes, illustrated many books, and other projects. **Address:** 40 Fifth Avenue, NYC 10014. **One-man Exhibitions:** New Orleans Museum, 1934; Julien Levy Gallery, NYC, 1944, 48; Caresse Crosby Gallery, Washington, D.C., 1945; American Contemporary Gallery, Hollywood, 1949; Galerie Les Pas Perdus, Paris, 1950; Honolulu Academy, 1952; Alexandre Iolas Gallery, NYC, 1953, 65; Galerie Furstenberg, Paris, 1954; Arthur Jeffress, London, 1955; Galerie Edouard Loeb and Galerie Mouradian-Vallotton, Paris, 1959, 62; Le Point Cardinal, Paris, 1961, 63, 66, 70; Galerie der Spiegel, Cologne, 1963; Amerika Haus, Berlin, 1964; Galerie Marie Suzanne Feigel, Basel, 1966; Casino Knokke, Knokke-le-Zout, Belgium, 1967; Galerie Alphonse Chave, Vance, 1967; Galerie Alexandre Iolas, Milan, 1971; Galleria Inaudi, Milan, 1971; Paris/Contemporain, 1974; Galerie Editions George Visat, Paris, 1974; Galerie Jan Krugier, Geneva, 1974; Galerie bel'Art, Stockholm, 1975, 78; Galerie Carneol, Goteborg, 1977; J.P.L. Fine Arts, London, 1978; Gimpel & Weitzenhoffer Gallery, NYC, 1979; Yares Gallery, Scottsdale, 1980; Stephen Mazoh Gallery, NYC, 1983; Gallery Schlesinger-Boisanté, NYC; Kent Fine Art, NYC, 1987, 89; Feingarten Galleries, Los Angeles, 1987; Simms Fine Art Gallery, New Orleans, 1987 Hooks-Epstein Galleries, Houston, 1987, 89; Mangel Gallery, Philadelphia, 1987; Gallery Schlesinger, NYC, 1988; Albany (Ga.) Museum of Art, 1988; Nahan Galleries, NYC, 1990. **Group:** de Young, Annual, 1935; AFA, Bel Ami International Art Competition: The Temptation of St. Anthony, circ., 1946; Brooklyn Museum, Surrealist and Abstract Art, 1951; U. of Arizona, Artists in Arizona, 1954; Salon de Mai, Paris, Annuals, 1954-68; Musée des Arts Décoratifs, Paris, L'Objet, 1962; St.-Etienne, Les peintres Belges et les Surrealistes, 1972; Paris/Beaubourg, Paris/New York, 1977; Hayward Gallery, London, Dada and Sur-

Mark Tansey, *Study for Derrida Queries de Man,* 1990.

realism Revisited, 1978; Paris/Beaubourg, Art Americain, 1981; NYU, Tracking the Marvelous, 1982; Chicago/Contemporary, Surrealism in Chicago Collections, 1984; Paris/Beaubourg, Kafka, 1984; École des Beaux Arts, American Drawings: 1930-50, 1985; Baruch College/CUNY, Women Artists of the Surrealist Movement, 1986; Fashion Institute of Technology, NYC, Fashion and Surrealism, 1987; Musée Cantonal des Beaux-Arts, Lausanne, La femme et le surrealisme, 1987. **Collections:** U. of Arizona; Chicago/AI; Lyon/Beaux-Arts; MOMA; Musée de la Ville de Paris; NYPL; New Orleans; Paris/Beaubourg; Tate Gallery; Tougaloo College; WMAA; Yale U. **Bibliography:** *Dorothea Tanning.*

TANSEY, MARK **b.** 1949, San Jose, Calif. **Studied:** Art Center College of Design, 1969, BFA; Harvard U., summer, 1974; Hunter College, 1975-78. **Address:** 90 Warren Street, NYC 10007. **Dealer:** Curt Marcus Gallery, NYC. **One-man Ex-**

hibitions: Grace Borgenicht Gallery, NYC, 1982, 84; John Berggruen Gallery, San Francisco, 1984; Houston/Contemporary, 1984; Curt Marcus Gallery, 1986, 87, 90; Basel/Kunsthalle, 1990. **Retrospective:** Seattle/AM, circ., 1990-91. **Group:** New Museum, Not Just for Laughs: The Art of Subversion, 1981; Drawing Center, NYC, New Drawing in America, 1982; Indianapolis, 1982; WMAA Biennial, 1983, 91; Los Angeles/MOCA, Automobile and Culture, 1984; MOMA, International Survey of Recent Painting and Sculpture, 1984; MMA, Figurative American Art of the 20th Century, 1985; XLII Venice Biennial, 1986; SFMA, Biennial IV, 1986; Colorado Springs/FA, The Figure in 20th Century American Art, 1987; Florida International U., American Art Today: The Portrait, 1987; Purchase/SUNY, The Window in 20th Century Art, 1987; Los Angeles/County MA, Avant-Garde in the Eighties, 1987; Kassel, Documenta VIII, 1987; NYU, Morality Tales, 1987; Florida International U., American Art Today: Narrative Painting, 1988; Fort Worth/Modern, 10 + 10, 1988; Frankfurt/Kunstverein, Prospect 89, 1989; The Art Gallery of Western Australia, Perth, Romance & Irony in Recent American Art, circ., 1989; Tokyo/Modern, Color and/or Monochrome, 1990. **Collections:** Carnegie; Chase Manhattan Bank; Indianapolis; Los Angeles/MOCA; MMA; Montreal/MFA; MOMA; SFMA; WMAA; Walker. **Bibliography:** Fox.

TAUBES, FREDERIC b. April 15, 1900, Lwow, Poland. **d.** June 20, 1981, Nyack, N.Y. **Studied:** Academy of Fine Arts, Munich, 1918-20, with Franz von Stuck, Max Doerner; Bauhaus, Weimar, 1920-21, with Josef Itten; and in Berlin and Italy. Traveled Europe extensively, USA, Africa, Near East, Far East. To USA, 1930. **Taught:** Mills College, 1938; U. of Hawaii, 1939; U. of Illinois, 1940-41; Cooper Union, 1943; U. of Wisconsin, 1943; U. of Oklahoma; London U.; Ox-

ford; Royal College of Art; contributing editor, *American Artist* magazine, 1943-62; columnist and American editor, *Artist* magazine; U. of Alberta. **Member:** Fellow, Royal Society of Arts; International Society of Arts and Letters; formulator of Taubes varnishes and Copal painting media, manufactured by Permanent Pigments Co. **One-man Exhibitions:** (first) Vienna/Stadt, 1921; The Midtown Galleries; San Diego; Los Angeles/County MA; SFMA; Sacramento/Crocker; Honolulu Academy; U. of Nebraska; Kansas City/Nelson; Mius Coflege; Seattle/AM. **Group:** PAFA, 1935-44; Chicago/AI, 1935-46; Carnegie, 1936-46; Corcoran, 1936-46; VMFA, 1938-46; Memphis/Brooks. **Collections:** American Locomotive Co.; Atlanta/AA; Britannica; de Young; IBM; Indiana U.; Kansas City/Nelson; MMA; Mills College; SFMA; San Diego; Santa Barbara/MA; Standard Oil Co.; Stony Brook/SUNY. **Bibliography:** Allen, C. C., ed.; Bowen 1; **Boswell, ed.;** Kent, N.; **Taubes 1, 2, 3, 4, 5, 6, 7, 8, 9, 10, 11, 12, 13;** Watson, E. W., 2.

**TCHELITCHEW, PAVEL
b.** September 21, 1898, District of Kaluga, near Moscow, Russia. **d.** July 31, 1957, Grotta Ferrata, Italy. **Studied:** U. of Moscow; Kiev Academy, 1918-20. Traveled Europe, USA, North Africa, USSR. To USA, 1934; citizen, 1952. Designed sets and costumes for ballets by Balanchine, Massine, and others. **One-man Exhibitions:** (first) Claridge Gallery, London, 1928; A. Tooth & Sons, London, 1933, 35, 38; Julien Levy Galleries, NYC, 1934, 37, 38; Arts Club of Chicago, 1935, 38; Durlacher Brothers, NYC, 1942, 45, 51; Hanover Gallery, London, 1949; Institute of Modern Art, Buenos Aires, 1949; Detroit/Institute, 1952; Galerie Rive Gauche, Paris, 1954, 56; Galleria d'Arte del Naviglio, Milan, 1955; Catherine Viviano Gallery, NYC, 1964, 67; Galerie Lucie Weile, Paris, 1966; MOMA, 1972; Alpine Club, London, 1972, 74, 76; Michael Rosenfeld Gallery, NYC, 1991. **Retrospectives:**

Durlacher Brothers, NYC, 1948; Gallery of Modern Art, NYC, 1964. **Group:** Many national and international exhibitions. **Collections:** Hartford/Wadsworth; Kansas City/Nelson; MMA; MOMA; U. of Michigan; Santa Barbara/MA; Tretyakov Art Gallery, Yale U. **Bibliography:** Bazin; Canaday; Cummings 4; Flanagan; Ford; Frost; Holme 1; Huyghe; **Kirstein 3; Kirstein, ed.**; Kuh 1; McCurdy, ed.; Mendelowitz; Neff, ed.; Pousette-Dart, ed.; Richardson, E.P.; **Soby 1, 7; Tyler, P., 1;** Wight 2.

TERAOKA, MASAMI b. January 13, 1936, Onomichi, Japan. **Studied:** Kwansei Gakuin University, Japan, 1954-55; Otis Art Institute, BA, MFA, 1964-68. **Awards:** Los Angeles/County MA, Kay Nielsen Memorial Purchase Award, 1978; National Endowment for the Arts, fellowship, 1980, 89. **Commissions:** various design projects for magazines. **Address:** c/o Dealer. **Dealer:** Pamela Auchincloss Gallery, NYC. **One-man Exhibitions:** International Museum of Erotic Art, San Francisco, 1973; David Stuart Gallery, Los Angeles, 1973; Space Gallery, Los Angeles, 1975, 77, 79, 82, 85, 86, 88; Minneapolis/Institute, 1976; Santa Barbara/MA, 1977; WMAA, circ., 1979; Palomar College, 1980; Jehu Gallery, San Francisco, 1980; Santa Clara/Triton, 1980; Zolla-Lieberman Gallery, Chicago, 1981; Oakland Museum, 1983; Santa Ana College, 1983; Jacksonville/AM, 1983; Japanese American Community and Cultural Center, Los Angeles, 1983; Allport Gallery, San Francisco, 1985; Amerika Haus, Berlin, 1985; Contemporary Arts Forum, Santa Barbara, 1985; Monterey Peninsula Museum of Art, 1986; Honolulu/Contemporary, circ., 1988; Victorian College of the Arts, Melbourne, 1989; AFA, circ., 1989; Iannetti Gallery, San Francisco, 1989; NYU, 1989; U. of Washington, 1990; Pamela Auchincloss Gallery, NYC, 1990, 92; Fuller Elwood, Seattle, 1991; Macquarie Galleries, Rushcutters Bay, Aus-

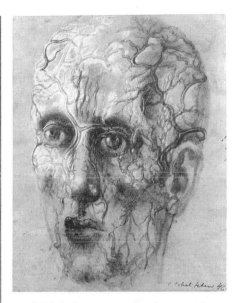

Pavel Tchelitchew, *Interior Landscape,* 1946.

tralia, 1992; Rebecca Hossak Gallery, London, 1992. **Group:** California Institue of Technology, In the Japanese Tradition, 1974; Los Angeles/County MA, L.A. 8, 1976; WMAA, Art About Art, 1978; Western Association of Art Museums, San Francisco, Déja Vu, circ., 1981; U. of California, Santa Cruz, Rejoice, 1983; AAIAL, 1983; Corcoran, Biennial, 1983; Sydney, Biennial, 1986; Walker, Tokyo: Form and Spirit, circ., 1986; Pomona College, Claremont, Calif., East/West: Contemporary Asian-American Art, 1986; Taipei Fine Arts Museum, Taipei, Taiwan, Contemporary Southern California Art, circ., 1987; Washington State U., Where Two Worlds Meet, 1989; Los Angeles Municipal Art Gallery, Raging at the Visible, 1990; MIT, Not So Simple Pleasures, 1990; Temple U., All for Love, 1991; Charlotte/Mint, In the Looking Glass, 1991; Honolulu Academy, Artists of Hawaii, 1991; AAIAL, 1991; ICI, From Media to Metaphor: Art About AIDS, circ., 1992. **Collections:** Albuquerque Museum; Atlantic Richfield Co.; California State U.; Cedars-Sinai Medical Center; Continental Insurance Co.; Federal Re-

serve Bank; Honolulu Academy; Honolulu Advertiser; Jacksonville/AM; Kansas City/Nelson; Laguna Beach Museum of Art; Los Angeles/County MA; Minneapolis/Institute; NMAA; NPG; Newport Harbor; Oakland Museum; Santa Barbara/MA; Smith College; Walker. **Bibliography:** Fox.

THEK, PAUL **b.** November 2, 1933, Brooklyn, N.Y. **d.** August 8, 1988, NYC. **Studied:** Cooper Union; ASL; Pratt Institute, 1951-54. Traveled Europe; resided Rome, 1967-75. **Taught:** Cooper Union. **Commissions:** Nederlands Dans Theater, sets and costumes for the ballet *Arena,* by Glen Tetley, 1969. **Awards:** Fulbright Fellowship, 1967-70; National Endowment for the Arts, 1975; CAPS Grant, 1976. **One-man Exhibitions:** Mirell Gallery, Miami, Fla., 1957; Galleria 88, Rome, 1963; The Pace Gallery, NYC, 1966; The Stable Gallery, NYC, 1964, 67, 69, 70; M. E. Thelen Gallery, Cologne, 1968, 72; Loernerscuit Gallery, Amsterdam, 1968, 69 (two-man); Amsterdam/Stedelijk, 1969; Stockholm/National, 1969, 71; Galerie 20, Amsterdam (two-man), 1969; Alexandre Iolas Gallery, NYC, 1975; Lucerne, 1973; Gallerie Stahli, Lucerne, 1973; Duisburg, 1973; Galerie Alexandre Iolas, Paris, 1976; Il Fante di

Paul Thek, *Star Lantern with Two Mice,* 1976.

Spade, Rome, 1977; Brooks Jackson Gallery Iolas, NYC, 1977, 80, 81, 83; Serpentine Gallery, London, 1981; Galerie Samy Yinge, Paris, 1982; Barbara Gladstone Gallery, NYC, 1984; Mokotoff Asian Arts, NYC, 1988; Brooke Alexander Gallery, NYC, 1988, 90, 91; Greenville, 1988; The Clocktower, NYC, 1989. **Retrospective:** ICA, U. of Pennsylvania. **Group:** MOMA, Art in the Mirror, 1966; ICA, U. of Pennsylvania, The Other Tradition, 1966; Carnegie, 1967; Indianapolis, 1968; Kassel, Documenta IV, 1968; Walker, 1968; Cologne, 1969; WMAA, Human Concern/Personal Torment, 1969; Walker, Figures/Environments, circ., 1970-71; La Jolla, Continuing Art, 1971; Kassel, Documenta V, 1972; Venice Biennials, 1976, 80; ICA, U. of Pennsylvania, Processions, 1977; Basel/Kunsthalle, Amerikanische Zeichnungen der siebziger Jahre, 1981; São Paulo Biennial, 1985; Humlebaek/Louisiana, Drawing Distinctions, 1981; Munich/Lenbachhaus, Tendenzan der Americanischen Zeichnung, 1982; Hirshhorn, Content, 1984; ICI, The Success of Failure, circ., 1987; Milwaukee, Word as Image, 1990. **Collections:** CNAC; Cologne. **Bibliography:** *Figures/Environments;* Kren; Lucie-Smith; Weintraub.

THIEBAUD, WAYNE **b.** November 15, 1920, Mesa, Ariz. **Studied:** San Jose State College; Sacramento State College, BA, MA. US Army Air Force, 1942-45. Traveled Europe, Mexico, USA. **Taught:** Sacramento City College, 1951-60; Sacramento State College, 1954-55; California School of Fine Arts, 1958; U. of California, Davis, 1960-; Cornell U., summer, 1967. Produced 11 educational motion pictures; 22-minute color film produced by Carr Films, 1971, covers 9 years of work. **Commissions:** California State Fair, 1950, 52, 55; Sacramento (Calif.) Municipal Utility Building, 1959 (mosaic mural); Oakland Ballet, sets and costumes for Brenda Ways' *That Point in Time,* 1987; Designs, Native Species

Stamp for California Department of Fish and Game, 1990. **Member:** AAIAL, NAD. **Awards:** California State Fair, Art Film Festival, First Prize, 1956; Film Council of America, Golden Reel Award, 1956 (American Film Festival, Chicago); Columbia Records Award, 1959 ($6,000); Scholastic Art Awards for the films *Space* and *Design,* 1961; Creative Research Foundation, $1,000 Grant, 1961; California College of Arts and Crafts, Hon. DFA, 1972; College Art Association, citation for most distinguished studio teacher, 1981; Dickinson College, Hon. DFA, 1983; U. of California, Davis, prize for teaching and scholarly achievements, $25,000, 1988; San Francisco Art Institute, Hon. DFA, 1988. **Address:** 1617 7th Ave., Sacramento, CA 95817. **Dealers:** Allan Stone Gallery, NYC; John Berggruen, San Francisco. **One-man Exhibitions:** (first) Sacramento/Crocker, 1951, 69; Artists Co-op Gallery, Sacramento, 1957, 58; SFMA, 1961, 78; de Young, 1962; Allan Stone Gallery, 1962-67, 77, 78, 79, 80, 86, 88; Galleria Schwarz; Stanford U., 1965; Albright Museum, Kansas City, Mo., 1966; Pasadena/AM; WMAA, 1971; John Berggruen, San Francisco, 1980, Denver, 1975; U. of California, Santa Cruz, 1976; U. of California, Davis, 1977; Diablo Valley College, 1977; Marilyn Butler Fine Arts, Santa Barbara, 1989. **Retrospectives:** Walker, 1979; Phoenix, 1976; Newport Harbor, 1986. **Group:** SFMA Annual; Chicago/AI Annual; WMAA Annual; Los Angeles/County MA; California Palace; Denver/AM; ICA, London; Pasadena/AM, New Paintings of Common Objects, 1962; Houston/Contemporary, Pop Goes the Easel, 1963; IX São Paulo Biennial, 1967; Kassel, Documenta V, 1972; and print exhibitions abroad. **Collections:** Achenbach Foundation; American Broadcasting Co.; Brandeis U.; Bryn Mawr College; Buffalo/Albright; California State Library; Chicago/AI; Corcoran; Dallas/MFA; Hartford/Wadsworth; Harvard U.; Houston/MFA; Immaculate Heart College; Kan-

sas City/Nelson; Library of Congress; MMA; MOMA; U. of Miami; Milwaukee; U. of Nebraska; Newark Museum; Oakland/AM; PMA; RISD; SFMA; Sacramento/Crocker; Sacramento State College; San Jose State College; Shasta College; Southern Illinois U.; Stanford U.; Time Inc.; Utah; WGMA; WMAA. **Bibliography:** Alloway 4; *America 1976;* Armstrong, T.; Arthur 1, 2, 4; De Salvo and Schimmerl; Gettings 2; Hunter, ed.; Lippard 5; Meisel; Murken-Altrogge; *New in the Seventies;* Osterwold; Sager; Seitz 3; Strand, ed.; *The State of California Painting;* Tsujimoto; Ward; Weller.

THOMAS, ROBERT C.
from 1st to 4th edition.

THOMPSON, BOB b. June 26, 1937, Louisville, Ky. d. May 30, 1966, Rome, Italy. **Studied:** Boston Museum School, 1955; U. of Louisville, 1955-58. Traveled Europe, North Africa; resided Paris, Ibiza, NYC, Rome. **Awards:** Walter K. Gutman Foundation Grant, 1961; John Hay Whitney Fellowship, 1962-63. **One-man Exhibitions:** Delancey Street Museum, NYC, 1960; Superior Street Gallery, Chicago, 1961; Martha Jackson Gallery, NYC, 1963, 65, 68; El Cosario Gallery, Ibiza, Spain, 1963; The Drawing Shop, NYC, 1963-64; Richard Gray Gallery, Chicago, 1964, 65; Paula Johnson Gallery, NYC, 1964; Donald Morris Gallery, 1965, 70; East End Gallery, Provincetown, 1965; Louisville/Speed, 1971; U. of Massachusetts, 1974; PAFA, 1976; Vanderwoude Tananbaum Gallery, NYC, 1983, 86; Miami-Dade Community College (two-man), circ., 1985; Hartford/Wadsworth, 1986. **Retrospectives:** New School for Social Research, 1969; Studio Museum in Harlem, NYC, 1978. **Group:** Martha Jackson Gallery, NYC, 1964; Dayton, International Selection, 1964; Yale U., 1964; New School for Social Research, 1965; Gallery 12 St. Marks, NYC, 1967; Star Turtle Gallery, NYC, The Tenants of

Sam Wapnowitz, 1969; Brooklyn Museum, Eight Afro-American Artists, 1971; Bucknell U., Since the Harlem Renaissance: Fifty Years of Afro-American Art, circ., 1983; Bergen Museum of Science and Art, Transitions: The Afro-American Artists, 1986. **Collections:** A.F.A.; American Republic Insurance Co.; Buffalo/Albright; Charlotte/Mint; Dayton/AI; Jay Dorf, Inc.; Mills College; Norfolk/ Chrysler. **Bibliography:** *The Figurative Fifties.*

TING, WALASSE **b.** October 13, 1929, Shanghai, China. To USA; citizen, 1970. Resided Paris, 1950-60. **Awards:** Guggenheim Foundation Fellowship, 1970. **Address:** 463 West Street, NYC 10014. **One-man Exhibitions:** Hong Kong, 1952; Paul Facchetti Gallery, Paris, 1954; Martha Jackson Gallery, NYC, 1959, 60; Lefebre Gallery, NYC, 1963, 66, 67, 68, 69, 70, 71, 72, 80; Galerie Birch, Copenhagen, 1963, 70, 75; Galerie de France, Paris, 1968; Galerie Adrien Maeght, Paris, 1974, 77. **Group:** Salon de Mai, Paris, 1964, 65, 66, 67, 68; Carnegie, International, 1961, 64, 67, 70. **Collections:** Amsterdam/Stedelijk; Chicago/AI; Detroit/Institute; SRGM; MOMA; Rockefeller U.; Buffalo/Albright; Norfolk/Chrysler.

TOBEY, MARK **b.** December 11, 1890, Centerville, Wisc. **d.** April 24, 1976, Basel, Switzerland. **Studied:** Chicago Art Institute School, 1908, with Frank Zimmerer, Prof. Reynolds. Traveled Europe, Mexico, USA, the Orient, extensively. **Taught:** Cornish School, Seattle, intermittently, 1923-29; Dartington Hall, Devonshire, England, 1931-38. Federal A.P.: Easel painting, 1938. **Awards:** Seattle/AM, Katherine Baker Memorial Award, 1940; MMA, Artists for Victory, $500 Prize, 1942; Portrait of America, Fourth Prize, 1945; NIAL, 1956; Guggenheim International, $1,000 Award, 1956; American Institute of Architects, Fine Arts Medal, 1957; XXIX Venice Biennial,

1958, First Prize of the Commune of Venice; *Art in America* magazine, 1958 ($1,000); elected to American Academy of Arts and Sciences, 1960 (fails to accept election); Skowhegan School, Painting Award, 1971. **One-man Exhibitions:** (first) M. Knoedler & Co., NYC, 1917; Arts Club of Chicago, 1928, 40; Romany Marie's Cafe Gallery, NYC, 1929; Cornish School, Seattle, 1930; Contemporary Arts Gallery, NYC, 1931; Paul Elder Gallery, San Francisco, 1934; Beaux Arts Gallery, London, 1934; Stanley Rose Gallery, Hollywood, 1935; Seattle/AM, 1942; The Willard Gallery, NYC, 1944, 45, 47, 49, 50, 51, 53, 54, 57, 71, 74; Margaret Brown Gallery, Boston, 1949, 54, 56; Portland, Ore./AM, 1950 (three-man); California Palace, circ., 1951; The U. of Chicago, 1952; Zoe Dusanne Gallery, Seattle, 1952; Otto Seligman Gallery, 1954, 57, 62; Chicago/AI, 1955; Gump's Gallery, San Francisco, 1955; Jeanne Bucher, Paris, 1955, 59, 68, 77; Paul Kantor Gallery, Beverly Hills, Calif., 1955; ICA, London, 1955; Victoria (B.C.), 1957; Galerie Stadler, Paris, 1958; St. Albans School, Washington, D.C., 1959; Frederic Hobbs Fine Art Center, San Francisco, 1960; Mannheim, 1960; Galerie Beyeler, Basel, 1961, 70, 71, 90; Royal Marks Gallery, 1961; Seattle World's Fair, 1962; Phillips, 1962; Hanover Gallery, 1968; Bon Marche, Seattle, 1969; PAFA, 1969; Baukunst Galerie, Cologne, 1971; WMAA, 1971; Galleria dell'Ariete, 1971; Tacoma, 1972; Cincinnati/AM, 1972; Galerie Biedermann, Munich, 1973; NCFA, 1974; Krefeld/Haus Lange, 1975; Foster-White Gallery, Seattle, 1980, 90; Alex Rosenberg Gallery, NYC, 1979; Haslem Fine Arts, Inc., Washington, D.C., 1979; Elaine Granz Gallery, San Francisco, 1976; George Belcher Gallery, San Francisco, 1978; La Boetie Inc., NYC, 1986; Philip Daverio Gallery, NYC, 1990, 91; Galerie Alice Pauli, Lausanne, 1990; Museo d'arte, Mendrisio, circ., 1989; Hachmeister Gallery, Munster, 1988; Galerie Erker, St. Gallen, 1986.

Retrospectives: Seattle/AM, circ., 1959, 70; Musée des Arts Décoratifs, 1961; MOMA, 1962; Kunstverein, Düsseldorf, 1966; Berne, 1966; Hannover/K-G, 1966; Amsterdam/Stedelijk, 1966; Dallas/MFA, 1968; National Gallery, 1984. **Group:** MOMA, Paintings by 19 Living Americans, 1929; New York World's Fair, 1939; Chicago/AI, 1940, 45, 47, 48, 51; MMA, 1942, 44, 45; MOMA, Romantic Painting in America, 1943; Brooklyn Museum, 1945, 51; Seattle/AM, 1945, 50, 51, 52, 53, 55, 56, 58; WMAA, 1945, 46, 47, 49, 62; Tate, 1946; MOMA, Fourteen Americans, circ., 1946, Utica, circ., 1947, XXIV, XXVIII & XXIX Venice Biennials, 1948, 56, 58; U. of Illinois, 1949, 50, 51, 55, 59; SFMA, 1949; Walker, Contemporary American Painting, 1950; MMA, American Paintings Today, 1950; MOMA, Abstract Painting and Sculpture in America, 1951; Ueno Art Gallery, Tokyo, 1951; U. of Minnesota, 40 American Painters, 1940-50, 1951; I & III São Paulo Biennials, 1951, 55; Carnegie, 1952, 55, 58, 61; International Biennial Exhibition of Paintings, Tokyo; Pavillion, Vendome, Aix-en-Provence, 1954; France/National, 50 ans d'art aux États-Unis, circ., Europe, 1955; Darmstadt/Kunsthalle, circ., 1956; III International Contemporary Art Exhibition, New Delhi, 1957; USIA, Eight American Artists, circ., Europe and Asia, 1957-58; WMAA, Nature in Abstraction, 1958; Brussels World's Fair, 1958; American Painting and Sculpture, Moscow, 1959; Kassel, Documenta II, 1959; Walker, 60 American Painters, 1960; Seattle World's Fair, 1962; National Gallery, American Art at Mid-Century, 1973; NCFA, Art of the Pacific Northwest, 1974. **Collections:** Andover/Phillips; Baltimore/MA; Boston/MFA; Brooklyn Museum; Buffalo/Albright; Carnegie; Chicago/AI; Detroit/Institute; Fondazione Thyssen Bornemisza; Hartford/Wadsworth; MMA; MOMA; Milwaukee; Phillips; Portland, Ore./AM; SFMA;, St. Louis/City; Seattle/AM; Utica; WMAA;

West Palm Beach/Norton; Zurich/Kunsthaus. **Bibliography:** Alvard; *Art of the Pacific Northwest;* Armstrong, T.; Ashbery; Ashton 5; Baur 5, 7; Beekman; Biddle 4; Bihalji-Merin; Blesh 1; Clark and Cowles; Eliot; **Feininger and Tobey;** Gaunt; Goodrich and Baur 1; Haftman; Henning; Hess, T.B., 1; Honisch and Jensen, eds.; Hulten; Hunter 1, 6; Hunter, ed.; Janis, S.; Kuh 2, 3; Langui; Leepa; Lynton; McCurdy, ed.; **Mark Tobey;** Mendelowitz; *Metro;* Miller, ed., 2; Murken-Altrogge; Neumeyer; Nordness, ed.; *Northwest Traditions;* Ponente; Pousette-Dart, ed.; Ragon 1, 2; Read 2; Restany 2; Richardson, E.P.; Rickey; Ritchie 1; **Roberts;** Rodman 1, 3; Rose, B., 1; **Seitz** 1, 6; Seuphor 1; Soby 5; Tapie 1; **Thomas; Tobey;** Tuchman 3; Weller; Wiesinger. Archives.

TODD, MICHAEL b. June 20, 1935, Omaha, Neb. **Studied:** U. of Notre Dame, 1957, BFA, magna cum laude; UCLA, 1959, MA. **Taught:** UCLA, 1959-61, San Diego, 1968-76; Bennington College, 1966-68; San Diego, 1968-76; California Institute of Arts, 1977; Otis Art Institute, 1978. **Member:** Artists Equity, Sculptors Guild. **Awards:** Woodrow Wilson Fellowship, 1957-59; Fulbright Fellowship (Paris), 1961-63; National Endowment for the Arts, 1974. **Address:** 2817 Clearwater Street, Los Angeles, Calif. 90039. **Dealers:** Charles Cowles Gallery, NYC; Kornblatt Gallery, Washington, D.C.; Tortue Gallery, Los Angeles; Gallery Paule Anglim, San Francisco. **One-man Exhibitions:** Hanover Gallery, 1964; The Pace Gallery, NYC, 1964; Henri Gallery, 1965, 68; Gertrude Kasle Gallery, Detroit, 1968; Salk Institute, La Jolla, 1969; Reese Palley Gallery, NYC, 1971; California State U., Fullerton, 1972; U. of Notre Dame, 1972; Palo Alto Square, 1973, 74; The Zabriskie Gallery, NYC, 1974, 76; Seder/Creigh Gallery, Coronado, Calif., 1975; Dag Hammarskjöld Plaza, NYC, 1976; Nicholas Wilder Gallery, Los Angeles, 1976; Charles Casat Gallery, La

Jolla, 1978; Oakland/AM, 1978; Paule Anglim Gallery, San Francisco, 1978; Tortue Gallery, Los Angeles, 1978, 1980, 82, 84, 87, 88; Diane Brown Gallery, Washington, D.C., 1978, 81; Arco Center for Visual Arts, Los Angeles, 1979; Betty Cunningham, NYC, 1979; Paule Anglim Associates, 1980, 82, 84; Claremont College, 1980; Charles Cowles Gallery, 1981, 83, 85; Paul Klein Gallery, Chicago, 1983, 85, 87, 88; Kornblatt Gallery, Washington, D.C., 1983, 85, 87; Bemis Project Gallery, Omaha, 1986; Peter Sremmel Gallery, Reno, 1986; Triton Museum, Monterey, Calif., 1986; Honolulu Academy, 1987; Milwaukee, 1987; U. of Nebraska, 1987; Chapman College, 1988; Laguna Beach Museum of Art, 1988; Palm Springs Desert Museum, 1989; Palos Verdes Art Gallery, 1990; Works Gallery, Long Beach, 1991; Klein Art Works, Chicago, 1991. **Group:** American Cultural Center, Paris, 1962; WMAA, 1965, 67, 68, 70; WMAA, Young America, 1965; Jewish Museum, Primary Structure Sculptures, 1966; Los Angeles/County MA, American Sculpture of the Sixties, circ., 1967; Corcoran, 1968; Maeght Foundation, 1970; San Diego, 1974; SFMA, California Painting and Sculpture: The Modern Era, 1976; Oakland Museum, One Hundred Years of California Sculpture, 1982; SFMA, Twenty American Artists, 1982; U. of Southern California, California Sculpture Show, circ., 1984; Sierra Nevada Museum of Art, West Coast Contemporary, 1988. **Collections:** California State U.; Hirshhorn; La Jolla; Los Angeles/County MA; MMA; U. of Nebraska; U. of Notre Dame; Oakland/AM; Palm Springs Desert Museum; Palomar College; Pasadena/AM; Portland, Ore./AM; SFMA; Southwestern Community College; Storm King Art Center; WMAA; Wayne State U.; Yale U. **Bibliography:** *California Sculpture Show.*

TOMLIN, BRADLEY WALKER

b. August 19, 1899, Syracuse, N.Y. **d.** May 11, 1953, NYC. **Studied:** Studio of Hugo Gari Wagner, 1913; Syracuse U., 1917-21;

Academie Colarossi, Paris, and Academie de la Grande Chaumiere, 1923. Traveled Europe. **Taught:** Buckley School, 1932-33; Sarah Lawrence College, 1932-41; Dalton School, NYC, 1933-34. **Member:** Federation of Modern Painters and Sculptors; Whitney Studio Club, NYC; Woodstock Artists Association. **Awards:** Scholarship to Wagner Studio, 1913; Syracuse U., Hiram Gee Fellowship; Scholarship to L. C. Tiffany Foundation, Oyster Bay, N.Y.; Carnegie, Hon. Men., 1946; U. of Illinois, P.P., 1949. **One-man Exhibitions:** Skaneateles and Cazenovia, N.Y., 1922; Anderson Galleries, NYC, 1923; Montross Gallery, NYC, 1926, 27; Frank K. M. Rehn Gallery, NYC, 1931, 44; Betty Parsons Gallery, NYC, 1950, 53; Phillips, 1955; Buffalo/Albright, 1975. **Retrospectives:** WMAA, circ., 1957; Hofstra U., 1975 **Group:** U. of Illinois, 1949, 51; MOMA, Abstract Painting and Sculpture in America, 1951; U. of Minnesota, 1951; MOMA, Fifteen Americans, circ., 1952; MMA, 1953; WMAA, The New Decade, 1954-55; France/National, 1955; MOMA, The New American Painting and Sculpture, 1969. **Collections:** Andover/Phillips; Cranbrook; U. of Illinois; MMA; Phillips; Utica; WMAA. **Bibliography:** *Abstract Expressionism;* Anfam; Armstrong, T.; Ashbery; Baur 7; Blesh 1; *Europa/Amerika;* Flanagan; Goodrich and Baur 1; Haftman; Hess, T. B., 1; Hobbs and Levin; Hunter 1, 6; Hunter, ed.; McCoubrey 1; McCurdy, ed.; Mendelowitz; Motherwell and Reinhardt, eds.; Pagano; Ponente; Pousette-Dart, ed.; Read 2; Ritchie 1; Rose, B., 1; **Sandler 4, 5;** Seuphor 1; Tuchman, ed.; Weller; *Woodstock: An American Art Colony, 1902-1977.* Archives.

TOOKER, GEORGE

b. August 5, 1920, NYC. **Studied:** Phillips Academy, 1936-38; Harvard U., AB, 1942; ASL, with Reginald Marsh, Paul Cadmus, Kenneth Hayes Miller, Harry Sternberg. US Marine Corps, 1942-43. Traveled

France, Italy, Great Britain. **Taught:** ASL, 1965-68. **Member:** AAIAL; NAD. **Commissions:** St. Francis of Assisi Church, Windsor, Vt., 1981. **Awards:** NIAL Grant, 1960; Vermont, Governor's Award for Excellence in the Arts, 1983. **Address:** Hartland, Vt. **Dealer:** Marisa del Re Gallery, NYC. **One-man Exhibitions:** (first) Hewitt Gallery, NYC, 1951, also 1955; Robert Isaacson Gallery, NYC, 1960, 62; Durlacher Brothers, NYC, 1964, 67; Dartmouth College, 1960, 62, 67; Marisa del Re Gallery, 1985, 88; Charleston/Gibbs, 1987; U. of Vermont, 1987; U. of Richmond, 1989; AVA, Lebanon, N.H., 1991. **Retrospective:** WMAA, 1974. **Group:** WMAA; MOMA; MMA, 1950, 52; Chicago, 1951; Corcoran, 1951; ICA, London; PAFA, 1952; XXVIII Venice Biennial, 1956; Carnegie, 1958; Festival of Two Worlds, Spoleto, 1958; Ridgefield/Aldrich, Homo Sapiens, 1982; Hirshhorn, Dreams and Nightmares, 1983; WMAA, Philip Morris, The Surreal City, 1930-1950, 1985. **Collections:** Chicago/AI; Dartmouth College; MMA; MOMA; NAD; NCFA; NMAA; Sara Roby Foundation; WMAA; Walker. **Bibliography:** Armstrong, T.; Garver 1, 2; Goodrich and Baur 1; Mendelowitz; Newmeyer; Nordness, ed.; Pousette-Dart, ed.; Rodman 1; Ward; Weller. Archives.

TOVISH, HAROLD b. July 31, 1921, NYC. **Studied:** WPA Art Project, with Andrew Berger; Columbia U., 1940-43, with Oronzio Maldarelli; Zadkine School of Sculpture, Paris, 1949-50; Academie de la Grande Chaumiere, 1950-51. Traveled France, Italy, Japan, Indonesia, Nepal, Iran, Turkey. **Taught:** New York State College of Ceramics, 1947-49; U. of Minnesota, 1951-54; Boston Museum School, 1957-66; U. of Hawaii, 1969-70; Boston U., 1971-. **Member:** Artists Equity; Boston Visual Artists Union. **Awards:** Minneapolis/Institute, First Prize, Sculpture, 1954; Boston Arts Festival, First Prize for Drawing, 1958, First Prize for

Sculpture, 1959; NIAL Grant, 1971. m. Marianna Pineda. **Address:** 380 Marlborough Street, Boston, MA 02115. **Dealer:** Howard Yezerski Gallery, Boston. **One-man Exhibitions:** (first) Walker, 1953; The Swetzoff Gallery, Boston, 1957, 60, 65; Fairweather-Hardin Gallery, 1960; Terry Dintenfass, Inc., 1965, 73, 80; Andover/Phillips, 1965; Alpha Gallery, Boston, 1968, 73, 86; Boston U., 1980. **Retrospectives:** Wheaton College, 1967; SRGM, 1968. **Group:** MMA, Artists for Victory, 1942; Toledo/MA, Sculpture Today, 1947; Walker, 1951; SFMA, 1952; Minneapolis/Institute, 1952, 54; WMAA, 1952, 54, 57, 60, 64, 67; Denver/AM, 1955; Carnegie, 1958; Chicago/AI, 1959; MOMA, Recent Sculpture USA, 1959; Venice Biennial; SRGM, The Joseph H. Hirshhorn Collection, 1962; Lincoln, Mass./De Cordova, 1964; U. of Illinois, 1964, 67, 68, 69; PAFA Annual, 1967; HemisFair '68, San Antonio, Tex., 1968; U. of Illinois, 1967, 69. **Collections:** Andover/Phillips; Boston/MFA; Boston Public Library; Chicago; College of William and Mary; U. of Hawaii; Hirshhorn; MMA; MOMA; Minneapolis/Institute; U. of Minnesota; PMA; SRGM; WMAA; Walker; Worcester/AM. **Bibliography:** Weller.

TOWNLEY, HUGH
from 1st to 5th edition.

TREIMAN, JOYCE b. May 29, 1922, Evanston, Ill. **d.** June 2, 1991, Santa Monica, Calif. **Studied:** Stephens College, 1941, AA; State U. of Iowa, with Philip Guston, Lester Longman, 1943, BFA. Traveled Europe, Mediterranean, Middle East. **Taught:** U. of Illinois, 1958-60; San Fernando Valley State College, 1968; UCLA, 1969-70; Art Center School, Los Angeles, 1968; California State U., Long Beach, 1977. **Awards:** Graduate Fellowship to State U. of Iowa, 1943; L. C. Tiffany Grant, 1947; Denver/AM, P.P., 1948; Springfield, Ill./State; Chicago/AI,

Mr. & Mrs. Frank H. Armstrong Prize, 1949; Chicago/AI, The Mr. & Mrs. Frank G. Logan Prize, 1951; Chicago/AI, Pauline Palmer Prize, 1953; Tupperware Art Fund, 1955; Chicago/AI, Martin B. Cahn Award, 1949, 60; Ford Foundation, P.P., 1960; Pasadena/AM, 1962; La Jolla, 1962; Tamarind Fellowship, 1962; Ford Foundation/A.F.A. Artist-in-Residence, 1963; Los Angeles, All-City Show, P.P., 1964, Sculpture Prize, 1966; Los Angeles Times, Woman of the Year for Art, 1965. **One-man Exhibitions:** (first) Paul Theobald Gallery, Chicago, 1942; John Snowden Gallery, Chicago, 1945; Chicago/AI, The Chicago Artists Room, 1947; Fairweather-Garnett Gallery, Evanston, Ill., 1950; Hewitt Gallery, NYC, 1950; Palmer House Galleries, Chicago, 1952; Elizabeth Nelson Gallery, Chicago, 1953; Feingarten Gallery, Chicago, 1955; Cliff Dwellers Club, Chicago, 1955; Fairweather-Hardin Gallery, Chicago, 1955, 58, 62, 64, 73, 78, 82, 86; The Willard Gallery, NYC, 1960; Felix Landau Gallery, Los Angeles, 1961, 64; The Forum Gallery, NYC, 1963, 66, 71, 75, 81; Adele Bednarz Gallery, Los Angeles, 1969, 71, 74, 76; Palos Verdes Art Center, circ., 1976; Tortue Gallery, Santa Monica, 1978, 79, 81, 83, 84, 88; Chicago/AI, 1979; UCLA, 1979; California State U., 1982; Portland, Ore./AM, 1982; Santa Barbara/MA, 1985; Schmidt-Bingham Gallery, NYC, 1986, 88, 90; U. of Southern California, circ., 1988; Davis Art Gallery, Columbia, Mo., circ., 1990. **Retrospectives:** La Jolla, 1972; Municipal Art Gallery, Los Angeles, 1978. **Group:** Denver/AM, 1943, 48, 55, 58, 60, 64; Chicago/AI Annuals, 1945-59, Directions in American Painting, 1946, 51, 54, 56, 59, 60, also 1964, 68; MMA, American Painters Under 35, 1950; U. of Illinois, 1950, 51, 52, 56, 61, 63; WMAA Annuals, 1951, 52, 53, 58, Young America, 1957; Library of Congress, 1954; Corcoran, 1957; Carnegie, 1955, 57; U. of Nebraska, 1957; PAFA, 1958; MOMA, Recent Painting USA: The Figure, circ.,

1962-63; WMAA, Fifty California Artists, 1962-63; Ravinia Festival, Highland Park, Ill.; U. of Illinois, 1965, 67, 69, 71, 74; NAD, 1972, 73; AAAL, 1974; Chicago/AI, Visions, 1976; ICA, Los Angeles, Current Directions in Southern California Art, 1978; Smithsonian, New American Monotypes, circ., 1978-80; NPG, American Portrait Drawings, 1979; Chicago/AI, 100 Artists—100 Years, 1980; Laguna Beach Museum of Art, Southern California Artists, 1981; Long Beach/MA, Drawings by Painters, 1982; IEF, Twentieth Century American Drawings: The Figure in Context, circ., 1984; MMA, Figurative American Art of the 20th Century, 1985; New Orleans, Landscape, Seascape, Citiscape, 1960-1985, circ., 1986; NAD, Annual, 1986, 88; Long Beach/MA, 20th Century Watercolors, 1988; Arkansas/AC, The Face, 1988; Rice U., California Monoprints, 1991. **Collections:** Abbott Laboratories; Ball State U.; U. of California, Santa Cruz; Chicago/AI; Denver/AM; Loan Association, Los Angeles; Illinois State U.; U. of Ilinois; International Minerals & Chemicals Corp.; State U. of Iowa; Little Rock/MFA; Long Beach/MA; Los Angeles/County MA; MMA; MOMA; National Gallery; Oakland Museum; Oberlin College; U. of Oregon; Orlando; Pasadena/AM; Portland, Ore./AM; San Fernando Valley State U.; Springfield, Ill./State; Santa Barbara/MA; Tulsa/Philbrook; Tupperware Museum; UCLA; Utah State U.; WMAA; Witchita/AM. **Bibliography:** Cummings 4; *Individual Realities;* Pousette-Dart, ed. Archives.

TROVA, ERNEST **b.** February 19, 1927, St. Louis, Mo. Self-taught in art. **Commissions:** Statuette for Council of Fashion Designers of America Award, 1981. **Awards:** National Recreational and Park Association, National Humanitarian Award, 1979; Fashion Designers of America Award, 1981; Henry Moore Grand Prize exhibition, Japan, 1983; St. Louis Business Journal, Enterprise Award, 1983.

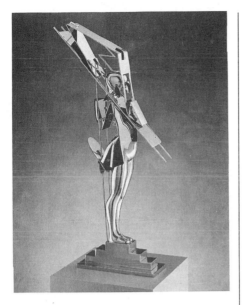

Ernest Trova, *FM/24" New Cut Figure #1*, 1985.

Address: Trova Foundation, 8112 Maryland Avenue, Suite 2000, St. Louis, MO 63105. **Dealer:** ACA Galleries, NYC. **One-man Exhibitions:** Image Gallery, St. Louis, 1959, 61; H. Balaban Carp Gallery, St. Louis, 1963; The Pace Gallery, Boston, 1963, NYC, 1963, 65, 67, 69, 70, 71, 73, 75, 76, 80, 81; Hanover Gallery, 1964, 66, 68, 70; Famous-Barr Co., St. Louis Bicentennial, 1964; MIT; Container Corp. of America, Chicago and NYC, 1965; The Pace Gallery, Columbus, 1966, 70, 75, 76; J. L. Hudson Art Gallery, Detroit, 1967; Harcus-Krakow Gallery, 1968; Dunkelman Gallery, Toronto, 1969; Gimpel & Hanover, 1970; Galerie der Spiegel, Cologne, 1970; Rene Block Gallery Ltd., 1970; Galerie Dieter Brusberg, Hanover, 1970; Fundacion Eugenio Mendoza, Caracas, 1971; Jerusalem/National, 1971; Makler Gallery, 1972; Galerie Charles Kriwin, Brussels, 1972; Elizabeth Stein Gallery, St. Louis, 1973; Phoenix, 1974; Hokin Gallery, Palm Beach, 1975; Hanover Gallery, London, 1979; Kingpitcher Gallery, Pittsburgh, 1975; Lakeview Center for the Arts & Sciences, Peoria, 1975;

Hokin Gallery, Chicago, 1978; Medici/Berenson Gallery, Miami, 1979; Arte/Contacto, Caracas, 1979. **Group:** Oakland/AM, Pop Art USA, 1963; Chicago/AI Annual, 1964, 67; SRGM, American Drawings, 1964; Dallas/MFA, 1965; SRGM, 1965-66; Walker, 1966; SFMA, 1966; WMAA, Art of the U.S., 1670-1966, 1966; WMAA Sculpture Annual, 1966, 68; VMFA, American Painting, 1966; U. of Illinois, 1967; SRGM, Sculpture International, 1967; MOMA, Dada, Surrealism and Their Heritage, 1968; Kassel, Documenta IV, 1968; WMMA, Human Concern/Personal Torment, 1969; ICA, U. of Pennsylvania, Highway, 1970; Cincinnati/Contemporary, Monumental Art, 1970; Museo de Arte Contemporaneo, Cali, Colombia, S.A., Bienal Graficas, 1973; V International Poster Biennial, Warsaw, 1974; Hirshhorn, Inaugural Exhibition, 1974; Anchorage, Sculpture: Looking into Three Dimensions, 1987. **Collections:** Brandeis U.; Buffalo/Albright; Baltimore/MA; Des Moines; High Museum; Houston/MFA; Indiana U.; Indianapolis; Kansas City/Nelson; Los Angeles/County MA; MMA; MOMA; NMAA; NYU; New Orleans Museum; Phoenix; RISD; Ridgefield/Aldrich; Raleigh/NCMA; Society of the Four Arts; Springfield, Mass./MFA; SRGM; St. Louis/City; Syracuse/Everson; Tate; VMFA; WMAA; Walker; Wichita State U.; Worcester/AM; Yale U. **Bibliography:** Finch; Friedman and van der Marck; Lippard 5; Rubin 1; Trier 1; Tuchman 1; Weller. Archives.

TRUE, DAVID F. b. February 24, 1942, Marietta, Ohio. **Studied:** Ohio U., 1966, BFA, 1967, MFA. Traveled Europe, USA. **Taught:** New Lincoln School, 1967-74. **Award:** National Endowment for the Arts, 1982. **Address:** 457 Broome Street, NYC, 10013. **Dealers:** Blum Helman Gallery, NYC; Crown Point Press, NYC. **One-man Exhibitions:** (first) Michael Walls Gallery, NYC, 1974; Edward Thorp Gallery,

David True, *Persona*, 1990.

NYC, 1977, 81, 82, 85; Barbara Krakow Gallery, Boston, 1986; Mangel Gallery, Philadelphia, 1987; Blum Helman Gallery, NYC, 1987, 88, 90. **Retrospective:** VMFA, 1984. **Group:** WMAA Biennial, 1977; WMAA, New Image Painting, 1979; Indianapolis, 1980; Norfolk/Chrysler, Reallegory, 1983; Hudson River Museum, New Vistas, 1984; MOMA, International Survey of Recent Painting and Sculpture, 1984; XLI Venice Biennale, 1984; Los Angeles/MOCA, Automobile and Culture, 1984; U. of North Carolina, Art on Paper, 1984; Youngstown/Butler, Mid-year, 1986; AAIAL, 1989; Walker, First Impressions, 1991. **Collections:** Dallas/MFA; MMA; MOMA; Mexico City/Tamayo; New School; Utica; VMFA; WMAA; Walker; Yale U.

TRUITT, ANNE b. March 16, 1921, Baltimore, Md. **Studied:** Bryn Mawr College, 1943, BA; ICA, Washington, D.C., 1948-49; Dallas/MFA, 1950. **Taught:** U. of Maryland, 1975-. **Member:** Yaddo Corporation, 1977-; director, 1980-; Ragdale Foundation, Advisory Board, 1980-. **Awards:** Guggenheim Foundation Fellowship, 1971; National Endowment for the Arts, 1972, 77, commission for sculpture, 1978; Yaddo Fellowship, 1974, 75, 78; Australia Council for the Arts, fellowship, 1981; Corcoran, Hon. DH, 1985; Kansas City Art Institute, Hon. DFA, 1987; Maryland Institute, Hon. DFA, 1991. **Address:** 3506 3rd St., N.W., Washington, D.C. 20016. **Dealers:** André Emmerich Gallery,

NYC; Pyramid Art Galleries Ltd. **One-man Exhibitions:** André Emmerich Gallery, NYC, 1963, 65, 69, 75, 80, 86, 91; Minami Gallery, 1964, 67; Baltimore/MA, 1969, 74; Pyramid Art Galleries Ltd., 1971, 73, 75, 77; WMAA, 1973; Corcoran, 1974; Bayley Museum, Charlottesville, 1975; U. of Virginia, 1976; Osuna Gallery, Washington, D.C., 1979, 81, 89, 91, 92; James Madison U., 1983; Artemesia Gallery, Chicago, 1983; Purchase/ SUNY, 1986; U. of Maryland, 1987; Baltimore/MA, 1992; Grimaldis Gallery, Baltimore, 1992; Bryn Mawr College, 1992; U. of North Carolina, 1992. **Group:** Pan American Union, Washington, D.C., Artists of the United States in Latin America, 1955; Hartford/Wadsworth, Black, White, and Grey, 1964; ICA, U. of Pennsylvania, 7 Sculptors, 1965; Jewish Museum, Primary Structure Sculptures, 1966; Los Angeles/County MA, American Sculpture of the Sixties, circ., 1967; HemisFair '68, San Antonio, Tex., 1968; WMAA, 1968, 70, 72; Chicago/Contemporary, Five Artists: A Logic of Vision, 1974; Corcoran Biennial, 1975; NCFA, Sculpture: American Directions, 1945-75, 1975; WMAA, 200 Years of American Sculpture, 1976; AAIAL, 1979; Brooklyn Museum, American Drawings in Black and White: 1970-1979, 1980; Milwaukee, Washington Color Painters, 1980; U. of Maryland, U. of Maryland Artists, 1983; École des Beaux-Arts, Paris, American Drawing: 1930-1980, circ., 1985; Rice U., Small-Scale Sculpture, 1991. **Collections:** U. of Arizona; Baltimore/MA; Buffalo/Albright; Charlotte/Mint; Corcoran; Hirshhorn; Houston/MFA; Houston/Menil; Institute for Policy Studies; MMA; MOMA; U. of Michigan; Milwaukee; NCFA; NMAA; NMWA; National Gallery; New Orleans Museum; PMA; St. Louis/City; Vassar College; WMAA; Walker.

TSUTAKAWA, GEORGE b. February 22, 1910, Seattle, Wash. **Studied:** U. of Washington, 1937, BA, MFA, 1950.

US Army, 1942-46. Traveled Europe, Japan, Southeast Asia, Near East, Orient, India, Egypt. **Taught:** U. of Washington, 1946-80. **Member:** American Institute of Architects. **Commissions:** Seattle Public Library; Renton Center, Renton, Wash.; Lloyd Center, Portland, Ore.; St. Marks Cathedral, Seattle; Century 21, Seattle World's Fair, 1962 (US Commemorative Medal); Northgate Shopping Center, Seattle; J.W. Robinson Department Store, Anaheim, Calif.; Pacific First Federal Savings and Loan Association, Tacoma, Wash.; Bon Marche Dept. Store, Tacoma, Wash.; Fresno (Calif.) Civic Mall; Commerce Tower, Kansas City, Mo. (sunken garden); University YMCA, Seattle; Lake City Library, Seattle; U. of Washington (Phi Mu fountain); Washington Cathedral, Washington, D.C.; UCLA School of Public Health; Jefferson Plaza, Indianapolis, 1971; Safeco Plaza, Seattle, 1973; The Pennsylvania State U., 1974; Expo '74, Spokane, US Commemorative Medal, 1974; Northwest Medical Center, Bellingham, 1976; City Hall Plaza, Aberdeen, Washington, 1977; North Kitsap H.S., Silverdale, Washington, 1979; Tsutsujigaoka Park, Sendai, Japan, 1981; Ohkura Park, Setagaya, Tokyo, 1982; Government Center, Toledo, Ohio, 1983; Governor's Mansion, Olympia, Wash., 1983. **Film:** *Three Northwest Artists: Roethke, Anderson, Tsutakawa,* 1976, 45 min. **Awards:** Washington State, Governor's Award of Commendation, 1967; Order of Rising Sun, Japan, 1981; Hon. DFA, Seattle U., 1986; Whitman College, Hon. Ph.D., 1986. **Address:** 3116 South Irving Street, Seattle, WA 98144. **Dealer:** Foster-White Gallery, Seattle. **One-man Exhibitions:** (first) Studio Gallery, Seattle, 1947; U. of Washington, 1950, 54; Press Club, Spokane, Wash., 1953; Zoe Dusanne Gallery, Seattle, 1953, 58; U. of Puget Sound, 1955, 64, 87; Tacoma; Seattle/AM, 1957; Foster-White Gallery, Seattle, 1977, 78, 84, 86, 87, 88; U. of Washington, 1984; Seattle/AM,

1985; Port Angeles Art Center, Washington, 1986; Seattle Center, 1987; Valley Museum of Northwest Art, 1987; Bellevue/AM, 1988; Beaux-Arts de Carcassone, France, circ., 1988. **Retrospectives:** Whitman College (with Morris Graves), 1978; Bellevue/AM, 1990. **Group:** Seattle/AM Annuals, 1933-; Oakland/AM, 1951; Spokane Art Center of Washington State U., 1954-57; III São Paulo Biennial, 1955; Vancouver, 1955, 57; SFMA, 1955, 58, 60; Portland, Ore./AM, 1955, 60; Yoseido Gallery, Tokyo, 1956; Santa Barbara/MA, 1959, 60, 61; San Diego, 1960; Los Angeles/County MA, 1960; Denver/AM, 1960, 64; Amerika Haus, East Berlin, International Arts Festival, 1965, 66; Expo '70, Osaka, 1970; NCFA, Art of the Pacific Northwest, 1974; U. of Oregon, Annual, 1968; U. of Washington, Art of the Thirties, 1972; AAIAL, 1978; Seattle, Northwest Traditions, 1978; Osaka/National, Pacific Northwest Artists and Japan, 1982; Seattle/AM, American Prints of the 1930s and 1940s, 1983. **Collections:** Bellevue, Wash.; Denver/MA; Luther Burbank Park, Mercer Island, Wash.; Memphis/Brooks; Santa Barbara/MA; Seattle/AM; Tacoma Art Museum; UCLA; U. of Washington. **Bibliography:** *Art of the Pacific Northwest;* Clark and Cowles; *Northwest Traditions.*

TUCKER, WILLIAM b. February 28, 1935, Cairo, Egypt. To USA, 1978; U.S. citizen, 1986. **Studied:** Oxford U., 1955-58; Central School of Art and Design, London, 1959-60. **Awards:** Leeds U., Gregory Fellowship in Sculpture, 1968; Guggenheim Foundation, fellowship, 1986; Sculpture Center, Award for Distinction in Sculpture, 1991. **Taught:** Goldsmith's College, London, 1962-66; St. Martin's School of Art, London, 1963-74; U. of West Ontario, 1976; Nova Scotia College of Art and Design, 1977; New York Studio School of Painting and Sculpture, 1978-81. **Address:** 99 Commercial Street, Brooklyn, NY 11222. **Dealer:**

David McKee Gallery, NYC. **One-man Exhibitions:** Grabowski Gallery, London, 1962; Rowan Gallery, London, 1963-65; Richard Feigen Gallery, NYC, 1965; Kasmin Gallery, London, 1966, 69, 70; Robert Elkon Gallery, NYC, 1968, 77, 79, 80, 82; Waddington Galleries, London, 1973; Hester van Royen Gallery, London, 1974; Galerie Wintersberger, Cologne, 1976; David Reids Gallery, Sydney, 1980; Posell Street Gallery, Melbourne, 1980; L'Isola Galleria, Rome, 1981, 84; Bernard Jacobson Gallery, Los Angeles, 1982; David McKee Gallery, NYC, 1984, 85, 86, 87, 91; Pamela Auchincloss Gallery, Santa Barbara, 1985, 87; Annely Juda Gallery, London, 1987; Gallery Paule Anglim, San Francisco, 1989; Lafayette College, 1992. **Group:** ICA, London, 26 Young Sculptors, 1960; Paris/Moderne, Biennale, 1961; Whitechapel Art Gallery, London, New Generation, 1965; Jewish Museum, Primary Structures, 1966; Kassel, Documenta IV, 1968; Royal Academy, London, British Sculptors, 1972; Hayward Gallery, London, The Condition of Sculpture, 1975; Sydney/AG, Biennial, 1976; MOMA, New Work on Paper I, circ., 1981; Whitechapel Art Gallery, London, British Sculpture in the 20th Century, 1981; C. W. Post College, Monumental Drawings by Sculptors, 1983; Hirshhorn, Drawings, 1974-1984, 1984; Bard College, Drawings, 1991; Rice U., Small-scale Sculpture, 1990. **Collections:** Aberdeen/AG; Brandeis U.; British Council; British Museum; Florida International U.; Hirshhorn; Humlebaek/Louisiana; MMA; MOMA; Melbourne/National; Rijksmuseum Kröller-Müller; SRGM; Storm King Art Center; Sydney/AG; Tate Gallery; UCLA; Victoria and Albert Museum; Walker.

TUM SUDEN, RICHARD

b. December 9, 1936, USA. **Studied:** Cooper Union, 1956-57; Wagner College, 1958, BA, cum laude; NYU, 1961; Hunter College, 1962, MFA, with

R. Motherwell, R. Kippold, W. Baziotes; Haystack Mountain School of Crafts, 1963; Brooklyn Museum School, 1965; Parsons School of Design. Traveled Europe, China, Japan, Canada, Great Britain. **Taught:** Cornell U., 1964; Hunter College, 1964, 72; Hull College of Art, England, 1964; New York Institute of Technology, 1967; U. of California, Davis, 1968; C. W. Post College, 1970-72; New School for Social Research, 1972, 73; ASL, 1973; U. of Minnesota, 1974; Parsons School of Design, NYC, 1974-. **Awards:** Brooklyn Museum Sculpture Prize, 1959; Yaddo Fellowship, 1964; CAPS, 1976. **Address:** 40 Great Jones Street, NYC 10012. **One-man Exhibitions:** Hilda Carmel Gallery, NYC, 1961; Tibor de Nagy Gallery, NYC, 1963, 64, 67, 68; Cornell U., 1964; French & Co., Inc., NYC, 1971; Nancy Hoffman Gallery, NYC, 1973, 74; New School for Social Research, NYC, 1975; Cole & Co., NYC, 1976. **Group:** Chicago/AI, 1965. **Collections:** Chase Manhattan Bank; MOMA; NYU; Rybak.

TUTTLE, RICHARD

b. 1941, Rahway, N.J. **Studied:** Trinity College, Hartford, Conn., 1963; Cooper Union, 1963-64. **Address:** c/o Dealer. **Dealers:** Mary Boone Gallery, NYC; Brooke Alexander Gallery, NYC. **One-man Exhibitions:** Betty Parsons Gallery, NYC, 1965, 67, 68, 70, 72, 74, 78, 82; Galeria Schmela, 1968; Nicholas Wilder Gallery, Los Angeles, 1969; Buffalo/Albright, 1970; Galerie Rudolph Zwirner, 1970, 72; Dallas/MFA, 1971; Galerie Lambert, Paris, 1972, 74, 76, 78; Galerie Schlesa, Düsseldorf, 1972; MOMA, 1972; Konrad Fischer Gallery, Düsseldorf, 1973; Kunstraum, Munich, 1973, 77; Weinberg Gallery, San Francisco, 1973, 78; Galerie Annemarie Verna, Zurich, 1973, 79, 81, 84, 87, 89, 90, 92; The Clocktower, NYC, 1973; Galleria Toselli, Milan, 1974, 85; Galleria Marilena Bonomo, Bari, 1974, 79, 85; Cusack Gallery, Houston, 1974, 75;

Nigel Greenwood, Inc., Ltd., London, 1974, 82; Parsons-Truman Gallery, NYC, 1975; d'Alessandro Ferranti, Rome, 1975; Hartford/Wadsworth, 1975; Otis Art Institute, Los Angeles, 1976; Brooke Alexander, Inc., NYC, 1976, 79, 90; Northwest Artists Workshop, Portland, Ore., 1976; Fine Arts Building Gallery, NYC, 1976; U. of Western Ontario, 1976; Graeme Murray Gallery, Edinburgh, 1976; Ohio State U., 1977; Ugo Ferranti, Rome, 1977, 78, 79; Kunsthalle, Basel, 1977; Galerie Heiner Friedrich, Munich, 1977; Young-Hoffman Gallery, Chicago, 1978; Brown U., 1978; Françoise Lambert, Milan, 1978; Ghent/Moderne, 1978; Galerie Schmela, Düsseldorf, 1978, 84, 88, 90; Amsterdam/Stedelijk, 1979; Truman Gallery, NYC, 1979; U. of California, Santa Barbara, 1979; Centre d'Arts Plastiques Contemporains, Bordeaux, 1979; Krefeld, 1980; Centre d'Art Contemporain, Geneva, 1980; California Institute of Technology, Pasadena, 1980; Galerie Yvon Lambert, Paris, 1981, 84, 87, 90; Ugo Alessandro Ferranti, Rome, 1982; Musée des Beaux-Arts de Calais, 1982; Blum Helman Gallery, NYC, 1983, 84, 86, 88, 90; Galerie Hubert Winter, Vienna, 1983, 87, 90; Daniel Weinberg Gallery, Los Angeles, 1984; Portland (Ore.) Center for the Visual Arts, 1984; Galeriet Kungsgatan, Lund, 1984; Paris/Moderne, 1986; Victoria Miro Gallery, London, 1986, 87, 90, 91; Reinhard Onasch Galerie, Berlin, 1986; Bordeaux/Contemporain, 1986; Neue Galerie, Graz, Austria, 1987; Galerie des Arenes, Nimes, 1987; Anders Tornberg Gallery, Lund, Sweden, 1987; Blum Helman Gallery, Los Angeles, 1987; Galerie Karsten Greve, Cologne, 1988; Thomas Segal Gallery, Boston, 1988; Galleria Alessandra Bonomo, Rome, 1989; Gallery Casa Sin Nombre, Santa Fe, 1989; Kabinett für Aktuelle Kunst, Bremerhaven, 1990; Hannover/Sprengel, 1990; A/D Gallery, NYC, 1990; Rhona Hoffman Gallery, Chicago, 1991; Fundacio La Caixa, Barcelona, 1991; Institute of Contemporary Art, Amsterdam, 1991; Galerie Pierre Huber, Geneva, 1991; Galerie Weber, Alexander y Cobo, Madrid, 1991; Galerie Meert Rihoux, Brussels, 1991; Kunstmuseum, Winterthur, 1992; Centre Julio Gonzalez, Valencia, 1991. **Retrospectives:** WMAA, 1975; ICA, London, 1985. **Group:** American Abstract Artists, 1968; Des Moines, Painting, Out from the Wall, 1968; Detroit/Institute, Other Ideas, 1969; Berne, When Attitudes Become Form, 1969; WMAA, Anti-Illusion: Procedures/Materials, 1969; Corcoran, 1969; Bennington College, Paintings Without Supports, 1971; Utica, 1972; Kassel, Documenta V, 1972; Stockholm/National, Young American Artists, 1973; MOMA, Printed, Folded, Cut and Torn, 1974; Baltimore/MA, 14 Artists, 1975; Princeton U., Line as Language; Six Artists Draw, 1974; A.F.A., Recent Drawings, 1977; Cincinnati/Contemporary, Bochner, Le Va, Rockburne, Tuttle, 1975; U. of North Carolina, Works on Paper, 1975; MOMA, Drawing Now, 1976; Amherst College, Critical Perspectives in American Art, 1976; Venice Biennial, 1976; Kassel, Documenta VI, 1977; Yale U., Long, Hewitt, Tuttle, 1977; Amsterdam/Stedelijk, Door Belldhouwers gemaakt, 1978; Amsterdam/Stedelijk, '60-'80: Attitudes, Concepts, Images, 1982; Kassel, Documenta VII, 1982; Ars 83, Helsinki, 1983; Los Angeles/MOCA, The First Show, 1983; P.S. 1, Long Island City, Abstract Painting, 1960-1969, 1983; WMAA, Minimalism to Expressionism, 1983; Indianapolis, Painting and Sculpture Today, 1984; Kasseler Kunstverein, Lunstverrin, Aquarelle, 1984; Montreal/MFA, Drawings by Sculptors, 1984; Amsterdam/Stedelijk, Costumes, 1984; Zurich, Spuren, Skulpturen, and Monumente, 1985; Krefeld/Haus Lange, In Offerner Form, 1985; Munster/WK, Wasserfarben-blatter von Joseph Beuys, 1985; WMAA, Sculptors Drawings, 1910-1980, 1985; Laforet Museum, Tokyo, Correspondences, 1985; Frankfurt/Kunst-

verein, Prospect 86, 1986; Fondation Cartier, Sculptures, 1986; WMAA, Biennial, 1987; Bielefeld, Beyond the Picture, 1987; Madison Art Center, Sculptors on Paper, circ., 1987; Albany (Ga.) Museum of Art, Immaterial Objects, 1989; U. of Rhode Island, Microsculpture, 1989; WMAA, The New Sculpture, 1965-1975, 1990. **Collections:** Amsterdam/Stedelijk; Bilderdiklaan/Stedelijk; Buffalo/Albright; Cologne; Cologne/Ludwig; Corcoran; Essen; Fondation Cartier; Hannover/ Sprengel; Harvard U.; High Museum; Hirshhorn; Humlebaek/Louisiana; Kassel/Staatliche; Krefeld/Kaiser Wilhelm; Lausanne/Beaux-Arts; MMA; MOMA; National Gallery of Canada; Oberlin College; Ottawa/National; Paris/Beaubourg; St. Louis/City; Seattle/AM; Stockholm/Moderna; U. of Texas; WMAA; Zurich. **Bibliography:** Armstrong, T.; *Art Now 74; Contemporanea;* De Wilde 2; Honisch and Jensen, eds.; Kardon 3; Kren; *List of Drawing Materials of Richard Tuttle, Options and Alternatives;* Pincus-Witten; Robins; *When Attitudes Become Form.*

TWARDOWICZ, STANLEY
b. July 8, 1917, Detroit, Mich. **Studied:** Skowhegan School, 1946-47, with Henry Poor. Traveled Mexico, Europe, Canada. **Taught:** The Ohio State U., 1946-51; Hofstra U., 1954, 66-86. **Awards:** Guggenheim Foundation Fellowship, 1956. **Address:** 57 Main Street, Northport, NY 11768; 133 Crooked Hill Road, Huntington, NY 11743. **One-man Exhibitions:** (first) Contemporary Arts Gallery, NYC, 1949, also 1951, 53, 56; The Peridot Gallery, NYC, 1958-61, 1963-65, 67, 68, 70; Dwan Gallery, 1959, 61; Columbus, 1963. **Retrospective:** Huntington, N.Y./Heckscher, 1974. **Group:** PAFA, 1950; SRGM, 1954; Chicago/AI, 1954, 55; WMAA, 1954, 55, 57, 64; Carnegie, 1955; São Paulo, 1960; U. of Nebraska, 1960; MOMA, The New American Painting and Sculpture, 1969.

Cy Twombly, *Untitled*, 1970.

Collections: Columbus; Fisk U.; Harvard U.; Hirshhorn; Huntington, N.Y./Heckscher; Los Angeles/County MA; MOMA; U. of Massachusetts; Milwaukee; NYU; Newark Museum; U. of North Carolina; St. Joseph/Albrecht; Vassar College; Youngstown/Butler.

TWOMBLY, CY
b. April 25, 1928, Lexington, Va. **Studied:** Boston Museum School; ASL; Black Mountain College, with Franz Kline, Robert Motherwell. Resides Rome, 1957-. **Address:** 149 via Monserrato, Rome, Italy. **Dealers:** Sperone Westwater Inc., NYC; Hirschl & Adler Modern, NYC. **One-man Exhibitions:** The Kootz Gallery, NYC, 1951; The Stable Gallery, 1953, 55, 57; Galleria del Cavallino, Venice, 1958; Galleria d'Arte del Naviglio, Milan, 1958, 60; La Tartaruga, Rome, 1958, 60, 63; Galerie 22, Düsseldorf, 1960; Leo Castelli, Inc., 1960, 64, 66, 67, 68, 72, 74, 76; Galerie J. Paris, 1961; Galerie Rudolf Zwirner, Essen, 1961, Cologne, 1963, 69; Notizie Gallery, Turin, 1962; Galleria del Leone, Venice, 1962; Brussels/Royaux, 1962, 65; Galerie Anne Abels, Cologne, 1963; Galerie Jacques Benador, Geneva, 1963,

75; Galerie Bonnier, Lausanne, 1963; Galerie Handschin, Basel, 1964; Galerie Friedrich & Dahlem, Munich, 1964; Amsterdam/Stedelijk, 1966; Milwaukee, 1968; Nicholas Wilder Gallery, 1969; Galerie Hans R. Neuendorf, Cologne, 1970; Stockholm/SFK, 1970; Galerie Bonnier, Geneva, 1970; Gian Enzo Sperone, Turin, 1971, 73; Yvon Lambert, Paris, 1971, 77, 80, 82; Galleria dell'Ariete, 1971; Galerie Mollenhoff, Cologne, 1971; Dunkelman Gallery, Toronto, 1972; Janie C. Lee Gallery, Houston, 1972; F. H. Mayor Gallery, London, 1973; Berne, 1973; Galerie Oppenheim, Brussels, 1973, 74; Galerie Heiner Friedrich, Munich, 1974; Modern Art Agency, Naples, 1975; Galerie Art in Progress, Munich, 1975; ICA, U. of Pennsylvania, 1975; SFMA, 1975; Galleria Bertesca, Genoa, 1975; Galerie Art in Progress, Düsseldorf, 1976, Paris/Moderne, 1976; Galerie Jacques Brosser, Paris, 1976; Gian Enzo Sperone, Rome, 1976, 84; School of Visual Arts, NYC, 1977; Galerie Klewan, Munich, 1978; Heiner Friedrich, Inc., NYC, 1978; Lucio Amelio Gallery, Naples, 1979; Galleriet, Lund, 1979; Galerie Karsten Greve, Cologne, 1979, 80, 82, 84; Southern Methodist U., 1980; Richard Hines Gallery, Seattle, 1980; PAC, Milan, 1980; Castelli Graphics, NYC, 1981; Sperone Westwater Fischer Inc., NYC, 1982; The Mayor Gallery, London, 1982, 84; Stephen Mazoh & Co., NYC, 1983; Lucio Amelio Gallery, Naples, 1984; Hirschl & Adler Modern, NYC, 1984, 86; Ulysses Gallery, Vienna, 1984; Bordeaux/Contemporain, 1984; Baden-Baden/Kunsthalle, 1984; Akira Ikeda Gallery, Tokyo, 1987; The Pace Gallery, NYC, 1988; Vrej Boghoomian Gallery, NYC, 1988; Houston/Menil, 1989; Des Moines, 1990; Gagosian Gallery, NYC, 1990; Galerie Thomas Ammann, Zurich, 1990. **Retrospectives:** WMAA, 1979; Newport Harbor, circ., 1981; Santa Barbara (Calif.) Contemporary Arts Center, 1984; Kunsthalle, Baden-Baden, 1984. **Group:**

Gutai 9, Osaka, 1958; Festival of Two Worlds, Spoleto, 1961; Premio Lissone, 1961; Premio Marzotto, 1962; Amsterdam/Stedelijk, Art and Writing, 1963; Salon du Mai, Paris, 1963; L'Aquila, Aspetti dell'Arte Contemporanea, 1963; SRGM, 1964; MOMA, 1966; NYU, 1967; WMAA Annual, 1967; Indianapolis/Herron, 1969; WMAA Biennials, 1969, 73; Indianapolis, 1969; Dublin/Municipal (ROSC), 1971; WMAA, The Structure of Color, 1971; Düsseldorf/Kunsthalle, Surrealität Bildrealitat, 1924-1974, 1974; MOMA, Drawing Now, 1976; SRGM, Twentieth Century American Drawings, 1976; Royal Academy, London, A New Spirit in Painting, 1981; SRGM, The New York School: Four Decades, 1982; Kassel, Documenta VII, 1982; Galeria Politi, Milan, Transavantgarde International, 1982; Internationale Kunstaussteflung Berlin, 1982; Pall Man Canada Ltd., American Accents, circ., 1983; Ars 83, Helsinki, 1983; Amsterdam/Stedelijk, La Grande Parade, 1984. **Collections:** Cologne; Darmstadt/Hessisches; First National City Bank, Houston; MOMA; Milwaukee; RISD; Rome/Nazionale; WMAA. **Bibliography:** Calas, N. and E.; *Contemporanea;* Cummings 5; De Salvo and Schimmel; De Wilde 1; Downes, ed.; *Europa/Amerika;* Gohr and Gachnang; **Heiner and Bastian;** Honisch and Jensen, eds.; *Individuals;* Joachimides and Rosenthal; *Kunst um 1970;* Lambert; *Metro;* Murken-Altrogge; Restany 2; Schwartz 1; Tomkins 2; Waldman 4.

TWORKOV, JACK b. August 15, 1900, Biala, Poland. **d.** September 4, 1982, Provincetown, Mass. To USA, 1913; citizen, 1928. **Studied:** Columbia U., 1920-23; NAD, 1923-25, with Ivan Olinsky, C. W. Hawthorne; privately with Ross Moffett, 1924-25; ASL, 1925-26, with Guy Du Bois, Boardman Robinson. **Taught:** Fieldston School, NYC, 1931; Queens College, 1948-55; American U., 1948-51; Black Mountain College, sum-

Jack Tworkov, *X on Circle in the Square,* 1981.

mer, 1952; Pratt Institute, 1955-58; Yale U., 1963-69; American Academy, Rome, 1972; Dartmouth College, 1973; Columbia U., 1973; Royal College of Art, London, 1974. **Federal A.P.:** Easel painting, 1935-41. **Member:** Century Association; AAIAL. **Awards:** Corcoran, William A. Clark Prize and Corcoran Gold Medal, 1963; Guggenheim Foundation Fellowship, 1970; Hon. DFA, Maryland Institute, 1971; Honorary Doctor of Humane Letters, Columbia U., 1972; Skowhegan School Painting Award, 1973; Hon. DFA, RISD, 1979. **One-man Exhibitions:** (first) ACA Gallery, 1940; Charles Egan Gallery, NYC, 1947, 49, 52, 54; Baltimore/MA, 1948; U. of Mississippi, 1954; Walker, 1957; The Stable Gallery, NYC, 1957, 58, 59; B. C. Holland Gallery, Chicago, 1960, 63; Leo Castelli, Inc., 1961, 63; Tulane U., 1961; Yale U., 1963; Gertrude Kasle Gallery, NYC, 1966, 67, 69, 71, 73; WMAA, 1971; Toledo/MA, 1971; Dartmouth College, 1973; Portland (Ore.) Center for the Visual Arts, 1974; Reed College, 1974; Denver/AM, 1974; Jack Glenn Gallery, Corona del Mar, 1974, 76; Harcus Krakow Rosen Sonnabend, 1974; Nancy Hoffman Gallery, NYC, 1974, 75, 77, 82, 83, 85; Ohio State U., 1975; Youngstown State U., 1975; Cincin-

nati/Contemporary, 1975; New Gallery, Cleveland, 1975; Washburn U., 1976; Jack Glenn Gallery, 1976; John Berggruen Gallery, San Francisco, 1976; Dobrick Gallery, Chicago, 1977; U. of California, Santa Barbara, 1977; Baum-Silverman Gallery, Los Angeles, 1979; RISD, 1980; Middlebury College, 1981; SRGM, 1982; AAIAL, 1983; Provincetown (Mass.) Art Association, 1983; Adams Middleton Gallery, Houston, 1985; PAFA, circ., 1986; The Century Association, NYC, 1983; André Emmerich Gallery, NYC, 1991. **Retrospectives:** WMAA, 1964; Third Eye Center, Glasgow, circ., 1979. **Group:** PAFA, 1929; MOMA, The New American Painting, circ., Europe, 1958-59; Kassel, Documenta II, 1959; Walker, 60 American Painters, 1960; Carnegie, 1961; SRGM, Abstract Expressionists and Imagists, 1961; U. of Illinois, 1961; SRGM/USIA, American Vanguard, circ., Europe, 1961-62; MOMA, Abstract American Drawings and Watercolors, circ., Latin America, 1961-63; Seattle World's Fair, 1962; ART:USA:Now, circ., 1962-67; WMAA Annual, 1963; Corcoran, 1963; MOMA, The New American Painting and Sculpture, 1969; VMFA, 12 American Painters, 1974; Santa Barbara/MA, Five Americans, 1974; Indianapolis, 1974; U. of Illinois, 1974; ASL, 100 Years, NYC, 1975; Fort Wayne, Hue and Far Cry of Color, 1976; Hirshhorn, The Golden Door: Artist Immigrants of America, 1876-1976, 1976; Milwaukee, From Foreign Shores, 1976; Rice U., Drawing Today in New York, circ., 1977; Chicago/AI, Drawings of the 70's, 1977; Montclair/AM, Drawing the Line, 1978; Philadelphia College of Art, Seventies Painting, 1978; Creighton U., A Century of Master Drawings, 1978; Pomona College, Black and White Are Colors, 1979; Brooklyn Museum, American Drawings in Black and White: 1970-1979, 1980; WMAA Biennial, 1981; AAIAL, 1981, 83; Baruch College, Paths to Discovery, 1992. **Collections:** AAAL; Allentown/AM; Amerada-Hess Corp., NYC; American U.;

Baltimore/ Albright; Brooklyn Museum; Buffalo/Albright; U. of California, Santa Barbara; Chase Manhattan Bank, NYC; Cleveland/MA; Dartmouth College; Denison U.; Detroit/Institute; Fort Wayne; Hartford/Wadsworth; Honolulu Academy; Indianapolis; Kent State U.; Little Rock/MFA; MMA; MOMA; McCrory Corp., NYC; NCFA; National Gallery; New Paltz/ SUNY; Owens-Corning Fiberglas Corp.; Phillips; Prudential Insurance Co. of America, Newark; RISD; Rockefeller Institute; SRGM; Santa Barbara/MA; Storm King Art Center; Toledo/MA; U. of Texas, Austin; Union Carbide Corp.; WGMA; WMAA; Walker; U. of Wisconsin; Yale U. **Bibliography:** Armstrong, T.; Ashbery; *Black and White Are Colors;* Downes, ed.; *From Foreign Shores;* Goodrich and Baur 1; Hess, T.B., 1; Hunter 1, 6; Hunter, ed.; *Metro;* Nordness, ed.; Plous; Pousette-Dart, ed.; Read 2; Rodman 3; Rose, B., 1; **Sandler 3**, 5; Tomkins 2. Archives.

U

URRY, STEVEN **b.** September 5, 1939, Chicago, Ill. **Studied:** U. of Chicago, 1957-59; Chicago/AI, 1957-59; California College of Arts and Crafts, 1960-61; SFAI, 1962-63. **Taught:** Chicago/AI, 1968; Cranbrook, 1970; U. of Kentucky, 1971, 72; Carnegie Mellon U., 1975. **Commissions:** Loyola U., 1969; Popeil Bros., Inc., 1971; Shire National Corp., 1975; Carnegie Mellon U., 1975; R. Lavin & Sons, 1976; Nebraska Bicentennial Interstate 80 Sculpture, 1976.

Awards: U. of Illinois, P.P., 1966; National Endowment for the Arts Award, 1966; Chicago/AI, Linde Prize, 1967; Chicago/AI, Emilie L. Wild Prize, 1967. **Address:** 64 Wooster Street, NYC 10012. **One-man Exhibitions:** Kendall College, Evanston, Ill., 1966; Dell Gallery, Chicago, 1966; The U. of Chicago, 1967, 68; Royal Marks Gallery, 1967; DePauw U., Chicago, 1968; Chicago/AI, 1969; The Zabriskie Gallery, NYC, 1969, 72, 76; Phyllis Kind Gallery, Chicago, 1972, 74; Hakeley Art Museum, Muskegon, Mich., 1977; Grand Rapids, 1977. **Group:** SFAI, 1962; Illinois Institute of Technology, Chicago, 1965; U. of Illinois, 1966, 74; Chicago/AI, 1967, 70; U. of Nebraska, 1970; Grand Rapids, Off the Pedestal, 1974; Stamford, Conn., American Salon des Refusés, 1976. **Collections:** Chicago/AI; Carnegie; Envair Corp.; Hakeley Art Museum, Muskegon, Mich.; U. of Illinois; K-Mart Corp.; Kendall College; NCFA; Loyola U.; Palm Springs Desert Museum; Playboy Enterprises, Inc.; Standard Oil Co.; U. of Wisconsin.

V

VALENTINE, DEWAIN b. August 27, 1936, Fort Collins, Colorado. **Studied:** U. of Colorado, BFA, 1958; MFA, 1960; Yale U. Summer School, Norfolk, Conn., 1958. **Taught:** U. of Colorado, 1958-61, 64-65; U. of California, Los Angeles, 1965-67. **Member:** Los Angeles/MOCA, Board of Trustees. **Awards:** Guggenheim Foundation Fellowship, 1980; National Endowment for the Arts, 1981. **Address:** 69 Market Street, Venice, CA 90291. **One-man Exhibitions:** U. of Colorado, 1958, 60; The Gallery, Denver, 1964; Douglas Gallery, Vancouver, 1968; ACE Gallery, Los Angeles, 1968; U. of California, Santa Barbara, 1968; U. of Washington, Seattle, 1969; U. of British Columbia, 1969; Galerie Bischofberger, Zurich, 1969; Pasadena/AM, 1970; Galerie Denise René, NYC, 1973; Walter Kelly Gallery, Chicago, 1973; San Jose/Museum of Art, 1974; Edward Thorp Gallery, Santa Barbara, 1974; Betty Gold, Los Angeles, 1974; La Jolla, 1975; Long Beach/MA, 1975; California State U., Northridge, 1975; Santa Barbara/MA, 1977; Los Angeles/County MA, 1979; U. of California, Irvine, 1979; Thomas Babeor Gallery, La Jolla, 1982; Laumeier Sculpture Park, 1982; Madison Art Center, 1983; Honolulu Academy, 1985. **Group:** WMAA Annuals, 1966, 68, 70; Los Angeles/County MA, American Sculpture of the Sixties, 1967; Portland, Ore./AM, West Coast Now, 1968;

HemisFair, '68, San Antonio, Tex., 1968; Museum of Contemporary Crafts, NYC, Plastic as Plastic, 1968; Jewish Museum, NYC, A Plastic Presence, 1969; Seattle/AM, American Art, Third Quarter Century, 1973; Chicago/AI, 1974; ICA, Los Angeles, One Hundred Plus, 1977; U. of Hartford, Conn., Southern California Drawings, 1980; U. of California, Irvine, Structural Imagery, 1980, San Diego, Sculpture in California, 1975-1980, 1980; Laguna Beach Museum of Art, Southern California Artists, 1981; U. of Southern California, California Sculpture Show, circ., 1984. **Collections:** Atlantic Richfield Co., Washington, D.C.; Avco Finance Corp.; Bradley U.; Chicago/AI; Colorado State U.; U. of Colorado; Denver/AM; Fourth Financial Corp., Wichita; Omaha/Joslyn; La Jolla; Los Angeles Times; Los Angeles/County MA; Milwaukee; U. of New Mexico; Newport Beach; Palm Springs Desert Museum; Pasadena/AM; Ridgefield/Aldrich; Roswell; San Diego; Stanford U.; Vancouver; WMAA; Xerox Corp., Rochester, N.Y. **Bibliography:** *California Sculpture Show.*

VALERIO, JAMES b. December 2, 1938, Chicago. **Studied:** Wright Jr. College, 1959-62; School of the Art Institute of Chicago, 1962-66, BFA, 1968, MFA. **Taught:** School of the Art Institute of Chicago, 1966-68; Rock Valley College, 1968-70; UCLA, 1970-79; Cornell U., 1979-82; Northwestern U., 1985-. **Awards:** School of the Art Institute of Chicago, Anne Louise Raymond Foreign Traveling Fellowship, 1968; National Endowment for the Arts, grant, 1985. **Address:** 1308 Gregory, Wilmette, Ill. 60091. **Dealers:** Frumkin/Adams Gallery, NYC; Fendrick Gallery, Washington, D.C. **One-man Exhibitions:** (first) Gerard John Hayes Gallery, Los Angeles, 1971, 72, 75; Tucson, 1973; Michael Walls Gallery, NYC, 1974; John Berggruen Gallery, San Francisco, 1977; Frumkin-Struve Gallery, Chicago, 1981,

84; Wilmington, 1983; Allan Frumkin Gallery, NYC, 1983, 87; Frumkin/Adams Gallery, NYC, 1990-91. **Group:** Chicago/AI, Chicago & Vicinity Show, 1969; Indianapolis, 1971; Long Beach/MA, American Portraits—Old and New, 1971; Kassel, Documenta V, 1973; Lincoln, Mass./De Cordova, The Super-Realist Vision, 1973; SFMA, Painting and Sculpture in California, 1976; ICA, Los Angeles, 100+, Current Directions in Southern California Art, 1977; Albuquerque Museum, Reflections of Realism, 1979; U. of Rochester, Uncommon Visions, 1979; Tulsa/Philbrook, Realism/Photorealism, 1980; Newport Harbor, Inside Out: Self Beyond Likeness, 1981; PAFA, Contemporary American Realism Since 1960, 1981; San Antonio/MA, Real, Really Real, Super Real, circ., 1981; Laguna Beach Museum of Art, The Real Thing: Southern California Realist Painting, 1982; U. of California, Santa Barbara, A Heritage Renewed: Representational Drawing Today, 1983; Houston/Contemporary, American Still Life, 1945-1983, circ., 1983; IEF, Twentieth Century American Drawing: The Figure in Context, circ., 1984; Isetan Museum of Art, Tokyo, American Realism: The Precise Image, 1985; SFMA, American Realism (Janss), circ., 1985; Arkansas/AC, Drawing Invitational, 1986; Huntsville Museum, Drawing: The New Tradition, 1987; Youngstown/Butler, Mid-year Exhibition, 1988; Florida State U., Monochrome/Polychrome, 1990; Arkansas/AC, The Figure, 1990; Orlando, Exquisite Painting, 1991; Miyagi Museum, Sendai, Japan, American Realism and Figurative Art, 1955-1990, circ., 1992. **Collections:** Albuquerque Museum; Arkansas/AC; Champion International; Chemical Bank; Huntsville; Iowa State U.; Long Beach/MA; Louisville/Speed; MMA; Michigan Bell, Inc.; PAFA; SRGM; Trenton/State; U. of Virginia; Wilmington. **Bibliography:** Arthur 3, 4; Cummings 4; Kirschner; Ward.

VAN BUREN, RICHARD
b. 1937, Syracuse, N.Y. **Studied:** San Francisco State College; U. of Mexico; Mexico City College. **Taught:** NYU; School of Visual Arts. **Address:** 155 Wooster Street, NYC 10012. **One-man Exhibitions:** New Mission Gallery, San Francisco, 1961; SFMA, 1962; Dilexi Gallery, San Francisco, 1964; Bykert Gallery, NYC, 1967, 68, 69; Bennington College, 1970; Ithaca College (three-man), 1970; Janie C. Lee Gallery, Dallas (two-man), 1971; Paula Cooper Gallery, NYC, 1972, 75, 77; Greene Street, NYC, 1973; The Texas Gallery, 1974; Rice U., 1974; City U. of New York, 1975; Jimenez & Algus Gallery, Brooklyn, N.Y.; CUNY, 1988. **Group:** SFMA, Bay Area Artists, 1964; Jewish Museum, Primary Structure Sculptures, 1966; ICA, U. of Pennsylvania, A Romantic Minimalism, 1967; U. of Illinois, 1967; Ridgefield/Aldrich, Cool Art: 1967, 1968; WMAA, 1968, 70; Milwaukee, A Plastic Presence, circ., 1969; Finch College, NYC, Art in Process, 1969; Chicago/AI, 1969, 72; Foundation Maeght, 1970; Akron/AI, Watercolors and Drawings by Young Americans, 1970; Walker, Works for New Spaces, 1971; Milwaukee, Directions 3: Eight Artists, 1971; Buffalo/Albright, Kid Stuff, 1971; Harvard U., New American Graphic Art, 1973; Cincinnati/Contemporary, Options 73/70, 1973; Indianapolis, 1974; VMFA, Works on Paper, 1974. **Collections:** MOMA; Walker. **Bibliography:** *Art Now 74.*

VANDER SLUIS, GEORGE
from 1st to 5th edition.

VASILIEFF, NICHOLAS
from 1st to 4th edition.

VASS, G.
from 1st to 3rd edition.

VENEZIA, MICHAEL **b.** July 23, 1935, Brooklyn, N.Y. **Studied:** Buffalo/SUNY, BS, 1963, with Peter Busa; U.

of Michigan, MFA, 1968; ASL, 1954. Traveled England. **Taught:** U. of Michigan, Ann Arbor, 1967-68; U. of Rochester, 1968-; Guildford College, Surrey, 1967-68; London College of Printing, 1967-68. Designed sets and projections for *Brechtsongs,* London, 1966. **Awards:** CAPS, 1974; L. C. Tiffany Grant, 1980; National Endowment for the Arts, 1981. **Address:** c/o Dealer. **Dealer:** Margarete Roeder Gallery, NYC. **One-man Exhibitions:** (first) Bykert Gallery, NYC, 1942, 73; Heiner Friedrich Gallery, NYC, 1976; Nina Freudenheim, Buffalo, 1976; Sperone Westwater Fischer, Inc., NYC, 1977, 79. **Retrospectives:** Detroit/Institute, 1980; U. of Rochester, 1986. **Group:** MOMA, Works on Paper, 1974; U. of North Carolina, Drawing About Drawing Today, 1979; U. of Rochester, Contemporary Drawings on Watercolors, 1980. **Collections:** Best Products; Canberra/National; Detroit/Institute; Hartford/Wadsworth; U. of Michigan; MOMA; National Gallery of Canada, Ottawa; Potsdam/SUNY; U. of Rochester; Whitney Communications.

VICENTE, ESTEBAN **b.** January 20, 1904, Turegano, Spain. **Studied:** Real Academia de Bellas Artes de San Fernando, Madrid, BA. Resided Paris, 1927-32. To USA, 1936. **Taught:** U. of California, Los Angeles and Berkeley, 1954-55; Queens College; Black Mountain College; High Field School, Falmouth, Mass.; NYU; Yale U.; in Puerto Rico; Princeton U., Artist-in-Residence, 1965, 69, 70, 71; New York Studio School, Paris, 1965-79; Honolulu Academy, 1969; American U., 1973; Columbia U., 1974. **Member:** Century Association; NAD. **Awards:** Ford Foundation, 1961, 62; Tamarind Fellowship, 1962; AAAL, 1971; Parsons School of Design, Hon. DFA, 1984; AAIAL, award, 1985; NAD, Saltus Gold Medal, 1986; AAIAL, Hassam-Speicher Purchase Award, 1988; Government of Spain, Gold Medal

of Honor in the arts. **Address:** Main Street, Bridgehampton, NY 11932; 1 West 67th Street, NYC 10023. **Dealer:** Berry-Hill Galleries, NYC. **One-man Exhibitions:** (first) Galeria Avinyo, Barcelona, 1931; Galeria Syra, Barcelona, 1931, 33; Ateneo de Madrid, 1933; Sala Busquets, Barcelona, 1932; Galeries d'Art Catalonia, Barcelona, 1934; Salon del Haraldo de Madrid, 1934; Kleemann Gallery, NYC, 1937; The Peridot Gallery, NYC, 1950, 51; Allan Frumkin Gallery, Chicago, 1953; Charles Egan Gallery, 1955; Rose Fried Gallery, 1957, 58; Leo Castelli, Inc., 1958; U. of Minnesota, 1959; Holland-Goldowsky Gallery, Chicago, 1960; André Emmerich Gallery, NYC, 1960, 62, 64, 65, 69, 72, 75; Primus-Stuart Gallery, Los Angeles, 1961; New Arts Gallery, Houston, 1962; B. C. Holland Gallery, 1963; Dayton/AI, 1963; St. John's Gallery, Annapolis, Md., 1963; Des Moines, 1967; Princeton U., 1967, 71; Cranbrook, 1968; Honolulu Academy, 1969; Benson Gallery, 1969, 72; Guild Hall, 1970, 92; J. L. Hudson Art Gallery, Detroit, 1972; Gruenebaum Gallery, NYC, 1979, 81, 83, 84, 85, 86; Hoshour Gallery, 1979; Light Gallery, Southampton, N.Y., 1979; Fischbach Gallery, NYC, 1977; Lise Hoshour Gallery, Albuquerque, 1979, 83; Yares Gallery, Scottsdale, 1979, 82, 82, 84, 87, 91; Matthew Scott Gallery, South Miami, 1987; Galeria Theo, Madrid, 1988; Berry-Hill Galleries, New York, 1989, 91, 92; Galeria Theo, Barcelona, 1990; Galeria Theo, Valencia, 1991; Louis Newman Galleries, Beverly Hills, 1991, 92; Galerie Lina Davidov, Paris, 1991; Palacio Lozoya, Segovia, 1992. **Retrospective:** Fundacion Banco Exterior de Espana, Madrid, 1987. **Group:** International Biennial Exchange of Paintings, Tokyo; Corcoran; The Kootz Gallery, NYC, New Talent, 1950; Ninth Street Exhibition, NYC, 1951; Carnegie, 1958, 59, 61, 62, 65, 67, 70; ICA, Boston, 100 Works on Paper, circ., Europe, 1959; Columbus, Contemporary American Painting, 1960; Walker, 60

American Painters, 1960; Chicago/AI, 1960, 66; MOMA, The Art of Assemblage, circ., 1961; SRGM, Abstract Expressionists and Imagists, 1961; SRGM/USIA, American Vanguard, circ., Europe, 1961-62; Seattle World's Fair, 1962; Hartford/ Wadsworth, Continuity and Change, 1962; São Paulo, 1963; New York World's Fair, 1964-65; Black Mountain College, 1966; MOMA, The New American Painting and Sculpture, 1969; U. of Texas, Abstract Expressionists and Imagists, 1976; NAD, 1977; Montclair/AM, Collage: American Masters, 1979; Houston/Contemporary, The Americans, Collage, 1982; NAD, 1982; SRGM, Aspects of Collage, 1988. **Collections:** Baltimore/MA; Brandeis U.; Brooklyn Museum; Buffalo/Albright; U. of California, Berkeley; Chase Manhattan Bank; Chicago/AI; Chicago/Contemporary; Ciba-Geigy Corp.; Corcoran; Dallas/MFA; Dartmouth College; Detroit/Institute; Hartford/Wadsworth; Hirshhorn; Honolulu Academy; Iowa State U.; Kansas City/Nelson; Los Angeles/County MA; MMA; MOMA; NAD; NCFA; NYU; Newark Museum; U. of North Carolina; Princeton U.; Reynolds Metals Co.; U. of Rochester; SFMA; SRGM; Shuttleworth Carton Co.; The Singer Company, Inc.; Tate; Trenton/State; Union Carbide Corp.; Vanderbilt U.: WGMA; WMAA; Walker; Worcester/AM: Yale U. **Bibliography:** Ashbery; Hess, T.B., 1; Hunter 6; Janis and Blesh 1; Sandler 5; Seitz 4. Archives.

VICKREY, ROBERT R. b. August 20, 1926, NYC. **Studied:** Yale U., 1950, BA, BFA; Wesleyan U.; Art Students League, NYC. **Taught:** Dartmouth College, 1987; has written several books on techniques. **Commissions:** 77 *Time* covers. Subject of film, *Robert Vickrey, Lyrical Realist,* 28 minutes, produced by Fairfield U. Made short films 1947-57. **Awards:** NAD, Joseph S. Isidor Gold Medal, 1970; NAD, S.J. Wallace Truman Prize; American Watercolor Society, 15 prizes. **Address:** Crystal

Lake Drive, Orleans, Mass. 02653. **Dealers:** Harmon-Meek Gallery, Naples, Fla.; ACA Gallery, NYC. **One-man Exhibitions:** (first) Creative Gallery, NYC, 1952; Midtown Galleries, NYC, biannually, 1953-78; Hirschl & Adler Galleries, NYC, 1979; Gallery Nicholas, Palm Beach, Fla., 1981; Harmon Gallery, Naples, Fla., 1981; Harmon-Meek Gallery, Naples, Fla., 1982-86; Munson Gallery, Chatham, Mass., 1976, 77, 78, 79, 80; ACA Galleries, 1980; Midwest Museum of American Art, Elkhart, Ind., 1985; Frances Aaronsen Gallery, Atlanta, 1985; Fairfield U., 1986; Fayetteville Museum, 1986; Ulrich Museum, Wichita, 1986; Arkansas/AC, 1986; Goddard Art Center, 1986; Dane G. Hansen Memorial Museum, Logan, Kansas, 1987; MacNider Museum, 1987; St. Joseph/Albrecht, 1987; Springfield, Mo./AM, 1988, 90. **Retrospectives:** U. of Arizona, 1973; Fairfield U., circ., 1982. **Group:** WMAA Annuals, 1951, 52, 53, 54, 55, 56, 57, 63; U. of Illinois, 1953, 55, 59; WMAA, 35 Americans, 1957; Youngstown/Butler, 1960, 61, 82; WMAA, Sixty Years of American Art, 1963; WMAA, The Theatre Collects, 1963; U. of Rochester, In Focus: A Look at Realism in Art, 1964; Purchase/SUNY, American Drawings and Watercolors, 1976; Norfolk/Chrysler, American Figure Painting, 1980; San Antonio/MA, Real, Really Real, Super Real, circ., 1981; WMAA, The Figurative Tradition, 1980. **Collections:** Atlanta U.; Brooklyn Museum; Chattanooga/Hunter; Colorado Springs/FA; Corcoran; Cornell U.; Florida Southern College; High Museum; IBM; Indianapolis; U. of Kansas; MMA; Memphis/Brooks; Michigan State U.; NAD; NMAA; NPG; New Britain/American; New Orleans Museum; Newark Museum; Norfolk/Chrysler; Oklahoma; Omaha/Joslyn; Princeton U.; Purchase/SUNY; Randolph-Macon College; Rio de Janeiro; Rutgers U.; San Diego; Syracuse U.; Trenton/State; Utica; VMFA; WMAA; Youngstown/Butler. **Bibliography:** Ward.

VOLLMER, RUTH
from 1st to 4th edition.

VON SCHLEGELL, DAVID
b. May 25, 1920, St. Louis, Mo. **d.** October 5, 1992, New Haven, Ct. **Studied:** U. of Michigan, 1940-42; ASL, with William Von Schlegell (his father) and Yasuo Kuniyoshi, 1945-48. US Air Force, 1943-44. **Taught:** Privately, 1950-55; U. of California, 1968; School of Visual Arts, NYC, 1969-70; Yale U., 1971-88. **Commissions:** Sculpture, Miami Lakes, Fla., 1974; State Park, Duluth, Minn., 1974; GSA, 1975; City of Baltimore, 1977; NASA, at Clark U., 1978; Arabian Royal Navy Headquarters Bldg., Saudi Arabia, 1978; Indiana U., 1979; Yeatmen's Cove Sculpture Project, Cincinnati, 1979; Tulsa International Airport, 1980. **Awards:** Rhode Island Arts Festival, First Prize, 1962; Carnegie, P.P., 1967; National Council on the Arts, $5,000 Award, 1968; Guggenheim Foundation Fellowship, 1974; Skowhegan School Medal for Sculpture, 1978. **One-man Exhibitions:** (first) The Swetzoff Gallery, Boston, 1955, also 1961; Poindexter Gallery, 1960; Stanhope Gallery, Boston, 1964; U. of New Hampshire, 1964; NYU (three-man), 1966; Ogunquit, 1965; Royal Marks Gallery, 1966-67; Ward-Nasse Gallery, Boston, 1968; Obelisk Gallery, 1968; Reese Palley Gallery, NYC, 1970, 71; The Pace Gallery, NYC, 1974-77; ICA, Boston, 1976. **Retrospective:** Brandeis U., 1968. **Group:** WMAA Annuals, 1960-68; ICA, Boston, 1963; Hartford/Wadsworth, 1963; WMAA, Contemporary American Sculpture, Selection 1, 1966; Jewish Museum, Primary Structures, 1966; Los Angeles/County MA, American Sculpture of the Sixties, 1967; Carnegie, 1967; Walker, Works on New Space, 1971; Middelheim Park, Antwerp, XI Sculpture Biennial, 1971; U. of Washington, 1971. **Collections:** Andover/Phillips; U. of California, Santa Barbara; Carnegie; Cornell U.; Hirshhorn; Lannan Foundation; Lincoln, Mass./De Cordova; MIT; U. of Massachusetts; Ogunquit; Ridgefield/Aldrich; RISD; South Mall, Albany; Storm King Art Center; WMAA; Yale U.

Bibliography: Calas, N. and E.; Davies; Tuchman 1.

VON WEIGAND, CHARMION
b. March 4, 1896, Chicago, Ill. **d.** June 9, 1985, NYC. **Studied:** Barnard College; Columbia U.; NYU; self-taught in art. Traveled Europe, Mexico. Subject of film *The Circle of Charmion von Weigand.* **Member:** American Abstract Artists (president, 1952-53). **Awards:** Cranbrook, Religious Art Exhibition, First Prize, 1969. **One-man Exhibitions:** Rose Fried Gallery, 1942, 48, 56; Saidenberg Gallery, 1952; John Heller, NYC, 1956; Zoe Dusanne Gallery, Seattle, 1958; La Cittadella d'Arte Internazionale e d'Avanguardia, Ascona, Switzerland, 1959; The Howard Wise Gallery, NYC, 1961; U. of Texas, 1969; Birmingham, Ala./MA, 1970; Galleria Fiamma Vigo, Rome and Venice, 1973; Annely Juda Fine Art, London, 1974; Noah Goldowsky Gallery, NYC, 1975; Andre Zarre Gallery, NYC, 1975; Marilyn Pearl Gallery, NYC, 1978, 81, 85, 90. **Group:** MOMA, The Art of Assemblage, circ., 1961; WMAA, Geometric Abstraction, 1962; WMAA, Annuals, 1955, 57, 64; U. of North Carolina, Art on Paper, 1967; Buffalo/Albright, Plus by Minus, 1968; American Abstract Artists, Annuals, 1964, 65, 67, 68, 72; Chicago/Contemporary, Post-Mondrian Abstraction in America, 1973; Springfield, Mass./MFA, Three American Purists, 1975; Paris/Beaubourg, Paris-New York, 1977; Newark Museum, Geometric Abstraction and Related Works, 1978; Yale U., Mondrian and New-Plasticism in America, 1979; AAIAL, 1980; MOMA, Contrasts of Form, 1985. **Collections:** Buffalo/Albright; Carnegie; Ciba-Geigy Corp.; Cincinnati/AM; Cleveland/MA; Container Corp. of America; Cornell U.; Hirshhorn; Indiana U.; MMA; MOMA; McCrory Corporation; Milwaukee; Montclair/AM; Mount Holyoke College; NYU; Newark Museum; New York Hospital; U. of North Carolina; U. of Notre Dame; SRGM; Seattle/AM; Springfield, Mass./MFA; U. of

Texas; WMAA. **Bibliography:** Janis and Blesh 1; MacAgy 2; Rickey; Seitz 4; Seuphor 1. Archives.

VON WICHT, JOHN b. February 3, 1888, Holstein, Germany. d. January 22, 1970, Brooklyn, N.Y. **Studied:** Private art school of the Grand Duke of Hesse, 1909-10, BA; School of Fine and Applied Arts, Berlin, 1912. Traveled Europe. To USA, 1923; citizen, 1936. **Taught:** ASL, 1951-52; John Herron Art Institute, 1953. **Member:** American Abstract Artists; Audubon Artists; Federation of Modern Painters and Sculptors; International Institute of Arts and Letters; SAGA. Federal A.P.: Mural painting. **Commissions:** Pan American Airways Terminal, Miami, Fla.; McGill U.; New York World's Fair, 1939; Pennsylvania Railroad Station, Trenton, N.J. **Awards:** Brooklyn Museum, First Prize, 1948, 49, P.P., 1951, 64; SAGA, Mrs. A.W. Erickson Prize, 1953; The Print Club, Philadelphia, William H. Walker Memorial Prize, 1957; Audubon Artists, Gold Medal of Honor, 1958; Ford Foundation, P.P., 1960; SAGA, P.P., 1967-68. **One-man Exhibitions:** (first in USA) Architects Building, NYC, 1936; 608 Fifth Avenue, NYC, 1939; Artists' Gallery, NYC, 1944; Kleemann Gallery, NYC, 1946, 47; UCLA, 1947; Passedoit Gallery, NYC, 1950, 51, 52, 54, 56, 57, 58; Indianapolis/Herron, 1953; Esther Robles Gallery, Los Angeles, 1959; Pasadena/AM, 1959; Liege, 1959; The Bertha Schaefer Gallery, NYC, 1960, 61, 62, 64, 66; Galerie Neufville, Paris, 1962; Grippi Gallery, 1966; Martin Diamond Fine Arts, NYC, 1984. **Retrospective:** Santa Barbara/MA, 1959. **Group:** California Palace, 1964; Brooklyn Museum; Audubon Artists; MMA; WMAA Annuals; Federation of Modern Painters and Sculptors; Corcoran; PAFA; SRGM; Carnegie; NAD; Chicago/AI. **Collections:** Baltimore/MA; Boston/MFA; Brandeis U.; Brooklyn Museum; Chase Manhattan Bank; Cincinnati/AM; Jewish Museum; S.C. Johnson & Son, Inc.; Library of Congress; Liege; Lincoln, Mass./De Cordova; MMA; MOMA; Madrid/Nacional; NCFA; PMA; Paris/Moderne; Norfolk/Chrysler; Stockholm/National; Union Carbide Corp.; WMAA; Yale U. **Bibliography:** Baur 7; Nordness, ed.; Pousette-Dart, ed. Archives.

VOULKOS, PETER b. January 29, 1924, Bozeman, Mont. **Studied:** Montana State College, BS; California College of Arts and Crafts, MFA. Traveled Italy, Japan. **Taught:** Archie Bray Foundation, Helena, Mont.; Black Mountain College; Los Angeles County Art Institute; Montana State U.; U. of California, Berkeley, 1959-85; Greenwich House Pottery, NYC; Teachers College, Columbia U. Voulkos and Company, 16mm film produced by Clyde Smith, 1972. **Awards:** RAC, First Prize; National Decorative Art Show, Wichita, Kans., First Prize; Portland, Ore./AM, Northwest Craft Show, First Prize; Pacific Coast Ceramic Show, First Prize; Denver/AM, P.P.; Cranbrook, P.P.; Smithsonian, P.P.; Los Angeles/County Fair, P.P.; Pasadena/AM, P.P.; Ford Foundation, P.P.; International Ceramic Exhibition, Ostend, Belgium, Silver Medal, 1959; International Ceramic Exhibition, Cannes, France, Gold Medal; I Paris Biennial, 1959; Rodin Museum Prize in Sculpture; SFMA, Ford Foundation, P.P.; L.H.D. (Hon.), Montana State U., 1968; Hon. DFA, SFAI, 1982; American Craft Council, Gold Medal, 1986; Guggenheim Foundation Fellowship, 1984; San Francisco Art Commission, Award of Honor, 1981; AAIAL, Louise Nevelson Award, 1992; California College of Arts and Crafts, Hon. PhD., 1972; Brandeis U., Creative Arts Award, 1982. **Address:** 1306 3rd Street, Berkeley, CA 94710. **Dealers:** Braunstein Gallery, San Francisco; Charles Cowles Gallery, NYC; Exhibit A Gallery, Chicago; Leedy-Voulkos Gallery, Kansas City, Mo. **One-man Exhibitions:** Gump's Gallery, San Francisco; U. of Florida; Historical Society of Montana; Felix Landau Gal-

Peter Voulkos, *Untitled (Stack)*, 1989.

lery; Chicago/AI; Bonniers, Inc., NYC.; Fresno State College; Scripps College; U. of Southern California; Pasadena/AM; David Stuart Gallery, 1967; Los Angeles/County MA; Hansen Gallery, San Francisco; Quay Gallery, San Francisco, 1968, 74, SFMA, 1972; Kansas City, 1975; Detroit/Institute, 1976; Exhibit A, Chicago, 1979; Braunstein-Quay Gallery, San Francisco, 1975, 78, 87; Charles Cowles Gallery, 1981, 83; Exhibit A Gallery, 1981, 84, 85; Thomas Segal Gallery, Boston, 1981; Braunstein Gallery, 1982, 84, 86; Morgan Gallery, Kansas City, Mo., 1983; Magnolia Editions, Oakland, Calif., 1984; Leedy-Voulkos Gallery, 1986; Point View Gallery, Tokyo, 1983. **Retrospective:** SFMA, circ., 1978. **Group:** MMA; Scripps College; Syracuse/Everson, National Ceramic Exhibition; U. of Tennessee; Brussels World's Fair, 1958; de Young; Seattle World's Fair, 1962; Stanford U.; Denver/AM; Smithsonian; Los Angeles/County MA; Battersea Park, London, International Sculpture Exhibition, 1963; Los Angeles State College, 1964; U. of California, Irvine, 1966; WMAA, 1970; WMAA, 200 Years of American Sculpture, 1976;

Houston/Contemporary, 1978; WMAA, Ceramic Sculpture: Six Artists, 1981; Los Angeles/County MA, Art in Los Angeles, 1981; Kansas City/Nelson, Ceramic Echoes, 1983; Los Angeles Municipal Art Gallery, Art in Clay, 1984; Seattle/AM, American Sculpture: Three Decades, 1984; Palo Alto Cultural Center, Clay Vessels, 1984; American Craft Museum, Poetry of the Physical, circ., 1986; Syracuse/Everson, American Ceramics Now, 1988. **Collections:** Arizona State U.; Art Gallery of Western Australia; Baltimore/MA; Archie Bray Foundation; Boston/MFA; U. of California; Corcoran; Cranbrook; Des Moines; Denver/AM; U. of Florida; City of Fresno; Fresno State College; Hall of Justice; Highland Park (Ill.) Public Library; Honolulu Academy; U. of Illinois; State U. of Iowa; Iowa State Teachers College; Japanese Craft Museum; Kansas City/Nelson; La Jolla; Los Angeles County Fair Association; Los Angeles/County MA; Minnesota/MA; MOMA; Montana State College; Museum of Contemporary Crafts; U. of Nebraska; Oakland/AM; PMA; Pasadena/AM; Phoenix; Portland, Ore./AM; SFMA; Sacramento/Crocker; St. Louis/City; Santa Barbara/MA; Seattle/AM; Smithsonian; Syracuse/Everson; Tokyo Folk Art Museum; UCLA; U. of Utah; WMAA; Wichita/AM; U. of Wisconsin. **Bibliography:** Read 3; *Report;* Selz, P., 2; Trier 1; Tuchman 1.

VYTLACIL, VACLAV

b. November 1, 1892, NYC. **d.** January 5, 1984, NYC. **Studied:** Chicago Art Institute School, 1908-12; ASL, 1912-14; Hofmann School, Munich, 1922-26. Traveled extensively; resided Europe 16 years. **Taught:** Minneapolis Institute School, 1918-22; U. of California, Berkeley, summers, 1927-28; ASL, 1928-69; California College of Arts and Crafts, summers, 1936, 37; Colorado Springs Fine Arts Center, summers, 1947, 48, 49; Chicago Art Institute School, 1954; U. of Georgia, 1968. **Member:** Federation of Modern Painters and Sculptors; American Abstract

Artists. Federal A.P.: Organized an art school in Harlem, NYC. **Awards:** Chicago/AI, William R. French Memorial Gold Medal. **One-man Exhibitions:** (first) Feigl Gallery, NYC, 1942; Phillips; U. of Rochester; Baltimore/MA; Minneapolis Institute School; The Krasner Gallery; Southern Vermont Art Center, Manchester; U. of Notre Dame, 1975; Martin Diamond Gallery, NYC, 1979, 81; Graham Gallery, NYC, 1988, 90. **Retrospective:** Montclair/AM, 1975. **Group:** American Abstract Artists Annuals; Federation of Modern Painters and Sculptors Annuals; Chicago/AI; Carnegie; PAFA; WMAA; Corcoran; MMA. **Collections:** ASL; Colorado Springs/FA; Dalton School; U. of Georgia; Hartford/Wadsworth; MMA; Montclair/AM; PAFA; Phillips; U. of Rochester; WMAA. **Bibliography:** Baur 7; Blesh 1; Cheney; Janis, S.; Lane and Larsen; Marter, Tarbell, and Wechsler; Pousette-Dart, ed.; Toher, ed. Archives.

W

WALD, SYLVIA b. October 30, 1915, Philadelphia. Pa. **Studied:** Moore Institute of Art, Science and Industry, Philadelphia, 1931-35. Traveled Europe, Central America, Greece, Spain, India, Nepal, Kashmir, Japan, Korea. Federal A.P.: Teacher. **Awards:** MOMA, P.P., 1941; Library of Congress, Pennell P.P., 1944; National Serigraph Society, NYC, First Prize, 1948; Brooklyn Museum, P.P., 1951, 54; Pratt Institute, International Miniature Competition, 1967; The Print Club, Philadelphia, 1969. **m.** Po Kim. **Address:** 417 Lafayette St., NYC 10003. **One-man Exhibitions:** (first) ACA Gallery, 1939; Kent State College, 1945; U. of Louisville, 1945, 49; National Serigraph Society, NYC, 1946; Grand Central Moderns, NYC, 1957; Devorah Sherman Gallery, 1960; Briarcliff (N.Y.) Public Library, 1966; New School for Social Research, 1967; Book Gallery, White Plains, N.Y., 1968; Benson Gallery, Bridgehampton, N.Y., 1977; Amerika Haus, Munich, 1979; Knoll International, Munich, 1979; Aaron Berman, NYC, 1981. **Group:** WMAA; National Sculpture Society, 1940; City of Philadelphia, Sculpture International, 1940; Chicago/AI, Directions in American Painting, 1941; Brooklyn Museum, Print Biennials; MOMA, 1941, 53, 56; Library of Congress, 1943, 52, 58; WMAA Annuals, 1948, 55; PAFA Annuals, 1950, 53, 54, 57; International Print Exhibition, Salzburg and Vienna, 1952; II

São Paulo Biennial, 1953; Smithsonian, Curators' Choice—1942-52, circ., USA, 1954; MOMA, 50 Years of American Art, circ., Europe, 1955; Brooklyn Museum, 10 Years of American Prints, 1947-56, 1956; Bordighera, 1957; PCA, American Prints Today, circ., 1959-62; New York Cultural Center, Women Choose Women, 1973; MOMA, American Prints: 1913-1963, 1974-75; Worcester/AM, A Spectrum of Innovation; Boston/MFA, American Colorprints. **Collections:** Aetna Oil Co.; American Association of University Women; Ball State U.; Bibliothèque Nationale; Brandeis U.; Brooklyn Museum; Howard U.; State U. of Iowa; Library of Congress; Louisville/Speed; U. of Louisville; MOMA; NYPL; National Gallery; U. of Nebraska; Ohio U.; U. of Oklahoma; PMA; Princeton U.; Raleigh/NCMA; Rutgers U.; SRGM; Toronto; Utica; Victoria and Albert Museum; WMAA; Walker; Worcester/AM. **Bibliography:** Peterdi. Archives.

WALDMAN, PAUL b. August 1, 1936, Erie, Pa. **Studied:** Brooklyn Museum School; Pratt Institute. **Taught:** New York Community College, 1963-64; Brooklyn Museum School, 1963-67; The Ohio State U., 1966; U. of California, Davis, 1966; School of Visual Arts, NYC, 1966-. **Awards:** Ford Foundation, Artist-in-Residence, 1965. **Address:** 38 West 26th Street, NYC. 10010. **Dealers:** Leo Castelli, Inc., NYC, and Farideh Cadot Gallery, Paris. **One-man Exhibitions:** (first) Allan Stone Gallery, 1963, 65; St. Joseph/Albrecht, 1966; Leo Castelli, Inc., NYC, 1973, 75, 78, 81, 84, 91; Blum Helman Gallery Inc., NYC, 1978; Kunsthalle Tranegarden, Copenhagen, 1981; Norbyllands Kunstmuseum, Aalborg, 1981; Castelli Graphics, NYC, 1984; Phyllis Kind Gallery, NYC, 1984, 91; Faridet Cadot Gallery, Paris, 1987, 91; Phyllis Kind Gallery, Chicago, 1988; Boca Raton, 1991. **Group:** Barnard College, Young Americans, 1962; Louis Alexander

Gallery, NYC, Recent American Drawings, 1962; WGMA, 1963, 64; Brandeis U., Recent American Drawings, 1964, Hartford/Wadsworth, Figures, 1964; U. of Colorado, Survey of World Painting and Sculpture, 1964; Brooklyn Museum, Print Biennials; Finch College, 1966, 67 (circ.), 68; Smithsonian, circ., Germany, 1967; WMAA Annual, 1967; Finch College, NYC, The Dominant Female, 1968; Hirshhorn, Inaugural Exhibition, 1974; Philadelphia College of Art, Private Notation, Artists' Sketchbooks, 1976; NYU, Precious Art, 1985; U. of North Carolina, Art on Paper, 1985; Kuznetsky Most Exhibition Hall, Moscow, Painting Beyond the Death of Painting, 1989. **Collections:** Achenbach Foundation; Baltimore/MA; Brandeis U.; Brooklyn Museum; U. of California; Carnegie; Colby College; Colgate U.; Cornell U.; Dartmouth College; Denver/AM; Des Moines; Fairleigh Dickinson U.; Harvard U.; Hirshhorn; John Hopkins U.; Houston/MFA; J. Turner Jones, Inc.; Kansas City/Nelson; Los Angeles/County MA; MIT; MOMA; U. of Massachusetts; Milwaukee; Mount Holyoke College; NYU; Newark Museum; Oberlin College; Pasadena/AM; RISD; U. of Rochester; Russell Sage College; Rutgers U.; San Diego/Contemporary; The Singer Company, Inc.; Smithsonian; SRGM; Stony Brook/ SUNY; Storm King Art Center; Toledo/MA; Vassar College; Washington U.; Williams College; Yale U.

WALKOWITZ, ABRAHAM
b. March 28, 1878, Tyumen, Russia. **d.** January 18, 1965. **Studied:** NAD; Academie Julian, Paris, with Jean Paul Laurens. Traveled Europe extensively. **Taught:** Educational Alliance, NYC. **Awards:** AAAL, Marjorie Peabody Waite Award, 1962. **One-man Exhibitions:** "291," NYC, 1912; The Downtown Gallery, NYC, 1930; Park Gallery, NYC, 1937; Brooklyn Museum, 1939; Newark Museum, 1941; NYPL, 1942; Schacht Gallery, NYC, 1944; Chinese Gallery, NYC,

1946; Charles Egan Gallery, 1947; Jewish Museum, 1949; Hartford/Wadsworth, 1950; ACA Gallery, NYC, 1955; The Zabriskie Gallery, NYC, 1959, 64, 66, 68, 69, 70, 73, 74; Danenberg Gallery, NYC, 1971. **Retrospectives:** Utah, 1974; Purchase/SUNY, 1982. **Group:** NAD, 1904; The Armory Show, 1913; Anderson Galleries, NYC, Forum Exhibition, 1916. **Collections:** Andover/Phillips; Boston/ MFA; Brooklyn Museum; Columbus; Kalamazoo/Institute; Library of Congress; MMA; MOMA; Newark Museum; Phillips; WMAA. **Bibliography:** *Avant-Garde Painting and Sculpture in America 1910-25;* Baur 7; Biddle 4; Blesh 1; Brown 2; Cahill and Barr, eds.; Cheney; Frank, ed.; Goodrich and Baur 1; Haftman; Hartmann; Hunter 5; Janis, S.; Levin 2; McCoubrey 1; McCurdy, ed.; Mellquist; Richardson, E.P.; Rose, B., 4; **Walkowitz 1, 2;** Wright 1. Archives.

WARHOL, ANDY (Andrew Warhola)
b. August 6, 1928, McKeesport, Pa. **d.** February 22, 1987, NYC. **Studied:** Carnegie, BFA, 1945-49. Illustrator for *Glamour* magazine, 1949-50; commercial artist, 1950-57; produced and directed films with Paul Morrissey; Executive producer, "Andy Warhol's TV," 1980-87. **Award:** Art Directors Club Medal, 1957. Publisher of Andy Warhol's *Interview.* **One-man Exhibitions:** Ferus Gallery, Los Angeles, 1962, 63; The Stable Gallery, NYC, 1962, 64; Ileana Sonnabend Gallery, Paris, 1964, 65, 67, 74; Leo Castelli, Inc., NYC, 1964, 66, 77, 82, 85, 87; Morris International Gallery, Toronto, 1965; Galleria Sperone, Turin, 1965; Galleria Rubbers, Buenos Aires, 1965; ICA, U. of Pennsylvania, 1965; Eva de Buren Gallery, Stockholm, 1965; ICA, Boston, 1966; Galerie Hans R. Neuendorf, Hamburg, 1966; Galerie Rudolf Zwirner, 1967; Stockholm/National, 1968; Rowan Gallery, London, 1968; Leo Castelli, Inc./David Whitney Gallery, NYC, 1969; Chicago/Contemporary, 1970; Eindhoven,

1970; Paris/Moderne, 1970; Tate, 1971; WMAA, 1971; Gotham Book Mart, NYC, 1971; Modern Art Agency, Naples, 1972; Walker, 1972; New Gallery, Cleveland, 1973; Musée Galliera, Paris, 1973; Jared Sable Gallery, Toronto, 1974; F. H. Mayor Gallery, London, 1974, 76; Margo Leavin Gallery, Los Angeles, 1975; Hugo Gallery, NYC, 1952; Bodley Gallery, NYC, 1956, 57, 58, 59, 62; Baltimore/MA, 1975; Greenberg Gallery, St. Louis, 1975, 87; Max Protetch Gallery, Washington, D.C., 1975; Düsseldorf/Kunsthalle, 1976; Freeman-Anacker, New Orleans, 1976; Arno Schefler Gallery, NYC, 1976; Coe Kerr Gallery, NYC 1976, (two-man), 77; Pyramid Art Galleries, Ltd., Washington, D.C., 1977; Sable-Castelli Gallery, Ltd., Toronto, 1977; ACE, Los Angeles, 1977; ACE, Venice, Calif., 1977, 78; Seattle/AM, 1977; Optica, Montreal, 1977; Galerie Heiner Friedrich, Cologne, 1977; Musike d'art et d'histoire, Geneva, 1978; Texas Gallery, Houston, 1978, 88; SMU, 1978; ICA, London, 1978; Humlebaek/Louisiana, 1978; Heiner Friedrich, Inc., NYC, 1979; Massimo Valsecchi Gallery, Milan, 1979; ACE Gallery, Vancouver, 1979; Hartford/Wadsworth, 1979; Lucio Amelio Gallery, Naples, Italy, 1980, 85; Amsterdam/Stedelijk, 1980, 81; Galerie Bruno Bischofberger, Zurich, 1980, 83, 84, 88; Centre d'Art Contemporain, Geneva, 1980; Gray Gaultney Gallery, NYC, 1980; Richard Hines Gallery, Seattle, 1980; Lisson Gallery, London, 1980; Jewish Museum, 1980; Palomar College, 1980; Portland (Ore.) Center for the Visual Arts, 1980; Galerie Daniel Templon, Paris, 1980, 82, 86; Virginia Commonwealth U., 1980; Thomas Babeor Gallery, La Jolla, 1981; Ronald Feldman Gallery, NYC, 1981; Thomas Segal Gallery, Boston, 1981; Galerie Watari, Tokyo, 1981, 87; Castelli-Goodman-Solomon, East Hampton, N.Y., 1982; Dover Museum, England, 1982; Galerie Kammer, Hamburg, 1982; Modernism Gallery, San Francisco,

1982; Galerie des Ponchettes, Nice, France, 1982; Galeria Vijande, Madrid, 1982; American Museum of Natural History, NYC, 1983; Fraenkel Gallery, San Francisco, 1983; Gloria Luria Gallery, Bay Harbor Islands, Fla., 1983; Govinda Gallery, Washington, D.C., 1983, 85; Ridgefield/Aldrich, 1983; Galerie Borjeson, Malmo, 1984; Delahunty Gallery, Dallas, 1984; Marisa del Re Gallery, NYC, 1985; Linda Farris Gallery, Seattle, 1985; Museo e Galleria Nazionale di Capodimonte, Naples, Italy, 1985; Bucknell U., 1985; Newport, R.I., 1985; Old Westbury/SUNY, 1985; Lehman College/CUNY, 1985; Vanguard Gallery, Philadelphia, 1985; Galerie Paul Maenz, Cologne, 1985; Dia Art Foundation, NYC, 1986; Anthony d'Offay Gallery, London, 1986, 88, 90; Gagosian Gallery, NYC, 1986, 88, 92; Evelyn Aimis Fine Arts, Toronto, 1986; Texas Christian U., circ., 1986; Galerie Lavignes-Bastille, Paris, 1986; Robert Miller Gallery, NYC, 1987, 89, circ., 1989; Galerie Bernd Klüser, Munich, 1987, 99; Librarie Beaubourg, Paris, 1987; Houston/Menil, 1987, 88; Galerie Gabrielle Maubrie, Paris, 1987; Acme Art, San Francisco, 1987; Pommery Gallery, Paris, 1987; Michael Kohn Gallery, Los Angeles, 1987; Galerie Thaddeus Ropac, Salzburg, 1987; Dia Art Foundation, Bridgehampton, 1987, 92; Akira Ikeda Gallery, Tokyo, 1987; Waddington Graphics, London, 1987, 88; Hamburg/Kunstverein, 1987; Hokin Gallery, Bay Harbor Islands, 1987; Cleveland/Contemporary, 1987; Stamford Museum, 1988; Michael Maloney Gallery, Santa Monica, 1988; Judith Goldberg Gallery, NYC, 1988; Ingber Gallery, NYC, 1988; Dorsky Gallery, NYC, 1988; Vrej Baghoomian Gallery, NYC, 1988, 91; WMAA, 1988, 91; Tubingen/Kunsthalle, circ., 1988; Galerie Beaubourg, Paris, 1988; U. of Maryland, 1989; Carnegie, 1989; ICA, U. of Pennsylvania, 1989; Galerie Aronowitsch, Stockholm, 1990; Jason McCoy Gallery, NYC, 1990; Galerie Linssen, Cologne, 1990; Fred Dorfman

Gallery, NYC, 1990; Galerie de Poche, Paris, 1990; Brooke Alexander Gallery, NYC, 1990; High Museum, 1990; Fundacion Juan March, Madrid, 1990-91; Gimpels Fils Gallery, London, 1990; Hamburg, 1990; Galerie JOS Jamar, Knokke Heist, 1991; Pace/MacGill Gallery, NYC, circ., 1992. **Retrospectives:** Stuttgart, Kunstverein, circ., 1976; Zurich, 1978; WMAA, 1979; Hannover/K-G, circ., 1981; MOMA, circ., 1989; Fondation Cartier, circ., 1990. **Group:** SRGM, Six Painters and the Object, circ., 1963; WGMA, The Popular Image, 1963; Kansas City/Nelson, 1963; Oakland/AM, Pop Art USA, 1963; ICA, London, The Popular Image, 1963; Stockholm/National, American Pop Art, 1964; Salon du Mai, Paris, 1964; U. of Rochester, 1964; Worcester/AM, 1965; Palais des Beaux-Arts, Brussels, 1965; Hamburger Kunstkabinett, 1965; SRGM, 1966; RISD, Recent Still Life, 1966; Flint/Institute, I Flint Invitational, 1966; Expo '67, Montreal, 1967; Detroit/Institute, Color, Image and Form, 1967; IX São Paulo Biennial, 1967; MOMA, The 1960's, 1967; Carnegie, 1967; Eindhoven, 1967; Palazzo Grassi, Venice, 1967; WMAA Annual, 1968; Jewish Museum, 1968; Kassel, Documenta IV, 1968; Milwaukee, Directions I: Options, circ., 1968; Finch College, NYC, 1968; Jewish Museum, Superlimited: Books, Boxes and Things, 1969; Ars 69, Helsinki, 1969; Indianapolis, 1969; U. of California, Irvine, New York: The Second Breakthrough, 1959-1964, 1969; Hayward Gallery, London, Pop Art, 1969; MMA, New York Painting and Sculpture, 1940-1970, 1969; Denver/AM, Report on the Sixties, 1969; Pasadena/AM, Painting in New York: 1944-1969, 1969; WMAA, 1969, 73; Expo '70, Osaka, 1970; Indianapolis, 1970; Kunsthalle, Nurnberg, The Thing as Object, 1970; Cincinnati/Contemporary, Monumental Art, 1970; Buffalo/Albright, Kid Stuff, 1971; Düsseldorf/Kunsthalle, Prospect, '71, 1971; ICA, U. of Pennsylva-nia, Grids, 1972; High Museum, The Modern Image, 1972; Detroit/Institute, Art in Space, 1973; Parcheggio di Vilia Borghese, Rome, Contemporanea, 1974; Seattle/AM, American Art Third Quarter Century, 1974; Chicago/AI, Idea and Image in Recent Art, 1974; WMAA, American Pop Art, 1974; Lincoln Center, NYC, The Florists Transworld Delivery Collection, 1974; MOMA, Drawings Now, 1976; High Museum, The New Image, 1976; SRGM, 20th Century American Drawing, 1976; Dallas/MFA, American Art Since 1945, 1976; Venice Biennial, 1976; Cambridge U., Jubilation, 1977; Minnesota/MA, American Drawing 1927-1977, 1977; WMAA, Art About Art, 1978; Buffalo/Albright, American Painting of the 1970s, circ., 1978; Pomona College, Black and White Are Colors, 1979; Milwaukee, Emergence and Progression, circ., 1979; Brooklyn Museum, American Drawings in Black and White: 1970-1979, 1980; Norfolk/Chrysler, American Figurative Painting, 1950-1980, 1980; Akron/AM, The Image in American Painting and Sculpture, 1950-1980, 1981; Royal Academy, London, A New Spirit in Painting, 1981; Kassel, Documenta VII, 1982; Houston/Contemporary, The Americans: The Collage, 1982; Internationale Kunstausstellung Berlin, 1982; Houston/Contemporary, American Still Life, 1945-1983, 1983; Krefeld/Haus Lange, Sweet Dreams Baby!: American Pop Graphics, 1983; WMAA, Blam!, 1984; Paris/Beaubourg, Livres d'Artistes, 1985; Sydney/AG, Pop Art, 1955-1970, circ., 1985; Fort Lauderdale, An American Renaissance, 1985; Fundacion Juan March, Madrid, Estructuras Repetitivas, 1986; Brown U., Definitive Statements, circ., 1986; Los Angeles Municipal Art Gallery, Hollywood Inside and Out, 1986; Youngstown/Butler, Midyear, 1986; ICA, London, Komik Ikonoklasm, 1987; U. of California, Berkeley, Made in USA, circ., 1987; Odakyo Gallery, Tokyo, Pop Art USA—UK, 1987; Cologne/Ludwig,

Marcel Duchamp and the Avant-Garde of 1950, 1988; MOMA, Committed to Print, 1988; Miami/Bass, The Future Now, 1989; Walker, First Impressions, 1989; MOMA, High and Low, circ., 1990; Bard College, Art What Thou Eat, 1990; Houston/Contemporary, Word as Image, 1991; Portland, Ore./AM, The Art of the Print, 1991; Martin-Gropius-Bau, Berlin, Metropolis, 1991; Guild Hall, Aspects of Collage, 1991; Nice/Contemporain, Collage du XXième siècle, 1991; Indianapolis, Power: Its Myths and Mores in American Art, 1992. **Collections:** Brandeis U.; Buffalo/Albright; Canberra/National; Chicago/AI; Cologne; Des Moines; Detroit/Institute; Hirshhorn; Kansas City/Nelson; Los Angeles/County MA; MOMA; MMA; PMA; Pasadena/AM; Stockholm/National; Tate; Toronto; WGMA; WMAA; Walker. **Bibliography:** Alloway 1, 4; Armstrong, Thomas; *Art Now 74*; Ashbery; Battcock, ed.; Becker and Vostell; *Black and White Are Colors;* Bourdon 2; Calas 2; Calas, N. and E.; *Contemporanea;* Coplans 3; **Coplans, Mekas, and Tomkins; Crone;** Danto; Davis, D.; Day 1; De Salvo and Schimmel; De Wilde 2; Dienst 1; Haskell 5; Honisch and Jensen, eds.; Hughes; *Europa/Amerika;* **Feldman and Schellmann;** Finch; Gohr and Gachnang; Green; **Hackett, ed.;** Honnef 2; Hughes; Hunter, ed.; *Individuals;* Joachimides and Rosenthal; Johnson, Ellen H.; Kardon; **Koch, S.;** Kosloff 3; *Kunst um 1970;* Lippard 5; Lucie-Smith; Murken-Altrogge; Plagens; Osterwold; *Report;* Rose, B., 1; Rublowsky; Russell and Gablik; Sandler 3, 5; Sager; Schwartz 1; Seitz 3; Siegel; Tomkins and Time-Life Books; Tomkins 2; Waldman 4; **Warhol; Warhol et al, eds.;** Whitney, ed.; Weller.

WARSHOW, HOWARD
from 1st to 4th edition.

WASHINGTON, JAMES W., JR.
b. November 10, 1909, Gloucester, Miss. Studied painting privately with Mark Tobey in Seattle. Changed from painting to sculpture in 1956. Traveled Mexico, Europe, Middle East. Federal A.P.: Teacher (Vicksburg, Miss.). **Taught:** Baptist Academy, Vicksburg, Miss., 1938; Western Washington College, 1968; Director, Baptists Training Union, Mt. Zion Baptist Church, Seattle, 1947-51. **Commissions:** Island Park School, Mercer Island, Seattle, Wash. (sculpture); First National Bank of Seattle, 1968; World Trade Center, Seattle; Odessa Brown Clinic, Seattle, 1981; Seattle Sheraton Hotel, 1982; Washington State Capitol Museum, Olympia, 1983. **Awards:** SFMA, P.P., 1956; Oakland/AM, P.P., 1957; Seattle World's Fair, Second Prize, 1962; Hon. DFA, Graduate Theological Union, 1975. **Address:** 1816 26th Avenue, Seattle, WA 98122. **Dealer:** Foster White Gallery, Seattle. **One-man Exhibitions:** (first) US Army Base, Auburn, Wash., 1954; Feingarten Gallery, Los Angeles, 1958; Haydon Calhoun Gallery, Dallas, 1960, 61; Nordness Galleries, 1962; Gordon Woodside Gallery, Seattle, 1963, 64, 65; Richard White Gallery, Seattle, 1968; St. Mary's College (Ind.), 1969; Foster White Gallery, Seattle, 1972, 74, 76, 78, 85, 89, 92; San Diego, American Baptist Sculpture, 1977. **Retrospectives:** Frey Museum, 1980; Bellevue, Wash., 1989. **Group:** Santa Barbara/MA, 1959; Otis Art Institute, 1963; Seattle World's Fair, 1962; Expo '70, Osaka, 1970; Seattle Urban League, 1978. **Collections:** Oakland/AM; SFMA; Seattle/AM. **Bibliography:** *Art of the Pacific Northwest;* Dover.

WATKINS, FRANKLIN
from 1st to 4th edition.

WATTS, ROBERT M.
from 1st to 5th edition.

WAYNE, JUNE
b. March 7, 1918, Chicago, Ill. Self-taught in art. Traveled Europe extensively. Federal A.P.: Easel painting. **Member:** Artists Equity; Society of Washington Printmakers; The Print

Club, Philadelphia; SAGA; Founder and director of Tamarind Lithography Workshop, Inc. (1959-75), funded by the Program in Humanities and the Arts of the Ford Foundation; Writers Guild of America, Women in Film; Women's Caucus for Art; Women in Business. Visiting Committee of the School of Visual and Environmental Studies, Harvard U., 1972-76. **Awards:** Los Angeles County Fair, P.P., 1950; Los Angeles/County MA, P.P., 1951; Library of Congress, Pennell P.P., 1953; The Print Club, Philadelphia, P.P., 1958; Pasadena/AM, P.P., 1958, 59; SAGA, Edna Pennypacker Stauffer Memorial Prize, 1963, Academy of Motion Pictures Arts and Sciences Nomination, documentary category, 1974; *The Golden Eagle* (film); AEA/AFEA, Recognition Award, 1978; Hon. DFA, International College, London, 1976; National Endowment for the Arts, 1980; YMCA, Silver Achievement Award, 1983; Los Angeles Printmaker Society Award, 1988; Hon. DFA, Atlanta College of Fine Arts, 1988; Hon. DFA, California College of Arts and Crafts, 1991; International Women's Forum Award, 1991; Art Table Award, NYC, 1991; and others. Advisor: Board of Directors, California Confederation of the Arts, 1975-. **Address:** 1108 North Tamarind Avenue, Los Angeles, CA 90038. Dealer: Associated American Artists, NYC. **One-man Exhibitions:** (first) Boulevard Gallery, Chicago, 1935; Mexico City/Nacional, 1936; SFMA, 1950; Santa Barbara/MA, 1950, 53, 58; Pasadena/AM, 1952; Chicago/AI, 1952; The Contemporaries, NYC, 1953; de Young, 1956; California Palace; Achenbach Foundation, 1958; Los Angeles/County MA, 1959; Long Beach/MA, 1959; Philadelphia Art Alliance, 1959; U. of New Mexico, 1968; U. of Iowa, 1970; Grunwald Graphic Arts Foundation, Los Angeles, 1971; Gimpel & Weitzenhoffer, 1972; Los Angeles Municipal Art, 1973; Van Doren Gallery, San Francisco, 1974, 76; Muchenthaler Cultural Center, Fullerton, Calif., 1974; La Demeure, Paris, 1975, 76; Artemisia, Chicago, 1975; U. of Wisconsin, Oshkosh, 1975; U. of Southern Colorado, 1976; Adams State College, 1976; French American Institute, Rennes, 1976; Brest, Musée Municipal, 1977; Rubicon Gallery, Los Altos, 1977; Cypress College, 1977; Les Premontres, Nancy, France, 1977; Palm Springs Desert Museum, 1977; Claremont College, 1978; Arizona State U., 1979; Corvallis Art Center, 1979; American Library, Brussels, 1978; Foundation Pescatore, Luxembourg, 1979; Maison de la Culture Andre Malraux, Reims, 1979; Musée de Chartres, 1979; Lyons, Musée, 1979; Occidental College, Los Angeles, 1980; Charleston Heights Art Center, Las Vegas, 1981; San Diego, 1981; Anita Seipp Gallery, Palo Alto, Calif., 1981; West Hills Community College, Coalinga, Calif., 1981; U. of Alabama, 1982; Des Moines, 1982; Jewish Museum, 1982; North Denton U., 1982; Sacramento/Crocker, 1982; Sunset Cultural Center, Carmel, Calif., 1982; Tobey C. Moss Gallery, Los Angeles, 1983, 85; Pomona College, 1983; San Jose Institute of Contemporary Art, 1983; Armstrong Gallery, NYC, 1984; A.A.A. 1985, 88; Galerie des Femmes, Paris, 1985; Print Club of Philadelphia, 1985; Macalester College, St. Paul, 1986; Fresno Art Museum, 1988; Macquarie Galleries, Sydney, 1989; Print Council of Australia, 1989; Brisbane City Hall Art Gallery, 1989; Benton Gallery, East Hampton, N.Y., 1989. **Retrospectives:** FAR Gallery, 1969; Cincinnati/AM, 1969. **Group:** Library of Congress; Brooklyn Museum; Seattle/AM; PAFA; U. of Illinois; Los Angeles/County MA; MMA; SAGA Annuals; MOMA, circ. (graphics); MOMA, Young American Printmakers, 1953; California State Fair; San Diego; Denver/AM; WMAA Annuals; São Paulo, 1955; Smithsonian; Achenbach Foundation; PCA, American Prints Today, circ., 1959-62; Paris/Moderne; The Japan Print Association, Tokyo, 1961; Smithsonian, 1964; CSCS, Fullerton, 1964; SFAI, 1965;

Idelle Weber, *Cambridge Series #9*, 1992.

Cincinnati/AM, 1968; and many others. **Collections:** AT&T; Achenbach Foundation; Atlantic Richfield Co.; Bibliothèque Nationale; Bibliothèque Royale de Belgique; UCLA; U. of California, Santa Barbara; Canberra/National; Chicago/AI; Cincinnati/AM; Columbia, S.C./MA; DePauw U.; Fort Worth; Grunwald Foundation; Iowa State U.; La Jolla; Lehigh U.; Library of Congress; Long Beach/MA; Los Angeles/County MA; MOMA; U. of Minnesota; NYPL; National Gallery; Newberry Library; U. of New Mexico; Northwestern U.; Oberlin College; PMA; Pasadena/AM; The Print Club, Philadelphia; San Diego; San Jose State College; Santa Barbara/MA; Smithsonian; Walker; Williams College. **Bibliography:** *Art: A Woman's Sensibility;* Karlstrom and Ehrlich; Rodman 1, 3. Archives.

WEBER, HUGO

from 1st to 4th edition.

WEBER, IDELLE **b.** March 12, 1932, Chicago, Ill. **Studied:** Scripps College; UCLA, BA, 1954, MA, 1955; Chouinard Art Institute, with Millard Sheets; Otis Art Institute; with Else Palmer Paynes and Theodore Lukits in Los Angeles; ASL, with Theodore Stamos; Brooklyn Museum, with Reuben Tam. Traveled England, Southern France, Italy, Spain, Greece. **Taught:** UCLA, 1955; NYU, 1976-80. **Member:** Women's Caucus for Art. **Awards:** Scripps College, Distinguished Alumna, 1992; College Art Association, Distinguished Teaching of Art Award, 1992. **Address:** 429 West Broadway, NYC 10012. **One-man Exhibitions:** (first) Bertha Schaefer Gallery, NYC, 1963, 64; Hundred Acres Gallery Ltd., NYC, 1973, 75, 77; Chatham College, 1979; OK Harris Works of Art, NYC, 1979, 82; Ruth Siegel Gallery, NYC, 1984, 85, 87; Arts Club of Chicago, 1986; Squibb Gallery, Princeton, 1988; Anthony Ralph Gallery, NYC, 1989, 91, 92. **Group:** SRGM, American Drawings, 1964; Worcester/AM, New Realism, 1965; Hartford/Wadsworth, New/Photo Realism, 1974; Wichita State U., The New Realism; Rip-Off or Reality?, 1975; San Antonio/McNay, American Artists '76: A Celebration, 1976; Smithsonian, America as Art, 1976; St. Petersburg, Fla., Photo Realism, 1978; U. of Connecticut, Photo Realism, 1979; San Antonio/MA, Real, Really Real, Super Real, circ., 1981; IEF, 20th Century American Drawings: The Figure in Context, circ., 1984; SFMA, American Realism (Janss), circ., 1985; Indianapolis, 1986; Hudson River Museum, Columnar, 1988; Fort Wayne/AM, Earthly Delights, 1988; Jacksonville/AM, Art in Bloom, 1989; U. of Florida, Divergent Styles, 1990; Yale U., Issues in Post-Modernism, 1990; Nassau County Museum of Art, In Sharp Focus, 1991. **Collections:** AT&T; Brooklyn Museum; Buffalo/Albright; Chemical Bank; Kansas City/Nelson; MMA; Metropolitan Life; NCFA; NYPL; U. of Rochester; San Antonio/McNay; VMFA; Worcester; Yale U. **Bibliography:** Cummings 4; Ward.

WEBER, MAX **b.** April 18, 1881, Byalestok, Russia. **d.** October 1961, Great Neck, N.Y. To USA, 1891. **Studied:** Pratt Institute, 1898-1900, with Arthur Dow; Academie Julian, Paris, 1905-06, with Jean

Paul Laurens; Academie de la Grande
Chaumiere; Academie Colarossi, Paris,
1906-7. Traveled Europe extensively.
Taught: Lynchburg, Va., public schools,
1901-3; U. of Virginia (summer); State
Normal School, Duluth, Minn., 1903-5;
helped organize a class under Henri
Matisee, Paris, 1907-8; White School of
Photography, NYC, 1914-18; ASL, 1920-
21, 1925-27; U. of Minnesota, 1931.
Member: Society of Independent Artists,
NYC (Director, 1918-19); American Art-
ists Congress (National Chairman, 1937,
Hon. National Chairman, 1938-40).
Awards: Chicago/AI, Potter Palmer Gold
Medal, 1928; PAFA, Joseph E. Temple
Gold Medal, 1941; Corcoran, Third
William A. Clark Prize, 1941; Chicago/AI,
Ada S. Garrett Prize, 1941; Pepsi-Cola,
Second Prize, 1945, 1946 ($500), 1947
($750); Carnegie, Fourth Prize, 1946; La
Tausca Competition, First Prize, 1946.
One-man Exhibitions: (first) Haas Gal-
lery, NYC, 1909; Photo-Secession, NYC,
1911; Murray Hill Gallery, NYC, 1912;
Ehrlich Galleries, NYC, 1915; Jones Gal-
lery, Baltimore, 1915; Montross Gallery,
NYC, 1915, 23; J. B. Neumann Gallery,
NYC, 1924, 25, 27, 30, 35, 37; The
Downtown Gallery, NYC, 1928, 57, 58;
Dayton/AI, 1938; A.A.A. Gallery, NYC,
1941, 70; Baltimore/MA, 1942; P. Rosen-
berg and Co., 1942, 43, 45, 46, 47; Carne-
gie, 1943; Santa Barbara/MA, 1947;
WMAA, 1949; Walker, 1949; California
Palace, 1949; Jewish Museum, 1956;
Weyhe Gallery, NYC, 1956; Brandeis U.,
1957; Pratt Institute, 1959; B'nai B'rith
Gallery, Washington, D.C., 1961; U. of
California, Santa Barbara, 1968; Dan-
enberg Gallery, 1969, 70, 71, 72; Graham
Gallery, 1970; Pratt Manhattan Center,
NYC, 1971; Long Beach/MA, 1971;
Alpha Gallery, Boston, 1974; Medici II
Gallery, Bay Harbor Island, Fla., 1974;
The Forum Gallery, NYC, 1975, 79, 81,
82, 86, 90, 91; Brooklyn Museum, 1992.
Retrospectives: Danenberg Gallery,
1969; Newark Museum, 1913, 59;

Galerie Bernheim-jeune, Paris, 1924;
MOMA, 1930; P. Rosenberg and Co.,
1944; A.F.A., circ., 1953; AAAL, Memo-
rial, 1962; Jewish Museum, 1983. **Group:**
MOMA, Paintings by 19 Living Ameri-
cans, 1929; Corcoran; Chicago/AI;
MOMA; WMAA; Pomona College,
Stieglitz Circle, 1958; Akademie der
Kunst, Berlin, American Art 1920-1940,
1980; IEF, Twentieth Century American
Drawings, circ., 1984. **Collections:** Ando-
ver/Phillips; Arizona State College; Balti-
more/MA; Bezalel Museum; Brandeis U.;
Britannica; Brooklyn Museum; Buffalo/Al-
bright; California Palace; Carnegie;
Chicago/AI; Cleveland/MA; Columbus;
Cranbrook; Dartmouth College; Des
Moines; Detroit/Institute; Fort Worth;
Hartford/Wadsworth; Harvard U.; How-
ard U.; State U. of Iowa; Jewish Theologi-
cal Seminary; Kansas City/Nelson; La
Jolla; Los Angeles/County MA; MMA;
MOMA; U. of Nebraska; Newark Muse-
um; U. of North Carolina; PMA; Phillips;
Sara Roby Foundation; San Antonio/Mc-
Nay; San Diego; Santa Barbara/MA; Seat-
tle/AM; Tel Aviv; Utica; Vassar College;
WMAA; Walker; West Palm Beach/Nor-
ton; Wichita/AM; Youngstown/Butler.
Bibliography: American Artists Congress,
Inc.; *Arthur Dove: The Years of Collage;*
Ashton 5; *Avant-Garde Painting & Sculp-
ture in America 1910-25;* Barker 1; Baur 7;
Bazin; Biddle 4; Blesh; Brown 2; Bulliet 1;
Cahill; Cahill and Barr, ed.; Cassou;
Cheney; Christensen; Cummings 4; Eisler;
Eliot; Flanagan; Flexner; Frost; *From
Foreign Shores;* Genauer; **Goodrich 9;**
Goodrich and Baur 1; Haftman;
Hartmann; Hess, T.B., 1; Hunter 6; *Index
of 20th Century Artists;* Janis, S.; Kootz 1, 2;
Lee and Burchwood; Levin 2; McCoubrey 1;
McCurdy, ed.; Marter, Tarbell, and
Wechsler; Mellquist; Mendelowitz;
Munsterberg; Newmeyer; Pagano; Pearson
1, 2; Phillips 1, 2; Poore; Pousette-Dart,
ed.; Read 2; Richardson, E.P.; Ringel, ed.;
Ritchie 1; Rose, B., 1; Rosenblum 1;
Sachs; Smith, S.C.K.; Schwartz 2; Soby 5;

Story; Sutton; **Weber 1, 2**; Wight 2. Archives.

WEEKS, JAMES **b.** December 1, 1922, Oakland, Calif. **Studied:** San Francisco Art Institute, 1940-42, with David Park; Nebraska State Teachers College, 1943; Hartwell School of Design, 1946-47; Escuela de Pintura y Excultura, Mexico City, 1951. US Army Air Force, 1942-45. **Taught:** San Francisco Art Institute, 1947-50, 1958, 64; Hartwell School of Design, 1948-50; California College of Arts and Crafts, 1958-59; UCLA, 1967-70; Tanglewood Summer Art Program, 1970-72, Brandeis U., 1973; Boston U., 1970-. **Commission:** US Department of the Interior, Bicentennial Program, 1975. **Awards:** Abraham Rosenberg Foundation Fellowship, 1952; Howard U., 1961; California Palace, 1961, 62; National Endowment for the Arts, grant, 1978; AAIAL, P.P., 1980. **Address:** 11 Notre Dame Road, Bedford, MA 01730. **Dealers:** Hirschl & Adler Modern, NYC; Charles Campbell Gallery, San Francisco. **One-man Exhibitions:** (first) Lucien Labaudt Gallery, San Francisco, 1951; California Palace, 1953; Gallery 6, San Francisco, 1955; The East-West Gallery, San Francisco, 1958; Poindexter Gallery, NYC, 1960, 61, 63, 74; Felix Landau Gallery, Los Angeles, 1963, 65, 66, 67, 70; Sunne Savage Gallery, Boston, 1976, 80; Charles Campbell, San Francisco, 1977, 81; Brandeis U., 1978; Hirschl & Adler Modern, NYC, 1985, 88. **Retrospectives:** SFMA, 1965; Boston U., 1971; Brandeis U., circ., 1978. **Group:** Los Angeles/County MA, 1957; Birmingham, Ala./MA, Figure Painting, 1961; Corcoran Biennial, 1961; California Palace, 1961, 62; Houston/MFA, 1961, 62; Yale U., 1962; St. Louis Artists' Guild, 1962; State U. of Iowa, Five Decades of the Figure, 1962; Chicago/AI, 1963; La Jolla, 1963; Skowhegan School, 1969; Carnegie, 1966; U. of Illinois, 1968; Scripps College, Figurative Painting, 1968; Expo '70, Osaka, 1970; Oakland/AM, A Period of Exploration, 1973; US Department of the Interior, America 1976, circ., 1976; Brown U., Recent Landscape Painting, 1979; AAIAL, 1980; PAFA, Perspectives on Contemporary American Realism, 1982; U. of California, Davis, Directions in Bay Area Painting, 1983; SFMA, American Realism (Janss), 1985; SFMA, Bay Area Figurative Art, 1950-1965, circ., 1990. **Collections:** A.F.A.; Boston/MFA; Boston Public Library; Brandeis U.; Capitol Records; Chemical Bank; Corcoran; First National Bank of Seattle; Hirshhorn; Howard U.; Lytton Savings and Loan Association; Mellon Bank; New England Mutual Life Insurance Co., Boston; Norfolk/Chrysler; Oakland; Ringling; SFMA; US Department of the Interior. **Bibliography:** *America 1976;* Arthur 2; McChesney.

WEINBERG, ELBERT **b.** May 27, 1928, Hartford, Conn. **d.** December 27, 1991. **Studied:** Hartford Art School, 1946-48 (certificate), with Henry Kreis; RISD, 1948-51, BFA with Waldemar Raemisch and Gilbert Franklin; Yale U., with Waldemar Raemisch 1953-55, MFA. **Taught:** RISD; Yale U.; Cooper Union; Union College. **Commissions:** Atlanta, Ga. (copper eagle for a facade); Alavath Achim Synagogue, Atlanta, Ga.; 405 Park Avenue, NYC (terra cotta mural); Jewish Museum, 1959 (sculpture for the garden); Brandeis U.; Colgate U.; Jewish Community Center, White Plains, N.Y.; Washington, (D.C.) Hebrew Congregation; Jewish Theological Seminary; Congregation Emanuel, Providence, R.I., 1978; Freedom Plaza, Wilmington, Del., 1980; Jewish Community Center, West Hartford, Ct., 1982; Embarcadero Center, San Francisco, 1982. **Awards:** Prix de Rome, 1951-53; ICA, London/Tate, International Unknown Political Prisoner Competition, Hon. Men., 1953; *Progressive Architecture* magazine, 1954; Yale U., Silver Medal for Achievement in the Arts, 1959; Guggenheim Foundation Fellowship, 1960; National Sculpture Society, Grant,

1991. **One-man Exhibitions:** Providence (R.I.) Art Club, 1951, 54; Grace Borgenicht Gallery, Inc., NYC, 1957-66, 69, 70, 75, 82; Menges Museum, Berkeley, 1974; Alpha Gallery, Boston, 1966, 69, 81; Schenectady, 1977. **Group:** WMAA, 1935, 36, 57, Annuals, 1957, 58, 60, 64, 65; Andover/Phillips, 1954; Silvermine Guild, 1954; Jewish Museum, 1954; ICA, Boston, 1957; Hartford/Wadsworth, Connecticut Artists, 1957; AAAL, 1958; A.F.A./USIA, Religious Art, circ., Europe, 1958-59; U. of Nebraska, 1958, 59, 61; Carnegie, 1958, 61; MOMA, Recent Sculpture USA, 1959; Chicago/AI, 1959, 61; Utica, 1960; Boston Arts Festival, 1961; PAFA, 1961; Smithsonian, 1961. **Collections:** Andover/Phillips; Boston/MFA; Brandeis U.; Brooklyn Museum; Colgate U.; Dartmouth College; 405 Park Avenue, NYC; Harcourt Brace Jovanovich, NYC; Hartford/Wadsworth; Jewish Museum; MOMA; RISD; Storm King Art Center; WMAA; Yale U. **Bibliography:** Chaet; Rodman 3.

WEINRIB, DAVID
from 2nd to 4th edition.

WEINER, LAWRENCE b. February 10, 1942, NYC. **Studied:** Hunter College. **Address:** 297 West 4th Street, NYC 10014. **Awards:** Arthur Köpke Prize, Copenhagen, 1991; Singer Prize, Amsterdam, 1988. **Dealers:** Leo Castelli Inc., NYC; Marian Goodman Gallery, NYC. **One-man Exhibitions:** (first) Mill Valley, Calif., 1960; Siegelaub Gallery, NYC, 1964, 65, 68; Art & Project, Amsterdam, 1969, 70, 72, 73, 84, 85; Konrad Fischer Gallery, Düsseldorf, 1969, 70, 72, 75, 81, 85, 89; Nova Scotia College of Art and Design, 1969, 70, 72, 79, 83, 85; Gian Enzo Sperone, Turin, 1969, 70, 72, 73; Wide White Space Gallery, Antwerp, 1969, 70, 72, 73, 77; Galerie Folker Skulima, Berlin, 1970; Yvon Lambert, Paris, 1970, 71, 72, 74, 77; Leo Castelli Inc., 1971, 72, 73, 74, 76, 79, 80, 81, 86,

91; California Institute of the Arts, Los Angeles, 1972; Munster, 1972; Galleria Toselli, Milan, 1972, 73, 74; Jack Wendler Gallery, London, 1972, 73; Kabinett für Aktuele Kunst, Bremerhaven, 1973, 75, 81; Modern Art Agency, Naples, 1973; Monchengladbach, 1973; Project Inc., Cambridge, Mass., 1973; Sperone Fischer Galleria, Rome, 1973; Claire S. Copley Gallery, Los Angeles, 1974, 77; Cusack Gallery, Houston, 1974; Gentofte Kommunes Kunstbibliotek, Hellerup, Denmark, 1974; Rolf Preisig Gallery, Basel, 1974, 75, 78; Max Protetch Gallery, Washington, D.C., 1974; Artists' Space, NYC, 1976; Basel/Kunsthalle, 1976; Eindhoven, 1976, 79, 80; ICA, London, 1976; The Kitchen, NYC, 1976, 77; P.S. 1, Long Island City, 1976, 77; Rudiger Schöttle, Munich, 1976, 78, 79; Robert Self Gallery, Newcastle-upon-Tyne, 1976; CEAC, Toronto, 1977; Centre d'Art Contemporain, Geneva, 1977, 80; Contemporary Art Society, Sydney, 1977; Laguna Gloria, 1977; Robert Self Gallery, London, 1977; U. of Chicago, 1978; InK, Zurich, 1978; Galeria Foksal, Warsaw, 1979; Françoise Lambert, Milan, 1979; Saman Gallery, Genoa, 1979; Galeria Akumulatory, Poznan, Poland, 1980; Chicago/Contemporary, 1980; Anthony d'Offay Gallery, London, 1980, 85, 88, 89; David Bellman Gallery, Toronto, 1981, 84; Berne, 1983; GEWAD, Ghent, 1983; Galeria Media, Neuchatel, 1983; Galerie Micheline Swaczer, Antwerp, 1983, 86, 89; U. of Cincinnati, 1984; ELAC, Lyon, 1984; Ohio State U., 1984; Galerie Daniel Templon, Paris, 1984, 85, 87, 89; A.I.A. Gallery, London, 1985; City Thoughts, Amsterdam, 1985; Le Coin du Miroir, Dijon, 1985; Fruitmarket Gallery, Edinburgh, 1985; Musée St. Pierre, 1985; Old Westbury/SUNY, 1985; Orchard Gallery, Derry, North Ireland, 1985; Paris/Moderne, 1985; Pier Art Center, Stremness, Orkney, Scotland, 1985; Art and Project Gallery, Amsterdam, 1985; AIR Gallery, London, 1986; Marian Goodman Gallery,

NYC, 1986, 89, 90; Chicago Arts Club, 1987; Exposorium Vrije Universite, Amsterdam, 1987; Le Magasin, Grenoble, 1986, 87; Jean Bernier Gallery, Athens, 1987; Krefeld/Haus Esters, 1988; Galerie Mai 36, Lucerne, 1988; Galleria Primo Piano, Rome, 1988; Stalke Galerie, Copenhagen, 1988; Galerie Pietro Sparta, Chagny, 1988; Gallery Senda, Hiroshima, 1989; Portikus, Frankfurt, 1989; Galerie Hubert Winter, Vienna, 1989; Galerie Le Gall et Peyroulet, Paris, 1989; Galerie Brigitte March, Stuttgart, 1989; Galerie Ascan Crone, Hamburg, 1989, 91; Ydessa Hendeles Art Foundation, Toronto, 1989; Galerie Christian Stein, Milan, 1989; Villeurbanne, Le Nouveau Musée, 1990; Stuart Regan Gallery, Los Angeles, 1990, 91; Galerie Jablonka, Cologne, 1990; Joods Historisch Museum, Amsterdam, 1990; Hirshhorn, 1990; Art and Project Gallery, Slootdorp, 1991; Galeria Marga Paz, Madrid, 1991; ICA, London, 1991; Galerie Susanne Ottesen, Copenhagen, 1991; DIA Art Center, NYC, 1991; Bordeaux/Contemporain, 1991; Brooke Alexander Editions, NYC, 1992. **Retrospectives:** Amsterdam/Stedelijk, 1988; SFMA, 1992. **Group:** Berne, When Attitudes Become Form, 1969; Düsseldorf/Kunsthalle, Prospect '69, 1969; Seattle/AM, 557, 087, 1969; Jewish Museum, Software, 1970; Arnhem, Sonsbeek '71, 1971; Humlebaek/Louisiana, American Art, 1950-1970, 1971; SRGM, Guggenheim International, 1981; Basel, Konzept Kunst, 1972; Kassel, Documenta V, 1972; XXXVI Venice Biennial, 1972; Lenbachhaus, Munich, Bilder-Objekte-Filme-Konzepte, 1973; Chicago/AI, Idea and Image in Recent Art, 1974; Düsseldorf/Kunsthalle, Prospect '74, 1974; Chicago/AI, 72nd American Exhibition, 1976; MOMA, Drawing Now, 1976; Chicago/Contemporary, A View of a Decade, 1977; Bochum, Words, 1979; Chicago/Contemporary, Options 3, 1980; Hayward Gallery, London, Pier and Ocean, 1980; Amsterdam/Stedelijk, Artists Books,

Neil Welliver, *Rock Barrier—E. Twin*, 1990.

1981; Cologne/Stadt, Westkunst, 1981; Purchase/SUNY, Soundings, 1981; Amsterdam/Stedelijk, '60-'80—Attitudes/Concepts/Images, 1982; New Museum, Language, Drama Source & Vision, 1983; P.S. 1., Long Island City, About Place, 1986; Amsterdam/Stedelijk, Wanderlieder, 1991. **Collections:** Amsterdam/Stedelijk; The Art Gallery of Ontario; British Museum; Canberra/National; Carnegie; Chase Manhattan Bank; Chicago/AI; Eindhoven; Ghent/Contemporary; The Hague; MOMA; Monchengladbach; Lyon/St. Pierre; Nova Scotia College of Art & Design; Paris/Beaubourg; Rijksmuseum Kröller-Müller; Rotterdam; Toronto; Toulon. **Bibliography:** Colpitt and Plous; De Wilde 2; Gohr and Gochnang; Robins; Sandler 3; Weintraub.

WELLIVER, NEIL b. July 22, 1929, Millville, Pa. **Studied:** Philadelphia Museum School, 1948-52, BFA; Yale U., with Josef Albers, James Brooks, Burgoyne Diller, Conrad Marca-Relli, 1953-54, MFA. Traveled Southeast Asia, Europe. **Taught:** Cooper Union, 1953-57; Yale U., 1955-65; Swarthmore College, 1966; U. of Pennsylvania, 1966-89. **Commissions:** Painted murals for the architect Paul Randolph. **Awards:** NAD, Samuel F. B. Morse Fellowship, 1962. **Address:**

RD 2, Lincolnville, ME 04849. **Dealer:** Marlborough Gallery, Inc., NYC. **One-man Exhibitions:** (first) Alexandra Grotto, Philadelphia, 1954; Boris Mirski Gallery, Boston, 1949; The Stable Gallery, NYC, 1962-65; Swarthmore College, 1966; Tibor de Nagy Gallery, NYC, 1968-69, 1970; McLeaf Gallery, Philadelphia, 1969; John Bernard Myers Gallery, NYC, 1970, 71; Parker Street 470 Gallery, Boston, 1970; U. of Rhode Island, 1974; Fischbach Gallery, NYC, 1974, 76, 79, 80, 81; Bates College, 1976; Munson Gallery, New Haven, 1977; Brooke Alexander, NYC, 1978; Florida International U., 1981; College of the Mainland, 1981; Southern Methodist U., 1983; Marlborough Gallery, Inc., NYC, 1983, 85, 87, 89, 91; Marlborough Fine Art Ltd., London, 1984; The Knight Gallery, Charlotte, N.C., 1984; Marlborough Fine Art Ltd., Tokyo, 1986; U. of Missouri, 1986; Dorry Gates Gallery, Kansas City, Mo., 1986; Rockland/Farnsworth, 1986; O'Farrell Gallery, Brunswick, Me., 1986, 88; Bates College, 1986; Harcus Gallery, Boston, 1986; Colby College, circ., 1989; U. of Hartford, 1990; Webb & Parsons, Burlington, 1990; Philharmonic Center for the Arts, Naples, 1991. **Retrospective:** Currier, circ., 1984. **Group:** PAFA Annual, 1962; A.F.A., Wit and Whimsy in 20th Century Art, circ., 1962-63; Baltimore/MA, 1963; Swarthmore College, Two Generations of American Art, 1964; U. of Illinois, 1964; Vassar College, 1968; PAFA, 1968; A.F.A., Painterly Realism, 1970; NIAL, 1971; Boston U., The American Landscape, 1972; U. of North Carolina, Works on Paper, 1972; WMAA Annuals, 1972, 73; U. of Nebraska, 1973; Queens Museum, New Images, 1974; Oklahoma, Contemporary American Landscape Painting, 1974; Tokyo, 1st Biennial of Figurative Painting, 1975; Lincoln, Mass./De Cordova, Candid Painting: American Genre 1950-1975, 1975; US Department of the Interior, America 1976, circ., 1976; U. of

Missouri, American Painterly Realists, 1977; PAFA, 8 Contemporary American Realists, 1977; Youngstown/Butler, Annual, 1977; William and Mary College, American Realism, 1978; Youngstown/Butler, Mid-Year Show, 1979; Danforth Museum, Aspects of the 70's, 1980; San Antonio/MA, Real, Really Real, Super Real, 1981; PAFA, Contemporary American Realism Since 1960, 1981; Utica, Appreciation of Realism, 1982; Lincoln, Mass./De Cordova, Henry Thoreau as a Source for Artistic Inspiration, 1984; Fort Lauderdale, An American Renaissance: Painting and Sculpture Since 1940, 1986; SFMA, American Realism (Janss), 1986; Bowdoin College, New England Now, 1988; U. of Arizona, The New Old Landscape, 1989; Florida International U., American Art Today: Contemporary Landscape, 1989. **Collections:** Amerada-Hess Corp., NYC; AT&T; Baltimore/MA; Bank of New York; Boston/MFA; Bowdoin College; Brandeis U.; Brooklyn Museum; Cameron Iron Works, Houston; Chase Manhattan Bank; Chicago/AI; Colby College; Commerce Bank of Kansas City; Currier; Des Moines; Federal Reserve Bank, Boston; Fukuoka; Hirshhorn; Houston/MFA; IBM; J. Henry Schroeder Banking Corp., NYC; Kansas City/Nelson; La Salle College; Lehman Brothers, NYC; Little Rock; Madison Art Center; MMA; MOMA; New England Life Insurance Co., Boston; NYU; U. of North Carolina; PAFA; PMA; Prudential Insurance Corp. of America, Newark; Philadelphia Free Library; Raleigh; SFMA; Smith College; Springfield, Mo./AM; Security Pacific Corp.; Los Angeles/County MA; SFMA; Trenton State; Utah; Vassar College; Westinghouse Electric Corp., Pittsburgh; WMAA; Youngstown/Butler. **Bibliography:** *America 1976;* Arthur 2, 4; Goodyear 1, 2; Strand ed.; Ward.

WELLS, LYNTON **b.** October 21, 1940, Baltimore, Md. **Studied:** RISD,

1962, BFA; Cranbrook, 1965, MFA. Resided Rome, 1961-62. **Taught:** Yale U., 1974; School of Visual Arts, NYC, 1976-. **Awards:** CAPS, 1975, 77; National Endowment for the Arts, grant, 1976. **Address:** 307 West Broadway, NYC 10013; Twin Lakes Road, Salisbury, Conn. 06068. **Dealer:** Baron/Boisanté Gallery, NYC. **One-man Exhibitions:** (first) Cranbrook, 1969, 72; Newark College of Engineering, 1969; Syracuse/Everson, 1971; Cunningham-Ward Gallery, NYC, 1973, 74; Jared Sable Gallery, Toronto, 1974, 75, 76; André Emmerich Gallery, NYC, 1975, 77; Claire S. Copley Gallery, Los Angeles, 1976; Galerie André Emmerich, Zurich, 1976; Sable-Castelli Gallery Ltd., Toronto, 1977, 78, 79, 80, 82, 83, 84; Nina Freudenheim Gallery, Buffalo, 1977; Grapestake Gallery, San Francisco, 1977; Droll/Kolbert Gallery, NYC, 1978; U. of Wisconsin, Eau Claire, 1979; Tortue Gallery, Los Angeles, 1979; Holly Solomon Gallery, NYC, 1980, 82, 83; Lawrence Oliver Gallery, Philadelphia, 1983, 85; Ruth Siegel Gallery, NYC, 1987. **Retrospective:** Princeton U., 1979. **Group:** MOMA, Photography into Sculpture, 1970; Walker, Figures/Environments, 1970-71; Vassar College, New American Abstract Painting, 1972; WMAA Biennial, 1973; Cincinnati/Contemporary, Options, 73/30, 1973; Rutgers U., Photographic Process as Medium, 1976; Cornell U., Photo/Synthesis, 1976; C.W. Post College, An Exploration of Photography, 1836-1976, 1976; Indianapolis, 1976; Santa Barbara/MA, Attitudes: Photography in the 1970s, 1979; Florida International U., Other Media, 1980. **Collections:** Arnot; Buffalo/Albright; Cincinnati/AM; Cornell U.; Dallas/MFA; Indianapolis; MOMA; U. of New Mexico; Princeton U.; U. of Sydney; Vassar College; U. of Virginia; VMFA; Walker.

WESLEY, JOHN b. November 25, 1928, Los Angeles, Calif. Traveled USA, Europe. **Taught:** School of Visual Arts, NYC, 1970-73. **Address:** 52 Barrow Street, NYC 10014. **One-man Exhibi-**

tions: The Elkon Gallery, NYC, 1963, 64, 65, 67, 69, 71, 72, 73, 74, 76, 78, 79, 80, 82, 83, 84; Galerie Rudolf Zwirner, 1973; Carl Solway Gallery, Cincinnati, 1974, 84, 85, 89; U. of Rochester, 1974; Galerie Onnasch, Berlin, 1982, 83; 101 Spring Street, NYC, 1987; Chinati Foundation, Marfa, Texas, 1990; Drew Gallery, Canterbury, England, 1990; fiction/non-fiction, NYC, 1990, 91; Galerie Antoine Candau, Paris, 1992. **Group:** Washington (D.C.) Gallery of Modern Art, Popular Image, 1965; Brussels/Beaux-Arts, Nouveau Realisme, 1967; A.F.A., The Figure International, 1967-68; WMAA, 1968, 69; Indianapolis, 1969; Kassel, Documenta V, 1972; Indianapolis, 1976; P.S. 1, Long Island City, N.Y., Another Aspect of Pop Art, 1978; WMAA, Art About Art, 1978; ICA, London, Komik Ikonoklasm, 1988; Royal Academy, London, Pop Art, circ., 1991. **Collections:** Basel; Brandeis U.; Chase Manhattan Bank; Dayton/AI; Minneapolis; Buffalo/Albright; Hartford/Wadsworth; Hirshhorn; U. of Kentucky; MOMA; Minneapolis/Institute; Newport Harbor; Pecos Art Museum; Portland, Ore./AM; U. of Rochester; U. of Texas. **Bibliography:** Cummings 4; De Salvo and Schimmel; Honisch and Jensen, eds.; Schwartz 2.

WESSELMANN, TOM b. February 23, 1931, Cincinnati, Ohio. **Studied:** Hiram College, 1949-51; U. of Cincinnati, BA (psychology), 1951-52; Art Academy of Cincinnati, 1954-56; Cooper Union, with Nicholas Marsicano, 1956-59. US Army, 1952-54. Subject of Drawing Society videotape, shown making a drawing, 1992. **Address:** 115 East 9th Street, NYC 10002. **Dealer:** Sidney Janis Gallery, NYC. **One-man Exhibitions:** (first) Tanager Gallery, NYC, 1961; Green Gallery, NYC, 1962, 64, 65; Ileana Sonnabend Gallery, Paris, 1966; Sidney Janis Gallery, NYC, 1966, 68, 70, 72, 74, 76, 79, 80, 82, 83, 85; Galleria Sperone, Turin, 1967; Dayton's Gallery 12,

Minneapolis, circ., 1968; Newport Harbor, circ., 1970; Jack Glenn Gallery, Corona del Mar, 1971; Rosa Esman Gallery, NYC, 1972; Galerie Aronowitsch, Stockholm, 1972; Multiples Inc., Los Angeles, 1973; California State U., Long Beach, circ., 1974; Galerie des 4 Mouvements, Paris, 1974; Boston, 1978; ICA, Boston, 1978; Serge De Bloe Gallery, Brussels, 1979; Ehrlich Gallery, NYC, 1979; Hokin Gallery, Miami, 1981, 85; Margo Leavin Gallery, Los Angeles, 1982; Carl Solway Gallery, Cincinnati, 1982; Delahunty Gallery, Dallas, 1983; Galerie Esperanza, Montreal, 1984; Sander Gallery, NYC, 1983; Modernism, San Francisco, 1984; Jeffrey Hoffeld & Co., NYC, 1985; MacIntosh/Drysdale Gallery, Houston, 1984; Hokin Gallery, Bay Harbor Islands, Fla., 1986; Galerie Quintana, Bogota, 1986; Galerie Joachim Becker, Cannes, 1986, 89, 90; Galerie Denise Rene/Hans Mayer, Düsseldorf, 1986; O.K. Harris Works of Art, NYC, 1986, 90; Galerie de France, Paris, 1987; Cooper Union, 1987; Queens Museum, 1987; Galerie Tokoro, Tokyo, 1988, 91; Mayor Gallery, London, 1988;

Tom Wesselmann, *Monica and Matisse Interior with Phonograph*, 1988-1990.

Blum Helman Gallery, Santa Monica, 1989, 90; Waddington Galleries, London, 1989; Maxwell Davidson Gallery, NYC, 1989; John C. Stoller & Co., Minneapolis, 1990; Gloria Luria Gallery, Bay Harbor Islands, Fla., 1990; Hokin Gallery, Palm Beach, 1990; Posner Gallery, Milwaukee, 1990; Studio Trisorio, Naples, 1990; Fay Gold Gallery, Atlanta, 1990; Wilkey Fine Arts, Medina, WA, 1990; Colorado State U., 1990; Edward Totah Gallery, London, 1991; Tasende Gallery, La Jolla, 1991. **Retrospectives:** Stein Gallery, Chicago, circ., 1988; Cincinnati/Contemporary, circ., 1991. **Group:** Sidney Janis Gallery, The New Realists, 1962; MOMA, Recent Painting USA: The Figure, circ., 1962-63; Dwan Gallery, 1962, 64; Ileana Sonnabend Gallery, Paris, 1963; Buffalo/Albright, Mixed Media and Pop Art, 1963; WGMA and ICA, London, The Popular Image, 1963; Amsterdam/Stedelijk, American Pop Art, 1964; Stockholm/National, 1964; Chicago/AI, 1964; Carnegie, 1964, 67; Milwaukee, 1965; Palais des Beaux-Arts, Brussels, 1965; WMAA, Young America, 1965; WMAA Annuals, 1965, 68, 72, 73; MOMA, Art in the Mirror, 1966; Toronto, 1966; WMAA, Art of the U.S. 1670-1966, 1966; RISD, Recent Still Life, 1966; IX São Paulo Biennial, 1967; Expo '67, Montreal, 1967; Trenton/State, Focus on Light, 1967; Kassel, Documenta IV, 1968; WMAA, Artists Under 40, 1968; Vancouver, circ., 1969; Cincinnati/Contemporary, Monumental Art, 1970; Mathildenhole, Darmstadt, III Internationale der Zeichnung, 1970; ICA, U. of Pennsylvania, Highway, 1970; Roko Gallery, Homage to Tanager: 1952-62, 1971; Dublin/Municipal, International Quadrennial (ROSC), 1971; Hofstra U., Art Around the Automobile, 1971; Chicago/AI, 1972, 74; WMAA, American Drawings, 1963-1973, 1973; Turin/Civico, La Fotografia e l'Arte, 1973; New School for Social Research, Erotic Art, 1973; Yale U., American Drawing: 1970-1973, 1973; WMAA, American Pop

Art, 1974; Corcoran Biennial, 1975; New York Cultural Center, Three Centuries of the American Nude, 1975; Philadelphia College of Art, Private Notations: Artists' Sketchbooks II, 1976; de Young, The Great American Foot Show, 1976; Sydney/AG; Illusions of Reality, 1976; Williamstown/Clark, The Dada/Surrealist Heritage, 1977; WMAA, Art About Art, 1978; Brooklyn Museum, American Drawings in Black and White, 1970-1979, 1980; Youngstown/Butler, 1982; Houston/Contemporary, American Still Life, 1945-1983, 1983; Osaka/National, Modern Nude Paintings, 1880-1983, 1983. **Collections:** Aachen/Suermondt; Brandeis U.; Buffalo/Albright; Cincinnati/AM; Cologne; Dallas/MFA; Darmstadt/Hessisches; Hirshhorn; U. of Kansas; Kansas City, Mo./Atkins; Krefeld/K-W; MOMA; Minneapolis/Institute; U. of Nebraska; Oslo; PMA; Princeton U.; Rice U.; U. of Texas; Walker; Washington U.; WMAA; Worcester/AM. **Bibliography:** Alloway 1, 4; Armstrong, Thomas; Battcock; ed.; Bihalji-Merin; *Black and White Are Colors;* Calas, N. and E.; *Celebrate Ohio;* Cummings 4; Davis, D.; Dienst 1; *Europa/Amerika;* Haskell 5; Honisch and Jensen, eds.; Hunter, ed.; *Kunst um 1970;* Lippard 5; Murken-Altrogge; Osterwald; Rose, B., 1; Rublowsky; Russell and Gablik; Sager; Sandler 3; Seitz 3; **Stealingworth;** Weller.

WESTERMANN, H. C. b. December 11, 1922, Los Angeles, Calif.

d. November 3, 1981, Danbury, Conn. **Studied:** Chicago Art Institute School, 1947-54, with Paul Wieghardt. US Marine Corps, World War II. Traveled the Orient. **Member:** Artists Equity. **Awards:** Chicago/AI, Campana Prize, 1964; National Council on the Arts, 1967; Tamarind Fellowship, 1968; São Paulo Biennial Prize, 1973; Chicago/AI, The Mr. & Mrs. Frank G. Logan Medal, 1974. **One-man Exhibitions:** Allan Frumkin Gallery, Chicago, 1957, also 1962, 67, 71, NYC, 1961, 63, 65, 67, 68, 70, 71, 73, 74, 76;

Dilexi Gallery, Los Angeles, 1962, San Francisco, 1963; Kansas City/Nelson, 1966; U. of California, Berkeley, 1971; Moore College of Art, Philadelphia, 1972; Galerie Rudolf Zwirner, Cologne, 1972; Galerie Hans R. Neuendorf, Hamburg, 1973; Galerie Thomas Borgmann, Cologne, 1973; James Corcoran Galleries, Los Angeles, 1974, 89; National College of Education, Wilmette, 1954; Rockford College, 1956; John Berggruen Gallery, 1977, 84; U. of Rhode Island, 1977; Xavier Fourcade, Inc., NYC, 1981; Morgan Gallery, Shawnee Mission, Mo., 1982; Akron/AM, 1982; John Berggruen Gallery, San Francisco, 1984; Chicago/AI, 1987; Lennon, Weinberg, Inc., NYC, 1988, 89; U. of Kansas, 1989; Frumkin/Adams Gallery, NYC, 1989; Compass Rose Ltd., Chicago, 1991. **Retrospectives:** Los Angeles/County MA, 1968; Chicago/Contemporary, 1969; WMAA, circ., 1978; Serpentine Gallery, London,

H. C. Westermann, *Homage to American Art (Dedicated to Elie Nadelman)*, 1965.

1981. **Group:** Houston/MFA; Hartford/Wadsworth; A.F.A.; MOMA, New Images of Man, 1959; MOMA, The Art of Assemblage, circ., 1961; U. of Illinois, 1961; Tate, Gulbenkian International, 1964; The Hague, New Realism, 1964; Chicago/AI, 1964, 67, and Exhibition Momentum; WMAA, 1964, 68; Worcester/AM, 1965; RISD, 1965; Walker, 1966; The Ohio State U., 1966; Los Angeles/County MA, 1967; Carnegie, 1967; Kassel, Documenta IV, 1968; ICA, U. of Pennsylvania, The Spirit of the Comics, 1969; WMAA, Human Concern/Personal Torment, 1969; La Jolla, Continuing Art, 1971; SRGM, 10 Independents, 1972; Chicago/Contemporary, Chicago Imagist Art, 1972; New York Cultural Center, 3D into 2D, 1973; WMAA, American Drawings: 1963-73, 1973; São Paulo Biennials, 1973, 74, 79; Chicago/AI, 1974; NCFA, Made in Chicago, 1974; Portland, Ore./AM, Masterworks in Wood: The Twentieth Century, 1975; NCFA, Sculpture: American Directions, 1945-1975, 1975; WMAA, 200 Years of American Sculpture, 1976; U. of Massachusetts, Critical Perspectives in American Art, 1976; Venice Biennial, 1976; Chicago Art Institute School, Visions, 1976; WMAA Biennials, 1977, 79; School of Visual Arts, NYC, The Intimate Gesture, 1979; Brooklyn Museum, American Drawings in Black and White, 1970-1979, 1980; Sunderland Arts Centre, Who Chicago?, 1980; Milwaukee, American Prints 1960-1980, 1982; WMAA, Block Prints, 1982; Sunderland (Eng.) Arts Centre, Drawing in Air, 1983; École des Beaux-Arts, Paris, American Drawing: 1930-1980, 1985; Renwick Gallery, The Boat Show: Fantastic Vessels, Fictional Voyages, 1989; Houston/Contemporary, Word as Image, 1991. **Collections:** Chicago/AI; Des Moines; Hartford/Wadsworth; Indiana U.; Los Angeles/County MA; Pasadena/AM; WMAA; Walker; Wichita/AM. **Bibliography:** Adrian; Atkinson; Cummings 4, 5; Friedman and van der Marck; Haskell 3;

Margaret Wharton, *Baby Bunting*, 1990.

Janis and Blesh; **Kozloff 1**; Lippard 5; Osterwald; Read 3; Rose, B., 1; Sandler 3; Schutze; Seitz 4; Tuchman 1; Weller; *Who Chicago?* Archives.

WHARTON, MARGARET A.
b. August 4, 1943, Portsmouth, Va. **Studied:** U. of Maryland, 1965, BS; School of the Art Institute of Chicago, 1975, MFA, with Ray Yoshida, James Zanzi, Richard Keane. Traveled USA, England. **Taught:** School of the Art Institute of Chicago, 1979. **Awards:** Chicago/AI, The Mr. & Mrs. Frank G. Logan Medal, 1974; National Endowment for the Arts, 1980; Awards in the Visual Arts, 1984. **Address:** 1334 Pinehurst, Glenview, Ill. 60025. **One-man Exhibitions:** (first) Phyllis Kind Gallery, Chicago, 1975, 80, 85, NYC, 1977, 78, 79, 81, 83; Chicago/Contemporary, circ., 1981. **Group:** School of the Art Institute of Chicago, Visions, 1976; U. of Illinois, 1976; ICA, U. of Pennsylvania, Improbable Furniture, 1977; John Michael Kohler Arts Center, Sheboygan, Wisc., American Chairs, 1978; Cincinnati/Contemporary, Chicago/Chicago, 1980; Indianapolis, 1980; Sunder-

land (Eng.) Arts Centre, Drawing in Air, 1983; Sacramento/Crocker, Contemporary American Wood Sculpture, 1984. **Collections:** Chicago/Contemporary; Madison Art Center; Seattle/AM; WMAA.

WHITMAN, ROBERT
from 2nd to 5th edition.

WIEGHARDT, PAUL
from 1st to 4th edition.

WIESENFELD, PAUL
from 1st to 5th edition.

WILDE, JOHN b. December 12, 1919, Milwaukee, Wisc. **Studied:** U. of Wisconsin, 1947, MA. **Taught:** U. of Wisconsin, Madison, 1948-82, Alfred Sessier Distinguished Professor Emeritus. **Awards:** PAFA, Lambert P.P., 1957; NAD, Childe Hassam P.P. 1961, 81; AAIAL, P.P., 1987. **Address:** RFD #1, Evansville, WI 53536. **Dealers:** Jane Haslem Gallery, Washington, D.C.; Harmon-Meek Gallery, Naples, Fla.; The Bradley Galleries, Milwaukee; Schmidt-Bingham Gallery, NYC. **One-man Exhibitions:** (first) U. of Wisconsin, 1942; David Porter Gallery, Washington, D.C., 1944; Kalamazoo/Institute, 1945; Layton School of Art, 1947; Milwaukee, 1948, 59; Pennsylvania College for Women, 1949; Hewitt Gallery, NYC, 1950, 53, 55; Bresler Galleries Inc., Milwaukee, 1949, 51, 53, 55, 58, 61, 63; Newman Brown, Chicago, 1953; Robert Isaacson Gallery, NYC, 1959, 61; Columbia, S.C./MA, 1960; Lane Gallery, Los Angeles, 1960; U. of Wisconsin, Milwaukee, 1960; Durlacher Brothers, NYC, 1963; The Banfer Gallery, 1968; Northern Illinois U., 1969; Veldman Galleries, 1971, 73; Nordness Galleries, 1971; Frank Oehlschlaeger Gallery, Chicago, 1974; Bradley Galleries, Milwaukee, 1979, 85, 91; Haslem Fine Arts, Inc., Washington, D.C., 1980; Milwaukee, 1982; David Findlay, Jr., Gallery, NYC, 1984; Schmidt-Bingham Gallery, NYC, 1986, 88, 90, 92;

Perimeter Gallery, Chicago, 1988, 90, 92. **Retrospectives:** Milwaukee, 1967; U. of Wisconsin, Madison, 1984; Milwaukee (three-man), 1982. **Group:** Chicago/AI, 1940, 41, 42, 51, 52, 54, Abstract and Surrealist Art, 1948; PAFA, 1941, 46, 50, 52, 53, 58, 59, 60, 62; Walker, 1947, 49, 51, 62, Reality and Fantasy, 1954; U. of Illinois, 1948, 52, 55, 57, 58, 61, 63; A.F.A., American Watercolors, 1949; MMA, 1950, 52, Americans Under 35, 1954; WMAA, 1950, 52, 53, 55, 56, 58, 60, 62, 70; Corcoran, 1953; Youngstown/Butler, 1953, 55, 57, 60; Denver/AM, 1955, 56; Hallmark Art Award, 1955, 58; MOMA, Recent Drawings USA, 1956; Carnegie, 1958; Detroit/Institute, 1959; ART:USA:Now, circ., 1962-67; NAD, 1968; St. Joseph/Albrecht, Drawing—America, 1973, 1973; A.F.A., American Master Drawings and Watercolors, 1976; San Diego American Drawings Invitational, 1977; U. of Nebraska, Things Seen, 1978; WMAA, 20th Century Drawings from the Permanent Collection, 1975; NPG, Distinguished American Portrait Drawings, 1980; Rutgers U., Realism & Realities, 1982; West Palm Beach/Norton, The Fine Line, 1985; New Orleans/Contemporary, Landscape, Seascape, Cityscape, 1960-1985, circ., 1986; WMAA, Philip Morris, The Changing Likeness, 1986; WMAA, Twentieth Century Drawings and Watercolors from the Whitney Museum, circ., 1987; Southwest Texas State U., Daring Conclusions, 1989; Madison Art Center, Triennial, 1990; Arkansas/AC, Silverpoint etcetera, circ., 1992. **Collections:** Arkansas/AC; Carnegie; Chicago/AI; De Beers Collection; Detroit/Institute; Hartford/Wadsworth; Kalamazoo/Institute; Little Rock/MFA; Marquette U.; Milwaukee; Milwaukee Journal; Minnesota/MA; NAD; NCFA; NMAA; U. of Nebraska; Neenah/Bergstrom; U. of North Carolina; PAFA; Rahr-West Museum; Rutgers U.; Sara Roby Foundation; St. Joseph/Albrecht; Santa Barbara/MA; Stony Brook/ SUNY; U. of

John Wilde, *July 1985, with a Headeian Landscape*, 1991.

Vermont; WMAA; Walker; Washington Federal Bank, Miami; U. of Wisconsin; Worcester/AM; Yale U.; Youngstown/Butler. **Bibliography:** Cummings 5; *John Wilde: Drawings 1940-84;* Lindy; Nordness, ed.; Wilde. Archives.

WILEY, WILLIAM T. b. October 21, 1937, Bedford, Ind. **Studied:** California School of Fine Arts, 1956-60, BFA. **Taught:** U. of California, Davis, 1962-73. **Awards:** CSFA, Painting Award, 1959, Fletcher Award, 1960; SFMA, First Prize, 1960; Oakland/AM, cash award, 1961; Chicago/AI, First Prize and Guest of Honor Award, 1961; Los Angeles/County MA, sculpture prize, 1962; San Francisco/MA, Nealie Sullivan Award, 1968; Chicago/AI, William H. Bartels Prize, 1976; Australian Arts Council, travel grant, 1980; AAIAL. **Address:** Box 661, Forest Knolls, Calif. 94933. **Dealers:** Allan Frumkin Gallery, NYC; Fuller Goldeen, San Francisco. **One-man Exhibitions:** RAC, 1960; Staempfli Gallery, NYC, 1960, 62, 64; The Lanyon Gallery, 1965; Allan Frumkin Gallery, NYC, 1968, 70, 73, 76, 79, 81, 83, 86, Chicago 1969, 74, 79; Hansen-Fuller Gallery, San Francisco, 1969, 71, 72, 75, 78, 80, 83; SFAI, 1969; Eugenia Butler, 1969; Studio Marconi, Milan, 1971; James Manolides Gallery, Seattle, 1972; Margo Leavin Gallery, 1972, 75, 76; Eindhoven, 1973; U. of Utah, 1974; U. of Texas, Austin (three-

man), 1975; MOMA, 1976; Galerie Paul Fachetti, Paris, 1977; Landfall Press Gallery, Chicago, 1978, 80, 88; Delahunty Gallery, Dallas, 1978; Galleria Odyssia, Rome, 1972; Galerie Richard Froncke, Ghent, 1972; Morgan Gallery, Shawnee Mission, 1978; Illinois State U., 1980; San Jose/MA, 1980; Cornish Institute, Seattle, 1980; Glen Hanson Gallery, Minneapolis, 1980; Realities Gallery, Brisbane, 1980; Emily Carr College, Vancouver, 1981; Florida State U., 1981; Santa Barbara Contemporary Arts Forum, 1982; Birmingham, 1983; Newport Beach, 1984; L.A. Louver Gallery, Venice, Calif., 1984, 87, 91, 92; Frumkin/Struve Gallery, Chicago, 1985; Moore College of Art, Philadelphia, 1986; Frankfurt/Kunstverein, 1987; Max Protetch Gallery, NYC, 1988, 91; Marsha Mateyka Gallery, Washington, D.C., 1988; U. of California, Davis, 1988; Crown Point Press, San Francisco, and NYC, 1989, Struve Gallery, Chicago, 1989; Fuller Gross Gallery, San Francisco, 1989; Persons & Lindell, Helsinki, 1990; Riva Yares Gallery, Scottsdale, 1990; Brandeis U., 1991; Corcoran, circ., 1991; Marian Locks Gallery, Philadelphia, 1992. **Retrospectives:** U. of California; Walker, circ., 1979; Baltimore/MA, 1979. **Group:** SFMA, 1959, 60; RAC, 1959, 60; San Francisco Art Festival, 1960; WMAA, Young America, 1960; Chicago/AI, 1961; U. of Illinois, 1961; U. of Nebraska, 1961; California Palace, 1961; WMAA, Fifty California Artists, 1962; Los Angeles/County MA, American Sculpture of the Sixties, 1967; U. of California, Berkeley, Funk, 1967; WMAA Annual, 1967, 73; Moore College of Art, Philadelphia, Beyond Literalism, 1968; Tampa Bay Art Center, Forty California Sculptors, 1968; Chicago/Contemporary, Violence in Recent American Art, 1968; Indianapolis, 1969; Berne, When Attitudes Become Form, 1969; MOMA, New Media, New Methods, circ., 1969; Eindhoven, Kompas IV, 1969-70; Foundation Maeght, 1970; Omaha/Joslyn, Looking West, 1970; SFAI, Centennial

Exhibition I, 1970; Sacramento/Crocker, Sacramento Sampler I, 1972; Kassel, Documenta V, 1972; Venice Biennial, 1972; Ringling, After Surrealism, 1972; WMAA, Extraordinary Realities, 1973; U. of Illinois, 1974; WMAA, Annual, 1974; Düsseldorf, Kunsthalle, Surrealitat-Bildrealitat: Words and Images, 1975; WMAA, 200 Years of American Sculpture, 1976; SFMA, Painting and Sculpture in California, 1976; Minnesota/MA, American Drawings, 1927-1977, 1977; U. of Texas, Austin, New in the Seventies, 1977; San Diego, American Drawing Invitational, 1977; The Hague, Recent Art from San Francisco, 1977; Houston/Contemporary, American Narrative/Story Art, 1977; ICA, Boston, Narration, 1978; Buffalo/Albright, American Painting of the 1970s, 1978; Rijeka, 6th International, Drawings, 1978; Denver/AM, Biennial, 1979; Brooklyn Museum, American Drawings in Black and White, 1970-1979, 1980; XXXIX Venice Biennial, 1980; Purchase/SUNY,

Soundings, 1981; Akron/AM, The Image in American Painting and Sculpture, 1981; U. of Santa Clara, Northern California Art of the Sixties, 1982; Oakland Museum, 100 Years of California Sculpture, 1982; Houston/Contemporary, The Americans: The Collage, 1982; SFMA, 20 American Artists, 1982; WMAA Biennial, 1983, Minimalism to Expressionism, 1983; Palm Springs Desert Museum, Return of the Narrative, 1984; MOMA, International Survey of Painting and Sculpture, 1984; Hirshhorn, Content, 1984; MOMA, International Survey of Painting and Sculpture, 1984; École des Beaux-Arts, Paris, American Drawing, 1930-1980, 1985; Purchase/SUNY, The Window in Twentieth Century Art, 1986; Fort Lauderdale, An American Renaissance, 1986; WMAA, Twentieth Century Drawings and Watercolors from the Whitney Museum, circ., 1987; Milwaukee, 1988; The World of Art Today, 1988; Indianpolis/Herron, Welcome Back, 1988; Little

William T. Wiley, *For M.W. and the Pure Desire*, 1988.

Rock, National Drawing Invitational, circ., 1988; UCLA, Forty Years of California Assemblage, 1989; Hofstra U., The Transparent Thread, circ., 1990; Milwaukee, Word as Image, 1990; U. of North Carolina, Art on Paper, 1990; AAIAL, 1991; Ridgefield/Aldrich, California Artists, 1991. **Collections:** Akron/AM; Baltimore/MA; Birmingham, Ala./MA; Boise; Boston/MFA; Brooklyn Museum; U. of California, Berkeley; Carnegie; Chicago/AI; Corcoran; Dallas/MFA; Denver/AM; Des Moines; Eindhoven; Fort Worth; Hirshhorn; U. of Idaho; U. of Illinois; Illinois Bell Telephone Company; Indiana U.; Indianapolis; U. of Kansas; Kansas City/Nelson; Los Angeles County/MA; U. of Massachusetts; MOMA; U. of Miami; Milwaukee; Mills College; Minneapolis/Institute; Oakland/AM; NMAA; U. of Nebraska; U. of New Mexico; Newport Harbor; U. of North Carolina; Oakland Museum; Oberlin College; Omaha/Joslyn; PAFA; PMA; Palm Springs; Red Deer College; SFMA; St. Louis; Sacramento/Crocker; San Diego/Contemporary; Seattle/AM; Smith College; Stanford U.; U. of Texas; Victoria (B.C.); WMAA; Walker; Worcester/AM; Yale U. **Bibliography:** *Art Now 74;* Cummings 4, 5; *Forty Years of California Assemblage; Individuals;* Lippard, ed.; *Report;* Richardson, B., 2; Sandler 3; Selz, P., 2; *The State of California Painting;* Tuchman 1; *When Attitudes Become Form; Drawings: The Pluralist Decade; New in the Seventies;* Waldman 4.

WILFRED, THOMAS (Richard Edgar Løvstrøm)
b. June 18, 1889, Naestved, Denmark. **d.** August 15, 1968, West Nyack, N.Y. **Studied:** Sorbonne. Traveled Europe, USA. **Awards:** Hon. Ph.D., Philadelphia College of Art, 1968. **Group:** MOMA, Fifteen Americans, circ., 1952; Stockholm/National, Art in Motion, 1961; Eindhoven, Kunst-Licht-Kunst, 1966; Walker and Milwaukee, Light Motion Space, 1967; Trenton/State, Focus on

Light, 1967; The Howard Wise Gallery, NYC, Lights in Orbit, 1967, and Festival of Lights, 1968; Worcester/AM, Light and Motion, 1968. **Collections:** Clairol, Inc.; Cleveland/MA; Honolulu Academy; MMA; MOMA; Omaha/Joslyn. **Bibliography:** Davis, D.; Rickey; Rubin 1.

WILKE, ULFERT
from 1st to 5th edition.

WILLENBECHER, JOHN
b. May 5, 1936, Macungie, Pa. **Studied:** Brown U. (with William Jordy, George Downing), BA, 1958; NYU (with Craig Hugh Smyth), 1958-61. Traveled Europe. **Taught:** Philadelphia College of Art, 1972-73; U. of Wisconsin, Milwaukee, 1981. Designed decor for Andre de Groat and Dancers, *Brushes of Conduct,* 1979; presented outdoor sculpture performance, Artpark, 1978. **Awards:** MacDowell Colony Grant, 1974; MacDowell Colony Fellowship, 1974, 80; National Endowment for the Arts, grant, 1977; **Address:** 145 West Broadway, NYC 10013. **One-man Exhibitions:** (first) Feigen-Herbert Gallery, NYC, 1963; Feigen-Palmer Gallery, Los Angeles, 1964; Richard Feigen Gallery, Chicago, 1964, 68, NYC, 1965, 67; A.M. Sachs Gallery, NYC, 1973, 75; Syracuse/Everson, 1975; Brown U., 1975; Arts Club of Chicago, 1976; Hamilton Gallery of Contemporary Art, NYC, 1977 (two-man), 79; Wright State U., 1977; U. of Massachusetts, 1977; Dartmouth College, 1977; U. of Rhode Island, 1978. **Retrospective:** Purchase/SUNY, 1979. **Group:** Buffalo/Albright, Mixed Media and Pop Art, 1963; ICA, U. of Pennsylvania, Current Art, 1965; RISD, 1965; WMAA, Young America, 1965; Eindhoven, Kunst-Licht-Kunst, 1966; U. of Illinois, 1967; WMAA Annual, 1968; Brooklyn Museum Print Exhibition, 1970; Indianapolis, 1970; Finch College, NYC, Projected Art, 1971; Rice U., Gray Is the Color, 1974; U. of North Carolina, Works on Paper, 1974; AAAL, 1974; Purchase/SUNY, Images of

Power, Sources of Energy, 1975; U. of California, Santa Barbara, Contemporary Tableau/Construction, 1977; Taft/Museum, Galaxies, 1978; Queens Museum, Private Myths: Unearthings of Contemporary Art, 1978. **Collections:** Alberta College of Art; AT&T, NYC; Austin; Brown U.; Boise-Cascade Corp.; Buffalo/Albright; Champion Paper, Inc.; Chase Manhattan Bank; Chicago/AI; Cornell U.; Hirshhorn; U. of Massachusetts; MMA; Paris/Beaubourg; PMA; U. of Pennsylvania; Purchase/SUNY; RISD; Ridgefield/Aldrich; SRGM; Syracuse/Everson; U. of Texas; 3M Company; WMAA. **Bibliography:** *John Willenbecher.*

WILLIAMS, HIRAM
from 1st to 4th edition.

WILLIAMS, NEIL
from 2nd to 5th edition.

WILLIAMS, WILLIAM T.
b. July 17, 1942, Cross Creek, N.C. **Studied:** City U. of New York; New York City Community College, AAS, 1960-62; Skowhegan School of Painting and Sculpture, 1965; Pratt Institute, BFA, 1962-66; Yale U., MFA, 1966-68. **Taught:** Pratt Institute, Brooklyn, 1970; School of Visual Arts, NYC, 1970; Brooklyn College, 1971-. **Awards:** National Endowment for the Arts, grant, 1965, 70; CAPS, 1975; Director pro tem., Skowhegan School of Painting and Sculpture, 1979; Guggenheim Foundation Fellowship, 1987. **Address:** 654 Broadway, NYC 10012. **One-man Exhibitions:** Reese Palley Gallery, NYC, 1971; Fisk U., 1975; Carlton Gallery, NYC, 1976; Illinois State U., 1976; Miami-Dade Community College, 1977; U. of Wisconsin, Menomonie, 1979; U. of Wisconsin, Madison, 1980. **Retrospective:** Studio Museum, 1992. **Group:** Studio Museum, NYC, X to the Fourth Power, 1969; WMAA Biennial, 1969; Foundation Maeght, St. Paul de Vence, L'Art vivant aux États-Unis, 1970; WMAA, Structure

of Color, 1971; Rice U., The Deluxe Show, 1971; U. of Utah, Drawings by New York Artists, circ., 1972; Hartford/Wadsworth, Extensions, 1974; Fisk U., Amistad II: Afro-American Art, 1975; National Museum, Lagos, Second World Black and African Festival of Art and Sculpture, 1977; Studio Museum, NYC, Another Generation, 1979; P.S. 1, Long Island City, Afro-American Abstraction, 1980. **Collections:** Chase Manhattan Bank, NYC; Colby College; Cornell U.; Fisk U.; Hartford/Wadsworth; MOMA; Morgan State U.; Schomberg Center for Research in Black Culture, NYC; Syracuse/Everson; WMAA; Yale U.

WILLIS, THORNTON **b.** May 25, 1936, Pensacola, Fla. **Studied:** Auburn U., with David Brisson; U. of Southern Mississippi, 1962, BS; with W. Lock, V. Merrifield; U. of Alabama, 1966, MFA; with Anita Granata, Melville Price. US Marines, 1954-57. Traveled Scandinavia. **Taught:** U. of Southern Mississippi; Wagner College; U. of New Orleans, 1972-73; Louisiana State U., 1983. **Member:** Artists Equity. **Awards:** Guggenheim Foundation Fellowship, 1978; National Endowment for the Arts, 1980; Gottlieb Foundation Grant, 1991. **m.** Vared Lieb. **Address:** 85 Mercer Street, NYC 10012. **Dealer:** Twining Gallery, NYC. **One-man Exhibitions:** (first) Henri Gallery, Washington, D.C., 1968, 87; Palley & Lowe Gallery, NYC, 1970; 55 Mercer Street Gallery, NYC, 1971; Galerie Simone Stern, New Orleans, 1972; Galerie Nordenhake, Malmo, 1980, 83; Oscarsson Hood Gallery, NYC, 1980, 82, 84; Marianne Deson Gallery, Chicago, 1981; Eason Gallery, Santa Fe, 1982; Nina Freudenheim, Buffalo, 1982; Galerie Gonet, Lausanne, 1982; Gloria Luria Gallery, Bay Harbor Islands, Fla., 1985; Oscarsson Siegeltuch Gallery, NYC, 1986; Twining Gallery, NYC, 1991. **Group:** NYU, American Painting: The Eighties, 1979; Cornell U., Painting Up Front, 1981; MOMA, New

Art II: Surfaces/Textures, 1981; MOMA, International Survey of Recent Painting and Sculpture, 1984. **Collections:** Buffalo/Albright; Carnegie Mellon U.; Chase Manhattan Bank; Cornell U.; Denver/AM; MOMA; Musée des Beaux Arts, Chaux-de-Fonds, Switzerland; Denver/AM; New Orleans Museum; Phillips; U. of Rochester; SRGM; U. of Sydney; WMAA.

WILMARTH, CHRISTOPHER
b. June 11, 1943, Sonoma, Calif. **d.** November 19, 1987, Brooklyn, N.Y. **Studied:** Cooper Union, 1960-62, 1964, 65, BFA. Traveled Europe, Peru, Romania. **Taught:** Cooper Union, 1969-80; Yale U., 1971-72; Columbia U., 1976-78. **Awards:** National Endowment for the Arts, 1968; Guggenheim Foundation Fellowship, 1970, 83; Chicago/AI, Norman Wait Harris Award, 1972; Brown U., Howard Foundation Fellowship, 1972; National Endowment for the Arts, grant 1977, 80; American Institute of Graphic Arts, certificate of excellence, 1983; Connecticut Art Directors Club, first place, 1985. **One-man Exhibitions:** (first) The Graham Gallery, NYC, 1968; Paula Cooper Gallery, NYC, 1971, 72; Galleria dell'Ariete, 1973; Janie C. Lee Gallery, Dallas and Houston, 1974; Weinberg Gallery, San Francisco, 1974; Rosa Esman Gallery, NYC, 1974; Hartford/Wadsworth, 1974, 77; St. Louis/City, 1975; Galerie Aronowitsch, Stockholm, 1975; Daniel Weinberg Gallery, San Francisco, 1978; Studio for the First Amendment, NYC, 1978, 80, 82; NYU, 1978; Seattle/AM, 1979; André Emmerich Gallery, NYC, 1978; Hirschl & Adler Modern, 1984, 86, 90. **Group:** WMAA, 1966, 68, 70, 73; Park Place Gallery, NYC, 1966; Foundation Maeght, 1970; Chicago/AI, 1972; MOMA, 1972, 74; MMA, 1974; Hayward Gallery, London, 1975; WMAA, 20 Years of American Sculpture, 1976; PMA, Eight Artists, 1978; WMAA Biennial, 1979; Buffalo/Albright, Eight

Christopher Wilmarth, *Corner Skin*, 1977.

Sculptors, 1979; MOMA, Contemporary Sculpture, 1979; Carnegie, International, 1983. **Collections:** Buffalo/Albright; Carnegie; Chicago/AI; Dallas/MFA; Denver/AM; Des Moines; Hartford/Wadsworth; Harvard U.; MMA; MOMA; NYU; Phoenix; Rice U.; PMA; Princeton U.; RISD; Seattle/AM; SFMA; St. Louis/City; Toledo/MA; Walker; Wichita/AM; WMAA; Woodward Foundation; Yale U. **Bibliography:** *Christopher Wilmarth: Layers;* Hughes.

WILSON, JANE b. April 29, 1924, Seymour, Iowa. **Studied:** State U. of Iowa, with Stuart Edie, James Lechay, Mauricio Lasansky, 1945, BA, PBK, 1947, MA (painting). Traveled Mexico, USA extensively, Europe. **Taught:** State U. of Iowa, 1947-49; Parsons School of Design, NYC, 1971-83; Columbia U., 1975-; Cooper Union, 1977-78; U. of Iowa, 1974; Pratt Institute, 1967-69; Columbia U., 1986-88; and privately. **Member:** NAD. **Awards:** Ingram Merrill Foundation Grant, 1963; L.C. Tiffany Grant, 1967; NAD, Ranger Fund P.P., 1977; AAIAL, Childe Hassam P.P., 1972, 73, 81; AAIAL, Award in Art, 1981, 1985; NAD, Adolph and Clara Obrig Prize, 1985, 87; NAD, Benjamin Altman Prize, 1990; Guild Hall, Spaeth Award for Painting, 1988. **Address:** 317 West 83rd Street, NYC 10024. **Dealer:** Fischbach Gallery, NYC. **One-man Exhibitions:** St. John's College, Annapolis, Md., 1951; Hansa Gallery, NYC, 1953, 55, 57; Esther Stuttman Gallery, NYC, 1958, 59; Tibor de Nagy Gallery, 1960-66; Gump's Gallery, 1963; Esther Baer Gallery, Santa Barbara, 1963, 64; The Graham Gallery, NYC, 1968, 69, 71, 73, 75; Fischbach Gallery, NYC, 1978, 81, 84, 85, 88, 90, 91; Sordoni Art Gallery, Wilkes-Barre, 1979; Bowling Green State U., 1971; Benson Gallery, East Hampton, N.Y. 1974; Westark Community College, 1976; Port Washington Public Library, 1979; Utica, 1980; Cornell U., 1982; Compass Rose Gallery, Chicago, 1988; Bachalier Cardonsky, Kent, Ct., 1988; American U., 1989; Benton Gallery, Southampton, 1989; U. of Virginia, 1990; Earl McGrath Gallery, Los Angeles, 1990; Dartmouth College, 1991. **Group:** Chicago/AI, 1946; The Stable Gallery Annuals, 1951, 52; MOMA, New Talent, circ., 1957-59; WMAA Annual, 1962; A.F.A., circ., 1963; MIT; Corcoran; New York World's Fair, 1964-65; Huntington, N.Y./Heckscher, The New Landscape, 1970; New York Cultural Center, The Realist Revival, 1972; Queens Museum, New Images, 1974; William and Mary College, American Realists, 1978; Hirshhorn, The Fifties: Aspects of Painting in New York, 1980; NAD, Next to Nature, 1981; Houston/Contemporary, American Still Life, 1945-1983, 1983; The Artists' Choice Museum, NYC, The First Eight Years, 1984; Loch Haven Art Center, Contemporary Romantic Landscape Painting, 1986; U. of Northern Iowa, The Homecoming Exhibition, 1986; NAD, Annual, 1987, 89, 91; U. of Massachusetts, Still Life Painting, 1987; Southampton/Parrish, Drawings on the East End, 1940-1988, 1988; U. of North Carolina, Art on Paper, 1988; Florida International U., American Art Today, 1989; Tampa/MA, At the Water's Edge, circ., 1989; Brooklyn College, The 1950s at the Tibor de Nagy Gallery, 1990; NAD, The Artist in the Garden, 1991; Miyagi Museum of Art, Sendai, Japan, American Realism, circ., 1991. **Collections:** Allied Bank, Dallas; Ashland Oil; Carnegie Corp., NYC; Chase Manhattan Bank; Chemical Bank; Cincinnati/AM; The Commerce Bank of Kansas City; Corcoran; Guild Hall; Hartford/Wadsworth; Hirshhorn; Indianapolis/Herron; Kalamazoo/Institute; MMA; MOMA; NAD; NYU; National Bank of Commerce, Dallas; Rockefeller Institute; Oneonta/SUNY; PAFA; Parker Pen Co.; The Singer Company, Inc.; Sofia; Southampton/Parrish; Uris Buildings Corp.; Vassar College; WMAA.

WINTERS, TERRY b. 1949, Brooklyn, N.Y. **Studied:** Pratt Institute, BFA, 1971. **Address:** 44 White Street, NYC, 10013. **Dealer:** Sonnabend Gallery, NYC. **One-man Exhibitions:** Sonnabend Gallery, NYC, 1982, 84, 86, 87, 90; Reed College, 1983; Jean Bernier, Athens, 1983; Daniel Weinberg Gallery, Los Angeles, 1984, 87; Lucerne, 1985; Yellowstone Art Center, 1986; Barbara Krakow Gallery, NYC, 1986; Tate, 1986; Castelli Graphics, NYC, 1986; Galerie Mukai, Tokyo, 1987, 89, 90; MIT, 1987; Boston/MFA, 1987;

Jane Wilson, *American Light,* 1991.

St. Louis/AM, 1987; Georgia State U., 1987; Galerie Max Hetzler, Cologne, 1988, 90, 91; U. of California, Santa Barbara, 1988; Milwaukee, 1989; Editions Ilene Kurtz, NYC, 1989; The New van Straaten Gallery, Chicago, 1991. **Retrospective:** Los Angeles/MOCA, circ., 1991. **Group:** AAIAL, 1982; The Drawing Center, NYC, New Drawing in America, 1982; Baltimore/MA, New Image, 1982; Tate Gallery, New Art, 1983; MIT, Affinities, 1983; Long Island U., Reflections, 1984; MOMA, An International Survey of Recent Painting and Sculpture, 1984; WMAA, Biennial, 1985; Cologne, Ludwig, Europa-Amerika, 1986; Brooklyn Museum, Monumental Drawing, 1986; Fort Lauderdale, An American Renaissance, 1986; Brooklyn Museum, Public and Private, 1986; WMAA, Three Printmakers, 1986; Laforet Museum, Tokyo, Correspondences, 1986; Royal Society of Edinburgh, International, 1987; Kansas City/AI, Drawn Out, 1987; Carnegie Mellon U., Drawings from the Eighties, 1987; WMAA, Biennial, 1987; Sonoma State U., The Monumental Image, 1987; MOMA, Watercolors, 1988; SRGM, Viewpoints, 1988; Dublin, ROSC '88, 1988; Walker, First Impressions, 1989; Wright State U.,

Science/Technology/Abstraction, 1989; Kansas City/Nelson, Organic Abstraction, 1990; Graphische Sammlung Albertina, Amerikanische Zeichnungen in der achtziger Jahren, 1990; Museo de Arte Contemporanea de Monterey, Mito Y Magia en America, 1991; Museo d'Arte Contemporanea di Trento, American Art of the '80s, 1992. **Collections:** Boston/MFA; WMAA; Walker.

WIRSUM, KARL b. September 27, 1939, Chicago, Ill. **Studied:** Chicago Art Institute School, 1961, BFA, 1966. **Address:** 1936 W. Bradley, Chicago, IL 60613. **Dealer:** Phyllis Kind Gallery, Chicago and NYC. **One-man Exhibitions:** Dell Gallery, Chicago, 1967; St. Xavier College, 1970; Wabash Transit Gallery, Chicago, 1971; Phyllis Kind Gallery, Chicago, 1974, 76, 78, 84, 86, 88, 89, 92; Phyllis Kind Gallery, NYC, 1977, 79, 86, 88; Chicago/Contemporary, 1980; Southeastern Center for Contemporary Art, Winston-Salem, N.C., 1982; College of DuPage, 1988. **Group:** Hyde Park Art Center, Chicago, The Hairy Who, 1966, 67, 68; WMAA Biennial, 1968; Chicago/Contemporary, Paintings to Be Read, Poetry to Be Seen, 1968; Chicago/Contemporary, Don Baum Sez, "Chicago Needs Famous Artists," 1969; ICA, U. of Pennsylvania, Spirit of the Comics, 1969; WMAA, Human Concern/Personal Torment, 1970; Chicago/Contemporary, Chicago Imagist Art, 1972; Ottawa/Ontario, What They're Up to in Chicago, 1972; São Paulo, XII Biennial, 1973; Chicago/AI, Former Famous Alumni, 1976; Sacramento/Crocker, The Chicago Connection, 1977; U. of North Carolina, Some Recent Art from Chicago, 1980; Ridgefield/Aldrich, New Dimensions in Drawing, 1981; P.S. 1, Figuratively Sculpting, 1981; Sunderland Arts Center, England, Who Chicago?, circ., 1980; Kansas City/AI, Chicago Imagists, circ., 1982; Indianapolis, Painting and Sculpture Today, 1982; Southern Ohio Museum, Portsmouth, The Last Laugh,

circ., 1983; U. of Tennessee, Contemporary Works on Paper, 1984; Chicago/AI, Chicago and Vicinity Drawing Exhibition, 1985; Laforet Museum, Tokyo, Correspondences, circ., 1985; ICA, London, Komik Ikonoklasm, circ., 1986; U. of Chicago, Drawings of the Chicago Imagists, 1987; U. of Chicago, The Chicago Imagist Print, 1987; Chicago/Terra, Surfaces, 1987; Bowling Green State U., Of New Account, 1987; Chicago Cultural Center, Urgent Messages, 1987; U. of California, Berkeley, Made in USA, 1987; U. of Wisconsin, Milwaukee, Seymour Rosofsky and the Chicago Imagist Tradition, 1988; Youngstown/Butler, California A to Z and Return, 1990; Central Washington U., 1990 Drawing Invitational, 1990; Milwaukee, Word as Image, circ., 1990; Western Illinois U., Illinois Painter's Invitational, 1992; School of the Chicago Art Institute, From America's Studio, 1992. **Collections:** AT&T; Arthur Anderson & Co.; Ball State U.; Chase Manhattan Bank; U. of Chicago; Chicago/AI; Chicago/Contemporary; Citibank; Elmhurst College; First National Bank of Chicago; U. of Illinois; Kalamazoo/Institute; Museum des 20. Jahrhunderts, Vienna; NMAA; U. of North Carolina; Northwestern Illinois U.; Springfield, Ill./State; WMAA. **Bibliography:** Adrian 1; Adrian and Born; Rose 2; *The Chicago Connection;* Kirschner; *Who Chicago?*

WITKIN, ISAAC **b.** May 10, 1936, Johannesburg, South Africa. To England, 1956; USA citizen, 1975. **Studied:** St. Martin's School, London, 1957-60, with Anthony Caro; assistant to Henry Moore, 1962-63. **Taught:** Maidstone College of Art, Kent, England, 1963; St. Martin's School of Art, 1963-65; Ravensbourne School of Art, 1964-65; Bennington College, 1965; Philadelphia College of Art; Parsons School of Design, NYC, 1975-. **Member:** Artists Equity; International Sculpture Center. **Address:** 137 Scrapetown Road, Pemberton, NJ

08068. **Dealer:** Marian Locks Gallery, Philadelphia. **One-man Exhibitions:** Rowan Gallery, London, 1963; Robert Elkon Gallery, NYC, 1965, 67, 69, 71, 73; Waddington Gallery, London, 1966, 68; Bridgeport U., 1970; Marlborough Gallery, NYC, 1975, 76, 78; Keene/Thorne, 1977; Tanglewood Music Festival, 1977; Hamilton Gallery of Contemporary Art, NYC, 1979; Dag Hammerskjold Plaza, NYC, 1981; McIntosh/Drysdale Gallery, Washington, D.C., 1982; Mattingly Baker Gallery, Dallas, 1982; Hirschl & Adler Modern, NYC, 1984, 85, 88; Jan Turner Gallery, Los Angeles, 1989; Patricia Hamilton at 112 Greene Street, NYC, 1990; Marian Locks Gallery, Philadelphia, 1991; Walker Hill Art Center, Seoul, 1992. **Retrospective:** Bennington College, 1971. **Group:** Whitechapel Art Gallery, London, The New Generation, 1965; Smith College, Inside Outside, 1965; Jewish Museum, NYC, Primary Structures, 1965; Paris Biennale, 1965; Sonsbeek, Holland, Open Air Sculpture, 1966; Amsterdam/Stedelijk, Nine English Sculptors; Hayward Gallery, London, Sculpture of the 60's, 1970; Storm King Art Center, Indoor Sculpture, Outdoors, 1973; Hayward Gallery, London, Condition of Sculpture, 1975; Hirshhorn, The Golden Door, 1976; AAAL, 1977; Indianapolis, 1978; Carnegie, International, 1983; Williams College, Six in Bronze, circ., 1984; Newark Museum, American Bronze Sculpture, 1850 to the Present, 1984; Sonoma State U., Works in Bronze, A Modern Survey, circ., 1984. **Collections:** American Republic Insurance Co.; Carnegie; Chase Manhattan Bank; Columbus; Federal Reserve Bank, Washington, D.C.; Hirshhorn; U. of Illinois; La Guardia Community College; Laumeier Sculpture Park; Milwaukee; MIT; NMAA; SFMA; Seoul/Contemporary; Storm King Art Center; U. of Sydney; Tate Gallery; City of Trenton; Vassar College; Wichita; Williams College; Wilmington; Worcester/AM.

WITKIN, JEROME b. September 13, 1939, Brooklyn, N.Y. **Studied:** High School of Music and Art, NYC, 1953-57; Cooper Union, 1957-60, with Nicholas Marsicano; Berlin Academy, 1961; U. of Pennsylvania, 1968-70, MFA. Traveled Europe. Resided Italy, 1960-62; Manchester, England, 1966-68. **Taught:** Maryland Institute; Moore College of Art, Philadelphia; American College, Switzerland; Syracuse U. **Member:** NAD. **Awards:** Guggenheim Foundation Fellowship, 1963; Pulitzer Fellowship, 1960. **Address:** 435 Whittier Avenue, Syracuse, NY 13204. **Dealer:** Sherry French Gallery, NYC. **One-man Exhibitions:** (first) Morris Gallery, NYC, 1962; Lake Erie College, 1971; Kraushaar Galleries, NYC, 1973, 76, 82; Cortland/SUNY, 1977; Lake Placid Center for the Arts, 1978; Pennsylvania State U., 1978; U. of New Hampshire, 1981; Oswego/SUNY, 1981; Syracuse Stage, 1984; Sherry French Gallery, NYC, 1985, 87; Columbia College of Art (two-man), 1985; Greenville, 1987; U. of Connecticut, 1988; Ivory/Kimpton Gallery, San Francisco, 1988; Kimpton Gallery, San Francisco, 1990; Oxford Gallery, Rochester, N.Y., 1990; Rutgers U., 1992. **Retrospectives:** The Pennsylvania State U., circ., 1983; Community College of the Finger Lakes, 1985; U. of Richmond, circ., 1986. **Group:** Yale U., American Drawing: 1970-1973, 1973; Lincoln, Mass./De Cordova, Candid Painting: American Genre 1950-75, 1975; San Antonio/MA, Real, Really Real, Super Real, circ., 1981; Utica, An Appreciation of Realism, 1982; NAD, 1985; Florida International U., American Art Today: Narrative Painting, 1988. **Collections:** Ball State U.; Canton Art Institute; Cleveland/MA; Columbia, S.C./MA; Cortland/SUNY; Delaware Art Museum; Exeter; Hirshhorn; Lake Erie College; La Salle College; Little Rock/MFA; MMA; U. of Maine; Miami-Dade College; Minnesota/MA; NAD; U. of New Hampshire; U. of North Carolina; Palm Springs Desert Museum; The Penn-

sylvania State U.; Rhode Island College; U. of Rochester; Syracuse/Everson; Syracuse U.; Uffizi Gallery; Youngstown/Butler.

WOELFFER, EMERSON b. July 27, 1914, Chicago, Ill. **Studied:** Chicago/AI School, with Francis Chapin, Boris Anisfeld, 1935-37, BA. US Air Force, 1939-42. Traveled USA, Mexico and Europe extensively. **Taught:** New Bauhaus, Chicago, 1941-49; Black Mountain College, 1949; Chouinard Art Institute, 1959; Colorado Springs Fine Arts Center; Southern Illinois U., 1962; California Institute of the Arts, Valencia, 1969-73; Honolulu Academy, 1970; Otis Art Institute, 1974-89; Parsons School of Design, Paris, summer, 1980. Federal A.P.: Easel painting and project assistant. **Awards:** SFMA, Hon. Men., 1948; Chicago/AI, Pauline Palmer Prize, 1948; Tamarind Fellowship, 1961, 70; US State Department Grant (Turkey), 1965; Guggenheim Foundation Fellowship, 1967-68; PAFA, Raymond A. Speiser Memorial Prize, 1968; Los Angeles All-City show, **P.P.**, 1968; Tamarind Institute, grant, 1983; Pollock-Krasner Foundation, grant, 1985; SRGM, Francis Greenberger Award, 1988; Otis Parsons Art Institute, Hon. Ph.D., 1991. **Address:** 475 Dustin Drive, Los Angeles, CA 90065. **Dealer:** Manny Silverman Gallery, Los Angeles. **One-man Exhibitions:** Bennington College, 1938; 740 Gallery, Chicago, 1946; Black Mountain College, 1949; Chicago/AI, 1951; Margaret Brown Gallery, Boston, 1951; Artists Gallery, NYC, 1951, 54; Paul Kantor Gallery, Beverly Hills, Calif., 1956, 60; Poindexter Gallery, NYC, 1959, 61, 75; Primus-Stuart Gallery, Los Angeles, 1961; La Jolla, 1962; Quay Gallery, 1968; David Stuart Gallery, 1969; Jodi Scully Gallery, 1972, 73; Phillips, 1974; Abe Adler Gallery, Los Angeles, 1978; Gruenebaum Gallery, NYC, 1979, 82, 84; ICA, San Jose, 1983; Wenger Gallery, Los Angeles, 1987; Manny Silverman Gallery, Los Angeles, 1990, 92; James Corcoran Gallery, Los Angeles, 1992.

Retrospectives: Pasadena/AM, 1962; Newport Harbor, 1974; California State U., Fullerton, 1982; Otis Parsons Art Institute, Los Angeles, 1992. **Group:** WMAA, Six American Painters 1947, 49; Salon des Réalites Nouvelles, Paris, 1948; ICA, Boston, 1950; MIT, Four Americans, 1952; Corcoran, 1952; Carnegie, 1952, 54, 55, 58; Houston/MFA, 1957; SRGM, 1962; WMAA, Fifty California Artists, 1962-63; Los Angeles/County MA, Post Painterly Abstraction, 1964; PAFA, 1968; Chicago/AI, 100 Artists—100 Years, 1979; Conejo Valley Art Museum, Thousand Oaks, Calif., 50s Abstract, 1980; Los Angeles/County MA, Los Angeles Prints, 1883-1990, 1980; Laguna Beach Museum of Art, Southern California Artists, 1981; Monterey Peninsula Museum of Art, California Contemporary, Recent Work of Twenty-Three Artists, 1983; Santa Fe, N.M., Paradox, 1991; Claremont College, American Abstract Drawings, 1992. **Collections:** ARCO; Amon Carter Museum; Avco Corp.; Baltimore/MA; Bibliothèque Nationale; California State U., Los Angeles; U. of California, Berkeley; Chicago/AI; Colorado Springs/FA; Dresdener Bank; Fort Worth; Honolulu Academy; U. of Illinois; U. of Iowa; Kansas City/AI; La Jolla; Los Angeles/County MA; MOMA; Milwaukee; New Orleans/Delgado; Newport Harbor; Pasadena/AM; Raleigh/NCMA; SFMA; Seattle/AM; UCLA; WGMA; WMAA. **Bibliography:** Ward. Archives.

WOFFORD, PHILIP b. August 14, 1935, Van Buren, Ark. **Studied:** U. of Arkansas, 1957, BA; U. of California, 1958. **Taught:** NYU, 1964-68; Bennington College, 1969-. **Awards:** Oakland Museum Bronze Medal, 1958; Woodrow Wilson Foundation Fellowship, 1957; National Endowment for the Arts, grant, 1974; CAPS, 1977. **Address:** RD #2, Hoosick Falls, NY 12090. **Dealer:** Frumkin/Adams Gallery, NYC. **One-man Exhibitions:** Green Gallery, NYC, 1962;

Allan Stone Gallery, NYC, 1964; David Whitney Gallery, NYC, 1970, 71; André Emmerich Gallery, NYC, 1972, 74, 76; Little Rock/MFA, 1973; Corcoran, 1972; Yale U., 1973; Pyramid Gallery, Washington, D.C., 1974; Windham College, 1974; Bennington College, 1975; Berenson Gallery, Bay Harbor Islands, 1976; Max Hutchinson Gallery, Houston, 1978; Osuna Gallery, Washington, D.C., 1979; Nancy Hoffman Gallery, NYC, 1979, 81, 83, 86; Carnegie, 1982; Frumkin/Adams Gallery, NYC, 1988, 89, 90, 91, 92; Eugene Binder Gallery, Dallas, 1988; Arthur Roger Gallery, New Orleans, 1989. **Group:** SFMA, 1958; Oakland/AM, 1958; Yale U., Young New York Painters, 1964; WMAA, 1969, 72, 73; WMAA, Lyrical Abstraction, 1971; Corcoran, The Way of Color, 1973; U. of Illinois, 1974; U. of Vermont, Landscape Images, 1976; MOMA, New Art II: Surfaces/Textures, 1981; Brooklyn Museum, American Drawing in Black and White, 1970-1980, 1980; Cranbrook, Viewpoint 86, 1986; Skidmore College, Out of Abstract Expressionism, 1991. **Collections:** Atlantic Richfield Corp.; Brooklyn Museum;

Philip Wofford, *Sash,* 1991.

Canberra/National; Carnegie; Columbus, Ga.; Corcoran; Northside Parklane National Bank; Owens-Corning Fiberglas Corp.; Prudential Insurance Co., St. Louis; RISD; Ridgefield/Aldrich; Seattle/AM; Syracuse/Everson; U. of Texas; WMAA. **Bibliography:** Siegel.

WOLFE, JAMES MARTIN
b. April 28, 1944, NYC. Autodidact. **Taught:** School of Visual Arts, NYC, 1979; Virginia Polytechnic and State U., 1978; Boston Museum School, 1980-81. **Commissions:** Johnstown (Pa.) Centennial, The James Wolfe Sculpture Trail, 10 sculptures, 1989. **Awards:** National Endowment for the Arts, 1974; Augustus Saint Gaudens Prize, 1984. **Address:** 2282 Manning Avenue, Los Angeles, CA 90064. **Dealer:** André Emmerich Gallery, NYC. **One-man Exhibitions:** (first) André Emmerich Gallery, NYC, 1973, 75, 76, 85, 86, 88; Meredith Long Contemporary Art, NYC, 1978, 79; Osuna Gallery, Washington, D.C., 1980; Virginia Polytechnic Institute and State U., 1981; Stephen Rosenberg Gallery, NYC, 1982, 83; Phillips Collection, 1986; Baumgartner Gallery, Washington, D.C., 1986, 88; Wentzel Gallery, Cologne, 1987; Rubiner Gallery, West Boomfield, Mich., 1987; Innenhof des Histrorischen Rathauses, Cologne, 1988; Don Stewart Gallery, Montreal, 1988; Galerie Am Tiergarten 62, Cologne, 1989; Lucy Berman Gallery, Palo Alto, Calif., 1990. **Group:** Phillips, Contemporary Sculpture, 1972; Dartmouth College, New England Sculpture, 1973; Cleveland/MA, Contemporary American Artists, 1974; Newport, R.I., Monumenta, 1974; Indianapolis, 1977; Houston/MFA, A Century of Modern Sculpture, 1882-1982, 1983; St. Lawrence U., Pre-Postmodern: Good in the Art of Our Time, 1985; AAIAL, 1987; Williams College, BIGlittle Sculpture, 1988; Philadelphia Art Alliance, Back to the Wall, 1989. **Collections:** American Airlines; American Express Corp.; Bethlehem Steel;

Boston/MFA; Cambria County Transit Authority; Edmonton Art Gallery; Exeter; Fort Wort; Harvard U.; Hirshhorn; Houston/MFA; Huntington, Va.; Michigan State U.; Mobil Oil Co.; NYNEX; Storm King Art Center; Syracuse U.; WMAA.

WOLFF, ROBERT
from 1st to 4th edition.

WOLFSON, SIDNEY
from 1st to 4th edition.

WONNER, PAUL JOHN
b. April 24, 1920, Tucson, Ariz. **Studied:** California College of Arts and Crafts, 1937-41, BA; ASL, 1947; U. of California, Berkeley, 1950-53, MA, 1955, MLS. US Army, 1941-45. Traveled Europe. **Taught:** U. of California, Berkeley, 1952-53, Los Angeles, 1962-63; Otis Art Institute, 1965-68; College of Creative Studies, 1968-71; Art Center, Los Angeles, 1973; California State U., Long Beach, 1975 and 81; U. of California, Davis, 1975-76; U. of Hawaii, 1978. **Commission:** San Francisco, Moscone Center, mural, 1981-82. **Address:** 468 Jersey Street, San Francisco, CA 94994. **Dealer:** John Berggruen Gallery, San Francisco. **One-man Exhibitions:** (first) de Young, 1955; San Francisco Art Association, 1956; Felix Landau Gallery, Los Angeles, 1959, 60, 62, 63, 64, 68, 71; Santa Barbara/MA, 1960; California Palace, 1961; Poindexter Gallery, NYC, 1962, 64, 71; Esther Baer Gallery, Santa Barbara, 1964 (two-man, with William T. Brown); San Antonio/McNay, 1965; Waddington Gallery, London, 1965; The Landau-Alan Gallery, NYC, 1967; Charles Campbell Gallery, 1972; Jodi Scully Gallery, 1973; John Berggruen Gallery, San Francisco, 1978, 81, 86, 88, 90; California State U., Long Beach, 1981; James Corcoran Gallery, Los Angeles, 1979, 80; Hirschl & Adler Modern, NYC, 1983, 87. **Group:** SRGM, Younger American Painters, 1954; III São Paulo Biennial, 1955; Walker, Vanguard, 1955; Oak-

land/AM, Contemporary Bay Area Figure
Painting, 1957; Festival of Two Worlds,
Spoleto, 1958; Carnegie, 1958, 64;
ART:USA:59, NYC, 1959; WMAA Annu-
als, 1959, 67; U. of Illinois, 1961, 63;
Chicago/AI Annuals, 1961, 64; VMFA,
American Painting, 1962; MOMA, Recent
Painting USA: The Figure, circ., 1962-63;
Denver/AM, 1964; Carnegie, Interna-
tional, 1964; U. of Oklahoma, East
Coast–West Coast Paintings, 1968; Oma-
ha/Joslyn, Looking West, circ., 1970; La
Jolla, Continuing Art, 1971; Eindhoven,
Relativerend Realisme, 1972; U. of
Illinois, 1974; SFMA, California Painting
and Sculpture: The Modern Era, 1976.
Collections: Chattanooga/Hunter;
Hirshhorn; Lytton Savings and Loan Asso-
ciation; MMA; MOMA; Minneapolis/In-
stitute; NCFA; U. of Nebraska; U. of
North Carolina; Oakland/AM; Reader's
Digest; SFMA; SRGM. **Bibliography:**
Arthur 3; Nordness, ed.; *The State of Cali-
fornia Painting;* Ward.

WOOD, GRANT b. February 13,
1891, Anamosa, Iowa. **d.** February 12,
1942, Iowa City, Iowa. **Studied:** State U.
of Iowa; Minneapolis School of Design;
Academie Julian, Paris. US Army, 1918-
19. Traveled Germany, France. **Taught:**
Rosedale, Iowa, 1911-12; Jackson, Iowa,
1919-23; Chicago Art Institute School,
1916; State U. of Iowa, 1934-42.
Member: NAD; National Society of
Mural Painters. Federal A.P.: Director,
Iowa Division, 1934. **Commissions:**
Cedar Rapids (Iowa) Memorial Building,
1926-28 (stained-glass window). **Awards:**
Iowa State Fair, First Prize, 1929, 30, 31,
32; Carnegie, 1934; Hon. Ph.D., U. of
Wisconsin; Hon. MA, Wesleyan U.; Hon.
DFA, Lawrence College; Hon. DFA,
Northwestern U. **One-man Exhibitions:**
Ferargil Galleries, NYC, 1935; Lakeside
Press Gallery, Chicago, 1935; Hudson D.
Walker Gallery, NYC, 1936; A.A.A. Galler-
ies, NYC, 1990; Davenport/MA, 1991.
Retrospectives: U. of Kansas, 1959;

Davenport/Municipal, 1966; Cedar Rap-
ids/AA, 1969; Minneapolis/Institute, circ.,
1983. **Group:** Chicago/AI, 1930; Carne-
gie, 1934; Iowa State Fair; WMAA.
Collections: Abbott Laboratories; Cedar
Rapids/AA; Chicago/AI; Dubuque/AA;
MMA; U. of Nebraska; Omaha/Joslyn;
Terre Haute/Swope; WMAA. **Bibliography:**
Armstrong, Thomas; Baigell 1; Barr 3;
Baur 7; Bazin; Beam; Beaton 1; Biddle 4;
Blanchard; Blesh 1; Boswell 1; Brown;
Canaday; Cheney; Christensen; **Corn;**
Craven, T., 1; Cummings 5; Eliot;
Finkelstein; Flanagan; **Garwood;** Gaunt;
Goodrich and Baur 1; Haftman; Hall;
Hunter 6; *Index of 20th Century Artists;*
Kent, R., ed.; Kootz 2; Kouvenhoven; Lee
and Burchwood; McCurdy, ed.; Mellquist;
Mendelowitz; Newmeyer; Pagano; Pearson 1;
Reese; Richardson, E.P.; **Rinard and Pyle;**
Rose, B., 1; Wight. Archives.

WOODMAN, TIMOTHY
b. March 4, 1952, Concord, N.H.
Studied: Skowhegan School of Painting
and Sculpture, 1970; RISD, 1970-71;
Cornell U., BFA, 1974; Yale U., MFA,
1976. **Commission:** W. K. Kellogg Foun-
dation, 1990. **Address:** 140 West Broad-
way, NYC 10013. **Dealer:** The Zabriskie
Gallery, NYC. **One-man Exhibitions:**
Carlton Gallery, NYC, 1977; Robert
Freidus Gallery, NYC, 1978; U. of Virgin-
ia, 1981; Cherrystone Gallery, Wellfleet,
Mass., 1981, 84; The Zabriskie Gallery,
NYC, 1981, 83, 85, 87, 89, 91; Greenberg
Gallery, St. Louis, 1983, 87; Fuller
Goldeen Gallery, San Francisco, 1984;
Asher/Faure Gallery, Los Angeles, 1986.
Group: Pratt Manhattan Center, Sculp-
ture in the Seventies: The Figure, 1980;
Milwaukee, Center Ring, 1981; Palm
Springs Desert Museum, Narrative Sculp-
ture, 1984; Cincinnati/Contemporary,
Body and Soul, 1985; MMA, The 1980s:
A New Generation, 1988. **Collections:**
American Express Corp.; Australian
National Bank; Bank of America; Chemi-
cal Bank; General Mills, Inc.; Hirshhorn;

Manufacturers Hanover Trust Co.; MMA; McCrory Corp.; Memphis/Brooks; Newark Museum; Shearson-Lehman Brothers.

WYETH, ANDREW b. July 21, 1917, Chadds Ford, Pa. Studied: with N. C. Wyeth. Member: NAD; Audubon Artists; NIAL; AAAL. Awards: AAAL, Medal of Merit, 1947; Hon. DFA, Harvard U., 1955; Hon. DFA, Colby College, 1955; Hon. DFA, Dickinson College, 1958; Hon. DFA, Swarthmore College, 1958; Freedom Medal, 1963; Hon. DFA, Princeton U.; Hon. DFA, Tufts U.; Hon. DFA, Franklin and Marshall College; Hon. DFA, Northeastern U.; Hon. DFA, Amherst College; Hon. DFA, Bowdoin College; Hon. DFA, U. of Pennsylvania; Hon. DFA, U. of Delaware; Hon. DFA, La Salle U. Address: Chadds Ford, PA 19317; Cushing, Me. Dealer: ACA Galleries, NYC. One-man Exhibitions: Currier, 1951; Doll and Richards, Boston, 1938, 40, 42, 44, 46; Macbeth Gallery, NYC, 1938, 39, 48; Rockland/Farnsworth, 1951, 63; de Young, 1956, 73; Santa Barbara/MA, 1956; Wilmington, 1957; M. Knoedler & Co., NYC, 1958; MIT, 1960; Buffalo/Albright, 1962; Pierpont Morgan Library, 1963; Corcoran, 1963; Harvard U., 1963; Southampton/Parrish, 1966; PAFA, 1966; WMAA, 1966; Chicago/AI, 1966; Baltimore/MA, 1966; Brandywine Museum, Chadds Ford, Pa., 1971; National Gallery, circ., 1986; ACA Galleries, NYC, 1993. Retrospectives: Tokyo/Modern, circ., 1974; MMA, 1976. Group: Houston/MFA; MOMA; PMA; Wilmington; PAFA, 1938, 39, 41-45, 49-52, 58, 63; WMAA, 1946, 48, 51, 52, 53, 56 57, 59, 63, 64; Carnegie, 1947-50, 52, 55, 58, 61, 64; U. of Illinois, 1948, 49, 63, 65, 69; A.F.A., 1954; Brussels World's Fair, 1958; Tate, 1963. Collections: Andover/Phillips; Boston/MFA; California Palace; Chicago/AI; Colby College; Currier; Dallas/MFA; Hartford/Wadsworth; Houston/MFA; MOMA; McDonnell & Co. Inc.; Montclair/AM; National Gallery; U. of Nebraska; New London; Omaha/Joslyn; Oslo/National; PMA; Rockford/Farnsworth; Utica; Wilmington; Winston-Salem Public Library. Bibliography: *Andrew Wyeth* (two-titles); Anfam; Armstrong, Thomas; Barker 1; Baur 7; Canaday; *8 American Masters of Watercolor;* Eliot; Flanagan; Gaunt; Hoving; Hunter 6; McCurdy, ed.; Mendelowitz; Nordness, ed.; O'Doherty; Pitz; Pousette-Dart, ed.; Richardson, E.P.; Rodman 1, 3; Rose, B., 1; Sachs; Ward; Watson, E.W., 1; **Wilmerding 2;** Wyeth, B.J.

WYETH, JAMES b. July 6, 1946, Wilmington, Del. Delaware Air National Guard, 1966-71. Subject of TV documentary, *A Portrait of Jamie Wyeth,* produced by Nebraska Educational Television, 1975. Address: Lookout Farm, 701 Smith Bridge Road, Wilmington, DE 19807; and Monhegan Island, ME. Dealer: James Graham & Sons, NYC. One-man Exhibitions: (first) M. Knoedler Gallery, NYC, 1966; Coe Kerr Gallery, NYC, 1974, (two-man) 76, 77; Hotel de Paris, Monte Carlo, 1980. Retrospectives: Omaha/Joslyn, 1975; PAFA, circ., 1980. Group: Brandywine River Museum, The Wyeth Family, 1971; PAFA, Contemporary American Realism Since 1960, circ., 1981; Anchorage, circ. 1983. Collections: Birmingham, Ala./MA; Brandywine River Museum; Greenville; Joslyn/Omaha; MOMA; NPG; Rockland/Farnsworth; Wilmington.

X

XCERON, JEAN b. February 24, 1890, Isari, Greece. d. March 29, 1967, NYC. To USA, 1904. **Studied:** The Corcoran School of Art, 1910-16, with George Lohr, Abraham Rattner. Resided Paris, 1927-37. Art reviewer for American newspapers from Paris, 1930-34. **Member:** American Abstract Artists; Federation of Modern Painters and Sculptors. Federal A.P.: Christian Science Chapel, Rikers Island, NYC, 1941-42 (murals). **Commissions:** U. of Georgia, 1947. **Awards:** U. of Illinois, P.P., 1951. **One-man Exhibitions:** (first) Galerie de France, Paris, 1931 (sponsored by Cahiers d'Art); Galerie Percier, Paris, 1933; Galerie Pierre, Paris, 1934; Garland Gallery, NYC, 1935; Karl Nierendorf Gallery, NYC, 1938; Bennington College, 1944; Sidney Janis Gallery, 1950; Rose Fried Gallery, NYC, 1955, 57, 60, 61, 62, 63, 64; The Peridot Gallery, NYC, 1971; Andre Zarre Gallery, NYC, 1975, 77, 80; Kouros Gallery, NYC, 1984. **Retrospectives:** Jean Xceron, circ., seven museums in the Southwest and on the West Coast, 1948-49; SRGM, 1952. **Group:** Independent Artists, NYC, 1921-24; Salon des Surindependents, Paris, 1931-35; New York World's Fair, 1939; Golden Gate International Exposition, San Francisco, 1939; SRGM, 1939-52, 54, 55, 56, 58, 62; American Abstract Artists, 1941-44, 1951-57; Carnegie, 1942, 43, 44, 44, 46, 47, 48, 49, 50, Federation of Modern Painters and Sculptors, 1945, 46, 48, 49, 50, 51, 53, 54, 55, 56; California Palace; WMAA Annuals, 1946, 49, 52, 56; Salon des Réalites Nouvelles, Paris, annually, 1947-52; U. of Illinois, 1948, 49, 50, 52, 55, 57; Houston/MFA, The Sphere of Mondrian, 1957; MOMA, circ., Latin America, 1963-64. **Collections:** Andover/Phillips; Brandeis U.; Carnegie; U. of Georgia; U. of Illinois; Karlsruhe; MOMA; NYU; U. of New Mexico; Phillips; Pittsfield/Berkshire; SRGM; Smith College; WMAA; Washington U.; Wellesley College. **Bibliography:** Bethers; Blanchard; Hess, T.B., 1; Hunter, ed.; Janis and Blesh 1; Kootz 2; Lane and Larsen; Pousette-Dart, ed.; Rickey; Rose, B., 1. Archives.

Y

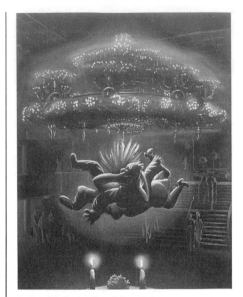

Robert Yarber, *Chandelier*, 1991.

YARBER, ROBERT **b.** 1948,
Dallas, Texas. **Studied:** Cooper Union,
BFA, 1967-71; Louisiana State U., MFA,
1974. **Taught:** U. of California, Berkeley,
1982, 83; U. of Texas, 1982, 83. **Awards:**
National Endowment for the Arts, fellow-
ship, 1983. **Address:** c/o Dealer. **Dealer:**
Sonnabend Gallery, NYC. **One-man Exhi-
bitions:** Bowery Gallery, NYC, 1970; U.
of New Orleans, 1974; Simon Lovinsky
Gallery, San Francisco, 1981; Dominican
College, San Rafael, 1981; Simon
Lovinsky Gallery, Los Angeles, 1981;
Steven Lieber Gallery, San Francisco,
1983; Asher/Faure Gallery, Los Angeles,
1984, 87; Southwest U., 1984; Mattingly
Baker Gallery, Dallas, 1984; Sonnabend
Gallery, NYC, 1985, 87, 90; Reed College,
1985; Thomas Cohn Arte Contempor-
anea, Rio de Janeiro, 1987; Greene Gal-
lery, Coconut Grove, Fla., 1987; The
Pennsylvania State U., circ., 1988; Gallery
Paule Anglim, San Francisco, 1989;
Galerie Langer-Fain, Paris, 1990; Lieber-
man & Saul Gallery, NYC, 1991; Galerie
Faust, Geneva, 1991. **Group:** Dallas/MFA,
Texas Painting and Sculpture Exhibitions,
1967; Smith College, Painterly Realism,
circ., 1971; California State U., San Bernar-
dino, Locations, 1981; Los Angeles/ICA,
Humor in Art, 1981; San Antonio/McNay,
Texas Figure Drawing, 1983; UCLA, Ceçi
n'est pas le surrealisme, circ., 1983; SFMA,
The Human Condition, 1984; Venice
Biennale, 1984; The New Museum, NYC,

Outside New York, 1984; Humboldt State
U., Modern Romances, 1984; WMAA,
Biennial, 1985; Indianapolis, Painting and
Sculpture Today, 1986; U. of New Mex-
ico, The Texas Transfer, 1986; Mid-
dlebury College, Recent American Pastels,
1988; Kuznetsky Most Exhibition Hall,
Moscow, Painting Beyond the Death of
Painting, circ., 1989; Amsterdam/Stedelijk,
Horn of Plenty, 1989; Charlotte/Mint,
In the Looking Glass, 1991. **Bibliography:**
Tomidy.

YEKTAI, MANOUCHER **b.** De-
cember 22, 1921, Teheran, Iran. U.S. Citi-
zen. **Studied:** with Amedée Ozenfant and
Robert Hale, 1945; Académie des Beaux-
Arts, Paris, 1946, with Andre Lhote. Pub-
lished several volumes of poetry. **Address:**
225 West 86th Street, NYC 10024. **One-
man Exhibitions:** Grace Borgenicht Gal-
lery, Inc., NYC, 1952-54; A.A.A. Gallery,
NYC, 1956; Poindexter Gallery, NYC,
1957, 59, 60, 62; Galerie Anderson-
Mayer, Paris, 1963; Galerie Semiha
Huber, Zurich, 1963; Picadilly Gallery,
London, 1963, 66, 72, 73; Felix Landau
Gallery, Los Angeles, 1963; Gertrude Kasle

Gallery, Detroit, 1965, 66, 67, 68, 70; Feingarten Gallery, Chicago; Robert Elkon Gallery, NYC; Gump's Gallery, San Francisco, 1964, 65; Benson Gallery, East Hampton, N.Y., 1967, 72; Alex Rosenberg Gallery, NYC, 1982, 84. **Group:** Salon des Comparaisons, Paris; Walker, 60 American Painters, 1960; Carnegie, 1961; USIA, Paris, 1961; MOMA, Recent Painting, USA: The Figure, circ., 1962-63; Chicago/AI, Directions in American Painting, 1963; Paris/Moderne, 1963. **Collections:** Baltimore/MA; Charleston/Carolina; MOMA; Syracuse/Everson; Union Carbide Corp.

YOSHIDA, RAY b. October 3, 1930, Kapaa, Kauai, Hawaii. **Studied:** U. of Hawaii, BA, 1951; Chicago Art Institute School, BAE, 1953; Syracuse U., MFA, 1958. US Army, 1954-56. Traveled Europe, Mexico, the Orient, South America. **Taught:** Syracuse U., 1956-57; Rochester Institute of Technology, 1957-58; Rockford College, 1959-61; Washington U., 1965; Chicago Art Institute School, 1965-80; School of the Art Institute of Chicago, 1971-. **Awards:** Frank G. Logan Medal, 1971; Illinois Art Council Grant, 1985. **Address:** 1944 N. Wood Street, Chicago, IL 60622. **Dealer:** Phyllis Kind Gallery, NYC and Chicago. **One-man Exhibitions:** Phyllis Kind Gallery, Chicago, 1975, 77, 81, 82, 89; Syracuse U., 1957; Rockford College, 1960; N.A.M.E. Gallery, Chicago, 1984; Temple U., 1985. **Group:** Chicago/Contemporary, Don Baum Sez "Chicago Needs Famous Artists," 1969; ICA, U. of Pennsylvania, Spirit of the Comics, 1969; SFAI, Surplus Slop from the Windy City, 1970; Chicago/Contemporary, Imagist Art, 1972; Ottawa/National, What They're Up to in Chicago, 1972; São Paulo, Biennial, 1974; NCFA, Made in Chicago, 1974; Chicago/AI, Famous Alumni, 1976; Sacramento/Crocker, The Chicago Connection, circ., 1976; Chicago/AI, 100 Artists—100 Years, 1979; U. of North Carolina, Some Recent Art from

Chicago, 1980; Sunderland (Eng.) Arts Centre, Who Chicago?, circ., 1980; Kansas City/AI, Chicago Imagists, 1982; WMAA, Downtown, The Comic Art Show, 1983; Honolulu/Contemporary, Kanyaku Imin Centennial Invitational, 1985; ICA, London, Komik Ikonoklasm, 1986; Chicago/Terra, Surfaces, 1987; Bowling Green State U., Of New Account, 1987; U. of Massachusetts, Amherst, Contemporary American Collage, circ., 1987; Randolph-Macon Women's College, Chicago, 1989; Los Angeles/County MA, Parallel Visions, circ., 1992; Chicago/AI, From America's Studio, 1992. **Collections:** AT&T, NYC; Ball State U.; Borg-Warner International Corporation; Chicago/AI; Chicago/Contemporary; Elmhurst College; First National Bank of Chicago; Hallmark Collection; Honolulu/Contemporary; Museum des 20. Jahrhunderts, Vienna; NMAA; Northern Ill. U.; Roosevelt U.; South Bend Art Center; Springfield, Ill./State; Syracuse/Everson. **Bibliography:** Adrian; *The Chicago Connection;* Kirschner; *Who Chicago?*

YOUNGERMAN, JACK
b. March 25, 1926, Webster Groves, Mo. **Studied:** U. of North Carolina (US Navy Training Program), 1944-46; U. of Missouri, 1947, BA; Academie des Beaux-Arts, Paris, 1947-48. Traveled Europe, Near East; resided Europe, 1947-54. Designed stage sets for *Histoire de Vasco,* produced by Jean-Louis Barrault, Paris, 1956, and *Deathwatch,* by Jean Genet, NYC, 1958. **Commissions:** Federal Court Building, Portland, Ore., 1975; PPG Industries/Howard Heinz Foundation, 1977; Neiman Marcus, Chicago. **Awards:** *Art in America* magazine, New Talent, 1959; National Endowment for the Arts, grant, 1972; Guggenheim Foundation Fellowship, 1976; National Endowment for the Arts, grant, 1984; US/Japan Exchange Fellowship, 1987. **Address:** 130 West 3rd Street, NYC 10012. **Dealer:** Washburn Gallery, NYC. **One-man Exhibitions:**

Galerie Arnaud, 1951; Gres Gallery, Washington, D.C., 1957 (two-man); Betty Parsons Gallery, NYC, 1957, 60, 61, 64, 65, 67, 68; Galleria dell'Ariete, 1962; Galerie Lawrence, Paris, 1962, 65; Everett Ellin Gallery, Los Angeles, 1963; Worcester/AM, 1965; MIT, 1966; Galerie Maeght, 1966; Phillips, 1968; The Pace Gallery, NYC, 1971, 72, 73, 75; J. L. Hudson Art Gallery, Detroit, 1971; The Berenson Gallery, 1972; Portland (Ore.) Center for the Visual Arts, 1972; Seattle/AM, 1972; Arts Club of Chicago, 1973; Galerie Denise René, Paris, 1973; Kingpitcher Gallery, Pittsburgh, 1974; Fendrick Gallery, Washington, D.C., 1974; Southampton/Parrish, 1976; Tampa Bay Museum, 1977; Truman Gallery, NYC, 1978; Washburn Gallery, Inc., NYC, 1981, 82, 84, 85, 91; Central Park, NYC, 1981; N.Y. Institute of Technology, Old Westbury, 1981; Stony Brook/SUNY, Alex Rosenberg Gallery, NYC, 1983; Heath Gallery, Atlanta, 1984; SRGM, 1986; Heland Wetterling Gallery, Stockholm, 1989. **Retrospective:** SRGM, 1986. **Group:** Galerie Maeght, Les Mains Eblories, 1950; Galerie Denise Rene, Paris, 1952; Carnegie, 1958, 61, 67, 71; MOMA, Sixteen Americans, circ., 1959; Corcoran, 1959, 62; Kimura Gallery, Tokyo, American Painters, 1960; SRGM, Abstract Expressionists and Imagists, 1961; Chicago/AI, 1961, 62; MOMA, Recent American Painting and Sculpture, circ., USA and Canada, 1961-62; Seattle World's Fair, 1962; International Biennial Exhibition of Paintings, Tokyo; SRGM, American Drawings, 1964; WMAA, A Decade of American Drawings, 1965; SRGM, Systemic Painting, 1966; Rotterdam, 1966; WMAA Annual, 1967; Utica, American Prints Today, 1968; Indianapolis, 1969; Jewish Museum, Superlimited: Books, Boxes, and Things, 1969; Foundation Maeght, L'Art Vivant, 1970; Carnegie, International, 1971; U. of North Carolina, Art on Paper, 1973; U. of Texas, Austin, Abstract Expressionists and Im-

Jack Youngerman, *Nexus*, 1987.

agists, 1976; Montgomery, Ala., Art Inc., 1979; Museo de Arte Moderno, Bogota, 25 Anos Despues, 1970; California State U., Northbridge, Americans in Paris: the 50s, 1979; Hirshhorn, The Fifties: Aspects of Painting in New York, 1980; Haus der Kunst, Munich, Amerikanische Malerie, 1930-1980, 1981; National Gallery and Yale U., Washington, D.C., The Folding Image, 1984; Los Angeles/County MA, The Spiritual in Art, 1986; High Museum, From Monet to Today, 1987; Southhampton/Parrish, Drawing on the East End, 1988; WMAA, Vital Signs, 1988; AAIAL, 1988. **Collections:** Amherst College; Baltimore/MA; Buffalo/Albright; U. of California, Berkeley; Carnegie; Chase Manhattan Bank; Chatanooga/Hunter; Chicago/AI; Columbus; Corcoran; Equitable Life Assurance Society; Foundation Maeght; Hartford/Wadsworth; High Museum; Hirshhorn; Houston/MFA; Humlebaek/Louisiana; Milwaukee; MOMA; NCFA; Newark Museum; Olympic Sculpture Park; Phillips; Reynolds Metals Co.; SRGM; VMFA; Vassar College; WMAA; Walker; Wichita/AM; Worcester/AM; Yale U. **Bibliography:** Alloway 3; Armstrong, Thomas; Battcock, ed.; Nordness, ed.; Rickey; Rose, B., 1; Sandler 5; Weller. Archives.

YRISSARY, MARIO
from 1st to 4th edition.

YUNKERS, ADJA b. July 15, 1900, Riga, Latvia. d. December 24, 1983, NYC. Studied: art in Leningrad, Berlin, Paris, and London. Traveled the world extensively; resided Paris 14 years, Stockholm during World War II. Edited and published art magazines *ARS* and *Creation* in Sweden, 1942-45. To USA, 1947; became a citizen. Taught: New School for Social Research, 1947-54; U. of New Mexico, summers, 1948, 49; Cooper Union, 1956-67; Honolulu Academy, 1964; U. of California, Berkeley, 1966; U. of Colorado, 1967; Columbia U., 1974; Bard College, 1969-78. Commissions: Syracuse U., 1966; Stony Brook/SUNY, 1967. Awards: Guggenheim Foundation Fellowship, 1949-50, renewed 1954-55; Ford Foundation, 1959; Chicago/AI, Norman Wait Harris Medal, 1961; Tamarind Fellowship, 1961. One-man Exhibitions: (first) Maria Kunde Gallery, Hamburg, 1921 or 1922; Galerie Per, Oslo; Tokanten (Gallery), Copenhagen, 1947-54; Kleemann Gallery, NYC; Corcoran; Smithsonian; Chicago/AI; Pasadena/AM; Colorado Springs/FA; Grace Borgenicht Gallery, Inc., NYC. 1954, 55; Galerie Paul Facchetti, Paris; Gallerie Schneider, Rome; Salon des Realites Nouvelles, Paris, 1955; Zwerner Gallery, London, 1957-59; Los Angeles/County MA; Rose Fried Gallery, NYC; The Howard Wise Gallery, Cleveland; André Emmerich Gallery, NYC; Honolulu Academy, 1964-65; The Zabriskie Gallery, NYC, 1974, 75; Nielsen Gallery, Boston, 1981; Allrich Gallery, San Francisco, 1982; C.D.S. Gallery, NYC, 1982; Fine Arts Museum of Long Island, 1984. Retrospectives: Baltimore/MA; U. of Utah; Mexico City/Nacional, 1975; Albion College, circ., 1982. Group: MOMA, The New American Painting and Sculpture, 1969. Collections: Arts Council of Great Britain; Atlanta/AA; Baltimore/MA; Basel; Bibliothèque Nationale; Bibliothèque Royale de Belgique; Boston/MFA; Brandeis U.; Brooklyn Museum; UCLA; Carnegie; Cleveland/MA; Colorado Springs/FA; Corcoran; Florence (Italy)/Modern; Hamburg; Harvard U.; Johannesburg/Municipal; Library of Congress; Lima, Peru; Louisville/Speed; MMA; MOMA; Memphis/Brooks; Minneapolis/Institute; Minnesota/MA; NCFA; NYPL; National Gallery; Oslo/National; PMA; The Print Club, Philadelphia; Rijksmuseum/Amsterdam; SRGM; São Paulo; Springfield, Mass./MFA; Stockholm/National; Trenton State; U. of Utah; Victoria and Albert Museum; WMAA; Walker; Wellesley College; Worcester/AM. Bibliography: Goodrich and Baur 1; *From Foreign Shores;* Nordness, ed.; Read 2. Archives.

Z

ZACHARIAS, ATHOS b. June 17, 1927, Marlborough, Mass. **Studied:** RISD, 1952, BFA; ASL, with Yasuo Kuniyoshi, summer, 1952; Cranbrook Academy of Art, with Zoltan Sepeshy, 1953, MFA. Traveled Europe, eastern USA. **Taught:** Brown U., 1953-55; Parsons School of Design, 1963-65; Long Island U., summer, 1967; Wagner College, 1969-. **Commissions:** Fram Corporation, 1963 (painting of explorer ship *Fram*). **Member:** Artists Equity. **Awards:** Scholarship to RISD, 1950; Longview Foundation Grant, 1962; Guild Hall, First and Second Prizes; Long Island U., P.P., 1968; MacDowell Colony Fellowship, 1969. **Address:** 463 West Street, NYC 10014. **One-man Exhibitions:** (first) Brown U., 1954; Great Jones Gallery, NYC, 1960; Joachim Gallery, Chicago, 1961; Gallery Mayer, NYC, 1961; Bob Keene, Southampton, N.Y., 1961-64; Louis Alexander Gallery, NYC, 1962, 63; Benson Gallery, Bridgehampton, NYC, 1962, 63, 67, 78, 92; Guild Hall, East Hampton, 1965, 80; Westbeth Gallery, NYC, 1970, 71; Landmark Gallery, Inc., NYC, 1973; Glassboro State College, 1976; James Yu Gallery, NYC, 1977; Fred Dorfman Gallery, NYC, 1978; Loonam Gallery, Bridgehampton, N.Y., 1981; Loft Gallery, Southampton, N.Y., 1981; Bologna-Landi Gallery, East Hampton, N.Y., 1982, 86, 87; Adagio Gallery, East Hampton, N.Y., 1983, 84; Vered Gallery, East Hampton, 1985; AAIAL, 1986; Eileen Michel Gallery, Woodmere, 1986; Benton Gallery, Southampton, 1986, 88; Galerie Kwartijn, Amsterdam, 1986, 87; Mat Gallery, Amsterdam, 1987; Nuance Gallery, Tampa, 1988; Laforet Museum, Tokyo, 1987; Owl 57 Gallery, Woodmere, N.Y., 1990; Providence Art Club, 1991; Arttra Gallery, Amsterdam, 1991. **Group:** Boston Arts Festival, 1954; ART: USA: 59, NYC, 1959; Raleigh/NCMA, 1959; Pan-Pacific Exhibition, circ., Japan, 1961; Tenth Street Days, NYC, 1978; Guild Hall, Objects by Artists, 1984; NAD, 1986. **Collections:** Best Products; Boston/MFA; Corcoran; E.F. Hutton & Company, NYC; Kalamazoo/Institute; McCrory Corp., NYC; U. of North Carolina; Phoenix; RISD; Westinghouse.

ZAJAC, JACK b. December 13, 1929, Youngstown, Ohio. **Studied:** Scripps College, 1949-53, with Millard Sheets, Henry McFee, Sueo Serisawa. Traveled the world extensively. Resided Rome, 1954-74. Changed from painting to sculpture, 1955. **Taught:** Pomona College, 1959; Dartmouth College, 1970. **Commissions:** Reynolds Metals Co., 1968. **Awards:** California State Scholarship, 1950; Youngstown/Butler, Second Prize, 1950; Pasadena/AM, P.P., 1951; Los Angeles/County MA, P.P., 1953, 58; Prix de Rome, 1954, 56, 57; AAAL, 1958; Guggenheim Foundation Fellowship, 1959; Limited Editions Club, $2,500 Prize for Etching, 1959; Sarasota Art Association, Prize for Sculpture, 1959; Grace Cathedral, San Francisco, Art in Religion, First Prize, 1960; National Religious Art Exhibition, Birmingham, Mich., 1962; NAD, Ellin P. Speyer Prize for Sculpture, 1983. **Address:** 1316 West Cliff Drive, Santa Cruz, CA 95060. **Dealer:** Stephen Wirtz Gallery, San Francisco. **One-man Exhibitions:** (first) Pasadena/AM, 1951; Felix Landau Gallery, Los Angeles, 1951, 53, 54, 56, 58, 60, 62, 63, 66, 68, 70; Santa Barbara/MA, 1953; Scripps College, 1955; Galleria Schneider, Rome, 1955; John Young Gallery, Honolulu, 1956; II

Segno Rome, 1957; The Downtown Gallery, NYC, 1960; Devorah Sheffnan Gallery, 1960; Roland, Browse and Delbanco, London, 1960; Gallery Marcus, Laguna Beach, Calif., 1961; The Landau-Alan Gallery, NYC, 1966, 68; Alpha Gallery, Boston, 1969; Fairweather-Hardin Gallery, Chicago, 1970; The Forum Gallery, NYC, 1971, 74, 78, 83; La Margherita Gallery, Rome, 1972; Galleria d'Arte l'Obelisco, 1973; Jodi Scully Gallery, Los Angeles, 1973; San Diego, 1975; Santa Barbara/MA, 1978; Mekler Gallery, Los Angeles, 1983; Stephen Wirtz Gallery, San Francisco, 1984. **Retrospectives:** Newport Harbor, 1965; California Institute of Technology, Pasadena, 1969; Temple U., Rome, 1969; Dartmouth College, 1970; El Paso Museum of Art, 1984. **Group:** Santa Barbara/MA, 1959; WMAA Annual, 1959; Chicago/AI, Annual, 1959; MOMA, Recent Sculpture USA, 1959; Los Angeles/County MA, 1959, 60; Claude Bernard, Paris, Aspects of American Sculpture, 1960; Smithsonian, Drawings by Sculptors, circ., USA, 1961-63; SRGM, The Joseph H. Hirshhorn Collection, 1962; WMAA, American Painters Today, circ., 1962, VMFA, American Painting, 1962; WMAA, Fifty California Artists, 1962-63; MOMA, Recent Painting USA: The Figure, circ., 1962-63; Carnegie International, 1965; U. of Illinois, 1965; Biennale de Roma, 1968; Laguna Beach Museum of Art, 1979. **Collections:** California Federal Savings and Loan Association; Gibraltar Savings & Loan Association; Hirshhorn; Home Savings and Loan Association; Kansas City/Nelson; Los Angeles/County MA; Lytton Savings and Loan Association; MOMA; Milwaukee; U. of Nebraska; PAFA; Pasadena/AM; Santa Barbara/MA; Stanford U.; State of California; Syracuse U.; Utica; Walker. **Bibliography:** Seldis and Wilke; Weller.

ZAKANITCH, ROBERT S.

b. May 24, 1935, Elizabeth, N.J. **Taught:** U. of California, San Diego, 1974; Chi-

cago Art Institute School, 1976. **m.** Patsy Norvell. **Address:** 78 Greene Street, NYC 10012. **Dealer:** Sidney Janis Gallery, Inc., NYC. **One-man Exhibitions:** Henri Gallery, Alexandria, Va., 1965; Stable Gallery, NYC, 1968; Reese Palley Gallery, NYC, 1970, 71; Holly Solomon Gallery, NYC, 1977; Galerie Liatowitsch, Basel, 1978; Robert Miller Gallery, NYC, 1978, 79, 80, 81, 84, 85, 88; Galerie Rudolf Zwirner, Cologne, 1979; Galerie Bischofberger, Zurich, 1980; Galerie Daniel Templon, Paris, 1980, 82, 87, 91; Akira Ikeda Gallery, Nagoya, Japan, 1981; The Greenberg Gallery, St. Louis, Mo., 1981; ICA, U. of Pennsylvania, 1981; Mayor Gallery, London, 1981; McIntosh-Drysdale Gallery, Washington, D.C., 1981; Asher/Faure, Los Angeles, 1982, 85; Harcus-Krakow Gallery, Boston, 1982; Michael H. Lord Gallery, Milwaukee, 1982; Makler Gallery, Philadelphia, 1982; Fondation de Château de Jau, France, 1983; Galerie 151, Palm Beach, 1983; McIntosh-Drysdale Gallery, Houston, 1983; Delahunty Gallery, Dallas, 1984; Harcus Gallery, Boston, 1984, 87; Helander Gallery, Palm Beach, 1985, 89; Yares Gallery, Scottsdale, 1987; Tavelli Williams Gallery, Aspen, 1988; Sidney Janis Gallery, NYC, 1990. **Group:** WMAA Annual, 1968; U. of Illinois, 1969; U. of Rochester, Aspects of Current Painting, 1971; WMAA, Structure of Color, 1971; Indianapolis, 1972; Vassar College, New American Abstract Painting, 1972; Corcoran, Biennial, 1973; P.S. 1, Long Island City, Pattern Painting, 1977; Rice U., Pattern and Decoration, 1978; Dayton/AI, Pattern Plus, 1979; The New Museum, NYC, The 1970s, 1979; ICA, U. of Pennsylvania, The Decorative Impulse, 1979; Mannheim/Kunstverein, Dekor, 1980; ICA, U. of Pennsylvania, Drawings: The Pluralist Decade, 1980; Indianapolis, 1980; XXXIX Venice Biennial, 1980; Illinois Wesleyan U., Pattern Painters, 1980; WMAA Biennial, 1981; Galeria Civica, Modena, Transavanguardia, 1982; Bonn, Back to the USA, circ., 1983;

MOMA, International Survey of Recent Painting and Sculptures, 1984; Municipal Museum of Art, Kitakyushu, Painting Now: The Restoration of Painterly Figuration, 1984; Columbus, American Art Now!, 1985. **Collections:** AT&T; Aachen/Ludwig; American Can Corp.; Blue Cross-Blue Shield; Chase Manhattan Bank; Hartford/Wadsworth; High Museum; Hirshhorn, Milwaukee; Musée de Strasbourg; Phoenix; PMA; Princeton U.; Ridgefield/Aldrich; VMFA; Vassar College; WMAA. **Bibliography:** *Back to the USA; Drawings: The Pluralist Decade;* Hiromoto; Murken-Altrogge; Robins. Archives.

ZAMMITT, NORMAN **b.** February 3, 1931, Toronto, Canada. US Air Force, 1951-56. US Citizen, 1956. **Studied:** Pasadena City College AA, 1950-51, 1956-57; Otis Art Institute, MFA, 1957-61. **Taught:** School of Fine Arts, Los Angeles, 1962-63; Occidental College, 1963; U. of New Mexico, 1963-64; CSCS, Fullerton, 1964-66; California Institute of the Arts, Los Angeles, 1967; U. of Southern California, 1968-69; UCLA, 1971-72. **Awards:** Pasadena City College, Ruth Estes Bissiri Memorial Scholarship, 1957; Otis Art Institute, four-year scholarship, 1957-61, 50th Anniversary Sculpture Exhibition, **P.P.**, 1968; Tamarind Fellowship; Guggenheim Foundation Fellowship, 1968; Long Beach/MA; Pollock-Krasner Foundation Grant, 1992. **Address:** 233 N. Wilson Avenue, Pasadena, CA 91106. **One-man Exhibitions:** Felix Landau Gallery, Los Angeles, 1962, 63, 69; Robert Schoelkopf Gallery, 1963; The Landau-Alan Gallery, NYC, 1967, 68; Santa Barbara/MA, 1968; Los Angeles/County MA, 1977; Corcoran, 1978; Flow Ace Gallery, Los Angeles, 1984; Loma Linda U., 1987; Pasadena City College, 1988. **Group:** Los Angeles/County MA, 1961, 64, American Sculpture of the Sixties, 1967; Pasadena/AM, 1962; U. of St. Thomas (Tex.), 1965; MOMA, 1965; U. of Illinois, 1967;

Hansen Gallery, San Francisco, 1967; Lytton Art Center, Los Angeles, 1967; Los Angeles/County MA, The Spiritual in Art, 1986. **Collections:** Corcoran; Hirshhorn; Library of Congress; Los Angeles/County MA; MOMA; National Gallery; Ridgefield/Aldrich; Rowland Institute for Science; SFMA; Seattle/AM. **Bibliography:** Davis, D.; Tuchman 1.

ZERBE, KARL
from 1st to 4th edition.

ZOGBAUM, WILFRID **b.** September 10, 1915, Newport, R.I. **d.** January 7, 1965, NYC. **Studied:** Yale U., 1933-34; with John Sloan, NYC, 1934-35; Hoffmann School, NYC and Provincetown, 1935-37 (class monitor). US Army, 1941-46. Traveled Europe, the Orient, West Indies, USA. Began sculpture, 1954. **Taught:** U. of California, Berkeley, 1957, 1961-63; U. of Minnesota, 1958; Pratt Institute, 1960-61; Southern Illinois U., 1961. **Member:** American Welding Society; Sculptors Guild. **Awards:** S. R. Guggenheim Fellowship for Painting, 1937; U. of California Institute for Creative Work in the Arts, 1963. **One-man Exhibitions:** (first) Alexander Iolas Gallery, 1952 (paintings); The Stable Gallery, NYC, 1954, 58; Walker, 1958; Staempfli Gallery, NYC, 1960; Obelisk Gallery, Washington, D.C., 1962; Dilexi Gallery, San Francisco, 1962; U. of California, Berkeley, 1962; Grace Borgenicht Gallery Inc., 1963; Everett Ellin Gallery, Los Angeles, 1963; Hansen-Fuller Gallery, San Francisco, 1969; SFMA, 1973; Zabriskie Gallery, NYC, 1979. **Group:** American Abstract Artists, 1935-41; Oakland/AM, 1957; U. of Nebraska, 1961; Baltimore/MA, 1961; MOMA, Modern American Drawings, circ., Europe, 1961-62; Seattle World's Fair, 1962; WMAA Annuals; Chicago/AI, 1962; Carnegie, 1962; Turin/Civico, 1962. **Collections:** Brooklyn Museum; U. of California; Hirshhorn; International Institute for Aesthetic Re-

search; New School for Social Research; SFMA; WMAA. **Bibliography:** Hunter, ed.; Tuchman 1. Archives.

ZORACH, MARGUERITE

b. September 25, 1887, Santa Rosa, Calif. **d.** June 27, 1968, Brooklyn, N.Y. **Studied:** in Paris, 1906-10. Traveled Europe, Mexico, Central America, and around the world, 1911-12. **Taught:** Provincetown, 1913-18; Columbia U., intermittently during the 1940s. **Commissions** (murals): US Post Offices, Peterborough, N.H., and Ripley, Tenn. **Awards:** Chicago/AI, The Mr. & Mrs. Frank G. Logan Medal, 1920; Golden Gate International Exposition, San Francisco, 1939, Silver Medal; Hon. Ph.D., Bates College. **m.** William Zorach. **One-man Exhibitions:** (first) The Daniel Gallery, NYC, 1915, also 1917; Montross Gallery, NYC, 1921; Joseph Brummer Gallery, NYC, 1930; The Downtown Gallery, NYC, 1935, 38; M. Knoedler & Co., NYC, 1944; Kraushaar Galleries, NYC, 1953, 57, 62, 68, 74, 91. **Retrospective:** NCFA, 1973. **Group:** Salon d'Automne, Paris, 1910; The Armory Show, 1913; WMAA; MOMA. **Collections:** Colby College; Louisville/Speed; MMA; MOMA; Massillon Museum; Newark Museum; WMAA. **Bibliography:** *Avant-Garde Painting & Sculpture in America, 1910-25;* Biddle 4; Brown 2; Cheney; Goodrich and Baur 1; Hunter 6; Marter, Tarbell, and Wechsler; Richardson, E.P.; Ringel, ed.; Tarbell; Wright 1. Archives.

ZORACH, WILLIAM **b.** February 28, 1887, Eurburg, Lithuania. **d.** November 15, 1966, Bath, Me. To USA, 1891. **Studied:** Cleveland Institute of Art, 1902-05; NAD, 1908-10; and in Paris, 1910-11. **Taught:** ASL, 1929-66; The Des Moines Art Center, 1954. **Member:** NIAL (vice-president, 1955-57); Sculptors Guild. **Commissions:** Radio City Music Hall, NYC, 1932; US Post Office, Benjamin Franklin Station, Washington, D.C., 1937; New York World's Fair, 1939;

Mayo Clinic, Rochester, Minn., 1954; Municipal Court Building, NYC, 1958; R.S. Reynolds Memorial Award, 1960 (a sculpture). **Awards:** Chicago/AI, The Mr. & Mrs. Frank G. Logan Medal, 1931, 32; Architectural League of New York, Hon. Men., 1939; Bates College, Citation, 1958; Hon. MA, Bowdoin College, 1958; NIAL, Gold Medal for Sculpture, 1961; PAFA, George D. Widener Memorial Gold Medal, 1962. **m.** Marguerite Zorach. **One-man Exhibitions:** Taylor Galleries, Cleveland, 1912; The Daniel Gallery, NYC, 1915, 16, 18; O'Brien's Gallery, Chicago, 1916; Dayton/AI, 1922; U. of Rochester, 1924; Kraushaar Galleries, NYC, 1924, 26, 48; Arts and Crafts Club, New Orleans, 1927; Eastman-Bolton Co., NYC, 1929; The Downtown Gallery, NYC, 1931, 32, 33, 36, 43, 44, 47, 51, 55, 67; Passedoit Gallery, NYC, 1937; Ansel Adams Gallery, San Francisco, 1941; Boston Museum School, 1941; Dallas/MFA, 1945; California Palace, 1946; San Diego, 1946; Pasadena/AM, 1946; Ten Thirty Gallery, Cleveland, 1948; Coleman Gallery, NYC, 1949; New Paltz/SUNY, 1950; Clearwater/Gulf Coast, 1952; Des Moines, 1954; San Antonio/McNay, 1956; Bowdoin College, 1958; Philadelphia Art Alliance, 1961; Coe College, 1961; Queens College, 1961; Brooklyn Museum, 1968; Danenberg Gallery, 1970; The Zabriskie Gallery, 1974, 81; Louis Newman Galleries, Beverly Hills, 1988. **Retrospectives:** ASL, 1950, 69; WMAA, circ., 1959. **Group:** Salon d'Automne, Paris, 1910; The Armory Show, 1913; Society of Independent Artists, NYC, 1914-16; Anderson Galleries, NYC, Forum Exhibition, 1916; PAFA, New Tendencies, 1918; A Century of Progress, Chicago, 1933-34; American Painting and Sculpture, Moscow, 1959; PAFA; MOMA; WMAA; Corcoran; Chicago/AI. **Collections:** AAAL; Andover/Phillips; Arizona State College; Baltimore/MA; Bezalel Museum; Buffalo/Albright; Chicago/AI; Cleveland/MA; Colby

College; Columbia U.; Columbus; Corcoran; Dallas/MFA; Des Moines; Dubuque/AA; Fairleigh Dickinson U.; Fort Worth; IBM; Los Angeles/County MA; MMA; MOMA; U. of Nebraska; Newark Museum; New Britain/American; Oberlin College; Ogunquit; PMA; The Pennsylvania State U.; Phillips; Pittsfield/Berkshire; Sara Roby Foundation; Shelburne; Syracuse U.; Tel Aviv; Terre Haute/Swope; Utica; VMFA; WMAA; West Palm Beach/Norton; Wichita/AM; Wilmington. **Bibliography:** *Avant-Garde Painting & Sculpture in America, 1910-25;* Baur 7; Beam; Biddle 4; Blesh 1; Brown 2; Brumme; Bryant, L.; Cahill and Barr, eds.; Cheney; Craven, W.; Flanagan; *From Foreign Shores;* Gertz; Goodrich and Baur 1; Hall; Halpert; **Hoopes;** Hunter 6; *Index of 20th Century Artists;* Jewell 2; Lee and Burchwood; Marter, Tarbell, and Wechsler; McCurdy, ed.; Mellquist; Mendelowitz; Myers 2; Neuhaus; Parkes; Pearson 2; Phillips 2; Richardson, E.P.; Ringel, ed.; Ritchie 3; Rose, B., 1; Seuphor 3; Weller; Wheeler; **Wingert;** Wright 1; **Zorach 1, 2.** Archives.

ZOX, LARRY **b.** May 31, 1936, Des Moines, Iowa. **Studied:** U. of Oklahoma, with Amelio Amero, Eugene Bavinger; Drake U., with Karl Mattern; The Des Moines Art Center, with George Grosz, Louis Bouche, Will Barnet. Traveled USA, Mexico, and Canada extensively. **Taught:** Cornell U., Artist-in-Residence, 1961; U. of North Carolina, Artist-in-Residence, 1967; School of Visual Arts, NYC, 1967-68, 1969-70; Juniata College, Artist-in-Residence, 1968; Dartmouth College, Artist-in-Residence, 1969; Yale U., 1972; Kent State U., 1974. **Awards:** Guggenheim Foundation Fellowship, 1967; National Council on the Arts Award, 1969; National Endowment for the Arts, Grant,

1969; Gottlieb Foundation, grant, 1985. **Address:** 238 Park Avenue South, NYC 10003. **One-man Exhibitions:** (first) The American Gallery, NYC, 1962; The Kornblee Gallery, NYC, 1964, 66, 68, 69, 70, 71; J. L. Hudson Art Gallery, Detroit, 1967; Galerie Rolf Ricke, Cologne, 1968; Colgate U., 1968; Dartmouth College, 1969; Janie C. Lee Gallery, Dallas, 1970, 74, Houston, 1974; Akron/AI, 1971; Des Moines, 1971, 74; WMAA, 1973; André Emmerich Gallery, NYC, 1973, 75, 76; Galerie Daniel Templon, Paris, 1975; Medici-Berenson Gallery, Bay Harbor Islands, 1978; Allen Rubiner Gallery, Royal, Mich., 1979; Carolyn Scheebeck Gallery, Cincinnati, 1980; Hokin Gallery, Bay Harbor Islands, 1981; Meredith Long & Co., Houston, 1981; Salander-O'Reilly Galleries, NYC, 1982; Rubiner Gallery, West Bloomfield, Mich., 1985, 90; Images Gallery, Toledo, 1986, 90; Percival Gallery, Des Moines, 1987, 89, 91; Gallery One, Toronto, 1991. **Group:** Des Moines, 1955, 56; Gallery of Modern Art, NYC, 1965; WMAA, Young America, 1965, Annuals, 1965-66, 1967-68, 69, 70, 73; Chicago/AI, 1965; Boston/MFA, 1966; SRGM, Systemic Painting, 1966; Expo '67, Montreal, 1967; New Delhi, First World Triennial, 1968; Kent State U., 1968; Worcester/AM, The Direct Image, 1969; The Edmonton Gallery, New Abstract Sculpture, 1977. **Collections:** Akron/AM; American Republic Insurance Co.; Boston/MFA; Chicago/AI; Columbia Broadcasting System; Cornell U.; Dallas/MFA; Dartmouth College; Des Moines; Des Moines Register & Tribune; Hirshhorn; Houston/MFA; Indianapolis; MOMA; National Bank of Des Moines; Oberlin College; Palm Springs Desert Museum; SRGM; South Mall, Albany; Tate; WMAA. **Bibliography:** Alloway 3; Battcock, ed.; Hunter, ed.; **Monte;** Rose, B., 1.

Bibliography

A. = Appendices; **B.** = Bibliography; **C.** = Chronologies; **D.** = Diagrams; **G.** = Glossary; **I.** = Illustrated; **P.** = Plans.

In cases of more than one entry for the same author, the numeral immediately following the author's name is keyed to the Bibliography section of the Artists' entries.

A supplemental list of Books of General Interest follows the main bibliography.

Abstraction création 1931-1936. Münster: Westfälisches Landesmuseum, 1978. Foreword by Peter Berghaus. Preface by Jacques Lassaigne. Essay by Gladys C. Fabre. I.B.D.C. (German and French text.) *Documentation and major survey of this art movement.*

ADAMS, HENRY. *Thomas Hart Benton: Drawing from Life.* New York: Abbeville Press, 1990. Foreword by Richard Andrews. I.B. *Drawings used as documents of the artist's life. Exhibition catalogue.*

ADAMS, PHILIP RHYS. 1. *Painter of Vision: Walt Kuhn.* Tucson: University of Arizona Art Gallery, 1966. Foreword by William B. Steadman. I. *Major retrospective catalogue.*

———, 2. Walt Kuhn. *Cincinnati: The Cincinnati Art Museum, 1960.* I. Monograph.

ADRIAN, DENNIS. 1. *Barbara Rossi: Selected Works: 1967-1990.* Chicago: The Renaissance Society, 1991. Essay by Carol Becker. I.B.C. *Review exhibition of significant Chicago artist.*

———, 2. *Sight Out of Mind: Essays and Criticism on Art.* Ann Arbor, MI: UMI Research Press, 1985. *Collected essays. The most intelligent post-World War II Chicago criticism.*

ADRIAN, DENNIS, and BORN, RICHARD A. *The Chicago Imagist Print: Ten Artists' Works, 1958-1987: A Catalogue Raisonné.* Chicago: The University of Chicago, 1987. Foreword by John Carswell. Preface by Timothy G. Goodsell. I.B. *Brief biographies. The best reference, including* Hairy Who *ephemera. Exhibition catalogue.*

ADRIANI, GOETZ; KOEPPLIN, DIETER; and ROSE, BARBARA. *Zeichnungen von Claes Oldenburg.* Tubingen: Kunsthalle Tubingen, 1975. I.B.C. (German text). *A major exhibition and study of the drawings.*

AGEE, WILLIAM C. 1. *Marca-Relli.* New York: The Whitney Museum of American Art, 1967. I.B. *Retrospective catalogue.*

———, 2. *Ralston Crawford.* Pasadena, CA: Twelve Trees Press, 1983. I.B.C. *Excellent introduction to the art and life; includes Crawford's statements.*

AGEE, WILLIAM C., and ROSE, BARBARA. *Patrick Henry Bruce: American Modernist.* New York: The Museum of Modern Art, 1979. I.C. *A catalogue raisonné. Documents the life and work of the painter.*

ALBERS, JOSEF. 1. *Day and Night.* Los Angeles: Tamarind Lithography Workshop, Inc., 1964. *Boxed folio of 10 lithographs (ed. 20).*

———, 2. *Despite Straight Lines.* New Haven, Conn.: Yale University Press, 1961. I.B. *Captions by Albers; analysis of his graphic constructions, by François Bucher.* (German edition, *Trotz der Geraden.* Berne: Benteli, 1961).

————, 3. *Homage to the Square. Ten Works by Josef Albers.* New Haven, Conn.: Ives-Sillman, 1962. Preface by Richard Lippold. *Ten color silkscreens in folio.*

————, 4. *Interaction of Color.* New Haven, Conn., and London: Yale University Press, 1963. I. *More than 200 color studies, with commentaries.*

————, 5. *Poems and Drawings.* New Haven, Conn.: Readymade Press, 1958. I. (German and English text.)

————, 6. *Poems and Drawings* (2nd ed., rev. and enlarged). New York: George Wittenborn, Inc., 1961. I. (Bilingual text.)

————, 7. *Zeichnungen-Drawings.* New York: George Wittenborn, Inc.; Berne: Spiral Press, 1956. (Text by Max Bill in German and English.) *Twelve b+w plates loose in folio.*

Alexander Archipenko. A Memorial Exhibition. Los Angeles: University of California, 1967. Foreword by Katherine Kuh. Archipenko Collection: Frances Archipenko. Life and Work: Frederick S. Wight. The Drawings and Prints: Donald H. Karshan. I.B. *Well-documented retrospective catalogue.*

Alexander Calder. Berlin: Akademie der Kunste, 1967. Preface by William Sandberg. I.B. (German text.) *Retrospective catalogue.*

Alexander Calder. New York: A Studio Book/Viking Press, 1971. Introduction by H. Harvard Arnason. Photographs and design by Ugo Mulas. I.B. *Photo survey of Calder, his works, and his milieu.*

Alexander Liberman: Painting and Sculpture 1950-1970. Washington, D.C.: Corcoran Gallery of Art, 1970. Introduction by James Pilgrim. I.B.C. *Retrospective catalogue.*

ALFIERI, BRUNO. *Gyorgy Kepes.* Ivrey, Italy: Centro Culturale Olivetti, 1958. I.B. *Monograph.*

Alfred Jensen. Bern: Kunsthalle Bern, 1973. I.B. (German and English text.) *Retrospective catalogue.*

Al Held. San Francisco: San Francisco Museum of Art, 1968. I.B. *One-man exhibition catalogue.*

ALLEN, CLARENCE CANNING, ed. *Are You Fed Up with Modern Art?* Tulsa, Okla.: The Rainbow Press, 1957. I. *Popular reaction against the new art.*

ALLEN, VIRGINIA. *Jim Dine Designs for "A Midsummer Night's Dream."* New York: The Museum of Modern Art, 1967. I. *Costume designs for the play.*

ALLOWAY, LAWRENCE. 1. *American Pop Art.* New York: Collier Books, 1974. I.B. *Exhibition survey of pop art.*

————, 2. *Samaras: Selected Works 1960-1966.* New York: The Pace Gallery, 1966. I.B. *Includes a statement by the artist.*

————, 3. *Systemic Painting.* New York: The Solomon R. Guggenheim Museum, 1966. I.B. *Catalogue including artists' statements.*

————, 4. *Topics in American Art since 1945.* New York: W. W. Norton & Co., Inc., 1975. I. *Collected reviews and articles written in the sixties and early seventies.*

————, 5. *William Baziotes.* New York: The Solomon R. Guggenheim Museum, 1965. I.B. *Retrospective catalogue.*

ALVARD, J. *Mark Tobey.* Paris: Musée des Arts Décoratifs, Palais du Louvre, 1961. I.B. (French and English text.) *Retrospective catalogue.*

America 1976. Washington, D.C.: The Hereward Lester Cooke Foundation, 1976. Foreword by Thomas S. Kleppe. Painting America First: Robert Rosenblum. Inclusive Painting: Neil Welliver. Pyrography: John Ashbery. On the United States Considered as a Landscape: Richard Howard. I. *US Department of the Interior commissions realist artists.*

AMERICAN ABSTRACT ARTISTS, ed. *American Abstract Artists.* New York: American Abstract Artists, 1946. I. *Documents members and activities.*

AMERICAN ARTISTS CONGRESS, INC. *America Today, a Book of 100 Prints.* New York: Equinox Cooperative Press, 1936. I.

AMERICAN ARTISTS GROUP, INC. 1. *Handbook of the American Artists Group.* New York: American Artists Group, Inc., 1935. I.B. *Members and organizational information.*

————, 2. *Missouri, Heart of the Nation.* New York: American Artists Group, Inc., 1947. I.B. *Midwest art of the 1930s and 1940s.*

————, 3. *Original Etchings, Lithographs and Woodcuts by American Artists.* New York: American Artists Group, Inc., 1936. I.

Amerikanischer Fotorealismus. Stuttgart: Wurttembergischer Kunstverein, 1972. Introduction by Uwe M. Schneede. I.C. (German text.) *Survey exhibition, including artists' statements.*

AMMANN, JEAN-CHRISTOPHE. *Richard Artschwager.* Basel: Kunsthalle Basel, 1985. (German and English text; French laid in.) B. *Retrospective catalogue.*

AMMANN, JEAN-CHRISTOPHE, and BUSSMANN, G. *Man Ray: Inventionen und Interpretationen.* Frankfurt: Frankfurter Kunstverein, 1979. *Retrospective catalogue: various essays; includes artist's statement.*

ANFAM, DAVID. *Abstract Expressionism.* New York: Thames and Hudson, 1990. I.B. *The traditional non-visual academic English approach to art.*

ARCHIPENKO, ALEXANDER. 1. *Archipenko, 50 Creative Years.* New York: Tekhne, 1960. I.B. *Autobiography.*

————, 2. *Archipentura.* New York: Anderson Galleries, 1928. B. *Exhibition catalogue.*

Arman: Selected Works 1958-1974. La Jolla: La Jolla Museum of Contemporary Art, 1974. Introduction by Jan van der Marck. I.B. *Retrospective catalogue.*

ARMITAGE, MERLE. *Rockwell Kent.* New York: Alfred A. Knopf, 1932. I.B. *Monograph.*

ARMSTRONG, RICHARD. 1. *David Park.* New York: Whitney Museum of American Art, 1988. Foreword by Tom Armstrong. I.B. *Retrospective catalogue; biographical essay.*

————, 2. *Richard Artschwager.* New York: Whitney Museum of American Art, 1988. *Retrospective catalogue.*

————, 3. *William Brice.* Los Angeles: Museum of Contemporary Art, 1986. B. *Exhibition catalogue.*

ARMSTRONG, RICHARD, and MARSHALL, RICHARD. *Five Painters in New York.* New York: Whitney Museum of American Art, 1984. B.C.I. *Exhibition catalogue. Decorative art and recent abstraction.*

ARMSTRONG, TOM. *Amerikanische Malerei, 1930-1980.* Munich: Prestel-Verlag, 1981. Essays by Tom Armstrong and Bernard Growe. I.B. (German text.) *Biographies. Succinct review of American art of this half century.*

ARNASON, H. HARVARD. 1. *Marca-Relli.* New York: Harry N. Abrams Inc., 1962. I. *Monograph.*

————, 2. *Robert Motherwell.* New York: Harry N. Abrams, Inc., 1982. I.B.C. *2nd revised edition of monograph.*

————, 3. *Philip Guston.* New York: The Solomon R. Guggenheim Museum, 1962. I.B. *Exhibition catalogue.*

————, 4. *Stuart Davis.* Minneapolis: The Walker Art Center, 1957. I. *Exhibition catalogue.*

————, 5. *Stuart Davis, Memorial Exhibition.* Washington, D.C.: National Collection of Fine Arts, 1965. I.B. *Major retrospective catalogue.*

————, 6. *Theodore Roszak.* Minneapolis: The Walker Art Center, 1956. I.B. *Exhibition catalogue.*

ARP, HANS. *Onze Peintres.* Zurich: Editions Girsberger, 1949. (French and German text.) I.

Art as a Muscular Principle. South Hadley, Mass.: Mount Holyoke College, 1975. I.B. *A study of ten artists and San Francisco, 1950-1965.*

Art: A Woman's Sensibility. Valencia, Calif: California Institute of the Arts, 1975. Introduction by Deena Metzger. I. *Exhibition catalogue; includes artists' statements.*

Arthur Dove: The Years of Collage. College Park, MD.: University of Maryland Art Gallery, 1967. I.B. *Major study of the collages of Dove.*

ARTHUR JOHN. 1. *Realism/Photorealism.* Tulsa: Philbrook Art Center, 1980. Foreword by Jesse G. Wright, Jr. I.C. *An examination and defense of this school of recent painting.*

————, 2. *Realist Drawings & Watercolors: Contemporary American Works on Paper.* Boston: New York Graphic Society, 1980. I. *Brief examination of various modes of realism.*

————, 3. *American Realism: The Precise Image.* Tokyo: The Isetan Museum of Art, 1985. B.C.I. (Japanese and English texts.) *Mostly photorealism.*

————, 4. *Realists at Work.* New York: Watson-Guptil Publications, n.d. I. *How to do it interviews.*

Art Now 74: A Celebration of the American Arts. Washington, D.C.: Artrend Foundation, 1974. Foreword by Jocelyn Kress. Introduction by Henry T. Hopkins and Maurice Tuchman. I. *Catalogue of performances and exhibition objects: includes artists' statements.*

Art of the Pacific Northwest: From the 1930s to the Present. Washington, D.C.: National Collection of Fine Arts, 1974. Foreword by Adelyn D. Breeskin. Introduction by Joshua C. Taylor. Essays by Rachel Griffin and Martha Kingsbury. I.B. *Important survey exhibition and catalogue.*

ASHBERY, JOHN. *Reported Sightings: Art Chronicles, 1957-1987.* New York: Alfred A. Knopf, 1989. I. Edited by David Bergman. *Collected writings on art and culture by the renowned poet.*

ASHBERY, JOHN, and MOFFETT, KENWORTH. *Fairfield Porter: Realist Painter in an Age of Abstraction.* Boston: Museum of Fine Arts, 1982. B.C. *Retrospective catalogue; includes other essays, an interview, and 5 poems by the painter.*

ASHTON, DORE. 1. *The Mosaics of Jeanne Reynal.* New York: George Wittenborn, Inc., 1964. *Monograph.*

————, 2. *Philip Guston.* New York: Grove Press, Inc., 1960. I.B. *Monograph.*

————, 3. *A Reading of Modern Art.* Cleveland and London: The Press of Case Western Reserve University, 1969. I. *Criticisms of recent modern art and literature.*

————, 4. *Richard Lindner.* New York: Harry N. Abrams Inc., 1970. I. *Monograph.*

————, 5. *The Unknown Shore.* Boston: Little, Brown and Co., 1962. I. *Collected essays mostly reprinted from Art and Architecture magazine.*

————, 6. *Yes, But ... A Critical Study of Philip Guston.* New York: The Viking Press, 1976. I.B.C. *An evaluation of the artist's work.*

ASHTON, DORE, ed. *A Joseph Cornell Album.* New York: Viking Press, 1974. I. *Collected writings by and about Cornell.*

ATKINSON, TRACY. *Directions I: Options 1968.* Milwaukee: Milwaukee Art Center, 1968. Preface by Lawrence Alloway. I. *Catalogue of "people involved in art" with statements by artists.*

AULT, LOUISE. *Artist in Woodstock. George Ault: The Independent Years.* Philadelphia: Dorrance & Co., 1978. *A brief life of the artist.*

AUPING, MICHAEL. *Abstract Expressionism: The Critical Developments.* New York: Harry N. Abrams, Inc., 1987. Foreword by Douglas G. Schultz. Multiple contributors. I.B.C. Bibliographies. *A quest for interpretation employing now mostly defunct critical terms. Exhibition catalogue with texts.*

Avant-Garde Painting and Sculpture in America: 1910-1925. Wilmington: Delaware Art Museum, 1975. Preface and acknowledgments by William Innes Homer. Foreword by Charles T. Wyrick, Jr. I.B.C. *Useful essays by various authors on modern tendencies in American art.*

AXSOM, RICHARD H. 1. *The Prints of Frank Stella: A Catalogue Raisonné.* New York: Hudson Hills Press, 1983. Foreword by Evan M. Maurer. B.C.G. *Exhibition and works catalogue for the years 1967-82.*

————, 2. *The Prints of Ellsworth Kelly: A Catalogue Raisonné, 1949-1985.* New York: Hudson Hills, 1987. I.B.G. Index. *Works catalogue.*

AXSOM, RICHARD H., with FLOYD, PHYLLIS. *The Prints of Ellsworth Kelly.* New York: Hudson Hills, 1987. I.B.G.C. Index. *Prints, posters, ephemera.*

Back to the USA. Cologne: Rheinland Verlag, 1983. B.I. (German text.) *Exhibition catalogue; survey of pattern and decoration, neo-expressionism, and other recent tendencies.*

BAIGELL, MATTHEW. 1. *The American Scene: American Paintings.* New York: Praeger Publishers (American Art and Artists of the 1930s), 1974. I.B. *Superficial survey.*

————, 2. *Thomas Hart Benton.* New York: Harry N. Abrams Inc., 1974. I.B.C. *Heavily illustrated monograph.*

BALDES, ALTON PARKER. *Six Maryland Artists.* Baltimore: Balboa Publishers, 1955. I.

BALDINGER, WALLACE S., in collaboration with Harry B. Green. *The Visual Arts.* New York: Holt, Rinehart and Winston, Inc., 1960. I.B. *Includes chapters on the visual arts.*

BALLO, FERDINANDO, ed. *Grosz.* Milan: Rosa e Balio Editori, 1956. I. (German and Italian text.) *Critical essays.*

BARKER, VIRGIL. 1. *From Realism to Reality in Recent American Painting.* Lincoln: University of Nebraska Press, 1959. I. *Essays on the rise of abstract and nonfigurative painting.*

————, 2. *Henry Lee McFee.* New York: The Whitney Museum of American Art (American Artists Series), 1931. I. *Monograph.*

BARNES, ALBERT C. *The Art in Painting.* Merion, Pa.: The Barnes Foundation Press, 1925. I. *Dr. Barnes's theories.*

BARR, ALFRED, H., Jr. 1. *Cubism and Abstract Art.* New York: The Museum of Modern Art, 1936. I.B. *Essays on Cubism and its evolution.*

————, 2. *Edward Hopper.* New York: The Museum of Modern Art, 1933. I.B. *Exhibition catalogue.*

————, 3. *What Is Modern Painting?* New York: The Museum of Modern Art, 1956. I. *Popular introduction to modern art.*

BARTLETT, JENNIFER. *In the Garden.* New York: Harry N. Abrams, Inc., 1982. Introduction by John Russell. *Folio of drawings with no text by the artist.*

BASKIN, LEONARD. *Leonard Baskin.* Brunswick, Me.: Bowdoin College, 1962. I.B. *Exhibition catalogue.*

BASKIN, LISA UNGER. *The Gehenna Press: The Work of Fifty Years.* Dallas: The Bridwell Library and The Gehenna Press, 1992. Foreword by Colin Franklin. Bibliography by Hosea Baskin. I.B. *Notes on the Books of Leonard Baskin. The classic bibliography of The Gehenna Press.*

BASTIAN, HEINER. *Cy Twombly: Catalogue of Printed Graphics.* New York: New York University Press, 1985. I. *Works catalogue.*

BATTCOCK, GREGORY, ed. *Minimal Art: A Critical Anthology.* New York: E.P. Dutton, 1968. I. *Critical essays reprinted from periodicals and exhibition catalogues.*

BAUDSON, PIERRE. *Steinberg: Zeichnungen und Collagen.* Hamburg: Hamburger Kunsthalle, 1968. Foreword by Helmut R. Leppien. I.B. (German text.) *Retrospective catalogue including an interview with the artist.*

BAUR, JOHN I. H. 1. *Charles Burchfield.* New York: The Whitney Museum of American Art, 1956. I.B. *Retrospective catalogue.*

————, 2. *George Grosz.* New York: The Whitney Museum of American Art, 1954. I.B. *Retrospective catalogue.*

————, 3. *Joseph Stella.* New York: The Whitney Museum of American Art, 1963. I.B. *Retrospective catalogue.*

————, 4. *Loren MacIver-Rice Pereira.* New York: The Whitney Museum of American Art, 1953. I.B. *Exhibition catalogue.*

————, 5. *Nature in Abstraction.* New York: The Macmillan Company, for The Whitney Museum of American Art, 1958. I.B. *Nature considered as catalyst for abstraction.*

————, 6. *Philip Evergood.* New York: Frederick A. Praeger, for The Whitney Museum of American Art, 1960. I.B. *Monograph.*

————, 7. *Evolution and Tradition in Modern American Art.* Cambridge, Mass.: Harvard University Press, 1959. I. *Important essays on conservative and advance guard art.*

BAYER, HERBERT. 1. *Book of Drawings.* Chicago: Paul Theobald and Co., 1961. I.B.

————, 2. *Herbert Bayer: Painter, Designer, Architect.* New York: Reinhold Publishing Co., 1967. I.B.D.P. *Autobiographical monograph.*

BAZALGETTE, LEON. *George Grosz.* Paris: Les Ecrivains Reunis, 1927. I.B. (French text.) *Monograph.*

BAZIN, GERMAIN. *History of Modern Painting.* New York: Hyperion Press, Harper and Brothers, 1951. I.B. *Includes recent American artists of international reputation.*

BEAM, PHILIP C. *The Language of Art.* New York: The Ronald Press, 1958. I.B. *Essays on interpretation.*

BECKER, JURGEN, and VOSTELL, WOLF. *Happenings, Fluxus, Pop, Nouveau Realism.* Reinbeckbei Hamburg: Rowohlt Verlag GMBH, 1965. I. *International survey.*

BEEKMAN, AARON. *The Functional Line in Painting.* New York: Thomas Yoseloff Inc., 1957. I.

BEEREN, WIM. 1. *Roy Lichtenstein.* Amsterdam: Stedelijk Museum, 1967. I.B. (Dutch and English text.) *Major retrospective catalogue includes interview of the artist by John Coplans.*

————, 2. *Walter de Maria.* Boymans-van Bueningen Museum, 1988. I.B.C. (In Dutch and English.) *Exhibition catalogue.*

BEGGS, THOMAS M. *Paul Manship.* Washington, D.C.: Smithsonian Institution, 1958. I. *Exhibition catalogue.*

BENSON, E.M. *John Marin, The Man and His Work.* Washington, D.C.: American Federation of Arts, 1935. *Monograph.*

BENTON, THOMAS HART. 1. *An American in Art.* Lawrence: University of Kansas, 1969. I. *Autobiography.*

————, 2. *An Artist in America.* New York: Robert M. McBride and Co., 1937. I. *Autobiography.*

————, 3. *Thomas Hart Benton.* New York: American Artists Group Inc., 1945. I. *Autobiographical monograph.*

————, 4. *Thomas Hart Benton.* Lawrence: University of Kansas, 1958. I. *Exhibition catalogue.*

BERMAN, EUGENE. *Imaginary Promenades in Italy.* New York: Pantheon Books, 1956. I. *Illustrated essays.*

Bernard Reder. Tel Aviv: The Tel Aviv Museum of Art, 1963. I.B. *Retrospective catalogue including statements by the artist.*

BERNSTOCK, JUDITH. *Joan Mitchell.* New York: Hudson Hills, 1988. Introduction by Thomas Levitt. I.B. *Retrospective catalogue.*

BETHERS, RAY. *How Paintings Happen.* New York: W.W. Norton and Co., 1951. I. *Artists at work.*

BIDDLE, GEORGE. 1. *An American Artist's Story.* Boston: Little, Brown and Co., 1939. I. *Autobiography.*

————, 2. *Ninety-Three Drawings.* Colorado Springs: Colorado Springs Fine Art Center, 1937. I. *Essays on Boardman Robinson's drawings.*

————, 3. *Tahitian Journal.* St. Paul: University of Minnesota, 1968. I. *Travel book.*

————, 4. *The Yes and No of Contemporary Art.* Cambridge, Mass.: Harvard University Press, 1957. I. *An artist comments on the contemporary scene.*

BIEDERMAN, CHARLES. 1. *Art as the Evolution of Visual Knowledge.* Red Wing, Minn.: Privately published, 1948. I.B. *History, aesthetics, and theory.*

————, 2. *Letters on the New Art.* Red Wing, MN.: Privately published, 1951. *Essays.*

————, 3. *The New Cezanne.* Red Wing, MN.: Art History, 1955. I.B. *Homage to Cezanne and theories of subsequent developments.*

————, 4. *Search for New Arts*. Red Wing, MN.: Art History, 1979. I.B. *Critical essays.*

BIHALJI-MERIN, OTO. *Adventures of Modern Art*. New York: Harry N. Abrams Inc., 1966. I.B. *Sets postwar Americans in the world art scene.*

BIRCHMAN, WILLIS. *Faces and Facts*. New York: Privately published, 1937. I. *Short biographies with photographs.*

BIRD, PAUL. *Fifty paintings by Walt Kuhn*. New York: Studio Publications, 1940. I. *Monograph.*

BIRNBAUM, MARTIN. *Introductions*. New York: Frederic Fairchild Sherman, 1919. *New talent in 1919.*

BITTNER, HUBERT. *George Grosz*. New York: A Golden Griffin Book, Arts, Inc., 1959. I. *Monograph.*

Black and White Are Colors: Paintings of the 1950s-1970s. Claremont, Calif.: Pomona College, 1979. Foreword by David W. Steadman. Essay by David S. Rubin. I. *A psychological-aesthetic investigation of the problems.*

BLANCH, ARNOLD. 1. *Arnold Blanch*. New York: American Artists Group Inc., 1945. I. *Autobiographical monograph.*

————, 2. *Methods and Techniques for Gouache Painting*. New York: American Artists Group Inc., 1946. I.

————, 3. *Painting for Enjoyment*. New York: Tudor Publishing Co., 1947. I.

BLANCHARD, FRANCES BRADSHAW. *Retreat from Likeness in the Theory of Painting*. New York: Columbia University Press, 1949. I.B. *From art as illustration to the object as art.*

BLESH, RUDI. 1. *Modern Art, USA. Men-Rebellion-Conquest 1900-1956*. New York: Alfred A. Knopf, 1956. I. *Popular study of American art from 1900 to 1956.*

————, 2. *Stuart Davis*. New York: Grove Press Inc., 1960. I. *Monograph.*

BOIS, YVES-ALAIN. *Ad Reinhardt*. New York: Museum of Modern Art, 1991. Preface by William Rubin. I.B.

BORN, WOLFGANG. *American Landscape Painting, an Interpretation*. New Haven, Conn.: Yale University Press, 1948. I.

BOSWELL, PEYTON, Jr. 1. *Modern American Painting*. New York: Dodd, Mead and Co., 1939. I. *Painting in the first 40 years of the twentieth century.*

————, 2. *Varnum Poor*. New York: Hyperion Press, Harper and Brothers, 1941. I.B. *Monograph.*

BOSWELL, PEYTON, Jr., ed. *An Appreciation of the Work of Frederic Taubes*. New York: Art Design Monographs, 1939. I. *Monographs.*

BOURDON, DAVID. 1. *Christo*. New York: Harry N. Abrams Inc., 1971. I.B.C. *Considerable biographical data included in this critical study.*

————, 2. *Warhol*. New York: Harry N. Abrams, 1986. I.B. *The biography.*

BOURGEADE, PIERRE. *Bonsoir, Man Ray*. Paris: Pierre Belfond, 1972. *An interview, in French.*

BOWMAN, RUSSELL. *Philip Pearlstein: The Complete Paintings*. New York: Alpine Fine Arts, 1983. I.B. *Works catalogue.*

BREESKIN, A. D. 1. *Franz Kline*. Washington, D.C.: Washington Gallery of Modern Art, 1962. I. *Retrospective catalogue.*

————, 2. *Ilya Bolotowsky*. New York: The Solomon R. Guggenheim Museum, 1974. I.B. *Retrospective catalogue; includes artist's statements.*

BRETON, ANDRE. 1. *Le Surrealisme et la peinture*. Paris: N.F.R., Gallimard, 1928. I. *The Surrealist movement in art.*

————, 2. *Le Surrealisme et la peinture*. New York: Brentano's, 1945. I. *Revised and expanded edition of the above entry.*

————, 3. *Le Surrealisme en 1947*. Paris: Editions Maeght, 1947.

————, 4. *Yves Tanguy.* New York: Pierre Matisse Editions, 1946. I. (French and English text.) *Monograph.*

BRION, MARCEL. 1. *Art abstract.* Paris: Editions Albin Michel, 1956. I. (French text.) *Development of abstract art in the twentieth century.*

————, 2. *Modern Painting: From Impressionism to Abstract Art.* London: Thames and Hudson, 1958. I.

BROOK, ALEXANDER. *Alexander Brook.* New York: American Artists Group Inc., 1945. I. *Autobiographical monograph.*

BROOKS, VAN WYCK. *John Sloan, a Painter's Life.* New York: E.P. Dutton, 1955. I. *Biography.*

BROWN, JULIA, ed. *Michael Heizer: Sculpture in Reverse.* Los Angeles: Museum of Contemporary Art, 1984. B.C. *Retrospective catalogue with interviews and documentation.*

BROWN, MILTON W. 1. *American Painting: From the Armory Show to the Depression.* Princeton, N.J.: Princeton University Press, 1955. I.B.

————, 2. *The Modern Spirit. American Painting 1908-1935.* London: Arts Council of Great Britain, 1977. Foreword by Joanna Drew. I.B. *Major study of American art of this period seen in Britain.*

Bruce Conner Drawings: 1955-1972. San Francisco: San Francisco Museum of Art, 1974. Preface by Ian McKibbin White. Introduction by Thomas H. Garver. I. *Retrospective catalogue of drawings.*

BRUCE, EDWARD, and WATSON, FORBES. *Art in Federal Buildings.* Washington, D.C.: Art in Federal Buildings, Inc., 1936. I.P.

Bruce Nauman. London: Whitechapel Art Gallery, 1986. Essays by Joan Simon and J.C. Ammann. B. *Exhibition catalogue.*

BRUMME, C. LUDWIG. *Contemporary American Sculpture.* New York: Crown Publishers Inc., 1948. I.B.

BRYANT, EDWARD. *Nell Blaine.* Southampton, N.Y.: Parrish Art Museum, 1974. I.B.C. *Retrospective exhibition catalogue.*

BRYANT, LORINDA M. *American Pictures and Their Painters.* New York: John Lane Co., 1917. I.

BULLIET, C. J. 1. *Apples and Madonnas.* Chicago: Pascal Covici, Inc., 1927. I. *Critical essays on American artists.*

————, 2. *The Significant Moderns and Their Pictures.* New York: Covici-Friede, Publishers, 1936. I.

BUNCE, LOUIS. *Louis Bunce.* Portland, Ore.: Portland Art Museum, 1955. I. *Exhibition catalogue.*

BURCHFIELD, CHARLES. 1. *Charles Burchfield.* Buffalo: Buffalo Fine Arts Academy, Albright Art Gallery, 1944. I. *Exhibition catalogue.*

————, 2. *Charles Burchfield.* New York: American Artists Group Inc., 1945. I. *Autobiographical monograph.*

————, 3. *Eugene Speicher.* Buffalo: Albright Art Gallery, 1950. I. *Exhibition catalogue.*

BURROUGHS, ALAN. *Kenneth Hayes Miller.* New York: The Whitney Museum of American Art (American Artists Series), 1931. I.B. *Exhibition catalogue.*

BUSH, MARTIN H. 1. *Ben Shahn: The Passion of Sacco and Vanzetti.* Syracuse: Syracuse University, 1968. I.B. *A history of the development of the mural.*

————, 2. *Sculpture by Duane Hanson.* Wichita: Wichita State University, 1985. I.B. *Exhibition catalogue.*

BUSH, MARTIN H., and MOFFETT, KENWORTH. *Goodnough.* Wichita: Wichita Art Museum, 1973. I.B.C. *Retrospective catalogue.*

BYWATERS, JERRY. 1. *Andrew Dasburg.* Dallas: Dallas Museum of Fine Arts, 1957. I. *Exhibition catalogue.*

————, 2. *Andrew Dasburg.* New York: American Federation of Arts, 1959. I. *Retrospective catalogue.*

CABANNE, PIERRE. *Dialogues with Marcel Duchamp.* Translated by Ron Padgett. New York: Viking Press (The Documents of 20th-Century Art), 1971. Preface by Salvador Dali. Introduction by Robert Motherwell. Appreciation by Jasper Johns. I.B.C. *Talking with Marcel, with an eye on history.*

CAGE, JOHN. *The Drawings of Morris Graves, with Comments by the Artist.* Boston: For the Drawing Society, Inc., by the New York Graphic Society Ltd., 1974. Preface by David Daniels. I.C. *Survey of drawings.*

CAHILL, HOLGER. *Max Weber.* New York: The Downtown Gallery, 1930. I. *Monograph.*

CAHILL, HOLGER, and BARR, ALFRED, H., Jr., eds. *Art in America, a Complete Survey.* New York: Reynal and Hitchcock, 1935. I.B. *Considers architecture, fine arts, folk art, etc.*

CALAS, NICOLAS. 1. *Bloodflames, 1947.* New York: Hugo Galleries, 1947. I. *Essays on the advance guard in New York in the 1940s.*

————, 2. *Transfigurations: Art Critical Essays on the Modern Period.* Ann Arbor, Mich.: UMI Research Press, 1985. Foreword and Preface by Donald Kuspit. B. *Collected art and literary criticism, some writings by Elena Calas and Andre Breton.*

CALAS, NICOLAS and ELENA. *Ikons and Images of the Sixties.* New York: E.P. Dutton, 1971. I. *Collected essays.*

CALDER, ALEXANDER. 1. *Calder: An Autobiography with Pictures.* New York: Pantheon Books, 1966. Foreword by Robert Osborn. I. *Folksy presentation of Calder's life.*

————, 2. *Three Young Rats.* New York: The Museum of Modern Art, 1946, 2nd ed. I. *A children's story.*

CALDER, ALEXANDER, and LIEDL, CHARLES. *Animal Sketching.* Pelham, N.Y.: Bridgeman Publishers, Inc., 1941, 6th ed. I.

California Sculpture Show. Los Angeles: University of Southern California, 1984. (English, Spanish, French, and German texts.) Foreword by Henry T. Hopkins. B. *Multiple texts in a brief examination of recent sculpture.*

CAMPOS, JULES. *Jose de Creeft.* New York: Erich S. Herrmann, Publisher, 1945. I. *Monographs.*

CANADAY, JOHN. *Mainstreams of Modern Art.* New York: Simon and Schuster, 1959. I. *Popular history of art.*

CARANDENTE, GIOVANNI. *Calder.* Milan: Electra Editrice, 1983. (Italian text.) B. *Retrospective catalogue of over 450 items 1906-1976.*

Carl Andre Sculpture: 1958-1974. Bern: Kunsthalle Bern, 1975. Foreword by Johannes Gachnang. Introduction by Carl Andre. I.B.C.

Carl Holty Memorial Exhibition. New York: Andrew Crispo Gallery, 1974. Introduction by Andrew J. Crispo. I.B.C. *Catalogue includes encomiums by friends.*

CARMEAN, E. A., Jr., et. al. *The Sculpture of Nancy Graves: A Catalogue Raisonné.* New York: Hudson Hills, 1987. I.B.C. *Works catalogue.*

CARMEAN, E. A., Jr., and RATHBONE, ELIZA E., with HESS, THOMAS B. *American Art at Mid-Century: The Subjects of the Artist.* Washington, D.C.: National Gallery of Art, 1978. Foreword by J. Carter Brown. I. *A review of the major post-World War II figures.*

Carol Summers. Woodcuts 1950-1967. San Francisco: San Francisco Museum of Art, 1967. Preface by Anneliese Hoyer. I. *Retrospective catalogue; includes statements by the artist.*

CASSOU, JEAN. *Gateway to the 20th Century.* New York: McGraw-Hill Book Co., Inc., 1962. I. *Development of nineteenth-century art and indications of its twentieth-century ramifications.*

CATHCART, LINDA L. *Milton Resnick Paintings 1945-1985.* Houston: Contemporary Arts Museum, 1985. B. *Retrospective catalogue.*

CELANT, GERMANO. 1. *Arte Povera.* New York: Praeger Publishers, 1969. I. *Catalogues artists' statements and illustrations of their works: earthworks, actual art, concept art.*

———, 2. *A Bottle of Notes and Some Voyages.* Sunderland, England: Northern Centre for Contemporary Art, 1988. Foreword by Tony Knipe and Dr. Terry Friedman. Essays by Claes Oldenburg, Coosje ven Bruggen, Gerhard Storck. I.B.D.C. *A thorough, diligent examination of many sculptures by Claes Oldenburg through texts, drawings, sketches and maquettes.*

Celebrate Ohio. Akron: Akron Art Institute, 1971. Foreword by Orrel Thompson. Introduced by Alfred Radloff. I.C. *Exhibition catalogue.*

CHAET, BERNARD. *Artists at Work.* Cambridge, Mass.: Webb Books Inc., 1960. I. *Interviews with artists.*

Charles Biederman: The Structurist Relief 1935-1964. Minneapolis: The Walker Art Center, 1965. Introduction by Jan van der Marck. I.B.G.C. *Retrospective catalogue.*

Charles Demuth: The Mechanical Encrusted on the Living. Santa Barbara: University of California Press, 1971. Introduction by Phyllis Plous. I.B.C. *A bad centennial retrospective catalogue.*

Charles Sheeler. Washington, D.C.: National Collection of Fine Arts, 1968. I.B. *Essays by Martin Friedman, Bartlett Hayes, Charles Millard; major retrospective catalogue.*

CHENEY, MARTHA CHANDLER. *Modern Art in America.* New York: Whittlesey House, McGraw-Hill Book Co., Inc., 1939. I.

The Chicago Connection. Sacramento: E.B. Crocker Art Gallery, 1976. Foreword by Wilma Beaty Cox. Introduction by Roger D. Clisby. I.B.C. *Survey exhibition of artists mostly born after the late 1930s.*

CHIPP, HERSCHEL B. *Theories of Modern Art.* Berkeley and Los Angeles: University of California Press, 1968. I.B. *Artists' statements.*

Chris Burden: A Twenty Year Survey. Newport Beach, Calif.: Newport Harbor Art Museum, 1988. I.B.C. *The artist as material and photo subject.*

CHRISTENSEN, ERWIN O. *The History of Western Art.* New York: New American Library, 1959. I.

CHRIST-JANER, ALBERT. *Christopher Wilmarth: Layers. Works from 1962-1984.* New York: Hirschl & Adler Modern, 1984. Preface by Dore Ashton. I.B.C. *Exhibition catalogue.*

Cityscape 1919-39. Urban Themes in American, German, and British Art. London: Arts Council of Great Britain, 1977. Preface by Joanna Drew. Essays by Ian Jeffrey and David Mellor. I. *A study of the city and its inhabitants through the art produced therein.*

Claes Oldenburg. New York: The Pace Gallery, 1992. Oldenburg interview by Arne Glimcher. I.B.C.A. *Exhibition catalogue of recent work.*

CLARK, SARAH, and COWLES, CHARLES. *Northwest Tradition.* Seattle: Seattle Art Museum, 1978. Introduction by Sarah Clark. Foreword by Willis F. Woods. B.C. *An essay by Martha Kingsbury examines modern art in the Northwest.*

CLEARWATER, BONNIE. *Mark Rothko: Works on Paper.* New York: Hudson Hills Press, 1984. Introduction by Dore Ashton. B.C. *Drawings and paintings on paper.*

Clyfford Still. Foreword by Katherine Kuh. Buffalo: The Buffalo Fine Arts Academy, 1966. I. *Exhibition catalogue; includes statements by the artist.*

CODOGNATI, ATTILIO. *de Kooning: dipinti, disigni, sculture.* Milan: Electa Editrice, 1985. I.B.C. (Italian and English texts.) *A poetic text with few insights.*

COKE, VAN DEREN. 1. *Norfeldt, the Painter.* The University of New Mexico Press, 1972. Foreword by Sheldon Cheney. I.B.C. *Exhibition catalogue.*

———, 2. *Taos and Santa Fe. The Artistic Environment. 1882-1942.* Albuquerque: University of New Mexico Press, 1963. I.

COLPITT, FRANCES, and PLOUS, PHYLLIS. *Knowledge: Aspects of Conceptual Art.* Santa Barbara, Calif.: University Art Museum, University of California Santa Barbara, 1992.

Foreword by Marla C. Berns. I.B.C. Biographies. *Information in search of art; a serious review of the adventures of typography and photography.*

CONE, JANE HARRISON. 1. *David Smith.* Cambridge, Mass.: Fogg Art Museum, 1966. I.B. *Exhibition catalogue; includes statements by the artist.*

————, 2. *Walter Darby Bannard.* Baltimore: The Baltimore Museum of Art, 1972. Foreword by Tom Le Freudenheim. I.B. *Retrospective catalogue; includes artist's statements.*

Contemporanea. Rome: Incontri Internazionali d'Arte, 1973. Introduction by Graziella Lonardi. I.B. (Italian and English text.) *Comprehensive international avant-garde exhibition: art, cinema, theatre, photography, books, visual poetry, etc.*

CONWILL, K. H., CAMPBELL, M.S., and PATTON, S.F. *Romare Bearden, 1940-1987.* New York: Abrams, 1991. I.B.C. *Monograph.*

COPLANS, JOHN. 1. *Ellsworth Kelly.* New York: Harry N. Abrams Inc., 1973. I.B.C. *Picturebook monograph.*

————, 2. *Roy Lichtenstein.* Pasadena: The Pasadena Art Museum, 1967. I.B. *Includes an interview with the artist.*

————, 3. *Serial Imagery.* Pasadena: The Pasadena Art Museum, 1968. I.B. *Includes statements by some artists.*

COPLANS, JOHN, ed. *Roy Lichtenstein.* New York: Praeger Publishers (Documentary Monographs in Modern Art), 1972. I.B. *Collected essays about the artist; monograph; biographical notes.*

COPLANS, JOHN, with contributions by JONAS MEKAS and CALVIN TOMKINS. *Andy Warhol.* Greenwich, Conn.: New York Graphic Society Ltd., 1970. I.B. *Monographic study; filmography.*

CORN, WANDA M. *Grant Wood: The Regionalist Vision.* New Haven, CT: Yale University Press, 1983. B.C. *Retrospective catalogue.*

Correspondance, an Exhibition of the Letters of Ray Johnson. Raleigh, N.C.: North Carolina Museum of Art, 1976. Foreword by Moussa M. Domit. Introduction by William S. Wilson. I. *Mail art from the New York Correspondance School.*

CORTISSOZ, ROYAL. 1. *American Artists.* New York: Charles Scribner's Sons, 1923. *Essays on noted artists of the late nineteenth and early twentieth century.*

————, 2. *Guy Pene Du Bois.* New York: The Whitney Museum of American Art (American Artists Series), 1931. I.B. *Monograph.*

CRAVEN, THOMAS. 1. *Modern Art, The Men, The Movements, The Meaning.* New York: Simon and Schuster, 1934. I. *Essays on twentieth-century American figurative artists.*

————, 2. *The Story of Painting: From Cave Pictures to Modern Art.* New York: Simon and Schuster, 1943. I. *Popular history of art.*

————, 3. *Thomas Hart Benton.* New York: Associated American Artists, 1939. I. *Monograph.*

CRAVEN, WAYNE. *Sculpture in America.* New York: Thomas Y. Crowell Co., 1968. I.B. *Historical survey of traditional sculpture.*

CRESPELLE, J. P. *Montparnasse vivant.* Paris: Hachette, 1962. I. *The panorama of Montparnasse life.*

CRICHTON, MICHAEL. *Jasper Johns.* New York: Harry N. Abrams Inc., Publishers, in association with The Whitney Museum of American Art, 1977. Foreword by Joseph F. Cullman, 3rd, and Tom Armstrong. I.B. *Exhibition catalogue.*

CRILE, SUSAN. *Ralph Humphrey: The Late Paintings on Paper.* New York: Hunter College, 1991. Foreword by Sanford Wurmfeld. Essays by Cynthia Stone and Joan Waltemath. I.B.C. *Reviews the work of the last decade of the artist's life.*

CRONE, RAINER. *Andy Warhol.* New York: Praeger Publishers, 1970. I.B. *Critical essays and catalogue of works; filmography.*

CROYDON, MICHAEL. *Ivan Albright.* New York: Abbeville Press, n.d. Foreword by Jean Dubuffet. B.C. *Monograph including artist's poetry and statements.*

CUMMINGS, PAUL. 1. *Artists in Their Own Words.* New York: St. Martin's Press, Inc., 1979. I. *Interviews.*

————, 2. *David Smith: The Drawings.* New York: Whitney Museum of American Art, 1979. Foreword by Tom Armstrong. *Retrospective catalogue.*

————, 3. *Irving Petlin Pastels.* New York: Kent Fine Art, Inc., 1988. I.B.C. *Essay examining the artist's pastels from 1961 to 1987.*

————, 4. *Twentieth Century American Drawings: The Figure in Context.* Washington, D.C.: International Exhibitions Foundation, 1984. I.B. *Exhibition catalogue reviewing the diverse treatment of the human figure in various contexts.*

————, 5. *20th Century Drawings: From the Whitney Museum of American Art.* New York: Whitney Museum of American Art, 1987. Foreword by Tom Armstrong. I.B. *Exhibition catalogue reviewing master drawings from the museum collection.*

————, 6. *Walter Murch.* Geneva: Galerie Jan Krugier, 1976. I.C. *Exhibition catalogue.*

CUMMINGS, PAUL, MERKERT, JORN, and STULLIG, CLAIRE. *Willem de Kooning: Drawings, Paintings, Sculpture.* New York: Whitney Museum of American Art, 1983. Foreword by Tom Armstrong. I.B.C. (German and English texts.) *Major retrospective catalogue.*

CURRY, JOHN STEUART. 1. *John Steuart Curry.* New York: American Artists Group Inc., 1945. I. *Autobiographical monograph.*

————, 2. *John Steuart Curry.* Syracuse, N.Y.: Joe and Emily Lowe Art Center, Syracuse University, 1956. I. *Exhibition catalogue.*

————, 3. *John Steuart Curry.* Lawrence: University of Kansas, 1957. I. *Exhibition catalogue.*

Dan Flavin. Cologne: Kunsthalle Koln, 1973. I.B. (German and English text.) *Artist's statement.*

DANTO, ARTHUR C. *The State of the Art.* New York: Prentice-Hall Press, 1987. I. *Collected essays from the popular column in* The Nation.

DAUBLER, THEODOR, and GOLL, IWAN. *Archipenko-Album.* Potsdam: Gustav Kiepenheuen Verlag, 1921. I. (German text.) *Monograph.*

David Simpson 1957-1967. San Francisco: San Francisco Museum of Art, 1967. Preface by John Humphrey. I.B. *Retrospective catalogue; includes statements by the artist.*

David Smith: The Prints. New York: Pace Editions, 1987. B.C. *Catalogue raisonné by Alexandra Schwartz with essay by Paul Cummings.*

DAVIDSON, MORRIS. 1. *An Approach to Modern Painting.* New York: Coward-McCann, Inc., 1948. I. *Appreciation of modern art.*

————, 2. *Understanding Modern Art.* New York: Coward-McCann, Inc., 1931. I. *Appreciation and understanding of modern concepts in art.*

DAVIES, HUGH MARLAIS. *Artist & Fabricator.* Amherst: University of Massachusetts, 1975. I. *Modern technology and commissioned sculpture; includes artists' statements.*

DAVIS, DOUGLAS. *Art and the Future.* New York: Praeger Publishers, 1973. I.B.D.G. *An effusion of the collaboration of art and science.*

DAVIS, STUART. *Stuart Davis.* New York: American Artists Group Inc., 1945. I. *Autobiographical monograph.*

DAWSON, FIELDING. *An Emotional Memoir of Franz Kline.* New York: Pantheon Books, 1967. I. *A personal memoir.*

DAY, HOLLIDAY T. 1. *Power: Its Myths and Mores in American Art, 1961-1991.* Indianapolis: Indianapolis Museum of Art, 1991. Foreword by Bret Waller. I. *Biographical sketches. Numerous critical jargon songs. A noisy and powerless exhibition of essentially non-art artifacts; a display of mindlessness.*

————, 2. *Shape of Space: The Sculpture of George Sugarman.* Omaha, NE: Joslyn Art Museum, 1981. Texts by Irving Sandler and Brad Davis. B.C. *Retrospective catalogue.*

The Decade Show: Frameworks of Identity in the 1980s. New York: Museum of Contemporary Hispanic Art. Introduction by Nilda Peraza, Marcia Tucker, Kinshasha Holdman

Conwill. Over a dozen essays by various writers. I.B.C. *Politics using art in a mindless manner.*

DE CREEFT, JOSE. *Jose de Creeft.* Athens: University of Georgia Press (American Sculptors Series), 1950. I. *Autobiographical monograph.*

DEHN, ADOLF. *Watercolor Painting.* New York: Studio Publications, 1945. I.

DE KOONING, WILLEM. *de Kooning: Drawings.* New York: Walker & Co., 1967. I. *Two dozen charcoal drawings with a statement by the artist.*

DENCH, ELLEN, and FEINBERG, JEAN E. *Jim Dine Prints, 1977-1985.* New York: Harper & Row, 1986. I.B.C. *Catalogue raisonné and exhibition catalogue.*

DE SALVO, DONNA, and SCHIMMEL, PAUL. *Hand-Painted Pop: American Art in Transition, 1955-62.* Los Angeles: Museum of Contemporary Art, 1992. Foreword by Richard Koshalek. Essays by assorted authors. I.B. *A re-evaluation of recent art, searching for history, even if superficial.*

DEVREE, CHARLOTTE. *Jose de Creeft.* New York: American Federation of Arts and The Ford Foundation, 1960. I. *Retrospective catalogue.*

DE VRIES, GERD, ed. *Uber Kunst/On Art.* Cologne: Verlag M. DuMont Schauberg, 1974. I.B. (German and English text.) *Artists' writings on art after 1965; exhibition lists.*

DE WILDE, EDY. 1. *La Grande Parade: Highlights in Painting after 1940.* Amsterdam: Stedelijk Museum, 1984. (Dutch and English texts.) *A panorama of painting from 1940 to the present.*

————, 2. *'60-'80: Attitudes/Concepts/Images.* Amsterdam: Stedelijk Museum, 1982. (Dutch and English texts.) I.B.C. *Multiple brief essays and artist statements.*

D'HARNONCOURT, ANNE, and McSHINE, KYNASTON, eds. *Marcel Duchamp.* New York: The Museum of Modern Art and the Philadelphia Museum of Art, 1973. Preface by Richard E. Oldenburg and Evan H. Turner. Introduction by Anne d'Harnoncourt. I.C.B. *Retrospective exhibition catalogue.*

DIAMONSTEIN, BARBARALEE. *Inside New York's Art World.* New York: Rizzoli International Publications, Inc., 1979. I. *Transcribed from video interviews at the New School. Popular; occasional insights.*

DIENST, ROLF GUNTER. 1. *Pop-Art.* Wiesbaden: Limes Verlag, 1965. I.B. (German text.) *Pop art in Europe and the USA.*

————, 2. *Richard Lindner.* New York: Harry N. Abrams Inc., 1970. I. *Critical study of the oeuvre.*

DIJKSTRA, BRAM, ed. *A Recognizable Image: William Carlos Williams on Art and Artists.* New York: New Directions, 1978. I. *Collected essays by the poet on visual art.*

DOCHTERMAN, LILLIAN. *The Quest of Charles Sheeler.* Iowa City: State University of Iowa, 1963. I. *Biography.*

DORIVAL, BERNARD. *Twentieth Century Painters.* New York: Universe Books, Inc.; Paris: Editions Pierre Tisne, 1958. I.B. *Painting in Europe and America.*

DORNER, ALEXANDER. *The Way Beyond Art.* New York: New York University Press, 1958. I. *Development of art and its influence in the museums.*

Dorothea Tanning. Mälmo: Mälmo Kunsthalle, 1993. Preface by Sunne Nordgen. Essays by John Russell, Dorothea Tanning, Alain Jouffroy, J. C. Bailly, Lasse Soderberg. I.B.C. (Swedish and English text.) *Retrospective catalogue with collected essays.*

DOTY, ROBERT. *Will Barnett.* New York: Harry N. Abrams, Inc., 1984. B.C. *Monograph.*

DOTY, ROBERT, ed. *Jane Freilicher: Paintings.* New York: Taplinger Publishing Co., Inc., 1986. B. *Retrospective catalogue including multiple short essays.*

DOVER, CEDRIC. *American Negro Art.* Greenwich, Conn.: New York Graphic Society, 1965. I.B. *Illustrated history.*

DOWNES, RACKSTRAW, ed. *Fairfield Porter: Art in Its Own Terms.* New York: Taplinger Publishing Co., 1979. I. *Collected critical writings by the artist-writer.*

The Drawings of Charles E. Burchfield. Cleveland: Print Club of Cleveland and The Cleveland Museum of Art, 1953. I. *Exhibition catalogue. (See also* Jones, ed.).

Drawings: The Pluralist Decade. Philadelphia: Institute of Contemporary Art, University of Pennsylvania, 1980. Introduction by Janet Kardon. I.C. *39th Venice Biennale, US Pavilion, exhibition catalogue: exploratory essays by several critics.*

DREIER, KATHERINE S. 1. *Burliuk.* New York: The Societe Anonyme, Inc., 1944. I. *Monograph.*

————, 2. *Western Art and the New Era, an Introduction to Modern Art.* New York: Brentano's, 1923. I. *Early polemic on abstract and nonfigurative art.*

DU BOIS, GUY PENE. 1. *Artists Say the Silliest Things.* New York: American Artists Group Inc., 1940. I. *Autobiography.*

————, 2. *Edward Hopper.* New York: The Whitney Museum of American Art (American Artists Series), 1931. I.B. *Monograph.*

————, 3. *Ernest Lawson.* New York: The Whitney Museum of American Art (American Artists Series), 1932. I.B. *Monograph.*

————, 4. *John Sloan.* New York: The Whitney Museum of American Art (American Artists Series), 1931. I.B. *Monograph.*

————, 5. *William Glackens.* New York: The Whitney Museum of American Art (American Artists Series), 1931. I.B. *Monograph.*

————, 6. *William Glackens.* New York: The Whitney Museum of American Art, 1939. *Exhibition catalogue.*

DUCHAMP, MARCEL. 1. *Marcel Duchamp.* Pasadena: The Pasadena Art Museum, 1963. I.B. *Exhibition catalogue.*

————, 2. *Marchand du Sel.* Paris: Le Terrain Vague, 1958. I.B. *Essays.*

Edward Kienholz. Düsseldorf: Stadtische Kunsthalle Düsseldorf, 1970. Introduction by Jurgen Harten. I.B.C. *Retrospective catalogue.*

Edward Kienholz: 11 + 11 Tableaux. Stockholm: Modern Museet, 1971. Introduction by K. G. P. Hulten. I.B. *Exhibition catalogue.*

8 American Masters of Watercolor. Los Angeles: County Museum of Art, 1968. Preface by Larry Curry. I.B. *Documented survey.*

EISLER, BENITA. *O'Keeffe and Stieglitz: An American Romance.* New York: Penguin Books, 1992. I.B. *Best-selling biography from porn to pseudo-psychology and back again.*

ELDERFIELD, JOHN. *Helen Frankenthaler.* New York: Harry N. Abrams, 1988. I.B.C. Index. *A complete review of the art and life of this painter, including quotes from the artist.*

————, 2. *Morris Louis.* New York: The Museum of Modern Art, 1986. Includes notes on methods, materials, and conservation problems. I.B.C. *Retrospective catalogue.*

ELIOT, ALEXANDER. *Three Hundred Years of American Painting.* New York: Time Inc., 1957. I.B. *Popular history of American art.*

ELLIOTT, JAMES. 1. "Stuart Davis." *Bulletin of the Los Angeles County Museum of Art,* Vol. XIV, No. 3, 1962. I. *Entire issue devoted to this essay.*

————, 2. *The Perfect Thought.* Berkeley, CA: U. of California, Berkeley, 1990. I.B.C. *Texts by assorted critics. Monograph/Retrospective catalogue of James L. Byars.*

ELSEN, ALBERT. 1. *Paul Jenkins.* New York: Harry N. Abrams Inc., 1973. I.B.C. *A major monograph.*

————, 2. *Purposes of Art.* New York: Holt Rinehart and Winston, Inc., 1962. I.B. *Elucidation of the art process.*

————, 3. *Seymour Lipton.* New York: Harry N. Abrams Inc., 1969. I. *Monograph.*

ELSEN, ALBERT, et. al. *Christo.* Sydney: Art Gallery of New South Wales, 1990. I.B. *Exhibition catalogue.*

ELY, CATHARINE BEACH. *The Modern Tendency in American Painting*. New York: Frederic Fairchild Sherman, 1925. I.

ETTING, EMLEN. *Drawing the Ballet*. New York: Studio Publications, 1944. I.

Eva Hesse: A Memorial Exhibition. New York: The Solomon R. Guggenheim Museum, 1972. I.B.C. *Retrospective exhibition catalogue; includes essays by Robert Pincus-Witten, Eva Hesse, Linda Shearer.*

Europa/Amerika. Cologne: Museum Ludwig, 1986. Texts by over 20 critics and historians. I.C. (German text.) *Examines art since 1940.*

EVANS, MYFANWY, ed. *The Painter's Object*. London: Gerald Howe Ltd., 1937. I. *Critical essays.*

FAITH, CREEKMORE, ed. *The Lithographs of Thomas Hart Benton*. Austin and London: University of Texas Press, 1969. I. *Catalogue of the prints; includes comments by the artist.*

FARNHAM, EMILY. *Charles Demuth: Behind a Laughing Mask*. Norman, Okla.: University of Oklahoma Press, 1971. I.B.C. *A poor book that fails profoundly.*

FARRELL, JAMES T. *The Paintings of Will Barnet*. New York: Press Eight, 1950. I. *Monograph.*

Fay Lansner. Swarthmore: Ava Books, 1976. Conversation with Irving H. Sandler. Introduction by Barbara Guest. I.B.C. *Illustrated essay.*

Feininger and Tobey: Years of Friendship, 1944-1956. The Complete Correspondence. New York: Achim Moeller Fine Art, Ltd., 1991. Foreword by Achim Moeller. Introduction by Stephan E. Hauser. I.B.G. Brief chronology. *Published with an exhibition of the two artists, revealing their common interests in art, life and the spirit.*

FEININGER, T. LUX. *Lyonel Feininger: At the Edge of the World*. New York: Frederick A. Praeger, 1968. I. *Essay on the development of imagery and ideas.*

FELDMAN, FRAYDA AND SCHELLMANN, JORGE. *Andy Warhol Prints: A Catalogue Raisonné*. New York: Ronald Feldman Fine Arts, 1985. I.B. Index. (also in a German edition). *Works catalogue.*

FERN, ALAN. *Leonard Baskin*. Annotated by Leonard Baskin. Washington, D.C.: Smithsonian Institution Press, 1971. I.B.C. *Exhibition catalogue, filmography.*

FIERENS, PAUL. *Sculpteurs d'aujourd'hui*. Paris: Editions de Chroniques de Jour, 1933. I. (French text.)

The Figurative Fifties: New York Figurative Expressionism. Newport Beach, CA: Newport Harbor Art Museum, 1989. Foreword by Kevin E. Consey. Essays by Klaus Kertess, Carter Ratcliff, Judith E. Stein, Paul Schimmel and numerous others on individual artists. I.B. *Exhibition chronology. A spirited defense.*

Figures/Environments. Minneapolis: The Walker Art Center, 1970. Introduction by Martin Friedman. I.C. *Exhibition catalogue.*

FINCH, CHRISTOPHER. *Pop Art: Object and Image*. New York: Studio Vista/Dutton Pictureback, 1968. I. *Well-illustrated popular assessment of international pop art.*

FINE, RUTH E. *John Marin*. Washington, D.C.: National Gallery of Art, 1990. Foreword by J. Carter Brown. I.B.C. *Retrospective built around the holdings of the National Gallery.*

FINKELSTEIN, SIDNEY. *Realism in Art*. New York: International Publishers, 1954.

FLANAGAN, GEORGE A. *Understanding and Enjoying Modern Art*. New York: Thomas Y. Crowen Co., 1962. I.B.

FLAVELL, M. KAY. *George Grosz*. New Haven: Yale University Press, 1988. I.B. *The biography.*

FLEXNER, JAMES THOMAS. *A Short History of American Painting*. Boston: Houghton Mifflin Co., 1950. I.B. *Authoritative history of American painting.*

FLINT, JANET. *The Prints of Louis Lozowick*. New York: Hudson Hills, 1982. Foreword by Alfred P. Maurice. I.B. Index. *Works catalogue.*

FLOCKHART, LOLITA L. W. *Art and Artists in New Jersey*. Somerville, N.J.: C.P. Hoagland Co., 1938. I.

FORD, CHARLES HENRI. *Poems for Painters.* New York: View Editions, 1945. I. *Poems illustrated by surrealist artists.*

Forerunners of American Abstraction. Pittsburgh: Museum of Art, Carnegie Institute, 1971. Foreword by Leon Anthony Arkus. Introduction by Herdis Bull Teilman. I.B. *Survey exhibition with biographical sketches.*

FORRESTA, MERRY, et. al. *Perpetual Motifs: The Art of Man Ray.* New York: Abbeville Press, 1988. I.B. *Numerous topics treated by various authors. Retrospective catalogue emphasizing the photography.*

Forty Years of California Assemblage. Los Angeles: Wight Art Gallery, University of California, Los Angeles. Preface by Edith A. Tonelli. Essays and Acknowledgments by Anny Ayres, Andrea Liss, Elizabeth Shepherd, Henry Hopkins, Peter Boswell, Philip Brookman, Verni Greenfield. I.B.C. *A simple academic review of the recent past in search of history.*

FOSTER, JOSEPH K. *Raphael Soyer, Drawings and Watercolors.* New York: Crown Publishers Inc., 1968. I. *A selection of 52 watercolors and 72 drawings.*

FOX, HOWARD N. *Avant-Garde in the Eighties.* Los Angeles: Los Angeles County Museum of Art, 1987. Foreword by Earl S. Powell, III. I.B. *An international examination in the brief efflorescence of the inventive during the 1980s and their eclipse.*

FRANK, WALDO, ed. *America and Alfred Stieglitz.* Garden City, N.Y.: Doubleday, Doran and Co., Inc., 1934. I. *A history of Alfred Stieglitz and his influence.*

FRASCONI, ANTONIO. *Against the Grain: The Woodcuts of Antonio Frasconi.* New York: Macmillan Publishing Co. Inc., 1974. Introduction by Nat Hentoff. Appreciation by Charles Parkhurst. I.D. *Thirty-five years of his woodcuts reviewed; includes section on his methods.*

Frederick Kiesler Architekt: 1890-1965. Vienna: Galerie Nachst St. Stephen, 1975. Introduction by Friedrich St. Florian. I.D.P. *Retrospective catalogue; includes artist's statements.*

FREUNDLICH, AUGUST L. *William Gropper: Retrospective.* Los Angeles: Ward Ritchie Press, 1968. I.B. *Retrospective catalogue including statements by the artist.*

FRIED, MICHAEL. 1. *Morris Louis.* Boston: Museum of Fine Arts, 1967. I.B. *Major retrospective catalogue including essay by Clement Greenberg.*

———, 2. *Morris Louis.* New York: Harry N. Abrams Inc., 1970. I. *Monograph.*

FRIEDMAN, B. H. 1. *Alfonso Ossorio.* New York: Harry N. Abrams Inc., 1971. I.B.C. *Picturebook monograph.*

———, 2. *Jackson Pollock: Energy Made Visible.* New York: McGraw-Hill Book Co., 1972. I.B. *A biographical study of the painter.*

———, 3. *Michael Lekakis: A Retrospective Exhibition.* New York, Kouros Gallery, 1987. I.C.

FRIEDMAN, B. H., ed. *School of New York: Some Younger Artists.* New York: Grove Press, Inc., 1959. I. *Younger artists of promise in the 1950s.*

FRIEDMAN, MARTIN. 1. *Adolph Gottlieb.* Minneapolis: The Walker Art Center, 1963. I.B. *Exhibition catalogue.*

———, 2. *14 Sculptors: The Industrial Edge.* Minneapolis: The Walker Art Center, 1969. I.B. *Exhibition catalogue with essays by Barbara Rose, Christopher Finch, and Martin Friedman.*

———, 3. *Nelson Wood Sculpture.* New York: E.P. Dutton, n.d. I.B.C. *Exhibition catalogue.*

FRIEDMAN, MARTIN, and VAN DER MARCK, JAN. *Eight Sculptors: The Ambiguous Image.* Minneapolis: The Walker Art Center, 1966. I.B.C. *Exhibition catalogue.*

Fritz Glarner. Bern: Kunsthalle Bern, 1972. Foreword by Max Bill. I.B. *Retrospective catalogue.*

From Foreign Shores. Milwaukee: Milwaukee Art Center, 1976. Introduction by I. Michael Danoff. I. *Bicentennial survey of emigrant artists from colonial times to the present.*

FROST, ROSAMOND. *Contemporary Art: The March of Art from Cezanne Until Now.* New York: Crown Publishers Inc., 1942. I.B.

FRY, EDWARD. *David Smith.* New York: The Solomon R. Guggenheim Museum, 1969. I.B. *Retrospective catalogue.*

FRY, EDWARD, and KUSPIT, DONALD. *Robert Morris: Works of the Eighties.* Newport Beach, CA: Newport Harbor Art Museum, 1986. B.C.I. *Exhibition catalogue includes multiple brief essays.*

Fundamentele Schilderkunst/Fundamental Painting. Amsterdam: Stedelijk Museum, 1975. Essay by Rini Dippel. Preface by E. de Wilde. I.B.C. *International minimalist painting.*

GABLIK, SUZI. *Progress in Art.* New York: Rizzoli International Publications Inc., 1977. I.B. *A proposed aesthetic for an abstract nonfigurative art.*

GABO, NAUM. *Of Divers Arts.* London: Faber and Faber, Ltd., 1962. I. *Critical essays.*

GALLATIN, A. E. 1. *American Watercolourists.* New York: E. P. Dutton, 1922. I.

———, 2. *Certain Contemporaries: A Set of Notes in Art Criticism.* New York: John Lane Co., 1916.

———, 3. *Gallatin Inconography.* n.p.: Privately published, 1934. I. *Genealogy through portraits.*

———, 4. *Gaston Lachaise.* New York: E.P. Dutton, 1924. I. *Critical essay.*

———, 5. *John Sloan.* New York: E.P. Dutton, 1925. I. *Critical essay.*

———, 6. *Paintings by Gallatin.* New York: Wittenborn, Schultz, Inc., 1948. I.B.

———, 7. *Paul Manship.* New York: John Lane Co., 1917. I.B. *Critical essay.*

———, 8. *Whistler, Notes and Footnotes.* New York: The Collector and Art Critic Co., 1907. I. *Critical essays.*

GARVER, THOMAS H. 1. *George Tooker.* San Francisco: California Palace of the Legion of Honor, 1974. I.B.C. *Retrospective catalogue.*

———, 2. *George Tooker.* New York: Clarkson Potter, Inc., Publishers, 1985. B.C. *Monograph with checklist of artist's paintings and prints.*

GARWOOD, DARRELL. *Artist in Iowa.* New York: W. W. Norton and Co., 1944. *Biography.*

GASCOYNE, DAVID. *A Short Survey of Surrealism.* London: Cobden-Sanderson, 1935. I. *Essays and documentation.*

GAUGH, HARRY F. 1. *de Kooning.* New York: Abbeville Press, 1983. B.C. *Eccentric monograph but includes artist's statements.*

———, 2. *The Vital Gesture: Franz Kline.* New York: Abbeville Press, 1985. I.B. *Suggests a new study of Kline is required.*

GAUNT, WILLIAM. *The Observer's Book of Modern Art from Impressionism to the Present Day.* London: Frederick Warne and Co. Ltd., 1964. I.G.

GENAUER, EMILY. *Best of Art.* Garden City, N.Y.: Doubleday and Co. Inc., 1948. I. *Painting during the 1940s.*

Gene Davis. San Francisco: San Francisco Museum of Art, 1968. Preface by Gerald Nordland. I.B. *One-man exhibition.*

Gene Davis: Drawings. New York: The Arts Publisher Inc., 1982. Introduction by Gene Boro. I. *Monograph on 30 years of drawings.*

George Grosz: Dessins et Aquarelles. Paris: Galerie Claude Bernard, 1966. Preface by Edouard Roditi. I. *Exhibition catalogue.*

George Rickey. Los Angeles: University of California, Los Angeles, 1971. An interview by Frederick S. Wight. I.B.D.C. *Exhibition catalogue.*

GEORGE, WALDEMAR. 1. *Les Artistes juifs et l'ecole de Paris.* Algiers: Editions du Congres Juif Mondial, 1959. I. (French text.)

———, 2. *John D. Graham.* Paris: Editions Le Triangle, n.d. I. *Critical essay.*

GERDTS, WILLIAM H., Jr. *Painting and Sculpture in New Jersey.* Princeton, N.J.: D. Van Nostrand, 1964. Foreword by Richard J. Hughes. I.B.D. *The first art history of New Jersey.*

GERSTNER, KARL. *Kalte Kunst.* Switzerland: Vertag Arthur Niggli, 1957. I. (German text.) *Hard-edge paintings and sculpture.*

GERTZ, ULRICH. *Contemporary Plastic Art.* Berlin: Rembrandt/Verlag, GMBH, 1955. I. (German and English text.) *Postwar painting in Europe, including American influence.*

GESKE, NORMAN A. *The Figurative Tradition in Recent American Art.* Washington, D.C.: National Collection of Fine Arts, 1968. *Catalogue for the 34th International Biennial, Venice.*

GETLEIN, FRANK. 1. *Chaim Gross.* New York: Harry N. Abrams Inc., 1974. I.B.C. *Illustrated monograph.*

————, 2. *Jack Levine.* New York: Harry N. Abrams Inc., n.d. I. *Monograph.*

————, 3. *Peter Blume.* New York: Kennedy Galleries, 1968. I. *Exhibition catalogue.*

GETLEIN, FRANK and DOROTHY. *Christianity in Art.* Milwaukee: The Bruce Publishing Co., 1959. I.B.

GETTINGS, FRANK. 1. *Different Drummers.* Washington, D.C.: Smithsonian Institution Press, 1988. Foreword by James T. Demetrion. I.B. *Exhibition catalogue of significant but eccentric artists.*

————, 2. *Drawings 1974-1984.* Washington, DC: Smithsonian Institution Press, 1984. Foreword by Abram Lerner. B.I.P. *International Survey Exhibition.*

GIEDION-WELCKER, CAROLA. 1. *Contemporary Sculpture: An Evolution in Volume and Space.* Documents of Modern Art, Vol. 12. New York: George Wittenborn, Inc., 1955. I.B.

————, 2. *Modern Plastic Art: Elements of Reality, Volume and Disintegration.* Zurich: Dr. H. Girsberger, 1937. I.B. *Twentieth-century sculpture.*

GLACKENS, IRA. *William Glackens and the Ashcan Group: The Emergence of Realism in American Art.* New York: Crown Publishers Inc., 1957. I.

GLENN, CONSTANCE W. *Jim Dine: Drawings.* New York: Harry N. Abrams Inc., 1985. B.I. *Monograph includes interviews and artist's statements.*

GLIMCHER, ARNOLD B. *Louise Nevelson.* New York: Praeger Publishers, 1972. I.C. *Monograph.*

GOHR, SIEGFRIED, and GACHNANG, JOHANNES. *Bilderstreit: Widerspruch, Einheit und Fragment in der Kunst seit 1960.* Cologne: DuMont, 1989. Multiple writers. I.B. (German text.) *Ancient philosophy employed in an attempt to find reason in recent questionable art.*

GOLDMAN, JUDITH. 1. *American Prints: Process and Proofs.* New York: Whitney Museum of American Art, 1981. Foreword by Tom Armstrong. Includes glossary of printing terminology. B.I. *Historical survey emphasizing 14 contemporary artists.*

————, 2. *James Rosenquist.* New York: Viking Press, 1985. I.B.C. *Major biographical and art study.*

GOLDSTEIN, ANN, and JACOB, MARY JANE. *A Forest of Signs: Art in the Crisis of Representation.* Los Angeles: The Museum of Contemporary Art, 1989.; Foreword by Richard Koshalek. Introduction by Ann Goldstein. I.B. Exhibition chronology. Index. *An examination of common images in search of art.*

GOLDWATER, MARGE, SMITH, ROBERTA, and TOMKINS, CALVIN. *Jennifer Bartlett.* New York: Abbeville Press, 1985. B.C. *Retrospective catalogue.*

GOLDWATER, ROBERT, and TREVES, MARCO, eds. *Artists on Art. From the XIV to the XX Century.* New York: Pantheon Books, 1945. I.

GOMRINGER, EUGEN. *Josef Albers.* New York: George Wittenborn, Inc., 1968. I.B. *Essays on all the aspects of Albers's work, with comments by the artist.*

GOODMAN, CYNTHIA. *Hans Hofmann.* New York and Munich: Prestel, 1990. I.B. *Exhibition catalogue.*

GOODRICH, LLOYD. 1. *American Watercolors and Winslow Homer.* New York: The Walker Art Center, for American Artists Group Inc., 1945. I.

———, 2. *The Drawings of Edwin Dickinson.* New Haven, Conn.: Yale University Press, 1963. I.

———, 3. *Edward Hopper.* New York: Penguin Books, 1949. I. *Monograph.*

———, 4. *Edward Hopper.* New York: The Whitney Museum of American Art, 1956. I.B. *Exhibition catalogue.*

———, 5. *Edwin Dickinson.* New York: The Whitney Museum of American Art, 1965. I.B. *Retrospective catalogue.*

———, 6. *John Sloan.* New York: The Whitney Museum of American Art, 1952. I.B. *Exhibition catalogue.* I.

———, 7. *Kuniyoshi.* New York: The Whitney Museum of American Art, 1948. I. *Exhibition catalogue.*

———, 8. *Max Weber.* New York: The Whitney Museum of American Art, 1949. I. *Exhibition catalogue.*

———, 9. *Raphael Soyer.* New York: The Whitney Museum of American Art, 1967. I.B. *Retrospective catalogue.*

———, 10. *Reginald Marsh.* New York: The Whitney Museum of American Art, 1955. I. *Exhibition catalogue.*

GOODRICH, LLOYD, and BAUR, JOHN I. H. 1. *American Art of Our Century.* New York: The Whitney Museum of American Art, 1961. I. *Development of American Art illustrated through the collection of the WMAA.*

———, 2. *Four American Expressionists.* New York: The Whitney Museum of American Art, 1949. I. *Exhibition catalogue: Doris Caesar, Chaim Gross, Kart Knaths, Abraham Rattner.*

GOODRICH, LLOYD, and IMGIZUMI, ATSUO. *Kuniyoshi.* Tokyo: National Museum of Modern Art, 1954. I. (Japanese and English text.) *Retrospective catalogue.*

GOODRICH, LLOYD, and MANDEL, PATRICIA FITZG. *John Heliker.* New York: The Whitney Museum of American Art, 1968. I.B. *Retrospective catalogue.*

GOODYEAR, FRANK H., Jr. 1. *8 Contemporary Realists.* Philadelphia: Pennsylvania Academy of the Fine Arts, 1977. Preface by Richard J. Boyle. Acknowledgments by Frank H. Goodyear, Jr. I. *An exploration of realism, its definitions and uses.*

———, 2. *Welliver.* New York: Rizzoli, 1985. Introduction by John Ashbery. *An appreciation.*

GOOSSEN, E. C. 1. *The Art of the Real USA 1948-1968.* New York: The Museum of Modern Art, 1968. I.B. *A proposal that some art is more "real" than other art.*

———, 2. *Ellsworth Kelly.* New York: The Museum of Modern Art, 1973. I.B.A. *Retrospective monograph.*

———, 3. *Helen Frankenthaler.* New York: The Whitney Museum of American Art, 1969. I.B. *Retrospective catalogue.*

———, 4. *Herbert Ferber.* New York: Abbeville, 1981. I.B. *Monograph.*

———, 5. *Stuart Davis.* New York: George Braziller, Inc., 1959. I.B. *Monograph.*

———, 6. *Three American Sculptors.* New York: Grove Press Inc., 1959. I. *Monograph: Herbert Ferber, David Hare, Ibram Lassaw.*

GORDON, JOHN. 1. *Franz Kline.* New York: The Whitney Museum of American Art, 1968. I.B.C. *Retrospective catalogue.*

———, 2. *Isamu Noguchi.* New York: The Whitney Museum of American Art, 1968. I.B.C. *Retrospective catalogue.*

———, 3. *Karl Schrag.* New York: American Federation of Arts and The Ford Foundation, 1960. I. *Retrospective catalogue.*

———, 4. *Louise Nevelson.* New York: The Whitney Museum of American Art, 1967. I.B. *Retrospective catalogue.*

Gordon Onslow-Ford: Retrospective Exhibition. Oakland, CA: Oakland Museum, 1980. Introduction by Harvey L. Jones. Foreword by Herschel B. Chipp. C. *Includes artist's statements.*

GOUMA-PETERSON, THALIA. *Breaking the Rules: Audrey Flack, A Retrospective, 1950-1990.* New York: Harry N. Abrams, Inc., 1992. Foreword by Peter Morrin. Numerous essays. I.B.C. Catalogue raisonné. *The complete documentation with critical essays.*

Graham, Gorky, Smith & Davis in the Thirties. Providence: Brown University, 1977. Foreword by William H. Jordy. Introduction by Ellen Lawrence. I.B.C. *Examines interplay and evolution of these artists' work in one decade.*

GRAHAM, JOHN D. *System and Dialectics of Art.* New York: Delphic Studios, 1937. *Critical essays.*

The Great Decade of American Abstraction: Modernist Art 1960 to 1970. Houston: The Museum of Fine Arts, 1974. Foreword by R. A. Carmean, Jr. Introduction by Philippe de Montebello. I.B. *Exhibition catalogue; reprints, critical essays, and essays on the conservation of colorfield paintings.*

GREEN, SAMUEL ADAMS. *Andy Warhol.* Philadelphia: Institute of Contemporary Art, 1965. I. *Exhibition catalogue.*

GREENBERG, CLEMENT. 1. *Art and Culture.* Boston: Beacon Press, 1961. *Critical essays.*

————, 2. *Hofmann.* Paris: The Pocket Museum, Editions George Fall, 1961. I. *Monograph.*

GREENGOOD, LILLIAN. *Great Artists of America.* New York: Thomas Y. Crowell Co., 1963. I.B. *Popular biographical essays.*

GREVENSTEIN, ALEXANDRA. *Richard Serra: Drawings, 1979-1990.* Bern: Benteli Verlag, 1990. I.B. (In German and English.) *Catalogue of drawings, and includes artist's text.*

GROSS, CHAIM. *Fantasy Drawings.* New York: Beechhurst Press (A Bittner Art Book), 1956. I. *Drawings.*

GROSSER, MAURICE. 1. *The Painter's Eye.* New York: Rinehart and Co., Inc., 1951. I. *Essays on diverse topics.*

————, 2. *Painting in Public.* New York: Alfred A. Knopf, 1948. *Autobiographical.*

GROSZ, GEORGE. 1. *George Grosz.* Berlin: Akadmie der Kunste, 1962. I. *Retrospective catalogue.*

————, 2. *George Grosz Drawings.* New York: H. Bittner and Co., 1944. I. *Drawings.*

————, 3. *Die Gezeichneten.* Berlin: Malik Verlag, 1930. I. (German text.) *Drawings.*

————, 4. *A Little Yes and a Big No. The Autobiography of George Grosz.* New York: The Dial Press, 1946. I.

————, 5. *Der Spiesser-Spiegel.* Dresden: Carl Reisser Verlag, 1925. I. (German text.) *Drawings.*

GROVE, NANCY. *Marisol.* Washington, D.C.: National Portrait Gallery, 1991. I.B. *Examines the images of noted public figures.*

GRUEN, JOHN. *Keith Haring: The Authorized Biography.* New York: Prentice Hall Press, 1991. I.B.C. *A compendium of edited interviews and miscellany.*

GUEST, BARBARA, and FRIEDMAN, B. H. *Goodnough.* Paris: The Pocket Museum, Editions George Fall, 1962. I. *Monograph.*

GUGGENHEIM, PEGGY, ed. *Art of This Century.* New York: Art of This Century, 1942. I. *Documents her New York gallery.*

GUTMAN, WALTER, K. *Raphael Soyer, Paintings and Drawings.* New York: Shorewood Publishing Co., Inc., 1960. I. *Monograph.*

HAAS, IRVIN. *A Treasury of Great Prints.* New York: Thomas Yoseloff Inc., 1959. I.

HACKETT, PAT. *The Andy Warhol Diaries.* New York: Warner Books, 1989. I. *The artist's own words.*

HAENLEIN, CARL. *New York Now.* Hannover: Kestner-Gesellschaft Hannover, 1982. (German text.) B.C. *Survey of the newest art of the early 1980s.*

HAFTMAN, WERNER. *Paintings in the Twentieth Century.* New York: Frederick A. Praeger, 1960. 2 vols. I. *A major history of twentieth-century art.*

HAHN, OTTO. *Arman.* Paris: Femand Hazan Editeur, 1972. I.B. (French text.) *Appreciation with biographical information.*

HALE, ROBERT BEVERLY. *Waldo Peirce.* New York: American Artists Group Inc., 1945. I. *Monograph.*

HALL, W. S. *Eyes on America.* New York: Studio Publications, 1939. I. *Figurative painting in America.*

HALPERT, EDITH GREGOR. *The Downtown Gallery.* New York: The Downtown Gallery, 1943. I. *Documents members of the gallery.*

HAMILTON, GEORGE H. *Josef Albers.* New Haven, Conn.: Yale University Art Gallery, 1956. I. *Exhibition catalogue.*

HAMILTON, RICHARD. *The Bride Stripped Bare by Her Bachelors, Even.* New York: George Wittenborn, Inc., 1960. *Documentary essay on Marcel Duchamp.*

HANSEN, AL. *A Primer of Happenings and Time/Space Art.* New York: Something Else Press Inc., 1965. I. *People, places, events, and Hansen in happenings and time/space.*

Happening & Fluxus. Cologne: Kolnischer Kunstverein. I.B.D.P.C. *The major documentary resource on happening, fluxus, events, non-art, 1959-1970.*

HARRISON, HELEN A. *Larry Rivers.* New York: Harper & Row, Publishers, 1984. B.C. *Monograph.*

HARTLEY, MARSDEN. *Adventures in the Arts.* New York: Boni and Liveright, Inc., 1921. *Autobiography.*

HARTMANN, SADIKICHI. *A History of American Art.* Boston: L.C. Page and Co., 1932, rev. ed., 2 vols. I. *Important history of American art.*

HASKELL, BARBARA. 1. *Arthur Dove.* San Francisco: San Francisco Museum of Art, 1974. I.B.C. *Retrospective catalogue.*

———, 2. *Blam! The Explosion of Pop, Minimalism, and Performance 1958-1964.* New York: Whitney Museum of American Art, 1984. Foreword by Tom Armstrong. I.B.C. *A miscellaneous view of vanguard art of the times. Includes an essay on independent cinema by John G. Hanhardt.*

———, 3. *Claes Oldenburg: Object into Monument.* Pasadena: The Pasadena Art Museum, 1971. I.B.C. *Exhibition catalogue with comments on individual pieces by the artist.*

———, 4. *H. C. W.* New York: The Whitney Museum of American Art. Introduction by Tom Armstrong. I.B.C. *Retrospective catalogue of H. C. Westermann.*

———, 5. *Marsden Hartley.* New York: The Whitney Museum of American Art in association with NYU Press, 1980. Forewords by Tom Armstrong and A. James Speyer. I.B.C. *Retrospective exhibition catalogue.*

———, 6. *Milton Avery.* New York: Whitney Museum of American Art, 1982. Foreword by Tom Armstrong. B.C.I. *Retrospective catalogue.*

HAYES, JEFFREY R. *Oscar Bluemner. Landscapes of Sorrow and Joy.* Washington, D.C.: Corcoran Gallery of Art, 1988. I. *Exhibition catalogue.*

HAYTER, S. W. 1. *About Prints.* London: Oxford University Press, 1962. I.B. *Print appreciation and techniques.*

———, 2. *New Ways of Gravure.* New York: Pantheon Books, 1949. I.D. *Printmaking techniques.*

HEADLEY, DIANE UPRIGHT. *The Drawings of Morris Louis.* Washington, D.C.: National Collection of Fine Arts, 1979. Foreword by Joshua C. Taylor. I. *Exhibition and catalogue raisonné.*

HELM, MacKINELY. *John Marin.* New York: Pellegrini and Cudahy, 1948. I. *Monograph.*

HELM, MacKINLEY, and WIGHT, FREDERICK S. *John Marin.* Boston: Institute of Modern Art, 1947. I. *Exhibition catalogue.*

HENNING, EDWARD. B. *Paths of Abstract Art.* Cleveland: The Cleveland Museum of Art, 1960. I. *Twentieth-century development of abstract art.*

HESS, HANS. *Lyonel Feininger.* London: Thames and Hudson, 1961. I.B. *Catalogue raisonné.*

HESS, THOMAS B. 1. *Abstract Painting: Background and American Phase.* New York: Viking Press, 1951. I. *Important documentation of abstract painting in America.*

———, 2. *Barnett Newman.* New York: Walker & Co., 1969. I.B. *Monograph.*

———, 3. *Barnett Newman.* New York: The Museum of Modern Art, 1971. I.B. *Retrospective monograph.*

———, 4. *Willem de Kooning.* New York: The Museum of Modern Art, 1968. I.B. *Retrospective monograph; includes statements by the artist.*

———, 5. *Willem de Kooning: Drawings.* Greenwich, Conn.: New York Graphic Society Ltd., 1972. I.B.C. *Essays on his drawings.*

HICKEY, DAVE, and PLAGENS, PETER. *The Works of Edward Ruscha.* New York: Hudson Hills Press, 1982. Introduction by Anne Livet. Foreword by Henry T. Hopkins. I.B.C. *Retrospective catalogue.*

HILDEBRANDT, HANS. *Alexander Archipenko.* Berlin: Ukrainske Slowo Publishers Ltd., 1923. I. (Ukrainian and English text.) *Monograph.*

HILL, ANTHONY, ed. *D.A.T.A.-Directions in Art, Theory and Aesthetics.* London: Faber and Faber, Ltd., 1968. I.B. *Collected statements by neoplastic and kinetic artists, including Charles Biederman.*

HIROMOTO, NOBUYUKI. *Painting Now.* Kyushu, Japan: Kitakyushu Municipal Museum of Art, 1984. Foreword by Kazuaki Mitsuiki. (Japanese and English texts.) B.

HIRSCH, RICHARD. *Charles Sheeler.* Allentown, Pa.: Allentown Art Museum, 1961. I. *Exhibition catalogue.*

HOBBS, ROBERT CARLETON. *Milton Avery.* New York: Hudson Hills Press, 1990. Introduction by Hilton Kramer. I. *Monograph.*

HOBBS, ROBERT CARLETON, and LEVIN, GAIL. *Abstract Expressionism: The Formative Years.* Ithaca: Herbert F. Johnson Museum of Art, 1978. Introduction by Thomas W. Leavitt and Tom Armstrong. I. *A singular account of the evolution of this theory.*

HOFMANN, HANS. *Search for the Real.* Andover, Mass.: Addison Gallery of American Art, 1948. I. *Hofmann's theory of painting.*

HOLLANDER, JOHN, and BRIGANTI, GUILIANO. *William Bailey.* New York: Rizzoli, 1991. I.B. *Monograph.*

HOLME, BRYAN. 1. *Master Drawing in Line.* New York: Studio Publications, 1948. I.

———, 2. *Master Drawings.* New York: Studio Publications, 1943. I.

HOLT, NANCY, ed. *The Writings of Robert Smithson: Essays with Illustrations.* New York: New York University Press, 1979. Introduction by Philip Leider. I. *Biographical note. The collected writings and interviews.*

HONIG, EDWIN. *Mauricio Lasansky: The Nazi Drawings.* Iowa City: Mauricio Lasansky Foundation, 1966. I. *Exhibition catalogue.*

HONISCH, DIETER, and JENSEN, JENS CHRISTIAN, eds. *Amerikanische Kunst von 1945 bis heute. Kunst der USA in europaischen Sammlungen.* Koln: DuMont Buchverlag, 1976. I.D. (German text.) *Collected essays in this major study on the exhibition of, collecting of, and critical efforts concerning American art. Works in public collections and lists of influential exhibitions.*

HONNEF, KLAUS. 1. *Concept Art.* Cologne: Phaidon Veriag, 1971. I. B.D.C. (German text.) *Critical essay including artists' statements and documentation.*

———, 2. *Contemporary Art.* Cologne: Taschen Verlag, 1990. I. Brief chronology. (German and/or English text.) *Essentially German, pitiful, neo-expressionism.*

HOOPES, DONELSON F. *William Zorach*. New York: Brooklyn Museum, 1968. I. *Retrospective of the paintings, drawings, and watercolors.*

HOPE, HENRY R. *The Sculpture of Jacques Lipchitz.* New York: The Museum of Modern Art, 1954. I.B. *Exhibition catalogue.*

HOPPER, EDWARD. *Edward Hopper.* New York: American Artists Group, Inc., 1945. I. *Autobiographical monograph.*

HOPPS, WALTER. *Frank Lobdell.* Pasadena: The Pasadena Art Museum, 1966. I. *Retrospective catalogue.*

HOVING, THOMAS. *Two Worlds of Andrew Wyeth: A Conversation with Andrew Wyeth.* Boston: Houghton Mifflin Co., 1978. I. *A lengthy interview.*

HOWARD, CHARLES. *Charles Howard.* San Francisco: California Palace of The Legion of Honor, 1946. I.B. *Exhibition catalogue.*

Howard Kanovitz. Duisburg: Wilhelm-Lehmbruck-Museum, 1974. I.B.C. (German and English text.) *Ten-year retrospective including artist's statements.*

HUBER, CARLO. *Cy Twombly. Bilder 1953-1972.* Bern: Kunsthalle Bern, 1973. Foreword by Carlo Huber and Michael Pelzet. I.C. (German text.) *Exhibition catalogue.*

HUGHES, ROBERT. *Nothing if Not Critical.* New York: Alfred A. Knopf, 1990. *Essays accumulated from* Time, *the cultural magazine, and other transient publications.*

HULTEN, K.G. PONTUS. *The Machine.* New York: The Museum of Modern Art, 1968. I.B. *Art and the mechanical age.*

HUMPHREY, JOHN. *Roy De Forest: Retrospective.* San Francisco: San Francisco Museum of Art, 1974. *I.B.C. Catalogue including artist's statements.*

HUNTER, SAM. 1. *Art since 1945.* New York: Harry N. Abrams Inc., 1958. I.B. *Comprehensive study of world art since 1945.*

————, 2. *Hans Hoffmann.* New York: Harry N. Abrams Inc., 1962. I.B. *Monograph.*

————, 3. *Isamu Noguchi.* New York: Abbeville, 1978. I.B. *Monograph.*

————, 4. *James Brooks.* New York: The Whitney Museum of American Art, 1963. I.B. *Retrospective catalogue.*

————, 5. *Larry Rivers.* New York: Harry N. Abrams Inc., 1970. I. *Monograph.*

————, 6. *Larry Rivers.* New York: Rizzoli, 1989. I.B. *Monograph.*

————, 7. *Modern American Painting and Sculpture.* New York: Dell Publishing Co., 1959. I. *Concise history of American art since 1900; includes biographies.*

————, 8. *Philip Guston.* New York: Jewish Museum 1966. I.B. *Major retrospective catalogue, including a dialogue with Harold Rosenberg.*

————, 9. *Rosenthal: Sculpture.* New York: M. Knoedler & Co., n.d. I. *Exhibition catalogue, including dialogue with the artist.*

HUNTER, SAM, ed. 1. *The Dada/Surrealist Heritage.* Williamstown: Sterling and Francine Clark Art Institute, 1977. I.B. *Williams College student exhibition of fine quality.*

————, 2. *New York Around the World: Painting and Sculpture.* New York: Harry N. Abrams Inc., 1966. I. *16 essays on the most modern art since 1945, updated to 1966.*

HUYGHE, RENE. *Histoire de l'art contemporain. La Peinture.* Paris: Librairie Felix Alcan, 1936. I.B. (French text.)

Index of 20th Century Artists. New York: The College Art Association, 1933-37, 4 vols. B. *Comprehensive reference on American artists of the 1920s and 1930s.*

Individual Realities in the California Art Scene. Tokyo: Sezon Museum of Art, 1991. Text by Josine Ianco-Starrles and Tetsuro Shimizu. I. *Exhibition catalogue. Various bold, bright images of the 1980s for the East.*

Individuals: A Selected History of Contemporary Art, 1945-1986. New York: Abbeville Press, 1986. Numerous essays by various critics. I. *A small museum's desire to redirect past history and proving reputations are made in New York.*

IRWIN, ROBERT. *Robert Irwin.* New York: The Whitney Museum of American Art, 1977. I.B.D.P. *Exhibition catalogue.*

Isabel Bishop. Tucson: University of Arizona Museum of Art, 1974. Foreword by Sheldon Reich. Introduction by Martin H. Bush. B. *Retrospective catalogue.*

Isamu Noguchi. Tokyo: Minami Gallery, 1973. I.D.C. (English and Japanese text.) *Exhibition catalogue: includes artist's statements.*

JACKMAN, RILLA EVELYN. *American Arts.* Chicago: Rand McNally and Co., 1928. I.B. *Popular essays on the arts.*

Jackson Pollock. Paris: Centre Georges Pompidou, 1982. (French text.) B.C.I. *Numerous short essays in a poorly printed retrospective catalogue.*

JACOBSON, J. Z., ed. *Art of Today: Chicago 1933.* Chicago: L. M. Stein, 1932. I.

JAKOVSKI, ANATOLE. *Arp, Calder, Helion, Miro, Pevsner, Seligmann.* Paris: Chez J. Povolozky, 1933. I. (French text.)

JANIS, HARRIET, and BLESH, RUDI. 1. *Collage. Personalities-Concepts-Techniques.* Philadelphia and New York: Chilton Co., 1962. I.G. *Documents development of collage in the world.*

――――, 2. *de Kooning.* New York: Grove Press Inc., 1960. I. *Monograph.*

JANIS, SIDNEY. *Abstract and Surrealist Art in America.* New York: Reynal and Hitchcock, 1944. I. *Essays on the two schools of art in the 1940s.*

Jan Matulka. 1890-1972. Washington,D.C.: Smithsonian Institution Press, 1980. Foreword by Joshua C. Taylor. Introduction by Patterson Sims and Merry A. Forresta. Essays by Patterson Sims, Merry A. Forresta, Dorothy Dehner, Janet A. Flint. I.B.C. *Retrospective catalogue; includes a checklist of prints.*

JENKINS, PAUL and ESTHER, eds. *Observations of Michael Tapie.* New York: George Wittenborn, Inc., 1956, I.A. *Collection of the critic's commentaries.*

JENKINS, PAUL with JENKINS, SUZANNE DONNELLY. *Anatomy of a Cloud.* New York: Harry N. Abrams, Inc., 1983. B.C. *Autobiography in words and pictures.*

JEWELL, EDWARD ALDEN. 1. *Alexander Brook.* New York: The Whitney Museum of American Art (American Artists Series), 1931. I.B. *Monograph.*

――――, 2. *... America.* New York: Alfred A. Knopf, 1930. I. *Critical essays.*

――――, 3. *Have We an American Art?* New York and Toronto: Longmans, Green and Co., 1939. *Critical essays.*

JOACHIMIDES, CHRISTOS M. and ROSENTHAL, NORMAN, eds. 1. *Metropolis.* New York: Rizzoli, 1991. Exhibition held at Martin-Gropius-Bau, Berlin, April 20 - July 21, 1991. Eleven essays describing the exhibition. I.B. *A sycophantic response to ever increasingly unintelligent art market.*

――――, 2. *Zeit Geist.* New York: George Braziller, Inc., 1983. B. *Seven essays accompany this review of international angst art.*

Joan Mitchell: My Five Years in the Country. Syracuse: Everson Museum of Art, 1972. Introduction by James Harithas. I.B.C. *Exhibition catalogue.*

John Altoon. San Francisco: San Francisco Museum of Art, 1967. Preface by Gerald Nordland. I.B. *Retrospective catalogue.*

John McLaughlin. La Jolla: La Jolla Museum of Contemporary Art, 1973. Foreword by Jay Belloli. Introduction by John McLaughlin. I.B.C. *Retrospective catalogue.*

John Wilde: Drawings 1940-1984. Madison, WI: Elvehjem Museum of Art, 1984. Appreciation by James Watrous. Foreword by Carlton Overland. *Retrospective catalogue of 435 drawings.*

John Willenbecher. Allentown: Allentown Art Museum, 1978. Foreword by Richard N. Gregg. Introduction by Jean-Louis Bourgeois. I.B. *Retrospective catalogue including artist's statements.*

JOHNSON, ELLEN H. *Modern Art and the Object.* New York: Harper & Row, Publishers (Icon Editions), 1976. I. Index. *Collected essays on modern art.*

JOHNSON, UNA E. 1. *Gabor Peterdi.* New York: Brooklyn Museum, 1959. I. *Exhibition catalogue.*

———, 2. *Isabel Bishop.* New York: Brooklyn Museum, 1964. I.B. *The prints and drawings of Miss Bishop with two essays by the artist.*

———, 3. *Paul Cadmus.* New York: Brooklyn Museum, 1968. I.B. *Catalogue of an exhibition of prints and drawings.*

Jonathan Borofsky: Dreams 1973-1981. London: Institute of Contemporary Art, 1981. B. *Multiple texts and artist's statements on note-taking.*

JONES, DAN BURNE. *The Prints of Rockwell Kent.* Chicago: The University of Chicago Press, 1975. Foreword by Carl Zigrosser. I.B. *Catalogue raisonné.*

JONES, EDITH H., ed. *The Drawings of Charles Burchfield.* New York: Frederick A. Praeger, 1968. I. *A pictorial survey. (See also under "Drawings . ." for Cleveland volume.)*

JORDAN, JIM M. and GOLDWATER, ROBERT. *The Paintings of Arshile Gorky: A Critical Catalogue.* New York: New York University Press, 1980. *Catalogue of paintings.*

Jose De Rivera: Retrospective Exhibition 1930-1971. La Jolla: La Jolla Museum of Contemporary Art, 1972. Introduction by Thomas B. Tibbs. I.C. *Includes catalogue raisonné of 191 works.*

Joseph Hirsch. Athens, Ga.: Georgia Museum of Art, 1970. Foreword by William D. Paul, Jr. Introduction by Frank Getlein. I.C.B. *Exhibition catalogue.*

JOYNER, BROOKS. *The Drawings of Arshile Gorky.* College Park, Md.: University of Maryland, 1969. Preface by George Levitine. Foreword by William H. Gerdts. I.B. *Major essay on the drawings.*

JUIN, HUBERT. *Seize peintres de la jeune ecole de Paris.* Paris: Le Musée de Poche, 1956. I.

KAPROW, ALLAN. *Assemblage, Environments and Happenings.* New York: Harry N. Abrams Inc., 1965. I. *Scripts. A major illustrated and documented book.*

KARDON, JANET. 1. *Siah Armajani.* Philadelphia: U. of Pennsylvania, 1985. B.C. *Retrospective catalogue.*

———, 2. *David Salle.* Philadelphia: Institute of Contemporary Art, University of Pennsylvania, 1986. Essay by Lisa Phillips. B.C. *Retrospective catalogue.*

———, 3. *1967: At the Crossroads.* Philadelphia: Institute of Contemporary Art, U. of Pennsylvania, 1987. Essays by Lucy R. Lippard, Barbara Rose, Janet Kardon, Irving Sandler, and Hal Foster. I.B.C. *A review of a single year, demonstrating how political criticism fails art.*

KARFIOL, BERNARD. *Bernard Karfiol.* New York: American Artists Group Inc., 1945. I. *Autobiographical monograph.*

Karl Schrag. Rockland, Me.: Farnsworth Art Museum, 1992. Essay by Carl Little. I.B.C. *Retrospective catalogue, includes artist's statements.*

KARLSTROM, PAUL J., and EHRLICH, SUSAN. *Turning the Tide: Early Los Angeles Modernists, 1920-1956.* Santa Barbara, CA: Santa Barbara Museum of Art, 1990. Foreword by Richard V. West. Introduction by Barry M. Heisler. I.B. *Lengthy essay by Karlstrom, individual artists treated by Ehrlich. The early days reviewed in an exhibition catalogue of noted and now forgotten artists.*

KARSHAN, DONALD. 1. *Archipenko: The Sculpture and Graphic Art.* Tubingen: Ernst Wasmuth Verlag, 1974. I.B.C. *Catalogue raisonné.*

———, 2. *Archipenko: Sculpture, Drawings, and Prints, 1908-1963.* Danville, OH: Centre College, 1985. Foreword by Richard L. Morrill. I.C. *Reviews and catalogues the author's collection.*

KASS, RAY. *Morris Graves: Visions of the Inner Eye.* New York: George Braziller, Inc., 1983. Introduction by Theodore F. Wolff. Foreword by Laughlin Phillips. B.C.I. *Retrospective catalogue with multiple essays.*

KATZ, LESLIE. *William Glackens in Retrospect.* St. Louis: The City Art Museum, 1966. I.B. *Major retrospective catalogue.*

KATZ, MARY LYNN. *Rauschenberg: Art and Life*. New York: Harry N. Abrams, 1990. I.B. *A Biography*.

Keith Haring. Bordeaux, France: C.A.P.C., Musée d'art contemporain, 1986. (French text.) C.B. *Includes numerous brief essays*.

KELDER, DIANE, ed. *Stuart Davis*. Documentary Monographs in Modern Art. New York: Praeger Publishers, 1971. I.B.C. *Collected writing of and about the artist. Monograph*.

KENT, NORMAN. *Drawings by American Artists*. New York: Watson-Guptill Publishing Co. Inc., 1947. I.

KENT, ROCKWELL. 1. *It's Me O Lord*. New York: Dodd, Mead and Co., 1955. I. *Autobiography*.

————, 2. *Rockwell Kent*. New York: American Artists Group Inc., 1945. I. *Autobiographical monograph*.

————, 3. *Rockwellkentiana*. New York: Harcourt, Brace and Co., 1945. I. *Autobiographical monograph*.

KENT, ROCKWELL, ed. *World Famous Paintings*. New York: Wise and Co., 1939. I. *Paintings of all ages*.

KEPES, GYORGY. 1. *Language of Vision*. Chicago: Paul Theobold and Co., 1944. I. *An aesthetic of seeing*.

————, 2. *The New Landscape in Art and Science*. Chicago: Paul Theobald and Co., 1956. I. *Convolutions of science and art*.

KEPES, GYORGY, ed. *The Visual Arts Today*. Middletown, Conn.: Wesleyan University Press, 1960. I.B. *Essays on architecture, fine arts, graphics, typography, etc.*

KIRBY, MICHAEL. *Happenings*. New York: E.P. Dutton, 1965. I. *A history with scripts of the happenings*.

KIRSCHNER, JUDITH RUSSI. *Surfaces: Two Decades of Painting in Chicago: Seventies and Eighties*. Chicago: Terra Museum of American Art, 1987. Foreword by Daniel J. Terra. I.B.C. Exhibition catalogue. *Review of recent trends in Chicago*.

KIRSTEIN, LINCOLN. 1. *Elie Nadelman*. New York: The Eakins Press, 1973. I.B. *Catalogue raisonné: monograph including artist's statements and writings*.

————, 2. *Elie Nadelman Drawings*. New York: H. Bittner and Co., 1949. I. *Drawings*.

————, 3. *Paul Cadmus*. New York: Imago Imprint Inc., 1984. B.C. *Essays and catalogue of paintings*.

————, 4. *Pavel Tchelitchew*. New York: Gallery of Modern Art, 1964. I.B. *Retrospective catalogue*.

————, 5. *The Sculpture of Elie Nadelman*. New York: The Museum of Modern Art, 1948. *Retrospective catalogue*.

KIRSTEIN, LINCOLN, ed. *Pavel Tchelitchew Drawings*. New York: H. Bittner and Co., 1947. I. *Drawings*.

KLIGMAN, RUTH. *Love Affair: A Memoir of Jackson Pollock*. New York: William Morrow & Co. Inc., 1974.

KOCH, JOHN. *John Koch in New York*. New York: Museum of the City of New York, 1963. I.B. *Retrospective catalogue*.

KOCH, STEPHEN. *Stargazer: Andy Warhol's World and His Films*. New York: Praeger Publishers, 1973. I. *Filmography*.

KOOTZ, SAMUEL M. 1. *Modern American Painters*. n.p.: Brewer and Warren Inc., 1930. I. *Survey of painting in the 1930s*.

————, 2. *New Frontiers in American Painting*. New York: Hastings House, 1943. I. *Surveys the advance guard in painting*.

KOSTELANETZ, RICHARD, ed. *Moholy-Nagy*. Documentary Monographs in Modern Art. New York: Praeger Publishers, 1970. I.B.D.C. *Edited essays by and about the artist. Monograph*.

KOUVENHOVEN, JOHN A. *Made in America: The Arts in Modern Civilization.* Garden City, N.Y.: Doubleday and Co. Inc., 1948. I.B. *Critical essays on American culture.*

KOZLOFF, MAX. 1. *H.C. Westermann.* Los Angeles: County Museum of Art, 1968. I.B. *Retrospective catalogue.*

———, 2. *Jasper Johns.* New York: Harry N. Abrams Inc., 1967. I.B. *Well-illustrated monograph.*

———, 3. *Renderings.* New York: Simon and Schuster, 1968. I. *Collected critical essays on modern art.*

KRAMER, HILTON. 1. *David Smith.* Los Angeles: County Museum of Art, 1965. I.B. *Includes statements by the artist.*

———, 2. *Milton Avery: Paintings, 1930-1960.* New York: Thomas Yoseloff Inc., 1962. I. *Monograph.*

———, 3. *Richard Lindner.* Boston: New York Graphic Society, 1978. I.B. *Monograph.*

———, 4. *The Sculpture of Gaston Lachaise.* New York: The Eakins Press, 1967. I.B. *Well-illustrated monograph.*

KRAUSS, ROSALIND E. 1. *Jules Olitski—Recent Painting.* Philadelphia: Institute of Contemporary Art, 1968. I.B. *Exhibition catalogue.*

———, 2. *The Originality of the Avant-Garde and Other Modernist Myths.* Cambridge, MA: MIT Press, 1985. I. *Collected thoughts on art as seen through recent French philosophy.*

———, 3. *Passages in Modern Sculpture.* New York City: The Viking Press, 1977. I.B. *Observations on sculptured objects from Rodin to the late twentieth century.*

KREN, ALFRED. *Drawing Distinctions: American Drawings of the Seventies.* Munich: Prestel-Verlag, 1981. (Separate German and English editions.) I.B.C. *Several miscellaneous essays examine this decade of drawing.*

KRIEGER, REGINE TESSIER. *Kay Sage.* Ithaca: Herbert F. Johnson Museum of Art, 1977. Foreword by Thomas W. Leavitt. I.B.C. *Retrospective catalogue; quotes from the artist's writings.*

KROLL, LEON. 1. *Leon Kroll.* Cleveland: Print Club of Cleveland and The Cleveland Museum of Art, 1945. I. *Exhibition catalogue.*

———, 2. *Leon Kroll.* New York: American Artists Group Inc., 1946. I. *Autobiographical monograph.*

KUENZLI, RUDOLF, ed. *Marcel Duchamp: Artist of the Century.* Cambridge, Mass.: MIT Press, 1989. I. *Critical observations.*

KUH, KATHARINE. 1. *Art Has Many Faces-The Nature of Art Presented Visually.* New York: Harper and Brothers, 1951. I.

———, 2. *The Artist's Voice: Talks with Seventeen Artists.* New York: Harper and Row, 1962. I.

———, 3. *Break-up: The Core of Modern Art.* Greenwich, Conn.: New York Graphic Society, 1965. I.

KUHN, WALT. 1. *The Story of The Armory Show.* n.p.: Privately published, 1938.

———, 2. *Walt Kuhn,* Cincinnati: The Cincinnati Art Museum, 1960. I. *Exhibition catalogue.*

KUNIYOSHI, YASUO. *Yasuo Kuniyoshi.* New York: American Artists Group Inc., 1945. I. *Autobiographical monograph.*

Kunst um 1970: Art Around 1970. Aachen: Neue Galerie der Stadt Aachen, 1972. Foreword by Wolfgang Becker. I.B. (German and English text.) *Mostly American art from the Peter Ludwig collection.*

KUSPIT, DONALD. *Leon Golub: Existential/Activist Painter.* New Brunswick, NJ: Rutgers University Press, 1985. B.C. *Monograph.*

KYROU, ADO. *Le Surrealisme au Cinema.* Paris: Le Terrain Vague, 1963. I.

LADER, MELVIN P. *Arshile Gorky.* New York: Abbeville Press, 1985. I.B.C. *Popular introduction to the artist.*

LAMBERT, YVON, with text by Roland Barthes. *Cy Twombly Catalogue Raisonné des Oeuvres sur Paper.* Milan: Multiples, 1979. I. (French and English text.) *A projected multi-volume series.*

LANDAUER, SUSAN. *Edward Corbett: A Retrospective.* Richmond, CA: Richmond Art Center, 1990. Foreword by Michael Schwager. I.B.C. Retrospective catalogue. *Well-documented catalogue of this significant artist's career.*

LANDON, EDWARD. *Picture Framing.* New York: American Artists Group Inc., 1945. I.

LANE, JAMES W. *Masters in Modern Art.* Boston: Chapman and Grimes, 1936. I.

LANE, JOHN R. *Stuart Davis: Art and Art Theory.* Brooklyn: The Brooklyn Museum, 1978. Foreword by Michael Botwinick. I.B.C.A. *A major study of this artist's work.*

LANE, JOHN R., and LARSEN, SUSAN C. *Abstract Painting and Sculpture in America 1922-1944.* Pittsburgh, PA: Carnegie Institute, 1983. B.I. *Numerous brief essays examine the rise of abstraction in this important survey.*

LANGSNER, JULES. *Man Ray.* Los Angeles: County Museum of Art, 1966. I.B. *Major exhibition catalogue including essays by the artist.*

LANGUI, EMILE. *Fifty Years of Modern Art.* New York: Frederick A. Praeger, 1959. I. *Critical historical survey.*

LARSON, PHILIP. *Burgoyne Diller.* Minneapolis: The Walker Art Center, 1971. I.B. *Retrospective exhibition.*

LARSON, PHILIP, and SCHJELDAHL, PETER. *De Kooning: Drawings/Sculptures.* New York: E.P. Dutton, 1974. Acknowledgements by Martin Friedman. I.B.C. *Exhibition catalogue.*

LEACH, FREDERICK D. *Paul Howard Manship: An Intimate View.* St. Paul: Minnesota Museum of Art, 1973. Prologue by Malcolm E. Lein. I.B. *Major retrospective catalogue; quotes from the artist.*

LEAVANS, ILEANA, and BRUCE, CHRIS. *No! Contemporary American DADA.* Seattle: Henery Art Gallery, 1985. I.B.C. (vol. 2 of 2 volumes slipcased.) Foreword by Harvey West. *Social problems lost for art.*

LEBEL, ROBERT. *Marcel Duchamp.* New York: Grove Press Inc., 1959. I.B. *Monograph.*

LEE, KATHRYN DEAN and BURCHWOOD, KATHARINE TYLER. *Art Then and Now.* New York: Appleton-Century-Crofts Inc., 1949. I. *A popular history.*

LEEPA, ALLEN. *The Challenge of Modern Art.* New York: Thomas Yoseloff Inc., 1957. I. *Problems presented by abstract and nonfigurative art.*

LEMBARK, CONNIE W. *The Prints of Sam Francis: A Catalogue Raisonné, 1960-1990.* New York: Hudson Hills, 1992. I.B.

LEVIN, GAIL. 1. *Edward Hopper, the Art and the Artist.* New York: W. W. Norton & Co. in association with The Whitney Museum of American Art, 1980. Foreword by Tom Armstrong. I.B.C. *Exhibition catalogue.*

―――, 2. *Synchromism and American Color Abstraction 1910-1925.* New York: George Braziuer, 1978. I.B.C.A. *Chronicles the evolution of Synchromism.*

LEVY, JULIEN. 1. *Arshile Gorky.* New York: Harry N. Abrams Inc., 1966. I.B. *Well-illustrated monograph.*

―――, 2. *Eugene Berman.* New York: American Studio Books, 1947. I. *Monograph.*

LEWISON, JEREMY. *Brice Marden Prints, 1961-1991.* London: Tate Gallery, 1991. I.B. *Exhibition catalogue featuring all his prints.*

LICHT, FRED. *Sculpture, 19th and 20th Centuries.* Greenwich, Conn.: New York Graphic Society, 1967. I. *Well-illustrated introduction to modern sculpture.*

LICHT, JENNIFER. *Eight Contemporary Artists.* New York: The Museum of Modern Art, 1974. I.B.D.C. *Small exhibition catalogue including artists' statements.*

LINDMAN, JOAN. *Fairfield Porter: A Catalogue Raisonné of His Prints.* Westbury, NY: Highland House Publishers Inc., 1981. B.C.

LINDY, CHRISTINE. *Superrealist Painting and Sculpture.* New York: William Morrow and Co., Inc., 1980. B.I. Exhibition chronology 1966-1978. *Examines the post-1960 confrontation between the photograph and realist painting.*

LIPCHITZ, JACQUES, with ARNASON, H. H. *My Life in Sculpture.* New York: Viking Press (Documents of Twentieth Century Art), 1972. I. *Biography.*

LIPMAN, JEAN, with WOLFE, RUTH, editorial director. *Calder's Universe.* New York: The Viking Press in cooperation with The Whitney Museum of American Art (A Studio Book), 1976. I.B.C. *Documents with joyfulness the artist's life, work, and friends.*

LIPPARD, LUCY R. 1. *Ad Reinhardt.* New York: Jewish Museum, 1967. Preface by Sam Hunter. I.B.D. *Major retrospective catalogue.*

————, 2. *Ad Reinhardt.* New York: Harry N. Abrams, Inc., 1981. B.C. *Monograph.*

————, 3. *Changing: Essays in Art Criticism.* New York: E.P. Dutton, 1971. Foreword by Gregory Battcock. I. *Collected essays, written mostly in the mid 1960s.*

————, 4. *From the Center: Feminist Essays on Women's Art.* New York: E.P. Dutton, 1976. I. Biography. *Collected essays on this topic.*

————, 5. *The Graphic Work of Philip Evergood. Selected Drawings and Complete Prints.* New York: Crown Publishers Inc., 1966. Foreword by Abram Lerner. Poem by James Michener. I. *Catalogue raisonné of prints augmented with selected drawings.*

————, 6. *Minimal Art.* The Hague: Haags Gemeentemuseum, 1968. Preface by E. Develing. I.B. (Dutch and English text.) *Important early minimal exhibition catalogue with artists' statements.*

————, 7. *Pop Art.* New York: Frederick Praeger, 1966. I. *Early international survey of Pop, with contributions by Lawrence Alloway, Nancy Marmer, Nicolas Calas.*

LIPPARD, LUCY R., ed. *Six Years: The Dematerialization of the Art Object from 1966 to 1972: a cross-reference book of information on some esthetic boundaries: consisting of a bibliography into which are inserted a fragmented text, artworks, documents, interviews, and symposia, arranged chronologically and focused on so-called conceptual or information or idea art with mentions of such vaguely designated areas as minimal, anti-form, systems, earth or process art, occurring now in the Americas, Europe, England, Australia, and Asia (with occasional political overtones).* New York: Praeger Publishers, 1973. Annotated by Lucy R. Lippard. I.B. *See title for description.*

LISLE, LAURIE. *Portrait of an Artist: A Biography of Georgia O'Keeffe.* New York: Seaview Books, 1980. B. *A well-researched popular essay.*

List of Drawing Material of Richard Tuttle and Appendices. Zurich: Gianfranco and Annemarie Verna and others, 1979. Foreword by Gianfranco Verna. I.C.A. *Catalogues 347 drawings; includes artist's statements.*

LIVINGSTON, JANE, and TUCKER, MARCIA. *Bruce Nauman: Work from 1965-1972.* Los Angeles: Los Angeles County Museum of Art, 1972. I.B.C. *Exhibition catalogue with critical essays.*

LOEFFLER, CARL E., and TONG, DARLENE. *Performance Anthology.* San Francisco: Contemporary Arts Press, 1980. I. Essays by numerous authors. *If you lack imagination and are bored, invent concept art and its offspring, bad acting.*

LOMBARDO, JOSEF VINCENT. *Chaim Gross.* New York: Dalton House Inc., 1949. I.B. Monograph.

LORAN, ERLE. 1. *Cezanne's Composition.* Berkeley: University of California Press, 1947. I.

————, 2. *Recent Gifts and Loans of Paintings by Hans Hoffmann.* Berkeley: University of California Press, 1964. I.

Lorser Feitelson and Helen Lundeberg: A Retrospective Exhibition. San Francisco: San Francisco Museum of Modern Art, 1980. I.B.C. *Catalogue with essays by Diane Degasis Moran.*

Louise Nevelson: Atmospheres and Environments. New York: Clarkson N. Potter, Inc., Publisher, in association with The Whitney Museum of American Art, 1980. Introduction by

Edward Albee. Preface and Acknowledgments by Tom Armstrong. Essays by Richard Marshall and Louise Wilson. I.B.C. *Exhibition catalogue.*

LOWRY, BATES. *The Visual Experience: An Introduction to Art.* Englewood Cliffs, N.J.: Prentice-Hall Inc.; New York: Harry N. Abrams Inc., 1961. I. *Methods for extending the visual experience.*

Lucas Samaras (Self: 1961-1991). Yokohama, Japan: Yomuri Shimbun, 1991. Essays by Kim Levin, Taro Amano, Sae Hayashi, Hiroshi Miyatake, Shino Kuraishi. I.B.C. (Japanese and English text.) *Major retrospective.*

LUCIC, KAREN. *Charles Sheeler and the Cult of the Machine.* London: Reaktion, 1991. I.B. *Cultural observations of the time.*

LUCIE-SMITH, EDWARD. *Art in the Seventies.* Ithaca: A Phaidon Book, Cornell University Press, 1980. I.B. *The 1970s, concentrating on the vanguard and the bizarre of the vanguard.*

LUDINGTON, TOWNSEND. *Marsden Hartley.* Boston: Little Brown & Co., 1992. I.B. *A biography of the artist.*

LUDMAN, JOAN. *Fairfield Porter: Catalogue of His Prints.* Westbury, N.Y.: Highland House, 1981. I.B. *Works catalogue of prints.*

LUNDE, KARL. *Isabel Bishop.* New York: Harry N. Abrams Inc., 1975. I.B.C. *Well-illustrated monograph.*

LYNTON, NORBERT. *The Modern World.* New York: McGraw-Hill Book Co., Inc., 1965. I.B.G. *Introduction to modernism in the arts.*

MacAGY, DOUGLAS. 1. *James Boynton.* New York: Barone Gallery, Inc., 1959. I. *Monograph.*

————, 2. *Plus by Minus: Today's Half-Century.* Buffalo: Albright-Knox Art Gallery, 1968. I.D.P. *Major survey of the development of "cool" art.*

MAN RAY. 1. *Alphabet for Adults.* Beverly Hills, Calif.: Copley Gallery, 1948. I.

————, 2. *Man Ray.* Pasadena, Calif.: Pasadena Art Institute, 1944. I. *Exhibition catalogue.*

————, 3. *Ogetti d'Affezione.* Turin: Giulio Einavdi, 1970. I. (Italian text.) *Catalogue of work.*

————, 4. *Self Portrait.* Boston: Little, Brown and Co., 1963. I. *Autobiography.*

Man Ray. Rome: Galleria Il Collezionista d'Arte Contemporanea, 1973. Introduction by Murizo Fagiolo. I.C. (Italian text.) *Retrospective catalogue.*

MARCHESSEAU, DANIEL. *The Intimate World of Alexander Calder.* New York: Harry N. Abrams, 1989. I.

Mark Tobey. Basel: Editions Beyeler, 1971. Introduction by John Russell. I.C. *Exhibition catalogue including essays by John Cage, Naum Gabo, and Lyonel Feininger, and artist's statements.*

MARLING, KARAL ANN. *Tom Benton and his Drawings.* Columbia: University of Missouri Press, 1981. B. *Popular monographic study of his drawings.*

MARSH, REGINALD. *Anatomy for Artists.* New York: American Artists Group Inc., 1945. I.

MARSHALL, RICHARD. *New Image Painting.* New York: The Whitney Museum of American Art, 1978. I.B.C. *A Return to anecdotal literary figure painting; includes artists' statements.*

MARSHALL, RICHARD, ed. *Alex Katz.* New York: Whitney Museum of American Art, 1986. Essay by Robert Rosenblum. I.B. *Retrospective catalogue.*

MARTER, JOAN M., TARBELL, ROBERTA K., and WECHSLER, JEFFREY. *Vanguard American Sculpture 1919-1939.* New Brunswick: Rutgers University Art Gallery, 1979. Introduction by Phillip Dennis Cate. I. *A major study of this tendency.*

MARTIN, HENRY. *Arman or Four and Twenty Blackbirds Baked in a Pie or Why Settle for Less When You Can Settle for More.* New York: Harry N. Abrams Inc., 1969. I.B. *A critical study of his art.*

MARTIN, J. L., NICHOLSON, B., and GABO, N., eds. *Circle.* London: Faber and Faber Ltd., 1937. I.B. *Essays on purist art.*

MARVALL, NICHOLAS P. *Alex Katz: The Complete Prints.* New York: Alpine Fine Arts, 1983. With an interview by Carter Ratcliff. I.B.

MASON, LAURIS, and LUDMAN, JOAN. *The Lithographs of George Bellows, 1916-1924.* Fort Worth, Texas: Amon Carter Museum, 1988. Introduction by Jean Bellows Booth. I. *Exhibition catalogue.*

MATHER, FRANK JEWETT, Jr. 1. *The American Spirit in Art.* New Haven, Conn.: Yale University Press, 1927. I. *Historical survey with commentary.*

——, 2. *Eugene Speicher.* New York: The Whitney Museum of American Art (American Artists Series), 1931. I.B. *Monograph.*

Mauricio Lasansky. Iowa City: University of Iowa Museum of Art, 1976. Acknowledgements by Jan K. Muhlert. Text by Joanna Moser, J. Michael Danoff, and Jan K. Muhlert. I.B.C. *Retrospective of prints and drawings.*

MAYERSON, CHARLOTTE LEON, ed. *Shadow and Light.* New York: Harcourt Brace & World, Inc., 1964. I. *Biography of Maurice Sterne, edited from the artist's own writings.*

McBRIDE, HENRY. *John Marin.* New York: The Museum of Modern Art, 1936. I.B. *Exhibition catalogue.*

McCAUSLAND, ELIZABETH. *Marsden Hartley.* Minneapolis: University of Minnesota Press, 1952. I. *Biography.*

McCHESNEY, MARY FULLER. *A Period of Exploration: San Francisco 1945-1950.* Oakland: The Oakland Museum, 1973. Introduction by Terry N. St. John. I.A. *An excellent study and survey of five years' activity surrounding the California School of Fine Arts, San Francisco: biographies.*

McCOUBREY, JOHN W. 1. *American Tradition in Painting.* New York: George Braziller, Inc., 1963. I.B. *Postulates an American tradition.*

——, 2. *Robert Indiana.* Philadelphia: Institute of Contemporary Art, University of Pennsylvania, 1968. I.B. *Retrospective catalogue including artist's statements.*

McCOY, GARNETT, ed. *David Smith.* Documentary Monographs in Modern Art. New York: Praeger Publishers, 1973. I.B.C. *Collected writings of the artist. Monograph.*

McCURDY, CHARLES, ed. *Modern Art ... A Pictorial Anthology.* New York: The Macmillan Company, 1958. I.B.

McMANUS, IRENE. *The Watercolor for Carolyn Brady: Including a Catalogue Raisonné.* New York: Hudson Hills Press, 1991. I.B.C. Exhibition list. *Flower still-life images, generally.*

McSHINE, KYNASTON, ed. *Joseph Cornell.* New York: The Museum of Modern Art, 1980. I.B. *Retrospective catalogue; includes essays by Dawn Ades, Carter Ratcliff, P. Adams Sitney, and Lynda Roscoe Hartigan.*

MEDFORD, RICHARD C. *Guy Pene Du Bois.* Hagerstown, Md.: Washington County Museum of Fine Arts, 1940. I. *Exhibition catalogue.*

MEDINA, JOSE RAMON. *Marisol.* Caracas: Ediciones Armitano, 1968. I. (Spanish text.) *Picture book of the sculpture.*

MEHRING, WALTER. *George Grosz. Thirty Drawings and Watercolors.* New York: Erich S. Herrmann, 1944. I. *Monograph.*

MEISEL, LOUIS K. *Photorealism.* New York: Harry N. Abrams, Inc., Publishers, 1989. Chronology of exhibitions. Foreword by Gregory Battcock. Introduction by Louis K. Meisel. I.B. *A variety of stylistic results in using photographs as a motif.*

MELLQUIST, JEROME. *The Emergence of an American Art.* New York: Charles Scribner's Sons, 1942.

Mel Ramos: Watercolors. Berkeley: Lancaster-Miller Publishers, 1979. Foreword by Mel Ramos. I.B.C. *Watercolors from the series "A Salute to Art History."*

MENDELOWITZ, DANIEL M. *A History of American Art.* New York: Holt, Rinehart and Winston, Inc., 1961. I.

MERKERT, JORN, ed. *David Smith: Sculpture and Drawings.* Munich: Prestel-Verlag, 1986. (Editions in English and German exist.) B.C.D. *Major retrospective catalogue with essays by various writers; selected writings by the artist.*

MESSER, THOMAS M. *Jan Muller.* New York: The Solomon R. Guggenheim Museum, 1962. I. *Retrospective catalogue.*

METRO International Directory of Contemporary Art. Milan: Metro, 1964. I.B. (English and Italian text.)

MEYER, URSULA. *Conceptual Art.* New York: E.P. Dutton, 1972. *Collected exegeses of concept art.*

MICHAELSON, KATHERINE J. and GURALNIK, NEHAMA. *Alexander Archipenko: A Centennial Tribute.* Washington, DC: National Gallery of Art, 1986. B.C. *Retrospective catalogue.*

MILLER, DOROTHY C., ed. 1. *Americans 1942. 18 Artists from 9 States.* New York: The Museum of Modern Art, 1942. I. *Documented exhibition catalogue.*

———, 2. *14 Americans.* New York: The Museum of Modern Art, 1946. I.B. *Documented exhibition catalogue.*

———, 3. *The Sculpture of John B. Flanagan.* New York: The Museum of Modern Art, 1942. I. *Retrospective catalogue.*

MILLER, KENNETH HAYES. *Kenneth Hayes Miller.* New York: Arts Students League, 1953. I. *Exhibition catalogue.*

MILLER, LYNN F. and SWENSON, SULLY S. *Lives and Works: Talks with Women Artists.* Metuchen, NJ: The Scarecrow Press, 1981. I. *Brief interviews.*

MILLIER, ARTHUR. 1. *Henry Lee McFee,* Claremont, Calif.: Scripps College, 1950. I. *Exhibition catalogue.*

———, 2. *Millard Sheets.* Los Angeles: Dalzell Hatfield Gallery, 1935. I. *Monograph.*

Miriam Schapiro: The Shrine, The Computer, and The Dollhouse. La Jolla: Mandeville Art Gallery, 1975. Introduction by Linda Nochlin. I.B. *Documentary exhibition catalogue including interview and essays.*

MOAK, PETER. *The Robert Laurent Memorial Exhibition.* Durham: University of New Hampshire, 1972. Foreword by Melvin J. Zabarsky. Essay by Henry Hope. I.B. *Retrospective exhibition catalogue.*

MOCSANYI, PAUL. *Karl Knaths.* Washington, D.C.: The Phillips Gallery, 1957. I.B. *Exhibition catalogue.*

MOFFETT, KENWORTH. *Jules Olitski.* Boston: Museum of Fine Arts, 1973. I.B. *Retrospective catalogue.*

MOHOLY-NAGY, LAZLO. 1. *A New Vision and Abstract of an Artist.* 4th rev. ed. New York: George Wittenborn, Inc., 1947. Preface by Walter Gropius. I.B. *A primer of modern design.* I.

———, 2. *Painting, Photography, Film.* Cambridge, Mass.: MIT Press, 1969. I. *English-language reprint of his famous book.*

MOHOLY-NAGY, SIBYL. 1. *Experiment in Totality.* New York: Harper and Brothers, 1950. I. *Biography: Lazlo Moholy-Nagy.*

———, 2. *Lazlo Moholy-Nagy.* Chicago: Museum of Contemporary Art, 1969. I.B. *Retrospective catalogue.*

MONTE, JAMES. *Larry Zox.* New York: The Whitney Museum of American Art, 1973. I.B.C. *Exhibition catalogue.*

MONTE, JAMES, and TUCKER, MARCIA. *Anti-illusion: Procedures/Materials.* New York: The Whitney Museum of American Art, 1969. I.B. *Survey of the anti-illusion expression.*

Monumenta. Newport, R.I.: Monumenta Newport Inc., 1974. Introduction by Sam Hunter. I. *Catalogue of an outdoor exhibition, including interviews and statements by the artists.*

MORGAN, ANN LEE. *Arthur Dove: Life and Works, with a Catalogue Raisonné.* Newark: University of Delaware Press, 1984. Foreword by Roxane Berry. B.I. Exhibition chronology. *Greatly flawed attempt at a works catalogue and biographical study.*

MORRIS, G. L. K. *American Abstract Artists.* New York: Ram Press, 1946. I.B. *Documentation of members.*

MORSE, JOHN D., ed. *Ben Shahn.* Documentary Monographs in Modern Art. New York: Praeger Publishers, 1972. I.B.C. *Collected writings of the artist. Monograph.*

MOSER, JOANN. 1. *Atelier 17: A 50th Anniversary Retrospective Exhibition.* Madison, Wis.: Elvehjem Art Center, 1977. Foreword by Eric S. McCready. I.B. *A history of Stanley William Hayter, his teaching and art, and the artists.*

———, 2. *The Graphic Art of Emil Ganso.* Iowa City: University of Iowa Museum of Art, 1980. I.C. *A study of the prints.*

MOTHERWELL, ROBERT. 1. *The Dada Painters and Poets.* New York: Wittenborn, Schultz, Inc., 1951. Documents of Modern Art, Vol. 8. I.B. *A documented history of this group.*

———, 2. *Robert Motherwell.* Northampton, Mass.: Smith College, 1962. I. *Exhibition catalogue.*

MOTHERWELL, ROBERT, ed. *Possibilities, No. 1.* New York:Wittenborn, Schultz, Inc., 1947. I. *An occasional review concerned with all the arts.*

MOTHERWELL, ROBERT, and REINHARDT, AD, eds. *Modern Artists in America.* New York: Wittenborn, Schultz, Inc., 1951. I.B. *The European and American advance guard in the 1940s.*

MULAS, UGO, and ARNASON, H. H. *Calder.* New York: A Studio Book/Viking Press, 1971. I.B. *Picture book with comments by Calder.*

MULLER, GREGOIRE. *The New Avant-garde.* New York: Praeger Publishers, 1972. I.D. *Photographs by Gianfranco Gorgoni documenting artists and works.*

MUNSTERBERG, HUGO. *Twentieth Century Painting.* New York: Philosophical Library, 1951. I. *Critical essays.*

MURDOCK, ROBERT M. 1. *Modular Paintings.* Buffalo: Albright-Knox Art Gallery, 1970. Foreword by Gordon M. Smith. I.C. *Exhibition catalogue.*

———, 2. *Nassos Daphnis.* Buffalo: Albright Knox Art Gallery, 1969. Foreword by Gordon M. Smith. I.B.C. *Retrospective catalogue.*

MURKEN-ALTROGGE, CHRISTA. *Von Expresionismus bis zum Soul and Body Art.* Cologne: DuMont Buchverlag, 1985. B.G. (German text.) *Persistant figuration related to abstraction.*

MURRELL, WILLIAM. 1. *Charles Demuth.* New York: The Whitney Museum of American Art (American Artists Series), 1931. I. *Monograph.*

———, 2. *Elie Nadelman.* Woodstock, N.Y.: Wilham M. Fischer, 1923. I. *Monograph.*

MURTHA, EDWIN. *Paul Manship.* New York: The MacMillan Company, 1957. I. *Monograph.*

MYERS, BERNARD. 1. *Fifty Great Artists.* New York: Bantam Books, 1953. I.B. *Historical essays.*

———, 2. *Understanding the Arts.* New York: Henry Holt and Co., 1958. I. *Art appreciation.*

MYERS, JANE, ed. *Stuart Davis.* Fort Worth, Texas: Amon Carter Museum of Western Art, 1986. Foreword by Jan K. Muhlert. I.B.D. *Catalogue raisonné of the prints includes quotes from the artist's writings.*

NAIFEH, STEVEN, with SMITH, GREGORY WHITE. 1. *Gene Davis.* New York: The Arts Publisher Inc., 1982. I.B. *Monograph.*

———, 2. *Jackson Pollock: An American Saga.* New York: Clarkson N. Potter 1989. I.B. *A commercialized, perverted view of an artist's tragic life.*

Nancy Graves. La Jolla: La Jolla Museum of Contemporary Art, 1973. Introduction by Jay Belloli. I.B.C. *Exhibition catalogue including artist's statements.*

Nancy Graves: Sculpture/Drawings/Films 1969-1971. Aachen: Neue Galerie im Alten Kurhaus, 1971. Introduction by Phyllis Tuchman. I.C. *Exhibition catalogue.*

NARODNY, IVAN. *American Artists.* New York: Roerich Museum Press, 1930. B. *Figurative painting before 1930.*

NASH, STEVEN A. and MERKERT, JORN, eds. *Naum Gabo.* Munich: Prestel-Verlag, 1986. B.C. (German text.) *Retrospective and works catalogue.*

Nathan Oliveira: A Survey Exhibition 1957-1983. San Francisco: San Francisco Museum of Modern Art, 1984. Essays by Thomas H. Garver and George W. Neubert. Foreword by Henry T. Hopkins. B.C. *Retrospective catalogue.*

NEFF, TERRY ANN R., ed. *In the Mind's Eye: Dada and Surrealism.* New York: Abbeville Press, 1986. Foreword by J. Michael Danoff. I. *Collected essays by several authors. Catalogue to the 1984 Chicago exhibition: Dada and Surrealism in Chicago Collections.*

NELSON, JUNE KOMPASS. *Harry Bertoia, Sculptor.* Detroit: Wayne State University Press, 1970. I.B.C. *Exhibition catalogue: the essay contains some biographical data.*

NEMSER, CINDY. *Art Talk.* New York: Charies Scribner's Sons, 1975. I.B.C. *Conversations with 12 women artists.*

NESS, JUNE L., ed. *Lyonel Feininger.* New York: Praeger Publishers (Documentary Monographs in Modern Art), 1974. I.B.C. *Collected writings of and about the artist. Monograph.*

NEUHAUS, EUGENE. *The History and Ideals of American Art.* Stanford, Calif.: Stanford University Press, 1931. I.B. *Critical essays.*

NEUMEYER, ALFRED. *The Search for Meaning in Modern Art.* Englewood Cliffs, N.J.: Prentice-Hall Inc. 1964. I. *Essays on the understanding of art.*

New in the Seventies. Austin: The University of Texas, 1977. Foreword by Donald B. Goodall. Introduction by Fred Seabolt. I.C. Some photos of artists. *Survey exhibition: figuration and abstraction.*

NEWMEYER, SARAH. *Enjoying Modern Art.* New York: Reinhold Publishing Co., 1955. I. *Popular essays on art appreciation.*

NEWTON, ERIC. 1. *The Arts of Man.* Greenwich, Conn.: New York Graphic Society, 1960. I. *Critical essays.*

———, 2. *In My View.* London: Longmans, Green and Co., 1950. *Critical essays.*

NOCHLIN, LINDA. *Philip Pearlstein.* Athens, Ga.: Georgia Museum of Art. Preface by William D. Paul, Jr. I.B.C. *Exhibition catalogue.*

NOGUCHI, ISAMU. 1. *A Sculptor's World.* New York: Harper and Row, 1968. Preface by R. Buckminster Fuller. I. *Autobiography.*

———, 2. *The Sculpture of Spaces.* New York: The Whitney Museum of American Art, 1980. Foreword by Tom Armstrong, I.C. *Exhibition catalogue concerned with sculpture, realized and unrealized projects, and theater sets.*

NORDLAND, GERALD. 1. *Gaston Lachaise.* Los Angeles: County Museum of Art, 1963. I.B. *Retrospective catalogue.*

———, 2. *Gaston Lachaise: The Man and His Work.* New York: George Braziller, Inc., 1974. I.B. *Monograph including artist's writings.*

———, 3. *Paul Jenkins: Retrospective.* Houston: Museum of Fine Arts, 1971. I.B.C. *Essay is brief sketch of the artist's life.*

NORDMARK, OLLE. *Fresco Painting.* New York: American Artists Group Inc., 1947. I.

NORDNESS, LEE, ed. *Art:USA:Now.* Lucerne: C. J. Bucher, 1962, 2 vols. I.B. *A collection catalogue with biographies and critical essays.*

NORMAN, DOROTHY, ed. *The Selected Writings of John Marin.* New York: Pellegrini and Cudahy, 1949. I. *Letters.*

Norman Lewis: A Retrospective. New York: The Graduate School and University Center of the City University of New York, 1976. Foreword by Milton W. Brown. Text by Thomas Lawson. I.B.C.

Northwest Traditions. Seattle: Seattle Art Museum, 1978. Foreword by Willis F. Woods. Essay by Martha Kingsbury. Organized by Charles Cowles and Sarah Clark. I.B.C. *Biographies. The Twentieth century, emphasizing the decades of the 1930s, '40s, '50s, '60s.*

O'CONNOR, FRANCIS V., and THAW, EUGENE. *Jackson Pollock.* New Haven and London: Yale University Press, 1978. I.B. *The major works catalogue.*

O'DOHERTY, BRIAN. *American Masters: The Voice and the Myth.* Photographed by Hans Namuth. New York: A Ridge Press Book/Random House, n.d. I.B. *Essays incorporating extracts from interviews.*

O'HARA, FRANK. 1. *Art Chronicles: 1954-1966.* New York: George Braziller, Inc., 1975. I.B. *Collected essays.*

————, 2. *David Smith.* London: Tate Gallery, 1966. I.B. *Retrospective catalogue.*

————, 3. *Franz Kline.* London: Whitechapel Art Gallery, 1964. I. *Exhibition catalogue.*

————, 4. *Jackson Pollock.* New York: George Braziller, Inc., 1959. I.B. *Monograph.*

————, 5. *Nakian.* New York: The Museum of Modern Art, 1966. I.B. *Retrospective catalogue.*

OLDENBURG, CLAES. 1. *Log May 1974 August 1976.* Stuttgart: Edition Hansjorg Mayer, 1976. 2. vols. in slipcase. I.B.C. *Press clips and photos of the artist at work.*

————, 2. *Notes in Hand.* New York: E.P. Dutton, 1971. I.B. *Miniature version of his sketchbooks.*

————, 3. *Proposals for Monuments and Buildings.* Chicago: Follett Publishing Co., 1969. I. *New concepts for decorating the landscape.*

————, 4. *Raw Notes.* Halifax: Nova Scotia College of Art and Design, 1973. I. *Documents and scripts for Stars, Moveyhouse, Massage, The Typewriter, annotated.*

Oldenburg: Six Themes. Minneapolis: The Walker Art Center, 1975. Introduction by Martin Friedman. I.B.C. *Exhibitions catalogue, including statements by the artist.*

OLSON, RUTH, and CHANIN, ABRAHAM. *Gabo-Pevsner.* New York: The Museum of Modern Art, 1948. I.B. *Exhibition catalogue.*

O'NEAL, BARBARA. *E. Lawson.* Ottawa: National Gallery of Canada, 1967. I.B. (French and English text.) *Retrospective catalogue.*

O'NEILL, JOHN P., ed. *Clyfford Still.* New York: The Metropolitan Museum of Art, 1979. Foreword by Philippe de Montebello. Essay by Katharine Kuh, and writings of the artist. I.B.C. *Exhibition catalogue.*

ONSLOW-FORD, GORDON. *Towards a New Subject in Painting.* San Francisco: San Francisco Museum of Art, 1948. I. *The artist's theory of painting.*

Options and Alternatives: Some Directions in Recent Art. New Haven: Yale University Art Gallery, 1973. Preface by Alan Shestack. "Toward a Definition" by Anne Coffin Hanson. "Notes on the Anatomy of an Exhibition" by Klaus Kertess. "Intellectual Cinema; A Reconsideration" by Annette Michelson. I.B.D. *Survey of new media and materials.*

ORMOND, MARK. *Joel Shapiro: Selected Drawings, 1968-1990.* Miami, Fla.: Center for the Fine Arts, 1991. Includes interview with the artist by Paul Cummings. I.B.C. *Serious exhibition catalogue review of the artist's drawings.*

Oscar Bluemner: American Colorist. Cambridge, Mass.: Fogg Art Museum, 1967. I.B. *Retrospective catalogue.*

OSTERWALD, TILMAN. *Pop Art.* Cologne: Benedikt Taschedn, 1990. I.B.C. (English and German text.) *A misunderstood, philosophical attack on Pop Art and American culture, employing antiquated journalistic language.*

PAALEN, WOLFGANG. *Form and Sense. Problems of Contemporary Art No. 1.* New York: Wittenborn and Co., 1945. I. *Essays in aesthetics.*

PACH, WALTER. 1. *Ananias or the False Artist.* New York: Harper and Brothers, 1928. I. *Critical essays.*

————, 2. *The Masters of Modern Art.* New York: B.W. Huebsch, Inc., 1926. I.B. *American and European art before 1926.*

————, 3. *Queer Thing, Painting.* New York: Harper and Brothers, 1938. I. *Autobiography.*

PAGANO, GRACE. *Contemporary American Painting. The Encyclopedia Britannica Collection.* New York: Duell, Sloan and Pearce, 1945. I.

PALMER, WILLIAM C. *William C. Palmer.* Utica, N.Y.: Munson-Williams Proctor Institute, 1956. I. *Exhibition catalogue.*

PARKES, KINETON. *The Art of Carved Sculpture.* New York: Charles Scribner's Sons, 1931, 2 vols. I.B.

PASSLOFF, PATRICIA. *The 30's. Painting in New York.* New York: Poindexter Gallery, 1963. I.

Paul Manship: Changing Taste in America. St. Paul: Minnesota Museum of Art, 1985. B. *Multiple essays re-examining the accomplishments of the sculptor.*

PEARSON, RALPH M. 1. *Experiencing American Pictures.* New York: Harper and Brothers, 1943. I. *Appreciation of modern art.*

————, 2. *The Modern Renaissance in American Art.* New York: Harper and Brothers, 1954. I. *Development of modern art in America.*

PEIRCE, WALDO. *Waldo Peirce.* New York: American Artists Group Inc., 1945. I. *Autobiographical monograph.*

PENROSE, ROLAND. *Man Ray.* Boston: New York Graphic Society Ltd., 1975. I.B. *Appreciation and biographical sketch.*

PERLMAN, BENNARD B. *The Immortal Eight.* New York: Exposition Press, 1962.

PETERDI, GABOR. *Printmaking: Methods Old and New.* New York: The Macmillan Company, 1959. I.

PHILLIPS, DUNCAN. 1. *The Artist Sees Differently.* New York: E. Weyhe, 1931. I. *Critical essays.*

————, 2. *A Collection in the Making.* New York: E. Weyhe, 1926. I. *Development of the Phillips collection in Washington, D.C.*

PHILLIPS, LISA. 1. *Frederick Kiesler.* New York: Whitney Museum of American Art, 1989. I.B. *Retrospective catalogue.*

————, 2. *The Third Dimension: Sculpture of the New York School.* New York: Whitney Museum of American Art, 1984. Foreword by Tom Armstrong. *Survey show re-examining the influence of nature-inspired abstraction.*

PINCUS-WITTEN, ROBERT. 1. *Entries (Maximalism).* New York: Out of London Press, 1983. I. *Collected essays.*

————, 2. *Postminimalism.* New York: Out of London Press, Inc., 1977. I. *Collected essays on recent American art, written between 1966 and 1976.*

PITTMAN, HOBSON. *Hobson Pittman.* Raleigh: North Carolina Museum of Art, 1963. I.B. *Retrospective catalogue.*

PITZ, HENRY C. *The Brandywine Tradition.* Boston: Houghton Mifflin Co., 1969. I.B. *Popular biographies of many recent painters, including Andrew Wyeth.*

PLAGENS, PETER. *Moonlight Blues: An Artist's Art Criticism.* Ann Arbor, Mich.: UMI Research Press, 1986. Foreword and Preface by Donald Kuspit. B. *Collected magazine criticism by the California painter-writer: nine hard years.*

PLOUS, PHYLLIS. *5 American Painters: Recent Work.* Santa Barbara, 1974. I.B. *Exhibition catalogue.*

Poets & Painters. Denver: Denver Art Museum, 1979. Foreword by Dianne Perry Vanderlip. Introduction by David Shapiro. I.B. *Urban artists' views accompanied by poems. Exhibition catalogue.*

POETTERL, JOCHEW. *John Chamberlain*. Baden-Baden: Staatliche Kunsthalle, 1991. I.B. (German and English text.) *Exhibition catalogue and works catalogue of metal sculpture from the 1950s to the present.*

POMEROY, RALPH. *Stamos*. New York: Harry N. Abrams Inc., 1974. I.B.C. *Monograph.*

PONENTE, NELLO. *Modern Painting: Contemporary Trends*. Geneva: Skira, 1960. I.B.

POORE, HENRY R. *Modern Art: Why, What and How?* New York: G.P. Putnam's, 1931. I. *Investigation into the reasons for modern art.*

PORTER, FAIRCHILD. *Thomas Eakins*. New York: George Braziller, Inc., 1959. I.B. *Monograph.*

POTTER, JEFFREY. *To a Violent Grave: An Oral Biography of Jackson Pollock*. New York: G.P. Putnam's Sons, 1985. B.I. *Conversational memories elicited from friends, relatives, and others.*

POUSETTE-DART, NATHANIEL, ed. *American Painting Today*. New York: Hastings House, 1956. I. *Pictorial documentation of American painting in the mid 1950s.*

PRASSE, LEONA E. PRASSE. *Lyonel Feininger: Catalogue of Graphic Work*. Cleveland: Cleveland Museum of Art, 1982. I.B. (German and English text.) *A catalogue of the artist's prints.*

PRINT CLUB OF CLEVELAND. *The Work of Rudy Pozzatti*. Cleveland: The Cleveland Museum of Art, 1955. I. *Exhibition catalogue.*

PRINT COUNCIL OF AMERICA. *Prints*. New York: Holt, Rinehart and Winston, Inc., 1962. I.

RAGON, MICHEL. 1. *L'Aventure de l'art abstrait*. Paris: Robert Laffont, 1956. I.B. (French text.) *Development of abstract art.* I.

————, 2. *Expression et non-figuration*. Paris: Editions de la Revue Neuf, 1951. I. (French text.) *Expressionism and the development of non-figurative art.*

RAMSEN, E. H. 1. *An Introduction to Modern Art*. London: Oxford University Press, 1940. I.

————, 2. *Sculpture: Theme and Variations Toward a Contemporary Aesthetic*. London: Lund Humphries, 1953. I.B.

RAND, HARRY. 1. *Arshile Gorky: The Implications of Symbols*. Montclair, NJ: Allanheld & Schram, 1981. B.I. *A bizarre interpretation of the artist's accomplishments.*

————, 2. *Paul Manship*. Washington, D.C.: National Museum of American Art, 1989. I.B. Exhibition catalogue.

————, 3. *Seymour Lipton: Aspects of Sculpture*. Washington, D.C.: National Collection of Fine Arts, 1979. Foreword by Joshua C. Taylor. I.B. *Illustrates the working methods from drawing to maquette to sculpture.*

Raymond Duchamp-Villon/Marcel Duchamp. Paris: Musée National d'Art Moderne, 1967. I.B. (French text.) *Major exhibition of the brothers.*

RAYNAL, MAURICE. 1. *A. Archipenko*. Rome: Valori Plastici, 1923. I. (French text.) *Monograph.*

————, 2. *Jacques Lipchitz*. Paris: Edition Jeanne Bucher, 1947. I. (French text.) *Monograph.*

————, 3. *Modern Painting*. Geneva: Skira 1953. I.B. *Survey of modern painting.*

————, 4. *Peinture moderne*. Geneva: Skira, 1953. I.B. (French text.)

READ, HERBERT. 1. *The Art of Sculpture*. Bollingen Series XXV, No. 3. New York: Pantheon Books, 1956. I. *Documented critical essays on connoisseurship of sculpture.*

————, 2. *A Concise History of Modern Painting*. New York: Frederick A. Praeger, 1959. I.B.

————, 3. *A Concise History of Modern Sculpture*. New York: Frederick A. Praeger, 1964. I.B. *Essay source book.*

————, 4. *The Quest and the Quarry*. Rome: Rome-New York Art Foundation Inc., 1961. I. *Critical essays.*

————, 5. *Surrealism*. New York: Harcourt, Brace and Co., 1939. I. *Essays on Surrealism.*

————, 6. *The Tenth Muse*. London: Routledge and Kegan Paul, 1957. I. *Critical essays.*

READ, HERBERT, and MARTIN, LESLIE. *Gabo*. London: Lund Humphries, 1957. I.B. *Monograph.*

Recent Figure Sculpture. Cambridge, Mass.: Fogg Art Museum and Harvard University, 1972. Preface by Daniel Robbins. Introduction by Jeanne L. Wasserman. I.B. *Small survey exhibition.*

REESE, ALBERT. *American Prize Prints of the 20th Century*. New York: American Artists Group Inc., 1949. I.

REICH, SHELDON. *John Marin: A Stylistic Analysis and Catalogue raisonné*. Tuscon: U. of Arizona Press, 1970. I.B. *Works catalogue.*

A Report on the Art and Technology Program of the Los Angeles County Museum: 1967-1971. Los Angeles: Los Angeles County Museum of Art, 1971. Introduction by Maurice Tuchman. Essay: Thoughts on Art and Technology, by Jane Livingston. I.D.P. *Documents an amalgam of art, science, and business.*

RESTANY, PIERRE. 1. *J. F. Koenig*. Paris: Galerie Arnaud, 1960. 1. (French and English text.) *Monograph.*

————, 2. *Lyrisme et abstraction*. Milan: Edizioni Apollinairi, 1960. I. (French text.) *Exposition of a lyrical theory in painting leading toward abstraction.*

RIBEMONT-DESSAIGNES, G. *Man Ray*. Paris: Librairie Gallimard, 1924. I. *Monograph.*

RICH, DANIEL CATTON. 1. *Georgia O'Keeffe*. Chicago: The Art Institute of Chicago, 1943. 1. *Retrospective catalogue.*

————, 2. *Georgia O'Keeffe*. Worcester, Mass.: The Worcester Art Museum, 1960. *Retrospective catalogue.*

Richard Diebenkorn: Paintings and Drawings, 1943-1976. Buffalo: Albright-Knox Art Gallery, 1976. Foreword by Robert T. Buck, Jr. Acknowledgments by Linda L. Cathcart. Essays by Robert T. Buck, Jr., Linda L. Cathcart, Gerald Nordland, and Maurice Tuchman. *Retrospective Catalogue.*

Richard Haas: An Architecture of Illusion. New York: Rizzoli, 1981. Preface by Paul Goldberger. *On trompe l'oeil mural painting.*

RICHARDSON, BRENDA. 1. *Barnett Newman: The Complete Drawings, 1944-1969*. Baltimore: The Baltimore Museum of Art, 1979. I.B. *Exhibition and catalogue raisonné.*

————, 2. *Joan Brown*. Berkeley: University of California, Berkeley, 1974. I.B. *Retrospective catalogue.*

————, 3. *William T. Wiley*. Berkeley: University of California, Berkeley, 1971. I.B. *Retrospective catalogue.*

RICHARDSON, E. P. *Painting in America, the Story of 450 Years*. New York: Thomas Y. Crowell Co., 1956. I.B. *Important history of American painting.*

RICHTER, HANS. *Dada Profile*. Zurich: Verlag Die Arche, 1961. I. (German text.) *Snapshot introductory essays on the Dadaists.*

RICKEY, GEORGE. *Constructivism: Origins and Evolution*. New York: George Braziller, Inc., 1967. I.B.D. Biographies. *History of this movement.*

RINARD, PARK, and PYLE, ARNOLD. *Grant Wood*. Chicago: Lakeside Press Galleries, 1935. I. *Exhibition catalogue.*

RINGEL, FRED J., ed. *America as Americans See It*. New York: The Literary Guild, 1932. I. *Anthology of the writings of various Americans on American culture.*

RITCHIE, ANDREW CARDUFF. 1. *Abstract Painting and Sculpture in America*. New York: The Museum of Modern Art, 1951. I.B. *Documented exhibition catalogue.*

————, 2. *Charles Demuth*. New York: The Museum of Modern Art, 1950. I.B. *Retrospective catalogue.*

————, 3. *Sculpture of the Twentieth Century.* New York: The Museum of Modern Art, 1952. I.B.

RIVERS, LARRY, with BRIGHTMAN, CAROL. *Drawings and Digressions.* New York: Clarkson N. Potter, Inc., Publishers, 1979. Foreword by John Ashbery. *Biographical sketches, travelogues, and salty art talk illustrated by the artist's drawings.*

RIVERS, LARRY, with WEINSTEIN, ARNOLD. *What Did I Do?: The Unauthorized Autobiography.* New York: Harper-Collins, 1992. I. *More than the life of the artist, a wild epic.*

ROBBINS, DANIEL. *Walter Murch.* Providence: Rhode Island School of Design, 1966. I.B. *Retrospective catalogue.*

Robert Barnes. Madison, WI: Madison Art Center, 1985. Introduction by Dennis Adrian. B. *Retrospective catalogue.*

Robert Beauchamp: An American Expressionist. Syracuse, NY: Everson Museum of Art, 1984. I.B.C. *Retrospective exhibition with a brief essay by April Kingsley and a self-interview by the artist.*

Robert Rauschenberg. Washington, D.C.: National Collection of Fine Arts, 1976. Foreword by Joshua C. Taylor. Acknowledgments by Walter Hopps. Essay by Lawrence Alloway. I.B.C. *Retrospective exhibition and documentation of projects.*

Robert Ryman. Amsterdam: Stedelijk Museum, 1974. I.B.C. *Retrospective catalogue.*

ROBERTS, COLETTE. *Mark Tobey.* New York: Grove Press Inc., 1959. I. *Monograph.*

ROBERTSON, BRYAN. 1. *Charles Howard.* London: Whitechapel Art Gallery, 1956. I. *Retrospective catalogue.*

————, 2. *Jackson Pollock.* New York: Harry N. Abrams Inc., 1960. I.B. *Monograph.*

ROBINS, CORINNE. *The Pluralist Era: American Art, 1968-1981.* New York: Harper & Row, 1984. I.B. *Essays reviewing the 1970s by selecting periferal art, objects, activities, and products, with allied social activities.*

RODMAN, SELDEN. 1. *Conversations with Artists.* New York: Capricorn Books, 1961. I.

————, 2. *The Eye of Man.* New York: Devin-Adair, 1955. I. *Polemic devised toward figuration.*

————, 3. *The Insiders.* Baton Rouge: Louisiana State University Press, 1960. I. *A thesis for figurative artists.*

ROSE, BARBARA. 1. *American Art since 1900, a Critical History.* New York: Frederick A. Praeger, 1967. I.B.

————, 2. *Claes Oldenburg.* New York: The Museum of Modern Art, 1969. I.B. *Retrospective catalogue.*

————, 3. *Frankenthaler.* New York: Harry N. Abrams Inc., 1971. I.B. *Monograph.*

————, 4. *Readings in American Art since 1900.* New York: Frederick A. Praeger, 1968. I.B. *Collected essays by and about artists and their work.*

ROSE, BARBARA, ed. 1. *Art as Art: The Selected Writings of Ad Reinhardt.* Documents of Twentieth-Century Art. New York: The Viking Press, 1975. I.B. *Anthology of the painter's writings.*

————, 2. *Art as Art: The Selected Writings of Ad Reinhardt.* Berkeley: U. of California, Berkeley, 1991. I.B.

ROSE, BERNICE. 1. *Allegories of Modernism.* New York: The Museum of Modern Art, 1992. I.B.C. *Publication to accompany a novel, misguided drawing exhibition.*

————, 2. *Jackson Pollock: Works on Paper.* New York: The Museum of Modern Art, 1969. I. *A study of the drawings.*

ROSE, BERNICE, and REA, ELIZABETH RICHEBOURG. *The Drawings of Roy Lichtenstein.* New York: The Museum of Modern Art, 1987. I.B. Exhibition catalogue. *Exhaustive study of the noted pop artist's drawings.*

ROSE, INGRID. Edited by Ralph Jentsch. *Werner Drewes: Catalogue Raisonné of His Prints.* Munich and New York: Esstingen, 1984. I.B. Concordance. (English and German text.)

ROSEN, RANDY, and BRAWER, CATHERINE C. *Making Their Mark: Women Artists Move into the Mainstream, 1970-85.* New York: Abbeville Press, 1989. Essays by assorted authors. I.B.G.A. Biographies. *A Maidenform, Inc. sponsored traveling exhibition.*

ROSENBERG, HAROLD. 1. *Arshile Gorky, The Man, The Time, The Idea.* New York: Horizon Press, Inc., 1962. I.B. *Monograph.*

————, 2. *De Kooning.* New York: Harry N. Abrams Inc., 1974. I.B.C. *Monograph.*

————, 3. *Saul Steinberg.* New York: Alfred A. Knopf in association with The Whitney Museum of American Art, 1978. Foreword by Paul H. Eliker and Tom Armstrong. I.B.C. *Major retrospective catalogue.*

ROSENBLUM, ROBERT. 1. *Cubism and Twentieth Century Art.* New York: Harry N. Abrams Inc., 1961. I.B. *Chronicles Cubism and its influence.*

————, 2. *Modern Painting and the Northern Romantic Tradition: Friedrich to Rothko.* New York: Harper and Row Publishers Inc., 1975. I.B. *Essays on the dark side of romantic painting.*

ROSENTHAL, MARK. *Neil Jenney: Paintings and Sculpture 1967-1980.* Berkeley, CA: University Art Museum, 1981. Foreword by James Elliott and Jean-Christophe Ammann. I.B. *Retrospective catalogue.*

ROSENTHAL, MARK, and MARSHALL, RICHARD. *Jonathan Borofsky.* Philadelphia: Philadelphia Museum of Art, 1984. B.C.I. *Includes artist's texts and statements.*

ROSENTHAL, NAN. *George Rickey.* New York: Harry N. Abrams, 1977. I.B. *Monograph.*

ROSENTHAL, NAN, and FINE, RUTH E. *The Drawings of Jasper Johns.* Washington, D.C.: National Gallery of Art, 1990. I.B. *Retrospective exhibition catalogue.*

ROSS, CLIFFORD, ed. and Introduction. *Abstract Expressionism: Creators and Critics: An Anthology.* New York: Harry N. Abrams, Inc., 1990. I.C. *Documentation from 1929 to 1970, artists' statements, critics' writings, and art journalism, a handy guide.*

ROTERS, EBERHARD. *Painters of the Bauhaus.* New York: Frederick A. Praeger, 1969. I.B. *A history of the master teachers.*

ROTHSCHILD, LEON. *Style in Art.* New York: Thomas Yoseloff Inc., 1960. I. *Critical essays.*

ROTHSCHILD, LINCOLN. *To Keep Art Alive: The Effort of Kenneth Hays Miller, American Painter.* Philadelphia: The Art Alliance Press, 1974. I.B. *Monograph.*

ROURKE, CONSTANCE. *Charles Sheeler, Artist in the American Tradition.* New York: Harcourt, Brace and Co., 1938. I. *Biography.*

ROWELL, MARGIT. *Qu'est-ce-que la sculpture moderne?* Paris: Centre Pompidou, 1986. Preface by Dominique Bozo. B. Index. *Includes essays by several critics.*

RUBIN, LAWRENCE. *Frank Stella: Paintings 1958-1965.* New York: Steward Tabori & Chang, Publishers, 1986. Introduction by Robert Rosenblum. B. *Catalogue raisonné.*

RUBIN, WILLIAM S. 1. *Dada, Surrealism, and Their Heritage.* New York: The Museum of Modern Art, 1968. I.B. *Chronology. Catalogue of controversial MOMA exhibition.*

————, 2. *Frank Stella.* New York: The Museum of Modern Art, 1970. I.B.C. *A major retrospective catalogue.*

RUBLOWSKY, JOHN. *Pop Art.* New York: Basic Books, 1965. I. *Pop art, its artists, dealers, collectors, and activities.*

RUHÉ, HARRY. *Fluxus, the Most Radical and Experimental Art Movement of the Sixties.* Amsterdam: 'A,' 1979. I.B.C. *Biographies. Major document on this international manifestation.*

RUSSELL, JOHN, and GABLIK, SUZI. *Pop Art Redefined.* New York: Frederick A. Praeger, 1969. I. *Includes statements by other critics.*

SACHS, PAUL J. *Modern Prints and Drawings.* New York: Alfred A. Knopf, 1954. I.B.

SAGER, PETER. *Neue Formen des Realismus.* Cologne: Verlag M. DuMont Schauberg, 1973. I.B.C. (German text.) *First international survey of various forms of new realist painting and sculpture; list of international group exhibitions; artists' statements.*

ST. JOHN, BRUCE. 1. *Isabel Bishop: The Affectionate Eye: Paintings, Drawings, and Aquatints, 1925-1982.* Los Angeles: Loyola Marymount University, 1985. I. Exhibition catalogue.

———, 2. *John Sloan.* American Art and Artists. New York: Praeger Publishers, 1971. I.B.C. *Appreciation and life of the artist.*

ST. JOHN, BRUCE, ed. *John Sloan's New York Scene.* With an introduction by Helen Farr Sloan. New York: Harper and Row, 1964. I. *Edited from diaries, notes, and correspondence of the artist dating from 1906 to 1913.*

SALVINI, ROBERTO. *Guida all'arte moderna.* Florence: L'arco, 1949. I.B. (Italian text.)

SAMARAS, LUCAS. 1.*Crude Delights.* New York: Pace Gallery Publications, 1980. *Rude imaginative tales.*

———, 2. *Samaras Album. Autointerview Autobiography Autopolaroid.* New York: The Whitney Museum of American Art and Pace Editions Inc., 1971. I. *The complete autoexposé of Samaras.*

Sam Francis. Paintings 1947-1972. Buffalo: Albright-Knox Art Gallery, 1972. I.B.C. *A major retrospective catalogue; contains essays by Franz Meyer; Wieland Schmied; Robert T. Buck, Jr.*

SANDLER, IRVING. 1. *Alex Katz.* New York: Harry N. Abrams, Inc., 1979. I.B. *Monograph.*

———, 2. *Al Held.* New York: Hudson Hills Press, 1984. I.B. *Monograph.*

———, 3. *American Art of the 1960s.* New York: Harper & Row, 1988. I.B. *Final section of the trilogy on mid-20th-century American Art. A major resource.*

———, 4. *Bradley Walker Tomlin.* Hempstead, N.Y.: Hofstra University, 1975. I.B. *Retrospective catalogue.*

———, 5. *The New York School: The Painters and Sculptors of the Fifties.* New York: Harper & Row, Publishers, 1978. I.B.A. *Review of the decade 1950-1960.*

———, 6. *The Triumph of American Painting: A History of Abstract Expressionism.* New York: Praeger Publishers, 1970. I.B.C. *A history of the mid-20th-century period.*

SASOWSKY, NORMAN. *Reginald Marsh. Etchings, Engravings, Lithographs.* New York: Frederick A. Praeger, 1956. I. *Catalogue raisonné.*

SAWYER, KENNETH. *The Paintings of Paul Jenkins.* Paris: Editions Two Cities, 1961. I. *Monograph.*

SCHEYER, ERNST. *Lyonel Feininger, Caricature and Fantasy.* Detroit: Wayne State University Press, 1964. I.B. *Documentary monograph drawn from letters and notes of the artist, showing development from cartoonist to painter.*

SCHMECKEBIER, LAURENCE E. 1. *Boris Margo.* Syracuse: School of Art, Syracuse University, 1968. I.B. *Exhibition catalogue, including a catalogue raisonné of the artist's prints.*

———, 2. *John Steuart Curry's Pageant of America.* New York: American Artists Group Inc., 1943. I. *Biography.*

SCHNEIDER, PIERRE. *Louvre Dialogues.* Translated from the French by Patricia Southgate. New York: Atheneum, 1971. I. *Interviews he made while walking through the Louvre.*

SCHULZE, FRANZ. *Fantastic Images: Chicago Art since 1945.* Chicago: Follett Publishing Co., 1972. I. *Eccentric figurative art from 1945 to 1972.*

SCHWABACHER, ETHEL K. *Arshile Gorky.* New York: The Whitney Museum of American Art, 1957. I.B. *Biography.*

SCHWARTZ, SANFORD. 1. *The Art Presence.* New York: Horizon Press, 1982. Index. I. *Collected essays, some rewritten.*

———, 2. *Artists and Writers.* New York: Yarrow Press, 1990. I. *Collected popular magazine reviews, on art new and old with other topics.*

———, 3. *Myron Stout.* New York: The Whitney Museum of American Art, 1980. Introduction by B. H. Friedman. I.B.C. *Retrospective exhibition catalogue including artist's statements.*

SCHWARZ, ARTURO. 1. *The Complete Works of Marcel Duchamp.* New York: Harry N. Abrams Inc., 1971 (2nd edition). I.B. *Biographical, critical catalogue raisonné: the major source book.*

————, 2. *Marcel Duchamp: Notes and Projects for the Large Glass.* New York: Harry N. Abrams Inc., 1969. I. *Facsimile reproduction of the notes for this work.*

SCOTT, DAVID W. *The Art of Stanton Macdonald-Wright.* Washington, D.C.: National Collection of Fine Arts, 1967. I.B. *Includes "A Treatise on Color" and selected writings of the artist. Retrospective catalogue.*

SCOTT, GAIL R. *Marsden Hartley.* New York: Abbeville Press, 1988. I. B. *Popular introduction to the artist.*

Sculpture and Drawings by Michael Lekakis. Dayton: Dayton Art Institute, 1968. Introduction by Priscilla Colt. I.C. *Appreciation.*

Sculpture of the Western Hemisphere. New York: International Business Machines Corp., 1942. I. *Catalogue of IBM sculpture collection*

SEITZ, WILLIAM C. 1. *Abstract Expressionist Painting in America.* Cambridge, MA: Harvard University Press, 1983. Foreword by Robert Motherwell. Introduction by Dore Ashton. C.I. *Remains the most sensitive and understanding study of this movement.*

————, 2. *Arshile Gorky.* New York: The Museum of Modern Art, 1962. Foreword by Julien Levy. I.B. *Retrospective catalogue.*

————, 3. *Art in the Age of Aquarius, 1955-1970.* Compiled and edited by Marla Price. Washington, D.C.: Smithsonian Press, 1992. Foreword by Robert Rosenblum. I.B.C. *New (1970s) texts by one of the best writers on American art.*

————, 4. *The Art of Assemblage.* New York: The Museum of Modern Art, 1961. I.B. *Documented exhibition catalogue.*

————, 5. *Hans Hofmann.* New York: The Museum of Modern Art, 1963. I.B. *Exhibition catalogue.*

————, 6. *Mark Tobey.* New York: The Museum of Modern Art, 1962. I.B. *Retrospective catalogue.*

SELDIS, HENRY J. *Rico Lebrun.* Los Angeles: County Museum of Art, 1967. I.B. *Retrospective catalogue with major documentation; notes on "Genesis" by Peter Selz.*

SELIGMANN, HERBERT J., ed. *Letters of John Marin.* New York: An American Place, 1931.

SELIGMANN, KURT. *The Mirror of Magic.* New York: Pantheon Books, 1948. I. *This artist was an authority on magic: his art reflects its influence.*

SELZ, JEAN. *Modern Sculpture.* New York: George Braziller, Inc., 1963. I.B. *Origins of modern sculpture from 1850 to 1920.*

SELZ, PETER. 1. *Directions in Kinetic Sculpture.* Berkeley: University of California, 1966. Preface by George Rickey. I.B. *International survey exhibition catalogue including artists' statements.*

————, 2. *Funk.* Berkeley: University of California, 1967. I.G. *Includes statements by artists.*

————, 3. *German Expressionist Painting.* Berkeley: University of California Press, 1957. I.B. *Major work documenting the development of German Expressionism and its influence.*

————, 4. *Hans Burkhardt: Desert Storms.* Los Angeles: Jack Rutberg Fine Art, 1991. I.B.C. Filmography. *Brief essay on recent painting with political content.*

————, 5. *Mark Rothko.* New York: The Museum of Modern Art, 1961. I.B. *Retrospective catalogue.*

SEUPHOR, MICHEL. 1. *Abstract Painting. 50 Years of Accomplishment, from Kandinsky to the Present.* New York: Dell Publishing Co., 1964. I.

————, 2. *L'Art abstrait.* Paris: Editions Maeght, 1949. I.B. (French text.)

————, 3. *The Sculpture of This Century.* Dictionary of Modern Sculpture. London: A. Zwemmer, Ltd., 1959. I.B.

7 Decades. Andover, Mass.: Addison Gallery of American Art, Phillips Academy, 1969. Foreword by Bartlett H. Hayes, Jr. I.C. *Exhibition catalogue, including artists' statements.*

SEYMOUR, CHARLES, Jr. *Tradition and Experiment in Modern Sculpture.* Washington, D.C.: The American University Press, 1949. I.

SHAHN, BEN. 1. *The Biography of Painting.* New York: Paragraphic Books, 1966. I. *A testament of the artist.*

———, 2. *The Shape of Content.* Cambridge, Mass.: Harvard University Press, 1957. I. *Critical essay.*

SHAHN, BERNARDA BRYSON. *Ben Shahn.* New York: Harry N. Abrams Inc., 1972. I.B.C. *Picture catalogue of works and biographical sketch.*

SHANES, ERIC. *Jack Beal.* New York: Hudson Hills, 1993. I.B.C. *Monograph.*

SHAPIRO, DAVID. *Jasper Johns: Drawings 1954-1984.* New York: Harry N. Abrams, Inc., 1984. B.I. Exhibition history. *Drawing encomiums.*

SHAPIRO, DAVID, ed. *Social Realism: Art as a Weapon.* New York: Frederick Ungar Publishing Co., 1973. I.B. *A study of the social implications of figurative art in the 1930s and 1940s.*

SHEARER, LINDA. *Brice Marden.* New York: The Solomon R. Guggenheim Museum, 1975. I.B. *A ten-year survey.*

SHEEHAN, SUSAN. *Robert Indiana Prints: A Catalogue Raisonné, 1951-1991.* New York: Susan Sheehan Gallery, 1991. I.B.C.

SIEGEL, JEANNE. *Artwords: Discourses on the 60s and 70s.* New York: Da Capo Press, 1992. *Graciously brief, often previously published or broadcast interviews.*

SIEGFRIED, JOAN C. *Bruce Conner.* Philadelphia: Institute of Contemporary Art, 1967. Preface by Stephen S. Prokopoff. I. *Retrospective catalogue.*

SIMS, LOWERY STOKES. *Stuart Davis: American Painter.* New York: Metropolitan Museum of Art, 1991. Essays and Acknowledgments by Lowery Stokes Sims and William C. Agee. Numerous essays on various aspects of the artist's work. I.B.C. *Major retrospective catalogue.*

SIMS, PATTERSON, and PULITZER, EMILY RAUH. *Ellsworth Kelly: Sculpture.* New York: Whitney Museum of American Art, 1982. Foreword by Tom Armstrong. I.B.C. *Exhibition catalogue including catalogue raisonné.*

SLOAN, HELEN FARR. *The Life and Times of John Sloan.* Wilmington, Del.: Wilmington Society of the Fine Arts, 1961. I.

SLOAN, HELEN FARR, ed. *American Art Nouveau: The Poster Period of John Sloan.* Lock Haven, Pa.: Privately published by Hammermill Paper Co., n.d. I. *New material on an unknown period of the artist's work.*

SLOAN, JOHN. 1. *The Art of John Sloan.* Brunswick, Me.: Walker Art Museum, Bowdoin College, 1962. *Exhibition catalogue.*

———, 2. *The Gist of Art.* New York: American Artists Group Inc., 1939. I. *The artist's theory of painting.*

———, 3. *John Sloan.* Andover, Mass.: Addison Gallery of American Art, Phillips Academy, 1938. I.B. *Exhibition catalogue.*

———, 4. *John Sloan.* New York: American Artists Group Inc., 1945. I. *Autobiographical monograph.*

———, 5. *John Sloan. Paintings and Prints.* Hanover, N.H.: Dartmouth College, 1946. I. *Exhibition catalogue.*

SLUSSER, JEAN PAUL. *Bernard Karfiol.* New York: The Whitney Museum of American Art (American Artists Series), 1931. I.B. *Monograph.*

SMITH, ANDRE. *Concerning the Education of a Print Collector.* New York: Harlow, Keppel and Co., 1941.

SMITH, BERNARD. *Moses Soyer.* New York: ACA Gallery, 1944. I. *Monograph.*

SMITH, BRYDEN. *Donald Judd.* Ottawa: National Gallery of Canada, 1975. I.B.C. *Retrospective catalogue and catalogue raisonné, 1960-1974.*

SMITH, DAVID. *David Smith.* New York: Holt, Rinehart and Winston, Inc., 1968. I. *Writings and photographs.*

SMITH, S.C. KAINES. *An Outline of Modern Painting.* London: The Medici Society, 1932. I. *Early documentation of twentieth-century art.*

SOBY, JAMES THRALL. 1. *After Picasso.* Hartford, Conn.: Edwin Valentine Mitchell; New York: Dodd, Mead and Co., 1935. I. *Critical essays.*

————, 2. *Ben Shahn.* New York: The Museum of Modern Art; West Drayton, England: Penguin Books, 1947. I. *Monograph.*

————, 3. *Ben Shahn.* New York: George Braziller Inc., 1963. I.B. *Monograph.*

————, 4. *Ben Shahn, His Graphic Work.* New York: George Braziller, Inc., 1957. *I.B. Monograph.*

————, 5. *Contemporary Painters.* New York: The Museum of Modern Art, 1948. I. *Documented exhibition catalogue.*

————, 6. *Modern Art and the New Past.* Norman: University of Oklahoma Press, 1957. *Critical essays and documentation.*

————, 7. *Tchelitchev.* New York: The Museum of Modern Art, 1942. I.B. *Exhibition catalogue.*

————, 8. *Yves Tanguy.* New York: The Museum of Modern Art, 1955. I.B. *Exhibition catalogue.*

Sol LeWitt. New York: The Museum of Modern Art, 1978. Introduction by Alicia Legg. Essays by Robert Rosenblum, Lucy R. Lippard, Bernice Rose. I.B.D. *Retrospective catalogue including artist's writings.*

SOLNIT, REBECCA. *Secret Exhibition: Six California Artists of the Cold War Era.* San Francisco: City Lights, 1990. I.B. *Journalistic, often inaccurate essays, examining the street-life artist in conjunction with serious artists. A social-political effusion.*

SOLOMON, DEBORAH. *Jackson Pollock: A Biography.* New York: Simon and Schuster, 1987. I.

SONTAG, SUSAN. *Against Interpretation.* New York: Dell Publishing Co., 1966. *Assorted collected essays.*

SOYER, MOSES. *Painting the Human Figure.* New York: Watson-Guptill Publishing Co., Inc., 1964. I. *How-to-paint book.*

SOYER, RAPHAEL. 1. *Homage to Thomas Eakins, etc.* Rebecca L. Soyer, ed. South Brunswick, N.J.: Thomas Yoseloff, Inc., 1965. I. *Travelogue and art-world personalities.*

————, 2. *A Painter's Pilgrimage. New* York: Crown Publishers Inc., 1962. I. *A European travelogue.*

————, 3. *Raphael Soyer.* New York: American Artists Group Inc., 1946. I. *Autobiographical monograph.*

SPEICHER, EUGENE. *Eugene Speicher.* New York: American Artists Group Inc., 1945. I. *Autobiographical monograph.*

SPIKE, JOHN T. *Fairfield Porter: An American Classic.* New York: Harry N. Abrams, 1992. I.B. Checklist of the paintings of Fairfield Porter by Joan Ludman. *The biography.*

STABER, MARGIT. *Fritz Glarner.* Zurich: ABC Verlag, 1976. (English and German text.) I.B.C. *Biography. The monograph and catalogue raisonné.*

The State of California Painting. New Plymouth, N.Z.: Govett-Brewster Art Gallery, 1972. Foreword by Robert H. Ballard. Introduction by Michael Walls. I.C. *Exhibition catalogue.*

STEALINGWORTH, SLIM (pseudonym). *Tom Wesselmann.* New York: Abbeville, 1980. I.B. *Monograph.*

STEARNS, ROBERT. *Dynamix.* Cincinnati: Contemporary Arts Center, 1982. I.C. *Exhibition catalogue. Chasing after the shallowness of glitz.*

STEIN, JUDITH, and SHAPIRO, DAVID. *Alfred Leslie: The Killing Cycle.* St. Louis, Mo.: The Saint Louis Art Museum, 1991. Foreword by James D. Burke. I. *Artist's biography. Meditation on the death of poet Frank O'Hara.*

STELLA, FRANK. *Working Space.* Cambridge, Mass.: Harvard University Press, 1986. I. *Discussion of older works of art.*

STORR, ROBERT, and TANNENBAUM, JUDITH. *Devil on the Stairs: Looking Back on the Eighties.* Philadelphia: Institute of Contemporary Art, University of Pennsylvania, 1991. Additional texts by Peter Schjeldahl and Patrick T. Murphy. I. *Brief artists' biographies. Military hagiography replaces a longing for old marxist rituals in criticism.*

STRAND, MARK, ed. *Art of the Real: Nine American Figurative Painters.* New York: Clarkson N. Potter, Inc., Publishers, 1983. Foreword by Robert Hughes. B.C. *Text from edited interviews. Portrait photos by Timothy Greenfield-Sanders.*

STEINBERG, LEO. *Jasper Johns.* New York: George Wittenborn, Inc., 1964. I.B. *Monograph.*

STEINBERG, SAUL. 1. *The Art of Living.* New York: Harper and Brothers, 1945. I. *Cartoons.*

——, 2. *The Passport.* New York: Harper and Brothers, 1945. I. *Cartoons.*

——, 3. *Steinberg Dessins.* Paris: N.R.F., Gallimard, 1955. I. *Cartoons.*

STORY, ALA. *First comprehensive retrospective exhibition in the West of Max Weber.* Santa Barbara: University of California, 1968. I.B. *Major retrospective catalogue.*

STRACHAN, W. J. *Towards Sculpture.* London: Thames and Hudson, 1976. I.B. *Biographies. From the classical tradition to Oldenburg: drawings, maquettes, and realized works.*

SUTTON, DENYS. *American Painting.* London: Avalon Press, 1948. I. *Mid-twentieth-century painting.*

SWEENEY, JAMES JOHNSON. 1. *Alexander Calder.* New York: The Museum of Modern Art, 1951. I.B. *Exhibition catalogue.*

——, 2. *Jacques Villon, Raymond Duchamp-Villon, Marcel Duchamp.* New York: The Solomon R. Guggenheim Museum, 1957. I.B. *Exhibition catalogue.*

——, 3. *Sam Francis.* Houston: Museum of Fine Arts of Houston, 1967. I. *Exhibition catalogue.*

——, 4. *Stuart Davis.* New York: The Museum of Modern Art, 1945. I.B. *Exhibition catalogue.*

SWEET, FREDERICK, A. *Ivan Albright.* Chicago: The Art Institute of Chicago, 1964. I. *Retrospective catalogue.*

SYLVESTER, JULIE. *John Chamberlain: A Catalogue Raisonné of the Sculpture 1954-1985.* New York: Hudson Hills Press, 1986. B.C. *Includes an essay by Klaus Kertess.*

TAFT, LORADO. *Modern Tendencies in Sculpture.* Chicago: The University of Chicago Press, 1921. I.

TAKIGUCHI, SHUZO. *Noguchi.* Tokyo: Bijutsu Shippan-Sha, 1953. I. *Monograph.*

TANGUY, YVES. *Un Recueil de Ses Ouevres/A Summary of His Work.* New York: Pierre Matisse, 1943. I.B. (French and English text.) *Catalogue raisonné.*

TAPIE, MICHEL. 1. *Un Arte autre.* Paris: Gabriel Giraud et Fils, 1952. I. (French text.) *Polemic thesis for advance-guard painting.*

——, 2. *Ossorio.* Turin: Edizioni d'Arte Fratelli Pozzo, 1961. I. (English and French text.) *Monograph.*

TARBELL, ROBERTA K. *Marguerite Zorach: The Early Years, 1908-1920.* Washington, D.C.: National Collection of Fine Arts, 1973. Foreword by Joshua C. Taylor. I.B.C. *Exhibition catalogue and detailed study of the artist's early life.*

TASHJIAN, DICKRAN. *Skyscraper Primitives.* Middletown, Conn.: Wesleyan University Press, 1975. I.B. *Observations on dadamerica.*

TAUBES, FREDERIC. 1. *Anatomy of Genius.* New York: Dodd, Mead and Co., 1948. I. *Critical essay.*

——, 2. *The Art and Techniques of Portrait Painting.* New York: Dodd, Mead and Co., 1957. I.

——, 3. *Better Frames for Your Pictures.* New York: Studio Publications, 1952. I.

————, 4. *Frederic Taubes.* New York: American Artists Group Inc., 1946. I.B. *Autobiographical monograph.*

————, 5. *The Mastery of Oil Painting.* New York: Studio Publications, 1953. I. *Technique.*

————, 6. *Modern Art, Sweet or Sour?* New York: Watson-Guptill Publishing Co. Inc., 1958. I. *Critical essays.*

————, 7. *The Painter's Question and Answer Book.* New York: Watson-Guptill Publishing Co. Inc., 1948. I. *Technique.*

————, 8. *Paintings and Essays on Art.* New York: Dodd, Mead and Co., 1950. I.

————, 9. *Pen and Ink Drawing, Art and Technique.* New York: Watson-Guptill Publishing Co. Inc., 1958. I.

————, 10. *Pictorical Composition and the Art of Drawing.* New York: Dodd, Mead and Co., 1949. I.

————, 11. *Studio Secrets.* New York: Watson-Guptill Publishing Co. Inc., 1943. I. *Technique.*

————, 12. *The Technique of Oil Painting.* New York: Dodd, Mead and Co., 1941. I.

————, 13. *You Don't Know What You Like.* New York: Dodd, Mead and Co., 1947. I. *Critical essays.*

TAVOLATO, ITALO. *George Grosz.* Rome: Valori Plastici, 1924. I. (French text.) *Monograph.*

TERENZIO, STEPHANIE. 1. *The Painter and The Printer: Robert Motherwell's Graphics, 1943-1980.* New York: The American Federation of Arts, 1980. Introduction includes a note by the artist on collaboration. I.B. *Biographical sketch. Catalogue raisonné by Dorothy C. Belknap.*

————, 2. *The Prints of Robert Motherwell: Catalogue Raisonné, 1943-1990.* New York: Rizzoli, 1990. I.B. *Revised edition of print catalogue.*

THOMAS, EDWARD B. *Mark Tobey.* Seattle: Seattle Art Museum, 1959. I. *Exhibition catalogue.*

Three Realists: Close, Estes, Raffael. Worcester, Mass.: The Worcester Art Museum, 1974. Foreword by Leon Shulman. I.B. *Exhibition catalogue.*

TILLIM, SIDNEY. *Richard Lindner.* Chicago: William and Noma Copley Foundation, n.d. I. *Monograph.*

TOBEY, MARK. *Mark Tobey.* New York: The Whitney Museum of American Art, 1951. I. *Exhibition catalogue.*

TOHER, JENNIFER, ed. *Beyond the Plane: American Construction 1930-1965.* Trenton: New Jersey State Museum, 1983. Introduction by Joan Marter. B. *Numerous brief essays examine the topic.*

TOMIDY, PAUL. *De-Persona.* Oakland, Calif.: The Oakland Museum, 1991. Introduction by Philip E. Linhares. Essays by Ronald Jones, Peter Schjeldahl. I.B.C. *Yet another yearning search for figurative art guided by unartistic, politically ambitious critics.*

TOMKINS, CALVIN. 1. *The Bride and the Bachelors.* New York: Viking Press, 1965. I. *Essays on the avant-garde.*

————, 2. *Off the Wall: Robert Rauschenberg and the Art World of Our Time.* Garden City: Doubleday & Co., Inc., 1980. I.C. *Extracts from "Profiles" in the New Yorker.*

TOMKINS, CALVIN, and the Editors of TIME-LIFE BOOKS. *The World of Marcel Duchamp.* New York: Time Inc., 1966. I.B.

Tony Smith: Painting and Sculpture. Baltimore: University of Maryland Art Gallery, 1974. Foreword by Eleanor Green. I. *Exhibition catalogue.*

Transparency, Reflection, Light, Space: Four Artists. Los Angeles: UCLA Art Galleries, 1971. Foreword by Frederick S. Wight. I.B.C. *Exhibition catalogue: interviews and artists' statements.*

TRIER, EDUARD. 1. *Form and Space: Sculpture in the 20th Century.* New York: Frederick A. Praeger, 1968. I.B. *Survey by concept.*

————, 2. *Moderne Plastik von August Rodin bis Marino Marini.* Frankfurt am Main: Buchergilde Gutenberg, 1955. I.B. (German text.) *Short illustrated history of twentieth-century sculpture.*

TROYEN, CAROL AND HIRSHLER, ERIC. *Charles Sheeler: Paintings and Drawings.* Boston: Museum of Fine Arts, 1987. I.B. *Retrospective catalogue.*

TSUJIMOTO, KAREN. *Wayne Thiebaud.* Seattle: U. of Washington Press, 1985. Exhibition history. Foreword by Henry T. Hopkins. B.C.I. *Retrospective catalogue.*

TUCHMAN, MAURICE. 1. *American Sculpture of the Sixties.* Los Angeles: County Museum of Art, 1967. I.B.G. *Major survey exhibition catalogue includes essays by 10 critics and statements by the artists.*

————, 2. *Edward Kienholz.* Los Angeles: County Museum of Art, 1966. I.B. *Retrospective catalogue.*

————, 3. *The Spiritual in Art: Abstract Painting 1890-1985.* Los Angeles: Los Angeles County Museum of Art, 1986. B.C.D. *Numerous essays by artists and scholars comprise this vast and unsparing confection of occultism.*

TUCHMAN, MAURICE, ed. *New York School. The First Generation: Paintings of the 1940s and 1950s.* Los Angeles: County Museum of Art, 1965. I.B. *Major exhibition catalogue with statements by artists and critics.*

TUCKER, MARCIA. *Al Held.* New York: The Whitney Museum of American Art, 1974. I.B.C. *Retrospective catalogue.*

TYLER, KENNETH E. *Josef Albers: White Line Squares.* Los Angeles: Gemini G.E.L., 1966. I.B. *Graphics exhibition catalogue includes artist's statements.*

TYLER, PARKER. 1. *The Divine Comedy of Pavel Tchelitchew.* New York: Fleet Publishing Co., 1967. I.B. *Biography.*

————, 2. *Marca-Relli.* Paris: The Pocket Museum, Editions George Fall, 1960. I. *Monograph.*

UPRIGHT, DIANE. 1. *Ellsworth Kelly: Works on Paper.* New York: Fort Worth Art Museum and Harry N. Abrams, Inc., 1987. Introduction by Henry Geldzahler. I.B. *Major exhibition catalogue.*

————, 2. *Morris Louis: The Complete Paintings.* New York: Harry N. Abrams, 1985. I.B. *Works catalogue.*

USA West Coast. Hamburg: Kunstverein in Hamburg, 1972. Foreword by Helmut Heissenbuttel. Essay by Helene Winer. I.C. (German and English text.) *Exhibition catalogue.*

VALENTINE, W. R. 1. *Letters of John B. Flanagan.* New York: Curt Valentine, 1942.

————, 2. *Origins of Modern Sculpture.* New York: Wittenborn and Co., 1946. I.

VAN BORK, BERT. *Jacques Lipchitz: The Artist at Work.* With a critical evaluation by Dr. Alfred Werner. New York: Crown Publishers Inc., 1966. I. *Well-illustrated popular essay about the artist at work.*

VAN BRUGGEN, COOSJE, and OLDENBURG, CLAES. *Claes Oldenburg: Large-Scale Projects, 1977-1980.* New York: Rizzoli International Publications, Inc. Includes essay on his monuments by R. H. Fuchs. I.D.P. *Biographies. Documentation on ten projects.*

VARGA, MARGIT. *Waldo Peirce.* New York: Hyperion Press, Harper and Brothers, 1941. I. *Monograph.*

VERKAUF, WILLY, ed. *Dada: Monograph of a Movement.* New York: Wittenborn and Co., 1957. I.B. *Documented monograph.*

VINE, NAOMI, and HALES, PETER BACON. *A Certain Slant of Light: The Contemporary American Landscape.* Dayton, Ohio: The Dayton Art Institute, 1989. Foreword by Bruce Evans. I.B.C. *A review of landscape painting by younger artists.*

VITRY, PAUL. *Paul Manship.* Paris: Editions de la Gazette des Beaux Arts, 1927. I. *Monograph.*

WALDBERG, PATRICK. 1. *Bernard Pfriem.* Chicago: William and Noma Copley Foundation, 1961. I. (French and English text.) *Monograph.*

————, 2. *Main et merveilles.* Paris: Mercure de France, 1961. I. *Essays on Surrealism.*

————, 3. *Surrealisms.* Geneva: Skira, 1962. I.B. *Documentation and essays on Surrealism.*

————, 4. *Surrealism.* New York: McGraw-Hill Co., Inc., 1965. I.B. Chronology. *A short history of Surrealism.*

WALDMAN, DIANE. 1. *Arshile Gorky, 1904-1948. A Retrospective.* New York: Harry N. Abrams, Inc., 1981. Preface by Thomas M. Messer. B.C.I. *Major retrospective catalogue.*

————, 2. *Carl Andre.* New York: The Solomon R. Guggenheim Museum, 1970. I.B. *A ten-year survey of Andre's work.*

————, 3. *Chryssa: Selected Works 1955-1967.* New York: The Pace Gallery, 1968. I.B. *Well-illustrated exhibition catalogue.*

————, 4. *Collage, Assemblage, and the Found Object.* New York: Harry N. Abrams, Inc., 1992. I.B. Index. *From the shallow collage to deep relief objects and theatrical happenings: a useful resource.*

————, 5. *Joseph Cornell.* New York: The Solomon R. Guggenheim Museum 1967. I.B. *Retrospective catalogue.*

————, 6. *Kenneth Noland: A Retrospective.* New York: The Solomon R. Guggenheim Museum, 1977. Preface and acknowledgments by Thomas M. Messer. I.B.C. *Retrospective catalogue.*

————, 7. *Mark Rothko, 1903-1970: A Retrospective.* New York: Harry N. Abrams Inc./The Solomon R. Guggenheim Museum, 1978. Acknowledgments and preface by Thomas M. Messer. Includes "The Aquamarine Sunrise: A Memory of Rothko," by Bernard Malamud. I.B.C. *Comprehensive retrospective.*

————, 8. *Robert Mangold.* New York: The Solomon R. Guggenheim Museum, 1971. I.B. *Exhibition catalogue.*

WALKOWITZ, ABRAHAM. 1. *A Demonstration of Objective, Abstract and Non-Objective Art.* Giraud, Kans.: Haldeman, Julius Press, 1945. I. *The artist's theories, illustrated.*

————, 2. *100 Drawings.* New York: B. W. Huebsch, Inc., 1925. I.

WARD, JOHN L. *American Realist Painting, 1945-1980.* Ann Arbor, Mich.: UMI Research Press, 1989. I.B. *A defense of realism, lost in the harsh clay of reality.*

WARHOL, ANDY. *The Philosophy of Andy Warhol.* New York: Harcourt Brace Jovanovich, 1975. *Artist's statements.*

WARHOL, ANDY; KONIG, KASPER; HULTEN, PONTUS; and GRANTH, OLLE. eds. *Andy Warhol.* Stockholm: Moderna Museet, 1968. I. *Pictorial history of the development of the artist, his work, and friends, including comments by the artist.*

WARHOL, ANDY, and HACKETT, PAT. *POPism: The Warhol '60s.* New York: Harcourt Brace Jovanovich, 1980. I. *Gossip or history: choose!*

WATSON, ERNEST, W. 1. *Color and Method in Painting.* New York: Watson-Guptill Publishing Co. Inc., 1942. I. *Studies of various artists' use of color.*

————, 2. *Twenty Painters and How They Work.* New York: Watson-Guptill Publishing Co. Inc., 1950. I.

WATSON, FORBES. *William Glackens.* New York: Duffield and Co., 1923. I. *Monograph.*

WEBER, NICHOLAS FOX. 1. *The Drawings of Josef Albers.* New Haven, CT: Yale University Press, 1984. I. *Survey of the drawings.*

————, 2. *Josef Albers: His Art and His Influence.* Montclair, NJ: Montclair Art Museum, 1981. C. *A review of the artist and his students.*

WEBER, MAX. 1. *Essays on Art.* n.p.: Privately published, 1916.

————, 2. *Max Weber.* New York: American Artists Group Inc., 1945. I. *Autobiographical monograph.*

WEINTRAUB, LINDA. *The Maximal Implications of the Minimal Line.* Annandale-on-Hudson, N.Y.: Bard College, 1985. Miscellaneous texts by various critics, includes artists' statements. I.B. *Confusion on the definition, function, and enjoyment of line.*

WEITEMEIER, HANNAH. *Moholy-Nagy.* Eindhoven, Holland: Stedelijk van Abbe-Museum, 1967. I. (Dutch and English text.) *Retrospective catalogue including statements by the artists.*

WELL, HENRY W., ed. *Selected Poems by Marsden Hartley.* New York: Viking Press, 1945. I.

WELLER, ALLEN S. *The Joys and Sorrows of Recent American Art.* Urbana: University of Illinois Press, 1968. I.

"What Abstract Art Means to Me." Bulletin of the Museum of Modern Art, Vol. XVIII, No. 3, Spring 1951. I. *Statements by leading artists.*

WHEELER, MONROE. *Painters and Sculptors of Modern America.* New York: Thomas Y. Crowell Co., 1942. I.

When Attitudes Become Form: Works/Concepts/Processes/Situations/Information. Bern: Kunsthalle Bern, 1969. Foreword by Harold Szeemann. Introduction by John A. Murphy. I.B.C. (English, French, and German text.) *Major international exhibition of above mentioned tendencies.*

WHITNEY, DAVID, ed. *Andy Warhol: Portraits of the 70s.* New York: Random House, in Association with The Whitney Museum of American Art, 1979. Foreword by Tom Armstrong. Essay by Robert Rosenblum. I. *Exhibition catalogue and picture book of commissioned portraits.*

Who Chicago? Sunderland, England: Sunderland Arts Centre, 1980. Preface by Tony Knipe. Introduction by Victor Musgrave. B.I. *Essays by Dennis Adrian, Russell Bowman, and Roger Brown examining 14 Chicago School artists.*

WIESINGER, VERNONIQUE. *Dessins Americains des collections nationales de 1760 à 1945. (American Drawings in the French National Collections, from 1760 to 1945).* Paris: Reunion des musées nationaux, 1991. Preface by Pierre Rosenberg. Various essays. B.D. (French and English text.) *Contains 426 works by Americans affiliated with France.*

WIGHT, FREDERICK, S. 1. *Hans Hofmann.* New York: The Whitney Museum of American Art, 1957. I. *Exhibition catalogue.*

————, 2. *Milestones of American Painting in Our Century.* New York: Chanticleer Press, 1949. I. *Historical view of American painting.*

————, 3. *Milton Avery.* Baltimore: Baltimore Museum of Art, 1952. I. *Exhibition catalogue.*

————, 4. *Nathan Oliveira.* Los Angeles: University of California, 1963. I. *Monograph.*

WIGHT, FREDERICK S.; BAUR, JOHN I.H.; and PHILLIPS, DUNCAN. *Morris Graves.* Berkeley: University of California Press, 1956. I.B. *Exhibition catalogue.*

WIGHT, FREDERICK S., and GOODRICH, LLOYD. *Hyman Bloom.* Boston: Institute of Contemporary Art, 1944. I. *Exhibition catalogue.*

WILDE, JOHN. *44 Wilde 1944.* Mt. Horeb, WI: The Perishable Press, 1984. Foreword by Lincoln Kirstein. I. *Drawings and text by the artist from 1944.*

WILENSKI, R. H. *The Modern Movement in Art.* London: Faber and Faber, Ltd., 1955. I. *European and American development of modern art.*

WILKIN, KAREN. 1. *Frankenthaler: Works on Paper 1949-1984.* New York: George Braziller, 1984. B.C.I. *Retrospective catalogue including artist's statements.*

————, 2. *Stuart Davis.* New York: Abbeville, 1987. I. B. *A popular introduction to the artist.*

WILLARD, CHARLOTTE. *Moses Soyer.* Cleveland: World Publishing Co., 1962. I. *Monograph.*

Willem de Kooning: Printer's Proofs from the Collection of Irwin Hollander, Master Printer. New York: Salander-O'Reilly Galleries, 1991. Introduction by Barry Walker. Text by Lanier

Graham and Dan Budnick. I. B. (German, Spanish, and English text.) *Illustrated checklist of a select group of lithographs.*

William Baziotes: A Retrospective Exhibition. Newport Beach: Newport Harbor Art Museum, 1978. Introduction by Michael Preble, with essays by Barbara Cavaliere and Mona Hadler. I.B.C. *An important study of the artist and his works.*

WILLIAMS, WILLIAM CARLOS. *Charles Sheeler.* New York: The Museum of Modern Art, 1939. I.B. *Exhibition catalogue.*

WILMERDING, JOHN. *Andrew Wyeth: The Helga Pictures.* New York: Harry N. Abrams, 1987. I. *Exhibition catalogue.*

WINGERT, PAUL S. The *Sculpture of William Zorach.* New York: Pitman Publishing Co., 1938. I.B. *Monograph.*

WINGLER, HANS M., ed. *Graphic Work from the Bauhaus.* Greenwich, Conn.: New York Graphic Society, 1968. I.B.

WOELFFER, EMERSON. *Emerson Woelffer.* Pasadena: The Pasadena Art Museum, 1962. I. *Exhibition catalogue.*

WOLANI, BARBARA A. *Arthur B. Carles: Painting with Color.* Philadelphia: Pennsylvania Academy of Fine Arts, 1983. B.C. *Retrospective catalogue.*

WOLFF, THEODORE L. *Enrico Donati: The Most Recent Work.* Paris: Prints Etc./Georges Fall, 1984. (English and French texts.) I.C. *Examines the paintings of the 1980s.*

WOOD, JAMES N. *Six Painters.* Buffalo: Albright-Knox Art Gallery, 1971. Foreword by Gordon M. Smith. I.B.C. *Exhibition catalogue.*

Woodstock: An American Art Colony 1902-1977. Poughkeepsie: Vassar College Art Gallery, 1977. Foreword by Peter Morrin. Introduction by Karal Ann Marling. I. *A history of the artists and their activities.*

WRIGHT, WILLARD HUNTINGTON. 1. *The Forum Exhibition of Modern American Painters.* New York: Anderson Galleries, 1916. I.B.

————, 2. *Modern Painting.* New York: Dodd, Mead and Co., 1927. I. *Essays on modern art.*

WYETH, BETSY JAMES. *Christina's World.* Boston: Houghton Mifflin Co., 1982. I. *History of the painting.*

YGLESIAS, HELEN. *Isabel Bishop.* New York: Rizzoli, 1989. Foreword by John Russell. Additional essay by Linda Weintraub. I.B.C. *Monograph.*

Yves Tanguy: Retrospective 1925-1955. Paris: Centre Georges Pompidou, 1982. (French text.) Preface by Dominique Bozo. Texts by Jean Manuel, Roland Penrose, Robert Lebel, Jose Piene. I.B.C. *Retrospective catalogue.*

ZAIDENBERG, ARTHUR, ed. *The Art of the Artists.* New York: Crown Publishers Inc., 1951. I. *Pictorial documentation of various artists.*

ZERVOS, CHRISTIAN. *Histoire de l'art contemporain.* Paris: Editions Cahiers d'Art, 1938. I.B. *Documented history of contemporary art.*

ZIGROSSER, CARL. 1. *The Artist in America.* New York: Alfred A. Knopf, 1942. I. *Critical essays and biographies.*

————, 2. *Mauricio Lasansky.* New York: American Federation of Arts, 1960. I. *Retrospective catalogue.*

ZORACH, WILLIAM. 1. *William Zorach.* New York: American Artists Group Inc., 1945. I. *Autobiographical monograph.*

————, 2. *Zorach Explains Sculpture, What It Is and How It Is Made.* New York: American Artists Group Inc., 1947. I.

Books of General Interest

AGEE, WILLIAM C. *The 1930's: Painting and Sculpture in America.* New York: Frederick A. Praeger, 1968. I.B. *Based on a Whitney Museum exhibition.*

ALBRIGHT, THOMAS. *Art in the San Francisco Bay Area 1945-1980.* Berkeley: University of California Press, 1985. Index. I. *Significant regional history.*

America: Traum und Depression 1920-40. 1980. I.B. Biographies (German text.) *A major survey of art, architecture, books, magazines, movies, posters, and photography in over 1,000 objects.*

AMERICAN ABSTRACT ARTISTS, ed. *The World of Abstract Art.* New York: George Wittenborn and Co., 1957. I. *Documentation of the group and its members.*

ARMSTRONG, TOM; CRAVEN, WAYNE; FEDER, NORMAN; HASKELL, BARBARA; KRAUSS, ROSALIND; ROBBINS, DANIEL; TUCKER, MARCIA. *200 Years of American Sculpture.* Boston: David R. Godine, Publisher, in association with The Whitney Museum of American Art, 1976. Foreword by Tom Armstrong. Introduction by David Rockefeller. I.B. *Major survey exhibition.*

ARNASON, H. HARVARD. *American Abstract Expressionists and Imagists.* New York: The Solomon R. Guggenheim Museum, 1961. B. *Documented exhibition catalogue.*

————. *History of Modern Art.* New York: Harry N. Abrams Inc., 1968. I.B. *The world of modern art, up to date.*

ARONSON, CHIL. *Artistes americains modernes de Paris.* Paris: Editions Le Triangle, 1932. I. (French text.)

ASHTON, DORE. *Modern American Sculpture.* New York: Harry N. Abrams Inc., 1968. I. *Well-illustrated survey book.*

————. *The New York School: A Cultural Reckoning.* New York: Viking Press, 1973. I.B. *Sociophilosophic observations on mid-20th-century New York art and culture.*

————. *Twentieth Century Artists on Art.* New York: Pantheon Books, 1985. I.B.G. *Selected quotes from catalogues, magazines, and other sources.*

BARR, ALFRED H., Jr., ed. *Masters of Modern Art.* New York: The Museum of Modern Art, 1955. I.B. *Major anthology of modern art.*

BATTCOCK, GREGORY, ed. *Idea Art.* New York: E.P. Dutton, 1973. I. *Reprints magazine pieces on concept art.*

————. *The New Art, a critical anthology.* New York: E.P. Dutton, 1966. I. *Reprints of selected vital essays from periodicals and museum catalogues, with a preface by the editor.*

————. *Super Realism.* New York: E.P. Dutton, 1975. I. *The initial critical anthology.*

————. *Why Art.* New York: E.P. Dutton & Co., Inc., 1977. I. *General essays on the 1960s and 1970s.*

BAZIN, GERMAIN. *The History of World Sculpture.* Greenwich, Conn.: New York Graphic Society, 1968.

BERMAN, GRETA, and WECHSLER, JEFFREY. *Realism and Realities: The Other Side of American Painting 1940-1960.* New Brunswick, NJ: Rutgers University Art Gallery, 1982. *Exhibition catalogue examines diverse approaches to "realism."*

BELMONT, I. J. *The Modern Dilemna in Art.* New York: Harbinger House, 1944. I. *Critical evaluation of increasing abstractionism.*

BERMAN, AVIS. *Rebels on Eighth Street: Juliana Force and The Whitney Museum of American Art.* New York: Atheneum, 1990. I.B. *Biography of the first director of the Whitney and the era when it was discovering American art.*

BETHERS, RAY. *Art Always Changes.* New York: Hastings House, 1958. I. *Critical essays.*

BROWN, MILTON W. *The Story of the Armory Show.* New York: The Joseph H. Hirshhorn Foundation, 1963. I.B. *Documented history of the famous exhibition.*

BURNHAM, JACK. *Beyond Modern Sculpture.* New York: George Braziller, Inc., 1968. I.B. *Survey of recent modern sculpture.*

CAHILL, HOLGER. *New Horizons in American Art.* New York: The Museum of Modern Art, 1936. I. *Exhibition catalogue related to Federal Art Project.*

CALAS, NICOLAS. *Art in the Age of Risk and Other Essays.* New York: E.P. Dutton, 1968. Introduction by Gregory Battcock. I. *A collection of essays from periodicals.*

CANADAY, JOHN. *Culture Gulch: Notes on Art and Its Public in the 1960s.* New York: Farrar, Straus and Giroux, 1969. I. *Essays garnered from the* New York Times.

CHENEY, SHELDON. *A Primer of Modern Art.* New York: Boni and Liveright, 1924. I.

————. *Sculpture of the World.* New York: Viking Press, 1968. I.B. *Valuable survey of the sculpture of all time.*

————. *The Story of Modern Art.* New York: Viking Press, 1958. I. *Popular history of modern art.*

CIRLOT, JUAN-EDUARDO. *Del Expresionismo a la Abstraccion.* Barcelona: Editorial Seix Barral, S.A., 1955. I. (Spanish text.) *Development of nonfigurative art.*

CRANE, AIMEE, ed. *Portrait of America.* New York: Hyperion Press, Harper and Brothers, 1945. I. *Critical essays.*

CRANE, DIANA. *The Transformation of the Avant-Garde: The New York Art World, 1940-1985.* Chicago and London: The University of Chicago Press, 1987. I.B. Charts. *Social science attempts to grapple with art using charts and lists.*

CUMMINGS, PAUL. *American Drawings: The 20th Century.* New York: The Viking Press, 1976. I.B. Index. *Survey of 120 artists.*

DANTO, ARTHUR. *State of the Art.* New York: Prentice Hall Press, 1987. I. *Collected critical, philosophical and art writings.*

DAVIDSON, ABRAHAM A. *Early American Modernist Painting 1910-1935.* New York: Harper & Row, Publishers, 1981. B.I. *Text-book approach to the modernist development emphasizing minor characters.*

DAVIDSON, MARSHALL B. *Life in America.* Boston: Houghton Mifflin Co., 1951, 2 vols. *Critical essays and documentation.*

DAVIS, DOUGLAS. *Artculture: Essays on the Post-Modern.* (Icon Editions.) New York: Harper & Row, Publishers, 1977. Introduction by Irving Sandler. I. *On politics, business, publicity, and art.*

DUBERMAN, MARTIN. *Black Mountain: An Exploration in Community.* New York: E.P. Dutton & Co., 1972. *Controversial history of this vanguard school.*

DUFFUS, R. L. *The American Renaissance.* New York: Alfred A. Knopf, 1928. *Critical discussion of American culture.*

FAULKNER, RAY; ZIEGFELD, EDWIN; and HILL, GEROLD. *Art Today. An Introduction to the Fine and Functional Arts.* New York: Henry Holt and Co., 1941.

FELDMAN, EDMUND BURKE. *Art as Image and Idea.* Englewood Cliffs, N.J.: Prentice-Hall Inc., 1967. I.B. *The great themes of all time in art.*

FERGUSON, RUSSELL. *Discourses: Conversations on Post-Modern Art and Culture.* Cambridge, Mass.: MIT Press, 1991. Foreword by Marcia Tucker. I.B. *Post-modern, post-Marxist, post-exciting texts.*

FERGUSON, RUSSELL, ed. *Out There: Marginalization of Contemporary Culture*. Cambridge, Mass.: MIT Press, 1990. Foreword by Marsha Tucker. I.B. *The title is a reference to its ambitions.*

FORD, CHARLES HENRI, ed. *View: Parade of the Avant-Garde*. Compiled by Catrina Neiman and Paul Nathan. New York: Thunder's Mouth Press, 1991. Foreword by Paul Bowles. Introduction by Catrina Neiman. I.B. Index to *View*, compiled by Judith Young Mallin. *The most cogent presentation and observation of the vanguard years from 1940-47.*

GARDNER, ALBERT TEN EYCK. *History of Water Color Painting in America*. New York: Reinhold Publishing Co., 1966. I. *Popular survey of watercolor painting from the late eighteenth century to the present time.*

GELDZAHLER, HENRY. *American Painting in the 20th Century*. New York: The Metropolitan Museum of Art, 1965. I.B. *A survey based mainly on the Museum's collection.*

GOODALL, DONALD B. *Partial Bibliography of American Abstract-Expressive Painting, 1943-58*. Los Angeles: University of Southern California, Department of Fine Arts, 1958. *Periodicals and a few books.*

GOODRICH, LLOYD. *Three Centuries of American Art*. New York: Frederick A. Praeger, 1966. I. *Survey book based on a Whitney Museum exhibition.*

———. *The Whitney Studio Club and American Art: 1900-1932*. New York: The Whitney Museum of American Art, 1975. I. *Reviews the Club's history and the founding of the Museum.*

GOODYEAR, FRANK H., Jr. *Contemporary American Realism Since 1960*. Boston: New York Graphic Society, 1981. B. *Exhibition catalogue reviews artists who examine the visual world.*

GOWANS, ALAN. *The Restless Art: A History of Painters and Painting, 1760-1960*. Philadelphia: J.B. Lippincott, 1966. I.B. *History developed by major artists and major works.*

GREGG, FREDERICK JAMES. *For and Against*. New York: Association of American Painters and Sculptors Inc., 1913. *Anthology of commentary on the Armory Show of 1913.*

GRUSKIN, ALAN D. *Painting in the USA*. Garden City, N.Y.: Doubleday and Co., 1946. I. *Survey of American painting in the 1940s.*

GUGGENHEIMER, RICHARD. *Sight and Insight, a Prediction of New Perceptions in Art*. New York: Harper and Brothers, 1945. *Critical discussion.*

HARSHE, ROBERT B. *A Reader's Guide to Modern Art*. San Francisco: The Wahlgreen Co., 1914. *Bibliography.*

HENNING, EDWARD B. *50 Years of Modern Art 1916-1966*. Cleveland: The Cleveland Museum of Art, 1966. I.B. *Extensive survey exhibition.*

HENRI, ADRIAN. *Total Art: Environments, Happenings, and Performance*. New York: Praeger Publishers, 1974. I.B.C.A. *International survey.*

HESS, THOMAS B., and BAKER, ELIZABETH C., eds. *Art and Sexual Politics*. New York: Collier Books, 1973. I. *Essays on women's role in the creative arts.*

HOOPES, DONELSON F. *American Watercolor Painting*. New York: Watson-Guptill Publishers, 1977. I.B. Biographies. *Popular introduction from the nineteenth century to the late twentieth century.*

HUNTER, SAM. *American Art of the 20th Century*. New York: Harry N. Abrams Inc., 1972. I.B. *An up-to-date survey.*

HUNTER, SAM, ed. *An American Renaissance: Painting and Sculpture Since 1940*. New York: Abbeville Press, 1986. Preface by George Bolge. Foreword by James D. Robinson III. B.I. *A greatly flawed review of the times.*

INGA-PIN, LUCIAN. *Performances: Happenings, Actions, Events, Activities, Installations*. Padova: Mastrogiacomo Editore, 1978. I.B. (Italian text, English supplement.) *Includes artists' statements.*

KARPEL, BERNARD, ed. *Arts in America: A Bibliography.* Washington, D.C.: Smithsonian Institution, 1979. B. 4 vols., indexed. *A massive research resource for most of the visual arts.*

KEAVENEY, SYDNEY STAN. *American Painting: A Guide to Information Sources.* Detroit: Gale Research Co., 1974.

KEPPEL, FREDERICK P., and DUFFUS, R. I. *The Arts in American Life.* New York: McGraw-Hill Book Co., Inc., 1933. *Survey of the arts and their development in America.*

KRAMER, HILTON. *The Age of the Avant-Garde: An Art Chronicle of 1956-1972.* New York: Farrar, Straus and Giroux, 1973. I. *Collected essays.*

KULTERMANN, UDO. *Art and Life.* Translated by John William Gabriel. New York: Praeger Publishers, 1971. I. *Investigations into happenings, events, environments; underground film, television, theater; intermedia, concept art.*

———. *The New Painting.* New York: Frederick A. Praeger Publishers, 1969. I.B.C. *International critical survey of art of the 1960s.*

Kunst der letzten 30 jahre. Vienna, Austria: Museum fur Moderner Kunst, 1979. B.I. *International review with essays by several authors.*

LASSALLE, HELENE. *Art Americain.* Paris: Musée National d'Art Moderne, 1981. Preface by Pontus Hulten. B. (French text.) *American art in this museum's collection; includes artists' statements and biographies.*

LIPPARD, LUCY. *955,000.* Vancouver, Canada: Vancouver Art Gallery, 1970. I.D.P. *An informative deck of 4 x 6 inch cards in a brown paper envelope.*

LOZOWICK, LOUIS. *100 Contemporary American Jewish Painters and Sculptors.* New York: YKUF Art Section, 1947. I. *Includes statements by the artists.*

LUCAS, E. LOUISE. *Art books, a basic bibliography on the fine arts.* Greenwich, Conn.: New York Graphic Society, 1968. B.

LUCIE-SMITH, EDWARD. *American Art Now.* New York: William Morrow & Co., Inc., 1985. Index. *A journalistic snapshot of recent art; includes artists' biographies.*

MARTIN, ALVIN. *American Realism: Twentieth-Century Drawings and Watercolors from the Glenn C. Janss Collection.* New York: Harry N. Abrams, Inc., 1986. Introduction by Glenn C. Janss. Foreword by Henry T. Hopkins. B.I. *Realism, mostly since 1960.*

McDARRAH, FRED W. *The Artist's World in Pictures.* New York: E.P. Dutton, 1961. I. *Major pictorial documentation of the art scene in the 1950s.*

McMAHON, A. PHILIP. *The Meaning of Art.* New York: W.W. Norton and Co., 1930. B.

———. *Preface to an American Philosophy of Art.* Chicago: The University of Chicago Press, 1945. B.

MORRIS, LLOYD R. *Incredible New York: 1850-1950.* New York: Random House, 1951. I. *Social history.*

MYERS, BERNARD S. *Modern Art in the Making.* New York: McGraw Hill Book Co., Inc., 1959. I.B. *Historical development of modern art.*

MYERS, BERNARD, S., ed. *Encyclopaedia of Painting. Painters and Painting of the World from Prehistoric Times to the Present Day.* New York: Crown Publishers Inc., 1955. I.

MYERS, JOHN BERNARD. *Tracking the Marvelous: A Life in the New York Art World.* New York: Random House, 1983. I. *Autobiography which reveals nearly all.*

NAYLOR, GILLIAN. *The Bauhaus.* New York: Studio Vista/Dutton Picturebacks, 1968. I. *Popular introduction to the Bauhaus program.*

NEUHAUS, EUGENE. *The Appreciation of Art.* Boston: Ginn and Co., 1924. I.

———. *Painters, Pictures, and the People.* San Francisco: Philopolis Press, 1918. I.

———. *New York-Downtown Manhattan: SoHo.* Berlin: Akademie der Kunste, 1976. Werner Duttmann. I. (German and English text.) *Documents SoHo history and recent art activities and individuals.*

NORMAN, DOROTHY. *Alfred Stieglitz. Introduction to an American Seer.* New York: Duell, Sloan and Pearce, 1960. I. *Appreciation, with his famous photographs.*

O'DOHERTY, BRIAN. *Object and Idea: An Art Critic's Journal 1961-1967.* New York: Simon and Schuster, 1967. *Collection of published essays.*

OERI, GEORGINE. *Man and His Images.* New York: Viking Press, 1968. I. *A way of seeing art.*

One Hundred Prints by 100 Artists of the Art Students League of New York: 1875-1975. New York: The Art Students League, 1975. Foreword by Judith Goldman. I. *Centennial print exhibition catalogue; biographies.*

One Hundredth Anniversary Exhibition of Paintings and Sculpture by 100 Artists Associated with the Art Students League of New York. New York: The Art Students League, 1975. Foreword by Lawrence Campbell. I. *Exhibition catalogue including short history of the League; biographies and appreciations.*

PACH, WALTER. *Modern Art in America.* New York: C. W. Kraushaar Art Galleries, 1928. I. *Concise discussion of modern art and its development.*

PARK, ESTHER AILEEN. *Mural Painters in America: A Biographical Index.* Pittsburg: Kansas State Teachers College, 1949.

PARKER, R. A. *First Papers of Surrealism.* New York: Coordinating Council of French Relief Societies Inc., 1942. *Documented exhibition catalogue.*

PLAGENS, PETER. *Sunshine Muse: Contemporary Art on the West Coast.* New York: Praeger Publishers, 1974. I.B. *Survey of 20th-century West Coast art, mostly post-World War II.*

Provincetown Painters 1890-1970. Syracuse: Everson Museum of Art, 1977. Foreword by Ronald A. Kuchta. "History of the Provincetown Art Colony," by Dorothy Gees Seckler. I.B.A. *Exhibition catalogue records by means of documents and art the history of this community and its artists.*

PUMA, FERNANDO. *Modern Art Looks Ahead.* New York: The Beechhurst Press, 1947. I. *Popular essays on art.*

REID, B. L. *The Man From New York: John Quinn and His Friends.* New York: Oxford University Press, 1968. I.B. *Biography of the master patron of the early twentieth century.*

RICH, DANIEL CATTON, ed. *Essays and Criticism of Henry McBride.* New York: Athenaeum Publishers, 1975. Prefatory essay by Lincoln Kirstein. I. Index. *The collected writings of this critic.*

RICHARDSON, E. P. *A Short History of Painting in America, the Story of 450 Years.* New York: Thomas Y. Crowell Co., 1963. I. *A basic history of American painting.*

―――. *Twentieth Century Painting.* Detroit: Detroit Institute of Arts, 1947, 4th ed. I.B. *Concise essays.*

RICHMAN, ROBERT, ed. *The Arts of Mid-Century.* New York: Horizon Press, Inc., 1954.

RITTERBUSH, PHILLIP C. *The Art of Organic Forms.* Washington, D.C.: Smithsonian Institution Press, 1969. I.B. *A science, art, and nature concept.*

ROBBINS, DANIEL. *The Neuberger Collection.* Preface by Roy R. Neuberger. Providence: Rhode Island School of Design, 1968. I. *Documented catalogue of a major modern collection.*

ROSE, BARBARA. *Autocritique: Essays on Art and Anti-Art, 1963-1987.* New York: Weidenfeld & Nicholson, 1988. I. *Collected journalist criticism which yearns for an index but lacks one.*

ROSE, BARBARA, and KALLIL, SUSIE. *Fresh Paint: The Houston School.* Austin, Texas: Texas Monthly Press, 1985. I.B.C. *History of Houston painting from 1900 to the present includes artists' statements and biographies.*

ROSENBERG, HAROLD. *Artworks and Packages.* New York: Horizon Press, Inc., 1969. I. *Essays, some of which first appeared in the* New Yorker.

―――. *The De-definition of Art: Action Art to Pop to Earthworks.* New York: Horizon Press, 1972. I. *Collected essays, mostly from the* New Yorker.

————. *Discovering the Present.* Chicago: The University of Chicago Press, 1973. *Collected essays on art, culture, and politics.*

SAYLOR, OLIVER M. *Revolution in the Arts.* New York: Brentano's, 1930. *Critical essays.*

SCHNIER, JACQUES. *Sculpture in Modern America.* Berkeley: University of California Press, 1948. I.B.

SEWCALL, JOHN IVES. *A History of Western Art.* New York: Holt, Rinehart and Winston, Inc., 1961. I.

SMITH, RALPH C. *A Biographical Index of American Artists.* Baltimore: The Williams and Wilkins Co., 1930. B.

STEBBINS, THEODORE E. Jr., **with the assistance of John Caldwell and Carol Troyen.** *American Master Drawings and Watercolors.* New York: Harper & Row Publishers, in association with The Drawing Society. 1976. Foreword by David Daniels. I.B. Index. *The only major survey of works on paper from the late seventeenth century to 1976.*

SWEENEY, JAMES JOHNSON. *Vision and Image.* New York: Simon and Schuster, 1968. B. *Concise commentary on our present-day culture.*

TASHJIAN, DICKRAN. *William Carlos Williams and the American Scene, 1920-1940.* New York: The Whitney Museum of American Art, 1978. I.B. *Appraisal of Dr. Williams's cultural interests and achievements and association with visual artists, utilizing literary documents and many works from the Whitney collection.*

WALLIS, BRIAN. *Art after Modernism: Rethinking Representation.* New York: The New Museum of Contemporary Art, 1984. Foreword by Marcia Tucker. Introduction by Brian Wallis. B.I. *Poorly printed adventures about socio-political art writing.*

WATSON, FORBES. *American Painting Today.* Washington, D.C.: American Federation of Arts, 1939. I. *Concerned with the period before World War I.*

WEAVER, JANE CALHOUN, ed. *Sadakichi Hartmann: Critical Modernist.* Berkeley, Calif: University of California Press, 1991. I.B.C. *The best American art critic from the turn of the century into the early decades.*

WESCHER, HERTA. *Die Collage.* Cologne: M. DuMont, 1968. I.B. (German text.) *The major history of collage.*

WESTON, NEVILLE. *Kaleidoscope of Modern Art.* London: Geo. C. Harrap & Co. Ltd., 1968. I.B. *Popular introduction to international modern art.*

WICKES, GEORGE. *Americans in Paris: 1903-1939.* Paris Review Editions. Garden City, New York: Doubleday & Co., Inc., 1969. I.B. *A history of Americans in the art world abroad.*

WILMERDING, JOHN. *A History of American Marine Painting.* Salem, Mass.: The Peabody Museum, 1968. I.B. *The major work on American marine painting.*

WILSON, RICHARD GUY; PILGRIM, DIANNE H.; and TASHJIAN, DICKRAN. *The Machine Age in America, 1918-1941.* Brooklyn, N.Y.: The Brooklyn Museum, 1986-87. *Exhibition catalogue.*

WOLFE, TOM. *The Painted Word.* New York: Farrar, Strauss & Giroux, 1975. I. *Common opinions on high culture by a cartoonist and journalist.*

YOUNG, A. R., ed. *Art Bibliography.* New York: Teachers College of Columbia University, 1941. *A bibliography for the educator.*

Author Bio

PAUL CUMMINGS studied art history at the University of Minnesota and theater history there and at the University of London. He spent twenty years as a theater technician and manager working on some 120 productions. For a dozen years he was director of oral history for the Archives of American Art, Smithsonian Institution, and editor for several years of *Archives of American Art Journal*. In 1970, he founded the *Print Collector's Newsletter*. He was the general editor of the series *Documentary Monographs in Modern Art*, issued by Praeger Publishers. For a dozen years he was Adjunct Curator, Drawings, at the Whitney Museum of American Art. While at the Whitney he organized several exhibitions, including *David Smith: The Drawings* and the drawing section of a Willem de Kooning retrospective. In 1978 he was elected president of the Drawing Society; the following year he founded *Drawing*, the bi-monthly journal of the Society. He has organized nearly 100 exhibitions since the early 1960s, lectured nationwide, written numerous catalogue essays and served as an advisor on sundry corporate cultural projects. He is the proprietor of Catchword Papers, a private press publishing modern poetry.